The Dictionary of Art · volume seventeen

The Dictionary of Art

17

Jansen

TO

Ketel

GROVE

The Dictionary of Art

edited by JANE TURNER, in thirty-four volumes, 1996

Reprinted with minor corrections, 1998, 2002

This edition is distributed within the United Kingdom and Europe
by Macmillan Publishers Limited, London, and within the United States and Canada by
Grove's Dictionaries Inc., New York.

Text keyboarded by Wearset Limited, Sunderland, England
Database management by Pindar plc, York, England
Imagesetting by William Clowes Limited, Suffolk, England
Printed and bound by China Translation and Printing Services Ltd, Hong Kong

British Library Cataloguing in Publication Data

The dictionary of art
 1. Art - Dictionaries 2. Art - History -
 Dictionaries
I. Turner, Jane
703

ISBN 1-884446-00-0

Library of Congress Cataloging in Publication Data

The dictionary of art / editor, Jane Turner.
 p. cm.
 Includes bibliographical references and index.
 Contents: 1. A to Anckerman
 ISBN 1-884446-00-0 (alk. paper)
 1. Art—Encyclopedias.
 I. Turner, Jane, 1956–
N31.D5 1996 96–13628
703—dc20 CIP

Contents

List of Colour Illustrations

PLATE I. **Jewellery**

Gold armbands with terminals in the form of a triton and tritoness holding Erotes, h. 150 mm and 159 mm, probably from northern Greece, *c.* 200 BC (New York, Metropolitan Museum of Art/Photo: Metropolitan Museum of Art, Rogers Fund, 1956; no. 56.11.5.6; photographer: Schecter Lee)

PLATE II. **Jewellery**

1. Corsage ornament, gold, enamel, diamonds and opals, l. 190 mm, made by René Lalique, France, 1898–1900 (Lisbon, Museu Calouste Gulbenkian/Photo: Art Archive of the Calouste Gulbenkian Foundation/© ADAGP, Paris, and DACS, London, 1996)

2. Thumb ring, soft gold inset with rubies and emeralds, enamelled interior, diam. 30 mm, from India, Mughal, first half of the 17th century (London, Victoria and Albert Museum/Photo: Board of Trustees of the Victoria and Albert Museum)

3. Panther clip, pavé-set with diamonds and calibré-cut sapphires on a cabochon sapphire, h. 55 mm, created for the Duchess of Windsor by Cartier, Paris, 1949 (sold Sotheby's, Geneva, 3 April 1987, lot 59/ Photo: Sotheby's)

PLATE III. **Jewellery**

1. Pendant, gold, cloisonné enamel and turquoise, h. 44 mm, from Egypt, Fatimid period, 12th century (New York, Metropolitan Museum of Art/Photo: Metropolitan Museum of Art, Theodore M. Davis Collection, Bequest of Theodore M. Davis, 1915; no. 30.95.37)

2. 'Diane' bracelet, gold, enamel and diamonds, diam. 69 mm, made by Alphonse Fouquet (model by Albert-Ernest Carrier-Belleuse; enamels by Paul Grandhomme), 1883 (Paris, Musée des Arts Décoratifs/Photo: Musée des Arts Décoratifs)

PLATE IV. **Jewellery**

1. Alfred Jewel, gold with a cloisonné enamel portrait, h. 63 mm, Anglo-Saxon, probably 9th century AD (Oxford, Ashmolean Museum/Photo: Ashmolean Museum)

2. 'Vulture' collar, gold and polychrome glass, w. 480 mm, from the tomb of Tutankhamun (*reg c.* 1332–*c.* 1323 BC), Egypt, New Kingdom, 18th Dynasty (Cairo, Egyptian Museum/Photo: Ronald Sheridan/Ancient Art and Architecture Collection, London)

General Abbreviations

The abbreviations employed throughout this dictionary, most of which are listed below, do not vary, except for capitalization, regardless of the context in which they are used, including bibliographical citations and for locations of works of art. The principle used to arrive at these abbreviations is that their full form should be easily deducible, and for this reason acronyms have generally been avoided (e.g. Los Angeles Co. Mus. A. instead of LACMA). The same abbreviation is adopted for cognate forms in foreign languages and in most cases for plural and adjectival forms (e.g. A.= Art, Arts, Arte, Arti etc). Not all related forms are listed below. Occasionally, if a name, for instance of an artists' group or exhibiting society, is repeated within the text of one article, it is cited in an abbreviated form after its first mention in full (e.g. The Pre-Raphaelite Brotherhood (PRB) was founded...); the same is true of archaeological periods and eras, which are abbreviated to initial letters in small capitals (e.g. In the Early Minoan (EM) period...). Such abbreviations do not appear in this list. For the reader's convenience, separate full lists of abbreviations for locations, periodical titles and standard reference books and series are included as Appendices A–C in vol. 33.

A.	Art, Arts	Anthropol.	Anthropology	Azerbaij.	Azerbaijani
A.C.	Arts Council	Antiqua.	Antiquarian, Antiquaries	B.	Bartsch [catalogue of Old Master prints]
Acad.	Academy	app.	appendix		
AD	Anno Domini	approx.	approximately	*b*	born
Add.	Additional, Addendum	AR	Arkansas (USA)	BA	Bachelor of Arts
addn	addition	ARA	Associate of the Royal Academy	Balt.	Baltic
Admin.	Administration			*bapt*	baptized
Adv.	Advances, Advanced	Arab.	Arabic	BArch	Bachelor of Architecture
Aesth.	Aesthetic(s)	Archaeol.	Archaeology	Bart	Baronet
Afr.	African	Archit.	Architecture, Architectural	Bask.	Basketry
Afrik.	Afrikaans, Afrikaner	Archv, Archvs	Archive(s)	BBC	British Broadcasting Corporation
A.G.	Art Gallery				
Agrar.	Agrarian	Arg.	Argentine	BC	Before Christ
Agric.	Agriculture	ARHA	Associate of the Royal Hibernian Academy	BC	British Columbia (Canada)
Agron.	Agronomy			BE	Buddhist era
Agy	Agency	ARIBA	Associate of the Royal Institute of British Architects	Beds	Bedfordshire (GB)
AH	Anno Hegirae			Behav.	Behavioural
A. Inst.	Art Institute	Armen.	Armenian	Belarus.	Belarusian
AK	Alaska (USA)	ARSA	Associate of the Royal Scottish Academy	Belg.	Belgian
AL	Alabama (USA)			Berks	Berkshire (GB)
Alb.	Albanian	Asiat.	Asiatic	Berwicks	Berwickshire (GB; old)
Alg.	Algerian	Assist.	Assistance	BFA	Bachelor of Fine Arts
Alta	Alberta (Canada)	Assoc.	Association	Bibl.	Bible, Biblical
Altern.	Alternative	Astron.	Astronomy	Bibliog.	Bibliography, Bibliographical
a.m.	ante meridiem [before noon]	AT&T	American Telephone & Telegraph Company	Biblioph.	Bibliophile
Amat.	Amateur	attrib.	attribution, attributed to	Biog.	Biography, Biographical
Amer.	American	Aug	August	Biol.	Biology, Biological
An.	Annals	Aust.	Austrian	bk, bks	book(s)
Anatol.	Anatolian	Austral.	Australian	Bkbinder	Bookbinder
Anc.	Ancient	Auth.	Author(s)	Bklore	Booklore
Annu.	Annual	Auton.	Autonomous	Bkshop	Bookshop
Anon.	Anonymous(ly)	Aux.	Auxiliary	BL	British Library
Ant.	Antique	Ave.	Avenue	Bld	Build
Anthol.	Anthology	AZ	Arizona (USA)	Bldg	Building

Bldr	Builder
BLitt	Bachelor of Letters/Literature
BM	British Museum
Boh.	Bohemian
Boliv.	Bolivian
Botan.	Botany, Botanical
BP	Before present (1950)
Braz.	Brazilian
BRD	Bundesrepublik Deutschland [Federal Republic of Germany (West Germany)]
Brecons	Breconshire (GB; old)
Brez.	Brezonek [lang. of Brittany]
Brit.	British
Bros	Brothers
BSc	Bachelor of Science
Bucks	Buckinghamshire (GB)
Bulg.	Bulgarian
Bull.	Bulletin
bur	buried
Burm.	Burmese
Byz.	Byzantine
C	Celsius
C.	Century
c.	*circa* [about]
CA	California
Cab.	Cabinet
Caerns	Caernarvonshire (GB; old)
C.A.G.	City Art Gallery
Cal.	Calendar
Callig.	Calligraphy
Cam.	Camera
Cambs	Cambridgeshire (GB)
can	canonized
Can.	Canadian
Cant.	Canton(s), Cantonal
Capt.	Captain
Cards	Cardiganshire (GB; old)
Carib.	Caribbean
Carms	Carmarthenshire (GB; old)
Cartog.	Cartography
Cat.	Catalan
cat.	catalogue
Cath.	Catholic
CBE	Commander of the Order of the British Empire
Celeb.	Celebration
Celt.	Celtic
Cent.	Centre, Central
Centen.	Centennial
Cer.	Ceramic
cf.	confer [compare]
Chap., Chaps	Chapter(s)
Chem.	Chemistry
Ches	Cheshire (GB)
Chil.	Chilean

Chin.	Chinese
Christ.	Christian, Christianity
Chron.	Chronicle
Cie	Compagnie [French]
Cinema.	Cinematography
Circ.	Circle
Civ.	Civil, Civic
Civiliz.	Civilization(s)
Class.	Classic, Classical
Clin.	Clinical
CO	Colorado (USA)
Co.	Company; County
Cod.	Codex, Codices
Col., Cols	Collection(s); Column(s)
Coll.	College
collab.	in collaboration with, collaborated, collaborative
Collct.	Collecting
Colloq.	Colloquies
Colomb.	Colombian
Colon.	Colonies, Colonial
Colr	Collector
Comm.	Commission; Community
Commerc.	Commercial
Communic.	Communications
Comp.	Comparative; compiled by, compiler
Concent.	Concentration
Concr.	Concrete
Confed.	Confederation
Confer.	Conference
Congol.	Congolese
Congr.	Congress
Conserv.	Conservation; Conservatory
Constr.	Construction(al)
cont.	continued
Contemp.	Contemporary
Contrib.	Contributions, Contributor(s)
Convalesc.	Convalescence
Convent.	Convention
Coop.	Cooperation
Coord.	Coordination
Copt.	Coptic
Corp.	Corporation, Corpus
Corr.	Correspondence
Cors.	Corsican
Cost.	Costume
Cret.	Cretan
Crim.	Criminal
Crit.	Critical, Criticism
Croat.	Croatian
CT	Connecticut (USA)
Cttee	Committee
Cub.	Cuban
Cult.	Cultural, Culture
Cumb.	Cumberland (GB; old)

Cur.	Curator, Curatorial, Curatorship
Curr.	Current(s)
CVO	Commander of the [Royal] Victorian Order
Cyclad.	Cycladic
Cyp.	Cypriot
Czech.	Czechoslovak
$	dollars
d	died
d.	denarius, denarii [penny, pence]
Dalmat.	Dalmatian
Dan.	Danish
DBE	Dame Commander of the Order of the British Empire
DC	District of Columbia (USA)
DDR	Deutsche Demokratische Republik [German Democratic Republic (East Germany)]
DE	Delaware (USA)
Dec	December
Dec.	Decorative
ded.	dedication, dedicated to
Democ.	Democracy, Democratic
Demog.	Demography, Demographic
Denbs	Denbighshire (GB; old)
dep.	deposited at
Dept	Department
Dept.	Departmental, Departments
Derbys	Derbyshire (GB)
Des.	Design
destr.	destroyed
Dev.	Development
Devon	Devonshire (GB)
Dial.	Dialogue
diam.	diameter
Diff.	Diffusion
Dig.	Digest
Dip. Eng.	Diploma in Engineering
Dir.	Direction, Directed
Directrt	Directorate
Disc.	Discussion
diss.	dissertation
Distr.	District
Div.	Division
DLitt	Doctor of Letters/Literature
DM	Deutsche Mark
Doc.	Document(s)
Doss.	Dossier
DPhil	Doctor of Philosophy
Dr	Doctor
Drg, Drgs	Drawing(s)
DSc	Doctor of Science/Historical Sciences
Dut.	Dutch
Dwell.	Dwelling
E.	East(ern)

| | | | | | | |
|---|---|---|---|---|---|
| EC | European (Economic) Community | figs | figures | Heb. | Hebrew |
| Eccles. | Ecclesiastical | Filip. | Filipina(s), Filipino(s) | Hell. | Hellenic |
| Econ. | Economic, Economies | Fin. | Finnish | Her. | Heritage |
| Ecuad. | Ecuadorean | FL | Florida (USA) | Herald. | Heraldry, Heraldic |
| ed. | editor, edited (by) | *fl* | *floruit* [he/she flourished] | Hereford & Worcs | Hereford & Worcester (GB) |
| edn | edition | Flem. | Flemish | | |
| eds | editors | Flints | Flintshire (GB; old) | Herts | Hertfordshire (GB) |
| Educ. | Education | Flk | Folk | HI | Hawaii (USA) |
| e.g. | *exempli gratia* [for example] | Flklore | Folklore | Hib. | Hibernia |
| Egyp. | Egyptian | fol., fols | folio(s) | Hisp. | Hispanic |
| Elem. | Element(s), Elementary | Found. | Foundation | Hist. | History, Historical |
| Emp. | Empirical | Fr. | French | HMS | His/Her Majesty's Ship |
| Emul. | Emulation | frag. | fragment | Hon. | Honorary, Honourable |
| Enc. | Encyclopedia | Fri. | Friday | Horiz. | Horizon |
| Encour. | Encouragement | FRIBA | Fellow of the Royal Institute of British Architects | Hort. | Horticulture |
| Eng. | English | | | Hosp. | Hospital(s) |
| Engin. | Engineer, Engineering | FRS | Fellow of the Royal Society, London | HRH | His/Her Royal Highness |
| Engr., Engrs | Engraving(s) | | | Human. | Humanities, Humanism |
| | | ft | foot, feet | Hung. | Hungarian |
| Envmt | Environment | Furn. | Furniture | Hunts | Huntingdonshire (GB; old) |
| Epig. | Epigraphy | Futur. | Futurist, Futurism | IA | Iowa |
| Episc. | Episcopal | g | gram(s) | ibid. | *ibidem* [in the same place] |
| Esp. | Especially | GA | Georgia (USA) | ICA | Institute of Contemporary Arts |
| Ess. | Essays | Gael. | Gaelic | | |
| est. | established | Gal., Gals | Gallery, Galleries | Ice. | Icelandic |
| etc | *etcetera* [and so on] | Gaz. | Gazette | Iconog. | Iconography |
| Ethnog. | Ethnography | GB | Great Britain | Iconol. | Iconology |
| Ethnol. | Ethnology | Gdn, Gdns | Garden(s) | ID | Idaho (USA) |
| Etrus. | Etruscan | Gdnr(s) | Gardener(s) | i.e. | *id est* [that is] |
| Eur. | European | Gen. | General | IL | Illinois (USA) |
| Evangel. | Evangelical | Geneal. | Genealogy, Genealogist | Illum. | Illumination |
| Exam. | Examination | Gent. | Gentleman, Gentlemen | illus. | illustrated, illustration |
| Excav. | Excavation, Excavated | Geog. | Geography | Imp. | Imperial |
| Exch. | Exchange | Geol. | Geology | IN | Indiana (USA) |
| Excurs. | Excursion | Geom. | Geometry | in., ins | inch(es) |
| exh. | exhibition | Georg. | Georgian | Inc. | Incorporated |
| Exp. | Exposition | Geosci. | Geoscience | inc. | incomplete |
| Expermntl | Experimental | Ger. | German, Germanic | incl. | includes, including, inclusive |
| Explor. | Exploration | G.I. | Government/General Issue (USA) | Incorp. | Incorporation |
| Expn | Expansion | | | Ind. | Indian |
| Ext. | External | Glams | Glamorganshire (GB; old) | Indep. | Independent |
| Extn | Extension | Glos | Gloucestershire (GB) | Indig. | Indigenous |
| f, ff | following page, following pages | Govt | Government | Indol. | Indology |
| | | Gr. | Greek | Indon. | Indonesian |
| F.A. | Fine Art(s) | Grad. | Graduate | Indust. | Industrial |
| Fac. | Faculty | Graph. | Graphic | Inf. | Information |
| facs. | facsimile | Green. | Greenlandic | Inq. | Inquiry |
| Fam. | Family | Gr.-Roman | Greco-Roman | Inscr. | Inscribed, Inscription |
| fasc. | fascicle | Gt | Great | Inst. | Institute(s) |
| *fd* | feastday (of a saint) | Gtr | Greater | Inst. A. | Institute of Art |
| Feb | February | Guat. | Guatemalan | Instr. | Instrument, Instrumental |
| Fed. | Federation, Federal | Gym. | Gymnasium | Int. | International |
| Fem. | Feminist | h. | height | Intell. | Intelligence |
| Fest. | Festival | ha | hectare | Inter. | Interior(s), Internal |
| fig. | figure (illustration) | Hait. | Haitian | Interdiscip. | Interdisciplinary |
| Fig. | Figurative | Hants | Hampshire (GB) | intro. | introduced by, introduction |
| | | Hb. | Handbook | inv. | inventory |

Inven.	Invention	m	metre(s)	Moldov.	Moldovan
Invest.	Investigation(s)	m.	married	MOMA	Museum of Modern Art
Iran.	Iranian	M.	Monsieur	Mon.	Monday
irreg.	irregular(ly)	MA	Master of Arts; Massachusetts (USA)	Mongol.	Mongolian
Islam.	Islamic			Mons	Monmouthshire (GB; old)
Isr.	Israeli	Mag.	Magazine	Montgoms	Montgomeryshire (GB; old)
It.	Italian	Maint.	Maintenance	Mor.	Moral
J.	Journal	Malay.	Malaysian	Morav.	Moravian
Jam.	Jamaican	Man.	Manitoba (Canada); Manual	Moroc.	Moroccan
Jan	January	Manuf.	Manufactures	Movt	Movement
Jap.	Japanese	Mar.	Marine, Maritime	MP	Member of Parliament
Jav.	Javanese	Mason.	Masonic	MPhil	Master of Philosophy
Jew.	Jewish	Mat.	Material(s)	MS	Mississippi (USA)
Jewel.	Jewellery	Math.	Mathematic	MS., MSS	manuscript(s)
Jord.	Jordanian	MBE	Member of the Order of the British Empire	MSc	Master of Science
jr	junior			MT	Montana (USA)
Juris.	Jurisdiction	MD	Doctor of Medicine; Maryland (USA)	Mt	Mount
KBE	Knight Commander of the Order of the British Empire			Mthly	Monthly
		ME	Maine (USA)	Mun.	Municipal
KCVO	Knight Commander of the Royal Victorian Order	Mech.	Mechanical	Mus.	Museum(s)
		Med.	Medieval; Medium, Media	Mus. A.	Museum of Art
kg	kilogram(s)	Medic.	Medical, Medicine	Mus. F.A.	Museum of Fine Art(s)
kHz	kilohertz	Medit.	Mediterranean	Music.	Musicology
km	kilometre(s)	Mem.	Memorial(s); Memoir(s)	N.	North(ern); National
Knowl.	Knowledge	Merions	Merionethshire (GB; old)	n	refractive index of a medium
Kor.	Korean	Meso-Amer.	Meso-American	n.	note
KS	Kansas (USA)	Mesop.	Mesopotamian	N.A.G.	National Art Gallery
KY	Kentucky (USA)	Met.	Metropolitan	Nat.	Natural, Nature
Kyrgyz.	Kyrgyzstani	Metal.	Metallurgy	Naut.	Nautical
£	libra, librae [pound, pounds sterling]	Mex.	Mexican	NB	New Brunswick (Canada)
l.	length	MFA	Master of Fine Arts	NC	North Carolina (USA)
LA	Louisiana (USA)	mg	milligram(s)	ND	North Dakota (USA)
Lab.	Laboratory	Mgmt	Management	n.d.	no date
Lancs	Lancashire (GB)	Mgr	Monsignor	NE	Nebraska; Northeast(ern)
Lang.	Language(s)	MI	Michigan	Neth.	Netherlandish
Lat.	Latin	Micrones.	Micronesian	Newslett.	Newsletter
Latv.	Latvian	Mid. Amer.	Middle American	Nfld	Newfoundland (Canada)
lb, lbs	pound(s) weight	Middx	Middlesex (GB; old)	N.G.	National Gallery
Leb.	Lebanese	Mid. E.	Middle Eastern	N.G.A.	National Gallery of Art
Lect.	Lecture	Mid. Eng.	Middle English	NH	New Hampshire (USA)
Legis.	Legislative	Mid Glam.	Mid Glamorgan (GB)	Niger.	Nigerian
Leics	Leicestershire (GB)	Mil.	Military	NJ	New Jersey (USA)
Lex.	Lexicon	Mill.	Millennium	NM	New Mexico (USA)
Lg.	Large	Min.	Ministry; Minutes	nm	nanometre (10^{-9} metre)
Lib., Libs	Library, Libraries	Misc.	Miscellaneous	nn.	notes
Liber.	Liberian	Miss.	Mission(s)	no., nos	number(s)
Libsp	Librarianship	Mlle	Mademoiselle	Nord.	Nordic
Lincs	Lincolnshire (GB)	mm	millimetre(s)	Norm.	Normal
Lit.	Literature	Mme	Madame	Northants	Northamptonshire (GB)
Lith.	Lithuanian	MN	Minnesota	Northumb.	Northumberland (GB)
Liturg.	Liturgical	Mnmt, Mnmts	Monument(s)	Norw.	Norwegian
LLB	Bachelor of Laws			Notts	Nottinghamshire (GB)
LLD	Doctor of Laws	Mnmtl	Monumental	Nov	November
Lt	Lieutenant	MO	Missouri (USA)	n.p.	no place (of publication)
Lt-Col.	Lieutenant-Colonel	Mod.	Modern, Modernist	N.P.G.	National Portrait Gallery
Ltd	Limited	Moldav.	Moldavian	nr	near

| | | | | | | |
|---|---|---|---|---|---|
| Nr E. | Near Eastern | Per. | Period | Ptg(s) | Painting(s) |
| NS | New Style; Nova Scotia (Canada) | Percep. | Perceptions | Pub. | Public |
| | | Perf. | Performance, Performing, Performed | pubd | published |
| n. s. | new series | | | Publ. | Publicity |
| NSW | New South Wales (Australia) | Period. | Periodical(s) | pubn(s) | publication(s) |
| NT | National Trust | Pers. | Persian | PVA | polyvinyl acetate |
| Ntbk | Notebook | Persp. | Perspectives | PVC | polyvinyl chloride |
| Numi. | Numismatic(s) | Peru. | Peruvian | Q. | quarterly |
| NV | Nevada (USA) | PhD | Doctor of Philosophy | 4to | quarto |
| NW | Northwest(ern) | Philol. | Philology | Qué. | Québec (Canada) |
| NWT | Northwest Territories (Canada) | Philos. | Philosophy | *R* | reprint |
| | | Phoen. | Phoenician | *r* | *recto* |
| NY | New York (USA) | Phot. | Photograph, Photography, Photographic | RA | Royal Academician |
| NZ | New Zealand | | | Radnors | Radnorshire (GB; old) |
| OBE | Officer of the Order of the British Empire | Phys. | Physician(s), Physics, Physique, Physical | RAF | Royal Air Force |
| | | | | Rec. | Record(s) |
| Obj. | Object(s), Objective | Physiog. | Physiognomy | red. | reduction, reduced for |
| Occas. | Occasional | Physiol. | Physiology | Ref. | Reference |
| Occident. | Occidental | Pict. | Picture(s), Pictorial | Refurb. | Refurbishment |
| Ocean. | Oceania | pl. | plate; plural | *reg* | *regit* [ruled] |
| Oct | October | Plan. | Planning | Reg. | Regional |
| 8vo | octavo | Planet. | Planetarium | Relig. | Religion, Religious |
| OFM | Order of Friars Minor | Plast. | Plastic | remod. | remodelled |
| OH | Ohio (USA) | pls | plates | Ren. | Renaissance |
| OK | Oklahoma (USA) | p.m. | post meridiem [after noon] | Rep. | Report(s) |
| Olymp. | Olympic | Polit. | Political | repr. | reprint(ed); reproduced, reproduction |
| OM | Order of Merit | Poly. | Polytechnic | | |
| Ont. | Ontario (Canada) | Polynes. | Polynesian | Represent. | Representation, Representative |
| op. | opus | Pop. | Popular | Res. | Research |
| opp. | opposite; opera [pl. of opus] | Port. | Portuguese | rest. | restored, restoration |
| OR | Oregon (USA) | Port. | Portfolio | Retro. | Retrospective |
| Org. | Organization | Posth. | Posthumous(ly) | rev. | revision, revised (by/for) |
| Orient. | Oriental | Pott. | Pottery | Rev. | Reverend; Review |
| Orthdx | Orthodox | POW | prisoner of war | RHA | Royal Hibernian Academician |
| OSB | Order of St Benedict | PRA | President of the Royal Academy | RI | Rhode Island (USA) |
| Ott. | Ottoman | | | RIBA | Royal Institute of British Architects |
| Oxon | Oxfordshire (GB) | Pract. | Practical | | |
| oz. | ounce(s) | Prefect. | Prefecture, Prefectural | RJ | Rio de Janeiro State |
| p | pence | Preserv. | Preservation | Rlwy | Railway |
| p., pp. | page(s) | prev. | previous(ly) | RSA | Royal Scottish Academy |
| PA | Pennsylvania (USA) | priv. | private | RSFSR | Russian Soviet Federated Socialist Republic |
| p.a. | per annum | PRO | Public Record Office | | |
| Pak. | Pakistani | Prob. | Problem(s) | Rt Hon. | Right Honourable |
| Palaeontol. | Palaeontology, Palaeontological | Proc. | Proceedings | Rur. | Rural |
| | | Prod. | Production | Rus. | Russian |
| Palest. | Palestinian | Prog. | Progress | S | San, Santa, Santo, Sant', São [Saint] |
| Pap. | Paper(s) | Proj. | Project(s) | | |
| para. | paragraph | Promot. | Promotion | S. | South(ern) |
| Parag. | Paraguayan | Prop. | Property, Properties | s. | solidus, solidi [shilling(s)] |
| Parl. | Parliament | Prov. | Province(s), Provincial | Sask. | Saskatchewan (Canada) |
| Paroch. | Parochial | Proven. | Provenance | Sat. | Saturday |
| Patriarch. | Patriarchate | Prt, Prts | Print(s) | SC | South Carolina (USA) |
| Patriot. | Patriotic | Prtg | Printing | Scand. | Scandinavian |
| Patrm. | Patrimony | pseud. | pseudonym | Sch. | School |
| Pav. | Pavilion | Psych. | Psychiatry, Psychiatric | Sci. | Science(s), Scientific |
| PEI | Prince Edward Island (Canada) | Psychol. | Psychology, Psychological | Scot. | Scottish |
| Pembs | Pembrokeshire (GB; old) | pt | part | Sculp. | Sculpture |

SD	South Dakota (USA)	suppl., suppls	supplement(s), supplementary	Urb.	Urban
SE	Southeast(ern)	Surv.	Survey	Urug.	Uruguayan
Sect.	Section	SW	Southwest(ern)	US	United States
Sel.	Selected	Swed.	Swedish	USA	United States of America
Semin.	Seminar(s), Seminary	Swi.	Swiss	USSR	Union of Soviet Socialist Republics
Semiot.	Semiotic	Symp.	Symposium		
Semit.	Semitic	Syr.	Syrian	UT	Utah
Sept	September	Tap.	Tapestry	*v*	*verso*
Ser.	Series	Tas.	Tasmanian	VA	Virginia (USA)
Serb.	Serbian	Tech.	Technical, Technique	V&A	Victoria and Albert Museum
Serv.	Service(s)	Technol.	Technology	Var.	Various
Sess.	Session, Sessional	Territ.	Territory	Venez.	Venezuelan
Settmt(s)	Settlement(s)	Theat.	Theatre	Vern.	Vernacular
S. Glam.	South Glamorgan (GB)	Theol.	Theology, Theological	Vict.	Victorian
Siber.	Siberian	Theor.	Theory, Theoretical	Vid.	Video
Sig.	Signature	Thurs.	Thursday	Viet.	Vietnamese
Sil.	Silesian	Tib.	Tibetan	viz.	*videlicet* [namely]
Sin.	Singhala	TN	Tennessee (USA)	vol., vols	volume(s)
sing.	singular	Top.	Topography	vs.	versus
SJ	Societas Jesu [Society of Jesus]	Trad.	Tradition(s), Traditional	VT	Vermont (USA)
Skt	Sanskrit	trans.	translation, translated by; transactions	Vulg.	Vulgarisation
Slav.	Slavic, Slavonic			W.	West(ern)
Slov.	Slovene, Slovenian	Transafr.	Transafrican	w.	width
Soc.	Society	Transatlant.	Transatlantic	WA	Washington (USA)
Social.	Socialism, Socialist	Transcarpath.	Transcarpathian	Warwicks	Warwickshire (GB)
Sociol.	Sociology	transcr.	transcribed by/for	Wed.	Wednesday
Sov.	Soviet	Triq.	Triquarterly	W. Glam.	West Glamorgan (GB)
SP	São Paulo State	Tropic.	Tropical	WI	Wisconsin (USA)
Sp.	Spanish	Tues.	Tuesday	Wilts	Wiltshire (GB)
sq.	square	Turk.	Turkish	Wkly	Weekly
sr	senior	Turkmen.	Turkmenistani	W. Midlands	West Midlands (GB)
Sri L.	Sri Lankan	TV	Television		
SS	Saints, Santi, Santissima, Santissimo, Santissimi; Steam ship	TX	Texas (USA)	Worcs	Worcestershire (GB; old)
		U.	University	Wtrcol.	Watercolour
SSR	Soviet Socialist Republic	UK	United Kingdom of Great Britain and Northern Ireland	WV	West Virginia (USA)
St	Saint, Sankt, Sint, Szent			WY	Wyoming (USA)
Staffs	Staffordshire (GB)	Ukrain.	Ukrainian	Yb., Y.-b.	Yearbook, Year-book
Ste	Sainte	Un.	Union	Yem.	Yemeni
Stud.	Study, Studies	Underwtr	Underwater	Yorks	Yorkshire (GB; old)
Subalp.	Subalpine	UNESCO	United Nations Educational, Scientific and Cultural Organization	Yug.	Yugoslavian
Sum.	Sumerian			Zamb.	Zambian
Sun.	Sunday	Univl	Universal	Zimb.	Zimbabwean
Sup.	Superior	unpubd	unpublished		

A Note on the Use of the Dictionary

This note is intended as a short guide to the basic editorial conventions adopted in this dictionary. For a fuller explanation, please refer to the Introduction, vol. 1, pp. xiii–xx.

Abbreviations in general use in the dictionary are listed on pp. vii–xii; those used in bibliographies and for locations of works of art or exhibition venues are listed in the Appendices in vol. 33.

Alphabetization of headings, which are distinguished in bold typeface, is letter by letter up to the first comma (ignoring spaces, hyphens, accents and any parenthesized or bracketed matter); the same principle applies thereafter. Abbreviations of 'Saint' and its foreign equivalents are alphabetized as if spelt out, and headings with the prefix 'Mc' appear under 'Mac'.

Authors' signatures appear at the end of the article or sequence of articles that the authors have contributed; in multipartite articles, any section that is unsigned is by the author of the next signed section. Where the article was compiled by the editors or in the few cases where an author has wished to remain anonymous, this is indicated by a square box (□) instead of a signature.

Bibliographies are arranged chronologically (within section, where divided) by order of year of first publication and, within years, alphabetically by authors' names. Abbreviations have been used for some standard reference books; these are cited in full in Appendix C in vol. 33, as are abbreviations of periodical titles (Appendix B). Abbreviated references to alphabetically arranged dictionaries and encyclopedias appear at the beginning of the bibliography (or section).

Biographical dates when cited in parentheses in running text at the first mention of a personal name indicate that the individual does not have an entry in the dictionary. The presence of parenthesized regnal dates for rulers and popes, however, does not necessarily indicate the lack of a biography of that person. Where no dates are provided for an artist or patron, the reader may assume that there is a biography of that individual in the dictionary (or, more rarely, that the person is so obscure that dates are not readily available).

Cross-references are distinguished by the use of small capital letters, with a large capital to indicate the initial letter of the entry to which the reader is directed; for example, 'He commissioned LEONARDO DA VINCI . . .' means that the entry is alphabetized under 'L'.

J
[continued]

Jansen, Hendricus [Henricus] (*b* The Hague, 2 Jan 1867; *d* Rotterdam, 5 Feb 1921). Dutch painter, designer and illustrator. From 1883 to 1885 he was a student at the Academie van Beeldende Kunsten in The Hague and then went to Liège and Paris. Between 1899 and 1901 he travelled with Marius Bauer to Egypt, Tunis and Morocco. After his return to the Netherlands in 1902 Middle Eastern motifs dominated his work. He is best known for his brightly coloured paintings of Arabian streets with sharp contrasts of light and dark. His work is easily distinguishable from that of Bauer because of its completely different interpretation of the subject, with clear outlines, a monumental conception and strong colours. Unlike the mystical Bauer, Jansen devoted little attention to the human figure in his paintings; he was much more interested in the rendering of architectural features, preferably in bright sunlight.

Jansen also produced pastels and a few etchings and lithographs, but otherwise concentrated on the applied arts. He created murals (for example in the former 'Terborch' coffee house on the Bezuidenhout in The Hague) and glass paintings. He illustrated M. Smit's *Tine*, J. Wolters's *Ida's huwelijk* [Ida's marriage] and Johan Gram's 'Hague sketches' in the *Haagsche Courant* (1893). He made a number of Bible illustrations, designed posters (the 'Spectator' series) and was art editor of *Elsevier's geïllustreerd maandschrift*. Jansen always signed his work 'Henricus'.

<div align="right">FRANSJE KUYVENHOVEN</div>

BIBLIOGRAPHY
Scheen
P. A. M. Boele van Hensbroek: 'Henricus', *Elsevier's Geïllus. Mdschr.*, xii/23 (1902), pp. 2–12
A. O.: 'Henricus', *Elsevier's Geïllus. Mdschr.*, xxviii/55 (1918), p. 224

<div align="right">GEERT JAN KOOT</div>

Jansenism. French religious movement. This controversial interpretation of Counter-Reformation spirituality within the Roman Catholic Church in France was named after Cornelius Jansen (1585–1638), Bishop of Ypres and scholar at Leuven, whose *Augustinus*, a treatise on St Augustine's doctrine of grace, was published in France in 1642. Its theology of grace was based on the most pessimistic elements in St Augustine's teaching: that human nature after the original fall was totally corrupted, and the power of concupiscence over free will was absolute, making grace necessary for every 'good work'.

Augustinus was published by Jansen's friend Jean Duvergier de Hauranne (1581–1643), known as Saint-Cyran, from the Benedictine abbey of which he was commendatory abbot; he put Jansen's theology into practice through his spiritual direction. He gathered as disciples some of the most promising young intellectuals among the *noblesse de robe* in Paris; among them were members of the family of the lawyer Antoine Arnauld, whose daughter Jacqueline Marie Angélique Arnauld (1591–1661) became Mère Angélique, the famous reforming abbess of the Cistercian convent of Port-Royal near Paris.

Saint-Cyran took as his model of ideal Christianity the early Church, the Church of the martyrs and anchorites; accordingly, his disciples were directed to withdraw as much as possible from the world and from any distractions from the goal of union with God. Jansenists defined works of art as such distractions or, worse, falsehood; they regarded art, especially the *bella natura* of the Italians, as a lie. They discouraged the practice of painting, music, poetry and all the arts, even in those who were gifted. And yet, paradoxically, they were constrained to admit the rights of art for several reasons. They did not want to be accused of adopting the iconoclasm of Calvin; they could not deny work to people who made their living from art, such as lace-makers; they recognized art as a gift of God, which could arouse devotion. Finally, they accepted sacred art as legitimate, provided it was a sign pointing to an object of faith.

The Jansenists' moral and theological rigour found no favour with religious or temporal authority; Louis XIV closed down Port-Royal in 1709, and *Unigenitus*, Clement XI's papal bull, roundly denounced Jansenist doctrine. The movement survived, however, in a progressively reduced form, till the end of the century.

It is debatable whether there is a 'Jansenist style', but the characteristics acceptable to Jansenists are present in the paintings of Philippe de Champaigne (*see* CHAMPAIGNE, (1)) and his nephew, Jean-Baptiste de Champaigne. The constitution of Port-Royal limited the number of paintings allowed in the convent, admitting only those that served as aids to meditation. The 30 paintings by Philippe de Champaigne and Jean-Baptiste de Champaigne for the convents of Port-Royal de Paris and Port-Royal des Champs depicted such themes as the Eucharist, the life and Passion of Jesus, penance and prayer. At each

convent, a *Last Supper* by Philippe de Champaigne hung behind the main altar (both Paris, Louvre). In his *Christ and the Woman of Samaria*, Jesus is depicted speaking of the 'living water', a eucharistic symbol; other scenes from the Gospels include the *Supper at Emmaus* (Ghent, Mus. S. Kst.), *John the Baptist and Jesus* (Grenoble, Mus. Grenoble) and the *Good Shepherd*, in which the branch of thorns at Jesus's feet evokes the Passion. This is also the subject of the *Mocking of Christ* and the *Crucifixion*, a painting of *Christ Nailed to the Cross*, arms extended (all Magny-les-Hameaux, Mus. N. Granges Port-Royal). The last-named work clearly refutes the polemic of a 'Jansenist Christ', hanging from the cross from raised arms, narrowed to exclude all but the chosen élite.

Eucharistic symbolism is also found in the waterfalls and streams of the four great landscapes that Philippe painted for Anne of Austria in 1656: *Zozima Giving Communion to Mary the Egyptian* (Tours, Mus. B.-A.); *Pelagia Praying on the Mount of Olives* (Mainz, Landesmus.); *St Mary the Penitent* (Paris, Louvre) and *St Paphnutius Delivering Thaïs* (Paris, Louvre). These all depict scenes from the *Vie des saints et des saintes des déserts*, by Antoine Arnauld, and illustrate the great Jansenist theme of liberation from sins of the flesh through prayer and penitence. Dorival (1976) comments on the striking quality of the light in these landscapes; in his lecture 'Sur les ombres' (see Fontaine), Champaigne expressed his concern with rendering light and shade as they appear in nature and introduced the theological aspect of his aesthetics through the image of the Divine Workman, whom the artist should imitate in separating light from dark. Jansenists likewise demanded truth in portraiture. This is strikingly illustrated in *Two Nuns of Port-Royal* (1662; *see* CHAMPAIGNE, (1), fig. 2), an ex-voto in which Champaigne depicts the miraculous healing of his daughter, Soeur Catherine, through the prayers of Mère Agnès (Paris, Louvre). The beautiful faces of the two women yet show the effects of age and suffering.

The chapel of Port-Royal de Paris (1648), built in the severe style acceptable to Jansenists, was the first major work of Antoine Le Pautre (*see* LE PAUTRE, (2)) whose plans underwent simplification and suppression at the demand of Mère Angélique; however in this she was probably influenced not so much by Jansenism as by Port-Royal's Cistercian heritage.

There exists a body of engravings of the late 17th century and early 18th that served as propaganda, either for or against Jansenism.

BIBLIOGRAPHY

Les Constitutions du monastère de Port-Royal du Saint Sacrement (Mons, 1665)

M. de Barcos: *Lettres inédites à J.-B. de Champaigne* (1674)

A. Fontaine: *Conférences inédites de l'académie royale de peinture: Discours de ... Philippe de Champaigne, 1672* (Paris, 1903)

P. Nicole: 'Introduction', *Epigrammatum Délectus* (Paris, 1659), Eng. trans. by J. V. Cunningham as *An Essay on True and Apparent Beauty* (Los Angeles, 1950)

B. Dorival: 'Le Jansénisme et l'art français', *Société des Amis de Port-Royal* (Paris, 1952), pp. 1–16

——: *Le Musée national des Granges de Port-Royal* (Paris, 1963)

L. Marin: 'Signe et représentation: Philippe de Champaigne et Port-Royal', *An., Econ., Soc., Civilis.*, xxv (1970), pp. 1–29

B. Dorival: *Philippe de Champaigne*, 2 vols (Paris, 1976)

M. Sharp Young: 'Convulsions and Conversions', *Apollo*, cxxiii (1986), pp. 123–5

B. Chédozeau: 'La Chapelle de Port-Royal de Paris', *Chron. Port-Royal: Un lieu de mémoire: Port-Royal de Paris*, xl (1991), pp. 73–90

S. Lely: 'L'Art au service de la prière: La Peinture à Port-Royal de Paris', *Chron. de Port-Royal: Un lieu de mémoire: Port-Royal de Paris*, xl (1991), pp. 91–118

F. ELLEN WEAVER-LAPORTE

Janson, Cornelis. *See* JONSON VAN CEULEN, CORNELIS, I.

Janssen. German family of artists. Theodor Janssen (*b* Jübborde, E. Frisia, 21 June 1816; *d* Düsseldorf, 21 June 1894) worked as an engraver at the Königlich Preussische Kunstakademie in Düsseldorf. His two sons, (1) Peter Janssen and (2) Karl Janssen, were also artists.

(1) Peter (Johann Theodor) Janssen (*b* Düsseldorf, 12 Dec 1844; *d* Düsseldorf, 19 Feb 1908). Painter. He trained with his father and then became a student at the Königlich Preussische Kunstakademie in Düsseldorf in 1859. He worked initially as an illustrator, but after completion of the fresco cycle *Hermann the Cheruscan* (1869; Krefeld, Kaiser Wilhelm Mus.) for the Rathaussaal in Krefeld, he began producing monumental frescoes after the manner of Peter Cornelius and Alfred Rethel. An easel painting he produced during this period, *Prayer of the Swiss before the Battle of Sempach, 1386* (1874; Düsseldorf, Kstmus.), shows how he concentrated on figurative representation and applied colour to evoke atmosphere. He painted nine scenes of the history of Erfurt for the Rathaus there (1878–81; *in situ*), in which he succeeded in combining the tradition of early 19th-century monumental painting with the more realistic style of contemporary easel painting. Janssen enlivened an austere figurative style with vigorous gestures and by approaching encaustic as if it were oil paint in terms of technique and coloration. Janssen's history paintings always represented the 'official' view. He has been most admired, however, for such portraits as *Andreas Achenbach* (1892; Düsseldorf, Kstmus.). He became deputy director of the Kunstakademie in Düsseldorf in 1893 and director in 1895.

BIBLIOGRAPHY

D. Bieber: *Peter Janssen als Historienmaler*, 2 vols (Bonn, 1979)

Die Düsseldorfer Malerschule (exh. cat., ed. W. von Kalnein; Düsseldorf, Kstmus., 1979)

BARBARA LANGE

(2) Karl Janssen (*b* Düsseldorf, 29 May 1855; *d* Düsseldorf, 2 Dec 1927). Sculptor and teacher, brother of (1) Peter Janssen. In 1875 he studied sculpture under August Wittig at the Königlich Preussische Kunstakademie, Düsseldorf, and from 1881 to 1883 he made a study trip to Rome. His most important early work is the tomb of the Düsseldorf industrialist *Albert Poensgen* (1883; Düsseldorf, North Cemetery). Together with Josef Tüshaus (1851–1901), in 1884 he created the festival decoration *Father Rhine and his Daughters* to celebrate Emperor William I's visit to Düsseldorf. Originally made in plaster, this work was so popular that it was cast in bronze in 1897 and erected as a fountain in front of the Ständehaus in Düsseldorf. The equestrian statue of *Emperor William I* (1896; Düsseldorf, Berliner-Allee) marks the climax of Janssen's neo-Baroque style. Through connections with the Henkels, a family of industrialists, he was able to undertake such important projects as the war memorial

(1925; bronze, assembly hall of administrative block, Firma Henkel, Düsseldorf-Holthausen), dedicated to those workers who were victims of World War I. A late work in the Art Deco style is the mausoleum of the *Henkel Family* (1925) in the North Cemetery in Düsseldorf, one of a series of prestigious tombs that he sculpted for that cemetery. After the death of Wittig, he became Professor of Sculpture at the Kunstakademie, Düsseldorf. Some of his pupils, such as Frédéric Coubillier and Wilhelm Lehmbruck, became important German sculptors in the first half of the 20th century.

BIBLIOGRAPHY

Thieme–Becker

H. Delvos: *Geschichte der Düsseldorfer Denkmäler, Gedenktafeln und Brunnen* (Düsseldorf, 1938)

P. Bloch: *Skulpturen des 19. Jahrhunderts im Rheinland* (Düsseldorf, 1975), pp. 59–61

J. Dresch: *Karl Janssen und die Düsseldorfer Bildhauerschule* (Düsseldorf, 1989)

INGE ZACHER

Janssen [Janssens; Janssen van Nuyssen], **Abraham** (*b* *c.* 1575; *bur* Antwerp, 25 Jan 1632). Flemish painter. He painted historical, religious and mythological subjects, often on a large scale, derived principally from antique sculpture and the art of Michelangelo and Raphael and, to a lesser degree, from certain contemporaries, including the Dutch late Mannerists and the Bolognese school. He was highly esteemed in Antwerp but suffered, then and subsequently, from the inevitable comparison with his contemporary and formidable rival Rubens, whose brilliance somewhat eclipsed his own achievements.

1. Life and work. 2. Working methods and technique.

1. LIFE AND WORK.

(i) Training and early career, to c. *1608.* In 1584–5 Janssen was apprenticed in Antwerp to the painter and art dealer Jan Snellinck I. By that time his father, Jan Janssen, had died, and his mother, Roelofken van Nuyssen (whose name he embodied in his signature), had married the Antwerp schoolmaster Assuerus Boon, a fairly well-off man with artistic and intellectual contacts. Thus Janssen's family circumstances and training provided a good basis for his career as a history painter, though it did not compare with that of Rubens. Janssen subsequently completed his training in Italy. He was recorded in Rome on 5 August 1598, and again on 26 March 1601 as a pupil of the Dutch painter Willem van Nieulandt I. At this time Janssen painted *Diana and Callisto* (1601; Budapest, Mus. F.A.). The figures, whose softness is strongly reminiscent of those of Jan Snellinck, are set in a wooded landscape, with still-life elements in the Flemish tradition. However, the conception of beauty, the poses, the *draperie mouillée* and the elaborate hairstyles already reflect Janssen's fascination for antique and Renaissance sculpture, which was to influence his work strongly. In addition to free borrowings from the Classical sculpture known as the *Spinario* at the centre (*see* STATUE, fig. 2) and Michelangelo's *Night* (*c.* 1522; Florence, S Lorenzo) on the right, the nymph on the extreme left is an exact copy of the Classical *Nymph with a Shell* (Paris, Louvre), which was in the Villa Borghese, Rome, as late as 1638.

Janssen returned to Antwerp *c.* 1602 and became a master in the Guild of St Luke. On 5 May 1602 he married Sara Goetkint, whose family was active in the art trade. Janssen's rising professional status was recognized by his appointment as senior dean of the guild in 1607–8, making it unlikely that he made a second journey to Italy, as is often claimed. Before 27 May 1603 Janssen completed the inside panels of a triptych with the *Virgin of St Luke* (Mechelen Cathedral) for the painters' guild in Mechelen, to replace the altarpiece by Jan Gossart and Michiel Coxcie (Prague, Hradčany Castle). The central panel is clearly an artistic response to the similar work that Marten de Vos, then highly influential among painters in Antwerp, had executed a year earlier for the Guild of St Luke. Also from this period are a number of works, rightly attributed to Janssen, signed with a monogram that has been read as *AJ* or *AB*; in the latter case it may stand for Abraham Boon, by which name (his stepfather's) he is referred to in a surviving document. Historically, the most important of these works is perhaps *Hercules Expelling Pan from Omphale's Bed* (1607; Copenhagen, Stat. Mus. Kst), in which Janssen is seen to have initiated in Antwerp a highly erotic genre, inspired primarily by Agostino Carracci's prints known as *Le Lascive* (*c.* 1590–95; B. 114, 123–36).

(ii) Rivalry with Rubens, c. *1608 and after.* Janssen's position as one of the most important history painters in the Netherlands was challenged by Rubens's return to Antwerp in 1608. The former's fame was not immediately eclipsed, however: between 1608–9 and 1618–19 both artists supplied paintings for three known ensembles. The first, rightly regarded as a masterpiece by Janssen, was *Scaldis and Antwerpia* (the 'Scheldt and Antwerp', 1610; Antwerp, Kon. Mus. S. Kst.; see fig. 1), an overmantel that, together with Rubens's *Adoration of the Magi* (Madrid, Prado), adorned the state room of the Antwerp Stadhuis during the negotiations with Spain that resulted in the Twelve-year Truce (9 April 1609). In its iconography and composition, this allegory is an ingenious transposition of Michelangelo's famous *Creation of Adam* (Rome, Vatican, Sistine Chapel): the vital contact between God the Father and Adam is paralleled by the cornucopia that the expectant maid, representing Antwerp, receives from the River Scheldt, her economic lifeline. One may wonder whether such an impressive work did not influence Rubens's painting in the period immediately following: there are, for example, similarities with his *Samson and Delilah* (*c.* 1609–10; London, N.G.; *see* BELGIUM, fig. 16), such as the colour of the garments of the female protagonists.

Five years later Janssen and Rubens each painted an overmantel for the Antwerp Stadhuis, this time for the assembly hall of the Oude Voetboog (Old Crossbowmen), the city's chief militia company. In contrast to Rubens's *Triumph of the Miles Christi* (1614; Kassel, Schloss Wilhelmshöhe), Janssen's *Peace and Plenty Binding the Arrows of War* (the 'Allegory of Concord', 1614; Wolverhampton, A.G.; see fig. 2) adheres strictly to the conventions of Cesare Ripa's *Iconologia*, thus illustrating the distance between Janssen and Rubens's erudite use of sources. The limitation of Janssen's literary source material is also noteworthy: for secular themes, for example, it is virtually confined to Ovid's *Metamorphoses*. Other features of

1. Abraham Janssen: *Scaldis and Antwerpia*, oil on panel, 1.74×3.08 m, 1610 (Antwerp, Koninklijk Museum voor Schone Kunsten); personifications of the River Scheldt and Antwerp

2. Abraham Janssen: *Peace and Plenty Binding the Arrows of War*, oil on panel, 1.57×2.64 m, 1614 (Wolverhampton Art Gallery)

Janssen's allegory are the lengthening of the figures' lower limbs—which accentuates, instead of alleviating, the perspectival distortion due to the height at which the work would have been hung—and the superfluous drapery, which bears little relation to the figures beneath. All this is in contrast to Rubens's balanced composition, which is perspectively and anatomically correct. Janssen's ponderous figures seem to be bowed under their own weight and that of their garments, a tendency taken to an extreme in the *Nymphs Filling the Horn of Achelous* (Seattle, WA, A. Mus.), a work that probably impressed the young Jacob Jordaens.

The contrast between Janssen's sculptural ideal and Rubens's artistic conception is well illustrated by their painted portraits for a series of Roman emperors. Janssen's *Nero* (1618; Berlin, Jagdschloss Grunewald) emphatically recalls its stone prototype (e.g. Florence, Uffizi), a practice directly contrary to Rubens's precept in his *De imitatione statuarum*. In his own *Julius Caesar* (1619; Berlin, Jagdschloss Grunewald), Rubens brilliantly demonstrated his idea of how the sculptural heritage of antiquity should be transformed on canvas into creatures of flesh and blood.

That Janssen was outclassed artistically by Rubens is not primarily to be explained by the opposition between the former's retrospective classicism (Gerson and ter Kuile) and the dynamic novelty of the latter's Baroque style. Janssen's fundamental weakness is that he did not fully transpose his artistic sources, while the highly inventive Rubens was far more skilled in fusing the manifold borrowings into a new organic unity. Characteristically, Janssen achieved his best work when he could rely, for the composition as well as subject-matter, on a great predecessor. Another good example is *Olympus*, which probably represents Venus begging Jupiter to deify Aeneas from Ovid's *Metamorphoses* (xiv, 585–603; see De Bosque) and forms a pendant to *Venus Deifying Aeneas* (both Munich, Alte Pin.). Here Janssen faithfully copied, in reverse, the composition designed by Raphael of *Venus Begging Jupiter to Accept Psyche among the Gods* frescoed on the vault of the loggia of the Villa Farnesina, Rome.

Janssen seems constantly to have drawn on the same limited sculptural repertory. The totally open, systematic way in which he borrowed from these sources and the conventional way in which he combined them set Janssen apart from his Netherlandish contemporaries. Highly characteristic is a combination such as in *Lascivia* (Brussels, Mus. A. Anc.): the composition is taken from a print by Hendrick Goltzius (B. 120) and the principal figure is derived from the antique statuary in the tradition of the *Venus de' Medici* (Florence, Uffizi). The influence of the Bolognese school is evident in the triptych of the *Coronation of the Virgin* (Antwerp, St Jakobskerk). The *Annunciation* on the outer panels is taken, in reverse, from a print by Agostino Carracci (B. 7) or Pellegrino Tibaldi (B. 8), and the figure of Christ on the central panel is a literal borrowing from Annibale Carracci's *Coronation of the Virgin* (New York, Met.), formerly in the Villa Aldobrandini, Rome. The *Raising of the Brazen Serpent* (*c*. 1605–6; Vienna, Pal. Schwarzenberg) strikingly resembles the work of the Dutch late Mannerists. Both in composition and in the handling of light, this work is at least as close to Cornelis Cornelisz. van Haarlem's *Death of the Children of Niobe* (1591; Copenhagen, Stat. Mus. Kst)—for example in the contoured shadows on the bodies—as to the works of Caravaggio with which it is usually compared. The influence of Caravaggio is usually secondary in Janssen's work, subordinate to the accentuation of his own sculptural ideal (see Müller Hofstede). Moreover, paintings of an indisputably Caravaggesque character, for example *Philemon and Baucis* (Wellesley Coll., MA, Mus.), are later in style than the Vienna painting, and it is even possible that Rubens played the part of an intermediary in passing on the Caravaggesque heritage.

There were two genres in which Janssen made a lasting personal contribution to the art of his time: allegorical scenes with a limited number of figures in close-up, for example *Gaiety and Melancholy* (versions, Valencia, Lassala priv. col., and Dijon, Mus. Magnin), and contemplative scenes of the Passion, in which the meekly suffering Christ, as an object of devotion, appears almost palpably to intrude into the space of the spectator. In at least one case, the *Lamentation* (Mechelen, St Janskerk), the painting hung in a place dedicated to the Eucharist, so that the body of Christ was present to the praying faithful. From the 1620s, while Janssen continued to be successful with paintings of this kind, Rubens, with his monumental and dynamic ensembles for foreign courts, was supplying a market to which Janssen had no access. Janssen's patronage was not confined to the cheap Spanish market, however, which he was able to reach more easily through his nephew Chrisostomus van Immerseel; he also executed more expensive commissions, both religious and secular, for local notables. The *Virgo inter Virgines* (after 1627; Lyon Cathedral), originally for the altar foundation and tomb of Jan Rogiersz. della Faille in the church of the Calced Carmelites in Antwerp, is an imposing example of Janssen's mature style, although it owes much to Rubens. In the 18th century it was still regarded as one of the finest paintings in Antwerp. Not long afterwards, however, Janssen's art was almost completely forgotten.

2. WORKING METHODS AND TECHNIQUE. Janssen's extant oeuvre is relatively small, due not only perhaps to the assaults of time but also to his slow working method, which can be detected in most of the paintings. Moreover, most of the surviving paintings are damaged, due to frequent cleaning and possibly to the vulnerability of the thinly applied paint. Some of the paintings are horizontal in format, with nearly life-size figures. In the case of secular works, at least, this may be attributed to their function as overmantels. There are, however, also many paintings, both secular and religious, that are vertical in format, measuring *c*. 1.2–1.5×0.8–1.0 m; these were probably intended for private patrons.

Janssen's works are difficult to date, chiefly because he often repeated motifs: technical or formal nuances in their elaboration, while important, are not a very precise indication of chronology. Typical of the entire oeuvre is the bole-coloured priming, reminiscent of Italian works, which gives the paintings a warm tonality, although the original effect would not have been as expressive as it has become with the increased transparency of the top layers of paint. This is evident, for example, in the outer garment of the figure of Patience in the otherwise well-preserved allegory of *Man Succumbing to the Burden of Time, but Assisted by Hope and Patience* (1609; Brussels, Mus. A. Anc.). In that work it is clear that after *c*. 1609 Janssen's figures are no longer as rigid as they were previously, while the coloration is not yet dominated by tones of red, blue and yellow as it was after *c*. 1614, as can be seen, for example, in the addition of the large yellow and blue areas in the clothing of the figure on the extreme left of *Peace and Plenty Binding the Arrows of War*. Unlike the red and white of the other principal figures, these primary colours are not based on Ripa's recommendations; they may instead have

been influenced by Rubens, who seems just then to have been inspired by the theory of primary colours of the Jesuit Aquilonius. Also from this time onwards the still-life elements clearly show the influence of Frans Snyders, not surprisingly, as the latter collaborated with Janssen, for example in *Meleager and Atalanta* (Berlin, Kaiser-Friedrich Mus., destr.) and perhaps also to an extent in *Sleeping Nymphs Spied on by Satyrs* (Kassel, Schloss Wilhelmshöhe).

The flesh tones, which, especially in Janssen's male figures, initially display an ochreous tint, become gradually paler and even chalk-like. From the mid-1620s the sculptural modelling of the figures becomes looser, as in the *Scourging of Christ* (1626; Ghent, St Michielskerk), while the atmosphere becomes elegiac, as in *Christ in the House of Martha and Mary* (Antwerp, St Pauluskerk) or in the later *Virgin and Child with St John* (Ponce, Mus. A.). The landscape in both works was painted by Jan Wildens; Janssen himself was not a skilled landscape painter, as revealed by his *Meleager and Atalanta* (Le Havre, Mus. B.-A.). There is also documentary evidence that Janssen collaborated with Jan Breughel II and Adriaen van Utrecht.

A large number of contemporaneous copies exist of several of Janssen's paintings (for illustration *see* JODE, (3)), some of excellent quality, suggesting the existence of a busy workshop. None of Janssen's known pupils, however, achieved any celebrity.

UNPUBLISHED SOURCES

Brussels, Mus. Royaux B.-A. [untitled dissertation by Mrs Heughebaert, *c.* 1952]
Leuven, Katholieke U. [thesis by R. Van Meer: *Schilderkunst in het teken van de contrareformatie in de St-Romboutskathedraal te Mechelen, 1585–1700* (Leuven, 1984), i, pp. 223–7]

BIBLIOGRAPHY

NKL; Thieme–Becker
T. Van Lerius: 'Abraham Janssens, Marten Pepyn en de schryvers der Levens vande Nederlandsche Kunstschilders', *Album der St-Lucasgilde* (Antwerp, 1855), pp. 37, 44–55 [earliest archival study, unsurpassed in its genre]
P. Rombouts and T. Van Lerius, eds: *De liggeren en andere historische archieven der antwerpse Sint Lucasgilde*, 2 vols (Antwerp and The Hague, 1864–76/*R* Amsterdam, 1961)
F. J. Van den Branden: *Geschiedenis der Antwerpsche schildersschool* (Antwerp, 1883), i, pp. 478–82; iii, pp. 297–393
R. Oldenbourg: 'Die niederländischen Imperatorenbilder im Königlichen Schlosse zu Berlin', *Jb. Kön. Preuss. Kstsamml.*, xxxviii (1917), pp. 203–12
——: 'Abraham Janssens', *Belgische Kunstdenkmäler* (Sonderdruck, 1922), pp. 243–58
J. Denucé: *Kunstuitvoer in de 17e eeuw te Antwerpen: De firma forchoudt*, Bronnen voor de Geschiedenis van de Vlaamsche Kunst, i (Antwerp, 1931)
——: *De Antwerpsche konstkamers: Inventarissen van kunstverzamelingen te Antwerpen in de 16e en 17e eeuwen*, Bronnen voor de Geschiedenis van de Vlaamsche Kunst, ii (Antwerp, 1932)
——: *Brieven en documenten betreffende Jan Breugel I en II*, Bronnen voor de Geschiedenis van de Vlaamsche Kunst, iii (Antwerp, 1934) [very important, but sometimes inaccurate]
N. Pevsner: 'Some Notes on Abraham Janssen', *Burl. Mag.* (1936), pp. 120–29 [concise, but one of the best stud. on the subject]
J. S. Held: '*The Burden of Time*: A Footnote on Abraham Janssens', *Bull.: Mus. Royaux B.-A. Belgique* (1952), pp. 11–17 [very useful]
Caravaggio en de Nederlanden (exh. cat., ed. E. Houtzager and D. Roggen; Utrecht, Cent. Mus.; Antwerp, Kon. Mus. S. Kst.; 1952), pp. xxix–xxx and 61–3
J. S. Held: 'The Authorship of Three Paintings in Mons', *Mus. Royaux B.-A. Belgique: Bull.*, ii (1953), pp. 99–114
H. Gerson and E. H. ter Kuile: *Art and Architecture in Belgium, 1600–1800*, Pelican Hist. A. (Harmondsworth, 1960), pp. 52–5, 63, 124
R. Longhi: 'Le prime incidenze caravaggesche in Abraham Janssens', *Paragone*, n. s. 2, clxxxiii (1965), pp. 51–2
R.-A. d'Hulst: '*Scaldis en Antwerpia*', *Openb. Kstbez.* (1969), pp. 4a–4b
J. Müller Hofstede: 'Abraham Janssens: Zur Problematik des flämischen Caravaggismus', *J. Berlin. Mus.*, xiii (1971), pp. 208–303 [265] [undoubtedly the most original and best recent study]
N. De Poorter: 'De Mens bezwijkend onder de Lasten van de Tijd wordt bijgestaan door Hoop en Geduld', *Openb. Kstbez.* (1972), pp. 19a–19b
E. Valdevieso: 'Abraham Janssens y Abraham van Diepenbeeck: Autores de las dos series de pinturas de los cincos sentidos del palacio de La Granja', *Bol. Mus. Prov. B.A. Valladolid* (1973), pp. 317–32 [doubtful attributions to Janssen]
D. Bodart: 'The *Allegory of Peace* by Abraham Janssens', *Burl. Mag.*, cxviii (1976), pp. 308–11
Le Peinture flamande au temps de Rubens: Trésors des Musées du Nord de la France, III (exh. cat. by F. Baligand, Lille, Mus. B.-A.; Calais, Mus. B.-A.; Arras, Mus. B.-A.; 1977), pp. 74–5 (L. Hardy-Marais), 185 (D. Vieville)
Le Siècle de Rubens dans les collections publiques françaises (exh. cat., ed. J. Foucart; Paris, Grand Pal., 1977–8), pp. 98–101
G. Chomer: 'The *Virgo inter Virgines* of Abraham Janssens', *Burl. Mag.*, cxxi (1979), pp. 508–11
A. De Bosque: *Mythologie et maniérisme dans les Pays-Bas: Peintures–dessins, 1570–1630* (Antwerp, 1985)
E. Duverger: *Antwerpse kunstinventarissen uit de zeventiende eeuw, I: 1600–1617*, Bronnen voor de Kunstgeschiedenis van de Nederlanden (Brussels, 1985), pp. 403–33
J. Van der Auwera: 'Rubens' *Kroning van de overwinnaar* te Kassel in het licht vn zijn bestemming', *Rubens and his World: Studies opgedragen aan Prof. Dr Ir. R.A. d'Hulst naar aanleiding van het vijfentwintigjarig bestaan van het Nationaal Centrum voor de Plastische Kunsten van de 16de en 17de eeuw* (Antwerp, 1985), pp. 147–55

J. VAN DER AUWERA

Janssen, Horst (*b* Hamburg, 14 Nov 1929; *d* 31 Aug 1995). German draughtsman and printmaker. He studied from 1946 until 1951 with the painter and engraver Alfred Mahlau (*b* 1894) at the Staatliche Kunsthochschule in Hamburg, where he was offered a professorship but rejected it. In the latter half of the 1950s he first made woodcuts combining expressive and Surrealist elements and then turned to engraving. His work is too personal to be identified as part of a tendency. Dreams and fantasies, often with erotic imagery, predominate among his numerous drawings and engravings and are at once an expression of free forms and the personal anxieties of the artist. His major themes are landscape, still-lifes, portraits and, repeatedly, his own, often distorted, revealing face. He particularly enjoyed basing his work on foreign works of art, which the viewer is supposed to recognize; he did not copy but rather quoted. His encounter with Far Eastern art was important and resulted in *Hokusai's Spaziergang* (1972). A particular characteristic of his work is the literary additions within the work, from individual sentences to complete texts.

WRITINGS

Hokusai's Spaziergang (Hamburg, 1972)

BIBLIOGRAPHY

C. Clément, ed.: *Ergo: 151 Selbstbildnisse, 1947–1979* (Stuttgart, 1980)
S. Blesin: *Horst Janssen* (Hamburg, 1984)

SEPP KERN

Janssens, François-Joseph (*b* Brussels, 25 Jan 1744; *d* Brussels, 22 Dec 1816). Flemish sculptor. He was a pupil of Peter Anton von Verschaffelt at the Académie in Brussels; later he became his associate and in 1763 worked with him at Mannheim. About 1764 Janssens visited Berne, then went on to Florence, remaining there a year before moving to Rome in 1766. He lived there for three years,

executing copies (untraced) after antique statues for an Englishman, possibly John Stuart, 3rd Earl of Bute. He received a commission from Brussels to make an *Apollo* (Brussels, Parc Bruxelles), a faithful copy of the *Apollino* (Florence, Uffizi). On his return to Brussels Janssen became a master sculptor in 1771 and from then on received many commissions. He took part in the decoration of several religious buildings, producing at first works of Baroque inspiration, such as the monumental *David* in the church of St Jacques sur Coudenberg in Brussels. However, concurrent secular commissions were undertaken in a wholly different, Neo-classical spirit, judging from the terracotta models that he left (Brussels, Mus. A. Anc.), from the works discussed by Popeliers, and from the few statues that have been rediscovered. Janssens was a close associate of the sculptor Karel van Poucke who was, like himself, one of the precursors of the new style. In 1784 they worked together on the decoration of the mausoleum of Bishop van Eersel XVI in St Bavo Cathedral in Ghent: Janssen executed the Neo-classical statue of *Faith*. It was, however, in secular subjects that Janssens was able to give full rein to his artistic imagination, as the outstanding *Adolescent Cupid* (1787; London, priv. col.), modelled with a characteristic softness, testifies. Also known to be by him is a bust of *Emmanuel de Cock* (1787; Brussels, Mus. A. Anc.).

BIBLIOGRAPHY

T. L. H. Popeliers: 'F. J. Janssens', *Histoire des Beaux-Arts; Trésor national: Recueil historique, littéraire, scientifique, artistique, commercial et industriel*, iv (Brussels, 1842)

1770–1830: Autour du Néo-classicisme en Belgique (exh. cat., Brussels, Mus. Ixelles, 1985), pp. 102–4

DOMINIQUE VAUTIER

Janssens, Hieronymus [Jeroom] (*bapt* Antwerp, 1 Oct 1624; *d* Antwerp, 1693). Flemish painter. In 1636–7 he was a pupil of Christoffel van der Lamen (1606–52), and by 1643–4 he was a master. He married Catharina van Dooren in 1650 and took on four pupils in the year 1651–2. Like van der Lamen, he specialized in dance scenes, set either inside a palace or outside on a terrace (e.g. the *Game of Hot-cockles*, 1656; Brussels, Mus. A. Anc.), and was thus nicknamed 'the dancer'. Janssens's paintings are often both signed and dated, with dates ranging from 1646 to 1661. Architecture plays an important role in his paintings and is based on existing buildings, such as Rubens's Italianate house in Antwerp. Janssens also used the prints of Hans Vredeman de Vries, as a source for perspectival effects. Playing with elements such as columns, pilasters and windows, he created imaginary, monumental constructions. In some cases the result was rather unconvincing: his complicated floor patterns, for instance, can look somewhat clumsy. The architectural features in Janssens's work add to the dramatic effect, which is further intensified by his use of chiaroscuro, giving the paintings a theatrical character.

BIBLIOGRAPHY

Bénézit

'Deux oeuvres capitales de Hieronymus Janssens Le Danseur, peintre de la mode et de l'élégance au XVIIe siècle', *Les Beaux-Arts* (22 May 1959), p. 7

F. C. Legrand: *Les Peintres flamands de genre au XVIIe siècle* (Brussels, 1963), pp. 87–95

De eeuw van Rubens [The age of Rubens] (exh. cat., ed. E. de Wilde; Brussels, Mus. A. Anc., 1965), pp. 106–7

M. D. Padron: 'Precisiones y adiciones a la pintura flamenca del siglo XVII en el Museo de San Carlos de Mejico', *Archv. Esp. A.*, liv (1981), p. 75

JETTY E. VAN DER STERRE

Janssens, Jan (*b* Ghent, 7 Aug 1590; *d* Ghent, *c.* 1650). Flemish painter, active also in Italy. He became a master in the painters' guild of his native Ghent in 1621, but before that he spent considerable time in Italy, particularly Rome, where he is documented in 1619 and 1620. There he became associated with the international Caravaggesque movement and was especially influenced by the paintings of the Utrecht Caravaggisti, such as Gerrit van Honthorst and Dirck van Baburen. Immediately after his return to Ghent, Janssens introduced the style of Caravaggio there. His altarpieces and other painted compositions with mercilessly realistic representations of biblical and hagiographic themes were particularly sought after for churches in and around Ghent. In these works Janssens achieved a high emotional impact by modelling the figures and objects with a strong light from a hidden source. Typical examples are the *Christ Crowned with Thorns* (1627; Ghent, St Peter) and the *Martyrdom of St Barbara* (Ghent, St Michael). Such paintings met the demand that sprang from the Counter-Reformation for strongly emotional representations of religious themes. Janssens also occasionally worked for a public that was more international in outlook, as is demonstrated by his *Caritas Romana* (Madrid, Real Acad. S Fernando), a painting that had already become part of the famous collection of the Marqués de Léganès during the artist's lifetime.

BIBLIOGRAPHY

D. Roggen, H. Pauwels and A. De Schrijver: 'Het Caravaggisme te Gent', *Gent. Bijdr. Kstgesch. & Oudhdknd.*, xii (1949–50), pp. 260–85

B. Nicolson: *The International Caravaggesque Movement* (Oxford, 1979), p. 62

HANS VLIEGHE

Janssens, Victor Honoré (*b* Brussels, 11 June 1658; *d* Brussels, 1736). Flemish painter and draughtsman. He was apprenticed to Lancelot Volders (*fl* 1657–?75) in Brussels from 1668 to 1675. He also studied with the Dutchman Pieter Molyn. He came under the patronage of Herzog Joachim II von Holstein-Plön, who supported his trip to Italy. In Rome he studied the works of Raphael and the ancient monuments and made drawings of the Roman Campagna. His highly popular small paintings were influenced by those of Francesco Albani. Janssens also painted a large altarpiece for the Jesuits of Naples.

Janssens returned to Brussels, where he became a master in 1689. His work in this period includes portraits and large tapestry cartoons illustrating fables and historical subjects for the Leyniers factory and Marcus de Vos (*fl* 1655–63). After 1695 Janssens received numerous commissions from the city and guilds to decorate the new buildings built to replace those lost in Louis XIV's bombardment of the city during the War of the Grand Alliance. These works made both his reputation and his fortune. His masterpiece is the allegorical *Meeting of the Gods* for the ceiling of the Brabant States Assembly Room (now Salle du Conseil Communal) in the Brussels Hôtel de Ville (1718; *in situ*). Also in the same room are tapestries woven from his designs (e.g. the *Abdication of Charles V*; *in situ*). In 1720 he was named court painter to Emperor

Charles VI, during which appointment he spent two years in Vienna and two in London.

Many of Janssens's known paintings remain in Brussels, for example *St Charles Borromeo Praying to the Virgin for the Plague Victims* and *Dido Ordering the Building of Carthage* (both Mus. A. Anc.), the *Dance of the Hours* (Mus. Com.), and *St Roch Healing the Plague Victims* and *Penitent King David* (both St Nicolas). Also attributed to Janssens is *Queen Clotilde before St Leonard of Noblac* (St Jean Baptiste au Béguinage). Although a second-rate painter, eclipsed by the fame of Rubens and van Dyck, Janssens was an important figure in the transition from the 17th century to the 18th. He is best known for having introduced Roman classicism to the southern Netherlands.

BIBLIOGRAPHY
BNB
D. Coekelberghs and P. Loze: *L'Eglise Saint-Jean Baptiste-au-Béguinage à Bruxelles et son mobilier* (Liège, [1980]), pp. 211–13

DOMINIQUE VAUTIER

Janssens, Wynand (*b* Brussels, 5 Feb 1827; *d* Brussels, Jan 1913). Belgian architect. He was the son of the architect Jean-Baptiste Janssens and studied architecture under Tieleman-Frans Suys (1844–8) in the Académie Royale des Beaux-Arts, Brussels. In 1851, after a period of study in England, he built a public bath building (destr.) at Rue des Tanneurs in the Marolles district of Brussels, one of the first examples of public baths and laundries constructed for working-class use. He collaborated with HENRI BEYAERT on the construction of the Banque Nationale (1860–67) in the Boulevard de Berlaimont, Brussels, and succeeded Joseph Poelaert (1863) as architect of the Renaissance Revival church of Ste Catherine,

Place Ste Catherine (interior completed 1873), both commissions attracting much attention. The construction of the Palais du Midi (1875) in the Avenue du Midi, Brussels, and his participation in the modernization (1878) of the Notre-Dame-aux-Neiges district changed the direction of his career. On behalf of property companies he undertook large housing developments in Brussels, for example the blocks of flats at 61, Avenue Louise (1886) and at 2, Rue de Florence (1892). With a rational and economical approach and in an eclectic style, he perfected the type of traditional middle-class house, guaranteeing architectural quality and profitability. He also decorated a number of private mansions and châteaux and received several foreign commissions, notably to undertake the restoration of Frederiksborg Castle, Hillerød (Zealand), for Christian IX, King of Denmark (*reg* 1863–1906).

BIBLIOGRAPHY
'Académie de Bruxelles: Deux siècles d'architecture', *Archvs Archit. Mod.* (Brussels, 1989), pp. 224–7

ANNETTE NEVE

Jansson, Eugène (Fredrik) (*b* Stockholm, 18 March 1862; *d* Stockholm, 15 June 1915). Swedish painter. His childhood was overshadowed by poverty and ill-health (including deafness), and he remained somewhat on the margins of society throughout his life. He studied (1881–2) at the Painting School run by Edvard Perséus (1841–90) and briefly at the Akademi för de Fria Konsterna in Stockholm; but he was largely self-taught. With the exception of two journeys abroad, which had very little influence on his art, he lived all his life in Stockholm, and it was the city that provided most of his subject-matter. In the mid-1880s Jansson was greatly stimulated by contact with Swedish artists returning from Paris, in particular Karl Nordström. Jansson's painting *Roslagsgatan* (1889; Stockholm, Thielska Gal.) clearly reveals Nordström's influence. Jansson was one of the first Swedish artists to concentrate on twilight scenes. He produced his first painting of this kind in 1883, but the 'blue period', for which he became well known, started in earnest in 1890 and lasted until 1905. In 1891 he moved to Södermalm, the workers' quarter of Stockholm, and took as the principal subject of his paintings views of the city at dawn and dusk as seen from his studio. The perspective of these views is topographically correct but undergoes greater decorative stylization than found in the work of any other Swedish painter of the time. In such paintings as *Riddarfjärden in Stockholm* (1898; Stockholm, Nmus.; see fig.) or *Nocturne* (1901; Stockholm, Thielska Gal.) Jansson transformed his motif of lights reflected in water into the billowing ornament typical of Art Nouveau. The character of these magnificent night views is visionary and dream-like, partly explained by the fact that they were deliberately painted from memory, without any attempt at preliminary on-the-spot study. The synthesizing and symbolic character of Jansson's paintings during his 'blue period' was also a result of the influence of the Norwegian artist Edvard Munch, whose works were shown at an exhibition that arrived in Stockholm from Berlin in 1894. The banker Ernest Thiel, a good friend and patron of Jansson, also admired and collected works by Munch. Jansson's *Rosenlundsgatan* (1895; Stockholm, Thielska Gal.), where the

Eugène Jansson: *Riddarfjärden in Stockholm*, oil on canvas, 1.50×1.35 m, 1898 (Stockholm, Nationalmuseum)

rhythmical stylization is especially strong, shows Munch's influence very clearly. Such works, showing nocturnal views of desolate streets, constituted another category in Jansson's output. In paintings such as *Hornsgatan at Night* (1902; Stockholm, Nmus.), a real location in all its banal detail is transformed into a landscape of the soul. Jansson established a melancholy, poetic mood similar to that evoked in contemporary Swedish poetry.

A third set of motifs was that of workers' tenements on the outskirts of the city, to which Jansson was drawn both through his commitment to socialism and through memories of his own impoverished childhood and adolescence. In these subjects, often shown in daylight, and thus with a generally lighter tone, there remains a touch of melancholy, so that the buildings are poignant in their simple dignity, as in the *Outskirts of the City* (1899; Stockholm, Nmus.). The clearest example of Jansson's commitment to socialism, however, is seen in the large painting of workers in a 1 May demonstration, *Demonstration Procession on Gärdet* (Stockholm, Folkets Hus). This powerful scene of figures and banners snaking across a plain under heavy clouds reveals Jansson as one of the few politically committed Scandinavian artists of this period to establish an adequate artistic form to express his views. Jansson also painted portraits, the most notable being a self-portrait, *Me* (1901), and a portrait of his patron *Ernest Thiel* (1902; both Stockholm, Thielska Gal.). Jansson's 'blue period' ended abruptly in 1905 and was followed by a series of large, light pictures of naked men bathing and doing gymnastics in the open air, for example *At the Navy Baths* (1907; Stockholm, Thielska Gal.). Such subjects were related to the emerging vogue for healthy living and also to Jansson's own obsession with his health. Jansson was not particularly successful in his lifetime, but he eventually came to be valued highly in Sweden, especially for his twilight scenes from the 1890s.

BIBLIOGRAPHY

N. G. Wollin: *Eugène Janssons måleri: Försök till gruppering och analys* [The paintings by Eugène Jansson: attempt at classification and analysis] (Stockholm, 1920)

G. Nordensvan: *Svensk konst och svenska konstnärer i det 19 århundradet* [Swedish art and Swedish artists in the 19th century] (Stockholm, 1928), ii, pp. 400–06

TORSTEN GUNNARSSON

Jansson, Karl Emanuel (*b* Finström, Åland Islands, 7 July 1846; *d* Jomala, Åland Islands, 1 June 1874). Finnish painter. He was the first Finnish painter to concentrate on themes of folk life who had himself risen from a poor peasant family. He received a small grant from the Finnish Arts Association to study at the School of Drawing in Turku (1860–62) and then at the Konstakademi in Stockholm (1862–7). In Stockholm he was particularly influenced by his teacher Johan Fredrik Höckert, whose colourful style was drawn from French tradition. Jansson often returned to subjects from his happy childhood in his paintings. His most successful figure study from this period is the *Smiling Old Woman* (1867/8; Helsinki, Athenaeum A. Mus.), in which his use of vivid colour is combined with freshness and immediacy in the characterization. Jansson's figure studies generally stand out at this period because of their sensitive and expressive quality.

Jansson obtained a scholarship to study in Düsseldorf between 1868 and 1870. He began painting subjects from the Finnish countryside, using Germans as his models. His most influential teacher was Benjamin Vautier, but it was Ludwig Knaus whom he particularly admired. Knaus's *Cardsharps* partly inspired Jansson's major work, the sombre *Åland Seamen in a Cabin Playing Cards* (Helsinki, Athenaeum A. Mus.). It is the first large-scale work to adapt psychological realism to a Finnish subject. The painting was well received at the Weltausstellung in Vienna in 1873 and at the Exposition Universelle in Paris in 1878, and it prompted the Academy of Arts in St Petersburg to grant Jansson official recognition as an artist. In the spring of 1871 he painted *Spruce Feller* (Turku, A. Mus.), which is significant as an early portrayal of Finnish working life in the manner of Jean-François Millet.

Jansson's second trip to Düsseldorf in the autumn of 1871 was interrupted by the onset of tuberculosis. Nevertheless, he managed to complete two of his compositions on folk themes, one of which, the comic scene *Courtship on the Åland Islands* (1871; Helsinki, Athenaeum A. Mus.), proved his greatest success in Finland. He travelled to Italy and Switzerland in the vain hope of improving his health, returning in 1873. Before he died he managed to complete a number of works, including the small canvas *At the Door of the Vestry* (1873–4; Helsinki, Athenaeum A. Mus.), which best demonstrates his sensitive use of colour and his delicate handling of light effects.

BIBLIOGRAPHY

B. O. Schauman: *K. E. Janssons minne* [A memento of K. E. Jansson] (Helsinki, 1880)

B. Hintze: *Karl Emanuel Jansson: En Åländsk målare* [Karl Emanuel Jansson: a painter from Åland] (Helsinki, 1926)

A. Reitala: 'Karl Emanuel Janssonin taide' [The art of Karl Emanuel Jansson], *Taidehist. Tutkimuksia/Ksthist. Stud.*, 2 (1976), pp. 77–118

AIMO REITALA

Janssone, Jan. *See* MERTENS, JAN.

Jansz., Dirc. *See under* MASTERS, ANONYMOUS, AND MONOGRAMMISTS, §I: MASTER OF THE VIRGO INTER VIRGINES.

Jan van Mergem. *See* JEAN DE MARVILLE.

Jan van Roome. *See* ROOME, JAN VAN.

Jan van Ruysbroeck [Ruisbroek; Berghe, Jan van den] (*b* ?1396; *d* Brussels, 2 May 1486). South Netherlandish architect. He probably took his name from the narrow Ruisbroek Valley that separates Coudenberg Hill from the Zavel, one of Brussels's oldest stone quarries. Like the KELDERMANS family of Mechelen, the van den Berghes of Brussels were a dynasty of quarry managers, stone merchants and contractors, and Jan's activities as a mason took place in this context. It is uncertain whether he can be identified with a member of Brussels city council of the same name who in 1421 was appointed as one of the first craftsmen's representatives. Jan played a part in renovating the residential wing of the Coudenberg Palace (1431–6; destr.) as a stone merchant and also in building the *lavatorium* and well (1442–5) of the hospital of Onze Lieve Vrouwe at Oudenaarde. This hexagonal structure, with rib vaults and a spire, was decorated with a series of sculptures

including representations of the Counts of Flanders. However, as a builder, Jan is known principally for his towers. His openwork octagonal lantern, capped with a stone spire (built probably between 1449 and 1455), tops the belfry of the town hall at Brussels and is one of the most important precursors of the many steeples built by the Keldermans family in the late 15th century and the early 16th. His even more Flamboyant stone spire for the former abbey church of St Geertrui in Leuven (*c.* 1452–3; rest. 19th century) is in the same vein. He was appointed architect to the duchy of Brabant by Philip the Good in 1459 and retained the position under both Charles the Bold and Mary of Burgundy, receiving the high salary that went with the post. In this capacity he undertook maintenance works at the royal residences at Vilvoorde (from 1460; designed by Matheus de Layens and Jehan Pinchon, ?1459; destr.), Tervuren and Genappe, and many other buildings, such as the royal windmills at Halen. His part in works at St Lambert's Cathedral, Liège (after 1451; destr. 1794) and Brussels Cathedral (from *c.* 1470) is not certain, but the choir of the collegiate church of SS Peter and Guido at Anderlecht, near Brussels, can be attributed to him with some confidence.

BNB

BIBLIOGRAPHY

D. Roggen and J. Withof: 'Grondleggers en grootmeesters der Brabantse gotiek' [Founders and architects of the Brabantine Gothic style], *Gent. Bijdr. Kstgesch.*, x (1944), pp. 188–92
A. Maesschalck and J. Viaene: *Het stadhuis van Brussel: Mensen en bouwkunst in Boergondisch Brabant* (Kessel-Lo, 1960)
——: 'Bouwmeester Jan van Ruisbroek, herdacht (1486–1986)', *Tijdschr. Brussel. Gesch.*, ii (1985), pp. 17–110

KRISTA DE JONGE

Jan Wellem. *See* WITTELSBACH, §II(3).

Janyns [Jannings; Jenins; Jenyns]. English family of architects. They worked in Oxford and in the service of the king during the 15th century and the early 16th.

(1) Robert Janyns (i) (*fl* 1438–64). His known career is contemporary with a period of development at Oxford University. At All Souls College, founded in 1438 by Archbishop Chichele (?1362–1443), he was mason in charge of building the Front Quad (1438–43), a two-storey range that includes the Old Library and the chapel. His next known commission, the bell-tower (1448–52) for Merton College Chapel, is one of the outstanding buildings of 15th-century Oxford. Its proportions, buttresses, battlements and pinnacles were repeated in William Orchard's Magdalen College Tower (1492–1500). Also in 1448, Janyns entered royal service as warden of masons at Eton College, Berks. His work at Oxford after 1452 probably included surveying the new Divinity Schools (1452–3) as well as further small works for All Souls and Merton, such as the carved panel above the Merton gateway (1463–4).

(2) Henry Janyns (*fl* 1453–84). Probably the son of (1) Robert Janyns (i). He served part of his apprenticeship (*c.* 1453–4) at Eton College and may have worked on the Merton gateway with Robert (i). He was commissioned *c.* 1475 to design the new St George's Chapel at Windsor Castle (*see* WINDSOR CASTLE, §2). This, the headquarters of the Order of the Garter, was conceived on a grander scale than the chapel at either Eton or King's College,

Cambridge. Although the length of the nave (71 m) was limited by lack of space, it was proportionally wide, requiring extremely shallow vaulting—as had been planned for Eton College Chapel. The five-sided apses that closed the narrow transepts were borrowed from the bay windows of secular architecture. Janyns's complex interior elevations represent the culmination of 15th-century Perpendicular design. He vaulted the choir aisles with fans, filling the central spandrels with quatrefoils enclosed within octagons. By 1484, the last year Janyns's name appears, the eastern end was virtually complete, except for the main vault of the choir.

(3) Robert Janyns (ii) (*d* Oct 1506). Probably the son of (2) Henry Janyns. He may have supervised the building of St George's Chapel, Windsor Castle, from 1484 and was king's master mason by the time he designed the Henry VII's Tower (completed 1501) at Windsor Castle, his principal documented work. Its oriel windows, with faceted lights derived from contemporary domestic architecture, may have been his invention. He remained at Windsor until 1505. He was also master mason at Greenwich Palace (1503–4) during the construction of the new chapel (destr.). The design of Henry VII's Chapel (1506–9) in Westminster Abbey has been attributed to Janyns on stylistic grounds (*see* LONDON, §V, 2(i)). Intended as a shrine to Henry VI, it epitomizes the late Perpendicular style. The internal elevations are similar to those at St George's Chapel but are even more lavish, and the design of the bay windows of the aisle was first seen in Janyns's tower at Windsor. The fan vault conceals the greater part of the transverse arches, and the deep tracery serves to conceal the masonry beneath.

BIBLIOGRAPHY

H. M. Colvin, ed.: *The History of the King's Works* (London, 1963–82), iii and iv
P. Kidson: 'The Architecture of St George's Chapel', *The St George's Chapel Quincentenary Handbook*, ed. M. Bond (Windsor, 1975)
W. Leedy: *Fan Vaulting: A Study of Form, Technique and Meaning* (London, 1975)
C. Wilson: *The Gothic Cathedral: The Architecture of the Great Church, 1130–1530* (London, 1990)

Japaljarri Sims, Paddy. *See* SIMS, PADDY JAPALJARRI.

Japan. East Asian country composed of some 3900 islands stretching north-east to south-west along the east coast of the Asian continent (see fig. 1). The four main islands are Honshu, Hokkaido, Kyushu and Shikoku. Japan occupies an area of 377,708 sq. km, with a population (in 1992) of slightly over 124 million.

I. Introduction. II. Religion and iconography. III. Architecture. IV. Urban planning. V. Sculpture. VI. Painting. VII. Calligraphy. VIII. Ceramics. IX. Prints and books. X. Lacquer. XI. Textiles. XII. Metalwork. XIII. Theatre and performing arts. XIV. Tea ceremony. XV. Folk art. XVI. Other arts. XVII. Treatises. XVIII. Art training and education. XIX. Patronage. XX. Archaeology. XXI. Collection and display. XXII. Connoisseurship and historiography.

DETAILED TABLE OF CONTENTS

1. Map of Japan; all the sites have separate entries in this dictionary

I. Introduction.

In this dictionary the modified Hepburn or Hyōjun romanization (*rōmaji*) of Japanese phonemes is used. Macrons are used throughout in all romanized Japanese, except on very well-known place names such as Tokyo, Kyoto and Honshu. For names of people born (or active) before the Meiji Restoration of 1868, the family name precedes the given name; the reverse order of names is used for people born (or active) after 1868. Individuals are, however, variously known in Japan by their family names, given names, nicknames (*adana*), other personal names (for example, formal literary names (*azana*), child, current, true, posthumous, house and Buddhist names) and, particularly relevant in this context, artistic names (*gō*), which include *haimyō* (names used by *haiku* poets) and *geimei* (actors' and performers' names). In artist biographies, the most important alternative names are given in square brackets after the article heading. Macrons are used on personal names.

1. Geography and peoples. 2. History. 3. Trade. 4. Concept of art. 5. Status of the artist.

1. GEOGRAPHY AND PEOPLES.

(i) Physical geography. Japan has a temperate ocean climate. The Kuroshio current and the Tsushima current flow northwards along the coasts of the Pacific Ocean and the Sea of Japan, warming the archipelago. East Asian monsoons bring warm, moist air from the Pacific in summer and cold, drier air from Eurasia in winter. The cold Asiatic air, however, can pick up considerable amounts of moisture when crossing the Sea of Japan, causing some of the heaviest snowfalls in the world along the western coast of Honshu. Mountains cover 76% of the country. The tallest of Japan's volcanoes, Mt Fuji (3776 m), is in the central region of Honshu, where the north–south ranges converge with the east–west ranges. About one-third of Japan's 200 volcanoes are active, and earthquakes occur daily. Japan's lakes are generally either mountain crater lakes or coastal brackish water lakes. Rivers are short and swift: the longest, the Shinano, is only 367 km from its source to the sea. The rivers are poor for inland navigation, but the contorted nature of the coastline creates good harbours for coastal navigation.

During the Pleistocene ice ages (*c.* 90,000–*c.* 10,000 BC) of the Palaeolithic era, Japan is thought to have been linked to continental Asia: Hokkaido to Siberia (now the La Pérouse or Sōya Strait) and western Japan to Korea (now the Tsushima Strait). Hokkaido and Honshu were also connected. Japan separated from the continent at the end of the ice ages when glaciers melted and sea-levels rose. This theory, together with Japan's great latitudinal range, would account for the country's rich variety of flora and fauna. Hokkaido's natural fauna resembles that of Siberia, the island of Okinawa has typical East Asian animals, whereas the other three main islands display a mix of East Asian and remnant North Asian fauna. About 70% of the country is forested. Boreal coniferous trees dominate in north-eastern Hokkaido, cool–temperate deciduous forests in northern and highland Honshu, temperate broadleaf evergreens in south-western Honshu, Shikoku and Kyushu, and Asian tropical evergreens in Okinawa.

Mineral resources are distributed fairly widely. Coal, iron ore, copper, gold, silver, lead, zinc, sulphur and tin occur, but limestone is probably the only mineral resource in which modern Japan approaches self-sufficiency.

(ii) Population and development. The oldest settled portions of Japan are Kyushu and the south-western half of Honshu. Traditionally the Japanese distinguish between the major regions of 'western Japan', centred on Osaka–Kobe–Kyoto, and 'eastern Japan', around Tokyo and Yokohama. Japan's population has always been unevenly distributed. Before industrialization in the late 19th century, the south-western part of Japan was densely populated, while the north-east was sparsely settled. During the next century there was a shift of population towards the major urban belt that developed along the Pacific coast, including the cities of TOKYO, YOKOHAMA, NAGOYA, KYOTO, OSAKA, KOBE, HIROSHIMA, Kitakyushu and Fukuoka. Today this region contains over half the country's population.

Honshu, Japan's main island, contains most of the Pacific coast urban belt as well as the country's highest mountains, most of its large lakes and its principal archaeological sites, temples, shrines and museums. Kyushu, to the south-west of Honshu, is Japan's third largest island and has played an important part in the nation's historical development. Fukuoka, Kitakyushu, Kumamoto and Kagoshima are major cities, and the port of NAGASAKI played a major role in foreign contact during the Edo period (Tokugawa shogunate, 1600–1868). Kyushu has a high proportion of Japan's active volcanoes. Shikoku, Japan's fourth largest island, has developed more slowly than Honshu and Kyushu. Its northern coast, which faces Honshu, experienced considerable industrial development in the late 20th century. The major cities are Matsuyama and Takamatsu. Settlement of Japan's northernmost and second largest island, Hokkaido, was sparse until the late 19th century, and the population remains small except in the capital, Sapporo. In this, and in its large plains and cold climate, Hokkaido differs from the rest of Japan. Okinawa, over 400 km south-west of Kyushu, was the

centre of a small kingdom before 1872. It has poor soil and a subtropical climate.

The earliest city in Japan is considered to have been Heijō or Heijōkyō (modern NARA), completed in AD 710, although large settlements such as Dazaifu pre-dated it. Heijō, Heian or Heiankyō (modern KYOTO) and other early capitals were modelled on Chinese and Korean cities with grid plans (see §IV, 2 below). Early commercial ports such as Sakai, however, were largely unplanned. With the exception of Kyoto, the imperial capital from AD 794 to 1868, most early cities were short-lived. Edo (modern TOKYO) did not become a city until after the Shogun Tokugawa Ieyasu (1543–1616) had completed his castle there in 1606. The modern conurbations of Japan consist essentially of the castle towns (see §IV, 3 below) that already existed by the end of the Edo period, linked together by extensive communications networks and vastly expanded by population growth.

Agriculture in Japan from the 2nd century BC to the 20th century was predominantly rice-based, with rice production declining significantly only after World War II.

(iii) Ethnic groups. The Japanese archipelago was inhabited by at least *c.* 28,000 BC and possibly even earlier (*see* §2 below). Settlers came to the islands from mainland Asia via glacial bridges (*see* §(i) above); most were of Mongoloid stock and racially closest to Koreans, the Tungus tribe and certain groups in northern China. It is not certain whether the two main Neolithic cultures of Japan, the Jōmon and Yayoi, were ethnically distinct. During the Yayoi period (*c.* 300 BC–*c.* AD 300), movements of people from the Korean peninsula brought Chinese culture to Japan.

Some time before the 1st century AD, the Yamato clan (named for a peninsula on the island of Honshu), probably mainly of Yayoi stock with some admixture of Jōmon, established political domination over the southern islands of Japan, while the aboriginal Ainu (see below) controlled the north. By the 5th century AD the Yamato had risen to superiority throughout the fledgling state. It is said that the imperial line in Japan is descended from the Yamato people. Yamato-Japanese are the majority ethnic group in modern Japan.

At least 4% of the population of present-day Japan belong to minority groups. These include the Ainu, once the racially and culturally distinct aboriginal people of northern Japan, although today most of the Ainu in Hokkaido are of mixed descent and have adopted majority Japanese culture. Although racially the same as the Yamato-Japanese, the inhabitants of the Ryukyu Archipelago, the Okinawans, remain a culturally distinct group. Other minorities include the *burakumin*, who are descended from castes that, during the Heian period (AD 794–1185), were segregated as unclean because they were involved in disposing of the dead and working with slaughtered animals.

BIBLIOGRAPHY

Kodansha Enc. Japan

T. C. Smith: *The Agrarian Origins of Modern Japan* (Stanford, 1959/*R* 1970)

G. T. Trewartha: *Japan: A Geography* (Madison, 1965/*R* 1970)

G. A. De Vos and H. Wagatsuma: *Japan's Invisible Race: Caste in Culture and Personality* (Berkeley, 1966)

J. Aono and S. Birukawa, eds: *Nihon chishi* [Regional geography of Japan], 21 vols (Tokyo, 1969–80)

C. Nakane: *Japanese Society* (Berkeley, 1970)

D. H. Kornhauser: *Urban Japan: Its Foundations and Growth* (London, 1976)

Geography of Japan, Association of Japanese Geographers (Tokyo, 1980)

G. A. De Vos and W. O. Wetherall: *Japan's Minorities: Burakumin, Koreans, Ainu and Okinawans*, Minority Rights Group Report, iii (London, 1983)

RICHARD LOUIS EDMONDS

2. HISTORY.

(i) Introduction. (ii) Prehistoric (before *c.* AD 552). (iii) Age of Aristocratic Houses (*c.* 552–1185). (iv) Age of Military Houses (1185–1868). (v) Modern (after 1868).

(i) Introduction. Japanese history has developed under certain circumstances that have markedly influenced the course of culture and art. Its geographic isolation protected it from foreign intrusion until the 19th century, and before Japan's defeat after World War II in 1945 the country had not been defeated or occupied by an outside power in two millennia. Although foreign influences have played an important role, Japan's geographic position has allowed it to exercise selective cultural borrowing. Japan's historical and cultural continuity is symbolized by the reigning imperial line, which dates back to the late 3rd century AD–early 5th and which in that time has experienced only one schism.

Through this long period of cultural development Japanese art has displayed certain consistent characteristics: love of nature and of natural materials, excellence in craftsmanship and design and a deep respect for native artistic tradition. The ISE SHRINE is often cited as the classic example in architecture. Constructed of wood in a precise joinery method requiring neither nails nor adhesive, it has been rebuilt in the same style every 20 years through most of the last 12 centuries, thus preserving the original design and demonstrating a capacity to maintain and sustain tradition despite periods of political upheaval. Over the centuries the Japanese have absorbed from foreign cultures, sometimes extensively, without disturbing the native sensibility. This is particularly evident in the evolution of the Buddhist arts, which began as outright Chinese–Korean imitations in the 7th century AD and evolved into purely Japanese representations in the 11th century.

There are many methods used to divide the narrative of Japanese history, and the preferred subdivisions sometimes depend on the context of discussion. The system of commonly used periods followed in this article (see fig. 2) and in general in the coverage of Japanese art in this dictionary uses the names of centres of political power (Asuka, Nara, Heian, Kamakura), of powerful political families (Ashikaga, Tokugawa) and, from 1868, the names of reigning emperors (Meiji, Taishō and Shōwa). These periods are grouped under the headings of 'ages', reflecting broader trends that affected styles of art.

(ii) Prehistoric (before c. AD 552). The people of the Palaeolithic era were hunters and gatherers who made and used stone tools and weapons. Palaeolithic sites include Iwajuku, Gunma Prefecture, in the Tōhoku region of Honshu, excavated in 1946; this site confirms that Japan was inhabited by at least *c.* 28,000 BC. Tools unearthed more recently at Zasaragi, Miyagi Prefecture, may be even

Christian calendar	Commonly used periods (*jidai*)		Major era names (*nengo*)	Westernized periods
10,000 BC				
9000 BC				
8000 BC	JŌMON (*c.* 10,000 – *c.* 300 BC)	Early (*c.* 10,000-*c.* 3500 BC)		
7000 BC				
6000 BC				
5000 BC				
4000 BC				Primitive (*genshi*)
3000 BC		Middle (*c.* 3500-*c.* 2500 BC)		
2000 BC		Late (*c.* 2500-*c.* 1000 BC)		
1000 BC		Final (*c.* 1000-*c.* 300 BC)		
0				
AD 100	Yayoi (*c.* 300 BC-*c.* AD 300)			
AD 200				
AD 300				
AD 400	Yamato, KOFUN or Tomb period (*c.* AD 300-710)			
AD 500				
AD 600		ASUKA (*c.* AD 552-645)	Taika (AD 645-50) Hakuhō (AD 672-86) Taihō (AD 701-04) Wadō (AD 708-15) Tenpyō (AD 729-49)	
		HAKUHŌ (AD 645-710)		
AD 700	NARA (AD 710-94)			
AD 800	HEIAN (AD 794-1185)		Jōgan (AD 859-77) Engi (AD 901-23)	Ancient (*kodai*)
AD 900				
AD 1000		Fujiwara (AD 894-1185)	Kahō (1094-6) Hōgen-Heiji (1156-60)	
AD 1100		Rokuhara (1167-85)		
AD 1200	KAMAKURA (1185-1333)		Jōkyū (1219-22)	
AD 1300	MUROMACHI or Ashikaga (1333-1568)		Kenmu (1334-8)	Medieval (*chusei*)
AD 1400		Nanbokuchō (1336-92)	Ōnin (1467-9)	
AD 1500		Sengoku (1467-1568)		
AD 1600	AZUCHI-MOMOYAMA (1568-1600)		Bunroku (1592-6)	
AD 1700	EDO or Tokugawa (1600-1868)		Genroku (1688-1704)	Early Modern (*kinsei*)
AD 1800			Bunka-Bunsei (1804-30) Tenpō (1830-44)	
	MEIJI (1868-1912)		MEIJI (1868-1912)	Modern (*kindai*)
	TAISHŌ (1912-26)		TAISHŌ (1912-26)	
AD 1900	SHŌWA (1926-89)		SHŌWA (1926-89)	
	HEISEI (1989-)		HEISEI (1989-)	Contemporary (*gendai*)

2. Chronological table of Japanese history

older (?c. 48,000 BP). Over 2000 Palaeolithic sites have been identified, yielding stone choppers, knives, scrapers and fine flake and blade tools. Later sites (c. 11,500–8000 BC) contained fine obsidian microliths. Stone weapons were used to hunt Naumann elephants throughout the archipelago, giant deer in Honshu and Kyushu and mammoth on Hokkaido. A Naumann elephant tusk found at Lake Nojiri, Nagano Prefecture, was clearly shaped by hunters and probably used as a tool. The late Pleistocene witnessed earthquakes, volcanic activity and crustal movements, leaving an acidic soil that has hindered the preservation of human fossil remains. Sites such as Akashi, Hyōgo Prefecture, and Hamakita, Shizuoka Prefecture, however, have revealed a profusion of animal fossils and tools. No pottery has been found from this era.

There were two main Neolithic cultures, the Jōmon and the Yayoi. Sites of the Jōmon culture (c. 10,000–c. 300 BC) are found in many parts of Japan. The name derives from the cord design on Jōmon pottery, which is similar to that of eastern Siberia, indicating a population movement from north-eastern Asia. The beginning of paddy cultivation in north-western Kyushu towards the end of the Jōmon period is evidence of permanent settlement. The Yayoi culture, from which the Japanese trace the origins of their civilization, flourished c. 300 BC–c. AD 300. It is named after the street in Tokyo where the first site was discovered, and it rapidly superseded Jōmon culture, spreading throughout Kyushu and along the Seto Inland Sea. It is not certain whether Yayoi culture was the product of substantial immigration from Korea and northern China or the result of rapid internal evolution, but the agricultural techniques used during this time were clearly related to those of the rice-growing areas of the Asian mainland. Rice cultivation brought with it village organization and a technology superior to that utilized by the earlier Jōmon peoples. During the early part of the Yayoi period, bronzeworking reached Japan from China by way of the Korean peninsula. The origins of the native SHINTO ('way of the gods') religion, which linked people together through worship of local, clan and nature divinities, may also date from this time (see also §II, 2 below). A sense of line and proportion, harmony of colour, a preference for natural materials, the craftsmanship expressed in Yayoi pottery, early shrine architecture and tomb figures called *haniwa* represent the earliest manifestations of characteristically Japanese aesthetics.

By the 5th century AD one clan, the Yamato, had achieved supremacy; the impressive scale of imperial tombs from the late 4th century to the early 5th provides ample evidence of the political authority of this clan before historical times.

(iii) Age of Aristocratic Houses (c. 552–1185).

(a) Asuka-Hakuhō periods (c. 552–710). Asuka was the political and cultural centre of Japan from the late 6th century AD to the early 8th. During this time, Japanese leaders, aware of a coalescing in China into what would become the Sui (581–618) and Tang (618–907) dynasties, began to transform the Japanese ruling system from one based on clan superiority to a centralized imperial bureaucracy modelled on the Chinese system. In 607 Prince

SHŌTOKU opened formal missions to China and, for the next two centuries, the Japanese studied and borrowed extensively from the Chinese. The introduction of Buddhism in the 6th century from the Asian mainland (see §II, 3 below) brought with it new styles of architectural design, a vast pantheon of divinities unknown to the native Shinto religion and a speculative attitude towards man and the universe also not found in Shinto. These imported ideas drastically altered Japanese painting, sculptural and architectural styles in the Asuka-Hakuhō periods and in the following Nara period but represented a cultural overlay rather than a rupture of native values.

(b) Nara (710–94). In 710 the first permanent capital was established in NARA (anc. Heijō), modelled after the Chinese capital of Chang'an (modern Xi'an, Shaanxi Province). Japanese borrowing from the continent reached a peak with the completion of the temple of Tōdaiji (see NARA, §III, 4) in 752, during the reign of Emperor SHŌMU. The dedication to that temple of numbers of imported artefacts belonging to Shōmu underlines Japan's position at the end of the ancient Silk Route, the great trade route that connected China to India, Persia and the Mediterranean ports. Chinese influence was manifest also in the adoption of Chinese characters, used phonetically, as a writing system for the Japanese language. However, the first Japanese histories, the *Kojiki* ('Record of ancient matters'; 712) and the *Nihon shoki* ('Chronicle of Japan'; 720), were written in Chinese, not Japanese, since Chinese was regarded as more dignified and Chinese characters did not lend themselves readily to the writing of Japanese.

(c) Heian (794–1185). In 794 the capital was transferred north of Nara to Heian (see KYOTO, §I), which remained the imperial capital until 1868. Sensing the decline of the Tang dynasty, the Japanese sent their last official mission to China in the early 9th century, withdrew inside their borders and began to integrate all that had been borrowed. A powerful noble family, the Fujiwara (see FUJIWARA (ii)), rose to usurp the power, though not the title, of the throne, thus bypassing the established offices of the Chinese-style bureaucratic system. From the 9th century to the late 11th, the Fujiwara, then at the height of their fortunes, also exerted a decisive influence on culture and the arts. Two major monuments to Fujiwara taste are the Phoenix Hall of the BYŌDŌIN at Uji, near modern Kyoto, completed in 1053, and the gilt–wood Amida Buddha sculpted by JŌCHŌ installed within. These and the wall and door panel paintings inside the Byōdōin reveal a conscious Japanization of mainland prototypes. Another masterpiece of Heian-period art is the illustrated version of *Genji monogatari* ('Tale of Genji'), a courtly romance by a Fujiwara court lady. It is one of the earliest extant narrative scrolls (*emakimono*). These cultural achievements testify to the brilliant amalgamation of borrowed forms with purely native expression attained by the Japanese.

(iv) Age of Military Houses (1185–1868). The history of the 12th century is marked by the struggles for supremacy between two military clans, the Taira and the Minamoto, that climaxed in the Genpei War (1180–85) from which the Minamoto emerged victorious. In 1192 the emperor accorded the title of shogun ('generalissimo') to Minamoto

no Yoritomo (1147–99), the first of a line of military leaders who controlled Japanese politics until 1868. With time, such warrior values as loyalty to one's lord, skills in the military arts and asceticism came to permeate Japanese culture and society.

(a) Kamakura (1185–1333). Yoritomo transferred the centre of power to his headquarters in Kamakura. His *bakufu* ('tent government' or shogunate) was a practical, ad hoc system of offices created according to need, and it worked effectively until the late 13th century. The 12th and 13th centuries were characterized by tumult and upheaval, culminating in two attempted invasions by the Mongols in 1274 and 1281. Responding to these critical times, three priests, Hōnen (1133–1212), Shinran (1173–1263) and Nichiren (1222–82), simplified Buddhist doctrine and brought it to the masses. The promise of salvation found wide acceptance. The spread of Buddhism to all classes throughout Japan is reflected in the subject-matter of many narrative scrolls (*emakimono*). Commissioned to replace icons in the Tōdaiji and Kōfukuji temples in Nara (*see* NARA, §III, 7), which had been damaged in the Genpei War, the master sculptor UNKEI combined the classical aristocratic style of the Nara and Heian periods with the muscular power of the new military age. Zen Buddhism, introduced into Japan in the late 12th century by the monk Eisai (1141–1215), found strong patronage among the warrior class. Its cultural implications were to flourish under the Ashikaga leaders.

(b) Muromachi (1333–1568). The founder of the ASHI-KAGA dynasty, Ashikaga Takauji (1305–58), established his headquarters in the Muromachi section of Kyoto. Under Ashikaga leadership, political power was held in a delicate balance between members of the family, who were dominant, and their key vassals (*shugo*). These vassals wrested the control of the provinces from any remaining influence of the earlier aristocratic system, and, during the Muromachi period, the position of the emperor reached its lowest ebb.

Three Ashikaga shoguns, Takauji, Yoshimitsu (1358–1408) and Yoshimasa (1435–90), were the most influential patrons of culture and the arts during this time. Takauji renewed formal contacts with China and imported wares from the new Ming dynasty (1368–1644), creating a new enthusiasm for Chinese arts and culture. Several Zen Buddhist temples in Kyoto, among them Myōshinji, Tō-fukuji, Shōkokuji and Daitokuji (*see* KYOTO, §IV, 5), served as centres of Chinese learning, poetry and *suibokuga* (Chinese-style landscape painting in monochrome ink; *see* §VI, 4(iii) below).

Ashikaga power reached its zenith under the third shogun, Yoshimitsu, who was most successful in holding the powerful clans in check. Early in the 15th century he retired to Kinkakuji (Temple of the Golden Pavilion; *see* KYOTO, §IV, 6) in the northern hills (Kitayama) of Kyoto. At his court exquisite *nō* theatre was performed by Kan'ami (1333–84) and his son Zeami (1363–1443), and an early form of the tea ceremony was practised using imported Chinese porcelain wares. Yoshimitsu's grandson Yoshi-masa attempted to emulate his grandfather's political acumen but retired in 1473 during the Ōnin War (1467–

77), which erupted in Kyoto among the Ashikaga vassals. He built a retirement villa in Higashiyama, where his cultural patronage and connoisseurship more than compensated for his failure to hold Ashikaga power intact. He gathered around him a number of skilled artists and craftsmen—*nō* performers, masters of the tea ceremony, potters, garden designers, painters of *suibokuga* and connoisseurs of Chinese *objets d'art*. From these gatherings emerged a brilliant synthesis of aristocratic, military and Zen values that became one of the most enduring traditions in the whole of Japanese cultural history. The period between 1467 and 1568 is known as the Sengoku (Warring States) period.

(c) Momoyama (1568–1600). The Momoyama or Azuchi–Momoyama period is named after the castles at these sites. The country was divided into numerous contending feudal domains until the emergence of three generals, ODA NOBUNAGA, TOYOTOMI HIDEYOSHI and Tokugawa Ieyasu (1543–1616), who unified the country in the second half of the 16th century. Westerners first appeared in Japan during this period of turmoil, and their records convey some of the most vivid images available of the period. The unifiers were ambitious men whose interest in the arts was largely political. Castles became splendidly ornamented structures rather than simply defensive outposts of wood and plaster (*see* §III, 4(ii)(c)). The programmes of paintings conceived to cover the vast expanses of interior wall space were carefully planned to serve the public as well as the personal requirements of the patrons and their families. Meeting these demands called for the combined efforts of several talented artists. Foremost of these was Kanō Eitoku (*see* KANŌ, (5)), commissioned first by Nobunaga to decorate Azuchi Castle (destr. 1582). His motifs drew on traditional Chinese-style (*suibokuga*) and Japanese-style (*Yamatoe*) painting (*see* §VI, 3(iii) below) to form a bold, innovative style. More than before, the arts in the Momoyama period were predominantly secular, except for Christian icons produced by Christian Japanese artists, as instructed by the missionaries. *Nanban* ('southern barbarian') painting (*see* §VI, 4(vi)(a) below), which developed in the 16th century, was the first attempt by Japanese artists to emulate Western style and subject-matter.

(d) Edo (1600–1868). In 1600 Japan was unified by Tokugawa Ieyasu; the shogunal dynasty he established lasted until 1868. The warriors of earlier generations became bureaucratic peace-keepers, and society was structured into four classes: military, agricultural, artisan and merchant. The hierarchical social system of the Tokugawa was underpinned by the teachings of Confucius, adapted into a new form called Neo-Confucianism, which promoted the idea that a man's identity stemmed primarily from his role in society. Group membership and family cohesion became key ethical values, which continued to permeate Japanese society into modern times. The country was divided into 262 feudal domains, each governed by a lord (daimyo). In 1639 Westerners were ordered to leave Japan, Christianity was banned and the Japanese entered into a period of isolation from the Western world. Despite such restrictions, a tremendous expansion took place in

the growth of markets, in varieties of agricultural products and in learning. A virtual renaissance enriched all the arts. Continuity was maintained in the traditional schools of painting—Kanō (*see* KANŌ SCHOOL) and Tosa (specializing in *Yamatoe*)—and the demands of new merchant patrons were served by new schools such as Rinpa (*see* §VI, 4(v) below) and *ukiyoe* ('floating world'; *see* §VI, 4(iv)(b) below) or by *Nanga* (Japanese literati painting based on the traditions of the Southern school of Ming-period China; *see* §VI, 4(vi) (e) below). A new interest in Western culture resulted in Western-style painting (*Yōga*; *see* §VI, 5(iv) below). Sculpture, which had reached its most innovative peak during the Kamakura period, was now turned to the production of miniatures, usually of wood or ivory, called *netsuke* (*see* §XVI, 17 below). Most famous of the Edo-period arts were the woodblock *ukiyoe* prints (*see* §IX, 2(iii) below), with images of courtesans and actors of the *kabuki* theatre (*see* §XIII, 2 below) and later of the Japanese landscape.

From the early 19th century, rapid changes began to occur in response to internal and external pressures. The Tokugawa system, which operated on precedent, had outlived its usefulness, and new forms of government were plainly needed. Western powers were insistently trying to persuade the Tokugawa officials to end their closed-door policy (*sakoku*). It fell to an American, Commodore Matthew Perry, with his expedition of 1853–4 and the treaty of Kanagawa in 1854, to reopen Japan to foreign trade after 200 years.

(v) Modern (after 1868). From the mid-19th century to the mid-20th Japan underwent monumental change, taking the West as its model in matters political, social and economic. Within little more than a generation Japan evolved from a military feudal nation into a limited constitutional monarchy under Emperor Meiji (*reg* 1868–1912). Feudal domains were abolished (1871) and replaced by prefectures; class divisions gave way to social and professional mobility. A powerful government was established, both to meet the requirements of the West and to reorganize and expand Japan's national structure. Western specialists were invited to Japan, and many Japanese were sponsored by the government to study abroad and bring back what would best serve Japan's drive to modernize. Diplomatic missions were sent to China and the West. By 1905 Japan had proved the success of her programme, becoming, in the Russo–Japanese War, the first Asian nation to defeat a major Western power. After a period of domination by military extremists during the 1930s and defeat at the end of World War II in 1945, Japan rebounded economically and culturally to emerge as a major world power.

In every field of art, the Japanese displayed an unquenchable desire to borrow and adapt Western ideas, so that every style that enjoyed a vogue in the West also found its counterpart in Japan. However, throughout the 20th century the Japanese also held on to their traditions. Painters worked in Western styles but at the same time strove to preserve the Japanese traditional style (*Nihonga*; *see* §VI, 5(iii) below) by adapting it to current tastes and demands. Tokyo became one of the flourishing cultural centres of the world, and modern Japanese architecture

(*see* §III, 5 below) attracted international admiration for its bold experimentation and its imaginative use of Eastern and Western traditions and trends.

BIBLIOGRAPHY

Kodansha Enc. Japan
No Yasumaro: *Kojiki* [Record of ancient matters] (AD 712); Eng. trans. by B. Hall Chamberlain, 2nd edn with notes by W. G. Aston (Kobe, 1932)
Prince Toneri: *Nihon shoki* [Chronicle of Japan] (AD 720); Eng. trans. by W. G. Aston as 'Nihongi', *Trans. & Proc. Japan Soc., London*, suppl. (1896) [whole issue]
Murasaki Shikibu: *Genji monogatari* (11th century); Eng. trans. as *The Tale of Genji*, Penguin Classics (Harmondsworth, 1981)
G. Sansom: *Japan, a Short Cultural History*, Cresset Historical Series (London, 1931, rev. 2/1962)
D. Keene, ed.: *Anthology of Japanese Literature, from Earliest Times to the Mid-19th Century* (New York, 1955)
G. Sansom: *History of Japan*, 3 vols (Stanford, 1958–63)
R. Tsunoda, ed.: *Sources of Japanese Tradition* (New York, 1958)
W. Beaseley: *The Modern History of Japan* (New York, 1963)
B. Smith: *Japan: A History in Art* (New York, 1964)
J. Hall, ed.: *Twelve Doors to Japan* (New York, 1965)
J. Hall: *Japan from Prehistory to Modern Times* (New York, 1970)
H. P. Varley: *Japanese Culture: A Short History* (London, 1973, rev. Honolulu, 3/1984)
E. Reischauer: *Japan, Tradition and Transformation* (Boston, 1978)
S. Katō: *A History of Japanese Literature*, 3 vols (Tokyo, 1979)
——: *Form, Style and Traditions: Reflections on Japanese Art and Society* (Tokyo, 1981)
E. Reischauer: *The Story of a Nation* (New York, 1981)
T. Ienaga: *Nihon bunka shi* [Japanese cultural history] (Tokyo, 1982)
W. Morton: *Japan, its History and Culture* (New York, 1984)
J. Lowe: *Into Japan* (London, 1985)
R. Pearson: *Windows on the Japanese Past: Studies in Archaeology and Prehistory* (Ann Arbor, 1986)
E. Reischauer: *The Japanese* (Cambridge, MA, 1988)

BONNIE ABIKO

3. TRADE.

(i) 3rd century AD–1185. (ii) Kamakura and Muromachi periods (1185–1568). (iii) Momoyama and Edo periods (1568–1868). (iv) After 1868.

(i) 3rd century AD–*1185.* According to Chinese records, Chinese and Japanese merchants engaged in some trade with each other as early as the 3rd century AD. Japanese trading contacts with Korea also appear to date back to this period. Trade was further expanded with the introduction of Buddhism into Japan in 552 and the political unification of the country in the 6th and 7th centuries. From 607 onwards official embassies were regularly dispatched to China. These continued throughout the Nara period (710–94) and, until 838, in the Heian period (794–1185). Trade was closely linked to diplomacy during these centuries. Attempting to model their civilization on that found in China during the Sui (581–618) and Tang (618–907) periods, the Japanese imported not only material goods but also institutional patterns, technological expertise and artistic skills. These were often carried to Japan by scholars, artists and technicians closely associated with the Buddhist faith, which played a central role in both private and official relations between the Japanese court and the Asian continent.

Evidence of the high artistic and aesthetic quality of the material objects brought to Japan by this early trade can be found in the Shōsōin, the treasure-house of the Tōdaiji temple complex in Nara (*see* NARA, §III, 3), which preserves many of the objects brought to Japan in 752 to commemorate the construction of the *Great Buddha* statue commissioned by Emperor SHŌMU. Less tangible aspects

of this trade can be seen in the architectural monuments of the age, such as Tōdaiji, HŌRYŪJI and Tōshōdaiji, as well as in the many creations in sculpture, painting and the minor arts that showed the influence of foreign artists, craftsmen and technicians.

By the mid-9th century, the once-flourishing trade with the continent that had brought goods to Japan not only from China and Korea but along the Silk Route from as far away as the Near East and Central Asia had slowed considerably. Official contacts with China ceased. While some private trade in such luxury goods as scrolls, Buddhist images and paintings, temple furnishings, books of verse and prose, drugs, incense and perfume persisted, Japan turned largely inward. China, in dynastic decline, appears to have temporarily lost its attractions. Preoccupied with internal affairs and domestically self-sufficient, Japanese aristocrats devoted themselves to creating a culturally refined world like that of the fictional Shining Prince immortalized by Lady Murasaki in her book *Genji mono-gatari* ('Tale of Genji'; *c.* 1005) and saw only a limited need for trade with the outside world.

(ii) Kamakura and Muromachi periods (1185–1568). It was not until the emergence of the Kamakura and ASHIKAGA shogunates that trade once again began to play a significant role in Japan's cultural and economic life. With the rise to power of the Song dynasty in China (960–1279), and with the strained economic and political conditions that accompanied Japan's transformation from centralized monarchy to early feudal state, both legitimate trade and piracy increased. Official relations with China, in abeyance since 894, were resumed by Taira no Kiyomori (1118–81) in the middle of the 12th century when he sent tribute to the Song government and received gifts in exchange. Both official and unofficial trade with China were further encouraged by Kiyomori's successor, Minamoto no Yoritomo (1147–99), after he became shogun in 1192. During the Kamakura period (1185–1333) many shogunal vassals, particularly those resident in western Japan, also engaged in foreign trade, and ports such as Munakata in northern Kyushu and Bōnotsu in southern Kyushu grew into trading centres. Imports from China during this period included silks, brocades, perfumes, sandalwood, copper coins and scarce commodities such as tea, incense and fine porcelains; exports consisted of gold, mercury, fans, lacquerware, screens, swords and timber.

Japan's relative backwardness in naval construction meant that most of this trade relied on Chinese ships, on which Zen Buddhist monks also travelled to Japan. Profits from trade often supported important monasteries and paid for construction projects such as the *Great Buddha* statue that was erected at the temple of Kōtokuin in KAMAKURA in 1252.

The Mongol invasions of 1274 and 1281 seriously inhibited contacts with the continent during the Yuan period (1279–1368) but gave an impetus for Japan to renew its interest in naval construction. With the collapse of the Kamakura order and the rise of the Ashikaga in 1336, the Ashikaga shoguns and their largely independent vassals, confronted by increasing political turmoil and a changing feudal structure that linked political survival with economic rationalization, turned increasingly to foreign trade. Japanese-built ships regularly frequented the ports of Korea, China and the Ryukyu Islands. Moreover, Japanese freebooters (*wakō*), like their Elizabethan counterparts in Europe, were quite willing to turn to piracy when legal attempts to trade were spurned by Koreans or Chinese. Warrior-merchants were only one of the new types of maritime 'traders'. In the early years of the Muromachi period (1333–1568), Zen monasteries, particularly Tenryūji in Kyoto, also took an active part in this trade. The *Tenryūji-bune* ('Tenryūji ship') was a trading vessel that in 1342 made the first government-authorized voyage to China after the Mongol invasions. Sponsors of the ship undertook to contribute cash for the building of Tenryūji in return for potential trading profits and protection from pirates. Ships belonging to other monasteries, Shinto shrines and local lords regularly made their way to China thereafter.

Confronted with continuing Japanese pirate attacks, the Koreans agreed in 1443 to substantial increases in the legitimate trade—some 50 ships annually—and granted the Japanese rights to maintain trading settlements in three Korean ports. In China the Ming dynasty (1368–1644) made similar efforts to control Japanese pirates through official trade negotiations. In 1402 Ashikaga Yoshimitsu (1358–1408) agreed to curb Japanese corsairs in exchange for renewed diplomatic relations with the continent. Recognized by the Ming as the 'King of Japan', Yoshimitsu in 1404 accepted a 'tributary' relationship to China that allowed him to send trade missions every ten years. This trade came to be known as the tally trade, after the official tallies of Japanese ships allowed to enter Chinese ports. While the tally trade never lived up to expectations, private trade continued to expand substantially in the late 15th century and early 16th. According to the records of the official tally trade, the 1483 'embassy' took to China raw materials, such as sulphur and copper, as well as manufactured goods, such as fans, scrolls and Japanese arms—some 37,000 swords. Imports during this period included silks, porcelains, books, paintings and, above all, copper coins. One 'embassy', in 1453, brought back more than 50 million coins, indicating the degree to which foreign trade was becoming an essential feature of Japanese domestic economic growth.

Political turmoil in Kyoto, particularly after the Ōnin War (1467–77), seems to have further aided commercial and cultural diffusion and development. Whereas interest in the fine arts had previously been limited to court circles and the monasteries, many of Japan's feudal lords at this time prided themselves on owning important works of art, some of continental origin, and invited great artists to their domains. Trading profits financed the visit of the painter Tōyō Sesshū to the Ōuchi house in Yamaguchi, where he painted his celebrated *Long Landscape Scroll* (*Landscapes of the Four Seasons*; 1486; Hōfu, Yamaguchi Prefect., Mōri Mus.).

(iii) Momoyama and Edo periods (1568–1868). During the 16th century Japan's greatest pre-modern expansion of trade and commerce took place. Japanese maritime traders were active not only in Korea and on the China coast but as far away as Siam, Burma, Sumatra and Java. It was in the Straits of Malacca that the Japanese first encountered

European traders. These soon followed them to Japan, the Portuguese arriving in 1542, the Spanish in 1584, and the Dutch and English setting up trading stations in 1609 and 1613 respectively. On the domestic front too, the political competition that eventually led to the reunification of the country under ODA NOBUNAGA, TOYOTOMI HIDEYOSHI and Tokugawa Ieyasu (1543–1616) spurred Japan's feudal lords into strenuous efforts to improve their economic position by encouraging internal as well as external commerce. New commercial centres, such as the port cities of Sakai (part of modern Osaka) and Hakata, were even temporarily able to challenge feudal authority as their citizens grew wealthy from the exchange of foreign and domestic goods. With the arrival of European traders there was a further boom, as sites such as NAGASAKI and Hirado (off the west coast of Kyushu) grew from mere fishing villages into major trade centres. For a time local lords vied with one another to have the Portuguese traders visit their ports, in some cases even offering to 'Christianize' their peasantry to assure the arrival of the European ships. In the 1590s, in an attempt to counter piracy and illegal trade, Toyotomi Hideyoshi initiated a system of issuing certain merchants with permits in the form of vermilion seals (*shuin*) in order to verify the protected status of their ships (*shuinsen*; see fig. 3).

However, the rise to power of the Tokugawa shoguns at the beginning of the Edo period (1600–1868) brought to a halt the Japanese commercial and trade expansion into East and South-east Asia that had marked the 16th century. In order to ensure domestic political tranquillity, the Tokugawa adopted a series of policies that proved inimical to trade. They largely closed Japan to European influences, including Christianity, expelling the Spanish in 1624 and the Portuguese in 1639. The English had abandoned their trading post at Hirado in 1623. The sole remaining representatives of Europe in Japan were the Dutch, who in 1641 were moved to the manmade island of Dejima in Nagasaki Harbour, where in prison-like conditions they were allowed to pursue a strictly controlled trade for the next two centuries. An edict of 1636 furthermore forbade Japanese to leave the country on pain of death and restricted naval construction to that of coastal vessels. Although a few Chinese ships were allowed to trade in Nagasaki and some licit and illicit trade took place through the Ryukyu Islands and with Korea through Tsushima Island in the Korea Strait, from the 1640s to the 1850s trade with the outside world ceased to be a major force in Japanese economic life.

In the mid-19th century the Western powers returned to Japan. Backed by the superior weapons of the scientific and industrial revolutions, Europeans and Americans clamoured for the opening of Japan to trade and foreign contacts. The Tokugawa had little choice but to accede, and in 1854 they signed the Kanagawa treaty (*see* §2 above). In 1858 Japan signed the first of the commercial treaties with the American minister Townsend Harris. These were followed in rapid succession by treaties with all the major European powers. Essentially 'unequal', these treaties called for the opening of six Japanese ports— Shimoda (on the south coast of central Honshu), Kanagawa (YOKOHAMA), Hakodate (in southern Hokkaido), Nagasaki, Hyōgo (KOBE) and Niigata (on the west coast

3. Japanese votive picture showing *shuinsen* (vermilion seal) ship, a type of vessel, combining the features of a Chinese junk and European caravel, used for overseas trade *c.* 1600, colours on wood, 1.85×2.08 m, 1634 (Kyoto, Kiyomizudera)

of Honshu)—to Western trade. In addition they fixed Japanese customs duties at low rates and provided extraterritoriality for Westerners residing in the treaty ports.

(iv) After 1868. The arrival of foreigners, unwelcome to many Japanese, and the mounting domestic inflation that stemmed from the export of vast quantities of gold helped to destabilize the already tottering Tokugawa regime, which in 1868 gave way to an imperial restoration. The Meiji Restoration (named after the newly enthroned boy-emperor) ushered in Japan's modern age. Under a group of able and youthful leaders, Japan rapidly transformed itself into a modern industrialized nation, taking the West as its model and importing not only Western goods but also large components of Western civilization in many fields such as architecture, painting and music.

The makers of modern Japan were well aware that their resource-poor country would have to rely on trade to improve its standard of living. It can be argued, indeed, that many of Japan's struggles in modern times—its imperialist expansion of the first two decades of the 20th century, its militaristic seizure of Manchuria and war with China in the 1930s and its role in World War II in the Pacific—had deep roots in the need to trade and to find markets. Japan was quick to counter the great influx of Western imports with export drives in silk, tea and copper in the later 19th century and textiles in the early 20th. Later, industry and exports developed, from light to heavy manufacturing, from textiles to shipbuilding, automobiles, photo-opticals, electronics and, in the latter part of the 20th century, to such advanced industries as computers and robotics. The 'world's factory', as many Japanese see their country, became the quintessential trading nation.

BIBLIOGRAPHY

Kodansha Enc. Japan: 'Dutch trade', 'Economic history', 'Foreign trade', 'National seclusion', 'Shipbuilding industry', 'Ships', 'Tally trade', 'Transportation', 'US, economic relations with, 1945–1973', 'Vermilion seal trade', '*Wakō*'

Y. Tabekoshi: *The Economic Aspects of the History of the Civilization of Japan*, 3 vols (New York, 1930)

E. Honjo: *The Social and Economic History of Japan* (Kyoto, 1935)

Y. Kuno: *Japanese Expansion on the Asiatic Continent*, 2 vols (Berkeley, 1937–40)

G. B. Sansom: *History of Japan*, 3 vols (Stanford, 1958–63)

J. W. Hall, M. B. Jansen, M. Kanai and D. Twitchett, eds: *The Cambridge History of Japan*, 6 vols (Cambridge, 1989–)

F. G. NOTEHELFER

4. CONCEPT OF ART. Japanese concepts of art evolved from a dynamic and mutually modifying interplay of indigenous, Chinese and Western constructs. This process began with the arrival of craftsmen from the Asian continent in the 6th century AD and continued in the late 20th century, as Japanese artists and critics grapple with post-modern art theory. In Japan, as elsewhere, there exists no single, all-embracing concept, but rather a mix of complementary and often contradictory ones that vary according to period and context. Many assumptions about art were prevalent long before they were clearly articulated in theoretical treatises and even before the modern term *bijutsu*, equivalent to the English 'art', was coined in the 1870s.

References to ceramics, sculpture and painting in 8th-century writings reveal that art was first understood to mean professional skills or crafts and that these were valued primarily for their educational, religious or political use (*see* §5 below). Art was usually made within a religious or ritual context that imbued both the process of creation and the outcome with a special aura of sanctity. Excellence of workmanship, which in the case of religious icons included adherence to canonical measurements, materials and iconography, was a primary consideration.

Buddhist scriptures such as the Lotus Sutra, translated from Sanskrit into Chinese in the 3rd century AD and available in Japan as early as the 6th century, contributed to the development of an instrumentalist outlook that held both the creation and veneration of works of art to be conducive to the attainment of enlightenment. This belief remained a conspicuous leitmotif in Japanese attitudes towards art until the Edo period (1600–1868). The monk KŪKAI, founder of the Shingon sect of Buddhism, placed special emphasis on the arts in his teachings and was perhaps the first Japanese to posit a theory of the visual arts. In his view, art, especially painting and sculpture, reveals the state of perfection, and beauty is a manifestation of the divine.

Poetic theory contributed significantly to Japanese concepts of art, especially in the secular realm. *Aware*, a term implying a sensitivity to the beauty and perishability of things, became a key concept in Japanese aesthetics from the Heian period (794–1185). Many forms of painting, as well as ceramics, lacquer and other forms classified as 'decorative' or minor arts in the West, were valued primarily for the poetic sentiments to which they gave visual expression or which were ascribed to them through names. Naming was an especially important practice in the context of the tea ceremony (*chanoyu*; *see* §XIV below).

Linking a teabowl or tea caddy to the courtly tradition through names, usually allusive words from classical *waka* (31-syllable) verse, helped to elevate these crafts to a special status, which they still enjoy.

The transplantation of Chinese culture in the 14th century by Zen (Chin. Chan) monks contributed to the diffusion of new forms of and attitudes towards art. The pre-eminence of Chinese-style ink painting (*suibokuga*) and calligraphy (*see* §§VI, 4(iii) and VII, 2(iv) below) coincided with growing sensitivity to individual expression, as manifested primarily in the qualities of line and wash. In Japan, as in China, many of the criteria and terms in which painting was discussed derived from those applied first to calligraphy. Calligraphy was considered to be not merely a means of communication but also of self-expression and of revealing the writer's inner character, and as such an art of the highest order.

The impact of Chinese ideas about art grew dramatically in the Edo period, reflecting, on the one hand, increased access to art and literature from the continent and, on the other, the strong Sinophile bias of the Tokugawa government. The official outlook on art was primarily moral and utilitarian rather than aesthetic. Following Confucian principles, it held that the practice and promotion of the arts by the ruling élite served to legitimate the regime, impart the proper moral values to the populace and ensure cosmic harmony. These officially sanctioned arts included painting, calligraphy, music, *nō* theatre (*see* §XIII, 1 below) and *chanoyu*, no clear differentiation being made between the visual and the performing arts. The classification of shogunal and daimyo possessions further reveals a hierarchy in which those arts that served official functions (*omote dōgu*) took precedence over those that satisfied private pleasures (*oku dōgu*). Articles from China or with Chinese connotations figured prominently among the former and those associated with the Japanese courtly tradition among the latter.

Many of the official artists serving the feudal government wrote treatises on art (*see also* §XVII below), which focused mainly on technical matters, although they often reiterated the importance of basic aesthetic principles, such as spirit resonance (Chin. *qiyun*, Jap. *ki*), derived from Chinese writings (for further discussion of Chinese concepts of art *see* CHINA, §§I, 7 and V, 5). Kanō Yasunobu summed up the basic outlook characteristic of these hereditary artistic lineages in his *Gadō yōketsu* ('Secrets of the way of painting'), namely that painting based on the study of models (*gakuga*) was superior to that based on innate talent (*shitsuga*).

Treatises by other artists reveal conflicting attitudes towards art in general and painting practice and theory in particular. One of the dominant themes in writings of the Edo period is the distinction and relative value of art created by amateur versus professional artists. This often heated issue followed aesthetic criteria and principles of classification that were important in the Chinese artistic tradition but not readily applicable to Japan. The term *sha'i* (Chin. *xieyi*; 'sketching the idea'), capturing the underlying sense or idea of a subject rather than merely its superficial appearance, represented the stated goal of many proponents of 'amateur art', especially painters associated with the literati (Chin. *wenren*; Jap. *bunjin*) tradition.

Criticism of the Sino–Japanese artistic tradition became prevalent in the 19th century among students of Dutch or Western studies (*Rangaku*), who appreciated Western realism for its rationalistic and utilitarian qualities. Shiba Kōkan, whose *Seiyo gaden* ('Discussion of Western painting'; 1799) paid special tribute to Western techniques of chiaroscuro and scientific perspective, was an early proponent of attitudes that became widespread among artists and critics of the early Meiji period (1868–1912). The adoption of Western techniques and concepts of art was linked to the nationalistic struggle to become a modern state.

Traditional Sino–Japanese concepts of art have not been entirely discarded since the Meiji era but rather overlaid with a multiplicity of newer ones imported from the West. Art in late 20th-century Japan has a participatory dimension not found in the West. Mastery of traditional arts, such as calligraphy, painting, *chanoyu* or flower arrangement (*see* §XVI, 9 below), is considered especially important for women. A hierarchical division between the 'fine' (*bijutsu*) and the 'decorative' (*kōgei*) arts has been accepted more readily among art critics and scholars than among practising artists. Both the continuing popularity of the tea ceremony and the impact of the nationalistic writings of MUNEYOSHI YANAGI, founder of the Japanese folk crafts or MINGEI movement, have assured ceramics, lacquer and other 'crafts' a status far higher than they enjoy in other industrialized nations. Despite the intermingling of value systems, a polarity between Western and Japanese art remains central to the modern concept of art in Japan. This division is especially pronounced in the practice of classifying modern Japanese painting into two distinct modes, *Nihonga* ('Japanese painting'; *see* §VI, 5(iii) below) and *Yōga* ('Western-style painting'; *see* §VI, 5(iv) below).

See also §XXII below.

BIBLIOGRAPHY

M. Ueda: *Literary and Art Theories in Japan* (Cleveland, OH, 1967)
S. Kato: *Form, Style, Tradition: Reflections on Japanese Art and Society*; Eng. trans. by J. Bester (Berkeley, 1971)
T. Sakazaki, ed.: *Nihon kaigaron taikei* [Overview of Japanese painting treatises], 5 vols (Tokyo, 1979)
G. Weigl: 'The Reception of Chinese Painting Models in Muromachi Japan', *Mnmt Nipponica*, xxxvi/3 (Autumn 1980), pp. 257–71
N. Tsuji: *Nihon bijutsu no mikata* [Japanese concepts of art], Nihon bijutsu no nagare [Currents in Japanese art], vii (Tokyo, 1991–2)

CHRISTINE M. E. GUTH

5. STATUS OF THE ARTIST.

(i) Introduction. (ii) Historical survey.

(i) Introduction. The concept of the status of the artist was introduced to Japan from the West only in the second half of the 19th century. In pre-modern Japan, there was no such generic term as 'artist': instead specific terms such as painter (*eshi*) or lacquer specialist (*maki eshi*) were used. The term *shokunin*, usually translated as 'artisan', was applied not only to those engaged in the production of the visual arts but also to performers, gamblers and anyone else engaged in non-agricultural activities. The terms *bijutsuka*, *geijutsuka* and *geinōka*, all meaning 'artist', appeared in the late 19th century as translations of the Western term. The artist/artisan dichotomy is a modern Western concept, although the term 'artist', designating an autonomous creator who imbues his work with his own personality, has been used in the West since the 15th century. In Japan before 1850, however, art in all media—painting, sculpture, architecture, lacquer, metalwork and ceramics—was largely the product of a cooperative enterprise, the workshop, much as it was in pre-Renaissance European art. Although the terms *bijutsu* (fine arts) and *kōgei* (decorative arts) emerged in Japan in the mid-19th century, Japan's rich heritage of 'decorative arts' was not swept aside with the introduction of Western ideas.

At the beginning of recorded history in Japan, the status of the artist was, in general, low, but over time it rose steadily. All artists of status and title were men. They arose from a wide range of social backgrounds: their status was connected with patronage and their skill and choice of subject-matter. The social status of an artist was not necessarily consistent with his financial situation. In pre-modern Japan, masters of different art forms—a lacquerer and a painter, for example—enjoyed similar degrees of prestige; the arts themselves were not ranked in a hierarchical way. However, the official lacquerer to the military élite had greater status than a professional city painter (*machi eshi*).

The technical and philosophical basis of traditional Japanese art owed much to Buddhist and Chinese importations from the 6th century AD onwards. In China after the Song period (AD 960–1279), only the scholar–amateur or gentleman was considered a true artist. Because of fundamental differences between Chinese and Japanese societies, however, almost all producers of art in traditional Japan were professionals, even Edo-period (1600–1868) painters who claimed to espouse Chinese amateur ideals. Chinese aesthetic theory, which accorded special distinction to the arts of the brush (poetry, calligraphy, painting), was influential but not dominant in traditional Japan. The Japanese sword, prized as the symbol of the military élite from ancient times, was part of the imperial regalia and among the most exalted of Japanese arts. The tea aesthetic (*see* §XIV below), which exerted a major influence on Japanese tastes and views of the arts from the 15th century, did not discriminate between fine and decorative art but prized a whole range of arts, including ceramics, lacquer, painting and calligraphy, textiles and metalwork.

The traditional primary unit of social organization in Japan for much of its history was the *ie* ('family' or 'household'). Consistent with this hierarchical, hereditary pattern of relationships was the existence of the *iemoto*, the founder or current head (and usually descendant of the founder) of a school. This system existed in rudimentary form in workshops engaged in the arts as early as the late 12th century, extending to literary and performing as well as visual arts. While the *iemoto* mode of organization changed over time and varied with each workshop and enterprise, its general characteristics were that the authority, property, social standing, secrets, techniques, skills and vocation of the workshop were all transmitted through the *iemoto*, who represented the unit to the outside world. His status was even more exalted if he was the founder of the lineage or the originator of that line's mode of production. The members of a workshop were usually related by blood, but this was not a requirement. Adopted members brought in to contribute talent or to maintain

the line severed all ties with their previous family and had full rights in their new family, assuming also its status and position in society. The *iemoto*, who maintained his position and title until his death, was responsible for selecting and training a successor.

(ii) Historical survey.

(a) 6th century AD–1600. (b) 1600–1868. (c) After 1868.

(a) 6th century AD–1600. When Buddhism was imported into Japan in the 6th century AD, a large number of technicians and specialists were required to produce the texts and images of the new religion. Many of their names appear in the earliest Japanese historical documents. With few exceptions, these early 'artists' were of foreign origin, low social status and relative anonymity. They were organized into hereditary occupational groups (*be*) that supported the imperial court from the late 5th century to the 7th. The influx of Korean specialists (*kikajin*) led to the reorganization of these *be* into 180 groups, reflecting the great diversity of skills even at this early time. Literacy was a qualification for the position of leader (*tomo no miyatsuko*) of a group, who supervised its work and was an official at court with the hereditary honorary title of *kabane*.

Sculptors. Sculptors comprised some of the earliest groups, because of their important role in producing the primary devotional objects of the new temples (*see* §V, 3 below). After the Taika Reform of 645, the earlier occupational groups were transformed into offices and workshops of the central government and imperial court, organized on principles imported from the continent. For the construction of the colossal Tōdaiji temple–monastery in the new capital of Nara (*see* NARA, §III, 4) in the mid-8th century, the Office of Tōdaiji Construction (Zō Tōdaiji-shi) was established at the site by the government. Within this office was a workshop for the production of Buddhist sculpture (*zōbutsujō*), which employed large numbers of specialists. Offices for temple construction (*zōjishi*) and sculpture workshops (*zōbussho*) of this kind were set up for many of the major temples established during the Nara period (710–94).

After the Tōdaiji office was closed in 789, many of its sculptors entered private studios. Also, from about the beginning of the 10th century, Buddhist monks such as Eri Ajari (852–935), who served at the temple Tōji in Kyoto, began to emerge as sculptors. Later that century, professional sculptors who enjoyed the patronage of the leading political and cultural figures of the day increasingly began to receive honours and shed their anonymity. The Buddhist sculptor (*busshi*) Kōshō was honoured in 998 with the ecclesiastical title of teacher (*kōshi*) of Tosa Province and later received a similar title for Ōmi Province.

The great monasteries of the 8th century were built primarily by the central government. The sculptors were not directly connected with the temple until the middle of the Heian period (794–1185), when temples established special relationships with either the imperial family or one of the great families of aristocrats at court and also with families of sculptors who worked exclusively for a particular temple. At that time 'great Buddhist sculptors' (*daibusshi*) of exceptional talent were distinguished from 'lesser sculptors' (*shōbusshi*) or assistants. For some large-scale projects, several *daibusshi* would work together and oversee the work of 100 or more assistants.

Although each workshop had a distinct hierarchy, it was not until the mid-Heian period that sculptors achieved some degree of independence and exalted status. The rise of the independent professional sculptor and the institution of the workshop system (*bussho*) for the production of Buddhist sculpture were due in part to such technological advances as joined-woodblock construction (*yosegi zukuri*). The perfector of this technique, JŌCHŌ, was the first Buddhist sculptor to receive the title of *hokkyō* (Bridge of the Law; 1022) and *hōgen* (Eye of the Law; 1048). These ecclesiastic titles had, since their institution in the 9th century, previously been reserved for the highest-ranking members of the Buddhist clergy. The awarding of these titles to Jōchō raised the social status of the professional Buddhist sculptor and set a precedent for the imperial court to bestow these titles on professional artists of all disciplines.

Other artists and craftsmen. Unlike the production of sculpture, which was concentrated at the imperial court and the major temples of the capital, the art of swordmaking developed regionally. Swordsmiths, because of the importance of their product in a society where political and economic power was held from the 12th century onwards by the military, had a high and independent status from early times. The cost of materials was an important factor in determining the independence and status of the artist in the Nara and Heian periods. A lacquer technique known as *makie* (*see* §X below) was, with painting, sculpture and swordmaking, one of the most highly developed and most highly prized arts at this time in Japan and abroad. However, lacquerers, unlike painters and swordsmiths, did not achieve the independence of the sculptors, largely because of the expense of their primary materials, lacquer and gold. Scribes and copyists had a relatively high status at court because their literacy skills were so highly prized. There was a considerable division of labour. A large scriptorium for copying *sūtra*s (the Shakyō-shi, *c*. 728; renamed the Shakyō-jō in 741) was established inside the imperial palace at Nara (*see* VII, 2 (i) below), and the copyist held the position of Eighth Court Rank, Lower Grade. Another office was established at Tōdaiji, and other smaller ones were founded by wealthy nobles.

In the 8th century, painters were organized in the Painting Bureau (Edakumi no Tsukasa) of the Ministry of Central Affairs (Nakatsukasa-shō), the highest of the eight ministries of state. Four master painters (*eshi*) and sixty assistants (*edakumi*) staffed the workshop, which was overseen by three bureaucrats. Again, there seems to have been division of labour among these painters, who generally worked in teams to undertake their many large commissions. Additionally, there were several groups of painters (*satoeshi*) in the provinces who were summoned to the capital for the largest projects. The status of painters at this time was lower than that of sculptors; no figures of

note are mentioned in the documents. The Painting Bureau was dissolved in 808, shortly after the transfer of the capital to Kyoto, and some time before 886 the Painting Bureau (Edokoro) was established at the imperial court. Painters themselves did not initially occupy a high position in the hierarchy of this office: the highest rank attained during the Heian period was that of *sumigaki* ('ink painter draughtsman' or artistic director). Not until the middle of the Kamakura period (1185–1333) did they attain the rank of *azukari* (director), the second highest position. The Bureau established the pattern for workshops attached to temples and shrines in the Kamakura and Muromachi (1333–1568) periods (*see also* §VI, 3(iii) below).

From about this time documents record the names of a few painters of exceptional ability, such as KOSE NO KANAOKA, an aristocrat who headed the Painting Bureau and is said to have been the first great Japanese painter. His descendants succeeded him as *azukari*, and thus he is also revered as the founder of the first of many schools of professional painters in Japan. This exalted position as painters in the service of the emperor was continued later by the TOSA SCHOOL, established in the late 15th century.

In the Kamakura period, temples and shrines established their own painting offices and sponsored professional painters of religious images (*ebusshi*). One of the most important schools of *ebusshi* was the TAKUMA, which flourished from the 10th century to the 14th. From the 14th century onwards painters emerged from the temples as sculptors had done several centuries before. Chodensu Minchō was representative of a large number of monks at this time who were active as painters while holding administrative positions within the monastery. Another monk-painter, Tenshō Shūbun, who was active *c.* 1414–63, also accepted commissions outside the monastery. He served as official painter to the Ashikaga shoguns, to which position Oguri Sōtan succeeded him in 1463.

The appearance of names and detailed biographies was a reflection of the growing status of painters, most of whom remained in the employ of temples or the military and court élite. As their works were mainly Buddhist paintings and were produced for their patrons, signatures were considered unnecessary and inappropriate. As the market for art expanded in the 15th century, workshops of independent professional painters began to appear outside the institutions to which production had earlier been confined. Tōyō Sesshū was one such independent artist who left the temple environment and functioned outside the monastery, establishing his own studio and working for provincial lords. After Sesshū's time, signed paintings became more common.

Many painting lineages in Japan continued for more than 200 years. The most enduring, productive and highly esteemed was the KANŌ SCHOOL, which served the military élite from the mid-15th century to the mid-19th. Their record of service and longevity was equalled, among producers of visual arts, only by the Gotō house of sword-furnishing producers and the Kōami house of *makie* lacquer specialists. These three lineages were all established under Ashikaga Yoshimasa (1436–90), whose lavish patronage of the arts produced an era known as the Higashiyama *bunka* ('Higashiyama culture'). The Kanō jealously guarded and denied to their rivals their status as

the official painters (*goyōeshi*; 'painter-in-residence') to the shoguns. The Kōami lacquerers were less successful in this area and had to share their official status with a number of other families. Nevertheless, each family workshop laid great value on its pedigree, as demonstrated by the elaborate genealogies prepared (and sometimes defended in legal battle) by the Kanō, Kōami and others.

(b) 1600–1868. In the Edo period (1600–1868), society was divided into four classes along Neo-Confucian principles. In this scheme, producers of objects, artisans, occupied the third rank after the ruling warrior class and the peasantry; only merchants had a lower social status. Artists in the service of the shogun such as the Kanō, Kōami and Gotō had the status and stipend of a retainer known as a bannerman (*hatamoto*). All claimed descent from warriors. Among the privileges accompanying this status was having audiences with the shogun.

The situation of the literati (*bunjin*) was quite different. They came from a wide range of social backgrounds but achieved considerable recognition, acclaim and income by virtue of the ideals they espoused, their talents and their association with Chinese culture. The status of the literati painters (*see* §VI, 4(iv)(d) below) was in sharp contrast to that of the painters and designers who catered to the market of the popular theatre and brothels (*ukiyo*; the 'floating world' of the pleasure quarters), although the latter group (*see* §VI, 4(iv)(b) below) benefited from a growing cult of the artist. As the Edo period went on, some warriors sacrificed their social status to engage in the visual arts as a path to a higher income and a more comfortable material life.

(c) After 1868. From the Meiji period (1868–1912), major changes occurred in the patronage and training of artists. Loss of previous forms of patronage resulted in the temporary displacement of many artists, but overall the status of the artist continued to rise. Government-supported art schools, such as the Tokyo University for Fine Arts and Music (formed in 1949 by uniting the Tokyo School of Fine Arts and the Tokyo School of Music, both founded 1887), became the most prestigious centres for the training of artists. The status and income of artists in contemporary Japan is quite high, partly because of the growing power of the Ministry of Education (Monbushō) and Agency for Cultural Affairs (Bunkachō), the increasing importance of national competitions, prizes and exhibitions and the rise of the art establishment. An artist's status is determined by a number of factors external to the quality of his work, including the distinction of his university, the reputation and standing of his teacher, participation in national exhibitions such as the Japan Art Exhibition (Nihon Bijutsu Tenrankai or Nitten; started in 1907), and the honour of selection to national organizations such as the Japan Art Academy (Nihon Geijutsuin).

In 1890, the Imperial Art Academy (Teishitsu Gigeiin) was established to support major figures in the visual arts. Those first honoured by selection to the Academy, five painters, two sculptors, one lacquerer, one metalworker and one textile maker, received a stipend in addition to their title. Between 1890 and 1944, 79 people were elevated to membership. Most worked in the visual arts; not until

1937 were musicians and writers admitted to the Academy. Since 1955, outstanding practitioners of traditional Japanese arts have been honoured by the national government as Holders of Important Intangible Cultural Properties and are popularly known as Living National Treasures (Ningen Kokuhō).

BIBLIOGRAPHY

Roberts
Kodansha Enc. Japan: 'Buddhist art', 'Buddhist sculpture', 'Painting'
R. T. Paine and A. Soper: *The Art and Architecture of Japan* (Harmondsworth, 1955, rev. 3/1981), pp. 19–26
M. Weidner, ed.: *Flowering in the Shadows: Women in the History of Chinese and Japanese Painting* (Honolulu, 1990)

WILLIAM SAMONIDES

II. Religion and iconography.

1. Prehistoric. 2. Shinto. 3. Buddhist. 4. Daoist. 5. Confucian and Neo-Confucian. 6. *Bushidō*. 7. Shugendō. 8. Folk.

1. PREHISTORIC. Little is known about early Japanese beliefs, largely because Japan had no system of writing until after the 6th century AD, when it came into contact with Chinese culture and Chinese Buddhism. Pottery vessels from the Jōmon period (*c.* 10,000–*c.* 300 BC) indicate something of the material life but nothing of the thought of the age. They are adorned with such patterns as diagonals, spirals, zigzags and herringbones, and some bear on the rim an image of the head of a rodent, snake or bird, but the significance of these decorations is not known. Few sculptures (*dogū*; 'clay figures') date from the Incipient or Earliest Jōmon (*c.* 10,000–*c.* 3500 BC), but in the Middle Jōmon period (*c.* 3500–*c.* 2500 BC) figures became plentiful. They probably also served a magical purpose. Some early, lumpish pieces evidently represent animals, and some later ones are clearly boars, bears and dogs. If the images were made to recreate real animals magically, in order to ensure an ample supply of food, they can be classed as fertility figures, or they may have been messengers of divinities. However, all of the Late and Final Jōmon (*c.* 2500–*c.* 300 BC) figures are anthropomorphic. They are frontal, usually symmetrical and heavily ornamented with incisions and applied designs of clay. Female sexuality is often emphasized in these figures, but less so than in the art of other cultures. Although many do not have emphatic breasts, bellies or buttocks and the vulva is not clearly marked, many scholars see them as symbols of the Mother Goddess, associated with procreation. According to other interpretations, *dogū* were merely toys or, since some appear to have been deliberately broken, images of enemies or images used in healing rituals, by which an infirmity was transferred to the clay figure. Crouching figurines—a Late Jōmon (*c.* 2500–*c.* 1000 BC) type—have been regarded as childbirth symbols or as objects used in simulated burial rites.

During the Yayoi period (*c.* 300 BC–*c.* AD 300) very different artefacts were produced. Finds include spears and swords, probably ceremonial or magical because they are too thin and too soft for use in combat, and bronze mirrors modelled on Chinese mirrors of the Han period (206 BC–AD 220). The most beautiful metal finds are *dōtaku*, works resembling elongated, flattened bells, usually with flanges at the sides. They range in size from 100 to 1300 mm. Since they were costly to produce and yet were deliberately buried, they were probably used in an agricultural fertility ceremony. Some *dōtaku* are ornamented with fine geometric patterns (e.g. lattices, spirals, triangles or zigzags) enclosed within horizontal bands or square blocks, and some have patterns of flowing water. If the designs contain any symbolic meaning, it has not yet been deciphered. A few *dōtaku* are adorned with 'thread-line reliefs' of sticklike representations of deer, birds, fish and turtles, and even of human figures pounding grain or hunting. Conceivably they were used in seasonal rituals.

During most of the Kofun or Tomb period (*c.* AD 300–710), at least until the advent of Buddhism in Japan in the 6th century AD, the chief works of art, in addition to ceramic vessels, were *haniwa* ('clay ring'), earthenware cylinders and hollow ceramic sculptures (*see* §V, 2(a) and (b) below). They were placed on the slopes and tops of the great mounds that served as tombs for ruling members of society. The mounds themselves were miniature sacred mountains or islands, as well as emblems of power and perhaps places to which the spirit could return. Some tomb vaults have colourful painted geometric designs—concentric circles, perhaps symbolizing mirrors or the sun, and triangles, perhaps symbolizing mountains—and rudimentary representations of human figures, horses and such objects as boats, fans and parasols, in what may be depictions of shamans conveying the soul to the next world. Boat-shaped coffins also suggest a voyage of the spirit.

The earliest *haniwa*, cylinders usually *c.* 500 mm tall, were built up out of smoothed slabs or coils of clay. They probably served as markers of a sacred place or perhaps as a fence encircling the dead and thus protecting the living. *Haniwa* from the latter part of the 4th century represent shields, quivers and ceremonial sunshades, all mounted on cylinders, as well as flat-bottomed houses. Human figures, mounted on cylinders and usually 500–1000 mm tall, first appeared in the late 4th century and became abundant thereafter, as did deer, boar, dogs and horses, all standing on four cylindrical legs, and birds mounted on cylinders. All of the earliest human figures seem to have been women, perhaps female shamans who could communicate with deities and with the dead (see fig. 4). Some of these figures hold a cup or wear headgear adorned with bells, possibly to help induce the shamanic trance, and wear jewellery, represented by clay pellets, around the neck, wrists and ankles. The jewels may have been intended to attract and then to harbour divinities. Incisions and painted designs on some of the faces suggest tattoos, ritual make-up or a disguise that would enable a shaman, having escorted a spirit to the underworld, to return unrecognized and thus unmolested by spirits. If all the earliest figures represent shamans, the later figures, which include warriors and lower-class persons such as farm-hands, may have been a secular development unrelated to any ritual, or they may represent the deceased's entourage. Images of deities are absent.

Some *haniwa*, such as shields and quivers, though never human figures, were decorated with *chokkomon* ('straight–curved pattern'), usually consisting of diagonal lines imposed on fragments of concentric circles. *Chokkomon* were also incised on shell bracelets and sword guards and cast on bronze mirrors, but the meaning of the patterns is

4. Protohistoric *haniwa* (clay sculpture) of seated female shaman dressed in *kesai* (ceremonial gown), h. 655 mm, from Ōizumi-cho, Gunma Prefecture, 7th century AD (Tokyo, National Museum)

own) temporarily resided. This concept of the divine as a place rather than a figure stimulated the building of shrines in which the *kami* might reside rather than the production of images. A divine place was often marked by a post-and-lintel gate (*torii*), and a shrine on the site might house some manmade objects of veneration such as swords, mirrors and necklaces of comma-shaped beads. The *kami* were not anthropomorphized until several centuries after the introduction of Buddhism.

Shinto and Buddhism co-existed more or less peacefully, partly because in general they did not compete: Shinto was chiefly concerned with health and generation, Buddhism with salvation. At least as early as the 8th century it was common to invite the local *kami* to serve as guardians of Buddhist temples, and by the late 8th century some *kami* were regarded as *bodhisattva*s (Skt: Buddhist 'enlightenment beings').

(ii) Artistic forms. Aside from a few controversial finds, the earliest known Shinto images are wooden sculptures dating from the mid-9th century. The commonest type, usually fairly small, represents a seated or kneeling man or woman dressed as a high-ranking courtier, perhaps reflecting the view that the *kami* were ancestors of noble families. These sculptures were usually made from a single piece of wood, hewn and carved with minimum violence to the wood, which Shinto belief held to be sacred. Many of the images are of females, who are especially important in Shinto, which has the Sun Goddess as one of its chief deities.

Two types of Shinto sculpture reveal features of Buddhist imagery. In one, a *kami* may be shown dressed, like a Buddha, in a monk's robe. Such sculptures might be confused with portrait sculptures of Buddhist monks, except that the faces of Shinto sculptures are relatively idealized, whereas Buddhist portrait sculptures show highly individualized faces. One *kami* often shown as a monk is Hachiman. Originally a *kami* of agriculture, he became associated with mining and metallurgy and thus with weapons. By the 8th century he was a god of war; nevertheless, he too is usually represented as a monk or, in painting, sometimes as a child in courtly dress. The other type deriving from Buddhist imagery, especially from the fierce images of Shingon Buddhism, is typified in sculptures of Zaō Gongen, the tutelary deity of Mt Kinpu in the Yoshino Mountains south of Nara. After becoming assimilated into the Buddhist pantheon, he was usually represented, like certain apotropaic Buddhist deities, with the angry countenance of a fierce guardian. His hair streams upward, his mouth grimaces, his right leg is raised as though about to stamp on an enemy, and he holds in one hand a stylized thunderbolt (a short rod with prongs at each end). Zaō Gongen also became a significant figure in Shugendō art (*see* §7 below). Less extreme in pose and facial expression but still conveying something of the wrath of Buddhist guardians of temples, are the pairs of Shinto guardians, one with his mouth open in anger, the other with his mouth grimly closed.

Another sort of guardian is the *koma-inu* ('lion-dog'), made of wood or stone. Pairs of these figures, one with the mouth open, the other with mouth closed, were placed in the outer corridors of a shrine. *Koma-inu* play no role

not known. They may have been meant to placate the dead or to represent the cosmos. The discovery of *chokkomon* on the walls of tombs has generated the interpretation that they are protective rings to guard the dead.

2. SHINTO.

(i) Introduction. Often described as the indigenous religion of Japan, SHINTO seems to have produced almost no visual art until some two centuries after the introduction of Buddhism into Japan in the 6th century AD. Indeed, the religion acquired the name Shinto ('the way of the gods' or 'the way of the *kami*') to distinguish it from *butsudō* ('the way of the Buddha'). A *kami* ('deity' or 'spirit') might dwell in any awe-inspiring natural thing or human being. In the earliest times, the objects of worship were natural phenomena, such as trees, waterfalls and mountains, where the spirits (who had no form of their

in early Shinto; the first reference to their presence in shrines dates from the late 11th century. Their origin is uncertain, but they were probably introduced into Shinto by courtiers, who had used them as secular decorations. Votive plaques called *kakebotoke* ('medallion Buddha') were suspended inside or outside shrines. These are discs to which are affixed small metal images of *bodhisattva*s. They derive from mirrors with incised images of Buddhist forms of Shinto deities.

The earliest references to Shinto painting occur in the 12th century, although the earliest extant paintings probably date from a century later. Common motifs are the deities in court dress, Hachiman as a monk or as a princely child, the Buddhist forms of the *kami* or the *kami* paired with their Buddhist forms, and shrines in a landscape.

According to the Dual Shinto (*ryōbu Shintō*) doctrine formulated from the 9th century onward, Buddhist deities were the 'essence' or 'true form' (*honji*) of the Shinto *kami*, while the *kami* were the local manifestations or 'traces' (*suijaku*). Thus the Sun Goddess of Shinto was an emanation or avatar of Dainichi Nyorai (Skt Mahavairochana Tathagata), the Great Sun Buddha. Among the most beautiful Shinto paintings are the shrine *maṇḍala*s that offer bird's-eye views of shrines (notably the Kasuga shrine and the three shrines at Kumano) in lyrical landscape settings. Of special interest are the 'essence and manifestation' (*honji–suijaku*) *maṇḍala*s, paintings that show both a particular shrine in its numinous setting and also its connection with Buddhism by means of small Buddhist images—the 'true forms' (*honji*) of the Shinto 'manifestations' (*suijaku*)—placed in or above the shrines or at the top of the composition. In the type known as the Kasuga Shrine *maṇḍala*, which shows five shrines, the local *kami* 'manifestations' appear in their five Buddhist 'true forms': these are usually Jūichimen (Eleven-headed) Kannon (Ekadashamukha Avalokiteshvara; the *bodhisattva* of compassion); Jizō (Kshitigarbha; the *bodhisattva* devoted to helping women and children); Shaka (Shakyamuni; the historical Buddha); Yakushi (Bhaishajyaguru; the Buddha of healing); and Monju (Manjushri; the *bodhisattva* of supreme wisdom). Above a mountain near the top of these paintings a sun or moon doubles as a mirror, symbolizing the divine presence and the stainless mind of the *kami*. Near the bottom of the painting there is usually a picture of the pagoda of Kōfukuji, the Buddhist temple adjacent to the Kasuga Grand Shrine at Nara (*see* BUDDHISM, §III, 10(ii)).

One especially common subject of Shinto painting is a historical figure, the courtier SUGAWARA NO MICHIZANE. Slandered and exiled from Kyoto to the southern island of Kyushu, Michizane was said to have taken vengeance after his death by using thunder and lightning to destroy the homes of his enemies. A shrine was soon dedicated to him at Kitano, a district of Kyoto, and he became deified with the name of Kitano Tenjin. Several narrative handscrolls show him wreaking destruction in the form of a thunder god. Hanging scrolls depict him in two ways: standing, dressed in the robes and cap of a Chinese scholar, and holding a plum blossom; or seated within a shrine, dressed in the clothes of a Japanese courtier and surrounded with plum blossoms. The Chinese garb derives from a legend that he flew to China, where he offered a

5. Kasuga deer *maṇḍala*, ink, colours and gold on silk, 1198×415 mm, 14th century (Boston, MA, Museum of Fine Arts)

plum branch to a noted Zen (Chin. Chan) master. The plums come from another legend, which has it that a beloved plum tree miraculously left his garden in Kyoto and transferred itself to his place of exile.

Not all Shinto representations, however, are of *kami* or of protectors of shrines. Among other images are deer (see fig. 5), foxes, horses and wrestlers (*sumō* was a form of entertainment offered to the gods). The deer and the fox are messengers of *kami*. Deer are regularly shown in the shrine *maṇḍala*s of the Kasuga sect, chiefly in the foreground; sometimes the chief subject of the painting is a single deer with a *sakaki* tree (*Cleyera ochnacea*) on its back and a sacred, moonlike mirror on the tree (symbolizing a *kami*). The mirror is usually adorned with pictures of five major Buddhist deities of Kasuga, or these deities may be symbolized by Siddham (Jap. *shittan*) letters, an Indian form of Sanskrit script, written in vertical columns. In some cases, however, there is a single large image or one large image and four Siddham characters. Deer also play a prominent role in the subject called the *Departure from Kashima*, showing tutelary deities being transferred from Kashima to Nara. The *kami* sit on deer, who stand on clouds.

A form of votive folk art is the use of *ema*, which are wooden plaques showing simple images of things symbolically offered or of things prayed for (*see* §XV, 2(v) below), hung by petitioners at shrines. The most commonly represented offering is a horse, and live horses are still kept at some Shinto shrines. The import of the prayers and the images that represent them are infinitely varied.

BIBLIOGRAPHY

J. E. Kidder jr: *Early Japanese Art: The Great Tombs and Treasures* (Princeton and London, 1964)
——: *The Birth of Japanese Art* (New York, 1965)
H. Kageyama: *Shintō bijutsu* [Shinto arts], Nihon no bijutsu [Arts of Japan], xviii (Tokyo, 1967); Eng. trans. by C. Guth as *The Arts of Shinto*, Arts of Japan, iv (New York and Tokyo, 1973)
J. M. Rosenfield and S. Shimada: *Traditions of Japanese Art: Selections from the Kimiko and John Powers Collection* (Cambridge, MA, 1970)
Shinto Arts: Nature, Gods and Man in Japan (exh. cat. by H. Kageyama and C. G. Kanda, New York, Japan Soc., 1976)
V. Hauge and T. Hauge: *Folk Traditions in Japanese Art* (New York, 1978)
S. Addiss, ed.: *Japanese Ghosts and Demons: Art of the Supernatural* (New York, 1985)
C. G. Kanda: *Shinzō: Hachiman Imagery and its Development* (Cambridge, MA, 1985)
S. Tyler: *The Cult of Kasuga Seen Through its Art* (Ann Arbor, 1992)

3. BUDDHIST.

(i) Introduction. (ii) Buddhas, *bodhisattva*s and symbolic gestures. (iii) *Ten*, *rakan* and monks. (iv) Laymen. (v) Attributes and thrones. (vi) Varieties of Buddhism.

(i) Introduction. Buddhism was first taught in India by Gautama Siddhartha (*c.* 560–*c.* 480 BC), a prince and a sage (Skt Shakyamuni; Jap. Shaka) of the Shakya clan. Vowing to save not only himself but all humankind from suffering, he left his princely life and for a while pursued a life of ascetic austerity, including severe fasts. He later abandoned austerities for the 'middle way' between sensuous luxury and ascetic isolation and achieved enlightenment or 'awakening', thereby becoming a Buddha (Jap. *hotoke* or *butsu*), an 'awakened' one. He then taught his doctrine of the Four Noble Truths: (1) life is sorrowful; (2) sorrow is due to craving; (3) sorrow can be eliminated only by ceasing to crave; (4) cessation of craving comes from living a disciplined, moral life. This fourth truth comprises the Eightfold Path: right view, right thought, right speech, right action, right livelihood, right effort, right mindfulness

and right concentration. The Buddha's act of teaching is often represented in art by a symbolic gesture and the Eightfold Path by a wheel with eight spokes. When Shaka gave his first sermon he is said to have 'set the Wheel in motion'.

Chinese Buddhism, which claimed descent from Indian Buddhism, began to flourish from about the 1st century AD, so that, by the time Japan felt its influence, by way of the Korean peninsula, towards the mid-6th century, it had been transformed by contact with Daoism, Confucianism, geomancy and divination. A Korean Buddhist monk who came to Japan in 602 was equipped to give instruction in a range of studies, including astronomy and 'the art of invisibility and magic'—matters scarcely connected with the early Buddhism of India—but the Japanese embraced these teachings along with Buddhism. Geomancy, for instance, which had long been practised in China, became important in Japan, where, under the name of *kasō*, it played a role in the planning of the early capitals and the layout of temples. Because the north-east was thought to be an inauspicious direction, Buddhist monasteries were built to the north-east of Kyoto, on Mt Hiei, in order to protect the city from evil forces. Geomancy also determined the axis of a temple, which usually faced south, the source of good emanations. A correlation was believed to exist between the order of the cosmos and the visible order of the physical world.

(ii) Buddhas, bodhisattva*s and symbolic gestures.* Although the teachings of the historical Buddha were chiefly concerned with the extinction of desire or selfhood so that one could emancipate oneself from the world, during its development Buddhism increased the number of Buddhas, so that it became virtually polytheistic (although all Buddhas are identical in essence). Further, the Buddhist pantheon was increased by the addition of attendants of the Buddhas. The chief rankings in the Buddhist hierarchy are Buddhas and *bodhisattva*s (Jap. *bosatsu*; beings destined to attain Buddhahood), *ten* or *tenbu* (Skt *deva*, female form *devī*; gods or inhabitants of the heavens) and *rakan* (Skt *arhat*s; saints or worthies; *see* §(iii) below).

A Buddha may usually be recognized by the snail-curl hair, the cranial protuberance (a sort of supermind), a tuft of hair in the forehead (in sculpture usually a round crystal or gem, in painting a gold dot), extended ear lobes (a vestige of the days when Shaka wore heavy, princely earrings) and a monk's robe for a garment. The Buddhas most often represented in Japanese art are Shaka; Amida (Skt Amitabha; the Buddha of infinite light and of the Western Paradise); Yakushi (Bhaishajyaguru; the Buddha of healing, recognizable by a covered medicine jar or a herb of healing that he holds in his left hand or in both hands); Miroku (Maitreya, the Buddha of the Future, who will become the next Buddha to preach in this world); and Dainichi (Mahavairochana; Great Illumination or Great Illuminator, also identified with the Buddha Roshana-/Rushana/Birushana). Images representing the historical Buddha at birth (*tanjō Shaka*; see fig. 6) show a standing child (already endowed with a cranial protuberance) dressed in a skirt, one hand pointing to the heavens, the other pointing to earth. The death of Shaka (Skt *parinirvāṇa*; Jap. *nehan*) is often represented, sometimes in

6. Figure of the historical Buddha at birth, gilt-bronze, h. 85 mm, from Asuka, 7th century AD (Massachusetts, private collection)

the sole upward on the opposite thigh). A seated *bodhisattva* is sometimes shown in a more relaxed posture called 'royal ease', with the right knee elevated, supporting the right arm. The left leg may hang down or it may be folded, resting on the platform.

A Buddha makes a *mudrā* or symbolic gesture. The commonest gestures are: meditation (*jōin*), with both hands together, resting on the lap; charity (*segan'in*), with one hand lowered, palm towards the viewer, fingers extending downwards in a gesture of giving; reassurance to the faithful (*semuiin*), with one hand elevated, palm towards the viewer, fingers extended upwards; and 'turning the Wheel of the Law' or the affirmation of the sovereignty of the Buddha and of the Buddhist Law (*tenbōrin'in*), of which there are several variant forms but usually with the palms of both hands facing the viewer, the tip of each index finger touching the tip of the corresponding thumb, thus making two circles in front of the chest. The 'wisdom fist' (*chi ken'in*), an important *mudrā* in Esoteric Buddhism, is associated with Dainichi; the right fist encircles the left index finger, while the other fingers of the left hand are bent into the left palm. This gesture indicates, among other things, supreme knowledge and the World of Being (the left index finger) protected by the World of the Buddhas.

*Bodhisattva*s are beings endowed with the wisdom and compassion necessary for entrance into *nirvāṇa* (Jap. *satori*; a condition of freedom from desire and hence from the cycle of birth, death and rebirth), but they have voluntarily postponed their own entrance into *nirvāṇa* in order to assist others to find enlightenment. These compassionate agents of the Buddhas are usually represented as ageless, with benign faces. Less austere than a Buddha, when they are shown standing they are often in a 'thrice-bent' pose (Skt *tribhaṅga*), rather like the contrapposto of Greek sculpture and painting. *Bodhisattva*s are sometimes depicted with many arms or with several heads, signifying their manifold ability to aid suffering mortals.

A *bodhisattva* usually takes a princely form; his hair is piled high on his head and, unlike most Buddhas, he wears princely attire (crown, scarves, a skirt and jewels). Buddhas and *bodhisattva*s are often gilded or painted gold, symbolizing their precious enlightened status. Frequently a Buddha is flanked by a pair of *bodhisattva*s, and the three figures are backed by a halo (usually decorated with lotus and flame patterns) indicating sanctity. Further, the triad may be set beneath an elaborate canopy symbolizing heaven. Thus, although the Buddha maintains an air of simplicity and introspection, his exalted spiritual state may be conveyed through princely and paradisaical imagery.

A fine example of a triad is that in Lady Tachibana's Shrine, a small shrine (early 8th century) kept in HŌRYŪJI. Inside the shrine, the top of which is designed to represent a heavenly canopy, are small bronze figures of the Buddha Amida (Skt Amitabha) and of two *bodhisattva*s, Seishi (Mahasthamaprapta) and Kannon (Avalokiteshvara). Amida is the most frequently represented Buddha in Japanese art. In this image he sits on a lotus that rises out of a bronze sheet with an elegant relief decoration of a lotus pond, but the *bodhisattva*s, more active in this world, stand rather than sit. Like Amida, however, each *bodhisattva* is supported by a lotus, the symbol of enlightenment,

sculpture but especially in painting. Shaka lies on his right side on a dais, facing towards the viewer's left, surrounded by followers and even by grieving animals. At the top Shaka's mother and attendants are shown descending on a cloud. Dainichi, prominent in Esoteric Buddhism, is the Cosmic Buddha, the source of all being. Unlike Shaka and other Buddhas who were *bodhisattva*s before they became Buddhas, Dainichi is a primordial Buddha. Because he is a world ruler and the source of all other Buddhas, Dainichi wears (unlike other Buddhas) a crown and jewellery, for example jewelled armbands.

A Buddha usually sits or stands on a lotus throne and is flanked by *bodhisattva*s and other attendants. Although some images show a Buddha—usually Miroku—enthroned with his legs hanging down (the so-called 'European position'), most images of a seated Buddha show him in the lotus position (i.e. with legs crossed, each foot with

for the lotus is rooted in the mud but blooms in the pure air, rather as the Buddha was born in the world but exists above it. Directly behind Amida an openwork halo encloses a lotus–sun. The lower part of the screen behind the three sculptures shows five figures born in Amida's Pure Land, decked in swirling scarves and seated in various postures on lotuses. At the top of the screen, in low relief, are the Seven Buddhas (five of the past, Shaka and the Buddha of the Future), all in one posture of withdrawn contemplation.

The *bodhisattva*s most commonly seen in Japanese images are Kannon, Jizō (Kshitigarbha), Fugen (Samantabhadra), Monju (Manjushri) and Miroku (Maitreya). Miroku, like Shaka, can be represented either as a Buddha or as a *bodhisattva*. Kannon, the *bodhisattva* of compassion or mercy, usually wears an image of Amida in his crown. Kannon appears in many forms: the Eleven-headed Kannon, with a head of Amida Buddha at the very top; the Thousand-armed Kannon, symbolizing his infinite wisdom and power to aid, though often only 40 arms are represented; the True Form Kannon, holding a lotus; the White-robed Kannon, often shown in a three-quarter view sitting in a relaxed pose on a rock overlooking water; the Nyoirin Kannon, a six-armed figure holding six attributes, the two that give him his name being the wish-granting jewel (*nyoi*) and the eight-spoked Wheel of the Law (*hōrin*) symbolizing the Eightfold Path; and the Horse-headed Kannon, usually with eight arms, four wrathful faces and a horse's head in his headdress. Because some images, especially of the White-robed Kannon, show a feminine face, Kannon is sometimes called the Goddess of Mercy.

Jizō, still immensely popular as the protector of women giving birth, children, travellers and warriors, is the only *bodhisattva* who is customarily not dressed as an Indian prince. He is shown as a monk, wearing a robe, holding a staff topped with jingling rings (a sign that he wanders as a mendicant saving sentient beings) and with his head shaved. Because his face is youthful and idealized, he can usually be distinguished from representations of monks, who are presented more naturalistically. Further, Jizō may have long earlobes, wear a necklace and carry a wish-granting jewel or a pearl to illuminate hell, into which he descends as a saviour, especially of children.

Fugen and Monju commonly flank Shaka. Fugen, associated with the dynamic aspect of Shaka, embodies the active teaching of the Buddha, whereas Monju embodies Shaka's innate wisdom or knowledge. Fugen and Monju may sit or stand on a lotus, but more often they are mounted, Fugen usually on a six-tusked white elephant, Monju on a lion. Both animals are symbols of sovereignty; the elephant's six tusks represent the purity of the six sensory and intellectual organs. Monju often holds in his left hand a lotus flower, on which may rest a book symbolizing his wisdom, and in his right hand an upright sword, symbolizing the triumph of wisdom. Although Monju, like Fugen, usually wears princely clothing, in Zen Buddhism Monju may be shown wearing a monk's robe or a garment of braided grass, in accordance with a legend that on one occasion, in the form of a youth in a grass robe, he explained to a worshipper that the simple truth of Buddhism had been obscured by innumerable commentaries.

Miroku, though sometimes shown as a Buddha in a monk's robe, can also be represented as a *bodhisattva* waiting for his last earthly incarnation, at which time he will become the Buddha of the Future (i.e. the next Buddha to preach in this world). In this role he is usually depicted seated in a particular pose of meditation, *hanka shii*: his right foot rests on the knee of his dangling left leg, his right elbow rests on his right knee and his right hand touches the right cheek of his inclined head. (A few images reverse the pose.) This pensive attitude is used also for some images of Shaka, showing him before he became a Buddha. As a *bodhisattva* Miroku is also represented, however, as a standing figure, usually holding a vase containing a long-stemmed lotus. The vase represents, among other things, the heart that has been emptied or freed from attachment so that it can receive the truth. It is associated with several *bodhisattva*s, especially Miroku and Kannon.

(iii) Ten, rakan and monks. Most Japanese *ten* or *tenbu* are derived from pre-Buddhist Indian gods and guardians. In contrast to the restrained figures who spiritually outrank them, the male *ten* are usually presented as highly dynamic figures, scowling or shouting and sometimes stamping. Among the *ten* are the Four Guardian Kings or Four Deva Kings (Jap. Shitennō; Skt *cāturmahārājikas*), originally Indian gods and law enforcers but assimilated to the Buddhist pantheon as protectors of the Buddha World at the cardinal points of the compass. They often stand at the four corners of an altar with a Buddha, each one trampling on a demon. The four are Bishamonten, also called Tamonten (Skt Vaishravana; north), with a pagoda on the palm of an uplifted hand, Zōchōten (Virudhaka; south), with a sword in his left hand, Jikokuten (Dhritarashtra; east), with a spear or lance in his left hand and a gem in his right hand, and Kōmokuten (Virupaksha; west), with a halberd in his left hand and a noose in his right. Bishamonten is the only one who also appears as an independent cult figure. Sometimes he stands on the hands or shoulders of a small female figure—the earth goddess—who is flanked by two small demons. In this form, often with a tall crown decorated with a bird, he is called Tobatsu Bishamonten. A larger group of *ten*, the Twelve Heavenly Guardians or Twelve Divine Generals (Jap. Jūni shinshō), attend the Buddha Yakushi, who made twelve vows to heal not only physical but also spiritual suffering. The *ten* who guard the entrance to a Buddhist temple are called the Two Kings (*Niō*), each of whom is a bare-chested, muscular strongman (*kongōrikishi*) wielding a thunderbolt (*kongō*; Skt *vajra*). One, called An, has his mouth open in a shout or exhalation of air, the other, Un, has his mouth closed in a grimace, but both are benevolent, the anger in their countenances being directed only at those who would violate the Buddhist law.

Emma-ten, mounted on a bullock, is derived from Yama, god of death in the Vedic tradition. Under the name Emma-ō, he was regarded in Japan from about the 10th century as the Overlord of Hell. Dressed as a Chinese judge, he holds a baton of office and presides, always with his mouth open in a shout, over the Ten Kings of Hell. The Ten Kings, who usually scowl or shout, wear Chinese garb, including hats with distinctive lateral projections.

Sitting behind desks and accompanied by scribes, they judge the wretches who are brought before them by demons. In some Japanese paintings, next to each king is the image of a Buddhist divinity, such as Shaka, Amida or Monju, indicating that the kings are emanations of the Buddhist law.

Other *ten* include Bonten (Skt Brahma), who may be shown mounted on a goose or geese, and Taishakuten (Indra), who may be mounted on a white elephant. Since these two figures derive from Brahmanic protective deities, they may have menacing faces, bear weapons and wear armour, though usually the armour is largely covered by flowing robes. Two female *ten* are Kichijōten (Skt Srimahadevi) and Benzaiten or Benten (Sarasvati). Kichijōten, a goddess of wealth and of beauty, is shown as a plump Chinese lady in court costume of the Tang period (618–907). Her left hand holds a jewel, the symbol of her power and of her generosity; her right hand makes the *mudrā* of charity. Benzaiten, goddess of music and of human fertility and the protector of children, often holds a *biwa*, a lutelike instrument.

A *rakan* (Skt *arhat*), originally a disciple of the Buddha, is a mortal who has achieved the wisdom and virtue that eliminates the causes of rebirth. At his death, therefore, instead of being reborn he will enter *nirvāṇa*. *Rakan* were apparently thought of as rather like Daoist immortals: old and usually ugly, a sign of their spiritual struggles, they are hermits who can perform such deeds as walking on water or taming tigers. They have the long earlobes associated with a Buddha, and, in keeping with the nationality of Shaka's disciples, they are usually shown with Indian features such as dark beards. They may be portrayed in groups or singly, although if a hanging scroll depicts a single *rakan* it must form part of a set. They are usually shown in a landscape setting, each with a nimbus but not a body halo, and often accompanied by an animal. One type of *rakan* painting shows Shaka flanked on each side by eight *rakan*.

Monks are often represented in portrait painting and in sculpture, nuns only rarely. Nuns do figure, however, in two of Japan's most important medieval narrative scrolls, *Shigisan engi emaki* ('The legends of Mt Shigi'; 12th century; Nara Prefecture, Chōgo Sonshiji) and *Taima mandara engi* ('Legends of the Taima *maṇḍala*'; *c*. 12th century; Kanagawa Prefecture, Kōmyōji). Obviously the images of Shaka's Ten Disciples (Jūdai deshi) and of early Buddhist patriarchs are not accurate likenesses of specific people, but even these imagined figures are commonly represented with naturalistic details such as wrinkles, not used in representing Buddhas and *bodhisattva*s. Some of these imagined portraits of historically remote figures, showing affinities with *rakan* painting, emphasize the ravages that time and the struggle for spirituality wreak on the flesh. Portraits done from life or from the artist's memory of the subject may also show the frailty of the flesh, though most such images show the subject as elderly but not deformed. Portraits usually show the monk seated cross-legged on a dais or on a Chinese chair, sometimes holding a rosary or a fly whisk (a symbol of spiritual authority). A famous picture of the priest Myōe (1173–1232) shows him, like a *rakan*, in a landscape setting; attended by birds, he sits meditating in a tree. External evidence indicates that the picture of Myōe is a good likeness, but the aim of even the most naturalistic images is less to represent the flesh than to communicate something of the subject's learning or devotion, thereby assisting the viewer to achieve an understanding of the Buddhist faith.

(iv) Laymen. Laymen play almost no role as subjects in Japanese Buddhist art except for Prince SHŌTOKU, prince regent and the greatest patron of early Buddhism in Japan. Three kinds of images of Shōtoku became especially popular: the two-year-old Shōtoku, hands together in prayer, upper body exposed, lower body wearing a red divided skirt; the adolescent who showed filial piety, holding a long-handled censer, the smoke of which purifies the air on behalf of his ill or deceased father; and the prince regent, holding a baton of office. One other layman, the semi-legendary Indian Vimalakirti (Jap. Yuima koji; Yuima the lay disciple), should be mentioned. The sagacious Yuima, said to have been an early follower of the historical Buddha, did not become a monk but nevertheless achieved great spiritual insight. Dedicating himself to assisting others to find salvation, he adopted the habit of feigning illness so that he could discourse on matters of reality with well-wishers. In one debate he is said to have equalled or bested the *bodhisattva* Monju. The frail Yuima, in the relatively few sculptures and paintings that depict him, is seated with an armrest, wearing a secular robe and the soft cap or headcloth of an invalid. He is usually, but not always, portrayed as an Indian, with a beard.

(v) Attributes and thrones. The lotus, Yakushi's medicine jar, the wish-granting jewel (*nyoi*), the Wheel of the Law (*hōrin*), the vase and the pagoda are among the objects held by or placed in close proximity to a figure, symbolizing a quality or power associated with the figure. The thunderbolt or *vajra*, a short rod with prongs at either end, is another (*see* §(vi)(a) below). The PAGODA (Jap. *sotoba* or *tō*) is ultimately derived from the Indian reliquary or stupa. A symbolic representation of the universe, it usually consists of three, five or seven storeys resting on a square earthen platform. The central pillar that runs through the entire structure is the cosmic axis or cosmic Mt Meru (or Sumeru) that unites heaven and earth; the flaming jewel in which the pagoda terminates stands for the precious truth of the Buddha. In Esoteric Buddhism the *gorintō* ('five-ringed pagoda') symbolizes the five elements. The five parts of this pagoda are, from the bottom, a square base (earth), a spherical body (water), a pyramidal roof (fire), a flat-topped hemisphere (air or wind) and a jewel-shaped finial (the void).

The lotus throne is by far the commonest throne in Japanese Buddhist art, but other types are sometimes shown, for instance an animal (lion, elephant, peacock, horse, ox), a platform draped with a heavenly cloth or a platform representing Mt Meru. This last throne, the *sendaiza*, consists of a series of platforms of diminishing size, one on top of the other, forming a truncated pyramid. On top of this rests a comparable inverted truncated pyramid, so that the highest platform, on which the image rests, is of the same size as the lowest. In paintings, the essential hour-glass shape of this throne is retained, but it

may be represented as a rock instead of a series of platforms.

(vi) Varieties of Buddhism. After its introduction to Japan in the 6th century, three developments in Buddhism were especially important for Japanese art: Esoteric Buddhism, Pure Land Buddhism and Zen Buddhism.

(a) Esoteric. (b) Pure Land. (c) Zen.

(a) Esoteric. Between the 9th and 11th centuries Esoteric or Tantric Buddhism (Jap. *mikkyō*; Skt Vajrayana), in the form of the Shingon and Tendai sects, increased what was already a large pantheon. The historical Buddha became one of many deities, all manifestations of transcendental principles. In particular, Esoteric Buddhism in the 9th and 10th centuries (though hospitable to images of Shinto *kami*) gave great prominence to fearsome, grimacing or baleful deities with multiple limbs and heads. Many of these figures, which contrast markedly with the poised, idealized figures typical of the 7th and 8th centuries, were intended to subdue obstacles to enlightenment. Through meditation, gestures and spells the worshipper could join his own Buddha-nature (inherent in all, but unperceived by most people because of disabling ignorance) with that of the Cosmic Buddha Dainichi, the source of all being. Among Dainichi's emanations are the *myōō*, guardian deities (usually in sets of five), whose terrifying appearances are meant to conquer evil spirits. Chief among these are the Kings of Bright Wisdom or Five Great Kings of the True Word (Jap. Go Daimyōō; Skt *vidyārājas*). The most important is Fudō (Skt Acala), who occupies the centre of an altar, with the other four (Gōzanze, Gundari, Kongō Yasha and Daiitoku) standing at the corners. Fudō, symbol of steadfastness, is easily recognized: his chubby body is red, blue or gold, his hair is gathered into a braid on the left side of his head, one of his bulging eyes may squint or look askance, and his grimacing mouth reveals two fanglike teeth, usually one pointing up, one down. Holding in his right hand a sword (often with a dragon coiled around it, symbolizing the power of Fudō's wisdom) to smite evil and in his left hand a lasso to bind evil and to rope in the recalcitrant, he usually sits or stands on a rocky crag in front of a fiery halo that symbolizes perfection. When not in a group of five *myōō*, Fudō is usually attended by two or eight youths. One other Wisdom King, Aizen (Skt Raga), is often shown separately in painting and in sculpture. Symbolizing passion (*ai*) that has taken the form of the desire for enlightenment, Aizen is red, has eight arms, an extra eye vertically oriented in his forehead and a wrathful countenance topped by a lion-mask. Despite his ferocious appearance, he is compassionate.

Esotericism produced new forms of old deities, new deities and a new form of painting, the *maṇḍala* or diagrammatic representation of realms of existence. By contemplating a *maṇḍala* a practitioner may achieve oneness with the Universal. (Shinto *maṇḍala*s (*see* §2 above) post-dated Esoteric *maṇḍala*s and were so called because of a fancied connection with Esoteric works.) These metaphysical paintings are of many sorts, but among the most important types are the *maṇḍala* of the Diamond World (*Kongōkai*; Skt *vajradhātu*) and the Matrix *maṇḍala*

(*Taizō*; Skt *garbhadhatu*), which together make the *maṇḍala* of Two Worlds (*Ryōgai* or *Ryobu*). The meanings of these works are immensely complicated, but it is known that the *maṇḍala* of the Diamond World, which resembles a checkerboard with nine squares, three rows of three squares each, symbolizes the innate reason of the Buddhas and represents the absolute, universal aspect of reality. A single figure of Dainichi sits in the top centre, his hands making the 'wisdom fist' (*see* §(ii) above). The nine miniature *maṇḍala*s of the Diamond World contain symbolic representations of over a thousand deities, arranged in circles of various sizes within the squares.

The Matrix *maṇḍala*, symbolizing the reason of sentient beings and the relative, individual aspect of reality, is equally but less obviously geometric. In the centre is Dainichi, sitting in an eight-petalled lotus (representing the Eightfold Path), his hands on his lap in a meditative gesture symbolizing, in some interpretations, the union of human and godhead, male and female, the world of form and the world of mind. A Wheel of the Law hangs from his neck. If we envision the lotus as a clock, then the Buddhas of the Four Directions sit at twelve, three, six and nine o'clock, each holding his hands in a symbolic gesture. Immediately below Dainichi is Amida, his hands in the *tenbōrin'in* gesture, with three fingers of the left hand overlapping the three free fingers of the right hand to symbolize earth, water and fire, which are said to conquer hate, greed and delusion. The circles formed by the thumbs and index fingers symbolize *nirvāṇa*. Dainichi and the four Buddhas who surround him are the Five Wisdom Buddhas (*gochi nyorai*), symbolizing five sorts of knowledge. Between the four Buddhas who surround Dainichi sit four *bodhisattva*s, who represent practices leading to enlightenment. This square with nine figures is the first 'court'; eleven other courts surround it, balanced in meanings and in numbers of figures, of which there are over four hundred. A court of compassion, for instance, balances a court of power. Not all *maṇḍala*s are paintings: sculpted images and even the buildings of a monastery can be arranged to form a *maṇḍala*.

Many symbolic objects (e.g. the lotus, the eight-spoked wheel, the vase) play important roles in Esoteric Buddhism, but the most important is the *vajra* (Jap. *kongō*), a short metal rod with a prong or several prongs at each end. The *vajra*, said to be of diamond hardness, destroys all falsehood, as wisdom destroys impediments to enlightenment. The single-pronged *vajra* represents the oneness of the universe; the three-pronged *vajra* represents, among other things, the Three Mysteries of act, word and thought (or body, speech and mind). The five-pronged *vajra*, in Japan the commonest form, may represent the Five Wisdoms, the five elements, five Buddhas and the Five Powers (faith, zeal, memory, concentration and wisdom). The bell with a *vajra* handle (Jap. *kongōrei*) combines the phenomenal world (the bell) with the adamantine world (the *vajra*). The sound of the bell—the illusory world of phenomena—is contrasted with the reality represented by the *vajra*.

(b) Pure Land. Jōdo (Pure Land) Buddhism was formalized in China in the 6th century but did not become highly important in Japan until the 11th century or widely

popular until the 12th. It focused on Amida Buddha, who presided over the Western Paradise, in which those who called on him would be reborn under such ideal conditions that they would be able to gain enlightenment. In sculpture and painting the chief deity is Amida, sometimes flanked by the *bodhisattvas* Seishi to his right and Kannon to his left (*see* §(ii) above). Seishi makes a gesture of salutation (*kongō-gasshō*; palms together at chest level, fingertips touching and pointed upward, as in the Western gesture for prayer), while Kannon offers a lotus throne on which the believer will be borne to heaven.

The chief forms of painting were: the Pure Land *maṇḍala*, a view of Amida enthroned in his sumptuous Pure Land with pavilions and jewelled trees, *bodhisattvas* and believers who are being reborn in a lotus pond; the Welcoming Descent (*raigō*), showing Amida descending on clouds to the earth or coming across a mountain, accompanied by Seishi and Kannon and other heavenly figures, to welcome a believer into his Pure Land; and narrative handscrolls recounting the founding of a temple or the life of an influential Jōdo priest. Other forms of painting, however, are also associated with the growth of Pure Land Buddhism. Because interest in the Pure Land was part of an interest in other realms, some handscrolls show the sad fate of those confined in hell or reborn as hungry ghosts. Mortals who did not achieve the enlightenment that frees them from rebirth might be reincarnated, according to their merit, in one of Six Realms of Rebirth or the Six Roads (Rokudō). The six realms, all illustrated in art, are, in descending order, the realms of heavenly beings, human beings, bellicose demons, animals, hungry ghosts and hell. Although hell is equipped with demons who punish and heaven with heavenly musicians, these realms are unlike the Christian hell and heaven, for they lack the notion of eternal punishment or eternal reward. Inhabitants of these realms, like inhabitants of the other four, are subject to rebirth in the same or another realm, but the inhabitants of heaven dwell in such favourable circumstances that they are strong candidates for the enlightenment that would then free them from the cycle of birth, death and rebirth.

(c) Zen. The third school of Buddhism important in the history of Japanese culture is Zen, which in Japan reached its artistic zenith between the late 13th century and the late 15th. Emphasizing meditation and self-discipline rather than the ritualism of Esoteric Buddhism or the salvation by faith of Pure Land Buddhism, Zen produced a kind of art quite different from the colourful, sumptuous art of the earlier schools. Although it made use of traditional icons, Zen is especially associated with monochrome ink painting, especially of a relatively spontaneous or evocative sort, and with portrait painting (*see* §VI, 3(i)(a) below). Because Zen put an enormous emphasis on the role of the teacher, a teacher might give an apt disciple a portrait (*chinsō*), often inscribed with a personal dedication (*jisan*) as a sort of diploma and source of further inspiration (*see also* §VII, 2(iv) below).

Although in China ink painting was not particularly associated with Chan (the Chinese name for what in Japan is called Zen), in Japan at first it was done exclusively by Zen practitioners. The earliest Japanese ink paintings usually show semi-legendary figures of the sect engaged in a characteristic action such as meditating, laughing, tearing up a *sūtra* text or sleeping. Among the most common subjects represented in figure painting are: Daruma; Kanzan, Jittoku and Bukan; Hotei; and Kensu. Daruma (Skt Bodhidharma), the Indian monk who was said to have brought Chan to China in the 6th century, is shown with a massive head, large staring eyes and a dark beard; if colour is used, his robe is red. The two commonest subjects involving Daruma (apart from paintings of the head only) depict him crossing the Yangzi River on a reed, before spending nine years meditating in northern China, or meditating in a cave. Kanzan (Chin. Hanshan) and Jittoku (Chin. Shide), two eccentric hermits given to ecstatic laughter, may be shown together or in a pair of hanging scrolls. Because Kanzan wrote poetry, he is usually shown holding a scroll. Jittoku, who worked in a monastery kitchen and fed Kanzan with leavings from the kitchen, is usually shown holding a broom. These two Daoist-like figures (often said to be incarnations of the *bodhisattvas* Monju and Fugen) had two friends, a Chan priest named Bukan (Chin. Fenggan), who supposedly found the orphan Jittoku and brought him to his monastery, and Bukan's pet tiger. When the four are shown dozing in a heap, the motif is called the Four Sleepers. Presumably these four have attained the tranquillity or freedom from desire that characterizes enlightenment. Hotei (Chin. Budai), very fat, has with him a bag full of treasures, which he dispenses. Sometimes he is regarded as an incarnation of Miroku. Kensu (Chin. Xianzi), who found enlightenment while catching shellfish, holds a shrimp. Since a Buddhist is not supposed to take life, much less eat it, pictures of Kensu suggest that enlightenment is not solely a matter of obeying rules. Other common Zen subjects include patriarchs such as the Fifth Patriarch, the Sixth Patriarch and Rinzai (Chin. Linji), as well as such eccentrics as Fuke (Chin. Puhua), who rings a bell, and Choka (Chin. Niaoke), who sits in a bird's nest. These figures are all legendary, but the historical Buddha, Shaka, is also depicted in ink paintings. One especially powerful motif shows him not as a remote Buddha but as a haggard, bearded ascetic descending a mountain, his hands beneath his robe clasped in front of his chest. The hidden hands probably symbolize the silent attainment of the ultimate truth. Paintings of *rakan* (enlightened ascetics, especially Shaka's early disciples) are another important part of the body of Zen art.

Countless Zen paintings of figures illustrate specific Zen stories, such as monks attaining enlightenment by being thrown into a river or by hearing the sound of a stone brushed away by a broom. Other Zen characters and activities (*zenki*) include Gutei (Chin. Zhuzhi) holding up one finger, Raisan (Chin. Lanzan) roasting yams, Kogan (Chin. Xianyan) sweeping in a bamboo grove, Nanzen (Chin. Nanquan) killing a cat, Tanka (Chin. Danxia) burning a statue of the Buddha and Eka (Chin. Huika) cutting off his arm. Because such subjects are common, and because ink paintings were, until the late 15th century, the province of Zen monks, many students of the art have scoured all the early ink paintings for a 'Zen' meaning. Thus, a picture of a waterfowl is said to suggest that enlightenment comes as swiftly as a waterfowl seizes a fish. However, since Zen came from China along with

other aspects of Chinese culture, it is likely that some of the pictures were intended to provoke literary and philosophical thoughts rather than specifically religious ones.

By the 16th century Buddhism in Japan had lost most of its power to create important art, although it continued to inspire large quantities of derivative images. From the early 17th century to the end of the 18th, however, the Zen sect developed a new form, which was to be the last Buddhist art of significance. This form has been called *Zenga*, literally 'Zen art' (*see* §VI, 4(vii) below), but the term is never used of the earlier ink paintings. *Zenga* is sometimes almost cartoon-like or childlike and often depicts in a highly abbreviated way the traditional legendary figures, or, in a few brushstrokes, it may show an ordinary object, such as a radish or a staff, with a brief calligraphic inscription that draws on Zen thought. A favourite motif is the *ensō* ('circle phase'), a boldly drawn circle, usually accompanied by an inscription. The *ensō* has no obvious specific meaning, but it surely suggests the Buddhist Wheel of the Law (i.e. Buddhist doctrine or truth) as well as the 'emptiness' or freedom from attachment that is at the heart of Buddhist teaching.

BIBLIOGRAPHY

E. D. Saunders: *Mudrā: A Study of Symbolic Gestures in Japanese Buddhist Sculpture* (Princeton, 1960)
D. Seckel: *Kunst des Buddhismus, Werden, Wanderung und Wandlung* (Baden-Baden, 1962); Eng. trans. by A. Keep as *The Art of Buddhism* (New York, 1964)
J. E. Kidder jr: *Early Japanese Art: The Great Tombs and Treasures* (Princeton and London, 1964)
——: *The Birth of Japanese Art* (New York, 1965)
J. Sugiyama: *Tempyō chōkoku* [Sculpture of the Tenpyō period], Nihon no bijutsu [Arts of Japan], xv (Tokyo, 1967); Eng. trans. by S. C. Morse as *Classic Buddhist Sculpture: The Tempyō Period*, Japanese Arts Library, iv (New York, 1982)
H. Ishida: *Mikkyōga*, Nihon no bijutsu [Arts of Japan], xxxiii (Tokyo, 1969); Eng. trans. by E. D. Saunders as *Esoteric Buddhist Painting*, Japanese Arts Library, xv (New York, 1987)
J. Okazaki: *Jōdo kyōga*, Nihon no bijutsu [Arts of Japan], xliii (Tokyo, 1969); Eng. trans. by E. ten Grotenhuis as *Pure Land Buddhist Painting*, Japanese Arts Library, iv (New York, 1977)
J. Fontein and M. L. Hickman: *Zen Painting and Calligraphy* (Boston, 1970)
J. M. Rosenfield and S. Shimada: *Traditions of Japanese Art: Selections from the Kimiko and John Powers Collection* (Cambridge, MA, 1970)
V. Hauge and T. Hauge: *Folk Traditions in Japanese Art* (New York, 1978)
Journey of the Three Jewels: Japanese Buddhist Paintings from Western Collections (exh. cat. by J. M. Rosenfield and E. ten Grotenhuis, New York, Asia House Gals, 1979)
S. Barnet and W. Burto: *Zen Ink Paintings* (New York, 1982)
K. Nishikawa and E. Sano: *The Great Age of Japanese Buddhist Sculpture, AD 600–1300* (Fort Worth, 1982)
A. Snodgrass: *The Matrix and Diamond World Maṇḍalas in Shingon Buddhism* (New Delhi, 1988)

4. DAOIST. The *Patriarchs of the Three Creeds*, an ink painting from *c.* 1400 attributed to the Zen monk Josetsu, shows the historical Buddha, Confucius and Laozi, the 6th-century BC father of Daoism. The idea had developed in China during the Song (960–1279) and Yuan (1279–1368) periods that the three creeds were paths to one truth. Laozi was thought to have been a Chinese court scholar, who, disgusted with the regime under which he lived, resigned, wrote the *Daode jing* ('The book of the way and its power') and then disappeared. (The known text may be Laozi's work or may be an anthology dating from the 3rd century BC.) The *Dao* ('way') is the underlying

harmony of the natural universe that the wise man seeks to embody in his own life. Thus, the skilled swimmer goes with the currents and the bamboo bends with the wind, unlike the massive, inflexible tree that is shattered by a storm. By contemplating the Way of the Universe, one frees oneself from desire or 'empties' oneself.

From even this brief summary one can see that Daoism bears some resemblance to the Buddhist idea of tranquillizing the mind, freeing oneself from attachment or achieving 'oneness with the all' (*see* §3 above). It is not surprising, then, that when Buddhism reached China from India it was in some ways interpreted in the light of (and modified by) Daoism, which was already long established there. Alongside this philosophical Daoism there developed in China a religious Daoism, which was founded in divination, alchemy, astrology, charms and the underworld. Its principal concerns were to ward off evil spirits, to obtain health, wealth and happiness, and especially to restore youth and win immortality, that is, to transcend or be liberated from the body. This was done by refining body and mind through diet, gymnastic practices and quietude. Chinese Buddhism absorbed some elements of Daoism, such as the Ten Kings of Hell. The Japanese, however, did not rigidly distinguish between Philosophical and Religious Daoism or even between Religious Daoism and certain aspects of Buddhism. The Daoist emphasis on long life or transcendence, for instance, in Japan blended with the Buddhist notion of eternal repose in a Pure Land.

Josetsu's painting bears two important inscriptions. The first, immediately above the painting, asserts the unity of the three creeds. The second, written on a separate sheet of paper attached above the first inscription, is by a different priest, who offers a brief comment on Buddhism and then goes on to say that:

> he might also have set down those Confucian doctrines lamenting the decline of morality in the present age. But when it comes to those mysterious Daoists who expound upon 'the dragon in the void', we do not have them in our country . . . 'Laozi's black ox did not cross the ocean'. So it is not to be wondered at that no one reads Daoist books.

In the absence of books, however, Chinese émigrés and Japanese visitors to China brought to Japan Southern Song-period (1127–1279) and Yuan-period Daoist paintings, with subjects suggesting both the vastness of nature and the need to attune oneself to it, or pictures of Daoist immortals (Chin. *xian*; Jap. *sennin*), who were analogous to Buddhist *rakan* (Skt *arhat*; monks who had achieved freedom from desire). These figures, thought to be historical miracle-workers who could fly and walk on water, were introduced into Zen iconography. Thus, the Japanese Zen painter Kichizan Minchō (1352–1431), drawing on Chinese sources, executed *Bodhidharma Flanked by Tieguai and Hama*. Tieguai (Jap. Tekkai), one of the most commonly depicted Daoist immortals, could exhale his soul into the void and roam widely on clouds and wind. During one such journey his disciples, thinking he had died, burnt his body. When he returned to earth, the only available body was that of a recently deceased crippled beggar, and it was this body that he assumed for the rest of his life. Paintings show him as a hairy, ugly figure

dressed in tattered clothing, supported by a crutch, with a gourd hanging from his side, and in the act of exhaling his soul. Hama (Jap. Gama) was thought to have been a court official who met a Daoist, resigned his office and thereafter devoted himself to the life of discipline that brought him immortality. He is depicted with a white, three-legged toad. Minchō's paintings themselves became models for later painters, who treated the theme with varying degrees of freedom. Among the most notable renditions of these two Daoist immortals are a pair of hanging scrolls (originally mounted on folding screens) by SESSON SHŪKEI, who also painted other Daoist immortals, including Qin-gao (Jap. Kinkō) riding through the sea and air on the King of Fish, a giant carp. According to legend, Kinkō was a 4th-century BC official who was versed in Daoist magic. After visiting the fish world for several months, he returned home, urged his followers never to kill fish and disappeared in mist or dived into the river, never to be seen again. Three other commonly depicted immortals are Zhangguolao (Jap. Chōkarō), Ludongbin (Jap. Rodōhin) and Jurōjin. Chōkarō possessed a magic mule or horse, which he kept in a gourd. Released from the gourd and sprayed with water from Chōkarō's mouth, the animal became full-size and carried his master on long journeys. Rodōhin is usually depicted standing on the head of an air-borne dragon. Jurōjin, the Old Man of Long Life, was regarded in Japan as one of the Seven Gods of Good Fortune. He can be recognized by his white beard, his staff and an accompanying deer, tortoise or crane.

Other important Daoist immortals who appear in Japanese art include Seiobo (Chin. Xi Wangmu), Queen Mother of the West, and Toofu (Chin. Dong Wanggong), Royal Lord of the East; Koshohei (Chin. Huangziping), who changes rocks into sheep; Ōshikyō (Chin. Wangzi-qiao), who rides a crane; Ōshitsu (Chin. Wangzhi), a Rip van Winkle figure; Tōbosaku (Chin. Dongfangso), who steals the peaches of immortality; and Mako (Chin. Maku), a female who ascended to heaven from a bridge. Frequently represented in painting are the *hasen* (Chin. *baxian*) or Eight Immortals, usually including Shōriken (Chin. Zhan-gliquan), Chōkarō, Kanshōshi (Chin. Hanziangzi), Tekkai, Sōkokukyū (Chin. Caoguojiu), Rodōhin, Ransaika (Chin. Lancaihe) and Kasenko (Chin. Hexiangu). The pair of screens by Kanō Sansetsu (Minneapolis, MN, Inst. A.; *see* KANŌ, (10)) is a good illustration of the Eight Immortals theme.

One of the places where immortals (as well as cranes, tortoises and stags) were thought to live was a legendary pine-covered island, Mt Hōrai, where immortality was conferred by the wine that flowed from a jade rock and by the fungus that grew beneath a jewelled tree. The subject was especially popular with late 18th-century painters of the Maruyama–Shijō school (*see* §VI, 4(viii) below) and with their successors. The crane and tortoise are often represented on textiles, and Japanese gardens sometimes represent Mt Hōrai, with rocks standing for crane and tortoise islands. *Sennin* are often also the subjects of Edo-period (1600–1868) *netsuke* (*see* §XVI, 17(viii) below), miniature carvings that served as toggles.

One other quasi-Daoist motif, the *Seven Sages of the Bamboo Grove*, shows men in a natural setting enjoying an escape from a world of political and social corruption.

Animated by wine, they talk about philosophical rather than political matters, engaging in a relaxing Daoist practice called 'pure conversation' (Jap. *seidan*). This motif occurs also in Confucian iconography (*see* §5 below).

In painting of the Edo period, one of the most common Daoist subjects continued to be the Eight Immortals. Of the eight, Shōriken usually wears a cape and carries a plumed fan, Kanshōshi stands by a peony, Sōkokukyū holds a wooden sceptre, Ransaika carries clappers, and Kasenko (a female) holds a long-stemmed lotus flower. Japanese artists occasionally altered the group members, substituting a favourite such as Gama for one of the lesser-known Immortals. The Eight Immortals often filled the *fusuma* panels in one room (*hasen no ma*) of Buddhist temples, were spread across a screen or were crowded on to a single hanging scroll. The auspicious associations of longevity largely account for the popularity of the Eight Immortals theme, but this subject may also relate to the idea of a natural paradise as an antidote to civilization represented by urban life or military rule.

BIBLIOGRAPHY
S. Little: *Realm of the Immortals: Daoism in the Arts of China* (Cleveland, 1988)

5. CONFUCIAN AND NEO-CONFUCIAN. Something of Confucianism may have been known in Japan as early as the 3rd or 4th century AD, but it was in the 6th century that it made its presence felt when, along with Buddhism, it became part of the great wave of Chinese influence. Confucius taught that human relations should be governed not by force but by moral principles, especially virtue and benevolence, and that every kind of relationship carries its own duties. Chiefly concerned with political and social relationships, Confucianism has no deity and no priest-hood, but it does embrace some ancestor worship and state ritual. Until the 12th century Confucian ideals informed Japanese thinking about the duties of the ruler and the ruled, but they exerted no conspicuous influence on art. During the Kamakura (1184–1333) and Muromachi (1333–1568) periods, Zen monks came into contact with the Neo-Confucianism of Zhu Xi (1130–1200), a school of thought that combined ethics, political ideals and cosmology (*see* CONFUCIANISM). The interest of the Japanese 'Confucian monks' (*jusō*) in these ideas spilt over into politics, but it was only in the late 16th century that Neo-Confucianism became dissociated from Buddhism and fairly widespread in Japan.

In 1568 the warlord Oda Nobunaga occupied Kyoto; in 1576, when he began to construct the luxurious Azuchi Castle, he commissioned Kanō Eitoku (*see* KANŌ, (5)), the leading painter of the age, to decorate the walls. The castle was destroyed after Nobunaga was assassinated in 1582, but a written account of Eitoku's paintings suggests the importance to a ruler of pictures on Confucian themes. The fourth storey apparently included not only paintings of pine trees and bamboo (symbols of the Confucian gentleman) but also a more obviously didactic work, a representation of the hermits Xu You and Chao Fu (Jap. Kyoyū and Sōha). When an emperor offered Xu You the successorship to the empire, Xu You felt so polluted that he washed out his ears in river water. His friend Chao Fu then would not cross the river or even let his ox drink

7. *Confucius at the Apricot Altar and his Two Disciples* by Kanō Tan'yū, ink and slight colour on silk, each panel 1042×748 mm, mid-17th century (Boston, MA, Museum of Fine Arts)

from it. The story was interpreted to mean that, if the ruler is deficient, just men will flee from political service. Confucian images were even prominent on the highest storey, the seventh. Although the sixth storey contained a Buddhist chapel decorated with paintings of the *Ten Great Disciples of Buddha* on the walls and Buddhist angels on the ceiling, the seventh was adorned with Eitoku's wall paintings showing virtuous Chinese rulers (some of whom had been specifically extolled by Confucius) and the sages, including Confucius himself, whose wisdom these rulers valued.

It is perhaps a mistake always to interpret these pictures in terms of the age. The *Seven Sages of the Bamboo Grove*, for instance, also said to have been on the seventh storey, depicted intoxicated government officials conversing, dancing and making music in the grove, a motif known in China from at least the late 4th century AD and in Japan from at least the 9th century. One view is that this essentially Daoist motif shows a brief, sanctioned release that enables the officials to return to their posts, renewed. Another parallels the story of Xu and Chao, seeing in the image a withdrawal from government service. Such readings hardly allow for the possibility that Nobunaga and other viewers simply enjoyed looking at a picture of revelry. Nevertheless, given the obvious didactic content of most pictures of Chinese scholars, it is clear that Nobunaga, like the Japanese rulers in the early 7th century, saw in Confucianism a philosophy that could be used to legitimize a political system.

Some of Eitoku's paintings with Confucian themes, or Chinese motifs that were taken to depict Confucian themes, have survived. In 1566 Eitoku executed ink paintings on eight sliding-door panels in the abbot's quarters at Jukōin, a subtemple of Daitokuji in Kyoto (*see* KYOTO, §IV, 5). The motif is called the Four Accomplishments (Jap. *kinkishoga*): cultivated Chinese gentlemen in a landscape or palace garden make music on a zither-like instrument (*kin*), play Chinese chess (*ki*), write calligraphy (*sho*) and paint pictures (*ga*). The idea derives from

painting of the Southern Song period (1127–1279) in China and from Japanese art from the Muromachi period onwards and is rooted in such Confucian texts as the *Li ji* ('Record of ritual') and the *Lun yu* ('Analects'), which say that perfection in music, poetry and calligraphy engenders the ethical perfection that is the foundation of a stable society. Although the didactic content was clear in early ink versions of the *Four Accomplishments*, showing the scholars in simple surroundings, later versions—namely of the Momoyama (1568–1600) and Edo (1600–1868) periods—treated the theme as a purely Chinese subject and were sometimes so lavish in colour and setting that the traditional message was obscured. A decade or so after the Azuchi Castle paintings, Eitoku's studio executed wall paintings called *Twenty-four Examples of Filial Piety* and *Chinese Hermits* (Kyoto, Nanzenji). Filial piety was part of a discipline that included loyalty to one's superiors.

Nobunaga's enthusiasm for Confucian thought was exceeded by that of Tokugawa Ieyasu (1543–1616), the first of the Tokugawa shoguns, and his successors. The Tokugawa of the 17th and 18th centuries fostered Neo-Confucianism, especially of the Zhu Xi school. Neo-Confucian academies were established, in which rather formal carved and painted portraits of Confucius and his disciples served as sources of inspiration. Confucius can be identified by his proximity to an apricot tree or the tip of an apricot twig and is sometimes depicted on the Apricot Terrace where he customarily met his pupils, as in a painting by Eitoku's grandson Kanō Tan'yū (see fig. 7). These portraits may seem impersonal to Western eyes, but they are in accord with Confucian thought, which values decorum over self-expression. Paintings of plants and trees, too, may express Confucian virtues. The bamboo bends low under adversity but does not break, and its hollowness symbolizes a mind free from selfish desires. The orchid blooms modestly and, like virtue, spreads a delicate fragrance. The blossoming plum, which even when desiccated sends forth new shoots and flowers, represents the aged scholar–gentleman. The evergreen

pine is a symbol of resolution and rectitude. The chrysanthemum, valued along with literature and friendship by the ancient Chinese poet Tao Yuanming, symbolizes the literary life.

BIBLIOGRAPHY
P. Nosco, ed.: *Confucianism and Tokugawa Culture* (Princeton, 1984)
J. Thomas Rimer and others: *Shisendo: Hall of the Poetry Immortals* (New York, 1991)

6. BUSHIDŌ. *Bushido* ('The way of the warrior') was the code of the samurai or *bushi* ('military gentry'). By the late 12th century a warrior élite had become in effect the rulers of Japan. Several important works of art depicted military virtues. For instance, a general commissioned the *Illustrated Scrolls of the Mongol Invasions* (two handscrolls, ink and colours on paper; Tokyo, Imp. Household Col.) to celebrate his role in the invasions of 1274 and 1281. However, the illustrated *Tale of Obusuma Saburō* (handscroll, ink and colours on paper; Tokyo, N. Mus.), also dating from the late 13th century, tells of two brothers, one devoted to military virtues and one to aesthetic matters. The extant portion of the incomplete story seems to suggest the need for both *bu* (military culture, such as courage and loyalty) and *bun* (civilian arts and aesthetic sensibility), while warning against excessive devotion to either.

In the Kamakura period narrative scrolls depicted battles, and the Muromachi and Momoyama periods produced screens of horse racing, hawks and hawking, and archery. A Muromachi-period six-panel folding screen (pair of screens, ink and colours and gold leaf on paper, *c.* 1560; Tokyo, N. Mus.) showing a stable with six fine horses, one to a panel, reflects the interest of the samurai and may be an allusion to military power. Similarly, screens of the *Battle of Sekigahara* (1600), in which Ieyasu defeated the supporters of the late Toyotomi Hideyoshi and became the ruler of Japan, glorify Ieyasu's power. Ieyasu is said to have owned two pairs of such screens.

While courage and loyalty had long been celebrated in art, the code of *bushido* was chiefly a romantic invention of the 17th and 18th centuries, especially associated with the Confucian scholar Yamaga Sokō (1622–85). *Bushido* combined the traditional military virtues with Confucian or Neo-Confucian ethics, insisting that the warrior's devotion to his lord manifested itself not only in loyalty and military competence but also in a general cultivation of mind, and especially in the ability to provide society with moral, intellectual and political leadership. Indeed, samurai in this period, having no battles to fight, were encouraged to become bureaucrats. By Confucianizing the feudal warrior code, Neo-Confucianism justified the existence of the samurai. The warrior became Confucius's 'gentleman', a man who was expected to cultivate the arts of peace so that, like a Chinese scholar–bureaucrat, he could fully serve the nation. Whereas in the Muromachi period many samurai were especially attracted to Zen Buddhism, with its austerity and unflinching attitude to death, under Tokugawa rule samurai were attracted to the civic virtues extolled by Neo-Confucianism.

The enormous interest in the Edo period (1600–1868) in military ceremony resulted also in the production of such things as highly decorated saddles, stirrups and fantastic helmets adorned, for instance, with horns and a

lion's mane, with the image of a fierce deity or with oak leaves (the food of Shinto divinities). These accoutrements were designed to inspire the wearer as much as to impress the viewer. Isamu Noguchi observed (p. 13) that:

> the Japanese warrior's helmet has more use than to protect the head. More mask than hat, it is a disguise to transform the wearer into a personage of otherworldly ferocity. Intended to frighten the enemy, an even more subtle function may be to transform the wearer. Thus garbed, his true status confirmed, he is the samurai dedicated to death governed by a code beyond the pale and beyond reproach.

Samurai power was much represented in art and in various ways. A striking example is a six-panel folding screen of Chinese lions (ink and colours with gold-leaf ground; Tokyo, Imp. Household Col.) attributed to Kanō Eitoku. Tradition holds that in 1582 Hideyoshi presented it as a peace offering to the daimyo of the Mōri clan. Measuring 2.25×4.6 m, it shows two muscular lions striding over a background of gold leaf. Thick black contour lines emphasize the vigour and strength of the animals; the gold symbolizes wealth. A more subtle reference is contained in Eitoku's massive *Cypress* (ink and colours with gold-leaf ground, 1.7×4.6 m, ?1590; Tokyo, N. Mus.), originally painted on four sliding doors and later mounted as an eight-panel screen. The tree rises immediately from the bottom of the picture and crowds its way to the top while spreading horizontally across the panels, in effect possessing its entire world. Some 25 years later Kanō Tan'yū executed wall paintings at Nijō Castle (*see* KYOTO, §IV, 9) of massive green and brown pine trees on a gold background. The pines, refusing to be confined to their panels, extend their bulk above the frieze rails into the upper panels, suggesting the irrepressible power not only of trees but also of the shogun.

BIBLIOGRAPHY
I. Noguchi: 'No Division between Artist and Mask', *Spectacular Helmets of Japan* (exh. cat. by A. Munroe, New York, Japan House Gal.; San Francisco, CA, Asian A. Mus.; 1985–6), p. 13
Y. Shimizu: *Japan: The Shaping of Daimyo Culture, 1185–1868* (Washington, 1988)

SYLVAN BARNET

7. SHUGENDŌ. Shugendo is a distinctively Japanese religious tradition combining indigenous and imported elements, formulated in the 7th century AD, purportedly by the legendary figure En no Gyōja (En no Ozunu; En the ascetic), who established the precedent of climbing sacred mountains as an ascetic technique for religious realization. Shugendō is the way (*dō*) of mastering (*shu*) mysterious power (*gen*), and those who practise it are known as *shugenja* or more popularly *yamabushi* ('those who lie or sleep in the mountains'). Shugendō helped forge, disseminate and perpetuate the blend of Shinto, Buddhism and other elements that constituted the popular world-view until the Meiji Restoration (1868) and to a certain extent still exists.

Before the time of En no Gyōja, who worked principally in the mountains of central Honshu, sacred mountains were worshipped only at their base, not climbed. The new tradition skilfully blended Japanese beliefs that mountains were the residences of spirits with Daoist notions of wizards (Jap. *sen* or *sennin*) living on mystical mountains

and with Buddhist forms of asceticism and ritual, especially magical techniques. Shugendō centres first arose in the Nara period (710–94) in and around the mountains of Yoshino, Kinpu and Kumano in central Honshu, to which the imperial family and nobility made pilgrimages. In the Kamakura (1184–1333) and Muromachi (1333–1568) periods, there were over 100 Shugendō sites at sacred mountains throughout Japan, not only at the original major centres but also at Haguro in north-eastern Honshu, Hiko on Kyushu and Ishizuchi on Shikoku. By this time the common people were participating in Shugendō practices.

Shugendō is broadly divided into two main branches reflecting two strands of Esoteric Buddhist influences. The Tōzan branch, organized by the monk Shōbō (834–909), included the 36 shrines and temples in the Yoshino–Kinpu region and was principally associated with the Shingon sect. The Honzan branch, which centred around the teachings of En no Gyōja, as the founder, and other figures such as Enchin (814–91; *see* ONJŌJI), came into being *c.* 1090 and was influenced by the Tendai sect. However, Shugendō was never unified nationally and is characterized by a high degree of local variation.

Yamabushi adopted their own costume, each element of which had symbolic significance, especially a small black cap (*tokin*), pilgrim's staff (*shakujō*) and conch-shell trumpet (*horagai*), and carried a portable altar and a symbolic axe (see fig. 8). Because of their colourful dress and their freedom of movement in a time of restricted travel, they gained a reputation as 'spies', a secularized and trivialized version of *yamabushi* that still prevails. *Yamabushi* confined themselves in the mountains for lengthy periods, learning magical techniques, undergoing severe asceticism, which included fasting and meditation, and performing rituals such as the *saitō goma*, an impressive fire ceremony. Having acquired special religious power, *yamabushi* travelled around the countryside carrying out rituals of healing, exorcism and seasonal renewal.

During the Edo period (1600–1868), however, *yamabushi* settled in villages, and much of the religious life of the common people depended on a recurring annual cycle of interaction between mountain and village, both by professional *yamabushi* and lay people. Lay people visited sacred mountains, especially during the summer, for devotional purposes. Shugendō's message was conveyed less through direct teaching, such as sermons, than through folk drama, such as the *yamabushi kagura*, ritual performances, such as exorcism and fire ceremonies, and the encouragement of the worship of Shinto and Buddhist divinities.

In 1872, in order to make Shinto the basis of the new Meiji state (1868–1912), the government made efforts to purify Shinto by shedding its Buddhist influences. Shugendō was accordingly proscribed, and its centres either disappeared or were split into Shinto and Buddhist institutions. After World War II some groups took advantage of the freedom of religion to reorganize. Because of its historical roots and development, Shugendō has sometimes been seen as a derivation or dilution of Shinto and Buddhist traditions, but folklorists and scholars of religion have increasingly recognized it as one of the major traditional religious practices in Japan.

8. Shugendō practitioners (*yamabushi*) in costume

Because of Shugendō's close ties with the common people, its artistic forms have differed from those found among aristocratic culture, and few Shugendō-inspired works have received the designations of National Treasure or Important Cultural Property. The strength of Shugendō art lies in its direct and forceful expression of the ethos of magical and ritual transformation of the world in the setting of sacred mountains.

Shugendō favoured the worship of ferocious Shinto deities (*aragami*) and the menacing figures of Esoteric Buddhism. Fudō Myōō (Skt Acala), one of the Five Great Kings of the True Word (Skt *vidyārāja*s; Jap. Go Dai-myōō), was seen as a means of suppressing evil and ensuring health, prosperity and peace. Sacred mountains provided the best setting for invoking these deities. However, perhaps the most distinctively Shugendō subject was Zaō Gongen (or Kongō Zaō Gongen), a fierce Buddhist divinity who appeared to En no Gyōja while he was practising asceticism in a mountain cave. Zaō Gongen is a Shugendō adaptation of figures of Esoteric Buddhism (*see* §3 above). Statues and paintings of Zaō Gongen were prominent at halls dedicated to his worship (Zaōdō). A typical image is the wooden sculpture by ENKŪ (1689; Saitama Prefecture, Kobuchi Kannon'in) portraying him with threatening grimace and streaming hair. In the Kamakura period, images of En no Gyōja became popular. He is usually depicted as an aged ascetic with a pilgrim's staff and garb, accompanied by two demon-like attendants, as in a 14th-century example at the temple of Ishiyamadera, Shiga Prefecture.

Perhaps the most visually striking example of Shugendō art, however, is the *mandara* (Skt *maṇḍala*; 'world picture'). While Shugendō art featured many of the more abstract *maṇḍala*s, such as are found in Esoteric Buddhism (e.g. *Mandala of the Two Realms: the Womb or Matrix and the Diamond*; 13th century; Nara, N. Mus.), it also fostered the creation of *maṇḍala*s that were lifelike depictions of such sacred mountains as Kumano (see fig. 82 below) and Mt Fuji. Such *maṇḍala*s illustrated not only the sacred mountain and its temples and shrines but also those who performed pilgrimage and purification rites. *Yamabushi*

and other itinerant religious practitioners used such pictures as visual aids to their performances and as exhortations to lay people to go on pilgrimage. *Maṇḍala*s of this type are often considered to be variations of Shinto and Buddhist art (*see* §§2 and 3 above), but it is equally valid to accept them as a religious and aesthetic contribution of Shugendō, a creed which itself illuminates certain indigenous and enduring features of Japanese culture.

BIBLIOGRAPHY

T. Wakamori: *Shugendōshi kenkyū* [A study of Shugendō history] (Tokyo, 1943)
G. Renondeau: *Le Shugendō: Histoire, doctrine et rites des anachorètes dits yamabushi*, Cahiers de la Société Asiatique, xviii (Paris, 1965)
H. O. Rotermund: *Die Yamabushi: Aspekte ihres Glaubens, Lebens und ihrer sozialen Funktion im japanischen Mittelalter* (Hamburg, 1968)
H. B. Earhart: *A Religious Study of the Mount Haguro Sect of Shugendō: An Example of Japanese Mountain Religion*, Monumenta Nipponica Monograph (Tokyo, 1970)
H. Miyake: *Shugendō girei no kenkyū* [A study of Shugendō rituals] (Tokyo, 1971)
T. Sawa: *Mikkyō no bijutsu* [Arts of Esoteric Buddhism], Nihon no bijutsu [Arts of Japan], viii (Tokyo, 1964); Eng. trans. by R. Gage as *Art in Esoteric Buddhism*, Heibonsha Surv. Jap. A., viii (New York and Tokyo, 1972)
S. Gorai, ed.: *Sangaku shūkyōshi kenkyū sōsho* [Studies in the history of mountain religion], 18 vols (Tokyo, 1975–84)
R. Tyler and P. Swanson, eds: 'Shugendō and Mountain Religion in Japan', *Jap. J. Relig. Stud.*, xvi/2–3 (1989) [whole issue]

H. BYRON EARHART

8. FOLK. Folk religion may be defined as a body of popular beliefs about divine beings that is transmitted to and acted on by the people without the aid of professional clergy. In Japan there is a large body of such beliefs, indebted to Indian and Chinese lore as well as to native traditions. The art that it has produced is largely FOLK ART, for example simple pictures and rough sculptures of lucky gods, of animals who are the messengers of the gods and of various sorts of demons. On the other hand, these motifs, along with Daoist immortals (*see* §4 above), are common also in *netsuke* (*see* §XVI, 17 below).

The three most popular Buddhist figures are Fudō Myōō, Jizō and Daruma (*see* §3 above). Fudō protects sailors, but stone images of him are also placed by roadside shrines at intersections, as also are images of Jizō, the *bodhisattva* who wears a monk's robe, rescues the dead from hell and guards children, miners, travellers and women in childbirth. Devotees express their gratitude for the birth of a healthy child by tying a brightly coloured, usually red, apron around the neck of small stone images of Jizō at a temple. He appears also in cemeteries, where a stone carved in his image is sometimes placed as a memorial to a dead child. Papier-mâché images of a legless Daruma, essentially the shape of an aubergine, are manufactured and the pupils of the eyes left unpainted. At the beginning of an enterprise the owner makes a wish for success and paints in one of the eyes. If the enterprise is successful, the second eye is painted in.

The Seven Lucky Gods (also called the Seven Gods of Good Fortune and the Seven Household Gods) are often represented by small sculptures or paintings. Ebisu holds a fishing rod and a fish; the god of the wealth of the sea, he brings daily food but is also the guardian of farmers and of merchants. Daikoku, the god of the wealth of the land, wears a floppy, baglike cap, holds a magic wealth-producing mallet in his right hand, has a bag over his shoulder and stands on two bales of rice. Bishamonten, one of the Buddhist Four Guardian Kings, is dressed in armour and holds a pagoda in his right hand. He too brings wealth. Benzaiten, the only female in the group, is a Buddhist *ten*. She is the goddess of music and may hold a lute (*biwa*) or sit on a rock around which a serpent or dragon is coiled. Fukurokuju, a bearded old dwarf with an extremely elongated forehead, is accompanied by a crane, a symbol of the longevity he is said to bestow. Jurōjin, the Old Man of Long Life, regarded as a Daoist immortal (*sennin*), is usually dressed in the robes and cap of a Chinese scholar and is accompanied by a deer or crane. Hotei, probably a Daoist figure who was assimilated into Zen Buddhism as a manifestation of the Buddha of the Future, is a god of happiness. He carries or sits on a sack containing treasures.

Two kinds of demons or goblins often represented are *tengu* and *oni*; they are less evil than the devil of Christianity. *Tengu* live in pines and cedars in mountainous regions, just as Shinto *kami* inhabit natural objects and sites; they have human bodies but beaks or long noses and are often winged. *Tengu* are mischievous, especially given to obstructing the work of Buddhist priests, although worldly priests are sometimes shown as *tengu* and hypocritical priests are said to become *tengu*. In pictures of the late 19th century, however, *tengu* are comic rather than terrifying. Masks of *tengu*, generally with a long nose rather than a beak, are also usually comic, partly because the nose is phallic. *Oni* are usually malevolent or at least troublesome. In Shinto they were thought to be departed souls in a sort of limbo or *kami* who, displaced by the deities of Buddhism, haunt the living. *Oni* have horns, fangs and usually claws rather than toenails or fingernails; the male *oni* usually wears a loincloth made of a tiger's skin. *Oni* often appear in *Ōtsue*, folk paintings from the town of Ōtsu. One of the commonest themes in *Ōtsue*, apparently satirizing hypocritical priests, shows the *oni* as an itinerant priest, a gong hanging on his chest, a mallet in his hand and a closed umbrella slung over his back. Another common *Ōtsue*, showing the *oni* bathing in a tub, has engendered contradictory interpretations: one that a clean devil is still a devil, another that even an *oni* can become purified if he cleanses his heart.

Animals play a large role in folk religion. The 12 animals of the zodiac govern the hours of the day, the months of the year and the years in a 12-year cycle. They are the tiger, boar, rat, snake, hare, dog, horse, ox, rooster, dragon, goat and monkey. Each animal has certain associations. For instance, men born in the year of the tiger (1938, 1950 etc.) are especially vigorous and lucky; men and women born in the year of the snake (1941, 1953 etc.) are especially attractive and are likely to experience marital difficulties; and men born in the year of the monkey (1944, 1956 etc.) do not have good relations with women.

The fox, the lion and the monkey are often represented in other contexts. The white fox is the messenger of a Shinto god called Inari Myōjin. Inari is usually represented as an old man bearing a sheaf of rice and accompanied by two foxes, one with a scroll, the other with a jewel in its mouth, but sometimes as a beautiful young woman. Most Inari shrines are guarded by a pair of foxes, the fox being so commonly represented as the messenger of the god

9. 'Beckoning cat' (*maneki-neko*), carved bamboo, h. 195 mm, 19th century (Nashville, TN, Vanderbilt University Gallery)

that it is often taken to be the god himself or herself. The lion appears in Buddhism as the vehicle of Monju, and pairs of lion-dogs (*koma inu*) guard Shinto shrines, but in folk religion the lion—more properly the *shishi*, an imaginary lion-dog—is best known in the lion dance. A ferocious-looking mask, usually painted red and with a hinged lower jaw, is held, not worn, in front of the face, while two or three people, one behind the other, crouch under a cloth and lunge and caper in a dance. The lion dance, thought to have been introduced from the Asian continent in the 7th century, by the Muromachi period had become a popular rite of exorcism. Monkeys most commonly appear as clay figurines in household shrines. The female monkey holds a baby at her breast, whereas the male embraces a large phallus. They represent appeals to the gods for sons or for safe childbirth and healthy children. Finally, the 'beckoning cat' (*maneki-neko*; see fig. 9), made of wood, clay, papier-mâché or bamboo, seems to Westerners to be saying goodbye, since the palm faces the viewer, but in fact it is signalling the viewer to approach. A symbol of good fortune, it commonly appears in shops, where it is meant to bring good fortune (i.e. customers) to the shopkeeper.

BIBLIOGRAPHY

V. Hauge and T. Hauge: *Folk Traditions in Japanese Art* (New York, 1978)
S. Addiss, ed.: *Japanese Ghosts and Demons: Art of the Supernatural* (New York, 1985)

SYLVAN BARNET

III. Architecture.

Japanese architecture presents many paradoxes, a fact that has led to several commonly held misconceptions. For instance, there is the illusion that traditional Japanese buildings are fragile confections of wood and paper. Yet the wood is usually not of the frail matchstick type but some of the most durable building material in the world, especially Japanese cypress, and mulberry paper is used only for light-admitting screens (SHŌJI), while sliding interior room dividers (FUSUMA) are made of solid wooden frames and strong opaque paper. Moreover, the general belief that Japanese buildings are simple in design, small in size and flimsy in construction overlooks the mainstream tradition of extremely large and durable structures built with sophisticated construction techniques and tools (*see* §1(ii)–(iv) below). For example, the Daibutsuden or Great Buddha Hall of Tōdaiji (*see* NARA, §III, 4) is reputed to be the largest timber-frame building in the world, 49.1 m high at the ridge-pole and with massive internal pillars nearly 2 m in diameter. Japan also has the largest castles ever constructed in the world, the giant citadels of Edo and OSAKA. It is also traditionally thought that Japanese architecture does not use a single nail, but in reality large-scale, pre-modern building projects required so many nails that a metalsmith was kept busy from dawn until dusk turning out the varied assortment of nails needed for floorboards, roof rafters and interior fittings. It is true, however, that nails do not perform the same major structural connections in Japanese buildings as they do elsewhere; the straight-grained cypress used for the structure of most ancient buildings would have split if nails had been hammered into it to connect the ends. Instead, the building frame is held together by an intricate system of mortice-and-tenon joinery. Angled and spliced joints have great strength and flexibility, permitting buildings to withstand earthquakes by absorbing the energy of the vibrations.

Many scholars have praised Japanese buildings that coincide with the modern taste for simplicity while dismissing those that do not. It has become fashionable among historians and architects, for instance, to condemn the TŌSHŌGŪ SHRINE mausoleum in Nikkō (Toshigi Prefect.) for its extravagant ornamentation, even as the Katsura Detached Palace (*see* KYOTO, §IV, 10) is admired for its simplicity. This subjective view ignores the fact that Tōshōgū is a supreme political statement by the 17th-century shogunal establishment and, as such, its style is eminently suited to its function. Conversely, recent restoration work at Katsura has revealed that the buildings were originally much more colourful than they now appear.

The most seductive of the illusions about Japanese architecture is the belief that the interiors are based on 'space–time' intervals known as *ma*, part of a general tendency to interpret Japanese traditional architecture in terms of modern Western spatial theories. *Ma* has been used since the 1960s to explain the system of design that created the subtle spatial qualities of the traditional Japanese interior. In reality, *ma* was used to designate a room, as in *kyakuma* ('the place for a guest'). In traditional

building practice it meant 'the space between', with emphasis on the role of the trabeate structure rather than the space it subtended.

Like all architecture, Japanese architecture results from a complex interplay of structure and proportion, of materials and placement. These are the realities that produced some of the most sublime aesthetic and spatial effects of any architectural tradition, and it is thus essential to understand the dynamics of Japanese building design and construction in order to understand the architectural tradition as a whole.

1. Introduction. 2. Pre- and protohistoric: Jōmon, Yayoi and Kofun. 3. Early: Asuka, Nara and Heian. 4. Late: Kamakura, Muromachi, Momoyama and Edo. 5. Modern: Meiji and after.

1. INTRODUCTION. Rather than dwell on illusion, the most useful way to interpret the reality of traditional Japanese architecture is to see it as the product of four separate but dynamically interacting spheres: the functional sphere of different building types created for different purposes (*see* §(i) below); the technological sphere of materials and tools (*see* §§(ii)–(iii) below); the human sphere of the skills and practices of the hereditary building professions and trades (*see* §§(iv)–(vi) below); and finally the historical sphere, in which architectural evolution can be seen as a response to changing political, religious, social, economic and technological conditions (*see* §§2–5 below).

(i) Building types. (ii) Materials. (iii) Tools. (iv) Building practice. (v) Design manuals. (vi) Builders and architects.

(i) Building types. Japanese architecture is extremely diverse in building type and function. The major categories of buildings are: religious, including Shinto shrines (*jinja, jingū*) and Buddhist temples (*ji'in*); official buildings, including palaces and centres of government (*goten*); mansions and retreats of the élite, whether civil or military aristocracy (*shinden, shoin, sukiya*); commoners' housing (*minka*), both rural (*nōka*) and urban (*machiya*); and military castles and fortifications (*shiro, jōkaku*). Historically, most building types shared common features, in particular a timber-frame structure with infill walls and overhanging roof, together with a common sequence of design and construction. However, there were fundamental differences in scale, site organization, decorative emphasis and building techniques between the different building types; specifically, each required members of a specialized branch of the carpentry profession to build them. The range included cinnabar-red painted temples with massive framing, such as Tōdaiji, Nara; delicately proportioned, plain wooden Shinto shrines, such as ISE SHRINE, Mie Prefecture; sumptuous palatial complexes, such as Nijo Castle, Kyoto (*see* KYOTO, §IV, 9); and restrained Zen Buddhist meditation halls, such as Ryōgen'in, Daitokuji, 2 km to the north in the same city (*see* KYOTO, §IV, 5). The daunting scale of Himeji Castle (*see* HIMEJI, §2) contrasts with the miniature size of the Taian tea-room at Myokian (Kyoto Prefect.), with a floor area of two *tatami* mats. Such dramatic differences in form and appearance usually, but not always, corresponded with differences in building function. It may have been usual for shrines to be restrained and temples ornate in appearance, but the 17th-century Nikkō Toshōgū (technically a

shrine), for example, exhibited an ostentation exceeding even the most exuberant palaces of its day.

Patrons also had a strong prescriptive effect on building forms. Principal patronage came first from the civil aristocracy, centred on the imperial capitals of Nara and then Kyoto, and later from the warrior class that formed shogunal governments based successively at Kamakura, Kyoto and Edo (modern Tokyo). The major Buddhist sects also required temple and monastic complexes that reflected their doctrinal and social positions and aesthetic preferences. These ranged from the austere, contemplative Zen monasteries of Kamakura and Kyoto to grand, state-sponsored monuments such as Tōdaiji. Building form also varied according to the topographical, climatic and geomantic character of the specific site, as well as the nature of the available or preferred materials (*see* §(ii) below).

(ii) Materials. The selection of materials for the various parts of the traditional Japanese building was dictated by function and aesthetics. Foundations, timber frames, floors, walls and roofs were all made of materials suitable to their specific role.

(a) Foundations. In traditional residential architecture, the foundations consisted of field or hewn stone, which provided individual footings for pillars. The frames of larger buildings such as temples rested on pounded earth podia reinforced and faced with stone, usually granite. In castles, dry walls of granite sometimes 40 m in height served as foundations for building superstructures.

(b) Structural and decorative timbers. The structure of most traditional architecture was timber-framed, and the pre-eminent structural wood for pillars and beams was *hinoki* (Japanese cypress; *Chamaecyparis obtusa*), a conifer noted for its beauty, strength and resilience without undue weight or propensity to warping. It grows to a height of 40–50 m, with a fine, straight grain, making it easy to work with hand tools and to split lengthways with wedges. *Hinoki* flourished in the mountains around the ancient capital region (Asuka/Nara) and was used for most monumental buildings from the 6th century AD until the 13th when supplies were depleted. *Hinoki* pillars survive in buildings such as the five-storey pagoda of HŌRYŪJI (7th century). Diminishing supplies of *hinoki* in the medieval period forced builders to substitute *akamatsu* or red pine (*Pinus densiflora*) and *keyaki* (*Zelkova accuminata*). In their natural state these trees had curved or crooked trunks, which made it difficult to fashion them into straight pillars and beams. Moreover, red pine is vulnerable both to damp and to attack by insects, while the deciduous *keyaki*, though durable, has a convoluted grain that is difficult to work. Because of their high cost, *hinoki*, *akamatsu* and *keyaki* were used principally in the monuments and residences of the élite. Farmers and townspeople favoured *kuromatsu* or black pine (*Pinus thunbergii*) and *tochi* or Japanese chestnut (*Aesculus turbinata*) for their residences and workplaces. Bamboo lashed together with smoked vines was used for the roof trusses in some farmhouses.

In addition to structural timbers, woods specially selected for the interior helped determine the character of residential buildings, especially those in *Sukiya* (tea house)

style. These materials ranged from consciously rustic unhewn timbers, bark, thatch and bamboo, to refined woods such as the imported rosewood, ebony and Chinese mulberry used for the ornamental shelving in the Shin-Goten of Katsura Detached Palace. *Sugi* or Japanese cedar (*Cryptomeria japonica*), a conifer with a pronounced straight grain, was prized for ornamental lintels (*nageshi*) and door panels, and cedar from northern Kyoto (*Kitayama sugi*), modified during growth to produce an irregularly patterned surface, was coveted for the *tokobashira* (main pillar) at the side of the TOKONOMA (decorative alcove). Unhewn *sakura* or Japanese cherry (*Prunus japonica*), with its natural textured surface and rich colour, was also frequently used for the *tokobashira*. In *Sukiya*-style architecture, bamboo was often employed for *tokonoma* lintels and the rafters adjacent to the garden. The large burrs and figured grain that make *keyaki* difficult to work also make it particularly desirable for decorative features, especially the main ledge of the *tokonoma*. The timber's hardness is well suited for carved pillar nosings, transom friezes and other sculpture. From 1668 the sumptuary edicts issued by the Tokugawa shogunate restricted the use of *keyaki* in gateways and *sugi* in door panels to the mansions of the daimyo (highest-ranking samurai).

In modern Japan these structural and decorative timbers were used only for high-class residences, restaurants and inns built in traditional style. Exhaustion of indigenous forests made it necessary to import cypress in large quantities from Taiwan. Because it is grown in a warmer climate, this timber has a lower density and wider grain than Japanese *hinoki*. Lauan (*Shorea contorta*) from the Philippines, Malaysia and Indonesia was used for Western-style interior finishing, and in the late 20th century 50×100 mm studs imported from North America were a popular substitute for materials used in conventional Japanese framing. Temples such as Zōjōji in Tokyo and Shinshōji near Narita were rebuilt in ferro-concrete in imitation of traditional wooden construction.

(c) Floors. Early Buddhist temples, government buildings and medieval Zen meditation halls had stone- or terracotta-tiled floors set directly on the foundation platform. Shinto shrines and later Buddhist temples had raised wooden floors, frequently made of *hinoki*. Farmhouses and urban dwellings had an area of pounded earth (the *doma*), often stone-flagged, and a raised wooden floor (the *toko*) made from locally available timbers such as black pine. Another material used for floors was *tatami*, densely packed rice straw enclosed in a cover of woven rush bound lengthwise. *Tatami* matting first appeared as a floor covering in the Heian period (AD 794–1185) and was initially laid over floorboards in *Shinden*-style mansions. By the 17th century it was used as a complete floor covering in important rooms in élite residences and in the houses of many commoners. In the late 20th century, however, floors of imported polished woods, synthetic substitutes and carpet became more common than *tatami*.

(d) Walls. Split logs were in general use for the load-bearing walls of storehouses before the 6th century AD. After the introduction of Buddhism, non-bearing walls became the norm in Japanese architecture, and these permitted the use of plaster and clay daubed over split bamboo and reed lathing. Sliding screens of wood, or wooden frames covered with translucent mulberry paper and opaque paper, provided flexible space dividers. Modern housing utilized stressed-skin wooden panels, gypsum board, glass and precast concrete panels as infill for steel-frame or 2×4 in. (*c.* 50×100 mm) stud structures. Composition board panels with sheet rock and ventilated filling allowed for better climate control in newer residences.

(e) Roofs. Terracotta roof tiling (*kawarabuki*) was used for most Buddhist temples and government buildings. Both rural and urban vernacular housing had roofs of coarse miscanthus reed thatch (*kayabuki*), finer straw thatch (*warabuki*) or cedar shingles (*itabuki*) held down by bamboo lattice and river stones. In the city of Edo in the 18th century, government edicts and low-cost loans encouraged builders to replace thatch and shingles with terracotta tiling because of the risk of fires. Shingles of cypress bark (*hiwadabuki*) or cypress wood (*kokerabuki*) were used for the residences of aristocrats and warriors and for Shinto shrines. The disadvantage of the need to replace these shingles periodically was offset by their ability to harmonize with a natural setting and to deaden the sound of falling rain. From the 17th century heavy-gauge copper sheeting (*dōbanbuki*) mounted over wooden formwork was used for the roofs of many large-scale buildings as it was both lightweight and fireproof. In modern housing, tiles were the preferred roofing material, followed by steel and aluminium sheeting, lightweight concrete panels and asphalt shingles. Thatch and shingle roofs that fell into disrepair were usually not replaced but weatherproofed with galvanized iron sheets.

(iii) Tools. In order to grasp the operational dynamics of the Japanese building tradition, it is important to understand the various types of tools available, their specific uses and their development. Even in the prehistoric Jōmon period (*c.* 10,000–*c.* 300 BC) and the Yayoi period (*c.* 300 BC–*c.* AD 300), the development of tool technology was closely related to building practice. Jōmon-period pit dwellings with simple, thatched-roof superstructures, were supported by posts set in the ground, and stone tools excavated at Jōmon sites show that the trees used for these posts were felled and roughly shaped with axes and adzes, which had flaked or polished stone heads. The use of iron tools as part of sustained building practice in Japan dates from the short but significant Yayoi period, when new immigrants from the continent established stable, agricultural communities with increasingly specialized use of iron tools. The widespread diffusion of axes, gimlets, mallets, planing knives and especially chisels and adzes resulted in dramatic improvements to the pit dwelling. Excavations at Toro and Yamaki, settlements that thrived in the 4th and 5th centuries AD, have revealed general use of sturdy, squared posts for roof support. Before the introduction of iron tools, posts were roughly hewn trunks, sometimes split but rarely squared. The absence of joinery on Jōmon timbers indicates that they were simply lashed firmly together with straw rope. However, at the Yamaki site a number of pillars and beams connected with sturdy mortice-and-tenon joints were discovered. Iron tools may

even be responsible for the most significant architectural development of the Yayoi period—the advent of a completely new building type, the raised-floor structure.

The creation of new building types and styles, however, is not necessarily dependent on new tools. The huge Buddhist temples and halls of the Asuka–Hakuhō periods (AD 552–710) and the Nara period (710–94) were constructed with the basic cutting and finishing tools imported from China in the Yayoi and Kofun or Tomb (c. AD 300–710) periods. For instance, the sophisticated overall effect presented by the late 7th-century kondō ('golden hall'; main image hall) and pagoda at Hōryūji was created using simple tools little changed from their predecessors of a century earlier. Carpenters had mastered the techniques of quartering large cypress trunks with wedges, then rounding them with adzes (chōna) and using long-handled planing knives (yariganna) to bring them to silken smoothness. Woodworking tools comprised chisels, adzes, planing knives and a rudimentary form of iron-bladed cross-cut saw, which worked more by grinding than by cutting. Inking lines, brushes and carpenters' squares were also used. Similarly, aristocratic mansions of the Heian period (794–1185) were constructed using tools for cutting and finishing timbers that were little changed from the Nara period. The methods of preparing pillars and beams, of cutting mortices and tenons and of smoothing surfaces with an adze and a planing knife remained firmly grounded in long-established convention.

In the 12th century the range of mechanical tools was complemented by an improved intellectual tool, the carpenter's square (sashigane), which provided exact scales of measurement and set right angles. A square-root scale (urame) added to the rear side of the measure's long arm set out the square-root values of the units shown on the front of the same arm. This deceptively simple device ranks among the most important of all inventions in the history of Japanese architecture. The new 'ready reckoner' enabled the carpenter to determine the dimensions of the squared member that could be cut from a round log, a calculation made necessary by the shift from round to squared pillars in residential architecture. This was one of the modifications to building styles that occurred as Japanese architecture matured in isolation from the continent. Round pillars were the norm in Chinese and Korean buildings, but the Japanese found, when sliding screens became standard, that it made better sense to use square pillars. The interface of screen and squared pillar is neater and keeps out draughts more efficiently than the clumsy connection made with a round pillar.

The new root scale also facilitated the calculation of curvature by describing parabolas based on square and cube roots. Master carpenters could thus quite readily design a variety of complex curved forms. This marked a fundamental turning-point in the design of the roof, the dominant visual element in Japanese building. The curvature of the roof and the placement of rafters and framing elements could be calculated by reading off tangents on the urame scale. The most dramatic consequent development was a Japanese type of cusped gable called the karahafu (which, misleadingly, may be translated as 'Chinese gable'), the alternating concave and convex curves of which required exactly symmetrical placement of rafters

and ribbing. By the 12th century, the karahafu was found adorning the side eaves of aristocratic gateways and the front barge-boards of court carriages. Thus the Heian period ended with one of the most important developments in Japanese tool technology, with fundamental implications for later design practices.

During the Kamakura (1184–1333) and Muromachi (1333–1568) periods, architectural styles from Northern Song-period (AD 960–1126) China were adapted in Japan. Both the monumental Daibutsu style from southern coastal China and the elegant Northern Song dynastic style (known as Zenshūyō in Japanese because of its association with Zen sects) called for significant alterations to the design and construction of Buddhist temple buildings. The carpenter's square was increasingly used experimentally as an instrument of design: tangents and triangulation, parabolas and polygons were explored by the carpenters as they met the challenge to re-create foreign styles. By the Muromachi period, the low and placid karahafu of the Heian period had achieved a soaring silhouette.

A radical change in cutting tools during these two periods was precipitated by a shortage of straight-grained timber of structural dimensions, a crisis that was compounded by the need to re-create difficult Song-period styles with their greater use of penetrating tie-beams. The increased demand for buildings during the Kamakura period created a severe drain on available material resources, and supplies of straight-grained timber, particularly hinoki, dwindled alarmingly. In order to offset their wood shortages, the carpenters of medieval Japan had to make more joints to connect smaller timbers and to use the capriciously grained keyaki for structural needs. This rendered the traditional technique of splitting and smoothing timbers useless. Improved tools were needed both for joinery and for longitudinal cutting of lumber.

The result was the development of steel-tipped cutting blades. This was one of the great technological innovations in architecture in the seven centuries between the end of the Heian period and the beginning of the modern period. Scenes of building activity in Kamakura-period paintings, particularly at the beginning of the illustrated handscrolls of the Kasuga gongen kenkie ('Illustrated scrolls of the miracle of the Kasuga deity'; 1309; Tokyo, Imp. Household Col.) and the Matsuzaki tenjin engi emaki ('The miraculous tales of Matsuzaki tenjin'; 1311; Suō Tenmangū Col.), provide important evidence that by the early 14th century the Japanese had improved the design of the cross-cut saw into a more efficient leaf-shaped blade (see fig. 10) and that cutting was performed with a pull-stroke instead of the thrusting action that had been needed in using the wrought-iron Chinese 'grinding saw'. These pull saws were made of laminated steel with the same techniques as were used to fashion the superlative steel of the warrior swords, and they marked a turning-point in the evolution of saws in Japan.

The Japanese also refined the manufacture of chisel blades and later plane blades by adding a cap of high-penetration carbon steel to a malleable iron core and then repeatedly heating, beating and quenching the blade. The flexibility of blades was further enhanced by tempering with clay, leaving the cutting edge exposed to give it a tougher temper from quenching. The chisel was the tool

10. Carpenters at work, detail showing the use of adzes, planing knives and the cross-cut saw with leaf-shaped blade and wedges; from the *Kasuga gongen kenkie* ('Illustrated scrolls of the miracle of the Kasuga deity'), set of handscrolls, 1309 (Tokyo, Imperial Household Collection)

most immediately affected by this new technology. Steel-tipped chisel blades helped carpenters to cut the penetrating ties needed for Chinese-inspired buildings, to make the stronger spliced joints needed to connect short timbers and to work the difficult *keyaki*.

The crisis of lumber supplies was finally resolved by the adoption from China of a two-man frame saw (*oga*) for rip-sawing lumber. Its use in Japan is first mentioned in documents describing building work carried out at Tōji in Kyoto in the 1420s. The Japanese were aware of the existence of the large frame saw by the 12th century but had not needed to use it while supplies of straight-grained timber suitable for longitudinal splitting were plentiful. With the depletion of timber stock in the medieval period, however, the frame saw became widely used to cut long pieces of convoluted grain lumber into cleanly finished structural timbers or neat, thin boards for use as flooring or wall and ceiling panels. It also prompted the creation of one of the most distinctive and beautiful of Japanese art forms—paintings done directly on wide cedar panels cut with the frame saw.

The best evidence of the freedom bestowed on carpenters by the frame saw is found at the abbot's quarters of the Ryōgen'in, a subtemple of Daitokuji, Kyoto. Built in about 1517, it is one of the few surviving buildings constructed in the 150 years between the introduction of the frame saw or rip saw and the disappearance of exposed timber flooring following the general adoption of *tatami* mats in residential architecture. The smooth floorboards in the central chamber are 6 to 7 m long and more than 500 mm wide. Even though they are of straight-grained cypress, it would have been impossible to split them to such generous and consistent dimensions without the frame saw.

During the Momoyama period (1568–1600) and the early Edo period (1600–1868), some of the most remarkable buildings in the history of Japanese architecture were built, including Nijō and Himeji castles, Katsura Detached Palace and the Tōshōgū mausoleum at Nikkō. Though disparate in form and function, the architectural style of all these buildings was decisively influenced by new cutting and finishing tools, which not only speeded up the construction process but also gave carpenters greater freedom for expression in wood design. Further innovations in the design of saws revolutionized the methods of turning raw lumber into architectural timbers, freeing carpenters from the drudgery involved in their preparation. The adaptation of the block-plane from China brought dramatic improvements to the finish of wood surfaces.

The invention in the late 16th century by Kyoto sawyers of a new one-man rip saw, the *maebiki-oga*, was very significant. With the escalating demand for timber created by massive construction projects in the late 16th century, the two-man frame saw proved too labour-intensive to use, nor could it be produced in sufficient numbers to meet the demand. The great length of its blade also made it difficult to forge. The *maebiki-oga* was short-bladed, easy to forge and its large raked teeth cut aggressively through the timber. It soon superseded the two-man frame saw as the mainstay of lumber preparation. Another type of saw that appeared during the Edo period was the *daigiri*. Consisting of a long blade up to about 3.5 m in length, it was used for cross-cutting felled logs to prescribed lengths. It came into general use around the turn of the 18th century and became the main tool of the men who did the felling and logging on remote mountain sites. It also became the common tool for rough cross-cutting and was found in every rural community until the mid-20th century.

The plane also underwent dramatic development in the 16th and 17th centuries. The push-plane was a block-plane worked with a pushing action by grasping two handles near the front. Used throughout China as well as south and west Asia, it was introduced to Japan by Chinese merchants trading at the ports of Nagasaki and Kobe in

the late 16th century. In Japan, in keeping with indigenous preference, the push-plane was converted into a block-plane worked by a pulling action. This simple block-plane opened up a new realm of efficient operation and creative possibility, rapidly replacing the adze and planing knife for smoothing surfaces of wood, which could be done more quickly and with less effort and skill. The block-plane also prompted the invention of gouging and grooving planes. These made it infinitely simpler and faster to fashion multiple sliding tracks and housings for screens and room dividers, opening the way for their more extensive use and the more flexible arrangement of interior space. Hitherto sliding tracks had been made by painstakingly attaching battens to the sills. Carpenters of the period also displayed their ingenuity by making a variety of moulding and bevelling planes to create different decorative effects on pillars and other interior detailing.

With the 'opening' of Japan in the mid-19th century, many aspects of Western culture were rapidly adapted to Japanese needs. Western architectural styles were deliberately adopted from early in the Meiji period (1868–1912) but Japanese builders generally continued to use traditional tools even when working in new styles for the simple reason that they were better. For instance the laminated steel produced by the master metalsmiths of Japan was superior in every way to anything produced in North American or European factories, and the Western push saw, with its thick blade and cumbersome cutting action, offered no advantages to the Japanese, already well served by their flexible, fine-bladed pull saws.

In contrast with the Meiji period, when foreign styles were fused with domestic production techniques, more recently Japan's success as an economic giant was purchased at the cost of architectural tradition. While the replacement of hand tools and techniques by power tools and mechanized mass production began in Europe and North America in the 19th century, in Japan the destruction of craft traditions occurred later and more rapidly, primarily from the early 1940s onwards. Power tools, first manufactured in Japan in 1957, were soon in universal use, even for structures in which traditional building techniques were needed. Senior carpenters may still own several hundred tools, but most of these lie unused in the tool box. The typical carpenter rarely uses more than 30 of the traditional hand tools. Carpenters use *sashigane* marked in centimetres and millimetres, and many younger carpenters do not recognize traditional units of measurement such as *shaku* and *sun* (*see* §(iv) below). Moreover, those precious distillations of Heian- and Kamakura-period design experience, the scales on the rear of the main arm of the carpenter's square, are rarely used to calculate curvature or lumber dimensions at the modern building site.

(iv) Building practice. Traditionally, the design of a Japanese building was conceived after consultation with the patron concerning size, function and the available budget. The master builder then established the building's exact siting and most favourable orientation on the basis of both practical and geomantic considerations: a southern orientation, for example, assured both maximum sunlight and protection from the malevolent cosmic forces thought to dwell in the north.

Construction of the building did not rely on detailed architectural drawings, but on proportions based on modules. These proportions or *kiwari* ('wood dividing') differed according to the period, the region and the individual workshop but were similar to the basic proportions of classical architecture. The primary module was the span of the post-and-lintel bay or *ken*; this was divided into 6 sub-units called *shaku* ('feet'), each further divided into 10 *sun* ('inches') and 100 *rin*. A pillar was typically one *shaku* wide, or a sixth of the width of the bay, but its actual length would differ according to workshop tradition, the function of the particular building and the size and type of timber available. It was only in 1886 that the *ken* was fixed at 1.82 m and the *shaku* at 303 mm in order to facilitate international trade. Architectural drawings came into use in the 16th century, at first more as a guide for patrons than for directing the builders' activities. The plan, simply set out on a board called *ezuita* ('plan' or 'design board'), showed the disposition of pillars on a grid but gave no dimensions or working instructions.

The *tatami* mat became another important module of design in the 16th and 17th centuries. By this time floors were completely covered in *tatami*, and it became aesthetically necessary to align pillars with mat borders to ensure interior unity. Pillars were positioned according to the dimensions and arrangement of mats, reversing the previous procedure in which mats were laid between existing pillars. This marked a shift from a structural module to a spatial module. By the 18th century *tatami* dimensions were standardized with the emergence of three basic sizes, of which the *Kyōnoma* (1970×985 mm) used in Kyoto was the largest.

The master builder selected all the important timbers, paying careful attention to their size, character and orientation within the building. For example wood from the south side of a tree is better adapted to hot summer sun and wood from the north side is better able to withstand cold. Moreover, the natural curve of a beam might dictate the configuration of the entire truss. Because the spirit of the tree from which the timber was taken had to be accommodated to the building site, and its original orientation to the north or south respected, the master builder himself frequently went into the mountains to find suitable trees and to understand their original environment. Timber was sometimes reused; a prized piece of *keyaki* owned by the patron or a pillar taken from an earlier building might set the mood and design for a particular room.

The principal pillars and beams and much of the interior detailing were prefabricated in the carpentry workshop before assembly at the building site. Each element was measured and marked, using a measuring rod (*kenzao*) 6 to 10 *shaku* long and a carpenter's square, and was then labelled to indicate its location on the grid-plan scheme. The most time-consuming part of the prefabrication process was the measuring and cutting of mortice-and-tenon joints to hold the building together, for which absolute precision was essential. Spliced joints (*tsugite*) were used for connecting beams and sills end to end, and angled joints (*shiguchi*) for securing members at oblique and right angles. Types ranged from the simple *arikake*

(dovetail joint) to the more complicated *kama-tsugi* (gooseneck spliced joint). One of the earliest and most reliable depictions of the prefabrication of a building is found among the handscrolls of the *Kasuga gongen kenkie* ('Illustrated scrolls of the miracle of the Kasuga deity'; see fig. 10 above). It shows construction being carried out for the Kasuga Grand Shrine in Nara (*see* NARA, §III, 2). On the right the *tōryō* (chief master builder), with his measuring rod resting on his shoulder, supervises operations, while at the centre three carpenters and an apprentice measure and mark large timbers using a square and pluck lines (*sumitsubo*). Behind them another team uses wedges and mallets to split large logs into pillars. Only small, leaf-shaped cross-cut saws can be seen, since the two-man frame saw and the one-man rip saw had not yet been introduced. The *Kasuga* scroll also shows carpenters making mortice-and-tenon joints in a shelter at the rear of the building site, where timber is stacked in preparation for assembly. Adzes and long-handled planing knives are in use for smoothing the surface of the split timbers.

After the ground-breaking ceremony, the plan of the building was laid out using a grid of string markers corresponding to the grid-plan board. Stone foundations were then laid and water levels (*mizubakari*) used to ensure that the ground surface was horizontal. The prefabricated parts for the frame were assembled on the foundations, and the frame could sometimes be erected in as little as a single day, as the carpenters were practised in this procedure. Pillars were set on their footings and braced with horizontal beams and ties; pent-roofed sections were added around the core of the building; the roof truss of heavy horizontal tie-beams and smaller vertical posts was placed on top of the wall frame; and the framing was completed by a ridge-raising ceremony (*jōtōshiki*). The laying of roofing materials followed, as tiles were carefully laid from the eaves to the ridge and from right to left along the curving roof surface; pantiles preceded cover tiles and the ridge was sealed with capping tiles. Shingle and thatch roofs were built up from the eaves to the ridge and were secured with bamboo cleats in the case of shingle and straw rope and wooden battens in the case of thatch. The roof weighed down the structure, strengthening the hold of the joinery. It also provided convenient shelter for the plasterers, carpenters and other craftsmen who then completed the walls and interior detailing, placing prefabricated sliding screens and *tatami* mats into their prescribed positions. Landscaping of the site proceeded concurrently with construction so that the building was integrated with its setting. Religious ceremonies marked the end of the project.

In the modern age, these traditional building practices were largely replaced by industrialized processes, including factory prefabrication. Computer-operated joinery machines produced, for example, facsimiles of the traditional mortice-and-tenon joints. This process of industrialization was facilitated by the high level of modular coordination and prefabrication in traditional building construction. In the contemporary housing industry, industrialized techniques produce room-sized units with the same masterly precision as automobile units: 15% of all houses built each year in the 1990s were made in factories. In traditional practice carpenters measured the completed framework

of the building and then made the necessary sliding screens, frames and furnishings. The contemporary custom builder takes the dimensions of standardized manufactured components, such as manufactured aluminium window frames, prefabricated bathroom units and system kitchens, and designs the building around them.

(v) Design manuals. Before the 16th century, carpenters' workshops left few written records because the process of transmission of their skills had been primarily oral and behavioural. From the late 16th century, however, the demand for large-scale buildings of unprecedented complexity greatly exceeded the supply of trained master builders. The workshops in government service had to resort to written manuals to ensure rapid and accurate training of new carpenters and the successful completion of building orders. These manuals, known as *hinagata-bon* ('blueprint books') or *hidensho* ('secretly transmitted writings'), included both technical drawings of buildings and written descriptions of the *kiwari* proportions employed in their design and construction. Long-established traditions were consolidated in these carpenters' manuals, of which the best-known extant example is *Shōmei* ('Elucidation of craft'; 1608), a five-volume work by Heinouchi Yoshimasa and his son, which contains plans, elevations and directions for establishing ratios to systematize and standardize the scale and proportions of structural parts of every major building type from palaces to pagodas.

(vi) Builders and architects. Trade and craft traditions in Japanese architecture developed over many generations. The process of building became a special way of life and a pattern of existential belief. This is evident in the observance of complex rituals, usually based on Shinto rites, throughout the process of construction, as well as in the esoteric nature of the organization and training of the professional carpenter. Important though it was, carpentry was only one profession among the many that were involved in building construction: fellers and sawyers were responsible for the harvesting and transportation of trees as well as their metamorphosis into workable timbers; master smiths forged the laminated steel blades for planes, chisels and saws as well as iron nails and clamps needed to strengthen the timber-frame structure; makers of mulberry paper provided the coverings for the *shōji* screens; stone masons, plasterers, roof tilers, copper-sheet roofers, thatchers and shinglers worked on the actual building, as did the makers of *shōji* screens and *fusuma* frames (known in the 17th century as *toshōji-shi* or 'masters of doors and *shōji*' and by the end of the 18th century as *tateguya*) and the makers of *tatami* mats (*tatamiya*); the allied cabinet-maker (*sashimonoshi*) crafted the chests (*tansu*) and other interior furnishings; and, finally, ornamental metalworkers, painters, sculptors and lacquer craftsmen each added to the finish of the building.

These professions were organized along similar lines, but each was autonomous in administration and activity. In the pyramid of building professions and allied craft trades, the carpenter was pre-eminent. This was due not to any significant difference in status or pay but simply to the fact that the upper echelon of master carpenters was responsible for the overall design and execution of the building and determined the work parameters of the other

professions. The carpenter was artisan and artist, architect and builder, involved in a single, organic process, like the medieval mason of Europe. This variety of roles is reflected in the Japanese word *daiku*, literally 'great craftsman' or 'great builder', which correctly represents the reality of a role that was far removed from a mere 'carpenter'.

The *daiku* profession was organized into family workshops based on a system of hereditary transmission of skills and techniques. Different workshops specialized in certain types and styles of building construction. The most specialized categories were the *miya-daiku*, responsible for temple and shrine architecture (*miya*), and the *sukiya-daiku*, specialists in the construction of buildings in the *Sukiya* (tea house) style for aristocrats, warriors and wealthy merchants. Within traditional carpentry practice there was an extensive hierarchy based on the master–disciple relationship. Typically, the *tōryō* (chief master builder) supervised design and execution and was answerable only to the client. However, major public works, sometimes involving thousands of common labourers in addition to members of the building professions, were supervised by high-ranking court or military aristocrats.

In AD 728 a government department, the Mokuryō (Construction Bureau), was established to carry out the construction of temples and public buildings and to coordinate urban planning for Nara. A special ministry was also set up to build the Heijō Palace, a compound over 1 sq. km containing the administrative and ceremonial halls of government as well as the residence of the emperor. In mid-century the building of the temple of Tōdaiji as the headquarters of state Buddhism was deemed so important that another ministry was established. The building department responsible for the prefabrication and assembly of the structures employed 227 site supervisors, 917 master builders and 1483 labourers. In the Heian period (794–1185), the government did not maintain a large architectural establishment, although families such as the Fujiwara had considerable numbers of craftsmen at their service, including professional makers of Buddhist images such as the famed JŌCHŌ, who carved the Amida Buddha at the BYŌDŌIN. By the Edo period (1600–1868), a commissioner of engineering works (*fushin bugyō*) and a commissioner of architectural works (*sakuji bugyō*) divided the responsibility for national projects such as the building of Edo and Osaka castles in the early 17th century. The general guilds (*za*) of the feudal domains were replaced by specialized craft guilds or associations (*shoku nakama*) based on a type of free enterprise. Craftsmen in the building trades comprised about a third of the entire artisan class, with carpentry by far the largest single component of the building industry. Families of élite master carpenters, such as the Heinouchi (*see* HEINOUCHI MASANOBU), the Kōra (*see* KŌRA MUNEHIRO BUNGO) and the Nakai, became the pre-eminent architectural firms, translating the worldly ambitions of rulers into castle keeps and gilded palaces. These families ran complex government building bureaucracies and presided over vast armies of craftsmen. The official government records for the reconstruction in the 1630s of the grandiose Tōshōgū at Nikkō show that it required 4.5 million days of labour to complete and that some 380,000 carpenters were engaged in the project. The Yōmeimon, the two-storey

gatehouse guarding the inner precinct—possibly the most vigorously decorated structure in the whole of Japanese history—required 55,970 days of carpenters' labour. The Nikkō shrines were not unique in their manpower requirements. More than 30 carpenter-days were needed per square metre for the rebuilding of the vast audience halls of the inner palace at Edo Castle, including the Great Audience Hall (Ōhiroma) of 1751.

When the style of domestic and commercial architecture in the burgeoning castle towns became more sophisticated in conscious emulation of the architecture of the élite, the building profession subdivided along specialist lines to meet the demands of the new urban market. Fellers, who used axes and the newly developed cross-cut saw to harvest timber from the hillsides, became a profession distinct from the sawyers, who concentrated their skills on the one-man rip saw (*maebiki-oga*) to supply squared timbers. The makers of *shōji* screens, *byōbu* frames and doors set up shop alongside cabinetmakers, who specialized in making wooden storage boxes with perfectly crafted joinery.

In the Meiji period (1868–1912), the construction of new Western-style factory buildings, government and commercial offices, as well as housing and urban development, placed new demands on traditional carpenters and family workshops, requiring speedy adjustment of design, materials and technique. Carpenters who had risen to the top of their profession in the service of samurai lords before 1868 had to turn their hands and their tools to creating a new physical environment suitable for a progressive modern state. Some young men were exposed to Western building and engineering techniques by travelling to Europe and North America, but many others gained their basic training under foreign professors and technical advisers, pre-eminent among whom was JOSIAH CONDER, who was employed on a contract basis by the new Meiji government (*see* §5 below). As part of the broad spectrum of social changes in the late 19th century, the Japanese set out to establish a Western-style architectural profession in which a distinction was made between design and construction, architect and builder. Influential architect–scholars of that generation, in particular CHŪTA ITŌ, argued strongly for the independence of architecture as a design profession along Western lines. Although sophisticated techniques of architectural draughtsmanship had evolved by the Edo period, the building designer had, until the Meiji period, remained on site and in touch with the techniques and materials of his buildings. The new division of art and craft had far-reaching consequences for Japanese carpenters and the entire process of building.

Until the turn of the 20th century construction projects were still largely in the hands of master carpenters who had been trained under the old system of apprenticeship, but this went into decline in the Meiji period, when educational reforms such as vocational training undercut traditional patterns of learning trades. Moreover, the complex, interrelated building professions remained intact until the outbreak in 1937 of war in China and the Pacific, during which time an entire generation of carpenters, roof tilers, plasterers, stone masons and others was lost. For the defeated nation there was a loss of confidence in

tradition that exacerbated the pragmatic process of Westernization inherited from the Meiji period.

In the pressing circumstances of post-war reconstruction, when industrialized mass production of housing components was the only solution to the chronic shortages of dwellings, skilled labour and materials, there was little room for creative compromise between new and old, and the traditions of many generations were swept away. Throughout the 1960s the priority given to rapid economic growth and technological development created a cultural climate in which craftsmen and their skills vanished, unable to compete with the machine-made products of the modern economy or to convince their children that there was dignity and fulfilment to be found in the traditional professions. Cost efficiency was part of the problem, but the loss of respect and self-esteem through deprivation of design initiative was the root cause. The separation of the roles of designer–architect and carpenter–builder meant that the organic nature of the traditional architectural process was destroyed and carpenters were demoted to the role of manual workers in a society that increasingly set great store by high educational attainment.

In the late 20th century modern large-scale construction was in the hands of giant contracting firms, especially Kajima, Shimizu, Ohbayashi, Taisei and Takenaka, all of which offered coordinated architectural design, building construction and engineering services. The training of personnel for the building industry emphasized adapted Western practices and took place at technical colleges and specialized trade schools.

Nonetheless, while traditional craftsmanship was threatened with extinction, the artistic heritage was not. Large-scale public and commercial architecture of the post-war decades was dominated by Japanese architects trained internationally and influenced by the International Style made fashionable by Walter Gropius and Le Corbusier. In such buildings as the Hiroshima Peace Memorial Museum (1955), KENZŌ TANGE, for example, used the elements of a rectilinear steel frame with glass infill that were typical of the International Style, but, in the measured spacing of the bays and strongly abstracted geometry of form, he retained a resonance with traditional Japanese architecture. Architects such as TADAO ANDŌ and FUMIHIKO MAKI retained or revived a sense of the craftsmanship of construction while maintaining their place on the cutting edge of international design and high-technology building systems in the 1980s and 1990s. Andō's residential architecture exploited the qualities inherent in reinforced concrete by creating wall surfaces and interplays of texture and light similar to those found in the traditional *shōji* screens of *sukiya* architecture. Maki's Tokyo Metropolitan Gymnasium, which has a span of 120 m in a zone where building height is limited to 30 m, is a work of international stature, but the plan and the sequence of movement and the intimacy of carefully constructed views around the vast site are similar to those of a traditional Japanese garden.

BIBLIOGRAPHY

Shokunin no rekishi [A history of craftsmen] (Tokyo, 1956, rev. 1965)
M. Endō: *Nihon shokuninshi no kenkyū* [Research on the history of Japanese craftsmen] (Tokyo, 1961)
C. Itō, K. Inui and Y. Ōkuma, eds: *Meiji-zen Nihon kenchiku gijutsushi* [History of Japanese building techniques before the Meiji period] (Tokyo, 1961)
H. Ōta: *Nihon kenchikushi josetsu* [An introduction to the history of Japanese architecture] (Tokyo, 1962, rev. 1969/*R* 1975)
H. Ōta, ed.: Eng. trans. by S. Kirishiki as *Traditional Japanese Architecture and Gardens* (Yokohama, 1972)
T. Muramatsu: *Daiku dōgu no rekishi* [History of Japanese carpenters' tools] (Tokyo, 1973)
Shinkenchikusha, ed.: *A Hundred Pictures of Daiku at Work* (Tokyo, 1974)
K. Seike: *Kigumi*; Eng. trans. by Y. Yobuko and R. M. Davis as *The Art of Japanese Joinery* (Tokyo, 1977)
K. Nishi and K. Hozumi: *Nihon kenchiku no ka fachi: seikatsu to kenchiku no rekishi* (Tokyo, 1983); Eng. trans. by H. M. Horton as *What is Japanese Architecture? A Survey of Traditional Japanese Architecture, with a List of Sites and a Map* (Tokyo and New York, 1985)
H. Engle: *Measure and Construction of the Japanese House* (Tokyo, 1985)
W. H. Coaldrake: *The Way of the Carpenter: Tools and Japanese Architecture* (Tokyo and New York, 1990)

W. H. COALDRAKE

2. PRE- AND PROTOHISTORIC: JŌMON, YAYOI AND KOFUN. The earliest buildings in Japan were simple shelters supported by thin wooden poles. The first art-historically significant structures, however, were Jōmon pit dwellings, Yayoi pile dwellings and Kofun tombs. Excavations conducted since World War II have provided important new data about this early architecture, which had previously been little studied.

(i) Dwellings and settlements. (ii) Tombs.

(i) Dwellings and settlements. Far more is known about the dwellings and storehouses of common people in pre-Buddhist Japan than in any other period of the country's history until the late 16th century. Evidence from 20th-century excavations and from images of dwellings found on mirrors, bells and clay models has made possible the reconstruction of actual structures as well as the recognition of distinct styles of the Jōmon, Yayoi and Kofun periods. Important as a source of information about prehistoric and protohistoric culture, aspects of these dwellings also served as prototypes for the construction of later Shinto shrines and commoners' houses. For example, pillars sunk directly into the ground, crossed finials, billets and detached pillars supporting only the ridge were familiar elements in later shrine architecture. The hard-packed earthen floors found in most pit dwellings and the elevated floors of granaries, both features with an ancient tradition, were later incorporated into rural and merchant housing design. By the beginning of the Heian period (AD 794–1185), pit dwellings were no longer being built in the Kyoto area, but isolated examples in north-east Japan were in use until the early Edo period (1600–1868).

(a) Jōmon period (*c.* 10,000–*c.* 300 BC). (b) Yayoi period (*c.* 300 BC–*c.* AD 300). (c) Kofun or Tomb period (*c.* AD 300–710).

(a) Jōmon period (c. *10,000*–c. *300* BC). The earliest remains of dwellings other than caves date from the Early Jōmon period (*c.* 5000–*c.* 3500 BC). Vestiges of these settlements of Neolithic hunters and gatherers have been found throughout Japan, usually on elevated tracts of land. Excavations at settlement sites usually yield numerous foundation remains, but pottery types indicate that only a fraction of these stood at any one time. It seems that dwellings were often enlarged and moved to accommodate

the needs of successive generations. Remains of individual Jōmon dwelling foundations number around 10,000.

The type of habitation used in these Jōmon settlements was the 'pit dwelling' (*tateana jūkyo*), a form of semi-subterranean housing well suited to cold climates and found across north-east Asia. Pit dwellings were made by first digging a foundation to a depth of 0.5–1 m. In the earliest dwellings a variable number of posts were then sunk to support a roof, four- or six-post examples being the most common. Pit shape differed according to period and location: Early Jōmon pits were square, while Middle Jōmon (*c.* 3500–*c.* 2500 BC) pits could also be oval, round, rectangular, square with rounded corners or irregular. Plans fall into two basic categories, those with a distinct long and short axis and those without, but both types are bilaterally symmetrical. Floor size increased over time, from about 4×4 m in the Early Jōmon period to an average (in circular examples) of 5–7 m in diameter. In the Middle Jōmon period, stone hearths began to appear in the centre of the pit. In cases such as the Hiraide site at Shiojiri, Nagano Prefecture, a floor was made of neatly laid stones. Dwellings had no fixed interior partitions, but the area encompassing the entry and hearth tended to be more communal than the periphery, which was used for sleeping.

In the Late and Final Jōmon periods (*c.* 2500–*c.* 300 BC), pits became shallower and often squarish in shape. Pit dwellings were often situated to form a crescent shape, in order to leave an open area for ceremonies and other communal gatherings. The forms taken by the pit dwelling superstructure are suggested by remains of Jōmon foundations and by post-Jōmon funerary artefacts, such as *haniwa* pottery models of houses (*see* §V, 2 below) and a 4th-century BC bronze mirror (the Kaoku monkyō, from Samida Takarazuka, Kitakatsuragi-gun, Nara Prefecture; Tokyo, N. Mus.) with pictures of dwellings on the back. Roofs were probably of thatch and usually of hipped or hip-and-gable design. Posts were probably joined at the tops by beams, which supported the bottom ends of the rafters that held the roof ridge and the top ends of those that extended to ground-level. Both gable- and side-entrance structures were used. Variations in pit shape and number of post-holes, however, suggest that, even in Jōmon times, a number of roof shapes and supporting configurations were employed.

(b) Yayoi period (c. 300 BC–c. AD 300).

Simple structures. With the introduction of wet-rice cultivation and iron tools in the 3rd century BC, dwelling types further proliferated. The settlements of the Yayoi period were often located on low, wet land suitable for paddy fields; dwelling pits consequently became shallower, to the point where some houses were built at ground-level. At the restored Late Yayoi Toro site in Shizuoka city, Shizuoka Prefecture (1st century AD), dwellings were surrounded by an earthen embankment (w. 2 m, h. 0.3 m) strengthened by interior wooden panels and an exterior wooden barricade. Hearths were located in the centre of the pits, which, to judge from fragments, may have been floored with wood to combat moisture. Several pits contain four post-holes around the hearths, in which fragments of the original posts remain. The four posts, with tie-beams

attached at their top ends, made a simple framework for the roof. Rafters set at a steep angle radiated from the tie-beams. Bound together, the rafters created a surface that could be covered with thatch, and their arrangement close to the outer circumference of the embankment wall left a usable ledge surrounding the interior. Short posts were erected at the centre of the front and rear tie-beams to support the ridge-pole; short rafters extended from ridge to tie-beams. A network of thin lath laid over this raised portion formed a surface for roofing. The ends were left open to allow smoke to escape and to provide ventilation.

Yayoi dwellings also included a type of ground-level structure with perpendicular exterior walls and eaves ending at about head-level, much higher than those of pit dwellings. More significant were the various structures elevated on pilings. Pile dwellings (*takayuka jūkyo*) were built either in separate settlements or together with pit dwellings. Evidence of pile dwellings is found in *haniwa* models (Meotoiwa site, Okayama Prefecture; Kurashiki Archaeol. Mus.), on the Samida Takarazuka mirror, on incised pot sherds from the Karako-Kagi site, Shiki-gun, Nara Prefecture (Tokyo, N. Mus.; Kyoto U., Fac. Lett. Archaeol. Col.), and on a ceremonial bronze bell (*dōtaku*) from the Sanuki Mountains, Kagawa Prefecture (Tokyo, N. Mus.). Judging from these images, it appears that walls were of wooden planks, but some dwellings may have been left almost entirely open. The area beneath the floor usually seems to have been open as well, but it is enclosed in the two examples on the Samida Takarazuka mirror. Pile dwellings may have been used either as residences of chieftains or as granaries, as they provided protection from rodents and dampness.

While some representations show hipped-and-gabled roofs, pitched or gabled roofs were more common. For example, a raised-floor granary at Toro can be reconstructed from evidence at the original site and from the designs on the Kagawa bronze bell and the Karako pottery fragments. According to this evidence, the granary rested on eight round posts set directly into the ground (*hottate bashira*). Large rounded plates placed atop the posts prevented rodents from entering. Flat, horizontal joists joined the posts, and eight uprights were set into these along each side. Planks were cut so that their ends criss-crossed alternately where they met the corner uprights. Wall plates on top of the boards received the rafters. The gable roof, open at each end, was covered with a thick layer of thatch. A removable ladder hewn from a single log provided access to the interior.

MARY NEIGHBOUR PARENT, H. MACK HORTON

Larger settlements. Three sites excavated in the 1980s and 1990s have yielded striking evidence of sophisticated architectural achievements during the Yayoi period. The site of Yoshinogari (Saga Prefecture, Kyushu), on a low hill overlooking the Saga Plain, was occupied throughout the Yayoi period. It differs from previously excavated sites in that it covers an exceptionally large area, already moated by *c.* 300 BC, containing the first known remains of tall, massive watch-towers, groups of large-scale, raised-floor storehouses, wells, settlements of pit dwellings and extensive burial mounds containing over 2000 large clay burial jars. Circular and oval pit dwellings of *c.* 12 sq. m were

prevalent from *c.* 300 BC to *c.* AD 100, and numerous rectangular storage pits were found close to them. Many small settlements had been built throughout the early Yayoi period, but by *c.* AD 100 larger ones were erected over the earlier sites. Yoshinogari, the largest of these villages, is assumed to have existed until the 4th or 5th century AD.

The pit dwellings at Yoshinogari were mostly rectangular, measuring *c.* 5–6×3–4 m, with low platforms made across one or both of the narrow ends for sitting or sleeping (see fig. 11). Large interiors also had a platform extending along the rear wall. Construction above the pits is presumed to have been similar to that of the earlier centuries. Post-holes discovered to the east of the dwellings indicate that there once existed about ten raised-floor storehouses.

Yoshinogari was ringed with moats, which unlike those at other sites of the Yayoi period were of two different types, being either V-shaped or flat-bottomed in section. Dwellings and storage pits were found both inside the inner moat and between the inner and outer moats. The inner moat revealed several semi-circular outward projections, believed to have contained watch-towers. Large post-holes indicate that the floors were about 6.5 m above ground-level. Penetrating tie-beams must have been used beneath the flooring on each level to strengthen and secure the posts. From the dimensions of and distance between the post-holes, the height of the watch-towers has been computed to have been 12 m. That tall structures existed during this period is known from incised drawings on pottery unearthed at Tottori Prefecture, Yodoechō, Inayoshi (also called Sumida) site.

The raised-floor storehouses of the second half of the 3rd century AD were three or four times bigger (5.0×6.5 m)

than those of the Toro site. It is not clear why the 30 or so storehouses (two reconstructed June 1992) beyond the outer moat were erected there. Like the watch-towers, the storehouses had six posts sunk directly into the ground, in post-holes measuring *c.* 1×1 m or 2.0×1.5 m. These rose in one piece to support the framework for the grid of beams that carried the flooring and continued upwards to sustain the framework formed by beams across the gable ends and along the sides. There is no evidence of plates around the posts below floor-level to prevent rodents from entering, as found on the raised-floor storehouses at Toro. The posts had mortises for inserting tie-beams so that the floor could be supported across the wide span at right angles to the ridge. Grooves on the posts above the flooring were for inserting broad planks to form enclosed walls. A post placed at each end of the gable was attached to the crossbeam, extending upwards to bear the ends of the ridge from which rafters extended to beyond the side beams of the upper frame. The gable ends were covered with thin plaited wooden or bamboo strips. The roof was thatched, and a framework of slender logs crowned the peak. The entrance was to the extreme left, with access by a ladder with shallow steps hewn from a single log. Yoshinogari has yielded the longest such ladder (4 m) yet discovered; its length shows that the storehouse floor must have been *c.* 3 m above ground-level.

Two pottery fragments from the early 1st century AD were unearthed at Tawaramoto-chō Karako-Kagi site, Shiki-gun, Nara Prefecture, in 1992. The smaller sherd (60×80 mm) is incised with two slanting lines on each side and a simple ladder. On the larger sherd (90×80 mm) is a representation of what appears to be part of a two- or three-storey tower with a hipped roof. The ridge and eave ends of the roof and the eave ends of the storey below

11. Prehistoric pit dwellings and watch-tower, Yoshinogari site, Saga Prefecture, Yayoi period, *c.* AD 100–300; reconstructions

12. Prehistoric building (?shrine), Ritō-chō, Shimogari site, Kurita-gun, Shiga Prefecture, Yayoi period, first half of the 3rd century AD; reconstruction

terminate in spiral patterns. On either side of the narrow upper storey are curvilinear forms that may represent birds, clouds or waves. Below this, radiating lines like those on the top roof are thought to depict the roof of a second storey. Japanese archaeologists believe that the structure represented is a religious shrine rather than a watch-tower and that it reflects strong influence from Eastern Han-period China (AD 25–220), as exemplified by the funerary model of a painted pottery tower-like house (h. c. 1.2m) found in a tomb (Kansas City, MO, Nelson–Atkins Mus. A.). Such incised pot-sherd drawings are the only evidence from before the 7th century AD of enclosed towers or other multi-storey buildings in Japan. Their discovery has intensified the controversy regarding the location of the legendary kingdom of Yamatai: Yoshino-gari and Karako-Kagi present themselves as candidates.

At the third site, Ritō-chō Shimogari, Kurita-gun, Shiga Prefecture, a large building, possibly a shrine, existed during the first half of the 3rd century (see fig. 12). It is a prototype of the *shinmei zukuri* ('shinmei construction') style of shrine architecture, best exemplified by the buildings at ISE SHRINE, Mie Prefecture (*see also* §3(i)(b) below). Like these, it was a raised-floor structure with centrally placed steps on the long side. Post-holes for ridge-supporting cypress-wood posts (fragments remain) were found 2.8 m beyond the boundaries of the east and west ends. The main body of the building measured 8.7 m east–west and 5.4 m north–south and was 8 m high. It is the largest shrine-like structure with free-standing, ridge-bearing posts so far discovered. It is presumed to have been a shrine, first because of the awe-inspiring size and grandeur of the roof, second because of an open space in front, assumed to have been a sacred area, and evidence of small, subordinate structures on each side, and third because an unfired-clay stand for offerings, of a type still used in shrine ceremonies, was unearthed, along with three fragments of crystal found at Shimogari site, an unusual find from the Yayoi period.

MARY NEIGHBOUR PARENT

*(c) Kofun or Tomb period (*c. AD *300–710).* Pile dwellings continued to be built in the Kofun period, and from then on their distinctive features were incorporated into shrine architecture. The raised-floor storehouse, for instance, is structurally related to the early *Taisha* style of shrine building, exemplified by IZUMO GRAND SHRINE, Shimane Prefecture (see also §3 (i)(b) below). Even the structure of the Shōsōin, the mid-8th-century treasure-house at Tōdaiji, Nara Prefecture (*see* NARA, §III, 4), is descended from the granary type. In the Kofun and following periods aristocrats also began to adapt raised-floor buildings for housing.

The Hiraide site, Shiojiri, Nagano Prefecture, contained 49 pit dwellings of the Kofun period. Rectangular in shape, these pits had timbers embedded in the earthen floor around the pit edge, which extended well above the ground. Four posts placed at a 45° angle to the corners supported the upper structural members. Long rafters, stretching well beyond the exterior wall, formed a base for thatch. Short posts set at intervals helped to carry the weight at the ends of the heavy rafters. The gables were open. The thatch was held down over the ridge by strips of bamboo lath running in a downward direction and crossed at the peak, creating a prototype for the finials (*chigi*) found on many Shinto shrines (*see* §3(i)(a) below). A hearth constructed of stones or clay was set against a wall through which a curved pipe extended to ground-level. A fire pit was built to heat water in a conical pot, and a second pot was fitted into the first for cooking rice.

The excavation in 1929 of the Chausuyama burial mound at Akabori village, Gunma Prefecture, produced an important group of *haniwa* model houses (Tokyo, N. Mus.; *see* §V, 2 below). The eight models probably represent the dwelling complex of a powerful 5th-century clan. The main house has 3×2 bays and a gable roof with enormously elevated barge-boards rising above the ridge. Six billets (*katsuogi*) laid across the ridge secure the straps that keep the woven mat roofing material in place. The entrance is on the long side, and the presence of windows constitutes a great advance in architectural construction. Two other houses are similar but lack billets and, although they have 2×2 bays, are not square; one bay contains a door, the other a window. Four storehouses, three with gable roofs and one with a hipped roof, resemble the raised-floor type of storage building in structure. Incised lines on the wall surfaces indicate timber construction. There are no windows, although circular apertures beneath the floor-level suggest openings for air circulation. The last building, perhaps a shed, is small and gabled.

BIBLIOGRAPHY

S. Gotoh: *A Study on the Excavations of an Ancient Tomb at Akaborimura*, Imperial Household Museum of Tokyo Memoir Series, vi (Tokyo, 1932)

M. Sekino: *Toro* [Toro: a report on the excavation of the Toro sites], 2 vols (Tokyo, 1949–54) [Eng. summary]

G. Fujishima: *Hiraide: Nagano-ken Sōgamura kodai shūraku iseki no sōgō kenkyū* [Hiraide: synthetic study on the remains of ancient villages at Sōgamura in Nagano Prefecture] (Tokyo, 1955) [Eng. summary]

T. Saitō: *Genshi (shūraku to jūkyo)* [Prehistoric (settlements and dwellings)] (1958), i of *Nihon zenshi* [Complete history of Japan] (Tokyo, 1958–)

J. E. Kidder: *Japan before Buddhism* (London, 1966)

Y. Kuraku and others: 'Tateana jūkyo to takayuka jūkyo' [Pit dwellings and raised-floor residences], *Nihon no kenchiku* [Japanese architecture], i (Tokyo, 1976–), pp. 35–81

T. Hashimoto: 'Jōmon jidai no jūkyo to shūraku' [Dwellings and settlements in the Jōmon period], *Jōmon jidai no Nihon* [Japan in the Jōmon period] (Tokyo, 1981)

C. Miyamoto: 'Jōmon jidai no tateana jūkyo' [Pit dwellings in the Jōmon period], *Kikan Kokogaku*, vii (1984)

——: *Jūkyo* [Residences] (1986), iv of *Nihon no kōkogaku* [Japanese archaeology] (Tokyo), pp. 175–216

M. Sahara: *Nihonjin no tanjō* [The birth of the Japanese people] (1987), i of *Nihon no rekishi* [Japanese history] (Tokyo, 1987–), pp. 178–200

Kangō shūraku Yoshinogari iseki gaihō [A summary of the remains of settlements and ringed moats at the Yoshinogari site], Saga Prefectural Kyōiku Iinkai (Tokyo, 1990)

M. Hudson and G. L. Barnes: 'Yoshinogari: A Settlement in Northern Kyushu', *Mnmt Nipponica*, xlvi/2 (1991), pp. 211–35

H. Ōtsuka and others: *Yoshinogari iseki wa kataru* [The remains at Yoshinogari] (Tokyo, 1992)

MARY NEIGHBOUR PARENT, H. MACK HORTON

(ii) Tombs. Since the burial practices of the Jōmon and Yayoi periods consisted only of interment in simple shell mounds, wide-mouthed jars (*kamekan*), dolmen (*shisekibo*) and square, ditched graves (*hokai shukobo*), the large and complex tomb mounds of the following period may be considered the first Japanese funerary architecture. The Japanese landscape is marked by thousands of tombs known as *kofun* ('old mound'). Usually grouped on low hills or plains, tombs are often arranged so that a large one is surrounded by small ones, but they may also be grouped randomly. The most substantial tomb concentrations occur in the outer Kantō, Kinki and Inland Sea areas, as well as in northern and south-eastern Kyushu. Because most tombs were built between the 3rd and 7th centuries AD, this span of nearly 400 years in Japanese architecture is known as the KOFUN PERIOD. Most tombs are composed of a simple round mound, although the tomb type usually identified with Japan is the *zenpōkōen* (keyhole tomb), so called because of its square front (*zenpōbu*; see fig. 13a) and circular back (*kōenbu*; 13b). These tombs were surrounded by a moat (*shugō*; 13c) and often a green belt (*shuteitai*); around the tomb perimeter there were sometimes satellite mounds (*baichō*; 13d). The diffusion of keyhole tombs is probably related to the rise and expansion of the Yamato (Japanese) state.

(a) Imperial. (b) Non-imperial.

(a) Imperial. The question of the development of tumuli is complicated by the existence of 'imperial' tombs. The first nine emperors, or 'great chiefs' of ancient Japanese literature, were apparently mythical, and their 'tombs' may well be natural hills. Moreover, the approximately 900 so-called imperial tombs, including all sorts of later graves, are under the jurisdiction of the Imperial Household Agency, which allows neither excavation of tombs nor publication of its own reports. Thus, objective examination of imperial tombs is impossible. Mounded or otherwise, all imperial tombs are called *misasagi* or *ryō*; the terms are usually translated as 'mausoleum'.

Many, but not all, imperial tombs are quite large. Among the 28 tumuli over 200 m in length, 14 are designated 'imperial': ten of emperors, that of the regent Jingū and three of consorts or princesses. The largest tombs are all imperial. Those of Ōjin, Nintoku and Richū—the 16th, 15th and 17th emperors—are 486, 430 and 360 m long

13. Plan of *zenpōkōen* (keyhole tomb) of Emperor Nintoku, Bakai, Osaka Prefecture, early 5th century AD: (a) *zenpōbu* (square front); (b) *kōenbu* (circular back); (c) *shugō* (moat); (d) *baichō* (satellite mound)

respectively. However, the next three largest tombs—Tsukuriyama, Takamatsu-chō, Okayama Prefecture (350 m), Ōtsuka, Toyonaka city, Osaka (330 m) and Misemaruyama, Asuka, Nara Prefecture (originally 318 m)—are not imperial.

Moats are considered a royal trademark because many imperial tumuli have them, and because moats are rarely used outside the Kinki area of imperial capitals. Not all imperial tombs are moated, however, and some tombs not designated as imperial have moats. The earliest moated tomb is the double-moated Tsudoshiroyama in Fujiidera city, Osaka Prefecture. Another tomb moat yielded a huge, fragmentary *haniwa* (funerary sculpture), perhaps a ceremonial canopy and a symbol of imperial status. This tumulus and several others are probably imperial tombs.

The earliest verified imperial tomb is the 240 m-long keyhole mound identified with Emperor Sujin (*reg* 97–30 BC). It lies along the Yamanobe-no-michi in Nara Prefecture and is an early type of hillside tomb. Because of the complicated topography of the area, the moat had to be stepped on two levels on one side and three on the other. By contrast, most moats on level terrain were formed naturally when the earth was scooped out to make the mound. Some moats, however, such as the three that girdle Emperor Nintoku's mound of the early 5th century AD (see fig. 13), required a great deal of additional labour.

Aerial views often show wide, halo-like swaths around large keyhole tombs. These 'green belts' may have been specially designated inviolable areas, intended as buffers between the realms of the living and the dead. The orientation of keyhole tombs within a group may vary by as much as 180°, although there is slightly more consistency in the direction of the burial room. Scholars have tried unsuccessfully to link adjacent tombs by imaginary lines and devise a comprehensive scheme. The reason for this desultory orientation probably lies with the necromancers

who decided on the location of the tomb, its direction and even the day of burial. Necromancers followed certain known principles, but intuition also came into play, which made the results unpredictable.

(b) Non-imperial. With the exception of imperial tombs, there is abundant information on excavated tombs, and many tombs are yet to be excavated. For instance, published records for 1984 show that in the Kinki region alone over 240 tombs were excavated: 9 in Shiga, more than 17 in Kyoto, 39 in Mie, 60 in Nara, 3 in Wakayama, more than 5 in Osaka and more than 110 in Hyōgo. This large number of sites, many of them well studied, has allowed scholars to establish a rough chronological development of tombs. Conventionally, Kofun tombs are divided into an Early period (4th century AD), a Middle period (5th century) and a Late period (6th and 7th centuries). Tombs dated to each period generally have in common such characteristics as the shape and size of the mound, the choice of terrain, the internal structure and the types of grave goods.

Some scholars have speculated that the small burial mounds of the Yayoi period were prototypes for the large tumuli of the Kofun period. The prevailing view is, however, that tribal expansion and alliances stimulated social development, with the result that the new type of tomb construction had a political character unconnected with the past. The Kofun tomb type was started in the Kinki region and took the form of immense mounds, such as Chausuyama, Hashihaka and Ōmiwa in Sakurai, Nara Prefecture. While almost all tombs were of the mound type, in several parts of the country tombs were later cut into stone cliffs (beginning *c.* 8th century AD). Usually modelled after the constructed tombs, they had vault-shaped rooms and dividing floor sills at the end of a short entrance hall. Tunnel tombs were dug into the compact loam bluffs of the Kantō Plain. Over 200 tombs, called the Yoshimi Hakketsu group, are concentrated along a tufa hillside at Yoshimi-chō, Saitama Prefecture. In later times cliff tombs were used as dwellings.

With the adoption of Buddhism in the mid-6th century AD in the Kinki region, members of the court and upper classes, who had hitherto built tombs, began to construct mortuary temples instead. Out of a total of *c.* 4500 tombs

in Nara Prefecture, only about 50 date from the 6th and 7th centuries. The decline in tombs can also be attributed to the increasing expense of building them. Controls on tomb building were imposed in the Taika Reform (646), which included an edict that began with the words, 'The poverty of our country is entirely due to the construction of tombs.' However, the discovery of 8th-century coins in provincial tombs shows that tomb building was continued away from the centre of government and in areas where Buddhism was slow to penetrate.

Mounds. Early-period keyhole tombs consisted of a round, high knoll with a long, low, rectangular projection that was used as a platform for grave-side ceremonies. Tombs of the Middle period, such as the large, moated imperial mounds in Osaka Prefecture, have much higher and wider fronts, equal in size to the knoll. The slopes were terraced and covered with small stones. Late tombs are generally smaller and often simply round, as more effort was given to improving the internal structure than to external appearance. Some late tombs are square-based with a round mound on top; a few are even vaguely octagonal, such as the dual tomb of Emperor Tenmu (*d* 686) and Empress Jitō (*d* 703) in Asuka, Nara Prefecture.

The shapes and proportions of tomb mounds suggest that certain principles guided their design. It is now thought that the standard unit of measurement was the northern Korean *shaku* (Jap. *komajaku,* about 0.24 m). The tombs of emperors Ōjin, Nintoku and Richū are 2000, 1800 and 1500 *shaku* in length respectively. A random selection of other tombs also exhibits round numbers. For instance, Uwanabe, Nara Prefecture (254 m), is 1050 *shaku,* Osahozuka, Miyazaki Prefecture (219 m), is 900 *shaku,* and the tomb assigned to Emperor Kinmei, Nara Prefecture (140 m), is 600 *shaku.*

Chambers. Changes in style are particularly apparent in the burial chambers themselves. By the 5th century AD, with negligible stoneworking skills but command of enormous manpower, teams of labourers were able to make even larger tomb mounds. These tombs were first equipped with shallow, stone-lined trenches near the crest to accommodate wooden coffins and later fitted with small rooms of rough, stacked stones and roofed with slabs or logs, which served as tight enclosures for stone sarcophagi. Some small chambers in Kyushu were shaped like boats, a shape also used for the outlines of floor sills that divided the space for multiple interments. Boats were common themes in tomb wall paintings, representing a shamanistic vehicle for contact with the spirit world. Dry walls at this time were made of chlorite schist, sandstone or slate, depending on the availability of materials. The typical tomb construction of this period was the pit-style stone chamber (*tateana-shiki sekishitsu;* 'vertical-hole-style stone room'); in this type of tomb a pit was sunk into a mound and the wooden coffin (*mokkan;* see fig. 14a) lowered into the pit and encased in a clay layer (*nendokaku;* 14b).

Korean immigrants in the 5th century AD brought stoneworking techniques associated with Chinese-style passageways and chamber tombs. These were built directly on the ground surface, then covered with earth. The change was not always absolute, as some tombs mixed the

14. Prehistoric tomb with pit-style stone chamber, *c.* 5th century AD, cross-section: (a) *mokkan* (wooden coffin); (b) *nendokaku* (clay layer surrounding coffin)

two systems. The earliest of the new type were probably the tombs at Marukumayama, Fukuoka Prefecture, and Yokotashimo, Saga Prefecture. The change in burial practice generated a new psychology and set of beliefs, including the idea of Yomi-no-kuni, the squalid and endless underground cavern that served as a kind of limbo for the dead. Yamato writers traditionally placed this underworld in what is now Shimane Prefecture. The corridor-style stone chamber (*yokoana-shiki sekishitsu*; 'horizontal-hole-style stone room') represented this cavelike concept, with its passageway (*sendō*; see fig.15a) leading to an antechamber (*zenshitsu*; 15b) and then to the main burial chamber (*genshitsu*; 15c). The horizontal sections were divided by stone frameworks and entrances: the *senmon* (entrance; 15d), *sode* (doorframe stones; 15e), lintel stone (15f), and *genmon* (main chamber entrance). Corbel vaults protruded from the shaped stones constituting the walls; usually they had straight, narrowing courses rising to a cap, but occasionally, as with the Idera Tomb in Kumamoto Prefecture, they were dome-shaped.

With the use of granite in tumuli in a large area extending from Kyushu to the Kinki region, tomb vaults became much larger. Measuring 25.2 m, the internal corridor and room in the Misemaruyama Tomb in Asuka, Nara Prefecture, is the longest in the country. The Miyajidake Tomb, Tsuyazaki-machi, Fukuoka Prefecture, with a total internal length of 22 m, is a continuous passageway with no widening for a chamber. Among tombs with antechambers, the longest is the double-roomed Ayazuka Tomb, Katsuyama-chō, Fukuoka Prefecture, measuring 19.4 m internally. High ceilings for the main chamber and huge crossing slabs are a particular feature of Kyoto–Nara area tombs. The chamber of Ishibutai in Asuka has two huge roofing slabs 4.7 m above the floor. The largest tombs have an internal drainage system for drawing off seeping water: typically, ditches were dug at the foot of the walls or in the centre of the passageway. The tomb floors are beds of fist-sized pebbles, and, where evidence remains, entrances were blocked by loose stones piled to a depth of several metres.

In some chambers in northern Kyushu a large, shelflike stone slab projects from the end wall, about 2 m above the floor, to protect the human remains below. Frequently, at the end of the tomb is a cistic arrangement of stone slabs resembling a frontless box wide enough to accommodate a transversally laid corpse. In the Ōtsuka Tomb, Fukuoka Prefecture, known for its extensive wall paintings, the niche for the dead had two headrests carved into the long floor slabs, recalling several early literary references to wives who asked to be buried with their husbands. This tomb also had two headrest stones lying on the pebble floor. Some cistic arrangements along side walls were apparently used for later burials.

One of the most technically perfect chambers is in the Eianji West Tomb, Tamana city, Kumamoto Prefecture. Each wall consists of one smooth rectangular slab almost 3.7 m wide and 1.75 m high, except the end wall, which is *c.* 3 m wide. Neat blocks form four lower courses of the corbel vault, while smaller stones carved with only slightly less precision constitute the upper courses. Three rows of trimly incised circles outlined in red paint make up the wall decorations. The peak of aesthetic perfection was

15. Prehistoric tomb with corridor-style stone chamber, *c.* 5th century AD, cross-section: (a) *sendō* (passageway); (b) *zenshitsu* (antechamber); (c) *genshitsu* (main burial chamber); (d) *senmon* (entrance); (e) *sode* (doorframe stones); (f) lintel stone; (g) *genmon* (main chamber entrance)

reached in the 7th-century West Monjuin Tomb in Sakurai, Nara Prefecture. Here, each stone for the chamber, passageway and roof is cut to fit on the surface like a finely finished ashlar.

One of the most remarkable features of tombs is the quarrying and transport of large stone. A wooden sledge (*shura*) was recovered in 1979 from a ditch at one of the tombs of the Mitsuzuka group, Fujiidera city, Osaka, where it had been abandoned after use. The sledge was over 10 m long, and it was probably used in the 7th century for moving large stones. The largest known stones used in tombs are the two blocks covering the chamber of the Ishibutai in Asuka, each estimated to weigh 60–80 tonnes. These particular stones were quarried locally, but many stones were transported great distances from hillside quarries to locations on the plains.

Sarcophagi. Many tomb chambers, notably in the Kinki region, are large enough for more than one stone sarcophagus. Gamoike, Mizudoro, Jingūyama and Misemaruyama tombs, all in Nara Prefecture, and Kamienyatsukiyama Tomb in Izumo city, Shimane Prefecture, have two sarcophagi. In the case of the Misemaruyama Tomb, an old drawing shows one sarcophagus against the back wall and another parallel to a side wall of the chamber. In some cases, a second sarcophagus might be introduced in the corridor if the chamber was not large enough. The earliest stone sarcophagi reproduced the appearance of log-shaped wooden coffins, while the lids of later sarcophagi took the shape of chests and houses. Sarcophagi could be of assembled stone slabs or hollowed-out stone blocks. The Nara Basin alone has about 400 house-shaped sarcophagi made of Mt Nijō tufa. Some hillside tombs ranging from the eastern Inland Sea area to the Kantō region contained clay coffins resembling stone ones, with double-sectioned lids and bodies and rows of short legs attached underneath.

See also §§V, 3 and VI, 3 below.

BIBLIOGRAPHY
Y. Kobayashi: *Sekai kōkogaku taikei 3: Nihon III* [Series of world archaeology 3: Japan III] (Tokyo, 1959, 4/1966)
T. Saito: *Nihon kofun no kenkyū* [Study of the old mounds of Japan] (Tokyo, 1961)

K. Mori: *Kofun no hakkutsu* [Excavation of old mounds] (Tokyo, 1965)

H. Ueda: *Zempō-kōen-fun* [Square-front round-back mounds] (Tokyo, 1969)

K. Kunugi: *Kofun no sekkei* [Plans of old mounds] (Tokyo, 1975)

S. Onoyama, ed.: *Kodai-shi hakkutsu 6: Kofun to kokka no naritachi* [Excavating ancient history 6: Old mounds and the formation of the state] (Tokyo, 1975)

M. Suenaga: *Kofun to kōkū taikan* [Grand view of old mounds from the air], 2 vols (Tokyo, 1975)

T. Shiraishi: *Kofun to chishiki* [Current knowledge of old mounds], Kōkogaku shiriisu [Archaeology series], xix (Tokyo, 1985)

J. EDWARD KIDDER JR

3. EARLY: ASUKA, NARA AND HEIAN. The early historic period—Asuka-Hakuhō (AD 552–710), Nara (710–94) and Heian (794–1185) periods—was a watershed for Japanese religious architecture. Although there are numerous extant examples of Shinto shrine and Buddhist temple architecture, both secular palaces and the humble dwellings of commoners are known chiefly through later reconstructions, excavations and secondary evidence such as diary accounts and paintings. Despite differences in function, the secular *shinden* and the Buddhist temple (and even some types of Shinto shrine) share a common origin in Chinese architecture of the Tang period (AD 618–907), which accounts for frequent similarities in technique and style. Most obviously, all these building types may be painted with Chinese cinnabar and fitted with metal and carved wood decorations resembling those on Chinese palatial architecture. However, although China was the ultimate source for much early Japanese architecture, Korea often served as an important intermediary. The complex relationship between Shinto and Buddhism (*see* §II, 2 and 3 above) is echoed in the architectural styles deployed in shrines and temples. While continental Buddhist theology and building style were transformed in accordance with Japanese taste and requirements, indigenous Shinto developed in the opposite direction, defining itself in regard to foreign Buddhism and adopting elements of continental architecture. Thus, despite fundamental differences, Buddhist and Shinto architecture evolved in relation to each other. The ultimate expression of this interaction is found in a syncretic system combining Shinto and Buddhism (*ryōbu Shinto*) and manifested architecturally in the construction of religious complexes containing both Shinto shrines and Buddhist temples, with an admixture of building types and styles.

(i) Shinto shrines. (ii) Buddhist temple precincts. (iii) *Shinden*.

(i) Shinto shrines. Shrines serve for the worship of either a local or a national deity or spirit (*kami*). They are entered through one or more *torii*, a post-and-lintel gate signalling the separation between the sacred and profane worlds. Shrine compounds can contain any number of buildings and sacred objects. These may include a facility for the preparation of food and other offerings, storehouses for shrine treasures and residences for the shrine priests. Through Buddhist influence, many shrines also came to include a worship hall (*haiden*). However, the most important building, both spiritually and architecturally, is the main hall or sanctuary (*honden* or, as in the case of Ise Shrine, *shōden*), which houses the *kami*. The *kami* may be local, regional, or regarded as the ancestor of a kinship group residing in the area. Most shrines house more than one deity.

(a) Origins and early development. (b) Early shrine styles. (c) *Kasuga* and *nagare zukuri*. (d) Later diversification of styles.

(a) Origins and early development. The need to build shrines evolved from the religious festivals that developed in the Yayoi period (*c.* 300 BC–*c.* AD 300) around the agricultural practices associated with the introduction of wet-rice cultivation from China *c.* 30 BC. There were festivals to give thanks for fruitful harvests, to ask for good crops and to pray against the possibility of natural calamities, and for these events some means to distinguish the sacred site from ordinary areas must have been sought. Initially this probably consisted of a simple fence (*tamagaki*) around the sacred area and an entrance gate (*torii*). Even today, this rudimentary shrine form, lacking a main building to house the *kami*, exists at such shrines as Ōmiwa in Nara Prefecture and Kanasara in Saitama Prefecture, where the entire mountain is sacred, and a massive rock (*iwasaka* or *iwakura*) at the summit serves as the residence of the deity. At other shrines, such as that on the sacred island of ŌKINOSHIMA in northern Kyushu, there are no structures whatsoever, only rock outcrops called *yorishiro* that mark the dwelling-place of the *kami*.

The formative features of early shrines—*tamagaki* and *torii*—were designed less to fulfil a practical function than to express metaphorically the existence of a sacred space. As festivals were performed repeatedly, a need arose for more elaborate structures, and the objects of veneration were gradually given concrete form. Initially, they were very primitive. By erecting a wooden column at the centre of the festival area, for example, the people believed that either the deity would appear or its spirit would descend from heaven to earth. The *shinno mihashira* ('sacred heart pillar') that stands beneath the main hall (*shōden*) at the Inner Shrine (Naikū) at Ise reflects this ancient tradition.

The first sanctuaries were probably small movable structures foreshadowing the portable shrines (*mikoshi*) still used to carry the deity during festival processions. From the construction techniques of shrines such as Kasuga in Nara and Kamo in Kyoto (*see* §(c) below) it can be deduced that such sanctuaries were originally movable. The Yuki and Suki halls of the Daijōkyu built for the enthronement of the Emperor are also thought to be forerunners of permanent shrine architecture. Many of the Daijōkyu's distinguishing features are shared by the Sumiyoshi style (*see* §(b) below).

(b) Early shrine styles. It was not until the 7th–9th centuries AD that Shinto architecture assumed its characteristic forms. This development followed from growing Buddhist influence through which Shinto deities took on anthropomorphic identities and from the need for permanent structures to house the objects such as mirrors, swords, and curved jewels (*magatama*) that symbolized the *kami*'s spiritual presence. Although the actual buildings are of late date, Sumiyoshi Shrine, Osaka, Ise Shrine, Mie Prefecture, and Izumo Shrine, Shimane Prefecture, are thought to represent the oldest styles of shrine architecture.

Sumiyoshi Shrine is dedicated to three sea gods and Empress Jingū, who, according to tradition, founded the shrine as an expression of thanks for the deities' protection. The prototype of what has come to be known as *Sumiyoshi zukuri* ('Sumiyoshi construction'), it consists of four

16. Ise Shrine, Inner Shrine or Naikū, view of *shōden* (main sanctuary); 7th-century form, reconstructed every 20 years

identical sanctuaries, three arranged one behind the other facing towards the sea and a fourth one slightly apart. All four structures are long and narrow, two bays on the front and four on the side, and have gable entries (*tsumairi*). The interior, which unlike Ise Shrine (see below) is low to the ground, is divided into two rooms. The exterior wooden walls are painted white, posts and other structural details vermilion. The gabled roofs are thatched with cypress bark and topped with ornamental ridge-weights (*katsuogi*) and bargeboards (*chigi*). The existing structures were last reconstructed in 1810, but they had a long history of periodic reconstruction between the 9th and the 15th centuries.

Shinto shrines attained a status comparable with that of Buddhist temples in the second half of the 7th century, when the goddess of the ISE SHRINE, Amaterasu Ōmikami, started to be worshipped as sun goddess and ancestral deity of the imperial family. Ise Shrine became and remained the principal Japanese shrine. It also acquired extensive lands when, in the 8th century, festivals began to be organized and overseen nationally. The vast Ise complex consists principally of two shrine compounds: the Inner Shrine (Naikū or Kōtai jingū), dedicated to Amaterasu Ōmikami, and the Outer Shrine (Gekū, or Toyouke Daijingū), dedicated to the rice deity Toyouke no Mikoto. Both compounds also encompass smaller sanctuaries devoted to the *kami* affiliated with the two main deities. The main Ise sanctuaries were built in *shinmei zukuri* ('shinmei construction'; see below), of which many elements were adopted in other shrine buildings.

The spiritual centre of the Inner Shrine or Naikū (see fig. 16) has two sites located side by side on the east and on the west. Each time rebuilding occurs (see below), the alternate site is used. The innermost space is surrounded by four rows of fences and, as it is considered the most sacred area, it is the location of the main shrine (*shōden*), which measures 10.9×5.5 m. The floor is highly elevated, and the building is encircled by a verandah (*mawari*). A covered staircase projecting from the south side of the building leads to the main entrance of the sanctuary; there is a gable at each end of the building. The type of front entrance (*hirairi*), parallel to the roof-ridge rather than the gable end, is also common to many later shrines. The plank walls on four sides have no openings except at the central doorway. On the ridge of the thick, zebra-grass roof are ten ridge-weights (*katsuogi*), and the bargeboards at the gable ends project upward through the roof to form two pairs of forked finials (*chigi*). The *katsuogi* and the *chigi* were regarded as divine symbols, and their use on secular buildings was prohibited. Two free-standing, ridge-supporting columns (*munamochi bashira*) outside the walls on the gable sides are another characteristic of buildings at Ise Shrine. All the shrine buildings have columns embedded in the earth instead of being set on stone bases, a practice adopted in palaces and storehouses of the Nara period (the gods were supposed to reside permanently in such shrines, rather than to descend there temporarily). The main shrine of the Outer Shrine has basically the same composition as that of the Inner Shrine, with some small differences in size, proportion and details.

The characteristics of the Ise Shrine represent a building method termed *shinmei zukuri*, which apparently developed before the introduction of Buddhist architecture into Japan and has its roots in granary construction rather than residential architecture. The *katsuogi*, *chigi* and *munamochi bashira* are stylized, refined forms of the primitive elements of the granary, and the elevated floor and closed interior further suggest this origin. Another noteworthy feature of Ise Shrine is that the shrine buildings are reconstructed every 20 years. This custom, known as *shikinen sengū*, was established by imperial order when Ise was originally built, so that the religious ceremonies and shrine forms would be handed down unchanged. Thus the present shrine buildings at Ise, although dating from their 61st rebuilding in 1993, faithfully reproduce their 7th-century forms.

Taisha zukuri ('grand shrine construction') is found only in Izumo Province (part of modern Shimane Prefect.). It is best represented by the Izumo Grand Shrine (for illustration *see* IZUMO GRAND SHRINE). Like Ise and Sumiyoshi, it is situated in an area that was of great political and military importance in ancient times. Legends and historical documentation describing the origins of shrines are scarce, but the story of the founding of Izumo Grand Shrine is an exception. According to the *Nihon shoki* ('Chronicle of Japan') and the *Kojiki* ('Record of ancient matters'), the shrine, dedicated to Amaterasu's grandson Ōkuninushi no Mikoto, was striking for its palatial height and grandeur. In the 11th and 12th centuries it reportedly collapsed frequently. The existing building dates from 1744 and incorporates many changes from that period. It is square in plan (10.9×10.9 m) and 24 m high from the ground to the top of the forked finials. Each side is divided into two bays. The sweeping, slightly curved gabled roof is covered with cypress bark and has purely ornamental ridge-weights and bargeboards. The entrance is on the gabled end. The stairway that leads to the entrance is covered; the roof is angled towards the gabled end. In the centre of the shrine there is a sacred post (*shinno mihashira*) with a symbolic import analogous to that at Ise Shrine. The oldest extant building in *taisha zukuri* is the Kamosu Shrine in Matsue city, Shimane Prefecture, which was rebuilt in 1583.

(c) Kasuga and nagare zukuri. *Kasuga zukuri* ('Kasuga construction') and *nagare zukuri* ('flowing construction') are the two most common shrine types. *Kasuga zukuri* is named after the Kasuga Shrines at the foot of Mt Mikasa near Nara, first built in the 730s to house the tutelary deities of the Fujiwara family. Since ancient times Mt Mikasa has been regarded as a sacred mountain where deities descended, and the site of its festival became the precinct of the Kasuga Shrine. Although the present buildings were reconstructed in 1863, the form was probably established in the Heian period. Before this time there was probably no permanent shrine. The main compound has four identical sanctuaries (*honden*), which stand in a row. Like the Sumiyoshi Shrine, the walls are painted white and the woodwork vermilion, a colouring scheme reflecting continental influence. Each shrine is small (1.83×2.64 m), and the four corner columns are set on a sill frame, a vestige of an age when shrines were portable. The long, overhanging roof is covered with cypress bark and has ornamental bargeboards and two ridge-weights (see fig. 17). The most characteristic feature of the *Kasuga zukuri* style is the covered gable entry stairway (*tsumairi*), a feature it shares with the Sumiyoshi style. The subtly curved pent roof over the staircase and the shape of the forked finials on the roof-ridge assist in dating this style to the Heian period. This style is found only in western Japan. The oldest extant examples are at the Kasugadō and Hakusandō at Enjōji, Nara, which date from the 12th century.

The *nagare zukuri* style is exemplified by two shrines, Kamikamo ('Upper Kamo' or Kamo Wakeikazuchi) Shrine and Shimokamo ('Lower Kamo' or Kamo no Mioya) Shrine, located along the Kamo River in Kyoto. They were first constructed at the end of the 7th century AD and were esteemed as the shrines of the guardian gods of the capital from the time of its transfer to Heian in 794. Each shrine has two south-facing sanctuaries, almost identical in size. Unlike the Shimokamo Shrine, where both sanctuaries are treated as permanent shrines, the eastern shrine at Kamikamo Shrine is the main shrine, while the western shrine is temporary, because it is not associated with a particular *kami*. It is used for housing the deity while the main shrine is under reconstruction or repair. As at Ise, there are two sites for the main shrine; the act of transferring the deity from the old main shrine through the temporary shrine to the new main shrine in itself had an important meaning. The present buildings at

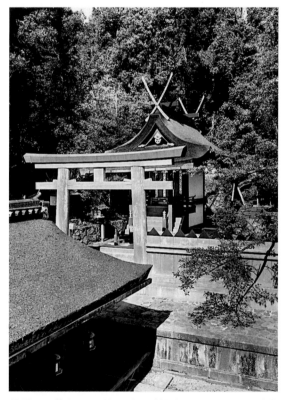

17. Kasuga Shrine, near Nara, view of *honden* (main sanctuary or hall) in *Kasuga zukuri* ('Kasuga construction'); present buildings date from 1863

the Kamo Shrines were reconstructed in 1864. The plan of the Kamikamo and Shimokamo shrines clearly shows the influence of Ise Shrine. The *nagare zukuri* style, like that of the main shrines at Kasuga, has a sill frame under the columns, but the dimensions are much larger (5.91×7.19 m). Each shrine consists of a single room, three bays wide and two bays long (see fig. 18). The wood of the exterior walls is stripped of bark and polished. The gable of the building is on the side, and as a result the porch roof continues in an unbroken line, connecting with the roof of the sanctuary building. As the term 'flowing construction' suggests, the line of the porch and sanctuary roof creates a dramatic sweep. A roof over the portico is supported in front by four square posts, which stand on a wooden platform (*hamayuka*). A verandah runs around the building. The oldest examples of the *nagare zukuri* (as well as the oldest surviving shrine buildings) are the *honden* of Ujigami Shrine in Uji, near Kyoto, which date from the 11th or 12th century.

(d) Later diversification of styles.

Hachiman zukuri ('Hachiman construction'). The main shrines at Usa Hachiman, Ōita Prefecture, Kyushu, best represent this style. The Usa shrines and others like it deify Hachiman, a syncretic deity who has been revered since the 8th century, when, according to legend, he assisted the imperial forces against rebels in Kyushu. There are three identical sanctuaries at the shrine, which are adjacent to each other. They were rebuilt between 1855 and 1861, although they are thought to illustrate 8th-century style. Each shrine consists of two separate buildings with gabled roofs, one in front and one at the rear, and a large gutter in the valley where the eaves of the two roofs meet. The entire exterior appears to be a continuous building, but the interior space is divided into two rooms (1×3 bays and 2×3 bays respectively) connected by a middle space (*ainoma*), which unites the two roofed structures. Since each room has a seat (*shinza*) for the *kami*, the front space cannot be regarded as a worship hall for the rear. The sanctuary roofs are decorated with forked finials and ridge-weights. Many elements of Buddhist architecture have been absorbed into this style, which probably shows the influence of the Buddhist *sōdō* ('twin pavilion').

Gongen zukuri ('Gongen construction'). This style, also known as *ishi no ma zukuri* and *yatsumune zukuri*, is represented by a class of buildings that were actually mausolea built in the form of shrines (*reibyō*). The first of these was the Kitano Shrine (also known as Tenmangū) in Kyoto, established in the 10th century to enshrine the vengeful ghost of SUGAWARA NO MICHIZANE, a distinguished statesman, scholar and poet. A covered stone passageway (*ishi no ma*) connects the main sanctuary and worship hall. Both buildings are roofed separately, creating complex roof lines, a feature reflected in the term *yatsumune zukuri* ('eight roofs construction'). The interaction between Buddhist and Shinto architecture is evident in this style, particularly in the organization of the buildings and in the curvilinear forms of roof eaves and gables, such as the *karahafu* ('undulating barge-board') that covers the canopy over the worship-hall staircase. *Gongen zukuri* was the only Shinto architectural style to be further developed

18. Shimokamo Shrine, Kyoto, *honden* (main sanctuary) in *nagare zukuri* ('flowing construction'); this mode of construction dates from the Nara (AD 710–94) or Heian period (794–1185); present building dates from 1864

during the Edo period (1600–1868). Because of the style's impressive scale and ornateness, it was adopted by the warlord Toyotomi Hideyoshi for his Hōkoku mausoleum (destr.) in Kyoto. Subsequently, the style of the Hōkoku mausoleum was used by the Tokugawa shogunate when building a number of shrines as mausolea for the Tokugawa family. Examples include the famous TŌSHŌGŪ SHRINE at Nikkō, Tochigi Prefecture (see fig. 19), which enshrines the warrior chieftain Tokugawa Ieyasu (1543–1616). Ieyasu was given the name *Gongen* ('incarnation'), hence the term for this style. Another example is the Osaki Hachiman Shrine in Sendai, Miyagi Prefecture.

Hie zukuri ('Hie construction'). The name of this style comes from the Hie Shrine (Ōtsu, Shiga Prefect.). The modern sanctuary was built in 1586, although the style of the shrine is thought to date from the Heian period. Typically it has 3×2 bays. The unusual treatment of the roof at Hie is characteristic of this style: the curvilinear eaves extend over the verandah on three sides, adding an extra room (*gejin*; 'outer chamber') to either side of the sanctuary and creating an unusual roof form called *sugaru-hafu* ('clinging gable'). When viewed from the façade, the roof appears to be in the *irimoya zukuri* ('hip-and-gable construction') format; seen from the rear, it seems to have been sheared off. The complex treatment of the roof eaves illustrates the refined form of the front-entry shrine sanctuary attained by adapting the elaborate building methods of Buddhist architecture.

19. Tōshōgū Shrine, Nikkō, plaza in front of Yomei Gate, showing *Gongen zukuri* ('Gongen construction'), 1636

Kibitsu Shrine. The Kibitsu Shrine in Okayama Prefecture was completed in the early 15th century. At Kibitsu the *honden* (main sanctuary or hall) is attached to the worship hall. The unusually large scale (about 15×18 m) and the roof of the *honden* distinguish it from other shrines. The *honden* rests on a raised foundation called *kamebara* ('turtle belly') that slopes gently upwards in the centre of the sanctuary where the *shinza* is located. The *honden* was designed in the *nagare zukuri* style but elaborated with double eaves and two dormer gables (*chidorigafu*). The shrine has also assimilated the *daibutsuyō* ('Great Buddha style') or *tenjikuyō* ('Indian style') from Buddhist architecture, in which several brackets are positioned on top of one another and inserted into the main supporting column (*see* §(ii) below).

Itsukushima Shrine. Located on the shore of Miyajima, a small island on the Inland Sea in Hiroshima Prefecture, Itsukushima is unusual both in layout and in setting. Since the shrine is built out over the water, at high tide it appears to be afloat. The present buildings date from 1241 to 1571, although the shrine itself is thought to have been founded in the Heian period. The shrine complex consists of various subsidiary shrines (*sessha*) attached to the main sanctuary, each venerating different *kami*. The *honden* of these *sessha* and the main *honden* have shingled roofs extending over both the front and back of the building and are in *ryōnagare zukuri* ('double flowing construction'). *Heiden* (offering halls), *haiden* (worship halls) and a *haraidono* (ablution pavilion) stand in front of the various *honden*. The *honden* are connected by a winding roofed

corridor (*kairō*) suggesting the influence of the *Shinden* residential architectural style. The overall appearance of the shrine closely resembles that of the palace of the Buddha Amida as represented in paintings of the Western Paradise.

BIBLIOGRAPHY

Prince Toneri: *Nihon shoki* [Chronicle of Japan] (AD 720); Eng. trans. by W. G. Aston as 'Nihongi', *Trans. & Proc. Jap. Soc., London*, suppl. (1896) [whole issue]

Ō No Yasumaro: *Kojiki* [Record of ancient matters] (AD 712); Eng. trans. by B. Hall Chamberlain as *Translation of 'Ko-ji-ki' or 'Records of Ancient Matters'*, 2nd edn with notes by W. G. Aston (Kobe, 1932)

T. Fukuyama: *Ise jingu no kenchiku to rekishi* [The architecture and history of Ise Shrine] (Kyoto, 1940)

——: *Jinja kozushū* [A collection of old pictures of shrines] (Kyoto, 1942)

Y. Watanabe: *Ise to Izumo*, Nihon no bijutsu [Arts of Japan], iii (Tokyo, 1964); Eng. trans. by R. Ricketts as *Shinto Art: Ise and Izumo Shrines*, Heibonsha Surv. Jap. A., iii (New York and Tokyo, 1974)

T. Fukuyama: *Nihon kenchikushi kenkyū* [Research on the history of Japanese architecture] (Tokyo, 1968)

E. Inagaki: *Jinja to reibyo* [Shinto shrines, architecture and mausolea] (Tokyo, 1968)

T. Fukuyama: *Nihon kenchikushi kenkyū zokuhen* [A sequel of studies on the history of Japanese architecture] (Tokyo, 1971)

E. Inagaki: *Shaden* [Shinto architecture] (1972), ii of *Nihon kenchikushi kisoshiryō shūsei* [A collection of drawings on Japanese architecture] (Tokyo)

H. Ota, ed.: *Japanese Architecture and Gardens* (Tokyo, 1972)

N. Kuroda: *Kasuga taisha kenchiku shiron* [The architectural history of Kasuga Shrine] (Kyoto, 1978)

T. Fukuyama: *Jinja kenchiku no kenkyū* [Research on shrine architecture] (Tokyo, 1984)

H. Ota: *Shaji kenchiku no kenkyū* [Research on architecture of Buddhist temples and Shinto shrines] (Tokyo, 1986)

EIZO INAGAKI

(ii) Buddhist temple precincts. Buddhist architecture is represented by buildings in Buddhist temple precincts, including the temples themselves, dormitories and other practical buildings, and halls for study, meditation, prayer and other types of training.

(a) Introduction. (b) Construction and design. (c) Building types and functions. (d) Layout.

(a) Introduction. During the Asuka (*c.* AD 552–710), Nara (710–94) and Heian (794–1185) periods, variations in Buddhist doctrine and the development of new sects led to innovation in building types as well as changes in temple plan and even location. For instance, the early focus on the pagoda gave way to the primacy of the main image hall; and the location of Asuka- and Nara-period temples within the capital, from where priests could influence affairs of state, was altered in the Heian period, when it was considered that the interests of both government and most Buddhist leaders would be better served if the temples were located in mountain sites. In terms of style, early Buddhist architecture evolved from Chinese styles of the 5th and 6th centuries AD, adopted in the Asuka period, to the Chinese Tang-period (618–907) style favoured in the early Nara period. This style was increasingly adapted to fit the requirements and taste of the Heian-period Japanese until, with the introduction of new continental modes of architecture in the late 12th century, it came to be considered the native Japanese style (Wayō).

It is conventionally accepted that Buddhism was formally introduced to Japan in AD 552 (*see* §II, 3 above). From then on, the Japanese adopted not only the religion but also many aspects of continental culture, including building styles. The *Nihon shoki* ('Chronicle of Japan'; completed 720), records that King Sŏng of the Korean state of Paekche presented the Japanese emperor with 'an image of Shakyamuni Buddha in gold and copper', and in 552 Soga no Iname (*d* 570), following the command of Emperor Kinmei (*reg* 539–71) to worship the Buddha as an experiment, 'purified his house and made it a temple'. Soon afterwards, a raging pestilence was attributed to the anger of the indigenous gods, the temple was destroyed and the image of Buddha housed there was thrown into the Naniwa (Osaka) Canal. In 577, Japanese envoys returned from the continent with six Koreans, among whom was a temple-architect.

Buddhism was finally given state support by Empress Suiko (*reg* 593–628) and the regent Shōtoku Taishi (*see* SHŌTOKU), and in 593, under the supervision of Soga no Umako (*d* 622), the pillar for the pagoda was erected at the temple Hōkōji (Asukadera), Nara Prefecture. The temple was completed in 596. During the last decade of the 6th century many temples were built, the largest being Shitennōji (*see* OSAKA, §II, 1) in Naniwa. The *Nihon shoki* records that by 606 Gangōji was known as the place where a huge bronze statue was enshrined in the *kondō* (main image hall). There is also a reference for the same year to a temple at Ikaruga near Nara city. Excavations at the Wakakusa site in the area corroborate the account in the *Nihon shoki* that the first temple known as HŌRYŪJI burnt to the ground in 670 and was rebuilt by 693, slightly to the north-west.

With continued Soga family support, Buddhism became firmly established by the first half of the 7th century, and Soga Kurayamada Ishikawamaro (*d* 649) is important in the history of Buddhist architecture as the founder, in 641, of Yamadadera, near Asukadera. Excavation of the site, begun in 1976, has unearthed the walls of several bays of the semi-enclosed corridor on the east side, all in an excellent state of preservation. They pre-date the oldest standing buildings, the pagoda and *kondō* at Hōryūji, and reveal some important structural differences.

Buddhist temple sites were generally chosen where land was reasonably level. Sometimes land was levelled manually as at Hōryūji, where the rise at the northern end was graded and the excess soil was used to fill the southern end. Temple buildings in towns were constructed according to the topography of the land.

During the 6th and 7th centuries, the arrangement of temple buildings within the main compound was based on a number of fixed plans (*see* §(d) below). By the 8th century, however, small subsidiary temples were often added within one precinct. A good example is the Hokkedō (Sangatsudō) at Tōdaiji, Nara Prefecture (*see* NARA, §III, 4), located in the hills east of the main compound. Shortly after the capital was moved from Nara (anc. Heijōkyō) to Kyoto (anc. Heiankyō) at the end of the 8th century, the new Esoteric sects Shingon and Tendai were introduced to Japan from China. In the Nara tradition of Tōdaiji and Saidaiji, the Great Eastern and Great Western temples, large temples such as the Tōji (Kyōōgokokuji) and Saiji (destr.) were erected at the south-eastern and south-western gates to the city. In general, however, the new sects preferred to establish mountain temples where halls, pagodas and other buildings had to be arranged in harmony with natural contours. The rigidly prescribed plans of the earlier periods were no longer adhered to.

(b) Construction and design. Entirely new methods of construction accompanied the introduction of Buddhism. Buildings were described by their number of bays, which were measured from pillar centre to pillar centre. Bays were not always the same width: for example, the end bays might be narrower than the three middle bays. A building five bays long and four bays deep would consist of two rectangles, one within the other, formed by the pillars surrounding the inner core and those defining the outer edge of the aisles. Such a structure could easily be extended lengthwise, but extension in the transverse direction remained a problem for several centuries. Temple buildings included a central core (*moya*), usually of 3×2 bays, and a surrounding aisle (*hisashi*), generally one bay deep, the front and back of which was two bays longer than the *moya. Hisashi* varied from one bay across the front to four, with one enclosing each side of the structure.

One early method of increasing the depth of a building was to attach another aisle to the front *hisashi*; this was called the *magobisashi* ('grandchild aisle'). Another method was to surround the *hisashi* with a *mokoshi*, a second aisle with a separate pent roof set lower than the main roof. A third way to increase depth was to position two gabled buildings one in front of the other, forming twin halls (*narabidō*). The fore hall (*raidō*) eventually became the worship area, an outer sanctuary (*gejin*) where laymen

could enter to pray; the rear hall became the inner sanctuary (*naijin*) containing the altar and statues.

Pillars were erected on a podium made of a hard-packed earthen core and rubble covered with a veneer of dressed stone. The pillars, some with decided entasis (swelling), were set on stone bases placed on the podium. A system of lengthwise and transverse beams connected the pillars, and tie-beams added strength. Two different arrangements of transverse beams were used when buildings were open to the underside of the roof. The first consisted of heavy transverse beams or rainbow beams (*kōryō*) across the *moya*. They were slightly curved and narrowed at each end for insertion into bearing blocks located on top of the inner row of pillars. Diagonal braces (*sasu*) were set on top of the rainbow beams, and these in turn carried bracket complexes (*see* BRACKET SYSTEM, §3), which supported the roof purlins and ridge. The second type had two rainbow beams, the upper one being shorter than the lower. These were separated by frog-leg struts (*kaerumata*) carrying bracket complexes to support the roof purlins. At the centre of the shorter rainbow beam, the same arrangement of frog-leg strut and bracket complex supported the ridge. This latter type is called double-rainbow beams and frog-leg struts (*nijū kōryō kaerumata*).

Various bracket complexes were used for both structural and aesthetic purposes. The simplest was a boat-shaped bracket arm. Other complexes combined bracket arms and bearing blocks placed on top of the pillars in order to carry the weight of the roof and retain a relatively open interior. Some brackets ran parallel to the wall plane; more complicated ones contained additional units placed at right angles to the wall; still others consisted of a series of projections creating stepped complexes. The most unusual type was the 'cloud-patterned' (*kumo tokyō*) bracket complex, found only at Hōryūji, Hokiji, the reconstructed Hōrinji and on the Tamamushi miniature shrine, all in a small region outside the city of Nara.

The building framework was frequently visible and originally painted vermilion. Non-load-bearing walls made of mud mixed with straw and coated with smooth plaster enclosed the structure. The roof was tiled. Various stylized lotus patterns decorated circular eave-end tiles, while arabesques enlivened broad, concave eave-end tiles. Ridge ends terminated with ogre-face tiles (*onigawara*) or in curved forms resembling fish tails (*shibi*). Rafters (*taruki*) were set in parallel rows. A single row was sufficient for less important buildings, but double rafters, including a second row of short 'flying rafters' (*hiendaruki*), could be added to the base rafters to extend the eaves and impart dignity to the main temple structures. Base rafters were held in place by an eave support (*kayaoi*), which also determined the amount of curvature given the eaves. A 'flying-rafter' support (*kioi*) was placed on top of the base rafters. Either round or square base rafters were used in the early periods, but the 'flying rafters' were always square. Later, only square rafters were used. A heavy tail rafter (*odaruki*) could be added for extra strength; it was supported on the outer end by a second stepped bracket complex.

In the 10th century, the Japanese devised a new system of roofing called *noyane* ('hidden roof'): this consisted of an exterior roof composed of rafters and a supporting framework unrelated to the visible rafters and their support system. This innovation allowed the builders to create any desired incline for the exterior roof, while maintaining a gentle pitch for the exposed rafters below. The earliest extant example is the roof erected over the *hisashi* of the Daikōdō (9×4 bays), the main lecture hall at Hōryūji, at the time of its reconstruction in 990. A double roof, both hidden and exposed, was constructed over the *hisashi* only. A ceiling over the *moya* became necessary to hide the rough construction extending from the hidden roof. The *noyane* system also allowed much deeper buildings to be constructed. Twin halls could be placed under one roof, as in the Mandaradō at Taimadera.

(c) Building types and functions. Before the Heian period (794–1185) there were about 12 essential types of Buddhist temple buildings. The pagoda (*see* PAGODA, §3) was derived from the Indian stupa via Chinese wooden towers. Ostensibly a reliquary for sacred objects, in Japan the pagoda functions primarily as a decorative element within the temple compound or as a symbolic monument. Early pagodas were of three, five, seven, nine or thirteen storeys. Today, except for small stone pagodas, only three- or five-storey examples remain from the early periods. Most representative is Hōryūji's five-storey pagoda, which includes a 'skirt layer' (*mokoshi*; a lean-to pent roof). The *kondō* ('golden hall' or 'main image hall') houses sacred images to which prayers are offered from outside the building. Again, the earliest example is the Hōryūji *kondō*, which also includes a *mokoshi*. The *hondō* ('main hall') is also an image hall. The term, although in use earlier, became widely used between the 12th century and the 16th, when interior space was customarily provided for worshippers. A good example is the main hall at Shin-yakushiji (*see* NARA, §III, 8). The *kōdō* ('lecture hall') was used for teaching novices, preaching, chanting sacred texts, meetings and ceremonies. The *kairō* is a roofed, semi-enclosed corridor or cloister, open only on the inner side facing the enclosed space. It surrounds the sacred precinct containing the pagoda and *kondō*. By the 8th century, *kairō* also enclosed subsidiary image halls, pagodas or even an empty space. The *chūmon* is the 'middle gate' to which the *kairō* was attached on each side. The *nanmon* or *nandaimon* ('southern gate' or 'great southern gate') served as the main entrance to the temple precinct. The *jikidō* is the refectory or dining hall for monks. The *sōbō* is a dormitory for priests or monks. The *shūrō* (or *shōrō*) is the belfry. The *kyōzō* (*kyōko*) is a repository for sacred texts (Skt *sūtra*s). Fine examples of most of the structures mentioned above exist at Hōryūji; in the case of the *chūmon* and the *jikidō*, these are also the earliest extant examples. *Azekura* are storehouses constructed of triangularly shaped logs with chamfered corners that produce a hexagon in section. Examples include the Tōdaiji's Shōsōin (*see* NARA, §III, 3) and the *hōzō* at Tōshōdaiji (*see* NARA, §III, 9), both treasure-houses, and the *kyōzō* at Tōshōdaiji, built to store *sūtra*s. One other type of building was the *hakkakudō*, a small octagonal hall popular in the 8th century. A fine example is Eizanji's octagonal hall, Gojō city, Nara Prefecture.

With the rise of Esoteric Shingon Buddhism in the Heian period, many new types of buildings were constructed, dedicated to individual deities or groups of deities or used for performing special rites. Common types include the Yakushidō ('Yakushi hall'), dedicated to the Buddha of healing (Skt Bhaishajyaguru) and exemplified by the structure at Daigoji, Kyoto Prefecture (*see* KYOTO, §IV, 3(i)), and the Mandaradō ('*mandala* hall'), such as that of Taimadera, Nara Prefecture, which houses a famous *mandala* representing Amida (Skt Amitabha), the Buddha of the Western Paradise, with myriad attendants, though this comprises a synthesis of Shingon and Pure Land beliefs. In addition, the *tahōtō* ('many-jewelled pagoda'), a two-storey pagoda with pent roofs on the first storey and a circular, white-plastered drum covered by a pyramidal roof set on four-stepped bracket complexes, became an important adjunct to the Esoteric Buddhist precinct, even replacing the ordinary pagoda in some cases. The earliest extant *tahōtō*, at Ishiyamadera, Shiga Prefecture, was built in 1194.

(d) Layout. In the 7th and 8th centuries temple buildings were arranged according to prescribed plans based mainly on those introduced from the continent. These can be divided into three types (see fig. 20). In the linear plan (20i), the south and middle gates, the pagoda, *kondō* and *kōdō* were placed along a south–north central axis. A cloister (*kairō*), attached on each side of the middle gate, surrounded the sacred area and terminated on either side of the *kōdō*. The belfry (*shōrō*) and *sūtra* repository (*kyōzō*) were outside to the rear; beyond were the dormitories (*sōbō*). This plan, from Korea, was used at Puyŏ, capital of Paekche (AD 350–663). Japanese examples include Shitennōji and Yamadadera. In the cruciform plan (20ii), the south and middle gates, the pagoda, a middle *kondō* and the *kōdō* followed the south–north central axis, while eastern and western *kondō* were placed on an east–west

axis in line with the pagoda. The *kōdō* was outside the cloister, along with the belfry and *sūtra* repository. This plan was based on those used in northern Korea during the Koguryŏ period (AD 313–68). An example is Hōkōji (Asukadera). The third type was the asymmetrical plan (20iii), in which a pagoda and one *kondō* were placed on an east–west axis surrounded by a cloister, with the *kōdō* and middle gate on the south–north central axis. In this plan, the position of the pagoda and *kondō* were sometimes reversed. Examples include Hōryūji, with the pagoda on the west and the *kondō* on the east, as well as the Kawaradera site excavation, where the pagoda is to the east and a *kondō* to the west, with a middle *kondō* on the central axis. The use of a lateral axis for the pagoda and *kondō* seems to have originated in Japan, since no continental source has been found.

The layout of temple precincts changed considerably during the 8th century. First, although a strong tendency towards symmetrical arrangement continued, with the southern and middle gates, *kondō*, *kōdō* and refectory placed on the central axis, the siting of two pagodas to east and west became common. In the early part of the century, at Yakushiji (*see* NARA, §III, 5), for example, the pagodas had prominent places inside the cloister to the right and left of the middle gate. Later in the century, the importance of pagodas diminished, and they were placed outside the cloister, as at Tōdaiji. Second, a semi-enclosed corridor could be attached on either side of an open, colonnaded front aisle (*hisashi*) and extended the full length of the *kondō*. This corridor formed an enclosure used for religious ceremonies. The mid-8th-century Tōshōdaiji *kondō* (7×4 bays) originally had this arrangement, but only the colonnaded porch remains. Third, as secondary sanctuaries were established within the main temple precinct, the pagoda lost its position as the focal point. At Kōfukuji, Nara Prefecture (*see* NARA, §III, 7), the pagoda was enclosed in a subsidiary compound with a *kondō* to

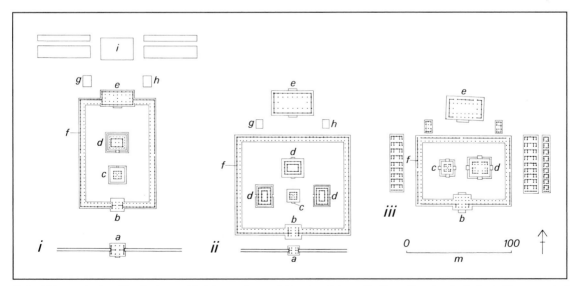

20. Buddhist temple plans, Nara Prefecture, 7th–8th centuries AD: (i) linear (e.g. Shitennōji); (ii) cruciform (e.g. Asukadera); (iii) asymmetrical (e.g. Hōryūji, *Saiin* West Precinct): (a) *nanmon* (south gate); (b) *chūmon* (middle gate); (c) *tō* (pagoda); (d) kondō (main image hall); (e) kōdō (lecture hall); (f) kairō (cloister); (g) shōrō (belfry); (h) kyōzō (sūtra repository); (i) sōbō (dormitories)

21. Nageiredō, Sanbutsuji, Tottori Prefecture, late Heian period, 10th–12th centuries AD; a good example of *kake zukuri* ('hanging construction')

During the 11th century, the powerful Fujiwara family gave strong support to the Jōdo or Pure Land sect centred on devotion to Amida Buddha (Skt Amitabha). Pure Land temples were often located in scenic areas near the capital, and there was a conscious attempt to integrate buildings and nature. Typically, buildings and gardens were designed to re-create the Western Paradise of Pure Land teaching. The layout of the Hōjōji (destr.), with its Amida hall (Muryōju'in) completed in 1020, is known to have been fairly symmetrical. It had a large pond with islands and many buildings, including halls dedicated to Amida as well as halls usually associated with Esoteric Buddhism. The Phoenix Hall (Hoōdō) of the BYŌDŌIN in Uji, Kyoto Prefecture, is the only extant 11th-century Amida hall and the only surviving example of Fujiwara architecture.

Amida halls continued to be built in the 12th century. At JŌRURIJI, Kyoto Prefecture, the *hondō* of 11×4 bays housing nine Amida statues remains, as does the pond. Chūsonji in Iwate Prefecture (*see* HIRAIZUMI, §2(i)) contains an exquisite small hall called the Konjikidō, built in 1124. The exact placement of the other buildings originally in the temple precinct is unclear, but it is known that they were scattered over rugged, tree-covered hills. The Nageiredō (see fig. 21) at Sanbutsuji, Tottori Prefecture, presumed to be from the late Heian period (10th–12th century AD), is a good example of *kake zukuri* ('hanging construction'). Completely integrated with nature, it is suspended on a steep cliff face and supported by tall posts and tie-beams.

BIBLIOGRAPHY

T. Fukuyama: *Heian Temples: Byōdōin and Chūsonji* (New York and Tokyo, 1956)
K. Asano: 'The Development of the Buddha Hall in Japan', *Osaka-shiritsu Daigaku Kōkogaku Kiyō*, iv (Osaka, 1962), pp. 91–110
M. Ōoka: *Temples of Nara and their Art* (New York and Tokyo, 1973)
M. N. Parent: 'A Reconsideration of the Role of Hōrinji in the History of Japanese Architecture', *Japan Architect* (Feb 1977), pp. 73–80
A. Soper: *The Evolution of Buddhist Architecture in Japan* (New York, 1978)
K. Suzuki: *Early Buddhist Architecture in Japan* (Tokyo and York, 1980)
M. N. Parent: 'Yamadadera: Tragedy and Triumph', *Mnmt Nipponica*, xxxix (1984), pp. 307–12
——: *The Roof in Japanese Buddhist Architecture* (New York and Tokyo, 1985)
——: 'Yamadadera: Excavations', *Mnmt Nipponica*, xl (1985), pp. 209–19
——: 'Buddhist Architecture', *A History of Architecture*, ed. B. Fletcher (London, 1987), pp. 727–38
K. Suzuki, ed.: *Fukugen Nihon taikan: To to garan* [A general survey of Japanese restoration: pagodas and Buddhist monasteries], ii (Tokyo, 1988)

MARY NEIGHBOUR PARENT

the east; excavations at Daianji, Nara Prefecture (*see* NARA, §III, 6), show that the eastern and western pagodas were built at a considerable distance outside the main southern gate. A fourth option was to build octagonal halls that were separate from the primary sanctuaries. At the Hōryūji East Precinct, for instance, the Yumedono is considerably removed from the main sanctuary. Finally, the considerable increase in provision of dormitories, usually erected behind or surrounding the *kōdō* but sometimes along the sides of the sanctuaries outside the cloisters, could transform the plan. Yakushiji, Tōdaiji and Daianji are all good examples.

In contrast to the formal temple layouts of the Asuka and Nara periods, temples built during the Heian period were marked by a greater informality in plan. This change in layout can be attributed to location in mountains as well as to the specific doctrine of new sects. The new Esoteric sects, escaping from the rigid order and magnificence of Nara temples, found a freedom in adapting buildings to the natural environment. For instance, the Tendai headquarters was at ENRYAKUJI on Mt Hiei, north-east of Kyoto, while Shingon was centred at Mt Kōya, Wakayama Prefecture. These were established in the 9th century, but all extant buildings at these sites are later. At Murōji, in the mountains of Nara Prefecture, the *kondō* and pagoda are placed relative to the topography. The *kondō* is on a ledge high above the main access to the temple, approached by a flight of steps; to the left, on a higher level, is a small, five-storey pagoda. There are no imposing gates or cloisters.

(iii) **Shinden.** The secular structures most frequently built during this period were pit dwellings, raised-floor storehouses and the ground-level houses of commoners. However, the type of architecture about which most is known and which is considered most important is the *shinden* ('sleeping hall') style, which was developed in the Heian period (AD 794–1185), for imperial palaces and the residences of court aristocrats.

(a) *Antecedents.* The antecedents of the *shinden* form can be traced to the élite residences of the Nara period (AD 710–94), buildings heavily dependent on continental prototypes (*see also* PALACE, §VI, 3). The style of Nara-period aristocratic residences is suggested by a hall once

owned by Lady Tachibana, consort of Emperor Shōmu, the founder of Tōdaiji. The structure was donated in 761 to HŌRYŪJI, where it was made over in a style appropriate to a monastery complex and named the Denpōdō (Hall for the Transmission of the Dharma). The original residence probably had a raised plank floor and a pitched roof of cypress bark, curved slightly upwards at the eaves. In plan it was 5 bays long by 4 wide, with a central core (*moya*) of 2×5 bays, delineated by two rows of round posts running the length of the interior. Beyond these posts, one-bay subsidiary spaces (*hisashi*) extended under the eaves. There was no ceiling. The design effected a gradual transition from exterior to interior, beginning with a plank verandah (two bays long by four bays wide) at the building's front gable end; the area closest to the front of the building was protected by the overhanging eaves of the pitched roof. The first two bays of the structure itself were walled only above the tie-beams, somewhat above head height, and the rear three bays were enclosed by interior and exterior partitions, the latter comprising doors opening on to narrow verandahs that ran the length of both sides. In its use of a cedar roof, raised plank floors, round posts, open interior space and fluid exterior partitioning, the Denpōdō clearly presaged *shinden*-style buildings.

(b) Heian period (794–1185). During this period the scale and the opulence of *shinden* structures were determined by the court rank of the owner. No *shinden* complexes from the period survive, but some have been conjecturally reconstructed based on evidence from excavations, diaries and picture scrolls (see fig. 22). One of the grandest *shinden* complexes was the Hōjūji Palace, built in Kyoto by Fujiwara Tamemitsu (942–92) and later owned by Emperor GoShirakawa (1127–92). Built on a rectangle of land surrounded by earthen walls roofed with tile (*tsuijibei*), the complex extended out from the south-facing *shinden*. Subsidiary halls called *tainoya* ('opposed buildings') were connected to the north and west by roofed corridors (*watadono*: walled; *sukiwatadono*: open-sided). A *koshinden* ('lesser *shinden*'), resembling the *tainoya* in style and function, was attached at the east. In many *shinden* complexes the main *shinden* was for the use of the parents, with *tainoya* for daughters and their husbands. Other corridors, called *rō*, projected south from both sides of the residence and were each bisected by a 'middle gate' (*chūmon*), the corridors often being called *chūmon rō* as a result. The corridors ended in pavilions overlooking a large pond and garden that filled the southern half of the property. Such structures were frequently called 'fountain pavilions' (*izumidono*) or 'fishing pavilions' (*tsuridono*). This main complex was surrounded by smaller structures for servants and storage.

The Shinsen'en palace of Emperor Kanmu (737–806), the monarch who initiated the move to the Heian capital, may well have been bilaterally symmetrical after the Chinese palace model, and some believe this to have been the ideal for *shinden* complexes as well. The plans of

22. *Shinden* mansion of the Heian period (AD 794–1185), reconstruction drawing: (a) *shinden* ('sleeping hall'); (b) *tainoya* ('opposed buildings'); (c) *watadono* ('walled roofed corridor'); (d) *sukiwatadono* ('open-sided roofed corridor'); (e) *koshinden* ('lesser *shinden*'); (f) *chūmon rō* ('projecting corridor bisected by a gate'); (g) *chūmon* ('middle gate'); (h) *tsuridono* ('fishing pavilion')

23. *Shinden*-style throne-room of the Imperial Palace, Kyoto, Heian period (AD 794–1185); rebuilt 1855

shinden mansions excavated to date, however, are asymmetrical, perhaps because of the inclusion of the south pond, which left no room for a south gate and instead necessitated entry from the east or west. The side entry in turn initiated a lateral progression through buildings originally oriented to the south, and plans developed irregularly in consequence. The result also accorded with a general tendency towards asymmetry in the developing Japanese aesthetic.

The main *shinden* of the Hōjūji Palace complex was rectangular, with its façade on the southern side bisected by a formal entrance staircase covered by a projecting eave. The hall overlooked a broad courtyard spread with white gravel, beyond which was the pond. The core (*moya*) of the building was two bays wide by seven bays long and was delineated by round posts. Secondary spaces (*hisashi*) one bay deep surrounded the core, and hurdle verandahs (*sunoko en*) bordered with ornamental railings (*kōran*) extended beyond the outer posts. The one-storey structure had a hip-and-gable roof of cedar bark, and the floor was raised on posts about 1 m above the ground.

The interior core of the *shinden* was open, with little privacy for occupants. Space was generally partitioned by movable non-folding standing screens (*tsuitate*), folding screens (*byōbu*), curtains (*kichō*) or light, hanging tapestries (*zeshō* or *zejō*). There were no ceilings. Floors were of polished wooden planks, but portable straw mats were used for sitting. Tables and shelves were portable. A fixed-wall room, the *nurigome*, was used for sleeping, but by the mid-Heian period a movable curtained dais (*chō*) was more frequently employed as a sleeping chamber. Exterior partitioning was achieved by reticulated shutters (*shitomidō*), which could be swung up and fastened to the underside of the roof during the day. Behind them bamboo blinds (*sudare*) and curtains (*kabeshiro*) were often hung as well. Swinging doors (*tsumado*) were used at the ends of buildings, and some sliding doors were employed.

By the end of the Heian period, the *shinden* form had begun to change, echoing shifts in social structure and living patterns. Space became less open and fluid, with the northern half of the building becoming more private in character, separated from the south and also subdivided by sliding panels (*fusuma*) or other partitions. Tertiary spaces (*magobisashi*) were often added beyond the northern *hisashi*, leaving the south for traditional ceremonies requiring large, open rooms. Eventually the area for daily living became an entirely separate structure, the *tsune no gosho*. This later development of the *shinden* can be seen in some of the buildings of the Kyoto Imperial Palace, rebuilt most recently in 1855 (see fig. 23).

BIBLIOGRAPHY

M. Fujioka: *Kyōto gosho* [The Kyoto Imperial Palace] (Tokyo, 1956)
S. Sugiyama: 'Hōjūjidono no kibo to ichi ni tsuite' [Scale and site of Hōjūji Palace], *Kenchiku-shi Kenkyū*, xxiii (1956), pp. 12–20

M. Kawakami: 'Shinden zukuri kara shoin zukuri e' [From the *shinden* to the *shoin* style], *Sekai kenchiku zenshū* [Compendium of architecture of the world], ii (Tokyo, 1960), pp. 42–51

H. Sawamura: 'Tojō to kyūshitsu' [Capitals and palaces], *Sekai kenchiku zenshū* [Compendium of architecture of the world], i (Tokyo, 1961), pp. 48–53

K. Kamei, ed.: *Heijōkyū* [Heijō Palace] (Tokyo, 1963)

T. Fukuyama: 'Kodai, jūtaku' [Ancient period, residences], *Kenchikugaku taikei* [Outline of architectural studies], iv/1 (Tokyo, 1968)

S. Ōta: *Shinden-zukuri no kenkyū* [Research on the Shinden style] (Tokyo, 1987)

H. MACK HORTON

4. LATE: KAMAKURA, MUROMACHI, MOMOYAMA AND EDO. This period exhibited a great variety of building styles and types. Japanese builders began to come into their own, assimilating foreign styles and producing structures that were both unique in conception and masterly in technique. Buddhist architecture, which had inherited older styles from Tang-period (AD 618–907) China, incorporated and adapted newer modes but remained relatively conservative compared with secular architecture. In secular buildings the old *shinden* form (*see* §3(iii) above) was preserved almost exclusively for imperial palaces, while the *shoin* form succeeded it as the dominant mode for other dwellings. In military architecture, castles came to be seen as symbols of the age. Although the castle originated in the military architecture of China and the West, the dramatic size, spectacular design and ingenious detail of Japanese examples testify to the vitality of Japanese architecture between 1185 and 1868.

Japanese architecture of the Kamakura (1185–1333) and Muromachi (1333–1568) periods underwent a significant evolution in technique and style, mirroring contemporaneous developments in sculpture and painting in the interplay between orthodox Japanized Tang-period styles and the newly imported Song-period (960–1279) styles. Specifically, the Daibutsu and Zen (Chin. Chan) styles from south China were adopted, then merged with the Wayō style ('Japanese style'). During the Momoyama (1568–1600) and early Edo (1600–1868) periods, many old temples were rebuilt, although usually in one of the established idioms and most often in the Mixed style. Late Ming-period (1368–1644) temple architecture, introduced in the 17th century, contrasted sharply with continental styles, which, through a long process of imitation, assimilation and invention, had become thoroughly Japanese and immediately distinguishable from contemporary Chinese idioms.

(i) Buddhist. (ii) Secular.

(i) Buddhist.

(a) Daibutsu style. (b) Zen style. (c) Wayō style. (d) Mixed style. (e) Other styles.

(a) Daibutsu style. The Daibutsu or Great Buddha style (*daibutsuyō*, also called *tenjikuyō* or 'Indian style') was brought to Japan from south China by the priest Chōgen (1121–1206). First used for rebuilding Tōdaiji (*see* NARA, §III, 4), including the Daibutsuden (Great Buddha Hall), the style takes its name from the Great Buddha (*Daibutsu*) sculptures, which were housed in monumental structures. The massive, complex structural members and high, open ceilings characteristic of this style generally had little appeal for the Japanese, who preferred a more intimate space with low ceilings, suited to the custom of sitting on the floor to worship. After Chōgen's death the style was little used outside the Nara area. Nevertheless, certain structural elements, reduced to a smaller scale, as well as some decorative motifs, gradually spread to outlying areas and became integrated with traditional building techniques. Only two buildings in the pure Daibutsu style survive: the Jōdodō (Amida hall) of 1194 at Jōdoji, Hyōgo Prefecture (see fig. 24), and the *nandaimon* ('great southern gate') of 1199 at Tōdaiji, Nara. In addition, the *sūtra* repository built in 1198 at Daigoji, Kyoto (*see* KYOTO, §IV, 3), is known through drawings, although the building burnt down in 1939. Because these buildings are the only ones that remain from the 12th century at their respective temples, it is difficult to assess the full impact of the Daibutsu style and to determine if any variation in temple plan was introduced along with it.

24. Jōdodō (Amida hall), Jōdoji, Hyōgo Prefecture, Daibutsu style, 1194

The function of the Daibutsu style, however, may be understood by examining its effect in buildings serving distinctly different purposes. The exterior of the Jōdodō (18×18 m) is unassuming, with low walls, a pyramidal roof and straight eaves. In contrast, the interior, open to the roof with huge structural members plainly visible, appears vast. The abrupt change from the modest exterior to the dramatic interior almost overpowers the worshipper. The towering *nandaimon*, with pillars 20 m high, similarly impresses worshippers as they enter the temple precinct and proceed to the Daibutsuden. The small *sūtra* repository, however, was intended simply for storage of sacred texts. Although in the Daibutsu style, the structure had no need to overwhelm or inspire, and thus it incorporates many features of the more familiar Wayō style in less obvious areas.

Characteristic of the style, and found on all three buildings, are rainbow beams (*kōryō*), strongly curved on the upper sides and narrowing at the ends to allow insertion into the pillars. The outer ends, or nosings, are tapered, and the tops are decorated with an undulating moulding. Rainbow beams were separated and supported by 'large bottle struts' (*taiheizuka*) instead of the traditional frog-leg struts (*kaerumata*). Three-stepped and six-stepped bracket complexes were used, the latter occurring on both the upper and lower roofs of the *nandaimon*. Some bracket arms directly carry purlins. In the Jōdodō only the ends of the bracket arms support bearing blocks, but blocks were lined up on the bracket arms of the *nandaimon* and at the Daigoji *sūtra* repository. Penetrating tie-beams replaced the non-penetrating type employed in the 12th century and before and in early Wayō-style buildings (*see* §(c) below). Fan rafters (*ōgidaruki*) were used at the corners and fascia boards, creating a neat finish at the ends of the single eaves. Only at the conservative *sūtra* repository was use made of the traditional eave support (*kayaoi*).

The early 13th-century belfry at Tōdaiji, built for the priest Eisai (1141–1215), is an important transitional building. It combines the fully visible massive framework, empty ceiling and decorative details of the Daibutsu style with comparatively small, four-stepped bracket complexes on pillars in the Zen style. Similarly, the roof is strongly curved as in the Zen style.

(b) Zen style. Eisai promoted the Zen sect and with it helped establish the architectural Zen style (*Zenshūyō*, also called *karayō* or 'Chinese style'), which was based largely on buildings in Hangzhou dating from the Southern Song period (1127–1279). Eisai's disciples are credited with the spread of the Zen style throughout the 13th century in the Kyoto area, as well as in such distant regions as Kamakura and northern Kyushu. However, no buildings in the pure Zen style remain from the 13th or 14th centuries. The only reliable evidence for the early Zen style is its obvious influences in more traditional buildings.

The configuration of buildings at Zen temples is far less clear than that of Japanese Buddhist temples before the 14th century. The oldest extant ground-plan (1331) of Kenchōji, Kyoto, shows the buildings arranged along a central axis with the Buddha hall (*butsuden*) as the focal point. Behind it is the lecture or *dharma* hall, now called the *hattō*. There is no pagoda. If pagodas exist at Zen

25. Octagonal pagoda, Anrakuji, Bessho Onsen, Nagano Prefecture, 14th century

temples, they are usually three-storey and located in a remote part of the precinct. The main gate at Zen temples is called the *sanmon*, meaning both 'mountain gate' and 'triple gate'. Another new building type given prominence in the temple plan is the *hōjō* (abbot's quarters).

The distinctive components of the Zen style are easily recognizable in Buddha halls, pagodas and gates. There is a preference for symmetry, which contrasts with the Japanese tendency toward asymmetry. For instance, many buildings feature a wide centre bay flanked by narrow side bays. All existing Zen structures have hidden roofs with *hanegi* (lever timbers) between inner and outer shells; in Buddha halls a smooth board ceiling, frequently with a dragon painted on it, covers the *moya* (central space), but structural members are visible in the *hisashi* (aisles) and *mokoshi* (lean-to pent roof). The pitch of the main roof is typically steep, and corners have a dynamic upward curve; yet the curve of the *mokoshi* roof is gentle. Bracket complexes (*see* BRACKET SYSTEM, §3) appear crowded, with a single bracket arm carrying up to five small bearing blocks. Bracket complexes are positioned not only above the pillars but also on the wall plates between them. The extra complexes distribute the weight of the roof more

evenly. Moreover, the many tail rafters with curved, tapered ends add to the exuberant character of the support system. The number of penetrating tie-beams is also greater. The corners of the extended ends of the head-penetrating tie-beams and wall-plates are moulded and their sides decorated with incised, scroll-like patterns.

Other characteristics of the Zen style include taller and more slender pillars, with their tops and bottoms rounded off. Because the floors were earthen or stone (*ishidatami*), pillars were set into stone or wooden bases. Complete fan raftering on the main roof contrasted with parallel raftering over the *mokoshi*. Instead of tiles, finely cut, multi-layered shingles were preferred for roofing. Even more distinctive were front façades, with ogee-arched windows (*katomado*) in the end bays, and panelled doors attached to pole hinges inserted into protruding, decorative sockets in the centre bays. Many Zen-style halls have rows of vertically undulating lath filling each bay above doors, windows and solid walls.

Examples of buildings in the mature Zen style include the *raidō* (front or worship hall) of 1352 of the *kaisandō* (memorial hall) at Eihōji, Tajimi, Gifu Prefecture; the *shariden* (relic hall) *c.* 15th century, at Engakuji, Kamakura, Kanagawa Prefecture; Shōfukuji's Jizōdō (Jizō hall) of 1407, Tokyo; and the 14th-century, three-storey, octagonal pagoda at Anrakuji, Bessho Onsen, Nagano Prefecture (see fig. 25).

(c) Wayō style. The old style of temple architecture, introduced from China from the 6th century to the 8th, had become thoroughly standardized in technique and form. So completely was it adapted to Japanese taste that, with the influx of new continental styles, this originally Chinese style was called Wayō ('Japanese style') to differentiate it from the new import. The orthodox Wayō style was widely used by the Esoteric Shingon and Tendai sects and by the Pure Land sects (Jōdoshū and Jōdoshinshū). Although the Wayō style is fundamentally conservative and deployed in temples with a view to emphasizing their real or desired orthodoxy, it was not untouched by the new foreign styles.

The Wayō style exists in its purest form and greatest number of examples in the Nara area, where the original six sects of Japanese Buddhism were based. The eastern *kondō* at Kōfukuji, Nara (*see* NARA, §III, 7), exemplifies the conservative mode undiluted by new styles. Rebuilt on its old podium in 1415, it retains the basic conservative plan with *hisashi* surrounding the *moya*. As in the mid-8th-century *kondō* of Tōshōdaiji (*see* NARA, §III, 9), the front *hisashi* forms an open colonnade. The floor is tiled, and a hidden roof stretches over the entire building. Like the Pure Land sects, the Esoteric Shingon and Tendai sects favoured the Wayō style, yet there was no preferred arrangement of temple buildings within the compound. However, a gate, *hondō* ('main hall') or *kondō* ('golden hall' or 'main image hall') and pagoda (*tahōtō*) were of prime importance; the pagoda was located to the side, or diagonally in front of, the *hondō*. A free-standing gate at the front edge of the temple precinct symbolized the division between the material and spiritual worlds. No fence was used.

Between the 12th century and the 16th the *hondō* replaced the pagoda as the focal point of the temple, and important changes also took place in the interior arrangement of the *hondō*. It no longer merely housed images; significant space was also allotted for worshippers. The interior superseded the exterior in importance. Because of the use of hidden roofs, a greater freedom in the placement of pillars allowed new divisions of interior space. Although

26. *Hondō* ('main hall'), Saimyōji, Shiga Prefecture, Wayō style, 13th century

the fundamental plan of *moya* and *hisashi* remained the underlying concept, some pillars could be eliminated, and others could be removed from traditional alignment to create unobstructed space wherever necessary. *Hondō* were often large structures varying from five to nine bays wide and often almost as deep. The notion of creating a meaningful distance between the supernatural and the mundane realms was realized by separating the two primary areas into the worship hall (*gejin* or *raidō*) at the front and the shadowy inner sanctuary (*naijin*) behind it. Lattice sliding screens, together with lozenge-patterned lattice filling the transoms above, enhanced the effect of connection and separation. The *naijin*, entered only by priests, contained images and accessories necessary for performing religious rites.

Diversity in height and type of ceilings is another characteristic of the Wayō style. Because ceilings were structurally independent of the hidden roof, they could easily be built to different heights. Ceilings are usually low in the *gejin* and high in the *naijin*, where they conform to the size of the sculptures. Ceiling types include board-and-batten, latticed, coffered, coved and coffered, and innumerable combinations of these. An open-beamed ceiling usually covers the *hisashi*.

The exterior of the orthodox Wayō-style *hondō* was characterized by simplicity. Pillars were joined by head-penetrating and non-penetrating tie-beams. Simple bracket complexes were placed on top of pillars, and load-bearing block-capped struts or frog-leg struts were placed in the intervals. Doors were plank or board faced with lattice (*shitomido*); the latter were separated horizontally so that the upper half could be raised and hooked under the eaves and the lower half could be lifted out if desired. A shallow wooden verandah might surround the entire building or simply run along the front and several bays along the sides. Step canopies (*kōhai*) were often placed over the steps. The 13th-century Saimyōji *hondō* (see fig. 26), Shiga Prefecture, is a superb example of the unadulterated Wayō style of the 12th–16th century.

27. *Hondō* ('main hall'), Kiyomizudera, Kyoto, *kake zukuri* ('hanging construction'), rebuilt 1633

(d) Mixed style. This style (*setchūyō*) pertains to buildings that are fundamentally in the Wayō style but contain strong elements of the Daibutsu and, in particular, Zen styles. From the second half of the 14th century structural and decorative elements from the new styles were incorporated into the Wayō style with such frequency that pure Wayō buildings from later dates are quite rare. The adoption of Chinese panelled doors with pole hinges, decorated nosings (*kibana*), ornate bracket arms with twin bearing blocks, solid-board frog-leg struts, bracket arms inserted directly into pillars, smooth board ceilings, bottle struts, lobster- or shrimp-shaped rainbow beams (*ebikōryō*) and decorative rainbow beams shows the fusion of the three styles. For instance, the Myōō'in *hondō*, Hiroshima Prefecture (1321), has double rainbow beams and bottle struts in the gable pediment in addition to a unique undulating arched ceiling with rainbow beams and solid-board frog-leg struts in the *gejin* (worship hall). A smooth-board ceiling is placed above the rainbow beams, which are separated by frog-leg struts in the *naijin* (inner sanctuary). Another excellent example with features of both Zen and Daibutsu styles is the *hondō* at Kakurinji, Hyōgo Prefecture, dating from 1397.

In the Momoyama and early Edo periods the Mixed style was frequently used for rebuilding temples destroyed in the preceding century of warfare. Under the direction of military leaders, temples were built on a massive scale and with magnificent detailing, which was meant to reflect their political power. For example, in Kyoto TOYOTOMI HIDEYOSHI sponsored the construction of the Mammoth Hōkōji, which included a giant wooden statue of the Buddha. The Daibutsuden at Tōdaiji, destroyed soon after its erection, was a similar structure. Reconstructed in 1688, it exhibits a medley of styles. For instance, the bracket complexes contain characteristics of both the Daibutsu and Zen styles, and another Zen element is the undulating gable over the entrance. The Wayō style is evident in the finely latticed coffered ceilings.

(e) Other styles. In the early 17th century a modular system (*kiwari*) of constructing temple buildings quickly and completely was perfected. Generally, in Edo-period (1600–1868) temple architecture, perfection of technique and large-scale construction took precedence over creativity. However, there were some noteworthy late developments in Buddhist architecture. First, *Gongen zukuri* Shinto shrine architecture (*see* §3(i)(c) above) was combined with standard Buddhist building types to produce a hybrid style much used for mausolea. A good example is the Daiyuin, a mausoleum built in Nikkō in 1653 for the third shogun, Tokugawa Iemitsu, which has an inner sanctum resembling a Zen-style edifice. Unlike a Zen-style hall, it is lacquered with gold and other colours. The intricate precision in all aspects of structural techniques is complemented by elegance and refinement of the decorative surfaces.

With the cessation of civil wars and relative prosperity, pilgrimages to temples became popular in the Edo period. The function of temples as centres of pilgrimage partly accounts for the grandiose size of many temple buildings. For example, the *hondō* of Kiyomizudera, Kyoto, rebuilt in 1633, measures 33.46×32.18 m (see fig. 27). As well as being extravagantly large, it is consciously dramatic in design. Representing the apogee of the *kake zukuri*

('hanging construction') method of construction, the *hondō* stage and side wings, secured on enormous posts and a network of tie-beams, overhang a steep hillside, and the whole structure is covered by a massive roof.

The transmission of the Chinese Chan (Zen) Buddhist sect Huangbo (Jap. Ōbaku) to Japan in the mid-17th century was accompanied by new Ming (1368–1644) and Qing (1644–1912) styles of temple architecture. The distinctive main hall (*dayūhōden*) characteristic of Ōbaku temples is preserved at Sōfukuji, Nagasaki, built in 1646, and at Manpukuji, Uji, Kyoto Prefecture, built in 1668. Both halls have strongly curved eaves on the main roofs and greatly extended, though less strongly curved, eaves over the *mokoshi* (lean-to pent roof). The bracket complexes, incised, scroll-like designs and moulded ornamentation on exposed ends of nosings, rainbow beams and wall plates reflect the later Chinese style.

BIBLIOGRAPHY

H. Ōta: *Chūsei no kenchiku* [Architecture of the medieval period] (Tokyo, 1953)

M. Suzuki: 'Shaji reibyō kenchiku' [Architecture of shrine, temple and mausoleum], *Nihon no kenchiku* [Architecture of Japan], ed. H. Ota, iv (Tokyo, 1976), pp. 35–68

M. Kawakami: 'Chūsei no ji'in kenchiku: Zenshūyo' [Architecture of the medieval period: Zen style], *Nihon no kenchiku* [Architecture of Japan], ed. H. Ōta, iii (Tokyo, 1977), pp. 111–62

K. Sūzuki: 'Chūsei no ji'in kenchiku: Daibutsuyō, Wayō' [Architecture of the medieval period: Daibutsu style, Wayō style], *Nihon no kenchiku* [Architecture of Japan], ed. H. Ōta, iii (Tokyo, 1977), pp. 39–107

MARY NEIGHBOUR PARENT

(ii) Secular. Japanese secular architecture of this period can be classified according to the social class of the patron. The palaces and villas of the élite differ markedly from the dwellings and shops of commoners in scale, level of craftsmanship, materials and attention to detail. In the 18th and 19th centuries, however, when the rising economic status of merchants and the increasing impoverishment of the samurai and the aristocracy blurred the established distinctions between classes, the Tokugawa government imposed sumptuary laws in an attempt to restore these differences (*see also* §XIV below).

(a) Elite buildings. (b) Commoners' dwellings. (c) Castles.

(a) Elite buildings. During the 12th–16th centuries, the official and residential complexes of the élite classes, particularly those of the military aristocracy, developed away from the usual secular *shinden* form (*see* §3(iii) above) established by courtiers of the Heian period (794–1185). Though the *shinden* style did not entirely die out, it came to be generally supplanted by the *shoin* ('book-hall' or 'study') style, which developed in part from the temple study. In contrast to the near-symmetry of the ideal *shinden* complex, *shoin* structures tended to be radically asymmetrical. Moreover, while *shinden* interiors were typically open, without built-in furnishings, the *shoin* was defined by its

28. Dōjinsai study in the Tōgūdō, Higashiyama Villa, now Jishōji (Ginkakuji), Kyoto, *c.* 1485

29. Guest Hall (*kyakuden*), Kōjōin subtemple, Onjōji (Miidera), Ōtsu, Shiga Prefecture, 1601

interior characteristics. The *shoin* style encompasses several variants—the prototypical *kaisho*, the mature *shoin*, the palatial Ōhiroma type and the *sukiya shoin*—discussed in order below.

Kaisho. The Muromachi Palace (destr.) in Kyoto of the shogun Ashikaga Yoshinori (1394–1441) retained a *shinden* built for ceremonial purposes in 1432, but with substantial modifications. The north side was more partitioned and irregular in plan than Heian-period examples, while the exterior of that side was fitted with sliding panels (*yarido*) instead of reticulated shutters, and with square posts rather than round ones. This palace complex also contained three independent structures called *kaisho* ('meeting places'), used for holding audiences as well as popular entertainments such as linked-verse (*renga*) and tea-tasting (*tōcha*) parties against a backdrop of exotic Chinese art objects (*karamono*). It was in these *kaisho* that the various elements later termed the *shoin* style first came together as a single architectural mode.

According to theoretical reconstructions, Yoshinori's *kaisho* were rectangular or nearly square, with projecting spaces at several corners, and they were divided roughly at the middle into a northern and a southern row of rooms. These plans were therefore quite different from the old *shinden* formula of a central core with radiating secondary spaces. Like the *shinden*, they were raised on posts, but they were flanked by wide verandahs (*hiroen*)

on one or more sides, then further surrounded by narrow, low verandahs (*ochien*) one step closer to the ground.

The likely appearance of these *kaisho* is suggested by the Tōgūdō, a small structure built by Yoshinori's son Ashikaga Yoshimasa (1436–90) *c.* 1485 at his Higashiyama Villa, now known as Jishōji or Ginkakuji, in eastern Kyoto (*see* KYOTO, §IV, 8). This, the oldest extant *shoin*, incorporates such characteristic features as a ceiling, paper-covered, sliding panels (*fusuma*) for interior partitions, frieze rails (*nageshi*) running the circumference of the rooms at head-level, square posts with slightly bevelled corners, floors completely covered by rectangular straw mats with silk borders (*tatami*) and louvred, sliding wooden panels (*mairado*), which can be opened to admit light through translucent paper screens (*shōji*) behind.

A corner room of the Tōgūdō, the Dōjinsai, includes an alcove with a built-in writing desk (*tsukeshoin*, originally termed *idashifuzukue*, 'desk for laying out writings') lit by small *shōji* and flanked by an alcove with built-in staggered shelves (*chigaidana*; see fig. 28). These two alcoves are the earliest extant examples and are thought to have developed from the movable shelves and tables used in *shinden*. Their juxtaposition here underscores their original function as places for the storage, perusal and composition of documents, but already in the Muromachi period (1333–1568) they were also being used for the display of art work. The

tsukeshoin and *chigaidana* are two hallmarks of the *shoin* style. A third is the decorative alcove (TOKONOMA), used in Yoshinori's *kaisho* but not in the Dōjinsai. One antecedent of the *tokonoma* is the raised floor or bench used in the Kamakura (1185–1333) and Muromachi periods as a place to sit. The Tōgudō has a built-in exterior alcove, the Tokoma, on its west wall that is of related character. A more direct precursor of the *shoin tokonoma* was a low table placed in front of hanging scrolls and used for the display of the 'three objects' (*mitsugusoku*): incense burner, flower vase and candlestand. The early built-in form of the *tokonoma*, originally called the *oshiita*, was wide and shallow, with a thick lintel (*otoshigake*) above. Its relatively high and thick floorboard was of a single plank of wood, separated from the *tatami* floor by a narrow baseboard (*kekomiita*). It came to be called the *toko* or *tokonoma* when the style reached maturity in the Momoyama period (1568–1603).

Mature shoin. The three basic *shoin* elements appear together regularly for the first time in the 16th century in the *shoin* at the abbots' quarters (*hōjō*) of Zen monasteries. In many cases, these *shoin* were also used for the preparation and drinking of tea. One such *shoin* is found in the early 16th-century Reiun'in subtemple of Myōshinji, Kyoto. The Reiun'in not only contains one of the oldest extant *tokonoma* but also the earliest remaining decorative panels (*chōdaigamae*), the only ones of the period located next to the *chigaidana*. The *chōdaigamae*, which open into a subsidiary space, slide on lower runners raised somewhat above *tatami* level and upper runners located a short distance below the upper frieze rail. They slide from sight when opened behind fixed panels (*sodekabe*) at the sides. Probably developed from the fixed-wall sleeping area in

Heian-period residences (the name means 'sleeping-room fixture'), the *chōdaigamae* became another touchstone of the formal *shoin*.

Between the 12th and 16th centuries the central structure of some warrior residences came to be known as the *shuden* ('main hall'). *Shoin* elements were gradually incorporated into such structures, and this phase of the development of the *shoin* is sometimes termed *Shuden* style. One late example of the *Shuden* style is the Guest Hall (*kyakuden*; 1601) at the Kōjōin subtemple of ONJŌJI (Miidera) in Ōtsu, Shiga Prefecture (see fig. 29). While including typical *shoin* elements, the Kōjōin Guest Hall also retains some *shinden* features, which, because of their use in aristocratic dwellings, implied high status. These elements include a pitched-roof *chūmon* (middle gate) entrance (a truncated version of the old *chūmon rō* corridor), swinging plank doors, louvred windows (*renjimado*) and a few reticulated shutters. A newer aspect of the Kōjōin Guest Hall was a carriage porch (*kurumayose*) with a cusped gable (*karahafu*) above. The cusped gable was common in *shinden*, but in later *shoin*-type buildings it gave way to a ceremonial entry alcove (*genkan*).

Hiroma. By the Momoyama period buildings of the *shoin* type had become the preferred mode for warrior residences, for guest halls in temples and even some mansions of court nobles. The most formal spaces built for the warrior élite were larger and more opulent variations of the *Shuden*-style *shoin*. The grandest of these was the Ōhiroma (Great Hall) of the Jurakudai Palace (1588; destr.) of Toyotomi Hideyoshi. As a result, large-scale *shoin* audience halls built over the next 50 years were often called *hiroma*.

30. Ninomaru Palace, Nijō Castle, Kyoto, 1626

One of the most splendid complexes incorporating *hiroma* is the Ninomaru Palace (1626) of Nijō Castle in Kyoto (see fig. 30; *see also* KYOTO, §IV, 9). Built to serve as the Kyoto residence of the Tokugawa shogun, it was meant both as a place of fortification and, more importantly, as a symbol of wealth and power. The central complex includes five large, multi-roomed halls, arranged in a zigzag pattern along a diagonal axis. The halls, separated by function and formality, are the Tōzamurai for samurai guards, the Shikidai for formal receptions, the Ōhiroma and Kohiroma (the latter now called the Kuroshoin, see fig. 31) for formal audiences and, in the rear, the Gozanoma (now called the Shiroshoin) for the master's personal use. Instead of the *shinden*-type exterior corridors used on earlier palaces, the Ninomaru Palace has interior corridors (*rōka*) that surround each hall and connect them together. There are also large kitchens and a spacious garden. The present tile roofs were originally of cedar bark.

When first completed, the Ninomaru complex included far more subsidiary structures that no longer remain, including the Palace of the Imperial Progress (Gyōkō goten), built for a sojourn there by Emperor GoMizunoo (1596–1680) in 1626, and a stage for performances of the *nō* drama, a favourite entertainment of warrior élites. At the height of its scale and grandeur, Nijō Castle included another entire building complex (the Honmaru, 1603, reconstructed 1626), with a five-storey donjon, both within an encircling moat. Another moat surrounded the entire castle.

The most formal audience chamber in the Ninomaru Ōhiroma was designed to reflect status differences in spatial terms (see fig. 32). The long, relatively low space features two areas: an upper area (*jōdan no ma*) whose floor is raised one step above a lower anteroom (*gedan no ma*), so that the occupant of the former literally looks down on the persons of lower status seated before him. The ascendancy of the *jōdan no ma* is further emphasized by its double-coved and coffered ceiling, which contrasts with the single-coved and coffered ceiling of the *gedan no ma*. A large lintel further distinguishes the two spaces. Moreover, the basic *shoin* elements—the *tokonoma, chigaidana, tsukeshoin* and *chōdaigamae*—had by this time become completely ornamental or symbolic. The *tsukeshoin* and *chigaidana*, which in earlier buildings had been contiguous for functional reasons, are now separated by the huge *tokonoma* or *ōdoko* ('great *tokonoma*'). Their purpose here is to delineate the area of greatest importance. Posts are planed in a formal square with slight corner bevels, and fittings of figured gold cover the junctions with frieze rails.

31. Kuroshoin (formerly Kohiroma) of the Ninomaru Palace, Nijō Castle, Kyoto, 1626

32. Audience chamber in the Ōhiroma (Great Hall) of the Ninomaru Palace, Nijō Castle, Kyoto, 1626; view of the upper area (*jōdan no ma*) as seen from the lower area (*gedan no ma*)

Walls are ornamented with brilliant polychrome paintings, often on gold-leaf backgrounds, and the wall spaces (*kokabe*) above those rails (plastered white in the Momoyama period) are also polychrome painted, visually rendering the room a solid cube of gold. It is therefore at this time, in the early Edo period, that the *shoin* achieves its most opulent expression. Walls are treated similarly in the Kuroshoin and Shiroshoin, but they are painted with progressively more congenial subjects and subdued colour schemes, reflecting the increasing informality of these rooms. The *hiroma*-type *shoin* no longer includes the *chūmon* entrance of earlier *shuden* structures, and the earlier pairs of exterior louvred sliding panels—with one translucent *shōji* screen behind—have been replaced by an unbroken line of *shōji* protected by 'rain panels' (*amado*) slid in front of the *shōji* at night or in inclement weather and stored in exterior cabinets during the daytime, thus greatly increasing interior light.

The Ninomaru and other shogunal palaces no longer extant represent the highest level of opulence the *shoin* style was to achieve. The multi-row *hiroma* plan meant that audiences could be held with the most elevated personage on the *jōdan* and those beneath on the *gedan* to the south, or he himself might sit on the *gedan* with the others in a third room to the east. After the devastating Meireki era fire of 1657 in the shogunal capital of Edo, however, daimyo tended to build the audience chambers of their Edo mansions with only a single row of rooms and called them not *ōhiroma* and *kohiroma* but greater

shoin (*ōjoin*) and lesser *shoin* (*kojoin*). With this, the formal *shoin* space reaches its final stage of development.

But despite the pervasive use of the *shoin* style, elements of the *shinden* continued to be selectively used, particularly in buildings associated with the court aristocracy. One example is the former Ichijōin (Nara), the abbot of which was traditionally a member of the imperial family. Its Imperial Apartments (1650) have a southern main façade bisected by a staircase with projecting overhead eaves and bordered by an ornamental railing. In addition to *shinden* elements, it contains a formal *shoin* space with *tokonoma*, *chigaidana* and *tsukeshoin*.

Sukiya shoin. At the same time as the Ninomaru Palace was being built, a more relaxed and intimate version of the *shoin* style was being employed in the informal spaces and private retreats of the upper classes. These structures use much of the formal *shoin* vocabulary, including *tokonoma*, *chigaidana*, *tsukeshoin*, *fusuma*, *shōji* with rain panels, ceilings and *tatami* mats, but the accent is on understated elegance rather than imposing grandeur. The *sukiya shoin* type is marked by reduced scale, unplaned or only partly planed posts and interior partitions either painted in ink monochrome or plastered in earth tones. The approach was influenced by the architecture of the tea house (*sukiya*) and its aesthetic of elegant simplicity and rustic naturalness (*see* §XIV, 1 and 2 below).

The finest *sukiya shoin*, built for persons of cultivated taste and exacting requirements, achieve an artless effect

through the most artful means. The *sukiya shoin* delights in caprice as well as restraint, and it displays a constant creative rethinking of the *shoin* formula which enabled it to retain artistic vitality long after the purely formal *shoin* space had become conceptually stagnant. Some spaces remain more formal and incorporate only selective *sukiya* touches, while others rival the tea house in the imaginative manipulation of design elements, including the style and arrangement of the *tokonoma*, *chigaidana* and *tsukeshoin*.

In *sukiya shoin* structures the *tokonoma* tends to be narrower and deeper than the older *oshiita* type, and its lintel is lower and more attenuated. The *tokonoma* is often floored with *tatami* and faced with a thick, decorative moulding (*tokogamachi*). Arrangements of the *chigaidana* designs also proliferate, the most opulent being the examples known as 'three shelves' (*sandana*): the 'Daigo Shelves' (*Daigodana*) of the Imperial Apartments (*c.* 1624–?44) in the Sanbōin subtemple of Daigoji (*see* KYOTO, §IV, 3(ii)), which are not set into the rear wall of the alcove but have their own carved backs; the 'Mist Shelves' (*Kasumidana*) in the Guest Hall (1677) of the Middle Villa (Naka no chaya) at Shugakuin Detached Palace (Shugakuin Rikyū; *see* KYOTO, §IV, 11), the five levels of which are suspended from the alcove ceiling; and the 'Katsura Shelves' (*Katsuradana*), a complex arrangement on the Imperial Dais in the New Palace (Shingoten) of Katsura Detached Palace (Katsura Rikyū; *see* KYOTO, §IV, 10). The earlier tripartite and bipartite shelves remain much in

evidence, however, and shelf alcoves are often fitted with upper and lower cupboards of varying formality. Where *tsukeshoin* are present, they often have ogee-arched windows (*katōmado*), but in some cases the *tsukeshoin* desks themselves are missing, leaving only the characteristic four short *shōji* screens on the wall. Most *sukiya shoin* include flat ceilings with simple battens (*saobuchi*), and the raised dais (*jōdan*) is employed only selectively. Despite the emphasis on refined understatement, *sukiya shoin* occasionally use rich colours on walls and even ceilings and exhibit a lavish attention to intricately wrought door-pulls and nail covers.

In contrast to the wide bay of the Heian-period *shinden*, the typical bay of the Edo-period (1600–1868) *sukiya shoin* is only *c.* 2 m wide. The size of the bay is, with few exceptions, fixed throughout a single structure and is related to the size of the mats that cover the whole floor. The mats, in turn, are accommodated to human proportions, as are the height of the frieze rails and upper runners for *fusuma* and *shōji*. These general correlations lend a basic unity of proportion and an underlying rhythm to the usually irregular *shoin* plan, and they contribute to its intimate scale.

Of the many fine *sukiya shoin* that survive from the Edo period, the most famous is the Katsura Detached Palace, built first in 1616 and then gradually enlarged over four decades by three generations of the Hachijōnomiya family of court nobles (see fig. 33). Its three main buildings,

33. Katsura Detached Palace, Kyoto, *c.* 1616–63

the Old Shoin (*c.* 1616), Middle Shoin (*c.* 1641) and New Palace (*c.* 1654–5 and *c.* 1663), are laid out in stepwise fashion, demonstrating the additive-space concept seen in many *shoin* plans. This design increases the number of views of the garden and pond from the interior. All three buildings have hip-and-gable roofs of cedar bark and are surrounded by unbroken lines of *shōji*, which can be opened or removed entirely in the warmer months. These features, together with the verandahs, contribute to the integration of interior and exterior spaces, a primary characteristic of the *sukiya shoin* style. Interiors include a variety of *tokonoma*, transom and *chigaidana* types, all made with fine woods and superlative craftsmanship and evincing the blend of ingenuity and refinement characteristic of the best *sukiya shoin* designs. Another example of a large-scale *sukiya shoin* space is the Kuroshoin (1656–7) of Nishi Honganji temple.

The *sukiya shoin* type eventually spread into residential architecture of the merchant class in the Edo period, and it forms the basis of the traditional Japanese house today.

(b) Commoners' dwellings. Commoners' residences (*minka*) of the period 1185–1868 range from the truly rustic dwellings of farmers to the houses of the lower-rank samurai, spacious inns for upper-class travellers and the mansions of wealthy urban merchants and rural village overseers. Commoners' dwellings are customarily divided into farmhouses (*nōka*) and urban residences (*machiya*), but the two categories share many characteristics.

Farmhouses. Before the later 20th century, most Japanese lived in farmhouses (*nōka*), although little is known about such houses before the 17th century, the period from which the earliest extant residences date. Some pit dwellings continued to be used in rural areas into the 16th century, but pictorial sources such as the *Shigisan engi emaki* ('Origins of Mt Shigi'; three-scroll set, second half of 12th century; Chōgosonshiji, Nara Prefecture; National Treasure) show that far more complex structures were also in use by late in the Heian period (794–1185). Depicted in the scroll is a house built on ground-level, with a plank roof pitched steeply over a central core (*moya*) and more gently over two peripheral spaces (*hisashi*). The *Ippen Shōnin eden* ('Pictorial biography of the Reverend Ippen; Kyoto, 1299) shows a slightly more refined residence, with a steep, thatched roof over the central core and planked sections over the *hisashi*, a large, open, plank-floor space leading through a door to an enclosed area within and an earth-floor extension at the rear making an L-shape with the rest of the building. *Rakuchū rakugai zu* ('Scenes inside and outside Kyoto'; late 16th century) gives examples of large, multi-structured farmhouse compounds enclosed by imposing walls.

It is believed that the raised sleeping area found in some pit dwellings evolved to the point where it occupies half of the interior in later ground-level farmhouses. The combination of earth-floor (*doma* or *niwa*) and raised-floor (*toko*) areas constitutes the basic formula of farmhouse design. The *doma* usually includes the entrance, clay

34. Yoshimura residence, Habikino, Osaka Prefecture, early 17th century with later additions; view of interior verandah (*hiroshiki*) of the raised-floor section (*toko*), seen from the earth-floor section (*doma*)

oven (*kamado*), an open hearth (*irori*), some storage space, a sleeping area for servants and often a stable; the *toko* is used for eating, for some types of work and for sleeping, often in an enclosed chamber. The *toko* continues to expand over time and, as with the *shinden* of aristocratic residences, to undergo further partitioning. One standard older plan, the *hiroma* (not to be confused with the *shoin hiroma* or 'grand hall' associated with the Ōhiroma; see §(a) above), includes a *doma* and a tripartite *toko* composed of a large space for daily living and two smaller spaces for sleeping and eating. The farmhouse plan reaches maturity in the 19th century, when the *toko* comes to be subdivided into four rooms intersecting at a single central point (the *yomadori* plan). *Toko* areas of six rooms or more also occur.

The basic structure of the posts and roof divides the farmhouse into a central core (*jōya*) and peripheral spaces (*geya*). While early examples have many interior posts, fewer are found in later examples, in which the weight of the roof is shifted to peripheral posts by more advanced beam systems. The beamwork over both the *doma* and *toko* areas of farmhouses is usually left visible, often to striking effect. Tertiary spaces (*matabisashi*) are occasionally employed. Several strategies for supporting the roof are in use, two of the most common being the *gasshō* style, which uses an inverted 'V' of heavy principal rafters, and the *wagoya*, which employs a matrix of struts and tiebeams. The roofs of most pre-modern farmhouses are thatched.

Farmhouse styles vary widely according to region, for the climate of an area dictates materials, roof type and even plan. All types, however, feature construction based on a framework of posts and beams and maintain the fundamental division into earth-floor and raised-floor sections. In the snowy regions of northern Honshu, for example, the traditional farmhouse includes a wing at right angles to the house itself for stables, which ensures access even in inclement weather. The *gasshō* style in Gifu and Toyama prefectures features three- and four-storey elevations under a pitched roof, the upper levels being used for sericulture. *Kudo*-style houses in Saga Prefecture, Kyushu, employ three thatched-roof sections connected at their ends to form a rectilinear 'U' in plan, with an enclosed central space roofed in tile.

One of the most famous farmhouses is the *takahe*-style residence of the Yoshimura family in Habikino, Osaka Prefecture, the oldest part of which is thought to date from the early 17th century. The house features a large earth-floor area connected to a regular, six-room raised section by a spacious interior verandah (*hiroshiki*; see fig. 34). Above is a variant of the *yamatomune* roof common to the region, with a steep, thatched central section, gently sloping eaves of tile and tall, stuccoed walls (*takahe*) at both gable ends. The façade, geometrically subsected by half-timbering, is noted for its beauty (see fig. 35).

At the end of the Yoshimura house farthest from the *doma* is an appended, multi-room section of *sukiya shoin* type. The anteroom and main sitting room (*zashiki*) are separated by a decorative transom, the sitting room includes a *tokonoma* and *tsukeshoin*, and both rooms have ceilings as well as a view out over a verandah. This formal

35. Yoshimura residence, south façade, Habikino, Osaka Prefecture, early 17th century with later additions

area also includes its own entry alcove (*genkan*). Though *shoin* furnishings were normally forbidden to the lower classes in the Edo period (1600–1868), the Yoshimura were general supervisors (*ōjōya*) of the surrounding villages and needed *shoin*-style rooms to host government officials. Many of the farmhouses and urban dwellings remaining from that period feature *zashiki* sections or separate *zashiki* structures, indicating that their owners belonged to the upper stratum of the commoner class.

Urban dwellings. Early urban dwellings (*machiya*) are known only through pictorial sources and other written records. The handscroll *Nenchu gyōji emaki* ('Annual rites and ceremonies'; 16 scrolls, 17th-century copies of 12th-century work (destr.); Tokyo, Tanaka Col.) depicts a contiguous row of plank-roofed, single-storey dwellings, with each house being two to four bays in width (*c.* 4–8 m). The façade of each structure contains an entrance and a wall with windows at shoulder height to its left. The entrance gives on to a *doma* (earth-floor) area. The outer wall obscures the view of the interior space next to the *doma* section, but dwellings of the sort depicted probably included a *toko* (raised-floor) area. This is clearly the case in one residence shown in the handscroll *Shigisan engi emaki*, where the *doma* section behind the entrance extends to the area behind the front windows, and the left side of the central core includes a *toko* separated from the front by a reticulated partition. Because the rear section under the eaves was probably earth-floored as well, the plan demonstrates the front-to-back *doma* plan (*tōriniwa*) common to urban dwellings of subsequent periods. The front

of the house abuts on the street, but at the side is a communal garden.

From the mid-15th century, the continued growth of castle towns (*jōkamachi*; *see* §IV, 3 below), post towns (*shukubamachi*), temple towns (*monzenmachi*) and market centres led to the elongation and narrowing of housing plots. The typical residence had three rooms front to back along a *doma* area running the length of the dwelling. Houses of two and, occasionally, three storeys began to be built with greater frequency, the upper spaces being very low at the eaves. With the relative stability and prosperity following the foundation of the Tokugawa shogunate in 1603, the urban centres of Edo (*see* TOKYO), OSAKA and NAGOYA underwent great expansion, and rows of small rear tenements (*uranagaya*) came to be built behind the more spacious structures of wealthier residents. Because of the frequency of destructive fires in these dense cities, tile roofs were encouraged for all buildings. Multi-storey godowns (*dozō*) with thick, fire-retarding walls of plaster also became popular.

The oldest commoner dwelling that can be precisely dated is the urban residence of the Kuriyama family in Gojō, Nara Prefecture, built in 1607. The next oldest with a fixed date is the Imanishi residence (Kashihara, Nara Prefecture, 1650), which includes two front rooms known as the *mise* ('shop') that were used for business transactions. Such commercial rooms are included in many urban dwellings.

Urban residences show marked regional variation. The lattice-fronted rows of plank-roofed houses at the post town of Tsumago in Nagano Prefecture, for example, differ from the houses of Kurashiki in Okayama Prefecture, with their tile roofs and white-plastered walls with inset rows of grey tile squares (*namakobei*). The sizes of bays and *tatami* mats also vary slightly according to region. Throughout the country, grand urban residences built for wealthy commoners often include a *shoin*-style *zashiki*. Originally for the reception of government officials, these elegant rooms were later designed for personal use and as symbols of wealth, in defiance of sumptuary laws. Residences such as the Imanishi house feature extremely spacious plans, which surpass those of most samurai dwellings. Moreover, houses of pleasure in large cities, for instance, the Sumiya in Kyoto (1640, with later additions), typically feature ingeniously designed and richly crafted *sukiya shoin* spaces meant for the enjoyment of wealthy and cultivated clients.

BIBLIOGRAPHY

GENERAL

E. Morse: *Japanese Homes and their Surroundings* (1896/R Tokyo and Rutland, VT, 1972)

H. Ōta, ed.: *Zusetsu Nihon jūtaku shi* [History of Japanese residences through illustrations] (Tokyo, 1948, rev. 1971)

S. Noji: *Chūsei jūtaku shi kenkyū* [Research on the history of medieval residences] (Tokyo, 1955)

R. T. Paine and A. Soper: *The Art and Architecture of Japan*, Pelican Hist. A. (Harmondsworth, 1955, rev. by D. B. Waterhouse and B. Kobayashi, 1981)

T. Itō: *Chūsei jūtaku shi* [History of medieval residences] (Tokyo, 1958)

H. Engel: *The Japanese House: A Tradition for Contemporary Architecture* (Tokyo and Rutland, VT, 1964)

H. Ōta, ed.: *Japanese Architecture and Gardens* (Tokyo, 1966)

T. Itō and Y. Futagawa: *Sukiya* (Kyoto, 1967); Eng. trans. as *The Elegant Japanese House: Traditional Sukiya Architecture* (New York and Tokyo, 1969)

K. Hirai: *Japanese Residences of the Early Modern period* (Tokyo, 1968)

N. Itōh: *Sumai* [The house], Nihon no bijutsu, vi (1969)

H. Ōta: *Nihon no jūtaku shi* [History of Japanese residences] (Tokyo, 1970)

——: *Tokonoma* [The decorative alcove] (Tokyo, 1978)

M. Fujioka: *Japanese Residences and Gardens: A Tradition of Integration*, Eng. trans. by H. M. Horton (New York, 1982)

K. Hirai: *Zusetsu jūtaku no rekishi* [History of Japanese architecture through illustrations] (Tokyo, 1982)

K. Nishi and K. Hozumi: *Nihon kenchiku no katachi* (Tokyo, 1983); Eng. trans. by H. M. Horton as *What is Japanese Architecture?* (New York, 1985)

H. Mae: *Sumai no rekishi tokuhon* [Reader in the history of houses], Tokyo bijutsu sensho [Select books by Tokyo Bijutsu], xvii (Tokyo, 1985)

K. Hirai: *Nihon jūtaku no rekishi* [History of Japanese residences] (Tokyo, 1986)

ELITE BUILDINGS

N. Ōkawa: *Katsura to Nikkō* (Tokyo, 1964); Eng. trans. by A. Woodhull and A. Miyamoto as *Edo Architecture: Katsura and Nikko*, Heibonsha Surv. Jap. A., xx (New York and Tokyo, 1975)

M. Fujioka: *Katsura rikyū* [Katsura Detached Palace] (Tokyo, 1965)

K. Hirai: *Shiro to shoin* (Tokyo, 1965); Eng. trans. by H. Sato and J. Ciliotta as *Feudal Architecture of Japan*, Heibonsha Surv. Jap. A., xiii (New York and Tokyo, 1973)

M. Kawakami and M. Nakamura: *Katsura-miya to chashitsu* [The architecture of the tea house and Katsura Detached Palace], Genshoku Nihon no bijutsu [Arts of Japan, illustrated] (Tokyo, 1967)

A. Naitō: *Shin Katsura rikyū ron* [New theory on Katsura Detached Palace] (Tokyo, 1967)

M. Fujioka: *Shiro to shoin* [Castles and *shoin*], Genshoku Nihon no bijutsu [Arts of Japan, illustrated], xii (Tokyo, 1968)

M. Kawakami: *Nihon chūsei jūtaku no kenkyū* [Research on medieval Japanese residences] (Tokyo, 1968)

M. Fujioka and K. Tsunenari: *Shoin*, 2 vols (Tokyo, 1969)

F. Hashimoto: *Shoin-zukuri* (Tokyo, 1972); Eng. trans. by H. Mack Horton as *Architecture in the Shoin Style*, Jap. A. Lib. (New York, 1981)

T. Itō and P. Novograd: 'The Development of *Shoin*-Style Architecture', *Japan in the Muromachi Age*, ed. J. W. Hall and T. Toyoda (Berkeley and London, 1977), pp. 227–39

A. Naitō: *Katsura: A Princely Retreat*, Eng. trans. by C. S. Terry (New York, 1977)

M. Kawakami: *Katsura rik yū to chashitsu* [Katsura Detached Palace and tea-houses], Genshoku Nihon no bijutsu [Arts of Japan, illustrated] (Tokyo, 1981)

M. Fujioka: *Kyoto Country Retreats: The Shugakuin and Katsura Palaces*, Great Japanese Art, Eng. trans. by B. A. Coats (New York, 1983)

COMMONERS' DWELLINGS

T. Itō: *Nihon no minka* [Commoners' residences of Japan], 10 vols (Tokyo, 1958–9)

T. Itō and Y. Futagawa: *Nihon no minka* (Tokyo, 1962); Eng. trans. as *The Essential Japanese House* (Tokyo, 1967)

T. Itō: *Minka* (Tokyo, 1965); Eng. trans. by R. L. Gage as *Traditional Domestic Architecture of Japan*, Heibonsha Surv. Jap. A., xxi (New York and Tokyo, 1972)

T. Itō and Y. Futagawa: *Nihon no minka/Traditional Japanese Houses* (Tokyo, 1980) [bilingual text]

C. Kawashima: *Minka: Traditional Houses of Rural Japan*, Eng. trans. by L. F. Riggs (New York, 1986)

H. MACK HORTON

(c) **Castles.** Castles (*shiro*, *-jo*) gave monumental expression to both political authority and military power in Japanese civilization. Only 12 castle keeps (*tenshu*) survive, including the soaring, multiple-tower keep of HIMEJI and the small but exquisitely proportioned keep of Hikone. Yet at the height of castle-building activity in the late 16th century and the early 17th, nearly 100 castles were built, many on a scale and with a technical sophistication equal or superior to that of the largest and most advanced castles built during the European Middle Ages and the Crusader campaigns to the Middle East.

Each province in Japan had one primary castle and several subsidiary fortifications, but these fell ready victim to changed political circumstance. Castles were deliberately demolished during the consolidation of Tokugawa shogunal government after 1615, and dozens were destroyed by the Meiji government after 1868 as part of the systematic dismantling of the feudal system. Fortified settlements, such as the Yoshinogari site in Saga Prefecture (*see* §2(i) above), were already the pattern for population and power in pre- and protohistoric times. From the 8th century AD sturdy palisaded enclosures were used to extend the power of the Nara imperial court into the Ezo- or Ainu-controlled regions of the north. From the 12th century, fortified manor houses, surrounded by dry moats and guarded by high wooden palisades and towers, were the basis for manorial government throughout the country. In times of conflict the warriors would retreat to nearby hilltop forts for protection. Fortifications in Japan, therefore, have a long history, but the castle had only a brief period of 63 years of full technical and stylistic maturity, beginning in 1576 with the construction of Azuchi Castle and ending with the last reconstruction of the keep of Edo (now Tokyo) in 1639. After that time castle construction virtually ceased as a result of a prohibition by the Tokugawa as part of the institutionalization of their nationwide authority. The patronage and power of the three national unifiers created the great castles of this era. Oda Nobunaga was responsible for Azuchi, Toyotomi Hideyoshi for Osaka, Fushimi and Jurakudai, and Tokugawa Ieyasu (1543–1616) sponsored the construction of the great citadel and city of Edo as the headquarters of his national government.

The castle as an institution was the symbolic focal point of this period. Its physical presence, particularly the soaring *tenshu* at the heart of each complex, was the most visible statement of the power of the warrior class. The castle also served as a palatial residence for regional and national rulers and the centre for the court and patronage of the arts, making its glittering array of buildings and activities a constant reminder of the authority of its patrons. As the substance of authority the castle was a bastion of military might. Castle construction was for a time the major activity of the age, requiring the massive mobilization of manpower and material that was possible only because of a total commitment to that end by the warrior leaders. Castles were also centres of civil administration for feudal domains of increasing size and complexity. Around these seats of government castle towns (*jōkamachi*; *see* §IV, 3 below) were established, which became hierarchically ordered representations of status within the political order as well as centres of commerce, culture, communications and population. Many of the major cities of Japan were founded as castle towns in this era, including Nagoya, Sendai, Shizuoka, Hiroshima, Okayama, Kōchi and, the largest of them all, Edo.

Azuchi. AZUCHI CASTLE inaugurated the age of castles. Built under the patronage of Nobunaga in 1576–9 on the eastern shore of Lake Biwa, it established the general architectural form and governmental role for later castles. Azuchi marked the watershed between earlier fortifications and the mature castle form. In particular, the keep had begun to outgrow its original function as a watch-tower

and storehouse (*see* MATSUMOTO CASTLE) to become the nerve-centre of the feudal castle. Azuchi was not built on a formidable mountain but on a hill close to the points of communication on the plains; it commanded the convergence upon the imperial capital of Kyoto of the main highways from eastern Japan. The town of Azuchi at the foot of the hill was one of the first consciously created towns of the new era: an infrastructure was established, and artisans and merchants were offered financial incentives to move to the town. The Jesuits, a ubiquitous presence in this internationalizing age, founded a church and theological seminary, as well as being much in evidence at Nobunaga's court.

Azuchi also departed radically from earlier castles in its style of fortifications, which protected the gilded keep at its centre. Stone walls and barbican gatehouses protected the approaches to the hilltop keep from the lower slopes. At strategic intervals corner towers were raised to provide a good view and concentrated fire power. The combined effect of the defensive installations and the ever-upward and uneven slope would have made successful attack extremely difficult. Only massive stone walls survive, for Azuchi was sacked and burnt as a result of treachery rather than siege within days of the assassination of its progenitor Nobunaga in 1582.

Himeji. Himeji is the finest extant example of castle architecture in Japan, with the most extensive set of outer fortifications and the most impressive of all enduring *tenshu* (see fig. 36). The extant castle belongs to the period of consolidation of political power after the Tokugawa victory at the Battle of Sekigahara in 1600. It was built in 1601–9 in the western part of the main Japanese island by Ikeda Terumasa (1564–1613), a key vassal of the Tokugawa. It was strategically sited to buttress the western perimeter of the sphere of the controlling Tokugawa with a massive fortification, held by a close and trusted ally, against the vanquished Mōri and their associates. Ikeda Terumasa was transferred to the Himeji fief immediately after the Battle of Sekigahara and began a major rebuilding project the following year. The *tenshu* complex, comprising the main keep, or Great Tenshu (Jap. Daitenshu), and three subsidiary *tenshu* grouped on a square plan and linked by connecting fortified parapets, was built in 1608–9. Work continued on the outer walls and structures until Ikeda's death in 1613. His ambitious plans had included the excavation of a canal to link Himeji with the Inland Sea, but this project was abandoned with his death. Contemporary records establish clearly the scale and character of Himeji at the time of its completion under Ikeda. The inner enclosure (Honmaru) was *c.* 91 m long on each of its four sides. The outer perimeter of the fortifications totalled nearly six km and enclosed an area about 1850 m north–south by 1420 m east–west.

The castle survives in the same general form as on completion. Occupying an area of some 23 ha, it is the largest castle in Japan, although in its day it was only the fourth largest, after Edo, Osaka and Nagoya. Set on two gently sloping hills on the Harima Plain, it makes clever use of the existing topography and is a perfect example of the type of fortification known as a *hirayamajiro* ('a castle

36. Himeji Castle, *tenshu* ('keep'), 1601–9; longitudinal section

on a hill on a plain'). The higher of the two hills, Himeyama, rises a modest 50 m and is the site of the inner enclosure protecting the main keep complex, and a surrounding compound, the Ninomaru (second enclosure). To the west is Sagiyama (White Heron Hill), on which stand the western enclosure (Nishinomaru) and its fortifications. The most impressive feature of the castle, apart from the keep complex, is its labyrinth-like defensive plan. This comprises a sequence of gateways and gate-houses organized in an irregular spiral plan, eventually reaching the site of the keeps and the palace that were set below it. The gateways provide access through the towering stone walls, which reach a height of 30 m in the vicinity of the keep complex, with additional defence afforded by a series of water-filled moats. The stone walls were constructed using the 'dry-wall' technique. The individual rocks were hewn into regular shapes, thereby simplifying the process of assembling the wall faces. Water outlets were provided at suitable places in the walls to allow drainage of accumulated water from behind the stone facing, the greatest threat to the structural viability of any such wall.

All who entered the castle grounds had to travel almost three times the straight-line distance between the outer entrance gateway and the keep complex. This was intended in part to counter the menace of firearms. The matchlock musket (arquebus) arrived in Japan in 1543 with the first

shipwrecked Portuguese sailors and the cannon in 1576. The musket played a decisive role in Nobunaga's victory at the Battle of Nagashino in 1575 but posed no real threat to castles built on such sturdy stone foundations. The cannon was never employed effectively against the Japanese castle because of poor casting and gunnery skill in Japan. There was some strengthening of walls and extension of outworks, some addition of iron plating on the wooden doors of gateways for protection against musket fire, but the overall effect of firearms on castle design was minimal. Had the forces of siege and artillery been brought fully to bear against the Japanese castle, exuberant and flamboyant castle forms would have given way to the smooth-walled, hunched shapes of later European castles.

The sophistication of the castle-building techniques of Himeji is evident, not only in the provision of three smaller keeps to enhance the spectacle and efficacy of the main *tenshu*, but also in the internal structure of the keep itself. It has a robust timber-frame structure held together by mortice-and-tenon joints. The entire structure is reinforced against earthquake from the basement to the upper storey, the seventh interior floor, by two massive pillars that pass through each level from the basement. The east pillar was originally a single trunk of silver fir (*momi*) 24.8 m long. The west pillar was created by tenoning together two tree trunks, the upper part of hemlock (*tsuga*)

and the lower of silver fir. The understanding of the mechanical properties of tall structures and the sureness and strength of the joints fashioned to splice and tenon this frame together are staggering, even in the light of modern technology. The castle builders inherited many of their skills and techniques from builders of religious structures, in particular the multi-storey Buddhist pagoda, which is the direct precedent for the castle.

BIBLIOGRAPHY

M. Hinago: *Shiro* (1970), Nihon no bijutsu [Arts of Japan] liv, (Tokyo, 1966–); Eng. trans. by W. H. Coaldrake as *Japanese Castles* (1986), Japanese Arts Library, xiv (Tokyo and New York, 1977–87)
K. Hirai: *Jōkaku I* [Castles I], xiv of *Nihon kenchikushi kiso shiryō shūsei* (Collection of the basic materials in Japanese architectural history], ed. H. Ōta (Tokyo, 1978)
T. Katō, ed.: *Himeji*, i of *Nihon meijō shusei* [Collection of famous castles in Japan] (Tokyo, 1984)

WILLIAM H. COALDRAKE

5. MODERN: MEIJI AND AFTER. Religious and vernacular structures continued to be built in traditional styles and techniques following the Meiji Restoration in 1868, but official government policy for the modernization of Japan aimed at parity with Europe in its public architecture and cities as well as in industrial and military affairs. Although there were signs of a new age of Modernism developing in architecture in Europe and the USA at this time, the primary concern of Meiji architecture was systematic Westernization on the model of orthodox, historical European styles rather than progressive ones. The development of the technology associated with modern architecture, especially steel and concrete construction, was already under way in Japan by c. 1900: the first steel-framed building appeared in the mid-1890s and the first reinforced-concrete building about 1905. However, the full potential of modern architecture was not realized until the decade after 1910, which marked an important change. The need to create new architectural forms appropriate to the building types of the modern era led some Japanese architects to realize that they must shake off the historicism of the 19th century and concentrate on investigating the new avant-garde movements in Europe. At the same time, other architects called for a revival of traditional styles, using Western building technology to arrive at new architectural forms. These two opposing approaches continued to dominate architectural discussion in Japan for many years.

Although the first modern buildings in Japan were completed in the 1920s, it was not until the 1950s that the International Style was firmly established there, aided by large-scale redevelopment after World War II that changed the organization of towns, suburbs and villages by the construction of extensive communications networks. In the 1960s Japanese architecture began to change and develop with greater speed and on a larger scale as a result of the wide acceptance of Modernism and the startling progress made in the development of modern building techniques. The limitations of international Modernism, in both style and ideology, became apparent at this time, however, and architects in Japan, as in other countries, began to seek alternatives for the post-modern era. This resulted in some of the most innovative designs seen anywhere in the world: Japanese architects in the late 20th century were among the most avant-garde in international developments in architecture.

(i) Westernization, 1868–c. 1920. (ii) International Modernism, c. 1920–60. (iii) 1960 and after.

(i) Westernization, 1868–c. 1920. In 1868 the new government's Ministry of Technology established a Building and Repairs Department to carry out the design of important public buildings. Its desire to use historical European models as the basis of these designs necessarily involved the use of foreign construction technology, particularly brick, and this increased Japanese reliance on foreign instruction. Several building engineers and architects were invited to act as advisers, and by 1879 a group of 13 foreigners was working for the government, seven of them English and the others French, Italian and Prussian. Three were qualified architects and the others were site engineers, civil engineers, masons and bricklayers. The Japanese government expected them not only to understand the kind of architecture required but also to teach the Japanese the entire Western building process from design to completion. At the same time, the government realized that, in order to transplant Western technology to Japan in a systematic manner, there was an urgent need to provide higher technical education for Japanese students. In 1871 the Kogakuryo, a technological institute, was set up in the Ministry of Technology, and in 1873 nine Englishmen, including Henry Dyer, came to Japan and established an engineering curriculum based on the British model. This institute became the College of Technology in 1877, its first students graduating in 1879; it eventually became a faculty of the Tokyo Imperial University (now the University of Tokyo).

Among the foreign architects who came to Japan, the Englishman JOSIAH CONDER was one of the most influential, not only for his buildings but also because he trained the first generation of Japanese architects in Western-style architecture. He came to Japan in 1877 at the age of 25 and was immediately appointed a professor at the College of Technology. At the same time he began some design work in the Building and Repairs Department. In 1888 Conder opened his own office in Tokyo and, until his

37. Josiah Conder: Iwasaki Villa, Hongo, Tokyo, 1896 and 1908

38. Tōkuma Katayama: Akasaka Detached Palace, Tokyo, 1909–19

death in 1920, designed and constructed more than 70 buildings in Japan; only seven of these survive. Conder's ambition was not to import English architecture to Japan but to invent a contemporary architectural style appropriate to the climate and traditions of Japan. Adopting an eclectic approach typical of the period, he first turned to Indian and Islamic architecture for forms that would give an 'Oriental' character to his work. For example, his Ueno Royal Museum, Tokyo, designed in 1881 soon after his arrival, was a two-storey brick building featuring arched openings that were original interpretations of Islamic curvilinear forms. He continued to experiment with various European styles in other works, including the Iwasaki Villa (1896 and 1908; see fig. 37), Tokyo; his Rokumeikan (Deer Cry Pavilion; 1883; destr.), named after a literary reference that was a symbol of Meiji culture, was a Renaissance Revival building that became the embodiment of the Meiji policy of *bunmei kaika* (civilization and enlightenment).

Other Europeans working in Japan at this time had a different approach. Several German architects were invited to Japan in 1886, and, rather than attempt to synthesize a new 'Oriental' style, they transplanted orthodox German styles intact. Thus ENDE & BÖCKMANN, the German architects commissioned in 1887 to work on a complex of government buildings including the new Diet (parliament) in the central Hibiya area of Tokyo, proposed a magnificent neo-Baroque design that was completely alien to the surrounding environment. The project, which was subject to opposition from traditionalist Japanese architects, was only partially realized at this time because of financial

difficulties and poor foundation condition on site, and the Diet building was not constructed until 1936 and then in an Art Deco style (designed by the Building and Repairs Department of the Ministry of Finance). However, the Ministry of Justice (1895) and Law Court (1896; destr. 1945) were constructed in a simplified version of the original design, and the solemn and dignified German style, with steep roofs, towers and domes, had a considerable influence on Japanese architects.

The urgent need for new construction meant that new graduates of the College of Technology started designing buildings immediately. Their work began to appear as early as the beginning of the 1880s, and before long their contribution began to challenge the domination of Western designers over Japanese architecture. In the 1880s and 1890s Japanese architects designed government and commercial offices, banks, hospitals, universities and grand residences, using eclectic design techniques and styles learnt from Conder and other foreign professors, from their own foreign studies or from magazines and books. Notable architects of this period include KINGO TATSUNO, Tatsuzo Sone (1852–1937), TŌKUMA KATAYAMA, Yuzuru Watanabe (1855–1930), Kozo Kawai (1856–1934) and Yorinako Tsumaki (1859–1916). Tatsuno was one of the first Japanese architects to go abroad, and he was a founding member of the Japan Institute of Architects in 1886; his most important works include the huge Neoclassical Bank of Japan (1890–96), Nihonbashi, Tokyo. Tsumaki designed the head office of Yokohama Special Bank (1904). Most of these works around the turn of the

19th century were modelled on various European buildings of the same period, but simplified and reduced in scale. Common characteristics included a rather crude, stiff building form, almost like a silhouette, which was intended to express the dignity of the new state but which also, of course, reflected the inexperience of the designers; the use of neo-Baroque elements in basically classicist designs, which reflected their high regard for the Baroque style; and the emphasis placed on the external appearances of buildings—often at the expense of interior planning and design—which reflected both limited budgets and the priority given to the design of the urban landscape.

Another problem that faced Japanese architects was the development of earthquake-proof construction techniques. The Nobi earthquake of 1891 revealed the weakness of brick structures and the need for reinforcement, and the San Francisco earthquake in 1906 showed the resistance offered by steel-framed and reinforced-concrete buildings. Although iron bars were used to reinforce brick structures in the mid-1890s, it was not until after 1906 that buildings of steel and concrete began to be constructed regularly in Japan, and only after the Kantō earthquake in 1923 did they become the standard form of construction.

The massive, Neo-classical Akasaka Detached Palace (1909–19; see fig. 38) in Tokyo, designed by Katayama, marked a turning-point in the development of Japanese architecture. Its completion represented the achievement by the Japanese of architectural design and construction techniques comparable to those in Europe and the USA—the goal of the Meiji Government—and this led to the upsurge of a latent interest in Japanese architectural traditions, with Japanese architects beginning to question the need for the wholesale adoption of Western styles. Similar sentiments had already been raised by such architects as CHŪTA ITŌ, who had opposed the neo-Baroque design for the Diet building and called for a revival of traditional Japanese architecture. During the 1920s attempts were made to apply traditional timber construction and roof forms to such modern building types as banks, government offices and hotels. Such traditionalism was generally seen as being too regional, however, and although the totally alien brick construction technique was replaced by reinforced concrete, which could be more easily moulded to traditional forms, the use of European revival styles continued into the 1930s, dominating streetscapes in Japanese cities.

(ii) International Modernism, c. 1920–60. In 1920 a group of recent graduates from Tokyo Imperial University, including SUTEMI HORIGUCHI and MAMORU YAMADA, formed the Japan Secession Group, the first movement in support of modern architecture in Japan. The group expressly sought a break from academic eclecticism, and its members took their inspiration from recent avant-garde European architecture, for example German Expressionism, as seen in Yamada's Central Telegraph Office (1925; destr.), Tokyo, and its use of parabolic arched forms. In spite of their youth and lack of experience, their work achieved widespread respect because it was seen to reflect the conditions of the times.

The development of modernist ideas in Japan was directly stimulated by foreign architects working there, including Frank Lloyd Wright, whose Imperial Hotel was built in Tokyo between 1919 and 1921 (destr. 1968), and, more importantly, ANTONÍN RAYMOND, who went to Tokyo as Wright's assistant and set up his own office there in 1920. He worked in the forms of early Modernism and became a highly influential figure in Japan with such buildings as the Tokyo Golf Club (1932), Asaka. His office also trained a number of Japanese students, including KUNIO MAEKAWA and JUNZŌ YOSHIMURA. At the same time, some Japanese architects began to travel to Europe to study and work; Maekawa and JUNZŌ SAKAKURA, for example, both worked with Le Corbusier in the late 1920s and early 1930s. Other influences came from the writings of foreign architects, particularly those of Bruno Taut, who lived in Japan from 1933 to 1936 and highlighted in his writings the similarity between traditional Japanese post-and-beam architecture and the essential frame structures of early Modernism, as well as their shared reliance on abstract, geometric forms. ISOYA YOSHIDA also recognized these similarities, and he developed in the 1930s a modern version of the *sukiya* (tea house) style of traditional Japanese residential architecture, using modern building technology and spatial planning. This approach, seen also in the later work of Horiguchi, was one of the most successful attempts to reconcile tradition and Modernism in Japanese architecture.

Important Modernist buildings designed by Japanese architects of the 1930s included the Central Post Office (1931; see fig. 39), Tokyo, by TETSURŌ YOSHIDA and the Nihon Dental College Hospital (1934), Tokyo, by Bunzo Yamaguchi (1902–78), both early examples of the International Style. Other notable works included the dormitory (1938) of Keio University, Yokohama, by YOSHIRŌ TANIGUCHI and the Meteorological Station (1938), Oshima Island, by Horiguchi. International acclaim was given to Sakakura's Japanese Pavilion (destr.) at the Exposition Internationale des Arts et Techniques dans la Vie Moderne (1937), Paris, in which a slender steel frame echoed the proportions and detailing of traditional Japanese timber construction, producing a uniquely Japanese interpretation of the International Style.

Modern architecture thus initially became established in Japan about ten years later than in Europe, but with

39. Tetsurō Yoshida: Central Post Office, Tokyo, 1931

40. Junzō Sakakura: Kanagawa Prefectural Museum of Modern Art, Kamakura, 1951

Japan's increasing nationalism in the 1930s and the government's suppression of progressive movements, opportunities for the continuing development of international Modernism diminished rapidly. Instead there were renewed calls for a national style that utilized traditional Japanese design in public architecture, and this resulted in the development of the Imperial Crown style, which incorporated traditional, heavy, curved and tiled roof forms. This was the style favoured by the government for such structures as the Tokyo Imperial Museum, now the main building of the Tokyo National Museum, completed by HITOSHI WATANABE in 1937; Kunio Maekawa was one of the few architects who resisted official policy, submitting a radically modern, flat-roofed design in the competition for the museum. During World War II two important government-sponsored competitions were held (1942, 1943), and although both required designs reflecting the ideology of the Great East Asia Co-Prosperity Sphere propounded by the Japanese military authorities, architects advocating modern architecture entered and Kenzō Tange, then a graduate student at Tokyo Imperial University, won first prize in each case. Tange's projects (both unexecuted), especially the second, for the Japan Cultural Institute in Bangkok, were furnished throughout with traditional Japanese motifs, but interpreted as a sensitive, modern re-evaluation of traditional architecture. Both were characterized by clear functional separation in the floor plans as

well as by a formal coordination of the whole. In these ways the ideas and methods of Modernism continued to develop in Japan, even during wartime.

Modernism was quickly revitalized in Japanese architecture after the war, particularly with the huge reconstruction and industrialization programmes of the 1950s. Important works of this period using reinforced concrete, steel and glass include the Reader's Digest Building (1951), Tokyo, by Antonin Raymond and the Kanagawa Prefectural Museum of Modern Art (1951; see fig. 40), Kamakura, by Junzō Sakakura. In 1952 Maekawa completed the first entirely prefabricated building, the Nihon Sogo Bank, Tokyo, and in 1954 the Kanagawa Prefectural Library and Auditorium, Yokohama. These works by Sakakura and Maekawa, with their pilotis and white, boxlike appearance, are quintessential examples of international Modernism, as is Kenzō Tange's first large project, the Peace Memorial Museum in Hiroshima, designed in 1946 to commemorate the victims of the atomic bomb. This complex, completed in 1955, incorporates Corbusian pilotis and delicate *brises-soleil* that echo the columns and screens of traditional architecture.

An intense debate about the role of Japanese tradition in modern architecture marked the mid- to late 1950s, in parallel with the declining influence throughout the world of the rigid internationalist and functionalist doctrines of

CIAM. Another significant influence on the debate was the impact of Le Corbusier's sculptural, reinforced-concrete work of this period, particularly at Chandigarh, as well as extensive investigations by Japanese architects into the possibilities of reinforced-concrete design. The immediate result of this 'Tradition Debate' was not the revival of traditional, refined Japanese forms but the development of a kind of robust primitivism that reinterpreted traditional timber construction in heavy, raw reinforced concrete. This can be seen in Tange's Kagawa Prefectural Office (1955–8), Takamatsu, an eight-storey reinforced-concrete building that at first glance has the appearance of a traditional Japanese post-and-beam structure. A similar development can be seen in the work of Sakakura and Maekawa, for example Maekawa's City Hall (1958–60), Kyoto, and the Tokyo Metropolitan Festival Hall in Tokyo (started 1958; for illustration see MAEKAWA, KUNIO), both of which contain multiple auditoriums. Both buildings are characterized by the massiveness of their concrete structures, in which no vestige of Maekawa's previous delicate style survives.

(iii) 1960 and after. During the 1960s phenomenal economic and urban growth and technological innovation caused radical changes in Japanese cities and rural areas, and the need to develop systematic planning and construction methods took precedence over tradition. Such architects as Kenzō Tange began to gain an international reputation, exposing trends in Japanese architecture to a new international audience. Views and theories developed in the 1950s came to fruition, modified in part by influences from the younger generation of Western architects who were seeking alternatives for the post-modern era, and Japanese architects began to involve themselves in advanced design concepts.

(a) Visionary schemes and Metabolism. (b) New Wave.

(a) Visionary schemes and Metabolism. Kenzō Tange's well-known urban plan for Tokyo Bay (1960; unexecuted; see URBAN PLANNING, fig. 17) was an imaginative, monumental project based upon the recognition of existing urban conditions. To save the megalopolis from urban confusion, Tange introduced a civic axis that extended right across the bay, along which he placed major government and commercial buildings as well as housing. Vertical circulation networks and large service shafts rising out of the water were planned at the intersecting points of the axis grid. Unlike traditional centripetal city plans, including those advocated by orthodox Modernism and CIAM, this project seemed to offer the possibility of an open system of spatial organization, capable of growth and linked by the traffic network. Tange's plan was highly influential among younger Japanese architects, many of whom studied with him at the University of Tokyo, and it heralded the development of the Metabolist theories that dominated the following decade.

In May 1960 more than 200 architects, designers and critics from 27 different countries met at the World Design Conference held in Tokyo, an event that stimulated the search for new directions in Japanese architecture. During the conference the Metabolist group (see METABOLISM) was launched under the direction of Noboru Kawazoe;

among its principal members were KIYONORI KIKUTAKE, KISHŌ KUROKAWA, FUMIHIKO MAKI and MASATO OTAKA. Its name and major themes—growth and change—were derived from analogy with biological processes and the eco-system, and it was based on an optimistic anticipation of unlimited development in industrial production and technological innovation, a view that seemed justified by the economic growth and increasing urbanization of the period, facilitated by standardization and mass production. Many of the projects by Metabolist architects, who all continued to work independently, were characterized by mechanistic yet organic visions of megastructures combined with interchangeable functional spaces—concepts shared with architects in other countries, for example the Archigram group in England. None of these visionary urban schemes was realized, but their emphasis on structural systems and technologies was expressed in other projects, notably Tange's Shizuoka Press and Broadcasting Center (1966–7) and Kurokawa's Nagakin Capsule Tower (1972; for illustration see METABOLISM), both in Shinbashi, Tokyo; in the latter, capsules mass-produced by the same process as transportation containers are fixed to the central shaft.

A somewhat different approach to monumental expression was employed by Tange in his National Gymnasia (1964; for illustration see TANGE, KENZŌ) for the Olympic Games in Tokyo and St Mary's Cathedral (1964), Tokyo, the most creative in the series of buildings in which Tange pursued a unity of building structure and function. The expressive, sweeping curves of the stadium's tensile steel roof forms, which reflect the essence of traditional Japanese architecture without direct quotation, were made possible only through the development of engineering technology and industrial techniques, while the structure of the cathedral, a stainless-steel shell formed in the shape of a cross by hyperbolic paraboloids, produces a dynamic space within.

A number of other architects were developing an expressionistic approach in smaller-scale buildings; examples include the Memorial Building for 26 Martyred Japanese Saints (1962), Nagasaki, by KENJI IMAI, who was greatly influenced by Antoní Gaudi. The interior of the Nissei Theatre in TŌGO MURANO's Nihon Life Insurance Building (1963), Hibiya, Tokyo, is also Gaudiesque, incorporating free-form walls and fantastic mosaic decoration; and SEIICHI SHIRAI exploited the expressive potential of wall surfaces by juxtaposing contrasting forms, materials and colours (e.g. Shinwa Bank head offices, 1966–75; Sasebo, Nagasaki Prefect.). An experimental interest in structural and spatial relationships was evident in the work of YOSHINOBU ASHIHARA, whereas the International Conference Hall (1966), Kyoto, by SACHIO OTANI and the Chiba Prefectural Library (1968), Chiba, by Masato Otaka recall the structuralist tendency of Maekawa's earlier work. During this period, the development of earthquake-proof high-rise building technology was seen in the 36-storey Kasumigaseki Building (1968), Tokyo, by the Mitsui Real Estate Agent and the Yamashito Design Office.

(b) New Wave. Expo 70, the World Exposition held in Osaka in 1970, was intended through its concentration on technology to summarize the achievements of the 1960s

and to predict continuing progress in the 1970s. Kenzō Tange was responsible for the Expo site plan and a huge space-frame roof over the Festival Plaza, several projects for the City of the Future were exhibited and Kishō Kurokawa designed some inventive capsule structures. In the event, however, the 1970s marked a turning-point, and with the oil crisis and increasing awareness of environmental problems the glorious future predicted in the 1960s faded away and a change began to appear in Japanese architecture. Reacting strongly against the chaos of the contemporary urban megalopolis, the New Wave of conceptualist avant-garde architects was bent not on restructuring society but providing breathing spaces within its confines. Theirs was a pluralist architecture of great novelty and creative power, offering a flexible diversity. Instead of Metabolist megastructures, more interest was placed on detail and on individual, often small-scale building, and this was reflected in a renewal of interest in housing developments.

A revival of interest in the vernacular in the late 1960s had initiated many design surveys of traditional villages, and architects had rediscovered the principles of urban and housing design governed by human lifestyles rather than abstract principles and monumental architecture. These ideas were expressed in a variety of projects: the Daigaku Seminary Housing (1963–70), Hachioji, Tokyo, by TAKAMASA YOSHIZAKA; the low, terraced houses of Sakuradai Court Village (1970), Yokohama, by SHŌZO

UCHII; the Pasadena Heights terraced housing (1974), Mishima, by Kikutake, which borrowed the verandah from traditional architecture as a means of circulation (for illustration *see* KIKUTAKE, KIYONORI); and Daikanyama Hillside Terrace flats (1967–76), Tokyo, by Fumihiko Maki. The latter, incorporating a series of public, semi-public and near-private spaces reinforcing the existing street pattern, reflected the ideas on 'Group' or 'Collective' form that were developed by Maki and Otaka and provided the basis for his contextual approach.

Concern with the relationship between the individual and the environment was characteristic in the work of several architects in the 1970s, including RIKEN YAMAMOTO and KAZUMASA YAMASHITA, who also designed 'Pop' buildings such as Face House (1973), Kyoto. It was a fundamental principle of the ARCHITEXT group formed in 1971 as a counter to Metabolism by MINORU TAKEYAMA, MAYUMI MIYAWAKI, TAKEFUMI AIDA, TAKAMITSU AZUMA and MAKOTO SUZUKI. The group published a magazine in support of a pluralistic and radical approach to architecture, and responses by group members ranged from Miyawaki's brightly coloured, defensive 'Box' houses of the 1970s to Azuma's expression of opposing concepts such as enclosure and openness. HIROSHI HARA's 'reflection houses' of the 1970s (e.g. Hara House, 1974, Machida City, near Tokyo) were designed as topological sequences of interior spaces that included 'urban' elements such as 'plazas' and thus recreated the city in miniature. Their

41. Arata Isozaki: Municipal Central Library, Kitakyushu City, 1972–5

implicit criticism of the reality of the external environment is echoed in the increasingly iconic, 'savage' concrete structures of the same period by KAZUO SHINOHARA and in TADAO ANDO's blank, introspective, geometric, concrete-walled courtyard houses (e.g. Azuma House, 1976; Sumiyoshi, Osaka), which offered an abstract, experiential contact with nature analogous with the traditional Japanese *haiku* poem. Other concerns were seen in the work of YUZURU TOMINAGA and OSAMU ISHIYAMA, who in the 1970s developed an 'alternative' architecture based on the use of cheap, mass-produced building components such as corrugated steel sheets, requiring a minimum of construction skills to erect.

An emphasis on architectural form and the treatment of surfaces, whether of stone, metallic tile or glass, which is characteristic of late Modernism, was also a feature of Japanese architecture in the 1970s and 1980s. This can be seen in several works by Kurokawa of this period, such as the National Ethnological Museum (1977), Suita, in which clarity of motif and formal arrangement almost entirely supersede the expression of technology. A parallel development can be seen in the work of ARATA ISOZAKI, one of the most influential avant-garde architects of the period. Echoing similar developments in the West, Isozaki's 'Mannerist' methodology was based on a view that architecture does not simply evolve from architectural heritage but is permeated by trends in such unrelated fields as Pop art, computerization, space technology and ecology; this resulted in the urge to 'dissolve' or 'deconstruct' modern architecture into a collection of independent parts. He preferred the geometry of the cube and the cylinder as unit forms, but these were cut, curved or connected to other disparate elements in order to recreate a fragmentary composition: for example, the Gunma Prefectural Museum of Modern Art (1971–4), Takasaki, is an additive composition of cubes, and the Municipal Central Library (1972–5; see fig. 41), Kitakyushu City, incorporates two long, curving, barrel-vaulted spaces.

The pluralist approach of the New Wave of the 1970s continued in the 1980s and after, sharpened by increasing awareness of social and environmental problems and of the cultural and historical context of architecture and the influence of Post-modernism. Responses ranged from the biological imagery developed by TEAM ZOO in the 1970s to the overtly mechanistic imagery of SHIN TAKAMATSU in the 1980s, culminating in the Week Building (1986), Kyoto, a fragmented composition of mechanistic parts. Fragmentation was also expressed in the tendency to layer wall surfaces, which in turn reflected the traditional Japanese concept of 'in between' space; this is seen in the work of several architects, including Kurokawa, Aida, Ando, Hara and KUNIHIKO HAYAKAWA. HIROMI FUJII employed fragmented orthogonal geometry to achieve an autonomous, timeless architecture, and Toyō Itō developed a minimalist, dematerialized architecture that was intended to symbolize the transience of urban dwellers; his own house, Silver Hut (1984; for illustration *see* ITŌ, TOYŌ), Tokyo, was a highly innovative interpretation of the traditional Japanese house using high technology. YUTAKA IZUE also reinterpreted traditional architecture in such high-tech materials as stainless steel and aluminium, whereas ITSUKO HASEGAWA used similar materials to

42. Kenzō Tange: Metropolitan Government Office, Tokyo, 1992

'architecturalize nature'. Hara's later work (e.g. Yamato International, 1987, Tokyo) turned his interiors inside out, dissolving boundaries and reflecting nature in translucent or metal skins, and an acute awareness of nature continued to inform Ando's later work (e.g. Mt Rokko Chapel, 1986, Kobe; for illustration *see* ANDO, TADAO). Many of these buildings reflected a continuing interest in the reconciliation of Japanese traditions, relationship with nature and philosophical thought with the modern urban environment and industrialized technology.

Japanese architecture in the last decades of the 20th century thus embodied an expansion of Modernism in various directions. Acceptance of the progressively fragmented nature of the urban environment is seen in Shinohara's Alumni Memorial Hall (1988) at Tokyo Institute of Technology, a composition of metallic, high-tech forms (for illustration *see* SHINOHARA, KAZUO), and in the abstract deconstructionist composition of the Wacoal Art Center's 'Spiral' façade (1985; *see* ALUMINIUM, fig. 1) by Maki and the Angelo Tarlazzi Building (1987) by HAJIME YATSUKA, both in Tokyo, in which the eclectic architectural elements serve as signs set in the sign-filled urban environment. A 'symbiosis' between technology and nature, past and future, East and West was sought by Kurokawa's later work (e.g. City Museum of Contemporary Art, 1988, Hiroshima; for illustration *see* KUROKAWA, KISHŌ). More overtly historicist works, reminiscent of some strands of European and American Post-modernism, were produced by Isozaki in the 1980s (e.g. Tsukuba Civic Center, 1983, Tsukuba; for illustration *see* ISOZAKI,

ARATA); by HIROSHI OE and YASUFUMI KIJIMA, whose Cue Saint Dome (1984), Kuma, is an exhibition hall with multiple domes that are reminiscent of Byzantine architecture; and by Kenzō Tange, whose Metropolitan Government Office (1992; see fig. 42), Shinjuku, Tokyo, is a massive twin-towered complex reminiscent of a Gothic cathedral set in a great urban piazza.

There is no distinct, unifying thread running through Japanese architecture of the late 20th century, apart from a focus on detail instead of the urban scale. It is clear that Isozaki's ideas and methodology had an enormous influence on the younger generation of architects, but each of them went on to develop individual responses, ideas and interpretations. The multiplicity of concepts embraced reflected the essential vitality of Japanese architecture, even if it did not clearly point the way to general solutions for the future.

BIBLIOGRAPHY

K. Abe: 'Meiji Architecture', *Japanese Art and Crafts in the Meiji Era*, ed. N. Ueno (Tokyo, 1958)
U. Kultermann, ed.: *New Japanese Architecture* (New York, 1960)
R. Boyd: *New Directions in Japanese Architecture* (London, 1968)
U. Kultermann, ed.: *Kenzō Tange: Architecture and Urban Design, 1946–1969* (New York, 1970)
T. Muramatsu: 'Ventures into Western Architecture', *Dialogue in Art: Japan and the West*, ed. C. Yamada (Tokyo and New York, 1976)
K. Kurokawa: *Metabolism in Architecture* (Boulder, 1977)
M. F. Ross: *Beyond Metabolism: The New Japanese Architecture* (New York, 1978)
A New Wave of Japanese Architecture (exh. cat., ed. K. Frampton; New York, Inst. Archit. & Urb. Stud., 1978)
C. Fawcett: *The New Japanese House* (New York, 1980)
E. Inagaki: 'Japan', *International Handbook of Contemporary Developments in Architecture*, ed. W. Sanderson (Westport and London, 1981)
B. Bognar: *Contemporary Japanese Architecture: Its Development and Challenge* (New York, 1985)
H. Suzuki, R. Banham and K. Kobayashi: *Contemporary Architecture of Japan, 1958–1984* (New York and London, 1985)
D. B. Stewart: *The Making of a Modern Japanese Architecture, 1868 to the Present* (Tokyo and New York, 1987)
B. Bognar: *The New Japanese Architecture* (New York, 1990)

EIZO INAGAKI

IV. Urban planning.

1. Early palace–capitals. 2. Chinese-style capital cities. 3. Castle towns. 4. Other towns.

1. EARLY PALACE-CAPITALS. Before the establishment of Fujiwara as the imperial capital in AD 694 (*see* §2(i) below), a new capital had been erected for each successive emperor and then demolished after his death. The *Nihon shoki* ('Chronicle of Japan'; AD 720) mentions the names of these palace–capitals, and some of them have been confirmed by 20th-century excavations in the Asuka region, a small district at the southern end of the Nara Plain, *c.* 25 km south of modern Nara. Although several temples were established in the region, little trace of urban planning has been detected. However, with the further development of the governmental system in the mid-7th century, buildings for official and other practical purposes, such as the water-clock, became necessary. Land planning must therefore have been considered by that time, and indeed archaeological investigations have revealed some traces of early urban or land planning dating to a time before the establishment of the Fujiwara capital.

Two early palaces were constructed outside the Asuka region: one in Naniwa (see fig. 43b; *see also* OSAKA, §I, 2)

43. Map showing ancient palaces and cities in south-central Honshu: (a) Fujiwara; (b) Naniwa; (c) Ōtsu; (d) Heijō; (e) Nagaoka; (f) Heian

in 645 and the other in Ōtsu, Shiga Prefecture (43c), in 667. Since Naniwa was an important harbour for trade with the continent, the palace was rebuilt in the 8th century. The town was again rebuilt around the religious centre of Ishiyama Honganji, established in 1496. From 1583 onwards Naniwa was expanded to become the castle town and commercial city of Osaka. Excavations have clarified the city's complicated history and revealed the ruins of the 7th- and 8th-century palaces, but no certain evidence for the design of the early city exists. The site of the Ōtsu palace was unknown until 20th-century excavations uncovered traces of large edifices, which could be identified as palace buildings. It is not clear whether a city had been laid out along with the palace.

2. CHINESE-STYLE CAPITAL CITIES. The first planned city in Japan was the capital city of FUJIWARA (i), established in 694 some 5 km north of the Asuka region (*see* §(i) below). It was laid out on a grid plan, along the lines of Chinese cities (*see* CHINA, §II, 3), as were the capitals established in the 8th century at Heijō (now NARA) and Heian (*see* KYOTO, §I). As the successive seats of the imperial palace and government, these cities had the suffix *-kyō* added to their names to indicate their status as capital.

(i) *Fujiwara.* This city (now Kashihara, Nara Prefecture; 43a) was based on the Chinese capital at Chang'an (now Xi'an). Its plan was rectangular, measuring 3180 m north–south and 2120 m east–west (see fig. 44a). The central compound was 615×236 m. The city was bordered by four highways running north–south and east–west through the Nara Plain. Excavations of the palace site started in 1934 and continued at various sites in the Fujiwara region after World War II, revealing the main part of the palace, the temple Daikandaiji (later called Daianji; *see* NARA, §III,

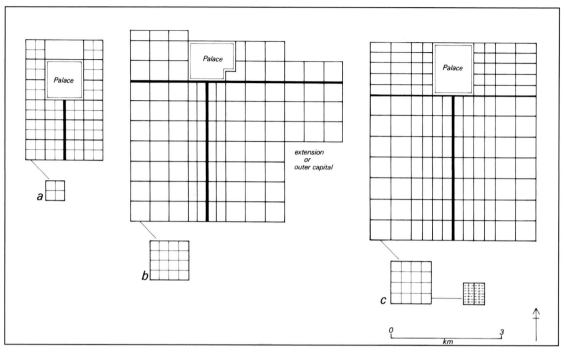

44. City plans of three Japanese capitals established from the late 7th century AD to the 8th: (a) Fujiwara; (b) Heijō; (c) Heian

6), and some other parts of the city. Late 20th-century excavations suggest that the Fujiwara capital may have been four times larger than the size usually given.

Fujiwara was divided into many square blocks by avenues running north–south and streets running east–west at regular intervals of 265 m. The central avenue was called Shujaku (or Suzaku), and there were four avenues to each side of it. From the centre to the perimeter, avenues were designated East First, East Second etc. There were thirteen streets, beginning from the north, named North End Street, First Street, Second Street and so on until Twelfth Street. Blocks were further divided into four equal sections by lanes running between avenues and streets. The actual sizes of the plots thus created differed from each other because the standard distance of 132.5 m between pairs of avenues or of streets was measured from the centres of roads, which themselves varied in width.

The palace, which was *c*. 112 ha in area, was in the centre of the city and faced south on to Sixth Street. Two Buddhist temples, Yakushiji (*see* NARA, §III, 5) and Daikandaiji, were established with support from the imperial household within the city zone. After only 16 years the palace and temples of Fujiwara were moved to a new capital, Heijō, and the whole city was devastated and buried under rice paddies for centuries.

(ii) Heijō. Heijō (now Nara) was established in 710 at the northern end of the Nara Plain, *c*. 20 km north of Fujiwara (see fig. 43d). After World War II, excavations at the palace site, temples and residences uncovered much new data. Fujiwara and Heijō were connected by two highways. One highway, starting from East End Avenue in Fujiwara, ran north and became East End Avenue in Heijō; West

End Avenue of the old capital was connected with Shujaku, the central avenue, in the new capital. The new capital was 4.24 km east–west, twice as wide as the old capital, and 4.77 km north to south. Heijō had four avenues on each side of Shujaku, as did Fujiwara, but only ten streets: the first two were called North First and South First streets, followed by Second to Ninth streets (see fig. 44b). There was an extension called the Outer Capital, bounded by East Fourth and East Seventh avenues (a distance of 1.59 km east–west) and South First and Fifth streets (2.12 km north–south). Heijō was thus 3.5 times larger than Fujiwara.

Square blocks surrounded by avenues and streets measured 530 m along each side and were divided into sixteen plots by three lanes running between the avenues and the streets. As at Fujiwara, the size of the plots depended on the width of avenues and streets. The Heijō Palace was in the north-central part of the city. It was a square with sides of 1060 m, with an extension of 265×795 m, giving a total area of *c*. 133 ha. The interior contained the main palace and residence of the emperor as well as many ministries and agencies. Four temples, Yakushiji, Daikandaiji, Gangōji (former Hōkōji) and Kōfukuji (*see* NARA, §III, 7), were moved from Fujiwara and Asuka to Heijō. Saidaiji was established within the city zone and Tōdaiji (*see* NARA, §III, 4) was erected adjacent to the outskirts of the capital. These six temples and HŌRYŪJI in Ikaruga were revered as the seven most prestigious temples. In addition many temples, such as Hokkeji and Tōshōdaiji (*see* NARA, §III, 9), were established inside the city zone, as were two market-places and the residences of aristocrats and commoners.

After the removal of the capital at the end of the 8th century, the main part of Heijō was abandoned and replaced by villages and rice paddies; only the outer capital remained as a temple town (*monzenmachi*) in front of Tōdaiji and Kōfukuji. The plain of Heijō was clearly based on a long unit of measurement (354–8 m), prohibited in AD 713, since when a shorter unit (295–8 m) was used in the construction of parts of roads and in all buildings.

(iii) Heian. The imperial household moved to NAGAOKA (see fig. 43e) in 783 and moved again to the new capital, Heian (now Kyoto; 43f) in 794. Nagaoka Palace was *c.* 28 km north-north-west of Heijō Palace. Excavations have revealed the site of the palace and traces of a network of roads. The Heian capital was established *c.* 36 km north of Heijō, when measured from palace to palace. According to an official record written in 927, Heian measured 4469 m from east to west and 5229 m from north to south. The area of Heian was almost the same as that of Heijō.

The Heian capital was also divided into blocks by avenues and streets; each block was further divided by lanes into 16 plots (see fig. 44c). Streets were named according to a numbering system from First to Ninth, but avenues were called by proper names, as were lanes. Heian was different from Heijō in that the sides of all the plots were the same, 119.3 m, because all roads were constructed so as to run outside the boundaries of the plots. When a plot was given to commoners, it was further divided into 32 housing lots by creating three narrow alleys running north–south.

The palace was in the centre of the northern part of the site and measured 1145×1372 m. The interior consisted of the emperor's palace and residence, as well as government ministries and agencies. In the city there were also many aristocratic residences. Unlike at Heijō, however, only two temples were initially allowed inside the city. The western half of Heian was abandoned after about a century because of its low, damp ground, and the city was extended to the eastern hillside across the River Kamo. The name Heian was changed to Kyoto in the 12th century, but the city kept its position as imperial capital until 1868. Although the palace was burnt down several times and, after 1179, the main hall was never reconstructed, the imperial palace has occupied the same site since the 14th century. Despite many changes in the course of its history, Kyoto has maintained the fundamental characteristic of the original capital city in its grid plan of roads.

3. CASTLE TOWNS.

(i) Introduction. The term *jōkamachi* ('town below the castle') is a literal description of many towns that took shape in the Edo period (1600–1868). When Japan was unified in the late 16th century, daimyo (feudal vassals) no longer used their old castles positioned on top of high hills but established new castles at prime locations in the centres of their provinces. These castles were generally constructed on top of low hills to show off the dignity of the lords and at points easily reached by highways or rivers. The residences of the daimyo and his retainers were

45. Castle town of Hikone, plan showing residential areas of various social groups

constructed on the hillsides, and the dwellings of the commoners were clustered around them. These new communities, ringing the castle and inhabited by people whose livelihood derived from it, were called castle towns.

After the collapse of the daimyo system after the Meiji Restoration in 1868, several castle towns developed into the leading cities of modern Japan. For example, Tokyo, Osaka, Nagoya, Fukuoka, Sendai and Kanazawa originated as castle towns. Castles and residential quarters for daimyo and retainers were moated, but in some cases one side of the castle faced a river or the sea, providing a means for both defence and escape. The towns around the castles were often laid out as part of the castle's defence: highways passing through towns were staggered at the entrances, which served as checkpoints, and roads inside towns sometimes intersected crossroads at irregular angles to prevent surveillance. Some entire towns were surrounded by rivers or canals to furnish both security and ready access. Even temples were placed in strategic positions. A good example of a strategically designed castle town is Hikone on Lake Biwa (see fig. 45).

It is difficult to identify a standard principle for road planning inside castle towns such as there was in capital

cities (*see* §2 above). However, highways typically functioned as axis roads, with several other roads set parallel. Plots for commoners' residences were narrow at the front, but deep, and connected at the rear to other plots facing in the opposite direction. Alleys often extended into these deep plots.

Because the daimyo favoured the development of commerce and industry, merchants and artisans gathered in castle towns. Initially, they gathered in groups according to their professions, and thus quarters of castle towns were named for drapers, dyers, carpenters, hoopers and horse dealers, for example. Since warriors' residences generally possessed large tracts of land and their houses were erected behind a long row of fences or clay walls, these districts enjoyed a serene atmosphere. Large and small gates were placed at needed intervals. In contrast, houses in commoners' quarters were generally of two storeys, or one storey with a loft, and stood in rows. Each town usually had a distinctive building style.

(ii) Edo. Edo, the predecessor of the modern capital, Tokyo, was established with the construction of its first castle in 1457. Although the town was still virtually undeveloped, Tokugawa Ieyasu (1543–1616) chose Edo as his seat of power in 1590 and started the renovation of the castle as well as the construction of a large castle town. Further progress was made when the Tokugawa shogunate was established there in 1603, and the town was 'completed' in 1636. The city zone at that time extended 4.5 km both north–south and east–west, that is, from the present northern outer moat or River Kanda in the north to Shiba in the south and from the west bank of the River Sumida in the east to a little west of the present inner moat. However, as Edo was the political seat of the Tokugawa government, almost 80% of the area was occupied by offices of the shogunate, residences of daimyo and retainers, and shrines and temples; commoners used the rest. The population is thought to have ranged from 150,000 to 300,000. Although the shogun had a vast castle, the residences of daimyo and retainers were generous in size and the precincts of shrines and temples were similarly large, commoners' residences were very small. Roads in their districts were arranged in a 120-m grid pattern, and each quarter was surrounded by roads and divided into many narrow plots, with an open public space in its centre.

Water and a few highways were the means of communication in Edo. Nihonbashi, a bridge in the centre of the city, was designated as the starting-point of Japanese highways and the point from which distances were measured. Several highways radiated out from Nihonbashi towards other provinces. Two streams running on the north and south sides of the castle (the northern one is now the northern outer moat and the southern one is the natural stream flowing from a pond called Tameike to Shinbashi) were connected at Yotsuya to form the outer moat around the castle. On completion of this work, Edo was unique in having a border of water composed of moats, rivers and seashores (see fig. 46).

Although Edo was frequently damaged by fire, including the devastating Meireki fire of 1657, it expanded after every disaster and became a large city, extending *c.* 12 km north–south and 11 km east–west, with an area of over

46. Edo Castle in the late 17th century, plan showing system of moats: (a) Nihonbashi bridge

56 sq. km. Nevertheless, 68% of this area was owned by the shogunate, daimyo and retainers, 16% occupied by shrines and temples, and only 16% inhabited by commoners. At that time the population probably ranged from *c.* 1.1 to 1.3 million, which made Edo one of the largest cities in the world.

With the Meiji Restoration of 1868, the old name Edo was changed to Tokyo ('eastern capital') to indicate that it was the imperial capital of Japan. The castle was converted to house the imperial palace, and land owned by daimyo and retainers was converted into sites for government and commercial buildings or residential quarters. The rapid development of modern Tokyo left only traces of Edo. The keeps, gates, ramparts and moats of the former castle remain, but almost all the daimyo residences were lost, except for a few gates moved to other places. Merchants' shops, which had unusual, heavily ornamented tile roofs, also disappeared, although the same style can be found in smaller cities near by, such as Kawagoe.

Tokyo has been destroyed twice, once by the Great Kantō Earthquake of 1923 and again by bombing raids in World War II, only to be rebuilt on a larger scale but with the basic plan of the old castle town intact. In preparation for the Tokyo Olympics of 1964, and in response to the increasing number of automobiles, existing avenues were widened to create major thoroughfares, and a new system of elevated highways was built, largely over old moats and rivers. Of the several remedies for the serious overcrowding of the city, best known is KENZŌ TANGE's Urban Plan for Tokyo Bay (1960), which proposed a grid of roads and apartment blocks built over the shallow bay (*see* §III, 5(iii)(a) above).

4. OTHER TOWNS. Not all Japanese towns and cities have developed according to the models discussed above. KAMAKURA, 45 km south-east of Tokyo, was the political capital and seat of the shogunate from 1192 to 1333. A main road running straight north-north-east from the seashore to the Shinto shrine Tsurugaoka Hachimangū made a strong central axis. It is thought that there were several blocks for the offices of the shogunate and the

residences of warriors on both sides of the main roads. Kamakura could not have been a big city, because the area was surrounded by a range of hills.

Imaichō, 20 km south of Nara, is a good example of a moated town, a type that was common in the Nara Plain during the 12th–16th centuries. Imaichō started as a 'temple town', built in front of a temple (*monzenmachi*), and grew into a rich, autonomous, commercial town in the 16th century. Moats were dug along the edges of the town to form a rectangle, and the excavated soil was banked up inside the moats for defence. In the western part of Imaichō, several main roads running east–west are connected by alleys running north–south. Houses generally face the main roads. In the eastern part of the town, blocks are surrounded by roads and houses may face in any direction. Presumably the former plan is the original. Although most moats and banks have been lost, the rows of buildings, some of which were erected in the 17th century, are well preserved.

Many post towns (*shukubamachi*) were established at the beginning of the 17th century, along with a new national network of highways. Chief among these were the 53 post towns between Kyoto and Edo along the Tōkaidō route. Although most of them have been damaged, Seki, in Mie Prefecture, retains its old buildings. In addition, several post towns, such as Tsumago and Narai, along the Nakasendō route running through the mountains, have been well preserved.

In the modern era, the grid plan was reintroduced in cities of the Meiji period (1868–1912), such as Sapporo, and in the redesign of such cities as Nagoya after World War II. From the 1960s onwards, 'new towns' were built on a model resembling English 'garden cities' and reflecting the ideas of LE CORBUSIER.

BIBLIOGRAPHY

Kodansha Enc. Japan: 'Asuka', 'Edo', 'Fujiwarakyō', 'Heiankyō', 'Heijōkyō', 'Kamakura', 'Naniwa'
A. Naitō: *Edo to Edo jō* [Edo and Edo Castle] (Tokyo, 1966)
J. W. Hall: *The Castle Town and Japan's Modern Urbanization* (Princeton, 1968)
K. Nishikawa: *Nihon toshi shi kenkyū* [Study of the history of Japanese cities] (Tokyo, 1972)
H. Ōta and others, eds: *Zusetsu Nihon no machinami* [Japanese townscapes, illustrated], 12 vols (Tokyo, 1982)
C. Miyamoto: *Heijōkyō: Kodai no toshi keikaku to kenchiku* [City planning and architecture in ancient times] (Tokyo, 1986)

NOBUO ITO

V. Sculpture.

This survey covers both large- and small-scale Japanese sculpture from prehistoric times to the present day. It is subdivided according to particular sculptural traditions, each of which is presented in broadly chronological terms.

1. Introduction. 2. Pre- and protohistoric. 3. Buddhist. 4. Shinto. 5. Portraiture. 6. Modern developments. 7. Conservation.

1. INTRODUCTION.

(i) Historical overview. (ii) Materials and techniques.

(i) Historical overview. The earliest extant figurines date from *c.* 15,000 BC (*see* §2 below). By *c.* 3000 BC people of the Jōmon culture (*c.* 10,000–*c.* 300 BC) were making figurines (*dogū*) that showed a powerful sense for sculpture (see fig. 47). The Yayoi culture (*c.* 300 BC–*c.* AD 300), with

47. Prehistoric sculpture, figurine (*dogū*) of a nursing mother and child, clay, h. 71 mm, from Miyata, Hachiōji city, Jōmon culture, *c.* 3500–*c.* 2500 BC (Sakura, Chiba Prefecture, National Museum of Japanese History)

its more stable way of life based on wet-field rice cultivation, had a greatly diminished need for magical forms, and refined utilitarian objects replaced the earlier sculptural vessels. As bronze and iron were introduced from the Asian continent, *dōtaku* (bell-shaped bronzes) were cast in varying sizes and decorated with line-reliefs showing subjects from daily life. During the Kofun or Tomb period (*c.* AD 300–710) cylindrical clay funerary figurines (*haniwa*) depicted men and women, animals, houses, boats and other objects (see figs 4 above and 51 below).

In the later 6th century AD Buddhist sculpture began to flourish (*see* §3 below). The first prominent sculptor was TORI BUSSHI, the favourite sculptor of Empress Suiko (reg 593–628). His masterpiece, the *Shaka Trinity* (623) in the *Kondō* (Golden Hall) at Hōryūji was made to commemorate the anniversary of the death of Prince SHŌTOKU, the first great patron of Buddhism in Japan. In 645 the Taika Reform brought the downfall of Tori's influential supporters, the Soga clan, and some sculpture of the period *c.* 645–70 shows Tori-style frontal orientation being replaced by an awareness of three-dimensionality.

A third stylistic development, the Hakuhō style (*see* §3(i)(c) below), was ushered in by Chinese envoys from the Tang dynasty (618–907) in 671. The Hakuhō style shows Tang influence in its striving for greater naturalism, round faces and fleshy bodies, and this tendency continued in the Nara period (710–94).

During the reign of Emperor SHŌMU Buddhist sculpture reached an apex of magnificence and size that symbolized both Japan's new imperial power and its

devotion. In 741, Shōmu decreed that provincial monasteries and nunneries be built and equipped with statuary. They were to be administered by Tōdaiji, Japan's largest and most splendid monastic establishment. Its main image was a colossal (h. 16 m) gilt-bronze statue of the *Great Buddha*, commonly called the *Daibutsu* (Skt Vairochana; *see* NARA, §III, 4 and fig. 5).

In 753 a new influx from Tang-period China came with the sculptors accompanying the monk Jianzhen, known to the Japanese as Ganjin (688–763). The Nara temple of Tōshōdaiji was built for Ganjin; its main icon was a hollow dry-lacquer seated statue of the *Great Buddha* (Jap. *Birushana* or *Daibutsu*). The Nara throne had supported Buddhism so excessively that it faced an economic crisis by the latter part of the 8th century. To some extent it must have been discontent with the Nara Buddhist establishment that prompted the sculptors of the 9th century to break so radically with Nara styles. They made statues of single blocks of wood (*ichiboku zukuri*) and stylized the drapery so as to emphasize the roundness of the tree trunk rather than the softness of the cloth (*see* §(ii) (b) below). Powerful mass and spiritual vigour replaced the idealized naturalism of Nara sculpture. Esoteric Buddhism (*mikkyō*), with its greatly expanded pantheon, contributed to this change in style.

In about the late 8th century, influenced by Esoteric Buddhist statuary, devotees of Shinto began to make statues of *kami* (*see* §II, 2 above) in an anthropomorphic form termed *shinzō* (*see also* §4 below). However, since *kami* were not conceived in terms of personal relations with the believer but rather as embodiments of more generalized spiritual power, many of the most important Shinto shrines (e.g. Ise, Izumo and Suwa) and almost all local shrines were without *shinzō*. Indeed, the materialization of the *kami* in human form would probably not have occurred without the example of Buddhist icons, and a certain tension remains between the relatively primitive conception of the *kami* and the highly sophisticated nature of Buddhist imagery.

After 894, when Japan discontinued its practice of periodically sending envoys to China, a more genuinely native style emerged, which developed over the next 300 years. During the 10th century worship of the Buddha Amida (Skt Amitabha) became increasingly popular, and aristocrats built replicas of Amida's Pure Land in their temples. Most famous is the Hōōdō (Phoenix Hall) of the Byōdōin in Uji, at the centre of which is a splendidly gilded statue of *Amida* by the sculptor JŌCHŌ (see fig. 61 below). This work was already recognized as a masterpiece at its consecration ceremonies in 1053. It became the model for generations of sculptors active in the flourishing IN and EN schools of Kyoto.

It may have been dissatisfaction with these schools that prompted the sculptor Raijō (1044–1119), a second-generation disciple of Jōchō, to leave Kyoto and move to Nara to participate in a restoration project at Kōfukuji of images destroyed by fire in 1096. In Nara, Raijō founded the KEI school, which, through the work of Raijō's descendant Kōkei (*fl* 1175–1200) and his son UNKEI, ultimately changed the course of Buddhist sculpture throughout Japan. Kei-school sculptures of the late 12th century continued to show the influence of Jōchō but also reflected contemporary styles from the Southern Song dynasty in China (1127–1279), with which the Japanese government had recently renewed relations.

The naturalism formulated in Nara by the Kei school during the early years of the Kamakura period (1185–1333) spread throughout Japan and flourished especially in government circles around Kamakura. During the second half of the 13th century Buddhist sculpture began to decline, probably owing to the popularity of the Zen and Pure Land sects, which required relatively little statuary. Later generations of sculptors turned to mask-making for the *nō* theatre and small-scale architectural sculpture for palaces, temples and shrines. They also made miniature sculptures such as *netsuke* and sword ornaments. In the 17th century, the eccentric priest ENKŪ travelled around Japan carving Buddhist images and depositing them at people's doorsteps. Other sculptors, such as Shimizu Ryūkei (*c.* 1659–1720), made secular statuettes of Kyoto people. From the later 19th century Japanese sculptors increasingly turned to Western styles, with only a few specialists working in the creation or repair of traditional Buddhist sculpture.

BIBLIOGRAPHY

T. Kuno: *Hōryūji no chōkoku* [Sculpture in the Hōryūji] (Tokyo, 1958) [Eng. summary]

T. Fukuyama: *Byōdōin to Chūsonji*, Nihon no bijutsu [Arts of Japan], ix (Tokyo, 1964); Eng. trans. by R. K. Jones as *Heian Temples: Byodo-in and Chuson-ji*, Heibonsha Surv. Jap. A., ix (New York and Tokyo, 1976)

T. Kobayashi: *Tōdaiji no Daibutsu* [The Great Buddha of Tōdaiji], Nihon no bijutsu [Arts of Japan], v (Tokyo, 1964); Eng. trans. by R. L. Gage as *Nara Buddhist Art: Todai-ji*, Heibonsha Surv. Jap. A., v (New York and Tokyo, 1975)

H. Mori: *Unkei to Kamakura chōkoku*, Nihon no bijutsu [Arts of Japan], xi (Tokyo, 1964); Eng. trans. by K. Eickmann as *Sculpture of the Kamakura Period*, Heibonsha Surv. Jap. A., xi (New York and Tokyo, 1974)

T. Sawa: *Mikkyō no bijutsu*, Nihon no bijutsu [Arts of Japan], viii (Tokyo, 1964); Eng. trans. by R. L. Gage as *Art in Japanese Esoteric Buddhism*, Heibonsha Surv. Jap. A. (New York and Tokyo, 1972)

S. Mizuno: *Hōryūji*, Nihon no bijutsu [Arts of Japan], iv (Tokyo, 1965); Eng. trans. by R. L. Gage as *Asuka Buddhist Art: Horyu-ji*, Heibonsha Surv. Jap. A., iv (New York and Tokyo, 1974)

B. Murata: *Butsuzō no mikata: gihō to hyōgen* [A view of Buddhist statues: technique and expression] (Tokyo, 1965)

M. Ooka: *Nara no tera*, Nihon no bijutsu [Arts of Japan], vii (Tokyo, 1965); Eng. trans. by D. Lishka as *Temples of Nara and their Art*, Heibonsha Surv. Jap. A., vii (New York and Tokyo, 1973)

S. Uehara: *Asuka Hakuhō chōkoku* [Sculpture of the Asuka and Hakuhō periods in Japanese art], Nihon no bijutsu [Arts of Japan], xxi (Tokyo, 1968)

K. Machida: *Jōdai chōkokushi no kenkyū* [Studies in ancient sculpture] (Tokyo, 1977)

J. Sugiyama: *Tempyō chōkoku* [Classic Buddhist Sculpture], Japanese Arts Library (Tokyo, 1982)

The Great Age of Japanese Buddhist Sculpture, AD 600–1300 (exh. cat. by K. Nishikawa and E. Sano, Fort Worth, TX, Kimbell A. Mus., 1982)

R. Hempel: *The Golden Age of Japan, 794–1192* (New York, 1983)

The Great Eastern Temple: Treasures of Japanese Buddhist Art from Tōdai-ji (exh. cat., Chicago, IL, A. Inst., 1986)

LUCIE R. WEINSTEIN

(ii) Materials and techniques.

(a) Clay. (b) Wood. (c) Bronze. (d) Lacquer. (e) Stone. (f) Iron.

(a) Clay. The earliest forms of Japanese sculpture were prehistoric clay *dogū* and *haniwa* figurines. With the development of Buddhist sculpture, clay remained an important medium and, in the late 7th century AD and the

8th, clay and lacquer were widely used at government-supported Buddhist workshops in Nara. Since a clay core had to be fashioned in order to make hollow dry-lacquer statues, the two techniques were closely related (*see also* §(d) below). Although the chronology of the development of clay and lacquer sculpture on the Asian continent is unclear, most scholars agree that in Japan the use of the two media in large-scale sculpture was introduced from China concurrently, and some sculptural groups, such as the 7th-century statues in the main hall of Taimadera, Nara Prefecture, include images in both media.

The clay and lacquer techniques were additive and were highly suited to the naturalistic styles popular in the Nara period (AD 710–94). During the 7th and 8th centuries the simplest clay statues were produced by constructing a wooden core that was wrapped with rice-straw rope to hold the clay. This form was then covered with a layer of coarse clay, mixed with rice straw and small stones, which was shaped into a rough approximation of the form. A second layer of fine clay and rice chaff gave the image its completed shape, and a finishing layer of even finer clay mixed with shredded paper and sometimes powdered mica was then applied and modelled into the final form. The image was then painted. Although many 8th-century statues have lost their pigmentation, the ferocious figure of the protective deity *Shūkongōjin* in the Sangatsudō of Tōdaiji, Nara, largely retains its original brilliant colours. Pigments such as vermilion, red lead, yellow ochre, malachite, azurite and gold were applied on a prepared kaolin ground in intricate patterns that must have been taken from contemporary textiles (*see* §XI below).

Images in clay such as the *bodhisattva*s *Gakkō and Nikkō* (*bodhisattva*s of the sun and moon), also in the Sangatsudō of Tōdaiji, and the dramatically posed *Guardians* (Jap. Niō) in the Middle Gate of Hōryūji (711) required more complex wooden cores. For these statues an armature was fashioned by joining together several pieces of wood. Slats were also nailed to the basic structural members to provide a framework for such areas as the flaring folds of the skirts, and bronze wire was used to support such fine areas as the fingers, ears and flowing scarves. Other statues, such as the standing *Buddha* (possibly Ratnasambhava) at Tōshōdaiji, Nara, had completely carved wooden cores; clay was used for surface modelling only.

From the end of the 8th century to the beginning of the 13th, clay gradually ceased to be a popular medium. With the transmission of Zen Buddhism to Japan and the introduction of Song-period (960–1279) Chinese sculptural methods, however, clay was revived as a material, but with a slightly different technique. While later statues also used a wooden core, only one or two layers of clay were used to build up the form, and lacquer was applied to the surface of the statue before polychroming. As can be seen in the portrait statue of the Zen master *Gidō Shūshin* (Kyoto, Jishiin), the resulting surface appeared more like that of wooden sculpture.

(b) Wood. Japan has been called the 'kingdom of wooden sculpture'. The earliest surviving examples date from the Yayoi period (*c.* 300 BC–*c.* AD 300), the carved containers from the Kansai being particularly fine (*see* §2

below). A few early Buddhist sculptures, including the *Yumedono Kannon* (see fig. 48), were fashioned from assembled blocks of camphor wood (*kusunoki*). Although bronze, clay and lacquer were utilized almost exclusively during the period from 650 to 750, by the late Nara period (710–94) wood was once again employed for images at privately sponsored temples throughout the Yamato region. As wood was abundantly available in Japan and less expensive than lacquer, wood sculpture largely replaced

48. *Yumedono Kannon* (Skt Avalokiteshvara), sometimes known as the *Guze Kannon*, gilded camphor wood, h. 1.79 m, early 7th century AD (Hōryūji, Yumedono)

lacquer by the end of the 8th century. Sculptors could not, however, model in wood as freely and naturalistically as in clay, which resulted in a more severe style. In succeeding centuries, Japanese cypress (*Chamaecyparis obtusa*; *hinoki*), Japanese nutmeg (*Torreya nucifera*; *kaya*), katsura (*Cercydiphyllum japonicum*), zelkova (*Zelkova serrata*; *keyaki*) and Japanese cherry (*Prunus serrulata*; *sakura*) were adopted for Buddhist imagery as well. Japanese cypress was especially popular because of its distinctive grain and capacity to take detail. During the 9th–12th centuries sculptors explored techniques of wood construction that were without precedent on the Asian continent.

The simplest technique for carving wood is exemplified by the austere, brooding image of the late 8th-century *Healing Buddha* at Jingoji. This was made almost entirely from a single block of Japanese cypress, although the sculptor employed additional pieces of wood for the snail-shaped curls and the forearms. In leaving his work unpainted the sculptor was probably making direct reference to the tradition of the legendary first image of the Buddha, said to have been carved of sandalwood. In addition, he intentionally left the marks of his chisel across the surface of the image to emphasize the nature of the material.

In the single-woodblock technique (*ichiboku zukuri*), used extensively in the late 8th century and early 9th, sculptors attempted to fashion the image from the block with the pith wood at the back. The form was first roughed out with an adze and then worked with successively finer chisels. Despite the best attempts to carve away as much of the resinous inner core as possible, single-block statues remained prone to cracking. By the mid-9th century sculptors had devised a technique to remove more of the inner core by hollowing (*uchiguri*) a rectangular area in the back of standing images from the shoulders to the ankles. The resulting cavity was covered with a board. On seated works the hollowing was done from the base up. Since the core was particularly susceptible to cracking, its removal protected the image; it also contributed to drying of the wood, which made the image lighter.

By the end of the 9th century many statues, such as the seated *Healing Buddha* at Shōjōji in Fukushima Prefecture, were made from a block of wood that was first split and then hollowed so that more of the sapwood could be removed. On images such as the seated *Miroku* (Skt Maitreya) at the Jison'in, Wakayama Prefecture, the entire back of the image was sheared off and then replaced with separately carved pieces of wood once the hollowing had been completed.

In order to create images larger than the available blocks of wood, sculptors began by the early 10th century to attach separately carved pieces for the knees of seated Buddhas. Gradually they developed a system of joining ('split-and-join' method; *warihagi*), whereby several blocks could be assembled and then carved. Each individual block was hollowed and then finished, and the pieces were reassembled with animal glue or small metal brackets, clamps or nails, lacquer or mortise and tenon. A sacred object could be placed in the hollow interior. The technique kept moisture out and gave the sculptor a new freedom to create standing figures in movement and large, seated statues with folded legs spread horizontally. An early example is the seated *Healing Buddha* at Rokuharamitsuji in Kyoto (h. 1.64 m; mid-10th century). The joined-woodblock technique (*yosegi zukuri*) was perfected by the 11th-century master JŌCHŌ, who used it for the celebrated *Amida* (Amitabha) at the Byōdōin in Uji (see fig. 61 below). On this work some sections of the body are only a few centimetres thick, although the areas with pleats are slightly thicker. The use of the joined-woodblock technique facilitated rapid production, since the image could be sculpted at the workshop and assembled at the site, with work divided among many assistants. Detailed assemblages of this kind were unknown outside Japan. For a statue 3 m high, the joined-woodblock technique used about three times the volume of materials used by the single-woodblock technique.

Wooden sculpture was finished in several ways. Many early wooden statues were finely carved from sandalwood or aromatic woods and left unpainted, except for such details as eyebrows, eyes and lips. On images that were to be polychromed, the surface of the wood was prepared with a coating of lacquer and clay (*sabi urushi*) and then in sequence with layers of cloth, black lacquer and kaolin, which was painted. On gilded statues the final layer of kaolin was omitted, and the gold leaf was applied directly to the black lacquer. Sometimes the gold-leafed or pigmented areas were further decorated with delicate patterns of cut-gold leaf (*kirikane*), created by cutting the leaf with a bamboo knife and burnishing them to the surface.

Most of the techniques of wood sculpture were established by the mid-Heian period. The naturalistic styles preferred by sculptors of the Kamakura period (1185–1333), however, required important technical innovations. In particular, the blocks of wood were hollowed less completely to accommodate more active poses. Naturalism was heightened by inlaying the eyes with glass crystal; the painted pupils were backed with cotton. Inlaid crystal eyes were the stylistic signature of a group of sculptors working in Nara during the late Heian and early Kamakura periods, although the technique was eventually adopted by artists throughout Japan.

By the end of the Kamakura period changes in Buddhist practice had reduced the demand for ritual sculpture. Furthermore, the sanctity of certain image types, such as Jōchō's *Amida* and the statues of the KEI school, discouraged any true innovation since most patrons desired images that replicated the formal qualities of those types. Statues from the later periods were significantly different only in that new varieties of pigments were used for ornamentation.

(c) Bronze. Metalworking was introduced into Japan early in the Yayoi period (*c.* 300 BC–*c.* AD 300), when *dōtaku* (ritual bells) were cast in bronze. After the introduction of Buddhism a few temple records document the casting of Buddhist images in precious metals, but most statues in metal were gilt-bronze. Bronze-casting in Japan was done by two different techniques: the lost-wax method was current from the Asuka period (552–710) to the late Heian period (794–1185) and the piece-mould method from the end of the Heian period.

The lost-wax method was used for almost all early gilt-bronze statues, from small private devotional images

popular during the 7th century, such as the 48 statues at HŌRYŪJI, to monumental images of the *Triad of the Healing Buddha* (Yakushi; Skt Bhaishajyaguru) at Yakushi-ji (*see* §3(ii) below; see also NARA, §III, 5). The technique was similar to that used in the West: first a model was made out of clay, most often around a support fashioned from iron wire. After drying, the model was entirely invested with layers of beeswax or vegetable wax. Bronze struts were added to the form (generally one on the front and others on the back and chest and at hip level) to prevent the succeeding outer shell from slipping and coming into contact with this inner model when the bronze was poured. The modelled wax-covered form was in turn covered with a thick layer of clay, forming the outer shell of the mould, which was then wrapped with iron wire so that the mould would not break apart during casting. Gates were opened in the clay so that the molten bronze could be poured into the mould. In order to allow the molten metal to reach such fine areas as the fingertips, channels were fashioned in wax and attached to the beeswax-layered form before it was covered in clay. The whole mould was heated and the wax allowed to escape, leaving a cavity in place of the form that had been modelled in the wax. Then molten bronze was prepared, consisting largely of copper with traces of such other elements as tin, arsenic, iron, lead, silver and bismuth. In most cases the mould was inverted and the bronze poured in from the pedestal, filling the area for the head first so that, if any escaping gas bubbles formed on the surface, they would not mar the fine features of the face. When the piece had completely cooled, the outer clay form was removed to reveal the bronze image. Later the inner clay core and the spacers were also removed. Invariably the image at this point was rough, and a burin was used to remove imperfections and to smooth the surface. In many cases the details of the facial features and the jewellery were worked with a chisel. The statue was then gilded by applying an amalgam of gold dust and mercury to the surface. When heated the mercury vaporized, leaving the gold adhering to the finished bronze statue.

The piece-mould technique was used for later bronzes such as the *Kannon* (Skt Avalokiteshvara; 1269; Boston, MA, Mus. F.A.) by Saichi (*fl* late 13th century). An original form was made out of wood or sometimes clay. If there were large protruding elements, such as the arms or knees of a seated statue, they were cast separately with tenoned joints so that they could be attached to the main form. A thick layer of clay was applied to the surface of the form, cut into two halves, dried and fired. Subsequently, a core section smaller than the original form was made out of clay braced with iron struts. Spacers (*kōgai*) were inserted to maintain the space between the outer and inner forms, and then the inner form was also fired. To ensure that the space between the outer and inner forms remained uniform during the casting the two halves were bound together with heavy wire. Channels were then made in the outer form into which the molten bronze could be poured. After the bronze had cooled the clay core and *kōgai* were removed. The surface was finished by chasing the metal at the site of the channels and along the seams where the halves of the mould had been joined together. Because the sculptor was able to fashion the original form out of

fine clay, the facial details and ornamentation were preserved in the casting process, and the image could be gilded after only the most summary finishing.

(d) Lacquer. Two different lacquer techniques were used in Japan: hollow dry lacquer (*dakkatsu kanshitsu*) and wood-core dry lacquer (*mokushin kanshitsu*). The former method was employed from the mid-7th century until the 8th; the latter gradually replaced it in the mid-8th century and was in use until the mid-9th century. The hollow dry-lacquer technique was a highly complicated and time-consuming process learnt from the Chinese, who had used it as early as the 4th century AD. The earliest extant examples in Japan are the *Four Guardian Kings* (Jap. Shitennō; Skt *cāturmahārājikas*) at Taimadera (late 7th century). The medium gained great popularity in the capital Heijō (Nara) and was used for such well-known works as the *Ten Great Disciples of Shaka Buddha* at Kōfukuji, the statues of *Fukūkenjaku Kannon* (Skt Amoghapasha Avalokiteshvara) and *Four Guardian Kings* in the Sangatsudō of Tōdaiji and the seated *Daibutsu* (Skt Vairochana; Great Buddha) in the Main Hall at Tōshōdaiji.

In China the process involved first constructing a rough form in clay with a wooden core and then covering it with up to ten layers of hemp soaked in lacquer from the varnish tree (*Rhus verniciflua*). In Japan a similar core was used, but the lacquer was applied more sparingly; research by Mizuno Keizaburō indicates that the lacquer was often spread on to the cloth surfaces in patches. In both countries, when the form was dry, the lacquered cloth was cut open and the interior clay removed, leaving a light shell. In order to give statues support and to prevent warping, a bracing system of three or four horizontal pieces of wood connected with vertical struts was then inserted into the open form. A damaged statue at Akishinodera, Nara, of which only the armature remains, indicates, however, that in some cases the lacquer-soaked cloth was applied directly to the bracing system. Once the bracing system was in place, the incision was stitched up with linen thread and the statue was covered with another layer of lacquer-soaked linen. To build up and model the features of the face and the folds of the drapery, the sculptor would use a spatula to apply a paste of lacquer, powdered incense and sawdust (*kokuso urushi*). For such details as the fingers and free-flowing scarves another mixture, consisting of lacquer and polishing powder, was applied over a wire base. The surface was finished with a layer of black lacquer. Gold foil and delicate motifs in bright mineral pigments were used to embellish the image.

There were numerous variations on the wood-core dry-lacquer technique. Essentially the process entailed the carving of a wooden core, which was covered with cloth and then lacquer paste. Scientific analysis using X-ray photography has shown how the construction of the wooden core evolved: in early works a process similar to that used for hollow dry-lacquer sculpture was used; later, the wooden image itself was allowed to determine much of the final form. In the *Amida* (Skt Amitabha) from the east bay of the Denpōdō at Hōryūji, for example, the wooden core was created from four pieces of wood that were then hollowed. The sculptor, however, unsure of the properties of his new medium, added internal wooden

braces similar to those found in hollow dry-lacquer images. The facial features and the folds of the garments were finished with layers of lacquer paste. The cores of other statues such as the *Eleven-headed Kannon* (Jap. Jūichimen Kannon; Skt Ekadashamukha Avalokiteshvara) at Shorinji, Nara Prefecture, were constructed from a single block of wood for the main part of the image and additional blocks for the arms. Often the main block of the core was hollowed so that it would not warp. Although lacquer paste was applied thickly to model the facial features, the carved wood dictated the form of the fluid folds of drapery that fall between the legs. During the first half of the 9th century lacquer was occasionally modelled directly on a carved wooden core. Works in this group, marking the last phase of lacquer sculpture in Japan, include the *Five Great Bodhisattvas of the Void* at Jingoji in Kyoto and the *Nyoirin Kannon* (Skt Chintamanichakra Avalokiteshvara) at Kanshinji, Osaka.

(e) Stone. In the history of Japanese sculpture stone never played such a prominent role as it did in China. There were no colossal cave complexes such as those at Yungang and Longmen. Nevertheless, over 150 images remain, dating from the Nara (710–94) to the Nanbokuchō (1336–92) periods. Most are distributed in the Yamato region. Although granite was the stone most commonly favoured, tufa, sandstone, slate and limestone were also used. Most images were roughly carved, but a few, such as the *Thousand-armed Kannon* (Jap. Senjū Kannon; Skt Sahasrabhiya Avalokiteshvara) at Otanidera in Ibaragi Prefecture, were covered with clay to allow for modelling of fine details. By the Edo period (1600–1868) stone was commonly used for small devotional images, such as the roadside statues of Jizō (Skt Kshitigarbha) found throughout Japan.

(f) Iron. Iron sculpture, which enjoyed limited popularity during the 13th and 14th centuries in western Japan, was created using the piece-mould technique (*see* §(c) above). However, sculptors faced great difficulty in removing the extra metal along the seams because of the hardness of the iron. Furthermore, because the material could not hold fine detail, the surface of the statues was often too rough to be gilded, so gold leaf or coloured pigments were applied instead.

BIBLIOGRAPHY
Kodansha Enc. Japan: 'Buddhist sculpture'
L. Warner: *Japanese Sculpture of the Tenpyō Period: Masterpieces of the Eighth Century* (Cambridge, MA, 1959)
T. Kobayashi: *Tōdaiji no daibutsu* [The Great Buddha of Tōdaiji], Nihon no bijutsu [Arts of Japan], v (Tokyo, 1964); Eng. trans. by R. L. Gage as *Nara Buddhist Art: Todai-ji*, Heibonsha Surv. Jap. A., v (New York and Tokyo, 1975)
H. Mori: *Unkei to Kamakura chōkoku* [Unkei and Kamakura-period sculpture], Nihon no bijutsu [Arts of Japan], xi (Tokyo, 1964); Eng. trans. by K. Eickmann as *Sculpture of the Kamakura Period*, Heibonsha Surv. Jap. A. (New York and Tokyo, 1974)
S. Mizuno: *Hōryūji*, Nihon no bijutsu [Arts of Japan], iv (Tokyo, 1965); Eng. trans. by R. L. Gage as *Asuka Buddhist Art: Horyu-ji*, Heibonsha Surv. Jap. A., iv (New York and Tokyo, 1975)
K. Asano and H. Mōri: *Nara no jiin to Tenpyō chōkoku* [Temples and sculpture of Nara in the Tenpyō period], Genshoku Nihon no bijutsu [Arts of Japan, illustrated], iii (Tokyo, 1966)
T. Kuno and K. Suzuki: *Hōryūji* [The sculpture and architecture of the Hōryūji], Genshoku Nihon no bijutsu [Arts of Japan, illustrated], ii (Tokyo, 1966)
B. Kurata: *Mikkyō jiin to jōkau chōkoku* [The sculpture of Esoteric Buddhism], Genshoku Nihon no bijutsu [Arts of Japan, illustrated], v (Tokyo, 1967)

ANNE NISHIMURA MORSE

2. PRE- AND PROTOHISTORIC.

(i) Palaeolithic (before *c.* 10,000 BC). (ii) Jōmon period (*c.* 10,000– *c.* 300 BC). (iii) Yayoi period (*c.* 300 BC–*c.* AD 300). (iv) Kofun period (*c.* AD 300–710).

(i) Palaeolithic (before c. 10,000 *BC).* As in many other parts of the world, art in Japan began with the manufacture of cult objects. The oldest examples of sculpture in Japan are two figurines of the Palaeolithic period dating from *c.* 15,000 BC: both are of a fertility goddess. One is an ivory figurine from Lake Nojiri in Nagano Prefecture (see fig. 49), the other a *sekibo* ('stone club', phallic stone) from

49. Prehistoric female figurine, ivory, h. 158 mm, from Lake Nojiri site, Nagano Prefecture, c. 15,000 BC (Shinshu District, Lake Nojiri Museum of Art)

the Iwato site in Ōita Prefecture. The ivory fertility goddess has been sheared off above the waist on one side but nonetheless shows technical accomplishment: it has a smooth, wasp-waisted, tapered end and a 'head'. Skilful workmanship and a streamlined style suggest a relationship with the female figurine tradition of northern Asia. The *sekibo* from Iwato was of chlorite schist (h. 100 mm) and unfinished pieces. Shaping was done by pecking; the eyes and mouth are barely defined in the enlarged head.

(ii) Jōmon period (c. 10,000–c. 300 BC). Low-fired clay figurines (*dogū*) were a common cult object in the Jōmon period. Most are assigned to the Middle (*c.* 3500–*c.* 2500 BC) and Late (*c.* 2500–*c.* 1000 BC) Jōmon periods, although those known to have been made chiefly in Chiba Prefecture in the Kantō region (eastern Japan) and in the Kinki region (central Japan) may be even older. From these areas they spread to the north and into the lower mountains west of the Kantō Plain.

(a) Early (c. 10,000–c. 3500 BC) and Middle (c. 3500–c. 2500 BC). Early *dogū* were small, triangular or roughly figure-of-eight-shaped pieces of clay, faceless or even headless, with a pair of torso bumps and occasionally with surface scratches. Slightly later figurines sometimes had a navel bump, a few more scratches or punched marks and more semblance of a head.

In the Middle Jōmon period *dogū* proliferated rapidly. They were a peculiar mix of anthropomorphic and zoomorphic forms: obese, upright, quasi-human bodies with low-hanging rumps and animal-like, often rodent-shaped heads. The eyes were sharply slanted, the mouth hare-lipped. Similar heads appear in the highly decorated rims of large vessels in mountain sites. Many faces have a pair of vertical lines extending below the eyes, presenting a 'crying' image. A unique example of this style was found at the Miyata site in Hachiōji city, west of Tokyo. This image of a mother nursing a child (h. 71 mm; Sakura, Chiba Prefect., N. Mus. Jap. Hist.) was recovered from the floor of a round house that was used for ritual purposes. The articulation of form is remarkable. The headless mother is seated as though on her haunches, with her legs turned back to the left; her knees bear incised spirals and other marks. Her right arm is curled forward and under the child, who seems to be encased in a papoose and whose head is turned up towards the mother's small, pendulous breasts.

Few figurines from the Jōmon period have been discovered in conditions that would indicate their use. A small number have been found in or near dwellings, but most seem to have been discarded at random. Many were intentionally broken, probably in the belief that this would release a malevolent spirit or perhaps that their magic should be terminated once they had served their purpose. The Middle Jōmon site of Hiraide in Nagano Prefecture provides the best archaeological evidence for their use. Pit-dwelling K, one of 17 Middle Jōmon house-pits uncovered, contained all the figurines of the village. All were broken. Their dissimilarities precluded the dwelling from being the residence of their maker, and it was isolated from others and had been burnt. It was therefore probably

a parturition house used for childbirth and eventually destroyed.

The Hiraide female figurines were presumably used in childbirth, perhaps as pain transfers. They were also probably related to the idea of a mother goddess (although the use of this term in Japanese dates only from the 19th century). It is clear that *dogū* in general—with an 8000-year span and a considerable geographical distribution—fulfilled many different functions. They are thought to have served as substitutes in healing by transferring the disease to the effigy or by releasing the pain-causing spirit from the broken figurine; as charms, talismans or amulets to enhance fertility and to prevent the incursions of demons, diseases and death; as instruments in customs related to the regeneration of life, including simulated burials; and in hunting rituals, in which the breaking of the effigies symbolized the sacrificial killing of animals to ensure future abundance of prey.

(b) Late (c. 2500–c. 1000 BC). The long use of coastal sites accounted for the accumulation of large shell mounds in the Late Jōmon period, some yielding more than 100 anthropomorphic figurines. Heart-shaped and tilted heads were more characteristic of objects from the western side of the Kantō Plain, while triangular heads with high ridges for eyes and mouth, heavily cord-marked, were typical of the east coast. Many of these figurines have breasts and show signs of pregnancy. While the Shakadō site in Yamanashi Prefecture, dating from the Middle to Late Jōmon periods, yielded an amazing collection of ritual objects, among which were 420 clay figurines, not all groups of Late Jōmon people produced figurines.

In addition, variations on the Late Jōmon type occurred. At inland sites, examples showed the tilted head borrowed from the western Kantō Plain, but to this was added a tubular body lined with holes. Another variation, from the southern Tōhoku region, is in a crouched position, the knees pulled up close to the abdomen.

(c) Final (c. 1000–c. 300 BC). Jōmon figurines dating from the final stages of the period were distributed throughout the country, although they were concentrated in the declining shell mounds of the Kantō Plain and in the thriving Tōhoku sites such as Kamegaoka (Aomori Prefecture). The coastal examples are small, owl-faced, narrow-waisted images with tiered hairdos, plunging necklines, appliqué disc-shaped eyes and mouths and ear-lobe spools. Many bear elaborate erased cord markings and are painted red.

The northern Kamegaoka style influenced a wide area, with insipid copies especially in the Chūbu and Kantō regions. They are frequently hollow, with paper-thin walls, and may be as tall as 300 mm. One type has a bloated body, stumpy arms and legs and greatly exaggerated eyes. Termed 'snow-goggle figurines' (*shakoki dogū*) by Japanese historians, they have hollows behind the eyes that may be interpreted as space boxes for the spirit or 'windows of the soul' (see fig. 50). No doubt the eyes were believed to ward off evil. Several other types in the north are supplemented by clay masks, the smallest miniature, the largest life-size; loose clay ears and noses that could be strung on the face; and small, toy-sized animals. In the Final Jōmon

50. Prehistoric *dogū* of 'snow-goggle' type, earthenware, h. 355 mm, from Kamegaoka, Aomori Prefecture, *c.* 1000–*c.* 300 BC (Tokyo, National Museum)

stage in northern Japan smaller, solid figurines of poorer clay and workmanship were produced.

Large, hollow, bell-shaped figurines occur from the western Kantō Plain towards the Nagano Mountains and are variously considered to date from the terminal part of the Jōmon period or from the transitional phase between the Jōmon and Yayoi periods. They are not usually found in dwelling areas. They have small, heavily lined faces and long necks. Their shape enables them to stand alone, and, in view of their size (up to 0.3 m), they may have been permanently set up at sacred places. Extant burials imply their use as burial containers for infants or children, but whether this was generally so is impossible to say.

(iii) Yayoi period (c. 300 BC–c. AD 300). Unlike Jōmon figurines, Yayoi-period sculpture does not follow a single thematic tradition but includes wood-carving and metal-work as well as ceramic sculpture. Wooden birds and rough, columnar human figures probably served as grave markers. Woodwork in the Kansai region was exceptionally fine, containers being made on simple lathes and carved in a low relief, with painted patterns called *ryūsui* ('flowing water'). Deer and houses were occasionally incised on pottery (*see* §VIII, 3 below). Human-like heads decorate some lids or the necks of pots and were possibly apotropaic. They are invariably heavily scratched on the face, particularly around the mouth, and often painted to suggest tattooing. With these exceptions, the Yayoi seem rather to have turned their energies to the pictorial arts and to the low-relief agrarian motifs illustrated on a few

of the bronze ritual bells (*dōtaku*) that are among the most provocative finds of the period.

(iv) Kofun period (c. AD 300–710).

(a) Haniwa.

Origins and early development. During the Kofun period, when large, mounded tombs were built (*see* §III, 2(ii) above), clay sculptures known as *haniwa* ('cylinders of clay') were produced. Large pottery models of weapons, ceremonial objects, houses and boats and enchanting depictions of birds, animals and humans were made to be placed on the external slopes of the keyhole and corridor tombs of the Japanese ruling class. The use of low-fired, porous red earthenware (*hagi*) and the technique of fashioning the models from slabs moulded into hollow cylinders evolved from the Yayoi pottery tradition; all the images have the naive character of native Japanese art, unlike the works produced in imitation of Chinese models.

Haniwa flourished from the late 5th century AD and, in areas outside the rising influence of Buddhist art, survived into the late 7th century. The *haji-be*, the occupational group to which tomb builders, wrestlers and potters belonged, was assigned the responsibility for making these images, but, as the quality varies greatly, it is likely that non-professional workmen were periodically pressed into service, especially in areas where *haji-be* groups did not exist. Credit for the introduction of *haniwa* is given to the semi-legendary early 4th-century emperor Suinin (*reg* ?29 BC–AD 70), whose experience with the grisly scene of immolation burials on the plain around the tomb of his brother—in which those accompanying the deceased were buried up to their necks and left to die—left him with a revulsion for the system. When the next occasion presented itself on the death of the empress four years later, skilled potters from Izumo were invited to Yamato to make clay images instead. This so pleased the Emperor that he decreed that the practice should be followed henceforth. The images were called *haniwa* or *tatemono* ('standing things'). Contrary to the legend, however, archaeological evidence shows that the production of cylinders, inanimate objects, birds and animals preceded that of human figures, few of which, moreover, were actually made in the Kansai region. Furthermore, there is no evidence that immolation burials were actually practised. The origins of the cylindrical stands with triangular perforations can be traced to the site at Miwa Miyayama in Okayama Prefecture at the end of the Yayoi period; others dating from the Kofun period are found in their thousands on some tombs. Cylinders became holders for pots, early examples having a morning-glory shape.

Apart from cylinders, early *haniwa* chiefly took the form of houses and ceremonial objects. House models appeared in the Kantō region by the 5th century, placed individually over the burial mound as the shelter for the spirit of the dead or in arrangements, as on the Akabori-mura Chau-suyama Tomb, Gunma Prefecture, which had seven small models. They display a rich man's estate: one gabled dwelling with ridge logs, one lesser gabled residence, three storehouses with raised floors (two with gabled roofs and one with hipped roof) and one barn or shed. Other *haniwa* on this tomb include replicas of armour, a sunshade, a

throne and a long-handled fan. At other tombs, shields, *tomo* (archers' wrist protectors), sheathed swords, bows, hoes, musical instruments and boats have been found.

Haniwa birds, which appeared earlier than animals, were usually barnyard and water fowl, the latter often placed near the foot of the tomb mound if it was moated. Alternatively, placed at the top of the mound, they symbolized the flight of the spirit of the dead. Horses were the first animals in *haniwa*; the oldest come from the large cluster of tombs near that of Emperor Nintoku (*reg* first half of 5th century AD). These examples have no riding bits, but later *haniwa* horses have such trappings as bits, saddle parts, stirrups and chains, straps, and flank and rump ornaments. Dwarfish human figures ride two horses from Gunma, one of which lacks a saddle and the normal trappings. Grooms are always small when seen against their horses. Other animals—boar, deer, dogs, cows and monkeys—enriched the menagerie as the practice expanded from the Kansai to the Kantō region in the 6th century.

Human subjects. *Haniwa* in human form were first produced in the 6th century in the Kansai, where, however, the practice of elaborate tomb burials declined after the introduction of Buddhism in the mid-6th century. Craftsmen from the Kantō, however, developed figures to their fullest potential, the variety of people portrayed constituting an outstanding contribution to the *haniwa* repertory. Although still structurally and technically dependent on the cylinder, figures show a broad range of costume or narrative pose, with much attention to detail, from which the viewer is able to distinguish age, sex and occupation. *Haniwa* were characteristically very simple, for a variety of reasons: they were produced in large numbers at short notice; they were required to be portable; they were placed some distance from the viewer; and they were disposed in such a way as to be constantly exposed to the weather and to encroaching vegetation. In some instances, ambition outstripped ability. Attempts to deal with complicated poses were rarely successful, the limbs being either non-existent or treated as telescoped, tubular appendages closely held to the body. Nevertheless, figures are endowed with a surprising vitality and range of personality, achieved by the subtle alteration of the shapes or angles of facial perforations.

The number of identifiable occupations is small: two main groups are males wearing military dress or carrying farm tools. Grooms can be identified by pose when a horse is near by. Late examples of cavalry in Gunma, Saitama and Chiba prefectures wear riding breeches and have all their arms and armour reproduced in precise detail; their hair is fashioned in a pair of long, braided locks and they wear large earrings. Chiefs or shamans are portrayed in full battle uniform (see fig. 51) when making sacrifices or asking, with a supplicant gesture, for counsel from the spirits (*kami*). Shield-bearers' bodies are usually merged with their shields, only the heads appearing above. Lightly armed soldiers, like bodyguards, carry only swords. Farmers carry sickles, scythes or both.

Images of women also range from the most prepossessing to the most pedestrian, but they are fewer in number than male figures and less often depict members

51. Protohistoric *haniwa* chief, earthenware, h. 749 mm, from Yahatabara, Gunma Prefecture, 6th–7th centuries AD (Tenri, Nara Prefecture, Sankōkan Museum)

of the aristocracy. One old and much-restored find is of a female shaman (*miko*) from Gunma Prefecture; she is seated on a throne, legs pendant, hair arranged in mortar-board fashion, wearing double necklaces and anklets of beads, single bracelets and a mirrored jingling bell at the waist (see fig. 4 above). Many females are shown serving, holding cups or bowls or even balancing jars on their heads. Commoners include a mother carrying a baby on her back and another nursing a child.

Some figurines are depicted playing musical instruments, singing or dancing. Only dancers and supplicants hold arms away from the body. Supplicant gestures are commonly found, with arms forward, hands almost touching. An imposing group from a tomb in Takasaki city, Gunma Prefecture, comprises seated worshippers or mourners. One fully dressed soldier with a tall, pointed cap sits in a yoga posture, hands at chin height; he is accompanied by male and female figures in similar pose, including a trio of women seated on an oval base. Facial expressions are surprisingly lifelike and often dramatic. Women are rarely distinguished facially from men, but they may sometimes be recognized by their hairstyles and, in areas such as Gunma, by small breasts or nipples.

Some later *haniwa* from the Kantō region were painted. Weapons were decorated with triangular patterns; more rarely, paint was applied in arcs and parallel curves. The faces and costumes of both military and civilian men and women were often painted. Face painting, chiefly red, extended out and down from the eyes. Costume painting, in red, deep purple or black, consisted mainly of filled

triangles. On all types of *haniwa*, paint was applied to the front of figures and objects only, which suggests that it was done to disguise rather than to beautify the figures and provides clear evidence that they faced away from the tomb. When *haniwa* were first placed on mounds in the Kansai region, they were set in a rectangle around the burial spot, facing the front of the tomb, weapons and armour at the ready as though to guard the dead. As the practice moved to northern and eastern Kantō tombs and became more elaborate, they were aligned along the slopes, simulating long funeral processions, their backs turned to the mounds.

Buddhism introduced radically different religious ideas, and the laws issued under the Taika Reform of 646 limited the construction of mounded tombs. After 700 cremation gradually became the preferred practice. *Haniwa* were already going out of style before the final demise of tumulus building, but not before this free and original art had flourished in an unrivalled way to decorate hundreds of tombs in the Kantō region.

(b) Yokoana. Another aspect of the pre-Buddhist Japanese sculpture comprises the rock-cut reliefs (*yokoana*) associated with tunnel tombs (*see also* §VI, 2). In the 6th and 7th centuries many *yokoana* were simply cut into the soft hillside rock, as in Kumamoto, or dug into the hard loam, as on the Kantō Plain. Among groups of *yokoana* a few had carvings around the entrances or painting or wall incisions on the interior. At Nabeta, Kumamoto Prefecture, where 54 tunnel tombs are ranged along the face of the cliff, the entrance of the largest contains a sunk relief about 2.5 m wide. The roughly hewn outlines depict a warrior and his weapons, a man holding a bow backwards, with a *tomo* (wrist guard), a large and a small quiver, a knife and shield; underneath, in the centre, is a quadruped, presumably a horse.

At the 24 Jōhon (or Ōmura) *yokoana* tombs on the outskirts of Hitoyoshi city, Kumamoto Prefecture, a flat carving of five horses and three bells is visible in tombs 7 and 8. One horse is saddled and another resembles a foal. Zigzags, perhaps representing a gable, mark the lintel over Tomb 8, with a triangle and quiver to one side. Quivers are often proportionally larger than surrounding imagery, probably symbolizing status. All this work is extremely rudimentary.

(c) Sarcophagi. Some late tunnel tombs, especially in the Inland Sea region, contained clay sarcophagi, which, in a few examples, were decorated on one end in low relief. The Hirafuku Tomb sarcophagus (see fig. 52) has a symmetrical scheme of a man standing between two long-tailed horses and holding their reins; above is a wavy line and on either side below a pair of knobbed rods. Long-tailed horses adorned for parades were common images at this time, but the Hirafuku example represents an unusual degree of formal balance.

BIBLIOGRAPHY
T. Esaka: *Dogū* [Clay figurines] (Tokyo, 1960)
Y. Kobayashi: *Haniwa*, Nihon tōji zenshu [Complete collection of Japanese earthenware], i (Tokyo, 1960)
F. Miki: *Haniwa: The Clay Sculpture of Protohistoric Japan* (Tokyo, 1960)
H. Takiguchi and H. Kuchioka: *Haniwa* (Tokyo, 1963)
J. E. Kidder: *The Birth of Japanese Art* (New York, 1965)
F. Miki: '*Haniwa no bi*' [The beauty of haniwa], *Nihon genshi bijutsu* [The

52. Protohistoric sarcophagus with relief decoration, clay, from Hirafuku Tomb, Okayama Prefecture, 7th century AD (Tokyo, National Museum)

beginnings of Japanese art], vi (Tokyo, 1966), pp. 137–41, 156–62, 190–96
——: *Haniwa*, Arts of Japan, viii (Tokyo, 1974)
I. Murai, ed.: *Kofun jidai* [Tomb period] (1974), ii of *Haniwa to ishi no zōkei* [Forms of *haniwa* and stone] (Tokyo)
——: *Kodaishi hakkutsu* [Digging up ancient history] (1974), vii of *Haniwa to ishi no zōkei* [Forms of *haniwa* and stone] (Tokyo)
T. Kobayashi and M. Kamei: *Dogū haniwa* [Clay figurines and *haniwa*], Nihon tōji zenshu [Complete collection of Japanese earthenware], iii (Tokyo, 1977)
Gunma no haniwa [*Haniwa* of Gunma] (exh. cat. by T. Yamakawa, Takasaki, Gunma Prefect. Mus. Hist., 1979)
Osaka-fu no haniwa [Haniwa of Osaka Prefecture] (exh. cat. by T. Nogami, Senhoku, Osaka Prefect. Archaeol. Mus., 1982)

J. EDWARD KIDDER JR

3. BUDDHIST. Buddhism was first introduced into Japan around the mid-6th century AD (*see* §II, 3 above). Its iconography was already highly developed, and, because the veneration of icons was an essential part of Buddhist practice (as it was not of the indigenous Japanese religions, notably Shinto; *see* §II, 2 above), Buddhist forms and conventions came to influence nearly all sculpture produced in religious contexts from the end of the 6th century to the modern period.

(i) Asuka–Hakuhō periods (*c.* AD 552–710). (ii) Nara period (AD 710–94). (iii) Heian period (794–1185). (iv) Kamakura period (1185–1333). (v) Muromachi, Momoyama and Edo periods (1333–1868).

*(i) Asuka–Hakuhō periods (*c. AD *552–710).*

(a) Asuka period (*c.* AD 552–645). (b) Hakuhō period (AD 645–710).

*(a) Asuka period (*c. AD *552–645).* Several of the greatest monuments of Japanese Buddhist sculpture date from the

Asuka-Hakuhō periods. From a pan-Asiatic perspective, these monuments are of extraordinary importance, for they represent on a large scale, in a variety of materials and with superb quality, icon types that developed in China, Korea and Japan, but are now largely lost on the continent. Various important, if limited, documentary sources exist for the study of Asuka-period sculpture, although often their authors may, for their own ends, have distorted historical veracity. Most significant is the *Nihon shoki* ('Chronicle of Japan'; AD 720), which has some entries for the 6th and 7th centuries that relate to Buddhist icons. Other texts, such as *Gangōji engi* (a historical record of the temple-monastery Asukadera), provide further information on the making of images. A few sculptures also bear inscriptions that record the circumstances of production. The corpus of monuments is surprisingly small, and attribution to Asuka-period Japan is uncertain. Several early works were undoubtedly produced on the Korean peninsula and brought to Japan; in other cases the provenance is unknown. Six large-scale monuments are known from this period, as are a few medium-sized works and some small gilt-bronze images, numbering in all about 20 examples. Bronze was the most common material for Asuka sculpture, but several important images were made of wood. None of the stone icons referred to in texts survives.

In 587 the pro-Buddhist Soga clan won a decisive victory and in 588 vowed to establish the Buddhist monastery that came to be known as the Asukadera. Craftsmen were summoned from the Korean peninsula, and from the early 590s other monasteries began to be erected and icons produced in Japan itself. Asukadera was built in the Asuka region, in the southern part of the Yamato Basin, and it is from this area that the period takes its name. Excavations at Asukadera in 1956–7 revealed a monumental complex with not one but three *kondō* ('golden halls'). Clearly the Soga leaders recognized the value of Buddhism not only as a religion but as an important component in their governmental system.

Towards the mid-7th century the power of the Soga clan, which had been so important to the initial growth of Buddhism in Japan, declined substantially. In 645 an anti-Soga coup, referred to as the Taika Reform, toppled the clan, and different groups assumed government. The style patronized by the Soga leaders fell out of fashion, and new styles came from the Asian continent, leading to the formation of the Hakuhō styles after *c.* 650 (*see* §(b) below).

The changes that can be observed in sculpture between *c.* 590 and *c.* 650 are explicable with reference to developments on the continent. Not until later did an independent process of stylistic evolution begin to emerge within Japan itself. However, Asuka sculpture is not only of great historical and religious significance but also reveals the freshness and vibrancy of the beginnings of a tradition.

It is difficult to determine what icons were installed in the three *kondō* of Asukadera. Only parts of the central (or north) *kondō* remain, housing a monumental bronze icon known as the Asuka *Great Buddha* (*Daibutsu*), which is unfortunately in such poor condition, owing to numerous fires and other calamities, that it is almost impossible to reconstruct its original appearance. Yet the *Great Buddha* was the sculpture that ushered in the age of Asuka Buddhist art.

A temple within the area now occupied by HŌRYŪJI seems to have been established early in the 7th century. The nature of the icons installed in this original temple is unknown. Archaeological evidence indicates that the earliest temple was destroyed by fire and the present structures erected after 670. The implications of this are fundamental for an understanding of Asuka art, for the main structure housing Asuka sculpture—the *kondō*—was not built until some time later. Consequently, if of Asuka date, the icons installed in the *kondō* must have been moved there from somewhere else.

'*Shaka Triad*'. The main icon of the Hōryūji Kondō, and one of the greatest extant monuments of Asian Buddhist art, is the large gilt-bronze *Shaka Triad*, enshrined in the centre of the hall (see fig. 53). Beautifully preserved, it includes a large bronze mandorla backing the three figures and a supporting wooden pedestal. Although the *Shaka Triad* is 3.82 m tall from the base of the pedestal to the tip of the mandorla, the central figure is only 0.86 m high, whereas the Asukadera *Great Buddha* is 2.76 m high. The sheer beauty of the *Shaka Triad* tends to obscure the fact that it was the result of more modest patronage, while the *Great Buddha* was obviously a commission of the very highest significance.

At the centre of the *Triad* is a figure of the historical Buddha, Shaka (Skt Shakyamuni). He wears a monk's robe and is seated cross-legged on a pedestal that represents the cosmic mountain. He is flanked by two smaller *bodhisattva*s who stand below him, each *c.* 0.91 m high.

53. *Shaka Triad*, gilt-bronze, h. 3.82 m, Asuka period, *c.* AD 623 (Ikaruga, Nara Prefecture, Hōryūji, Kondō)

Shaka displays several of the important iconographic, symbolic traits of the Buddha, including the *uṣṇīṣa*, a cranial protuberance; the snail-shell curls of hair; the *ūrṇā*, a mark on the brow between the eyes; the elongated ears; and the gilt, which indicates the golden colour of the Buddha's skin. He holds his right hand in the gesture of protection or reassurance known as *abhaya mudrā*, the left in the *vara mudrā*. In contrast to these features, which are seen throughout Asian Buddhist art, the Hōryūji Shaka also has a number of stylistic features that are characteristic of the Asuka period. Particularly important are the precisely modulated, almond-shaped eyes and the very sharply contoured lines of the lips, which some observers have interpreted as forming an 'archaic smile' (a term borrowed from ancient Greek sculpture). The quite large size of the head and hands in comparison to the body is certainly typical for an archaic style, as is the way the heavy robe hides the body. The folds of the drapery fall in linear patterns, a trait derived from China, where artists tended to transform the strongly plastic values of the Indian tradition into a linear structure. The drapery overhang, which cascades over the front of the pedestal, is a striking instance of this and is almost as prominent an aspect of the total composition as the Buddha himself.

The two flanking *bodhisattva*s, who stand on lotus pedestals, are Yakuō and Yakujō. They grasp in their fingers small jewels, which symbolize the power of healing. Their crowns are high, rather complex forms, with elaborate ornamentation. Their faces bear a resemblance to that of Shaka but are not identical to it. Their bodies, like that of the Buddha, are rendered without much sculptural plasticity, but are generally hidden under the robes. The *bodhisattva*s wear a standard costume, including a long scarf, a type of undershirt and a lower garment like a skirt or *dhotī*. Particularly interesting is the arrangement of the scarf, which crosses over the front of the legs in an X-pattern and then passes up over the arms before hanging down at the two sides in 'fish-tail' folds. This latter characteristic is frequently seen in Asuka-period images. Appropriately, the *bodhisattva*s wear jewellery, including necklaces and bracelets, signifying their princely status.

The *Shaka Triad* has a long inscription on the back of the mandorla, with a date equivalent to 623. Some doubts exist as to its authenticity, although it seems certain that the *Triad* was indeed made at about this time. The inscription also refers to a sculptor known as TORI BUSSHI; this and related works are commonly said to be in the Tori style. A more appropriate designation would be the Soga–Tori style, acknowledging the roles of both patron and supervisor. Basically, the style and iconography of the *Shaka Triad* of Hōryūji derive from northern Chinese sculpture of a type developed during the later Northern Wei (386–534) and Eastern Wei (534–50) periods. What might be called the 'Late Wei style' was transmitted to the Korean peninsula, primarily to the kingdoms of Koguryŏ and Paekche (mid-6th century) and thence, soon after, to Japan.

'*Yumedono Kannon*'. This Kannon (Skt Avalokiteshvara), sometimes referred to as the *Guze Kannon*, is located in the Yumedono (Hall of Dreams), the main structure of the east precinct of Hōryūji. It is a large-scale (h. 1.79 m) image carved from a single block of camphor wood (see fig. 48 above). As well as being exceptionally beautiful, it is well known because of the rather romantic circumstances in which it was first made public. In the late 19th century ERNEST FRANCISCO FENOLLOSA and Okakura Tenshin began to survey ancient Japanese art and persuaded the authorities at Hōryūji to allow them to investigate the 'secret image' (*hibutsu*) enshrined in the Yumedono. After unrolling layer after layer of fabric, which was wrapped around the icon as if it was a mummy, they reached the statue, which they discovered to be in nearly immaculate condition, with much of the gilt and some of the colouring of the face preserved.

Although this figure displays stylistic resemblances to the flanking *bodhisattva*s of the *Shaka Triad*, there are significant differences. Most important is that it is an independent icon, rather than part of a larger composition, and thus is designed to be seen by itself. In contrast to the relatively squat proportions of the *Shaka Triad bodhisattva*s, the *Yumedono Kannon* has a strongly upward-soaring quality, from the broad fish-tail folds at the base up through the elegant contours of the halo to the sharp point at the peak. The image is designed to be seen to best advantage from the front and has a high degree of linear schematization in the articulation of such details as the drapery folds. The face is related to those of the *Triad*, and the two monuments clearly belong to closely related stylistic lineages, although probably not from the hands of the same sculptor. The *Yumedono Kannon* may date slightly later than the *Shaka Triad*, perhaps from the 630s, although this is a matter of debate.

'*Kudara Kannon*'. A second life-size, wooden *bodhisattva* of the Asuka period housed at Hōryūji is the *Kudara Kannon*, formerly housed in the Kondō but now kept in the Treasure House (see fig. 54). It is slightly larger than the *Yumedono Kannon* (h. 2.11 m), but is carved in the same technique from a single block of camphor wood. (Some extremities in both images are made from separate pieces of wood.) Unlike the surface of the *Yumedono Kannon*, which was gilded, that of the *Kudara Kannon* was brilliantly polychromed, although most of the pigment is now lost. Both these figures wear elaborate openwork metal crowns studded with hardstones.

Stylistically, the two statues could hardly be more dissimilar. While the *Yumedono Kannon*, like the *Shaka Triad*, is in the Soga–Tori style, the *Kudara Kannon* comes from a different lineage. Both figures are tall, with rather elongated proportions, but the strongly columnar structure of the *Kudara Kannon* emphasizes its verticality. The fish-tail folds are parallel to the sides of the image, thus enhancing the columnar effect, which is broken only by the right arm and hand, held out in front in a poignant gesture symbolizing the benevolence of the *bodhisattva*. The facial features of the *Kudara Kannon* are softer; the mouth is smaller, gentler and more delicate, betokening a move away from the archaic traits of the Soga–Tori group of images. Needless to say, this development did not take place in Japan but rather reflected different strands of continental influence, specifically, perhaps, southern Chinese currents. Both of these lineages were transmitted to Japan via the Korean peninsula, and the word 'Kudara' is

set of the *Four Guardian Kings* (Jap. Shitennō; Skt *cāturmahārājikā*s) that guard the altar of the Kondō at Hōryūji, each king guarding one of the four cardinal directions. The individual figures in the Hōryūji group are almost identical, except for the position of the arms. The image of *Tamonten*, the Guardian of the North, is made of wood with a polychromed surface, which suggests a connection in stylistic lineage with the *Kudara Kannon*. The columnar structure is also present, although as a guardian figure *Tamonten* has a more bulky, massive body. Moreover, he wears armour and carries a spear and stands on a demon-vehicle symbolizing the evil forces he subdues. Later images of guardians were often represented as highly active, energetic deities, but the Asuka figures are some-what staid and solemn, still within a generally archaic style. They are dated to the end of the Asuka period.

Within the quite small corpus of Asuka sculpture a surprising variety of different deities is represented. At Kōryūji in Kyoto is an image of *Miroku* (Skt Maitreya; the Buddha of the Future, destined to become the immediate successor to the historical Buddha, Shaka). The cult of Maitreya was extremely important on the Korean penin-sula during the Three Kingdoms period (*c.* 300–668), and many sculptures remain from that time, some made of bronze, others of stone. Since there are unfortunately virtually no examples of early wooden sculpture extant on the peninsula, the Kōryūji *Miroku* assumes special signif-icance, for it is made of red pine. It is modelled on the large, gilt-bronze image of *Miroku* in Korea (Seoul, N. Mus.); indeed its provenance is disputed, some Japanese scholars arguing that it is an import from the peninsula rather than a Japanese work.

The Kōryūji *Miroku*, like other examples of this icon-ography, is depicted as a contemplating figure, with the right hand lightly touching the cheek and the right leg resting on the left knee. He wears the crown of a *bodhisattva* and originally had an independent metal necklace, which is now lost. The face has a gentle, meditative expression, and the upper body, which is undraped, looks soft and youthful. No member of the Buddhist pantheon has a more tender, appealing quality.

One more important large-scale icon is the *Yakushi* (Skt Bhaishajyaguru) in the Kondō at Hōryūji. It is made of bronze, is 0.63 m tall and bears an inscription with a date corresponding to 607, although on stylistic grounds an attribution to the period after the Hōryūji fire of 670 is in fact more likely. Several smaller bronze images can be dated to the Asuka period. Some of these are closely related to the images discussed above, others reflect different stylistic lineages. In many cases quite close prototypes can be found on the Korean peninsula.

54. *Kudara Kannon*, camphor wood, h. 2.11 m, Asuka period, second quarter of the 7th century AD (Ikaruga, Nara Prefecture, Hōryūji, Treasure House)

a Japanese reading of the characters for the Korean kingdom of Paekche. Most scholars date the *Kudara Kannon* to the second quarter of the 7th century.

Other works. Images were made in the Asuka period not only of Buddhas and *bodhisattva*s but also of numerous other deities that rank lower in the pantheon, including a variety of guardian figures. An important example is the

BIBLIOGRAPHY

Kodansha Enc. Japan: 'Buddhist Sculpture'

R. T. Paine and A. Soper: *The Art and Architecture of Japan*, Pelican Hist. A. (Harmondsworth, 1955, rev. 3/1981)

D. Seckel: *The Art of Buddhism*, Arts of the World, xiv (New York, 1964)

S. Mizuno: *Hōryūji*, Nihon no bijutsu [Arts of Japan], iv (Tokyo, 1965); Eng. trans. by R. L. Gage as *Asuka Buddhist Art: Horyu-ji*, Heibonsha Surv. Jap. A., iv (New York and Tokyo, 1974)

T. Kuno and K. Suzuki: *Hōryūji*, Genshoku Nihon no bijutsu [Arts of Japan, illustrated], ii (Tokyo, 1966)

T. Kuno: *Yumedono Kannon to Kudara Kannon* [The Yumedono Kannon and the Kudara Kannon] (Tokyo, 1973)

S. Mizuno: *Asuka Buddhist Art: Hōryū-ji*, trans. by Richard L. Gage (New York and Tokyo, 1974)

B. Kurata: *Hōryū-ji: Temple of the Exalted Law*, trans. by W. Chie Ishibashi (New York, Japan Soc., 1981)

K. Mizuno: *Hōryū-ji: Kondō Shaka Sanzon* [The Shaka Triad in the Hōryūji Kondō] (Tokyo, 1992)

(b) Hakuhō period (AD 645–710). The period from the Taika Reform of 645 to 710, when the Japanese capital was moved to Nara, is often termed the Hakuhō period. It has a transitional character, marked by Japan's gradual move towards unification in response to the political unification of Korea, yet its art has its own distinctive flavour. Echoing the period's political complexity, Hakuhō sculpture manifests great stylistic diversity. Whereas the monuments of the previous period tend to fall into a limited number of categories, with the Soga-Tori group predominating, Hakuhō sculpture displays a wide range of traits and styles deriving from Chinese and Korean sources. The multiplicity of currents seen in images of the Sui period (581–618) in China had a strong impact on Korean sculpture, which in turn had a profound effect on Japanese art from about the mid-7th century.

The corpus of Hakuhō sculpture is considerably larger than that of the earlier Asuka period. The most important category comprises small gilt-bronze icons, of which many examples can be found over a wide area of Japan, suggesting a development in religious practice whereby icons of modest scale were used for private devotion in the mansions of the ruling class. More monumental icons, which served as the focus for communal worship in temples and monasteries, were also made during the period, but most of those known from documentary sources have been lost.

Small icons. Undoubtedly the greatest collection of small-scale gilt-bronze Buddhist icons is the group referred to as the *Forty-eight Buddhist Deities*, originally kept at HŌRYŪJI (donated to the Imperial Household Agency at the end of the 19th century; now Tokyo, N. Mus.). Presumably few, if any, of these images were produced for Hōryūji itself; rather, they were originally objects of private devotion that were later offered to temples where they could be properly enshrined. Thus the *Forty-eight Buddhist Deities* is not a unified stylistic grouping but rather exemplifies the striking diversity of 7th-century sculpture.

One figure in this group (see fig. 55), a seated *Miroku* image, represents a deity that continued to be extremely popular during the Hakuhō period, with examples found throughout Japan. This *Miroku* is a typical Hakuhō sculpture, with a three-plaque crown, heavy jewellery and full, fleshy modelling of face and body. Contrasting with the earlier Soga–Tori style, here the drapery shows a more realistic manner, the folds arranged in gently flowing curves. Given the great popularity of this deity on the Korean peninsula, it seems likely that this *Miroku* reflects currents in sculpture of the later Three Kingdoms (1st century BC–7th century AD). Hakuhō sculpture is perhaps most fully exemplified by the extraordinary Tachibana Shrine (late 7th century; Ikaruga, Nara Prefect., Hōryūji), one of two full-scale devotional shrines that were originally for private use and have been preserved at Hōryūji (the other is the Tamamushi Shrine, *c.* 650). Normally, the

55. *Miroku*, gilt-bronze, h. 294 mm, Hakuhō period, second half of the 7th century AD (Tokyo, National Museum); from the *Forty-eight Buddhist Deities*

doors of the main compartment are kept shut, only to be opened for specific religious services.

Although factual evidence is lacking, the Tachibana Shrine is linked by tradition with an important court lady, Tachibana no Michiyo (*d* 733), who was the mother of the 8th-century empress Kōmyō. Furthermore, the superlative craftsmanship of this unique monument is evidence that none other than a member of the highest élite could have afforded it.

The icon housed in the Tachibana Shrine is a gilt-bronze *Amida Triad* (see fig. 56), consisting of a central, seated Buddha, Amida (Skt Amitabha), flanked by two standing *bodhisattva*s, Kannon (Avalokiteshvara) and Seishi (Mahasthamaprapta). Each figure is supported by a lotus pedestal, which grows out of a lotus pond at the base of the compartment. Backing the three deities is an intricate screen with an exquisite relief representation of the Western Paradise of Amida. The entire sculptural group must have been deeply moving to the contemporary worshipper. The three figures are rather small, Amida being 340 mm high and the flanking *bodhisattva*s about 288 mm. In terms

56. *Amida Triad*, gilt-bronze, h. 340 mm, Hakuhō period, late 7th century AD (Ikaruga, Nara Prefecture, Hōryūji, Tachibana Shrine)

of stylistic development, Amida has moved on substantially from the severe, archaic style of the Shaka (Shakyamuni) of the *Shaka Triad* (*see* §(a) above). The Hakuhō-period figures have gentle expressions; there is a certain sense of the modelling of body forms, and the folds of the drapery flow naturally across the body. In short, the figures are represented in a more naturalistic, approachable way. However, it would once again be a mistake to ascribe this evolution to internal Japanese developments, for there is strong evidence linking the style of the Tachibana Shrine figures to slightly earlier monuments in Sui-period China and the Unified Silla kingdom of Korea (AD 668–918).

The gilt-bronze screen that backs the *Amida Triad* is one of the most precious monuments of East Asian Buddhist art. Standing out from the screen proper, behind the head of Amida, is a complex, openwork halo, with a multi-petalled lotus flower at its centre. Directly below the upper, scalloped edge of the screen are depictions of seven subsidiary Buddhas. In the middle register of the screen are five newborn souls, each squatting in a different pose on a lotus flower, paying obeisance to the three central deities. The lotus flowers that support the souls are represented growing out of the same lotus pond that supports the pedestals of the *Amida Triad*. The poignant

evocation symbolizes the Indian conception of the purity of a glistening white lotus that can emerge unsullied from a muddy pond.

Larger icons. A few intermediate-sized Hakuhō sculptures also exist. A superb example is the famous *Yumechigai* ('dream-changing') *Kannon* (Ikaruga, Nara Prefect., Hōryūji; see fig. 57). It is 870 mm tall, more than twice as tall as the typical small-scale image, yet substantially shorter than life-size or monumental icons. Consequently, it is difficult to determine whether it was intended for private worship or for installation in a temple or monastery, although the latter seems more likely.

The *Yumechigai Kannon* is a fully mature version of the Hakuhō style, which probably indicates a date of *c.* 700. The three-plaque crown, the heavy jewellery strings and the characteristic arrangement of the scarf passing in front of the legs in two registers are all diagnostic traits of the Hakuhō style, deriving ultimately from Chinese and Korean models. Still more striking is the overall conception of the icon, with its full, fleshy face and the sensuous modelling of the chest area. Both sculptor and patron evidently wished to create an icon that seemed not distant and mysterious, but appeared to be in close personal

represent Yakushi (Skt Bhaishajyaguru) or Miroku (Maitreya). The history of the image is unclear. It was discovered at the temple in 1909, but there are no references to its existence there in early times. Although some scholars have argued that it was made in the Kantō region, it was probably in fact made in a workshop in the capital. The accomplished casting technique as well as the size of the sculpture (818 mm) are the hallmarks of an experienced workshop, and provincial manufacture is thus almost certainly precluded.

The round face has precisely delineated features, fleshy cheeks and a slight smile playing across the lips. While the upper torso is long, the legs are rather short; the chest and abdomen are subtly modelled. Particularly impressive is the treatment of the robe, with broadly spaced folds sweeping down from the left shoulder across the belly and around the right side. The sculptor has successfully achieved a balance and harmony between the sculptural volumes and the linear rhythms produced by the drapery folds. It is difficult to find a specific continental prototype for the *Jindaiji Buddha*. The most appropriate stylistic sources would seem to be Northern Zhou and Northern Qi (550–77) elements, as synthesized in Sui-period sculpture and transmitted by way of Korea of the early Unified Silla period. Some scholars see the appearance of a more distinctly Japanese style in this figure, and certainly by this stage it is possible that indigenous tastes were beginning to assert their force.

57. *Yumechigai Kannon*, gilt-bronze, h. 870 mm, Hakuhō period, c. AD 700 (Ikaruga, Nara Prefecture, Hōryūji)

contact with the human realm. It is this immediate, emotional quality that most strongly differentiates mainstream Hakuhō sculpture from that of the preceding and following periods.

Something of the diversity of Hakuhō sculpture can be seen in a Buddha, seated in Western pose with legs pendant, enshrined at Jindaiji, Tokyo (see fig. 58). While standing Buddhas or those seated in a lotus position are common, the pose of the *Jindaiji Buddha* is relatively rare. Although the Buddha is ordinarily identified as Shaka, the iconography of this figure is uncertain: it may perhaps

58. *Jindaiji Buddha*, bronze, h. 818 mm, Hakuhō period, second half of the 7th century AD (Tokyo, Jindaiji)

BIBLIOGRAPHY
Kodansha Enc. Japan: 'Buddhist Sculpture'
S. Mizuno: *Hōryūji*, Nihon no bijutsu [Arts of Japan], iv (Tokyo, 1965); Eng. trans. by R. L. Gage as *Asuka Buddhist Art: Horyu-ji*, Heibonsha Suru. Jap. A., iv (New York and Tokyo, 1974)
T. Kuno and K. Suzuki: *Hōryūji*, Genshoku Nihon no bijutsu [Arts of Japan, illustrated], ii (Tokyo, 1966)
Tokubetsu-ten, kondō-butsu: Chūgoku, Chosen, Nihon [Special exhibition, gilt-bronze Buddhist statues: China, Korea, Japan] (exh. cat., Tokyo, N. Mus., 1987)

DONALD F. MCCALLUM

(ii) Nara period (AD 710–94). The sculpture of the Nara period is distinguished by the adaptation and reinterpretation of continental styles and techniques. Throughout much of the 8th century Japan was part of the cultural sphere of the cosmopolitan Tang dynasty (618–907), and the capital at Heijō (now NARA) was literally the eastern terminus of the Silk Route. Contacts with the Asian continent were inevitably sporadic, and Chinese and Korean styles were gradually reformulated by the Japanese. Even so, the resulting images remained closely linked to their continental prototypes. By the end of the 8th century, however, the Japanese had begun to develop more indigenous forms of sculptural expression that reached their maturation during the Heian period (*see* §(iii) below).

During much of the 8th century imagery was produced for rituals at government-supported monasteries to provide protection for the state and safety from calamities. Images of Shaka (Skt Shakyamuni, the historical Buddha), Dainichi Nyorai or Rushana (Vairochana, the Cosmic or Great Illuminator Buddha) and Kannon (Avalokiteshvara, the *bodhisattva* of compassion) were the most frequent objects of devotion at these temples. Esoteric forms of Kannon, as well as images of Yakushi (Bhaishajyagura, the Buddha of healing), were worshipped on a more popular level to provide other more immanental benefits.

The history of 8th-century sculpture can be divided into three periods. The first spans the years between 710, when the Heijō capital was founded, and 743, when Emperor SHŌMU issued an imperial edict proclaiming his intention to construct the *Great Buddha* (*Daibutsu*), a monumental image of Dainichi Nyorai, at Tōdaiji (*see* NARA, §III, 4). The second covers the years from 743 until 757, when the *Great Buddha* and the temple that housed it were completed. The final stage terminates in 794 with the founding of the new capital of Heian (Kyoto).

The first two stages are characterized by close adaptation of continental styles and techniques. Sculptors worked for officially sponsored temple construction workshops and produced images in the costly and labour-intensive materials of clay, lacquer and bronze. After the *Great Buddha* was completed in 757, however, government-sponsored temple construction projects declined in number; the official Buddhist sculpture workshop (*Nara bussho*) at Tōdaiji was closed in 789. By the early 760s images were produced at independent temples such as Tōshōdaiji, and wood gradually became the dominant medium of the sculptor's craft (*see* §1(ii) above).

(a) 710–43. (b) 743–57. (c) 757–94.

(a) 710–43. Some of the first works of the Nara period are the clay sculptures in the base storey of the five-storey pagoda at HŌRYŪJI, which date from 711, the year after

59. *Triad of the Healing Buddha*, gilt-bronze, h. 2.55 m (Buddha), 3.09 m and 3.12 m (*bodhisattva*s), Nara period, ?*c.* AD 718 (Nara, Yakushiji)

the establishment of the new capital. Hōryūji, which had been founded in the early 7th century, had burnt to the ground in 670 (*see* §(i)(a) above). Reconstruction of the main compound proceeded slowly, and the *Two Guardians* (Jap. Niō) in the Middle Gate and the panoramic scenes in the pagoda were some of the last works to be completed in the refurbishing. The panoramas, which would originally have been brightly polychromed, were placed in grottoes with fanciful rock formations made of clay. They consist of the *Debate between Vimalakirti and Manjushri* (Jap. Yuima Koji and Monju) to the east, the *Division of the Relics of Shaka* to the west, the *Nirvāna of the Buddha* to the north and the *Paradise of Maitreya* to the south. Of these, the *Debate* and the *Nirvāna* remain the most complete.

Although intriguing connections between the individual subjects of the panoramas and the history of Hōryūji have been proposed, no explanation has been found for this particular grouping in a single structure. Each of the diminutive sculptures (h. *c.* 500 mm) was modelled in clay around a wooden core wrapped with straw rope. The statues in these groupings are distinguished by a more naturalistic treatment of pose and expression than in works of the preceding decades, most evident in the intense expressions and contorted bodies of the mourning monks in the *Nirvāna* scene. Although no metropolitan examples remain, documents indicate that clay was a popular medium in China during the later 7th century, and

the distinctive style of the Hōryūji pagoda figures may have been introduced to Japan by envoys returning home in the early 8th century.

As the construction of the new capital progressed during the 710s, many of the most influential temples of the preceding century were moved to Heijō. As early as 710, Yamashinadera, the tutelary temple of the powerful Fujiwara clan, was relocated to Nara and renamed Kōfukuji. Imperially supported temples were also rebuilt. Daikandaiji, one of the early centres of state Buddhism, was moved in 716 and renamed Daianji. Hōkōji (also known as Asukadera), the first temple to be founded in Japan (*see* §(i) above), was transferred to the capital in 718 and renamed Gangōji. At each monastery the erection and furbishing of the halls was supervised by a government-supported construction bureau. By 720 there were 48 temples in the new capital, which resulted in a rapid increase in sculptural activity.

Yakushiji, the temple dedicated to the Buddha of healing, had been founded near the Fujiwara capital in 680; it too was moved in 718. The dating of the monumental bronze *Triad of the Healing Buddha* (see fig. 59), which is the main image of the temple, is one of the most controversial issues concerning Japanese Buddhist sculpture. Many scholars argue that the statues were transported to Heijō in 718, but some say that they were made soon after the founding of the temple or that they were not cast until the late 690s. Most convincing in terms of style and technique is the theory that the *Triad* was newly sculpted after the temple was relocated. The statues, which were originally gilded, were produced in the lost-wax technique (*see* §1(ii)(c) above) and were cast in a single pour—evidence of the level of technical sophistication in the government-sponsored temple workshops of the capital. The main image is of the *jōroku* (16 ft) size, thought symbolically to incorporate the proportions of the historical Buddha. The natural proportions, sense of equipoise and fluid drapery of all three images, as well as the animated poses of the attendants, reflect the sophisticated understanding of Chinese styles of the late 7th century. The motifs on the base equally testify to the internationalism of the Buddhist world in the 8th century. Along the upper edge of the pedestal is an arabesque of grapes, a motif with origins in the ancient world. The oval and diamond lozenge patterns below and on the corners are derived from Sasanian sources from ancient Iran, and the mythical animals on the four faces of the base are Chinese geomantic symbols of the four cardinal directions.

The concern with naturalism that characterizes the sculpture of the first part of the Nara period culminates in the statues of the *Ten Great Disciples of the Shaka* and *Eight Classes of Protectors of the Buddhist Faith* at Kōfukuji. The statues were commissioned in 734 by Empress KŌMYŌ as part of a larger sculptural programme in the West Main Hall created to ensure the peaceful repose of her deceased mother. The *Protectors* and six of the *Disciples* are all that survive.

The constraints of the hollow dry-lacquer technique in which the statues were done (*see* §1(ii)(d) above) meant that the sculptors could not impart much animation to the poses of the images, even though the facial features were

60. *Asura*, hollow dry lacquer with polychrome, h. 1.53 m Nara period, *c.* AD 734 (Nara, Kōfukuji)

modelled with great sensitivity to the human form. Although identification of the disciples is purely arbitrary, the images are not types but possess considerable individuality. Similarly the *Protectors*, despite their function as demonic guardians and their supernatural forms, remain highly approachable; the three faces of *Asura* (Skt Ashura) (see fig. 60), for example, conveys great compassion.

(b) 743–57. The second phase of the Nara period is dominated by the *Great Buddha* project at Tōdaiji. Emperor Shōmu's famous edict of 743 on the subject (see de Bary) ran:

> Therefore all who join in the fellowship of this undertaking must be sincerely pious in order to obtain its great blessings . . . If there are some desirous in helping in the construction of this image, though they have no more to offer than a twig or a handful of dirt they should be permitted to do so.

Although Shōmu's ideal was to create a Buddhist state centred around the supreme authority of the throne and the Buddhist *dharma*, he was motivated by political realities as well. The image and the temple to house it were to be the centre of a national system of monasteries and nunneries. Shōmu had ordered their construction two years earlier to extend the authority of the central government into the provinces. Moreover, both projects were to

provide the nation and the throne with protection from the political turmoils that disrupted the capital in the early 740s. In addition, Shōmu and his consort Kōmyō were keenly aware of similar projects in China and felt great rivalry with the court of Emperor Gaozong (*reg* 650–83) and his consort Empress Wu (625–705).

Work on the *Great Buddha* began in 744, and the project was moved to the grounds of what was later known as Tōdaiji, at the eastern edge of Heijō, in 745. In the early 740s, however, Shōmu and Kōmyō commissioned a group of monumental hollow dry-lacquer statues for the Hok-kedō of Tōdaiji that were also intended to provide protection for the nation. Although the textual sources for the distinctive arrangement of deities in the hall are unclear, it seems to be derived in part from the *Sūtra of the Sovereign Kings of the Golden Light Ray*, which espouses a doctrine of divine kingship based on the teachings of the Buddha. The main image of the complex is a statue of *Fukūkenjaku Kannon* (Skt Amoghapasha), an Esoteric manifestation of Avalokiteshvara, the *bodhisattva* of compassion, which was worshipped to provide protection from disasters, in this case the 740 rebellion against Shōmu's government by the courtier Fujiwara no Hirotsugu (*d* 740).

The multi-armed manifestation of *Fukūkenjaku* (h. 3.62 m) is attended by *Bonten* (Skt Brahma; h. 4.03 m) and *Taishakuten* (Indra; h. 3.79 m), the two *Thunderbolt Kings* (Vajrarāja; h. 3.26 and 3.06 m) and the *Shitennō* (*cāturmahārājikas*; the Four Guardian Kings of the cardinal directions; h. 3–3.15 m). The full body and the severe expression of the main image contrast markedly with the idealized naturalism of the statue of *Asura* in the Kōfukuji group, and the dramatic poses of the attendant guardian figures reflect a greater mastery of the hollow dry-lacquer technique than the Kōfukuji statues. The motifs on the armour of the attendants faithfully reproduce textile patterns of the Nara period. Other contemporary works include the clay statues of the guardian *Shūkongōjin* (h. 1.74 m) and the *bodhisattvas Nikkō* (Skt Suryaprabha; h. 2.06 m) and *Gakkō* (Chandraprabha; h. 2.07 m) in the same hall, as well as the *Four Guardian Kings* (h. 1.61–1.65 m) in the Kaidan'in.

The creation of the *Great Buddha* was a massive undertaking; no statue on such a scale had ever been made in Japan. Production was overseen by KUNINAKA NO MURAJI KIMIMARO, who, like many other sculptors of the period, was of Korean immigrant stock. Huge amounts of ore and charcoal were collected in preparation, and the casting alone took 11 months, was done in 8 stages and consumed 372,075 man-days of skilled labour. After each stage, repairs had to be carried out, a process that lasted until 755. In addition, the 966 snail-shaped curls of hair had to be cast individually and set in place on the head; this alone took from 750 to 755.

Before the project was complete the flanking statues of the *bodhisattvas Cintamanichakra* (Jap. Nyoirin) and *Akashagarbha* and the attendant statues of the *Four Guardian Kings* had to be sculpted, the giant wooden hall to house the images erected, and the representations of the Paradise of Shaka had to be engraved on the lotus petals of the base. Finally, the entire statue had to be gilded. The whole project, except for the mandorla behind the main image, seems to have been completed by 757,

although, because of the ill-health of Emperor Shōmu, the dedicatory ceremony was held in 752, when the project was only partly complete. The present statue in the Great Buddha Hall is a reconstruction of late 17th-century date. The legs and the lotus pedestal are all that remain from the original image, so that its former appearance can only be conjectured. The lotus petals of the base seem to be derived from Chinese styles of the early 8th century.

(c) 757–94. While Shōmu's *Great Buddha* project did briefly unify the early Japanese nation, the economic strain it caused—a contemporary chronicle described the project as having 'used up the bronze in the nation'—ultimately meant the demise of the theocracy envisioned by the Emperor. Nevertheless, the official Buddhist sculpture workshop at Tōdaiji remained an important centre of artistic activity until it was closed in 789.

Perhaps the most moving of all the statues dating from this final stage of Nara sculpture is the seated portrait of *Jianzhen* (Jap. Ganjin; 688–763), a Chinese master of the *vinaya* (Jap. Ritsu) sect who was invited to Japan by Shōmu to raise the level of Japanese Buddhism. Sculpted immediately before his death in 763, in the hollow dry-lacquer technique, the image captures the deep spirituality of the monk (see fig. 69 below). Also sculpted by the Buddhist workshop was the main image of Tōshōdaiji (*see* NARA, §III, 9), a private sanctuary founded by Ganjin in 756. Dating from the early 760s, this hollow dry-lacquer statue of the *Great Buddha* (h. 3.05 m) reflects the stylistic changes characteristic of the imagery of the period. Whereas the fluid treatment of the garment is a legacy of early 8th-century styles, the over-size proportions of the head, the massive body and the brooding expression dominated by the elongated eyes are traits previously unknown in Japan. This style has its roots in China of the second quarter of the 8th century and must have been introduced to Japan by the monks and sculptors who accompanied Ganjin.

During the 760s a new lacquer technique was devised by the Buddhist workshop sculptors, partly reflecting their reduced influence and financial circumstances. Known as wood-core dry lacquer (*mokushin kanshitsu*), it used a permanent carved wooden armature instead of the clay core, which meant that fewer layers of costly lacquer and linen cloth were needed to complete an image (*see* §1(ii)(d) above). It came to replace the hollow dry-lacquer technique, although some statues, such as two of the three *Amida Triads* in the Denpōdō at Hōryūji, continued to be made by that means. The earliest extant images made by the wood-core technique are the statues of *Eleven-headed Kannon* from Kannonji (h. 1.73 m) and Shōrinji (h. 2.1 m) in Nara. Both show perceptibly larger body volumes and a severity of expression in keeping with the prevalent stylistic trends. Other noteworthy wood-core dry-lacquer images in Nara include the seated *Buddhas of the Four Directions* (h. 708–50 mm) at Saidaiji, the less well-known *Amida Triad* at the Konbuin and the *Thousand-armed Kannon* (h. 5.36 m) in the Main Hall at Tōshōdaiji.

Contemporary with the statue of the *Great Buddha* is a group of carved wood statues, also at Tōshōdaiji, that had a profound impact on the stylistic development of the sculpture of the Early Heian period. Although there are

no records of a studio at the temple, the large number of extant late 8th-century works housed there inevitably leads to this conclusion.

Wood had not been favoured as a material in Japan for over a century. It is thought that among the group that accompanied Ganjin to Japan were artists skilled in crafting small, finely carved, unpainted images in sandalwood and other aromatic woods. At Tōshōdaiji they worked in more readily available materials, such as Japanese cypress (*hinoki*), and in a larger scale to produce the statues traditionally said to be of the *Healing Buddha* (h. 1.65 m), *Shūhōō Bosatsu* (h. 1.73 m) and *Shishiku Bosatsu* (h. 1.72 m): the last two are both probably statues of Amoghapasha or Fukūkenjaku. The *Healing Buddha* is strictly frontal in its orientation and carved from a single block that included the pedestal on which it stands. The artist emphasized the heavy volumes of the body with deeply carved concentric drapery folds, a distinct departure from the refined elegance of the mid-8th-century styles.

Whereas the technical and stylistic innovations first made at Tōshōdaiji were initiated by immigrant Chinese craftsmen, they seem to have struck a sympathetic chord among the Japanese. Wood rapidly joined lacquer as a preferred material of the sculptor's craft, and Japanese artists began to exploit the materials in ways unknown on the continent. The appeal of wood seems to have been partially rooted in the indigenous Shinto tradition (*see* §II, 2 above), which ascribed great sanctity to monumental trees. In fact, the earliest extant Shinto statues carved from solid monumental blocks of wood date from the very end of the 8th century (*see* §4 below). Other artists created wooden sculptures in more conservative styles, such as eight statues at Daianji (760s). The wood-core dry-lacquer technique was adopted by sculptors at the Tōshōdaiji studio as well, reflecting considerable interchange between independent and government-supported sculptors during the late 8th century.

Although contemporary tales mention numerous statues in small provincial devotional halls, few such statues remain from outside the Nara region. A standing, solid wood *bodhisattva* (h. 1.4 m) at Shōkaji (Kagawa Prefecture, Shikoku) is believed to have been carved as a direct copy of the image of *Shūhōō Bosatsu* at Tōshōdaiji and to have been transported there from Nara in the late 8th century. Wood-core dry-lacquer and solid wood images of *bodhisattva*s (h. 2.04 and 2.15 m) have also been found at Shō Village (Ehime Prefecture, Shikoku). Their stiff poses and awkward proportions suggest that these are provincial interpretations of metropolitan styles.

The spread of Buddhism throughout Japan during the second half of the 8th century resulted in important changes in patronage. The Buddhist faith ceased to be the prerogative of the ruling classes, and consequently the need for imagery increased as the number of privately supported temples multiplied. The renewed use of wood provided sculptors with a readily available and inexpensive material in the capital and provinces alike. Although relations with China remained constant during the early 9th century, artists were never again to rely so closely on continental styles.

BIBLIOGRAPHY

Kodansha Enc. Japan: 'Buddhist sculpture'
T. de Bary, ed.: *Sources of Japanese Tradition*, i (New York, 1958), p. 104
T. Kobayashi: *Tōdaiji no Daibutsu*, Nihon no bijutsu [Arts of Japan], v (Tokyo, 1964); Eng. trans. by R. L. Gage as *Nara Buddhist Art: Todaiji*, Heibonsha Surv. Jap. A., v (New York and Tokyo, 1975)
M. Ooka: *Nara no tera*, Nihon no bijutsu [Arts of Japan], vii (Tokyo, 1965); Eng. trans. by D. Lishka as *Temples of Nara and their Art*, Heibonsha Surv. Jap. A., vii (New York and Tokyo, 1973)

(iii) Heian period (794–1185). The sculpture of the Heian period defies easy characterization. During the first stage, which lasted from the late 8th century to the early 10th, sculptors continued to refine and adapt the wood and lacquer styles of the Nara period (*see* §(ii) above). At the same time Japanese art came under the influence of Esoteric Buddhism (*see* §II, 3 above), and during the 9th century, under the influence of the Buddhist sculpture, Shinto imagery appeared for the first time (*see* §II, 2 above; *see also* §4(ii) below). Although employing styles that derived from continental prototypes, the sculptors of the early Heian period soon abandoned the materials popular during the 8th century to work exclusively in wood, which was readily available throughout Japan. By emphasizing the qualities inherent in their material, they produced works that stood in stark contrast to their stylistic sources.

The history of the sculpture of the second phase of the Heian period (10th–12th centuries) is equally complex. In general its imagery shows the development and perpetuation of wholly indigenous modes of artistic expression. Although a more consistent pattern of stylistic evolution,

61. *Amida*, wood covered with gold leaf and lacquer, h. 2.84 m, Heian period, 1053 (Uji, Kyoto Prefecture, Byōdōin, Hōōdō)

culminating in works such as the seated *Amida* (Skt Amitabha) by JŌCHŌ at the Byōdōin in Uji (see fig. 61), can be recognized from the late 9th century onwards, works in the 9th-century style of unpainted wood sculpture continued to be made as well.

From about the 1060s, an unprecedented number of works appeared throughout Japan in a unified style that was distinguished by extreme idealization and great elegance and replicated the formal qualities of the Buddhist sculpture produced in Kyoto during the first half of the 11th century. By the 1150s, however, artists outside the capital were seeking ways to break with this dominant style.

(a) Early (AD 794–late 9th century). (b) Middle (late 9th century–mid-11th). (c) Late (mid-11th century–1185).

(a) Early (AD 794–late 9th century).

Introduction. Sculpture at the beginning of the 9th century can be roughly divided into two large stylistic groups: a lacquer group, which reflects the survival of the forms and techniques of the official Buddhist sculpture workshop (*Nara bussho*) at Tōdaiji (see NARA, §III, 4), the grandest of the state-sponsored temples of the 8th century; and a wood group, which reflects the new carving techniques and forms introduced from China at Tōshōdaiji (see NARA, §III, 9), an independent temple founded by the Chinese monk Jianzhen (Jap. Ganjin; 688–763) in Nara in 759.

Among the artists thought to have accompanied Ganjin when he arrived in Japan in 753 were sculptors skilled at crafting sandalwood. Small, finely carved, unpainted images in this exotic material were thought to have great sanctity because the legendary first image of the Buddha was said to have been carved from ox-head sandalwood. By the end of the 8th century Japanese artists had adopted both the tradition of working in unpainted wood and the distinctive style of late Tang-period (618–907) sculpture with its emphasis on full, corpulent bodies, elongated lower torsos and sharply defined, concentric drapery folds over the stomach, hips and legs.

One of the first statues from the period to reflect this distinctive mode of sculptural expression is the seated image of *Yakushi* or the *Healing Buddha* (Skt Bhaishajyaguru; h. 1.86 m) at Shinyakushiji in Nara. Sculpted during the late 8th century from a number of blocks of *Torreya nucifera* (Jap. *kaya*) taken from a single tree, the image was left unpainted except for the details of the facial features. The large bulging eyes, full round cheeks and massive body are traits derived from late Tang-period styles, but they attain a new intensity under the hand of the Japanese sculptor and contrast with the more naturalistic forms produced during the first half of the 8th century. Characteristic of this work and most other wooden statues of the early Heian period is the technique used to carve the concentric drapery folds (Jap. *honpashiki*; 'rolling waves'), in which a high, rounded fold, undercut into an asymmetrical cross-section, alternates with a lower, sharp fold with a symmetrical cross-section, resulting in a striking surface pattern.

Another work illustrative of the radical formal change in Buddhist sculpture at around this time is the standing image of the *Healing Buddha* at Jingoji, Kyoto (*c.* 782–93; h. 1.7 m). It is of particular significance because the circumstances surrounding its creation are known: the work was commissioned by the courtier Wake no Kiyomaro (733–99) to provide protection from the spirit of a vengeful monk whose political ambitions Kiyomaro had quashed.

The government-sponsored Office of Tōdaiji Construction and the official Buddhist sculpture workshop housed within it had been closed in 789 because of their resistance to the move to the new capital. Although some artists employed there must have left Nara for Nagaoka and then Heian (now Kyoto), a number of extant works in wood-core dry-lacquer technique attest to the fact that others continued to receive commissions throughout the Nara region. Originally, this technique must have been adopted as an economy measure in the wake of the financially draining *Great Buddha* project at Tōdaiji (see §(ii)(b) above). Subsequently, it was employed for most government-sanctioned commissions during the second half of the 8th century and beyond. In fact, the only dated works in the lacquer group are the Nara-period statues of the *Four Guardian Kings* (Jap. Shitennō; Skt *cāturmahārājika*s; h. 1.36–1.39 m; Nara, Kōfukuji, North Octagonal Hall), originally sculpted in 791 for Daianji. The energy and intensity of these figures contrast markedly with the idealized *Guardians* of the mid-8th century. Another work in wood-core dry lacquer from Nara is a standing *Healing Buddha* (*c.* 796–815; h. 3.7 m; Tōshōdaiji, Main Hall).

62. *Kongō Kokūzō* ('the thunderbolt-carrier'), one of the *Five Great Bodhisattvas of the Void*, wood, h. *c.* 976 mm, early AD 840s (Jingōji, near Kyoto)

Influence of Esoteric Buddhism. The first extant works in the new capital of Heian that reflect the styles and techniques of the *Nara bussho* are the statues on the altar in the Lecture Hall at Tōji (officially known as Kyōōgokokuji), which were completed in 839. Control of this temple–monastery was ceded to the Shingon monk KŪKAI (Kōbō Daishi) in 823. The visual arts were integral to Kūkai's Esoteric Buddhist practice (*see also* §II, 3 above): Buddhahood might be attained at the sight of the attitudes and hand gestures (*mudrā*s) of the holy images. In the 9th century Shingon, and later Tendai, which had been introduced to Japan by Kūkai's contemporary Saichō (767–822), became the official sect of the imperial establishment. Under the influence of Esoteric Buddhism the Japanese Buddhist pantheon rapidly increased in size and new deities were sculpted in increasing numbers. The 21 statues arranged in the form of a *maṇḍala* on the altar of the Tōji Lecture Hall are the earliest extant images to reflect these new doctrines. Fourteen of the statues in the group date from 839; the other seven—the *Five Buddhas* that make up the central unit on the altar, the central image of the *Five Bodhisattvas* and perhaps the statue of *Bishamonten* (or Tamonten; Skt Vaishravana; the Guardian King of the North)—are later replacements. All the original statues preserve some formal and technical links with the styles of the Buddhist sculpture workshop, but the expressive tenor has changed significantly. This change is most evident in the statues of the *Five Wisdom Kings* (or Five Kings of the True Word; Jap. Go Daimyōō; h. 1.75–2.08 m), with their ferocious expressions, multiple arms and legs, complex hand gestures and agitated postures. These occupy the western third of the altar.

The styles and techniques of lacquer sculpture were adapted for many of the images incorporating Esoteric iconography sculpted during the mid-9th century. Noteworthy examples include the *Five Great Bodhisattvas of the Void* at Jingōji (h. 976–991 mm; see fig. 62) and the seated *Nyoirin Kannon* (Skt Chintamanichakra Avalokiteshvara; h. 1.09 m) at Kanshinji (both Kyoto, early 840s). These works were made in a variation of the wood-core dry-lacquer technique. In some places the lacquer is so thin that the form of the carved core determines the form of the image, while in others it is thicker and has been modelled. The statue at Kanshinji, characterized by the sensuous modelling of the arms and face, is important because much of its original polychrome remains intact.

Provincial sculpture in wood. Whereas mid-9th-century works in lacquer seem to have been made almost exclusively for Esoteric temples or metropolitan patrons, works in wood can be found throughout Japan. Unfortunately, little is known of the circumstances of their production. Some of the most prominent of the many examples are the *Eleven-headed Kannon* (see fig. 63) at Hokkeji and the standing *Healing Buddha* (h. 1.66 m) at Gangōji, both in Nara. Although the arrangement of the drapery in parallel folds on the *Healing Buddha* has its sources in the unpainted wood sculpture of the late 8th century, the treatment has become more conventionalized. The folds are shallower and greater in number, resulting in a schematic surface pattern. The statue at Gangōji is technically important for its use of the hollowing technique, which

63. *Eleven-headed Kannon*, wood, h. *c.* 670 mm, Heian period, 9th century (Nara, Hokkeji)

prevented the wood from splitting (*see* §1(ii)(b) above). Hollowing of the wood cores of wood-core dry-lacquer imagery was done increasingly during the second half of the 9th century.

The wide acceptance of Buddhism among the provincial populace during the Early Heian period resulted in an outburst of sculptural activity throughout Japan. During the 9th and 10th centuries popular belief often focused on images of the Healing Buddha (Jap. Yakushi) and Esoteric manifestations of Kannon (Skt Avalokiteshvara), the *bodhisattva* of compassion, worshipped for immediate benefits in this world—to counteract outbreaks of disease, to seek salvation from calamities and to gain protection from vengeful spirits. Images in this category include the *Healing Buddha* (862; h. 1.26 m) at Kuroishidera in northern Japan, the *Triad of the Healing Buddha* (h. 1.42 m) at Shōjōji in Aizu Wakamatsu and the *Eleven-headed Kannon* (h. 1.46 m) at Hagadera in Obama. Although these works reflect the predominant styles of the period, the carving tends to be rougher, the forms less fully realized and the poses more awkward than on their metropolitan counterparts. Further proof of their regional origins is the fact

that the statue at Kuroishidera was carved from *katsura* and those at Shōjōji from elm (*harunire*), woods that occur primarily in northern Japan.

(b) Middle (late 9th century–mid-11th). The Shōjōji statue incorporated a major technical innovation that was further refined in the succeeding centuries. The large block of elm from which the image was carved was first split in two to remove more of the pith wood than would be possible through hollowing, and the two halves were then rejoined. Further technical refinements in joining are seen in images of the early 10th century. The main image of the *Triad of the Healing Buddha* at Daigoji in Kyoto (907; h. 1.77 m) was carved from four pieces of Japanese cypress: one was for the torso and one for the legs, both of which were first hollowed; and one additional piece was attached for each of the shoulders and arms. The splitting and joining techniques used on these two works were precursors to the joined-woodblock technique (*yosegi zukuri*) of the 11th century (*see* §1(ii)(b) above).

By the end of the 9th century artists were beginning to produce images with more introspective countenances and greater formal balance, as is seen by comparing the *Healing Buddha* at Shōjōji with the seated *Amida* at Ninnaji, Kyoto (888; h. 900 mm). Although sculpted no more than 20 years later, the *Amida* exudes a benign serenity absent in the earlier work. In contrast to the relatively small number of rounded drapery folds on the garment of the Ninnaji *Amida*, the robe of the *Healing Buddha* creates abstract geometric patterns through a series of concentric and parallel folds. Whereas the Shōjōji statue looks to the styles of the early 9th century, the Ninnaji *Amida* marks the first step in a pattern of consistent stylistic evolution that culminated in the ethereal, idealized styles of sculpture of the mid-11th century known as the Wayō ('Japanese') style. Other important precursors of the Wayō style are the *Amida Triad* from Seikaji (897; now Kyoto, Seiryōji) and the statue of *Amida* at Gansenji, Kyoto Prefecture (946; h. 2.85 m). The volumes of the body are less than in sculpture of the late 9th century, and the drapery folds of the garment delineate essentially two-dimensional patterns.

Theological developments in the late 10th century had profound implications for the history of Buddhist sculpture. The rapid rise in the popularity of Amida and his Western Paradise in the early 11th century can be traced directly to the appearance of the *Ōjō yōshū* ('Teachings essential for rebirth') written in 984–5 by the Tendai monk Genshin (942–1017). Its doctrine of unbending faith in the compassion of Amida struck a responsive chord among members of the aristocratic élite and in particular the regent, Fujiwara no Michinaga (966–1027). Amida was also believed to be the only hope of salvation at the end of the Buddhist Law (*mappō*), which was calculated to begin in 1052. As a result, the aristocrats of the capital commissioned numerous halls dedicated to Amida, all of which needed to be furnished with statuary. Kōjō (*fl* 990–1020) and his son JŌCHŌ developed an elegant, restrained style of Buddhist imagery that reflected the aesthetic ideals of Michinaga and his contemporaries. Most of Kōjō's commissions for Michinaga have been destroyed by fire; one that remains is the extensively restored seated *Fudō* (Skt Acala; h. 2.65 m; Kyoto, Doshuin, a subtemple of

Tōfukuji). One of Jōchō's most important works, the seated *Amida* (Skt Amitabha; 1053) at Byōdōin (see fig. 61 above) also fortunately escaped destruction. The *Amida* is of the standard *jōroku* (16 ft) size, thought to incorporate symbolically the proportions of the historical Buddha. Both the facial expression and the forms of the body are much idealized, and the solemn grace of the image is heightened by its stable, relaxed pose. The image sits on a high, multi-layered pedestal and in front of a huge gilded mandorla, intricately carved and ornamented with small statues of *bodhisattvas*. Suspended from the ceiling is an ornate gilded canopy, and attached to the upper walls are 52 statues of priests, heavenly musicians and *bodhisattvas* in rhythmical poses representing Amitabha's entourage. The pedestal, mandorla, canopy and the small statues were all carved by Jōchō and his assistants. The statue is carved from Japanese cypress in the joined-woodblock technique. The torso was carved from four blocks and the legs from two; smaller pieces of wood were added to finish the image. To complete the statue the wood was sealed with a layer of cloth and lacquer and then covered in gold leaf.

Little is known about the organization of sculptors during the first two centuries of the Heian period. At Daigoji, for example, and probably elsewhere, monks were in charge of the production of imagery. The development of the joined-woodblock technique and the huge demand for imagery resulted in important changes in studio organization, with many assistants needed, as well as in the status of sculptors. After Jōchō's death, three of his pupils set up independent studios, which became the main schools of sculpture during the last part of the Heian period. Since most sculptors from the mid-Heian period onwards were not monks, honorary monastic titles were conferred upon them as rewards for their artistic achievements. Jōchō was the first artist to receive such a distinction.

Despite the prominent position accorded the Wayō style throughout the 11th and 12th centuries, the legacy of the unpainted wood styles of the 9th century did not totally disappear. The seated *Healing Buddha* (1013; h. 1.08 m) at Kōfukuji and the standing *Healing Buddha* (*c.* 1050; h. 888 mm) at Hōkaiji in Kyoto are just two of a number of images that perpetuate the tradition. The statue at Kōfukuji, executed in the single-woodblock technique, is characterized by sharply carved drapery folds, full proportions and severe expression. The Hōkaiji statue is of unpainted cherry wood, and the robe is carved with many concentric folds. However, the surface has been ornamented with elegant patterns in cut-gold leaf (*kiri-kane*), reflecting contemporary metropolitan tastes.

(c) Late (mid-11th century–1185). This was a period of considerable social change, when politics in the capital were dominated by a succession of four retired emperors. The popularity of faith in the powers of salvation of Amida and the desire to be reborn in that deity's magnificent Western Paradise were at their peak. Jōchō's chief disciple, Chōsei (*d* 1091), and his son Kakujō (*d* 1077) continued to receive commissions from the aristocrats of the capital. None of Kakujō's works remains, but one group of extant statues dating from 1064 can be directly associated with Chōsei—the *Bodhisattvas of the Sun and*

Moon (h. 1.74–1.75 m) and the *Twelve Divine Generals* (h. 1.11–1.23 m; Kyoto, Kōryūji). The characteristics of Jōchō's style are readily recognizable in the carefully regulated poses of the generals and the two-dimensional drapery of the *bodhisattvas*.

In and En schools. During the next generation sculptural production divided into clearly defined lineages. Kakujō's chief disciple, Injō (*d* 1108), succeeded his master and formed what has come to be known as the IN school, whereas Chōsei was succeeded by Ensei (*d* 1134), who founded the competing EN school. One work by Ensei is all that remains of their many commissions, but details, particularly of Ensei's work, are known through records. For example, Emperor GoShirakawa (*reg* 1072–86), an active patron of sculpture, is said to have commissioned 5470 Buddhist paintings, 5 monumental Buddhas, 126 'sixteen-foot' Buddhas, 66 'eight-foot' Buddhas, over 3150 life-size Buddhas and some 2930 small Buddhas (less than 1m high). Raijō (1054–1119), another disciple and possibly son of Kakujō, was appointed official sculptor for Kōfukuji in Nara in 1103. Although his activities were eclipsed by those of his rivals during the first half of the 12th century, his successors became prominent sculptors during the Kamakura period (1185–1333; *see* §3(iv) below).

The distinctive characteristics of the sculpture of the Late Heian period may be seen in almost any of the works in the Jōchō idiom. The seated *Amida* (h. 2.24 m) at the Hōkongōin, a temple in the capital founded by the consort of GoToba, the third of the retired emperors, is a prime example. The work is generally dated to 1130 and attributed to Inkaku (*fl* 1110–40), Injō's successor as head of the In school. Even a cursory glance reveals its direct links to Jōchō's masterpiece in the proportions of the body, the arrangement of the drapery and the placid facial expression, although closer examination reveals the extreme codification of that style in the taut surfaces of the body, the stylized pleats of the garment and an absence of the deep spirituality with which Jōchō imbued his image.

Although the Wayō style is most often associated with aristocratic patronage, it was favoured by patrons of all classes and for images of a great variety of iconographic types. The *Amida* at the Hōkongōin is almost identical with contemporary works from eastern, western and northern Japan. Similar drapery folds, full cheeks and hard surfaces are found on the statue of *Shaka* (Skt Shakyamuni; h. 830 mm) at the Yakushidō in Yakuno-cho at the northern edge of Kyoto Prefecture, on the statue of the *Healing Buddha* (h. 1.34 m) at Burakuji, a rural temple in Kochi Prefecture, Shikoku, as well as on the three seated statues of *Amida* (h. 496–655 mm) produced over a 60-year span by the military governors of northern Japan for their mortuary chapel, the Konjikidō at Chūsonji, Hiraizumi.

The aristocrats of the 11th and 12th centuries also deeply revered the Lotus *sūtra*, since this text promised salvation to men and women alike. The text was often copied on elegantly decorated papers, which were buried in order to preserve them for the time of the coming of the Future Buddha, Miroku (Skt Maitreya). Since the *sūtra* containers were often made of bronze, this practice resulted in a revival of bronze sculpture, which was almost unknown as a material during the 9th and 10th centuries.

Bronze was also favoured for images of syncretic Shinto–Buddhist deities such as Zaō Gongen.

The absence of suitable material meant that stone sculpture in Japan never held the dominant position that it had on the continent. Throughout the Heian period, however, statues were carved on naturally occurring outcrops of rock at isolated sites, probably as the focus of local devotional cults. During the 11th and 12th centuries two large-scale projects were undertaken on the Kunisaki peninsula on the island of Kyushu.

Other important works in wood of the period include the *Four Guardian Kings* (late 11th century; h. 1.67–1.69 m) at Jōruriji in Kyoto Prefecture, noteworthy for the complex polychrome patterns and *kirikane* on the drapery, the statue of *Kichijōten* (the goddess of wealth and beauty; Skt Sri Lakshmi or Srimahadevi; late 12th century; *see* fig. 64), also at Jōruriji, in which contrasting colour is used to brilliant effect to emphasize the carved lines, and the

64. *Kichijōten*, wood and polychrome, h. 890 mm, Heian period, late 12th century (Jōruiji, Kyoto Prefecture)

statue of *Fugen Riding an Elephant* (Skt Samantabhadra; h. 552 mm; Tokyo, Ōkura Shūkokan Mus.), its gently clasped hands entwined with scarves reflecting the popularity of belief in the Lotus *sūtra*.

Less well known is a group of statues found almost exclusively in eastern and northern Japan, distinguished by their roughly carved, unpainted surfaces; for example the standing *Eleven-headed Kannon* (h. 1.81 m) at Gūmyōji in Yokohama. On these statues (*natabori*), instead of leaving the marks of a finishing chisel, as on the unpainted statues of the Early Heian period, the artists left deep parallel striations across the entire surface—perhaps as a conscious reaction against the refined styles favoured by aristocrats in the capital.

The artists of the In and En schools continued to receive commissions in Heian throughout the second half of the 11th century, and the images they produced continued to perpetuate the Jōchō style. In at least one contemporary record Jōchō's statue is referred to as embodying the 'true style' (*honyō*) of Buddhist imagery, and other diaries describe imperial patrons rejecting works because they did not approximate Jōchō's statue closely enough.

Second generation of Nara sculptors. Stylistic change appeared first in Nara, where the sculptors in the lineage of Raijō had often been employed to repair and restore old statues at such powerful sanctuaries as Kōfukuji. Although no extant works can be attributed to Kōjō (*fl* 1115–50), who was the second-generation master in this line of Nara sculptors (*Nara busshi*), the seated *Amida Triad* (1151; h. 1.43 m), at Chōgakuji in Tenri, is symptomatic of the change. The sculptor has abandoned the two-dimensional drapery folds of the Jōchō style and replaced them with plastic folds that create an active surface pattern. To enliven his image further and heighten the naturalistic effect, the sculptor inlaid the eyes from inside the head with glass crystal and painted the pupils in ink ringed with red. The pose of the attendants, with one leg pendant, had been particularly popular during the 8th century, an indication that the sculptor was as adept at reinterpreting the styles of the past as he was at making technical innovations.

The more naturalistic treatment of the body and the adoption of inlaid crystal for the eyes became the most distinctive stylistic signatures of sculptors from Nara at the end of the Heian period. For the eyes, pieces of shaped crystal were inserted into the eye sockets and fixed in place with bamboo pins; black paint and silk or paper simulated the pupils and the whites (*see* POLYCHROMY, §2). Another typical Late Heian work is the seated *Dainichi nyorai* (Skt Mahavairochana; Great Buddha; 1176; h. 982 mm) carved by UNKEI for Enjōji. It stands in stark contrast to the images of the *Five Wisdom Kings* (Kyoto, Daikakuji) carved by Myōen (*d* 1200), the last head of the En school, for the retired emperor, GoShirakawa (*reg* 1555–8) in the same year. This group is thought by some scholars to have been modelled on the 9th-century *Five Wisdom Kings* in the Lecture Hall at Tōji (*see* §(a) above), indicating how styles from the Early Heian period maintained their currency. Unlike their sources, however, the statues by Myōen display a delicacy that is somewhat incongruous with their ferocious appearance.

The burning of the great temples of Kōfukuji and Tōdaiji in Nara in 1180 essentially marked the end of the Heian period in sculpture. Although members of the In and En schools helped to refurbish the many images that were lost in the fires, they were rapidly eclipsed by the *Nara busshi*, who were the pre-eminent sculptors of the late 12th century.

BIBLIOGRAPHY
S. Maruo: *Fujiwara no chōkoku* [Sculpture of the Fujiwara] (Tokyo, 1934)
R. T. Paine and A. Soper: *The Art and Architecture of Japan*, Pelican Hist. A. (Harmondsworth, 1955, rev. 3/1981)
T. Fukuyama: *Byōdōin to Chūsonji*, Nihon no bijutsu [Arts of Japan], ix (Tokyo, 1964); Eng. trans. by R. K. Jones as *Heian Temples: Byodo-in and Chuson-ji*, Heibonsha Surv. Jap. A., ix (New York and Tokyo, 1976)
Kūkai: 'Memorial on the Presentation of the List of Newly Presented Sutras', *Sources of the Japanese Tradition*, ed. W. T. de Bary (New York, 1964)
B. Kurata: *Mikkyō jiin to jōgan chōkoku* [The sculpture of Esoteric Buddhism], Genshoku Nihon no bijutsu [Arts of Japan, illustrated], v (Tokyo, 1967)
J. Rosenfield: *Japanese Arts of the Heian Period, 794–1185* (New York, 1967)
G. Nakano: *Fujiwara chōkoku* [Fujiwara sculpture], Nihon no bijutsu [Arts of Japan], l (Tokyo, 1970)

SAMUEL C. MORSE

(iv) Kamakura period (1185–1333). The principal sculptors of the Kamakura period were the masters of the KEI school who, between the second half of the 12th century and the early 13th, created a new style of sculpture. The term Kei school (*kei ha*), applied by modern art historians, derives from the fact that many of these masters of Buddhist sculpture had the character *kei* ('to congratulate') in their names. Initially, KŌKEI, UNKEI and others were based in Nara, and in the 12th century and later they were called *Nara busshi* ('Nara Buddhist masters') or *Nankyō busshi* ('southern capital Buddhist masters'), even though Unkei eventually moved the school's headquarters to Heiankyo (now Kyoto).

The mid-12th century marked the beginning of a period when a new style, different from the Jōchō style (*Jōchō yōshiki*) and from that of the In and En schools, was developed by the *Nara busshi* (*see* §(iii) above). In 1176, under the guidance of his father Kōkei, Unkei produced the wooden statue of *Dainichi* (Skt Mahavairochana; the Buddha who expounded Esoteric Buddhism) for the Enjōji in Nara. The direction of the new style is apparent in the use of crystal for the eyes and in the rhythmic body forms with tense waists. The trend is advanced in the wooden statue of *Jizō* (Skt Kshitigarbha; a *bodhisattva*, dressed as a monk, who delivers people from the world; 1177; Shizuoka, Zuirinji), which is thought to have been created by Kōkei. The intensity of expression has increased, the drapery is more fluid and the powerful force of the bending torso marks a clear departure from the Jōchō style.

(a) Early (1185–1223). (b) Middle (1223–56). (c) Late (1256–1333).

(a) Early (1185–1223). In 1180 the two large Nara temples, Tōdaiji and Kōfukuji (*see* NARA, §III, 4 and 7), had been largely destroyed by fire by the Heike [Taira] family forces. The restoration of the two temples began

almost immediately, and the *Nara busshi* played an important role in the production of the Buddhist imagery. It was during this period of restoration that a new Kamakura-period style was established. Inson (1120–98) of the In school and Myōen (*d* ?1199) of the En school were in charge of the restoration programme at Kōfukuji; the *Nara busshi* Seichō (*fl* 1181–94) took charge of the creation of the statues for the Saikondō (West Main Hall) and Kōkei of those of the Nan'endō. About 1185, Seichō went to Kamakura, where he produced the Buddhist images (destr.) for the Shōchōjuin for Minamoto no Yoritomo (1147–99), who had just established the Kamakura shogunate. In 1186, Unkei created such works as the wooden statues of the *Amida* (Skt Amitabha; Buddha of the Western Paradise), the *Triad of Fudō* (Skt Acala; the Immovable One) and *Bishamonten* (Skt Vaishravana; Guardian King of the North) at the Ganjōjuin in Shizuoka for an important member of the shogunate, Hōjō no Tokimasa (1138–1215). In each figure the fierce eyes and nose, the massive torsos, tensed in the primary areas, and the richly varied drapery illustrate a style in which a sense of movement and naturalism is emphasized. Commissions for the Kamakura shoguns generated works that reflected the vitality of the age, in particular the rough and animated spirit of the samurai of the Kantō region, and ultimately brought the Kei school to prominence and power.

In 1189, during the restoration programme at Kōfukuji, such statues as Kōkei's *Fukūkenjaku Kannon* (Skt Amoghapasha Avalokiteshvara), the *Shitennō* (Skt *cāturmahārājika*s; Four Guardian Kings), the *Hossō rokuso* (Six Patriarchs of the Hossō Sect) and the *Honzon* ('principal image') at the Saikondō (only the head remains), conjectured to be by Seichō, were completed. Each of these statues possesses the same special qualities as the Ganjōjuin figures. Particularly in the portraits of the *Hossō rokuso*, the bold, undulating drapery forms and exaggerated features of the subject created an expressive effect, encapsulating the new Kamakura-period sculptural style. In 1194 Seichō received the ecclesiastical title *hokkyō* (Bridge of the Law), which marked the end of his career.

At Tōdaiji in 1194 Kaikei and Jōkaku (*b c*. mid-12th century), followers of Kōkei, created the wooden *Niten* (Two Devas; destr.) for the Chūmon (Middle Gate), and in 1196 Kōkei, Unkei, Kaikei and Jōkaku produced the wooden statues of the *Shitennō* (destr.) and *Kyōji* (Attendants; destr.) for the Daibutsuden. This was Kōkei's last project; after this period Kōkei's son Unkei became the head of the school. In 1203 the giant wooden image of the *Kongōrikishi* or *Niō* (temple gate guardians; see fig. 65) was completed for the Nandaimon (Southern Main Gate) in about 70 days, probably by Unkei as *daibusshi* (master sculptor), together with Kaikei, Jōkaku, Tankei (1173–?1256) and various disciples or assistants (*shōbusshi*; 'lesser Buddhist master'). Such rapid production entailed many assistants and the use of the joined-woodblock construction technique (*yosegi zukuri*) that had become widespread after the late Heian period. The fact that the restoration of the statuary at Tōdaiji, the foremost large imperial temple constructed in the Heian period, was given to Kei school sculptors testifies to the value that was accorded them and their new style of sculpture.

The restoration work was also an important factor in the subsequent development of the Kei school. The *Nara busshi* at Tōdaiji worked under the guidance of the monk Chōgen (Shunjōbō Chōgen; 1121–1206), who had a rich understanding of the culture of the contemporary Chinese Song dynasty (960–1279) and indeed had urged the Chinese craftsman Chen Heqing (Jap. Chin Nakei; *fl* 1183–1217) to undertake the metalwork on the temple's *Great Buddha*. Song-period cultural ideas were thus reflected in the works of the Kei-school masters of the period. In 1197 Unkei repaired the statuary in the 9th-century lecture hall at Tōji (Kyōōgokokuji) in Kyoto. These and other works show the style of the Kei-school Buddhist masters to have been deeply rooted in classical sculpture before the time of Jōchō. The Nara region, where they had their headquarters, was a rich repository of Buddhist sculpture of the 8th century, an environment that provided them with favourable influences.

In 1203 Unkei was elevated to *hōin* (Seal of the Law), the highest ecclesiastical rank awarded to Buddhist monks by the government. His style at this time was essentially a continuation of that of his earlier work but more refined, as is evinced in the voluminous drapery and lithe torsos of his figures. From 1208 to 1212 Unkei led his sons and disciples in the production of pieces for the Hokuendō at the Kōfukuji. Representative works of his late period, they have a lean and severe feel and lack the rich craftsmanship of many of his early images; but they have a tension that is testimony to the attainment of the height of perfection in three-dimensional art. Moreover, the best features of Buddhist sculpture from before the Kamakura period are incorporated in these statues, for example in the drapery and the shapes of the faces. The Hokuendō works stand as a testament to the development of Japanese Buddhist sculpture after the 7th century. On each of the statues are recorded the names of Unkei's sons and disciples, who may have executed the projects, although it was Unkei who led the entire group and it is his superb workmanship and artistry that permeate the images. This period not only marked the pinnacle of Unkei's personal style but was also a golden age for his whole studio.

Seikei (1183–1212) and Genkei (*fl* 1183–1226), who created the images of the Hokuendō under the leadership of Unkei, were mentioned for their artistic skill in the *Hokkekyō*, or *Myōhō renge kyō* (Lotus Sutra; Ueno priv. col.), commissioned and hand-copied by Unkei in 1183, thus indicating their senior position as sculptors of Unkei's school. The work also mentions the then extant wooden *Amida Triad* (1196) at the Honeiji in Saitama as the work of the sculptor Sōkei (*fl* 1183–96); the extant wooden *Dainichi* (1210) of Shuzenji in Shizuoka as a work by the sculptor Jikkei (*fl* 1183–1210) and the *Amida Triad* of the Yakushidō at Kuwabara in Shizuoka, which is thought to have been completed earlier. The style of Sōkei and Jōkei was associated with Unkei's, but they added a number of individualistic elements and exhibited a lesser degree of skill, which, it is conjectured, represents the level of mastery of the average member of the Kei school. In 1210 Unkei moved the headquarters of his sculpture workshop from Nara to Kyoto.

It is possible that Kaikei was a student of Kōkei and a fellow student of Unkei. The first known reference to

65. Unkei and others: *Kongōrikishi* or *Niō* (temple gate guardian), wood, h. *c.* 8.4 m, Nandaimon (Southern Main Gate), Tōdaiji, Nara, 1203

Kaikei occurs in 1181 in Unkei's *Hokkekyō*. Kaikei's extant works number about 40. The pieces (all in wood) from the first half of his career illustrate a powerful style common to other masters of the Kei school. He was one of the principal sculptors involved in the restoration at Tōdaiji. He was closely associated with Chōgen and members of the aristocracy and collaborated frequently with other members of the Kei school, but, unlike Unkei, he also undertook individual projects. Extant works such as the wooden *Sōgyō Hachimanshin* (Hachiman as a monk) at Tōdaiji (1201) and the standing *Amida* of the *Shunjōdō* (also Tōdaiji; 1202) illustrate his easily understood, individualistic style with its contours and beautifully arranged surface drapery. This period represents the peak of Kaikei's style. His later painterly and figural style is fully seen in the wooden *Amida Triad* (1221) of the Kōdaiin of Wakayama and in the standing figures (wood; h. 3 *shaku*, c. 1 m) of the *Raigō Amida* (Buddha welcoming souls into his Paradise; e.g. at the Shunjōdō), a theme popular during this period. Kaikei's *Amida* greatly influenced the forms of subsequent sculptures of Amida that were referred to as being in the *An'amiyō* ('An'ami style') after Kaikei's *gō* (artist's name) of An Amida Butsu. The style continued to be familiar into the Edo period (1600–1868). The extant works of Gyōkai (*fl* ?1216–51), a premier student of Kaikei, include the wooden *Shaka* (Skt Shakyamuni; the historical Buddha) of Daihōonji in Kyoto (1220–27) and the *Amida* of Amidaji in Shiga (1235). Gyōkai's style was essentially a continuation of Kaikei's, yet he simplified his method of carving, for example in the drapery and the faces of his images, and his works tended towards formalization. Other students of Kaikei included Eikai (*fl* 1254–6), who produced the wooden *Jizō bosatsu* (the *bodhisattva* Kshitigarbha) of Chōmeiji in Shiga (1254), and Chōkai (*fl* 1256), who made the *Monju Bosatsu* (Manjushri, the *bodhisattva* of supreme wisdom) for the lecture hall of Tōdaiji, together with Tankei, in 1256.

It is thought that Jōkei was also one of Kōkei's leading students. During the rebuilding of Kōfukuji he created the wooden *Yuima koji* (Skt Vimalakirti; Yuima the lay disciple; 1196) for the Tōkondō (East Main Hall). This superbly realistic work reveals the artistic inheritance of such pieces by Kōkei as the *Hossō rokuso* at the Nan'endō. In 1201–2 Jōkei carved the wooden *Bonten* (Brahma) and the *Taishakuten* (Indra; Tokyo, Nezu A. Mus.) for the Tōkondō. Of the many statues at the Tōkondō, the wooden image of *Jūnishinshō* (the Twelve Divine Generals; c. 1207) may also be by Jōkei. The *Shaka nyorai* of the Bujōji in Kyoto (1199) and the *Miroku bosatsu* of the Chūshōin at Tōdaiji (c. 1199), which strongly reflect the influence of Buddhist painting from Song-period China, are thought to be the works of Kei-school masters.

(b) Middle (1223–56). After Unkei's death in 1223 his eldest son, Tankei (1173–?1256), became head of the school. Tankei's first project was the *Niō* (guardian deities) of the Nandaimon (Great South Gate) at Tōdaiji (c. 1197), which was completed by the students of the school under his leadership. In the Kōfukuji Hokuendō figures (1212), Tankei took charge of the *Jikokuten* (Skt Dhrtarashtra; Guardian King of the East; destr.), one of the *Shitennō*, which was originally under Unkei's supervision. It was at this time that he received the ecclesiastical rank of *hōgen* (Eye of the Law). In 1213 he was elevated to *hōin* (Seal of the Law) for his work on the images (destr.) of the Nine-storey Pagoda at the Hosshōji in Kyoto. In 1218 he began work as a master sculptor (*daibusshi*), together with Inken (*fl* 1200–33), on the *Shibutsu* (Four Buddhas; destr.) at the Tōtō (Eastern Pagoda) at Tōdaiji. In 1223 he and Kaikei divided the work on the statuary (destr.) at the Enmadō at Daigoji in Kyoto. In 1224 he began an *Amida* (destr.), as a prayer for the salvation of his parents, which was enshrined at the Jōrengein, built in 1229. After 1224, he worked on his representative pieces, the statues (destr.) at the halls at Kōzanji in Kyoto, and he became the *daibusshi* for the restoration of the 1000 images of the *Senjū Kannon* (Skt Sahasrabhuja Avalokitesvara; Thousand-armed Kannon) of the Rengeōin, Kyoto, which had been destroyed by fire in 1249. The middle section of the *Senjū Kannon* (now the principal object of worship of the Sanjūsangendō at Myōhōin; *see* §(c) below) was completed by Kōen (*b* 1207; *d* after 1275) and Kōsei (*fl* 1237–54) under his leadership. Tankei died in 1256 during the making of the *Senjū Kannon*, for which he was the *daibusshi*, at the Lecture Hall of Tōdaiji. It was completed by Kōen. Other extant works by Tankei include ten standing images of the *Senjū Kannon* at Myōhōin, as well as the wooden triad of *Bishamonten* (Skt Naishravana; Guardian King of the North; date unknown) at the Sekkeiji in Kōchi. The wooden *Byakkōshin* (White Bright God) and the *Zenmyōshin* (Virtuous Mysterious God) of Kōzanji in Kyoto may also be his work.

Tankei's style is based on Unkei's but with an added softness; as such, it is typical of the sculpture of the generation following Unkei. However, compared with the masters of the early Kamakura period, such as Unkei, there is no doubt that these works convey feeling less powerfully and are less individualistic in character. The artist and date of the wooden *Fūjin* (God of wind), *Raijin* (God of thunder) and *Nijū Hachibushū* (Multitude of 28) at the Myōhōin Sanjūsangendō are unknown, but they are superb extant examples by Kei-school masters of about the mid-13th century.

Unkei's other sons included, from eldest to youngest, Kōun (*fl* 1199–1218), Kōben (*fl* 1199–1215), Kōshō (*fl* 1199–1233), Unkga (*fl* 1199–1255) and Unjo (*fl* 1199–1208). Under their father's guidance, they participated in the work on the *Niō* statues (destr.) at the Nandaimon at Tōji in Kyoto and on the statues of the Hokuendō at Kōfukuji. From inscriptions it is known that Kōkei made the *Zōchōten* (Virudhaka; the Guardian King of the South; destr.), Kōben the *Kōmokuten* (Virupaksha; the Guardian King of the West; destr.), Kōshō the *Tamonten* or *Bishamonten* (destr.) and Unka the *Muchaku* (Ashanga; a philosopher; destr.), while Unjo probably took charge of the work on the *Seshin* (Vasubandhu; a Buddhist priest; *see also* §5 below). Extant works of Kōben include the *Ryūtōki* (Dragon-lantern Demon) of Kōfukuji. Those of Unjo include the bronze statues of the *Amida* of the Kondō (Golden Hall) of Hōryūji in Nara, the *Kyōji* on the left-hand side (1232) and the wooden *Kōbō Daishi* of the Mieidō at Tōji in Kyoto (1233). His extant works, like Tankei's, are in the rich, naturalistic style that continued the tradition of Unkei.

Another leading Kei sculptor was Higojōkei (*b* 1184; *d* after 1256), also known as Higobettō or Higohokkyō, who was approximately contemporary with Tankei. His artistic activity was unique, and inscriptions on his extant works refer to the *Nanpō ha* ('southern direction school'). In 1224 he made the wooden *Rokkannon* (Six Kannon) of the Daihōonji in Kyoto, in 1226 the *Shō Kannon* of the Kuramadera in Kyoto (see fig. 66), and in 1256 the *Yuima koji* (destr.), one of the statues of the lecture hall at Tōdaiji, a project principally supervised by Tankei. Other extant works include such statues as the wooden *Kongōrikishi* of the Ōzōji in Gifu (1256). The special characteristic of style is the extremely realistic treatment of facial features, which seem to reflect the sentiments of living individuals and convey an impression of worldliness. He seems to have been strongly influenced by Buddhist painting of Song-period (960–1279) China. Higojōkei's style was a forerunner of Buddhist images that gradually became common in the later half of the 13th century.

The *Nara busshi* Zen'en (1197–1258) was active principally in Nara. It is not known whether he worked with either Unkei or Tankei; nevertheless, his work, which is technically superb, reveals that he had thoroughly studied Unkei's style. He made the wooden *Jūichimen Kannon* (Skt Ekadasamukha Avalokiteshvara; Eleven-headed Kannon; 1221; Nara, N. Mus.), the wooden *Shaka nyorai* (1225; Sashizudō), the wooden *Jizō bosatsu* (1240; Nara, Yakushiji), which had been commissioned by the monks of Tōdaiji, the wooden *Aizen myōō* (Skt Ragaraja or Vajrarajapriya; King of Passion; 1247; Nara, Saidaiji), which was commissioned by the monk Eison, among other extant examples. Dates and similarities in style have led scholars to conjecture that the *hokkyō* (Bridge of the Law) Zenkei, who produced the wooden *Shaka nyorai* together with Zōkin (*b* 1194; *d* after 1249), Gyōsai (*b* 1198; *d* after 1249), Kankei (*b* 1214; *d* after 1254) and others for the Saidaiji in Nara in 1249, was in fact Zen'en. During this period it was not unusual for monks to change their names. In 1255 Zenkei began the production of the wooden *Monju bosatsu* of Hannyaji in Nara, a project that was commissioned by Eison, but he died three years later. The *Shishi* (clay figurines; destr.) of Hannyaji, which had been left unfinished by Zen'en, were completed by his son Zenshun (*fl* 1263–82). Other extant examples of Zenshun's sculpture include the wooden *Shōtoku Taishi* ('Prince Shōtoku') of the Gokurakubō of Gangōji in Nara (1268) and the wooden image of *Eison* of Saidaiji, also in Nara (1280). As in these works, the sculpture of the Zenkei or Zen'en school often had a connection with the monk Eison, who first promulgated the Ritsu sect of Shingon Buddhism in Japan. Other Buddhist sculptors who were active in his circle were Kaisei (*fl* 1242–56) and Enkaku (*fl* 1263–6).

There are extant works by Kei-school masters from Unkei onwards in the Kantō region. The Buddhist sculptor Keizen (*fl* 1246), who made the wooden *Shōtoku Taishi* for the Tenshūji in Saitama in 1246, may also have been a member of the Kei school. From the mid-13th century sculptors developed an unusual style in the Kamakura region, based on the work of Unkei but also influenced by the sculpture of Song-period China. Examples are the wooden *Shokōō* (King Shokōō) of Ennōji in Kanagawa by

66. Higojōkei (attrib.): *Shō Kannon*, wood, h. 1.77 m, 1226 (Kyoto, Kuramadera)

Kōyū (1251) and the bronze *Amida* of the Kōtokuin in Kanagawa, which was begun in 1252.

(c) Late (1256–1333). After the death of Tankei in 1256, Kōen (*b* 1207; *d* after 1275) became the leading figure among third-generation Buddhist sculptors of the Kamakura period. Kōen served as *shōbusshi* (assistant) to Tankei on the wooden *Senjū Kannon* of the principal image

of the Rengeōin (1254), and six of the thousand pieces that were made by Kōen remain. Kōen completed the work on the *Senjū Kannon* (destr.) at the lecture hall of Tōdaiji for the master Tankei, who died during the project. Other extant sculptures by Kōen include the wooden *Jizō bosatsu* (1249; Cologne, Mus. Ostasiat. Kst), the wooden *Monju gozon* (Monjushri Quintet; 1273; formerly Tokyo, Nakamura priv. col.; now Tokyo, Agy Cult. Affairs) and the *Aizen myōō* of the Jingoji in Kyoto (1275). He drew on Tankei's style, yet gradually established an exaggerated, formalized version of it, as did other sculptors of the late Kamakura period. Technically Kōen's work does not compare favourably with the work of earlier generations.

The generation following Kōen included the *hokkyō* Unjitsu (*fl* 1280) and others who participated in the restoration of the *Jūichimen Kannon* at Haseji, which had been destroyed by fire in 1280. The artists who assisted Unjitsu with this project—Tankō (*fl* 1279–1333), Keishū (*fl* ?1259–85), Keien (*fl* 1259–89), Keishun (*b* 1228; *d* after 1286) and others—corresponded in age with the fourth generation in the lineage of Unkei. Extant works by Keishū and Tankō include the wooden *Kongōrikishi* of Shōjiji in Kyoto (1285) and, by Tankō alone, the wooden *Monju bosatsu* at the Monjudō in Fukuoka (1333). Kōyo (*fl* 1326–46), who called himself a fifth-generation descendant of Unkei, and Kōshun (*fl* 1315–69), a sixth-generation descendant, were active towards the end of the Kamakura period and into the Muromachi period (*see* §(v) below).

BIBLIOGRAPHY

H. Mōri: *Busshi Kaikei ron* [Essay on the *busshi* Kaikei] (Tokyo, 1961, rev. 1987)
S. Nishikawa, ed.: 'Kamakura chōkoku' [Kamakura sculpture], *Nihon no Bijutsu*, x1 (1969) [whole issue]
——: *Kōfukuji 2* (1970), viii of *Nara rokudaiji taikan* [General view of the six great temples of Nara] (Tokyo, 1968–73)
K. Mizuno: *Unkei to Kamakura chōkoku* [Unkei and Kamakura sculpture] (Tokyo, 1972)
S. Nishikawa, ed.: *Tōdaiji 3* (1972), xi of *Nara rokudaiji taikan* [General view of the six great temples of Nara] (Tokyo, 1968–73)
S. Tanabe, ed.: 'Unkei to Kaikei' [Unkei and Kaikei], *Nihon no Bijutsu*, xxviii (1972) [whole issue]
H. Mōri: 'Jōchō yori Unkei e—Fujiwara jidai no Nara busshi' [From Jōchō to Unkei—the *Nara busshi* of the Fujiwara period], *Bijutsushi*, 31 (1975), pp. 83–97
K. Nishikawa: *Chōkoku (Kamakura)* [Sculpture (Kamakura)], Bunkozai kōza Nihon no bijutsu [Lecture of cultural properties of Japanese art], vii (Tokyo, 1977)
T. Kobayashi: *Nihon chōkoku sakka kenkyū* [Research on the artists of Japanese sculpture] (Yokohama, 1978)
Tokubetsuten zuroku Kamakura jidai no chōkoku [Pictorial catalogue of the special exhibition: Sculpture of the Kamakura period] (exh. cat., Tokyo, N. Mus., 1979)
K. Mizuno: *Unkei to Kaikei* [Unkei and Kaikei], Nihon no bijutsu zenshū [Complex collection of Japanese art], x (Tokyo, 1991)

HIROMICHI SOEJIMA

(v) Muromachi, Momoyama and Edo periods (1333–1868).
While an enormous amount of Buddhist sculpture remains from the Muromachi period (1333–1568), Japanese Buddhist sculpture is almost invariably defined in terms of earlier images dating from between *c.* 590 and *c.* 1250. The main reason for this is the transfer of creative energy to painting seen in the Muromachi and subsequent periods and the attendant shift in focus of scholarly attention from sculpture to the Zen painting tradition of the 14th century and later. The general lack of interest in sculptural icons by Zen sects meant that they did not become important patrons of sculpture as had the older Buddhist sects such as Shingon, Tendai and Jōdo. Nevertheless, these older sects continued to require standard Buddhist icons, as did newer movements. Moreover, the establishment of new temples, loss of images through fire and other causes, or the pious dedication of new icons gave rise to the steady production of sculpture during this period.

Inscribed images, which were especially abundant during the Muromachi period (1568–1600), combined with other documentary data, are an invaluable source of information about the family lineages of sculptors, the organization of major studios and the modes of production and indeed the history of Japanese sculpture. Given the historical importance of Muromachi sculpture and the related documentation, it cannot be denied that the actual monuments are somewhat lacking in aesthetic appeal and seem uninspired, showing signs of what may be called 'stylistic fatigue'.

The constant repetition of earlier stylistic and iconographic formulae, without the infusion of new artistic, doctrinal or social components, must almost inevitably have led to the production of bland, dispirited pieces. Not that the images were technically inadequate; rather, it was their technical excellence—extremely elaborate surface pattern and complexity of detail—that tended to weaken the overall expressive character of the works.

67. Enkū: *Fūdō Triad*, showing Fūdō Myōō with two attendants, wood, h. 890 mm, second half of the 17th century (Seiryūji, Tochigi Prefecture)

Little sculpture can be ascribed to the Momoyama period (1568–1600), the era when Japan was reunified after a lengthy period of internecine warfare. Perhaps most significant was the repair work carried out on the Tōdaiji *Great Buddha* and the construction by the military leader Toyotomi Hideyoshi of a new *Great Buddha* for his Kyoto temple, Hōkōji. However, the Edo period (1600–1868) is far more significant to the history of Japanese Buddhist sculpture than has been generally recognized. The sort of orthodox sculpture seen in the Muromachi period continued to be made, and such important sculptors as Hōzan Tankai (1629–1716) and Shimizu Ryūkei were active. In addition, various important commissions were carried out, including further repair work at Tōdaiji. Nevertheless, the monuments produced during these centuries by orthodox sculptors, like those of the Muromachi period, are generally of limited aesthetic interest. The exceptions to this rather melancholy assessment of the Edo period include two of the greatest Japanese Buddhist sculptors, ENKŪ and MYŌMAN MOKUJIKI. Unlike nearly all sculptors during the Muromachi and Edo periods, who were affiliated with studios, Enkū and Mokujiki were both itinerant monks who travelled throughout the Japanese islands making images, primarily in remote areas, and thus bringing Buddhist practice to rural communities where it had not previously been important. Despite the primacy of their missionary vocations, both monks, especially Enkū, were superlative sculptors who carved large numbers of fascinating images (see fig. 67). The very excellence of their work seems to result fundamentally from their distance from the orthodox traditions and must reflect something of the new vitality of the countryside during the Edo period.

BIBLIOGRAPHY

Muromachi jidai butsuzō chōkoku [Buddhist sculpture of the Muromachi period], Nara National Museum (Nara, 1970)

S. Uehara: 'Muromachi chōkoku' [Muromachi sculpture], *Nihon No Bijutsu*, xcviii (1974)

S. Tanabe and M. Honma: *Chōkoku: Nanbokuchō-kindai* [Sculpture: Nanboku period to modern times], Bunkazai koza Nihon no bijutsu, [Lectures on cultural properties: Japanese art] viii (Tokyo, 1977)

4. SHINTO.

(i) Introduction. (ii) Early Heian *shinzō*, 9th–10th centuries. (iii) Later Heian *shinzō*, 11th–12th centuries. (iv) Kamakura and later *shinzō*.

(i) Introduction. While an extraordinary number of Buddhist images exist (*see* §3 above), the corpus of SHINTO sculpture is relatively small. This is because virtually all Buddhist temples have sculptural icons, but Shinto shrines usually do not possess representations of the deities in anthropomorphic form (*see also* §II, 2 above). Instead, the Shinto deities (*kami*) are believed to be incarnated in symbolic objects, such as a mirror or jewel, or in natural forms, such as a tree or rock. The overwhelming stimulus that Buddhism exerted on Japan from the 6th century altered all pre-existing religious traditions to a greater or lesser extent, and evidence suggests that three-dimensional depictions of the *kami* resulted from the influence of Buddhist imagery; it is thus impossible to discuss Shinto sculpture (*shinzō*) without reference to the Buddhist tradition.

Shinto shrines usually occupy an area that includes natural forms such as trees, rocks or water, and their structural components are primitive (*see* §III, 3(i) above). The *kami* are not conceived in terms of close personal relations with the believers but rather as embodiments of more generalized spiritual power, and many of the most important shrines do not have anthropomorphic sculptures of *kami*.

Shinzō can ordinarily be distinguished from Buddhist images in terms of formal characteristics, and they evidently encode a different range of meanings. Generally *shinzō* were made by Buddhist sculptors who nevertheless would have endeavoured to incorporate into the *shinzō* the particular qualities attributed to the *kami*. Thus, although there are no absolute distinctions between *shinzō* and Buddhist images, four main points of difference may be observed. First, although some *shinzō* are life-size, most are quite small, and they are never made in the monumental format so frequently seen in Buddhist imagery. Second, *shinzō* tend to be much simpler than Buddhist icons, lacking such attributes as complicated drapery elements and elaborate jewellery. Third, *shinzō* tend, with certain exceptions, to emphasize the natural quality of the wood and exploit its characteristics. Fourth, although a few *shinzō* have rather stern, even awe-inspiring expressions, most have a tranquil, somewhat bland character and generally lack the strong spirituality of Buddhist icons.

Within the Buddhist tradition there is the concept of the 'hidden Buddha' (*hibutsu*), an icon housed in a closed shrine box and revealed to the faithful only occasionally. Although it is probable that the *hibutsu* concept affected Shinto practice, the great secrecy in which *shinzō* are enshrined seems more ubiquitous. At the most basic level there was no reason to show a *shinzō*, for it was not conceived of as an object of meditation or contemplation, nor were there any rituals that required the worshipper to confront the image directly. *Shinzō* are extremely limited in narrative content, do not convey information about the activities of the *kami* and provide only a quite generalized version of the *kami*'s appearance. Narrative information concerning the *kami* was, when needed, imparted through pictorial representations that were not secret. In general, *shinzō* are not especially impressive as religious imagery, and thus it may be that maintaining an aura of mystery was thought to contribute to the potency of religious belief. Worshippers never expected to see the main object of worship (*shintai*) of a shrine, which, whether it was a *shinzō* or not, was treated as too sacred or powerful to be revealed to human eyes.

(ii) Early Heian shinzō, 9th–10th centuries. It is possible that *shinzō* were made by the second half of the 8th century, but the earliest extant images are from the 9th century, at the beginning of the Heian period (794–1185). Perhaps the earliest *shinzō* are the two triads of *Hachiman and Two Attendants*, depicting Hachiman as a monk with two female attendants, one kept at the great Shingon temple of Tōji, Kyoto (mid-9th century; h. 1.1 m), the other at Yakushiji, Nara (late 9th–early 10th century; h. 360–80 mm). The two sets are closely related in iconography but differ in technique and style. Hachiman, one of the most important *kami*, is the most frequently depicted in *shinzō* form. His cult, originating at the Usa Shrine in northern Kyushu, combined a variety of beliefs and

practices that had a broad enough appeal to allow nationwide acceptance. Hachiman was especially closely associated with Buddhism and became central to official religious policy and practice. In 749 Hachiman was transferred from the Usa Shrine to Tōdaiji in Nara. In 859 the Iwashimizu Hachiman Shrine was established near the then capital Heiankyō (now Kyoto), and in 1180 the Tsurugaoka Hachiman Shrine was dedicated in Kamakura (*see* KAMAKURA, §1(ii)), the seat of the military government. These shrines were centres of the state cult of Hachiman and indicate clearly the status of the deity. Interestingly, none of the shrines had a *shinzō* as the central object of worship, nor does it appear that 8th-century Tōdaiji had one either; thus, early sculptural depictions of Hachiman are best seen enshrined in temples that are not primarily known as centres of Hachiman worship.

The Tōji *Hachiman Triad* was not 'discovered' until 1956, when restoration was being carried out at the temple. The fact that the images were hidden away in boxes indicates the degree of secrecy that often surrounded *shinzō*. Hachiman is portrayed as a monk, with shaven head and monastic robes, while the two female attendants have long hair and robes similar to Hachiman's except that they have decorative borders at the hems. These figures are the only examples of *shinzō* made in the wood-core dry-lacquer technique (*mokushin kanshitsu*), a peculiar feature, since ordinarily Shinto images emphasize the natural qualities of wood. However, scientific examination has revealed that all three were made from the same decayed log, used presumably because this wood was holy (*shinboku*; 'holy wood'). Stylistically, the *Hachiman Triad* is closely related to a number of mid-9th-century Buddhist sculptures in the orthodox style at Tōji and other temples.

In the *Hachiman Triad* at Yakushiji the figures are less than half as tall as those of Tōji, and are executed in the woodblock technique instead of dry lacquer. Significantly, these images are also carved from a single log, and it is interesting to note that the central axes of the figures are aligned to the heart of the wood. Since this procedure is not practical, as it leads to cracking, it must have been employed because of the symbolic importance attached to the wood. However, these images are not in the most characteristic pure wood form of early Heian sculpture since each has elaborate polychromy, although the typical deeply cut, emphatic carving of the drapery folds is very much in evidence, especially in the Hachiman figure. Hachiman is characterized as a monk, like his Tōji counterpart, but the Yakushiji women wear robes that appear to be court costumes, and their heavy coiffures may have a similar significance. Both triads reflect the Buddhist arrangement of a Buddha flanked by two *bodhisattva*s (see fig. 53 above), who are typically shown as feminine. This congruence with Buddhist icon grouping, plus the monk form of Hachiman, places the Tōji and Yakushiji triads directly within a Buddhist ideological context.

Other early Heian *shinzō* are less directly related to Buddhist imagery in appearance. An especially impressive example is a group of three images at the Matsunōō Shrine, Kyoto (late 9th century), consisting of two male deities and one female. This does not seem to be a triad, although one male and the female may be meant as a pair, perhaps representing the main *kami* of the shrine and his consort. Although the principal male deity reflects Buddhist influence in the cross-legged pose, he wears a court robe and cap and holds a *shaku* (a wooden plaque symbolizing court rank) in front of his chest in the original form. In contrast to the soft, rather bland facial expressions of the Hachiman images of Tōji and Yakushiji, the Matsunōō *kami* has an expression full of strength and intensity. He has a full beard, further distancing him from standard Buddhist imagery, and his hair is arranged in heavy locks that fall over the chest. The severe, hieratic character of this image and the emphasis on the natural quality of the wood typify one important lineage of Shinto sculpture.

The female deity (see fig. 68), presumably the consort, of the Matsunōō Shrine has a softer facial expression, lacking the sternness of the male, and yet her expression is much more intense than those of the attendant female deities of the Tōji and Yakushiji groups. This intensity is also seen in the very sharply carved, powerfully symmetrical drapery folds of the robe. The second male at the Matsunōō Shrine is softer in expression than the other two figures; he is perhaps the youthful son of the principal pair. Female deities are much more common in *shinzō* than in Buddhist imagery, a clear indication of the far greater importance of the feminine element in Shinto.

An important group of *shinzō* is found at Kumano Hayatama Shrine in Wakayama Prefecture. Kumano has long been one of the most sacred areas of Japan; it has many shrines and temples and was an important destination for pilgrims in the medieval period. Particularly important *shinzō* are the representations of Hayatama Ōkami and his consort Fusumi Ōkami (*c.* 10th century).

68. Female *kami*, polychrome wood, h. 970 mm, late 9th century (Kyoto, Matsunōō Shrine)

This pair has some features in common with that of the Matsunōō Shrine, although they are less forceful in overall expression.

Another 10th-century *shinzō* is the depiction of Uga no Mikoto at the Ozu Shrine in Shiga Prefecture. Although small (500 mm), it is monumental in conception. The goddess has her hair arranged in the usual court mode, with heavy locks, but most interesting is the sharp triangular configuration produced as the hair falls down the sides of the face to the body. Her face has an intense, brooding expression, with downcast eyes and lips pursed. She wears the typical court robes, and the drapery is generalized in execution, with only a few strongly articulated folds over the legs. Uga no Mikoto is seated with her right leg flat on the ground and left leg raised, supporting her left hand. This pose is seen in other female *shinzō* and may relate to the characteristic seated pose of Korean women.

(iii) Later Heian shinzō, 11th–12th centuries. The monuments discussed above can be dated with considerable confidence on the basis of style. However, there are numerous *shinzō* attributed to the Heian period that are difficult to date precisely, primarily because they are so simple in formal characteristics. The development of Heian Buddhist sculpture cannot be used as a comparative standard, since the developments seen in Buddhist imagery from the early part of the 11th century were not reflected in *shinzō*. The complex joined-woodblock technique (*yosegi zukuri*) and lavish surface treatment with gilt and polychromy were not thought appropriate for Shinto images, which continued to be made in the single-woodblock technique (*ichiboku zukuri*), a technique that valued the integrity of the log. It seems that a basic single-woodblock format was established in the early Heian period and continued to be the norm during the late Heian. Consequently, it can be assumed that many of the *shinzō* given a general Heian-period attribution were made between the late 10th century and the 12th. A more specific placement of these images is arguably unimportant since they are so uniform in character. The images from the later part of this period seem 'softer' and more generalized.

In addition to these *shinzō*, there are a few monuments that bear inscribed dates of the 12th century. Unfortunately, in terms of establishing a chronology, each of these images is quite idiosyncratic in form, with little relationship to the broader category of undated *shinzō*. Thus *Tarōten and Two Attendants* (Chōanji, Oita Prefecture) by Kakugi, dated 1130, consists of three standing male figures in a format different from other *shinzō*. A pair of Shinto guardians called *Zuishin* (Takanojinja, Okayama Prefecture), made by Gensei in 1162, is also isolated in the corpus of Heian *shinzō*, although there is another pair made in the Kamakura period. Finally, there is a representation of *Zaō Gongen*, a Shugendō deity (*see* §II, 7 above) in Sanbutsuji, Tottori Prefecture, dated 1168, but the vigorous action seen in his pose is unique to this deity, and as an iconographical type it is much closer to Buddhist Esoteric deities than to *shinzō*.

(iv) Kamakura and later shinzō. *Shinzō* continued to be produced extensively during the Kamakura period (1185–

1333). Hachiman was often represented in monk form, but also, in at least two important examples, in court robes. The best-known *shinzō* of the period is the representation by KAIKEI of *Hachiman* in monk form at the great temple of Tōdaiji, Nara (1201; National Treasure). Substantial documentary evidence describes the complicated process by which the temple authorities gained court approval to have the image made, and how they went about finding an appropriate model for their image. This effort reveals the seriousness with which the making of a *shinzō* was taken during the Heian and Kamakura periods.

In technique and style the Tōdaiji *Hachiman* must be considered within the context of contemporaneous Buddhist sculpture. It is constructed in the joined-woodblock technique and shows the brilliant colours more often seen in Buddhist imagery. Particularly striking is the high degree of naturalism in facial features, proportions and treatment of robes, traits characteristic of early Kamakura-period sculpture (*see* §3(iv) above).

Later images of Hachiman in monk form include an example carved by Kōshun in 1328 (Boston, MA, Mus. F.A.) and another piece at Tsuboi Hachiman Shrine, Osaka, made by Raien and Jitsuen in 1354. More interesting than these, however, are the *shinzō* that represent Hachiman as a courtier, apparently an innovation of the Kamakura period. A single figure of *Hachiman* (1277–88), at the Hatogamine Shrine, Nagano Prefecture, shows the *kami* wearing a court hat and soft court robes, his hands placed in front in order to grasp the *shaku*, the symbol of political authority. In a *Hachiman Triad* at Akaana Hachiman Shrine, Shimane Prefecture, carved by Kyōkaku in 1326, Hachiman again wears the court hat and robes and holds the *shaku*, but the robes are represented as though stiffly starched. This is a characteristic well known from Kamakura-period secular portraiture, as for example in the portrait of *Uesugi Shigefusa* at Meigetsuin in Kamakura (*see* §5 below). The two female attendants, also in court costume, may reflect the Buddhist triad format with flanking *bodhisattva*s.

A very different *kami* is the representation of *Tamayorihime* at Yoshino Mikumari Shrine, Nara Prefecture (1251). She wears the elegant, multi-layered costume of an aristocratic court lady as seen in secular painting. Her hair and facial expression are similarly aristocratic, and it would be difficult to identify this statue as a *shinzō* on the basis of appearance alone.

Shinzō continued to be made during the Muromachi (1333–1568) and Edo (1600–1868) periods; indeed, many of the 'generalized' images that are difficult to place may date from these centuries. However, it is difficult to isolate any developments in style, technique or iconography that originated during these periods.

BIBLIOGRAPHY

N. Oka: *Shinzō chōkoku no kenkyū* [Research on *shinzō* sculpture] (Tokyo, 1971)

Mainichi Shimbunsha, ed.: *Chōkoku* [Sculpture], Jūyō Bunkazai [Important cultural property], v (Tokyo, 1972)

C. G. Kanda: *Shinzō: Hachiman Imagery and its Development* (Cambridge, MA, 1985); review by D. F. McCallum in *Mnmt Nipponica*, xli (1986), pp. 477–88

DONALD F. MCCALLUM

5. PORTRAITURE.

(i) Introduction. (ii) Nara period (AD 710–94). (iii) Heian period (794–1185). (iv) Kamakura period (1185–1333). (v) Muromachi period (1333–1868) and later.

(i) Introduction. Japanese portrait sculpture developed within a Buddhist context, and most subjects of sculpted portraits were religious personages, whether legendary or historical. Even when lay subjects began to be portrayed in the Kamakura period (1185–1333), their sculpted portraits were enshrined in temples with which they had been closely affiliated. This association of portrait sculpture with Buddhist liturgy complicates the definition of portrait sculpture in Japan, since portraits indeed frequently served as objects of worship. Moreover, the distinction between historical and imaginary portraits is blurred: that is, true portraiture, in which the character of a specific individual is depicted on the basis of direct observation, becomes confused with attributive portraiture, in which external attributes traditionally associated with the subject are used to identify him. The devotional character of Japanese portrait sculpture also fostered such unusual practices as making unclothed statues, which the devotee could dress in actual garments, depositing the subject's remains in the statue or implanting his hair into the head to strengthen the identification of portrait with subject, and investing the subject with attributes associated with Buddhist deities.

In the Buddhist context, in which the human body was considered simply a perishable receptacle, the physical depiction of specific individuals could be justified only if this could further the propagation and understanding of the faith or if, as in the case of Zen portraiture (*chinsō*), it marked the prominence of the subject, for example, a venerated monk, within the chain of transmission of the

Buddhist law. Almost all early Japanese portrait statues were therefore posthumous; portraits of living subjects (*juzō*) appear to have been produced only from the Kamakura period. Those Japanese sculpted portraits that were strongly influenced by realistic trends in Chinese art were also successful as true portraiture. Examples are the statues of the monk *Ganjin* (Chin. Jianzhen; 688–763) in Tōshōdaiji, Nara (see fig. 69), and *Chōgen* (Shunjōbō Chōgen; 1120–1206) in Tōdaiji, Nara, both completed about the year of their subject's death. Aside from these two kinds of portrait, sculpture tended to rely on the attributive qualities of the subject, making little attempt to portray the actual appearance.

(ii) Nara period (AD 710–94). The earliest examples of portrait sculpture in Japan date from the middle of the 8th century and represent monks, in the manner in which *luohan* (Skt *arhat*s) were traditionally represented in China. The first and foremost sculpted portrait is the statue of *Ganjin* (fig. 69), the Chinese founder of the Japanese Ritsu sect, housed in its own portrait hall (Mieidō) on the site of his former residence. It was made in the hollow dry-lacquer technique (*dakkatsu kanshitsu*) prevalent during the 8th century, a plastic technique well suited to convey the character of the subject. The only other extant portrait sculpture of the Nara period is the statue of the monk *Gyōshin* (*d* 750), also in hollow dry-lacquer and dating from the mid-8th century. This portrait attempts to convey the strong personality of the monk who was instrumental in the reconstruction of the East Precinct of Hōryūji; the statue is enshrined in the Yumedono on the site.

(iii) Heian period (794–1185). Two different currents are apparent in portrait sculpture of the early Heian period. One is that of the preceding era, while the other reflects the characteristics of single-woodblock construction (*ichiboku zukuri*) widely used at the time. Statues of the type made in the Nara period include that of the Ritsu monk *Dōsen* (*fl* mid-8th century) in the Yumedono of Hōryūji, probably made shortly after his death, in clay with polychromy, a medium associated with the Nara period. The 9th-century statue of *Gien* (*d* 728) in Okadera, Nara, was produced long after the death of the subject, who is depicted with the long, pierced earlobes of a Buddhist deity. Executed in wood with a thick layer of lacquer mixed with wood shavings (*kokuso urushi*), it follows stylistically in the tradition of Nara-period dry-lacquer sculpture. A statue of *Yuima* (Skt Vimalakirti, h. 918 mm) in Hokkeji in Nara depicts an Indian lay devotee who is supposed to have lived during the lifetime of the historical Buddha Shakyamuni (Jap. Shaka). He is treated in an unidealized manner closer to portraiture than to cult images.

The statue of the monk *Mangan Shōnin* (*d* 816) in the Hakone Shrine, Kanagawa Prefecture, made shortly after his death, is an example of portraiture in the single-woodblock construction technique. The disciples who commissioned this work were familiar with the subject, but the image nonetheless possesses the folds at the neck and the elongated earlobes that are attributes of Buddhist deities, underscoring the devotional aspect of much early Japanese portraiture. The wooden head of the monk

69. *Ganjin*, hollow dry lacquer, h. 805 mm, *c.* 763 (Nara, Tōshōdaiji)

Ennin (794–864) placed in his coffin in Risshakuji, Yamagata Prefecture, depicts his visage immediately after his death. This work exemplifies the association between posthumous monk portraits and their physical remains.

In the late Heian period, painted portraits overshadowed sculpted ones, which tended increasingly to be conceived as objects of worship rather than true portraits. This general trend is apparent in a series of statues of the Tendai monk Enchin (814–91). The *Okotsu Daishi* statue, which contains his remains and is housed in Onjōji, Shiga Prefecture, was produced shortly after his death. It still possesses the massive quality of early Heian sculpture, but the features are schematic, the egg-shaped head being the single distinguishing characteristic. The *Sannōin Daishi* statue of Enchin, also in Onjōji, which displays increasing stylization, was produced soon after the *Okotsu Daishi* and was based on it. The 1143 statue of *Enchin* in Shōgoin, Kyoto, by Ryōsei (*fl* mid-12th century) was in turn modelled on the *Sannōin Daishi*.

Schematic rendering is apparent also in the imposing statue (*c.* 1019) of *Rōben* (689–773) and in an interesting sub-group of this genre—images of *Prince Shōtoku* that began to be produced during this period, with the rise of his cult, and continued to be widely made during the Kamakura period (1185–1333). This quasi-divine prince was represented in different stages of his life, usually without distinctive portrait-like features. Thus statues of him at Hōryūji, one at the age of seven (E-den; 1069) by Enkai (*fl* mid-12th century) and one as regent (Shōryōin; 1121), are imaginary depictions, the latter clearly conceived as an object of worship.

(iv) Kamakura period (1185–1333).

(a) Introduction. In general, the aesthetic of the Kamakura period drew on the art of the Nara period (710–94) and on elements newly introduced from China in its emphasis on naturalistic depiction, which reinvigorated portrait sculpture. So did the rise of new Buddhist sects and the renewal of older ones, which placed increasing emphasis on the personalities of their founders and masters.

Early in the period the great sculptors of the KEI school, working in the joined-woodblock technique (*yosegi zukuri*), produced some of the finest works of portraiture, both true and attributive, in the entire corpus of the genre in Japan (*see also* §3(iv) above). KŌKEI carved the naturalistic set of *Six Patriarchs of the Hossō Sect* (*Hossō rokuso*), housed in the Nan'endō of Kōfukuji, in 1188–9. He differentiated his subjects not through psychological depiction but by exaggerating their features and varying their poses. The style attained mature expression in the works of UNKEI and his sons, such as the figures representing the Indian monk–philosophers *Muchaku* (Skt Ashanga) and *Seshin* (Skt Vasubandhu) in the Hokuendō of Kōfukuji (1208). These imaginary portraits are devoid of the exaggeration apparent in the group of *Hossō Patriarchs* and depict the monks as men of character and intelligence. Though conceived so that each can stand alone, they complement each other as a pair.

Chinese culture of the Song period (960–1279) also greatly influenced Kamakura-period portraiture. The monk Shunjōbō Chōgen was an important vehicle for this influence and was probably responsible for introducing the practice of commissioning portraits of oneself. Statues of *Chōgen* in Shindaibutsuji, Mie Prefecture, and Amidaji, Yamaguchi Prefecture, are noteworthy for having been made during the subject's lifetime. The statue carved immediately after his death in 1206 represents the finest example of true Kamakura-period portraiture and ranks alongside the statue of *Ganjin* in Tōshōdaiji (see fig. 69 above) as a masterpiece of the genre. Probably sculpted by a member of the Kei school, this portrait is uncompromisingly naturalistic, not only representing Chōgen at a specific time in his life but also conveying the particulars of his character.

(b) Pure Land sect. In contrast to this interest in the subject's psychology, a new trend emerged in the treatment of patriarchs and proselytizers of Pure Land (Jōdo) teachings. Peripatetic monks began to be shown in descriptive attitudes characteristic of their activities; the best-known example is the statue of the Buddhist saint *Kūya* (903–72) in Rokuharamitsuji, Kyoto, carved by Kōshō (*fl* early 13th century) before 1207. Kūya is shown as a full-length figure, walking while chanting the *nenbutsu* ('*Namu Amida butsu*'; 'Hail Amida Buddha'), which is represented by six small figures of Amida emerging from his mouth, and beating a drum hung from his neck. The depiction of individual physical attributes was clearly not considered central: a later statue of *Kūya* in Jōdoji, Ehime Prefecture, has different facial features, although the pose and the attributes are similar.

Another example of a Pure Land monk shown in a characteristic activity is that of the Tang-period (618–907) Chinese abbot *Shandao*, the finest of whose sculpted portraits is in Raigōji, Nara (13th century). He is shown seated with his hands held in prayer, and his opened mouth intones the *nenbutsu* that was also represented by six small Amida figures (now lost).

(c) Other Buddhist sects. Portraits were also needed of the founders of the older Buddhist sects. Many statues of KŪKAI produced for Shingon temples survive. Documentary evidence refers to portraits of the monk sculpted in the Heian period, but the earliest—and finest—extant example is the imaginary portrait by Kōshō (1233; Tōji, Mieidō). Its form is based on conventions established during the Heian period, showing the monk seated holding a thunderbolt (*kongō*; Skt *vajra*) in his right hand and a rosary in his left. All later portrait statues of Kūkai follow this same form, such as the statue (1249–56) in Rokuharamitsuji by Chōkai (*fl* mid-13th century), the relief (1302) in Jingōji, Kyoto, by Jōkei (*fl* late 13th century–early 14th) and the statue (*c.* 1325) in the Gokurakubō of Gangōji, Nara.

In comparison, extant sculpted portraits of the Tendai monk Saichō (766–822) are rare. Documents attest to the existence of a life-size portrait (now lost) in the Daishidō of Enryakuji on Mt Hiei, Shiga Prefecture, but the oldest surviving example is the statue in Kannonji in Shiga (1224). Provincial and unprepossessing, it is important primarily for its rarity and for its depiction of the monk in what is interpreted as his typical form, seated with eyes

closed and hands joined in meditation, his head covered with a scarf.

(d) Lay portraits. In the Rokuharamitsuji are three sculpted portraits of laymen: one traditionally believed to represent the Heian-period military leader *Taira no Kiyo-mori* (1118–81), and a pair depicting the sculptors *Unkei* and *Tankei* (1173–1256). Though the figures are all shown in monks' robes, these statues prefigure an important development in late Kamakura-period sculpture: the advent of the formal lay portrait. The finest examples of this genre are the statue of *Hōjō Tokiyori* (1227–63; regent of the Kamakura shogunate) in Kenchōji, Kamakura; the portrait of *Uesugi Shigefusa* (*fl* mid-13th century) in the Meigetsuin, Kamakura, also in Kanagawa Prefecture; and the figure (Tokyo, N. Mus.) identified as *Minamoto no Yoritomo* (1147–99), all dating from about 1263. Edo-period (1600–1868) documentation refers to sculpted portraits of warriors in court dress housed in a number of temples in Kamakura, indicating that this idiom was not as rare as the handful of extant examples would suggest and that the genre was no longer restricted to religious personages. Early Kamakura-period painted portraits (*ni-see*) of similar subjects no doubt served as the catalyst for the emergence of this type, and, as in *nisee*, the facial features are carefully rendered but the bodies and garments are schematized.

*(e) Zen portraits (*chinsō*).* Another development in portrait sculpture that owes its origins to a specific painting tradition, in this case Chinese, is that of the Zen portrait. *Chinsō* paintings were presented by master to disciple as a symbol of the transmission of Zen teachings, but sculpted *chinsō* memorialized their subjects as embodiments of Zen character. *Chinsō* figures vary little and are shown seated in chairs with their bodies enveloped in stylized robes; interest focuses on the face of the individual.

The earliest known *chinsō* sculpture is the statue (1275) of the monk *Kakushin* (Hottō or Hattō Kokushi; 1207–98) in Ankokuji, Hiroshima Prefecture. The *chinsō* of *Bukkō Kokushi* (Chin. Wuxue Zuyuan; 1226–86) in En-gakuji, Kamakura, has a naturalistic face, but the drapery is only cursorily rendered. Formal exaggeration and increased stylization in the treatment of the garment are seen in the pair of *chinsō* (1329) in Anrakuji, Nagano Prefecture, representing the Japanese monk *Yuisen* (*fl* mid-13th century), who had travelled to China, and the Chinese monk *Huiren* (Jap. Enin; *fl* mid- to late 13th century), who returned to Japan in Yuisen's company. Though the figure of *Huiren* is more substantial, the main difference between the two images resides in their clearly delineated facial features.

(v) Muromachi period (1333–1568) to 1868. Throughout the 14th century the production of *chinsō* (Zen portraits) continued unabated and along the same lines. The Zen sect was one of the few religious orders that continued to commission portrait statues. The best of these is the statue of *Musō Kokushi* (1275–1351), the pre-eminent Zen monk of this era, in Zuisenji, Kanagawa Prefecture, produced shortly after his death. The *chinsō* of the monk *Motsugai* (*d* 1351), in contrast, made by Chōsō (*fl* late 14th century) in 1370 (Tokyo, Fusaiji), is ponderous and highly stylized,

the mask-like visage prefiguring developments of the following period.

While painting flowered during the Muromachi period, invigorated by Chinese influences, sculpture did not experience the same revitalization. Noteworthy portraits, however, were still produced, no doubt a reflection of the dedication inspired by the individual subjects. The unusual clay statue of *Jun'yū Naiku* (*fl* 10th century) enshrined in the temple he restored, the Ishiyamadera in Shiga Prefecture, was dedicated in 1398 and is reminiscent of Kamakura-period portraiture. The expressive, technically proficient statue of the 6th-century Indian monk *Bodhi-dharma* in Darumadera, Nara, was sculpted by Shūkei (*fl* early 15th century) in 1430 and painted by the famed ink painter Shūbun (*fl* early to mid-15th century). Both of these are imaginary portraits, but in the statue of the Zen monk *Ikkyū* (1394–1481) in Shūon'an, Kyoto, produced immediately after his death, the accuracy of the likeness was underscored by implanting the hair of the deceased in the eyebrows, upper lip and chin of the statue. The features are carefully individualized and frankly rendered, in sharp contrast to the broadly treated drapery.

In portraits where the character of the subject was not of primary importance, the facial features, too, tended to become as undifferentiated and stylized as the garments, the jutting sleeves giving the images a doll-like quality. The results, in adult subjects, were uninspiring, as in the group of the *Fifteen Generations of the Ashikaga Shoguns* (*c.* 1542; Kyoto, Tōjiin) by Kakutei and Kakukichi (both *fl* mid-16th century). In a child portrait, such as that of *Toyotomi Sutemaru* (1588–91), son of the warlord Hideyoshi, in Rinkain, Kyoto, the stylization and doll-like quality are less incongruous.

Edo-period (1600–1868) portrait sculpture largely demonstrates the recycling of older forms, resulting in works of little interest in either the religious or the secular sphere. In the absence of invigorating influences, the genre was largely spent, and it was not until the introduction of Western art to Japan in the Meiji era (1868–1912) that mainstream sculpture was freed from the traditional Buddhist context and permitted to develop in new directions.

BIBLIOGRAPHY

T. Fukuyama: 'Minamoto Yoritomo zō, Hōjō Tokiyori zō, Uesugi Shige-fusa zō ni tsuite' [On the statues of Minamoto Yoritomo, Hōjō Tokiyori and Uesugi Shigefusa], *Kenchikushi*, iii (1941), pp. 279–82

S. Hamada: 'Nihon kodai no shōzō chōkoku ni tsuite' [On the portrait sculptures of ancient Japan], *Kokka*, 214 (1947)

Kamakura no shōzō chōkoku [The portrait sculpture of the Kamakura period], Collection of the Pictorial Records of the Kamakura National Treasure Museum, viii (Kamakura, 1961)

J. Rosenfield: 'Studies in Japanese Portraiture: The Statue of Vimalakirti at Hokke-ji', *A. Orient.*, vi (1966), pp. 213–22

H. Mōri: 'Shōzō chōkoku' [Portrait sculpture], *Nihon No Bijutsu*, x (1967) [whole issue]; Eng. trans. and adaptation by W. C. Ishibashi as *Japanese Portrait Sculpture*, Japanese Arts Library, ii (Tokyo and New York, 1977)

J. Rosenfield: 'The Sedgwick Statue of the Infant Shōtoku Taishi', *Archvs Asian A.*, xxii (1968–9), pp. 56–79

T. Kobayashi: *Shōzō chōkoku* [Portrait sculpture] (Tokyo, 1969)

T. Kameda and others: *Men to shōzō* [Masks and portraiture], Genshoku Nihon no bijutsu [Arts of Japan, illustrated], xxiii (Tokyo, 1971, rev. 1980)

K. Nishikawa: *Chinsō chōkoku* [Chinsō sculpture], Nihon no bijutsu [Arts of Japan], cxxiii (Tokyo, 1976)

Nihon no shōzō [Japanese portraiture] (exh. cat., Kyoto, N. Mus., 1978)

Nihon no bukkyō o kizuita hitobito: sono shōzō to sho [The individuals who established Japanese Buddhism: their portraits and calligraphy] (exh. cat., Nara, N. Mus., 1981)

Z. Shimizu: 'Nihon no shōzō chōkoku to Chōraku-ji no Jishū chōkoku' [Japanese portrait sculpture and the sculpture of the Ji sect in the Chōrakuji], *Chōraku-ji Sennen* [Chōrakuji: one thousand years] (Kyoto, 1982)

CHIE ISHIBASHI

6. MODERN DEVELOPMENTS. The modern (*kindai*) era in Japan is usually taken as the period after the Meiji Restoration of 1868. This time is generally divided into three periods: Meiji (1868–1912), Taishō (1912–26) and Shōwa (1926–89); a fourth period, Heisei, began in 1989. Like other aspects of Japanese culture, sculpture received a strong impetus from contact and exchange with cultures abroad, initially from Europe and after World War II from the United States of America. This, together with the evolution of indigenous elements, resulted in the emergence of unique artistic traditions. In painting, this process produced the differing *Nihonga* (Japanese-style) and *Yōga* (Western-style) painting. In sculpture, a distinction may be made initially between works in wood (Japanese-style) and stone (Western-style). Apart from this, sculpture differed from painting in lacking pronounced individualistic elements, largely because, as an art form, it had suffered a long period of decline: for some centuries before the Meiji Restoration, sculpture was not thought of as fine art, and 'carved objects' were accorded only the low status of 'handicrafts'.

(i) Meiji period (1868–1912). (ii) Taishō period (1912–26). (iii) Shōwa period (1926–89).

(i) Meiji period (1868–1912). In the early Meiji period, sculpted works, apart from those made from ivory or gold, were generally in wood. The field was divided between such specialists as *netsuke* masters, who produced small craftlike images for cherished use (*see* §XVI, 17 below), makers of *hina ningyō* ('festival dolls'), court artists of architectural sculpture, and Buddhist masters (*busshi*) who created religious images. Amid the upheaval of the Meiji Restoration, 'carved objects' lost their function in society and consequently the demand for them declined. At the 1873 Vienna World Exhibition, the unique arts and crafts of Japan were favourably received, and, in an effort to promote Japanese exports, the Japanese government encouraged the production of traditional art and craft objects. Ivory sculpture witnessed a temporary revival, and the tradition of wooden sculpture continued, albeit on a smaller scale, thanks to the efforts of such artists as Kōun Takamura (1852–1934).

(a) Introduction of Western-style sculpture. In 1876, in the grounds of the Kōbu Daigakkō (Technical School), the Kōbu Bijutsu Gakkō (Technical Art School) was established as the first educational system under government auspices that provided instruction in Western art. At the opening of the school, the Italian ANTONIO FONTANESI and three foreign lecturers were employed, and Vincenzo Ragusa (1841–1928) was placed in charge of instruction in sculpture. Ragusa, a native of Palermo in Sicily, had won a competition held by the Italian government to select an instructor of sculpture for Japan. He was the only instructor in the department of sculpture at the school and, although tuition fees were exempt, there were no

students in this department, since none concentrated specifically on sculpture. The regulations of the Technical Art School stated: 'The study of sculpture is the instruction of the imitation of form [*butsukei mozō*] of all varieties [of sculpture] that resemble plaster of Paris. . .'. At that time, the Japanese regarded Western-style sculpture, as presented by Ragusa, as one aspect of the Meiji-period 'civilization and enlightenment' (*bunmei kaika*), and, like other imported objects, they viewed it with curiosity and wonder. Western painting, with its realistic depictions, was also greatly admired and respected. The concept of 'imitation of form' was therefore accepted without any opposition and literally interpreted by Ragusa, who tried to instil techniques that were faithful to the objective of realism. The principle of the 'imitation of form' profoundly influenced Japanese developments in sculpture.

However, Fontanesi returned to Italy because of ill-health and, in the unrest of civil war and the rise of ultra-nationalism in reaction to the Westernization of the early Meiji period, the scope and freedom of operation of the Technical Art School were curtailed. In 1882, following the graduation of Ujihirō Ōkuma (1856–1934) and 20 others, the sculpture department was abolished. Ragusa also returned to Italy, and in 1883 the school was closed down.

Nevertheless, as Kōun Takamura recorded in his *Kōun kaikodan* ('Reminiscences of Kōun'), schools of sculptors working in the Western style and in the traditional techniques of wooden and ivory sculpture continued to be active. It was Kōun who, while ivory sculpture was at its height, attempted to revive the declining medium of wooden sculpture, and, by integrating Western elements of realism, reformed it and adapted it to the new age.

(b) Government subsidization. After the closure of the Technical Art School, demands were heard for a new government art school and for art education within the standard curriculum. In 1887 the expatriate American ERNEST FRANCISCO FENOLLOSA and TENSHIN OKAKURA founded the Tōkyō Bijutsu Gakkō (Tokyo Fine Arts School), where departments in painting, sculpture and the crafts were set up. The school opened officially in 1889, but instruction in oil painting and Western-style modelled sculpture was excluded until 1896 and 1899 respectively. In the inhospitable political environment, many Western-style artists went abroad to train: Moriyoshi Naganuma (1857–1942) to Italy, Ujihirō Ōkuma to Italy and France, and Shigai Kitamura (1871–1927) to France, while Uzan Shirai travelled throughout Europe.

In the 1890s sculpture began to attain renewed social recognition and works were produced in large quantities, ranging from small-scale images that had hitherto been prized as *objets d'art* to large bronze sculptures. For the Chicago World Exposition of 1893, the Japanese government subsidized artists' production costs in an effort to promote traditional Japanese arts. The works displayed included Kōun Takamura's *Ageing Monkey* (*Rōen*; 1893; Tokyo, N. Mus.; see fig. 70); *Goddess of Art* (*Gigeiten zō*) by Kyūichi Takenuchi (1857–1916); *White-robed Kannon* (*Hakui Kannon*), a relief sculpture by Kōmei Ishikawa (1852–1913); and Kisai Yamada's relief sculpture *Tale of Heiji* (*Heiji monogatari*). These are representative works

70. Kōun Takamura: *Ageing Monkey*, wood, h. 1.06 m (with base), 1893 (Tokyo, National Museum)

of the period. Also in 1893, Ujihirō Ōkuma produced *Image of Ōmura Masujirō* (*Ōmura Masujirō zō*) and Kōun Takamura *Image of Nankō* (*Nankō zō* or *Kusunoki Masahige*). Takamura completed *Image of Saigō Takamori* (*Saigō Takamori zō*) in 1897. He had shifted from working in wood to cast images after a period of alternating between wooden and modelled sculpture.

In 1907, the Monbushō Bijutsu Tenrankai or Bunten (Art Exhibition of the Ministry of Education) was formed, the first exhibition under government auspices in Japan and an important event for the development of sculpture. Although a distinction was made between wooden and modelled forms, it was the first time that sculpture had been publicly presented as art, thus confirming its position alongside painting as one of the fine arts. An important consideration in the selection of the panel was a balance of interests: among the ten or so judges were scholars and sculptors of both wood and modelled objects, including Kōun Takamura and Taketarō Shinkei (1868–1927). As the Bunten grew, progressive artists such as Fumio Asakura (1883–1964), Taimu Tatehata (1880–1942), Morie Ogiwara, Chōun Yamazaki (1867–1954) and Unkai Yonehara were drawn in. The Bunten gained a reputation as a forum for the exhibition of works by new artists, both traditional and radical, and as a pioneer in the art world, stimulating a growing public interest. In terms of artistic style, however, the works shown tended to conform with the notions of realism and naturalistic illustration and with the 'imitation of form' of Western-style sculpture as promulgated by Ragusa and developed by Japanese artists.

(c) Further Western contacts. Morie Ogiwara, having mastered painting, left Nagano Prefecture for Tokyo, where he found the art that surrounded him unfulfilling. He travelled to New York and Paris, seeking an answer to the question, 'What is art?', until, in 1904, he found a clue in the work of AUGUSTE RODIN, whose *The Thinker* he saw in a Paris salon. 'That which we hope for in art,' Rodin said, 'is not that which is a realistic [photographic] representation but rather a living representation.' Ogiwara's works *Monkaku, Image of Hōjō Torakichi* (*Hōjō Torakichi zō*) and *Woman* (*Onna*; 1910; Tokyo, N. Mus. Mod. A.), which were exhibited in the Bunten after his return to Japan, were not the traditional faithful depictions of the exterior form of an object but rather represented the true beauty of the inner spirit. The subjectivity of this realism differed from that seen in the 'imitation of form'. Ogiwara and his contemporary Kōtarō Takamura, who returned to Japan somewhat later, opened the way to the first serious attempts at modern sculpture and had a great impact on such artists as Kōgan Tobari (1882–1927), Teijirō Nakahara and Tsuruzō Ishii. In 1910, just two years after his return to Japan, the 30-year-old Ogiwara suddenly died. The fresh and lively charm and youthful frankness, the firm grip on reality and the abundance of artistic spirit seen in Ogiwara's unfinished work *Woman* are representative of sculpture of the Meiji period.

The efforts by Ogiwara and Kōtarō Takamura had stimulated interest in Rodin. In its November 1910 issue, the magazine *Shirakaba* ('White birch') published an authoritative introduction to Rodin entitled 'Rodan dainanajū kai tanjō kinen gō' ('Issue commemorating the 70th birthday of Rodin'). As a result, in 1911 Rodin sent three sculptures to Japan that were put on public display the following year at the 4th annual *Shirakaba* exhibition. After 1907, many young Japanese artists who had studied in Europe returned, deeply influenced by the works of the Impressionists, Neo-Impressionists and Late Impressionists. They forcefully set out an ideology of modern art that emphasized subjective expression and respect for individual character.

(ii) Taishō period (1912–26). The most important event in Taishō-period art was the creation in 1914 of the Nikakai (Second Division Society) and the revival of the Nihon Bijutsuin (Japan Fine Arts Academy), both of which provided an alternative to official government exhibitions. As a result, the structure of the Japanese art world changed and became more complex, the various artistic groups being based on public subscription. Sculpture, however, because of Ogiwara's early death, was neglected within the Bunten and was pursued only within unofficial groups.

The Japan Fine Arts Academy was conceived by Taikan Yokoyama and Misei Kosugi to follow in the footsteps of Okakura Tenshin, who had died the previous year, to promote 'Institute exhibitions' (Inten) and to encourage open research. Western-style painting and sculpture sections were set up alongside a department for *Nihonga* (Japanese-style) painting. The sculpture section initially

included the wood sculptors Denchū Hiragushi (1872–1979), Chōzan Satō (1888–1963), Hakurei Yoshida and Shin Naitō. After the second exhibition, Tsuruzō Ishii, Kōyū Fujii and others, who were active artists and had received prizes in the early period of the Bunten, joined the Academy, as did others who, under Ogiwara's influence, had shifted from painting to sculpture. Gradually, modelled sculpture came to occupy an important place in the Academy's exhibits, the work of artists of the unofficial groups who opposed the Bunten.

From the serious work undertaken at the research institute, a strain of subjective realism evolved. At the same time, the Nikakai, one of the unofficial groups, established a sculpture section in 1919. The dominant figure of this section was Yūsō Fujikawa (1882–1935), who had graduated from the sculpture department of the Tokyo School of Art before studying in France and working as an assistant to the ageing Rodin. Whereas Rodin's style was full of passion, however, Fujikawa's was rather static. His works spring from an unaffected observation of nature and are characterized by consistent technique, realism and a soft sensibility. The Nikakai, which adopted a progressive stance, also displayed the works of OSSIP ZADKINE and others. In its early days, Fujikawa was a rather isolated figure, working on the fringes of the Nikakai; it was only in the late 1920s, when the research centre became a private school within the public sector, that he moved to centre stage. In 1919, the Teikoku Bijutsuin or Teiten (Imperial Art Academy) was established; Kōun Takamura and Taketarō Shinkai became members of the sculpture section. Organization of government exhibitions passed from the Bunten to the Teiten (and subsequently to other bodies).

While a student at the Tokyo School of Art, Kōun Takamura's eldest son, Kōtarō, impressed by photographs of Rodin's *The Thinker* in the magazine *Sutedeo* ('Studio'), went to study in Paris. Rodin's powerful artistic instincts made him realize the universality of art; yet Kōtarō was to find himself in the frustrating situation of being, in his outlook on art, at odds with his father, whom he respected and loved. After his return to Japan he produced works of art and was active as a critic. In his *Rodin no kotoba* ('Rodin's words'), a translation of Rodin's work, he developed the idea that the essentials of all modelled sculpture were movement, volume or mass and surface within an entire unified structure of form. This formula was taken up by the keenest sculptors of later generations. Kōtarō was not a prolific artist, partly because he devoted time also to poetry and criticism; his few extant works of wood sculpture are heavily modelled pieces of considerable charm.

(iii) Shōwa period (1926–89).

(a) Early (1926–39). By about 1935 Japanese art had attained a degree of maturity. Sculpture societies were under the strict control of the government, which, in 1935, attempted a large-scale reorganization; confusion reigned as small societies divided and intermingled. In 1937 the original Imperial Art Academy was reorganized into the Teikoku Geijutsuin (also Imperial Art Academy), government exhibitions were again placed within the ambit of

the Ministry of Education (Monbushō) and gradually the situation came under control. Tsuruzō Ishii and Denchū Hiragushi headed the sculpture section of the new Imperial Art Academy.

After 1928 the Kokuga Sōsaku Kyōkai (National Creative Painting Association) was extended to embrace sculpture. Kōtarō Takamura participated in the society's activities but without exhibiting works. Hiroatsu Takada (*b* 1900), Shin Hongō (1905–80) and younger artists from the Tokyo School of Art joined together in 1939 to form the sculpture section of the Shin Seisakuha Kyōkai (New Creative Association), which became a new power among the unofficial schools. Ossip Zadkine, ALEXANDER ARCHIPENKO and others were brought to the attention of Japanese sculptors via the Nikakai group under Yūsō Fujikawa (1882–1935) and his colleagues. After Fujikawa, the central figure was Yoshitomo Watanabe. In 1926 Sogan Saitō and Jitsuzō Hinako with Yasuji Ogishima, Kanji Yō and others set up a framework for considering the relationship between architecture and sculpture, and it was through them that modernism evolved in Japan.

(b) Late (1939–89).

Post-war revival. Under the oppressive atmosphere of wartime control, sculpture, like the other arts, suffered a steady decline, but after World War II, with the development of international communications and trade, a comparable international movement in the arts took place. The concept of sculpture underwent tremendous change, such as would have been unthinkable in the pre-war period; the emergence of new subject-matter and the development of scientific processes contributed vastly to the remarkable expansion of the expressive limits of the art form.

In the atmosphere of confusion and desolation after the war, art nevertheless achieved a new beginning. Groups of artists that had joined together during the war, and others that had been dissolved, re-formed. The structure of the art world essentially comprised public art groups, a situation that continues to exist. One month after Japan's defeat it was decided that the Monbushō and the Art Academy would reorganize an exhibition, the Nihon Bijutsu Tenrankai (Japanese Art Exhibition) or Nitten, to take place the following spring. In keeping with the democratization that occurred under the American Occupation, the Nitten was soon changed to a corporate body under private management.

While the earlier art groups were revived, new groups were being formed in quick succession, for example the Kōdō Bijutsu Kyōkai (Action Art Society) and the Daini Kikai (Association of the Second Period). Exhibitions of contemporary art, however, were organized for a fixed period by newspaper companies, thereby increasing the demand for new works. The principal companies involved were: from 1949, the *Yomiuri* newspaper, with its Nihon Andepandan Ten (Japanese Independent Exhibition); from 1950, the *Asahi* newspaper, with its Senbatsu Shūsaku Bijutsu Ten (Exhibition of Selected Outstanding Art); and from 1952, the *Mainichi* newspaper, with the Nihon Kokusai Bijutsu Ten (Japanese International Art

Exhibition) and the Gendai Nihon Bijutsu Ten (Contemporary Japanese Art Exhibition). These exhibitions, each one different, were organized mutually every other year and were bigger than those that had gone before, as well as attracting much greater attention. The notion of publicly supported art groups became widely recognized and accepted. The Shell Art Awards, part of the same system of public support, were created in 1956, and thereafter public competitions such as the Kokusai Seinen Bijutsuka Ten (International Exhibition of Young Artists) and the *Mainichi* newspaper's Konkūru Japan Atō Fuesudeibaru (Competition of the Japanese Art Festival) became popular. These exhibitions opened the way for new artists.

In pre-war Japan, the collection of contemporary art was not pursued seriously, except by private museums such as the Ōhara Museum of Art at Kurashiki. However, in 1951 the Kanagawa Prefectural Museum of Modern Art, Kamakura, was founded, to be followed in 1952 by the National Museum of Modern Art, Tokyo. Thereafter, public and private art museums began to be set up all over the country, establishing the groundwork for exhibitions of contemporary art. The changes in the structure of the art world were accompanied by a sudden influx of trends from abroad, warmly received, and an enthusiasm for exhibitions of international art, which altered the way in which artistic values were presented and perceived.

Developments in abstract and representational sculpture. Before World War II, hardly any Japanese artists had experimented with abstract sculpture, which aroused the first stirrings of interest only *c.* 1950 and which, with few exceptions (see fig. 71), has gained little ground since. In 1951 the Gendai Furansu bijutsu ten (Exhibition of Contemporary French Art), underwritten principally by the *Mainichi* newspaper and tagged the *Saron dōme Tōkyō ten* ('Salon de Tokyo exhibition'), marked the arrival in Japan of abstract sculpture and invoked a strong reaction to work that for the first time communicated to Japanese viewers the situation of contemporary European artists who had also experienced the war. The sculptures did not venture beyond small, multi-faceted, geometric works by EMILE GILIOLI and others, and many represented a syncretic form of modernism. Nevertheless, their expression and simple forms were not only novel but also profoundly influential. In 1950, moreover, Isamu Noguchi had visited Japan for the first time and had become a strong advocate of closer connection between society and sculpture, a concept that accorded well with Japanese attitudes at that time.

71. Yoshishige Saitō: *Complex 501*, lacquer on wood, 3.4×8.0×4.2 m, 1989 (Tokyo, Tokyo Gallery)

Abstract styles, ranging from Cubism to Structuralism, were sought after by Second Division Society artists, and some sculptors experimented with organic abstraction, which employed simplified forms. Abstract Expressionism, which was characterized by increased complexity of organic forms, was popular among certain artists. The Informel movement, which inspired the 1956 exhibition Sekai-Konnichi no Bijutsu (Present-day World Art) sponsored by the *Asahi* newspaper, and the process of 'organic structure or form', principally employed by Henry Moore, clearly had a great impact on sculpture.

Accompanying the rise of Abstract Expressionism came a change in non-realistic 'material' sculpture. The word *gushō* ('concrete' or 'material') was first used about 1950. More than half the sculptors were affiliated with the Niten, and some changes occurred within that sculptural tradition; yet the elements of naturalism were strongly rooted. In 1947 the Shinjukai was formed, an organization of painters and sculptors who had studied in France from the end of the Taishō period to the Shōwa period. It included the sculptors Yoshi Kinouchi (1892–1977), Takashi Kimizu and Toyoichi Yamamoto, whose styles matured after the war. The change from realism to representation, which was strongly affected by changes in society, was seen in works by the Shin Seisaku Kyōkai (New Creative Association) artists such as Shin Hongō, Yasutake Funakoshi (*b* 1912) and others in the mid-1950s. Their works were rooted in the tradition of French modern realism, but their supple sensitivity was something new. The late 1950s, however, brought a new questioning of and reaction against this order. Beginning with Marino Marini, modern Italian sculpture was introduced to Japan, providing a strong incentive for the transformation of representational sculpture. The younger generation, who had begun to work after the war, now appeared on the scene with their own individualistic styles.

National and international trends and exhibitions, 1950 onwards. Modern Japanese artists began to participate in major exhibitions abroad after the 1951 (first) São Paulo Biennial. Thereafter the number of annual exhibitions, such as the Venice Biennale, increased, with Japanese artists periodically taking part. Opportunities also increasingly arose for abstract sculptors to display their work. In 1965–6 the travelling exhibition New Japanese Painting and Sculpture opened at the Museum of Modern Art in New York. This was followed in 1967 by the International Art Exhibition from the Guggenheim and in the 1970s by the India Triennial Exhibition, the Paris Youth Biennial and Düsseldorf Municipal Art Museum's Japan—The Traditional and the Modern. The Middelheim Open Air Sculpture Biennial in Antwerp took place in 1967 and 1975. In the 1980s exhibitions of modern Japan arts abroad were mounted much more frequently, including the Avant-garde Arts of Japan—1910–1970 at the Pompidou Centre in Paris, the Belgian Europalia '89 Japan and the 1988–90 travelling American exhibition Against Nature. Sculpture played an important part in these exhibitions. The number of Japanese sculptors living and working abroad also gradually increased.

72. Katsura Funakoshi: *Like a Pile of Unfinished Books*, polychrome wood and marble, h. 800 mm, 1983 (Tokyo, Nishimura Gallery)

In 1963, at Manatsuru Beach in Kanagawa Prefecture, six sculptors participated in an outdoor and indoor exhibition, part of the Sekai kindai chōkoku Nihon shinpojūmu (Symposium of Modern World Sculpture). In 1969, in Osaka, the Kokusai tekbō chōkoku shinpojūmu (International Iron and Steel Sculpture Symposium) was started, one of many symposia mounted to show and discuss the diverse subject-matter and standards of sculpture from throughout the world.

From about 1960 onwards, Japanese sculpture took a sudden leap forward. This is reflected in the formation (1960) of the Shūdan Gendai Chōkoku (Modern Sculpture Group) by avant-garde sculptors, who were free of any of the existing artistic constraints. The National Museum of Modern Art and the Kanagawa Prefectural Museum of Modern Art played an important role in encouraging new directions in sculpture. In 1963 the National Museum organized the exhibition Chōkoku no shinseidai (The New Age of Sculpture), which presented the changing concepts

about sculptural objects of artists in their 30s. The Shūdan '58 nogai chōkoku ten (The Group Open-Air Sculpture Exhibition of 1958) at the Kanagawa Prefectural Museum of Modern Art gave a boost to further open-air exhibitions, some on a large scale, such as the Zenkoku chōkoku konkūru ten (The National Exhibition of Sculpture Competition) in the city of Ube, Yamaguchi Prefecture, in 1963. It was not long before the cities of Yamaguchi and Kobe were cooperating in organizing a biennial. In 1969 the Hakone Open-Air Museum and in 1981 the Takehara Art Museum in Migahara were opened, and exhibitions of abstract sculpture, for example the Henri Moa daishōten (Henry Moore Prize Exhibition), and of representational sculpture, for example the Rodan daishōten (Rodin Prize Exhibition), were held there in alternate years. Open-air sculpture exhibitions not only provided outlets for artistic expression; they also heightened public awareness of modern sculpture and to a large extent established the boundaries of the medium. Representational sculpture developed a close relationship with the urban environment and was actively incorporated into city planning, where the idea of 'the new construction of sculpture' took firm root.

All the plastic arts underwent radical changes after the 1960s, reflecting trends in the Western art world. Innovation was the order of the day, and many individualistic styles were developed (see fig. 72). In an attempt not to overstretch the meaning implicit in the earlier word *chōkoku* ('sculpture'), the term *rittai zōkei* ('concrete form') was adopted. Those active in the plastic arts referred disparagingly to *monoha* or conceptual art, distrusted the concrete existence of art and denied its autonomous, conclusive character: an 'environmental change' had occurred in the relationship between a work of art and the viewer. Without question, the internationalizing of art has served to strengthen the multi-faceted nature of modern Japanese sculpture.

BIBLIOGRAPHY
Kodansha Enc. Japan: 'Sculpture, modern'
M. Kawakita: *Kindai bijutsu no nagare*, Nihon no bijutsu [Arts of Japan], xxiv (Tokyo, 1965); Eng. trans. by C. S. Terry as *Modern Currents in Japanese Art*, Heibonsha Surv. Jap. A., xxiv (New York and Tokyo, 1974)
Y. Kōjiro and others: *Kindai no kenchiku, chōkoku, kōgei* [Contemporary architecture, sculpture and views of Japan], Genshoku Nihon no bijutsu [Arts of Japan, illustrated], xxviii (Tokyo, 1972)
T. Hijikata: *Kindai chōkoku to gendai chōkoku* [Modern and contemporary sculpture] (1977), xii of *Hijikata Teiichi chosaku shu* [Collected works of Hijikata Teiichi] (Tokyo, 1976–8)
T. Miki: *Chōkoku* [Sculpture] (1979), xiii of *Genshoku gendai Nihon no bijutsu* [Modern arts of Japan, illustrated] (Tokyo, 1978–80)
T. Sakai: *Chōkoku no niwa: Gendai chōkoku no sekai* [The sculpture garden: the world of modern sculpture] (Tokyo, 1982)

TAMON MIKI

7. CONSERVATION. In accordance with the Law for the Protection of Cultural Properties (*Bunkazai hogohō*), important works of art in Japan are designated and protected as National Treasures (*Kohuhō*) or Important Cultural Properties (*Jūyō bunkazai*). Among these are 2525 items of sculpture; in each item there are generally 3, 4, 8 or 12 individual statues, although the numbers vary widely. Wooden objects number 2200, those of bronze and iron 197, dry lacquer 49, clay 20, and stone or miscellaneous other materials 20 (*see also* §1(ii) above).

Summers in Japan are hot, with high humidity, and the winters cold, with low humidity, although the relative humidity in Japan throughout the year is higher than in either Europe or North America. Repeated changes in humidity cause corrosion of iron, decay and deformation of wood and desiccation and shrinkage of joints. Insects and worms cause porousness, and destructive mould leaves stains. Sculptures kept in museums are of course stored in controlled conditions, with a standard temperature of 22°C or lower and a relative humidity of 60% ±5%. Most Buddhist sculptures were objects of worship and were therefore kept in temples constructed of wood, or in the open, in which case they were not preserved. The wooden temple buildings that have survived are those that were adapted to the climatic conditions. The surroundings of the temples were kept clean, and dust carried by the wind was removed from the images. At some temples the doors to small shrines containing Buddhist images were opened only once each year or even less often (there are even temples that possess secret Buddhas) and these images have retained their colour wonderfully, as well as their original form in many cases. The surfaces of some wooden sculptures were left bare, but most were painted, and, because of such effects as shrinkage, the paint on wood images flaked or chalked and peeled easily, weakening the piece.

In Japan restoration work on sculpture is done solely to maintain the present state of the object and to prevent further damage; reconstruction is not undertaken, and broken and lost areas are generally not replaced. Undesirable elements that have been added to a piece are removed. Before restoration, a careful report of the condition of the image is made and photographs taken. The piece is then fumigated to kill insects and mould. Next, the parts are disassembled, all insect holes are filled and the decomposed areas are vulcanized (strengthened). The piece is then reassembled, using techniques that were customary at the time of its production. Traditional materials—iron nails and clamps, wood, lacquer and animal glue—are used. If necessary in the interests of preservation, the decayed parts of the wood are scraped off and replaced with new wood. In order to stop the paint from peeling, a watery solution of seaweed glue (*funori*) is applied, both before and after the image is dismantled.

When the damage cannot be repaired with traditional restoration materials and techniques, synthetic resins may be used, for example acrylic resin to stop paint from peeling. Wooden areas that have suffered severe decay and as a result have become fragile are hardened by being coated with synthetic resins. Cavities may be plugged with epoxy resins mixed with fillers. The Conservation Department of the Tokyo National Research Institute of Cultural Properties (Tokyo Kokuritsu Bunkazai Kenkyujō) has led the development of scientific methods used in the restoration of Buddhist statues.

In the late 20th century, the principal Japanese studio working on the protection of Buddhist images was the Bijutsuin (Conservation Studio). It was set up in 1897 by Tenshin Okakura (also the first Curator of Japanese Art at the Boston Museum of Fine Arts) and later became a corporation, as well as a designated Intangible Cultural Property. It had a studio in the conservation laboratory of

the Kyoto National Museum, where 31 technicians (*busshi*, or Buddhist sculptors) were active in the restoration of the masterpieces of Japanese Buddhist sculpture and of the small numbers of dry-lacquer statues and clay figures produced in the 8th century. Museum conservators of all countries visited these studios to learn some of the distinctive methods used by Japanese restorers.

BIBLIOGRAPHY

B. Kurata: 'Conservation of Wooden Sculpture in Japan', *Proceedings of the International Symposium on the Conservation and Restoration of Cultural Property—Conservation of Wood: Tokyo, 1977*, pp. 67–75

K. Nishikawa and Y. Emoto: 'Coloring Technique and Repair Methods for Wooden Cultural Properties', *Proceedings of the International Symposium on the Conservation and Restoration of Cultural Property—Conservation of Wood: Tokyo 1977*, pp. 185–93

K. Nishikawa: 'Conservation of Wooden Sculpture', *Proceedings of the International Symposium on the Conservation and Restoration of Cultural Property—The Conservation of Wooden Cultural Property: Tokyo, 1982*, pp. 134–45

H. Onodera: 'The Repair of the Wooden Sculptures', *Proceedings of the International Symposium on the Conservation and Restoration of Cultural Property—The Conservation of Wooden Cultural Property: Tokyo, 1982*, pp. 147–56

KYOTARO NISHIKAWA

VI. Painting.

From its humble origin on the walls of 5th-century tombs to the panoply of 20th-century styles, painting has been a sensitive expression of Japanese culture. Although traditional interpretations have often focused on the technical refinement and surface beauty of Japanese painting, as in all cultures, painting in Japan both reflects and shapes the deepest and most complex values of the society. At the broadest level, the continuing Japanese adaptation of foreign cultures—whether those of Korea, China or Europe—is best revealed in painting. More specifically, painting was deployed to serve the ideologies of its patrons, who ranged from priests of competing Buddhist sects to members of often antagonistic social classes. Thus, Japanese painting represents nearly the full history of Japanese religious, philosophical and social ideas.

Unlike Chinese art, in which the dominance of literati critics led to the rejection and devaluation of other modes, Japanese painting is extremely broad not only in patronage but in style, subject, function and form. Although most painting formats originated in China, the Japanese made far greater use of the folding screen and hanging scroll and also developed the new folding-fan and *fusuma* (sliding door or wall) formats. In Japan painting served functions from the most grandiose to the most humble: paintings decorated the great screens of state that flanked the halls of government as well as the small hanging scrolls to be found in the alcove (*tokonoma*) of most homes. Similarly, common subjects ranged from paragons of Chinese philosophy and religion to the birds and flowers beloved in Japanese poetry. Most diverse are the styles of Japanese painting, which include copies, adaptations and creative syntheses of almost every style ever developed in East Asia and Europe. Finally, painting in Japan is often coupled with prose or poetry, presenting a sophisticated play of text and image. With the exception of early wall paintings (*see* §2 below), this article is mainly concerned with paintings done on paper or silk. Painted decoration applied to sculpture or ceramics, for example, is discussed elsewhere (*see* §§V above and VIII below), as is the art of calligraphy (*see* §VII below), which was often closely related to painting.

□

1. Materials and techniques. 2. Protohistoric. 3. Early (mid-7th century–early 14th). 4. Late (14th century–1868). 5. Modern (after 1868).

1. MATERIALS AND TECHNIQUES.

(i) Supports. Traditional Japanese paintings are primarily done in a watercolour technique on flexible supports, usually silk or paper. Some other works form part of decorated lacquer objects (*see* §X below). In the period after 1868, artists working in Western styles used a wider variety of materials and techniques.

The earliest known Japanese paintings are those on the walls of Kofun-period (*c.* AD 300–710) tombs, mostly dating from the 5th to 7th centuries AD (*see* §2 below). Paint was applied either directly on the stone slab (typical of tombs in Kyushu) or over a ground layer of clay or calcium carbonate (as in the TAKAMATSUZUKA Tomb near Nara). Other early works are temple wall paintings, notably those in HŌRYŪJI (7th–8th centuries), which were executed on a mud plaster with a thin priming of white clay, the design being transferred from a cartoon by impressing with a stylus.

Paper and papermaking were introduced from China. The *Nihongi* (or *Nihon shoki*) refers to the latter in AD 610, but most scholars believe that knowledge of the material and its manufacture pre-dates this by an unknown amount. Paper was needed for writing in the 7th century, though much may have been imported, and by the 8th century it may have been used for paintings. In these early periods, hanging scroll paintings more often utilized silk, and paper was mostly found in handscrolls, usually associated with calligraphy (*see* §VII below). In time, especially after the Heian period (794–1185), paper was increasingly used in all Japanese painting formats, including screens. Hemp or rami were widely used in papers of the Nara period (AD 710–94) but declined in importance during the Heian period. Fibre from the white inner bark of certain plants has been of the greatest importance in papers for artistic purposes (*see* §XVI, 18 below). *Kōzo* (made from *Broussonetia papyrifera*, *B. kazinoki* and *B. kaempferi*) goes back to the earliest papermaking. *Ganpi* (made from *Wikstroemia canescens*, *W. japonica* and *W. sikokiana*), employed from the early Heian period, was highly regarded as a painting support. *Mitsumata* (made from *Edgeworthia papyrifera*) came later, the first recorded use being in 1598 (see Tsien and Needham, 1985, p. 334). The use of all three fibres in Japanese hand papermaking continues to the present day. The use of other bark fibres and of bamboo seems to have been minor. Since the 1870s wood pulp has been added to some types of handmade paper.

The making of silk fabrics was also introduced from China, but the early Japanese history is obscure. Silk is found in many of the earliest hanging scrolls. These are Buddhist works, with extant examples dating from the first half of the 11th century; an example is a set of three featuring the Amida Buddha in Hokkeji, Nara (Akiyama, 1961, p. 44). In paintings the silk threads are almost always

untwisted, or nearly so. Plain (or tabby) weaves are the most common, with variants such as the weft thread being doubled. Painting silks are frequently woven openly, with appreciable interstitial space between threads, making the fabric somewhat transparent and allowing penetration of the paint into the support.

Other support materials include hemp cloth, sometimes found in Nara-period works. More common are wooden panels: sliding doors of wood (*see* FUSUMA) sometimes carry paintings (*itae*), and painted wooden plaques (*ema*) have long been donated to Shinto shrines.

(ii) Binding media and pigments. Animal glue (*nikawa*) is the principal binding medium for paints, as well as being used in a SIZE for preparation of the support. It has been suggested, though not verified, that other water-soluble binders were used for Buddhist paintings because of the reluctance to destroy animal life. Drying oils have been found, mostly over lacquered wood, and the 19th-century artist SHIBATA ZESHIN experimented with lacquer in paintings on paper. In Japan animal glue is generally made from skin, most often cowhide, although little is known of the history of gluemaking before the 19th century. In the modern version of traditional gluemaking, depilation of the skin is assisted by lime treatment; this is followed by an acid soak, thorough washing, and cooking of the skin in water just below boiling point. This converts the collagen into a form that dissolves in hot water and gels upon cooling. The dried gel is redissolved in hot water at a low percentage concentration to form the paint vehicle.

Supports of silk or paper were commonly sized using a solution (*dōsa*) of the same animal glue with the addition of alum. This served to make the surface less permeable to paint. Screen paintings were often sized heavily, while scroll paintings, where paint penetration is an advantage, often had lighter sizing.

Evaporation of water from a dilute glue solution leaves a porous, 'lean' paint component. With many pigments this leads to a soft, matt appearance, especially with applications thick enough to be opaque. The materials offer some flexibility to the painter, who may vary the support permeability, the glue concentration and the thickness of application to control both texture and colour.

Of the main pigments (*see also* PIGMENT) found in traditional Japanese painting (see fig. 73), many were introduced around the 6th century following the advent of Buddhism. (Japanese names in fig. 74 are those commonly used at present and may not conform with those found in historical documents; minor pigments and some introduced in the 19th or 20th century are not listed.) Arguably the most important Japanese painting material was the black ink produced in stick form from soot or lampblack and glue (*see* §XVI, 13 below; *see also* INK, §§I and II, 1(i)).

It is sometimes said that colours in traditional Japanese painting are based primarily on mineral pigments. This is only partly true. However, minerals such as malachite and azurite have been consistently well used and lend themselves to a degree of colour control by particle-size grading. Sieving and elutriation of the pulverized mineral separates coarser grades (having a deeper colour) from finer grades (having progressively lighter colours), the effect being enhanced by the 'lean', porous paint components. Pigment grading was greatly elaborated in the 20th century, up to 15 grades being available. A three-grade separation has been traced historically in China to the 14th century, and Oguchi (1969) has suggested it may have been used in Japan in the Nara period. Colour variations are occasionally achieved by mixing pigments, but less frequently in Japanese painting than in the West.

(iii) Application of paint. The available materials permit a wide variety of painting techniques, which range from highly spontaneous to carefully predetermined. Applications may vary from the thinnest wash to an opaque layer. A lightly sized, penetrable support is often appropriate for a spontaneous approach, especially with ink paintings. Although artists do not usually apply ground layers as in Western painting, they do use layers of different paint components. Artists often paint on top of gold or silver leaf applied to the paper support of screens (the leafing does not usually extend under larger, opaquely painted areas). Metallic leaf makes a paper support relatively impenetrable, as does heavy size application. This permits finely detailed painting and the use of techniques such as *tarashikomi* ('dripping in') in which water or ink is dripped on to a layer of paint or water while it is still liquid on the support.

Silk supports, commonly with an open weave, permit the application of paint at the back as well as the front. This helps stabilize a heavy paint application. The technique is best known in Buddhist painting but is also found in secular painting such as *ukiyoe* ('pictures of the floating world'; *see* §4 (iv)(b) below). Gold leaf may also be applied to the back of silk to give a 'shimmery' effect. Several other techniques are used for gold and silver: design elements may be constructed from fine strips and small geometrical shapes cut from gold leaf (*kirikane*); the metals may be sprinkled or stencilled on the support; or, most commonly, pulverized gold or silver are used as pigments in the same glue-based vehicle as other mineral or vegetable pigments.

BIBLIOGRAPHY

Nihongi. Chronicles of Japan from the Earliest Times to AD 697, 2 vols; Eng. trans. by W. G. Aston (London, 1896/*R* Vermont, 1972)

D. Hunter: *Papermaking: The History and Technique of an Ancient Craft* (New York, 1943, 2/1947)

T. Akiyama: *Japanese Painting* (Geneva, 1961)

H. Oguchi: *Nihonga no chakushoku zairyō ni kansuru kagakuteki kenkyū* [Scientific investigations on colour materials in Japanese paintings], *Bull. Fac. F.A.: Tokyo U. F.A. & Mus.*, v (1969), pp. 27–82 [Japanese text]

E. Grilli: *The Art of the Japanese Screen* (New York, 1970)

S. Hughes: *Washi: The World of Japanese Paper* (Tokyo, 1978)

T. Barrett: *Nagashizuki: The Japanese Craft of Hand Papermaking* (North Hills, PA, 1979); rev. as *Japanese Papermaking, Traditions, Tools and Techniques* (New York, 1983)

E. W. FitzHugh: 'A Pigment Census of Japanese *ukiyo-e* Paintings in the Freer Gallery of Art', *A. Orient.*, xi (1979), pp. 27–38

K. Yamasaki and Y. Emoto: 'Pigments Used in Japanese Paintings from the Protohistoric Period through the 19th Century', *A. Orient.*, xi (1979), pp. 1–14

J. Winter: '"Lead White" in Japanese Paintings', *Stud. Conserv.*, xxvi (1981), pp. 89–101

T. Akiyama: 'Japanese Wall Painting: An Art-historical Overview', *International Symposium on the Conservation and Restoration of Cultural Property: Conservation and Restoration of Mural Paintings: Tokyo, 1984*, pp. 21–36

Colour	English name	Japanese name	Chemical nature and origin	Dates
Red	Cinnabar	Shinsha	Mercuric sulphide (HgS) Mineral	6th century AD-modern
Red	Vermilion	Shu	Mercuric sulphide (HgS) Artificial	6th century AD-modern
Red to brownish-red	Red ochre	Bengara	Iron oxide (Fe_2O_3) Mineral	Early to modern
Red to brownish-red	Red iron	Bengara	Iron oxide (Fe_2O_3) Artificial	Unknown to modern
Red to purplish	Organic reds	Enji	Various insect and plant products	?8th-?19th century
Orange	Red lead	Entan	Lead tetroxide (Pb_3O_4) Artificial	6th century AD-modern
Yellow	Yellow ochre	Ōdo	Hydrated iron oxide (FeO (OH)) Mineral	Early to modern
Yellow	Orpiment	Shiō; sekiō	Arsenic trisulphide (As_2S_3) Mineral	Unknown to modern
Yellow	Gamboge	Tō-tō	Plant resin, imported	8th century AD-modern
Dull yellow	Litharge	Mitsudasō	Lead monoxide (PbO) Artificial	Probably 7th-11th century
Metallic yellow	Gold	Kin	Gold metal	?6th century AD -?modern
Green	Malachite	Rokushō	Basic copper carbonate ($CuCO_3$ Cu (OH)$_2$) Mineral	6th century AD-modern
Dull green	Green	Rokudo	Celadonite glaucanite Minerals	Kofun period
Blue	Azurite	Gunjō	Basic copper carbonate (2$CuCO_3$ Cu (OH)$_2$)	6th century AD-modern
Blue	Smalt	Hana-konjō	Cobalt-glass Artificial	?17th-?19th century
Dark blue	Prussian blue	Konjō	Complex iron cyanide Artificial	18th century onwards
Dark blue	Indigo	Ai	Organic compound made from various plants	8th century AD (or earlier)-19th century AD
White	Lead white	Enpaku	Various lead compounds Artificial	6th or 7th century AD-modern
White	Oyster-shell white	Gofun	Calcium carbonate ($CaCO_3$) from molluscs	15th or 16th century-modern
White	White earth	Hakudo	White clays and quartz	Early to 15th-16th century
Metallic white	Silver	Gin	Silver metal	?6th century AD-modern

73. Table of pigments used in traditional Japanese painting

T. Morita: ' "Nikawa": Traditional Production of Animal Glue in Japan', *International Institute for Conservation: Preprints of the Contributions to the Paris Congress: Paris, 1984*, pp. 121–2

J. Winter: 'Natural Adhesives in East Asian Paintings', *International Institute for Conservation: Preprints of the Contributions to the Paris Congress: Paris, 1984*, pp. 117–20

T. H. Tsien and J. Needham: 'Paper and Printing', *Chemistry and Chemical Technology*, Science and Civilisation in China, V/i (Cambridge, 1985), pp. 331–47

P. Wills: 'Japanese Sericulture', *Orientations*, xvi (1985), pp. 44–9

J. Winter: 'Paints and Supports in Far Eastern Pictorial Art', *Paper Conservator*, ix (1985), pp. 24–31

——: 'Some Material Points in the Care of East Asian Paintings', *Int. J. Mus. Mgmt & Cur.*, iv (1985), pp. 251–64

K. Toishi and H. Washizuka: *Characteristics of Japanese Art That Condition its Care* (Tokyo, [1987])

JOHN WINTER

2. PROTOHISTORIC. While painted decoration appears on objects dating from before the Kofun period (*c.* AD 300–710), the bulk of pre-Buddhist painting in Japan appears in decorated tombs (*sōshoku kofun*) of the 5th–7th centuries AD. In the early stages, painting was often a supplement to crude relief carving on stone. With the changing internal structure of tombs (*see* §III, 2(ii) above), painting gradually became the chief art form before the practice of decorating tombs disappeared.

(i) Introduction. Decorated tombs are defined in Japan as those with wall carvings, incisions, scratchings and paintings, decoration on stone and clay sarcophagi, and reliefs around entrances and inside rock-cut and loam-cut tunnel tombs. Continental models stimulated the practice of tomb painting, but the Japanese inability to reproduce the techniques of painting on hewn and plastered stones (the Japanese painted on unprepared surfaces with unmixed pigments) or to train a core of skilled artisans kept the styles different, so that many Japanese archaeologists deny any connection. The 'Japanese style' remained both technically and stylistically undeveloped (using stick figures, inconsistent scale, disorganized groupings and non-naturalistic colours) until Buddhist subjects and techniques were introduced by foreign craftsmen.

According to archaeological evidence, the first examples of tomb painting appeared in the latter half of the 5th century in the Chikugo River valley on the north-western coast of Kyushu. This area has the largest concentration of decorated tombs. A second group is situated in the Kikuchi River valley in north-western Kumamoto Prefecture on the west coast of Kyushu. A third group is in central and western Kumamoto Prefecture. Many of these tombs have been looted, with the result that the extant wall paintings provide the only indications of the nature of the grave goods.

By the 6th century decorated tombs had appeared on Honshu, where their distribution is more random. Further development of decorated tombs on Honshu was inhibited by the sumptuary laws of 646, set forth by Prince Shōtoku, which changed burial practices by prohibiting human interment and encouraged the acceptance of Buddhism. By the mid-7th century, Kofun-period ritual and its associated artistic practices had been eclipsed by cremation and Buddhist practice, and by the end of the 7th century had disappeared. The number of currently known extant decorated tombs in Kyushu is 107, of which 43 are in Fukuoka Prefecture, 48 in Kumamoto Prefecture and 16 altogether in Saga, Ōita and Nagasaki prefectures. In Honshu, at sites between Okayama Prefecture in the south-west and Fukushima Prefecture in the north-east, there are 54 decorated tombs.

(ii) Materials and techniques. The imprecision of popular Japanese terms for materials contributes to the difficulty of establishing the precise properties of the pigments used in tomb paintings. Even after technical studies have become available, the same vague terms are used to explain the results. It is therefore impossible to determine with certainty the Japanese or continental origins of the colours or the techniques employed in various locales at various times. The pigments were derived from minerals produced from pulverized stone or clay. They include red, from ochre (*bengara*), haematite or cinnabar (*shu*) giving natural vermilion (mercuric sulphide); yellow, from yellow ochre (*ōdo*) or limonite; white, from kaolin (*hakudō*) or kaolinite (china clay); and black, initially from pyrolusite, an oxide of manganese (*mankankō*), but later, under Buddhist influence, from carbon (*sumi*). Green poses a unique problem, even terminologically, since the Chinese and Japanese until modern times used the same word for green and blue. Green is almost exclusive to the Ōtsuka Tomb (*c.* 550 AD, Fukuoka Prefecture). One analysis has shown the pigment to be from the powder of green rocks containing chlorite (*ryōkudeiseki*, a group name for various minerals that are hydrated iron, magnesium and aluminium silicates); another study identified the Ōtsuka green as glauconite (*kairyōkuseki*), which could have been a source also for the blue pigment that occurs in many tombs. The pigments were never mixed with each other, and normally no more than four colours were applied in any one chamber, red being the most widely used in the extant examples. Studies have yet to determine the fixing agent.

During the 5th century the interior structure of tombs in south-western Japan changed from a single room of small, stacked stones to accommodate three bodies (*tateanashiki sekishitsu*; 'vertical hole, stone chamber') to a passageway with one or two burial chambers (*yokoanashiki sekishitsu*; 'horizontal hole, stone chamber') of larger, more carefully hewn stones. The large stones used to construct the walls of the *yokoanashiki sekishitsu* provided the unbroken surface needed to complete a painting programme of any size, and, as painting styles were adapted to the passageway-and-chamber tomb style, decoration was centred on the back wall of the burial chambers, as in the 6th-century Benkeigaana Tomb in Kumamoto Prefecture. In the transitional period, however, vestiges of the former construction were still used in a number of tombs, which provided little unbroken painting surface. This limitation was overcome in the latter half of the 5th century, when long, smooth slabs about a metre high were set against the walls to serve as wall screens (*sekishō*). These were painted and carved, usually with rows of geometric patterns or depictions of pieces of military equipment. The elongated shape discouraged anything more than the systematic repetition of simple motifs.

(iii) Subject-matter and design. Abstract patterns such as the *chokkomon* ('straight-curved'; a pattern composed of rectangles cut by diagonals, the quadrants filled with arcs of many sizes) were the most common motifs used in

Japanese painted tombs, followed by the depiction of implements, utensils, military equipment (often horse trappings and swords), and anthropomorphic and zoomorphic figures. These motifs were generally combined. Celestial motifs such as the sun, moon and stars were illustrated rarely, as were wave patterns. Shapes resembling starfish with tails are generally accepted as ceremonial fans such as existed in Chinese mythology.

The finest example of painted wall screens is in the Idera Tomb (*c.* 500; Kumamoto Prefecture), where screens surround the entire interior. Above them are individual stones painted in red, blue and white and outlined in low relief. The decoration on the screens is a mature form of the *chokkomon*, generally alternating with pairs of concentric circles. *Chokkomon* are found on many funerary articles, such as shell bracelets, stone headrests and *haniwa* (clay cylinders; *see also* §V, 2(iv)(a) above) and may be carved, etched or painted. A cistic screen in the Senzoku Tomb in Okayama Prefecture has fine relief *chokkomon* but lacks the concentric circles, as do the fragmentary wall screens of the Nagazare Tomb in Kumamoto Prefecture. Decoration on the lids of the stone sarcophagi of the Sekijinyama Tomb in Fukuoka and the Kamogo Tomb in Kumamoto resembles the Idera Tomb pattern system. A mechanical device like a compass was used to mark the arcs in Idera, as numerous pinpoints on the stones attest.

The symbolism of *chokkomon* is difficult to interpret. Connections have been made with the Chinese-influenced designs of the Tomb of the Four Guardians (*c.* 6th–7th century AD; Tong'gou, P'yŏngan Bukdo Province, near the Yalu River, Korea). It is also conjectured that the concentric circles associated with *chokkomon* represented mirrors and sun symbols, both identified with the Sun Goddess, Amaterasu Ōmikami, whose attributes included purity, light and new life. The *chokkomon* is often said to be a device to placate the spirit of the dead, to fence in the interior of the tomb or to shackle the spirit to the tomb out of concern for the safety of the living. Nonetheless, when the term was first introduced by Japanese archaeologists in their report on the Idera Tomb in 1917, it was taken to mean a 'skeuomorph'—that is, a greatly debased pattern too far removed from its origin to be traceable. The nebulous character of pre-Buddhist Japanese religion compounds the difficulties of interpretation of such motifs, but some, such as the *warabidemon* ('fern-frond pattern') do suggest identifiable symbols. The *warabidemon*, which resembles a pair of horns, may be interpreted as a shaman's antlers, worn as a disguise in discharging his official mission of escorting the dead to the other world. The Chibusan Tomb in Kumamoto has the only recognizable painting of a shaman, a small, standing, frontal figure, white above the waist and black below, with arms raised, wearing a set of horns or a three-pronged crown.

By the end of the 6th century compositions embodied more complex ideas and in some cases even had narrative qualities. Abstract geometric patterns, such as triangles, lozenges, zigzags and solid circles, were depicted with swords, quivers and shield motifs and, in the most elaborate examples, with motifs such as boats, horses, birds, human figures, fish and reptilian creatures. The latter no doubt had an apotropaic function, serving as spiritual vehicles for the dead on their journey to the other world. An elaborate composition of repeated geometric patterns and figures is seen in the partially destroyed Ōtsuka Tomb (see fig. 74). Earmarked for demolition in 1934, the tomb was saved, although without its passage-way, when it was discovered to have its entire inner surface covered with paint. Flanking the door of the main chamber on huge side slabs is a pair of black horses above a pair of brown horses. They are painted with some attention to detail, the horse trappings being clearly discernible. The large lintel stone above bears hornlike patterns, and its inside is covered with triangles in several colours. The walls of the main chamber, composed of enormous blocks of granite, carry rows of shields and triangles against a red background. The niche at the back (south-west) has two hollowed-out headrests in the sandstone floor slab. Side supports and a shelf make a burial compartment; the interior and the back slab are covered with small painted triangles in red, yellow, green and black, while the wall and corbel vault bear numerous yellow dots on the red paint, perhaps illustrating the Dome of Heaven. Small upright stones in front at either end of the burial compartment have 'horn' and fan patterns. Depressions in the top of these two stones were probably used for burning oil at the final obsequies.

Many tombs were painted only, as the granite of the interior was too difficult to carve. Examples include the Benkeigaana Tomb and the Mezurashizuka Tomb (*c.* late 6th century, Fukuoka Prefecture). The only surviving part of the Mezurashizuka, the large end slab, is executed in red and blue. The narrative scene occupies every available space, a feature typical of Japanese figural wall paintings. On the left side of the slab are a small boat guided by a man with an oar in his hand, a bird in the prow and a large concentric circle overhead, possibly a sun symbol. Three gigantic quivers constitute the centre of the composition, two of them under large arching 'horns'. The right side is badly effaced, but part of it is recognizable as a toad. The entire scene is placed above horizontal lines that traverse the block. Both Daoist and shamanist elements are evident in the Mezurashizuka: the boat, human shaman, the avian guiding spirit and the sun and moon symbols. These components recur throughout Japanese narrative tomb paintings.

Narrative scenes displaying motifs connected with the hunt or a battle are seen at the Gorōyama Tomb (*c.* late 6th century, Fukuoka Prefecture). The painted slabs within the tomb suggest horses with riders, large quivers and two circles in red, blue and green. The hunted or the enemy, as the case may be, is missing. This type of composition is analogous to scenes of the 'happy hunting ground' commonly found in Chinese funerary art and in such Korean tombs as the Tomb of the Dancers (5th–6th century; Tong'gou, P'yŏngan Bukdo Province) of the Koguryŏ kingdom.

The most advanced example of a painted tomb with respect to conception and composition is the 6th-century TAKEHARA TOMB (Fukuoka Prefecture). Arranged in tiers between a pair of vertical fans are a mythical animal with red tongue and talons, wavelike patterns, a large boat, a helmeted man and a horse, and another quadruped and

74. Tomb painting, Ōtsuka Tomb, Fukuoka Prefecture, late 6th century AD; reconstruction cutaway drawing

small boat. The resemblance to the Chinese sequence of elements and flanking fans is striking enough, but certain components are closer to the ancient wall paintings of the Koguryŏ kingdom that feature the 'heavenly horse' (Kor. *chŏllima*) and flying dragons similar to the mythical beast. The boat may be indigenous to Japan. Boats, indeed, were painted, carved or scratched on tomb walls singly or in veritable armadas (e.g. Onizuka Tomb, Ōita Prefecture; Kazuhara and Karimata tombs, Kumamoto Prefecture). Flotillas are shown with leaf-shaped and rectangular sails unfurled.

With the spread of Buddhism, temples began to replace tombs as repositories for the dead of the élite, and imperial restrictions on the size and ostentatiousness of tombs caused their building to cease gradually during the 7th century.

BIBLIOGRAPHY
K. Hamada and S. Umehara: *Higo ni okeru sōshoku aru kofun oyobi yokoana* [Decorated and tunnel tombs in Higo], Kyōto Teikoku Daigaku Bunka Daigaku Kōkogaku Kenkyū [Archaeological research at the College of Culture, Kyoto Imperial University], i (Kyoto, 1917)
K. Hamada, S. Umehara and S. Shimada: *Kyūshū ni okeru sōshoku aru kofun: Yayoi-shiki doki katashiki bunrui zuroku* [Decorated tombs in Kyushu: an illustrated catalogue of Yayoi-style pottery types], Kyōto Teikoku Daigaku Bungakubu Kōkogaku Kenkyū [Archaeological research at the Faculty of Letters, Kyoto Imperial University], iii (Kyoto, 1919), pp. 1–55
J. E. Kidder: *Early Japanese Art* (London, 1964)
Y. Kobayashi and Y. Fujimoto: *Sōshoku kofun* [Decorated tombs] (Tokyo, 1964)
T. Saito: *Kofun hekiga* [Tomb wall paintings], Nihon genshi bijutsu [The beginnings of Japanese art], v (Tokyo, 1965)
T. Mori: *Sōshoku kofun* [Decorated tombs] (Tokyo, 1972)
S. Omatsu, ed.: *Sōshoku kofun to monyō* [Decorated tombs and designs], Kodaishi hakkutsu [Digging up ancient history], iii (Tokyo, 1973)
H. Mizuo: *Sōshoku kofun* [Decorated tombs] (Tokyo, 1977)

J. EDWARD KIDDER JR

3. EARLY (MID-7TH CENTURY–EARLY 14TH). Japanese painting of this period begins with tomb murals and the decoration of a Buddhist household shrine. From the start of the Heian period (794), a rich courtly tradition developed alongside Buddhist painting, although, as in other fields of Japanese art before the mid-14th century (notably calligraphy; *see* §VII below), it is seldom possible fully to distinguish between religious and secular themes and contexts, and Buddhism pervades most forms of artistic expression.

(i) Buddhist. (ii) Shinto. (iii) *Yamatoe*. (iv) *Karae*.

(i) Buddhist. Japanese Buddhist painting is based thematically on Indian and Chinese teachings, and stylistically primarily on Chinese models (*see* CHINA, §XII, 2). As foreign themes and styles were synthesized and transformed, a native Japanese Buddhist tradition emerged. Most Japanese Buddhist paintings are either devotional pictures (*sonzō*) or edifying narratives (*monogatarie*), although the two categories can overlap, and there are many other important types, such as iconographic drawings and portraits. Devotional paintings of Buddhist deities were (and still are) objects of ritual and contemplation, used in ceremonies or to enhance a sanctuary or even domestic

settings such as priests' quarters. These devotional works can be wall, pillar or screen paintings, but are usually hanging scrolls (*kakemono*), painted on silk. Narrative painting includes depictions of holy persons' lives, illustrations of the origins of temples, representations of the events described in a holy text and depictions of miraculous stories about deities. These narratives are usually handscrolls, but they can also be hanging scrolls or screen paintings.

(a) Asuka-Hakuhō (*c.* 552–710) and Nara (710–94) periods. (b) Heian period (794–1185). (c) Kamakura period (1185–1333).

(a) Asuka-Hakuhō (c. 552–710) and Nara (710–94) periods. The oldest surviving Buddhist paintings in Japan, dating from the mid-7th century, adorn the wooden household shrine of Tamamushi Zushi (Beetle-wing Shrine) on its tall, boxlike pedestal (Ikaruga, Nara Prefecture, Hōryūji; see fig. 75). The red and black colours on the painting were created by mixing lacquer and pigments, and the yellow and green colours result from a mixture of pigments with lead oxide and vegetable oil. Sacred figures from the hierarchy of Mahayana Buddhism ('Buddhism of the Great Vehicle')—Buddhas, *bodhisattva*s (Jap. *bosatsu*), guardian figures and *arhat*s (Jap. *rakan*)—appear in these paintings (*see* §II, 3 above; *see also* BUDDHISM, §III, 10). The front door panels of this shrine present two celestial guardians, while the side door panels show four *bodhisattva*s. The back panel presents a mountain scene with three Buddhas seated in pagodas. The interior walls of the shrine are decorated with rows of tiny seated Buddhas, suggesting the thousand-Buddha theme. The front panel of the tall pedestal shows monks worshipping the relics of the historical Buddha, Shaka (Skt Shakyamuni); the back panel depicts the mythical Mt Sumeru, which rises through the centre of the Buddhist universe. The two side panels of the pedestal illustrate two *jātaka* (birth) stories from the previous lives of Shaka: on the left, the legend of a young ascetic who sacrifices his life to hear a profound revelation; on the right, the story of a prince who sacrifices himself to feed a starving tigress and her cubs. All these scenes are painted in an elongated, graceful manner that recalls Chinese styles of the mid-6th century.

In around 700, four Pure Land scenes, each presided over by a Buddha, were painted on the interior walls of the Golden Hall (Kondō) at HŌRYŪJI. On the west wall appears the *Pure Land of Amida* (Skt Amitabha; the Buddha of the Western Pure Land or Paradise). The identification of the other three Pure Land scenes has been debated, but it seems likely that the east wall shows the *Pure Land of Shaka*, and that the north wall presents the *Pure Land of Miroku* (Maitreya; the Future Buddha) and the *Pure Land of Yakushi* (Bhaishajyaguru; the Healing Buddha). Each Buddha sits enthroned, attended by *bodhisattva*s and celestial guardians. On the corner walls are depicted eight standing or seated *bodhisattva*s, facing each other in pairs, and, above them, meditating hermits and flying celestials. Originally the Hōryūji paintings were brightly coloured with mineral pigments of red, green, blue, yellow, purple, white and black applied *a secco* to the wall surfaces over a ground of layers of fine white clay. Although badly scorched when a fire broke out in the

75. Household shrine of Tamamushi Zushi, side panel of pedestal, wood decorated with lacquer and oil-based pigments, h. *c.* 650 mm, mid-7th century AD; National Treasure (Ikaruga, Nara Prefecture, Hōryūji)

Golden Hall during repair work in 1949, the paintings survive in outlines, and restoration based on excellent photographs attests to their former glory. Compared with the paintings on the Tamamushi Shrine, the Hōryūji wall paintings show the more rounded, volumetric forms seen in Chinese 7th-century paintings. They also show signs of a style traceable from India through Central Asia and China, confirming the international character of early Japanese Buddhist art.

Several 8th-century Japanese paintings reflect the sophisticated forms of the contemporary Chinese painting styles. One is the full-bodied, elegant image, brightly coloured and highlighted with gold, of the goddess of beauty, wealth and good fortune *Kichijōten* (Skt Shri Lakshmi or Shri Mahadevi; Nara, Yakushiji; see fig. 76). The temple of Tōdaiji in Nara originally housed a depiction of a graceful, red-robed Shaka preaching in the mountains

76. *Kichijōten*, ink, colours and gold on hemp, 533×320 mm, 8th century; National Treasure (Nara, Yakushiji)

attended by *bodhisattva*s (late 8th century; Boston, MA, Mus. F.A.). The landscape that provides a backdrop recalls the massed, intricate mountain forms of Tang-period (618–907) painting.

Other 8th-century paintings are found in versions (e.g. Kyoto, Daigoji) of the *E inga kyō* ('Illustrated *sūtra* of cause and effect'), handscrolls devoted mainly to the life of Shaka in his last earthly existence, when he achieved Buddhahood. The pictures run continuously above the corresponding text in regular script (*kaisho*), and both pictures and text are read as the scrolls are unrolled. Clothing and architectural forms can be related to Chinese imagery of the late 6th century and the 7th, whereas landscape elements reflect early 8th-century styles. The paintings seem to have been created between 730 and 770, perhaps in the government-sponsored *sūtra* copying bureau in Heijō (now Nara). Vividly coloured and lively in presentation, these works foreshadow the great handscroll paintings of the 12th century and later.

(b) Heian period (794–1185). In 794 the capital was moved to Heian (now Kyoto), and at virtually the same time Tantric Buddhism was introduced from China. Tantric imagery is distinguished from earlier imagery by the prominence given to *maṇḍala*s and also by a new type of Buddha represented wearing jewels and a crown. The number of sacred figures greatly increased, often including deities of Hindu origin. Many Tantric deities have ferocious expressions and multiple limbs and heads to indicate their supernatural power and fierce determination to save all beings. Female deities were especially honoured in Tantric Buddhism. The painted and sculpted images of some Tantric deities became *hibutsu* ('secret images or deities') meant to be seen only by the initiated. Iconographic drawings helped introduce Tantric deities to Japan, and Tantric paintings were often created by monk–artists as a form of religious devotion.

The most important *maṇḍala* of the Shingon and Tendai sects of Tantric Buddhism is the *maṇḍala* of the Two Worlds (*Ryōgai mandara*), introduced to Japan by KŪKAI on his return from China in 806. It consists of a pair of geometric configurations focused on Dainichi (Skt Mahāvairochana; 'the Great Illuminator'). The *Taizōkai* ('Womb' or 'Matrix World') *maṇḍala*, which expresses Dainichi's great compassion as it is revealed in the conditioned world, shows Dainichi in the centre of an eight-petalled lotus flower in a central court. Surrounding this central court are 11 rectangular courts or halls (Jap. *in*), filled not only with hundreds of deities but also with creatures from lower realms of existence. *The Kongōkai* ('Diamond World') *maṇḍala* represents Dainichi's wisdom as it is revealed in the unconditioned Buddha realm. It is composed of nine almost square assemblies (*kue*), three registers of three assemblies; Dainichi appears alone in the middle assembly of the top register. The oldest surviving example of the *maṇḍala* of the Two Worlds, done in gold and silver pigment on purple damask, is popularly called the *Takao mandara* (*c.* 830; Kyoto, Jingoji). Although many of the figures are abraded, the others convey the sense of fullness and of pliant flexibility that characterizes contemporary Tang painting. In the oldest extant polychrome *maṇḍala* of the Two Worlds (859–80; Kyoto, Tōji (Kyōōgokokuji)), the figures are vibrantly coloured, and their individually expressive faces are highlighted with heavy shading reminiscent of Buddhist painting produced in north-west China and eastern Central Asia, particularly at DUNHUANG, during the period of Tibetan control (*c.* 787–848). The *maṇḍala* of the Two Worlds painted in 951 on the interior walls and pillars of the five-storey pagoda at Daigoji, near Kyoto, is another early example. Many of the Daigoji paintings show the beginnings of a transitional style, displaying a greater clarity of line, a lightness of execution and, in the case of certain figures, a brighter colour scheme. The termination of diplomatic relations with China in the late 9th century probably stimulated the development of an indigenous style in the second half of the Heian period. In the category of *besson* ('individual deities') *maṇḍala*s, the deities, most of whom were originally found in the *maṇḍala* of the Two Worlds, are shown at the centres of their own configurations and in relationship to other sacred figures.

Full-bodied and serene paintings of important Tantric deities depicted alone exist from the early Heian period. Examples include the mid-9th-century *Twelve Devas* (Jap.

Jūniten; personifications of natural elements such as the sun, moon and water; Nara, Saidaiji). Powerful images from the mid-Heian period are three brilliant red figures from an original set of the *Five Great Power Bodhisattvas* (*Godai rikki bosatsu*), invoked to protect the nation (late 10th or early 11th century; Wakayama Prefecture, Mt Kōya).

Two important mid-11th-century paintings are the *Daiitoku myōō* (Boston, MA, Mus. F.A.; see fig. 77) and the *Blue Fudō* (Kyoto, Shoren'in). Daiitoku and Fudō are two of the Wisdom Kings (*myōō*), personifications of the rage of Dainichi when he is confronted with delusion and ignorance. Daiitoku's supernatural power is indicated by his six heads, arms and legs, and blue skin; his ability to triumph over death is signified by his water buffalo mount, traditionally associated with the Indian Lord of Death, Yama. The blue-skinned, wall-eyed, double-fanged Fudō, attended by two youths, holds a serpent-entwined sword and a lasso to rope in the recalcitrant. Flames leap up behind each figure. Although their physical features are not portrayed naturalistically, these well-modelled, powerful figures with their pliant outlines seem surprisingly naturalistic. A 9th-century painting of the so-called Yellow Fudō, a form of Fudō revealed to the Tendai chief abbot

77. *Daiitoku myōō*, ink, colours and gold on silk, 1.92×1.18 m, mid-11th century (Boston, MA, Museum of Fine Arts)

Enchin (814–91), is revered as a secret treasure at the temple Onjōji, Shiga Prefecture. Its reproduction is prohibited, but a 12th-century copy (Kyoto, Manshuin) shows a volumetric, front-facing yellow figure, his eyes highlighted with gold leaf.

In a set of the *Five Wisdom Kings* (*Godai Myōō*; 1127; Kyoto, Tōji), each figure is completely surrounded by flames. This work, along with a set of *Twelve Devas* (shown seated; also 1127; Kyoto, N. Mus.), was intended for use in ceremonies at the Shingon'in of the imperial palace. The paintings exemplify the native aesthetic, closely allied to aristocratic taste, that developed in the 11th and 12th centuries. Characteristic are the carefully delineated, often slender figures, the soft and glowing colour harmonies, the many exquisite decorative motifs on the robes of the deities and the skilful application of gold and silver leaf, including threads of cut-gold leaf (*kirikane*). Other Tantric paintings of the middle and late 12th century, which convey a similarly elegant and refined taste and an almost decorative abstractness, include *Batō* (Horse-headed) *Kannon* (Boston, MA, Mus. F.A.), *Shaka* (Kyoto, Jingoji), *Kokūzo bosatsu* and *Kujaku* (Peacock) *myōō* (both Tokyo, N. Mus.), the *Bodhisattva Fugen Enmei* (Prolonger of Life; Kyoto, Matsunoodera) and *Senjū* (Thousand-armed) *Kannon* (Tokyo, N. Mus.).

Although Tantric Buddhism was the dominant Buddhist tradition for most of the Heian period, it mingled with and stimulated the growth of other doctrines, including Pure Land doctrines. Amida, the Lord of the Western Pure Land, had been known since the introduction of Buddhism in the 6th century and was venerated particularly from the 7th century. With the fear that the 'End of the Buddhist Law' (*mappō*) would occur in the year 1052, Heian-period believers called with increasing fervour on Amida's name and patronized religious establishments and works of art in an effort to attain birth and salvation in the Western Pure Land.

Pure Land doctrines promised that Amida and his celestial attendants, foremost among them the *bodhisattvas* Kannon (Skt Avalokiteshvara) and Seishi (Skt Mahāsthāmaprāpta), would descend to greet devotees at the moment of death and guide them to the Western Pure Land to attain enlightenment. The concept of the *raigō* ('coming to welcome') descent provided the inspiration for many visionary—and typically Japanese—paintings from the Late Heian period onwards. The earliest extant representations of the theme are found on the interior walls and doors of the BYŌDŌIN, near Kyoto, a temple that was built on the site of the country estate of the eminent statesman Fujiwara no Michinaga (966–1028). Completed in 1053, these paintings of the welcoming descent, which were originally coloured brightly in hues of red, yellow, green, purple, blue and orange, correspond to the various levels of the Pure Land in which devotees might be born, depending on their store of merit. The paintings also include representations of the gentle Japanese landscape in the four seasons.

A visionary *raigō* from the 12th century is the *Descent of Amida and the Celestial Multitude* (three hanging scrolls; ex-Enryakuji, now on Mt Kōya). Brilliantly coloured, with abundant gold-leaf decoration, this work shows a golden-bodied Amida descending on a swirling bank of clouds

78. Frontispiece from the *Taira Family Sūtras* (*Heike nōgyō*), ink, colours, gold and silver on paper, h. 255 mm, dedicated 1164; National Treasure (Miyajima, Hiroshima Prefecture, Itsukushima Shrine)

above a patch of Japanese landscape; he is attended by 33 sacred figures, some of whom smile merrily. A painting that conveys a feeling of welcome to the Pure Land features the *bodhisattva* Fugen (Skt Samantabhadra) mounted on his elephant (mid-12th century; Tokyo, N. Mus.). The exquisitely drawn and delicately coloured and gilded *Nirvāṇa of the Buddha* (1086; Mt Kōya) depicts the final great enlightenment of Shaka as he lies on his deathbed, beneath sal trees that have miraculously burst into bloom, surrounded by creatures (animal, human and sacred) from various classes of existence. This painting was originally meant to be displayed at death ceremonies held on the 15th day of the second lunar month. An unusual painting showing Shaka sitting up in his coffin to confront his grieving mother and other devotees and to explain his spiritual transformation is *Shaka Rising from his Golden Coffin* (late 11th century; Kyoto, N. Mus.). A set of paintings, also from the late 11th century, shows the 16 disciples of the Buddha (Jap. *rakan*; Skt *arhat*) who remain in this world to uphold the Buddhist Law. Based on Chinese models, these paintings (ex-Shōju Raigōji, Shiga Prefecture, now Tokyo, N. Mus.) present the *rakan* in a natural, humanized fashion that contrasts with other Chinese traditions in which they are shown as grotesque, wonder-working monks.

From about the 8th century, the *Shōtoku Taishi eden* ('Pictorial biography of Prince Shōtoku') became a frequent subject for paintings. A famous version reflecting Shōtoku's cult status as an early patron of Buddhism, painted on silk (1069; Tokyo, N. Mus.) and originally mounted on the walls of the Edono (Picture Hall) at Hōryūji, is the oldest extant example of this theme and one of the early explorations of the *Yamatoe* (traditional Japanese) style. Also of note were the frontispieces to *sūtras* (sacred texts) painted in the late Heian period. Some, although done in gold and silver pigment on indigo paper, were fairly simple, schematic drawings, such as the frontispieces from three transcriptions of the *sūtras* at Chūsonji, Hiraizumi (12th century). Others were more gorgeously decorated, such as the frontispieces to the Lotus Sutra transcription (the *Heike nōgyō*; *sūtras* consecrated by the Heike) commissioned by Taira Kiyomori (1118–81) and other members of the Taira (or Heike) family and dedicated to the Itsukushima Shrine, Miyajima, Hiroshima Prefecture, in 1164 (33-scroll set, colour, gold and silver on paper; see fig. 78). Paintings adorn the outer covers and frontispieces, and the texts are written on richly ornamented papers. Works such as these express the sumptuous aristocratic taste that had come to inform much of Japanese Buddhist painting by the mid-12th century.

(c) Kamakura period (1185–1333). After the rise to power of the Minamoto clan and the shift of the political capital from Heian to Kamakura in eastern Japan, subtle changes started to occur in Buddhist painting. Many of these changes were the result of new relations with China, informal diplomatic ties having been resumed in the 1160s.

A pair of six-panel screens of the standing Juniten (Twelve Devas; 1191; Tōji) shows much of the old aristocratic aesthetic, although the cooler colour scheme and the emphasis on calligraphic line reflect styles of Song-period China (960–1279). Based on issues of style some scholars have recently wondered whether these screens might have been painted as late as the mid-13th century. The *Butsugen butsumo* ('Buddha-eye Buddha-mother'), representing a being who sees through to the essence of things (late 12th century; Kyoto, Kōzanji), is conservative in its even, linear treatment and refined presentation but reflects Song-period Chinese styles in the elimination of brilliant colour (a white figure in a white garment sits on a white lotus) and in the elongated treatment of the deity's body and facial features. The famous monk Myōe (Kōben; 1173–1232) of Kōzanji, whose inscription appears on the *Butsugen butsumo*, is the subject of a (probably 1230s) painting attributed to Myōe's disciple, Enichibō Jōnin (*fl* early 13th century). Myōe sits meditating in a tree, in an intricate grove. The conception reveals an intimate response to Japanese landscape, and the calligraphic presentation again makes reference to Song-period painting.

From the 13th century onwards, various Pure Land sects began to take form. The Pure Land (Jōdo) sect based on the teachings of Hōnen (1133–1212) adopted as its principal icon a complex vision of the Western Pure Land popularly called the *Taima maṇḍala* (Jap. *mandara*). These *Taima maṇḍala*s, painted in the 13th century and later, were patterned on an almost 4 m-square tapestry imported from China in the 8th century, clearly depicting the nine levels of paradise. The *raigō* ('coming to welcome') theme continued to take on new forms, including the *yamagoe* ('crossing the mountains') *raigō* showing Amida rising from the waist up, behind a range of mountains, accompained by only a few attendants. An example is the delicately coloured and coolly rational *Descent of Amida across the Mountains* (first half of 13th century; Kyoto, Zenrinji; see fig. 79). A *yamagoe raigō* from the first half of the 14th century (Kyoto, Konkaikōmyōji) presents a golden-bodied, golden-robed triad: Amida holds strands from a cord, attached to the painting, which a dying devotee could hold to help effect his birth into the Pure Land. The *Swift (Haya) Raigō of Amida and the Twenty-five Bodhisattvas* (Kyoto, Chionin; 13th century) shows a golden, sacred group descending on a precipitous angle to the lower right-hand corner of the composition. Pure Land didactic tales such as the 'White Path Crossing Two Rivers' (*niga byakudō*), in which a devotee must tread a narrow white path between two raging rivers in order to reach the Western Pure Land, became popular from the 13th century onwards. In the late 12th century and the 13th, new imagery introduced from China was assimilated. For instance, the Ten Kings of Hell (Jūōzu), who determine the punishment of those whose deeds prohibit their birth in the Pure Land, were painted frequently at this time.

During the late Heian and early Kamakura periods, *emakimono* (or *emaki*; narrative handscroll paintings or picture scrolls) achieved prominence. Many *emaki* from the 12th century and later are Buddhist in subject-matter. They unroll horizontally, from right to left, and are usually painted on paper.

79. *Descent of Amida across the Mountains*, hanging scroll, ink and colours on silk, 1.38×1.18 m, first half of the 13th century; National Treasure (Kyoto, Zenrinji)

Several outstanding Buddhist-inspired *emaki* of the late 12th century depict alternatives to birth in the Pure Land. These include the *Scrolls of Hell* (*Jigoku zōshi*; colours on paper, h. 261 mm; one scroll each in Tokyo, N. Mus. and Nara, N. Mus.; various fragments in Seattle, WA, A. Mus. and Boston, MA, Mus. F.A.). The *Scrolls of Hell* show sinners suffering horrible torments in hell; the vividly coloured scenes are interspersed with corresponding passages from *sūtra*s. Another riveting *emaki* from the same period is the *Scrolls of the Hungry Ghosts* (*Gaki zōshi*; one scroll each Tokyo, N. Mus. and Kyoto, N. Mus.; see fig. 80). Painted with a gruesome attention to detail, the scrolls show the torments of one of the six paths of existence (*rokudō*), namely, the path of hungry ghosts, where sinners are doomed to a hunger and thirst that can never be satisfied. Their *kana* (Japanese phonetic) texts are derived from teachings in the *sūtra*s. The sufferings of the human world are depicted in the late 12th-century *Scroll of Diseases and Deformities* (*Yamai no sōshi*; colours on paper, h. 252 mm; e.g. Sekido Col.).

The *Scrolls of Frolicking Animals and People* (*Chōjū jinbutsu giga*; two scrolls of four done in the 12th century, probably before 1150; ink on paper, h. 318 mm; Kōzanji) and the *Legends of Mt Shigi* (*Shigisan engi*; 12th century, after 1150; Nara, Chōgosonshiji) differ in several ways from the *Hell*, *Hungry Ghosts* and *Diseases* scrolls. The *Frolicking Animals* and *Shigi* scrolls contain lengthy pictorial sections uninterrupted by text; strong colours are absent—ink alone is used in the *Frolicking Animals* scrolls

80. *Scrolls of the Hungry Ghosts* (detail), fragment of a handscroll, ink and colours on paper, h. 272 mm, late 12th century; National Treasure (Kyoto, National Museum)

and pale colours in the *Shigi* paintings; and the scrolls are informed by a warmly humorous tone. The *Scrolls of Frolicking Animals and People* parody the Buddhist establishment (for example a frog sits, Buddha-like, on a throne), and the *Legends of Mt Shigi* illustrates miraculous and sometimes amusing stories of a 10th-century monk who built a temple on Mt Shigi in Yamato Province.

Buddhist narrative works (*engi*) include the pictorial biographies of holy persons (*eden*), usually eminent monks or priests but sometimes devout lay people. Notable examples are the two 13th-century sets of narrative picture scrolls, the *Tales of Gishō and Gangyō* (*Kōzanji* or *Kegon engi emaki*) and the 14th-century *Pictorial Biography of the Holy Man Hōnen* (*Hōnen shōnin eden*; Kyoto, Chion'in). The evocative *Life of the Holy Man Ippen* (*Ippen hijirie*; h. 377 mm, 11 scrolls Kyoto, Kankikōji; one scroll in Tokyo, N. Mus.), painted in colours on silk instead of the usual paper, is securely dated to 1299. It was produced in collaboration between the Saionji family, Ippen's brother and the painter En'i (or Hōgen En'i; *fl c.* 1299). Other Buddhist narrative works depict the usually legendary origins of temples or holy places. One example is the late 12th-century *Origins of Kokawadera* (*Kokawadera engi*; Wakayama Prefecture, Kokawadera, which features two stories about the Thousand-armed Kannon venerated there. The *Origins of the Taima Maṇḍala* (*Taima mandara engi emaki*; Kanagawa Prefect., Kōmyōji, 13th century) depicts the miraculous events that led to the weaving of the 8th-century *Taima maṇḍala*. Handscrolls were the most common format for *eden* and *engi*, but hanging scrolls were also used. *Eden* and *engi* were expressions of the highly evolved Japanese Buddhist narrative painting tradition.

BIBLIOGRAPHY

T. Naitō: *Hōryūji hekiga no kenkyū*; ed. and Eng. trans. as *The Wall Paintings of Hōryūji* by W. R. B. Acker and B. Rowland (Baltimore, 1943)

D. Seckel: *Grundzüge der buddhistischen Malerei* (Tokyo, 1945)

S. Elisséeff and M. Takaaki: *Japan: Ancient Buddhist Paintings*, UNESCO World Art, ii (Greenwich, CT, 1959)

D. Seckel: *Emaki* (Zurich, 1959); Eng. trans. by J. M. Brownjohn as *Emakimono: The Art of the Japanese Painted Handscroll* (London and New York, 1972)

R. Tajima: *Les Deux Grands Maṇḍalas et la doctrine de l'ésotérisme Shingon* (Paris and Tokyo, 1959)

T. Akiyama: *Japanese Painting* (Lausanne, 1961/*R* New York, 1977)

S. F. Moran: 'Kichijōten, a Painting of the Nara Period', *Artibus Asiae*, xxv/4 (1962), pp. 237–79

H. Ishida: *Mikkyōga*, Nihon no bijutsu [Arts of Japan], xxxiii (Tokyo, 1969); Eng. trans. by E. D. Saunders as *Esoteric Buddhist Painting*, Japanese Arts Library, xv (Tokyo and New York, 1987)

J. Meech: 'A Painting of Daiitoku from the Bigelow Collection', *Boston Mus. Bull.*, lxvii/347 (1969), pp. 18–43

O. Takata and T. Yanagisawa: 'Butsuga' [Buddhist painting], Genshoku Nihon no Bijutsu [Arts of Japan, illustrated], vii (1969)

J. Okazaki: *Jōdokyōga*, Nihon no bijutsu [Arts of Japan], xliii (Tokyo, 1969); Eng. trans. by E. ten Grotenhuis as *Pure Land Buddhist Painting*, Japanese Arts Library, iv (Tokyo and New York, 1977)

H. Okudaira: *Emakimono*, Nihon no bijutsu [Arts of Japan], ii; Eng. adaptation by E. ten Grotenhuis as *Narrative Picture Scrolls*, Arts of Japan, v (New York and Tokyo, 1973)

J. Meech-Pekarik: 'Disguised Scripts and Hidden Poems in an Illustrated Heian Sutra: Ashide and Uta-e in the Heike Nōgyō', *Archvs Asian A.*, xxxi (1977–8), pp. 52–78

Eros and Cosmos in Maṇḍala: the Maṇḍalas of the Two Worlds at the Kyōō Gokokuji (exh. cat.; photographs by Y. Ishimoto; Eng. trans. by C. S. Terry; Tokyo, Seibu Mus. A., 1978)

Journey of the Three Jewels: Japanese Buddhist Paintings from Western Collections (exh. cat. by J. M. Rosenfield and E. ten Grotenhuis; New York, Asia House Gals., 1979)

M. Murase: *Emaki: Narrative Scrolls from Japan* (New York, 1983)

E. ten Grotenhuis: 'Rebirth of an Icon: The Taima *Maṇḍala* in Medieval Japan', *Archvs Asian A.*, xxxvi (1983), pp. 59–87

M. Kiyota: 'Shingon Mikkyō's Twofold *Maṇḍala*: Paradoxes and Integration', *J. Int. Assoc. Buddhist Stud.*, x/1 (1987), pp. 91–116

B. Kurata and Y. Tamura: *Art of the Lotus Sūtra: Japanese Masterpieces* (Tokyo, 1987)
W. J. Tanabe: *Paintings of the Lotus Sūtra* (Tokyo, 1988)
K. L. Brock: 'Chinese Maiden, Silla Monk: Zenmyō and her Thirteenth-century Japanese Audience', *Flowering in the Shadows: Women in the History of Chinese and Japanese Painting*, ed. M. Weidner (Honolulu, 1990), pp. 185–218
A. Yoshitaka: *Butsuga no kanshō kiso chishiki* [An intellectual foundation for appreciating Buddhist painting] (Tokyo, 1991)
Y. Motohiro: *Mandara no kanshō kiso chishiki* [An intellectual foundation for appreciating mandalas] (Tokyo, 1991)
K. L. Brock: 'The Making and Remaking of Miraculous Origins of Mt. Shigi', *Archus Asian A.*, xlv (1992), pp. 42–71
ELIZABETH TEN GROTENHUIS

(ii) Shinto. SHINTO became a national religion in Japan around the end of the 8th century AD (*see* §II, 2 above). The earliest Shinto art works, apart from temples and shrines, were sculptures of deities, tree carvings (*tachiki-butsu*; 'standing tree Buddhas', the oldest examples of which date from the 10th century) and Shinto *maṇḍala*s (Jap. *mandara*), devotional diagrams representing in Japan the practice of worshipping native Shinto deities (*kami*) as avatars (*suijaku*; 'manifestations' or 'traces') of Buddhist deities (*honji*; 'true form' or 'essence'), who would bring salvation to the living. In the *maṇḍala*s, as in religious thought, *kami* and Buddhas were regarded as equal and sometimes even merged together.

(a) Suijaku maṇḍalas. These can be traced back to the 12th century and depict the deity or deities of a shrine or the shrine itself. Most extant examples belong to the late 13th century or the 14th. Several varieties existed: *honji-butsu maṇḍala*s were principally depictions of the 'original Buddhas' of the shrine, while *suijakujin maṇḍala*s were

principally depictions of its *suijaku* deities (see fig. 81); *honjaku maṇḍala*s depicted both the original Buddhas and their *suijaku* forms. *Shakei* ('shrine view') *maṇḍala*s showed the configuration of the shrine and, in many cases, the *honji* Buddhas and *suijaku* gods. *Yōgō* ('apparition') *maṇḍala*s depicted the apparition of the gods to humanity. In addition, some *maṇḍala*s represented the particular characteristics of individual shrines, such as the 'deer *maṇḍala*s' of Kasuga Grand Shrine.

The *suijaku maṇḍala*s were much impacted by the *maṇḍala*s of Esoteric Buddhism (*see* §II, 3 above), as is shown by the regular geometrical arrangement of the ranks of Buddhas (*honji*) and *suijaku* gods. For instance, one of the earliest examples, the 13th-century Hie *maṇḍala* in the temple Enryakuji, depicting Mt Hieizan and its shrine buildings, is painted exactly in the manner of a Buddhist *maṇḍala*; only the number of sacred images and the way they are arranged distinguish it as a Shinto *maṇḍala*. The marked Buddhist influence is due to the strong connection between Hie Shrine and Enryakuji.

(b) Kasuga maṇḍalas. The painting of Kasuga *maṇḍala*s began at almost the same time as Hie *maṇḍala*s; they differed from the Hie *maṇḍala*s in carrying a view of the shrine of Kasuga and, in the upper part, *honji* Buddhas and *siddhaṃ* (Jap. *shittan*) script (a script for writing the form of Sanskrit used in the Buddhist world). In all the shrine-view *maṇḍala*s the shrine was painted with accuracy and in great detail, a characteristic confined to Shinto *maṇḍala*s and an indicator of the importance of shrines in Shinto belief of this period. In some Kasuga *maṇḍala*s, called Kasuga Kōfukuji or Kasuga Shrine (*Kasuga shaji*)

81. *Manifestation of Kasuga Wakamiya Incarnate as a Young Prince*, frontispiece of the *Kongō-hannya-kyō*, h. 260 mm (Tokyo, Gotoh Museum)

*mandala*s, the Buddhas enshrined in Kōfukuji are shown in the lower part. Because Kasuga Shrine was the tutelary shrine of Fujiwara family, Kasuga *mandala*s were created for these aristocratic patrons.

The *bodhisattva* Jizō (Skt Kshitigarbha) was depicted on *mandala*s because the site of the Kasuga shrine had in early times been a cemetery, and Jizō was believed to intercede on behalf of sinners in hell. These portraits are identical with Buddhist portraits of Jizō, except for the addition of other *honji* Buddhas in the upper part. 'Deer *mandala*s' show deer as emissaries of the Kasuga Shrine, bearing a sacred tree on their backs, against a background of the woods within the shrine precincts. They are accurate contemporary animal portraits.

(c) Kumano mandalas. Kumano *mandala*s were as important as Hie and Kasuga *mandala*s, although according to written sources slightly later in origin. The three shrines of Kumano attracted believers nationwide and generated a large variety of *mandala*s. In the centre of a typical *mandala*, the *honji* Buddhas are depicted in a form modelled on the Court of the Eight-petalled Lotus at the centre of a *Taizōkai mandara* ('Matrix' or 'womb World' *mandala*; Skt *Garbha mandala*); in the upper part are the closely related gods of the peaks of Ōdaigahara, such as En no Gyōja (*b* 634), regarded as the founder of the Shugendō religion (*see* §II, 7 above) and in the lower part are depicted the gods of the shrine, such as Inabane Ōji. It is essentially a variation on the original Buddhist *mandala*.

In the case of the late 13th-century Kumano *mandala* in Shōgōin (Kyoto, Sakyō Ward), in place of the lotus-form court are images of deities arranged in several lines; the natural background is strongly emphasized. Other examples depict only *honji* Buddhas and *suijaku* gods; the realistic effect is heightened by a curtain draped over the top part of the picture surface and steps in the lower half.

The Kumano *mandala* in the Cleveland Museum of Art (see fig. 82) depicts the three Kumano shrines in the manner of the Kasuga *mandala*s; there is also an inconspicuous group of *honji* Buddhas. The style is more naturalistic than that of a Kasuga *mandala* and, like the Iwashimizu *mandala* (*c.* 1300; from Iwashimizu Hachiman Shrine, Kyoto), which is of the same type but has no *honji* Buddhas, shows the painting style of Song-period (960–1279) China, imported to Japan in the Kamakura period (1185–1333). In the latter part of the Kamakura period this highly naturalistic style pervaded the *mandala*s of other shrines, including Hie *mandala*s. The deities shown in the upper and lower parts of the Kumano *honji* Buddha *mandala*s are depicted as human: for example old men rest in a corner of the picture or woodcutters come down from the mountains carrying wood. These genre figures show how human existence was viewed within the religious context at the time and were also influential on later pilgrimage *mandala*s.

The Eleven-headed Kannon (Jūichimen Kannon; Skt Ekadashamukha Avalokiteshvara) of Kumano Shrine is the *honji* Buddha of the Nachi Waterfall, himself worshipped as a god. Nachi Waterfall has been worshipped by the Japanese since the earliest period of nature worship. There are, accordingly, a number of excellent 13th- and

82. 14th-century Shinto *mandala* from the Kumano Sanzan Shrines, 1.34×0.62 m (Cleveland, OH, Cleveland Museum of Art)

14th-century portraits of the Eleven-headed Kannon. In many cases, Kannon is shown manifesting himself to humanity, with the waterfall in the background as in the *Picture of Nachi Waterfall* (see fig. 83), which is regarded as a masterwork of early Japanese landscape painting; the sun-disc drawn in the upper edge of the picture marks it as a Nachi Waterfall *mandala*. This picture is the supreme example of a Kumano *mandala* with a naturalism that exceeds that of other Kumano *mandala*s. Such naturalism is also found in pictorial histories of shrines and temples and such works as the *Ippen hirijie* ('Life of the Holy Man Ippen'; Kyoto, Kankōji). Shinto, having nature worship at its essence, conceives as divine the faithful depiction of nature. Hence Shinto paintings and other religious works

83. *Picture of Nachi Waterfall*, colours on silk, 1594×579 mm, late 13th century (Tokyo, Nezu Art Museum)

these depicted the object of the prayer and were hung at shrines by petitioners (*see also* §XV, 2(v)).

BIBLIOGRAPHY
Kodansha Enc. Japan, 'Maṇḍala'
R. T. Paine and A. Soper: *The Art and Architecture of Japan* (Harmondsworth, 1955, rev. 3/1981), pp. 72, 77, 82
H. Kageyama: *Shintō bijutsu*, Nihon no bijutsu [Arts of Japan], xviii (Tokyo, 1967); Eng. trans. by C. Guth as *The Arts of Shinto*, Arts of Japan, iv (New York and Tokyo, 1973)
Shinto Arts: Nature, Gods and Man in Japan (exh. cat. by H. Kageyama and C. G. Kanda, New York, Japan Soc., 1976)

KŌZŌ SASAKI

(iii) Yamatoe.

(a) Introduction. (b) Painters. (c) Screen, door and wall painting. (d) Picture scrolls and books. (e) Fans and decorated scriptures. (f) Portraiture.

(a) Introduction. *Yamatoe* is both an ancient word and the subject of a modern discourse. The word (literally 'painting of Yamato') summons up mental and visual images of Yamato Province (now Nara Prefecture), the mountain-enclosed plain that was once the heartland of the earliest Japanese rulers. Yamato also serves as a nativist designation for Japan, hence *Yamatoe* may be translated as 'Japanese painting'. Pre-modern references to *Yamatoe*, beginning in 999, were almost all written in Chinese characters, the word 'painting' (pronounced *e* or *ga*) being prefaced either with the ancient Sinocentric word for Japan (*wa*, 'short people') or with an alternate character (also read *wa* but meaning 'harmony'), the latter generally preferred by Japanese writers. In the 1930s, *yamato* came to be written in the Japanese phonetic syllabary, stressing the word's ancestry as an indigenous Japanese word (*yamato-kotoba*). *Yamatoe* is therefore an ideologically charged term, in both written form and expressive content.

In both its ancient and modern usages the term imposes a dualistic view of Japanese culture: that native elements are defined in opposition to what is foreign. In its narrowest Heian-period (AD 794–1185) usage, *Yamatoe* was used in opposition to *Karae* ('Tang painting'; *see* §(iv) below) and referred exclusively to the subject-matter of folding screens (*byōbu*). By the 17th century, *Yamatoe* had come to designate 'native' styles, subjects and painters' lineages as distinguishable from *Kanga*, Japanese paintings derived from Chinese paintings imported into Japan from the 13th century. In 20th-century parlance, *Yamatoe* connotes aesthetic or spiritual qualities characterized as 'uniquely Japanese', and paintings imbued with such qualities produced before the Meiji period (1868–1912). The modern equivalent is *Nihonga*.

Yamatoe is now understood to refer broadly, if somewhat elusively, to format, subject, style and even patronage. Screens produced for court patrons were originally the only format termed *Yamatoe*. They depicted courtly activities, seasonal vignettes and famous places celebrated in poetry. By contrast, the many narrative picture scrolls (*emaki* or *emakimono*) of all periods now subsumed under the designation *Yamatoe* depict diverse narrative subjects of interest to and sponsored by a wide and equally diverse audience. '*Yamatoe* style' in general refers to the use of mineral pigments and even gold, conventionalized figure types derived from those of the late Heian period, soft, rounded mountain shapes, two-dimensional patterning and a preponderance of seasonal motifs and narrative

have always displayed a degree of naturalism largely absent from painting in other fields.

(d) Other forms. From these types of *maṇḍala* were derived all other Shinto *maṇḍala*s. The 'apparition' *maṇḍala*s treat the various deities as part of legend and have as their chief subject the intercourse between humanity and the gods. Many of them, for reasons that are not fully understood, bear inscriptions by Zen priests. Early Shinto paintings also took the form of illustrated handscrolls (*emakimono*), large numbers of which depicted the origins of a shrine or miracles performed by its deities, such as the *Kitano Tenjin engi* (*c.* 1219; Kyoto, Kitano Shrine), a set of handscrolls on the life of Sugawara no Michizane and the origins of the temple dedicated to his spirit. Like the Shinto *maṇḍala*s, many of these were created in painting workshops in shrine or temple compounds and stylistically resemble Buddhist paintings of the time. *Ema* (votive plaques) were another form of early Shinto art;

subjects derived from Japanese poetry and prose. As used today by some writers, the term *Yamatoe* implies 'our uniquely Japanese style of decorative court painting'. Whether they personally accept or reject this definition of *Yamatoe*, all writers acknowledge that its ultimate sources were Chinese.

This article dicusses the diversity of 'secular' painting of the Heian and Kamakura (1185–1333) periods, using *Yamatoe* only in its most limited and original sense to describe screens of native subject-matter produced under courtly inspiration. Also discussed are other genres of painting, extant or known from documentary evidence, including some with obviously religious content or function.

(b) Painters. The identities and activities of painters of the Heian and Kamakura periods are as varied as the paintings. Few extant works bear their makers' signatures, but attributions, both secure and doubtful, are numerous. Throughout the period, professional court painters worked at the Imperial Painting Bureau (Edokoro) in the palace. The position of director (*azukari*) was obtained through imperial appointment, apparently changing with the accession of each new emperor. During the Heian period the director was a court official, rather than a painter, but by the early 13th century this was no longer the case. The head painter, selected on the basis of his talent, held the title of 'ink painter' (*sumigaki*), and it was he who produced both the preliminary sketches and the underdrawings. Colour was added by other painters, some working in mineral, some in organic pigments. Assistants prepared the colours and other materials. The *sumigaki* also produced pictorial designs for clothing, lacquerware and other applied arts.

Heian-period court painters' names are known from documentary sources, beginning with Kudara no Kawanari (783–853) and Kose no Kanaoka (*fl c.* 862–95), both painters of Chinese subjects. Kanaoka was the first of many Painting Bureau artists bearing the Kose family name. His descendants Kinmochi, Kintada (both *fl* mid-10th century) and Hirotaka (*fl c.* 995–1023) played an important role in the transformation of imported painting styles and subjects. Members of the Kose family remained active in Kyoto and Nara, until the mid-15th century, but they did not have an exclusive hold on the Painting Bureau. The names of court painters of the Fujiwara, Minamoto, Nakahara and other families are also recorded. Asukabe Tsunenori (*fl c.* 945–?99) painted the first recorded *Yamatoe* screen in 999. Takashina Takakane (*fl c.* 1309–30) was the first director of the Painting Bureau for whom reliable attributions exist.

In addition to court painters, Buddhist painters (*ebusshi*) were attached to temples and engaged primarily in the production of formal devotional images. *Ebusshi* were also called upon to decorate the walls of aristocratic devotional halls with Buddhist images and narratives. Most famous of this group are Kakuyū (Toba Sōjō; 1053–1140), a high-ranking cleric to whom numerous dubious attributions exist, and Hōgen En'i (*fl c.* 1299), who collaborated on the *Life of the Holy Man Ippen* (*Ippen hijirie*; *see* §(i) above).

Many members of the aristocracy, both men and women, also painted as an avocation. Such amateurs occasionally joined their professional counterparts by providing sketches or other directions. Two ladies-in-waiting, Lady Tosa (*fl c.* 1130s) and Lady Kii (*d* 1167), were known at court for their painting in the mid-12th century. Fujiwara no Takanobu and his son Nobuzane were both adept at sketching the likenesses of their fellow aristocrats and established a family tradition of informal portraiture (*see* §(f) below).

Records show that, despite outward differences in their training or affiliation, court painters sometimes painted devotional icons and Buddhist painters collaborated in the production of narratives. During the Heian and Kamakura periods, paintings were produced through collaborative effort between the patrons who commissioned, directed and approved the works and the painters, scribes and their assistants. Even those painters who gained a modicum of fame worked within the long-established system of imperial and aristocratic patronage of painting.

(c) Screen, door and wall painting. Owing to the repeated destruction of Heian (now Kyoto) over the centuries, 'secular painting' of the 9th century to the mid-11th can be studied only through documentary evidence, the screen, door and wall paintings having disappeared. The very few extant screens from the mid-11th century to the early 14th are generally discussed together with contemporary religious paintings from the walls of Buddhist temples, thus offering a glimpse of large-format painting of the Heian and Kamakura periods.

Imperial and aristocratic. Poetry anthologies, courtiers' diaries and historical annals provide numerous clues to the nature of 9th-century screen painting. They suggest that Japanese painting of this period was indistinguishable in subject and style from that on the continent. In the newly built Imperial Palace and the aristocratic mansions, large-scale wall or screen paintings provided images of foreign lands or personages. Thirty-six such screen paintings were removed from the Shōsōin imperial repository (Nara, Tōdaiji) and sold in 814. Some or all of these screens had been imported in the 8th century, and all depicted exotic scenes such as immortal isles, Tang palaces or men and women of the past. Their subsequent whereabouts are unknown: they must have been displayed on special occasions and often copied.

The paintings in the Imperial Palace itself—the door-panel paintings of Confucian worthies in the Shishinden, the landscapes on the walls and door-panel paintings of Lake Kunming (a famous lake in Chang'an, now Xi'an, Shaanxi Province) and the 'wild seas' in the Seiryōden imperial residence—must all have been modelled on such imported prototypes. Before his retirement in 823, Emperor Saga along with three other poets celebrated the Seiryōden landscapes in Chinese verse. These descriptions are the earliest known examples in Japan of poems springing from a poet's appreciation of a painting. Perhaps these Chinese poems were written out on decorated paper squares (*shikishi*) and affixed to the paintings, providing viewers with a literary as well as a visual experience.

Much 9th-century screen painting may be closely linked to the Chinese literary tradition, as is suggested by the popularity in Japan of the Tang-period poet Bai Juyi (Bo Juyi; 772–846). During this same period the Japanese syllabary (*kana*) was developed and used to write native, 31-syllable poems (*waka*). The first screen poems in Japanese (*byōbu uta*) survive in *Kokinwakashū* ('Collection of poems from ancient and modern times'; often called *Kokinshū*; 905), the first imperial anthology of Japanese verse. The earliest, dating from the 850s, refers to a waterfall on a screen painting in the Imperial Palace. A screen produced during the 870s depicted autumn leaves falling into the Tatsuta River, a place made famous in poetry. Neither the two poems, recorded in the *Kokinwakashū*, nor the headnotes reveal whether the Tatsuta screen was devoted to this single autumnal subject or whether the scene was but one among many views of famous places in the four seasons. While the subject was Japanese, the painter probably used stylistic conventions derived from screens on Chinese themes, possibly with figures painted in contemporary Japanese dress.

The composition of screen poems became increasingly fashionable during the last two decades of the 9th century and throughout the 10th. A poetic cycle usually progressed through the four seasons (*shiki*), often incorporating references to famous places (*meisho*) or to seasonal activities (*tsukinami*). S. Ienaga's research (1942) on Heian-period screen poems reveals that an essential characteristic of early screen painting was imagery of the four seasons or the twelve months. The poems themselves suggest that screens often incorporated multiple scenes as vignettes placed within a larger landscape setting. Topics were often given to several poets in advance, and when the screen was finished the best poems were selected to be written out by the finest calligraphers. Other poems were composed more spontaneously, as when a poet was moved by a scene in the screen; in other cases existing poems directly inspired a painting.

Screen painting of the 10th century developed the trends begun in the 9th. Screens continued to have Chinese subjects, but after official relations with China were broken off in 894, Japan's cultural ties with the continent grew more distant. From this time on, an increasing number of screens on Japanese subjects were produced. The first documented use of the word *Yamatoe* appears in 999 in a brief description of a screen produced for Shōshi (988–1074), the daughter of the powerful chancellor Fujiwara no Michinaga (966–1028), and painted by the celebrated Asukabe Tsunenori.

The production of screens depicting activities and famous places in the four seasons peaked about the turn of the 11th century. Whereas in the 9th and 10th centuries screens had been produced for special occasions and were accompanied by specially commissioned poetry, during the 11th century painted screens and door panels came into more common use in aristocratic mansions. The writing of Japanese screen poems quickly declined, even as celebratory screens on Chinese themes continued to be produced in considerable numbers. For example, as late as 1152, six four-seasons screens depicting selections from Bai Juyi's poetry and, accompanied by Chinese poems,

surrounded the imperial dais at the 50th birthday celebration of retired Emperor Toba (*reg* 1107–23).

The most lavish production of screens was for the Great Harvest Festival (Daijōsai) held to consecrate a new emperor. Eastern (Yuki) and Western (Suki) districts were selected to supply new rice. The use of screens in the celebrations can be traced to the reign of Emperor Ninmyō (*reg* 833–50), when 40 were presented during the Yuki ceremony and 20 at the Suki. At that time all the screens presumably represented Chinese subjects and were inscribed in Chinese. Japanese subjects made their appearance by the first half of the 10th century, when the noted *kana* calligrapher ONO NO MICHIKAZE was chosen twice to write out the poems. From Fujiwara no Michinaga's time onwards, enduring precedents were set and detailed records kept: the screen poems were commissioned from the finest poets, the paintings were produced in the Painting Bureau, and the poems were brushed by the ablest calligraphers of the age. The term *Yamatoe* in reference to the Great Harvest Festival screens first appeared, paired with screens of Chinese subjects, in 1168.

The single extant Heian-period landscape screen (*senzui byōbu*), formerly owned by the Shingon-sect temple Tōji, Kyoto (now Kyoto, N. Mus.; see fig. 84), illustrates the ambiguities inherent in the *Karae–Yamatoe* dichotomy.

84. Landscape screen (detail), colours on silk, each panel 1.4×0.43 m, from Tōji, Kyoto, mid-11th century (Kyoto, National Museum)

The subject—a Chinese scholar–hermit receiving visitors at his thatched cottage—should perhaps be seen as *Karae* (*see* §(iv) below), but most scholars describe this screen as an example of '*Yamatoe* style'. Flowering wisteria (*fuji*) pinpoints the season as late spring and may also suggest an association with the Fujiwara family. The landscape motifs are easily traced to Tang-period precedents, as are the clothing and details of the Chinese figures and horses; yet the stiff drawing and awkward articulation suggest that this composition is a distant copy of an imported screen. Similarities in the brushwork and colouring of the landscape to extant paintings dated 1053 in the Hōōdō (Phoenix Hall) at the Byōdōin, Uji, allow a tentative mid-11th-century date. The screen may have been made for an aristocrat or for an emperor's birthday celebration, but, some time after its creation, perhaps in the late 12th century, it came to be used at Tōji as a backdrop during Shingon initiation rites.

Other Shingon-sect temples have screens for similar purposes that date from the Kamakura period and later. The restored landscape screen (mid-13th century; Tokyo, N. Mus.; see fig. 85) belonging to Jingoji is considered the best surviving evidence for the appearance of lost *Yamatoe* screens, although the six panels are currently mounted out of order. It depicts three separate architectural complexes within a broad landscape of low hills leading to distant taller mountains in the upper areas of the screen. Painted squares along the top edge, lacking calligraphy, imitate coloured poem-papers. Each of the architectural settings, from an aristocratic mansion to a rustic country house,

serves as the focus of a romantic encounter, while vignettes of rural life dot the surrounding countryside. Autumn foliage scattered throughout the composition denotes the season, as do several of the activities, such as men cutting reed stalks or women gathering nuts. Other motifs, such as lotus in full bloom or people bathing in a stream, relate to summer. The Jingoji screen may thus have been one of a larger set devoted to the seasons, but its late date of production has suggested that it may have been created expressly for use in a Shingon temple.

Buddhist. In addition to the many screens painted for court and aristocratic use, several documentary records mention large-format narrative paintings on walls or panels produced for Buddhist temples. As was the case for large hanging scrolls, these wall paintings were often produced for lectures given by resident monks, who were prompted by texts and labels in the paintings. One of the earliest of these large-format paintings was the *Life of Prince Shōtoku*, produced for the Osaka temple of Shitennōji (771). Paintings depicting the *Life of the Buddha* (Jap. Shaka, Skt Shakyamuni) and *Amida's* (Skt Amitabha) *Welcoming Descent to Nine Classes* adorned the walls and doors of Fujiwara no Michinaga's temple Hōjōji begun in 1019. During the 1130s the Hōkongōin had panel paintings based on Chinese texts, as well as a depiction of an emperor's flower-viewing excursion. Several references to illustrated biographies of Shingon patriarchs also appear at this time. Panel paintings produced for the Saishōkōin in 1173 depicted scenes from the Lotus *sūtra* as well as contemporary events, while those in the Saishō Shitennōin in 1207 incorporated views of famous places.

All these wall paintings in Kyoto temples have long been lost, but a few extant wall paintings, removed from their original buildings, are characterized by Buddhist themes in the foreground, set against seasonal landscapes. The doors and walls from the Hōōdō at the Byōdōin provide a glimpse of Heian-period painting at its best, despite their ruinous condition. Chancellor Fujiwara no Yorimichi (990–1074) followed his father's (Michinaga's) precedent in the design for the Hōōdō, completed in 1053. Depictions of *Amida's Welcoming Descent to Nine Classes* on the doors and walls of the central bays are accompanied by a representation of Amida's Western Paradise, and a narrative cycle of *Meditations on the Sun*, all based on the *Kanmuryōjukyō* (Chin. *Kuanwu liangshou ching*; 'Sūtra on the meditation of the Buddha of infinite life'). The subjects of each painting are identified in texts from the *sūtra* written out on painted coloured squares. A 13th-century miscellany attributes them to the otherwise unknown Tamenari.

Four of the door compositions preserve something of their original appearance. Modern repairs to the hall and paintings revealed notations on the doors confirming that the paintings were organized according to the seasons: clockwise, beginning on the north side, are spring, summer, autumn and winter. Each composition depicts the descent of Amida (*raigō*, 'coming to welcome') to a believer, whose abode is set in a brilliantly coloured landscape. The scenes vary according to the social position or merit of the believer, from aristocratic laymen in their mansions to a humble ascetic in a mountain hermitage. Carefully drawn

85. Landscape screen (detail), colours on silk, each panel 1.1×0.37 m, from Jingoji, Kyoto, early to mid-13th century (Kyoto, Jingoji, on loan to Tokyo, National Museum)

architecture, the inclusion of such seasonal motifs as deer or turning maples, and the profusion of figures populating the scenes show the painter's attention to otherwise extraneous poetic detail. Most writers, taking primarily into account the landscape and seasonal details, consider these doors and walls to be the epitome of Heian-period '*Yamatoe* style', and use these details as the basis for dating the Tōji 'landscape' mentioned above. Contemporary viewers would probably not have labelled either work as *Yamatoe*.

The *Pictorial Biography of Prince Shōtoku* (*Shōtoku Taishi eden*; Tokyo, N. Mus., Hōryūji Treasure Hall), painted by the otherwise unknown Hata Chitei in 1069, is a rare example of a narrative cycle designed for semi-public lectures. These panels originally adorned the interior walls of the Edono (Painting Hall) at Hōryūji (Nara Prefecture) and may have been based on the lost 8th-century cycle at Shitennōji in Osaka. Despite extensive retouching, the Hōryūji cycle retains its mid-11th-century composition and underdrawing. Organized geographically, events that occurred on the Yamato Plain are situated in the right (east) panel, Shōtoku's Ikaruga Palace and Hōryūji appear near the centre, while Shitennōji, the ocean and China are placed in the left (west) panel. Distant events are depicted across the top of several panels in reduced scale, which, coupled with the repeated diagonal lines of the architecture, creates a consistent bird's-eye view and spatial recession throughout. While the spatial logic of the composition recalls Chinese prototypes, many of the stylistic tendencies found in later 12th-century picture scrolls are already evident. These include idealized pictures of aristocratic figures, rendered in heavy pigments; exaggerated, lively portrayals of members of the lower classes drawn in ink line and lighter colours; and roofs removed to reveal interior scenes. The *Pictorial Biography of Prince Shōtoku* was painted 15 years after the Hōōdō doors and walls, yet it takes a more conservative approach, both in composition and landscape details.

Several paintings survive from the dismantled Shingon hall of Eikyūji, Nara Prefecture. The set includes four *Guardian Kings* (13th century; Boston, MA, Mus. F.A.), depictions of the origin of the two Shingon-sect *sūtra*s (Osaka, Fujita Mus. A.) and a set of eight *Lives of Shingon Patriarchs* (*Shingon hassō gyōjōzu*; Tokyo, Idemitsu Mus. A.). The latter ten paintings, which can be dated to 1136, place their narratives in seasonal landscapes set in India, China and Japan. As in the previous paintings, the viewpoint is high, with architectural settings arranged on a diagonal. Each painting is filled with finely drawn narrative or seasonal detail, which may be compared to extant 12th-century picture scrolls.

(d) Picture scrolls and books. Because so many screens and wall paintings have been lost, narrative picture scrolls now comprise the bulk of extant Heian and Kamakura 'secular' painting. Considered exemplars of *Yamatoe*, and admired as 'uniquely Japanese', picture scrolls in reality represent a wide variety of styles and subjects, many of them religious, and in some cases derived directly from Chinese models.

Court literature. Screen paintings of the 10th century were populated with intimate views of aristocratic men and women, of travellers in the mountains or of rural folk. Some literary historians have suggested that such screen paintings played a role in the creation of poetic tales (*uta monogatari*) such as the 10th-century *Tales of Ise* (*Ise monogatari*) or *Tales of Yamato* (*Yamato monogatari*). A scene in a screen painting with its accompanying poem could have served as the inspiration for an oral tale, told and later written down by court women. Such prose narratives, incorporating more or less poetry, were created throughout the 10th and 11th centuries. The finest of these is Lady Murasaki Shikibu's (*c.* 973–*c.* 1025; see fig. 258 below) *Tale of Genji* (*Genji monogatari*; *c.* 1000). Eventually these court tales came to be illustrated in the small-scale horizontal scroll or book (*sōshi*) formats (*see also* §IX, 2 below). Like screen paintings, the first picture scrolls and books produced in Japan must have been inspired by Chinese prototypes such as Bai Juyi's *Song of Everlasting Sorrow* (Chin. *Chang heng ge*). References to illustrated court tales (*monogatarie*) appear at the same time as such works were being composed and written down. The earliest recorded example was given to Empress Atsuko (872–907) by her cultured ladies-in-waiting. The *Tale of Genji* suggests that the reading and exchanging of illustrated tales were important pastimes among court ladies, and that such paintings could also be created for political as well as aesthetic reasons.

The earliest pictorial version of the *Tale of Genji* (which is also the earliest extant *monogatarie*) dates from *c.* 1120–40. It consists of 20 fragments of painting and many more of text, largely divided between the Tokugawa Art Museum in Nagoya (*see* COLOUR, colour pl. IV, figs 2 and 3) and the Gotoh Museum in Tokyo. According to T. Akiyama's reconstruction, the entire 54-chapter tale was excerpted in an original set of ten scrolls, allowing for one to three illustrations per chapter, or ten per scroll. The text, highly abridged, is written out almost exclusively in elegant *kana* calligraphy on gold- and silver-coloured paper. The task of producing the scrolls is believed to have been shared by four or five groups of aristocrats, who selected the scenes, edited the texts and commissioned painters and calligraphers to execute them.

In the surviving paintings (about one-fifth of the total), the paper was entirely covered in heavy mineral pigments. Exposed underdrawings in pale ink and modern X-ray photographs reveal that the outlines were often redrawn or modified in the course of production. Elsewhere notations in ink underneath the colours confirm the division of labour between the painters who drew the ink lines and those who applied pigments. The pigments were applied in layers to build up flat, opaque planes of colour, a technique known as *tsukurie* ('built-up pictures'). This feature, a characteristic of '*Yamatoe* style', was nonetheless derived from Chinese painting.

Interior views focusing on significant, emotional moments are the predominant compositional type. In many cases a scene depicts a poetic exchange, described in the previous text. Few scenes show people standing or in motion. Rooms are seen from an elevated viewpoint, sometimes through the beams of a non-existent roof, a compositional device modern writers call *fukinuki yatai*

('blown-off roof'). The painters varied their overall compositions using diagonally divided indoor–outdoor scenes, frontal parallel views and an occasional outdoor setting.

The figure drawing represents conventions developed perhaps a century earlier. Faces and hands emerge from voluminous soft garments that do not reveal the bodies underneath. Noblemen and women alike have plump, pear-shaped heads painted white and with abbreviated facial features now universally described as *hikime kagihana* ('line for an eye, hook for a nose'). High foreheads accented by thick black eyebrows are another feature shared by men and women. The long black hair of women seen from behind comes to a point at the top of their heads. The only indicators of age or of lesser social status are thinner and shorter hair and, in profile views, the addition of a nose.

The several stylistic characteristics associated with the illustrated *Tale of Genji* continued in other examples of illustrated court literature, such as the *Tale of Nezame* (*Nezame monogatari emaki*; colours on paper, h. 258 mm; Nara, Yamato Bunkakan) and the *Tale of the Eighth Month* (*Hatsuki monogatari emaki*; colours on paper, h. 233 mm; Nagoya, Tokugawa A. Mus.), both dating from the late 12th century, and the *Diary of Murasaki Shikibu* (*Murasaki Shikibu nikki ekotoba*; 1230s; colours on paper, h. 310 mm; Tokyo, Gotoh Mus.; Osaka, Fujita Mus. A.; Japan, priv. col.). As in the *Genji* scrolls, the texts of these scrolls are written in *kana* on lavishly decorated paper. The figural styles and compositions differ slightly from *Genji* in the first two examples, while in the third the figures have more expressive faces and active poses, and they occupy more descriptive spatial settings. A variant style is the elimination of colour, reducing the painting to fine lines and patterns in monochrome ink (*hakubyō*; 'white drawing'). While this ink-line technique may have existed as early as Murasaki's time, the earliest extant work is a fragment of a *Tale of Genji* book (13th century; ink on paper; Nara, Yamato Bunkakan). Court literature, especially the *Tale of Genji*, in both full-colour and monochrome versions, continued to be an important subject for court painters in later periods.

Short narrative tales. Illustrated short narrative tales (originally also called *monogatari*, now known as *setsuwa*) may stem ultimately from narrative cycles depicting the life and former lives of Shaka. The earliest extant examples appear in the mid-7th-century Tamamushi Shrine at Hōryūji and the mid-8th-century *Illustrated Sūtra of Cause and Effect* (*E inga kyō*; e.g. Kyoto, Daigoji and Jōbonrendaiji, and other cols; *see* §(i) above). These latter scrolls are the earliest extant Chinese or Japanese narrative picture scrolls. The gap between these *sūtra*s and the next extant examples of such illustrated narratives is filled only by such tale collections as the *Miraculous Stories of Japan* (*Nihon ryōiki* or *Nihon reiiki*; *c.* 823), compiled by the Buddhist monk Kyōkai [Keikai], and especially the *Illustrated Three Jewels* (*Sanbōe*; 984), compiled for a tonsured princess to explain the history of Buddhism and its practice in Japan. In the 11th and 12th centuries religious and secular tales were being gathered into compendia by learned members of the clergy and upper classes. By the mid-13th century, short Buddhist moral tales or more lengthy lives of important Buddhist patriarchs had replaced the earlier poetic romances as the most common type of illustrated literature.

The two most important 12th-century examples of illustrated tales are the *Tale of the Ban Major Counsellor* (*Ban Dainagon ekotoba*; three-scroll set, colours on paper, h. 315 mm; Tokyo, Idemitsu Mus. A.) and the *Miraculous Origins of Mt Shigi* (*Shigisan engi emaki*; three-scroll set, colours on paper, h. 317 mm; Nara Prefecture, Chōgosonshiji; see fig. 86). The former details the deliberate burning of the Ōten Gate of the Imperial Palace in 866 by Ban Yoshio (809–68). The three connected stories in the *Miraculous Origins of Mt Shigi* have less to do with historical fact than with inspiring piety. They focus on the saintly activities of a reclusive ascetic monk named Myōren and his sister, a nun, and each seems intended to prove the sacredness of Mt Shigi and the efficacy of the temple's founder.

The events of *Ban Major Counsellor* and *Mt Shigi* are narrated in short paragraphs of *kana* text written on undecorated paper. Each text is followed by a lengthy painting in which scene changes, often framed by mist or trees, are signalled by the frequent reappearance of the

86. *Miraculous Origins of Mt Shigi*, detail from scroll I, colours on paper, h. 317 mm, mid- to late 12th century (Nara Prefecture, Chōgosonshiji)

protagonists. In a few startling instances, the same figure appears repeatedly within a short space, indicating a quick passage of time. This narrative device (now called *iji dōzu*) is used sparingly but effectively in other illustrated tales as well. *Ban Major Counsellor* is noted for its crowd scenes, the atmosphere of excitement and the gestures of the figures. *Mt Shigi* has in addition a wealth of genre detail, landscape settings and an ever-changing viewpoint. The painters of both scrolls relied on fluent ink lines to create the exaggerated features of lower-class figures. Both scroll sets have lost much of the original mineral pigments once used for garments and interior and exterior details. The dating of both of these picture scroll sets is uncertain. Analyses of costume, customs and architectural details have suggested a range of 1160–80 for both these scrolls, but their absolute and relative dates remain uncertain.

Several other examples of short tales rendered in continuous compositions survive from the 12th and 13th centuries. Closely linked to *Ban Major Counsellor* in style is the *Legend of Hikohohodemi* (*Hikohohodemi no mikoto emaki*; Fukui Prefecture, Myōtsūji; Kyoto, N. Mus.; and other cols), known through several 17th-century copies, and *Minister Kibi's Visit to Tang China* (*Kibi Daijin nittō*; colours on paper, h. 321 mm; Boston, MA, Mus. F.A.). *Hikohohodemi* depicts an ancient tale about the legendary ancestors of the imperial family, while *Minister Kibi* follows a Japanese ambassador to Tang-period China and pokes fun at his Chinese captors. The *Miraculous Origins of Kokawadera* (*Kokawadera engi emaki*; colours on paper, h. 306 mm; Wakayama Prefecture, Kokawadera) illustrates two related stories about an image of the Thousand-armed Kannon worshipped in Kii Province (now Wakayama Prefecture) and appears to be a copy of an original produced in the late 12th century.

None of these earlier 'tale' scrolls can be dated with certainty, nor can their patrons be verified. By contrast, the *Tales of Gishō and Gangyō* (or *Biographies of the Patriarchs of the Kegon Sect*; Jap. *Kegonshū soshi eden* or *Kegon engi emaki*; seven-scroll set, colours on paper, h. 315 mm) is still owned by Kōzanji, Kyoto, the temple to which it was given by 1250. Their content, focusing on two Korean monks, may be closely linked to the interests of lay patrons who supported the Kōzanji community and revered the temple's founder, Myōe (1173–1232), who undoubtedly played a role in the scrolls' creation. These scrolls are sometimes categorized as 'lives of eminent monks' (*kōsōden*), but the texts are more akin to illustrated tale literature than to biography. The *Gishō* scrolls also include a lengthy question-and-answer commentary, a feature not found in any other picture scroll.

The *Tales of Gishō and Gangyō* is equally important as evidence of the reception of Song-period styles and motifs in Japanese painting of the early 13th century. Figures, motifs and entire compositions in the *Gishō* scrolls were copied or modified from newly imported works, especially woodcut-illustrated Buddhist or secular texts. The *Gangyō* scrolls incorporate knowledge of newly imported Buddhist portraits. These Chinese characteristics link them to other contemporary picture scrolls such as the *Pilgrimage of Sudhana* (*Zenzai dōji emaki*; Nara, Tōdaiji), a tale about an Indian youth seeking enlightenment, derived from Kegon-sect scripture.

A few other tale scrolls of the 13th and 14th centuries may be included in this group: the *Tale of Obusuma Saburō* (*Obusuma Saburō ekotoba*; Tokyo, N. Mus.), similar in style to the *Poetry Contest on the Newly Selected Scenic Spots of Ise Province* (*Ise shin meishoe uta awase*; 1295, Ise Shrine); the *Life of Saigyō* (*Saigyō monogatari*; 13th century, Nagoya, Tokugawa A. Mus.), noteworthy for its fine landscape settings; the *Tale of Lord Haseo* (*Haseo sōshi*; Tokyo, Eisei Bunko) and the *Tale of a Painter* (*Eshi no sōshi*; Tokyo, Imp. Household Col.), both from the early 14th century and similar in their large-figure style.

The problem of Onnae *and* otokoe. The obvious contrast between illustrated court literature such as the *Tale of Genji* and short narrative tales such as *Mt Shigi* and *Ban Major Counsellor* has led some Japanese and Western scholars to re-evaluate an elusive pair of terms found in Heian-period documents. *Onnae*, which may be translated as 'painting of a woman', 'painting by a woman' or 'women's painting', indicates, in their view, the elegant, heavily painted 'feminine' style of *Genji*. The designation *otokoe* ('painting of a man', 'painting by a man' or 'men's painting') is used to characterize the quickly rendered, lively brushwork and animated activity of *Mt Shigi*. Some writers identify *onnae* as a private and amateur activity, practised by women, which suggests that *otokoe* is conversely the 'public' work of professional painters. This male-female dichotomy parallels a similar one in Heian-period discussions of calligraphy, with *onnade* ('women's hand') referring to *kana* calligraphy and *otokode* ('men's hand') to writing in Chinese. Yet the notion that Heian-period aristocrats discussed painting styles and techniques in gender terms is questionable and the evidence for such a view is lacking. *Onnae* appears only seven times in contemporary documents, the earliest dating from 974, in contexts too varied to support a single definition. Still fewer clues are available for *otokoe*, which occurs twice only, both times in contrast to *onnae*, and neither in connection with the type of short narrative tale represented by *Mt Shigi*. Many scholars now consider *onnae* to have been synonymous with *monogatarie*, on the presumption that both were produced by and for a female audience. However, the use of *otokoe* as an all-encompassing designation either for short narrative tales or for other genres of picture scrolls cannot be supported.

Biographies and temple and shrine histories. Lengthy chronological accounts, such as a monk's biography, legends associated with a Buddhist temple, a Shinto shrine or their deities, were produced in increasing numbers in the 13th and later centuries. The texts of these works make heavy use of Chinese characters, suggesting a highly literate audience. Many survive in multiple versions, both as picture scroll sets and later as hanging scrolls, evidence that they frequently served didactic purposes.

The earliest extant example of a chronological narrative is the over-size *Miraculous Origins of Kitano Tenjin* (*Kitano Tenjin engi emaki*; *c.* 1219; incomplete eight-scroll set, colours on paper, h. 520 mm; Kyoto, Kitano Shrine), which recounts the life of Sugawara no Michizane and his eventual deification as Tenjin. Its extraordinary scale, heavy mineral pigments and wealth of narrative detail set it apart from most other scrolls. Michizane's story was illustrated frequently, and versions were made for Tenjin

shrines throughout the country. The best of these is the *Miraculous Origins of Matsuzaki Tenjin* (*Matsuzaki Tenjin engi emaki*; 1311; colours on paper, h. 359 mm; Yamaguchi Prefecture, Hōfu Tenmangū).

Many more temple and shrine histories were produced in the 14th century. *Miracles of the Kasuga Deity* (*Kasuga gongen genkie*; 1309; 20-scroll set, colours on silk, h. 412 mm; Tokyo, Imp. Household Col.) was painted by the director of the Painting Bureau, Takashina Takakane, at the behest of the Saionji family, a branch of the Fujiwara. Fujiwara clan patronage also lay behind the *Miraculous Origins of Ishiyamadera* (*Ishiyamadera engi*; 14th century; colours on paper, h. 336 mm; Shiga Prefecture, Ishiyamadera), begun during Takakane's time.

While illustrated 'lives of eminent monks' may be traced to a lost set of screen paintings (1102) depicting the travels of Jōjin (1011–81) in China, the earliest recorded picture scroll set appears in a record with the title *Lives of Our Country's Four Great Teachers* (*Honchō shi daishi dene*; 1212). In 1237 the first illustrated life of Hōnen (1133–1212) appeared (*Honchō sōshi denkie*; not extant), followed by those of a host of other monks, both native and foreign. These scrolls generally present their protagonists' lives chronologically from birth to death, including the circumstances of their tonsuring, their travels and their teaching activities, as well as events relating to their followers. The texts are not strictly factual, as miracles or other digressions are often included.

Among Japanese monks, illustrated versions of the lives of Kūkai, Ryōnin (1073–1132), Hōnen, Shinran (1173–1262) and Ippen (1239–89) are the most numerous. The *Life of the Holy Man Ippen* presents bird's-eye-view landscape panoramas, similar, perhaps, to lost screens depicting famous places. Subtle washes in ink and mineral pigments, as well as certain compositional details, suggest that the painter had been exposed to newly imported Song-period landscape paintings.

Of the few biographical scrolls devoted to the activities of foreign monks, the extensive travels of the two Chinese monks Xuanzang (Jap. Genjō; 602–64) to India and Jianzhen (Jap. Ganjin; 688–763) to Japan obliged Japanese painters to depict foreign subjects. *Ganjin's Eastern Expedition* (*Tōseiden emaki*; 1298, five-scroll set, colours on paper, h. 375 mm; Nara, Tōshōdaiji), produced by Rokurōbei Rengyō (*fl* late 13th century), an otherwise unknown painter from Kamakura, was executed in a style derived from recently imported paintings of the 500 *rakan* (Skt *arhat*, a sage who has attained release from the cycle of rebirth). Ink landscapes and bird-and-flower motifs adorn the screens and sliding-door panels in decidedly Chinese architectural settings. The painters of the *Travels of Genjō* (*Genjō sanzoe*; 12-scroll set, colours on paper, h. 402 mm; Osaka, Fujita A. Mus.) also made use of imported compositions and motifs, but the heavily coloured and embellished style is more characteristic of the early 14th-century Court Painting Bureau during Takakane's tenure.

Other genres. While court literature, short narrative tales and chronological accounts make up the largest number of picture scrolls, a few other genres may be noted. Several scrolls depict aristocrats suffering the torments of hells and diseases or of hungry ghosts in search of food (*see*

also §(i) above). Illustrated woodcut texts imported from China inspired late 12th-century scrolls such as the *Pilgrimage of Sudhana* (see above) and mid-13th-century illustrations of the Lotus Sutra (e.g. New York, Met.). Several 13th-century scrolls depict the violence and heroism of warriors in battle based on war tales (*gunki monogatari*) that were both written down and told orally at that time. The *Tale of the Heiji Rebellion* (*Heiji monogatari ekotoba*; Boston, MA, Mus. F.A.; Tokyo, N. Mus. and Seikadō Bunko) provides the most graphic depictions of the devastation of war, while the *Mongol Invasions* (*Mōko shūrai ekotoba*; 1293; Tokyo, Imp. Household Col.) glorifies one warrior's role in the defence of Japan. A few picture scrolls contain no text, such as the *Annual Rites and Ceremonies* (*Nenchū gyōji emaki*; *c.* 1173), known only from 17th-century copies, and the well-known satirical *Scrolls of Frolicking Animals and People* (*Chōjū jinbutsu giga*; 12th–13th centuries). The monochromatic drawing style and fluent depictions of animals in the later scrolls suggest that they were painted by Buddhist monk-painters practised in iconographical drawings.

(e) Fans and decorated scriptures. A few fans have been preserved through special circumstances, for example the slatted cypress examples given to the Sada (Shimane Prefecture) and Itsukushima (Hiroshima Prefecture) shrines. The Itsukushima fan presents a bird's-eye view of noblemen enjoying cherry blossoms (second half of 12th century, colours on wood, w. 160 mm). An impressive set of fan papers was given to Shitennōji in the 1150s (Osaka, Shitennōji; Tokyo, N. Mus.). These were folded and bound into book format to receive the texts of the Lotus Sutra, which was then carefully written out in black ink or gold paint on top of the original paintings of scenes of courtly life. Some fans appear to illustrate passages from court literature, but most depict seasonal activities, with summer topics predominating. Both aristocrats and commoners are shown going about their daily activities in scenes that greatly expand upon the repertory of subjects found in contemporary picture scrolls, such as *Tale of Nezame*, *Ban Major Counsellor* or *Mt Shigi*.

Closely related to these fans and picture scrolls of the courtly type are decorated versions of the Lotus Sutra produced from the 11th century to the 13th by coteries of aristocratic men and women. One such project took place in 1021, the *sūtra* being transcribed and dedicated on behalf of Empress Kenshi (997–1027). The literary descriptions of the varied techniques used and of specific frontispieces to the scrolls accord well with extant examples from the late 12th century, especially the *Taira Family Sūtras* (*Heike nōgyo*; see fig. 78 above). These paintings vividly reveal the close interrelationship between Buddhist and secular painting of the period.

(f) Portraiture. 'Secular' Japanese portraits usually served religious or didactic functions. Before the late 12th century, most portraits did not involve a confrontation with the sitter. Rather, portraits were imaginary creations produced long after the subject's death. Portraits of emperors, aristocrats, Buddhist monks and nuns, warriors and lay men and women were hung in residential chapels, Buddhist temples and even Shinto shrines, where they

served as the focus of memorial ceremonies. Most were large, full-colour paintings on silk, often accompanied by a poetic or praiseworthy inscription above the image.

The first Japanese layman to be honoured with a portrait was almost certainly Prince Shōtoku, subject of the earliest extant portrait (?7th century; Tokyo, Imp. Household Col.). The pose of the prince flanked by two attendant boys echoes Chinese imperial portraits. During the late Nara and the Heian periods, imaginary portraits of Confucius and his followers were the focus of ceremonies carried out in the university. Other Chinese sages adorned the walls of the audience hall in the Imperial Palace, and later versions of these paintings show standing Chinese figures beneath eulogies inscribed on poem-papers. The representation of the Tang-period poet Bai Juyi in screen paintings may have inspired imaginary hanging-scroll portraits of the Japanese poet Kakinomoto Hitomaro (*fl c.* 687–707), honoured at poetry gatherings beginning in 1118. By about 1180, imaginary portraits of the Thirty-six Immortal Poets (*Sanjūrokkasene*) accompanied collections of their poems, in handscroll format. Two well-known 13th-century handscroll versions survive, the Agedatami and Satake scrolls, both of which are fragmented and scattered among several collections in Japan and the USA (e.g. Washington, DC, Freer).

The creation of imaginary poet-portraits in the late 12th century paralleled a new departure in the history of 'secular' portraiture: the representation of living aristocrats in depictions of court activities. At Saishōkōin, wall paintings (destr.) depicting three recent imperial outings included faces of the participants rendered in 1173 by Fujiwara no Takanobu (*see* FUJIWARA (ii), (6)), a poet and talented amateur painter. Takanobu is often credited with three formal portraits used in memorial ceremonies at Jingoji (see fig. 87). Their execution, however, suggests the work of professional painters, and it is doubtful that all were drawn from life. Their date and the attribution to Takanobu continue to be the subject of hot debate.

Takanobu became the progenitor of a family of portrait painters that lasted into the mid-14th century. His son Fujiwara no Nobuzane (*see* FUJIWARA (ii), (8)) became known for *nisee* ('likeness pictures'), especially sketches made of participants at contemporary court events. A portrait of *Retired Emperor GoToba* (*reg* 1183–98; Minase Shrine), made before GoToba's journey into exile in 1221, is reliably attributed to Nobuzane. Its small scale and the use of paper suggest that it was meant to serve as a model for a formal memorial portrait on silk. Nobuzane may also have painted the imaginary poet-portraits of the Satake version of the *Thirty-six Immortal Poets*. The portrait of *Hanazono* (*reg* 1308–18; Kyoto, Chōfukuji) painted in 1338 by Nobuzane's great-great-grandson Gōshin (*fl c.* 1319–40s) marks the end of the informal *nisee* tradition.

Formal memorial portraits of lay subjects became increasingly common from the Kamakura period, as members of the ruling Hōjō and Ashikaga families commissioned portraits for their family temples. Professional painters, especially members of the Tosa family (*see* TOSA SCHOOL), brought the nascent realism of the Jingoji portraits to fruition in the 14th century and later.

87. Fujiwara no Takanobu (attrib.): *Yoritomo*, colours on silk, 1394×1118 mm, from Jingoji, Kyoto, late 12th century (Kyoto, Jingoji)

BIBLIOGRAPHY

S. Shimomise: *Yamatoe to Karae* [*Yamatoe* and *Karae*] (Tokyo, 1927)
I. Tanaka: '*Yamatoe* josetsu' [Introduction to *Yamatoe*] (1933), *Tanaka Ichimatsu kaigashi ronshū* [Collected writings of Tanaka Ichimatsu on the history of painting] (Tokyo, 1985), pp. 51–85
S. Ienaga: *Jōdai Yamatoe nenpyō* [Chronology of ancient *Yamatoe*] (1942, rev. Tokyo, 1966)
——: *Jōdai Yamatoe zenshi* [Complete history of ancient *Yamatoe*] (1942, rev. Tokyo, 1966)
A. Soper: 'The Rise of Yamato-e', *A. Bull.*, xxiv/4 (1942), pp. 351–79
S. Shimomise: *Yamatoeshi kenkyū* [Research on the history of *Yamatoe*] (Tokyo, 1944)
——: *Yamatoe* (Kyoto, 1946)
S. Ienaga: *Yamatoe ron* [A discussion of *Yamatoe*] (Tokyo, 1947)
I. Tanaka, ed.: *Nihon emakimono zenshū* [Complete collection of Japanese picture scrolls], 24 vols (Tokyo, 1958–69); repr. and expanded in *Shinshū Nihon emakimono zenshū* [New edition of complete collection of Japanese picture scrolls], ed. I. Tanaka, 29 vols and 3 suppls (Tokyo, 1975–81)
H. Okudaira: *Emakimono* (1966), Nihon no bijutsu [Arts of Japan], ii (Tokyo, 1964–9); Eng. trans. and adaptation by E. ten Grotenhuis as *Narrative Picture Scrolls*, Japan Arts Library, iv (New York, 1973)
A. Soper: 'A Ninth-century Landscape Painting in the Japanese Imperial Palace and Some Chinese Parallels', *Artibus Asiae*, xxix (1967), pp. 335–50
S. Miyajima: 'Jūyon seiki ni okeru edokoro azukari no keifu' [Lineage of directors of the Painting Bureau during the 14th century], *Bijutsushi*, xx/4 (1973), pp. 87–104
T. Miya: *Shōzōga* [Portraiture] (1975), Nihon no bijutsu: Bukku obu bukkusu [Arts of Japan: book of books], xxxiii (Tokyo, 1973–5)
T. Yanagisawa: 'Shingon hassō gyōjōzu to haiji Eikyūji Shingondō shōjie' [Paintings depicting the lives of eight patriarchs of the Shingon sect, originally owned by Eikyūji], *Bijutsu Kenkyū*, 300 (1976), pp. 50–71, pls I–IX; 302 (1976), pp. 119–42, pls III–IX; 304 (1977), pp. 189–210, pls III–IX; 332 (1985), pp. 113–28, pls I–VII; 337 (1987), pp. 97–112, pls VII–X
S. Komatsu, ed.: *Nihon emaki taisei* [Compilation of Japanese picture scrolls], 27 vols (Tokyo, 1977–82)

J. Meech-Pekarik: 'Disguised Scripts and Hidden Poems in an Illustrated Heian *Sūtra*', *Archvs Asian A.*, xxxi (1977–8), pp. 52–78

Y. Shimizu: 'Seasons and Places in *Yamato* Painting and Poetry', *A. Orient.*, xii (1981), pp. 1–14 [with 4 pp. of pls]

S. Komatsu, ed.: *Zoku Nihon emaki taisei* [Compilation of Japanese picture scrolls, continued], 20 vols (Tokyo, 1981–4)

S. Miyajima: 'Kose-ha ron-Heian jidai no kyūtei eshi' [Court painters of the Heian period: a study of the Kose school], *Bukkyō Bijutsu*, 167 (1986), pp. 11–26; 169 (1986), pp. 98–120

W. J. Tanabe: *Paintings of the Lotus Sutra* (New York, 1988)

M. Nakano, H. Hirata, M. Sano, eds: *Ōchō emaki to sōshokukyō* [Courtly picture scrolls and decorated *sūtras*] (1990), vii of *Nihon bijutsu zenshū* [Complete collection of Japanese art] (Tokyo, 1990–)

R. Tyler: *The Miracles of the Kasuga Deity* (New York, 1990)

T. Akiyama: 'Women Painters at the Heian Court'; Eng. trans. and adaptation by M. Graybill, *Flowering in the Shadows: Women in the History of Chinese and Japanese Painting*, ed. M. Weidner (Honolulu, 1992), pp. 159–84

K. L. Brock: 'Chinese Maiden, Silla Monk: Zenmyō and her Thirteenth-century Japanese Audience', *Flowering in the Shadows: Women in the History of Chinese and Japanese Painting*, ed. M. Weidner (Honolulu, 1992), pp. 185–218

——: 'The Making and Remaking of *Miraculous Origins of Mt Shigi*', *Archvs Asian A.*, xlv (1992), pp. 42–71

L. S. Kaufman: 'Nature, Courtly Imagery, and Sacred Meaning in the *Ippen Hijiri-e*', *Flowing Traces: Buddhism in the Literary and Visual Arts of Japan*, ed. J. H. Sanford, W. R. LaFleur and M. Nagatomi (Princeton, 1992), pp. 47–75

J. S. Mostow: 'Painted Poems, Forgotten Words: Poem-pictures and Classical Japanese Literature', *Mnmnt. Nipponica*, xlvii/3 (1992), pp. 323–46

K. Chino: *Jū-jūsan seiki no bijutsu: Ōchōbi no sekai* [The art of the 10th to 13th centuries: the world of courtly beauty] (1993), iii of *Iwanami Nihon bijutsu no nagare* [Iwanami's 'The Flow of Japanese Art'], ed. N. Tsuji (Tokyo, ?–1993)

Yamatoe: Miyabi no keifu [Japanese painting in the tradition of courtly elegance], Tokyo, N. Mus. (Tokyo, 1993)

M. Nakano, ed.: *Engie to nisee* [Origin paintings and likeness pictures] (1993), ix of *Nihon bijutsu zenshū* [Complete collection of Japanese art] (Tokyo, 1990–)

Y. Hirata: *Ebusshi no jidai* [The age of Buddhist painters], 2 vols (Tokyo, 1994)

S. Miyajima: '*Shōzōga*' [Portraiture] in *Nihon rekishi sōsho* [Collected works on Japanese history] (Tokyo, 1994)

T. Shinbo and others, eds: *Emakimono sōran* [Comprehensive survey of picture scrolls] (Tokyo, 1995)

M. Yonekura: *Minamoto Yoritomo zō: chinmoku no shōzōga* [The image of Minamoto Yoritomo: a silent portrait], E wa kataru [Cultural memory in arts] (Tokyo, 1995)

(iv) Karae. Unlike *Yamatoe*, *Karae* ('Tang painting'; from China of the Tang period, AD 618–907) has not become the subject of a modern discourse. The two words were, however, often paired and contrasted; moreover, Japanese painting of the Heian period (794–1185) was undeniably based on imported Chinese precedents. The term *Karae* appears in the documentary record in the late 10th century, a few years earlier than *Yamatoe*, in reference to a 'soft screen curtain' hung in the palace during a banquet. Notwithstanding this late reference, Chinese and Korean paintings, especially of Buddhist subjects, had been imported into Japan since the 7th century. In the mid-8th century imported screen paintings of exotic subjects were placed in the Shōsōin imperial repository, Nara, only to be removed less than a century later. In the early 9th century, paintings of Chinese subjects and styles adorned the interior of the newly built Imperial Palace, where they became the inspiration for Chinese poetry (*see* §(iii) above).

In documentary sources *Karae* is generally used, like *Yamatoe*, to describe a screen painting. *Karae* screens were produced for celebratory occasions, for the Great Harvest Festival and for the personal use of imperial and aristocratic owners. For instance, in 1135, a *Karae* screen (not otherwise described) was used in a ceremony for a young prince's entry into the Ninnaji monastery in Kyoto. Not all paintings on Chinese subjects were necessarily referred to as *Karae*: an equally common term is *honmon* ('original writing'), which refers to subject-matter drawn from Chinese literature. In 1152, six four-seasons *honmon* screens, depicting selections from Bai Juyi's poetry and accompanied by Chinese poems, surrounded the imperial dais at the 50th birthday celebration of the retired emperor Toba (*reg* 1107–23). However, most paintings on Chinese subjects are not classified in the documents as either *Karae* or *honmon*, having instead obviously Chinese titles such as *Seven Sages of the Bamboo Grove*, *Daoists under Pines* or *Selections from Bai Juyi's Poetry*. The landscape screen formerly belonging to Tōji (*see* §(iii)(c) above and fig. 84 above) is the only extant Heian-period painting that could be identified as a *Karae* or *honmon* screen.

The word *Karae* also appears in court literature written by women—tales, diaries or miscellaneous jottings—where the scene before their eyes might be described as 'like a painting' or, occasionally, 'like a *Karae*', the implication then being that the image was exotic or extraordinary. A woman's hair dressed and piled up on top of her head might be so described because it contrasted with the usual practice of letting the hair hang straight down over the shoulders.

Chinese narrative paintings in handscroll or album format were also known during this period and certainly served as a source of inspiration both for writers of court tales and for their illustrators. The protagonists of *Tale of a Hollow Tree* (*Utsuho monogatari*; late 10th century) and *Tale of Middle Counsellor Hamamatsu* (*Hamamatsu chūnagon monogatari*; late 11th century), for instance, both visit Tang-period China. Murasaki Shikibu (*c.* 973–*c.* 1025), herself clearly well versed in Chinese matters, mentions two illustrated Chinese narratives in her *Tale of Genji* (*c.* 1000): the tale of exile of the Han-period (206 BC–AD 220) court lady Wang Zhaojun and the ill-fated love affair of the Chinese emperor Xuanzong (*reg* AD 712–56) and his favoured concubine, Yang Guifei, celebrated in Bai Juyi's *Song of Everlasting Sorrow* (Chin. *Chang heng ge*). The second of these was made into a picture-scroll set (not extant) in 1159.

In and after the 13th century, the term *Karae* continued to be used to designate imported Chinese and Korean paintings of the Song (960–1279), Koryō (918–1392) and later periods. By the late 17th century, if not sooner, the word *Kanga* ('Han painting') had replaced *Karae* in reference specifically to monochrome-ink paintings both imported into and produced in Japan.

BIBLIOGRAPHY

T. Akiyama: *Heian jidai sezokuga no kenkyū* [Research on the secular painting of the Heian period] (Tokyo, 1964)

A. Soper: 'A Ninth-century Landscape Painting in the Japanese Imperial Palace and Some Chinese Parallels', *Artibus Asiae*, xxix (1967), pp. 335–50

H. Kawaguchi: 'Waga kuni ni okeru daiga bungaku no tenkai' [The development of painting-inspired literature in our country], *Nihon kanbungakushi ronkō* [Essays on the history of Japanese literature in Chinese], ed. T. Yamagishi (Tokyo, 1974)

KAREN L. BROCK

4. LATE (14TH CENTURY–1868).

(i) Historical overview. (ii) *Yamatoe*. (iii) Ink painting: Muromachi period.
(iv) Genre painting. (v) *Rinpa* painting. (vi) Foreign-influenced painting.
(vii) *Zenga*. (viii) Naturalistic painting: Maruyama–Shijō school.

(i) Historical overview.

(a) Muromachi period (1333–1568). (b) Momoyama period (1568–1600).
(c) Edo period (1600–1868).

(a) Muromachi period (1333–1568). Painting in the
Muromachi period was dominated by Chinese-derived
suibokuga ('monochrome ink painting') styles. During this
Sinophile period, *Yamatoe* ('traditional' Japanese painting;
see §3(iii) above and (ii) below) was a conservative
tradition, primarily the province of the TOSA SCHOOL and
associated with delicately detailed depictions of traditional
Japanese themes favoured by the court aristocracy. Over
the course of the 16th century, all the stylistic features of
Yamatoe, except for the delicacy of detail of Tosa-school
works, were appropriated by painters of the KANŌ
SCHOOL. Already in the late Muromachi period, they and
others had begun the process of Japanizing the Chinese
monochrome styles by patternizing brushwork, flattening
shapes and monumentalizing forms on large-scale Japa-
nese formats such as *byōbu* (folding screens) and *fusuma*
(sliding door panels). These formats were collectively
known, along with other painted wall surfaces, as *shōhekiga*.
The Chinese subjects and styles that were dominant in
the temples and among the élite of the day gave way in
the following Momoyama period (1568–1600) to the
bright, bold and glittering compositions favoured by the
new military rulers. Through the centuries of preference
for *suibokuga* and Chinese and Zen themes, the painters
of the Tosa school had received court-based patronage
and preserved the *Yamatoe* tradition. Near the beginning
of the 16th century, Kanō Motonobu (*see* KANŌ, (2)) is
said to have married the daughter of Tosa Mitsunobu (*see*
TOSA, (1)), then the head of the Tosa school, and
eventually to have succeeded to the leadership of the Tosa
family enterprise. What resulted from this marriage be-
tween two artistic lineages was a merger also of two artistic
styles. As Kanō artists incorporated more elements from
the *Yamatoe* tradition, the monumental decorative style
that so dominated the taste of the Momoyama period
gradually evolved.

(b) Momoyama period (1568–1600). The Momoyama
period was, in several important ways, a time of transition
between the Muromachi and Edo periods. Many of the
important schools and styles of Edo painting, for example,
were founded or came to maturity in the Momoyama
period. First, and most frequently noted, however, Mo-
moyama artists infused Japanese painting with energy,
boldness and decorative splendour, qualities often sup-
posed to be emblematic of the period itself. Second, and
equally characteristic, the monochrome ink painting that
was so prevalent in the Muromachi period became the
subject of experimentation. Ink was used sensitively to
evoke the values of Zen or the *wabi* ('rustic simplicity')
aesthetic of the tea ceremony (*chanoyu*; *see* §XIV below)
or to suggest the character of Daoist and Confucian
Chinese figure subjects. Third, ink painting styles were

modified by fusion with the rich materials (mineral pig-
ments and gold), flattened shapes and decorative patterns
associated with *Yamatoe*.
At this time centralized power was re-established in
Japan. The 'three unifiers', Oda Nobunaga, Toyotomi
Hideyoshi and Tokugawa Ieyasu (1542–1616), used high
culture, including *chanoyu*, *waka* (classical 31-syllable po-
etry) composition and *nō* drama (*see* §XIII, 1 below), to
help legitimize their political rule. Painting, in particular,
provided a means of displaying the patron's wealth and
power as well as demonstrating his knowledge and sophis-
tication. In addition to the auspicious associations of bird
and flower themes (e.g. the crane as a symbol of longevity),
the ubiquitous Chinese scholar–hermits and Daoist im-
mortals depicted in the Momoyama period expressed ideas
of Chinese learning and the rejection of worldly power
central to the warlord's claims to rule on behalf of the
public good. The mix of styles associated with the Chinese
and Japanese traditions may also have had political signif-
icance, paralleling the synthesis of Chinese and Japanese
ideology deployed by military rulers.
The decoration of the castles and palaces of these
leaders provided employment for several painting schools.
The KANŌ SCHOOL and the UNKOKU school in particular
benefited from military patronage, the former serving as
official painters-in-residence (*goyō eshi*) to the Tokugawa
government and the latter functioning in a similar capacity
to the Momoyama warlords and, later, to the powerful
Mōri family in western Honshu. The growth of urban life
around the castles of military leaders led to patronage
from the samurai and merchants who clustered in the
shadows of the mighty warlords and their buildings.
Commissions from Buddhist temples also proliferated, as
buildings were reconstructed, refurbished and expanded
in the newly stabilized environment. Zen temples, notably
Daitokuji, Myōshinji and Kenninji in Kyoto, and the
headquarters of other sects, such as Chionji of the Jōdo
(Pure Land) sect and Nishi Honganji of the Jōdo Shinshū
(New Pure Land) sect, all contain extensive painting cycles
executed by the leading studios of the Momoyama (and
early Edo) periods. Artists were also called upon to paint
interior spaces in aristocratic villas, as well as in homes of
wealthy merchants.
The Momoyama period was marked by the emergence
of a handful of artists whose creativity and skill in painting
matched the military power and political cunning of the
warlords. Kanō Eitoku (*see* KANŌ, (5)) established the
important connection with military patrons. After execut-
ing paintings for Nobunaga's AZUCHI CASTLE from 1576
to 1579, he went on to lead his studio in fulfilling
commissions for Hideyoshi's Osaka Castle in 1587 and
his Jurakudai Palace in Kyoto in 1588. Kanō artists led by
Eitoku fused Japanese and Chinese painting styles into
kinpeki (polychrome on gold ground) *shōhekiga*—the
Momoyama period's most obvious contribution to Japa-
nese painting. After Eitoku's death, the Kanō school under
Mitsunobu (*see* KANŌ, (7)) faced stiff competition from a
number of artists who had either trained in the Kanō
studio or been influenced by its styles. In order to compete
with the Kanō school, these artists needed not only talent
and social connections but an artistic pedigree, a require-
ment that led to many fanciful genealogies. Soga Chokuan

(*see* SOGA, (1)) claimed descent from the Muromachi-period Soga painters of Daitokuji; his follower Nichokuan (*fl* first half of 17th century) proclaimed himself the sixth-generation student of Soga Jasoku (*see* SOGA) and of TENSHŌ SHŪBUN. UNKOKU TŌGAN, a self-styled descendant of TOYŌ SESSHŪ, executed a number of *fusuma* paintings for Zen temples in Kyoto but in his last decades worked primarily for the daimyo patron Mōri Terumoto (1553–1625) in the city of Yamaguchi. Although he created a few notable *kinpeki* works, Tōgan is best known for his sharply delineated monochrome landscape and figure paintings, which often echo the work of Sesshū, whose studio name, Unkoku, he appropriated and passed on to his long line of followers. HASEGAWA TŌHAKU too claimed to be a latter-day Sesshū and certainly incorporated elements of Sesshū's style into his own work. Tōhaku's paintings, whether in the *kinpeki*, ink monochrome or synthetic ink-on-gold modes, were consistently among the most creative works of the Momoyama period, and he had numerous followers (see fig. 88). Virtuoso brushwork, daring compositions and intriguing plays of space earned Tōhaku commissions from all manner of patrons. Similarly broad in pictorial range and brilliant in execution was KAIHŌ YŪSHŌ, an artist who probably trained in the Kanō school but established his own styles in monochrome and *kinpeki*. His paintings exemplify the opulence and power as well as the refinement and subtlety of Momoyama culture. The Tosa school, preservers and purveyors of the court tradition throughout the Muromachi period, also experienced a revival in the Momoyama period. Tosa Mitsuyoshi (1539–1613) and Tosa Mitsunori (1583–1638)

expanded on the styles and subjects pioneered by their forebears and in doing so gained new patrons. Such was the demand for painting in the Momoyama period that anonymous artists, often loosely affiliated with Kanō studios and termed *machi eshi* (town painters), conducted a brisk business in painting fans, screens and other works for their clients. Subjects typically included genre scenes, famous places (*meishō*) and seasonal motifs—themes combined in the popular *rakuchū rakugai* ('scenes in and around the capital') pictures. This emphasis on modern urban subjects is often seen as the basis of Edo-period *ukiyoe* (*see* §(iv)(b) below).

BIBLIOGRAPHY

Y. Yamane: *Momoyama no fūzokuga*, Nihon no bijutsu [Arts of Japan], xvii (Tokyo, 1967); Eng. trans. by J. Shields as *Momoyama Genre Painting*, Heibonsha Surv. Jap. A., xvii (New York and Tokyo, 1973)

T. Takeda: *Tōhaku, Yūshō*, Suiboku bijutsu taikei [Compendium of ink painting arts], ix (Tokyo, 1973)

Momoyama: Japanese Art in the Age of Grandeur (exh. cat., ed. J. Meech; New York, Met., 1975)

T. Doi: *Momoyama no shōhekiga* [Momoyama decorative painting] (Tokyo, 1964); Eng. trans. by E. Crawford (New York, 1977)

T. Takeda: *Kanō Eitoku*, Nihon no bijutsu [Arts of Japan], iii (Tokyo); Eng. trans. by H. Horton and C. Kaputa as *Kanō Eitoku*, Japanese Arts Library, iii (Tokyo and New York, 1977)

M. Kawai and A. Wakisaka: *Momoyama no shōhekiga: Eitoku, Tōhaku, Yūshō* [Wall and screen painting of the Momoyama period: Eitoku, Tōhaku, Yūshō], Nihon no bijutsu zenshū [Complete collection of arts of Japan], xvii (Tokyo, 1978)

M. Takeda: *Shōhekiga* [Wall and screen paintings], Nihon no bijutsu [Arts of Japan], xvii (Tokyo, 1979)

G. Elison and B. Smith, eds: *Warlords, Artists, and Commoners: Japan in the Sixteenth Century* (Honolulu, 1981)

The Triumph of Japanese Style: 16th Century Art in Japan (exh. cat., ed. M. Cunningham; Cleveland, OH, Mus. A., 1991)

JOAN H. O'MARA

(c) Edo period (1600–1868). From the Momoyama period onwards, Japanese painting was marked by a diversity of pictorial subjects and styles unmatched in earlier epochs, a radical broadening largely attributable to the increased range of patrons and socio-cultural stratification in the Momoyama and Edo periods. Aristocrats and Buddhist priests continued to commission paintings, depite their more marginal social status. Military men, important patrons in the Muromachi period, solidified their power and called upon artists to help express their political hegemony and claim to cultural supremacy in paintings meant for castles and palaces. The merchant class, encompassing the entrenched *machishū* (wealthy burghers of Kyoto) and the more plebeian *edokko* ('sons of Edo'), together with their brethren in burgeoning cities such as Osaka and Nagoya, comprised the newest and most dynamic group of patrons. The sheer number and wealth of these patrons stimulated the production of painting, and their often different values directly informed the plethora of styles developed from the 16th to 19th centuries.

Historians have often compared the Momoyama period, when Japan was in intimate cultural contact with European culture, with the Edo period, when Japan was officially closed to the outside world except for limited trade with the Chinese and Dutch through Nagasaki. But with the exception of Western styles adapted in Japanese Christian

88. Hasegawa school: *Birds and Flowers of the Four Seasons, fusuma* (door panel), ink, colours, gold and silver on paper, *c.* 1.73×1.41 m, early 17th century (London, British Museum)

art and Western subjects painted in Japanese styles (*Nanban* art; *see* §(vi)(a) below), contemporary foreign culture had relatively little impact on Momoyama painting. In contrast, the most creative—and often the most successful—Edo painters were fascinated with foreign styles and ideas. Chinese literati painting and theory of the late Ming and Qing periods (1368–1911) formed the basis of *Nanga* (or *Bunjinga*; *see* §(vi)(c) below), while more decorative Chinese styles of bird-and-flower painting (*kachōga*) were transformed into the so-called Nagasaki school of painting (*see* §(vi)(c) and (d) below). European techniques such as one-point perspective and volumetric shading were imitated by such artists as SHIBA KŌKAN, Aōdō Denzen and ODANO NAOTAKE and incorporated into paintings by MARUYAMA ŌKYO and his followers of the Maruyama-Shijo school (*see* §(viii) below). Foreign ideas, such as the emphasis on eccentricity in radical Wang Yangming (1472–1529) Neo-Confucianism (Jap. Yōmeigaku), more subtly influenced a range of 18th-century artists.

Many of the Momoyama schools continued into the Edo period but underwent important transformations. While the followers of Tōhaku and Yūshō faded quickly and the Tosa school died, only to be resurrected by Sumiyoshi Jokei (*see* SUMIYOSHI, (1)), the Kanō and Unkoku schools flourished. Major artists such as Kanō Tan'yū (*see* KANŌ, (11)) and Unkoku Tōeki (*b* 1591), however, chose not to parallel the styles of their illustrious relatives but instead created relatively new images by drawing on the painting of an earlier age or incorporating themes and styles associated with other traditions. The success of these schools was based as much on the strength of their patrons as on the adaptability of the artists.

As the main branches of the Kanō school came increasingly to be associated with the Tokugawa government and Chinese themes, other artists allied themselves with styles and subjects that had quite different implications. To a large degree, the history of Edo painting is the story of different social classes and political affiliations expressed in pictorial subject and style. Artists in the Rinpa lineage (*see* §(v) below) enjoyed the patronage of wealthy merchants and aristocrats for whom their references to styles and themes from Japanese court culture must have resonated. The genesis of the Rinpa tradition in the art of Hon'ami Kōetsu (*see* HON'AMI, (1)) and TAWARAYA SOTATSU, both townsmen and artisans, attests to the generative role of Momoyama culture in much Edo-period painting. That the main proponent and eponym of the style, OGATA KŌRIN, was the son of a merchant with ties to the imperial family is not surprising. However, SAKAI HŌITSU, self-proclaimed heir to Kōrin, was the son of a daimyo, which indicates the complex relationships between class and painting styles. The point is underlined by the fact that both men also trained first under Kanō teachers; Hōitsu proceeded to further study with masters of the *ukiyoe*, Maruyama–Shijō and *Nanga* schools. Merchant-class artists who worked in the *fūzokuga* (*see* §(iv)(a) below) and *ukiyoe* traditions not only painted scenes of everyday Japanese life but, in the case of the latter group, also satirized 'classical' Chinese and Japanese subjects in such a way as to suggest the ascendancy of their own social class. *Ukiyoe* artists often referred to themselves as *Yamato eshi* ('Japanese painters'), largely to distinguish

themselves and their merchant-class culture from the Sinophile airs of many Kanō artists and their patrons in the Tokugawa government.

A distinctive feature of the Edo period, especially in the 18th and 19th centuries, was that *ukiyoe* artists, though often talented as poets, writers and graphic designers, were engaged in art as a commercial activity. The fierce competition between artists to sell their paintings drove them to search for fresh styles and new ideas even as it led artists often to ally themselves with established traditions and render conventional subjects. The adaptation of foreign styles and ideas served as a statement of artists' and patrons' cultural distance from the orthodoxy of Kanō painting (and Tokugawa power) and, at the same time, provided new and prestigious models that were creatively stimulating and commercially viable. *Nanga*, with its implications of up-to-date Chinese learning and the elevated 'amateur' status of its literati artists, fused with an often appealing pictorial surface, provides a prime example of the political and commercial implications of Edo-period painting. For all their creativity and breadth of talent, such artists as Ike Taiga (*see* IKE, (1)), YOSA BUSON and URAGAMI GYOKUDŌ were faced with the dilemma of whether to paint to express themselves or to cater to the tastes of their customers. The same conflict between creative exploration and commercial appeal was felt by Maruyama Ōkyo and MATSUMURA GOSHUN, founders of the lyrically naturalistic Maruyama-Shijō school. Even individualist painters such as Soga Shōhaku (*see* SOGA, (2)), NAGASAWA ROSETSU and ITŌ JAKUCHŪ turned their 'eccentricity' to use both as a legitimate theory of creative exploration and as a means of fostering a unique artistic style and persona. The notion that style is a consciously chosen mode of expressing ideas may even be extended to painting by Zen priests. In the *Zenga* ('Zen painting'; *see* §(vii) below) of priest–painters such as HAKUIN EKAKU and SENGAI GIBON, the choice of spontaneous, abbreviated brushwork and ink monochrome served as an effective metaphor for the Zen mind and experience.

BIBLIOGRAPHY

The Great Japan Exhibition: Arts of the Edo Period, 1600–1868 (exh. cat., ed. W. Watson; London, RA, 1981)
Japanese Ink Painting (exh. cat., by S. Miyajime and Y. Satō, Los Angeles, CA, Co. Mus. A., 1985)
Word in Flower (exh. cat., ed. C. Wheelwright; New Haven, CT, Yale U. A.G., 1989)

<div align="right">KEN BROWN</div>

(ii) *Yamatoe.*

(a) Introduction. (b) Screen, door and wall painting. (c) Picture scrolls, fans and portraits.

(a) Introduction. The word *Yamatoe* (painting of *Yamato*, i.e. Japan; *see also* §3(iii) above) has commonly been employed to designate the secular painting of the 12th and 13th centuries, especially screen paintings of seasonal subjects now lost and extant narrative picture scrolls. Until the late 1970s later *Yamatoe* was little studied or understood. Since then, previously unknown paintings have surfaced, others have been reconsidered, and much new material has become available through exhibitions and publications. As a result, orthodox accounts of the development of Japanese painting are being revised. In particular, a more complete and diverse image of painting of the Muromachi period (1333–1568) has emerged.

By the late 13th century, themes, motifs and techniques borrowed from newly imported Chinese paintings were being incorporated as details into Japanese picture scrolls and possibly into large-format painting as well. When paintings again began to be imported—initially as objects of Buddhist devotion and ceremony and later as valued collectors' items—the distinction between native and foreign styles and subject-matters in Japanese painting became clear-cut. While the term *Yamatoe* is not encountered in 14th–16th-century sources, all of the earlier formats and genres—screens and door panels, picture scrolls and books, fan paintings and decorated papers—continued to evolve and serve important functions in later centuries.

In 1693 Kanō Einō (1634–97) in his *Honchō gashi* ('History of our country's painting') made the long-standing distinction between native and foreign painting explicit: 'The styles of ancient paintings split into two, that called "Japanese painting" (*Waga* or *Yamatoe*) and that called "Chinese painting" (*Kanga*)'. In Einō's view, the greatest ancient practitioners of *Yamatoe* were Toba Sōjō (Kakuyū; 1053–1140) and Fujiwara no Nobuzane (*see* FUJIWARA (ii), (8)); among his contemporaries, members of the TOSA family 'specialized in *Yamatoe*'. Einō wrote his strongly Sinophile text to celebrate his own lineage, the KANŌ, who 'added Japanese painting to Chinese painting' to create a synthesis; at the same time he subtly denigrated *Yamatoe* and its practitioners. Indeed, during the Edo period (1600–1868) the label *Yamatoe* became firmly associated with conservatism and even Japanese nationalism. In Einō's day, members of the SUMIYOSHI SCHOOL preserved traditional subjects and styles as they took on the duties of connoisseurs and restorers of such paintings. In the first half of the 19th century Tanaka Totsugen (1760–1823) and Reizai Tamechika (1823–64) copied ancient paintings, sought aristocratic and imperial patrons and actively joined in the contemporary restorationist movements. *Yamatoe* continued to be linked with nationalist tendencies in the Meiji era (1868–1912) and led ultimately to the creation of *Nihonga*, its modern descendant (*see* §5(iii) below).

Scholars in the 20th century have been much preoccupied with establishing a clear-cut lineage of *Yamatoe* from the Heian period (AD 794–1185) onwards, a complicated task, given the difficulty of determining whether such distinctions existed in the minds of contemporary painters. For instance, painters of the *Rinpa* tradition (*see* §(v) below) such as Tawaraya Sōtatsu, Ogata Kōrin and Sakai Hōitsu, who derived their innovative styles and subjects directly from conventions of late medieval screens and picture scrolls, have not generally been categorized by modern scholars as *Yamatoe* painters. Similarly, the works of the woodblock-print designer Okumura Masanobu, who proudly signed himself 'painter of Yamato' in numerous prints, are not considered examples of *Yamatoe*. The following discussion focuses only on the generally accepted categories of *Yamatoe* found in Muromachi-period painting. Later *Yamatoe* is covered in entries on the schools and the individual painters mentioned above.

(b) Screen, door and wall painting. Of works done before the 15th century, few screen paintings and no sliding door panels survive. Many secondary sources testify to their seasonal subject-matter, mineral pigments and semi-public or ceremonial functions. With regard to the 15th and 16th centuries, literary sources, details in contemporary picture scrolls and paintings discovered in the late 20th century vividly counteract the older view that the period had nothing to offer but monochrome ink painting (*see* §(iii) below). In fact, brightly painted door panels, standing screens or decorative alcoves (*tokonoma*) depicting seasonal subjects often served as backdrops for the viewing of ink paintings. Meeting halls (*kaishō*) built for the Ashikaga shoguns Yoshinori (1394–1441) and Yoshimasa (1436–90), both avid enthusiasts of Chinese painting, may have had rooms with traditional 'famous-place' (*meisho*) subjects painted on the sliding doors. Glimpses of such colourful interiors with ink hanging scrolls hung against gold backgrounds occur in picture scrolls of the late 15th century, as in details of the *Life of Kakunyo* (1482; scroll 3, colours on paper; Kyoto, Nishi Honganji). Many other picture scrolls depict door-panel paintings in élite residences and monks' quarters covered in overall compositions of pines, water-birds, grasses and other seasonal motifs. Picture scrolls also show screen paintings performing several functions, for example as backdrops for meetings between a host and a guest, as protective temporary walls surrounding sleepers. Screens were also much sought after to provide an elegant backdrop for courtly gatherings as well as for funerals of the military élite. 'Gold screens' (*kinbyōbu*) were sent by the Ashikaga shoguns as prized diplomatic gifts to China and Korea.

Extant screens from the same period exhibit a range of seasonal and narrative subject-matter drawn ultimately from earlier traditions. Unfortunately, most of these screens have been long separated from their original contexts and owners, and they are generally unsigned. Given the long-standing association of *Yamatoe* with the Tosa school, it is not surprising that some are attributed to Tosa painters. The most famous are the vibrant *Sun and Moon Landscapes* (colours, gold and silver on paper; both 1.47×3.13 m; Osaka, Kongōji). On the right screen (the sun landscape) blossoming cherry trees dot the high, rounded mountain slopes. Crashing waves pound the shores in the summer section that extends across both screens, while on the left screen (the moon) a distant, snow-capped range of hills glows under the moonlight. Gold and silver applied with various techniques augment the bright green of pines and hills. This pair of screens was probably used in Shingon-sect Buddhist initiation ceremonies for members of the imperial family or the military élite, who were patrons of this temple.

Flowers and Trees of the Four Seasons (colours, gold and silver on paper; both 1.50×3.62 m; Tokyo, Idemitsu Mus. A.) is representative of the screens that have been discovered in the later 20th century. Flowering plums, pines, summer flowers, bamboo, bush clover and reddened maples are seen in turn from right to left across the 12 panels, the whole united by a flowing stream across the bottom of the composition. Gold- and silver-dusted clouds float among the branches. A closely related pair of six-panel folding screens is *Bamboo in the Four Seasons* (see fig. 89), attributed to Tosa Mitsunobu (*see* TOSA, (1)). In addition to seasonal themes, other extant screens illustrate a pine beach, the Uji bridge and willows, horses in a stable

89. Tosa Mitsunobu (attrib.): *Bamboo in the Four Seasons*, left screen of pair of six-fold screens, colours on paper, 1.74×3.82 m, late 15th century (New York, Metropolitan Museum of Art)

and scenes from such classic narratives as the *Tale of Genji* (*Genji monogatari*). A few screens depicting scenes in and around Kyoto (*rakuchū rakugai zu*) combine a new interest in contemporary genre detail with traditional themes of seasons and famous places. Members of both the Kanō and Tosa workshops are known to have painted these subjects.

(c) *Picture scrolls, fans and portraits.* Picture scrolls dating from the 14th century to the mid-16th survive in considerable numbers and are well documented. They comprise two broad categories: first, formal histories of religious figures, shrines and native deities (*kami*), Buddhist temples and their icons; second, less formal, lively tales of contemporary or past events and people. Both groups were made at the behest of the imperial, military and monastic élites.

The *Miraculous Origins of the All-permeating Nenbutsu* (1414–17; three scrolls; Kyoto, Seiryōji), for example, was a formal set intended for donation to a Buddhist temple. Based directly on 14th-century versions of the same subject, this set was commissioned by Emperor Go-Komatsu (*reg* 1382–1412), who himself wrote out the preface. Six prominent painters produced the nineteen paintings, which were accompanied by text passages contributed by the shogun Ashikaga Yoshimochi and other members of the élite. Many similar collaborative scrolls were later produced within the circle of Sanjōnishi Sanetaka (1455–1537), a noted calligrapher and scholar of classical literature, who was frequently called upon to write the texts of picture scrolls produced by Tosa Mitsunobu and his son Mitsumochi (*see* TOSA, (2)). The latter's *Miraculous Origins of Mulberry-seed Temple* (1532; three scrolls, h. 357 mm; Shiga Prefect., Kuwanomidera), painted in lavish mineral pigments and gold, thoroughly combines seasonal, landscape and court interior imagery with the representations of contemporary costumes and the newly famous places of Ōmi Province.

The second group of picture scrolls is quite varied in style and subject-matter. Some appear to be painted by members of the Imperial Painting Bureau (Edokoro). Others are amateurish in style or execution. In the mid-15th century several unusual scrolls were produced for Prince Fushimi Sadafusa (Gosukōin; 1372–1456). The *Tale of the Fukutomi* (two scrolls; colours on paper; h. 312 mm; Kyoto, Shunpōin) is an amusing tale of a low-class man who made his fortune by demonstrating his ability to break wind at will. Lively conversations written out by Sadafusa himself occupy the empty spaces interspersed among the paintings, a feature typical of this genre. A distinctive sub-category of scrolls consists of 'small paintings' (*koe*), so called because they are generally half or a third the height of normal picture scrolls. *Koe* vary considerably in subject and style, from the several full-colour folk tales attributed to Tosa Mitsunobu to the lively ink-line rendering of the *Tale of Genji* (see fig. 90), attributed to the noblewoman Keifukuin Gyokuei.

Many anonymous scrolls and picture books dating from the Muromachi to the Edo period (1600–1868) have been subsumed under the misnomers 'companion tales' (*otogi zōshi*) or 'Nara picture books' (*Nara ehon*). Publication and exhibition of noteworthy collections in the Chester Beatty Library, Dublin, the New York Public Library, the Bibliothèque Nationale, Paris, and the Suntory Museum, Tokyo, have made these works more accessible, but many problems remain concerning their categorization, their audience, the circumstances of their production and their dating.

By the late 15th century, painted fans were produced by Kanō and Tosa workshops as well as by unnamed town painters (*machi eshi*) of Kyoto. Since fans were made for a practical purpose, they generally owe their preservation to early collectors who had them pasted on screens or gathered into albums. On a pair of *Tale of Genji* screens (colours and gold on paper; each 15.5×36.4 m; Hiroshima, Jōdoji), 60 fans are pasted on a background of kudzu vines. Each fan illustrates an episode from the tale revealed

90. Keifukuin Gyokuei (attrib.): *Tale of Genji* (detail), six handscrolls, ink on paper, each h. 98 mm, 1554 (New York, Public Library)

beneath golden mist, on which is written a line or two of text and a favourite poem. Chapter order is eschewed, as the episodes are rearranged according to season, from early spring at far right to winter at far left. From about the 16th century onwards, memorial portraits of members of the élite were produced in great numbers, especially by Tosa-school painters. Portraits generally followed conventions established in the late 12th century, but with an increasing attention to capturing a true likeness of the subject.

BIBLIOGRAPHY

E. Kano: *Honchō gashi* [History of our country's painting] (1693); comp. and annotated by K. Masaaki (Kyoto, 1985)

Y. Yoshida: *Tosa Mitsunobu*, v of *Nihon bijutsu kaiga zenshū* [Complete collection of Japanese painting] (Tokyo, 1979)

S. Komatsu, ed.: *Zoku Nihon emaki taisei* [Compilation of Japanese picture scrolls, continued], 20 vols (Tokyo, 1981–4)

B. Klein: *Japanese Kinbyōbu: The Gold-leafed Folding Screens of the Muromachi Period (1333–1573)*; adapted and expanded by C. Wheelwright (Ascona, 1984)

Edo no Yamatoe [The *Yamatoe* of the Edo period] (exh. cat., Tokyo, Suntory Mus., 1985)

S. Miyajima: *Tosa Mitsunobu to Tosaha no keifu* [Tosa Mitsunobu and the lineage of the Tosa school], Nihon no bijutsu [Arts of Japan], ccxlvii (1986) [whole issue]

M. Murase: *Tales of Japan: Scrolls and Prints from the New York Public Library* (New York, 1986)

T. Nakamura: *Reizei Tamechika to fukkō Yamatoe* [Reizei Tamechika and the *Yamatoe* revival], Nihon no bijutsu [Arts of Japan], cclxi (1988) [whole issue]

T. Toda, T. Ebine and K. Chino, eds: *Suibokuga to chūsei emaki* [Ink painting and medieval-period picture scrolls], Nihon bijutsu zenshū [Complete collection of the arts of Japan], xii (Tokyo, 1992)

N. Tsuji and others, eds: *Sesshū to Yamatoe byōbu* [Sesshū and *Yamatoe* screens], Nihon bijutsu zenshū [Complete collection of the arts of Japan], xiii (Tokyo, 1993)

S. Komatsu, ed.: *Zoku Zoku Nihon emaki taisei denki, engi hen* [Compilation of Japanese picture scrolls, continued: biographies and original tales], 8 vols (Tokyo, 1993–5)

J. Pigeot and K. Kosugi: *Voyages en d'autres mondes: Récits japonais du XVIe siècle* (Paris, 1993)

Q. Phillips: *Honchōgashi*, Archvs Asian A. (1994)

K. Brock: 'The Shogun's Painting Match', Mnmt Nipponica, l/4 (Winter 1995), pp. 433–84

KAREN L. BROCK

(iii) Ink painting: Muromachi period. Starting in the 13th century, Chan(Zen)-orientated Chinese painting (*see* CHINA, §V, 3(ii)) was introduced to Japan by travelling

monks. The milieu from which these Chan-oriented paintings sprang was that of 13th- and 14th-century Chan circles in southern China, centring on the temple system known as the 'five mountains' and 'ten temples', most of which were near the Southern Song capital, Lín'an (modern Hangzhou, Zhejiang Province). In such paintings, iconography had begun to expand the usual range, notably the historical Buddha (Skt Shakyamuri, Jap. Shaka), *bodhisattva*s such as the popular White-robed Guanyin (Jap. Kannon); 'Chan activity' paintings (Jap. *zenkiga*); and portraits of Zen masters (Jap. *chinsō*), which articulated the deep bond between a master and his disciple. By the 12th century depictions of the 'free and uncommitted saints' (Chin. *san sheng*) were included, among whom the eccentric and much-beloved Budai (Jap. Hotei, 'Cloth bag'), Hanshan, Shide, Zhutou ('Boar's head') and Xianzi (Jap. Ken'su, 'Shrimp eater') were particularly favoured. While more orthodox subjects, such as Buddhas or *bodhisattva*s, were usually painted in a relatively detailed and conventional manner, often employing some colour, the style often seen in depictions of the eccentrics has been shown to have derived from what had been nicknamed apparition painting (Chin. *wangliang hua*), because of the use of extremely faint ink and very light inkwash, a manner originating in the 12th century. A number of such works, datable from the inscriptions by Chan masters above them and ranging from the mid-13th century, have been preserved in Japanese collections. Although some such Chinese works may have been executed by Chan masters, and hence qualify as Chan (Zen) painting, a term often used indiscriminately in late 20th-century scholarship, the ink paintings produced in Japan in this period were normally by low-ranking monk–painters (*ebusshi*), many of whom were virtually professional painters.

During the 13th century the Hōjō regents in Kamakura (*see* BUDDHISM, §III, 10) began to invite Chan masters from China such as Lanchi Daolong (1213–78), who came to Kamakura in 1249 and founded the Song-style Kenchōji monastery in 1253, and Wuxue Zuyuan (1226–86), who arrived in Kamakura in 1279 and founded the great Engakuji in 1282. The schools from which these masters

evolved were, significantly, those linked with the Huqiu school of Chan, which, in China, had tended to maintain close connections with leading literati and political leaders. This of itself began to define the nature of the most powerful elements in Zen circles in Japan.

Zen culture became more distinctly articulated in terms of its artistic leanings with the arrival in Japan of the highly erudite Yishan Yining (1247–1317) in 1299, a master skilled in several forms of Chinese secular literature, a respected calligrapher and a figure who characterizes the gradual infiltration of the Chan sect in China by members of the literati class, increasingly filled by entrants who had failed the metropolitan civil service examinations. As a result Zen monks began to sanction the composition of secular Chinese literature, notably the popular 4/7 verse form, which gave birth in Zen circles to the increasingly secular *gozan bungaku* ('five mountains literature'), a movement deplored by such monks as Musō Sōseki who denigrated them as 'laymen with shaven heads' despite his own scholastic interests. From his school emerged some of the more notable literati monks, including Gido Shūshin (1324–88) and Zekkai Chūshin (1346–1405); in the 15th century the movement shifted its focus from Chinese secular literature proper to Confucian scholarship and historical studies.

Patronage of primarily Rinzai (Chin. Linji) Zen was provided by the Hōjō clan, by several emperors, including GoDaigo (*reg* 1319–31, 1333–9), and by several provincial barons, including Ashikaga Takauji (*reg* 1338–58), the founder of the Ashikaga regime in Kyoto. Musō Sōseki, in particular, benefited from all these sectors, and gradually the dual system of the *gozan* ('five mountains') *jissatsu* ('ten temples') in both Kamakura and Kyoto became more clearly articulated. By 1379, shogun Ashikaga Yoshimitsu (*reg* 1367–95) had centralized the administration of the system under the post of *Tenka Sōraku* ('Registrar general of monks'), which effectively brought monastic affairs under closer control of the Ashikaga shoguns.

Painting trends in Japanese monasteries began with emphasis on self-inscribed portraits of Zen masters (Jap. *chinsō*) and subjects such as Bodhidharma meditating. With the arrival of Yishan Yining in 1299 a more varied range of subjects and styles emerged, among which have survived examples of more informal portraits, and other less obviously Zen-oriented themes such as reeds, geese and even traces of a set of landscape paintings, the *Eight Views of Xiao and Xiang* by Shikan and inscribed with Yishan's secular verses. The latter works are the shadows of traditions of relatively secular subjects for ink décor in monasteries, which in Kamakura narrative handscrolls is widely evidenced in the form of *gachūga* ('paintings within paintings'), scenes of monks' lives surrounded by sliding-door paintings of landscapes, reeds or geese, for example, in Song-oriented ink-painting styles.

(a) Early practitioners. (b) *Ebusshi*. (c) The amateur tradition. (d) Poem-paintings and literary clubs. (e) Josetsu and Ashikaga cultural hegemony. (f) Shūbun school and *kaisho* décor. (g) Post-Shūbun schools. (h) Tōyō Sesshū and provincial courts.

(a) Early practitioners. The career of the monk-painter MOKUAN REIEN provides a window on the early stages of Muromachi-period ink painting. He travelled to China in 1326 or 1328, where he visited several major monasteries near the Southern Song capital of Lín'an (Hangzhou, Zhejiang Province) and painted works that were inscribed by the abbots in whose temples he was staying. His extant works include portraits of the 'eccentric' painter Hotei (see fig. 91), among which his *Hoteizu* ('Hotei pointing at the moon'; Atami, MOA Mus. A.) was inscribed by Liaoan Qingyu, Abbot of Benjue si (*fl* 1333–43). This work clearly derives from the 'apparition painting' (*mōryōga*) tradition,

91. Mokuan Reien: *Hotei*, hanging scroll, ink on paper, h. 1.14 m, ?c. 1340 (Kyoto, Sumitomo Collection)

which can be seen in several mid-13th-century Chinese works preserved in Japan.

Unlike Mokuan, who spent some 20 years in China, his contemporary KAŌ SŌNEN illustrates the more common scenario of a painter confined to studying Chinese paintings available in Japan, notably works of the *mōryōga* tradition. His few surviving works feature the 'eccentrics' *Hanshan* (mid-14th century; Japan, priv. col.) and *Ken'su* ('Shrimp eater'; mid-14th century; Tokyo, N. Mus.) in a minimal, lightly washed landscape context. There is also a pair of narrow-format ink paintings, *Chikujakuzu* ('Sparrows and bamboo'; Nara, Yamato Bunkaken) and *Baijakuzu* ('Sparrows and plum'; Tokyo, Umezawa Col. Gal.), which, to judge from contemporary evidence, must have flanked a central iconic work. This kind of arrangement, which has no known precedent in China, illustrates a significant trend in Japanese ink painting. Unrelated subjects—such as Shakyamuni (the historical Buddha; Jap. Shaka) emerging from the mountains and plum blossom paintings—would be grouped as a form of triptych. While this juxtaposition might seem iconologically random, examples from the works of the late 14th-century painter Ue Gukei (*fl c.* 1375) demonstrate that some such groupings are open to interpretation in Zen terms. His *Byakue Kannon* ('White-robed Kannon') flanked by *Gyōshō sansuizu* ('Woodcutter in landscape' and 'Fisherman in landscape') may be seen as composite representation of the Potalaka Paradise of Kannon. There is also evidence of Japanese groupings of originally unrelated Chinese works, for example a triptych of *Shakyamuni Emerging from the Mountains* with two *Snow Landscapes* (Tokyo, N. Mus.; Hinohara Col.) by Liang Kai. In iconological terms, this arrangement becomes a composite of the landscape traditionally associated with the historical Buddha's pre-enlightenment ascetic exercises. Such arrangements were so common by the mid-15th century that they were the central theme of *Gyomotsu on'e mokuroku* ('A record of the paintings in the shogunal collection'), the curatorial notebook compiled by the shogunal painter–connoisseur Nōami (*see* AMI, (1)).

(b) Ebusshi. These were monks whose profession within the monastic sphere was painting. The Muromachi-period *ebusshi* tradition began with RYŌZEN, who was long confused in Edo-period (1600–1868) connoisseurship with Kaō Sōnen but who has since emerged as a very different kind of painter. His works include the *Jūrokurakan* ('Sixteen *arhat*s'; mid-14th century; Kyoto, Kenninji) in the style of the professional Chinese Ningbo dōshakuga (Buddhist and Daoist paintings) painters. Ryozen's *Nehanzu* ('Nirvāṇa of the Buddha'; 1328; Fukui Prefect., Hongakuji) places his *floruit* period earlier in the 14th century than had previously been believed. The many highly competent works that survive suggest that Ryōzen was a painter with considerable professional training. His works include *Shaka Flanked by the Bodhisattvas Monju and Fugen* (mid-14th century; Hyōgo Prefect., Kiyoshi-kōjin-seichōji), again in the style of the Ningbo school. He was a master of several styles, including that seen in his *White-robed Kannon* (1348–55; Aichi Prefect., Myōkōji), inscribed by Abbot Kenpō Shidon (*fl* 1337; *d* 1361) *c.* 1347–9, and the brilliant, informal painting *Hakurozu*

('Egret among reeds'; mid-14th century; Tokyo, Asano Col.) in a style that can be associated with the tradition of MUQI.

The *ebusshi* tradition was continued by the many monk–painters working in Zen temples. Minchō (1351–1431), a monk from the Tōfukuji in Kyoto, was a prolific artist. He produced richly coloured paintings in the Ningbo manner, including *Gohyaku rakan* ('500 *arhat*s'; 1386; Tokyo, Nezu A. Mus.; Kyoto, Tōfukuji). His *Bodhidharma Meditating in the Cave* (flanked by two paintings of Daoist magicians; *c.* 1390–1400; Kyoto, Tōfukuji) is executed in an extremely abbreviated, powerful and almost sketchy style. He also painted a portrait of the founder of Tōfukuji in an informal manner and formal *chinsō* (portraits of Zen priests).

Later Kyoto painters such as Isshi (*fl* 1420–25) further developed these traditions, incorporating a notably Korean style in Kannon paintings, which seem based on such contemporary Korean works as the set of *Sanjūsan Kannon* ('33 Kannons'; Kyoto, Kenchōji), which have been erroneously attributed to Kenkō Shōkei. Sekkyakushi (*fl c.* 1452) further abbreviated this putatively Korean manner in several Kannon paintings and works associated with the Zen ox-herding painting tradition, based on the long-established tradition of the Ten Ox Paintings (the ten stages of Chan enlightenment). Later Reisai (*fl* 1435–62) continued the tradition of professionalism in paintings of *bodhisattva*s, such as *Monju bosatsu* ('Monju on a lion'; Tokyo, N. Mus.) and his very competent *Nehanzu* ('Nirvana scene'; 1435; Kyoto, Daizōkyōji). Some of his finest works, however, include *Hanshan and Shide in a Landscape*, paired with *Fenggan and his Tiger* (both late 15th century; New York, Burke Col.), together forming what were more often portrayed as the 'Four Sleepers'. Reisai also produced a brilliant *Hanshan* (Tokyo, Gotoh Mus.), which, like the pair noted above, is a variation on the theme of the hallowed style of Liang Kai.

(c) The amateur tradition. Contrasted against this background of professional *ebusshi* monk–painters are a few amateur painters, who were also Zen monks but who drew on a very different cultural tradition. These include TESSHŪ TOKUSAI, who visited China and was appointed primate of Zhengtian si in Suzhou. After his return to Japan he served as abbot of two provincial temples before becoming abbot of the Manjuji, the prestigious *gozan* monastery in Kyoto, in 1362. He painted informal ink paintings of reeds and geese, but he is best known for his orchid paintings, which drew on the traditions of the Yuan-period literati amateur painting of Zhao Mengfu (*see* ZHAO, (1)) and of the early 14th-century Chan monk–painter, Xuechuang Puming (*fl* 1340–50). Tesshū's works are imbued with a poetic, informal charm and a playfulness tempered with a close attention to naturalism. Like his amateur counterparts in China, he was a master of calligraphy; he excelled in the style of the Tang monk Huaisu.

GYOKUEN BONPŌ embarked on his illustrious career as a monk under Shunoku Myōha, a nephew and disciple of Musō Sōseki. After rising through the ranks and gaining two provincial abbacies, he became abbot of Kenninji in Kyoto *c.* 1409. In 1413, when he became abbot of Nanzenji in Kyoto, Shogun Ashikaga Yoshimochi attended the

inauguration ceremony. Gyokuen's poetic inscriptions, prefaces and poems appear on many of the surviving poem–paintings (*shigajiku*) of the era. He excelled in bamboo-and-orchid paintings, which progress from playful simplicity to an increasingly close engagement with the problems of naturalism in this mode, to which he contributed an extraordinarily poetic verve and a creative vigour reaching far beyond the bounds established by Tesshū.

Another painter who was neither wholly professional nor true amateur was Ue Gukei (*see also* §(a) above). Gukei's works include parts of what were originally two triptychs of Kannon, flanked on either side by landscapes in styles that clearly derive inspiration from 14th-century washy landscapes of the type sometimes seen in the background of *rakan* paintings by Ryōzen or his counterparts but draw on the tradition of highly abbreviated landscapes seen in the work of the late Southern Song monk–painter and literatus YUJIAN. Gukei seems to have experimented with a wide variety of styles, including a professional Buddhist style in his *Shaka Emerging from the Mountains* (late 14th century) or *Budōzu* ('Grapes') based on the works of the Chinese monk–amateur Wen Riguan (*d* 1295). He also painted an engaging *Hoteizu* ('Hotei'; late 14th century; Osaka, Masaki A. Mus.), in a variant of the *mōryōga* tradition.

(d) Poem-paintings and literary clubs. From the late 14th century, monks in certain major Kyoto temples began to group themselves into literary clubs, which met in *gozan* temples to celebrate particular events, often the departure of a friend to a distant post. The poetic and painted material for such meetings had long been explored in somewhat similar circumstances in 14th-century Suzhou, which clearly inspired the then much-changed ideology of the metropolitan Japanese monk. He found, typically, much in common between his role as a virtually civil minion of the feudal regime, acting as diplomat, drafter of diplomatic or official documents, manager of the taxes on the large estates controlled by some monasteries, and that of the traditional Chinese scholar–bureaucrat. Hence the secular literature associated with such activities would typically focus on the sentiments shared by friends separated by official duties or similar themes. The results of such meetings were the production of numerous poems on a given theme, chosen for the occasion, often a phrase from classical Chinese secular literature. Gradually, in place of the poem-scroll produced for these meetings, a series of poems would be composed in the usual manner and then transcribed on to a hanging scroll (*shigajiku*), at the bottom of which a painter would provide his version of the theme. One such work is *Saimon shingetsuzu* ('New moon over the brushwood fence'; 1405; Osaka, Fujita Mus. A.), based on a parting theme found in a poem by Du Fu (712–70), and painted by a painter whose name and rank were so much below that of the monks that he does not identify himself by even so much as a seal.

(e) Josetsu and Ashikaga cultural hegemony. The painter JOSETSU was the first painter to be identified on a poem-painting scroll. His *Hyōnenzu* ('Catching a catfish with a gourd'; see fig. 92), produced on the order of 'the shogun', most probably Yoshimochi, about 1413–15, refers to a

92. Josetsu:*Catching a Catfish with a Gourd*, hanging scroll, ink on paper, *c.* 1413–15 (Kyoto, Myōshinji)

familiar Zen *kōan* (riddle) whose conundrum, or theme for meditation, is how to catch the large catfish with a narrow-mouthed gourd. The painting is of key importance as the first example of shogunal patronage of such works. The preface by Daigaku Shūsū informs us that the 'shogun ordered the painter Josetsu to paint [the work] on a small screen in the "new mode"' (*shinyō*; Shimao, 1986). While Shimao's arguments redefine the shinyō as the overall format of the poem–painting scroll, it remains important to note that the earlier interpretation of this as 'the new [painting] style' can be shown to have a significance beyond that which has been demonstrated to date. The style of the painting clearly combines elements from the tradition of the Southern Song academician Liang Kai and those of his contemporary academicians Ma Yuan (*see* MA, (1)) and XIA GUI. This particular combination of traditions had already taken place in China by the Yuan period (1279–1368), as is shown in *Tuhui baojian* (1365), a record concerning Liu Yao, a little-known painter whose work was collected in 15th-century Japan. It is thus unlikely to have been the invention of Josetsu himself.

What is perhaps more significant is that all the three paintings that are most clearly associated with Josetsu— *Hyōnenzu* (see fig. 92), *Sankyōzu* ('The three teachings'; Kyoto, Ryōsokuin) and *Wang Xizhi Inscribing a Fan* (early 15th century; Kyoto, N. Mus.)—are all clearly based on the style of the Liang Kai school, and this may be viewed as evidence of a marked fashion for Liang Kai style that

lasted throughout the first three decades of the 15th century. The evidence for this is seen both in the numerous paintings by Liang Kai owned and displayed by the shogun in the 1430s and in the presence of a Liang Kai-style room in Ashikaga Yoshinori's (1394–1441) New *Kaisho* (Reception Hall). The latter is decorated with Japanese paintings of *Agriculture*, based on a well-known model scroll then supposed to be by Liang Kai, which itself was the model for other mural paintings in later Muromachi mansions and temples, notably the Agriculture Room in Ashikaga Yoshimasa's (1436–90) Higashiyama villa (1483) and the extant Agriculture Room in the Daisenin (1513). A Kanō-school copy of the model scroll and its encomium by the shogunal curator Sōami still exists, and a later Chinese version held by some to be the original Liang Kai is now in the Museum of Art, Cleveland, OH.

The importance of the fashion for the Liang Kai school style must be analysed in the context of the evolution of the stylistic and thematic focus in the late 14th century to mid-15th. Throughout the 14th and 15th centuries, the name of Muqi was held synonymous with the highest values in Zen-oriented painting. It was only when the shoguns emerged as major collectors of Chinese masterpieces, hence promoters of these icons of Chinese culture, that the pattern begins to change. Here, one may identify the shift from a primary preoccupation with Zen-orientated themes to one associated with the predominantly secular styles of the Song Academy. This trend is visible in the form of the gradual increase in collecting of Ma-Xia works and in the closely associated Shūbun school modes (*see* §(f) below). However, before this trend was clearly articulated, it is clear that the shoguns from Ashikaga Yoshimitsu (*reg* 1367–95) to Ashikaga Yoshinori (*reg* 1428–41) demonstrated considerable interest in imagery associated with the Song imperial academy, notably in works supposedly by the great aesthete–emperor Hui-zong (*reg* 1101–25) and in those of Liang Kai. One may here read the importance of Liang Kai at this time of significant shift, as an example of identifying with a figurehead in Chinese painting history who spanned with consummate skill a very wide range of styles, including both Zen-orientated and more conventional Buddhist styles, as well as a variety of secular styles, including a literati-orientated figure painting style, a landscape style and even a genre painting style. From this it is clear that the importance of Liang Kai for Josetsu, for the shoguns and in other works of the first 30 years of the 15th century is tangible evidence of a transition from preoccupation with Zen-oriented works, to those associated with the promotion by the shoguns of a new and more imperial cultural image. Here, hegemony is read as the shoguns' will to dominate, in cultural terms, the whole structure of Japanese society, starting from the Japanese imperial court and including baronial samurai society. This trend was manifested quite dramatically in the social metaphor of Yoshimitsu's Kinkakuji (Golden Pavilion; *c.* 1392; *see* KYOTO, §IV, 6), in which Chinese style, ascendant in the third floor, sits atop the samurai mansion style of the second floor, all above the aristocratic court style of the first floor; a similar policy was renewed with considerable energy by Ashikaga Yoshinori in his China trade, art collecting and extensive and similarly articulated building programme of the 1430s.

(f) Shūbun school and kaisho décor. The persona of TENSHŌ SHŪBUN, active as a painter–monk and administrator in the Shōkokuji *c.* 1420–58, has been accorded undue weight in painting histories from the Edo period (1600–1868), largely on account of the self-justifying genealogies of generations of later painters who invoked the hallowed names of Josetsu and Shūbun, the founders of the pseudo-academy in Shōkokuji. Nevertheless, this temple, the hub of Ashikaga monastic administration, exercised considerable influence on fashions in and beyond the capital. Stylistically, the works by or associated with Shūbun may be seen to have articulated and dominated the fashion for Ma-Xia school one-corner landscapes, above which senior monks were invited to write secular Chinese poems. A typical example, quite probably by Shūbun himself, is *Chikusai dokusho* ('Reading books in a bamboo studio'; see fig. 93).

By the 1450s obscure figures such as BUNSEI, who painted for the Daitokuji abbot Yōsō Sōi (1376–1458), and Tenyū Shōkei had emerged as leaders in a new trend for spacious lake landscapes that featured more emphasis on poetic and expansive spaciousness, which is a painted metaphor for the expansive poetic feelings expressed in the poems above. Together with this came a new interest in describing the landscape more logically and consistently. By the 1460s there are examples in the works of both

93. Shūbun (attrib.): *Reading Books in a Bamboo Studio*, ink and light colours on paper, 1348×333 mm, 1446 or before (Tokyo, National Museum)

Bunsei and Tenyū of more consistent ground-plans and more logically organized compositions, which parallel the directions explored by TŌYŌ SESSHŪ at the same period (*see* §(h) below). However, despite interest in the development of individual painters who are barely mentioned in contemporary records and datable only by inscriptions on their works, it is probably more useful to consider their role in the overall social context of *kaisho* ('reception hall') décor. The very detailed record of emperor GoHanazono's (*reg* 1428–64) visit in 1437 to Yoshinori's Muromachi residence, describing its three newly built *kaisho* and impressive exhibition of famous Chinese paintings, provides evidence of a distinct concern in shogunal and daimyo circles for the presentation—in both the Chinese works displayed on these occasions and the Japanese works that complemented them—of imagery that well matched the lifestyle and self-image of the exhibitor (whether shogun or daimyo) as seen in the entirety of his cultural environment. The painted décor of certain rooms often complemented the view from that point of a carefully designed garden, which itself had significant associations with Chinese cultural themes and values. Hence the painted images themselves presented increasingly spacious landscape vistas that augmented their physical environment. Paintings stressing spaciousness in their composition may be seen against the background of trends in mural décor, notably in screen paintings of the four seasons (with Xiao-Xiang motifs) of Shūbun-school folding screens (*byōbu*), such as *Shiki sansui zu byōbu* ('Four seasons landscape'; late 15th century; screens, Tokyo, Matsudaira Col.), and sliding doors (*fusuma*). Such works were often commissioned by the shogun via the shogunal curators, the AMI school painter–connoisseurs, after which leading monks would be instructed to write Chinese secular poems for each panel. This was a direct reversal of the practice of the early part of the 15th century, when paintings were adjunct illustrations to groups of poems by leading monks. Painting was now centre stage, and the *gozan* monks, minions of the shogun, were ordered to add poems. Likewise, in contrast to the image of the secluded hut of the (monk) scholar-recluse, which had dominated poem-paintings in the first quarter of the 15th century—the imagery of Shūbun-school screens began to focus increasingly on elegant and elaborate pavilions derived from the iconography of early Ming (1368–1644) painting (*see* CHINA, §V, 4(i)(d)), as in the *Shiki sansui zu byōbu* ('Four seasons landscape'; late 15th century) screens attributed to Shūbun (Tokyo, N. Mus.).

(g) Post-Shūbun schools. Among the noteworthy post-Shūbun schools is the group of painters associated with the fundamentalist monk IKKYŪ SŌJUN, which included a disciple of Shūbun called Hyōbu Saiyo (*fl* late 15th century); and a painter known from his seal as Sekiyō, who is thought to have painted the sliding-door works in the Shinjuan, a subtemple of the Daitokuji dedicated to Ikkyū's memory in 1491; and Sōjō (*fl* early 16th century). Some of these painters have been associated with what came to be known as the Soga school. The works of Sekiyō, in particular, further illustrate the trends towards extreme spaciousness in mural décor and combine this with an incisive economy of brushwork. The Ami school

of painter–connoisseur–curators, namely Nōami, Geiami and Sōami (*see* AMI), also illustrate these trends, although their individual styles are relatively distinct. Nōami deliberately modelled his style on Muqi in flower-and-bird (*kachō*) painting particularly, Southern Song academy flower-and-bird painting and Zen-oriented figural styles. Geiami picked up the trend for Ma–Xia, or particularly Xia Gui-orientated style, which his pupil Kenkō Shōkei brought back to his home region of Kamakura, founding a school there. Sōami, the greatest of these painters, was skilled in the Ma–Xia style, but he developed his real forte in a landscape manner that was a fine blend of Song-orientated Muqi style combined with that of Gao Ranhui (*fl* ?14th century), a follower of the Mi Fu–Mi Yuren tradition. His style expressed his full and sensitive grasp of the ground from which these traditions had sprung up in China. He is the first true SOUTHERN SCHOOL painter of Japan, to borrow a famous term from Dong Qichang. Sōami's greatest works are found in the sliding-door paintings from the Daisen'in, now remounted as hanging scrolls, of the *Shōshō hakkeizu* ('Eight views of Xiao and Xiang'; *c.* 1513). These works demonstrate that what had originated with shogunal-orientated fashions was now the centrepiece of a monastery whose overall programme of décor reflected trends that had become increasingly clear in the latter half of the 15th century.

(h) Tōyō Sesshū and provincial courts. Against these trends, and as a distinct and somewhat rebellious counterpart, the career of Tōyō Sesshū may be seen as an example of the desire to escape from the perhaps somewhat stifling atmosphere of Kyoto, in which he had been nurtured since his early entry into the Shōkokuji *c.* 1430. Sesshū left the capital *c.* 1463 and found a patron in Ouchi Yoshihiro (1356–1400), a major participant in the officially limited tally trade with China. He seized the opportunity to accompany the monk–diplomats on the boat Ouchi sponsored in 1467, sailed to Ningbo and proceeded on to Hangzhou and further north to Beijing, where he painted works which were praised by the Chief Examiner. His range of styles developed significantly from this point, and it becomes clear from his many surviving works painted after 1469 that he had mastered many styles, most of them derived from what he had encountered in Ming China. These include a Ming-orientated image of Muqi, Ming images of GAO KEGONG, LI TANG and especially of Xia Gui, which he later developed as a major style in his long landscape handscrolls such as *Sansui chokan* ('Long landscape handscroll'; 1486; Hofu, Mori Mus.), and an interesting and for Japan entirely new Ming, or more probably Ningbo-derived, richly coloured bird-and-flower style. In addition, there are examples of his mastery of the Yujian style, which he must have studied in Kyoto (*c.* 1495). This culminated in his famous *Haboku sansui* ('Splashed ink landscape'; 1495; Tokyo, N. Mus.).

Sesshū's career moves and his resistance to the dominance of Kyoto and shogun-dominated circles highlight new trends that emerged from the increasing political and cultural fragmentation of Japan after the Onin Wars (1469–79). The wars were a symbol of the political emasculation of the Ashikaga and point to the new age of *gekokujō* ('topsy-turvy world') of the civil wars of the 16th century,

which culminated in the dominance of the new dictators, Oda Nobunaga, Toyotomi Hideyoshi and, finally, Tokugawa Ieyasu (1543–1616), the founder of the new Edo regime. In this world, daimyo courts in the provinces were served by such painters as Sesson Shūkei in eastern Japan, who catered to the tastes of the age in his extraordinary, often violent, distortions of the old schemes in landscapes and other genres, and developed a brilliant Yujian style (for illustration *see* SESSON SHŪKEI), among many others.

The Kanō school, under the leadership of Kanō Motonobu especially, diversified its patronage and established a new and dominant orthodoxy in Kyoto and Odawara. This became an increasingly powerful force as members of the Kanō school won the patronage of the new dictators, and it served to legitimize their achievements with often elaborately coloured figural and landscape compositions painted on gold leaf, in the context of impressively decorated castles and mansions.

BIBLIOGRAPHY

S. Shimada: 'Mōryōga' [Apparition paintings], pt 1, *Bijutsu Kenkyū*, 84 (1938), pp. 534–43; pt 2, *Bijutsu Kenkyū*, 86 (1939), pp. 48–56
R. Edwards: 'Ue Gukei: 14th Century Ink Painter', *A. Orient.*, vii (1968), pp. 169–78
I. Tanaka: *Shūbun kara, Sesshū* [Shūbun to Sesshū], Nihon no bijutsu [Arts of Japan] (Tokyo, 1969); Eng. trans. by B. Darling as *Japanese Ink Painting: Shubun to Sesshu*, Heibonsha Surv. Jap. A., xii (New York, San Francisco and Tokyo, 1972)
J. Fontein and M. L. Hickman: *Zen Painting and Calligraphy* (Boston, 1970)
M. Murase: 'Farewell Paintings of China: Chinese Gifts to Japanese Visitors', *Artibus Asiae*, xxxii (1970), pp. 211–36
H. Kanazawa: *Shoki suibokuga* [Early ink painting], Nihon no bijutsu [Arts of Japan], lxix (Tokyo, 1972); Eng. trans. by B. Ford as *Japanese Ink Painting: Early Zen Masterpieces*, Japanese Arts Library, viii (Tokyo and New York, 1979)
H. Brinker: *Die Zen-buddhistische Bildnismalerei in China und Japan*, Münchner Ostasiatische Studien, x (Wiesbaden, 1973)
C. D. M. Zainie: *Early Japanese Ink Painting* (diss., Seattle, U. WA, 1973)
T. Matsushita: *Ink Painting*, Eng. trans. and ed. by M. Collcutt, *Arts of Japan*, vii (New York and Tokyo, 1974)
Y. Shimizu: *Problems of Mokuan Reien (?1323–1345)* (diss., Princeton U., NJ, 1974)
R. P. Stanley-Baker: 'Gakuō's Eight Views of Hsiao and Hsiang', *Orient. A.*, xx/3 (1974), pp. 283–303
I. Tanaka, ed.: *Kaō, Mokuan, Minchō*, Suiboku bijutsu taikei [Compendium of the art of ink painting] (Tokyo, 1974)
M. Murase: *Japanese Art: Selections from the Mary and Jackson Burke Collection* (New York, 1975)
A. Watanabe: 'Shōshō hakkeizu' [Paintings of the eight views of Xiao and Xiang], *Nihon No Bijutsu*, 124 (1976)
Japanese Ink Paintings from American Collections: The Muromachi Period: An Exhibition in Honour of Shūjirō Shimada (exh. cat., ed. Y. Shimizu and C. Wheelwright; Princeton U., NJ, A. Mus., 1976)
J. W. Hall and T. Toyoda, eds: *Japan in the Muromachi Age* (Berkeley, Los Angeles and London, 1977)
C. D. M. Zainie: 'Ryōzen, from *Ebusshi* to Zen Painter', *Artibus Asiae*, xli/1 (1978), pp. 93–123
R. P. Stanley-Baker: *Mid-Muromachi Paintings of the Eight Views of Hsaio and Hsiang* (diss., Princeton U., NJ, 1979)
Song of the Brush: Japanese Paintings from the Sansō Collection (exh. cat., ed. J. M. Rosenfield; Seattle, WA, A. Mus.; New York, Japan House Gal.; 1979)
G. Elison and B. L. Smith, eds: *Warlords, Artists and Commoners: Japan in the Sixteenth Century* (Honolulu, 1981)
R. P. Stanley-Baker: 'Some Proposals Concerning the Transmission to Muromachi Japan of Styles Associated with Painters from Chekiang of the Late Yüan and Early Ming', *Suzuki Kei sensei kanreki kinen* [Festschrift for Professor Suzuki Kei: essays on Chinese painting history] (Tokyo, 1981)
C. K. Wheelwright: 'Kanō Painters of the Sixteenth Century AD: The Development of Motonobu's Daisen-in Style', *Archvs Asian A.*, 34 (1981), pp. 6–31

——: *Kano Shoei* (diss., Princeton U., NJ, 1981)
M. Collcutt: *Five Mountains: The Rinzai Monastic Institution in Medieval Japan* (Cambridge, MA, 1982)
R. P. Stanley-Baker: 'New Initiatives in Late 15th Century Japanese Ink Painting', *Proceedings ICRCP: Inter-regional Influences in East Asian Art* (Tokyo, 1982)
H. Brinker: *Shussan Shaka: Darstellung in der Malerei Ostasiens* (Berne, 1983)
Y. Shimizu and J. M. Rosenfield: *Masters of Japanese Calligraphy, 8th to 19th Century* (New York, 1985)
A. Shimao: 'Hyōnenzu no kenkyū: Daigaku Shūshū no jo ni mieru "shinyō" wo chūshin ni' [Study of *Catfish with a Gourd*: the meaning of 'new mode' in the inscription by Daigaku Shūshū], *Bijusu Kenkyū*, 33 (1986), pp. 24–37
A. Watanabe, H. Kanazawa and P. Varley: *Of Water and Ink: Muromachi-period Paintings from Japan, 1392–1568* (Seattle and London, 1986)
H. Ogawa: 'Daisen-in hōjō fusuma-e kō' [On the sliding door paintings in the abbot's residence of the Daisen-in], *Kokka*, 1120–22 (1989)
R. P. Stanley-Baker: 'The Ashikaga Shogunal Collection and its Setting: A Matrix for 15th Century Landscape Painting', *Influence on Oriental Art: International Symposium on Art Historical Studies: Kyoto, 1990*, pp. 87–100
A. Shimao: 'Sesshū Tōyō no kenkyo (1): Sesshū no imeeji senryaku' [A study of Sesshū Tōyō (1): the artist's tactics in the spread of his image], *Bijutsu Kenkyū*, 351 (Jan 1992), pp. 196–213
——: 'Sesshū Tōyō no kenkyo (2)' [A study of Sesshū Tōyō (2)], *Bijutsu Kenkyū*, 356 (March 1993), pp. 204–17 [covers painters described in the *gozan* lit.]
R. P. Stanley-Baker: 'Muromachi jidai no zashiki kazari to bunka teki shidōken' [Mansion décor and cultural hegemony in the Muromachi period], *Zenshū jiin to tei'en: Nanbokuchō Muromachi no kenchiku, chōkoku, kogei* [Zen sect temples and gardens: architecture, sculpture and crafts of the Nanbokuchō and Muromachi periods], xi of *Nihon bijutsu zenshū* (Tokyo, 1993), pp. 168–73
——: 'Afterword: Marching in Time, Muromachi Ink Painting and the Zhe School', *Painters of the Great Ming: The Imperial Court and the Zhe School* (exh. cat., ed. R. Barnhart; Dallas, TX, Mus. A., 1993), pp. 333–48
T. Ebine: 'Suibokuga: Mokuan kara Minchō' [Ink painting: from Mokuan to Minchō], *Nihon No Bijutsu*, 333 (1994)
S. Miyajima: 'Suibokuga: Daitokujiha to Jasoku' [Ink painting: Daitokuji and Jasoku], *Nihon No Bijutsu*, 336 (1994)
A. Shimaō: 'Suibokuga: Nōami kara Kanohae' [Ink painting: from Nōami to the Kano school], *Nihon No Bijutsu*, 338 (1994)
A. Watanabe: 'Suibokuga: Sesshu to sono ryūha' [Ink painting: Sesshū and his school], *Nihon No Bijutsu*, 335 (1994)

RICHARD P. STANLEY-BAKER

(iv) Genre painting.

(a) *Fūzokuga.* (b) *Ukiyoe.*

(a) *Fūzokuga.* This type of genre painting depicted the activities and appearance of people in contemporary society. The word *fūzoku* ('custom') has been used since ancient times in Japan to refer to patterns of life in various social classes, but *fūzokuga* is an art-historical term coined in modern times to describe a large category of paintings produced in the Kyoto region from *c.* 1575 to 1675, reflecting fascination with patterns of behaviour and fashions in dress in the secular world. The themes and styles of *fūzokuga* developed during the 16th century from traditional *Yamatoe* (Japanese-style) paintings of the seasons (*shikie*), pictures of famous places (*meishoe*) and depictions of annual customs (*tsukinamie*). *Fūzokuga* evolved in two major phases, in the Keichō (1596–1615) and Kan'ei (1624–44) eras, before being displaced in the last decade of the 17th century by the idealized depictions of beautiful women and portrayals of actors characteristic of *ukiyoe* ('pictures of the floating world'; *see* §(b) below).

In its first phase *fūzokuga* expressed the optimism and group solidarity of the Momoyama period (1568–1633),

when more than a century of civil war climaxed in a drive to national unification that was achieved in 1600. Early genre painting was nurtured in the capital of Kyoto, commissioned by powerful warriors and courtiers and painted by important artists of the KANŌ SCHOOL on large-scale folding screens and sliding-door panels intended to promote an environment of relaxed enjoyment of worldly pleasures. One of the earliest genre paintings, *Scenes in and out of the Capital* (*Rakuchū rakugai zu*; *c.* 1573; Japan, priv. col.) painted by Kanō Eitoku (*see* KANŌ, (5)), presents a panorama of Kyoto that ranges across the spectrum of annual events and daily activities of all classes in a peacefully ordered society.

Favourite subjects in *fūzokuga* of the Keichō era were groups of people enjoying the outdoors—picnicking or dancing under spring cherry blossoms or autumn maples at famous sites around Kyoto. *Maple Viewing at Takao* (*Takao kanpū zu*; Tokyo, N. Mus.; see fig. 94) by Kanō Hideyori (*see* KANŌ, (4)) shows several parties eating, drinking, playing music and dancing under flame-red maples near the famous temple of Jingoji. *Merrymaking under Blossoming Trees* (*Kaka yūraku zu*; Tokyo, N. Mus.), painted about 30 years later by Kanō Naganobu (1577–1664), omits reference to the specific locale but gives even more prominence to the young lord and his party being entertained by fashionable *kabuki* actresses.

Demand for *fūzokuga* increased remarkably after 1600. Lively annual events such as the Gion Festival and the Kamo Horse Race were popular subjects, as were archery, dog chasing, horsemanship and falconry, the sports of warriors. These semi-documentary themes, along with *kabuki* performances on makeshift stages and spectacles commemorating decisive battles, depicted swarms of energetic people in large, open-air settings. Also popular were screens (*Nanban byōbu*; *see* §(vi)(a) below) showing Portuguese traders and missionaries disembarking from their great ships, which were laden with exotic goods. An important landmark of Keichō-era *fūzokuga* is the cycle of annual events of the Kyoto–Osaka region painted in

1614 by Kanō Sadanobu (1597–1623) and his studio for the Tokugawa family at Nagoya Castle.

As the Tokugawa shoguns (who governed Japan in the Edo period, 1600–1868) steadily imposed restrictions to ensure order and consolidate their control over the populace, group solidarity became more stratified. Artists' attention shifted *c.* 1620 from the public pageants embracing all of society to the private pleasures offered to some in Kyoto's developing entertainment districts. Paintings on large surfaces for use in warriors' mansions gave way to smaller screens intended for merchants' town houses. Features unrelated to the focus on personal amusements were dropped, and a new element of sensuality came to the fore. Especially popular during the Kan'ei-era were montages of amusements. A pair of two-panel folding screens (Tokyo, Seikadō Bunko) surveys the kaleidoscope of entertainments available on the bed of the River Kamo at Shijōgawara, Kyoto, with courtesans parading on a *kabuki* stage and trained dogs jumping through hoops, archers practising marksmanship and crowds gaping at a caged porcupine. Other paintings, notably the *Sōōji Screens* (*Sōōji byōbu*) in the Tokugawa Reimeikai Foundation, Tokyo, celebrate the hedonism of brothels; in a two-storey pleasure palace, clients are shown idly conversing and engaging in frivolities, while others enjoy the facilities of an adjoining bathhouse or dance to music performed in surrounding gardens. Kan'ei-era *fūzokuga* included paintings of private parties, held to offer the pleasure of social association rather than to mark an occasion. The *Hikone Screen* (*Hikone byōbu*; Shiga Prefect., Ii priv. col.) shows men and women languidly playing parlour games and listening to music in an unspecified setting of abstract gold space. Their dreamlike realm is not part of the real world.

The attention given to superficial appearance frequently focused on fashionable femininity for its own sake. The key notion in one group of paintings was the semblance of beauty: vividly patterned kimonos are arranged by a tableau of models on the *Matsuura Screens* (*Matsuura byōbu*; Nara Prefect., Yamato Bunkakan); in the *tagasode* ('whose sleeves?') screens, tastefully displayed costumes

94. Kanō Hideyori: *Maple Viewing at Takao*, six-panel folding screen, colours on paper, 1.49×3.64 m, *c.* 1570 (Tokyo, National Museum)

appear alone as symbols of feminine elegance. In another group the deportment of women is shown in stylized manner: charming weavers pose gracefully at their looms (Atami, MOA Mus. A.); an exquisitely attired dancer sways delicately on each panel of a small folding screen (Kyoto, N. Mus.).

As stylish charm became the order of the day, paintings of a single standing beauty became popular, smaller scrolls replaced screens as the preferred format and the volume of standardized production increased. The final phase of Japanese *fūzokuga* is typified by the Kanbun *bijin* or 'beauty of the Kanbun era' (1661–73). Delicate and romantic, these paintings sweeten reality, omitting reference to the townsman's daily routine, refining the sensuality of his diversions and mirroring his fantasies. As the centre of popular culture shifted from Kyoto to Edo (now Tokyo) during the last quarter of the 17th century, stereotyped expressions of *fūzokuga* gave way to the new creations of early *ukiyoe* (*see* §(b) below).

BIBLIOGRAPHY

Y. Yamane: *Momoyama Genre Painting*, Eng. trans. by J. M. Shields (New York, 1973)
T. Takeda, Y. Yamane and C. Yoshizawa, eds: *Nihon byōbue shūsei* [Survey of Japanese screen paintings], xi–xiv (Tokyo, 1977–80)
T. Hayashiya, Y. Yamane and T. Takeda, eds: *Kinsei fūzoku zufu* [Pictorial record of early modern genre] (Tokyo, 1982–4)

CAROLYN WHEELWRIGHT

(b) Ukiyoe. The genre of *ukiyoe* ('pictures of the floating world') is primarily associated with woodblock prints (*hanga*) and illustrated books (*ehon*; *see* §IX, 2(iii)(a) below). However, it is impossible to obtain a clear understanding of the form's early development without reference to the tradition of *ukiyoe* painting (*nikuhitsuga*; 'original painting'; polychrome painting; also *nikuhitsu ukiyoe*), which flourished throughout the Edo period (1600–1868).

Early development, 17th century–late 18th. Nikuhitsuga grew out of the genre paintings (*fūzokuga*; *see* §(a) above) produced from the Momoyama period (1568–1600) to the 1660s, primarily in Kyoto. During the Edo period the painter IWASA MATABEI was erroneously dubbed the founder of *ukiyoe*. He was the son of a minor provincial daimyo, who excelled in both the Tosa and Kanō styles (*see* §(i)(a) above). His own social status and that of his patrons (who included major daimyo and the shogun) make him an unlikely candidate as the originator of a populist artistic movement based in Japan's cities. The man usually credited with producing the first *ukiyoe* prints is the print designer, book illustrator and painter HISHIKAWA MORONOBU, active in Edo (now Tokyo). A student of Kanō, Tosa and genre painting, Moronobu developed a new, vital style that catered to the tastes of his merchant patrons. He painted vivid depictions of the 'floating world' of the Edo pleasure quarters, as in the *Nakamuraza byōbu* ('Scene at the Nakamura Theatre'; folding screen; Boston, MA, Mus. F.A.). Although Moronobu's school did not produce any distinguished artists, he was a major influence on Torii Kiyonobu I (*see* TORII, (1)), OKUMURA MASANOBU, Kaigetsudō Ando (*see* KAIGETSUDŌ, (1)), MIYAGAWA CHŌSHUN and NISHIKAWA SUKENOBU in Kyoto,

95. Katsukawa Shunshō: *Customs and Manners of Women of the 12 Months, c.* 1770s (Atami, MOA Museum of Art)

who established *ukiyoe* as the most vital artistic current of the Edo period.

During the early 18th century, *ukiyoe* show a rich stylistic cross-fertilization between *nikuhitsuga* paintings and woodblock prints. Although there was a difference in the audience for *ukiyoe* painting, which often used costly, high-quality materials, and for prints, which were mass-produced, artists treated the same themes in both media: chiefly *bijinga* ('pictures of beautiful women'; famous Edo beauties and courtesans from the Yoshiwara pleasure quarter) and *yakushae* ('pictures of actors'; scenes from *kabuki* and *nō* theatre).

The Kaigetsudō school, led by Kaigetsudō Ando, specialized in paintings of courtesans. Ando's tall, regal, somewhat haughty beauties, such as his *Bijin* ('Beauty';

c. 1710; Boston, MA, Mus. F.A.), were immensely popular and influenced the early Torii masters. Another artist who concentrated on painting was Miyagawa Chōshun (for illustration *see* MIYAGAWA CHŌSHUN). He is known for his refined paintings of courtesans, but it was the skill as a colourist he showed in his handscrolls of theatrical and festival scenes that brought him to the attention of the Kanō masters in charge of the restoration of the Tokugawa family mausoleum in Nikkō (Tochigi Prefect.). The Miyagawa school had its most lasting impact on Baioken Eishun (*fl* 1704–63) and Kawamata Tsuneyuki (?1676–?1741), who never designed prints.

One of the most influential *ukiyoe* masters of the second quarter of the 18th century, Nishikawa Sukenobu, is primarily known for his paintings and book illustrations. A student of Kanō Einō and Tosa Mitsusuke, he produced few single-sheet prints, probably because the format was not popular in the conservative artistic circles of Japan's old imperial capital. Another painter from western Japan was Tsukioka Settei (1711–86), a Kanō-trained artist who worked in Osaka.

In the 1770s Katsukawa Shunshō (*see* KATSUKAWA, (1)), who had studied with a pupil of Miyagawa Chōshun, emerged as the leading designer of actor prints. But it is in his paintings of beautiful women, which include the *mitatee* ('parody picture') of *Chikurin shichiken* ('Seven sages of the bamboo grove'; Tokyo, F.A. Univ.) and *Fujo fūzoku jūnikagetsu* ('Customs and manners of women of the 12 months'; Atami, MOA Mus. A.; see fig. 95), that he demonstrated his full abilities as a colourist and designer. This latter series, among the *ukiyoe* paintings known to have been in the collection of the feudal lord Matsuura Seizan (1760–1841), offers important evidence of samurai patronage of *ukiyoe*.

Late 18th century–19th. Like their predecessors, leading *ukiyoe* masters of the late 18th century and the 19th, including KITAGAWA UTAMARO and the masters of the landscape print, KATSUSHIKA HOKUSAI and ANDŌ HIROSHIGE, continued to produce paintings in addition to prints and book illustrations. The few surviving paintings by Utamaro include stylishly attired beauties, as well as more complex figural compositions within architectural settings. Hokusai's surviving corpus includes several hundred paintings of encyclopedic range. These include beauties, themes from Chinese and Japanese history and legend, genre and landscape. The richly polychromed *Tametomo and the Demon of Onigashima Island* (London, BM) is a representative example of Hokusai's treatment of Japanese legend. His figural style, with its energetic delineation of drapery, was widely imitated by his pupils, of whom Tessai Hokuba (1771–1844) was among the most gifted painters.

Although Hiroshige produced many compositions featuring standing beauties, he is best known for his paintings celebrating well-known sites in Edo and the provinces. During the Ka'ei era (1848–54) he and his studio painted between 100 and 200 sets of diptychs and triptychs of such subjects. His paintings are distinguished by the sensitive use of atmospheric ink wash to evoke actual places. His followers, Suzuki Hiroshige II (1826–69) and Suzuki Hiroshige III (?1842–94), were also successful landscape painters.

Members of the UTAGAWA school, including Utagawa Kunisada, who adopted the name Toyokuni III in 1844, and Utagawa Kuniyoshi (*see* UTAGAWA, (5) and (6)), though best known for their prolific output of prints, also distinguished themselves in the realm of painting. Most of Kunisada's paintings, featuring posturing actors and seductive beauties, date from after 1830. A noted work from this period is an album of *Scenes of Kabuki and the Yoshiwara* (Tokyo, Seikadō Bunko). Kuniyoshi's paintings are often characterized by the imaginative, irreverent playfulness that also distinguishes his prints.

The tradition of *ukiyoe* painting, often inflected by elements derived from European painting, continued well into the Meiji period (1868–1912), but its development is not as well charted as that of woodblock prints. Representative artists include TSUKIOKA YOSHITOSHI, a pupil of Kuniyoshi noted for his gory treatment of historical themes and erotically charged portrayals of courtesans, Hashimoto Chikanobu (1838–1912), a painter of sentimentally idealized beauties, and Kaburagi Kiyokata (1878–1973), who referred to himself as the last painter in the *ukiyoe* line.

BIBLIOGRAPHY
M. Narazaki, ed.: *Nikuhitsu ukiyoe*, 10 vols (Tokyo, 1980–82)
——: *Hizō ukiyoe taikan* [*Ukiyoe* paintings and prints in Western collections], 13 vols (Tokyo, 1987–90)
T. Clark: *Ukiyoe Paintings in the British Museum* (London, 1992)

SHUGO ASANO, CHRISTINE GUTH

(v) Rinpa. The *Rinpa* school and style of decorative painting and crafts design originated in Kyoto in the 17th century, spread to Edo (now Tokyo) in the mid-18th and continued to be practised until the early 20th, when it was subsumed into the *Nihonga* school of modern Japanese-style painting (*see* §5(iii) below). The basis of the *Rinpa* manner was the work of the painter TAWARAYA SŌTATSU and the calligrapher, potter and lacquerware designer Hon'ami Kōetsu (*see* HON'AMI, (1)), who worked together in the first decades of the 17th century. However, it was given its definitive form by Kōetsu's great-nephew, the painter and designer Ogata Kōrin (*see* OGATA, (1)), after whom it is named (*rin* from Kōrin; *pa*: 'school'). *Rinpa* is characterized by a fusion of the classical imagery of both the Heian period (AD 794–1185) and the early part of the Kamakura period (1185–1333) with the bold and sumptuous style of the Momoyama period (1568–1600; *see* §(i)(b) above). Unlike other, officially sponsored painters of the time, such as the members of the TOSA SCHOOL and the KANŌ SCHOOL, *Rinpa* masters had no regular sources of patronage, and, although they often collaborated with one another, they had little continuous workshop tradition. This left them free to explore a diversity of media and expressive techniques instead of repeating or refining an inherited repertory of subject and style, as was the case in the officially sponsored schools.

(a) Kyoto, before 1644. (b) Transition from Kyoto to Edo, 1644–*c*. 1800. (c) Edo, after *c*. 1800.

(a) Kyoto, before 1644. The development of the *Rinpa* style was connected with the revival of the classical culture of Kyoto by the *machishū*, a group of upper-class merchants that had gained power in the city during the civil wars of the 15th and 16th centuries. In the course of their

96. Tawaraya Sōtatsu: *Waves at Matsushima*, pair of six-panel folding screens, ink and colours on gold foil, each 1.52×3.56 m, early 17th century (Washington, DC, Freer Gallery of Art)

rise the merchants had begun to identify with the city's aristocratic past, and, when they were stripped of much of their economic and political power by Tokugawa Ieyasu (1542–1616) in the early 17th century, many of the old families turned their interests to cultural affairs. Among these was the Hon'ami family, led at this time by Hon'ami Kōetsu. *Rinpa* was born through the collaboration of Kōetsu, who was principally interested in calligraphy, ceramics and lacquerware, with the painter Tawaraya Sōtatsu. Sōtatsu is thought to have been the master of an *eya* ('picture shop'), a workshop specializing in the decoration of folding screens, fans, poem sheets, shells and textiles. These were painted in the vigorous, stylized manner of the *Yamatoe* folding screens of the 15th and 16th centuries (*see* §3(iii) above). Sōtatsu refined this style, increasing its schematization and compositional rigour and adding elements drawn from the ancient narrative handscroll tradition. His earliest surviving works are poem sheets and scrolls decorated with floral and animal themes

and often inscribed with verses in the hand of Kōetsu. Sōtatsu's decoration provides an elegant compositional foil for Kōetsu's calligraphy and creates a wistful mood appropriate to the appreciation of the poetry. His prolific production of these modest pieces seems to have established Sōtatsu as a painter in his own right by the 1620s, when he is thought to have begun painting in monochrome ink. This work (e.g. the hanging scroll *Lotus and Waterfowl*; Kyoto, N. Mus.; *see* TAWARAYA SŌTATSU, fig. 2) is marked by the use of the *mokkotsu* ('boneless'; painting without outlines) technique and *tarashikomi* (adding pigment to an undried wash to create blurred and pooled effects). By the 1630s Sōtatsu and his workshop were receiving commissions for large folding screens with designs inspired by classical themes (see fig. 96). These works contrast colour and contour, movement and repose, literary references and visual sumptuousness.

The heyday of Kōetsu and Sōtatsu coincided with the period of increased cultural activity that is sometimes

called the Kan'ei Renaissance (after the Kan'ei era, 1624–44). At its centre was the salon of Emperor GoMizunoo (*reg* 1611–29) and Empress Masako (Tōfukumon'in; 1607–78), the younger sister of the shogun Tokugawa Iemitsu (1604–51), who provided them with a lavish government stipend. Their salon, combining imperial prestige and the inventiveness of the merchant class, was fertile ground for new initiatives in the visual arts. Sōtatsu is known to have been painting large panel compositions for the imperial library in 1630, and Hōrin Shōshō (1592–1668), an intimate of the imperial family, mentioned the use of an ink painting by Sōtatsu in a tea ceremony. Despite a suggestion of resistance to the Tokugawa shoguns contained within the classical revival, the Kyoto salons of this period were also frequented by the military, who had developed their own taste for courtly sophistication. Among the provincial warlords most attentive to Kyoto culture was the Maeda family of Kanazawa in Kaga Province (now part of Ishikawa Prefecture). Around 1640 they appear to have lured Sōtatsu's successor, Tawaraya Sōsetsu (*fl* mid-17th century), away from Kyoto to work in their own domain. There Sōsetsu concentrated on screen and panel paintings of flowers and grasses, further schematizing Sōtatsu's prototypes. A similar manner can be seen in the works of Kitagawa Sōsetsu (*fl* late 17th century–early 18th), a presumed follower of Sōsetsu who worked in the same region.

(b) Transition from Kyoto to Edo, 1644–c. 1800. By the late 17th century the population of Kyoto included a class of self-conscious and self-indulgent bourgeois from whose ranks emerged the brothers Ogata Kōrin and Ogata Kenzan (*see* OGATA, (2)), whose great-grandfather, Ogata Dōhaku (*d* 1604), was Hon'ami Kōetsu's brother-in-law. Influenced by the work of Sōtatsu and Kōetsu and immersed in the fashions of their own milieu, they produced a style of painting that was both refined and stunningly accessible. Kōrin, the elder of the two, is known to have possessed articles produced in the workshops of Sōtatsu and Kōetsu, and numerous sketches preserved in the Konishi archive (Osaka, Mun. Mus.; Tokyo, Agy Cult. Affairs; Japan, priv. col.; see Yamane, 1962) show his study the works by the former. His first exercises in painting date from the 1690s and consist of decorated textiles, fans and other functional objects. The challenge of composing for different surfaces and materials encouraged his distinctive propensity for simple, fluid and abstract design. From about 1700 he took up painting in earnest. His experiments in this period produced one true masterpiece, a pair of six-panel folding screens entitled *Irises* (*c*. 1700; Tokyo, Nezu A. Mus.; for illustration *see* OGATA). The clusters of plants displayed against a gold ground have precedents in the work of Sōtatsu and Sōsetsu, but the peculiar synthesis of sumptuousness and economy is his own. Between 1704 or 1705 and 1709 Kōrin lived in Edo, where he was able to study works in monochrome ink by the great masters of the Muromachi period (1333–1568), Tōyō Sesshū and Sesson Shūkei, though he complained in a letter of 1709 that he was bored with copying the old masters. On his return to Kyoto he pursued two directions: painting in monochrome ink, with his new, invigorated, 'quick-stroke' style, and a renewed interest in

the decorative art of Sōtatsu. These initiatives fused in the masterpiece *Red and White Plum Blossoms* (Atami, MOA Mus. A.), which juxtaposes a languid, highly stylized body of water with comparatively naturalistic and vigorously painted plum trees. In this work the tremendous vitality of Sōtatsu's screen compositions has given way to greater abstraction and a subtle sensuality. Kōrin also achieved recognition for his painted lacquerware produced in the manner of Kōetsu and for his painted textile designs, a major monument being a kimono decorated with autumn flowers and grasses (*c*. 1705; Tokyo, N. Mus.), thought to have been painted for the Fuyuki family in Edo. Kōrin's younger brother Kenzan excelled as a calligrapher and potter, and with the brothers' participation in this wide range of crafts the *Rinpa* style achieved its broadest dissemination. Numerous design manuals and kimono pattern books (*hiinagata*) testify to their impact on the crafts industry.

For all his prowess as a painter, Kōrin seems to have had few followers. One was WATANABE SHIKŌ, who painted landscapes in the Kanō manner and a few hand-scrolls in the Tosa style as well as nature and figure studies after Kōrin; the latter include *Mt Yoshino* (Japan, priv. col.), a pair of six-panel folding screens in which the rhythmic and entirely artificial mountain shapes contrast with the more detailed and credible cherry trees, a convention typical of the artist. A less gifted but more faithful follower was Fukae Roshū (1699–1757), son of an official at the Kyoto silver mint. Kōrin may have met him through his patron, another mint official named Nakamura Kuranosuke (1669–1730), but the period of contact must have been brief, for Roshū was 18 at the time of Kōrin's death. Roshū is known for his classical compositions inspired by Sōtatsu, such as *Ivy Lane* (Tokyo, Umezawa Mem. Found.), and flowers-and-grasses compositions in the style of Kōrin.

About 1731 Kōrin's brother Kenzan moved to Edo, where he manufactured a small number of ceramics but seems to have been in greater demand as a painter. He painted both in a style derived from that of his brother and in a more expressive style that was closest to the Zen painting tradition. In 1738 he presented a set of Kōrin's fan paintings to Tatebayashi Kagei (*fl* mid-18th century), apparently a doctor who had formerly been in the service of the Maeda family. Kagei's paintings, usually hanging scrolls of flowers, grasses and trees in a turgid *Rinpa* style, often bear the *Masatoki* seal used by Kōrin in his last years; this has prompted speculation that Kagei was designated by Kenzan as Kōrin's artistic heir. Kagei's best-known work is a hanging scroll portraying the deified statesman Sugawara no Michizane, commonly known as *Tenjin* (Tokyo, Eisei Bunko). The execution of the pine and plum trees flanking the subject and the content and calligraphic style of the inscription show a debt to Kenzan's late work. Kagei's success in perpetuating the *Rinpa* style in Edo is uncertain, but it was taken up by Tawaraya Sōri (*fl* late 18th century). Among the handful of Sōri's surviving works is a six-panel folding screen entitled *Maple Leaves* (priv. col.; see Link and Shimbo, no. 33), in which the decoratively placed clusters of trees and the generous expanse of undecorated gold foil show a careful study of Kōrin's work.

97. Suzuki Kiitsu: *Leaves in Rain*, pair of hanging scrolls, ink and colours on silk, each 1194×356 mm, early 19th century (Los Angeles, CA, County Museum of Art)

(c) Edo, after c. *1800.* By the turn of the 19th century there was a revival of the *Rinpa* style, in which the publication in 1802 of the *Kōrin gafu* ('Book of paintings by Kōrin') played a major role. Its compiler was Nakamura Hōchū, a painter who probably lived and worked in Osaka and who visited Edo around 1800. Hōchū's work, preserved mostly on folding fans and woodblock-printed books, is a charmingly mannered rendering of the Kōrin style, with a particularly rich use of *tarashikomi* (adding pigment to an undried wash). However, the central figure in the *Rinpa* revival in Edo was the painter and book designer SAKAI HŌITSU. A member of the family that had supported Kōrin in the early 18th century, Hōitsu had access to good examples of Kōrin's work and the means to pursue a study of them, and he may also have had direct contact with the *Rinpa* tradition through Tawaraya Sōri. Hōitsu's early work was eclectic, absorbing the *ukiyoe* ('pictures of the floating world') style of Utagawa Toyoharu (*see* UTAGAWA, (1) and §(iv)(b) above) and perhaps

the Nagasaki style of bird-and-flower painting advocated by Sō Shiseki. It is said that his friend, the painter Tani Bunchō, advised Hōitsu to pursue the *Rinpa* style, and from the first decade of the 19th century Hōitsu's works began to exhibit *Rinpa* characteristics. Hōitsu was also important for his contribution to *Rinpa* scholarship, publishing biographical material from the Ogata family papers, which he had discovered in the possession of the Konishi family in Kyoto *c.* 1807, and collections of prints in the manner of Kōrin and Kenzan. His efforts constitute the foundation for later *Rinpa* studies: for instance the chapter on the Kōetsu school (i.e. *Rinpa*) in the *Koga bikō* ('Handbook of classical painting') by Asaoka Okisada (1800–56) is deeply indebted to Hōitsu. The *Koga bikō* lists 43 artists of the Kōetsu school, far more than are known from extant works.

Hōitsu's mature style exhibits a debt to the earlier *Rinpa* masters, but there are new subjects and a change with regard to detail, which became more profuse, sharper and less artificial. An interest in the humour and wit associated with Edo culture is also present. These characteristics were perpetuated in the work of Hōitsu's most prominent follower, SUZUKI KIITSU. The growing sense of naturalism was further enhanced by a broadened palette, one similar to that used by *ukiyoe* painters from the 1830s. A pair of hanging scrolls by Kiitsu, *Leaves in Rain* (Los Angeles, CA, Co. Mus. A.; see fig. 97), retains the traditional *Rinpa* approach to the isolation and selective placement of motifs, but there is descriptive colour and linear detail, atmosphere and light. In the work of Kiitsu, *Rinpa* comes closest to being absorbed by the naturalistic tendencies inherent in Japanese painting in the second half of the Edo period (1600–1868). The commitment to nature also precluded a continuation of the great work in crafts accomplished by the earlier *Rinpa* masters. Kiitsu was succeeded by a number of *Rinpa*-style painters who worked in an increasingly mannered style, such as his son Suzuki Shuitsu (1823–99), Ikeda Koson (1802–67) and Sakai Dōitsu (1845–1913).

The *Rinpa* style underwent a second revival at the turn of the 20th century. The paintings of Sōtatsu and Kōrin influenced exponents of the *Nihonga* style such as Taikan Yokoyama, Shunshō Hishida and Kanzan Shimomura (1873–1930). *Rinpa* continued to be influential in both ceramics and textile design; in painting it was most felicitously expressed in the work of Matazō Kayama.

BIBLIOGRAPHY

EARLY SOURCES

Nakamura Hōchū: *Kōrin gafu* [Book of paintings by Kōrin], 2 vols (n.p., 1802)
Sakai Hōitsu: *Ogata ryū ryaku inpu* [Brief compendium of Ogata-school seals] (Edo, 1813/*R* 1815)
——: *Kōrin hyakuzu* [One hundred pictures by Kōrin], 2 vols (Edo, 1815–26)
——: *Kenzan iboku* [Surviving works of Kenzan] (Edo, 1823)
Asaoka Okisada: *Koga bikō* [Handbook of classical painting] (Edo, *c.* 1845–53); rev. by K. Ota as *Zōtei koga bikō* [Presentation of the Handbook of Classical Painting] (Tokyo, 1904)

GENERAL

Y. Yamane: *Konishike kyūzō Kōrin kankei shiryō to sono kenkyū* [Material relating to Kōrin formerly in the Konishi collection and its research] (Tokyo, 1962)
T. Hayashiya, ed.: *Kōetsu* (Tokyo, 1964)
Rinpa (exh. cat., Tokyo, N. Mus., 1972)

Y. Yamane, ed.: *Rinpa kaiga zenshū* [Complete collection of *Rinpa* paintings], 5 vols (Tokyo, 1977–80)
Exquisite Visions: Rinpa Paintings from Japan (exh. cat. by H. Link and T. Shimbo, Honolulu, Acad. A., 1980)

RICHARD L. WILSON

(vi) Foreign-influenced painting. During the 16th and 17th centuries Japan traded with and received immigrants from foreign countries, particularly Portugal, Holland and elsewhere in Europe, but also from China and South-east Asia. The Japanese became familiar with imported works of art, and the influence of European styles and subject-matter is evident in the painting of this period (*see* §§(a) and (b) below). From 1639 to 1854, Japan retreated into virtual isolation from the outside world, with the port of Nagasaki the only point of entry for foreign goods and the only place where foreign traders were permitted to reside. Nevertheless, Japanese painting remained highly receptive to outside influences, particularly from China and Europe, as can be seen in works of the 'Nagasaki school' from the mid-17th century to the mid-19th (*see* §§(c) and (d) below).

(a) *Nanban* screen painting. (b) *Yōfūga*: Jesuit influence. (c) Nagasaki school. (d) *Nanga*.

(a) Nanban screen painting. The term *Nanban* ('southern barbarians', primarily used to designate Europeans arriving from the south) is applied both to works of art imported from abroad and, more importantly, to works created in Japan on the basis of contact with foreigners, mostly during the Muromachi (1333–1568) and Momoyama (1568–1600) periods and the early part of the Edo period (1600–1868). *Nanban* art (*Nanban bijutsu*), which includes both painting and craft, represents the first fusion in Japan between Western and Eastern art forms. The painting can be divided into two categories. The first consists of works by various artists already working in Japan who adopted European motifs but continued to use traditional Japanese painting techniques. The most representative pieces in this category are *Nanban byōbu* (*Nanban* screens; see fig. 98).

The second comprises *Yōfūga* ('Western-style pictures'; *see* §(b) below).

The principal period of production of *Nanban byōbu*, coinciding with the height of *Nanban* culture in Japan, lasted about half a century from the first examples made in the 1590s by members of the KANŌ SCHOOL to the beginning of the era in which Japan was closed to foreigners (*sakoku*, 1639–c. 1853/4). There are over 60 screens showing foreigners, made between the 16th century and the 19th; most show scenes in and around the capital, Kyoto (*rakuchū rakugai zu*).

These screens were usually made in pairs. About 40 are six-panel screens, showing, on the left-hand side, scenes of great black foreign ships (Portuguese carracks from Macao) docked in harbours, with cargo being unloaded (*Nanban funabito kōzu*; 'pictures of harbours with foreign ships'), and, on the right, merchant shops in the port towns (*Nanbanjin kōeki zu*; 'pictures of foreign commerce'), the captain-major under his protective state parasol and groups of sailors or Jesuit priests and their acolytes walking through the streets to the churches (recognizable by the cross on top) while natives of the towns look on with curiosity at these foreigners. Although many of the screens in this group were illustrated by anonymous *machi eshi* ('town painters'), there are superb examples from the Kanō school in the collections of the Osaka Castle Museum of Art and Nanban Culture Hall. About 11 screens, with basic compositions attributed to Kanō Naizen (1570–1616), have both ship and foreign commerce scenes on the right-hand screen, while the left-hand screen bears imaginary images of foreign ships, groups of foreigners, palaces and ports of foreign countries such as Goa (e.g. Kobe, Mun. Mus. A.; Lisbon, Mus. N. A. Ant.). A third group of about nine screens, produced by Kanō Sanraku (*see* KANŌ, (8)) and other members of the Kanō school (Tokyo, Suntory Mus. A.), have right-hand panels with essentially the same motifs, though

98. Kanō Sanraku (attrib.): *Southern Barbarians*, pair of six-panel folding screens, colours on paper, each 1.82×3.71 m, late 16th century (Tokyo, Suntory Museum of Art)

portrayed differently, and left-hand panels depicting European captains seated in a row on curved balconies. A few *Nanban* screens depict groups of elegant dancers or commercial dealings in the shops or streets of the city. After the mid-19th century pieces no longer bore images of foreign ships. Many examples of *Nanban* screens were passed down through shipping and merchant families, and one descended through a daimyo family, thus allowing their history to be traced and understood.

The ships on *Nanban* screens were probably viewed as 'treasure ships' bringing good fortune and prosperity to the native businesses, although their large black forms create a powerful and disturbing impression. Boarding these ships are people wearing strange and unfamiliar clothing. Merchants probably liked this unusual style that incorporated their wishes for commercial success into the imagery of the screens. The long sea journeys of that time were dangerous and the work of the seafarers was arduous, but the screens do not convey danger and hardship. In the individualistic works of Kanō Naizen, the seamen perform spectacular acrobatic feats using nets, masts or the ship's anchor; the captain may be eating or even taking part in games. *Nanban* screens show how foreigners were seen through the eyes of the Japanese of the time. A few screens, especially those made by painters who were not Kanō masters, depict imaginary views of foreigners. For example, the *Kage yūraku zu* ('Pictures of entertainment under the flowers') screens (Kobe, Mun. Mus. A.; Tokyo, Suntory Mus. A.) show two parties performing an elegant circle dance under cherry blossoms. Figures disguised as the Seven Gods of Good Fortune fill the centre of one, and a figure depicted as a foreigner occupies the centre of the second. Perhaps *Nanban* screens were popular because they helped to make more understandable the strange, exotic power possessed by foreigners.

In the second and third categories of screen, the spacious foreign scenes and the figures of foreign women—whom the Japanese had never seen and whose appearance was known only through engravings or descriptions—gradually gave way to images of Chinese court ladies or royal palaces. In some examples, figures were shown wearing Mongolian clothing. Parallels existed not only with the major themes but also with the motifs and compositions of screens from Tang-period China (AD 618–907) that had recently been taken up by the Kanō school. In practice, as few Japanese artists had seen foreign ships or foreigners at first hand, they adapted their knowledge of China—which the Japanese knew better and which had long been a destination for Japanese voyagers—to suit their image of the foreign world. These works probably satisfied the popular taste for the exotic.

(b) Yōfūga: Jesuit influence.

Introduction. Early *Yōfūga* ('Western-style pictures') were produced largely within the Jesuit 'school' of painting (*Iezuzu kaigaha*) as a means of proselytizing Christianity. The Jesuit Society (*see* JESUIT ORDER, §IV, 1) and its affiliates produced secular as well as religious paintings, and even making such objects as organs and clocks. Members of the Jesuit Society residing in Japan visited Rome several times in the 1580s but were unable to procure sufficient religious paintings to satisfy the demands of Christian proselytism. Visitador Alessandro Valignano (1539–1606) helped to promulgate Christianity in Japan by encouraging the establishment of the Jesuit mission press. In 1583 the young Italian monk–painter Brother Giovanni Niccolò (Nicolao) travelled to Japan, where he organized courses on Western painting and engraving at the Jesuits' boys' school in Kyushu. In 1590 the first mission to the West, envoys of the Christian daimyo of Kyushu, took a printing press back to Japan. To compensate for the shortage of religious images, copperplate etchings and copies of the Bible were printed using movable type (*katsuji*). Thereafter, however, great numbers of religious pictures produced by the Jesuit painting school were destroyed, owing to severe religious prosecution. The only extant examples include works confiscated from the Nagasaki Bugyōjo (Nagasaki Centre of Shogunal Administration; Tokyo, N. Mus.), from the Mito House (Mito Akira Study Centre), and from the Date House of Sendai (objects connected with Hasekuro Tsunenaga; Sendai, City Mus.), and images passed down in extreme secrecy by families of Christian believers in Fukui and northern Osaka (discovered 1920s). Moreover, a number of *nando gami* ('gods of the closet'; hidden Christian images) survived in families of *kakure kirishidan* ('secret Christians') in places such as Nagasaki Prefecture. Few such works, however, are in a distinctly Western style, and they are better described as examples of folk art. Developments in Nagasaki in the 18th and 19th centuries are discussed elsewhere (*see* §(c) below).

Early use of Western materials and styles. Western-style painters in Japan made use of conventional chiaroscuro as a matter of course but were able to express linear perspective only incompletely, displaying greater skill with the use of aerial perspective in landscapes. Japanese Western-style painters learnt the form of figures and compositions from prints or with instruction from religious leaders; generally they did not have the opportunity or the incentive to reproduce images from actual observation. Most of the motifs depicted in Western-style painting were taken directly from such Western works as the *Picture of Martyrs* triptych (Rome, Pal. Gesù). There are several extant imported oil paintings, but works in the medium by Japanese are quite rare; an example is *Christ as the Salvator Mundi* (inscription 1597; Tōdai University Library), discovered in Ibaraki city. It is a reproduction on a sheet of copper of a copperplate etching by Philip Gallé (*see* GALLÉ, (1)) after the 16th-century Flemish painter and draughtsman MARTEN DE VOS. The face of Christ in this work is manneristic but supremely beautiful. A similar work, found in the same region, is the diptych *Fifteen Mysteries of St Mary*. It seems to date from before the canonization in 1622 of the founder of the Society of Jesus, Ignatius Loyola, and Francisco Xavier, the first known Christian missionary to Japan, although by this time the Jesuit painting school was already in decline. The work was executed, like many of the Western-style paintings of this period, on paper using traditional Japanese pigments and glue.

Secular subjects. Relatively few *Yōfūga* concern secular themes such as customs and manners. Their subjects

include single or multiple figures of armed Western kings and aristocrats, and rows of women on each panel of the screen (Nagasaki, Prefect. A. Mus.; Boston, MA, Mus. F.A.). The letters of members of the Jesuit Society report that samurai were fond of such pictures, including those of battle scenes. The rare screen *Battle of Elephants* (Kōsero, Mus. A.) was based on a copperplate etching by Cornelis Cort of the *Battle of Lepanto* after Giulio Romano's *Battle of Zama*. Jesuit artists also painted screens of the world based on those produced as wall paintings in 16th-century Italian royal palaces. The *World Map*, published in Amsterdam in 1606/7 by Willem J. Blaeu (1571–1638), became the model for such screens as the *One Thousand Coloured Pictures* (*Manzu saizu*; bird's-eye views of 28 cities and a world map; Tokyo, Imp. Household Col.) or *Four Cities and World Map* (*Shi toshi to seikai zu*; Kobe, City Mus.), in which the pictures of the city of Rome are based on the *Beato Ignatius Loyola* (1610; Amsterdam). In the upper portion of Blaeu's map are ten kings of various countries on horseback; seven of these figures were borrowed in the *Pictures of Royal Leaders Riding* (*Ōkō kiba zu*; passed down to Wakamatsu Castle, Aizu city; now Kobe, Mun. Mus. A., and Tokyo, Suntory Mus. A.). An eighth figure was taken from a copperplate etching of pictures of ancient Roman emperors. Painters in Japanese styles also created one-panel screens depicting maps of Japan and of the world that were similar to Western-style map screens. These map screens represent a close intermingling of Western and Japanese painting styles.

Five extant *Yōfūga* screens depict pastoral scenes in which European aristocrats are shown at leisure in gardens, with ocean inlets in the background. Four of these have in common the theme of a 'contradictory' secular world, adapting the picture of Paternus from among the 25 hermits (*Tropheum vitae solitariae*) depicted in a copperplate etching of the *Palace of the Gods of Love* by one of the SADELER family of reproduction engravers (after Marten de Vos). In the centre, aristocratic women and men play music that provokes sensual desires. In other pieces (Atami, MOA Mus. A.; Tokyo, Eisei Bunko), at the extreme left is a scene of a grape vineyard taken from the copperplate etching the *Blood of Christ* by Jerome (Hieronymus) Wierix (*see* WIERIX, (2); after a work by de Vos that hints at the Christian Passion). In this work hidden symbolism linking the profane and the secular is discernible. In the opposing panels of the screen, hermits, friars and youths are depicted, presumably as an allusion to the religious life. Religious symbolism is also found in a hunting scene included in another work (Osaka, Nanban Cult. Hall). In a similar picture of fields and parks (passed down through the Kuroda family of Kyushu, now Fukuoka, A. Mus.), the frequent changes of season common in Japanese painting are shown from right to left. Three examples exist of screens in which each whole panel is devoted to an independent subject, the themes apparently alluding to religious life.

Later development. In the wake of religious persecution and the closing of the country to foreigners—works of religious allegory gave way to pictures simply of customs and manners (*fūzokuga*; *see* §(iv)(a) above). Those painted in a Western style were called *yōfū seifukuga*. Some were handed down in daimyo houses, to which they were donated by the Jesuit Society, perhaps as a means of preserving and promoting the faith.

Another category of Western-style paintings has religious and educational, but non-Christian, subjects as their principal theme. These works were made by *shingata* ('believers') artists who had absorbed the classical style of the Jesuit Society painters. European soldiers, women and monks were among their subjects. *Shingata* may have become independent after receiving training from the Jesuit Society. Although the names of some painters are recorded in Japanese documents and in the writings of the Jesuit Society, none is common to both sources and no *shingata* names occur in either. Western-style techniques did not generally infiltrate the various schools of Japanese painting, being perhaps too foreign; shading, for example, was used only in depicting the ships and the foreigners in *Nanban* screens. Although the *Yōfūga* of the Jesuit Society were a splendid aspect of Momoyama-period art, their influence on subsequent generations was minimal.

BIBLIOGRAPHY
Y. Okamoto: *Nanban bijutsu*, Nihon no bijutsu [Arts of Japan], xix (Tokyo, 1965); Eng. trans. by R. K. Jones as *The Nanban Art of Japan*, Heibonsha Surv. Jap. A., xix (New York and Tokyo, 1972)
——: *Nanban byōbu* [Nanban screens], 2 vols (1970)
F. G. Gutiérrez: 'A Survey of *Nanban* Art', *The Southern Barbarians*, ed. M. Cooper (1971)
Y. Yamane: *Momoyama Genre Painting* (Tokyo, 1973)
M. H. M. Pinto: *Biombos Namban/Namban Screens* (Lisbon, 1986)

MITSURO SAKAMOTO

(c) Nagasaki school. As Japan's major port for foreign trade from the mid-16th century until the Meiji Restoration in 1868, Nagasaki was an important centre for new trends in the visual arts. In the period 1639–1854 foreign residents in Nagasaki were restricted to separate areas, the Dutch on the manmade islet of Dejima in Nagasaki Harbour in 1641 and the Chinese—at first allowed to live where they pleased—from 1688 confined within a walled settlement in Nagasaki proper. Still, the Chinese presence was more strongly felt than that of the Westerners. Chinese immigrants—monks, teachers and artists—as well as the books and art made Nagasaki an important centre for diffusion of continental culture. The Chinese also acted as middlemen in the transmission of Western knowledge; it was primarily through Chinese translations of European books that Japanese scholars became acquainted with Western learning and through Chinese techniques of naturalistic depiction that Nagasaki artists adopted Western methods of drawing. Three types of painting are generally included under the term *Nagasakiha* ('Nagasaki-school painting'). The earliest of these was brought into Japan in the 17th century by Chinese monks of the Ōbaku (Chin. Huangbo) sect of Zen (Chin. Chan) Buddhism. Also from China was the bird-and-flower style of SHEN NANPIN (Jap. Chin Nanpin), characterized by a precise naturalism and colour modelling. Nagasaki *Yōfūga* ('Western-style painting') of the 18th–19th centuries is distinguished by dependence on European techniques of drawing and shading.

Ōbaku. In the mid-17th century Rinzai Zen (Chin. Linji Chan) monks emigrated to Japan, where they founded what became known as the Ōbaku (Chin. Huangbo) sect. They brought calligraphy and painting styles based on late

Ming-period (1368–1644) art. Works by Ōbaku monks ranged from the broadly brushed, dynamic ink paintings on bamboo by Taihō (1691–1774) to the tightly controlled, highly coloured paintings of Zen patriarchs and other religious figures by monk–artists such as ITSUNEN SHŌYŪ. This latter style, seen in Itsunen's painting of *Hotei* (1662; Kobe, City Mus.) and his set of six hanging scrolls of Zen patriarchs (1668; Uji, Manpukuji), is affiliated with painting of the KANŌ SCHOOL; indeed the Ōbaku and Kanō schools absorbed elements of each other's styles.

Ōbaku painting also includes a style of portraiture (*chinzō*) concerned with individual physiognomy and employing a method of volumetric shading (for the subjects' faces) believed by some scholars to derive from chiaroscuro. Kita Genki's portrait (*fl* 1664–98) of the Ōbaku monk and calligrapher Mokuan (Chin. Mu'an; 1611–84; inscription dated 1681; Kobe, City Mus.) is typical of this genre. There is no background. Mokuan sits directly facing the viewer, his robes, chair and accoutrements indicating his status and his own inscription above confirming his identity. While the face is softly modelled, the shading is so symmetrical as to function also as surface pattern. The chair and the strongly delineated and coloured robes create a bold design against the white paper. Genki's followers, such as Kita Sōun (*fl* 17th century), tended to simplify the shading of the robe and the detail of the facial features.

Shen Nanpin school. From the early 18th century, Chinese artists were regularly invited to Japan by the government as part of an official effort to train Japanese artists in Chinese painting styles. The Chinese painters travelled on trading ships to Japan from the southern coastal provinces, primarily Zhejiang and Fujian. The professional painter Shen Nanpin arrived in Nagasaki at the end of 1731 and quickly attracted a large group of followers. By the time he returned to China in the autumn of 1733, he had established a popular style of decorative yet naturalistic bird-and-flower painting. Nanpin's style was based primarily on Ming-period academic bird-and-flower painting, on the compositional formulae, bright colours and detailed brushwork of such artists as the 15th-century painter Lu Ji. Nanpin typically placed birds or animals on a shallow stage, balancing this horizontal element with a tree or landform extending up one side. There is rarely a middle ground; the foreground is dramatically silhouetted against a bare expanse indicating the sky.

Nanpin strove for a careful balance between naturalism and artifice. In *Pair of Cranes under Peach Tree* (1758; Nagasaki, Mun. Mus.), the detailed, almost feather-by-feather depiction of the cranes, the colouring on the necks and heads and the pose of the birds are all true to life. At the same time, the cranes are carefully positioned for design effect, one with its body stretched horizontally, the other standing. The graceful curves of their necks balance each other and are echoed in the peach branch above. Characteristic of Nanpin's style is the distinction between the detailed, coloured treatment of the birds and the looser ink painting of tree trunk, rock and water. The work resonated with one aspect of contemporary taste in its

richly decorative style, superb craftsmanship, auspicious subject and expensive materials.

Nanpin's work also appealed strongly to the growing taste for naturalistic depiction associated with Western art. His concern with botanical accuracy and use of volumetric shading had much in common with contemporary Western-style painting, although these qualities had precedents in academic styles of the Northern Song (AD 960–1126) and Ming periods. To Japanese used to the dramatically outlined forms in Kanō-school bird-and-flower painting, Nanpin's style seemed realistic. Unlike Western-style artists, Nanpin modelled with light and shade irrespective of a specific light source or shadows. While there is clear foreground recession, the transition to a middle ground and background is not clear, and spatial relationships are not always logical.

After his departure, Nanpin continued to send paintings to Japan, where the demand for them remained strong. Works by him or members of his family dated after 1733 are extant in Japan, along with many copies and forgeries. Nanpin's many commissions included lavish, large-scale works, such as the pair of six-panel folding screens of cranes and deer painted on silk (1750; Tokyo, Idemitsu Mus. A.). However, Nanpin's work was criticized, especially by proponents of literati painting (*Nanga*; see §(d) below). Nakayama Kōyō (1717–80), Kuwayama Gyokushū and Nakabayashi Chikutō (1776–1853) called Nanpin a skilled craftsman rather than a true artist. For his bright colours, concern with capturing outward appearances and professional standing they dismissed Nanpin as a member of the Northern school of academic painters identified by DONG QICHANG. Still, Nanpin influenced literati as well as other schools of Japanese painting.

Nanpin arrived in Nagasaki with two of his students, Gao Kan and Gao Jun (both *fl* mid-18th century); other Chinese artists resident in Nagasaki and working in similar styles included Zheng Pei (*fl* mid-18th century), Fang Xiyuan (1736–after 1793) and Fang Hanyuan (*fl* mid-18th century). Zheng Pei, a pupil of Nanpin, helped form the Nagasaki school. His *Peonies in Wind* (Kobe, City Mus.) has the attention to both botanical accuracy and grace of line, as well as of 'boneless' painting (*mokkotsu*; Chin. *mogu*) and 'hidden outline', that were characteristic of Nanpin's work. In the latter technique, a delicate bounding line was painted over with colour to render it almost invisible. Zheng Pei helped popularize the use of 'boneless' colour washes to depict plants and birds.

Japanese followers of Shen Nanpin modified his style in significant ways: the complex surfaces built up through the layering of small strokes were simplified, shapes were flattened, outlines highlighted and surface design emphasized. These modifications are evident in the work of Nanpin's student Kumashiro Yūhi (1713–72). Yūhi's work was much in demand from government officials who wished to decorate their residences with Chinese-style paintings. His *Cormorant Catching Fish* (*Roji sokugyo zu*; 1755; Nagoya, Tokugawa A. Mus.), for example, was commissioned by the Tokugawa family and painted on silk imported from China for that purpose. In *Ducks and Willow* (Kobe, City Mus.) and *Pair of Crane Immortals* (*Senkaku karei*; Japan, priv. col.) Yūhi characteristically subordinated a sense of spatial recession in the landscape

to the careful arrangement of motifs across an extremely shallow foreground. This is particularly evident in *Crane Immortals*, where the water, rocks and plants function equally as flat design and landscape background. In painting his motifs, Yūhi relied less on Nanpin's method of layering strokes of colour and ink and more on ink line and wash. The feathers of the birds form regular patterns, and, in *Ducks and Willow*, the knot-holes of the tree stand out as distinct, almost abstract, shapes. The emphasis on surface design particularly appealed to Yūhi's contemporary audience. These qualities are stronger still in the work of Yūhi's pupils, such as Otomo Gekko (*fl* late 18th century–early 19th), whose *Pair of Cranes* (Kobe, City Mus.) follows Yūhi's *Crane Immortals* in composition and conception but features further simplification of form, heavier use of line and more anthropomorphic treatment of the birds.

A highly individual interpretation of the Nanpin style can be seen in the work of Kakutei (1722–85), another student of Yūhi. Kakutei was an Ōbaku Zen monk at the temple Seifukuji in Nagasaki and thus had ready access to Chinese and Japanese paintings in Ōbaku collections. In some works he used a looser ink style, close to that of Ōbaku painters such as Taihō. Other works were executed in a brightly coloured and detailed style dependent on the themes and compositional formulae of the Shen Nanpin school; examples include *Peonies and Red-billed Blue Magpie* (1769) and *White Hawk and Pine* (both Kobe, City Mus.). These paintings show the intense effect achieved through a juxtaposition of brilliant colours compressed into an almost flat foreground plane, the distortion of natural forms for surface design and the startling coexistence of detailed naturalism and blatant artificiality.

The Nagasaki school of bird-and-flower painting had an important impact on Japanese painting far beyond the city of Nagasaki itself (see fig. 99). Painters such as Otomo Gekko and Kakutei, who moved to the Kansai and Kantō areas after studying with Kumashiro Yūhi, helped popularize the Nanpin style in those areas. Of great and early importance in the formation and dissemination of the Nagasaki school was Yūhi's pupil Sō SHISEKI, a native of Edo who travelled to Nagasaki in 1740. He studied there with Yūhi and possibly also with the Chinese painter Song Ziyan (Jap. Sō Shigan; active in Nagasaki 1758–60), from whom he took his name. On his return to Edo, Shiseki attracted many students, including the Western-style painter and scholar SHIBA KŌKAN.

Shiseki's mastery of the Nagasaki style can be seen in his *Cat beneath Blossoming Peonies* (Japan, priv. col.) and *Rooster beneath Willow* (1769; Japan, priv. col.). The compositions follow the standard Nanpin formula. Like Yūhi, Shiseki simplified the landscape components and emphasized surface design. The rooster, cat, flowers and butterfly are painted in exquisite detail, each hair or feather rendered with a separate stroke. Like Nanpin, Shiseki used tiny strokes of bright white or gold, to give depth to the fur or feathers and to create a luxurious surface.

The detailed naturalism of Shiseki's work may also be related to Western painting; he was familiar with botanical texts imported from the West and China and made copies of the engraved illustrations in these texts. In his carefully detailed drawings copied from the six-volume zoological

99. Kishi Ganku: *Cat Killing a Bird*, hanging scroll, ink and colours on silk, 954×350 mm, 1782 (London, British Museum)

encyclopedia by Johannes Jonstonus (imported in 1663), Shiseki attempted to reproduce not only the exact appearance of the animals but also a sense of volume through shading and highlighting. He produced many of the illustrations for HIRAGA GENNAI's *Butsurui hinshitsu* ('Classification of various materials'; 1763).

Also important for the diffusion of Nanpin's style was the publication of woodblock-printed books (*gafu*) illustrating brush techniques and motifs. Sō Shiseki's *Kokon gasō* ('Illustrated manual of painting past and present'; 1770) included copies of animals from the Jonstonus

encyclopedia and entire paintings by Nanpin, Shiseki himself and other Nagasaki-trained artists. The *Ransai gafu* (1782) by another pupil of Yūhi, Mori Ransai (1740–1801), was a kind of step-by-step guide for artists, illustrating techniques for the depiction of flowers, trees, rocks, water and birds. The careful attention to design that underlay Nanpin's style is made clear in the treatment of volume in trees, represented by geometrical forms expressing the balanced arrangement of trunks and branches.

Yōfūga.

Introduction. A major focus of Japan's interest in the West from the late 17th century until the late 19th was European science and technology. By the time the prohibition on Western books was officially relaxed in 1720, Japan was avidly importing medical, botanical, geographical and other scientific texts, some in their original versions and others in Chinese translations. The engraved illustrations in these books provided a crucial source for the Japanese artist's understanding of the goals and techniques of Western painting.

The aspects of Western painting most readily adopted by Edo-period (1600–1868) artists in Nagasaki and elsewhere were the techniques of chiaroscuro and one-point perspective and the use of a thin, unvariegated line instead of the modulated brushstroke. In Western chiaroscuro, shading was produced by applying graded colour independently of line, whereas in traditional Chinese and Japanese painting, ink wash was more often laid along a strong outline, creating a sense of flat pattern as well as some suggestion of three-dimensionality. The assumed presence of a light source and the cast shadow were elements of Western painting that had not hitherto been used by Eastern artists but that appeared consistently in Nagasaki *Yōfūga*. Nagasaki artists were also strongly drawn to the objective representation in Western scientific illustrations. This emphasis on outward appearance instead of spiritual essence contrasted with the traditional ideals of Japanese art but was well suited to the growing Japanese interest in cataloguing the native flora and fauna.

The regulation that all imported items be checked and catalogued led in 1697 to the creation of a bureau of official inspectors, the *karae mekiki* ('appraisers of Chinese paintings'), responsible for judging the authenticity and value of art objects imported into Nagasaki and producing copies for the official records. The *mekiki* artists were among the few Japanese allowed to enter Dejima. Their duties, which included sketching the trade goods shipped to Nagasaki, gave them unusual access to European and Chinese paintings and books and thus an early and direct acquaintance with Western techniques of drawing and shading.

The highest positions in the *mekiki* bureau were dominated by four families: Watanabe, Ikko, Ishizaki and Araki. Around them grew a network of lesser painters and apprentices largely unknown beyond brief entries in contemporary biographies. The office of *karae mekiki* carried the status of official painter-in-attendance (*goyō eshi*) to the shogun. The best-known *mekiki* artists produced works for wealthy bureaucrats in Nagasaki and are known primarily through these commissioned works.

The official *karae mekiki* style was restrained, because the artist's goal was faithful reproduction. In such early works as the Edo-period *Handscroll of One Hundred Birds* (ink and colours on paper, 0.29×24.85 m; Nagasaki, Prefect. A. Mus.) by Araki Genkei (1698–?1766) and *Realistic Sketches of Birds* (handscroll, ink and colour on silk, 0.31×5.78 m; Japan, priv. col.) by Ohara Keizan (*d* 1773), Western influence can be seen in the concern with precise, objective representation. The techniques, however, are taken from the KANŌ SCHOOL and from contemporary Chinese styles. European techniques were not fully incorporated until the later 18th century. Western-style Nagasaki painting was established principally by Wakasugi Isohachi (1759–1805), Araki Jogen (1765–1824), Ishizaki Yūshi (1768–1846) and Kawahara Keiga (1786–after 1860).

Wakasugi Isohachi. Isohachi was an independent artist whose position as an administrator in the Nagasaki government connected him to the *mekiki* painters and to imported books and paintings. He relied heavily on European works for compositions and techniques. *Equestrian Falconer* (*Takajū zu*; hanging scroll now framed, oil on canvas, 1269×500 mm; Tokyo, U.A., A. Mus.) and *Falconer with Owl* (framed, oil on canvas, 617×420 mm; Japan, priv. col.), for example, were based on engravings by the German JOHANN ELIAS RIDINGER. A series of prints by Ridinger illustrating the amusements of nobles circulated in Japan by the mid-18th century; the Akita-school painter ODANO NAOTAKE, among others, used several of them as models. In these two paintings, Isohachi displayed an ability to manipulate shades of colour to achieve a subtle impression of three-dimensional form comparable to that of the original engravings. At the same time, he altered his model in ways characteristic of other Western-style painters by emphasizing shading and simplifying areas of shadow into distinct shapes. The strong vertical components in the background of both paintings bracket the recession into deep distance in a manner recalling traditional Chinese compositions.

Two framed hanging scrolls in oils on canvas are *Landscape in Holland* (*Oranda fukei zu*; 1347×575 mm; Kobe, City Mus.) and *Flower Basket with Butterflies* (*Hanakago ni chō*; 1348×574 mm; Kobe, City Mus.); these are probably Isohachi's own compositions and indicate the mixture of influences absorbed by artists of the Nagasaki school. The placement of the exotic flowering tree on a knoll in the far left foreground in *Landscape in Holland* conforms with compositional conventions of Shen Nanpin and his followers. The brushwork in the land forms is also based on Chinese styles. The colouring, the sense of solid form created through chiaroscuro and the signature in roman letters placed in a cartouche are Western. The simplified geometrical structures of the buildings may have been taken from Qing-period (1644–1911), Western-style painting.

Araki Jogen. Jogen worked as a *karae mekiki*, inheriting the position as the adopted son of Araki Genyū (1728–94). He retired from official service in 1807. Although there is no evidence of a direct connection, the similarities between his painting and that of Isohachi may indicate that Jogen was his pupil. Jogen's knowledge of such

100. Araki Jogen: *Foreign City on the Sea*, oil on canvas, 892×589 mm, 1805 (Kobe, City Museum)

European techniques as glazing, which produced the deep, clear colours characteristic of his painting, suggests that he may have been taught by a Dutch amateur artist resident on Dejima.

Five paintings by Jogen of Westerners in landscape settings are extant, all of them done in oils on canvas. The late 18th-century European style of the figures and costumes, the dominance of deep blues and browns and the compositions suggest that Jogen was working from the latest imported works. Like Isohachi, Jogen built up colour in a Western manner to create the illusion of three-dimensional form. In such works as *Foreign City on the Sea* (*Hinkai tojō zu*; see fig. 100), he surpassed Isohachi in achieving a Western sense of space and light. Indeed, of all Nagasaki artists, Jogen came closest to producing truly Western painting.

Ishizaki Yūshi. Yūshi was Araki Genyū's son but succeeded to the position of *karae mekiki* in the Ishizaki family. He entered the bureau in 1781 at the age of 14, was later appointed a chief appraiser and retired in 1832. According to contemporary sources, Yūshi was known for his Western-style painting and his painting on glass, another European technique. He worked in a wide variety of styles, however, and most of his extant paintings show little of this influence. In *Nagasaki Harbour* (*Nagasaki kō zu*; 1820, hanging scroll, ink and colour on silk,

840×1480 mm; Nagasaki, Mun. Mus.), done in conjunction with his *mekiki* duties, Yūshi combined the forms, colouring and brush techniques associated with *Yamatoe* ('Japanese-style painting') with the lowered horizon typical of Western painting.

Kawahara Keiga. Yūshi was likely to have been a mentor of one of the most successful Nagasaki painters, Kawahara Keiga, who enjoyed greater access to Western art and to the Dutch than did the earlier Nagasaki painters. This was partly thanks to the sponsorship of Yūshi; it also reflected a relaxation of the government's attitude towards contact with the West during the Bunka era (1804–18).

Keiga was well acquainted with PHILIPP FRANZ VON SIEBOLD, the German physician who disseminated Western knowledge in Japan before his expulsion in 1828. After Siebold's arrival in 1823, Keiga was employed to make detailed sketches for Siebold's book on Japanese ethnology and natural history. A number of precise botanical drawings done by Keiga at Siebold's request remain. It is possible that Keiga learnt from Carolus Hubert de Villeneuve, a painter and illustrator who was Siebold's assistant. A set of engravings by the French artist LOUIS-LÉOPOLD BOILLY, brought to Japan in the 1820s, served Keiga as an important source on Western drawing and shading. In the *Art Critics* (1825, framed, colour on paper, 556×441 mm; Nagasaki, Ushijima col.), the position and exaggerated expressions of the figures are copied from the *Amateurs of Paintings* by Boilly (1823; London, BM), but Keiga's work is quite different in impact from its model in the harder outline, the application of shading in a pattern along the lines, a general tendency to flatten shape and to make it more abstract and a further exaggeration of facial features and expression.

More than earlier Nagasaki artists, Keiga harmonized Western and traditional techniques, as in paintings done on two sides of the same screen, the *Blomhoff Family* (*Buronhofu kazoku zu*) and *Nagasaki Harbour* (*Nagasaki kō zu*; Edo period, colour on silk, 690×855 mm; Kobe, City Mus.). In the *Blomhoff Family* facial features are softly shaded and there is a concern with individual physiognomy. The composition, however, consists of strongly bounded shapes across a flat surface, and the exquisite detail recalls TOSA SCHOOL painting. In *Nagasaki Harbour*, a sense of expansive space and of light is created primarily by Western means: colour, shading and diminution of form towards the horizon. At the same time, the clear rendering of details is firmly in the *Yamatoe* tradition (*see* §(ii) above).

Many Western-influenced paintings in the Nagasaki school were produced anonymously or by artists about whom nothing is recorded. Two anonymous Edo-period horizontal hanging scrolls, done in colours on paper, are *Sending Ancestor Spirits back to the Underworld* (307×400 mm) and the *Bean-scattering Ceremony* (305×395 mm; Leiden, Rijksmus. Vlkenknd.); both display an overlay of Western shading on *Yamatoe*-style figures in the treatment of Japanese genre subjects. In composition and proportions these works follow the handscroll format, but the figures are conceived as three-dimensional forms, each with its own shadow, and set into an illusionistic space.

Although Nagasaki *Yōfūga* painters played a key role in Japan's absorption of European art and culture, they

created works that were essentially copies of European paintings, or eclectic works based not on Western but on traditional Japanese techniques. They did not fully assimilate, interpret or develop Western techniques and thus failed to evolve an enduring new style of Japanese painting. The Nagasaki school in the end became merely a provincial school and ceased to have much significance after the mid-19th century.

BIBLIOGRAPHY

M. Hosono: *Yōfūhanga*, Nihon no bijutsu [Arts of Japan], xxxvi (Tokyo, 1969); Eng. trans. and adaptation by L. R. Craighill as *Nagasaki Prints and Early Copperplates*, Japanese Arts Library, vi (Tokyo and New York, 1978)

M. Sakamoto, T. Sugase and F. Naruse: *Nanban bijutsu to yōfūga* (Nanban art and Western-style painting], Genshoku Nihon no bijutsu [Arts of Japan, illustrated], xxv (Tokyo, 1970)

C. French: *Through Closed Doors: Western Influence on Japanese Art 1639–1853* (Rochester, MI, 1977)

Ōbaku: Zen Painting and Calligraphy (exh. cat. by S. Addiss, Lawrence, U. KS, Spencer Mus. A.; New Orleans, LA, Mus. A., 1978)

Kawahara Keiga ten [Catalogue of the works of Kawahara Keiga], Leiden, Rijksmus. Vlkenknd. cat. (Tokyo, 1980)

T. Koshinaka and others, eds: *Nagasakiha no kachōga: Shen Nanpin to sono shūhen* [Bird-and-flower painting of the Nagasaki school: Shen Nanpin and his group], 2 vols (Kyoto, 1981)

C. Yamanouchi: *Nihon Nangashi* [History of Japanese literati painting] (Tokyo, 1981)

Ōbaku bijutsu [Ōbaku painting], Zen Nihon senchadō renmei [The federation of *sencha* practitioners of all Japan] (Uji, 1982)

M. Browne: 'Portraits of Foreigners by Kawahara Keiga', *A. Orient.*, xv (1985), pp. 31–45

Yōfū hyōgen no dōnyū [Development of Western realism in Japan] (exh. cat. by M. Ozaki, Tokyo, N. Mus. Mod. A., 1985)

Sō Shiseki to sono jidai [Sō Shiseki and his times], Itabashi kuritsu bijutsukan [Habashi Prefectural Museum] (Tokyo, 1986)

T. Yamakawa and R. Nakajima, eds: *Sō Shiseki gashū* [Paintings of Sō Shiseki] (Tokyo, 1986)

Japanese Quest for a New Vision: The Impact of Visiting Chinese Painters, 1600–1900 (exh. cat. by S. Addiss, Lawrence, U. KS, Spencer Mus. A., 1986)

Nihon hakubutsu gakuji shi [The beginnings of Western natural history in Japan] (Tokyo, 1987)

An Exhibition of Huangpo Chan/Ōbaku Zen Calligraphy and Painting (exh. cat., U. Hong Kong, Fung Ping Shan Mus., 1989)

H. Kondō: 'Shen Nanpin no sokuseki' [Shen Nanpin's career as an artist], *Kobijutsu*, 93 (Jan 1990)

K. Narusawa: 'Nihon no Nanpin keiga nōto' [Notes on Japanese paintings in the style of Nanpin], *Kobijutsu*, 93 (Jan 1990)

Ingen zenji to Ōbaku shu no kaiga-ten [Exhibition of priest Ingen and paintings from the Ōbaku sect] (exh. cat., Kobe, City Mus., 1991)

M. Jansen: *China in the Tokugawa World* (Cambridge, MA, 1992)

CAROL MORLAND

(d) Nanga. Nanga ('literati painting'; from Jap. *nan-shuga*, 'Southern-style painting'; also termed *Bunjinga*, 'scholar painting') was one of the most important styles of Japanese painting from the middle of the Edo period (1600–1868) to the Taishō (1912–26) period. *Nanga* can be divided into six generations of artists, beginning with the pioneers in the 18th century.

Introduction. The concept of *Nanga* is derived from the Ming-period (1368–1644) artist and theorist DONG QI-CHANG's theoretical division of Chinese painting into two traditions (*see* CHINA, §V, 4(ii)): the Northern school, which was considered more professional and stressed verisimilitude but was thought less worthy of praise; and the Southern school of amateur scholar–artists who aimed to express their inner feelings in their paintings and to whom Dong allotted a higher status. Certain features have been considered characteristic of Chinese literati painting.

Although the Southern school was considered amateur rather than professional, in practice some literati artists either sold their works or received gifts or other favours in return for their paintings. Many of them, however, were receiving salaries in the Chinese bureaucracy and therefore did not depend for their livelihood on sales of their art. They were thus able to paint as they wished rather than in accordance with orders from patrons. In theory, and usually in practice, literati paintings were created out of the artist's inner vision and were intended as a form of subtle communication with people of like minds. Not only were many works given by one artist to another, but scholars and poets added poems to paintings executed both by their friends and by earlier generations of artists. Thus in most cases a personal spirit prevailed over a purely commercial one.

Because painting, poetry and calligraphy—collectively known as the Three Perfections—were closely connected in the minds of Chinese literati, certain subjects were adopted, the foremost being landscape. Scholars were taught the use of brush and ink from early childhood, and it was natural for them to use calligraphic brushwork in their paintings and to imbue their works with a poetic spirit. They frequently combined the three arts into a single work, adding poems in various calligraphic scripts to their paintings. Moreover, literati often painted in the style of the old masters, as they believed this brought them into direct communication with scholars and poets of the past. They knew that the references would be appreciated by the viewers but that the artist's individual nature could not help but emerge through personal idiosyncrasies in the brushwork.

Nanga was never a school in the sense of the studios of the TOSA SCHOOL and KANŌ SCHOOL. Instead, *Nanga*, like *Zenga* (painting and calligraphy by Zen monks of the 17th to 20th centuries; *see* §(vii) below), formed a looser tradition with mutual influences between artists but no systematized rules. In every generation of literati artists there was a wide range of attitudes towards art as well as differing techniques, styles and subject-matter. In the pure literati mode, poets, painters and calligraphers such as GION NANKAI, URAGAMI GYOKUDŌ, KAMEDA BŌSAI, MURASE TAIITSU and TOMIOKA TESSAI painted as expressions of their inner spirit; they were less concerned with professional values than with adhering strictly to Chinese literati ideals. A second group were professional artists, such as SAKAKI HYAKUSEN, YOSA BUSON, TANI BUNCHŌ, Hine Taizan (1813–69) and Noguchi Shōhin (1847–1917), who adopted new painting styles from China more for their artistic possibilities than for the ideology that they represented.

The Japanese were slow to accept literati painting. It was not until an appropriate cultural climate was thoroughly established in Japan that scholar–painters could flourish. In the 17th century the Tokugawa shogunate decided that Neo-Confucianism, rather than Buddhism, would be the official government philosophy (*see also* §II, 5 above). Education in the Confucian classics led to a new Japanese interest in the scholarly arts of the literati. Poetry and calligraphy had long been favoured by Japanese Zen monks, but literati painting was not seriously practised in Japan until the end of the 18th century, except for a time

in the early Muromachi period (1333–1568). It was natural, therefore, that in the early Edo period Chinese-style poetry and calligraphy developed more quickly than literati painting. When the Chinese literatus Zhen Yuanyun (Jap. Chin Genpin; 1587–1671) went to Japan in 1638, he wielded little influence as a painter, despite his popularity as a poet and martial arts expert. By 1720, however, when the merchant and artist I Fujiu (I Fukyū; 1698–after 1747) began visiting Nagasaki, he was hailed as an exemplar of Chinese literati painting. Thus in the intervening century a new group of educated scholars, officials and merchants interested in literati ideals was established in Japan, and they were ready to receive and develop a painting tradition that expressed their Sinophile values in pictorial terms.

Another reason for the hesitant emergence of Japanese literati painting was that in Japan a Chinese-style bureaucracy, based on competitive written examinations stressing knowledge of the Confucian classics, was never established. In Japan the hereditary nature of official positions hindered the full development of a Confucian educational system, but eventually the scholar–official class grew to become an important part of the cultural fabric of the country. However, even when literati painting had been established in Japan, it did not carry the same meanings as on the continent, and not all Japanese literati painters would have been considered true literati by Chinese standards. Literati painting in China was centred on the depiction of landscape, whereas in Japan other themes, such as the highly detailed tradition of bird-and-flower painting (*kachōga*), were occasionally adopted, even though they were considered out of place, if not anathema, to Chinese literati. This combination of seemingly contradictory Chinese styles within Japanese literati painting was due in part to the types of Chinese painting available to literati of the Edo period. The varied character of imported works made it impossible in Japan to distinguish strictly between the Northern and the Southern styles of China.

There were three main sources for the study of the Chinese literati tradition available to the Japanese: imported woodblock books, imported paintings and the work of visiting Chinese artists active in Nagasaki. Although imported books such as the *Mustard Seed Garden Painting Manual* (Chin. *Jieziyuan huazhuan*, compiled by Wang Gai, *c.* 1679–1701), published in Japan in 1748 and 1753 as the *Kaishien gaden*, and the compilation of Chinese poems and painting designs in the *Eight Collected Painting Albums* (Chin. *Bazhong huapu*; 1620s), published in Japan in 1672 under the collective title *Hasshu gafu*, were not completely literati in spirit, they were important early models. The *Mustard Seed Garden Painting Manual*, for example, codified the style of the NANJING SCHOOL and made it accessible to Japanese literati, who eagerly studied its painting models and its Chinese painting subjects and techniques.

By the 18th century Chinese paintings of the late Ming and early Qing (1644–1911) periods were being brought to Japan in large numbers. These imported works consisted mainly of paintings by professional, not literati, artists of the more commercialized schools of painting, such as that in Suzhou (see 1972 exh. cat.). If accounts and inscriptions by Japanese artists are reliable, however, other works by or after orthodox Chinese literati painters such as TANG

YIN or HUANG GONGWANG may also have entered the country at this time. This seems confirmed by examples still in Japan, which can be correlated with the works of Japanese literati, an example being the close stylistic relationship between the hanging scroll *Stone Cliff at the Pond of Heaven* (Osaka, Fujita Mus. A.), with a signature of Huang Gongwang, and the work of the Japanese artists Sakaki Hyakusen and Noro Kaiseki (1747–1828).

Knowledge of Chinese painting styles was also gained through contact with such visiting artists as the landscape painters I Fujiu and Jiang Jiapu (Kō Kaho; 1744–after 1839) who, together with Fei Qinghu (Hi Kangen) and Zhang Kun (Chō Shūkoku; *c.* 1744–after 1817), were referred to as the Four Great Masters from Abroad. The degree to which these visiting artists had direct contact with Japanese literati painters is unclear. I Fujiu's paintings and poetry were copied and published in such works as the *I Fukyū, Ike Taiga sansui gafu* ('Album of landscapes by I Fujiu and Ike Taiga'; 1803; Lawrence, U. KS, Spencer Mus. A.) by Kan Tenju (1727–95). The major impact of Jiang Jiapu, a versatile artist who first visited Nagasaki in 1804 and who painted in a conservative literati manner of the Qing period, was on the works of the artists Hidaka Tetsuō (1791–1871), Kinoshita Itsuun (1799–1866) and Miura Gomon (1809–60), collectively known as the Three Nagasaki *bunjin*.

The bird-and-flower painting tradition of the Ming period was taken to Japan in the 1730s by the Chinese émigré professional artist SHEN NANPIN and to a lesser degree by artists working in the style of the Chinese painter YUN SHOUPING, whose *mokkotsu* ('boneless'; Chin. *mogu*) manner of painting became integrated with the style of Shen Nanpin. Bird-and-flower painting was disseminated in Japan by Shen's pupil Kumashiro Yūhi (1713–72) and by Yūhi's followers (*see* §(c) above). Such Confucian themes as the 'four gentlemen' (bamboo, plum, orchid and chrysanthemum) were introduced by monks of the Ōbaku (Chin. Huangbo) sect who arrived in 1644 from Fujian Province after the fall of the Ming dynasty.

Edo period, first generation. Until the end of the 18th century and the beginning of the 19th, most literati painters lived in or near the old imperial capital of Kyoto. However, during the early 19th century the new capital of Edo (now Tokyo) became the second centre of literati activity and a place in which a more open and relaxed artistic climate prevailed. By the end of the Edo period literati painting had an established position in the major artistic centres of Osaka–Kyoto, Nagoya and Edo.

The first *Nanga* master was Gion Nankai, who was respected primarily as a scholar, Chinese-language poet and calligrapher even more than as an artist. In his life and work he epitomized the literati ideal: he was best known as a calligrapher and painter of the subjects most valued by the Chinese literati, namely landscapes and the 'four gentlemen' (e.g. his undated hanging scroll *Plum*; Tokyo, Govt Cult. Cent.; see fig. 101). A second *Nanga* pioneer, Sakaki Hyakusen, made his living primarily as a painter. Unlike Nankai, who drew much inspiration from imported woodblock-printed books, Hyakusen copied paintings of the late Ming period, delving into Chinese traditions more for the artistic possibilities that they offered than for their

101. Gion Nankai: *Plum*, hanging scroll, ink on paper, 775×320 mm, 18th century (Tokyo, Government Cultural Centre)

literati ideals. His technique is closely related to the brushwork styles of the first half of the 17th century and the 18th. Besides typical literati subjects, he painted birds, flowers and figures and excelled at the abbreviated *haiga* (*haiku* paintings), which had no Chinese precedents. YANAGISAWA KIEN, even more eclectic than Hyakusen, painted a broad range of subjects in as great a variety of styles, including the decorative bird-and-flower technique of Shen Nanpin. Kien liked to use finger painting (*shitōga*) in his illustrations of bamboo (e.g. hanging scroll, Nara Prefect., Aota priv. col.; see Yonezawa and Yoshizawa, fig. 12), in which he dipped his fingers and fingernails into ink and painted directly on the paper.

Edo period, second generation. Despite the adventurous spirit and often excellent painting of these pioneers, literati painting is regarded as coming into its own with the two second-generation masters Ike Taiga (*see* IKE, (1)) and Yosa Buson. Although they differed from each other stylistically, Taiga and Buson contributed greatly to the shift from a largely Chinese-based literati style to one that

was more Japanese and more personal. Taiga blended many elements from Chinese and Japanese painting and calligraphy traditions in his work. An experimental artist, he painted with traditional brushes, with rolled-up paper and with his fingers, depicting 'true views' (*shinkeizu*) of Japanese scenic spots as well as imaginary Chinese landscapes, Buddhist figures and portraits of his friends, all with a bravura that gives his work a sense of joy and exuberance rare in literati painting. Even his simplest paintings convey a mastery of design and a unique, unfettered and spontaneous love of brushwork. Unlike Taiga, Buson did not take easily to brushwork. He was principally a master of *haiku* poetry—he is ranked second only to the poet Matsuo Bashō (1644–94)—and only later became an artist of note. His paintings were often done to support his career as a poet, and he persevered until he became a great master of the brush. He practised the *haiga* tradition as well as the naturalistic bird-and-flower style of Shen Nanpin. Particularly in his final years, he produced paintings that capture almost palpably the changing moods of nature.

Edo period, third generation. These artists originally revealed the influence of Taiga or Buson in their works. Followers of Buson include Ki Baitei (1734–1810) and YOKOI KINKOKU, who followed Buson's style although he never studied directly under the master. Taiga's pupils include the *waka* (a 31-syllable form) poet Ike Gyokuran, who became his wife, and the theorist–painter Kuwayama Gyokushū. The samurai Noro Kaiseki (1747–1828) was also one of Taiga's students; later he painted in a more conservative Sinophile style, as seen in the hanging scroll *Autumn Landscape* (1811; Tokyo, N. Mus.), which shows the influence of Huang Gongwang. More significant in this generation, however, were several painters who developed individualistic styles while incorporating their knowledge of Chinese painting techniques, such as overlapping texture strokes of increasingly darker and drier ink tones. Foremost among these masters was URAGAMI GYOKUDŌ, a musician, poet and calligrapher who developed late in life into one of the most vibrant of all literati painters. Unlike earlier *Nanga* masters, Gyokudō limited his subject-matter to landscapes, and he was not interested in exploring a great variety of brushwork styles. Instead, he built up asymmetrical layers of similar, strongly calligraphic brushstrokes to create images of textural richness and imposing force. Two of Gyokudō's literati friends from Osaka, Okada Beisanjin (*see* OKADA, (1)) and Totoki Baigai (1749–1804), were also *Nanga* painters of this generation. Like Gyokudō, they excelled in poetry, calligraphy and landscape painting, each with his own bold and strongly personal flavour, as in Baigai's hanging scroll *Living by Flowing Waters* (see 1976 exh. cat., no. 55). Another friend of Gyokudō was the Kyushu samurai–official TANOMURA CHIKUDEN. With his delicate sensibilities, Chikuden produced some of the most refined and poetic Japanese work in the style of paintings of the Ming and Qing periods, for example the handscroll *White Clouds and Verdant Mountains* (1827; Tokyo, N. Mus.). As a theorist Chikuden wrote several treatises, such as the *Chikudensō shiyūgaroku* ('Records of paintings of teachers and friends of Chikuden'; 1833), in which he commented

on a great number of painters of his own and earlier generations and attempted to refine the principles of Japanese literati painting.

Another literati individualist of the third generation was Aoki Mokubei (*see* AOKI MOKUBEI, §1), who was best known during his life as a potter. Mokubei's charming but somewhat rare landscape paintings combine balanced compositional formats with forceful brushwork, using dark accents over washed mists.

Edo period, fourth generation. Owing to the increasing popularity of *Nanga* with the official and educated merchant classes, many of the fourth-generation *Nanga* painters were able to support themselves by their art and thus no longer held teaching or bureaucratic positions. They developed their painting techniques to a high level of excellence, though sometimes at the cost of imaginative and creative compositions.

Perhaps because more Ming- and Qing-period paintings became available for study during the late 18th century and the early 19th, this generation continued the trend towards a more Sinophile style begun by their mentors, who, in the cases of Uragami Shunkin (1779–1846) and Okada Hankō (*see* OKADA, (2)), were their fathers. Shunkin and Hankō exhibit highly evolved skills in brushwork and a more conservative approach to the Chinese tradition than earlier literati artists, as seen in Shunkin's six-fold screen *Landscapes of Spring and Autumn* (see 1975 exh. cat., no. 78).

Also of this generation were two masters from Nagoya, Nakabayashi Chikutō (1776–1853) and YAMAMOTO BAIITSU. Chikutō moved permanently to Kyoto from Nagoya in 1815. In his theoretical writings on art, he advised young painters not to follow the models of Taiga and Buson, who he felt made too free an interpretation of the Chinese literati tradition, but instead to study Chinese works directly. He himself gradually evolved personal variations of the most important Chinese literati styles of the past, including that of the 10th-century painter DONG YUAN, whose influence is evident in Chikutō's *Rain in the Spring Trees* (hanging scroll, 1838; New Orleans, LA, Mus. A.; see fig. 102). Baiitsu, on the other hand, used his exceptional talent not only in literati subjects such as landscape and bamboo but also in bird-and-flower paintings, in which he matched colourful decorative appeal with subtle and refined brushwork.

Although there were a few Edo masters, such as Kameda Bōsai, who painted in the pure literati spirit as an adjunct to poetry and calligraphy, the best-known literati in Edo were more eclectic. The most successful was Tani Bunchō, who painted subjects in a wide variety of styles and genres, including *Nanga*, Tosa, Buddhist, European, Nagasaki, *ukiyoe* ('pictures of the floating world') and Maruyama–Shijō (*see* §(iv)(b) and §§(c)–(d) above and §(vii) below). His great popularity in later life meant that he had to paint quickly, often in a rough manner, but his earlier paintings show controlled brushwork and a highly developed sense of composition.

Because of his success as painter and teacher, Bunchō became one of the most influential Japanese artists of the 19th century. Among his numerous pupils was his wife, Tani Kankan (1770–99), an accomplished landscape

102. Nakabayashi Chikutō: *Rain in the Spring Trees*, hanging scroll, *sumi* and colours on silk, 914×305 mm, 1838 (New Orleans, LA, New Orleans Museum of Art)

painter. Another of Bunchō's better-known pupils was the samurai WATANABE KAZAN, who also painted in a number of styles. While Bunchō was more professional in spirit, Kazan was more experimental, attempting new techniques as much from artistic curiosity as from a desire to master every possible form of painting. Although celebrated for his highly naturalistic portraits, Kazan also depicted bird-and-flower subjects using the *mokkotsu* ('boneless') technique, which was further developed for the same subject-matter by his student Tsubaki Chinzan (1801–54), who was influenced by the style of Yun Shouping. Chinzan's

soft brush technique and refined colour, as in the pair of six-fold screens *The Four Gentlemen* (1850; Tokyo, Imp. Household Col.), brought him much recognition. Also regarded as a member of this generation was Chikuden's pupil Takahashi Sōhei (*c.* 1804–35), who followed his master's decorative style in bird-and-flower painting and was also a talented landscape painter.

Edo period, fifth generation. While such painters as Hine Taizan were content to carry on the tradition of their teachers, others sought more dynamic styles. The ferment leading to the Meiji Restoration (1868) gave literati painters the opportunity to test their ideals. Most literati were loyalists supporting the emperor, and some of them were deeply involved in the political world.

Fujimoto Tesseki (1817–63), a samurai from Okayama who was killed in an attempt to rally pro-imperial forces against the Tokugawa shogunate, for example, became skilled in Chinese historical and literary studies as well as poetry, painting and calligraphy. Works such as *Sages beneath Twin Pines* (1856; Okayama Prefect., K. Ogino priv. col.; see 1985 exh. cat., no. 61) evince his bold personality through dynamic and swirling brushwork. Nakabayashi Chikkei (1816–67), the son of Chikutō, followed his father's conservative Sinophile style in his early works, but his romantic temperament led him to produce more naturalistic and richly coloured paintings. Dissatisfied with the plebeian world around him, he became known for eccentric behaviour such as painting in the nude, even in the presence of visitors, or walking through Kyoto brandishing a sword in honour of the noble samurai spirit of past eras.

For a discussion of the sixth *Nanga* generation see §5(ii) below.

BIBLIOGRAPHY

S. Umezawa: *Nihon Nanga shi* [The history of Japanese *Nanga*] (Tokyo, 1919)
O. Furukawa: *Nanga ronsui* [*Nanga* discussions] (Tokyo, 1943)
K. Tanaka: *Shoki Nanga no kenkyū* [Research on early *Nanga*] (Tokyo, 1962)
I. Niijina: *Nihon no Bunjinga* [Literati painting of Japan] (Tokyo, 1966)
Y. Yonezawa and C. Yoshizawa: *Bunjinga* [Literati painting], Nihon no bijutsu [Arts of Japan] (Tokyo, 1966); Eng. trans. and adaptation by B. I. Monroe as *Japanese Painting in the Literati Style*, Heibonsha Surv. Jap. A., xxiii (New York and Tokyo, 1974)
Scholar Painters of Japan: The Nanga School (exh. cat. by J. Cahill, New York, Asia House Gals, 1972)
Japanese Art: Selections from the Mary and Jackson Burke Collection (exh. cat. by M. Murase, New York, Met., 1975)
C. Yoshizawa: *Nihon no Nanga* [Japanese *Nanga*] (1976), suppl. i of *Suiboku bijutsu taikei* [Compendium of ink painting art], ed. I. Tanaka and Y. Yonezawa (Tokyo, 1973–7)
Zenga and Nanga: Paintings by Japanese Monks and Scholars (exh. cat. by S. Addiss, New Orleans, LA, Mus. A., 1976)
Nanga: Idealist Painting of Japan (exh. cat. by J. Stanley-Baker, Victoria, BC, A.G. Gtr Victoria, 1980)
C. Yamanouchi: *Nihon Nanga shi* [The history of Japanese *Nanga*], Tokyo, 1981)
J. Cahill: *Sakaki Hyakusen and Early Nanga Painting*, Japan Research Monograph (Berkeley, 1983)
Japanese Ink Painting (exh. cat. by S. Miyajima and Y. Satō, Los Angeles, CA, Co. Mus. A.; Tokyo, Agy Cult. Affairs; 1985)
Japanese Quest for a New Vision (exh. cat., ed. S. Addiss and others; Lawrence, U. KS, Spencer Mus. A., 1986)
Japanese Women Artists, 1600–1900 (exh. cat. by P. Fister, Lawrence, U. KS, Spencer Mus. A., 1988)
M. Takeuchi: *Taiga's True Views* (Stanford, 1992)

STEPHEN ADDISS

(vii) Zenga.

(a) Introduction. In the early 17th century the Tokugawa shoguns, having pacified the country, placed Confucian scholars in advisory positions and entrusted them with the education of the samurai class. Buddhist temples lost their official patronage, and Zen was forced to change its orientation from the ruling classes to the common people. Zen temples could no longer afford to support professional monk–painters (*ebusshi*) and only serious students of Zen entered the priesthood. Zen monks began to brush calligraphy and to paint simple pictures as part of their

103. Hakuin Ekaku: *Landscape with a Bridge*, ink on paper, 1186×523 mm, 1748–68 (Tokyo, Hosokawa and Hara)

religious training. Although they had little training in painting, most had a good grounding in calligraphy, which formed the basis for *Zenga* ('Zen painting').

The most common subjects of *Zenga* were past Zen masters and scenes of their lives, which were often inscribed with poems or *kōan* (riddles). Stylistically, *Zenga* generally looked unprofessional and were painted in bold strokes, which they regarded as the outward expression of the Buddha-nature, but may also be metaphors for Zen experience.

Most *Zenga* were produced by the Rinzai (Chin. Linji) sect, thanks in part to the activities of the great monk-painter HAKUIN EKAKU in the 18th century. Hakuin not only revitalized the sect but also incorporated painting as an important activity of Zen practice. Hakuin and his followers used popular motifs from local folklore and other familiar subjects in order to appeal to the common people. These borrowed motifs were often used in humorous or satirical ways to achieve the priests' didactic goals. *Zenga* painted after Hakuin sometimes appear vulgar when compared to Chinese or earlier Japanese Zen paintings.

(b) Daitokuji. The artists who produced Zen art in the first decade of the 17th century were connected directly or indirectly with Daitokuji in Kyoto. The aristocratic KONOE NOBUTADA, an excellent calligrapher, received Zen instruction from Daitokuji abbots and painted in a nascent *Zenga* style. His *Meditating Daruma* (Skt Bodhidharma; see 1989 exh. cat., pl. 8), which depicts Daruma from behind, appears to consist of only two brushstrokes and embodies direct simplicity graced by refinement. Another early *Zenga* painter, Isshi Bunshu (1608–46), was a pupil of the noted Zen master and abbot of Daitokuji TAKUAN SŌHŌ. Also of aristocratic birth, Isshi enjoyed popularity at court. His *Daruma Meditating* (see 1989 exh. cat., pl. 18) depicts Daruma's profile in controlled but expressive strokes by varying thickness, tonality and amount of moisture.

The Daruma paintings of Nobutada and Isshi are reminiscent of ink paintings by KAŌ SŌNEN and MOKUAN REIEN, early practitioners of Japanese ink painting in the Muromachi period (1333–1568; *see* §(iii) above). The four artists share abbreviated and expressive brushstrokes enhanced by aristocratic refinement. The elegant taste of Nobutada and Isshi was favoured by early Edo-period tea masters, and their works were often displayed at tea gatherings (*see* §XIV, 1 below). This highbrow early *Zenga* style is quite different from the *Zenga* of Hakuin and his followers.

(c) 'Eccentrics'. In the second quarter of the 17th century, *Zenga* became eccentric and individualistic as more provincial Zen monks began painting. The most distinctive early provincial *Zenga* painter was FŪGAI EKUN, who retired from the world and lived as a recluse in a cave. He painted past Zen masters, particularly Daruma and Hotei (Chin. Budai). One of Fugai's Daruma paintings, *Daruma Meditating* (Wright Col.), inspired Hakuin and became the prototype for many of Hakuin's later Daruma paintings, particularly in the bold and powerful brushstrokes and the comical stare of Daruma's eyes.

104. Tōrei Enji: *Walking-stick of Master Tĕ-shan*, ink on paper, 830×250 mm, second half of the 18th century (Numazu, Tanaka Collection)

Zenga is connected with the religious revitalization promoted by HAKUIN EKAKU, a low-ranking Rinzai master who established a thriving Zen centre in his native village of Hara at the foot of Mt Fuji. Hakuin saw moral decay and gross materialism afflicting the nation and resolved to bring people back to a more spiritual and meaningful

existence. His extraordinary charisma and dignity enabled him to attract thousands of followers and to avoid compromising offers of patronage. Trained as a calligrapher, he began painting *Zenga* after the age of 60 and did not stop until his death at the age of 84.

Hakuin's painting style is characterized by an artlessness that shows no hint of the finesse of professional technique. His unorthodox, down-to-earth and dynamic style was a direct expression of his open-hearted character. More than 1000 works by Hakuin survive, ranging from the familiar Daruma portraits (for illustration *see* HAKUIN EKAKU) to subjects observed in the world around him (see fig. 103). A typical Daruma portrait is his *Daruma in Red* (ink and colour on paper; 1920×1120 mm; Manjuji, Ōita Col.) consisting of a looming figure of Daruma in a red robe, painted in broad, expressive strokes, set against a pitch-black background.

Typical of the many new *Zenga* subjects pioneered by Hakuin is Otafuku, a humble courtesan who performed the most menial tasks with a smile. Hakuin considered her an incarnation of a *bodhisattva* who remained in the world to save mankind. She appears in *Curing Haemorrhoids* (Tokyo, Eisei Bunko) applying moxa to the rear of a greedy man, wearing a kimono sporting the Chinese character for money. The scene's humour and vulgar wit are at the core of Hakuin's art. These provocative paintings are classified as *giga* (satirical paintings), but the didactic intent is obvious from Hakuin's inscription.

Among his many followers, Hakuin's most famous disciples were Tōrei Enji (1721–92) and Suiō Genro (1717–89), who used Hakuin's motifs but developed their own brushwork. Among Tōrei's extant works is his broadly brushed painting *Walking-stick of Master Tě-shan* (see fig. 104). In the 19th century, many Zen priests painted *Zenga* in the spirit of Hakuin. Most famous was SENGAI GIBON, a peasant trained in Rinzai Zen, who led an itinerant life before settling down in Hakata, Kyushu, in 1788. More bohemian and reclusive than Hakuin, he began painting childlike *Zenga* after the age of 50. His works also reveal greater versatility in brushwork and a wider range of subject-matter, and they are considerably lighter than Hakuin's in form as well as content.

BIBLIOGRAPHY
J. Fontein and M. L. Hickman: *Zen Painting and Calligraphy* (Boston, 1970)
K. Brasch: *Zenga to Nihon bunka* [Zen painting and Japanese culture] (Tokyo, 1975)
S. Fukushima and S. Kato: *Zenga no sekai* [The world of Zen painting] (Tokyo, 1978)
The Art of Zen: Paintings and Calligraphy by Japanese Monks, 1600–1925 (exh. cat. by S. Addiss, Lawrence, U. KS, Spencer Mus. A., 1989)

SADAKO OHKI

(viii) Naturalistic painting: Maruyama–Shijō school. The Maruyama–Shijō school was created in the middle of the Edo period (1600–1868) by the Kyoto painter MARUYAMA ŌKYO and further developed by his student MATSUMURA GOSHUN, who, in his later years, lived, as did many of his students, in Shijō–Sakaimachi, Kyoto. As the school attached much importance to the naturalistic depiction of nature and urban scenes in the environs of Kyoto that were intimately known to viewers and readily recognizable, it has also been called the *shaseiha* ('school of depiction') or Kyōha ('Kyoto school').

(a) Introduction. (b) Work and influence of Maruyama Ōkyo. (c) Work and influence of Matsumura Goshun.

(a) Introduction. In the Edo period, specifically from the Hōreki to the Tenmei eras (1751–89), positivism was gaining widespread acceptance in Japan, not only in medicine and production but also in literature and art. Class divisions became more pronounced, with wealth being concentrated in the hands of landowners and merchants, while urban dwellers and farmers were impoverished: this led to an increase in social instability. Artistic invention had stagnated following the death of Ogata Kōrin in 1716, and even long-established schools such as the Kanō school had lapsed into monotony and repetition. New artistic impetus came with the appearance on the scene of such artists as YOSA BUSON, ITŌ JAKUCHŪ, Ike Taiga (*see* IKE, (1)), Soga Shōhaku (*see* SOGA, (2)) and Maruyama Ōkyo. Centred principally in Kyoto, these artists all strove to achieve a 'true' method of painting that was at the same time individualistic. This search took them in three directions: the development of *Nanga* (literati painting; *see* §(vi)(d) above) by Buson and Taiga; the creation of a strongly eccentric individualism by Jakuchū and Shōhaku; and the formation of Ōkyo's naturalistic Maruyama school.

Ōkyo was the youngest among these artists, and his search for realism and clarity was already evident in his earliest works (1765), which were immediately well received in the Kamigata (Kyoto–Osaka) region. Hitherto, the arts in Kyoto had been the province of aristocrats, who were highly educated literati. Ōkyo brought to the fore for the first time an expressionistic style that satisfied the artistic demands of ordinary urban dwellers. The American ERNEST FRANCISCO FENOLLOSA, invited to Tokyo University at the beginning of the Meiji period (1868–1912), wrote in his *Epochs of Chinese and Japanese Art* that, while the Kanō and Rinpa (*see* §(v) above) schools were considered to be creators of art for the ruling classes, the Maruyama and Shijō schools represented the culture of the common people. Along with *ukiyoe* ('pictures of the floating world'; *see* §(iv)(b) above), which catered for people in Edo (now Tokyo) and the Kantō region, the Maruyama–Shijō school was one of the two popular arts of the Edo period.

(b) Work and influence of Maruyama Ōkyo. Ōkyo's paintings characteristically appealed directly to the visual senses and the emotions and did not require scholarship or culture for their appreciation. The people of Kyoto, weary of the subjectivity of *Nanga*-style works and the predictable output of the Kanō and of the Tosa school, welcomed the freshness and accessibility of Ōkyo's paintings. He developed a clear, decorative style, which adhered to the traditions of East Asian painting in, for example, subject-matter, the treatment of space and in brush technique.

At the age of 15 or 16 Ōkyo was apprenticed in a toyshop in Kyoto, where he produced *meganee* ('eyeglass pictures') used for the popular *nozoki karakuri* (a device in which the picture was reflected in a mirror and enlarged by a magnifying lens to produce a three-dimensional image). *Meganee* employed the vanishing one-point perspective of Western-style painting, which became one

ingredient in Ōkyo's later naturalistic technique. He began to study painting with the Kanō-school painter Ishida Yūtei (1721–86) and became associated with members of the Tsuruzawa branch of the Edo-period Kanō school. Although Ōkyo soon distanced himself from Yūtei's style, the influence of the Kanō school remained. His *Old Pine Tree in the Snow* (*Setsushō zu*; see fig. 105) is signed Senrei (he changed his signature to Ōkyo in the following year). In this work he rejected the formality of the Kanō and Rinpa schools, opened up new possibilities in landscape painting and created a milestone that established the Maruyama style. The beauty of nature, as seen by the naked eye, was conveyed by the accomplished use of such

techniques as *katabokashi* (chiaroscuro) and *tsuketate* (depiction of an object without contour lines). Natural effects of dark and light were created with *tsuketate*: each stroke is executed without pause after the brush has been saturated with water and ink (both dark and light are used) applied to its tip. The use of *tsuketate* subsequently became a trademark technique of the Maruyama school. In the late 1760s Ōkyo was commissioned by Yūjō, the head priest of the Enman'in at the temple Enjōji, in Ōtsu, to produce a didactic work illustrating the law of cause and effect, a concept rooted in Buddhist teaching. Ōkyo completed the *Nanpuku zukan* ('Picture scrolls of fortunes and misfortunes'; Osaka, Manno Mus.) in 1768. The three scrolls respectively (top to bottom) illustrate *Tensai* ('Natural calamity'), *Jinsai* ('Human calamity') and *Sufuku* ('Fortunes of age'). They are remarkable for their truthful power; for them Ōkyo apparently drew the human figure from life.

The *Sensai Maruyama sensei den* ('Record of master Sensai Maruyama'), written by Ōkyo's student Oku Bunmei (*d* 1813), noted that Ōkyo always emphasized that the key to painting was realistic depiction, a conviction encouraged by his encounters with the work of, for example, WATANABE SHIKŌ, SHEN NANPIN and Sensen (Chin. Qian Xuan). Shikō had worked in the genres of *kachōga* ('pictures of birds and flowers') and pastoral *denen fūzoku zu* ('pictures of customs and manners of fields and gardens'). His style of depicting nature drew on the techniques of both the Rinpa and Kanō schools. Ōkyo copied Shikō's *Shinsha chōrui zukan* ('Picture scroll of true depictions of fowl'; Japan, priv. col.); he seems, moreover, to have studied Shikō's modern positivist philosophy. The realistic, Qing-period (1644–1911) painting style of Shen Nanpin achieved popularity in the painting circles of the Kansai region in the 1750s and later (*see* §(vi)(c) above); Ōkyo enthusiastically studied their realistic manner while avoiding their foreign elements. Sensen, a painter of the Southern Song period (1127–1279), was known for his pure, refined style. Works by Ōkyo done in 1771, such as the three scrolls of the *Kachō shasei zukan* ('Picture scroll of the depiction of birds and flowers'; Japan, priv. col.) and the *Chōchō shasei chō* ('Album of the depiction of butterflies'; Tokyo, N. Mus.), are the products of minute scientific observation. The *Ame naka sansui zu byōbu* ('Screen(s) of pictures of landscape in rain'; 1769; Emman'in) is an abbreviated and delicately executed depiction of an actual scene known to the artist. In *Fukayama osawa zu byōbu* ('Screen of pictures of the great fields of Fukayama'; Ninnaji), the rendering of the horned owl, the forms of the trees and the shapes of the ducks on the lake, as well as the surrounding spaces, prefigure modern landscape painting.

From the 1770s Ōkyo integrated the two major traditions of Western-style painting into his work—the precise depiction of nature and vanishing perspective—trying to develop a personal decorative painting style applied to door-and-wall painting (*shōhekiga*). An example of Ōkyo's mature brush technique is the *Unryū zu byōbu* ('Screens of pictures of dragons in clouds', also known as 'Dragons in billowing clouds'; 1773), in which the dragons are shown flying vigorously through clouds and waves; a sense of power is conveyed by the use of rings, blotches

105. Maruyama Ōkyo: *Old Pine Tree in the Snow*, ink and pale gold on silk, 1765 (Tokyo, National Museum)

and spattered indigo ink and the *tarashikomi* technique, in which ink is allowed to drip or flow on to a wet surface. A contrasting work, *Amatake fūchiku zu byōbu* ('Screen(s) of pictures of bamboo in rain'; 1776; Enkōji), is executed with few brushstrokes in delicate dark and light ink. In the late 1780s Ōkyo was commissioned to produce door-and-wall paintings in many temples and shrines. The *Kakushigi zu fusuma* ('Sliding door of Kakushigi'; Daijōji, Hyōgo Prefect.) has a gold-leaf ground, unlike most of the other works, which are ink paintings. Ōkyo was also a prolific creator of elaborate and meticulous large-scale paintings. Unlike other painters, he did not apparently care for travel, and it seems probable that the sliding-door paintings for Sōdōji and Muryōji were produced in Kyoto and delivered by his student NAGASAWA ROSETSU.

In 1790, Ōkyo and his students undertook to produce door-and-wall paintings at the Kyoto imperial palace to replace those that had been destroyed by fire in 1788. With his students Rōsetsu, Goshun and Gessen he executed *fusuma* (sliding doors) and other works at Myōhōin at the invitation of Prince Shin'nin (*reg* 1780–1817). In his last years, despite ill-health and worsening eyesight, Ōkyo produced some powerful pieces of brushwork, for example *Waterfall* (1794; Omote Shoin; for illustration *see* MARUYAMA ŌKYO).

After Ōkyo's death in 1795, the Maruyama school continued under the leadership of his son Ōzui (1766–1829). Rather than developing his own personal style, Ōzui retained that of his father. The style became one of the representative modes in Kyoto painting circles, largely thanks to Ōkyo's *monjuttetsu* (Ten Great Disciples). These disciples were Komai Genki (1747–97), Nagasawa Rosetsu, Yamaato Kakurei (n.d.), Watanabe Nangaku (1767–1813), Mori Tetsuzan (1775–1841, *see also* MORI SOSEN), Nishimura Nantei (*d* 1834), Yoshimura Kōkei (1769–1836), Yamaguchi Soken (1758–1818), Oku Bunmei and the priest Gessan (1721–1809). Similar styles were followed by such literati as Minagawa Kien (1734–1807), and Ōkyo's influence is evident in the close observation of nature by painters of the Mori school, notably in depictions of monkeys by MORI SOSEN. Among the Ten Disciples, Genki specialized in the depiction of *bijin* ('beauties') in the style of Tang-period (AD 618–907) Chinese artists; Soken was also known for his *bijinga* ('pictures of beautiful women'). Tetsuzan painted naturalistic pictures of animals, in particular Chinese lions and tigers. Nangaku too produced *bijinga* and was a skilful painter of fish. Nangaku and Tetsuzan turned out such superb students as Ōnishi Chinnen (1792–1851) and Mori Kansai (1814–94). All ten of the disciples, however, were essentially imitators of Ōkyo's ink techniques, and after a time Matsumura Goshun's Shijō school began to gain more practitioners and more popularity. Alone among the disciples Nagasawa Rosetsu, Ōkyo's leading pupil, developed independent technical initiatives. In 1787 he travelled to southern Kii (now Wakayama Prefect.) as Ōkyo's representative; several of his *fusumae* there survive. He was also Ōkyo's most important assistant, producing door-and-wall paintings for the temple Daijōji. Thereafter, eschewing his teacher's objective realism, he began to paint with a remarkable subjectivity.

Because Ōkyo's first teacher had been an adherent of the Kanō school, the Maruyama school likewise initially combined conservatism with a gentle intellectualism. It was Goshun who injected a generous amount of urban wit into contemporary painting. Commenting on Ōkyo's work, the late Edo-period scholar–artist RAI SAN'YŌ found it to be 'a true depiction' but 'it cannot be called painting'; Goshun's work, by contrast, not only was true to life but also had elegance and tone in its ink- and brushwork and thus qualified as true painting. Goshun's presence revivified the Maruyama school and gained for it the support of the literate and intellectual classes, who were wearying of Ōkyo's style.

(c) Work and influence of Matsumura Goshun. As a young man, Matsumura Goshun tried his hand at various accomplishments, such as painting, *haiku* poems and music, but it was not until he was laid off from the mint at which he worked in 1772 that he turned to painting as a career. He first studied with Ōnishi Suigetsu; when Suigetsu died, he entered the studio of Yosa Buson. Goshun assimilated much of Buson's style but by 1777 was beginning to show an individualistic expressiveness of his own. His *Rakan zu* ('Picture(s) of *arhat*s'; 1777; Ikeda, Itsuō A. Mus.) display a mature detachment unusual in such a young man; the brushstrokes are lithe, sharp and crisp. *Kiba shuryō zu* ('Pictures of mounted hunters') and studies of two Chinese eccentrics, *Hanshan* (Jap. Kanzan) and *Shide* (Jap. Jittoku), done in 1779 (both Ikeda, Itsuō A. Mus.), reveal his emerging taste for bold distortion and a strong brush style, and his humorous treatment of rural scenes.

In 1781, when Goshun was 30, he lost both his father and his wife and, to recover, took up a peripatetic life in Ikeda in Settsu Province (now Osaka Prefect.). Goshun's Ikeda period, which lasted until 1789, was a time of great activity and considerable importance in his artistic career, when he produced such superb works as the *Ryūro gunkin zu byōbu* ('Screen(s) of pictures of herons, birds and willows') and the *Sansui setchū gunchō zu byōbu* ('Screen(s) of pictures of groups of birds in a landscape in snow'; both Japan, priv. cols) and *Hibiscus and Blue Heron on-stump* (1782; Hyōgo, Kurokawa Kobunka Research Institute; for illustration *see* MATSUMURA GOSHUN). The works of this period mark the highpoint of Goshun's *Nanga* (literati) style, which adhered largely to that of Buson, in turn derived from painters of the Southern Song period. Goshun's patrons in Ikeda were upper-class merchants, for whom he produced paintings and in whose social pastimes he participated.

In 1783 Goshun travelled to Kyoto to tend Buson in his last illness. In *Tōenmei gasan* ('Picture of Tōenmei'; Chin. Tao yuanming; Ikeda, Itsuō A. Mus.), he selected verses from Buson's posthumous manuscripts and, pasting them together on a sheet, added paintings of his own to make a scroll. With the money earned from this he arranged the marriage of Buson's surviving daughter. In 1784 he published Buson's manuscript *Shinkateki* ('Plucking new flowers'), accompanied by seven of his own illustrations. He then returned to Ikeda and thence to Kyoto in 1789.

After losing the powerful spiritual support of Buson, Goshun was soon drawn towards Maruyama Ōkyo. Goshun had already participated with Ōkyo's students in producing *fusumae* at Daijōji in 1787. In a room of the guest-quarters, Goshun created the *Gun sanro chō zu* ('Picture of mountain peaks in dew'; Daijōji, Hyōgo Prefect.), executed in Buson's Southern Song-period style. While *fusumae* in the Kashihara House—*Shunkō sansui zu* ('Picture of spring countryside mountains') and *Shunkō gunō zu* ('Picture of groups of wild ducks in autumn countryside')—show the influence of the Southern Song style, the ducks and autumnal grasses are depicted realistically, and the artist has used the *tsuketate* brush techniques of the Maruyama school. After Buson's death in 1784, Goshun supposedly asked to become Ōkyo's pupil, but Ōkyo declined, having been an admirer of Goshun's talents for some years. Certainly the two became close friends, and after the great Kyoto fire of 1788 Goshun is believed to have taken temporary refuge with Ōkyo at the Kiun'in temple; this presumably proved the decisive impulse for his move to the Maruyama school. Other works of this period include *White Plum Trees* (see fig. 106).

Although at this time national literature, and especially its realistic character, was preferred to Chinese poetry, thus creating a milieu in which realistic painting too could flourish, Goshun's transition from the style of the Southern Song painters to that of the Maruyama school

106. Matsumura Goshun: *White Plum Trees* (detail), pair of six-panel folding screens, ink and light colours on silk, 1.75×3.73 m, *c.* 1790 (Ikeda, Itsuō Art Museum)

took years. He found it impossible simply to imitate the Maruyama school, needing instead to create a new and individualistic Shijō-school style. By 1795, when the Maruyama school was engaged in a second wave of production of *fusumae* at Daijōji, Goshun's assimilation of the Maruyama style had become strikingly apparent in such works as the *Kōsaku zu* ('Pictures(s) of rice harvest'). The rural scenes are depicted realistically, with the use of clear expanses or the *tsuketate* technique, but the brushwork is lyrically soft and fluid.

In the same year Ōkyo died, and from then on Goshun became increasingly committed to establishing his own style. A collaborative work with KISHI GANKU, the *Sansui zu* ('Picture(s) of landscape'; 1796; Tokyo, Sch. F.A.), reveals the freshness and charm of Goshun's painting of this period. Between about 1795 and 1804 he produced such works as the *Kōsaku zu* (*fusuma* in the Kuroshoin, Nishi Honganji temple), *Sansui zu* ('Pictures of landscape'; *fusuma* in the Shiroshoin, Myōhōin), *Buryōtōgen zu* ('Picture of Utopia'; Toyama, Mem. Mus.), *Keikan ui, Chihen sekki zu* ('Pictures of the threat of rain in a ravine, snowy lake scene'; Japan, priv. col.) and *Sosai zu* ('Picture(s) of vegetables'; Sumitomi Col.), which represent Goshun's complete abandonment of the Southern Song-school style. The clear, accessible view of nature is fully in evidence, the *tsuketate* brushstrokes are soft and rhythmic, and the overall impression is harmonious and refined. In *Hakubune zu* ('Picture of anchoring ships'; *c.* 1804–05; Kyoto, Daigoji, Sanbōin Okushoin), painted on four tall *fusuma*, he used a series of dry strokes for the script, known as *suberi rakkan* ('sliding artist's signature'), a feature of all his later works.

After Ōkyo's death, Goshun in turn received patronage from Prince Shin'nin of the Myōhōin and was invited to produce work connected with the imperial palace. Goshun became the leading Kyoto painter of his day, and his work, with its unconventional, lyrical quality, was perfectly in tune with contemporary taste. According to the scholar Ueda Akinari (1734–1809), Goshun, though sociable and popular, was somewhat otherworldly, whereas Ōkyo was a true artisan, clever but unrefined and content with only the basic necessities of life. These differences were reflected in their painting styles and those of the schools they founded, the realism of the Maruyama school gradually ceding place to increasing subjectivity.

After Goshun's death, the Shijō school was furthered by students such as the prolific and brilliant MATSUMURA KEIBUN and OKAMOTO TOYOHIKO. Keibun (who was Goshun's half-brother but 27 years his junior) and Toyohiko specialized in bird-and-flower pictures and landscapes respectively, and they were known as the Pair of Bright Jewels (*sōheki*) of the late Edo-period Shijō school. Toyohiko thoroughly learnt the painting techniques of Goshun and faithfully reproduced his style, which combined realism with literati elements. He made a superb head of the Shijō school and had numerous students such as SHIBATA ZESHIN, Tanaka Nikka (*d* 1845) and Mihata Jōryū (*fl* 1830–43). Shiokawa Bunrin (1808–77), who in 1868 established the society Jounsha and trained such artists as KŌNO BAIREI, was a central figure in the school during the last decade or so of the Edo period. Bunrin studied with Toyohiko and was an admirer of Buson.

Along with Yokoyama Seiki (1793–1865), Nakajima Raishō (1796–1871) and Kishi Renzan (1805–59), he was one of the Four Great Masters of the period. The Jounsha was a social and research association of Kyoto artists from all schools.

Towards the end of the Edo period, Japanese society and the economy underwent change. Artistic circles weakened and the Maruyama–Shijō school too began to break up. With the advent of the Meiji period, the expanding urban society expected art that was clear and easy to understand; this gave the impetus to a return to realism. Shijō-school styles were taken over and developed by Bairei's student Seihō Takeuchi, and they played a large part in the rise of *Nihonga* (see §5(iii) below). In the early 20th century, the realism and romanticism of Maruyama–Shijō painting were adopted by members of the LINGNAN SCHOOL in China.

BIBLIOGRAPHY

S. Suzuki: 'Ōkyo to Goshun' [Ōkyo and Goshun], *Nihon no Bijutsu*, xxxix (1969) [whole issue]
C. H. Mitchell: *The Illustrated Books of the Nanga, Maruyama, Shijō and other Related Schools of Japan* (Los Angeles, 1972)
J. Hillier: *The Uninhibited Brush: Japanese Art in the Shijō Style* (London, 1974)
T. Yamakawa: *Ōkyo, Goshun*, Nihon no bijutsu kaiga zenshu [Complete collection of Japanese painting], xxii (Tokyo, 1980)
Ōkyo and the Maruyama–Shijō School of Japanese Painting (exh. cat. by J. Sasaki, St Louis, MO, A. Mus., 1980)
S. Addiss and others: *A Myriad of Autumn Leaves: Japanese Art from the Kurt and Millie Gitter Collection* (New Orleans, 1983)
R. Okada: *Goshun* (Ikeda, 1983)

MOTOAKI KONO

5. MODERN (AFTER 1868).

(i) Introduction. (ii) *Nanga*. (iii) *Nihonga*. (iv) *Yōga*. (v) Avant-garde.

(i) Introduction. Following the resumption of open trade relations between Japan and the West in the late 1850s, the shogunate officially encouraged the study of Western art as a technical skill vital for industrialization, technological development and military preparedness. The Bansho Shirabesho (Institute for the Study of Foreign Documents), established in 1856 to facilitate the conduct of foreign relations, engaged Kawakami Tōgai (1827–81)—a scholar of Dutch learning who had also trained as an artist—to undertake in 1861 the study of Western art. The following year he began to teach samurai, scholars and KANŌ SCHOOL artists such as TAKAHASHI YŪICHI and Kanō Tomonobu (1843–1912). Other students attended his private academy in Tokyo or those of Kunisawa Shinkurō (1847–77), Yokoyama Matsusaburō (1838–84) and Takahashi Yūichi, who became the leading oil painter in the Western style (*Yōga*) of the early Meiji period (1868–1912; see §(iv) below). Charles Wirgman (1832–91), a correspondent of the *Illustrated London News*, also gave instruction in Western painting during the late 1850s and the 1860s. Kawakami taught at the Military Academy in Numazu and, with the aid of Takahashi, prepared the text for a course in Western drawing that was included in the curriculum of a new nationwide system of elementary schools established in 1872.

After the Meiji Restoration of 1868 Japan set out rapidly to assimilate Western culture and technology so that it could successfully compete with the West. In order to earn the foreign currency needed for industrialization, the government sought to boost its principal export items—silk, tea and traditional crafts. Foreign experts such as Gottfried Wagener (1831–92) were engaged to introduce Western materials and techniques into the manufacture of textiles, pottery, lacquer, cloisonné and other traditional crafts, thereby greatly influencing their evolution. Early *Yōga* artists, such as Goseda Hōryū (1827–92), produced pseudo-Western portraits and other exotic works for a foreign clientele. Such concurrent and interrelated developments blur the distinction (usual in Japanese practice) between the Japanese-style painting of the period (*Nihonga*; see §(ii) below) and *Yōga*, although *Yōga* was regarded as viable and prestigious and traditional Japanese arts as practically valueless.

The Kōbu Bijutsu Gakkō (Technical Art School) was founded in 1876 by the government to train students in the Beaux-Arts tradition then in vogue. The Technical Art School offered only traditional Western techniques of naturalistic oil painting and sculpture. The objective was more practical than artistic, as the government urgently needed Japanese painters to master the realistic techniques of Western art so that they could produce illustrations for scientific, military and industrial purposes. Since Italian artisans were considered the most technically accomplished, the Ministry of Public Works engaged an Italian painter, ANTONIO FONTANESI, a sculptor, Vincenzo Ragusa (1841–1928) and an architectural draughtsman, Giovanni Vincenzo Cappelletti, to train students to erect and decorate industrial plants and official buildings.

In the Meiji period the basic tenets of modern Japanese painting were established. In particular, the distinction between *Yōga* and *Nihonga* became clear. However, the restrictions on materials considered appropriate for *Nihonga* hampered the development of this style and ultimately led to its decline. In the Taishō period (1912–26) avant-garde art concepts (see §(iv) below) first reached Japan; European movements such as Cubism, Futurism, Structuralism and Dada were absorbed, being used not merely doctrinally and artistically but also 'politically' in the rivalry between different groups of Japanese artists.

MICHIYO MORIOKA

(ii) Nanga. In the early Meiji period, most traditional Japanese arts were called into question by the new pro-Western intelligentsia, but *Nanga* prevailed owing to the Chinese-style education that many of the new leaders had received. Sixth-generation *Nanga* artists of this period (for earlier generations see §4(vi)(d) above) can be divided between those who continued the conservative tradition established by the literati painters of the Edo period and those who developed more eccentric styles. Masters of the conservative tradition include two of Chikuden's pupils from Kyushu, Hoashi Kyōu (1810–84), who also studied under Uragami Shunkin and Rai San'yō, and Tanomura Chokonyū (1814–1907). Their paintings, for instance Kyōu's hanging scroll of bamboo *Wind Stirs a Delicate Fragrance* (1870; Okayama Prefect., K. Ogino priv. col., see 1985 exh. cat., no. 61), faithfully followed traditional literati compositions with refined brushwork and visual references to Chinese literati traditions of the past.

One of the most individualistic artists of the Meiji period was Murase Taiitsu. He painted both landscapes

and Japanese historical and literary figures in a rapid linear style, with frequent touches of humour, as for example in his portrait of the poet–monk Saigyō, *Saigyō and the Silver Cat* (New Orleans, LA, priv. col.; see fig. 107). Yamanaka Shinten'ō (1822–85), another artist with a distinctive style, exemplified the spirit of the true literatus of the early Meiji period. Accomplished in Chinese studies, he produced poems, paintings and calligraphy with a blunt vigour as expressions of his individual spirit. He claimed that his paintings belonged to no school but merely depicted the place where his spirit could reside. Yasuda Rōzan's (1830–82) adventurous determination to learn Chinese painting styles took him first to Nagasaki, where he studied under the monk–artist Hidaka Tetsuō, one of the Three Nagasaki *bunjin*. Wishing to investigate Chinese painting more

107. Murase Taiitsu: *Saigyō and the Silver Cat*, *sumi* on paper, 1270×305 mm, *c.* 1870–80 (New Orleans, LA, private collection)

deeply, Rōzan sailed in 1864 to China, a crime punishable by death under Tokugawa rule. In Shanghai he became the pupil of Hu Gongshou (1823–86), which made him the first and only major *Nanga* master to study directly and at length with an important Chinese painter. Under the succeeding Meiji government, travel to and from China was permitted, and in 1873 Rōzan returned to Tokyo where he became an established literati artist.

Women painters were generally welcomed into the literati school. Two women *Nanga* artists of the sixth generation exemplified the conservative and individualistic sides of Meiji literati painting. Noguchi Shōhin, a pupil of Hine Taizan, was able to support her husband and family through her art, an unusual achievement for a Japanese woman at that time. She was eventually appointed official artist to the imperial household in 1904, painting bird-and-flower subjects and landscapes, such as the hanging scroll *Mountains in Autumn* (1910; Philadelphia, PA, Mus. A.). She also portrayed human figures, particularly women, in a refined, conservative vein. The Tokyo painter OKU-HARA SEIKO, by contrast, was a mostly self-taught individualist who dressed and acted like a man. Her early works display a bold use of free brushwork in complex compositions. In 1891, at a time when literati painting was losing popularity, Seiko retired to a village in the Kumagaya region just north of Tokyo. This move may also have promoted a change in her painting style, which was thereafter marked by more detail and colour.

What had been for the literati pioneers of the 17th century a fresh and adventurous artistic tradition from China became, by the Taishō period (1912–26), an entrenched school of painting that generally resisted the new trends from the Western world. The most famous late master was Tomioka Tessai, who produced an astonishing number of expressive paintings, especially in his later years. Tessai's works have the rough vigour of Shinten'ō, who served to some extent as his mentor, but display a greater range of subject-matter and style. Although it is generally believed that the creativity of the tradition died with Tessai, a select number of later artists, for example the 'eccentric' painters Irie Shikai (*fl c.* 1920–40) and Kodōjin Fukuda (1865–1944), continued to paint creatively in the *Nanga* tradition.

BIBLIOGRAPHY

Y. Yonezawa and C. Yoshizawa: *Bunjinga* [Literati painting], Nihon no bijutsu [Arts of Japan] (Tokyo, 1966); Eng. trans. and adaptation by B. I. Monroe as *Japanese Painting in the Literati Style*, Heibonsha Surv. Jap. A., xxiii (New York and Tokyo, 1974)

For further bibliography *see* §4(vi)(d) above.

STEPHEN ADDISS

(iii) Nihonga. The term *Nihonga* (Japanese-style painting) came into common use during the second decade of the Meiji period (1868–1912) in order to distinguish modern Japanese-style painting from *Yōga* (*see* §(iv) below) and from *Yamatoe* (*see* §§3(ii)(a) and 4(ii) above), the older, traditional style of Japanese painting. *Nihonga* is characterized by the use of traditional materials and techniques: the painting was executed on paper or silk; black ink was used in combination with colours derived from mineral pigments and pulverized oyster or clam shells; and the binder was *nikawa*, a glue made from animal bone and skin.

(a) Meiji period (1868–1912). (b) Taishō period (1912–26) and after.

(a) Meiji period (1868–1912). With the new interest in Western painting styles, and continued fascination with literati painting (*Nanga* or *Bunjinga*; *see* §(ii) above; *see also* §4(vi)(d) above), the initial decade of the Meiji period was generally bleak for Japanese traditional arts. The painters of the KANŌ SCHOOL and TOSA SCHOOL in particular suffered greatly, having suddenly lost the official patronage they had enjoyed during the Edo period (1600–1868). Less affected were the artists supported by the townspeople. In Tokyo, for example, TSUKIOKA YOSHI-TOSHI continued to create *ukiyoe* ('pictures of the floating world'; *see* §4(iv)(b) above), while SHIBATA ZESHIN and KAWANABE KYŌSAI worked in a combination of styles. In Kyoto, where the naturalistic painters of the Maruyama–Shijō school (*see* §4(viii) above) had been dominant since the end of the Edo period, Mori Kansai (1814–94), Shiokawa Bunrin (1808–77) and Kishi Chikudō (1826–97) transmitted the tradition to the new era. They painted landscapes and bird-and-flower subjects, although Chikudō was particularly well known for his paintings of tigers.

During the second decade of the Meiji period a nationalistic sentiment gradually emerged in the Japanese art world. As a result of a positive reception to Japanese traditional arts at the 1873 Weltausstellung in Vienna, the Meiji government decided to promote Japanese arts for export to the West. In 1879 a group of officials who had promoted Japan's participation in expositions at home and abroad and who wanted to protect traditional painting formed a semi-official art organization called the Ryūchikai (Dragon Pond Society; renamed the Nihon Bijutsu Kyō-kai, or Japan Fine Arts Association, in 1886). The Ryūchikai sponsored a series of exhibitions aimed at reviving interest in native arts among the public, the painters and exporters of art to Europe and America. The arrival in Tokyo of ERNEST FRANCISCO FENOLLOSA in 1878 also contributed to the change in the artistic climate. Fenollosa, who was invited by the Meiji government to teach philosophy and economics at the Imperial University in Tokyo, became deeply enamoured of Japanese art. He began to collect and became a connoisseur of traditional Japanese painting. Tenshin Okakura, an Imperial University student who assisted Fenollosa during this time, figured prominently in the later development of *Nihonga*.

Fenollosa championed traditional Japanese painting, particularly that of the Kanō school, and promoted its continuation in a modernized form. Two important *Nihonga* artists in Tokyo who became involved in this new movement were the Kanō-school painters Kanō Hōgai (*see* KANŌ, (16)) and HASHIMOTO GAHŌ. Hōgai and Gahō later became involved in Fenollosa and Tenshin Kangakai (Painting Appreciation Society, est. 1884), which advocated the practice of *Nihonga*. Responding to urging from Fenollosa, Hōgai attempted to create modern Japanese-style painting, as seen in the hanging scroll *Bodhisattva of Mercy* (*Hibo Kannon*; 1888; Tokyo, U. F. A. & Music). In works such as this Hōgai demonstrated the superb craftsmanship of Japanese painting tradition on the one hand, and an innovative use of colour outline and a convincing rendition of atmospheric space on the other.

The resurgence of traditional Japanese painting culminated in the opening of the Tōkyō Bijutsu Gakkō (Tokyo Art School; now the University of Fine Arts and Music in Tokyo) in 1889, where only *Nihonga* and traditional wood sculpture, metalwork and lacquerware techniques were taught. Hashimoto Gahō became the first professor of *Nihonga*, and Tenshin Okakura quickly rose to the position of principal. Tenshin further advocated the need to create modern Japanese painting, but his artistic view was broader than Fenollosa's. He encouraged students not only to study older traditional styles of Japanese painting but also to examine Western-style painting.

Three leading disciples of Tenshin and Gahō were SHUNSŌ HISHIDA, TAIKAN YOKOYAMA and KANZAN SHIMOMURA (1873–1930). When Tenshin resigned from the Tokyo Art School and founded the Nihon Bijutsuin (Japan Art Institute) in 1898, Gahō, Shunsō, Taikan and Kanzan followed their mentor and became members of this institute, which was the source of the most controversial attempts to modernize the *Nihonga* tradition. Stimulated by their interest in the work of contemporary *Yōga* artists, painters of the Japan Art Institute, particularly Shunsō and Taikan, experimented in the depiction of air and light in their paintings. This resulted in a technique called *morōtai* ('vague manner'), in which boundary lines, the primary tool of expression in traditional Japanese painting, were largely abandoned in order to create the sense of atmosphere and light. The earlier wash technique known as *mokkotsu* ('boneless'; Chin. *mogu*) had been used by Chinese and Japanese painters to achieve the sense of three-dimensionality of objects in painting, but *morōtai* was far more radical in concept and in technique. Taikan's *Rape Plants* (*Na no ha*; 1900; Japan, priv. col.; see Hosono, pl. 10) is an excellent example of *morōtai* technique. By eliminating the outline almost entirely and applying colours to the large surface area with a wide brush, Taikan creates a feeling of warm spring air and sunlight. For many critics at the time, *morōtai* paintings resembled Western painting too closely in style; the term itself was derogatory, implying that it was not sincere or authentic Japanese painting.

Whereas Fenollosa and Tenshin's circle in Tokyo developed *Nihonga* using the Kanō painting style as a basis, the Maruyama–Shijō tradition eventually became the foundation of *Nihonga* in Meiji-period Kyoto. The distinct artistic development in the two cities resulted in the geographical polarization of *Nihonga* between Tokyo and Kyoto *gadan* ('art group' or 'art circle'), a term that carried not only artistic but also political overtones, in that Tokyo was seen as more modern or progressive. Although the modernizing trend did not engulf Kyoto as it did Tokyo in the early Meiji years, some Kyoto artists were keenly aware of changing times. KŌNO BAIREI, for example, a versatile Maruyama–Shijō painter, was instrumental, with other artists, in founding in 1880 the Kyōto Furitsu Gagakkō (Kyoto Prefectural School of Painting), the first professional art institution in Japan where both *Nihonga* and *Yōga* were taught. After Fenollosa's visit to Kyoto in 1886, however, some younger artists began to modernize the Japanese-style painting tradition.

One young Kyoto painter deeply moved by Fenollosa's urge to update this tradition was SEIHŌ TAKEUCHI, who in 1900 travelled to Europe, one of the earliest *Nihonga*

painters to do so. On his return he created a series of romantic landscape paintings showing foreign-inspired scenes in Japanese traditional media. A prolific artist and discerning teacher, Seihō became the leader of the Kyoto *gadan* and one of the most influential painters in Japan. Other important Kyoto artists of Seihō's generation were Hobun Kikuchi (1862–1918), Kōkyō Taniguchi (1864–1915), Kakō Tsuji (1870–1931) and Shunkyō Yamamoto (1871–1933).

In 1907 the government established the Bunten (abbreviation of Monbushō Bijutsu Tenrankai, or Ministry of Education Art Exhibition), an art exhibition modelled after the French Salon and divided into *Nihonga*, *Yōga* and sculpture sections. The Bunten enabled Japanese artists to compete on a national level and made the public more art-conscious, while the social prestige associated with the official exhibition intensified the rivalry among the different groups of artists with regard to the selection of jury members and works to be exhibited. The Bunten evolved into an independent establishment, transforming itself eventually into the current Nitten (Nihon Bijutsu Tenrankai, Japanese Art Exhibition).

(b) Taishō period (1912–26 and after). The concept of individualism that gained ground in the Meiji period, with Japan's increasing national confidence, became manifest in the art of the Taishō period (1912–26). Modernizing influences came from Europe, among them Post-Impressionism, Fauvism and Cubism. Taishō-period painting developed in multiple directions, with specialist groups following historical, popular and naturalistic genres, and the art associated with the Bunten began to represent the orthodox stream in general. Important among the many artists who centred their activities on the official Salon during the Taishō and early Shōwa (1926–89) periods were Hyakusui Hirafuku (1877–1933), Kiyokata Kaburagi (or Kaburaki; 1878–1972), SHŌEN UEMURA and Kansetsu Hashimoto (1883–1944). Kiyokata specialized in figure painting and created some of the most memorable portraits

in *Nihonga*. Shōen, the foremost woman painter of her time, concentrated on the still-popular *bijinga* ('paintings of beautiful women').

The two important *Nihonga* movements of the Taishō period, however, were led by groups independent of the Bunten circle. Owing to financial difficulties, the Japan Art Institute led by Tenshin declined considerably by the end of the Meiji period. After Tenshin's death in 1913, his protégés, Taikan and Kanzan, decided to restore the Institute as an active centre of Tokyo *Nihonga* artists. In 1914 they founded the Saikō Nihon Bijutsuin (New Japan Art Institute). Among the associated artists were Shikō Imamura (1880–1916), YUKIHIKO YASUDA, KOKEI KOBAYASHI, SEISON MAEDA, Keisen Tomita (1879–1936), Ryūshi Kawabata (1885–1935) and GYOSHŪ HAYAMI. Shikō achieved a stunning expressiveness in *Tropical Country Scroll* (*Nekkoku no maki*; see fig. 108) through a combination of impressionistic brushwork, bird's-eye perspective and bright colours. The use of colour for expressive purposes became a leading characteristic of Taishō-period *Nihonga*. Kokei, Yukihiko and Seison painted diverse subject-matter, including historical themes, and sought to create a new *Nihonga* inspired by the classical *Yamatoe* painting. In contrast, Tomita achieved a strongly individualistic style that assimilated the expressive brushwork of *Nanga* painting. Ryūshi Kawabata experimented widely and established a powerful, decorative style characterized by monumental scale and bold use of colour.

The Kokuga Sōsaku Kyōkai (National Creative Painting Society), established in 1918, initiated another noteworthy *Nihonga* movement of the Taishō period. Active members of this group included BAKUSEN TSUCHIDA, Shihō Sakakibara (1887–1971), Chikkyō Ono (1889–1979) and KAGAKU MURAKAMI. The group called for honest and heartfelt expression uninhibited by existing traditions. The members were united not so much by stylistic affinity as by a passionate belief in individual freedom of expression and a determination to create a truly modern form of

108. Shikō Imamura: *Tropical Country Scroll* (detail), handscroll, colours on paper, 457×9545 mm, 1914 (Tokyo, National Museum)

109. Hisako Kajiwara: *Train Station in the Early Evening*, colours on silk, 1902×833 mm, 1918 (Kyoto, City Art Museum)

Nihonga. The paintings shown at their annual exhibitions, therefore, displayed a diversity in style and theme. Bakusen's *Bathhouse Woman* (*Yuna*; 1918; Tokyo, N. Mus. Mod. A.) represented one facet of this group in its monumentality, striking colour combination and unrestrained expression of sensual beauty. *Train Station in the Early Evening* (*Kureyuku teiryusho*; 1918; see fig. 109) by Hisako Kajiwara (1896–1988) exemplified another facet in its depiction of a weary and tired waitress. The unidealized image of working-class women had rarely been seen in Japan before; some Taishō-period artists such as Hisako

demonstrated a strong interest in the social issues of the time.

In both Tokyo and Kyoto *Nihonga* after the mid-Taishō period there was an interest in naturalistic detail stimulated by the contemporary *Yōga* movement. The belief in individualism was reflected in an emphasis on the artist's personal ability to see and an insistence on honouring that individual way of seeing. This was one way for *Nihonga* artists to liberate themselves from the established modes of painting. In Gyoshū Hayami's *Dancing Girl of Kyoto* (*Kyo no maiko*; 1920; Tokyo, N. Mus.), the artist pursues, as far as possible in *Nihonga* media, the optical reality of the figure and her surroundings.

Certain artists in the Taishō period declined to confine themselves to conventional standards, in art or life. Yumeji Takehisa (1884–1934) began his career as an illustrator and was entirely self-taught. His romantic depiction of women greatly appealed to the masses. Executed mostly in watercolour on paper or silk in the traditional hanging scroll and screen formats, Yumeji's paintings defied ordinary categorization, as did his vagabond lifestyle.

The optimistic and permissive mood of the Taishō period, underpinned by unprecedented economic prosperity, did not last long. By the late Taishō period the economy of Japan was in depression, and in 1923 one of the worst earthquakes in Japanese history devastated Tokyo. During the first decade of the Shōwa period the parliamentary system of government that had begun to take root during the previous period gave way to a military-backed regime. During this period of rising nationalistic sentiment, the romantic yearning for individualism, as seen in Taishō-period *Nihonga*, was replaced generally by a cooler and more restrained style. Kokei Kobayashi's work *Hair* (*Kami*; 1930; Tokyo, Eisei Bunko) best exemplifies this trend. Kokei achieved aesthetic purity in this work through austere composition, an exquisite colour scheme and severe, controlled line. As Japan's military involvement escalated from the outbreak of the Sino-Japanese War in 1937 to World War II, the activities of both *Nihonga* and *Yōga* artists were restricted. Most were compelled to depict war themes and nationalistic subjects or document actual battle scenes as dispatch artists.

After World War II, Japan entered a new, active period of Westernization. Although *Nihonga* was denounced by many as outdated, the tradition did not die. In their effort to answer the demand for contemporary forms of expression, *Nihonga* artists increasingly assimilated the techniques and styles derived from *Yōga* with an emphasis on formal elements. Post-World War II *Nihonga* is thus sometimes indistinguishable in subject and style from *Yōga*, except for the use of traditional materials. Among the artists working after the war were Misao Yokoyama (1920–73), MATAZŌ KAYAMA, IKUO HIRAYAMA, YASUSHI SUGIYAMA, GYOSHŪ HAYAMI and Hitoshi Komatsu (*b* 1902).

BIBLIOGRAPHY
K. Kanzaki: *Kyōto ni okeru Nihongashi* [History of *Nihonga* in Kyoto] (Kyoto, 1929)
R. Saitō: *Nihon bijutsuinshi* [History of the Japan Art Institute] (Tokyo, 1944)
L. W. Chisholm: *Fenollosa: The Far East and American Culture* (New Haven and London, 1963)
N. Asano, Y. Kobayashi and G. Hosokawa, eds: *Genshoku Meiji hyakunen bijutsukan* [Japanese art during the 100 years since Meiji, illustrated]

(Tokyo, 1967)

T. Nakamura: 'Meiji no Nihonga' [*Nihonga* of the Meiji period], *Nihon No Bijutsu*, xvii (1967) [whole issue]

M. Torao: *Modern Japanese Paintings: An Art in Transition* (Tokyo, 1967)

I. Oka and K. Kumamoto, eds: *Meiji*, Nihon kaigakan [Japan picture gallery], ix (Tokyo, 1969)

T. Hijikata, ed.: *Gendai* [Contemporary period], Nihon kaigakan, xi (Tokyo, 1971)

S. Suzuki, ed.: *Taishō*, Nihon kaigakan, x (Tokyo, 1971)

M. Kawakita: *Kindai no Nihonga* [Modern Japanese-style painting], Genshoku Nihon no bijutsu [Arts of Japan, illustrated], xxvi (Tokyo, 1972)

M. Hosono: *Yokoyama Taikan*, Gendai Nihon bijutsu zenshū [Complete collection of Japanese modern art], ii (Tokyo, 1972–4)

S. Fujimoto, ed.: *Nihon no kindai bijutsu: Bakumatsu kara gendai made* [Japanese modern art: from the end of the Edo period to modern times] (Tokyo, 1974)

T. Tanikawa and M. Kawakita, eds: *Gendai Nihon no bijutsu* [Japanese modern art]

Kyoto Gadan: Edo matsu Meiji no gaintachi [Kyoto painters during the late Edo and early Meiji periods] (exh. cat., Kyoto, City A. Mus., 1977)

S. Takahashi and M. Kawakita, eds: *Gendai Nihon bijinga zenshū* [Complete collection of modern Japanese painting of beautiful women], 12 vols (Tokyo, 1977–9)

M. Kawakita: *Nihon bijutsu no dentō to gendai* [Tradition of Japanese art in modern times] (1977), i of *Kawakita Michiaki bijutsuronshū* [A collection of the art theories of Kawakita Michiaki] (Tokyo, 1977–8)

M. Kawakita and S. Takashina: *Kindai Nihon kaigashi* [History of modern Japanese painting] (Tokyo, 1978)

H. Iinkai, ed.: *Nittenshi* [History of the Nitten], 20 vols (Tokyo, 1980–88)

MICHIYO MORIOKA

(iv) Yōga.1

(a) Meiji period (1868–1912). The Technical Art School founded in 1876 (*see* §(i) above) attracted all manner of students eager to study with foreign teachers and to have access to Western painting supplies and illustrative materials not otherwise available in Japan. These young Japanese artists, some already trained by native teachers, appreciated the talents and tutelage of its head, Antonio Fontanesi, but the elderly painter, ill and disillusioned with the project, resigned in 1878. His abler pupils also had higher ambitions and, deeming his replacement, Prospero Ferretti, greatly inferior, they resigned to form Jūichikai (Society of Eleven), which included such important early *Yōga* artists as Shōtarō Koyama (1857–1916), Hisashi Matsuoka, Seijurō Nakamura, CHŪ ASAI, Hōsui Yamamoto (1850–1906) and Yoshimatsu Goseda. Ferretti was replaced early in 1880 by Achille San Giovanni, who continued to train the remaining students, including Yukihiko Soyama, Masaaki Horie and Masazo Fuji. By the time the school closed in 1883, the government had prepared some pupils for further study abroad, it had appointed the basic staff to meet its architectural and artistic needs and to train others and it had furthered the training of some painters who later won prizes both at home and abroad.

Another important contribution to the development of *Yōga* was the tutelage of the Italian engraver Edoardo Chiossone, who was engaged by the Printing Bureau of the Ministry of Finance to train the Japanese to produce counterfeit-proof paper currency and financial and legal documents essential to the Meiji government. He taught the newest techniques of engraving and printing to those

110. Eisaku Wada: *Old Woman*, oil on canvas, 940×1365 mm, 1908 (Tokyo, National Museum of Modern Art)

technicians and artists employed by the Printing Bureau, among them Kiyoō Kawamura and Teiko Ishii, as well as to the temporary employees of private printing companies. This led to the widespread use of Western-style art for official purposes and textbook illustration. Chiossone's portrayal of the Meiji emperor and government officials for state purposes furthered the development of Western-style portraiture. His search for appropriate national imagery, such as his representation of the legendary Empress Jingū on a banknote, anticipated the efforts of *Yōga* artists, such as Naojirō Harada (1863–99) and SHIGERU AOKI, to nationalize a foreign technique by depicting themes from Japanese legend. These new printing techniques also facilitated the reproduction of traditional works of art and thereby enlarged the appreciation of Japan's artistic heritage both at home and abroad.

Government plans to establish a permanent art school that would teach both Japanese and Western courses were thwarted by a faction in the Ministry of Education, led by Ryūichi Kuki (1852–1931), which managed to defer the establishment of the Tokyo Art School, headed by Tenshin Okakura, until 1889 when they could ensure that the curriculum would be restricted to the traditional arts. Although *Yōga* artists had participated in previous national and international expositions, they were debarred from the first and second National Competitive Painting Exhibitions (Naikoku Kaiga Kyōshinkai) held in Tokyo in 1882 and 1884. Apart from teaching and limited private patronage they were dependent on the government for employment and the opportunity to exhibit. Hence they viewed with alarm the appointment in 1887 of Ryūichi Kuki as director of the Imperial Museum (now Tokyo, N. Mus.) and thus *de facto* vice-president of national and international expositions and chief juror. The *Yōga* artists therefore banded together in 1889 to form the Meiji Bijutsukai (Meiji Art Society), which held its first exhibition that year, attended by the empress and members of the court.

In 1890 the society also exhibited for the first time some 80 European paintings lent by Tadamasa Hayashi. Although some members reluctantly participated in the third National Industrial Exposition (Naikoku Kangyō Hakurankai) held in Tokyo in 1890, they boycotted the World's Columbian Exposition held in Chicago in 1893. Thus, on the first occasion when Japan was permitted, despite differences in media and category, to exhibit in the Fine Arts Building, *Yōga* and women artists were absent, and the committee, led by Kuki, set the precedent for exhibiting extremely large, lavish and elaborate works of art and 'art crafts' as a means of securing national recognition and international acclaim.

Whatever the ultimate evaluation of his achievements as a painter, SEIKI KURODA must be credited with raising the status of the *Yōga* artist. His noble ancestry, political and social prestige, and personal wealth and charm enabled him on his return in 1893, after close to a decade of study and travel in Europe, to improve the position of the embattled *Yōga* artists. Together with his colleague Keiichirō Kume (1866–1934) and two artists they had known abroad, Hōsui Yamamoto and Kiyoshi Goda, they organized a private school that attracted TAKEJI FUJISHIMA, Saburōsuke Okada (1869–1939), Eisaku Wada (1874–

111. Ryūzaburō Umehara: *Landscape in Shiroyama*, oil and Japanese pigments on canvas, 810×650 mm, 1938 (Tokyo, National Museum of Modern Art)

1959; see fig. 110) and other talented pupils and where Kuroda transmitted the *plein-air* painting he had learnt from Raphaël Collin (1850–1916). Kuroda was able to override Kuki's attempt to debar his prize-winning painting of a nude, *Morning Toilette* (1893; untraced after World War II), from the fourth National Industrial Exposition held in Kyoto in 1895 (for illustration *see* KURODA SEIKI). The following year Kuroda and Kume, assisted by Fujishima, Okada and Wada, were invited, during the brief tenure of their friend Prince Saionji as Minister of Education, to establish a department of Western-style painting at the Tokyo Art School, which became the principal official school for study of Western-style art. A month later they withdrew from the Meiji Art Society because of differences over style and established Hakubakai (White Horse Society), which was the dominant organization of *Yōga* artists for the remainder of the Meiji period.

New organizations and artistic currents vied for attention. The Taiheiyō Gakai (Pacific Painting Society), organized in 1899, numbered among its members Hiroshi Yoshida (1876–1950), Hachirō Nakagawa, Kunishirō Mitsutani (1874–1936), Takeshirō Kanokogi, Banka Maruyama, Fusetsu Nakamura (1866–1943), Tojirō Oshita and Hakutei Ishii (1882–1958), all of whom had studied in France, mostly with JEAN-PAUL LAURENS. A pervasive mood of historicism and romanticism influenced the work of Shigeru Aoki and to a lesser degree that of Fujishima, Okada, Wada and Hiromitsu Nakazawa. Another important development was the establishment in Kyoto by Chū Asai, on his return from Paris in 1902, of the Kansai

Bijutsuin (Kansai Art Academy), where this highly gifted artist trained RYŪZABURŌ UMEHARA, SŌTARŌ YASUI, Jutarō Kuroda and Seifū Tsuda (1880–1978). Trained in the milieu of the traditional arts, both Umehara (see fig. 111) and Yasui visited France and, after their return, became leading artists of the Taishō (1912–26) and Shōwa (1926–89) periods; yet neither reached his full potential, Yasui because of a sense of alienation and Umehara because he was too indiscriminately admired and sought after.

(b) Taishō period (1912–26) and after. Yōga artists were both helped and harmed by the establishment of the Bunten, the Japanese version of the Paris Salon, in 1907. (The name was changed after 1919 to Teiten, or Imperial Art Academy Exhibition.) By Japanese custom, the masters and disciples of all the major factions were allocated prizes on an alternating basis, a practice that furnished little insight into individual accomplishments or significant trends and may even have inhibited more independent and creative developments. To escape the heavy hand of government, artists banded together, less on the basis of shared artistic values than to secure the chance to exhibit, gain public recognition and find patrons. One such group was the Shunyōkai (Spring Season Society), which developed Japanese Fauvism. Also organized in 1914 in opposition to the Bunten was the NIKAKAI (Second Division Society). Its members included Umehara, Yasui, Tsuda, Shintarō Yamashita (1881–1966), Misei Kosugi, Ikuma Arishima (1882–1974), Hanjirō Sakamoto and Kunzō Minami, and their competitive experiments in a number of styles set the tone for the Taishō and early Shōwa periods. Influenced by Impressionism, Post-Impressionism, Cubism, Fauvism and literary journals such as *Shirakaba* ('White Birch'), Yori Saitō (1885–1959) organized Fyūzankai (Fusain or Sketching Society) in 1910 in the hope of affording artists greater freedom to experiment. Among its members were the two most creative Taishō-period painters, Ryūsei Kishida and Tetsugoro Yorozu. Other interesting figures were Shōji Sekine (1899–1919), Narashige Koide and Tsune Nakamura. All of them sought in differing ways to absorb and internalize artistic currents from abroad and their dialogue in Japan with *Nihonga (see* §(iii) above).

Yōga artists had not only to acclimatize themselves to the sweeping political, social and economic changes of the Meiji era but also to contend with such practical difficulties as the fact that, even in the early Shōwa period, most Japanese still resided in traditional homes that did not offer ideal opportunities for the display of their art. People who favoured *Yōga*, such as university professors, literary figures and leading businessmen, often lacked a discriminating appreciation of the traditional arts and had only a limited, superficial and largely literary acquaintance with Western art. Recognition too often went to the most flamboyant artists returning from abroad with the latest fashion, to the artists most sorely afflicted at home or abroad, such as Yuzō Seiki, or to the artist whose ideals they found most commendable, such as Hanjirō Sakamoto. Such subjective and topical judgements rarely coincide with Western appraisals, which are based on different criteria and attitudes, including ethnocentricity. The gap

between Japanese and foreign estimation of *Yōga* is greater than in any other aspect of Japanese art, even its earliest and most esoteric forms, and is widened by the unfamiliarity of the Western art public with the century of Japanese Western-style painting after 1868. By the late 20th century, although the division between *Yōga* and *Nihonga* persisted, it was increasingly irrelevant and arbitrary.

BIBLIOGRAPHY
M. Harada: *Meiji no yōga*, Nihon no bijutsu [Arts of Japan], xxx (Tokyo, 1968); Eng. trans. by A. Murakata as *Meiji Western Painting*, Arts of Japan, vi (New York and Tokyo, 1974)
Paris in Japan: The Japanese Encounter with European Painting (exh. cat. by S. Takashina, J. T. Rimer and G. D. Bolas, Tokyo, Japan Found.; St Louis, MO, Washington U., 1987–8)

ELLEN CONANT

(v) Avant-garde.

(a) *c.* 1910–45. (b) After 1945.

(a) c. *1910–45.* Japanese avant-garde art grew out of the most radical faction of the NIKAKAI (Second Division Society; *see* §(iv)(b) above) in the mid-1910s. Many Futurist and Cubist works by TETSUGŌRŌ YOROZU, TAI KANBARA, SEIJI TŌGŌ and others were shown at the fourth Nikakai exhibition in 1917. As a result, the Miraiha Bijutsu Kyōkai (Futurist Art Society) was established in 1920 by, among others, Kamenosuke Ogata (1900–42), Masamu Yanase (1900–45) and the Russians David Burlyuk (*see* BURLYUK, (1)) and Victor Porimov. The Miraiha was not meant merely to reproduce the trends of Italian Futurism but rather to represent Futurist art in the loose sense. However, through Burlyuk's contribution, it assumed aspects of Russian Futurism, not only in terms of

112. Harue Koga: *Avalokiteshvara*, oil on canvas, 910×725 mm, 1922 (Tokyo, National Museum of Modern Art)

style but also in as much as the seeds of awareness of the avant-garde were planted in its young members.

In 1923 Kazumasa Nakagawa (*b* 1893), who had studied with Matisse, and Tomoe Yabe (*b* 1892), who, as a pupil of Maurice Denis, had experienced Purism, returned from France and, with Tai Kanbara as the central figure, founded the group Akushon (Action), along with HARUE KOGA, Minoru Nakahara (*b* 1893) and others. In the same year, the MAVO group was organized by TOMOYOSHI MURA-YAMA, Masamu Yanase and Kamenosuke Ogata. Murayama, who had spent over a year in Berlin and returned to Japan influenced by Russian Structuralism and the collages of Kurt Schwitters, took Akushon to task for its imitation of the latest European trends. The MAVO group produced works that ranged from Structuralist to Dadaist.

Each of these small groups was short-lived, enthusiastically meeting, parting and re-forming. In 1924, however, Hideichirō Kinoshita took the lead in arbitrating between avant-garde artists, forming the Sanka Zōkei Bijutsu Kyōkai (Three Division Plastic Arts Society). It too splintered almost immediately, one part of the group drifting along with the rise of socialism into the proletariat art movement.

The various new European artistic trends that had been introduced to Japan by avant-garde artists in the Taishō period (1912–26) were widely dispersed and popularized in the following Shōwa period (1926–89), while radical artists continued to be active. The Nikakai remained operative, its lead followed by such groups as the Senkyūhyaku Sanjū-nen Kyōkai (1930 Society; Fauvist, founded by Harue Koga, Yatarō Noguchi (*b* 1899), Kigai Kawaguchi and ICHIRŌ FUKUZAWA); the Dokuritsu Bijutsu Kyōkai (Independent Art Society; Fauvist, founded by Katsuzō Satomi (1895–1981), Zentarō Kojima (*b* 1892) and others); and the Shin Seisaku Kyōkai (New Art Work

Society of Toshio Nakanishi (1900–48), Genichirō Inokuma (*b* 1902) and others). Each had its particular characteristics, the wide range of styles adopted including Cubism, Dada, Futurism and Surrealism.

Mainstream art during the time of the Shin Bunten (New Bunten, 1937–44) developed along modernized 'Neo-classical' lines. Oil painters became appreciably more proficient than their predecessors in the Taishō period, demonstrating a deep understanding of the medium and its capabilities and producing works of high quality, although largely in imitation of Western styles.

Western Surrealism also had an impact, although Japanese Surrealism was again largely imitative. It was first seen in the work of such artists as Harue Koga (as demonstrated in his treatment of traditional Buddhist subjects such as *Avalokiteshvara* (Jap. Kannon; see fig. 112), Kōtarō Migishi (1902–34) and, notably, Ichirō Fukuzawa, who returned to Japan in 1931 after a seven-year stay in France, where he was heavily influenced by such artists as Giorgio De Chirico and Max Ernst. The Surrealist movement in Japan remained active during the 1930s.

In the five or six years before 1941 Japan was becoming increasingly militaristic. Folk arts were severely suppressed by the government and already by about 1933 had been virtually annihilated. Interestingly, this period coincided with the birth of a number of short-lived avant-garde groups such as the Shinjidai Yōga Ten (New Era Western Painting Exhibition) and the Kokushoku Yōga Ten (Black Western Painting Exhibition), rebel groups that united their members in opposition to the state, as did the Jiyū Bijutsu Kyōkai (Independent Art Society; principally abstract art, 1937), the Kyūshitsu Kai (Room Nine Society; mixed styles, 1938) and the Bijutsu Bunka Kyōkai (Art Culture Society; principally Surrealist, 1939), one member

113. Ai Mitsu: *Landscape with an Eye*, oil on canvas, 1938 (Tokyo, National Museum of Modern Art)

of which was AI MITSU (an example of his disturbing, semi-abstract style is *Landscape with an Eye*; see fig. 113). There was no clear distinction between academic and avant-garde painting during this time; in fact, the avant-garde character of art resided mostly in its political connotation, functioning as a protest movement. Nevertheless, there was a danger that avant-garde art might degenerate into stylization and academicism, and it was the keen awareness of this possibility that kept the movement alive after the war. Key figures in this process were JIRŌ YOSHIHARA, whose abstract works were sometimes reminiscent of Zen ink paintings (e.g. *White on Black*; see fig. 114), and YOSHISHIGE SAITŌ.

During the war certain painters were employed by the government to create documentary works. This inevitably resulted in a transformation of their styles and a suppression of all forms of individual expression. The artists included Fujita Tsuguji, Ichirō Fukuzawa and Iwao Uchida (1900–53). Their works, which are no more than depictions of a harsh reality, indicate that Japanese painting after the end of the 19th century had, in the drift towards academicism, lost much of its force and independence. The transfer to official painting was therefore not a big step.

(b) After 1945. After the war Japanese painting stagnated. Partly because of a lack of materials and because painting in the United States was also at a low ebb, Japanese artists turned principally to sculpture and three-dimensional art, producing some noteworthy individualistic works. During the Allied Occupation (1945–52) the information entering Japan about Western art was naturally limited, but in due course the United States began to make efforts to help Japan regain its pre-war structure and systems. Group exhibitions, beginning with the government-sponsored Nitten (Japanese Art Exhibition) and the Nikakai, were resumed in newly organized forms. Taisei Meigaten (Exhibitions of Famous Works of the Occident), showing paintings of the late Meiji period or the Taishō, were staged repeatedly. The ECOLE DE PARIS style of Ebihara Kinosuke (1904–70) and SHIKANOSUKE OKA and the Japanized version of Impressionism of Ryūzaburō Umehara or SŌTARŌ YASUI, both carried over from pre-war days, moved into the limelight. There was a general feeling of a revival of the *ancien régime*. Adherents of the Shinjin Gakai (Painting Society of New Talent), among them Masao Tsuruoka, Saburō Asō, Shunsuke Matsumoto, TARŌ OKAMOTO and Tatsuoki Nanbata, also produced some noteworthy works. Nevertheless, in the late 1940s restrictions on the importation of books and works of art and on travel were almost as stringent as during and before the war; the return to pre-war trends was therefore hardly surprising.

With the advent of the 1950s, however, international trade began to increase, and news of artistic trends in the West flooded into Japan. As in the second half of the 19th century, but to a lesser degree, this led to a certain conflict between foreign and native, modern and traditional. The situation gave rise to such groups as the Salon de Nu, the Informel, the Nihon Abusutorakuto Āto Kurabu (Japanese Abstract Art Club; founded in 1953 by Saburō Hasegawa) and the Misshitsu-no-kaiga (Secret Room

114. Jirō Yoshihara: *White on Black*, oil on canvas, 1820×2275 mm, 1965 (Tokyo, National Museum of Modern Art)

Painting), and to some admirable pieces of reportage painting.

From the mid-1950s to the mid-1960s a number of new avant-garde groups sprang up, including the Gutai Bijutsu Kyōkai (Concrete Art Society) of the Kansai (Kyoto–Osaka) region (with Jirō Yoshihara, Kazuo Shiraga (*b* 1924), Atsuko Tanaka (*b* 1932), Akira Kanayama, Saburō Murakami, Sadamasa Motonaga (*b* 1922) and others), the Kyushuha (Kyushu School) and the Neo-Dadaist Tokyo Hangeijutsu (Anti-Art Society; with adherents such as SHUSAKU ARAKAWA, Tetsumi Kudō, Natsuyuki Nakanishi (*b* 1935), Tomio Miki and Jirō Takamatsu). These trends were contemporaneous with analogous Western movements yet developed independently, without imitation of or stimulation by the West. Underlying them was 'the ideology of the dissolution of form', brought about by a worldwide questioning of the very foundations of art. In Japan this led to the dissolution of the modern form before it was even properly established. Japanese art, which differed greatly from its Western counterpart, therefore began to tread a new and independent path with the establishment of the Gutai and Kyushu schools and the Anti-Art Society.

The Monoha (Object School), which existed from the end of the 1960s to the first half of the 1970s, was another association of people keen to resolve the question of what constituted art after the period of the 'dissolution of form'. Like the Gutai, it was exclusive to Japan. Chronologically, it corresponded to the era of conceptual art in the West but differed from that movement in acknowledging the existence of artistic limits. Like the Gutai, Kyushu School and the Anti-Art Society, it produced mainly three-dimensional, utilitarian art objects in which the question of 'form' was the main consideration.

From the mid-1960s many Pop art paintings were executed (for example by Shinjirō Okamoto and Kōichi Tateishi). Other painters created work in a Minimalist style or excelled as abstract artists, and from the late 1970s there were some interesting painters such as Kosai Hori

115. Kosai Hori: *I Saw Birds in ROMA I*, acrylic, natural pigment and Chinese ink on paper and canvas, 2.27×3.64 m, 1991 (Tokyo, Muramatsu Gallery)

(*b* 1946), who made eclectic use of modern and traditional materials (as in *I Saw Birds in ROMA I*, 1991; see fig. 115). On the whole, however, post-war Japanese painting has been undistinguished: at no time has painting been the driving force of the age. Perhaps, in view of the dramatic upheavals and contradictions of Japan's history, it was inevitable that modern painting in Japan would encounter difficulties much greater than those in most other nations.

BIBLIOGRAPHY

M. Kawakita: *Kindai bijutsu no nagare*, Nihon no bijutsu [Arts of Japan], xxiv (Tokyo, 1965); Eng. trans. by C. S. Terry as *Modern Currents in Japanese Art*, Heibonsha Surv. Jap. A., xxiv (New York and Tokyo, 1974)
M. Torao: *Modern Japanese Paintings: An Art in Transition* (Tokyo, 1967)
N. Tanio: *Contemporary Japanese-style Painting* (Tokyo, 1969)
M. Kawakita: *Kindai no Nihonga* [Modern Japanese-style painting], Genshoku Nihon no bijutsu [Arts of Japan, illustrated], xxvi (Tokyo, 1970)
M. Sakamoto and others: *Nanban bijutsu to yōfūga* [Western-style painting of the Edo period], Genshoku Nihon no bijutsu [Arts of Japan, illustrated], xxv (Tokyo, 1970)
S. Takashina: *Kindai no Yōga* [Modern Western-style painting in Japan], Genshoku Nihon no bijutsu [Arts of Japan, illustrated], xxvii (Tokyo, 1971)
S. Fukimoto, ed.: *Nihon no kindai bijutsu: Bakumatsu kara gendai made* [Japanese modern art: from the end of the Edo period to modern times] (Tokyo, 1974)
T. Tanikawa and M. Kawakita, eds: *Gendai Nihon no bijutsu* [Japanese modern art], 14 vols (Tokyo, 1974–7)
T. Toru: *Japanese Art in World Perspective* (Tokyo, 1976)
T. Hijikata and M. Kawakita, eds: *Genshoku gendai Nihon no bijutsu* [Modern arts of Japan, illustrated], 18 vols (Tokyo, 1977–80)
M. Kawakita and S. Takashina: *Kindai Nihon kaigashi* [History of modern Japanese painting] (Tokyo, 1978)

SHIGEO CHIBA

6. CONSERVATION. Painting conservation in Japan has always required the application of outstanding skills, not only in the presentation and mounting of paintings but also in their conservation. No painting, whether mounted on a folding screen, a sliding door or a horizontal or vertical scroll, can be worked on or moved unless certain operations are carried out to ensure its safe conservation. The *hyogushi* ('master-framer') is not therefore merely a picture framer but a highly qualified professional with complete mastery of the key: paper, silk, mineral pigments, ink, animal glue and starch paste, as well as wood and metal. He must also possess historical and regional knowledge of the different types of traditional mountings (*see* MOUNTING, §§1 and 2). It takes a minimum of ten years for a craftsman to become thoroughly proficient as a *hyogushi*. Increasingly, Western restorers have shown interest in the vital and wide-ranging role of the *hyogushi* and in the techniques used (see fig. 116).

(*i*) *Workshop and tools.* The picture framer's workshop is set out in the traditional way. The floor is covered with matting, and on it are positioned one or more work boards made of solid wood and mounted on low trestles. The craftsmen work kneeling or sitting on the floor. The work requires at least two people, but some of the larger workshops employ ten or even twelve. The surface of the work-benches used for wetting out is covered in brown lacquer. The reverse side is kept for dry work (measuring, cutting, joining together and small drying operations done under the press). The *hyogushi* uses an impressive range of brushes, each with a precise use, based on its shape and

the type and length of its bristles; all have evolved over the centuries. The sizing brush (*noribake*) and the finishing brush (*uwabake*) are made of goat's hair and are extremely supple. A small amount of pig hair added to the shorter-haired squeezing brush (*higoki*) and the longer-haired joining brush (*tsukemawashi*) makes them somewhat firmer. The polishing brush (*nadebake*) is made from a blend of long hemp and palm fibres; the same combination, but in greater bulk, is used for the heavier pounding brush (*uchibake*). The delicate water brush (*mizubake*), used for moistening, is made from deer hair. In addition to the *tachihocho*—a knife with a large, crescent-shaped blade used for cutting silks and papers along a ruler's edge—each craftsman has an awl, scissors, reglets, tweezers and a number of bamboo spatulas (*hera*), of different sizes, which he cuts and shapes for himself. These spatulas are indispensable, being used for a variety of dry work, including folding, marking, separating thicknesses, fraying the edges of paper and detaching paintings from the drying board.

(ii) Mounting, preventive and restoration techniques. Most pictorial works in Japan are done on silk or paper, both of which are extremely supple. After completion, they all need to be lined with Japanese paper (*washi*), applied in one or more thicknesses; this creates perfect tension as well as giving protection. The operation is done by applying a paper to the reverse side of the painting using a diluted starch paste. The choice of paper, its thickness, the actual number of lining papers, the time necessary for drying and the different concentrations of starch are all matters for the picture framer, who must also consider the choice of silk or brocade for the surround of the painting and the type and size of the mounting. The remarkable properties of *washi*, in particular its ability to stretch and shrink, make it the basic material of the *hyogushi*, and it is used in most operations and for all types of pictorial representation. The use of starch paste as the main adhesive is connected with one of the most important characteristics of the paper: its reversibility. This adhesive (*nori*) is prepared in the workshop as required. It is a task normally given to apprentices but is not to be undertaken lightly. The wheat starch (gluten-free flour) is mixed with a large amount of water and then simmered, while being stirred continuously, for about 45 minutes. After the adhesive has cooled, it is filtered before use.

Apart from the normal damage likely to affect any work on paper (folds, tears, holes, separation, mould, dust, insects etc), the *hyogushi* may find other problems linked to certain methods of presentation and usually caused by instability or movement. Flexible supports such as scrolls, for example, often show lateral cracks running parallel with the piece of wood around which they are rolled and unrolled. Other fissures can also appear in the mounting of brocades, particularly at the beginning of the roll where

116. Conservation studio specializing in East Asian pictures at the British Museum, London

it is attached to the wooden roller. Other types of problem arise with folding screens and *fusuma* (sliding doors), flexible, supple surfaces that undergo continuous handling, being opened, closed, moved or rearranged. Dirty marks occur, particularly from manual handling, around handles or at other contact points. Sometimes the work suffers vertical or zigzag tears or tears that run diagonally from one of the corners: this is usually due to the play of the wooden frame underneath its paper covering. Further, the damage caused by insects finding a home in the wooden frames can be considerable. In most such cases the painting needs to be remounted on a new frame after restoration. The frame is made to measure by a specialist, then carefully prepared for the mounter, using many successive layers of paper, as in *karibari* (see below).

During restoration, paintings are subjected to many processes. Often the back of the painting has to be treated to wash away the successive layers of old lining papers before replacing them. This operation, which may be long and hazardous if the painting has suffered major damage, has to be carried out in a moist atmosphere, as does even a straightforward remounting. Fugitive colours are refixed, usually with a solution of animal glue, the traditional CONSOLIDANT for paintings in East Asia, although sometimes a polysaccharide extract from seaweed (*funori*) is used as a fixative instead. The painted surface is then covered with absorbent paper and the painting turned face down on the work-bench. When it has been thoroughly wetted on the reverse side, it is laid out completely flat on the bench. The lining papers are then peeled away one at a time, sometimes even millimetre by millimetre. This operation may be completed in a few minutes, but more often it will take several hours, even several days in the case of larger works. After the reverse side of the painting has been stripped, the various treatments can be started— strengthening, reinforcing where appropriate and, in the case of paintings done on paper, filling in any gaps. Thereafter a new lining is put into position. Paintings done on silk are mended at a later stage, from the face side, after lining and drying under tension. Such works are eventually dyed to the ground colour in the hope of avoiding repainting.

Paintings are dried under tension, either provisionally or permanently, on specially designed work-benches called *karibari*. These are made on the same principle as the leaf of a folding screen or a *fusuma*: a mesh of fine brackets of *Cryptomeria japonica* wood (the odour of which is long-lasting and keeps insects away) is used as the base, and this is covered with several layers of *washi*. The paper is applied in six successive stages, with a drying process after each. The wire-lines of each layer of paper are positioned perpendicularly to those of each preceding one. The two final layers, called 'cushion layers' (*ukebari* or *ukashibari*), make up a sort of uniform empty space, small sheets having been pasted down only round the edges. This ensures an even spread of tension beneath the final visible layer, which remains interconnected with all the others.

After drying, the resultant surface of the panel is coated with *kakishibu* (the fermented juice of the kaki fruit), which allows the paper covering to harden and at the same time makes it more or less watertight. Some paintings, once mounted and stretched, need to remain on the bench for several months. All workshops, therefore, possess numerous *karibari*, which are made by the craftsmen themselves, frequently from old frames and in many types and sizes.

BIBLIOGRAPHY

N. Usami and G. Yamamoto: *Hyogu no shiori* [Guide to the profession of *hyogushi*] (Kyoto, 1975)
Zhu Yuanshou: *Guo hua biao bei zhuang heng* [Mounting and presentation of Chinese paintings] (Taipei, 1975)
'*Washi*', *Taiyo* (1979) [whole issue]
M. Koyano: *Japanese Scroll Paintings: A Handbook of Mounting Techniques* (Washington, DC, 1979)
Pan Jixing: *Zhongguo zaozhi jishu shigao* [Essay on the technical history of paper manufacture in China] (Beijing, 1979)
Feng Pengsheng: *Zhongguo shuhua zhuangbiao gaishuo* [General principles of mounting of Chinese paintings and calligraphies] (Shanghai, 1980)
R. van Gulik: *Chinese Pictorial Art as Viewed by the Connoisseur* (Acker, 1981)
Shuhua de zhuangbiao yu xiufu [Mounting and restoration of calligraphy and painting], Palace Museum Restoration Workshop (Beijing, 1981)
Chen Xiuxiong: *Biao bei yishu zhi yanjiu* [Study on the art of mounting paintings] (Taipei, 1982)
Y. Yuyama: *Hyoso no giho* [The technique of mounting paintings] (Tokyo, 1982)
'Adhésifs et consolidants', *I.I.C. Tenth Congress: Paris, 1984*, pp. 122–33
Chagake to kire [Mounting of paintings and fabrics used in the tea ceremony] (Tokyo, 1984)
P. Wills and N. Pickwoad: '*Hyogu*: The Japanese Tradition in Picture Conservation', *Pap. Conservator*, ix (1985) [whole issue, esp. pp. 54–60]
P. Webber and M. Huxtable: '*Karibari*: The Japanese Drying-board', *Pap. Conservator*, ix (1985)
'The Conservation of Far Eastern Art', *I.I.C. Kyoto Congress: London, 1988*

CLAIRE ILLOUZ

VII. Calligraphy.

In Japan the art of calligraphy (*shodō*; 'the way of writing') is not seen merely as the skill of beautiful handwriting but also occupies an elevated cultural and philosophical position alongside poetry and painting. For most of its history it has been closely associated with scholarship. Although it shares the tools, media and techniques of painting, calligraphy has traditionally been regarded as the superior art because of its potential for revealing the writer's heart and mind. Consequently, its practice has been widespread among Japanese of all ages and backgrounds. The self-discipline, cultivation and philosophical overtones inherent in the practice of calligraphy are acknowledged by its 19th-century designation as *shodō* ('the way of the brush').

Calligraphy has had a profound and pervasive influence on the development of the Japanese aesthetic sensibility. This influence is evident not only in the subtle interplay of word and image inherent in art forms such as Buddhist scriptures, narrative handscrolls and monochrome ink painting, but also in textile and lacquer design. Calligraphy has also contributed to the development of modern graphic arts.

1. Introduction. 2. Principal traditions.

1. INTRODUCTION.

(i) Development of Japanese scripts. (ii) Materials, techniques and design. (iii) Historical overview.

(i) Development of Japanese scripts.

(a) Origins. Before Japan came into contact with China in the 3rd century AD, it had developed no writing system of its own. Early Japanese rulers, faced with a growing

need for documents and correspondence, had to rely on Korean 'delegates' to aid in continental affairs. Korea had been under Chinese influence since the 1st century BC and was therefore much more advanced than Japan in its knowledge of Chinese civilization and culture. Eventually, the Japanese began to study the Chinese writing system themselves, a process that was hastened, from the 5th century onwards, by a flood of Chinese literature arriving from the continent. This included Confucian classics, histories and poetry anthologies and, finally, the introduction of the Buddhist canon in 552 by way of Korea.

As the Japanese struggled towards unification during the 6th century, they became conscious of their need of an organized writing system for official, diplomatic, educational and practical purposes. Moreover, encouraged by China's rich culture, they were eager to create their own literature and histories. Learning to read and write Chinese was a major undertaking, but attempting to use the Chinese writing system to communicate the Japanese language was even more difficult, because of fundamental structural differences between the two languages.

The Chinese writing system, originally largely pictographic, had incorporated ideographic and phonetic elements into a system of logograms (signs that individually represent entire words) rather than an alphabet of phonetic symbols from which words could be constructed. Moreover, the Chinese language is monosyllabic and uninflected: sounds that would otherwise be homophones are distinguished through the use of vocal tones, which make the sounds rise or fall. In contrast, the Japanese language is polysyllabic and agglutinative: verbs and adjectives are altered and distinguished by many suffixes. As a result, Chinese ideograms could not be adopted into the Japanese grammar structure without considerable modification.

By borrowing the monosyllabic sounds associated with the Chinese ideograms, the Japanese were able to construct a syllabic form of writing. In the earliest system an initial Chinese character (Jap. *kanji*) was used only to establish meaning, and to this character other *kanji* would be added in order to modify the word in accordance with Japanese grammar. For example, in the Japanese word *ikimasu* ('to go'), an initial *kanji* meaning 'to go' in Chinese would be followed by three other *kanji* used strictly for their phonetic sounds ('ki', 'ma' and 'su') in order to complete the Japanese word. This system of employing Chinese ideograms separately to represent sound and meaning came to be known as the *man'yōgana* system. It was used primarily to record Japanese names and for poetry, most remarkably in the earliest Japanese poetry anthology, the *Man'yōshū* ('Collection of ten thousand leaves'; mid-8th century).

(b) Introduction of Chinese calligraphy. At the same time as using Chinese characters to create their own documents and texts, the Japanese developed an interest in the three calligraphic script styles that were reaching maturity in China at that time: regular script (Chin. *zhenshu*, Jap. *kaisho*), running script (Chin. *xingshu*, Jap. *gyōsho*) and cursive script (Chin. *caoshu*, Jap. *sōsho*). The uniformity, discipline and legibility of regular script made it ideal for the copying of Buddhist texts (Skt *sūtras*) in China during the Sui (581–618) and Tang (618–907) periods. Examples

of these texts eventually reached Japan and greatly influenced early Buddhist art of the Asuka-Hakuhō (552–710) and Nara (710–94) periods. Extant examples of Chinese-influenced regular script from the Asuka-Hakuhō periods include the inscription, dated 623, on the *Shaka Triad* at Hōryūji, Nara (*see* §V, 3(i) above). During this early period, regular script was also used in most official documents and texts.

As Buddhism gained acceptance among the Japanese nobility (*see* §II, 3 above), its followers became increasingly aware of the importance of *sūtra* copying (*shakyō*), a practice that is believed to have begun during the Asuka-Hakuhō periods and flourished under the reign of the 8th-century emperor Shōmu. Contemporary records indicate that there were 41 separate scriptoria—imperial, monastic and private—in the city of Nara during the first half of the 8th century. The calligraphy of the earliest *sūtras* copied in Japan during the Nara period reflects the delicacy and individuality of Sui-period models. By the 760s, calligraphy used in Japanese *sūtra* copying and for other texts was becoming more rigorously uniform, reflecting the new stylistic vogue of the Tang period. The weightiness and structural stability of this style came to be regarded as the classic calligraphic style for Buddhist texts (*see* §2(i) below), as seen in the *Avataṁsaka sūtra* (Jap. *Kegonkyō*) donated in 744 to Tōdaiji in Nara (New York, Met.).

As the various scriptoria tried to meet the demands for handwritten texts by monasteries and private patrons, *sūtra* copyists developed certain variations in script style in order to facilitate the copying process. This simplified form of *sūtra* script was known as *shakyōtai*. Its characters were simplified by subtle changes to spacing, modifications to pressure on the brush and the replacement of separately delineated strokes by a few contiguous strokes within a single character. Such was the skill of the scribes, however, that these alterations did not distort the disciplined structure of the original regular-script ideal.

(c) Development of kana. During the 9th century Japanese syllabic writing (*kana*) developed out of the *man'yōgana* system, and two separate syllabaries came to replace the cumbersome double use of characters. The two new systems were *hiragana* ('smooth *kana*') and *katakana* ('square *kana*'). *Hiragana* emerged from the rounded, fluid shapes of cursive script (*sōsho*), and *katakana* was derived from a single element of a character written in standard script (*kaisho*). *Hiragana* became the more prevalent system, with *katakana* being used primarily to distinguish words borrowed from other languages.

The development of these *kana* scripts was crucial to the continued development of native Japanese literature and aesthetics. Unlike the Chinese ideographs, which each represented a whole word, *hiragana* and *katakana* represented phonetic sounds suited to the Japanese spoken language. The Japanese could now record their own vernacular with a set number of 46 basic and 25 variant characters; these represented sounds rather than meaning and could be endlessly combined to convey native Japanese pronunciations, meanings and grammar patterns.

Despite the development of these systems, the Japanese did not abandon the use of Chinese characters (*kanji*) but continued to assimilate them into their own system.

117. Calligraphy in *hiragana* script, book page mounted as hanging scroll, from *Ishiyama-gire* ('Poems of Ki no Tsurayuki'), attributed to Fujiwara no Sadanobu; ink on paper decorated with floral scrolls printed in mica ink, birds and flowers stamped in silver ink, 201×159 mm, first half of the 12th century (Seattle, WA, Seattle Art Museum)

Moreover, the *kanji* took on a dual purpose in Japanese literature: they retained their Chinese-derived pronunciations (referred to as *on* readings) but could also be read with their native Japanese pronunciations (*kun* readings). For example, the *kanji* meaning 'mountain' can be read both with the *on* pronunciation, as *san*, and with the *kun* pronunciation, as *yama*. Moreover, the word for 'mountain' can also be written syllabically in Japanese in either *hiragana* or *katakana*.

(d) *Court aesthetics.* During the Heian period (794–1185) a gender distinction arose between writings made in Chinese characters and those in the native *kana* syllabary. Because Japanese women were discouraged from studying Chinese culture, including its writing system, they eagerly sought to learn *kana* (*see* §2(ii)(b) below). As a result, much of the Japanese literature produced during this period in the vernacular, including the 11th-century novel *Genji monogatari* ('Tale of Genji') by Lady Murasaki Shikibu (*d* 978), was written by women. Men, by contrast, still viewed Chinese learning and writing as true scholarship and continued to use primarily Chinese characters. *Hiragana* came to be referred to as 'women's hand' or 'women's writing' (*onnade* or *onna moji*), and Chinese characters as 'men's hand' or 'men's writing' (*otokode* or *otoko moji*). The exception was the use by both men and women of

hiragana in the writing of elegant court poetry, which represented the high refinement of the age and to which *hiragana*, with its lucid simplicity, was thought to be naturally suited (*see* §2(iii) below). The page from *Ishiyama-gire* ('Poems of Ki no Tsurayuki'; see fig. 117), attributed to Fujiwara no Sadanobu (*see* FUJIWARA (ii), (3)), is a lovely example of this court aesthetic.

In contrast to the squarish form and autonomy of each character in standard script (*kaisho*), the form and arrangement of *kana* in *hiragana* script is looser, with as many as six characters linked together by a single gesture of the brush. The orderly columns of *kaisho* are replaced by irregularly indented lines of writing, such that the tops of the lines may make diagonal patterns across the page. This relaxed form of calligraphy is termed 'scattered writing' (*chirashi gaki*).

The development of native script styles not only allowed Japanese calligraphers to express themselves in their own language but also contributed to an entirely new aesthetic of elegant court-style calligraphy. Furthermore, because they never abandoned the use of Chinese characters, Japanese calligraphers have been able to create remarkable compositions in which the weighty, complex Chinese characters are offset by the slender, simplified *kana* script. Although Japanese calligraphers still often write in Chinese, their major contribution to the art of calligraphy has been the transformation of a Chinese writing system and art form into a uniquely Japanese aesthetic.

BIBLIOGRAPHY
Y. Nakata: *Sho*, Nihon no bijutsu [Arts of Japan], xxvii (Tokyo, 1967); Eng. trans. by A. Woodhull as *The Art of Japanese Calligraphy*, Heibonsha Surv. Jap. A., xxvii (Tokyo, 1973)
S. Addiss and others: *Calligraphy of China and Japan: The Grand Tradition* (Michigan, 1975)
Masters of Japanese Calligraphy, 8th–19th Century (exh. cat. by Y. Shimizu and J. M. Rosenfield, New York, Japan House Gal., 1984)
C. J. Earnshaw: *Sho: Japanese Calligraphy* (Kobe, 1985)
From Concept to Context: Approaches to Asian and Islamic Calligraphy (exh. cat. by S. Fu, G. Lowry and A. Yonemura, Washington, Freer, 1986)
S. Komatsu and K. S. Wong, eds: *Chinese and Japanese Calligraphy Spanning Two Thousand Years: The Heinz Götze Collection, Heidelberg* (Munich, 1989)

AUDREY YOSHIKO SEO

(ii) *Materials, techniques and design.*

(a) *Introduction.* In Japanese calligraphy, as in East Asian art in general, blank space is not a negative quality but is understood to embody the eternal space beyond the two-dimensional surface plane and is thus appreciated for its beauty. An interesting and attractive arrangement is achieved, first and foremost, by avoiding mechanical regularity and by seeking an interaction between the filled and the empty spaces, as, for example, in a piece attributed to Ki no Tsurayuki (see fig. 118). This work displays the most developed stage of flowing *kana* (Japanese syllabic script) calligraphy (*see* §(i) above), with subtle yet expressive brushwork arranged in five simple, slightly tilting columns, the heads and tails of which are never parallel. The beauty of the lines in *kana* calligraphy depends on ink tones. Light ink tones, which do not suit the rigid Chinese characters, are an integral part of *kana* calligraphy. Black is the main ink in use, but blue, brown and purple tints are also available. The distinctions between dark and

light ink and between old and new ink are important to calligraphers, most of whom prefer ink that is at least 100 years old, mainly because of its subdued tone but also because of its excellent long-term adhesiveness to paper, even when the paper is mounted.

(b) Ink. Calligraphic ink (Chinese ink; Jap. *sumi*) has traditionally been made of pine soot (carbon) or vegetable lampblack mixed with resin (albuminous collagen) or lacquer. In the 20th century mineral oil black mixed with glue has become more widely available. It is sold mainly as a rectangular stick; before use it is mixed with water and ground back into liquid form on an inkstone (*suzuri*). The water is dropped from a small metal or ceramic water dropper (*suiteki*), and the ground ink is pooled in a small indentation at one end of the inkstone. Liquefied ink should be used immediately or very soon after it is made, unless a calligrapher intends to make a special effect of the separation between sticky glue and black water. If not kept sealed, ink dries up and cakes after several hours in the air. Popular Japanese inkstones fall on Mohs' hardness scale between 2.5 and 3.5 or between gypsum and fluorite. Good inkstone has a well-distributed rough surface that allows the ink to be ground quickly. The roughness is not palpable to the untrained and can only be observed through a microscope. The time needed to grind the ink sufficiently on the inkstone depends on the amount of ink required and the hardness of the inkstick and inkstone. This process should not be regarded as a tedious chore but as a time for meditation and preparation for the calligraphic work itself. Modern calligraphers also use fluid ink that has already been stirred and sometimes thickened with artificial materials (this is used especially for monumental works, where clearer structures in the brushstroke are desired), poster and oil paints and other artificial materials. In special cases aluminium paste may be used on a black surface, with natural lacquer added to give the effect of gold tinting, reminiscent of old lacquer.

(c) Brushes. Brushes are by far the most important of calligraphic materials. All standard East Asian brushes come to a perfect point in the centre, the hairs in the core group being surrounded by shorter hairs of basically three different lengths. Within these limits different types of brushes are possible, made from various animal hairs. Sheep hair, being the softest, is often favoured by advanced calligraphers. It absorbs a large amount of ink in one dip and can cover a long sweep of writing from the point of saturation until the ink runs dry, leaving only broken traces. Because of its softness, the hair bends in every direction, allowing the calligrapher to exhibit his technical mastery. For the same reason, however, soft-hair brushes are not suitable for beginners, for whom mixed-hair brushes are recommended. The springy hair of deer, horse, rabbit, raccoon, weasel or wolf, among others, is mixed with sheep hair to make a firmer brush. Avant-garde (*zen'ei*; *see* §2(vii)) calligraphers and Zen-inspired calligraphers may use special brushes made of bird feathers, palm leaves, straws, plant stems, willow branches or young bamboos. They also use brushes up to the thickness of an arm, made from various animal hairs. For the decorative, ribbon-like script of *hihaku* ('flying white'), they may use

118. Calligraphy attributed to Ki no Tsurayuki, from the set of *Sunshōan shikishi*, ink on coloured *shikishi* (paper square, usually for writing poems), 129×123 mm, 10th–11th centuries (Tokyo, Gotoh Museum)

spatula-like implements. Occasionally implements are dispensed with altogether and the writing is done with the fingers or feet. In classical calligraphy thick brushes (*futofude*) are used for the main text and slender brushes (*hosofude*) are used for writing inscriptions, signatures, small characters or fine cursive script. For the Sanskrit letters written in Buddhist or Shinto amulets to avert evil, unusual flat, wide brushes are used. The traditional low tables continue to be used, but artists often lay out large sheets on the floor and move their whole body over this surface, body, brush and ink-line being unified into one rhythmic entity.

(d) Paper. Paper for calligraphy is often misleadingly termed 'rice paper', but in fact it is made of various vegetable fibres, notably paper mulberry (*Broussonetia papyrifera*; Jap. *kōzo*) and *Wikstroemia ganpi* or *sikokiana* (Jap. *ganpi* or *hishi*), which have been produced since the 8th century; other sources have included *Edgeworthia papyrifera* or *chrysantha* (Jap. *mitsumata*), since the 16th century, and wheat and rice straw since the mid-19th century. Paper mulberry bushes, which grow easily anywhere in Japan, have traditionally been the most common source.

Whereas Chinese paper (*karakami*) is made from old hemp cloth, which is processed vegetable fibre and highly absorbent, Japanese paper (*washi*) is made directly from raw vegetable fibre and has low absorbency. Calligraphers using *kanji* (Chinese characters) therefore prefer Chinese paper, which permits ample penetration of the ink, while *kana* calligraphers prefer Japanese paper to obtain the smooth, flowing lines essential to this type of writing.

Because freshly made absorbent paper is moist, ink may spread profusely. Calligraphers often lay such paper aside for at least three years to dry in the air, after which it will absorb just the right amount of ink to produce depth. Avant-garde calligraphers also use Western paper, textiles or wooden panels as writing surfaces.

Various additives are used to decorate the paper: colour dye, mica, size, alum, wax, ink marbling, white ground powder (*gofun*), of which the best quality is ground mother-of-pearl shell, and gold and silver leaves or powder. Some paper is assembled in a collage technique. Japanese calligraphy itself remains always in vogue, but its presentation changes with the times. In modern homes traditional formats, such as hanging scrolls and handscrolls, are appreciated less than works mounted in Western frames.

See also §XVI, 4, 13 and 18 below and LINE, §1.

BIBLIOGRAPHY
Y. Nishikawa, ed.: *Kana* [*Kana* script], Shodō Kōza [Course on calligraphy], iv (Tokyo, 1971)
K. Ōsawa: *Sho o kagaku suru* [Scientifically examining calligraphy] (Tokyo, 1974)
S. Ijima, ed.: *Shodō jiten* [Dictionary of calligraphy] (Tokyo, 1975)
S. Morita, ed.: *Sho to bokushō* [Calligraphy and ink impressions], Kindai no bijutsu [Modern art], xxviii (Tokyo, 1975)
J. Silbergeld: *Chinese Painting Style* (Seattle, 1982), pp. 5–30
J. Imai, ed.: *Sho to hito to kotoba* [Calligraphy, man and words], Art japonesque: Nihon no bi to bunka [Japanese beauty and culture], vi (Tokyo, 1983)
S. Aoyama and others: *Words in Motion: Modern Japanese Calligraphy* (Tokyo, 1984)

(iii) Historical overview.

(a) Before AD 794. (b) Heian period (794–1185). (c) Kamakura, Muromachi and Momoyama periods (1185–1600). (d) Edo period (1600–1868). (e) Modern (after 1868).

(a) Before AD 794. By the 4th century AD the Yamato people had extended their control over the western part of Japan. From then until the 6th century they were allied with Paekche, the kingdom in the south-western part of the Korean peninsula, and during that time they learnt the writing system in use among Paekche scholars (*see also* §(i)(b) above). By the reign of Emperor Bidatsu (572–85), immigrant scholars from the continent and their descendants had formed groups under the leadership of the Achiki in Yamato (Nara area) and the Wani in Kawachi (Osaka area); these groups were officially recognized under the title Fumino Obito ('Head of literature'), and they used their specialized skills of literary composition and calligraphy to serve the Yamato court. These scribes, the earliest known Japanese calligraphers, were obviously important at a time when only a few members of the ruling class could handle written documents.

The oldest extant handwritten text on a sheet of paper brushed by a Japanese is the *Hokke Gisho* ('Commentary on the Lotus *sutra*'; four handscrolls, each 0.26×13.3–15.28 m; *c.* 609–15; Tokyo, Imp. Household Col.), attributed to Prince SHŌTOKU. The calligraphic style, using clerical (Jap. *reisho*; Chin. *lishu*) and cursive (Jap. *sōsho*; Chin. *caoshu*) scripts, resembles that of the Six Dynasties period (222–589) in China, indicating that the Japanese had by then shifted their focus of learning more directly to China. By the early 7th century, ruling-class people in the Nara region appear to have acquired writing skills.

Many more official documents exist from the Nara period (710–94) than from earlier times. This was because the Taihō code of penal and administrative laws, promulgated in 702, had established procedures to which literate officials were essential. In order to legitimate the imperial line, semi-historical narratives were compiled, notably the *Kojiki* ('Record of ancient matters'; 712) and the *Nihon shoki* (or *Nihongi*; 'Chronicle of Japan'; 720). Ō no Yasumaro (*d* 723) and Hieda no Are, recorded as the compilers of the *Kojiki*, were also involved in compiling the *Nihon shoki*. Yasumaro was evidently familiar with continental culture and well versed in Chinese writing of the Six Dynasties period. He rose to the fifth rank of 16 ranks of officials, scribes and record-keepers and in 716 held the title Minister of Popular Affairs (Minbushō).

Sutra copying was another distinctive phenomenon of the Nara period (*see* §2(i) below). Inspired by the devotion to Buddhism of Emperor SHŌMU, scribes copied many thousands of volumes of Buddhist scriptures, mainly at the more than 20 state-run scriptoria (*shakyōjo*). Employees of these scriptoria did not have high ranks, but they were treated as technically skilled craftsmen. The copyist who wrote the text for the *Kako genzai inga kyō emaki* (popularly known as *E inga kyō*; 'Illustrated *sutra* of past and present cause and effect'), the earliest extant handscroll (*emakimono*) in Japan (*c.* 8th century; Kyoto, Daigoji, Hōon'in; Nara, Kōfukuji), held the rank third from lowest among the 16 ranks but must nevertheless have been an experienced copyist or he would not have been allowed the prestigious task of brushing a text to accompany a picture. Inexperienced copyists presumably had lower ranks than his; moreover, their wages were reduced if they omitted even one character. Private *sutra* copying was done by devout aristocrats of various ranks.

(b) Heian period (794–1185). More is known about those who specialized in keeping records at court from the early 9th century. They were officials of the Ministry of Central Affairs (Nakatsukasashō) and were called either Dai Naiki ('Great inner recorder') or Shō Naiki ('Lesser inner recorder'), respectively 9th and 11th from the top of the 16 ranks. The recorders were not mere copyists but composed and brushed such important documents as imperial edicts. Additionally, Geki ('Outer recorders') kept records of day-to-day administrative affairs.

Extant works from the first half of the 9th century are attributed to such famous calligraphers as Emperor SAGA and the priests Saichō (766–822) and KŪKAI. Kūkai attained the most prominence, not only as a founder of the Shingon sect of Esoteric Buddhism (*see* §II, 3 above) but also as the first fully fledged Japanese calligrapher, displaying stylistic diversity as well as spiritual depth. He was skilled not only in regular script (*shinsho*), which dominated *sutra* copying, but also in running (*gyōsho*) and grass or cursive (*sōsho*) scripts, and he dared to experiment with unusual scripts (*hihakutai*) when writing Sanskrit and with exaggerated ornamental scripts. In his *Shōryōshū*, an anthology of poems and prose pieces, Kūkai claimed that calligraphy should incorporate tradition with individuality and reveal the calligrapher's personal response to nature. With his emergence, Japanese calligraphy was elevated to the higher aesthetic realm of art and philosophy.

During the Middle Heian period (897–1068), three famous calligraphers from high-ranking aristocratic families represented the flowering of Wayō (Japanese-style) calligraphy, which, in contrast to the more formal and rigid Chinese calligraphy, was known for its feminine elegance (*see* §2(ii) below). The three were ONO NO MICHIKAZE, Fujiwara no Sari (*see* FUJIWARA (ii), (1)) and Fujiwara no Kōzei (*see* FUJIWARA (ii), (2)). They were commissioned to write numerous calligraphies, for example to be mounted on folding screens for display in imperial halls and private mansions or to be used as models for carving wooden plaques on palace gates. Among them, Kōzei held the highest rank, and his calligraphy is often considered the culmination of Wayō. The calligraphic lineage of Sesonji, named after the Buddhist temple of Kōzei's family, lasted for 17 generations, filling the role of official recorders at court. The Sesonji lineage later also produced several offshoots.

Michikaze, Sari and Kōzei probably enjoyed the highest social status of all prominent calligraphers in Japanese history, with the exception of emperors. This was because the Heian court, where political and cultural leadership were combined, regarded calligraphy as the most important artistic accomplishment for all nobles, both men and women, serving both practical and aesthetic purposes.

Towards the end of the Heian period, absentee aristocratic landlords found themselves powerless before the emerging warrior class. The new leaders quickly recognized that they could not rule the country by coercion alone and must learn to handle administrative and legal documents as well as master such cultural skills as calligraphy, poetry and painting. In these matters, the warriors employed Kyoto courtiers and Buddhist priests to teach and advise them. Meanwhile, emperors and Kyoto nobles were eager to maintain their social rank and cultural heritage by cultivating calligraphy, poetry and music, skills that compensated for the loss of political power.

(c) Kamakura, Muromachi and Momoyama periods (1185–1600). 'Lineage' calligraphy (*ryūgi shodō*) divided into many branches from the Sesonji and other lineages proliferated, each elaborating inherited family formulae for artistic skills. The 'lineage' calligraphy used at court and then adapted at shogunal headquarters was expected to exemplify orderly form without strong individualism. Thus it gradually fell to the level of uninspired conformity. The priest Prince SON'EN, a son of Emperor Fushimi, revitalized lineage calligraphy by synthesizing the traditional, aristocratic, flowing style of Fujiwara no Kōzei with newly arrived Chinese elements of boldness and clarity, thereby establishing another lineage, Shōren'in *ryū*. Later called the Oie *ryū* ('official house' lineage), this became the most popular style in the 17th century (*see* §2(iii) below). The calligraphers of the 12th–16th centuries most admired by modern critics, however, came from non-professional backgrounds and were free of such conformity. They included *waka* (a 31-syllable form) poets such as Fujiwara no Shunzei (*see* FUJIWARA (ii), (5)) and his son Fujiwara no Teika (*see* FUJIWARA (ii), (7)), valued for their idiosyncratic styles, and later Zen priests, such as Eisai (1141–1215) and Dōgen (1200–53), who went to China

and introduced to Japan the calligraphy of the Song (960–1279) and Yuan (1279–1368) periods.

Because of the political turmoil in China before and after the establishment of the Mongol Yuan dynasty, many Chinese Chan (Jap. Zen) priests took refuge in Japan in the late Kamakura (1185–1333) and early Muromachi (1333–1568) periods. They were welcomed by the leaders of Japan and were given permission to head important Zen monasteries, as they had profound knowledge of Zen Buddhism and Zhu Xi (Jap. Shushigaku) Confucianism and were well versed in poetry and new calligraphic styles. They revitalized scholarship on the Chinese classics; furthermore, their calligraphies were highly treasured by the Japanese, particularly for the spontaneity of their style, which shaped Zen-inspired calligraphy in Japan.

During the Muromachi period, the Japanese tea ceremony (*chanoyu*), which had been greatly influenced by the tea-drinking etiquette practised in Zen temples, evolved under the patronage of the military aristocracy and wealthy merchants. From the late 15th century, calligraphic scrolls figured prominently in the displays at tea ceremonies. At first only calligraphy by Chinese Zen priests (*bokuseki*; 'ink traces') was shown, but in time calligraphic fragments by courtiers of the Heian and Kamakura periods (*Kohitsugire*; 'fragments of ancient calligraphy'), as well as works by Japanese priests of Daitokuji active in the promotion of diffusion of *chanoyu* in 17th-century Kyoto, were also displayed. Later practioners of *chanoyu* whose distinctive calligraphic styles were cherished by subsequent generations include Hosokawa Yūsai (1534–1610), a daimyo who practised the tea ceremony and was a talented calligrapher, poet and scholar of traditional Japanese poetry; KOBORI ENSHŪ and Kanamori Sōwa (1584–1656), both partial to classical court aesthetics; and teamasters SEN NO RIKYŪ and his grandson Sen Sōtan (1578–1658). Not only did the tea ceremony foster the growth of calligraphy connoisseurship in Japan, but the survival of many ancient examples of calligraphy can be attributed to their treasured status as *chagake* ('tea hangings').

(d) Edo period (1600–1868). The dramatic political and social changes of the Momoyama (1568–1600) and early Edo periods were accompanied by a revival of court culture, adapted to suit the taste of both powerful warlords and newly affluent merchants. There were three calligraphers of note in this period, known as the Kan'ei no Sanpitsu (Three Great Brushes of Kan'ei; Kan'ei era 1625–43): Hon'ami Kōetsu (*see* HON'AMI, (1)), son of a prestigious sword connoisseur and a talented artist, KONOE NOBUTADA, a high-ranking courtier at Kyoto, and SHŌKADŌ SHŌJŌ, a Shingon Buddhist priest, well known as a highly educated intellectual. The first two expressed their frustration with sterile lineage calligraphy in their individualistic calligraphic styles. Shōkadō, however, retained and developed the Shōren'in style (*see* §2(iii) below), which was employed by the official recorders (*yūhitsu*) of the Tokugawa shogunate; consequently, his style became popular during the period.

In the 17th century, the adoption of Neo-Confucianism by the Tokugawa administration stimulated study of the Chinese classics and poems, which in turn promoted interest in Chinese-style calligraphy, called *Karayō*. The

introduction of Ōbaku (Chin. Huangbo) Zen in the mid-17th century encouraged this trend. While Wayō lineage calligraphy was artistically stagnant, a number of interesting Karayō calligraphers appeared. They were mainly Confucian scholars, Buddhist priests such as JIUN SONJA and RYŌKAN, literati artists such as Ike Taiga (*see* IKE, (1)), ICHIKAWA BEIAN and NUKINA KAIOKU. The occupation of professional calligrapher was now recorded for the first time.

By the early 18th century, the rising urban cash economy allowed Japanese townspeople to enjoy a higher level of material wealth. Even peasants' children went to Edo, Osaka and other large cities to work in small shops. Learning to read, write and count became increasingly important as business contracts and legal documents were exchanged much more widely than ever before. Commoners' children learnt basic skills at both domain-run schools and temple schools (*terakoya*). Consequently educators were in demand. *Terakoya* teachers included retired policemen, Buddhist and Shinto priests, impoverished samurai and even widows from the samurai class; all had to be reasonably good calligraphers. The calligraphic style taught in these schools was called Oie *ryū* ('official family'; *see* §(c) above), a standardized form of the Shōren'in style that was adopted by the Tokugawa shogunate for all official correspondence and legal documents.

(e) Modern (after 1868). In the 19th century, the practice of calligraphy among all social classes fostered the emergence of commercialized calligraphy and painting parties (*shogakai*; *kaigakai*) where, for a fee, 'guests' could brush a scroll individually or as a group under the guidance of a professional artist. Despite the adoption of many artists of Western culture during the Meiji period (1868–1912), this kind of gathering continued to be popular during the first decades of the Meiji era. The painting by KAWANABE KYŌSAI entitled *Calligraphy and Painting Party* (see fig. 119) shows the lively mood of such a party attended by men, women and even children.

Although calligraphy remained an important form of artistic expression in some circles, many Western-style artists challenged its status as an art form. In 1882, the artist Shōtarō Koyama (1857–1916) authored a now famous article entitled 'Sho wa bijutsu narazu' ('Calligraphy is not an art') in which he declared that written characters are merely symbols of spoken language and lack the expressive power of painting or sculpture. His utilitarian argument was successfully rebutted by Kakuzō (Tenshin) Okakura (1862–1913), who would become an influential voice in the promotion of all aspects of traditional Japanese culture.

In the educational sphere, controversies also developed over the use of Chinese characters and *kana* and even over the relative merits of the brush and the pen. Despite these skirmishes, calligraphy continued to be taught in schools, and both artistic and scholarly interest in calligraphy remained relatively high during the Meiji (1868–1912) and Taishō (1912–1926) periods.

In the 1960s there was a surge of interest in calligraphy, partly because of economic prosperity but particularly because of a recurring interest in traditional art. Calligraphy is still considered by some as the most conservative and

119. Kawanabe Kyōsai: *Calligraphy and Painting Party* (detail), hanging scroll, ink and colours on paper, 1.39×0.69 m, 1880 (Cleveland, OH, Cleveland Museum of Art)

traditional but also the most aristocratic of hobbies. Its appeal derives from the quiet discipline it requires and its capacity to reveal the calligrapher's inner nature and his or her appreciation of subtle beauty. Nine-tenths of those who take private calligraphy lessons today are women, many of them mothers over 40 who have already raised their children.

As in the early years of the 20th century, calligraphy is pursued in general by practitioners striving either to create visual beauty or to pursue scholarship. Of the scholar-calligraphers, who are increasingly few in number, some are poets. Like the more numerous artist-calligraphers, they often have to teach for a living at colleges and universities or conduct research at private or public museums. Many of the best-known Japanese calligraphers combine the two disciplines. Calligraphy (*sho*) is promoted

as a subject in schools and also taught privately to children, among whom it enjoys great popularity. Amateur calligraphers constitute a large proportion of those attending exhibitions. Although *sho* is regarded as the queen of the arts, there has been no reluctance to use the expressive, artistically structured script symbols as decoration or as design motifs, for which purposes they are particularly appropriate. Examples of such uses are found in product design, on posters and advertisements and, above all, in the famous traditional Japanese art of packaging. The wide range of uses and users contributes to the enormous vitality of calligraphy in the late 20th century.

BIBLIOGRAPHY

K. Shimonaka, ed.: *Shodō zenshū* [Complete collection of calligraphy], ix, xi–xiv, xviii–xx, xxii, xxiii (Tokyo, 1954–8)

Y. Nakata: *Sho* [Calligraphy], Nihon no bijutsu [Arts of Japan], xxvii (Tokyo, 1967); Eng. trans. by A. Woodhull as *The Art of Japanese Calligraphy*, Heibonsha Surv. Jap. A., xxvii (New York and Tokyo, 1973)

T. Horie: *Sho* [Calligraphy], Nihon no bijutsu [Arts of Japan], xxx (Tokyo, 1969)

S. Komatsu: *Nihon shoryū zenshi* [History of Japanese calligraphic styles and schools] (Tokyo, 1970)

Y. Nakata: *Nihon shodō no keifu* [Genealogical record of Japanese calligraphy] (Tokyo, 1970)

The Courtly Tradition in Japanese Art and Literature: Selections from the Hofer and Hyde Collections (exh. cat. by J. M. Rosenfield, F. E. Cranston and E. A. Cranston, Cambridge, MA, Fogg, 1973)

Y. Nakata, ed.: *Nihon shodōshi* [History of Japanese calligraphy], Shodō geijutsu [Art of calligraphy], app. iv (Tokyo, 1977)

S. Ishibashi, ed.: *Meiji Taishō no sho* [Calligraphy from the Meiji and Taishō periods], Kindai no bijutsu [Art of the modern period], xliv (Tokyo, 1978)

Tokubetsuten Nihon no sho [Special exhibition of Japanese calligraphy] (exh. cat. by S. Komatsu and others, Tokyo, N. Mus., 1978)

K. Okuyama: *Nihon shodō kyōiku shi* [History of calligraphic education in Japan], Nihon bunka shi sōsho [Collection of Japanese cultural history], vi (Tokyo, 1982)

Masters of Japanese Calligraphy, 8th–19th Century (exh. cat. by Y. Shimizu and J. M. Rosenfield, New York, Japan House Gal. and Asia Soc. Gals, 1984–5)

Y. Shimizu, ed.: *Japan: The Shaping of Daimyo Culture, 1185–1868* (Washington, DC, 1988)

SADAKO OHKI

2. PRINCIPAL TRADITIONS. Although it shares the tools, media and techniques of painting, calligraphy has traditionally been considered the superior art, because of its potential for revealing the writer's heart and mind. The esteem it enjoys as an art form and its potential for self-expression have combined to make the practice of calligraphy widespread among Japanese of all ages and all backgrounds, and it has had a profound and pervasive influence on the development of the Japanese arts in general. In addition to its importance as an autonomous art form, it is an integral component in narrative picture scrolls (*emaki*) and monochrome ink painting (*suibokuga*). Beautifully written poems, phrases or even single characters are also commonly used in ceramic decoration, lacquer and textile design. Historically, several distinct traditions of calligraphic art can be discerned. The earliest centred on the copying of Buddhist *sūtras* (this practice continues to the present day, although it has long ceased to be associated with the production of calligraphic masterpieces). Calligraphy remains influential in the development of modern Japanese graphic arts and design. This survey presents a broadly chronological view of the principal calligraphic schools and styles.

□

(i) Buddhist scriptures. (ii) Early courtly styles. (iii) Shōren'in school. (iv) Zen Buddhist masters. (v) Kyoto revival of late courtly styles. (vi) Literati. (vii) Modern.

(i) Buddhist scriptures. Calligraphy in Japan began and has continued to flourish in a religious context. The chief reasons for this are the reverence for the written word and the conviction that scripture copying is an act of devotion that helps the writers or other individuals designated by them to accumulate Buddhist merit, thereby enhancing their chances of attaining enlightenment. Consequently, professional calligraphers, monks and nuns, as well as the laity may all participate in this activity.

(a) Before AD 794. (b) Heian period (794–1185). (c) Kamakura period (1185–1333) and after.

(a) Before AD 794. When Buddhism entered Japan from the mainland in the 6th century AD (*see* §II, 3 above), adherents of the new religion soon thoroughly assimilated its attitudes towards the study, recitation and copying of *sūtra*s. These sacred texts, originally written in Pali or Sanskrit, had been translated into Chinese over the course of centuries, and in its early stages Japanese Buddhism relied on the labour-intensive practice of *shakyō* (*sūtra* copying) to provide texts for the rapidly growing number of temples. *Shakyō*, which can also refer to the copied scrolls themselves, as distinct from printed versions, were almost always copied on sheets of paper pasted together to make long, continuous handscrolls. Printed versions of *sūtra*s were already being used widely in China by the 10th century, and a printed version of the entire Buddhist canon was available in 983, but in Japan hand-copying remained the primary means of reproducing texts for six or seven more centuries, partly because of the relatively late acceptance of printing technology and partly because of a well-entrenched belief in the religious merit associated with the manual copying of *sūtra*s.

Early handscrolls. One of the earliest surviving specimens of Japanese calligraphy on paper, *Hokke gisho* ('Commentary on the Lotus *sūtra*'; four scrolls, each scroll 0.26×13.3–15.28 m; *c.* 609–15; Tokyo, Imp. Household Col.), is attributed to PRINCE SHŌTOKU, to whom history ascribes a major role in the development of Japanese Buddhism. Though this manuscript is clearly an uncorrected draft, it shows the influence of Chinese calligraphy of the Six Dynasties (222–589) and early Sui (581–618) periods (*see* CHINA, §IV, 2(ii)). Other evidence of the official support for Buddhism in the 7th century was the project of copying the entire Buddhist canon (Jap. *Issaikyo*; Skt *Tripiṭaka*), undertaken at Kawaradera in Nara in 673 at the behest of Emperor Tenmu (*reg* 672–86). The oldest surviving dated *sūtra* manuscript is the *Kongōjō darani kyō* ('Diamond *dhāraṇī sūtra*'), which, as the postscript makes clear, was executed in 686 after funds were collected from several individuals and thus belongs to the category of *sūtra*s called *chishiki kyō* (*sūtra*s commissioned by individual donations).

Postscripts of other early *sūtra* scrolls indicate that some were meant as propitiatory offerings to hasten the recovery of ailing members of the imperial clan, such as Emperor

Monmu (*reg* 697–707) in 702, or to avert natural calamities such as droughts and earthquakes. *Sūtra*s were also commissioned by individuals to accumulate the merit needed for their salvation or to transfer merit to deceased relatives.

Sūtra copying continued to enjoy imperial patronage into the 8th century under Emperor SHŌMU and his consort Empress KŌMYŌ. Notably, during Shōmu's reign some 24 complete sets of the Buddhist canon, each at that time numbering 5048 volumes, were commissioned. That the imperial couple were both also talented calligraphers can be seen from a selection of verse passages on Buddhist themes attributed to Shōmu and from Kōmyō's copy of the *Yue Yi lun* (Jap. *Gaku Kiron*; 'Essay on Yue Yi'), an account of a Chinese general of the 3rd century BC, written in small regular script (Jap. *kaisho*) in the style of Wang xizhi (*see* WANG (i), (1); Jap. Ōgishi), which is among the most cherished calligraphic specimens of the age (all Nara, Shōsōin).

Official scriptoria. During Shōmu's reign the government established a scriptorium in the imperial palace compound *c.* 728; at first known as the Shakyōshi, it was renamed Shakyōjo in 741. The creation of a separate workshop for the copying of *sūtra* commentaries in 743 attests that scholarly interest in Buddhism accompanied the devotional and political aspects. Scriptoria were also established at several temples in the Nara area, notably at Tōdaiji, which was the leading establishment in a network of state-supported temples in the provinces.

In the context of the prevailing official ideology of *chingo kokka* ('pacifying and protecting the state'), the copying of *sūtra*s was charged with political significance: local temples relied on the scriptoria of the capital for the texts they needed, while the reciting and copying of the texts was thought to promote the peace and prosperity of the incipient nation state. In 737 Emperor Shōmu commissioned a complete set of the 600-scroll *Daihannya kyō* ('Greater *sūtra* of the perfection of wisdom') to be placed in each temple in the provinces. Surviving works created by these official scriptoria include the set of the entire canon sponsored by Shōmu in 734, a set sponsored by the daughter of Fujiwara no Fusasaki (681–737) and sets sponsored by Empress Kōmyō in 740 and 743.

The copyists at these state- and temple-sponsored scriptoria, who were known as *shakyōsei* or *kyōsei*, were selected through strict examinations that tested their knowledge of Chinese characters and their skill in *kaisho* (regular script), in which *sūtra*s were almost invariably written. The special variety of *kaisho* used, called *shakyōtai*, was an eminently legible though slightly flattened style based on Chinese models from the Sui (581–618) and Tang (618–907) periods. Each stroke had to be executed rapidly but distinctly and firmly. *Sūtra*s of the Nara period (710–94) in Japan were inscribed in a Sui-period style that was looser and more idiosyncratic than the upright, regimented style of Tang-period models that came to the fore in the mid-Nara period. At the end of the Nara

120. Buddhist calligraphy and scenes from the *Life of Shaka*, *E inga kyō* ('Illustrated *sūtra* of cause and effect'; detail), coloured inks on paper, l. 264 mm, 8th century; National Treasure (Nara, National Museum)

period, a softer, more rounded style gradually evolved, anticipating the development of *Wayō* ('Japanese style') calligraphy that emerged in the 10th century.

Following conventions that had been established in China during the Six Dynasties period (*c.* 265–589), *sūtra*s were usually written in columns of 17 (rarely 19) standard-sized characters or 32–4 small characters. Most *sūtra*s were written with ink on plain paper made of hemp (*Cannabis sativa*) or paper mulberry (*Broussonetia papyrifera*) fibre, although, in continuance of Chinese tradition, the paper was often tinted a pale yellow-brown using a dye that warded off insects and added strength to the paper (*see* §XVI, 18 below). Decorated *sūtra*s (*sōshoku kyō*) were first created during the 8th century, not the 10th century as is commonly thought, when aristocratic patrons sometimes commissioned texts to be incribed in gold or silver on paper dyed indigo or deep purple. An outstanding example from the late 8th century is the *Konshi ginji kegon kyō* ('The flower-garland *sūtra* written in silver characters on indigo-dyed paper'), which was damaged by fire in 1667 (hence its nickname, 'The charred *sūtra* of Niga-tsudō') and survives in various fragments (e.g. Nara, Shōsoin). Another type of decorated *sūtra*, based on Chinese models, has a band of illustrations running across its upper register; an example is the *Kako genzai inga kyō* ('Sūtra of cause and effect, past and present'; better known as *E inga kyō*, 'Illustrated *sūtra* of cause and effect'; 8th century), which has disarmingly simple illustrations rendered in opaque colours depicting the life of Shaka (Skt Shakyamuni, the historical Buddha; see fig. 120).

(b) Heian period (794–1185).

9th century. A lull in the activity of the copyists occurred after 794, when the capital moved to Heian (now Kyoto) and most of the major scriptoria were disbanded. The most cherished extant calligraphic works of this period are those by or attributed to famous religious leaders, the most prominent being Saichō (767–822) and KŪKAI (Kōbō daishi), the founders of the Tendai and Shingon sects respectively. Saichō is known to have copied *sūtra*s regularly and, on one occasion, presented a copy of the Lotus *sūtra* written in gold characters to Emperor SAGA, who was himself a calligrapher of high repute. Extant sets of letters exchanged by Saichō and Kūkai (known respectively as the *Kyūkakujō* (Nara, N. Mus.) and *Fūshinjō* (Kyoto, Kyōō Gokokuji (also known as Toji)); 812–13) are treasured as models for calligraphy practice. Kūkai left a small corpus of writings on Chinese and Japanese calligraphic and poetic practices of the day (in a collection of essays made by one of his disciples and called the *Shōryōshū*; text in Inaba, 1965, 3rd ed. rev.).

From the same period come several works, once attributed to Kūkai, in an unusual writing style called *hihaku* ('flying white') script, which is executed with a flat, coarse-bristle brush designed to create wide bands of parallel strokes. The brush, held at a uniform angle, is swept across the paper so as to create abrupt line vacillations and other dramatic internal variations. The finest surviving example of this genre is an inscription for the portraits of the Seven Patriarchs of the Shingon sect (Kyoto, Tōji). Another example, destroyed by fire in the

20th century but recorded in a set of fine photographs, was called the *Jū nyoze* ('Ten suchnesses'; Nakata, 1973, pl. 69), because it includes calligraphic renditions of ten Buddhist expressions beginning with the word *nyoze* taken from the 'Expedient Means' chapter of the Lotus *sūtra*. In this work, the calligrapher cleverly incorporated pictorial elements into the rendering of the characters. Though *hihaku* is considered merely one of many miscellaneous decorative scripts in the East Asian tradition, its immediate visual impact makes it one variety of calligraphy readily accessible to modern Japanese and Western viewers alike.

10th–12th centuries. During the 10th century there was a renewed enthusiasm for *sūtra* copying, especially in private circles, as a result of the growth of Buddhist sects, such as Tendai, that revered the Lotus *sūtra* (*Hokkekyō*) as their primary scripture. Aristocratic *kechien* ('karma-relation' groups) collaborated on the copying of a *sūtra* or sponsored the copying by professional *kyōshi* ('sūtra masters'). Many sets of the Lotus *sūtra* were created in this way as *kechien kyō*, including the two representative sets of the late Heian period, the *Kunōji kyō* and *Heike nōkyō*.

The Lotus *sūtra* was a popular text for copying, partly because of the teachings of the *sūtra* itself, which promise merit and reward to those who copy the text or have it copied or who treat it with veneration. This reverence for the text as sacred object, reflecting the general respect for the written word and calligraphy during the Heian period, lay behind the assiduity with which artisans worked on decorated papers, mountings and frontispiece illustrations for *sūtra* texts (not unlike the care medieval Christian monks lavished on illuminated gospels and psalters). During the period 894–1185 (termed the Fujiwara period and often referred to as the golden age of Japanese culture), rebirth in the Pure Land, the Buddhist Paradise, became the goal of both aristocrats and commoners; Buddhist scholar–priests had created a widespread belief that the age of the end of the Buddhist Law (*mappō*) was to begin in 1052. This fundamental religious pessimism coupled with an unlimited exaltation of beauty led to a renewed sponsorship of *sūtra*s, with results impressive both in quantity and quality. Between 1100 and 1185 alone the Buddhist canon was commissioned 56 times. Accounts even tell of individuals copying the entire Buddhist canon single-handed (*ippitsu Issaikyō*); the courtier Fujiwara no Sadanobu (*see* FUJIWARA (ii), (3)), the fifth-generation head of the Sesonji school of calligraphy, gave 23 years to this formidable task. Similarly, the priest Ryōyū (1159–1242) proved his commitment to the Buddhist Law in 42 years of scribal diligence; over 4000 of his scrolls survive.

Although quantity was sometimes taken as evidence of religious piety, aesthetic quality was the prevailing concern of court circles, which produced lavish *sūtra* frontispieces using expensive materials. For instance, the set of Lotus *sūtra* scrolls (*Kunōji kyō*) commissioned *c.* 1141 by retired Emperor Toba (*reg* 1107–23) and presented to Kunōji (later dispersed) is famous for its sumptuous but restrained use of gold and silver decorated papers. More extravagant is the *Heike nōkyō*, a set of 33 scrolls of the Lotus *sūtra* commissioned by the courtier Taira no Kiyomori (1118–81) and donated in 1164 to Itsukushima Shrine (still *in*

121. Buddhist calligraphy on a Lotus Sutra, coloured inks on fan-shaped paper, mounted in a booklet, ?12th century (Osaka, Shitennōji)

situ) in Hiroshima Prefecture. It was fashioned from a stunning variety of decorated papers and adorned with exquisite frontispiece illustrations inspired by Buddhist themes. The term *jinzen jinbi* ('supreme virtue through supreme beauty'), which occurs in the preface to this set of scrolls, well expresses the aesthetic and religious motivations of the work.

Inscribing *sūtra*s on blue or purple paper with gold or silver characters also remained a standard practice through the centuries, and many Heian-period examples sponsored by wealthy patrons survive. Other *sūtra*s of this period are accompanied by frontispiece illustrations, often rendered in gold or silver line drawings, that are connected to the message of the *sūtra* with varying degrees of literalness or that depict Buddhist deities. During this period too, *sūtra*s began to be executed on *karakami* ('Chinese paper'), originally imported but later produced in Japan using dyed paper with traditional Chinese decorative motifs printed in mica. There are also several texts in which each character is enclosed in a decorative cartouche, sometimes outlined in the shape of a small stupa (pagoda) or placed beside miniature drawings of Buddhas or above the lotus blossoms so common in Buddhist iconography. One of the most sophisticated modes of inscribing and decorating scriptures involved the use of a rebus-like form of writing called *ashide* ('reed writing'). In *ashide*, pictures functioning as sounds are combined with *kana* syllables to form familiar phrases or even poems. The frontispieces of the *Heike nōgyo* and *Kunōji kyō* are noted for their use of this suble and playful calligraphic style.

A notable exception to *sūtra*s presented in scroll format is the finely decorated *Senmen Hokkekyō sasshi* ('Album of the Lotus *sūtra* copied on fans'; probably 12th century),

in which the sacred aura of Buddhist texts contrasts with the secular underpainting of genre scenes or bird-and-flower paintings (Osaka, Shitennōji; Tokyo, N. Mus.; other priv. cols; see fig. 121).

Unlike Zen priests of the Kamakura period, whose brushstrokes were thought to reflect their spiritual attainments (*see* §(iv) below), *sūtra* copyists were compelled to follow convention and avoid individual interpretation. All the same, the use of a boldly inscribed regular script lent an aura of unwavering truth and authority to these sacred texts. Among a large corpus of works executed in a routine and sometimes slipshod fashion, many surviving pieces are prized for their strength of brushwork and unpretentious dignity. These regular *sūtra* scripts, like Western medieval Gothic and italic scripts, are notable for their uniformity, the harmonious spacing between words and letters and the proportion and balance within each letter.

(c) Kamakura period (1185–1333) and after. With the upsurge of popular religious observance and sentiment in the Kamakura period, *sūtra* copying was less fervently practised, especially when printed *sūtra*s (Jap. *hankyō*) became more widely available—the most important early set being the *Kasuga-ban* ('Kasuga edition', produced at Kōfukuji and Kasuga Shrine, Nara; widely distributed). However, even these printed versions show a strong reliance on Chinese calligraphy styles of the Tang period (618–907). Printed *sūtra*s were usually produced as small *orihon* (accordion books), a format convenient for reading in temple ceremonies. By the 14th century, *sūtra* copying ceased to be a major vehicle for calligraphic achievement; in the handscroll and single-sheet format, however, it was carried on through the centuries by individuals as a form

of religious practice. The relatively short, 217-character *Hannya shingyō* ('Heart *sūtra*') has replaced the Lotus *sutra*, in modern times, as the favourite text for this practice.

BIBLIOGRAPHY

Y. Inaba and others, eds: *Kōbō Daishi zenshū* (Tokyo and Kyoto, 1910/*R* Osaka, 1965, 1978)
M. Ishida: *Shakyō yori mitaru Narachō bukkyō no kenkyū* [Study of Buddhism of the Nara period based on *sūtra* manuscripts] (Tokyo, 1930) [with brief Eng. summary]
Y. Nakata: *The Art of Japanese Calligraphy* (New York and Tokyo, 1973)
The Courtly Tradition in Japanese Art and Literature: Selections from the Hofer and Hyde Collections (exh. cat. by J. M. Rosenfield, F. E. Cranston and E. A. Cranston, Cambridge, MA, Fogg, 1973)
K. Tanaka: *Nihon shakyō sōkan* [Comprehensive catalogue of *sūtra* copies in Japan] (Kyoto, 1974)
S. Komatsu: *Heike nōkyō no kenkyū* [Study of the *sūtra* dedicated by the Taira clan to Itsukushima Shrine] (Tokyo, 1976)
J. Meech: 'Disguised Scripts and Hidden Poems in an Illustrated Heian *Sūtra*: *ashide* and *uta-e* in the *Heike nōgyō*', *Archvs Asian A.*, xxxi (1977–8), pp. 53–78
N. Ōyama, ed.: *Shakyō* [*Sūtra* copying], Nihon no bijutsu [Arts of Japan], clvi (Tokyo, 1979)
Narachō shakyō [Manuscript *sūtra*s of Nara-period Japan] (exh. cat., Nara, N. Mus., 1983)
B. Kurata and Y. Tamura, eds: *The Art of the Lotus Sutra: Japanese Masterpieces* (Tokyo, 1987)
W. J. Tanabe: *Paintings of the Lotus Sutra* (New York and Tokyo, 1988)
G. J. Tanabe jr and W. J. Tanabe, eds: *The Lotus Sutra in Japanese Culture* (Honolulu, 1989)

(ii) Early courtly styles. While there are examples of calligraphy by members of the court dating from before the 9th century (*see* §(i)(a) above), the term 'courtly' usually applies to styles developed in the Heian period (794–1185) and later.

(a) Early Heian period (AD 794–897). (b) Middle Heian period (897–1086). (c) Late Heian period (1086–1185). (d) Early Kamakura period (1185–1249).

*(a) Early Heian period (*AD *794–897).* As in earlier times, both court and religious calligraphy of the Early Heian period relied on Chinese models, especially those associated with the famous 4th-century calligrapher Wang xizhi (*see* WANG (i), (1)). Among the most talented calligraphers of the age were KŪKAI (*see* §(i) above), Emperor SAGA and the courtier TACHIBANA NO HAYAN-ARI, who came to be known as the Sanpitsu (Three Brushes) of the Early Heian period. Kūkai, the founder of the Shingon sect (*see* §II, 3 above), was undoubtedly the most influential calligrapher of the age. He reputedly worked in a variety of styles, including those of the Tang-period (618–907) calligraphers OUYANG XUN and Yan Zhenqing (709–85).

In 822, in commemoration of the death of the priest Saichō, Emperor Saga inscribed a set of Chinese poems by members of the court and clergy; the only surviving scroll of this set, *Koku Chō Shōnin shi* ('Poems mourning for Priest Saichō'; Japan, priv. col.), is written in a highly mannered cursive script. Another work in his hand is the *Kōjō kaichō* ('certificate of ordination for Monk Kōjō'; Japan, priv. col.) drawn up in 823 for Kōjō (779–857), a prominent disciple of Saichō. Since the writing in this work shows the influence of Ouyang Xun, Kūkai's mediation is frequently inferred.

About the style of Tachibana no Hayanari little is known. Connoisseurs of calligraphy of the Edo period (1600–1868) ascribed to him the *Ito Naishinnō ganmon*

('The prayer of Imperial Princess Ito'), a dedication written on behalf of Princess Ito when she donated land to Yamashinadera (now Kōfukuji, Nara) in 833. Certainly Hayanari was active at this time. Whether or not it is his work, the dedication—distinguished by the handprints of the princess in red seal-ink—is an important example of official court calligraphy of the 9th century (Tokyo, Imp. Household Col.).

Emperor Daigo (*reg* 897–930) is also said to have learnt the style of Kūkai and had direct access to calligraphy models the Buddhist master brought back from China. His transcription of poems by Bai Luotian (Bo Juyi; Jap. Hakurakuten; 772–846) in *kyōsō* (wild-cursive) script calls to mind the eccentric styles of Zhang Xu (*fl* 710–50) and his disciple HUAI SU. Models of Chinese poetry texts rendered in cursive script played a key role in the evolution of *kana* (Japanese phonetic) scripts (*see* §1(i)(c) above).

(b) Middle Heian period (897–1086). Before the end of the 9th century, Japan's official diplomatic relations with China had gradually lapsed. The waning influence of China and the growing prestige of *waka* poetry (a 31-syllable form written in Japanese) are most clearly reflected in the imperially sponsored *Kokin wakashū* (or *Kokinshū*, 'Collection of Japanese poems from ancient and modern times'; *c*. 905). The period of most vigorous innovation and development in Japanese calligraphy occurred in the Middle Heian period, at a time when court literature also attained the peak of refinement. In particular, the poetry, diaries and novels of court women had high literary merit and won lasting popularity. Japanese was invariably the medium of these women's belles-lettres, whereas official documents and diaries by male courtiers were recorded in Chinese.

Edo-period critics tended, out of a sense of historical symmetry, to associate each era of calligraphy with a triumvirate of noted calligraphers. Thus, the great calligraphers of the Middle Heian period came to be referred to as the Sanseki ('three brush traces'): ONO NO MICHI-KAZE, Fujiwara no Sari (*see* FUJIWARA (ii), (1)) and Fujiwara no Kōzei (*see* FUJIWARA (ii), (2)). All were prominent courtiers, not professional calligraphers, but their prestige in their own day and their place in history are largely due to their calligraphic skills. In a society where rank and proximity to the emperor counted for so much, the highest honour to which a courtier–calligrapher could aspire was an imperial commission to inscribe poems for a set of ceremonial screens (*Yuki-suki no byōbu*) created to commemorate the enthronement ceremonies and exalt the imperial line. Each of the Sanseki was so distinguished at least once; in later generations a number of Kōzei's descendants—calligraphers of the Sesonji lineage—also had this honour.

Ono no Michikaze was active as a court calligrapher throughout the first half of the 10th century, spanning the reigns of the emperors Daigo, Suzaku (*reg* 930–46) and Murakami (*reg* 946–67). His calligraphy, following the tastes of the time, was based on models of Wang Xizhi but already softened to suit Japanese courtly sensibilities. Lady Murasaki Shikibu (*d* ?1014), the author of *Genji monogatari* ('Tale of Genji'; *c*. 1005), who lived just a

122. Early courtly calligraphy by Fujiwara no Yukinari: *Hakurakuten shikan*, poems by Bai Luotian (detail), handscroll, ink on paper, 254×2652 mm, 11th century; National Treasure (Tokyo, National Museum)

generation or two after Michikaze and had surely seen actual examples of his hand, described his calligraphy in one passage of her novel as 'dazzlingly modern'. The most famous of his surviving works, *Byōbu dodai* ('Draft for an inscription on a screen', *c.* 928; Tokyo, Imp. Household Col.), is a rough draft for a screen with Chinese poems by Ōe no Asatsuna (886–957), a contemporary of Michikaze. In the same style is the *Chishō Daishi shigō chokusho* ('Imperial decree bestowing the posthumous name Chijō Daishi'; Tokyo, N. Mus.), written on behalf of Emperor Daigo, in which a posthumous name and rank were bestowed on the priest Enchin (814–91). Both works substantiate the accepted view of Michikaze as an innovator in the Japanese tradition. Poems by Bo Juyi inscribed on Chinese silk, collectively referred to as the *Ayaji-gire* ('Fragments of calligraphy on patterned silk'; Tokyo, e.g. Maeda Ikutokukai Found. Lib.; Umezawa Mem. Found.) and *Kinuji-gire* ('Fragments of calligraphy on silk', e.g. Tokyo, N. Mus., Homma A. Mus.), survive from the 10th century; they include fragments quite possibly written by Michikaze. No examples of his works in *kana* (Japanese syllabic) script survive, although numerous works of the later Heian period have been attributed to him.

While still in his twenties, Fujiwara no Sari had the honour of inscribing poem cards for the coronation screens for Emperor En'yu (*reg* 969–84); he was later commissioned for the same task by the emperors Kazan (*reg* 984–6) and Ichijō (*reg* 986–1011). A sheet of poetry written in 969 when he was 26 years old is treasured as the oldest surviving poetry written on *kaishi* ('bosom paper'; paper carried in the breast folds of a kimono and used, among other purposes, for inscribing poems). While Sari continued to rely heavily on Chinese models, he also played a crucial role in the development of Wayō (Japanese-style) calligraphy. The boldest stylist among the Sanseki, he often used idiosyncratic (sometimes almost indecipherable) cursive variants of characters, as seen in his hastily written letters.

The court career of Fujiwara no Kōzei coincided with the brilliant flowering of culture at the Heian court under the regency of Fujiwara no Michinaga (966–1027). Born into an influential branch of the Fujiwara clan, Kōzei was active from an early age in the uppermost echelons of court society and served as an adviser to Emperor Ichijō. In several regards Kōzei was the archetypal courtier–calligrapher, whose mastery of both court politics and the skills of poetry and calligraphy earned him the esteem or jealousy of his peers. He was often called on to inscribe works for the emperor and high-ranking nobles and had the duty of transcribing the proceedings of poetry gatherings. Kōzei's own diary, *Gonki* ('Diary of the counsellor'; Kamakura-period manuscript is earliest surviving copy, Tokyo, Imp. Household Col.), reveals that he owned or sometimes borrowed calligraphy texts written by his predecessor Michikaze to use as models. He relates a dream in which Michikaze hovers before him to convey secret teachings of calligraphy. The most famous surviving work by Kōzei is a section of a scroll including eight poems by Bai Luotian (*Hakurakuten shikan*), in which the characters are clearly articulated and smoothly refined, like those of Michikaze (see fig. 122). Similar traits can be discerned in Kōzei's *Honnōji-gire*, a transcription of Chinese poems by Japanese poets, rendered in semi-cursive (*gyōsho*) and cursive (*sōsho*) scripts (Kyoto, Honnōji).

The *Kōya-gire* ('Mt Kōya fragments'; sections of a manuscript of the *Kokin wakashū*, named after the Buddhist monastic complex on Mt Kōya, Wakayama Prefecture) are said to represent the *Kōzeifū* ('Kōzei style'; see fig. 123). Traditionally attributed to Ki no Tsurayuki (*c.* 872–945), a diarist and poet of the Early Heian period, they can be more accurately dated on stylistic grounds to the mid-11th century. They originally consisted of nine scrolls, but in the 17th century they were cut into small sections and remounted as hanging scrolls or pasted into calligraphy albums (*tekagami*). Modern scholars, recognizing the work of three different hands, refer to *Kōya-gire* styles I, II and III. There are good grounds for identifying one of the calligraphers as Minamoto no Kaneyuki (*fl* mid-11th century), some of whose dated works are extant.

123. Early courtly *kana* calligraphy in the form of a poem from the *Kōya-gire*, style I, of the *Kokin wakashū* ('Collection of Japanese poems from ancient and modern times'), handscroll mounted as a hanging scroll, ink on paper, 259×410 mm, mid-11th century; Important Cultural Property (Tokyo, Gotoh Museum)

These fragments are central to the study of the evolution of court calligraphy.

(c) Late Heian period (1086–1185). Perhaps the most ambitious calligraphy project of the Heian period was the *Honganj-bon Sanjūrokunin kashū* ('Honganji version of the collection of the 36 master poets'; Kyoto, Nishi Honganji), a compilation originally made by Fujiwara no Kintō (996–1041). In about 1112, twenty of the most talented calligraphers of the age were commissioned to transcribe the poems. Though anonymous, several of the volumes have been attributed to Fujiwara no Sadanobu (*see* FUJIWARA (ii), (3)) or to others working closely to Sesonji-school models (see below). While some of the scribes still wrote in the controlled, conservative style of the *Kōya-gire*, others displayed a more rapid and spontaneous style that emerged in the 12th century. Every form of decoration imaginable was used on the sumptuously decorated papers: dyeing, mica embossing, stencilling or underpainting in gold and silver, ink marbling. Perhaps the most distinctive feature is the use of papers of different colours, cut and torn into random shapes and pasted together to create striking collages (*tsugigami*). Two volumes from this set, containing poems by Ki no Tsurayuki and Lady Ise (?877–?940) respectively, were sold in 1929. The detached pages of these two volumes are called the *Ishiyama-gire* (a reference to an earlier site of Nishi Honganji temple).

Kōzei's orthodox and refined style established a standard that formed the basis of the first major school (*ryū*) of court calligraphy and came to be known as the Sesonji *ryū* (named after the family temple established by Kōzei). At first, a number of his descendants, while using their ancestry as a badge of prestige, produced calligraphy in their own distinctive style. Fujiwara no Korefusa (1030–96), for example, the third-generation head of the school and Kōzei's grandson, wrote in a clearly articulated yet freer and more vigorous style than Kōzei. Several works survive by Korefusa in both *kana* and *kanji* (Chinese characters), including the *Ranshi-bon Man'yōshū* ('Collection of 10,000 leaves', Ranji version) and the *Jūgoban utaawase*, the transcription of a poetry contest in 15 rounds. The style of these works is quite different from the orthodox style generally associated with Kōzei, yet it is similar to works traditionally attributed to him, such as the Kumogami and Sekido versions of the popular collection *Wakan rōeishū* ('Collection of Chinese and Japanese poems for recitation'; compiled *c.* 1013 by Fujiwara no Kintō). After Korefusa's time, court calligraphy exhibits a trend towards rapid brushwork and more purposeful variation. Korefusa's grandson Fujiwara no Sadanobu left dated works for each stage of his career, from which it is clear that he was more concerned with the overall flow of a column of writing than with the construction of individual characters. His style had much in common with that of Korefusa, providing evidence that calligraphic models and instructions were handed down within the family.

By the 12th century, calligraphers of the Sesonji lineage had become concerned with codifying the teachings of their predecessors and reaffirming the prestige of the school. The first stage of this process was the writing of

manuals that recorded conventions that had traditionally been transmitted orally from parent to child or from teacher to pupil. One of the earliest such manuals is the *Yakaku teikinshō* ('Evening crane family precepts'), written by Fujiwara no Koreyuki (*d* 1174), the sixth head of the school, as a guidebook of calligraphic conventions and court etiquette for fledgling calligraphers such as his daughter, for whom it was originally composed. A representative example of Koreyuki's talents is the *Ashide shitae Wakan rōeishū* ('*Wakan rōeishū* on paper decorated with reed script designs', 1160; Kyoto, N. Mus.), in which he transcribed Chinese and Japanese poems on paper with grass designs and *kana* characters used as decorative motifs (*ashide*, 'reed script').

Although not a direct descendant of Kōzei, Fujiwara no Norinaga (1109–80) was one of the most prominent calligraphers of the 12th century working in the idiom of the Sesonji school and writing official documents. Modern comparative research has added some other manuscripts to the body of his work, including the text to two chapters of the *Genji monogatari emaki* ('Picture scroll of the *Tale of Genji*') and the text of *Ban Dainagon ekotoba* ('Picture story of the Ban Major Counsellor'; three scrolls, late 12th century; Tokyo, Idemitsu Mus. A.). He was also the author of *Saiyōshō* ('Notes on talent'), an important treatise on calligraphy, which was transmitted through Fujiwara no Koretsune (?1169–?1227), the seventh head of the Sesonji school.

Since the Edo period, the term 'Sesonji style' has usually been applied to the style practised by the descendants of Sesonji Yukiyoshi (1179–1255), the eighth head of the lineage. His successors also used Sesonji rather than Fujiwara as their family name. To revive the prestige of the school, Yukiyoshi reverted to the eminently legible and refined style that had been regarded as orthodox a century earlier, but the works of this period never matched the masterpieces of the 11th and 12th centuries. Through the 13th century, a number of competent but hardly inspired calligraphers of the Sesonji lineage carried on the traditions of court calligraphy. Sesonji Tsunetada (1247–?1320) and his sons Yukifusa (*d* 1337) and Yukitada (*d* 1350) had connections with the Shōren'in, a temple in Kyoto that later became the centre of the next major tradition of court calligraphy (*see* §(iii) below). The Sesonji school officially came to an end in the 16th century with the death of the 17th-generation head, Sesonji Yukisue (1476–1532). However, the heritage of its calligraphy models, its secret teachings and court patronage were transferred to the Jimyōin *ryū*, which was founded by Jimyōin Motoharu (1453–1535), a courtier who studied calligraphy under Sesonji Yukitaka (1412–78), the sixteenth head of the Sesonji school. While the Jimyōin school lasted through the Edo period, its practitioners steadfastly adhered to traditional Sesonji conventions of the 13th and 14th centuries.

The first major offshoot of the Sesonji school was the Hosshōji school, established by followers of Fujiwara no Tadamichi (*see* FUJIWARA (ii), (4)). Tadamichi served as Imperial Regent and Prime Minister during the Late Heian period, when the most powerful branch of the Fujiwara family was being supplanted by the Taira. Although in his youth he followed Kōzei's style and never lost its clarity,

Tadamichi was an expressive calligrapher who used his brush more roughly and with purposeful inelegance, perhaps influenced in the brusqueness of his style by his grandfather, Fujiwara no Moromichi (1062–99). Drafts of 29 of his letters survive.

(d) Early Kamakura period (1185–1249). The Hosshōji school lasted throughout the Kamakura period (1185–1333) and influenced its contemporaries of the Sesonji lineage. Its most prominent offshoot was the Gokyōgoku school, founded by Tadamichi's grandson Gokyōgoku Yoshitsune (Fujiwara no Yoshitsune; 1169–1206), a courtier, poet and calligrapher. Many works attributed to him, such as the *Murasaki Shikibu nikki ekotoba* (Text of the Lady Murasaki picture scroll'; e.g. Tokyo, Gotoh Mus.; Osaka, Fujita Mus. A.) and the *Mame shikishi* ('Small-size poem cards'; various collections), are representative works of the Gokyōgoku style, which was less vigorous and rough than Tadamichi's and which became the predominant style of the 13th and 14th centuries.

The calligraphy of the Early Kamakura period was subject to two parallel and opposing trends: one was towards the codification and stylistic integration of existing court styles of the Sesonji, Hosshōji and Gokyōgoku schools; the other was the increasing recognition of individual and idiosyncratic styles—often developed by the major poets and critics of the age, especially those of the Mikohidari circle of poets. Fujiwara no Mototoshi (1056–1142), one of the poetic arbiters of this group of innovators, was a brilliant and unconventional student of poetry but said to be reactionary in his tastes. Fragments of the *Wakan rōeishū* known as the *Tagagire* ('Taga fragments'; Kyoto, Yōmei Bunko) and fragments of the *Shinsen rōeishū* ('New collection of Chinese and Japanese poems for recitation') known as the *Yamana-gire*, firmly attributed to Mototoshi, reveal an idiosyncratic but unpretentious hand, devoid of the mannerisms of court calligraphy.

The same can be said of Fujiwara no Shunzei (*see* FUJIWARA (ii), (5)), who studied poetry under Mototoshi. The similarities in their writing styles may indicate not a direct transmission of calligraphic practices but rather that learning poetry in that age involved making copies of one's teacher's prized manuscripts. In poetry Shunzei admired *yūgen*, an ideal of mysterious beauty tinged by sadness or deprivation, and perhaps sought the same in his calligraphy. A number of examples of Shunzei's calligraphy survive, including the much-cherished *Hino-gire*, fragments of the seventh imperial anthology, the *Senzai wakashū* ('Collection of a thousand years'; *c.* 1188), which he inscribed at the age of 74 in a highly idiosyncratic hand: the strokes are highly attenuated, but accented with abrupt, boldly brushed turns.

Shunzei's son Fujiwara no Teika (*see* FUJIWARA (ii), (7)) not only perpetuated the Mikohidari tradition of poetry but was prominent as a critic and editor of Heian-period classics. For the last five or six years of his life, Teika walked with difficulty and thus spent his time copying these classics or directing assistants. Many of the modern editions of Japanese literary classics, including the *Genji monogatari* ('Tale of Genji'), derive from manuscripts made by Teika's private scriptorium. Although Teika never

thought of himself as a talented calligrapher, his descendants and the tea masters of later generations held his handwriting in high esteem.

Soon after his death, Teika's heirs argued over inheritance of property and the leadership of the Teika school of poetry. Eventually they split into three branches, the Nijō, Reizei and Kyōgoku. Though not the strongest politically, the Reizei line inherited the most important literary manuscripts and passed to the competing Nijō line many forged documents. Not only were texts and commentaries copied verbatim, but the idiosyncrasies of the 'Teika style' were also reproduced and passed down, generation after generation, until they became convention. Teika's own journal, *Meigetsuki* ('Bright moon diary', intermittently covering the period from 1180 to 1235; e.g. Tokyo, N. Mus.; Gotoh Mus.; Yenri Cent. Lib.), written in literary Chinese, survives in sections. Also extant is a set of the *Ogura shikishi* ('Ogura poem cards'; *c.* 1235; e.g. Kyoto, Yōmei Bunko; Nara, Yamato Bunkakan; Tokyo, N. Mus.; see *Teika-yō*, 1987, pls 66–76), with poems of the extremely popular *Ogura hyakunin isshu* ('Ogura collection of a hundred poets, one poem each') inscribed by Teika or followers imitating his distinctive style; later a number of these *shikishi* were prized by tea masters. Particularly in the 14th–16th centuries, much prestige was attached to the Teika manner, which continues to be emulated. There are probably more sub-schools tracing their roots back to Teika than to any other calligrapher.

During the Early Kamakura period members of the imperial family were among the most talented calligraphers. Retired Emperor GOTOBA wrote on *kaishi* paper commemorating visits to the Kumano shrines (three Shinto shrines in the Kumano district, Wakayama Prefecture). In his youth, Emperor FUSHIMI studied Kōzei style, as is demonstrated by his transcription of the *Gosen wakashū* ('Later collection of Japanese poetry'). Having mastered Chinese models of the Song period (960–1279) while working within the classical Japanese idiom, he won high praise, and his work was accordingly held up as a representative example of the esteemed *Jōdai-yō* ('classical style') of calligraphy.

BIBLIOGRAPHY

K. Shimonaka, ed.: *Shodō zenshū* [Complete collection of calligraphy], n. s., 26 vols (Tokyo, 1954–68)

S. Komatsu: *Nihon shoryū zenshi* [History of Japanese calligraphic styles and schools], 2 vols (Tokyo, 1970)

Y. Nakata: *Nihon shodō no keifu* [Genealogical record of Japanese calligraphy] (Tokyo, 1970)

Y. Nakata, ed.: *Shodō geijutsu* [Art of calligraphy], 24 vols (Tokyo, 1970–73)

S. Komatsu: *Kohitsu* [Classical Japanese calligraphy] (Tokyo, 1972)

M. Kinoshita: *Tekagami* [Calligraphy albums], Nihon no bijutsu [Arts of Japan], lxxxiv (Tokyo, 1973)

Y. Nakata: *The Art of Japanese Calligraphy* (New York and Tokyo, 1973)

The Courtly Tradition in Japanese Art and Literature: Selections from the Hofer and Hyde Collections (exh. cat. by J. M. Rosenfield, F. E. Cranston and E. A. Cranston, Cambridge, MA, Fogg, 1973)

Nihon meiseki sōkan [Collection of famous Japanese calligraphy], 100 vols (Tokyo, 1976–86)

S. Komatsu, ed.: *Nihon shoseki taikan* [Collection of calligraphy of leading persons in Japan], 25 vols (Tokyo, 1977–81)

Y. Haruna: *Kohitsu daijiten* [Encyclopedia of classical Japanese calligraphy] (Tokyo, 1979)

M. Furuya: *Heian jidai no sho* [Calligraphy of the Heian period], Nihon no bijutsu [Arts of Japan], clxxx (Tokyo, 1981)

M. Kinoshita: *Kamakura jidai no sho* [Calligraphy of the Kamakura period], Nihon no bijutsu [Arts of Japan], clxxxi (Tokyo, 1981)

Masters of Japanese Calligraphy, 8th–19th Century (exh. cat. by Y. Shimizu and J. M. Rosenfield, New York, Japan House Gal. and Asia Soc. Gals, 1984–5)

S. Komatsu, ed.: *Nihon shodō jiten* [Handbook of Japanese calligraphy] (Tokyo, 1987)

Teika-yō [Teika-style calligraphy] (exh. cat., Tokyo, Gotoh Mus., 1987)

G. Decoker: 'Secret Teachings in Medieval Calligraphy: Jubokushō and Saiyōshō', *Mnmt Nipponica*, xxxxiii/2 (1988), pp. 197–228; xxxxiii/3 (1988), pp. 261–78

S. Komatsu: *Kohitsugaku taisei* [Compendium of research on calligraphy], 30 vols (Tokyo, 1989–93)

C. H. Uyehara: *Japanese Calligraphy: A Bibliographic Study* (New York, 1991)

Shika to sho [Poems and calligraphy] (exh. cat., Tokyo, N. Mus., 1991) [with repr. of wks and Eng. summary]

M. Furuya: 'Gokyōgoku Yoshitsune to Hosshōji-ryū shohō no tenkai: Mitsui bunko-bon shikaishi o chūshin toshite' [Gokyōgoku Yoshitsune and the development of the calligraphic style of the Hosshōji school: a poem on *kaishi* paper in the collection of Mitsui Bunko], *Museum* [Tokyo], 498 (1992), pp. 4–21

G. DeCoker and A. Kerr: '*Yakaku Teikinshō*: Secret Teachings of the Sesonji School of Calligraphy', *Mnmt Nipponica*, xxxxix/3 (1994), pp. 315–29

J. T. Carpenter: 'Authority and Conformity in Twelfth-Century Japanese Court Calligraphy', *Proceedings of the 39th International Conference of Orientalists in Japan* (Tokyo, 1995), pp. 97–117

JOHN T. CARPENTER

(iii) Shōren'in school. Around the time of Sesonji Yukitada (*d* 1350), a member of the 12th generation of the Sesonji school (*see* §(ii)(c) above) in the Late Kamakura period (1249–1333), one of the most important and influential calligraphers in the history of Japanese calligraphy emerged. The style of Prince SON'EN (1298–1356), sixth son of Emperor Fushimi, later became known as the Shōren'in, Son'en or Awata school. The tradition of this school was established through hereditary succession by the abbots of the Shōren'in Temple (one of the most famous of the *monzeki* temples, the abbots of which were Buddhist monks or nuns who were members of the imperial family) at Awataguchi, in the foothills of the eastern mountains in Kyoto. Prince Son'en's calligraphy and that of the Shōren'in school incorporated new elements, while revitalizing the styles and retaining the methods of the old masters. Rich and fluent, it found astonishing popularity throughout the Edo period (1600–1868), and was widely practised not only by the aristocracy and military leaders but also by commoners.

(a) Prince Son'en. (b) Later practitioners.

(a) Prince Son'en. Brought up in the imperial court, Prince Son'en was surrounded by accomplished calligraphers, including his grandfather, Emperor GoFukakusa (*reg* 1246–60), and his elder brothers, the emperors Go-Fushimi (*reg* 1298–1301) and Hanazono (*reg* 1308–18). He was 14 when he first expressed his desire to learn calligraphy from Sesonji Tsunetada (1247–?1320), a wish conveyed to the master by the monk Kakuin (*fl c.* early 14th century). Before accepting Son'en as his pupil, Tsunetada asked to see an example of his calligraphy. After examining it, he praised its excellence and encouraged Son'en to continue, but said that he, at 65, was too old to teach Son'en, recommending instead his son Yukitada. Tsunetada advised Son'en to make a particular study of *mana*

(Chinese characters used as units of meaning), as exemplified by Fujiwara no Kozei (*see* FUJIWARA (ii), (2)), and *kana* (Japanese syllabic characters), as used by Sesonji Koretsune (*d* 1227). Later Son'en studied with Tsunetada's other son, Yukifusa (*d* 1337), until 1332 and from him learnt to write on *shikishi* (square writing paper, usually for poems) and to copy Buddhist *sūtra*s. Son'en's early calligraphy lessons, however, seem to have been interrupted for a few years from 1314, when he went into seclusion at the Kujōbō, probably a subtemple of Kyōō-gokokuji (or Tōji) in Kyoto, to study Shingon Esoteric Buddhism (*see* §II, 3 above).

Son'en's own highly organized theory of calligraphy no doubt came partly from his reading of the treatises and secret teachings of his predecessors, notably the *Yakaku teikinshō* (compiled *c*. 1170s by Fujiwara no Koreyuki (1138–75) and giving instructions on materials and techniques and listing the names of certain noted calligraphers), the *Saiyoshō* (compiled *c*. 1177 by Fujiwara no Koretsune (*fl c*. 12th century) and containing rules about calligraphy) and the *Kirinshō* (a treatise on calligraphy in six volumes, compiled *c*. 1341 by Sesonji-school masters). One of Son'en's major works was the *Jubokushō* ('Treatise on calligraphy'), a short set of instructions on *juboku* (calligraphy; Chin. *ru mu*; literally 'to enter wood'), a term derived from the deep penetration into the wood of ink from the brush of the 4th-century Chinese calligrapher Wang Xizhi (*see* WANG (i), (1)). The oldest extant manuscript version of the *Jubokushō* (Tokyo, Maeda Ikutokukai Found. Lib.) was copied by the monk Gishitsu in 1369. The work expressed Son'en's thinking with great clarity, emphasizing the essence of calligraphy, rather than its forms, methods of execution or implements, and revealing his firm belief in the quality of traditional Japanese calligraphy, especially that of the Heian period (794–1185), and his dislike of the contemporary penchant for Chinese calligraphy of the Song period (960–1279). His treatise is believed to have been written for presentation to the 15-year-old emperor GoKōgon (*reg* 1351–71) on the day of his *fumihajime* (initiation into study) ceremony in 1352. The highly acclaimed treatise, long considered one of the most innovative theoretical writings on Japanese calligraphy, comprised 20 itemized entries, of which brief extracts are given below.

How to hold the brush. It is very important to hold the brush correctly from the beginning of your lessons. If you do not, it will be hard to correct your bad habit.

Model books. To practise calligraphy, follow a model book (*tehon*) step by step. You should not copy an entire model scroll at one time; first only one or two [Chinese] poems, then repeat this several times for several days.... The mental image of this model will appear sharp and clear in your mind, and you will be able to proceed from memory without deviating in the least.

Size of characters. At the beginning you will tend to write a larger character than the model scroll, but you must practise writing in the same size as the model. Also, when the character is much larger than the model, the strokes will be slender. This is bad.

Importance of brushwork. Good or bad calligraphy depends on a person's handling of the brush. This too has to be learnt from the finest calligraphic models of the classical period.... The form of a character reflects a person's appearance, and the vigour of the brush reflects the operation of a person's mental attitude. Therefore, if you learn the way of calligraphy based on the earlier masters' mental attitude, you will obtain naturally their subtle essence.

Brushwork of early masters. The handling of the brush by the earlier masters [of the Heian period] reveals vigorous spirit everywhere in the execution and no weak strokes.... An excellent calligrapher puts his spirit into such places as the point where the brush tip starts the first stroke, the end of a vertical or horizontal stroke, the bending section of a stroke and the end of the stroke where the brush tip is lifted.

Cultivation of good habits. To avoid bad habits, concentrate on learning the right fundamental attitude [which leads you to achieve the right configuration]. People who, without knowing the Way of calligraphy or receiving the oral transmission, insist on trying to master the art by sheer application will, for the most part, be incapable of finding the correct Way.... Even when they see old calligraphy, they do not practise [relatively easy] examples of extremely fine and fluid line, but start to flourish the vigorous brush of an accomplished master, earnestly trying to capture the inimitable freshness of the sophisticated passages before their eyes. If you study the orthodox forms wholeheartedly ... you will be able to write freely in the untrammelled style of the old masters.

Avoidance of an extraordinary style. Talented beginners often envy the popular calligraphic execution of fancy forms such as reversed characters, a character written in highly cursive manner (often called *kyōsō*; Chin. *kuang caoshu*; literally, 'crazy grass' or wild cursive script), and split-brush execution leaving spaces in the dots and strokes (*utsuboji*; literally, 'hollow character').... It is very important to practise to write beautifully and correctly many times. The great path is distant and difficult to follow; the wrong course is near and easy to take.

Regular, running and cursive scripts. About characters in the *shin* (*shinsho* or *kaisho*; Chin. *zhenshu*, *kaishu*; regular), *gyō* (*gyōsho*; Chin. *xingshu*; running) and *sō* (*sōsho*; Chin. *caoshu*; cursive) scripts. First you should learn the *gyō* script, because it is the style of middle or moderate form.

Record of progress. The progress of your practice should be detectable. Every five or ten days you should write once without looking at the model book and record the date. When you look at these attempts later, good or bad calligraphy will become apparent.

Unevenness in practice. When you are a beginner, during practice, there will be a sudden failure in the brush movement and the characters will not resemble the model book. Unexpected things will happen. At these times you will fall into a slump and start feeling bored. If you pay no attention and practise the same way as you have, within four or five to ten days the situation will improve. At the beginning you should never stop practising.

Structure of daily practice. For a while you should practise one or two *toki* [two or four hours] a day.

Choosing a model book. If a beginner learns from the finest examples of the Sanseki (Three Brushes of the Heian period: ONO NO MICHIKAZE, Fujiwara no Sari (*see* FUJIWARA (ii), (1)) and Fujiwara no Kōzei), simply thinking that they look interesting or impressive, without consulting an experienced calligrapher, he will damage his style, because even the calligraphy of the Sanseki is not always of an even quality.

Diversity of models. It is important to survey many models, but at the same time limit yourself to one for practice. If you inspect several books, you will become knowledgeable.

Copying of correspondence. Do not take correspondence (*shōsoku*) as the model, as is often done nowadays. Contrary to their better judgement, calligraphers often have written many letters in response to people's requests for models. Letters are not concerned with forms or styles of characters, rather they are executed spontaneously. Thus it is rare for a letter to be used as a model, even one written in the calligraphy of an earlier master.

Choice of brush. Even for practice, it is better to use a good brush.... You should select a brush according to the writing paper. A brush made with rabbit hair is good for *dashi* (paper pounded with a mallet to make a lustrous surface); for ordinary paper (*soshi*; untreated paper, softer than *dashi*) a brush of deer hair is good.

Choice of inkstick. For your practice, the *fujishiro* inkstick [the best quality among Japanese ink sticks] should be used. The Chinese inkstick [the highest quality] is rare. If you do not take proper care, even a Chinese inkstick will be ruined. Always wipe it off after use and put it unwrapped in a lacquer container. This is a matter of the highest secrecy.

Choice of writing paper. For your formal practice, spindletree (paper mulberry; *Broussonetia papyrifera*) paper (*danshi*; thick, white, with a crêpelike surface; *see* §XVI, 18 below) is to be used. For *shin* calligraphy, glossy paper (*dashi*) is good. Any paper may be used for ordinary everyday writing.

Art of Juboku. About Japan's superiority to China. The name of KŪKAI is well known in China because he replaced calligraphy by imperial order on the palace wall where the original calligraphy by Wang Xizhi had been damaged... One may conclude that there have been many outstanding calligraphers in Japan. Hence, although in various arts Chinese styles have been introduced, in calligraphy one need not force oneself to rely on the explanations in Chinese books. Since the time of Yukinari [Kōzei] we have followed the traditional [oral] teachings of successive generations of that family; no other teachings have been employed. The recently fashionable style of Song-period calligraphy is largely lacking in divinity and subtlety. These days men in literary circles imitate Song-style calligraphy; they execute official documents and poems composed at palace banquets in extremely strange forms of characters, all of which is highly improper. In Japan we always pursue the traces of the past and try not to lose our national style. But China is different; they change the old styles and spread the new customs of the day; thus the calligraphy styles are altered as well. Sugawara no Michizane in the early Heian period was outstanding. Michikaze succeeded him. These excellent calligraphers shared similar styles. Sukemasa [Sari] and Yukinari [Kōzei] followed the style of Michikaze. Thereafter the three pre-eminent calligraphic styles, *Yaseki* (calligraphy of Michikaze), *Saseki* (calligraphy of Sukemasa) and *Gonseki* (calligraphy of Yukinari), have been regarded as the present authority (*gengon*) on calligraphy up to this day, and all the calligraphers have followed these styles.

Styles and periods. Around the time of Kūkai, calligraphy was more or less in one style. After Michikaze, each calligrapher followed his own style. Although Yukinari too followed Michikaze's style, he did to a certain extent develop his own manner of execution. After that, from the time of the retired emperor GoIchijō (*reg* 986–1011) until the time of the emperors Shirakawa (*reg* 1073–87) and Toba (*reg* 1107–23), calligraphy good and bad was in the style of Yukinari. ... In recent years, the calligraphy of the retired emperor Fushimi has been frequently praised, especially for his *kana*. ... In *kana*, he seems to have taken Sukemasa's style as his model. [Interestingly, this passage indicates that Son'en, who was advised by Sesonji Tsunetada to study Yukinari's *kana*, had arrived at his own views.] Descendants of Yukinari have all followed his style [exactly]. ... Although in outward appearance calligraphic style appears to have changed from one period to another, its inner truth is utterly the same.

Employment of an accomplished calligrapher. The *nōsho* [this term can also refer to calligraphy itself] is one approved by the senior authorities [on calligraphy] or appointed by the imperial family to be official calligrapher (*kakiyaku*).

124. Model calligraphy attributed to Prince Son'en (detail), handscroll, ink on paper decorated with blue and purple cloud patterns (*kumogami*), 319×217 mm, mid-14th century (Cambridge, MA, Arthur M. Sackler Museum)

[But] even if a calligrapher had a quite divine and subtle hand, he would be obliged to yield, without hope of renown, to a more qualified [contemporary] calligrapher than himself.

The *Shōtetsu monogatari* (*karonsho*; writing on *waka* poetry; two vols, *c.*1448–50) by the monk and poet Shōtetsu (1381–1459) comments on the calligraphic styles of Son'en and his father, comparing them to the interior decoration of a room, in which the father's style mixes Japanese and Chinese objects in the alcove, while Son'en's is purely Japanese. The *Hakushi monjū* by the Tang-period (618–907) Chinese poet Bo Jui (772–846) served Son'en as a model book for learning characters as well as poems, his copy probably having been executed by Michizane from the original. His calligraphic style can be summed up as Wayō (Japanese-style) calligraphy, brought to perfection by embodying and expressing the beauty and elegance of the work of ancient masters. When the retired emperor Hanazono (*reg* 1308–18) compiled the poetry anthology *Fūga wakashū* in 1346, Son'en was chosen to execute the poems for the final copy. Other examples of his calligraphy include correspondence, official documents, model books for calligraphy lessons (see fig. 124), the *Shūkashō* (a compilation of practical vocabularies) and the *Mon'yōki* (old customs of *monzeki* temples).

(b) Later practitioners. The Shōren'in school represented an exemplary style of practical calligraphy and achieved wide popularity among all classes of people, producing countless model books for calligraphy lessons in both *waji* (Japanese letters) and *kanji* (Chinese characters). Shōren'in calligraphy was also employed by the military government for writing official documents. The school remained the dominant school of Japanese calligraphy throughout the Muromachi period (1333–1568) and continued into the Edo period (1600–1868) under the name of Oie ('official house') *ryū*. However, in the late 16th century

separate new developments in calligraphy came to the fore. Innovative artists, such as Hon'ami Kōetsu (*see* HON'AMI, (1)), KONOE NOBUTADA, SHŌKADŌ SHŌJŌ and KARASUMARU MITSUHIRO, having begun their calligraphic training in the Shōren'in school, emerged as independent masters and flourished in the early Edo period (*see* §(v) below). Shōren'in calligraphy continued to exist in parallel with other lineages and was still practised in the 20th century. The abbots of Shōren'in Temple were often distinguished for their calligraphic skills, among them (in the 14th and 15th centuries) Sondō, Dōen, Son'ō (Sonnō) and Sonden.

Sondō (1332–1403), the eleventh son of Emperor GoFushimi (*reg* 1298–1301), produced many letters, model books for calligraphy lessons (see fig. 125) and *waka* poems written on *kaishi* (writing paper folded and carried in one's pocket; all extant). Dōen (1364–85) was the ninth son of Emperor GoKōgon (*reg* 1351–71) and in his short life produced numerous model books for calligraphy lessons and *ganmon* (offertory letters expressing the wish of the devotee). Son'ō (*d* 1514), after whom the Son'ō school of calligraphy, an offshoot of the Shoren'in school, was named, was the second son of Nijō Moshimoto (1390–1445). Many *ōraimono* (books of instruction for young people written in the manner of correspondence), letters and certificates of authentication in his hand exist. Sonden (1472–1504), the monk's name of Prince Takaatsu, was the second son of Emperor GoTsuchimikado (*reg* 1464–1500) and became Son'ō's disciple. Some examples of his writing are on *tanzaku* (narrow strips of paper, *c.* 300 mm long, for writing poems), others are found in *ōraimono*. Particularly noted for his calligraphic ability, he was also talented in *waka* poetry and linked verse.

Other noted abbot–calligraphers of later generations include Sonchin (1504–50), founder of the Sonchin school, Sonchō (1552–97), known for his booklet on the rules of brush writing (*hippō*), with eight categorized entries and

125. Model calligraphy attributed to Prince Sondō (detail), from *Wakan rōeishū* ('Anthology of Japanese and Chinese poems for recitation'), handscroll, ink on paper decorated with gold and silver and autumn-grass patterns in colour pigments, 327×2320 mm, late 14th century (Cambridge, MA, Arthur M. Sackler Museum)

analytical illustrations, and Sonjun (1591–1653), founder of the Sonjun school and noted for innumerable calligraphic writings and works of scholarship, including a revised and enlarged edition of Son'en's *Mon'yōki*.

BIBLIOGRAPHY

H. Hanawa, ed.: *Gunsho ruijū* [A collection of Japanese literature] (Tokyo, 1820/*R* 1874–1914), vi (*R* 1899), pp. 1159–78; xviii (*R* 1902), pp. 891–915

Dainihon shiryō [Collected source material for the history of Japan], Tokyo Teikoku Daigaku, ser. 6, xvii (Tokyo, 1920), pp. 198–216

K. Kuroita, ed.: *Zokushi gushō* [History of calligraphy] (1931), xiii and xiv of *Kokushi taikei: shintei zōho* [Collection of manuscripts relating to the history of Japan] (Tokyo, 1929–58)

Juboku hishō [Collation of calligraphy], Maeda Ikutoku Kai Sonkeikaku Library (Tokyo, 1938) [facs.]

M. Taga: 'Sesonji ke shodō to Son'en ryū no seiritsu' [On the calligraphy of the Sesonji and Son'en schools], *Gasetsu*, 52 (1941), pp. 321–31; 53 (1941), pp. 371–9; 55 (1941), pp. 551–63

K. Shimonaka, ed.: *Shodō zenshū* [Complete collection of calligraphy] (Tokyo, 1954–68): xx; xxii, pp. 1–6

'Shōtetsu monogatari' [Tales of Shōtetsu], *Karonshū nōgakuronshū* [Selected works on the theory of *waka* and *nō* plays], annotated by S. Misamatsu and M. Nishio, Nihon Koten bungaku taikei [A survey of Japanese classical literature], lxv (Tokyo, 1961), p. 201

S. Komatsu: *Nihon shoryū zenshi* [History of Japanese calligraphic styles and schools], 2 vols (Tokyo, 1970), i, pp. 224–7, 304–46; ii, pp. 76–113

Y. Nakata: *Nihon shodō no keifu* [Genealogical record of Japanese calligraphy] (Tokyo, 1970), pp. 165–77

T. Akai: '*Jubokushō*, *Kodai chūsei geijutsuron* [Discussion of ancient and medieval art], Nihon shisō taikei [Corpus of Japanese thought], xxiii (Tokyo, 1973), pp. 249–60

The Courtly Tradition in Japanese Art and Literature: Selections from the Hofer and Hyde Collections (exh. cat. by J. M. Rosenfield, F. E. Cranston and E. A. Cranston, Cambridge, MA, Fogg, 1973)

S. Komatsu, ed.: *Nihon shoseki taikan* [Collection of calligraphy of leading persons in Japan] (Tokyo, 1977–81)

Masters of Japanese Calligraphy 8th–19th Century (exh. cat. by Y. Shimizu and J. M. Rosenfield, New York, Japan House Gal. and Asia Soc. Gals, 1984–5)

FUMIKO E. CRANSTON

(iv) Zen Buddhist masters.

(a) Introduction. (b) Forms. (c) Historical development.

(a) Introduction. From at least the Late Kamakura period (1249–1333), the evocative term *bokuseki* ('ink traces'; Chin. *moji*) was employed in Japan to designate works of calligraphy by Zen (Chin. Chan) Buddhist monks (see fig. 126). In China the term *moji*, referring to pieces of calligraphy in general, is well documented before the Tang period (618–907). It was through the Chinese Chan masters who came to Japan during the formative period of Zen Buddhism in the 13th century (*see* §II, 3 above) and the Japanese pilgrims who travelled to China in the Song period (960–1279) that *bokuseki* acquired its present limited, specific meaning. The authors of the *Butsu nichi an kōmotsu mokuroku* (1363; suppl. 1365), an inventory of a sizeable collection of Chinese calligraphy and painting kept in the Butsunichian, a small temple compound of the famous Zen monastery of Engaku in Kamakura, applied the term to a work of calligraphy written by the celebrated Chan master Wuzhun Shifan (1177–1249), although *shinseki* ('true traces' or 'genuine vestiges') was the term they more frequently used. Both terms imply two essential aspects of Zen calligraphy: on the one hand, the 'traces' of ink left behind by the brush on paper or silk, manifestations of the creative force, which is perceptible even in the final result; on the other, the unmistakable individuality and true character of the writer. In Chinese treatises on art, works of calligraphy as well as paintings are sometimes described as 'mind prints' (*xinyin*), comparable to personal signatures. As the art historian Guo Ruoxu wrote *c*. 1080:

> They originate from the source of the mind and are perfected in the imagination to take shape as *traces*, which, being in accord with the mind, are called 'prints' Even more so in the case of calligraphy and painting, since they issue from emotions and thoughts to be matched on silk and paper; what are they if not 'prints'? Signatures, furthermore, contain all of one's nobility or baseness, misery or prosperity.

Clearly, at least some types of writings were given the status of graphological documents, and ancient terms such as *bokuseki* or *shinseki* from the beginning incorporated aesthetic and artistic values as well as personal qualities of learning, refinement and reputation.

126. Zen priestly calligraphy (*bokuseki*), ink on paper (New York, private collection)

127. Confirmation name (*jigō* or *dōgō*) of an unidentified disciple, written by his master Rankei Dōryū, hanging scroll, ink on paper, 320×600 mm, third quarter of the 13th century (Tokyo, Umezawa Memorial Museum)

Partly as a result of a deep feeling of respect for the religious content of the written word, but more because of its authentic message and its new standards of excellence, Zen calligraphy acquired a kind of awe-inspiring mystique. The continuing appeal that individualized, uninhibited 'ink traces' had for both religious and secular circles in Japan created a great demand for them and resulted in many fine collections, catalogues and competent connoisseurship. The *Bokuseki soshiden* ('Transmission of ink traces of the patriarchs'), edited by Fujino Shūhō in 1805, contains no fewer than 223 names of eminent masters, 119 of them Chinese, 104 Japanese. Even more important sources of knowledge of works of Zen calligraphy are the 'Recorded sayings' (*goroku*) of revered patriarchs and priests; these voluminous records were usually compiled by disciples. Most surviving *bokuseki* are still in Zen monasteries, particularly in Kyoto and Kamakura, but several good specimens are in public and private collections in Japan (e.g. Tokyo, N. Mus., Hatakeyama Col., Idemitsu Mus. A., Nezu A. Mus.; Kyoto, N. Mus.; Nara, N. Mus.) and the West.

Although Zen relied primarily on non-scriptural transmission of the Buddhist law, 'ink traces' of the venerated masters and eminent priests came to be of crucial significance to Zen adherents. The deep concern for the authentic, uninterrupted transmission of the 'seal of the Buddha mind' (*busshin'in*) and the subsequent preoccupation with patriarchal genealogies stimulated the production and distribution of 'true vestiges' of the spiritual ancestors and religious teachers. Thus, Zen calligraphy came to manifest one of the fundamental Zen characteristics, the intimate relationship between master and pupil. The practice of presenting a handwritten certificate or a painted portrait to a disciple seems to be closely related to the ancient custom among the first patriarchs of the school to transmit the 'robe of the Law' (*hō'e*) to their designated successors in order to witness the authenticity of legitimate lineage. At the same time the Zen master would often inscribe his portrait with a personal dedication (*jisan*), acknowledging the advanced stage of his disciple's state of enlightenment. Perhaps in no other form of East Asian art is the written word so intimately connected in purpose and meaning with the painted image as in Zen portraiture. The portrait and the teacher's advice or encouragement in the colophon were constant reminders and reinforcements of 'the transmission [of the law] by mind to mind' (*ishindenshin*).

(b) Forms. The Zen ideal and monastic environment gave rise to a large variety of *bokuseki*, which, according to content, purpose or function, may be divided into the following general categories:

Fuhōjō. Instructions for Zen priests designated as the successors in a spiritual line or in a particular monastic office.

Gakuji or *haiji.* Tablets inscribed in large Chinese characters, hung over the entrances to halls, offices or other buildings in a Zen monastery and giving their names or monastic functions.

Geju. Verses (Skt *gāthā*) that succinctly raised essential issues of Zen, sometimes in metrical form with conventional rhymes and tones, sometimes entirely freely.

Hōgo. Statements of faith ('*dharma* words') in the form of sermons, essays or poems for students and patrons.

Inkajō. A certificate of approbation, certifying that a Zen student had fulfilled all the requirements for recognition as a master.

Jigō or *dōgō*. 'Confirmation names', usually consisting of two large Chinese characters, conferred on Zen disciples on the occasion of their approbation (see fig. 127).

Kankinbō. Public announcements for special meetings and events in a Zen monastery, such as study gatherings or scripture-reading sessions.

Sekitoku. Letters from Zen teachers to their former students or their colleagues in other temples.

Sōbetsugo. 'Words of farewell' in the form of poems or short aphorisms, customarily composed when a Zen monk retired, was assigned to another institution or left the monastery for other reasons.

Shindōgo. 'Words for advancement on the way' to enlightenment, containing all sorts of hints from an experienced Zen master for the younger generation of monks and Zen adherents.

Shingi. Regulations for the Zen monastic life.

Yuige. 'Bequest words', the religious testament or last precept of a Zen master, usually in verse form and written with a shaky hand while on the deathbed.

(c) Historical development. In the Kamakura (1185–1333) and Muromachi (1333–1568) periods, after two centuries of restricted exchange with the continent, Song-period (960–1279) China began to have a strong impact on Japan's social, economic and cultural character. By the end of the 14th century, Zen was among the most active and influential religious schools in the country. The metropolitan Zen monasteries of Kyoto and Kamakura were organized into a hierarchical system (*gozan*; 'five mountains'), and the privileged monks living there exercised such a pervasive influence on the culture of the day that the entire tradition of Chinese learning came to be known as *gozan bunka* ('culture of the five mountains'). It was in this stimulating milieu that talented priests composed 'Chinese' poems, exchanged verses, joined together in literary societies (*yūsha*), gathered to admire and inscribe paintings and wrote out bold statements of doctrine. Most of them shared an admiration for styles of calligraphy of the Song and Yuan (1279–1368) periods, which they could study through imported models by accomplished masters such as Su Shi, HUANG TINGJIAN, Wuzhun Shifan (1177–1249), Zhang Jizhi (1186–1266) or ZHAO MENGFU. The other sources of inspiration and instruction were immigrant Chinese living in Japan, among them such celebrated Zen abbots as Lanqi Daolong (RANKEI DŌRYŪ), Wuxue Zuyuan (Mugaku Sogen, 1226–86) and Yishan Yining (Issan Ichinei, 1247–1317). Zen calligraphy in Japan developed into various schools, just as courtly and aristocratic traditions did (*see* §§(ii) and (iii) above). More than in other Buddhist schools, Zen monks emulated their masters' calligraphic styles along with their teachings, which insisted on the awakening and realization of the Buddhanature within the self. Zen tended to encourage individuality to the point of eccentricity and strongly supported unconventional, highly personal styles of writing.

Within Zen circles *bokuseki* began from the 15th century to play an essential part in the tea ceremony (*chanoyu*), in which there was growing interest, not only because they expressed appropriate ideas but also because their evocative artistic qualities were congenial to the spirit of the 'tea people' (*chajin*) (*see* §XIV below). Mounted as hanging scrolls (*chagake*), these works were displayed as the focal points of attention in the *tokonoma* (decorative alcove) and thus regarded as prized art objects. *Bokuseki* were also much appreciated and extensively emulated in secular society, particularly among the powerful military class in Kamakura and Kyoto, and soon adorned the residences of samurai as well as the teahouses (*chashitsu*) of the castles of aristocrats.

Although the collapse of the Ashikaga government at the end of the Muromachi period and the establishment of the Tokugawa military regime at the beginning of the Edo period occasioned dramatic changes in the Zen Buddhist communities, currents of inspiration from China continued to flow into Japan. By the mid-17th century Chinese émigré–monks of the Ōbaku branch of Rinzai Zen brought fresh vitality to Japanese culture (*see also* §(vi)(b) below). Several prominent monks of this line, who lived in MANPUKUJI, the Ōbaku headquarters, were superb calligraphers. Yin yuan Long qi (INGEN RYŪKI), the founding abbot of the Manpukuji, his successor Muan Xingtao (SHŌTŌ MOKUAN) and Jifei Ruyi (Sokuhi Nyoitsu) became known as the Ōbaku no sanpitsu (Three Brushes of Ōbaku). Their vigorous calligraphy is characterized by a fluid, semi-cursive style of writing, popular in Ming-period (1368–1644) China.

Despite growing spiritual apathy accompanying the dawn of the industrial age in Japan in the late 18th century and early 19th, Zen Buddhism produced an astonishing number of outstanding figures. Calligraphy was their most expressive art form and an essential means to communicate their religious message. Works by such brilliant and prolific writers as HAKUIN EKAKU, Jiun Onkō (1718–1804), SENGAI GIBON and Daigu Ryōkan (1758–1831) were technically unsophisticated and consciously imbued with simplicity, spontaneity and an extraordinary expressive vigour. Such work exerted a powerful influence on modern calligraphy.

BIBLIOGRAPHY
H. Tayama: *Zenrin bokuseki* [Calligraphy of the Zen masters], 3 vols (Tokyo, 1955)
S. Hisamatsu: *Zen to bijutsu* (Kyoto, 1958); Eng. trans. by T. Gishin as *Zen and the Fine Arts* (Tokyo, 1971)
H. Tayama: *Zoku zenrin bokuseki* [Further calligraphy of the Zen masters] (Tokyo, 1961)
K. Brasch and T. Senzoku: *Die kalligraphische Kunst Japans* (Tokyo, 1963)
S. Furuta: *Zensō no yuige* [Bequest verses of Zen monks] (Tokyo, 1965, rev. 1987)
T. Horie: *Bokuseki* [Ink traces], Nihon no bijutsu [Arts of Japan], v (Tokyo, 1966)
K. Okuda and others, eds: *Ōbaku iboku chō* [Album of Ōbaku autographs] (Uji, 1967)
Japanese Ink Painting and Calligraphy: From the Collection of the Tokiwayama Bunko, Kamakura, Japan (exh. cat. by H. Sugahara, New York, Brooklyn Mus., 1967)
T. Horie: *Sho* [Calligraphy], Genshoku Nihon no bijutsu [Arts of Japan, illustrated], xxii (Tokyo, 1970)
A. Imaeda: *Shintei zusetsu bokuseki soshiden* [Illustrated commentary on the ink traces of the religious founders, revised] (Tokyo, 1970)
Zen Painting and Calligraphy (exh. cat. by J. Fontein and M. L. Hickman, Boston, MA, Mus. F.A., 1970)
Jūyō Buntiazai, ed.: *Nihon kosō iboku* [The calligraphy of famous monks], 3 vols (Tokyo, 1970–71)

G. Armbruster and H. Brinker, eds: *Pinsel und Tusche: Sammlung Heinz Grötze* (Heidelberg, 1975); Eng. trans. as *Brush and Ink* (Heidelberg, 1976)

Sho: Pinselschrift und Malerei in Japan vom 7.–19. Jahrhundert (exh. cat. by R. Goepper and H. Yoshikawa, Cologne, 1975)

H. Tayama: *Zenrin bokuseki shūi* [Gleanings from the calligraphy of the Zen masters], 3 vols (Tokyo, 1977)

K. Haga: *Bokuseki taikan* [Survey of Zen ink traces], 3 vols (Tokyo, 1977–9)

Nihon no sho: Japanese Calligraphy (exh. cat., Tokyo, N. Mus., 1978)

Ōbaku: Zen Painting and Calligraphy (exh. cat. by S. Addiss and K. S. Wong, Lawrence, KS, Spencer Mus. A., 1978)

M. Kinoshita, ed.: *Bokuseki to Zenshū kaiga* [Ink traces and Zen painting], Nihon bijutsu zenshū [Complete survey of Japanese art], xiv (Tokyo, 1979)

Zen und die Künste: Tuschmalerei und Pinselschrift aus Japan (exh. cat. by K. Terayama and J. Van Bragt, Cologne, 1979)

T. Horie: *Muromachi jidai no sho* [Calligraphy of the Muromachi period], Nihon no bijutsu [Arts of Japan], clxxxii (Tokyo, 1981) [whole issue]

M. Kinoshita: *Kamakura jidai no sho* [Calligraphy of the Kamakura period], Nihon no bijutsu [Arts of Japan], clxxxi (Tokyo, 1981) [whole issue]

K. Korezawa, ed.: *Edo jidai no sho* [Calligraphy of the Edo period], Nihon no bijutsu [Arts of Japan], clxxxiv (Tokyo, 1981) [whole issue]

Zen to bijutsu [The arts of Zen Buddhism] (exh. cat., Kyoto, N. Mus., 1981)

Worte des Buddha: Kalligraphien japanischer Priester der Gegenwart: Sammlung Seiko Kono, Abt des Daian-ji, Nara (exh. cat. by R. Goepper, Cologne, 1982)

Masters of Japanese Calligraphy 8th–19th Century (exh. cat. by Y. Shimizu and J. M. Rosenfield, New York, Japan House Gal. and Asia Soc. Gals, 1984–5)

H. Götze, ed.: *Chinesische und japanische Kalligraphien aus zwei Jahrtausenden: Die Sammlung Heinz Götze, Heidelberg* (Munich, 1987)

S. Shimada and Y. Iriya, eds: *Zenrin gasan* [Painting colophon from Japanese Zen milieu] (Tokyo, 1987)

S. Addiss: *The Art of Zen: Painting and Calligraphy of Japanese Monks* (New York, 1989)

Zen. Meister der Meditation in Bildern und Schriften (exh. cat. by H. Brinker and H. Kanazawa, Zurich, Mus. Rietberg, 1993)

H. Brinker: 'Spuren des Selbst. Schriftzeugnisse zen-buddhistischer Meister aus dem mittelalterlichen Japan', *Das andere China. Festschrift für Wolfgang Bauer*, ed. H. Schmidt-Glintzer (1995)

HELMUT BRINKER

(v) Kyoto revival of late courtly styles. During the Momoyama (1568–1600) and early Edo (1600–1868) periods many changes occurred in Japanese calligraphy, as in most areas of Japanese life and culture. After decades of devastating warfare, the newly reunited Japanese were eager for reminders of great eras of the past, especially the glories of the Heian period (794–1185). The subdued, Zen-influenced, Chinese-style arts of the Muromachi period (1333–1568) were no longer dominant, and a return to the refined beauty associated with the Heian court was encouraged by the patronage of new government leaders as well as by the court and wealthy merchants. In calligraphy one of the most notable changes was the revival of *Wayō* (Japanese style) calligraphy, using classical *waka* poetry (a 31-syllable form) of past epochs for the texts. The tradition of late courtly calligraphy, never forgotten, was given new life and glory, especially by the Three Brushes of the Kan'ei era (Jap. Kan'ei no sanpitsu): KONOE NOBUTADA, Hon'ami Kōetsu (*see* HON'AMI, (1)) and SHŌKADŌ SHŌJŌ. The epithet is actually a misnomer, as Nobutada had died ten years before the Kan'ei era began in 1624. Nevertheless, with one addition to be noted below, the three artists were the finest calligraphers of their time, creating a bold new tradition, centred on the capital city of Heian (now Kyoto), that has not since been equalled for sumptuous beauty. The fact that the three masters came from three different social classes demonstrates how late courtly calligraphy was beginning to move from the small circle of aristocrats who had dominated it in the past into a wider context, a development that proved irreversible.

(a) Masters of the 16th–17th centuries. The calligrapher Konoe Nobutada was a member of one of the leading families in Japan. The Konoe were descended from the Fujiwara clan and traditionally served at court in high-ranking posts. Nobutada's father, Sakihisa (1536–1612), had served the emperor as Regent, while amassing a large collection of Chinese and Japanese calligraphy. Nobutada himself rose rapidly through the court hierarchy, reaching the ceremonial position of Minister of the Left by the age of 21. Exiled for two years for a military indiscretion, he concentrated on poetry and calligraphy before returning to Kyoto, where he became a cultural leader and studied Zen at Daitokuji with TAKUAN SŌHŌ. Nobutada gradually regained favour with the emperor and from 1605 to 1607 was Senior Regent, a largely ceremonial position. The rest of his life was taken up with cultural activities. Nobutada created strong and elegant calligraphy on many formats, including screens, decorated *tanzaku* (poem slips) and *shikishi* (poem squares). In his youth he followed the fluent Shōren'in style (*see* §(iii) above), which was popular at court. Gradually, however, he developed a more individual style that incorporated both the angularity of Fujiwara no Teika's work (*see* FUJIWARA (ii), (7)) and the rough power of Zen calligraphy. He also brushed extremely bold and simple ink paintings of such subjects as Tenjin, the deity of poetry (examples in New Orleans, LA, Gitter Col.), and Daruma, the first patriarch of Zen. His calligraphic tradition was carried on by later members of the Konoe family.

Hon'ami Kōetsu came from the artisan class; his father was a connoisseur of swords. Kōetsu grew up to be an admirer and practitioner of many arts, including *nō* drama, ceramics, lacquer and the tea ceremony. His artistic talents were recognized by the shogunate, and in 1615 he was granted land in Takagamine, just outside Kyoto, where he established a community of artists and artisans and produced his most famous works, including several long handscrolls with painted and stamped designs by Tawaraya Sōtatsu over which Kōetsu added fluent and resonant calligraphy (examples in Seattle, WA, A. Mus.). Kōetsu's brushwork is characterized by extreme variations between thick and thin lines, well-balanced spacing between columns of writing, subtle relationships between his calligraphy and the designs on the decorated paper, and his use of famous poetry from anthologies of the Heian and Kamakura (1185–1333) periods. Kōetsu created a new tradition of bold and rich calligraphy that went far beyond revival of the past and represented the aesthetic ideals of the age.

Shōkadō Shōjō was also a member of the Kyoto cultured élite, although he lived his mature years at Takinomotobō, a subtemple on Mt Otoko, south of Kyoto. A monk of the Esoteric Shingon sect, Shōkadō participated in such cultural activities as painting, *waka* poetry, flower arranging

128. Karasumaru Mitsuhiro: *Tōkōki* ('Memoir of the eastern journey'; detail), late courtly calligraphy on a handscroll, ink on decorated papers, 0.29×8.68 m, *c.* 1630 (Lawrence, KS, University of Kansas, Spencer Museum of Art)

and garden design. He maintained friendships with Confucian scholars, Zen monks, warriors and courtiers, frequently through the medium of the tea ceremony, of which he was a noted master. As a calligrapher, Shōkadō exemplified the eclectic nature of the masters of the Kyoto revival. He was trained in the Shōren'in style, studying at one time with Konoe Sakihisa, but also mastered the Teika tradition, the Heian-period style of ONO NO MICHIKAZE and the styles of Chinese masters of the Yuan (1279–1368) and Ming (1368–1644) periods (see CHINA, §IV, 2(v) and (vi)). In addition, Shōkadō was one of the leaders in the revival of the style of KŪKAI (Kōbō Daishi), known as the Daishi *ryū* (lineage; see also §(vi)(c) below), which featured ornamental curving extensions to some brushstrokes and was used by Shōkadō when he was writing out Chinese poetry.

A fourth contemporary master of late courtly calligraphy, sometimes called the Fourth Brush, was KARASU-MARU MITSUHIRO (1579–1638). In many ways his career recalls that of Nobutada. The Karasumaru were hereditary courtiers of high rank, and Mitsuhiro eventually rose to become an important emissary between the court of Emperor GoMizunoo (*reg* 1611–29) and the shogunate in Edo (now Tokyo). Mitsuhiro also studied Zen with Isshi Bunshu (1608–46) and became a talented practitioner of the tea ceremony.

Mitsuhiro's calligraphy differs from that of the Three Brushes of the Kan'ei era in that it is more spontaneous and impetuous in expression. Although he studied with Kōetsu, Mitsuhiro was not satisfied with the elegant and classically balanced style of his master and wrote with dramatic brushstrokes in more eccentric compositions. This may have resulted in part from his studies of the angular Teika tradition as well as of Chinese masters of cursive script, but ultimately Mitsuhiro's style derived from his own personality, which was daring and adventurous. One of his masterpieces, a long handscroll on decorated paper that describes a journey to Edo, demonstrates his bold brushwork in both painting and calligraphy (see fig. 128).

The tradition of refined late courtly calligraphy was carried on not only by high-ranking courtiers but also by members of the imperial family. Every emperor was trained and expected to write with great skill, and several produced calligraphy that was personally expressive. Included among these were the emperors GoYōzei (*reg* 1586–1611), GoMizunoo (who was a noted *waka* poet) and Reigen (*reg* 1663–87). Imperial calligraphy is still very highly admired in Japan.

(*b*) *18th–19th centuries.* Although later calligraphers may not have equalled the sumptuous styles of the four great masters of the 16th–17th centuries, there were many fine writers who created calligraphy of great beauty in the revived late courtly tradition. Among these was Konoe Iehiro (1667–1736) of the Konoe family of courtiers. He was also a noted poet, painter and garden designer and founded his own schools of flower arranging and tea ceremony. He showed greatest talent in calligraphy, mastering all five Chinese scripts as well as the Japanese *kana* syllabary. Iehiro was extremely eclectic and did not create as individual a style as those of the four earlier masters, but his brushwork consistently combined great strength with elegant refinement.

As the Edo period advanced, shogunal support of Neo-Confucianism (*see* §II, 5 above) led to a greatly increased interest in Chinese literati culture (*see* §(vi) below). However, during the 18th century there was a reaction to Chinese cultural and cultural influence and a revival of interest in Shinto and early Japanese literature that gave rise to the Kokugaku (National Learning) movement. Early styles of Japanese calligraphy were also increasingly admired and emulated. The Kokugaku scholars carried on their own revival of *kana* calligraphy, in a more deliberate and scholarly way than the Three Brushes. These calligraphers brushed some very attractive work, usually *waka* poems in relatively small formats.

The revival of late courtly calligraphy developed primarily in Kyoto, but in the middle and later Edo period it was not restricted to the cultural or scholarly élite or even to men. Three generations of women who ran a teahouse in the Gion Park, for example, were fine *waka* poets with individual styles of calligraphy that added fresh impetus to the classical tradition. Kaji (*fl* early 18th century) founded the Matsuya, where she served steeped tea to customers who also enjoyed hearing her recite poetry. Both her verse and her calligraphy display her lively and often passionate

temperament. Kaji's adopted daughter Yuri (1694–1764) was an equally fine poet but displayed a less emotional personality, as her graceful *waka* and her calligraphy attest. Kaji's love affair with a man of the samurai class resulted in a daughter named Ike Gyokuran, who continued the family tradition of composing *waka* verse and who also became a fine painter in the literati style, studying with her husband, Ike Taiga (*see* IKE, (1)). Comparing the calligraphy of the Three Women of Gion is instructive. Kaji's writing is full of dramatic sweeps of the brush. Yuri's writing preserves a purity of line, and her compositions are more regular and balanced. Gyokuran's writing shows the most variation of thin and thick lines, echoing her painting style.

The beginning of the Meiji period in 1868 brought far-reaching changes to Japan, and for a time traditional arts such as late courtly calligraphy were held in low repute. Nevertheless, several fine poets continued to write in styles that followed past models while adding personally expressive touches. The most idiosyncratic style belonged to the nun ŌTAGAKI RENGETSU. Twice widowed in her youth before taking Buddhist orders, Rengetsu became adept not only at poetry, painting and calligraphy but also at pottery. She typically inscribed her verses on her pottery, either by incising the clay with a sharp implement or by brushing her calligraphy on the surface of the vessels with dark underglaze. Rengetsu's calligraphy has a remarkable tensile strength underlying her seemingly delicate brushwork. Her artistry demonstrates the continued vitality of the Japanese *waka* poetry and calligraphy tradition, which by the late 19th century had become thoroughly integrated into Japanese society.

BIBLIOGRAPHY

K. Shimonaka, ed.: *Shodō zenshū* [Complete collection of calligraphy], xxii–xxiii (Tokyo, 1966)
S. Komatsu, ed.: *Nihon shoryū zenshi* [History of Japanese Zen calligraphy styles and schools] (Tokyo, 1970)
Y. Haruna: *Kan'ei no sanpitsu* [The Three Brushes of the Kan'ei era] (Tokyo, 1971)
S. Komatsu, ed.: *Nihon shoseki taikan* [Collection of calligraphy of leading persons in Japan], xiv–xxv (Tokyo, 1978–80)
K. Korezawa, ed.: *Edo jidai no sho* [Calligraphy of the Edo period], Nihon No bijutsu [Arts of Japan], clxxxiv (Tokyo, 1981)
Masters of Japanese Calligraphy 8th–19th Century (exh. cat. by Y. Shimizu and J. M. Rosenfield, New York, Japan House Gal. and Asia Soc. Gals, 1984–5)
P. Fister: *Japanese Women Artists, 1600–1900* (Lawrence, KS, 1988)
S. Addiss: 'The Three Women of Gion', *Flowering in the Shadows*, ed. M. Weidner (Honolulu, 1991), pp. 241–64

(vi) Literati.

(a) Introduction. (b) Ōbaku masters. (c) Founders of *Karayō*. (d) Confucian scholars. (e) Painter–calligraphers. (f) Masters of the late Edo and Meiji periods.

(a) Introduction. Literati calligraphy, often called *Karayō* ('Chinese style'), flourished during the Edo (1600–1868) and Meiji (1868–1912) periods. Chinese-style calligraphy had been used and admired in Japan since the 4th century (*see* §1(iii) above), but it was not until the 17th century that the full flavour of literati calligraphy was known. In the 18th and 19th centuries it became one of the main forms of visual expression.

The education that most higher-level members of society received at this time was based on the Chinese classics, and the arts of painting, poetry and calligraphy were all transformed by the Sinophile leanings not only of scholars but also of officials, artists and many members of the samurai and merchant classes, encouraged by the Tokugawa government. In addition, the influx of Chinese immigrants, including the monks of the Ōbaku Zen (Chin. Chan) sect (*see* §(b) below), was an important stimulus to the *Karayō* tradition in Japan.

The pioneer of literati calligraphy in the Edo period was ISHIKAWA JŌZAN. From 1615 to 1623, under a form of house arrest for having disobeyed an order of his Tokugawa masters, he plunged into Confucian studies, and, after serving the Asano clan from 1623 to 1635, he retired to lead a literati life in Kyoto, where he later built a scholarly retreat named the Shisendō (Hall of Poetic Immortals). In his calligraphy, Jōzan specialized in clerical script (*reisho*), an antique and formal style of writing that had until then been very little practised in Japan. Basing his script on Ming-period (1368–1644) prototypes, he developed an elegant form of calligraphy that had both decorative beauty and a suggestion of the antique. Jōzan commissioned Kanō Tan'yū (*see* KANŌ, (11)) to paint the portraits of the great poets of the Han (206 BC–AD 220) to Song (960–1279) periods. In this collection, the *Sanjū rokushisen* ('Thirty-six immortal Chinese poets'), Jōzan added a notable example of each poet's work, written in clerical script. The works were then hung in the Shisendō. Two of Jōzan's Confucian scholar friends were also skilled in calligraphy. Hayashi Razan (1583–1657), founder of the official Confucian academy for the shogunate, wrote in modest but attractive regular script (*shinsho* or *kaisho*), while Hitomi Chikudo (1628–96) sometimes used clerical script in a style modelled on that of Jōzan.

(b) Ōbaku masters. A primary stimulus to literati calligraphy in Japan was the arrival of the Ōbaku monks from China in the mid-17th century. Many were excellent calligraphers in the stylistic traditions of the late Ming period. The Three Brushes of Ōbaku were the patriarch INGEN RYŪKI (Yinyuan Longqi), who wrote in a massive but fluent style, his successor MOKUAN SHŌTŌ (Muan Xingtao), whose calligraphy was more blunt and powerful, and Ingen's follower SOKUHI NYOITSU (Jifei Ruyi), who developed his own dynamic form of brushwork within the Ōbaku tradition.

The most influential Ōbaku calligrapher was DOKURYŪ SHŌEKI (Duli Xingyi), a Chinese poet, seal-carver, medical expert and scholar. He had received thorough training in calligraphy during his youth, studying such classical models as the regular script of Yan Zhenqing (709–85) and the 'wild-cursive' script (*kyōsō*) of HUAISU. He later mastered the styles of certain calligraphers of the Song (960–1279), Yuan (1279–1368) and Ming (1368–1644) periods, such as Wang Chong (1494–1533). He arrived in Nagasaki in 1653 and studied with Ingen. Dokuryū wrote in all five major script forms—seal (*tensho*), clerical (*reisho*), regular, running (*gyōsho*) and cursive (*sōsho*)—which, through his example, became popular on handscrolls in the Edo period.

Dokuryū criticized Japanese calligraphers of his time, first for not knowing the basic etymology of Chinese characters and their six basic types of formations, and

second for not holding the brush vertically over the paper with the tips of the fingers. In his view, the Japanese custom of holding the paper up with one hand and writing with the other could not produce correct brushstrokes, the basis of calligraphic beauty. His own writing was fluent, relaxed and inventive, utilizing a variety of character formations and impeccable brushwork. Dokuryū's direct pupils, such as KŌ TEN'I (Kō Gentai), and their followers became the most important *Karayō* calligraphers of the succeeding generations.

(c) *Founders of Karayō*. Kitajima Setsuzan (1636–97) is often considered the Japanese founder of *Karayō* (Chinese-style) calligraphy. He studied with Sokuhi and Dokuryū and with a Chinese calligrapher named Yu Lide, who taught him the calligraphic style of the Ming-period master WEN ZHENGMING. In 1677 he moved to Edo (now Tokyo), where he soon became the leading *Karayō* calligrapher in the capital. Known as an eccentric who loved wine (he is said to have traded his writings for sake at so many words per bottle), he eventually returned to Nagasaki, where he led a life of poverty and indulged in the literati arts of poetry and calligraphy. His works show his thorough mastery of Chinese traditions as well as his untramelled personality (see fig. 129).

Setsuzan's chief pupil was HOSOI KŌTAKU. While serving noble families and the shogunate, he became expert in seal-carving, military studies, armaments, fencing, archery, spear-fighting, equestrianism, astronomy, surveying, poetry in both Japanese and Chinese, painting (bamboo and grapes being his favourite subjects) and, notably, *Karayō* calligraphy (*see* fig. 130).

Kōtaku followed the style of the 4th-century master Wang Xizhi (*see* WANG (i), (1)) as transmitted through ZHAO MENGFU and Wen Zhengming. Although he admired their works, he believed that the styles of Tang-period (618–907) masters had correct forms but lacked spirit, while Song-period masters had spirit but not form. Kōtaku wrote several books on the 'correct' traditions in calligraphy he had learned from Setsuzan, which included discussions of how to hold the brush and how to make the 'eight basic strokes' correctly. The shogunate awarded him 24 sheets of silver for writing out a document that was sent to Korea stamped with his hand-carved seals. He had several outstanding pupils, including Seki Shikyō (1697–1765), Hirabayashi Atsunobu (1696–1753), Iida Hyakusen (1694–1767) and Matsushita Useki (1699–1779). Another pupil, Mitsui Shinna (1703–82), became so successful in Edo that a kind of cloth dyed with patterns from his seal-script calligraphy became known in Japan as *Shinna-zome*.

Perhaps the most successful *Karayō* calligrapher of the late 18th century was Sawada Tōkō (1732–96). Tōkō learnt the style of Wang Chong, as had Dokuryū, but soon decided that the Ming-period calligraphers were too individualistic and advocated returning to the styles of the masters of the Wei (220–65), Jin (265–420) and Tang periods. He particularly commended Wang Xizhi but also admired the regular script of Yu Shinan (558–638) and the seal scripts of Li Si of the Jin period and Li Yangbing of the Tang period. Tōkō claimed that, if one modelled one's style on that of a great early calligrapher, one could achieve

129. Literati calligraphy in the form of a single line by Kitajima Setsuzan, ink on paper, second half of the 17th century (Shōka Collection)

true mastery of the brush and eventually would naturally develop a personal style. Tōkō's own calligraphy exemplifies the graceful quality (*fūin*) that he praised in the work of Wang Xizhi.

130. Literati calligraphy on a six-panel screen by Hosoi Kōtaku, ink on paper, each panel 1548×560 mm, total width 3657 mm, late 17th century–early 18th (Lawrence, KS, University of Kansas, Spencer Museum of Art)

While Tōkō led the 'traditionalist' literati calligraphers, a second stream of *Karayō* developed, known as the Daishi *ryū* (school or lineage) because the masters followed the slightly ornate style of the monk KŪKAI (Kōbō Daishi), who brought Shingon Buddhism to Japan. Led by Fujiki Atsunao (1580–1648), this group included Toriyama Sonpo (*d* 1679), Sasaki Shizuma (1619–95), Kitamuki Unchiku (1632–1703) and Terai Yōsetsu (1640–1711). Stylistic characteristics of this tradition, such as the upward, wriggling strokes concluding some characters, can also be seen in the Chinese-style calligraphy of Shōkadō Shōjō and Kanō Tan'yū. Shizuma and Yōsetsu, who were professional calligraphers, based their widespread teachings on the 'eight basic strokes' and 'seventy-two methods of brush movement'. They were sometimes criticized, however, for following Korean rather than Chinese copybooks and for not being well enough versed in the classic style of Wang Xizhi.

(d) Confucian scholars. Another group of Japanese who practised Chinese-style calligraphy were Confucian scholars, many of whom taught in the private clan schools established throughout Japan. Notable among these were Itō Jinsai (1627–1705) and his son Tōgai (1670–1736), who led a movement away from the Neo-Confucianism of the Song and Ming periods in favour of studying the original writings of Confucius and Mencius. Jinsai's calligraphy was austere, but Tōgai excelled in bold, large calligraphy, using a running script modelled upon that of Zhao Mengfu.

Perhaps the finest calligrapher–scholar of his era was Ogyū Sorai (1666–1728), who set up his own school of 'ancient learning'. Although he studied the original texts of Confucianism and admired early literature and poetry, Sorai was a leader of a third stream of *Karayō*, called 'reformist' because it followed styles of the Song, Yuan and especially Ming periods. Sorai's calligraphy shows his affinity for the work of such cursive-script masters as ZHU YUNMING and Kō Ten'i, but it is also highly individualistic, with a distinctive pattern of tension and release in his often angular brushwork. Sorai's pupil Hattori Nankaku (1683–1759), who compiled a famous selection of Tang-period poetry, also wrote in cursive script with a Ming-period flavour.

Scholars of the following generation who excelled in calligraphy included Ryū Sōro (or Ryū Kobi, 1714–92), who served the Hikone clan; Murase Kōtei (1734–1807) of the Akita clan, who admired the works of SU SHI; Shibano Ritsuzan (1736–1807), a scholar for the shogunate who also followed Su Shi's calligraphy; Koga Seiri (1750–1817), who served the shogunate and followed the style of DONG QICHANG; and Minagawa Kien (1734–1807), who enjoyed both calligraphy and painting and followed the methods of Wang Xizhi. In Osaka the scholar-calligraphers tended to follow Ming-period models such as Zhu Yunming. Leading masters included Miyake Sekian (1665–1730), Goi Ranshū (1697–1762), Nakai Riken (1732–1817), and Nakai Chikuzan (1730–1804).

(e) Painter–calligraphers. In the early 18th century Japanese literati painting (*Bunjinga*) in the Chinese style developed; many of the painters were also fine *Karayō* calligraphers. The pioneer *Bunjinga* artist GION NANKAI absorbed the influence of Ōbaku calligraphy and wrote in

all five basic scripts. YANAGISAWA KIEN also had Ōbaku connections and wrote in the Hosoi Kōtaku tradition after Wen Zhengming. KŌ FUYŌ was particularly noted for his seal script and seal carvings, which showed his study of both Ming-period and ancient models. His friend Kan Tenju (1727–95), a pupil of Matsushita Useki, was a strict traditionalist. Tenju did much to promote *Karayō* by issuing a number of books that reproduced classical models. A friend of Fuyō and Tenju was the great literati painter Ike Taiga (*see* IKE, (1)), a child prodigy in calligraphy. When trying to make a living selling fans, he kept his account

131. Literati calligraphy in the form of a poem in cursive script by Kameda Bōsai: *Old Trees*, ink on paper, late 18th century–early 19th (Shōka Collection)

books in seal script, and his individualistic transformations of many different models in all five scripts made him a leader in the *Karayō* tradition.

In Osaka, Chō Tōsai (1713–96) and his pupils Totoki Baigai (1733–1804) and Rai Shunsui (1746–1816) exemplified the 'reformist' trend, excelling in cursive script in the Zhu Yunming tradition. Shunsui's son RAI SAN'YŌ became one of the leading early 19th-century literati masters of the Kyoto area. His calligraphy shows the early influence of his father's style as well as his study of the works of Mi Fu and Dong Qichang. He then developed a dynamic and fluent individual manner, which was and remains highly valued. San'yō's closest friend, the poet Shinozaki Shōchiku (1781–1851), wrote in a smoothly rolling style and insisted that calligraphers learn from the direct study of old masters.

Foremost among several calligraphers who achieved great success in Edo was KAMEDA BŌSAI, who first studied with Mitsui Shinna. He excelled in what was called a 'wriggling earthworm' form of cursive script (see fig. 131). His style was influenced by his study of Huaisu and by the work of the Zen monk RYŌKAN, but Bōsai's brushwork shows an individualist pattern of alternating speeds and varying levels of tension that make it unique.

Ichikawa Kansai (1749–1820) followed the school of Hosoi Kōtaku, still active in Edo, and also learnt from the styles of Mi Fu and Dong Qichang. He became known as one of the Four Poets of Edo. The others were his pupils Kashiwagi Jōtei (1763–1819), known for his graceful calligraphy, Ōkubo Shibutsu (1767–1837), who modelled his cursive script after that of SUN GUOTING of the Tang period, and Kikuchi Gozan (1769–1849), who followed Qing-period (1644–1911) masters and excelled in regular–running script.

(f) Masters of the late Edo and Meiji periods. The three most famous masters of literati calligraphy in the late Edo period (Bakumatsu no sanpitsu; Three Brushes of the late Edo period) were ICHIKAWA BEIAN, MAKI RYŌKO and NUKINA KAIOKU. As a youth Beian conceived a great admiration for the calligraphy of Mi Fu, on whom he published a book at the age of 23. He went on to a long career of collecting rubbings of Chinese works, publishing copybooks and other volumes relating to calligraphy and scholarly arts, and writing in all scripts with great skill and confidence. He has been considered a member of the 'reformist' tradition, partly because he published a volume on three Qing-period calligraphy methods, but he also explored the works and styles of Chinese masters of the Jin and Tang periods.

Maki Ryōko came from Echigo (Niigata Prefecture) to study in Edo, where he developed a conservative style in all five scripts. He is considered a 'traditionalist' calligrapher, following the regular-script style of OUYANG XUN and the running–cursive method of Wang Xizhi as transmitted by Zhao Mengfu and Dong Qichang. When in the mood, he could write a thousand sheets of calligraphy with great brush strength, and one of his seals indicates that he considered himself the finest calligrapher 'in a thousand years'. His many published copybooks made him a major influence on later *Karayō*.

After the death of San'yō, Nukina Kaioku became the leading literati calligrapher of the Kyoto area. He first copied from various model books then collected many different volumes reproducing Wang Xizhi's calligraphy, the finest of which was taken from a Song-period rubbing. Determined to study early Chinese styles as directly as possible, he sought out as many original examples as he could in Japan. He was extremely impressed with the writings of Kūkai (Kōbō Daishi) and eventually developed a style based upon Tang-period works as well as Japanese masterpieces of the past. His admiration for Japanese as well as Chinese calligraphy of early eras made him unique among 'traditionalist' *Karayō* masters.

Interest in Chinese-style calligraphy continued throughout the Meiji period, with leading masters such as Nakabayashi Gochiku (1827–1913) and IWAYA ICHIROKU exploring new transformations of ancient scripts. Individualists such as Yamaoka Tesshū (1836–88), MURASE TAIITSU and Yamanaka Shinten'ō (1822–85) worked in the *Karayō* tradition, which continue to command respect and influence in the late 20th century.

Despite the reliance on Chinese models, whether 'traditional' or 'reformist', certain features distinguish Japanese *Karayō* from Chinese calligraphy (*see* CHINA, §IV, 1). One is the Japanese preference for dramatic personal expression over perfection of individual brushstrokes. Calligraphers such as Kō Ten'i exaggerated the styles of their Chinese models and teachers to produce richly evocative works, in which character structure and formal stroke elements were subordinated to the mood and flavour of the whole work. Japanese calligraphers also experimented with variations of ink tones; masters such as Shizuma and Taiga often used grey ink rather than the lustrous black preferred by almost all Chinese literati. Finally, the Japanese did not hesitate to mix styles and script forms in a single work, finding consistency of effect less interesting than creative flux. Japanese artists took more risks than their counterparts on the continent. As a result, literati calligraphy in Japan has shown great variety.

BIBLIOGRAPHY
S. Komatsu: *Nihon shoryū zenshi* [History of Japanese Zen calligraphy styles and schools] (Tokyo, 1970)
Nihon shodō taikei [Survey of Japanese calligraphy], vii (Tokyo, 1972)
Sho no Nihonshi [History of Japanese calligraphy], vi (Tokyo, 1975)
N. Tsuchida: *Gakusha* [Scholars], v of *Sho to jinbutsu* [Calligraphy and people] (Tokyo, 1978)
S. Komatsu, ed.: *Nihon shoseki taikan* [Collection of calligraphy of leading persons in Japan], xiv–xxv (Tokyo, 1978–80)
C. Yamanouchi: *Kinsei jusha no sho* [Calligraphy of modern Confucianists] (Tokyo, 1980)
K. Korezawa, ed.: *Edo jidai no sho* [Calligraphy of the Edo period], Nihon No bijutsu [Arts of Japan], clxxxiv (Tokyo, 1981)
S. Komatsu: *Karayō* [Chinese-style calligraphy], Nihon no sho [Japanese calligraphy], xii (Tokyo, 1983)
The World of Kameda Bōsai: The Calligraphy, Poetry, Painting and Artistic Circle of a Japanese Literatus (exh. cat. by S. Addiss, New Orleans, LA, Mus. A.; Seattle, WA, A. Mus.; Lawrence, U. KS, Spencer Mus. A.; Ann Arbor, U. MI Mus. A.; 1984)
S. Addiss: 'Yamanake Shinten'ō: The Albatross of Painting', *Mnmt Nipponica*, xlviii/3 (Autumn 1993), pp. 316–36

STEPHEN ADDISS

(vii) Modern.

(a) Introduction. Modern creative calligraphy is generally described as *sho* ('calligraphy') to distinguish it from shodō ('way of the brush'), the traditional discipline of calligraphy. All modern calligraphers are familiar with, and have a high regard for, every type of script, from the ancient oracle bone and seal scripts used in writing *kanji* to the various scripts used in writing *kana*. Historical forms are studied, for example by means of *rinsho* ('empathetic copying'). Many calligraphers (*shoka*) work in classical forms, but the most important modern artists are avant-garde (*zen'ei shoka*). This genre of calligraphy falls into two groups. In one, the writers create freely drawn symbols out of an ink line. This group is relatively small. In the other group, writers adapt existing *kanji* and *kana*. The essential feature of avant-garde calligraphy is not total novelty of form but rather a reaction against the emphasis on form and technique at the expense of expressive content. Consequently, modern writers search for up-to-date means of expression using familiar *kanji* and *kana* both in terms of the written characters themselves and in terms of their compositional arrangement.

For avant-garde writing masters, the complexity of a character and the expressiveness of the brushstroke are what count; legibility is not important (nor was it in the case of classic cursive scripts). Abstract Expressionism and action painting were influenced by avant-garde calligraphy, but modern calligraphers themselves reject any automatism of the kind that sometimes characterized these Western art forms. In adapting *kanji* and *kana*, artists have seldom abandoned the basic structure; at most, they have given extra emphasis to certain parts and further refined the cursive forms. This creates a certain dynamic, pulling some lines and sections of the structure closer together and driving others further apart. Simplified, powerful structures, which are closely related to the old forms but are nonetheless modern, often give an impression of monumentality achieved by foreshortening. The structures seem at times to have a markedly soft fluidity or, equally often, a strongly architectural quality or a dynamic energy. The ink may be applied transparently thinly in various gradations or extremely thickly in dense black. The writers allow for accidental effects, such as splashes, drips and shadowy areas where the ink has run.

The writing styles used in modern Japanese calligraphy are often traced back to KUSAKABE MEIKAKU and the revival of the art in the late Edo period (1600–1868). Kusakabe Meikaku was directly influenced by Chinese calligraphy, having studied Chinese folding books containing ink rubbings taken from stelae: he was famous for his stone inscriptions. He also studied and admired the work of NUKINA KAIOKU. Most of the main modern writing masters draw on his work and that of his large circle of pupils. An equally important group regards Nishikawa Shundō (1847–1915) as their artistic ancestor, largely because of his assiduous studies of Chinese stone inscriptions. Although he did not have many followers, he had many pupils, such that a Shundō *ryū* (school or lineage) has emerged. There are somewhat fewer *kana* writing masters, but they too have enjoyed a renaissance and been accorded greater appreciation since the 19th century. The *kana* style is particularly well suited to the inscription of modern poems. Tada Shin'ai is regarded as the first of the modern *kana* masters. A Shinto official and a scholar, he studied old scrolls of poems, and in the field of *kana*

calligraphy he started discussions aimed at reform. Shugyō Oguchi (1864–1920), a *waka* poet and scholar of the classical *sōgana* script (a cursive form of *man'yōgana*, an early set of syllabic script from which the modern *katakana* and *hiragana* are derived), was important mainly for his rediscovery of the famous *Sanjūrokuninshū* ('Collection of the 36 poets') manuscripts in the temple of Nishi Honganji in Kyoto. Hyakuren Ono (1864–1941), a scholar of Heian-period (794–1185) calligraphy, was famous for the scrolls he has written of his own poems.

(b) Masters and principal groups of the 19th–20th centuries. In the late 19th century, calligraphy masters began to emerge from their narrow circle, mounting public exhibitions with increasing frequency from 1878. Some groups sprang up around a master who acted as a teacher; others simply represented the coming together of like-minded individuals. Groups continue to be formed in these ways, and some of them maintain academies. Among the principal modern groups are Kenshin shodōkai (founded 1939), Keiseikai (1940), Nihon shodō bijutsuin (1945), Nihon shogeiin (1946), Dokuritsu shojindan (1952), Bokujinkai (1952), Sōrosha (1961) and Sōgen shodōkai (1963). The avant-garde trend began in the 1920s and 1930s, the strongest impulses coming initially from Tenrai Hidai (1872–1939), a pupil of Kusakabe Meikaku. After working in the calligraphy department of the Ministry of Education, he eventually opened his own calligraphy school. He concentrated his research on the wooden tablets used by Chinese of the Han period (206 BC–AD 220). He also rediscovered and reinterpreted the *fugyō-hō* method, a recommended means of handling the brush by moving the hand up and down, which dated from the Tang period (618–907) and was brought to Japan by KŪKAI. Tenrai's adaptation of this technique was widely taken up by avant-garde calligraphers.

Members of modern *sho* (calligraphy) groups come from every social stratum and profession, often including teachers, who give instruction in *sho* in schools. Some leading intellectuals are able to devote themselves entirely to their work, publishing specialist magazines and giving instruction, sometimes heading their own schools of calligraphy.

Modern *sho* in Japan divides, very generally, into two schools of thought, although no clear dividing line can be drawn between the two. In one, aesthetic expression is central, along with a certain attractiveness of form. The other school is more interested in philosophical exploration on several planes, a dimension largely determined by Zen Buddhism. In this context, the masters have succeeded in combining implement, material and human being into an inseparable whole. Paper ceases to be a purely passive object and becomes one with the brush, which becomes one with the hand and with the writer's body in its entirety. *Sho* written in this way may be regarded as the writer's self-portrait. The process demands intense comprehension and concentration but has nevertheless been mastered by a considerable number of calligraphers.

132. Nankoku Hidai: *Work 61–6*, ink on paper, 0.70×1.01 m, 1961 (Yokohama, artist's collection)

133. Shiryū Morita: *Breaking*, ink on paper, 0.93×1.36 m, 1961 (New York, Dr. Harvey H. Corman collection)

Several modern calligraphers have become noted for their individual styles and treatment of *kanji* or *kana*. Joryū Matsui (*b* 1900), a pupil of Hōchiku Yoshida (1890–1940), writes slightly archaic-looking characters with a soft brush. Yasushi Nishikawa (*b* 1902), a pupil of Nishikawa Shundō, created an expressive reinterpretation of the old Chinese seal script. Taiun Yanagida (*b* 1902), a pupil of Tairoku Yanagida (1862–1932), specialized in powerful regular-script *kanji* with occasional soft accents. Sōkyū Ueda (1899–1968), a pupil of Tenrai Hidai, wrote with such a powerful, fibrous brushstroke that the writings appear to be rushing headlong; sometimes he almost entirely abandoned the structure of the characters. Other pupils of Tenrai include Yūkei Tejima (1901–87), who created *sho* that had a powerful structure and yet often looked almost transparent, as if brushed by a hovering hand; Sōfū Ōkabe (*b* 1910), who wrote *kanji* of monumental structure with powerful brushstrokes; and Nankoku Hidai (*b* 1912), who studied classical Chinese *kanji* but also created free ink-forms, which are imbued with both dynamism and a quiet serenity (see fig. 132). The characters of Taihō Yamazaki (*b* 1908), a pupil of Yūkei Tejima, are also powerful in structure although written with a soft hand. Three pupils of Sōkyū Ueda have made their mark on modern calligraphy: Shiryū Morita (*b* 1912) had many followers and pupils; his work is characterized by a richly structured line with intense expressive strength (see fig. 133); Sesson Uno (*b* 1912) reverted from monumental free forms to *kanji*, which he writes with a well balanced serenity. Yūichi Inoue (1916–85) was a master of powerfully expressive, energetic *sho*, that have an immediate impact. The great masters of *kana* calligraphy include Hyakuren Ono's pupil Gōhō Hibino (1901–86), who made a study of classical *kana* characters and developed these into a poetic *kana* style of his own. Keikin Hori (*b* 1907), a pupil of Shokin Hidai (1885–1948), followed the structure of the old *kana* syllable characters but endowed them with a new lively form. Shoha Hidai (1904–1972), another pupil of Shokin Hidai, found in the powerful yet soft *kana* characters a style well suited to her

modern poem manuscripts. TŌKŌ SHINODA is a calligrapher and painter especially noted for her works in Chinese ink (*sumi*).

BIBLIOGRAPHY

Sinn und Zeichen (exh. cat., Darmstadt, Stadt Darmstadt, 1962)
S. Morita: 'Sho: Japanische Schreibkunst', *Schrift und Bild* (exh. cat., Baden-Baden, Staatl. Ksthalle, 1963), pp. 53–8
I. Schaarschmidt-Richter: 'Ostasiatische Schriftzeichen: Ostasiatisches Schreiben', *Schrift und Bild* (exh. cat., Baden-Baden, Staatl. Ksthalle, 1963), pp. 59–71
O. Kaneko: *Kaneko Ōtei* (Tokyo, 1970)
Words in Motion: Modern Japanese Calligraphy (exh. cat. by S. Ayoama and others, Washington, DC, 46. Cong., 1984)

IRMTRAUD SCHAARSCHMIDT-RICHTER

VIII. Ceramics.

Japan has an exceptionally long and rich history of ceramic production. Earthenwares were created as early as the Jōmon period (*c.* 10,000–*c.* 300 BC; *see* §2(ii) below), giving Japan one of the oldest ceramic traditions in the world (see fig. 134). Japan is further distinguished by the unusual esteem that ceramics hold within its artistic tradition, owing to the enduring popularity of the tea ceremony (*chanoyu*; *see* §XIV, 1 below).

1. Materials and techniques. 2. Early, before 1185. 3. Late, 1185–1868. 4. Modern, after 1868.

1. MATERIALS AND TECHNIQUES. After some ten millennia of near-independent development, starting early in the Jōmon period (*c.* 10,000–*c.* 300 BC), Japanese ceramics fell under a succession of influences from the Asian continent, manifested in direct importation of personnel and technology as well as in efforts at duplicating foreign models with indigenous tools and materials. By the late 16th century, however, specifically Japanese characteristics came to be embraced, and further stylized, under the canons of the tea ceremony. Yet the Japanese never abandoned interest in technical refinement; in the late 19th century, in particular, there was a vigorous investigation of new methods, this time introduced from the West.

(i) Clays. (ii) Forming techniques. (iii) Decoration. (iv) Glazes and overglaze enamels. (v) Kilns. (vi) Kiln marks.

(i) Clays. The pottery clays found in the Japanese archipelago range from fusible earthenwares to refractory kaolins. From the Jōmon period (*c.* 10,000–*c.* 300 BC) to the Yayoi period (*c.* 300 BC–*c.* AD 300), Japanese potters relied on highly plastic, iron-bearing shale and alluvial clays. Preparation was confined to addition of temper. Organic materials appear in much of the early Jōmon-period work, but sand or crushed stone predominates thereafter. Further refinements came about under Chinese influence in the 8th and 9th centuries AD, when potters of Nara three-colour ware (*sansai*) and Heian ash-glazed wares (*see* §2(i)(d) and (ii)(b) below) sought out white, refractory clays and enhanced their fineness through levigation. In contrast to this general trend towards refinement, the peculiarities, if not faults, of many regional stonewares attracted the interest of tea masters in the late 16th century (*see* §XIV, 3 below). The varieties of clay range from the coarse, vitrifiable buff clays of KARATSU

134. Map of ceramics production sites in Japan; those sites with separate entries in this dictionary are distinguished by CROSS-REFERENCE TYPE

and Shino (Mino, Gifu Prefecture; *see* MINO) to the fine, fusible red clays of TOKONAME and BIZEN.

Porcelain stone was discovered at Izumiyama, Kyushu, in the early 17th century (*see* §3(iii) below), and in 1662 a much larger deposit began to be worked on Amakusa Island, just off the southern coast of Kyushu. These materials were stone-ground and levigated and were used for a porcelain body either alone or with an admixture of kaolin.

(ii) Forming techniques. Jōmon-period potters used simple additive techniques, particularly coiling, to form their wares. In the early Yayoi period the hammer-and-anvil method was added to the coiling process, and from the middle of the Yayoi period there is also evidence of

finishing, although not forming, on a simple turntable. Haji ware, a type of earthenware that superseded the Yayoi tradition (*see* §2(i) below), features slab-forming and drape-moulding techniques in addition to the earlier methods.

The first use of the potter's wheel in Japan can be seen in Sue ware (*see* §2(iii)(a) below), which emerged in the mid-5th century AD under the influence of Korean Silla ware (*see* KOREA, §VI, 2(ii)). While Sue wares combined wheel and coiling (coil-and-throw) techniques, the lead-glazed earthenwares made under Chinese influence from the 8th to the 10th centuries include forms made entirely on the potter's wheel. Combinations of the above techniques persisted into the early modern period. By that time most potters in central Japan were working with the large

hand-turned wheel, which was probably introduced from China in the 14th century. From the late 16th century, potters in western Japan took up the fast-turning kick-wheel imported from Korea.

In the seventeenth century Kyoto potters, inspired by lacquerware shapes, engineered elaborate slab-built boxes and trays, often decorated with openwork. In the late 19th century European advisers such as Gottfried Wagener (1831–92) introduced Japanese potters to plaster-moulding and slip-casting techniques.

(iii) Decoration. In contrast to many Neolithic traditions outside Japan, Jōmon potters preferred plastic expression to painting. Their methods included cord-marking, incising and applied decoration (see fig. 135). The end of the period was also a time of isolated experiments with lacquer coatings. Yayoi-period wares featured smooth surfaces, incised or burnished, with only occasional appliqué; thin iron-oxide washes were also employed. Sue ware (*see* §2(ii)(a) below) largely maintained the Korean Silla tradition of incised decoration, with occasional use of appliqué. Nara three-colour ware and green-glazed ware (*see* §2(i)(d) below) featured glaze painting and dipping. The decorative potential of ash glaze was also recognized in the 9th century AD, when potters in central Japan began to apply it deliberately to their wares (*see* §2(ii)(b) below).

Although clay slip had been used in China from the early centuries AD, the Japanese did not recognize its decorative potential until the late 16th century, when it was applied with great freedom and imagination in Mino wares such as Shino and Oribe (*see* §3(i)(d) below). Underglaze painting in iron, then cobalt, appeared on many Japanese ceramics in the 17th century following the development of a transparent high-temperature glaze. In addition to these standard techniques, many regional methods have arisen out of particular materials and processes. For example, the *hidasuki* effect of red streaks

135. Jōmon ceramic vessel with *kaengata* (flame motifs), low-fired clay (Nagaoka, Municipal Science Museum)

on unglazed Bizen ware originally resulted from scorch marks left by the straw used in kiln packing.

(iv) Glazes and overglaze enamels. Japanese potters may have observed the natural ash deposits on the Korean-influenced Sue wares fired from the mid-5th century AD, but there was no attempt at deliberate ash glazing until the late 8th century, when potters at SANAGE in central Japan began to apply a solution of softwood ash in an attempt to imitate the Yue celadons (pale green glazed ceramics) imported from southern China (*see* CHINA, §VII, 2(iii)(b)). Intermittent experiments with deliberate ash glazes continued until the early 14th century. From that time potters began to add clay to the ash to control fluidity and harden the greenish-yellow glaze. The introduction of a ferrous clay into the batch also resulted in the first iron-glazed wares.

While the clay–ash technology persisted in central Japan, particularly in the SETO region, new influences from Korea encouraged the use of feldspar, first in western Japan. Feldspar, an alumino-silicate of sodium and/or potassium, is a principal ingredient in high-temperature glazes. Feldspar alone yields a viscous, milky glaze. Additions of hardwood ash render it transparent, and additions of rice-straw ash turn it a bluish white. In the late 19th century, however, industrial potters gradually abandoned wood ash in favour of limestone, which is more consistent in its chemical composition.

A document preserved in the Shōsōin treasure-house (Nara, Tōdaiji) reveals that in the 8th century AD Japanese potters understood the basic formula for lead glaze (a mixture of lead oxide and siliceous rock). Additions of mineral colorants, such as copper or iron, produce green or brown glazes. Together with the transparent base recipe, they constituted the palette for the Nara three-colour wares (*sansai*; *see* §2(i)(d) below). In the 9th and 10th centuries green was used exclusively, in imitation of Chinese celadon (*see* CHINA, §VII, 2(iii)(b)). Lead glazes fell into disuse for the next five centuries but were revived in Kyoto in the late 16th century. At that time the RAKU family contrived new types of lead glazes, notably a black glaze coloured by Kamogawa stone, a ferro-manganic rock found in the bed of the River Kamo in Kyoto.

Overglaze enamel technology, based on the use of a pre-fired glass called frit, was imported from China into Kyushu in the mid-17th century. Enamels were probably first applied to ARITA porcelains in the 1640s (*see* §3(iii)(b) below), and within a short time NONOMURA NINSEI introduced the technique in Kyoto.

(v) Kilns. From the Jōmon period to the mid-5th century AD, wares were stacked in simple pits and covered with combustible material, which was then ignited. Temperatures seldom exceeded 800°C, and surfaces were generally reduced as a result of poor combustion. A cleaner-burning fire was achieved in the Yayoi period, and many pots show the bright red colour of an oxidizing flame. The introduction of sloping tunnel kilns (*anagama*; see fig. 136, top left) for Sue wares in the mid-5th century ushered in the era of constructed kilns. These kilns, excavated out of hillsides, could achieve temperatures up to 1200°C, sufficient for the partial vitrification of wares. An excess of fuel introduced at the end of the firing sealed the pots

136. Types of kiln: (top left) tunnel kiln (*anagama*): (a) intake port; (b) fire-box; (c) support pillar; (d) ware chamber; (e) flue; (top right) cylindrical kiln; (centre) single-vaulted, multi-chambered climbing kiln (*waridake noborigama*): (f) fire-mouth; (g) fire-box; (h) chambers; (i) stoking port; (j) access door; (bottom) multi-vaulted, multi-chambered climbing kiln (*noborigama*): (k) fire-mouth; (l) fire-box; (m) stoking port; (n) stacking area; (o) flue; (p) access door

with carbon. The smaller, cylindrical updraught kiln (see fig. 136, top right) was probably introduced in the 8th century along with Chinese technology for making lead-glazed earthenwares. Advanced kiln control is demonstrated in the oxidized colours of the glazes.

In the 9th century another wave of Chinese influence resulted in a new type of tunnel kiln, which featured a dividing pillar at the fire-mouth and utilized a repertory of setting tools to stack wares efficiently. The larger fire-mouth allowed temperatures to rise as high as 1240°C, sufficient to melt an applied ash glaze. Excavations in the Mino region (Gifu Prefecture) of central Japan provide a particularly clear picture of kiln development in the 14th and 15th centuries. At the beginning of the 16th century the subterranean *anagama* was replaced by the *ōgama*, which was built over a sloping shallow trench. An interior saggar wall and row of pillars encouraged a faster-drawing down-draught atmosphere, and side doors eliminated the chore of loading the kiln through the fire-mouth.

The single-vaulted, multi-chambered climbing kiln (*waridake noborigama*; see fig. 136, centre) appears to have been built first at Mt Kishidake, Kyushu, for the firing of Karatsu wares in the late 16th century. This design

permitted control of atmosphere and temperature in individually stoked chambers. The classical *noborigama*, consisting of a series of stepped domed chambers (see fig. 136, bottom), was adopted from China in the early 17th century, completing the trend towards efficient down-draught firing. This type of kiln persisted in many regions into the second half of the 20th century. Fossil-fuel kilns were introduced from the West in the Meiji period (1868–1912), providing some remedy for a chronic shortage of firewood, but Japanese potters and connoisseurs have maintained a reverence for wood-fired ceramics.

RICHARD L. WILSON

(vi) Kiln marks. These are formalized patterns or Chinese characters (*kanji*), which serve no decorative purpose, on kiln tools and kiln products. The kiln marks on early unglazed wares produced during the Kofun (*c.* AD 300–710), Nara (710–94) and Heian (794–1185) periods are called *heraki* (marks made with the *hera*—a potter's pointed tool), those on wares produced from the Heian period to the Momoyama period (1568–1600) are called *kokumon* ('engraved crests'), and those on Edo-period (1600–1868) pottery and porcelain are called *kamain* ('kiln marks'). These can be divided into four types: engraved Chinese characters, engraved vertical lines, simple linear patterns and recognized seals or signatures.

(a) Heraki. Kiln marks have been applied to ceramic vessels since the first ceilinged kilns were constructed to produce earthenware vessels in the 5th century (*see* §(v) above). The main types of *heraki* are combinations of straight lines engraved on the underside of lids or bases. They are found throughout Japan, mainly on small pieces such as cups and lidded bowls. The uniformity and positioning of *heraki* indicate that these were not intended to be seen by the users of the vessels but to differentiate the wares of several potters sharing the same kiln. In the Tokiyama 206-I kiln (Osaka Prefecture), 54 of 160 lidded earthenware bowls were marked with three *heraki*, indicating ownership of the wares. The wares excavated from the 8th-century Oibō kiln (Gifu Prefecture) are marked with the characters *Minokoku* ('Mino Province'), which indicates that the kiln was an officially managed enterprise.

(b) Kokumon. In contrast to *heraki*, *kokumon* show marked differences according to region and period. *Kokumon* derived from *heraki* and probably served the same purpose. The most common are patterns of incised lines and the Chinese characters *dai* ('great') and *jō* ('above'). In Tokoname, instead of drawing marks with a *hera*, a stamp for *kokumon* was developed. This had the additional function of strengthening jars made by coiling. Over time *kokumon* began to play a decorative role, and this was accompanied by the appearance of seals with designs ranging from simple combinations of straight lines to crestlike patterns such as the tripple comma, the four-leaved wood sorrel, the wisteria comma, oine fan, snake-eye, horse's bit (a Greek cross in a circle) and arrow flights. These *kokumon* were applied mainly to *hachi* (bowls, pots) and *kama* (urns, vases), and rarely to small pieces such as cups. They were placed, drawn large, on the upper part of the vessel (see fig. 137). *Kokumon* became more decorative

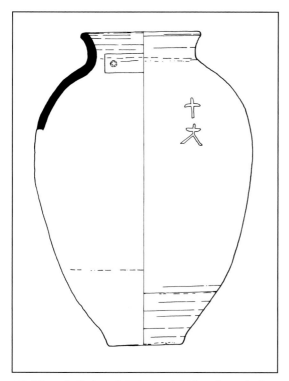

137. Kiln marks (*kokumon*), *jū* ('ten') and *dai* ('great'), on a jar from Susugama, Ishikawa Prefecture

than *heraki*, reflecting the increasing commercialization of pottery.

The characters *dai*, *jō* and *man* ('many', 'myriad') were believed to ward off bad luck and continued in use from early earthenware to late pottery. Other characters with religious or spiritual associations include the numbers nine and one (*kyū*, *ichi*) and the combination of ten and great (*jū*, *dai*; see fig. 137).

(c) Kamain. During the Momoyama (1568–1600) and Edo (1600–1868) periods the pottery industry changed dramatically. Kilns increased in size and were used by associations of potters. As a result, the use of kiln marks to identify different craftsmen became more important. In Kyoto, new kilns were established on the slopes of Higashiyama to the east of the city. Kyoto kiln marks included 'Iwakura', 'Kiyomizu' and 'Awataguchi'. The gorgeously coloured Omuro ware, one of the Kyoto wares produced at the kiln of NONOMURA NINSEI (Seiemon), is identifiable by a mark granted by Ninnaji; the first character of the mark is the *nin* of Ninnaji and the second the *sei* of Seiemon. Ogata Kenzan (*see* OGATA, (2), §1(i)), who made Ninsei ware, signed his work 'Kenzan'. Kenzan ware was made by other potters, and their use of the Kenzan seal can be thought of as also being a trademark.

BIBLIOGRAPHY

H. Sanders: *The World of Japanese Ceramics* (Tokyo, 1967)
T. Mikami: *Toki* [Ceramics], Nihon no bijutsu [Arts of Japan], xxix (Tokyo, 1968); Eng. trans. by A. Herring as *The Art of Japanese Ceramics*, Heibonsha. Surv. Jap. A., xxix (Tokyo and New York, 1972)
M. Onishi: *Tōgei no dentō gihō* [Traditional techniques in the ceramic arts] (Kyoto, 1978)
R. J. Faulkner and O. I. Impey: *Shino and Oribe Kiln Sites* (Oxford, 1981)
K. Nagahara and K. Yamaguchi, eds: *Yōgyō* [Ceramics], Nihon gijutsu no shakai shi [Japanese technology in social history], iv (Tokyo, 1984)

MASAAKI ARAKAWA

2. EARLY, BEFORE 1185. Japanese ceramics produced up to the end of the Heian period (AD 794–1185) can be broadly divided into low-fired wares, most of which were fired in open pits at temperatures generally below 800° C, and the increasingly sophisticated high-fired wares produced after the introduction of kiln technology from Korea in the mid-5th century AD (*see* §1(iv) above).

(i) Low-fired wares. (ii) High-fired wares.

(i) Low-fired wares. The first pottery produced in Japan was low-fired reddish *doki* ('earthenware'). Throughout the world, the use of earthenware by various groups is thought to have begun over ten thousand years ago and to have been generally symptomatic of the development of settled societies, in that the clay was fired and hardened in the flames of hearths. Low, deep, bowl-shaped vessels were the first to be made, followed by the emergence of cooking and storage vessels. The oldest Japanese ceramics were previously considered to be Jōmon earthenware (see §(a) below), which can be traced back to *c.* 8500 BC. Earthenware fragments dating to as early as *c.* 10,000 BC are now known, although the relationship of this earthenware to the development of Jōmon types is unclear.

(a) Jōmon period (*c.* 10,000–*c.* 300 BC). (b) Yayoi period (*c.* 300 BC–*c.* AD 300). (c) Kofun period (*c.* AD 300–710). (d) Nara (710–94) and Heian (794–1185) periods: lead-glazed wares.

(a) Jōmon period (c. 10,000–c. 300 BC). The term Jōmon derives from the cord-marked pottery (*jō*, 'cord'; *mon*, 'marking') that characterizes this period and that was first described by EDWARD MORSE in his excavation report of the ŌMORI SHELL-MOUND in 1879. Radiocarbon dating indicates that Jōmon pottery was first made *c.* 8500 BC; it continued to be made until it was replaced by Yayoi pottery in around 300 BC in northern Kyushu. The chronology of Jōmon pottery was established by Sugao Yamanouchi (1902–70), who used existing pottery typology of the Kantō and Tōhoku regions in the late 1930s to divide the period into five successive stages: *Sōki* (Earliest), *Zenki* (Early), *Chūki* (Middle), *Kōki* (Late) and *Banki* (Latest). This framework remains substantially unchanged.

Current evidence from dating, stratigraphy and style place the earliest Jōmon pottery in the Sempukuji Cave (Nagasaki Prefecture), where the initial ceramic layer contained remains of small, brownish vessels decorated with bean-shaped pellets (*toryūmon*) in horizontal rows. A linear-relief (*ryūsenmon*) type follows at Sempukuji and is in the first ceramic layer at the Fukui (Nagasaki Prefecture). Linear relief—applied or pinched fine bands of clay—appeared in numerous sites in the Tōhoku region. However, the thickness and coarseness of relief lines on round-bottomed pots increase with the distance from the point of origin. Another type, nail-marked (*tsumegatamon*), is mixed in the lowest layers with linear-relief pottery in many sites. It is decorated with short, arc-shaped marks, often made with a stick. All three types were grouped in a new category by Yamanouchi, who added an earlier phase

called *Sōsōki* ('grassroots'; Incipient or Sub-earliest). This phase is associated with Mesolithic culture in Japan.

Cord-marked pottery first appeared in shell-mounds as discarded cooking pots for shellfish. This cultural development is used as the start of Earliest Jōmon. Bullet-shaped or pointed-bottomed cooking pots about 250 mm high bear embryonic cord-marking made by rolling a small stick wound with a single strand of fibre (*yoriitomon*) over the surface. The same pot shapes were carved-stick rolled (rouletted; *oshigatamon*) in western Japan and most often shell-marked and shell-imprinted in northern Japan.

The appearance of full cord-marking done with two or more twisted and knotted fibres marks the start of Early Jōmon. Flat-bottomed vessels were more suitable for use on hard indoor floors, and fibre-tempering occurred for a short period when vessels became larger and flat bottoms were attached. Decoration resembling fingernail impressions in arcs or parallel lines, again called *tsumegatamon*, was done with the end of a small split reed or bamboo (*sasa* grass), prompting the first serious attempts at artistic designs. Pots were constructed with coils of clay, well dried, then probably warmed near a fire for several hours. They were baked for a short time in an open fire probably rarely exceeding 700° C. The chief type site in the Kinki region (Kyoto–Osaka region) is Kitashirakawa, Kyoto, and in the Kantō region, Moroiso (Kanagawa Prefecture).

A warmer climate and population growth stimulated a cultural plateau in Middle Jōmon. Semi-sedentary groups concentrated in the mixed forest region across central Japan, from the eastern prefectures of Ibaragi, Chiba and Tokyo to the western prefectures of Niigata, Ishikawa and Toyama. The Yatsugatake Range in Yamanashi and Nagano prefectures has especially large Middle Jōmon sites. Vast quantities of pots were made in large sizes, while new forms were created to suit new needs: fireplace bowls, lamps, footed vessels and barrel-shaped pots. Most notable is the rugged sculptural character of the decoration, such as raised, notched ridges outlining panels and rims heavily loaded with ornamental handles, loops and rings. Sites in the central mountains sometimes yield pots with snakes and animal heads set into the rim decoration. The extreme forms of decoration of the earlier half of the Middle Jōmon gave way to more modest, curvilinear patterns in relief and spaces filled with oblique cord-marking. The clay is coarse and salmon to reddish in colour. Katsusaka (Kanagawa Prefecture) is the type name for the earlier half and Kasori E, from the Kasori shell-mound (Chiba Prefecture), the name for the later half. As in all other stages, numerous local type names are applied to minor variations.

As the climate worsened, deteriorating conditions forced the population to disperse. Considerable resettling took place in Late Jōmon, and east-coast shell-mounds increased rapidly in size as the coastal resources replaced other foods. Carefully selected clay, used for smaller, modestly decorated vessels, produced a style very different from the heavily embellished style of the Middle Jōmon. Flaring vase shapes (see fig. 138), bowls and spouted vessels became the chief forms. Short patches of cord-marking are confined to parts of the vessels and were rubbed off where they ran over, hence the name 'erased cord-marking' (*surikeshi jōmon*). There are also examples

138. Jōmon ceramic vessel with flared rim, low-fired earthenware, from Ichikawa, Chiba Prefecture (Tokyo, National Museum)

of fine-notched ridges that run along the rims and become vertical outlines for panels of incised spirals or other consistently repeated patterns. These are tied to the rim projections. Shapes were enhanced by linear decoration in predictable patterns, greatly changing the principles of decoration.

Cord-marking was finally introduced to Kyushu as Honshū people moved south and west. Zoned cord-marking occurred throughout Japan, the only form of decoration to do so. It was known in the Kantō region as Horinouchi type, from a shell-mound in Chiba Prefecture, and later, in a more refined form, as Kasori B. Small stylistic differences have led to the use of endless numbers of local type names.

Population migrations eroded the regional character of the culture in the wake of the evacuation of Middle Jōmon areas, but, as satisfactory food sources were found and the population became sedentary, regional variations re-emerged as a trait of Latest Jōmon. The major culture area in Latest Jōmon was in northern Japan. Large sites have yielded vast numbers of skilfully made, mostly small vessels: bowls, cups, plates, flasks, vases, spouted vessels and incense burners. Cooking pots show less decoration, usually cord-marking. One large class of northern pottery is named after the peat site of KAMEGAOKA, but the finer points of the typology are based on a complicated sequence

from the cluster of Ōbora shell-mounds (Iwate Prefecture).

The clay is almost temper-free, sides are often paper-thin, and surfaces are frequently burnished or occasionally lacquered in red. Most vessels bear narrow bands of slanted, S-shaped patterns with birdlike and dragonlike configurations. The raised surfaces are either plain or cord-marked. Complicated rhythms create a high level of aesthetic interest. The decoration could be construed to reflect a connection with metal- or lacquerwork, perhaps of Chinese Han-period (206 BC–AD 220) origin, but Ya-manouchi expressed the most widely held view that the origins of Kamegaoka motifs can be found in earlier Jōmon pottery.

(b) Yayoi period (c. 300 BC–c. AD 300). This period is subdivided into Early (*c.* 300–*c.* 100 BC), Middle (*c.* 100 BC–*c.* AD 100) and Late (*c.* AD 100–*c.* 300). The first pottery produced by Yayoi-period rice farmers is believed to have been made at Itazuke on the outskirts of Fukuoka (Fukuoka Prefecture). It is almost indistinguishable from the Yūsu type of Latest Jōmon, both in pot shapes and in the combed and brushed surfaces. But Yayoi potters turned increasingly to plain and undecorated surfaces in Kyushu and added varieties of bottle and globular body shapes with narrow necks and flared mouths (see fig. 139) unknown in the Jōmon period. Ongagawa, named after the large River Fukuoka, is the chief type, which spread with time to the Kinki region.

Early Yayoi pottery is made of slightly sandy clay, built up in rings with thin sides, and it takes on a bleached brown and, later, a light yellowish, reddish or buff colour. Kilns have not been identified, suggesting few major changes in firing since Jōmon times. Firing temperatures ranged between 600° and 800° C, the reddish colour being derived from oxidation of the clay. The decoration was incised, scratched, combed, brushed, cord-marked or painted or a combination of these techniques. Brilliant red

surfaces were produced by dipping pots into jars of cinnabar or iron oxide, followed by polishing. Throughout Early Yayoi only simple cooking and storage jars were made.

During the Middle Yayoi period in Kyushu there was a great demand for single and paired burial jars (*kamekan*). Some were enormous vessels, with widened and flattened rims to facilitate closure. Clay strips encircle the pots where the walls taper towards the foot. The major type for these in Kyushu is Sugu, named after a burial site in Fukuoka.

The modest amount of surface painting seen from the outset in northern Kyushu increased to become a major decorative form in the Kinki region, particularly in Late Yayoi. Red ornamental patterns resembling symmetrically grouped rows of leaves were used at Karako (Nara Prefecture). Kinki-area craftsmen, working in bronze, pottery and wood, decorated their products more than elsewhere, perhaps stimulated by the development of a turntable and a simple lathe for shaping wooden vessels. Horizontal lines surroundng the neck turned into the *ryūsui* ('flowing water') patterns of fine parallel returned lines common to all arts of the Kinki region. During the Middle and Late Yayoi this pottery spread towards the north, cord-marking eventually being adopted and elaborated in the Tōhoku region. While borrowed from the earlier Jōmon style, the workmanship is in more sharply defined zones on globular vessels with narrow necks and collars in the Kantō and on non-Jōmon bottle and deep-pot shapes farther north.

From the Middle Yayoi period more stemmed cups and stands entered the repertory, especially high-pedestalled bowls (*takatsuki*), which were the utensils for a society supplementing its ceremonies. Pouring vessels also appeared. A few pots in the Kantō and lower Tōhoku regions are capped with anthropomorphic heads, and others in the second half of Middle Yayoi bear incised dancing figures, deer, birds, boars and raised-floor storehouses, in sites as widely scattered as Nara, Tottori, Hyōgo and Fukuoka prefectures.

Along with more use of paint and emphasis on collars and cord-marking in Late Yayoi, this period is represented by many similar countrywide traits. In south-western Japan, Late Yayoi evolved into the Haji style (see §(c) below), and more complicated shapes were produced in the north.

(c) Kofun period (c. AD 300–710). Several important new pottery types began to be produced during this period, in some cases continuing to be made well into later centuries.

Haji ware is named after the *hajibe* (clay workers' occupational group that built tombs). It directly succeeded Yayoi, carrying on the tradition of domestic earthenware production in the Kofun period. Haji first served in both daily and ceremonial uses, then in the 5th century it was supplanted by high-fired grey Sue ware (see §(ii)(a) below) for grave goods. Some Haji pieces are always found in tombs, suggesting that the Sue producers could never quite meet the demand. Cooking and storage jars, bowls, plates and stands are common (see fig. 140); decoration is exceptionally rare. Bottoms are generally rounded,

139. Yayoi ceramic vessel with narrow neck and flared mouth, red pottery, h. 123 mm (London, British Museum)

140. Haji ware, assemblage of low-fired red pottery vessels, max. h. 151 mm, Kofun period (London, British Museum)

perhaps because sunken storage jars set the style for all Haji ware. Rice steamers (*koshiki*) have perforated bases, with side lugs to act as hooks for stacking on the rims of other pots when in use. Many pots are without bottoms so that they can be assembled into stove pipes or flues for the kitchen. Some pottery firing was done inside houses, but a few outdoor shallow-trench kilns have been found. Occasionally, late Haji was fired in an *anagama* (see fig. 134 above), the kind of tunnel kiln used for Sue, as indicated by the recovery of both Sue and Haji sherds together in one *anagama*. The Haji character was kept by maintaining a low temperature with open vents.

Satsumon ware (from *satsu*, 'to rub' or 'brush'; *mon*, 'marks') was produced in Hokkaido and paralleled Haji. Radiocarbon dates indicate a duration from the Kofun period to the 13th century. The shapes of the deep pots and bowls on pedestals compare favourably with Haji, but the surface was smoothed by brushing; the crosshatching near the rim on Haji and the zigzag hatching around the body on Satsumon are totally unrelated.

Products of the Okhotsk culture along the northern Hokkaido rim and the islands of the Okhotsk Sea were close in time to Satsumon but ended around the 11th century. Dark-greyish pots of simple shape flare from a rather wide base to the shoulder then are in-turned towards the mouth. They bear thin, undulating strips of clay near the shoulder. Smaller vessels are spouted.

BIBLIOGRAPHY
E. J. Kidder jr: *Prehistoric Japanese Arts: Jōmon Pottery* (1968)

J. EDWARD KIDDER JR

(d) Nara (710–94) and Heian (794–1185) periods: lead-glazed wares. Although other types of low-fired ware continued to be produced in the Nara and Heian periods, it is the glazed wares that are predominantly of interest. The three-colour (*sansaitōki*) and two-colour (*nisaitōki*) glazed ceramics of the Nara period and the green-glazed (*ryokuyūtōki*) wares of the Nara and Heian periods are among the rarest Japanese ceramics. This is due to the limited production and to the fragility of the clay body

and the lead glazes. Nevertheless, since the 1960s information gained from careful scientific excavations and examination of ceramic remains has allowed clearer understanding of these wares.

It is known that Japanese potters were able to create lead glaze from at least the 8th century AD (*see* §1(iv) above), and, to date, lead-glazed ceramics have been excavated at nearly 300 sites throughout Japan. Most of these sites were either palaces, temples, tombs, shrines, government offices, kilns or sacred locations where religious rituals were performed. Hundreds of pieces of two-coloured and green-glazed ware have been found in the remains of the Heijō Imperial Palace (Nara) and at numerous sites in Kyoto. Because the shapes, body decoration, glaze and clay of the fragments can be divided into a few basic types, there were clearly only a small number of kilns producing lead-glazed wares. In addition, because the remains of green-glaze kilns have been discovered almost exclusively in the vicinity of Kyoto, Nara and Nagoya, production was probably limited to these areas.

Early green-glazed ware. This appears to have been the first intentionally glazed ware produced in Japan, although this supposition is disputed. The 80 pieces of green-glazed ware, comprising mainly small fragments of bowls, dishes and flat tiles datable to the late 7th century that were excavated in 1957 and 1964 at Kawaharadera in Nara, provide the most convincing evidence for this theory. The clay body is highly refined and low fired (at c. 800°C) to earthenware hardness under oxidizing conditions. Buff or slightly reddish in colour, the clay body is soft and easily broken. The green glaze is thin, rather uneven in application, and varies from pale lime to dark green. It is made of a 50% to 60% lead flux, the green colour being the result of the addition of a small amount of copper. Lead glazes, such as green glaze and all the other two- or three-coloured glazes, mature at a low temperature (c. 750–800°C) and are not very durable.

Numerous kilns located in the southern part of the Korean peninsula produced green-glazed ware that, in

shape, decoration and manufacture, closely resembles that found in Japan. Owing to these similarities and the discovery of a few fragments of Korean green-glazed ware in Japan at the Taikantaiji, Nara, and other sites, it has been suggested that imported Korean green-glazed ware served as the prototype for the ware made in Japan. It is known from historical records that there was great cultural intercourse and trade between Japan and Korea at this time.

Two- and three-colour wares. During the 8th century the focus of trade switched from Korea to Tang-period (618–907) China. Numerous luxury goods were imported for the use of the emperor and his court, as well as for temples. Of these items, two- and three-colour glazed ceramics were highly prized and treasured by the Japanese (*see* CHINA, §VII, 3(iii) and 4(ii)). These wares were so popular that the government ordered that kilns be established in Japan to produce similar ceramics. That ceramic kilns were actually constructed is known from the *Zōbutsusho saku-motsuchō* (*Record of the Works of the Buddhist Sculpture Academy*; 734), a document preserved in the Shōsōin treasurehouse, Nara.

141. Nara three-colour glazed ware, drum body, h. 383 mm, 8th century (Nara, Shōsōin)

Unfortunately, the remains of these kilns have not been discovered, but a remarkable group of 8th-century two- and three-coloured ceramics has been preserved in the Shōsōin. Of the 57 complete pieces and 36 fragments most are dishes and bowls, but there is also a drum body (see fig. 141), a pagoda and a bottle. In addition to the green-glazed ware, there are pieces of three-colour ware, usually green, white and yellowish brown, and of two-colour ware, usually green and white. All the pieces appear to have been fired twice. In the first firing the body was baked to earthenware hardness, then a glaze was applied and the piece was fired a second time. Most pieces were probably used as eating utensils or in religious ceremonies at the Tōdaiji Temple.

It was once thought that all the Shōsōin pieces were made in China and imported to Japan, but a major re-examination was undertaken in the early 1960s. After careful scrutiny it was determined for the following reasons that the Shōsōin pieces had been made in Japan: all were thrown on a clockwise-turning wheel, while Chinese Tang-period three-coloured pieces were mainly made in moulds or thrown on an anticlockwise-turning wheel; the bodies of Tang pieces were usually covered with a white slip before application of the glaze, whereas none of the Shōsōin pieces showed evidence of a white slip; and, whereas many pieces of Tang three-coloured ware are decorated with applied medallions, none of the Shōsōin pieces have such decoration.

Heian-period green-glazed wares. In the late 8th century it seems three-coloured ware suddenly ceased to be made, and only green-glazed production continued. This was due to several factors, one being that the Chinese ceased exporting three-coloured ware and instead sent glazed stonewares, such as Yue ware (*see* CHINA, §VII, 3(iii)(a)), and porcelains to Japan. Another reason, perhaps the more important, was the drastic social and political changes that took place within the imperial household, the government and temples when the capital was moved from Nara to Heian (now Kyoto) in 794.

Two 9th-century kilns that produced green-glazed wares have been excavated at Kamigamo and Iwakura (both Kyoto). They produced tiles, small bowls and dishes with a dark grey, nearly stoneware-hard body and with a dark-green glaze. These pieces were evidently fired twice, since the body was fired to a higher temperature than the glaze. In addition, many fragments of green-glazed ware and a few of two-coloured ware (dark green on green) have been found at other sites in and around Kyoto. Not all these fragments, however, have a grey, hard body; some have softer, reddish bodies. For this reason it seems that production of both types continued for some time. Most of these are fragments of bowls, dishes and jars that were intended for use primarily in religious ceremonies.

By the 10th century green-glazed ware was being produced at numerous sites in central Honshū, though still in limited quantities. SANAGE, which became the major centre for ash-glazed ceramics (*see* §1(iv) above) during the Heian period, produced the finest-quality green-glazed ware ever made in Japan. The range of shapes, intended primarily for use in temples, shrines and government offices, was expanded to meet the demands of domestic consumers. In addition to bowls, dishes and jars,

the Sanage kilns produced a wide variety of ceramics, including *sūtra* cases, spittoons, incense burners, four-legged jars, flower vases and three-legged dishes. Most pieces have a hard, grey body with a thinly applied green glaze, but a few have a softer, buff or reddish-coloured body. By the end of the 11th century, however, the production of green-glazed ware at Sanage appears to have stopped entirely. In other areas of Japan, such as in northern Kyushu and Gifu Prefecture, there was limited production of green-glazed ware during the Heian period, but these sites are not well understood. No green-glazed ware appears to have been made in Japan after the 12th century.

BIBLIOGRAPHY

K. Miyazaki, ed.: *Nihon no sansai to ryokuyū* [Japanese green-glazed and three-colour ceramics] (Tokyo, 1974)
S. Narasaki: *Sansai, ryokuyū* [Three-colour and green-glazed ware] (1977), Nihon tōji zenshū [Complete collection of Japanese ceramics], v (Tokyo, 1976–7)

RICHARD L. MELLOTT

(ii) High-fired wares.

(a) Sue. (b) Ash-glazed.

(a) Sue. Sue ware was the earliest stoneware (i.e. clay ware fired at *c.* 1200–1300° C) produced in Japan. Its manufacture began in the 5th century AD and continued in outlying areas until the 14th century. Although several regional variations have been identified, Sue was remarkably homogeneous throughout Japan. The function of Sue ware, however, changed over time: during the Kofun period (*c.* AD 300–710) it was primarily a funerary ware; during the Nara (710–94) and Heian (794–1185) periods, it became an élite tableware; and finally it was used as a utilitarian ware and for ritual vessels for Buddhist altars. The term *sueki* ('Sue ware') was coined in the 1930s by the archaeologist Shuichi Gotō (1888–1960), from a reference to the ware in the 8th-century *Man'yōshū* ('Collection of 10,000 leaves') poetry anthology.

Kofun period (c. AD 300–710). Sue ware belongs to a grey stoneware tradition imported from southern Korea. The earliest Korean stonewares were Kaya and Silla wares from south-eastern Korea (*see* KOREA, §VI, 2(i)). Kaya ware appears both in Kyushu and in the large tumuli (*kofun*) in the Osaka area. To meet the demand for funerary wares for the élite, a large production centre was established in the mid-5th century in the region of the present-day village of Suemura (Osaka Prefecture), close to the imperial court. From the beginning the production of Sue ware was governed by political factors, and the vessels at Suemura were probably made by Korean Kaya potters brought to Japan.

Approximately 1000 tunnel kilns (*anagama*; see fig. 136 above) were documented at Suemura before being destroyed for a housing development in the 1960s. The reduction atmosphere during the final stage of the firing produced the ware's characteristic grey colour. Wood-ash glaze often occurred naturally on the side of the vessel facing the tunnel entrance, where the fuel—usually red pine—was burnt. Regional production was limited until the beginning of the 6th century, when kiln centres were established throughout the Inland Sea region (Setonaikai) and along the Japan Sea and Pacific coasts. The funerary

ware produced at these sites paralleled Kaya ware in shape and decoration. The adoption and production of this ware as containers for funerary offerings formed part of a change in Kofun-period burial beliefs and practices in the second half of the 5th century; it was thought that the deceased must be provided with sufficient grave goods to ensure well-being in the underworld (*Yomi no kuni*).

A peculiar feature of Kofun-period Sue ware is the way vessels were assembled: pedestals, rims and bodies were often coil-made separately, then joined together and finished on a turntable. A good example is the flat-sided suspension jar type (*teihei*), consisting of two flat bowls joined vertically together with an added spout and hook handles, such as the piece excavated from the Nishimiyama Tomb, Hyōgo Prefecture (6th century; Tokyo, N. Mus.). The manufacturing marks on this type of body consist of comb-markings concentric with the base of the bowl. Thus, the comb-marking appears as a bull's-eye on each side of the vessel rather than encircling the body. Other Kofun-period Sue vessels have rounded bases, trimmed with a spatula, clearly showing the direction of the trimming. Large jars were formed by paddling and then smoothing the surface with wet leather, cloth or fingers. Such jars were virtually the only types of Kofun-period Sue ware put to utilitarian purposes—namely storage or *sake* making. Vessel shapes included covered bowl sets, pedestalled or stemmed bowls (*takatsuki*) with or without covers, jars and jar stands for the ritual serving of liquids, and various speciality shapes. They were decorated with combed wavy-line bands, comb-tooth punctates and incised lines. Pedestals were perforated with aligned or alternating rectangular or triangular holes. Few pieces had handles, and spouts were narrow, flared necks placed on or off centre; in some cases bamboo sections were inserted into holes to serve as spouts (see fig. 142).

Possibly the best known types of Kofun-period Sue ware are the *sōshoku sueki* ('decorated Sue ware') and *toritsuke* ('with bird attached') *sōshoku sueki*, which are unique in their ornamentation with sculptured anthropomorphic and zoomorphic motifs. In *sōshoku sueki*, examples of crude, hand-moulded images of human figures engaged in *sumo* wrestling, dancing or riding and images of deer, horses and wild boars were applied on the shoulders of jars. In *toritsuke sōshoku sueki*, birds were applied as finials to the lids of jars. These pieces were mainly produced in western Japan and are linked stylistically with their Korean Kaya and Silla predecessors. While their elaborate shapes mark them as the most outstanding examples of Sue ware, they comprise only a small portion of Sue production and were manufactured only from *c.* AD 550–650. Other shapes, not classified as decorated Sue ware but of unusual quality, include jars in leather-bag or ring shapes, such as the pieces excavated at Mukaiharamachi, Hiroshima Prefecture (6th–7th century; Tokyo, N. Mus.).

During the 5th century, Sue ware was almost exclusively for funerary use, while domestic ware consisted of Haji ware (*see* §2(i)(c) above). However, Sue shapes began to influence Haji vessels, and in the 7th century Sue was used with Haji for domestic uses, albeit initially by the aristocracy.

142. Sue ware assemblage stoneware, mostly ash-glazed, max. h. 526 mm, from central Honshū and Shikoku (London, British Museum)

Nara (710–94) and Heian (794–1185) periods. With the gradual decline of tomb construction towards the end of the 7th century and the introduction of the Tang-period (618–907) Chinese administrative system, Sue ware was produced as tableware for provincial officials and the imperial élite. Many Sue ware pieces of the 7th and 8th centuries were marked by characters indicating their destination or to which imperial office they belonged. The imperial court used vast quantities of domestic Sue, levied as taxes on producer villages. With Sue fulfilling a utilitarian role, other imported wares, including the Chinese-influenced *sansai* ('three-colour'; *see* §(i)(d) above), acquired more prestige. During this time the kilns at SANAGE became more important than those at Suemura. The Sanage kilns were smaller, but with a new type of chimney construction. When kilns wore out, they were not rehabilitated as was customary in the Kofun period, but a new kiln was built alongside. Other, smaller kiln centres of production were active throughout Japan.

Mass production led to a specialization of shapes, with many Sanage kilns producing only one or two types. Products included unglazed, plain, utilitarian wares, such as raised plates with solid pedestals, ring-footed bowls and narrow-necked jars, and Buddhist begging bowls, cremation jars and administrative inkstones. With the mass production of Sue tableware, all decoration was reduced to a minimum. Conversely, the striations or lattice designs from carved wooden paddles were left on the interior of large jars and the ring pattern from carved wooden anvils on the exterior, as less effort was devoted to finishing. Many bowls have flat, spatula-cut bases; it is not certain whether they were thrown on the wheel or not. Throwing

is not clearly demonstrated until string-cut bases appear on small vessels in the 9th century.

By the end of the 8th century wood-ash glaze was developed and intentionally applied to certain vessels (*see* §§1(iv) above and (b) below). This ash-glazed stoneware was characteristic of the Heian period. Sue ware included ewers and jars. Extant examples are decorated with etched linear patterns, plant or animal motifs, such as the jar ornamented with autumnal plants (11th–12th century; Tokyo, Keio U.), or with applied elements, such as the 9th-century jar from Mt Otowa (Kyoto, Kiyomizudera). Sue ware also inspired the production of regional wares such as the unglazed bowls called YAMACHAWAN. In addition, Heian period Sue ware has generally been recognized as the source of the later unglazed ceramic tradition from BIZEN, IGA and SHIGARAKI (*see* §3(ii)(a) below).

BIBLIOGRAPHY
S. Tanabe: *Sueki* [Sue ware], Toki taikei [Compendium of ceramics] (Tokyo, 1975)
S. Haraguchi: *Sueki* [Sue ware], iv of *Nihon no genshi bijutsu* [The primitive arts of Japan] (Tokyo, 1979)
S. Tanabe: *Sueki taisei* [Compilation of Sue ware] (Tokyo, 1981)
GINA L. BARNES

(b) Ash-glazed.

Introduction. The first intentionally applied ash-glazed ware (*shiki*) was made during the second half of the 8th century at the SANAGE kilns. This kiln complex was the largest and most important ceramic production centre throughout the Heian period (794–1185). Previously, during the Nara period (710–94), a scarcity of imported Chinese three-colour (*sansai*; Chin. *sancai*) lead-glazed

ware and Yue ware (*see* CHINA, §VII, 3(iii)) caused the government to establish kilns in Japan to produce imitations (*see* §(i)(d) above). Japanese two- and three-colour lead-glazed wares made during the 8th century, along with intentionally ash-glazed wares, were the direct result of government edicts. Because lead-glazed wares were duplicated in Japan soon after their importation, it is believed that either potters or technical manuals were provided by the Chinese. In the case of ash-glazed ware, however, excavations at Japanese kiln sites indicate that no such assistance was provided by the Chinese. Rather, a process of trial and error probably governed the development of ash-glazed ware in Japan.

Since at least the mid-5th century, potters in Japan had produced a hard, grey-bodied stoneware called Sue ware (*see* §(a) above). This widely produced ware sometimes had an ash glaze on its upper surface, caused accidentally during the firing process. This natural ash glaze usually does not cover the entire surface and is typically uneven, often with rivulets running down the sides; it is usually a dark olive-green colour. It was not until the late 8th century, however, when they were asked to duplicate the Chinese Yue wares, that Japanese potters began to experiment systematically with deliberate application of dry wood ash. The first experiments were made at the Sanage kilns, where suitable clay deposits were found to make the first ash-glazed wares. Ash glaze melts at *c.* 1240°C, and a clay able to withstand this high temperature is necessary.

Although it was doubtless the Sue ware potters who originally provided a technological basis for the emerging ash-glaze kilns, almost from the beginning the deliberately ash-glazed ware can be distinguished from Sue ware. The clay body is usually harder than Sue ware because ash-glazed pieces were placed nearest the fire-box where the kiln reached its highest temperature; the glaze, while a similar dark olive colour to that found on Sue ware, is typically rather thin and evenly applied. The clay used in making ash-glazed wares, almost from the earliest kilns, is noticeably lighter in colour and finer in consistency; and many of the shapes, such as Buddhist ritual water vessels (Skt *kundikā*s), are unique to the ash-glazed kilns.

Development of technology and forms. All early ash-glaze-producing kilns also made Sue ware. The differences between the wares suggest that there was one group of potters making Sue ware and another making ash-glazed ware; they merely shared the kilns. In addition, at many kilns, the bodies of pieces that were later to receive a coat of green lead glaze (*see* §(iv) above) were fired together with Sue ware and ash-glazed ware. Most likely they were made by the same artisans who made ash-glazed ware.

The early ash-glazed kilns were a variation of the through-draught or tunnel kiln (*anagama*; see fig. 136 above). During the 8th century the atmosphere within such kilns was generally neither totally oxidizing nor reducing, but because of the small size of the kiln mouth it tended to be reducing. By the mid-9th century, however, a true reducing atmosphere could be maintained. This was the result of the placement of a removable pillar (*bunenbo*) just inside the kiln mouth, allowing both the flames from the fire and the amount of air entering the kiln to be better

controlled. Furthermore, in order to raise the temperature, the angle of incline was increased from 25° to *c.* 35°.

The shapes produced at the earliest ash-glazed kilns include various bowls and dishes, tall-necked jars, water vases and flat pitchers (see fig. 143). Several represent variations of Sue-ware shapes, but others, like the water vase, are new shapes derived from recently imported metal or ceramic Chinese prototypes. In the 9th century (and again in the 10th) many other foreign-influenced shapes appeared. Among the new shapes were tea bowls, *kundikā*s, four-legged jars, jars with two earlike handles, ewers, incense burners and spittoons. New decorative techniques were also employed: the surface of bowls and the sides of ewers were incised with floral patterns before glazing; the tops of incense burners were cut with a reticulated pattern of flowers and butterflies; and sometimes underglaze iron painting was used.

From the shapes and excavation contexts of ash-glazed ware throughout Japan, it seems that from the late 8th century to the end of the 10th the main customers for this product were the imperial household, courtiers and other high-ranking government officials, as well as shrines and temples. Less expensive earthenware and Sue ware was used in ordinary households.

The best-quality ash-glazed wares were made at Sanage during the 9th and 10th centuries. In the 11th century, with the increase in trade between Japan and China, large amounts of foreign ceramics began to be imported into Japan—nearly enough, in fact, to satisfy the demands of upper-class customers. This caused a precipitous decline in production at Sanage. The potters, who had already sacrificed much of former quality to the demands of mass production, began limiting their shapes chiefly to bowls and dishes. These quickly made, unglazed or crudely glazed bowls are called *yamachawan*. By the end of the Heian period ash-glaze technology had spread to several areas in central Japan including SETO, which became the major centre for glazed wares during the 16th century (*see* §3(i)(c) below).

143. Early ash-glazed stoneware (*shiki*), flat pitcher, h. 82 mm, diam. 134 mm, from Sanage kiln complex, *c.* 800–50 (San Francisco, CA, Asian Art Museum of San Francisco)

BIBLIOGRAPHY

S. Narasaki: *Shirashi*, Nihon tōji zenshū [Complete collection of Japanese ceramics], vi (Tokyo, 1976–7)

RICHARD L. MELLOTT

3. LATE, 1185–1868.

(i) Glazed wares. (ii) Unglazed wares. (iii) Porcelain and overglaze enamels.

(i) Glazed wares. This article discusses the development of deliberately glazed wares, excluding porcelain (*see* §(iii) below).

(a) Introduction. (b) 13th–15th centuries: Koseto wares. (c) 16th century: Seto and Mino wares and the rise of the tea ceremony. (d) 17th century: spread of glazed ware manufacture. (e) 18th century–1868.

(a) Introduction. In the mid-12th century, towards the end of the Heian period (794–1185), the stoneware produced in Japan could be divided broadly into two types: Sue-related wares and *shiki*-related wares. Sue-related manufacture was distinguished by the use of techniques similar to those employed in the making of Sue wares (*see* §2(ii)(a) above); the main features of such products were their lack of artificial glaze and the greyish-black colour of their bodies resulting from strong reduction firing in *anagama* ('tunnel kilns') without flame-dividing pillars. By contrast, *shiki*-related manufacture was distinguished by the use of *anagama* with flame-dividing pillars and the practice of firing under neutral to oxidizing conditions.

The transition from Sue to Sue-related production during the 12th century and early 13th involved a shift towards the manufacture of unglazed, narrow-mouthed storage jars (*tsubo*), wide-mouthed storage jars (*kame*) and mixing mortars (*suribachi*) (*see* §(ii)(a) below). The transition from *shiki* to *shiki*-related production during the same period involved the emergence of three new types of manufacture. The first was of unglazed storage jars and mixing mortars, similar in kind to those from Sue-related kilns but different in appearance because of the more neutral conditions under which they were fired. The second type comprised rough, unglazed bowls, small dishes and mixing mortars and is known generically as YAMACHAWAN. The third type of *shiki*-related manufacture was of high-quality glazed wares. These were made in several parts of the Tokai region during the mid–late 12th century, but during the 13th century Koseto wares (*see* §(b) below) became the dominant variety, causing glazed-ware manufacture in areas other than Seto to come to a virtual standstill. In general, the 13th century was a period of consolidation, when manufacturing techniques and product ranges were standardized at kiln groups throughout Japan. Within Seto, both *yamachawan* and Koseto wares were made; potters in western Seto made nothing but *yamachawan* wares, while those in central and eastern Seto made both types of ware.

(b) 13th–15th centuries: Koseto wares. Koseto wares were distinguished by finely textured and slightly off-white clay, by artificially applied glaze and by the way in which many of their shapes were based on imported Chinese ceramics. They were first made in SETO in the late 12th century. Subsequently manufactured in neighbouring MINO as well, their production ceased with the introduction of new kiln technology in the early 16th century.

Vessel types and production patterns. Having first appeared in relatively small numbers, Koseto wares were made in increasing quantity as the 13th century progressed. The most numerous types were flasks (see fig. 144), ewers and four-eared jars. These were used mainly as Buddhist cinerary urns and funeral wares and as Shinto offertory vessels. The highpoint for ceremonial Koseto wares came during the early 14th century. In addition to the many types of ware made during the 13th century, incense burners, altar vases and other shapes for religious use were also made. The demand for Buddhist paraphernalia reflected in the nature of Koseto production during the 13th century and early 14th resulted from the spread of Buddhist practices. The simplified teachings of the Pure Land (Jōdō) and Nichiren sects brought Buddhism to a much wider section of the populace than ever before (*see* §II, 3 above). Among the military élite, ruling from Kamakura, the doctrines of Zen Buddhism were the most favoured. Buddhism was no longer the sole preserve of the Kyoto aristocracy but was practised throughout the country at all levels of society.

During the second half of the 14th century ceremonial wares declined in favour of utilitarian products, so that by the beginning of the 15th century the former comprised

144. Koseto ware flask, stoneware with ash glaze over incised and impressed decoration, h. 267 mm, from Seto kilns, 1325–50 (London, Victoria and Albert Museum)

only a small part of the Koseto potters' output. Utilitarian wares in standard shapes and sizes were the main concern. Kitchenware included grating dishes and mortars. Bowls, dishes and basins were produced for use at table. *Tenmoku* teabowls were, as their name suggests, used specifically as teabowls, their large numbers reflecting the growing popularity of tea drinking (*see also* §XIV, 1 below).

The shift in emphasis from ceremonial to utilitarian products was brought about both by greater availability of imported Chinese ceramics suitable for ceremonial purposes and by the growth in demand for high-quality domestic ceramics from an expanding and increasingly affluent military élite. These developments were the result of increased commercial activity in Kyoto and the provinces, encouraged by the Ashikaga shogunate and its vassals.

If in the early 14th century Koseto wares reached their most elaborate and sophisticated form, it was during the early 15th century that output reached its highest level. This peak was followed by a falling off in kiln numbers and the dispersal of potter groups. Some moved westwards into central Seto to build their kilns in areas that had previously been occupied by specialist *yamachawan* potters. Others crossed the provincial border to the north, a movement that subsequently developed into the Mino glazed-ware industry of the Momoyama period (1568–1600).

Changes in the nature of the shapes produced at Koseto kilns and shifts in production volume were accompanied by developments in manufacturing techniques. Until the mid-14th century it was usual for large shapes to be coil-built and for small shapes to be wheel-thrown. During the second half of the 14th century larger shapes were increasingly wheel-thrown, and by the mid-15th century coil-building had become almost obsolete. Improved wheel technology facilitated the mass production of utilitarian wares as well as the making of saggars. Standardization of methods of finishing bases and feet also took place. Turned foot-rings were usual on bowl shapes, while most other wares had flat bases which were either trimmed or, more usually, left with the spiral marks caused by the use of the cutting thread when they were removed from the wheel.

The evolution of sophisticated forms of surface decoration was closely related to the high output of ceremonial wares during the early 14th century. Nearly all the shapes on which stamping, incising and appliqué are found are either of the cinerary-urn, burial-accessory or offertory-vessel types, or of the temple ritual-ware type. The subsequent decline of ceremonial ware production was paralleled by the simplification of decorative motifs and the abandonment of all methods of surface decoration except combing.

Glazes. The prevalence of caramel-coloured iron glaze was also linked to the fortunes of ceremonial ware production in the early 14th century. In contrast, the appearance during the second half of the 14th century of the more stable form of brownish-black iron glaze characteristic of later Koseto production was the result of attempts to imitate Chinese *tenmoku* teabowls and other forms of teaware. This second type of iron glaze was used without discrimination during the 15th century on ceremonial and utilitarian wares alike. Rust-coloured iron slip glaze also appeared during the late 14th century. It was commonly used at 15th-century kilns on large utilitarian shapes for kitchen use. Yellowish-green ash glaze was the most ubiquitous of all Koseto glaze types. It was the only glaze type used during the 13th century and is found on all but a few shapes from the 14th and 15th centuries.

Chinese influence. Japanese sites have yielded many varieties of Chinese ceramics, mainly white, green and brown or black glazed wares from the southern Chinese provinces of Zhejiang, Jiangxi, Fujian and Guangdong, to which Koseto wares are clearly related (*see* CHINA, §VII, 3(iv)(b) and 4(ii)). With regard to the process of imitation, it is interesting that, although Koseto wares are often similar in shape to Chinese ceramics, they differ considerably in technique and decorative style. The Koseto potters did not have the technical means to make accurate reproductions of Chinese glazes, and they applied brown iron glaze to jars, flasks, ewers, incense burners, altar vases and other shapes that would have been white- or green-glazed wares in China. Another difference is that, although moulding and incising were the main methods of surface decoration on Chinese ceramics, complex decoration on Koseto wares was most commonly achieved through stamping. Moulds were used rarely, and then only to produce sprigs and buttons for appliqué decoration. Incising was used more often but, compared with that on Chinese ceramics, is unsophisticated. The decorative motifs on Koseto wares vary from being quite close to those on Chinese wares to being only vaguely related. These disparities suggest that, in most cases, the Koseto potters had access only to descriptions, drawings or models of Chinese prototypes rather than to actual vessels.

Kiln technology. The extent to which the evolution of Koseto kiln technology can be charted is limited by the relatively small number of kiln excavations that have been carried out. Evidence suggests that the kilns used during the 13th century were similar to *yamachawan*-producing kilns of the same period. During the 14th and 15th centuries there was a tendency for the widest point of the kiln to be built lower down the main chamber. Eventually, by the mid-15th century, it had been moved to immediately above the flame-dividing pillar. This change in design took place just as pressure for mass production caused the potters to formulate standard stacking procedures using regularly sized saggars. The use of saggars meant that it was less risky to place wares immediately above the firebox than if they were unprotected. This in turn meant that kilns could be built with their widest points lower down, enabling the potters to place more wares in the hottest part of the kiln and thus improve the efficiency of their firings.

(c) 16th century: Seto and Mino wares and the rise of the tea ceremony. During the 15th century the pattern of glazed ceramic production and consumption in Japan remained essentially the same as it had been during the previous two centuries. Chinese ceramics were prized above any other form of ware, whether for ceremonial or domestic purposes, and Koseto wares, the most sophisticated of native

145. Mino wares (clockwise from left): Yellow Seto ware vase, stoneware with yellow glaze, h. 194 mm, 1585–1600; Shino ware ewer, stoneware with whitish glaze over decoration in underglaze brown, h. 152 mm, 1585–1600; Oribe ware dish, stoneware with clear and green glazes over decoration in underglaze brown, l. 122 mm, 1600–30 (London, Victoria and Albert Museum)

breakthrough, in that it allowed Japanese potters to go beyond the simple copying of Chinese porcelain shapes to imitate their colour and decorative schemes. Dishes and bowls resembling imported porcelain were made in large quantities, and underglaze painting in iron oxide simulated the effects of decoration in underglaze blue.

Another contribution to the development of Mino ceramics from the 1580s onwards was the demand for purpose-made teawares. Shino wares were made in various exotic shapes, and Black Seto and Yellow Seto wares (see fig. 145) were developed specially for the tea market. The cult of *chanoyu* (tea ceremony; *see* §XIV, 1 below) had been evolving since the end of the 15th century. During the first half of the 16th century it was practised mainly by wealthy merchants in the growing ports and cities of Kyoto, Nara, Sakai (Osaka Prefecture) and Hakata (Fukuoka Prefecture). The ceramics they used included classical Chinese wares of the kinds favoured since the 13th century, and various more rustic wares that they discovered among ordinary utilitarian products of Chinese, Korean and Japanese origin. As the popularity of the tea ceremony spread to the ruling military classes during the 1580s and 1590s, the number of tea devotees rose dramatically. The increase in demand for tea utensils and the natural desire of connoisseurs to have wares made to their own specifications led to the appearance of purpose-made tea ceramics and the placing of orders not only at Japanese kilns but at Chinese and Korean kilns as well.

While the tea ceremony was important in encouraging the development of many new and strikingly original ceramic types (see fig. 145), it was only one among many forces that reshaped the face of the Japanese ceramic industry in the Momoyama and early Edo (1600–1868) periods. Taking Mino wares as an example, there is evidence that the production of teabowls, water jars and other shapes whose usage was limited to the tea-room was significantly less than that of sophisticated tablewares. The latter were probably marketed for use not only in *kaiseki* (the meal constituting the first part of a tea ceremony) but also in settings unconnected to the tea ceremony although influenced by prevailing tastes in tea utensils. A more important point that emerges from the analysis of excavated material is that the output of tea-related wares, both of the tea-room and tableware types, was small in comparison to that of utilitarian ceramics, even at kiln sites renowned for their high-quality wares. It is clear that the blossoming of creativity that gave rise to the more elaborate forms of ceramics from Mino and elsewhere depended on the existence of a sound commercial base concerned with the manufacture of ordinary domestic products.

(d) 17th century: spread of glazed ware manufacture. The buoyancy of the national economy, the consolidation of fiefdoms under military rulers intent on increasing local commerce and industry, and the demand from tea devotees for new sorts of products all contributed to the changes that transformed the face of the Japanese ceramic industry during the first half of the 17th century.

Mino and Seto. In Mino the proliferation of *ōgama* kilns and the advent of new ceramic types were followed, in

products, were marketed as substitutes for Chinese imports. Changes began to occur at the beginning of the 16th century, both in unglazed (*see* §(ii) below) and glazed ceramics. In Seto and Mino a new era was ushered in as potters developed a more efficient type of kiln known as the *ōgama* (*see* §1(v) above). Initially developed in Seto, *ōgama* technology spread rapidly in the early 16th century, causing the decline of *anagama* kilns and the end of Koseto production throughout the area.

Until the early 1580s the products of Seto and Mino *ōgama* were almost exclusively utilitarian wares, the most common shapes being *tenmoku* teabowls, small dishes, grating mortars and oil dishes. This preoccupation with simple, if high-quality, domestic ceramics was the culmination of the shift in emphasis from ceremonial to utilitarian production that had started in the mid-14th century (*see* §(b) above). As with utilitarian Koseto wares, surface decoration was minimal. The ash, iron and iron slip glazes were also the same as those used in the 15th century. Owing to differences in firing conditions, however, the glazes on *ōgama* products emerged with greater intensity of lustre and colour than on Koseto wares.

Chinese precedent continued to be the most important influence on the work of Seto and Mino potters, both before and after the *ōgama* industry reached full maturity in the early 1580s. For reasons not altogether certain there was a temporary suspension of ceramic manufacture in Seto during the last two decades of the 16th century. Production was entirely concentrated in Mino, where there was a rapid proliferation of kilns following the development of Shino wares and their characteristically thick white feldspar glaze (*see* §1(iv) above). This was a revolutionary

about 1600, by the introduction of the *noborigama* (multi-chambered climbing kiln; see fig. 136 above) from KAR-ATSU in western Japan. This larger and more efficient type of kiln enabled the potters to increase their productivity even further, and *noborigama* technology spread rapidly through both Mino and Seto, soon being introduced into most of the pottery villages that were to be active during the Edo period (1600–1868). During the first quarter of the 17th century various highly flamboyant ceramics in 'Oribe' style (Black Oribe, Oribe Black, Shino Oribe, Green Oribe, Red Oribe, Narumi Oribe and Mino Iga wares; see fig. 145) were made at kilns in the same Mino villages north of the Toki River that had produced tea-related wares during the 1580s and 1590s. Output declined after about 1630 as fashions in tea ceramics shifted in favour of wares from other parts of the country. Efforts were concentrated on high-quality but essentially utilitarian iron-glazed products and celadon-like Ofuke wares. The name Ofuke came from the very similar wares that were made as 'official' wares in the Ofuke-no-Maru compound inside Nagoya Castle from the late 17th century. Kilns south of the Toki River, including those in Seto, made mainly utilitarian ash- and iron-glazed wares and white-glazed products similar to earlier Shino wares.

Growth of provincial centres. Developments elsewhere in Japan were no less far-reaching. The nature of production at existing kiln groups such as ECHIZEN, TOKONAME, SHIGARAKI, TANBA and BIZEN changed. New kilns were established in parts of the country that had not seen ceramic production since the Kamakura (1185–1333) and Muromachi (1333–1568) periods. In western Japan, for example, the arrival of Korean potters led to the establishment of several new kiln groups, the Karatsu–Arita complex being the largest (*see* ARITA). In central Japan the most important development was the emergence of Kyoto as a major ceramic centre (see below). The spread of technology from existing complexes such as Seto–Mino also gave rise to smaller kiln groups, which, scattered about the country, started to produce ceramics for local consumption.

Evidence from Shigaraki shows that the potters changed from unglazed to glazed-ware manufacture in the early 17th century. Initial experiments with glazing during the second half of the 16th century were paralleled by the introduction of new kiln technology. Remains have been found of long single-chambered climbing kilns with stoking holes along their length (*hebigama*; 'snake kilns'). These were replaced in the early 17th century by multi-chambered climbing kilns. In Tanba glaze technology and multi-chambered climbing kilns were introduced in the early 1600s. In Bizen in the late 16th century potters abandoned their hillside workshops and built three large communal single-chambered kilns in the valley around the village of Imbe. Rather than change to glazed ware production as at Shigaraki and Tanba, however, they continued to concentrate on unglazed ceramics. In Tokoname there are indications of experiments with kiln technology from the late 16th century. Products from Echizen show that glazing techniques were introduced during the early 17th century. Common to all these kiln groups was an increase in product variety. Storage jars and mixing mortars continued

146. Tea-related wares (clockwise from left): (a) Shigaraki ware teabowl, stoneware with natural ash glaze, diam. 108 mm, 1590–1630; (b) Tanba ware water-jar, stoneware with greenish brown glaze over incised vertical striations, h. 152 mm, 1600–50; (c) Bizen ware tea caddy, stoneware with natural ash glaze and firing marks, h. 73 mm, 1590–1630 (London, Victoria and Albert Museum)

to be important, but many other kinds of utilitarian product were made as well. Shigaraki (and neighbouring Iga; now Mie Prefecture), Tanba and Bizen are also known for some remarkable tea-related wares produced from the end of the 16th century onwards (see fig. 146).

In western Japan, Korean potters arriving in the aftermath of Toyotomi Hideyoshi's campaigns against Korea during the 1590s were responsible for the development of stoneware manufacture in such places as HAGI, AGANO, TAKATORI, Karatsu and SATSUMA (see fig. 147). They made a wide variety of glazed utilitarian tablewares and kitchenware, and a small number of sophisticated tea-related ceramics. In Karatsu, the most important of these kiln groups, there had been a few potters working since the mid-16th century, but it was not until the mid-1590s that the industry became really significant. Karatsu wares were shipped to many parts of Japan and were soon competing with products from Seto and Mino for a share of the national market.

The importance of Karatsu wares declined during the first half of the 17th century as the discovery of porcelain stone in neighbouring Arita led to the growth of a native porcelain industry (*see* §(iii) below). Excavations at Japanese consumer sites show that there had been great interest in Chinese porcelain since at least the early 16th century, and the potters in Arita found an immediate market for their products. Growing demand meant that by the mid-17th century, when large orders for porcelain were also being placed by European merchants, most of the potters in the Karatsu–Arita area had switched from stoneware to porcelain manufacture. During the first half of the 17th century, output consisted mainly of blue-and-white wares, with a smaller number of green and brown-glazed wares

147. Late glazed ceramics: (left) Hagi ware teabowl, stoneware with crackled grey glaze, h. 140 mm, 1650–1750; (right) Karatsu ware bottle, stoneware with white and brown glazes, h. 248 mm, 1590–1630 (London, Victoria and Albert Museum)

also being made. During the second half of the century, following the introduction of enamelling technology in the 1650s, the repertory expanded to include wares with overglaze decoration.

Kyoto. Although its production of ceramics grew during the 17th century to equal that of Seto–Mino and Karatsu–Arita, Kyoto was remarkable, given its longstanding position as capital of Japan, for not having developed a significant ceramic industry earlier in its history. The first distinctive form of ceramics made there were low-fired Raku wares, which were made from the end of the 1570s in answer to the demand for purpose-made tea wares. Raku wares, however, were a highly specialized product (*see* CERAMICS, colour pl. II, fig. 2) and had little to do with the types of commercially produced stoneware and porcelain that constituted the mainstream of Kyoto ceramics during the Edo period.

The first half of the 17th century in Kyoto was a formative period when styles and techniques were introduced from various existing kiln groups. Seto and Mino were early influences, but it was the introduction of overglaze enamelling techniques in the mid-17th century (*see* §(iii) below) that determined the nature of future production. Enamel decorated wares reached an early peak of sophistication at the hands of the potter NONOMURA NINSEI. During the second half of the 17th century they became the staple product of the numerous kilns that had been established in various parts of Kyoto.

Later 17th-century developments. By the mid-17th century Seto–Mino, Kyoto and Karatsu–Arita had emerged as Japan's three main ceramic centres. While the large urban populations of Kyoto and Osaka absorbed the bulk of Kyoto production, ceramics from Karatsu–Arita and Seto–Mino were marketed more widely. Wares from the former were known in most parts of western and central Japan by the mid-17th century and later found their way up the north-eastern coast and also to Edo (now Tokyo). The emergence of Kyoto and Karatsu–Arita as large ceramic centres destroyed any chances the Seto–Mino potters might have had of competing in the central and western domestic markets. By the mid-17th century nearly all their efforts were directed, as indeed they had been during earlier centuries, towards central-eastern and eastern Japan, with Edo as the main target. Production at Seto–Mino, Kyoto and Karatsu–Arita was complemented by manufacture at smaller kiln groups scattered across the country. Apart from storage jars from such centres as Echizen, Tokoname, Shigaraki, Tanba and Bizen, which continued to be distributed quite widely, most wares from lesser kiln groups were for local distribution. This overall pattern was further consolidated during the second half of the 17th century.

BIBLIOGRAPHY
S. Hayashiya, T. Hayashiya and M. Nakamura: *Cha no bijutsu* [Tea ceremony arts], Nihon no bijutsu [Arts of Japan], xv (Tokyo, 1955); Eng. trans. by P. Macadam as *Japanese Arts and the Tea Ceremony*, Heibonsha Surv. Jap. A., xv (Tokyo, 1974)
T. Mikami: *Tōki* [Ceramics], Nihon no bijutsu [Arts of Japan], xxix (Tokyo, 1968); Eng. trans. by A. Herring as *The Art of Japanese Ceramics*, Heibonsha Surv. Jap. A., xxix (Tokyo, 1973)
R. Fujioka: *Chadōgu* [Tea cermony utensils], Nihon no bijutsu [Arts of Japan], xxii (Tokyo, 1968); Eng. trans. by L. A. Cort as *Tea Ceremony Utensils*, Arts of Japan, iii (Tokyo, 1973)
S. Hayashiya: *Shino*, Nihon tōji zenshū [Complete collection of Japanese ceramics], xv (Tokyo, 1975)
K. Mizuno and Y. Yoshioka: *Echizen, Suzu*, Nihon tōji zenshū, vii (Tokyo, 1976)
S. Narasaki: *Shirashi*, Nihon tōji zenshū, vi (Tokyo, 1976)
——: *Seto Mino*, Nihon tōji zenshū, ix (Tokyo, 1976)
M. Satō: *Karatsu*, Nihon tōji zenshū, xvii (Tokyo, 1976)
J. Takeuchi: *Oribe*, Nihon tōji zenshū, xvi (Tokyo, 1976)
I. Akabane and K. Onoda: *Tokoname Atsumi*, Nihon tōji zenshū, viii (Tokyo, 1977)
S. Hayashiya: *Iga*, Nihon tōji zenshū, xiii (Tokyo, 1977)
A. Itō and S. Uenishi: *Bizen*, Nihon tōji zenshū, x (Tokyo, 1977)
M. Kawahara: *Shigaraki*, Nihon tōji zenshū, xii (Tokyo, 1977)
S. Narasaki: *Tanba*, Nihon tōji zenshū, xi (Tokyo, 1977)
J. Takeuchi: *Kiseto Setoguro*, Nihon tōji zenshū, xiv (Tokyo, 1977)
S. Tanabe and M. Tanaka: *Sueki*, Nihon tōji zenshū, iv (Tokyo, 1977)
S. Hayashiya: *Hagi Takatori Agano*, Nihon tōji zenshū, xviii (Tokyo, 1978)
M. Satō: *Satsuma*, Nihon tōji zenshū, xix (Tokyo, 1978)
L. Cort: *Shigaraki: Potters' Valley* (Tokyo, 1979)
Chanoyu: Japanese Tea Ceremony (exh. cat. by S. Hayashiya and others; New York, Japan House Gal.; Kyoto, Urasenke Found; Tokyo, Goto Mus.; 1979)
Shino and Oribe Kiln Sites: A Loan Exhibition of Mino Shards from Toki City (exh. cat. by R. Faulkner and O. Impey; Oxford, Ashmolean, 1981)
J. Becker: *Karatsu Ware: A Tradition of Diversity* (Tokyo, 1986)
R. Faulkner: *Seto and Mino Kiln Sites: An Archaeological Survey of the Japanese Medieval Glazed Ware Tradition and its Early Modern Transformation* (diss., U. Oxford, 1987)
L. L. Wilson: *The Art of Ogata Kenzan: Persona and Production in Japanese Ceramics* (New York and Tokyo, 1991)
L. A. Cort: *Japanese Collections in the Freer Gallery of Art: Seto and Mino Ceramics* (Honolulu, 1992)
RUPERT FAULKNER

(e) *18th century–1868.* New kilns making utilitarian wares had appeared all over the country in the mid-17th century. Some of these were under the control of the feudal domains, while others were established by groups of families, sometimes with the support of merchants.

148. Tsutsumi stoneware *kame* (storage jar), h. 440 mm, mid-19th century (Hautefort, private collection)

jars (*tsubo*), sometimes lidded, for tea and other commodities, or spouted, for soy sauce (*shoyutsugi*). Sake was stored in large flasks (*tokkuri*; see fig. 149), decanted into smaller flasks (*choshi*) and drunk from small cups (*sakazuki*). Flasks with a wide base were made for use on ships (*funadokkuri*). Food preparation and service wares included bowls (*hachi*), some with spouts (*katakuchi*), teacups (*chawan*) and rice bowls, plates (*sara*), cooking pots (*nabe*), teapots (*dobin, kyusu*), water bottles (*yutampo*; see fig. 150) and rice steamers (*mushiki*), as well as graters and mortars (*suribachi*). Japanese homes were heated with charcoal braziers (*hibachi*) and lit by oil-lamps (*teshaku*) or candles held in holders (*toshinzara*). More refined wares, not produced in all folk kilns, included gourd-shaped vases (*hyotandokkuri*), offertory jars for altars (*omikkidokkuri*) and incense jars (*koro*) and burners (*kogo*). Small water containers (*suiteki*) were used for calligraphy and painting, and a variety of wares were made for gardening and flower arrangement, including planters (*uekibachi*) and vases (*kabin*).

The straightforward style, decoration and shape of these folk wares attracted the attention of MUNEYOSHI YANAGI, founder of the folk-craft movement, in the early 20th century (*see* §XV below; *see also* MINGEI). Not all the

Such potteries can be described as 'folk kilns', and the wares they made gradually replaced many traditional wooden, lacquered and iron wares for domestic use. Some folk kilns were centred on the old production sites, near clay deposits known for several centuries, but the kiln technology they employed was usually new. By the mid-18th century potters trained in either western or central Japan were to be found throughout the country because of the proliferation of kilns and the growth in local demand.

Pottery was a family affair, though potters sometimes had other jobs, such as farming or even soldiering, a practice that caused the closure of 40% of the Aizu-Hongō (Fukushima Prefect.) kilns during the civil war of 1868. The pottery business was handed down from father to son, although a system of apprenticeship (*minarai/totei*) also developed. Apprentices learnt their skill on the job, with little formal training. When there was no male heir, the eldest daughter would marry a potter who took his father-in-law's name.

In some areas of Japan there were communal kilns, where the production of an individual household was not sufficient to sustain a family kiln. Typical of these folk kilns is the Onta pottery tradition (Ōita Prefect.). The men dug the clay, which was then prepared by the women after crushing. The men threw the pots, though women made some items by hand. The women prepared the raw materials for the glazes and glazed smaller items, while the men glazed the larger pieces and fired the kilns. Local potters also carefully guarded the secrets of their clay preparation and, in particular, of glaze compositions and firing techniques.

The agrarian economy of Edo-period (1600–1868) Japan largely determined the range and shapes of the products wares by folk kilns. These included large storage jars (*kame*; see fig. 148) for water, rice and pickles, smaller

149. Narushima stoneware *tokkuri* (sake flask), h. 455 mm, mid-19th century (Hautefort, private collection)

150. Shiraiwa stoneware *yutampo* (hot-water bottle), h. 255 mm, mid-19th century (Hautefort, private collection)

products of folk kilns were works of art, but many were made with an instinct for sound shape and glazed with casual charm. Stoneware clays were dug locally and were frequently mediocre in quality. Folk pots were often decorated with a simple base glaze, with an overglaze that was trailed, dipped or splashed on the rim or side. The *namako* ('sea slug') ash glaze that produces an opalescent purplish or bluish effect, depending on the materials used, characterized many folk wares. Its variations can be found as far afield as the Shodai kilns (Kumamoto Prefect.), the Shiraiwa kilns (Akita Prefect.) and the Tsutsumi kilns (Miygi Prefect.). Other common glazes were a black glaze made from clays rich in iron or manganese oxides and a lustrous amber-brown glaze known as *ame* ('wheat gluten').

The popularity of porcelain in the 18th and 19th centuries including a burgeoning export market led to the decline of many traditional stoneware kilns, including KARATSU, and to attempts to imitate porcelain in areas where suitable raw materials were not available. At Hirashimizu (Yamagata Prefect.), for example, large sake flasks were made from the local stoneware clay and then covered with a thick white slip. Overglaze blue decoration was added in the local version of the Imari decorative style (*see* §(iii) below), with energetic brushwork and a touch of overglaze green or brown.

Similar wares were made at Obori (Fukushima Prefect.), where the folk kilns used an extremely light stoneware body for large sake flasks, covered in slip and decorated to resemble porcelains, though the necks were covered in a distinctive thick brown glaze. Once a local kiln had established its range of wares, styles and glazes the potters of succeeding generations were apparently content to carry on production with little change. Potters never signed their work, except to distinguish it with a family or kiln

mark (*see* §1(v) above) when it was fired in a communal kiln.

Although some folk wares were bought by tea masters, the folk potteries did not make tea wares. The *goyō gama* (command kilns) established by the daimyō developed to provide tea or presentation wares, and in complete contrast to the anonymous craftsmen who produced folk wares, during the Edo period individual potters rose to prominence, particularly in Kyoto, with the highly distinctive work of NONOMURA NINSEI and Ogata Kenzan (*see* OGATA, (2)). These potters and their successors, OKUDA EISEN, AOKI MOKKUBEI, TAKAHASHI DŌHACHI and EIRAKU HOZEN, produced a huge variety of work, including tea wares, some influenced by quite different periods of the Chinese and Korean ceramic traditions.

Kyoto became a centre for a wide range of activity, including low-temperature RAKU wares and simple rustic wares, stonewares, underglaze-blue porcelains and complex overglaze enamels (*see* KYOTO, §III). In general, the enormous increase in production of ceramics throughout the Edo period brought about a proliferation of shapes and styles, some lacking the strength of the work of previous periods.

BIBLIOGRAPHY
H. Munsterberg: *The Folk Arts of Japan* (Rutland and Tokyo, 1958)
——: *The Ceramic Art of Japan* (Rutland and Tokyo, 1964)
H. Sandars: *The World of Japanese Ceramics* (Tokyo and Palo Alto, 1967)
D. Rhodes: *Tamba Pottery* (Tokyo and New York, 1970)
R. Castile: *The Way of Tea* (New York and Tokyo, 1971)
H. Gorham: *Japanese and Oriental Ceramics* (Rutland and Tokyo, 1971)
S. Yanagi: *The Unknown Craftsman* (Tokyo and New York, 1972)
M. Sato: *Kyoto Ceramics*, Arts of Japan, ii (New York and Tokyo, 1973)
D. Hale: *Tōhoku no yakimono* [Ceramics of Tōhoku] (Tokyo, 1974)
B. Moeran: *Lost Innocence: Folk Craft Potters of Onta, Japan* (Los Angeles and London, 1984)
Mingei Masterpieces of Japanese Folkcraft, Japanese Folkcraft Museum (Tokyo, New York and London, 1991)

DAVID HALE

(ii) Unglazed wares. Unglazed Japanese ceramics in the period 1185–1868 represent an important aspect of Japanese culture and daily life, particularly in the earlier part of this period. Known generically as *muyū tōki* (unglazed pottery), these ceramics were used by people of all classes and therefore provide essential information on the everyday life of Japanese people before the 16th century. While most unglazed wares before the 20th century were manufactured for utilitarian purposes, the influence of the *chanoyu* (tea ceremony; *see* §XIV, below) and its related aesthetics fostered an appreciation for the rough, unfinished appearance of unglazed stonewares that has spread in the 20th century to influence ceramic enthusiasts throughout the world.

(a) 1185–*c*. 1500. (b) *c*. 1500–1868.

(a) 1185–c. 1500. Unglazed Japanese wares of this period are roughly classified into three groups, based on the types of early ware from which they are descended. The first of these is the *doki* earthenware tradition, second is the Sue-ware line of unglazed stoneware and third is the *shirashi*-related group descended from early ash-glazed ware. However, the products of later wares, with the exception of earthenwares, generally bear little resemblance to the types from which they are descended; hence the classification serves only to link production in the late period with that of the early period. The changes that took

place in ceramic production around the 12th century may be attributed to several factors. The rigid class distinctions that had been observed during the previous centuries gradually became more relaxed, and the slow transformation of the manorial to the feudal system led to increased areas of arable land. Kilns that had previously made wares to serve ornamental or religious functions changed their production to serve agricultural needs instead. Travel between provinces became more common, and new technology spread to relatively remote areas, where it was integrated into existing production. Furthermore, the introduction of fine ceramics such as celadons from China and Korea brought about the demise of many kilns producing tablewares and altered the types of ware fired at most others.

Earthenwares. These accounted for most of the ceramics utilized in Japan before the 16th century. They not only appear to have been the only type of ceramic used by the lower levels of society but were commonly used even by the upper class, though for limited functions. Earthenwares are divided into three groups. The first type is known as Haji ware, a red, oxidized earthenware fired at temperatures below 1000° C, which was descended from ware first produced in the 2nd to 3rd century AD (*see* §2(i)(c) above). It was used particularly for functions connected with fire, in the form of kettles and braziers, especially before iron utensils of these shapes came into wide use. Haji wares were not fired in kilns but in holes dug in the ground, and little is known about the artisans who produced them. Although earthenware was sometimes painted in earlier periods, painted Haji of the 12th century and later is rare. *Kawarake* (roof-tile type), the second group, comprises reduction-fired (grey or black) earthenware; this had spread from the 10th to 12th century throughout central and western Japan. Bowls and plates of simple design formed the majority of output, but some areas of western Japan also produced wide- and narrow-mouthed jars. Related to this is the third type of production, *kawara* (roof tiles) themselves, which were fired at temperatures of 1000–1300° C. *Kawara* production continued without interruption between the 12th and the 16th centuries. However, it served only the upper class, and the most active areas of production were, therefore, near the capital, Kyoto. During this period tiles were often decorated with comma patterns (*tomoe*) or arabesque (*karakusa*) designs.

Sue-related wares. Although production of Sue ware (*see* §2(ii)(a) above) had ended by the 12th century, its techniques and certain shapes were carried on at some later kilns, where production was centred almost entirely on large utilitarian objects. The stoneware kilns of the 12th–16th century have been popularly known as the Six Old Kilns (*Rokkoyō*: SETO, TOKONAME, SHIGARAKI, TANBA, ECHIZEN and BIZEN), but archaeological evidence has proved this term to be a misnomer. It is now estimated that there were at least 40 different ceramic areas active in Japan during the period. With the exception of Seto, however, the products of these areas were extremely limited. The three major shapes produced at stoneware kilns after the 12th century were narrow-mouthed jars (*tsubo*), wide-mouthed jars (*kame*) and

mortars (*suribachi*). Sue-ware kilns can be divided into those which produced brown stonewares and those producing grey stonewares.

The only brown stoneware type to develop directly from the Sue kilns was produced in Bizen (now Okayama Prefect.). Shigaraki, Iga and Tanba were also once considered descendants of the Sue line, but it has been concluded that these three owed their development in part to influence from *shirashi* line kilns (see below). Bizen ware began some time in the 12th century and at first was grey in appearance, like Sue, due to its being fired in a reducing flame. It was also sometimes decorated with combed designs in the manner of some Sue pieces. In the 13th century, however, the firing flame gradually changed, first to a neutral atmosphere and then to an oxidizing flame, causing the products to fire a reddish-brown colour. On top of this was often a light ash deposit resembling sprinkled sesame seeds and therefore known as *gomayu* (sesame glaze). The kilns in which these wares were fired are termed *anagama* ('tunnel kilns'; see fig. 136 above). During this period clay from the mountains was used to make wide- and narrow-mouthed jars and mortars.

In the late 15th century a new type of kiln was developed that allowed production on a greater scale than had been previously possible. Called *ogama* ('big kilns'; *see* §1(iv) above), these kilns were located on flat land rather than in the mountains and were sufficiently large to fire the wares produced by a number of potters together at one time. Suitable clay was procured from the rice-fields, and the range of wares expanded. At first only beaked jars and jars with four lugs were made, but later smaller jars and pots were added, some of which were adopted for use as utensils for the tea ceremony. This eventually resulted in production of pieces made specially for the tea ceremony, beginning in the 16th century.

Grey stone wares. Originally, only the ceramic areas of Suzu (Ishikawa Prefecture) and Kameyama (Okayama Prefecture) were thought to belong to this group, but excavations have revealed a large number of kiln sites spread throughout the main island of Honshu, and consumer sites have yielded significant quantities of wares produced at kilns not yet discovered. Whereas the Suzu kiln group produced a large variety of wares, including imitations of Chinese celadon shapes, other kilns fired mainly wide- and narrow-mouthed jars. Kilns in eastern Japan were somewhat more advanced than those in the west, producing flat-bottomed pieces rather than the round-bottomed ones that derived from Sue-ware production. Unlike Sue wares, some pieces dating from the 13th to 14th century were formed by coiling clay into the general shape and then beating it until it formed a smooth wall of the vessel. Decoration is found on some examples, especially on Suzu wares, including combed, stamped and incised decoration, and handles are found on certain narrow-mouthed jars as well. That little has generally been known about these wares is due to the fact that all kilns of this type became defunct by the mid-15th century.

Shirashi-related wares. Intentionally ash-glazed stoneware (*shirashi*) had first been made in Japan in the later 8th century (*see* §2(ii)(b) above). This line of ceramic production developed during the 12th century and early

13th into the manufacture of new types of both glazed (*see* §(i) above) and unglazed wares. The unglazed wares fall broadly into two types: multi-purpose jars and YA-MACHAWAN ('mountain teabowl'; rough utilitarian tablewares).

Kilns firing unglazed white tablewares during the 12th century and later were centred on the Sanage kiln group in Aichi Prefecture, extending south to the Okayama kiln group (Mie Prefecture) and north to the Sarayama kiln group (Shizuoka Prefecture). Although many of these kilns had previously fired high-quality glazed ware, the competition from imported Chinese ceramics became such that those that did not cease production completely were forced to make coarser products in greater quantities for sale to landowning farmers and other middle-class consumers. They made only unglazed tablewares and died out during the 13th to 14th century, either because they were unable to adapt to meet the needs of the market for agricultural implements or because of competition from the nearby areas of Seto–Mino and Tokoname.

Another group of kilns originally made some wares similar to *shirashi* types but cannot be called true *shirashi*-related kilns. Their adaptability meant that they were able to continue producing even after the importation of large numbers of Chinese ceramics and the establishment of a strong glazed-ware production at the Seto–Mino kilns. The three major examples of kilns of this type are the Tokoname kilns located on the Chita peninsula and the Atsumi (Aichi Prefecture) kilns on the Atsumi peninsula, both in Aichi Prefecture, and the Echizen kilns in Fukui Prefecture.

Tokoname ware began to be made around the mid-12th century under the influence of *shirashi* kilns in the Sanage area. Kilns were of the tunnel kiln (*anagama*) type, over 3000 of which are said to exist. Products included not only the wide- and narrow-mouthed jars found at many other kilns of the period but great quantities of rough *yamachawan* bowls and bottle vases similar to ones produced at Sanage kilns. Large jars were utilized for agricultural purposes, but smaller ones were used as cinerary urns throughout Japan and generally fired reddish-brown in colour, in contrast to *yamachawan*, which were white. Wares of all types, however, display natural glaze formed through the accumulation of ash during firing. Though the number of kilns declined in the 15th and 16th centuries, and Tokoname wares were never adopted for use in the tea ceremony, because of their usefulness in agriculture their production did not die out.

The Atsumi kilns may have begun as early as the late 11th century and for much of their history had status as official kilns, making wares to order for governors, shrines and temples in the area. In that capacity they produced ceramic sheaths for bronze *sūtra* containers (*kyōzutsu*), cinerary jars and even ceramic pagodas and roof tiles, as well as *yamachawan*-style bowls and plates. Some pieces of Atsumi ware have inscriptions and dates corresponding mainly to the 12th century. In addition, tiles inscribed with the character *Tō* ('east') were fired for use at the Buddhist temple Tōdaiji (Nara). Many examples of cinerary jars were incised with plant designs, which apparently held a religious significance connected with reincarnation. At-sumi kilns were *anagama* with high roofs to help prevent

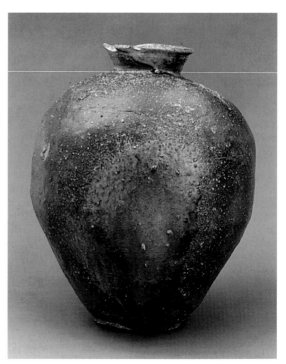

151. Shigaraki ware jar, stoneware with accumulation of vitrified ash on surface, h. 479 mm, 15th century (Seattle, WA, Seattle Art Museum)

damage during firing, since the clay used for Atsumi ware had low fire resistance. By the mid-13th century production had degenerated to mainly *yamachawan*, and by the beginning of the 15th century nearly all of the kilns had ceased to operate.

The origins of Echizen ware are not certain, but it seems that glazed ware was produced there in the early 12th century. By the 13th century, however, production had become centred on storage jars with wide and narrow mouths and mortars, all made by coiling, and finished on the handwheel. Some early examples display beaten patterns on the shoulder, a result of beating to strengthen the coils. Later this effect became decorative and was employed more widely and with complicated patterns carved on the beating paddles. Incised and combed decorations were also employed. Examples are usually brown in colour, with ash accretions on the outer surface. Due to the proximity of the Echizen kilns to the Japan Sea, products were distributed by ship throughout central and northern Japan.

The final category of kilns associated with white stoneware production are those whose earliest products were later than other areas and therefore are not directly traceable to either Sue ware or *shirashi* production. They are classified as *shirashi*-related kilns because they are generally supposed to owe their origins to Tokoname ware, a type descended directly from *shirashi* ware. The principal kilns of this type, Shigaraki (Shiga Prefect.), IGA (Mie Prefect.) and Tanba (Hyōgo Prefect.), all appear to have begun firing in the 13th century.

Shigaraki and Iga wares were fired in adjacent areas of two provinces, and their products are almost indistinguishable before the 16th century, so they will be treated here together. Although they are generally classified as Sue-related kilns, there is no concrete evidence to link them with Sue-ware production. It may be that technology from earlier established utilitarian wares (in particular Tokoname) was responsible for the development of the kilns. The major products were narrow- and wide-mouthed jars (see fig. 151), of various sizes, and mortars. The pieces were made of iron-bearing clay and were fired in tunnel kilns. The clay of some (but not all) products was full of the white feldspathic particles that became the distinguishing characteristic of Shigaraki ware. Decorative cross-hatched incising is found on the shoulders of some pieces, but most are only decorated with the flow of ash glaze that collected naturally while the objects were being fired.

Tanba ware is also thought to have begun from the influence of an existing utilitarian kiln (or kilns) such as Tokoname. Production centred on wide- and narrow-mouthed jars, with only a limited number of mortars produced. Firing occurred in single-chamber *anagama* similar to those used at other kilns of the period, and the clay was a rather fine grey-white stoneware that fired to orange-red on the outer surface. Large vessels were formed by coiling, with only small objects made using the hand-turned potter's wheel. The most outstanding visual aspect of Tanba jars is the bright green ash glaze that collected on the shoulders of many examples during firing, although some pieces display incised decoration as well.

Although the development of unglazed ceramics from the 12th century to the mid-16th is extremely complex and not yet fully understood, their importance to Japanese life, particularly in rural areas, should not be underestimated. Even on the island of Kyushu, where stoneware production did not take place during this period, jars and mortars from Bizen were imported and widely used. Because of their use on remote farms, away from hard surfaces and rarely moved, significant numbers of stoneware jars have survived to the present day. In spite of their original use, examples of these wares are now proudly displayed in museums throughout Japan and the West, and the connoisseurship of their natural glazes and fired bodies has become highly detailed. Although limited in range, the endless variety of surface decoration, mysteriously produced by the kiln flame, in itself gives stoneware jars of this period an attractiveness widely appreciated in the late 20th century.

(b) c. 1500–1868.

Introduction. Although production of unglazed wares was overshadowed by glazed wares from the late 16th century, unglazed pieces in fact continued to be made in relatively large quantities. Compared to earlier examples, they are on the whole aesthetically less pleasing, but this can be attributed to the development of mass-production techniques and the utilitarian purpose for which most unglazed wares were produced. A number of developments occurred after 1550 which had far-reaching consequences for the production of unglazed ceramics. As the country was gradually unified under Oda Nobunaga,

Toyotomi Hideyoshi and Tokugawa Ieyasu (1543–1616), control of the provinces became more centralized, and daimyo were forced to exercise increased discipline in the governing of their fiefs. Of particular importance were the land surveys ordered by Hideyoshi in the late 16th century, which made warlords aware of the true production of the areas they controlled. As a result of this, knowledge of ceramic-producing districts increased, and members of the military élite and upper merchant class led the demand for rustic ceramics suitable for *chanoyu* (tea ceremony), which those responsible for production at rural kilns were only too happy to supply. Iga kilns, which originally fired only utilitarian wares similar to Shigaraki, are the most obvious example of this trend. Under the influence of tea masters thought to include FURUTA ORIBE, these kilns produced teawares that, in addition to being distorted in form, were fired and refired for long periods in order to

152. Iga flower vase (Narihira), stoneware, h. 277 mm, diam. 125 mm (base), Azuchi-Momoyama period (1568–1600) (Tokyo, Mitsui Bunko)

achieve sufficient natural ash glaze build-up to produce a suitably hoary appearance (see fig. 152).

An even more important development was the introduction of Korean artisans specializing in ceramics and their technology in the last decade of the 16th century. As the climbing kiln (*noborigama*; see fig. 136 above) was gradually adopted throughout Japan, kilns that had previously fired unglazed ware in *anagama* or *ogama* kilns changed to firing glazed ware, which was watertight without requiring the days of successive firing necessary to harden unglazed wares. By the early 17th century production of glazed ware had been adopted at all of the formerly unglazed stoneware kilns. Bizen, however, continued to produce some unglazed ware, and even its glazed pieces (known as *Imbede*, 'Imbe style') were only covered with a thin transparent glaze that made them appear to be unglazed.

Earthenwares. Earthenware continued to be made until the end of the Edo period (1600–1868), including kitchen objects such as braziers (*hibachi*) and even, especially during the 17th century, lower-class tablewares. An interesting development in the area of utilitarian wares was the appearance in the mid-17th century of small salt jars (*shiotsubo* or *shioyaki tsubo*), which began in the Kyoto–Osaka area and spread to various parts of Japan. Because they were made and distributed throughout the 19th century and developed along easily identifiable lines, *shiotsubo* are invaluable dating references for Edo-period sites. With the rapid growth of towns and cities at this time, roof-tile production also expanded tremendously, and manufacture was begun or expanded near all major population centres.

Refined products of the *kawarake* (roof-tile) type were made at the Kamachi kiln in the Yanagawa Province (Fukuoka Prefecture) as early as the 16th century. The founder, Ienaga Sansaburō Masachika, came from neighbouring Hizen (Saga Prefecture) and received designation

as a superlative craftsman in a 1592 letter from Toyotomi Hideyoshi himself. Throughout the Edo period the kiln produced high-quality braziers, incense burners and ash vessels for the tea ceremony, many polished to a high shine or intricately carved. These were given by the Yanagawa clan as special gifts to members of other clans or the Tokugawa shoguns.

Nara tea-ceremony braziers (*Nara-buro*) by Nishimura Sōshirō (*fl* 16th century) were also prized by Hideyoshi and the Nishimura line continued as the premier producers of tea-ceremony braziers throughout much of the Edo period. The Kyoto potter Eiraku Hozen was the adopted 11th generation of the Nishimura family. Other Edo-period producers of tea-ceremony braziers were Imado ware of Musashi Province and Minato ware of Izumi Province.

Earthenware was also used for making clay figures or dolls (*ningyō*). Shinto shrines in particular produced simple, moulded (often painted) figures that were mass produced and available to worshippers at nominal cost. These were enshrined in the home *kamidana* ('god shelf'; domestic altar). Of higher aesthetic standard were varieties of increasingly refined clay dolls, led by Kyoto's Fushimi *ningyō*, manufactured at workshops around the country. Few of these workshops produced dolls on any significant scale, however, until the 19th century.

Stonewares. Although in this period most of the kilns that had formerly produced unglazed ware changed to glazed ware in order to compete with new kilns utilizing Korean technology, in remote areas competition was not so fierce and unglazed ware continued to be made. The origin of the earliest Okinawan stonewares is not known, but it is thought to have occurred at least as early as the 16th century. Not only large wide- and narrow-mouthed storage jars but smaller pieces such as bowls were fired at early kilns such as Kina. Even after the introduction of glaze technology by the conquering Shimazu clan in 1617, unglazed wares continued to be made at the Chibana, Wakuta and Tsuboya kilns. The unglazed ceramic guardian lion roof pieces (see fig. 153) so typical of traditional Okinawan homes were the products of these kilns.

Large utilitarian jars of unglazed or thinly glazed stoneware continued to be made in various areas of Japan, even those in which great numbers of fine ceramics were being produced. Some KARATSU kilns that were too far removed from the Arita kaolin source to make porcelain production practical turned to firing these large wares for the agricultural market in the late 17th century. The Yokino kilns on the island of Tanegashima off the southern coast of Kyushu produced similar types of unglazed jar as well as large ewers and even flower vases. Unfortunately, little research has been done on unglazed utilitarian wares of the Edo period, perhaps because of a lack of aesthetic appreciation.

Imitations of earlier unglazed teawares were made at various specialist teaware kilns. In particular Shigaraki tea pieces were made in Kyoto by artisans specializing in ceramics, who used either clay brought from Shigaraki itself or clay that they mixed to give the rough effect of Shigaraki ware. The Kyoto artist Nin'ami Dōhachi (1740–1804) produced copies of unglazed wares among his many

153. *Kara-jishi* (mythical lion) roof-tile, unglazed grey pottery, h. 470 mm, 19th century (New York, The Brooklyn Museum)

ceramic creations. By the 19th century experimentation with traditional ceramic techniques was such that examples of unglazed ware were being made in limited quantities at many different kilns, although few display any real artistic inspiration.

The rise in the use of steeped tea (*sencha*) in the 19th century opened the way for the introduction of a new type of unglazed ceramic, *zisha* (Chin. 'purple sand') ware from China. Teapots of this fine, hard stoneware were first imported through Nagasaki, but soon domestic production took over the bulk of demand. Particularly fine examples were produced at the Banko kilns which were originally located in Ise Province (Mie Prefecture) but spread production as far as Edo (now Tokyo).

BIBLIOGRAPHY

D. Rhodes: *Tanba Pottery* (Tokyo, 1970)
S. Jenyns: *Japanese Pottery* (London, 1971)
K. Mizuno and Y. Yoshioka: *Echizen, Suzu*, Nihon tōji zenshū [Complete collection of Japanese ceramics] (Tokyo, 1976)
S. Narasaki: *Shirashi*, Nihon tōji zenshū, vi (Tokyo, 1976)
I. Akabane and K. Onoda: *Tokoname, Atsumi*, Nihon tōji zenshū, viii (Tokyo, 1977)
S. Hayashiya: *Iga*, Nihon tōji zenshū, xiii (Tokyo, 1977)
A. Itō and S. Uenishi: *Bizen*, Nihon tōji zenshū, x (Tokyo, 1977)
S. Narasaki: *Tanba*, Nihon tōji zenshū, xi (Tokyo, 1977)
S. Tanabe and M. Tanaka: *Sueki*, Nihon tōji zenshū, iv (Tokyo, 1977)
L. Cort: *Shigaraki: Potters' Valley* (Tokyo, 1979)
Chanoyu: Japanese Tea Ceremony (exh. cat., ed. S. Hayashiya and others; New York, Japan House Gal.; Kyoto, Urasenke Found.; Tokyo, Gotoh Mus., 1979)

ANDREW MASKE

(iii) Porcelain and overglaze enamels.

(a) Before c. *1640.* Porcelain had long been imported from China before it was first made in Japan in the early 17th century. Production began in ARITA on the island of Kyushu, in multi-chambered kilns previously used for firing Karatsu ware. This area, then known as Hizen Province, was governed by two clans, the Nabeshima and the Matsuura, both of which actively promoted porcelain production. The porcelain produced in the Arita region, much of it expressly for export, is often known in the West as Imari ware, after the port from which it was shipped.

The techniques and decoration of Arita porcelain owe much to Korean and Chinese influence (*see* CHINA, §VII, 4(ii) and KOREA, §VI, 5(ii)). The Korean ceramic craftsman Ri Sanpei (1579–1655), who was brought back to Japan following Toyotomi Hideyoshi's invasions of Korea (1592–7), is traditionally credited with the discovery of kaolin and the development of porcelain production at the Tengudani kilns in Arita. According to the *Oboegaki* ('Recollections'), Sanpei (later called by the Japanese name Kingae Sanbei) moved to Arita in 1616, so it is assumed that the first firings occurred around this time. The discovery in 1967 of Ri Sanpei's name in the registry of a temple near the kiln confirmed the veracity of this tradition.

The earliest Japanese porcelain wares were mainly blue and white (*sometsuke*; 'dyed ware') imitating those of Korea, but white china was also produced. These pieces, termed *Shoki Imari* ('Early Imari'), tend to be small and fairly crudely decorated. As demand for porcelain—especially underglaze blue-and-white—grew, new kilns were established, so that by the 1640s there were around 30

kilns in the Arita region. After the mid-17th century Korean influence waned, and Chinese models became the major source of inspiration for the more flamboyantly decorated and enamelled *Ko Imari* ('Old Imari') wares.

Because porcelain provided an important source of income, the Nabeshima clan developed kilns early in the Edo period (1600–1868). An office of kiln production, under the direction of a kiln governor (*tokikata no yaku*), was instituted in 1637 to supervise the felling of trees for use in firings. To consolidate production, 13 kiln areas were established in Arita, and 826 craftsmen from 11 kilns were transferred there. Production was carried out with utmost secrecy to prevent technical secrets from being discovered by rival kilns.

(b) c. *1640–1868.* Porcelains with overglaze enamels in red, green and yellow were first produced in Arita in the 1640s. Records of the Sakaida Kakiemon family credit a Chinese ceramicist with the origins of overglaze enamelling, production of which is said to have begun in 1647, but modern scholarship has shown these records to be of questionable reliability. Given the range in colour and design motifs, it is clear that there were several workshops producing such wares. Although all are often called

154. Porcelain figure of a young man, decorated in overglaze enamels in Kakiemon style, h. 302 mm, *c.* 1680 (London, British Museum)

155. Porcelain Arita ware, 17th century (left to right): (a) tankard decorated with motifs of peonies and butterflies, h. 245 mm; (b) jug with European coat of arms, h. 221 mm; (c) V.O.C. (Vereenigde Oostindische Compagnie) dish, diam. 343 mm; (d) apothecary's bottle, h. 233 mm; (e) figure of a carouser astride a barrel, h. 365 mm (London, British Museum)

KAKIEMON, after the family traditionally credited with the development of the enamelling technique, the Kakiemon kiln was probably not started until the 1680s. Production is thought to have continued there until the 1730s or 1740s. Kakiemon ware is distinguished by its translucent, milky-white body (*negoshide*) and high-quality enamels. Deep plates and bowls are especially common, but large moulded figures with brightly enamelled clothing also feature Kakiemon enamels (see fig. 154).

The excavation in 1990 of Akachō (Enameller's Ward) in Arita city revealed that polychrome glazed enamels of the type once thought to have been made in the KUTANI kilns in Kaga fief (now Ishikawa Prefecture) were being fired in Arita until the 1660s. Kutani wares, which were made for the domestic market, are glazed in a dark palette including blue, violet, green and yellow and feature Chinese bird-and-flower motifs, landscapes and figures, as well as striking geometric motifs. In addition, there are overglaze enamels with novel designs known as *Aode Kutani* ('Blue-painted Kutani') after their predominantly blue or blue-green colours. The location of kilns, dates of production and typology of Kutani wares are topics of considerable disagreement among scholars.

In around 1675 the Nabeshima established its official clan kilns or *Odōguyama* at Okawachi. These kilns specialized in the production of presentation pieces for military or court families or for exchange with various daimyo. The principal pieces of early NABESHIMA ware were large plates made to standard sizes of one, five and seven *shaku* (one *shaku*=303 mm). The large repertory of designs drew inspiration from textile pattern books, and the method of application derived from techniques used in stencil dyeing and lacquering. In addition to blue-and-white wares and celadons (pale green wares), Nabeshima ceramics include the superb overglaze enamels known as *Iro Nabeshima* ('Coloured Nabeshima'). Because of the careful control and high standards of production, the quality of Nabeshima ware is uniformly high.

Records of the Dutch East India Company indicate that a few Japanese porcelains were being purchased in the 1650s. These were used as apothecary jars in the company pharmacy at its headquarters in Batavia. Dutch records also reveal that in 1658 Chinese merchants were shipping Japanese porcelains from Japan to Amoy and that the following year the Dutch ordered a large volume (almost 65,000 pieces) of Arita porcelain for shipment to the Middle East. For about 20 years after the fall of the Ming dynasty in 1644 Japanese porcelain enjoyed a near monopoly on exports to Europe. To meet the growing demand for export wares (see fig. 155), some kilns were closed, others moved and new ones opened.

The production of *Ko Imari* at the Arita kilns reached a zenith in the 1680s. These include blue-and-white wares, enamelled wares and polychrome enamels decorated with gold. Many feature a rich overall decoration of floral and arabesque motifs adapted from Chinese porcelains of the late Ming and early Qing (1644–1911) periods. Wares made for export range in shape from large jars, bottles and coffee urns to tureens, all decorated in a wide range of often intricate patterns designed to appeal to European usages and tastes. By the second quarter of the 18th century, the great demand for Imari wares in both the domestic and international markets led to highly standardized shapes and decor.

At the end of the 18th century a number of new kilns were opened in Hizen and elsewhere, chiefly for the production of wares for the domestic market. These included the Tobe kilns (Shikoku, Ehime Prefecture), the Mita kilns (Hyōgo Prefecture, Mita city), the Kyoto kilns (*see* KYOTO, §III) and those in the SETO and MINO areas. Particularly fine porcelains were made in the Hirado kilns of Mikawachi, not far west of Arita. The high quality and plasticity of the white clay found there made it possible to create unusually intricate forms. In the 19th century ceramic sculpture—in particular, moulded animals and birds and flowers—became a speciality of Hirado (see fig. 156). In the early Meiji period (1868–1912) many porcelains from Hirado as well as from older kilns in the Arita area were displayed to great acclaim at the International Expositions in Paris, Vienna and Philadelphia.

156. Porcelain Hirado ware, mid- to late 19th century (left to right): (a) long-necked bottle, h. 220 mm; (b) ring-handled jar, h. 265 mm, signed *Dai Nippon Nagasakiken Mikawachi Satomi Takejiro* ('Satomi Takejiro of Mikawachi in Nagasaki Prefecture, Japan'); (c) incense burner, inscribed *Dai Nippon Hirado san Mikawachi Koseki sei* ('Made by Koseki of Mikawachi, product of Hirado, Japan'), h. 368 mm; (d) lidded jar, inscribed *Sato Take sei* ('Made by Sato Take'), h. 218 mm; (e) small *shishi* ('lion') with openwork ball, h. 95 mm; (f) large *shishi* with openwork ball, h. 495 mm (London, British Museum)

BIBLIOGRAPHY

R. Cleveland: *Two Hundred Years of Japanese Porcelain* (St Louis, 1970)
S. Shimazaki: *Kutani*, Nihon tōji zenshu [Complete collection of Japanese ceramics] (Tokyo, 1975)
S. Nakagawa: *Kutani Ware* (Tokyo, 1979)
J. Becker: *Karatsu Ware: A Tradition of Diversity* (Tokyo, 1986)
Imari kokutani meihinten [Exhibition of famous Old Kutani wares] (exh. cat., Ishikawa Pref. Mus. A., 1987)

HIROKO NISHIDA

4. MODERN, AFTER 1868. After Japan was opened to the West during the Meiji period (1868–1912), Japanese potters quickly assimilated foreign kiln technology and glazing methods, but they overemphasized technique and complex designs drawn from painting and textiles at the expense of new and original ideas. The traditional system in which an assistant potted a piece that the ceramicist then decorated often produced disharmony of form and design. However, in the Taishō period (1912–26) there were positive changes in all these areas, marking the beginning of modern Japanese ceramics.

(i) Traditional wares. (ii) Non-traditional wares and ceramic sculpture.

(i) Traditional wares.

(a) Folk art movement. (b) Momoyama revival. (c) Song revival. (d) Post-war developments.

(a) Folk art movement. Japan's folk-art movement (*see* MINGEI), like England's, by which it was influenced, was a reaction to the decline of regional styles and traditional craft techniques sparked by the industrial revolution. It espoused the beauty of handmade as opposed to machine-made objects, and its leading Japanese apostle was MU-NEYOSHI YANAGI, who stressed the spontaneity and unselfconsciousness of the hitherto neglected work of anonymous Korean and Japanese craftsmen. In 1926 he was joined by the potters SHŌJI HAMADA and KANJIRŌ KAWAI in founding the Japan Folk Craft Society (Nihon mingei kyōkai) in 1934 and became the first director of the Japan Folk Craft Museum (Nihon mingeikan) in 1936. Hamada, Kawai and KENKICHI TOMIMOTO were all interested in painting and folk art and emphasized ceramics for everyday use, simplicity of design, harmony of decoration and shape and the use of traditional techniques. They visited the West and befriended the potter BERNARD LEACH, who went on to promulgate the Japanese folk-ceramics style in England.

In 1924 Hamada moved to the isolated pottery village of Mashiko (Tochigi Prefecture). Potting with a hand wheel, the oldest and hardest kind to manage, he used inferior local clay and kept refining a small repertory of simple but effective designs influenced by folk ceramics. He favoured simple glazes, including a lustrous reddish-brown persimmon glaze (a type of saturated iron glaze), traditionally used in Mashiko, which he perfected and made famous. He produced about 5000 pieces annually, which varied greatly in quality. He concentrated on wax resist, *hakeme* (brush-mark), polychrome overglaze (usually red or green), iron-oxide, but he is best known for his trailed designs, on bowls and plates, executed by pouring from a ladle.

Less well known in the West was Kanjirō Kawai, who had great early success with dauntingly skilful adaptations of Chinese and Korean porcelains. By 1925 he abandoned them for folk-style pottery. From 1929 to 1948 he successfully assimilated Korean Chosŏn-period (1392–1910) designs (*see* KOREA, §VI, 5). He pursued a greater range of decorative techniques than Hamada, including wax resist, *neriage* (marbling), underglaze-blue brushwork, SGRAFFITO and inlaid decoration, and was particularly known for the beauty of his *gosu* (a cobalt oxide blue with iron-oxide inclusions) and *shinsha* (underglaze copper red)

glazes. After World War II Kawai concentrated on mould-made pieces with unusual shapes, complex glazes and relief designs often reminiscent of the works of GEORGES BRAQUE and JOAN MIRÓ. During the 1960s he favoured a style of abstract expressionist splashes of bright colours.

Kenkichi Tomimoto, who first studied architecture, interior design, painting, stained glass and textile design, also later diverged from the folk-art movement. Until 1926 his work, much of it stoneware, reflected naive Chosŏn-period ceramics. Thereafter he mostly made porcelains: plain white, more delicate than their 17th–19th-century Korean prototypes; simple and boldly brushed underglaze blue and white; and striking and often sumptuous polychrome overglaze enamelled pieces influenced by 17th–19th-century KUTANI ware. In 1946 he began teaching at Kyoto Fine Arts University, where his emphasis on studying older works, devising original designs and maintaining harmony of decoration and shape helped nurture many outstanding pupils.

(b) Momoyama revival. Another group of potters studied and re-created utilitarian pottery styles that had been adapted to the tea ceremony during the Momoyama period (1568–1600; see §XIV, 3 below). For example, Tōyō Kaneshige (1896–1967) revived the long-sterile BIZEN teaware tradition after discovering how to make Momoyama-style pieces in 1930. Equally famous are the adaptations by Toyozō Arakawa (*b* 1894) of Momoyama Shino, Black Seto and Yellow Seto ware, which he learnt to make after extensive study and excavations of old kiln sites. The supreme eclectic ROSANJIN KITAŌJI was unlike narrower specialists such as Kaneshige and Arakawa. He did not start to study ceramics until he was 32, had relatively little training, did not throw most of his own pots and instead concentrated on their decoration. He was prolific in his often innovative work based on many facets of Chinese and Japanese ceramics. His output varied greatly in quality.

(c) Song revival. A renewed Taishō-period (1912–26) interest in Chinese Song-period (960–1279) ceramics was first taken to great heights by the graceful, restrained and painstakingly executed porcelains of Hazan Itaya (1872–

1963), the most innovative of which were his matte glaze, powdery, pastel polychrome works with elegant relief modelling and naturalistic but abstract designs. Then in 1939 Munemaro Ishiguro (1893–1968) perfected Japan's finest persimmon *tenmoku* glaze (derived from 13th-century Chinese prototypes; see CHINA, §VII, 3(iv)) and in 1940 the first tree-leaf *tenmoku*, partridge-spotted ware and Henan *tenmoku*. After World War II he devised striking, non-traditional pieces with bold, simple and vigorous designs. The imaginative reworking by Hajime Katō (1900–68) of late Ming-period (1368–1644) porcelain styles included white porcelain, colourful green-and-yellow glazed works with gold or silver decoration, strongly designed red, green and yellow pieces and subtle but strong underglaze red wares (see CHINA, §VII, 3(vi)). From 1955 to 1964 he taught at Tokyo Fine Arts University, where he organized the ceramics department, which became one of the two most important in the country.

(d) Post-war developments. Japanese museums tend to stress traditional Japanese, Chinese and Korean art. Hence much of the output of post-war Japanese studio ceramics is a reworking of standard East Asian glaze styles. Moreover, tea ceremony (*chadō*), flower arrangement (*ikebana*; see §XVI, 9 below) and table setting dictate a small repertory of shapes and glazes.

Among the many contemporary folk-style potters Shōji Hamada's protégé, Tatsuzō Shimaoka (*b* 1919), is best known for his rope-impressed designs, but he often reworks Hamada's shapes and decorative motifs without his powerful brushwork. Also notable are the *neriage* (marbling) and polychrome pieces and Korean-inspired white porcelains of Tsuneji Ueda (*b* 1914). They are similar to those of the porcelain specialist Kōichi Takita (*b* 1927), who also studied with Hamada, Tomimoto and Hajime Katō and in Korea. His underglaze blue-and-white pieces and polychrome works show vigorous modelling and brushwork.

Song- and Ming-period Chinese ceramics are favourite starting points for modern Japanese potters. Generally their glazes are flawless and their potting extremely accurate. Thus, the work of Koheiji Miura (*b* 1933) is even more jewel-like (see fig. 157) than its Guan-ware (see CHINA, §VII, 3(iv)(b)) prototypes, while the celadons of Shinobu Kawase (*b* 1950) employ less conventional shapes. Mineo Okabe (1919–90) exploits striking cracked-ice effects and non-traditional colours. Other outstanding celadon specialists are Isami Matsumoto (*b* 1931), Sansei Suzuki (*b* 1936) and Hiroshi Nakajima (*b* 1941). Kiyoshi Hara (*b* 1938) specializes in Song-style iron-glaze pieces and re-creations of Jun ware (see CHINA, §VII, 3(iv)(b)) with a modern flavour, while Kawase's father, Chikushun (*b* 1923), excels in the underglaze-blue and overglaze *doucai* (Chin. contrasting colours) polychrome-enamel style that started in the 15th century (see CHINA, §VII, 3(vi)). *Seihakuji*, a white-bodied ware with a thin, translucent bluish-tinged glaze inspired by Southern Song *qingbai* wares (see CHINA, §VII, 3(iv)(b)), is also popular with modern Japanese porcelain makers. Its acknowledged master, Kaiji Tsukamoto (1912–90), has been designated a Living National Treasure, but Manji Inoue (*b* 1929) is not far behind him. The impeccable purity of these

157. Koheiji Miura: sake cup, stoneware with crackled celadon glaze, h. 51 mm, 1975 (New York, The Brooklyn Museum)

porcelain artists' glazes is partly due to their use of electric or gas-fired kilns that produce more even temperatures than wood-fired kilns. Also fashionable are modern *tenmoku* pieces. Particularly noted for them are Morikazu Kimura (*b* 1923) and Uichi Shimizu (*b* 1925), the latter also declared a Living National Treasure.

The 1950 Law for the Protection of Cultural Properties enhanced the popularity of traditional Japanese styles. It designated certain individuals as Holders of Important Intangible Cultural Properties (Living National Treasures) for their skill in preserving traditional crafts. These include folk-art pottery and the Shino, Bizen, Black Seto, Karatsu, Hagi and Oribe styles, genres favoured by Momoyama-period tea masters (*see* §3(i) above), and the blue-and-white, Kutani, Kakiemon and polychrome Nabeshima porcelain styles (*see* §3(iii) above). Over 100 studio potters specialize in the rich but sombre-coloured, unglazed, high-fired stoneware made in Bizen since the Kamakura period (1185–1333). Distinguished specialists along conventional lines include Kei Fujiwara (1899–1988), Sozan Kaneshige (*b* 1909), Ken Fujiwara (1925–77) and Yū Fujiwara (*b* 1933). A handful of Bizen potters such as Izuru Yamamoto (*b* 1944), Michiaki Kaneshige (*b* 1934) and Kōsuke Kaneshige (*b* 1941), the sons of Living National Treasures Tōshū Yamamoto (*b* 1906) and Tōyō Kaneshige, and Togaku Mori (*b* 1937) have tried to escape the dead hand of tradition with modern decorated or sculptural pieces.

The coarse reddish-brown ware made in SHIGARAKI is also popular. Many fine Shigaraki specialists, such as the fourth-generation Naokata Ueda (1898–1975), Sadamitsu Sugimoto (*b* 1935) and Shirō Ōtani (*b* 1936), pursued a traditional approach, while Seimei Tsuji (*b* 1927) and his wife Kyō Tsuji (*b* 1930) stretched its limits with unconventional, sculptural shapes and unusual designs. Another teaware fashionable with many specialists is Shino. Fine traditional work has been done by Seizō Katō (*b* 1930), Osamu Suzuki (*b* 1934), Kōzō Katō (*b* 1935) and Hidetake Andō (*b* 1938). Toshisada Wakao (*b* 1933), however, extended its range by using striking *Rinpa*-style designs (*see* OGATA). The TOKONAME potters' pieces are in a clay like that of their supposed prototypes but only distantly resemble them. Most notable are Issei Ezaki (*b* 1918) and his pupils Kimiaki Takeuchi (*b* 1948) and Mikio Ōsako (*b* 1940). Still less traditional are the works of Sekisui Itō (*b* 1941) from Sado Island (Niigata Prefecture), who specializes in unglazed stonewares and made the local dark-red clay look as if it were dipped in smoke by accenting it with contrasting black and grey markings.

Currently in their 13th and 14th generations of potters, the Kyushu-based Imaizumi and Sakaida families have inherited the polychrome overglaze decorated porcelain traditions of Nabeshima and KAKIEMON wares dating back to the 17th century (*see* §3(iii) above). The original designs of Imaemon Imaezumi XIII (*b* 1926) followed the spirit but not the letter of this old design tradition, while Sakaida Kakiemon XIV (*b* 1934) extended the conventions of traditional Kakiemon designs. Others, like Tōjirō Kitade (1898–1968) and Fujio Kitade (*b* 1919), used the vivid red, blue, green, yellow and aubergine of late-17th-century KUTANI porcelain in more innovative, abstract and modern designs. Similarly, Takahisa Furukawa

(*b* 1940) and his wife Toshiko (*b* 1939) with their strongly drawn and well-composed naturalistic designs have widened the scope of Ogata Kenzan's *Rinpa* style of decorated pottery, while the motifs of Motohiko Itō's (*b* 1939) cloth-impressed works range from naturalistic to near abstract.

Underglaze decorated porcelain is the weakest area in modern Japanese ceramics. After being designated a Living National Treasure for his underglaze blue-and-white porcelain in 1967, Yūzō Kondō's (1902–85) strong designs became increasingly repetitive, harsh and stiff. On the other hand, younger underglaze blue-and-white specialists with more sensitive brushwork have been overly influenced by traditional designs. However, the sturdily potted pieces of Susumu Ikuta (*b* 1934) have interesting shapes and strongly brushed, well-composed, unusual designs with a vital, flamboyant and original flavour. By contrast Katsumi Eguchi's (*b* 1936) sophisticated but regular and repetitive designs use an original paper-dye-resist technique.

(ii) Non-traditional wares and ceramic sculpture. Not surprisingly, official exhibition work has tended to become increasingly stereotyped in form, glaze and design. Although some exhibitions include an avant-garde category, potters who want to innovate without sacrificing their livelihood have done so by making functional pieces with non-traditional shapes, glazes and designs. Thus, Shigetaka Katō (*b* 1927), a son of Tokuro Katō (*b* 1898), Japan's doyen of classical Momoyama-glaze styles, supplements his more conventional teabowls with flower vases and tea-ceremony water jars with powerful, irregular, chunky and scored shapes. Seijiro Tsukamoto's (*b* 1944) unglazed, high-fired stoneware pieces capitalize on simple, geometrical forms enhanced by subtle tonal variations, suggest metal sculpture and are in the spirit of the BAUHAUS and CONSTRUCTIVISM. Kiyoyuki Katō's (*b* 1931) work is also influenced by modern Western sculpture. Whether functional or not, Katō's work makes the best of ash and iron glazes and complicated surfaces that suggest those of archaic Chinese bronzes (see fig. 158). The work of Kinpei Nakamura (*b* 1935), a more doctrinaire proponent of ceramic sculpture who was impressed by the American potters Paul Soldner (*b* 1921) and Peter Voulkos (*b* 1924) and Western sculpture, shows their influence and that of colourful American avant-garde ceramics.

Non-traditional functional pieces also exploit new surface effects and designs. Kōsei Matsui (*b* 1927), a pupil of the famous older ceramicist Kōichi Tamura (*b* 1918), is a pioneer in both. He has made his name with the difficult, slow and painstaking *neriage* technique that was first employed in China during the Tang period (618–907). Some of his pieces are smooth and muted in colour, but he is best known for those with complicated, rough-textured surfaces. With the aid of metallic oxides he has progressed from monochrome white, grey and tan works to ones with patches of colour reminiscent of colour-field painting. One of the most innovative and influential functional potters was Shōji Kamoda (1933–83). Unaffiliated with any group, this pupil of Kenkichi Tomimoto changed his style whenever he felt he had mastered it. Another pupil of Tomimoto, Hiroaki Morino (*b* 1934), was exposed to modern Western art through teaching ceramics in the United States. Many of his heavily potted

158. Kiyoyuki Katō: vase, ash-glazed stoneware, h. 423 mm, 1982 (Philadelphia, PA, University of Pennsylvania, University Museum)

functional pieces have smooth leather-like surfaces with carefully worked out abstract, dark-grey designs against a reddish background. Although based on the metalwork on old Japanese chests and reminiscent of American Navaho Indian pottery, some of them are clearly influenced by such modern Western painters as FRANZ KLINE. The ever-changing style of the functional pieces of the young Mashiko potter Kenzō Okada (b 1948) depends on effective and interesting shapes and abstract designs at times reminiscent of Western painters such as the American LARRY POONS and the English op artist BRIDGET RILEY. Zenji Miyashita (b 1939), the son of a distinguished traditional porcelain specialist, studied with the Living National Treasure Yaichi Kusube (1897–1984) and taught abroad. Like Kiyoyuki Katō and Morino he pursues both ceramic sculpture and functional pieces, for which he keeps inventing original shapes, glazes and motifs.

Decorative, representational ceramic sculpture in Japan goes as far back as the Kamakura period (1185–1333). However, it was not until after World War II that Japanese potters started to attempt abstract ceramic sculpture. They were and continue to be subject to Western influences, which have included such artists as Pablo Picasso and the Japanese-born American sculptor Noguchi Isamu (b 1904), Scandinavian crafts, the Bauhaus, industrial art, American abstract painting and modern European and American sculpture.

Abstract ceramic sculpture started in Japan in the 1950s. At first derivative and without any compelling reason to use clay rather than metal or stone, it later made better use of ceramic techniques. Outstanding here are KAZUO YAGI and Osamu Suzuki (b 1926). Yagi's work, which pre-dates the cruder efforts of the American Peter Voulkos, evolved through several styles, all of which have a humorous, organic quality and depend on conceptual irony and paradox. Suzuki's, based on the 'analysis of form' approach of Cubism, has always emphasized simple, compact shapes. He uses Shigaraki clay and an electric kiln to produce smooth, rich reddish-brown pieces. Some are reminiscent of Western sculpture, while others seem like abstract versions of the early Kofun period (c. AD 300–710) haniwa pottery funerary figures (see §V, 2(iv)(a) above) or seem to refer to pottery of the Jōmon period (c. 10,000–300 BC; see §2(i) above). In 1978 he began to make celadon-like pieces in a gas-fired kiln. Sueharu Fukami (b 1927), a specialist in seihakuji (see §(i)(d) above), makes effective and sculptural functional pieces but is best known for his abstract ceramic sculptures, which are both mould-made and slip-cast. Like certain Western minimalist sculptors he favours compact linear or columnar forms. Hiroshi Seto (b 1941), a pupil of Tomimoto who greatly admired Shōji Kamoda, taught in the West and makes both functional pieces and ceramic sculpture. The stripe is a design element in all his work, which includes undulating and faceted vases and twisted rings, suggesting the influence of both op art and the work of HANS ARP. The compact, balanced, slablike forms of Hiroaki Morino's sculpture are enhanced by excellent abstract décor, a subtle sense of colour and a refined feeling for surface textures. Like much traditional Buddhist sculpture they are not meant to be seen in the round. Yet another innovator in both sculptural functional ceramics and ceramic sculpture is Tatsusuke Kuriki (b 1943).

Besides Yagi and Suzuki only a handful of potters specialize in ceramic sculpture. Their work is marked by fine technique but often lacks design or glaze features that would immediately distinguish it from modern Western art. Satoru Hoshino (b 1945) and Takako Araki (b 1921) stand out. Hoshino's sculpture is multifaceted in technique and style. Among his most effective creations are a series of compact black pieces that remind one of three-dimensional topographical maps. Araki's subject-matter is highly restricted. She creates many variations on the theme of the book, and her haunting images of decayed or burnt Bibles are not easily dismissed.

BIBLIOGRAPHY

S. Yanagi: *Hamada Shōji sakuhinshū* [The collected works of Hamada Shōji] (Tokyo, 1966)
Rosanjin, 20th-century Master Potter of Japan (exh. cat. by S. B. Cardozo, New York, 1972)
T. Mikami: *The Art of Japanese Ceramics* (New York, 1972)
S. Peterson: *Shōji Hamada: A Potter's Way and Work* (Tokyo, 1974)
Twenty-six Contemporary Japanese Potters (exh. cat. by F. Baekeland, Syracuse, 1978)
R. Moes: *The Brooklyn Museum: Japanese Ceramics* (Brooklyn, 1979)
M. Imaizumi: *Nabeshima* (Tokyo, 1981)
Yakimono kara zōkei e [From pottery to modelling] (exh. cat. by Y. Inui and others, Otsu, 1981)
T. Nagatake: *Kakiemon* (Tokyo, 1981)
K. Yoshida, ed.: *Gendai Nihon no tōgei* [Modern Japanese ceramics], 16 vols (Tokyo, 1982–5)
H. Harada and others: *Living National Treasures of Japan* (Boston, 1983)

Japanese Ceramics Today: Masterworks from the Kikuchi Collection (exh. cat. by S. Hayashiya and K. Tsuji, Washington, 1983)

K. Hinton-Braaton: 'Kanjirō Kawai', *Orientations*, xiv/11 (1983), pp. 28–41

Kawai Kanjirō—Kindai no Kyoshō [Kanjirō Kawai—A Master of Modern Ceramics] (exh. cat. by M. Hasebe and others, Tokyo, 1984)

R. Kuroda: *Shino* (Tokyo, 1984)

M. Unagami and others: *Tōgei nenkan '85* [Ceramics annual '85] (Kyoto, 1984)

H. Cortazzi: 'Tatsuzo Shimaoka: Japanese Potter', *A. Asia*, xv/2 (1985), pp. 73–9

Erde und Feuer: Traditionelle japanische Keramik der Gegenwart (exh. cat. by G. Jahn and others, Munich, 1985)

B. Moeran: 'Exhibiting in Japan, Part I', *Cer. Mthly*, xxx/3 (1985), pp. 21–7

——: 'Exhibiting in Japan, Part II', *Cer. Mthly*, xxx/4 (1985), pp. 19–21; 55–7

Pacific Connections (exh. cat. by T. Smith, G. Clark and D. A. Wasil, Los Angeles, 1985)

R. Faulkner: 'Contemporary Japanese Ceramics in the Victoria and Albert Museum', *Orientations*, xvii/12 (1986), pp. 32–7

Y. Yoshiaki: 'Personale de Sueharu Fukami Premio Faenza '85', *44 Concorso internazionale della ceramica d'arte: Faenza, 1986*, pp. 33–48

F. Baekeland: 'Modern Japanese Studio Ceramics: The First Generation of Potters', *Orientations*, xviii/11 (1987), pp. 46–53

B. Moeran: 'The Art World of Contemporary Japanese Ceramics', *J. Jap. Stud.*, xiii/1 (1987), pp. 27–50

Kamoda Shōji ten: Gendai tōgei no bi [A Kamoda Shōji exhibition: the beauty of contemporary ceramics] (exh. cat. by K. Nakonodō and M. Hasebe, Tokyo, 1987)

F. Baekeland: 'Modern Japanese Studio Ceramics: Developments in Traditional Chinese, Japanese and Korean Ceramic styles', *Orientations*, xix/6 (1988), pp. 50–61

——: 'Modern Japanese Studio Ceramics: The Revolt Against Tradition', *Orientations*, xx/1 (1989), pp. 33–47

Modern Japanese Ceramics in American Collections (exh. cat. by F. Baekeland and R. Moes, New York, 1993)

FREDERICK BAEKELAND

IX. Prints and books.

The history of printing, as seen from extant examples, began in Japan in the 8th century under the auspices of Buddhist temples and the aristocracy (*see* §1 below). It continued as such, with a hiatus from the 8th century to the 11th, until the 16th century, when woodblock-printed secular works first appeared. With the changing social and political climate of the Edo period (1600–1868), secular printmaking and book publishing (see fig. 159) flourished (*see* §§2 and 3 below), and Japanese artists created a rich tradition, in particular, in the production of individual woodblock prints of the *ukiyoe* ('pictures of the floating world') genre. Nearly all the works discussed in this article were produced by woodblock-printing, although other methods, such as intaglio, became part of the printmaker's repertory in the 20th century. Books produced in the 19th century and after using Western-style movable-type printing are excluded, as are certain categories of objects that were decorated through the use of the printmaking process, for example the early printed fabrics in the Shōsōin treasure house in Nara or decorated paper scrolls.

159. Nishimura Nantei: *Monkeys on a Rope* from *Nantei gafu* ('Book of pictures by Nantei'), double-page woodbook print, each *c.* 225×152 mm, 1804 (London, British Museum)

160. Colophon from the *Daihannyaharamitta kyō*, woodblock print on a mixture of *ganpi* and mulberry paper dyed yellow, h. 240 mm, *c*. 1223–7 (London, British Library)

1. Early development, before *c*. 1600. 2. Edo period (1600–1868) and after: books. 3. Edo period (1600–1868) and after: prints.

1. EARLY DEVELOPMENT, BEFORE *c*. 1600. Woodblock-printing is thought to have originated in China (*see* CHINA, §XIII, 19), and the technique was introduced to Japan from Korea or China. The earliest extant examples of printing in Japan are Buddhist texts (Skt *sūtra*), the *Hyakumantō dhārani* ('One million pagoda Buddhist *dhārani* or charms'), which were produced under the sponsorship of Empress Shōtoku (*reg* 764–70). These comprise single strips of paper, ranging from 440 to 570 mm long and up to *c*. 55 mm wide, that were printed with religious texts, rolled up and enshrined in miniature wooden pagodas. Their production is believed to have been an act of contrition and thanksgiving by the Empress after the defeat of a rebellion against her Buddhist-orientated court. Ten of the major Buddhist temples of the period reportedly received 100,000 pagodas each; of these HŌRYŪJI alone now possesses extant *Hyakumantō dhārani* and wooden pagodas, and there are a few examples in other collections (e.g. London, BM). Whether these Buddhist charms were printed exclusively using blocks of wood or, as is more likely, with plates of copper or bronze is unclear. The uneven printing suggests metal plates; in this process woodblocks would probably have been employed as moulds from which metal plates were cast.

No examples are extant of works printed in Japan between the end of the 8th century and the 11th. This may be because the clergy, who, along with the aristocracy, continued to dominate the printmaking process until the end of the 16th century, still copied works by hand: *sūtra* copying (*shakyō*) was one means of gaining religious merit. From the 11th century, when printing resumed in Japan; largely because of the return from China of student monks with examples of the Buddhist canon, there were two principal centres of printing, Nara and Kyoto. It is not known which of these two cities began printing first. Provincial temples also made prints, albeit on a relatively minor scale.

Towards the end of the 11th century, printing projects were undertaken by the six temples of Nara, Kōfukuji, Tōdaiji, Yakushiji, Saidaiji, Hōryūji and Tōshōdaiji. The works printed by these institutions were naturally religious texts and *sūtra*s, either in *kansubon* (scrolls) or, in rarer cases, in the *orihon* (concertina books) format. The earliest reliably dated Nara work was produced at Kōfukuji: entitled the *Jōyuishikiron* (Skt *Vijñapti mātratāsiddhi śāstra*), it is a ten-scroll religious text of the Hossō Buddhist sect, with a printed date of 1088. Because of the temple's close association with the Kasuga Shrine in Nara, the Kōfukuji publications are referred to as *Kasugaban* ('Kasuga editions'). Kōfukuji continued its printing activities throughout the Kamakura period (1185–1333), undertaking such enormous projects as the 600-scroll *Daihannyaharamitta kyō* (Skt *Prajñāpāramitā sūtra*; 'the *sūtra* of the perfection of wisdom'; *c*. 1223–7; see fig. 160). Works produced at the other temples, collectively referred to as *Naraban* ('Nara editions'), also date from the Kamakura period, when Nara's printing activity was at its height. During the Muromachi period (1333–1568), this activity dwindled as the city of Nara and the Buddhist sects associated with it declined in the wake of civil wars.

The Kamakura period was also the heyday of Kyoto as a printing centre, although some records suggest that printed *surikyōban* (memorials for the dead, or texts associated with convalescence from illness) were made in Kyoto in the 11th century. Kyoto differed from Nara in that many temples of both Esoteric and Zen Buddhist sects undertook printing during the 13th century, including the monasteries on Mt Hiei and Mt Kōya and temples in Kyoto itself. So too did the *gozan* ('five mountains'; a hierarchy of major temples), both in Kyoto and in Kamakura. Of several high-quality texts, the *Hōnen shōnin zō* ('Portrait of the priest Hōnen'; 1315) is noteworthy for its use of a rare single-sheet illustration with text, depicting Hōnen (1133–1212). Printing in Kyoto, as in Nara, declined in the Muromachi period.

In addition to printed *sūtra* texts, small impressions of Buddhist figures (*inbutsu*), such as the various forms of the Buddhas and *bodhisattva*s, were printed on cloth or paper with a woodblock, seal or stamp. Although the earliest extant example dates from the second half of the 12th century, some examples may have been produced as early as the Nara (710–94) and Heian (794–1185) periods. These *inbutsu* were the earliest form of printed illustration in books, although they were produced for purposes that were primarily religious and devotional, not artistic.

In the late 16th century movable type was introduced almost simultaneously from two independent sources: in 1582 a mission sent to Europe by the Kyushu daimyo of

Ōtomo, Arima and Ōmura brought back a printing press from Lisbon or Rome as well as a number of European printers; and during the Korean campaigns of Toyotomi Hideyoshi in 1592 and 1597 printing presses and printers were brought back from Korea, where movable type had long been in use. Using the printing press obtained in Europe, foreign Jesuits resident in Japan published the *kirishitan ban* ('Christian printings') between *c.* 1591 and 1611. The Korean tradition of movable type was more easily integrated into Japan and therefore of more consequence: its influence is seen in the official *chokuhan* ('imperial printings' of Chinese philosophical works), Buddhist texts and private and commercial projects. The most beautiful movable-type works were the *Sagabon* ('Saga books'), a series of exquisitely printed and illustrated Japanese classics produced by Hon'ami Kōetsu (*see* HON'AMI, (1)) and Suminokura Soan (1571–1632) in the first two decades of the 17th century.

BIBLIOGRAPHY
T. F. Carter: *The Invention of Printing in China and its Spread Westward* (New York, 1925, rev. L. C. Goodrich, New York, 1955)
D. Chibbett: *The History of Japanese Printing and Book Illustration* (Tokyo and New York, 1977)
MATTHI FORRER, AMY REIGLE STEPHENS

2. EDO PERIOD (1600–1868) AND AFTER: BOOKS. This article is concerned with commercially produced woodblock-printed secular books of the Edo period and later. These represent a sustained artistic achievement in terms of quantity, standard of production, quality of design and richness of subject-matter. The making of books required the close collaboration of artists, calligraphers, block-cutters and printers and presupposed the existence of a wide audience. Apart from certain of the illustrated books of KATSUSHIKA HOKUSAI, such as his *Fugaku hyakkei* ('One hundred views of Fuji'; 1835–42), Japanese woodblock-printed books have been little known in the West, even by enthusiasts for colour woodblock prints. Largely through the efforts of the art historian Jack Hillier in the 1980s, a wider audience has been gained for them.

(i) Format and production. (ii) Social context. (iii) Illustrated books.

(i) Format and production. In the last decade of the 16th century movable type came to be used widely in Japan. This new technology derived from two sources: Europe, via Catholic missionaries, and Korea, under the patronage of powerful Japanese regional lords (daimyo). Movable type enjoyed a brief vogue—of special note were the *Sagabon*, luxury editions of Japanese literary works superbly printed for private distribution, mostly between 1608 and 1615—but by 1650 it had been rejected in favour of the traditional practice of cutting the entire contents of the page into one printing block. The rejection of movable type is considered to have been a decisive factor in the development of the illustrated book, for the same process

161. Book illustrated by Yamaguchi Soken: *Arm Pillow* from *Yamato jinbutsu gafu* ('Picture book of Japanese people'), showing double-page woodblock-printed illustration with central *nodo* ('well') between facing pages, paper and black ink, 258×333 mm, 1800 (London, British Museum)

could be used to produce text and illustrations, both being cut into and printed from one block. The Japanese made only one important contribution to this technology, the introduction of a system of alignment that made accurate colour printing possible. Although first developed in the mid-17th century, this system did not come into general use until the 1760s, when the capabilities of colour printing began to be exploited with spectacular results.

The aesthetic encounter with a Japanese book of the Edo or Meiji (1868–1912) periods begins with its wrapper (*fukuro* e.g. London, BM; Leiden, Rijksmus. Vlkenknd.). Few of these survive, but those that do are finely printed and often very well designed. Underneath the wrapper would be the book's flexible covers (*hyōshi*), consisting of a thick core of paper of inferior quality finished with finer-quality paper and usually unobtrusively decorated. Designs were sometimes printed or stencilled on the covers, but usually they were simply embossed with patterns that ranged from interlocking geometric figures to complex landscapes. Printed title slips (*daisen*), often presenting the title in fine calligraphy, were pasted on the covers. Japanese books were designed to be read from right to left and thus opened to reveal the title page on the right, pasted on the inside front cover and facing the first page of the preface on the left. The quality of the calligraphy, with its rich depth of ink, and the fineness and warm translucence of the paper (*see* §XVI, 18 below) added a sensual dimension to the reader's first impressions of the book.

While the earliest illustrations in Japanese books (*c.* 13th century) had occupied a single page and faced a page of text, in the 1680s experiments with horizontal compositions running across two pages proved so successful that double-page illustrations quickly became the norm. In this format, the contents of each page were enclosed within a frame, with a discontinuity in the central 'well' (*nodo*) where the facing pages met (see fig. 161). Artists of all

schools who provided illustrations for books proved remarkably successful in creating designs that bridged that gap, irrespective of the subject-matter they were illustrating or whether the finished result was printed in black ink alone or in colour. The Japanese eye encountered no difficulty in perceiving the two parts of such book illustrations as a whole.

The production of most illustrated woodblock-printed books involved the following steps. Calligraphers copied out the text to be printed on thin paper on which margins had been pre-printed. Artists (or copyists working from artists' sketches) produced the finished version of any accompanying illustrations on the same sheet. The finished sheet went to the block-cutter, who pasted it face down on to a prepared block of cherry or catalpa wood and then cut away the wood around the characters of the text and the lines of the drawing. (If the illustrations were to be in colour, separate blocks were cut for each colour after the production of the outline or key block.) The finished block was held in place and inked, after which a sheet of paper was laid on it and rubbed firmly from behind with a round pad (*baren*). The sheet was then lifted and hung up to dry. Two pages were carved on each printing block; thus two pages were printed on each sheet of paper. These were not facing pages but rather pages that would appear back to back in the finished book; the two halves of a double-page illustration were cut into separate blocks and printed on separate sheets of paper. Each sheet, which was printed on one side only, was then folded in half to make two pages, with the printed surface to the outside. The folded sheets required to make up a volume were then collated, stacked and sewn together, at four points, at their open ends. Finally the cover was sewn on to the firmly assembled pages. The outer edge of the book was never trimmed but presented the folded end of each printed sheet. Nearly all Japanese books were bound by this method, known as *fukuro-toji* (see fig. 162).

A small number of books were bound as albums (*chō*), in which case each double-page spread was printed on a single sheet. The sheets were then folded with the printed surface to the inside and attached, sheet to sheet, at the outer edge. This allowed for uninterrupted double-page compositions. Only the most lavish illustrated books, usually specially commissioned, were produced in this costly fashion.

Soon after the Meiji Restoration (1868), Western printing techniques replaced woodblock-printing for most purposes, but some notable volumes of illustrations continued to be produced by traditional methods into the 20th century. Today woodblock printing is used almost exclusively to produce facsimiles of famous Edo-period books.

(ii) Social context. The spread of literacy in Japanese society at large in the 17th century created a new market for books and contributed to the secularization of printing. The number of publishers active throughout the country increased between the mid-17th century and the mid-18th from some 100 to over 600, and by 1800 publishers were found not only in the administrative capital Edo (now Tokyo), in Kyoto and in Osaka but also in some 50 other locations. Enterprising publishers were able to exploit the

162. Japanese book formats: (a) *kansubon*; (b) *orihon*; (c) *fukuro-toji*

available technology to meet the requirements of a growing audience, while easy access to books facilitated the further spread of literacy. The new readers, most of whom were commoner town-dwellers and a significant proportion of whom were women, were not interested in religious texts or official histories. They sought racy, entertaining literature set in their own world (such as the popular novels in serial form (*gohanmono*) common in the early 19th century). It was for such books that the first extended sequences of illustrations that formed an integral part of the text were produced. Many of the early illustrations were explicitly erotic. Two types of popular fiction were the *ukiyo-zōshi* ('books of the floating world') and the *sharebon* ('witty book') about life in the pleasure quarters, mainly Edo. *Kibyōshi* ('yellow cover') books told juvenile or adventure stories and moral tales.

(iii) *Illustrated books.* In the late 17th century a new, native style of book illustration was created by HISHIKAWA MORONOBU, whose work was characterized by a subtle, flexible line and the masterful use of areas of solid black. Although he provided illustrations for historical romances and anthologies of poetry, his most compelling images were of courtesans, often depicted in sexual acts. He established the highest standard for book illustration, and his successors, such as NISHIKAWA SUKENOBU, continued in the same tradition, with women the main subject of their work.

A growing interest in Chinese painting among literati in the first half of the 18th century led to the importation of and widespread familiarity with Chinese painting manuals, such as the *Mustard Seed Garden Painting Manual* (Chin. *Jieziyuan huazhuan*, compiled by Wang Gai *c.* 1679–1701), which were colour-printed and profusely illustrated (*see also* §VI, 4(vi)(d)). The introduction of these books stimulated the production of new kinds of illustrated books and provided an impetus for the development of colour printing in Japan. Publishers produced their own editions of Chinese titles (e.g. the *Kaishien gaden*, 1748 and 1753, the Japanese edition of the *Mustard Seed Manual*) as well as instruction manuals by Japanese artists based closely on Chinese prototypes. By the 1740s, however, the woodblock-printed book was firmly established as a creative medium in its own right, and volumes of illustrations appeared in which the didactic intent was barely discernible. Images no longer needed to be adjuncts to a text or reproductions of paintings, and artists were offered a means of expression that differed from those available to them in painting. Moreover, the expertise of block-cutters and printers was such that they were able to interpret—a more appropriate word than reproduce—the intention of the artist with remarkable fidelity. Because books were mass-produced, artists could reach a wider audience than ever before. The demand for such books came from prosperous commoners and lower-ranking samurai who shared aspirations to higher culture.

The types of books for which illustrations were provided in the 17th and 18th centuries included not only popular novels but also collections of poetry, handbooks detailing the attributes of leading courtesans and stars of the *kabuki* stage, manuals for students of painting, calligraphy, falconry and many other subjects, botanical studies, travel books and medical texts. A significant body of books, however, existed simply for their illustrations.

The KANŌ-school artist Tachibana Morikuni was among the first to exploit the new possibilities created by the high level of technical mastery available, making a major contribution to the genre of pure picture book with monochrome books such as *Unpitsu soga* ('Rough Sketches of a Moving Brush'; 1749). Other artists followed suit, notably Tatebe Ryōtai (1719–74), Yamaguchi Soken (1759–1818; see fig. 161), Kawamura Bunpō (1779–1821), Ōnishi Chinnen (1792–1851), Chō Gesshō (1772–1832) and Keisai Masayoshi (1764–1824). The contents of their books included figures in both Chinese and Japanese dress, finished landscapes, the components of landscapes (trees, rocks, bridges, houses, etc), animals, especially birds, and flowers and plants including bamboo. An outstanding example is the *Bunpō gafu* ('Book of Drawings by Bunpō'; 1807), which in its 30 double-page illustrations presents in rotation human figures, landscapes and bird-and-flower studies.

The images of a second category of books were generated by a vogue for the composition of poetry in the late 18th century and the first half of the 19th that swept all classes of society. Amateur poets often commissioned illustrations for their published poems from artists of all schools. Some of the most spectacular examples of Japanese printing are found in the resultant books. The *ukiyoe* artist KITAGAWA UTAMARO produced outstanding books of this kind, such as *Ehon mushi erabi* (1788), *Shioi no tsuto* (*c.* 1790) and *Momo chidori kyōka awase* (*c.* 1791)—his 'insect', 'shell' and 'bird' books respectively. Some books in this category were later reprinted with the poems omitted.

A third broad category of illustrated books recorded in detail the *ukiyo* ('floating world'), the liveliest manifestation of the popular culture of the Edo period, which encompassed the pleasures offered by the restaurants, theatres, brothels and amusement centres that had sprung up in the towns of Japan. Their colour, noise and excitement were vividly depicted in contemporary popular art and literature. All the major *ukiyoe* artists, including SUZUKI HARUNOBU, Kitagawa Utamaro, Utagawa Toyokuni I (*see* UTAGAWA, (2)), Utagawa Kunisada I (*see* UTAGAWA, (5)), Keisai Eisen, ANDŌ HIROSHIGE and KATSUSHIKA HOKUSAI, produced book designs glorifying this world. These ranged from the cheapest novels illustrated with line drawings only to sumptuously printed multicoloured picture books recording the lives of the leading actors and courtesans. This category also included many erotic works.

Not all artists active in the 18th and 19th centuries produced illustrated books, but all schools were represented among those who did. *Ukiyoe* artists, who devoted themselves almost entirely to recording the lives of courtesans and actors in a 'representational' style, were no less successful in exploiting the potential of book illustration than artists of the 'impressionistic' *Nanga* and Maruyama–Shijō schools (*see* §VI, 4(vi)(d) and (viii) above). The richly illustrated, large-format (280×180 mm) 'picture books' (*ehon* and *gafu*) were expensive and represented the top end of the market. Throughout the period demand grew steadily for cheaply produced, smaller (180×130 mm) illustrated novels of little aesthetic interest, in which the

text literally flowed around the figures to fill all empty spaces in the design. Clearly, the publishing industry catered to readers of all tastes, from the most discerning to the semi-literate. Substantial numbers of practical illustrated books were also produced in the 19th century, including guidebooks, botanical studies and medical texts; but only rarely did the artistic quality of their illustrations rise above what was required by their didactic purpose.

BIBLIOGRAPHY

C. H. Mitchell and O. Ueda: *The Illustrated Books of the Nanga, Maruyama, Shijō and other Related Schools of Japan: A Bibliography* (Los Angeles, 1972)

D. Chibbett: *The History of Japanese Printing and Book Illustration* (Tokyo and New York, 1977)

J. Hillier: *The Art of Hokusai in Book Illustration* (London, 1980)

Japanese Prints: 300 Years of Albums and Books (exh. cat. by J. Hillier and L. Smith, London, BM, 1980)

M. Forrer: *Eirakuya Tōshirō, Publisher at Nagoya: A Contribution to the History of Publishing in 19th-century Japan*, Japonica Neerlandica, i (Amsterdam, 1985)

J. Hillier: *The Art of the Japanese Book*, 2 vols (London, 1987)

Y. Brown: *Japanese Book Illustration* (London, 1988)

Y. Brown, ed.: *Japanese Studies: Papers Presented at a Colloquium at the School of Oriental and African Studies: London, 1988*, British Library Occasional Papers, xi

J. Hillier: *The Japanese Picture Book: A Selection from the Ravicz Collection* (New York, 1991)

ELLIS TINIOS

3. EDO PERIOD (1600–1868) AND AFTER: PRINTS. Towards the end of the 17th century the single-sheet woodblock print became a distinct art form in Japan, and its development from the Edo period is thus traced separately from that of printed secular texts and illustrated books (*see* §2 above), although the technology employed in all types of woodblock printing was basically the same. Pictorial woodblock prints of the *ukiyoe* genre ('pictures of the floating world'), which usually comprised images on single sheets of paper, sometimes complemented by poetic or other inscriptions, enjoyed widespread and long-lasting popularity. Especially since their discovery by the Western public in the 19th century, they have come to be considered as among the most quintessentially Japanese of art forms. In the 20th century (*see* §(ii) below), other printmaking methods were also employed by Japanese artists.

(i) Materials and techniques. (ii) Production, subject-matter and social context. (iii) Historical development.

(i) Materials and techniques. In its isolation during the Edo period (1600–1868) Japan evolved and refined a highly sophisticated and successful method of reproducing images in quantities from woodblocks. The basic method was similar to that of the Western CHIAROSCURO WOODCUT, and some ideas may have arrived via China from Europe. The Japanese achievement was to adapt, develop and commercialize the concept. Woodblock printing was used at that time principally for *ukiyoe*. Every material and tool utilized for this purpose was handcrafted. Except for certain pigments, the various elements were naturally available in Japan: the correct paper fibre, the right pigments, the bamboo *baren* (a pad used to take the impression from the woodblock by rubbing the paper vigorously with a circular motion) and wood for the blocks. The printmaking process was a collaborative effort by a number of skilled craftsmen including the artist or designer, carver, printer and publisher.

(a) Process and tools. (b) Decorative techniques.

(a) Process and tools. Using a brush, usually made of deer's fur, and *sumi* (Chinese ink), the artist drew the initial design (*gakō*) on thin Japanese paper (best quality *minogami*); alterations were made by pentiment. The design was passed to a block-copyist (*hanshitagaki*), who elaborated and produced an accurate and detailed finished underdrawing (*hanshitae*) for the woodblock. After 1842, when government reforms instituted a period of austerity and moral restraint, publication was conditional on official approval. Once this was obtained, the *hanshitae* could be pasted face down with rice starch (*himenori*) on a prepared block of white mountain cherry (*Prunus mutabilis*; Jap. *shiro yamazakura*). Other, harder woods were used for more specialized effects. To make the drawing easier to see from the reverse side and thus to facilitate the block-cutter's task of cutting the image, a layer of paper was peeled off using the flat of the finger or through the application of hempseed oils, which resulted in a similarly translucent effect. After cutting, this initial block was the keyblock or *sumi*-block that furnished the black outline of the finished print and reproduced mirror images for pasting on to other blocks, so that the colour parts of the design could be cut. To align these various blocks accurately, the keyblock had a notch—key mark or registration mark (*kentō*)—cut into one corner and a short raised ridge along an adjacent side. Like the rest of the design, these were duplicated on every colour block. The paper for printing was aligned against these *kentō*, allowing very accurate registration of colours. Any slight discrepancy due to the expansion or contraction of the wood or the inaccurate cutting of the paper was counteracted by plugging the block with slivers of cherry wood next to the *kentō* notches.

The cutting of a set of blocks (see fig. 163), together with any alterations, could be completed in two or three days. The woodcutter used four basic types of tools, although there was considerable variation in the sizes at his disposal: the *kagatana* or *tō*, a knife for cutting around the drawing; the *aisuke*, a digging chisel with an arc-shaped blade, used to clear the areas of superfluous wood between the lines; the *marunomi*, a gouge or small, round chisel shaped like a tube split down the middle; and the *nomi*, a chisel with a cutting edge that was arc-shaped in cross-section and was used in conjunction with the mallet (*kizuchi*) to clear large expanses of wood. The wood was cut along the grain. The method used is classed as relief printing rather than intaglio and is therefore unrelated to the European technique of wood-engraving. The impression of the wood grain was transferred from the block to the paper during printing and is visible on most early impressions taken before the blocks became too worn. This feature of Japanese woodblock prints was occasionally deliberately exploited to convey, for example, water or raked sand. The scholar Ishii Kendo states that before the Edo period woods such as *keyaki* (*Zelkova serrata*; zelkova) were inlaid on the block to give the benefit of the grain in specially selected areas. This deliberate 'imitation' of the wood grain (*itame mokuhan*) is frequently found on actor prints by such artists as Utagawa Kunisada (*see* UTAGAWA, (5)) and on designs incorporating wood

into the picture, as in the copying of votive tablets. The wood was replicated by choosing a tight, highly figured block that had minimal planing or may have been treated with water or steam to raise the grain. Pigment was first applied, possibly with a pad rather than a brush, and the paper then impressed strongly, thereby reproducing every small feature of the piece of wood. As no two blocks of wood have the same pattern, the impression of the grain is the unequivocal method of determining authenticity.

Corrections, damage or alterations to the block were made by plugging it with new wedges of wood. The block-cutting studios became extremely adept at making these insertions, which were not uncommon, especially in the late 19th century, and are most often to be seen in the prints of *bijin* ('beautiful women'). The heads of *bijin*, with their delicate face outlines and intricate hair, were the most difficult to cut, and their production was left to the accomplished *atama-bori* ('head-carver'). Other areas on blocks that sometimes had these insertions are the hands or changes to a title or an actor's or courtesan's name.

Proofs (*kyōgō*) were pulled from the keyblock, often 20 or more, depending on the number of colour blocks required. Before they were passed to the printer, the proofs were given to the artist, who indicated the colours on each and how they were to be graded. The block-cutter and the artist or printer (see fig. 164) were not the same person: both sat cross-legged on the floor, with the block on a low stand; the printer had the block angled slightly away from him, the block-cutter had it angled towards him. Pigment was spread on the block with brushes (*hake*) made from the hair of a horse's mane. To give depth, thickness and better adhesion, rice-starch paste was added to the block and mixed with the colour. After the blocks were charged with pigment, dry rice flour was sometimes dusted over to give added sparkle. Paper sized with a mixture of alum and a glue extracted from deer antler, bone or skin cooked in hot water was stacked, slightly dampened, ready for use. Most Japanese prints were printed on one of two types of *kōzo* (mulberry; genus *Broussonetia*) paper: *masa* and *hōsho*. Before the advent of full-colour prints (*nishikie*) in the mid-18th century, *masa* was used, but between *c.* 1765 and 1840 nearly all paper couched for prints was *hōsho*. When the sumptuary laws of 1842 banned *hōsho* because of its luxurious nature and cost, *masa* was reintroduced.

The impression was taken from the cut wood by rhythmically applying pressure to the paper with a *baren*, a flat disc *c.* 133 mm wide of twisted and knotted bamboo cord held within a lacquered frame, the surface being covered with bamboo leaf. Considerable force could be exerted using this pad. The rubbing incidentally produced circular or semicircular lines, which are most visible on plain grounds or on the reverse side of prints. The gradation of colour on the block was achieved by various shading techniques (*bokashi*), using brushes partly loaded with pigment drawn across dampened areas or by wiping with a cotton cloth. *Ita bokashi* ('wood shading') involved gradually lowering the wood on the area in question so that it printed with no sharp edges. (*See also* PRINTS, §III, 1 and 6.)

(b) Decorative techniques. Certain unique techniques evolved for embellishing designs. The Japonistes in

163. Japanese printing tools and printing block, *c.* 1860 (London, Victoria and Albert Museum)

France—captivated as they were by the graphic expressiveness of Japanese decorative design—experimented with these during the second half of the 19th century (*see* JAPONISME). They are seen to best advantage on the luxurious *surimono* ('printed thing'; sumptuous prints that were privately printed in small quantities) that utilized a thick, de luxe *hōsho* paper.

Karazuri. In *karazuri* (blind–printing, gaufrage, EMBOSSING or goffering), used on monochrome Japanese prints from *c.* 1730, a block was cut but no pigment was applied. Instead, a little moisture was added to the block, the paper placed on the surface and the image transferred by rubbing the paper with an ivory tool, usually the canine tooth of a wild boar. Shallow blind–printing could also be created using a *baren* or the tip of the elbow. Deep outlines (*kimekomi*) of figures or objects were made in the same way, but the paper was gently tapped using a hammer with gutta-percha pads. Before the Meiji period (1868–1912), printers sometimes used both heels on the paper to extract deep gaufrage, a method known as *kimedashi*. The entire

164. Emil Orlik: *Printer Rubbing Paper on Woodblock with a 'baren'*, woodcut, 197×157 mm, 1901 (Amsterdam, Rijksmuseum)

outlines of objects such as rolls of cloth or paper or animals such as rabbits (alive or made of snow), cockerels or mice were printed in this way. Gaufrage was also well represented in the *chūban* ('middle format') prints of Suzuki Harunobu and Isoda Koryūsai (e.g. *Golden Pheasant and Peonies*, c. 1769–70; Lausanne, Reise priv. col.) and in *shunga* ('spring picture', a euphemism for erotic prints) by Harunobu and others, where the deep outlining of figures benefited from the superior-quality paper. More elaborate blind-printing effects were achieved by gluing textured gauzes such as muslin or randomly spread particles such as sand to the required part of the block, instead of carving the block. Some of the designs of KITAGAWA UTAMARO were thus produced as 'net prints' (*nunomezuri*). In order to print a fine mesh pattern, such as that of a mosquito net or fishing net, two blocks were cut and printed at right angles or diagonally to each other. *Karazuri* designs resemble a reversed Braille outline and are best seen when obliquely lit.

Tsuyazuri. In the *tsuyazuri* (surface polishing or burnishing) method a glazed area was produced, which was intended to resemble silk or lacquer. It was made by rubbing the print surface vigorously with a round piece of porcelain or ivory. The block was cut from a proof print taken from the required region, which was pasted face up on the wood. Similar results were obtained in portraits by applying glue to such parts as the eyes. There are also a number of print sets, primarily by Utagawa Kuniyoshi (*see* UTAGAWA, (6)) and Utagawa Yoshiiku (1833–1904), which have a sheen over the entire printed surface. In the Kuniyoshi prints the method created a surface reminiscent of Western oil paintings or book illustrations, whereas in the series by Yoshiiku entitled 'A Photographic Picture'

(or 'Mirror') it created a surface gloss like that of a photograph. A hard wax was probably added to help achieve the high polish on these prints. Dense blacks were made by overprinting layers of ink, usually with a separately cut block and using undiluted ink of the best quality. A lustrous black was obtained by an admixture of rice-paste to the block or by the addition of *dosa* (a size made of glue and alum). Overprinting a rich black—derived from the best inksticks heated in a mortar—on normal ink and grey also produced a rich sheen, which was used in the representation of women's hair. Detailed cutting and printing were needed to depict the often elaborate coiffures, especially after the *ōkubie* ('large head picture') format developed in the late 18th century. To handle these close-ups, a technique evolved of cutting and overprinting from two or three blocks to achieve the required textural effect and depth of black. It started with the basic grey ground, which also provided the contour of the hair; the next block was printed further in and slightly to the side to produce a pattern of alternating dark and light in the hair; finally a second printing was taken from this block or a third variant block was used.

Kirifuki or fukibokashi. This spray-shading technique was used to depict snow, steam, spray, dust or mist. Pigment or *gofun* (generally powdered white chalk mixed with glue or size and water) was sprayed on to prints by shaking the brush or by drawing the thumb sharply across the brush. Fine spray effects were also achieved by blowing through a right-angled bamboo or metal tube, of which one end was dipped into the pigment, which was distributed via a gap at the vertex by capillary action. Incidentally, Henri de Toulouse-Lautrec claimed to have invented this technique (Fr. *crachis*), when in fact Henri-Gabriel Ibels (if not others too) was using the process before him. Ibels, in turn, had copied it from Japanese prints.

*Mica grounds (*kira*).* Crushed mica was used on some privately issued prints and de luxe publications. Mica was either mixed with pigments or applied over already printed colour grounds, so that, in addition to the strong silvery-grey sheen noticeable on such works as the *Actor Segawa Tomisaburō as Yadorigi in a Play Performed in 1794* by Tōshūsai Sharaku (London, BM) or *Firefly Catching* by Eishosai Chōki (1794–5; London, BM), it was possible to create areas of pink, yellow, brown, black and grey. Egg white and rice paste were used for preference to stick the mica to the print surface. Large areas, such as the backgrounds of *ōkubie*, were executed by first printing from a separate block using egg white or rice paste and then, with a stencil, sprinkling and brushing the mica on with a very soft brush.

Other effects. Some *surimono* were printed with metal powders such as gold (*kiri*), which was in reality brass dust. One of this metal's constituent parts is copper: this reacts with the sulphur in the air to form basic copper sulphate, which 'burns' through paper. Thus *kiri* was used successfully on the thick *hōsho* paper of *surimono* but caused deterioration and breakage on paper of normal thickness, such as was used for the *shunga* prints of Torii Kiyonaga (*see* TORII, (8)). On certain prints *kiri* was randomly distributed or scattered over pigment or on

prepared grounds, for example in Utamaro's series *Seirō juni toki tsuzuki* ('The twelve hours of the green houses'; *c.* 1795). This technique too was copied by Toulouse-Lautrec on the lithograph *Miss Loïe Fuller* (1893; *see* PRINTS, fig. 13), where the gold was applied with a cotton pad. Silver (*gin*), in fact lead powder, and pure copper powder (*akegane*) were added to the print blocks with small brushes resembling toothbrushes (*hakubake*), so that they stuck to the paper where a paste print (*norizuri*) had previously been printed. Real gold or silver leaf was used sparingly, and then chiefly for de luxe albums and, of course, paintings. Flakes of mother-of-pearl (*aogai*) from the abalone shell (*awabi*), used on selected prints, albums and *surimono*, were applied to prepared grounds of glue or size.

Japanese prints, moreover, used a comprehensive palette of organic and inorganic pigments. Because many of these were sensitive to light and water, especially the organic dyes used on 18th-century prints, many extant prints have faded. Organic pigments were extracted from mineral earths, flowers, bark, grasses and other plants, for example dayflower (*aobana*), safflower (*beni*), gamboge (*shio*), orpiment (*kio*), red lead (*tan*), indigo (*ai*), vermilion (*shu*) and azurite (*gunjō*). Great importance was attached to the grinding and making of these pigments, which required considerable skill. Each colour was kept in an individual porcelain bowl, to which several drops of water were added before use to dilute the dye. Prussian blue was added to the palette from 1829 onwards, and in about the mid-19th century synthetic dyes, mostly anilines (extracted from coal–tar), were introduced. There were thousands of these, classified by their colour rather than their chemical composition, the most notable being aniline black, blue and yellow. Synthetic dyes were not only more intense, faster and brighter than natural dyes but were also cheaper to manufacture.

BIBLIOGRAPHY

K. Isshi: *Nishikie no hori to suri* [The engraving and printing of full-colour Japanese prints] (Tokyo, 1929)
T. Volker: *Ukiyoe Quartet: Publisher, Designer, Engraver and Printer* (Leiden, 1949)
J. R. Hillier: *The Japanese Print: A New Approach* (London, 1960, R Rutland, VT, 1975)
——: *Utamaro: Colour Prints and Paintings* (London, 1961)
——: *Japanese Colour Prints* (London, 1966)
T. Tokuriki: *Wood-block Print Primer* (Tokyo, 1970)
R. S. Keyes: *The Art of Surimono: Privately Published Japanese Woodblock Prints and Books in the Chester Beatty Library, Dublin*, 2 vols (London, 1985)

RICHARD KRUML

(ii) Production, subject-matter and social context. The colour woodblock prints of the Edo period (1600–1868) designed by artists of the *ukiyoe* school (*see* §VI, 4(iv)(b) above) were ephemeral items, published in large editions for a broad audience. They were never intended to be 'high art' but were unabashedly popular and utterly commercial in intent, thriving on novelty, brightness and impermanence. The industry that produced these prints was based on independent craftsmen—designers, block-cutters and printers—whose efforts were coordinated by publishers and booksellers. The technology employed was identical to that used to produce text for books and broadsheets (*see* §2 above). The intellectual and artistic élites disdained woodblock prints as mere reproductions pandering to vulgar tastes, while the authorities, more out of concern for political stability than public morality, closely regulated their production and content.

There was a high degree of standardization in the industry. The *ōban* ('large format') print (380×250 mm), which is most often encountered today, came into wide use in the 1780s and by 1800 had become the preferred size for commercially produced prints. It entirely displaced the *hosoban* ('narrow format') print (330×145 mm), which had come to be employed extensively for actor prints in the 18th century. A variant *ōban* format was the *hashirae* ('pillar picture'), which consisted of two *ōban* sheets aligned vertically and was meant to imitate hanging-scroll paintings. Huge numbers of fan prints, in both folding and round fan format, were also issued (e.g. SUZUKI HARUNOBU's design of a fan vendor, *c.* 1785, Berlin, Mus. Ostasiat. Kst) but, because they were articles intended for everyday use, few survive.

Ōban prints were rarely issued as single sheets but rather in sets of from three to twelve or more sheets. These multiple-sheet prints might be linked thematically to such subjects as the three metropolises of Edo (now Tokyo), Osaka and Kyoto, the Five Chivalrous Commoners of popular lore, the six Jade Rivers (Tamagawa) or the twelve months. Numbers such as 'the thirty-two types' encountered in titles of sets of beauties were notional, the sets so entitled actually containing just ten designs. Distinct from these sets, which consisted of independent designs, were triptychs and polyptychs. In these the design spread from sheet to sheet, but, at the same time, each individual sheet was contrived to stand on its own as a satisfying composition.

Evidence from the prints themselves, contemporary book illustrations and fiction indicates that, once purchased, most commercially produced prints were pasted on walls or screens. As a result, they were easily ruined as their colours quickly faded and their surfaces became soiled. Other prints, kept in boxes or baskets to be viewed from time to time by adults and played with by children, fared little better. It was a simple matter to replace old prints with bright, fresh, inexpensive new ones. Only a small proportion of the vast number of prints produced were kept in good condition.

Print designers had always to keep their public in mind if they wished to succeed. Kawasaki Kyosen, the son of the last print designers to work in Osaka, observed in a reminiscence on print production in the 1870s (Kawasaki Kyosen, 1973, pp. 318–20) that 'No matter how well theatre prints were designed, if the faces of the figures were not exact likenesses of the actors they would not sell at all, and the publishers took a terrific loss.'

A single, commercially produced print cost about as much as a bowl of noodles or a haircut, half the price of the cheapest admission to a *kabuki* theatre. At these prices, a publisher had to produce and sell large runs of prints in order to meet his initial capital outlay and operating costs and still show a profit. His expenses included the cost of buying an original design and materials (including wood for the blocks, paper and pigments). He then had to pay the block-cutter and the printer. Finally he had to cover the expense of distributing and selling the print.

The standard unit of production in the first half of the 19th century was 1000 prints. Many thousands of pulls could be taken from a block before it began to show signs of wear, and an experienced printer could take 3000 pulls from a keyblock (the outline block) or 600 to 1800 pulls from a colour block in a day. Total output from Edo's dozens of publishers reached millions of individual sheets; prints were also produced, though in much smaller numbers, in Osaka, Kyoto and Nagoya.

In addition to the commercial products there were privately produced prints known as *surimono* (literally, 'printed thing'), issued in limited editions of perhaps 50 or 75 prints, and usually in a format just over one quarter the size of the standard *ōban* print. No expense was spared in their production: the finest paper, most costly pigments and meticulous printing techniques were employed, and the results can well be described as opulent. *Surimono* served as greeting cards or mementos of particular events and almost always carried poems by the individual or individuals who commissioned them. The subjects portrayed in *surimono* extended beyond beauties, actors and heroes to include inanimate objects in designs of great distinction. Painters of the Maruyama–Shijō school (*see* §VI, 4(viii) above) and other lineages, who never involved themselves in the production of commercial prints, designed *surimono* side by side with *ukiyoe* artists.

(a) Edo period (1600–1868). Most commercially produced prints of the Edo period depicted the twin pillars of popular culture: *kabuki* actors and the women of the entertainment quarters. *Sumo* wrestlers, gods and spirits, birds and flowers, famous heroes and landscapes were minor print genres throughout most of the period. Around 1830 the balance shifted, with increased production of prints of heroes and landscapes. The many sets of landscape prints that appeared in the 1830s, 1840s and 1850s helped to assuage the wanderlust of the general public, whose movements were subject to strict government

regulation. The sets of warrior prints of the 1840s and 1850s, although superficially orthodox in their exaltation of past examples of loyalty and self-sacrifice, in fact reflected a critique of the existing political order, in the name of service to society and loyalty to emperor, that had been initiated by middle-ranking samurai and was to provide the theoretical justification for the overthrow of the shogunate in the 1860s.

Although the range of subject-matter was wide, most prints (including fan prints) depicted *kabuki* actors in their latest stage hits. A few actor prints commemorated such events as an actor's name change, his return to the Edo stage from a provincial tour or his death. The women who appeared in prints—whether well-known courtesans and geishas or simply idealized representations of feminine beauty—were always depicted in the latest kimono patterns and hairstyles (as in *Models for Fashion* by ISODA KORYŪSAI; *c.* 1770s; Tokyo, Riccar A. Mus.).

In order to ensure that actors were recognizable, from the third quarter of the 18th century schools of print designers established and strictly adhered to standardized likenesses (*nigao*). In earlier actor prints, poses and roles were readily identifiable but not the facial characteristics of the individual actor. When Katsukawa Shunshō (*see* KATSUKAWA, (1)) first introduced *nigao*, his contemporaries praised him for portraying, within the conventions of his school, the actual facial features of actors (as did Shunshō's pupil Katsukawa Shunchō (*see* KATSUKAWA, (4)) in, for example, *Sawamura Sōjūrō III*; *c.* 1780s; Leiden, Rijksmus. Vlkenknd.). Thereafter, whether in full-figure or half-length portraits, the clear delineation of the outline of the face in three-quarter profile received top priority. Profile and full-face depictions were attempted only rarely. Costumes, the hair and the body itself served as a frame for setting off the *nigao*. As theatrical images, representing the star as he wished his public to perceive him, these prints were extremely successful.

165. Utagawa Kunisada I: *Print Shop*, triptych of full-colour woodblock prints, each 380×250 mm, 1858 (Rome, Museo Nazionale d'Arte Orientale)

The print trade prospered from the late 17th century into the mid-19th: the casual way in which prints were treated and the topicality of their subject-matter created a self-renewing demand. Although landscape and warrior prints, which gained popularity from 1830, were not topical, they lent themselves to 'serialization' in large sets. In the course of the 1830s the industry cultivated the market for such sets.

In 1842, as part of a programme of economic and political reforms, ministers of state who considered prints detrimental to public morals forbade the further production of prints of *kabuki* actors, courtesans and geishas. Designers and publishers were exhorted to produce prints that would educate women and children in loyalty and filial piety. Official decrees could not stifle popular demand, however, and the industry was resilient enough to find ways to subvert the intent of the reforms. Beauties were identified as 'paragons of virtue', and actors were thinly disguised as 'loyal heroes from the past'. Nonetheless, for over a decade it was necessary to dissociate the images of actors from current stage productions so as not to fall foul of the censors. This restriction was turned to advantage. By freeing actor portraits from specific performances it became possible to gather them together in retrospective sets of 30, 50 or more sheets presenting the leading actors of the *kabuki* stage, both living and dead, in their most memorable roles. The large sets of landscape and warrior prints of the preceding decade provided the model for sets on this scale. Without exception, the actors in the larger sets were presented in half-length, a format that had hitherto been used only sparingly.

From the late 1840s, the individual sheets that made up sets of actor, warrior and landscape prints were often numbered sequentially and issued with title and contents sheets, all of which indicates that they were intended to be bound in albums rather than pasted on walls and screens. They represented a new, less ephemeral category of print, promoted by designers and publishers in the aftermath of the reforms of 1842. In the illustration of a print shop by Utagawa Kunisada I (*see* UTAGAWA, (5)) produced in 1858, two large sets of prints are advertised on the board at the left of the left-hand sheet (see fig. 165).

(b) Modern period (after 1868). Production of woodblock prints continued after the collapse of the Tokugawa shogunate in the 1860s. For a time there was a great vogue for prints illustrating things foreign or recording current events such as the Satsuma Rebellion (late 1870s) or notorious murders. As pictorial journalism, these prints represented a major departure from past practice. Despite its exploration of new genres, the industry proved unable to compete with the photographic and printing technologies imported from the West in providing cheap and appealing pictures for popular consumption. It enjoyed a brief reprieve by meeting a sudden demand for prints illustrating Japan's victories in the Sino-Japanese War of 1894–5. Some 3000 print designs were issued in less than a year, and over 100,000 copies of the most popular designs were sold. When the war ended in the spring of 1895, so too did the demand for the prints. Meanwhile, the demand for actor prints, the mainstay of the industry, dried up. In the autumn of 1895 barely 200 copies of actor

prints were sold. Although woodblock prints were issued to chronicle Japan's participation in the Allied Expedition to crush the Boxer Uprising (1900–01) and to glorify Japan's victories in the Russo-Japanese War of 1904–5, the day of the mass-produced, popular woodblock print was over.

In the 20th century woodblock printing was revived in new contexts. These ranged from the meticulous if sterile reproduction of famous works of art to the *sōsaku hanga* ('creative prints') movement, in which the artist was responsible for all stages of print production, including design, block-cutting and printing. From 1915 to 1940, a neo-*ukiyo* style ran parallel with the *sōsaku hanga* movement (*see* §(iii)(g) below). The neo-*ukiyo* movement was based on publishers contracting artists, block-cutters and printers to produce prints of women, actors and landscapes for a largely foreign clientele. These prints were issued in numbered, limited editions and were intended for an exclusive audience. The contrast with Edo-period prints could not have been greater.

BIBLIOGRAPHY

J. R. Hillier: *The Japanese Print: A New Approach* (London, 1960/R Rutland, VT, 1975)

S. Takahashi: 'Edo no Ukiyo-e-shi', *Nihon No Bijutsu* [Arts of Japan], xxii (1964); Eng. trans. by R. Stanley-Baker as *Traditional Woodblock Prints in Japan*, Heibonsha Surv. Jap. A., xxii (New York and Tokyo, 1972)

D. Keene: 'The Sino-Japanese War of 1894–95 and Japanese Culture', *Landscapes and Portraits: Appreciations of Japanese Culture* (Tokyo, 1971), pp. 259–99

Kawasaki Kyosen: *How Actor Prints Are Made* (trans. R. S. Keyes and K. Mizushima in *The Theatrical World of Osaka Prints: A Collection of Eighteenth and Nineteenth Century Japanese Woodblock Prints in the Philadelphia Museum of Art* (Philadelphia, 1973)

R. S. Keyes and K. Mizushima: *The Theatrical World of Osaka Prints: A Collection of Eighteenth and Nineteenth Century Japanese Woodblock Prints in the Philadelphia Museum of Art* (Philadelphia, 1973)

R. Lane: *Images from the Floating World: The Japanese Print, Including an Illustrated Dictionary of Ukiyo-e* (Oxford, 1978)

R. Illing: *The Art of Japanese Prints* (London, 1980)

P. Morse: 'Tokuno's Description of Japanese Print-making', *Essays on Japanese Art Presented to Jack Hillier*, ed. M. Forrer (London, 1982), pp. 125–34

M. Miller Kanda: *Color Woodblock Printmaking: The Traditional Method of Ukiyo-e* (Tokyo, 1989)

T. Akai: 'The Common People and Painting', Eng. trans. by T. Clark, *Tokugawa Japan: The Social and Economic Antecedents of Modern Japan*, ed. C. Nakane and S. Ōishi (Tokyo, 1990)

H. Merritt: *Modern Japanese Woodblock Prints: The Early Years* (Honolulu, 1990)

E. Swinton: *In Battle's Light: Woodblock Prints of Japan's Early Modern Wars* (Worcester, MA, 1991)

S. Thompson and H. D. Harootunian: *Undercurrents in the Floating World: Censorship and Japanese Prints* (New York, 1991)

ELLIS TINIOS

(iii) Historical development.

(a) *c.* 1600–*c.* 1760. (b) *c.* 1760–*c.* 1780. (c) *c.* 1780–*c.* 1800. (d) *c.* 1800–*c.* 1820. (e) *c.* 1820–1868. (f) 1868–*c.* 1900. (g) After *c.* 1900.

(a) c. *1600*–c. *1760.*

Introduction. Although movable type, introduced in the late 16th century (*see* §1 above), continued to be used for official publications until the 19th century, it was largely superseded around 1650 by the more economical woodblock-printing technique, which permitted the quick manufacture of new type when necessary. Moreover,

illustrations were easier to incorporate using blocks rather than movable type.

The diffusion of woodblock-printing in the 17th century owed its success to the socio-political circumstances of the Edo period (1600–1868). The establishment of the Tokugawa shogunate in 1600 had ushered in a period of relative internal peace and economic prosperity after centuries of turmoil. The shogunate divided the population into discrete social groups. Among these the members of the merchant community, however wealthy, were accorded a low status and excluded from official culture. In response, they and the artisans who populated the developing urban centres of the period, such as Edo (now Tokyo), Osaka and Kyoto, sought to create their own cultural milieu. It was this urban class, collectively called *chōnin* ('townspeople') and known for its irrepressible vitality, who established a world of pleasure and entertainment, the *ukiyo* ('floating world'). The lesser samurai also played a part in the development of this alternative culture. They sought heroes and idols, and they found them not only in the energetic actors of the newly emerged *kabuki* theatre— the most important *kabuki* theatres in Edo were founded in 1624, 1634 and the 1660s—but also in the courtesans of the pleasure quarters that grew up at the beginning of the 17th century (Shimabara in Kyoto, Yoshiwara in Edo, and Shinmachi in Osaka). The world of entertainment was further distanced from mainstream society after the Great Meireki Fire of 1657 destroyed much of Edo. The entertainment and theatre districts, considered unsavoury by the central government, were removed to the outskirts of the city, as had been intended before the fire. The Yoshiwara, rebuilt as the Shin Yoshiwara (New Yoshiwara), flourished, providing pleasure and amusement day and night.

Early ukiyoe prints. The most celebrated *kabuki* actors and courtesans formed the principal subject-matter for *ukiyoe* artists in this early period (*see also* §(ii)(b) above). Their prints were enthusiastically received, evidence not only of the popularity of their subjects but also of their capacity to express the aspirations and ideals of the general public. Throughout the Edo period, *ukiyoe* prints recorded the tastes, fashions and way of life of the entire urban class.

Initially, commercial woodblock-printing comprised texts with occasional illustrations. By the mid-17th century, however, imagery had become a necessary part of the text. Book illustrations in this period (*see* §2 above) were produced in Kyoto by artists such as the Kanbun Master (*fl c.* 1660–73) and Yoshida Hanbei (*fl c.* 1665–88). The work of HISHIKAWA MORONOBU and Sugimura Jihei (*fl c.* 1681–1703) of Edo was the most important in crystallizing an *ukiyoe* style in the late 17th century. By the mid-18th century, Edo had become the cradle of the *ukiyoe* movement and compared to other cities it played a particularly instrumental role in the history of the single-sheet print. The works of the masters, in both Kyoto and Edo, whether black-and-white (*sumizurie*: 'ink-print pictures') or hand-coloured, are characterized by their dynamic, clear compositions. By the 18th century compositions had become more complex and more refined, losing, however, much of their expressive force in

166. Torii Kiyonobu I: *Actor Ichikawa Kuzō as Miura Arajirō*, *tane* ('tan picture') print, 295×158 mm, 1718 (Honolulu, HI, Academy of Arts)

the process. Most of these early works were erotic pictures (*shunga*: 'spring pictures'), finely engraved and printed on high-quality paper. These prints continued to be produced throughout the Edo period, in books and later also in broadsheets, with designs by such artists as Moronobu, KITAGAWA UTAMARO, SUZUKI HARUNOBU and KATSU-SHIKA HOKUSAI.

The spread of *ukiyo* imagery from book format to independent sheets occurred in the late 17th century. An early example is Moronobu's *Yoshiwara no tei* ('Images of the Yoshiwara'), a series of 12 large black-and-white prints (late 17th century; Tokyo, N. Mus.) in the *ōban* format ('large format', *c.* 380×260 mm). Not long afterwards the first broadsheets of actors (*yakushae*) were produced (around the end of the 17th century). Their establishment as a genre is ascribed to the first-generation head of the Torii studio, Torii Kiyonobu I (*see* TORII, (1)). Kiyonobu quickly secured for the Torii school the monopoly of the

production of theatre placards (up to 3×1 m) to be posted in front of *kabuki* theatres. Although few of these placards survive, an impression of them can be gleaned from contemporary printed broadsheets and *banzuke* (playbills) showing actors, captured in a moment of action or dance, yet portrayed as impressive, solemn figures. The impact of these prints derives from their size, which is considerably larger than the standard *ōban* that appeared much later, and from the characteristically simple composition of a single standing figure with patterned garments. Most of the actors are identified by their names, which sometimes appear on the print, and by their actor crest, pictured in the upper portion or at the side of the composition as well as on the actor's garment. In the *Actor Ichikawa Kuzō as Miura Arajirō* by Torii Kiyonobu I (see fig. 166), the crest is seen both in the upper portion of the print and on the actor's costume; his name appears to the left. From *c.* 1700 onwards, prints were frequently hand-coloured with a red pigment (*tan*), hence their name, *tane* ('tan pictures').

167. Kaigetsudō Dohan: *Standing Beauty*, *sumizurie* ('black-and-white ink-printed picture'), *ōban* (large format), *c.* 380×260 mm, early 17th century (New York, Metropolitan Museum of Art)

The Torii school remained largely faithful to the stylistic model established by Kiyonobu until the second half of the 18th century. However, they reduced their print formats in 1725 in response to government edicts of 1720 restricting printing, they introduced printed colour in 1745, and they refined the style and employed improved technology to create more detailed representations. For all their fidelity to tradition, the prints created during the 1730s by the early Torii masters—Torii Kiyomasu II (see TORII, (4)), Torii Kiyonobu II (*fl* 1725–*c.* 1760) and Torii Kiyoshige (see TORII, (5)) among them—had lost much of the vigour of early actor portraits.

The early Torii masters also executed vigorously designed portraits of beautiful women (*bijinga*), similar in style and presentation to those of actors. Kiyonobu's ideal of full-faced beauties was a particular source of inspiration to numerous later printmakers such as OKUMURA MASANOBU and the Kaigetsudō studio. Founded by Kaigetsudō Andō (see KAIGETSUDŌ, (1)) in the early 18th century, the members of the Kaigetsudō school at first specialized in portraits of beauties, but they produced relatively few prints compared to the number of paintings for which they are best known and upon which their prints were based (see §VI, 4(ix)). No woodblock prints by Andō himself survive; those extant are by his followers Kaigetsudō Dohan (see KAIGETSUDŌ, (3)), Kaigetsudō Doshin (*fl* 1710s) and Kaigetsudō Anchi (see KAIGETSUDŌ, (2)). From 1704 to 1720 they produced some extremely important black-and-white prints in which unidentified, inaccessible beauties, clad in fashionable, elegantly decorated kimonos and set against a plain background, are portrayed with sweeping lines (as in the statuesque *Standing Beauty* by Kaigetsudō Dohan; see fig. 167). Like actor prints, most of these prints of beauties went to the rich merchants of large cities.

Effects of government restrictions of 1720. In 1720 the government imposed restrictions on the production of prints and books, ordering the reduction of both the size of prints and the use of colour, which was still applied by hand. These measures marked the end of the large-format print. Courtesans and actors (including those who played feminine roles) were thereafter represented in prints of smaller, narrower format (*hosoban*; 'narrow prints'; usually *c.* 300×140 mm). The subject's features therefore appeared thinner and weaker, although the artist compensated for this by giving close attention to detail.

Government restrictions seemed to stimulate creative solutions such as the *hashirae* ('pillar picture'), a new, very narrow format (usually *c.* 680–730×130–160 mm). The unusual shape of the *hashirae* inspired artists to produce interesting and daring compositions, such as full-length figures cropped on one side. An example of slightly later date is the *Actor Onoe Kikugorō as Kichisa* by Okumura Masanobu (1744; Honolulu, HI, Acad. A.). The pillar print flourished from the second half of the 1760s, in the hands of such artists as Suzuki Harunobu, ISODA KŌRYŪSAI, ISHIKAWA TOYONOBU and later of Torii Kiyonaga (see TORII, (8)) and Kitagawa Utamaro. Okumura's *Onoe Kikugorō* is hand-coloured and an example of another genre that gained popularity in the 1720s; the *urushie* ('lacquer picture'). The *urushie* artist replicated the appearance of black lacquer by applying glue to areas printed in

black, such as for the hair and kimono patterns and contours. About 1720 too, the first *benie* ('beni pictures') were made; these were prints coloured by hand using the pink pigment of the safflower plant (*Carthamus tinctorius*; Jap. *benibana*).

The vogue for both *urushie* and *benie* continued until about 1740. Spanning this period was the work of the *ukiyoe* print designer Okumura Toshinobu (*c.* 1717–42), one of the few pupils of Masanobu. Most of his works depicted actors, principally *onnagata* (actors in female roles) or beauties. In his *Yuagari bijin to niwatori* ('Beauty after the bath and rooster'; *ōban urushie*; Tokyo, N. Mus.), the woman is loosely draped in her kimono, her nude torso partially revealed. Prints such as this, called *abunae* ('risqué pictures'), were popular in the mid-18th century.

Perspective prints and Western influence. Toshinobu's teacher, Masanobu, was also notable for designing, in 1739, the first perspective print according to the Western principle of vanishing perspective. This was no doubt introduced via China although already known in Japan from Western books. These *ukie* ('floating pictures' or perspective prints), which were in vogue during the 1740s, used perspective to depict interior scenes, especially of theatres, with relative accuracy. Early *ukie* are best represented by Okumura—his illustration of the interior of the Nakamuraza in Edo, for example—and by Nishimura Shigenaga (?1697–1756), who used perspective to present both interior and exterior views. Examples (both Tokyo, N. Mus.) are the *Shin Yoshiwara tsukimi no zashiki* ('A perspective view of the moon-viewing parlour in the New Yoshiwara'; 332×465 mm; mid-18th century) and the *Ukie gosairei Karajin gyōretsu e* ('Perspective print of the festival procession of Chinese [*sic*: in fact Koreans]'). The notion of perspective was explored further in the 1760s and 1770s by such artists as Utagawa Toyoharu (*see* UTAGAWA, (1)), the founder of the Utagawa studio, who illustrated not only Japanese but also Western subjects, incorporating landscape elements in the background (e.g. *Oranda ukie sunadori no zu*; 'Perspective picture of Dutch fishing'; Leiden, Rijksmus. Vlkenknd.). Prints such as this demonstrate the impact of Dutch studies (*rangaku*; 'Western studies') on the work of numerous artists after 1720, when the eighth Tokugawa shogun, Yoshimune (1684–1751), repealed the ban on Western books unrelated to Christianity.

Nishikawa Sukenobu. From 1720 to 1750, the Kamigata (Kyoto–Osaka region) print designer Nishikawa Sukenobu introduced, in his designs for illustrated books (for illustration *see* NISHIKAWA SUKENOBU), albums and paintings a totally new feminine image. His women are very young, barely out of adolescence, petite and, above all, elegant and extremely graceful. This ideal of feminine beauty was a shift away from the statuesque beauties of the early Torii and the Kaigetsudō masters. Sukenobu's style was taken up by Edo artists, most notably by Harunobu from 1765 onwards. Sukenobu's printed works were all in black and white, although at that time several techniques of hand-colouring broadsheets were being developed.

Early colour printing. Printing with colour, although known in illustrated books since the introduction of the

system of registration (*kentō*) by the Edo publisher Emiya in 1744 (*see* §2(i) above), had yet to be used in broadsheets. By 1745 printmakers were using colour, albeit with a restricted palette, characteristically pink and green. Called *benizure* ('pink-printed pictures'), these prints were popular from *c.* 1740 until the 1760s. From 1750 to 1760, for example, numerous examples of *hosoban benizure* were published, designed by such Torii-school artists as Kiyonobu II, Kiyomasu II, Kiyohiro, Kiyotsune and Kiyomitsu I, as well as Suzuki Harunobu, Ishikawa Toyonobu and Nishimura Shigenaga. Between 1740 and 1750 Toyonobu and Shigenaga had already produced many *hosoban* prints representing actors in successful roles.

(b) c. 1760–c. 1780.

Development of full-colour printing. By 1765 the process of full-colour printing on single sheets was sufficiently advanced to permit a theoretically infinite number of colours. Suzuki Harunobu figured prominently in the diffusion of full-colour printing. In 1765 he and other artists, such as Tachibana Minkō (*fl* 1760s–70s) and Komatsuken (*d* 1794), were commissioned to design the compositions for a series of full-colour pictorial calendars (*egoyomi*) issued privately for various different patrons and

168. Isoda Koryūsai: *Interior of Kyokumaruya*, from the series *Hinagata wakana no hatsumoyō* ('First designs of the young leaves, in pattern form'), *nishikie* ('brocade print'), 389×264 mm, late 1770s (Tokyo, Riccar Art Museum)

published on the occasion of the New Year for distribution to members of poetry clubs. In these new, polychromatic works, called *Azuma nishikie* ('brocade prints of the eastern capital') for their iridescent coloration, Harunobu adopted the youthful feminine image pioneered by Sukenobu (*see* §(a) above). Soon these pieces were commercially released, establishing the market for the full-colour print, which then experienced a rapid diffusion, parallel with advancing technology. The calendar designs in the series *Zashiki hakkei* ('Eight parlour views'; Chicago, IL, A. Inst.) were the work of Harunobu. The series was executed in the new *chūban* ('middle format', *c.* 260×190 mm) and classed as *surimono* (literally 'printed object' but in fact de luxe prints). Sukenobu's influence on Harunobu's representation of women is clearly evident. Initially the series was published privately, with only the name of the patron and originator of the design project, Kyosen, on the prints. It was later printed commercially, first without Kyosen's name and later with that of Harunobu only.

The refinement of the polychrome print and the new style of representing beautiful women epitomize what is meant by *ukiyoe*. Harunobu specialized in depicting the svelte wives of rich merchants, courtesans of the Yoshiwara or even episodes from classical literature, set against background scenes, as did his followers Suzuki Harushige (*see* SHIBA KŌKAN), Isoda Koryūsai, Yamamoto Fujinobu (*fl* 1751–72), Tanaka Masanobu (*fl* 1770–75) and, less directly, IPPITSUSAI BUNCHŌ. These artists were unmistakably influenced by Harunobu's manner of portraying petite women, although Kōkan and Koryūsai among others eventually developed their own individualistic styles. Kōkan was especially drawn to Western techniques, while Koryūsai leaned towards interesting compositions of groups of women, as in his master series, the *Hinagata wakana no hatsumoyō* ('First designs of the young leaves, in pattern form'; over 140 designs, each 389×264 mm; late 1770s; Tokyo, Riccar A. Mus.). The series, which was continued by Torii Kiyonaga, depicts courtesans (the 'young leaves' of the title) wearing the fashions of the New Year. In one print in the series (see fig. 168), the three courtesans of the 'greenhouse' (brothel) called Kyokumaruya are shown admiring a kimono lining decorated with a picture of Mt Fuji.

Katsukawa school. Contemporary with *bijinga* was a new wave of actor prints, executed by such artists as Bunchō and Katsukawa Shunshō (*see* KATSUKAWA, (1)), which exploited the expressive potential of the polychrome print. Bunchō, an independent, and Shunshō, the founder of the Katsukawa school, are highly regarded for their realistic, lively treatment of the subject, in which aspects of the actor's persona were readily identifiable (e.g. Shunshō's pentaptych illustrating *kabuki* actors of the Nakamura, Onoue, Ichikawa and Sawamura familes in their roles in the popular play *Sukeroku*; Berlin, Staatsbib. Preuss. Kultbes.).

Their style was immediately successful, notably because it differed so markedly from the work of the traditional Torii studio, which was less advanced in terms of range of colours, register and other printmaking techniques. However, the success of the Katsukawa studio was mainly due to the appeal that their work held for the increasing

169. Katsukawa Shunshō: *Actor Sawamura Sōjūrō III Preparing for a Fight*, polychrome print with surface polishing on hair, left section of a *hosoban* (narrow format) diptych, 309×139 mm, 1780s (Amsterdam, Rijksmuseum)

number of fans of the actors they portrayed, those wealthy merchants who were the principal theatre-goers in the second half of the 18th century. These fans formed clubs dedicated to their favourite actors and were keen buyers of the portraits that showed their idols, whose repertory they knew by heart, in successful roles. For them, to mention in a print an actor's name or his roles, as the Torii masters had done, was superfluous; what they expected to find were expressive attitudes, scenes of pathos and characters in poses of violent confrontation. Such was the

content of the prints of the Katsukawa masters, beginning with Shunshō (e.g. the *Actor Sawamura Sōjūrō III Preparing for a Fight*; see fig. 169) and continuing with his followers, such as Shunkō (*see* KATSUKAWA, (2)), Shun'ei (for illustration *see* KATSUKAWA, (3)), Shunjō (*d* 1787) and Shunsen (*see* KATSUKAWA, (5)). The elevated prices charged for luxuriously printed pieces by the Katsukawa did not in any way impede their sale.

Shunshō and his followers, like most of their contemporaries, used the *hosoban* and then, from the end of the 1770s, the *ōban* format, which, because of the standardization of paper sizes and various technical constraints, continued to be the most common print size throughout the 19th century. Many *ōban* compositions featured detailed backgrounds such as building interiors, theatre props or realistic landscapes. In the *Actor Otani Hiroji III Backstage* by Shunshō (Chicago, IL, A. Inst.), the actor is shown seated, putting on make-up backstage in the company of two other men; on a shelf in the background is his costume box. The *ōban* actor prints of this period were also executed in the form of diptychs, triptychs or pentaptychs, in which the background spread continuously across the sheets, and by 1785 the same was true of prints of women and courtesans.

Beside these, the Torii actor prints soon appeared antiquated, although their limited polychromatization made them cheaper and thus more accessible to the general public. The rich theatre-lovers of 1770–89, however, were ready to pay for a more extensive palette, higher-quality paper and the larger *ōban* format, the more so because the *ōban* offered a great range of expressive possibilities. Here art and life imitated each other: men might behave in the *aragoto* ('rough stuff') theatrical manner that represented brute force (*see* §XIII below) and women like *onnagata* (actors in female roles). The prints were the medium for conveying and emphasizing such modes of behaviour.

A compositional format that gained popularity around this time was the *ōkubie* ('large-head picture'), in which the head of the character filled the entire frame of the image. It is believed that Katsukawa Shunkō's untitled series of five actor portraits in 1789 marked the first appearance of single-sheet *ōkubie*, a format later used for pictures of courtesans too. The *ōkubie* was an adaptation of existing formats, not an innovation. In the print by Harunobu of a *Fan Vendor* (see fig. 170) the fans on the vendor's cart include one illustrated with an actor *ōkubie*, suggesting that the format may have already been in use before Shunkō created his series—which nevertheless helped to develop the actor print.

In addition to actor prints, which were the mainstay of the Katsukawa repertory, members of the school in the 18th century, such as Shunchō and Shunzan, also created competent portrayals of beautiful women. Yet another theme adopted by the school and received enthusiastically was the depiction of *sumo* wrestlers. In the Edo period, *sumo*, hitherto principally a religious ritual, became a sport fervently followed by the general public and therefore an apt subject for the *ukiyoe* print designer. Independent prints of *sumo*—tournaments, wrestlers—were relatively unusual before the sport gained popularity in the 1780s, when the theme was taken up by Katsukawa Shunshō (a

170. Suzuki Harunobu: *Fan Vendor*, polychrome print, 282×214 mm, 1760s (Berlin, Museum für Ostasiatische Kunst)

great fan of the gargantuan wrestler Tanikaze) and continued by his followers (for example Shunkō's print of the *Sumo Wrestlers Tanikaze, Edogasaki and Kashiwado*; late 18th century; Tokyo, N. Mus.).

(c) c. 1780–c. 1800.

Introduction. In the 1780s prosperous merchants frequently profited from speculation in the wake of poor harvests and other natural catastrophes. In 1788 the reforms of the Kansei era (1789–1801) sought to restore the economy by restricting luxury consumption, and in the next few years many artists, writers and publishers, such as the publisher Tsutaya Jūzaburō, fell victim to these laws. Moreover, after 1791 prints were required to carry censorship seals (*kiwame*). Nevertheless, far from being stifled by such circumscription, artistic creativity seems to have been stimulated, and continuing technical improvements gave a boost to the art of printmaking.

Incomparably expressive actor prints were executed in the 1780s and 1790s by such artists as Tōshūsai Sharaku (for illustration *see* TŌSHŪSAI SHARAKU) and the Utagawa-school print designers Toyokuni (for illustration *see* UTAGAWA, (2)) and Kunimasa (*see* UTAGAWA, (3)). Change was also evident in the theme of beautiful women. After the period of the 'woman–child' created by Harunobu and his followers, there had been a return in the 1770s to the ideal of the older, more mature woman, of normal size and proportion. This image of feminine beauty persisted throughout the decade and was epitomized in the work of

KITAO SHIGEMASA and his followers Kitao Masanobu (for illustration *see* KITAO MASANOBU), better known in Japan as the fiction writer Santō Kyōden, and Kitao Masayoshi (1764–1824). Shigemasa's series *Tōhō nanboku no bijin* ('Beauties of east, west, south and north') and Masayoshi's print *Willow Branch* (18th century; Tokyo, N. Mus.) are examples. Hairstyles and dress depicted in prints also reflected the shifts in fashion. During Harunobu's time, hair had often been worn pulled straight back and arranged into a variety of short twists, fastened by a large comb and pins. In the 1770s beauties wore their hair in high chignons attached by pins and combs, and side locks were pulled over whalebone supports that extended them out to the sides. In the 1780s, however, the silhouettes became elongated, even long-limbed, perhaps reflecting the effects of the famine that ravaged the country. This type was promoted especially by Torii Kiyonaga, who remained influential until the 1790s (e.g. his triptych *Women Visiting Enoshima*, c. 1785–8; London, BM), and by Katsukawa Shunchō (*see* KATSUKAWA, (4); e.g. the *Seven Sages in Modern Dress*, c. 1788; London, BM).

Kitagawa Utamaro and his contemporaries. It was KITA-GAWA UTAMARO, indebted stylistically to Kiyonaga, who played the key role in the depiction of women in the late 18th century. After executing numerous *ōkubie* portraits of well-known courtesans in the early 1790s—such as *Fujō ninsō juppin* ('Ten physiognomical aspects of women'), which continued as *Fujin sōgaku juttei* ('Ten physiognomical types of women')—he devoted many series to portraits of unidentified ordinary women going about their daily activities (for example the *ōban* triptych *Drying* or the *ōban* diptych of *Kitchen Beauties* (both Tokyo, N. Mus.). The public had always been willing to purchase portraits of fashionable, high-ranking courtesans, popular geishas, women engaged in elegant pastimes and celebrated beauties such as Ohisa, the hostess of the Edo tea house of Takashimaya near Ryōgoku Bridge and a favourite subject of Utamaro (e.g. the *Beauty Ohisa*, c. 1792–3; London, BM). The representation of an unknown woman, endowed with expression and feeling, was, however, new and significant. Such portraits ceased to be mere facets of popular culture and rose to attain a higher level of artistic expression.

Contemporary with Utamaro were a number of competent artists who also specialized in portraits of women, including EISHŌSAI CHŌKI, HOSODA EISHI and his pupils Chōkōsai Eishō (*fl* 1793–9), Hosoda Eiri (*fl* c. 1790–1800) and Ichirakutei Eisui (*fl* 1797–1804). While these artists may have been indebted to the *bijinga* tradition established by Kiyonaga and Utamaro in their choice of compositional format (e.g. *ōkubie*), their handling of the subject was strikingly different. Eishi's portraits of exceptionally refined beauties rivalled those of Utamaro. Eishō pursued an individualistic style, preferring a rather more robust and down-to-earth ideal of feminine beauty, as seen in the triptych *Zashiki bon odori* ('The Buddhist Feast of Lanterns [*bon*] in a tea house'; Tokyo, N. Mus.). Chōki's distinctive beauties were characteristically slender; the rare *Catching Fireflies* (mid-1790s; Honolulu, HI, Acad. A.), in which the fireflies shimmer against a grey mica ground, is typical.

Verse illustrations. Another stage in the evolution of the woodblock print was marked by the *haiku* verses published in the late 1770s by amateur poets. They contained illustrations unconnected with the usual *ukiyoe* subjects and created by artists of other established schools, such as the naturalistic Maruyama–Shijō and the literati (*Nanga*) schools (*see* §VI, 4(viii) and (vi(e)) above). The de luxe prints known as *surimono* were frequently augmented with poems, unlike pictorial calendars (*egoyomi*), which had no text. *Surimono* production began in the 1790s. Whereas single-sheet prints were sold by commercial publishers, *surimono* remained within the milieu of poetry clubs. Being privately published, they were made with the most sumptuous materials and the most refined printing techniques. They were often commissioned by an amateur poet who wanted to illustrate a poem and would suggest ideas to the artist. Particularly at the New Year, poets sought to outdo each other in devising ever more beautiful *surimono* with increasingly lavish designs. Several artists produced exquisite examples, such as KUBO SHUNMAN, with his *Three Women Enjoying a New-Year Surimono* (late 1790s; New York, Pub. Lib.), and Katsushika Hokusai, who, with Kitao Masanobu, designed *Courtesans and Attendants Watching a Cuckoo* (late 1790s; Dublin, Chester Beatty Lib.).

Nagasaki prints. In the 18th century the city of Nagasaki was an important centre for *rangaku* (Dutch or Western studies) and for the importation of culture both from the West and from China. After 1639, the Chinese and Dutch were the only foreigners permitted to reside in Japan, and they were restricted to enclosed compounds in Nagasaki. When domestic travel restrictions were eased somewhat in the Edo period, many Japanese went to Nagasaki in the hope of glimpsing its foreign residents. In response to the demand for images of these foreign residents, Nagasaki publishers and artists developed their own type of woodblock prints called *Nagasaki miyage* ('Nagasaki souvenirs'), which featured as subjects the customs, appearance and even the ships of the Chinese and the Dutch; standard motifs were often reused in different prints (*see* NAGASAKI, §2). The origins of Nagasaki prints are unknown but may extend as far back as the mid-17th century, to such pieces as the *World Map and Peoples of Various Lands* (?1645; block print with added tempera; Kobe, City Mus.). The heyday of *Nagasaki miyage* was the period from the end of the 18th century to the mid-19th.

Nagasaki prints did not have the sophistication of those produced in Edo, being characterized by naivety both in composition and in execution. Simple methods were used to apply colour to the early examples, which were printed on poor-quality Chinese paper by techniques similar to those of Chinese Suzhou woodblock prints (*see* CHINA, §XIII, 19). In the early 19th century a stencil method gained widespread popularity because it facilitated quick production; it was eventually eclipsed by the technique of full-colour printing imported by the Edo print designer Isono Bunsai (*d* 1857). Bunsai, said to have studied in Edo with Keisai Eisen (1790–1848), the main *bijinga* artist of his time, is one of the few known artists of Nagasaki prints. By both marriage and adoption he gained entry

into the Yamatoya, one of the prominent Nagasaki publishing houses in the mid-1830s, which published some of the most accomplished Nagasaki prints. One such is the anonymous *Oranda fujin no zu* ('Dutch women'; 1818; Kobe, City Mus. Nanban A.,), which depicts Mevrouw Cock Blomhoff, who arrived in Japan in the 1810s with her infant son but, because shogunal policy barred foreign women in Nagasaki, was soon deported. The impact of Bunsai on the evolution of Nagasaki prints was such that their production ceased within a few years of his death, although another factor contributing to their demise was the opening of the country to the West in the 1850s.

(d) c. 1800–c. 1820.

Introduction. In the period 1789–1801 (the Kansei era), the Japanese woodblock print had reached the summit of its stylistic evolution, especially in the treatment of the traditional themes of the *kabuki* theatre and beautiful women. The technical potential of the woodblock printing process appeared to be fully exploited by the Kansei era, in particular in the printing of harmonious colours (*see* §(i) above), making the Japanese woodblock print the most advanced in the world. By the beginning of the 19th century, however, the artistic future of the Japanese print seemed uncertain. When Utamaro died in 1806, he left several students who continued to design prints (e.g. Kitagawa Utamaro II, *d* 1831; *Mitate Scene from the Drama Imoseyama, ōban* triptych, n.d., Tokyo, N. Mus.), but they added nothing to the innovative style already established by their master. In the field of actor prints, the Torii tradition virtually died out with Kiyonaga's defection to *bijinga* in the 1780s. His pupil and successor, the fifth-generation head of the Torii school, Kiyomine or Kiyomitsu II (1787–1868), to whose development Kiyonaga devoted himself in the last years of his life, created a few theatre prints, but his principal work consisted of beauties in the style of Kiyonaga, as in his series *Azuma nishiki bijin awase* ('Brocade pictures of beauties of the East compared'; 1808). By the early 19th century the Katsukawa school was all but dead, and those few members who were still working—Katsukawa Shuntei (1770–1820) and Katsukawa Shunsen (*c.* 1782–98, for example—were hardly carrying on the tradition of actor prints. Shuntei produced not only portraits of actors and beauties and a number of warrior prints but also some Western-style landscapes, such as the series *Ōmi hakkei* ('Eight views [of Lake Biwa] in Ōmi Province'; Tokyo, N. Mus.). The masters of certain other schools, such as Kitao Shigemasa, had almost ceased to design prints.

Utagawa Toyokuni, Katsushika Hokusai and their contemporaries. The most promising print designers of the first years of the 19th century were Utagawa Toyokuni I (*see* UTAGAWA, (2)) and KATSUSHIKA HOKUSAI. While Toyokuni occupied an important role as head of the Utagawa school, he had accomplished his finest works in the 1790s, as is shown by the superb series *Yakusha butai no sugatae* ('Actors on the stage'; *c.* 1794–5; Tokyo, N. Mus.), which testified to his ability to produce 'likeness' portraits of individual actors. By the early 19th century his style was beginning to border on Mannerism, and his actor portraits were noticeably weaker, although there were

times when he regained artistic inspiration (e.g. *Actor Ichikawa Danzō IV*; *c.* 1804; see Gotō, pl. 165). Hokusai worked for most of the 1790s on private commissions from amateur poets or poetry circles, who published *surimono* and albums after his print designs. These prints were not distributed through commercial outlets, and therefore Hokusai's work was not at this time acknowledged by the general public. He continued to create *surimono* into the 19th century, using in the 1810s the square format (*shikishiban*) that found favour from about 1808. From about 1805 he began making many commercial prints, mostly cheaply produced landscapes, but his main works for the general public before about 1812 consisted of illustrations of popular novels of the *gohanmono* type (a type of fiction usually based on historical themes) by the foremost writers of the day. His style was constantly developing: in the celebrated volumes of the (*Denshin kaishu*) *Hokusai manga* ('Hokusai sketches'; 1814–20; London, BM) he was already experimenting with the possibilities of landscape. Nonetheless Hokusai's real impact on Japanese art came later, with his superb refinement of the landscape print.

Toyokuni, Hokusai and their followers, such as the Utagawa school and Hokusai's pupil Shōtei Hokuju (*b* 1763), became agents of an important evolution in *ukiyoe* at the beginning of the 19th century, when economic prosperity permitted polychrome woodblock prints of a high quality to be made available to a wider section of the public than hitherto. Large runs of carefully executed prints were released and sold for a modest price. The resulting increase in demand explains why so many repetitive works by artists such as OKUDA EISEN, Eizan and Shunsen (*see* KATSUKAWA, (5)) were published and why a great master such as Toyokuni was able to survive as a print designer so long after the peak of his career.

The print-buying public at this time were not, however, party to the intellectual culture that characterized the late 18th century; unfamiliar with the theatre and its performers, they required the names of actors and their roles to appear for identification on prints. Untitled portraits of anonymous women generally left the public indifferent, while the print market was inundated with thousands of prints depicting the known courtesans who paraded on the main avenue of the pleasure quarters. Such prints were produced by Kitagawa Utamaro II, Hidemaro II (*fl* early 19th century), Kikumaro, Torii Kiyomine, Kikugawa Eizan, Keisai Eisen and others, with only subtle stylistic differences between one artist and another. Faces and attitudes varied little, but all the prints tended to reflect the current public interest in vivid, multicoloured kimono patterns: for example Eizan's series of three prints, *Fūryū meisho setsugekka* ('Famous views of elegance: snow, moon and flower'; 1810), or Eisen's *ōban* triptych *Night Lantern in Autumn Leaves* (*c.* 1820s; see Gotō, pls 48–50).

Kiyomine, Eisen and Eizan remained the leading *bijinga* artists until the mid-1830s, after which time the genre gradually lost much of its charm. Although quantity and repetition were the order of the day, some attractive designs continued to be made.

Surimono. While large runs of prints were available to the common people, certain prints must have been reserved for the rich merchant class, who required subjects

printed with care and in limited quantity, such as *surimono*. The composing of *kyōka* ('mad verse', a 31-syllable verse form), for which artists such as Hokusai and Kubo Shunman were already receiving design commissions in the 1790s, attained widespread popularity in the 18th century.

In the 1810s and 1820s especially, poetry clubs issued extremely lavish prints in large runs of between about 400 and 2000. These employed the latest technical refinements, notably the use of pulverized metals, the application of mica or relief printing (*see* §(i) above). Their contents too were highly sophisticated: the artistic level of the image, the pleasing integration of the literary allusions with the compositions, the interplay between image and poem, and the internal harmony of the poem itself were all matters of competition between clubs. During this period Shunman and the students of Hokusai, such as Ryūryūkyo Shinsai (*fl* 1799–1823), Toyota Hokkei (1780–1850) and Yashima Gakutei (*fl* 1815–52), were the principal *surimono* artists. Toyohiro, Kunisada and Eisen were also comparatively prolific.

Shinsai ranks as one of the earliest *surimono* designers to render subjects other than people, for example the print published towards the end of his career entitled *Koi yama* ('Carp float (*yama* is the abbreviation of *yamaboko*, meaning 'float'); 1820; Dublin, Chester Beatty Lib.). Like Shinsai, Yashima Gakutei produced little commercial work, instead creating many striking illustrations for poetry anthologies and *surimono*, such as his relatively early work *Morning Glories, Scissors and Porcelain Bowl* (*c*. 1818) or his representation of one of the Seven Gods of Good Fortune, *Daikoku as a Woman with a Rat* (*c*. 1827–8; both Dublin, Chester Beatty Lib.). Inanimate objects and scenes that evoked nature were favourite subjects that lent themselves to intellectual amusement, with the incorporation of associations, allusions and multiple meanings that reflected the culture of their creators and tested the knowledge of their viewers.

Early landscape and historical prints. The early 19th century also witnessed the creation of two print genres, the landscape and the historical theme. In the 18th century landscape had appeared in prints only as an adjunct to the figures. It was first accepted as a subject in its own right in the long *surimono* format (220×550 mm) and in such works as *Fuji over Cherry Blossom* (*c*. early 1800s; Amsterdam, Rijksmus.) and several poetry albums by Hokusai. Artists took inspiration from an extraordinarily popular picaresque novel by Jippensha Ikku (1765–1831), *Tōkaidōchū hizakurige* ('Shanks's mare along the Tokaido'), which was published in annual instalments from 1802 to 1822. It describes the ribald adventures of two rogues, Kita and Yaji, as they travel along the Tokaido, the major highway between Edo and Kyoto. The novel's success immediately prompted a number of artists to illustrate the landscapes described in the story. Even Utamaro and Toyokuni added landscapes in cartouches to their prints of beauties and actors. During the first decades of the 19th century, Hokusai alone probably designed seven complete series of the *Tōkaidō gōjusantsugi no uchi* ('Fifty-three stages on the Tokaido'), mostly in a rather small format like his other landscapes of this period. In the

1820s several of his students, for example Shinsai and Hokuju, were producing prints exclusively of landscapes aimed at a relatively well-to-do public, while at the same time many artists outside Hokusai's circle, such as Chōki and Eishō, were making Tokaido series.

(e) c. 1820–1868.

Landscape prints: Hokusai and Hiroshige. The commercial breakthrough of the landscape print came in the early 1830s with Hokusai's series *Fugaku sanjūrokkei* ('Thirty-six views of Mt Fuji'; Tokyo, N. Mus.), the first set of landscape prints destined for the general public. After a first group of some ten prints were issued, the publisher, Nishimurai Yohachi, announced a series in the *ōban* format entirely printed in diverse tones of Prussian blue dye. Unlike blue vegetable dye, which rapidly fades to a buff tone, Prussian blue is not fugitive. The new dye had appeared in Japan at the end of the 18th century and was initially used in painting, although it was also used in rare examples of prints in the 1810s and 1820s. Hokusai's series, however, was the first large-scale application of the colour in prints. The publicity associated with the exotic new dye created a demand that justified the elevated production costs. The popularity of prints using Prussian blue, known as *aizurie* ('indigo-printed pictures' or 'blue pictures'), spread to subjects other than landscapes. Eisen's triptych the *Grand Courtesans Sugatano and Nanabito with Attendants* (*c*. 1830; London, BM), for example, was printed entirely in various blue tones.

Subsequent series by Hokusai (not *aizurie*) were also aimed at a wider audience. These included *Shokoku taki meguri* ('A journey to the famous waterfalls of all the provinces'; *c*. 1832; Tokyo, N. Mus.), *Shokoku meikyō kiran* ('A journey along the bridges in all the provinces'; *c*. 1831–2) and *Shika shashinkyō* ('A true mirror of Chinese and Japanese poems'; *c*.1828–33), as well as some series dedicated to birds and flowers.

While landscape was only one of many genres for which Hokusai was celebrated, it was ANDŌ HIROSHIGE's chief claim to fame. Perceiving that the public had enthusiastically accepted the genre, in 1833 he created his own series of the *Tōkaidō gojūsantsugi no uchi* ('Fifty-three stages on the Tokaido'; Tokyo, N. Mus.), which quickly won him acclaim. While Hokusai's publishers were located in central Edo, Hiroshige initially worked for such publishing houses as Iwatoya, Nishimura and Daikokuya, which were situated at points of exit on the periphery of the city. Many of his buyers were travellers leaving Edo who wanted to take with them a souvenir of the administrative capital; consequently, the more popular prints were produced in tens of thousands. Such extraordinary success encouraged him to create other well-known series such as the *Meisho Edo hyakkei* ('One hundred views of Edo'; 1856–9), parts of which would later be reproduced by the Dutch artist Vincent van Gogh, and *Ōmi hakkei no uchi* ('Eight views [of Lake Biwa] in Ōmi Province'; *c*. 1834). This overabundant productivity—due perhaps more to pressure from his publisher and enormous public demand than to personal inspiration—sometimes incurred a cost in terms of quality. The artist's talent is clearly revealed only in the relatively

rare examples of his designs that were accorded the best printing techniques.

Utagawa school. Hiroshige was a pupil of the Utagawa school, which was perhaps the foremost print studio throughout the 19th century (*see also* §(d) above). The studio was established in the 18th century by Toyoharu and further developed by his pupil Toyokuni I. Their followers rank among the most important artists of the 19th century: Kunimasa (*see* UTAGAWA, (3)), noted for his large-head portraits; Toyohiro (*see* UTAGAWA, (4)), perhaps best known as the teacher of Hiroshige; and Kunisada I and Kuniyoshi (*see* UTAGAWA, (5) and (6)). Several less prominent students of these masters, particularly of Toyokuni, were also active, among them Toyokuni II (1777–1835), Kuninaga (*d* 1829), Kuninao (1793–1854), Kunitora (*fl* early 19th century), and Kuniyasu (1794–1832) and his students such as Kunihiro (*fl c.* 1815–43).

The principal masters of the Utagawa school were prodigiously productive: Hiroshige's total output is estimated at about 40,000 works, Kunisada's at 50,000 and Kuniyoshi's at about 20,000. This compares with Harunobu and Utamaro, who made about 1000 and 2000 print designs respectively. The huge upsurge in demand for prints in the 19th century was thus matched with a corresponding increase in supply. In the 18th century there had been about 200 print designers; in the 19th, the Utagawa studios alone comprised more than 450 artists. Similarly, the number of publishers rose from a few dozen to many hundreds.

Within the Utagawa studio, artists were not always restricted to a specialized genre. Though primarily a landscape artist, Hiroshige also designed historical and actor prints. These were the speciality of Kuniyoshi and Kunisada, who nevertheless both executed landscape prints and included naturalistic landscape settings in their prints of actors, courtesans and historical themes when this became fashionable in the 1840s. Initially Kunisada and Kuniyoshi produced prints of actors and beauties in a style established by Toyokuni, characterized by somewhat elongated faces, bold expressions and elaborate costumes. From the 1820s until his death in 1864 Kunisada dominated this field. While adapting himself to the demands of the public, he was able to follow his own artistic inclinations. Even in his routine work, he was at pains to create surprising compositions and to find a balance between ubiquitous character types and individual portraits. Even though large numbers of almost identical Kunisada prints were produced, most at least engage the attention of the viewer.

Kuniyoshi's first print based on a historical warrior theme (*mushae*) was the triptych *Ghost of Taira no Tomomori at Daimotsu Bay* (*c.* 1818; Springfield, MA, Mus. F.A.), but it was not until the late 1820s that he achieved great success in this genre, with the publication (1827–30) of his single-sheet prints of the 108 heroes of the Chinese novel *Shui hu zhuan* ('Tales of the water margin'; translated and adapted as *Suikoden* by the Japanese novelist Takizawa Bakin (1767–1848) and published in serial form). Kuniyoshi's choice of theme was prompted by the favourable reception of Hokusai's 91-volume version, *Shinpen Suikogaden* ('Illustrated new edition of the *Suikoden*'; 1805–

35; London, BM), of which Hokusai completed 61 volumes and his student Taito II (*fl* 1810–53) the others. Such was the popularity of Kuniyoshi's work that some of his admirers had their bodies tattooed with representations of his bold *Suikoden* heroes, a number of whom were themselves tattooed. Kuniyoshi's work continued in the same stylistic vein: dramatic episodes illustrating a glorious past, with subjects in fierce and bold attitudes, immortalizing, for example, many of the figures of the battles of the Taira–Minamoto War of 1180–85. He also designed many landscapes, which show the influence of Western perspective, as in the series *Kōso goichidai ryakuzu* ('Abridged biography of the priest Nichiren'; *c.* 1831; Springfield, MA, Mus. F.A.). Perhaps the best-known piece from this series is *Snow at Tsukuhara, Sado Island*, showing the priest Nichiren (1222–82) going into exile. The print is known in two states, one, in Western fashion, with a definite horizon line and one without.

Osaka prints. Whereas Edo was incontestably the centre of *ukiyoe* in the 18th and 19th centuries, the manufacture of woodblock prints in Osaka—traditionally a city of prosperous merchants—had not become widespread until the end of the 18th century. It then flourished particularly in the first half of the 19th century.

The earliest documented Osaka print is a stencilled portrait (*kappazuri*) of 1770, the *Actor Nakamura Utaemon I as the Priest Seigen* by Okamoto Masafusa (*fl* 1751–81). Although Masafusa has been called 'the grandfather of actor portraiture in Osaka' (see Keyes and Mizushima, 1973, p. 24), it was not until the 19th century that the manufacture of prints in Osaka began to thrive. Most Osaka prints from this period portrayed the theatrical world. They were primarily the full-colour *nishikie* ('brocade prints'), although stencil printing, a process unique to the Kamigata region, was employed by artists such as Nagahide (*fl c.* 1804–48), for example *Arashi Kichisaburō II as Yojirō* (1807; Philadelphia, PA, Mus. A.). The first Osaka artist said to have designed full-colour single sheets was Ryūkōsai (*fl* 1782–1816). His rare *hosoban* prints often showed a full-length figure set against a blank or simply decorated background. The style of the left panel of a *hosoban* triptych, the *Actor Onoe Shinshichi I* (1793; Philadelphia, PA, Mus. A.), is reminiscent of the Katsukawa school and may have had an impact on Tōshūsai Sharaku. Ryūkōsai's student Hanbei Shōkōsai (*fl* 1795–1809) was adept in the depiction of actor busts (e.g. the *Actor Nakamura Utaemon III as Hanazono Michitsune*; 1806; Philadelphia, PA, Mus. A.). The Edo-born Nakamura Utaemon III, at the time the premier *kabuki* actor in the *aragoto* ('rough stuff') manner, undoubtedly had a tremendous impact on the production of Osaka prints after his decision to settle there in 1819.

Among the talented pupils of Shōkōsai was Shunkōsai Hokushū (*fl c.* 1808–32), whose *ōban* prints monopolized the Osaka printmaking world in the 1820s. One example is the *Actors Nakamura Utaemon II as Kanawa Gorō Imakuni and Arashi Koroku IV as Omiwa* (1821; Philadelphia, PA, Mus. A.), which employs both gold and vibrant pigments. Such prints show the influence of the Utagawa school and are evidence that, by the first decades of the 19th century, the cutting of the woodblock and the

171. Shunkōsai Hokuei: *Actors Nakamura Utaemon III as Kasahara Roo and Nakamura Shikan II as Miyamoto Musashi*, polychrome print, *ōban* (large format) diptych, each sheet *c.* 380×260 mm, 1835 (Philadelphia, PA, Museum of Art)

printing process were generally more meticulous in Osaka than in Edo. Moreover, higher-quality materials were used, notably metal powders such as gold and silver. It was perhaps these qualities that in the 1820s attracted a number of Edo artists, such as Yanagawa Shigenobu, to Osaka.

When compared to the level of print production in Edo, that of Osaka was low. Between the late 18th century and the 19th approximately 10–15,000 single-sheet designs were produced by some 200 print masters. The number of publishers was consequently quite small, the market generally being dominated by a handful of publishing houses at any given time. Nevertheless, Osaka prints had a unique vigour, and the dramatic power that became characteristic of this tradition was continued by Hokushū's pupil Shunkōsai Hokuei (*fl* 1820s–30s) in such works as the *Actors Nakamura Utaemon III as Kasahara Roo and Nakamura Shikan II as Miyamoto Musashi* (see fig. 171).

The ban on the production of actor prints under the reforms of the Tenpō era (1830–44; see below) severely affected the Osaka market. However, from the late 1840s to the 1860s Osaka prints underwent a revival, thanks largely to the efforts of Utagawa Hirosada (*c.* 1810–64), a native of Osaka who had studied with Utagawa Kunisada in Edo. In 1847 he published the first Osaka actor print to appear in defiance of the restrictive edicts, and this prompted a revival of the genre. Hirosada's bold use of colour and flamboyant style were exploited to the full by

his designs of *kabuki* actors in expressive stances, whether shown in *ōkubie* or in full-length portraits, as in the triptych *Nakamura Utaemon IV as Nuregami Chōgorō, Mimasu Daigorō IV as Oseki, Kataoka Ichizō I as the Wine Seller Kanbei and Jitsukawa Ensaburō as Hanaregoma Chōkichi* (1851; Japan, Ikeda Bunko).

After Hirosada's retirement in 1853, his pupil Hirosada II (n.d.) continued the Osaka tradition, albeit with work of less character. Other active contemporaries in Osaka included Hasegawa Sadanobu I (1809–79) and Utagawa Kunimasu (*fl* 1830–52), and by the late Edo and early Meiji (1868–1912) periods there were a number of Osaka artists who took their names from Utāgawa Kuniyoshi, the most memorable being Utagawa Yoshitaki (1841–99). By the end of the 19th century, however, the Osaka tradition had fallen into decline. At its height there had been constant contacts between Edo and Osaka, not only in the sphere of theatre but also of art, and the artists of both cities influenced each other. For example, Hokusai adapted designs for his book entitled *Hyōsui kiga* (1818; London, BM) from Ryūkōsai's *Gekijō gashi* ('Pictorial history of the theatre'; 1803; London, BM), for which extant blocks were recut and replugged.

Effects of the Tenpō reforms. In the second half of the 19th century, social and political changes as well as natural and agricultural disasters produced an economic crisis, in

which the publication of novels was interrupted and the production of woodblock prints suffered. The Tenpō reforms of 1842 included sumptuary laws, according to which printmakers were required not only to see that prints carried censor seals and dates but also to reduce the size and range of their palette; subjects such as actors and courtesans were banned. The Tenpō reforms were a formidable blow to Kunisada but a godsend for Kuniyoshi, and they added to the success of Hiroshige's landscapes. Other artists such as Eisen adapted blocks from earlier works. He had already been active in producing landscape prints, the best known being the collaborative series with Hiroshige of the *Kisokaidō rokujūkyū tsugi no uchi* ('Sixty-nine stations on the Kisokaido'; late 1830s; Tokyo, N. Mus.). After the Tenpō reforms, Eisen concentrated increasingly on his writing, one of his most notable works being the *Zoku ukiyoe ruikō* ('Miscellaneous thoughts on *ukiyoe*, revised'), an edited version of one of the major *ukiyoe* historical references, *Ukiyoe ruikō* ('Miscellaneous thoughts on *ukiyoe*').

Yokohama prints. When, in the late 1850s, after two centuries of isolation, Japan opened its ports to foreign powers (*see* §I, 3 above), the official commercial trading ports witnessed an influx of foreigners. In Yokohama, a day trip to the south of Edo, curiosity about their appearance, customs, architecture and technology gave birth to a genre of prints called *Yokohamae* ('Yokohama pictures'), although the term refers generally to prints published in Edo by Edo artists between 1859 and the 1870s (*see also* YOKOHAMA, §1). The commercial demand for *Yokohamae* was enormous, particularly in the first three years of publication. It is estimated that during this time alone over 800 designs were published. Yokohama prints were commonly, although not always, published in series of five, after the five nations with which Japan had signed extra-territorial trade treaties (United States, Netherlands, France, Great Britain and Russia), a sixth sometimes being incorporated to represent China. The subject-matter of Yokohama prints was not consistently derived from direct observation. Some employed stereotyped motifs or copied compositional elements, for example European women's dress, from such foreign publications as the American Frank Leslie's *Illustrated Newspaper*, or aspects from Nagasaki prints, which sometimes resulted in eclectic compositions. Yet there are works by such artists as Utagawa Sadahide (1807–73; e.g. *Picture of Western Traders at Yokohama Transporting Merchandise*; 1861; New York, Met.) and Utagawa Yoshikazu (*fl c.* 1850–70; e.g. *English Couple*; 1861; see 1990 exh. cat., fig. 20; this depicts the woman holding a Yokohama print) that are significant not only as historical documents but also as examples of latter-day *ukiyoe*. Many *Yokohamae* artists were students of the Utagawa school: Sadahide and Kunihisa (1832–91) were pupils of Kunisada, Yoshikazu and Yoshitora (*fl c.* 1850–80) of Kuniyoshi, while Hiroshige II (1826–69) and Hiroshige III (1842–94) were relatively undistinguished followers of Andō Hiroshige.

(f) 1868–c. 1900. The beginning of the Meiji period (1868–1912) marked the end of over 250 years of Tokugawa rule and the reinstatement of the direct rule by the emperor. In the wave of ensuing social, political and economic changes, traditional Japanese prints were unable to maintain their former quality, particularly in the face of the national eagerness to modernize, which in practice meant westernize. Print designers, in common with artists of other traditional art forms, found survival in the early Meiji period difficult, but a few managed to continue by adapting to the public's new demands and tastes. For example, TSUKIOKA YOSHITOSHI endeavoured to preserve the tradition of his teacher Kuniyoshi by devoting himself to historical themes. His works often interpret elements of the macabre, the mysterious or even the grotesque in an individualistic fashion hitherto unknown, as in the quietly haunting print of the *Ghost of Genji's Lover* from one of his most accomplished series, *Tsuki hyakushi* ('One hundred aspects of the Moon'; 1885–92; Amsterdam, Rijksmus.). Among Kuniyoshi's students was another master of the bizarre, Kyōsai Kawanabe; his unusual impressionistic style is seen in the series *Kyōsai rakuga* ('Abbreviated pictures by Kyōsai'; 1874; Saitama Prefect., Kyōsai Memorial Museum; Tokyo, Municipal Central Library).

Toyohara Kunichika (1835–1900) trained under Utagawa Kunisada who directly continued the tradition of actor portraits. He was best known for his many series of *ōkubie* actor portraits in the *ōban* format (see fig. 172). He made innovative use of triptychs, often showing either a half-length figure of an actor in close-up or one actor spread out dramatically over the three sheets. Kunichika's reputation has been affected somewhat by his enormous output, but his best work was exciting and flamboyant, and he is remembered as the last great *ukiyoe* ('picture of the floating world') actor print designer.

Many Meiji artists, as well as the public, were conscious of Western art—elements can be seen in the works of both Yoshitoshi and Kyōsai—and many print designers from this period blend Western techniques of realism and atmosphere with Japanese sensibility, regardless of the subject matter. For example, KIYOCHIKA KOBAYASHI produced landscapes (see fig. 173), as well as war scenes and portraits, in a style that reveals his training in both Western and Japanese art but also continues the Edo tradition. His student, Yasuji Inoue (1864–89), in particular, was a skilled designer of Meiji-period scenes and landscapes. He continued, for example, the Edo tradition of illustrating famous places with his contribution to the 1881 series of popular places in Tokyo (USA, priv. col.). Like Kiyochika and many of his contemporaries, Toshikata (1866–1908), a pupil of Yoshitoshi, executed scenes of the Sino-Japanese War of 1894–5 (for example, the triptych of the *Chinese Admiral Ding Su Shang Committing Suicide after the Destruction of the Chinese Fleet*; 1887; USA, priv. col.) and the Russo-Japanese War of 1904–5. However, he was also adept at prints of beauties, training men like Kiyotaka Kaburagi (1878–1973). Kiyotaka would specialize in the re-creation of a nostalgic *bijin* image and like many artists of the period produced numerous illustrations for novels.

Two artists who succeeded in marrying the aesthetic of the West with *ukiyoe* were a pupil of Kunichika, Yōshū Chikanobu (1838–1912; e.g. the series *Shin bijin*, 'True beauties'; 1897; USA, priv. col.), and Gekkō Ogata (1859–

172. Toyohara Kunichika: *ōkubie* actor portrait from the *Danjūrō hyakkaban* ('One hundred roles of Ichikawa Danjūrō') series, polychrome print, *ōban* (large format), *c*. 380×260 mm, *c*. 1894–8

173. Kiyochika Kobayashi: *Night on the Sumidagawa*, polychrome print, *ōban* (large format), *c.* 380×260 mm, 1893 (Kamakura, Kanagawa Prefectural Museum of Art)

1920; e.g. the series *Bijin meisho awase*, 'Beauties at famous places, compared'; 1897–1901; USA, priv. col.). Each of these artists and others were important transitional figures in the evolution of the print in the late 19th century and while the rupture with the purely traditional world of *ukiyoe* was clearly irreparable, their early work set the stage for developments in the early 20th century (*see* §2(ii) below).

BIBLIOGRAPHY

E. F. Strange: *Japanese Colour Prints* (London, 1904, rev. 3/1923)
B. Steward: *Subjects Portrayed in Japanese Prints: A Collector's Guide to all the Subjects Illustrated* (London and New York, 1922)
L. Binyon and J. O'Brien Sexton: *Japanese Colour Prints* (London, 1923, rev. 3/1972)
J. Kurth: *Die Geschichte des japanischen Holzschnitts*, 3 vols (Leipzig, 1925–9)
T. Kondo, ed.: *Ukiyoe zenshū* [Complete collection of *ukiyoe*], 6 vols (Tokyo, 1956–8)
D. B. Waterhouse: *Harunobu and his Age: The Development of Colour Printing in Japan* (London, 1964)
H. C. Gunsaulus: *Harunobu, Koryūsai, Shigemasa and their Followers and Contemporaries* (1965), ii of *The Clarence Buckingham Collection of Japanese Prints* (Chicago, 1955–65)
T. Yoshida: *Ukiyoe jiten* [Dictionary of *ukiyoe*], 3 vols (Tokyo, 1965–71)
M. Hosono: *Yōfūhanga* [Western prints], Nihon no bijutsu [Arts of Japan], xxxvi (Tokyo, 1969); Eng. trans. by L. R. Craighill as *Nagasaki Prints and Early Copperplates*, Japanese Arts Library, vi (Tokyo, 1978)
R. S. Keyes and K. Mizushima: *The Theatrical World of Osaka Prints: A Collection of Eighteenth and Nineteenth Century Japanese Woodblock Prints in the Philadelphia Museum of Art* (Philadelphia, 1973)
S. Gotō, ed.: *Ukiyoe taikei* [Compendium of *ukiyoe*], 17 vols (Tokyo, 1975–8)
J. R. Hillier: *Japanese Prints and Drawings from the Vever Collection*, 3 vols (London, 1976)
D. Chibbett: *The History of Japanese Printing and Book Illustration* (Tokyo and New York, 1977)

Through Closed Doors: Western Influence on Japanese Art 1639–1853 (exh. cat. by C. French, Kobe, Mus. Nanban A.; Rochester, MI, Oakland U., Meadow Brook A.G.; 1977)
Ukiyoe taikan [Comprehensive view of *ukiyoe*], Zayūhō kankōkai, 12 vols (Tokyo, 1977–80)
R. Lane: *Images from the Floating World: The Japanese Print* (Oxford, 1978)
T. Yura and K. Yura: *Ukiyoe ruiko* [Miscellaneous notes on *ukiyoe*] (Tokyo, 1979)
Genshoku ukiyoe daihyakkajiten [Encyclopaedia of *ukiyoe*, illustrated], Genshoku *ukiyoe* daihyakka jiten iinkai, 11 vols (Tokyo, 1980–82)
M. Forrer, ed.: *Essays on Japanese Art Presented to Jack Hillier* (London, 1982)
R. S. Keyes: *Japanese Woodblock Prints: A Catalogue of the Mary A. Ainsworth Collection*, Oberlin Coll., OH, Allen Mem. A. Mus. cat. (Oberlin, 1984)
Ukiyoe: Kyū Matsukata korekushon o chūshin to shite [*Ukiyoe*: focus on the former Matsukata collection] (exh. cat., Tokyo, N. Mus., 1984)
R. S. Keyes: *The Art of Surimono: Privately Published Japanese Woodblock Prints and Books in the Chester Beatty Library, Dublin*, 2 vols (London, 1985)
J. Meech-Pekarik: *The World of the Meiji Print: Impressions of a New Civilization* (New York and Tokyo, 1986)
Ukiyoe: Images of Unknown Japan (exh. cat., ed. L. Smith; London, BM, 1988)
H. Smith II: *Kiyochika: Artist of Meiji Japan* (Santa Barbara, 1988)
Yokohama: Prints from Nineteenth-century Japan (exh. cat. by A. Yonemura, Washington, DC, Sackler Gal., 1990)

MATTHI FORRER, AMY REIGLE STEPHENS

(g) After c. 1900.

Introduction. Japanese printmakers were active throughout the 20th century and in general flourished. In contrast to earlier periods, all the greatest figures were heavily influenced in style and technique by foreign artists, particularly from Western Europe and North America. More

important still, scarcely a major Japanese printmaker of the 20th century failed to benefit from foreign sales. This was equally true for artists working in the most traditional styles and techniques, for example Shinsui Itō (1898–1972), and for those who espoused the most Western of materials and subject-matter such as CHIMEI HAMADA. The international acclaim accorded SHIKŌ MUNAKATA from about 1955 until his death in 1975 gave all Japanese print-artists an abiding sense of purpose and self-confidence. However, the global awareness that distinguished Japanese artists of the 20th century from their predecessors conversely aroused in them a persistent and sometimes acute sense of conflict about the integrity of their Japanese identity. This had the advantage of preserving the art of the woodblock print throughout the century in a healthy state, despite the constant rise in the use of foreign printing techniques, and of stimulating the development of peculiarly Japanese skills in stencil-printing as practised by, for example, YOSHITOSHI MORI. Many of the major figures, such as KŌSHIRŌ ONCHI, Munakata and Hideo Hagiwara (1913–), continued to work in woodblock, but there were also important contributions after 1945 in intaglio (Hamada and YŌZŌ HAMAGUCHI), silkscreen (Gaku Onogi) and mixed media (TETSUYA NODA). Only in lithography have the Japanese failed so far to produce an important master, although work of a high standard has been produced, for example the charming landscapes and townscapes of Kazuma Oda (1882–1956).

Since around 1955 the main market for prints shifted from the collector or connoisseur, whether Japanese or foreign, to museums and galleries and to ordinary people buying art to hang on their walls. Artists also tended to work towards displaying at major annual or biennial print exhibitions, and their works have generally increased in size. Since around 1955, too, young artists have usually come from art schools rather than from older-style artists' studios or printers' workshops. At most times during the 20th century, some Japanese artists were working and studying abroad. Similarly, foreign artists worked for varying periods in Japan, attracted by the native skills in papermaking and woodblock-cutting and printing. Mary Cassatt led the way, even before 1900, to be followed by such artists as Elizabeth Keith, PAUL JACOULET and Cliff Karhu.

In the 20th century, Japanese printmaking was rarely dominated by painting, and few of the major printmakers were equally good painters or even painters at all. Shinsui, Murai and Onogi were exceptional in this respect. In the 20th century, but not previously, the Japanese have drawn a clear distinction between a design made to become an original print (*hanga*) and a print made by somebody else after a painting (*fukusei hanga*, or later *esutampu*). In practice, as in much Japanese art history, this distinction has often been blurred, especially in woodblock and screenprint production.

Decline of ukiyoe. In 1900, the traditional commercial method of production of woodblock prints was still intact (*see* §(i) above). Publishers in Tokyo, Kyoto and Osaka commissioned artists to produce annotated sketches, which the blockcutters and printers then turned into finished editions of sheet prints, either singly or in larger

series. However, prints on two of the old *ukiyoe* themes, the *kabuki* theatre and the landscape or townscape, had already almost ceased to be produced, and the third, portrayals of beautiful women of the demi-monde (*bijinga*), continued only in a rather enfeebled form in the hands of minor artists such as Toshikata Mizuno (1866–1908) and Gekkō Ogata (1859–1920) up to about 1910. Yoshitoshi, the last important traditional *ukiyoe* master, had died in 1892, and his able successor, the painter Kiyokata Kaburagi (1878–1972), preferred to work on small-scale prints inserted as illustrations in novels produced in Western formats. He continued to do these until about 1918, after which he concentrated mainly on painting in the new *Nihonga* style (*see* §VI, 5(ii) above). KIYOCHIKA KOBAYASHI too had almost abandoned the sheet print by 1900.

The Russo-Japanese War of 1904–5 provided a welcome last impetus to the woodblock print as journalism, continuing a tradition that had flourished since the end of the period of national seclusion in 1854. Many artists, including Hanko Kajita (1870–1917) and Kōgyo Tsukioka (1869–1927), converted sketches or photographs sent back from the war into prints remarkably speedily using the old methods. These were frequently diptychs and triptychs, sometimes even in vertical arrangements. The cutting and printing were done with astonishing skill, but the violently energetic style varied little from artist to artist. Sales were not as high as in earlier wars; magazine photojournalism was equally popular and soon superseded the work of printmakers.

A vogue for illustrated novels, including those using the more recently imported European techniques of metal-engraving, wood-engraving and lithography, and the decline of interest in the old subjects of sheet prints forced popular publishers into production of smaller-format series of landscape, bird, flower and animal studies, many of them by Koson Ohara (later called Shōson; 1877–1945) and Shōtei Takahashi (1871–1944). They are technically so refined that they are often mistaken for watercolours in Europe and North America, where the greater number were exported. By *c*. 1910 these too were going out of fashion.

Revivals of ukiyoe *and other traditional forms and methods before 1945.* The Japanese victory over Russia in 1905 gave immense confidence to the nation, which in turn gave an immediate impetus towards retaining or renewing traditional arts and crafts, including woodblock-printing. The Kyoto publishing house Unsōdō, for example, turned at this time to de luxe albums and portfolios for a small but highly sophisticated public, most of whom still lived in the city. Its 'star' artist was the young Sekka Kamizaka (1886–1942), a painter in the style of the Rinpa school (*see* §VI, 4(v) above), of which he was the last major master. His three-volume set of folding albums, *Momoyogusa* (1909), is one of the monuments of Japanese design and of the woodblock print. Unsōdō's commitment to him illustrates the shift away from employing only the most popular artists to design prints in favour of artists of any school. This was partly a reversion to a tradition dating back to the mid-18th century of 'reproductions' in woodblock form of the brush paintings of major artists. Until the late

174. Shinsui Itō: *Sudden Shower*, colour woodblock print, 443×301 mm, 1917 (London, British Museum)

19th century these were almost always in book formats; thereafter they began to appear also as portfolios. *Momoyogusa* itself first appeared as a series of smaller portfolios. The trend to diversity is more noticeable still in the first edition of Sōseki Natsume's (1867–1916) great comic novel *I Am a Cat* (*Wagahai wa neko de aru*, 1905) designed by Goyō Hashiguchi (1880–1921), a pupil of the oil painter Seiki Kuroda, with woodblock illustrations by Western-style artists including CHŪ ASAI. Another typical minor masterpiece of the period was *Hanshin meisho zue* ('Pictures of famous spots in Kobe and Osaka'), published by the Tokyo firm of Bunendō in 1916, with fresh landscapes and townscapes by a group of five artists including Rinsaku Akamatsu. Akamatsu later produced other series published by Bunendō under the direction of Kanae Tanejiro, of which perhaps the best is *Thirty-six Views of Osaka*, a moving exercise in post-war nostalgia (1947). Until well after 1945 Tanejiro was also responsible for many beautifully illustrated travel books and portfolios with woodblock illustrations, of which the most sumptuous is *Shina taikan* (1916), illustrated by Bisen Fukuda. Nostalgia was the keynote of all *shin hanga* ('new prints'), which came into existence in 1915 with the launching of sheet prints

of *bijinga* by the Tokyo publisher Shōzaburō Watanabe (1885–1962). Having enjoyed export success with the rather muted prints by Shotei, he nevertheless sought something more direct, bold and colourful, which he found in the work of the young artists Shinsui Itō and Hasui Kawase (1883–1957), both pupils of Kiyokata.

Shinsui's *Before the Mirror* of 1915 was the first true *shin hanga* print, using the old line and flat colour technique of *ukiyoe* but with fresh and bold pigments inspired by the new palette used in *Nihonga* painting (*see* §VI, 5(ii) above). Kiyokata himself pioneered *Nihonga* in the field of female portraiture. As in *Nihonga*, a new repertory of poses and a hint of modelling of bold contours were borrowed from recent Western art, breathing new life into the old genre for a few more decades (see fig. 174). Some of Shinsui's early designs were made specifically for prints, as the *ukiyoe* artists had done, but for most of his career after 1923 he allowed his publisher to develop woodblock prints from original brushed *bijinga* on paper or silk, of which he became the acknowledged master. These prints fall nearly within the definition of *esutampu*, a term applied after 1945 to print reproductions from paintings.

Several minor traditional female portraitists followed Shinsui's example, including Kotondo Torii (1900–77) and Hakuho Hirano (1879–1957). More influential was the work of Goyō Hashiguchi (1880–1921), who first trained as a European-style painter and illustrator. Late in his career he became enthused with the desire to revive the glories of the *ukiyoe* print and worked briefly with Watanabe before his extreme perfectionism led him to break with the publisher and to produce a handful of classic portraits in small editions himself. *A Woman Combing her Hair* (1920) was an example.

Watanabe also promoted a revival of landscapes and townscapes, beginning with Shinsui's eloquently austere *Eight Views of Lake Biwa* (1917–18) and continuing with designs by Hasui Kawase, whose early sets such as *Twelve Views of Tokyo* and *Souvenirs of Travel* (the two first series) remain the classics in this field. His lyrical delight in the Japanese landscape echoed that of *Nihonga* at the same period, and he adopted some of its techniques, such as a selective use of shading. He retained the traditional use of colour and of muted line, concealing as much as possible to heighten the illusion of light and shade and hence of 'modernity'. After 1923, Hasui became prolific, producing some 600 designs up to his death, although never noticeably extending his emotional or technical range. The somewhat less prolific Hiroshi Yoshida (1876–1950) also at first worked with Watanabe but by 1925 had set up his own workshop to produce woodblock-printed landscapes, both of Japan and of other countries such as the USA and India. Yoshida adapted traditional techniques in his prints, partly to reproduce the effects of his partly Westernized watercolours and oil paintings. Overprinting of one colour block on another gave his prints an unmistakable palette and made his work popular in North America as well as in Japan in the 1930s. As travel outside Japan became discouraged by the militarist regime, landscape prints of the native scene enjoyed an immense vogue. Other good but minor Tokyo artists in this mode included Shirō Kasamatsu (*b* 1898), Koitsu Ishiwatari (1897–1987) and, in his youth, Yoshida's son Toshi Yoshida (*b* 1911).

Tradition was again revived in the powerful *kabuki* actor portraits by Shunsen Natori (1886–1900) and Koka (Toyonari) Yamamura (1881–1942), inspired both by the enduring popularity of the work of TŌSHŪSAI SHARAKU and by Watanabe's technical encouragement. These developments in Tokyo were echoed in the rival city of Kyoto under the leadership of the publisher Shotaro Satō, who published fine actor prints and landscapes by Kanpo Yoshikawa (1894–1979) and a few distinguished female portraits by Miki Suizan (1887–1957). Tomikichirō Tokuriki (*b* 1902), originally a *Nihonga* painter, was more influential in the long run through his work as an independent *sōsaku hanga* ('creative print') artist (see below) with traditional publishers, for whom in the 1930s he created several series, such as *Thirty-six Views of Mount Fuji* and *Thirty Views of Kyoto*. These gave new life to the landscape/townscape tradition and preserved it after 1945, when *shin hanga* was in rapid decline in Tokyo. More striking landscapes were produced by his colleagues Benji Asada (*b* 1899) and Tobei Kamei (1901–77), who also worked in female portraiture; but Tokuriki remained, through his own post-war publishing company and his teaching of woodblock technique, a major figure in the preservation of older graphic and aesthetic traditions. He taught a number of foreign students, who actively spread Japanese woodblock methods in the Western world.

Shin hanga in effect retreated into the picturesque past, which made this work highly popular abroad in the 1930s. True *ukiyoe* had historically been concerned with current fashion and the poignancy of the passing urban world of entertainment, fashion and love. These themes were effectively taken up in the period 1905–35 by more independent artists, most notably Yumeji Takehisa (1884–1934), a Western-style painter, illustrator and poet, whose wistful, large-eyed women and depressed, bearded young men became the fashionable type for his generation. He designed few sheet prints, except for a prized few from the brief period from 1914 when he was running a store in Minotoya with his mistress, but his style greatly influenced graphic art in the form of book illustrations, book and sheet-music covers and woodblock *esutampu* taken from his paintings and sketches. His freedom of expression also served as a crucial model for Kōshirō Onchi (see below). Other artists who capitalized on the vogue for modernity included Tsunetomi Kitano (1880–1947; e.g. *Spring and Autumn in the Pleasure Quarters*; 1918), Kiyoshi Kobayakawa (1896–1948) and Toraji Ishikawa (1875–1964), whose *Ten Nudes* (1934) are highly valued for their racy flavour and brilliantly handled colour contrasts.

Sōsaku hanga and European influences, 1919–45. Sōsaku hanga ('creative prints') was a term that expressed the ideals of an association of artists founded in 1919 by Kanae Yamamoto (1882–1946). They believed erroneously that Western artists not only designed their own prints but also did their own printing and publishing. Under the slogan 'Self-designed, self-printed', they entered into an ultimately successful struggle to give artists rather than publishers control of the production of prints and to establish prints as an art separate from painting but equally valid. The result was that hardly any printmakers of this school were also serious painters. This distinction too was based on a misconception, not dispelled until the 1950s: that Western print artists were not primarily painters as well. These beliefs, wrong though they were, gave the movement ideals, pride and drive, which kept it going in the rather unsympathetic climate up to 1945.

Generally the artists worked in adaptations of Western print styles, especially those of recent French pre-Cubist art and of German Expressionism. These tendencies are noticeable in the work done before 1945 by Kōshirō Onchi, who was nevertheless the most individual of the *sōsaku hanga* artists, equally strong in perceptive depictions of modern women (much influenced by his friend Yumeji Takehisa), the Tokyo urban scene, Japanese landscape and pure abstraction. He worked mainly in colour. His triptych *The Sea* (1937) was the most ambitious print made in Japan up to that time, in both subject-matter and size. Like all his friends and colleagues, he was a printer in his spare time only, earning his living by other means, in his case designing over 1000 books. Onchi nearly always cut his own blocks and did his own printing, which was a further brake on productivity and hence self-sufficiency. Other artists of the school frequently used artisans such as Bonkotsu Igami (1875–1933) to cut the blocks and publishers to sell them but retained control of quality. This method was used in group-series such as *One Hundred New Views of Tokyo* (1929–32), designed by eight artists led by Onchi. One of these artists, Un'ichi Hiratsuka (*b* 1895), was also a great figure of the movement. He became a skilled cutter and frequently did work for his colleagues, but his fame rests on his early colour prints, such as the superb *Tokyo after the Earthquake* (set of 12; 1924–7), and his many black-and-white works, mainly depicting Japanese landscapes (e.g. *Steps of the Jakkoin*, 1960), which represent a graphic revival of the East Asian ink-painting tradition. Hiratsuka was almost the only *sōsaku hanga* artist who earned his living through woodblock-printing, cutting blocks and teaching. In 1935 he began to teach the first ever course in woodblock-printing at Tokyo School of Fine Arts, thus achieving one of the great objectives of the movement. Other great figures associated with him were Umetarō Azechi (*b* 1902), creator of poetic mountain landscapes, Senpan Maekawa (1889–1960), who adopted a simple, powerful style allied to the Folk Art Movement (*see* MINGEI; *see also* §XV below), and Tadashige Ono (1909–90) of the short-lived Proletarian Art Movement, whose brilliant, thick colours over black-printed paper are unmistakable. All three flourished particularly in the atmosphere of greater freedom of expression after 1945, as did Onchi and Hiratsuka.

Hiratsuka's major influence, however, was on the young Shikō Munakata, generally regarded as Japan's greatest print artist of the 20th century. Munakata started as a minor painter but was drawn to black-and-white printing and studied the techniques of cutting with Hiratsuka in 1928. By 1936 he had allied himself with the Mingei Movement, led by the art historian and theoretician MUNEYOSHI (or Sōetsu) YANAGI, which also attracted the stencil artist Keisuke Serizawa. Munakata's early series on Buddhist themes, such as the *Kegonkyō* (1937) and the *Goddess Kannon* (1938), exemplify his combination of East Asian religious themes with folk art and show an astonishing sense of energy.

After 1945. Munakata flourished after 1945, winning international acclaim in 1955 at the São Paulo Biennale and selling much to American collectors. After 1945 he began regularly adding brilliant colours by hand to the backs of his prints, notably in his *Munakata's Views on the Tōkaidō Road* series (1964). Munakata inspired a host of pupils and imitators. The stencil artist Yoshitoshi Mori did not take up printmaking until the 1950s, when he won much admiration for his vigour, humour and boldness of design, mostly on Japanese genre and theatrical themes. He was the only figure who equalled Munakata in energy without being overwhelmed by his influence.

The explosion of interest in *sōsaku hanga* artists generally and Munakata specifically after the war, and especially after 1955, allowed many of them to earn their living solely or mainly as printmakers. They included, in addition to those already mentioned, Onchi's talented pupils Gen Yamaguchi (1903–76), Haku Maki (*b* 1924) and Masaji Yoshida (1917–71), all of whom created variations of the restrained and somewhat elevated abstraction typical of their master's late years. They were all woodblock artists, but their rise in prosperity gave encouragement to artists working in other modes, for example using the Western techniques of intaglio, screenprint, lithograph or mixed media. Many of these trained formally at the Tokyo University of Fine Arts and Music, where a strong intaglio tradition was established by TETSURŌ KOMAI. He had himself been trained by KIYOSHI HASEGAWA, who had spent most of his career in Paris. Both produced modest still-lifes imbued with the spiritual intensity characteristic of *yūgen* (a Japanese aesthetic ideal connoting mystery, darkness and calm). The dense colour mezzotints, mainly of fruit, by Yōzō Hamaguchi followed in the same tradition. Chimei Hamada's intaglio studies of war, insanity, neurosis and urban dislocation are remarkable for their depth of feeling (e.g. *Lament of the Young Recruit*; 1951–4), as is the dense blue screenprint abstract *Landscapes* of the painter Gaku Onogi (1924–76). The obliquely expressed passion and unease in his work are characteristic of many Japanese artists who were young during the war in the Pacific. Kenji Yoshida (*b* 1924), who worked in Paris for some 30 years, conveyed a similar quality with the deep colour of his abstract etchings.

Yoshida was one of many young artists who, from the late 1950s, spent long periods working in Europe or the USA, bringing back knowledge of new styles, especially Pop and psychedelic art, conceptual art and developments in the use of screenprints, mixed media and monoprint. The Pop art screenprints of Go Yayanagi (*b* 1933) combined motifs from Japan's distinctive past, such as the 11th-century fiction masterpiece, the *Tale of Genji*, with international themes, creating a selfconscious tension characteristic of many late 20th-century Japanese print artists. This phenomenon is most noticeable in the powerfully erotic and violent series the *War of the Minamoto and the Taira* (screenprint; 1985) by the satirical cartoonist Hideo Takeda (*b* 1948). Of the many artists who from the mid-1960s took up the American vogue for using photographic images as the basis for prints, Tetsuya Noda achieved the greatest international approval. He always used contemporary material (see fig. 175), considerably softened and distanced, however, by his preliminary work

175. Tetsuya Noda: *Diary: June 24th '78*, mimeograph and screenprint with woodblock, 978×628 mm, 1978 (London, British Museum)

on the photographic plates and the addition of woodblock-printed backgrounds. In the field of conceptual art, Shōichi Ida (*b* 1940) used a succession of mixed-media processes to temper extreme inventiveness with a restrained elegance characteristic of classical Japanese aesthetics.

Although the trend after 1960 was towards internationalization, some artists, while working in newer styles, vigorously explored fresh possibilities in the old woodblock techniques. Principal among these was Hideo Hagiwara, a master at creating a sense of surface excitement that was matched by the surging energy of the colours. Akira Kurosaki (*b* 1937) produced his early work himself but later increasingly used a personal cutter and printer in a reversion to the old cooperative method. His work, however, is a strongly individual, finely finished exploration of a weirdly coloured dream-world influenced by Surrealism. Reacting against the compactness of his works, Seiko Kawachi (*b* 1948) has produced ever bigger semi-abstract visions of urban brutality, culminating in his enormous four-sheet masterpiece, *Flying* (1985). In the 1980s Kokei Tsuruya (*b* 1946) was acclaimed for his brilliantly disturbing revivals of the old *kabuki* portrait tradition printed in small editions on very thin paper, often with mica backgrounds that illustrate the power of Japanese traditions to reassert themselves periodically in modernized forms.

BIBLIOGRAPHY

O. Statler: *Modern Japanese Prints: An Art Reborn* (Rutland, VT, and Tokyo, 1956)

R. Lane: *Masters of the Japanese Print* (New York and London, 1962)

J. R. Hillier: *Japanese Colour Prints* (London, 1966)

——: *The Japanese Print: A New Approach* (Rutland, VT, 1975)

D. Chibbett: *The History of Japanese Printing and Book Illustration* (Tokyo and New York, 1977)

L. Smith: *The Japanese Print since 1900: Old Dreams and New Visions* (London, 1983)

H. Fujii: *Shikō Munakata* (Tokyo, 1985)

J. Meech-Pekarik: *The World of the Meiji Print: Impressions of a New Civilization* (New York and Tokyo, 1986)

T. Ogura and others: *The Complete Woodblock Prints of Yoshida Hiroshi* (Tokyo, 1987)

A. R. Stephens, ed.: *The New Wave: Twentieth Century Japanese Prints from the R. O. Muller Collection* (London, 1992)

LAWRENCE SMITH

X. Lacquer.

Lacquer has been used in Japan since the end of the Early Jōmon period (*c.* 10,000–*c.* 3500 BC) to protect and decorate objects, especially those made of fragile or porous materials such as wood, bamboo, earthenware, textile and leather. The physical properties of lacquer, in particular its resistance to moisture and degradation, make it a useful coating for utensils for food preparation and service, storage containers, furniture, sculpture and wooden architectural elements (for further discussion of the technical characteristics of lacquer *see* LACQUER, §I). The aesthetic qualities of lacquer—an incomparable natural gloss and a capacity for vivid, permanent coloration—have been appreciated in Japan since prehistoric times. Lacquerware of many types, but especially objects decorated in gold and silver with the various techniques known collectively as *makie* ('sprinkled picture'), is a consummate expression of Japanese aesthetic sensibility and a distinctive achievement of Japanese art. As a decorative medium, lacquer has had a high status in Japan from the earliest recorded times. The value and prestige of lacquerware is reflected in its patrons, including emperors, noble families, daimyo, Buddhist temples and Shinto shrines. Lacquer finishes have been a universal feature of the surroundings of the Japanese upper classes at least since the Nara period (AD 710–94).

For the use of lacquer in folk art *see* §XV, 5 below.

1. Materials and techniques. 2. Historical survey.

1. MATERIALS AND TECHNIQUES.

(i) Construction. Japanese lacquer objects most commonly have a wooden core made by turning or by joining flat and shaped sections. Joints, which are held together without nails and carefully concealed, are adhered and reinforced with lacquer. The rims of boxes and circular containers may overlap the base or fit flush to a ledge on the base. Metal fittings are sometimes attached to lacquer objects. These include pewter or silver rim and corner reinforcements and rings for the cords used to secure lids in place.

Japanese lacquerers have created specialized shapes that are distinctive to the medium. Because surface finish plays such an important role in lacquer decoration, the shape of the object is an integral aesthetic component. Japanese lacquer objects such as boxes and furniture characteristically have rounded or bevelled corners and sleek contours that avoid abrupt transitions between planar surfaces and enhance the beauty of the lacquer finish.

Dry lacquer (*kanshitsu*) is a technique for forming objects in which hemp cloth is soaked in lacquer and shaped over a supporting mould that is removed after the lacquer hardens. The technique, imported to Japan, probably from China, in the 8th century AD, is still favoured for making complex shapes and very thin, lightweight objects.

Wood is not the only base employed in traditional Japanese lacquerwork, and lacquer coatings have been applied to objects made of bamboo or woven plant materials and to ceramics since the Early Jōmon period. Except for metal armour, which lacquer protects from corrosion, the application of lacquer to metal bases is rare. Metals are, however, frequently used in the surface decoration of lacquer objects. Lacquer coatings are also found on leather, although leather treated in this way tends to shrink and warp.

(ii) Preparation and priming. Lacquer can be applied directly to wood as a varnish, as is frequently done in Japanese buildings and for the frames of sliding doors (*fusuma*) and folding screens (*byōbu*). Fine furniture and other pieces intended for elaborate decoration are carefully prepared through a series of processes that contribute to the remarkable durability of Japanese lacquer objects, which can survive perfectly intact for centuries. After the surface of the object has been sealed with a coat of liquid lacquer, all or part of the object may be reinforced with a layer of textile. This is followed by the application of layers of lacquer mixed with other materials to a pasty consistency. After hardening, each layer is smoothed with abrasives, such as pumice, to remove all tool marks. Lacquer in increasing grades of purity and quality, usually coloured black or red, is then applied. The object is finished by polishing with fine abrasives, such as charcoal or powdered deer antler, or it is sent to a specialist if more elaborate decoration is required.

(iii) Decoration. Japanese lacquerers have a remarkably diverse repertory of decorative techniques, with a distinct preference for surface effects that accommodate to the shape and contours of an object.

(a) Coloured. Lacquer can be successfully combined with natural pigments to produce vivid colours (*see* LACQUER, colour pl. I, fig. 1). The most common are red, usually produced by the addition of vermilion (mercuric sulphide, called cinnabar in its natural form), and black, usually produced by the addition of iron treated with acetic acid. Japanese lacquers of the pre-modern period (before 1868) may also be brown, green and yellow. Since the 19th century Japanese lacquerers have experimented with various synthetic pigments to produce colours previously uncharacteristic of lacquer, including blue, purple, pink and ivory. Plain black or red lacquer, used as a varnish without further decoration, was the most common type of lacquer in both the prehistoric and historic periods. Negoro ware, named after a large temple complex formerly in Wakayama Prefecture, is an important type of utilitarian

lacquerware. Typically, Negoro ware has an undercoating of black lacquer covered with red lacquer, but a few pieces have black lacquer over red or combinations of both colours. As the piece is used, the surface colour wears away irregularly, exposing the contrasting undercoating, a subtle effect that is regarded as beautiful in Japan.

The simplest type of surface decoration, which appears in some of the earliest excavated lacquer objects from the Early Jōmon period, is achieved by applying lines or areas of coloured lacquer over a contrasting ground. Lacquer painting (*urushie*) was the principal form of decoration before the 8th century AD, when a variety of complex decorative techniques were introduced to Japan, probably from China. Painted lacquer *inrō* (containers; *see* §2(vii) below), writing boxes and tiered boxes were produced in the RYŪKYŪ islands from the early 18th century onwards. *Tsuiku* ('piled-up brocade') is the technique most closely associated with the islands: in one form, various hardstones, soapstones, woods and stained ivory were inlaid into the surface to form a picture in high relief; in another, coloured lacquer putty was used as appliqué.

(b) Inlaid. Among the techniques introduced during the Nara period (AD 710–94) were mother-of-pearl inlay (*raden*) and gold- and silver-foil inlay (*hyōmon* or *heidatsu*). These materials, cut and engraved into graceful patterns, provide a sumptuous contrast with the glossy surface of a lacquered object. A particularly fine finish can be achieved by covering the entire surface with lacquer after inlaying, then polishing the lacquer back to re-expose the decoration. Ryūkyūan lacquer with mother-of-pearl inlay, from the island of Okinawa, was important in the 17th and 18th centuries. Examples include table screens, writing boxes and bowls. *Chinkinbori* ('incised gold' or 'sunk gold') is a technique in which gold leaf is laid into grooves formed in the lacquer with a V-shaped stylus. This technique was also used with high refinement on Okinawa from the 15th century to the 17th, to make circular containers for ceremonial jewellery, dishes on pedestal feet and tiered boxes with matching stands.

(c) Makie. The most characteristic and highly developed decorative technique for Japanese lacquer is *makie* ('sprinkled picture'), a collective term for various methods of creating designs by using gold and silver particles applied to lacquer while it is still damp (*see* LACQUER, colour pl. I, fig. 1). *Makie* was first practised in the 8th century. Simple linear designs were the first to be executed in *makie*, but Japanese lacquerers rapidly developed techniques to create subtly glittering grounds by lightly strewing gold or silver powder on black lacquer or cloudlike patterns by using slightly denser sprinklings. Combinations of linear and ground patterns made possible pictorial effects as subtle as those of painting.

In *nashiji* ('pear skin') *makie*, coarse gold flakes are embedded into translucent, amber-coloured lacquer. This technique is usually a ground treatment, but occasionally it is also found as a contrasting treatment for elements of a pictorial design. *Ikakeji* ('poured ground'), a ground treatment using a dense sprinkling of fine gold that is burnished after setting, creates a surface that appears to be made of gold. In *hiramakie* ('flat sprinkled picture'),

gold or silver powder is sprinkled on a line or area delineated in liquid lacquer then allowed to set. *Hiramakie* is not polished, so that the decorated area is slightly raised. In the contrasting *togidashi* ('polished out') *makie*, the decorated area is polished to create a perfectly smooth surface. In *takamakie* ('relief sprinkled picture'), a technique developed in the Kamakura period (1185–1333), relief designs are created by building up areas using lacquer mixed with other materials. The surface is finished with gold and silver *makie*. Gold and silver leaf cut in squares, threads and other shapes, such as flower petals, brilliantly enhance *makie* designs. In the lacquerware of later periods, especially from the 14th century onwards, sumptuous effects were achieved by the occasional use of design elements made of cast silver and gold. Relief decorations made of such materials as carved coral or shell are set on the surface of some lacquerware from the Edo period (1600–1868) and later.

(d) Kamakurabori. The hardness of lacquer makes it a suitable medium for engraving and carving in relief. In *Kamakurabori* ('Kamakura carving'), a technique probably inspired by Chinese carved lacquers imported during the 14th century, relief designs are carved into wooden objects, then lacquered in black and red.

2. HISTORICAL SURVEY.

(i) Prehistoric period (before mid-6th century AD). (ii) Early historic period (mid-6th century AD–794). (iii) Heian period (794–1185). (iv) Kamakura period (1185–1333). (v) Muromachi period (1333–1568). (vi) Momoyama period (1568–1600). (vii) Edo period (1600–1868). (viii) Meiji period (1868–1912). (ix) Modern period (after 1912).

(i) Prehistoric period (before mid-6th century AD). The use of lacquer in Japan during the Jōmon period (*c.* 10,000–*c.* 300 BC) is now well established by archaeological evidence. The earliest lacquered objects so far found in Japan come from sites dated to the end of the Early Jōmon period (*c.* 10,000–*c.* 3500 BC); they are roughly contemporaneous with the earliest excavated Chinese lacquer objects from Hemudu (*c.* 3700 BC). The discovery of well-preserved lacquer objects in Early Jōmon sites disproves the earlier theory that Japan had no native source of lacquer and that lacquer trees and lacquering techniques were introduced to Japan from China during the 1st millennium BC. The relatively advanced techniques seen in these pieces suggest that the use of lacquer had already undergone some independent development in Japan by the end of the Early Jōmon period.

Jōmon-period objects made of pottery, wood and bamboo display coatings of both red and black lacquer and simple designs applied in one colour over the other. Scientific investigation has revealed that multiple coatings of lacquer were already being used, not merely simple varnishes of the unprocessed latex. The patterns found on Jōmon lacquerware sometimes resemble the cord-marking and spiral patterns of the pottery for which the culture is best known, as in the lacquered clay bowl from Ondashi, Yamagata Prefecture. Artefacts excavated from the Late Jōmon Nakayama site in Akitra Prefecture indicate that preparatory methods, such as straining, were already practised by Jōmon lacquerers. Lacquer objects from the Yayoi (*c.* 300 BC–*c.* AD 300) and later historic periods have

also been excavated. Excavations from these sites, including some as recent as the Edo period, yielded tools for lacquer processing and manufacture, which shed light on the evolution of Japanese lacquer technology. Other sites yielded lacquer objects for everyday use, many previously unknown since it had not been possible to preserve them.

(ii) Early historic period (mid-6th century AD–794). During the Asuka (later part of the 6th century AD–710) and Nara (710–94) periods the techniques of lacquer manufacture developed rapidly through contact with China and Korea. Another factor was the establishment of a central government in the Nara region. The demand for lacquer was vastly increased for the production of serving utensils, furniture, architecture and the sculpture required by the Buddhist religion, which had been introduced from Korea and China in the mid-6th century. The Taihō Ritsuryō

176. Dry lacquer statue of *Kubanda*, painted, h. 1.5 m, Nara period, AD 710–94 (Nara, Kōfukuji)

(Taihō Code, AD 710) established a Lacquer Bureau under the control of the Ministry of Finance. The economic importance of lacquer is indicated by governmental orders to plant lacquer trees and by the collection of lacquer as a tax in kind.

Lacquered objects were made of wood, moulded leather and the recently introduced technique of dry lacquer. Dry lacquer was used for sculpture (*see* §V, 1(ii)(d) above), ranging from small figures for private worship to larger statues, such as the famous ones (see fig. 176) in Kōfukuji in Nara (*see* NARA, §III, 7), and a monumental gilded dry-lacquer sculpture 3.6 m in height of the Buddhist deity Fūkūkenjaku Kannon (Skt Amaghapasha Avalokiteshvara) in Tōdaiji in Nara (*see* NARA, §III, 4).

Lacquer objects preserved in the mid-8th-century Shō-sōin imperial repository (*see* NARA, §III, 3) reveal the variety and quality of decorative techniques known in Japan during this period. Many were imported from continental Asia, principally from Tang-period China (AD 618–907), and it is likely that many of the advanced methods of lacquer decoration also originated there. Among the decorative techniques of Shōsōin lacquers are inlay techniques, using mother-of-pearl and gold and silver foil and lacquer painting. The finest example of lacquer painting from this period is the 7th-century Tamamushi Shrine from Hōryūji in Nara. The shrine has paintings of Buddhist deities and legends of the Buddha's former lives executed in red, ochre, green and brown lacquer on a black ground. Until the discovery of wall paintings in several tomb-mounds (*kofun*) from the Kofun period, the Tamamushi Shrine was the earliest known example of figure painting in Japan (*see* §VI, 3(i)(a) above).

Makie was the most important new decorative technique to appear during the Nara period. The earliest example of the technique is a sword scabbard in the Shōsōin. The simple decoration, executed with relatively coarse gold powder sprinkled over patterns of clouds, birds and animals, is typical of early *makie*, which later became the dominant Japanese technique of lacquer decoration.

(iii) Heian period (794–1185). When the capital moved to Heian (now Kyoto) in 794, artists and craftsmen followed their imperial and aristocratic patrons to the new city, which established itself as the leading centre for the production of fine *makie* decoration. Even in the late 19th century, when Japanese lacquerware was sought after by foreign collectors, Kyoto *makie* was regarded as superior in quality to lacquerware produced in other centres. Many of the surviving lacquer objects from the Heian period have been in the care of Buddhist temples or Shinto shrines. Some pieces, such as altar tables and boxes and chests used to store Buddhist texts (Skt *sūtras*), were specifically made for use in religious buildings; other fine pieces, such as boxes for personal possessions, entered the temples and shrines as donations.

Makie specialists expanded their repertory of techniques to encompass ground treatments and diffuse, cloudlike effects as well as linear designs. Using only gold and silver, they created sumptuous patterns and pictorial designs on furniture and containers. A few lacquer objects of the late Heian period combine inlaid mother-of-pearl with *makie*.

177. Lacquer, *makie*, mother-of-pearl and gilt-bronze embellishments (detail) on the pillars and altar of the Konjikidō (Golden Hall), Chūsonji, Hiraizumi, Iwate Prefecture, Heian period, 1124

The *makie* designs on the interior and exterior of Heian-period boxes are closely related stylistically to the decorative designs of paper for fine calligraphy and to the gold and silver illustrations on the paper frontispieces of luxury editions of *sūtra*s.

The religious fervour of aristocratic families, who were the principal patrons of the arts, funded the use of lacquer for the buildings and furnishings of Buddhist temples and Shinto shrines. Lacquer was also used extensively for the surfaces of Buddhist sculptures, many of which were also gilded. One of the finest examples of the architectural use of lacquer during the Heian period is the Konjikidō (Golden Hall; 1124) of Chūsonji, a Buddhist temple in Hiraizumi (Iwate Prefecture; *see* HIRAIZUMI, §2(i)(b)). Lacquer, *makie* and mother-of-pearl embellish most of the interior pillars and surfaces around the altar (see fig. 177), creating a sumptuous effect that evokes the Buddhist Pure Land (Jōdo), a paradise where the faithful are reborn.

(iv) Kamakura period (1185–1333). With the ascendancy of the warrior class during the late 12th century, new patrons emerged. Among the most outstanding surviving examples of the lacquerwork of the early Kamakura period are saddles decorated with intricate plant motifs of mother-of-pearl inlay. Lacquer was also applied to iron armour, helmets, stirrups, the handles of weapons and sword scabbards, as a protection against moisture and wear as well as a form of decoration. Like the aristocrats of Kyoto, warrior patrons, once they were secure in their political control, developed an appreciation of fine lacquer objects.

Kamakura-period *makie* objects were finely finished with precisely delineated, intricate designs. Decorative techniques included *takamakie* and *ikakeji* (*see* §1(iii)(c) above). Inlays of mother-of-pearl and silver and gold foil were often combined with *makie* in Kamakura-period designs. Ring fittings to hold silk cords used to secure the lids of lacquer boxes were often shaped and decorated by specialist metalworkers to complement the lacquer design. Some of the most spectacular *makie* objects of this period were *tebako* boxes used by women for such personal items as cosmetics and combs. Many of these are still in family shrines, usually Shinto, to which they were donated after the owner's death.

The earliest examples of Negoro ware datable by inscription are from the Kamakura period. Coated with red and black lacquer, Negoro ware is a sturdy, functional lacquerware that was often used for communal food service in Buddhist temples. Archaeological excavations have yielded everyday dishes and utensils lacquered in red or black with simple, sketchy decoration in the contrasting colour. These finds are shedding light on the types of lacquer objects made for daily use, as these were usually not preserved and handed down like more valuable *makie* pieces.

(v) Muromachi period (1333–1568). Under the Ashikaga shoguns, Chinese religious and artistic traditions exerted a profound and lasting influence on Japanese culture. Buddhist temples of the Zen sect were founded by learned Chinese monks who brought with them an appreciation of their native literature, painting and crafts. The Ashikaga collected and encouraged the importation of Chinese books, paintings, ceramics and lacquerware, which they displayed in their residences alongside the work of Japanese artists.

Kamakurabori (*see* §1(iii)(d) above) was probably inspired by Chinese carved lacquers imported during the 14th century. Early *Kamakurabori* lacquers, such as an incense box with a carved peony design from the Nanzenji in Kyoto resemble carved lacquers from Ming-period (1368–1644) China. *Kamakurabori* designs soon diverged from Chinese styles, however, and evolved to emphasize the nuances of wood-carving (see fig. 178). *Makie* designs strongly reflected the literary ambience of the age. Many designs incorporated seasonal references or literary allusions, and several included elements of Japanese calligraphy in the form of characters embedded in the contours of pictorial motifs, a type of design known as *ashide utae* ('reed writing poetry–painting'). The *makie* objects surviving from the Muromachi period include many pieces associated with writing, such as low desks to be used by a writer seated on the floor and writing boxes (*suzuribako*). Technically, Muromachi *makie* often incorporates elements in low relief or *takamakie*, and many pieces have embellishments such as small solid-silver balls representing dewdrops, heavy silver discs or crescents representing the moon and occasionally gold discs for the sun.

The Ashikaga shoguns commissioned fine *makie* pieces from master artists who belonged to families specializing

in *makie* (*see also* §(vii) below). The most celebrated lacquers are known as Higashiyama *makie*, after the residence of the shogun Ashikaga Yoshimasa (1435–90). Among the surviving *makie* works of all periods, one of the most famous and beautiful is the Kasugayama Writing Box (see fig. 179), which is decorated with a landscape beneath a full moon. The deer in the scene allude to an autumnal poem from the anthology *Kokinshū* ('Collection from ancient and modern times'; *c.* 905).

The influence of the finest Muromachi-period *makie*, especially pieces associated with late 15th-century Higashiyama culture, continued into succeeding centuries. The Tokugawa shoguns, who ruled Japan from 1630 to 1867, were avid collectors of Muromachi-period lacquers. Occasionally, they commissioned copies of famous antique objects from outstanding artists. In contrast to the elaborate lacquer designs of the 15th century, those of the 16th century tended towards simplicity. Decorative schemes employed fewer motifs, usually larger in scale than the detailed designs of the previous century. Technical complexity was also reduced.

The tea ceremony (*chanoyu*; see §XIV, 1 below), first introduced in Zen temples, flourished during the 16th century. Initially, tea was served in ceramic bowls held in lacquer stands imported from China. Later, *natsume*, a type of Japanese lacquered tea caddy, which had a smooth, seamless shape with a flush-fitting lid, became one of the favoured tea utensils. Small *makie* boxes from earlier periods were occasionally used as incense containers in the tearoom.

(vi) Momoyama period (1568–1600). Lacquer design during the Momoyama period, when Japan was reunified after a century of intermittent warfare among competing daimyo, reflects the energetic spirit of the era. A saddle with a *takamakie* design of grasses on a black lacquer ground is typical (Tokyo, N. Mus.). Once owned by Toyotomi Hideyoshi, a powerful daimyo and patron, the saddle design is based on a sketch attributed to the painter Kanō Eitoku (*see* KANŌ, (5)).

(a) Kōdaiji makie. The Kōdaiji, a mortuary shrine in Kyoto built for Hideyoshi by his widow, gives its name to a style of lacquer decoration that is characteristic of Momoyama-period design. The interior architecture and objects made for the Kōdaiji are the most famous examples of this style, in which autumnal motifs of chrysanthemums and flowering grasses are delineated in *makie* and *nashiji* against a plain black background. Some Kōdaiji-style objects are divided diagonally into contrasting fields of black and *nashiji* ground, with different motifs decorating each area. This design is also seen in the textiles of the period. Although based on autumnal motifs that have important symbolic meaning in Japanese literature and art, Kōdaiji *makie* depends on visual contrast and dramatic effects rather than on the literary associations that were so important to Muromachi patrons.

(b) Nanban lacquer. A contrasting type of lacquerware produced during the period is called *Nanban* ('southern barbarian') lacquer. These objects, typically decorated with mother-of-pearl and gold and silver *makie* (see fig. 180), often in simple and somewhat less refined designs than

178. *Kamakurabori* incense box with carved peony design, lacquer on carved wood, h. 25 mm, diam. 84 mm, Muromachi period, 15th century (Washington, DC, Freer Gallery of Art)

other *makie*, were produced for export to Europe (*see* LACQUER, §II, 1 and colour pl. II, fig. 2), with which trade had begun after the accidental landing of Portuguese sailors in southern Japan in 1543. The shapes of *Nanban* lacquers, which include domed coffers, bookstands and shrines for oil paintings of Christian subjects, as well as many decorative elements, are based on foreign sources. *Nanban* lacquers were immediately accorded great value

179. Kasugayama Writing Box, lacquer on wood with gold and silver, 220×239×49 mm, Muromachi period, second half of the 15th century (Tokyo, Nezu Art Museum)

180. *Nanban* lacquer chest, lacquer on wood with mother-of-pearl and gold, gilt-copper fittings, 533×1063×453mm, Momoyama or early Edo period, late 16th century–early 17th (Washington, DC, Freer Gallery of Art)

in Europe, and many remain in collections there. The earliest term for lacquer in the English language was 'Japan', and the unique aesthetic qualities of Japanese lacquer inspired European techniques that were termed 'japanning' (*see* LACQUER, §I, 3).

(vii) Edo period (1600–1868). Political stability under the Tokugawa shogunate, along with the rise of commerce and the development of a merchant class in new urban centres such as Edo (now Tokyo), stimulated a great diversity of lacquer production. For the first time, significant numbers of skilled lacquerers moved from Kyoto towards new patrons, including the shoguns in Edo and the provincial daimyo who sought to establish prestigious craft production in their domains. Especially in Edo, both private commissions and commercial production increased as the use of lacquer objects became more widespread in the general population.

Patrons of the warrior class, including provincial daimyo and the Tokugawa shoguns, who were in essence the most powerful of the daimyo, commissioned *makie* pieces for their own use. During the peace that lasted for more than 250 years, the armour, helmets, swords, saddles and stirrups that had been essential to their survival assumed a predominantly ceremonial function. Lacquer decoration, especially *makie*, came to be regarded by the shogunate as an emblem of wealth, status and political power and

accordingly became elaborate, even flamboyant. From the early 17th century and throughout their rule, the shoguns issued sumptuary regulations that restricted the ownership, use and display of property and possessions on the basis of rank and family connection. An 18th-century decree, for example, restricted the use of *makie* on a gold ground to the members of the ruling Tokugawa house. Lesser daimyo were allowed to use only lacquerware decorated with gold family crests against a plain black ground. The most lavish projects were those commissioned by the shogun. Residential palaces, such as Nijō Castle (*see* KYOTO, §IV, 9) and the TŌSHŌGŪ SHRINE built in Nikkō for Tokugawa Ieyasu (1543–1616), the first Tokugawa shogun, were richly decorated with lacquer, gilding and polychrome painting.

One of the most characteristic types of lacquerware made for daimyo and shoguns during the Edo period was the lacquer dowry, an assemblage of furniture and personal storage boxes commissioned for a bride. The lacquer dowry was often nothing more than a display of wealth and status and was not intended for regular use. Included in the dowry were palanquins, which were the prerogative of daimyo and others of high social rank. The large quantities of lacquer required for such purposes, coupled with sumptuary laws, often resulted in a monotonous uniformity of design in lacquers made for high-ranking daimyo households.

Lacquerers were among the artists who served daimyo and shoguns to produce official commissions. The most skilful lacquerers were in great demand for individual commissions or as artists in service to a specific patron. Such official appointments tended to favour such families as the Koami, the Koma and Igarashi, who had already established relationships with élite patrons over generations.

Not only the shogun but also powerful daimyo occasionally established lacquer workshops in their domains. In the 17th century, Igarashi Dōho (*d* 1678), master lacquerer of a family whose ancestors had received prestigious commissions from the Ashikaga shoguns, moved from Kyoto to Kanazawa to serve Maeda Toshitsune, daimyo of Kaga (now Ishikawa Prefect.). By transferring the highest level of skill from Kyoto to Kaga, Dōho established a centre for lacquer production in an area that remained an important centre for decorative lacquerware in the late 20th century.

Patrons often commissioned contemporary lacquerers to make copies of famous antique lacquer objects that had been handed down through families or presented as gifts for special occasions. To ensure the accuracy of the copy, the lacquerer might be given access to the original. By doing this type of work, élite Edo-period lacquerers became familiar with the techniques and designs of earlier lacquers, but the custom of copying also probably contributed to the conservatism of design that characterizes lacquerware made for daimyo patrons.

Despite this conservative tendency in official circles, innovations in technique and design were widespread in Edo-period lacquerwork for townspeople, whether that made in Kyoto, the traditional home of lacquer production, in Edo, which became a major manufacturing centre from the 17th century onwards, or elsewhere. Distinctive lacquers, applied to objects for domestic or religious use, were also produced in smaller centres. Negoro ware, for example, named after its first place of manufacture at Negoro Temple, Kii Province, was carved or turned from wood in simple, robust shapes and lacquered first with black and then with vermilion; when, in time, the red wore through to reveal the black base, the ware acquired an appearance of antiquity that was much admired (see fig. 181).

One source of new ideas during the early Edo period was the collaboration between lacquerers and professional artists in other media. For instance, the calligrapher and sword connoisseur Hon'ami Kōetsu (*see* HON'AMI, (1), §3) is not known to have practised *makie* himself, but he was sufficiently familiar with its techniques to be able to direct professional lacquerers when they were working on an order. The design of a writing box (Tokyo, N. Mus.), with a remarkable domed lid, spanned by the motif of a bridge made of a thick band of lead and decorated with calligraphic characters in solid silver, is attributed to Kōetsu. Similarly dramatic designs are attributed to the painter and textile designer Ogata Kōrin (*see* OGATA, (1), §1(ii)). His two-tiered writing box (Tokyo, N. Mus.) decorated with a design of irises and an eight-part bridge (*yatsuhashi*), an allusion to an episode in the Heian classic *Ise monagatari* ('Tales of Ise'), has a bold, overall design in gold *makie* and inlaid mother-of-pearl and uses lead for

181. Negoro ware, ritual sake bottle, red lacquer over black on wood, h. 335 mm, 16th–17th centuries (London, British Museum)

the bridges. In its simplicity and balance, the piece resembles Kōrin's paintings on large folding screens. Lacquerers also found inspiration in printed books illustrated with woodblock prints, which were inexpensive and widely available from bookshops and itinerant vendors.

Most lacquer artists active during the 18th and 19th centuries made *inrō*, small containers for herbal medicines (*see* §XVI, 17 below and LACQUER, colour pl. I, fig. 1), which were then highly fashionable. The variety of design adapted to their miniature form was infinite, ranging from elegant *makie* burnished to a perfectly seamless finish to depictions of popular legends. *Inrō* were accessories in which personal taste could be expressed, and certain individuals had collections from which they could select an appropriate design for any occasion.

Technical innovations included an expanded use of metal inlays, especially those made of lead or tin. Artists of the 18th century developed techniques for imitating other materials in lacquer, such as wood, bamboo and antique Chinese ink (*sumi*). These faithful reproductions can be very difficult to identify as such. Such *trompe l'oeil* lacquers appealed to foreign collectors, who were able to purchase these novel items after Japan re-opened its ports to overseas trade in the late 19th century.

Although probably not responsible for inventing all the techniques for which he is often given credit, Ogawa Haritsu (Ritsuō; 1663–1747) is recognized as the outstanding early practitioner of a variety of methods for imitating

182. Lacquer dowry set by Kōami Nagashige and others, lacquer, gold and silver on wood with gold and silver fittings, 774×778×382 mm, Edo period, 1637–9 (Nagoya, Tokugawa Art Museum)

non-lacquer materials, including metals and antique Chinese ink. Several *inrō* and a writing box (Tokyo, N. Mus.) exhibit these techniques. Haritsu's work also incorporates inlays of a variety of materials, including pottery decorated with coloured enamels.

Lacquerers of the Edo period worked in small family workshops, a structure that probably was not very different from that of earlier periods. Younger family members assisted with preparatory processes, while specialized work and supervision were done by senior members of the family. For large commissions, such as a lacquer dowry for a bride of high social status, several families might cooperate by taking responsibility for specific items or processes. Although lacquerers were probably familiar with a number of techniques, there was some specialization. The decorators, or *makie* specialists, had higher status than those who applied the preliminary coats to lacquer objects. Lacquer workshops maintained relationships with suppliers of materials needed for their work, such as gold powders for *makie* or shell for *raden*. Many of the simple tools needed for lacquerwork were handmade by the lacquer artist.

The Kōami family is the best-documented family of lacquerers active during the Edo period. Family records provide genealogies extending back to the 15th century, when their patrons included the Ashikaga shoguns. The Kōami family worked on the decoration of the Kōdaiji, the finest architectural example of Momoyama-period lacquer decoration (*see* §(vi)(a) above). Kōami Nagashige (1599–1651) was the master lacquerer in charge of the splendid lacquer dowry commissioned by the shogun

Tokugawa Iemitsu (1604–51) for the marriage of his daughter (see fig. 182). Several other families of lacquerers were closely associated with the Tokugawa house in Edo. The Kajikawa family, who were principally known for *inrō*, were official lacquerers to the shogun. Lacquerwork associated with the Kajikawa varies in quality, and individual attributions are difficult because most members of the family used the same seal. The Yamada family also served the shoguns in the capacity of official *inrō* makers. They used the artist's names Jōka and Jōkasai.

Other notable Edo-period lacquerers were the Koma and the Shiomi. The Koma family first appeared in the 17th century, when several generations of the family signed their work Kyūhaku. Beginning in the second half of the 18th century, three generations of the family used the artist's name Koma Kansai. The first lacquerer of the Shiomi lineage, Shiomi Masanari (1647–c. 1722), specialized in burnished *makie*, using the technique known as *togidashi makie* ('polished-out sprinkled picture'; *see* §1(iii)(c) above). Lacquerers of the Shiomi school created designs of exceptional finesse.

Outside Edo and Kyoto, several families served wealthy provincial daimyo. Notable among these were the Igarashi lacquerers, whose genealogies date back to the Muromachi period, when the obscure Igarashi Shinsai is said to have worked for the shogun Ashikaga Yoshimasa (1436–90). In the early Edo period Igarashi Dōho (*d* 1678) moved to the town of Kanazawa in Kaga to serve the daimyo of the Maeda family. Lacquer pieces attributed to Dōho display outstanding technique and a conservative, but graceful style employing *takamakie*, with inlays of gold, solid silver and occasionally mother-of-pearl. The Iizuka, of whom the first was Iizuka Tōyō (*fl c.* 1760–80), served daimyo of the Hachisuka family of Awa (domain, now Tokushima Prefecture). Many designs by the first Iizuka Tōyō are dramatic and innovative in style.

(viii) Meiji period (1868–1912). Like other artisans, lacquerers, especially those dependent on patrons for commissions, faced a disruptive adjustment to the new era of modernization and foreign trade after the restoration of the imperial line in 1868. Those who had already engaged in commercial activities tried to produce lacquerware for the new foreign residents of Japan. They rushed to produce a vast array of hastily manufactured *makie* pieces with glittering surface appeal but relatively poor design and durability. Many of these pieces were designed in unprecedented shapes. The enthusiasm of Americans and Europeans for Japanese gold lacquers was given impetus by displays of lacquerware at international expositions from the 1860s. On realizing the potential of *makie* as a demonstration of the skills of Japanese craftworkers and as an art that could be uniquely identified with Japan, expert lacquerers were encouraged to produce showpieces of gold *makie* specifically for the Japanese pavilions at overseas expositions.

The establishment of a department of lacquerwork at the Tokyo School of Fine Arts in 1889 provided lacquerers with a broader exposure to the arts than traditional apprenticeship. Moreover, as museums were established, exhibitions of antique lacquer pieces, previously seen only by privileged lacquerers who served wealthy patrons,

allowed young lacquerers to explore the history and techniques not only of Japanese lacquerwork but also of objects from China, Korea, Okinawa and South-east Asia.

Shirayama Shōsai (1853–1923), a prominent lacquerer of the Meiji period and a faculty member of the Tokyo School of Fine Arts, campaigned tirelessly for the recognition of lacquerers as individual artists rather than as industrial craftsmen, a customary classification in the late 19th century. SHIBATA ZESHIN (1807–91), a versatile lacquerer who also studied painting, was an outstanding artist whose career spanned the transition from Edo to Meiji. He studied earlier techniques and also created innovations, such as painting in lacquer on paper, substituting lacquer and *makie* techniques for traditional pigments.

(ix) Modern period (after 1912). Lacquerers first had an opportunity to show their work at a national exhibition in 1913, when the Ministry of Agriculture instituted a crafts exhibition. In 1927, after a long struggle, crafts were included in the yearly Imperial Art Exhibition (Teiten). Individual lacquerers, some of whom, for instance Gonroku Matsuda (1896–1986), were trained at the Tokyo School of Fine Arts, achieved early recognition for their outstanding technique and originality (see fig. 183). Matsuda is one of the lacquer artists to have won official recognition for his work with the award of the title Holder of Intangible Cultural Property (also known as Living National Treasure, *Ningen kokukō*).

Government-sponsored exhibitions, competitions and awards have replaced in part the patronage of the past and enabled Japanese lacquerers to maintain the highest technical and artistic standards. Contemporary Japanese lacquer artists have drawn from their own or other Asian traditions and experimented with new techniques and materials, such as synthetic pigments, to produce lacquerwork of a variety and quality that is unsurpassed anywhere in the world.

See also RYŪKŪ.

BIBLIOGRAPHY

M. Boyer: *Japanese Export Lacquer from the Seventeenth Century in the National Museum of Denmark* (Copenhagen, 1959)
B. von Ragué: *Geschichte der japanischen Lackkunst* (Berlin, 1967); Eng. trans. by A. R. de Wasserman as *A History of Japanese Lacquerwork* (Toronto and Buffalo, 1976)
H. Arakawa: '*Makie*', *Nihon No Bijutsu*, xxxv (March 1969) [whole issue]
A. Haino: *Kamakurabori* [Kamakura carving] (Kyoto, 1977)
J. Okada: *Tōyō shitsugeishi no kenkyū* [Study of the history of East Asian lacquer art] (Tokyo, 1978)
J. Okada, G. Matsuda and H. Arakawa: *Nihon no shitsugei* [Japanese lacquer art], 6 vols (Tokyo, 1978)
Japanese Lacquer (exh. cat. by A. Yonemura, Washington, DC, Freer, 1979)
Japanese Lacquer, 1600–1900: Selections from the Charles A. Greenfield Collection (exh. cat. by A. Pekarik, New York, Met., 1980)
W. Watson, ed.: *Lacquerwork in Asia and Beyond: London, Percival David Foundation, 1982, Colloquies on Art and Archaeology in Asia*, xi (London, 1982)
Kindai Nihon no shitsugei (exh. cat., Tokyo, N. Mus. Mod. A., 1982); Eng. trans. by R. L. Gage as *Japanese Lacquer Art: Modern Masterpieces* (New York and Tokyo, 1982)
H. Arakawa: *Raden* [Mother-of-pearl inlaid lacquer] (Tokyo, 1985)
S. Kawada: *Negoro* (Kyoto, 1985)
T. Koike: *Hatsune no chōdo* [Hatsune *makie* lacquer furnishings] (Nagoya, 1985)
N. S. Bromelle and P. Smith, eds: *Urushi: Proceedings of the 1985 Urushi Study Group* (Marina del Ray, CA, 1988)

183. Lacquer covered box with animal motifs by Gonroku Matsuda, lacquer on aluminium mesh with gold and silver, 161×251×218 mm, Taishō period, 1919 (Tokyo, University of Fine Arts and Music)

T. Koike: *Konrei* [Trousseau heirlooms of daimyo ladies] (Nagoya, 1991)
East Asian Lacquer: The Florence and Herbert Irving Collection (exh. cat. by J. C. Y. Watt and B. B. Ford, New York, Met., 1991)
N. K. Davey and S. G. Tripp: *The Garrett Collection: Japanese Art: Lacquer, Inrō, Netsuke* (London, 1993)

ANN YONEMURA

XI. Textiles.

1. Introduction. 2. Historical survey.

1. INTRODUCTION. In Japan, textiles played a central role in the culture and economy from the Yayoi period (*c.* 300 BC–*c.* AD 300). They were used not only for garments but also for banners, religious covers, room dividers, carriers, screens and paintings. Textiles and their raw materials also substituted for money as taxes, tribute, gifts, bequests, fees and dowries. Traditional Japanese textiles were woven from bast fibres, silk or (after the 16th century) cotton. In addition, paper, either as flat sheets or formed into string for weaving, and animal skins were converted into textiles. Designs were either worked into the fabric in the process of weaving, braiding or netting, or applied later as surface decoration. The latter includes embroidery (see fig. 184), painting, block-printing, direct stencilling and resist-dye techniques such as bound-resist and block-dyeing, paste-resist and wax-resist (*see* TEXTILE, §III, 1(ii)(a)–(e)). Each has a history of its own, flourishing at a specific period. Changes in lifestyle and clothing styles (*see* §XVI, 7 below) encouraged the development of successive techniques. In broad terms, woven decoration increasingly gave place to surface decoration.

(i) Materials and techniques. (ii) Design. (iii) Production and social context.

184. Embroidery of *Shaka Preaching at the Vulture Peak*, h. *c.* 2.04 m, late Asuka period, AD 352–710 (Nara, National Museum)

(i) Materials and techniques.

(a) Weaving. (b) Dyeing and decoration.

(a) Weaving. Fragments of weaving and spinning tools unearthed from the Yayoi and Kofun (*c.* AD 300–710) periods suggest the use of a simple backstrap loom, consisting of a few parallel sticks for the warp beams and shed separator and simple notched bobbins for passing the weft through the shed (*see* TEXTILE, §II, 1(i)). In addition, a low stool was apparently indispensable, suggesting that the weaver sat with legs outstretched so as to make the best use of his or her body to create tension. Spindle weights show that fibres were either spun or twisted with a hand spindle.

The earliest fibres were apparently tree- or grass-bast fibres (*see* TEXTILE, colour pl. VII, fig. 2), both of which are still used in certain contexts. It has been suggested (see Cort) that the reason for their persistence is twofold. On the one hand, they have continued to play an important role in sacred state rituals, their special symbolic value deriving from important references in the early mythologies of Japan and in the first poetic anthology, the 8th-century *Man'yōshū* ('Collection of 10,000 leaves'). For example, in the imperial investiture ceremonies a dark, thick, rough cloth (*tafu, aratae*) woven from tree-bast fibres is offered during the night to the 'rough spirit', who is then pacified and harmonized with the 'smooth spirit' residing in the glossy, soft, white grass-bast fibre cloth (*asa, nigitae*). On the other hand, nationalist and folklore revival movements seek to preserve the techniques of

bast-fibre processing practised by necessity in remote mountain areas until the 1970s and 1980s.

Silk was reputedly introduced from China in the 2nd century AD (*see* §2(i) below). Twill-pattern silk (*aya*) became the favoured textile for court clothing and is still made for official court robes such as *jūnihitoe*. *Aya* can refer to plain twill (easily distinguishable by the diagonal rib formed by each weft or warp passing over two or more threads before going under one or more threads, this pattern being displaced by one thread in adjacent rows). More common in early *aya* textiles, however, was a figured twill with two sets of wefts (or warps), one creating a base, possibly in plain weave, and the other a twill pattern. To weave *aya* a loom with at least three heddles was used.

No actual looms remain from the period between the 6th century and the 16th. One of the earliest illustrations of a loom appears in the 13th-century *Taima mandara engi* ('Taima *maṇḍala* scroll'), housed at Kōmyōji, Kanagawa Prefecture. Depicted is a wooden frame with shed separator placed seven-eighths of the way up and string heddles suspended in front of the shed separator from rigged levers. According to the scroll, the *maṇḍala* was done in tapestry weave, for which the loom with its anchored breast beam (the breast beam on a backstrap loom is tied to the weaver's waist) and simple heddle system would be most suitable. Perhaps the Nara-period (710–94) tapestries were woven on such a loom (*see* §2(ii) below).

Probably the plain-weave textiles of the 7th and 8th centuries were woven on more efficient forms of the backstrap loom (*izaribata*), such as are still used in Okinawa and rural districts in Japan and have counterparts in both China and Korea. The raised wooden frame gives these backstrap looms greater sturdiness than primitive unanchored sticks. One shed is held open by a triangular frame or by shed-separating sticks. The other shed is operated by string heddles hung from a stick suspended in front of the shed separator. A pulley system is rigged to allow the weaver to raise the string heddles by pulling on a rope with one foot. For weaving *aya*, gauze and warp-faced *nishiki* cloth, it would be possible to rig extra string heddles on the frame backstrap, as is still done in rural China, although probably more elaborate and efficient looms, such as the draw loom, were in use.

To produce gauze, crossed warp threads are held in place by a weft and then allowed to uncross again. Hand-picking each warp cross is a common, if laborious, method, allowing for free pattern manipulation. The intricate, lacy-patterned *ra* gauzes in the Shōsōin, Nara, are excellent examples. A more efficient method is to rig string heddles that pass between and under one or more warps and pick up the adjacent warp, drawing it under its neighbour(s) and then up to form a shed. In this way, a whole row of intertwining can be manipulated mechanically, and weaving progresses more speedily. The method was used in the Edo period (1600–1868) to weave simple and complex gauze.

Warp-faced *nishiki* had supplementary warps of two to six colours set close together. This required extra warp beams for each colour. Monochrome wefts were of two kinds. The main wefts created the ground structure of the fabric, while the secondary wefts lay hidden in the cloth, except when needed to bind the pattern warps as dictated

185. Japanese weft-patterned silk with a design of clouds and creatures from Chinese mythology, late 17th century (New York, private collection)

by the pattern. Scholars presume that the weft-patterned *nishiki* in the Shōsōin were woven on a draw loom (*sorabikibata*) operated by two people (see Matsumoto), since the size and complexities of the patterns and the accuracy of the repeat suggest that they were not hand-picked (the alternative used for weft-patterned textiles in South America). The weaver sat at the loom controlling the ground structure of the fabric and placing in the wefts; at appropriate moments, an assistant pulled up the pattern warps for the weaver. Weft-faced *nishiki* is the reverse of warp-faced *nishiki*: a main warp builds the structure while a secondary warp binds the pattern weft to the surface of the fabric.

Much later woodblock book illustrations of draw looms from the 18th and 19th centuries show a standing loom with stable breast beam and a tall frame in the centre above the heddles (*see* TEXTILE, §II, 1(ii)). Mounted on this frame is the assistant weaver pulling threads guided by a set of pattern strings. On such looms were woven the wonderful weft-patterned *nō* robes (*see* §XIII, 1(iii) below), priests' robes (*kesa*) and fanciful *obi* sashes. Commentaries from the 16th century on the secrets of the 'new' standing draw loom suggest that either this form of draw loom was

lost between the Nara and late Muromachi (1333–1568) periods or that in the Nara period the draw loom had a different form, closer to the frame backstrap loom. Which-ever the case, the weft-patterned textiles (see fig. 185) woven on the later draw looms differed structurally from the Nara-period *nishiki*. On the one hand, the damasks and satins with gold or silver patterns had glossy, warp-faced grounds and weft pattern held down by a secondary warp. On the other hand, the *atsuita* and *karaori* fabrics used for *nō* costumes had a balanced twill ground (neither warp- nor weft-faced) and long weft floats forming much larger-scale pattern repeats. These were woven on a draw loom until the Meiji period (1868–1912), when Jacquard looms with a punch-card system (*see* TEXTILE, §II, 1(ii)) were substituted for the draw boy.

In the Edo period, satins, figured satins and plain silk were woven on standing looms or draw looms, while frame backstrap looms continued to be used in rural areas for bast fibres and some cotton. The advantage of the latter is that it does not overstretch the warp threads while opening the shed. The flexible tension control based on the natural movement of the human body proved partic-ularly important for non-elastic bast threads but was also useful in weaving *kasuri* (a type of ikat).

Kasuri based on plain weave, with resist-dyed threads forming a pattern, needs to be carefully adjusted during the weaving process. Warp *kasuri* often involves shifting threads dyed as a block by degrees. To make sure each thread is aligned properly, a ladder of closely spaced slats (*mokuhiki*) is used while winding the threads on to the warp beam. The higher the slat a thread has to travel through, the greater the pattern displacement. Some weavers found it easier not to wind the *kasuri*-dyed threads on to the beam, instead tying them to weighted spools and passing them through a slatted frame during the weaving process. For picture-weft *kasuri*, a guide thread is wound to and fro round pins placed down the sides of a block at intervals that exactly match the dimensions and spacing of the final woven weft. The pattern is either painted or stamped on the stretched thread, which is then unwound and used as a guide in binding the real weft for resist dyeing (*see* TEXTILE, §III, 1(ii)(a)).

(b) Dyeing and decoration.

Dyes. Simple dyes, such as phellodendron (*kihada*), that required no mordant seem to have been known already in Japan in the Yayoi period. Fragments of silk from the 5th-century Tsukinowa tumulus in Okayama retain vestiges of red from madder (*akane*), blue, probably from wild indigo (*yamaai*), and green produced by overdyeing yellow and blue (mordants were needed to set red and yellow). The *Rubia akane* species of madder (known in Japan as 'Western madder') has customarily been used in place of the commoner *Rubia tinctorum*; it contains purpurin but not alizarin (*see* DYE, §2). References in the *Nihon shoki* ('Chronicle of Japan') and the *Man'yōshū* to 'rubbed dyeing' (*surizome*) have been taken to suggest that the indigo leaves, and possibly earth pigments, were rubbed directly on to the fabric. More common was to place the dye material in water, extract its essence and then dip yarn or cloth into the bath. The main mordant used was lye, extracted by passing water through tree or straw ash. Iron contained in some waters and muds helped produce dark shades. These mordants remained standard until the 17th century and are still used. By the 5th or 6th century, trade with China led to the importation of cultivated plants producing what became some of the most favoured dyes: gromwell (*murasaki*), the roots (*shikon*) of which dye purple; safflower (*benibana*), with petals that produce shades of light to deep pink; and buckwheat indigo (*tade ai*), the leaves of which contain a sky blue when used fresh but can be fermented to produce deep shades of navy. Most of these dyes are also used as medicines, and it was believed that a garment infused with the spirit of a dye plant could ward off illness. Indeed, the excellent state of preservation of various papers and cloths treated with phellodendron and indigo has proved the effectiveness of these dyes as insecticides. In addition, the Japanese adopted the Chinese cosmological system, in which certain colours were associated with specific directions of the compass, seasons, organs of the body and virtues of conduct, and consequently established a colour coding for their court ranks.

Chemical dyes were introduced early in the 20th century and are in general use. However, even in the late 20th century natural dyes are often preferred for the finest pieces. The *mingei* folk craft movement (*see* §XV below), which began at a period when natural dyes were still common, encouraged many artists and craftspeople to continue the traditions of natural dyeing and to research ancient techniques.

Embroidery. Exactly what types of embroidery tools were used for the Asuka–Hakuho period (AD 552–710) chain stitch, the Nara period satin stitch and the dense Buddhist scrolls of the Kamakura period (1185–1333) remains unclear. Such illustrations as the *Shokunin zukushie* ('Depictions of trades'; early 17th century; Tokyo, Suntory Mus. A.) by Kanō Yoshinobu (1552–1640) show a large wooden frame used by embroiderers and dyers to stretch the long, narrow strip of kimono cloth. The embroiderer could kneel at the raised frame and stitch up and down through the taut cloth. During the Edo period (1600–1868) embroidery techniques became increasingly varied and realistic, including padding for bulk with filler between the cloth and the embroidery, overlay stitching and couching of heavy gold thread. While the earlier embroidery thread had no twist, late Edo-period thread had twist added to it, and the effects of this extra textural element were carefully calculated when the thread was used.

Braiding. By the 16th century weavers had also begun to use frames and stands for braiding to aid in organizing the increasing number of strands and to help weight the braided thread. Most popular were the round stand (*marudai*) with a raised circular top containing a central hole through which the finished round, square or flat braid descended; the square stand (*kakudai*) for simpler twisted round and square braids worked upwards; the bamboo stand (*ayatakedai*), similar to a weaving loom and producing flat braids; and the large stand (*takadai*), where the braider sat within the frame manipulating over a hundred bobbins to form complex pictorial braids.

Block-, wax- and bound-resist. Surface decoration required its own tools. No tools from the 8th century remain, but those used for similar textiles later in Japan and India are evidence of the view that the *kyōkechi* block-resist pieces were created by clamping together two large wooden blocks carved with identical mirror-image patterns, which when placed face to face created isolated hollow areas. Dye poured through holes in the back of the block reached each pattern 'pool' and penetrated the cloth clamped between the blocks (*see* TEXTILE, §III, 1(ii)(e)). Several pieces could be dyed at the same time. Characteristic 'white' outlines appear around each figure where the blocks of wood carved with identical patterns joined and clamped in place the folded cloth. The folding and clamping were best suited to thin cloth, such as fine silk or gauze, and resulted in symmetrical, mirror-image patterns. A variation of block-resist without the white outlines, 'shaded dyeing' (*ungenzome*) created bands of ever-deepening colours, a theme popular in paintings and furniture decoration of the time and one that was repeated in the Heian period (794–1185) for women's ceremonial gowns (*jūnihitoe*) in the form of layering of solid-colour garments. The only vestige of block-resist dyeing still in existence is

the single-colour block-resist *itajime* used to pattern the linings of court ladies' robes.

The carved, presumably wooden blocks for 8th-century wax-resist (*rōkechi*) textiles were probably stamps, held in the hand, as for Indonesian batiks (*see* INDONESIA, §V). The stamps were dipped in wax to reserve portions of the fabric from dye. Patterns were printed in one, two or three colours, either small repeats or complex compositions, such as animals standing under a tree (*see* TEXTILE, §III, 1(ii)(b)). In the 20th century many kimono artists chose hand-drawn wax-resist to produce designs that had once been done in the softer-edged paste-resist (wax withstands higher temperatures).

Bound-resist or tie-dye went by various names in different historical periods (*kōkechi, kukushi, shibori*); it produces square or round dots of various sizes and patterns and requires only a few tools (*see* TEXTILE, §III, 1(ii)(a)). The simplicity of this technique may be one reason why tie-dye was the only one of the three early resist techniques to persist and develop, with the result that by the 16th century it had become a highly varied, elaborate and precise art. From the beginning it seems to have been used more for simple textiles, suggesting it was a commoners' art.

In the 8th century some examples may well have been done 'free-hand' by picking up a small area of cloth and wrapping thick thread around the base to make a resist circle or square. Other pieces suggest simple stitching or folding and binding to create corrugated straight lines. The shaded dyeing (*ungenzome*) may have been done by folding the cloth and clamping the areas to be reserved between protective blocks. Late Heian-period illustrations such as the fan *sūtra*s (*senmen shakyō*; Tokyo, N. Mus.) depict garments with designs that look as if they were decorated with bound-resist, thus indicating that the art has had a continuous history, at least for commoners' clothes. The stitched and bound techniques that evolved to create the beautiful *tsujigahana* textiles of the 16th century required the maker to sew tiny stitches around the pattern area, pulling the thread tight so that the cloth bunched up, and covering the area to be reserved (either the inside or the outside of the pattern) with a protective cap. Designs on a white background were particularly difficult, and probably only a portion of the cloth was dipped into the vat (*tsumamizome*; see fig. 186).

From the Edo period onwards, all bound-, shaped- or block-resist techniques were described as *shibori*, a term derived from the word meaning 'to squeeze, wring or press'. The 'fawn-spot' (*kanoko shibori*) patterns of closely set resist squares and rounds with tiny dyed centres that became popular at the beginning of the Edo period were created with the aid of a hook to anchor the centre of each 'spot' as it was bound. After dyeing, when the threads were cut, these points were retained as small peaks in the pattern. The result was genuinely three-dimensional, unlike a stencilled imitation, although the effect could be simulated by stencilling an imitation over a perforated surface. As cotton *shibori* dyeing became more popular, myriad techniques evolved, including wrapping the cloth around a pole and crushing it before binding it to produce a pattern like a spider-web or folding and stitching geometric

186. Kanō Yoshinobu: painted screen panel of dyers from *Shokunin zukushie* ('Depictions of trades') showing: (centre) man dressed in a small-patterned robe stencilling gold leaf over a stretched robe (*kosode*); (left) seated man checking quality of dyed cloth; (right) woman kneeling at an indigo vat immersing a portion of cloth in indigo dye (*tsumamizome* dyeing technique); (foreground) children stretching dyed cloth out to dry (other dyed bolts are laid out on latticework above shop, and finished fabrics lie ready for sale on racks); (back, left) piece of bound-resist and gold-leaf stencilled cloth hanging from the eaves of the shop; 577×421 mm, early 17th century; Important Cultural Property (Tokyo, Suntory Museum of Art)

repeat designs. Each method had its name and tended to be associated with a particular locality.

Stencils and paste-resist. It is often suggested that the first examples of stencil dyeing in Japan were the coloured patterns in leather armour plates and the large ink images of lions (*ban'e*) from the Kamakura period. Some examples of Nara-period repeat patterns on leather and ramie in the Shōsōin, however, may have been done with stencils. In all the early examples, colour was applied through the holes in a pre-cut stencil. The same method was used for the gold- and silver-leaf decorations on 16th- and 17th-century *surihaku* and on *nō* costumes, only in this case adhesive was applied through the stencil and metallic leaf laid on top. Reverse patterning developed when the Japanese devised a rice-paste resist that could be forced through the stencil to reserve white areas when a fabric was immersed in a dye. This method was used for the 'small-pattern' (*komon*) designs that were popular on men's

187. Cotton carrying cloth, decorated with free-hand rice-paste (*tsutsugaki*) resist dyeing, 800×762 mm, from Kyushu, early 20th century (Honolulu, HI, Honolulu Academy of Arts)

matched suits (*kamishimo*). Since the pattern units were small, there was no need to strengthen the stencil paper. For the complex designs with large cut-out areas that developed in the late Edo period, a netted backing was placed on the stencil paper, which stiffened with persimmon juice (*shibugami*). Many of these papers have become art objects to be collected in their own right. The *bingata* textiles of Okinawa are particularly beautiful examples of hand-painted, stencil-resist work (*see* TEXTILE, §III, 1(ii)(e)). Collections of these textiles are held at the Japan Folk Art Museum, Tokyo, the National Museum, Tokyo, and the Okinawa Prefectural Museum, Shuri. Their bright pinks, strong yellows, purples and blues are delicately outlined with fine white lines. Large pattern units cleverly arranged at 90° angles or turned over to give a mirror image create flowing designs with rhythmic variation. The *bingata* textiles inspired a number of modern textile artists, such as Keisuke Serizawa (1895–94; Living National Treasure), to create colourful, large-scale stencil-resist pieces.

Rice-paste resist, applied free-hand without a stencil, developed in the 17th century for the pictorial and floral designs of *yūzen* dyeing (*see* §2(vii)(a) below). Bold, humorous designs appear on *kyōgen* (*see* §XIII, 1(iii) below) costume vests (*karaginu*). Similar in technique, but done mainly on cotton with bold designs, is the country art of *tsutsugaki* (see fig. 187), named after the cone used to hold the resist paste. To create hand-drawn rice-paste resist, the maker had first to sketch the basic outlines of the motif on the cloth with charcoal or with fugitive ink (*aobana*) extracted from the spider-wort (*tsuyugusa*). Then the cloth was stretched taut, and paste resist was squeezed

through the mouth of a funnel along the lines of the design. Care was needed to keep a steady flow with even thickness. For *yūzen* and *chayazome* (*see* §2(vii)(a) below) the lines were thin; for *tsutsugaki* stronger, more robust lines of varied thickness were used. To aid the absorption of the dye, the whole cloth was then painted with soybean liquid (*gojiru*). Next the inner areas were brushed with dye using shading in spots. Before dyeing the background, all the motifs were covered with paste on both sides of the cloth. For *tsutsugaki*, *chayazome* and some Edo-period *yūzen* pieces, the paste-resisted cloth was immersed in a vat to dye the background. In other cases, the background colour was brushed on with a broad brush. Finally, hot water or steam set the colour and helped remove the paste (see fig. 186).

(ii) Design. Despite the strong influence of Chinese textile motifs, the Japanese gradually developed their own aesthetic, which was intimate, quintessential and poetic. Most ancient Japanese textiles replicate Chinese, Persian, Mongolian and Korean motifs: roundels filled with hunting scenes or floral patterns, arabesques of intertwining leafy vines and animals under a standing tree are seen in myriad variations. By the Heian period (794–1185), these dense, symmetrical, geometrically composed designs were still in evidence, the most frequently used being medallions, diamond lattice, hexagons, arabesques and undulating lines, and these are the 'motifs of the nobility' (*yūsoku*) that have come to be associated with the court of Heian (now Kyoto). The layered robes worn by the court women already featured sparsely distributed, asymmetrically balanced designs, an appreciation of the use of void space and an interest in subtle interplay of colour. After an interval in which textiles were heavily influenced by Chinese designs, the same characteristics emerged again as being distinctively Japanese in the Momoyama (1568–1600) and Edo (1600–1868) periods.

Many of the textiles from the Momoyama and Edo periods combined 'Chinese' and 'Japanese' elements. The Japanese generally consider as 'Chinese' such geometric formations as squares, hexagons and key-fret lozenges and such supernatural figures as dragons, mythical lions and phoenixes. 'Japanese' elements include floral patterns, pastoral and seashore scenes, small fauna, evocations of classical poetry and decorative script. Often the Chinese elements were embedded in the fabric, while the Japanese aesthetic dominated the overall design. A mid-17th-century Kanbun *kosode*, for instance, might have a ground pattern of interlocking frets (*sayagata*)—such as was popular on Chinese Ming-period (1368–1644) figured satins—which would be subtly noticeable in the large empty space over the left hip or would enliven an unembroidered black area but which would lie hidden among playful floral patterns that spread out boldly in an arc from left shoulder to hem. The composite of geometric and free-flowing, of lattice background and floral foreground, was a favourite not only for street *kosode* but also for *nō* costumes and was even used in cloths made for priests' robes (*kesa*).

The literary element in design appears both in the love of motifs alluding to imagery in classic poetry and in the placement of characters on the cloths. Genji wheels suggest the 'battle of the carriages' in the *Tale of Genji*.

Chrysanthemums floating in running water evoke the *nō* play *Kiku jidō* ('Chrysanthemum boy'). A ceremonial wrapper might have the character for good luck couched in gold. Script characters sometimes outline the division between two contrasting areas, such as the characters reading 'young bamboo' on a *kosode* formerly in the Nomura Collection, in allusion to a poem in the 'Butterflies' chapter of the *Tale of Genji* (see fig. 188). Just as in poetry, so too in Japanese textiles, indirect allusion, layering of imagery and suggestive contrast play an important role in the combining of motifs.

Scenic views were painted on textiles as early as the Nara period. In the Heian period landscapes decorated screens, and inked pictures of pines embellishing the trailing train (*mo*) added a painterly finish to the layered court costume (*jūnihitoe*). Large shaded leaves and dewdrops were hand-painted on Momoyama-period *tsujigahana* cloths, as also were ink-wash scenes, brushed on the garment as if it were a canvas. In the Edo period artists such as OGATA KŌRIN painted floral designs and landscapes directly on *kosode* (e.g. Tokyo, N. Mus.).

Family crests could also be design motifs. These circular emblems (*mon; see* HERALDRY, §VII) began to be used during the Kamakura period as identification marks on fighting warriors. One style of warrior's suit, the *daimon*, had large crests placed conspicuously on the sleeves and centre back. Later smaller crests, similarly placed, decorated formal garments, and large renditions were used on cloth signs that hung in front of shops. Many of the motifs worked into larger patterns on robes are found crystallized in the crests. Gingko leaves and cherry, chrysanthemum, paulownia or plum petals appear in a vast variety of forms. Cranes, swallows and geese spread their wings in single, double or triple images. Interlocking commas (*tomoe*), overlapping hexagons, layered diamonds forming a 'pine bark' pattern and spiralling squares representing lightning bolts are only a few of the geometric notions incorporated in crests. In the Edo period, merchant families created their own crests to express their aggressive, flamboyant tastes. Some of these crests form visual puns or picture puzzles, while others incorporate a character from the family name. Existing crests were varied by adding square or round borders, reversing black and white, turning the figures around, back to front or sideways; bending, folding or twisting the original shape; isolating elements; or abbreviating units.

(iii) Production and social context. From the earliest times until the Nara period, immigrants from the Asian continent brought weaving skills to Japan. Many, such as the Hata family, settled and were given clan status. The Nishiki family, who wove the ornate warp-patterned and weft-patterned *nishiki* cloth, were appointed as official weavers at the Nara court in the Weaving Office (Oribe no tsukasa) set up in 701. It is thought that the best cloths were produced by the Weaving Office for imperial and court use, while the inferior pieces came from the provinces. An Office of Needleworkers and a Palace Dyeing Office were also established.

These textile offices continued to operate throughout the Heian period but, from the mid-Heian period, were in competition with private operations. At the end of the

188. Two robes (*kosode*) draped over a screen, both in bound-resist (*shibori*), featuring poetic allusions represented by Chinese characters dividing the contrasting design fields: (left) figured satin with gold couching; (right) silk crêpe (*chirimen*) with upper character in large area divisions of bound-resist (*kanoko shibori*) on red, lower character in blue stencilled *kanoko*, late 17th century (Sakura, Chiba Prefecture, National Museum of Japanese History)

Heian period, all production was in private hands. During the 14th–16th centuries the quantity of imported Chinese cloth and the zeal with which it was sought might suggest reduced capacity among the Japanese weavers; the truth, however, was that there was an increased demand for silks as the warrior class began to dress more elegantly. Most of the weaving district of Kyoto was demolished in the Ōnin Wars (1467–77). Many of the weavers fled to the port city of Sakai, just south of Osaka and a major channel for Chinese imports, where they studied the new weaving styles and embroidery that were evolving in Ming-period China. When they returned, after a short period of struggle among themselves, they settled in the Nishijin ('Western camp') area, which remains the centre of weaving in Kyoto. For self-protection in turbulent times, the weavers formed guilds. The Nerinuki guild produced fine, glossy plain weave, while the Ōtoneri monopolized *aya* and weft-patterned cloths (*mon-ori*). A hierarchy of weaving families emerged, some receiving official protection from the Ashikaga shogunate and others imperial sanction to produce court costumes, inheriting, so to speak, the functions of the old Weaving Office. By the Momoyama period, drawing on knowledge brought from Sakai, the Japanese started to produce their own satins, figured satins and damask on new, improved looms and to imitate large-scale, weft-patterned fabrics such as the *atsuita*. Individual families held the secrets to special technical details and vied with each other to invent new methods.

In the Edo period the guilds were disbanded, but individuals soon formed provincial textile groups. Efforts by the Tokugawa shoguns at the end of the 17th century to stimulate the native silk industry and restrict imported

yarn furthered the growing internal trade and interdependence of specialized areas within Japan. Plain white silks, ramie and cotton were often produced in the provinces, while Kyoto produced luxury cloths. In particular the Takahata ('floor-loom house') was renowned for high-quality satin. In the face of threats such as a silk ban in 1841 and the convulsive changes of the Meiji Restoration and modernization, the Nishijin weavers reorganized their union several times, but the basic structure remains in the late 20th century, with a few dominant families controlling the weaving business and many others supplying the labour force.

2. HISTORICAL SURVEY.

(i) Before AD 552. (ii) Asuka–Hakuho (552–710) and Nara (710–94) periods. (iii) Heian period (794–1185). (iv) Kamakura period (1185–1333). (v) Muromachi period (1333–1568). (vi) Momoyama period (1568–1600). (vii) Edo period (1600–1868). (viii) Meiji period (1868–1912) and after.

(i) Before AD *552.* The earliest fragments of actual cloth were unearthed from the Jōmon-period (*c.* 10,000–*c.* 300 BC) Torihama shell mound in Fukui Prefecture. Here hemp warps were twined around spaced hemp wefts, presumably by hand without the aid of a loom. The fibres used before the Yayoi period (*c.* 300 BC–AD 300) were probably the long fibres that rest in the inner bark of various types of trees, such as the paper mulberry (*Broussonetia*, Jap. *kōzo*; *Broussonetia papyrifera*, Jap. *kuwa, kaji*), lime (*Tilia*, Jap. *shina*) and elm (*Ulmus*, Jap. *nire*), or vines such as wisteria (*Wisteria*, Jap. *fuji*) and kudzu (*Pueraria thunbergiana*, Jap. *kuzu*), for these are still worked into rough cloth in remote areas of Japan. Around the beginning of the Yayoi period, grass-bast fibres (*asa*) such as hemp and ramie were introduced from the Asian continent, possibly along with weaving techniques. The grass-bast fibres had the advantage of being cultivable and requiring less laborious processing than the soaking, rotting, boiling, beating and then splitting and joining required for tree-bast fibres. They also weave into a softer, more lustrous fabric, more suitable for wearing next to the skin. Garments made from these fibres, for a long time the basic textile of the commoners and of summer wear for the aristocracy, are prized and command high prices, continuing to be produced in present-day Japan (*see* §1(i) above).

Fragments of plain-weave cloth stuck to Yayoi-period swords and mirrors have been unearthed in the Arita, Hie and Tateiwa remains in Fukuoka Prefecture and show that the art of weaving dates back at least 2000 years. The *Nihon shoki* ('Chronicle of Japan'; 720) cites the legend that the Chinese presented a gift of silkworms to Emperor Seimu (a legendary figure; dates given in *Nihon shoki* as AD 131–91), and evidence points to sericulture dating from at least the 2nd century AD, if not considerably earlier. The earliest written record of Japanese textiles appears in the Chinese *History of the Wei Kingdom* among the 'Accounts of the Japanese People' (Chin. *Wo ren zhuan*; Jap. *Gishi wa jiden*; 3rd century AD), which states that the Japanese cultivated and wove silk as well as grass-bast fibres. Among gifts sent from Princess Himiko of Japan to the Chinese emperor in AD 238 and AD 243 it lists rough and fine silk and 'two-coloured' (*nishiki*) cloth. Although the term

nishiki was used later in reference to compound warp- or weft-patterned textiles, the *nishiki* sent by Himiko was probably multicoloured, striped, plain-weave cloth. Some scholars have suggested it was ikat-dyed (*see* TEXTILE, §III, 1(ii)(a)), like the imported *kanton nishiki* (*c.* 6th–7th century; Tokyo, N. Mus.), but, since similarly complex ikat patterns were only developed in the Edo period (1600–1868), this is dubious.

The first remnants of what must have been protective bags were found rusted to ceremonial mirrors and arrows unearthed from monumental graves of the Kofun period (*c.* AD 300–710). Under the emperors Ōjin (late 4th century–early 5th) and Yūryaku (second half of 5th century), immigrant weavers were encouraged to settle and teach their craft. The Korean Hata ('loom') family settled in what is now western Kyoto and still carry on their art. From the Chinese country of Wu (Jap. Kure), according to the *Nihon shoki*, skilled women weavers arrived in the 3rd century to establish a line of twill-pattern (*aya*) weavers (*see* §1(i) above). This *aya* cloth became a staple textile for court clothing and was much in demand until the decline of the nobility in the 12th century.

(ii) Asuka–Hakuhō (552–710) and Nara (710–94) periods. Textiles from a broad spectrum have been fortuitously preserved from the 7th and 8th centuries, mainly in HŌRYŪJI, a monastery established by Prince Shōtoku, and in the Shōsōin repository of the Nara temple Tōdaiji (*see* NARA, §III, 4). They are known collectively as *jōdaigire* ('ancient textiles'). In addition to being among the most beautiful examples of Japanese textiles, they represent almost all types of weaving and dyeing techniques and provide invaluable insight into the patterns and techniques used not only in Japan but also in other Asian countries. Textiles brought along the Silk Route came from as far away as Egypt, India and Persia as well as from China, Manchuria, Korea and South-east Asia. While the Hōryūji collection consists of 7th-century, primarily Buddhist, articles such as banners, priests' robes (*kesa*), altarpieces and cloth cases, the Shōsōin collection dates from the mid-8th century and includes, besides religious objects, household utensils and the personal effects of Emperor Shōmu, such as robes, hats, shoes, dance costumes, rugs, wrappers, bags, silk screens, cords and braids.

Examples of *aya* cloth dating from the 7th century are preserved among the treasures of Hōryūji. They are compound weaves with tabby-woven grounds and weft- or warp-faced patterns bound in twill. Examples from the 8th century, housed in the Shōsōin, demonstrate as well the more advanced techniques of twill patterning on a twill ground, including simple twill patterns, such as herringbone or bird's-eye, and compound twills, woven with double warps and wefts. The textural monochrome designs created were highly intricate and included grapevine arabesques, floral motifs and even hunting scenes with lions standing under a tree, appearing in repetitive blocks. Although the most complex of these textiles may have been imported from along the Silk Route (and indeed some scholars attribute the bulk of the ancient textiles to foreign origin), others (see Matsumoto) believe that most of them were produced in Japan. Records indicate that *aya* cloth was paid as a tax from the provinces.

Plain-weave textiles were either bast (*tafu* and *asa*) or heavy (*ashiginu*) and fine (*usuginu*) silk. Light, gossamer clothes were of open-weave silk or simple gauze (*sha*). Patterning appeared not only in the figured twills but also as supplementary warp or weft in *nishiki* fabrics, as tapestry on a plain-weave ground or without a ground (*tsuzureori*), and intertwined in complex pieces of gauze (*ra*). Of these the most profuse are the *nishiki*.

As Matsumoto points out, the 8th-century fabrics show a considerable technical advance over those of the 7th century, corresponding to technological developments in mainland China. Tang-period (618–907) styles and techniques can be seen not only in the more complex twill on twill *aya* of the 8th century but also in advances in *nishiki* techniques. The rare examples of *nishiki* from the 7th century are all warp-faced *nishiki* of two, or at most three, colours. In contrast, the 8th-century *nishiki* include more complex-warp *nishiki* of four to six colours, with patterns such as lion masks, temple scenes and interlocking jewel circles, and also weft-faced *nishiki* with a supplementary weft pattern. Although the weft-faced *nishiki* required a more complex loom, it also had the advantage of free manipulation of shapes and unlimited colours. Medallions filled with elaborate scenes and enclosed in a chain of circles, scrolling vines with leaves and flowers branching out at rhythmic intervals (*karakusa*) and fantastic 'Buddha-visage' flowers (*hōsōge*) are only some of the numerous motifs woven into these fabrics. Weft-faced *nishiki* quickly became overridingly popular. Supplementary weft patterning formed the basis for *nishiki* of subsequent centuries, and production of warp-faced *nishiki* ceased. Flat braids added a decorative finish to many banners, bags and outfits. Plaids, stripes, 'V's and undulating bands appeared, beautifully interwoven with contrasting or complementary colours. Most likely (see Kinoshita), these were not braided on a wooden frame, as became the custom later, but with a loop system manipulated solely on the fingers.

Various types of dyes are attested by the Shōsōin and Hōryūji textiles (*see* §1(ii) above). Prince Shōtoku established purple as the colour for robes and hats worn by the highest rank, then blue, red, yellow, white and black in descending order, though subsequent codes changed the order and increased the shades. Purple, madder red and safflower crimson were idealized in poetry, being prized for the intricacies of their dyeing processes. The textiles of the Shōsōin and Hōryūji reflect a love of deep, rich colours combined either in contrast or in graduated shades.

In addition to dyeing yarn for woven designs, the 7th–8th-century dyers used resist techniques (*see* §1(ii) above) plus direct rubbing and painting to create colour patterns on pre-woven cloth. Wax-resist patterns were printed and dyed in one or two baths, and they include both simple repeats and complex compositions such as animals standing under a tree. Bound resist was used more for simple textiles, suggesting that it was a commoners' art. The third and most popular technique, block-resist, produced multicoloured, flowing designs, often of flowers and birds.

Embroidery, following Chinese models, decorated banners and religious cloths, such as the *Tenjukoku mandara shūchō* embroidery on a gauze ground (late 6th century; Chūgūji nunnery, Nara Prefect.). The major embroidery technique of the 7th century comprised rows of chain stitch, creating solid areas and outlines. By the 8th century, in addition to the chain stitch used for medallions and figures of the Buddhist pantheon, satin stitch and stem stitch were used to create thick, tactile representations of birds and flowers. Most of the embroidery was double-faced, meticulously stitched by women of the court. These women may also have stitched the stunning patchwork priests' robes (*kesa*), known as the 'robes of excrement' (*funzōe*) because they were composed of 'useless' rags. As many as six layers of silk or ramie of various irregular shapes were quilted together with tiny running stitches to form patterns suggestive of misty mountains, clouds or waves.

(iii) Heian period (794–1185). Although few textiles remain from the Heian period, it is clear from abundant references in literature and depictions in paintings that cloth played a central role in the lives of the Heian courtiers, not just for their elaborate dress but also for interior decoration. The early 10th-century record of court rituals, the *Engi shiki* ('Procedures of the Engi era'), lists textiles, silk thread and dyes among the provincial taxes. It also details the production methods for textiles and dyes. The *Engi shiki* established the correct forms and processes for future generations. Predominant among the textiles of the Heian period were *aya* (figured twills), used for male and female court robes. Warp-faced *nishiki*, complex-gauze, wax-resist and multicoloured block-resist techniques fell into disuse. From the wide variety of techniques and materials learnt during the Nara period, the Japanese seem to have selected those that best suited their sensibility and discarded the others. Since emphasis was on the muted, subtle and naturalistic, simplicity won over complexity, and colour harmony played an increasingly important role.

(iv) Kamakura period (1185–1333). The rare examples of textiles dating from the 13th and 14th centuries include beautiful embroideries of Buddhist figures, densely filled with textural variation to produce a realistic effect, and large stencilled ink medallions (*ban'e*), often representing a lion. Stencilling appeared on the armour worn by the newly established warrior class. Leather, often decorated with elegant designs, was used for the chest plate and for the rectangular plaques for shoulder guards and skirts. Pieces were lashed together with beautifully braided cords. Many of the types of braids (*kumihimo*) used in later years evolved out of the braids developed for armour.

(v) Muromachi period (1333–1568). Trade with Ming-period China (1368–1644) flourished in the 14th and 15th centuries. Imported textiles, such as satin (*shusu*), figured satins (*rinzu*), damask (*donsu*), gauzes (*rō* and *sha*), crêpe (*chirimen*) and silks with weft-patterning in gold (*kinran*) or silver (*ginran*), were tailored into robes, made into protective bags and formed decorative mountings for hanging-scroll paintings. As the tea ceremony spread (*see* §XIV below) valued utensils were given names, and the protective bags made for them out of small cuttings of prized foreign textiles in turn received names. Soon, other cloths of the same pattern were referred to by the same name, and a whole class of imported weft-patterned and striped textiles were collectively known as 'named textiles'

(*meibutsugire*). Small repetitive patterns done on earth colours and dark greens, blues and reds appeared in harmonizing or complementary colours. These exotic, imported fabrics also included the Mughul-inspired *mōru* and the cotton-and-silk double-cloth *ōdon*. Fabrics imported from India passed through the trading city of Ayutthaya in Thailand; the Japanese consequently acquired a taste for Thai-style, gold-painted textiles (*see* THAILAND, §VIII), for which they paid high prices. It was common for bolts of these prized cloths to be presented as special rewards and gifts. Records suggest that, as a result, Muromachi-period *nō* costumes were fashioned in part from imported textiles such as *kinran*, and even later, in the Edo period (1600–1868), the broad-sleeved male *nō* costumes (*kariginu, happi*) continued to use similar patterns, often greatly magnified.

In addition to the flood of foreign textiles, handscrolls (*emaki*) and other depictions of daily life suggest advances in native techniques in two areas of surface decoration. Bound-resist, which had remained the major decorative technique for the common classes, found new expression in larger patterns and more complex methods. By stitching around the outline of a pattern before binding it and capping it with a layer of bamboo bark to reserve it from dyeing, the makers could control the shape of the designs. At first stitched-, bound- and capped-resist was used to create large fields of colour (*somewake*), such as on the shoulder and hem of a garment. These fields might then be embroidered or hand-painted with pictorial designs. Experimentation led to increasingly precise control of small units. By the 16th century, stitched- and bound-resist fabrics with elaborate, dense, floral patterns, such as those on the banners presented to the temple Negorodera in 1530, were produced by combining indigo and yellow and restitching reserved areas for separate dippings. This produced cloth in varying shades of green, yellow and blue. Finally, silver foil was pasted on to some leaves to create a fourth colour. This particular style of stitched- and bound-resist is known as *tsujigahana* ('flowers at the crossing').

Stencil dyeing (*katazome*) was applied in new areas (*see* §1(i)(b) above). As the 'large-crest' (*daimon*) robe of the warrior class became more popular, the Japanese looked for easy methods of creating large, circular white areas, which could be painted with a family emblem. Rather than applying colour directly through a stencil, they experimented using rice paste pressed through the stencil to create white, undyed areas. By the 16th century, rice paste, based on glutinous rice (*mochiko*) applied through stencils cut with small repetitive motifs, was the basis for resist-dyeing the popular 'small pattern' (*komon*) bast-fibre textiles used to make matched suits (*kamishimo*). Textiles with medium-size patterns were called *chugata*.

(vi) Momoyama period (1568–1600). In the last quarter of the 16th century, as the great military leaders worked to reunify Japan, a growing independent spirit among the commoners stimulated the textile industry. Overt elegance and competitive self-adornment encouraged the creation of outstanding textiles. From this period, as from the 8th century, considerable numbers of textiles have been preserved.

Technological advances in weaving and embroidery in Ming-period China affected Japanese taste. Long, glossy floats and more pictorial representation set the fashion. Heavy woven cloths imported on thick boards (*atsuita*) had large-scale designs, a repeat often spanning half the width of the fabric. The Japanese weaver Tawaraya (dates unknown), inspired by the *atsuita* techniques, is alleged to have invented the 'Chinese weave' (*karaori*), which had long weft pattern floats, of glossy, untwisted silk that bulged softly up from the ground weave, creating a three-dimensional effect. Garments tailored from *karaori* fabric were in style during the Momoyama period and persisted into the 20th century, primarily as *nō* costumes. Similar in effect was the new Chinese-style 'float stitch' (*watashi-nui*) in embroidery, which used long parallel stitches that travelled back and forth on the surface of the fabric and were anchored by tiny picks along the edges of the motifs on the wrong side of the fabric. Embroidered garments (*nuihaku*) of the period were densely covered with glossy silk stitches; areas left unembroidered had gold or silver leaf applied to the cloth (see fig. 189).

The technique of pasting gold or silver on to cloth by applying an adhesive through a stencil and then laying thin gold or silver leaf on it (*surihaku*) was known already from imported Ming-period gold-imprinted cloths (*inkin*). Similar delicate designs in gold (*kirikane*) appeared as decorations on the robes of Buddhist statues as early as the Heian period. In the Momoyama period, gold- and silver-leaf imprinting often appeared in combination with hand-drawn details and with stitched- and bound-resist in *tsujigahana* fabrics.

189. Embroidered and gold-leaf stencilled silk *nō* costume (*nuihaku*), 1.60×1.33m, Momoyama period, 1573–1615 (Chicago, IL, Art Institute of Chicago)

Tsujigahana bound-resist became increasingly complex; outlines were precise and well controlled. Densely patterned small designs sometimes combined three or four different colours. Garments were often designed as a composite image with bold, sweeping overall designs against large areas of white. One robe, reputedly owned by the warlord Toyotomi Hideyoshi, has three distinct design areas. Along the hem stands a row of white arrows against a dark green ground; across the shoulders appear paulownia crests reserved in white against a band of purple, and the white midriff bears scattered paulownia motifs with pale blue sprigs lightly sprinkled above adjacent leaves in moss green, purple and tan. During the Keichō years (1596–1615) bridging the Momoyama and Edo periods, dark grounds that displayed the metallic imprint to advantage gained increasing favour. The thin, flexible, glossy plain-weave silk *nerinuki* (weft-glossed/warp-unglossed or 'hard' silk) that was popular during the Momoyama period was particularly well suited to minutely stitched and bound-resist techniques. By the beginning of the 17th century the Japanese had begun to manufacture many of the satins, damasks and other textiles formerly imported from China. These were heavier than the *nerinuki*, and the woven fabric pattern often competed with the stitched and bound pattern to ill effect.

Trade with Portugal, Spain and Holland introduced the Japanese to European textiles, in particular velvet (*birōdo*). The European traders also carried fabrics such as cotton calico (*sarasa*) and dye-stuffs from South-east Asia and India. Even after the ports were closed in the early 17th century, the Japanese continued to import, through the Dutch, such fabrics as Indian cottons, which were to have a profound influence on their own textile production and designs. The dyes and mordants brought on Dutch ships expanded the palette considerably.

(vii) Edo period (1600–1868). The *kosode*, a floor-length, pocket-sleeved precursor of the modern kimono, was well established as the universal garment of all classes by the Edo period (*see* §XVI, 7 below). Textile development centred on the *kosode* and its decoration.

(a) Silk. (b) Cotton.

(a) Silk. During this period, more and more emphasis was laid on surface decoration of satins and damask rather than in weft-patterned woven designs, which became relegated to costumes for the *nō* stage and Buddhist paraphernalia. Early 17th-century surface decoration techniques expanded on those of the Momoyama period: bound-resist, gold- and silver-leaf imprint and embroidery. Embroidery no longer covered the entire cloth but served as highlights. Consequently the 'float stitch' gave way to shorter stitches placed in various directions. Couched (*koma-nui*) gold thread appeared sparingly. In 1657 and again in 1661 devastating fires destroyed much of Kyoto, the centre of the textile industry. Partly in response to the tremendous demand for robes to refurnish wardrobes, partly as a reflection of the taste of the more settled second generation under the peaceful reign of the Tokugawa shoguns and partly as a result of sumptuary laws restricting certain materials and dyes to the military aristocracy, new techniques were devised for speedier colourful decoration.

Named after the Kanbun era (1661–73), the Kanbun style used large area divisions: a broad, arched sweep from left shoulder to hem was decorated, the rest left white. Substitutes for the laborious and time-consuming bound-resist (*see* §1(i)(b) above) included stencilled paste-resist, which had been used to imitate bound-resist dots in *komon* patterns on bast fibres. The presence of what are probably stencilled paste-resist dots on the Keishōin *kosode* at Gokokuji Temple, Tokyo, reputedly worn by the concubine of the third Tokugawa shogun, Iemitsu (1603–51), indicates that the technique was known before the fires. In the second half of the 17th century, paste-resist techniques gradually superseded bound-resist.

In two respects the new paste-resist differed fundamentally from previous methods. First, a method for applying the paste free-hand through a funnel was devised, making it easy to create flowing, painterly designs with clear edges. Second, the dye was applied with a brush on stretched cloth, rather than by immersing the cloth in a dye vat. This made possible unlimited colour range, fine control and shading. Since some of the basic dyes, such as indigo and the popular but restricted crimson from safflower, could not be applied with a brush for technical reasons, dyers combined stitch- and bound-resist with paste-resist so as to be able to vat-dye the background colours and brush-dye the pattern motifs (*see* TEXTILE, §III, 1(ii)(e)).

The brushed-on, paste-resisted textiles are referred to generally as *yūzen*, from the name of a fan painter, Miyazaki Yūzensai (*fl* second half of 17th century). Yūzensai did not invent the dye techniques but created popular designs suited to paste-resist dyeing. He published one fashion book (*hinagata-bon*) of *kosode* designs in 1692; other designs identified as 'Yūzen style' had appeared in earlier fashion books of 1686, 1687 and 1688. The designs are multicoloured, with fine lines and delicate shading. Floral themes predominate, though many are highly pictorial, showing landscapes and buildings (see fig. 190). *Yūzen* dyeing was quick to gain popularity and set the style for the lavish robes of the Genroku era (1688–1704); it remained one of the main traditional methods of surface decoration. The types of *yūzen* were known by geographical area: Kyo *yūzen* from Kyoto had bright, aristocratic designs; Kaga *yūzen* from Kaga (now Kanazawa) stood out for its subtly-shaded, realistic pieces; and Edo *yūzen* from Tokyo was more flamboyant, with bold colours and scenic designs from everyday life.

The 18th-century silk textiles continued the techniques of the 17th century, *yūzen* predominating, sometimes highlighted with spots of embroidery. On *nuihaku*, now made only as *nō* costumes, an interest in naturalistic effect encouraged sophisticated use of such stitches as satin stitch (*hira-nui*), long-and-short stitch (*sashi-nui*) and stem stitch (*matsui-nui*). Bird feathers or flower petals and leaves were done with special care.

The waist sash (*obi*) used to secure the *kosode* broadened over the centuries: in the Muromachi period it was about 50 mm wide; at the beginning of the 17th century it was about 75 mm wide; by the mid-18th century it had grown to some 250 mm; and by the early 19th century it was over 300 mm. At the same time, it grew in length to more than 3.5 m, being wound around the midriff several times and tied in decorative bows in front, at the side or at the

190. Robe (*kosode*), white silk crêpe (*chirimen*), with stitch-resist (*shibori*), paste-resist (*yūzen*) and embroidered design of views of Kyoto and plants of the four seasons, h. 1480 mm, second half of the 18th century (Sakura, Chiba Prefecture, National Museum of Japanese History)

back. The *obi* also became increasingly elaborate. Woven patterns in tapestry and weft-patterning created rich, heavy sashes. Gauze-weave sashes were worn in summer. Hand-painted or resist-dyed sashes mirrored the *kosode* decorations, and simple checks or stripes were used for everyday wear. The growing importance of the *obi* stimulated not only the weaving studios, which had been producing weft-patterned brocade textiles primarily for the priesthood and the *nō* theatre, but also tapestry production. As the *obi* gained in importance, the areas of decoration on the *kosode* began to concentrate at the hem, edges of the sleeves and sometimes the collar. Earth colours, blues and greys were common as grounds.

Robes worn unbelted as outer cloaks, such as the wadded *uchikake*, continued to have decoration over the entire garment, either in small repetitive woven repeats or in large pictorial sweeps. The latter were particularly popular as wedding gowns, often in matching pairs of red and white, with bold patterns using various dye techniques and elaborate embroidery accented by couched gold thread. Visions of the elegance of courtly life, such as breeze-blown cloth room dividers or scattered jewels, were common motifs. Also decorated with scenes representing Heian-period court life were the *goshodoki* ('views of the imperial palace'). Although at first glance these master-pieces of scenic detail appear to be simple landscapes,

details evoke passages from classic literature. Favourite themes come from the *Tales of Ise*, *The Tale of Genji* and *nō* plays. Phrases from classical Chinese and Japanese poetry may also be found embroidered into the scene. Literary allusion on a garment was an unspoken code that suggested the education of the wearer.

In summer cool ramie robes (*katabira*) were preferred. Court women of the middle rank wore ramie decorated with delicate pictorial landscapes in shades of blue and an occasional embroidery highlight (*chayazome* or *chayatsuji*). The main areas were paste-resisted and vat-dyed in indigo or sometimes a light tan. Details were painted in with pigment from indigo sticks (*aibō*). Many of the scenic views represented had classical references. Ramie robes dyed in various shades of brown (*honzome*) were the prerogative of upper-ranking court women.

(b) Cotton. Sophisticated use of paste-resist (*see* §(a) above) had its counterpart in country textiles. By the mid-18th century cotton had become the staple fibre of the lower classes. Since cotton fibres absorb dye less easily than silk, the colour range was more restricted. Indigo proved particularly well suited to cotton dyeing, and most country textiles had indigo as their base colour. Almost every town had its local indigo dyer (*aishi*), who maintained the temperamental indigo vat and dyed cloth and yarn for the surrounding area. Bolts of cloth intended as bedcovers might have paste-resist stencilled, repetitive patterns of flower arabesques, while cotton summer kimonos (*yukata*) bore paste-resist patterns of flowers, fish, birds and water scenes. For celebrations and festive occasions in the country large square cloths (*furoshiki*), banners, room dividers (*noren*) and bridal bedding were decorated with hand-drawn, paste-resisted pictures (*tsutsugaki*) representing such felicitous symbols as cranes, turtles and Mt Hōrai (long life) or pines, bamboo and plums (strength of character and persistence through adversity).

Bound-resist methods for decorating cotton multiplied. Inventive techniques produced delicate repeat patterns, such as 'sunrise spots', or overall pictorial designs, such as carp leaping up a waterfall. The towns of Arimatsu and Narumi outside modern Nagoya (Aichi Prefecture) prospered by selling their marvellous indigo stitch-resist (*shibori*) cloths to those passing along the Tokaidō road from Tokyo to Kyoto.

The indigo dyer dyed yarn as well as cloth. This yarn might be ikat-dyed (i.e. pre-measured to the length of the warp or width of the weft, with areas bound off to protect the dye from penetrating). These would then be woven by the farmers' wives into ikat or *kasuri* cloth (see fig. 191), the resisted areas creating a built-in pattern in the plain-weave textile. *Kasuri* dyeing was introduced into Japan from the Ryūkū islands (Okinawa) after the Satsuma daimyo in southern Kyushu annexed the area in 1609 and demanded *kasuri* textiles as tribute. At first these superior textiles woven in ramie (*jōfu*) and banana fibre (*bashōfu*) were worn only by the warrior class, but by the mid-18th century *kasuri* had become so popular that several regions started to copy it. *Kasuri* developed first in 1660 in the mountainous areas of Echigo (now Niigata Prefecture) where ramie was grown, after which western and finally

eastern Japan adopted it for cotton weaving. Each developed a distinctive style, yet the excellent trade routes between areas resulted also in mutual copying of designs, materials and techniques.

Simple ikat known as *shimekuri* had been in use already in the Heian period (794–1185) for broad braids (*hirao*) worn as belts and in the Muromachi (1333–1568) and Momoyama (1568–1600) periods to create grounds for weft-patterned garments with alternating blocks (*dangawari*). These were, however, categorically different from the delicate, geometric *kasuri* designs of Okinawa and from the denser, more ornate Japanese *kasuri*, whose ultimate expression was in intricate weft *kasuri* pictures (*egasuri*; see fig. 213 below). While the broad fields of the early garments were based entirely on resist binding the warp threads, many later *kasuri* designs were purely weft-controlled. Others combined warp-and-weft-resist. In weaving, the resisted areas could be shifted by degrees in a predetermined order to form a pattern. A 20 mm white line in the weft might be used to form squares, parallelograms or flowing curves suggestive of flying birds or running water, or worked against another white patch to form 'X' shapes. Inventive alternatives for producing small, intricate patterns included clamping the threads between carved boards as well as weaving thin weft on to a much heavier warp, dyeing the cloth, unravelling the weft and reusing the splotchy thread as warp or weft (*see* TEXTILE, §III, 1(ii)(a)).

Kasuri often appeared mixed with stripes and plaids, which had a long history as the staple decorative technique for everyday gowns of most classes and for interior decoration. Many local areas produced their own special varieties of stripes and plaids on cotton in the basic commoners' colours of browns, blues and greys (plain-weave handspun silk, *tsumugi*, appeared in stripes of more varied colours). In line with Japanese aesthetic sensibility, subtle sophistication lent even simple stripes a striking elegance. Irregularly balanced stripes of varying thickness created complex rhythms, and progressively deeper colour demonstrated the Japanese love of shading.

Stitching to strengthen the cloth and to secure quilting was worked to decorative effect. The villagers often used large running stitches with thick white thread to create geometric designs on plain indigo cotton (*sashiko*). Particularly elaborate were the dense 'weave stitch' (*kogin*), creating a thick, warm cloth, and the anthropomorphically decorated appliqué garments of the Ainu from Hokkaido.

(viii) Meiji period (1868–1912) and after. With modernization in the second half of the 19th century, textiles were the first area to industrialize. Drawing on their traditional workshops and skills, the Japanese began to mobilize the silk industry towards mass production. Missions sent to Europe to study textile production totally revamped Nishijin weaving (*nishijin-ori*; high-quality silk fabrics produced in the Nishijin district of Kyoto) by introducing the Jacquard loom, which was later adapted and improved to suit Japanese needs. As the complex supplementary weft patterns were transferred to punch cards, enabling a single weaver to control the entire loom, the two-man-operated draw loom fell into disuse. In a nationwide effort to compete on the world market, many village girls were

191. Ramie and cotton robe, with tie-dye (*kasuri*) design, h. 1202 mm, from Yaeyama Islands, Okinawa, *c.* 17th century (Tokyo, Folk Crafts Museum)

indentured to long hours of reeling silk filaments from cocoons in steaming pots under hard conditions. In the early 20th century, silkworms were interbred to create more even (but less tough and lustrous) fibres, which could be machine-processed to produce silk stockings. Then came chemical dyes with their modern hues and simpler methods.

Many traditional crafts were abandoned as the Japanese turned towards Western dress. Production of the braids (*kumihimo*) that had been used to lash together armour, the symbol of the warrior class, was threatened with extinction with the defeat of military rule. In an effort to maintain the livelihood of the braiders, alternative uses for the braids were sought. When a revival of Japanese costume came about in the early 20th century, round and square braids were substituted for the cloth-covered cords that secured the *obi* sash in place, and new life was breathed into the traditional craft. At the same time, old garments were sold off by the impoverished lords and bought by collectors such as Shiro Nomura (1879–1943), whose collection had many exhibitions abroad. Others, such as Muneyoshi Yanagi (1889–1961), sought to bring to light the beauty of the simple cloths made in the villages for family use.

After World War II the Japanese started producing synthetic textiles for the world market, but competition from other Asian nations from about the 1970s onwards forced the Japanese to cut production and concentrate more on fashion and styling. In the late 20th century kimonos are seen less and less frequently on the street, even on festive occasions, and are used primarily as costumes for traditional entertainment. The vicious circle

of low demand and steeply rising prices that prohibit casual buying has threatened the heart of the silk-weaving and dyeing workshops.

In an effort to preserve traditional crafts, the Japanese government has recognized outstanding craftsmen as Living National Treasures. Regular competitive exhibitions of national and regional traditional craft or industrial arts organizations lend incentive and inspiration. Local agencies encourage the young to learn traditional weaving, spinning and dyeing skills, and mass media as well as cultural organizations work to acquaint the public with traditional crafts.

BIBLIOGRAPHY

Y. Okada: *Textiles and Lacquer* (Tokyo, 1958)
H. B. Minnich: *Japanese Costume and the Makers of its Elegant Tradition* (Rutland, VT, and Tokyo, 1963/*R* 1986)
S. Noma: *Kosode to Nō-ishō* [Costume and dress], Nihon no bijutsu [Arts of Japan], xvi (Tokyo, 1965); Eng. trans. by A. Nikovskis as *Japanese Costume and Textile Arts*, Heibonsha Surv. Jap. A., xvi (New York and Tokyo, 1974)
S. Mizoguchi: *Monyō*, Nihon no bijutsu [Arts of Japan], xxix (Tokyo, 1968); Eng. trans. and adaptation by L. A. Cort as *Design Motifs*, Arts of Japan, i (New York and Tokyo, 1973)
H. Suzuki: *Living Crafts of Okinawa* (Tokyo, 1973)
Japan Society: *Tagasode: Whose Sleeves... Kimono from the Kanebo Collection* (New York, 1976)
M. Dusenburg: 'Kasuri: A Japanese Textile', *Textile Mus. J.* (1978), pp. 41–64
E. Oda: 'Meibutsu-gire' [Named textiles], *Genshoku no Bi*, viii (1980), pp. 65–72; Eng. trans. by M. Bethe as 'Meibutsugire: Famous Chanoyu Fabrics', *Chanoyu Q.*, xlv (Kyoto, 1986), pp. 7–23
T. Itō: *Tsujigahana zome* [Tsujigahana dyeing] (Tokyo, 1981); Eng. trans by M. Bethe as *Tsujigahana: The Flower of Japanese Textile Art* (Tokyo and New York, 1981/*R* Tokyo, 1985)
M. V. Hays and R. E. Hays: *Fukusa: The Shojiro Nomura Fukusa Collections* (Oakland, 1983)
Y. Wada, M. K. Rice and J. Barton: *Shibori: The Inventive Art of Japanese Shaped Resist Dyeing* (Tokyo, 1983)
K. Matsumoto: *Shōsōingire to Asuka Tenpyō no senshoku/Jōdai-gire: Seventh and Eighth Century Textiles in Japan from the Shōsōin and Hōryū-ji* (Kyoto, 1984) [Eng. text by S. Kaneko and R. Mellott]
M. Lyman: 'Distant Mountains: The Influence of Funzō-e on the Tradition of Buddhist Clerical Robes in Japan', *Textile Mus. J.*, xxiii (1984)
Kosode: 16th–19th Century Textiles from the Nomura Collection (exh. cat. by A. M. Stinchecum, M. Bethe and M. Paul; New York, Japan Soc., 1984)
R. M. Brandon: *Country Textiles of Japan: The Art of Tsutsugaki* (Tokyo, 1986)
M. Kinoshita: 'A Braiding Technique Documented in an Early Nineteenth-century Japanese Treatise Soshun Bikō', *Textile Mus. J.*, xxv (1986)
K. Sahashi, ed.: *Exquisite: The World of Japanese Kumihimo Braiding* (Tokyo, 1988)
Robes of Elegance: Japanese Kimonos of the 16th–20th Centuries (exh. cat. by H. Ishimura and N. Maruyama with essays by T. Yamanobe; Eng. trans. by H. Ward; Raleigh, NC Mus. A., 1988)
S. Yang and R. Narasin: *Textile Art of Japan* (Tokyo, 1989)
A. Kennedy: *Japanese Costume: History and Tradition* (Paris, 1990)
A. M. Stinchecum: 'A Common Thread: Japanese Ikat Textiles', *Asian A.*, iii/1 (1990)
L. A. Cort: 'Three Archaic Japanese Textiles', *Cloth and Human Experience*, ed. A. B. Weiner and J. Schneider, Smithsonian Series in Ethnographic Inquiry (Washington, 1991)
M. Bethe and others: *Patterns and Poetry: Nō Robes from the Lucy Aldrich Collection at the Museum of Art, Rhode Island School of Design* (Providence, RI, 1992)
D. C. Gluckman and S. Takeda: *When Art Became Fashion: Kosode in Edo-Period Japan* (Los Angeles, 1992)
'Five Centuries of Japanese Kimono: On this Sleeve of Fondest Dreams', Art Institute of Chicago, *Mus. Stud.*, xviii/1 (1992)
Kyoto Shoin's Art Library of Japanese Textiles, 20 vols (Kyoto, 1993–4) [bilingual text]

MONICA BETHE

XII. Metalwork.

1. Materials and techniques. 2. Historical survey.

1. MATERIALS AND TECHNIQUES.

(i) Metals and alloys. The Japanese archipelago has modest deposits of all major metals, the most common being iron, copper, zinc and lead. Following ancient Chinese practice, Japanese metalworkers traditionally identified gold (*kin*), silver (*gin*), copper (*akagane*; 'red metal'), tin (*suzu*) and iron (*tetsu*) as the five true metals (*gokin*). The largest gold deposits are found in the east of the country, while the richest silver deposits tend to be concentrated in the west. This uneven distribution led to the use of gold coinage in the Kanto region, centred around Edo (now Tokyo), and of silver coinage in the Kinki (Osaka–Nara–Kyoto) region (*see* §XVI, 5 below). Until the discovery of the first gold mine on the main island of Honshu in the 8th century AD, gold was extracted from river sands by placer mining. During the Edo period (1600–1868) the most productive gold mines were on Sado Island (Niigata Prefect.; discovered in 1601) and in Kushikino (Kagoshima Prefect.). The Ikuno silver mine (Hyōgo Prefect.), discovered in AD 807, saw the peak of its production during the Edo period, producing an average of 14.8 tons annually. Another important source of silver for the Tokugawa shogunate, the Iwami mine (Iwami Prov., now Shimane Prefect.), produced its greatest yield of 3836.25 kg in 1704.

Although iron ore is rare in Japan, iron sand is readily available. During the Yayoi period (*c.* 300 BC–*c.* AD 300) iron was imported from the Korean peninsula in the form of ingots or finished objects, which were melted down and recast. Limited domestic production of iron began around the 1st century BC. In the 16th century AD a type of iron known as *nanbantetsu* ('southern-barbarian iron') was imported by Portuguese ships to be made into swords. In the 17th century, after the Portuguese were expelled, the Dutch supplied the Japanese with iron through the port of Nagasaki.

Tin and lead are found in many areas, but the only premodern mine was in Satsuma Province (now Kagoshima Prefect.). These two metals were not highly valued by the Japanese, who mined lead and tin deposits to extract the silver contained in them. Deposits of copper have been exploited in western Japan since the 7th and 8th centuries in Nagato and Suō (now Yamaguchi Prefect.). Copper was mainly used in alloys, most commonly bronze (*karakane*; 'Chinese metal'; *see* BRONZE, §I), which was first imported from the continent in the form of bronze weapons (*see* §XVI, 1) but was being produced domestically around the 1st century BC. The Japanese developed a number of alloys (*gōkin*) for decorative purposes, including *shakudō* (usually copper with 1–6% gold and 0–1% silver; *see* METAL, §V), *shibuichi* ('one-fourth'; three parts copper and one part silver; also the generic term for several silver alloys), *hakudō* ('white bronze'; copper and tin), *sawari* (or *sahari*; copper, tin, lead and silver) and *shirome* (pewter; lead and tin).

(ii) Smelting and working processes. Bronze and iron smelting techniques were imported from China through the Korean peninsula in the Yayoi period. During the succeeding

Kofun period (*c.* AD 300–710) several metalworking techniques, including forging, engraving (*senbori*), openwork (*sukashibori*) and hammering (*tankin*), were introduced from the Continent. The predominance of iron-sand over iron-ore deposits led the Japanese to develop the *tatarabuki* smelting process for iron and steel. The process known before the 7th century was refined in Izumo Province (now Shimane Prefect.) in the 13th century. Blasts of air were blown through bellows into a clay furnace (*tatara*), raising the temperature to melt the iron sand into iron or steel. During the Edo period *tatara* were 2.7 m long, 900 mm wide, 1 m high, and 90 to 150 mm thick.

Moulds for bronze weapons and ritual objects have been found in sites dating to the 1st century BC. In the 6th century AD the lost-wax process was introduced from the Korean peninsula. It was used to make Buddhist statuary from the Asuka–Hakuhō period (552–710). Statuary and large cast objects were made by the piece-mould process (*see* BRONZE, §II). The lost-wax process was used in the Heian (794–1185) and Kamakura (1185–1333) periods to make votive lanterns for shrines and temples, ritual objects and temple bells and in the Muromachi (1333–1568), Momoyama (1568–1600) and Edo periods to make kettles for the tea ceremony. Western techniques of smelting and metalworking were introduced to Japan during the Bakumatsu (late Edo period) and Meiji (1868–1912) periods .

(iii) Decoration. During the Kofun period gold was used to gild other metals, especially bronze and copper. Other decorative techniques included piercing, inlay and engraving. The scarcity of gold led to its strict control by successive central governments, beginning in the 9th century, when sumptuary laws reserved its use to high-ranking court officials. As a result, gold was rarely used for personal adornment but mainly for gilding Buddhist statuary and ritual objects (*kirikane*; gilding with gold or silver), in inlay decoration or to produce decorative effects in combination with other materials, as in the *makie* technique ('sprinkled picture'; gold and silver on lacquer; *see* §X above). During the Momoyama period gold and silver were used extensively in painting and in the decoration of the castles of powerful daimyo (*see* §III, 4(ii)(c) above). Silver and alloys were used in inlay decoration and in techniques such as *mokume* ('wood grain'; *see* METAL, §IV). □

2. HISTORICAL SURVEY.

(i) Before mid-6th century AD. (ii) Asuka–Hakuhō (552–710) and Nara (710–94) periods. (iii) Heian period (794–1185). (iv) Kamakura (1185–1333) and Muromachi (1333–1568) periods. (v) Momoyama (1568–1600) and Edo (1600–1868) periods. (vi) Meiji period (1868–1912) and later.

(i) Before mid-6th century AD. The history of Japanese metalwork begins in the Yayoi period (*c.* 300 BC–AD 300). Around the 3rd century BC bronze swords (*dōken*), spearheads (*dōhoko*) and halberd heads (*dōka*) were imported from Korea (*see* §XVI, 1 below). Moulds for *dōken* and *dōhoko* discovered in Kyushu, particularly in Saga Prefecture, have brought forward the date for domestic production of bronze weapons to the first half of the Yayoi period (*c.* 1st century BC). Cast bronze mirrors (*seidōkyō*) were first introduced in the mid-Yayoi period (*c.* 200–

c. 100 BC). The oldest mirrors, known as *tachiyusaimon* (multiple-knob, fine-pattern mirrors), which have cast-relief geometric designs, have been found in Kashira (Osaka Prefect.), Gose (Nara Prefect.) and Shimonoseki (Yamaguchi Prefect.). Their resemblance to Chinese Han-period (206 BC–AD 220) mirrors and Korean mirrors makes it likely that they were imported from the mainland. Smaller mirrors were made domestically, but these were decorated with simple designs and made of poor-quality bronze (*see* MIRROR, §II, 2 and 3).

The most unusual pieces of metalwork of the Yayoi period are cast *dōtaku* ('bronze bells'; *see* fig. 192). Their stylistic predecessors can be found in the Korean peninsula, but *dōtaku* are distinctively Japanese artefacts. Cylindrical in shape, with handles on the upper part and fin-shaped projections on the sides, *dōtaku* range in size from 100 to 1300 mm. Early *dōtaku* have internal clappers and were probably used as musical instruments. They are decorated with cast-relief geometrical designs and representations of animals, human figures and village scenes, which, along with similar designs on Yayoi stonework and ceramics, are the earliest Japanese pictorial art. Approximately 450 *dōtaku* have been excavated to date, mainly

192. Bronze *dōtaku* (bell) with a relief design of crossed hands, h. 479 mm, Yayoi period, *c.* 300 BC–*c.* AD 300 (Tokyo, National Museum)

193. Bronze mirror with a relief design of human figures, h. 208 mm, Kofun period, *c.* AD 300–710 (Tokyo, National Museum)

from the Kinki (Osaka–Kyoto) region, in contrast to bronze weapons, which have been found in Kyushu and Shikoku. The discovery of caches of *dōtaku* buried outside Yayoi village sites suggests that they were used in agrarian rituals.

The massive burial mounds (*kofun*) built for the rulers of the Kofun period (*c.* AD 300–710) are rich in grave goods, which include ceramics and metalwork. Unlike the mainly cast objects of the Yayoi period, Kofun-period metalwork displays inlaying, piercing, engraving, hammering, forging and gilding. The most numerous items found in burial mounds are mirrors (see fig. 193), many of which were imported from China during the Han, Three Kingdoms (AD 220–80) and Six Dynasties (310–581) periods (*see* CHINA, §VI, 3(v), (vi) and (vii)). Japanese craftsmen made copies of Chinese mirrors and also created native 'bell mirrors', which have four to twelve bells attached around the circumference. The mirrors are decorated with designs of hunting scenes, houses and abstract patterns unique to Japan, including the *chokkomon* ('straight-curved pattern'), composed of straight lines and arcs, and the fern-frond pattern.

Accompanying the mirrors are Japanese and Korean gold and gilt-bronze personal ornaments, horse trappings (*gyōyō*; 'gingko leaf'; from the leaf-shaped design originating from China's Six Dynasties period) and sword fittings. Among the items recovered from the Edo Funayama Tomb (Kumamoto Prefect.), the Sanmizuka Tomb (Ibaragi Prefect.) and the FUJINOKI TOMB are gold and gilt-copper jewellery and crowns decorated with openwork animal, mythical animal and plant motifs. Earrings were made in two styles: decorative pendants, attached to rings with one, two or three chains, and ring earrings, which are either gilded iron or silver- or gold-gilt copper. A gold ring

excavated from Okinojima (Shimane Prefect.) has a flower motif on a diamond-shaped base. By the end of the Kofun period, Japanese craftsmen had mastered the basic repertory of metalworking techniques, which they then refined during the following centuries.

(ii) Asuka–Hakuhō (552–710) and Nara (710–94) periods. The introduction of Buddhism in the 6th century AD led to an improvement in casting techniques to produce Buddhist images and ritual objects. Korean metalworkers sent from the kingdom of Paekche taught the Japanese the lost-wax process to cast bronze statuary. Early examples of this process are the *Shakyamuni Triad* (623; see fig. 53 above) and *Shakyamuni* (7th century; Nara, Asukadera) by TORI BUSSHI (*see also* §V, 3(i) above).

One of the masterpieces of Asuka–Hakuhō-period metalwork is the gilt-bronze *ban* ('banner'; Tokyo, N. Mus.; see fig. 194). The *kanchōban* (h. 5 m) consists of a *tengai* (canopy) with *yōraku* (strings of metal plates cut in the shape of gems) and smaller *ban* attached to the four sides, and a *ban* in six sections hung from the centre of the canopy. The metal sheets are pierced and engraved to create the designs of *apsarasas* playing musical instruments, *bodhisattvas*, *sharitō* (pagoda-shaped reliquaries) and vine motifs. Other techniques used during the period include hammering, as seen in the *Jakubigata egoro* ('censer with magpie-tail handle'; Tokyo, N. Mus.), and repoussé (*oshidashi*), an embossing technique using thin sheets of bronze that allowed the mass production of Buddhist images, as in the *Amida Triad* (see fig. 56 above).

The Nara period is characterized by large-scale three-dimensional Buddhist statuary, the largest of which is the 16 m *Daibutsu* (Great Buddha; 746–57; Nara, Tōdaiji; *see* NARA, §III, 4). Other large cast objects include *suien* ('water flames'; ornaments on the top of pagodas) and temple bells, such as those in Myōshinji (698; Kyoto), Kōfukuji (727; Nara) and Tsurugi Shrine (770; Fukui Prefect.). Smaller pieces of Nara-period metalwork have been preserved in the Shōsōin repository (Tōdaiji; *see* NARA, §III, 3). The collection includes mirrors, musical instruments, keys and locks, braziers, coins and Buddhist ritual objects. Although many of the metalwork pieces in the Shōsōin were produced domestically, the decorations, which include engraved designs of phoenixes and floral motifs, were inspired by Chinese Tang-period (618–907) models. In some pieces, notably mirrors, techniques other than metalwork were used to produce decorative effects. These include *raden* (shell inlay), *hyōmon* (a process in which gold and silver plates are secured to the metal surface with lacquer), *gimbari* (silver plate) and *ruriden* (a precursor of cloisonné; *see* §XVI, 8 below).

(iii) Heian period (794–1185). In the 9th century Japanese monks returning from China with the doctrines of Esoteric Buddhism (*see* §II, 3 above) brought back with them texts (*sūtras*) and 129 ritual implements of a type not known during the Nara period. Of these only three pieces have survived (Kyoto, Tōji): a 'thunderbolt (Skt *vajra*) bowl' (*kongōban*), a five-pointed handbell (*kongōrei*) and a five-pointed pounder (*kongōsho*). These implements were soon copied by Japanese metalworkers, leading to the formulation of a Japanese style. Originally modelled on ancient Indian weapons, Esoteric Buddhist implements displayed

194. Gilt-bronze *ban* ('banner') from a *kanchōban*, pierced and line-engraved, h. 710 mm, Asuka–Hakuhō period, AD 552–710 (Tokyo, National Museum)

have been added as decoration. A gilt-bronze *vajra* bowl from the same period has elegant *nekoashi* ('cat's paw') feet, and its entire surface is engraved with floral designs. Other examples of the shift away from the plain designs of the Nara period to more delicate, decorative forms are *keman* (hanging ornaments for a Buddhist sanctuary) and *keko* (basket-shaped flower containers). In the gilt-copper fan-shaped *keman* in the Konjikidō of Chūsonji (Iwate Prefect.; *see* HIRAIZUMI, §2), two embossed *karyōbinga* (Skt *kalaviṅka*, *gandharva*; birds with human heads) are surrounded by vines that have been engraved to produce a three-dimensional effect. Another technique popular during the period was to produce contrasts by gilding in both gold and silver, as in the *keko* in Jinjōji (Shiga Prefect.).

Large cast objects produced during the Heian period include temple bells and votive lanterns. The bells at Jingōji, Kyoto (875), and Eizanji, Nara (917), have Japan's finest cast calligraphic inscriptions. The hitherto unseen designs of *apsarasas* and lions on the bell in Heitōin, Kyoto (mid-11th century), were strongly influenced by designs on Korean bells. The bronze votive lantern in front of the Nanendō (816; Nara, Kōfukuji) has a calligraphic inscription similar in style to the bell at Jingōji cast by using the lost-wax method.

Politically, the Heian period saw the flowering of court culture in Japan. Aristocratic patronage of temples and shrines was reflected in lavish gifts. Among these are the *Heike nōkyō* (Heike *sūtra*) and *sūtra* box (*c.* 1167; Hiroshima, Itsukushima Shrine), the latter decorated with gilt-bronze and silver relief designs of dragon and clouds, and a *sūtra* container with incised floral design (Mantokuji). However, gifts to religious institutions were not the only means the Heian-period élite had to express its taste for luxury; contemporary sources record that large numbers of solid-silver cups, dishes, chopsticks, boxes and pagodas were produced for the Kyoto aristocracy.

The late Heian period saw the emergence of the belief that the world was entering into the third and final age of Buddhism (*Mappō*). In anticipation of the appearance of the future Buddha, Maitreya, *sūtra* mounds (*kyōzuka*) were built throughout Japan. The practice continued until the Edo period (1600–1868) but was most popular during the Kamakura period (1185–1333). *Sūtra*s were buried in boxes or in cast bronze pagodas, as in Narahara Shrine (Aichi Prefect.) and Kuramadera (Kyoto), or engraved on metal cylinders. The first dated *sūtra* cylinder, made for the imperial regent Fujiwara no Michinaga (966–1028) in 1007, is engraved with 511 Chinese characters (Nara Prefect., Yoshino, Kinpusen). A *sūtra* box made for Michinaga's granddaughter buried on Mt Hiei in 1031 has engraved floral designs gilded in silver and gold around a central inscription of Chinese characters reading *Myōhō rengekyō* (also *Hokkekyō*; Lotus Sutra). A contrasting design unearthed at Kinpusenji is an oblong-shaped *sūtra* box with re-entrant corners (*irisumi*) mounted on a base with long, curved legs known as *sagiashi* ('heron's legs'). The box is a masterpiece of the caster's art, and its only decoration, a thick covering of gold, serves to emphasize the beauty and simplicity of its form.

As contacts with China became less frequent and ceased altogether in the second half of the 10th century, there

acutely angled forms. Their shapes, which were strictly prescribed by *giki* ('ritual manuals'), did not vary, but during the late Heian period there was a tendency to use richer materials and more elaborate decorative techniques. The tip of the 12th-century gilt-bronze five-pointed hand-bell with figures of the attendants of the eighth Buddha has lost its sharpness, and floral patterns and arabesques

was a gradual naturalization of Chinese styles in all the arts, including metalwork. One example of this trend can be seen in the development of *wakyō* ('Japanese mirrors'). Early Heian-period mirrors, such as the one made for Sugawara no Michizane with a Chinese figure playing the *biwa*' (Osaka, Domyōji Tenmangu), is in Tang-period style (*see* CHINA, §VI, 3(vii)). However, the edged mirror with a pair of phoenixes and flowers of good fortune (988) and the mirror with a pair of birds and arabesques (Mie Prefect., Shitennōji; placed inside a Buddhist statue in 1077) show Chinese compositions, but the softness in the treatment represents a clear shift to Japanese style. Shortly afterwards there was a change in iconography from Chinese flowers of good fortune to native flowers and trees and from Chinese phoenixes to Japanese birds, such as cranes, sparrows and herons. Among the 600 mirrors excavated from Hagurozan (Yamagata Prefect.), most of the Heian-period pieces have delicate Japanese-style plant and animal designs. In addition to changes in iconography, *wakyō* were thinner and had upturned plain circular rims instead of the eight-lobed or eight-pointed rims of Chinese mirrors. The central cord-knob was reduced in size and was usually cast in the form of a flower. Mirrors were also buried in *sūtra* mounds and prior to burial were decorated with *kyōzō* ('mirror images'), typically representations of Buddhist and Shinto deities engraved in fine line on the reflecting side. The *Zuika sōhōohachiryōkyō* (see above) has a hairline engraving of an *Amida Triad*.

(iv) Kamakura (1185–1333) and Muromachi (1333–1568) periods. The techniques and styles of Heian-period metalwork continued into the Kamakura period. However, the shift of power from the imperial court aristocracy in Kyoto to the warrior élite in Kamakura gave metalworkers new patrons with different tastes and requirements. In the Kamakura period and, to an even greater extent, in the Muromachi period, the finest examples of Japanese metalwork are swords and sword fittings and armour (*see* §XVI, 1 below).

An example of early Kamakura-period metalwork is the *keko* (basket-shaped flower container) in Jinshōji. The entire piece is an openwork design of flowering vines, which have been chiselled to give a sculptural effect. The flowers are gilded and the leaves silver-plated. The grace of the vine and the contrast of gold and silver are in the spirit of the Heian period, but the density of the design is evidence of the dawning of a new style. Similar flowering-vine motifs can be seen on *mikoshi* (portable shrines) from several shrines. Possibly the finest example of metalwork of the period is the *sharitō* (pagoda-shaped reliquary) belonging to Saidaiji (Nara). The pagoda shows an extremely skilful use of the techniques of openwork, gilding and low and high relief. Other noteworthy Buddhist pieces include the *kakebotoke* ('hanging Buddhas') of Batō Kannon (Hayagriva; 1271; Higashi Kannonji), a set of Buddhist vessels (Aichi Prefect., Iwayadera) and instruments for exorcism (see fig. 195).

Development in the casting of *wakyō* ('Japanese mirrors') was also considerable, allowing for a wider range of decorative motifs, with more complex and more realistic designs. Some mirrors were decorated with *utae* ('poem-picture'), in which the texts of the poems were incorporated in the design. Towards the end of the Kamakura period there was a short-lived renaissance of Chinese style inspired by the importation of large numbers of Song-period (960–1279) mirrors, which were made in the antique Han-period style (*see* CHINA, §VI, 3(viii)). Japanese mirrors of this type often show Chinese saw-tooth or comb-tooth decorations on the outer zone of the mirror and Japanese decoration on the inner zone.

Buddhist ritual objects were also made in the Muromachi period, and several pieces show the influence of Chinese Ming-period (1368–1644) bronzes (*see* CHINA, §VI, 3(ix)), but in general techniques and styles were inferior to those of earlier periods. A much more significant development at the end of the Muromachi period was the appearance of the first tea kettles (*kama*) made for the tea ceremony (*see* §XIV, 1 and 3 below). Iron cooking kettles had been made from early times, but with the rise of the tea ceremony tea kettles became art objects in their own right. The most celebrated kettles were made in Ashiya (Chikuzen Prov., now Fukuoka Prefect.) and Tenmyō (Shimotsuke Prov., now Tochigi Prefect.). Ashiya kettles (*Ashiyagama*) are characterized by a smooth surface and elegant design (see fig. 196), while Tenmyō kettles (*Tenmyōgama*) were admired for their plain, rough surfaces. Other notable examples of Muromachi-period metalwork are a bronze dragon head (1443) and a hanging lantern with a design of plum and bamboo (both Tokyo, N. Mus.; see fig. 197). Another item that appeared late in the Muromachi period was the *oi*, which was used by itinerant monks to carry *sūtra*s and ritual objects. The external surface of the *oi* was often covered with bronze plates with pierced and incised designs.

195. Gilt-bronze instruments for Buddhist exorcism, a *gokorei* bell and a *dorje*, resting on a four-footed tray, h. 182 mm, Heian period, 794–1185 (Tokyo, National Museum)

(v) Momoyama (1568–1600) and Edo (1600–1868) periods. As in the Kamakura and Muromachi periods the most accomplished pieces of metalwork were swords and sword fittings and armour (*see* §XVI, 1 below) made for the samurai élite. Another use of decorative metalwork during the period was in the architectural fittings of temples, shrines and castles. The great castles of Azuchi (*see* AZUCHI CASTLE), Fushimi and Osaka, the showcases of the hegemons Oda Nobunaga and Toyotomi Hideyoshi, were destroyed or dismantled by their successors, but similar fittings can be seen in the pillar ornaments, sliding-door catches (*hikite*) and nail-head covers of Sanbōin (Kyoto, Daigōji), the Karamon ('Chinese gate'; Kyoto, Toyokuni Shrine) and the Mikumari Shrine (Nara Prefect., Yoshino). The mortuary complex built at Nikkō (Tochigi Prefect.) for the Tokugawa shoguns also displays a wide range of decorative metalwork (*see* TŌSHŌGŪ SHRINE).

The adoption of the tea ceremony by daimyo led to an increased demand for tea ceremony utensils and kettles. In addition to the Ashiya and Tenmyō kettles prized since the Muromachi period, Kyoto kettles came to prominence during the Momoyama period. The kettles were cast by the lost-wax process and were often designed by leading artists of the day, such as TŌYŌ SESSHŪ and Tosa Mitsunobu (*see* TOSA, (1)). The tea kettle maker Nagoshi Yashichirō Zensei is said to have made a kettle for the tea master Takeno Jōō. His son and successor, Yaemon, was also responsible for casting the giant bell for the Daibutsuden at Asukadera (Nara Prefect.). Nishimura Dōnin (1504–55), another master tea kettle maker employed by Jōō, also cast temple bells and lanterns. His pupil Tsuji Yojirō made kettles for SEN NO RIKYŪ, who was Toyotomi Hideyoshi's tea master. Hideyoshi, a man of humble origins who rose to become imperial regent, had lavish personal tastes. It is recorded that he commissioned solid-gold tea kettles and tea ceremony utensils. A more restrained piece thought to have been used by him is an iron kettle with the design of a chrysanthemum and *kiri* (paulownia), the Toyotomi crest (Tokyo, N. Mus.).

In the Edo period the Nagoshi family split into two, one branch moving to Edo while the other remained in Kyoto. Other celebrated kettle makers of the Edo period include the Hori, an offshoot of the Nagoshi family in Edo, and the Onishi, an Edo-based offshoot of the Kyoto Nagoshi family. Apart from kettle makers, Kanaya Gorosaburō (*fl* early Edo period) and Shikata Annosuke (or Ryūbundō; *fl* 1804–29) distinguished themselves as metal casters in Kyoto. Kanaya is noted for decorating bronze ware, while Shikata produced *sencha* (steeped-tea) tea ceremony ware and kettles. His pupil Hata Zoroku (1823–90) excelled at copying antique Chinese bronzes.

While most celebrated metalworkers of the age were sword and tea kettle makers, several outstanding craftsmen, including Ao Ietsugu, continued the age-old tradition of mirror casting. *Ekagami* (mirrors with handles), which had first appeared during the Muromachi period, were further refined during the Momoyama and Edo periods. The cord-knob disappeared altogether, affording greater freedom of design. In the early Edo period *ekagami* with new and distinctive designs appeared, as in the bronze mirror with relief design of willow tree and raft (Tokyo,

196. Iron kettle for the tea ceremony, with a design of a seaside pine grove, Ashiya ware, h. 167 mm, Muromachi period, 1333–1568 (Tokyo, National Museum)

197. Bronze hanging lantern with an openwork design of plum trees and bamboo, h. 310 mm, 1550 (Tokyo, National Museum)

N. Mus.; see fig. 198). However, mirrors were later produced in such numbers that their quality declined and their designs became coarse and stereotyped.

Other metalwork items made during the Edo period include *netsuke* (*see* §XVI, 17 below) and *okimono* (ornaments displayed in the decorative alcove, the *tokonoma*).

198. Bronze *ekagami* (mirror with a handle), with a relief design of willow and a raft, by Itani Hoju, diam. 125 mm, Edo period, 1600–1868 (Tokyo, National Museum)

These include extremely realistic three-dimensional depictions of birds and animals, made of iron, which often have articulated bodies.

(vi) Meiji period (1868–1912) and later. The Meiji-period separation of Shinto and Buddhism and the edicts against swordwearing that preceded the abolition of samurai status deprived Japanese metalworkers of their traditional patrons and reduced them to penury. The situation changed with the Vienna Exhibition (1873), where Japanese metalwork was so well received that the government decided to encourage the production of pieces for export. An improving economy at home and international exhibitions gradually increased demand. However, metalwork remained a conservative field, tied to Edo-period production techniques and styles until the late 19th century to the early 20th.

Workers in cast metal, who had previously made Buddhist statuary, bells, lanterns, *okimono* and writing and tea ceremony implements, concentrated on the last three and added vases to their repertory. Hakusai Ōkuni (1856–1934) was one of the leading casters of the period. An iron teapot by him has a striking design of a dragon in high relief coiled around it. The lid is copper with a gold knob set in a lotus leaf, which provides a contrast to the darker body (Richard and Dallas Finn Col.). Takusai

Honma (1812–1919) made tea ceremony and writing utensils with intricate designs. Chokichi Suzuki (1848–1919), a professor at Tokyo Fine Arts School, excelled in realistic bird and animal *okimono*. At the Columbian Exposition held in Chicago in 1893 he exhibited a set of 12 falcons on lacquer perches (Tokyo, Met. A. Mus.). Another piece by Suzuki, which expresses the baroque feeling of Meiji-period decorative art, is his *Silver Stand with Ball*, a dynamic design of a dragon emerging from the waves holding a crystal ball (Boston, MA, Mus. F.A.).

In the 20th century the Japanese government began to award the title Living National Treasure to outstanding practitioners of the traditional Japanese crafts. Metalworkers who were awarded this honour include the caster Toyochika Takamura (1890–1972), Shōdō Sasaki (1882–1961), the engraver and inlay artist Kiyoshi Unno (1884–1956), the gong-maker Iraku Uozumi (1886–1964) and the tea kettle maker Tesshi Nagamo (1900–77).

BIBLIOGRAPHY

Y. Tazawa, M. Ishizawa, I. Kondō and J. Okada, eds: *Ceramics and Metalwork* (1952), iv of *Pageant of Japanese Art* (Tokyo, 1952)
H. Batterson Boger: *The Traditional Arts of Japan* (London, 1964)
L. Frederic: *Japan: Art and Civilization* (London, 1969)
R. Takao and others: *Sasakishōdō, Unno Kiyoshi, Uozumi Iraku* (1979), xxviii of *Ningen kokuhō shirizu* [Living National Treasures] (Tokyo, 1977–80)
T. Hida: *Takamura Toyochika* (1980), xxvi of *Ningen kokuhō shirizu* [Living National Treasures] (Tokyo, 1977–80)
Y. Nagano: *Nagano Tesshi* (1980), xxvii of *Ningen kokuhō shirizu* [Living National Treasures] (Tokyo, 1977–80)
Imperial Japan: The Art of the Meiji Period (1868–1912) (exh. cat. by F. Baekland, Ithaca, NY, Cornell U., Johnson Mus. A.; Utica, NY, Munson–Williams–Proctor Inst.; Cincinnati, OH, A. Mus.; Portland, OR, A. Mus.; 1980–81)
M. Ishizawa and others: *The Heritage of Japanese Art* (Tokyo, 1982)
S. Matsumoto: *Dōken, dōtaku, Somu to Izuno okoku no jidai* [The *dōken* and *dōtaku* of the Somu and Izuno kingdoms] (Tokyo, 1985)
Nihon no kinkō [Japanese metalwork] (exh. cat., Tokyo, N. Mus., 1985)
H. Takakura: *Nihon kinzokuki shutsugenki no kenkyū* [Studies in early Japanese metalwork] (Tokyo, 1990)

KAZUTOSHI HARADA

XIII. Theatre and performing arts.

The traditions of Japanese theatre, in particular *nō* and *kabuki*, permeate many areas of artistic and cultural life. This article discusses the development of major dramatic and dance forms in relation to the associated architecture and the arts of theatrical costume and make-up. Theatrical traditions have also influenced other art forms in Japan, most notably the woodblock print (*see* §IX, 3 above).

1. *Nō*. 2. *Kabuki*. 3. *Bugaku*.

1. NŌ.

(i) Introduction. (ii) Architecture and stage design. (iii) Costume.

(i) Introduction. The performing art of *nō*, which combines literature, drama, dance and music, is considered to be the highest form of Japanese theatrical art. It originated in Japan in about the 14th century and owes much to various traditions of folk entertainment, such as *sarugaku* (monkey dances), *dengaku* (field dances) and *kagura* (holy dances and music dedicated to the gods). The last was the oldest of all; it was initially performed in the open air and later on platforms or in special buildings. Between the 6th and 8th centuries various kinds of dances and music with dramatic action were introduced from the Asian continent.

One of these, *gagaku*, became Japanized and was promoted by the court and large shrines and temples. It is still performed, on an unroofed and unwalled platform with a central section raised a step above the surrounding area. Examples of platforms exist at ITSUKUSHIMA SHRINE, Hiroshima Prefecture (13th century), and at HŌRYŪJI, Nara Prefecture (17th century); the latter can be assembled and dismantled as needed. Other performing arts of more popular character were also introduced from the continent and became part of Japanese culture. *Nō* has its origins in these popular performing arts, but it was perfected by Kiyotsugu Kannami (1333–84) and his son, Motokiyo Zeami (1363–1443), who created the stylistic features of *nō*, wrote many of the dramas and adopted elements from *kagura* and combined them with other traditional dances and music such as accompanied religious rituals. *Nō* became a formal music-drama for the military élite, gaining sophistication and depth under the patronage of the Ashikaga shogunate of the Muromachi period (1333–1568). As a performing art it has been much admired for its profound beauty and refinement and for its subtle allusions to other cultural forms, especially poetry and literature.

Nō is performed by a main actor, a supporting actor, subsidiary actors and four musicians playing a flute, a small hand-drum, a larger hand-drum and a big drum beaten with two sticks. Many chanters also take part. Actors wear gorgeous costumes, and the main actor is nearly always masked (*see* §XVI, 15(ii)(c) below). Like *nō*, the allied form of *kyōgen* also originated from popular music-drama, but later it became a highly refined comedy performed between two *nō* plays. Five schools of *nō*—*kanze*, *hōshō*, *kongō*, *konparu* and *kita*—all patronized by the military aristocracy, prospered throughout the Edo period (1600–1868). Thanks to the support of the upper classes, *nō* continued to flourish after the Meiji period (1868–1912). However, since World War II, because of the precariousness of its long-term existence, the government has intervened to promote *nō* by designating the art of the most prominent players and their association as Important Intangible Cultural Properties and by establishing the National *Nō* Theatre.

(ii) Architecture and stage design. *Nō* is sometimes performed on a temporary platform when it takes place in a shrine or temple and is dedicated to a god or to Buddha. The evening bonfire *nō* at Kōfukuji in Nara is a good example. However, it is usually performed on a formal conventional stage. *Nō* stages used to be constructed in the courtyards of *shoin*-style mansions (*see* §III, 4(ii)(a) above) and faced the main buildings. There was no fixed space for an audience, because *nō* was meant to be played in front of a select group of noblemen, who could watch it from raised parts of the floor, while at the same time it remained inaccessible to their families and retainers. By contrast, in modern *nō* theatres of ferro-concrete construction, several hundred fixed seats are provided in front of the built-in stages, which are still of traditional style.

Buildings for performing *nō* are divided into two areas, front and rear. The central part of the front area is the stage (*butai*) on which the main scenes of *nō* are performed. Positions for musicians and stage assistants are on the rear extension (*atoza*) of the stage. The chanters occupy a place on the left extension (*jiutaiza*) of the stage. The actors' entrance and exit passage (*hashigakari*) leads diagonally back from the right side of the rear extension, where main scenes of *nō* are also sometimes played. The courtyard in front of the stage and the passage are paved with large white stones, which are intended to illuminate the actors by reflecting the sunlight.

The square stage has sides of 5.5–6.0 m or three standard Japanese bays (one bay equals 1.8–2.0 m). The stage is open and has only four posts, one in each corner. These posts have names: the front-right post is the target post (*mitsuke-bashira*); the other three—the main actors' post (rear-right), the supporting actors' post (front-left) and the flute post (rear-left)—are named for their proximity to these performers. The floor of the stage is 800–900 mm above the ground-level of the courtyard and is made of thick planks running from front to back. The area beneath the floor of the stage is enclosed by vertical boards. Attached to the front edge of the stage at the centre is a temporary step that is rarely used. Traditionally, several big ceramic pots were set under the floor of the stage in order to magnify the sound of the actors' steps. A well-pounded mixture of earth and lime could produce the same effect. The posts at the four corners of the stage support the framework of the roof. The roof is usually gabled, and the front gable is richly decorated, but there are examples of hip-and-gable roofs with a gable facing front. The open ceiling reveals rafters and sheathing. A reel attached at the middle of the ridge that runs from front to back is used for hanging a large bell, the rope of which is fastened to a ring on one corner of the flute post. The bell is exceptional, as all other stage settings are placed on the stage.

The rear extension is directly connected to the rear edge of the stage and is 2.7 m deep. The rear and left sides are walled with vertical boards on which an old, gnarled pine tree and straight bamboo are painted. This wall painting forms a permanent backdrop; in this type of theatre, sets are not changed. In the left wall of the rear extension is a small side gate (*kiridoguchi*) with a sliding door. This gate is used by chanters and stage assistants. The floor planks of the rear stage, unlike those of the main stage, run from side to side. The ceiling has an exposed pent roof to reflect sound. The floor of the left extension is also continuous with the main stage. Usually there is a partition at the rear, but the other sides are open and bordered by low railings. Some of the left extensions are covered by a pent roof, others by the roof of the stage.

The passage connects the waiting room (*kagaminoma*) and the rear extension. Its boarded floor slopes up slightly towards the waiting-room, at the entrance to which there is a curtain. The passage is about 1.5 m wide; its exact length is not specified by tradition, but existing examples are about 13 m long. It is always divided by posts into three bays, each of which is open and railed. In the courtyard in front of the passage are three small pine trees, one to each bay. Behind the stage are several dressing-rooms opening on to a corridor, which also connects them with the waiting-room and the side gate.

199. *Nō* stage, Nishi Honganji, Kyoto, 1581

An early *nō* stage can be seen in a 15th-century folding screen depicting the scenery in and around Kyoto. However, extant stages date from the late 16th century and after. Two of the oldest stages are found at Nishi and Higashi Honganji, Kyoto (see fig. 199). One is inscribed with the date 1581, the other is presumed to date from the 1620s. Both are within the inner courtyards of the *shoin*-style residence of the abbots, typical situations for *nō* stages at that time. Stages at ITSUKUSHIMA SHRINE and at Nunakuma Shrine, Hiroshima Prefecture, are presumed to have been constructed in the 17th century or after; the latter could originally be assembled and dismantled at will but is now fixed.

BIBLIOGRAPHY
S. Kitao: *Kokuhō nō butai* [*Nō* stages designated as National Treasures] (Tokyo, 1942)
P. G. O'Neil: *A Guide to Nō* (Tokyo, 1954)
S. Kawatake, ed.: *Engeki hyakka daijiten* [Encyclopedia of performing arts], 6 vols (Tokyo, 1960–62)

NOBUO ITO

(iii) Costume. *Nō* costumes, with their elegance, elaborate weaves and sophisticated interplay of motifs, lend brilliance to the bare wooden stage on which the plays are performed (*see* §(ii) above). Stiff and bulky, these brocade (or supplementary weft patterning), satin and gauze garments, when donned in combination with mask and wig, so obscure the body lines of the actor that the stage figure becomes like a puppet manipulated from within. While the cut, weave and draping styles of the costumes indicate the rank, position and personality of the stage figure, the colours and patterns help to set the scene for the play and aid in the realization of its poetic images.

(a) Production. (b) Types. (c) Historical developments.

(a) Production. The production of a *nō* costume requires the efforts of numerous craftsmen working in a coordinated network. It begins with silk-raising and reeling. Then the skeins are dyed in the 50 or so standard colours used for the *nō* stage. Threads for the warp tend to be left with the gum on them (*kiito*). Reeling on to spools, setting the warp, tying up the warp, drafting the design and setting the pattern heddles are all done by separate specialists in Nishijin, the weaving district of Kyoto. Finally, three types of weft are woven in on the warped loom: unglossed ground threads (*kiito*) woven in a twill for stiff robes with supplementary weft patterning in a variation of satin weave for lined cloaks for men and a gauze weave for unlined cloaks; glossed threads (*nerinuki*) for a pattern that appears in a float design; and gold- or silver-foiled paper strips (*kinpaku* or *ginpaku*) for metallic ground-pattern highlights. Weaving progresses on all three levels at once, each manipulated by a different set of controls on the two-man draw loom (*sorabikibata*) or the one-man punch-card Jacquard-style loom.

The distinction between ground and pattern serves as a means of categorizing costume design. In addition to solid colours, the grounds of many of the brocade robes, such as the *atsuita* and *Karaori*, are blocks of alternating colours forming a chequer-board pattern known as *dangawari*. The colour separation is produced by tie-dyeing the warp

threads in a large ikat pattern. Undergarments such as the *noshime* and the *surihaku* are often divided horizontally, the shoulder and hem being in one colour and the waist area in a contrasting colour (*kata suso*). Sometimes unexposed areas are left undecorated. Broad-sleeved cloaks tend to have solid-colour grounds.

Superimposed on such grounds are embroidered or woven pictorial motifs. Sometimes the distribution of the motif patterns ignores the ground divisions, forming one large overall repeat, or it may follow them, changing with each colour change. In yet other cases the motif patterns alternate, but in different-size blocks from the ground. While embroidered designs often have a free-flowing pictorial realism, the brocade patterns follow a set repeat. Variation of colour within each pattern repeat, as well as variation in the placement of motifs by clever use of mirror image and reversal of order, creates a sense of constant change that defies the repetition built into the weaving techniques. The final product has a marvellous interplay of texture and pattern that has gained the admiration of textile-lovers around the world.

(b) Types. The costume for each role is composed of layers of garments, including undergarments (*kitsuke*), outer robes with box sleeves (*kosode*), outer cloaks (*ōsode*), pantaloons (*hakama*) and various types of accessories (*see also* §XVI, 7 below). There are only about twenty types of garments (described briefly below), following four or five basic cuts, differentiated by variations in detail of weave and cut. When selecting specific garments the actor considers colour and pattern. Floral patterns (of native Japanese inspiration) are often associated with women and more geometric, formal patterns (often of Chinese derivation) with men. Red is the colour of youth, and robes without red are relegated to older characters. White is worn by aged gods, angels and some ghosts or spirits. By judicious choice of costume from a limited range, the actor expresses his interpretation of the play.

Kosodemono (kosode-style garments). Undergarments and brocade robes are cut to *kosode* style, a T-shape with single-width pocket sleeves sewn up on the outer edge as far as the wrist. *Kosode*-style garments are distinguished by their weave and to some extent by their patterns (*see* §XVI, 7 below).

Karaori. A brocade kimono for women.

Atsuita. A twill-ground man's kimono with either a check or brocade pattern.

Atsuita karaori. A brocade kimono often worn by warrior-courtiers.

Surihaku. An under-kimono of white satin weave with imprinted decorations in gold/silver foil.

Noshime. A man's undergarment of lustrous woven silk.

Nuihaku. An embroidered satin kimono worn as an outer robe, often with stencilled gold-foil decorations (see fig. 200).

Koshimaki. Two *nuihaku* worn together, one exposed above the waist and the other folded down at the waist so that the sleeves hang over the hips.

Ōsodemono. Outer cloaks with broad, open sleeves (*ōsodemono*) are often, but not always, donned over the *kosode*. Many are descendants of court costumes of the Heian period (794–1185), the *sokutai* and the *kariginu*, although some, such as the *chōken*, were designed specifically for the *nō* stage. The different types of broad-sleeved outer cloaks can be distinguished by their cut and weave.

Nōshi. A loose mantle with double-width sleeves for men or women.

Kariginu. A round-necked hunting cloak with double-width sleeves.

Happi. A man's cloak with double-width sleeves and front and back panels joined by a strap at the hem.

Sobatsugi. An abbreviated, sleeveless version of the *happi*.

Chōken. A dancing cloak of gauze weave in unglossed silk with a design woven in gold and colours; the front and back panels fall free.

Maiginu. A woman's dancing cloak of gauze weave woven with unglossed silk and an overall design in gold; the front and back panels are joined part of the way down the side.

Mizugoromo. A plain-colour travelling cloak in either plain or open weave; worn by men and women.

Hitatare. A suit of matching jacket and long trailing divided skirts; lined and woven in bast fibre.

200. *Nō* costume, embroidered satin kimono (*nuihaku*) with lightning diamonds stencilled in gold, late 16th century (Okayama, Museum of Art)

Suō. Identical in cut and fabric to the *hitatare* but unlined.

Hakama. Pantaloons or *hakama* are broad, pleated, 'divided skirts', often stiffened at the back to increase the volume, so that in wear they form a large hump at the back.

Ōguchi. A plain-coloured divided skirt with large pleats in front and stiffened, gathered panels at the back.

Hangiri. A broad divided skirt with dynamic gold or silver designs.

Sashinuki. Courtier's pleated pantaloons, gathered at the ankles and worn over *ōguchi*.

Chigobakama. A child's divided skirt.

Other accessories.

Kazura obi. A hair-band worn by women over the wig but under the mask at forehead level.

Koshi obi. A belt sash.

Kanmuri. A tiara, crown or special hat.

Kazura. A woman's wig, parted in the middle and bound in a loose pony-tail at the nape of the neck.

Kashira. A wig of long flowing hair flaring about the face and cascading down the back.

Costumes for kyōgen. Kyōgen is the comic sister art to *nō* and its costumes include many of the same garments, such as *atsuita, karaori, noshime, suō* and *hitatare*. In addition, there is the *kataginu*, a special *kyōgen*-style vest. This is a square vest with tabs to hold it down; it is often decorated with a large paste-resist design of homely objects such as turnips or crabs.

(c) Historical development. During the Muromachi period (1333–1568), when it first began to exist as a performing art in its own right, *nō* was the beneficiary of patronage from the Ashikaga shogunate, from whom presents of garments and payment in bolts of cloth were common. Moreover, it was the custom in the 14th and 15th centuries for members of the audience to reward good acting by stripping off their outer garments and throwing them on the stage, thus providing the actors with additional items for their wardrobes. These were sometimes retailored for greater stage effect but nonetheless reflected everyday wear of the time. In the 16th and 17th centuries, when formerly imported brocades, figured satins and embroidered cloths began to be manufactured in Japan, *nō* costumes increased in elegance and variety. Notes by the 16th-century actor Shimotsusa suggest some regulation of dress for given roles. It was not until the 18th century, however, that thorough codification defined which types of garments were to be worn for each role of every play in the repertory. The impetus behind this was partly the incorporation of *nō* performances into shogunal ceremonial court functions, and the resulting establishment of many local *nō* troupes supported by the daimyo.

By the 18th century, *nō* costumes, which continued to reflect 15th- and 16th-century styles, had become so different from everyday wear that their production and tailoring became a specialized art. Even in the 20th century the colours, patterns, weaves and cut of the *nō* robes continue to reflect orthodox forms rather than follow the fashions of the day. This is not to say there was no evolution after the 18th century. Technical virtuosity and ingenuity of design mark late Edo-period (1600–1868) costumes. The introduction of the Jacquard loom in the late 19th century and its adaptation to Japanese needs revolutionized the weaving of *nō* costumes; as a result patterns and details became increasingly complex and intricate. Moreover, the introduction of chemical dyes greatly increased the possible colour range and reduced the time and expense of dyeing, although orthodoxy tended to preserve the old colour schemes.

Many of the best collections of costumes were amassed during the Edo period by the shoguns and daimyo for their personal troupes. Of these, particularly outstanding are the Ikeda collection in Okayama, the Maeda collection in Kanazawa, the Tokugawa collection in Nagoya and the Hosokawa collection in Kōchi. The Ii collection in Hikone preserves some items that escaped the fire following the Kanto earthquake of 1923, which caused massive losses. In addition, the *nō* theatres own costumes for use in performance. While many of these are newly made to order from the looms of Nishijin in Kyoto, some are old treasures from the Edo period. The wear and tear of performance demands constant replenishing of the costume stock. Other good collections of *nō* costumes include those at the Tokyo National Museum, the *Nō* Costume Museum in Sasayama, Hyōgo Prefecture, the Museum of Fine Arts, Boston, MA, and the Rhode Island School of Design Museum of Art, Providence, RI.

BIBLIOGRAPHY

T. Yamanobe: *Nō shōzoku mon'yōshū* [*Nō* costume designs] (Tokyo, 1969)

K. Kirihata: *Kyōgen no shōzoku: Suō kataginu* [*Kyōgen* costumes: *suō* and *kataginu*] (Kyoto, 1976)

The Tokugawa Collection: Nō Robes and Masks (exh. cat., New York, Japan Soc., 1977)

K. Yoshioka: *Nō shōzoku* [*Nō* costumes], Senshoku no bi [Textile art], iv (Kyoto, 1980) [with English captions]

Y. Harada: *Itsukushima jinja nō shōzoku* [*Nō* costumes of Itsukushima Shrine] (Kyoto, 1981)

Kongōkei nōgaku hihōten [*Nō* treasures of the Kongō family] (Tokyo, 1983)

K. Kirihata and S. Masuda, eds: *Ii kei denrai: Nō shōzoku hyaku sugata* [*Nō* costumes of the Ii family] (Tokyo, 1984) [with English text]

K. Kirihata: *Okayama bijutsukanzo: Ikeda kei denrai nō shōzoku* [*Nō* costumes of the Ikeda family at the Okayama Museum of Art] (Kyoto, 1986)

Nō shōzoku hen [*Nō* play costume], Tokyo Kokuritsu Hakubutsukan Zuhan Mokuroku [Illustrated catalogues of the Tokyo National Museum] (Tokyo, 1987)

Nō kyōgen shōzoku [*Nō* and *kyōgen* play costumes], Tokyo, N. Mus. (Tokyo, 1987)

The World of Nō Costumes, Yamagouchi Nō Costume Research Centre (Kyoto, 1989)

I. Nagasaki and M. Bethe: *Patterns and Poetry: Nō Robes from the Lucy Truman Aldrich Collection* (Providence, 1992)

MONICA BETHE

2. KABUKI.

(i) Introduction. (ii) Architecture and stage design. (iii) Costume. (iv) Make-up.

(i) Introduction. Kabuki is a performing art that developed in Japan in the early 17th century in Kyoto and has since become highly popular. *Kabuki* originated from a folk

dance for pacifying the souls of those who had died during the civil wars of the 15th and 16th centuries. It was a woman called Izumo no Okuni (*fl c.* 1600), an attendant at Izumo Shrine, who added realistic actions to the folk dance that she performed on the dry bed of the Kamogawa River in Kyoto. Sometimes wearing men's clothes, she danced with *kyōgen* actors disguised as women and with other female entertainers. This new style of dance was called *kabuki*, as were others performed in the same period by prostitutes. In 1629 such dances were prohibited because they were thought to corrupt public morals. A third type of *kabuki* arose to replace them, involving handsome young actors, but this too was banned in 1652 for the same reason. The present *kabuki* developed from a fourth type of performance, played exclusively by adults. Since then, all parts in *kabuki* have been taken by male actors.

From the 1660s *kabuki* became a multi-act play. In the Genroku era (1688–1704), when wealth was concentrated in cities, two different styles of *kabuki* emerged, one in Edo (now Tokyo) and one in Kamigata (now the Kyoto–Osaka area). Edo *kabuki* plots generally concentrated on the activities of brave men, Kamigata plots on the behaviour of elegant but weak men. *Kabuki* continued to develop, particularly at the beginning of the 18th century, again at the beginning of the 19th and finally in the mid-19th century. Realistic and sensual scenes and quick changes of costume became popular.

In the Meiji period (1868–1912), Western influences helped to modernize *kabuki*, and many masterpieces for the new art were produced, although the general preference was for re-creations of the classics. Since World War II the Japanese government has been trying to preserve *kabuki*, and the skills of a number of prominent *kabuki* actors and their association have been designated Living National Treasures. The National Theatre in Tokyo, established in 1966, trains young actors and promotes research and performances, specializing in presenting entire plays (which may last as long as five hours). The Kabukiza (Kabuki Theatre), which opened in 1889 in Tokyo, generally offers acts and scenes from complete plays, along with a dance piece.

(ii) Architecture and stage design.

(a) Historical development.

16th–18th centuries. In the late 16th century and early 17th *kabuki* was performed in temporary buildings, constructed wherever space was available, for example in shrine precincts or on dry river beds. However, in Edo (now Tokyo), after permission was granted by the government in 1624, permanent theatres were established one after another from 1633 to 1660. Between 1624 and 1643, theatres were also built in the Kamigata region (Kyoto–Osaka). Nevertheless, the theatrical architecture was fairly rudimentary at that time, with a style of stage inherited from that of the *nō* theatre. The sides of the stage were two or three bays long, one bay being 1.8–2.0 m. The stage had a post at each of its corners and a gabled roof and a passage (*hashigakari*) led off from one side of it. The stage resembled the *nō* stage in all respects, except that the *kabuki* stage was surrounded by a short, ornamental

curtain that hung just under the eaves, creating a showy atmosphere. The audience sat in floored and roofed boxes or in an unroofed pit floored with turf. This area was surrounded by criss-crossed bamboo stakes and was hidden from external view by hanging straw mats, except for an opening in which were two small gates (*kido*), one an entrance and one an exit. Above the entrance was a raised, railed platform (*yagura*) where a drum was beaten to announce the start of the day's performance (if indeed there was one: rain could preclude performance at theatres with open-air pits).

In the 1660s, as *kabuki* developed into a multi-act drama, the design of the stage began to diverge from that of the *nō* stage and to develop in its own way. A draw-curtain at the front edge of the stage was provided for the first time *c.* 1664, and stage sets became elaborate. The ramp or auxiliary stage (*hanamichi*), which passed through the audience to the back of the theatre, appeared in place of the passage *c.* 1668. Furthermore, in the late 17th century, the width of stage was extended from three bays to five, and the dressing-rooms and boxes became three-storey structures.

In the first half of the 18th century, epoch-making changes occurred in Japanese theatrical architecture. In 1723, because many theatres had burnt down and because of the general prevalence of fire in Edo, the shogunate issued fire regulations stating that theatres must be roofed with tiles and enclosed by plastered walls. As a result, all later *kabuki* theatres were single buildings entirely covered by a tile roof. In those days, theatres commonly had a stage six and a half bays wide and five bays deep, a ramp eight bays long and boxes three storeys high. Innovations included the addition of an apron stage to the main stage and of a small platform in the middle of the pit, connected by a narrow passage to the middle of the runway: these enabled the audience to obtain a closer view of the actors' faces.

In the second half of the 18th century, many new mechanical devices were introduced, which helped to make *kabuki* more entertaining. A lift (*seriage*) for carrying actors and stage sets from the basement to the stage was invented in 1753, and the revolving circular platform on and flush with the stage (*mawaributai*) was designed in 1758, followed by the double-concentric revolving stage. From 1759, a small lift (*suppon*) was placed a quarter of the distance along the ramp from the stage. The roof over the stage was eliminated in 1761. Another innovation was the method of changing the stage sets: a large-scale set would be turned through 90° to reveal the next set painted on the bottom. Sliding sets with wheels at the bottom were devised in 1766: scenes would be changed by moving the sets towards the right and left wings. By 1789, actors could be removed promptly from the front of a set by rotating a square part of the set around a vertical axis. A secondary temporary runway was introduced between 1772 and 1781.

19th–20th centuries. In the first half of the 19th century, when much other Japanese culture was in decline, the *kabuki* theatre developed still further in terms of both architecture and stage design, attaining its present form. In Edo *kabuki* theatres were concentrated in one central

area by order of the shogunate after some major fires in 1841, and *kabuki* prospered there until the end of the Edo period (1868).

A typical *kabuki* theatre in the 19th century was a large building, which included the entrance, audience area, stage and dressing-rooms (see fig. 201). The stage was six to seven bays wide. The left side (*shimote*) of the stage, as seen from the rear of the stage, was called the 'upper direction' and the right side (*kamite*) the 'lower direction'. These expressions were essential components in the production of *kabuki*, defining the actors' normal positions on the stage. Those playing men, high-ranking persons, teachers, parents and elder brothers and sisters took seats at places near the left side, while actors playing women, low-ranking persons, students, children and younger brothers and sisters took their seats on the right side. At the front edge of the stage were draw-curtains, which could be pulled to one or both sides. The stage contained a revolving platform and a lift, both operated from a basement underneath it. Large wings were built to accommodate movable stage sets. In the 17th century musicians sat side by side at the rear of the stage, but in the early 18th century their seats were moved to the left in both Edo and Kamigata. In the early 19th century, in Edo only, they were moved again, to the right side of the stage. Above the stage was a latticework ceiling from which scenery was hung and artificial snow (small pieces of white paper or flowers) was scattered.

The ramp not only gave actors access to the stage but also was the setting for certain dramatic actions, such as sudden appearances or exits. The ramp was connected to the front of the stage at a point a little to the right of centre. The ramps in Edo and in Kamigata differed from each other. In Kamigata, the ramp ran straight from the stage to the rear of the pit and into a small room with a curtained doorway. Beneath the ramp was a basement connecting this small room with the dressing-rooms. In Edo, the ramp ran diagonally from the stage to the rear corner of the pit, where it connected with a passage that ran behind the boxes. In the basement were the dressing-rooms and a passage that terminated at the small lift of the runway. Occasionally a temporary runway was constructed opposite the main runway. Near the intersection of stage and runway was a well, where ghosts and spies appeared and disappeared.

Boxes and a pit comprised the audience area. Since traditionally most theatres faced south, the right side of the audience facing the stage was called 'east' and the left side was called 'west'. The boxes in which some of the audience sat were laid out on three sides (east, west and rear), and each had two or three storeys. Usually 15 boxes were in the east section, 16 in the west and 9 in the rear. Low partitions divided the audience pit, except for the rear, into many squares. The large-span roof erected over the building was in the early years supported by posts placed inside the pit, but these were later replaced by huge transverse beams laid to bear the framework of the roof and later still by a new system composed of diagonal angle braces, purlins and smaller transverse beams. The dressing-rooms at the back of the stage actually had three storeys, which, in order to evade restrictions, were camouflaged as two storeys and a mezzanine. Rooms for the manager, the playwright, set makers, musicians and new actors were on the ground floor, rooms for actors who played women's parts only (*onnagata*) on the mezzanine, and rooms for actors playing men's parts on the first floor. Theatres became outwardly more splendid. A raised platform enclosed by a curtain was erected on the pent roof over the entrance, and pictures and ranking lists of actors were displayed above the entrance.

From the Meiji period (1868–1912) *kabuki* theatres developed further by incorporating European styles. In 1896, the proscenium arch common to European theatres

201. Utagawa Toyokuni: *Inside a Kabuki Theatre*, woodblock triptych, each section 377×249 mm, *c.* 1800 (London, British Museum)

was introduced. The width of the stage expanded first to more than ten bays and then to fifteen. Stage sets also developed greatly, and the pit was filled with seats. The candles and rape-oil lamps that had illuminated the stage in the Edo period were replaced one after another by petroleum lamps, gas lights, carbon arcs and finally electricity. Modern safety standards for theatrical buildings are very strict, requiring that such buildings be soundly constructed and proof against earthquakes and fire.

(b) Provincial theatres. Kabuki developed mainly in urban areas, such as Edo and Kamigata, but from the 18th century onwards spread to provincial areas, concurrently with the growth of the rural economy. Theatres or stages were established in both urban and rural areas all over the country, but strolling companies of *kabuki* actors were also common, and ordinary people enjoyed playing *kabuki* by themselves.

Although all the old theatres in Edo and Kamigata have disappeared, two provincial theatres survive and are preserved as Important Cultural Properties. One is Konpira-ōshibai at Kotohira, Kagawa Prefecture, a town that developed in front of Kotohira Shrine. Konpira-ōshibai was established in 1838 as a *kabuki* theatre, in imitation of a theatre in Osaka, and built in its present form in 1855 (see fig. 202). It has a stage seven and a half bays wide, with a revolving platform on stage and a lift. The main ramp runs straight to the small room and has a small lift; there is also a temporary ramp. The pit is divided into many squares, and two-storey boxes are arranged on three sides. The roof is gabled, and there is also a pent roof with a raised platform attached to the front gable end.

The second provincial theatre is Kurehaza, established in 1874 at Ikeda, Osaka Prefecture, and moved in 1971 to the Meiji Mura, an open-air museum of Meiji-period buildings and artefacts in Inuyama, Aichi Prefecture. It is small, with a stage only about five bays wide. Even so, a revolving platform and a lift are present, as are the main ramp, which has a small lift, and a temporary ramp. The audience area consists of a pit and two-storey east, west and rear boxes. Because of the small scale of the building, the dressing-rooms are above the entrance. This theatre also has a gabled roof with eaves and a raised platform on the pent roof.

Hundreds of *kabuki* stages remain in rural areas: those at Kami-miharada, Gunma Prefecture, at Shōdoshima, Kagawa Prefecture, and at the Nihon Minkaen (an open-air museum), Kanagawa Prefecture (originally at Daiō-chō, Mie Prefecture), are representative examples. Most of these theatres are small, consisting of nothing more than stages; but even these usually have revolving platforms and lifts. Some odd devices are to be seen at these simple stages, such as side walls that can be pulled down to become floors on the same level as the stage. Temporary walls surrounding the stages create wings. Rear walls may contain windows that open to reveal landscapes, which effectively become sets. The spectators' area is usually left

202. Konpira-ōshibai *kabuki* theatre, Kotohira, Kagawa Prefecture, 1855

open and covered with turf, but at Shōdoshima it resembles terraced fields with stone ramparts. At Kami-miharada, a temporary shelter is provided by arching thin green trees and covering them with straw mats.

BIBLIOGRAPHY

K. Gotō: *Nihon gekijō shi* [History of Japanese theatres] (Tokyo, 1925)
S. Miyake: *Kabuki Drama*, Tourist Library, vii (Tokyo, 1938/R 1963)
A. Suda: *Nihon gekijō shi no kenkyū* [Study on the history of Japanese theatres] (Tokyo, 1957)
A. S. Halford and G. M. Halford: *The Kabuki Handbook: A Guide to Understanding and Appreciation* (Rutland, VT, 1963)
Y. Hattori, T. Tomita and T. Hirosue, eds: *Kabuki jiten* [Encyclopedia of kabuki] (Tokyo, 1983)

NOBUO ITO

(iii) Costume. The basic *kabuki* costume is the kimono that was fashionable in the 17th and 18th centuries. Its aesthetically dominant feature is a stylized realism, the degree of which varies according to the type of *kabuki*. Traditionally, the three categories of *kabuki* are *jidaimono* (historical plays), *sewamono* (bourgeois or domestic plays) and *shosagoto* (dance or pantomime scenes).

In *jidaimono*, the costumes are usually representative of those worn at court in the Nara (710–94), Heian (794–1185) and Kamakura (1185–1333) periods. Noblemen wear large *daimon* (big seal) kimonos with outsize leggings, which hinder them from making sudden thrusts with their swords; every nobleman carries one long sword for outdoor combat and a shorter one for indoor fights. Noblewomen wear silk kimonos, which vary according to their social position. The highest-ranking princess is clad in several layers of kimonos, with graded colours at the revers, and baggy red trousers or a divided skirt (*hakama*) worn over the kimonos.

The costumes are not designed with historical correctness in mind but rather for theatrical effect. Moreover, the actor's name is prominently displayed on the kimono, either in the form of his crest or by characteristic patterns woven into the silk, or both. Dramas dealing with warriors are normally set in the more austere Kamakura period; in these the warriors wear elaborate armour and carry two swords and sometimes a bow, arrows and quiver as well. Since *kabuki* is a theatre of star performers, the main actor's overall appearance must not be disturbed by walk-on players and extras, whose roles and functions are generally easily identified by their somewhat subdued costumes.

Many *kabuki* plays deal with contemporary political affairs. The most famous example is *Kanadehon chūshingura* ('The treasury of loyal retainers'), featuring the Akō vendetta of 1703, in which 47 *rōnin* (masterless samurai) revenge the death of their master. In order to avoid censorship, the play was set in a fictitious past: some of the costumes hint at the Heian period, others are in the contemporary fashions of the middle of the Edo period (1600–1868), producing an interesting aesthetic juxtaposition.

Sewamono were introduced at the beginning of the 18th century. The heroes belonged to the merchant class, and the plays were often set in the red-light districts of Osaka or Kyoto. Typically, the plot features an impoverished yet attractive young merchant having an affair with a woman of pleasure (*yūjō*). While he is clad in the contemporary style of the 18th century, usually a cotton kimono (with the actor's crest and his special pattern), the *yūjō* wears a fancy kimono with a gorgeous robe (*uchikake*).

Spectators in Edo (now Tokyo) were especially attracted by the *aragoto* ('rough stuff') plays performed by the Ichikawa family of actors. In this category, the hero appears as a superman, his tremendous strength being symbolized by the extravagance of his costume. In the play *Shibaraku* ('Wait a moment!'), for example, the hero Kamakura Gongorō Kagemasa wears a heavy kimono made from brocade, over it a huge overcoat, with each sleeve (*sode*) more than 1 sq. m in area, and a huge, richly decorated belt sash (*obi*) holding the buttonless kimono together. He even wears three swords instead of the normal two. When the actor moves he needs two assistants—clad completely in black to convey the illusion that they are invisible. In all *aragoto* plays the costumes enhance the appearance of the actors and reinforce their characters, but at the same time they constitute an aesthetic pleasure in their own right.

In the so-called *hengemono* (quick-change plays), it is the costume that plays the central role. Several outfits are worn one over the other. By pulling meticulously arranged threads (*hikinuki*), actor and assistant, working in perfect unison, can transform the appearance of the actor on the open stage in a matter of seconds.

Shosagoto costumes employ the widest range of fantasy. Women's kimonos, in particular, are of rich silk materials fashioned in the most fanciful way. Often, motifs from nature lend the costume its character: a butterfly or a serpent, perhaps, for a woman's costume, a lion for a male costume. Plays derived from the repertory of *nō* or *kyōgen* are generally performed with costumes that closely resemble those used in the original versions.

Once costumes are created for specific roles, they are preserved and their design is handed down from generation to generation, thus contributing to the aesthetic concept of a traditional art. Only the most famous and senior actors are allowed to introduce new costumes, a spectacular deviation from the rules.

(iv) Make-up. Make-up in *kabuki* is highly stylized and is used to standardize specific facial expressions rather than to enhance the actor's own personality. One of the earliest forms of *kabuki* consisted of dances by female (*yūjō*) and male (*wakashū*) prostitutes (*see* §(i) above), and it is from this style of *kabuki* that many of the conventions in make-up derive. Since the mid-17th century, all female roles in a *kabuki* drama have been played by men. Special artistry is required to create artificially the subtlety and charm of princesses or of women from the pleasure quarters. To this end, the actor's eyebrows are shaved, and the face, neck and both hands are whitened with paste, so that all traces of personal expression are eliminated. Make-up of the eye area varies according to the type of woman to be portrayed (maiden, *yūjō*, married woman, noble heroine or bourgeoise): eyebrows are painted on with a brush higher up the forehead than the normal position, and the eyes themselves are made up in appropriate colours—a faded red for a maiden or noblewoman, a dark blue for a demon or witch. In order to bring out the beauty of the face, the mouth is reduced to a small red circle, and the teeth are blackened. By contrast, peasants and old women

of low social ranking are given sun-tanned, wrinkled faces. Noblemen (*jitsugoto*) are portrayed fairly realistically, with faces that are essentially white—albeit with black lips—and eyebrows shaped in accordance with their character.

In the late 17th century, two actors, Ichikawa Danjūrō I and his son Danjūrō II, created a new type of character, a hero endowed with superhuman powers, who was central to the *aragoto* ('rough stuff') plays. In order to emphasize their strength, they painted their facial muscles and blood vessels, using red for heroes, blue for villains and brownish-violet for demons. The lines were not executed with precisely drawn edges but rather faded down towards the lower part of the head (*bokashi*). In 1837, 18 famous scenes and short acts (*Kabuki jūhachiban*: '18 Kabuki dramas') were claimed as the artistic property of the Ichikawa family of actors. The make-up prototypes of this collection are especially famous and display the whole range of 'frozen' expressions associated with this genre (*kumadori*). During the period 1688–1704 a new character was created: he was an impoverished yet chic bourgeois member of the merchant class. His make-up (*wagoto*: 'elegant style') was rather subdued, consisting of a white face with black eyebrows and dark red lips.

Kabuki make-up was created originally for barely illuminated theatres, in which only the faces of the main actors were lit by a candle: under modern spotlights it may seem somewhat exaggerated. Formerly, natural colours were used, but modern actors prefer Western-style make-up products. All actors do their faces themselves, according to methods and patterns learnt from their forefathers.

BIBLIOGRAPHY

H. Sone and K. Torii: *Kabuki Costume and Makeups* (New York and Tokyo, 1957)
R. M. Shaver: *Kabuki Costume* (Rutland, VT, and Tokyo, 1966/*R* 1990)
J. Brandon, W. P. Malm and D. H. Shirley: *Studies in Kabuki: Its Acting, Music, Historical Context* (Honolulu, 1978)
S. L. Leiter: *Kabuki Encyclopedia: An English-language Adaptation of Kabuki Jiten* (Westport, CT, and London, 1979)

THOMAS LEIMS

3. BUGAKU. These are court dances that accompany Japanese court music (*gagaku*), performed by a small orchestra composed of wind and string instruments and drums. These slow, graceful dances were at their height in the Heian period (794–1185) and reflect the refined, elegant aesthetic of that time. The origins of the dances reach as far back as the 6th century, when a wide variety of Chinese, Korean and South-east Asian dances were imported into Japan. The art remains alive in a few areas of Japan, supported by the imperial household and performed by a small number of professional musicians and dancers at shrines associated with the emperor. During the Heian period these dances, performed by official court musicians and dancers of the court Bureau of Music as well as by members of the aristocracy, were the highlight both of many court functions and, performed by amateur courtiers, of pleasurable pastimes such as cherry-viewing and moon-gazing parties. Horse races, archery contests and football games also often ended in a performance of *bugaku*.

Bugaku as a unified form dates from the 9th century, when the court Bureau of Music selected a limited number

of musical scales and dance styles and either recast or discarded pieces that did not belong. They divided the repertory into two groups according to country of origin. Those imported from China (*Tōgaku*) or South-east Asia (*Rin'yūgaku*) became Dances of the Left (*sanomai*), those originating in Mongolia (*Bokkai*) or Korea (*Komagaku*) were Dances of the Right (*unomai*). The two styles of dances are performed alternately in pairs (*taigaimai*), the dancers appearing from opposite sides of the square stage, while the musicians sit on the appropriate sides. Each orchestra is backed by a large drum (*dadaiko*). For Dances of the Left this drum has red cords and a bright golden sun on top of its flame-coloured wooden frame decorated with fiery dragons; it is placed at the back of the stage on the left side as seen from the audience. For Dances of the Right, the large drum has green cords and a large silver moon atop a flame-coloured frame decorated with a pair of phoenixes; it is placed at the back of the stage on the right side. This colour symbolism is retained in the costumes of the dancers. The two styles of dance differ in various refinements, such as the way in which the dancers mark the beats with a swing of the foot and the position of the fingers. The accompanying styles of music also use somewhat different instruments and rhythmic systems. The masks, too, are paired, since the contents of the dances in each pair tend to be related. Occasionally a dance programme includes more than one pair.

A programme consists of three types of dance. First come quiet, slow dances (*hiramai*) performed by four or six people dancing in unison. The dancers generally wear the full and flowing layered costume (*kasane shōzoku*) consisting of a broad-sleeved, long-tailed undergarment (*shita gasane*), an embroidered sleeveless vest (*hanpi*), a gauze over-cloak (*hō*) with a long trailing tail and wide pantaloons (*uenohakama*), generally gathered at the ankles by stiff leg-guards (*fukake*). The costume may be varied by slipping off one or both sleeves of the cloak or dispensing with it altogether. The broad silk sleeves wave gracefully with the sustained opening and closing movements of the arms. The primary colours in the cuffs, hems and cloaks are set off by the clean white of the undergarments. Only a few of the quiet dances require masks (*see* §XVI, 15 below). These tend to have gentle expressions and are simply constructed.

Next come the more active military dances (*bunomai*), for which the dancers are dressed in simulated armour and carry spears and swords. The costumes for *Taiheiraku* and *Shinnō* replicate the armour found on guardian statues in temples, complete with braided breastplates, metal-embellished wrist and shin protectors, and gargoyle-shaped shoulder guards and belt buckles.

Solo dances in faster rhythms and with more dynamic movements (*hashirimai*) end the programme. Among these are the popular pieces of *Genjōraku*, the snake charmer, and of *Ryōō*, a victory dance also performed to induce rain, perhaps by association with the dragon perched on top of the mask. Costumes for running dances are distinguished by an oval vest (*ryōtō*), often fringed with hemp fibres. To facilitate movement, the sleeves are cut narrower than for the layered costume and are gathered at the wrists. The masks tend to be larger than those for quiet dances, and their exaggerated features gain impact

203. *Bugaku* mask of *Ryōō*, the dragon king, gold and colours on lacquer, with horsehair moustache and beard, h. 335 mm, 17th century (London, British Museum)

through the use of many mechanical devices that create a surrealistic imagery, such as dangling chins, rotating eyeballs and jiggling face plates (see fig. 203).

Illustrations of *bugaku* were quite popular in handscrolls (*emaki*) and folding screens (*byōbu*) from the 12th to the 19th centuries. Particularly famous are the 12th-century ink scroll *Shinzei kogakuzu* ('Shinzei's illustrations of ancient music'; Tokyo, U. F. A. & Music), the *Bugakuzu* (Kyoto, Yōmei Bunko) and the *Ōei kogakuzu* ('Illustrations of ancient music in the Ōei era') by Tosa Mitsunobu (copy in colours and ink; Tokyo, N. Mus.). Also well known are the *Bugaku byōbu* standing screens by TAWARAYA SŌTATSU (Kyoto, Daigoji Hōjuin Treasury) and by Tosa Tōō (*fl* 18th century).

BIBLIOGRAPHY
C. Koma: *Kyōkunshō* [Book of instruction] (Kyoto, 1233); ed. as ii of *Nihonkotenzenshū* [Complete collection of Japanese literary classics] (Tokyo, 1928)
S. Abe: *Gakkaroku* [The records of a musician] (Kyoto, 1690); ed. in *Nihon zenshū kankōkai* [Complete record of Japanese customs] (Tokyo, 1935)
R. Garfius: *Gagaku: The Music and Dances of the Japanese Imperial Household* (New York, 1957)
T. Hayashiya: *Chūseigeinōshi no kenkyū* [Studies of medieval performing arts] (Tokyo, 1960)
Gagaku, Nihon no kotengeinō [Classical performing arts of Japan], ii, Geinōshi kenkyūkai (Tokyo, 1970)
M. Togi: *Gagaku* [Court music], vii of *Nihon no dentō* (Tokyo, 1971)
N. Kyōtarō: *Bugakumen* [*Bugaku* masks] (Tokyo, 1971); Eng. trans. by M. Bethe (Tokyo, 1978)
E. Harish-Schneider: *A History of Japanese Music* (London, 1973)
N. Ohigashi and others: *Bugaku/Bugaku Treasures from the Kasuga Shrine* (Nara, 1984) [bilingual text]

MONICA BETHE

XIV. Tea ceremony.

The etiquette of tea drinking and its associated arts occupy a unique place in Japanese social history and artistic development. From the late 15th century onwards the tea ceremony has served as a focus for artistic production, architectural development and the cultivation of art appreciation and connoisseurship.

1. Introduction. 2. Architecture. 3. Utensils. 4. Calligraphy.

1. INTRODUCTION.

(i) History. (ii) Philosophy.

(i) History. Tea was probably known in Japan by the 8th century AD. The practice of tea drinking began in China in ancient times, and methods of preparing tea evolved under three different dynasties. In the Tang period (AD 618–907) tea was boiled with salt, butter and other milk products; whipping powdered tea in water was practised in the Song period (960–1279); and extracting tea by steeping it in hot water was developed in the Ming period (1368–1644), a tradition known as *sencha* (infused green tea). The Japanese tea ceremony (*chadō*; also pronounced *sadō*; the Way of tea; or *chanoyu*, literally 'boiled water for tea') developed from the Song-period practice of tea drinking. Tea was probably the subject of connoisseurship at the Japanese court in the 9th century (see §XXII below). Its popularity declined, however, until the priest Eisai (1141–1215), who had studied Zen Buddhism in China, brought tea back to Japan in 1191. He encouraged the spread of tea cultivation and succeeded in growing high-quality tea in the suburbs of Kyoto. He also tried to popularize tea drinking by publishing the *Kissa yōjōki*, in which he expounded the method of production and beneficial effects of tea. Tea was drunk in 13th-century Zen temples to prevent drowsiness during meditation and as a form of communion, the bowl being passed from hand to hand. Until the 14th century, however, the only other uses of tea were as offerings to Buddha or, occasionally, as alms for the masses. In the 14th century, at the beginning of a civil war, there were tea competitions (*tōcha*), popular among nobles and warriors, in which participants had to guess where the tea had been produced by sampling dozens of cups of tea. These competitions, unlike the later tea ceremony, had an atmosphere of luxury, gaiety and even vulgarity. An enormous number of art objects imported from China were given as prizes or used to decorate the banquet chambers. After the competition magnificent banquets and alcohol were served.

From the late 14th century to the latter half of the 15th, Japan enjoyed peace under the ASHIKAGA shogunate established in Kyoto. The shoguns were great lovers of cultural activities, such as composing 31-syllable poems

(*waka*) and linked poems (*renga*), watching *nō* plays and holding tea ceremonies. Rooms for these tea meetings and receptions were designed to be completely floored with *tatami* mats (the standard size of one *tatami* in Kyoto is 1.91×0.955 m), in contrast to traditional boarded floors, and were provided with fixed elements, such as alcoves (*toko*), shelves (*tana*) and desks for displaying Chinese art objects (*karamono*). This new residential style was called the *Shoin* style (*shoin zukuri*; 'book hall or study construction'; *see* §III, 4(ii)(a) above), and the tea ceremony then current is now known as 'study-room tea'. Tea was prepared by professional tea servers sitting in front of the utensil shelves (*daisu*) placed in small rooms or at the end of corridors, and the prepared tea was then carried to the master and his guests. The intimate nature and subtle aesthetics of this manner of drinking tea formed the basis of the tea ceremony. Towards the end of the 15th century it became customary for the host to prepare the tea in the presence of four or five male guests and serve them in an act of humility.

Special aesthetic advisers to the shogun, known as *dōbōshū*, were hired to join him in discussing literature, painting and other arts, including the tea ceremony (*see* AMI). These advisers were also responsible for studying, cataloguing and caring for the objects used in tea gatherings. Ashikaga Yoshimasa (1435–90), the eighth shogun, was particularly devoted to literature and culture and even designed a study room, the Dōjinsai, in his private Buddha hall at his Higashiyama Villa (now the Buddhist temple Ginkakuji), Kyoto. This room, though not a tea-room, is recognized as the first example of a four-and-a-half-mat room (*c.* 8.2 sq. m), a size that later became standard for tea-rooms. This size is said to have been based on the cell of Vimalikirti (Jap. Yuima koji; Yuima the lay disciple), an ancient Indian follower of the Buddha.

MURATA JUKŌ was the acknowledged founder of the *chanoyu* tea ceremony. He erected a four-and-a-half-mat tea house in the late 15th century. Though not completely divorced from the tradition of the *shoin* style, it was fairly simple and probably represented the first stage in the development of the rural cottage (*sōan*) type characteristic of the mature tea house. Such hermitage-style huts had walls of unfinished plaster and unsquared pillars. The practice of serving tea in an unpretentious environment later came to be called *wabicha* ('poverty tea'). The term comes from a word implying loneliness, but *wabi* had a positive connotation, suggesting the Zen and Daoist concept of liberation from material and emotional concerns. To participate in a *wabi* tea ceremony was to enter a way of life: 'Basically, drinking tea is an ordinary experience, but in the ceremony the experience is so concentrated that one finds himself encouraged to look within, to discover not a new self but the natural self so often covered up by successive layers of civilization' (Castile, pp. 19–20). From the late 15th century to the late 16th a great change occurred in Japanese aesthetics: Japanese art objects began to be appreciated along with Chinese, and the taste for lavish arts gave way to an admiration for the beauty of seemingly unfinished but well arranged objects. For example, rustic dwellings built inside Kyoto but conveying the air of villages in the hills were favoured by a growing number of aesthete poets and tea fanciers. This new aesthetic was described at the time as a preference for the 'chilled and withered' (*hiekareta*).

In the late 16th century the tea ceremony became popular in Sakai, a port city made prosperous by overseas trade and inhabited by wealthy merchants. These powerful merchants (*nayashū*) used tea-rooms as gathering places to discuss their affairs. At that time, even wealthy commoners lived crowded together on fairly small plots, which partly accounts for the smallness of tea-rooms. SEN NO RIKYŪ (see fig. 204), who established the modern form of the tea ceremony, was himself a Sakai merchant. He sought a quiet simplicity (*wabi*) in tea, which he made manifest

204. Tea ceremony master *Sen no Rikyū* by Hasegawa Tōhaku, 1595 (Kyoto, Fushin'an)

in the perfection of the *sōan*-style tea house. Rikyū preferred four-and-a-half-mat and two-mat (*c.* 3.6 sq. m) tea-rooms, as well as three-and-a-*daime*-mat (*c.* 6.9 sq. m) rooms, the *daime* being a mat of three–quarters the standard length and usually used only as the utensil mat. By severely limiting the area of tea-rooms, Rikyū emphasized the communion of the host and his guests and gave the tea ceremony a new spiritual dimension. His only surviving tea-room has mud-plastered walls and is two mats in area.

A contemporary and patron of Rikyū, the warlord TOYOTOMI HIDEYOSHI, also contributed to the development of the tea ceremony. Although he grew up a poor farmer, Hideyoshi loved the tea ceremony. Among the many tea-rooms he commissioned, the best known is the three-mat (*c.* 5.5 sq. m) prefabricated tea-room, made of wood but covered with gold leaf, in which he served tea to the emperor. This luxurious tea-room served to display Hideyoshi's power, as well as his political use of the ostentatious and flamboyant (*bassara*), but he also enjoyed the *wabi*-style tea ceremony held in a *sōan*-style tea-room. Hideyoshi hired Rikyū as his chief tea master and entrusted him with the management of his collection of art objects. Other feudal lords (daimyo) vied to secure the services of Rikyū and other famous tea masters as their teachers.

Although Rikyū was eventually condemned by Hideyoshi to commit suicide in 1591, this period may be regarded as the golden age of the tea ceremony. In the first half of the 17th century many tea masters appeared among the ranks of daimyo. FURUTA ORIBE, Oda Uraku (1547–1621) and KOBORI ENSHŪ all designed their own tea-rooms, and the use of *daime* became popular. Enshū, who was familiar with Japanese classical culture through his association with court nobles and monks, is especially noted for his design of tea-rooms with a 'refined rusticity' (*kirei sabi*). In 1594, three years after Rikyū's death, his grandson Sōtan (1578–1658) was allowed to become a tea master. Striving to propagate Rikyū's taste for quiet simplicity, he established a tea lineage, the Senke. This was soon divided into three schools, Omotesenke, Urasenke and Mushakōjisenke, all of which prospered, along with many branch schools. Earlier tea masters made their living as advisers to the daimyo, but after the late 18th century tea masters taught the tea ceremony to nobles, samurai and monks, as well as to wealthy townsmen and farmers who wished to receive cultural training. In response to these new trends, various light and easy plans for tea-rooms were devised by tea masters.

The earliest known reference to infused green tea (*sencha*) in Japan dates from the Muromachi period (1333–1568), although proper utensils for its preparation (different from those used in *chanoyu*) were probably imported to Japan from China only in the early 17th century. Zen monks of the Ōbaku (Chin. Huangbo) sect drank *sencha* in keeping with their liking for Ming-period cultural pursuits, and it was an Ōbaku monk, Kō Yūgai (Baisaō; 'old tea seller'; 1675–1763), who is credited with spreading the custom to the general population by selling *sencha* in Kyoto. *Sencha* drinking became more popular in the 18th century, when the preference for Chinese culture was at its height. The custom was characterized by *seifuryū* (Chinese elegance), a very different aesthetic from the rustic simplicity of *chanoyu*. By the early 19th century *sencha* drinking had become mainly a casual, unceremonious activity, except among literati, who partook of it in a variety of informal settings; but by the early Meiji period (1868–1912) it had acquired a sense of ritual like that associated with *chanoyu* and was experienced in formalized and aesthetically controlled settings.

The *chanoyu* ceremony declined after Japan was opened to the outside world in 1868, because it was thought to be an old custom that should be abolished. It soon revived, and from the end of the 19th century to World War I the tea ceremony prospered with the support of newly emergent capitalists. The tea ceremony has been popular among women since the 1890s, being recognized as an important part of their cultural training.

(ii) Philosophy. The first person to explain the essence of the Japanese tea ceremony to the outside world was Tenshin (Kakuzō) Okakura, who published *The Book of Tea* in 1906 in New York. Okakura defined and praised the tea ceremony as the religion of aestheticism, the adoration of the beautiful among everyday facts and as a work of art. He located its origin in Daoism, and specifically in the teachings of the Chinese philosopher Laozi (*b* ?604 BC), which were later absorbed in Zen Buddhism. According to Okakura all tea masters, including Rikyū, studied Zen and tried to introduce it into their daily lives, as proved by the saying: 'Zen and tea are one.' Attitudes associated with Zen, however, appear in many aspects of Japanese culture and art, and the cult of tea handed down in Zen temples is largely different from the tea ceremony developed by Rikyū.

Nevertheless, although the influence of Zen can be exaggerated, the experience of the *wabi* tea ceremony is often expressed in terms of Buddhist (mingled with Daoist and Confucian) ideas: the stepping-stones in the garden (*see* §2(iii) below), so willing to be trodden on, and the water in the basin, so willing to take away defilement, teach humility; the weathered hut is a reminder of both transience and endurance, and the simplicity and small scale of the whole represent the unimportance of size and showiness. One bows close to the ground to enter the hut through its 'crawling-in entrance' (*nijiriguchi*) and, once inside, unfolds oneself in a remote world. Far from feeling cramped or confined, one experiences a liberation of spirit. Rikyū remarked that the complicated matter of tea practice is nothing more than sharing a bowl of tea with others. Doing that simple task with such full attention that all sense of selfhood and separation is lost, however, is not easy. The short dialogues between host and head guest, crucial parts of the ritual when questions about utensils are asked and answered, are opportunities not just for showing off utensils or one's knowledge of them but for so-called 'profound questions and mundane answers'. Questions that are apparently of a practical nature conceal questions about the identity of the self and the meaning of life but are couched in terms that render them answerable.

Modern philosophers view the tea ceremony as a kind of performing art, defining it, for example, as an art of production through the medium of bodily posturing. It is differentiated from such arts as dancing and theatre in the

following ways: performers and spectators are not divided from each other; separation from daily life is not complete; and the ceremony encompasses such factors as courtesy and training for social life. Furthermore, the historical works that had long been accepted as containing the genuine thoughts of Rikyū and other early masters have mostly been shown to post-date their supposed authors by many decades. Studies of more reliable historical materials show that the tea ceremony was not in the past regarded as the esoteric spiritual exercise it has traditionally been seen as. Nevertheless, Rikyū and other prominent tea masters certainly wished the tea ceremony to represent a short but relaxed interval removed from the pressures of mundane life. Their catchwords were 'quiet simplicity' (*wabi*) and 'mellow, experienced taste' (*sabi*), notions not generally understood in modern times. Current thinking places the essence of the tea ceremony in harmony (*wa*), reverence (*kei*), purity (*sei*) and calm (*jaku*).

BIBLIOGRAPHY
K. Okakura: *The Book of Tea* (New York, 1906)
A. L. Sadler: *Cha-no-yu: The Japanese Tea Ceremony* (London, 1933/R Rutland, VT, 1963)
J. M. Rosenfield and S. Shimada: *Traditions of Japanese Art: Selections from the Kimiko and John Powers Collection* (Cambridge, MA, 1970)
R. Castile: *The Way of Tea* (New York, 1971)
S. Hayashiya and others: *Chanoyu: Japanese Tea Ceremony* (New York, 1979)
P. J. Graham: '*Sencha* and its Contribution to the Spread of Chinese Literati Culture in Edo Period Japan', *Orient. A.* (1985), pp. 186–95
P. Varley and I. Kumakura, eds: *Tea in Japan: Essays on the History of Chanoyu* (Honolulu, 1989)

2. ARCHITECTURE. Tea houses or tea-rooms (*chashitsu* or *sukiya*) are special spaces built or used for the tea ceremony. Usually quite small, they typically have areas of four-and-a-half *tatami* mats (*c.* 8.2 sq. m), accompanied by an even smaller kitchen (see fig. 205). In both interior and exterior design, most tea-rooms are meant to suggest simple, humble rural cottages, but certain fittings and equipment are installed, and the appearance of natural rusticity is often the result of considerable work and expense. Rooms both smaller and larger than four-and-a-half mats have also been used for the tea ceremony; in modern times, especially, quite spacious rooms are used to accommodate a large number of guests. Modern tea ceremonies have also been held in rooms with wooden floors and furnished with desks and chairs. In short, virtually any room may be used for the tea ceremony. In order to hold a formal tea ceremony, however, a garden (*roji*) attached to the tea-room is necessary because some important parts of the ceremony are enacted in the garden.

(i) Small tea-rooms. (ii) Larger tea-rooms. (iii) Gardens.

(i) Small tea-rooms.

(a) Introduction. (b) Types.

(a) Introduction. The rural cottage style known as *sōan* ('grass hut') is basic to the design of small tea-rooms. Such tea-rooms are small and light in design and constructed from plain, natural materials. Symmetry, repetition and unnatural juxtaposition are avoided. Posts are generally slender logs unplaned at the corners, although bamboo may be used for decorative intermediate posts. The walls between the posts are usually made of natural-coloured clay. Of the two types of window, the first consists of

205. Tea-room of the Ryūkōin, Daitokuji, Kyoto, 17th century

paper sliding doors (*shōji*) set between thin wooden sills and lintels, with rows of thin vertical bamboo nailed outside. The second type, called *shitajimado*, consists of square or circular openings left in the middle of the clay wall and filled with bamboo lattice tied with vines. This type of window is closed by *shōji* that slide from one side. Various types and dispositions of windows are characteristic of tea-rooms. Board panels hung on the exterior both protect the windows and limit the light coming into the rooms.

There are also two kinds of guests' entrances: those for noblemen and 'crawling-in entrances' (*nijiriguchi*). Entrances for noblemen are 1.5–1.6 m high from base to lintel and wide enough to enter standing. Crawling-in entrances allow guests to enter the tea-room directly from the garden; they are only *c.* 600 mm wide and 670 mm high. Because the base of the entrance is about 500 mm above ground-level, a big stepping-stone is placed in front of the entrance to enable guests to crawl in with little difficulty. Crawling-in entrances are closed from the outside with sliding board doors. The exterior of the doors is covered with upright boards, but the interior is plain. They can be latched from inside. Above the crawling-in entrances are large windows; occasionally small transom windows are placed above these. Simple wooden shelves are fixed near the crawling-in entrances for samurai to leave their swords before entering the tea-room. Pent roofs protect the entrances and these shelves.

The eaves of the main roof usually extend 500–600 mm from purlins on the top of the post, and rafters made of thin logs or bamboo are typically arranged at intervals of about 450 mm. On the rafters pairs of thin bamboo shafts are placed horizontally at intervals of 200–300 mm; thin sheathing is placed parallel to the rafters. There are, however, many variants in roof designs. Roofs are mainly gabled or hipped and gabled, although hipped or pyramidal roofs are also found. Boards inscribed with the name of the tea-room are commonly hung under the gables. Roofs are usually either shingled or thatched but, because of fire

hazard and the perishability of natural materials, tiled or copper roofs also constructed in the 20th century. The pitch of a shingled roof ranges from 4:10 to 6:10 and that of a thatched roof may be 9:10, 10:10 or more. Roofs may have skylights with lids that can be raised, with paper screens set inside the skylights. The all-important floor of a tea-room is usually covered by *tatami* mats, although board floors are occasionally used.

(b) Types. Tea-room plans vary widely, but the following are the basic types. Tea-room plans are defined by the floor area measured in *tatami* or *daime* mats.

206. Tea-room plans: (top left) Yūin (four-and-a-half mats; Kyoto, Urasenke); (top right) Taian (two mats; Ōyamazaki, Kyoto Prefecture, Myokian); (bottom left) Teigyokuken (two mats and a *daime*; Kyoto, Daitokuji, Shinjuan); (bottom right) Joan (two-and-a-half mats and a *daime*, with a triangular board floor; Inuyama, Aichi Prefecture): (a) guests' entrance; (b) host's entrance; (c) serving entrance; (d) *tokonoma*; (e) *dōko*; (f) hearth; (g) hanging shelf

Four-and-a-half-mat. The Yūin tea-room at Urasenke headquarters in Kyoto (see fig. 206) is illustrative of the fundamental four-and-a-half-mat plan and interior design. It has a crawling-in entrance at the eastern end of the south wall. A guest entering through the crawling-in entrance faces a TOKONOMA in the eastern half of the north wall. The mat laid east–west in front of the *tokonoma* is called the mat of distinction because it was used only by noblemen; the second mat, laid along the east wall between the mat of distinction and the entrance, is the guests' mat; the third mat, laid along the south wall, is the host's entrance mat; the fourth mat, laid along the west wall, is the utensil mat where the host performs the tea ceremony; the last mat, a half-size square in the centre of the room, is called the hearth mat. A hearth 430 mm square is set in the north-western corner of the hearth mat from November to May. This arrangement of the hearth is called the four-and-a-half-mat type (*yojōhangiri*). During other months hearths in all tea-rooms are covered, and instead a movable furnace is placed on the utensil mat. When the hearth of a four-and-a-half-mat tea-room is covered, it is proper that the disposition of mats be slightly changed: a half-size mat is laid at the south-western corner and serves as the host's entrance mat; and a full-size mat, called the passage mat, is laid north–south between the guests' mat and the host's entrance mat.

The *tokonoma*, 1.4 m wide and 0.8 m deep, has a raised and matted dais edged with a baseboard. The post at its west side and the baseboard are made of simple logs. Above the lintel is a narrow wall. The post in the north-western corner of the room is concealed in the wall except for a small portion at the top, presumably exposed to make the room look wider. In the middle of the west wall is a *dōko*; the term generally means a built-in cupboard for utensils but in this case designates merely a low opening 600 mm wide with a sliding paper door through which utensils are passed. The host's entrance, 600 mm wide, is at the southern end of the west wall and is covered by a sliding door papered on both sides. The east wall has only one *shitajimado* window. The south wall, divided by a post, also has one *shitajimado* diagonally above the crawling-in entrance.

The lower parts of the interior walls are papered. White paper up to a height of 240 mm is used on the walls around the utensil mat and dark blue paper 550 mm high on the other walls. The former is presumably effective for setting off the host's performance, and the latter serves to protect the guests' clothes from damage. The ceiling is made of wicker and bamboo battens. The plan in which the hearth is on the right side of the utensil mat is most convenient for performing the tea ceremony. Tea-rooms with reversed plans are shown in old documents, but there are few extant examples.

Two-mat. The Taian at Ōyamazaki, Kyoto Prefecture (see fig. 206), is believed to have been designed in the late 16th century by SEN NO RIKYŪ and is the best example of a two-mat tea-room. Its crawling-in entrance, at the eastern end of the south side, is somewhat larger than usual (h. 790 mm, w. 720 mm). Above the entrance is a large window with rows of vertical bamboo. One mat extending from the crawling-in entrance towards the *tokonoma* serves

for guests, while the other, the utensil mat laid to the west of the guests' mat, contains the hearth in the north-west corner. This disposition is called the corner hearth (*sumiro*). The hearth, measuring 410 mm square, is a little smaller than most. The rough walls are made of clay mixed with straw, and their lower sections are covered with paper as at the Yūin. The *tokonoma* on the north wall, 1.2 m wide and 0.7 m deep, is unique in that the two rear posts and the ceiling are plastered with clay. The north-western corner post is concealed by the north wall. Clay-covered walls and posts effectively create a feeling of space and richness in this small room. The west wall has a lintel and, under it, a short post 500 mm away from the south-western corner. The rest of the west wall is taken up by the host's entrance, consisting of a pair of sliding doors papered on both sides. The east wall, bisected vertically by a thin bamboo pole that reaches from the ceiling to just below the middle of the wall, has two *shitajimado*.

The ceiling is divided into three parts: the first, 500 mm wide, is in front of the *tokonoma*; the second, 800 mm wide, is above the utensil mat and the third covers the remaining area. Although the first two are both 1.8 m high and built with the same style of board-and-bamboo batten, the battens run east–west in the first one and north–south in the second. The third section, by contrast, is an exposed ceiling angling from west to east. Presumably, this design was made to distinguish different areas for noblemen, host and guests. At Taian there is an anteroom of one mat and a board of the same length but only 240 mm wide. This room has a utensil shelf at its north-eastern corner, a door on the north wall leading to the kitchen, and a small *shitajimado* in the south and west walls. Consequently, the Taian could also be used as a three-mat tea-room.

*One-and-a-*daime-*mat*. Although the Konnichian at Urasenke headquarters, Kyoto Prefecture, has an area of two mats, the utensil mat is in fact shortened to one *daime*, and the remaining area is floored with a single board. Guests enter through the crawling-in entrance on the south side, but there is no formal *tokonoma* on the north side. The host enters from the north side and sits facing south to perform the ceremony. The hearth is at the front right corner of the utensil mat. This plan is called the opposite hearth type (*mukōgiri*).

Three-mat. In addition to the square plans described above, there were rectangular plans using three or four mats. The Kan'in'seki tea-room at Jukōin, Kyoto, is a rare extant three-mat tea-room. The plan is similar to that of the whole Taian including its anteroom, in that it has also a hanging shelf and a wall about 500 mm wide at the front right corner of the utensil mat. Nevertheless, there are many differences. A thin middle post (*nakabashira*) is placed at the end of the wall where the Taian has a short post, and this wall terminates in a batten placed about 600 mm above the mat, so that the lower part is left open. The hearth is positioned along the left edge of the middle mat between the *nakabashira* and the centre. The design and placement of the *tokonoma*, crawling-in and host's entrances are also different from those at the Taian.

Daime. Tea-rooms of three or four mats were unpopular in the Edo period (1600–1868), probably because of

their formal atmosphere and cramped conditions. Instead, plans with *daime* became increasingly common. The Fushin'an tea-room at Omotesenke headquarters in Kyoto has a plan of three mats and a *daime* connected to their short side. The *daime* has an additional narrow board on its side. The arrangement of shelf, *nakabashira* and hearth is the same as at Kan'in'noseki, except that the *nakabashira* stands at the mid-point on the edge of the hearth mat. This disposition is called *daimegiri*. A waiter's arched entrance with a sliding door papered on both sides is set next to the *tokonoma*. The En'an tea-room, Kyoto Prefecture, has the same *daimegiri* arrangement as Fushin'an, although the utensil mat is attached to the long side of the three mats. The twisted log used for the *nakabashira* is an innovation, as are the three *shitajimado* disposed on the walls around the utensil mat to brighten the host's seat. This tea-room is unique in plan, having a single mat for the participants and a waiter's entrance opening on to this mat. Although actually built considerably later, Fushin'an and En'nan recall the atmosphere of the original structures built in the first half of the 17th century. Each room has symbolic significance for its respective tea school. An example of a two-and-a-*daime*-mat tea-room is the Teigyokuken at Shinjuan, Daitokuji, Kyoto (see fig. 206). Although it dates from the 18th century, it has an old-fashioned arrangement with an entrance through which guests crawl into an inner court and, after washing their hands and mouths, proceed through a noblemen's entrance. The arrangement of the *daime* is standardized in the manner of En'nan, but the host's and waiter's entrances are combined into a pair of sliding doors papered on both sides. On the side wall of the *tokonoma* is a *shitajimado*, providing illumination for the hanging scroll on the wall of the *tokonoma*.

Other. The Joan tea-room, built in Kyoto in 1616 by Oda Uraku and now located in Inuyama, Aichi Prefecture (see fig. 206), has a crawling-in entrance placed not on the façade but on the interior side wall next to a small earth floor. Inside the crawling-in entrance, the guests' mat extends forwards, and the mat of distinction and the *tokonoma* are on the left. A *nakabashira* stands where the front edges of these two mats join. There are two more mats on either side of the *nakabashira*: the left one, the utensil mat, 1.6 m long with the hearth placed in the inner right corner, is conventionally called the *daime*, although it is longer than most *daime*; the right one is half a mat in length. Along the border of these two mats is a board panel with an arched opening at the front of the hearth. In addition to its unique disposition, this room has other peculiar features. The first is the triangular board floor between the utensil mat and *tokonoma*, through which the waiter must pass to serve guests, as there is no waiter's entrance. The second is a dense row of bamboo nailed on the outside of the two windows on the wall facing the *daime* and the half mat; subtle bands of light are thus cast through the paper screens. The final singular feature is the use of old calendars pasted on the lower part of the walls.

Other unusual arrangements employed in tea-rooms include the use of a large display wall (*dōangakoi* or *sōteigakoi*) with an opening between the host's mat and the guests' mats, as at Yodominoseki, Saiōin, Kyoto

Prefecture, where the paper-covered door at the opening may be slid back after preparations for the tea ceremony are completed. The *nakaita*, a board placed between the host's and guests' mats, is divided into two parts, and the hearth is set between them; the width of board is thus the same as that of the hearth (430 mm). An example of this 18th–century development is seen at Saan, Gyokurin'in, Kyoto Prefecture.

(ii) Larger tea-rooms. Rooms larger than four-and-a-half mats are sometimes used as tea-rooms. In the 17th century the formal *shoin* style was largely abandoned in favour of the simpler and more elegant *sukiya* style (see §III, 4(ii)(a) above). Posts and non-penetrating tie-beams, where used at all, were left completely or partially unplaned. Hearths were usually positioned in the same way as in four-and-a-half-mat rooms (*hiromagiri* or *yojōhangiri* mode). However, other arrangements, such as *daimegiri*, *mukōgiri* and *sumiro*, or their reverse types, are also found. Virtually all large tea-rooms (and many small ones) have kitchens (*mizuya*) attached. These are often three to six mats in area and have a recess 1–1.7 m wide and 0.5–1 m deep. At the bottom of the recess is a sink with a bamboo grate for washing and draining vessels. Above it are several shelves and cupboards to store utensils.

(iii) Gardens. Tea gardens (*roji*), surrounded by walls with only a small gateway, originated from a simple inner court in front of the tea-room. In the 16th century non-flowering trees and grasses were added to this space, and lanterns were positioned at carefully determined places. The formal garden is divided into two parts, the outer (*soto roji*) and the inner (*naka roji*). A waiting arbour (*machiai*) and a toilet are in the outer garden. Guests walk on stepping-stones to a middle gate, where they are greeted by the host. The gate may be either the traditional crawling-in entrance or a simple wicket made of thatch and bamboo. In the inner garden there is also a simple waiting arbour (*koshikake*) and an ornamental toilet. Guests again proceed on stepping-stones and purify their hands and mouths at a low water-basin (*tsukubai*). They then continue to the entrance of the teahouse.

BIBLIOGRAPHY

K. Okakura: *The Book of Tea* (New York, 1906)
A. L. Sadler: *Cha-no-yu: The Japanese Tea Ceremony* (London, 1933/R Rutland, VT, 1963)
S. Horiguchi: *Rikyū no chashitsu* [Tea-rooms by Rikyū] (Tokyo, 1949)
M. Nakamura: *Chashitsu no kenkyū* [Research on tea-rooms] (Tokyo, 1971)
H. Ōta and M. Nakamura, eds: *Chashitsu* [Tea-rooms], Nihon kenchiku shi kiso shiryō shūsei [Collections of the basic materials for the history of Japanese architecture], xx (Tokyo, 1974)

NOBUO ITO

3. UTENSILS. The ritual of the tea ceremony determines what utensils (*chadōgu*) are used and in what ways. The rich repertory of utensils (see fig. 207) and furniture is the result of nearly 1000 years of tea drinking in China and Japan, although a surprising number and variety of utensils have always been required. Indeed, both the utensils and the ritual described in the court records of Emperor Huizong (*reg* 1101–25) conform with present practice in more than general features.

207. Tea ceremony utensils, portable, for outdoor use (from left to right): bamboo tea-whisk and holder; porcelain napkin-holder, decorated in underglaze blue in *sometsuke* style; teabowl container, black lacquer with gold *makie*, h. 120 mm; tea-caddy, ?Takatori ware, with turned ivory lid; teabowl, painted Karatsu ware, 17th century; all other items probably 18th century (London, British Museum)

(i) Types and functions. From its earliest development, the ritual has required the following items: a room large enough for the number of guests (*kyaku* or *ka*, originally a euphemism for Zen trainees); a Buddhist statue, painted icon (*honzon*) or a hanging scroll (*jiku*), which may be either an ink painting (*suibokuga*) or a sample of calligraphy (*bokuseki*; *see* §4 below), perhaps a Zen saying (*zengo*) written by a priest; flowers and incense (and candles, if the ceremony is held in a temple or at night in a tea-room); fresh green tea-leaves and tea jars (*chatsubo*) for storing them; mortars and pestles for grinding the leaves into powdered tea (*matcha*); tea containers (*chaire*, *natsume*, *usuki*) in which to serve the powdered tea; a fine silk bag to cover the container (*shifuku*); spoons (*chashaku*) for scooping the tea into teabowls; ceramic teabowls (*chawan*) from which to drink; charcoal braziers (*furo*, *ro*) and iron kettles (*kama*) for boiling water; rests made of ceramic or bamboo (*futaoki*) for the kettle lids; long-handled ladles (*hishaku*) for scooping water; hot-water pitchers (*tetsubin*) for certain ceremonies; whisks (*chasen*) made of bamboo or metal for mixing the tea and water; cold-water containers (*mizusashi*) and pitchers (*mizutsugi*); waste-water containers (*kensui*); various serving dishes for ritual food (*kaiseki* or *chakaiseki*) and the food itself; and napkins (*chakin*). In China, the furniture (tables and stands, chairs and stools) was important as well, as it was also at first in Japan, where Chinese procedures were followed to the letter. By the end of the 14th century, flat-based tables (*daisu*) and stands (*tana*) were retained for some ceremonies, including the more formal (i.e. Chinese) ceremonies, but chairs and stools were dispensed with altogether

because they were incompatible with the soft *tatami* mat floors of *shoin*-style rooms.

The now standard silk purifying cloth (*fukusa*) is among the items added to the ritual by the Japanese. It may have been inspired in the 16th century by the Jesuit practice of purifying the chalice of the Eucharist. In any case, the *fukusa* is not mentioned in old Chinese records but has been an ubiquitous item of tea practice since the time of SEN NO RIKYŪ, the tea master from whom all modern schools of tea derive (three of them being direct Sen family lineages). However, Christian practitioners of the tea ritual, beginning with the Jesuits, have enshrined Christian icons and Bibles instead of the Buddhist articles listed above.

The consequences of the tea ceremony for Japanese ceramic art were enormous. From the late 16th century onwards, water containers and teabowls have been specially manufactured for *chanoyu*, sometimes in the tradition of older wares, sometimes with new shapes and glazes. Among the glazed teawares especially created for the tea ceremony are RAKU, SETO, HAGI, KARATSU, SHIGARAKI and Oribe. Raku, a soft, low-fired, lead-glazed ware, began to be made in the late 16th century. Raku teabowls have always been hand-built, reflecting the potter's individuality. They are rounded, with a slightly constricted rim, and are usually red, with a thick black glaze (*see* CERAMICS, colour pl. II, fig. 2). Hagi ware, from Yamaguchi Prefecture, is high-fired and usually finished with a thin yellowish or milky glaze. Karatsu, a port in Kyushu, has been producing high-fired ceramics since the mid-16th century, some pieces being made specifically for the tea ceremony.

(ii) Appreciation and symbolism. Tea utensils were not merely functional objects used in the preparation and consumption of tea but works of art to be collected, appreciated and displayed for their aesthetic and historical value. As such, tea utensils have long been catalogued and ranked by connoisseurs. For instance, the powerful tea master and clan leader Matsudaira Fumai (1751–1818) compiled a list of 'famous tea utensils' (*meibutsu*), dividing them into seven classes, the highest of which (*omeibutsu*) came from China of the Tang (AD 618–907), Song (960–1279) and Yuan (1279–1368) periods and were brought to Japan during the Muromachi period (1333–1568). The *Inaba Tenmoku* teabowl (Tokyo, Seikadō Bunko), so named because between 1723 and 1868 it was owned by the Inaba family of Yodo Castle, is at the top of the *omeibutsu* category. The list includes virtually every known tea utensil with a pedigree (*yuisho*) or history that made it of interest to Japanese tea masters. Also on Fumai's list are Korean and Japanese utensils that were sought after between the 16th and 19th centuries. Prime examples are the Korean *Kizaemon Ido* bowl, an *omeibutsu* first owned by Takeda Kizaemon, who gave it to Lord Honda Tadayoshi around 1600 (National Treasure); and the *chuko meibutsu*, a red Raku teabowl known as *Mu-ichi-butsu* ('Not separate beings!') made by Chōjirō (1516–92), the founder of the Raku lineage. Close copies of most of these 'famous tea utensils' and many others are available in tea utensil stores (*chadoguya*) throughout Japan. The huge repertory of tea procedures (*temae*) that students must learn in order to be able to participate at a formal tea-gathering (*chaji, chakai*) requires that they have access to these copies, which are known as 'practice utensils' or *okeiko-dogu* and come in high and low grades.

Many of the famous utensils, even those housed in museums, are still used. Moreover, most have names and histories that must be memorized by anyone who wishes to use them. In addition, there are procedures that take hours of practice every week. Any utensil used in the ceremony requires the same degree of practical and academic skill of the tea student. Such attention to objects might suggest that tea practice is entirely materialistic, unless the motivations and attitudes behind it are understood. Teabowls are to be treasured not simply because they are old and valuable but because they remind us of the fragility of individual lives. They are symbols of the separate selves guests perceive themselves (and are perceived by others) to be. Potters may impress their Buddha names (e.g. 'Easy Enlightenment') on the bottoms of the bowls to give the bowls identity as the Awakened Being that all guests have the potential to become. At the climax of the ceremony, after the guests have shared tea from the same bowl, the host washes away the residue and presides over the death of individual selfhood.

All vessels used in the tea ritual have a clear front and back, because only in this way can they function as agents of the spiritual unification of 'self' and 'other'. When preparing a bowl of tea, the host faces the front of the bowl, but when he offers it to the head guest he turns it so that the front faces the guest (the 'other'). The head guest receives it that way but, before drinking from the bowl, turns it back towards the host, who then becomes the 'other'. In this way, 'the distinction between self and other disappears'. The procedure for handling the bowl makes it clear to participants where the front of the bowl is even if no design or marks distinguish its face. Furthermore, on most types of bowls the potter's seal is impressed on the bottom in such a way that when a teabowl facing the viewer is turned upside down the mark is legible on the left side of the foot. In this way procedures (*temae*) and artistic traditions serve the cause of sacramental necessity. The principle of balancing opposites contained in the *in-yō* (Chin. *yin–yang*) system of belief is served in the tea ceremony and its utensils.

BIBLIOGRAPHY

J. M. Rosenfield and S. Shimada: *Traditions of Japanese Art: Selections from the Kimiko and John Powers Collection* (Cambridge, MA, 1970)
R. Castile: *The Way of Tea* (New York, 1971)
S. Hayashima and others: *Chanoyu: Japanese Tea Ceremony* (New York, 1979)

□

4. CALLIGRAPHY. From its beginnings in the elaborate tea gatherings hosted by the Ashikaga shoguns, the tea ceremony formed the focus for the display and appreciation of art objects (*see also* §XXII below). These came to include not only the utensils used in the preparation and drinking of tea (*see* §3 above) but other objects too, in particular paintings, flower arrangements (*ikebana; see* §XVI, 9 below) and calligraphy.

(i) Early use of *bokuseki* and other forms. (ii) Influence of 16th–early 17th-century tea masters. (iii) Development after the late 17th century.

(i) Early use of bokuseki *and other forms.* From the late 15th century, a number of prominent merchant-class tea masters, most of whom had studied Zen, promoted the display of *bokuseki* ('ink traces'), the calligraphy of Zen priests (*see* §VII, 2(iv) above). Although at first only calligraphy by Chinese Zen (Chin. Chan) priests was displayed at tea gatherings, works by Japanese priests of Daitokuji, a Rinzai Zen temple (*see* KYOTO, §IV, 5), also came to be highly regarded. The content of *bokuseki* varied greatly—perhaps a Buddhist verse, or a communication between master and disciple—but the handwriting of an eminent Zen priest hung in the reception area or *tokonoma* (decorative alcove) of a tea-room was thought to convey an aura of spirituality, solemnity and aestheticism. MURATA SHUKŌ, tea master for Ashikaga Yoshimasa (1436–90), was instrumental in the development of the *wabi* style of tea ceremony that stressed austerity and harmony with nature and called for a serene, contemplative atmosphere (*see* §1 above). Such a setting was ideal for the appreciation of calligraphy. Jukō's use of *bokuseki* at tea gatherings set the precedent for their veneration. One of the most famous of all *bokuseki* is an *inkajō* (certificate of enlightenment or approbation) written by the Song-period (960–1279) master Yuanwu Keqin (Engo Kokugon; 1063–1135) and presented to Jukō by his teacher, the iconoclast Zen priest IKKYŪ SŌJUN. It is commonly known as the *Nagare Engo* ('Drifting Engo'), because it is said to have drifted across the ocean to Japan (see fig. 208).

TAKENO JŌŌ, who further refined *wabi*-style tea, was the first tea master known to have displayed examples of calligraphy by Fujiwara no Teika (*see* FUJIWARA (ii), (7)), poet and editor of Japanese literary classics. Fragments of ancient handscrolls were also used in the tea ceremony.

208. Yuanwu Keqin (Engo Kokugon): *inkajō* (certificate of enlightenment or approbation) known as *Nagare Engo* ('Drifting Engo'), hanging scroll, 521×439 mm, late 11th century or early 12th; National Treasure (Tokyo, National Museum)

These were prized for both their poetry and their calligraphy and were known as *kohitsugire* ('fragments of ancient calligraphy') or *utagire* ('fragments of Japanese poetry'). Throughout the evolution of the tea ceremony, two kinds of hanging scroll were used in parallel: Zen-inspired *bokuseki*, used for their spiritual and didactic qualities, and *utagire*, which recalled courtly ideals. As a rule, tea masters carefully considered seasonal allusions in a poem scroll or painting before deciding on modes of display in the tea-room. While the tea ceremony fostered the growth of calligraphy connoisseurship in Japan, the survival of many ancient and fragile *kohitsugire* and *bokuseki* can be attributed to their treasured status as *chagake* ('tea hangings').

(ii) Influence of 16th–early 17th-century tea masters. More than any other master, SEN NO RIKYŪ shaped the codes of the tea ceremony. In Rikyū's tea-room designs, the focal point was the *tokonoma*, where flower arrangements or hanging scrolls (*kakemono*) of calligraphy were displayed. Rikyū owned many famous *bokuseki*, including one each by DAITŌ KOKUSHI and MUSŌ SOSEKI and two by Yuanwu Keqin. On occasion Rikyū used *bokuseki* by Kokei Sōchin (1532–95) who, though 10 years his junior, was his Zen master and personal confidant for nearly 30 years. FURUTA ORIBE commonly displayed works of calligraphy by living priests or prominent cultural figures. Although it had been the convention to display a calligraphic scroll during the first sitting of a tea gathering and flowers during the second, Oribe often used both calligraphy and flowers in the first sitting and removed the

flowers for the second. Just as Oribe had a predilection for extremely misshapen tea bowls, so too he used unorthodox, often illegible, calligraphy.

From the 16th century to the mid-17th, there was a renewed interest in Heian-period (794–1184) court culture and 'traditional' Japanese tastes. A representative figure was Hon'ami Kōetsu (*see* HON'AMI, (1)), a practitioner of tea who studied under Oribe and had regular contact with warrior-class tea practitioners. Kōetsu, the Shingon priest SHŌKADŌ SHŌJŌ and Konoe Nobutada came to be recognized as the Kan'ei no Sanpitsu (Three Brushes of the Kan'ei period; *see* §VII, 2(v) above); the latter two were also prominent in tea circles. The courtier–poet KARASUMARU MITSUHIRO, also active in the same tea circles, was well known for his cursive *kana* calligraphy.

KOBORI ENSHŪ, who in his youth had studied with Furuta Oribe, was a noted designer of tea houses and gardens and also emphasized the role of calligraphy in the tea ceremony. According to surviving records of his tea gatherings, he nearly always displayed calligraphy, occasionally using precious examples of the work of Fujiwara no Teika. Enshū was an assiduous practitioner of Teika-style calligraphy and owned a rare early manuscript copy of a short treatise on calligraphy by Teika, whose calligraphy was thought to manifest unaffected refinement (*kirei sabi*), the aesthetic ideal promoted by Enshū. Its squat, slightly abrupt and distorted lines appealed to Enshū in the same way as did teaware moulded in dynamic, expressive and irregular forms. Yet Enshū retained an awareness of courtly sentiment not found in Oribe's outright iconoclasm. Other tea practitioners of the first half of the 17th century, whose distinctive calligraphic styles were cherished by succeeding generations, included Kanamori Sōwa (1584–1656), who, like Enshū, was partial to classical court aesthetics, and Sen Sōtan (1578–1658), a leading tea master of the merchant élite, whose disciples continued the tradition of his grandfather, Rikyū.

Although court calligraphy enjoyed a revival, *bokuseki* (always written in classical Chinese) never fell out of fashion. Enshū frequently used examples of calligraphy by his own Zen master, Shun'oku Sōen (1529–1611), as did other tea practitioners who studied Zen at Daitokuji. From the early 17th century, one-line sayings (*ichigyōmono* or *ichigyōsho*) written by Zen priests in bold, eccentric characters became increasingly popular. Not only were *ichigyōmono* by living priests readily available, but the large size of the characters made them easier to read in the dimly lit tea-rooms, and their brevity made them more understandable than the long, often obscure, inscriptions on *bokuseki* by Chinese masters.

One of the primary writings on the tea ceremony, *Nanpōroku* ('The chronicles of Nanpo'), ostensibly compiled by one of Rikyū's pupils and rediscovered in the late 17th century, records the tea master's teachings on various subjects. Rikyū is reputed to have stated of calligraphy: 'There is no implement more important than the hanging scroll, which allows the host and guests to immerse themselves in the spirit of the tea ceremony . . . By revering the spirit of the words, one can appreciate the virtue of the person who wrote it.' This passage, the *locus classicus* on the use of scrolls in the tea ceremony, reinforced the practice of using *bokuseki* rather than paintings.

Since Rikyū's time there had been a steady decline in the emphasis placed on the didactic message of *bokuseki* and a parallel increase in the attention given to its expressive aspects, especially since brushwork was thought to express in subtle ways the spiritual enlightenment of the writer. Out of this belief came the practice of using the letters or pages from journals of eminent tea masters as tea scrolls, even though these were not originally conceived as works of art.

(iii) Development after the late 17th century. Katagiri Sekishū (or Sadamasa; 1605–73) carried on the tradition of *chanoyu* for the warrior class and served as curator of the Tokugawa family art collection. His preferences in tea ceremony utensils and hanging scrolls influenced generations of followers, including members of the Matsudaira family. Konoe Iehiro (Yorakuin; 1667–1736), a member of the court and a priest, promoted a synthesis of Heian-period courtly aesthetics and the tea ceremony. He was an expert at copying (*rinsho*) classic works of Chinese and Japanese calligraphy. In his *tokonoma* displays he often used calligraphy written on *kaishi*, a type of writing paper once carried in the folds of a courtier's kimono (its dimensions varied but were usually *c.* h. 300 mm, w. 450 mm). His sanction of the use of *kaishi* encouraged tea masters to use this format more often for *tokonoma* hangings.

During the 18th and 19th centuries, the most prominent tea practitioners were members of the traditional warrior class. For example, Matsudaira Fumai (Harusato; 1751–1818), a member of a branch of the Tokugawa family, was an avid practitioner of both Zen and the tea ceremony. Using exacting standards of connoisseurship, he assembled a prominent collection of *meibutsu* ('famous tea objects'), including the 'certificate of enlightenment' by Yuanwu Keqin. Fumai's own calligraphy style was influenced by Teika. Matsudaira Sadanobu (1758–1829) was another warrior–aesthete who, while advocating frugality in every aspect of government and personal conduct (including the tea ceremony), was, at the same time, a devoted collector of tea implements. His remarks concerning calligraphy scrolls used in the tea ceremony restated in Confucian terms Rikyū's notion that the virtue of eminent personalities was revealed by words written in their own hand.

During the Meiji period (1868–1912), a time when Western industry and culture were being introduced on a sweeping scale, there was a general decline in the practice of the tea ceremony, calligraphy and other traditional arts. Proving an exception to this trend were a number of prominent leaders in business and political circles who shared an interest in preserving the tea ceremony as a means of cultivating closer personal and business ties, as well as showing off their prized works of art. Thus they vied with each other to acquire tea implements, paintings and calligraphies suitable for display in the tea-room alcove—many of which had provenances traceable to tea connoisseurs of the past. During the 1930s and 1940s, after many of these prominent collectors had died, their collections were consolidated into private museums or in some cases put on the market, allowing many museums in the West to acquire important works.

During the post-war period, the popularization of the tea ceremony, especially among women, helped rekindle an interest in calligraphy. The display of a scroll of calligraphy remained *de rigueur* at tea ceremonies. As in the past, authorship, provenance, age and the contents of a scroll were all taken into consideration in the selection of a scroll for the tea alcove. Yet, as prices for medieval *bokuseki* soared beyond the budgets of all but museums and the wealthiest collectors, works by contemporary priests or professional calligraphers were commonly used instead. Although training as a tea instructor usually included the mastery of the rudiments of connoisseurship of utensils and calligraphy, in the late 20th century the number of individuals who could easily decipher cursive inscriptions or comprehend the meaning of inscriptions in Chinese declined sharply.

BIBLIOGRAPHY

Cha no bijutsu [Art of the tea ceremony] (exh. cat., Tokyo, N. Mus., 1980)
K. Haga: 'The Appreciation of Zen Scrolls', *Chanoyu Q.*, 36 (1983), pp. 7–25
F. Nakashima: 'Picture versus Word: Trends in *Tokonoma* Display', *Chanoyu Q.*, 35 (1983), pp. 7–15
T. Ayamura: 'Kaishi Scrolls for *Chanoyu*', *Chanoyu Q.*, 38 (1984), pp. 23–35
Masters of Japanese Calligraphy, 8th–19th century (exh. cat. by Y. Shimizu and J. M. Rosenfield, New York, Japan House Gal., 1984)
T. Masuda: *Chajin no sho* [Calligraphy of tea masters] (Tokyo, 1985)
T. Horie, ed.: *Chagake no sho* [Calligraphy of tea ceremony scrolls], 4 vols (Tokyo, 1986)
P. Varley and I. Kumakura, eds: *Tea in Japan: Essays on the History of Chanoyu* (Honolulu, 1989)
J. Anderson: *An Introduction to Japanese Tea Ritual* (Albany, 1991)
C. M. E. Guth: *Art, Tea, and Industry: Masuda Takashi and the Mitsui Circle* (Princeton, 1993)

JOHN T. CARPENTER

XV. Folk art.

The term 'folk art' is generally applied to the art of the 'common people' in pre-industrial Japan, from about the 12th century to the 19th, though with some survivals into the modern period (after 1868). It embraces religious paintings, prints and sculpture and broad areas of such crafts as ceramics, textiles and woodwork.

1. Introduction. 2. Painting, sculpture and other figurative arts. 3. Ceramics. 4. Textiles. 5. Wood and lacquerware. 6. Furniture. 7. Other crafts.

1. INTRODUCTION. The concept of 'the people's art' of Japan was first enunciated in 1926 by MUNEYOSHI YANAGI, who was struck by the beauty in everyday utilitarian wares—objects dismissed as *getemono* or *zakki* (low-class or commonplace things)—and invented for them the term *mingei* ('folk crafts' or 'the people's art', commonly rendered as 'folk art'; *see also* MINGEI). Yanagi's writings and organizing initiatives inspired a movement aimed at preserving the legacy of old folk crafts and encouraging continued local *mingei* production in the face of sweeping industrialization. As a result, many collections of folk art were formed, such as the outstanding collection of the Japan Folk Art Museum (Nihon Mingeikan), Tokyo, and *mingei* became part of Japan's cultural consciousness. Ultimately, however, Yanagi's original meaning was obscured by the marketing of new commercial products of dubious quality under the *mingei* banner as well as by the emergence of '*mingei*-school' artists, whose work was not truly folk art.

Yanagi and his followers were primarily advocates and rescuers of what they perceived as neglected art and endangered craft traditions. In the same period wide-ranging studies of folklife were developed by such folklorists as Kunio Yanagita (1895–1961) and Keizō Shibusawa (1896–1963), which resulted in voluminous reports and collections of artefacts later incorporated in historical and ethnographic museums at local, prefectural and national levels. To the folk lexicon were added the terms *mingu* (folk tools and utensils) and *minzoku bunkazai* (folk cultural assets), among others. While in the post-war period *ko* ('old') was sometimes prefixed to *mingei* (as *komingei*) to rescue that term for genuine folk art, *minshū geijutsu* ('people's arts') became the preferred term in exhibitions sponsored by official agencies, and *minzoku geijutsu* ('folk arts') was adopted by cultural anthropologists. Since the time of the *mingei* and *minzoku* pioneers, the understanding and appreciation of Japan's folk art and culture have been enhanced by a wealth of new information, including many specialized studies and the results of archaeological research.

The significant period for folk art reaches at least as far back as the late 12th century, at the beginning of what is sometimes called Japan's medieval age (*chūsei*; 12th–16th century). The common people of that time were predominantly those who worked the soil, ranging from small landholders to serfs, as well as artisans, traders, fishermen and mountain people such as woodcutters, miners and other nomadic workers. Others were religious workers of humble birth, particularly itinerants and activists in the popular faiths. Throughout the ensuing 700 years of feudal military rule, the social order was pervasively stratified, having subgroups and rankings within each class and occupation. However, status was not immutable. In the Muromachi period (1333–1568) frequent peasant uprisings accelerated a trend to autonomy at village level. Dislocated farmers and artisans also moved to the growing cities, becoming part of a new urban commercial class, which developed its own hierarchy. In the early part of the Edo period (1600–1868) the shogunate, aiming to centralize authority, restrain social mobility and bolster revenue from the farming areas, formalized the division of society into four classes: in descending order, the samurai ruling class (*shi*) and the commoner classes of farmers (*nō*), artisans (*kō*) and merchants (*shō*). However, the codes and regulations and frequent sumptuary edicts issued to enforce this system were generally ineffective, and the class structure decayed as many samurai lost their base of support, and as merchants accumulated wealth and power, becoming a new élite that shaped Edo culture. In 1869 the four-class system was abolished.

The social and economic patterns of feudalistic society carried over, to a degree, into the modern era; and though diminished by industrialization and the adoption of Western ways in the Meiji period (1868–1912), some traditional folk crafts survived into the 20th century. In time, however, the 'folk' character faded and finally, in the new Japan of the late 20th century, virtually ceased to exist, as handcrafted items became high-class and high-cost, and the 'common people' became Japan's middle class.

Partly as a result of this history, the terms 'common people' and 'folk art' embody certain ambiguities, as, for example, when commoners rose in station and acquired privilege; or when folk art forms were adopted by the ruling class; or conversely, when craft industries supported by the ruling entity lost that support and reverted to folk status. In many examples, folk genres have been absorbed into the mainstream of Japanese art. The history of 'folk art' runs parallel with that of 'fine' or 'aristocratic' art, and the dividing line is not sharp and indeed may shift. It is certain, however, that increased awareness of that history has greatly enhanced the appreciation and understanding of the culture and people of Japan.

2. PAINTING, SCULPTURE AND OTHER FIGURATIVE ARTS. The sculpture, painting and other figurative arts of the common people (*see* §2 below) were mainly expressions of popular religion which was a complex layering of shamanism, Shinto, Buddhism, Daoism and other components. The practitioners of popular religion—itinerant priests, including *yamabushi* (adherents of the ascetic mountain-centred religion Shugendō; *see* §II, 7 above), Shinto *oshi* (professional prayers of supplicants) and various healers, exorcists, diviners and fund-raisers—spread new religious ideas and were the first public educators. With other itinerants, notably artisans and entertainers, they were major contributors to Japanese folk culture. The religious forms now called folk art were not consciously contrived as art but were made for devotional use or as teaching aids. However, some art forms such as *Ōtsue* (folk paintings from Otsu) that began as religious expression became increasingly secular in their later stages, and other secular forms including certain printed books and genre paintings have been described as folk art or as having folk qualities (see §(vii) below).

(i) Pilgrimage *maṇḍala*s. (ii) *Ema*. (iii) *Ōtsue*. (iv) Wood sculpture. (v) Stone wayside figures. (vi) Masks and puppet heads. (vii) Other forms.

(i) Pilgrimage maṇḍalas. Pilgrimages to holy places deep in the mountains began in the Nara period (710–94) and became almost obligatory for the nobility in the following Heian period (794–1185). Most famous of the early pilgrimage sites were the three Kumano District shrines in Wakayama Prefecture, whose Shinto deities were linked with popular Buddhism, Kinpusenji in Nara Prefecture, also a centre of syncretic faith, and Mt Kōya, the monastic complex for Shingon Esoteric Buddhism in Wakayama Prefecture. Over the centuries, with the rise of popular faiths and the problems of maintaining the great religious institutions, the once-exclusive devotional practices were gradually opened to broader segments of the populace. In the mid-15th century, for example, the Ise shrines (*see* ISE SHRINE), which until the late Heian period had been restricted imperial family sanctuaries, became so destitute that religious workers were sent out to solicit support and encourage pilgrimages by rural people. From about then until the beginning of the Edo period (1600–1868), religious paintings called *shaji sankei* ('shrine and temple pilgrimage') *maṇḍala*s were used as visual aids for proselytizing lectures (*etoki*) by itinerant Shugendō priests (*yamabushi*) and Shinto supplicants (*oshi*). The surviving *maṇḍala*s illustrate the popular faiths and culture of their time.

*Shaji sankei maṇḍala*s are aerial views of a shrine or temple building complex, like Shinto *miya* (shrine) *maṇḍala*s, but unlike them (*see* §VI, 3(ii) above) are crowded with human activity. Most contain scenes recounting the *engi* ('founding legend') of the institution, miracle stories associated with famous priests of the faith, historical occurrences, performances of religious drama and music, and ordinary people in the course of their pilgrimage and worship. The touches of contemporary life are intended to make the scenes more accessible to the viewer and thus serve as an encouragement to join a pilgrimage.

Pilgrimage *maṇḍala*s, attributed to artists attached to temples and shrines or to independent workshops, generally had a naïve quality but were full of local colour and atmosphere. Most were on paper, painted with inexpensive pigments called *doro enogu* ('mud paint'). Ink was sometimes used to depict foliage. Some had loops at the top for hanging and could be folded for easy transport. There are many indications that *shaji sankei maṇḍala*s were produced in volume, especially those of the great Kumano shrine complex in Wakayama Prefecture. Surviving examples from the Muromachi (1333–1568) and Momoyama (1568–1600) periods show such other subjects as Mt Fuji, the temples Nariaiji, Kiyomizudera, Kimiidera and Chōmeiji, Ise and Taga Shrine.

In the Edo period pilgrimages occurred in extraordinary numbers, particularly to the shrines at Ise. From 1650, at roughly 60-year intervals, mass pilgrimages to Ise involved whole communities; the largest were in 1705, 1771 and 1830, each with several million participants, according to contemporary accounts. After the early Edo period, however, few pilgrimage *maṇḍala*s were produced, presumably because there was no longer a need to appeal for pilgrims.

(ii) Ema. Ema ('horse pictures') were votive offerings that at first represented horses but later many other subjects. The offering of live horses to shrines in times of natural calamity was an ancient magico–religious rite based on the belief that horses were the mounts of the gods. According to early records, such as the *Hokuzanshō* (949), models of horses in clay or wood were sometimes substituted for live horses. Several small wooden plaques with linear horse paintings and holes at the top for hanging, discovered in 1972 in an 8th-century stratum at the Iba site in Hamamatsu (Shizuoka Prefecture), are believed to be early examples of pictorial substitute. The practice of giving *ema* as votive offerings may have arisen from these early practices. The term first appears in the prose and poetry anthology *Honchō manzui*, compiled 1037–45 by Fujiwara no Akihira (986–1066), which includes an invocation that originally accompanied a *shikishi ema* (an *ema* painted on a decorative square of paper) and other gifts to the Kitano Tenjin Shrine, Kyoto, in 1012. Narrative scrolls of the 13th and 14th centuries show such objects hung at shrines and temples or on trees, and fragments of *ema* found at Taimadera and Akishinodera have been dated to the Kamakura (1185–1333) and early Muromachi

209. *Child in Bath*, *ko-ema* (small votive offering), colours on panel, 105×152 mm, 19th century (Osaka, private collection)

periods respectively. All of these are of the type known as *ko-ema* (small *ema*), which continued to proliferate in later periods, although overshadowed after the mid-15th century by *ō-ema* (large *ema*). The latter often bore the names of donors, usually warriors or rich merchants, and the signatures of famous artists such as Kanō Sansetsu (*see* KANO, (10)), who painted an *ema* dedicated to the temple Kiyomizudera in Kyoto in 1637. To accommodate these oversized offerings, special offertory pavilions were erected in shrines. The *ko-ema* that were hung on building exteriors soon deteriorated because of their exposure to the elements and were periodically removed to make space for new offerings. Thus few early *ko-ema* have survived, except for the considerable numbers preserved at Kasuga Shrine and the east *kondō* (main hall) of Kōfukuji, both in Nara. At the latter, the *shishi* (lion) replaced the horse as the favoured subject to suit the worship of Monju (Skt Manjushri; the *bodhisattva* of meditation or of supreme wisdom), who rode a *shishi*. The Tōhoku region (northern Honshu), famous for horse-breeding, has a legacy of fine horse *ema*; one of the oldest is a prancing pony *ko-ema* of the mid-15th century (Aomori Prefecture, Shichinohe, Fudōdō), a prototype that was still being copied in the Edo period.

Many *funa ema* (ship *ema*) are found in shrines and some temples along the Japan Sea coast and around the Inland Sea. Most of these were produced by *emaya* (*ema* shops) and given by crew members of *Kitamaesen*, the ships that plied this route (Kitamae sea route) between Osaka and Hokkaido. Standard *funa-ema* depicted the hoped-for calm seas, usually with a distant shoreline graced by a shrine of Sumiyoshi Myōjin or Kotohiragū (the guardian gods of seafarers). Some, however, were graphic portrayals of shipwreck, inscribed with the exact date of the disaster. These were given in thanks by the fortunate survivors. *Funa-ema* were generally of medium size, the exceptions being the early *ō-ema* given by shipping companies plying the South Pacific trade routes. Other calamities, notably earthquakes and fires, were commemorated in like manner, as were happier events such as *okage mairi* (mass pilgrimages to Ise), festival dances, rice plantings and harvests.

Ko-ema of the Edo period and later survive in great quantities, especially the very small examples of a personal nature. Many of these were appeals for cures for specific maladies, such as internal ailments, skin, eye or ear trouble and infertility, or for help with other problems such as addiction to gambling, fornication, wine or tobacco, or even a child's aversion to having a haircut or a bath, as in an example from the 19th century (Osaka, priv. col.; see fig. 209). Some of the paintings portrayed the problem or its remedy, others the deity or deity's messenger to whom the supplication was addressed. Most were produced by *emaya* in more or less standardized versions, but home-made *ko-ema* were not uncommon. The best were painted with freedom and lively wit, reminiscent of Ōtsue.

(iii) Ōtsue. Ōtsue ('Ōtsu pictures') are named after the town of Ōtsu near Kyoto, and their execution is attributed to residents of the nearby farming communities of Ōtani and Oiwake. They were sold at roadside stands to travellers on the Tōkaido (Eastern Sea Road; a highway from Edo

210. *Devil Bathing*, *Ōtsue*, hanging scroll, colours on paper, 628×228 mm, late 17th century or early 18th (Ōtsu, private collection)

(now Tokyo) to Kyoto). Adapting the form and subjects of Buddhist woodblock prints produced at Kyoto temples, the enterprising villagers began, by the mid-17th century, to make their own devotional paintings. From the outset, *Ōtsue* were distinguished by their spontaneity and vitality, and pilgrims to Kyoto and environs found them handy because of the built-in device called *kakibyōsō*—an instant, ready-to-hang painted mounting complete with bamboo roller. The early subjects were the deities Amida, Fudō,

Jizō, Shōmen-Kongō, Uhōdōji, Tenjin, Hachiman and about a dozen others. Various techniques were employed to facilitate mass production, such as the use of spot stencils to block in areas of colour, compasses for circles, ruler-drawn lines and, in the case of the *Jūsan-butsu* ('Thirteen Buddhas') images, small woodblocks for the Buddhas. With or without such aids, the free linear paintings were executed with speed and verve in both ink and colour. As indicated in the frequent references to *Ōtsue* by men of letters, such as Ihara Saikaku (1642–93) in his novel *Kōshoku ichidai otoko* ('The man who loved love'; 1862), secular themes had become popular by the late 17th century, while the depiction of religious subjects declined. Folk heroes popular in contemporary theatre were represented in *Ōtsue* by dashing male figures inspired by *kabuki* theatre, along with female beauties similar to those found in *ukiyoe* ('pictures of the floating world'; *see* §VI, 4(iv)(b) above). Subjects also included animals and creatures of legend, for example the satirical paintings on the subject of *oni* ('devil', 'goblin'), which lampooned human behaviour, as in *Devil Bathing* (late 17th century or early 18th; see fig. 210). About 120 *Ōtsue* subjects have been identified; the actual number may have exceeded 300. The biting satire and virtuoso brushwork of the *Ōtsue* of the late 17th century and early 18th made this period the high point of the genre.

In the late 18th century, influenced by the syncretic Confucian movement called Shingaku, *Ōtsue* painters began adding moralistic inscriptions to their paintings, mostly derived from the preachings of Tejima Toan (1718–86), an active promulgator of the movement. The paintings became smaller, and subjects were chosen to convey feudalistic admonitions urging moderation, self-restraint and submission. Some were not without humour, and the brushwork was fluid and competent.

By the end of the 18th century *Ōtsue* was declining as an art form but had become part of the popular culture. Famous artists produced *Ōtsue*-style paintings, and *Ōtsue* subjects were used in the theatre, for example the dance mime *Fujimusume* ('Wisteria maiden'), first performed in 1826. In their last years, from the middle to the late 19th century, *Ōtsue* deteriorated to mere charms. They were limited to ten subjects, as portrayed in the Edo-period popular ballad *Ōtsue bushi*, were small in size and bore signatures and seals never seen in earlier *Ōtsue*.

(iv) Wood sculpture. While the great traditions of Japanese Buddhist sculpture were nurtured by professional trainees in Buddhist temples, there was a great deal of unorthodox image-making in remote regions by ascetic priests or other self-taught carvers from at least as early as the Heian period (794–1185). Two early styles, one commonly known as *natabori* ('hatchet-carved', though the characteristic rhythmic gouge marks of most *natabori* were made with a broad, round-point chisel), and the other as the 'standing-tree' style, carved on living trees, have often been mentioned as antecedents to the styles of two itinerant Buddhist sculptors of the Edo period (1600–1868), ENKŪ and MYŌMAN MOKUJIKI. Other unorthodox styles and iconography emerged, with greater freedom and emphasis on local deities as the distance from the capital increased, while orthodox Buddhist sculpture declined

steadily in the Muromachi (1568–1600) and Edo periods (*see* §V, 4(i)(d) and fig. 67 above).

Enkū, a Tendai priest with Shugendō training, gave free expression to his own religious vision. For more than 300 years his sculptures were known to few other than rural people, for whom they were objects of worship, imbued with magical powers to heal and protect. With hatchet and chisel he carved numerous images for worshippers in rural temples and shrines. He also carved images on living trees on mountain-tops. As a Shugen priest, Enkū aspired to be (and was in the eyes of the people) a miracle-worker; his image-making was part of his magical powers evoked in prayer and propitiation.

Mokujiki, active a century later, was an ascetic priest of the Shingon sect and carver of images in remote areas, many of which were rediscovered in the 1920s by Muneyoshi Yanagi. Mokujiki created undulating surfaces in a search for strong, curvilinear, often spiral movement in garment folds and flames. His serious pilgrimages began when he was in his mid-50s and continued until shortly before his death at the age of 92. Images from his later years are characterized by a singular smile.

While Enkū and Mokujiki were the most talented and prolific of the ascetic priest–sculptors, others were active in the Edo period. In the 1950s, when enthusiasts systematically searched remote mountain shrines and temples for Enkū's work, they found, alongside the objects of their quest, many works by unknown carvers, an indication of the strength of this tradition of devotional image-making. On a domestic level, village carvers made wood-carvings—found in almost every country and urban household—of household gods, such as Ebisu, Daikoku and Hotei, the three most popular of the Seven Gods of Good Fortune, and Kōjin, who became a kitchen god called *kamado no kami* ('god of the fireplace'). Ruggedly carved Kōjin masks are still found above the wood-stoves in rural houses.

(v) Stone wayside figures. Far-reaching Buddhist evangelism is reflected also in the abundance of stone images, particularly the small, free-standing devotional figures found on the wayside throughout Japan. These increased in number after the Muromachi period as itinerant priests were joined by masons and farmers in their mission to supply benevolent and protective deities for the local populace and travellers. The carvings were of uneven quality, but compensating for any lack of technical competence was their lively conception and great charm of expression. Subjects included all the popular deities, the most common being Jizō (Skt Kshitigarbha), protector of children and travellers. Congregations of images are found in many places, such as the Five Hundred Rakan at Uryū and Hōjō in Hyōgo Prefecture and at Kitain, Kawagoe, Saitama Prefecture. The horde of fantastic deities, including a cat-god and gods of wine and gold, at Yasumiya Shrine, Shonara, Nagano Prefecture, is also well known. An Edo-period custom of placing 33 images of Kannon (Skt Avalokiteshvara) in temple grounds or along the approaches to a temple provided a short-cut substitute for a Kannon pilgrimage (originally a pilgrimage to the 33 temples in the Kansai area designated in the late Heian period as sacred stations of Kannon worship, later imitated in other areas).

Wayside guardian figures, a great many of them Jizō figures placed in memory of deceased children, were also collected and assembled in temple compounds in later years, as at Tōdaiji in Nara, Mibudera in Kyoto and the Fumon'in on Sado Island.

(vi) Masks and puppet heads. The ritual use of masks (including dance headpieces) has endured for many centuries in Japan, although in modern times some practices that once had religious meaning are more in the nature of entertainment or celebration of tradition. Festivals, New Year observances, rice-planting rituals, exorcism and dance rituals have been among the many occasions for wearing masks. These were of various creatures, real or imagined, and were made mostly in wood but also in cloth, paper and papier-mâché (*see* §XVI, 15 below).

The popular folk dance called *shishimai* ('lion dance') is rooted in early native beliefs pertaining to a mythical animal with the power to vanquish evil spirits. This dance form was influenced by the masked dance–drama *gigaku shishimai*, transmitted from Korea in the 7th century and developed as part of the *kagura* ('sacred dances of Shinto') repertory. These early origins are reflected in the varied styles of *shishi* heads, ranging from the classical *karajishi*

(a mythical Chinese lion) in central Japan to the doglike, narrow-headed types of mountainous regions, which show the influence of mountain religion. Surviving throughout Japan are expressive examples carved in wood, lacquered (mostly in red and black, but white and brown examples are known) and sometimes gilded. Unpainted versions made by mountain ascetics, who were often performers of *shishimai*, are also found. In festivals the *mikoshi* (sacred palanquin) symbolically bearing the *kami* (deity) is preceded by a *shishi* to purify the way. Two, sometimes three, performers are concealed under a colourful cloth representing the lion, the lead performer holding the headpiece. In some areas an enormous *shishi* head is carried on the shoulders of youths in festival processions. In a different kind of *shishi* dance in northern Japan, each performer wears a deer or boar head (both locally called *shishi*) and a drum slung in front.

Shishimai are also in the repertory of *kadozuke*, door-to-door street performers, who for a fee administer short rites of purification or exorcism or confer New Year blessings. Other masks used in *kadozuke* represent Harukoma (a comic character) and the fox messenger of Inari Myōjin, a popular Shinto agricultural deity with whom the

211. Dance masks in painted wood representing: (left) the fox messenger of Inari Myōjin (a Shinto agricultural deity), h. 240 mm; (right) Harukoma (comic character) in the image of the miner Mikata Tajima, h. 190 mm, Edo period, 1600–1868 (both Sado Island, private collection)

messenger is often confused (see fig. 211). The *okame* (a good-natured, homely woman) and *hyottoko* (a man with a protruding puckered mouth) are comic masks used in folk plays and farming-village festivals. *Oni* and *tengu* (long-nosed goblin) masks appear in seasonal rituals; among the most famous examples are the demon masks used in the *ondeko* ('demon drum') rites of Sado Island.

Puppetry has existed in Japan for more than a millennium, and puppets of various kinds have entered local tradition throughout the country. Puppet performances until the 16th century were mostly associated with religious rites, serving to instruct as well as entertain. In the early 17th century puppetry was combined with the narrative chant called *jōruri*, accompanied by the *shamisen* (plucked three-string instrument) newly imported from the Ryukyu Islands. This puppet ballad–drama (*ningyō jōruri*) became enormously popular, especially as performed at the puppet theatre in Osaka, for which plays were written by such celebrated dramatists as Chikamatsu Monzaemon (1653–1724). Eventually the professional puppet theatre became known as *bunraku*, after the organizer of an Osaka puppet troupe named Uemura Bunrakuken (*d* 1810), a native of the island of Awaji, where there was a related puppetry tradition. *Bunraku* was a key influence in the development of *kabuki* and was also emulated by provincial puppet groups. (For further discussion on theatre types *see* §XIII, 2 and 3.)

Bunraku puppet heads (*kashira*) were carved with great art and sensitivity for character. In the professional theatre, however, the puppets were made to represent idealized roles, rather than individual personalities, and as such were employed as 'actors' in repertory. Although the dolls are physically smaller than humans, their heightened qualities—the purity of the maiden, the often tragic manliness of the male lead, the diabolic odiousness of the 'enemy role' characters and the sensual allure of the courtesan—give them a presence larger than life. *Kashira* are carved from blocks of seasoned *hinoki* (*Chamaecyparis obtusa*) and provided with strings and other mechanisms to manipulate the movable parts, such as eyes, eyebrows and mouth. Single-piece heads are employed in the Bunya theatre of Sado and other provincial puppet theatres. Unfortunately, many superb *kashira* have been destroyed, but the tradition survives because of revived interest in traditional performing arts.

(vii) Other forms. A unique genre of folk sculpture is that of the glazed ceramic *komainu* ('lion–dogs') made in the Seto–Mino area from the Kamakura (1185–1333) to Meiji (1868–1912) periods and given as votive offerings to shrines by the common folk of the area. The form gradually evolved from a lionlike mythical animal to likenesses of familiar animals such as dogs and foxes. Modelled with great charm and often earthy humour, they were made in pairs, one with mouth open, one with mouth closed, following convention, and ranged in size from less than 100 mm to around 600 mm. More than a thousand are estimated to survive; the largest collection of about 200 is housed at the Aichi Prefectural Ceramic Museum in Seto.

Small prints of Buddhist deities were made in quantity from the Kamakura period, for popular use as votive objects or talismans. In the 15th century, growing demand for devotional pictures for the common people resulted in production of large single-deity prints, sometimes hand-coloured or overpainted, which in turn inspired *Ōtsue* (see above). The prints also led to woodblock-printed illustrated books; among these, appearing in the early 17th century and now called folk art, were *tanroku-bon*, and later, in the early 18th century, printed versions of the illustrated story books called *Nara ehon*.

As townspeople prospered in the Edo period, the merchant culture dominated the urban scene; the popular theatres of Kabuki and Bunraku and the thriving pleasure quarters spawned the opulent fashions of Edo apparel and the *ukiyoe* prints, which developed from advertisements for actors and courtesans. Powerful merchants were patrons of painting and many artists of *chōnin* (townsman) background rose to prominence. On the peripheries of this generally élitist milieu were art forms that have been called folk art, among them paintings of folklife (both urban and rural) by *machi-eshi*, particularly those known as *shikomie* (apprentice paintings). Yanagi has also cited for their folk qualities the *doroe* (mud pictures) by unknown 19th-century artists, inspired by Western perspective and painted with cheap opaque pigments; popular subjects were Dutch ships and foreigners, daimyo mansions, views of Nagasaki and other urban scenes.

3. CERAMICS. The best-known and most studied of Japanese folk crafts is ceramics, owing to the survival of many collectable wares of the Edo period (1600–1868) and of handed-down examples of farm jars of the medieval period (*c.* 12th–16th centuries), their history further illuminated by intensive archaeological investigations. The folk aspect of ceramics is popularly associated with *minyō* (folk kilns)—essentially small rural kilns serving a local area—of the Edo period or later. However in the medieval era kiln groups in many parts of the country made wares for farm and household use, only those active to the present day being well known.

(i) Heian (794–1185), Kamakura (1185–1333) and Muromachi (1333–1568) periods. (ii) Momoyama (1568–1600) and Edo (1600–1868) periods. (iii) Modern period (after 1868).

(i) Heian (794–1185), Kamakura (1185–1333) and Muromachi (1333–1568) periods. Beginning in the late Heian period a fundamental change took place in ceramic production, as advances in agriculture expanded the need for durable containers for storage, seed-soaking and mixing and grinding. Accordingly, farmer–potters created rugged stonewares in versatile basic shapes of *tsubo* (jar), *kame* (wide-mouthed jar) and *suribachi* (mortar), using coarse local clays. The wares were coil-built and fired, without glazing, to a vitreous state in *anagama* ('cave kilns') dug into hillsides. Long heating with quantities of wood fuel produced a heavy fall-out of ash and a build-up of natural glaze, which often pooled and ran in dramatic cascades or rivulets on the side of the vessel facing the flames. Surfaces were further textured and coloured with kiln debris and areas of scorch and flashing (*see* §VIII, 6(ii) above).

The development of the wares is traced to the early 12th century at kilns on the Chita peninsula, south of Nagoya, Aichi Prefecture, in the area of Tokoname. In the

12th century, patronage by religious institutions was extensive at TOKONAME and related kilns, notably Atsumi. However, wares made for farm and domestic uses predominated at Tokoname, which became the greatest production area of medieval stonewares, its output being distributed by land and sea routes throughout Japan.

Also, during this time, centres that had previously produced *sueki* ('Sue ware'), a grey stoneware made during the 5th to 12th centuries, continuing in some remote areas to the 14th century (*see* §VIII, 4(i) above), turned to making large farm jars and mortars. Some kilns were strongly influenced by Tokoname, for example those at ECHIZEN and Kaga on the Japan Sea coast and a number of kilns in the Tōhoku region of north-eastern Honshu. At BIZEN (now Okayama Prefecture), a major *sueki* centre until the 12th century, a refractory mountain clay (amended from the late Muromachi period with highly plastic clay mined from paddy fields) was used in wares of great character and strength. By the 13th century, kilns in TANBA Province (now part of Hyōgo Prefecture) were producing sturdy brown stoneware jars, often with prominent draperies of greenish natural glaze. From about this time, kilns in SHIGARAKI (now in Shiga Prefecture) were also producing wares distinctive for their warm colours and surface texture with flecks of unfused feldspar, tiny eruptions and splits. Some localities continued the *sueki* technology of heavy reduction in the kiln at the end of the firing, thus creating smoky-grey rather than brown versions of *kame*, *tsubo* and *suribachi*. Outstanding among such kilns were those at Suzu, Ishikawa Prefecture, whose beautifully formed wares were widely distributed in the north.

By the 16th century a few specialized shapes had developed, including the small jar known as *ohaguro tsubo* ('tooth-blackening jar') produced at Echizen and many other kilns—continued at rural kilns throughout the Edo period—and the *ooke* (or *ogoke*; a bucket for coiling bast fibres used in cloth weaving) for which Shigaraki is noted, although it was also made at Echizen, Tokoname and other kilns. These jars were among the objects prized by 16th-century tea practitioners, who adopted the *ooke*—dubbed *onioke* ('devil bucket')—as a *mizusashi* (fresh-water jar) and the *ohaguro tsubo* as a hanging flower vase for the tea ceremony (*see* §XIV, 3 above).

The early stonewares were variously affected by the ascendancy of the tea ceremony in the 16th century. Its influence came early to BIZEN, where potters successfully adapted their craft to utensils in the *wabi* ('rustic simplicity') spirit (*see* §XIV, 1 above). Shigaraki, in a tea-growing area, became a supplier of tea-leaf jars, with glazing introduced by the late 16th century.

For political reasons, Tokoname was largely cut off from tea patronage and, in decline, continued limited production of utility wares. Meanwhile, the SANAGE tradition of glazed ceramics was carried on at SETO (Aichi Prefecture) and later at MINO (Gifu Prefecture). In the Muromachi period the Seto kilns had been noted for their ritual vases and tewares inspired by Chinese models, produced for temples and the aristocracy. By the 16th century the creative role in tea passed to the Mino kilns, as the Seto kilns turned increasingly to the production of popular household wares.

(ii) Momoyama (1568–1600) and Edo (1600–1868) periods.

(a) Korean influence and Karatsu stonewares. The Momoyama period, a period of glory for tea ceramics, was for most common-use wares a time of transition to applied glazes and multi-chambered climbing kilns (*see* KOREA, §VI, 5), which enabled greater and more efficient production. By the 17th century, most unglazed stonewares for common farm and household use had passed from the scene, the kilns that produced them being either defunct or converted to new styles and technology.

Korean-style ceramics were made from the mid 16th-century at Kishidake near the port city of KARATSU, in the northern Kyushu domain of Matsuura, from which traders and pirates had long roamed the Korean coast. A new wave of Korean influence followed the Korean campaigns (1592–8) of Toyotomi Hideyoshi, when many captive potters were brought back by generals obsessed with the paraphernalia of tea. These potters were instrumental in the wide dissemination of new technology. Remarkably, the wares that fuelled this aristocratic pursuit were humble rice bowls used by Korean monks and common folk.

With this influx of potters and technology of glazed stonewares, many new kilns were established in the Keichō era (1596–1615) in the Matsuura region and in central and southern Kyushu, which, while providing tea utensils for the lords, made utilitarian wares in quantity for the local populace. When kaolin was found in the early 17th century in the vicinity of ARITA, Saga Prefecture, kilns there quickly converted to porcelain production. In the face of this competition, the brief flowering of Karatsu was nearly at an end, although limited production of teawares continued throughout the Edo period.

A number of kilns in the Takeo area south of Karatsu turned, however, to making robust stonewares for everyday use in the surrounding farm areas. These wares, known as *Takeo karatsu* or *kōki karatsu* ('later' Karatsu), were quite different in character from the *kokaratsu* ('old Karatsu'), with effective use of iron-brown, copper-green and ash glazes, and brushed, combed and finger-drawn designs in white slip. Notable products of the Kotaji and Niwaki kilns were huge kneading bowls, with pine-tree designs boldly sketched in green and amber glazes—a combination called *nisai karatsu* ('two-colour' Karatsu)—and large plates with combed slip and *nisai* glaze splashes. Pine trees were a favourite theme at the Yumino kiln, especially on the wide-mouthed jars for which this kiln became famous. Bamboo, plum, landscape and animal designs in green and amber over white slip are also seen on Yumino jars, bottles and kneading bowls. The Kuromuta kiln, founded by Koreans at the end of the 16th century and in operation until the modern era, made a broad range of kitchen and farm wares, notably sake bottles and abacus-bead-shaped teapots. Among other kilns producing *kōki karatsu* wares for common use were Yakimine, Uchidayama Taitani and Shiinomine.

(b) Arita and other porcelains. The earliest Arita porcelains showed strong Korean character, but Chinese influence soon prevailed at the 'inner' kilns closely controlled by lords of the Nabeshima domain, reflecting their taste and commercial interests. By the second half of the 17th

century, refined enamel-decorated wares were being produced for the lords (*see* §VIII, 7 above) along with great quantities of showy porcelains for export. However, in the 'outer' mountain areas (*sotoyama*), the Yanbeta, Nagobaru and Komizo kilns produced porcelain utensils for farmers, townspeople and wayside eating-houses from as early as the Kan'ei era (1624–44). These wares were generally thick and heavy, with freely painted underglaze-blue designs in low-grade local cobalt. Especially notable were the large plates made at the Yanbeta kilns, used for serving food at family gatherings, with exuberant, almost wildly drawn landscape creations. Utilitarian porcelain wares, such as food bowls and wine bottles, became widely available to the common people as production spread to other areas. The popular *soba joko* (noodle-sauce cups) were made best at Arita but also at Tobe, Odo and Nōsayama in Shikoku and at Seto, Kyoto, Izushi and Kotō in central Japan. The designs, in underglaze blue, showed lively imagination, ranging from geometric and floral patterns, landscapes and animals to people, buildings, conveyances and creatures of legend. Later *soba joko* were also made with enamel-colour designs and solid-colour glazes.

(c) Other Kyushu folk wares. Folk kilns outside the Karatsu and Arita areas of Kyushu are traced to other groups of Koreans brought in to make teawares or to create trade revenues for the domainal lords. In southern Kyushu the most notable were the Naeshirogawa kilns, founded by Koreans who arrived in Japan at the end of the 16th century and moved in 1605 to Naeshirogawa, where they produced white, black, blue-and-white and, later, enamelled SATSUMA ware for the Shimazu clan lords. However, for the use of common folk, the Naeshirogawa kilns continued to make *kuromon* ('black wares'), sturdy,

212. Seto-ware *ishizara* ('stone plate'), painted with maple-leaf and stream motif, diam. 254 mm, 19th century (New York, Metropolitan Museum of Art)

black-glazed stonewares in basically Korean shapes, notably *hanzu* (wide-mouthed jars for fermenting wine), *yamajoka* (large cooking pots with spouts and handles) and *unsuke* (large sake bottles with spouts).

Of particular interest among Kyushu folk kilns is Onta (Ōita Prefecture), founded in 1705 as an offshoot of Koishiwara, a kiln established earlier to make tea utensils for the Kuroda daimyo but which also supplied wares to meet the needs of the surrounding farming communities. Onta had abundant deposits of clay and mountain streams from which water was sluiced to operate giant levered pestles called *karausu* ('Chinese stamps') to crush the rock-hard clay. Until the late 20th century families of the tiny community, all descendants of the founders, divided their efforts between pottery and farming. Decorative techniques effectively employed at Onta included *uchihake*, a rhythmic dabbing of a broad brush on the slip-covered surface of the ware as it turns on the wheel, to make patterns such as *kasame* (umbrella pattern), and chatter marking using *tobiganna* ('jumping tools'). These and finger-marked patterns and poured-glaze designs were applied to large serving plates, water jars, lidded jars in many sizes, spouted bottles and a variety of smaller utensils.

(d) Tanba and Seto wares. The Tanba kilns continued to serve mainly farm and household needs and, more than any others surviving from the Muromachi period, maintained their folk character and quality throughout the Edo period, notwithstanding frequent innovations in style and technique. About the beginning of the 17th century the old tunnel kilns in Tanba were replaced by long, climbing kilns termed *jagama* ('snake kilns') constructed partly above ground, with fuel-stoking holes along their length. Glazing was introduced, beginning with applied ash glazes and a thin slip glaze called *akadobe* ('red slip'), which gave the stoneware a reddish sheen. Dramatic effects were achieved by the combination of this with a lustrous black glaze poured over the neck and shoulders of jars and bottles. For an occasional decorative touch, leaf patterns were created by adhering actual leaves to the vessel body before glazing. Representative forms of early Edo-period Tanba ware were *funa-dokkuri* (ships' sake bottles), tall *rakkyō-dokkuri* (scallion-shaped sake bottles) and *sanshō tsubo* (jars for *sanshō*, a pepper-like spice and a speciality of the region), along with large storage jars of several kinds. From the middle to the late Edo period new glazes and shapes were added to the Tanba repertory, including a remarkable variety of *sake* bottles.

In the same period, the Hora kilns in Seto were producing the folk wares called *ishizara* ('stone plates') and *umanome zara* ('horse-eye plates'). *Ishizara* were painted with astonishing facility and exuberant style with landscape, floral, animal and abstract designs and calligraphy, using underglaze iron and cobalt blue under transparent ash-feldspar glaze (e.g. an *ishizara* with maple-leaf and stream motifs, 19th century; see fig. 212). Rugged *ishizara* and *unanome zara* were commonly used to serve *nishin* (herring) and *nishime* (cooked vegetables) at roadside inns. Another noted Seto product of the late Edo period was the *abura zara* (oil plates) used to catch drips in lampstands. These low-rimmed saucers were typically

decorated with underglaze iron sketches of landscapes or with floral motifs, often combined with segments of Oribe green glaze.

(e) Other wares. On the Japan Sea coast of western Honshu an informal tea style called *botebotecha*, which combined tea with rice broth, beans, bean paste, pickles and other ingredients, became popular in farming and fishing villages. Bowls for this service, called *botebotecha-wan*, were made at kilns in Iwami and Izumo provinces (now Shimane Prefecture), the greatest quantity being produced at Fujina, an Izumo kiln founded in 1764. The bowls were ample, rounded forms glazed in green, amber and white. Fujina is known also for its later adoption of yellow glazes using galena, a lead sulphate.

Although remains of ancient and several medieval stoneware kiln groups of both Tokoname and Suzu lines are found in northern Japan, this area was slow to develop substantial pottery industries, in part because of the abundance of inexpensive lacquer and wood utensils. However, in the late Edo period many small kilns were established, mostly under the aegis of local lords, by potters lured from major centres such as Seto or by local potters trained at those centres. The products of the *hanyō* (domainal or official kilns) were often provincial imitations of the decorative ceramics of Kyoto and Arita. At the same time, a distinctive northern folk style emerged, characterized by robust stoneware shapes and the use of thick, opaque glazes including white, copper-green and especially the mottled, purplish-blue opalescent glaze called *namako* ('sea-slug'). Iron glazes in lustrous amber or brown were also employed, often in combination with *namako* or white. Products of these kilns included storage jars, *yutōshi* (rice-warming pots) and *tokkuri* and *kuttsuki dokkuri* (spouted bottles). The two largest of the northern ceramics centres were Sōma and Aizu-Hongō in Fukushima Prefecture.

(iii) Modern period (after 1868). By the end of the Edo period kilns were in operation in every part of the country, after proliferating remarkably in the first half of the 19th century. Many, including the more prominent, were sponsored by the lords. These *hanyō* included kilns serving the local market or trade channels through wholesalers and were a significant source of domainal revenue.

After the abolition of the daimyo domain system in 1871, the former *hanyō* were deprived of official support but on the other hand freed from official restrictions. Provincial kilns with an established base in the community were able to survive as *minyō* (folk kilns). Some, especially regional porcelain producers such as Hirashimizu and the main kilns at Aizu-Hongō, prospered in the 1870s and 1880s. One of the former *hanyō*, established in 1853 as a commercial supplier to the Edo market, was Mashiko, later to become the famous home of SHŌJI HAMADA and several other *mingei* potters. Well known among Mashiko wares was the landscape teapot, a design borrowed in the Meiji period (1868–1912) from the Kōyama kiln at Shigaraki, where other glazed household wares had been made since the mid-Edo period.

However, craft industries were soon caught up in the country's rush to modernize through mechanization and

mass production, and, as Western influence spread, the fortunes of traditional crafts declined. With expansion of the rail system, rural kilns also had to compete with cheap porcelains widely distributed from major centres. The *mingei* movement in the 1920s and 1930s was responsible for reinvigorating and bringing to public attention, through exhibitions, publications and provision of retail outlets, a number of folk kilns struggling to survive. It was not until the post-war period, however, especially between the 1950s and the 1970s, that the '*mingei* boom'—in which folk ceramics were the major component—developed. Among the kilns involved were Onta, Koishiwara, Naeshirogawa, Tsuboya (Okinawa), Tobe, Fujina, Yumachi, Ushinoto, Mashiko, Aizu-Hongō and Tanba Tachikui. By this time *mingei* had come to mean 'folk-style' crafts, commercial wares not for local or peasant use but for the urban middle class. Unfortunately, with commercial success came a much-deplored deterioration of quality at some kilns.

Mingei played only a modest role, however, in the post-war *yakimono būmu* ('ceramic boom'), which involved thousands of studio potters and commercial kilns, from the traditional to the avant-garde (*see* §VIII, 4 above). The efforts of many potters continue to be aimed at creative new work within the ceramic traditions of the past, including those of the unglazed stonewares. While modern products cannot properly be called folk art, there is no doubt that they have been strongly influenced by the rediscovery of the natural beauty of wares fired in primitive kilns and the varied attractions of later provincial ceramics.

4. TEXTILES. Until the modern era textiles for the common people were mostly the work of housewives and young girls. Almost every household had a loom, and girls were trained early in spinning, weaving and embroidery, skills that were important credentials for marriage and in which they would engage throughout their married lives. In some areas piecework was required as tax payment or sold to wholesalers for extra income, thus creating cottage industries.

(i) Materials and techniques. (ii) Woven designs. (iii) Dyed designs. (iv) Needlework. (v) Ainu robes.

(i) Materials and techniques. Before the widespread use of cotton, clothing worn by the common people was made from various bast fibres, such as *taima* (hemp), which was cultivated, *choma* (rami), grown wild or cultivated, and *kōzo* (paper mulberry), *shina* (Japanese linden), *fuji* (wisteria and other vines), *kuzu* (kudzu or arrowroot) and *irakusa* (nettle), which were all gathered from the wild. In Okinawa, *bashō* (a plantain fibre) was used in addition to other fibres. All of these were loosely termed *asa*; in modern usage the term also includes imported linen and jute. Cotton yarn and fabrics had been imported from China since the early 13th century and from Korea about a century later. However domestic cultivation began only in the 16th century after which time it spread quickly through the country, revolutionizing clothing for the common folk and replacing *asa* in all but the northern provinces and Okinawa by the mid-18th century. Sericulture was an important home industry, but sumptuary edicts prohibited peasants from wearing silk until the Meiji

period (1868–1912) with the exception of homespun waste silk (*tsumugi*).

Traditional Japanese dyes were all natural, most of them vegetable. Of the many colours obtained from grasses, leaves, flowers, seeds, bark, wood and roots, the predominant colour for the common people was dark blue from *ai* (indigo) obtained from the *tade ai* (*Polygonum tinctorium* Ait.) plant. Indigo was not only thoroughly compatible with cotton and a durable colour with little fading but also had the property of strengthening cotton fibre, making it the ideal dye for work clothing. *Tade ai* was once widely home-grown, but as indigo cultivation became a thriving industry in the Edo period (1600–1868), the long, arduous process of dyeing was left to professional dyers (*kōya*). Other colours used by the common people were lighter shades of blue from indigo and earth tones from many sources such as *tsurubami* (an oak, *Quercus acutissima* Carruth.), *asen* (*Acacia catechu* Willd.), *kurumi* (walnut, *Juglans sieboldiana* Maxim.) and *gobaishi* (the cysts formed by parasites on *nurude, Rhus javanica* L.).

The loom commonly used in households was the *jibata* (ground loom), also called *izaribata*, a low, body-tension or backstrap loom. In the Edo period the *takahata* (high loom), the prototypes of which were used in official workshops from early times, was sometimes rented by entrepreneurs to households for order work, especially when villagers joined together to create small workshops. (For further discussion *see* §XI above.)

(ii) Woven designs. Medieval scrolls and fan paintings show commoners wearing clothing with checks and horizontal stripes, but no examples of the fabrics survive. In the early 17th century, vertically striped cotton fabrics imported from India and South-east Asia inspired Japanese versions known as *shima* ('island', the imports having come via the South Sea Islands), which became the most popular fabrics of the Edo period before the widespread use of *kasuri* (ikat). Farmers' wives kept *shimachō* ('stripe albums'), in which examples of their *shima* (later including *kasuri* and other weaves) were pasted for reference.

The technique of *kasuri*, in which resist designs are created by weaving yarns dyed after patterned tying, was transmitted to Okinawa from South-east Asia in the 14th and 15th centuries. After Okinawa fell under the domination of the southern Kyushu domain of Satsuma in 1609, annual tribute in the form of fabrics brought *kasuri* to Satsuma, where local production of the fabric known as *Satsuma gasuri* began *c.* 1740. In the late 17th or the early 18th century the technique was transmitted by other trade routes to Echigo Province (now in Niigata Prefecture), where it was applied to the famous Echigo *jōfu*, a fine grade of rami, and its crêpe version, *chijimi*. With increased use of cotton in the 18th century, the *kasuri* method spread rapidly throughout the farming communities of western and central Japan. For cotton work clothing, *kongasuri* ('indigo *kasuri*') predominated and became the typical folk fabric of the late Edo and Meiji periods. Women were much devoted to the craft, and many localities had a heroine said to have 'invented' *kasuri*. In the 19th century, cottage industries producing *kasuri* developed into major production centres, notably Kurume (northern Kyushu), Iyo (Shikoku) and Bingo (Hiroshima);

all produced cotton *kongasuri*. In Yamato (Nara), white *kasuri* was made in both cotton and *asa*, and *asa kasuri* also continued at Omi (Shiga Prefecture) and Echigo.

A distinctively Japanese elaboration of the *kasuri* technique was *egasuri* ('picture ikat'), in which a naturalistic pictorial design was created in the resist-dyed weft. Felicitous motifs such as pine, bamboo and plum, tigers (see fig. 213), tortoises, cranes and carp were most common, but subjects extended to dolls, castles, even umbrellas and bicycles. An important aid to repeating *kasuri* designs in the weft, the *taneito* ('seed yarn'; a guide yarn made by stencilling), was invented in 1839 in Kurume. It was later superseded by other techniques of thread dyeing, such as the board-clamping method used at Kurume, Yamato and Omi. *Egasuri* was often combined with geometric motifs in double ikat (both warp and weft yarns resist-dyed) or

213. *Egasuri* ('picture ikat') with tiger and bamboo design, woven cotton, 620×322 mm, 19th century (Toronto, Royal Ontario Museum)

stripes. Besides work clothing, such as *monpe* (farmers' trousers, worn by both sexes) and *hanten* (work jackets), popular uses of *kasuri* fabrics were for *noren* (curtains), *furoshiki* (wrappers) and covers for *zabuton* (floor cushions) and *futon* (bedding).

In Okinawa, superb fabrics of banana fibre (*bashōfu*) were standard for commoners' wear by the early 17th century. These fabrics were made from the inner fibres of the 'trunk' (formed by the convergent basal leaf stalks) of a cultivated plantain (*Musa balbisiana*), the coarse outer fibres being used for cushions or bedding. They were woven plain or in stripes or *kasuri*.

Okinawan decorative handtowels (*tisaji*) were woven by girls as gifts or protective talismans for their seafaring menfolk. *Kasuri* and a distinctive swivel weave called *hanaui* ('flower weave') were among the weaves employed. In *hanaui*, coloured yarns were worked into the banana, cotton or rami ground during the weaving, giving an embroidered effect. Yomitan, once a prosperous trading post, was noted for its rich variety of *tisaji*.

A thick fabric for floor cushions and bedding as well as farmers' clothing, known generally as *Tanbafu* ('Tanba cloth'), though locally called *shimanuki* (striped weft), was made at Sajimachi in Tanba Province from the late Edo period. It was woven in stripes or plaids of heavy yarn dyed in tan and shades of indigo or green, with strands of white waste silk in the weft for added strength. After a decline in the Meiji period, *Tanbafu* was revived in the 1920s through the efforts of Yanagi and his followers. Small-scale production continues.

(iii) Dyed designs. A design on commoners' clothing frequently seen in narrative scrolls, early genre paintings and *ukiyoe* prints is that of *shibori* ('tie-dye'), a resist-dyeing method known in Japan since ancient times. In the Edo period (1600–1868) *shibori*-tieing became a cottage industry in several areas. Most famous was the cotton *shibori* made at Arimatsu and sold at Narumi (and known by either name); the two were adjacent towns (now part of Nagoya) on the Tōkaidō highway, Narumi being one of the '53 stages' made famous by Hiroshige. Arimatsu *shibori* was dyed mainly in indigo and used particularly for *yukata* (an unlined cotton garment for casual after-bath wear) and *tenugui* (handtowels), sold as local specialities to travellers. Other cotton tie-dye production centres were Hakata and Amagi (Kyushu), where production flourished in the late Edo period, and Hanawa and Morioka (Tōhoku), known particularly for madder-red and purple dyes of the region.

The method of *katazome* (stencil dyeing) using a glutinous rice-paste resist was well established in the 16th century, although earlier use of direct stencilling is documented. The earliest extant examples of direct-stencil designs are not, however, on fabrics but are the patterned leathers used in armour from the late Heian (794–1185) to Kamakura (1185–1333) periods. When the Edo government prescribed silk *komon*, fine-pattern, stencil-dyed fabrics, for the samurai class, commoners for their cotton apparel adopted larger stencil designs called *chūgata* ('medium-sized figure') produced by professional stencil cutters in Shiroko near Ise. *Yukata* fabric was made by applying the resist through stencils on both sides of the fabric and dyeing by immersion in indigo. For floral and arabesque designs on bedding-covers the resist was usually stencilled on one side only and the ground coloured with a brush; these bedding fabrics, known as *karakusa-zome* ('arabesque dyeing'), show the influence of Indian block-printed cotton textiles imported to Japan in earlier times. By the late Edo period most communities had skilled dyers making these fabrics. In Okinawa, where the gorgeous *bingata* ('red stencil' but multicoloured) stencil-dyed fabrics were made for the royal family and the aristocracy, the common folk were allowed the use of small-pattern, stencil-dyed fabrics in indigo and black (*aigata*). Fabrics were banana cloth and rami.

A free-hand dyeing technique called *tsutsugaki* or *tsutsubiki* was widely employed for common-use fabrics by local dyers. The application of the resist, which entailed squeezing rice paste out of a *tsutsu*, a conical tube formed of paper waterproofed with persimmon tannin, was easily mastered by housewives. Dyeing was then left to the dye shops. The *tsutsugaki* technique was well suited for large, unitary pictorial designs and was particularly favoured for the decoration on *futon* and *yogi* (padded kimono-shaped bedding), which were often part of a bride's trousseau; designs were chosen to symbolize longevity and prosperity and on occasion incorporated family crests. Other articles suitable for this free-hand designing were *noren* (chest covers), *maiwai* (fishermen's ceremonial robes), *katsugi* or *kazuki* (robes that extended over the head), *happi* coats for festivals, banners for the boys' festival, *furoshiki* (cloth wrappers) and slings for carrying babies. In Okinawa *tsutsugaki* designs were dyed on rami *uchikui* (*furoshiki* used for gift-giving) and on curtains for dance–drama performances.

(iv) Needlework. *Sashiko*, a technique of stitching together layers of cloth, with or without padding, for extra warmth or strength, has a history almost as old as that of textiles. The practice of using the stitches to produce artistic geometric and pictorial designs is of uncertain age but was highly developed by the Edo period. It flourished especially in northern Japan, where the freezing winters necessitated warm clothing and afforded time for indoor activity. The stitching was usually in white yarn on indigo-dyed fabric or black yarn on white, on anything from simple work clothes and heavily padded firemen's outfits to striking garments with pictorial designs traced in fine running stitch.

Outstanding among the northern *sashiko* were the Tsugaru *kogin* from Aomori Prefecture and Nanbu *hishizashi* from Iwate Prefecture. The *kogin* style emerged in the late 18th century, reaching full development in the 19th century with the availability of cotton yarn from the southern provinces. This precious commodity was used to embroider dense geometric patterns based on the diamond motif, covering the upper half of the bodice of an *asa* robe. The embroidery was usually white on black or indigo fabric. Girls in Tsugaru were initiated in the art of *kogin* at the age of eight or nine and were taught the 50 or so basic designs, all variations of the diamond pattern.

Nanbu *hishizashi* was also a diamond-pattern embroidery, usually in cotton yarn on *asa*, but the lozenges were smaller and placed horizontally. About 350 designs have

been identified. Originally the colours were white and shades of blue embroidered on light blue or white fabric, used for the standard work outfit of a short coat, outer sleeveless jacket and breeches. In the early 20th century, brightly coloured woollen yarns inspired a brief flowering of colourful aprons in imaginative and varied colour combinations and juxtapositions of the lozenge units. (For further discussion on clothing *see* §XVI, 7 below.)

(v) Ainu robes. Robes worn by the aboriginal Ainu people (*see* §I, 2 above) have received widespread attention. The earliest Ainu clothing was fashioned from animal skins, including, remarkably, those of fish and birds. Ainu textile costumes were characterized by strong abstract overall symmetrical design, with distinctive and ever-present motifs strikingly executed in appliqué and embroidery. The motifs were based on Ainu belief in the protective power of certain magic symbols, most importantly the thorn (Ainu *aiushi*) and spiral (*moleu*). Ainu textiles were originally woven from the inner bark of elm or linden or from nettle, using simple body-tension looms. In the late Edo and Meiji periods, however, when most of the surviving costumes were made, the Ainu obtained Japanese fabrics and yarn as well as Japanese and Chinese costumes through trade. At first used sparingly, the acquired fabrics were cut in ribbons and attached in angular patterns to the wood-fibre robe, from the neck openings down the front and back and around the hem and sleeve openings. Superimposed on the ribbons were curvilinear designs chain-stitched in white yarn. Called in Ainu *attushi*, these were the heaviest and most durable of the Ainu robes (*see* TEXTILE, colour pl. VII, fig. 2). In the later robes called *ruumpe* in Ainu, strips of imported cotton or silk were freely combined in complex and imaginative appliqués. Some of the most stunning Ainu designs were created in the *kaparamip*, in which large pieces of fabric in solid

214. Ainu *kaparamip* robe, cotton appliqué, l. 1.23 m, 19th century (Shizuoka, Municipal Serizawa Keisuke Art Museum)

colours and curvilinear cuts were laid over contrasting grounds, as in a 19th-century example in Shizuoka (see fig. 214). In the latest development in Ainu costumes, called *chijiri* in Ainu, the fabric was embroidered without appliqué, in linear arabesques of seemingly endless variety.

5. WOOD AND LACQUERWARE. Wooden implements have been in common use in Japan from prehistoric times. Excavations of such ancient habitation sites as the Yayoi-period (*c.* 300 BC–AD 300) site of Toro, Shizuoka Prefecture, have yielded a vast array of wooden farm tools, footgear and vessels. Large kneading bowls, spouted bowls, massive mortars and water-storage urns or tubs were carved at home, and many, though rough hewn, were works of beauty and character. Nomadic woodworkers (*kijishi* or *kijihiki*) provided the more refined lathe-worked wooden wares and joinery. Until the Muromachi period *kijishi* groups moved freely through the forests of Japan, gradually dispersing throughout the country. By the early Edo period (1600–1868) a number of them had settled in special quarters of castle and temple towns where they worked in close collaboration with the *nushi* (lacquerers). The wood bases are still provided, in a typical lacquer centre, by *kijishi*, some of whom specialize in particular types of base products. The most commonly used woods are *keyaki* (keyaki; *Zelkova serrata*) for bowls, and *sugi* (Japanese red cedar; *Cryptomeria japonica*), *hinoki* (hinoki cypress; *Chamaecyparis obtusa*), *asunaro* (hiba; *Thujopsis dolabrata* Sieb. and Zucc.) and *hōnoki* (Japanese big-leaf magnolia; *Magnolia hypoleuca*) for joinery.

Although the technique of lacquering had been known in Japan since the Jōmon period (*c.* 10,000–*c.* 300 BC; *see* §X above), lacquerware utensils were not widely used by the common people until the Muromachi period (AD 1333–1568). Illustrated handscrolls and genre paintings of the Muromachi and early Edo periods, such as the 13th-century *Kokawadera engi* ('The founding legends of Kokawadera'; Wakayama Prefecture, Kokawadera), show plain lacquer bowls, similar to modern soup bowls, in use by commoners. Most common-use lacquer articles have perished, but an idea of their character may be gained from the temple wares called Negoro, named after Negoroji, a huge medieval priestly enclave in Kii Province, now Wakayama Prefecture, which was destroyed by the warlord Toyotomi Hideyoshi in 1585. Although no evidence from the site remains, Edo-period writings indicate that artisans in the temple community produced and marketed red and black lacquerwares, including great quantities of everyday wares and a variety of religious utensils. Lacquer production at Buddhist temples was common at the time. After the temple Negoroji's destruction, its priests and artisans were widely dispersed and, it is believed, contributed their expertise to lacquer production at other centres, notably Wajima, Aizu, Yoshino, Kuroe and Satsuma. It is difficult to know the source of the so-called Negoro wares today; and Negoro has become a generic term for a type of red lacquer—left unpolished, with brush marks showing—over a black laquer undercoating, which shows through after prolonged use, an effect much prized. Variations included red with black trim or vice versa and combinations with Shunkei lacquer. Simple functional beauty, clean lines and

215. *Tsunodaru* ('horned cask'), lacquer on wood and bamboo, h. 570 mm, 19th century (Tsuruoka, Chidō Museum)

Jōhōji, is characterized by the use of yellow and green lacquer in addition to the red and black *e-urushi*. Jōhōji, a centre for the collection of urushiol (the sap of the Japanese lac tree, the unrefined base of lacquer), was known in the Edo period for its utilitarian lacquerware, most of it produced by farmers in their spare time. Other *e-urushi* and *mitsudae* wares popular in the Edo period were *bon* (trays), mostly round, some in red and black, others with ground colours in brown, yellow or green. These were decorated in a wide range of motifs, including flowers, birds and animals, historic figures and rural scenes.

The most striking folk lacquerwares surviving from the Edo period and the Meiji period (1868–1912) are the wine and food vessels made for special occasions in the lives of the common people—betrothal and wedding ceremonies, New Year festivities and seasonal festivals. Especially notable among the ceremonial sake casks was the *tsunodaru* ('horned cask'), a bucket made of wood staves, with two opposing staves much elongated for the handle, giving the cask a horned look (see fig. 215). Large spouted bowls (*hiage*) in red or black lacquer were used for pouring sake. In the Shōnai area near Tsuruoka, *usagidaru* ('rabbit casks'), with round bodies and long handles suggesting ears, and *sodedaru* ('sleeve-casks') or *sashi-daru* ('joinery casks') were made in pairs for wedding gifts of sake.

The most widely used food vessels were bent-wood products called *magemono*, made of thin-shaved wood bent round to form a container, the overlapping sections being sewn with cherry bark as a decorative touch. In Shunkei lacquerware, the *magemono* were stained reddish-orange or pale yellow and coated with a clear lacquer, with perilla oil added for lustre. The centres most famous for Shunkei, which was effectively used for other utensils and furniture, were Hida Takayama, Hirasawa, Kiso-Fukushima and Noshiro.

6. FURNITURE. In the traditional Japanese home, living space was uncluttered and furniture minimal. Storage space was built-in or provided in a separate storeroom. While the aristocracy made sparing use of elegant cabinetry and display shelving, the average peasant, at least until the 19th century, needed and could afford only a willow-bough or bamboo trunk or plain wood box (*hitsu*) in which to store his personal belongings. However, in the Edo period (1600–1868), the growth of cities, coastal commerce and an urban merchant class created the need for means of storing and handling trade goods. Built-in chests of drawers were devised in the 17th century for clothing and accessory shops, and by that time portable small chests were in use, including money-boxes and specialized chests for food caterers, barbers, fan shops, medicine vendors and other tradesmen. Although held in check by the sumptuary edicts of the Tokugawa shogunate, the living conditions of the wealthier townspeople created needs for chests of drawers (*tansu*). The clothes chest (*ishōdansu*, or *kosodedansu* as it was known then) appears in the *Wakan sansai zue*, an illustrated encyclopedia of the early 18th century, and it occurs in *ukiyoe* prints and in the plays of Chikamatsu Monzaemon. Shops required *chōdansu* ('accounting chests'), which were sometimes massive. Long boxes (*nagamochi*) mounted on wheels to help escape fire had been in use in the early Edo period but were

purity of form characterize old Negoro. The more elaborate shapes of special temple pieces were made under Chinese stylistic influence.

Excavations at sites of the 13th–14th centuries show that *e-urushi* (lacquerware with painted designs) had a long tradition in the provinces. In the late 16th and early 17th centuries imported decorated lacquerware aroused new interest in both *e-urushi* and *mitsudae* (lacquerware painted with oil-based pigments). Their popularity spurred production in castle and temple towns, highway posts and farming villages, each with local variations of colour and design. In the Nanbu region (Iwate Prefecture) of northern Japan, a provincial ware known as Hidehira-nuri—so named in the 19th century after the 12th-century ruler of the region, Fujiwara no Hidehira (*d* 1187)—was characterized by bold use of gold leaf in lozenge shapes or crosshatch patterns over red or black lacquer, combined with *e-urushi* designs of floral and stylized clouds, mostly on lidded bowls. Its rustic elegance attracted both tea devotees and *mingei* enthusiasts, but its origins and early history are unknown. In the Edo period the style was much imitated, with variations, at other regional lacquer centres, notably Aizu (now Fukushima Prefecture). A similar Edo-period Nanbu lacquerware, sometimes called

banned in Edo (now Tokyo), Osaka and Kyoto in 1683 because of the congestion they had created in the Great Meireki Fire of 1657 in Edo. In the provinces a later form, the *kurumadansu* ('wheeled chest'), continued to be used throughout the Edo period for the mobile storage of important documents.

For modern collectors the most popular of the old storage chests are the *funadansu* ('ship's chests'), ruggedly constructed and liberally reinforced with ornamental metal fittings. These appeared about the beginning of the 18th century and proliferated in the 19th. They were used on the *sengokusen* ('thousand-*koku* ships'), which plied the Kitamae Sea route. The *funadansu* were of two basic kinds: the portable ship's safe and the captain's clothes chest. The first to be developed was a type of safe called *kakesuzuri*, a portable safe for the ship's documents, diaries, navigation charts, seals and money. It was a boxlike form with interior drawers behind a single door in front, the door lavished with cut-iron openwork incorporating hinges, lock and crest or trademark; a carrying handle was centred on top of the chest. The name reflects its derivation from the medieval accounts box, which had an inkstone (*suzuri*) in a lift-out tray under a hinged top lid. A later expanded and diversified form serving the same purpose was the *chōbako* (accounts box), which included examples with two doors combined with drawers, others with a removable front panel over drawers and some with drawers alone. Carrying handles were fixed on the lateral ends. The captain's clothing chests (*hangai*; 'half-chest') were longer boxes made in stackable pairs. All of these chests featured elaborate metal fittings, many strikingly handsome, and carefully chosen woods, usually *keyaki*—often burl for the front and straight-grained for the remaining exterior—and *kiri* (*Paulownia imperialis*) for the interior drawers. Some were finished in Shunkei lacquer.

As the general standard of living improved in the Meiji and Taishō (1912–26) periods, *tansu* were in much greater demand, and production for domestic use developed in many areas. The greater availability of lumber and of woodworking tools facilitated construction and lowered the cost. Among the leading production centres noted for their distinctive styles of wood finishing or metal fittings were the city of Sendai and the prefectures of Yamagata, Niigata, Ishikawa, Tottori and Shimane.

Other wood furnishings adopted for home use by a broadening segment of the population were *hibachi* (braziers), *andon* (lamps), *tana* (shelves), low tables and *tsuitate* (rigid screens). Of particular interest are *zushi* (small shrines) and the massive wooden *jizaigake* (pot hooks) used with adjustable hangers to suspend kettles over the open hearth.

7. Other crafts.

(i) Metalwork. The principal source of iron in Japan before the modern era was iron sand, which was recovered from mountain soil by a laborious and costly process of sluicing (*see* §XIII above). The extraction of iron was carried on by itinerant workers, as was iron smithery in rural areas. Some of the itinerant smiths later settled on the fringes of villages and towns where, as *nokaji* ('field smiths', as distinct from swordsmiths), they made and repaired farm implements. From medieval times other smiths engaged in various specialities, such as the making of nails, cutlery and woodworkers' and other trade tools, often of extraordinary quality and functional beauty.

A specialized metal craft was the making of *kanagu* (metal fittings) for *tansu* (chests of drawers), cut from sheet iron with hammer and chisel, the sheet having been beaten from ingots (until sheet metal became available). *Kanagu* were intended to reinforce the wood at points of stress but were also marvellously decorative. The *kanaguya* (metal craftsmen) worked in close collaboration with the *hakoya* (boxmakers); in Matsumoto alone there were 60 *kanaguya* in the Meiji period.

Metal-casting was done by a different group of artisans, the *imonoshi* or *imoji*, who were specialized according to their products, such as temple paraphernalia, mirrors and kettles. The Nanbu region produced excellent *kama* (iron cauldrons), still found in old farmhouses, and the famous Nanbu *tetsubin* (iron kettles), which were used for *sencha*, an informal style of serving tea popularized in the late Edo and Meiji periods. Other metalwork centres were Yamagata, Seki, Sakai, Takefu, Takaoka and Kōchi; their products included locks, *jizaikagi* (adjusters for kettle hooks), *kiseru* (long tobacco pipes) and implements having to do with fire or lighting, such as ash rakes, tongs, oil lamps and candle-holders.

(ii) Bamboo and basketwork. The remarkable properties of bamboo—its strength, resilience, durability and lightness, and its long straight fibres that can be split to the thinness of thread—give it an extraordinary range of uses. Although its multiple architectural uses have been largely replaced by industrial material, numerous traditional bamboo products, such as baskets, lanterns, umbrellas, furniture, toys and utensils, in infinite variety are still part of Japanese everyday life. Bamboo work is carried on by artisans and home craftsmen in many parts of Japan. Kyushu, with more than a third of the nation's bamboo, sustains the greatest home industry. Uses depend on species, of which several hundred are grown in Japan.

Baskets and other woven articles have also been made from the woody vine of akebia (Jap. *akebi*; *Akebia quinata*), wild grape and wisteria vine, bark of cherry and birch, shaved wood, willow branches, wheat and rice straw, rush and paper cord. Beautiful and durable shoulder baskets for carrying lunch or tools were woven by woodsmen from cherry bark. Rice straw, abundant around farms, was put to many uses, such as making hats and sandals. In the colder areas it was bound and woven into sturdy snowboots and hoods. Straw raincapes (*mino*) and sun-capes were decorated with multicoloured yarn on the shoulders. In northern Japan backpads (*bandori*) were used to cushion heavy loads; those made for carrying bridal chests in wedding processions were fashioned with special care, interweaving colourful yarns, strips of fabric, vines and bark in endlessly imaginative designs. Straw was also used for ritual objects associated with popular religion. Straw work was a cold-season indoor activity for men, often done socially, with members of the community taking turns to host straw-work gatherings.

(iii) Kanban. The common meaning of *kanban* is a shop sign advertising a name, trade or service or an individual

product. *Kanban* can be traced to the markets of the Nara period, but it was the prosperous and competitive world of commerce in the mid-Edo period that spurred their extraordinary development. *Kanban* came to symbolize the honour and reputation of commercial establishments, and design and craftsmanship were lavished on eye-catching creations.

Most of the older *kanban* that have survived are of solid wood and metal, although those made of perishable materials such as paper on thin wood or bamboo frames were far more common in their time. Among the latter were *andon* (paper-covered lamps) with shop names or goods for sale written in bold calligraphy; cloth or rope *noren* (curtains) with dyed insignia were also common. As more durable *kanban* came into favour, they tended to be conventionalized according to the type of product or service. Giant models of a commodity were displayed by shops specializing in seals and stamps, tobacco pipes, combs, inkstones, abacuses, umbrellas, eye-glasses, brushes and musical instruments, to name a few. Many such speciality shops were owned by the artisans who made the product. Most of these *kanban* were of wood, in the round, incorporating metal parts and partially lacquered or painted. Other shop signs were wooden plaques with calligraphy or pictorial representations in low relief or painted. Most of these types of *kanban* were hung from the eaves (*nokikanban*) and usually taken down at closing time, although permanent horizontal *kanban* giving the shop name were mounted above the eaves. When shops began to diversify their merchandise, they often accumulated several different kinds of *kanban*, including those advertising particular medicines, tobacco or other brand-name products.

(iv) Paper artefacts. Because of its tensile strength, durability and pliancy, as well as its translucence and beauty of colour and texture, Japanese paper (*washi*) found manifold uses rivalling those of bamboo, with which it was often combined. Paper had been developed in many elegant forms serving the needs of the nobility, government or religious institutions for almost a thousand years before it became more widely available to the common people in the late Muromachi period (1333–1568; see §XVI, 18 below). By that time papermaking had spread throughout the country, and farmers engaged part-time in the laborious craft for extra income.

In the Edo period (1600–1868) the uses of *washi* multiplied, especially among commoners living in towns. Since *washi* both transmits and filters light, it was used in light-transmitting screens (*akari shōji*; now generally known as SHŌJI), in *andon* (paper-covered lamps) that were portable, free-standing or wall-mounted; and in *chōchin* (collapsible lanterns), made by papering over a thin filament of bamboo wound around a removable wooden frame. *Amagasa* (umbrellas), made of bamboo and paper waterproofed with perilla oil, developed in their folding form in the late 16th century, and production of *kasagami* (umbrella paper) spread throughout the country in the early Edo period.

The technique of papering over bamboo, wisteria or shaved-wood basketry and waterproofing with *shibu* (persimmon tannin) or lacquer was used in *nurigasa* (wide conical or dome-shaped hats), boxes and trays, among many other products.

Kamiko (paper kimonos) were made from *washi* softened by crushing and sizing. Once worn mainly by priests, *kamiko* spread to the common people in the Edo period and were favoured especially in the north where cotton was scarce. *Kamiko* made convenient nightwear for itinerants, domestics and the poor. From early times *washi* was used for ritual and votive objects and is still used for festival lanterns, fans, kites, stencils for dyeing and papier-mâché dolls.

In the modern era, traditional papermaking by hand was among the crafts most adversely affected by industrialization. In an effort to preserve the craft, the government has designated certain papermaking groups and individuals Important Intangible Cultural Assets. One such individual is Eishirō Abe (*b* 1902), known for his *ganpi* (*Wikstroemia sikokiana*) paper. Since the early 1930s, he has devoted much effort to the development of '*mingei*' paper. Of more than 50 communities still engaged in traditional papermaking, a few have joined the *mingei* movement.

BIBLIOGRAPHY

GENERAL

M. Yanagi, ed.: *Kōgei* [Crafts] (Tokyo, 1931–51)

Gekkan mingei [Mingei monthly], Nihon Mingei Kyōkai [Association of Japanese folk art] (Tokyo, 1939–42)

Mingei [Folk art], Nihon Mingei Kyōkai [Association of Japanese folk art] (Tokyo, 1942–4, 1946–8, 1955–88)

M. Yanagi, ed.: *Mingei zukan* [A harvest of folk crafts], 3 vols (Tokyo, 1960–63)

T. Endō and K. Miyamoto: *Nihon no mingu* [Japanese folk art and design], 4 vols (Tokyo, 1964–7)

M. Endō: *Nihon no shokunin* [Artisans of Japan] (Tokyo, 1965)

K. Shibusawa, ed.: *Emakimono ni yoru Nihon jōmin seikatsu ebiki* [Index of Japanese folk life according to picture scrolls], 5 vols (Tokyo, 1965–8)

M. Yoshida: *Nihon no shokunin zō* [Portraits of Japanese artisans] (Kyoto, 1966)

K. Muraoka and K. Okamura: *Mingei* [Folk art], Nihon no bijutsu [Arts of Japan], xxvi (Tokyo, 1967); Eng. trans. by D. S. Stegmaier as *Folk Arts and Crafts of Japan*, Heibonsha Surv. Jap. A., xxvi (New York and Tokyo, 1973)

K. Yanagita: *Teihon Yanagita Kunio shū* [Comprehensive works of Kunio Yanagita], 35 vols and index (Tokyo, 1968–71)

H. Tahara: 'Mingu' [Folk implements], *Nihon No Bijutsu*, lviii (1971) [whole issue]

H. Mizuo: 'Mingei' [Folk crafts], *Kindai no bijutsu* [Modern art], xi (Tokyo, 1972)

T. Sugimura and H. Suzuki: *Living Crafts of Okinawa* (New York, 1973)

Dewa Shōnai no mingu [Folk implements of Dewa Shōnai],Tsuruoka, Chidō Mus. cat. (Tokyo, 1973)

M. Yoshida: *Nihon no shokunin* [Artisans of Japan] (Tokyo, 1976)

V. Hauge and T. Hauge: *Folk Traditions in Japanese Art* (Tokyo, 1978)

Nihon no dentō: Hurashi no bi [Traditions of Japan: beauty in everyday life] (exh. cat. by H. Iwai and E. Fukuda, Kobe, Hyōgo Prefect. MOMA, 1979)

M. Yanagi: *Yanagi Muneyoshi zenshū* [Comprehensive works of Muneyoshi Yanagi], 20 vols (Tokyo, 1980–82)

H. Iwai and E. Fukuda, eds: *Mingei no bi: Dentō kōgei hakubutsukan* [The beauty of *mingei*: traditional crafts museums], Nihon no hakubutsukan [Japanese art museums], i (Tokyo, 1982)

Yō no bi: The Beauty of Japanese Folk Art (exh. cat. by W. J. Rathbun, Seattle, WA, A. Mus., 1983)

National Museum of Japanese History: English Guide (Sakura, 1989)

Mingei: Masterpieces of Japanese Folkcraft, Tokyo, Flk Crafts Mus. cat. (Tokyo, New York and London, 1991)

Japanese Folk Art: A Triumph of Simplicity (exh. cat. by E. von Erdberg and R. Moes, New York, Japan Soc., 1992)

PAINTING

M. Yanagi: *Ōtsue zuroku* [An illustrated catalogue of *Ōtsue*] (Tokyo, 1960)

Ko-ezu [Old picture maps] (exh. cat. by H. Kageyama and others, Kyoto, N. Mus., 1968)

H. Iwai and N. Kōyama: *Nihon no ema* [*Ema* of Japan] (Kyoto, 1970)

S. Katagiri, ed.: *Ōtsue* (Ōtsu, 1971)

T. Ono: 'Ōtsue kō' [On *Ōtsue*], *Kobijutsu*, xxxiii/3 (1971), pp. 46–66

T. Naniwada: 'Ko-ezu' [Old picture maps], *Nihon No Bijutsu*, lxxii (1972) [whole issue]

T. Kawada: 'Ema', *Nihon No Bijutsu*, xcii (1974) [whole issue]

J. Suzuki: *Ōtsue no bi* [The beauty of *Ōtsue*] (Tokyo, 1975)

R. Makino, K. Nishikubo and Y. Tone: *Nihon no funaema* [Ship *ema* of Japan] (Tokyo, 1977)

S. Katagiri and T. Ono: *Ōtsue: Kaidō ni umareta minga* [*Ōtsue*: folk painting born on the highway] (Tokyo, 1987)

T. Akai: 'The Common People and Painting', *Tokugawa Japan: The Social and Economic Antecedents of Modern Japan*, ed. C. Nakane and S. Oishi (Tokyo, 1990), pp. 167–91

M. Shimosaka: 'Sankei mandara' [Pilgrimage *maṇḍalas*], *Nihon No Bijutsu*, cccxxxi (1993) [whole issue]

SCULPTURE AND OTHER FIGURATIVE ARTS

T. Kuno: 'Natabori to mikansei zō' [*Natobori* and unfinished sculpture], *Bijutsu Kenkyū*, cciii (1959), pp. 212–24

——: 'Tachiki butsu ni tsuite' [On the 'standing-tree' style of Buddhist sculpture], *Bijutsu Kenkyū*, ccxvii (1961), pp. 43–58

——: 'Gyōjakei no chōkoku' [Non-ecclesiastic style of Japanese Buddhist sculpture], *Museum*, cxxx (1962), pp. 2–4

S. Gorai: *Bishō butsu: Mokujiki no shōgai* [The smiling Buddha: the life of Mokujiki] (Kyoto, 1966)

T. Hijikata: *Mokujiki no chōkoku* [Sculpture of Mokujiki] (Tokyo, 1966)

K. Tanahashi: *Mokujikibutsu* [Mokujiki Buddhas] (Tokyo, 1973)

M. Honma: *Enkū to Mokujiki* [Enkū and Mokujiki], Nihon no bijutsu [Arts of Japan], xxxv (Tokyo, 1974)

Y. Ikeda, ed.: *Bunraku no kashira* [*Bunraku* puppet heads] (Tokyo, 1974)

J. Morita: *Ishi no ko-botoke tachi* [Little stone images] (Tokyo, 1974)

T. Kuno: *Sekibutsu* [Buddhist stone sculpture], Nihon no bijutsu [Arts of Japan], xxxvi (Tokyo, 1975)

M. Shitō: *Iwate no shishi gashira* [Shishi heads of Iwate] (Kitakami, 1975)

G. F. Dotzenko: *Enkū: Master Carver* (Tokyo, 1976)

S. Honda: *Tōji no koma inu* [Ceramic *Koma inu*] (Tokyo, 1976)

K. Tanahashi: *Itan no hotoketachi* [The Buddhas of heresy] (Tokyo, 1977)

T. Yoshida and T. Kojima: *Shishi no heiya* [The plain of shishi] (Tokyo, 1977)

K. Tanahashi: *Enkū: Sculptor of a Thousand Buddhas* (Boulder, 1982)

B. Yoshida: 'Bunraku ningyō no kashira' [*Bunraku* puppet heads], *Gekkan Bunkazai*, ccxlvi (1984), pp. 24–9

CERAMICS

D. Rhodes: *Tamba Pottery* (Tokyo, 1970)

T. Katō, ed.: *Genshoku tōki daijiten* [Encyclopedia of ceramics in colour] (Kyoto, 1972)

H. Mizuo: *Minyō no tabi* [A tour of folk kilns] (Tokyo, 1972)

F. Koyama and others, eds: *Tōji taikei* [A comprehensive survey of ceramics], 48 vols (Tokyo, 1972–8) [see esp. vols vii, viii, ix, x, xiii, xvi, xix and xxvii]

S. Kikuta: *Seto no kotōji* [Old ceramics of Seto] (Kyoto, 1973)

W. Mizumachi: *Ko-garatsu* [Old Karatsu], 2 vols (Tokyo, 1973)

H. Umeki: *Onta yaki* [Onta ware] (Tokyo, 1973)

T. Nagatake: *Hizen tōji no keifu* [Lineage of Hizen ceramics] (Tokyo, 1974)

Y. Noma: *Naeshirogawa* (Tokyo, 1974)

S. Narazaki: *Seto Bizen Suzu*, Nihon no bijutsu [Arts of Japan], xxxiii (Tokyo, 1976)

Nihon tōji zenshū [Complete collection of Japanese ceramics], 30 vols (Tokyo, 1976–8) [see esp. vols vii, viii, ix, x, xi, xii, xvii and xxiii]

T. Nakanishi: *Ko-Tanba* [Old Tanba] (Tokyo, 1978)

L. A. Cort: *Shigaraki, Potters' Valley* (Tokyo, 1979)

T. Mitsuoka, S. Narazaki and S. Hayashiya, eds: *Nihon yakimono shūsei* [A selection of Japanese ceramics], 12 vols (Tokyo, 1980–82)

B. Moeran: *Lost Innocence: Folk Craft Potters of Onta, Japan* (Berkeley, 1984)

Nihon no tōji [Japanese ceramics] (exh. cat. by I. Akabane and others, Tokyo, N. Mus., 1985)

L. A. Cort: *Seto and Mino Ceramics: Japanese Collections in the Freer Gallery of Art* (Washington, DC, 1992)

Yashu no bi: Ko-garatsu no nagare: Momoyama kara Edo [Rustic beauty: the lineage of old Karatsu: Momoyama to Edo] (exh. cat. by

S. Hayashiya and T. Nakazato, Tokyo; Osaka; Fukuoka; and elsewhere; 1993)

TEXTILES

Textile Designs of Japan, Japan Textile Color Design Center, 3 vols (Osaka, 1959–61)

H. Oda: *E-gasuri* [Picture ikats] (Tokyo, 1966)

T. Yamanobe: 'Some' [Dyeing], *Nihon No Bijutsu*, vii (1966) [whole issue]

S. Kodama: *Ainu fukushoku no chōsa* [A survey of Ainu apparel] (Hokkaido, 1968)

Y. Tsunoyama: *Nihon senshoku hattatsushi* [A history of the development of Japanese textiles] (Tokyo, 1968)

S. Gotō: *Mingei tsutsugaki* [*Mingei* free-hand resist dyeing] (Kyoto, 1969)

T. Yamanobe: *Shima* [Stripes], Nihon no senshoku geijutsu sōsho [Japanese textile art series] (Kyoto, 1970)

S. Fukui: *Zusetsu Nihon no kasuri bunkashi* [An illustrated cultural history of Japanese ikat] (Kyoto, 1973)

H. Oda and others: *Aizome no kasuri* [Indigo-dyed ikat] (1974), vi of *Senshoku to seikatsu* [Textiles and living] (Kyoto, 1974–7), pp. 10–75

T. Yamanobe: *Kasuri* [Ikat], Nihon no senshoku geijutsu sōsho [Japanese textile art series] (Kyoto, 1974)

R. Uemura and others: *Ryūkyū no dentō orimono* [Traditional textiles of Ryūkyū], iv of *Senshoku to seikatsu* [Textiles and living] (Kyoto, 1974–7), pp. 5–91

J. L. Larsen: *The Dyer's Art: Ikat, Batik, Plangi* (New York, 1976)

T. Tanaka and R. Tanaka: *Okinawa orimono no kenkyū* [A study of Okinawa woven textiles], 2 vols (Kyoto, 1976)

H. Itakura and others, eds: *Genshoku senshoku daijiten* [Encyclopaedia of textiles in colour] (Kyoto, 1977)

E. Kamiya: *Katazome* [Stencil dyeing], Nihon no senshoku geijutsu sōsho [Japanese textile art series] (Kyoto, 1977)

C. Tanaka: *Nanbu tsuzure hishizashi moyōshū* [A collection of *Nanbu* diamond pattern embroidery designs] (Aomori, 1977)

C. Tanaka and others: *Tsugaru kogin, Nanbu hishizashi*, xvi of *Senshoku to seikatsu* [Textiles and living] (Kyoto, 1977), pp. 1–58

A. Tonaki: *Kijoka no bashōfu* [Banana cloth of Kijoka], Ningen Kokuhō Shirīzu [Living National Treasures series], xxxi (Tokyo, 1977)

M. Dusenbury: 'Kasuri: A Japanese Textile', *Textile Mus. J.*, xvii (1978), pp. 41–64

T. Mori and others: *Ise Shin meishoe utaawase, Tōhokuin shokunin utaawase emaki, Tsurugaoka hōjō shokunin utaawase emaki, Sanjūniban shokunin utaawase emaki* [Scrolls of the new poetry contest of the famous views of Ise, poetry contest of the pictures of Tsurugaoka and poetry contest among persons of various occupations in 32 rounds] (1978), xxviii of *Shinshū Nihon emakimono zenshū* [New edition of the complete collection of Japanese picture scrolls], ed. I. Tanaka (Tokyo, 1975–8)

M. Kodama: 'Kita no kōgei: Ainu, Gilyak no mokuchō to ifuku' [Crafts of the north: apparel and woodwork of the Ainu and Gilyak], *Gekkan Bunkazai*, ccix (1981), pp. 34–40, 54

E. Nakano and B. B. Stephan: *Japanese Stencil Dyeing* (New York and Tokyo, 1982)

Y. Wada, M. K. Rice and J. Barton: *Shibori: The Inventive Art of Japanese Shaped Resist Dyeing* (New York and Tokyo, 1983)

Country Textiles of Japan: The Art of Tsutsugaki (exh. cat. by R. M. Brandon, Honolulu, HI, Acad. A., 1986)

Y. Sachio, ed.: *Japanese Folk Textiles: An American Collection* (Tokyo, 1988)

Beyond the Tanabata Bridge: Traditional Japanese Textiles (exh. cat., ed. W. J. Rathbun; Washington, DC, Textile Mus.; Birmingham, AL, Mus. A.; Seattle, WA, A. Mus.; 1993–4)

WOOD AND LACQUERWARE

G. Sawaguchi: *Nihon shikkō no kenkyū* [Study of Japanese lacquer] (Tokyo, 1966)

H. Sugimoto: *Kijiya* [Woodworkers] (Tokyo, 1973)

T. Morita: *Ki no ko-mingei* [Old *mingei* in wood] (Tokyo, 1975)

T. Kawada: 'Negoro-nuri' [Negoro lacquerware], *Nihon No Bijutsu*, cxx (1976) [whole issue]

H. Arakawa: *Negoro to urushie* [Negoro and painted lacquer] (1979), v of *Nihon no shitsugei* [Lacquer art of Japan], ed. J. Okada, G. Matsuda and H. Arakawa (Tokyo, 1978–9)

——: 'Urushi to urushie' [Lacquer and painted lacquer], *Nihon No Bijutsu*, clxiii (1979) [whole issue]

N. Suzuki: 'Shikkō (Chūsei-hen)' [Lacquer (medieval)], *Nihon No Bijutsu*, ccxxx (1985) [whole issue]

H. Yamagishi: *Urushi: Nurimono fudoki* [Lacquer: a regional study], 2 vols (Tokyo, 1985)

FURNITURE

M. Yanagi: *Funadansu* [Ship chests] (1974), iii of *Yanagi Muneyoshi shū* [The Yanagi Muneyoshi collection] (Tokyo, 1974)

K. Koizumi: *Wakagu* [Japanese furniture], Nihon no bijutsu [Arts of Japan] (Tokyo, 1977)

Wadansu [Japanese chests], Tonami Wadansu Kenkyūkai [Tonami research association of Japanese chests] (Toyama, 1978)

T. Heineken and K. Heineken: *Tansu: Traditional Japanese Cabinetry* (Tokyo, 1981)

OTHER CRAFTS

B. Jugaku: *Papermaking by Hand in Japan* (Tokyo, 1959)

E. Abe: *Kamisuki gojunen* [Fifty years of papermaking] (Tokyo, 1963)

T. Sugawara, T. Kusayanagi and Y. Maeda: 'Kinkō' [Metalwork], Nihon no kōgei [Japanese crafts], iii (Kyoto, 1966)

R. Austin, D. Levy and K. Ueda: *Bamboo* (Tokyo, 1972)

S. Sato: *Zusetsu take kōgei: Take kara kōgeihin made* [Bamboo crafts, illustrated: from bamboo to craft object](Tokyo, 1974)

S. Tsuboi: *Kōshō gigei: Kanban-kō* [Kanban: a craft for industry and commerce], Tsuboi Shōgorō shū [Collected works of Shōgoru Tsuboi], Nihon kōkogaku senshū [Anthology of Japanese archaeology], ed. C. Serizawa and others, ii, iii (Tokyo, 1975), pp. 260–88

T. Sugimura, T. Hayashiya and M. Yoshida: *Nihon no tetsu* [Iron in Japan] (Tokyo, 1975)

B. Jugaku: *Washi rakuyō shō* [Stray notes on Japanese paper] (Tokyo, 1976)

H. Takizawa: *Tōkaki hyakushu kyakuwa* [One hundred lamps] (Tokyo, 1976)

T. Akioka: *Nihonjin no tedōgu* [Japanese hand tools] (Osaka, 1977)

Y. Hayashi: *Edo kanban zufu* [Album of shop signs of Edo] (Tokyo, 1977)

S. Hughes: *Washi: The World of Japanese Paper* (Tokyo, 1978)

K. Kudō: *Japanese Bamboo Baskets* (Tokyo, 1980)

S. Yagihashi: *Washi: Fūdo, rekishi, gihō* [Japanese paper: environment, history, technique] (Tokyo, 1981)

Y. Kume: *Washi seikatsushi* [History of Japanese paper in living] (Tokyo, 1982)

J. Lowe: *Japanese Crafts* (London, 1983)

Kanban: Shop Signs of Japan (exh. cat. by F. Gibney and L. Sneider, New York, Japan House Gal., 1983)

M. Hirose: *Kami no mingu* [Paper folk implements] (Tokyo, 1985)

VICTOR HAUGE, TAKAKO HAUGE

XVI. Other arts.

The subjects discussed in this section reflect modern art-historical classification systems that were not recognized in pre-modern Japan (*see* §I, 5 above). The art forms are therefore not necessarily considered as such in Japan, but their inclusion conforms largely with comparable sections elsewhere in the *Dictionary of Art*.

1. Arms and armour. 2. Bamboo and basketwork. 3. Bonsai. 4. Brush. 5. Coins. 6. Dolls. 7. Dress. 8. Enamels. 9. Flower arrangement. 10. Food. 11. Furniture. 12. Glass. 13. Inkstone and inkstick. 14. Kites. 15. Masks. 16. Musical instruments. 17. *Netsuke*. 18. Paper. 19. Puppets. 20. Seals. 21. Tattoos.

1. ARMS AND ARMOUR. Japanese militaria (*bugu*) include offensive and defensive body armour, edged weapons, archery equipment and horse trappings; specifically, the term covers helmets and body armour (*katchū* or *yoroi kabuto*) and weapons (*buki*). These were originally made for practical purposes but in time came to be appreciated for their decorative and ritual qualities as well. Many of the surviving pre-modern arms and armour are preserved in the Shinto shrines to which they were donated upon the death of their owners.

(i) Before AD 710. (ii) Nara (710–94) and Heian (794–1185) periods. (iii) Kamakura period (1185–1333). (iv) Muromachi period (1333–1568). (v) Momoyama period (1568–1600). (vi) Edo period (1600–1868). (vii) Modern period (after 1868).

(i) Before AD *710.* In the Jōmon period (*c.* 10,000–*c.* 300 BC) hand-held lithics and triangular points were used for hunting. Distinct weapons such as large, flat, double-edged socketed spearheads (*dōhoko*), non-socketed halberds with perforations for lashing to a pole (*dōka*) and straight pommelled swords (*dōken*) appeared with the introduction of bronze-casting technology from the continent during the Yayoi period (*c.* 300 BC–*c.* AD 300; *see* §XII, 2(i) above). In the Kofun period (*c.* AD 300–710) burial mound (*kofun*) funerary goods show changes in weapon types and material. In the 4th century AD arrowheads, straight swords and simple round stirrups made of iron appeared. In the 5th century warriors favoured heavy, flexible cuirasses made of small plates of iron tied together and extending over the hips (*keikō*) or shorter, inflexible torso coverings constructed of large, riveted iron plates (*tankō*). There were also matching helmets with flat, crescent-shaped visors and cup-shaped ornaments (*mabisashitsuki*) or prominent front crowns and short visors (*shokakutsuki*). Actual examples of these two styles of iron body armour exist, as do large terracotta sculptural representations (*haniwa*) from 6th-century tombs in Saitama Prefecture (Tokyo, N. Mus.; *see* §V, 2 above). A terracotta image of a horse shows bridle pieces, decorative bits, bells and round stirrups of a type similar to actual examples (Tokyo, N. Mus.). Iron swords composed of a series of upward-pointing rods on a straight, central wand damascened with gold Chinese characters have been found in tombs in Nara and Kumamoto prefectures. The distinctive feature of late Kofun-period tumuli are cast-gilt copper objects, including cup-shaped stirrups (*tsubō abumi*), bridle and bit fastenings (*sei bagu*) and filigree saddle parts, all of which show continental influence.

(ii) Nara (710–94) and Heian (794–1185) periods. The distinctive Japanese sword began to appear in the 8th century with the development of steel. Control of carbon content enabled the Japanese to forge colour and texture into blades, bevel the edges and angle the points, differentiating them from continental swords. During the 9th and 10th centuries, improvements in steel technology led swordmakers to lengthen and curve blades and to add ridge lines to both sides. The new blade (*tachi*) tapered from point to hilt, the latter being set at an oblique angle. These swords were worn cutting edge down on the warrior's left. Steel halberds (*naginata*) and steel daggers (*tantō*) also appeared. Halberd blades were as wide and long as a *tachi* but had greater curve and were mounted on a pole approximately 1–2 m long. Examples of the short *tantō*, used for close combat, are extremely rare.

Although Japanese warriors in this period used swords, they were primarily mounted archers. They used bows (*yumi*) that were short (1.8–2.1 m) but strong, constructed of a wood core between two layers of bamboo and bound with rattan (*fusetake no yumi*). Arrows ranged from 480 mm to 910 mm and included such specialized types as the 'turnip-shaped arrow' (*kabura ya*) used for signalling and setting fires. New steel points ranged from short ones, triangular in cross-section, to highly decorative blades with pierced designs of cherry blossoms and Chinese characters. Quivers (*ebira*) were squarish wooden boxes with back braces and slatted openings on top, the bottom section covered in leather or bear fur decorated with fireflies with spread wings (*tonbo*), a symbol of valour. Heian-period

216. Japanese suit of armour with tassets (*dōmaru*), silk, leather, gold and copper, late 14th century (London, Victoria and Albert Museum)

warriors also appear in paintings wearing a cloth-covered, slatted arrow trap (*horo*) on their backs. Crossbows from the period survive but are all of Chinese manufacture, and they never played a prominent role in Japan.

Two new kinds of Japanese saddle (*wagura*) appeared: the robust war saddle with finger grips on either side of the pommel (*gunjigura*) and a thinner type (*suigangura*). Both kinds and their related horse trappings (*bagu*) were decorated with lacquer and shell inlays, the patterns matching the stirrups, which artisans had reshaped from the bronze cup stirrup of the Kofun period into the long-sole iron stirrup (*naga abumi*). Large leather pads (*aori*) protected the horse's belly from the stirrups, and a thick, two-layered pad (*hada kiritsuki*) protected it from the saddle.

The new steel weapons and more powerful bows required a new type of armour, the Great Harness (*Ōyoroi*), derived from the *keikō* cuirass. The Great Harness cuirass was a large box with front, back and left panels of leather, with the right side protected by a separate rib protector (*wakiita*) to increase freedom of movement. The panels bear stencilled images of esoteric Buddhist deities, such as Fudō Myōō or the Five Kings of Brightness (Godai Myōō), patrons of warriors. Four panels (*kusazuri*), each composed of tiers of leather plates tightly bound with bright silk lacing (*ito odoshi*) or leather thongs, formed the skirt. A small upper chest plate on the right (*sendan no ita*) and another on the left (*kyubi no ita*) provided mobility while protecting. Over-sized shoulder-guards (*osode*) of

tightly laced leather were tied on to the back of the cuirass with cords formed into a firefly-shaped bow (*agemaki*). Matched helmets had crowns of multiple overlapping plates secured with large exposed rivets (*hoshi*) and steeply pitched visors. Matching neck guards (*shikoro*) extended on either side of the face, forming blowbacks (*fukigaeshi*). These helmets had large, two-pronged ornaments called hoe shapes (*kuwagata*), which actually represented antlers. Warriors wore these unlined helmets over a soft cap (*eboshi*) tied on with a white headband (*hachimaki*). Fabric sleeves (*kote*), later highly decorated with chainmail and metalwork, brocade undershirts and skirts (*hitatare*), hammered and hinged iron greaves with raised knee caps and bear-fur or straw footwear (*waraji*) worn over split-toed socks (*tabi*) of leather completed the ensemble. Lower ranks wore a simple, one-piece suit with tassets (*dōmaru*; see fig. 216 for a late 14th-century example) or a breastplate without tassets (*haramaki*).

(iii) Kamakura period (1185–1333). The development of the first military government by the Minamoto clan after the Genpei Wars (1180–85) and their subsequent victory over the Mongol invaders transformed armour from battle gear into ceremonial objects. The best source of information for the armour of the early part of this period is the *Mōko shūrai ekotoba* ('Illustrated scrolls of the Mongol invasions'; 1293; Tokyo, Imp. Household Col.), commissioned by Takezaki Suenaga (*b* 1246). Actual examples of armour of this time include the elaborate 'red suit', the Great Harness and helmet in the Kushibiki Hachimangū Shrine (Aomori Prefect.) and other National Treasures in the Hachimangū (Kamakura, Kanagawa Prefect.) and Kasuga Taisha (Nara).

As different forms of mounted target practice (*yabusame* and *tanren*, also *kasagake*) and dog hunting (*inuomono*) developed, layered and lacquered rattan-wrapped bows with off-centre grips appeared. Falconry with its equipment became popular as well. New schools of swordsmiths made longer and heavier blades (some up to 1.5 m long) of higher quality with elaborate mountings (*koshirae*). Most swords that are now classed as National Treasures date from the Kamakura period.

(iv) Muromachi period (1333–1568). During this period arms reverted from ceremonial objects to implements of war, not ceremony; increased warfare and arms production necessitated simplification. Mounted archers now wore *dōmaru*-type armour, but kept their Great Harness shoulder-guards. Helmets (*hagi awase suji kabuto*) were made of a maximum of 32 ridged plates without exposed rivets, the ridges encased in gilt copper (*fukurin*) and the crown decorated with long, flat, gilt arrows (*shinotare*). The size of frontal horns (*kuwagata*), their brackets and the crown opening (*tehen*) were reduced. A new horsehoof-shaped visor (*koma mabisashi*) accommodated a rudimentary iron cheek and forehead protector (*hanburi*).

Eventually, halberd-wielding foot-soldiers dominated the battlefield. Halberd blades were made to a maximum of 820 mm, taking either the 'cormorant's neck' (*uno no kubi tsukuri*) or 'drooping crown' (*kanmuri otoshi*) shapes. Armour was made with half the previous number of plates by using a new double-plate (*iyo kozane*), and it fitted

better at the waist. More complex lacing composed of eight strands appeared. Examples of such armour can be found in the Ichinomiya Oyama Shrine (Ehime Prefect.). The tassets of the Great Harness began to be detached and suspended by cords from the lower edge of the cuirass.

The incessant warfare of the 15th and 16th centuries led daimyo to increase the size of their armies, necessitating more equipment, which in turn required faster production. Furthermore, the introduction of European technology after the arrival of the Portuguese in 1542 provoked dramatic changes in Japanese military hardware. Helmets changed to a new pumpkin shape (*acoda*) made of 12 to 32 plates, with fewer crown ornaments (*shinotare*) and smaller blowbacks. Only the neck guard remained large and round. The chest plate on the cuirass changed in shape to the form of a ginkgo leaf (*gyōyō*). Leather decorated with floral prints in browns and reds stencilled on a pale ground (*shōheigawa*) replaced metalwork and lacquering on the visor, blowbacks and upper plate of the shoulder-guards. The name *shōheigawa* originates from the Chinese characters for the Shōhei era (1346–68), which were included as part of the stencil design, but this does not mean that armour using this design was necessarily made in the 14th century. A thin, indigo-dyed deer hide stencilled with white iris designs (*shōbugawa*; also called *kozakuragawa* when stencilled with cherry blossoms) also appeared. A lower jaw cover with movable nose (*me no shita hoate*) and a separate tiered and laced throat guard (*nodowa*) replaced the earlier forehead and cheek cover (*hanburi*).

Sword production increased but quality declined, except for blades made in Bizen Province (Okayama Prefect.) before 1450. Dismounted fighting required drawing and completing a stroke in one continuous motion, resulting in the creation of the *katana*. *Katana* blades are shorter than *tachi* blades and are worn vertically with the cutting edge up. A companion blade, always shorter and usually about 600 mm long, called a *wakizashi*, was also worn cutting edge up. The pair became known as 'large and small' (*daishō*), the symbol of the warrior until the end of the Edo period (1600–1868).

Foot-soldiers' spears (*yari*) had blades of various lengths and shapes mounted on 4 m-long bamboo or evergreen oak (*kashi*) poles. Halberd blades averaged 600 mm in length and were mounted on red lacquered oak poles up to 2.7 m long. A *katana* blade mounted on a short pole (*nagamaki*) also appeared.

Other Muromachi-period arms include a lightweight quiver (*utsubo*), an enclosed pear-shaped wooden box with a long upper bulge made of lacquered papier-mâché (*hariko*) or bamboo, sometimes decorated with fur or leather as waterproofing. Archers continued to use the rattan-wrapped compound bow and also had a smaller version about 300 mm long for seated use.

The second stage in the development of arms in this period began with the arrival of the Portuguese (*nanban*; 'southern barbarians') and the introduction of the matchlock musket (*tanegashima*). The Kunitomo family in Nagahama (Shiga Prefect.) and others in the port city of Sakai (now Osaka) produced matchlocks that changed the nature of battle and, therefore, of armour. Armour had to be strong enough to ward off musket balls yet remain light enough for long-distance travel.

Daimyo began to adopt the highly individualized *kawari kabuto* ('spectacular helmet') with its fantastic shapes. Although spectacular in appearance, the helmet itself consisted of a simple, round, close-fitting bowl with an integral curved visor (*zunari kabuto*). This helmet could be worn alone or as the basis for the more elaborate designs executed in leather, iron, fur or lacquered papier-mâché.

One traditional form of helmet also survived but made with an average of 62 plates. This helmet had a horsehoof-shaped visor, smaller blowbacks and, in place of the horns (*kuwagata*), various ornaments (*maedate*) in forms taken from nature and legend. The neck guard (*shikoro*) shrank in closer to the head as the oversized shoulder-guards were replaced by smaller versions (*kosode*) or omitted. The most popular type of neck guard was one that sloped off the shoulders (*hineno*).

Tōsei gusoku ('modern armour') developed from a combination of European and Japanese components and consisted of a helmet, face mask, a two- to five-plate cuirass that opened on the left side (*domaro*), sleeves (*kote*), and a new apron-like thigh guard (*haidate*) of chainmail and/or small plates and greaves (*suneate*). *Tōsei gusoku* was mostly of metal or leather with very little lacing (this, when present, was usually in pairs; *sugake ito odoshi*). Many cuirasses incorporated an interior cushion attached to a reinforced collar (*eri mawashi*) and epaulettes (*kohire*) to reduce the discomfort caused by wearing a small flag (*hata, gunki*) on a pole thrust into a bracketing system (*sashigane*) attached to the back. Some early *tōsei gusoku*, for example that of Tokugawa Ieyasu (1543–1616), used pigeon-breasted cuirasses with Japanese additions (Nikkō, Tōshōgū Col.).

Battle flags and other insignia developed late in the Muromachi period. Three types existed: long banners (*nobori hata*), such as the 'two-storey' *furin kazan* ('wind-forest-fire-mountain') flag of Takeda Shingen (1521–73); the equally tall horse banner (*uma jirushi*), with its fanciful shapes and unusual materials; and the small square flag (*gunki*) used alone or on armour. Daimyo also increased the use of house crests (*mon*).

(v) Momoyama period (1568–1600). Daimyo began to commission European-style arms and armour from native craftsmen and to use European motifs in their family crests (*mon*), horse trappings and armour. The Japanese made their own versions of the European cuirass (*wasei nanbandō*) and by turning around the peach-shaped helmet (*momo kabuto*) made it resemble the Iberian morion. Warlords competed with each other not only on the battlefield but also in the commissioning of increasingly unusual armour. According to legend, Tokugawa Ieyasu ordered his black-lacquer cushion-shaped helmet and small-plate armour (*iyo kazane tōsei gusoku*), now in the Kunozan Tōshōgū Shrine (Shizuoka Prefect.), after they appeared to him in a dream. The daimyo Date Masamune (1567–1636) based his black-lacquered straight-sided five-plate suits (Sendai, Miyagi Prefect., Mus. A.) on designs in the tradition of the Yukinoshita family of armourers after he lured armour-makers to his castle town of Sendai from Kamakura. Another unusual style of armour unique to the Momoyama period was the two-plate cuirass hammered

into the shape of a naked male torso. This armour was worn with a bear-fur-covered helmet (*niō dō gusoku*; Tokyo, N. Mus.). Such repoussé armour was sometimes made to appear as if the warrior was exposing one shoulder out of a laced cuirass (*kata nugi gusoku*; Tokyo, N. Mus.). Daimyo also began to wear surcoats (*jinbaori*) based on European clothing.

After 1568 the New Sword (*Shintō*) appeared, against which all earlier blades are called Old Swords (*Kotō*). Metalsmiths experimented with different kinds of domestic and imported iron ores and with reworking scrap metals, perfected hammering and tempering, and produced a New Sword blade that was lighter in colour than Old Sword blades and had a well-defined edge pattern (*hamon*).

(vi) Edo period (1600–1868). During this period the ceremonial function of arms and armour revived. Although the country was at peace, the ruling military élite required arms and armour as outward symbols of rank (*omote dōgu*) and patronized nine major schools of armourers (Myōchin, Saotome, Haruta, Iwai, Yukinoshita, Bamen, Nio, Ichiguchi and Nakasone), in addition to many independent artisans. Some of these hereditary lines of armourers had been patronized earlier by the Ashikaga shoguns. There were 11 configurations of *tōsei gusoku* and several forms of the Great Harness. Some armourers continued to make spectacular helmets, but others made older forms, now sometimes worn with a full face mask. Low-ranking warriors wore foot-soldiers' helmets (*jingasa*) of iron or lacquered papier-mâché. By the mid-Edo period, however, armour was so eclectic that books explaining how to wear and display armour appeared, such as Arai Hakuseki's (1657–1725) *Honchō gunkikō* ('Treatise on our country's implements of war'; *c.* 1704–8), and others including *Senki yōryaku* ('Outline of arms use'; 1735), *Buki kōshō* ('Investigation of weapons'; 1779), the *Gunyōki* ('Account of military use'; 1761) and *Buki sode kagami* ('Reflections on arms'; 1840).

Warriors displayed or wore their armour on special occasions but wore their swords daily. Sword guards (*tsuba*) and other metal fittings were ornately decorated in gold, silver and lacquer. Eventually, wealthy merchants in Osaka began to wear a single short sword (*wakizashi*), which was required to be less than 600 mm in length to distinguish it from the weapons of the warriors. Blades made from 1800 to the end of the Edo period are called New New Blades (*Shinshintō*). In such swords smiths tried but failed to recreate the form of the old blades (*Kotō*).

Edo-period pole arms included many spears and halberds. One distinctive spearhead shape was the cross (*jūmonji*). The shogunate assigned specific spearheads to each warrior house, to be mounted on extremely long poles of 2 m or more and to be used as a means of identification (*mochiyari*). These were registered along with family crests in books (*bukan*). Police used three pole arms (*mitsu dōgu*): the long, T-shaped rake (*tsugubō*), the smaller sleeve tangler (*sodegarumi*) and the two-pronged pitchfork (*sasumata*).

The military class practised archery and horsemanship as prescribed by the *Buke Shohatto* ('Laws for military houses'). Edo-period bows were long, compound and had off-centre grips. All past arrow types were made and displayed in special racks along with box-shaped and pear-shaped quivers. Specially decorated pads and saddles with flamboyant decorations called horse towers (*uma tō*) played major roles in local festivals. Important saddle-makers from Ise Province (now Mie Prefect.) created highly decorative works in gold lacquer (*makie*; *see* §XI above), high-relief lacquer (*takaniku makie*) and shell inlay (*raden*) for use in ceremonial processions, ritual hunts (*makigari*) or as part of their function as police (*uma mawashi*). The long stirrups (*nagaabumi*) now had an iron frame with wooden-slat insoles that were either lacquered or inlaid with mother-of-pearl. Stirrups either matched a companion saddle or were made for presentation. Stirrup designs reflected regional differences, and the three major schools of stirrup design were in Kaga (now Ishikawa Prefect.), Nagoya and Kyoto. Kaga stirrups were bold in form, those of Nagoya sedate, conservative and with distinctive shoulders, and Kyoto types were delicate and flowery. The Kaga and Nagoya styles derived from the Kyoto style.

(vii) Modern period (after 1868). In the 1870s the government abolished the samurai class. Traditional arms and armour gave way to European uniforms. Many impoverished former warriors sold their swords to foreigners. During World War II, officers wore machine-made dress swords based on European designs but without any of the qualities of past blades. After the war the Occupation authorities ordered all Japanese swords to be destroyed, but Provost Marshal Colonel Victor Caldwell of the Eighth Army modified the order so that it applied mainly to the modern swords made for the war. Many old swords were nonetheless destroyed or removed from Japan as souvenirs. Renewed interest in Japanese swords as art objects led to the foundation of the Sword Museum (Tokyo) and the Japan Society for the Research and Preservation of Arms and Armour (Tokyo, Shinjuku).

BIBLIOGRAPHY

J. Conder: 'History of Japanese Costume II: Armour', *Trans. Asiat. Soc. Japan*, ix (1881), pp. 254–80
M. Garbutt: 'Japanese Armour from the Inside', *Trans. & Proc. Japan Soc., London*, xi (1914), pp. 134–85
H. Yamagami: *Shin nihon katchū no kenkyū* [New study of Japanese arms and armour], 2 vols (Tokyo, 1928)
G. Stone: *A Glossary of the Construction, Decoration and Use of Arms and Armour* (New York, 1961)
H. Robinson: *Oriental Armour* (London, 1967)
——: *Japanese Arms and Armour* (New York, 1969)
S. Komatsu, ed.: *Heiji monogatari emaki/Mōko ekotoba shūrai* [The tale of Heiji and the Mongol invasion], *Nihon emakimono zenshū* [Complete collection of Japanese handscrolls], ix (Tokyo, 1969)
K. Satō and O. Motoharu: *Katchū to tōken* [Armour and swords], Genshoku nihon no bijutsu [Japanese art in colour], xxi (Tokyo, 1970)
K. Iida: *Yari naginata nyūmon* [Introduction of Japanese spears and halberds] (Tokyo, 1973)
Nihon no buki bugu [Japanese arms and armour] (exh. cat., Tokyo, N. Mus., 1976)
Nippontō: Art Swords of Japan, the Walter A. Compton Collection (exh. cat., ed. W. Compton and others; New York, Japan House Gal., 1976) [cat. of the finest col. of swords outside Japan]
K. Homma and K. Satō, eds: *Shinpan Nippontō kōza* [New course in Japanese swords] (Tokyo, 1978)
K. Yoshikawa, ed.: *Koji ruien, heiji bu* [Miscellany of ancient matters, military] (Tokyo, 1979)
The Shogun Age Exhibition (exh. cat. by T. Satō, T. Koike and others, Nagoya, Tokugawa A. Mus., 1983)
S. V. Grancsay: *Arms and Armor* (New York, 1986)

K. Kaneda-Chapplear: *Japanese Armour Makers for the Samurai* (Tokyo, 1987)
Y. Shimizu, ed.: *Japan: The Shaping of Daimyo Culture, 1185–1868* (Washington, DC, 1988)
Y. Sasama: *Zūroku Nihon no katchū bugu jiten* [Illustrated dictionary of Japanese arms and armour] (Tokyo, 1989)

TERRY HIENER

2. BAMBOO AND BASKETWORK. Since prehistoric times, BAMBOO has been one of the most versatile and ubiquitous of materials in Japan for the making of objects, from simple utilitarian devices to carefully crafted articles esteemed as artistic creations, and it has long occupied an important place in Japanese daily and ritual life. Bamboo is one of the three plants displayed on felicitous occasions to bring good fortune. It is commonly used for baskets, weapons, toys, musical instruments, notably flutes (*see* §16 below), tools, combs, tea ceremony utensils, furniture, window blinds and curtains (*sudare*, for dividing inner from outer rooms), architectural elements, *netsuke* (*see* §17 below) and paraphernalia for the scholar's studio (including brush handles and brush pots). Bamboo wares and baskets are often associated wholly with the folk tradition (*see* §XV, 7(ii) above), but this is an inaccurate notion arising out of modern Western definitions of art, in particular distinctions between 'fine' and 'applied' arts. Although most closely associated with bamboo, baskets have been made from other materials, including cane, wisteria vine and leather strips. They are divided into two categories: rough (*kago*) and fine (*zaro*) weave.

The earliest known Japanese bamboo crafts are baskets, made of woven strips of bamboo covered with lacquer, which date from the later part of the Jōmon period (*c.* 2500–*c.* 300 BC). As early as the Nara period (AD 710–94), bamboo was used to make diverse articles, such as baskets (used to hold flowers during religious ceremonies), gaming boards, wrappers for sacred texts (Skt *sūtra*s), writing implements, musical instruments and furniture, examples of which have been preserved in the Shōsōin imperial repository at Tōdaiji, Nara.

The artistic significance of bamboo increased dramatically in the Momoyama period (1568–1600), when consciously rustic bamboo items in native taste (*wagumi*) came to serve as indispensable elements in defining the tea ceremony's ideal of beauty (*wabi*; *see also* §XIV, 2 and 3 above). Bamboo was used in the architecture of the tearoom, for balcony rails, interior panelling and other fixtures, and for fences and gates in the garden. Essential tea-ceremony utensils made from bamboo include long, slender and tiny tea scoops (*chashaku*) for small pinches of powdered tea, which were carved by the tea masters themselves, and tea whisks (*chasen*). The tea master Sen no Rikyū is credited with designing the first *sō*-style (informal) flower container (*hanaire*) made from a single joint of bamboo (*see* SEN NO RIKYŪ, fig. 2). Bamboo also began to be fashioned into coarsely woven baskets (based on those used by fishermen and farmers) for use as flower containers (*hanakago*) in the alcove (*tokonoma*) of the tearoom (*see also* §9 below).

During the Edo period (1600–1868), alongside the continued refinement of bamboo and basketwork of the *wagumi* type, there was also a strong interest in *Karamono* (Chinese-style) crafts and wares. Bamboo was prized for its associations with the literati of China, who considered it symbolic of resilience and strength in the face of adversity, being capable of bending without breaking, and who used it both as a material for crafts and as a subject for paintings. Bamboo crafts became closely associated with a newly created tea ceremony called *sencha* (infused tea), which was first popular among Sinophile scholars. Originally, Chinese utensils and imported furniture were used at *sencha* gatherings, but by the early 19th century Japanese craftsmen had become adept at copying Chinese styles of the Ming (1368–1644) and Qing (1644–1911) periods. Important bamboo crafts for *sencha* include picnic baskets (*teiran*) of lacquered and woven bamboo, tea scoops for leaf tea (*chago*) in the shape of Chinese scholars' wristrests, elaborately woven baskets for flower arrangements, hearth screens (*robyō*) and free-standing shelves (*tana*) to hold the serving utensils. The unprecedented popularity of *sencha* throughout the 19th century helped fuel the modern interest in bamboo arts, especially basketwork, and it is because of the influence of *sencha* that basketmakers first began signing their work. Baskets in both *wagumi* and *Karamono* styles and other bamboo objects continue to be made, including bamboo bird and insect cages. The leading modern bamboo craftsman was Shōunsai Shōno (1904–74), designated a Living National Treasure in 1967.

BIBLIOGRAPHY
H. Ikeda: *Take no shugei* [Bamboo craft] (Tokyo, 1965)
F. Ryōichi: 'Chadogu' [Tea ceremony utensils], *Nihon No Bijutsu*, xxii (1968) [whole issue]; Eng. trans. by L.A. Cort as *Tea Ceremony Utensils* (New York and Tokyo, 1973)
B. Hickman: *Japanese Craft Materials and their Application* (London, 1977)
K. Kudo: *Japanese Bamboo Baskets* (Tokyo and New York, 1980)
Take no kōgei: Kindai ni okeru tenkai [The craft of bamboo: developments in the modern era] (exh. cat. by M. Hasabe and others, Tokyo, N. Mus. Mod. A., 1985)
K. Aoyama, ed.: *Senchadō bijutsu taikan* [Compendium of the arts of *sencha*] (Tokyo, 1986)
Containing Beauty: Japanese Bamboo Flower Baskets (exh. cat. by T. M. McCallum, Los Angeles, UCLA, Mus. Cult. Hist., 1988)

PATRICIA J. GRAHAM

3. BONSAI. Bonsai, 'the art of miniature trees', is a horticultural art form that attained its highest development in Japan. The term bonsai (Jap. *bon*, a shallow tray or pot; *sai*, to plant; both singular and plural) refers both to a technique of growing and training trees or shrubs, herbs and grasses in ceramic containers so as to create artistic objects and to the miniature trees themselves. Bonsai plants should possess all the beauty and simplicity of plants found in their natural environment, although they are only a fraction of the normal size (in general, between 50 and 1000 mm high).

The plants are arranged in artistic compositions or scenes designed to give an illusion of natural landscape and to reproduce the dignified beauty of trees, herbs or grasses that have survived long exposure to the forces of nature. Bonsai also express spiritual concepts in objective form: the art or 'way' of bonsai (*bonsaidō*), which has its origins in the SHINTO religion, is a means of learning to love and respect nature and of apprehending other universal truths. To create bonsai, three basic virtues—truth (*shin*), goodness (*zen*) and beauty (*bi*)—are needed, and the bonsai itself expresses another three-way relationship,

between the tree, the grower and the life-giving force or deity. Bonsai compositions are appreciated for their beauty and elegance much as are painting and sculpture.

The Japanese practise other similar arts that involve creating a view or scene with stones (*bonseki*), with a mixture of natural and artificial materials (*bonkei*) or using a stone with sand in a tray or on a wooden stand (*suiseki*).

(i) Practice and aesthetics. (ii) History.

(i) Practice and aesthetics. The elements to be considered in bonsai include plants, containers and soil.

(a) Plants. The plants are usually not dwarf varieties but are grown within a restricted space and kept small by pruning; nevertheless, they must give the impression of having grown in the natural state without human intervention. Plants used as bonsai must exhibit all aspects of natural growth, including ageing, and the branches must be of varied thickness tapering gracefully to the apex. Since leaf size is relatively unaffected by the dwarfing process, small-leaved trees such as pine and maple make the most pleasingly proportioned bonsai. There should be a harmonious relationship between the shape and colour of the container and the bonsai. The total composition should have overall balance, stability and beauty (see fig. 217).

A bonsai must always be viewed from the front when it is displayed in a decorative alcove (TOKONOMA), but it is often seen in the round (*see* §(c) below). To appreciate it fully, the viewer needs to observe and understand a wide range of elements, such as the way the roots emerge at the soil line, the appearance of the trunk as it rises above the

soil, the width, length and curvature of the trunk, the appearance of the bark, the position and size of the crown of the tree and the illusion of age. To be considered also are the artistic arrangement of the branches, the shape and colour of the leaves and seasonal changes, the variation in colour and shape of the blossoms and fruit and the condition of surface planting.

Bonsai are classified into four groups (Yoshimura and Halford, p. 65) based on the overall shapes and training styles. Group I includes formal upright, informal upright, slanting, semi-cascade, cascade, literati-style, coiled, broom, split-trunk, driftwood, windswept, exposed-root, root-over-rock, clinging-to-rock, twisted-trunk and octopus-shape. Group II includes twin-trunk, clump, stump, straight-line, raft and sinuous. Group III are group plantings of two or more separate trees with their own roots, in a natural or a clustered group. Two, three, five, seven and nine are the most common numbers of trees. Group IV contains group plantings that are not true bonsai but tray-landscape seasonal groups and plantings of herbs, grasses and shrubs.

(b) Containers and cultivation. The bonsai container serves a purpose similar to that of a frame for a painting. It is chosen to show off the subject to the greatest advantage, and its size, shape and colour depend on the species of tree and its desired ultimate size and shape. The size of the container provides a sense of stability as an element of the artistic statement. Formal bonsai (including most evergreens) are planted in containers that are rectangular or square with perpendicular sides and a straight-edged bottom and top. For a lighter effect, round or oval containers with inconspicuous legs and sides slanting out from the bottom may be used. For informal arrangement, rectangular, square, petal-shaped, hexagonal, octagonal, round, oval or irregular containers are used. The sides may be concave or convex, with flared, straight or rolled edges, and the legs embellished with cloud formations or other ornamentation or, alternatively, quite inconspicuous. Trees trained in the slanting styles, such as the cascade and the windswept styles (*see* §(a) above), look best in round or equilateral containers; the tree placed slightly off-centre from front to back, with the trunk or branches sweeping down over the side. Bonsai are planted so that the branches harmonize with the shape of the container to the best advantage when seen from the front. If branches are longer on one side than the other, the trunk is placed in such a way as to give the longest branches the greater area to spread over the container. Moreover, bonsai are always planted off-centre, since the centre is deemed in Shinto to be the meeting-place of heaven and earth or of the divine and the human and is thus a place on which nothing must intrude.

The colour of the container should contrast with the colour of the tree. Evergreens and conifers are usually planted in brown, red, grey or black unglazed containers to set off the foliage. Junipers, with their bright green foliage, reddish tint in the bark and driftwood effects, are often planted in unglazed terracotta containers. Deciduous plants that have flowers, fruits or berries are planted in highly glazed containers of various colours to complement or contrast with the bonsai.

217. Bonsai, *Pinus pentaphylla* var. *himekomatsu*, h. 630 mm, age *c.* 200 years (private collection)

Since bonsai are grown in containers with limited space, they need careful watering and wither if allowed to dry out, even for a few days. Soil suitable for bonsai must have high air permeability, a high capacity to retain water and neutral pH value. If the plants need alkaline or acid soils, as some bonsai species do, appropriate chemicals can be added to the soil. It is impossible to grow bonsai without sunlight and, like all plants, they need fertilizer in small amounts. To produce better results water-soluble products can be used. Temperate bonsai should be grown outside, tropical bonsai can be grown indoors, but all bonsai must be protected from climatic extremes. Their growth is limited and trained by pruning, repotting, removing new growth and wiring. If properly cared for, bonsai can live several hundred years, and many outstanding specimens are revered not only for their aesthetic qualities but also for their age.

(c) Display. There are three styles of bonsai display: *shin*, *gyō* and *sō*. They may be likened to the three different scripts in calligraphy used when writing *kanji* (Chinese characters; see §VII, 1(i)(b) above), namely regular script (*shinsho*), running script (*gyōsho*) and grass or cursive script (*sōsho*). The *shin* style of bonsai is angular and dignified, as for example pines with straight trunks. Softness and gentleness are characteristic of the *gyō* style, used to display maple, hornbeam and elm. The *sō* style is more casual than the *gyō*: it serves mainly to display trees that have been raised in the *Bunjin* (literati) style or plants other than trees.

Since the Taishō period (1912–26) bonsai have been displayed in *tokonoma*. Before that time it was not customary to place anything containing soil in this area of the home. A bonsai is never displayed alone in the alcove but is always accompanied by a hanging scroll and an ornament, a piece of carving or a fine rock, or a second smaller bonsai, which should contrast with the first, for example a small herb or rock planting to offset a single tree. The principal bonsai represents man, the scroll heaven and the subsidiary ornament earth. Without these three elements the display would be thought to lack balance. The principal bonsai is always placed on some form of stand or base and positioned so that the longer of the main lower branches point towards the centre of the *tokonoma*. The hanging scroll is a work of calligraphy or painting and is hung on the wall, behind and slightly to one side of the bonsai. In displaying bonsai, consideration should be given to the species most suitable to the season. A willow, which creates an impression of coolness, would be appropriate in summer, while in winter the Japanese plum (*ume*) would suggest the coming of spring. The theme of the hanging scroll usually represents a time of year, specifically about a month later than that symbolized by the bonsai. Thus a cherry bonsai symbolizing April should be combined with a picture scroll depicting irises, which bloom in May. Such a combination expresses the flow of time.

(ii) History. The art of bonsai is said to date back to the late Han period (206 BC–AD 220) in China. During the Southern Song period (1127–1279), according to historical records, potted trees became so popular that pines and other species were on sale in flower markets held almost daily. Potted trees were probably first brought to Japan from China by Zen (Chin. Chan) Buddhist priests in the late Heian period (794–1185) or early Kamakura (1185–1333). Miniature potted trees are depicted in the picture scrolls *Kasuga gongen genki* (attributed to Takashima Takakane; *c.* 1309–30) and *Saigyō monogatari emaki* (*c.* 1250–70). Bonsai cultivation became prevalent around the end of the Kamakura period, especially among the nobility. The essayist Yoshida Kenkō (*c.* 1283–*c.* 1352), well known for his book *Tsurezuregusa* ('Essays in idleness'; *c.* 1330), was known for his taste in bonsai. A *nō* play (see §XIII, 1 above) entitled *Hachi nō ki*, written by Motokiyo Zeami (1363–1443), shows that bonsai had found general acceptance among the upper classes by his time, but it was not until the Edo-period (1600–1868) that bonsai acquired general popularity.

The work of late Edo-period literary figures such as RAI SAN'YŌ and *Nanga* or *Bunjinga* (Southern school or literati) painters (see §VI, 4(vi)(d) above), such as TANOMURA CHIKUDEN and Ike Taiga (see IKE, (1)), had a marked effect on the study of bonsai in the early Meiji period (1868–1912). *Nanga*-style painting was characterized by the subjective depiction of a landscape through soft simple lines. Bonsai art of a similar nature first appeared in the Kansai district around Kyoto and Osaka, then spread and was accepted in the Kantō district of central Honshu.

A method of shaping potted trees by wiring branches was devised in China at the beginning of the 19th century and was introduced into Japan in the early Meiji period, along with large quantities of Chinese containers. This paved the way for the bonsai techniques used subsequently. According to Yuji Yoshimura (see Koreshoff, p. 7), a group of Japanese classicists, poets and artists met in the city of Itami, near Osaka, in the early 1800s to discuss styles in potted trees: it was they who decided to call the art form *bonsai*. In 1892, an exhibition of the best bonsai was held to give more exposure to this art. With the growing popularity of bonsai in the Meiji period came books, periodicals and a magazine on bonsai cultivation.

From the late Taishō period (1912–26) and the early years of the Shōwa period (1926–89) it was the fashion, at every level of society, to cultivate azaleas (*satsuki*), which at the time were not regarded as bonsai. Following the formation of a national azalea association, a public azalea exhibition was held in 1925 in Hibiya Park, Tokyo, which contributed to acceptance of the azalea as a bonsai plant. The first public exhibition of bonsai, sponsored by a bonsai magazine, was held in October 1927 at the Asahi Shinbun Hall in Tokyo. Various masterpieces of the Taishō and Shōwa eras were shown. In 1934 the first annual Kokufu Bonsai exhibition was held in the art gallery in Ueno Park, Tokyo. The Nihon Bonsai Association, established in 1964, has affiliated organizations in over 30 countries. In the year of its foundation, the Association held a great bonsai exhibition in Hibiya Park to mark the Tokyo Olympics. In 1970 bonsai were displayed at the Osaka World Exposition, an exhibition since held annually in Expo '70 Commemoration Park, Senri, Osaka. Foreign members can participate by sending in transparencies of their entries; these are enlarged to poster size and mounted in the display areas.

Bonsai reached the United States as early as 1892–4, when examples were auctioned to the public in the Boston area. Lars Anderson, ambassador to Japan, brought a collection to that area in the 1900s; it was donated to the Arnold Arboretum in 1937. The Brooklyn Botanic Garden was given the Ernest F. Coe Collection in 1925. Bonsai are now grown in Europe, South Africa, South America, Australia and the United States, largely as a result of imports by Japanese immigrants. The first World Bonsai Convention was held in Ōmiya, Japan, in April 1989, at which a World Bonsai Friendship Federation was formally inaugurated, with conventions to be held every four years. The second such convention was held in Orlando, Florida, in May 1993.

BIBLIOGRAPHY

S. Nozaki: *Dwarf Trees (Bonsai)* (Tokyo, 1940)
N. Kobayashi: *Bonsai, Miniature Potted Trees*, Tourist Library, xiii (Tokyo, 1951)
Y. Yoshimura and G. M. Halford: *The Japanese Art of Miniature Trees and Landscapes: Their Creation, Care and Enjoyment* (Rutland, VT, and Tokyo, 1957)
K. Yashiroda: *Bonsai Japanese Miniature Trees* (Newton, MA, 1960)
K. Murata: *Bonsai Miniature Potted Trees* (Tokyo, 1964)
B. Smith: *A History in Art* (New York, 1964)
K. Komai: *Bonsai in California*, iii (Los Angeles, 1969)
J. Y. Naka: *Bonsai Techniques* (Santa Monica, CA, 1973)
J. Stowell: 'Art in Bonsai: Bonsai Is a Horticultural Art Form', *Bonsai J.*, viii/3 (1974), pp. 62–5
K. Masakumi: 'What Is Bonsai?', *The East*, xiii/9–10 (1977), pp. 67–72
——: 'The History of Bonsai', *The East*, xiii/11–12 (1977), pp. 63–6; xiv/1–2 (1978), pp. 48–51
——: 'How to Raise Bonsai', *The East*, xiv/3–4 (1978), pp. 66–8; xiv/5–6 (1978), pp. 63–8; xiv/7–8 (1978), pp. 65–7
——: 'How to Display Bonsai', *The East*, xiv/9–10 (1978), pp. 48–50
J. P. Stowell: *The Beginner's Guide to American Bonsai* (Tokyo, 1978)
D. R. Koreshoff: *Bonsai: Its Art, Science, History and Philosophy* (Brisbane, 1984)
T. Ishikawa: *KoKoRo: The Soul of Japan* (Tokyo, 1986)

JERALD P. STOWELL

4. BRUSH. Brush, inkstone, inkstick and paper are the four most important art implements for the educated élite of East Asia (*see also* §§13 and 18 below), and for calligraphers and painters the brush ranks highest, as it is the direct instrument of calligraphic skill. Although brush tips made of animal hair deteriorate over time, brush trunks made of harder materials, such as bamboo, ceramics, wood, lacquer and precious metals, have survived for centuries and been preserved as objects of aesthetic appreciation. The oldest extant brush found in Chang-sha, Hunan Province, China, dates from the Warring States period (481–221 BC). The oldest brushes in Japan are in the Shōsōin repository in Nara. They have trunks of spotted bamboo and are either of Chinese Tang-period (AD 618–907) origin or of indigenous Japanese manufacture.

In China, Japan, Korea and Vietnam, brush tips for both calligraphy and painting traditionally consist of animal hair that is tied and usually tucked into a bamboo trunk. Sophisticated brushes, prototypes for modern brushes, were already being produced during the Han period (206 BC–AD 220) in China. Since then, the unique potential for sensitive expression offered by brush and ink has dominated the two-dimensional arts of China, Japan and neighbouring countries. The brushes are believed to be able to express not only the calligrapher's or painter's skill and his mood at the time of creation but also his personality as a whole. Once drawn, brushstrokes cannot be erased; therefore spontaneity and 'living' lines are highly valued. It is no exaggeration to say that the spirituality of the East developed in tandem with the aesthetic possibilities of the brush.

Whether a brush can convey life or not is determined by its tip. The selection of hair therefore requires careful attention, particularly of the central and longest hair called the 'life hair' (Jap. *inochige*). Animal hair used at one time or another for brushes includes that of sheep, horse, rabbit, wolf (in modern times mostly dog), cat, weasel, Japanese sable, raccoon, flying squirrel, squirrel and deer. The first four are the types most frequently used now to make brush tips for writing Chinese characters.

Brush tips made from the highest-quality sheep's hair are expensive but long-lasting, and their softness, absorbency and flexibility are well suited to sophisticated calligraphy. Brushes of mixed sheep's and horse's hair are popular with beginners, because they are moderately priced and the relative stiffness of horse's hair keeps the brush from bending too much and getting out of control. Calligraphers who specialize in writing in the flowing and wiry *kana* (Japanese phonetic) script often use brushes made of the hair of weasel (*itachi*), Japanese sable (*ten*), mink and cat, as such hair is capable of producing comparatively powerful lines.

Hair from almost any part of the horse can be used for brushes. The long tail hair can make huge brushes, some as tall as a human adult. Avant-garde (*zen'ei*; *see* §VII, 2(vii) above) artists sometimes deliberately select the coarsest horse-hair brushes to produce the wild and broken traces of 'flying white' (*hihaku*) strokes. Rabbit's fur, which has a springy quality, produces sharp and pointed lines and is often used to make brushes for writing small characters. Hair from the wolf and the dog is not absorbent but is capable of producing wiry and unbroken lines on treated, non-absorbent paper. With the dwindling population of wolves in the world today, brush tips described as wolf's hair are in fact often made of dog's or weasel's hair. Cat's hair and raccoon's hair are suitable for small characters and are both often used for the copying of Buddhist *sūtra*s. Raccoon's hair is said to have been introduced to Japan from China by Kūkai (Kōbō Daishi), the founder of Shingon-sect Esoteric Buddhism in Japan. Brush tips may also be made of unusual materials such as bamboo or Japanese cypress split into thin pieces, grasses or grain stalks and ears, straw, willow stems, bird feathers and palm fibre. Many of these special brush tips are made for unorthodox Zen and avant-garde art.

The size, shape and quality of brushes are determined not only by the animal hairs used but also by the way in which the lengths of hair are combined around a central core (see fig. 218). A bunch of shorter hair surrounds the core to provide the thickening at the base and in the middle section of the brush. The outer layer of hair covers and curves around the shorter hair, reaching to the tip. The natural thinning towards the ends of animal hairs also contributes to the gradual tapering of the brush tip. Brushes made before the Ming period (1368–1644) in China had rolled-up paper as the core of the brush. This was replaced, in the Ming period, by hair stiffened with paste. In Japan, brush size is generally classified according

218. Japanese artists' brushes (from right to left): numbers 1–8 mainly for writing Chinese characters of medium to large size; numbers 9–15 mainly for writing *kana* (Japanese phonetic) script or copying Buddhist *sūtra*s in small characters

to the diameter of the brush trunk, which varies from more than 28 mm to 5 mm or less. Medium-size brushes are suitable for writing two to six vertical Chinese characters on *hanshi* paper, which is approximately 245×335 mm.

Brushes for painting are basically the same as those for calligraphy except that, because clear, subtle ink washes are indispensable to ink painting, the brushes have to withstand more immersion in water. Japanese painting brushes can be roughly divided into five types according to their function. *Tsuketate* is the brush most used for painting principal motifs such as bamboo and orchid in broad strokes; *kumadori* is for shading; *mensō* for fine details, such as facial components or the central sections of flowers; *tentsuke* for the dots and short strokes indicating water, land masses and moss; and *kegaki* for drawing hair.

See also §VII, 1(ii)(c) above, BRUSH and BRUSHLINE.

BIBLIOGRAPHY
K. Ōsawa: *Sho o kagaku suru* [Calligraphy scientifically examined] (Tokyo, 1974)
Y. Kimura: *Fude* [Brush] (Kyoto, 1981)
J. Silbergeld: *Chinese Painting Style: Media, Methods and Principles of Form* (Seattle and London, 1982)
S. Uno: *Fude, kami, shogu* [Brush, paper and other implements], ii of *Bunbō seigan* [Scholars' accoutrements] (Tokyo, 1986)
W. Uemura: *Fude, sumi, suzuri, kami* [Brush, inkstick, inkstone, paper] (Tokyo, 1987)
'Bunbō shihō no subete' [Everything on the four treasures of study implements], *Sumi Supesharu*, 11 (1992)

SADAKO OHKI

5. COINS. In pre-modern Japan, unlike in the West, coins were not objects of artistic interest. Although there is some evidence that scholars of the late Edo period (1700–1868) collected coins of earlier periods, they were motivated by historical rather than aesthetic considerations.

(i) Before c. 1600. Coins were first issued in Japan during the 8th century AD as one element of the process of establishing a Chinese-style system of administration. Chinese coins of the Tang period (618–907) provided the inspiration for the first Japanese coins. In 708 the Japanese imperial court at Nara issued cast silver and copper coins with central square holes and the four-character inscription *Wadō kaichin* (Chin. *Hetong kaizhen*; 'coin of the opening of the Wadō era'; 707–15; see fig. 219a; *see also* CHINA, §XIII, 7). As on the Chinese prototype, the inscription was positioned above, below, to right and left of the central hole and written in the calligraphic style known as clerical script (*reisho*).

The Japanese and Heian imperial court issued Chinese-style coinage in Heian (now Kyoto) from 794 to 958, during which period 14 designs were used. An excellent standard was maintained throughout the period, but the clerical script was replaced by pattern script in 848. However, a lack of ability to maintain the economic stability of the coinage led to a gradual reduction in the size of coins from *c.* 26 mm to *c.* 18 mm, so that the

219. Japanese coins: (a) bronze coin from Nara, inscribed *Wadō kaichin* ('coin of the opening of the Wadō era'), issued AD 708; (b) bronze coin of the Tokugawa shogunate, inscribed *Kan'ei tsūhō* ('coin of the Kanei era'), issued c. 1740; (c) gold *ōban* of Tokugawa Ieyasu, issued 1601; (d) silver one-*bu* coin of the Tokugawa shogunate, issued c. 1835 (London, British Museum)

corresponding reduction of the inscription impaired the appearance of the calligraphy. The same lack of economic control brought about the abandonment of the issue of coinage after 958 until the 16th century.

From the 13th century to the 16th Chinese coins were used in Japan. When Japanese coin production was resumed, the first issues were exact replicas of Chinese Ming-period (1368–1644) coins. Many crude, privately made copies of Chinese coins were also in circulation at the time.

The first attempt to make Chinese-style coins with locally created inscriptions occurred in the late 1500s, when silver and gold coins with the usual central square hole and four-character inscription were cast with the inscription *Tenshō tsūhō* ('coin of the Tenshō era'). Similar issues followed, silver coins in the mid-1590s and copper in the early 1600s. All were inscribed with poorly designed pattern script, and none was successful as currency.

During the same period a new kind of coinage, which used a locally developed model distinct both from Chinese and European coinage, was issued in Japan. The new coins were made of gold and silver and were modelled on the gold and silver ingots already used as currency in Japan. The ingots were normally cast oval or rectangular slabs that were hammered flat. The coins were the same shape but were marked with inscribed or emblematic stamps to identify the issuer. In addition, the larger gold coins were inscribed by hand in black ink with their weight and the signature of the mint master. The first of these appears to have been made under the authority of Toyotomi Hideyoshi. In 1601 the issue of these gold and silver coins was centralized by Ieyasu (1543–1616), the first Tokugawa shogun (see fig. 219c and d).

(ii) After c. 1600. In 1626 Shogun Tokugawa Iemitsu (1604–51) created a new Chinese-style bronze coinage, inscribed *Kan'ei tsūhō* ('coin of the Kan'ei era') in a neat and firm *kaishu* (pattern or regular) script. With this he established a stable system of small denominations to complement the gold and silver coins. These coins continued to be issued and used until the 19th century. The *Kan'ei tsūhō* inscription was used for bronze and later for iron coins until the 1860s. Many minor variations were made in the calligraphy of the *Kan'ei tsūhō* coins, some intentional but most reflecting the successive copying of the original inscription. These variations are now used to distinguish the many different mints and periods of issue (see fig. 219b).

In the 1760s a larger brass version of the *Kan'ei tsūhō* was issued with a wave-pattern design on the back to indicate that it was to 'flow' in circulation. This new coin was worth four of the regular bronze coins. During the same period iron coins were issued in some regions to replace the bronze issues. In some provinces regular bronze coins were cast at local mints with a single character mint mark on the back. An issue of iron wave-pattern coins was made in the 1860s with mint marks in the Japanese phonetic script (*katakana*).

Three other issues of multiple denomination coins were made to circulate alongside the *Kan'ei tsūhō* coins (known as *mon*). A ten-*mon* coin inscribed *Hōei tsūhō* was issued in 1708, a 100-*mon*, *Tenpō tsūho*, in 1835 and a four-*mon*, *Bunkyū eihō*, in 1863. The *Tenpō tsūhō* was oval with a square hole, an attempt to combine the shape of the contemporary gold coins with the traditional Chinese-style coinage.

During the mid-19th century a number of local coinages were also issued, mostly on the model of the shogunate's coinage, but some with novel designs, such as the lead bars of Kanra District (Jōshū Province), with a vertical inscription in Chinese characters, and the swordguard coins of the Akita clan (Ugo Province), decorated with a dragon and phoenix design, both issued in the 1860s.

The traditional coinages, both shogunal and local, came to an abrupt end with the overthrow of the last Tokugawa

shogun and the restoration of imperial power in 1868. By 1871 a new coinage system based on contemporary Western coinage was issued. The coinage used traditional Japanese motifs: dragons, chrysanthemums, paulownia sprays, sunbursts and the imperial crest. It was inscribed in Chinese characters, but its overall presentation was entirely in the manner of European coinage. The 1871 coins were made at a new mint at Osaka using British machinery and British designs. The pattern established in 1871 has been followed by the Japanese mint ever since, although with increasing diversity in the choice of emblems.

As in China, there has been a strong tradition of using coins as good luck charms. Imitation coins with propitious inscriptions and pictorial designs were also made from the 17th century. The pictorial designs often feature popular Japanese deities, for example Daikoku, the god of wealth, and Ebisu, the god of fishermen.

BIBLIOGRAPHY

N. G. Munro: *Coins of Japan* (Yokohama, 1904)
N. Jacobs and C. C. Vermeule: *Japanese Coinage* (New York, 1972)
Zuroku: Nippon no kanei [Illustrated record: Japanese money], 11 vols, ed. Bank of Japan Research Unit (Tokyo, 1972–6)
I. Gunji: *Nippon kanei zukan* [Illustrated catalogue of Japanese money] (Tokyo, 1981)

JOE CRIBB

6. DOLLS.

(i) Introduction. (ii) Types.

(i) Introduction. The Japanese word for doll, *ningyō*, derives from an archaic pronunciation of the Chinese characters for 'human' and 'form'. Decorative and folk-art dolls trace their origin to prehistoric figurines, which were cult objects, invested with magical, protective, religious and fecundity-giving powers. These ritual overtones were present even when dolls appear to be purely decorative. The earliest doll-like forms included *dogū* (baked clay figurines) of the Jōmon period (*c.* 10,000–*c.* 300 BC); *haniwa* ('clay cylinders'; see §V, 2(iv)(a) above and figs 49 and 51) placed around mounded tombs of the Kofun period (*c.* AD 300–710); and *sutebina* ('casting off figures') used in purification rites of the 6th and 7th centuries. A variety of doll-like figurines were enshrined in both Buddhist and Shinto shrines from the Nara period (AD 710–94) onwards; other small bronze figures excavated at Nara in 1992 were probably used for exorcism.

Evidence from the two greatest Japanese literary classics of the Heian period (794–1185) suggests that displaying dolls was already an established custom at that time. Murasaki Shikibu in the *Tale of Genji* (*Genji monogatari*, *c.* 1005) described dolls and a dolls' house. The *Pillow Book* (*Makura no sōshi*; *c.* 1000) by Sei Shōnagon lists 'adorable things' and 'things that arouse a fond memory of the past', including the dolls and objects used during the 'display of dolls' (*hina asobi*). *Hina*, another word for doll, comes from the Sanskrit word meaning 'small'.

Perhaps no other country has ever produced such a wide variety of dolls for all tastes. Dollmaking was a thriving family craft and an important source of revenue, especially in the peaceful and prosperous Edo period (1600–1868). Skills were passed down through the generations, and occasionally an outstanding maker of *ningyō* was noted in art chronicles. Several modern dollmakers with exceptional skill in traditional forms have been awarded the title of Living National Treasure. In 1955 Gōyō Hirata (1903–81) and Ryūjo Hori (artist's name of Matsue Yamada, 1897–1984) were so designated for their costume dolls of carved wood, and in 1961 Juzō Kagoshima (1898–1982) received the title for his moulded paper dolls. Sono Noguchi (*b* 1907) and Toshiko Ichihashi (*b* 1907), doll designers, were designated Living National Treasures in 1985 and 1988 respectively.

(ii) Types.

(a) *Hina*. (b) *Gosho*. (c) Kamo and *kimekomi*. (d) Saga. (e) Nara. (f) *Kokeshi*. (g) Ichimatsu. (h) *Tsuchibina*. (i) Other types.

(a) Hina. The best-known dolls are ceremonial dolls (*hina*) displayed on Girls' Day (Hina Matsuri, 3 March) and Boys' Day (now Children's Day, Tango no Sekku, 5 May). The array of dolls representing the imperial court with all its trappings is designed primarily to teach social hierarchy, etiquette and national history. A complete *hina* set consists of 15 court figures, while the reduced version comprises just a large emperor and empress (imperial palace dolls; *dairibina*). The warrior dolls (*musha ningyō*) of Boys' Day, mainly representing famous military heroes of Japanese history, were added to the samurai's panoply of weapons and accoutrements in the Edo period (1600–1868). Recognizable by their helmets, armour and weapons, they symbolized manliness, endurance and bravery—the *bushidō* ('the way of the warrior') that figured so prominently in Japanese life. Dolls of legendary figures and *kabuki* actors in famous roles were also made. The characteristics of these costume dolls (*ishōbina*) are a straw body; wooden, white-painted hands; a detachable head covered with *gofun* (pulverized oyster-shell and glue) on a wooden or metal peg; encrusted glass or mica eyes; and implanted hair or a wig (human or silk). The elaborate clothes, shaped over paper and thin wood-shavings and glued on, are made of silk and brocade, often richly embroidered. In the Genroku era (1688–1704) the Tokugawa shogun Yoshimune (1684–1751) issued sumptuary edicts limiting the size of dolls to 200 mm; dollmakers compensated by making elaborate and costly miniatures with ivory heads, hands and accessories or totally in ivory.

(b) Gosho. The traditional *gosho* (imperial palace doll; see fig. 220) represents a chubby, half-naked baby boy with a disproportionately large head and white skin. Originally made only in Kyoto, *gosho* rapidly became popular throughout Japan. High-ranking nobles, travelling to Edo (now Tokyo) on shogunal business, were given these token dolls as a talisman for a safe trip, good luck and healthy male offspring. Imperial concubines kept them as fertility charms. The oldest examples were made of moulded clay covered with *gofun* (Kyoto and Tokyo N. Mus; Tokyo, Yoshitoku Coll.; Saitama Prefect., Nishizawa Mem. Mus.; Kyoto Prefect., Reiganji and Hokyoji temples). Later, the finest figures were made of the wood of the paulownia tree, and later still commercial replicas were made of sawdust and glue or moulded pottery. Although there are some dressed and wigged versions, the typical *gosho*'s clothes are either pasted or painted on.

220. *Gosho* doll, *gofun* (oyster-shell paste) and colours on moulded clay base, h. 100 mm, Edo period, 1600–1868 (Japan, private collection)

(c) Kamo and kimekomi. The Kamo doll was made in the 18th century by craftsmen in the service of the Kami-Gamo Shrine in Kyoto, to be sold as charms and souvenirs. The design was deeply incised in a small willow-wood figure, then covered with textiles that were tightly pushed into the grooves (*kimekomi*) to suggest the way drapery normally falls. The method is attributed to Takahashi Tadashige (*fl c.* 1740). Heads, hands and feet were carved and left in the natural wood colour. Modern dolls made using this technique are known as *kimekomi* dolls.

(d) Saga. These dolls (named after the Saga district of Kyoto) are the most enigmatic and most aesthetically complex, as well as the rarest, of all Japanese dolls. They originated in the early 17th century, and most scholars agree that they were made by sculptors of Buddhist images (*busshi*) or the artisans who carved *nō* masks (*menuchi*). The basic figure was made of wood covered with a layer of *sabi* (a mixture of powdered baked clay and lacquer). The palette of rich yet sober colours undoubtedly resembles that used for the raised patterns and ornamental gilding on the robes of Buddhist statuary. There are playful versions, which, when moved, shake their heads and put out their tongues. Most examples portray children at play or young temple attendants (*dōji*) holding small animals.

(e) Nara. The Kasuga Shrine in Nara, where some of the first performances of *nō* theatre took place (*see* §XIII, 1 above), was also the origin of the Nara doll, which almost invariably represents a *nō* actor. The figures are cut from cypress wood and painted in strong, bright hues embellished with gold. Sharp, angular planes are produced with the use of one tool only (*ittōbori*; 'one-knife carving'), a method that seems primitive but is well suited to rendering the stiff, heavy costumes of colourful brocade worn in *nō* theatre. The first Nara *ningyō* that flourished in the Kan'ei era (1624–43) are ascribed to Okano Heiemon.

His family carried on the tradition for 13 generations. Morikawa Toen (1820–94), known as the master carver of Nara *ningyō*, also made *netsuke*.

(f) Kokeshi. These are limbless wooden dolls and perhaps the easiest type to identify, although many variations exist on the sphere-and-cylinder theme, permitting recognition of their place of origin. *Kokeshi* are exclusive to the northern prefectures of Honshu, with one exception: an elaborately lacquered version made in Yamaguchi Prefecture, southern Honshu. Possible origins are the totem-like figures of the Ainu of Hokkaido or a regional shamanistic folk religion in which two dressed mulberry sticks with carved or painted faces (*Oshirasama, Ohinasama*) were worshipped. The name (*ko*, 'child'; *keshi*, 'erasing') suggests that *kokeshi* dolls were memorials to young girls sold to geisha houses or to dead children or victims of abortion or infanticide in times of extreme poverty. A September festival held in Narugo, Miyagi Prefecture, has cremation services for the 'unborn' (defective) dolls made during the year; by contrast, the most beautiful are dedicated to the shrine deity.

(g) Ichimatsu. The Ichimatsu doll (see fig. 221) owes its name to a handsome *kabuki* actor, Sanogawa Ichimatsu I of Kyoto (1722–63). Famous for feminine roles, he was the idol of his day. The female doll rapidly became more popular than the male and was known by other names such as Yamato doll (after the ancient name for Japan) and *furisode ningyō* (long-sleeved kimono doll). A boy–girl pair was the classic present for children celebrating the 'Seven-Five-Three' Festival (Shichigosan, 15 November, when five-year-old boys and seven- or three-year-old girls are taken to a local Shinto shrine to pray for an auspicious future). Ichimatsu dolls were also given to young brides to symbolize the wish for healthy children. The oldest ancestor of the Ichimatsu doll was the wooden-jointed

221. Ichimatsu doll, head, arms and legs covered in *gofun* (oyster-shell paste), glass eyes and human hair, h. 400 mm, Meiji period, 1868–1912 (Japan, private collection)

mitsuore doll, which could be changed from male to female by a change of clothes and wig. Of all Japanese ornamental dolls, Ichimatsu dolls most closely resemble Western-style playthings, having real hair, inlaid glass eyes and supple textile strips that join the limbs to the body so that it can easily be dressed. They have extensive wardrobes and accessories that are all made to scale.

(h) Tsuchibina. The clay doll (*tsuchibina*) was a more plebeian decorative statuette that had its ancestry in prehistoric times and figured in the folk-art tradition. Pressed in double wooden or clay moulds, the two halves were joined, brightly painted, then fired at low temperature. Some were made as votive offerings for shrines. A crude type of doll (16th century) from the Fushimi Inari Shrine in Kyoto was said, when deliberately broken, to free children from possession by evil spirits. *Tsuchibina* were

made in kilns throughout Japan, the best known being the Tsutsumi, Sagara and Hanamaki kilns in northern Honshu, and Inuyama and Fushimi in central Honshu. Production continues only in Hakata, Kyushu, where refined and modernized versions of the old models are made.

(i) Other types. There are many more lesser-known types of ornamental dolls, effectively mirroring the facets of Japanese life, culture, fashions, customs and superstitions: the colourful 'cherry' (*sakura*) souvenir doll; the slim, paper 'elder sister' (*anesama*), lacking facial features; the standing paper couple (*tachibina*); the dynamic and eccentrically posed actor (*takeda*); the fetish-like straw doll (*wara*); children in baskets (*izumeko*); the extensive family of papier-mâché self-righting dolls (*daruma*) in many shapes and sizes; the miniature image of a tea picker (*Uji*) made of the wood of the tea bush; the flat, padded doll on a stick (*oshiebina*); and the ingenious balancing doll (*mamezo*). Japanese soldiers fighting in the Pacific during World War II carried or tied to their belts a small protective doll mascot. Automaton dolls (*karakuri*; 'trick' dolls) are highly sophisticated; they include large, articulated puppets manipulated by men concealed inside a 'festival chariot' (*dashi*), and small 'sitting-room' (*zashiki*) model dolls with a clockwork mechanism. The Kobe *ningyō* is a rare doll that executes simple movements when a button is turned manually. The 'tea serving doll' (*chahak-obi*) has a complicated built-in mechanism that allows it to walk the length of a table with a cup of tea, stop when the cup is lifted and return to its sender when the empty cup is replaced. All these dolls are driven by intricate handmade mechanisms.

BIBLIOGRAPHY

S. L. Gulick: *Dolls of Friendship* (New York, 1929)
G. Caiger: *Dolls on Display* (Tokyo, 1933)
Dolls of Japan/Poupées japonaises (exh. cat. by T. Nishizawa, Tokyo, 1934; exh. Stedel. Feestzaal, Antwerp)
T. Yamada: *Nihon ningyō shi* [The history of Japanese dolls] (Tokyo, 1942)
I. Schaarschmidt-Richter: *Japanische Puppen* (Munich, 1962)
T. Kitamura: *Ningyō* [Dolls], Nihon no bijutsu [Arts of Japan], xi (Tokyo, 1967)
R. Saitō: *Nihon ningyō gangu jiten* [Dictionary of Japanese dolls and toys] (Tokyo, 1968)
J. Gribbin and D. Gribbin: *Japanese Antique Dolls* (Tokyo, 1984)
Karakuri Ningyō: An Exhibition of Ancient Festival Robots of Japan, (London, Barbican A. G., 1985)
L. Baten: *Japanese Dolls: The Image and the Motif* (Tokyo, 1986)
T. Yamada: *Zusetsu Nihon ningyō shi* [Illustrated history of Japanese dolls] (Tokyo, 1991)
L. Baten: *Japanese Folk Toys: The Playful Arts* (Tokyo, 1992)
——: *Playthings and Pastimes in Japanese Prints* (New York and Tokyo, 1995)
Ningyō: The Art of the Human Figurine (exh. cat. by S. Kawakami, New York, Japan Soc., 1995)

LEA BATEN

7. DRESS.

(i) Introduction. (ii) Historical survey.

(i) Introduction. The Japanese word for clothing, *kimono*, is usually thought of as referring to a T-shaped gown with box sleeves, long, narrow front and back panels and extra panels that cross in the front of the body. This type of garment was called a *kosode* ('small sleeve') until the 20th century and has been the basic secular robe for both men and women of all classes since the 16th century. The

kosode evolved originally from Chinese, Korean and Mongolian garments, which consisted either of tunics and trousers or blouses over long, flowing skirts. Eventually these forms fused into a robe that reached from shoulder to floor. Sleeves began as tubes, broadened into large, open squares (*ōsode* or *hirosode*) and later were sewn up at the cuff to form the pocket that characterizes the *kosode*.

The construction of the *kosode* is fundamental to the aesthetics that evolved around it and a key to the distinguishing features of Japanese clothing. Its simple straight lines often tempt the designer to bold decorative schemes that treat the entire garment as a single entity or a picture plane, but it is equally suited to more standard textile designs, such as woven stripes or dyed repeats. The *kosode* is neither tailored to fit a specific body, as Western clothing is, nor a rectangular length of cloth draped to form a garment, like the Indian *sārī* or the South-east Asian sarong, but halfway between. The long, narrow bolt used to make Japanese clothing is cut, but sparingly and not along a diagonal or curve. The panels are assembled to a standard size, which is then adjusted to individual measurements through draping. Sashes and cords to hold the robe in place become an integral decorative and functional element. The loose, open construction allows for layering of similarly cut robes.

Religious garments have evolved with secular clothes, although of course they are different in many respects. Shinto robes tend to reflect old court styles and are often white and red. Buddhist robes vary by sect, the standard colour being black, except for priests of the highest rank. In addition to their robes, Buddhists wear draped across their shoulders a rectangular cloth (*kesa*), a descendant of the Indian *kashaya* said to have been worn by the historical Buddha, Shakyamuni (Jap. Shaka). Although scripture dictates that *kesa* be constructed of patched, worthless scraps, beautiful examples, such as the *funzōe* among the treasures from Hōryūji (Tokyo, N. Mus.), remain from as early as the 7th century. By the Edo period (1600–1868), rich brocade *kesa* had become popular, some of them woven to simulate patchwork.

(For further discussion of dress types and fashions *see* §XI above; for theatrical costumes *see* §XIII, 1(iii) and 2(iii) above.)

(ii) Historical survey.

(a) Before AD 794. (b) Heian period (794–1185). (c) Kamakura (1185–1333) and Muromachi (1333–1568) periods. (d) Momoyama (1568–1600) and Edo (1600–1868) periods. (e) Modern period (after 1868).

(a) Before AD *794.* The earliest representations of clothed figures appear on bronze bells (*dōtaku*) of the Yayoi period (*c.* 300 BC–*c.* AD 300) excavated in Kagawa Prefecture and suggest a simple poncho worn by both men and women, probably woven of bast fibres. In the 3rd century AD a new culture was established. Clay figurines (*haniwa*) found in the large tombs of this period (*kofun*) suggest a sophisticated knowledge of weaving and sewing. Men wore belted tunics (*kinu*) over pantaloons (*hakama*). Cords bound the baggy pants below the knee and the open sleeves below the elbows, helping to mould the garments to the body and reduce encumbrance while

riding. Decorative ties securing the front panels embellished the outfits, and bracelets, earrings and necklaces were worn. Women wore long, flowing, pleated skirts (*mō*) topped by a thigh-length blouse (also called *kinu*). Like its successor, the *kosode*, the *kinu* had tube sleeves and front panels that crossed to form a 'V' at the neck and was held in place by a long, broad sash, decoratively tied.

Depictions of figures in the *Tenjukoku mandara shūchō* embroidery (622; fragments partly rewoven in the 13th century; kept at the Chūgūji nunnery, nr Hōryūji, south of Nara; see fig. 222) suggest the influence of Chinese fashions of the Han period (206 BC–AD 220). Men wore round-necked tunics (*hō*) with tube sleeves, knee-length skirts (*hirami*) and loose trousers (*uenohakama*). The portrait (late 7th century–early 8th; Tokyo, N. Mus.) from Hōryūji of Prince SHŌTOKU, patron of Buddhism, shows him wearing an ankle-length *hō* with long, full sleeves. In an effort to establish a government in Japan along Chinese lines, Prince Shōtoku fixed 12 court ranks. Long, round-necked *hō*, essentially obscuring the *hirami* and *hakama*, became the ceremonial court uniform, rank being indicated by the colour and fabric of the robe and hat (*kan* or *kanmuri*). Examples of *hō* in the Shōsōin, Nara, repository of Tōdaiji, have a slight flare to the cut of the tunic and square-set sleeves, open at the cuff but narrower than the sleeves that developed in later centuries. Belts and sashes were made of soft, flat braids, and the cloth shoes were fashioned into boat shapes. Small, gauze-weave hats complemented the looped-ponytail hairstyles. The upper robes of court ladies also became fuller, with longer sleeves. A patterned vest (*karaginu*) was added for formal occasions. Many robes were woven with designs such as the prized, weft-patterned *nishiki* or the bold, multicoloured, block-resist *kyōkechi*. Decorative cuffs, a long flowing stole, cloth sashes and a round fan completed this costume of contrasting colours, weaves and dye techniques. In the bronze figure of *Queen Maya and the Birth of Buddha* (in which the Buddha, born from her side, emerges from her sleeve in an attitude of prayer; see fig. 223), the Queen wears a wide-sleeved, V-necked long robe fastened with a

222. Japanese dress of the Asuka–Hakuhō periods (AD 552–710): (left) woman in *kinu* (thigh-length blouse) and *mō* (long, pleated skirt); (right) man in *hō* (round-necked tunic), *hirao* (flat sash) and *uenohakama* (loose trousers), details from the *Tenjukoku mandara shūchō* embroidery, 622; National Treasure (Nara, Horyuji, Chūgūji)

223. Japanese dress of the Asuka–Hakuhō periods (AD 552–710), *Queen Maya and the Birth of Buddha*, bronze, h. 1.24 m (Tokyo, National Museum)

broad swirling sash. The modern draping style of crossing the left panel over the right dates from some time in this early period; hitherto, as in this example, right over left had been customary.

(b) Heian period (794–1185). The removal of the capital north to Heiankyō (now Kyoto) marked the start of four centuries of comparative peace, during which garments were slowly adapted to the Japanese climate and customs. Loose robes of similar cut to those of the Nara period (710–94) were layered to produce volume. Sleeves became broader and wider, open at the cuff. Long trains trailed behind the wearer, impeding movement. Formal wear for men (*sokutai*) and women (*karaginumō* or *jūnihitoe*) epitomized the stately, elegant refinement of the Heian court, so well described in novels and illustrated scrolls (*emaki*) of the time such as Murasaki Shikibu's *The Tale of Genji*. Similar garments, but in abbreviated style and with fewer layers, were worn on informal occasions.

Male ceremonial court dress consisted of a long outer robe (*hō*) with broad, double-width, open sleeves, a vest, an inner robe (*shitagasane*) with a train trailing several feet behind the wearer and pantaloons bound at the ankles and given bulk by stiff underpantaloons (*ōguchi*). These garments were held in place by a studded leather belt (*ishi no obi*) and a flat sash (*hirao*), left dangling decoratively in front. The lacquered cap (*kanmuri*) had a tall projection at the back and 'whiskers' at the side over the ears. Wadded white socks (*shitōzu*) fitted neatly into black-lacquered boat-shaped shoes, such as are still worn by Shinto priests. Regulation of the colour of the outer robe by rank persisted. On informal occasions men wore ankle-bound

pantaloons (*sashinuki*) with either a *nōshi*, a tunic-like garment that had front and back panels joined by a broad strip of cloth at the hem, or a *kariginu* hunting cloak, which had laces at the cuffs allowing them to be gathered up at the wrist. In the following centuries, round collars were replaced by V-shaped, crossed collars, the vertically overlapping front panels disappeared and upper robes were tucked into the pantaloons rather than being draped over them. However, the styles worn by men in the Heian period persist in the late 20th century as ceremonial court clothing, and derivative garments are worn for court dances (*bugaku*) and for *nō* drama.

Women's court styles changed more than men's during the Heian period. The long skirt (*mō*) became a decorative train falling to the back and often painted with scenes from nature, while the 'blouse' crossed in a V-shape grew to more than floor-length and was donned in multiple layers. From inside to out the layers consisted of white, unlined robes (*hitoe*), long, pleated trousers (*hakama*), lined robes (*uchiki*), a lustrous *uchiginu* and a smaller woven garment of two-toned pattern (*uwagi*). On the very top was a narrow, jacket-like *karaginu* and finally the *mō* train. Five or more *uchiki* woven in solid-colour, figured twill (*aya*) comprised a standard set, each robe of a slightly smaller cut so that when layered they created elegant strips of colour along the collar line and sleeve edges. Great care was taken to make the combined colours of *uchiki* and other robes poetically in tune with the season through delicate shadings and complementary juxtaposition. For informal occasions the lined *uchiki* became the central robe, and at other times, such as in summer or when travelling, abbreviated forms prevailed that were cooler and allowed for greater ease of movement.

(c) Kamakura (1185–1333) and Muromachi (1333–1568) periods. The court life that prevailed during the Heian period crumbled after 1185, when Minamoto no Yorimoto became the *de facto* ruler of Japan and established his military government in Kamakura. The emperor was left with a small core of courtiers, who carried on the age-old rituals and preserved the traditional customs and garments. Turbulent though the Kamakura period was, it was also a time of opportunity and of social and economic development, when the lower classes rose in importance. Clothing reflected these changes: not only was court dress simplified to accommodate greater physical activity (and impoverished purses) but also commoners' garment forms were incorporated into the wardrobes of the military aristocracy. In the course of these centuries of transition, the *kosode* emerged as the universal garment. For the aristocracy, the *kosode* with full-length sleeves and sewn-up wrist openings was originally a white underrobe, which surfaced as the outer layers of formal robes were stripped away. For commoners the upper tunics lengthened. The round collar of male dress gave way to crossed panels forming a 'V'.

Picture scrolls, such as the Kamakura-period *Tale of the Heiji* (Tokyo, N. Mus.), illustrate a wide variety of costumes worn by the warrior class. For formal occasions they wore the hunting cloak (*kariginu*) of the Heian-period nobility, but for everyday use the *kosode* was worn under matched suits woven of stiff bast fibres, the staple textile

of commoners since prehistoric times. In keeping with the growing power of the warrior class, these matched suits were tailored with an eye to volume. They had double-width, broad, open-cuffed sleeves, which, however, could easily be hitched up so as not to encumber movement. The upper part was tucked into pleated pants (*hakama*), which came in a variety of cuts: broad and open at the bottom, gathered at the knee for riding; or slim and extra long (*nagabakama*), so that they trailed behind and encouraged a distinctive swishing walk. Matched suits included the unlined *suō*, the lined *hitatare* (both resist-decorated with either large bold images or small repetitive patterns called *komon*) and the 'large crest' (*daimon*), which had round, stencilled circles containing family heraldic signs (*mon*) on both sleeves and centre back, echoed also on the pantaloons. This established a design that is still seen on formal black *kosode* known as *montsuki*. It also stimulated the development in the 17th century of paste-resist designs such as the multicoloured, hand-drawn *yūzen* (*see* §XI, 1(b) above). For battle, the samurai wore over their matched suits armour made of slabs of lacquer and leather lashed together to form a tunic, with separate shoulder protectors, gauntlets and leg covers.

Women, no longer house-bound ornaments, adopted ankle-length garments and reduced the number of layers to three or four. The robes with wrist-length open-cuffed sleeves could be crossed in front and secured with a sash or draped over the head as a cloak. The earliest illustration of a woman wearing a closed-cuff *kosode* as a single outer robe appears in the scroll of the *Miraculous Oracles of Kasuga* (1309). By the 15th century women of most classes were wearing *kosode*, hitched up at the waist and the excess folded over the securing waist cord to form a blousy top. Layering was still common, but instead of achieving a multicoloured look by interweaving layers of solid colours, as in the Heian period, the outer *kosode* began to be decorated so as to incorporate contrasting patterns and colours into the single garment. Designs based on opposing areas prevailed, such as differing schemes on left and right (*katamigawari*) or patchwork-like blocks of design (*dangawari*), or the shoulder and hem might be decorated while the waist area was left blank (*katasuso*). These divisions were often bordered by irregular outlines, for example jagged diamonds representing pine bark (*matsukawabishi*) or flowing curves suggesting sand spits (*suhama*).

(d) Momoyama (1568–1600) and Edo (1600–1868) periods. By the 16th century, upward social movement and the growth of cities had led to greater affluence. The love of gold and of ostentatious display was revealed not only in the lavish decoration of houses and castles but also in the clothing. For women, the *kosode* became established as the main robe, and new techniques of decoration evolved. Elaborate tie-dye techniques, overall embroidery, gold stencilling, inked drawings and large, pictorial, weft-patterned weaves were used separately or in combination, making robes of the Momoyama period some of the most stunning in Japanese history. Draping was loose, and often the outermost garment was slipped off the shoulders and allowed to hang like a skirt in 'waist-wrap' style (*koshimaki*; see fig. 224). Men wore similar *kosode* as undergarments,

224. Japanese dress of the Momoyama period (1568–1600), showing the kimono folded down at the waist in 'waist-wrap' style (*koshimaki*); detail from Unkoku Tōgan: *Flower Viewing and Hawking*, folding screen, 16th century (Atami, MOA Museum of Art)

visible under the abbreviated matched suit (*kamishimo*) with vestlike upper. The innovative spirit of the age can be seen not only in the wide variety of styles but also in the materials used. Dutch trade led to clothing made with European tapestry and velvet as well as some jackets with feather designs, such as the brown cock-feather *jimbaori* with a white gourd design of the warlord Toyotomi

Hideyoshi and another with a butterfly design (Tokyo, N. Mus.) said to have belonged to the military leader Oda Nobunaga. Many of the most elegant robes preserved from the Momoyama period belonged to the first Tokugawa shogun, Ieyasu (1542–1616), one of the unifiers of the nation.

During the Edo period dress appropriate to each class was regularized by sumptuary law. The *kosode* with even-width panels for the main body and sleeves was worn by everyone, but distinctions occurred in the fibres, dyes, weaves and techniques used for patterning (*see* TEXTILE, colour pl. VII, fig. 2). Fashion became competitive, inspiring ever new methods of decoration, generally achieved through inventive dye techniques. As the waist sash (*obi*) broadened, draping became tighter and more restrictive. The size of the sash also influenced the overall design. Fashion books (*hinagatabon*) and extant *kosode* from the early 17th century exhibit a dynamic curve extending from left arm to hem, while the waist area remains blank. In the flamboyant robes of the Genroku era (1688–1704) little blank space remained. For a time, smaller, more sober patterns prevailed until, in the mid-18th century, these began to give way to growing areas of solid colour; the sash also played an increasingly important role. Variations on the cut of the *kosode* include the trailing-sleeved *furisode* and an unbelted, outer gown with wadded hem, the *uchikake*.

(e) Modern period (after 1868). Modernization induced first men and then women to abandon the *kosode* for Western clothes. Native Japanese garments are now worn primarily for special occasions and traditional occupations or by the very old. In an attempt to save the numerous crafts and industries associated with producing the *kosode*, effort is being put into devising simpler methods of draping and developing new, easy-to-wear garments based on the *kosode* cut.

BIBLIOGRAPHY
H. B. Minnich: *Japanese Costume and the Makers of its Elegant Tradition* (Rutland, VT, 1963/*R* 1986)
T. Kitamura: *Nihon fukushokushi* [History of Japanese clothing] (Tokyo, 1979)
T. Ito: *Tsujigahana zome* [Tsujigahana dyeing] (Tokyo, 1981); Eng. trans. by M. Bethe as *Tsujigahana: The Flower of Japanese Textile Art* (Tokyo, 1981/*R* 1985)
Kosode: 16th–19th Century Textiles from the Nomura Collection (exh. cat. by A. M. Stinchecum, New York, Japan Soc., 1984)
A. Kennedy: *Japanese Costume: History and Tradition* (Paris, 1990)
When Art Became Fashion: Kosode in Edo-Period Japan (exh. cat., ed. D. Gluckman and S. Takeda; Los Angeles, CA, Co. Mus. A., 1992)
N. Maruyama: *Clothes of the Samurai Warriors* (Kyoto, 1994)
MONICA BETHE

8. ENAMELS. The Japanese term for enamelling, *shippō* ('seven treasures'), suggests that enamels may have been created as substitutes for inlaid precious stones. In the enamelling process a silicate mixture is fused by firing to a metal base, producing a sparkling, coloured surface. Early Japanese enamelled works were mainly produced by the champlevé technique, in which enamel is poured into compartments hammered into (repoussé), gouged out of or cast in metal. The use of wires (*cloisons*) to form compartments is equally ancient, but cloisonné did not become the dominant method of enamelling in Japan until the late 19th century, when the precision and delicacy of the pieces were unsurpassed (*see* ENAMEL, §§1 and 2(i) and (ii)).

(i) Origins, before c. *1600.* The technique of enamelling was introduced to East Asia from western Asia and Europe, where early examples from Mycenae date from as far back as the 13th century BC. The first enamelled objects produced in East Asia were discovered in Korean tombs (Seoul, N. Mus.) of the Koguryŏ and Silla kingdoms dating from the Three Kingdoms period (57 BC–AD 668). The earliest Japanese enamelled works are a set of bronze coffin plaques excavated from the Kegoshi Tomb (late 7th century; Nara, Asukamura, Educ. Comm.). These hexagonal plaques were attached to a lacquered casket, and their stylistic similarities to Korean enamels indicate continental, rather than native, origins. Another early example of Japanese enamelling is the mirror in the Shōsōin repository (Nara, Tōdaiji); objects in the collection are traditionally dated before 756. Other early enamelled pieces include the door fittings of Byōdōin (Uji, Kyoto Prefect.), which was dedicated in 1052. All early Japanese enamels were probably created by heating glass rods, molten drops from which were then directed into heated metal compartments.

The molten glass process differed from the European and Near Eastern convention of adding powdered silicates that fused on firing, a technology not introduced to East Asia until China's Yuan period (1279–1368). It was probably introduced into Japan during the Momoyama period (1568–1600), but its exact source is unknown. A Korean origin has been hypothesized, part of the aftermath of Toyotomi Hideyoshi's abortive invasions of Korea in the 1590s. However, few, if any, enamelled works can be attributed to 16th-century Korea with any certainty. A more probable, though unsubstantiated, source was China itself, either directly or through Portuguese intermediaries during the second half of the 16th century.

(ii) c. *1600–1868.* It was not until the beginning of the 17th century that enamelled works were made in substantial numbers in Japan. Artisans produced fittings for swords and chests, writing accoutrements for scholars' desks, Christian crucifixes and architectural embellishments such as nail covers and door pulls for sliding screens. Hirata Hikoshirō (Dōnin; 1591–1646) is said to have been the first Japanese master to work with true enamel, rather than molten glass. Japanese literary sources credit him and his lineage with the introduction and the development of the art of enamelling. Dōnin was appointed maker of sword fittings for the Tokugawa shogun, and his descendants became hereditary metalsmiths and enamellers to successive shoguns, concentrating their talents on elegant sword fittings.

The early 17th-century spirit of grandeur in Japanese arts provided an ideal milieu for brilliantly enamelled fittings on buildings and furniture. An exuberant taste for gorgeous colour and fine metalwork led to an era of remarkable enamelling that continued until the early 18th century. Literary sources and temple archives provide a basis for compiling a corpus of datable stylistic monuments.

The enamelled works produced during this period were primarily in champlevé with the occasional use of *cloisons*.

The architectural members and furnishings of shogun Tokugawa Ieyasu's (1542–1616) mausoleum, the Tōshōgū Shrine (1616–19; Nikkō, Tochigi Prefect.), were sumptuously embellished with enamelled metal fittings. These brilliantly coloured adornments shone with green, blue, ruby red and white enamels. In contrast to the ostentatious brilliance of Nikkō, the Kyoto style is elegantly simple and the colours are more subdued. The nail covers in the Kuroshoin of Nishi Honganji, produced in 1657, and those of the Katsura and Shūgakuin palaces were created with understated refinement.

During the Edo period (1600–1868) enamelling was an art executed principally by metalworkers, which accounts for the great sensitivity it evinced to metal forms. Coloured enamels were selectively applied to areas where they would function most effectively in the overall design. This harmonious relationship between enamelling and metalwork became an established feature of the mid-17th-century style.

The period from the mid-17th century to the early 18th was a halcyon era for the creation of enamelled objects. Its apogee was in the early 18th century, when the complete technical mastery of enamelling and the disciplined use of the medium for artistic ends were achieved. One of the finest artistic works of this period was the Onarigoten (now Hongo and Ueno, Tokyo), an elaborate palace complex of 48 buildings constructed in 1702 for Lord Maeda Shōun. Its exquisite embellishments exemplify the high standards of workmanship of the period in both enamel and metal.

During the late Edo period the production of enamelled works decreased, as did their quality. With the work of Kaji Tsunekichi (1803–83), however, the art was revitalized, and he is traditionally considered the founder of modern Japanese enamelling. One of Kaji's important accomplishments was the creation of enamelled works in the round, a form far more challenging than two-dimensional plaques. He also developed the use of delicate, ribbon-like silver threads attached to the metal base as *cloisons* and improvised the means to set *cloison* wires into enamel flux before firing, rather than soldering them to the metal base. In 1838 he made his first free-standing cloisonné-enamelled piece based on his studies of Chinese prototypes. Kaji's most lasting contribution to the art of enamelling was his influence as teacher and mentor: the major masters of modern enamelling in Japan have been his students or their disciples. Not only did he create a new artistic movement through his work, but he trained the artists for a new age.

(iii) After 1868. Although Kaji revitalized the art of enamelling, it was not until the beginning of the Meiji period (1868–1912) that major innovations initiated a renewed flowering. The invention of new colours and refinements in the *cloisons* eventually produced enamels that rivalled the finest porcelains in terms of craftsmanship and subtle beauty. The impetus initiated by Kaji was continued by Tsukamoto Kaisuke (1828–97), with whom a new generation of enamellers emerged. The Chinese-influenced style of Kaji was replaced in the mid-1860s by a more traditionally Japanese aesthetic. Artisans created shapes that resembled Japanese ceremonial vessels, taking patterns from native brocades and ceramics and pictorial designs from paintings.

In around 1865 Kaisuke successfully created an enamelled scene of Nagoya Castle. He discovered how to fire enamels on large wares, and in 1868 he became the first to apply cloisonné enamels to a ceramic body. Work with ceramic bodies led to the invention of new, softer colours and more refined and flexible wirework, improvements that were essential for the subsequent development of a naturalistic style.

From the mid-1860s onwards, production for export provided the economic foundation for a flourishing cloisonné enamel industry. Kaisuke's student Hayashi Kodenji (1832–1911), who was later to create cloisonné objects admired for their remarkable naturalism and intricate detail, was among the first to sell his work in Yokohama, the first port to be opened to foreign trade.

In 1875 the trading firm of Ahrens & Company built a cloisonné factory in Tsukiji (Tokyo), and Kaisuke was invited to work there with the German chemist Gottfried Wagener (1831–92). During the three years of the company's existence, Wagener introduced many improvements in the preparation and application of enamels: he replaced dull, opaque enamels with sparkling, colourful ones; he introduced new chemicals to brighten the enamels and augment the palette of colours and shades, most notably sky blue; and he controlled firing temperatures to prevent body warpage and refired pieces to improve surface lustre.

Among the most celebrated modern Japanese enamellers was Yasuyuki Namikawa (1845–1927) of Kyoto, who left the service of Prince Fushimi for a career as an artist. In the early 1870s he devoted himself to cloisonné enamels. His creations are admired for stunning naturalism, technical excellence and exploitation of the aesthetic potential of cloisonné, as well as for the refined elegance of his wirework and the subtle beauty of his colours (see fig. 225). Yasuyuki also introduced important technical innovations, notably the invention in 1879 of brilliant mirror-black and transparent cloisonné enamels. By 1893 his works were free of supporting background wires, allowing open areas unobstructed by *cloisons*. This was the successful culmination of the long process of experimentation that had begun about 1875.

Yasuyuki's Tokyo contemporary Sōsuke Namikawa (1847–1910) was equally famous. He preferred pictorial subjects, and in 1881 he first began reproducing classic Japanese paintings in cloisonné enamel in a remarkably naturalistic style. Sōsuke was especially lauded for his *cloison*-less enamels (*musen shippō*), in which he firmly controlled the placement and flow of glazes. By 1889 he and his assistants were creating wire-free works of such precision and subtlety of tonal gradation that they resembled brush paintings in enamel.

The period from 1880 to 1914 was the golden age of modern Japanese enamelling. A vast array of technical inventions allowed artists to exploit the medium fully, utilizing a wide range of colours from delicate pastels to rich, dark hues. Innovations included *moriage* (enamels rendered in sculptural relief), *basse taille* and *plique à jour* (*see* ENAMEL, §2(iii) and (v)). Designs ranged from

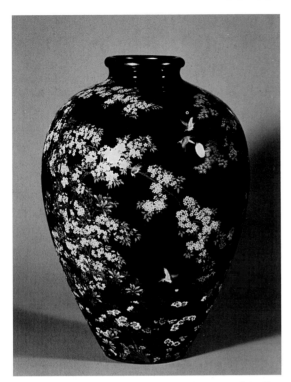

225. Enamel cloisonné vase with birds and flowers of the Four Seasons by Yasuyuki Namikawa, h. 362 mm, *c.* 1900 (Tokyo, Imperial Household Collection)

decorative abstract patterns to highly naturalistic compositions of birds and flowers and realistic renderings of perceptively observed nature. The flourishing market for enamels encouraged artists to indulge in lavish detail, painstaking workmanship and the use of opulent materials.

Since the 1960s there has been renewed interest in the art of enamelling. The impetus has come from artists not only in Tokyo, Nagoya and Kyoto, but throughout Japan. Developments in chemistry have enabled enamellers to produce new permutations of colours and shades as well as striking blends of hues with suffused tonalities. Technological advances in electric kilns and precision temperature controls have increased the artistic possibilities for the cloisonné artist. Commissions for huge architectural wall decorations, for subtly refined tea ceremony utensils and for elegant fashion accessories have attracted talented artists to the medium.

BIBLIOGRAPHY

J. Bowes: *Japanese Enamels* (London, 1886)
——: *Notes on Shippō* (London, 1895)
H. Garner: *Chinese and Japanese Cloisonné Enamels* (London, 1962)
M. Yoshimura: *Shippō* [Enamelware] (Kyoto, 1966)
H. Brinker and D. Seckel: 'The Cloisonné Mirror in the Shōsōin', *Artibus Asiae*, xxxii (1970), pp. 315–35
D. Blair: *A History of Glass in Japan* (Tokyo, 1973)
S. Hayashi: *Shippō no moyo* [Pattern of enamels] (Kyoto, 1977)
N. Suzuki: *Nihon no shippō* [Japanese enamels] (Kyoto, 1979)
J. Sugiyama: *Tōyo kodai garasu* [Ancient oriental glass] (Tokyo, 1980)
M. Yoshida: *Nakahara Tessen kyō shippō moyo shū* [A book of Kyoto [school] enamelling patterns by Nakahara Tessen] (Kyoto, 1981)
L. Coben and D. Ferster: *Japanese Cloisonné* (Tokyo, 1982)

GEORGE KUWAYAMA

9. FLOWER ARRANGEMENT.

(i) Introduction. (ii) Historical development.

(i) Introduction. The Japanese art of *ikebana* (from *ikeru*, 'to keep alive', and *hana*, 'flowers'), also known as *kadō* (the way of flowers), involves the arrangement of flowers and branches. Although the custom of offering flowers at shrines and the use of flowers for decoration are universal, *ikebana* has, since the 15th century (*see* §(ii) below), developed into a unique and undisputed art form that is also a spiritual discipline. *Ikebana* artists explore the relationship between man and nature in a changing world. Characteristic are the attention given to the selection of plant materials, the technical skills involved in fixing these securely in an appropriate container and the artistic skills required to assess their relationship to each other and to the surrounding space. In the 20th century *ikebana* spread world-wide and, particularly since 1960, underwent radical changes.

Ikebana arrangements generally display the following characteristics. The focal point, from which the arrangement is designed to be viewed, is outside the arrangement itself. The three-dimensional arrangement has an asymmetric balance, with the material being placed off-centre, reaching forwards and upwards. Space (*kūkan*) is incorporated into the design, forming an integral part of it. Following the *in-yō* (Chin. *yin-yang*) principle, opposites of line and form, space and mass, light and dark balance each other; groupings of odd numbers, particularly three, five and seven, are favoured. Influenced by Zen Buddhism, *ikebana* tends towards understatement, line being more important than colour. Its ephemerality is acknowledged in the choice of seasonal material and the inclusion of buds, open flowers and withered leaves.

The study of *ikebana* has three aspects. First, technique (*jutsu*): this includes mastering the skills of cutting (*kiru*) and fixing (*tameru*) heavy branches and delicate stems in different types of containers; the use of *ikebana* scissors (*hasami*) and pin-holders (*kenzan* or *shippo*) for *moribana* arrangements and traditional supports (*kubari*) for *rikka*, *seika* or *nagaire* arrangements (*see* §(ii) below); learning to bend, shape and balance material; learning to prune and trim to develop or elucidate a line; and the study of colour and form, of material, and of techniques for prolonging the plants' life in the vase. Second, theory involves studying the styles and terminology, the history of *ikebana* and background knowledge about styles of containers, the materials used for them, and flowers appropriate to different seasons or festivals; and keeping up to date with current developments. Third, the 'Way' (*dō* or *michi*) is the philosophical or spiritual aspect that makes *ikebana* different from Western flower arrangement; through *ikebana* the student engages in a spiritual path, finding his or her own way of development.

(ii) Historical development. Ikebana is rooted in the Japanese reverence for nature and in the indigenous beliefs associated with SHINTO. The practice of offering evergreen branches at Shinto shrines may be the origin of *ikebana*.

(a) 6th–18th centuries. (b) 19th–20th centuries.

(a) 6th–18th centuries. Formal flower offerings were introduced from China and Korea with Buddhism in

around the 6th century AD and are depicted on early stone engravings and paintings. According to tradition the ritual offering of flowers (*kuge*) to the Buddha was introduced to Japan in the early 7th century by a nobleman, Ono no Imoko, who, at the behest of Prince Shōtoku, led the first Japanese diplomatic missions to China in 607 and 608. When Ono no Imoko retired from diplomatic service, he entered the priesthood, took the name Senmu and built a hut near a pond (Ike no bō) in the grounds of the Rokkakudō (Hexagonal) Temple in Kyoto, established by Shōtoku, where he daily offered flowers to the Buddha. Hence comes the name of the oldest school of *ikebana*, the Ikenobō school, which regards Senmu as its founder.

The earliest practitioners of *ikebana* were priests. Three traditional offerings (*mitsugusoku*; comprising an incense burner flanked by flowers and a candle) were placed on the altar in front of the Buddha image. Native flowers were arranged in a metal container in what came to be known as the *tatebana* or *tatehana* ('standing flower') style. Such offerings, depicted in early scrolls, tapestries and carvings, represented the donor's hope that his prayer, like the upward-reaching flowers, would rise up towards heaven and reach the attention of the Buddha.

During the Heian period (794–1185) the practice of flower arrangement spread among the nobility and samurai. *Hana awase* (floral competitions), in which flowers were displayed on palace verandahs and poetry composed about them, were popular in the 14th century, and vases were specially imported from China for these events. The *Kaoiri no kadensho*, one of the earliest texts on *ikebana*, shows flowers arranged in baskets hung from verandah eaves and in rectangular, sand-filled bronze basins. One such display, the *Shichiseki horaku no hana*, formed part of the Tanabata (Star Festival) *hana awase*, which took place in the time of the Ashikaga shogun Yoshimitsu (1358–1408).

These developments coincided with the evolution of *shoin zukuri* ('book hall or study construction') in residential architecture, incorporating an alcove (*oshiita*), the

226. Flower arrangement (*ikebana*), *rikka* 'standing flowers' style

forerunner of the TOKONOMA (decorative alcove), on the north wall of the reception hall (*zashiki*). The *oshiita* had space in which to hang a calligraphic or painted scroll and in front a board where the incense burner and flower arrangement stood. Artistic advisers (*dōbōshū*) of discriminating taste selected and supplied paintings, bronzes and vases, arranged flowers and developed styles to suit this space. Leading *dōbōshū* were Nōami and Sōami (*see* AMI, (1) and (3)), Ryuami and Mon'ami, the latter two being renowned for their skill in arranging *tatebana*.

Tatebana were originally arranged for ceremonial occasions. The type of container, the shape of the arrangement and the type of material were all prescribed. The main stem (*shin no hana*) was one and a half times the height of the container and stood upright with two flowers at its base, the lower one to the left of the main stem, the other to its right. This characteristic three-point form, reflecting its Buddhist origins, is typical of all classical *ikebana*. Formal rules for *tatebana* were given in the *Sendensho*, a compilation of writings made between 1444 and 1536, which also illustrated the informal *nageire hana* ('thrown-in flower' style), in which flowers for everyday use were arranged freely and naturally in simple tall ceramic or bamboo containers.

Two outstanding 16th-century *ikebana* masters were Ikenobō Senno, author of *Senno kuden*, who stated that material should be arranged to reveal its fundamental nature, and Ikenobō Sen'ei, who distinguished three modes for *tatebana*: *shin*, *gyō* and *sō*. *Shin* is the formal mode where the main stem stands straight; *gyō*, less formal, with the main branch curving naturally; while *sō* is a small, informal arrangement for a shelf or hanging container. All later classical styles conform with these three categories.

In the Momoyama period (1568–1600) native Japanese arts grew in assurance and maturity. Houses of the nobility were larger, and the grand *rikka* ('standing flowers') style developed to suit their spacious rooms. The *rikka* style is said to date from 1462, when the *ikenobō iemoto* (head master), Sengyō (Senkei), created a sensational arrangement in a gold vase. The *Ikenobō Sen'ei densho* (1545) lays down rules for *rikka*, which is extremely complex and highly systematized and symbolically represents a landscape (see fig. 226). *Rikka* arrangements may be 2 m tall. They are made in a formal container (*usubata*), a tall, bronze, curved vase opening to a wide mouth and filled to the brim with water. The branches are fixed in a central well and supported by a tightly bound bundle of cut rice straw (*komi-dome*).

Nine branches (originally seven) are used, arranged as if emerging from a single stem placed in the centre of the container. From this stem branches reach out from a point 100 mm above the water-level (*mizugiwa*) to form a three-dimensional arrangement. Pine or cypress is traditionally used for the main branch (*shin*), which stands straight (*sugushin*) in a centrally placed arrangement, curves to the right (*gyakugatte*) when placed on the right or curves to the left (*hongatte*) when placed on the left. The entire arrangement is divided into the sunlit or positive side (Jap. *yō*; Chin. *yang*) and the shaded or negative side (Jap. *in*; Chin. *yin*).

In the first half of the 17th century the head master Senkō II, with the support of Emperor GoMizunoo

(*reg* 1611–29), who sponsored many *rikka* exhibitions at court, popularized *rikka* among the nobility. *Rikka* reached its acme later in the century when it attracted the interest and patronage of the wealthy merchant class.

Suna no mono is a less formal style dating from the same period as *rikka*. It is made in a shallow bronze, sand-filled container (*sunabachi*) and also suggests a landscape. From this developed other shallow-container miniature landscape arts, such as *bonsai* (*see* §3 above), *bonkei* (landscape) and *bonseki* (stone garden).

Chabana ('tea flowers') was a smaller arrangement developed by Sen no Rikyū, who reformed and simplified the tea ceremony. *Chabana* is a fluid, informal style, which, in marked contrast to *rikka*, often uses only a single flower in a rustic ceramic or bamboo container.

During the Genroku period (1688–1704) the *Sukiya* style (*sukiya zukuri*, 'tea house construction') of domestic architecture developed with simpler, smaller rooms, of which the *tokonoma* was a feature. This alcove became the setting for decorative objects, such as a hanging scroll (*kakemono*) and an *ikebana* to one side of it. The dimensions of the *tokonoma* (some 2×2×1 m) required a proportionally smaller arrangement, and the influence of Zen led to a demand for simpler styles. Because *tokonoma* arrangements could be viewed from the front only, material was fixed to lean forwards in the three-dimensional manner typical of later *ikebana*.

In the early 18th century the Tokugawa shogunate introduced sumptuary laws to curb a tendency towards ostentatious display. A simplified formal style of *ikebana* developed that incorporated some of the formality of *rikka* but was influenced by the austerity of Zen. This style ('living flowers') is called *shōka* by the Ikenobō school and *seika* by other schools, *seika* being the more widely used term. As in *rikka*, the material is arranged to appear as a single stem rising from the mouth of an upright container. Originally this was an *usubata*, but later bamboo, pottery and other materials were used. Three main branches (*ten*, *chi* and *jin*, representing respectively heaven, earth and man) are arranged to form an asymmetric triangle expressing the essence of the plant's natural form. The main branch curves but should not reach beyond the circumference of the container, and its tip should be vertically in line with its base. The second branch, placed behind the *shin*, curves in the same direction, while the third is placed in front and reaches towards the viewer at an angle of 45°. In traditional *seika* only one (*isshuike*) or two (*nishuike*) kinds of material are used (modern *seika* commonly uses three (*sanshuike*)).

In the Muromachi period (1333–1568) *tsuribana*, informal arrangements in 'ship' and later 'moon' containers suspended from the ceiling by a chain or rope, had become popular. When the *tokonoma* became a common feature in Japanese homes, a new arrangement called *kakebana* was designed to hang from the supporting post (*tokubashira*) at the side of the *tokonoma*. Gourds, baskets or simple ceramic containers were used. Hanging arrangements were frequently used in the tea ceremony.

A key figure in popularizing *ikebana* through exhibitions was Chiba Ryuboku, founder of the Genji school, which moved from Osaka to Edo (now Tokyo) in 1762. He instituted a system of graded certificates and probably formally initiated the *iemoto* (head master) system. Many other masters followed Chiba to Edo. By 1770 several schools had been established, among them the Koryū school by Imai Isshikensofu, the Enshū school by Shunjuike Ichiyo, the Kōdō school by Mochizuki Ruinsai and the Sōami *ryū* (school or lineage).

(*b*) *19th–20th centuries.* The Misho *ryū* was founded in Osaka in the early 19th century by Ippo Mishosai. Schools developed individual philosophies, drawing on Chinese aesthetics, Daoist thought and Confucianism. Common to all was the concept of three branches symbolizing heaven (respect) and earth (obedience), with man in harmony with both. *Nageire*, a small, informal, slanting arrangement dating from the 16th century, remained popular into the 1860s. It was marked by the use of unusual upright containers and materials and was favoured by the intellectuals and literati of Edo in the form known as *bunjin'ike* (literati style).

The opening of Japan to the West at the time of the Meiji Restoration (1868) radically affected *ikebana* along with all other aspects of Japanese life. Many schools of *ikebana* declined, but *bunjin'ike* and *seika* continued to have wide support, as reflected in the architect and connoisseur Josiah Conder's *Floral Art of Japan* (1891), the first book on *ikebana* by a Westerner. Western influence on architecture and interior design and the introduction of new flowers and plants from the West called for fresh approaches to *ikebana*. The first to respond was Unshin Ohara (1861–1914), exhibiting in Osaka in 1897, who developed the upright *moribana* ('piled-up') style using a shallow, flat-bottomed container (*suiban*) and stressing colour and natural form, while retaining the traditional three lines. It rapidly became popular, and the Ohara school was founded in 1912.

Radical innovations in *ikebana* in the 20th century were *jiyūka* ('free-style') and *zokeibana* ('free creative use of flowers'), both forms that permit self-expression. Leading exponents included Chōka Adachi (1887–1969), Mirei Shigemori (1878–1937), Sōfū Teshigahara (1900–79), Bunpo Nakayama (1899–1986) and Hōun Ohara (*b* 1908). In 1930 Teshigahara, Nakayama and Shigemori issued the *Declaration on the Newly Risen Ikebana*, advocating an *ikebana* free from 'feudal' restrictions. Avant-garde *ikebana* (*zen'eibana*), a post-war development, was revolutionary both in its approach to and its choice of materials. In the Three Masters Exhibition held in Osaka and Tokyo in 1951, the three leading exponents of *zen'eibana* (Nakayama, Ohara and Teshigahara) used metal, glass and plastic as well as flowers and branches, often creating huge sculptural constructions to express abstract and surreal concepts hitherto unknown in *ikebana*. Such leading exponents as Hiroshi Teshigahara (*Iemoto* of the Sōgetsu school) and Kasen Yoshimura (*Iemoto* of the Ryūseiha school) continued in the late 20th century to explore the potential of *ikebana*. Some of their work, created out of doors, is more akin to environmental art than to flower arrangement, but modern man's confrontation with nature remains a central theme, the short-lived nature of the art reflecting man's mortality.

After the Meiji Restoration *ikebana*—like the tea ceremony, traditional music, calligraphy and other arts—was

considered a desirable accomplishment for well-bred, marriageable young women. Until *c.* 1930 it was customary for *ikebana* masters to give lessons in the homes of upper-class families, but thereafter Chōka Adachi and others established schools that attracted students in larger numbers and from a much wider range of social backgrounds. Large groups could be taught by new teaching methods and prepared texts, including correspondence courses. There are thought to be some 3000 established *ikebana* schools in Japan, having 15–20 million students, most of them young women. Ikenobo remains one of the largest schools, teaching both traditional and modern styles. The other two largest, the Ohara and the Sōgetsu schools, may also have as many as three million students each. Other important schools are the Koryū Shoto Kai and Ryūseiha. Schools are invariably run on the traditional *iemoto* system, with the headship passing to the *iemoto*'s eldest son or daughter or to his adopted heir.

Ikebana was little known abroad until after World War II, when it was admired and studied by wives of Allied military officials and other foreigners stationed in Japan during the Occupation. Many of these qualified as teachers and returned to their home countries as enthusiastic advocates of the art. *Ikebana* is perhaps best known in the USA but is also increasingly practised in Britain, Germany, France, Switzerland, Australia, New Zealand, southern Africa, Latin America, the Middle East, India and Southeast Asia and has had a considerable influence on Western taste. Japanese *ikebana* masters frequently travel abroad to attend conferences, demonstrate, exhibit and teach, which further stimulates interest. Several *iemoto* have received honours from foreign governments in recognition of their artistic achievements. In 1956 Ellen Gordon Allen (1898–1972), wife of an American army officer, founded Ikebana International in Tokyo. This organization, which has more than 100 chapters in some 40 countries, maintains links with over 12,000 members drawn from different *ikebana* schools through a quarterly magazine and by means of national, regional and international conferences and a World Convention held in Japan every 5 years.

BIBLIOGRAPHY

Ikenobō Senji, ed.: *Sendensho* (1445–1536) [compilation of texts with instructions for 53 arrangements]
Sen'ami: *Sen'ami kadensho* (1552)
Inoyaki Sanzaemon: *Rikka zy oyobi sunanomono* (1673)
J. Tauemon: *Nageire kadensho* (1684)
Toshuken: *Rikka imaiyo sugata* (1688)
T. Takeda: *Heika ron* [*Bunjin* flower book] (1819)
J. Conder: *The Floral Art of Japan* (1891)
K. Ohara: *Shiki no moribana* [Four-seasons *moribana*] (1918)
Kadō kosho shusei, 5 vols (1931)
A. Koehn: *The Art of Japanese Flower Arrangement* (1934)
Kadō zenshū [Complete collection of Japanese flower arrangement], 12 vols (1935)
S. Mirei: *Ikebana geijutsu* [Art of *ikebana*] (1949)
G. L. Herrigel: *Zen in the Art of Flower Arrangement*; Eng. trans. by R. F. C. Hull (1958)
N. J. Sparnon: *Japanese Flower Arrangement, Classical and Modern* (1960)
Flower Arrangement the Ikebana Way (1962)
S. Teshigahara: *Sōfu: His Boundless World of Flowers and Form* (1966)
D. Richie and M. Weatherby, eds: *The Masters' Book of Ikebana* (1966)
Y. Fujiwara: *Rikka: The Soul of Japanese Flower Arrangement*; Eng. trans. by N. Sparnon (1976)
S. Ikenobō: *Ikenobō Sen'ei* (1977)
P. Swerda: *Creating Japanese Shōka* (1979)
S. Komoda and H. Pointer: *Ikebana Spirit and Technique* (1980)
Ikebana bunkashi [History of *ikebana*] ([1980])
K. Masanobu: *Ikebana no michi* (1985); Eng. trans. by J. Gluck and S. Gluck as *The History of Ikebana* (1986)

ELIZABETH PALMER

10. FOOD. The history of food preparation in Japan is long and complex. Although foreign influences have been absorbed, especially from China, Portugal and France, Japanese cuisine remains highly distinctive and varied. The presentation of food may be considered a minor art form in its own right, with interrelations to other visual arts. Even in the preparation of a packed lunchbox (*bentō*), the greatest care is taken in the choice of the container and the colour and placement of the food items (see fig. 227). As in the West, certain foods provide particular opportunities for visual display, notably *sushi* (raw or marinated fish and other ingredients on a base of lightly fermented cooked rice), *kashi* (cakes) and prepared dishes, especially those connected with Buddhism and the tea ceremony (*see* §XIV, 1 above).

The earliest reference to *sushi* is on an inscribed wooden tally (Nara, N. Res. Inst. Cult. Properties), which was found in excavations at the site of the Heijō Palace, Nara (early 8th century AD), and which records a gift of sea bream (*tai*) from Wakasa Province (now Fukui Prefecture). *Sushi* is also mentioned several times in the Yōrō legal code (completed 718). The *Engishiki* ('Procedures of the Engi era'; 905–27; completed 930) specified that the provinces should pay taxes in the form of *sushi*. Documentary sources therefore list some early ingredients of *sushi* but contain little about methods of preparation and presentation. From the second half of the 17th century acetic acid was substituted for lactic acid as a fermentation agent, and *sushi*-making divided into two main traditions, Kansai and Edo (now Tokyo). The former uses less salt, but there are also aesthetic differences, particularly in the design of display pieces, which may be modelled to suggest *nō* plays or other literary themes. *Edomaezushi* ('Tokyo sushi') is more flamboyant in style and colour; one speciality is an elaborate rolled type of *sushi* suggestive of cloisonné medallions. Both schools carve fish in floral, seasonal and other motifs taken from the standard vocabulary of traditional Japanese ornament. The carving of fish and other food is done with *hōchō*, special knives that are forged like Japanese swords and treated with a similar reverence. By the Muromachi period (1333–1568) there were some five formal lineages of carving (*shiki hōchō*). At least one of these, Ikamaryū ('Ikama style'), survives in Kyoto (at the Mankamerō Restaurant).

The earliest evidence for pounded-rice sweetmeats (*mochi*) comes from late Yayoi-period (*c.* 300 BC–*c.* AD 300) tombs. In the 7th and 8th centuries Chinese cakes (*tōgashi*) were introduced, and documentary sources classify them in various ways. Some of these antique types are still made, but the introduction of tea-drinking in the late 12th century stimulated the development of new cakes, designed especially for the tea ceremony and known generally as *tenshin* ('snack'). As in everything associated with the tea ceremony, cakes appropriate to the season, place and occasion must be selected and presented as elegantly as possible. In the 14th century Zen Buddhist contacts with China led to the introduction of *manjū*

227. Food packed in a lacquer *bentō* box with a decorated lid

(sweet dumplings), often stamped with a decorative design. In the 16th century the Portuguese introduced new kinds of cakes, using sugar. In 1589 *yōkan*, a confection made from sweetened bean-paste and agar-agar, was devised for an entertainment given by Toyotomi Hideyoshi at his palace in Kyoto. By the 18th century cakemaking, still strongly influenced by the tea ceremony, had settled into two rival streams: *Kyōgashi* (from Kyoto) and *Jōgashi* (from Edo) as well as many regional specialties (*meibutsu*; 'famous products'). Exquisitely wrapped and packaged cakes are exchanged as gifts (*omiyage*). Many have literary and historical associations that are cleverly expressed in their shapes and decoration. Some, especially for the tea ceremony and for religious purposes, are carefully pressed in wooden moulds.

Tenshin properly describes savoury dishes served in connection with a tea ceremony. Such tea-ceremony cuisine (*kaiseki ryōri*; 'warm stone cuisine', like a stone to warm the stomach) reflects the influence of Buddhist vegetarian cuisine (*shōjin ryōri*; 'cuisine for spiritual progress') and the tense aesthetic values of Zen Buddhism. For *shōjin ryōri*, *kaiseki ryōri* and other formal occasions, it is customary to use trays with feet (*zen*), of which there are many types, each with its own style of arrangement and historical associations. The history of *zen* is illuminated from handscroll painting and other pictorial sources, as well as from documents. Originally there were separate styles for noble and military families (*shiki sanzen* and *honzen* respectively); but a series of banquets given by the Shogun Tokugawa Hidetada (1579–1633) in 1626, for Emperor Gomizunoo (*reg* 1611–29), combined both. The modern etiquette for using *zen* is simpler, but still dictated both by the nature of the occasion and by the formal lineages of cuisine and carving. It goes without saying that the choice of pottery bowls and other utensils for food and drink is always of the utmost importance. *Kaiseki ryōri* ('cuisine for seated meeting places')—using a different word *kaiseki*—is the general name today for banquet cuisine. It is most often prepared by fine restaurants (*ryōtei*) and inns (*ryokan*), some of which, especially in the Kansai area, have a history stretching back three or four centuries.

BIBLIOGRAPHY

M. Watanabe: *Nihon shoku seikatsu shi* [A history of Japanese food] (Tokyo, 1964)

H. Oka: *Tsutsumu: An Introduction to an Exhibition of the Art of the Japanese Package* (exh. cat., New York, Japan House Gal., 1975)

A. Shinbunsha, ed.: *Nihon no okashi* [Japanese cakes] (Tokyo, 1976)

S. Araki, ed.: *Sushi gijutsu kyōkasho (Kansaizushi hen)* [Textbook of *sushi* technique (Kansai *sushi*)] (Tokyo, 1978)

K. Katō, ed.: *Sushi gijutsu kyōkasho (Edomaezushi hen)* [Textbook of *sushi* technique (Tokyo *sushi*)] (Tokyo, 1978)

K. Kawakami, ed.: *Ryōri bunken kaidai*, Shirīzu shoku bunka no hakken [The discovery of food culture series], ix (Tokyo, 1978)

M. Yamaguchi: *Daidokoro dōgu no rekishi* [History of kitchen utensils] (Tokyo, 1978)

T. Yanagihara: *Denshō Nihon ryōri* [Traditional Japanese cookery] (Tokyo, 1978)

Y. Murai, ed.: *Kyōryōri no rekishi* [History of Kyoto cuisine], Shirīzu shoku bunka no hakken [The discovery of food culture series], iv (Tokyo, 1979)

K. Tsuji: *(Kara) Tenshin* (Kyoto, 1980)

I. Tsuji: *Nihon no aji to bunka* [Japanese flavour and culture] (Tokyo, 1982)

N. Ishige, ed.: *Higashi Ajia no shokuji bunka* [The food culture of east Asia] (Tokyo, 1985)

Y. Tsuchiya: *A Feast for the Ages: The Japanese Art of Flower Arrangement* (Tokyo, 1985)

M. Yoshida and T. Sesoko, ed.: *Naorai: Communion of the Table* (Tokyo, 1989)

L. Cort: 'Japanese Ceramics and Cuisine', *Asian A.* (Winter 1990), pp. 9–35

DAVID WATERHOUSE

11. FURNITURE. Japan's floor-level lifestyle has precluded the development of items of furniture associated in other cultures with chair-level living. Another factor limiting the range of Japanese furnishings is the gradual transformation of once discrete items of furniture used for seating and partitioning, such as *tatami* (woven rice-straw mats covered with rushes) and *shōji* (translucent paper screens), into architectural components of the traditional Japanese house.

(i) Materials and techniques. Japanese craftsmen traditionally classified timber into evergreen (*acerose*), broadleaf and imported woods (*karaki*; 'Chinese wood'). The most favoured evergreen woods were the resilient, fine-grained Japanese cypress (*hinoki*; *Chamaecyparis obtusa*), Japanese cryptomeria (*sugi*; *Cryptomeria Japonica*) and Japanese yew (*ichii*; *Taxus crespidata*). Broadleaf woods included zelkova (*keyaki*; *Zelkova serrator*), paulownia (*kiri*; *Paulownia tomentosa*), mulberry (*kuwa*; *Morus alba*), Japanese chestnut (*kuri*; *Castanea crenata*) and the horse chestnut (*Aesculus turbinata*). *Karaki*, such as red sandalwood (*shitan*; *Pterocarpus santalinus*), ebony (*kokutan*; *Diospyrus ebenus*), Indian rosewood (*tagayasan*; *Dalbergia nigra*) and aloe wood (*jin*; *Liliaceae alsinae*) were imported to Japan as early as the Nara period (AD 710–94).

The predominance of wood as the main building material in Japan led to the development of advanced joinery techniques for both furniture and architecture. Joinery was considered such an important part of furniture-making that Japanese furnishings were referred to as *sashimono* ('fitted things'; especially unfinished pieces or pieces with a clear lacquer finish showing joinery). The earliest examples of *sashimono* techniques are the primitive tenon-fittings (*hozo sashi*) found on arrowheads of the Jōmon period (*c.* 10,000–*c.* 300 BC). Simple joints such as plain tenon joints (*hira hozo tsugi*), slant-through tenon joints (*keisha tōshi hozo tsugi*) and keyed-through tenon joints (*kusabi tōshi hozo tsugi*) were employed in Yayoi-period (*c.* 300 BC–*c.* AD 300) footed trays (*takatsuki*). Kofun-period (*c.* AD 300–710) sarcophagi show stopped-lap butt joints (*tsutsumi uchitsuke tsugi*) and plain-slot joints (*hira oiire tsugi*). The greatest progress in joinery was made during the Asuka–Hakuhō (AD 552–710) and Nara (710–94) periods, when the Japanese developed the full repertory of joints. However, because of the slow development of woodworking tools and low economic growth, these techniques did not become widespread until the Edo period (1600–1868).

Japan has an ancient tradition of furniture made of unfinished cryptomeria and Japanese cypress wood, such as tray-tables (*zen*) and storage chests (*tansu*). Unfinished Japanese cypress, which is a symbol of purity, is also used for ritual objects and buildings connected with the Shinto religion. *Yasha* (dry finish) was produced by varnishing wood with a liquid obtained from boiling the seeds of the birch-family shrub, *yashabushi* (*Alnus firma*). Dry finish was a preferred finish for paulownia wood, as it enhanced its natural colour without obscuring the beauty of the grain. The most common wood finish for furnishing was lacquer, which was used as protective coating and decorative finishing and sometimes as an adhesive. Lacquer finishes include *kijironuri* (a coat of transparent lacquer on plain or tinted wood), *fukinsushinuri* ('wiped-on lacquer'; repeated application of clear lacquer), *shunkeinuri* (a single coat of clear lacquer on yellow-stained wood), *hananuri* (coloured lacquer mixed with perilla oil to give a high-gloss finish, usually black or dark red), *roiro* (repeated application and polishing of coats of clear lacquer over a black lacquer base) and *negoro* (vermilion over black lacquer). More elaborate decorative techniques, such as *makie* ('sprinkled picture'; gold and silver applied on black lacquer), *raden* (mother-of-pearl inlay) and lacquer carving (*tsuishu* and *Kamakurabori*, 'Kamakura carving'; see §X above), were reserved for pieces destined for the court and military élites.

Metal fittings (*kanagu*) on furniture consisted of locks (*jōmae*), hinges (*chōtsugai*), pulls and pole handles (*sao tōshi*), latches (*tome kanagu*), sash hardware (*obi kanagu*) and decorative hardware (*kazari kanagu*), which served the dual function of decoration and reinforcement. Decorative techniques such as openwork and line engraving were applied to iron, copper, brass, nickel-silver, silver and certain alloys (see §XII, 1 above).

(ii) Historical development. The earliest Japanese houses were Jōmon-period circular pit dwellings and square pit dwellings with rounded corners. Inside was a central hearth, and the floor was covered by woven mats (*mushiro*). The introduction of rice agriculture during the Yayoi period was accompanied by wide-ranging changes in domestic lifestyles. The ruling classes lived in rectangular raised-floor dwellings, with a sleeping area at the rear separated by a braided or matted grass wall. The antechamber was free space, partitioned by *sudare* (bamboo blinds). During the Kofun period *agura* ('legged saddle') seats were used by chieftains as symbols of authority. These include four-legged chairs, platforms with railings and folding chairs. Beds (*yuka*) were also used by the élite. However, daily life was lived at floor-level, and the only items of furniture in common use were storage coffers (*hitsu*).

The introduction during the Asuka–Hakuho period of Buddhism and of a centralized administrative system modelled on Sui-period (581–618) and Tang-period (618–907) China was accompanied by the adoption of a chair-level lifestyle by the Japanese court. Several richly decorated pieces of imported Chinese furniture from the period are preserved in the Shōsōin repository (see NARA, §III, 3; see also CHINA, §XI, 2(ii)). Court furnishings included *chōdai* (beds with canopy and curtains), *ishi* (chairs of state), Persian rugs, single-panel screens (*tsuitate*), folding screens (*byōbu*), Japanese-style (*wabitsu*) coffers without legs and Chinese-style (*karabitsu*) coffers with legs. Three examples of *zushi* storage cabinets are preserved in the Shōsōin. The finest is a double-doored zelkova-burl cabinet with two shelves, which stands on a Chinese-style openwork base.

The Shinden style appeared at the beginning of the Heian period (794–1185) and was based on domestic Chinese architecture (see §III, 3(iii) above). With no fixed internal or external walls, the function of dividing space was taken by *tsuitate*, *shōji*, *sudare*, *tobari* (cloth room curtains) and *byōbu*. Seating was provided by *komo* (woven straw mats), *mushiro* and *tatami*. *Wabitsu* and *karabitsu*

were still used for storage, and a representative piece from the period is the *Hōōmon karabitsu* (coffer with legs and phoenix roundels; Ikaruga, Hōryūji), which is decorated with mother-of-pearl inlay. The method of dividing space and arranging furniture for various ceremonies was called *shitsurai*. The *shitsurai* for daily life consisted of a sleeping area with a *chōdai* at the centre of the *shinden* and a sitting area enclosed by *byōbu* with *tatami* mats to the front and *zushidana* (three-tiered shelves) to the side.

With the gradual introduction of the tea ceremony, domestic life in the Kamakura period (1185–1333) was again lived completely at floor-level. *Shitsurai* furniture was abandoned, and *shōji* and *chōdai* became architectural features of a new style of domestic architecture: the *shoin* style (*see* §III, 4(ii)(a) above). This was perfected during the Edo period (1600–1868), when its main features were a great room or hall (*zashiki*), with a floor completely covered by *tatami* and with a raised dais (*jōdan no ma*) for the shogun or daimyo at one end. The *jōdan no ma* contained a *tokonoma* (alcove) and asymmetrical shelves (*chigaidana*). The pillars and ceiling beams were lacquered, the paper-covered sliding doors (*fusuma*) were painted in the lavish *konpeki* ('gold-and-blue') style and the ceiling was decorated with intricately carved transoms (*ranma*). This luxury was matched by the personal effects of the dowry furniture made for the daughters of the shogun and important daimyo. A typical dowry might consist of 60 pieces of lacquerwork, including sets of shelves (*zushidana*, *kurodana*, 'black shelves'; *shodana*, 'small shelves'), Chinese-style coffers, folding screens and desks (*see* fig. 228).

In the 17th century the whole country was enriched. Wealth spread from the great commercial centres of Edo (now Tokyo), Kyoto and Osaka to the provinces, leading to the development of a wealthy commercial class and an unprecedented demand for all types of domestic furnishings. The typical furniture found in an Edo-period townsman's home included *tansu*, most commonly *ishōdansu* (clothing chests) and *chadansu* (tea chests), *tabakobon* (tobacco boxes), *hibachi* (braziers), *kotatsu* (quilt frames placed over a *hibachi*), *zenibako* (money boxes), *haribako* (sewing boxes) and *kyōdai* (vanity boxes, dressing tables). The opening of the country to Western influence in the second half of the 19th century initiated a transition from floor-level to chair-level living. Government reforms during the Meiji period (1868–1912) actively promoted the introduction of Western furnishings into schools and offices, but private domestic furnishings only began to change in the post-war period.

BIBLIOGRAPHY

K. Koizumi: *Wakagu* [Japanese furniture] (Tokyo, 1977); Eng. trans. by A. Birnbaum as *Traditional Japanese Furniture* (Tokyo and New York, 1986)
K. Seike: *The Art of Japanese Joinery* (Tokyo and New York, 1977)
S. Gotō, ed.: *Shōsōin no mokkō* [Woodwork objects in the Shōsōin] (Tokyo, 1978)
T. Heineken and K. Heineken: *Tansu/Traditional Japanese Cabinetry* (Tokyo and New York, 1981)
R. Clarke: *Japanese Antique Furniture* (Tokyo and New York, 1983)
T. Freese: *Die Kunstwerke des japanischen Schreiners* (Stuttgart, 1991)

KAZUKO KOIZUMI

12. GLASS. Until about the 6th AD century glass was regarded in Japan as a sacred substance; it was rare, and

228. Set of shelves, black lacquer with gold *makie* and gilt-bronze fittings, l. 970 mm, 18th–19th centuries (London, British Museum)

beads of it were thought to have a protective nature. For this reason, and because true gemstones were almost unknown in Japan, glass was used much as other cultures used gemstones. Its use in any form, however, was not widespread until modern times. With the exception of beads, few examples of glass from before the Edo period (1600–1868) survive. They mainly comprise those that have been preserved in Buddhist temples, including the Shōsōin treasure-house near Nara, and Shinto shrines. Existing documentary evidence can be difficult to correlate with surviving objects, partly because of lack of knowledge about ancient production techniques and partly because of confusion about the meanings of glass-related terminology. Good collections of glass produced later than the 8th century AD are held in the Museum of Art, Toledo, OH; Museum of Glass, Corning, NY; and the Biidoro Shiryōkō (Historical Glass Museum) in Hyōgo Prefecture.

(i) To 1600. Glass production in Japan appears to have begun during the mid-Yayoi period (*c.* 300 BC–*c.* AD 300) and probably entailed melting down and re-forming glass objects brought from China or Korea, where glass beads were being produced before the 8th century BC (*see* CHINA, §XIII, 10(i)). Japanese production was limited to relatively few sites and consisted primarily of beads of three types: comma-shaped *magatama* (curved beads), *kudatama* (tubular beads) and *kodama* (small beads). The beads were worn on the body in strings, possibly as amulets, and were buried with the dead. The discovery of moulds (Kyushu University, Archaeological Research Institute) for casting *magatama* is proof of domestic production. Both lead glass and soda-lime glass (*see* GLASS, §I) were made.

In the Kofun period (*c.* AD 300–710) glass was produced in much greater quantities, although still in the form of relatively simple objects, principally beads. Bead shapes and colours, however, proliferated as technical skill increased. Among additional types made were *tombodama* (dragonfly beads), *natsumedama* (jujube beads), multicoloured *kuchinashidama* (gardenia—i.e. seed—beads) and

kirikodama (faceted beads). *Haniwa* (clay cylinder sculptures that were placed on tombs in prehistoric times; *see* §V, 2 above) represented people wearing beads on the head, neck, wrists and ankles. After about the mid-Kofun period glass insets were applied to metal objects such as crowns, horse trappings and gold ear pendants. Drops of molten glass were apparently used in the earlier Japanese enamels (*see* §8 above). A few other extremely rare glass articles, such as bracelets and vessels, are thought to be of native manufacture. Glassmaking seems to have been a cottage industry without centralized direction, and known pieces vary considerably in quality. Blown glass was first produced in Japan in this period, though again only for beads.

With the introduction of Buddhism from Korea in the 6th century, elaborate tomb burials almost ceased; at the same time new glass technology, craftsmen and customs of use were imported. The government's Yōrō Code (Yōrō Ritsuryō) of 718 indicates that a bureau of casting (*omono no tsukasa*) existed to supervise the casting of glass and metal for official use. The glass in question comprised beads and vessels, mainly for Buddhist religious purposes. Fewer carved, tubular and dragonfly beads were made, while *tsuyudama* ('dewdrop beads') for use as hanging ornaments and *nejiridama* ('twisted beads') were developed. These new types were used in complex structures of stringed beads called *yōraku*. Most of the glass vessels were receptacles for Buddhist relics (*shariki*) enshrined in temples or cinerary jars. These vessels were usually colourless, but some were blue or green. Japanese leaded glass of this period is distinguishable from that of China and the ancient Near East by its high lead content (which makes for easy handworking and a brilliance of finish).

By the Nara period (710–94) high standards of glassmaking had been achieved. Great quantities of well-made beads were used in for example crowns, Buddhist utensils, sashes, cloth and shoes. New types included: *hankyūdama* (hemispherical beads); unpierced *hiradama* (flat beads) and *mentoridama* (faceted beads) used as game pieces; beads of blown glass; and *tsujidama*, beads with bores in four directions for increasingly complex *yōraku*. Beads were sometimes set in glass inlays used in *sūtra* boxes and ritual sceptres and swords. They also formed one component of *chindangu*, objects interred beneath temple altars to appease the spirits of the soil that had been disturbed by the temple's construction. Vessels of glass were made only rarely, as fewer *shari* (relics) were installed in pagodas. A few of the glass vessels in the Shōsōin may be of native manufacture. More numerous among the preserved pieces are *tosu* (small knives) with glass hilts ground to shape, a technique not known in earlier pieces. Among other native glass objects in the Shōsōin are ends of scroll rods (*jikutan*) used for rolling manuscripts. A gilded mirror is ornamented with cloisonné-like inlaid glass. Some of the presumed Japanese glass in the Shōsōin has been shown to have a lead content of over 70%.

Glass production seems to have declined somewhat in the Heian period (794–1185), particularly after the civil war (935–40) of the Jōhei–Tengyō periods (931–48), when government offices for glassmaking and some other crafts were abolished. Glass was made on a small scale, possibly by Buddhist priests. Literary and pictorial references, however, show that glass was still a familiar part of life for at least the upper classes. Beads of traditional types were used in new ways, such as on bronze altar decorations or to adorn horse trappings. *Yōraku* became more common and still more elaborate, and beads were included among the contents of *sūtra* mounds (*kyōzuka*).

In the Kamakura (1185–1333), Muromachi (1333–1568) and Momoyama (1568–1600) periods Japanese glassmaking almost stopped. In the Kamakura period beads were still made, primarily for *yōraku*, but glass vessels and other pieces were not. Instead, glass was imported from China and Korea. Literary references are even rarer, and glass depicted in paintings is mostly of Chinese origin. Extant glass beads of the Muromachi period are few and of coarse workmanship, and the use of bead *yōraku* declined drastically. In the Momoyama period glass vessels presented as gifts by Western missionaries and traders to feudal lords were prized for their rarity.

(ii) After 1600. In the Edo period (1600–1868) foreign glass was imported via Nagasaki by the Dutch and Chinese, who were the only foreigners permitted to live in Japan for much of that time. As acquaintance with glass objects grew, so did demand, first among the daimyo and later among wealthy merchants. Since the number of foreign ships bringing goods was limited to a few each year, enterprising craftsmen set out to meet the new demand for glass (then known as *biidoro*) by learning the technique of its manufacture. The publication in 1713 of a detailed explanation of glassmaking (in an encyclopedia by Terashima Ryōan called *Wakan sanzai zue*, published in Osaka) shows that the secret of fine glassmaking, which had died out in the previous centuries, had been reacquired by the late 17th century and perhaps earlier. The technology used in Japan was probably developed from an amalgamation of Western and Chinese first-hand instruction and Western books.

The shapes, colours and uses of beads proliferated in the Edo period. Among the new types were *sujidama* ('striped beads'), *gangidama* ('zigzag (line) beads'), patterned *sarasadama* ('Indian fabric beads') and *kinsuishōdama* ('gold crystal beads'), which were modelled on the mineral aventurine, a variety of quartz. Beads were widely used as *ojime* (stops on the pull-cord of tobacco pouches), on *inrō* (medicine boxes; *see* §17 below) and as Buddhist rosaries. Osaka was the major centre of beadmaking.

Once Japanese manufacture was established, a great array of glass vessels became available. By the 19th century articles offered for sale included Western-style wine decanters and glasses, sake cups, teapots and caddies, platters, bowls, spouted vessels of various shapes, nested cups and goldfish bowls. Not only clear glass but blue, green, red and other colours were available, and cut glass was also made (see fig. 229), especially at the glassworks sponsored by the Shimazu clan of Satsuma Province (now Kagoshima Prefect.).

Being a rare and beautiful material, glass was used more for non-essential and decorative rather than practical items. Decorative items included glass toys (especially the popular *pokon pokon* noisemaker), wind chimes, hair ornaments, combs, *netsuke*, pipes, paperweights, desk screens and painted or engraved glass panels (*biidoroe*). Scientific

229. Glass decanters, blown, cased and cut in colourless and transparent cobalt blue glass, h. 254 mm, from Satsuma Province, mid-19th century (Corning, NY, Museum of Glass)

and medical instruments such as thermometers and barometers were among the practical items that were produced on a limited scale. Glass was ground for eye lenses from the early 17th century, and a method for making hand-mirrors was developed, even though sheet-glass technology was not acquired until the 19th century.

After the Meiji Restoration of 1868 glass manufacture expanded slowly. Although Western mass-production techniques were introduced, the traditional view that glass was a luxury material kept demand low, especially for practical items. In spite of the fact that sheet glass and other multiple-use glasses were introduced, along with relatively sophisticated pressing techniques, tank furnaces, cast-iron moulds and acid-etching of designs, marketing failures hindered expansion of the industry until c. 1900. Decorative glass light bulbs and lampshades were added to the range of products, which were increasingly made in factories using more modern techniques.

By the Shōwa period (1926–89) glassware was used in every Japanese home, and beverage bottles and window-glass became commonplace. As in the West, the production of decorative glass developed along two lines. Mass production spread nationwide, and some items of Japanese manufacture became world famous. Studio artists, on the other hand, produced works of art for a much smaller clientele. Japanese glass artists in the late 20th century produce conventional pieces such as statuary monuments while experimenting with new ideas. Some searched their national roots for inspiration and developed glassware modelled on the traditional forms that were originally made in other media. Japanese glass is both aesthetically and technically in the forefront of world art.

BIBLIOGRAPHY
Treasures of the Shōsōin, Nara, Shōsōin cat., 3 vols (Tokyo, 1960–62)
D. Blair: *A History of Glass in Japan* (New York, 1973)
Exhibition of Shōsōin Treasures (exh. cat., Nara, N. Mus., 1985)
Japanese Glass in the Shōwa Period (exh. cat., Sapporo, Hokkaidō Mus. Mod. A., 1987)

ANDREW MASKE

13. INKSTONE AND INKSTICK. Inkstone (*suzuri*), inkstick (*sumi*), brush and paper are the four most important implements used by East Asian scholars, painters and calligraphers. Throughout East Asia, these implements assumed both functional and aesthetic connotations. The scholarly élite often collected inkstones and inksticks, and in Japan these often figured as decorative motifs in lacquer and textiles. The inkstone is generally made from natural stone and takes the form of a slab with a depression for water at one end. The inkstick is traditionally made from soot or vegetable lampblack, collected and mixed with glue. Dry inkstick is ground lightly with water on the surface of the inkstone to produce liquefied black ink (*see also* §VII, 1(ii) above).

Japan is not naturally rich in the tufa and argillite (clay-slate) rocks that make fine inkstones, the most important property of which is a roughness of surface texture (*hōbō*) that lends a shiny sparkle to the liquefied ink. Inkstones should also have stability, balance and some weight, although most of the more famous inkstones are relatively small. They should be beautiful to look at and moist and delicate to the touch. Some have subtle shades of colour, others variegated areas of bright purple, blue, green, red, grey, brown or yellow on the black ground. Inkstones occasionally incorporate natural patterns; others may have designs, such as figures, landscapes, fruit and trees, incised on them by stone sculptors. The design and the carving should have a traditional elegance. Inkstones are valued as much for their pedigree as for their natural qualities. Inkstones may be made from materials other than natural stones, for example ceramics, metal, gemstones, bamboo and natural or lacquer-coated wood. Ceramic inkstones (*tōken* or *tōjiken*) were popular in the Nara period (710–94) before natural stone deposits were found, and were made in increasing quantities in the Edo period (1600–1868). They were appreciated for their decorative qualities and benefited from the boom in the manufacture of ceramics (especially utensils) caused by the rise of the tea ceremony (*see* §XIV above).

The earliest extant written record of natural inkstones in Japan is the *Wakan Kenpu*, 'Album of Japanese and Chinese inkstones' (3 vols, compiled by Toba Kisō, 1795). The first volume of the album is devoted to the 46 famous inkstones from Japan, including the 16 that date from the Heian period (794–1185). Extant inkstones dating from the Heian or Kamakura (1185–1333) periods and contained in elaborate *makie* (gold-flecked) lacquer boxes were mostly excavated from the gorges of Mt Takao and Mt Atago in the Kyoto region and are accordingly called

tsukinowaishi or *atagoishi* (the suffix *-ishi* means 'stone'). Other sites were exploited for inkstones in the Kamakura period. The inkstones used by officials of the Kamakura shogunate were purple stones from the group called *tanoura ishi* excavated from Moji in Fukuoka Prefecture. From the Edo period onwards, many more excavation sites came into use, often supported by local daimyo.

The two best-known types of inkstone are Akama and Amahata, named after their places of origin; Akama is near Shimonoseki, western Honshu, and Amahata near Mt Fuji in western Yamanashi Prefecture. Akama stones were first excavated during the Kamakura period; those of red or purplish colour resembled the famous Chinese Duan or Duanqi (Jap. Tankei) stones. The site now yields stones that are too hard and smooth. Amahata still yields stones of excellent quality, but in far fewer quantities than it once did. Old Amahata stones reputedly resembled another famous Chinese inkstone called She stone or Shezhou yan (Jap. Kyūjūken). Although Japanese literati began collecting and recording inkstones from China in the Edo period, the most famous examples were imported into Japan only after the Sino–Japanese War of 1894. Some of the best calligraphic materials in the world are preserved in such Japanese calligraphic institutions as Yoshida Hōchiku Memorial Hall, Tokyo, and other private collections.

It is unclear when inkstick-making techniques were brought to Japan, but the *Nihon shoki* ('Chronicle of Japan'; AD 720) records that in 610 the priest Tam Chi (Jap. Donchō) from the Korean kingdom of Koguryŏ (37 BC–AD 668), who excelled in making paper and ink, was presented to the Japanese court. A record entitled *Toshoryō zōbokushiki* ('Library Office inkstick production bye-law'; part of the *Engishiki*, 'Procedures of the Engi era'; before 927) indicates that the production of inksticks was standardized by the early 10th century. The first sources were sites in (modern) Kyoto, Hyōgo and Ōita prefectures. In the late Heian period and the Kamakura period, inksticks were obtained also from Fujishiro in Kii (Wakayama Prefecture) and Busa in Ōmi (Shiga Prefecture). The use of soot made by burning vegetable oil rather than pine wood revolutionized inkstick production. It became more systematic and large scale in the 15th century. Nara became the leading site for inkstick production in the 16th century, a position it has maintained.

Glues made from deer, pigs, cows and various fish are the binding agents for soot in the production of Japanese inksticks. Chinese and Japanese inksticks differ in glue types and methods of processing. Calligraphers agree that it is best to let newly made inksticks dry for a few years before use. High-quality inksticks between 10 and 50 years old are generally considered the best, as they produce ink that is subtle in tone and adheres well to paper, making it less likely to wash away in the mounting process. Antique inksticks are valued more for their surface beauty than for the quality of their ink. Microscopic investigation reveals that a good inkstick ground on a good inkstone produces minute, three-dimensional ink grains that penetrate well into paper to create subtlety and depth.

Japanese inksticks are measured in *chō* (*c.* 15 g). In 1991 an ink company in Nara, the largest in Japan, produced between five and six million *chō* for nationwide distribution. Inksticks made of coal, naphthalene and fuel oil currently comprise almost 60% of all Japanese production. The rest are of better quality and are made from such vegetable oils as sesame, rape seed, tung (Chinese varnish tree) and yew.

BIBLIOGRAPHY

Kodansha Enc. Japan: 'Calligraphy'
K. Ōsawa: *Sho o kagaku suru* [Calligraphy scientifically examined] (Tokyo, 1974)
I. Kubota: *Suzuri no chishiki to kanshō* [Knowledge of and appreciation for inkstone] (Tokyo, 1977)
W. Uemura: *Fude, sumi, suzuri, kami* [Brush, inkstick, inkstone, paper] (Tokyo, 1977, rev. 1987)
S. Kitabatake and G. Kitabatake: *Suzuri no kihon chishiki* [Basic knowledge about inkstone] (Tokyo, 1980)
S. Fujiki, ed.: *Suzuri no jiten* [Encyclopedia of inkstone] (Tokyo, 1984)
H. Nakura: *Nihon no suzuri* [Japanese inkstone] (Tokyo, 1986)
S. Uno: *Suzuri, sumi* [Inkstone and inkstick] (1986), i of *Bunbō seigan* [Scholar's accoutrements] (Tokyo, 1986–)
S. Uno: *Koboku no chishiki to kanshō* [Knowledge of and appreciation for old inksticks] (Tokyo, 1989)
'Bunbō shihō no subete' [Everything on the four treasures of study implements], *Sumi Supesharu*, xi (April 1992)

SADAKO OHKI

14. KITES. Kites (*tako, ikanobori, ika*) are popularly believed to have been invented in China around the 1st century AD (*see* CHINA, §XIII, 17) and were introduced to Japan perhaps as early as the Nara period (710–94). A gazetteer of 713, the *Hizen no Kuni fudoki*, and the *Nihongi* ('Chronicle of Japan'; 720) mention the existence of kites in Japan, while the earliest recorded use of a Japanese word for kite, *kami tobi* ('paper hawk'), occurs in the *Wamyō ruijū shō*, a Chinese–Japanese dictionary compiled *c.* 934 by Minamoto Shitagō (911–83). The paper-hawk form is of Chinese origin. Made in the shape of a T or of a bird's body with wings extended, it is well designed aerodynamically, relatively simple in construction and lends itself to the naturalistic depiction of creatures associated with flight, including birds and insects, as well as human personages and gods. Bearing numerous painted images, from *yakko* (a warrior's manservant) in Japan to the Eight Immortals in China, it continues to be one of the more familiar kite forms found in both countries. Early Japanese kite painting tended to consist of unpretentious renderings of prevalent Chinese motifs, the symbolism and the nature images being common to both cultures.

Apart from basic structures, however, few elements of Chinese influence are to be seen in traditional Japanese kite art. While Chinese kites are usually formidably complicated three-dimensional structures, their Japanese counterparts are more often flat (flown bowed to improve stability), although many are constructed so as to flap and flutter, which makes them appear three-dimensional. While Chinese kites tend to bear mimetic, representational images, Japanese kites characteristically feature abstract, emblematic designs of simplified natural phenomena. Both countries use bamboo for the framework, a material uniquely suited to kites by virtue of its strength, flexibility and availability. In Japan traditional kite covers are made exclusively of high-quality *washi* (handmade) paper (never of silk, as in China).

At the beginning of the 18th century a kite mania swept across Japan. Western encyclopedias picture Japan's skies

filled with kites and shopkeepers standing at their doorways, engrossed in flying kites to the neglect of their trade. Countless laws were enacted regulating the size of kites, which had grown so large that on descent they were capable of dislodging roof tiles and destroying crops; other (patently unenforceable) laws were enacted to prevent the use of garish colours, which were deemed unseemly. Kites were used in religious ceremonies connected with planting and harvesting. In some areas it was the custom to tie stalks of rice to the kite, which had been blessed by a priest, as a symbolic offering of thanks. Kites could also be purchased at temples and shrines as talismans against sickness and misfortune.

Pictures of famous personages of the *kabuki* theatre (*see* §XIII, 2 above) were among the first inherently Japanese images to appear on kites. Visitors to Tokyo requested kitemakers, of whom there were purportedly over 100 in the city in the 18th century, to paint the dramatic faces of their favourite characters on their kite souvenirs. The grimacing warrior portraits were realistic renditions of the highly stylized *kabuki* theatre make-up and costume. Kitemakers regularly attended *kabuki* performances so as to be able to add to their repertory of images. *Ukiyoe* ('pictures of the floating world') woodblock prints were also a source of inspiration, as were *nishikie* ('brocade paintings'; polychrome prints). The dramatic flourishes of Japanese calligraphy were reflected in the characteristic thick and thin brushstrokes used to paint the black ink outlines (*sumie*; 'ink pictures') of kites. Kite drawing was vigorous, bold and vividly coloured.

The term 'kite art' in Japan refers not only to the painting on the surface, but also to the kite as a kinetic object, the kite in flight. The Japanese kite artist is responsible for all aspects of the kite: fashioning and precisely balancing the bamboo framework; applying tough handmade paper (purchased from papermakers); painting; and, finally, positioning and tying the bridle strings crucial to successful flight. Of supreme importance to most kitemakers is that a kite must, above all, fly well, beauty being implicit in its function.

Kites vary in size. It has long been the custom in Japan (and China) for kite artists to demonstrate their skills at making tiny kites (15–20 mm sq.); while at the other extreme, giant *ōdako* kites made and flown in kite festivals, as a community activity in several Japanese prefectures in the late 20th century, are routinely in excess of 50 sq. m and weigh more than 750 kg (see below). Kites made by professional kite artists sold for flying and display on holidays range on the average from 1.5 to 5 sq. m. Each region in Japan has traditional kites and varieties of distinctive shapes. The southern port city of Nagasaki, for example, experienced direct influence from India in the early 17th century and is renowned for an Indian-derived, diamond-shaped fighter kite, the Nagasaki *hata* ('flag') kite. The round *fugu* blowfish kite with a hole in the middle (from Shimonoseki, Yamaguchi Prefecture) is similar to the traditional Korean rectangular fighter-kite design with a hole at mid-point; both are probably derived from Chinese kites (this detail adds stability to a kite's flight, as do the tail and the bowing of the kite surface). The *sode* kite from Chonan, Chiba Prefecture, is made in the shape of the Japanese kimono.

Each generation of kite artists brings something of its personal style to kite painting, while maintaining the region's traditional shapes and subject-matter. In the late 20th century there were some 35 traditional kite artists still working in Japan. Kitemaking is ordinarily a full-time occupation, although the artists sometimes need to supplement their incomes. Unlike in the West, kites are made exclusively by kite artists, who are therefore hard-pressed to keep up with demand at the height of the kite season. Although kitemakers maintain an ancient tradition of anonymity, signing their kites only by place of origin, families of kite artists may trace their association with kites back through three and four generations. This lineage is often continued by apprenticeship or adoption. Most practitioners are male, but there are several highly esteemed women kitemakers.

Kites in Japan today are traditionally associated with New Year and Children's Day (5 May). The Children's Day (or spring) kite festivals are spectacular celebrations. In the coastal city of Hamamatsu, Shizuoka Prefecture, where kites are recorded as having been flown for more than 400 years, the May festival (see fig. 230) attracts a million visitors, who come to view a vigorous kite battle (*tako-gassen*) involving beautifully crafted kites, some as large as 3.3 m sq. and equipped with hemp strings designed to cut and tear, the object being to down or disable an opponent's kite. In a festival held in Shirone, Niigata Prefecture, giant *ōdako* kites measuring 5.45×7.25 m are flown by competing teams from opposite banks of a wide

230. Children's Day kite festival at Nakataijima sand dunes, Hamamatsu, Shizuoka Prefecture

canal. This week-long festival has been held every year in June for 300 years. Since *c.* 1730 *ōdako* kites have flown on 3 and 5 May above Hōshubana, Saitama Prefecture. The traditional kites now made measure 13×15 m, weigh 800 kg and have a covering made of 1500 sheets of strong Japanese rice paper; they require 50 men to launch them. Even the largest of the traditional Japanese kites still made (from Shirone; 19.07×14.10 m), which broke the world record for size in 1980, does not compare with the *wanwan* kite, made in the 1930s in Naruto, Tokushima Prefecture, which was reputedly 24 m in diameter and weighed 2500 kg. Although the number of traditional kite masters steadily diminished in the late 20th century, enthusiasm for kites continued to grow in Japan with huge audiences for traditional kite festivals. Japanese kite teams fly modern versions of traditional kites (employing contemporary materials) regularly in international kite festivals throughout the world; amateur kitemakers continue to work in traditional modes as well as making significant contributions to world wide development of modern kite inventions and exhibition flying; there are some 2000 members in the Nihon no Tako no Kai (Japanese Kite Association; headquarters in Tokyo); excellent books on the history of Japanese kites as well as every facet of modern kitemaking and kite-flying are staples in the publishing industry; and there are lavish new museums dedicated to kites, from the oldest, Tokyo's Taimaiken Japan Kite Museum, to the Okado Rekishi no Yakata (Giant Kite History Museum) in Shirone, Niigata Prefecture, built at a cost of 15 million dollars and dedicated in 1994.

BIBLIOGRAPHY

C. Hart: *Kites: An Historical Survey* (New York, 1967)
T. Saito: *High Fliers: Colorful Kites from Japan* (San Francisco, 1969)
Y. Tawara and K. Sonobe: *Nihon no tako* [Kites of Japan] (Tokyo, 1970)
T. Saitō: *Tako no katachi* [Kite shapes] (Tokyo, 1971)
T. Hiroi: *Tako* [Kites] (Tokyo, 1973)
T. Streeter: *The Art of the Japanese Kite* (New York and Tokyo, 1974)
D. Pelham: *The Penguin Book of Kites* (Harmondsworth and New York, 1976)
K. Niizaka: *Nihon no Tako* [Kites of Japan] (Tokyo, 1978)
T. Saitō, T. S. Modegi and M. Modegi: *Nihon no tako dai zenshū* [Complete collection of Japanese kites: 250 kites] (Tokyo, 1978)
K. Niizaka: *Tako no harashi* [Talking about kites] (1981)
Bessatsu bijutsu techo: Tako [Fine arts journal: kites] (Tokyo, 1982)
M. Modegi: *Edo dako dai zenshū: Teizo Hashimoto* [Complete collection of Edo kites: Teizo Hashimoto] (Tokyo, 1988)
P. Eibel and I. Matsumoto: *Bilder für den Himmel* (Osaka and Munich, 1992)

TAL STREETER

15. MASKS. Masks have played an important role since prehistoric times in Japanese rituals, festivals and theatrical arts. The finest examples are connected with three performing arts: *gigaku*, *bugaku* and the allied forms of *nō* and *kyōgen* (*see also* §XIII, 1 and 3 above).

(i) Introduction. (ii) Types.

(i) Introduction.

(a) Materials. Nearly all Japanese masks are carved from wood, Japanese cypress (*hinoki*) being the most prevalent, particularly after the 11th century. Other woods include paulownia (*kiri*) and camphor (*kusu*), used for many 7th- and 8th-century masks, as well as various hard and soft woods for provincial masks. Almost all the masks are carved out of a single block, starting with the general features. The back is then hollowed out, and, working on front and back simultaneously, the carver opens holes for the eyes, nose and mouth, and finally refines and smooths the face of the mask. In some cases, particularly for the larger masks (*gigaku*, *gyōdō* ('processional') and some *bugaku* masks), reinforcing braces are added, or the mask is split and re-fused to strengthen it. The mask is then primed, sometimes with a thin layer of lacquer, and painted. The traces left by the carving tools are generally exposed on the back, thus providing important clues about the quality of the workmanship and the identity of the carver. An evenly thin, well-hollowed mask is regarded as being of high quality. Its lightness makes it easy to wear, and its regular thickness permits it to withstand humidity and temperature changes without warping.

Other materials include clay, which was used for prehistoric masks, cloth and paper for some *gigaku* and *bugaku* masks, papier-mâché for folk masks and dry lacquer, used for some 8th-century *gigaku* masks. One *bugaku* mask of Ryōō (a grotesque animal mask; Osaka, Fujita Mus. A.) has a damaged nose and lacks the original dragon decoration but retains the liquid modelling characteristic of dry lacquer and provides important insight into early prototypes of *bugaku* masks.

(b) Forms and functions. The oldest masks (Kumamoto, Ataka Shell Mound) are round clay faces, about life-size, dating from the middle and late Jōmon period (*c.* 10,000–*c.* 300 BC). Presumably these served as tools in shamanistic rituals, acting as symbolic intermediaries between the worlds of the sacred and the profane. With the adoption of Buddhism and the importation of Chinese culture in the 7th and 8th centuries, a layer of intellectualization clothed the rituals and weakened the immediacy of the shamanistic role of the mask. This is not to say that masks ceased to be regarded by the Japanese as imbued with superhuman spirits but that the donning of the mask was no longer correlated with outright possession. Rather the mask served to free the wearer of his ego, of the limitations of time and space, and thereby enabled him to express a more universal being. In a SHINTO religious context the mask is an object of worship; in theatrical performances it embodies a character or personality. Often these two functions are fused.

Gigaku masks were used for temple processions followed by short satirical sketches; they date from the 7th and 8th centuries AD. *Bugaku* masks, worn for the elegant, restrained court dances, mostly date from the 11th century to the 14th. *Nō* masks epitomize the restrained, symbolic dance dramas of the *nō* theatre, while *kyōgen* masks add relish to the accompanying *kyōgen* comedies; both types have been made during the last 600 years. In addition, a wide variety of masks used in local festivals are commonly described as *gyōdō* ('processional') masks, though some may also be referred to as *kagura men* (Shinto dance masks) or *minzoku kamen* (folk masks).

While many African and Indonesian masks are tools for possession, and some traditional Western masks are aids for disguise, Japanese masks belong to a middle ground. Their features range from symbolic suggestiveness to idealized, naturalistic portrayal but are neither transfixingly abstract nor vulgarly realistic. The largest masks

(*gigaku* masks) may be as much as 430 mm high, the smallest fit neatly on a child's face (h. *c*. 150 mm), but Japanese masks in general stay close to human dimensions, unlike African masks, which range from 20–30 mm to over 2 m in height (*see also* AFRICA, §VI, 3; INDONESIA, §VIII).

Japanese masks, being thought of as tools rather than art objects, are often unsigned. Such inscriptions as do exist indicate the place or occasion for which the masks were made, the name of the mask, the date it was made or restored and sometimes the name of the carver. Similar information may be written on the storage bags or in temple records. Inscriptions may be brushed in ink, gold or lacquer, or they may be incised or burnt into the wood. During the Edo period (1600–1868) many of the carvers of *nō* and *kyōgen* masks created personal insignia (*kao*) with which to sign their masks. Faking the insignia of famous carvers falls within the definition of faithful reproduction.

(ii) Types.

(a) *Gigaku.* (b) *Bugaku.* (c) *Nō* and *kyōgen.* (d) Processional and festival.

(a) Gigaku. The *Nihon shoki* ('Chronicle of Japan'; AD 720) reports that in 612 the Korean monk Mimashi brought to Japan performances from the kingdom of Wu (Jap. *kure* or *go*) in southern China. A procession of masked figures would circumambulate a temple ground and then perform a set series of short pantomimed skits to musical accompaniment. Although popular during the 7th and 8th centuries, *gigaku* had all but died out by 1233, according to the *Kyōkunshō* ('Book of instruction'; 1233), notes by a court dancer, Koma no Chikazane, detailing dance practices, especially *bugaku*. Masks and remnants of costumes preserved in the Hōryūji treasure-house and the Shōsōin repository of Tōdaiji in Nara serve as valuable clues in reconstructing the art.

The large *gigaku* masks fit like a helmet over the head and are deep enough to cover the ears of the wearer. The fleshy, long-nosed faces and empathetic expressions of some of the *gigaku* masks suggest origins further to the west than Wu, while the flatter faces and 'archaic smiles' of others bear close resemblance to artistic styles of the Northern Wei period in China (386–535) and the Asuka–Hakuhō period in Japan (*c*. 552–710). Humanity and emotional depth emanate from the faces.

Fourteen types of mask make up the set required for a *gigaku* programme; these were often produced by one or two sculptors for a given occasion. For the gala performances accompanying the eye-opening ceremony of the *Great Buddha* statue at Tōdaiji in 752 (*see* NARA, §III, 4), master sculptors (*busshi*) such as Enkinshi, Kieishi and Shōri no Uonari produced sets of *gigaku* masks, each distinctive in style and technique. The finest were inscribed with signature, date and role and carved from paulownia wood, then primed with a lacquer base coat on which paints in many colours were applied with careful attention to shading. Other fine masks were of dry lacquer.

Written records and pictorial representations permit some of the players to be identified. The long-nosed, smiling Chidō led the procession, purifying the way. Young

231. *Gigaku* mask of Suikojū, carved in the style of Shōri no Uonari, polychrome on wood, 237×293×295 mm, 8th century AD (Nara, Tōdaiji, Shōsōin)

boy lion-tamers guided Shishi, a Chinese dog–lion portrayed by two people. The members of a somewhat ribald skit included the handsome, crowned Man of Wu (Goko); the gentle Maid of Wu (Gojo); the ugly lecher, Kuron, who tried to seduce the Maid; and her fierce, muscular saviour, Rikishi, with his companion Kongō. Next came a mythical garuda bird (Karura), dancing to flute music, followed by a solo skit of a wise, elderly Brahmin (Baramon) washing babies' nappies. More sober was the melancholy old widower, Taikofu, in prayer, accompanied by two full-faced youths (Taikoji). The programme ended with a Dionysian group of hearty, red-faced revellers (Suikojū; see fig. 231) entertained with their dignified Persian king (Suikoō).

(b) Bugaku. Many other forms of music and dance were imported in the 7th and 8th centuries from Korea, China and South-east Asia. Then, during the 9th century, the emperors Saga (*reg* 809–23) and Ninmyō (*reg* 833–50) oversaw a wholesale systematization and standardization of these performances, leading to the birth of Japanese court dance, *bugaku*, performed to the accompaniment of the *gagaku* orchestra for government ceremonies. Many courtiers were amateur performers.

Introduction. Masks, which were worn for about a third of the pieces, had their origins on the Asian continent but were refined to reflect the elegant aesthetic of the court during the Heian period (794–1185). Subtler and less naturalistic than *gigaku* masks, *bugaku* masks seem to crystallize an emotion, to universalize a moment. They

appear abstract, intellectualized. The use of gimmicks such as swinging noses, dangling chins (*tsuriago*) and rotating eyes (*dōgan*) on many of the more dynamic masks increases the sense of satirical detachment. While *gigaku* masks represent characters in skits, *bugaku* masks embellish dances, adding an otherworldly dimension. Vague, sometimes conflicting stories substantiate the 'meaning' of the mask, but, with one or two exceptions, the dances should be seen as abstract encounters with life rather than as narratives.

Most extant *bugaku* masks date from the mid-Heian period to the Kamakura period (1185–1333); more recent copies also exist. Some of the earliest examples are dated 1052 and housed in Tamukeyama Shrine, Nara. These have a naive simplicity, with large almond-shaped eyes, thin, arched eyebrows and a lobed medallion incised in the centre of the forehead. They are painted with kaolin directly on the wood and coloured with earth pigments.

Examples from the 12th century, at the height of *bugaku* mask production, include highly refined works signed by such master Buddhist sculptors as Inshō (*fl* mid- to late 12th century; Nara, Kasuga Grand Shrine), Shamon Gyōmyō (*fl* mid- to late 12th century; Itsukushima Shrine) and Unkei and Jōkei (*fl* early 13th century) of the Kei school. Other *bugaku* masks are housed in such temples and shrines as Tōdaiji and Hōryūji in Nara and Shitennōji in Osaka. Many of these are carved of cypress and have been finished with a lacquer prime, sometimes strengthened by a layer of cloth, on which lies a kaolin base painted with earth pigments and *sumi* (Chinese ink).

After the establishment of the Kamakura shogunate in 1185, the imperial court lost its power. As the courtiers dispersed to outlying areas, *bugaku* spread. For a while the dances continued, under the auspices of local temples and shrines. Masks remained in demand for about a century, and many Kamakura-period masks, such as those preserved at Atsuta Shrine in Nagoya, show a high sophistication in both artistry and technique. By the 15th century *bugaku* had dwindled to a handful of dancers connected to the imperial court or participating in provincial festivals. During the Edo period (1600–1868) there was a slight revival, and some good copies of old masks were made. Few masks are made any longer, although the troupe connected with the imperial household is nationally endowed, and the art remains active in select temples and shrines.

Character types. In expression *bugaku* masks range from naturalistic portrayals, such as the sole female mask Ayakiri, with its mild eyes, broad cheek-bones and small, daintily smiling mouth, to schematic renditions of the fabulous figures. The masks can be divided into three classes, loosely correlated with the style of dance for which they are worn (*see* §XIII, 3 above). *Hiramai* dances are slow-moving and quiet, and many are performed without masks. Those masks that are worn are often close to human proportions. Some, such as the bright red face of Chikyū or the clown face of Shintoriso, have bizarre colouring. Masks for military dances (*bunomai*) are more intensely expressive. They have elongated faces with stern features such as flaring nostrils, glaring eyes and furry eyebrows. Masks for the energetic running dances (*hashirimai*) represent beasts and other non-human beings. The wrinkled, gold-faced Ryōō bears a dragon crouching on its head; the mask of Nasori represents a blue dragon with silver tusks; the red Batō mask with long strands of indigo-dyed cord for hair suggests a mythical horse. *Bugaku* dances and their masks are alternatively grouped into 'right' and 'left', loosely equivalent to country of origin: Korea and Manchuria or China and South-east Asia respectively.

Some 30 types of *bugaku* masks remain. The largest variety belongs to the *hiramai* group, which includes not only such human representations as the old man, Saisōro, and the beautiful maid, Ayakiri, but also more eccentric figures, such as the cranes, called Korobase or Hassen. Although there are no more than five types of *hashirimai* mask, by far the greatest quantity of extant masks belongs to this group. These were the masks, with their animalistic features and gimmicky rotating eyes, dangling chins, clacking rope hair and jiggling face-plates (*dōbō*), that caught the imagination of the people and were adopted for rituals such as rain invocations. Scattered about the country can be found a wide spectrum of permutations on these more grotesque masks.

A number of *bugaku* masks have *gigaku* counterparts. Both types of performance include masks for inebriated barbarians, but, while the *gigaku* Suikojū masks (see fig. 231 above) represent both old and young men exhibiting all manner of drunkenness, the *bugaku* equivalent, known as Kotokuraku, appear all of a kind, with round, red faces, ebullient smiles, small foreheads and high-bridged, long, swinging noses. The *gigaku* Suikojū represent over-indulgence; the *bugaku* Kotokuraku embody the easy mood of unguarded revelry.

A similar contrast between the naturalistic and the schematic appears in the paper and cloth masks. The Shōsōin and Hōryūji own a number of ragged, burlap squares depicting bearded men, with holes for eyes and features painted in flowing *sumi* lines. Although their use is uncertain, these cloth masks have long been housed with the *gigaku* paraphernalia. In contrast are the cloth and paper masks for the *bugaku* dances of Ama, Soriko and Kotokuraku (the host, being a native Japanese, does not don a wooden mask). Parallel lines, triangles and circles on a white rectangle suggest eyes, nose and beard.

The bird figures of the *gigaku* Karura and the *bugaku* Korobase are clearly related, although the former is quite large (h. *c.* 300 mm) and the latter, particularly in its 13th-century rendition, small and flat (h. 190 mm, depth 100 mm). Both Karura and Korobase masks are painted red and green, have full jowls and large round eyes and carry something in their beak, but, while the Karura mask has a fleshy fullness, the Korobase mask often appears to be a collection of circular patterns with a foreshortened beak.

(c) Nō and kyōgen. The *nō* drama and accompanying *kyōgen* comedies grew out of folk entertainments, particularly *sarugaku* (skits and acrobatics) and seasonal festivals such as *dengaku* (field dances centred around the production of rice). In the late 14th century and early 15th, under

the patronage of the Ashikaga shogunate, the plays developed into sophisticated symbolic and poetic dramas.

Introduction. By far the oldest *nō* and *kyōgen* masks were made for the ritual performance of Okina ('Old man'). Fine 12th- or 13th-century Okina masks bear inscriptions by the carvers Nikkō, Miroku and Kasuga (dates all unknown). During the 14th and 15th centuries, when *nō* drama was developing, ten sculptors, each specializing in one kind of mask, created what was to become the standard repertory of masks. Drawing on rural festival masks for inspiration, they began by working on masks for non-human roles and old men. Most prolific among these early mask makers were Shakuzuru Yoshinari (*fl* ?13th century), who made demon masks, Fukurai Ishō Hyōe Masatomo (*fl* 14th century) and Koushi Kiyomitsu (*fl* 15th century), who created old men's masks, Yasha (*fl* 15th century), who produced masks of crazed people, and Himi Munetada (*fl* 15th century), a maker of ghost masks. Masks for women's roles were developed to allow not only young boys but also master actors to play the delicate, poetic, feminine roles. The carver Ishikawa Tatsuemon Shigemasa (*fl* 14th century) is known for his hauntingly beautiful masks of young women, particularly the archetypal Koomote mask. The *dengaku* player Zōami Hisatsugu (*fl* 14th century), admired for his elegant dancing, also carved masks; his Zōonna is still used for roles of angels. Not until the mid-15th century did masks appear for the roles of young and middle-aged men. These depicted warrior–courtiers of the Heike and Genji clans and figures from Chinese legends. In the plays that featured men and were set in the present, rather than in a dream memory (*mugen nō*), the actor used his own features as a mask (*hitamen*).

Six carvers of the 16th century expanded on the basic set of masks but, by the 17th century, following the general trend towards standardization in the Edo period (1600–1868), mask carvers turned more and more to making copies (*utsushi*) of the old model masks (*honmen*). Methods of antiquing developed. Technical finesse was prized. *Nō* mask carving became a family profession passed on through five lines, of which by far the most prolific were the Ōno Deme family, headed by the first-rate carver Deme Zekan Yoshimitsu (*d* 1616) and his son Deme Yūkan Mitsuyasu (*d* 1652). Also outstanding was Kawachi Daijō Ieshige (*d* 1645) of the Ōmi Izeki family.

Character types. Correlations with statuary can be seen in *nō* masks of virulent gods and demons, which, like the paired Niō guardians of gates, either have wide mouths exposing bright red tongues, for example the Tobide ('bulging-eye') mask, or tightly clenched lips, as in the Beshimi mask. The features of *nō* masks derive from native models, unlike the continental models used for *gigaku* or *bugaku* masks. The more distinctly human figures often resemble portrait sculpture, and their smooth, flat features, broad cheeks and flush eyes all reflect the Japanese physiognomy. Smaller than either of their forerunners, the *nō* masks cover less of the head, lying in front of the face without the depth to cover the ears of the wearer.

The masks of humans have balanced, even features in repose, but slight variations in carving of the left and right sides of a mask set up tensions, making it capable of conveying myriad emotions when the slow, flowing movements of the actor and the consequent play of shadows over the contours bring it to life. Joy, fear and agony lie within a single wooden face. Some observers see in these uncannily subtle masks a 'middle expression', others find no expression in them. Whatever the interpretation, the intimacy and inner intensity of *nō* masks serve as a perfect medium for the transcendent emotions and spiritual dynamics that lie at the centre of the *nō* drama.

The *nō* masks represent human types rather than specific characters, and, like actors, they can play a variety of roles. The mask of a young woman, Koomote, can be used for roles in some 50 plays, and the Chūjo mask can be worn for any of the warrior plays featuring young Heike aristocrats. By contrast, each *gigaku* and *bugaku* mask corresponds with one role only. In *nō* theatre, equally, a single role may be performed with a number of different masks, and detailed rules specify which masks can be worn for each play. Within those rules, the choice lies with the actor and reflects his interpretation of the play. Codification was set during the 18th century, when *nō* was the official entertainment of the shogunal court, and many of the daimyo not only supported acting troupes but also studied *nō* as amateurs. Some 200 standard *nō* plays are performed, and for these a basic stock of masks numbers around 80, although over 250 different types exist. These can be grouped variously: one useful classification corresponds loosely with the five categories of *nō* plays (gods, men, women, ghosts and demons).

The gods include masks of elderly male gods (Okina, Maijō, Ishiōjō), of fabulous, gilded, goggle-eyed gods (Tobide), of muscular, golden-eyed, vigorous gods (Tenjin, Shintai, Mikazuki) and of sublime ladies (Zōonna, Deigan). Among the men's masks are old men (Kojo, Asakurajo, Waraijo), middle-aged warriors (Heita), young men (Chūjo, Atsumori, Kantan), youths (Kasshiki, Dōji) and blind men (Semimaru, Yoroboshi, Kagekiyo). Masks of sprites, such as the drunken sea-dweller Shōjō and the spirit of eternal youth, Jidō, resemble those of youths. Among the women's masks are old women with sunken cheeks and white hair (Rōjō, Komachi, Uba), middle-aged women suffering from the loss of a loved one (Fukai, Shakumi) and full-cheeked, smiling girls (Koomote, Magojiro (see fig. 232), Wakaonna, Fushikizo). Crazed women have straggling hair and questioning eyebrows (Masugami).

Ghosts suffering in hell for maltreatment or unresolved attachments have gaunt, skull-like faces exposing sharp bones (Yaseotoko, Yaseonna, Kawazu). Women possessed by jealousy sprout horns, show fangs and transform into serpents, with golden balls for eyes, set deep under furrowed brows (Hanya, Hashihime). Demons and beasts include dragon-gods or 'bad old men' (Akujo) with bulging eyes and thick beards, tight-lipped, malevolent spirits such as Shikami and playful lions (Shishi).

Kyōgen masks technically belong to the same category as *nō* masks, and some are created by the same carvers as *nō* masks, others by *kyōgen* actors themselves. They are about the same size as *nō* masks, made also of cypress wood, painted similarly with a gesso (*gofun*) base on which pigments are used to sharpen the features. The difference lies in their expression and use. While *nō* masks have a

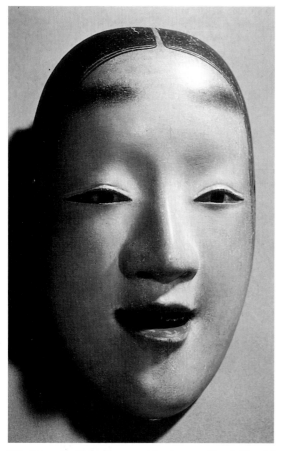

is the collection at the temple Mibudera, in Nakagyō Ward, Kyoto, where mimed, masked farces (*Mibu kyōgen*) have been performed since the 13th century. Sculpturally akin to *nō* and *kyōgen* masks, these are of high quality, spanning a broad spectrum of *nō*, *kyōgen* and other characters.

(d) Processional and festival. Buddhist and Shinto ceremonies require masks for such rituals as exorcism rites (*oni barai*, *tsuina*), lion dances (*shishimai*), enactments of the descent of Amida Buddha (*raigō*), plays about mythology (*shibai kagura*) and seasonal agricultural ceremonies. Horned goblins (Oni) are probably the most ubiquitous of all Japanese folk masks. These grotesque red, green, black and blue masks, which first appeared around the 12th century, are visualizations of the evil spirits and bearers of ill-fortune. The *tsuina* purification rites, originally performed to exorcize spirits from the imperial palace, are carried out in every Japanese household at the beginning of February (Setsubun). In many temples such rites are dramatized by muscular masked figures being pelted with dried beans until they are driven away. Oni masks have grotesquely intensified features, gaping mouths exposing fangs, thickened eyebrows and one, two or three horns (see fig. 234). Vigorously and roughly carved, Oni masks often appear in sets of father, mother and children.

Chinese dog-lions (Shishi) appear in festivals as large, dancing body puppets. The festival Shishi is operated by two people, one serving as the front feet and manipulating a huge wooden head with large clapping jaws and wiggling ears, the other bent under a long green and white cotton

232. *Nō* mask of Magojiro, carved by the actor Kongō Magojirō Hisatsugu (*d* 1564) in the image of his deceased wife, polychrome with gesso (*gofun*) base on cypress wood (*hinoki*), 260×122 mm (Kyoto, Kongo *Nō* Theatre)

dramatic intensity that draws the viewer in and transmits pathos and psychic strength, the *kyōgen* masks are playful, humorous commentaries on stock figures. While most *nō* plays use masks for their main role (*shite*) and some supporting roles (*tsure*), mostly female, but not for other roles, most *kyōgen* parts are unmasked. In *kyōgen*, masks are worn only for the roles of gods, demons (Buaku; see fig. 233), animals such as the fox (Kitsune) and monkey (Saru), insects such as mosquitoes (Usobuki) and mushrooms or other vegetables. While the *nō* actor dons his mask with a ritual expressive of the sanctity and spiritual force lodged in the mask, the *kyōgen* actor often uses the mask as a ploy, placing it before his face in full view of the audience to disguise himself to another stage figure. Unmasking as a revelation of the true identity is a common device in *kyōgen*. This differs from *nō*, in which a ghost may first appear disguised as a human without a mask (e.g. Atsumori) and reappear in his true form masked.

Good collections of *nō* and *kyōgen* masks belong to the main theatres of the five schools of *nō* acting, to private actors and to museums both in Japan and abroad. In addition, many shrines and temples have old *nō* and *kyōgen* masks, which they use in annual festivals. Of special note

233. *Kyōgen* mask of Buaku, carved by Hōrai, polychrome with gesso (*gofun*) base on cypress wood (*hinoki*), h. 189 mm, early 16th century (Tokyo, National Museum)

234. Festival mask of Chichi Oni (father goblin), used in *tsuina* purification rites, polychrome on cypress wood (*hinoki*), restored 1346 (Fukui Prefecture, Katashiha Shrine)

cloth to form the body and hind legs of the lion. Shishi dances and prances, undulating and swaying, snapping its jaws at an enthralled audience. The lion dance, which probably originated in India or Ceylon and has counterparts throughout Asia, was brought to Japan as a part of *gigaku* and later spread to rural areas, where it was incorporated into folk festivals. The Shishi masks in the Shōsōin treasure-house, Nara, made for the *Great Buddha* ceremony in 752 (*see* §(a) above), have protruding, movable jaws with fangs and curling red tongues. Fleshy dog noses erupt in front of large, glaring, round eyes (in some cases carved separately so that they can rotate). Knobbly eyebrows may be enhanced by tufts of hair; the dog ears, carved separately, wiggle and rotate in their holes. Black, deep brown, and bright red paint flashes with gold and silver highlights around the eyes and teeth. Also possibly a derivative of a *gigaku* mask is that of the king (Hanataka or Ōmai), used in folk festivals. The stern features, sharp lines and concentrated expression of these red-lacquered masks are tempered by a long, upward-swerving nose.

The Buddhist Pure Land ceremony of the enactment of the descent of Amida (Skt Amitabha; Buddha of the Western Paradise) to save souls and transport them to his paradise requires masks that envelop the head, transfiguring men into Amida's 25 accompanying *bodhisattva*s. Carved according to canonical strictures, these large masks, many of them gilded, with downturned eyes, closed, relaxed lips and long lobed ears, have the meditative grace of an image of worship (see fig. 235).

Most of the *gyōdō* ('processional') *bodhisattva* masks date from the 12th century or later, but records indicate

that other *bodhisattva* masks were used in the 8th-century Buddhist rituals (*kuyō*) and for a *bugaku* dance that is no longer performed. A mask representing a *bodhisattva* also appears in the *nō* play *Zegai*. Other Buddhist masks represent figures from Esoteric Buddhism, such as gods (Skt *deva*s; Jap. *ten*) and the Eight Heavenly Beings (Skt *dharmapāla*s; Jap. Hachibushū). Those kept at Hōryūji, and at Tōji in Kyoto, date from the Heian period (794–1185). Serving primarily as a symbol in religious rituals, these masks lack the pathos and the dynamism of the mainstream masks.

Masks are worn for the Shinto plays enacting the ancient creation myths (*sato kagura*), performed primarily in western Japan. The *kagura* masks are naive and ingenuous. Their rough contours and simplified, unshaded painting reflect the rustic nature of the plays. Most date from the 15th century or later. Masks for seasonal Shinto festivals comprise a wide variety of figures, including wrinkled old men, wizened and disfigured women and animal spirits (*see* §XV and fig. 211 above). In many cases these masks hang for most of the year in the eaves of a shrine as a 'god-body' (*shintai*), to ward off evil spirits. Shinto masks are sometimes donned in peculiar ways—slanted over the forehead like a visor or cocked to one side—with the result that the mask appears to participate in the ritual as a separate entity, removed from the performer.

The independent life of a mask, whether Shinto or not, is a reality for most Japanese. The carver is said to lend the spirit in the tree a face, infusing it with a life-power, which awakens as the dancer dons the mask. The dancer's performance may further endow the mask and raise it to a sacerdotal rank: thus, the demonic *nō* mask at the temple Shōbō, Sado Island, is treasured for its capacity to invoke rain when it was donned by Zeami (1336–1443), the actor

235. *Gyōdō* ('processional') mask of a *bodhisattva* (Jap. *bosatsu*), polychrome on cypress wood (*hinoki*), 1201 (Ono City, Hyōgo Prefecture, Jōdōji)

and playwright who established *nō* as a classic theatrical art. No matter how technically superb a mask may be, if it lacks a spirit it cannot be brought to life. Conversely, masks with excessively vibrant spirits can be malevolent. According to legend, a dancer will die within a year of donning the *bugaku* mask Saizōrō. These notions serve as a reminder that masks are not only evocative objects of art and theatrical tools but also invocations of the spirit world.

BIBLIOGRAPHY

F. Perzynski: *Japanische Masken nō und kyōgen* (Berlin, 1925)
R. Kaneko: *Nihon no men* [Japanese masks] (Tokyo, 1936)
T. Nogami: *Nōmenronkō* [Essays on *nō* masks] (Tokyo, 1944)
Y. Nakamura: *Nō to nōmen no sekai* [The world of *nō* and *nō* masks], 2 vols (Kyoto, 1963)
T. Yamanouchi: *Minzoku no kamen* [Folk masks] (Tokyo, 1968)
R. Kaneko: *Kamen no bi* [The beauty of masks] (Tokyo, 1969)
Y. Nakamura: *Nō no men* [Nō masks] (Kyoto, 1969)
Kamenshū [Mask collection], Tokyo, N. Mus. cat. (Tokyo, 1970)
K. Nishikawa: *Bugaku men* [Bugaku masks], Nihon no bijutsu [Arts of Japan] (Tokyo, 1971); Eng. trans. by M. Bethe as *Bugaku Masks*, Japanese Arts Library, v (Tokyo, 1978)
G. Gabbert: *Die Masken des Bugaku: Profane japanische Tanzmasken der Heian und Kamakura-Zeit* (Wiesbaden, 1972)
Shōsōin no gigakumen [Gigaku masks in the Shōsōin repository], Imperial Household (Tokyo, 1972)
R. Kaneko: 'Nōkyōgenmen' [Nō and kyōgen masks], Nihon No Bijutsu (1975) [whole issue]
J. Morita: *Nō no omote* [Nō masks] (Tokyo, 1976)
H. Goto and M. Toida: *Nōmen* [Nō masks] (Tokyo, 1977)
S. Noma: *Nihon kamenshi* [History of Japanese masks] (Tokyo, 1978)
S. Tanabe: 'Gyōdōmen to shishito' [Gyōdō masks and Shishi masks], *Nihon No Bijutsu*, 185 (1981) [whole issue]
T. Nakanishi and K. Komma: *Nōmen* (Osaka, 1981); Eng. trans. by D. Kenny as *Nō Masks* (Osaka, 1983)
S. Tanabe: *Nōmen* [Nō masks] (Tokyo, 1981)
R. Teele, ed.: *Nō/Kyōgen Masks and Performance* (Claremont, CA, 1984)
Hōryūji Treasures: Gigaku Masks, Tokyo, N. Mus. cat. (Tokyo, 1984)
S. Uehara: 'Gigakumen' [Gigaku masks], Nihon No Bijutsu, 233 (1985) [whole issue]
Old Masks: Religion and Performing Arts (exh. cat., Kyoto, N. Mus., 1985)
H. Goto: *Nihon no komen* [Old masks of Japan] (Tokyo, 1989)

MONICA BETHE

16. MUSICAL INSTRUMENTS. A wide range of musical instruments traditionally has been used in Japan for Shinto, Buddhist and court ceremonial, for accompaniment in the dramatic arts and for personal enjoyment. While the *wagon*, a short-board zither with six strings, bamboo flutes and drums of various types are employed in Shinto ritual, Buddhist ceremony is characterized by its heavy reliance on percussive instruments such as drums and gongs. Japanese court music, *gagaku* ('elegant music'), which evolved mainly through continental influence from the 6th century AD, is the oldest orchestral music in Japan; it makes use of percussion, string and wind instruments. While the musical accompaniment for *kabuki* drama also employs these three basic orchestral units, the *nō* ensemble consists only of a bamboo flute (*nōkan*) and two to three drums (*see also* §XIII, 1(i), 2(i) and 3 above). Mastery of a musical instrument has long been considered an important cultural accomplishment for both men and women.

(i) Before c. 1550. The earliest known objects that could have been used as musical instruments in Japan are the bell-shaped *dōtaku* of the Yayoi period (*c.* 300 BC–*c.* AD 300). Although the exact function of these objects is not known, early *dōtaku* have an internal clapper capable of producing sound. Sets of bronze jingles (*suzu*), like those used by shamanic priestesses, and horse trappings with jingles have been found in Kofun-period (*c.* AD 300–710) burial mounds (*see* §XII, 2(i) and (ii) above). One *haniwa* ('clay ring') figurine (Tokyo, N. Mus.) from Gunma Prefecture depicts a shaman on her throne, with a *suzu* fastened to her waist; others depict horses wearing jingles. Another *haniwa* figure is shown playing the ancient type of *wagon*; and there is also a *haniwa* model of a *wagon*, as well as actual excavated instruments (all Tokyo, N. Mus.; *see* §V, 2 above).

An extraordinary collection of musical instruments dating from the 8th century is contained in the Shōsōin treasure-house in the Tōdaiji, Nara. About 130 complete instruments and fragments are preserved. Several must have been brought from China or Korea, but others appear to have been made by craftsmen working in Japan. Among the imported items is a Chinese *qin* (seven-stringed long zither) of lacquered paulownia wood, elaborately inlaid with gold and silver, and datable by inscription to 735. Its overall style of decoration is reminiscent of contemporary Tang-period (618–907) work, and its complex iconographic scheme includes a vignette of a musical scene.

The Shōsōin collection also contains three kinds of lute, mostly of sandalwood or maple and beautifully decorated on the back with mother-of-pearl, tortoiseshell and marquetry inlays. The sound-boards of these instruments have a plectrum guard (*kanbachi*), typically a strip of hide embellished with a miniature painting. In one case, however—a unique five-stringed *biwa*—the *kanbachi* is of tortoiseshell with mother-of-pearl inlay, depicting a musician playing a four-stringed *biwa* while riding a Bactrian camel. Of the other plectrum-guards, one outstanding piece depicts a party of musicians riding a white elephant through a desolate ravine; another shows hunters on horseback, musicians and other figures in a mountain landscape. Both of these miniatures shed light on contemporary Chinese painting, of which few other examples have survived. Another lute, of the type known as *genkan*, after Yuanxian, one of the Seven Sages of the Bamboo Grove, is decorated with southern Chinese imagery: inlaid parakeets on the back and a group of seated sages on the plectrum-guard. All these instruments are probably of Chinese workmanship, but a pottery hour-glass drum body, decorated in typical Tang-period *sancai* (Jap. *sansai*; 'three-colour') technique, with green, mustard-yellow and cream glaze, may have been manufactured in Japan (see fig. 141 above). Other instruments in the Shōsōin include Korean and Japanese zithers, angled harps (from Korea), mouth-organs, panpipes, transverse and vertical flutes, tuned metal plates, various hour-glass drums, as well as miscellaneous parts and accessories for instruments. In many cases, this material assists in the interpretation of musical scenes in contemporary art from Japan, Korea, China and further afield.

The Shōsōin collection includes other pieces on which musical instruments are depicted. Of these, the most important is a type of wooden bow (*dankyū*), covered with small ink drawings of *sangaku* performers and musicians with instruments: among them cymbals, clappers, gong, angled harp, lute, mouth-organ, transverse and vertical flutes, panpipes and several kinds of drum.

Many bronze monastery bells—some large and finely decorated—have been preserved from the Nara period (710–94) onwards. One early example, at Tōdaiji, has relief figures of heavenly musicians. There are also important Kamakura-period (1185–1333) bells at Kenchōji and Engakuji (both Kanagawa Prefecture). Some fine early ritual gongs (*kei*) and Tantric handbells are also preserved. Except for such Buddhist material, few other actual instruments earlier than the 17th century appear to have survived, though there is abundant literary and documentary evidence for the history of early Japanese music. There are also many depictions of instruments in Heian-period (794–1185) and Kamakura-period art; notably countless depictions of the heavenly orchestra of Amida (Skt Amitabha; Buddha of the Western Paradise). Early examples of heavenly musicians are wooden figurines in an altar canopy (second half of 7th century); and in a wall painting of Amida's paradise (*c.* 710; both Nara, Hōryūji). Thereafter, outstanding examples are wooden figurines in the cornice at Byōdōin (*c.* 1053; Kyoto, Uji) and the great Amida *raigō* triptych at the Yūshi Hachimankō Jūhakkain, Wakayama Prefecture (early 12th century).

Musical instruments appear occasionally also in secular painting, particularly in narrative handscrolls. One of the surviving illustrations of the *Genji monogatari emaki* ('Tale of Genji handscroll'; late 12th century), in the *Yadorigi* chapter (Chap. 49), depicts Prince Niou playing the *biwa* (Nagoya, Tokugawa A. Mus.). Another important pictorial source is *Shinzei kogaku zu* ('Shinzei's pictures of ancient music and dance'), a handscroll with ink drawings of court dancers and musicians. Although it exists only in 15th-century and later copies, it probably dates back to the early Heian period.

(ii) After c. 1550. During the first period of Christian influence in Japan, in the later 16th century and early 17th, musical instruments and musical automata were brought from Europe, and for a short period bamboo pipe organs were built in Japan. European instruments—especially the harp and various kinds of plucked lute—are depicted in several allegorical screen paintings of European musicians in pastoral landscapes and in single paintings of musicians, executed by Japanese Christian artists in the late 16th century and early 17th. There are also two early Japanese Christian bells, dated 1577 and 1612, and two lacquered wooden drum-bodies bearing Portuguese motifs.

Many fine musical instruments from the 17th century onwards are preserved in Japanese and foreign collections, but they have been little studied. There are also many genre paintings and *ukiyoe* ('picture of the floating world') woodblock prints and book illustrations that depict music-making. In the 17th century the most commonly shown instruments are the *shamisen* (three-stringed long lute), *koto* (13-stringed long zither; see fig. 236) and *hitoyogiri* (short vertical flute). By the mid-18th century the *shamisen* and *koto* are still most often seen, but the *hitoyogiri* has given way to the *shakuhachi* (thick vertical flute) and the *kokyū* (bowed long lute). Transverse flutes and various kinds of drum, as used in theatre and festival music, also appear in *ukiyoe* prints; as do the instruments of court music and of visiting Korean delegations. Prints published in Nagasaki (*see* §IX, 3(iii)(c) above) occasionally show

236. Japanese musical instrument, the *koto*, depicted in *Homing Geese of the koto Bridges* (*Kotoji no rakugan*), attributed to Suzuki Harunobu, from *Zashiki hakkei* ('Eight parlour views'), woodblock print, 279×208 mm, *c.* 1766 (Worcester, MA, Worcester Art Museum)

Chinese musicians. Sometimes too there is iconographic evidence of instruments that are barely known from documentary sources: for example the *hatchōgane*, a tuned gong set used by itinerant street musicians. In general, *ukiyoe* subjects offer most material for musical iconography.

Finally, some of the hand written or printed instrumental tablatures and vocal notation for Japanese music merit consideration as visual art. Many examples have survived, of which the most outstanding is the superb set of *nō* chant-books in 100 volumes (Washington, DC, Freer), printed in movable type on decorative paper for Hon'ami kōetsu at the beginning of the 17th century.

BIBLIOGRAPHY

S. Umehara: *Dōtaku no kenkyū* [A study of *dōtaku*] (Tokyo, 1927)

K. Hayashi: *Shōsōin gakki no kenkyū* [A study of the Shōsōin musical instruments] (Tokyo, 1964)

H. Tanabe: *Nihon no gakki* [Japan's musical instruments] (Tokyo, 1964)

Shōsōin no gakki [The musical instruments of the Shōsōin], ed. Shōsōin Jimusho (Tokyo, 1967)

W. Malm: *Japanese Music and Musical Instruments* (Rutland, VT, and Tokyo, 1968)

Y. Yonezawa: 'The Style of "Musicians Riding an Elephant" and the Transition in Landscape Painting', *Acta Asiat.*, xv (1968), pp. 1–25

D. Waterhouse: 'An Early Illustration of the Four-stringed *Kokyū*, with a Disquisition on the History of Japan's only Bowed Musical Instrument', *Orient. A.*, xvi (1970), pp. 162–8

O. Mensink: *Japanse prenten met muziek* (The Hague, 1975)

G. A. H. Vlam: *Western-style Secular Painting in Japan* (diss., U. MI, Ann Arbor, 1976)

K. Hirano and K. Fukushima, eds: *Nihon ongaku, kayō shiryō shū (gakufu sōshū hen)* [Sources of early Japanese music: specimens of early notation in facsimile] (Tokyo, 1977)

M. Sullivan: *The Sui and Tang Dynasties* (1980), ii of *Chinese Landscape Painting* (Berkeley, 1962–)

S. Kishibe: *Tempyō no hibiki: Shōsōin no gakki* [The sound of Tempyō: the musical instruments of the Shōsōin] (Tokyo, 1984)

O. Mensink: 'Strings, Bows and Bridges: Some Provisional Remarks on the *Kokyū* in Woodblock Prints', *Andon*, 15 (1984), pp. 1–9

——: 'The *Hatchōgane*: Oral and Literary Aspects of an Almost Forgotten Musical Instrument', *The Oral and Literate in Music*, ed. Y. Tokumaru and O. Yamaguchi (Tokyo, 1986), pp. 342–52

D. Waterhouse: 'Korean Music, Trick Horsemanship and Elephants in Tokugawa Japan', *The Oral and Literate in Music*, ed. Y. Tokumaru and O. Yamaguchi (Tokyo, 1986), pp. 353–70

DAVID WATERHOUSE

17. NETSUKE. *Netsuke* are carved toggles, usually of ivory or wood, used to secure *sagemono* ('hanging objects') to the *obi* (sash) of a man's kimono.

(i) Introduction. (ii) Historical development.

(i) Introduction.

(a) Form and use. (b) Materials. (c) Types and makers.

(a) Form and use. The absence of pockets in traditional Japanese garments led to the development of the *netsuke–sagemono* ensemble, which was in common use throughout the Edo period (1600–1868) and into the Meiji (1868–1912) and Taishō (1912–26) periods, when the kimono was gradually replaced by the Western suit for everyday wear (*see* §7 above). The most common *sagemono* were *inrō* (lacquer boxes with compartments), which were originally cases to carry seals and ink but later evolved into

237. *Netsuke* of *manjū* type, signed *Ichiyusai* (seal) *Naomitsu* (1867–1931), depicting Kugutsune, the Japanese Amazon, stopping a runaway horse by stepping on its halter, ivory, diam. 54 mm (Raymond Bushell private collection, on loan to Los Angeles, CA, County Museum of Art)

containers for traditional Chinese medicines. Other *sagemono* include tobacco pouches (*tabako-ire*), purses (*kinchaku*), seals, pipe cases (*kiseruzutsu*), writing sets (*yatate*) and flint and steel bags (*hiuchibukuro*). The *ojime*, a small spherical bead, tightened and loosened the cord to give access to the *sagemono*. Sumptuary laws of the Edo period restricted the wearing of the gold lacquer *inrō* to the upper-class courtier and samurai, while lower classes had tobacco pouches.

Netsuke originated in China, particularly northern China and Mongolia, though the time and manner of their introduction into Japan is obscure. The Chinese article is called a toggle to distinguish it from the Japanese *netsuke*. The toggle and the *netsuke* were functionally identical, but in Japan *netsuke*-carving became an independent art form, the thematic range of which covered the whole of the human and natural worlds. In Japan also, widespread demand and appreciation led to the development of hereditary schools of *netsuke*-carvers in major cities as well as in the provinces. Many *netsuke* are inscribed with the artistic names (*gō*) of the master carvers (*netsukeshi*) who made them.

Netsuke range in size from 20 mm to 150 mm, averaging 40 to 50 mm. In general, *netsuke* carved before 1800 tend to be larger than those of later periods. *Netsuke* also differed according to the type of *sagemono* they complemented. Brocade and leather purses or pouches were safe from impact damage and took large, heavy *netsuke*, while fragile lacquer *inrō* required small, light *netsuke*. Whether large or small, *netsuke* needed to be durable enough to withstand the wear of daily use. Designs were rounded and compact; projections and appendages were avoided, since a protruding sword or an extended arm, for example, might catch on a sleeve or break. Delicate details were recessed and protected. Because *netsuke* were designed to be hand-held, all surfaces had to be scrupulously finished. Finally, holes for the cords had to be drilled without marring the design.

(b) Materials. About three-quarters of all *netsuke* are made of wood or ivory (*zoge*; see fig. 237). The next most common material is stag antler (*kazunō*), but a wide variety of materials have been used, including buffalo horn (*suigyū*), rhinoceros horn (*saikaku*), bamboo (*take*), ceramics, metal, lacquer, black coral (*umimatsu*), coral (*sango*), vegetable ivory (corozo nut), jet or peat (*umoregi*), amber (*kohaku*), tortoiseshell (*bekkō*), mother-of-pearl, glass, crystal and stone.

Most ivory *netsuke* are made of elephant tusk. While the term ivory is often loosely used to include all animal teeth, it should be distinguished from the marine ivories (walrus, narwhal and sperm whale), hippopotamus tooth or wild boar tusk. Marine ivories often lack the bulk for full-size *netsuke*. Walrus and narwhal (*ikkaku*) often have large hollow central channels running most of their length, leaving a skimpy remainder. A great attraction of narwhal, however, is its live, translucent lustre. Walrus tusk is irregularly circular in cross-section. The area around the central hollow core is distinguished by a characteristic yellowish, granulated or cellular mass. Narwhal is easily identified by the spiral grooving of the bark of the tusk; it was exorbitantly valued as a rare and even magical material,

and *netsuke*-carvers often left a small area of the bark uncarved for identification. Whale tooth tends to be soft in its outer diameter, and unsuspected dentine flecks sometimes render whole areas unsuitable for carving. Hippopotamus tooth (*kaba no ha*) is dense and hard but not always of sufficient bulk for a normal *netsuke*. It may be identified by its almost dead, whitish colour. Hornbill ivory (*hōnen*) is distinguished by its canary-yellow mass and reddish-orange skin. Boar tusk (*inoshishi no kiba*), being narrow, triangular and partially hollow, is usually suitable for relief carving. Trophy *netsuke* are *netsuke* made from articles a hunter or sportsman might acquire, for example bear, wolf or tiger teeth; parts of the jaw of a wolf or badger, a boar tusk or a crane's leg.

Elephant ivory may be identified in cross-section by its characteristic pattern of intersecting arcs. In longitudinal section the pattern appears as alternating light and dark pencil lines. The ample dimensions, uniform density, fine texture and sensitive registry of elephant ivory make it an ideal carving material.

Among the woods, boxwood (*tsuge*) was favoured (see fig. 238). It is hard, fine-grained, registers minute details and takes a lustrous polish. Boxwood was rarely left in its natural yellowish or blond colour; it was usually stained in various shades of brown to conceal tiny surface knots. Other preferred woods include cherry (*sakura*), persimmon (*kaki*), black persimmon (*kurogaki*), sandalwood (*byakudan*), yew (*ichii*), paulownia (*kiri*), camellia (*tsubaki*), zelkova (*tsuki*), cryptomeria (*sugi*), camphor (*kusunoki*) and cypress (*hinoki*). Rare imported woods such as ebony (*kokutan*), ironwood (*tagayasan*) and teak (*chiku*) were also used. Identification of woods is often difficult, particularly after staining or lacquering. Jet and peat (*umoregi*), though organic in origin, have no grain.

Netsuke in metal, lacquer or ceramics, though far less numerous than those in ivory or wood, often represent the work of distinguished craftsmen in those media (*see* §(c) below).

(c) *Types and makers. Netsuke* can be classified into several types. Carving in the round is known as *katabori* ('figure carving'). *Manjū netsuke* are named from their similarity to a round flat cake (see fig. 239). The flat surfaces of the *manjū* provide the background for various techniques of relief carving. The material may be one solid block or two matched sections. The advantage of the *manjū* is that it has two surfaces, which can be used to portray more than one episode or aspect of a subject. By extension, *manjū* include oval and geometrical shapes. *Ryūsa* are perforated *manjū*. The design is created by hollowing out the material and cutting away superfluous areas, leaving an intact relief. *Sashi netsuke* have an attenuated or elongated shape, and are worn thrust deep in the *obi* to support the *sagemono*. Cords are attached to the upper end of the *sashi* instead of the centre. The elongation of the *sashi* often produced amusing distortions and exaggerations.

Souvenir *netsuke* were produced in popular sightseeing areas by *ittōbori* ('single-knife carving'), a technique of rapidly shaping surfaces in angular planes. They were often enhanced with colours and made inexpensive presents (*omiyage*) for friends and relatives. An example of a

238. Boxwood *netsuke*, signed *Ryōsai*, depicting the Senkyō ('hole-in-the-chest people', a legendary Chinese tribe), h. 48 mm, mid-19th century (Raymond Bushell private collection, on loan to Los Angeles, CA, County Museum of Art)

souvenir *netsuke* is the *Uji ningyō* ('Uji doll') carved from local teabush wood (*cha*) to represent a typical Uji teapicker. *Netsuke* with secondary functions include seals, compasses, sundials, chopsticks, spyglasses, folding knives, ashtrays, candlesticks, whistles, sake cups, talismans, writing brushes, abaci and lighters.

The demand for *netsuke* attracted craftsmen who were not primarily *netsukeshi* ('*netsuke*-carvers'). Pottery and porcelain *netsuke* in the Hirado, BIZEN, Banko, Seiji and RAKU wares are fairly common, and *netsuke* bear the mark or signature of such illustrious ceramicists as Aoki Mokubei (*see* AOKI MOKUBEI, §2), Takahashi Dōhachi, EIRAKU HOZEN, Mashimizu Zōroku (1822–77), Eiraku Wazen (son of Hozen; 1823–96), Miura Tōtarō (*gō* Ken'ya; 1825–89) and Makuzu Kōzan (1842–1916).

The great lacquer schools, Kajikawa, Koma and Somada, produced lacquer *netsuke* to match their *inrō*. They also created separate lacquer *netsuke* to meet an expanding demand. Many gold lacquer *netsuke* bear the signatures of superb lacquerers such as Iizuka Tōyō (*gō* Tōyō or Kanshōsai; *fl* 1746–71), Hara Yōyūsai (1772–1845), Koma Kansai (1767–1835), Shibata Zeshin and Ikeda Taishin (1825–1903).

Kagamibuta ('mirror lid') *netsuke* are named after the burnished bronze mirrors that preceded glass mirrors. The *kagamibuta* mirror consisted of a metal disc or lid set in a bowl of ivory, wood or other material. It was devised by swordsmiths as an outlet for their craft following the prohibition against carrying swords in 1876. They transferred their remarkable techniques from the sword guard (*tsuba*) to the *kagamibuta*, which they produced in metals and alloys in rare hues, such as violet black and olive brown. They etched, engraved and chased; they inlaid in

239. *Netsuke* of *manjū* type, signed *Mitsuhiro*, depicting geese and the moon, wood inlaid with ivory and pearl; attached to *inrō*, signed *Yōyūsai* (1761–1828), depicting cranes in flight, lacquered in gold, silver and kubon alloy on mirror-black ground, h. 81 mm, w. 63 mm (Raymond Bushell private collection, on loan to Los Angeles, CA, County Museum of Art)

colour combinations poetically called 'painting with a chisel' (*tagane de kebiku*); and they produced minutely detailed backgrounds, such as fish-roe (*nanako*) and stone-grain (*ishime*) patterns. Shojo Tenmin (*fl* 1830–43), Fushimi Jisaburō (*gō* Natsuo; 1828–98) and Shōmin Unno (1845–1915) were among the metalworkers who produced *kagamibuta*, and two or three artists who used the *gō* Shūraku (all *fl* mid-19th century) specialized in making the metal discs for *kagamibuta netsuke*.

Carvers of stage masks reduced their works to diminutive dimensions in order to take advantage of the demand for *netsuke*. The names found most commonly on *netsuke* masks were those of the great Deme family, particularly Uman, Saman and Jōman (all *fl* before *c*. 1780). Among superior specialists in authentic *netsuke* were Higuchi Shūgetsu (*fl* 1764–71), Takahashi Kumakgichi (*gō* Hōzan; *fl* early 19th century) and Ono Mataemon (*gō* Ryūmin; *fl* mid-19th century).

About half of all *netsuke* are signed. *Netsuke* made before the mid-18th century tend to be unsigned, while later ones tend to be signed. Early *netsuke* were generally made by *netsukeko*, associations of craftsmen who followed traditional practices and did not sign their works. Later *netsukeshi* were professional *netsuke*-carvers who were devoted full-time to the craft, created new designs and techniques and signed their names, following the

practice of other artists such as painters, potters and metalworkers. The respective placement, however, of unsigned and signed *netsuke* in earlier and later periods is not a firm rule: *netsukeshi* did not invariably sign, and some conservative craftsmen adhered to the traditional practice of leaving their work unsigned. Nonoguchi Ryūho (1595–1669) is thought to have been the first *netsukeshi*, but there is not a single recorded *netsuke* that bears his name.

(ii) Historical development.

(a) Origins, before c. *1700.* It is not certain when the first *netsuke* appeared in Japan. Speculative evidence places the *netsuke* as early as the 8th century. The *Kojiki* ('Records of ancient matters'; 712) relates how a warrior-prince used his flint and steel pouch (*hiuchibukuro*) to ignite a blazing curtain of dry grass to thwart his enemies. The pouch was attached to his dagger hilt, which acted as a *netsuke* to support the pouch. Thirteenth-century handscrolls represent hunters and warriors with *hiuchibukuro* attached to their dagger hilts. The use of the *hiuchibukuro* pouch expanded to include coins, and by the end of the 16th century it had evolved into a purse (*kinchaku*) for coins and other valuables.

In the 16th century the plain black lacquer *inrō* came into fashion, and by the 17th century it had developed into the decorated gold lacquer *inrō*. The spread of *inrō* and *kinchaku* presupposes the existence of *netsuke*. Contemporary handscrolls occasionally provide clear views of *sagemono*, but voluminous kimono sleeves obstruct the view of the *netsuke*.

Originally, a bit of bamboo, a shell, a gourd or even a stone served as a *netsuke*, so long as there was a place for attaching cords. Care in selecting an interesting node, twig or root, with minimal shaping, probably marked the beginnings of an artistic concern with *netsuke*. Not until the 17th century, however, are there indications in secondary sources of the developing craft of *netsuke* carving.

(b) c. *1700–1868.*

Individual netsukeshi. The publication in 1781 of the *Sōkenkishō* ('Appreciation of superior sword furnishings') by Inaba Tsūryū (sometimes called Michitatsu) marks the first concrete reference to *netsuke*: the seventh and final volume of this work is devoted to *netsuke* and *ojime* (in the entire Edo period this was the only book on the subject). The *Sōkenkishō* lists 55 *netsuke*-carvers with skimpy biographical data and woodblock-printed illustrations of subjects and types that were presumably popular at the time.

Of the 55 *Sōkenkishō* carvers, 18 were among the leading *netsukeshi* of the 18th century. Gechū and Masanao (of Kyoto) were noted for their powerful, original models, Izumiya Shichiemon (*gō* Tomotada) for his rendering of cattle, Issai (or Ogasawara) for his use of marine ivory, Mitsuharu (of Kyoto) for his *shishi* (Chinese lions), Garaku (or Risuke; of Osaka) and Yamaguchi Okatomo (of Kyoto) for their variety of subject-matter, Yoshimura Shūzan (or Shujiro; *gō* Tansenso; of Osaka; *d* 1776) for his painted fantasy figures, Shuzan Nagamachi (*gō* Kurobei; of Osaka) for his painted *nō* actors, Tanaka Minkō

(or Iwaemon; 1735–1816) for his bold animals, Kita Kiuemon (*gō* Tametaka; of Nagoya) for his grotesque models, Higuchi Shūgetsu for facial expressions, Tsuji (no other names known) for his minuscule signature, often concealed in a cord hole, Shumemaru (or Unjudō; of Osaka) for the rarity of his work, Yoshinaga (or Kōyōken; of Kyoto) for his representations of Shōki, the demon queller, Miwa (of Edo) for his muscular aborigines and Deme Jōman, Deme Saman and Deme Uman for their *nō* mask *netsuke*.

Four other carvers, Ōmiya Kahei (of Osaka), Yoshimoto, Sanko Kohei and Satake Sōshichi (of Osaka), are known from only one or two examples. Five others are known not by their signatures but for their creation of new types of *netsuke*: Karamono Kyūbei (of Osaka) for cast-metal openwork *netsuke*, Tsuchiya Ichiraku (*gō* Bōtōken; of Osaka) for woven cane (*to*) and bamboo, Toshimaya Ihei (of Osaka) for woven silver and copper ribbons, Negoro Sōkyu (of Osaka) for figures in blotchy red and black lacquer and Ryūsa (of Edo) for his perforated designs.

Netsukeshi of the period not listed in the *Sōkenkishō* include Shimizu Tomihari (*gō* Seiyōdō; 1733–1811) and his daughter, Bunshōjo (1764–1838), residing in Iwami Province (now Shimane Prefect.). Their style is distinguished by a partiality for wild boar tusk, insect subjects and miniscule inscriptions giving era dates and locations. Jobun (*fl* before 1800) preferred high-quality boxwood, which he stained and polished to a lustrous yellowish-brown. His subjects were people of the everyday world in antic activities. Kokei (*fl* before 1800) worked in boxwood, which he stained in various shades of brown. He preferred carving animals, particularly those of the Chinese zodiac. His work shows a strong kinship with that of Minkō.

Among the major 19th-century carvers active before the Meiji period (1868–1912) were Naitō Sensuke (*gō* Toyomasa; 1773–1856) and his pupil Toyokazu (*fl* early 19th century); both carved wooden animals. Toyomasa's animals were valued for their dramatic and lifelike poses and their thick lustrous patina, Toyokazu's for their protean variety in a prolific output. Shigemasa (*fl* 1801–29) was noted for his brilliant use of stain to simulate contiguous segments, colours and textures, for example, the contrast between the snail's hard, dry shell and soft, moist body.

Ōhara Gushi (or Mitsuhiro; *gō* Sessado; 1810–75) carved in both ivory and wood. His sensitive artistry transformed the most commonplace article, for example an iron teapot, into an object of grace and beauty. His ivory stain simulated the texture of a ceramic glaze. Kaigyokucai Masatsugu (*gō* Kaigyoku; 1813–92) used only the finest materials, particularly *tokata*, a South-east Asian ivory characterized by a glowing lustre, a faint, delicate grain and a pinkish cast. His work was marked by painstaking concern for detail, purity of craftsmanship and elegance of finish. Bazan (of Gifu; 1833–97) was influenced by the *haiku* (17-syllable poem) form. His spare, simple subjects represent natural scenes: a rotten pear, an insect camouflaged on a twig, a fly feeding on a persimmon. Nagai Rantei (*fl* mid-19th century) preferred ivory. He was innovative, versatile and prolific in subject, material and treatment. Miyasaka Hakuryū (*gō* Shoundo; *fl* 1854–

9) specialized in tigers. Hōraku (*fl* mid-19th century) specialized in bats, a rare subject in *netsuke*, often using ebony or peat. Kagetoshi (of Nagoya; *fl* mid-19th century) excelled at carving miniature palaces and pavilions, complete with bridges, gardens and processions.

Growth of demand and changes in use. Many of the 55 carvers named in the *Sōkenkishō* made *netsuke* as a sideline; the publication of the *Sōkenkishō* signalled a transition from a period of moderate demand, which could be met by sideline work, to a burgeoning demand that required the full-time effort of many carvers. From being a modest anonymous artisan, the *netsuke*-carver became a professional artist. One reason was the pipe-smoking craze that swept the country. Another was the emergence of the merchant class. Prosperous businessmen, denied the privilege of wearing gold lacquer, silks and swords, turned to sumptuous brocade and leather (*kawa*) pouches, accompanied by superbly carved *netsuke*, to display their wealth, elegance and individuality. Among merchants a ritual developed of smoking a pipe or two while comparing pouches and *netsuke*, before getting down to business. An efficient commercial infrastructure of importers and dealers in fine-quality materials encouraged the demand; entrepreneurs financed and distributed the work of the *netsukeshi*; and numerous shopkeepers and associations of dealers in purse, pouch, pipe and tobacco popularized various styles and fads. The golden age of *netsuke*-carving lasted from *c.* 1760 to 1880.

(c) After 1868. The Meiji Restoration (1868) marked the beginning of a gradual decline in the use of *netsuke*. A popular style had been to use the *netsuke* for suspending both the pipecase and the tobacco pouch, but an improved pipecase thrust into the *obi* (sash) was substituted for the *netsuke*. Further momentum to the decline of *netsuke* was given by the gradual adoption of cigarette-smoking. A final blow to the practical *netsuke* was the general acceptance of the Western business suit as a replacement for traditional Japanese dress. By the end of the Taishō period (1912–26) *netsuke* for wear or adornment were becoming passé.

Some outstanding carvers with distinctive styles appeared in the Meiji and Taishō periods. Suzuki Tetsugoro (*gō* Tōkoku; also known as Fuzui and Bairyu; *fl* mid-19th century) was self-taught and mastered the distinctive techniques of combining and inlaying a wide variety of materials. Ozaki Sozo (*gō* Kokusai; *fl* 1861–1911) worked principally in stag antler, a material most *netsukeshi* shunned as misshapen and intractable, with its spongy marrow and pimpled or corrugated surface. Kokusai's genius was to find in the most awkward section of antler some aspect of whimsy or humour. He often conceived his amusing distortions and exaggerations in the very deformity of the material. Stag-antler *netsuke* by or in the style of Kokusai are known as *Kokusaibori* ('Kokusai carvings').

Sanshō Wada (*gō* Kokeisai; 1871–1936; of Osaka) carved comical *netsuke*. His *gō* means 'Three Laughs': thus his labourer is shown cross-eyed with drink and his fishmonger's features are twisted like the boiled octopus

he peddles. Shin Harai (or Kyusai; *gō* Tetsugen, Tetsugendō; 1879–1938) carved in the style of Kaigyokusai, whom he imitated and occasionally surpassed. Despite his youth, his work was exhibited at the Paris International Exhibition of 1895. The friendship of Morita Kisaburo (*gō* Sōko; 1879–1942) and Jiemon Ouchi (*gō* Gyokusō; 1879–1944) began with their teenage apprenticeship to Seitaro Miyazaki (*gō* Josō; 1855–1910), and although they never collaborated their common training produced a similarity of subject, technique and treatment. Their polish was semi-transparent, revealing the natural beauty of wood grain (see fig. 240). Gyokusō's son Jiro (*gō* Sōsui; 1911–72) and Nishino Shotaro (*gō* Shōko; 1915–71) were leading pupils of Sōko.

After the opening of Japan in the 1860s Western collectors discovered *netsuke* and foreign export proliferated, rescuing the craft from collapse. In the 1980s about thirty or forty Japanese *netsukeshi* and six or seven Europeans and Americans were carving *netsuke*. Miriam Kinsey's *Living Masters of Netsuke* (1984) names Norigoshi Tachihara (*gō* Kangyoku), Katsutoshi Saito (Bishu), Hideo Sakurai (Hideyuki), Isamu Komada (Ryushi), Akihide, Hiroshi Nakamura (Kodo), Katsumasa Nakagawa (Masatoshi), Meigin Hiraga (Meigyokusai), Meikei and Minosuke Omura (Keuin) among the leading Japanese contemporaries, and Michael Birch, Michael Webb, George Weil, David Blissett and David Abel among the Westerners.

BIBLIOGRAPHY

Inaba Tsūryū (Michitatsu): *Sōkenkishō* [Appreciation of superior sword furnishings], vii (Osaka, 1781) [this volume, not separately titled, deals with *netsuke* and *ojime*]

A. Brockhaus: *Netsuke* (Leipzig, 1909)

A. Hull Grundy: 'Stagshorn and Other Quaint *Netsuke*', *Orient. A.*, n. s., vi/3 (Autumn 1960)

R. Bushell: *The Netsuke Handbook of Ueda Reikichi* (Rutland and Tokyo, 1961)

A. Hull Grundy: '*Netsuke* Carvers of the Iwami School', *A. Orient.*, iv (1961)

——: '*Netsuke* by Nanka and Nanyo', *Orient. A.*, n. s., vii/3 (Autumn 1961), pp. 107–18

——: 'Tomotada and Okatomo in Relation to the Kyoto School of *Netsuke* Carvers', *Ant. Colr* (1963); pt I: June, pp. 107–13; pt II: Oct, pp. 205–10

R. Bushell: *The Wonderful World of Netsuke* (Rutland and Tokyo, 1964)

M. Hillier: 'Kagetoshi and his *Netsuke*', *Orient. A.*, n. s., x/1 (Spring 1964), pp. 37–41

M. L. O'Brien: *Netsuke: A Guide for Collectors* (Rutland and Tokyo, 1965)

E. Ryerson: *The Netsuke of Japan: Legends, History, Folklore and Customs* (New York and London, 1968)

R. Bushell: *Collectors' Netsuke* (New York and Tokyo, 1971)

——: *An Introduction to Netsuke* (New York and Tokyo, 1971)

——: '*Netsuke* and *Inrō*', *The Collectors' Encyclopedia of Antiques* (London, 1973), pp. 562–77

——: '*Masatoshi*: The Last of the *Netsuke* Artists', *A. Asia*, iii/4 (July–Aug 1973)

N. K. Davey: *Netsuke: A Comprehensive Study Based on the M. T. Hindson Collection* (London, 1974)

R. Bushell: *Netsuke Familiar and Unfamiliar* (New York and Tokyo, 1975)

M. Hillier: '*Sessai unkin zu fu*' [Book of designs by Sessai Unkin], *Orient. A.*, n. s., xxi/3 (Autumn 1975), pp. 252–8

R. Barker and L. Smith: *Netsuke: The Miniature Sculpture of Japan* (London, 1976)

R. Bushell: 'Ceramic *Netsuke*', *A. Asia*, vi/2 (Mar–Apr 1976), pp. 25–31

——: *The Inrō Handbook* (New York and Tokyo, 1979)

M. Mikoshiba and R. Bushell: '*Netsuke* and the *Sōkenkishō*', *A. Asia*, x/6 (Nov–Dec 1980), pp. 103–17

Masatoshi (Tokisada Nakamura): *The Art of Netsuke Carving* (Tokyo and New York, 1981/*R* 1992)

G. Lazarnick: *Netsuke and Inrō Artists, and How to Read their Signatures* (Honolulu, 1982)

R. Bushell: 'Shōko, an Untypical *Netsuke* Carver', *A. Asia*, xiii/2 (Mar–Apr 1983), pp. 55–61

——: 'Travels by *Netsuke*', *A. Asia*, xiv/2 (Mar–Apr 1984), pp. 104–9

M. Kinsey: *Living Masters of Netsuke* (Tokyo and New York, 1984)

R. Bushell: *Netsuke Masks* (Tokyo, New York and San Francisco, 1985)

G. Lazarnick, ed.: *Meinertzhagen Card Index* (New York, 1986)

R. Bushell: 'To Donate or not to Donate', *A. Asia* (Jan–Feb 1995) [25th anniversary issue, devoted wholly to Japanese art]

RAYMOND BUSHELL

240. *Netsuke* signed *Sōko*, depicting Niō (protector of Buddhism) and a demon, wood, h. 49 mm, early 20th century (Raymond Bushell private collection, on loan to Los Angeles, CA, County Museum of Art)

18. PAPER. Paper, probably invented in China in the mid-2nd century BC, was introduced into Japan during the 4th century AD. The *Nihon shoki* ('Chronicle of Japan'; AD 720) refers to records and censuses that were compiled in the 6th century AD and to paper itself in AD 610. It is not known whether this paper was made in Japan or imported from China—which, in the quantities needed for a census such as that of AD 540, would have been costly (*see also* CHINA, §XIII, 18). The oldest paper manuscript to survive in Japan is the *Hokke giso* (Tokyo, Agency for Cultural Affairs), a commentary on the Lotus *sūtra* (Skt *Saddharmapuṇḍarīka sūtra*), attributed to Prince Shōtoku and written *c.* AD 609–15, possibly on Chinese paper. Home-produced paper for writing was presumably in adequate supply by AD 645, the year of the Taika Reform, when a national census and accounts were compiled. The

oldest extant domestically produced papers that can be accurately dated (Nara, Shōsōin) were made in the provinces of Mino (now part of Gifu Prefect.), Echizen (now part of Fukui Prefect.), Chikuzen (now part of Fukuoka Prefect.) and Bizen (now parts of Ōita and Fukuoka prefectures) around the turn of the 8th century AD and were census records for those provinces.

(i) Materials and techniques. (ii) History.

(i) Materials and techniques. In early papermaking in Japan the three most important sources of fibre for hand-moulded papers (*washi*) were hemp (*asa*; *Cannabis sativa*), paper mulberry (*kōzo*; *Broussonetia papyrifera, B. kaempferi* or *B. kazinoki*) and *ganpi* (*Wikstroemia sikokiana, W. canescens* or *W. japonica*). Other fibres were used experimentally. Hemp appears to have lost favour by the 10th century but *mitsumata* (*Edgeworthia papyrifera* or *E. chrysantha*) was added to the list in the late 16th century, although it was not much used until the 19th. *Kōzo, ganpi* and *mitsumata* are still the primary fibres used for handmade paper in Japan, *kōzo* having been the chief source since the Edo period (1600–1868). Since the 1870s wood pulp was often added to some cheaper types of handmade paper. *Kōzo* fibre, which is about ten times longer than wood-pulp fibre, makes a tough sheet. *Mitsumata* papers have soft, glossy surfaces and are insect-resistant; they are often used in Japan for calligraphy and printmaking. *Ganpi* papers, which are translucent and have fine, lustrous surfaces, have many applications, ranging from tracing to wound dressing. *Ganpi* paper was first used in Western printmaking by Rembrandt *c.* 1647.

The bark of *kōzo* and *mitsumata* is collected from cultivated shrubs, while that of *ganpi* is gathered from the wild. The stock from which paper is moulded is made from the white, inner bast layer of bark, which is peeled, bleached, boiled in lye to remove lignin and tree fats, reduced to a pulp by beating and mixed in water in a large wooden vat *c.* 600×1200 mm. Bark is harvested in late autumn and the paper itself made in winter, when low temperatures discourage mould growth and tighten the fibres.

Two methods of moulding paper (see fig. 241) are employed in Japan. The older, called *tamezuki* ('dip-and-drain papermaking'), was introduced from China *c.* AD 600 and is essentially the same method as that used in the West. The other is a native technique called *nagashizuki* ('dip-and-cast moulding'), which probably evolved in the 8th century; it is the more important of the two methods. The mould is a flexible screen made from finely split bamboo strips, or miscanthus reed, held in place with silk thread. When moulding paper this is placed on a rigid wooden frame and held in place with another called the deckle. In *tamezuki* excess water is allowed to drain completely through the mesh of the mould cover, while in *nagashizuki* the surplus stock, once sufficient has been used to cover the mould, is cast back into the vat in a wavelike action. The stock in *nagashizuki* contains a mucilage, obtained from the roots of such plants as *Hibiscus manihot* (*neri*), *Abelmoschus manihot* (*tororo*) or *Hydrangea paniculata* (peagee hydrangea; *noriutsugi*). This makes the stock more viscous, which delays draining time and permits greater control over paper thickness and

241. Artisan making Japanese paper; woodblock print from the *Kamisuki chōhōki* ('Treasury of papermaking'), 183×128 mm, 1798 (London, British Library)

readier couching without the need for interleaving felts such as are used in *tamezuki*. Each sheet or waterleaf is repeatedly laminated by dipping into the vat of stock before being turned out on to a pile of sheets called a block, which ultimately consists of 400–600 sheets. The block is pressed to remove excess water, after which the sheets are separated and spread on a board to dry. No subsequent sizing or finishing is necessary.

(ii) History.

(a) Nara period (AD 710–94). The establishment of the imperial court at Nara, the centralization of political power and the founding of many Buddhist temples in the area created a considerable demand for writing paper, which made the Nara period the first age of papermaking in Japan. Many examples are extant from that time, ranging from plain *kōzo* and hemp papers used for official reports and records to a large variety of dyed and otherwise decorated samples, some with gold leaf and dust (Nara, Shōsōin). Many of the finer plain papers, made from *ganpi*, were used for *sūtra* copying, while the decorative papers were used as bindings, scroll end-papers and wrappings. Indigo-dyed paper was particularly favoured for copying religious texts and commentaries (e.g. Tōdaiji Kenmotsu-chō of Tenpyō-hōji 2, AD 758). The Shōsōin, amongst other things, holds sample sheets and books of contemporary paper and many thousands of documents. Many of

these are written on on both sides (palimpsests), indicating that paper, although available, could not be wasted.

(b) Heian period (794–1185). The Heian period was the 'golden age' of papermaking in Japan. With the move to the new capital of Heian (now Kyoto), a reduction in the political involvement of the priesthood and the flowering of courtly culture, a new demand for paper arose, not only for official stationery but also for luxury decorated papers on which to write poems and keep diaries. Many of the techniques developed in this period, such as those used to make *suminagashi*, *tsugigami* and *uchigumo*, and all remain in use in the late 20th century; some produce papers so exquisite that the sheets themselves are almost works of art.

In order to fulfil its own requirements, the government set up *c.* 806–9 an official mill, the Kan'yain (also known as the Shiokuin) on the banks of the River Kamiyagawa or Kan'ya in Heian. The papers made in this mill, collectively called *kan'yagami*, were moulded mainly from hemp, *kōzo* or *ganpi*. A rarer paper, based on the bark of the *kurara* shrub (*Sophora angustifolia*) and called *kujinshi*, was also prepared there. For some time the Kan'yain continued to be the main producer, becoming famous not only for its plain stationery but also for its wide range of coloured papers (*kan'ya no shikishi*). Before long, however, provincially made papers came to the attention of the aristocracy. The 'plump' *kōzo* papers, such as *danshi* ('crêped' paper), *michinokugami* and the finer *minogami*, were particularly favoured. This encouraged the provincial makers to supply the finished product directly to clients in the capital rather than the raw material to the Kan'yain, which was severely hit by an acute lack of quality bark. As the finest bark was retained by provincial papermakers for their own use only poor quality raw materials were sent to the Kanyain as tax. The result was that the official mill had to turn its attention to making papers from recycled waste (*shukushi*). As it was not always possible to remove all the ink from the waste, this paper tended to be grey, a feature much admired by calligraphers, who used such varieties as *suiunshi* ('water-cloud paper') or *usuzumigami* ('pale-ink paper').

Suminagashi (see PAPER, DECORATIVE, colour pl. I, fig. 3), a kind of ink-marbled *ganpi* paper, also appeared for the first time during this period. It was made by dripping ink on to the surface of a dish of clean water, and agitating the surface with a thin sliver of wood dipped in pine resin. When the desired marbled effect was achieved a sheet of *ganpi* paper was laid on to the surface and quickly removed—the ink pattern being retained on the surface of the paper. *Ganpi* papers were the base for many of the decorated types, such as *karakami*, which bore overstamped or stencilled Chinese-style motifs and was popular for writing poetry and for bindings. Another innovation was the technique of overmoulding with different coloured stock on plain white or off-white *ganpi* paper. Paper with passages of blue at top and bottom was called *uchigumo* ('cloud' paper). Coloured stock dripped on to white paper produced *tobigumo* ('floating-cloud' paper). Together with *suminagashi* these were popular for making *tanzaku* (narrow strips of paper used for writing poems).

Great care was taken in selecting paper appropriate to particular activities. The 12th-century *Sanjūrokuninkashu* ('Anthologies of the 36 poets'; Kyoto, Nishi Honganji) is an almost encyclopedic sample book of the finest papers available in the early 12th century. The colours, patterns and sometimes pictorial decoration of the final sheets were carefully contrived to complement the sentiment of each verse, such that a single book encompassed all the best types. Each page was made by joining pieces of differently decorated paper in a technique called *tsugigami*.

Many different papers were also employed in the production of the *Heike nōkyō*, a collection of exquisitely decorated manuscript *sūtra*s presented to Itsukushima Shrine by Taira no Kiyomori in 1164 (*see also* §VII, 2(i) above). Particularly noteworthy are the sheets of *unkamon*, tinted pale yellow–brown with misty passages of sprayed mica pigment and scatterings of gold leaf, chosen to symbolize the radiant light of paradise.

(c) Kamakura (1185–1333), Muromachi (1333–1568) and Momoyama (1568–1600) periods. With the establishment of a feudal military government in Kamakura in 1185, the power and wealth of the old court aristocracy of Kyoto declined, although in many respects the court remained the arbiter of elegance. A dictionary called the *Kagaku-shū*, published in 1444, listed many of the luxury papers already famous in the preceding age as well as several new varieties. Certain papers became the subject of trade monopolies set up by nobles, and papermakers were encouraged by the establishment of guilds in the Muromachi period (1333–1568). On the whole, however, luxury papers became the choice of a minority of consumers, and they were outstripped in demand by more utilitarian papers. The warrior class favoured *kōzo* papers of the *danshi* type, such as *hikiawase*, so called because twists of it were used to seal armour joints, and *sugiharashi*, first produced for private consumption in Harima (now Hyōgo Prefect.) The conservative tones and textures of such papers were in keeping with the contemporary taste for practicality.

An increase in the number of markets, the development of printing and the more extensive use of paper for making screen and partition coverings were important stimuli to paper production. From early in the 12th century several religious institutions engaged in printing religious texts, preferring plain papers that were humble in spirit. Prime among these were the Kasuga Grand Shrine, the temples of Mt Kōya and, later, the five Rinzai-sect Zen temples of Kyoto. All depended on local mills for their supply of paper.

Maniaishi, a loaded *ganpi* paper first recorded in 1278, was perhaps the most important paper used in architecture. *Fusuma maniai* (partition paper) was moulded into sheets of *c.* 395×970 mm, and it took five such sheets to cover a partition (*see also* FUSUMA). *Byōbu maniai* (screen paper) was a little smaller. *Maniai* was also used for making *kakemono* (hanging scrolls) and *emakimono* (horizontal scrolls). Calligraphers were particularly fond of *torinoko*, a fine, off-white paper with a texture like an eggshell. Like *maniai*, this was made in Echizen and Nashio in Settsu (now Hyōgo Prefect.), and contained a filler of fine white

clay called *amako* or *tsuchi*. Loaded papers are less absorbent than those without fillers and are more suitable for painting.

Perhaps the most famous of all papers during this period, and the favourite of the daimyo, was *hōsho*, a white *danshi*-type paper from Echizen. First recorded in 1573, it was a thick *kōzo* paper made from the finest raw materials. Its popularity as stationery encouraged other centres in Japan to manufacture *hōsho*-type paper, but that from Echizen kept its reputation as *Nippon ichi* ('the number one [paper] of all Japan').

Of almost equal status was paper from Mino, which produced more paper than any other province at that time. *Minogami* was high in quality, low in price and produced in such quantities that the word became synonymous with paper. It refers in fact to a range of different types. An interesting variety of *minogami* is *tengujōshi*, a fine paper in both weight and quality. Between 1580 and 1596 *senkashi* from Iyo (now Ehime Prefect.) was in great demand. It was made in seven different colours with the use of natural dyes. A characteristic of *senkashi* was that each sheet was made by laminating two sheets back to back, one being moulded on a coarse mould cover, the other on a fine one. Lamination was also used in the production of paper clothing (*kamiko*). A stronger paper called *shifu*, made from a weft of twisted paper woven into a warp of silk or cotton, made use of paper's excellent insulating qualities.

(d) Edo period (1600–1868). The establishment of the Tokugawa shogunate in Edo (now Tokyo) ushered in a period of peace in Japan and encouraged a revival of learning. Many new papers appeared during this period, and output increased greatly. The shogunate established an official publishing house in Suruga (now part of Shizuoka Prefect.), and other printing centres soon sprang up in the provinces. *Hōsho* and *shuzenjigami*, made in Shuzenji, a town in eastern Shizuoka Prefecture, were adopted as the official stationery of the shogunate, and many daimyo established mills in their fiefs so that they too could have a regular and personal supply.

The publication of printed books and *ukiyoe* ('pictures of the floating world') woodblock prints developed briskly during the Edo period and *hanshi* was used in enormous quantities by publishers. The term *hanshi*—'half-paper'—derives from the fact that whole sheets, proving too large, were folded or cut in half. Although there were no national standard paper sizes, *minogami* and *hanshi* ('half sheet') and their half sizes came to be the standards for most printed books. Echizen *hōsho* was used by the *ukiyoe* printmakers almost to the exclusion of all other papers. In this process too block and paper sizes determined the sizes of prints.

Paper has also been used in Japan to make PAPERCUT stencils and stencils for various textile dyeing techniques (*see* §XI above; *see also* STENCILLING), such as *yūzen* (paste resist), *komon* (small repeat motif), *chūgata* (medium repeat motif) and *daimon* (large repeat motif); as a base (paper pulp mixed with sawdust) for a wide range of lacquer goods, such as boxes, helmets and hats (*see* §X above; *see also* PAPIER-MÂCHÉ); and in the manufacture of fans, lanterns and toys. Stencil paper treated with persimmon juice to render it water resistant is known as *shi bugami*.

(e) Meiji period (1868–1912) and after. Western paper-making technology was introduced to Japan during the

242. Highly prepared and glazed paper used in a folding album of the *Tale of Genji*; *Ukifune* ('A boat upon the water'; chapter 51), calligraphy attributed to Ōi no Mikado Tsunetaka (*c.* 1613–82), painting in the style of the Tosa school, brush and ink with gold, each page 121×119 mm, Edo period, mid-17th century (London, British Museum)

1870s, causing a decline in the next few decades in the production of traditional handmade paper, which was inevitably more costly. Nonetheless, sufficient demand remained to ensure that the craft remained viable, not least because the crafted product has qualities of strength and durability that cannot be reproduced by industrial methods. The *mingei* (folk crafts) movement of the early 20th century also helped to keep traditional papermaking skills alive (*see* §XV above). Handmade paper is still produced, in increasing quantities and variety, for the appreciation and consumption not only of the Japanese but also of Western artists. Certain papers from Izumo, Shimane, Fukui and Gifu prefectures have been designated as Important Intangible Cultural Assets and some papermakers as Living National Treasures, including Eishirō Abe, a maker of *ganpi* paper, and Ichibei Iwano, a maker of Echizen *hōsho*. In post-war years several Western craftsmen visited Japan to learn the techniques for themselves. 'Japanese' paper is now made around the world. High-quality handmade papers are essential for many forms of painting and calligraphy (see fig. 242). They are used also in such other arts as paper sculpture, *origami* (folding paper into decorative shapes) and dollmaking.

See also PAPER, §§I and III and PAPER, DECORATIVE, §1.

BIBLIOGRAPHY

Kodansha Enc. Japan, 'Washi'
S. Sorimachi: *Washi kankei bunken mokuroku* [Bibliography of material concerning Japanese paper] (Tokyo, 1961)
B. Jugaku: *Nihon no kami* [Japanese paper] (Tokyo, 1967)
Shōsōin no kami [The papers of the Shōsōin], ed. Shōsōin Jimusho (Tokyo, 1970)
Y. Kume: *Washi no bunka-shi* [A cultural history of paper in Japan] (Tokyo, 1976)
B. Hickman: 'Japanese Handmade Paper: Materials and Techniques', *Japan Soc. London Bull.*, 81 (1977), pp. 9–16
S. Machida: *Washi bunka* [Paper culture] (Kyoto, 1977)
S. Hughes: *Washi: The World of Japanese Paper* (Tokyo, 1978)
K. Maekawa: *Edo no kamisaiku* [Papercraft of Edo] (Tokyo, 1978)
Y. Kume: *Washi seikatsu-shi* [Handmade paper and its uses] (Tokyo, 1982)
T. Barrett: *Japanese Papermaking* (Tokyo, 1983)
T. Kondō: *Ōchō tsugigami* [Decorated papers of the Heian period] (Tokyo, 1985)
Tsuen-hsuin Tsien: 'Paper and Printing', *Science and Civilization in China*, v/1 (Cambridge, 1986)
A. Shinbun-sha, ed.: *Washi jiten* [Dictionary of Japanese paper] (Tokyo, 1986)

B. HICKMAN

19. PUPPETS.

(i) Origins. The origins of Japanese puppets can be traced back to religious rituals. Their direct predecessor is thought to have been the *mitegura* staff, which was used by priests in a mystery ritual in the 7th century AD to summon the gods. Puppets were subsequently used for the same purpose. Theatrical puppets were first recorded in Japan in the 11th century, when *kogutsu mawashi*, probably stick or rod puppets, were demonstrated by wandering troupes of puppeteers, who in time settled by the temples. At first the puppets were shown in erotic scenes, but by the 12th and 13th centuries they were used to illustrate stories about the temples' patrons. It is not clear when marionettes (string puppets) first appeared in Japan. Imitations of the well-known puppets from Rajasthan may have been imported from India during the 14th century; it is also possible that they were introduced by the Portuguese in the 17th century. It was in the 16th century that puppet replicas of performers in the *nō* theatre (*see* §XIII, 1 above) first appeared, mainly on Awajishima, an island near Kobe. They took the form of *Ebisu kaki*, named after Ebisu, one of the seven Gods of Good Fortune, and played an important role in his temple in Nichinomiya (now Hyōgo Prefecture). They were relatively small and were attached to a stick, with internal threads to manipulate the hands. They appeared on a small stage, consisting of a chest on a sling, and often performed the dance of Ebisu. In the 16th century also *hotoke mawashi* puppets developed and were shown in the grounds of Buddhist temples and Shinto shrines. These were hand-puppets that were manipulated by the puppeteer without the use of a stage, but with a reciter telling the story. This type of theatre gave rise to the *sekkyō bushi* tradition, which staged sketches propounding moral teachings. These types of puppeteers soon began to collaborate with the descendants of *kataribe* and *biwahashi*, roving story tellers who accompanied themselves on the *biwa* and, from the 16th century, the *shamisen* (types of lute).

(ii) Ningyō jōruri. From the 16th century the art of the story-teller was called *jōruri*, after the Princess Jōruri, a character in a popular story. At the beginning of the 17th century the storyteller's art fused with that of puppetry into *ningyō jōruri* or *ningyō shibai* (*ningyō* meaning 'puppet' and *shibai* meaning 'story'). Initially, *ningyō jōruri* employed puppets of the *Ebisu kaki* style, which were gradually enlarged and improved, in imitation of the elegant court *gigaku* dance masks (*see* §15 above). Takemoto Gidayū (1651–1714) was famous for a new form of recitation consisting of a synthesis of different styles that had existed up to his time, mixed with new melodies and intonations taken from *nō* and folk-songs. This new style was called *gidayū bushi*. Gidayū contributed to the development of *ningyō jōruri*, which, through his efforts, attained its classical form. He turned it into a theatrical ceremony with some ingredients of old dance, *nō* and *ko-jōruri* ('old' *jōruri*) and staged the plays of the great Japanese writer Chikamatsu Monzaemon (1653–1724). At first puppeteers worked behind a screen, giving performances in theatres, but at the beginning of the 18th century the screen was lowered, exposing the puppeteers, as in *sekkyō bushi*, particularly for performances in mansions of the wealthy. The height of the puppets was constantly increasing, but they were still manipulated by only one puppeteer.

Even more innovative changes were introduced after Gidayū's death by the celebrated puppeteer Yoshida Bunsaburō (*d* after 1760). Yoshida developed the puppets' framework and mechanized their faces and hands with the help of internal strings (giving them movable eyes, eyebrows and fingers). He also established the tradition of using three puppeteers, dressed in hooded black costumes, to animate the puppets. The chanter and the musician were moved to the side of the stage. By the end of the 18th century, female puppets had attained a height of 1 m and male puppets 1.2 m. They were dressed in stylized historical costume. Their faces were still artistically related

to the *gigaku* dance masks, while their mechanization imitated *bugaku* dance masks (*see* §15 above). *Ningyō shibai* theatre is still widespread in the centre of Japan and on Awajishima. Rural puppeteers often perform in the theatres attached to Shinto shrines.

(iii) Bunraku. At the end of the 18th century the puppeteer Uemura Bunrakuken (*b* 1737) left Awajishima to give performances in Osaka, where his successor, Bunrakuken II (*d* 1887; known as Bunraku no shibai) established a theatre, giving his name to the modern *bunraku* theatre. The celebrated *bunraku* puppeteer Yoshida Bungorō III (1869–1962) was active in the 1930s, and this style of theatre has remained very popular.

Bunraku is performed on a large box stage with several partitions and a back-cloth, plus a small revolving stage for the reciter and musical accompanist. Modern female puppets are 900 mm tall and weigh about 6 kg, while male puppets are 1350 mm tall and weigh up to 20 kg each.

243. Puppet head (*kashira*) representing an old woman (Roba), *bunraku* type, showing the neck pivot and shaft mechanism, wood, Edo period, 1600–1868 (Osaka, Osakajo Tenshukaku)

Their heads (*kashira*), carved from wood, are fixed to a neck and are rotatable (see fig. 243). They are attached to the body by a shaft that has several openings for the rods used to animate the eyes, eyebrows and lips, and an instrument for setting the strings in motion. The puppets' wigs are made of human or yak hair, and there are 28 basic hairstyles, including some that can transform the puppets' characters (for example, turning a beautiful woman into a demon). The faces are modelled on human features, if sometimes exaggerated, and reveal the influence of *nō* theatre. The bodies are empty cylinders made of bamboo. The cylinder is closed off by the wooden plate of the collar-bone, into which the puppet's neck is inserted. The inner tube of the body contains shafts for holding up the puppet and for operating its right hand. The left hand, which is somewhat longer, contains a separate mechanism for operating the fingers. The legs are suspended by threads attached to the main bodywork, and the feet are fitted with bamboo shanks. Female puppets do not, however, have feet.

The performance is conducted by the reciter, accompanied by the *shamisen* (lute). The main characters are each operated by three puppeteers. The chief puppeteer (*omozukai*) operates the puppet and its right hand, at the same time manipulating the face. One assistant (*hatarizukai*) operates the puppet's left hand, the other (*ashizukai*) its legs. The repertory is mainly classical.

(iv) Other types. Japan has many forms of puppet theatre, most of which continue as a living tradition. *Kuruma ningyō* ('puppets on wheels') were invented by Koruyu Nishikawa in the mid-19th century and performed in Osaka in the 1870s; they can still be seen in the Tokyo region. They are modelled on *bunraku* puppets, but each is manipulated by one player seated on a small stool on wheels, which allows him to move quickly around an open stage. He holds the puppet in front of him and uses levers to operate its arms. The female *ningyō shibai*, also called *otoma bunraku*, have been performed by groups of women since the second half of the 19th century. Puppets similar to those of *bunraku* are also manipulated by one player holding the figure in front of her. The head of the puppet is attached by strings to the player's head, while the limbs are operated by the player's hands. The puppets from Nakatsu on the island of Kyushu have a long history and appear in ritual dances. They are small statues, each with an extended leg that serves as a hand-grip for the puppeteer and with movable arms that can be raised by a string attached to the back.

The Kyoto region has a flourishing tradition of lantern-like puppets similar to Chinese Chaozhou puppets (*see* CHINA, §XIII, 20), which are carried in display cases in processions dedicated to the worship of the goddess Kami. The puppet theatre is an enlarged replica of these cases, the puppets being operated from the back by rods. Fire puppets are found in Obari and Takaoka to the north of Tokyo. Operated by a system of strings and pulleys, they move over and above the rooftop on a cable, then, having performed their tasks and set off fireworks, they return to the puppeteers' stage. The puppets from Yume on the island of Kyushu are a widespread type of mechanical puppet used throughout central Japan from the 17th

century and called *karakuri ningyō*. They appear in numerous festivals displayed on ornamental chariots and forming a pageant. At Yume the theatre is a two-storey building, with room for an orchestra on the top storey. The stage has a special track, and each puppet is fitted with a mechanism so that it returns to its original starting-point after it has completed a single movement. The puppeteers push the puppets out to the centre of the stage with poles, which they also use to activate the mechanism.

Glove puppets are known only in northern Japan, where they date from the 17th century. There are two types: those whose head is placed over and operated by the fingers, and those whose head is placed on a stick that is turned by two fingers while the remaining fingers operate the puppet's hands. The faces sometimes have flexible parts, which can make them look grotesque, comic or frightening. These puppets are exhibited above a screen in 'cops and robbers' comedy stories, without the use of a reciter.

Marionette theatre repertory originated from *sekkyō bushi* in the 17th century and has been practised by the Yuki theatre group since the 18th century. This type of theatre can still be seen in the Izumo region and in Tokyo. In the 19th century (from which time the earliest descriptions date), marionettes had seven or eight strings, and sometimes separate rods for operating the hands. In the second half of the 20th century the marionette tradition was modernized by Kinosuke Takeda (1923–79) and his partner Sennosuke Takeda (*b* 1930), who introduced to their productions the principle of a modern approach to typical Japanese themes. Many other companies tried new styles, tending to realism of expression (for example the Kogei theatre of Kyoto) or to caricature or expressionism (the La Clarté troupe from Osaka). Taiji Kawajiri (*b* 1914), in his PUK theatre in Tokyo, favoured a Western repertory and puppets in Western styles. Susumu Tange (*b* 1938) attempted a Chinese style and Chinese themes in the Muzubiza company from Nagoya. He also experimented with a refined comedic interpretation of the traditional *jōruri* plays.

See also §XV, 2(vi) above.

BIBLIOGRAPHY

A. C. Scott: *The Puppet Theatre of Japan* (Rutland, VT, and Tokyo, 1963)
H. Shuzaburo: *Bunraku: Japan's Unique Puppet Theatre* (Tokyo, 1964)
D. Keene: *Bunraku: The Art of the Japanese Puppet* (Tokyo, 1965)
C. Dunn: *The Early Japanese Puppet Drama* (London, 1966)
B. Ortolani: 'Das Japanische Theater', *Fernöstliches Theater*, ed. H. Kindermann (Stuttgart, 1966), pp. 391–526
T. Ando: *Bunraku: The Puppet Theatre* (New York and Tokyo, 1970)
J. Pimpaneau: *Fantômes manipulés: Le Théâtre de poupées au Japon* (Paris, 1978)

HENRYK JURKOWSKI

20. SEALS.

(i) Types and uses. (ii) Schools and styles. (iii) Connoisseurship and collecting.

(i) *Types and uses.*

(a) *Origins and early development.* Seals are thought to have originated in Mesopotamia in the latter part of the 5th millennium BC (*see* ANCIENT NEAR EAST, §II, 1). When their use spread to China, official seals were adopted by the centralized administration of the Qin (221–206 BC)

and Han (206 BC–AD 220) dynasties. The granting of a seal signified appointment to a post, the title of which was engraved on the seal. These personal seals were eventually used, impressed into clay, to seal letters or packages as proof that they were complete. Examples of clay fragments known as *fengjian* ('seal-mud') were first discovered in Sichuan in 1822.

Intaglio seals produced characters in relief on clay. When used with an inkpad, however, to stamp paper or silk to denote authorship, official position or ownership, the concave characters did not pick up any of the red colour, while the relief surface printed red. In Japanese, these effects are sometimes called 'male' and 'female', but, because there is some confusion as to whether the terms refer to the surface of the seal or to the impression it makes, the terms 'white character' and 'red character', according to the impression left by the seal, are more useful.

(b) *Yamato seals.* The earliest official and private seals are known as *Yamato koin* ('Yamato ancient seals'). Their use was regulated in accordance with the administrative code. The seal system was modelled on that of China in the Han and Sui (AD 581–618) periods. Official seals included the *nai in* (imperial seal), the *ge in* of the Daijōkan (or Dajōkan; Grand Council of State) and those for various ministries (*tsukasa*), provinces (*kuni*), storehouses, villages and districts (*gō*), armies, shrines and temples and official posts. Private seals, which were occasionally used for official purposes, included those of families (such as the *Emike no in, naike shi in, Sekizen tōke*) and of individuals. No seal was permitted to be larger than the 870 mm imperial seal, and private seals were smaller than official ones. Both private and official seals were red-character seals cast in bronze with characters in archaic or seal script (*tensho*). In the Nara period (710–94) the seal might be applied over the entire paper surface, but in the Heian period (794–1185) fewer impressions were made. The seal was also impressed on the continuation parts of volumes of a collection, series or documents. In the earliest period signatures alone were proof of authorship; the custom of using name seals as an equivalent, which still prevails, developed only later.

(c) *Authorship and thread seals.* The seals used by the Chan (Jap. Zen) priests of the Song (960–1279) and Yuan (1279–1368) periods in China, which were imported into Japan along with Zen Buddhism, represented the beginning of a new age in the history of Japanese seals. In the Kamakura period (1185–1333) one of these priests, Enni (Shōitsu Kokushi; 1202–80) of the temple Tōfukuji in Kyoto, had a seal engraved with the characters 'En ni'; two of his boxwood seals given to his pupils are extant. Lanqi Daolong (Jap. Rankei Dōryū), Wuxue Zuyuan (Mugaku Sogen; 1226–86) and Yishan Yining (Issan Ichinei; 1247–1317), also from China, each had personal seals of both red- and white-character types and with richly varied and decorative designs. Ink painting and calligraphy and the seals applied to them were appreciated as complementary.

Muromachi-period (1333–1568) seals perpetuated Chinese custom. They included the author seals of the painter–

priests Tenshō Shūbun, and Tōyō Sesshū, and the author seals and *inshu* or *kanbō* seals impressed at the top right of the work by Zen priests, who also added complementary inscriptions. Collectors' seals were applied to calligraphy and painting scrolls. The personal seals owned by warriors in the late Muromachi period and the Momoyama period (1568–1600) were either square or round red-character seals, many with a great sense of dynamism. In addition to names, they were sometimes engraved with mottoes expressing doctrines or beliefs or with animal designs. They included some fashionably exotic emblems, such as Roman letters or a Christian crucifix. It was not until the Edo period (1600–1868), when Chinese literati styles became popular in Japan, that these early stirrings of interest and experiment matured into an appreciation of seals and seal-carving as an art form.

When raw silk thread was imported from China in the Ming period (1368–1644), a bronze 'thread seal' (*ito in*) was delivered with each catty (Chin. *jin*; *c.* 500 g) of silk, to be impressed as a receipt. The handles of these seals were in the form of lions, tigers, dragons, elephants, dogs and human figures in various poses. Although the same animals were shown as in the Han-period seals, they were depicted differently. The seals were either round or square, of the red-character type, and the characters were stylized and elegant. Along with the simple, ancient Yamato seals, they found favour with and were occasionally used by connoisseurs. The warlord and unifier of Japan, Toyotomi Hideyoshi, used a round thread seal. KŌ FUYŌ, the principal advocate of *Kotai* ('old form') seal-carving (*see* §(ii)(b) below) in the Edo period, helped to popularize both thread seals and the ancient seals from the Qin and Han periods, collected them himself and assisted friends with the compilation of seal albums.

(d) Fine art seal-carving. The seals used by Confucian scholars and poets of the early Edo period, such as Fujiwara no Seika (1561–1619), Hayashi Razan (1583–1657) and ISHIKAWA JŌZAN, were part of the tradition of medieval authorship seals, and the seals used by the artist-craftsmen Hon'ami Kōetsu (*see* HON'AMI, (1)) and TAWARAYA SŌTATSU reflected the style of the Yamato seals. These were, however, carved or cast for practical use, and prime importance was attached to the impression made by the seal; the seals themselves and the finer aesthetic points of their carving were not the objects of appreciation. It was only in the second half of the Edo period that the plastic beauty of the seal-carving itself came to be admired and seals made and appraised with reference to artistic criteria. This aesthetic and the seal-carving techniques associated with it derived from China of the Ming and Qing (1644–1911) periods.

Twelve cutting techniques, based on the theories of Chinese seal-carvers, were brought to Japan and taught by Zen Buddhist priests such as DOKURYŪ SHŌEKI of the Ōbaku sect and SHIN'ETSU of the Sōtō sect. The twelve techniques were (with minor variations in terminology): standard (*sei*), stopped (*ryū*), double cut (*sōnyū*), dancing (*bu*), single cut (*tannyū*), buried (*mai*), cutting (*setsu*), impact (*shō*), reach (*chi*), flat (*hei*), 'pike above, fissure below' (*sōjō rokuka*) and light (*kei*). Other terms, such as composite (*fuku*), covered (*fuku*), curved (*han*), flying

(*hi*), reserved (*jū*), piercing (*shi*), supplementary (*ho*) and loose (*kan*), have also been handed down, but it is not known specifically to what these refer. In *Jūnitōhō shōsetsu* ('A detailed explanation of the twelve cutting techniques'; 1815), Futamura Baizan, a pupil of Kō Fuyō, used the phrase *tantō chokunyū* ('direct entry with a single blade') to denote one of the twelve cutting techniques. The analogy was with the military tactic in which a single warrior cuts his way into the enemy camp, thus, figuratively, penetrating directly to the heart of matters.

(ii) Schools and styles.

(a) *Kondai*, *c.* 1600–*c.* 1780. (b) *Kotai*, *c.* 1760–*c.* 1850. (c) Modern, after *c.* 1850.

(a) Kondai, c. 1600–c. 1780. Dokuryū and Shin'etsu (*see* §1(d) above) are revered as the founders of Japanese seal-carving, originating the *Kondai* ('modern form') style of carving. Like them, many of the other priests who came to Japan from China in the early Edo period were of the Ōbaku sect (*see* §II, 3 above). They included the skilled seal-carvers INGEN RYŪKI, MOKUAN SHŌTŌ, SOKUHI NYOITSU, Kōsen (Gao quan); 1633–95), Mokusu (Mozi; 1596–1657) and Hōjō (Fangjing; 1663–1706), and Rankoku (Langu; *d* 1707). Kō Gentai (1649–1722), a pupil of Dokuryū, was also an able seal-carver. Sakakibara Kōshū (1655–1706), said to have learnt carving techniques from Shin'etsu, wrote many works of great erudition; his *Insho hōko* ('Additional considerations on seals') was probably the first Japanese study of seals. His seal album *Unsō suitetsu* was admired by his friend Kō Gentai.

Early Edo school. Ikenaga Dōun (Ippō) of Edo (now Tokyo) studied under Kōshū. Matsuura Seiken and his son Imai Junsai (1658–1718) rivalled each other in their studies of seals and their carving technique. Seiken was a talented calligrapher, knowledgeable about ancient seals and an enthusiastic seal-carver. Junsai was a talented engraver, who went to Edo in 1686 to stay at the home of Ikenaga Dōun. He too was knowledgeable about seals and devised a method of printing models for calligraphy practice. All three artists contributed greatly to setting the course of Japanese seal-making. They are known, from the area in which they were active, as the Early Edo school, although their practices and techniques originated in Nagasaki. The style of this school was 'modern' (*Kondai*), in the tradition of late Ming-period decorative seal script, and although technically accomplished and characterized by varied and decorative design, it lacked artistic depth.

Dōun and HOSOI KŌTAKU, one of the greatest masters of the Chinese (*Karayō*) style of calligraphy, were the leading exponents of the *Kondai* style of seal-carving, which aimed at a wide range of expressive forms. Kōtaku learnt his carving technique from Matsuura Seiken and mastered the decorative seal script developed by Huang Daoqian of the Qing period (1644–1911). Study of Gonjō Butsuzen's Ming-period (1368–1644) album of reproduction seals *Shūkan gitetsu* helped him to polish his technical skills (Dōun is said to have learnt it too). He received a succession of commissions for seals from aristocrats, priests and literati and in 1724 was commanded by the shogunate to carve the official seal to be applied to the reply given to a Korean envoy. The seal album *Kikatsudō*

244. Ikenaga Dōun: seal reading *Ike Dōunin*, from the *Ittō banshō* ('One blade, a myriad images'), *c.* 1700 (Suita, N. Mizuta Shūhōshitsu private collection)

inpu contains the impressions of Kōtaku's seals and those of his son and pupil Kyūkō (1711–82). More than 20 of Kōtaku's seals are preserved in the temple Manganji, in Todoriki, Tokyo.

Ikenaga Dōun's *Ittō banshō* ('One blade, a myriad images') was a fine example of early Edo-period seal-carving (see fig. 244) and of the *Kondai* style, with its emphasis on decoration. This deservedly famous album, prepared with the guidance and cooperation of his teacher Kōshū (1655–1706) and friend Imai Junsai, was published in 1713 and established Dōun's reputation among later generations. Consisting of *Senjimon* (the Chinese 'thousand-character' classic), divided into different character forms and styles and with 500 seal impressions, supplemented by Dōun's personal seals, it shows supreme technical skill. All those who contributed prefaces to the work praised Dōun's superlative carving technique.

The seal-carvers who continued the tradition of the Early Edo school and the *Kondai* style included Kōtaku's son Kyūkō, his pupils Kan Shikyō (1697–1765) and Mitsui Shinna (1700–82), his acquaintance Matsushita Useki (1699–1779) and Dōun's pupil Katsuma Ryūsui, all of whom were excellent calligraphers and seal-carvers and enjoyed great popularity in Edo. Additionally, Ninkai (1696–1761) of Hōshōji, Musashi, published the seal album *Hakka inpu*, to which the poet Hattori Nankaku (1683–1759) contributed an introduction. Kawamura Meikei published seal albums including *Genpo sekigyoku* and *Zushoheki*. Nagai Shōgen carved seals modelled on the ancient seals of the Qin and Han periods and in 1753 prepared the work *Ippen gongyoku*.

Early Naniwa school. The *Kondai* style was adopted, somewhat later than in Edo, in Naniwa (now Osaka) by the early Naniwa school, of which the leading figure was Niō (later Ō) Mōsho (1687–1755). Talented both in calligraphy and seal-carving, he was adept both at seal script and clerical script (*reisho*). His seal albums included *Mōsho shikan*. Among his best pupils in the *Kondai* style were the priest Itsuzan (1702–78) and Tsuga Teishō (1718–94). Itsuzan prepared the seal albums *Kinsenfu* and *Shūrai inpu* (see fig. 245), published a reproduction seal album

and produced studies of seal script including *Tensho senjimon* ('Thousand-character classic in seal script') and *Koten rongo* ('Ancient seal Confucian analects').

Tsuga Teishō compiled the seal album *Zen-tō meifu* ('A comprehensive album of Tang-period names'; 1714), in which he stated that he relied on Mōsho's carving technique. The album comprises seals, both red- and white-character, of the family names of Tang-period poets and lines from their verse, along with various private seals. It was edited by Maki Kagaku, who became Mōsho's successor. In 1791 Teishō produced the album *Kan-ri sofu*, in which he recarved the names of personalities who were active in the dramatic period of Chinese history from the latter part of the Han period to the period of the Three Kingdoms (AD 220–66). He was a pioneer of the form of popular, Chinese-influenced narrative known as *yomihon* ('reading–books') but also published the rigorously edited dictionary *Kōki jiten*. Another known seal-carver of the early Naniwa school was Ri Tōhaku. He produced printed seal albums such as *Rōtetsu gien*, *Senjimon inpu* ('Thousand-character seal album') and *Tōshi inpu* (a seal album of Tang-period poems).

Nagasaki school. Seal-carvers who had a direct connection with Nagasaki, the gateway through which Chinese culture had traditionally entered Japan, included Shimizu Gan'ō (1712–93), born there to Chinese parents. A skilled poet, calligrapher and painter, he learnt seal-carving from masters who had come to Japan from Qing-period China. In 1756 he prepared the seal albums *Yōwadō inpu* and *Chōchūkan inpu*. His album of large seals, *Koin byōbu*, carved and printed in imitation of the Ming-period *Han gu ji*, is well known. Tō Eifu, who was born in Edo and visited Nagasaki in the Kyōhō period (1716–36), also, like Gan'ō, studied the carving techniques of Dong Sanqiao. One of his pupils was Tanaka Ryōan (1747–1802), who lived in Edo and, although he belonged to the *Kondai* school, was known for the freedom of his carving and the facility of his technique, carving more than 40,000 seals. His seal album *Ryutake inpu* ran into scores of volumes

245. Itsuzan: seal reading *Shūrai*, from the seal album *Shūrai inpu*, *c.* mid-18th century (Suita, N. Mizuta Shūhōshitsu private collection)

and shows his mastery of the art of carving. In the introduction to this album, he wrote that his teacher, Tō Eifu, had learnt the 'twelve carving techniques' during a visit to distant Nagasaki.

Other well-known seal-carvers who were born in Nagasaki and subsequently lived in the Kyoto–Osaka area included Nagata Tōsenshi and Chō Tōsai (1713–86). Tōsenshi developed a style that was notable for its decorative properties and in 1789 published the seal album *Tōsenshi inpu* ('Tōsenshi's seal album'). Tōsai had a wide circle of friends among the literati of Naniwa and taught Rai Shunsui (1746–1816), who produced the seal albums *Seikan yokyō* (1748), *Zoku-Seikan yokyō* (1755), *Gekijō yoyū* (1760) and *Raidō yūki* (1777). His seals display scholarly elegance and exquisite taste.

Later exponents. *Kondai*-style seal-carvers were still active in Kyoto at the time when Kō Fuyō began to advocate a return to 'old form' (*Kotai*) seal-carving (*see* §(b) below). The Kyoto seal-carvers of the *Kondai* school included Katayama Naoyoshi, who published the seal album *Shō kokan inpu*, Tonomura Atai, who published *Hakkosai inpu* (1756), *Chōin untōhō* ('Blade techniques for seal-carving'; 1778) and *Atai jifu* (1778), Rin Kanshō, who published *Renkin-shū*, the Confucianist Ryū Sōro (1715–92), and YANAGISAWA KIEN, a pioneer of literati painting, who carved seals replete with *Kondai* characteristics. The works of all of these appear in seal albums prepared by their successors.

Two Ōbaku priests, Kō Fuyō's seniors and close friends, also carved seals. Go Shion (*d* 1785) is said to have studied under Hosoi Kōtaku and Niō Mōsho; in 1743 he prepared a seal album in imitation of the *Lian zhu yin pu* of the Ming-period carver Zhu Jushan. He was also a scholar who studied under Hattori Nankaku (1683–1759), a pupil of Ogyū Sorai (1666–1728). Shūnan (1711–67) was very close to Go Shion, and together they compiled an album containing the impressions of their carved seals (Tenri, Cent. Lib., Kobidō Bunko). They both granted inscriptions for seal-carving implements to Fuyō and moreover gave him great spiritual encouragement.

(b) Kotai, c. 1760–c. 1850. The *Kotai* ('old form') style of seal-carving evolved in the late 18th century and was based on a return to the earliest forms of Japanese seals. Its chief advocate was KŌ FUYŌ, a student and admirer of the bronze seals of the Qin and Han periods. The oldest extant seal in Japan was discovered in 1784 by a farmer, beneath a huge rock in a stone tomb-chamber in Hakata, Chikuzen (now Fukuoka Prefect.). It was a gold, snake-handled, white-character seal engraved with the characters *Kan no wa no na(no) kokuō* (see fig. 246) and had probably been sent from a late Han period emperor to the ancient Japanese kingdom of Nanokuni. Two months later Kō Fuyō died, having already been accused of forging the seal. He was known to believe that the ancient seals of the Qin and Han periods represented aesthetic perfection and that the mainly decorative seal-carving of the Ming and Qing periods did not merit preservation.

Impressions from the newly found gold seal rapidly achieved a wide circulation. Many studies of it were published and imitations made. Fuyō may have seen an impression; had he set eyes on the actual seal, he would have been astonished by its austere serenity and golden effulgence. The baseless notion that Fuyō had forged the seal was, in a negative way, a tribute to his reputation as a pioneer who recognized the artistic value of ancient seals before anyone else and brought the same enlightened appreciation to others.

Kō Fuyō and his followers. The notion of a return to an 'archaic' style of high elegance and the concomitant need to rid the systemization, forms and carving of seals of modern 'abuses' were in keeping with the trend towards classicism that then permeated all forms of art in Japan. Proponents of this theme included Tō Chō (1748–1816), who argued the case in *Chōko in'yō*, and KIMURA KEN-KADŌ, who published the *Yin zheng fu shuo* ('A true account of seals') by Gan Yang of the Ming period, with diacritical marks for it to be read as Japanese. It is a measure of the achievement of Kō Fuyō (known as the Sage of Seals) that, in spite of having no access to real ancient seals from the Qin and Han periods and little opportunity to see accurate impressions from them, he was still able to grasp the essence of the antique rather than merely to imitate. By referring to Ming-period albums of impressions of reproduction seals, such as Su Xiaomin's

246. Seal engraved with the characters *Kan no wa no na(no) kokuō*, gold, 22×23 mm, 108.7 g, probably Chinese, Eastern Han period (AD 25–220), discovered in Hakata, Fukuoka City, 1784 (Fukuoka, Fukuoka City Museum)

247. Kō Fuyō: seal reading *Chochihaku*, from the *Bunbō shiyū inki*, *c.* mid-18th century (Suita, N. Mizuta Shūhōshitsu private collection)

Sumin yinlue, Wang Yannian's *Gumin jigu yinpu* and Zhang Yiling's *Chengqing guanyin pu*, and incorporating certain techniques of the *Kondai* style, he established an elegant and refined style of Japanese seal-carving, for which he is greatly revered (see fig. 247).

Seal-carvers of Fuyō's *Kotai* school flourished throughout Japan, in Kyoto, Osaka, Edo, Ise, Mino, Owari and Izumo. Perhaps because of his constant contact with and the influence of his teacher, Gen Iryō of Kyoto, who edited the *Kō Fuyō shi'inpu* ('Album of Kō Fuyō's personal seals'), had a refined style that was faithful to that of Fuyō and lacked any spark of individualism. It may have been this that made him so admirable an editor of the album. The Fuyō school was especially strong in the region of Osaka and included SŌ SHII, the editor of the seal albums *Insekikō* and *Ingosan*, who was known as the Shadow of Fuyō; Katsu Shikin, whose seal albums *Toan sensei inpu* and *Katsu Shikin inpu* ('Katsu Shikin's seal album') show his outstanding carving technique and verse-writing talent; and Maegawa Kyoshū, who wrote the *Keikoinshi* ('Practice seal history'). A seal album that illustrates well the overall style of the Osaka school is the memorial seal album *Kōka in'ei* (a title suggested by a phrase of Fuyō's), prepared at a farewell seal-impressing ceremony held in 1797 at Osaka to mark the departure of Inage Okuzan (1755–1823) for Edo. At the beginning of the volumes of the seal album are the seals of 'four studio friends' carved by Fuyō, showing the strength of feeling between master and pupils. Kimura Kenkadō was known for his collections of classic texts, painting, calligraphy and various objects of interest. Most literati visiting Osaka came to see him, and his visitors' book, the *Kenkadō nikki* ('Kenkadō diary'), is a valuable source on the history of the literati world. In 1764 he and Fukuhara Shōshū (1735–68) carved the name of an emissary from Korea and gave it to Fuyō as a token of friendship.

Edo. One member of the Fuyō school in Edo was Hamamura Zōroku I (*see* ZŌROKU). The school he founded continued to flourish until the Meiji period (1868–1912), along with the other great Edo school, the Jōhekikyo school of Masuda Kinsai (*see* MASUDA), which followed the tradition of the Early Edo school (*see* §(a) above). Like Zōroku, Tō Hittan was among those who were host to Fuyō when he came to Edo. Hittan prepared the seal album *Gyokutō shōja inshū*. Ueda Katei followed

the carving style of Fuyō and published the seal album *Saishindō inpu*, the introduction to which included the phrase 'the seals are already in the east', meaning that the *Kotai* style had already spread to Edo. Tomiyama Keijun (*d* 1799), a member of a family of hereditary carpenters to the shogunate, who studied seal-carving under Fuyō, was known for his *Kinkan meifu*, a seal album of the names of famous *kabuki* actors.

Inage Okuzan, author of several albums, moved from the Shikoku region to Edo, where he collected, from the calligraphy of Fuyō's closest friend, the painter and calligrapher Ike Taiga (*see* IKE, (1)), the seven characters that meant 'the grave of Master Fuyō Ōshima'. These were to be inscribed on the gravestone of the recently deceased master as part of an epitaph. This task was carried out by Zōroku II (*see* ZŌROKU) and others, and in 1812, 28 years after Fuyō's death, the stone was erected at Muryō in Koishikawa.

Provinces. The *Kotai* school in the tradition of Fuyō spread to the provinces, a process summarized in *Kō Fuyō jūsankaikinen inpu* ('Seal album in commemoration of the 13th anniversary of the death of Kō Fuyō'). Ise was the birthplace of Go Shion and Shūnan, friends of Fuyō, and, being a centre of the Shinto faith, was the home of cultured priests and thus closely connected with Fuyō, who had an interest in the higher forms of courtly learning. *Indō shoka kakuron* ('Accurate account of the practitioners of the way of the seal'), a series of essays by Tō Shunmin (Morishima Shikisai; 1754–1820) of Ise, is a valuable source of information on *Kotai*-school seal-carving. Mimura Baizan (1759–1835) of Jōhachiman, Mino (now Gifu Prefect.), published *Ichikudō inpu* as well as a detailed explanation of the 'twelve carving techniques'. The *Fūjin zuihitsu* by Yo Ennen (Yamaguchi Bokusan; 1746–1819) of Owari (Aichi Prefect.) and the *Zagaki* by Tō Seika (1748–1810) of Izumo (Shimane Prefect.) are fascinating collections of anecdotes through which the character of Kō Fuyō can be glimpsed.

Literati. For the scholars of the Edo period (1600–1868), seal-carving was not simply an avocation but also an indispensable method of etymological study. Accordingly, Confucianists and literati read and wrote works on seals and had some knowledge of the techniques of carving. Generations of the encyclopedists of the Itō family of Kyoto were fine seal-carvers. Literati and scholars such as Rai Shunsui (1746–1816) of Aki and his son RAI SAN'YŌ, Shinozaki Shōchiku (1781–1851) of Naniwa, NUKINA KAIOKU, ICHIKAWA BEIAN and Tachihara Kyōsho (1785–1840) of Mito, were excellent seal-carvers. The literati painters TANI BUNCHŌ of Edo and Rin Jikkō (1777–1813) of Mito also showed talent in seal-carving.

(c) Modern, after c. 1850. As the end of the Edo period approached, Japanese seal-carvers began to employ the extravagantly decorative techniques of the *Kondai* style, eventually incorporating the fluent carving style of the Setsu (Chin. Zhe) and Tō (Chin. Deng) schools imported from Qing-period China to produce a new and modern style of seal-carving. Migumo Senshō (1769–1844) of Kyoto studied under Katsu Shikin and possessed a *Kotai* style of great skill and beauty. He was a connoisseur of

elegant pursuits, a master of the tea ceremony and seal-carving; he composed the seal album *Kaisai shinji*. One of his pupils, Nakamura Suichiku (1807–72), was in the service of the Konoe family and carved the imperial and the province seals. Mibu Suiseki (1791–1871) of Tosa (now Kōchi Prefect.) was a talented calligrapher, painter and seal-carver. Gō Hokusho (1798–1863), also a fine calligrapher and seal-carver, made effective use of the style of the Sekiko school, who used ancient Chinese drum-shaped stones and ancient script, in seals such as can be seen in his albums *Ushū inryaku* and *Gōshi inpu*. Many of the publications of the last years of the Edo period had *hanshita* (manuscripts prepared for woodblocks) by Hokushō. Gyōtoku Gyokukō (1828–1901), one of Hokushō's pupils, was a fine literati painter who prepared the seal album *Fūjin yogei*. Another follower of the Sekiko-school style was Hasegawa Ennen (1803–87), who compiled the *Hakuaidōshū koinpu* ('Album of ancient seals in the collection of Hakuaidō'), a massive album of reproductions of ancient Japanese seals.

Abe Kenshū (1793–1862) studied under his father, Abe Ryōzan, before going to live in Naniwa. Sogō Setsudō (*b* 1795), who was born in Sanuki (now Kagawa Prefect.) and moved to Naniwa, was a talented calligrapher, *koto* (zither) player and seal-carver in the ancient Yamato style (*see* §(i)(b) above). One of Ryōzan's pupils was Hosokawa Rinkoku (1782–1842), also of Sanuki, whose reputation spread to Kyoto and Edo, such that he became known as the leading carver of the time. He produced the seal album *Shishō*. Hagura Katei (1799–1887) of Kyoto and Yamamoto Chikuun (1820–88) were among Rinkoku's talented pupils. Katei was priest of the Fushimi Inari Shrine in Kyoto and carved an imperial seal as well as preparing the seal album *Katei inpu* ('Katei's seal album'). Chikuun was born in Bizen (now Okayama Prefect.), moved to Kyoto and published the seal album *Shōka gūkō*. Tanabe Gengen (1796–1858), a temple samurai of Tōji in Kyoto, devised and produced porcelain seals (*jiin*); many masters contributed prefaces to his album *Gengen jiinpu*, in which they praised his skill. Rai Rissai (1803–63) of Kyoto came from the same family as Rai San'yō (and is likewise buried at Chōrakuji, Higashiyama); he too had a high reputation for seal-carving.

Sone Sunsai (1798–1852) of Edo, a pupil of Masuda Kinsai and a great scholar of seals, wrote *Kokin inrei* ('Seals of the past and present'), *Inrin sōsetsu* ('Series of explanations of seals') and *Kōwa inshōko* ('Considerations on seals of imperial Japan'). Kosone Kendō (1828–85), who was born in Nagasaki and involved in the conclusion of the trade treaty with China, carved the emperor's seal and the state seal. Kanzan Yamada (1856–1918) took Kandō and Fukui Tan'in (1801–85) of Ise as his teachers and was employed by the temple Hanshan si in Suzhou, China, where he cast a new bell. He published the seal album *Rakan inpu*. His successor was Shōhei Yamada (1899–1962). Keisho Nakai (1831–1909) was a member of a family of hereditary decorators (*kazari-shi*) to the shogunate. He studied under Masuda Gūsho and Hamamura Zōroku III, modelled himself on Fuyō and became an imperial craftsman, carving the state seal. His many publications included *Kantankyō insui* ('A selection of Kantankyō's seals'), *Kantankyō yuikei* ('Bequeathed images

of Kantankyō'), *Nihon koin taisei* ('Collected ancient Japanese seals'), *Tenchō inten* ('Collection of imperial seals'), *Zoku inpu kōryaku* ('Brief considerations on seal albums, part 2') and *Nihon injinden* ('Japanese seals and biographies'), and he completed extensive studies of the history of Japanese seal-carving, preserving the memory and reputation of Kō Fuyō. Keisho successfully founded modern seal studies and had many pupils.

Abei Rekidō (1808–83) lived in Kyoto and carved the emperor's imperial seal and state seal. He published the seal album *Tetsunyoi inpu*. Shinoda Kaishin (1827–1902), a pupil of Rekidō, was born in Mino (now Gifu Prefect.) and lived in Kyoto, carving in a style that incorporated the strength of the Chinese Zhe school and producing the seal album *Ichinichi rokuji kōkisshōsōdō inpu*.

SENRO KAWAI went to China in 1900 and was taught personally by Wu Changshi, through whom he came into contact with the elaborate modern seal-carving of previous carvers such as Wu Rangzhi (1799–1870) and Zhao Zhiqian of the school of Deng Wanbai (1743–1805). Among his albums were *Senro inson* ('Extant seals of Senro'; 1932) and *Keijudō inson* ('Extant seals of Keijudō'; 1947). Tetsujō Kuwana (1864–1938) was born in Toyama, Etchū, lived in Kyoto and produced the seal albums *Kyūkashitsu inson* and *Tenkōkaku inson*. Kojō Sonoda (1886–1968), who concentrated on the collection and study of old bronze seals, was his pupil.

Daiu Maruyama (1838–1916) was born in Nagoya and lived in Kumamoto and elsewhere. In 1879 he went to Shanghai to study under Xu Sangeng (1826–90), returning to live in Surugadai, Tokyo, when he had learnt his intricate style. He published the seal album *Gakuhoan inzei*. Randai Nakamura (1856–1915) also went to China in pursuit of this new style. He produced the seal albums *Suikandō inson* and *Randai inshū*. Daiu's son Ryōshū and Randai's son Ranseki were also seal-carvers.

(iii) Connoisseurship and collecting. By the early Edo period, the practice had begun of compiling albums of seals impressed on ancient calligraphy and paintings, to act as a means of identifying works of art and, to some extent, in appreciation of the seals themselves. Seal albums for reference purposes published in the mid-17th century included *Kundaikansouchōkiji* ('A catalogue of Tang seals'; 1643), *Wakanrekidai gashimei shazu* ('Copies of the names of painters of the historical periods of China and Japan'; 1647), *Kuntaikan'in* ('Royal and official seals'; 1652) and *Gun'in hōkan* ('A catalogue of Japanese and Chinese seals'; 1659). In response to demand from connoisseurs, these continued to be published over the next two centuries in, for example, the seal catalogues *Banbō zensho* (1693), *Kun'in hosei* (1799) and *Kokinshōga kanteibinran* (1847).

Notable writings on seals dating from this time include Hosoi Kōtaku's *Tentai idōka* ('Seal forms') and Ikenaga Dōun's *Tensui* and *Renju tenmon*. Reference works concerning the six methods of explicating Chinese characters and Chinese texts were also published. Xu Guan's specialist work on seal-carving, *Gujin yinshi* ('A history of ancient and modern seals'), was published in 1697. Sakakibara Kōshū (1655–1706) wrote *Insho hōko* ('Considerations on seals'). *Xuegu bian* ('Studying the old') by Wu Qiuyan, published in 1743, served as an introduction to

seal-carving. Boku Mokei published the *Teppitsu shūgi* ('Collected tributes to seal-carving') in Japanese in 1752. Works of instruction such as Ōe Genpo's (1728–94) *Maniawase hayagakumon* ('Instant learning') and *Gaku-yoku* ('Aids to learning') also provided easily comprehensible accounts of seal-carving. The *Sekika insetsu* ('Chinese stone seals') of 1761, in parallel with the *Kotai* school and Kō Fuyō, advocated a return to the past and the ancient seals of the Qin and Han periods. That trend was even more clearly in evidence in Tō Chō's introduction to his *Biko in'yō* (1782).

The *Kotai* school's studies of seal-carving were more authentic and thorough. Sō Shii's *Insekikō* was a distinctive account and artistic assessment of the seal albums that had come to Japan; even in China there was then no comparable writing on the subject of seals. Shii also edited the *Ingosan*, a vocabulary of seal-carving, and cooperated with his friend Katsu Shikin in the publication of the *Kanten senjimon* ('The Han-period seal thousand-character classic') by his teacher Kō Fuyō, as well as making other valuable contributions to the study of seals. Ida Keishi of Settchū (now Wakayama Prefect.), Ueda Akinari (1734–1809) of Osaka and Minagawa Kien (1734–1807) of Kyoto all wrote on the codification or style of seals with special reference to the gold seal discovered in Chikuzen (*see* §(ii)(b) above). Albums of ancient Japanese seals were prepared by Tō Teikan (1722–89), Matsudaira Sadanobu (1758–1829) and Hoida Tadatomo (1792–1847), and Kō Fuyō collected and carved reproductions of ancient seals. Maegawa Kyoshū, a follower of Fuyō, carved witty reproductions of ancient seals in an idiosyncratic style and published these as *Keiko inshi* ('A practice seal history').

After the beginning of the modern era (Meiji Restoration, 1868), some excellent etymological reference works were published, of which the works by Chikusan Takada (1861–1946), *Kochūhen* ('Ancient readings'; 1925), *Kanji shōkai* ('A detailed explication of Chinese characters'; 1912) and *Hosei chōyōkaku jikan* (1925), are regarded as the most authoritative. Advances in printing techniques have permitted the publication of many more accurate albums of author seals, useful for the authentication of calligraphy and painting. For the first time, connoisseurs began to collect Han-period bronze seals and their impressions in clay, a development that started when Yang Shoujing came to Japan in 1880. Publications such as Junzō Gō's (1825–1910) *Shōsekisanbō inpu* and *Shōseki-sanbo inkō* followed (produced with the cooperation of Keisho Nakai). Collections held by Seidō Fujii (1873–1943), Kojō Sonoda (1886–1968), Tokua Ōtani (1878–1948); the Teihyōkaku of the Mitsui family, the Yūchikusai of the Ueno family, the Fūen of the Ōta family of Morioka; and the Neiraku Art Gallery of the Nakamura family of Nara are all important. All of these individuals and families, having prepared catalogues and seal albums and made collections of Japanese and Chinese seal albums, became international authorities on the subject of Japanese seals. Chikusei Mimura (1872–1953) and Keisho Nakai (1841–1919), who modelled himself on Kō Fuyō, made great contributions to Japanese seal studies through assiduous collection and study of data about seal albums, calligraphers and seal-carvers.

BIBLIOGRAPHY

S. Shinozaki: *Yamato koin* [Yamato ancient seals] (Tokyo, 1941)
T. Aida: *Nihonkoin shinkō* [New thoughts on ancient Japanese seals] (Tokyo, 1947)
T. Kiuchi, ed.: *Nihon no koin* [The ancient seals of Japan] (Tokyo, 1965)
Y. Nakata, ed.: *Nihon no tenkoku* [Japanese seal-carving] (Tokyo, 1966)
M. Ogino: *Inshō* [Seals] (1966)
H. Yamauchi, ed.: *Sekiinzai—chishiki to kanshō* [Stone seals—knowledge and appreciation] (Tokyo, 1967)
K. Kanda and S. Tanaka, eds: *Inpu Nihon* [Japanese seal albums], Shodō zenshū [Complete collection of calligraphy], suppl. ii (Tokyo, 1968)
C. Mimura: *Ise to Teenkokuka* [Ise and seal-carvers], v of *Mimura Chikusei shū* (Tokyo, 1983)

NORIHISA MIZUTA

21. TATTOOS. The indelible marking of the human body with pigment injected into the skin has been practised in Japan since the 8th century AD; its use as a personal form of adornment dates to the Edo period (1600–1868). Two other distinct traditions of tattooing (*irezumi*; 'to insert ink') have been practised in the Japanese archipelago, in Hokkaido, among the AINU, and on the RYUKYU Islands. The traditional implement used by the Japanese tattoo artist is his personal set of needles (*hari*), of which from one to as many as 30 may be mounted on a wood or bamboo handle by fine wire or thread. The tattoo artist's colours were originally natural mineral and vegetable pigments diluted in rice paste. The outline of the design was first applied on the surface of the skin with brush and ink and then filled in with colours and shading techniques (*bokashi*), using the broad tattooing shaft with the greatest number of needles. Japanese tattoo art, which is characterized by elaborate patterns and the use of multiple colours and shading, almost resembles painting with three-dimensional and perspective effects.

The main sources of inspiration for decorative tattoos during the Edo period were subjects found in the popular *ukiyoe* woodblock prints of the period (*see* §IX, 3(iii) above), figures from popular myths and legends, religious and erotic subjects, and plant and animal motifs. The usual practice is for a single design to be executed on the back of the body, extending over the shoulders, arms and chest. Among the Ainu, women were tattooed around the mouth to symbolize coming of age, while the inhabitants of the Ryukyu Islands had designs tattooed on the back of their hands.

The first reference to tattooing in Japan appears in the *Nihon shoki* ('Chronicle of Japan'; AD 720), which records the use of tattoos on the face and body as a form of punishment. The practice was derived from ancient Chinese penal codes and continued throughout later periods, but the best evidence for its use dates from the Edo period, when it was formalized in various legal codes by the Tokugawa shogunate. Penal tattooing was abolished in 1870. The development of figurative tattoos originated in the second half of the 18th century. One of the main factors leading to its emergence at the beginning of the 19th century was the publication of the Japanese version of the popular Chinese classic novel *Shui hu zhuan* (Jap. *Suikoden*; 'Tales of the water margin'; early 16th century), based on the legendary exploits of a band of heroes active during the Northern Song period (AD 960–1127). Several of the novel's heroes were profusely tattooed on their bodies with designs of dragons and blossoming flowers. *Suikoden* was produced in various illustrated editions by

248. Tattooed hero, woodblock print by Utagawa Kuniyoshi, from the series *Tsūzoku Suikoden gōketsu hyakuhachinin no hitori* ('The 108 heroes of the popular *Suikoden*'), 1827 (London, British Museum)

KATSUSHIKA HOKUSAI. The tattooed heroes were particularly popular with the public and were also depicted in single-sheet prints. Utagawa Kuniyoshi (*see* UTAGAWA, (6)), who specialized in warrior prints, produced a series of 108 prints entitled *Tsūzoku Suikoden gōketsu hyakuhachinin no hitori* ('The 108 heroes of the popular *Suikoden*'; 1827; see fig. 248). Tattoos were restricted to those considered to represent the lower orders of urban society: craftsmen and artisans, construction workers, day labourers and servants. Others who favoured tattoos were the city firemen (*machihikeshi*). In addition to its decorative purpose, the tattoo may also have been conceived as a form of protection. A particularly popular design was clouds and dragon, which had amuletic and awe-inspiring attributes.

As tattoo art became established, artists who had begun their careers in a field related to the graphic arts, woodblock and metalwork engravers, became master tattoo artists. These included the Yamada family, who adopted the artist's name (*gō*) Horibun. Living tattoo artists include Horiyoshi, Horisada and Horiuno III.

For further discussion *see* TATTOO.

BIBLIOGRAPHY
D. C. McCallum: 'Historical and Cultural Dimensions of the Tattoo in Japan', *Marks of Civilization: Artistic Transformation of the Human Body*, ed. A. Rubin (Los Angeles, 1988), pp. 109–33

WILLEM VAN GULIK

XVII. Treatises.

Japanese art treatises can be divided roughly into theoretical and practical works, although some treatises fit into both categories. Although the distinction is often a fine one, treatises may be defined as different from catalogues of art collections or even writings on connoisseurship (*see* §XXII below). Although they are fewer in number than Chinese texts and lack their great age, Japanese treatises nonetheless offer a glimpse into the attitudes of artists and the values attributed to the art they produced. Because many specific treatises are discussed elsewhere in this dictionary in the context of Japanese artistic forms, schools or artists, this article elucidates some of the fundamental principles of Japanese art treatises, while also surveying some of the better-known writings from a range of artistic disciplines.

1. Introduction. 2. Painting. 3. Garden design and other arts.

1. INTRODUCTION. Treatises were written in virtually every field of artistic endeavour, ranging from MAEGAWA KYOSHŪ's authoritative *Keiko inshi* ('History of seal-carving instruction'; 1778) on seal-carving to Nanpō Sōkei's *Nanpōroku* ('Record of Nanpō'), which purports to record the teaching of Sen no Rikyū in the tea ceremony; yet only in painting was there a profusion of treatises, and then only during the Edo period (1600–1868). Most treatises were considered secret texts (*hidensho*), which, rather than being broadly disseminated, were given from master to disciple or passed hereditarily among members of a single school. In time, however, some were disseminated through illicit handwritten or woodblock-printed copies. Theoretical treatises were often designed to advance the position of the writer and his artistic associates, and many were written, from the outset, for circulation. Treatises were not only a way of preserving knowledge but also a means of giving cohesion to an artistic lineage; they lent the weight of textual authority and historical legitimacy to those who possessed them. Treatises typically contained a thumbnail sketch of the history of the art form, often citing origins in China or even India, and arguing implicitly or explicitly for the pre-eminence of that art within Japanese culture.

Japanese art treatises probably have their genesis in the tradition of Buddhist commentaries and, more directly, in secular Chinese writing on art and literature, on which models they demonstrate their reliance in format and content. However, while treatises on painting and calligraphy exist from the 1st millennium AD in China, Japanese art treatises did not appear until much later. Another source of inspiration was the long tradition of critical writing on Japanese literature. Although there is little thematic connection, esoteric literary works such as the *Kokin denju* ('Transmission of the *Kokinshū*') in classical *waka* poetry, *Renri hishō* ('Secrets of *renga* composition') in linked verse (*renga*) and *Shikadō* ('Way of the highest flower') in *nō* drama probably played a minor role in stimulating the production of art treatises.

Japanese treatises were frequently set down by the student of a great artist, with whom the actual relationship may be tenuous, but attribution of the ideas in the treatise to the named master demonstrates the importance of

establishing a pedigree. In some cases a single name might be attached to a treatise when it was in fact the work of a team of writers or of generations of artists. In other cases, treatises reflected no more than the particular viewpoint of a single author. Treatises on artistic praxis were often marked by abbreviated, concrete language and were frequently illustrated, while theoretical exegeses tended to speak in a more philosophical and cryptic voice. In either case, treatises were usually put at the ideological service of the author or his school and thus proliferated in times of strong competition, most notably in the Edo period, an era of artistic florescence. The predilection for treatises in highly competitive fields such as painting was no doubt a spur to their production in other artistic fields. Treatises may also have been produced in such profusion during the Edo period in response to a perceived need to preserve old traditions that had previously been handed down orally.

2. PAINTING.

(i) Introduction. Painting treatises (*garon*) first appeared in the Edo period but soon became the largest category of art treatise in Japan. The genre consists centrally of works on painting theory, criticism and principles of classification, but it is often extended to include writings on subject-matter, history and even biographies of painters (*gaden*). As with other treatises, *garon* stimulated new production even as they provided a historical and theoretical rationale for extant works. Modern scholars have identified the earliest theoretical discussions of painting in the 'Broom Tree' chapter of *Genji monogatari* ('Tale of Genji'; early 11th century) and section 11 of the folk-tale anthology *Kokon chomonju* ('Stories heard from old and new writers'; 1204). However, the first independent painting treatise is commonly held to be *Tōhaku gasetsu* ('Tōhaku's explanations of painting'; 1592). Set down by a friend of the great painter Hasegawa Tōhaku, the rather desultory work includes the master's evaluations of famous Chinese and Japanese paintings. Given the intense competition for painting commissions in the early 17th century, *Tōhaku gasetsu* was probably written to bolster the rapidly flagging fortunes of Hasegawa-school painters.

(ii) Kanō school. In the mid-17th century, an upsurge in the writing of treatises was provoked by the arrival of painting treatises from China, competition between schools, and the requirement by shogunal patrons that their employees possess suitable pedigrees. The KANŌ SCHOOL, painters-in-residence to the shogunate, initiated the vogue for textual legitimacy when Kanō Ikkei (1599–1662) issued *Kōsoshū* ('Themes in Chinese painting') in 1623. The three-part work opens with a section on Chinese painting theory, proceeds to an encyclopedic list of Chinese painting themes and concludes with a copy of *Kundaikan sayū chōki*, the 15th-century catalogue of the Ashikaga shoguns' art collection. While *Kōsoshū* was certainly of practical use to Kanō artists in their roles both as painters and as connoisseurs of old paintings, its chief value, by its very existence, was to underscore their status as the pre-eminent and 'official' painting school. To underline their status *vis-à-vis* other schools and other branches of the school, authors of the Kanō school produced artists'

biographies that invariably cast a positive light on their own lineage. This sequence of biographies started with Ikkei's *Tansei jakubokushū* (*c.* 1650), included the anonymous and now lost *Tokai hōkan* (*c.* 1660s), *Bengyokushū* ('Discriminating jade from stone'; 1672) and *Gakō benran* ('Handbook on painters'; *c.* 1680), and culminated in Kanō Einō's (1631–97) *Honchō gashi* ('History of imperial court painting'; 1691). Including more than 400 painters' biographies, signatures and seals, at first glance *Honchō gashi* seems an objective compendium of fact, but closer reading reveals a distinctly partisan character. Later Kanō-related biographies include *Gakō senran* ('Deep probes into the skill of painting'; 1740) by Ōoka Shunboku (1680–1763); a supplement (1819) to *Honchō gashi*, known as *Zoku honchō gashi* or *Kōchō meiga shūi*; and *Koga bikō* ('Commentaries on old paintings'; *c.* 1845) by Asaoka Okisada (1800–56).

Aside from their attempts to control history implicit in the writing of biographies, Kanō artists hoped to place their stamp on future generations by producing texts on theory. *Gadō yōketsu* ('Secret principles on the way of painting'; 1680) by Kanō Yasunobu (*see* KANŌ, (13)) was a manual meant to be given to Kanō students as a certificate of mastery. In it, Yasunobu gave detailed instructions on painting technique and theory and set out his famous theory of 'talent and training', which stated that artists whose skill derived from training were to be preferred to those who merely had natural talent. A more comprehensive Kanō treatise is Hayashi Moriatsu's *Gasen* ('Net of painting'; 1721), which devotes six volumes to painting theory, technique and connoisseurship. The work clearly supports Kanō orthodoxy, first by praising the practice of learning by copying old paintings and then by criticizing the work of Kanō rivals.

(iii) Other schools. The rivals duly responded by producing their own treatises. About 1678 Tosa Mitsuoki (*see* TOSA, (3)), activist leader of the TOSA SCHOOL, produced *Honchō gahō taiden* ('Summary of the rules of Japanese painting'), in which he took a leaf out of the Kanō book by interpreting venerable Chinese rules of painting to demonstrate the 'superiority' of Tosa technique and theory. The strongest theoretical challenge to Kanō hegemony came from the progressive Sinophile painters of the *Nanga* (or *Bunjinga*; literati) tradition (*see* §VI, 4(vi)(e) above). Nakayama Kōyō's (1746–99) *Gatan keiroku* ('Miscellany of talks about paintings'; 1775) was the earliest Japanese treatise to draw on DONG QICHANG's theories of professional and amateur painters in order to denounce the Kanō method and its 'artisan' practioners. The strongest expositions of *Nanga* values were KUWAYAMA GYOKU-SHŪ's *Gyokushū gashu* ('Gyokushū's importance of painting'; 1790) and *Kaiji higen* ('Humble words on painting'; 1799), which sought to identify and celebrate amateur, individualistic painters within the Japanese tradition (for further discussion of this debate *see* §XXII below). In response to these attacks, the government-sponsored Confucian scholar Hirazawa Kyokuzan (1731–91) wrote *Kokugaron* ('Treatise on native painting'; 1788), a rather confused work in which he attempted to defend contemporary Kanō painting by tracing its antecedents in earlier Japanese painting.

As *Nanga* artists took on elements of orthodoxy and gained commercial success in the early 19th century, their many treatises focused criticism less on the now-moribund Kanō school than on the commercially potent naturalism practised by artists of the Maruyama–Shijō school (*see* §VI, 4(viii) above). In his *Gadō kongōsho* ('*Vajra* on the way of painting'; 1801) and *Chikutō garon* ('Chikutō's painting theory'), Nakabayashi Chikutō (1776–1853) deployed orthodox Chinese literati painting theory to point up the 'weaknesses' of painting styles based on naturalism. Several treatises by TANOMURA CHIKUDEN, including *Sanchūjin jōzetsu* ('Chatter of a mountain dweller'; 1835), constitute an unofficial history of *Nanga* painters and paintings and set out his '100 rules for painting'.

The Western-style naturalist painters defended themselves with treatises of their own. SATAKE SHOZAN's *Gahō kōryō* ('Art of painting'), *Gato rikai* ('Understanding painting') and *Tanseibu* ('Red and blue') of 1778 set forth the principles of shading and linear perspective characteristic of their *Ranga* ('Dutch painting') style. Better known is SHIBA KōKAN's *Seiyō gadan* ('Discussion of Western painting'; 1799), which deplored the subjectivity of Chinese and Japanese art while praising the practical objectivity of Western naturalism. The abbot Yūjō's (1723–73) *Banshi* and Oku Bunmei's (*d* 1813) *Sensai Maruyama-sensei den* (1801), which differed in format from most treatises, recorded MARUYAMA ōKYO's ideas on drawing from life. Another lesser student presenting the teachings of a school or master, as was common practice, was Shirai Kayō (*fl* 1840–60), whose *Gajō yōryaku* ('Brief account of painting doctrine'; 1831) was an outline of Kishi-school painting.

In an artistic world marked by fierce commercial, stylistic and doctrinal competition and where the written treatise offered a convenient means of self-definition, *ukiyoe* artists (*see* §VI, 4(iv)(b) above) also entered the fray. By 1738 when NISHIKAWA SUKENOBU illustrated the painting manual *Gahō saishikihō* ('Painting laws: the methods of colouring'), *ukiyoe* artists had begun to link themselves to Japanese tradition as defined by the term *Yamatoe* ('Japanese painting'; *see* §VI, 4(ii) above). This idea was forcefully developed in IKEDA EISEN's 'Yamato eshi ukiyoe no kō' ('Theory of *ukiyoe* of Japanese painters'), which appeared in *Zōho ukiyoe ruikō* in 1833. Ōta Nanpo (1747–1823), in *Ukiyoe ruikō* ('Currents of thought on *ukiyoe*'), provided a comprehensive biography of *ukiyoe* artists, which invests them with authority equal to that of artists included in Kanō-school treatises.

3. GARDEN DESIGN AND OTHER ARTS. The earliest Japanese art treatise is the work on garden design popularly known as *Sakuteiki* ('Records of making gardens') but originally called *Senzai hishō* ('Secret extracts on gardens'). Attributed to Tachibana no Toshitsuna (1028–94), a low-ranking aristocrat, *Sakuteiki* was transmitted in several variant 'secret' manuscripts before it was published as part of another work in the Edo period. The introduction to *Sakuteiki* discusses the fundamental principles of garden design, stressing the importance of adapting the styles of past masters and learning from nature (for further discussion *see* GARDEN, §VI, 3). Most of the work details the

design features of large pond gardens for aristocratic *Shinden*-style villas (*see* §III, 3(iii) above).

Another famous early garden treatise, also a secret text, is *Senzui narabi ni yagyōnozu* ('Illustrations for designing mountain, water and hillside field landscapes'), compiled by the obscure mid-15th-century priest Zōen. While *Sakuteiki* seems to have been aimed at the patrons or designers of gardens, the more practical *Senzui* appears to have been written for garden builders. *Senzui* discusses in detail and illustrates the choice and arrangement of stones and trees in small temple gardens. At the same time, the philosophical basis of the text mixes elements of Chinese geomancy and Zen.

The most significant garden treatise of the Edo period is *Tsukiyama teizōden* ('Records of building gardens and artificial mountains'), published by Kitamura Enkin in 1735. The three volumes gathered together many earlier texts but also added illustrations of extant gardens. In 1828 the Kyoto garden designer Akizato Ritō reproduced Enkin's text and appended a second volume, which classified and illustrated the types of residential garden popular in the late Edo period. Ritō's popular book formed the basis for much later writing on gardens, particularly JOSIAH CONDER's influential *Landscape Gardening in Japan*, the first English-language book on Japanese gardens and methods of their construction.

The mix of practical advice and philosophizing found in garden treatises was paralleled in the critical writing of other disciplines, as was the garden designers' refrain that artistic creation should follow principles of nature. In the art of flower arrangement (*ikebana*; *see* §XVI, 9 above) treatises were written by masters of various schools; the best known are those of the venerable Ikenobō lineage. The earliest *ikebana* treatise may have been *Sendenshō* ('Selections from a recluse's teaching'), but it was largely superseded in 1542 by Sennō's *Sennō kuden* ('Sennō's book of secrets'). Sennō (*d c.* 1555) first listed things to avoid in flower arrangement, then detailed the proper methods of the art as well as its applicability to various social functions. He took pains to argue the superiority of flower arrangement over the arts of painting and garden design and, in the fashion of contemporary writers of treatises, suggested that the proper practice of *ikebana* may be an aid to enlightenment.

Writers of most treatises realized that rules are essential for learning any art but, applied too rigidly, may be stultifying. Similarly, the authors were aware of the tension between the need to set themselves squarely on the side of historical precedent and the need to establish the particular qualities that made their teaching unique and superior. These concerns are clearly in evidence in Ojio Yūshō's *Hitsudō hidenshō* ('Secrets of calligraphy'), in style and content perhaps the most comprehensible of many calligraphy treatises. Written in the question-and-answer format, it was probably in fact the work of Yūshō's disciple Taki Yūden. *Hitsudō hidenshō* is representative of most calligraphy treatises and, indeed, similar to those on most other art forms in its treatment of artistic production as a living entity. In keeping with Chinese ideas on calligraphy, Yūshō characterized the successfully brushed line as full of movement, breath and vitality, while the improper brushstroke was likened to an ill or inanimate object. The

parts of the line, like those of a garden stone, were compared to the parts of the human body. The almost invariable recourse to natural metaphor in Japanese treatises clearly derived from Chinese writings but was so thoroughly absorbed into the Japanese tradition that it became one of its principal characteristics.

While most treatises attempted to create at least a semblance of philosophical and literary merit, one group of writings concentrated on practical matters of technique. An early example of the purely technical treatise is *Shōmei* ('The elucidation of craft'), a construction manual written in 1608 by the master builder HEINOUCHI MASANOBU. Its five scrolls describe procedures for the construction of gates, shrines, pagodas, temple halls and residential structures. Other examples of practical manuals are *Tōkō hitsuyō* ('Essentials for the potter') by Ogata Kenzan and *Tōji seihō* ('Pottery techniques'), both dating from 1737 (*see* OGATA, (2), §1(iii)). *Tōkō hitsuyō*, the more detailed of the two, discusses various types of clay, glaze and pigment, both for Ogata's own style and that of the great potter Nonomura Ninsei.

BIBLIOGRAPHY

Tachibana no Toshitsuna, attrib.: *Sakuteiki* [Making gardens] (11th century AD); Eng. trans. by S. Shimoyama as *Sakuteiki: The Book of the Garden* (Tokyo, 1976); Fr. trans. by P. Rambach as *Sakutei-ki ou Le Livre secret du jardin japonais* (Geneva, 1973)
Zōen: *Senzui narabi ni yagyōnozu* [Illustrations for designing mountain, water and hillside field landscapes] (mid-15th century AD); Eng. trans. by D. Slawson as *Secret Teachings in the Art of Japanese Gardens* (Tokyo, 1987)
Ogata Kenzan: *Tōkō hitsuyō* [Essentials for the potter] (1737); Eng. trans. by R. Wilson as *The Art of Ogata Kenzan* (New York and Tokyo, 1991)
Ikeda Eisen: 'Yamato eshi ukiyoe no kō' [Theory of *ukiyoe* of Japanese painters], *Zōho ukiyoe ruikō* (1833)
J. Conder: *Landscape Gardening in Japan* (London, 1893)
Zoku gunsho ruijū, xiv (Tokyo, 1912)
Kokusho Kankōkai, ed.: *Nihon shogaen* (Tokyo, 1914)
T. Sakazaki: *Nihon garon taikan* [General discussions on Japanese painting], 3 vols (Tokyo, 1926–8)
M. Ueda: *Literary and Art Theories in Japan* (Cleveland, OH, 1967)
K. Uehara, ed.: *Kaisetsu Senzui narabi ni yagyō no zu* (Tokyo, 1972)
K. Saitō: *Zukai Sakuteiki* (Tokyo, 1979)
For information on early sources please refer to the body of this article.

KEN BROWN

XVIII. Art training and education.

1. Introduction. 2. Before 1868. 3. 1868–1945. 4. After 1945.

1. INTRODUCTION. The concept of art education is of Western origin and can be applied in the Japanese context only from the last quarter of the 19th century. Before then, Japan was a pre-industrial society, in which artistic skill was handed down through elaborate networks of teachers, families (*ke*; literally 'houses') and lineages (*ha*). In general, the relation between teacher (*shishō*) and disciple (*deshi*) was extremely close, and the regime imposed on the latter could be demanding, particularly for an *uchi-deshi* ('inner disciple'), who lived in the master's house. Treated as a member of the family, often he ended by becoming son in law, through marriage or adoption. Details of the system varied according to period, place, social stratum and art form. As in China, fairly sharp distinctions can be made between the work and training of professional artists and those of amateurs, and similarly between lay artists and those belonging to one of the orders of Buddhism. Details of the training that Japanese artists received before the 19th century are often unavailable but can to some extent be inferred from our knowledge of the changing social situation. Traditional biographies of artists commonly list the names of teachers, if these cannot be deduced from the artistic names (*gō*) bestowed by the teacher himself.

The general name for the mode of transmission is *ryūgi* ('method for (artistic) lineages (*ryūha*)'). As in European craft guilds, the transmission was partly secret (*himitsu*), but in some cases pattern-books or handscrolls illustrating techniques have survived, as well as collections of sketches and 'reduced drawings' (*shukuzu*). Similar modes of transmission existed in both visual and performing arts and were formalized during the Edo period (1600–1868) into the *iemoto* ('house-source') system, which survives in many performing arts. In the visual arts, the custom of taking a (professional) name (*nanori*), hereditary in a teacher's family, was largely confined to crafts such as metalwork or *netsuke*-carving (*see* §§XII and XVI, 17 above).

In all the arts, oral instruction and learning by imitation were the norm. Especially in painting and calligraphy (*see* §§VI and VII above), lip-service was paid to Daoist and Zen-inspired notions of spontaneity and freedom of expression, but in practice drawing from nature was less important than the mastery of technique. On the other hand, pupils whose vision or ability went beyond that of their teacher were at liberty to found their own *ha* and frequently did so. Japanese artists, like their Chinese counterparts, often made copies of other artists' work, but they were less prone to treat this exercise as an end in itself. Thus Japanese painting, for example, exhibits great variety in both style and subject-matter.

2. BEFORE 1868. Early chronicles such as the *Nihon shoki* ('Chronicle of Japan'; AD 720) mention social or familial groups known as *be*, usually distinguished according to occupation, such as painters, weavers, potters and saddlers. Within these extended families, which were often of Korean or Chinese origin, artistic skill was jealously guarded. *Be* varied in social standing and in the range of talents that they professed: the first known master of Buddhist sculpture, TORI BUSSHI (early 7th century), belonged to the *be* of saddlers (Kuratsukuri), and a later Kuratsukuri was known for his silk brocade. However, a decree of 646 abolishing the old *be* system must have affected transmission in the arts.

In 604 a decree of the Regent, Prince Shōtoku, had established in several parts of Yamato Province and elsewhere communities of immigrant artists who worked on projects of Buddhist painting. These communities, granted tax relief and placed under the patronage of wealthy clans, introduced new artistic techniques and styles from the mainland and transmitted them to their descendants. The *Yōrō ritsuryō*, a far-reaching legal code promulgated in 718, set up a Bureau of Painting (Edakumi no tsukasa), attached to the Central Department of State (Nakatsukasa-shō). Its staff included sixty ordinary artists (*egakibe*), supervised by master painters (*eshi*) of four different ranks. Its primary function was to execute paintings (and painted decoration) for government-sponsored monasteries. The offices for lacquerers, weavers and

stitchers came under the Department of Finance (Ōkura-shō), while sculptors, metalworkers, potters and other craftsmen were under the Imperial Household Department (Kunai-shō). This new organization of the arts clearly had consequences for the training of the artist, although the details of its operation are obscure. The collections of the Shōsōin treasure-house in Nara (see NARA, §III, 3) best exemplify the high levels of craftsmanship attained by the middle of the century.

The Bureau of Painting was absorbed by another office in 808. Nevertheless, during the 9th century the status of the painter steadily improved. After the creation at court of the Office of Painting (Edokoro) some time before 886, individual artistic lineages began to emerge, that of the KOSE family being the earliest. Several generations of this family served as honoured government artists. In the 13th century offices of painting were created at major monasteries and shrines, an artist being appointed to each (a procedure known as shiki). By the 14th century important private monasteries (in) also had their own workshops. The ASHIKAGA shogunate in the 15th century first patronized artists of the KANŌ family; these, and painters of the rival TOSA lineage, provided the two largest pools of talent for the art of the ruling classes until the late 19th century. In addition to these professional artists, their pupils included aristocratic lay people. Genji monogatari ('Tale of Genji'; early 11th century) and other early court sources show that aristocrats of both sexes took great interest in painting as a pastime.

Meanwhile, it had also been possible, since at least the Heian period (794–1185), for men in holy orders to take up one of the arts, especially painting or calligraphy. Professional Buddhist sculptors and specialists in iconographic painting were known as busshi or bukkō. Information is available from the late 11th century about family lineages, and a number of iconographic sketch-books are extant, having been handed down in such families. Monk–painters were called ebusshi; from the 14th century onwards they were to be found especially in Zen monasteries, some of which became known as training centres for Zen painters (gasō). In Kyoto the most celebrated were Shōkokuji, Tōfukuji (damaged 1995 by earthquake) and Daitokuji. During this period many Zen-connected artists also went to study in China.

In the late 16th century Jesuit and other missionaries from Europe taught oil painting and encouraged their Japanese pupils to depict Christian and other Western subjects, at seminaries in Arima (Kyushu) and elsewhere. Jesuit records preserve details of the curriculum and notes on individual students. In 1614, however, the Arima seminary had to be evacuated to Macao when many Christians and other foreigners were expelled from Japan by its military leaders.

From the 17th century to the mid-19th there was a proliferation of new styles in painting. Although Japan was technically a closed country, some of these styles show Chinese, Dutch and other foreign influences, which found their way in mainly through Nagasaki (see §VI, 4(vi)(c) above). Several Chinese teachers of painting were active during the 18th century. The Ōbaku school of Zen, founded by Chinese monks in the mid-17th century at Manpukuji, near Kyoto, was another new factor, bringing

to Japan the arts of late Ming-period (1368–1644) China, in particular calligraphy, architecture, poetry and garden design. The Neo-Confucian creed of the Edo period dictated what was taught in schools, including both the monastic schools (terakoya) and private academies (shijuku). Pupils were tutored in the Four Accomplishments—poetry, music, painting and calligraphy—the last of which was studied by every pupil. From the 11th century, in particular, Chinese pedagogues codified types of brushstroke, composition and other elements of painting, and by the 17th century detailed manuals of brush-painting had been produced. The first Japanese edition of the Jiezi yuan huazhuan (Chin.: 'Mustard-seed garden manual of painting'; completed 1701) was published in 1748, and it was known and used before this. During the 18th and 19th centuries many other encyclopedias and compendia of woodcut illustrations, published in Japan, provided artists at all levels of skill with source material in a variety of styles. The use of such copybook models was facilitated by the spread of popular printing from the late 17th century onwards, but it encouraged stereotyping in many art forms, in Japan as in Europe. This is apparent above all in the 'official' painting of later artists of the KANŌ SCHOOL and TOSA SCHOOL. Kanō painting was taught in state-supported offices of painting, whose graduates trained along lines laid out by Kanō Tan'yū and Kanō Tsunenobu (see KANŌ, (11) and (14)), ranked as samurai. The Tosa lineage and its junior branch, the SUMIYOSHI SCHOOL, enjoyed like privileges. Craftsmen, who were classed as artisans (kō), clustered around the many castle towns (jōkamachi) of local fiefs; this made for greater regional diversity in crafts and decorative arts.

Japanese artists and their teachers displayed a recurrent concern for detail and for practice and a tendency to treat both as ritual. At the same time there has been a relative lack of interest in the kind of scholastic discussion to be found in Chinese texts on painting, from the time of Xie He (fl second quarter of 6th century AD) to that of DONG QICHANG. Isolated collections of notes by artists were available, such as the Tōhaku gasetsu, recording the opinions of HASEGAWA TŌHAKU, or Honchō gasan by TANI BUNCHŌ, but there was relatively little theoretical discourse that might have guided art students, except in the works of such Neo-Confucian teachers as Ogyū Sorai (1666–1728) and RAI SAN'YŌ.

3. 1868–1945.

(i) Institutional initiatives. The political, administrative and social upheaval of the Meiji Restoration had profound consequences for the arts in Japan. In 1861 Kawakami Tōgai (1827–81) headed a shogunal office responsible for studying Dutch manuals of drawing and painting, but these were valued for their relevance to science rather than to art or education. In 1872 the first major educational reforms of the Meiji period (1868–1912) included provision for the teaching of art in the new state-run elementary schools, and from 1871 the Ministry of Education published a series of illustrated textbooks based on European and American sources. Three textbooks on colour, published in 1875 and 1876, introduced the Newtonian theory of the spectrum of light and the seven colours of the

prism, the idea of three primary colours and a new approach to colour mixing. All this was illustrated with colour charts and diagrams. From 1878 a new series of textbooks included more illustrations of Japanese subjects, although the guiding principles were still foreign, and there was no distinction between books for elementary students and those for higher grades. The textbooks particularly encouraged drawing in pencil (*enpitsu*; 'lead brush') and the use of tracing (*ringa* or *rinkaku*). Another favoured method of instruction was *keikaku*, copying with a super-imposed grid of straight lines.

In 1876 the government founded the Technical Art School (Kōbu Bijutsu Gakkō) and invited several teachers from Italy to join its staff. These included ANTONIO FONTANESI, who taught painting, and Vincenzo Ragusa (1841–1927), who taught sculpture (*see* §V, 6 above). Although strictly this school was established to encourage industrial arts, it soon attracted students eager to learn Western-style painting and sculpture. Tōgai himself had taught oil painting, partly privately, and his pupil TAKA-HASHI YUICHI also studied privately with Charles Wirgman (1835–91), an artist for the *Illustrated London News*. Other private teachers of Western painting in the 1870s were Yokoyama Matsusaburō (1834–84), who had studied in Batavia and elsewhere, Kunisawa Shinkurō (1847–77), who had studied for five years in England, and Soyama Yukihiko (Ono Yoshiyasu; 1859–92), a graduate of the Technical Art School.

The Technical Art School ceased to exist in 1883. The Kyoto Prefectural School of Painting (Kyōto-fu Gagakkō), the oldest existing school of fine art in Japan, was founded in 1880. Its syllabus was subsequently enlarged to include various other subjects, and its name changed; amalgamated with its sister institution, the Kyoto City Special School of Painting (Kyōto Shiritsu Kaiga Senmon Gakkō; founded in 1909), it acquired university status in 1950. Since 1969 it has been the Fine Arts Division of Kyoto City University of the Arts (Kyōto Shiritsu Geijutsu Daigaku).

A new period in Japanese education began in 1885 with the appointment of Mori Arinori (1847–89) as Minister of Education. The tiered system set up by him extended to university level and was closely regulated by the government. Textbooks were prescribed; and moral factors in education had to be considered. Meanwhile a new national pride (itself partly stimulated by the West) was beginning to sweep through Japan, leading in art education to a revival of interest in brush-painting (*mōhitsu-ga*) and the development of *Nihonga* (Japanese-style painting; *see* §VI, 5(iii) above). Typically, *Nihonga* uses traditional water-based pigments, Japanese paper and mounting, unlike *Yōga* (Western-style) painting, which uses oils on canvas (*see* §VI, 5(iv) above). The case for *Nihonga* and for the painting of contemporary Kanō-school artists was led by ERNEST FRANCISCO FENOLLOSA, invited from the United States to teach at Tokyo Imperial University, and his best-known student, TENSHIN OKAKURA. They were opposed by Koyama Shōtarō (1857–1916), a former student of Fontanesi. Ironically, both sides inclined towards the naturalism of contemporary Western painting, and the debate turned into a sterile argument over the respective merits of brush-painting and pencil-drawing. It continued until 1902, when a Ministry of Education report proposed

249. Tokyo University of Fine Arts and Music (Tōkyō Geijutsu Daigaku), founded 1949

new directions for education in drawing and handicrafts. Thereafter, until 1945, art textbooks were approved for nationwide use by the Ministry. At first parallel sets of textbooks were issued, for brush-painting and for pencil-drawing, but with similar contents. In *Shintei gajō* (1910–13), a textbook that was in use until 1932, the distinction was ignored.

In 1889 the government-sponsored Tokyo Fine Arts School (Tōkyō Bijutsu Gakkō) opened, and Tenshin Okakura, newly returned from America, was invited to become its head. He resigned in 1897, after a quarrel with the authorities, and in 1898 founded a private academy, the Japan Institute of Fine Arts (Nihon Bijutsuin). For many years these two institutions offered the best instruction in *Yōga* and *Nihonga* respectively. One influential teacher at the Tokyo Fine Arts School was KURODA SEIKI, who had studied in France. Before the outbreak of World War II, many other Japanese artists studied in France, while smaller numbers went to other Western countries. The Tokyo Fine Arts School was closed in 1952, after the founding in 1949 of Tokyo University of Fine Arts and Music (Tōkyō Geijutsu Daigaku; see fig. 249), with its still active Fine Art Department.

(ii) Effect of Western educational theories. Between 1904 and 1945 hundreds of Ministry-approved art textbooks were published. Some were intended for the teacher's use and introduced the latest pedagogic methods from the USA or Europe. Among the former were the Dalton Plan, from Massachusetts; the Project Method, devised by the American William H. Kilpatrick; and the theories of Arthur Wesley Dow (1857–1922) of Columbia University, who contrasted the 'academic' and 'synthetic' methods of teaching art and urged the integration of drawing and crafts in the curriculum. All these systems, and their Japanese advocates, sought to encourage individual initiative in the child. They contrasted with the authoritarian tenor of education in the Meiji period and earlier, were in keeping with the new democratic spirit of the 1920s and were matched in other Japanese arts of the period. In general, the value of feeling and experience was stressed. German and French theories of education, influenced by

philosophical idealism, centred on concepts of freedom and creativity. The BAUHAUS method, a special case, was introduced to Japan by an architect, Renshichirō Kawakita, who in 1932 established an institute of architecture and technology, Shin Kenchiku Kōgei Kenkyūjo Institute of New Architecture and Techology, to study and teach new architecture from both theoretical and technical points of view. With an educator, Katsuo Takei, he published a treatise on constructionist education (*kōsei kyōiku*) in 1934, in which the development of an awareness of plastic form (*zōkei*) was emphasized. As in Germany, the Bauhaus experiment was short-lived, but its principles found their way into the post-war teaching of design. During the 1920s and 1930s Japanese architects also went to study in Germany, some of them with Walter Gropius, or to Paris to study with Le Corbusier.

The most imaginative movement of the pre-war period was that started in 1919 by the painter and printmaker Kanae Yamamoto (1882–1946), who had studied in France and also absorbed ideas in Russia on his way home. The book in which he advocated 'free drawing' (*jiyūga*) was written in an engaging personal style and helped spread the movement across Japan. He rejected tracing and the use of copybooks and said that the child should look with open eyes at the world outside, before sketching creatively. In the 1930s another movement of the same kind but of independent origin was led by Jitsusaburō Aoki, an art teacher in Shimane Prefecture, who instituted a curriculum relying on the child's first-hand observation of village and country life. Abstract art and other styles of avant-garde art (*zen'ei bijutsu*; see §VI, 5(v) above) also found followers from the 1920s onwards; during World War II an independent group of painters in Hokkaido taught social realism.

All these movements undercut the Ministry of Education's attempts to impose uniformity in the state-controlled schools. Private schools and teachers in any case followed their own bent. Conservative critics such as the painter Ryūsei Kishida, a pupil of Kuroda, continued to stress moral factors in art education, and the inexhaustible subject of curriculum reform received much attention. During the 1930s there were also new textbooks, still conventional in plan, but more up-to-date and varied in subject-matter.

Most of the above-mentioned liberal trends were halted during the later 1930s, as Japan adopted a more military posture at home and abroad. In 1937 all education was brought under the direct control of the Cabinet, and a series of reforms between 1941 and May 1945 was designed to inculcate patriotism. The *Kokutai no hongi* ('Cardinal principles of the national entity of Japan'; 1937), used in all schools until the end of the war, identified and praised *Yamatoe* and other traditional Japanese art forms as part of the 'national way'. Art textbooks of the period promoted *Nihonga*, with the addition of military subjects.

4. AFTER 1945. During the Allied Occupation (Aug 1945–March 1952) a completely new system of education was introduced, on American lines, embodying (from 1947) an integrated programme that ran through primary school (six years) and middle school (three years). A special report accompanying these reforms was devoted to the teaching of drawing (*zuga*) and crafts (*kōsaku*). Wartime art textbooks and the *Kokutai no hongi* were banned. The Ministry of Education was again in charge: although in the 1950s many independent organizations sprang up to spread popular art education, they were restrained in 1958 by new Ministry guidelines on education. Although the latter were revised in 1968, the problems they created with their artificial examination requirements remain at all levels of education. One consequence has been the proliferation of private 'cram' schools (*juku*).

Meanwhile Japan has been open to all the latest fashions from abroad in art and art education. 'Design' (*dezain*) appeared as a primary-school subject in a Ministry bulletin as early as 1958. Another bulletin of the same year, on middle schools, divided the art curriculum into Expression (covering various subjects, including design) and Appreciation, with most marks going to the former. A landmark for Japanese art educators was the holding of the 17th meeting of the International Society for Education through Art (INSEA) in Tokyo in 1965. A message was read from the Honorary President, Sir HERBERT READ, whose views on art education were already widely known in Japan. The two leading art schools in Japan remain those of the Tokyo and Kyoto Universities of the Arts, but there are other publicly funded art schools, notably the Kanazawa College of Fine and Industrial Arts (Kanazawa Bijutsu Kōgei Daigaku; founded 1946), and several well-known private colleges, especially in Tokyo and Osaka.

BIBLIOGRAPHY

J. O. Gauntlett and R. K. Hall, eds: *Kokutai no hongi* [Cardinal principles of the national entity of Japan] (Cambridge, MA, 1949/*R* Newton, MA, 1974)
R. P. Dore: *Education in Tokugawa Japan* (London, 1965)
Y. Yamagata: *Nihon bijutsu kyōiku shi* [History of art education in Japan] (Tokyo, 1967)
T. Odagiri: *Senjika hoppō bijutsu kyōiku undō: Umorete ita kiroku* [Art education in wartime Hokkaido: hidden archives] (Tokyo, 1974)
Fontanēji, Raguza to Meiji zenki no bijutsu/Fontanesi, Ragusa e l'arte giapponese nel primo periodo Meiji (exh. cat., Tokyo, N. Mus. Mod. A., 1977)
S. Kurata and T. Nakamura: *Nihon bijutsu kyōiku no hensen: kyōkasho, bunken ni yoru taikei* [Changes in Japanese art education: an outline based on textbooks and documents] (Tokyo, 1979)

DAVID WATERHOUSE

XIX. Patronage.

Patronage by the imperial court, shoguns, feudal lords and members of the merchant class was a conspicuous force in the development of Japanese art since the introduction of Buddhism in the 6th century AD. Historically, patterns of patronage varied widely depending on the social status of the patron, the identity of the artist and the nature of the commission. The distinction between artists and craftsmen was not as clearly drawn in Japan as in post-Renaissance Europe, but the artistic endeavours of painters and calligraphers were generally more highly regarded than those of sculptors, potters and lacquerers. The Romantic notion of the artist as a creative genius, unappreciated and isolated from the society in which he lived, was unknown in pre-modern Japan.

1. 6th–12th centuries. 2. 13th–16th centuries. 3. 17th century–late 19th. 4. Late 19th century onwards.

1. 6TH–12TH CENTURIES. Patronage of the arts was traditionally inspired as much by religious beliefs and the

250. Tōdaiji, Nara, interior of the *hokkedō* or Sangatsudō (Third-month Hall), AD 746–8, view from the south-west

desire for political and social prestige as by aesthetic appreciation. Almost all works commissioned by the nobility during the 6th, 7th and 8th centuries were religious in nature, although they often had political overtones as well. Incentives for the construction of Buddhist temples and installation of painting and statuary therein can be found in many Buddhist scriptures. The Lotus Sutra, an influential text throughout East Asia, promises salvation to those who commission, dedicate or create works of art. Despite the promise that all benefit equally from involvement in the creation of a work of art, the paucity of signed works and references to artists during this era suggests that it was the patron or patrons who were perceived as the real creators and therefore the chief beneficiaries of any merit that might accrue from such a pious deed.

During the Nara period (710–94), major commissions for sculpture, painting and calligraphy (principally copies of Buddhist scriptures) were executed by artisans affiliated to workshops in the grounds of Buddhist temples such as Tōdaiji in Nara. These workshops, organized along hereditary family lines, were supported chiefly by the imperial court in order to ensure the welfare of the state and its rulers. Similar guildlike workshops, called *be*, comprising painters, sculptors, lacquerers and metal- and leatherworkers, had existed before the establishment of a centralized government at Nara, but they had been under the control of individual families rather than the state (*see* §XVIII, 2 above).

Artistic activity at Tōdaiji was especially intense during the reigns of Emperor SHŌMU (*reg* AD 724–49) and his consort, Empress KŌMYŌ, two exceptionally pious Buddhist patrons who spent lavishly to build and furnish Tōdaiji (see fig. 250) and the provincial temples under its jurisdiction. Emperor Shōmu was the driving force behind one of the most ambitious sculptural enterprises in Japanese history, the construction of a colossal statue of the *Great Buddha* or *Daibutsu* (*see* NARA, §III, 4 and fig. 5). This statue symbolized the union of church and state, the emperor being likened to the Buddha as the ultimate source of authority. At Shōmu's orders, state coffers were drained to finance the creation of this statue. To foster national unity, Gyōgi (670–749), the first of many itinerant monks (*kanjinshoku*) appointed to solicit funds for Tōdaiji, travelled about the countryside collecting donations from the populace.

The nature of artistic production in the Heian period (794–1185) was profoundly altered by the diffusion of new ideas promoted by KŪKAI (Kōbō Daishi), founder of the Shingon sect of Buddhism. In his eyes, works of art were not merely objects of devotion but the very embodiment of the divine and, as such, equal to texts in their power to impart Buddhist truths. Buddhist temples consequently promoted painting as a part of religious training and required that religious painting and statuary be fashioned by men who had taken religious orders. The conferral of the ecclesiastical titles *hokkyō* (Bridge of the Law), *hōin* (Seal of the Law) and *hōgen* (Eye of the Law)

on particularly gifted Buddhist sculptors and painters attests that monk–artists enjoyed greater respect and recognition than their secular predecessors. The ruling élite continued to bestow such titles on painters of various schools until the end of the Edo period (1600–1868), long after their religious connotations had been forgotten.

Encouraged by the Buddhist hope of salvation through artistic creation, many members of the aristocracy, both men and women, became personally involved as amateur painters and calligraphers in large-scale devotional projects, especially *sūtra* copying (see fig. 121 above), to the extent that the line between artist and patron was often blurred. The *Heike nōgyō*, a lavishly decorated and illustrated set of scrolls inscribed with the text of the Lotus Sutra, dedicated in 1164 by Taira Kiyomori (1118–81) and members of his family, exemplifies this kind of collaborative project. The people involved were linked not only by family ties but also as members of a *karma*-relation group (*kechien*), formed to promote the spiritual welfare of their members or someone designated by them. Patronage of religious imagery by *kechien* groups, which existed at all social levels, became increasingly common in the Kamakura period (1185–1333).

In the Heian period projects carried out with private backing often rivalled in scale, magnificence and influence those carried out under the auspices of the imperial family. Fujiwara no Michinaga (966–1028) and his son Yorimichi (992–1074) contributed through their patronage to shaping the dominant styles of architecture, painting and sculpture of the 11th and 12th centuries. The Phoenix Hall at BYŌDŌIN in Uji, a villa converted into a temple by Yorimichi and dedicated in 1053, established an enduring and influential standard of opulent elegance.

Although religious arts predominated in the Heian period, a tradition of secular painting, called *Yamatoe* by modern art historians, also emerged. This drew inspiration from native *waka* poetry and prose works such as the *Tale of Genji* (*Genji monogatari*; 11th century). Commissions for paintings of this type were executed chiefly by painters employed by the court Office of Painting (Kyūtei Edokoro) under the direction of the painter-in-chief (*edokoro azukari*). Unlike temple painting bureaux, those supported by the court were staffed by laymen. Imperially supported painting studios modelled after the one founded in the 9th century were in existence until the end of the Edo period (*see also* §XVIII, 2 above). After the 14th century they were staffed by artists of the hereditary TOSA SCHOOL, which traced its origins to the court painter KOSE NO KANAOKA.

2. 13TH–16TH CENTURIES. The spread of new methods of ink painting (*suibokuga*) that accompanied the introduction of Zen (Chin. Chan) Buddhism from China in the 13th century had a profound influence on the relations between artist and patron in Japan. While traditional Buddhist devotional painting required technical precision and adherence to established iconographic models, ink painting permitted greater stylistic and thematic freedom and, like calligraphy, with which it had much in common, revealed the painter's character in a way other forms of painting could not (*see also* §VI, 4(iii) above). Recognition of the ink painter's individual creative powers,

combined with respect for the knowledge of Chinese culture presupposed by his adoption of Chinese themes and styles, prepared the way for the emergence of official cultural advisers known as *dōbōshū* ('companions'), of whom Nōami, Geiami and Sōami, who served the ASHIKAGA shoguns of the Muromachi period (1333–1568), were the most influential (*see* AMI). Their wide-ranging duties included participation in poetry gatherings, the decoration of banquet chambers, painting and connoisseurship (*see* §XXII below). Nōami and Sōami's *Kundaikan sayū chōki*, a guide to the connoisseurship of Chinese art and to the arrangement of paintings and other *objets d'art* in the decorative alcove (*tokonoma*) and adjoining shelves of the formal reception room, established norms of connoisseurship and artistic display that prevailed until the end of the Edo period.

The Ashikaga rulers, particularly the third and fifth shoguns, Yoshimitsu (1358–1408) and Yoshimasa (1436–90), established new aesthetic standards in many areas. In addition to ink painting, they promoted landscape gardening, textiles, lacquer and the tea ceremony (*chanoyu*; *see* §XIV, 1 above). Yoshimasa was the first ruler to retain the services of a tea master to instruct him in the ceremonial preparation of tea, and MURATA JUKŌ was the first in a line of tea masters of merchant-class background to serve the ruling élite as adviser in artistic as well as business matters. The most celebrated was the 16th-century master SEN NO RIKYŪ.

The Ashikaga shoguns' devotion to cultural pursuits led to loss of political authority and dispersal of wealth and culture from the Kyoto capital to the provinces. As a result, schools of ink painting came into existence in the 15th and 16th centuries supported by provincial lords such as the Ōuchi of Suo Province (now in Yamaguchi Prefect.), patrons of TŌYŌ SESSHŪ, one of the most influential ink painters of his generation. Provincial centres of culture continued to grow after the country was reunified under Tokugawa Ieyasu (1542–1616), as the feudal rulers (daimyo) of rival domains sought to demonstrate their wealth and cultivation as well as to promote local artistic production for economic reasons. The Maeda, daimyo of Kaga, for instance, were noted for their promotion of lacquerware and ceramics, while the Matsuura, daimyo of Hizen, promoted porcelain production.

3. 17TH CENTURY–LATE 19TH. Official patronage of the arts reached its apogee under the shoguns and daimyo of the Edo period (1600–1868), painters of the KANŌ SCHOOL being its most conspicuous beneficiaries. The Kanō were noted for their adaptation of monochrome ink-painting styles and themes to the decorative requirements of large-scale screen painting. Although the heroic style of Kanō Eitoku (*see* KANŌ, (5)) had particularly appealed to the warlords Oda Nobunaga (1534–82) and Toyotomi Hideyoshi (1537–98), whose castles he and his assistants had decorated (*see* AZUCHI CASTLE), the Tokugawa rulers favoured the more tempered treatment of themes and styles developed by Eitoku's grandson Kanō Tan'yū (*see* KANŌ, (11)).

Appointed in 1623, Tan'yū was the first official painter (*goyō eshi*) to the Tokugawa shogun. Subsequently the shogunate also retained the services of three other Kanō

ateliers. The heads of these four ateliers, known after their locations in Edo as Kajibashi, Nakabashi, Kobikichō and Hamachō, were designated *oku eshi* ('inner artists'). The artists of sixteen Kanō ateliers founded by the sons and collateral members of the four main lines, known as *omote eshi* ('second-level painters'), served the daimyo. The *goyō eshi*'s chief duty was to design and execute large cycles of paintings required as part of the interior décor of the residences, temples and shrines belonging to or supported by the Tokugawa and daimyo. The painter-in-residence also served as official connoisseur and authenticator of paintings and as painting instructor to the shogun and his family.

The leading artists of the Kanō school enjoyed social standing and financial security shared by few other painters of the Edo period. Because of the large number, geographical distribution and official nature of their decorative projects, their themes and styles had a nationwide influence. Like the European academies, which they resembled in many respects, the Kanō workshops were the bastions of time-honoured, conservative painting styles that, particularly in the 18th and 19th centuries, were often criticized by more innovative artists. The Kanō school's association with the national rulers, however, guaranteed their authority even after creative leadership had passed to other hands.

The Kanō painters were by no means the sole beneficiaries of the Tokugawa, who also retained the services of painters of the SUMIYOSHI SCHOOL, a branch of the Tosa school, who were specialists in native themes and styles. For the creation of lacquer objects, particularly the elaborate sets required as part of a dowry, they retained the services of outstanding lacquerers of the Igarashi and Kōami families, who had earlier served the Ashikaga shoguns. Successive Tokugawa shoguns also patronized craftsmen of the Gotō family, who specialized in swords and sword fittings. Like their Kanō-school counterparts, official shogunal craftsmen received regular stipends in exchange for lifetime employment.

Many craft items produced during the Edo period—especially lacquer, ceramics, bamboo and metalwork—were designed for use in the tea ceremony, which was promoted among all social classes by the Senke, the three tea schools founded in the 17th century by Sen no Rikyū's grandsons. To supply the teawares required by their students, the Senke, which had branches throughout the country, instituted a formal patronage system analogous to that prevailing under the shoguns. Ten families of craftsmen, each with a different specialization, flourished under their patronage. Rikyū himself had set the precedent for commissioning tea utensils to his personal taste (*konomi*) and specifications by his patronage of the potter Chōjirō (1516–92). Chōjirō's heirs, who specialized in hand-moulded, low-fired RAKU pottery, as well as the heirs of the men who made cast-iron kettles and bamboo flower containers for Rikyū, still enjoy the patronage of the Senke tea schools.

Over the course of the Edo period, prosperous merchants, chiefly in Kyoto, Osaka and Edo, assumed an increasingly prominent role as patrons of the arts. Relationships between artists and their merchant patrons varied widely but were generally of a more informal and egalitarian nature than those that involved members of the ruling class. The Osaka sake brewer KIMURA KENKADŌ, himself an amateur painter in the *Nanga* (literati) tradition (*see* §VI, 4(vi)(e) above), offered food and housing in exchange for paintings by and instruction from literati painters and even helped to organize cultural gatherings to display the talents of his protégés and attract new patrons for them. By the end of the Edo period, private patronage and direct sales or commissions engendered through shops, exhibitions (*see* §XXI, 3 below), auctions and art dealers had become as influential in shaping the nation's artistic taste as the official system of patronage that depended on the shogun and his feudal retainers.

4. LATE 19TH CENTURY ONWARDS. The traditional system of feudal patronage was largely abandoned during the Meiji period (1868–1912), to be replaced first by government subsidies for firms that would produce high-quality crafts for sale at international expositions in Europe and America (*see* §XXI, 3 below), and later by imperial patronage of individual artists. The Kiritsu Kōshō Kaisha (Kiritsu Industrial and Commercial Company), founded in 1873, was the first recipient of such government largesse; the first imperial awards to artists, chiefly craftsmen who had assisted in the decoration of the imperial palace, were made in 1884. As government involvement in the arts declined, new wealthy industrialists, such as the Yokohama silk exporter Hara Tomitarō and Masuda Takashi, director of Mitsui Trading Company, played an increasingly important role as patrons of the arts.

In the Taishō and early Shōwa eras, the state took an active role in promoting and sponsoring the arts through exhibitions such as the Bunten (an acronym for *Monbushō bijutsu tenrankai*). This annual painting and sculpture exhibition, established in 1907, and sponsored by the Ministry of Culture, was only one of many official and semi-official events through which the government has sought to guide aesthetic taste. Since the 1950s, Japanese corporate patronage of architecture, painting and sculpture has played an increasingly important role in both the domestic and international art markets. Many of the museums that have opened during the past decades enjoy corporate sponsorship.

BIBLIOGRAPHY

T. Fukuyama: *Byōdōin to Chūsonji*, Nihon no bijutsu [Arts of Japan], ix (Tokyo, 1964); Eng. trans. by R. K. Jones as *Heian Temples: Byodo-in and Chuson-ji*, Heibonsha Surv. Jap. A., ix (Tokyo and New York, 1976)

Higashiyama Gyomotsu: Zakkanshitsuin ni kansuru shin shiryō o chūshin ni [Treasures of the Higashiyama Collection: based on new materials bearing the Zakkanshitsu seal] (exh. cat., Tokyo; Nezu A. Mus.; Nagoya, Tokugawa A. Mus., 1976)

Scripture of the Lotus Blossom of the Fine Dharma (The Lotus Sutra); Eng. trans. by L. Hurvitz (New York, 1976)

M. Miyamoto: 'Osaka bunjin to Kimura Kenkadō no dentō' [Kimura Kenkadō and the Osaka literary tradition], *Kobijutsu*, 53 (1977), pp. 43–51

H. P. Varley: 'Ashikaga Yoshimitsu and the World of Kitayama: Social Change and Shogunal Patronage in Early Muromachi Japan', *Japan in the Muromachi Age*, ed. J. W. Hall and T. Toyoda (Berkeley, 1977), pp. 183–204

Z. Shimizu: 'Heian zenki ni okeru konin soshiki no hensen—somei no bukkō kara no busshie' [Changes in the status of Buddhist sculptors during the early Heian period: from lay to monk sculptors], *Bukkyō Geijutsu*, 133 (1980), pp. 72–86; 135 (1981), pp. 61–75

Y. Shimizu: 'Workshop Management of the Early Kanō Painters, ca. AD 1530–1600', *Archvs Asian A.*, xxxiv (1981), pp. 20–45

C. Wheelwright: 'A Visualization of Eitoku's Lost Paintings at Azuchi Castle', *Warlords, Artists and Commoners: Japan in the Sixteenth Century*, ed. G. Elison and B. L. Smith (Honolulu, 1981), pp. 87–113

The Great Eastern Temple: Treasures of Japanese Buddhist Art from Tōdaiji (exh. cat., ed. Y. Mino; Chicago, IL, A. Inst., 1986)

Japan: The Shaping of Daimyo Culture 1185–1868 (exh. cat., ed. Y. Shimizu; Washington, DC, N.G.A., 1988–9)

W. Tanabe: *Paintings of the Lotus Sutra* (Tokyo and New York, 1988)

The Tokugawa Collection: The Japan of the Shoguns (exh. cat. by P. Theberge, Y. Tokugawa and R. Little, Montreal, Mus. F.A., 1989), pp. 41–51

C. M. E. Guth: *Art, Tea and Industry: Masuda Takashi and the Mitsui Circle* (Princeton, 1993)

CHRISTINE M. E. GUTH

XX. Archaeology.

1. Before 1868. 2. Meiji period (1868–1912). 3. After 1912.

1. BEFORE 1868. Modern Japanese archaeology originated in the later Edo period (1600–1868), when interest in antiquities stimulated both historical research and the collecting of curiosities. Edo-period historians were most interested in written records, and questions of Japan's ancient past were answered by reference to two revered mythical records: the *Kojiki* ('Records of ancient matters'; AD 712) and *Nihon shoki* (or *Nihongi*; 'Chronicle of Japan'; AD 720). They set forth Japan's early history, origin, legends and genealogies, along with the notion that the Japanese islands and the imperial family were of divine origin. Such indeed was the orthodox view concerning the country's past until World War II, although even during the Edo period a few Japanese historians recognized that material remains were a valid and worthwhile source of information about the ancient past. Most notable among them was Tō Teikan (1731–98), a Confucian historian from Kyoto, who catalogued the roof-tiles from ancient sites as a means of studying the distribution of early historic temples and castles. In 1791 he published the *Shōkōhatsu*, a discussion of early Japanese culture, which included a study of the dress of *haniwa* (clay figurines; *see* §V, 2 above). He knew these figurines were very ancient and representative of historical events yet he had no chronological basis on which to date them. Observing that their clothing was like Korean dress, he concluded that Japan's first rulers had come from the continent. Another Edo-period historian who turned his attention to archaeological materials was Arai Hakuseki (1656–1725). In 1725 a friend presented him with several stone arrow points from northern Japan; Hakuseki identified them as man-made objects but interpreted them strictly in the light of various Chinese historical records. To him they were evidence that the primitive peoples described in Chinese chronicles had once occupied northern Japan. Hakuseki's conclusion that the people responsible for ancient materials were not Japanese remained current in Japanese scholarship up to the 1950s and is in many ways still at the core of Japanese archaeological research. In interpretation of all archaeological materials a text-based approach remained standard.

Throughout the middle and late Edo period, popular displays called *bussankai* ('products meetings') were organized to disseminate practical agricultural knowledge. While the organizers saw little practical utility in ancient stone tools and other archaeological objects, they regularly included them in *bussankai* and published catalogues as interesting sidelights to the useful devices and improved crops they emphasized. In this way *bussankai* helped establish standards for displaying archaeological objects and fostered collector interest.

The activities of a number of private collectors of antiquities and curiosities in the late Edo period made significant contributions to the establishment of academic archaeology in Japan. The use of natural rocks as tasteful objects for the *tokonoma* (decorative alcove) became popular at this time, and, in collecting and cataloguing unusual rocks for this purpose, rock fanciers became aware of a wide range of archaeological materials. Excavated pots and other artefacts were used as interior decoration and described in popular publications. The leading rock collector of the age was Kiuchi Sekitei (1724–1801). In his multi-volume work *Ukonshi*, a treatise on rocks, other natural phenomena and archaeology, issued in instalments between 1773 and 1801, he discussed both artefacts and natural rocks and fossils and systematically separated natural and artificial objects. He also distinguished between chipped and polished stone tools and further assigned stone tools to functional categories such as 'spoons', 'spools' and 'spears'. Like contemporary collectors, Sekitei described all stone and pottery artefacts as dating from the 'Age of the Gods' (when Japan was inhabited only by a host of deities, as chronicled in the *Kojiki* and *Nihon shoki*), but he clearly understood that the artefacts he had collected had been left behind by ancient people, whom he identified as the 'Ezo' or Ainu. In that way he helped to popularize and perpetuate the idea that the ancient inhabitants of Japan were not the ancestors of the modern Japanese. Unlike such scholars as Hakuseki, who used Chinese sources, Sekitei employed Japanese sources to postulate the course of ancient history.

2. MEIJI PERIOD (1868–1912). The establishment of modern field archaeology in Japan is usually attributed to EDWARD SYLVESTER MORSE (see fig. 251), an American zoologist and archaeologist who went to Japan in 1877 to study molluscs. Shortly after his arrival, he noted the remains of a prehistoric shell midden near Ōmori along the railway tracks between Yokohama and Tokyo; later, while teaching zoology at Tokyo Imperial University, Morse and his students excavated the ŌMORI SHELL-MOUND site. Morse introduced the idea of prehistory to Japan and helped to legitimize and popularize archaeological research. After he left in 1879, Japanese researchers continued to pursue the new study of archaeology. As they had only occasional contact with research in Europe and the USA, their work came to have many distinctive features.

Archaeology enjoyed great support and popularity throughout the Meiji period (see fig. 252), partly because the restoration of the imperial line in 1868 stimulated central government interest in the ancient past. A law protecting the burial mounds of the imperial ancestors was passed in 1880, after government officials began recording burial mounds and their contents in an attempt to locate and identify the tombs of imperial ancestors mentioned in the *Kojiki* and *Nihon shoki*. Excavation of the tombs by archaeologists and investigation of the

251. Edward Sylvester Morse (1838–1925), who influenced the development of archaeology in Japan; from a photograph by the Benjamin Kimball Studios

protohistoric period in general were blocked by officials unwilling to question the mythical records, which upheld the belief in the divine origins of the imperial line.

Meiji-period archaeologists focused instead on Neolithic materials and on the establishment of their discipline. The National Museum, established in Tokyo in 1872, included an archaeological section, and archaeology programmes were included in imperial universities established in Tokyo and Kyoto. In 1884 the Tokyo Anthropological Association (Tōkyō Jinruigakkai; now the Anthropological Association of Japan, or Nihon Jinruigakkai) was formed

252. Kofun-period coffin, Sue ware, high-fired pottery, l. 1.45 m, excavated by William Gowland from a stone chambered dolmen at Sakuraidani, near Osaka, in 1884 (London, British Museum)

under the leadership of Shōgorō Tsuboi (1863–1913) to support both archaeological and ethnographic research. This association and the Archaeology Association (Kōkogaku Kyōkai), formed in 1896 by the archaeologist Yonekichi Miyake (1860–1929) and now called the Association for Japanese Archaeology (Nihon Kōkogaku Kyōkai), represented the two schools of Japanese archaeological studies. The journal of the Anthropological Association, *Jinruigakkai Hōkoku*, became an important focus both for descriptions of archaeological materials and for heated debates about the ethnic affiliation of stone tools, pottery and other material found throughout Japan. These debates centred on whether the Neolithic inhabitants of Japan should be equated with the Ainu or some other group. Tsuboi led a faction that believed the ancient inhabitants of Japan were neither Ainu nor Japanese but one of the groups mentioned in the mythical records. While the debates arose largely out of documentary evidence, systematic excavations began to reveal the complexity of Japan's archaeological record.

3. AFTER 1912. By the end of the Meiji period the country's major prehistoric periods—the Jōmon (corresponding roughly to the Mesolithic and Neolithic; *c.* 10,000–*c.* 300 BC), Yayoi (Bronze and Iron Ages; *c.* 300 BC–AD 300) and Kofun or Tomb (usually described as protohistoric; *c.* AD 300–700)—had been identified and their chronological order established (*see also* §I, 2 above). The main thrust of Japanese archaeology in the years before World War II—during the Taishō (1912–26) and early Shōwa (1926–89) periods—was clarification of the prehistoric cultural sequence. The stylistic richness of cord-marked Jōmon pottery proved hard to explain. Anthropologist Ryūzō Torii (1870–1953) suggested that various styles of pottery reflected different cultures that had coexisted in antiquity. However, Hikohichirō Matsumoto (1887–1975), working in shell middens in northern Honshu, used geological methods of stratigraphic analysis to show that there was significant temporal variation within the Jōmon materials. Sugao Yamanouchi (1902–70) brought order to research on the Jōmon period by refining a methodology for ceramic typology. By the late 1930s he had shown that major stylistic variations reflected chronological subdivisions of the Jōmon period. He also established a five-period framework for the systematic study of the Jōmon period, which he believed began around 3000 BC, although modern radiocarbon dating has revealed examples of Jōmon pottery from *c.* 10,000 BC (*see also* §VIII, 2(i) above). Kōsaku Hamada (1881–1938) led the way in systematic study of materials of both the Yayoi and Kofun periods. In 1919 Hamada proposed a classification of Yayoi ceramics that was expanded throughout the 1920s and 1930s to accommodate both chronological and functional variations of the ware. In 1936 Hamada also proposed a basic chronology for the keyhole-shaped burial mounds (*zenpōkōenfun*; *see* §III, 2(ii) and fig. 13 above). In general, archaeological research carried out in the years before World War II emphasized the study of objects; relatively little attention was given to cultural interpretations. Even so, some archaeologists ran foul of

the nationalistic pre-war government and lost their university posts or were in other ways harassed for allegedly insulting the dignity of the imperial family.

Research slowed down during World War II and the early post-war years. From the 1930s to the early 1960s the main emphasis was on expanding and clarifying the chronological prehistoric framework established by Yamanouchi and others. In the search for the time limits of the Jōmon period, it was discovered that the Japanese past was more complex than had been thought. In 1946, true Palaeolithic (before *c*. 10,000 BC) artefacts were discovered at Iwajuku in Gumma Prefecture, giving Japanese archaeologists an enormous new research challenge. The political openness of the post-war years encouraged archaeologists to explore new topics. In 1949 Namio Egami (*b* 1906) suggested that the historic Japanese state and the imperial family had originated when horse-riding peoples invaded Japan from the Asian mainland. The 'horse-riders' theory (*kiba minzoku setsu*) caused great controversy and is still questioned by many scholars but encouraged archaeologists studying the Kofun period to re-evaluate their data. Major tombs were still protected from excavation, but post-war research showed clearly that many of the identifications made by Meiji-period officials were incorrect and even that a few supposedly ancient mounds had actually been made during the Edo period.

From the early 1950s onwards the Association for Japanese Archaeology formed research groups to focus on specific problem areas. One group undertook interdisciplinary investigations of a major rice-growing village of the Yayoi period at Toro, Shizuoka Prefecture. Other groups addressed more general topics, such as the origins of the agricultural way of life of the Yayoi period and—through investigation of cave sites—the link between Palaeolithic and Jōmon cultures. A team approach to research remains characteristic of Japanese archaeology.

Issues of chronology and cultural classification in Japanese archaeology had largely been solved by 1965–7, when publication of the seven-volume series *Nihon no kōkogaku* ('The archaeology of Japan') presented a synthesis of the field. At just that time, however, Japan's economic growth led to a massive increase in the number of and support for salvage excavations, which allowed Japanese archaeologists to unearth entire communities and examine large areas. By the 1980s several thousand such sites were being investigated (e.g. over 13,000 in 1982). These new results, together with new theoretical interests, shifted the focus of Japanese archaeology from chronology to an understanding of past societies, in particular the ecological basis and social organization of Jōmon-period societies. The possibility that some Jōmon communities practised agriculture was investigated by the systematic analysis of seeds, bones and other ecological remains. The origin, spread and organization of rice cultivation occupy specialists in the Yayoi period. Researchers studying both the Yayoi and Kofun periods have concentrated on gaining an understanding of the growth of political units and the final formation of the early Japanese state.

Archaeology and preservation of all kinds of cultural materials are now administered nationally by the Cultural Affairs Agency (Bunkachō). Locally, these affairs are handled by boards of education. Museums are maintained by many different levels of government, and communities often preserve important archaeological sites as public parks. For these reasons important archaeological objects are often stored and displayed near their place of discovery. Strong tradition requires developers to pay for the excavation of sites threatened by construction, so that communities do not have to pay for such salvage excavations and often view them as positive signs of growth and development.

BIBLIOGRAPHY

Nihon no kōkogaku [The archaeology of Japan], 7 vols (Tokyo, 1965–7)
T. Saitō: *Nihon kōkogakushi* [A history of Japanese archaeology] (Tokyo, 1974)
M. Maruyama: *Studies in the Intellectual History of Tokugawa Japan* (Tokyo, 1975)
C. M. Aikens and T. Higuchi: *Prehistory of Japan* (New York, 1982)
R. J. Pearson, G. L. Barnes and K. L. Hutterer, eds: *Windows on the Japanese Past: Studies in Archaeology and Prehistory* (Ann Arbor, 1986)

PETER BLEED

XXI. Collection and display.

1. Collectors and collections. 2. Museums. 3. Exhibitions.

1. COLLECTORS AND COLLECTIONS. A detailed history of art collecting in Japan has yet to be written. The very words used to denote 'collecting' or 'collection' (*shūshū*) and 'collector' (*shūshūka*) are translations from English and of comparatively recent origin. *Kōzuka*, which has the same connotation, appears to be a translation of 'dilettante'. Nevertheless there is a long tradition of collecting in Japan: the excellent condition of many antique works of art and the large numbers that have survived, despite fire and other disasters, bear witness to this; the psychology of personal and institutional accumulation is well understood; and the attendant art of connoisseurship (*kantei*) also has a long history (*see* §XXII below).

(i) Introduction. (ii) To 1868. (iii) After 1868.

(i) Introduction. Collecting in Japan has been influenced to some extent by Chinese custom, but major paintings have changed hands less often than in China, and fewer collectors' seals and colophons are attached to them. Some famous paintings, such as the long landscape handscroll executed by TŌYŌ SESSHŪ in 1486 for the Mōri family, remain with the original owners, and the great monastery collections in Nara (*see* NARA, §I) go back to the 7th century. Since the late 19th century the pattern of Japanese collecting has changed, and it continues to change in response to socio-economic conditions, although the situation differs from that in other advanced nations. Because of lack of space and for security against fire and theft, collections are usually kept in storage, ideally in a separate and specially constructed building, the *kura* (also sometimes written with Chinese characters which may also be read as *zō*, *sō* or *ko*). Usually only a few pieces are displayed at any one time, though special visitors may be shown more.

In the 1930s some private collectors made their collections more available by founding private museums (*see* §2 below). During the 1950s, after a new Museum Law provided protection for museums and offered tax advantages, several more followed suit, and thereafter the pace quickened. It is impossible, however, to make a firm distinction between private collections and museums.

Private museums established to commemorate the life and work of a particular artist are not included in this survey, except for those that have resulted from the collecting activity of another party or reflect a collection made by an artist of other people's work. Many private museums remain under the control of the founder's family after his death, and tax laws have generally discouraged owners from making donations of their collections to national or other publicly owned museums.

Not surprisingly, Japanese collectors have above all sought out and appreciated Japanese art. Traditionally preference was given to painting, calligraphy, ceramics and other decorative arts, especially those associated with the tea ceremony, and swords. Stimulated partly by Western interest, Japanese also began in the 20th century seriously to collect *ukiyoe* ('pictures of the floating world') prints, illustrated books (*ehon*), Japanese export art, decorative arts of the Edo period (1600–1868) and folk art (*mingei*). Scrolls of painting and calligraphy from before the Kamakura period (1185–1333), or belonging to Zen traditions, and *Nanga* (literati painting) received comparatively little attention from individual collectors, as did Buddhist art, especially sculpture, which was too large for most private owners. In several fields Western collectors have initiated reappraisals in Japanese taste, but other classes of object, such as tea utensils, calligraphy and *Nihonga* (Japanese traditional painting), although highly prized in Japan, have had little appeal in the West. Outside Europe and North America, Japanese art has attracted few collectors. Notable exceptions include the donations of the Tata family to the Prince of Wales Museum of Western India in Bombay, which included a collection of Edo-period decorative arts. Chinese connoisseurs respond most readily to *Nanga* painting and other arts that exhibit Chinese qualities.

(ii) To 1868. The oldest collections in Japan, apart from the contents of imperial tombs, are those of Buddhist monasteries in and around Nara. Among these, pride of place is occupied by HŌRYŪJI (founded in the 6th century) and Tōdaiji (8th century; see NARA, §III, 4). The repository of Tōdaiji, the Shōsōin (see NARA, §III, 3), contains not only religious objects but also the secular collections and personal effects of Emperor Shōmu (*reg* 724–49). Some of the old monasteries continue to enrich their collections: Tōshōdaiji (see NARA, §III, 9), for example, has commissioned murals from the *Nihonga* artist Kaii Higashiyama (*b* 1908), and the abbot, Kōjun Morimoto (*fl* 1990s), has formed a unique collection of scrolls, tea-ceremony pieces and objects of vertu.

The monasteries established in and around Heian (now Kyoto), from the time when it became the capital in 794, also accumulated vast collections of art objects and documents, many of which have still not been inventoried by modern scholars. Because of the destruction of the Tendai-school monasteries on Mt Hiei in the late 16th century, more has been preserved by the Shingon school of Buddhism, particularly on Mt Kōya and at Kyōōgokokuji (Tōji) in Kyoto, but rich collections exist at such Tendai foundations as ONJŌJI and Chūsonji (see HIRAIZUMI, §2(i)). Among later schools of Japanese Buddhism, the collections of the Zen monasteries in Kyoto are most

important, those of Daitokuji (see KYOTO, §IV, 5) being outstanding. Some large Shinto shrines, notably those of Kasuga (see NARA, §III, 2), ITSUKUSHIMA and Kumano (Wakayama Prefect.), also preserve significant collections. Japan is dotted with thousands of monastery and shrine collections, large and small, the contents of which have been little investigated, except for periods before 1600.

From the Heian period (794–1185) onwards literary sources begin to mention the private collections of aristocrats. The 'Picture Competition' chapter (chap. 17) of *Genji monogatari* ('Tale of Genji'; 11th century) describes a hoard of antique and modern paintings at Prince Genji's palace in the capital (see also §XXII below). Then, as now, paintings were rolled up and kept in wooden boxes when not on view. The 8th-century inventory of the Shōsōin, *Tōdaiji kenmotsuchō*, lists painted screens according to style and subject-matter. In the 15th century the ASHIKAGA shoguns collected paintings and other objects from China. Although these collections have been dispersed, a catalogue survives listing especially the Chinese paintings owned by Ashikaga Yoshimitsu (1358–1408). From it many extant works may be identified, including late 13th-century paintings by MUQI and mid-13th-century paintings by YU JIAN. This catalogue, *Gyomotsu on'e mokuroku*, was compiled by Nōami and transcribed by his grandson Sōami (see AMI, (1) and (3)), who together also compiled the *Kundaikan sayū chōki* (1476–1511), a classified list of Chinese painters, together with notes on Chinese ceramics and the decoration of *tokonoma* (alcoves), all based on the collections of Ashikaga Yoshimasa (1436–90).

The taste for things Chinese was continued by the tea masters of the 16th century. The possession and display of *meibutsu* ('famous objects') were important elements of the tea cult from its early days, and tea masters chose the design of tea-rooms appropriate to different grades of *meibutsu* (see §XIV, 2 and 3 above). The military leaders Oda Nobunaga and Toyotomi Hideyoshi both collected, or rather commandeered, prized paintings, tea canisters, teabowls and other objects for the ceremony. The military expedition that Hideyoshi sent to Korea in 1592 was undertaken primarily in order to capture Korean pottery and potters.

The popularity of the tea ceremony and its accoutrements continued unabated during the 17th century. The distinct aesthetic tastes of various tea masters determined the preferred shapes and decoration of utensils, the layout of the tea-room and other features; these choices in turn influenced the nature of their patrons' collections. The most eager acolytes came from the rising merchant class, who used their often considerable wealth to acquire treasures and then passed these down within their families. Two of the leading collectors of the Edo period were Kōnoike Dōoku (1655–1736), an Osaka merchant, and Matsudaira Harusato (or Matsudaira Fumai; 1751–1818), daimyo of Izumo (now Shimane Prefect.). Fumai compiled a catalogue of his collection of 583 tea utensils (*Unshū kura chō*) and elaborate antiquarian works on *meibutsu*. These scholarly endeavours partly reflected contemporary Neo-Confucian concerns, but KOBORI ENSHŪ, describing his own collection in *Enshū goshū jūhappin*, had already in the early 17th century graded *meibutsu* into three categories, according to age, just as sword collectors distinguished

between weapons made before 1600 and those made after. Fumai owned some famous bowls, and pieces from his collection acquired a cachet of their own. Other catalogues of *meibutsu* were *Matsuya meibutsu shū*, concerning the collection of Matsuya Hisamasa (*d* 1598), *Ganka meibutsu ki* (1660), describing collections of the shogun and others, *Chūko meibutsu ki* (late 17th century) and *Meibutsu ki* (1705–15), by Matsudaira Morimura. (For further discussion of catalogues *see* §XXII below.)

In China the literati often collected paintings and other objects to grace their studies. In Japan, collections of *meibutsu* for the tea ceremony played a comparable role in the formation of taste, but the Japanese men of letters were generally not in a position to obtain important *meibutsu* or classical works of art. The pattern and role of collecting in the two countries therefore differed significantly, although the old-established ruling families in both had accumulations of heirlooms, those of certain Japanese fiefs (*han*) being outstanding (*see also* CHINA, §XVIII).

The earliest Western collections of Japanese art were mainly of lacquer, porcelain and a few other export items, brought to Europe by the Dutch East India Company from about the 17th century onwards. Before that, presentation pieces, such as suits of armour, had found their way to Portugal, England, Italy and elsewhere. Large quantities of Japanese art from the late 18th century and the early 19th reached Europe on Dutch ships, although its recipients did not always clearly distinguish it from Chinese art. Individuals from other Western countries brought back collections, for example the Germans Engelbert Kaempfer (1651–1716; Japanese books; London, BM) and PHILIPP FRANZ VON SIEBOLD (*ukiyoe* prints and ethnographical, botanical and utilitarian items; Leiden, Rijksmus. Vlkenknd.).

(iii) After 1868.

(a) Japanese. (b) Western.

(a) Japanese. The abolition of the shogunate and other changes associated with the Meiji Restoration of 1868 profoundly affected the way of life of the old samurai class. Some, however, embraced commerce and industry; and the mercantile traditions of Edo, Osaka and other cities continued to flourish. Some great collections were formed in the Meiji period (1868–1912), especially by successful businessmen. Some of these collections continued family traditions dating back to the 17th century, but newly available types of art, such as Chinese bronzes and contemporary Japanese painting, and new considerations of art history were grafted on to the *meibutsu* heritage. The taste for Western art and Japanese art in a Western idiom was less easily assimilated; and before World War II there were few collectors of such material. The main collectors of French and European art were Torajirō Kojima (1881–1929) and KŌJIRŌ MATSUKATA, both of whom had lived and worked in Europe. Matsukata's extensive collections were partly stored in France, where they included a major collection of *ukiyoe* prints acquired there *en bloc*. After his death, they passed to the national museums in Tokyo.

During the late 19th century leading collectors of antique Japanese and Chinese art included Yanosuke Iwasaki (1851–1908) and his son Koyata Iwasaki (1879–

1945), both presidents of the Mitsubishi Corporation, and Takashi Masuda (1848–1938), director of the Mitsui Manufacturing Company (Mitsui Bussan). The Iwasaki Collection and Library are housed at the Seikadō Library (Seikadō Bunko) in Tokyo, opened in 1940 with over 200,000 books from the personal library of Koyata Iwasaki and 5000 works of art. An art museum (see fig. 253) was constructed (1988–91) adjacent to the library and officially opened in 1992 with a special exhibition to commemorate the 100th anniversary of the establishment of the library. Masuda's collection, however, was dispersed: many pieces went to his friend Issei Hatakeyama (1881–1971) and then to the Hatakeyama Collection (Hatakeyama Kinenkan), Tokyo. Another collector who worked for the Mitsui Company was Ginjirō Fujiwara (1869–1960).

Major collections of classical East Asian art were formed before World War II by many businessmen, for whom the tea ceremony, *meibutsu* and the appreciation of art objects offered a cultivated form of relaxation. Many of these collections have become private museums. Thus, Kihachirō Ōkura (1837–1928; Tokyo, Ōkura Shūkokan Mus.) was an armaments manufacturer; Ryūhei Murayama (1850–1933; Kobe, Kōsetsu Mus. A.) was founder of the Asahi Newspaper Company; Kaichirō Nezu (1860–1940; Tokyo, Nezu A. Mus. (Nezu Bijutsuka)) was a railway magnate; Jihei Kanō (1862–1951; Kobe, Hakutsuru F.A. Mus. (Hakutsuru Bijutsukan)) was a sake brewer, who had been inspired to collect early Chinese art when, as a young man, he saw pieces from the Shōsōin. Denzaburō Fujita (1841–1912; Osaka, Fujita Mus. A. (Fujita Bijutsukan)) and his family were merchant barons, originally from the Hagi clan of Chōshū; Yasuzaemon Matsunaga (1875–1971; Odawara, Matsunaga Mem. Hall, Kanagawa Prefecture, 1959–80, then Fukuoka A. Mus. (Fukuoka Bijutsukan), Fukuoka Prefect.) was president of Tōhō Electric Power Company; Ichizō Kobayashi (1873–1957; Keda, Itsuō A. Museum) had business interests in railways and electric light, as well as being founder of the Tōhō Film Company and the Takarazuka Girls' Revue Theatre; and Keita Gotoh (1882–1959; Tokyo, Gotoh Mus.) headed the Tōkyū department store group. Some collectors had less conventional tastes: Kōzui Ōtani drew on the resources of Nishi Honganji, his great family monastery in Kyoto, to bring back objects from Central Asia (part of the collection now in Tokyo, N. Mus.); Hajime Ikenaga (*b* 1891) formed a unique collection of early Japanese art with European influence and founded the Kobe City Museum of Nanban Art to house it; Fusajirō Abe (1868–1937) formed an important collection of Chinese paintings, which was presented to the Osaka Municipal Museum of Art (Ōsaka–Shiritsu Bijutsukan) in 1943; and MUNEYOSHI YANAGI founded the Japan Folk Crafts Museum (Nihon Mingeikan) and led the Japanese movement to collect and study folk arts.

During the 1920s and 1930s many aristocratic collections were broken up and sold at auction. However, a number of *han* collections survived. Of these, the largest and most important is that of the Tokugawa daimyo of Owari Province, now housed in the Tokugawa Art Museum (Tokugawa Reimeikai Foundation), Nagoya. Other such collections include those of the Date family of Sendai, the Matsuura of Hirado, the Ii of Hikone, the Mōri of

253. Seikadō Bunko Art Museum, Tokyo, opened 1992

Suō, the Sakai of Tsuruoka, Uzen, the Shimazu of Satsuma and the Maeda of Kanazawa. Older than any of these, however, is the Kanazawa Bunko in Yokohama, which has preserved the large library and archives of the Hōjō family since about 1260 and which also includes Buddhist sculpture, portraits of the Hōjō and other works of art. The collections under the jurisdiction of the Imperial Household Agency, comprising holdings of the various imperial palaces and domains, have been depleted over the centuries but include important material from the 17th century onwards, as well as the unexcavated contents of early imperial tombs.

In the post-war period many new collectors have come forward, notably in such fields as *ukiyoe* paintings and prints, *Nihonga*, ceramics, later Zen art, folk arts and swords. There are also more collectors of Western-style Japanese art. Notable individuals (and the museums that hold their collections) include Torao Ōita (Yamato Bunkakan, Nara), Taneji Yamazaki (Yamatane Mus. A. (Yamatane Bijutsukan), Tokyo), Sōichirō Ōhara, son of Magosaburō Ōhara (1909–68; Kurashiki, Ōhara Mus. A.), Sazō Idemitsu (Tokyo, Idemitsu Mus. A.), Keizō Saji (*b* 1919; Tokyo, Suntory Mus.), Shinji Hiraki (Tokyo, Riccar A. Mus. (Rikkā Bijutsukan)) and Seizō Ōta (*d* 1977; Tokyo, Ōta Mem. Mus. A. (Ōta Kinen Bijutsukan)). In addition to such private museums, new collections have been formed both nationally and regionally by institutions

and by various of the new religions (*see* §2 below), including the Church of World Messianity (Atami, MOA Mus. A. (MOA Bijutsukan)) and Tenrikyō (Tenri, Nara Prefect., Sankōkan Mus.).

(b) Western. After the opening of Japan in the mid-19th century, a wave of enthusiasm for things Japanese swept through Europe. It centred on Japanese prints and decorative arts, was encouraged by Japanese participation at world trade fairs and was strongest in France, home of the largest number of artists as well as collectors. In Paris, Tadamasa Hayashi (1853–1908) and Samuel Bing (1838–1905) were the pre-eminent dealers, their most popular commodity being *ukiyoe*. Hayashi's record book, now lost, showed that between 1890 and 1901 he imported 860 boxes of Japanese antiquities to Paris, including 156,487 prints. The early French collectors followed the lead of Edmond de Goncourt (1822–96), who recommended that collections be broken up after the owner's death so that a new generation might savour the joys of acquisition. As a result, the major Western collections of Japanese prints are outside France.

Serious American interest in Japanese art also dates from the last two decades of the 19th century. Unlike their European counterparts, several collectors obtained objects during residence in Japan or through visits there. Important collections of *ukiyoe* were made, but American taste

embraced many other kinds of Japanese art too. The largest and most varied collection was that of the Museum of Fine Arts, Boston, MA, where the teachings of ERNEST FRANCISCO FENOLLOSA and Tenshin Okakura were a great stimulus. Fenollosa's own collection of Japanese paintings was purchased for the museum by Charles G. Weld (1857–1911), while Okakura secured major pieces of sculpture. Boston was further enriched by the collections of William Sturgis Bigelow (1850–1936; prints and Buddhist art), Denman W. Ross (prints), William S. and John T. Spaulding (prints) and EDWARD SYLVESTER MORSE (ceramics). Morse also made a huge collection of objects illustrative of daily life in Japan (Salem, MA, Peabody Essex Mus.).

Another outstanding collector of Asian art was CHARLES LANG FREER, whose Japanese collection, made between 1887 and 1919, was especially rich in *Rinpa* paintings and illustrated books. The Freer Gallery of Art (see fig. 254) in Washington, DC, was created by him to house his Asian collections. In New York and Chicago other circles of collectors sought Japanese prints first and foremost, the greatest collection being that of Clarence Buckingham (*d* 1913; Chicago, IL, A. Inst.). Like others of the period, he was guided by Frederick W. Gookin, a Chicago banker who became the most knowledgeable American connoisseur of his time. The irrepressible architect Frank Lloyd Wright, also of Chicago, collected for himself and acted as an agent for others.

Meanwhile, in Europe the initiative passed briefly from France to England, where the foundations of the extensive Japanese collections at the British Museum in London were laid before World War I. However, the founding of the Oriental Ceramic Society, the Shang-period (*c*. 1600–*c*. 1050 BC) finds at the tombs of Anyang (Henan Prov., China; excavated from 1928 onwards) and opportunities for acquiring fine Chinese art all diverted the attention of many collectors away from Japan. Japanese art dealers active in the West, such as Sadajirō Yamanaka (1866–1936) and Ryūsendō Mayuyama (*d* 1935), handled Chinese art as much as Japanese and found that the latter was widely regarded as imitative and inferior. Langdon Warner (1881–1955), who had travelled widely in both China and Japan, helped to persuade Americans otherwise through his teaching and writing on Japanese art, but serious foreign collecting of Japanese art did not resume until after 1945.

The Occupation period (1945–52) sparked new interest in Japan among American collectors and presented new opportunities. Major private collectors included Dr and Mrs Richard P. Gale (Japanese paintings and prints; Minneapolis, MN, Inst. A.), Harry Packard (various kinds of art; New York, Met.), James Michener (prints; Honolulu, HI, Acad. A.), Mr and Mrs Jackson Burke (paintings, sculpture), Mr and Mrs John Powers (paintings) and Mr and Mrs Joe D. Price (Edo-period painting; Los Angeles, CA, Co. Mus. A.). All these represented new levels of sophistication among Western collections. In Europe, the

254. A Japanese gallery in the Freer Gallery of Art, Washington, DC, housing part of the Asian collection of Charles Lang Freer

most noteworthy collections since World War II have been those of RALPH HARARI (paintings and drawings), Baron Eduard von Heydt (Zurich, Rietberg Mus.) and Felix Tikotin (Haifa, Tikotin Mus. Jap. A.).

BIBLIOGRAPHY

R. Koechlin: *Souvenirs d'un vieil amateur d'art de l'Extrême-Orient* (Chalon-sur-Saône, 1930)
A. L. Sadler: *Cha-no-yu: The Japanese Tea Ceremony* (Kobe and London, 1933/*R* Rutland, VT, and Tokyo, 1963)
C. Lancaster: *The Japanese Influence in America* (New York, 1963/*R* 1983)
J. Mayuyama, ed.: *Ōbei shūzō Nihon bijutsu zuroku* [Japanese art in the West] (Tokyo, 1966) [with list of pls in Eng.]
S. Shimada and M. Narazaki, eds: *Zaigai hihō* [Japanese paintings in Western collections], 3 vols (Tokyo, 1969)
T. Hayashiya, M. Nakamura and S. Hayashiya: *Japanese Arts and the Tea Ceremony* (New York and Tokyo, 1974)
'Kaigai e ryūshutsu shita hihō' [Japanese art in the world], *Beissatsu Taiyō/Nihon no Kokoro*, xxi (1977) [whole issue]
S. Ozaki, ed.: *Watakushi bijutsukan* [Private art galleries] (Tokyo, 1980)
N. Sugawara: *Bijutsukan ima* [Art galleries today] (Tokyo, 1984)

DAVID WATERHOUSE

2. MUSEUMS.

(i) Japanese. (ii) Foreign.

(i) Japanese. Unlike Western museums, which typically display their greatest treasures at all times, Japanese museums follow a very different policy in regard to 'fine arts'. The most famous works are shown rarely and then for short periods of time. Moreover, in the national museums, paintings are displayed for only about four weeks, with new works displayed at the beginning of each month. Following the tradition of Buddhist temples, which exhibit treasures during the autumn and spring when the weather is best, most museums put out their most notable works during these seasons. In the dry winter and humid summer months, lesser paintings and special exhibitions of ceramics are often shown. Special exhibitions are invariably held in the autumn and spring at national, prefectural, municipal and private museums. Some small private museums, especially those in the Osaka–Kobe region, are open during these seasons only. Because most works in a museum are not on constant display, the vast majority of museums allow bona fide scholars access to works in storage if arrangement is made in writing in advance. Most special exhibitions are accompanied by catalogues; many of the smaller, private museums have complete catalogues of their collections. Catalogues, like museum display labels, are in Japanese, although the national museums and some others include basic information in English in both.

The art and archaeological museums of Japan are noted not only for their quality and their number but also for their diversity. There are seven national museums, three in Tokyo, two in Kyoto and one each in Nara and Osaka. Tokyo, Kyoto and Nara each have a museum of traditional Japanese art, founded to preserve and exhibit objects from temples and shrines. All three have important collections of their own. Other categories include regional museums, the treasure-houses of Buddhist temples and Shinto shrines, museums founded by individuals, companies or religious sects, those housing specialist collections and open-air architectural museums.

(a) National and regional. (b) Treasure-houses. (c) Founded by individuals, companies or religious sects. (d) Specialist. (e) Open-air architectural.

(a) National and regional. The Tokyo National Museum, established in 1872 by the Japanese government, is the largest in the country and has the finest and most extensive collection of Japanese art in the world. It consists of a complex of four buildings: the main building, housing the arts of Japan; a second building in the Beaux-Arts style for the archaeological collections; a third to exhibit the Chinese, Korean, South-east Asian and Indian objects and temporary shows; the fourth to house the material of the Asuka-Hakuhō (AD 552–710), Nara (710–94) and Heian (794–1185) periods given to the Imperial Household in 1878 by the authorities of the Buddhist temple Hōryūji at Nara and now on loan to the Tokyo National Museum. The Kyoto National Museum offers a view of Japanese art equal to that of Tokyo in quality, if not in extent. Appropriately, the Nara National Museum, having so many early Buddhist temples in the immediate vicinity, specializes in Buddhist art.

Almost every prefecture in Japan has a prefectural art or history museum, and many cities have municipal museums. Their collections generally contain specimens of local archaeology and ethnography, as well as modern Japanese art (usually by local artists). Items from regional temples and shrines or local private collections may also be on deposit. The buildings are almost all post-war, large and often handsome. A few also collect modern Western art. A proliferation of archaeological excavations undertaken since 1945 by either government agencies or universities (*see* §XX above) has led to the construction of many on-site archaeological museums.

(b) Treasure-houses. Before 1940, Buddhist temples were largely under the patronage of the Imperial Household. Following the restructuring of the government in 1945, this financial support no longer existed, and many temples found themselves without funds for their maintenance. Some of the older and more important temples had long had treasure-houses in which their most valuable artefacts were kept; now almost every Buddhist temple has such a building, to which admission is charged. Japan reputedly has the oldest art collection in the world (although it has never functioned as a museum in the modern sense), that of the Shōsōin, the treasure-house of Tōdaiji, Nara (*see* NARA, §III, 3). It contains the personal belongings of Emperor Shōmu (*reg* AD 724–49), dedicated to the temple by his widow, Kōmyō, in 756, objects used in the inauguration of the *Daibutsu* (the bronze *Great Buddha*) of the temple in 752 and other 8th-century pieces. Many ancient Shinto shrines also display their treasures in post-war buildings.

(c) Founded by individuals, companies or religious sects. Numerous private collections (*see* §1 above) have opened to the public since 1945. Many are in Tokyo or the Kyoto–Osaka area and contain classic Japanese and Chinese art of as high a standard as that of the national museums. Some are single-theme collections, for example of tea ceremony objects or Chinese bronzes, others cover a wide range of Japanese, Chinese and Western objects and works of art. The Tokugawa Art Museum in Nagoya houses a

collection of over 10,000 historical art items amassed by the Tokugawa family and presented to the city in 1935; it also contains the world's finest collection of Japanese *nō* robes. Several Japanese companies own and run their own art museums as subsidiaries, partly for the tax benefits available but more importantly for the associated prestige. Company museums in Tokyo include the Suntory Museum of Art, the property of Suntory Ltd; the Bridgestone Art Museum, sponsored by the Ishibashi Foundation; and the Seiji Tōgō Museum, property of the Yasuda Fire and Marine Insurance Company, famous for its purchase in the 1980s of van Gogh's *Sunflowers*. Others include the Hakone Open Air Museum (see fig. 255), founded by the Fuji Sankei Communications Group, and the Hiroshima Museum of Art, established to commemorate the 100th anniversary of the Hiroshima Bank (*see* §(d) below). Museums founded and operated by a religious sect are a special feature of the Japanese art world. The MOA Museum of Art, Atami, with its rich collection of Chinese and Japanese art of all periods, belongs to the Church of World Messianity; the Sōka Gakkai ('value-creating society') owns the Fuji Art Museum, Fujinomiya, and its holdings of European and Asian art; and the Tenri sect (Tenrikyō) runs the Sankōkan Museum, Tenri, Nara Prefecture, which exhibits Japanese, Korean and Chinese pre-Buddhist antiquities and ethnographical material from Asia, Europe and Africa.

(d) Specialist. The largest and most representative collection of 19th- and 20th-century Japanese art is owned by the National Museum of Modern Art, Tokyo. Its counterparts in Kyoto and Osaka hold the work of both Japanese and foreign artists. In response to popular interest in modern Japanese art, special museums have been built in many other cities, such as Fukuoka, Fukushima, Itō, Kamakura (see fig. 40 above), Kitakyūshū, Kōfu, Saitama (Urawa), Sapporo, Shimonoseki and Utsunomiya. Some of these have also amassed collections of contemporary Western art. The Ōhara Museum of Art, Kurashiki, was the first in Japan to show exclusively Western art (*see* ŌHARA). At the Hakone Open-Air Museum modern Western and Japanese sculpture and painting fill the vast park and the museum building; a separate building is dedicated to the work of Picasso. The Hiroshima Museum of Art features 19th- and early 20th-century French paintings and Japanese paintings in both traditional and Western styles. Avant-garde Western and Japanese art can be seen at the Iwaki Municipal Museum of Art, at the Museum of Modern Art (Seibu Takanawa) at Karuizawa and at the Toyama Museum of Modern Art.

Not surprisingly, given their importance in Japanese culture, some museums are wholly devoted to ceramics, for example the Kyushu Ceramics Museum at Arita (built 1980), the Aichi Prefectural Ceramics Museum at Seto (also 1980s), the two ceramic museums at Bizen, the Old Tanba Pottery Museum at Sasayama, Hyobo Prefecture, the Hyōgo Ceramics Museum in Kobe, the Raku Ceramics Museum in Kyoto and the Kurita Museum in Ashikaga. The Museum of Oriental Ceramics, Osaka, houses the famous Ataka collection of Chinese and Korean ceramics. In Tokyo, two museums are given over to calligraphy

255. Hakone Open Air Museum (Chōkoku no mori Bijutsukan; 'sculpture forest museum'), Hakone-machi, Kanagawa Prefecture

(Mus. Callig. and Japan Callig. Mus.) and one to the sword (Jap. Sword Mus.).

Museums that specialize in *Nanban* art (objects related to foreigners) are the Nanban Culture Hall in Osaka and the Kobe City Museum, which now holds, but only occasionally displays, the excellent *Nanban* collection of the former Kobe City Museum of Nanban Art.

Among the many museums devoted to one artist are those holding the works of the painters Ike Taiga (*see* IKE, (1)), Gyokudō Kawai, TOMIOKA TESSAI and Taikan Yokoyama, the sculptors Fumio Asakura (1883–1964) and Shin Hongō (1905–80), the potters Kei Fujiwara (1899–1983), Kanjirō Kawai and Kenkichi Tomimoto (1886–1963), the photographer Ken Domon (*b* 1909), the printmaker Shiko Munakata and the textile designer Keisuke Serizawa.

The earliest and most important collection of Japanese folk art (*see* §XV above; *see also* MINGEI) is that of the Japan Folk Art Museum, Tokyo, but exhibitions of ethnography and folk art can be found scattered all over Japan. One of the more unusual forms of Japanese folk art is that of the Ainu, aboriginal inhabitants of the Japanese archipelago, now to be found on Hokkaido. There is an assortment of this material in the Ainu Museum at Shiraoi. The Ainu objects gathered by the American missionary Dr John Batchelor (1854–1944) are held by Hokkaido University in Sapporo.

(e) Open-air architectural. The Japanese have made a great effort to preserve farm buildings, houses and early Western-style structures threatened by rapid industrialization and social change. Buildings of the Meiji (1868–1912) and Taishō (1912–26) periods, mostly in the Western style, have been re-erected at the Meiji-Mura Museum, Inuyama (see fig. 256), and both Western and Japanese structures from Hokkaido are on display at the Historical Museum of Hokkaido near Sapporo. Villas and other buildings that embody the best in classic Japanese architecture are in the Sankei'en, Yokohama. Less sophisticated buildings may be seen at the Edo-period village near Kanazawa (Hyakumangoku Bunkaen Edomura Mus.), while various types of farmhouses are gathered together

256. Aerial view of Meiji-Mura Museum, Inuyama, Aichi Prefecture, opened 1965; open-air museum for preserving and exhibiting Japanese architecture of the Meiji period (1868–1912)

at the Hida Folklore Museum, Takayama, the Rural Residence Museum (Shikoku Minka Hakubutsukan), Takamatsu, the Open-Air Museum of Japanese Farmhouses, Toyonaka, and the Open-Air Museum of Japanese Traditional Houses, Kawasaki. All of these have typical furnishings.

(ii) Foreign. Western museums did not begin to collect Japanese art systematically until the late 19th century. The most extensive collections outside Japan are in the museums of northern Europe and the USA. In London both the British Museum and the Victoria and Albert Museum have large Japanese holdings. The Chester Beatty Library and Gallery of Oriental Art in Dublin holds a fine collection of important manuscripts. The Musée Guimet, Paris, has a Japanese section containing good ceramics and lacquer and some paintings, prints and sculpture. A large collection of prints is held by the Musées Royaux d'Art et d'Histoire in Brussels. The Collections Baur in Geneva specialize in *inrō* (seal cases) and *netsuke* (ornamental toggles). In Germany there are Japanese collections in Berlin, Cologne, Düsseldorf, Hamburg and Stuttgart and in Holland in the Rijksmuseum in Amsterdam and in the folk art museums in Rotterdam (Mus. Vlkenknd.) and Leiden (Rijksmus. Vlkenknd.), the last noted for the material brought from Japan in the 1820s by PHILIPP FRANZ BALTHAZAR VON SIEBOLD. The Albertina in Vienna has a large number of prints, while the folk museum

(Mus. Vlkerknd.) houses other Japanese material. A collection of late 19th-century objects can be found in the Museo Orientale, Ca' Pesaro, Venice.

In Israel the Museum of Modern Art at Haifa contains paintings and prints. Japanese art may be seen in Canada in museums in Montreal (Mus. F.A.), Toronto (Royal Ont. Mus.) and Victoria (A.G. Gtr Victoria), and in Australia in Melbourne (N.G. Victoria) and Sydney (A.G. NSW). In the USA, the Museum of Fine Arts, Boston, has the most extensive (and one of the earliest) collections of Japanese art outside Japan, the core of the collection being the group of objects assembled by ERNEST FRANCISCO FENOLLOSA in the late 19th century. Collections of equal quality, but smaller, are in the Freer Gallery of Art, Washington, DC, and the Museum of Art, Cleveland, OH, both of which have been strengthened by purchases made after 1945. Similar acquisitions have brought the Seattle Art Museum to first rank, and a large purchase in 1975 helped fill the Japanese galleries in the Metropolitan Museum, New York, which were handsomely reinstalled in 1987. The Arthur M. Sackler Museum at Harvard University, Cambridge, MA, and the museums of Honolulu (Acad. A.), Chicago, Kansas City (Nelson–Atkins Mus. A.) and Philadelphia (Mus. A.) all have Japanese departments. The addition of the Price Collection of *Rinpa* material (*see* §VI, 4(v) above) has enhanced the holdings of the Los Angeles County Museum of Art. Smaller collections of Japanese art are in the New York Public

Library and in museums in Brooklyn, Baltimore, Buffalo, Cincinnati, Denver, Fort Worth, St Louis, Springfield, MA, Detroit, Worcester, MA, Minneapolis, New Orleans, Portland and Richmond, VA, among others. The Peabody Museum of Salem, MA, has a fine group of Japanese household objects, and the university museums of Cornell (Ithaca, NY), Michigan (Ann Arbor, MI), Oberlin College (Oberlin, OH), Princeton (Princeton, NJ) and Yale (New Haven, CT) also have Japanese sections.

BIBLIOGRAPHY
K. Hudson and A. Nicholls, eds: *The Directory of World Museums* (New York, 1975)
Zenkoku hakubutsukan sōran [A general survey of museums in Japan], Nihon hakubutsu kyōkai [The association of Japanese museums], 2 vols (Tokyo, 1978)
Directory of Asian Museums 1985, UNESCO-ICOM Documentation Centre (Paris, 1985)
L. P. Roberts: *Roberts' Guide to Japanese Museums of Art and Archaeology* (Tokyo, 1987)

LAURANCE P. ROBERTS

3. EXHIBITIONS. The notion of a public exhibition of art scarcely existed in Japan before the late 19th century. Paintings and other works of art were commonly viewed in a private setting: at a court poetry gathering, a tea ceremony or among small circles of friends. Large private houses might display sets of painted *shōji* panels, especially *fusuma*, but, unlike their counterparts in Europe and elsewhere, they were otherwise largely bare of art, except for the TOKONOMA (decorative alcove). Public displays of art were to be seen in Japan, particularly in the gateways and altar halls of Buddhist monasteries and along the cornices of open halls in Shinto shrines, where *ema* (votive plaques) or sets of portraits of the Thirty-six Poetic Immortals might be hung in wooden frames. Privately sponsored side-shows and other spectacles (*misemono*), at which automata, freaks and other marvels were displayed, were common in Osaka and Edo (now Tokyo) from the 17th century onwards, often in the precincts of shrines and monasteries; and might also include exhibits or demonstrations of painting, glass-blowing and other crafts.

(i) To 1945. Japan arrived on the international scene too late to participate in the Great Exhibition of 1851 in London, though *ukiyo* ('pictures of the floating world') prints from Western collections were shown in the South Kensington Exhibition of 1862 and the Paris Exposition of 1867. In Japan in 1872 the first public art exhibition, sponsored by the new Ministry of Education, took place at the Seidō, the Confucian shrine at Yushima, Tokyo; works of antique and modern Japanese art, including oil paintings, were shown. In the following year Japan had a display and garden at the Weltausstellung in Vienna, with show pieces of contemporary Japanese decorative arts and handicrafts. The Tokyo and Vienna exhibitions were intended to promote trade and industry as well as images of the new Japan. They led to the creation in 1876 of the Technical Art School (*see* §XVIII above) and to the founding in 1874 of the Kiritsu Commercial and Industrial Company (Kiritsu Kōshō Kaisha), a private company that received state support to manufacture and market overseas Japanese goods of various kinds. After the Vienna exhibition, Japan regularly took part in world fairs, notably those in Philadelphia (Centennial International Exposition, 1876), Paris (Exposition Universelle, 1878 and 1900) and Chicago (Columbian Exposition, 1893). Other companies, including Mitsui Bussan, also showed their wares at these exhibitions. In Japan there were five National Industrial Fairs between 1877 and 1903, as well as smaller local fairs.

The Japanese display in Paris in 1900 was especially large and included for the first time historic paintings and sculptures on loan from collections in Japan. The organizer, Tadamasa Hayashi (1853–1908), who had originally come to Paris as an agent for the 1878 show, had built up a large business as an antique dealer, and wanted to introduce classic art of Japan to the West. For many years, however, Western interest continued to focus on *ukiyo* and Japanese decorative arts: between 1909 and 1913 five major exhibitions of *ukiyo*, drawn from private French collections, were held at the Musée des Arts Décoratifs in Paris.

In 1874 a second state-sponsored exhibition was held in Tokyo of oil paintings and calligraphy by TAKAHASHI YŪICHI and other pioneers in the use of Western techniques. A year later, another exhibition, of oils and watercolours, helped to stimulate the formation of several private art groups interested in Western-style painting, including the Meiji Art Society (Meiji Bijutsukai, 1888) and the White Horse Society (Hakubakai, 1896). The former held its first exhibition in Ueno Park, Tokyo, in 1889 and a second in 1890, which also contained works by European artists such as Charles-François Daubigny, Jean-François Millet and Edgar Degas. Western-style artists also exhibited at the National Industrial Fair of 1890. The Meiji Art Society was dissolved in 1900 but was refounded in 1902 as the Pacific Painting Society (Taiheiyō Gakai); its successor, the Pacific Fine Art Society (Taiheiyō Bijutsukai), organizes annual exhibitions in Tokyo and elsewhere. The White Horse Society, representing a rival style of French-inspired painting, sponsored 13 exhibitions up to 1910, when it was dissolved. (*See also* §VI, 5(v) above.)

In 1907 the Ministry of Education began to sponsor annual exhibitions modelled on those of the French Salon and divided into three categories: Western-style painting (*Yōga*), Japanese-style painting (*Nihonga*) and sculpture. At first the exhibition was known as the Ministry of Education Fine Arts Exhibition (Monbushō Bijutsu Tenrankai), usually abbreviated to Bunten. In 1919 the name was changed to Imperial Art Academy Exhibition (Teikoku Bijutsuin Tenrankai) or Teiten. It held exhibitions every year, except 1923, until 1934; new sections were added for crafts in 1927 and for prints in 1932. Twice reorganized (1935 and 1937) as the New Bunten (Shin Bunten), it continued until 1944. It resumed activities in 1946 after World War II, and a calligraphy section was added in 1948. Further restructuring and changes of name took place until 1958, when the organization became independent, as the Japan Art Exhibition or Nitten (see fig. 257). The Bunten/Teiten/Nitten exhibitions occupy much the same place in Japanese artistic life as academy exhibitions in Europe. Other societies promoted *Nihonga*, the most conspicuous being the Japan Institute of Fine Arts (Nihon Bijutsuin), founded in 1898 by Tenshin

257. View of crafts section, 25th Nitten (Japan Art Exhibition), 1993

Okakura and others; since 1914 its exhibitions have been known as Inten. Originally its ranks included sculptors and craftsmen as well as painters, and until 1920 it included Western art, but since 1961 it has limited itself to Japanese-style painting only.

Many other private art groups were formed in the 30 years before World War II, and most of them sponsored exhibitions, representing many styles and types of contemporary Japanese art. The activities of these groups, especially in Tokyo, helped to create an awareness of the latest kinds of art, although relatively few exhibitions contained examples of Western art, which was known at first hand mainly by artists who had lived and worked abroad, and to a few private collectors.

Among the many groups vying for attention was the Nikakai, which was set up in 1914 in opposition to the Bunten. During the 1920s and earlier 1930s exhibitions mounted by Nikakai and its splinter groups were a showcase for modern and experimental art in Japan, including Cubism, Futurism, Constructivism, Surrealism and Dada. It has held annual exhibitions since it was reorganized in late 1945. Another group was Fusainkai, which in its short existence (1912–13) sponsored two exhibitions to promote Fauvism. The Japan Creative Print Association, formed in 1918, represented the interests of the new generation of printmakers by exhibitions and other means. In 1931 it was absorbed into the Japanese Print Association, which continues to hold annual exhibitions.

The militaristic tendencies of the late 1930s and World War II necessarily had a dampening effect on Japanese artistic life. Nevertheless, the Japanese exhibit at the Berlin Olympic Games of 1936 included the work of such artists as the printmakers Shikō Munakata and Kōshirō Onchi. In 1939 a major exhibition in Berlin of Japanese classical art included no fewer than 29 National Treasures and 57 Important Art Objects; nothing of such quality was seen again in Western countries until 1953. In Japan itself major museums were closed during the war and their collections put in storage.

(ii) After 1945. The first post-war exhibition at the Tokyo National Museum, in 1947, was of reproductions only. This was followed by exhibitions devoted to KATSUSHIKA HOKUSAI (1948), *Nanga* painting (1950; *see* §VI, 4(vi)(e)

above) and art of the Rinpa school (1950; *see* §VI, 4(v) above).

Exhibition of modern art in Japan revived more quickly. Six Nitten shows were mounted between 1946 and 1950, and there were solo exhibitions by Seison Maeda in 1947, Ryūzaburō Umehara and Sōtarō Yasui in 1949, Shōen Uemura in 1947 and 1950, Taikan Yokoyama in 1949, Tsuguji Fujita (1886–1968) in 1950, Hanjirō Sakamoto in 1950, Isamu Noguchi in 1950 and Kiyokata Kaburagi (1872–1972) in 1950. There were also numerous group shows. The first post-war exhibitions of Western art, drawn from Japanese collections, were sponsored by the Yomiuri Newspaper Company in 1947 and 1948. Reproductions of French paintings (1948) and Italian paintings (1950) were also exhibited. In 1951, however, there were several loan exhibitions from abroad, of works by Salon de Mai artists, by Picasso (two exhibitions, one of pottery only) and by Matisse. The following year there was a Braque exhibition, and others of modern Belgian and of Indian art. In addition, three new museums of modern art opened in 1951–2: the Kanagawa Prefectural Museum of Modern Art, Kamakura; the Bridgestone Art Museum, Tokyo; and the National Museum of Modern Art, Tokyo. Since then, countless exhibitions of art from abroad have been held, among which the big Louvre show (1954–5) and those that included the *Venus de Milo* (1964) and the *Mona Lisa* (1974) may be singled out.

Japanese art began to be shown abroad quite soon after the war. The first loan exhibition of classical art, in San Francisco, coincided with the Peace Conference there in 1951. In 1953 a larger exhibition travelled to five US cities. A comparable exhibition was shown in London at the Victoria and Albert Museum in 1958. Another travelling exhibition went to three US cities and to Toronto in 1965–6. Since then, several other, more specialized exhibitions have been taken to North America or to Europe, including a large show of Edo-period (1600–1868) art at the Royal Academy of Arts, London, 1981–2, and many varied exhibitions based on collections of Japanese art in North America or Europe have also been held. Much attention has been excited by loan exhibitions to Japan itself from, for example, the Museum of Fine Arts, Boston, the Rijksmuseum voor Volkenkunde, Leiden, the Shin'enkan (now Los Angeles, CA, Co. Mus. A.), the Burke collection (USA) and the British Museum, London.

Living Japanese artists first showed their work abroad after the war at the São Paulo Biennale (1951), the Second Lugano International Print Exhibition (1952) and the Venice Biennale (1952). Many Japanese artists also went to study or live abroad: major exhibitions of work by contemporary Japanese artists in Europe (1972–3) and the Americas (1973–4) were held at the Kyoto and Tokyo National Museums of Modern Art.

The calendar of art exhibitions in Japan follows the seasons, in that the greatest concentration occurs in spring and autumn, and delicate antique objects tend not to be shown during the wettest months. Most exhibitions are of short duration, and the smaller museums commonly rotate selections from their permanent collections. Many exhibitions of old and new art take place in the top-floor galleries of department stores. Innumerable smaller exhibitions are held in commercial art galleries and others,

including work by amateur groups, in local municipal galleries. Major exhibitions are often sponsored by the large newspaper companies in collaboration with museums.

BIBLIOGRAPHY

Ausstellung altjapanischer Kunst, Berlin (exh. cat., Berlin, Staatl. Museen, 1939)

Exhibition of Japanese Painting and Sculpture Sponsored by the Government of Japan (exh. cat., Commission for Protection of Cultural Properties; Washington, DC, N.G.A.; New York, Met.; Boston, MA, Mus. F.A.; Chicago, IL, A. Inst.; Seattle, WA, A. Mus.; 1953)

Art Treasures from Japan: An Exhibition of Paintings and Sculpture (exh. cat., National Commission for Protection of Cultural Properties; London, V&A, 1958)

Art Treasures from Japan (exh. cat., National Commission for Protection of Cultural Properties; Tokyo, 1965)

M. Furukawa: *Misemono no kenkyū* [Research on side-shows] (Tokyo, 1970)

Yōroppa no Nihon sakka/Japanese Artists in Europe (exh. cat., Kyoto, N. Mus. Mod. A., 1972–3)

H. Fux: *Japan aus der Weltausstellung in Wien 1873* (Vienna, 1973)

Amerika no Nihon sakka/Japanese Artists in the Americas (exh. cat., Kyoto, N. Mus. Mod. A., 1973; Tokyo, 1974)

The Great Japan Exhibition: Art of the Edo Period, 1600–1868 (exh. cat., ed. W. Watson; London, RA, 1981–2)

T. R. H. Havens: *Artist and Patron in Post-war Japan: Dance, Music, Theater and the Visual Arts, 1955–1980* (Princeton, 1982)

DAVID WATERHOUSE

XXII. Connoisseurship and historiography.

Connoisseurship, the identification, authentication and evaluation of works of art on the basis of aesthetic and historical criteria, was not recognized as an independent activity in Japan until the Muromachi period (1333–1568). Although its development was influenced by Chinese writings on and attitudes towards art, the criteria for judging aesthetic merit and the actual practice of connoisseurship differed significantly. In Japan appreciation of a work of art was conditioned as much by its emotional and sensual appeal as by appreciation of its formal properties. Moreover, from the 15th century, connoisseurship was dominated by professionals rather than by discriminating amateurs. These professionals, chiefly painters of the hereditary KANŌ SCHOOL and TOSA SCHOOL, also produced the first critical writings on art. These works, largely modelled on Chinese texts, were followed in the 18th and 19th centuries by more interpretive ones written by painters of the *Nanga* (literati) school (*see* §VI, 4(vi)(d) above). Although connoisseurship as such did not exist before the 15th century, many of the aesthetic ideals that were to guide the judgement of quality in art can be traced to a tradition of literary criticism associated with poetry that evolved in the Heian period (794–1184). Indeed, much of the vocabulary used in discussing works of art was appropriated from poetry. 'Japanese poetry has its seed in the human heart and finds expression in myriad leaves', the celebrated opening sentence of Ki no Tsurayuki's preface to the *Kokinshū*, an imperial anthology of poetry compiled 902–20, established the correspondence between human emotions and the natural world that is central to many forms of artistic expression in Japan.

1. Painting contests and catalogues. 2. Tea ceremony. 3. Professional connoisseurship. 4. Historiography, criticism and theory.

1. PAINTING CONTESTS AND CATALOGUES. The judgements rendered in an imaginary painting contest (*eawase*), a description of which occupies an entire chapter in *Genji monogatari* ('Tale of Genji'; 11th century) by Murasaki Shikibu, offer clear evidence of the importance of this emotional quality in Japanese connoisseurship. In painting contests, a practice first popularized by the nobility of the Heian period, pairs of paintings, old and new, native and imported, professional and amateur, were compared and evaluated. In the fictional contest described by Murasaki Shikibu, the most admired paintings were those of Prince Genji, an amateur artist. His impressionistic views of the bleak, windswept shores of Suma, where he had been exiled, were painted with such genuine feeling that they moved viewers to tears. A work of art that provoked this kind of emotional response was said to possess *aware* or *mono no aware*. For the courtier of the period, *aware*, which implied a sensitivity to the beauty and perishability of all things, was the most esteemed of all expressive qualities.

The emergence of a new conception of connoisseurship based on recognition of personal style was linked to the formation of the ASHIKAGA shogunal collections (*see also* §XXI, 1 above). Although the Ashikaga shoguns, who ruled from 1336 to 1573, were noted aesthetes, they relied heavily on the judgement of their cultural advisers or companions (*dōbōshū*), the most influential of whom were Nōami, Geiami and Sōami (*see* AMI). The duties of the *dōbōshū* included painting—all were skilled in monochrome ink painting (*suibokuga*)—preparing and supervising formal receptions for the shogun and evaluating and cataloguing the shogunal collection. They established connoisseurship as a professional activity by formulating a system of classification, identification and attribution that continued to guide collectors and connoisseurs for centuries.

Their principles are set forth in the *Kundaikan sayū chōki*, an illustrated and annotated catalogue and guide to the decoration of the TOKONAMA (alcove) and adjoining shelves, compiled by Nōami and expanded (1566) by his grandson Sōami. The text begins with a list of works attributed by the authors on the basis of theme and style to Chinese painters active in the Song (960–1279) and Yuan (1279–1368) periods. These are ranked by quality as 'upper', 'middle' or 'lower' grade, a tripartite system modelled on that found in many Chinese treatises on art and later adopted for classifying Japanese paintings as well. The list of paintings is followed by annotated diagrams demonstrating proper display in the *tokonoma* and adjoining shelves, and appropriate combinations with other works of art so as to create a harmonious ensemble. The final section of the text offers a typological classification of ceramics and lacquer. Nōami's descriptive nomenclature of ceramics established the foundations for the connoisseurship of both Chinese and Japanese teawares.

The *Kundaikan sayū chōki* had a profound effect on Japanese taste in art. Nōami's aesthetic judgement was so widely respected that many of his attributions remained unchallenged until modern times. Compositions by the Chinese artists he extolled served as models for generations of Japanese painters. His predilection for grouping as triptychs (usually a figure flanked by landscapes or animals) paintings that were originally designed as independent

compositions established standards for pictorial production and display that served as examples to the Tokugawa shoguns and the feudal lords of the Edo period (1600–1868).

2. TEA CEREMONY. The formation of large collections of painting, calligraphy, ceramics and lacquer for the tea ceremony, *chanoyu* (*see* §XIV, 1 above), during the Momoyama (1568–1600) and Edo periods contributed to connoisseurship. The term *mekiki* ('discernment'), which comes closest to the Western term 'connoisseurship', is first found in *Yamanoue Sōjiki*, the writings of the tea master Yamanoue Sōji (1544–90), a disciple of the 'father of *chanoyu*', SEN NO RIKYŪ. Sōji believed that no one could become a true master of *chanoyu* without a sense of artistic discrimination. This assessment was reiterated in later writings on tea, such as Nanbō Sōkei's *Sōjinboku* (1691), in which the ability to discriminate between good and bad art takes on moralistic overtones.

Sōjinboku, which purported to be a faithful record of Rikyū's teachings, contributed greatly to the diffusion of the ideal of *wabi* (rustic simplicity, imperfection) as the central animating aesthetic of *chanoyu*. *Wabi* is an aesthetic principle that rejects material values and overt expression. Both the spiritual values of Zen Buddhism and poetic theory influenced its development. Diffusion of this ideal of imperfect beauty both shaped and mirrored the appreciation of monochrome ink paintings. It also contributed to the popularity of unglazed, rough-textured and even misshapen ceramics of the types produced in the kilns of Bizen and Iga.

For the practitioner of *chanoyu*, connoisseurship involved not only the identification of the types and styles of utensils used in preparing and drinking tea but also familiarity with their history (*see* §XIV, 3 above). Knowledge of the history of a tea utensil—the identity of its creator, the names of its owners and the occasions when it was used—was integral to its aesthetic appreciation. For celebrated teawares, this information was set down in records of tea gatherings (*chakaiki*) and compendia of renowned teawares (*meibutsu*) old and new. One such compendium is the comprehensive *Kokon meibutsu ruijū* ('Classified collection of renowned wares of ancient and modern times'), compiled by the feudal lord Matsudaira Fumai (1751–1829), an avid collector noted for his discriminating taste. The history of ordinary teawares was generally inscribed on documents that were carefully preserved together with the object. In many cases, this information was certified by professional tea masters or dealers in teawares.

3. PROFESSIONAL CONNOISSEURSHIP. A phenomenon of the Edo period (1600–1868) was the rise of families of professional connoisseurs, each a specialist in a particular medium or style. Members of the Kanō, Tosa and SUMIYOSHI schools of painting were dominant in pictorial arts. All acquired their knowledge through personal practice and access to the paintings in the collections of their shogunal patrons. These professional connoisseurs, having determined the authorship and quality of works on the basis of subject, style and seals, often added their own signatures, seals and comments to attest to their authenticity. Kanō Tan'yū (*see* KANŌ, (11)), the painter-in-attendance to the Tokugawa shogun, was especially active as an appraiser of Chinese and Japanese paintings. Records of the paintings he examined between 1661 and 1674 survive in the form of small sketches (*shukuzu*; see fig. 258). These include notations about the identity of the painter and seals, transcribed versions of inscriptions accompanying the picture and notes on ownership and value. Originally intended for Tan'yū and his studio's own study, these sketches, dispersed in the 19th century, are unique sources of information and are widely consulted by art historians.

258. Connoisseur sketches (*shukuzu*) by Kanō Tan'yū, detail of a handscroll, ink and light colour on paper, 303×4111 mm, mid-17th century (London, British Museum)

The Kohitsu family, founded by Kohitsu Ryōsa (1572–1662), specialized in the connoisseurship of calligraphy. Members of this professional family, whose name means 'antique writing', were active as authenticators, appraisers and art dealers until the Meiji period (1868–1912). The legacy of their taste and attributions is attested by the existence of many albums containing rare calligraphic fragments cut from handscrolls, books and Buddhist scriptures. These fragments are arranged according to the historical period and social standing of the calligrapher, reflecting the correspondence, deeply rooted in the Sino–Japanese tradition, between noble character and calligraphic skill.

4. HISTORIOGRAPHY, CRITICISM AND THEORY. Although comments about artists and their works appear occasionally in classical Japanese literature, diaries and essays, little critical writing about art was produced before the 17th century. Artists of the Kanō school were the first to address issues of connoisseurship, historiography and criticism in a systematic way. For the most part, authors were seeking to display their erudition and to identify themselves as the true heirs to the styles, themes and values of Chinese painting rather than to elucidate the theoretical underpinnings of Chinese painting and their application in Japan. *Tansei jakubokushū* ('A forest of paintings') and *Kosōshū* ('Themes in Chinese painting'), both by Kanō Ikkei (1599–1662), are generally recognized as the first Japanese writings on aesthetic theory. Both works are deeply indebted to earlier Chinese writings on art, especially to the *Tu hui bao jian* ('Remarks on painting and painters'; 1365) of Xia Wenyan. Establishing a practice that was to be followed in most Japanese treatises, Ikkei's *Kosōshū* begins with an enumeration and explanation of the Six Laws, the Three Grades of Quality, the Twelve Faults and the Six Essentials, all basic principles in Chinese art theory. For Ikkei, as for later Japanese writers, spirit resonance or vital force (Chin. *qiyun*; Jap. *kiin*), the first of Xie He's Six Laws of painting, was by far the most desirable aesthetic quality.

The first history of Japanese painting, *Honchō gashi* ('History of Japanese painting'), compiled by Kanō Einō (1634–1700), appeared in 1678. It contains brief biographical sketches of 405 artists from the Nara period (AD 710–94) to the late 17th century, with special emphasis on the members of the Kanō lineage, and information about their themes, styles and techniques. This is followed by a description of the tools of the artist. An addendum also includes reproductions of artists' seals. *Honchō gashi* was the basis for later biographical dictionaries such as *Koga bikō* ('Commentaries on old paintings'), a comprehensive work listing more than 3800 painters compiled by Asaoka Okisada (1800–56), and *Fusō meiga den* by Hori Naonori (1806–80) and Kurokawa Harumura (1798–1866). These voluminous compendia, together with *Koko gafu* ('Catalogue of ancient paintings in Japan'), also by Kurokawa Harumura, established the Japanese canon of painters and their themes.

Honchō gahō taiden ('Summary of the rules of Japanese painting') marks a watershed in the effort to formulate a theory of Japanese painting. It was written *c.* 1678 by Tosa Mitsuoki (*see* TOSA, (3)), a leading exponent of the courtly *Yamatoe* painting style. Although it was primarily a practical handbook for Tosa artists, its author sought to apply Chinese artistic theory to the values and practices espoused by his school to demonstrate the superiority of Tosa over Kanō painting styles. Mitsuoki's interpretation of Chinese principles reveals a sensitivity to seasonal and emotive values rooted in the aesthetics of Japanese poetry. The contents of *Honchō gahō taiden*, as of many texts by members of hereditary schools, were jealously guarded professional secrets, but references to it in other writings suggest that its contents were in fact known to artists of rival schools.

The rise of the *Nanga* or literati school of painters in the 18th and 19th centuries contributed to a heightened appreciation of personal expressiveness in painting. Unlike the Kanō painters, whose work derived chiefly from the painting of professional, academic masters of the Southern Song period (1127–1279), literati painters drew inspiration from a wide range of artistic sources, identifying most closely with the tradition of amateur scholar painting that began in the Yuan period (1279–1368) and continued throughout the Qing period (1644–1911). Japanese literati looked down on the Kanō painters as technicians who aimed for little more than copybook perfection.

Much of the theoretical writing about art during the later Edo period reflects the hostility between these two schools, each of which claimed to be the true heir to the grand tradition of Chinese painting. Japanese literati, who were well versed in Chinese literary and artistic theory, borrowed freely from Chinese writings to bolster their position. Nakayama Kōyō (1746–99), the author of *Gatan keiroku* ('Miscellany of talks about paintings'; 1775), was the first to recognize the Chinese distinction between the Northern (professional, academic) and Southern (amateur, individualistic) schools that formed the basis for *Nanga* painters' denunciation of the Kanō. However, KUWAYAMA GYOKUSHŪ, a close friend of the noted painter Ike Taiga (*see* IKE, (1)), was the first to assimilate and interpret the vast corpus of Chinese literati writing in the light of actual artistic practice in Japan. In his *Kaiji higen* ('Humble words on painting'), for instance, he identified KONOE NOBUTADA, SHŌKADŌ SHŌJŌ, TAWARAYA SŌTATSU and Ogata Kōrin (*see* OGATA, (1)) as Japanese exponents of the Southern school of painting. This eclectic group, which in fact included both professional and amateur painters active in the 17th century and the early 18th, aroused his admiration by their lofty character and cultivation. Not all literati writers, however, shared Gyokushū's conviction that artistic personality and individuality, rather than subject-matter or style, should be the chief criteria for evaluating quality in painting. Nakabayashi Chikutō (1776–1853) and other literati of the 19th century returned to an insistence on proper adherence to Chinese pictorial models.

The final volley in the verbal battle between the Kanō and the literati school was fired in the Meiji period by ERNEST FRANCISCO FENOLLOSA, an American art collector instrumental in fostering and guiding the taste for Japanese art in the USA. Fenollosa, who acquired his knowledge of Japanese art chiefly from professional connoisseurs of the Kanō family and who was ignorant of the cultural underpinnings of literati painting, championed the

Kanō masters while lambasting their rivals. He characterized *Nanga* as a style of 'misshapen cows, gentlemen with trepanned skulls and wriggleworm branches', concluding that 'from any universal point of view, their art is hardly more than an awkward joke' (see Fenollosa, ii, p. 165). Although appreciation of literati painting was slow to develop in the West, it came to be admired for the very expressionistic qualities that earned it Fenollosa's disdain.

Since the Meiji era (1868–1912), growing familiarity with western art historical discourse has led to the emergence of a multiplicity of new and often conflicting aesthetic value systems. Traditional attitudes towards art that had grown out of the interplay of Chinese and Japanese sensibilities were not entirely discarded but rather overlaid with imported ones. Widespread acceptance of categories such as 'fine' and 'decorative' arts (Jap. *bijutsu* and *kōgei*) and of the hierarchical relationship between them have had a profound impact on the appreciation and interpretation of both traditional and contemporary art. Western art theory has lent new legitimacy to the use of art for moralistic, educational and propaganda purposes, as is evident, for instance, in the classification of Japanese painting into two distinct modes, Nihonga, 'Japanese painting', and Yōga, 'Western-style painting' (*see* §VI, 5 above). The influence of Romanticism, with its emphasis on artistic inspiration, emotionalism and genius, given early expression in the writings of Kōtarō Takamura (1883–1954), is still prevalent in contemporary art criticism. The glorification of the craftsman central to the theoretical writings of MUNEYOSHI YANAGI, founder of the Japanese Folk Crafts or Mingei movement, also continues to be a potent force in modern Japanese art historical thinking.

BIBLIOGRAPHY

Murasaki Shikibu: *Genji monogatari* (11th century AD); Eng. trans. as *The Tale of Genji* by A. Waley (Boston, MA, 1925–33); by E. Seidensticker (New York, 1976)
E. Fenollosa: *Epochs of Chinese and Japanese Art*, 2 vols (New York, 1912/R 1963)
T. Sakazaki: *Nihon garon taikan* [Compendium of writings on Japanese painting] (Tokyo, 1926–8)
——: 'Nihon no garon ni tsuite' [On Japanese paintings], *Kokka*, 598 (1940), pp. 258–65
——: 'Nihon no garon ni tsuite', *Kokka*, 599 (1940), pp. 283–9
T. Munro: *Oriental Aesthetics* (Cleveland, OH, 1956)
M. Ueda: *Literary and Art Theories in Japan* (Cleveland, OH, 1967)
J. Cahill: *Scholar Painters of Japan: The Nanga School* (New York, 1972)
A. Tanihata: 'Men of Tea: An Evaluation of Yamanoue Sōji', *Chanoyu Q.*, 26 (1980), pp. 50–60
——: 'Men of Tea: An Evaluation of Yamanoue Sōji', *Chanoyu Q.*, 27 (1980), pp. 51–8
G. C. Weigl: 'The Reception of Chinese Painting Models in Muromachi Japan', *Mnmt Nipponica*, xxxvi/3 (1980), pp. 257–72
A. Tanihata: 'Men of Tea: An Evaluation of Yamanoue Sōji', *Chanoyu Q.*, 28 (1981), pp. 45–56
Paris in Japan: The Japanese Encounter with European Painting (exh. cat. by S. Takashina and T. Rimer, St Louis, MO, George Washington U., 1987)
P. Varley and I. Kumakura, eds: *Tea in Japan: Essays on the History of Chanoyu* (Honolulu, 1989)
M. Takeuchi: *Taiga's True Views: The Language of Landscape Painting in Eighteenth Century Japan* (Stanford, CA, 1992)

For information on early sources please refer to the body of this article.

CHRISTINE M. E. GUTH

Japonisme. French term used to describe a range of European borrowings from Japanese art. It was coined in 1872 by the French critic, collector and printmaker Philippe Burty 'to designate a new field of study—artistic, historic and ethnographic', encompassing decorative objects with Japanese designs (similar to 18th-century CHINOISERIE), paintings of scenes set in Japan, and Western paintings, prints and decorative arts influenced by Japanese aesthetics. Scholars in the 20th century have distinguished *japonaiserie*, the depiction of Japanese subjects or objects in a Western style, from Japonisme, the more profound influence of Japanese aesthetics on Western art.

1. ORIGINS AND DIFFUSION. There has been wide debate over who was the first artist in the West to discover Japanese art and over the date of this discovery. According to Bénédite, Félix Bracquemond first came under the influence of Japanese art after seeing the first volume of Katsushika Hokusai's *Hokusai manga* ('Hokusai's ten thousand sketches', 1814) at the printshop of Auguste Delâtre in Paris in 1856. Adams argued that the American artist John La Farge was first: he began acquiring Japanese art in 1856 and had made decorative paintings reflecting its influence by 1859. Other authors conclude that since Japan began actively to export its wares only about 1859, Western artists could not have known Japanese art until the early 1860s.

Japanese works, however, were available in Europe before 1854, the year in which the American Commodore Matthew Calbraith Perry (1794–1858) opened Japan to trade with the West with the signing of the Kanagawa Treaty. Dutch merchants, in particular, in Japan were permitted limited trade through the island of Dejima and collected paintings, illustrated books, prints and *objets d'art*, which joined such public collections in Europe as the Etnografiska Museet, Stockholm, the Bibliothèque Nationale, Paris, the British Museum, London, and the Rijksmuseum voor Volkenkunde, Leiden.

Following Japan's opening to trade, access to Japanese wares as well as European public interest increased. Various artefacts were sold at public auctions and in Parisian curiosity shops, such as L'Empire Chinoise and Mme Desoye's store on the Rue de Rivoli, also known as la Porte Chinoise. In London, Farmer & Roger's Oriental Warehouse (later known as Liberty & Co.) opened in 1862. These shops sold both Chinese and Japanese art and were gathering-spots for artists, critics and collectors who found a new fashion in oriental art. In Britain James Abbott McNeill Whistler, D. G. Rossetti, W. M. Rossetti, John Everett Millais, Edward Burne-Jones, Sir Lawrence Alma-Tadema, Charles Keene, E. W. Godwin, William Morris, William Burges, Rutherford Alcock (1809–97), John Leighton (1822–1912), R. Norman Shaw and Christopher Dresser purchased Japanese objects at Farmer & Roger's in the early 1860s or otherwise recorded their interest in the art and culture of Japan. In France in the 1860s the writers Charles Baudelaire, Edmond and Jules de Goncourt, Théophile Gautier, Emile Zola and Jules Husson Champfleury and the artists Jean-François Millet, Théodore Rousseau, James Tissot, Alfred (Emile-Léopold) Stevens, Edouard Manet, Edgar Degas and Claude Monet began collecting Japanese art. About 1866 Burty, Zacharie Astruc, Henri Fantin-Latour, Jules Jacquemart,

Alphonse Hirsch (1843–84), M. L. Solon and Bracquemond formed the secret Société du Jing-lar, a club devoted to the study and promotion of Japanese culture.

Major exhibitions also fuelled European enthusiasm for the decorative and pictorial arts of Japan: the International Exhibition in London (1862), the Musée Oriental (founded 1865) at the Union Centrale des Beaux-Arts (later the Musée des Arts Décoratifs) and the Exposition Universelle in Paris in 1867 were the most important early exhibitions. In the 1860s such institutions as the South Kensington Museum (later the Victoria & Albert Museum) and the British Museum in London, and the Bibliothèque Nationale and Union Centrale des Beaux-Arts in Paris, added Japanese art to their holdings. The Österreichisches Museum für Angewandte Kunst, Vienna, bought Japanese works from the displays at the Exposition Universelle of 1873. In the late 19th century such dealers as Kanezaburō Wakai, Tadamasa Hayashi (1851–1905) and Siegfried Bing also promoted Japanese art.

2. PAINTING AND GRAPHIC ARTS. From the early 1860s Japonisme could be found in nearly all media across a variety of stylistic movements. In painting and the graphic arts it influenced the asymmetrical compositions of Degas and Henri Toulouse-Lautrec, the book illustrations of Walter Crane and the wood-engravings of Winslow Homer. The flatter modelling of Manet, Whistler, the Impressionists, Vincent van Gogh, Paul Gauguin and the Nabis had roots in Japanese sources, as did the pure colours and flat outlined forms preferred by many of these painters. Japanese art also inspired similar decorative qualities in the work of the Eastern European artists Emil Orlik and Otto Eckmann. The calligraphic line of oriental ink painting influenced the Impressionist brushstroke, the drawings and prints of Pierre Bonnard and Edouard Vuillard, as well as graphic works by Manet, van Gogh and Toulouse-Lautrec in France and Aubrey Beardsley in England. For the Pre-Raphaelites, the all-over patterning, the naive style of outlined forms and the subject of women in Japanese prints was as interesting as late medieval and early Italian painting. In Italy the Macchiaioli group also studied and was inspired by the dramatic compositions and strong colours of Japanese prints. Such American artists as La Farge, Homer, Elihu Vedder, William Merritt Chase, John H. Twachtman and Maurice Prendergast were influenced by Japanese composition and design and often incorporated oriental motifs into their works. Later Helen Hyde (b 1868), Will Bradley, Louis John Rhead and Arthur W. Dow (1857–1922) adopted Japanese styles and effects in their graphic art.

The introduction of Japanese colour woodcuts to the West from the mid-19th century dramatically affected the history of printmaking. The woodcut revival of Auguste Lepère, Henri Rivière, Félix Vallotton, Ernst Hermann Walther (b 1858) and Eckmann was inspired by Japanese sources. Similarly, Japanese achievements in colour printing promoted the explosion in colour lithography (see fig.) and colour etching of the late 19th century.

3. DECORATIVE ARTS. Japonisme in the decorative arts at first consisted primarily of imitations of Japanese models, with stylistic features paralleling Japonisme in

Henri Rivière: *In the Tower*, colour lithograph, 168×213 mm; from *Les Trente-six Vues de la Tour Eiffel* (Paris, 1888–1902) (New York, Public Library)

painting; features such as asymmetrical compositions, pure bright colours combined in complementary colour schemes, and bold flat patterns and motifs. Many of these were copied directly from Japanese craftsmen's manuals and dyers' stencils. Japanese inspiration is evident in the products of the French manufacturers Christofle & Co. and Haviland & Co. of Limoges, in the designs of Joseph Bouvier (1840–1901), Bracquemond, Jean Charles Cazin and Camille Moreau (1840–97), and in the cloisonné enamels of Alexis Falize (1811–98) and his son Lucien Falize (1839–97).

In the late 19th century the popularity of Japanese design continued; it is particularly evident in products of the Arts and Crafts movement and Art Nouveau, for example in the glasswork of Eugène Rousseau (1827–91), the ceramic decorations of Joseph-Théodore Deck (1823–91) and Emile Gallé, and the jewellery of René Lalique. In American and British decorative arts Japonisme appears in works produced by the Rookwood Pottery of Cincinnati, OH, which employed Japanese craftsmen, in the bold, patterned textile designs of A. H. Mackmurdo and Candace Wheeler, in the designs of Louis Comfort Tiffany's stained glass and in the naturalistic motives applied to silver manufactured by Tiffany & Co. of New York, as well as in the architecture of Frank Lloyd Wright.

4. CONCLUSION. Western artists sought inspiration in Japanese art for a variety of reasons. In the applied arts Japonisme arose from a widespread study of historic decoration, stemming from a desire to improve the quality of design in manufactured goods. The study of Japanese models also promoted a broader interest in principles of decorative design; during the late 19th century publications on decoration and the applied arts grew in number, and Japanese examples were frequently included.

In Britain, the allure of Japanese art coincided with a fascination for the decorative styles, pure colours and spiritual quality of medieval art and early Italian painting. In France, the critic Astruc, among others, advocated the

model of Japanese originality as an antidote to the belaboured academic tradition. In the mid-19th century European artists had begun to draw inspiration from such non-traditional sources as caricatures, popular prints and, in France, brightly coloured *Epinal* woodcuts. Japanese *ukiyo-e* prints, which were often compared to these media, shared with them a graphic expressiveness, popular subject-matter, naive, archaizing style and original compositions.

It was the Japanese approach to form—expressive line, abstract graphic style, decorative colours and dramatic asymmetrical compositions—that most influenced Western artists. In 1905 the English critic C. J. Holmes wrote: 'Oriental art is almost wholly symbolic … the artist conveys to the educated spectator a sense of things beyond the mere matter of his picture—something which the most elaborate and complete representation would fail to convey' (Holmes, 1905, p. 5). As Holmes suggested, the study of Japanese art contributed to the birth of formalist aesthetics in the 20th century.

BIBLIOGRAPHY

W. M. Rossetti: 'Japanese Woodcuts', *The Reader* (31 Oct 1863), pp. 501–3 (7 Nov 1863), pp. 537–40
E. Chesneau: 'Beaux-arts, l'art japonais', *Les Nations rivales dans l'art* (Paris, 1868), pp. 415–54
P. Burty: 'Japonisme', *Ren. Litt. & A.*, i (1872), pp. 25–6, 59–60, 83–4, 106–7, 122–3; ii (1873), pp. 3–5
——: 'Japonisme', *L'Art*, ii (1875), pp. 1–7, 330–42; v (1876), pp. 49–58, 278–82; vi (1876), pp. 150–55
E. Chesneau: 'Exposition Universelle, le Japon à Paris', *Gaz. B.-A.*, n.s., xviii (1878), pp. 385–97, 841–56
Le Blanc du Vernet: 'L'Art japonais', *L'Art*, xxi (1880), pp. 132–3, 250–55; xxii (1880), pp. 229–32; xxix (1882), pp. 249–53
L. Bénédite: 'Félix Bracquemond, l'animalier', *A. & Déc.*, xvii (1905), pp. 35–47
C. J. Holmes: 'The Uses of Japanese Art to Europe', *Burl. Mag.*, viii (1905), pp. 3–11
R. Graul: *Ostasiatische Kunst und ihr Einfluss auf Europa* (Leipzig, 1906)
E. Scheyer: 'Far Eastern Art and French Impressionism', *A.Q.*, vi (1943), pp. 116–43
C. Lancaster: *The Japanese Influence in America* (New York, 1963)
The Great Wave: The Influence of Japanese Woodcuts on French Prints (exh. cat., ed. C. F. Ives; New York, Met., 1974)
Japonisme: Japanese Influence on French Art, 1854–1910 (exh. cat., ed. G. Weisberg; Cleveland, OH, Mus. A., 1975)
C. Yamada: *Dialogue in Art: Japan and the West* (Tokyo and New York, 1976)
D. Bromfield: *The Art of Japan in later 19th Century Europe: Problems of Art Criticism and Theory* (diss., U. Leeds, 1977)
Japonisme in Art: An International Symposium: Tokyo, 1979
Ukiyo-e Prints and the Impressionist Painters: Meeting of the East and the West (exh. cat., Tokyo, Sunshine Mus.; Osaka, Mun. Mus. A.; Fukuoka, A. Mus.; 1979)
K. Berger: *Japonismus in der westlichen Malerei, 1860–1920* (Munich, 1980)
S. Wichmann: *Japonisme: The Japanese Influence on Western Art in the Nineteenth and Twentieth Centuries* (New York, 1981)
Japonismus und Art Nouveau: Europäische Graphik aus den Sammlungen des Museums für Kunst und Gewerbe Hamburg (exh. cat., Hamburg, Mus. Kst & Gew., 1981)
E. Evett: *Critical Reception of Japanese Art in Late Nineteenth Century Europe* (Ann Arbor, 1982)
D. Johnson: 'Japanese Prints in Europe before 1840', *Burl. Mag.*, cxxiv (1982), pp. 341–8
P. Floyd: *Japonisme in Context: Documentation, Criticism, Aesthetic Reactions* (diss., Ann Arbor, U. MI, 1983)
H. Adams: 'John La Farge's Discovery of Japanese Art: A new Perspective on the Origins of *Japonisme*', *A. Bull.*, lxvii (1985), pp. 449–85
P. Floyd: 'Documentary Evidence for the Availability of Japanese Imagery in Europe in 19th-century Public Collections', *A. Bull.*, lxviii (1986), pp. 105–41
Le Japonisme (exh. cat., Paris, Grand Pal.; Tokyo, N. Mus. W.A.; 1988)
P. Floyd: *Seeking the Floating World: The Japanese Spirit in Turn-of-the-Century French Art* (Tokyo, 1989)

PHYLIS FLOYD

Jappelli, Giuseppe (*b* Venice, 14 May 1783; *d* Venice, 8 May 1852). Italian architect, engineer and landscape designer. He was a prominent Neo-classical architect but was also a noted eclectic, much admired, for example, by Pietro Selvatico, and he introduced the taste for the romantic garden to Italy. He attended courses in architecture and figure drawing at the Accademia Clementina, Bologna (1789–9). This school, which was in the forefront of theatre design and technique, provided a stimulating and enlightened cultural environment; his teachers included Angelo Venturoli (1749–1821) and Francesco Tadolini (1723–1805). After obtaining his diploma in 1800, he moved to Padua, and in 1803 he entered the studio of Giovanni Valle, a mapmaker, where he became a qualified surveyor. He collaborated with the engineer Paolo Artico between 1804 and 1806 on defence works on the River Piave, and in 1807, with the architect Daniele Danieletti (1756–1822), he restored the old prison in Carrara Castle. The same year he was also appointed as an engineer in the Regio Corpo di Acque e Strade in the Brenta region. His works of this period included decorating the town hall (1809) in Padua for the unveiling of a painting by Francesco Alberi (1765–1836) dedicated to Napoleon. In 1813 he enrolled in the French army and was promoted to the post of captain in the entourage of Eugène de Beauharnais.

After the end of Napoleonic rule in Italy in 1814, Jappelli concentrated on restructuring in the English style the Sommi Picenardi park, Cremona. He returned to Padua when it was annexed to the Lombardo Veneto kingdom in 1815, and on the occasion of the visit of the Emperor of Austria, Francis I (*reg* 1804–35), and his consort, Maria Lodovica (1787–1816), he designed the decorations for the great hall in the Palazzo della Ragione, creating a 'romantic garden' there for the night of 20 December 1815. This famous event confirmed his reputation as a creator of gardens, and in 1816 he began work on gardens at S Elena di Battaglia for Agostino Meneghini and the park of Cittadella-Vigodarzere (now Valmarana) at Saonara, near Padua, for Antonio Vigodarzere. The latter contained all the theatrical ingredients typical of the romantic tradition: the studied use of clumps of vegetation, a lake, a grotto and an artificial hill. Its most renowned feature, however, was the Gothic Revival chapel of the Templars (completed 1833), incorporating complex masonic symbolism. The grotto was decorated with papier-mâché stalactites and was dominated by a great statue of *Baphomet*, a hermaphrodite idol and tutelary god of the Gnostic sect. The sculptor Rinaldo Rinaldi (1793–1873), with Luigi Ferrari (1810–94) and Natale Sanavio (*b* Padua, 9 Sept 1827; *d* 28 Dec 1905), collaborated on the building using such materials as wood, stucco and papier mâché, associated with stage sets.

In 1817 Jappelli married Eloisa, daughter of Conte Pietro Petrobelli, a well-known Jacobin militant, and joined the Freemasons' Lodge, frequenting the city's radical and pro-Jacobin circles. Between 1819 and 1821 he executed an important public commission, the municipal abattoir

(now the Istituto d'Arte Pietro Selvatico), in Padua between the canal of S Sofia and the River Piovego. With an impressive Doric portico, it was designed according to the new health regulations established under the Napoleonic code; it had a triangular plan, in the centre of which was a large circular courtyard for the slaughtering and a machine for drawing water from the Piovego. The contemporary debate on the suitability of styles and the functional use of the Greek Revival explains Jappelli's stylistic choice, which was also partly influenced by his studies at Paestum, as several of his drawings in the Museo Civico di Padova show (Cartolare Jappelli, cat. no. 1486, 1487). While involved in planning the abattoir he was also preparing plans for the Palazzo Comunale of Piove di Sacco.

Jappelli's most interesting architectural and urban-planning projects were produced after 1822: plans for a new prison, a university complex overlooking the district of Prato della Valle and a new street layout for Padua (unexecuted); designs for the Loggia Amulea (executed 1861) and for Antonio Pedrocchi's café in Padua; and the rebuilding of the spa of Abano Terme. The Caffè Pedrocchi in Padua, one of Jappelli's most important private commissions, was begun in 1826 and completed between 1831 and 1842 (see fig.). An engineer, Giuseppe Bisacco, was initially employed as director, but in 1826 Pedrocchi turned to Jappelli, who was assisted by Bartolomeo Franceschini of Verona. It is a functional building on an irregular site in the shape of a harpsichord. At the south and north-east corners are little loggias in the Greek Revival style. The ground-floor premises were inaugurated on 9 June 1831, and the upper rooms were opened to the public on 16 September 1842. Each room on the upper floors, intended to house the Casino del Nobili, was decorated in a different style, partly to mask the irregularity of the trapezoidal plan. At the top of the main staircase was the Etruscan room, used as a changing-room; it was followed by the Greek room, octagonal in plan, with frescoes of *Plato's Academy* by Giovanni Demin (1786–1859); the small rotunda, with frescoes by Ippolito Caffi on themes based on the Roman liking for ruins; the armoury; the Renaissance room, with a ceiling fresco by Vincenzo Gazzotto (*b* 1807) of the *Triumph of Civilization*, and the Herculaneum room with eight frescoes of the *Festivals of Diana* by Pietro Paoletti (1801–47). This led into the great ballroom dedicated to the composer Gioacchino Rossini (1792–1868), decorated in the Empire style and incorporating the Napoleonic symbol of gilded bees. Moorish taste was evident in the cloakrooms, with contributions by Giovanni Demin, and Egyptian taste in the little room, the ceiling of which is covered with stars, clearly in homage to Giovanni Battista Piranesi and the Paduan explorer and archaeologist Giovanni Battista Belzoni (1778–1823). Jappelli also attended to the design of the furnishings, including chairs, tables and lamps, as well as to the coffee-making machines. A theatrical addition to the café, the 'Pedrocchino', was later built (1837–9) in a Gothic Revival style, with the collaboration of Franceschini and decorative contributions by Antonio Gradenigo (1806–84). It was probably influenced by Jappelli's visit to Britain in 1836–7, where he designed a funerary monument

Giuseppe Jappelli: main façade of the Caffè Pedrocchi, Padua, begun 1826; lithograph by Andrea Tosini, second half of the 19th century (Padua, Biblioteca Civica)

(unexecuted) for Alexander Douglas, 10th Duke of Hamilton, in Lanarkshire, Scotland.

Jappelli received many requests for consultations and opinions for the layout of parks in the English style in Padua and the rest of Italy, and he worked on these while also making numerous trips abroad. In 1827 he was working on the Villa Gera at Conegliano in the Veneto; in 1829 his first Paduan garden, for Baron Treves at the Domenico Cerato hospital complex, was still unfinished. From 1834 to 1835 he was engaged in a large-scale work of marshland reclamation at Castelguelfo, near Parma, for Baron Testa and finishing work on a well-known garden at Castelguelfo, near Parma. In 1835 he was in Paris and from 1836 to 1837 in England. During these years he also laid out parks for the Villa Torlonia (completed 1840) in Via Nomentana, Rome, of Prince Alessandro Torlonia, which included a Gothic Revival chapel; for Agostino Sopranzi at Tradate, near Varese; for the Trieste family at Vaccarino, near Padua; and for the counts of Hierschel at Precenicco, in Friuli. His last works in Padua, apart from a general consultation for the Pacchierotti garden, were the house and garden for his friend Giacomo Andrea Giacomini (1839) and the renovation of the Teatro Verdi (1846–7). In 1850, after working on the theatre of S Benedetto in Venice, he planned the general rearrangement of the buildings belonging to the Chamber of Commerce (unexecuted).

UNPUBLISHED SOURCES

Padua, Bib. Civ., MS. C. M. 481/14 [*Memorie del giardiniere e dell'agricoltore*]
Padua, Bib. Civ., MS. C. M. 481/23 [*Studio del riordinamento generale degli edifizi appartenenti al commercio nella R. Città di Venezia*]

BIBLIOGRAPHY

P. Selvatico: 'Architettura: A Jacopo Cabianca', *Gaz. Privileg. Venezia*, cxcviii (1838)
A. Falconetti: *Il Caffè Pedrocchi, 1831–9, giugno–1931* (Padua, 1842)
C. Cimegotto and O. Ronchi, eds: *Il Caffè Pedrocchi, 1831–1931* (Padua, 1931)
N. Pevsner: 'Pedrocchino and Some Allied Problems', *Archit. Rev.* [London], cxxii/727 (1957), pp. 112–15
N. Gallimberti: *Giuseppe Jappelli* (Padua, 1963)
A. Rowan: 'Jappelli and Cicognara', *Archit. Rev.* [London], cxliii (1968), pp. 225–8
B. Mazza: 'Carte d'archivio per la storia del Caffè Pedrocchi', *Per Maria Cionini Visani: Scritti di amici* (Turin, 1977), pp. 149–53
M. Azzi Visentini: 'Per un'opera di G. Jappelli in Inghilterra: Il Mausoleo Hamilton', *A. Ven.*, xxxi (1977), pp. 157–67
L. Puppi: 'Giuseppe Jappelli: Invenzione e scienza, architetture e utopie fra rivoluzione e restaurazione', *Padova: Case e Palazzi*, ed. L. Puppi and F. Zuliani (Vicenza, 1977), pp. 223–69
B. Mazza: *Jappelli e Padova* (Padua, 1978)
L. Puppi: *Il Caffè Pedrocchi in Padova* (Vicenza, 1980)
Giuseppe Jappelli e il suo tempo: Atti del convegno internazionale di studi: Padova, 1977, ed. G. Mazzi (Padua, 1982)
B. Mazza: 'A proposito di Giuseppe Jappelli e del giardino romantico', *Mus. Patavinum*, ii/1 (1984), pp. 145–50
B. Mazza, ed.: *Il Caffè Pedrocchi in Padova: Un luogo per la società civile* (Padua, 1984)
B. Mazza and L. Puppi: *Guida storica al Caffè Pedrocchi di Padova* (Castelfranco Veneto, 1984)
B. Mazza: 'Interventi di Giuseppe Jappelli nella zona termale euganea', *Stile e struttura delle città termali* (Bergamo, 1985), pp. 19–30
G. Mazzi: 'Lineamenti di una fortuna critica: G. Jappelli nelle guide e nelle pubblicazioni periodiche ottocentesche', *Boll. Mus. Civ. Padova*, lxxiv (1985), pp. 147–73
B. Mazza: 'Disegni inediti di Jappelli all'archivio di stato di Padova', *A. Friuli, A. Trieste*, 12–13 (1993), pp. 112–20

BARBARA MAZZA

Jaquard [Jacquart]. *See* JACQUARD, JOSEPH-MARIE.

Jaquerio, Giacomo (*b* Turin, *c.* 1380; *d* Turin, 27 April 1453). Italian painter. He is first mentioned in 1401 in Geneva, where he painted an allegorical fresco of the punishments of hell for the Dominican convent of Plain Palais (destr.). The fresco is recorded in a 16th-century print containing an inscription that states that it was painted by *Jacomo Jaquerio de Civitate Taurini*. Jaquerio moved between Turin and Geneva throughout his life. By 1403 he had joined the service of Ludovico, Duke of Acaia, the ruler of Turin. That year he was paid for unknown work in the Duke's castle (now Palazzo Madama) in that city, and in 1407 and 1408 he was recorded in the Acaia palazzo in Pinerolo.

By 1411 Jaquerio had returned to Geneva, where he produced two images of *St Maurice* for a new patron, Amadeus VIII, 1st Duke of Savoy and the future antipope Felix V. His service for Ludovico of Acaia continued, however, and from 1415 to 1418 Jaquerio was in Pinerolo again. There he provided stained glass for a chapel and frescoes.

By 1426 the cadet branch of the Acaia had died out, and its territories were absorbed by the Duchy of Savoy. Thereafter Giacomo Jaquerio was called the 'pittore di nostro signore' at the court of Amadeus VIII. Documents from 1426 to 1429 show that he frescoed the Savoy family chapel in the castle (destr. 1626) of Thonon on Lake Geneva. Jaquerio also carried out his duties as a court artist, painting the Savoy arms on the gates of San Maurizio Canavese, near Turin, in 1428 and several jousting lances for the Duke.

For most of 1430 Jaquerio was in Geneva, where he made a deposition in favour of Baptista da Mantova, a Benedictine preacher accused of heresy. The artist's strong religious fervour, which may explain some of the unusual iconography in his frescoes, is shown by the fact that he listened to this preacher whenever possible in both Turin and Geneva. Records after 1430 are scarce; he was noted in Turin in 1440.

Jaquerio left only one signed work, a frescoed *Virgin and Child with Saints* in the church of S Antonio di Ranverso, outside Turin. Two cycles of the *Life of St Anthony* and the *Life of St Biagio* in the same church have also been attributed to Jaquerio and his school. Jaquerio's figures are created with strong outlines and have vibrant, caricatured faces. In his most impressive work in Ranverso, the fresco of the *Road to Calvary*, the figures verge on the grotesque. The influence of Jean Bapteur has been noted in Jaquerio's work. The most secure attributions to Jaquerio are two panels representing the *Liberation of St Peter* and the *Salvation of St Peter* (Turin, Mus. Civ. A. Ant.). In Geneva, two further works have been given to him or a close follower: a detached fresco with angels from the church of Notre Dame (Geneva, Mus. A. & Hist.) and a *Madonna of Mercy* in St Gervais.

Numerous 15th-century Piedmontese paintings have been attributed to or associated with Jaquerio, but the definition of his oeuvre has been complicated by the discovery of a stylistically similar artist, Aimone Dux of Pavia, who is known to have been at the Savoy court in 1417 and to have worked in Piedmont until 1461; the signature *Aymo Dux* has been discovered on a cycle of

Virtues and Vices (Villafranca Piemonte, Capella di Missione) that shares many of Jaquerio's characteristics. Works formerly attributed to Jaquerio are therefore now often given to Dux. These include a fresco cycle of standing saints in the courtyard of the Castle of Fenis, near Aosta, the *Nine Worthies* and the *Fountain of Youth* in the main hall of the Castello della Manta, Manta, and the *Life of St Peter* in S Pietro, Pianezza, near Turin.

BIBLIOGRAPHY

G. Bertea: 'Gli affreschi di Giacomo Jaquerio nella chiesa dell'abbazie di Sant'Antonio di Ranverso', *Atti. Soc. Piemont. Archeol. & B.A.*, viii (1914), pp. 194–207

A. C. Murat: 'Considerazione della pittura piedmontese verso la metà del secolo XV', *Boll. Stor.-Bibliog. Subalp.*, xxxviii (1936), pp. 43–79

N. Gabrielli: 'Un dipinto su tavola di Giacomo Jaquerio', *Boll. Stor.-Bibliog.-Subalp.*, xliii (1941), pp. 197–201

V. Viale: 'Notizie di una pittura di Giacomo Jaquerio a Ginevra', *Atti Soc. Piemont. Archeol. & B.A.* (1947), pp. 42–3

R. Carità: 'La pittura del ducato di Amadeo VIII: Revisione di Giacomo Jaquerio', *Boll. A.*, xli (1956), pp. 109–22

N. Gabrielli: 'Aimone Duce: Pittore a Villafranca Sabauda', *Studies in the History of Art Dedicated to William E. Suida* (London, 1959), pp. 81–5

A. Griseri: 'Nuovi referimenti per Giacomo Jaquerio', *Paragone*, x/115 (1959), pp. 18–35

——: 'Percorso di Giacomo Jaquerio', *Paragone*, xi/129 (1960), pp. 3–16

C. Gardet: 'De la peinture dans les états de Savoie au XVième siècle', *Genava*, ii (1963), pp. 407–43

A. Griseri: *Jaquerio e il realismo gotico in Piemonte* (Turin, 1965)

Giacomo Jaquerio e il gotico internazionale (exh. cat., ed. E. Castelnuovo and others; Turin, Pal. Madama, 1979)

E. Castelnuovo: 'Postlogium Jaquerianorum', *Rev. A.*, lii (1981), pp. 41–6

E. SAMUELS WELCH

Jaquotot, (Marie-)Victoire (*b* Paris, 15 Jan 1772; *d* Toulouse, 27 April 1855). French porcelain painter. She was employed until 1842 at the Sèvres factory where she worked initially as an anonymous painter of cups and plates in the cameo style but gradually became a renowned painter of coloured figures on porcelain plaques. While at Sèvres she received private commissions and trained pupils in her Paris studio.

The plaques ranged in size from 155×115 mm to 580×400 mm, and her work took two main forms. She was a skilled portrait painter, much sought after by the prominent figures of her time. She painted the *Emperor Napoleon* (1813; Paris, priv. col.), the *Vicomtesse de Senonnes* (1820; Paris, Mus. A. Déc.), *Mrs Patterson* (1818; Stratfield Saye House, Hants) and the *Countess of Woronzow* (1819; Stockholm, Nmus.). She also copied both Old Masters, such as Raphael's *La Belle Jardinière* (1816; Sèvres, Mus. N. Cér.), and contemporary painters, such as Girodet's *Danaë* (1827; Montpellier, Mus. Fabre) and Baron Gérard's *Psyche and Cupid* (1824; Sèvres, Mus. N. Cér.). Reproducing oil paintings on ceramics was not new but the idea of recording Europe's artistic heritage on porcelain received particular encouragement from Alexandre Brongniart, Director of the Sèvres factory. He perfected the art of casting large plaques in 1814, which enabled Jaquotot to work on a larger scale and develop her refined technique.

BIBLIOGRAPHY

R. Jean: 'Madame Victoire Jaquotot, peintre sur porcelaines: Un Chapitre de l'histoire de la manufacture de Sèvres', *Bull. Soc. Hist. A. Fr.* (1913), pp. 509–17

Raphaël & l'art français (exh. cat., Paris, Grand Pal., 1983), pp. 259–61

R. Ruckert: 'Marie-Victoire Jaquotot (1772–1855)', *Die Weltkunst*, ii/17 (1985), pp. 2352–8

ANNE LAJOIX

Jara, José (*b* Tecamachalco, nr Puebla, 1867; *d* Morelia, 1939). Mexican painter. In his early years as a student at the Escuela Nacional de Bellas Artes he produced history paintings on indigenous themes, as was then the custom. His *Foundation of Mexico City* (Mexico City, Mus. N.A.), for which he won first prize when it was exhibited at the Escuela in 1889, is subdued in colouring and painted in a meticulously detailed style; its almost photographic appearance presaged the move towards naturalism that dominated Mexican art in the 1890s. Jara also applied himself to regional folkloric painting, whose development was already being fostered in the Escuela Nacional de Bellas Artes. His *Funeral Wake* (Mexico City, Mus. N.A.), awarded a bronze medal when exhibited under the title *Burial of an Indian Man* in 1889 at the Exposition Universelle in Paris, treated a popular theme in an uplifting way thanks to its generous format and classic pyramidal composition. Jara continued portraying popular customs after moving in the 1890s to Morelia, where he taught drawing and painting at the local Escuela de Bellas Artes.

After considerably lightening his palette in the late 1890s, Jara began to concentrate more on landscapes, favouring intimate and unassuming rural scenes. Although small in scale, these pictures (e.g. Guadalajara, Xavier Torres Ladrón de Guevara priv. col.) have an intense luminosity and a rich texture that vigorously evoke the purely material beauty of the objects depicted, in a style more akin to that of Courbet and his followers than to that of the Impressionists.

BIBLIOGRAPHY

José Jara (1867–1939) (exh. cat., essays A. L. Roura and A. Castellanos, Mexico City, Mus. N.A., 1984)

FAUSTO RAMÍREZ

Jaramillo, Manuel Samaniego y. *See* SAMANIEGO Y JARAMILLO, MANUEL.

Jarché, James (*b* London, Sept 1890; *d* London, 6 Aug 1965). English photographer. He studied photography with his father from 1901 to 1904 while attending St Olave's Grammar School in London. From 1906 to 1907 he worked as a press photographer for the *Daily Telegraph* newspaper and in the latter year was a photographic apprentice at Argent Archer studios in London. He then worked as a press photographer for the World's Graphic Press Agency in London from 1908 to 1912, producing photographs such as *Blériot After Crossing the Channel* (1909; see Hopkinson, p. 224). He was a staff photographer for the *Daily Sketch* newspaper from 1912 to 1928, during which time he took photos such as *Marshal Foch, Lloyd George and Aristide Briand at Chequers* (1919; see Hopkinson, pp. 216–17). It was through these photographs of important personalities and events that he made his name on Fleet Street. Several of these early works appeared in his autobiography, *People I Have Shot* (1934).

Following his time at the *Daily Sketch* Jarché worked as a photographer for Odham's Press on the *Daily Herald* newspaper and the *Weekly Illustrated* magazine. He was chief cameraman of the *Daily Herald* in the early 1930s

and was the first Fleet Street photographer to make consistent use of the small 35mm camera. He was chief cameraman for the *Weekly Illustrated* from 1934 until 1938, when it became *The Illustrated*, carrying on in the same position until the latter's demise in 1957. He also worked for the *Daily Mail* from 1953 to 1959. During the interwar period he was perhaps the most celebrated of British photojournalists, capturing numerous images of life in England under the Depression.

PHOTOGRAPHIC PUBLICATIONS

People I Have Shot (London, 1934)

BIBLIOGRAPHY

Contemp. Phots

Thirties: British Art and Design Before the War (exh. cat., ed. J. Hawkins and M. Hollis; London, Hayward Gal., 1979), pp. 109–17, 247–64

T. Hopkinson: *Treasures of the Royal Photographic Society, 1839–1919* (London, 1980), pp. 38, 216–18, 224

Jardin, Karel du. *See* DU JARDIN, KAREL.

Jardin, Nicolas-Henri (*b* Saint Germain-des-Noyers, Seine-et-Marne, 22 March 1720; *d* Saint Germain-des-Noyers, 31 Aug 1799). French architect and teacher, active in Denmark. He trained at the Académie Royale d'Architecture in Paris from 1735 to 1741 and won the Prix de Rome. He lived in Rome between 1744 and 1747. With his fellow academicians Pierre-Martin Dumont, Louis-Joseph Le Lorrain, the sculptor Jacques-François-Joseph Saly and the painter Joseph-Marie Vien, Jardin took a new and imaginative approach to classicism and was greatly influenced by Piranesi. In 1754 Jardin was called to Denmark, on the instigation of Saly, to take over the design of the Frederikskirke after the death of the court architect, Niels Eigtved, whose Rococo project was now considered outmoded. Jardin's first design (1755) for the Frederikskirke had colonnades surrounding the whole of the square body and engaged towers, which had strange cylindrical layering, on the transverse axis; the dome surmounted a tall plain attic storey and dramatically stepped drum. The size and forms of this important project shocked the authorities, and they demanded modifications. The approved project of 1756 is much less radical and respects Eigtved's rotunda foundations, having more traditional Baroque forms. Dwindling funds hampered construction, however, which was finally halted in 1770. Jardin was dismissed, and the structure lay half-finished until it was completed to a modified design by Ferdinand Meldahl in 1894.

In 1757 Jardin remodelled the dining-room at Moltke House in Copenhagen (*see* DENMARK, fig. 14); with free-standing columns screening service areas at both ends and strictly compartmentalized walls and ceiling, it is one of the earliest Neo-classical interiors in Europe. The garden pavilion (*c.* 1760) is in the form of a domed, circular peripteral structure embedded in the angle of the garden walls, its façade articulated with clean-cut oval windows, urns and swags. He employed a similar conjunction of forms in the launching pavilion (1763) at the Naval Arsenal in Copenhagen and in the maison de plaisance (1759–65) for Count Bernstorff north of Copenhagen. Here the semi-projecting oval salon is tied into the façade of the compact block with horizontal rustication, in a neat,

characteristically French way. There is considerable stress on wall surface with tall, narrow windows and discreet decoration. The same effect is evident in the barracks (1765–9) of Sølvgade, Copenhagen, enriched only by the elegant, concave gate-wall.

Jardin created richer façades, with giant pilasters, in two remodellings, the villa of Marienlyst (1760–62), near Elsinore, which is reminiscent of Anges-Jacques Gabriel's Petit Trianon (1762), and Thott House (1763–4), Copenhagen, where a pediment with a scrolled escutcheon and cornucopias is characteristic of Jardin's rather drooping ornamental style. At the Yellow Palace (1764), Amaliegade 18, Copenhagen, the unifying rules laid down for the area by Eigtved in 1750 were disregarded; Jardin created a flamboyant façade for his *nouveau riche* patron, with a slightly incoherent surface pattern. Most of Jardin's interiors, however, displayed a cool, reticent style, while his rooms at Christiansborg Palace, which culminated in the huge, galleried ballroom, were more traditionally sumptuous. Jardin also made an important contribution to the development in Denmark of the formal French garden. Count Moltke's gardens at Marienlyst and Bregentved were early examples; but Jardin's magnificent plan for the remodelling at Fredensborg was only partly realized, in the Grand Avenue and Marble Garden.

Jardin had widespread influence in Denmark, both as professor at the newly founded School of Architecture and also through his employment of several of his pupils as assistants. During his 16 years as the leading architect in Denmark he elevated its old-fashioned provincialism to the peak of European Neo-classical style. In 1771 he was forced back to France by political upheavals, which were accompanied by antipathy to foreigners at the Academy.

BIBLIOGRAPHY

F. Meldahl: *Frederikskirken i København* (Copenhagen, 1896)

C. Elling: *Documents inédits concernant les projets de A.-J. Gabriel et N.-H. Jardin pour l'église Frédéric à Copenhague* (Copenhagen, 1931)

S. Eriksen: *Early Neo-classicism in France* (London, 1974)

A. Braham: *The Architecture of the French Enlightenment* (London, 1980)

HANNE RAABYEMAGLE

Jarema, Maria (*b* Stary Sambor, nr Kraków, 24 Nov 1908; *d* Kraków, 1 Nov 1958). Polish sculptor and painter. She studied at the Academy of Fine Arts, Kraków (1929–35), under Ksawery Dunikowski. She was a member of the radical left-wing KRAKÓW GROUP. Although during the 1930s sculpture was her main medium, only four early works survived World War II, among them a non-figurative, architectural tombstone, a monument to Kraków workers killed in riots in 1936. In *Nude* (1938) the forms are simple and almost abstract, somewhat reminiscent of Brancusi, but their interrelations are complex and elaborate. In her paintings this same simplicity of forms and motifs turns into richness of texture and compositional structure. Until World War II Jarema also acted, and she designed costumes for the painters' experimental theatre Cricot. Difficulties during the War forced her to abandon sculpture, and she later returned to it only occasionally.

Jarema took part in the first exhibition of modern art held in Kraków in 1948, the last and most important manifestation of the avant-garde prior to the dominance of Socialist Realism in 1949–55, when she abstained from

public exhibitions. Her most important works are those from the 1950s: the series of *Figures, Heads, Grasps, Utterances, Rhythms* and *Penetrations*, which are monotypes, distemper paintings or combinations of both. The light and transparent forms, which seem to dance and interpenetrate, are imbued with musical qualities. The pictorial use of counterpoint and abstract composition produces visual equivalents of motion, of balletic movement and of melody. In *Heads* and *Grasps* the form is anthropomorphic and allusive; elsewhere, through purely abstract means, it alludes, as in *Cracks*, to particular sounds. In 1957 Jarema joined the recently reactivated Kraków group, and in 1958 she had a one-woman show at the Venice Biennale.

BIBLIOGRAPHY
H. Blum: *Maria Jarema* (Kraków, 1965)
M. Porębski: *Maria Jarema* (Warsaw, 1968)
Maria Jarema, 1908–1958: Rzeźby, obrazy, rysunki [Maria Jarema, 1908–1958: sculptures, paintings, drawings] (exh. cat., ed. A. Kodurowa; Warsaw, N. Mus., 1978)

EWA MIKINA

Jareño y Alarcón, Francisco (*b* Albacete, 24 Feb 1818; *d* Madrid, 8 Oct 1892). Spanish architect and teacher. He initially embarked on an ecclesiastical career, which he abandoned in 1844 in order to enter the newly founded Escuela de Arquitectura, Madrid. He completed his studies in 1848 and established himself as an architect in 1852, after travel in Europe on a fellowship. In 1855 he was appointed to a professorship in the Escuela de Arquitectura to teach art history. Stylistically, he was influenced by the shifting tastes of the period, ranging from an initial adherence to classicism to a version of eclecticism that incorporated neo-*Mudéjar* and neo-Gothic elements. His most ambitious work is the Palacio de Bibliotecas y Museos (1866–92; now the Biblioteca Nacional y Museo Arqueológico Nacional; *see* SPAIN, fig. 9), Madrid. Although the plans were altered somewhat by his successor, Antonio Ruiz de Salces, the building preserves Jareño's intention to create a monumental work, with neo-Hellenic forms influenced by Schinkel, using luxurious materials and abundant interior ironwork. In 1867 Jareño became a member of the Real Academia de Bellas Artes de San Fernando, giving as his acceptance speech a talk entitled 'De la arquitectura policromática', and in 1874–5 he was Director of the Escuela de Arquitectura. He received numerous honours, his Hospital del Niño Jesús (1879), Madrid, earning international recognition in various exhibitions.

BIBLIOGRAPHY
J. A. Gaya: *Arte del siglo XIX* (Madrid, 1966)
P. Navascués: *Arquitectura y arquitectos madrileños del siglo XIX* (Madrid, 1973)
P. Navascués and others: *Del Neoclasicismo al Modernismo* (Madrid, 1979)

ALBERTO VILLAR MOVELLÁN

Jarmo. Prehistoric site in the Zagros mountains in northeast Iraq, *c.* 45 km east of Kirkuk. It flourished *c.* 6800–6000 BC and was one of the earliest village-farming settlements in the Ancient Near East. The site (1.3 ha) yielded a wide range of artefacts, including stone vessels, pottery and clay figurines (Baghdad, Iraq Mus.; U. Chicago, IL, Orient. Inst. Mus.). It was excavated by R. J. Braidwood as part of the multi-site Iraq–Jarmo Prehistoric Project

(1948, 1950–51, 1955). Twelve building levels were found. Houses were small, less than 36 sq. m in total area, and consisted of several small rectilinear rooms with *tauf* (packed mud) walls on stone foundations. Clay floors were laid over a thin layer of reeds; some rooms had partial cobble pavements (*see also* MESOPOTAMIA, §II, 1). Fine ground stone vessels, mostly bowls of varied shapes, characterized the early levels; other ground stone artefacts included personal ornaments and tools. Handmade buff pottery with simple shapes, such as rounded or carinated bowls and pots, first appeared in the later levels. The earlier pottery had a burnished slip or simple linear painted decoration; the later pottery was coarser and more friable (*see also* MESOPOTAMIA, §V, 1). Numerous unbaked clay figurines, both human and animal, were found, in styles ranging from the naturalistic to the schematic. Most human figurines were female, with both heavily pregnant and schematic, slender types. Identifiable animals included domesticated sheep, goats and dogs, and wild pigs. Bone awls, needles, spoons and jewellery occurred. The chipped stone assemblage consisted of both flake and blade tools, including microliths.

See also MESOPOTAMIA, §I, 2(i)(b).

BIBLIOGRAPHY
R. J. Braidwood and B. Howe: *Prehistoric Investigations in Iraqi Kurdistan*, Studies in Ancient Oriental Civilization, 31 (Chicago, 1960)
L. S. Braidwood and others, eds: *Prehistoric Archaeology along the Zagros Flanks*, Oriental Institute Publication 105 (Chicago, 1983)

ROBERT C. HENRICKSON

Järnefelt, Eero [Erik] **(Nikolai)** (*b* Viipuri [now Vyborg, Russia], 8 Nov 1863; *d* Helsinki, 15 Nov 1937). Finnish painter. He came from a Swedish-speaking Finnophile family of artists, writers and composers descended from the Baltic aristocracy. He studied at the Academy of Art in St Petersburg (1883–6) under his uncle Mikhail Klodt (1832–1902), and at the Académie Julian in Paris (1886–91). In Paris he embraced the *plein-air* naturalism favoured by Jules Bastien-Lepage and Pascal-Adolphe-Jean Dagnan-Bouveret, among others, as well as by Järnefelt's fellow countryman Albert Edelfelt. He then became interested in the problem of the depiction of light in *plein-air* painting, as in *Lefranc, Wine Merchant, Boulevard de Clichy, Paris* (1888; Helsinki, Athenaeum A. Mus.). The depiction of Finnish folk themes in a *plein-air* style, however, is most typical of his work of the 1880s, for example *Boat from Savo* (1888; Hämeenlinna, A. Mus.; see fig.), which won him a gold medal at the Exposition Universelle in Paris in 1889.

Järnefelt was an extremely important portrait painter. In his portraits of the 1880s he concentrated on showing his subjects in realistic and familiar settings. Among the most striking are those of *Dean H. G. T. Brofeldt* (1888; Espoo, Riitta Juva priv. col., see 1985 exh. cat., p. 131), *Professor Johan Philip Palmén* and of the artist's father-in-law *C. G. Swan* (both 1890; Helsinki, Athenaeum A. Mus.), in which the subject is seen obliquely from the rear, so that his surroundings rather than the man himself provide our image of him.

At the beginning of the 1890s Järnefelt, who had been brought up on the borders of Karelia, became inspired by the Karelian movement, which was founded on the belief

Eero Järnefelt: *Boat from Savo*, oil on canvas, 1.60×0.82 m, 1888
(Hämeenlinna, Hämeenlinna Art Museum)

that the ancient origins of Finland's national epic, the
Kalevala, lay in that region. Järnefelt, along with artists
such as Akseli Gallen-Kallela, Järnefelt's brother-in-law
the composer Jean Sibelius and the writer Juhani Aho,
wandered deep into Karelia in an attempt to discover the
people and landscapes of Finland in their most natural
form. In eastern Finland Järnefelt discovered the untamed
landscapes of the Koli region. In the same spirit he painted
the folk-singer *Larin Paraske* (1893; priv. col., see Wen-
nervirta, p. 163) singing a lament. Järnefelt strove to
represent nature according to the tenets of Realism.
However, even in his early Karelian paintings, there are
traces of the Romanticism that emerged in the 1890s and
that took the form of National Romanticism in Finland.
He was never attracted by Symbolism, although his style
in this period shows clear evidence of a more Synthetist
tendency: he gave greater importance to outlines and
applied colour in more even tones, not least in his portraits,
which at this period lost their settings. Some of his most
expressive portraits date from the 1890s, such as those of
Mathilda Wrede (1896; Helsinki, Athenaeum A. Mus.) and
J. R. Danielson-Kalmari (1896; Helsinki, Hämäläis Stu-
dents' Un.).

In 1893 Järnefelt produced one of his most famous
paintings, *The Wage Slaves (Burn Beating)* (Helsinki,
Athenaeum A. Mus.). Its theme is the felling of trees for
burning, a traditional practice designed to enrich the soil
for cultivation. The painting shows several Finns bent
over their task amid the burning wood and brush. In the
background is the bluish gleam of a typically Finnish lake.
The work provoked a range of interpretations: some saw

it as an example of straightforward Realism, while others
saw it as an expression of pathos, or even as an idealistically
symbolic image of the spirit and resilience of the Finnish
nation. Painted towards the end of the 19th century,
Järnefelt's large-scale panoramas of Koli, for example *Koli*
(1.61×1.97 m, 1899; Helsinki, Athenaeum A. Mus.),
convey the same message. They are silent protests against
the increasingly repressive rule of the Russian authorities,
and assertions of Finnish independence. Despite such
sentiments Järnefelt shunned the more radical tendencies
in both Realism and Symbolism. He was not attracted by
the enthusiasm for pure colours that dominated Finnish
art around 1910. He preferred to pursue steadily his own
rather conservative line for the rest of his life. Widely
known as a portrait painter, he continued to produce
landscapes, for example a series of Italian landscape
gouaches in the 1920s and 1930s.

BIBLIOGRAPHY
L. Wennervirta: *Eero Järnefelt* (Helsinki, 1950)
*Northern Light: Realism and Symbolism in Scandinavian Painting, 1880–
 1910* (exh. cat., New York, Brooklyn Mus., 1982)
1880-tal i nordiskt måleri [The 1880s in Nordic painting] (exh. cat.,
 Stockholm, Nmus., 1985)
Dreams of a Summer Night (exh. cat., London, ACGB, 1986)
 SALME SARAJAS-KORTE

Jarnuszkiewicz, Jerzy (*b* Kalisz, 27 Feb 1919). Polish
sculptor. He studied at the School of Decorative Art and
Industrial Crafts, Kraków (1936–8), the Municipal School
of Decorative Arts and Painting, Warsaw (1938–9), and
the Academy of Fine Arts, Warsaw (1946–50), with
Tadeusz Breyer (1884–1952) and Franciszek Strynkiewicz
(*b* 1893). From 1950 to 1985 Jarnuszkiewicz taught sculp-
ture at the Academy of Fine Arts, Warsaw.

Jarnuszkiewicz's early work is connected with the period
of Socialist Realism in Polish art. At that time he produced
sculptural groups of soldiers (1950) at the Cemetery-
Mausoleum for Soviet Soldiers in Warsaw as well as reliefs
of working people (1952) on the buildings of the Mar-
szałkowska Residential District in Warsaw. By the late
1950s, Jarnuszkiewicz began to work in metal (e.g. a series
of openwork structures entitled *Windows*) and to engage
in close cooperation with the architect Oskar Hansen (e.g.
the joint design by Jarnuszkiewicz, Hansen and the graphic
artist Julian Pałka (*b* 1923) of the international monument
(1957) to the memory of the victims of Fascism in the
Auschwitz concentration camp). During the 1970s and
1980s, Jarnuszkiewicz returned to representative, realistic
sculpture (e.g. the monument to the Pope and the Primate,
1983, in the courtyard of the Catholic University of
Lublin, or metaphoric sculpture (e.g. the series *Muzzles*,
1973–8). Jarnuszkiewicz had great success as a teacher,
cooperating with Hansen and utilizing the latter's concept
of the Open Form. Many sculptors made a start in
Jarnuszkiewicz's studio, including Maciej Szańkowski,
Grzegorz Kowalski, Karol Broniatowski and Krzysztof
Bednarski. His studio was connected, especially during the
1960s and 1970s, to the growth in Poland of performance
art and conceptual art.

BIBLIOGRAPHY
25 lat pracy pedagogicznej Jerzego Jarnuszkiewicza [25 years of the pedagog-
 ical work of Jerzy Jarnuszkiewicz] (exh. cat., Warsaw, Cent. Office A.
 Exh.; Warsaw, Zachęta Gal.; 1975)

W Kregu pracowni Jarnuszkiewicza [In the sphere of Jarnuszkiewicz's studio] (exh. cat., Warsaw, Mus. Acad. F.A., 1985)

WOJCIECH WŁODARCZYK

Jarry, Alfred (*b* Laval, 8 Sept 1873; *d* Paris, 1 Nov 1907). French writer. While at school in Rennes (1888–91) he developed a caricature of a grotesque figure of Stupidity, which he named Ubu, based on a teacher. On arriving in Paris to prepare for the entrance examination to the Ecole Normale Supérieure (1891–3), he became involved in Symbolist circles and with the review *Le Mercure de France*. He frequented literary salons, especially those of Stéphane Mallarmé and the *Mercure*. In 1894, with REMY DE GOURMONT, he founded a luxurious review of art, *L'Ymagier*, which proposed to resuscitate the popular imagery of Epinal prints and of Troyes, and which appealed to contemporary artists such as Emile Bernard and Henri Rousseau. He then edited *Perhinderion*, a print publication for which he specially cast ancient typographical characters. He mixed with the painters of Pont-Aven and defended Charles Filiger in *Le Mercure de France*.

Jarry directed his efforts towards the historic first performance of his play *Ubu Roi* at the Théâtre de l'Oeuvre in December 1896. He befriended Paul Sérusier, Pierre Bonnard, Paul Ranson and Edouard Vuillard, who collaborated on the scenery of the play, a single canvas backdrop intended as a synthesis of all possible landscapes in all climates. Jarry's achievement, in rejecting the naturalist vision of the theatre along with Symbolist abstraction, was to discover in the staging of *Ubu* a new path, which would later issue in the new theatre of the 1950s. *Ubu Roi* is regarded as the first work in the theatrical movement later called Theatre of the Absurd. Jarry's principles of absurdity, incoherence and anarchic behaviour coalesced in the figure of Ubu, who reappeared in multiple incarnations until the end of Jarry's life. Jarry represented him graphically, sometimes in bourgeois moustache with small round hat, dressed in a grey costume, sometimes in a huge balloon, his head in the form of a pear, covered with a greatcoat 'in philosophic wool', with a spiral stamped on his belly.

Jarry's narratives, which are extremely concentrated and discontinuous, develop this logic of the absurd and also often evoke the imaginary universe of contemporary artists such as Toulouse-Lautrec, Bonnard and Aubrey Beardsley. His novels continue the same absurdist principles ('la pataphysique') as outlined in *Gestes et opinions du Dr Faustroll, pataphysicien* (complete edn Paris, 1911), for example the principle of the equivalence of opposites and the confluence of dream and conscious thought. His numerous articles, published in *La Revue blanche* under the title of 'Spéculations' and later collected in *La Chandelle verte* (Paris, 1963), provide evidence of his originality and his ability to transform the mundane universe with verbal games and a rigorously applied irrational logic, later adopted and extended by Dada and Surrealism. Jarry succeeded in uniting his life and his writings to such an extent that his contemporaries took him for Ubu, but his last, unfinished, novel, *La Dragonne*, which blends universal myths in a curious syncretism, marks a return to tradition and testifies to his control.

WRITINGS
Oeuvres complètes, 3 vols (Paris, 1972–88)

BIBLIOGRAPHY
M. Arrive: *Les Langages de Jarry: Essai de sémiotique littéraire* (Paris, 1972)
F. Caradec: *A la recherche d'Alfred Jarry* (Paris, 1974)
N. Arnaud: *Alfred Jarry, d'Ubu roi au Dr Faustroll* (Paris, 1976)
H. Béhar: *Jarry dramaturge* (Paris, 1980)
K. Beaumont: *Alfred Jarry: A Critical and Biographical Study* (Leicester, 1984)
H. Bordillon: *Gestes et opinions d'Alfred Jarry écrivain* (Laval, 1986)
H. Béhar: *Les Cultures de Jarry* (Paris, 1988)

HENRI BÉHAR

Jarry, Nicolas (*b* ?Paris, *c.* 1605–10; *d* ?Paris, before 18 Sept 1666). French calligrapher. He is known from the baptismal record of his son (26 April 1637) to have held the appointment of Noteur de la Musique du Roy. Works ascribed to him (107 according to Portalis, 46 according to Brunet) include books of prayers and devotion as well as secular manuscripts, most of them intended for such prestigious patrons as Louis XIV, his mother Anne of Austria (1601–66), Cardinal de Richelieu and various other notables. Jarry's earliest known manuscript is probably the *Preparatio ad missam* (octavo, 1633), made for Dominique Séguier, Bishop of Meaux; in 1639 he executed the folio *Preparatio ad missam*, bound with the arms of Cardinal de Richelieu, and in 1640, the *Psaultier de Jésus contenant de très dévotes prières* (octavo; Paris, Bib. N., MS. fr. 14851) either for Nicole, Duchesse de Lorraine (*d* 1657), or more likely, for her sister (and sister-in-law) Claude de Lorraine. Outstanding among the many volumes that Jarry produced is *La Guirlande de Julie* (100 vellum leaves, folio, 1640; French priv. col.). It is a collection of poems composed by frequenters of the salon of Catherine de Vivonne, Marquise de Rambouillet, and ornamented with paintings; it was commissioned by Charles Montausier, Duc de Sainte-Maure (1610–90), as a name-day present to Julie Lucine d'Angennes, the Marquise's daughter, with whom he was in love. The 61 madrigals in the volume allude to the 29 flowers each painted on a separate leaf of vellum by Nicolas Robert and also displayed in a single wreath at the head of the volume. Jarry made two copies of *La Guirlande*, which is considered a masterpiece of taste, preciosity and gallantry: an octavo volume of 40 leaves and a quarto volume of 43 paper leaves (both 1641); these are without the paintings. Other notable works by Jarry include an Italian poem, *La prigione di Filindo il Constante* (folio, 1643; Paris, Bib. N., MS. it. 578); *Le Temple de la Gloire, où l'on peut voir les éloges et les portraits des illustres princesses de l'auguste Maison d'Austriche qui ont porté le nom Anne* (folio, 1647; Paris, Bib. Mazarine, no. 2212) for Anne of Austria; Jean de La Fontaine's poem *Adonis* (folio, 1658; Paris, Petit Pal.) for Nicolas Fouquet, Surintendant des Finances; and the *Poésies de Tristan l'Hermite* (quarto, n.d.; Paris, Bib. N., MS. fr. 14981), a collection of poems addressed to Gaston, Duc d'Orléans, brother of Louis XIII. All these works bear testimony not only to the accuracy and clarity that Jarry brought to his script, both letters and music, but to the beauty of the whole. In an age when printing was supplanting calligraphy, the profusion and quality of his work and the high rank of those who commissioned it confirm Jarry's reputation as the most celebrated calligrapher of the 17th century.

BIBLIOGRAPHY

Abbé J.-J. Rive: *Notices historiques & critiques de deux manuscrits uniques & très précieux: 'La Guirlande de Julie'* (Paris, 1779), pp. 1–14

J. C. Brunet: *Manuel du libraire & amateur de livres*, iii (Paris, 1862), cols 511–15; i, suppl. (1878), cols 692–3; ii, suppl. (1880), col. 1043

R. Portalis: *Nicolas Jarry et la calligraphie au XVIIème siècle* (Paris, 1896)

C. de Saint-Aymour: 'Un Document concernant Nicolas Jarry célèbre calligraphe du XVIIème siècle', *Bull. Soc. Hist. Paris & Ile-de-France*, xliv (1917), pp. 41–3

ALEXANDRA SKLIAR-PIGUET

Jarvis, Charles. *See* JERVAS, CHARLES.

Jarvis, John Wesley (*bapt* South Shields, nr Newcastle upon Tyne, 1 July 1781; *d* New York, 12 Jan 1840). American painter of English birth. He grew up in Philadelphia, PA, where he knew many of the city's resident artists and was apprenticed to Edward Savage, whom he remembered as an 'ignorant beast . . . not qualified to teach me any art but that of deception' (Bolton and Groce, pp. 299–300). Jarvis cultivated a formidable natural artistic talent through his own efforts. By 1802 he was established in New York as an engraver and very soon thereafter formed a profitable portrait business with Joseph Wood (*c.* 1778–1830). In 1807 he opened his own studio and from then on was a proficient and celebrated society painter, numbering many statesmen and such writers as Washington Irving among his patrons.

As Jarvis was essentially self-taught, his work lacks a certain grace and finesse, and his style is more vigorous than refined. Yet his finest works are visually lively, and his acutely objective approach reveals much of the sitter's temperament and personality. In his full-length portrait of *Daniel D. Tompkins* (New York, NY Hist. Soc.) the beautifully painted figure and dramatic sky suggest the authority and energy that Tompkins brought to his political career. Many of Jarvis's portraits capture a spirit of national pride and optimism characteristic of this period of American history; that of *Samuel Chester Reid* (1815; Minneapolis, MN, Inst. A.) shows a hero of the War of 1812, poised on the deck of his ship engaged in battle, as an embodiment of courage and command. Jarvis's only known sculpture, a plaster bust of *Thomas Paine* (New York, NY Hist. Soc.), is naturalistically and dramatically modelled.

Jarvis's considerable artistic and social skills made him the most sought after and wealthiest portrait painter in America during the first quarter of the 19th century. Besides working in his New York studio, where John Quidor and Henry Inman were among his apprentices, he made frequent painting excursions to Boston, MA, Baltimore, MD, Washington, DC, New Orleans, LA, and elsewhere. He exhibited in New York at the National Academy of Design and regularly at the American Academy of Fine Arts (1816–33). Having had an undisciplined lifestyle and having suffered a stroke in 1834, he died in penury.

BIBLIOGRAPHY

T. Bolton and G. C. Groce: 'John Wesley Jarvis: An Account of his Life and the First Catalogue of his Work', *A. Q.* [Detroit], i (1938), pp. 299–321

H. E. Dickson: 'John Wesley Jarvis: Knickerbocker Painter', *NY Hist. Soc. Q.*, xxiv/2 (1940), pp. 47–64

——: *John Wesley Jarvis, American Painter, 1780–1840* (New York, 1949)

JOHN DRISCOLL

Jasna Góra monastery. *See under* CZĘSTOCHOWA.

Jasoku. *See under* SOGA.

Jasokuken. *See* KANŌ, (10).

Jaspar, (Dieudonné) Paul (*b* Liège, 23 June 1859; *d* Liège, 18 Feb 1945). Belgian architect. He attended courses in drawing and architecture at the Académie Royale des Beaux-Arts in Liège and then at the Académie Royale des Beaux-Arts in Brussels, where he was a fellow student of Victor Horta and Paul Hankar. With the latter, his future brother-in-law, he entered Henri Beyaert's studio in 1879, and there he received a training based on the precepts of Eugène Viollet-le-Duc. In 1884 he settled in Liège and began building houses in a spirit that was very close to the Art Nouveau works of Hankar in Brussels. In 1905 he erected two public buildings in Liège whose daring method of construction placed him among the architectural avant-garde. The Galeries Liègeoises department store (destr. *c.* 1950) used glazing and a visible steel framework to produce the effect of a seven-storey glass cage. In contrast, the Renommée public hall (destr. *c.* 1950) was one of the first large buildings in the world constructed in exposed reinforced concrete; its vast hall was covered by three reinforced-concrete, thin-shell domes, 15 m in diameter, supported by arches arranged in fascicles. Jaspar later turned increasingly towards archaeology, arts and crafts and to the traditional architecture of the Meuse region, subjects in which he specialized. Subsequently he made notable attempts to reconcile traditional Meuse forms with new materials. After World War I he took part in the reconstruction of towns by reinterpreting regional traditions, notably at Dinant and Visé. He founded the Musée d'Architecture de la Ville (1916) and the Musée de la Vie Wallonne (1917), both in Liège.

UNPUBLISHED SOURCES

Brussels, Archvs Arch. Mod. [autobiography]

WRITINGS

Du Vieux, du Neuf (Liège, 1898, rev. 1907)

BIBLIOGRAPHY

V. G. Martiny: 'Notice sur Dieudonné Paul Jaspar', *Annu. Acad. Royale Belgique/Jb. Kon. Acad. Belgïe*, cxliii (1977), p. 76

MARIE DEMANET

Jasulaitis. *See* WEST, MARGARET.

Jauch, Joachim Daniel (*b* Saxony, 1684; *d* Warsaw, 3 May 1754). German architect, active in Poland. He began his career in Dresden, where he was noted in 1705 as a lieutenant in the Saxon Engineering Corps. He moved to Warsaw in 1714 and was in charge of the Royal Office of Works from 1715 to 1754 for Augustus II and Augustus III, successive monarchs of the Wettin dynasty. In the light of recent research, Jauch should be primarily regarded as an organizer of building works. As such, he was in charge of the most important royal works in and around Warsaw, including the large urban planning projects known as the Saxon and the Ujazdów schemes. In 1734 Jauch designed the chapel in the Saxon Palace (rebuilt 1838–42; destr. 1939–44), and in 1724–31 he designed the Ujazdów Calvary, a Way of the Cross with chapels of the Passion, the columns and crosses of which have been

preserved at Plac Trzech Krzyży (Three Crosses Square). Part of the scheme was later transformed into Ujazdowskie Avenue, which is still one of Warsaw's most important thoroughfares. In 1736 Jauch built the royal chapel in the Capuchin church in Miodowa Street, while in 1751–6 he built the church of St Lawrence in the Wola suburb. The buildings and architectural decorations that he designed represent a modest variation on the late Baroque theme that was mandatory in Warsaw and Dresden in the second quarter of the 18th century. Jauch's drawings are preserved in the Staatsarchiv, Dresden.

BIBLIOGRAPHY
W. Hentschel: *Die sächsische Baukunst des 18. Jahrhunderts in Polen* (Berlin, 1967); review by Z. Bieniecki in *Biul. Hist. Sztuki*, xxxii (1970), pp. 352–9
S. Lorentz and J. Durko: 'Dyskusja nad książką Waltera Hentschla "Saskie budownictwo XVIII w. w Polsche"' [A discussion of Walter Hentschel's book "Saxon architecture of the 18th century in Poland"], *Biul. Hist. Szt.*, xxxii (1970), no. 3/4, pp. 349–51

ANDRZEJ ROTTERMUND

Jaunpur. Town *c.* 58 km north-west of Varanasi in Uttar Pradesh, India. Founded by Firuz Shah Tughluq (*reg* AD 1351–88) in 1359 and completed by his half-brother Malik Ibrahim, it was built on the bank of the Gumti River and became a stronghold of the Delhi Sultanate against the Sultans of Bengal. It was constructed on an Islamic plan, with a fort set at one side of a walled town. Much of the old street layout of Jaunpur has been preserved, although the town walls have been demolished. The ramparts and parts of the fort date from the time of Firuz Shah; the walls were restored during the Mughal period (1526–1858). Inside the fort, the Qal'a Masjid (1376) consists of a prayer-hall with three domed bays, the façade having a central arch flanked by flat-roofed colonnades. The columns of the outer row are in pairs, a characteristic both of the Tughluq period (1320–1413) and of the later architecture of Jaunpur.

On the disintegration of the Tughluq empire, a governor of Jaunpur, Khwaja Jahan (1394–8), declared its independence and founded the Sharqi Sultanate, and in the absence of a rich and powerful court in Delhi, Jaunpur soon became a centre of art and learning in north India. A number of illustrated manuscripts of this period from Jaunpur provide rare examples of north Indian sultanate miniatures (*see* INDIAN SUBCONTINENT, §V, 3(ii)(b)). The earliest building of the Sharqi Sultans is the impressive Atala Masjid (1377–1404; *see* INDIAN SUBCONTINENT, fig. 89). Built with material taken from earlier temples, the mosque is a colonnaded structure constructed around a central courtyard; on the exterior (except for the qibla wall) a series of chambers is surmounted by a colonnade. Prominent features of the building are the three gateway screens in front of the prayer-hall; the central screen is three times higher than the colonnade, hiding the massive dome behind. This type of screen, with a large central arch flanked by tapered square towers, became a distinctive feature of Sharqi architecture and can be found in such other Jaunpur mosques as the partly ruined Khalis Mukhlis Masjid (*c.* 1430), the La'l Darvaza Masjid (*c.* 1450) and the Jhanjhri Masjid (*c.* 1430). Of the last, only the gateway screen, bearing finely carved ornament and Islamic inscriptions, survives. The latest Sharqi building is the Jami'

Masjid (*c.* 1470) of Husayn Shah (*reg* 1458–79), which is similar to the Atala Masjid but on a much grander scale.

The Sharqi kingdom came to a violent end in 1477, when the Delhi Sultan Sikandar Lodi took over and in an act of revenge destroyed all the town's monuments except the mosques noted above. The town, however, revived under the MUGHAL dynasty, and the fort was restored with newly constructed gates. An impressive structure of this time is a bridge (1564–8) built by the governor Mun'im Khan. Inside the fort are a number of Mughal buildings, including a bathhouse.

See also INDIAN SUBCONTINENT, §III, 6(ii)(b).

BIBLIOGRAPHY
Archaeol. Surv. India, Rep., xi (1880), pp. 102–26
A. Führer and E. W. Smith: *The Sharqi Architecture of Jaunpur*, Archaeol. Surv. India, New Imp. Ser., i (Calcutta, 1889)
J. Marshall: 'The Monuments of Muslim India', *The Cambridge History of India*, iii (Cambridge, 1928), pp. 625–9
P. Brown: *Indian Architecture (Islamic Period)* (?Bombay, [1942] 1956), pp. 42–6

NATALIE H. SHOKOOHY

Jaussely, Léon (*b* Toulouse, 9 Jan 1875; *d* Givry, Saône et Loire, 28 Dec 1932). French architect and urban planner. He entered the Ecole des Beaux-Arts in Toulouse in 1890, before leaving for Paris where he was awarded the Premier Grand Prix de Rome in 1903. He was one of the generation of students from the Ecole des Beaux-Arts whose passionate interest in 'urban art' led them to found the Société Française des Architectes Urbanistes in 1913. In 1905, while he was at the Académie de France in Rome (where he studied the forum of Pompeii), Jaussely won the competition and the commission for the planned expansion of Barcelona; he travelled to the Catalan capital to put the finishing touches to his design. In 1910 he took part in a competition for the extension plans of Berlin. The designs Jaussely submitted in 1919 for the competition for the expansion of Paris, which he developed in collaboration with Roger-Henri Expert and Louis Sollier (1885–1957), were intended to make the capital and its surrounding area into a 'unique economic organism'; despite being unrealized, they influenced later work, and Jaussely received the first prize.

Devoted to making urban planning a 'science', and a pioneer of the idea and practice of zoning, Jaussely developed expansion designs during the 1920s for Carcassonne, Pau, Vittel and Grenoble, where he was chief architect for the Exposition Internationale de la Houille Blanche et du Tourisme in 1925. He developed an ambitious and subtle expansion plan for Toulouse and a garden city for the neighbouring town of Muret. He became President of the Société Française des Architectes Urbanistes and taught at the Ecole des Beaux-Arts and the Institut d'Urbanisme of Paris University where he introduced a course in urban design. At the same time he designed a number of post offices and the Musée des Arts Africains at the Exposition Coloniale (now Musée National des Arts Africains et Océaniens) in Paris, on which he worked with Albert Laprade from 1929 to 1931.

BIBLIOGRAPHY
M. Torres i Capell, ed.: *Inicis de la urbanística municipal de Barcelona* (Barcelona, 1985)

R. Papillault: *L'Urbanisme comme science ou le dernier rêve de Léon Jaussely* (diss., Paris, Ecole Archit. Paris-La Villette, 1990)

JEAN-LOUIS COHEN

Java. *See under* INDONESIA.

Javacheff, Christo. *See* CHRISTO AND JEANNE-CLAUDE.

Jawlensky, Alexei [Yavlensky, Aleksey (Georgevich); Alexis; Alexej von] (*b* Torzhok, Russia, 26 March 1864; *d* Wiesbaden, 15 March 1941). Russian painter and printmaker, active in Germany. When he was ten, his family moved to Moscow. Following family tradition, he was originally educated for a military career, attending cadet school, and, later, the Alexander Military School in Moscow. However, while still a cadet, he became interested in painting. At the age of 16, he visited the Moscow World Exposition, which had a profound influence on him. He subsequently spent all of his leisure time at the Tret'yakov State Gallery, Moscow. In 1884 he was commissioned as a lieutenant in the Samogita Infantry–Grenadier's Regiment, based in Moscow. In 1889 he transferred to a regiment in St Petersburg, and later enrolled in the Academy of Art (1889–96), where he was a student of Il'ya Repin. Indeed his works of this period reflected some of the conventions of Realism (e.g. *W. W. Mathé Working*, 1892; St Petersburg, Rus. Mus.). Seeking to escape the limitations on expression exhorted by the Russian art establishment, in 1896 Jawlensky and his colleagues Igor Grabar, Dmitry Kardovsky and MARIANNE WEREFKIN moved to Munich to study with Anton Ažbe. Here he made the acquaintance of another expatriate Russian artist,

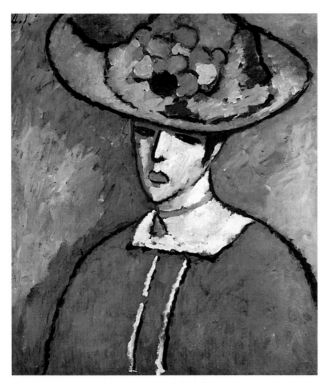

Alexei Jawlensky: *Schokko with a Wide-brimmed Hat*, oil on board mounted on canvas, 750×650 mm, 1910 (New York, private collection)

Vasily Kandinsky. In Munich Jawlensky began his lasting experimentation in the combination of colour, line, and form to express his innermost self (e.g. *Hyacinth*, c. 1902; Munich, Lenbachhaus).

In the early years of the 20th century, backed by the considerable wealth of his companion Werefkin, Jawlensky spent his summers travelling throughout Europe, including France, where his works were exhibited in Paris with the Fauves at the Salon d'Automne of 1905. Travelling exposed him to a diverse range of artists, techniques, and artistic theories during a formative stage in his own career as a painter. His work, initially characterized by simplified forms, flat areas of colour and heavy black outlines, was in many ways a synthesis of the myriad influences to which he was exposed. As well as the influence of Russian icons and folk art, Ažbe imparted a sense of the importance of line and colour. In Paris, Jawlensky became familiar with the works of Vincent van Gogh, and some of his paintings reflect elements of van Gogh's technique and approach to his subject-matter (e.g. *Village in Bayern (Wasserburg)*, 1907; Wiesbaden, Mus. Wiesbaden). In particular his symbolic and expressive use of bright colour was more characteristic of van Gogh and Paul Gauguin than of the German Expressionists, with whom he had the greatest contact. In 1905 Jawlensky visited Ferdinand Hodler, and two years later he began his long friendship with Jan Verkade and met Paul Sérusier. Together, Verkade and Sérusier transmitted to Jawlensky both practical and theoretical elements of the work of the Nabis, and Synthetist principles of art. The Theosophy and mysticism of the Nabis, with their emphasis on the importance of the soul, struck a responsive chord in Jawlensky, who sought in his art to mirror his own inner being. The combination of technique and spirituality characteristic of these movements, when linked to Jawlensky's own experience and emerging style, resulted in a period of enormous creativity and productivity.

Between 1908 and 1910 Jawlensky and Werefkin spent summers in the Bavarian Alps with Kandinsky and his companion Gabriele Münter. Here, through painting landscapes of their mountainous surroundings (e.g. Jawlensky's *Summer Evening in Murnau*, 1908–9; Munich, Lenbachhaus), they experimented with one another's techniques and discussed the theoretical bases of their art. In 1909 they helped to found the NEUE KÜNSTLERVEREINIGUNG MÜNCHEN (NKVM). After a break-away group formed the BLAUE REITER in 1911, Jawlensky remained in the NKVM until 1912, when works by him were shown at the Blaue Reiter exhibitions. During this period he made a vital contribution to the development of Expressionism (*see* EXPRESSIONISM, §1). In addition to his landscapes of this period, Jawlensky also produced many portraits. Like all of his work, his treatment of the human face and figure varied over time. In the years preceding World War I, for example, Jawlensky produced portraits of figures dressed colourfully (e.g. *Schokko with a Wide-brimmed Hat*, 1910; see fig.) or even exotically (e.g. *Barbarian Princess*, 1912; Hagen, Osthaus Mus.). However, following a trip to the Baltic coast, and renewed contact with Henri Matisse in 1911 and Emil Nolde in 1912, Jawlensky turned increasingly to the expressive use of colour and form alone in his portraits. He often stripped from his art the distraction of

brightly coloured apparel to emphasize the individual depicted and the artist's own underlying state of mind (e.g. *Head of a Woman*, 1912; Berlin, Alte N.G.).

This dynamic period in Jawlensky's life and art was abruptly cut short by the outbreak of World War I. Expelled from Germany in 1914, he moved to Switzerland. Here he began *Variations*, a cycle of landscape paintings of the view from his window at isolated St Prex on Lake Geneva. The works in this series became increasingly abstract and were continued long after he had left St Prex (e.g. *Variation*, 1916; and *Variation No. 84*, 1921; both Wiesbaden, Mus. Wiesbaden). In ill-health he spent the end of the war in Ascona. While in St Prex, Jawlensky had first met Galka Scheyer, a young art student who was captivated by his works. Scheyer's expressions of admiration and support reinvigorated Jawlensky's art and (with less success) his finances, first by embracing his theoretical and stylistic tenets, and later by promoting his work in Europe and the USA.

After a hiatus in experimentation with the human form, Jawlensky produced perhaps his best-known series, the *Mystical Heads* (1917–19), and the *Saviour's Faces* (1918–20), which are reminiscent of the traditional Russian Orthodox icons of his childhood. In these works he attempted to further reduce conventional portraiture to abstract line, form and, especially, colour (e.g. *Head of a Girl*, 1918; Ascona, Mus. Com. A. Mod.; and *Christ*, 1920; Long Beach, CA, Mus. A.). In 1921 he began another cycle in the same vein, his *Abstract* (sometimes called *Constructivist*) *Heads* (1921–35), for example *Abstract Head: Red Light* (1930; Wiesbaden, Mus. Wiesbaden). His graphic art also included highly simplified, almost geometric heads, such as the lithograph *Head II* (1921–2; Wiesbaden, Mus. Wiesbaden).

In 1922, after marrying Werefkin's former maid Hélène Nesnakomoff, the mother of his only son, Andreas, born before their marriage, Jawlensky took up residence in Wiesbaden. In 1924 he organized the BLUE FOUR, whose works, thanks to Scheyer's tireless promotion, were jointly exhibited in Germany and the USA. From 1929 Jawlensky suffered from a crippling arthritis that severely limited his creative activity. During this final period of his life he endured not only poor health and near poverty but the threat of official persecution as well. In 1933 the Nazis forbade the display of his 'degenerate' works. Nevertheless he continued his series of increasingly abstract faces, producing more than 1000 works in the *Meditations* series (1934–7), which included examples of abstract landscapes and still-lifes, as well as portraits. These series represented further variations on the face broken down into its component parts, using geometric shapes, line and colour to convey the mood of the painting and, hence, that of the painter himself. Jawlensky's state of mind is vividly reflected in these works, as he adopted an increasingly dark, brooding palette (e.g. *Large Meditation III, No. 16*, 1937; Wiesbaden, Mus. Wiesbaden). By 1937, when his physical condition forced him to cease painting altogether, these faces had been deconstructed to their most basic form: a cross forming the expressive brow, nose and mouth of the subject, on a richly coloured background (e.g. *Meditation*, 1937; Zurich, Ksthaus). No longer able

to use art as a means of conveying his innermost self, Jawlensky began to dictate his memoirs in 1938.

BIBLIOGRAPHY
C. Weiler: *Alexej Jawlensky* (Cologne, 1959)
Alexei Jawlensky: A Centennial Exhibition (exh. cat. by J. T. Demetrion, Pasadena, CA, A. Mus., 1964), pp. 11–15
Alexei Jawlensky, 1864–1941 (exh. cat., ed. A. Zweite; Munich, Lenbachhaus; Baden-Baden, Staatl. Ksthalle; 1983)
Alexej Jawlensky: Zeichnung, Graphik, Dokumente (exh. cat. by B. Fäthke, Wiesbaden, Mus. Wiesbaden, 1983)
D. Rodenbach: *Alexej von Jawlensky: Leben und druckgraphisches Werk* (Hannover, 1985)
Alexej Jawlensky, Gemälde, 1908–1937 (exh. cat., ed. W. Wittrock; Düsseldorf, Ksthnd., 1986)
A. Zweite, ed.: *The Blue Rider in the Lenbachhaus, Munich: Masterpieces by Franz Marc, Vassily Kandinsky, Gabriele Münter, Alexei Jawlensky, August Macke, Paul Klee* (Munich, 1989) [incl. contributions and biog. of Jawlensky by A. Hoberg]
'Memoir by the Artist Dictated to Lisa Kümmel, Wiesbaden, 1937', *Alexej von Jawlensky: Catalogue Raisonné of the Oil Paintings, i: 1890–1914*, by M. Jawlensky, L. Pieroni-Jawlensky and A. Jawlensky (London, 1991), pp. 25–33
Alexej von Jawlensky (exh. cat., Wiesbaden, Mus. Wiesbaden, 1991)
Alexej Jawlensky: From Appearance to Essence (exh. cat. by A. Mochon, Long Beach, CA, Mus. A., 1991)
 E. KASINEC, R. H. DAVIS JR

Jayakarta. *See* JAKARTA.

Jazet, Jean-Pierre-Marie (*b* Paris, 31 July 1788; *d* Paris, 18 Aug 1871). French printmaker. He was trained by his uncle, Philibert-Louis Debucourt, and soon became one of his best pupils. At an early age he was successfully producing and selling prints and drawings of the subjects favoured by Debucourt, such as hunts, landscapes and genre scenes. He soon mastered the technique of aquatint, which became his speciality.

Jazet made his début at the Salon in 1817; by this time he was working exclusively on reproductive etchings after paintings. However it was not until the 1819 Salon when he exhibited *Général Lasalle* (1818; Paris, Bib. N.) after Antoine-Jean Gros and *The Bivouac of Colonel Moncey* (1819; Paris, Bib. N.) after Horace Vernet that his reputation became established. He was particularly fond of the work of Vernet, which he had first seen in 1816, and he later produced aquatints after such paintings as *The Defence of the Clichy Barrier* (1822; Paris, Bib. N.) and *Judith and Holofernes* (1838; Paris, Bib. N.). He also reproduced the works of such painters as Jacques-Louis David, Anne-Louis Girodet, Paul-Emile Destouches (1794–1874), Charles de Steuben (1788–1856) and Hippolyte Bellangé. He specialized in pictures depicting events of the First Empire, such as *The Battle of Essling, 22 May 1809* (1831; Paris, Bib. N.) after Bellangé and *The Battle of Waterloo* (1836; Paris, Bib. N.) after de Steuben. These works gained him considerable popularity but he was also criticized for concentrating on such restricted subject-matter. The demand for his works led him to work over-hastily and occasionally to choose poor paintings. He was awarded the Légion d'honneur in 1846 and continued to exhibit at the Salon until 1865.

BIBLIOGRAPHY
H. Beraldi: *Les Graveurs du XIXe siècle* (Paris, 1885–92), viii, pp. 223–34
Inventaire du fonds français après 1800 (Paris, Bib. N., 1930–), xi, pp. 284–309
For further bibliography *see* DEBUCOURT, PHILIBERT-LOUIS.

Jazzar, 'Abd al-Hadi al-. *See* GAZZAR, 'ABD AL-HADI AL-.

Jbeil. *See* BYBLOS.

Jean, Duc de Berry. *See* VALOIS, (3).

Jean II, Duke of Bourbon. *See* BOURBON, §I(1).

Jean [Jehan], Dreux (*b* Paris; *fl* Brussels, 1448; *d c.* 1468). Franco-Flemish illuminator, scribe and designer. He was first paid for restoring old books and writing and illustrating new ones for Philip the Good, Duke of Burgundy, on 26 January 1448, a task that he continued for the next eight years, being rewarded with the title of ducal *valet de chambre* in October 1449. In 1456 he ceased this exclusive work; in order to widen his clientele, he purchased citizenship in Bruges the following year, probably because of a new ordinance limiting the practice of illumination to citizens. He paid dues to the Bruges guild until 1462 but continued to live in Brussels near the ducal palace on the Coudenberg. Here he joined the Brotherhood of the Holy Cross in 1463, the membership of which comprised ducal servants and city leaders, including Rogier van der Weyden. In 1464 Jean became *valet de chambre* to the Duke's heir, Charles de Charolais; he was probably still alive in 1464, when he is mentioned in a payment of quit-rent on his house.

Jean's one documented work is the modernization in 1451 of the Grandes Heures of Philip the Bold, Philip the Good's grandfather (vol. i: Cambridge, Fitzwilliam, MS. 3–1954; Brussels, Bib. Royale Albert 1er, MSS. 11035–7). The new miniatures are by at least ten artists, however, many of them known in other collaboratively illustrated books, such as Philip's tiny Book of Hours (Munich, Bayer. Staatsbib., Cod. gall. 40) and three with texts by Jean Wauquelin of Mons: the first volume of the *Chronicles of Hainault* (Brussels, Bib. Royale Albert 1er, MS. 9242), a *Roman d'Alexandre* (Paris, Bib. N., MS. fr. 9342) and a *Roman de Girart de Roussillon* (Vienna, Österreich. Nbib., Cod. 2549), copied in 1448. Consequently the additions, although casting light on Dreux Jean as an overseer, do not immediately show his style as a painter.

Nevertheless, an accumulation of evidence supports Jean's long-suspected identity with one of the artists, the Master of the Girart de Roussillon. The Girart Master, author of the frontispiece and several of the final miniatures in the eponymous work (see fig.), was close to the Duke. He included Philip the Good's emblems in his miniatures, painted his portrait more accurately than any of the others except the artist of the *Chronicles of Hainault* frontispiece (attributed to Rogier van der Weyden) and added it to three miniatures by another hand in the Munich Book of Hours. He set the style for at least five associates in the *Girart de Roussillon* and in the fine *Chroniques de*

Dreux Jean: *The People Struggle with the Nobility and Clergy over Girart's Place of Burial*; miniature from the *Roman de Girart de Roussillon*, after 1448 (Vienna, Österreichische Nationalbibliothek, MS. 2549, fol. 177*v*)

Jerusalem abbrégiées (Vienna, Österreich. Nbib., Cod. 2533), probably made directly after the completion of the layout model in December 1455 (Tournai, Bib. Ville, MS. 133; destr. World War II). Most importantly, patterns originally used for the Wauquelin manuscripts survived in his shop and were reused in combination for the *Chronicles of Jerusalem* and a follower's *Chronicles of Normandy* (London, BL, Yates Thompson MS. 33). Added to these considerations, the coincidence in date of the first documented payment to Dreux Jean with the beginning of the decoration of the *Chronicles of Hainault* makes it almost certain that the Girart Master is to be identified with Dreux Jean, director of the renewal of the Duke's library.

Jean's style is perceived more clearly in the later miniatures of the *Girart de Roussillon* than in the frontispiece, in which the portraits of Philip the Good and his court demanded a more cautious technique. Wiry but insubstantial figures are depicted in spacious settings with a loose 'tickling' stroke (Winkler) that models flesh areas in juxtaposed red and black. This painterly technique achieves an optic integration of figures and surroundings in the smaller miniatures, in the *Girart de Roussillon*'s last borders and in the *Chronicles of Jerusalem*, but it is less successful in the large miniatures, particularly in such manuscripts of the late 1450s as the grisaille *Passion de St Adrien* (priv. col., see 1959 exh. cat., no. 171) and in a second copy of Wauquelin's *Alexander* (Paris, Petit Pal., MS. 456). The technique becomes even looser after 1460: in another Book of Hours of Philip the Good (Paris, Bib. N., MS. nouv. acq. fr.14428), an *Invention et translation du corps de St Antoine* (Malibu, CA, Getty Mus., MS. Ludwig XI 8), and in a grisaille copy of St Augustine's moral treatises (Madrid, Bib N., MS. Vit.25-2). The quality is higher in two works for the Duke, also in grisaille: a *Composition de sainte écriture*, transcribed, like the St Augustine, by David Aubert in 1462, and a copy of Jean Gerson's *Passion de Nostre Seigneur* (both Brussels, Bib. Royale Albert 1er, MS. 9017 and MSS. 9081–2, respectively).

The style was continued by the follower responsible for the *Chronicles of Normandy* and by the Master of Guillebert de Lannoy, named after the author of an *Instruction d'un jeune prince* (Brussels, Bib. Royale Albert 1er, MS. 10976), who collaborated in several of Jean's books and who some time after 1468 painted a *Benois seront les misericordieux* (Brussels, Bib. Royale Albert 1er, MS. 9296) for Charles the Bold's Duchess, Margaret of York. Jean seems also to have trained more independent artists: certain figure types, landscape features and border decoration in the *Chronicles of Jerusalem* anticipate those of Lieven van Lathem, and one of its illuminators collaborated in the first stage of van Lathem's Hours of Mary of Burgundy (Vienna, Österreich. Nbib., MS. 1857). A border of flowers on a gold ground in the *Chronicles of Jerusalem* anticipates those developed by the Master of Mary of Burgundy, and the Girart style may have been the source for the artist's dark palette and deep landscapes. Finally, one of Jean's chief associates in the *Girart de Roussillon* and in the *Chronicles of Jerusalem* may have been the Brussels Master of the Legend of St Barbara.

Dreux Jean also worked on the design of tapestries. Certain figures from the Hainault *Chronicle* are found in the *Faits des romains* series (Berne, Hist. Mus.). Jean's parchment roll of drawings after the Golden Fleece wall paintings in Philip's castle at Hesdin (Berlin, Kupferstich-kab.; *see* BROEDERLAM, MELCHIOR) seems to have been a preliminary design for another such series.

BIBLIOGRAPHY
A. Pinchart: *Archives des arts, sciences et lettres*, 3 vols (Ghent, 1860–63), i, pp. 101–2; ii, pp. 151–6, 190–91
F. Winkler: *Die flämische Buchmalerei* (Leipzig, 1925), pp. 41–58
Le Siècle d'or de la miniature flamande: Le Mécénat de Philippe le Bon (exh. cat., ed. L. M. J. Delaissé; Brussels, Pal. B.-A., 1959)
A. de Schryver: 'Pour une meilleure orientation à propos du Maître de Girart de Roussillon', *Rogier van der Weyden en zijn tijd. Internationaal Colloquium: Brussels, 1964*, pp. 43–82
A. H. van Buren: 'New Evidence for Jean Wauquelin's Activity in the Chroniques de Hainaut and for the Date of the Miniatures', *Scriptorium*, xxvi (1972), pp. 249–68; xxvii (1973), p. 318
P. Cockshaw: 'La Miniature à Bruxelles sous le règne de Philippe le Bon', *Rogier van der Weyden/Rogier de la Pasture* (exh. cat., Brussels, Mus. Com., 1979), pp. 116–25
F. Wormald and P. M. Giles: *A Descriptive Catalogue of the Additional Illuminated Manuscripts in the Fitzwilliam Museum* (Cambridge, 1982), pp. 479–99
A. H. van Buren: 'Jean Wauquelin de Mons et la production du livre aux Pays-Bas', *Pub. Cent. Eur. Etud. Burgondomédianes*, xxiii (1983), pp. 53–74
O. Pächt, U. Jenni and D. Thoss: *Die illuminierten Handschriften und Inkunabeln der österreichischen Nationalbibliothek. Flämische Schule*, i (Vienna, 1983), pp. 34–77 [with full bibliography]
A. H. van Buren: 'Dreux Jean and the Library of Philip the Good' (in preparation)

ANNE HAGOPIAN VAN BUREN

Jean [Jehan] **d'Arbois** [Arbosio, Giovanni d'] (*b* ?Arbois, Jura; *fl c.* 1365–99). French painter. He is known only through documentary references. In 1373 he was recalled from Lombardy by Philip II, Duke of Burgundy, and several payments to him were recorded in the Duke's accounts from 10 May 1373. Letters of 21 June 1373 attest to the Duke's desire to retain Jean in Paris, and he worked there from 21 June to 9 December 1373; no precise details are given on the nature of this work. From 5 March 1375 Jean followed the Duke on his travels, in particular to Bruges, where he was paid on 14 July 1375. He was last mentioned in the Duke's accounts on 19 October of that year.

A subsequent return to Lombardy and a career in Pavia can be hypothesized on the basis of literary and archival references to a painter of the same name. In *De republica* the Lombard humanist Uberto Decembrio (1350–1427) named 'Iohanne Arbosio' with Michelino da Besozzo and Gentile da Fabriano as the most famous painters of their time. This Iohanne Arbosio is identifiable as the painter Giovanni degli Erbosi (*d* 1399 or earlier), who was recorded in Pavia, where he probably worked in S Pietro in Ciel d'Oro at the same time as Michelino da Besozzo. Jean d'Arbois can also be identified as Johanis de Herbosio, father of the painter STEFANO DA VERONA.

BIBLIOGRAPHY
B. Prost: *Inventaires mobiliers et extraits des comptes des Ducs de Bourgogne*, i (Paris, 1902), pp. 333, 336, 438–9, 449
M. Bouchot: *Les Primitifs français* (Paris, 1904), pp. 145–51
C. Sterling: *La Peinture française: Les Primitifs* (Paris, 1938), p. 50
——: *La Peinture française: Les Peintures du moyen âge* (Paris, 1942), note 30
G. Troescher: *Burgundische Malerei*, i (Berlin, 1966), pp. 35–6, note 376
E. Moench: 'Stefano da Verona: La Quête d'une double paternité', *Z. Kstgesch.*, xlix/2 (1986), pp. 220–28

ESTHER MOENCH

Jean d'Arras (*d* before 1299). French sculptor. In 1299 his widow was paid for work that he had executed on the tomb of *Philip III*, commissioned for Saint-Denis Abbey church and completed between 1298 and 1307 under the direction of Pierre de Chelles. The black marble sarcophagus has disappeared but the white marble effigy remains, mounted on a modern base now located in the transept. The King, according to the conventions of the time, is represented as in life, his eyes open and his left hand grasping the strap of his mantle. The effigy is often considered to be a portrait of the King, who died at Perpignan in 1285 during his unsuccessful Aragonese campaign. The similarity of the features to the roughly contemporary statue of *Louis IX* now in the parish church at Mainneville (Eure) and the head of the youngest *Magus* from the choir-screen at Notre-Dame, Paris, suggests, however, that all three represent idealized images of the reigning monarch, Philip IV. Such a hypothesis gains credence from the fact that Pierre de Chelles was at this time also head of the workshop occupied at Notre-Dame.

BIBLIOGRAPHY

Lami; Thieme–Becker

A. Erlande-Brandenburg: *Le Roi est mort: Etude sur les funérailles, les sépultures et les tombeaux des rois de France jusqu'à la fin du XIIIe siècle* (Paris, 1975), pp. 171–2 [with extensive bibliog.]

D. Gillerman: *The Clôture of Notre-Dame and its Role in the Fourteenth-century Choir Program* (New York, 1977), pp. 116–18

M. Beaulieu and V. Beyer: *Dictionnaire des sculpteurs français du moyen âge* (Paris, 1992), p. 54

DOROTHY GILLERMAN

Jean de Beaumetz (*b* ?Beaumetz-lès-Loges, nr Arras, *c.* 1335; *d* Dijon, 16 Oct 1396). Franco-Flemish painter. He was first recorded living in Arras, where by 1360 he had married and was receiving rents. In June 1361 Beaumetz was granted residency in Valenciennes, and by August he had painted a statue (destr.) that had been restored by the sculptor André Beauneveu for the aldermen's hall. In 1371 Beaumetz was in Paris carrying out unspecified works for Philip the Bold, Duke of Burgundy. The Duke had sent him to Burgundy by 1375, and by April 1376 he was named ducal painter to replace Jean d'Arbois. Beaumetz first worked in Dijon on the decoration of the oratory and apartments of the palace and then on the adjacent Sainte Chapelle. He was in charge of decorative schemes in the Duke's Burgundian residences and of the embellishment of the charterhouse of Champmol. He was also responsible for the decoration of countless pennons and harnesses, for maintaining polychromy and for such tasks as painting on linen a large composition with the Virgin and saints, a ducal gift to the Carthusians of Lugny in 1378. During the years 1373–87 and 1390–91 Beaumetz was supervising work at the castles of Rouvres, Germolles and Argilly. For the last—his single most important project after Champmol—he probably supplied an important altarpiece.

In December 1387 Beaumetz began work on the Champmol church; the wood vaulting was coloured, and linen strips bearing the ducal arms were fixed to the walls for the day of consecration, 24 May 1388. By mid-1389, when his workshop included as many as 19 assistants, the decoration of the nave was complete. During the next four years Beaumetz directed his attention to the two ducal oratories, where much of the work was carried out by assistants, principally the northerners Girart of Nivelles and Torquim of Ghent. Beaumetz himself concentrated on altarpieces: one, of the *Coronation of the Virgin* with the *Annunciation* and *Visitation* on the wings, was destined for the upper oratory (Chapelle des Anges); others were for the sacristy and an altar in the adjoining vestibule. Twenty-six devotional panels were also required, one for each monk's cell, one for the prior and one probably for the chapter house. Beaumetz worked on these with the help of an assistant, Girard de la Chapelle, from August to December 1390 and again in 1395. Two panels with a Carthusian kneeling before the Crucifixion (Paris, Louvre; see fig.; Cleveland, OH, Mus. A.) are probably part of that commission and form the basis for knowledge of Beaumetz's style. Both, suffused with conventional Sienese elements, seem reflections of Simone Martini's Orsini polyptych (Antwerp, Kon. Mus. S. Kst.; Berlin, Gemäldegal.; Paris, Louvre), which has a provenance from Dijon. Despite the indubitable relationship between the two Crucifixions, however, there are differences of style. The Louvre panel reflects contemporary Artois/Franco-Flemish trends, marked by lively, expressive drawing and colouristic effects, and thus Beaumetz's own formation. Based on these criteria, a panel with the *Virgin and Child* (New York, Frick) is attributed to Beaumetz.

Before 21 November 1393, Philip the Bold had sent Beaumetz, with Claus Sluter and Jean, Duc de Berry's new castle at Mehun-sur-Yèvre, 'to examine certain painted works as well as sculptures'. In March 1394 the painter was in Bruges on the Duke's order; by May 1396 he completed paintings in Dijon that were then brought to

Jean de Beaumetz: *Calvary with a Carthusian*, tempera and gold on panel, 601×482 mm, 1390–95 (Paris, Musée du Louvre)

the Duke in Paris. Mentioned more frequently in the accounts than any other master, Beaumetz had clearly been the favoured artist of Philip the Bold and the one to whom the broadest responsibilities had been delegated.

BIBLIOGRAPHY

C. Dehaisnes: *Documents et extraits divers concernant l'histoire de l'art dans la Flandre, l'Artois et le Hainaut avant le XVe siècle*, 2 vols (Lille, 1886)
C. Monget: *La Chartreuse de Dijon d'après les documents des archives de Dijon*, 3 vols (Montreuil-sur-Mer, 1898–1905)
B. Prost and H. Prost: *Inventaires mobiliers et extraits des comptes des ducs de Bourgogne de la maison de Valois (1363–1477)*, 2 vols (Paris, 1902–8)
C. Sterling: 'Oeuvres retrouvées de Jean de Beaumetz, peintre de Philippe le Hardi', *Bull. Mus. Royaux B.-A. Belgique*, iv (1955), pp. 57–82
P. de Winter: *The Patronage of Philippe le Hardi, Duke of Burgundy (1364–1404)* (diss., New York U., Inst. F.A., 1976)
——: 'Art from the Duchy of Burgundy', *Bull. Cleveland Mus. A.*, lxxiv (1987), pp. 406–51

PATRICK M. DE WINTER

Jean de Brecquessent (*fl* 1299–1331). French sculptor. His name suggests that he came from Brexent, near Etaples (Pas-de-Calais). In 1299 he received payment for six angels and six wooden columns, presumably an altar enclosure for the chapel of the château (destr.) of Mahaut, Countess of Artois at Hesdin. In 1313–14 he was in Paris, again employed to complete architectural elements for the tomb of *Otto IV, Count of Burgundy* (mostly destr.), her late husband (*reg* 1279–1303). Like other sculptors working in Paris at this time, he also found work outside the capital, in effect bringing the style of the French royal court to more remote corners of the realm. Between 1331 and 1342 Aimone, Count of Savoy (*reg* 1329–43), erected a burial chapel in the Cistercian abbey of Hautecombe (Savoie). In addition to the Count's tomb, sculptural decoration consisting of a set of the 12 Apostles and an altarpiece with scenes from the *Infancy of Christ* have been attributed to Jean de Brecquessent's workshop. The chapel was severely damaged during the Revolution and subject to radical restoration in the 19th century. Remains of the sculpture are currently located in the parish church of Saint-Girod (Savoie), at the Musée Savoisien, Chambéry, and at Hautecombe Abbey.

BIBLIOGRAPHY

Lami; Thieme-Becker
C. Blanchard: 'Histoire de l'abbaye d'Hautecombe', *Mém. Acad. Sci., B.-Lett. & A. Savoie*, 3rd ser., i (1875), pp. 3–74
Les Fastes du Gothique: Le Siècle de Charles V (exh. cat., Paris, Grand Pal., 1981–2), nos 15–17, p. 432
M. Beaulieu and V. Beyer: *Dictionnaire des sculpteurs français du moyen âge* (Paris, 1992), pp. 244–5

DOROTHY GILLERMAN

Jean de Bruges. *See* BOUDOLF, JAN.

Jean de Cambrai [Rouppi; de Rouppy; Rupy] (*fl* 1375–6; *d* 1438). South Netherlandish sculptor. The name de Rouppy suggests that he was born in the village of Roupy, near Saint-Quentin in the region of Cambrai. He is first documented among the stone-carvers working on the spire of Cambrai Cathedral in 1375–6. In 1386–7 he was paid a salary of 15 francs a month by Jean, Duc de Berry, the first indication that he was in the Duc's service at Bourges, apparently working with the sculptor André Beauneveu. In 1397 he was referred to as the Duc's 'varlet de chambre', and in 1401–2 as the 'imagier' of the Duc,

presumably succeeding Beauneveu, who had previously held the post and who died in 1401–3. He received presents from Jean de Berry in 1401 and 1413, and the collar of broom-cods (one of the Duc's emblems) was bestowed on him by the Duc's nephew, Charles VI, King of France, in 1403.

In 1449 Jean de Cambrai's heirs were paid 300 livres for the alabaster effigy of the Duc de Berry that he had carved for the Duc's tomb in the Sainte-Chapelle, Bourges, subsequently completed by Etienne Bobillet (*fl* 1453) and Paul Mosselman (*fl* 1453–67) on the instructions of Charles VII of France. The date of Cambrai's work on the tomb is unknown; he may have started shortly after 1404 and perhaps ceased on the Duc's death in 1416. The tomb was badly damaged in the 18th century, but the effigy survives in the crypt of Bourges Cathedral. Jean de Berry is shown with his feet resting on a bear, one of his emblems; the style is concise and strongly characterized and emphasizes the volumes of the forms. The bulbous visage has wrinkles on the forehead and around the eyes, incised in the otherwise relatively undetailed surface. The decorative possibilities of the hair and jewelled crown are not exploited. The shallow, regular drapery folds are a characteristic of the sculptor. Five of the weepers that originally decorated the tomb (Bourges, Mus. Berry; St Petersburg, Hermitage, Denys Cochin priv. col., see Erlande-Brandenburg, nos 17, 20) have been attributed to Jean de Cambrai. The design of the tomb was based on that of *Philip the Bold, Duke of Burgundy* (Dijon, Mus. B.-A.), by Claus Sluter. Jean de Cambrai lacked both Sluter's power and commitment to surface detail but could have learnt from his naturalistic approach.

In April 1408 the Celestine monastery of Marcoussis was opened, and Jean de Berry presented it with a marble or alabaster figure of the Virgin, *c.* 2 m high. This has been identified as the white marble statue of the *Virgin and Child* (Marcoussis, parish church) and attributed on the basis of its style to Jean de Cambrai. The wriggling child presents two roses to the Virgin and plays with the ring on her hand. The image is monumental and modest yet lyrical. The Virgin stands virtually erect, the contour of the figure simple. The shallow, vertical drapery folds are conceived as inseparable from the block-like form and do not reveal the figure beneath. Surface textures are simplified, and the Virgin's face is unstylized.

Two other works have been attributed to Jean de Cambrai. The statues of the *Duc de Berry* and his second wife *Jeanne de Boulogne* in Bourges Cathedral (formerly placed to either side of a statue of the *Virgin and Child* with angels on the altar of Notre-Dame-la-Blanche in the Sainte-Chapelle, Bourges) are severely over-restored. The figures, and the original heads of the Duc and his wife as sketched by Hans Holbein the younger (*c.* 1524; Basle, Kstmus.), reveal many of the characteristics of Jean de Berry's tomb, justifying the attribution. The second work is the figure with folded arms (*c.* 1405; Bourges, Hôtel Jacques Coeur) from the remains of a series of prophets largely produced by Beauneveu, thought to have decorated the exterior of the destroyed Sainte-Chapelle, Bourges.

BIBLIOGRAPHY

A. de Champeaux and P. Gauchery: *Les Travaux d'art executés pour Jean de France, Duc de Berry* (Paris, 1894), pp. 28–9, 35, 37–8, 98–101, 117, 202

P. Pradel: 'Un Nouveau Prophète de la Sainte-Chapelle de Bourges', *Rev. A.*, iii (1953), p. 58

——: 'Nouveaux Documents sur le tombeaux de Jean de Berry, frère de Charles V', *Mnmts Piot*, xlix (1957), pp. 141–57

F. Zschokke: 'Die Zeichnungen Hans Holbein d.J. nach den Bildnisstatuen des Herzogs und der Herzogin von Berry in Bourges', *Z. Schweiz. Archäol. & Kstgesch.*, xviii (1958), p. 181

S. K. Scher: 'Un Problème de la sculpture en Berry: Les Statues de Morogues', *Rev. A.*, xiii (1971), pp. 11–24

Die Parler und der schöne Stil, 1350–1400: Europäische Kunst unter den Luxemburgern, i (exh. cat., ed. A. Legner; Cologne, Schnütgen-Mus., 1978), p. 56

A. Erlande-Brandenburg: 'Jean de Cambrai, sculpteur de Jean de France, Duc de Berry', *Mnmts Piot*, lxiii (1980), pp. 143–86

KIM W. WOODS

Jean de Chelles. *See* CHELLES, DE, (1).

Jean de la Huerta. *See* JUAN DE LA HUERTA.

Jean de Laval (*fl* 1463–8). French illuminator and painter. He is documented in the service of Charles, Duc de Berry, and, on one occasion, working for his older brother, King Louis XI. In all probability Jean de Laval is the true identity of the artist referred to as the MASTER OF CHARLES OF FRANCE (*see* MASTERS, ANONYMOUS, AND MONOGRAMMISTS, §I). Three painters have been connected with Charles of France: Jean de Laval, Henri de Vulcop, and Jean Guillemer. Of these, Jean de Laval is the only one mentioned in ducal accounts as 'peintre de mondit seigneur'. He was paid in 1463–4 the substantial sum of 66 livres tournois, 100 sous in 1467 and, in 1468, 8 livres, 8 sous, and 12 livres for unspecified works. In May and September 1464 Laval is also mentioned in a royal account as 'peintre de Mgr le duc de Berry' when he painted a scarlet war pennant for the captain of Louis XI's guard. Henri de Vulcop, who was not part of the ducal household, is in all probability identifiable with the MASTER OF COËTIVY (*see* MASTERS, ANONYMOUS, AND MONOGRAMMISTS, §I), whose pronounced Netherlandish style is noticeably different from that of the Master of Charles of France. Guillemer, whose name does not figure in extant ducal accounts, has been loosely connected with Charles's patronage from judicial interrogations in Tours to which he submitted in late January 1472; Louis XI's investigator, Tristan l'Ermite, suspected the artist of spying for the League of the Public Weal headed by Charles of France. In his testimony, however, Guillemer claimed to have been illuminator to Charles d'Anjou, Comte de Maine (uncle and godfather of Charles of France), and to have sought Anjou's recommendation so that he might be granted a commission by Charles of France for a Breviary. Such a recommendation would seem necessary only if Guillemer's work was unknown to the young Charles. Consequently the evidence suggests that Jean de Laval is the artist most likely to be identifiable as the Master of Charles of France.

BIBLIOGRAPHY

J. J. Guiffrey: 'Peintres, imagiers, verriers, maçons, enlumineurs, écrivains, et libraires du XIVe et XVe siècle', *Nouv. Archvs A. Fr.*, vi (1878), p. 193

A. Lecoy de la Marche: 'Interrogatoire d'un enlumineur par Tristan l'Ermite', *Rev. A. Chrét.*, xxxv (1892), pp. 396–408

H. Stein: *Charles de France, frère de Louis XI* (Paris, 1919)

N. Reynaud: 'La Résurrection de Lazare et le Maître de Coëtivy', *Rev. Louvre*, xv (1965), pp. 171–82

——: 'Un Peintre français cartonnier de tapisseries du XVe siècle: Henri de Vulcop', *Rev. A.* (Paris), xxii (1973), pp. 6–21

Jean [Hennequin] **de Liège (i)** (*fl c.* 1360; *d* 1381). South Netherlandish sculptor, mainly active in Paris. He is sometimes held to have been a pupil of Jean Pépin de Huy. Among Jean de Liège's achievements in the creation of major funerary sculpture was the development of an architectural tomb type that included small weepers around the sarcophagus, which dramatically suggest that the deceased will be mourned eternally. His style is marked by a subtle treatment of surfaces with smooth transitions between one plane and the next and by particularly delicate facial renderings. His bequest of a sizable sum for masses for the soul of Queen Joanna of Boulogne (1326–61), an unusual endowment from a sculptor, suggests that she had been influential in his settling in Paris. Jean de Liège is thought to be the sculptor commissioned by the Dauphin Charles, the future Charles V, shortly after 1360 to produce the tomb of his infant daughters *Bonne* (bust, Antwerp, Mus. Mayer van den Bergh) and *Joanna* (untraced), who were buried at the Cistercian abbey of St Antoine-des-Champs, Paris. Also from this abbey is a stylistically related *Virgin with the Christ Child Holding a Bird* (Lisbon, Mus. Gulbenkian). In 1361 the sculptor carved the tomb (untraced) of *Joanna of Brittany*, wife of Robert de Cassel, for the Dominican church in Orléans. It included ornaments of copper and gilding by the goldsmith Hermant Lalemant. In 1365 Jean de Liège produced standing figures of *Charles V* and *Joanna of Bourbon* (sometimes identified with statues in Paris, Louvre), the most prominent sculptures—flanking the entrance—in a programme that glorified the Valois dynasty on the great spiral staircase (destr. 1624) at the Palais du Louvre (*see* RAYMOND DU TEMPLE).

In 1366–7 Jean de Liège was in England, where Queen Philippa of Hainault (1314–69), wife of Edward III, commissioned a tomb for herself to be placed in Edward the Confessor's Chapel in Westminster Abbey. Her recumbent figure, that of a seemingly good-natured, middle-aged matron, is one of the earliest royal effigies to depart from an idealistic rendering in favour of a more naturalistic and accurate portrait. The tomb originally included 32 weepers on separate projecting bases alongside the sarcophagus that are visually linked by overhanging canopies and identified by shields below (only a young woman holding a dog remains). The scheme was adopted on subsequent French tombs, notably that of *Charles V and Joanna of Bourbon* (1376–9; decorative fragments, Paris, Mus. A. Déc.), which Jean de Liège probably designed for Saint-Denis Abbey, incorporating the recumbent statue of the monarch (*in situ*) carved in 1364 by André Beauneveu, and that of a generation later of *Philip the Bold, Duke of Burgundy* (Dijon, Mus. B.-A.), where the niches evolved into a running arcade.

In 1367–8 Jean de Liège was paid 1000 francs by Charles V for an alabaster and marble tomb (destr. 1736; recorded in Oxford, Bodleian Lib., MS. Gough Gaignières 2, fol. 43), to be placed over the King's heart in the choir of Rouen Cathedral. In 1372 he received 440 livres parisis for the tomb to be laid over the entrails of Charles IV (*reg* 1322–8) and his third wife Joanna of Evreux (1310–

71) at Maubuisson Abbey. The less than life-size recumbent figures (Paris, Louvre) are depicted clutching a pouch that symbolically holds their viscera, the earliest representation of this iconography. If their physiognomies, with faint smiles, are rather conventional, they are carefully delineated and suggest, especially in the case of Joanna, a physical presence. In 1372 the sculptor was also paid for the placement of a tomb for Joanna of Evreux's body at Saint-Denis and one for her heart in the Franciscan church in Paris. By 1381 Jean de Liège had created a double tomb for her daughters with recumbent alabaster figures on a black Dinand marble sarcophagus. Here *Blanche, Duchess of Orléans* (*d* 1392; Saint-Denis Abbey) is depicted with mild realism, the wimple set at a slight diagonal accentuating facial features with more suggestion of personality than appears on those of her parents (see above). The sculptor probably never actually saw her sister Marie of France (*d* 1341), but the lively physiognomy of her bust (New York, Met.; see fig.) includes a pointed nose, marked jawbone and chin framed by fashionable braids, combining rigorous forms with a remarkable tenderness. Around 1379 Jean de Liège produced and installed statues (destr. 18th century) of *St John the Baptist, Cardinal-Chancellor Jean de Dormans* and his brother *Guillaume de Dormans* on the portal of the chapel (consecrated 1380) of the Collège de Beauvais in Paris; he was also commissioned to make a statue of the *Virgin and Child* (untraced) for the interior.

The posthumous inventory of Jean de Liège's workshop attests to his wide range of activity (Vidier). Listed among sculptures in the course of completion were a relief of the *Life of St Martin*; statues of the *Virgin*; one of *St John the Baptist*, commissioned by Charles V for his funerary chapel at Saint-Denis, which, according to an agreement, would be painted by Jean d'Orléans; a *Crucifixion*, an *Annunciation* and a *Nativity*; a tomb for Philippe de l'Aulnoy, the Royal Steward, and his wife Agnès for the church of Moussy-le-Vieux; a stone statue of a knight; and an alabaster statue dressed as a burgess. Also listed are stone statues of *Charles V* and *Joanna of Bourbon* estimated at 40 francs, which may have been designed for the portal of the Sainte-chapelle at Vincennes, where work was in progress in the late 1370s and 1380s. The workshop was partly inherited, partly acquired, by his former assistant Robert Loisel, who completed the works and established himself in his own right.

Jean de Liège has been the subject of continuing scholarship, and attributions made to him are still debated. Among these are several tomb figures including *Mary of Spain, Countess of Alençon* (*d* 1379) and *Margaret, Countess of Flanders* (*d* 1382; both Saint-Denis Abbey); a statue of *St John the Evangelist* (*c.* 1380; Paris, Mus. Cluny, Cl.19.255); and relief fragments of altarpieces: a *Visitation* (*c.* 1370; Paris, Mus. Cluny, Cl.18.845); an *Angel Annunciate* (*c.* 1375–80; New York, Met., 17.190.30) and figures attending the *Crucifixion* (*c.* 1380; Paris, Louvre).

BIBLIOGRAPHY

A. Vidier: 'Un Tombier liégeois à Paris au XIVe siècle: Inventaire de la succession de Hennequin de Liège, 1382–1383', *Mém. Soc. Hist. Paris & Ile de France*, xxx (1903), pp. 281–308

M. Devigne: *La Sculpture mosane du XIIe au XVIe siècle: Contribution à l'étude de l'art dans la région de la Meuse moyenne* (Paris and Brussels, 1932)

Jean de Liège (i): *Marie of France*, alabaster with traces of polychromy, h. 310 mm, *c.* 1380–81 (New York, Metropolitan Museum of Art)

L. Stone: *Sculpture in Britain: The Middle Ages*, Pelican Hist. A. (Harmondsworth, 1955, rev. 2/1972)

G. Schmidt: 'Beiträge zu Stil und Oeuvre des Jean de Liège', *Met. Mus. J.*, iv (1971), pp. 81–107

Les Fastes du gothique: Le Siècle de Charles V (exh. cat., Paris, Grand Pal., 1981–2), nos 65–8, 70, 78–81, p. 432

Jean de Liège (ii) (*fl* 1381–1403). Franco-Flemish sculptor. He is documented in Dijon in 1381 as 'tailleur de menues oeuvres en pierre et en bois'. On the commission of Philip the Bold, Duke of Burgundy, he worked on several campaigns to embellish the Charterhouse of Champmol (*see* DIJON, §IV, 1(ii)). Jean first produced the main doors of the church, including armorials in relief. Subsequently he carved choir-stalls that in 1388 were praised by fellow artists as 'plus belles et … soubtil ouvraige qu'il ne les devait faire'. The following year he prepared for Jean de Beaumetz, the court painter, panels and frames for altarpieces. In 1399–1400 he produced thrones with canopies for the officiant, the deacon and the subdeacon. The back of the deacon's seat (Dijon, Mus. B.-A.), the only extant element, is incisively carved with the device and arms of John the Fearless as Comte de Nevers (before 1404) and with angels that are South Netherlandish in style. For Philip the Bold's château at Argilly, Jean carved a statue of the *Virgin* under an elaborate canopy (destr.). He was also called on to work at the Duke's château of Conflans, outside Paris.

In 1399 the sculptor was commissioned by Louis I, Duke of Orléans, to make a carved altarpiece with six standing statues (destr.) for St Pol, Paris, and in 1401 for the same patron an alabaster *Presentation of the Virgin* (destr.) for the chapter room of the Célestins. He is last recorded in 1403, when Margaret, Duchess of Burgundy, commissioned from 'maistre Jehan de Liège charpentier

demourant à Paris' two cribs, two tubs and two 'chapelles' (all untraced) for the child of her son Anthony of Burgundy, Duke of Brabant (*reg* 1406–15). The 'iohannes de leodio' who signed and dated (1387) the choir-stalls with shields and figurative subjects in St François, Lausanne, on commission from Amadeus VII, Count of Savoy (*reg* 1383–91), for whom he worked at the castles of Chillon and Ripaille, may be the same Jean de Liège.

BIBLIOGRAPHY

E. Bach: 'Les Stalles gothiques de Lausanne', *Anz. Schweiz. Altertknd.*, xxxi (1929), pp. 119–30

M. Devigne: *La Sculpture mosane du XIIe au XVIe siècle: Contribution à l'étude de l'art dans la région de la Meuse moyenne* (Paris and Brussels, 1932)

P. Quarré: 'Un Dossier de chaire de la Chartreuse de Champmol, oeuvre de Jean de Liège', *Miscellanea: Prof. Dr. D. Roggen*, ed. E. J. Hoebeke (Antwerp, 1957), pp. 219–28

P. de Winter: *The Patronage of Philippe le Hardi, Duke of Burgundy, 1364–1404* (diss., New York U., 1976)

Jean de Limbourg. *See under* LIMBOURG, DE.

Jean de Maisoncelles (*fl* 1426–39). French painter. He is first documented in 1426, when he was producing wall paintings in churches in Besançon (destr.). During the 1430s he was the most important painter in Dijon, and he was probably responsible for the panel of the *Presentation with Kneeling Donors* (Dijon, Mus. B.-A.), formerly in the charterhouse of Champmol. This combines figure types derived from the Master of Flémalle with Eyckian motifs: the depiction of the scene in a church interior resembles Jan van Eyck's *Virgin and Child in a Church* (Berlin, Gemäldegal.). Maisoncelles may have executed the wall paintings depicting a *Circumcision* and a *Baptism* that were recorded in Notre-Dame, Dijon, by Louis Joseph Ypermann (1892; Paris, Mus. Mnmts Fr., 10.187). On 17 March 1436 Maisoncelles received payment from the Burgundian treasury for a waist-length portrait of *Philip the Good, Duke of Burgundy* (untraced), specified as being 3 ft by 2½, placed beside those of former dukes in the sanctuary of Champmol. The 16th-century serial bust-length portraits of Philip, epitomized by a panel in Cincinnati (Cincinnati, OH, A. Mus.), might be versions of Maisoncelles's portrait, though in these the Duke is crowned, which differs from the commission's specifications (he was shown wearing the Order of the Golden Fleece), and his wrinkled face appears older than that of a man who was 40 in 1436. That year the painter was granted a tax abatement by the Dijon municipality. In 1436–7 Maisoncelles received payments towards a large wall painting of the *Dance of Death* in the cloister of the Sainte-Chapelle in Dijon (destr. 1803). In 1439 Maisoncelles was in Besançon producing, with Jean de Pestinien (1380–1463), an illuminator also established in Dijon, wall paintings (destr.) in the chapel of Notre-Dame in the cathedral.

BIBLIOGRAPHY

P. Brune: *Dictionnaire des artistes et ouvriers d'art de la Franche-Comté* (Paris, 1912)

P. Quarré: 'Du Maître de Flémalle à Jean de Maisoncelles, la *Circoncision* et le *Baptême*, peintures murales de Notre-Dame de Dijon', *Rev. des A.*, viii/6 (1958), pp. 251–7

G. Troescher: *Burgundische Malerei*, 2 vols (Berlin, 1966)

PATRICK M. DE WINTER

Jean de Marville [Hennequin, Hannequin de Marvile; Jan van Mergem; Jehan de Marville; Jehan de Mervile] (*fl* 1366–89). South Netherlandish sculptor, active in Burgundy. Although few works remain that can be securely attributed to him, his style is similar to that used in the keystone bosses at the Tour de Bar, Dijon, the chimney capitals of Germolles or the donor consoles on the portal of the Charterhouse, Dijon; he is recorded as working in ivory, wood and stone. In 1366 Jean de Marville was working in the collegiate church of St Pierre in Lille, while in 1369 at Rouen, with Jean de Liège (ii), he was paid for *ceretaines ymaiges et maconneries* in Charles V's Chapel in Rouen Cathedral. In 1371 he was again in Lille. In 1372 Marville was in the household of Philip the Bold, Duke of Burgundy, as the first court sculptor, *ymagier et varlet de chambre*, a position he held until his death. From 1372 until the construction of the Charterhouse of Champmol, Marville was involved in various sculptural and decorative projects for Philip's many residences. He employed over 20 Netherlandish assistants, including CLAUS SLUTER. With Drouet de Dammartin as architect, Jean de Marville and the master mason Jacques de Neuilly (*fl c.* 1367–97) were involved in designing and building the Charterhouse, for which Marville probably planned the sculptural portal, although it was later changed by Sluter. In 1381 the ducal accounts mention a commission fee for a tomb for *Philip the Bold*, which was to be carved of alabaster (Dijon, Mus. B.-A.). Marville was probably responsible for the innovative overall design as well as carving the arcade. After his death, the tomb was finished by his successors as *ymagier*, Claus Sluter and Claus de Werve.

BIBLIOGRAPHY

C. Dehaisnes: *Documents et extraits divers concernant l'histoire de l'art dans la Flandre, l'Artois & le Hainaut avant le XVe siècle*, 2 vols (Lille, 1886)

C. Monget: *La Chartreuse de Dijon d'après les documents des archives de Bourgogne*, 3 vols (Montreuil-sur-mer, 1898–1905)

D. Roggen: 'Hennequin de Marville en zijn atelier te Dijon', *Gent. Bijdr. Kstgesch.*, i (1934), pp. 173–205

K. Morand: *Claus Sluter* (Austin, 1991)

SARA JANE PEARMAN

Jean de Paris. *See* PERRÉAL, JEAN.

Jean de Rouen. *See* JOÃO DE RUÃO.

Jean de Valenciennes [van Valenchine] (*fl* Bruges, 1379–86). Netherlandish sculptor. He is cited in 1379 at the head of a team of (unnamed) sculptors in charge of the decoration of Bruges Town Hall, the construction of which was begun in 1376; it is assumed that this work involved the sculpture of the façade, consisting of a series of life-size statues of counts of Flanders and religious figures (destr. 1792), supported on historiated consoles. In 1383 the artist was paid for the vault decoration in the chapel of the ducal residence (*Prinsenhof*) in Bruges. He was last mentioned in 1385–6, when he was contracted to execute bosses, foliage and rosette ornaments for the wooden vault of the Aldermen's Room in the Town Hall. He probably either died or left the city soon after this date.

It is generally agreed that 14 figural consoles from the Town Hall façade (now kept inside the building), known to have been in place by May 1379, can be attributed to

Jean de Valenciennes and his workshop. These works are of considerable importance. Although varied in quality and clearly by a number of different hands, two of the finer consoles in the series (one representing a bearded prophet with an angel, the other carousing lovers and a hair-washing) exhibit a style close to that of the earliest works of CLAUS SLUTER in the Charterhouse, Dijon (west portal, trumeau *Virgin and Child*).

Other works in Bruges that can be attributed to the same workshop on the basis of style include six figural rib consoles and a boss (*c.* 1380–85) decorating a staircase vault in the eastern part of the Town Hall; several fragments of wooden gables set with carvings of human heads (*c.* 1380–85), formerly part of the dormer windows of the same building (now Bruges Gruuthusemus.; Ghent, St Lukas Mus.); and a historiated console (*c.* 1380) located in the ground-floor passage of the Belfry.

BIBLIOGRAPHY

A. Louis: 'Les Consoles de l'Hôtel de Ville de Bruges', *Belg. Tijdschr. Oudhdknd. & Kstgesch.*, viii (1937), pp. 199–207

A. Janssens de Bisthoven: 'Het beeldhouwwerk van het Brugsche Stadhuis', *Gent. Bijdr. Kstgesch. & Oudhdknd.*, x (1944), pp. 7–81

Flanders in the Fifteenth Century: Art and Civilization (exh. cat., Detroit, MI, Inst. A., 1960), pp. 229–31

M. Vanroose: *Enkele aspecten van de Brugse beeldhouwkunst tijdens de Periode, 1376–1467* (MA thesis, Ghent U., 1971)

J. Luckhardt: 'Das Portrait Erzherzog Rudolph IV von Österreich bei seinem Grabmal: Versuche zur Deutung seines dualistischen Grabbildis', *Die Parler und der Schöne Stil, 1350–1400: Europäische Kunst unter den Luxemburgern* (exh. cat., ed. A. Legner; Cologne, Museen Stadt, 1978), i, pp. 81–2

J. STEYAERT

Jean d'Orbais (*fl* early 13th century). French architect. He is known only from an inscription on the labyrinth of the nave pavement of Reims Cathedral, which was recorded in the 17th century by Canon Cocquault: 'l'image d'un Jehan d'Orbais m[aî]tre des dits ouvrages qui encommencea la coiffe de l'église' ('the likeness of one Jehan d'Orbais master of the said works who began the chevet of the church'). He was shown in the upper right-hand corner of the labyrinth and, according to a 16th-century drawing, appeared to be outlining a plan. Orbais is a village in the former diocese of Soissons, south of the Marne, where the former Benedictine abbey church, on which Jean may have worked, still remains. In 1897 Demaison attributed to Jean d'Orbais the design, plan and beginning of construction of the chevet of Reims Cathedral, begun in 1211. It has been argued that the first master was perhaps the anonymous figure represented in the centre of the labyrinth; this, however, was probably the Bishop, Aubry de Humbert (1207–18), and the attribution of the start of the cathedral to Jean d'Orbais is generally accepted. Judging by the architecture, Jean seems to have been familiar with St Rémi, Reims, and the cathedral workshops at Soissons and Chartres, but it is not known how long he remained master of works of Reims Cathedral nor for how much of the chevet he was actually responsible.

BIBLIOGRAPHY

L. Demaison: 'Les Architectes de la cathédrale de Reims', *Bull. Archéol. Cté Trav. Hist. & Sci.* (1897), pp. 3–40

R. Branner: 'Jean d'Orbais and the Cathedral of Reims', *A. Bull.*, xliii (1961), pp. 131–3

H. Reinhardt: *La Cathédrale de Reims: Son histoire, son architecture, sa sculpture, ses vitraux* (Paris, 1963), pp. 101–14

ANNE PRACHE

Jean d'Orléans (*fl* 1361; *d.* 1416–1425). French painter. He was *huissier de salle* and *valet de chambre* to the French kings John II, Charles V and Charles VI until *c.* 1407. He was probably the son of GIRARD D'ORLÉANS, painter to Philip VI (*reg* 1328–50) and John II. In May 1364 Jean painted a monumental deer, symbol of the king's justice, in the Palais in Paris. In 1365 he furnished a panel of 'bois d'Ilande' and coronation thrones. The following year he painted the audience hall in the Louvre, and in 1372 he appraised paintings, the property of Joanna of Evreux, Queen of France (*d* 1371). In 1378 he worked at the castle of Saint-Germain-en-Laye. Five years later he coloured a statue of *St John the Baptist* commissioned by Charles V from Jean de Liège (i) for his funerary chapel at Saint-Denis Abbey. On the order of Charles VI, Jean painted statues of *Apostles* at the royal residence of St Pol in Paris. Jean d'Orléans was most probably the painter who in 1369 produced 'tableaux à ymages' for Jean, Duc de Berry. He also worked for Philip the Bold, Duke of Burgundy. In 1371 he coloured a crib for John, Philip's first-born child, and in 1372 he appraised paintings in Dijon. In 1377, again for Philip the Bold, he painted two scenes on a panel that included jewelled work by Jean (Hennequin) du Vivier (*fl* 1359–1401). In June 1383 Philip rewarded the artist for panels by his hand that he brought to Dijon as a gift of Jean, Duc de Berry. A month later Jean delivered to Philip a diptych with round panels depicting *Christ Risen from the Tomb*, the *Virgin Supported by St John*, and *St Christopher* and the *Lamb of God*; he also painted lances.

In 1385 Jean d'Orléans painted panels and decked armour for a joust of King Charles VI at Cambrai. Two years later the King ordered a large leather case for a picture made by the artist. In 1390 Jean painted two images of the Virgin, one each for the King and his brother Louis, and restored a picture that included figures of the Virgin, SS Denis, Louis of France and Louis of Toulouse. He supplied a quadriptych depicting the *Virgin, SS Catherine, John the Baptist and George* within gilded silver mounts, painted reliquaries and made shields for the Queen's entry into Paris. In 1392 Jean painted an *Annunciation* for the Dauphin Charles's room. During the 1390s he also restored wall paintings at Vincennes, including a large *St Christopher* near the King's apartments. In August 1391 Jean d'Orléans headed the Paris painters' Corporation when new statutes were promulgated.

Although no documented works by this important painter are known to survive, he has often been identified as the MASTER OF THE PAREMENT DE NARBONNE (*see* MASTERS, ANONYMOUS, AND MONOGRAMMISTS, §I). The first campaign in the Très Belles Heures de Notre-Dame (Paris, Bib. N., MS. nouv. acq. lat. 3093 and Paris, Louvre, R.F. 2022–4; *see* TURIN-MILAN HOURS) and a pen drawing of an archer (Oxford, Christ Church Pict. Gal.) have also been attributed to him. A lost cycle of wall paintings depicting the *Dance of Death* (1425) in the cemetery cloisters of the Innocents in Paris has been held to be his work. It is uncertain whether Jean d'Orléans is to be identified with the painter of the same name who was apparently in Jean de Berry's service by 1408: a pomander with painted scenes, 'gift of Jehannin d'Orléans', is mentioned in the Duc's inventory of that year. In 1416 this

artist executed works at Bourges Cathedral in connection with the Duc's funeral.

BIBLIOGRAPHY

V. Dufour: *Recherches sur la dance macabre peinte en 1425 au cimetière des Innocents* (Paris, 1873)

P. Durrieu: 'La Peinture en France de Jean le Bon à la mort de Charles V (1350–1380)', *Histoire de l'art*, ed. A. Michel, iii (Paris, 1907), pp. 101–71

P. Henwood: 'Jean d'Orléans peintre des rois Jean II, Charles V et Charles VI (1361–1407)', *Gaz. B.-A.*, xcv (1980), pp. 137–40

PATRICK M. DE WINTER

Jean le Loup (*fl* early 13th century). French architect. Master of works of Reims Cathedral in the 13th century, he is known by an inscription that appeared on the labyrinth of the nave pavement of the church. Canon Cocquault recorded this in the 17th century, before the destruction of the pavement: 'l'image d'un ma[ît]rē Jehan le Loup qui fut m[aî]tre des ouvrages d'icelle église l'espace de seize ans et commencea les portaux d'icelle' ('a picture of Master Jehan le Loup who was master of the works of this church for 16 years and began its doorways'). According to a 16th-century drawing he was shown at the bottom left of the labyrinth and appeared to hold a pair of compasses. The origins of Jean le Loup and the dates of his activity at Reims are unknown. He is generally considered to have been the second architect of the cathedral after Jean d'Orbais, but he did not appear next to him in the labyrinth, and he has been identified as the third architect or even the first (Panofsky). He must have begun the west façade, since he began the portals, but the date is controversial. In fact he could have worked on a first façade project that was never realized, of which the portals were erected in a later campaign on the north transept during the years 1230–40, or he could have begun the present façade *c.* 1252.

BIBLIOGRAPHY

L. Demaison: 'Les Architectes de la cathédrale de Reims', *Bull. Archéol. Cté Trav. Hist. & Sci.*, (1897), pp. 3–40

E. Panofsky: 'Über die Reihenfolge der vier Meister von Reims', *Jb. Kstwiss.*, iv (1927), pp. 55–82

H. Reinhardt: *La Cathédrale de Reims: Son histoire, son architecture, sa sculpture, ses vitraux* (Paris, 1963), pp. 115–22

ANNE PRACHE

Jean le Noir [Passion Master] (*fl* 1331–75). French illuminator. He is first mentioned in 1331, in the service of Yoland of Flanders, Duchess of Bar. Later he left her employ to work for King John II of France (*reg* 1350–64). In 1358, during John's imprisonment in London, le Noir and his daughter Bourgot, who is also mentioned as an illuminator ('enlumineresse'), were given a house in Paris by the regent Charles, in recognition of services rendered to the King. In 1372 le Noir received gifts from Jean, Duc de Berry, for whom he must have been working at the time. Again, in a document of 1375, while living in Bourges, he is said to have received gifts from the Duc and is referred to as 'illuminator to the King and to the Duc'.

Despite the fact that Jean le Noir was an illuminator of repute, working for the most important patrons of his day, no miniatures can be attributed to him with certainty. Delisle first suggested that the illumination of the Hours of Yoland of Flanders (London, BL, Yates Thompson MS. 27) might be his work, given that the miniatures are dated to the period he spent in the employ of the Duchess. Although badly damaged in a flood, the manuscript is one of the finest extant Parisian productions of the 14th century. The miniatures are stylistically very close to the work of Jean Pucelle and are lively, often almost agitated in their narrative style.

More recently Jean le Noir has been identified with the Passion Master, an anonymous illuminator who appears to have worked under the same succession of patrons, and to whom the Hours of Yoland, among other manuscripts, is attributed. Meiss identified this Master as one of five hands distinguishable within the Petites Heures of Jean, Duc de Berry (*c.* 1370–75; Paris, Bib. N., MS. lat. 18014); so-called because he was responsible for the illustration of the Passion cycle (see fig.). The hand of the Passion Master becomes recognizable first in the Hours of Yoland, painted after 1353, and then in the Breviary of Charles V (Paris, Bib. N., MS. lat. 1052; for illustration *see* VALOIS, (2)), which was illuminated some time before 1380 when it appeared in Charles's collection. The work of the Passion Master in the Petites Heures continues the style of these manuscripts. The same features recur in all three manuscripts, in particular the palette of rather cool, dusty colours, and the delightful, often humorous depiction of animals. Characteristic too are the rocky landscapes

Jean le Noir (attrib.): *Crucifixion*; miniature from the Petites Heures of Jean, Duc de Berry, 215×145 mm, *c.* 1370–75 (Paris, Bibliothèque Nationale, MS. lat. 18014, fol. 89*v*)

and agitated, expressive figures. The Passion Master was Pucelle's greatest follower, and his work carried the influence of Pucelle into the second half of the 14th century. There is good evidence to suggest that a copybook of the Pucelle workshop travelled with this Master. Although his style resembles that of Pucelle, his work lacks the same profundity but is rather invested with an intense emotional charge peculiar to these manuscripts. The influence of Jan Boudolf and his associates, with whom the Passion Master worked on the Breviary, is evident in the increasing volume of his forms.

Meiss also identified a later style of the Passion Master, in the Hours of St John the Baptist of the Petites Heures, which displays a new interest in the problems of representing depth. Among other works attributed to the Passion Master by Avril are the Psalter of Bonne of Luxemburg (New York, Cloisters, MS. 69.88), illuminated before 1349, the Hours of Joanna of Navarre (Paris, Bib. N., MS. nouv. acq. lat. 3145), the Missal of the Sainte-Chapelle (Lyon, Bib. Mun., MS. 5122), an Epistolary (London, BL, Yates Thompson MS. 34) and an Evangeliary (Paris, Bib. Arsenal, MS. 161).

BIBLIOGRAPHY

Thieme-Becker

L. Delisle: *Recherches sur la librairie de Charles V*, i (Paris, 1907), pp. 80, 365–6, 405, 408
F. de Mély: *Les Miniaturistes* (Paris, 1913), i of *Les Primitifs et leurs signatures*, pp. 91, 407
H. M. R. Martin: *La Miniature française du XIIIe au XVe siècle* (Paris, 1923), pp. 38–42
K. Morand: *Jean Pucelle* (Oxford, 1962)
O. Pächt and J. G. Alexander: *Illuminated Manuscripts in the Bodleian Library, Oxford*, i (Oxford, 1966), p. 47
M. Meiss: *French Painting in the Time of Jean de Berry: The Late Fourteenth Century and the Patronage of the Duke* (London, 1967), pp. 44, 160–69
F. Avril: 'Trois Manuscrits de l'entourage de Jean Pucelle', *Rev. A. [Paris]*, ix (1970), pp. 37–48

Jeanneret, Charles-Edouard. *See* LE CORBUSIER.

Jeanneret, Pierre (*b* Geneva, 22 March 1896; *d* Geneva, 4 Dec 1967). Swiss architect and furniture designer. He was a cousin of Le Corbusier, with whom he twice went into partnership. He graduated from the Ecole des Beaux-Arts, Geneva, and in 1921–2 on Le Corbusier's recommendation he worked with Auguste Perret and Gustave Perret in Paris. In 1922 he went into partnership with his cousin, and in 1923 they built the Besnus Villa (now altered), Vaucresson, near Paris. This first partnership was marked by a number of major projects and works (*see* LE CORBUSIER). Jeanneret's contribution to the partnership was considerable, not least in introducing a professionalism in following through projects and work on site, and he often stimulated and provoked his cousin's imagination or moderated it with his own realism. He often drew the first sketches for plans that he then gradually reworked and refined with Le Corbusier, and he also played an important part in ensuring the office's continuity, coordinating work and maintaining tight control over all the technical aspects. Moreover, his contribution in the use of metal and the industrialization and standardization of buildings, central to Corbusier's projects between the World Wars, was fundamental.

From 1937 to 1940 Jeanneret also worked with Charlotte Perriand, designing furniture in aluminium and wood, and the two formed a research team with Jean Prouvé to develop prefabricated housing. In 1940, reacting to Le Corbusier's authoritarianism and his leanings towards the Vichy regime, Jeanneret left his cousin and joined the Bureau Central de la Construction in Grenoble, created in 1939 by Georges Blanchon. There he continued his investigations with Prouvé and André Masson, and together they built a number of prefabricated houses. Then, faced with the shortage of metal, he designed structural elements and furniture in wood. Later, when members of the Bureau had joined the Resistance, Jeanneret continued working, alone or with others, on projects including a theoretical study (1944) on housing problems in anticipation of the post-war reconstruction, a project (1945–6) for a school at Uriage, a study for urban planning in Grenoble, a project (1946; with Georges Blanchon) for a *unité d'habitation* for Puteaux and a project (1947; with Georges Blanchon) for a block of flats, Villeneuve-Saint-Georges, near Paris. From 1946 to 1951, he also worked with Prouvé on a system of houses with prefabricated elements, but with the exception of a house (1947) on the Ile de Bréhat, Brittany, and a secondary school (1949; with Dominique Escorsat) at Béziers, few projects came to fruition. He did not hesitate, therefore, when in 1950 Le Corbusier suggested reforming their partnership to execute the master plan for Chandigarh, the capital of the Punjab. Jeanneret lived on the site and took personal charge of the project, on which E. Maxwell Fry and Jane Drew also worked but where Le Corbusier made rare appearances. He assimilated the Indian building tradition and used it in the architectural and technical solutions he formulated with his cousin. Admired locally, and with the support of his friend Jawaharlal Nehru, prime minister of India from 1947 to 1964, he also built a number of works of his own in the Punjab. The Gandhi Memorial (*c.* 1960), Chandigarh, housing a library and conference hall and sited on a lake, and the town of Talwara (1964–5) in the Punjab count among his major works. He left India in 1965, in poor health, and returned to Geneva.

BIBLIOGRAPHY

P. A. Emery, R. Reverdin and G. Barbey: 'Hommage à Pierre Jeanneret', *Werk*, 6 (1968), pp. 377–96
H. Cauquil: *Pierre, l'autre Jeanneret*, suppl. to 'Le Corbusier: L'atelier 35 Rue de Sèvres', *Bull. Inf. Archit.*, 114 (1987)
C. Courtiau: 'Jeanneret', *Le Corbusier: Une Encyclopédie* (exh. cat., ed. J. Lucan; Paris, Pompidou, 1987), pp. 214–15

GILLES RAGOT

Jean Pépin de Huy (*b* ?Huy, nr Liège; *fl* 1311–29). Netherlandish sculptor. He is mentioned as a *tombier* (tomb sculptor) and citizen of Paris in 1312, when he was in the service of Mahaut, Countess of Artois. Most of his work is documented but untraced: the alabaster sculpture for Mahaut of 1312 and a slab supported by lions for the tomb of Mahaut's father Robert II, Count of Artois (*d* 1302), for Maubuisson Abbey, near Pontoise; a marble canopy for a statue for the convent of Ste Claire near Saint-Omer (1322); two alabaster works (1322); and two further works in alabaster for the nuns of La Thieulloye, near Arras (1326). Also in 1326 Louis, Comte de Clermont, commissioned a tomb for his sister Marguerite de Bourbon

(*d* 1309), first wife of Jean, Comte de Flandres, for the Jacobite church in Paris, and in 1329 Jean Pépin de Huy made statues of the *Virgin and Child* and *St James* for the Dominican church at Poligny (Jura).

Jean Pépin de Huy's surviving documented works were catalogued by Baron. In 1312 he sculpted the tomb of *Otto IV, Count of Burgundy* (*d* 1303), husband of Mahaut d'Artois, for the abbey church of Cherlieu (figure fragment, Vesoul, Cousin priv. col.). The stylistically related and also fragmentary tomb figure of *John of Burgundy*, Mahaut's son who died in infancy, was originally made for the Dominican church at Poligny in 1315 (now in the chapel of Darbonnay, Jura). Between 1317 and 1320 Jean Pépin created the tomb of his patroness's son *Robert d'Artois* (*d* 1317) for the Discalced Carmelite church in Paris (now Saint-Denis Abbey), with an effigy dressed as a knight. In 1329 he made a *Virgin and Child* (marble; h. 650 mm) as a gift from Mahaut of Artois to the Carthusian nuns of Gosnay, Pas-de-Calais (Gosnay, parish church). In addition to these works, Schmidt attributed to Jean Pépin de Huy the effigy of *Philip d'Artois* (*d* 1298), younger brother of Mahaut d'Artois, which is known only in an engraving by Bernard de Montfaucon (*Les Monumens de la monarchie française*, 5 vols, Paris, 1729–33) but shows affinities to Pepin's early work. The head of a female effigy (Arras, Mus. B.-A.) is presumably later. The tombs of *Philip IV* (*d* 1314) and his sons *Louis X* (*d* 1316), *Philip V* (*d* 1322) and *Charles IV* (*d* 1328) in Saint-Denis Abbey, dating from 1327–9, may also derive from Jean Pépin's workshop.

Jean Pépin de Huy was the first Netherlandish sculptor of significance to be resident in Paris during the 14th century. His work almost certainly influenced the naturalism of such masters as Jean de Liège (i) and André Beauneveu.

BIBLIOGRAPHY

Thieme–Becker

M. Devigne: *La Sculpture mosane du XIIe au XVIe siècle* (Paris and Brussels, 1932)

F. Baron: 'Un Artiste du XIVe siècle: Jean Pépin de Huy. Problèmes d'attribution', *Bull. Soc. Hist. A. Fr.* (1960), pp. 89–94

G. Schmidt: 'Drei Pariser Marmorbildhauer des 14. Jahrhunderts. I. Jean Pépin de Huy: Stand der Forschung und offene Fragen', *Wien. Jb. Kstgesch.*, xxiv (1971), pp. 160–68

F. Baron: 'Le Gisant de Jean de Bourgogne, fils de Mahaut d'Artois, oeuvre de Jean Pépin de Huy', *Bull. Soc. N. Antiqua. France* (1985), pp. 161–2

SUSANNA BICHLER

Jeanron, Philippe-Auguste (*b* Boulogne-sur-Mer, 10 May 1809; *d* Comborn, 8 April 1877). French painter, museum director and writer. In 1815 he returned to France with his father, who had been a prisoner of war in Britain. He was a pupil at the Collège Bourbon in Paris and subsequently spent several years in Haute-Vienne, where he worked in the ironworks. He returned to Paris in 1828 and became friendly with several painters, including Xavier Sigalon and François Souchon (1787–1857), who gave him advice on painting technique. While pursuing his career as a painter (he exhibited regularly at the Salon between 1831 and 1848), he participated in Republican politics in the circles of the leading opposition figures, Godefroy Cavaignac and Alexandre Ledru-Rollin. He demonstrated his political commitment through his involvement in the Revolution of July 1830, in the Société Libre de Peinture et de Sculpture and in his various articles for newspapers and reviews such as *Pandore*, *Revue française* and *Revue du Nord*, which argue that the academic tradition in art should be rejected in favour of realism in the service of the people. He published a pamphlet on *Les Origines et les progrès de l'art* in 1835.

Jeanron's dedication to the Republican cause and to a 'democratic' art was rewarded after the Revolution of February 1848, when he was appointed head of the national museums, a position which he held until June 1849. He was very active in this post and can be credited with some impressive achievements. He provided for the conservation of the art treasures of the Louvre and also undertook substantial and urgent repairs to the building, obtaining two million francs from the Assemblée Constituante for the decoration of the Galerie d'Apollon and a variety of other work. He was responsible for classifying the museum's paintings in chronological order and by schools, and he also reorganized the Chalcographie as well as opening the Egyptian department and setting up a printing house for engravings. He was instrumental in setting up a free exhibition in the Tuileries, which contained 5000 paintings and sculptures. After visiting the provinces on a number of occasions he wrote a report—at once harsh and depressing—on the often lamentable state of French provincial museums. He was dismissed following the anti-Republican reaction to the abortive left-wing insurrection of 13 June 1849 and was given an obscure sinecure, the directorship of the Musée des Beaux-Arts, Marseille. Under the Second Empire his active involvement in the arts continued, although he had little influence on the new regime; he was awarded a Croix d'Honneur during the Exposition Universelle of 1855 and became a correspondent of the Institut in 1863.

Apart from his polemical pamphlets, official reports, an annotated edition of Vasari's *Vite* (1839–42) and some strange, partly autobiographical memoirs, Jeanron produced a large number of paintings between 1831 and 1876, which mirrored his political beliefs. His first exhibited work was the *Young Patriots* (exh. Salon 1831; Caen, Mus. B.-A.), which owed much to Delacroix's *Liberty on the Barricades* (1830; Paris, Louvre). During the 1830s he established a reputation as a leading Realist painter, depicting scenes from the daily life of working people, such as *Peasants of Limousin* (exh. Salon 1834; Lille, Mus. B.-A.), *Striking Workers* (?1833; untraced) and his most important work in this genre, *Blacksmiths from Corrèze* (exh. Salon 1836; untraced), which was praised by Thoré for its contemporary subject-matter. From the 1850s he increasingly painted landscapes, of the Boulogne area (e.g. the *Abandoned Port of Ambleteuse*, 1850; untraced; and *Workers Putting Up Telegraph Lines at Cap Gris-Nez*), and of coastal Provence (e.g. *View of Notre Dame de la Garde, the Château d'If and the Islands*, 1865; untraced). He also produced portraits, watercolours and drawings.

BIBLIOGRAPHY

E. About: *Moniteur Univl* (5 Sept 1857)

M. Rousseau: *La Vie et l'oeuvre de Philippe-Auguste Jeanron: Peintre, écrivain, directeur des Musées Nationaux, 1808–1877* (diss., Paris, Louvre, 1935)

The Realist Tradition: French Painting and Drawing, 1830–1900 (exh. cat. by G. P. Weisberg, Cleveland, OH, Mus. A., 1980), pp. 296–7

PAUL GERBOD

Jean sans Peur, 2nd Valois Duke of Burgundy. *See* BURGUNDY, (2).

Jean van Brussel. *See* ROOME, JAN VAN.

Jeaurat, Etienne (*b* Paris, 9 Feb 1699; *d* Versailles, 14 Dec 1789). French painter and draughtsman. He was a favourite pupil of Nicolas Vleughels, who, when appointed director of the Académie Française in Rome in 1724, took Jeaurat with him, though it is hard to discern any Italian influence at all in Jeaurat's work. Jeaurat was approved (*agréé*) by the Académie Royale, Paris, in 1731 and was received (*reçu*) two years later as a history painter with his *Pyramis and Thisbe* (1733; Roanne, Mus. Déchelelte). Jeaurat rose to the highest posts in the Académie, becoming professor in 1743, rector in 1765 and chancellor in 1781. He exhibited regularly at the Salon between 1737 and 1769, and the Gobelins factory made tapestries after his designs. Unlike his exact contemporary Chardin, Jeaurat had a highly successful official career with his many posts—in 1767, for instance, he was also appointed Garde des Tableaux du Roi at Versailles—and he was always accepted as a history painter, an ambition that constantly eluded Greuze.

In 1747 Charles-François Le Normand de Tournehem selected Jeaurat and nine other top academicians for the *Concours libre* to re-establish the priority of history painting. Jeaurat's *Diogenes Drinking from his Hand after Breaking his Cup* (Fontainebleau, Château) was among the 11 paintings commissioned and displayed in the Galerie d'Apollon in the Louvre. Besides his rather dry and conservative history paintings, of which he did fewer and fewer, Jeaurat also painted still-lifes and portraits, but he is best known for his genre subjects, particularly scenes of Paris street-life and domestic interiors. His most interesting pictures are those executed in the 1750s recording the urban appearance of Paris and its assorted inhabitants in a way seldom previously attempted in France (five at Madresfield Court, Malvern; see 1968 exh. cat., nos 345–9). The subjects include a police raid, prostitutes (see fig.), shellers of peas and a painter moving house. These paintings are vivid, raucous and Hogarthian, although not overtly moralizing or sequential. Hogarth's engravings of London street-life, such as the *Four Times of the Day*, were well known in Paris and obviously exerted considerable influence on Jeaurat.

Denis Diderot once called Jeaurat 'the Vadé of painting', a reference to Jean-Joseph Vadé (1720–57), who wrote

Etienne Jeaurat: *Prostitutes Being Taken to the Police Station*, oil on canvas, 650×820 mm, *c.* 1757 (Paris, Musée Carnavalet)

coarse comedies incorporating the jargon of the streets. Jeaurat and Vadé belonged to the same intellectual circle, the Société du Bout de Banc presided over by the actress Mlle Quinaut, and they cultivated a rather academic interest in popular language and slang. Among this circle were Alexis Piron (1689–1773), Charles Collé (1709–83), Charles-François Panard (1674–1765) and the Comte de Caylus, of whom Jeaurat painted a large group portrait entitled *Piron et ses amis à la table* (Paris, Louvre). Many of Jeaurat's paintings were reproduced in prints by, among others, Bernard Lépicié, Jean-Joseph Balechou and François Lucas, as well as his own brother Edmé Jeaurat (1688–1738), whose son Nicolas Henry Jeaurat (*b* 1728) studied painting with his uncle Etienne.

BIBLIOGRAPHY

Bellier de La Chavignerie–Auvray
'Exposition des petits maîtres, Berlin 1910', *Les Arts* [Paris] (July 1910)
E. Dacier: *La Gravure de genre et de moeurs au 18e siècle* (Paris, 1925)
France in the 18th Century (exh. cat., London, RA, 1968)
P. Wescher: 'Etienne Jeaurat and the French Eighteenth-century *Genre de moeurs*', *A. Q.* [Detroit], xxxii (1969), pp. 153–65
W. Kalnein and M. Levey: *Art and Architecture of the 18th Century in France*, Pelican Hist. A. (Harmondsworth, 1972)
P. Conisbee: *Painting in Eighteenth-century France* (New York, 1981), p. 168

S. J. TURNER

Jebel Aruda. Site of a settlement of the late Uruk period (*c.* 3300–3100 BC) on a conspicuous hill 80 km east of Aleppo, Syria. It was established on a ridge parallel to the right bank of the River Euphrates, separated by a wadi from the main body of the hill. Most of the settlement was excavated by a Dutch team under the direction of H. J. Franken and G. van Driel between 1975 and 1982. Finds are in the National Museum at Aleppo, but most of the pottery is in the Rijksuniversiteit at Leiden.

The settlement was associated with a small sanctuary clearly visible from contemporary settlements at Hadidi and across the river to the north. The temples are, however, shielded from Tall el Hajj and the major settlement of HABUBA KABIRA to the south by a high spur. In the first phase the sanctuary consisted of a small but massive building known as the Red Temple. It was built with bricks of the so-called Riemchen type, made from the local reddish subsoil, and decorated with exterior niches, as were generally used in religious architecture. The tripartite plan is typical of the period, with a rectangular central hall containing a podium. The temple stood on a low platform with steps in front of the three entrances. It was surrounded by a courtyard, enclosed by a low wall with two gate-houses to the south and west. A stairway (h. 2 m) in front of the south gate led to a higher area, now entirely denuded. To the north the wall was pierced by a simple door, from which stairs led to a lower kitchen building.

In a second period the kitchen was covered by terracing, the top of which was approached from the west by a double stairway. A second temple, constructed of mud bricks using grey river valley material, was erected to the north of the Red Temple. It is similar in plan, although here the pedestal is set against the south wall of the central room. The western gate-house of the Red Temple and part of the temenos wall were demolished, and a new kitchen was added to the north of the extended temple platform. In this phase, or earlier, a row of rooms was added to the east of the southern gateway. In the following phase the area between the high ground to the south and the houses to the north was covered by a terrace of stone casemates filled with grey mud brick. Although the terrace reached at least the level of the higher, eroded area, no trace of the buildings erected on it has survived.

A settlement of about 15 houses extended along the ridge on both sides of the temple complex. The houses were closely packed and are of the usual Uruk period tripartite plan (*see* MESOPOTAMIA, §II, 3), although sometimes adapted to the available building space. Some of the houses to the north were rebuilt at least once, while others bear traces of minor alterations. Larger houses have domestic quarters arranged around courtyards, but there are also smaller, simpler constructions. The houses to the south are better preserved, rising in two steps against the slope of the hill, which was extensively terraced. The settlement was burnt with its contents, which included tablets with numbers only, both sealed and unsealed. Sealings with Uruk and Jemdet Nasr type impressions (*see* ANCIENT NEAR EAST, §II, 1 (ii)) occur in the same contexts. Metal is scarce, although a hoard of flat axes and a tanged dagger were found. Poorly worked flint (local chert) continued to be used, but obsidian is rare. The pottery shows the full range of late Uruk wares, including 'flowerpots', Uruk-red shouldered vessels, and a varied series of large storage containers, as well as cooking pots of various types.

BIBLIOGRAPHY

G. van Driel and C. van Driel: 'Jebel Aruda, 1977–1978', *Akkadica*, xii (1979), pp. 2–28
G. van Driel: 'Tablets from Jebel Aruda', *Zikir Šumim: Assyriological Studies Presented to F. R. Kraus on the Occasion of his Seventieth Birthday* (Leiden, 1982), pp. 12–25
——: 'Jebel Aruda: The 1982 Season of Excavation: Interim Report', *Akkadica*, xxvi (1982), pp. 34–62
J. Hanbury Tenison: 'The 1982 Flaked Stone Assemblage at Jebel Aruda, Syria', *Akkadica*, xxvi (1982), pp. 27–33

G. VAN DRIEL

Jeckyll [Jeckell], Thomas (*b* Norwich, 1827; *d* Norwich, 1881). English designer and architect. He began his career as an architect, designing and restoring parish churches in the Gothic Revival style. In 1859 he entered into a close association with the iron and brass foundry of Barnard, Bishop & Barnard of Norwich. Jeckyll pioneered the use of the Anglo-Japanese style for furnishings. His fireplace surrounds, grates, chairs, tables and benches often incorporate roundels containing Japanese-inspired floral and geometric ornament. Jeckyll's foliate-patterned ironwork was featured in Barnard, Bishop & Barnard's pavilion at the International Exhibition of 1862 in London, and he designed the foundry's cast- and wrought-iron pavilion for the Centennial Exhibition of 1876 in Philadelphia. This two-storey structure was supported by bracketed columns elaborately decorated with a variety of birds and flowers and was surrounded by railings in the form of sunflowers, a motif that was later adapted to firedogs.

During the 1870s Jeckyll was one of several Aesthetic Movement architects and artists responsible for the interiors of 1 Holland Park, London, the home of the collector Aleco Ionides. Jeckyll's interior (1876) for the dining-room at 49 Princes Gate, London, for F. R. Leyland

features a pendent ceiling and shelves with delicate vertical supports set against walls covered in Spanish leather; it became known as the 'Peacock Room' (Washington, DC, Freer) after its later painted decoration by James McNeill Whistler. In 1877 Jeckyll became mentally ill; he died in the Norwich Asylum four years later.

BIBLIOGRAPHY

M. Girouard: *Sweetness and Light: The Queen Anne Movement, 1860–1900* (Oxford, 1977/*R* New Haven and London, 1984)

In Pursuit of Beauty: Americans and the Aesthetic Movement (exh. cat., New York, Met., 1986)

JOELLEN SECONDO

Jefferson, Thomas (*b* Shadwell, VA, 13 April 1743; *d* Monticello, VA, 4 July 1826). American statesman and architect. One of the great founding fathers of the American nation, he was a self-taught and influential architect whose work was influenced by his first-hand experience of French architecture and his admiration for Classical architecture. 'Architecture is my delight, and putting up and pulling down one of my favorite amusements', he is reputed to have said. His major works are his own house, MONTICELLO, VA, the State Capitol at RICHMOND, VA, and his innovative designs for the University of Virginia, Charlottesville. He also conducted one of the earliest systematic archaeological investigations of a native North American site, excavating a burial mound on his Virginia farm in 1784.

1. Early architectural interests, before 1784. 2. Paris, 1784–9. 3. Architectural work in America, 1789–1826.

1. EARLY ARCHITECTURAL INTERESTS, BEFORE 1784. Son of a surveyor working in Virginia, he went on his father's death to stay with his cousins at Tuckahoe, an early 18th-century plantation still existing on the lower James River. The H-shaped house had ingenious dome-shaped plaster ceilings in the office and schoolroom, possibly an influence on his later work. While a student at the College of William and Mary, Williamsburg, VA, in 1760–62, he bought his first architectural book, probably James Leoni's *The Architecture of A. Palladio* (London, 1715–20 or the edition of 1742 or both). His next purchase was probably James Gibbs's *Rules for Drawing the Several Parts of Architecture* (London, 1732). The buildings of Williamsburg did not appeal to him, and he was highly critical of the college and hospital, even preparing plans to improve the college. He also made drawings for an octagonal chapel, probably for Williamsburg (not executed).

As early as 1767 Jefferson began planning his own house, Monticello, on an isolated hilltop on the family property at Shadwell. For three years he made preliminary studies, inspired by Leoni, Gibbs and Robert Morris's *Select Architecture* (London, 1755). His first design was a centre block with flanking wings, similar to the Semple House (*c.* 1770) in Williamsburg. The two-storey portico, similar to that of the Villa Pisani by Andrea Palladio, became a favourite detail in late 18th-century American architecture. In 1770 the family house burned, making the building of his own home a necessity. By November 1770 the first outbuilding with only two rooms, known today as the South Pavilion, was completed, and Jefferson moved in, bringing his wife there after his marriage in 1772. He continued to work on and alter Monticello almost as long as he lived. In 1776 he made proposals to the House of Delegates in Virginia for a new capitol in Richmond. Separate buildings for the various branches of the government were proposed for the first time. Four years later a decision to erect was accepted, and Jefferson was appointed head of the building committee.

2. PARIS, 1784–9. In 1784 Jefferson went to Paris as American ambassador. There he met Charles-Louis Clérisseau, the French antiquarian and architect, whose *Antiquités de la France: Monumens de Nismes* [Nîmes] (Paris, 1778) had introduced Jefferson to the Maison Carrée (*see* NÎMES, fig. 2), which Jefferson described as 'the most perfect model existing of what may be called Cubic architecture'. With the help of Clérisseau, Jefferson sent a model, based on the Maison Carrée, to Richmond. The architectural orders on the portico were changed from Corinthian to Ionic because of the scarcity of stone-carvers in America, and Jefferson adapted the interior for the separate legislative, executive and judicial functions. Building of the Virginia State Capitol started in 1785 and was completed in 1799. It marked the first use in America of a Classical temple as a model for a public building and set an influential example for American official architecture (*see* UNITED STATES OF AMERICA, fig. 5).

While in Europe, Jefferson witnessed urban developments in Paris, studying at first-hand the work of Claude-Nicolas Ledoux, Etienne-Louis Boullée, Jacques Molinos and Jacques-Guillaume Legrand, and benefiting from the intellectual and artistic environment. He also added to his collection of books on architecture, notably with Antoine Desgodets's *Les Edifices antiques de Rome* (Paris, 1682) and Roland Fréart de Chambray's *Parallèle de l'architecture antique et la moderne* (Paris, 1650). From this French experience he became fascinated by octagons, semi-octagons, circles and spheres, later experimenting with the square and the interlocking of ingenious geometrical spaces. Thus when he returned to America in 1789 he possessed a professional breadth of architectural knowledge.

Influenced by European experiments in rehabilitating criminals through solitary confinement, Jefferson prepared designs in 1785 for a semicircular prison with individual cells placed at the periphery, on three storeys. It was based on a design of 1765 by Pierre-Gabriel Bugniet. Jefferson sent his plan to Richmond, VA, where it was later adapted by Benjamin Henry Latrobe for the State Penitentiary (1797–8). Jefferson's residence in Paris was the Hôtel de Langeac, designed from 1768 by Jean-François-Thérèse Chalgrin: Jefferson appreciated the elegance, comfort and privacy of the Hôtel. All the bedrooms had dressing-rooms and water closets as well as their own sitting-rooms. In 1786 Jefferson made a tour of English gardens accompanied by John Adams, the American ambassador to London. He admired the English landscape garden, noting his comments in his copy of Thomas Whately's *Observations on Modern Gardening* (London, 1770).

3. ARCHITECTURAL WORK IN AMERICA, 1789–1826.

(i) Plans for Washington, DC, and work on Monticello and other houses. On his return to America, Jefferson took

great interest in the plans for the new capital of the United States, which George Washington decided should be located at the settlements of Carrollsburg and Hamburgh in the Territory of Columbia (on the north shore of the Potomac River), in preference to New York or Philadelphia. Jefferson presented the city's architect, PIERRE CHARLES L'ENFANT, with 22 maps of European cities (see WASHINGTON, DC, §I, 2). Jefferson's advocacy of Classical architecture and his personal experience of European cities influenced the planning of Washington and had a lasting effect on American architecture. Many of his ideas were carried out. In 1792 he entered a competition for the President's House under an assumed name, basing his design on Palladio's Villa Rotonda.

Thomas Jefferson was President of the United States of America from 1801 to 1809, and during this time he continued to add ideas to the plan of Washington, redesigning Pennsylvania Avenue to contain a road separated by rows of trees from the walks on either side. From 1803 Latrobe was employed as Surveyor of the Public Buildings in Washington, where he oversaw further work on the Capitol, the President's House and the Washington Navy Yard.

In 1796 Jefferson started remodelling and enlarging Monticello, a scheme he had been considering during his stay in Paris. His first house derived mainly from Palladio; the alterations were based on designs by Antoine Desgodets, Charles Errard the younger and Roland Fréart de Chambray, reflecting the development of his architectural ideas and his reading. These changes resulted in the appearance of a symmetrical one-storey brick house with a prominent wooden balustrade. The west garden façade has a central pedimented portico crowned by a low octagonal drum and shallow dome. Three expert builders from Philadelphia were employed: James Dinsmore from 1798, and James Oldham and John Neilson from 1801.

The remodelling was substantially completed by 1809. Numerous ingenious inventions with practical implications were devised.

Jefferson designed several houses for friends, including Edgemont, VA (c. 1797), Edgehill, VA (before 1798, destr. and rebuilt), Farmington, KY (1809), Barboursville, VA (1817–22) and Bremo, VA (1818–20), which was built by John Neilson. The houses show a Palladian influence in the treatment of porticos and arcades; most have a single storey, and some have mezzanines, used variously for bedrooms or storage. Bremo is similar to Monticello in its hilltop location, Tuscan orders on the porticos and internal layout. Jefferson's most original small house design was for his own country retreat, Poplar Forest, near Lynchburg, VA (1806–12). The house is an octagon, with octagonal rooms that create a perfectly square dining-room at the centre. The dining-room was lit by an ingenious glass skylight that doubled as a system for gathering water. The garden, and even the privies, are also based on the octagon. Of all the house forms he attempted, the rotunda was Jefferson's favourite. Three different schemes (not executed) were based on Palladio's Villa Rotonda: the Governor's House in Williamsburg (1778–1801), the Governor's House in Richmond (c. 1780) and the President's House in Washington (1792). Although his designs for houses often featured domes, the only dome built was at Monticello.

(ii) University of Virginia, Charlottesville. As early as 1805 Jefferson had realized that a new university was needed in central Virginia, conceiving it as 'an academical village' rather than a single large building. He proposed a long lawn or green, with five pavilions on both sides, each representing a different discipline, with a lecture-room and professor's apartments. The idea may be based on the château of Marly, Louis XIV's favourite retreat near

Thomas Jefferson: University of Virginia, section and elevation of the Rotunda; drawing, c. 1822, Rotunda constructed 1823–6 (Charlottesville, VA, University of Virginia Library)

Versailles, a building Jefferson had visited while in France. He consulted William Thornton and Latrobe, welcoming Latrobe's suggestion for a rotunda as the focal point and Thornton's idea of pavilions at the corner of the lawn to express the change of direction.

Jefferson designed the Rotunda (see fig.), basing it on the Pantheon in Rome with its proportions reduced by one half. This magnificent and domed building (1823–6), with two tiers of windows behind the six-columned portico and pediment, faces the lawn, with a view of the distant mountains. (This view was subsequently impeded by Stanford White's building of 1897–9.) Jefferson subtly emphasized the view by gradually increasing the spaces between the pavilions, thus falsifying the perspective and increasing the apparent length of the lawn. The interior of the Rotunda was designed with a ground floor for scientific experiments, the main first floor for lectures and the top floor for the library.

The cornerstone of the University was laid in 1817, when Jefferson was already 74 years old. He not only designed and supervised the construction but also raised money to keep the work advancing, successfully defending the idea of separate pavilions against the legislature's wish for a single building. Each pavilion had an architectural order derived from a different Roman temple, giving variety within a unified scheme and intended to serve as an example for teachers of architecture. Jefferson even suggested the first American school for architectural studies, with Francesco Milizia's *Architecture civile* (3 vols, Bassano, 1813; from the Italian *Principi di architettura civile*; Finale, 1791; Bassano, 1785, 1804) to be used as a textbook. The book contains practical information, including a design for cast-iron linings in fireplaces to reflect the heat more efficiently, which Jefferson adapted for fireplaces in the upper floor of the pavilions.

The University of Virginia was opened in 1825, when the Rotunda was almost completed. The University, with its imposing buildings, forms Jefferson's masterpiece, triumphantly grafting the building tradition of ancient Rome on to the practice of contemporary American architecture. The influence of this fusion has proved to be enduring. During this period Jefferson also designed courthouses for Botetourt and Buckingham counties, VA (1818 and 1821; both destr.), in the Neo-classical style, and Christ Church, Charlottesville, VA (1824–6, destr.), with a portico *in antis*, which derives from St Philippe du Roule in Paris (1764–84) by Jean-François-Thérèse Chalgrin.

WRITINGS

Notes on the State of Virginia (London, 1787); ed. W. Peden (New York, 1954)

T. J. Randolph, ed.: *Autobiography* (1829); ed. D. Malone (New York, 1959)

BIBLIOGRAPHY

H. B. Adams: *Thomas Jefferson and the University of Virginia* (Washington, 1888)

P. L. Ford, ed.: *The Writings of Thomas Jefferson*, 10 vols (New York, 1892–9)

F. Kimball: *Thomas Jefferson, Architect: Original Designs in the Collection of Thomas Jefferson Coolidge, Junior, with an Essay and Notes* (Boston, 1916/*R* New York, 1968)

E. M. Betts, ed.: *Thomas Jefferson's Garden Book, 1766–1824* (Philadelphia, 1944)

E. D. Berman: *Thomas Jefferson among the Arts* (New York, 1947)

H. C. Rice jr: *L'Hôtel de Langeac: Jefferson's Paris Residence, 1785–1789* (Monticello and Paris, 1947)

D. Malone: *Jefferson*, 6 vols (Boston, 1948–84)

F. Kimball: 'Jefferson and the Public Buildings of Virginia: I. Williamsburg, 1770–1776', *Huntington Lib. Q.*, xii (1949), pp. 115–20

J. P. Boyd, ed.: *The Papers of Thomas Jefferson* (Princeton, 1950)

C. Lancaster: 'Jefferson's Architectural Indebtedness to Robert Morris', *J. Soc. Archit. Historians*, x (1951), p. 4

E. M. Sowerby: *Catalogue of the Library of Thomas Jefferson* (Washington, 1955) [with annotations]

W. B. O'Neal: *Jefferson's Buildings at the University of Virginia: The Rotunda* (Charlottesville, 1960)

F. D. Nichols: *Thomas Jefferson's Architectural Drawings* (Charlottesville, 1961, rev. Boston, 5/1984)

F. D. Nichols and J. A. Bear jr: *Monticello* (Charlottesville, 1967, rev. 1982)

F. J. B. Watson: 'French Eighteenth-century Art in Boston', *Apollo*, xc (1969), pp. 474–83

M. D. Peterson: *Thomas Jefferson and the New Nation: A Biography* (New York, 1970)

F. D. Nichols: 'Poplar Forest', *Ironworker*, xxxviii (1974), pp. 2–13

FREDERICK D. NICHOLS

Jeffrey & Co. English wallpaper manufacturing company founded *c.* 1836. The company, variously known as Jeffrey, Wise & Co., Jeffrey, Wise & Horne (1842), Horne & Allen (1843) and Jeffrey, Allen & Co., produced pattern books (*c.* 1837–52) of cylinder machine prints and block prints in traditional designs (London, V&A, see Oman and Hamilton, no. 692A), together with reproductions of works of art, which were shown at the Great Exhibition at Crystal Palace, London, in 1851. In 1864 Jeffrey & Co., then in Whitechapel, merged with Holmes & Aubert of Islington, London, taking over and enlarging their Islington premises. The skill of the company's block printers led to two important commissions: the printing of wallpapers for Morris & Co. from 1864 onwards and, in 1865, of wallpapers designed by Owen Jones for the Viceroy's Palace, Cairo.

In 1866 Metford Warner (1843–1930) joined the firm as a junior partner, becoming sole proprietor in 1871. As a result of contemporary criticisms of wallpaper design, Warner took the initiative and in 1869 began to commission well-known architects and artists to design for the firm. Some, including William Burges, Charles Locke Eastlake, E. W. Godwin ('Sparrow and Bamboo', 1872; Manchester, C.A.G.) and Heywood Sumner ('The Vine', 1893; London, V&A), designed wallpapers exclusively for Jeffrey's. Although not all were commercially successful—Walter Crane's richly coloured designs (*see* WALLPAPER, colour pl. V, fig. 1) were expensive to print and had a limited market—they were widely publicized, and some were machine printed for the mass market. In 1872, under Warner, the company introduced the horizontal division of the wall into three sections: a frieze at the top, with a filling below and a dado from skirting level to a height of about 1.20 m. Complementary papers were designed for each section, and in the 1870s Jeffrey & Co. launched a new form of wallpaper design that combined frieze, filling and dado in one overall design. In 1873, at Metford Warner's insistence, wallpapers were admitted to the Fine Arts Exhibition held at the Albert Hall, London, where Jeffrey & Co. was awarded a medal for design and colouring. In 1898 Warner's sons Horace Warner (1871–1939) and Albert Warner were taken into partnership. Control of the company passed to them in the late 1920s shortly before Jeffrey's was taken over by the Wall Paper

Manufacturers Ltd, when manufacturing transferred to Arthur Sanderson & Sons.

BIBLIOGRAPHY

A. V. Sugden and J. L. Edmondson: *A History of English Wallpaper, 1509–1914* (London, 1926)

C. C. Oman and J. Hamilton: *Wallpapers: A History and Illustrated Catalogue of the Collection of the Victoria and Albert Museum* (London, 1982)

G. Saunders: *Ornate Wallpapers* (London, 1985)

A Decorative Art: 19th Century Wallpapers in the Whitworth Art Gallery (exh. cat. by J. Banham, U. Manchester, Whitworth A.G., 1985)

Walter Crane: Artist, Designer & Socialist (exh. cat., ed. G. Smith; U. Manchester, Whitworth A.G., 1989)

CLARE TAYLOR

Jegg, Stephan (*b* Schernegg, 1674; *d* Markt St Florian, 14 Jan 1749). Austrian cabinetmaker. His life was spent working as a joiner at ST FLORIAN ABBEY. In 1703 he was making architectural sections for the new church seating. In 1708 and 1711 he was making architectural models, including one for the main doorway that was executed in 1713 by the sculptor Leonhard Sattler, with whom Jegg worked as a lifelong partner, with Sattler working mainly on the sculptural figure decoration. In 1711–12 Jegg was paid 450 florins for building the altar in the Marienkapelle, for which he also made the stalls. In 1719 he made five long and five shorter tables, a cupboard with three sections and a reading pulpit for the winter refectory in the Leopoldinischer Südtrakt; none of these has survived. Together with Sattler he decorated the interiors of several rooms in 1722 and worked on the *Prunkschrank*, a splendidly decorated clock-cabinet (*in situ*). He worked in the new Kunstkammer from 1724 to 1728 and made the new sacristy cupboards (1726) for the parish church of St Peter am Wimberg. In 1739 the Prälatensakristei was refurnished, and Jegg produced several cupboards for it. After his death his son Johann Christian Jegg took over the joinery workshop.

BIBLIOGRAPHY

F. Windisch-Graetz: 'Barocke Möbelkunst in Österreich: Überblick und Forschungslage', *St Florian Erbe und Vermächtnis: Festschrift zur 900-Jahr-Feier*, Mitteilungen des oberösterreichischen Landesarchivs, 10 (Vienna, 1971), pp. 346–96

T. Korth: *Stift St Florian* (Nuremberg, 1975)

GABRIELE RAMSAUER

Jegher [Jeghers]. Flemish family of designers and woodcutters. (1) Christoffel Jegher is noted as one of the most successful interpreters of Rubens's paintings and for reviving the difficult skill of the multi-block chiaroscuro woodcut. His son (2) Jan Christoffel Jegher, a much lesser talent, worked in a similar style to his father's.

(1) Christoffel Jegher (*b* Antwerp, *bapt* 24 Aug 1596; *d* Antwerp, between 18 Sept 1652 and 17 Sept 1653). He worked from 1625 to *c*. 1643 for the Antwerp publishing house Plantin–Moretus, producing book illustrations, ornamental initials, vignettes and similar book decorations, using a language of Baroque forms. His woodcuts appear in the Plantin Missals of 1626, 1628 and 1632, and in the Breviaries of 1627, 1631–2, 1636 and 1642. He also completed *c*. 50 woodcuts for Juan Eusebio Nieremberg's *Historia naturae* (1635).

Jegher was the only woodcutter to be appointed to work in Rubens's studio in the 1630s, the earliest documentary evidence of which dates from 1633, when in July, August and September, Plantin–Moretus invoiced Rubens for two prints (presumably Hollstein, nos 6 and 10), which marked the beginning of the collaboration between the two artists. Indeed, Jegher's place in art history as the most important woodcutter of his time rests exclusively on the nine large single-page woodcuts—all undated—that also resulted from his close collaboration with Rubens in the 1630s. The woodcuts, which were produced under Rubens's supervision, are remarkable for their use of tailored lines and half-tone crosshatching to make the transition from dark to light, a technique borrowed from engraving. The inherent nature of the coarse woodcut medium and the effects that could be achieved with it were fully exploited, however, particularly in the rendering of the human form.

Two of the nine prints, the *Rest on the Flight into Egypt* (Hollstein, no. 4) and the *Garden of Love* (Hollstein, no. 17), are variations of pictures by Rubens from the 1630s (both Madrid, Prado), while the *Drunken Silenus* (Hollstein, no. 16) was a subject used by Rubens for panel paintings in the 1620s. Three of the woodcuts, the *Temptation of Christ* (Hollstein, no. 6), the *Coronation of the Virgin* (Hollstein, no. 10) and *Hercules Fighting Anger and Strife* (Hollstein, no. 15), can be traced back to ceiling paintings by Rubens, those depicting the first two subjects (destr. 1718) formerly in the Jesuit church of St Corolus Borromeus in Antwerp, that depicting the third in the Banqueting House, Whitehall, London, which was completed in 1634. The surviving preparatory drawings by Rubens (New York, Met.) for both halves of the woodcut of the *Garden of Love* are particularly sketchy in style, but the preparatory drawings for the *Drunken Silenus* (Paris, Louvre), also by Rubens, correspond much more closely to the finished woodcut. The print of *Susanna and the Elders* (Hollstein, no. 1; see fig.) is based on a drawing by a pupil (perhaps an exact copy of a missing picture) which was retouched in ink by Rubens.

It is clear from a series of retouched trial proofs that Rubens influenced Jegher's work. He determined the distribution of the light values by overpainting the proof impressions with zinc white and correcting them in ink, and he even laid down the contours. Three of the prints—the *Rest on the Flight into Egypt*, *Christ and the Infant John the Baptist* (Hollstein, no. 5) and the portrait of *Doge Cornaro* (Hollstein, no. 20)—are chiaroscuro, or coloured, woodcuts; with these Jegher revived a technique introduced to the Netherlands by Hendrick Goltzius and his successors (*see* WOODCUT, CHIAROSCURO, §2). The technical brilliance of the *Doge Cornaro*, which was printed in three tones of brown with the middle clay plate adding the dominant lines, is reminiscent of the portrait of *Hans Baumgartner* (1512) by Jost de Negker.

In the 1630s Jegher also made a series of woodcuts based on preparatory drawings by Erasmus Quellinus (ii), a member of Rubens's studio, without the participation of Rubens himself. These works, which are not to the same high standard as the woodcuts after Rubens, are a *Head of Christ* in profile (1633; Hollstein, no. 9), based on a drawing by Raphael; a full-length portrait of *Ferdinand of*

H. F. Bouchery and F. van den Wijngaert: *P. P. Rubens en het Plantijnsche Huis* (Antwerp and Utrecht, 1941), pp. 61–3

M. L. Myers: 'Rubens and the Woodcut of Christoffel Jegher', *Bull. Met.*, xxv (1966), pp. 7–23

L. de Pauw-de Veen: 'Opmerking aangaande de fragmentaire proefdruk van de houtsnede *Suzanna en de grijsaards* door Christoffel Jegher naar Pieter Paul Rubens' [Remarks concerning the fragment of the proof for the woodcut *Susanna and the Elders* by Christoffel Jegher after Pieter Paul Rubens], *Mus. Royaux B.-A. Belgique: Bull.*, n. s. 1, xv (1967), pp. 23–34

K. Renger: '*Rubens dedit dedicavitque*: Rubens' Beschäftigung mit der Druckgraphik, II. Teil: Radierung und Holzschnitt—Die Widmungen', *Jb. Berlin. Mus.*, xvii (1975), pp. 166–213

H. Lehmann-Haupt: *An Introduction to the Woodcut of the Seventeenth Century* (New York, 1977), pp. 79–96, 158–9

PETER KRÜGER

Jehan, Dreux. *See* JEAN, DREUX.

Jehan de Bondolf. *See* BOUDOLF, JAN.

Jehan de Marvile [Mervile]. *See* JEAN DE MARVILLE.

Jehol. *See* CHENGDE.

Jeitun. *See* DZHEYTUN.

Jekyll, Gertrude (*b* London, 29 Nov 1843; *d* Godalming, Surrey, 8 Dec 1932). English garden designer and writer. Best remembered for her books on horticulture and the gardens she made with the architect EDWIN LUTYENS, she first trained (1861–3) as a painter at the Kensington School of Art, London, and (*c.* 1870) under Hercules Brabazon Brabazon. Private means allowed her to concentrate on learning one art or craft after another, from embroidery to stone-carving. In 1882 she began contributing horticultural articles to magazines and advising acquaintances on planting schemes. She met the young Lutyens in 1889 and introduced him to some of his first important clients. He designed Munstead Wood, Godalming, for her in 1896. True to her Arts and Crafts background, Jekyll promoted the cottage-garden style of old-fashioned flowers, informally planted; her opinions and expertise made her a household name. Her first book, *Wood and Garden*, illustrated with her own photographs, appeared in 1899. Her schemes for about 300 gardens are known (numerous plans, Berkeley, U. CA, Coll. Envmt. Des., Doc. Col.), of which about 100 involved Lutyens, with whom she was most active between *c.* 1890 and *c.* 1910. Good (restored) examples of their joint undertakings are Deanery Garden (1899–1901; *see* LUTYENS, EDWIN, fig. 1), Sonning, Berks, and Hestercombe (1904), Somerset (*see* GARDEN, §VIII, 5 and fig. 60). Among her notable independent commissions is the garden (1917) at Barrington Court, Somerset.

WRITINGS

with L. Weaver: *Gardens for Small Country Houses* (London, 1912/*R* Woodbridge, 1981, 5/1924)

Garden Ornament (London, 1918, rev. with C. Hussey, 1927/*R* Woodbridge, 1982)

E. Lawrence, ed.: *The Gardener's Essential Gertrude Jekyll* (New York, 1964/*R* London, 1991)

D. Hinge: 'Gertrude Jekyll, 1843–1932: A Bibliography of her Writings', *J. Gdn. Hist.*, ii (1982), pp. 285–92

BIBLIOGRAPHY

J. Brown: *Gardens of a Golden Afternoon: The Story of A Partnership, Edwin Lutyens and Gertrude Jekyll* (London, 1982)

D. Ottewill: *The Edwardian Garden* (New Haven and London, 1989), pp. 59–65, 67–95, 126–30, 194–6

Christoffel Jegher: *Susanna and the Elders*, woodcut, trial proof, 265×162 mm, *c.* 1633 (Antwerp, Stedelijk Prentenkabinet)

Austria (Hollstein, no. 19); and a print of *Two Angels* (Hollstein, no. 18), which was used in J. Andries's *Catechismus necessaria ad salutem scientia* (Antwerp, 1654). He also executed 19 of the 144 chiaroscuro woodcut medallions for the reprint of Hubertus Goltzius's *Icones imperatorum* (1645). Some of the illustrations Jegher produced for Nieremberg's *Historia naturae* may also have been influenced by his collaboration with Rubens, suggested particularly by their open composition, effective division of light and shade, and emphatic lines.

(2) **Jan Christoffel Jegher** (*b* Antwerp, *bapt* 3 Nov 1618; *d* Antwerp, between 12 Dec 1666 and 18 Sept 1667). Son of (1) Christoffel Jegher. Early in his career he worked for Plantin and produced, as one of his first works, their colophon, based on a design by Rubens. In 1643–4 he was accepted as a master in the Antwerp Guild of St Luke. He executed printers' signs, ornamental letters, alphabets, small book illustrations and woodcuts with images of ceremonial processions based on his own and other designs. Abraham van Diepenbeeck, Erasmus Quellinus (ii) and Anthonis Sallaert provided the designs for Jan Christoffel's successful woodcuts of the *Life of Christ* in Jodocus Andries's *Perpetua crux* (Antwerp, 1649). Although adept at working on a small scale, Jan Christoffel lacked the skills of his father.

BIBLIOGRAPHY

Hollstein: *Dut. & Flem.*; Thieme–Becker

F. van den Wijngaert: *Inventaris der Rubeniaanschen prentkunst* (Antwerp, 1940), pp. 61–3

J. B. Tankard and M. R. Van Walkenburgh: *Gertrude Jekyll: A Vision of Garden and Wood* (London, 1989)

S. Festing: *Gertrude Jekyll* (London, 1991)

F. Gunn: *Lost Gardens of Gertrude Jekyll* (London, 1991)

R. Bisgrove: *The Gardens of Gertrude Jekyll* (London, 1992)

ROBERT WILLIAMS

Jelgava [Ger. Mitau; Rus. Mitava]. Latvian city *c.* 50 km south-west of Riga on the River Lielupe, with a population of *c.* 65,000. It was the capital of the Duchy of Kurland (now the Kurzeme region) from 1561 to 1795. Founded in 1226 as a fortress for the Livonian Order, from the early 17th century Jelgava was developed on a grid plan. In 1738–40 Bartolomeo Francesco Rastrelli began work on a palace for Ernest-John Biron, Duke of Kurland (*reg* 1737–40 and 1763–9), a favourite of Empress Anne (*reg* 1730–40), on the site of a 13th-century castle of the Livonian Order. The palace is a large three-storey Baroque building linked by passageways to two-storey wings and was completed by Rastrelli in the 1760s (*see* RASTRELLI, (2)). Other important buildings in the town include the Lutheran church of St Anne (1573–1641), with a tall tower on its west front, and the Academia Petrina, founded by Peter Biron, Duke of Kurland (*reg* 1769–95), and built in 1773–5 in late Baroque style by the Danish architect Severin Jensen (1723–after 1809) to replace a palace belonging to the Empress Anne. The Villa Medem (1835–6; by Johann Berlitz) is in Empire style, with a large Ionic portico on its main façade. The Academia Petrina (known from 1806 as the Gymnasium Illustre) houses the Jelgava Museum (founded 1818), containing applied art, ethnographical collections and Latvian painting, sculpture and drawing.

BIBLIOGRAPHY

J. Lacmanis: *Jelgavas pils* [Jelgava's palace] (Riga, 1979)

Belorussiya, Litva, Latviya, Estoniya: Spravochnik-putevoditel' [Belarus', Lithuania, Latvia, Estonia: A guide] (Moscow and Leipzig, 1986)

M. I. ANDREYEV

Jelgerhuis, Johannes (*b* Leeuwarden, 24 Sept 1770; *d* Amsterdam, 6 Oct 1836). Dutch painter, illustrator, printmaker and actor. He received his training from his father, Rienk Jelgerhuis (1729–1806), and from the landscape painter Pieter (Pietersz.) Barbiers II. While travelling with his father through the Dutch Republic he produced illustrations for almanacs, political cartoons and engravings of current events. In 1806 he settled in Amsterdam.

Jelgerhuis was famous primarily as an actor; his manual for actors, *Theoretische lessen over de gesticulatie en mimiek*, was published in 1827 by Pieter Meijer Warnars, whose bookshop Jelgerhuis had depicted in an attractive painting in 1820, *The Bookshop of Pieter Meijer Warnars on the Vijgendam, Amsterdam* (Amsterdam, Rijksmus.). With his drawings and paintings of towns (e.g. *A Street in Amersfoort*, 1826; Amsterdam, Rijksmus.), landscapes and church interiors and his portraits he achieved a distinctive place for himself among Dutch artists. His scenes are remarkable for their lively rendering of human activity, unusual in topographical drawings of the period, although the figures in his subtle, brightly lit paintings often seem somewhat clumsy.

Jelgerhuis took part in the Exhibition of Living Masters established in 1808 by Louis Bonaparte, King of Holland.

He became a teacher and director of the Department of Drawing of the Amsterdam society VW. In 1822 he was elected a member of the Royal Academy of Visual Arts in Amsterdam. Towards the end of his life his popularity as an actor declined, and he had more time to paint. The contents of his studio were auctioned in Amsterdam on 12 December 1836.

Scheen

BIBLIOGRAPHY

E. R. M. Taverne: 'Johannes Jelgerhuis (1770–1836) as Painter and Draftsman', *Antiek*, iv (1969), pp. 65–72

Johannes Jelgerhuis Rzn.: Acteur-schilder, 1770–1836 (exh. cat. by F. Asselbergs and others; Nijmegen, De Waag; Leiden, Stedel. Mus. Lakenhal; Amsterdam, Theatmus.; 1969–70)

P. KNOLLE

Jelles, E(vert) J(elle) (*b* Tjepoe, Java, 4 July 1932). Dutch architect. During his studies at the Technische Hogeschool of Delft, dominated in the 1950s by traditionalists, Jelles belonged to a small group of oppositional students who were followers of Cornelis van Eesteren and J. H. van den Broek, professors under whom he received his degree in 1960. In contrast to his fellow student and contemporary Herman Hertzberger (who, with Aldo van Eyck, was the moving force behind a more formal tradition), Jelles continued to believe in the relevance of the principles of the Functionalists, and his work wholeheartedly embraces a machine aesthetic. He rejected unilateral dogmas, however. Apart from the many buildings he designed for rational lumber construction, for example the holiday residence (1967–8) in Gieten, and his efforts in the field of plastics and their use as finishing elements, for example the Shell Research Laboratory (1965–7) in Rijswijk, the most important constants in his work are the development of the modular floor-plan and a closely related concept: linear growth. Perfect examples of the latter modular architectonic compositions are the WAVIN office building (1970–72) in Zwolle and the semi-permanent microcentre (1972) in Delft. These compositions consist of a number of parallel slices of different lengths slipping past one another, each capable of linear growth. Within the modular grid, interior walls can be freely positioned, but elements deviating in function and size (e.g. stairways, shafts and toilets) are 'plugged' into the sides. It is the inverse of a central core plan (such as still exists in earlier work by Jelles), which is a static form extendible only by duplication. The classical square floor-plan, in which space floats in all directions, is found in earlier work by Jelles, for example the kiosk (1963) in Amsterdam.

BIBLIOGRAPHY

Jelle Jelles, Werken 1960– en verder (n.d.)

'Ir. Jelle Jelles', *Tijdschr. Archit. & Beeld. Kst.*, 13 (1969), pp. 320–43

D'LAINE CAMP

Jellett, Mainie [Mary Harriet] (*b* Dublin, 20 April 1897; *d* Dublin, 16 Feb 1944). Irish painter. She was educated privately and had her first painting lessons from Elizabeth Yeats (1868–1940), Sarah Cecilia Harrison (1863–1941) and May Manning (*d* 1930). In 1913 she went to Brittany to paint and the following year entered the Metropolitan School of Art in Dublin. From 1917 she studied under Sickert in the Westminster School in London. After a visit to Spain in 1920 she followed another Irish artist, Evie

Hone, to Paris to study under André Lhôte; in 1921 they turned for instruction to Albert Gleizes, with whom they worked at intervals for the next ten years. From 1918 to 1921 Jellett exhibited portraits and landscapes at the Royal Hibernian Academy, Dublin, but by 1923 she had turned to a Cubist idiom and was lecturing and publishing essays on abstract art, noting its affinity with Celtic art. (For example of 1923 work *see* IRELAND, fig. 11). *Homage to Fra Angelico* (1928; Dublin, priv. col., see MacCarvill, 1958, p. 57), based on the *Coronation of the Virgin* in the Louvre, was her first abstract painting to be received favourably in Dublin. Thereafter her larger paintings took a religious direction, culminating in *The Ninth Hour* and *Deposition* (both 1941; Dublin, Hugh Lane Mun. Gal.), in which colour, rhythm and harmonious Cubist forms define recognizable symbols. She also made stage designs for the theatre and ballet and decorated the Irish Pavilion at the Glasgow Fair in 1938. In 1943 she was one of the founders of the Irish Exhibition of Living Art, of which she was the first chairman, but she died before the first exhibition.

WRITINGS
E. MacCarvill, ed.: *Mainie Jellett: The Artist's Vision* (Dublin, 1958)

BIBLIOGRAPHY
Mainie Jellett, 1897–1944 (exh. cat. by E. MacCarvill, Dublin, Hugh Lane Mun. Gal., 1962)
Irish Women Artists from the 18th Century to the Present Day (exh. cat., Dublin, N.G., 1987)
Mainie Jellett, 1897–1944 (exh. cat., Dublin, Irish MOMA, 1991–2)
B. Arnold: *Mainie Jellett* (Dublin, 1992)

HILARY PYLE

Jellicoe, Sir Geoffrey (Alan) (*b* London, 8 Oct 1900). English landscape designer, urban planner, architect and writer. He was educated in London at the Architectural Association School (1919–24). His book *Italian Gardens of the Renaissance* (with J. C. Shepherd), derived from student research, was published in 1925, the year in which he qualified as an architect. He soon established his practice in London. In the 1930s he was instrumental in developing the Institute of Landscape Architects (now the Landscape Institute) as a professional body. He taught at the Architectural Association School (1928–33), becoming its Principal in 1939. His projects of the 1930s include the village plan (1933) for Broadway, Hereford & Worcs, a model document under the Town and Country Planning Act of 1932, and, with Russell Page (1906–85), a pioneer modernist restaurant and visitors' centre (1934) at Cheddar Gorge, Somerset. Important garden designs of these years include Ditchley Park (1935–9), Oxon, and works for Royal Lodge, Windsor, Berks (1936–9). After World War II Jellicoe received many public commissions for landscape and planning works, such as Hemel Hempstead New Town (1947; Water Gardens completed 1959), Church Hill, Walsall, W. Midlands (1952), and the Rutherford High Energy Laboratory, Harwell, Oxon (1960). In 1965 he completed the memorial to John F. Kennedy at Runnymede, Berks. He undertook numerous private garden designs in England until his official retirement in 1979; he was knighted that year. Thereafter he continued to accept selected commissions, notably for the garden (1980–84) at Sutton Place, Guildford, Surrey, two major garden designs for the Italian cities of Modena (1980–84) and Brescia (1983), and designs (1984–8) for the Moody

Historical Gardens, Galveston, TX, and for the Atlanta Historical Society, Atlanta, GA (*see* GARDEN, §VIII, 5). His best-known achievement in private garden design is that for Shute House, Donhead St Mary, Wilts, commissioned in 1968. Jellicoe is regarded as one of the leading exponents of 20th-century landscape design, which he claimed will become the art of the whole environment.

WRITINGS
with J. C. Shepherd: *Italian Gardens of the Renaissance* (London, 1925)
Studies in Landscape Design, 3 vols (Oxford, 1960–70)
with S. Jellicoe: *The Landscape of Man* (London, 1975, 2/1991)
The Landscape of Civilisation (London, 1989)

BIBLIOGRAPHY
Contemp. Architects
M. Spens: 'Admirable Jellicoe', *Archit. Rev.* [London], clxxxvi (1989), pp. 85–92
L. Bolton: 'Water Born', *House & Gdn*, xlvi/11 (1991), pp. 130–33 [on Shute House Garden]
M. Spens: *Gardens of the Mind: The Genius of Geoffrey Jellicoe* (London, 1992)
——: *Jellicoe at Shute* (London, 1993)
——: *The Complete Landscapes of Geoffrey Jellicoe* (London and New York, 1994)

MICHAEL SPENS

Jelling. Site of a 10th-century AD royal burial in Jutland, Denmark. The find gave its name to a major style of Viking art, often spelt 'Jellinge' in English (*see* VIKING ART, §II, 1(v)(e)). The royal Danish monuments at Jelling constitute one of the most impressive Viking-period sites in Scandinavia. The monuments and their associated artefacts are of central importance for the characterization and chronology of 10th-century Viking art, both because of their high status and quality, and for the fact that they span the change from paganism to Christianity in a known historical context. They comprise an empty burial mound (the North Mound, begun winter 958–9), a mound without a grave (the South Mound, completed *c.* 970), two rune-stones and the remains of a large stone setting. The inscription on the smaller of the two rune-stones (lacking pictorial ornament) indicates that some part of this complex was erected by King Gorm in memory of his wife, Queen Thyre. The large rune-stone, described below, was erected by their son, Harald Bluetooth, both as a memorial to his parents and as a proclamation of Denmark's official conversion to Christianity.

Beneath the present stone church, probably built *c.* 1100, there have been excavated the burnt remains of three timber buildings, which had succeeded each other, the earliest containing a central grave in which had been placed the disarticulated skeleton of a 40- to 50-year-old man. This is probably the body of the pagan King Gorm, removed from the North Mound by his newly converted son to be buried in the first church on the site.

It is the ornament on a small silver cup, 420 mm high (Copenhagen, Nmus.; *see* VIKING ART, fig. 11), one of the grave goods left in the North Mound, that has given the name of Jelling to the Viking-age style. The style was earlier defined also in relation to the ornament on the large rune-stone, particularly the 'Great Beast' face, but this is now taken as characteristic of the later 10th-century Mammen style (*see* VIKING ART, §II, 1(vi)(f)). The construction of the burial-chamber in the North Mound at Jelling was started in the winter of 958/9, according to dating by dendrochronology.

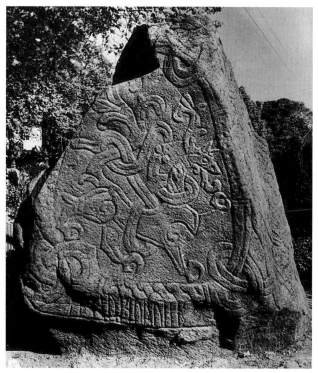

Jelling, King Harald's rune-stone, side B, showing a lion-like beast entwined with a snake, 960s (or 960–85)

The large rune-stone is situated halfway between the two mounds. It is a pyramidal granite boulder (2.43 m high) with three faces carved in low relief, no doubt originally painted. One face is mostly covered with the runic inscription, in bands, which continues below the pictures on the other two faces, the first being of a lion-like 'Great Beast', entwined with a snake (see fig.) and the second of a tendril-entwined Crucifixion (*see* VIKING ART, fig. 7). The most likely date for this most magnificent of all surviving Viking-period stone sculptures lies in the 960s, immediately following Harald's conversion to Christianity and during his alterations to the Jelling complex, although it has often been placed in the closing years of his reign (980–85). This royal memorial apparently marks the introduction of pictorial stone carving into southern Scandinavia, as it seems to have formed the model for other such stones as the new fashion spread during the latter part of the 10th century. The depiction of the Crucifixion, however, remains unique.

See also VIKING ART, §II, 1.

BIBLIOGRAPHY
K. J. Krogh: 'The Royal Viking-Age Monuments at Jelling in the Light of Recent Archaeological Excavations: A Preliminary Report', *Acta Archaeologica*, liii (1982), pp. 183–216 [with full references to earlier work at, and discussions of, the site; notably 'Jelling Problems', *Med. Scandinavia*, vii (1974), pp. 156–234]
K. Christensen and K. J. Krogh: 'Jelling-højene dateret' [The Jelling mounds dated], *Nmus. Arbejdsmk* (1987), pp. 223–30 [English summary, p. 231]

JAMES GRAHAM-CAMPBELL

Jelovšek [Ilovšek; Illouschegg]**, Franc** (*b* Mengeš, 4 Oct 1700; *d* Laibach [now Ljubljana], 31 May 1764). Slovenian painter and draughtsman. Influenced by Giulio Quaglio (1668–1751), Venetian art and Austrian Baroque painting, he executed frescoes in Laibach (1731, 1733–4, 1744, St Peter; 1734, Pri vitezu), in the chapel of Kodeljevo Castle (1734) and in several Slovenian churches, including those at Sladka Gora (1752–3) and Groblje (1759–61), and in Croatia (1752; Samobor). His scenes from antiquity are preserved in Goričane Castle near Ljubljana. He also produced oil paintings, such as the *Holy Family* (1734; Ljubljana, N.G.), altar paintings, sundials (1754; Brdo church, nr Lukovica) and painted tapestries (tempera on canvas; Ljubljana, N. Mus.).

BIBLIOGRAPHY
S. Mikuž: 'Ilovšek Franc: Baročni slikar, 1700–1764' [Ilovšek Franc: baroque painter, 1700–1764], *Zborn. Umetnostno Zgodovino*, xvi (1939–40), pp. 1–61

KSENIJA ROZMAN

Jen I. *See* REN YI.

Jenewein, Felix (*b* Kutná Hora, 4 Aug 1857; *d* Brno, 2 Jan 1905). Bohemian painter and draughtsman. He studied under Jan Swerts (1820–79) at the Prague Academy of Visual Arts (1873–8) and under Josef Mathias von Trenkwald (1824–97) at the Vienna Akademie der Bildenden Künste (1879–80). He assisted Trenkwald on the decoration of the Votivkirche at Vienna. His own monumental religious paintings—notably the murals (*c.* 1900), depicting biblical characters, for the Heilige Familie Church, Neu-Ottakring, Vienna—were more successful in Vienna than in Prague, where he lived after 1880. From 1902 he worked in Brno as an illustrator and drawing teacher. He was known mainly for his drawings and watercolours of Bible subjects, Czech history, and his own symbolic compositions (for instance, *Blood Tax*, 1882; Prague, N.G., Convent of St Agnes). In Bohemia he aligned himself first with the lyrical tradition of Josef Mánes; later he was influenced by Late Gothic models. In the 1870s and 1880s his work was characterized by elements of neo-Romanticism; it subsequently became more pessimistic and deliberately anachronistic. The style and spiritual content of his work became increasingly clearly defined up to the end of the century. He frequently used stylized silhouettes and large splashes of colour to express the human condition; the mood of his pictures is often apocalyptic, as in his most famous cycle of gouaches, *Plague* (1900; Prague, N.G., Convent of St Agnes).

BIBLIOGRAPHY
Thieme–Becker
J. Deml: *Dílo Felix Jenewina* [The work of Felix Jenewein] (Prague, 1928) [résumé in Fr. and Ger.]
E. Trnková: *Felix Jenewein* (exh. cat., Ostrava, A.G., 1967)
G. Kesnerová: 'F. Jenewein', *Tschechische Kunst 1878–1914* (exh. cat., ed. J. Kotalík; Darmstadt, Ausstellhallen Mathildenhöhe, 1984), ii, pp. 98–9

ROMAN PRAHL

Jen Hsiung. *See* REN XIONG.

Jenins [Jenyns]. *See* JANYNS.

Jen Jen-fa. *See* REN RENFA.

Jenkins, (William) Paul (*b* Kansas City, MO, 12 July 1923). American painter. He studied from 1938 to 1941 at Kansas City Art Institute in Missouri, and after serving

an apprenticeship in a ceramics factory he attended the Art Students League in New York (1948–52). Around 1953 he moved to Paris to distance himself from the pervasive intellectual influence of American Abstract Expressionism. He developed an interest in the accidental effects of colour in motion under minimal control of the medium, staining the canvas rather than painting it with a brush, colouring by flow rather than by application.

On returning in 1956 to the USA, where he first saw works by Helen Frankenthaler and Morris Louis, Jenkins began to use a technique of pouring oil paint or thinner acrylic paint on to white primed canvas from corner to corner. Manipulating the canvas to direct the flow and fusion of his characteristically intense colours, he sometimes pulled the canvas back on itself to create flaring or tapering channels, while on other occasions he lay the canvas on the floor, hooking it up at one side so that surges of colour would flood down it. Instead of brushes he used blade-like devices to regulate the flow of paint. This interest in the interaction of chance and control using a fluid material probably had its origins in Jenkins's experience of working with glazes in the ceramics factory, where he observed the magical transformation that flow and heat can induce in colours. His typical paintings, such as *Phenomena Yonder Near* (1964; London, Tate), have the generic title of *Phenomena*. Scale, variations of colour and strengths of tone determine the visual choreography.

BIBLIOGRAPHY
K. B. Sawyer: *The Paintings of Paul Jenkins* (Paris, 1961)
J. Cassou: *Jenkins* (London, 1963)
A. Elsen: *Paul Jenkins* (New York, 1973)

STEPHEN F. THORPE

Jenkins, Thomas (*b* Devon, 21 Dec 1722; *d* Yarmouth, ?15 May 1798). English dealer, painter and banker. He is thought to have studied painting in London under Thomas Hudson. In 1752 he arrived in Rome, where he shared lodgings with Richard Wilson. Of his career as a painter there remain only records of a few portraits and history paintings. He had begun dealing in art by 1754; although the parish records in Rome continued until 1773 to describe him as a painter, he seems to have abandoned painting early to dedicate himself to entrepreneurial activities. He was nevertheless elected a member of the Accademia di S Luca in 1761. He was a close friend of Thomas Hollis, through whose good offices he was elected a Fellow of the Society of Arts in 1757; for more than a decade he engaged in a regular correspondence with the Society, and his letters and drawings constitute one of the best surviving accounts of excavations in Italy. He became a protégé of Cardinal Alessandro Albani, who represented the British monarchy's interests at the papal court, and thus was close to members of Albani's circle, such as Johann Joachim Winckelmann and Anton Raphael Mengs. Being a Protestant, he incurred the enmity of the Catholic Jacobite party in Rome; he also inspired professional jealousy, and such painters as Jonathan Skelton recorded disputes with him, although overall he was generous towards young British artists. He was particularly friendly with the Irish sculptor Christopher Hewetson and with Carlo Albacini (*d* after 1807), a Roman sculptor and restorer.

As an art dealer and banker, Jenkins came to dominate the art market in Rome in the second half of the 18th century. As a businessman he was ruthless, and stories abound alleging his involvement in dishonest practices; Joseph Nollekens described his workshop in the Colosseum that produced fake antique gems. Some of these stories appear to be unjustified. He was unquestionably a man of learning and high intelligence, possessing wealth, status and influence. For more than 30 years he was an unofficial British representative to the Holy See; he was on terms of warm friendship with Pope Clement XIV, playing a significant role in supplying such antiquities as the Barbarini Candelabra to the new papal museum at the Vatican, and he also enjoyed ready access to Clement's successor Pius VI. Between 1763 and the 1790s Jenkins arranged a series of visits to Rome by members of the Hanoverian royal family.

In the 1760s and 1770s Jenkins's clientele proliferated. He sold important pictures and especially antiques to clients who included Thomas Hollis, William Locke, William Weddell, Charles Townley, Lyde Browne, John Spencer, 1st Earl Spencer, Clive of India, John Campbell, 1st Baron Cawdor, Sir Richard Worsley and innumerable others. From around 1780, when the war with France effectively closed the sea routes to England, Jenkins directed his attention to northern Europe, where his clients included the Empress Catherine II of Russia (with whom he fell out), Prince Stanisław Poniatowski and many other German, Austrian, Polish and Russian nobles.

Jenkins was closely involved in the business of excavation, often forming consortia to undertake such projects as the dredging of the Tiber in 1774. He established his bank around 1777 and by the late 1780s was reducing his activities as a dealer in pictures and marble sculptures, although in 1785 he astonished Rome by purchasing *en bloc* the famous collection of antiquities of the Villa Negroni, which he then proceeded to sell piecemeal to clients throughout Europe. Thereafter, he tended to specialize in buying and selling antique gems. He intended to retire eventually to England, but the French occupation of Rome in February 1798 forced him to flee the city, forfeiting his property and possessions, not only because of his quasi-diplomatic status, but because he had helped to supply the British forces in the Mediterranean. He died immediately on landing in England.

BIBLIOGRAPHY
DNB
A. Michaelis: *Ancient Marbles in Great Britain* (Cambridge, 1882), pp. 75–80
T. Ashby: 'Thomas Jenkins in Rome', *Pap. Brit. Sch. Rome*, vi (1913), pp. 487–511
S. R. Pierce: 'Thomas Jenkins in Rome: In the Light of Letters, Records and Drawings at the Society of Antiquaries in London', *Antiqua. J.*, xlv (1965), pp. 200–29
B. Ford: 'Thomas Jenkins: Banker, Dealer and Unofficial British Agent', *Apollo*, xcix (1974), pp. 416–25
G. Vaughan: 'James Hugh Smith Barry as a Collector of Antiquities', *Apollo*, cxxvi (1987), pp. 5–8
——: 'Albacini and his English Patrons', *J. Hist. Col.*, iii (1991), pp. 183–97
——: 'The Restoration of Classical Sculpture in the Eighteenth Century and the Problem of Authenticity', *Why Fakes Matter: Essays on Problems of Authenticity*, ed. M. Jones (London, 1992), pp. 41–50

GERARD VAUGHAN

Jennens, Charles (*b* Gopsall, Leics, 1700; *d* Gopsall, 20 Nov 1773). English patron, collector and writer. The grandson of a wealthy Birmingham ironmaster, he was educated at Balliol College, Oxford. Subsequently he divided his time mainly between London and the family estate at Gopsall, which he inherited, along with properties in five other counties, in 1747. Jennens is remembered now for his collaborations with the composer George Frideric Handel, for whom he compiled several librettos for oratorios, including *Messiah* (first performed in 1742), but he also published editions of five tragedies by William Shakespeare. Modern critics' derogatory comments on Jennens have been influenced by abusive allegations by his rival Shakespeare editor, George Steevens, who envied Jennens's scrupulous and forward-looking scholarship. In his own lifetime Jennens was better known for his large art collection, comprising over 500 works, which reflected his deep religious commitment, his loyalty to the deposed Stuart royal family, his enthusiasm for Italian art and, in later life, his interest in contemporary English artists.

Around 1749 Jennens apparently engaged the architects William Hiorne (*c.* 1712–76) and his brother David Hiorne (*d* 1758) to transform Gopsall Hall, a Jacobean house, into a magnificent and richly decorated Palladian mansion, probably to the designs of the master carpenter John Westley (1702–69). Gopsall Hall was not completed until *c.* 1760 (destr. 1951), before which the brothers also built the stables. Jennens lavished equal attention and expense on his gardens: numerous temples were designed for the grounds, of which several were built. The finest of these was the monument (1764) to his close friend, the Virgil scholar *Edward Holdsworth* (*d* 1746): for this the architect James Paine collaborated with the Hiornes on an Ionic rotunda, which was set up over a cenotaph by Richard Hayward (1728–1800) and surmounted by Louis-François Roubiliac's personified figure of *Religion* (or *Fides Christianae, c.* 1764; rotunda partly destr. 1835; cenotaph and *Religion* now Leicester, Belgrave Hall), which was unique among Roubiliac's output. Jennens's enthusiasm in later life for English painters—his purchases included several works by Francis Hayman (e.g. the *Resurrection*, before 1761; untraced) as well as landscapes by George Lambert and Thomas Gainsborough—shows a bias towards those associated with the St Martin's Lane School, London. After Jennens's death, his estate and collection of paintings and sculptures, which included works then attributed to Rembrandt, Peter Paul Rubens, Salvator Rosa, Frans Hals, Carlo Maratti and other Dutch and Italian Old Masters (itemized by the Dodsleys and by Martyn), passed to the Hon. Assheton Curzon (*d* 1797). Curzon sold almost one third of the collection the following year (London, Langford's, 27–8 April 1774); what remained was dispersed after sales at Gopsall in 1918 and 1920.

BIBLIOGRAPHY
Colvin; *DNB*; *Grove 6*
R. Dodsley and J. Dodsley: *London and its Environs Described*, v (London, 1761), pp. 76–97
T. Martyn: *The English Connoisseur: Containing an Account of . . . Painting, Sculpture &c in the Palaces and Seats of the Nobility and Principal Gentry in England*, i (London, 1766), pp. 117–43
A. Rowan: *Garden Buildings* (Feltham, 1968), pp. 18–25
T. F. Friedman: 'Hiorn, William and David', *Catalogue of the Drawings Collection of the RIBA, G-K* (London, 1973), pp. 130–32
T. V. Parry: *A Temple at Gopsall Park* (diss., U. Manchester, 1981)
Roubiliac's Statue 'Religion', Leicester, Mus. & A.G. (Leicester, 1981)
Francis Hayman (exh. cat. by B. Allen, New Haven, CT, Yale Cent. Brit. A.; London, Kenwood House; 1987), pp. 60–62
R. Smith: 'The Achievements of Charles Jennens', *Music & Lett.*, 70 (1989), pp. 161–90 [with illus.]
The Independent (23 December 1992), p. 11 [remains of rotunda discovered]
RUTH SMITH, with ROBERT WILLIAMS

Jenney, Neil (*b* Torrington, CT, 1945). American painter. He studied at the Massachusetts College of Art in Boston from 1964 to 1966 before settling in New York, where he began producing paintings enclosed by aggressively three-dimensional frames that continued to reveal his early training as a sculptor; in many cases the title of the work was displayed in large letters on the frame itself. In the first such pictures he used broad brushwork and generally juxtaposed the image of a human figure with an object in a theatrical or allegorical manner suggesting love, despair or aggression. In *Them and Us* (1969; New York, MOMA), for example, the Cold War is symbolized by the images of a Soviet fighter aeroplane and an American set in an atmosphere of agitated brushwork. By the 1980s his preference for sparseness and for emblematic imagery led him increasingly towards abstraction, although by continuing to emphasize the association between the picture and its title he remained committed to the role of subject-matter.

BIBLIOGRAPHY
Neil Jenney: Paintings and Sculpture, 1967–1980 (exh. cat. by M. Rosenthal, Berkeley, U. CA, A. Mus., 1981)
KLAUS OTTMANN

Jenney, William Le Baron (*b* Fairhaven, MA, 25 Sept 1832; *d* Los Angeles, CA, 15 June 1907). American architect. The son of a prosperous merchant, he studied at Phillips Academy, Andover, MA, and in 1859 entered the Lawrence Scientific School, Harvard College, Cambridge, MA, to study engineering. He took the unusual step of studying at the Ecole Centrale des Arts et Manufactures in Paris (1853–6). In contrast to the course at the Ecole des Beaux-Arts, which stressed the art of design, the course at the Ecole Centrale focused more on expressing function in industrial design and on an empirical and pragmatic approach. Jenney worked for a French railway company for a few years and returned to the USA at the outbreak of the Civil War (1861). He served in the Union Army Corps of Engineers, being discharged in 1866 with the rank of major.

In 1868 Jenney established an architectural practice in Chicago (see CHICAGO, §1). Gradually he focused on the design of office and loft buildings, making the structures more efficient and enlarging the windows. Such buildings as his Portland Block (1872; destr.) attracted promising young architects to his office, including Louis Sullivan, William Holabird, Martin Roche, Daniel H. Burnham and Enoch H. Turnock; their work developed the distinctive image of the Chicago skyscraper (see SKYSCRAPER, §2(i)).

For the first Leiter Building (1879; destr.) Jenney used an internal skeleton of iron, with slender iron columns embedded in the exterior wall carrying the floor beams; otherwise the exterior masonry wall carried its own weight, which was reduced due to the extremely broad windows.

In the Chicago branch of the Home Insurance Company (1883–5; destr. 1931; *see* CHICAGO, fig. 1), working with engineer George B. Whitney, Jenney took the decisive step of using a complete steel frame above the second floor, with metal lintels carrying all exterior masonry cladding and the windows. This was the first building constructed around a steel skeleton. Working with engineer Louis E. Ritter (1864–1934), in 1889–90 he also used an iron-and-steel skeletal frame for the whole of the taller Manhattan Building, 431 S. Dearborn Street, also adding diagonal wind bracing. None of these office blocks as yet had exterior masonry skins commensurate with the daring of their internal frames. In the granite exterior of the huge Sears, Roebuck & Company Store (1889–91), State and Van Buren Streets in Chicago, he finally clearly expressed the presence of the internal iron and steel skeleton.

After 1891, when Jenney formed a partnership with William B. Mundie (1863–1939), the firm produced the elegantly restrained Ludington Building (1891) and the Montgomery Ward (later Fair) Store (1891–2; destr.). The Morton Building (1896), 538 S. Dearborn Street, and the Chicago Garment Center (1904–5), Franklin and Van Buren Streets, continued this tradition of straightforward structural expression. In 1893 Jenney & Mundie participated in producing designs for the World's Columbian Exposition in Chicago. Jenney then retired and in 1905 moved to Los Angeles. More than any other architect Jenney was instrumental in establishing the character of Chicago office building and contributing to the structural development of the modern metal-framed skyscraper.

WRITINGS
'Construction of a Heavy Fireproof Building on Compressible Soil', *Engin. Rec., Bldg Rec. & Sanitary Engin.*, xiii (1885), pp. 32–3

BIBLIOGRAPHY
DAB; *Macmillan Enc. Architects*
A. Woltersdorf: 'The Father of the Skeleton Frame Building', *W. Architect*, xxxiii (1924), pp. 21–3
J. C. Webster: 'The Skyscraper: Logical and Historical Considerations', *J. Soc. Archit. Hist.*, xviii (1959), pp. 126–39
C. W. Condit: *The Chicago School of Architecture: A History of Commercial and Public Building in the Chicago Area* (Chicago, 1964)
T. Turak: 'Ecole Centrale and Modern Architecture: The Education of William Le Baron Jenney', *J. Soc. Archit. Hist.*, xxix (1970), pp. 40–47
J. Zukowsky, ed.: *Chicago Architecture, 1872–1922: Birth of a Metropolis* (Munich, 1987)

LELAND M. ROTH

Jennys. American artists. Richard Jennys (*fl* 1766–1801) and William Jennys (*fl* 1793–1808) were successful itinerant portrait, miniature and ornamental painters working mainly in New England; Richard was also an engraver. They both founded art schools and collaborated on several occasions, jointly signing portraits from 1795 to 1801. They were probably related, William possibly being the son and apprentice of Richard. While they were relatively prolific artists, the basic details of their lives, such as dates of birth and death, remain unknown.

The Jennyses worked in an accomplished but highly conservative mid-18th-century portrait style, in which the sitter is represented bust-length within an oval. The continued use of this format may reflect, in part, Richard's work as an engraver while in Boston. About 1766 Richard executed his first known work, a mezzotint of the *Rev. Jonathan Mayhew* (Worcester, MA, Amer. Antiqua. Soc.),

pastor of the West Church in Boston. As well as the format, the sharp value contrasts and hard outlines characteristic of line engravings are stylistic elements found in the later oil portraits of the Jennyses.

Richard Jennys is known to have worked in Boston in the 1760s and later in the West Indies. In 1783 he was in South Carolina, where he advertised his intention to pursue portrait painting 'in all its branches'. From 1785 to 1791 he painted both large and miniature portraits in Savannah, GA. He also visited the West Indies during this time. In 1792 he opened his art school in New Haven, CT. From there he travelled to New Milford, CT, where he painted portraits intermittently from 1794 to 1798. William's association with Richard is first documented at this time in the account book of their patron, Jared Lane (ex-CT Hist. Soc., Hartford). Approximately 15 portraits of New Milford subjects have been documented or attributed to Richard and William Jennys, including portraits of Lane's in-laws, *Captain Lazarus Ruggles* and his wife *Hannah Ruggles* (New York, Kennedy Gals). The Jennyses faithfully recorded their subjects' features, often in an unflattering manner, and this intense realism resulted in powerful characterizations. The Jennyses travelled throughout New England in the 1790s, jointly signing such portraits as *Captain David Judson* and *Gifsel Warner Judson* (both 1799; Norfolk, VA, Chrysler Mus.) and *Mrs David Longenecker* (1801; Philadelphia, PA, Hist. Soc.). The latter portrait is Richard's last known work. William Jennys is listed in New York City directories for 1797–8, and after 1800 he travelled to central Massachusetts and Vermont and then to Portsmouth, NH, and Newburyport, MA. His last known documented work is the portrait of *James Clarkson* of Newburyport (1807; priv. col., see Warren, 1955, fig. 2).

BIBLIOGRAPHY
W. L. Warren: 'The Jennys Portraits', *CT Soc. Bull.*, xx/4 (1955), pp. 97–128
——: 'A Checklist of Jennys Portraits', *CT Soc. Bull.*, xxi/2 (1956), pp. 33–64
——: 'Captain Simon Fitch of Lebanon', *CT Soc. Bull.*, xxvi/4 (1961), pp. 120–21
E. M. Kornhauser and C. S. Schloss: 'Painting and Other Pictorial Arts', *The Great River: Art and Society of the Connecticut River Valley* (Hartford, 1985), pp. 138, 165–6
Ralph Earl: The Face of the Young Republic (exh. cat. by E. M. Kornhauser and others, New Haven, CT, 1991)

ELIZABETH MANKIN KORNHAUSER

Jen Po-n'ien. *See* REN YI.

Jensen, Alfred (Julio) (*b* Guatemala City, 11 Dec 1903; *d* Glen Ridge, NJ, 4 April 1981). American painter and printmaker of Guatemalan birth. Of Polish, German and Danish heritage, he started school in Denmark and completed high school in San Diego, CA, after working as a seaman and as a farmer in Guatemala. He eventually decided to train as a painter, studying at the San Diego Fine Arts School in 1925 and with Hans Hofmann in Munich in 1926–7. He settled permanently in the USA only in 1934. The patronage of Saidie Alder May (*d* 1951), a wealthy woman whom he met in 1927 as a fellow student of Hofmann, made it possible for him to dedicate himself to the study of colour theory (especially that of Johann Wolfgang von Goethe), Mayan and Inca cultures, science,

mathematics and philosophy. Much of this knowledge was later transposed into complex, diagrammatic pictures such as *Family Portrait* (1958) and *The Great Mystery II* (1960; both Buffalo, NY, Albright–Knox A.G.), which are characterized by grid structures of tiny squares in bright opaque colours.

Although there is sometimes a superficial resemblance between works by Jensen and the use of particular motifs by other artists—for example the colour circles of Robert Delaunay and Sonia Delaunay or the numbers of Jasper Johns—his purpose in using such forms and symbols was highly personal, bordering on the metaphysical. The complexity of the relationships of colour was paralleled by mathematical sequences which reflected Jensen's interest in magical numerical systems. In works of the 1970s, such as *Doric Order* (1972; Pittsburgh, PA, Carnegie), he returned to the use of repeated signs, letters and especially numbers, which he had first used around 1960.

BIBLIOGRAPHY

Alfred Jensen (exh. cat., ed. W. Schmied; Hannover, Kestner-Ges.; Humlebæk, Louisiana Mus.; Baden-Baden, Staatl. Ksthalle; and elsewhere; 1973)

Alfred Jensen: Paintings and Diagrams from the Years 1957–1977 (exh. cat. by L. Cathcart and M. Tucker, Buffalo, NY, Albright–Knox A.G., 1978)

Alfred Jensen: Paintings and Works on Paper (exh. cat., essays P. Schjeldahl and M. Reidelbach; New York, Guggenheim, 1985)

ALBERTO CERNUSCHI

Jensen, Christian Albrecht (*b* Bredsted, nr Husum, 26 June 1792; *d* Copenhagen, 13 July 1870). Danish painter. Apart from his many copies of Old Masters, he is exceptional in Danish art of his time in devoting himself solely to portrait painting. He went to Copenhagen *c.* 1810 to study at the Kongelige Danske Kunstakademi, where he was taught by Christian August Lorentzen (1749–1828), with whom he also studied privately. In 1816 Jensen embarked on an extended educational journey to Rome. In Rome he painted a series of small, intimate portraits of acquaintances, and in these paintings he developed his own style. His masterpiece is his portrait of the sculptor *Hermann Ernst Freund* (1819; Copenhagen, Stat. Mus. Kst; see fig.), in which he depicted his good friend and colleague as a romantic artist, with open-neck shirt, beret and long hair. Although the portrait is small in scale, it is detailed in its characterization.

Financial hardship forced Jensen to leave Rome and return home in 1821, and his new portrait style quickly gained great popularity among the Copenhagen public. From the mid-1820s to 1840 Jensen was the most popular portrait painter in Denmark. One of the highlights of this period is the portrait of *Birgitte Søbøtker Hohlenberg, née Malling* (1826; Copenhagen, Stat. Mus. Kst), in which he caught the expression of the young girl with light brushstrokes. From a purely painterly point of view the picture shows his skill in fusing light and colour. In 1828 Jensen applied for the position of professor at the Kunstakademi after Lorentzen. He was passed over, however, in favour of Freund. To safeguard his financial position Jensen began to provide copies for the portrait collection at Frederiksborg Slot in 1832. This occupation soon met with opposition from the art historian Niels Lauritz Høyen,

Christian Albrecht Jensen: *Hermann Ernst Freund*, oil on copper, 200×130 mm, 1819 (Copenhagen, Statens Museum for Kunst)

who favoured having only original portraits in the collection. Jensen was under the king's protection, however, and he retained the employment until 1847. Høyen's criticism was countered by Jensen providing original portraits instead of copies, and he produced a series of portraits of the most prominent men of the time, including the *Ørsted Brothers*, the author *Adam Oehlenschläger* and the painter *C. W. Eckersberg*. These portraits show that he had also mastered the major representational portrait. Høyen was, however, one of the period's arbiters of taste, and his aversion to Jensen, together with a change of taste in portrait painting in the 1830s, contributed to the artist receiving fewer and fewer commissions. In response Jensen travelled abroad, to England, Russia and Germany. This came to an end in 1848 because of the Danish–German war, which also strengthened the antipathy against him, since, having been born in Schleswig, he sympathized with the opponents. His situation worsened because his protector, King Christian VIII, died the same year.

Jensen was saved by being appointed in 1849 as an assistant in the Kongelige Kobberstiksamling, Copenhagen, where he remained until his death. During this period he painted only a few portraits. The last is from 1858 and depicts the University Senate Councillor *Andreas Gottlob Rudelbach* (Copenhagen, Stat. Mus. Kst). This work is the culmination of Jensen's career as a portrait painter; it is a

powerful depiction of the ageing man, without idealization, and the subject is enlivened with intense glowing colours. The painting marks the end of a long career as a portrait painter and is a masterpiece of the period. After his death Jensen was soon forgotten. Only in the early 20th century was his work rehabilitated, and he came to be considered one of the greatest portrait painters of the Danish Golden Age.

BIBLIOGRAPHY
S. Schultz: *C. A. Jensen*, 2 vols (Copenhagen, 1932)
Danish Painting: The Golden Age (exh. cat., London, N.G., 1984)
C. M. Smidt: *Portraetmaleren C. A. Jensen* [The portrait painter C. A. Jensen] (Copenhagen, 1986)

ELISABETH CEDERSTRØM

Jensen, Georg (Arthur) (*b* Rådvad, nr Copenhagen, 31 Aug 1866; *d* Copenhagen, 2 Oct 1935). Danish silversmith and sculptor. He was the son of a blacksmith, and at the age of 14 he was apprenticed to the goldsmith A. Andersen in Copenhagen. In 1884 he became a journeyman and in 1887 he enrolled at the Kongelige Danske Kunstakademi, where he studied sculpture with Theobald Stein (1829–1901), Bertel Thorvaldsen's successor; a bronze cast of his *Harvester* of 1891 is in the courtyard of the Georg Jensen silversmithy in Copenhagen. After graduating in 1892 Jensen took up ceramics, working with Joachim Petersen (1870–1943), and in 1900 his work was awarded an honourable mention at the Exposition Universelle in Paris. In the same year he received a grant to travel in France and Italy; it was during this trip that he became interested in the applied arts. On his return to Copenhagen, Jensen worked for the silversmith Mogens Ballin, and in 1904 he opened his own workshop, primarily making jewellery. His brooch of 1905, 'No. 20' (Copenhagen, Jensen Mus.), is representative of many of his early designs, which show the influence of Art Nouveau and are often characterized by full, simple forms incorporating stylized bird and flower motifs. In 1906 he produced his first complete set of flatware, 'Continental', which was still in production in the 1980s. Distinctive for its restraint and the interplay between its strong silhouette and a surface animated by small hammermarks, it is a clear expression of his involvement with the Arts and Crafts Movement. Many of Jensen's most famous pieces were produced between 1908 and 1918. In 1914 the Louvre, Paris, bought a silver bowl (1912), subsequently known as the 'Louvre bowl'. It shows both the slightly low, bulbous profile and the use of discrete bands of decoration that are typical of his hollow-ware.

Jensen's two closest collaborators were the architect and painter Johan Rohde and Harald Nielsen (1892–1977), who joined the workshop in 1907 and 1909 respectively. Rohde was responsible for several important designs, including the successful flatware pattern 'Acorn' (1915). Nielsen started as a chaser and subsequently became a draughtsman and, in the 1920s, a designer. His flatware 'Pyramid' (1926; e.g. Copenhagen, Jensen Mus.) reflects a blend of Jensen's influence and a sensitivity to contemporary movements, in this case Art Deco, that is characteristic of his work. After Jensen's death Nielsen became artistic director of the smithy, and under his leadership the firm continued to produce the work of other designers, including Sigvard Bernadotte (*b* 1907), Henning Koppel (1918–81) and Jensen's son, Søren Georg Jensen (*b* 1917).

BIBLIOGRAPHY
Georg Jensen Silversmithy: 77 Artists, 75 Years (exh. cat., Washington, DC, Renwick Gal., 1980)
D. R. McFadden, ed.: *Scandinavian Modern Design, 1880–1980* (New York, 1982)
J. E. R. Møller: *Georg Jensen: The Danish Silversmith* (Copenhagen, 1984)

ELIZABETH LUNNING

Jensen [Johnson], **Gerrit** [Garrard; Garrett; Gerrard] (*fl c.* 1680–1715; *d* London, 2 Dec 1715). English cabinetmaker. He has previously been described as Flemish or Dutch but is more likely to have been of a family long domiciled in England. He was an important supplier of furniture and mirrors to the royal palaces from the later part of the reign of Charles II (*reg* 1660–85): his earliest recorded royal commission was in 1680, when he supplied 'a cabinet and frame table-stands and glass' as a gift for the sultan of Morocco. Jensen's name appears frequently in the royal accounts during the reign of William III and Mary II: in an inventory (1697) of the Queen's possessions at Kensington Palace, London, tables, glasses and stands inlaid with metal that 'came in after her death from Mr Johnson' are mentioned. It appears that he had a close relationship with Pierre Gole and was strongly influenced by the work of Daniel Marot I, Gole's brother-in-law. Consequently, Jensen's furniture reflects the fashionable French court styles, and he was the only cabinetmaker working in England at this period who is known to have used metal inlays in his work. He also employed elaborate marquetry, for example in a writing-table made for Kensington Palace (1690; Windsor Castle, Berks, Royal Col.), and japanned work. Other examples of Jensen's work are at Kensington Palace and Hampton Court, London, and work attributed to his workshop is at Chatsworth, Derbys; Knole, Kent, NT; Burghley House, Cambs; Petworth House, W. Sussex, NT; and in the Duke of Buccleuch's private collection.

BIBLIOGRAPHY
R. Edwards and M. Jourdain: *Georgian Cabinet-makers* (London, 1944, rev. 3/1955)
R. Edwards: *The Shorter Dictionary of English Furniture* (London, 1964)
G. Beard and C. Gilbert, eds: *Dictionary of English Furniture Makers, 1660–1840* (London, 1986)

BRIAN AUSTEN

Jensen, Jens (*b* Dybbøl, Denmark, 13 Sept 1860; *d* Ellison Bay, WI, 1 Oct 1951). American landscape architect of Danish birth. He began building his reputation as a designer in 1888 when he delighted the Chicago public with his design for the American Garden in Union Park. With it he set the tone for a lifetime of creating natural parks and gardens. During a stormy career with Chicago's West Parks, Jensen reshaped Union, Humboldt, Garfield and Douglas parks. His work on Columbus Park (1916) is generally regarded as the best of his designs for Chicago's West Parks System. During the same period he designed numerous residential gardens for the élite of Chicago and across the Midwest. He established close friendships with the architects of the Prairie school and occasionally collaborated with them on projects.

Throughout his career Jensen attempted to relate forms and materials to the surrounding native landscape. Designs

were not intended to be copies of nature, but symbolic representations using colour, texture, sunlight and shadow, seasonal change, and careful manipulation of space to evoke a deep emotional response. He saw a value in plants then thought to be common weeds and used them in ecological patterns as found in the wild. His design of 1935 for Lincoln Memorial Garden in Springfield, IL, attempted to re-create the landscape of Illinois that Abraham Lincoln might have experienced. For Jensen there was an obvious continuum between design and conservation. He sought to awaken the public to the beauty and cycles of nature; through groups such as the Prairie Club and the Friends of our Native Landscape he sought to preserve remnants of wild natural heritage. His efforts led to the creation of the Forest Preserve system surrounding Chicago and the state park system of Illinois. In 1934 Jensen founded The Clearing in Ellison Bay, WI, a school dedicated to an integrated study of the arts and crafts and of nature.

WRITINGS

'The Naturalistic Treatment in a Metropolitan Park', *Amer. Landscape Architect*, ii/1 (1930), pp. 34–8
Siftings, the Major Portion of the Clearing and Collected Writings (Chicago, 1956)

BIBLIOGRAPHY

L. Eaton: *Landscape Artist in America: The Life and Work of Jens Jensen* (Chicago, 1964)
R. Grese: *Jens Jensen: Maker of Natural Parks and Gardens* (Baltimore, 1992)

ROBERT E. GRESE

Jensen-Klint, P(eder) V(ilhelm) (*b* Skelskør, 21 June 1853; *d* Copenhagen, 1 Dec 1930). Danish architect and painter. After training as a structural engineer at the Polyteknisk Lreanstalt, Copenhagen, he studied at the Malerskole of the Kunstakademi (1878–85). Jensen-Klint turned from painting to architecture and craftwork. He was closely attached to the Grundtvigian Folk High School. He grieved for the decline of craftsmanship and saw the development of academic architecture as meaningless; he wanted to give architecture back to the people by recovering 'the scarlet thread of tradition that binds generation to generation'. He thought classicism had broken the continuity he considered necessary for healthy development. He himself returned to Gothic and Baroque forms and praised the example of Paul Schultze-Naumburg. Jensen-Klint believed that young students should study regional building styles. In Denmark brick was the only natural building material. When young he had noticed that the growth pattern of sea and snail shells was so regular (logarithmic spiral) that dimension only and not form altered, reflecting the Aristotelian principle of 'unity in diversity'. Jensen-Klint wanted to create architecture based on the same simple laws. His first house (1896), Sofievej 27, Copenhagen, was in red brick with mussel shells carved in limestone above the windows. Jensen-Klint strove for integrity in craftsmanship and materials, and simplicity and strength in the expression. His houses at Søbakken 15 (1902), Onsgårdsvej 12 (1905) and Gardes Allé 36 (1915), all in Copenhagen, and H. N. Rasmussen's Gymnastic Institute (1900), Vodroffsvej 49–51, are a continuation of the free historicism of J. D. Herholdt (1818–1902).

Jensen-Klint sought to homogenize the residential district. He wished to evolve a modern house style out of regional architectural tradition. His ideas, which were the foundation of a line of development in Danish architecture, were carried on through Drawing Aid (1907), which continued as the National Association for Better Architecture (1915). The Stationsby (Station Town), constructed for the national exhibition in Århus (1909), demonstrated this development. Jensen-Klint designed the forge and the smith's house. His church plans date from 1907 with a proposal for a national monument, which he called 'a crystallized nodule of Danish church towers' each with its bell tuned to the others. The first plan (1912), in collaboration with Ivar Bentsen, took the form of a Gothic crossed vault. The proposal for the final plan, a triple-aisled cathedral, was complete in 1913 and the model made in 1914. A variant was a proposal for a church in Århus (1913), whose twin towers earned it the title Tveje ('forked') Aars. The design was repeated in St Hans Tveje (1916–20), Odense. The blind corbie gables of village churches could be proportioned to suit the place and the aim. His son, KAARE KLINT, designed variations on this theme with the Church of Bethlehem (1930) in Copenhagen. In 1921 it was decided that the Grundtvig Church (*see* BRICK, fig. 15) should be built on high-lying undeveloped ground at Bispebjerg, near Copenhagen. The area around the church was bounded by two-storey dwellings whose axes repeat the chief motifs of the monument. The church was an expressionistic interpretation of the Danish village church, and the materials, yellow brick and red roofing tiles, bore witness to Jensen-Klint's 'unity of material and a harmonious regularity in all forms'. The tower was consecrated in 1927, and the church was completed in 1940 under the direction of Kaare Klint.

WRITINGS

'Hus i Hellerup', *Arkitekten DK*, x/50 (1907–8), pp. 545–7
Bygmesterskolen [The school of master builders] (Copenhagen, 1911)
'Grundtvigs kirke og Bispebjerg', *Arkitekten DK*, xxi (1918–19), pp. 214–48
'Udviklingslinien i Dansk kunst', *Arkitekten DK*, xxi (1918–19), pp. 237–41

BIBLIOGRAPHY

V. Wanscher: 'P. V. J. Klint', *Arkitekten DK*, ix/5 (1906–7), pp. 165–71
M. Clemmensen: 'P. V. J. Klint', *Arkitekten DK*, xxviii (1926), pp. 249–54
J. Marstrand: *Grundtvigs Mindekirke paa Bispebjerg* [Grundtvig's memorial church at Bispebjerg] (Copenhagen, 1932)
K. Fisker: 'Den Klintske skole', *Arkitektur DK*, vii/2 (1963), pp. 37–80

LISBET BALSLEV JØRGENSEN

Jenson, Nicolas (*b* Sommevoire, Marne, *c.* 1420; *d* Venice, after 7 Sept 1480). French printer and publisher. Having served his apprenticeship at the Royal Mint in Paris, he was promoted to the position of Master of the Mint at Tours. He may have been sent to Mainz in 1458 by Charles VII, King of France, to learn printing. By 1470 he was an established publisher in Venice, producing four editions in that year including Cicero's *Epistolae ad atticum* and *Rhetorica novus et vetus*. In 1471 he printed eighteen editions and in 1472 ten. In 1473 he formed an association with Jacques Le Rouge of Chablis, who started to print using Jenson's type in late 1473. In 1474 he fought off strong German competition by entering into partnership with two German entrepreneurs, Johannes Rauchfas and

Peter Ugelheimer, both of Frankfurt am Main. They formed the company 'Nicolaus Jenson et socii', which probably lasted until 1480. Of the 98 books attributed to Jenson, 29 are religious, 24 are Classical texts and at least 10 are on medical subjects. He achieved a pre-eminent position in Venetian publishing. In 1475 he was made Count Palatine by Pope Sixtus IV. In May 1480, in amalgamation with his main rivals in Venice, he started a new firm called 'Zuan de Cologna e Nic. Ienson e compagni', which involved nine partners. The first book with this imprint appeared in November 1480. In his will, dated 7 September 1480, his type was left to Ugelheimer, who apparently sold it to Andrea Torresani, Aldo Manuzio's father-in-law.

See also TYPOGRAPHY, §I and fig. 1.

BIBLIOGRAPHY

L. V. Gerulaitis: *Printing and Publishing in Fifteenth-century Venice* (Chicago, 1976)
M. Lowry: *Venetian Printing: Nicolas Jenson and the Rise of the Roman Letterform* (Herning, 1989) [Eng. and Dan. text]
——: *Nicolas Jenson and the Rise of Venetian Publishing in Renaissance Europe* (Oxford, 1991)

LAURA SUFFIELD

Jen Wei-ch'ang. *See* REN XIONG.

Jenyns, (Roger) Soame (*b* Newmarket, 24 April 1904; *d* Cambridge, 14 Oct 1976). English art historian. After studying at the University of Cambridge, he entered the Hong Kong civil service, becoming fluent in Cantonese. In 1931 he joined the staff of the British Museum, London; apart from service in the Royal Navy during World War II, he remained there until his retirement in 1967, organizing the Chinese and Japanese ceramic collections both chronologically and regionally. His most important publications, covering the Ming (1368–1644) and Qing (1644–1911) periods, are *Later Chinese Porcelain* (1951) and *Ming Pottery and Porcelain* (1953), both of which draw on sources not easily accessible at the time and include historical material unavailable elsewhere. His lively, often controversial style of lecturing did much to stimulate interest in East Asian art.

WRITINGS

A Background to Chinese Painting (London, 1935)
with M. Jourdain: *Chinese Export Art in the 18th Century* (London, 1950)
Later Chinese Porcelain: The Ch'ing Dynasty (1644–1912) (London, 1951, 4/1971)
Ming Pottery and Porcelain (London, 1953/*R* 1988)
Japanese Porcelain (exh. cat., London, A. Council Gal., 1956)
with W. Watson: *Chinese Art: The Minor Arts*, 2 vols (London, 1963–5; ii/*R* 1981)
Japanese Porcelain (London, 1965)
Japanese Pottery (London, 1971)

MARGARET MEDLEY

Jerabis [Jerablus]. *See* CARCHEMISH.

Jerash. *See* GERASA.

Jerichau. Danish family of artists. The sculptor (1) J. A. Jerichau married the painter and writer Elisabeth Baumann (*b* 27 Nov 1819; *d* 11 July 1881) in Rome in 1846. Her background (she was born in the country house of Jolibord near Warsaw) and her training made her work closer to the European tradition than to contemporary

Danish nationalist tendencies. Their son Harald Jerichau (*b* 18 Aug 1851; *d* 6 March 1878) became a painter of genre scenes and landscapes largely related to his extensive travels in Europe. His brother Holger Hvitfeldt Jerichau (*b* 29 April 1861; *d* 25 Dec 1900), also a painter, travelled widely in Europe, Russia and India, although some of his autumn and winter landscapes from his youth in Denmark are among his most successful works. Holger's son (2) Jens Adolf Jerichau is regarded as the first Danish Expressionist painter.

Thieme–Becker

BIBLIOGRAPHY

E. Jerichau Baumann: *Ungdomserindringer* [Memoirs of youth] (Copenhagen, 1874)
——: *Til erindring om Harald Jerichau* [In memory of Harald Jerichau] (Copenhagen, 1879)
——: *Brogede rejsebilleder* [Motley travel sketches] (Copenhagen, 1881)
N. Bøgh: *Elisabeth Jerichau-Baumann: En karakteristik* [Elisabeth Jerichau-Baumann: a character sketch] (Copenhagen, 1886)

(1) J(ens) A(dolf) Jerichau (*b* Assens, Fyn, 17 April 1816; *d* Neder Dråby, nr Frederikssund, 24 July 1883). Sculptor and teacher. He studied at the Kongelige Danske Kunstakademi in Copenhagen (1831–8), initially as a painter, then from 1836 as a sculptor under Hermann Ernst Freund. From summer 1838 he studied in Rome, where he worked in Bertel Thorvaldsen's studio for a year. Apart from a brief stay in Denmark in the summer of 1846, he remained in Rome until 1849. The last 34 years of his life he spent in Denmark as a professor, in the life class at the Kunstakademi, and he became its Director in 1857–63.

Jerichau's first major work, the sculpted frieze the *Nuptials of Alexander and Roxane*, was conceived in Rome in 1842. It was ordered for the newly built Christiansborg Slot and was finished only in 1864. It was lost in the fire at the palace in 1884, but fragments of it remain (Copenhagen, Ny Carlsberg Glyp.), along with reconstructions by his assistant H. Conradsen (1817–1905). The work displayed a close relationship to Thorvaldsen's *Alexander Frieze* (1812), and the artist immediately gained a reputation as the most talented successor of the great Danish sculptor. With *Hercules and Hebe* (original cast, 1845; Copenhagen, Ny Carlsberg Glyp.; marble, 1847–52; Copenhagen, Christiansborg Slot), an over-life-size figure group, Jerichau achieved a new litheness of form and a strong plasticity coupled with a naturalness and expansiveness of rhythmical lines. The work was criticized for its strong dependence on ancient models. In fact it combines traits from the Venus de Milo and the Belvedere Torso with features strongly reminiscent of Thorvaldsen's work.

After this criticism Jerichau decided to create a work based exclusively on the study of nature. The *Panther Hunter* (1845–6; Copenhagen, Stat. Mus. Kst) is undoubtedly a masterpiece, with its dynamic strength and highly dramatic tension checked by its classical form. This marked a radical break with the Neo-classicism of Thorvaldsen. The *Panther Hunter* was also criticized, but this time for being too true to nature. Nevertheless, the two figure groups ensured Jerichau international fame. By now his feeling for form and excellent treatment of material had matured, and with the major works that followed he introduced a modern psychological approach. *Adam and Eve after the Fall* (1848–9; marble, 1891 by August Vilhelm

Saabye (1823–1916); Copenhagen, Ny Carlsberg Glyp.) and *Adam and Eve before the Fall* (1863; marble, 1904 by Edvard Harald Bentzen (1833–1914); Copenhagen, Ny Carlsberg Glyp.) are both excellent examples of the noble yet intimate style of Jerichau's mature works. The late sculptures display a deepening concern for intimate moods, his favourite subjects being young girls and biblical scenes.

BIBLIOGRAPHY

N. Bøgh: *Erindringer af og om Jens Adolf Jerichau* [Memoirs by and reminiscences of Jens Adolf Jerichau] (Copenhagen, 1884)

S. Michaëlis: *Billedhuggeren J. A. Jerichau* [The sculptor J. A. Jerichau] (Copenhagen, 1906)

K. Voss: *Friluftsstudie og virkelighedsskildring* [Plein air study and representation of real life] (Copenhagen, 1974), iv of *Dansk Kunsthistorie*, pp. 374–82

JENS PETER MUNK

(2) Jens Adolf Jerichau (*b* Copenhagen, 12 Dec 1890; *d* Paris, 16 Aug 1916). Painter, grandson of (1) J. A. Jerichau. After the death of his father, Holger Hvitfeldt Jerichau, he trained as an architect for some years, but in 1910 he turned to painting, reaching artistic maturity early. He studied briefly (1911–12) at the Kongelige Danske Kunstakademi in Copenhagen. Of chief importance was his friendship with the art historian Wilhelm Wanscher (1875–1961), whose studies of Raphael and Michelangelo inspired Jerichau's early figure compositions. He also was deeply impressed by an exhibition of French painting at the Kunstforeningen, Copenhagen in 1911, which included works by Gauguin and Cézanne. During a trip to France in 1912 he divided his time between the Musée du Louvre and viewing the works of Gauguin, Cézanne and van Gogh in Ambroise Vollard's gallery and the Pellerin collection. Between 1913 and 1915 he painted a series of large compositions that united these heterogeneous influences in a dramatic, simplified figurative style dominated by an Expressionist treatment of form and colour. A key work is *Sacrifice/Man Seeks Omens*, painted in three versions in 1914–15 (third version; Humlebæk, Louisiana Mus.). In 1915 he spent several months in southern France, where he painted a series of Fauve-inspired landscapes (e.g. *Great Palm Tree*; Copenhagen, Stat. Mus. Kst). Later that year he went to Spain, where he painted such monumental pictures as *Cardinal* (Silkeborg, Kstmus.) and *Birth of Eve* (Copenhagen, Stat. Mus. Kst). His entire oeuvre was presented in February 1916 at an exhibition in Copenhagen and sold afterwards at auction. Jerichau then went to Paris, where he met both Matisse and Picasso and resumed work on large figure compositions. *Hecuba* (1916; Copenhagen, priv. col.) is a particularly powerful projection of the inner psychological conflicts that led him to take his own life.

BIBLIOGRAPHY

Jens Adolf Jerichau, preface V. Hammershøi (sale cat., Copenhagen, 1916)

W. Wanscher: *Jens Adolf Jerichau* (Copenhagen, 1930)

T. Andersen: *Jens Adolf Jerichau* (Copenhagen, 1983) [cat. rais., bibliog. and biog.]

TROELS ANDERSEN

Jerichow Abbey. Former Premonstratensian abbey, dedicated to SS Mary and Nicholas, 50 km north-east of Magdeburg, Germany. Jerichow Abbey is the most important early brick building in northern Germany. It was founded in 1144 by Hartwig von Stade, canon of Magdeburg Cathedral, on a site near his castle; the first community came from the Abbey of Our Lady in Magdeburg. Jerichow was originally established as the temporary seat of the diocese of Havelberg, which had not then been re-Christianized after the Slavic uprising in 983. The canons found the riotous population disturbing, and in 1148 Bishop Anselm of Havelberg, in agreement with Archbishop Friedrich of Magdeburg, transferred the abbey to a site north of the town. Construction of the church and monastery began at this time. The papal confirmation of 1159 mentions the abbey as well as the old parish church, and archiepiscopal documents of 1172 and 1178 mention abbey buildings and a church. Construction began with the apse, choir, transepts and eastern parts of the nave, using small basalt blocks. Further construction was in brick, only the imposts of the piers being worked in sandstone. In a second building campaign *c.* 1178, barrel-vaulted chapels with apses were added on either side of the choir and a crypt was constructed under the choir and crossing. The two-tower west façade with nave gallery was built *c.* 1240 and the south wing of the cloister was also built in the middle of the 13th century. The foundation was dissolved in 1552 and later it came into lay hands. In 1945 it became State property. The abbey church was restored in 1856 and again from 1955 to 1960; the abbey buildings were restored in 1969, after which they were converted into a museum.

The overall layout follows the church of the mother house of Our Lady in Magdeburg, though there are influences from the Augustinian abbey churches in the Harz region, such as Gröningen and Hamersleben. The church is a three-aisled, cruciform basilica with flat roof (see fig.). The four easternmost pairs of piers are columnar. The presbytery with main apse is flanked by side chapels with barrel vaults and apsidioles. Under the raised presbytery and crossing is a high two-aisled crypt of four bays with groin vaults, which opens on to the nave through an arcade, an arrangement following Italian prototypes transmitted via Magdeburg. The columnar piers of the crossing have trapezoidal capitals made of brick. The piers of the westernmost nave bay are rectangular with imposts but without capitals. The six windows in the unarticulated upper register are not on axis with the five nave arches. On the crossing arches traces remain of the original painted lining-out, made to resemble masonry blocks. The westwork has a rectangular central section that extends beyond flanking stair towers.

The east end with its three apses, slender proportions and harmonious architectural elements may be considered the principal façade of the church. Wide corner pilasters and narrower intermediate pilasters rise from a richly decorated socle. These terminate in intersecting arches, consoles and zigzag mouldings, all of which are also present on the gables. The apse windows are stepped and have engaged quarter roll mouldings with cushion capitals. On the transepts, the north aisle and the west end are portals with stepped, round arches and engaged roll mouldings.

The origins of Jerichow's architectural and decorative forms are not yet established and the origins of the brick construction are also debated. The decorative friezes in

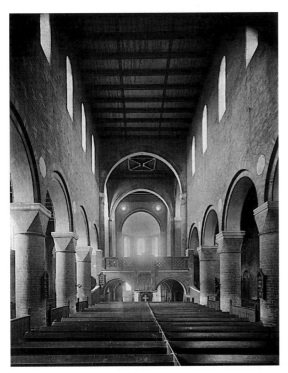

Jerichow Abbey, interior of the nave looking east, begun *c.* 1148

the choir and nave and the trapezoidal nave capitals of the columnar piers can be compared with northern Italian examples. The impost decoration on the crossing piers and on the first nave piers is from Lower Saxony and may suggest a connection with Denmark (there are similar features at Ringsted and Bjernede). The decoration of the crypt, however, in particular the deeply carved shell, palmette and large-scale interlace patterns, corresponds to mid-12th-century work in southern Lorraine and to somewhat later work in Alsace (e.g. Schlettstadt, St Foi, 1162) and on the upper Rhine (e.g. Otterberg, begun before 1190). The capitals of the crypt apse may be compared with work in the cloister of Magdeburg Cathedral. The technique of brick construction probably came to Jerichow from various sources, and the region of Burgundy and Lorraine was perhaps as important in this respect as northern Italy and Flanders; the technique could have been communicated as easily through the connections of the Premonstratensian Order as through settlers travelling to this eastern colonial region.

The monastic buildings south of the church are largely preserved. A portal with ornamental columns leads from the south transept into the east wing of the cloister. The mid-13th-century east range contains the stair to the dormitory, the library, the chapter house, a passage and the kitchen with small adjoining room. The chapter house has two aisles of three bays each and extends to the east beyond the line of the cloister range. The groin vaults have transverse arches and wall ribs; the capitals of the two free-standing columns are decorated with palmettes. A stepped, double portal with enclosing arch and inset roll moulding leads from the cloister. Beside the portal is a

window of two openings with round arches. The kitchen is a hall of four bays with central columns that, with engaged consoles, carry groin vaults without transverse arches. The south wing, which was built after 1240, contains the summer and winter refectories, both of two aisles and four wide bays. The north wall of the summer refectory originally opened on to the cloister through four arches; these were walled up at an early date, although the free-standing columns are still extant in the masonry of the wall. These three free-standing columns have attic bases with spurs; the moulded capitals have acanthus and vine-scroll decoration in high relief that is partially undercut. The winter refectory has more restrained forms. The west wing of the cloister was used as the abbey workshop. It underwent substantial alterations and, according to an inscription, was given additional storeys in 1504. A gateway between these buildings and the church leads to the cemetery. The groin-vaulted cloister has pointed arches which open on to the garth. Both cloister and refectory were probably revaulted in the 15th century. The north range is not preserved.

BIBLIOGRAPHY

G. Scheja: *Die romanische Baukunst in der Mark Brandenburg* (diss. U. Berlin, 1939)

J. M. Zeisner: *Die Klosterkirche in Jerichow* (Leipzig, 1940)

H. Müther and W. Volk: *Die Klosterkirche zu Jerichow* (Berlin, 1958)

M. Untermann: *Kirchenbauten der Prämonstratenser: Untersuchungen zu Problemen der Ordensbaukunst im 12. Jahrhundert* (Cologne, 1984)

ERNST ULLMANN

Jerico [Jericho; Ariha; Yeriho]. Site on the west bank of the River Jordan some 12 km north-west of the Dead Sea. It lies in a fertile oasis created by a freshwater spring, the 'Ayn al-Sultan, which accounts for its importance from early times. The site is best known as the location of the oldest city in the world, dating from *c.* 8000 BC (see below). During the Roman period the city moved to the area of the modern town, and from the 2nd century BC the Hasmonaean and Herodian rulers built palaces and gardens at Tulul Abu al-Alaiq on the Wadi Qilt, about 2 km east of modern Jerico; a hippodrome and amphitheatre mentioned by Josephus have been tentatively identified near by at Tel al-Sammarat. Some 3 km north of modern Jerico lies the hunting palace of KHIRBAT AL-MAFJAR, a fine example of Umayyad palace architecture attributed to the caliph al-Walid II (*reg* AD 743–4). Later constructions include Crusader churches (now ruined) and a monastery, the Jebel Qüruntul or Mount of Temptation (rebuilt 1874), the traditional site of the temptation of Jesus by Satan. In 1993 the modern city became the centre of Palestinian autonomy in the West Bank.

The ancient city of Jerico, Tel al-Sultan, flourished in Syria-Palestine between the early Neolithic period and the 1st century AD. The site was excavated by Captain Charles Warren (1869), Ernst Sellin and Carl Watzinger (1907–9), and John Garstang (1930–36). However, it was during the excavations of Kathleen Kenyon (1952–8) that the earliest levels were exposed, establishing the unique character of the site and providing an important contribution to the early history of settlement and agriculture. The excavation also threw new light on the development of stone architecture during the Pre-pottery Neolithic A period (*c.* 8000–7000 BC). Deposits dated to the Pre-pottery Neolithic B period (*c.* 7000–6000 BC) yielded a number of plastered

skulls, a type of artefact found only at Jerico and at a very limited number of other sites in the area. The finds were divided between a number of museums, including the Rockefeller Museum in Jerusalem and the British Museum in London.

Towards the middle of the 8th millennium BC a stone wall was constructed around the hitherto open site. It survives to a height of 7 m and was twice rebuilt, the second time with a ditch 8 m wide and 2 m deep cut in the bedrock. Behind the wall stands a circular stone tower, 8.25 m high, 10 m in diameter at the base and tapering to 7 m diameter at the top. Within the tower, from bottom to top, runs a straight, steeply angled staircase with its 22 treads and roof-slabs of hammer-dressed stone. A short passage leads from the foot of the stairs out of the tower. The walls of the stairway, which are slightly bulging, were coated with mud plaster (the handprints of the plasterers are still visible), as was most of the tower's exterior.

There are several views about the purpose of these structures, which incorporate a number of innovative features. While there are contemporary and earlier settlements with domestic structures, Jerico is the earliest site where large-scale buildings, implying a considerable level of social organization, have been found (see SYRIA-PALESTINE, §II). More than this, they indicate a degree of planning and skill in the use of masonry: collecting or quarrying the stone, hammer-dressing the roofing and tread slabs, laying out the foundations of the tower and the line of the wall on a secure base, building both structures to the required height while maintaining a constant angle of batter on both and of circularity on the tower, incorporating a staircase at a constant size and slope, bonding the tower and the wall, and partially bonding in subsequent thickening surfaces of the wall. It seems most unlikely that these innovations in planning and technique could all have arisen at one site and in a comparatively short space of time, but if there are earlier or even contemporary sites showing such skills in building, they have yet to be discovered.

During the subsequent Pre-pottery Neolithic B period, there are signs throughout the Levant of artistic activity, attested by figurines, wall paintings and modelled and carved artefacts. Their significance is usually assumed to be cultic or religious. At Jerico, unbaked clay or plaster figures of a little less than life-size (Jerusalem, Rockefeller Mus.) were found by both Garstang and Kenyon, and skulls with superimposed plaster faces (e.g. Amman, Jordan Archaeol. Mus. and London, BM) by Kenyon. Similar, though by no means identical, figures and heads have been found at other sites of roughly comparable date (RAMAD, Beisamun, AIN GHAZAL and Nahal Hemar). The Garstang excavation yielded two very fragmentary groups, each of three figures and apparently representing a man, woman and child. The figures were of clay modelled over an armature of reed bundles, a technique found also in the larger and better-preserved group from Ain Ghazal. The surface of the best preserved of the Garstang figures is carefully moulded to show such features as the cheekbones and eyebrow ridges. The open eyes are represented by shells, and stripes of red paint indicate beard and hair.

The plastered skulls found by Kenyon (see fig.) are similar to those discovered at Ramad and Beisamun (see

Jerico, skull with superimposed plaster features, from the Pre-pottery Neolithic B levels, c. 7000–c. 6000 BC (Amman, Jordan Archaeological Museum)

also SYRIA-PALESTINE, §I, 2(i)). Ten skulls were excavated altogether, in all but one case without the mandibles. The plastered features do not necessarily correspond with the underlying bone structure, and may therefore not be meant to depict the owners of the skulls as they were in life. In one case the eyes are represented by cowrie shells with their apertures exposed as horizontal slits, in the others by fragments of shell broken to give slit-like vertical pupils. Even within this small group there are differences in the style and skill of execution, suggesting that they were made by different hands. In all cases, however, the upper frontal part of the face seems to have been the most carefully worked, while less attention was given to the mouth, chin and ears. The overall impression, at least to the modern eye, is of calm, unsmiling and alert dignity.

The site continued in occupation through the subsequent phases of the later Neolithic and Bronze Age, although there were several periods of abandonment. The stone wall of the Pre-pottery Neolithic A phase was replaced in the Bronze Age by massive mud-brick defences, built higher up the tell. For these periods the architecture and the objects found on the tell are paralleled at many other sites in the Levant, although there are considerable regional differences in such artefacts as pottery and metalwork. The evidence for occupation of the tell during the Late Bronze Age (i.e. the time traditionally ascribed to Joshua's attack, celebrated in the Bible) and the Iron Age has been largely lost because of erosion.

The large number of rock-cut tombs found by both Garstang and Kenyon to the west and north of the tell are of particular interest. These range in date from Kenyon's 'Proto-urban' (one tomb of this period has been dated by

radiocarbon to the last centuries of the 4th millennium BC) through to the Roman occupation of the 1st century AD. The earlier tombs suffered a degree of erosion, but most of the tomb chambers from the end of the Early Bronze Age (*c.* 2300 BC) survive intact. There is, moreover, a remarkable level of preservation of organic material, with wood, bone, textiles, basketry and leatherwork preserved in recognizable form. Of special note are a number of stools and three-legged tables (with joints similar to those found in Egyptian furniture of the same period), toilet boxes with inlaid bone ornament, coiled baskets and fragments of clothing, as well as objects commonly more resistant to decay, such as scarabs, toggle-pins and weapons. The standard of craftsmanship is high, and even though the wooden objects are warped and shrunken, the quality of finish and ornament is still visible.

BIBLIOGRAPHY

C. R. Conder and H. H. Kitchener: *Judaea*, iii of *The Survey of Western Palestine* (London, 1883), pp. 224–6 [quotes from the notes of Captain Charles Warren]
E. Sellin and C. Watzinger: *Jericho: Die Ergebnisse der Ausgrabungen* (Leipzig, 1913)
J. Garstang and J. B. E. Garstang: *The Story of Jericho* (London, 1948)
K. M. Kenyon and T. A. Holland: *Excavations at Jericho*, 5 vols (London, 1960–83) [incl. a cat. of tombs excavated 1952–8]
R. Amiran: 'Myths of the Creation of Man and the Jericho Statues', *Bull. Amer. Sch. Orient. Res.*, 167 (1962), pp. 23–5
E. Strouhal: 'Five Plastered Skulls from Pre-pottery Neolithic B Jericho: Anthropological Study', *Paléorient*, i (1973), pp. 231–47
P. Dorrell: 'The Uniqueness of Jericho', *Archaeology in the Levant*, ed. P. R. S. Moorey and P. J. Parr (Warminster, 1978), pp. 11–18
J. R. Bartlett: *Jericho* (Guildford, 1982)

PETER DORRELL

Jernberg, August (*b* Gävle, 16 Sept 1826; *d* Düsseldorf, 22 June 1896). Swedish painter. He studied at the Konstakademi in Stockholm (1843–6) and continued in Paris, under Thomas Couture and others, from 1847 to 1853. He settled in Düsseldorf and lived there from 1854 until his death. Jernberg began his career chiefly as a portrait painter. He also chose themes from Norse mythology, for example *Loki and Sigyn* (1856; priv. col.), and biblical subjects including *Christ Driving the Money-changers from the Temple* (1857; Göteborg, Kstmus.). Early in the 1860s he began to depict the human life around him in genre paintings of Düsseldorf and the small towns in the Rhine Valley and Westphalia, as in *Westphalian Peasant Celebration* (1861; Stockholm Nmus.) and *Seeking a Loan* (1867; Göteborg, Kstmus.). On various trips to France, the Netherlands and Sweden he painted similar themes but also produced pure landscapes. He often used his wife and children as models, as for instance in *A Budding Talent* (1863; Göteborg, Kstmus.).

Like most other Scandinavian artists working in Düsseldorf in the 1850s and 1860s, Jernberg was chiefly interested in portraying family scenes that were vivid, comical or moving. But he also composed pictures of sociological interest, for example the *Ladies of the Manor Visiting a Peasant's House* (1856) or *Homecoming of the Drunkard* (both priv. col.). He started to paint still-lifes in the 1860s; these show his skilful treatment of colour and his success, despite his dependence on Dutch and Flemish 17th-century models, in liberating himself from the typically dull colours of Düsseldorf art to a greater extent than most of his contemporaries.

BIBLIOGRAPHY

SVKL
Düsseldorfmålare (exh. cat., Stockholm, Nmus., 1976), pp. 51, 107

HANS-OLOF BOSTRÖM

Jerndorff, August (Andreas) (*b* Oldenburg, 25 Jan 1846; *d* Copenhagen, 28 July 1906). Danish painter, illustrator and ceramicist of German origin. He trained in Copenhagen at the Akademi, graduating in 1868. In his early years as an artist he was much in demand as a portrait painter: his skill is clear in examples such as *Partikulier Kunze and his Son* (1871; Copenhagen, Hirschsprungske Saml.). The subjects of this and later portraits are clearly marked by their environment, their way of life and their occupations. Jerndorff also painted historical portraits, such as the full-length figures of officers from the war of 1848–50 and the war of 1864: *Claude du Pat* (1855), *General Bülow* (1890), *Colonel Lunding* (1892) and *General Rye* (1895; all Hillerød, Frederiksborg Slot). Jerndorff's biblical compositions are rather arid and academic, but his landscapes, such as *Autumn on the Heath* (1895; Randers, Kstmus.), seem fresh and spontaneous in treatment. Most of Jerndorff's landscape paintings are small, intimate studies with careful rendering of flowers and plants. He was also an imaginative illustrator, notably for editions of Danish folk tales. He also produced ceramics, working together with the Utterslev artists—a group, formed during the 1880s, which produced pictures, reliefs and sculptures. Jerndorff was in contact with many younger Danish artists, and in 1880 he was among those who founded a Copenhagen art school independent from the Akademi.

BIBLIOGRAPHY

H. C. Christensen: *August Jerndorff 1846–1906: Fortegnelse over hans arbejder* [August Jerndorff: catalogue of his works] (Copenhagen, 1906)
August Jerndorff (exh. cat., Copenhagen, Kstforen., 1908)

GITTE VALENTINER

Jerome, Fra. *See* HAWES, JOHN CYRIL.

Jérôme de Fiesole [?Girolamo da Fiesole] (*fl* 1499–1507). Italian sculptor, active in France. A document of 1499 mentions him as the only sculptor employed by Anne of Brittany (1477–1514) to realize the tomb of her parents, *Francis II, 10th Duke of Brittany and Marguerite of Foix* (marble; Nantes Cathedral), and also of her children by Charles VIII (marble; Tours Cathedral). However, the recumbent effigies of the first tomb, which was designed by Jean Perréal, were executed by Michel Colombe between 1502 and 1507 (for illustration *see* COLOMBE, (1)). It is possible that Jérôme was responsible for the decoration of the base of the monument with its white marble pilasters and shell-headed niches of red marble. Vitry believed that the design and execution of the decoration of the second tomb could be attributed to him with greater certainty. An Italian Renaissance repertory of ornament, exceptional in France in the early 16th century, appears on the sarcophagus, while the recumbent statues of the deceased are French in conception and style and come from the workshop of Colombe. It has been

suggested, not entirely convincingly, that Jérôme contributed the decorative Renaissance framing to the *Entombment* (usually attributed to Colombe) in the abbey church at Solesmes, Sarthe, and that he contributed to the decoration of the tomb of *Cardinal Georges I d'Amboise and Cardinal Georges II d'Amboise*, his nephew, in Rouen Cathedral.

BIBLIOGRAPHY

Thieme–Becker

P. Vitry: *Michel Colombe et la sculpture française de son temps* (Paris, 1901)

PHILIPPE ROUILLARD

Jerome of Ascoli. *See* NICHOLAS IV.

Jeronimites. *See* HIERONYMITES.

Jerónimo de Ruão [Jérôme de Rouen] (*b* Coimbra, *c.* 1530; *d* Belém, Lisbon, 24 Jan 1601). Portuguese architect of French descent. He was the son of JOÃO DE RUÃO. His family connections led him towards sculpture, but he preferred architecture, beginning on the military side like his youngest brother, Simão de Ruão (who returned from Rome in 1566 and became known as an engineer in India in 1568). After an apprenticeship in Lisbon with Miguel de Arruda, working in the royal palace at Xabregas, at one time as a page of the royal bedchamber (1556), Jerónimo went to the Algarve in 1559 to design ports suitable for fortification. But he reacted against this military tendency, and after an obscure period in which his father's influence must have been decisive (or he may have also visited Italy) he began to specialize in religious architecture, developing a personal style, nervous and highly decorative, that made him the favourite architect of the Queen Regent Catherine, widow of John III. By 1564 Queen Catherine must have chosen him to complete the Hieronymite monastery at Belém and remodel her Manueline mausoleum in a more modern style; until the end of his life he remained Master of Works at Belém. He married a daughter of the captain of the Tower of Belém, settled in the neighbourhood (it remained the family residence until the 18th century) and was buried in the monastery cloister.

The sequence of his work there is easy to establish. The internal arrangement of the cloister, with a pool in the centre of which was an island with flower-boxes and seats decorated with glazed tiles (*azulejos*), was completed in 1567. In 1572 the new choir was begun, with elephant-supported tombs—to which Manuel I and John III were translated—made from marble from the quarries of Vila Viçosa. A fountain at the end of the dormitory and the small Ionic cloister (both demolished in the 19th century) were highly praised by contemporaries. To a later phase (1587–91) belongs the redecoration of the transept, with chapels to house the tombs of the sons of Manuel I (north) and John III (south), where the four remarkable carved frontals are perhaps attributable to Jerónimo. Also by him must be the design for the floor (completed 1631) and the sacristy coffer.

He was also involved in the construction of the church of Nossa Senhora da Luz (1575) at Carnide (aisles and façade destr. 1755). It had one of the most splendid interiors of the time. The 'feminine' quality of the design can also be discerned in the choir (*c.* 1590) of the Conceição Church in Lisbon.

The style of Jerónimo de Ruão may be defined as classical Mannerism, in which the purist tendency stemming from the work of Diogo de Torralva at Tomar Abbey and a Flemish-inspired taste for ornament co-exist in unresolved tension. The preference for polished marble in subtle colour combinations used for the mouldings of windows, niches or painted panels seems to be peculiar to him, but the strapwork that crowns the transept chapels in the Hieronymite monastery comes directly from Antwerp engravings by Cornelis Bos. This antithesis is best seen in the apse of the monastery, in the contrast between the cold, almost military, exterior and the sanctuary–mausoleum, of which the textbook Corinthian and Ionic orders constitute a masterpiece of 16th-century European architecture.

BIBLIOGRAPHY

M. Sampaio Ribeiro: 'Do sítio do Restelo e das suas igrejas', *Anais*, ii (1949), p. 277

G. Kubler: *Portuguese Plain Architecture* (Middletown, 1972)

J. E. Horta Correia: 'A arquitectura—maneirosmo e estile chão', *História da arte em Portugal*, vii (Lisbon, 1986), pp. 100, 114–17

RAFAEL MOREIRA

Jerrems, Carol (Joyce) (*b* Melbourne, 14 March 1949; *d* Melbourne, 21 Feb 1980). Australian photographer. She studied photography at Prahran College of Advanced Education in Melbourne from 1967 to 1970, graduating with a Diploma of Art and Design. She received a technical teacher's certificate from Hawthorn Teachers College in 1971 and during the 1970s taught photography in Melbourne, Sydney and Hobart. Her earliest photographs were in the photo-documentary style that was taken up by many young Australian photographers in the 1970s. She worked in black and white, taking photographs generally with the consent of her subjects. She did not use flash or distorting wide-angle lenses because she wanted her photographs to be 'natural' and 'real'. Jerrems began to exhibit in Melbourne in 1973, and in 1974 her photographs of a broad spectrum of Australian women were published in *A Book about Australian Women*, an introduction to International Women's Year.

By 1975 Jerrem's style was fully formed. She collaborated with her subjects, often friends and acquaintances, to produce an event for the photograph, such as *Vale Street* (1975; Canberra, N.G.), which became an icon of the 1970s. Her directorial role was in keeping with her interests in film making. She held solo exhibitions in Melbourne and Sydney in 1976 and 1978 and was a recipient of a Visual Arts Board travel grant in 1975. The archive of her photographs is held at the Australian National Gallery, Canberra.

BIBLIOGRAPHY

Aspects of the Philip Morris Collection: Four Australian Photographers (exh. cat., Visual Arts Board of the Australian Council, Paris, 1979)

Australian Photographers: The Philip Morris Collection (exh. cat., Philip Morris Arts Grant, Melbourne, 1979)

Living in the 70s. Photographs by Carol Jerrems (exh. cat. by Helen Ennis and Bob Jenyns, Hobart, U. of Tasmania, 1990)

HELEN ENNIS

Jerusalem [Heb. Yerushalayim; Arab. al-Quds]. City divided by the border between Israel and Jordan, sacred to the three monotheistic religions of Judaism, Christianity and Islam. It is built on limestone hills in the central

plateau of Judaea, and limited by the Kidron Valley on the east and the Hinnom Valley on the west and south.

I. History and urban development. II. Buildings.

I. History and urban development.

1. Before AD 638. 2. 638–1186. 3. 1187–1917. 4. After 1917.

1. BEFORE AD 638. Although the earliest remains go back to the 3rd millennium BC, the name is first attested in Egyptian texts of the 19th to 18th centuries BC in a form that must be a transcription of the Semitic 'Urusalim', which is found in the 14th-century BC Amarna letters (*see* AMARNA, EL-; it means 'the foundation of [the god] Shalem'). Strongly fortified by 1800 BC, Jerusalem came to historical prominence when captured by David (*reg c.* 1000–*c.* 961 BC) around 1000 BC (2 Samuel 5:6–10). As his capital it enshrined the Ark of the Covenant, for which Solomon (*reg* 961–922 BC) built the first temple (1 Kings 6–7; *see* §II, 1(ii) below). In the 8th century BC the

city expanded west of its original site on the Ophel ridge. It was destroyed by the Babylonians in 586 BC, and its inhabitants were deported. A much smaller number returned from exile in Babylon in 538 BC. Zerubbabel restored Solomon's temple in the 6th century BC (Ezra 5–6). The absence of any Hellenistic remains on the western hill indicates that they reoccupied an area not much bigger than the city of David and Solomon.

Jerusalem suffered severely in the wars (201–198 BC) between the Ptolemies of Egypt and the Seleucids of Syria, and its fortifications were torn down by Antiochos IV of Syria (*reg* 170–164 BC) during the Maccabaean rebellion. The account of Flavius Josephus (*b* AD 37/38) of the line of the new wall erected by Jonathan and Simon Maccabaeus between 160 and 134 BC (*Jewish War* [AD 75–9] V.142–5) has been verified by recent excavations, but his description of the city it surrounded (*Antiquities of the Jews* XII–XIV) contains some serious anachronisms (see

1. Jerusalem, plan: (a) Antonia Fortress; (b) Damascus Gate; (c) Church of the Holy Sepulchre; (d) Tomb of Mary; (e) site of Byzantine church; (f) Dome of the Rock; (g) Aqsa Mosque; (h) Dome of the Chain; (i) Citadel; (j) St Anne; (k) Armenian cathedral of St James; (l) 'Mosque of 'Umar' and remains of the hostel of the Knights Templar; (m) Tomb of David; (n) Pool of Shiloh; (o) Rockefeller Museum; (p) Temple Mount; (q) Solomon's Stables; (r) Chapel of the Ascension; (s) David's Tower; (t) Mount of Olives

Eng. trans. by H. St. J. Thackeray; London, 1966). The city at this stage occupied the two hills between the Hinnom and Kidron valleys. Its eastern and western limits were to remain constant until the mid-19th century, but its northern and southern boundaries were to fluctuate a number of times.

Jerusalem fell to the Roman general Pompey (106–48 BC) in late autumn 63 BC, and in one way or another it was to remain under Roman control for seven centuries. HEROD THE GREAT became king of Judaea in 37 BC. His capture of Jerusalem in that year crowned a three-year campaign to establish his sovereignty, and he made the city reflect the glory of his new dignity. Herodian Jerusalem is described by Flavius Josephus (*Jewish War* V.136–247, VI.220–441). To protect himself Herod first built the Antonia Fortress (destr.; see fig. 1a) north of the temple and then ensured the support of his followers by providing them with a theatre and a hippodrome. These gave great offence to pious Jews, but Herod's political ability and brutality soon made his position impregnable. About 25 BC Herod built himself a magnificent palace on the western hill; parts of this palace survive, for example David's Tower (1s), now part of the Citadel (1i). Its grandeur can be gauged from the fact that Phasael, one of its three defensive towers, was greater than the Pharos of Alexandria (*see* ALEXANDRIA, §2(i)), one of the seven wonders of the ancient world. Herod's most enduring achievement, however, was the replacement of the Solomonic temple by a completely new edifice. Its gigantic platform remained a central feature of the city throughout its subsequent

history. These accomplishments stimulated further construction, and the quality of life that the wealthy enjoyed in Herodian Jerusalem is graphically illustrated by the series of fine mansions excavated (1969–78) in the Jewish Quarter.

Herod's absolute fidelity to Emperor Augustus made his kingdom a key element in the defence of the eastern frontier of the Roman Empire. When Herod's son and successor, Archelaus (*reg* 4 BC–AD 6), failed to guarantee the same security, Rome had to assume direct control. Thus, from AD 6 to AD 70 Roman procurators governed Judaea from Caesarea. The reign of Herod Agrippa I (*reg* AD 41–4) was a brief exception, and the line of the third northern wall attributed to him (Flavius Josephus, *Jewish War* V.147) is still an enigma. Direct Roman control stimulated the rise of Jewish nationalism, which found violent expression in the First Revolt (AD 66–70). The damage done to Jerusalem by the fighting between different Jewish factions was nothing compared to the devastation left by the Roman general and later emperor, Titus (*reg* AD 79–81), after the victory of AD 70. The southern part of the city became host to the Tenth Legion Fretensis, whose legate now controlled Palestine. It was to remain a legion camp for almost 200 years.

On a journey through the east in AD 130 Emperor Hadrian added lustre to the glory of Rome by immense benefactions to cities and provinces. The restoration of Jerusalem was part of his project, but the idea of a pagan city on their most sacred site was anathema to Jews, and it sparked the Second Revolt (AD 131–5). After a vicious struggle Rome emerged victorious, and Jerusalem was

2. Jerusalem, earliest surviving plan of the city from the Madaba map, floor mosaic, Madaba, Jordan, *c.* AD 565

turned into a Roman colony with the name Aelia Capitolina. To maintain its pagan character only Gentiles could become residents. It is not certain exactly when Jews began to be permitted to return on one day a year to lament their loss.

The stones of the ruined Herodian temple served as a quarry for the buildings listed in the 7th-century *Chronicon Paschale*: 'the two public baths, the Capitoline temple, the four-galleried Nymphaeum, the Twelve previously known as the Steps Gates (a colonade) and the quadrangular esplanade'. The erection of a public library in the 2nd century AD by Alexander, Bishop of Aelia (*d* 251), attests the strength of the Christian presence, but the only church mentioned is the 'little church of God' on Mt Sion. Urban development was limited to the northern half of the present Old City, because the legion camp continued to occupy the southern half. The Capitoline Temple (AD 135) stood on a podium above the old quarry in which Jesus Christ (*d* ?AD 30) had been executed and buried. It lay just west of the Cardo Maximus running south from the restored free-standing northern gate (now Damascus Gate; see fig. 1b). The gate later became part of the city wall erected after the departure of the Tenth Legion at the end of the 3rd century.

Constantine the Great was already committed to Christianity when EUSEBIOS OF CAESAREA directed his attention in 325 to the importance of Palestine for the new religion. In Jerusalem, Constantine demolished the Capitoline Temple and excavated to bedrock to reveal Golgotha and the tomb of Christ. On the site he erected the Church of the Holy Sepulchre (326–37; fig. 1c; *see also* §II, 2(i) below), the splendour of which is described by Eusebios (*Life of Constantine* 33–40). This made Jerusalem a centre of pilgrimage, and a number of pilgrims left accounts that throw light on the Byzantine city depicted in the 6th-century Madaba map (see fig. 2; *see also* EARLY CHRISTIAN AND BYZANTINE ART, §III, 3(i)(e)). Monasteries and churches proliferated. By the mid-5th century the demand on space had become so great that Empress Eudokia (*d* AD 460) extended the city wall to include Mt Sion and the City of David. The last great building of the Byzantine period was the church of New St Mary (the Nea) erected by Justinian I in 543. Like other religious edifices it became a target for the destructive energies of the Persians during their brief occupation of the city in 614.

2. 638–1186. Jerusalem, which had served as the first qibla, or direction of prayer, for Muslims from 622 to 624 (*see* ISLAM, §II), was a focus of Muslim attention from the earliest years of Islam. The city, known initially to the Muslims as Iliya' (Lat. Aelia) and later as al-Quds ('the holy'), surrendered to Muslim forces in early 638, but events surrounding the conquest are shrouded in legend. The caliph 'Umar (*reg* 634–44), for example, is said to have visited the city and toured its religous sites, and his name is commonly associated with several important Islamic buildings there. As the conditions of surrender safeguarded to Christians the continued use of their churches, Muslims used the area of the Temple, which had been largely abandoned in the Byzantine period, for their place of

3. Jerusalem, from the Mount of Olives, with the Dome of the Rock in the foreground and the Church of the Holy Sepulchre in the middle distance

prayer. This, the Noble Sanctuary (Arab. *al-haram al-Sharif*), would remain the focus of Muslim activity in the city for several centuries (see fig. 1p above). The pilgrim Arculf, who visited Jerusalem *c.* 670, described the Muslims' first place of prayer on Temple Mount as a rude quadrangular structure of planks and great beams able to hold some 3000 worshippers, but it was soon replaced by a more substantial structure (*see* §II, 1(iv) below). The city retained its Christian character, and when Mu'awiya, governor of Syria and founder of the Umayyad dynasty, received homage as caliph there in July 660 he reportedly prayed at Golgotha, Gethsemane and the Tomb of Mary (1d), in acknowledgement of the Christian antecedents of Islam. The work of clearing and reconstructing the Haram al-Sharif was probably begun during the reign of Mu'awiya I (*reg* 661–80), for the construction of the Dome of the Rock (691; see fig. 1f above and fig. 3; *see also* §II, 1(iii) below) and the Aqsa Mosque (see fig. 1g above; *see also* §II, 1(iv) below), the earliest Islamic monuments to survive there, presuppose that the area had been cleared, the walls repaired and stairs and gates erected. The exact chronology of these constructions is still a matter of debate. The Dome of the Chain (Arab. *qubbat al-silsila*; 1h), perhaps the Umayyad treasury, was erected east of the Dome of the Rock. Several large buildings with central courts and long rooms have been excavated to the south of the Haram al-Sharif. They probably formed an administrative and residential complex and indicate that the Muslims settled south and west of the Haram. By the 8th century Muslims generally accepted Jerusalem as the third sanctuary of Islam after Mecca and Medina.

Under the Abbasid dynasty, Jerusalem in particular and Palestine in general declined in importance as the political centre shifted to Iraq. The population decreased, and earthquakes damaged several buildings, including the Aqsa Mosque and the Holy Sepulchre, which were subsequently restored. Increasing numbers of Christian pilgrims came to Jerusalem, where they were housed in hospices constructed on the orders of Charlemagne and his successors.

For Muslims, Jerusalem acquired a new role as the scene of the Last Judgement and the gate to paradise. The newly acquired sanctity of the city meant that many pious or important individuals chose to spend their last days there or be buried there. Scores of small commemorative structures (Arab. *maqām* and *qubba*) were erected, and gates and mihrabs (*see* MIHRAB) were set up to honour the biblical prophets venerated by Muslims. Friction between religious communities increased in the 10th century. The Holy Sepulchre was damaged by fire (938) and pillaged (966). The Bedouins and heretical Qarmatians sacked the city, even after it came under the domination of the Fatimid caliphs of Egypt. The persecution of Jews and Christians by the erratic Fatimid caliph al-Hakim (*reg* 996–1021) culminated in the destruction of the Holy Sepulchre in 1009. The city was left in ruins, particularly after the earthquake of 1016 in which the dome of the Dome of the Rock collapsed.

By the mid-11th century the city had replaced Ramla as the main city of Palestine, perhaps because Jerusalem was more defensible against Bedouin and Turkoman raids. The Fatimids abandoned Eudokia's extension of the city walls to the south and strengthened those remaining in 1033 and 1063, giving them approximately their present location. The old Cardo Maximus and the Decumanus effectively divided this region into four quarters, which acquired distinctive religio-ethnic identities. The north-west quadrant around the Holy Sepulchre was populated by Christians, and the hospice south of the Holy Sepulchre became a large complex attended by Benedictine monks. The Jews lived in the north-east quarter and the Muslims in the southern half. The double and triple underground gates south of the Haram were blocked, and the main entrances to the Haram shifted to the west to give access to the commercial centre. According to the Persian traveller Nāsir-i Khusraw (*b* 1003; visited Jerusalem 1047), the Bab al-Silsila (Gate of the Chain) was decorated with beautiful mosaics. Under Fatimid patronage, the splendour and significance of the main sanctuaries of Jerusalem increased, but this development was thwarted at the end of the 11th century. More Christians visited the city in 1065: for example, a caravan of 7000 pilgrims arrived from southern Germany and Holland. In 1071 Jerusalem was taken by Atsiz ibu Abaq for the Saljuqs of Iran. The Fatimids besieged the city in 1098 and held it until 15 July 1099, when it was taken by the First Crusade and the LATIN KINGDOM OF JERUSALEM was established.

The crusaders massacred the Muslims and Jews in the city, and non-Christians were thereafter forbidden to reside there. Christian Arabs from Syria and Palestine settled in the old Jewish quarter, which was renamed the Syrian quarter; Armenians occupied the south-west quarter and Germans the south-east. The crusaders enlarged the Citadel in the middle of the west wall (see fig. 1i above), which protected the royal palace of the Latin Kingdom of Jerusalem immediately to the south. The city was a centre for the administration, court, ecclesiastical authorities and monastic and military–religious orders. Mosques were converted into churches or used as secular buildings. In 1109 the Knights Hospitaller took over the hospice run by the Benedictines south of the Holy Sepulchre and erected a great new building capable of receiving 4000

pilgrims (1l). In the Haram al-Sharif the Aqsa Mosque (1g) was transformed into a palace and subsequently became the military and religious centre of the Knights Templar in 1128. The Dome of the Rock, renamed the Templum Domini, served as a church. To accommodate the thousands of pilgrims who arrived annually many new churches and buildings were built, including the church of St Anne (1140; rest. 19th century; 1j; *see also* JERUSALEM, LATIN KINGDOM OF, fig. 3), the Armenian cathedral of St James (1142–65; 1k), with narrow aisles flanking a wide nave surmounted by a dome supported on six crossing ribs, and the Holy Sepulchre (1c; *see also* §II, 2 below).

3. 1187–1917. On 2 October 1187 the Ayyubid sultan Salah al-Din (*reg* 1169–93) took Jerusalem from the crusaders after a short siege; unlike the crusaders, the Muslims allowed the inhabitants to ransom themselves. The population became predominantly Muslim, as only Christians following the Eastern Rite remained, and Muslim refugees migrated from Ashqelon. For Muslims, Jerusalem acquired an enhanced religious aura because it had been rescued from the crusaders; the city was regarded as a domicile of prophets and saints and scene of the Resurrection and Last Judgement. The walls and citadel were rebuilt, Muslim shrines returned to their original function, and many Christian buildings were rededicated to Islam. The church of St Anne (see fig. 1j), for example, became the Salahiyya Madrasa, named after its founder, Salah al-Din. The hostel of the Knights Hospitaller (1l) was converted into a hospital (Arab. *maristān/muristān*), which gave its name to the Muristan district. The Christians retained control of the Holy Sepulchre, but pilgrimage to it was suspended until 1192. Sites on the Haram al-Sharif were resanctified, but the original associations were often confused. The buildings of the crusader period provided carved stone spolia for new construction, particularly near the Bab al-Silsila. In 1219, to deter the Christians from retaking Jerusalem and using it as a base, the Ayyubid sultan of Damascus, al-Malik al-Mu'azzam (*reg* 1218–27), dismantled the fortifications.

Jerusalem was incorporated after 1260 into the domains of the Mamluk sultans of Egypt. The city was rebuilt as the sultans restored or repaired the great sanctuaries, provided them with water and erected major institutions. Their actions were imitated by lesser princes and private individuals; this building boom gave the city many beautiful buildings and altered its appearance as profoundly as had Herod the Great. Apart from holiness and tourism, the only industry was the manufacture of soap from olive oil. Jerusalem enjoyed a peculiar role as a leading place of exile for dismissed members of the Mamluk nobility, who mingled with Muslim divines and mystics living on stipends from pious foundations. Mt Zion, to the south of the city, was the scene of endless contests between Christians, Muslims and even Jews involving cycles of demolition and reconstruction of buildings. For example, a Franciscan monastery was erected there in 1335, and a synagogue was destroyed in 1474 and subsequently restored. Some 90 buildings remaining from the period 1200–1500 testify to the enormous building activity, which was concentrated on the western and northern sides of the Haram and its approaches, for only two Muslim buildings were erected

in the western half of the city. Older gates to the Haram lost importance, and new ones, such as the Bab al-Qattanin (1336–7), the cotton merchants' gate, led from the Haram to a commercial centre. Brilliantly coloured façades dominated the rebuilt northern and western porticos; the functions of these buildings were no longer related to the sanctity of the Haram. Rather, they gained prestige by their proximity to the sanctuary. The buildings included such standard types in Mamluk architecture (*see* ISLAMIC ART, §II, 6(iii)(a)) as schools, orphanages, libraries, hospices, hospitals, caravanserais, baths, latrines and fountains. Unlike the capital, Cairo, there were more charitable institutions than private ones in Jerusalem. Built of stone with closely jointed courses, often in alternating colours, these buildings display such decorative feats as joggled voussoirs and *muqarnas* pendants. The sobriety of decoration is relieved by mouldings around openings and inscribed bands and cartouches. The variety of vaulting is particularly noteworthy, ranging from *muqarnas* semi-domes to barrel vaults. Particularly splendid buildings were erected by Tankiz, Viceroy of Syria (*reg* 1312–40), who repaired the aqueduct from Solomon's pools and erected the Tankiziyya Madrasa as well as the Suq al-Qattatin (1336). The Mamluk sultan Qa'itbay (*reg* 1468–96) erected the stunning Ashrafiyya Madrasa (1482; still extant) and a lovely fountain near by on the Haram.

The Ottoman sultan Selim (*reg* 1512–20) took Jerusalem during his campaign against the Mamluks in 1516–17. His son and successor, Süleyman (*reg* 1520–66), left an enduring imprint on the city; he rebuilt the walls (1537–41), renovated the Dome of the Rock (see fig. 1f above), repaired the aqueduct and erected four public fountains within the city and one near the Sultan's Pool at the foot of Mt Zion. The sultan and his wife, Hürrem (1500–88), created many endowments, including a soup kitchen (destr.); its cauldrons and other impressive remains are in the Haram Museum. Under the early Ottomans the population tripled, and a toll was levied on visitors to the Holy Sepulchre. The city was given as a tax farm by the Ottoman sultans by means of a grant, whose recipient changed every two or three years, and it quickly entered into a decline that lasted until the mid-19th century. In 1806 the population was estimated at only 8000 and was victimized by arbitrary and excessive taxation. The aqueduct system was not maintained, and visitors spoke of the stench and filth.

The reversal of the city's fortunes began with the establishment of British, French and Russian consulates in 1841 and the transformation of the population from predominantly Muslim to predominantly Christian and Jewish. In order to win trade agreements and foreign investment at home the Ottomans were forced to make concessions to the Europeans. 'Abd al-Majid (*reg* 1839–61) gave the Salahiyya Madrasa to the French emperor Napoleon III in 1856, under whom it was restored to its original use. Part of the Muristan district was presented to Prussia, and a Protestant church was erected. Western penetration was strengthened by the Crimean War (1853–6): the Christian powers were allowed to raise their flags, and Christians were allowed to ring church bells. Christian families became important in local affairs.

Improved security led to an increase of visitors, who became an important source of revenue, and to the establishment of Christian mission schools and hospitals. Jewish immigration from Europe and Russia increased, because Jews from outside the Ottoman empire could claim the protection of European consuls. Thus Ashkenazim enjoyed greater advantages than the Sephardim, who had started to arrive in the 17th century. The dire poverty of the Jewish community challenged the generosity of Jews abroad, who gradually supplied funds to create jobs and to found hospitals and schools. The greatest of these benefactors was Sir Moses Montefiore (1784–1885), who was the first to settle Jews outside the walled city (1860). In the same year Ludwig Schneller built a Christian orphanage north-west of the city. The real stimulus to urban development, however, was the construction of the Russian compound (1864) capable of housing 1000 pilgrims. The commercial opportunities generated by such a concentration of visitors led to the establishment of a new Jewish quarter, Nahalat Shiva (1869), on the other side of the newly metalled road to Jaffa. These gains were consolidated by Christian and Jewish immigration throughout the century. American and European Christians spearheaded expansion north and south of the Old City, while Jews concentrated in the western and north-western sectors. The architecture of these developments shows a continuing concern for security. Housing areas were designed so that the backs of adjoining houses formed a wall, and gates that could be locked were placed at the ends of streets; institutions were surrounded by forbidding walls. These developments were at the expense of the indigenous Muslim inhabitants, who did not benefit from the prosperity and protection that foreigners enjoyed. The seeds of conflict were already beginning to sprout in the 1880s and 1890s, with short-lived efforts to inhibit Jewish immigration.

BIBLIOGRAPHY

Enc. Islam/2: 'Al-Kuds'

B. Amico: *Trattato delle piante e imagini de i sacri edificii di Terra Santa* (Rome, 1609); Eng. trans. by T. Bellorini and E. Hoade as *Plans of the Sacred Edifices of the Holy Land* (Jerusalem, 1953)

A. Salzmann: *Jérusalem: Études et reproductions photographiques des monuments de la Ville Sainte* (Paris, 1855–6)

Chronicon Paschale (7th century AD); ed. in *PG*, xcii 1860), col. 613

F. de Saulcy: *Voyage en Terre Sainte, 1862* (Paris, 1865)

C. W. Wilson: *Ordnance Survey of Jerusalem* (London, 1865/*R* Jerusalem, 1980)

L.-H. Vincent and F.-M. Abel: *Jérusalem: Recherches de topographie, d'archéologie et d'histoire: Jérusalem nouvelle*, 3 vols (Paris, 1914–26)

K. A. C. Creswell: *Early Muslim Architecture*, i (Oxford, 1932, rev. 1969)

A.-S. Marmardji: *Textes géographiques arabes sur la Palestine* (Paris, 1951)

L.-H. Vincent and M.-A. Steve: *Jérusalem de l'Ancien Testament*, 3 vols (Paris, 1954–6)

The Jewish War and Other Selections from Flavius Josephus; Eng. trans. by H. St. J. Thackeray and R. Marcus (London, 1966)

D. Bahat: *Jerusalem: Selected Plans of Historical Sites and Monumental Buildings* (Jerusalem, 1969)

B. Mazar and M. Ben-Dov: *Excavations in the Old City of Jerusalem near the Temple Mount: The Omayyad Structures near the Temple Mount* (Jerusalem, 1971)

J. Wilkinson: *Egeria's Travels in the Holy Land* (London, 1971, rev. Jerusalem, 1981)

——: 'Ancient Jerusalem: Its Water Supply and Population', *Palestine Explor. Q.*, cxvi (1974), pp. 33–51

——: *Jerusalem Pilgrims before the Crusades* (Warminster, 1977)

N. Schur: *Jerusalem in Pilgrims' and Travellers' Accounts: A Thematic Bibliography of Western Christian Itineraries, 1300–1917* (Jerusalem, 1980)

D. Bahat: *Carta's Historical Atlas of Jerusalem: An Illustrated Survey* (Jerusalem, 1983)

S. Schein: 'Between Mount Moriah and the Holy Sepulchre: The Changing Traditions of the Temple Mount in the Central Middle Ages', *Traditio*, xl (1984), pp. 175–95

M. Gilbert: *Jerusalem: Rebirth of a City* (Jerusalem, 1985)

F. E. Peters: *Jerusalem: The Holy City in the Eyes of Chroniclers, Visitors, Pilgrims and Prophets from the Days of Abraham to the Beginnings of Modern Times* (Princeton, 1985)

Nasir-i Khusraw: *Safarnāma* [10th-century Persia]; Eng. trans. by W. M. Thackston as *Naser-e Khosraw's Book of Travels* (Albany, NY, 1986), pp. 21–38

M. H. Burgoyne with D. Richards: *Mamluk Jerusalem* (London, 1987)

A. G. Walls: *Geometry and Architecture in Islamic Jerusalem: A Study of the Ashrafiyya* (London, 1990)

J. Raby and J. Johns, eds: *Bayt al-Maqdis: 'Abd al-Malik's Jerusalem.* (Oxford, 1992)

A. Elad: *Medieval Jerusalem and Islamic Worship: Holy Places, Ceremonies, Pilgrimage* (Leiden, 1995)

JEROME MURPHY O'CONNOR

4. AFTER 1917. The entry of General Edmund Allenby (1861–1936) into Jerusalem in 1917 marked the emergence of the urban era of the city, signalling a series of events that have affected its planning and design. Jerusalem became the administrative capital of the British Mandate in Palestine. Sir Ronald Storrs (1881–1955), Governor of Jerusalem from 1917 to 1926, immediately forbade the demolition of historic buildings and ordered the use of stone as a building material. In 1918 he instructed W. H. McLean (1877–1967) to draw up regulations to protect its special character. The convening of the Pro-Jerusalem Society in the same year created a public consensus for civic planning in Jerusalem. Three urban plans were made by Patrick Geddes and C. R. Ashbee in 1919, 1920 and 1922. Geddes's formal approach could be described as 'urbes ante mura'. Qualitative measures included planting trees, zoning and the introduction of municipal bye-laws. AUSTEN ST BARBE HARRISON was chief architect between 1923 and 1937 and designed the

Rockefeller Museum (1927–34; formerly the Palestine Archaeological Museum; see fig. 1o above), among other buildings. The next Civic Adviser, A. CLIFFORD HOLLIDAY, prepared a plan in 1930 that developed a coherent radial road system, a commercial centre and rehabilitation areas. Henry Kendall, influenced by Patrick Abercrombie's work, consolidated the plan in 1944, augmenting it with detailed planning areas. Two earthquakes in 1927 and 1936 resulted in design controls and height restrictions, and the advent of a piped water supply in 1934 created the potential for greater urban growth. Politically, the Arab riots of 1929 and 1936 strengthened the pattern of segregated ethnic neighbourhoods. ERICH MENDELSOHN lived in Jerusalem from 1934 to 1941 and designed the Hadassah Medical Complex on Mt Scopus.

The consistent principle of urban planning in Jerusalem has been the isolation of the Old City by means of a green belt around the walls. Urban design was marked by the strong presence of new European concepts. The Zionist dream, the Garden City movement and visionary ideals of Jerusalem merged to create new approaches to design in the city. The British School attempted to restore local traditions by developing small craft factories and studying local images and forms. The factories were in the spirit of the English Modernism that had evolved from the philosophies of William Morris. This generated two eclectic styles, the neo-classical and the neo-eastern (or neo-Hebraic).

By the time the Mandate was terminated in 1948 the city's population had grown from 14,500 in 1918 to 170,000. After the British departed, Jerusalem was divided between Israel and Jordan, stunting its growth. Both sides preserved the basic structure and intent of Kendall's plan of 1944, with amendments prepared by Michael Szwif (1909–58) in Israel, and by Kendall (1965) and Brown International for Jordan. ARIEH SHARON and others were

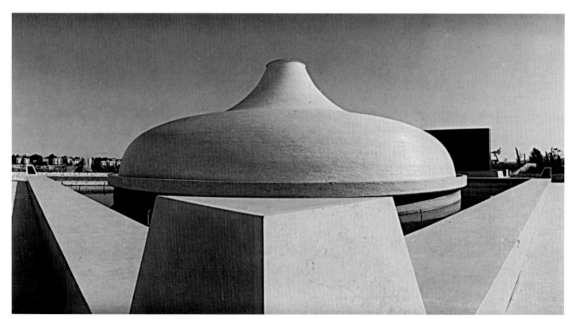

4. Jerusalem, Israel Museum, Shrine of the Book, 1965

commissioned by the Ministry of the Interior and the Jerusalem Municipality to design the Old City and environs as part of a special area plan. The new master plan for Greater Jerusalem (1964–8) has since provided guidelines for the city's development. AL MANSFELD designed the Israel Museum with interiors by Dora Gat (1965; see fig. 4), and Josef Klarwein designed the Knesset (associate designer, Joseph Harwein; completed 1966); the latter has tapestries and mosaics by Marc Chagall, who also made the stained-glass windows at the synagogue of the Hebrew University Hadassah Medical Centre, Ein Karem.

The Six Day War reunified Jerusalem in 1967, and large-scale development took place, doubling the population within 20 years. New technology was developed to replace the traditional methods of cutting stone, now used as a facing material. A special commission was set up to control the planning and design of the Old City and its environs in an effort to preserve its character. In 1970 Teddy Kollek (b 1911), Mayor of Jerusalem, convened an international advisory body, the Jerusalem Committee, also to monitor aspects of planning and design. This committee, together with local public action, brought about policy changes, including restriction on high building and development, since partially lifted, downgrading of the proposed road system and a greater emphasis on conservation, parks and social issues. During this period two rings of residential neighbourhoods were established. The first, completed in the 1970s, formed an extension of the built-up area linking the Mt Scopus enclave. The second ring, consisting of four outer dormitory suburbs, each with over 5000 units, marked a departure from the incremental patterns of past growth. This growth, combined with archaeological discoveries, led to greater emphasis being placed on conservation especially in and around the Old City and neighbourhoods built in the 19th century. Jerusalem (the Old City and walls) was designated by UNESCO as a World Heritage Site in 1982. The city now covers 10,800 ha and has a population of 465,000.

BIBLIOGRAPHY

C. R. Ashbee: *Jerusalem, 1918–1920* (London, 1921) [records of the Pro-Jerusalem Council]

H. Kendall: *The Jerusalem City Plan* (London, 1948)

D. Amiran, A. Shachar and I. Kimhi, eds: *Atlas of Jerusalem* (New York, 1973)

A. Kutcher: *The New Jerusalem: Planning and Politics* (London, 1973)

A. Sharon: *Planning Jerusalem: The Old City and its Environs* (Jerusalem, 1973)

M. Gilbert: *Jerusalem: Illustrated History Atlas* (New York, 1977)

D. Kroyanker: *Jerusalem: Planning and Development*, 2 vols (Jerusalem, 1982–5)

——: *Jerusalem Architecture: Periods and Styles*, 6 vols (Jerusalem, 1993)

MICHAEL TURNER

II. Buildings.

1. Temple Mount. 2. Church of the Holy Sepulchre.

1. TEMPLE MOUNT.

(i) Introduction. (ii) The Temple. (iii) The Dome of the Rock. (iv) Aqsa Mosque.

(i) Introduction. Mt Moriah, the site of the Temple, is situated on the west side of the Kidron Valley and east of the Tyropoeon. The threshing-floor of Araunah the Jebusite, purchased by David on which to build an altar (2 Samuel 24:18–25), and subsequently the site of the Temple

built by his son, Solomon, was an elevated, exposed spot at the summit of this mountain associated with the sacrifice of Isaac (Genesis 22:1–19; *see* §(iii) below). Although not recorded in the biblical narrative of the construction of Solomon's Temple (2 Chronicles 3–4), terraced walls must have been constructed around the slopes of Mt Moriah to provide a platform on which to build. On this platform or acropolis stood the Temple and its courts, the King's House and the House of the Pharaoh's Daughter. Immediately to the south stood the Throne Hall, the Hall of Columns and the House of the Forest of Lebanon. The exact size of the First Temple platform cannot be determined, as the measurements given by Flavius Josephus (*b* AD 37/38) are not reliable for this early period. The Mishnah gives the dimensions of the Temple platform of the period following the return from exile in Babylon in 538 BC as a square having sides of 500 cubits (262.5 m; Middot 2:1). In the 1970s and 1980s a study of the evidence visible on the present-day Temple Mount (see fig. 1p above) and the position of the various cisterns that lie beneath the platform, when combined with the surviving literary sources, led to a convincing location for the platform.

Following the destruction of the Syrian fortress called the Akra, built by Antiochus IV Epiphanes (*reg* 175–164 BC) on the southern spur of the Temple Mount in 168 BC, the Maccabaeans added approximately 42 m to the platform, to include the area formerly occupied by the enemy garrison. Herod the Great was responsible for the most complete change in the area's topography. He doubled the area of the Temple Mount to 144,000 sq. m, equalling the most imposing sacred precincts in the Roman world. The main extension was to the north, which necessitated the complete filling in of a small valley. A new western wall was built approximately 25 m to the west of the previous platform, filling in part of the Tyropoeon Valley. The southern extension was for a large basilical construction, known as the Royal Stoa. Only the line of the eastern wall remained unchanged. At the south-east corner the podium was supported by large underground vaulted structures; in places the platform stood *c.* 20 m above the surrounding street level.

Extensive archaeological excavations have made it possible to draw up a fairly complete picture of Herod's Temple Mount. There were four gates in the western wall, of which the two lower suburban gates (known by the names of their discoverers, Warren and Barclay) were connected with the upper court level by underground staircases. The northernmost of the upper gates stood over the so-called Wilson's Arch. This is probably a later restoration of the first in a series of arches built to support the Royal Bridge, which spanned the Tyropoeon Valley, linking the Temple Mount with the upper city to the west. The second of the upper gates, the Royal Portico, stood over the present-day Robinson's Arch and was connected with the street below by a monumental stairway. In the southern wall were the two Huldah Gates, named after the prophetess. The westernmost of these, the Double Gate, had two openings, probably allowing the circulation of two-way traffic, and a massive stairway, *c.* 64 m wide, led up to it. The wide plaza in front of the southern wall

was comparable to those of contemporary cities such as Athens and Priene. Josephus mentions the existence of an eastern Shushan Gate, but its location has not been confirmed.

After the destruction of the Temple by Titus in AD 70 the retaining walls of the Temple Mount were deliberately left in ruins as a testimony to the destruction of the Jewish state. A shrine to Jupiter Capitolinus was built on the site of the Temple: in front of it stood a column that bore a statue of Hadrian. The Temple Mount was bereft of any construction whatever during the Byzantine period, as the focus then moved to the Church of the Holy Sepulchre (see fig. 1c above). The Muslim period (AD 638–1099) brought the restoration of the former status of the Temple Mount with the construction of a new religio-political complex, which included the Dome of the Rock (1f) and the Aqsa Mosque (1g). In their turn, the crusaders transformed these constructions for ecclesiastical use, renaming the Dome of the Rock the Temple of the Lord. During the latter period the vaulted structures under the platform at the south-east corner of the Temple Mount acquired the fanciful name of Solomon's Stables (1q).

(ii) The Temple. The biblical record (1 Chronicles 28) describes how David gave the divinely inspired pattern of the Temple to Solomon (*see* JEWISH ART, §II, 1(i)). Although parallels have been drawn with Neo-Hittite and Aramaean citadels such as TELL TAYINAT, its plan closely resembles the uniquely Israelite plan of the tabernacle in the wilderness, erected by Moses and the children of Israel (Exodus 25–7). Solomon's Temple was rectangular, 60 cubits (33.6 m) long, 20 cubits (11.2 m) wide and 30 cubits (16.8 m) high. An entrance porch fronted by the two columns, Jachin and Boaz, stood to the east and on the other three sides were three storeys of side-chambers, which were connected by winding staircases. The Temple walls were constructed of layers of stone and cedar wood, overlaid with gold. The height of the porch, given as 120 cubits (67.2 m; 2 Chronicles 3:4), poses the greatest problem for the various reconstructions that have been attempted. The exact position of the two columns is also

unclear, with some reconstructions placing them as free-standing columns in front of the porch, while others incorporate them into the gateway to support the lintel.

The porch or *ulam* led into the Holy or *hekhal*, which measured 20×40 cubits (11.2×22.4 m), and in which stood the Table of the Shewbread, the Golden Candlestick and the Incense Altar. An embroidered veil separated the Holy from the Holy of Holies or *debir*, a square of 20 cubits (11.2 m), in which stood the Ark of the Covenant, the receptacle for the tables of the Law that had been given to Moses on Mt Sinai. The Ark was covered by the mercy seat, a lid made entirely of gold, out of which were sculpted two cherubim. Once a year, on the Day of Atonement, the High Priest entered alone into the Holy to offer sacrifice for himself and for the sins of the people. The Temple was built as 'an habitation for the mighty God of Jacob' (Psalms 132:5). All the sacrifices took place in the Inner Court, in which stood the Altar of Burnt Offering and the Bronze Sea, an enormous water-tank supported by 12 bronze oxen, in which the priests were ritually cleansed. Ten lavers standing on wheeled bases also held water 'to wash in them such things as they offered for the burnt offering' (2 Chronicles 4:6). The imposing edifice suffered various modifications during the period of the Kings and was destroyed in 586 BC by the Babylonian Nebuchadnezzar II (*reg* 604–562 BC). Following the years of exile it was rebuilt under Zerubbabel. This second Temple was so lacking in the splendour of the 'first house' that the old men wept to see it. Although no trace remains, it is probable that the original plan was adhered to.

Herod the Great's Temple was merely a reconstruction of this former one and therefore retained the name of 'Second Temple'. Employing 1000 trained priests to accomplish the work, he built a sanctuary in the Eastern Hellenistic style, of which it was written, 'He who has not seen Herod's Temple has never seen a stately structure in his life' (Baba Bathra 4:1). Abundant data on Herod's Temple are supplied both by Josephus and in the Mishnah tractate Middot. Although Herod was confined to the same ground-plan by the sanctity of the site, his ambition showed itself in the elevation of the porch to 100 cubits

5. Jerusalem, Temple Mount during the Second Temple period, before AD 70; reconstruction drawing

(56 m), only slightly less than that of Solomon. He also raised the overall height of the Temple by constructing an additional storey above the original two-chambered building (see fig. 5).

The Holy and the Holy of Holies contained the same fittings as before; some of these are vividly depicted on reliefs on the Arch of Titus in the Roman Forum, which portray the Romans carrying away their trophies from the Temple in triumph. As to the general appearance of the Temple, Josephus writes: 'the Temple appeared to strangers, when they were at a distance, like a mountain covered with snow, for as to those parts of it that were not gilt, they were exceeding white' (*Jewish War* V.v.6). A parapet with spikes was built around the edge of the Temple roof to prevent birds soiling the sanctuary walls. The Altar of Burnt Offering and the laver stood in the Inner Court, as did the various tables used in the preparation of the animals for sacrifice. To the east lay the Court of the Priests, then the Court of the Israelites and finally the Court of the Women. The Court of the Gentiles surrounded these internal courts and was separated from them by a latticed railing or *soreg*. Magnificent colonnades surrounded the entire outer court. The colonnade on the eastern side of the court was called Solomon's porch (John 10:23, Acts 3:11), indicating that it was built before the other three porches, which were built by Herod. The Royal Stoa, which ran the full length of the southern wall, was the most impressive of the colonnades. It was built in the shape of a basilica, with 162 monolithic columns in four rows dividing it into a central nave and two aisles. It was probably from this part of the Temple that Jesus cast out the merchants and moneychangers (Mark 11:15).

BIBLIOGRAPHY
Flavius Josephus: *Jewish War* [AD 75–9]; ed. and Eng. trans. by H. St J. Thackeray and others, Loeb Class. Lib. (London, 1926–65)
G. Smith: *History of Jerusalem* (Jerusalem, 1907/*R* n.d.)
K. Watzinger: *Denkmäler Palästinas*, i (Leipzig, 1933), pp. 89–95
F. Hollis: *The Archaeology of Herod's Temple* (London, 1934)
M. Avi-Yonah: 'The Second Temple', *Sepher Yerushalayim (The Book of Jerusalem)*, ed. M. Avi-Yonah, i (Jerusalem and Tel Aviv, 1956), pp. 392–418
L. Vincent and A. Stève: *Jérusalem de l'Ancien Testament*, ii (Paris, 1956)
R. de Vaux: *Les Institutions de l'Ancien Testament*, ii/3 (Cerf, 1960)
B. Mazar: *The Excavations in the Old City of Jerusalem* (Jerusalem, 1969)
——: *The Archaeological Excavations near the Temple Mount* (Jerusalem, 1971)
——: 'The Archaeological Excavations near the Temple Mount', *Jerusalem Revealed*, ed. Y. Yadin (Jerusalem, 1975), pp. 25–40
——: *The Mountain of the Lord* (New York, 1975)
T. Busink: *Der Tempel von Jerusalem* (Leiden, 1980)
B. Mazar: 'The Royal Stoa in the Southern Part of the Temple Mount', *Recent Archaeology in the Land of Israel*, ed. H. Shanks (Washington, DC, 1984), pp. 141–7
——: 'The Temple Mount', *Proceedings of the International Congress on Biblical Archaeology. Biblical Archaeology Today: Jerusalem, 1985*, pp. 463–8
K. Prag: *Jerusalem*, Blue Guide (London and New York, 1989)
L. Ritmeyer and K. Ritmeyer: 'Reconstructing Herod's Temple Mount', *Bibl. Archaeol. Rev.*, xv/6 (1989), pp. 23–53

LEEN RITMEYER

(iii) The Dome of the Rock [Arab. Qubbat al-Sakhra]. The earliest major monument of Islamic architecture to survive, the Dome of the Rock (see fig. 1f above) was erected by the Umayyad caliph 'Abd al-Malik (*reg* AD 685–705) near the centre of the Haram al-Sharif. The building is dated by inscription to 692. In form it comprises an octagon,

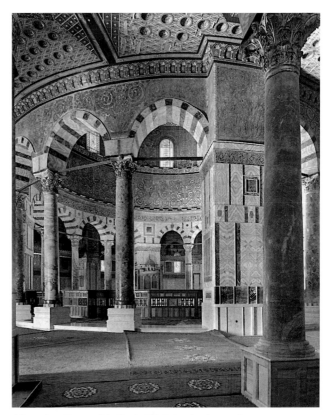

6. Jerusalem, Dome of the Rock, 691–2; interior (restored)

which successively encloses an open-plan octagon marked by 8 piers and 16 columns, and an inner ring of 4 piers and 12 columns; this makes a total of 40 supports, which number is widely held to have symbolic significance. Above the inner ring rises a circular drum crowned by a wooden dome, which was gold-plated in the Middle Ages. The building (see ISLAMIC ART, fig. 17) is thus a typical martyrium, and the plan reflects the natural continuity between Late Antique or Byzantine architecture and the earliest Islamic architecture in Syria. The particular choice of model may have had another purpose, for in early Islamic Jerusalem the most celebrated martyrium was the domed centralized building (also raised over a rock) erected by Constantine the Great to mark the site of the Holy Sepulchre (1c; *see also* §II, 2(i) below). The almost exact correspondence (within 40 mm) between the diameters of the two domes suggests that the Muslim building was intended to rival this most prestigious of all Christian buildings.

Originally both exterior and interior of the Dome of the Rock were sheathed in gold and green mosaic, the most lavish use of external mosaic recorded in ancient or medieval times. Most of the interior mosaic survives (see fig. 6); its themes highlight fantastic vegetal forms (such as scrolls and trees, often jewelled), chalices and vases. These motifs may have been intended as references to the Koranic paradise, which emphasises fertility, supernal trees, jewels and precious goblets, but they may also have

triumphal associations. A long (*c.* 250 m) band of inscriptions in gold on blue runs above the mosaics on either side of the inner octagon. The inscriptions are almost exclusively Koranic in content and reveal that part of the function of the building was to proclaim the superiority of the new faith in this citadel of Christianity and Judaism, the two monotheistic faiths of which Islam was the seal. The inscriptions exalt the oneness of God, attack the notion that he can have a son, offer encouragement to embrace Islam, and warn of the consequences of rejecting it; but they say nothing at all about the huge irregular rock (18×13 m) that occupies the centre of the building. Traditionally identified as the site of Adam's creation and of Abraham's intended sacrifice of Isaac, it was also from the 9th century associated with Muhammad's ascent to the Seven Heavens on his miraculous Night Journey (Arab. *miʿrāj*) from Mecca to Jerusalem and back. Other Umayyad decoration includes embossed copper plaques and marble inlaid with vegetal motifs in black mastic, or with natural graining (perhaps evoking the waters of Paradise); the capitals and columns are spolia of varied origin.

The earliest commentary (*c.* 874) on the building, by the Shiʿite historian al-Yaʿqubi, associates the Dome of the Rock with the civil war of the 680s, during which Mecca fell into rebel hands, and asserts that it was built to replace the Kaʿba as the goal of Muslim pilgrimage. This seems too crude a formulation to carry conviction, but the monument could well have been intended as a supplementary object of pilgrimage, a function it maintains to this day. Features such as the double ambulatory, huge cleared space with immemorially sacred associations, venerated rock, and the black stone set in its principal mihrab, would have certainly helped the building to function as a pilgrimage centre resembling Mecca. Furthermore Jerusalem was the original direction of prayer in Islam.

The post-Umayyad history of the Dome of the Rock confirms its politico-religious significance. The Abbasid caliph al-Maʾmun (*reg* 813–33) altered the original inscription to claim that he had built the monument. Major restorations under the Fatimid caliph al-Zahir (*reg* 1021–36) are commemorated by inscriptions. The crusaders held it to be Solomon's Temple itself (the high iron screen they installed around the exposed bedrock was removed during modern restoration). The rededication of the building by Salah al-Din was made into a major political event, and one of his immediate successors had a wooden balustrade erected around the rock. In the 14th century members of the Mamluk dynasty renovated the wooden ceilings of the ambulatory and the central dome. The Ottoman sultan Süleyman redecorated the building as part of a programme of embellishing the holy cities of Islam. He replaced the exterior mosaics with glazed tiles; and these, admittedly much restored, survive to this day. Various other Ottoman patrons restored the ceilings and replaced window grilles with stained glass. In the 20th century six major restoration campaigns have taken place, and the building has become a symbol of Palestinian resistance and Islamic fundamentalism.

BIBLIOGRAPHY

Enc. Islam/2: 'Kubbat al-Sakhra'

K. A. C. Creswell: *Early Muslim Architecture*, i (Oxford, 1932, rev. 1969), pp. 65–129, 215–322

O. Grabar: 'The Umayyad Dome of the Rock in Jerusalem', *A. Orient.*, iii (1959), pp. 33–62

W. Caskel: *Der Felsendom und die Wallfahrt nach Jerusalem* (Cologne, 1963)

P. Soucek: 'The Temple of Solomon in Islamic Legend and Art', *The Temple of Solomon*, ed. J. Gutmann (Missoula, MT, 1976), pp. 73–123

E. Baer: 'The Mihrab in the Cave of the Dome of the Rock', *Muqarnas*, iii (1985), pp. 8–19

O. Grabar: 'The Meaning of the Dome of the Rock', *The Medieval Mediterranean: Cross-Cultural Contacts*, ed. M. J. Chiat and K. L. Reyerson (St Cloud, MN, 1988), pp. 1–10

M. Rosen-Ayalon: *The Early Islamic Monuments of al-Haram al-Sharif: An Iconographic Study* (Jerusalem, 1989)

N. Rabbat: 'The Meaning of the Umayyad Dome of the Rock', *Muqarnas*, vi (1990), pp. 12–21

S. S. Blair: 'What is the Date of the Dome of the Rock?', *'Abd al-Malik's Jerusalem*, ed. J. Raby and J. Johns (Oxford, in preparation)

(iv) Aqsa Mosque [Arab. Masjid al-Aqsā]. The congregational mosque of Jerusalem is located at the southern end of the Haram al-Sharif (see fig. 1g above) on a line with the Dome of the Rock (*see* §(iii) above). It is the third holiest mosque in Islam after those at Mecca and Medina. The building has a complicated history, and Hamilton's excavations from 1938 to 1942, together with later, inadequately published work, have identified various stages of construction, the dates of which are controversial. A makeshift temporary mosque, perhaps reusing parts of Herod's Stoa (*see* §1(i) above), was put up soon after 637, a clear and early signal of Muslim awareness that the location of mosques could have political significance. This was replaced by three successive structures: the first by ʿAbd al-Malik, the second by al-Walid I (*reg* 705–15) and the third by the Abbasid caliphs al-Mansur (*reg* 754–75) and al-Mahdi (*reg* 775–85). Their lateral (east–west) dimensions are unknown.

The first of these mosques (Aqsa I) measured 50.8 m north–south; its roof was carried on fenestrated walls resting on arcades of marble columns. Some of this early structure can still be seen to the east of the present dome and includes the central part of the south wall itself. Three spolia capitals with animal designs were reused in this area. This mosque proved too small, for a major extension (Aqsa II) was undertaken. Another 19 sq. m of covered area was added to the north, and the interior space was articulated more boldly. The mosque acquired its distinctive many-naved form, with a raised and wider central gable and a dome over the second bay in front of the mihrab. This was the embryonic T-plan so popular in later MOSQUE architecture. The aisles were perpendicular to the qibla wall; their length necessitated a clerestory for adequate lighting. No courtyard was necessary because of the presence of the Haram to the north. Leading into the sanctuary, a triple gateway, with three central arches larger than those on either side, was the centrepiece of a vast extended façade of probably 15 arches. The central nave had 20 great tie-beams; their intersection with the bearing walls was originally marked by 40 carved and painted panels, which comprise the principal survivals of Umayyad woodwork.

After an earthquake in 747, the Umayyad mosque collapsed, and its remains were incorporated into Aqsa III. Work completed by al-Mahdi *c.* 780 comprised at least the central nave and a pair of aisles. It was in an irreproachably Umayyad style, featuring plaster-coated

columns bearing fake marble graining, vegetal designs and small painted triangles of a kind familiar in floor mosaics.

A second earthquake damaged the mosque in 1016 and a third actually destroyed part of it in December 1033. A new dome of imperial size and splendour, with unprecedented sphero-triangular pendentives resting on squinches, was immediately ordered by the Fatimid caliph al-Zahir. According to an inscription, the work (sometimes known as Aqsa IV) was finished in October 1035, and the speed is striking evidence of the importance attached to the mosque by this time. The Fatimid repairs recast the northern section and reduced the mosque to its present scale: relatively narrow from east to west but long from north to south. The dome area was decorated in mosaic, a medium quite outmoded by this time, and its use is an eloquent tribute to the prescriptive power of the Umayyad remains at the Haram. The austere style of the inscription is quite out of line with contemporary taste and was intended to recall Umayyad inscriptions at the Dome of the Rock, constituting one of the earliest examples of antiquarianism in Islamic art. The inscription cites Koran xvii:1 concerning Muhammad's miraculous journey from Mecca to the 'further-most Mosque' (Arab. 'al-masjid al-aqsā) and is proof that this event was firmly associated with the mosque by this date. A long inscription (1065) in stone above the central entrance records unspecified restorations under the Fatimid caliph al-Mustansir (*reg* 1036–94).

The mosque underwent little damage at the hands of the crusaders (1099–1187), who considered it the palace of Solomon, although they dubbed it his temple. The building served as a palace for the kings of Jerusalem and then for the Knights Templar. The crusaders added a vaulted portico to the northern façade and began other additions to the east and west of the mosque. Massive vaulted aisles still stand to the west, as does the portal known as Bab Ilyas, which has a Crusader arch displaying cushion voussoirs. In reconstructing the north porch of the mosque the Ayyubids (*reg* 1169–1260) clearly built on and reused Crusader work, but it is difficult to disentangle the two campaigns. A new mihrab decorated in polychrome marble and mosaic was inserted into the mosque by Salah al-Din to commemorate its rededication to Islam, and the celebrated minbar (destr.) that Nur al-Din Zangi (*reg* 1146–74) had ordered in 1168–9 in anticipation of taking Jerusalem was brought from Aleppo and ceremonially installed in the mosque (*see* ISLAMIC ART, §VII, 1(i)(b)). Inscriptions above the central arch of the portico and on the interior of its dome mention al-Mu'azzam 'Isa ibn al-Malik al-'Adil (*reg* 1218–27), who—claiming royal titles in advance of his accession—had the porch constructed in 1217–18. Other Ayyubid work probably includes the tie-beams in the arcades of the nave and the southern aisle; they are painted with boldly coloured vegetal and geometric designs showing stellar and solar themes appropriate to their location and interspersed with a few kufic and cursive inscriptions.

Mamluk work in the mosque is represented by a splendid pair of large hexagonal tiles in the north portico, each inscribed and subdivided into hexagons and triangles, and by four doors on the north side of the mosque, bearing the names of Salih (*reg* 1351–4) and Sha'ban (*reg* 1345–6).

In 1350 Hasan (*reg* 1347–61 with interruption) rebuilt the north-east corner of the mosque, while other inscriptions testify to the activities of Qa'itbay and al-Ghawri (*reg* 1501–17). Inscriptions were occasionally placed on the walls of the Aqsa Mosque to commemorate the righting of some financial injustice by a visiting sultan. Many of the window grilles of the south wall are probably medieval. The mosque was continually repaired and embellished throughout the period of Ottoman rule (from 1517), culminating in major campaigns of conservation and reconstruction in the first half of the 20th century. An annexe to the west houses the Islamic Museum.

For illustration *see* MOSQUE, fig. 1.

BIBLIOGRAPHY

K. A. C. Creswell: *Early Muslim Architecture*, i (Oxford, 1932, rev. 1969), pp. 32–5, 373–80
S. A. S. Husseini: 'Inscription of the Khalif el-Mustansir Billah 458 A.H. (=A.D. 1065)', *Q. Dept Ant. Palestine*, ix (1939), pp. 77–80
R. W. Hamilton: *The Structural History of the Aqsā Mosque* (Oxford, 1949)
K. A. C. Creswell: *A Short Account of Early Muslim Architecture* (Harmondsworth, 1958, rev. Aldershot, 1989), pp. 8, 73–82
H. Stern: 'Recherches sur la mosquée al-Aqsa et sur ses mosaïques', *A. Orient.*, v (1963), pp. 27–48
J. Wilkinson: *Column Capitals in al-Haram al-Sharif* (Jerusalem, 1987), pp. 19–20, 22–7
R. W. Hamilton: 'Once Again the Aqsa', *Bayt-al-Maqdis: 'Abd al-Malik's Jerusalem*, ix of *Oxford Stud. Islam. A.*, ed. J. Raby and J. Johns (Oxford, 1994)

ROBERT HILLENBRAND

2. CHURCH OF THE HOLY SEPULCHRE.

(i) 326–1099. (ii) After 1099.

(i) 326–1099. The early history and appearance of the church remain uncertain, owing to the many changes that have taken place on the site and the impossibility of thorough excavation. All architectural development was conditioned by the sites of the Crucifixion (Calvary) and the Tomb of Christ, in a former stone quarry. Fixed points of lesser significance were the grotto now known as the Prison of Christ and St Helena's crypt, the underground cave where St Helena discovered the Cross. After the rediscovery of the Holy Places by Constantine in 326 they immediately became the focus of Christian veneration. Both Calvary and the Tomb of Christ were isolated by cutting away the surrounding rock and earth, making them free-standing blocks, not unlike the surviving rock tombs in the Kidron Valley. Between 326 and 337 the Tomb of Christ was surrounded by the so-called Anastasis (Resurrection) Rotunda. East of this was a roughly rectangular courtyard, surrounded by a peristyle, with Calvary forming the south-east corner and the Prison the north-east corner. To the east of the courtyard itself was a large five-aisled basilica, its apse facing to the west, and enclosing the crypt of St Helena.

The details of the 4th-century layout are still disputed, but the outlines of the scheme are generally agreed. The main elements were all fairly traditional, notably the rotunda enclosing the Tomb, which derived directly from royal and imperial mausolea, but the combination of rotunda, courtyard and basilica was most unusual. Although the three elements can be described separately, the site was always conceived as a unified whole. The rotunda consisted of a massive exterior wall, containing three small apses at the cardinal points (except the east, which faced

on to the courtyard). Within was a two-storey circular colonnade, forming an ambulatory around the Sepulchre. The structure may originally have been unroofed, but it was certainly covered by the end of the 4th century. Much of the Constantinian masonry of the outer wall survives, but the internal columns, although retaining their original disposition, have been replaced. In front of the rotunda was a stone-paved courtyard, surrounded by a colonnaded walkway. The rock of Calvary projected in the south-east corner, and was surmounted by a great cross. A small chapel, the church of Golgotha itself, was situated south of the rock. The main church was Constantine's great basilica, also known as the Martyrium, east of the courtyard. The apse, at the west end and adjoining the courtyard, has been excavated, while two of the doors of the atrium, which preceded the basilica to the east, survive as foundations within later buildings. This gives a total length for basilica and atrium of 75 m. It had double aisles, surmounted by galleries, thus resembling the Constantinian basilica of St Peter in Rome. The roof was of wood and the whole was, according to EUSEBIOS OF CAESAREA, magnificently decorated, sheathed in marble and with a coffered ceiling painted in gold. The result was a very splendid group of buildings; the early pilgrim would have approached a triple gateway and entered the atrium of the basilica, a large colonnaded courtyard. Beyond this was the basilica itself, splendidly adorned and sheltering St Helena's crypt. A door at the end of the basilica led into a second colonnaded court, containing the rock and cross of Calvary, the shrine known as the Prison of Christ, with the rotunda rising on its far side.

Since Constantine's time the site has undergone many changes. In 614 Jerusalem fell to the Persians, and the Holy Sepulchre and associated buildings were sacked. Restorations were carried out by the Patriarch Modestus, and the Christian shrines survived the Arab conquest of 638. In 1009, however, the fanatical caliph al-Hakim ordered the systematic destruction of the Holy Sepulchre. The basilica was entirely demolished, Calvary and the Sepulchre mutilated, but somewhat surprisingly the external wall of the Anastasis Rotunda seems to have been left largely intact. After several years of desolation the Byzantine rulers of Constantinople obtained permission to restore the site, and the work was completed in 1048, in the reign of Constantine IX Monomachos. The rotunda was rebuilt, using the surviving Constantinian walls, but with the addition of a gallery at first floor level and the insertion of a tall apse on the eastern side. A conical timber roof covered the whole structure, which thus acquired the appearance of a centrally planned Byzantine church rather than a Roman mausoleum. The courtyard to the east, containing the sites of Calvary and the Prison, was also restored, remaining an open space and closed on its eastern side (where the basilica had stood) by a wall containing three small apses. The complete disappearance of the basilica meant that the whole site was now oriented. The courtyard must have somewhat resembled a cloister, with a colonnaded walkway on three sides, surmounted by a gallery which was linked to the new gallery of the rotunda. The main entrance to the site was on the south side of the courtyard.

(ii) After 1099. When the crusaders conquered Jerusalem in 1099 their immediate concern was to restore and beautify the Holy Sepulchre still further, and work began very shortly after the conquest. It was completed (or nearly so) by the 50th anniversary of the fall of Jerusalem, for it was consecrated on that day, 15 July 1149. The crusader plan was in essence simple (see fig. 7). It was to enclose the open courtyard in a new, roofed structure, which would form the transepts and chancel of the church, with the rotunda remaining and taking the place of a nave. The ground-plan of the new part of the church was a familiar Romanesque one, the east end consisting of an apse and ambulatory, with three radiating chapels. Calvary was enclosed by the south transept, the Prison by the north, and a passage from the ambulatory led down to the crypt of St Helena. To join the rotunda to the rest of the church, the Byzantine apse was demolished. Architecturally, the crusader church was an amalgam of various Western design features. Built mostly of limestone it had two storeys of equal height, consisting of a main arcade and gallery. The arches were lightly pointed throughout, and the transept arms and choir were covered by quadripartite ribbed vaults, with a dome over the crossing. The elevation and vaulting suggest Burgundian and northern French origins, while the main entrance to the church, the south transept façade (see fig. 8), has been compared with the south transept doorways of Santiago de Compostela (*see* SANTIAGO DE COMPOSTELA, fig. 2) and St Sernin, Toulouse. The crusaders made a considerable effort to preserve

7. Jerusalem, ground-plan of the Church of the Holy Sepulchre, consecrated 1149: (a) Holy Sepulchre; (b) rotunda; (c) Calvary; (d) Prison of Christ; (e) ambulatory; (f) cloister, with the crypt of St Helena below

what they believed to be the original fabric of the church, notably in the rotunda, but also in the north transept, where a section of the 11th-century courtyard arcade remains. The whole interior of the building was most lavishly decorated in mosaic and paint, while the south transept façade was elaborately decorated with sculpture. The Sepulchre itself was enclosed in a sumptuous aedicula, constructed of marble and intricately carved. There is some reason to believe that the north transept was completed after the consecration, and in the second half of the 12th century a cloister (destr.) was added, east of the main apse and over the roof of St Helena's Chapel. The cloister itself was surrounded by the conventual buildings for the Augustinian canons of the Sepulchre. The bell-tower, adjacent to the south transept façade, was added at the same time.

After the fall of Jerusalem in 1187 the church was spared, but it has suffered some wilful damage and considerable neglect. The claims of the competing Christian denominations caused the building to be partitioned off into separate areas, and this was a contributing factor to a disastrous fire in 1808, which destroyed much of the fabric. Further severe damage was caused by the restorations that followed the fire, when much of the east end was entirely rebuilt. The crusader aedicula over the Sepulchre was replaced by the present structure. The building was threatened further by a severe earthquake in 1927, when the rotunda had to be shored up with scaffolding. Full restoration did not begin until 1962, but now the visitor can get some impression of the historic nature of the building and of its component parts. The Romanesque transepts and ambulatory survive, with the 19th-century choir. The rotunda retains something of its Byzantine appearance, and the Constantinian masonry is visible in its outer walls. The church is swallowed up by the mass of surrounding buildings, the only clear space from which it can be seen being the parvis in front of the south transept. However, despite the mutilations of the centuries, the Holy Sepulchre remains a fascinating complex of structures and is of key importance for several phases of medieval architectural history, 'imitations' being built all over Europe (*see* SEPULCHRE CHURCH).

BIBLIOGRAPHY
C. de Vogüé: *Les Eglises de la Terre Sainte* (Paris, 1860)
C. Enlart: *Les Monuments des croisés dans le royaume de Jérusalem* (Paris, 1925–8)
W. Harvey: *Church of the Holy Sepulchre, Jerusalem: Structural Survey, Final Report* (Oxford, 1935)
C. Coüasnon: *The Church of the Holy Sepulchre in Jerusalem* (London, 1974)
V. Corbo: *Il Santo Sepolcro di Gerusalemme: Aspetti archeologici dalle origini al periodo crociato*, 3 vols (Jerusalem, 1982)

For further bibliography *see* §I, 3 above.

ALAN BORG

Jerusalem, Latin Kingdom of [Crusader States]. One of four Crusader States that were established on mainland Syria-Palestine during and after the First Crusade (*see* CRUSADES), which was launched in 1095 by Pope Urban II (*reg* 1088–99) to protect the Holy Land against the Muslims. Besides the Latin Kingdom itself, three main states at least nominally recognized the suzerainty of the king who resided in Jerusalem: the County of Edessa, the

8. Jerusalem, Church of the Holy Sepulchre, south transept façade

Principality of Antioch and the County of Tripoli, whose lords lived in the title city. The Crusader States came to an end in 1291.

I. History. II. Art and architecture.

I. History.

1. COUNTY OF EDESSA. Located mainly in south-east Anatolia, it was both the first Crusader State to be established in 1098 and the first to be eliminated, between 1144 and 1151. The County was considerably smaller than the Latin Kingdom, measuring only slightly over 240 km across its longest dimension. It had a large population of Armenians, who had invited in and supported the Franks, and Syrian Jacobites, who favoured the Muslims. Baldwin I of Boulogne (*reg* 1098–1100) was proclaimed ruler of Edessa while the main Crusader army was besieging Antioch (now Antakya). At its inception the County was largely centred around the cities of Edessa (now Urfa), Samosata (now Samsat), Aintab (now Gaziantep) and Tel Bashir (now Turbessel) in the Euphrates Valley at the south-east end of the Taurus Mountains, just north of where the river enters the Syrian desert; by 1118 its territory had been expanded north-east to Gargar (now Gerger), north-west to Maraş and south-west to Corice (anc. Cyrrhus). Latin bishops were established in Edessa and Maraş under the jurisdiction of the Latin Patriarch of Antioch.

In April 1118 Baldwin II of Edessa (*reg* 1100–1118) became King of Jerusalem (*reg* 1118–31). His successor, Joscelin I (*reg* 1118–31), maintained the frontiers until 1128 when Gargar was lost to Zangi (*d* 1146) and, as Zangi's power waxed, that of Edessa waned. The end

came soon after Zangi captured Montferrand (Barin) in 1138 and the death of the Byzantine Emperor John II Comnenus (*reg* 1118–43), leaving the northern territories exposed and vulnerable. Edessa fell in December 1144, and by 1146 Joscelin II (*reg* 1131–50) had lost everything east of the River Euphrates. The County of Edessa ceased to exist by the end of the summer of 1151.

2. PRINCIPALITY OF ANTIOCH. Located mainly in north-west Syria, it was established under Bohemund I of Taranto (*reg* 1098–1111) after the Crusaders captured the city in June 1098. It was the second state to be eliminated, in 1268. The Principality was founded largely in the passing of the First Crusade and came into existence mostly fully formed: at its greatest extent in the early 12th century it stretched from the Cilician coastal plain in the north with the cities of Tarsus, Adana and Mamistra (now Misis), along the coast down to Margat Castle (now Marqab), its main cities being Latakia (anc. Laodicea; Arab. al-Lādhiqiyya) in the south and Antioch with its port of St Simeon and Alexandretta (now Iskenderun) to the north.

Of all the Crusader States, Antioch was most closely tied to the Byzantine empire through territorial proximity, the venerable Patriarchal See of Antioch and by Bohemund's oath as a vassal of Alexios I Komnenos (*reg* 1081–1118). Its history in the 12th century was thus a mixture of Byzantine attempts to claim territorial control, Turkish incursions and Crusader efforts to safeguard this pivotal state on the northern frontier. The leadership and stability of the principality was frequently the responsibility of the Latin Patriarchs, especially Bernard de Valence (1100–35) and Aimery de Limoges (1141–93), who ruled a Frankish population that was mostly Norman Sicilian combined with an indigenous population of Greeks, Syrian Jacobites and some Armenians.

Antioch steadily lost territories at the time of Zangi's incursions into Edessa. After 1160 it was joined to the County of Tripoli by personal bequest under the inheritance of Raymond III (*reg* 1152–87). The last great prince of Antioch, Bohemund IV (*reg* 1187–1233), steered a course independent of the great conflicts of the Latin Kingdom, in particular the divisive Lombard war in which partisans of Emperor Frederick II fought the Jerusalem barons for power. His successor, Bohemund V (*reg* 1233–52), found an Antioch isolated in the north, commercially inert and divided by Muslim Latakia from its holdings farther south; Antioch managed to hold on only in an increasingly weakened and vulnerable condition. In May 1268 Antioch was swiftly taken and destroyed by the Mamluk Sultan Baybars (*reg* 1260–77).

3. LATIN KINGDOM OF JERUSALEM. The state directly under the control of the Latin king, it was founded as a result of the First Crusade, which conquered Jerusalem on 15 July 1099. Godfrey de Bouillon (*reg* 1099–1100) took the title *advocatus sancti sepulchri*, but subsequent rulers were crowned as kings. They resided in Jerusalem until 1187 after which they mainly resided in St Jean d'Acre (now 'Akko) or on Cyprus. A Latin patriarch of Jerusalem was installed in the church of the Holy Sepulchre in 1099 and Latin bishops were established in the major sees under Crusader control. Greek, Syrian Orthodox and Armenian clergy were largely excluded at first from the main Christian holy sites in Jerusalem, Bethlehem (the church of the Nativity), and Nazareth (the Cathedral of the Annunciation), but were allowed to have their own churches.

In 1100 the Latin Kingdom included only Jerusalem, the capital, Jaffa, on the coast, Ramla and Lydda (now Lod) in the corridor inland, Nablus and Galilee to the north, and Bethlehem and Hebron to the south. It achieved its greatest extent in the period between the First and Second Crusades (1099–1145), when all the coastal cities were captured except for Ascalon (now Ashqelon), taken in 1153. In length the kingdom was 480 km from Beirut to Aqaba, and inland it extended to the Sea of Galilee, the Dead Sea and outposts at Kerak (now Kir-haresheth), Krak de Montréal (now al-Shawbak) and Petra.

The Crusaders maintained these borders until the invasions of Salah al-Din between 1185 and 1189. Jerusalem, Bethlehem and Nazareth were lost after the Battle of Hattin in July 1187 and by 1189 only Tyre (now Sur) and the castle of Belfort overlooking the Litani Valley were retained of the original kingdom. The Third Crusade (1189–92) regained the coastal plain from Jaffa to Tyre, but all the holy sites and main inland cities including Jerusalem remained in Muslim hands. The king, the patriarch and most of the dispossessed nobles and bishops took up residence at St Jean d'Acre, which became the *de facto* capital between 1192 and 1291. Access to Jerusalem, Bethlehem and Nazareth with their holy sites was regained only through a treaty negotiated by Emperor Frederick II on the Crusade of 1228–9, but subsequent internal conflicts so weakened the Crusader States that in 1244 the Kwarezmian Turks captured Jerusalem and the Crusaders never again controlled the holy city.

The Crusade of Louis IX of France in 1248–50 and his residence at St Jean d'Acre from 1250 to 1254 resulted in substantial strengthening of Crusader defences but no recovered territory. Between 1265 and 1270, however, Baybars captured several major cities and castles, including Caesarea (now Hal Qesari; 1265), Safed (now Zefat; 1266), Latakia (1267), Antioch and Belfort (1268) and Krak des Chevaliers (1271). A series of truces saved the Crusaders further losses until Sultan al-Ashraf Khalil (*reg* 1290–93) took Tripoli in 1289 and Acre in May 1291, after which the remaining mainland Crusader castles and ports were quickly captured and, except for Beirut, destroyed to prevent the Franks returning to Outremer.

4. COUNTY OF TRIPOLI. Located between Antioch and the Latin Kingdom in north Lebanon and south Syria, it was the last Crusader State to be established, in 1109. It was governed by the successors of Raymond IV of Toulouse (*d* 1105), and was eliminated in 1289. Its security depended on the stability of its neighbours. In 1174 it was formally joined to Antioch. Tripoli was by far the smallest of the Crusader States, a narrow Christian isthmus stretching *c.* 125 km along the coast from the Dog River north of Beirut to a point just south of Margat Castle and limited by the hills inland. Even at its greatest extent it never reached the River Orontes to the east and its major stronghold at Krak des Chevaliers was less than 40 km from the sea. Other strategic towns were Tortosa (Tartus)

on the north coast and Gibelet (anc. Byblos; now Gebeil, Jbeil) on the south, with Tripoli (now Trâblous) roughly in the middle. A Latin bishop was installed at Tripoli in 1109, and by 1140 there were also bishops at Tortosa and Gibelet, under the jurisdiction of Antioch. The main native Christian population was Maronite, with some Syrian Jacobites and few Armenians.

The 12th-century counts of Tripoli tended to be long-lived, and the County prospered. By the time of the Second Crusade the military orders were installed there, with the Knights Hospitaller taking control of Krak des Chevaliers in the 1140s and the Knights Templar at Tortosa in the 1150s. Following the invasion of Salah al-Din in 1187, the orders managed to retain the largest 'islands' of Crusader holdings in Tripoli, at Tortosa and around Krak, Chastel Blanc (now Ṣafita) and Margat. By 1197, following the Third Crusade, almost all its territory had been restored, the only Crusader State to approach its configuration of before 1187. Tripoli, with Tyre and Acre, formed the heart of the Crusader States and in the hard-pressed circumstances of the 13th century the Count of Tripoli also became the Prince of Antioch. Once again Tripoli was blessed with long-lived rulers, and during this time only Krak des Chevaliers was captured (by Baybars in 1271), but after Tripoli itself fell to Kalavun (*reg* 1279–90) in 1289, Tortosa could hold out only until 1291.

II. Art and architecture.

1. Introduction. 2. 1098–*c*. 1131. 3. *c*. 1131–89. 4. 1189–1291. 5. Conclusion.

1. INTRODUCTION. Crusader art, commissioned in the States between 1099 and 1291 for Crusaders and Frankish settlers, such as Italian merchants, and their offspring, forms an important chapter in the history of European medieval art. The architecture, painting (mosaics, frescoes, manuscript illumination, panel paintings, icons), sculpture, metalwork, coins and seals produced by a variety of local and western artists are gradually being recognized, evaluated and characterized as a coherent and independent corpus. It can be seen as a European-Near Eastern phenomenon, rooted in western European religious and secular content and figural traditions, but with Levantine stylistic inspiration derived from Roman, Early Christian, Byzantine, Armenian, Syrian and Muslim sources to go with the imported aspects of both the Romanesque and Gothic decorative repertory. Even though Crusader art was bound to the West by its patrons, most of whom were Europeans (the Church, the rulers and settlers, the Italian merchants), and by some, but by no means all, of its artists, it was not simply the art of the Crusader and Frankish settlers in the Holy Land: it was devised uniquely for the Christian Holy Places, and was at one and the same time an art of pilgrimage, royalty, the Church and the military orders, and a sacred and secular art for knights, nobles and merchants in the Near East. It was produced by Western artists as well as local Arab Christian masons, Greek and Syrian Orthodox as well as Maronite painters, local-born Frankish sculptors and Armenian architects.

Owing to its artistic resources and location Crusader art necessarily followed its own chronological development; it relied on local materials and was inspired by its Levantine context. Although parallels can often be found between Crusader and western European or Byzantine art, it cannot be automatically presumed that the Crusader development follows one of the latter, nor that the Crusader chronology is necessarily close to theirs. They should not even be related directly without clear evidence. Western stylistic developments occurred in the Crusader East in similar but not necessarily the same manifestations 25 years or more later without direct causal ties; parallel developments occurred independently in East and West, as, for example, in the employment of the broad pointed arch characteristic of all Crusader ecclesiastical architecture; and evidence is mounting that Crusader panel painting played a central role in transmitting knowledge of the Byzantine tradition to 12th- and 13th-century Italian painters. Finally, although Crusader art developed more slowly and along different lines from that of the European West, there were discernible phases: the formative period lasted until the 1130s, followed by a phase of flourishing activity that continued until *c*. 1180, focused especially on the reigns of Queen Melisende (1131–61) and Almaric I (*reg* 1162–74). After an austere period following the loss of Jerusalem to Salah al-Din, Crusader art flourished again in the 13th century, stimulated by the advent of Louis IX in the Latin Kingdom in 1250 and lasting until the fall of Acre in 1291.

2. 1098–*c*. 1131. The main contingents of the First Crusade came from different parts of Europe with a variety of artistic traditions. Godfrey de Bouillon and his men, for example, came from the Duchy of Lorraine with its important centres of metalwork, while Raymond IV of Toulouse led an army from the south of France where major developments were underway in Romanesque architecture and sculpture. During the conquest of Antioch the first Crusader relic, the Holy Lance, was discovered following a miraculous vision and its reliquary was no doubt one of the first works of art commissioned by the Crusaders that Count Raymond carried to the siege of Jerusalem. The Crusader victory against the Egyptians near Ascalon in August 1098 was also the occasion for the introduction of a new and more important relic, that of the True Cross, which was rediscovered in Jerusalem after its capture and soon became the royal Crusader ensign, and for which another new Crusader reliquary was presumably commissioned.

Up to 1118 the Franks were challenged to expand and consolidate their defensive perimeter and to secure the great holy sites they had come to liberate: the Holy Sepulchre in Jerusalem, the grotto of the Nativity in Bethlehem and the place of the Annunciation in Nazareth. There was extensive building activity, repairing newly captured fortifications along the coast or building castles and fortified positions inland. Baldwin I built the castle of Monréal in 1115 on a hilltop site to protect the eastern border of the kingdom. Earlier at Gibelet in 1104 a rectangular fort with square towers and a central donjon was built with masonry re-used from the ancient site of BYBLOS, to anchor the city walls around the port.

The church of the Holy Sepulchre in Jerusalem was the focus for important construction after 1112. A cloister for the canons was erected, the aedicule of the Holy Sepulchre

1. Latin Kingdom of Jerusalem, reliquary cross from Denkendorf, silver gilt and gemstones, h. 230 mm, c. 1130 (Stuttgart, Württemberg-isches Landesmuseum)

was completely renovated in 1119 and by 1131 plans were underway to reconfigure the entire church. At Nazareth the tiny, ruined Byzantine church of the Annunciation (*see* NAZARETH, §1) was rebuilt along modest but more Western lines. Very little survives among the figural arts: a fresco of the enthroned *Virgin and Child* painted on to a column in the church of the Nativity at Bethlehem (*see* BETHLEHEM, §1) is the major early exemplar. Dated 1130 by an inscription, this painting reflects both the artist's Italian Romanesque stylistic training and his interest in

imperial Byzantine iconography. Not surprisingly Jerusalem seems to have been the centre for the other arts: from the first the Crusader kings were buried under canopied tombs in front of the Calvary chapel, and manuscripts, some of which were decorated, seem to have been produced at the Holy Sepulchre from the 1120s. Otherwise the most lively production was found in metalwork from a quarter of the city next to the Holy Sepulchre. Reliquaries of the True Cross, such as the example from Denkendorf (*c.* 1130; Stuttgart, Württemberg. Landesmus.; see fig. 1), reflect Crusader interest in relics from the Holy Land enclosed in golden vessels with beaded gold decoration and stamped images of angels and Evangelist symbols, using a repertory and techniques that derive from Italian, German and Byzantine goldsmiths.

In the northern Crusader States there is very sparse evidence for artistic production. It must have mirrored Jerusalem to some extent, but it also showed independent features. The main early evidence is coinage: in Edessa there are types derived from both Byzantine and south Italian sources, especially a standing armed warrior holding a cross on an issue from 1104–8, reflecting late 11th-century coins of Roger of Hauteville, Count of Sicily (*reg* 1072–1101). In Antioch coins were heavily based on Byzantine types, but Tancred (*reg* 1111–12) also issued the first Frankish coins with Latin inscriptions.

Castles demonstrate the most remarkable Crusader achievements in the north, especially Saone, south-east of Latakia, which was built in the 1120s on a huge defensive spur originally occupied by a Byzantine fortress. The formidable defensive characteristics added by the Crusaders include the precipitous ditch at the east end with its bridge support in the form of a stone 'needle' cut in the rock and topped with masonry courses. The church of St John in Gibelet appears to be one of the earliest major Crusader churches outside Jerusalem, with St John's, Beirut, and the rebuilding of the impressive cathedral in Tyre after the city was captured in 1124. These churches are similar, with a plan of nave and two aisles ending in three apses. The apsidal design seems to emulate Byzantine sources. The flat roof lines are Levantine and the broad pointed arches are probably derived from Arab buildings; but the barrel- and groin-vaulted interiors and absence of domes reflect western Romanesque practice.

3. *c.* 1131–89. Although the evidence is fragmentary it is clear that the Franks stimulated considerable artistic production even in the early years. Much more important work is extant from the most flourishing period during the reigns of Fulk (*reg* 1131–43), Queen Melisende, Baldwin III (*reg* 1143–63) and Almaric I, until the incursions of Salah al-Din in 1187. Melisende was perhaps the most active of these patrons. The Psalter named after her (London, BL, MS. Egerton 1139; see fig. 2; *see also* MELISENDE PSALTER), possibly executed from *c.* 1135, was produced by five or six western-trained artists and a scribe possibly from northern France. One of the artists, Basilius, signed the Deësis in Latin. The obvious interest in Byzantine painting demonstrated in the 24 full-page miniatures produced by Basilius is reflected by the other two major painters. The manuscript, with its striking and diverse paintings, its calendar with notable English features

2. Latin Kingdom of Jerusalem, *Anastasis*, miniature from the Psalter of Queen Melisende, ?from *c.* 1135 (London, British Library, MS. Egerton 1139, fol. 9*v*)

and its ivory covers with Byzantine and western imagery, epitomizes fully for the first time the synthesis of East and West in Crusader art.

Melisende's name is also associated with important architectural projects. She established the Convent of St Lazarus at Bethany (ruined) for her youngest sister Yvetta in 1143, and richly endowed it with land and gifts. Buildings she personally patronized or at least contributed to in the 1140s and 1150s are extant in Jerusalem (*see* JERUSALEM, §I, 2), including the churches of the Holy Sepulchre, St Anne (see fig. 3) and St James. During the late 1150s she also had a place prepared for her burial in the Tomb of the Virgin in the Valley of Josaphat. The most significant of these projects was the church of the Holy Sepulchre (*see* JERUSALEM, §II, 2(i)), for the Sepulchre of Christ was the most important of the Holy Places, eclipsing even his birthplace in Bethlehem or the grotto of the Annunciation in Nazareth.

The church of the Holy Sepulchre epitomized in architecture, sculpture and painting on a monumental scale what the Melisende Psalter offered on a more intimate personal level. Whereas the plan and masonry of the basilica were French, the dome was Levantine-inspired and the main exterior façade was conceived with a double portal perhaps modelled on the Golden Gate in Jerusalem or western pilgrimage churches such as Santiago de Compostela (*see* SANTIAGO DE COMPOSTELA, §1(i)) and

St Sernin, Toulouse (*see* TOULOUSE, §2(1)(b)). Pilgrims' accounts describe the rich mosaic decoration of the interior (destr., except for the *Christ in Majesty* in the Calvary chapel vault). The façade was articulated with a Roman-inspired cornice and a repertory of sculpture drawn from Early Christian and western Romanesque sources (*see* ROMANESQUE, §III, 1(vii)).

The two most famous extant sculptures are the historiated (west) lintel with six scenes from the *Raising of Lazarus* to the *Last Supper*, and the vine-scroll (east) lintel with human figures and predatory birds, both of which may derive from Italian sources. Mosaics filled the tympanum of at least the western portal, a probable reflection of the Italo-Mediterranean inspiration for this façade. The Crusader church of the Holy Sepulchre was a masterwork, integrating the different holy sites, and, although decorated by a variety of artists, it unified the artistic traditions that Crusader patrons could draw on for this central shrine church. The church of the Holy Sepulchre was dedicated on 15 July 1149.

Elsewhere in Jerusalem the Knights Hospitaller complex was under construction and its churches were decorated with figural sculpture in a robust French Romanesque style. Important fragments survive in the Museum of the Greek Orthodox Patriarchate. On the Haram the Dome of the Rock was dedicated by the Crusaders as the Temple of the Lord in 1142, and important metalwork including bronze candlesticks and a large iron grille (Jerusalem, al-Haram al-Sharif Mus.) of outstanding quality decorated the interior. At the southern end of the Haram the Knights Templar took over the al-Aqsa mosque, which was thought to be the Temple of Solomon, and in the second half of

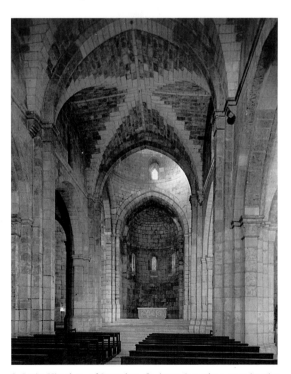

3. Latin Kingdom of Jerusalem, St Anne, Jerusalem, nave interior *c.* 1140

4. Latin Kingdom of Jerusalem, Cathedral of the Annunciation, Nazareth, limestone capital depicting the Virgin leading an Apostle by the hand, c. 1170

strongest between 1143 and 1169. Besides church building at the major holy sites and at the churches dedicated to St John in Ramla and Sebaste, some of the best known Crusader castles were also built during this period, including Kerak, which was started in 1142 on the eastern frontier, the alterations to KRAK DES CHEVALIERS after 1170, and BELVOIR CASTLE, which was rebuilt to a concentric plan after 1168.

the century they pursued an active building programme (*see* KNIGHTS TEMPLAR, §2). An exquisite wet-leaf acanthus style of architectural sculpture was developed between the middle of the century and the fall of Jerusalem in 1187. Although it mostly survives re-used in Arab buildings such as the Dikka of the al-Aqsa mosque, this sculpture ranks with the Nazareth capitals (*see* NAZARETH, §1) as the finest Crusader stone-carving.

Outside Jerusalem, Nazareth and Bethlehem emerged between about 1160 and 1187 as significant artistic centres. At Nazareth, Archbishop Letard (elected 1158) apparently enlarged the Crusader church (Cathedral of the Annunciation) and planned the most extensive programme of figural sculpture extant from a Crusader site. The capitals (see fig. 4) were probably carved in the 1170s to decorate a shrine monument over the grotto of the Annunciation, and other sculptures including a handsome torso of St Peter were intended to decorate the west façade of the church, reflecting characteristic French style and practice. The artists, however, may have been native-born Franks, trained by westerners.

In the Church of the Nativity at Bethlehem, painting on the nave columns continued, and a sumptuous new programme of mosaics, completed by 1169, was patronized by the Bishop of Bethlehem, the King of Jerusalem and the Emperor of Byzantium, a unique moment of political and artistic unity. A Syrian mosaicist named Basil placed angels between the clerestory windows (see fig. 5); symbolic images of church councils with extensive texts and lavish foliate designs reminiscent of the Dome of the Rock decorated the nave; and Christological scenes reflecting the main Church festivals are found in the transepts. In the grotto itself, a striking mosaic of the *Nativity* echoes the high quality of fresco painting found near by in the Hospitaller church of Abū-Ghosh (Qariet al-'Inab). Byzantine influence on the art of the Crusader States was

5. Latin Kingdom of Jerusalem, Church of the Nativity, Bethlehem, clerestory mosaic of Angel with artist's name, Basil, in Latin and Syriac, c. 1169

Even these formidable defensive positions could not deter Salah al-Din, however, and his great victory over the Crusaders at Hattin in July 1187, followed by two years of conquest, almost halted Crusader artistic production. Only at Margat Castle do wall-painting fragments survive from this period, in a Byzantinizing style.

4. 1189–1291. In the wake of the Third Crusade (1189–92) there was a resurgence of castle building led by the military orders, and aspects of the Gothic style began to appear in architecture. The Hospitallers at Margat expanded the fortifications with an angled gateway (see fig. 6) in the existing outer wall, and an inner fortification with, at the southern end, a massive cylindrical keep comparable to the later COUCY-LE-CHÂTEAU in France; living-quarters and a chapel were attached. The alterations to Krak des Chevaliers included a programme of Byzantine style frescoes in the chapel and a loggia with Gothic tracery and naturalistic, foliate sculpture decoration in the main hall. The Templars were equally active in the defence of the kingdom. In 1217–18, with the aid of pilgrims from nearby Acre, they built Château Pèlerin at 'Athlith (see KNIGHTS TEMPLAR, §2), which was guarded on three sides by the sea; the massive walls on the landward side were never breached. Inside, the great hall was decorated with sensitively carved human-headed corbels in Gothic style, and there was a circular chapel. By the time of Frederick II's Crusade in 1228–9, the Templars and Hospitallers controlled virtually all the most important castles, but, although the orders sponsored the building of extensive fortifications, they did not develop separate architectural styles. Among the other orders prominent in the Latin Kingdom, the Teutonic Order built Montfort (1226–9), a formidable castle north-east of Acre, as their headquarters in Outremer.

Predictably there was little church building in the Crusader States during this troubled time. The most important example is the completion of Tortosa Cathedral, which had been begun in the 12th century. It has a nave and two aisles with notable foliate sculpture of high quality on the interior capitals, but hardly any figural carving. The austere lines of the flat roof and heavy side walls and the façade of the exterior are broken only on the west end by five large if slender lancet windows with pointed arches, thin colonettes and heavy mouldings.

Not surprisingly the figural arts were also very limited at this time. The Riccardiana Psalter (Florence, Bib. Riccardiana, MS. 323), probably commissioned by Frederick II for his third wife, Isabella (1214–41), daughter of King John of England (reg 1199–1216), is the only extant luxury manuscript produced in Jerusalem between 1229 and 1244, following the treaty negotiated by the Emperor. While exhibiting a distinctive blend of eastern and western features characteristic of Crusader work, the specific German and English aspects combined with the Byzantine style here represent the nature of the commission, a gift from Outremer ordered by a German emperor for an English princess.

The relentless Mamluk invasions between 1250 and 1291 had little effect on artistic output, apparently owing to the intervening long periods of truce. Production sharply increased from 1250 to 1254 under the patronage

6. Latin Kingdom of Jerusalem, Margat Castle, main entrance and round towers, looking west, c. 1200

of Louis IX, who was resident in Acre during those years and rebuilt the fortifications of Jaffa, Caesarea and Sidon. At Acre the entire northern suburb of Montmusard was walled in to create a large new residential quarter with its royal market and to join the assemblage of special quarters within the old city that belonged to the Italian maritime powers, the Hospitallers (see KNIGHTS HOSPITALLER, §2), the Templars, the Patriarch and the Crown.

With Louis's departure architectural activity was reduced, but painting continued unabated until 1291. Louis IX was again instrumental in setting a certain standard of work with the commission of a handsome royal Bible (Paris, Bib. Arsenal, MS. 5211) written in Old French and decorated with frontispieces to the selected books. The artist worked in an accomplished Franco-Byzantine style strongly related to frescoes of St Francis of Assisi painted in the church of the Kyriotissa (now Kalenderhane Camii) in Constantinople. Subsequent work by artists in Acre in manuscript illumination and panel painting exhibited variations on this blend of Byzantine and western European styles and maintained a surprisingly high quality. A Missal (Perugia, Bib. Capitolare, MS. 6) seems to be the work of Venetian and French artists working jointly under Byzantine influence. Icons painted at St Jean d'Acre, at St Catherine's Monastery, Sinai, and elsewhere in the Crusader sphere of influence demonstrate the strength and longevity of both the Franco-Byzantine and Italo-Byzantine styles in the second half of the 13th century. A triptych now in St Catherine's Monastery, Sinai, with the enthroned Virgin and Child in the centre and with scenes of the *Life of the Virgin* on the interior of the wings and saints on the exterior, illustrates the juxtaposition of these styles in a single work.

Secular art became an important aspect of Crusader production after 1250, reflecting contemporary cultural

7. Latin Kingdom of Jerusalem, *Death of King Fulk with Melisende Mourning* and the *Coronation of King Baldwin III; miniature* from the *History of Outremer*, Acre, *c.* 1286 (Paris, Bibliothèque Nationale, MS. fr. 9084, fol. 197*r*)

developments in western Europe. An *Histoire Universelle* (London, BL, Add. MS. 15268), possibly executed in 1285 as a gift for the Latin King Henry II of Lusignan (*reg* 1285–91), has illustrations in a Franco-Byzantine style with a frontispiece miniature showing clear knowledge and imitation of Islamic decoration. History texts were especially popular in the Crusader States (*see* CHRONICLES AND HISTORIES, MANUSCRIPT): the most popular of all was the *History of Outremer* (*Historia rerum in partibus transmarinis gestarum*) by William of Tyre (Guillaume de Tyr; *d* 1184/5), translated into Old French; seven illustrated manuscripts survive from Acre and one from Antioch. The climax of Crusader miniature painting in the late 13th century was reached when a French artist, recently arrived and working for the Hospitallers, painted at least six manuscripts including a Bible in Old French (Paris, Bib. N., MS. nouv. acq. fr. 1404) and three codices of the *History of Outremer*. One *History* manuscript (Paris, Bib. N., MS. fr. 9084; see fig. 7) even shows that this artist completed work begun in an Italo-Byzantine style. While purely Gothic in conception, his work gradually absorbed various aspects of his Crusader surroundings. His latest extant painting was executed only months before the fall of Acre in May 1291.

5. CONCLUSION. While Crusader architectural projects were undertaken throughout the period 1099–1291, the greatest output of sculpture and monumental painting was centred in the Latin Kingdom in the 12th century, and most surviving manuscripts and icons were made in Acre between 1250 and 1291. Given the aspects of Romanesque and Gothic style that appeared in the Latin Kingdom, architecture appears to be the most conservative medium, but it achieved an important independence derived from its mixture of Levantine site, local materials, European

and Armenian architects, Muslim and Byzantine architectural models, western and local Christian masons and Frankish patrons. The church of the Holy Sepulchre is a significant example and was a major achievement: at its dedication in 1149 it was not only the greatest burial church built over the most important holy site in Christendom, but it also established the independent, if eclectic, broad pointed-arch Crusader style with a mixed Western and Levantine decorative repertory derived from its multiple sources of inspiration. Moreover the most outstanding castles, all in the County of Tripoli or the Principality of Antioch, such as Krak des Chevaliers, Margat and Saone, are unique. In painting and sculpture, the distinctive blend of eastern and western stylistic characteristics is perhaps more directly evident, especially in painting, but in all media throughout the Crusader States this blend was established early in the 12th century and developed continuously until 1291.

After St Jean d'Acre fell to the Mamluks in 1291, Crusader artistic activity ceased on mainland Syria-Palestine. Many buildings were damaged or destroyed, but some survived and were put to use by their new rulers: present-day 'Akko substantially consists of Crusader buildings. Churches became mosques, for example the churches of St John at Ramla, Sebaste and Beirut. Some castles, such as Krak des Chevaliers, even became independent towns. Much monumental painting was whitewashed or plastered over and no doubt more will come to light along with the discoveries at Krak des Chevaliers and Margat. Some portable objects were saved, because they were sent home to Europe as pilgrims' souvenirs, private gifts or diplomatic bequests of relics. All the extant Crusader manuscripts so far identified are preserved in European collections, and most Crusader panel paintings are located in one place: St Catherine's Monastery, Sinai. There is a series of Crusader

reliquaries of the True Cross in European and American collections (e.g. Paris, Louvre; Cleveland, OH, Mus. A.).

In the 1920s Camille Enlart could say that Crusader art was mainly a French colonial art, very little of which could be dated after 1187. In the wake of substantial progress in Byzantine studies and research in the art and history of the Crusader States, it is known that Italian- and Greek-trained artists played as important a role as French artists and architects. Frankish artists born in the Crusader States also, however, played a significant role, as yet little understood, just as the art of the indigenous Christians (Syrian and Greek Orthodox, Maronites and Armenians) needs further study. Great progress has been made in the identification of works of Crusader painting, sculpture and metalwork since the 1950s and the distinctive characteristics of the art of the Crusaders in the Holy Land have begun to be recognized.

BIBLIOGRAPHY

HISTORIES

H. W. Hazard, ed.: *The Art and Architecture of the Crusader States* (1977), iv of *A History of the Crusades*, general ed. K. M. Setton, 6 vols (Madison and London, 1962–89)

H. E. Mayer and others: 'Select Bibliography of the Crusades', *The Impact of the Crusades on Europe*, ed. H.W. Hazard and N.P. Zacour (1989), vi of *A History of the Crusades* (Madison and London, 1962–89), pp. 511–664

J. Folda: *The Art of the Crusaders in the Holy Land, 1089–1187* (New York, 1995)

ARCHITECTURE

C. J. M. de Vogüé: *Les Eglises de la Terre Sainte* (Paris, 1860)

E. G. Rey: *Etude sur les monuments de l'architecture militaire des croisés en Syrie et dans l'île de Chypre* (Paris, 1871)

R. W. Schultz, ed.: *The Church of the Nativity at Bethlehem* (London, 1910)

P. Viaud: *Nazareth et ses deux églises de l'Annonciation et de St Joseph* (Paris, 1910)

L. H. Vincent and F. M. Abel: *Bethléem: Le Sanctuaire de la Nativité* (Paris, 1914)

——: *Jérusalem nouvelle*, ii of *Jérusalem* (Paris, 1914–26)

K. Schmaltz: *Mater Ecclesiarum: Die Grabeskirche in Jerusalem* (Jerusalem, 1918/R Leipzig, 1984)

C. Enlart: *Les Monuments des croisés dans le Royaume de Jérusalem: Architecture religieuse et civile*, 2 vols (Paris, 1925–8)

P. Deschamps: *Les Châteaux des croisés en Terre Sainte*, 3 vols (Paris, 1934–73)

T. E. Lawrence: *Crusader Castles* (London, 1936); ed. D. Pringle (Oxford, 1988)

W. Mueller-Wiener: *Burgen der Kreuzritter* (Munich and Berlin, 1966; Eng. trans. London, 1966)

D. Pringle: *The Churches of the Crusader Kingdom of Jerusalem: A Corpus* (Cambridge, 1992)

H. Kennedy: *Crusader Castles* (Cambridge, 1994)

PAINTING

H. Buchthal: *Miniature Painting in the Kingdom of Jerusalem: A Corpus* (Oxford, 1957)

K. Weitzmann: 'Thirteenth-century Crusader Icons on Mount Sinai', *A. Bull.*, xlv (1963), pp. 179–203

——: 'Icon Painting in the Crusader Kingdom', *Dumbarton Oaks Pap.*, xx (1966), pp. 49–83

J. Folda: *Crusader Manuscript Illumination at Saint-Jean d'Acre, 1275–1291* (Princeton, 1976)

J. Folda and others: 'Crusader Frescoes at Crac des Chevaliers and Marqab Castle', *Dumbarton Oaks Pap.*, xxxvi (1982), pp. 177–210

K. Weitzmann: 'Crusader Icons and Maniera Greca', *Byzanz und der Westen* (Vienna, 1984), pp. 143–70

G. Kühnel: *Wall Painting in the Latin Kingdom of Jerusalem* (Berlin, 1988)

SCULPTURE

P. Deschamps: 'La Sculpture française en Palestine et en Syrie à l'époque des croisades', *Mnmts Piot*, xxxi (1930), pp. 91–118

A. Borg: 'Observations on the Historiated Lintel of the Holy Sepulchre, Jerusalem', *J. Warb. & Court. Inst.*, xxxii (1969), pp. 25–40

M. Barasch: *Crusader Figural Sculpture in the Holy Land* (Jerusalem, 1971)

N. Kenaan: 'Local Christian Art in Twelfth Century Jerusalem', *Israel Explor. J.*, xxiii (1973), pp. 167–75, 221–9

H. Buschhausen: *Die süditalienische Bauplastik im Königreich Jerusalem von König Wilhelm II. bis Kaiser Friedrich II* (Vienna, 1978)

Z. Jacoby: 'The Tomb of Baldwin V, King of Jerusalem (1185–1186), and the Workshop of the Temple Area', *Gesta*, xviii/2 (1979), pp. 3–14

J. Folda: *The Nazareth Capitals and the Crusader Shrine of the Annunciation* (University Park, PA, and London, 1986)

MINOR ARTS AND INSCRIPTIONS

S. de Sandoli: *Corpus Inscriptionum Crucesignatorum Terrae Sanctae* (Jerusalem, 1974)

H. E. Mayer: *Das Siegelwesen in den Kreuzfahrerstaaten* (Munich, 1978)

D. M. Metcalf: *Coinage of the Crusades and the Latin East* (London, 1983)

H. Meurer: 'Zu den Staurotheken der Kreuzfahrer', *Z. Kstgesch.*, xlviii (1985), pp. 65–76

SPECIAL STUDIES

M. Benvenisti: *The Crusaders in the Holy Land* (Jerusalem, 1970)

J. Prawer: 'Crusader Cities', *The Medieval City*, ed. H. A. Miskimin, D. Herlihy and A. L. Udovitch (New Haven and London, 1977), pp. 179–99

D. Jacoby: 'Crusader Acre in the Thirteenth Century: Urban Layout and Topography', *Stud. Med.*, n. s. 2, xx (1979), pp. 1–45

Atti del XXIV Congresso internazionale di storia dell'arte. Il Medio Oriente e l'Occidente nell'arte del XIII secolo: Bologna, 1979

P. W. Edbury and D. M. Metcalf, eds: *Coinage in the Latin East*, Brit. Archaeol. Rep. Int. Ser., lxxvii (Oxford, 1980)

J. Folda, ed.: *Crusader Art in the Twelfth Century*, Brit. Archaeol. Rep. Int. Ser., clii (Oxford, 1982)

V. Goss and C. V. Bornstein, eds: *The Meeting of Two Worlds: Cultural Exchange between East and West during the Period of the Crusades* (Kalamazoo, 1986)

J. Wilkinson: *Jerusalem Pilgrimage, 1099–1185* (London, 1988)

JAROSLAV FOLDA

Jervas [Jarvis], **Charles** (*b* Dublin, *c.* 1675; *d* London, 2 Nov 1739). Irish painter and collector, active in England. From 1694 to 1695 he was Godfrey Kneller's pupil and assistant in London. Around 1698 he painted small copies (Oxford, All Souls, Codrington Lib.) of the Raphael cartoons at Hampton Court Palace, which he sold to Dr George Clarke of All Souls, Oxford. In 1699 he went to Rome via Paris, funded by Dr Clarke and others. In 1709 he returned to England and built up a successful practice as a fashionable portrait painter. He had literary ambitions and painted portraits of a number of his intellectual friends, including *Jonathan Swift* (1710) and *Alexander Pope* (both London, N.P.G.). Pope had painting lessons from Jervas and in 1713 addressed a poem to him, which was prefixed to Dryden's translation (1716 edn) of Charles-Alphonse Du Fresnoy's *De arte graphica* (1641–5). Jervas's own translation of Cervantes's *Don Quixote* was published posthumously (under the name Jarvis) in 1742.

Jervas's most appealing works are his portraits of fashionable beauties, often dressed as shepherdesses or country girls and posed in landscape settings, as in the double portrait of *Martha and Teresa Blount* (*c.* 1715; Mapledurham House, Oxon). As he consciously imitated Anthony van Dyck's drapery techniques, this aspect of his work is of a higher standard than is usual in early Georgian portraiture; however, George Vertue commented that Jervas's portraits were 'like fan painting ... no blood in them' (London, BL, Add. MS. 23076). They have a distinctly mannered aspect with a limited repertory of poses, elongated bodies and, among his women, a striking family resemblance in the faces.

In 1723 Jervas unexpectedly succeeded Kneller as Principal Painter to King George I, retaining the position under George II. He made several painting trips to Ireland

(1715–16, 1717–21, 1729 and 1734). In 1738, for reasons of health and possibly in order to buy paintings for the royal family, he went to Italy, returning to London in 1739. By the time of his death he had accumulated a large and miscellaneous collection of paintings, prints, drawings, maiolica and sculpture, as well as an exceptional number of copies after Rubens and van Dyck (many of the latter by Jervas himself). They were dispersed in a series of sales in March 1740.

BIBLIOGRAPHY

A Catalogue of the Collection of Pictures, Prints and Drawings of the Late Charles Jarvis (1740)

E. Waterhouse: *Painting in Britain, 1530 to 1790*, Pelican Hist. A. (London, 1953, rev. 4/1978), pp. 149–50

——: 'Kneller's Successor', *Country Life*, cxvii (10 March 1955), p. 675

Irish Portraits, 1660–1860, Dublin, N.G. cat. (Dublin, 1969), no. 14

A. Crookshank and the Knight of Glin: *The Painters of Ireland, c. 1660–1920* (London, 1978), pp. 34–6

M. Kirby Talley: 'Extracts from Charles Jervas's *Sale Catalogues* (1739): An Account of Eighteenth-century Painting Materials and Equipment', *Burl. Mag.*, cxx (1978), pp. 6–8, 11

Manners and Morals: Painting in the Age of Hogarth (exh. cat., ed. E. Einberg; London, Tate, 1987–8), p. 46

SUSAN MORRIS

Jespers, Oscar (*b* Borgerhout, nr Antwerp, 22 May 1887; *d* Brussels, 1 Dec 1970). Belgian sculptor. The son of the Belgian sculptor Emile Jespers (1862–1918), he attended the Koninklijk Akademie voor Schone Kunsten in Antwerp from 1900 and the Hoger Instituut voor Schone Kunsten from 1908 to 1911. At the beginning of his career he came under the influence of Auguste Rodin, Rik Wouters, Constantin Meunier and George Minne, and later that of Ossip Zadkine. He was a friend of the Belgian painter Paul Joostens (1889–1960) and of the poet Paul Van Ostaijen. He made his first direct carvings in 1917 in a tentative Cubist style. His Constructivism began to assert itself in 1921, while he was finding a balance between material and technique, but later in the decade he moved towards Expressionism. In Brussels he belonged to Sélection and then to Le Centaure, and he formed friendships with Constant Permeke, Gustave De Smet, Frits Van den Berghe and Edgard Tytgat.

In 1927 Henry Van de Velde founded the Ecole Nationale Supérieure d'Architecture et des Arts Décoratifs La Cambre in Brussels and appointed Jespers director of the sculpture class. After such works as *Young Woman* (1930; Brussels, Mus. A. Mod.), a life-size figure carved in wood, the main emphasis of his Expressionism was on an anti-intellectual primitivism, which lasted until 1935, when official and monumental commissions led him to develop other techniques. After 1946 he executed many female figures in plaster, intended for casting in bronze, and a tranquil static quality began to appear. He returned to direct carving around 1953, in sculptures produced in heavy, compact blocks such as the *Prisoner* (granite, 700×435×715 mm, 1953; Brussels, Mus. A. Mod.). He also worked in bronze, terracotta and white marble.

BIBLIOGRAPHY

Oscar Jespers (exh. cat. by E. Langui and A. De Ridder, Brussels, Mus. Ixelles, 1966)

E. Langui: 'Oscar Jespers: L'Homme et son art', *Oscar Jespers, sculptures, dessins* (exh. cat., Paris, Mus. Rodin, 1977)

J. Boyens: *Oscar Jespers: Zijn beeldhouwwerk met een overzicht van de tekeningen* [Oscar Jespers: his sculptures with a survey of his drawings] (Antwerp, 1982)

PIERRE BAUDSON

Jesuit Order [Society of Jesus]. Order of secular clergy recognized by Pope Paul III in 1540. Of all the new orders of secular clergy founded in the Counter-Reformation period (16th and 17th centuries) the Jesuits were to become the most numerous and influential. At first regarded with suspicion by the papacy, they gradually came to be recognized as the most powerful force in the Roman Catholic recovery. The canonization in 1622 of two of the original Jesuits, IGNATIUS LOYOLA and Francis Xavier, marked the complete acceptance of the order into the ranks of Catholic orthodoxy.

1. Introduction. 2. Iconography. 3. Patronage. 4. Missions.

1. INTRODUCTION. In 1528 Ignatius Loyola, after making a pilgrimage to Jerusalem, began a seven-year period of study in Paris. While there he gathered around him a group of six friends who were to form the nucleus of the new order, and in 1534 they took the vows of poverty and chastity, promising to go as pilgrims to Jerusalem, or, failing that, to offer their services to the Pope. In 1537, after a period in Venice hoping to embark for Jerusalem, the friends, now nine in number, moved to Rome. In 1540 they decided to form a new order, which was recognized by Pope Paul III that year.

Like the Theatines and the Oratorians, also founded in the 16th century, the Jesuits are secular clergy, neither cloistered nor bound by the recitation of regular offices. They wear no special dress but instead adopt the normal priest's clothing of whichever region they inhabit. They are not obliged to undergo any penances or fasts that would undermine their fitness to serve the Catholic cause. They are not allowed to own personal property or hold ecclesiastical benefices, living instead on alms and benefactions. According to the constitution drawn up by St Ignatius, a Jesuit has to take the usual three monastic vows of poverty, chastity and obedience. In addition he has to take a fourth vow of obedience to the papacy, promising to go wherever the Pope should choose to send him. It was this fourth vow that gave the order its flexibility and extended its influence across the globe. A bull of 1540 restricted its number to 60, but this limit was relaxed four years later and from this time onwards the numbers grew rapidly: at the death of St Ignatius in 1556 there were 938 Jesuits, by 1626 the number had grown to 15,544, and in 1749 there were 22,589 members, about half of them fully qualified priests.

The training of a Jesuit priest is a long and intensive process. The vows are taken after a two-year spell as a novice. There follows a further period of about 12 years of study and practical experience, although this depends on the individual's previous educational level. Priests are ordained a year before the end of their training. Education was from the start one of the principal roles of the Jesuit Order, with the added advantage that by educating the sons of the privileged classes, for instance at the Collegio dei Nobili in Turin, they could hope to attract the interest of future wealthy benefactors. The schools, colleges and

universities run by the Jesuits throughout the world insist on the highest intellectual standards. The highly centralized Jesuit organization is headed by a General, elected for life, to whom the 'provinces' into which the order is divided report. Jesuit houses, or 'colleges', are governed by a Superior, who can hold office for a maximum of six years.

The success of Jesuit missionary work was enhanced by the Jesuit practice of studying the languages and cultures of the countries in which the priests worked. This undoubtedly contributed to the success of Jesuit missions, which was particularly outstanding in India, East Asia and Latin America (*see* §4 below). In North America the adventurous mission work of French Jesuits among Canadian Indians was recorded in their dispatches, later published as the *Jesuit Relations*. The intellectual rigour of the Jesuit Order also equipped them to further the Catholic cause in the Protestant areas of northern Europe. However, their rigid conservatism during the Enlightenment led to their increasing unpopularity, even in Catholic countries, and the order was eventually suppressed in 1773. Its educational role continued in some areas, and in 1814 its restoration allowed Jesuit activities to resume world-wide.

2. ICONOGRAPHY. Although practice of St Ignatius's *Spiritual Exercises* (composed 1521–35; published 1548), a guide to meditation on biblical themes such as the mysteries of the life of Christ, requires the imagination to recreate scenes in the mind's eye, their author was fully aware of the value of religious images in stimulating prayer. Juan de Valdés Leal's painting *A Jesuit Conversion* (*c.* 1660; York, C.A.G.) shows a young man meditating over an open book in front of a picture of the *Crucifixion*, encouraged by an unseen angel behind him. Recognizing the value of sacred images not only as aids to prayer but also as agents of propaganda, the Jesuits evolved a remarkably coherent repertory of religious subject-matter. Unique to the Jesuit Order was the emphasis placed on the name of Jesus. Il Gesù in Rome was the first church named after Jesus (its full dedication is to God, the name of Jesus and the Virgin), and in the *Triumph of the Name of Jesus* on the vault there, frescoed by Giovanni Battista Gaulli in 1676–9, the letters IHS (the abbreviation of the Greek form of the name of Jesus commonly found in paintings) glow in the centre of the heavens beneath the dove of the Holy Spirit (*see* GAULLI, GIOVANNI BATTISTA, fig. 1). On the high altarpiece of the Jesuit church in Bamberg, the Jesuit artist Andrea Pozzo depicted *Heaven, Earth and Hell Worshipping the Name of Jesus* (1700–01; *in situ*). A much more easily illustrated subject was the occasion on which Christ was given the name Jesus, namely the Circumcision. This became a popular Jesuit theme, as it was also the first occasion on which Christ shed blood. The high altar of Il Gesù in Rome is dedicated to the Circumcision, a 19th-century version having replaced Girolamo Muziano's original altarpiece (commissioned 1587), and in 1605 Rubens painted a *Circumcision* for the high altarpiece of the Jesuit church of S Ambrogio, Genoa (*in situ*).

Before Ignatius Loyola and Francis Xavier were canonized in 1622, there were no Jesuit saints. Guercino's beautiful altarpiece of *St Gregory the Great with St Ignatius*

and St Francis Xavier (London, D. Mahon priv. col., see L. Salerno: *I dipinti del Guercino* (Rome, 1988), no. 112) must commemorate their canonization by Pope Gregory XV, but Rubens anticipated their recognition when, *c.* 1617–18, he painted his two huge canvases (now in Vienna, Ksthist. Mus.) for the high altar of the Jesuit church in Antwerp, one showing the *Miracles of St Ignatius* and the other the *Miracles of St Francis Xavier*, each to be hung for half the year. In both altarpieces the saints stand triumphantly aloft, casting out devils and healing the sick from the crowds around them. St Ignatius is usually depicted as a balding, dark-haired, bearded figure in black Jesuit robes. In 1609 the *Vita beati Ignatii Loiolae* was published in Rome to celebrate his beatification, with engraved illustrations for which Rubens contributed drawings, and in 1685–8 and 1697–1701 Pozzo executed frescoes showing scenes from the *Life of St Ignatius* in the choir of the church of S Ignazio, Rome (*in situ*). On the vault of the same church, in 1691–4, Pozzo painted his huge fresco, in remarkable *di sotto in sù* illusionistic perspective, of the *Glory of St Ignatius* (*in situ*), a spectacular apotheosis scene signifying the worldwide victory of the Catholic Church. The life of St Francis Xavier provided an opportunity to introduce exotic local colour. The most popular subject was Francis's lonely death on an island off China, which in Carlo Maratti's version, painted for Il Gesù in Rome in 1676, led to the surprising inclusion of figures in feathered headdresses. At about the same time Gaulli was painting an altarpiece of the same subject for S Andrea al Quirinale, the church of the Jesuit novices in Rome, providing a simpler and perhaps more poignant version showing the saint alone on his bed of straw, clutching his crucifix and accompanied only by angels. A more restrained approach can be seen in Poussin's formally composed altarpiece illustrating a *Miracle of St Francis Xavier* (Paris, Louvre) for the church of the Jesuit Noviciate in Paris, commissioned in 1641.

St Ignatius and St Francis Xavier were still the only Jesuits to have been canonized when Alessandro Algardi executed his relief of *St Ignatius and the Early Saints of the Jesuit Order*, commissioned in 1629 for the bronze urn to contain the ashes of St Ignatius in Il Gesù in Rome. Among those included in the relief were St Ignatius and his successor as General, Francis Borgia, who was to be canonized in 1670, as well as several missionaries and Stanislas Kostka (1550–68), a young Pole who became a Jesuit novice in Rome but died there at the age of only 18; he was canonized in 1726. A marble statue by Pierre Legros (ii) in Kostka's cell in the noviciate at S Andrea al Quirinale movingly portrays him lying on his deathbed (1702–3; *in situ*). From the start the Jesuits glorified Christian martyrdom, thus encouraging those embarking on dangerous missions. In the later 16th century the Society acquired the Early Christian church of S Stefano Rotondo (*see* ROME, §V, 22) as the German–Hungarian Jesuit college and decorated its walls with lurid scenes of martyrdom by Cristoforo Roncalli. An illustrated guide to Christian iconography, *Evangelicae historiae imagines* (Antwerp, 1593) by the Jesuit father J. Nadal, shows how Flemish realism could be used to make scenes of suffering more vivid. Those martyrs who were also effective apostles were given particular emphasis in Jesuit imagery: the two

chapels nearest the entrance to Il Gesù in Rome are dedicated to St Andrew, St Peter and St Paul.

The Jesuits' promotion of all those aspects of Catholic doctrine that were rejected by Protestants also led to the great popularity of angels, scenes from the life of the Virgin, representations of the Eucharist, or, more symbolically, the Passion and depictions of Heaven, Hell and Purgatory. In the original iconography of Il Gesù, the two transepts were dedicated to the Crucifixion and the Resurrection, while the chapels on either side of the choir were dedicated to the Virgin and St Francis of Assisi (in honour of Francis Xavier and Francis Borgia; neither of them at that time canonized). As an agent of the Catholic and papal cause, Jesuit art also directly promoted the stamping out of heresy. Legros provided an unusually literal representation in the small cherub energetically tearing up a huge, and presumably heretical, book in his marble group *Religion Overthrowing Heresy* on the right side of the monumental altar of S Ignazio in Il Gesù. On the left side is a glorification of Jesuit mission work by another French sculptor, Jean Théodon, representing *Faith Crushing Idolatry* (marble; 1695–9).

Indeed, apart from the celebration of the name of Jesus and the commemoration of their own saints and martyrs, the Jesuits played a central role in formulating a more general Counter-Reformation iconography, applicable to any branch of the Catholic Church. The techniques of perspective and illusion pioneered in Jesuit drama were applied, too, to their more permanent religious art, and while the role of the Jesuits in promoting the richness and theatricality generally associated with the Baroque style is not easy to define, the fact that they acknowledged the persuasive value of religious images from the outset helped to steer Counter-Reformation art away from austerity and towards more emotional modes of expression. On the other hand, some early Jesuits were suspicious of decorative richness for its own sake, even in churches, and Bernini's extravagant set-piece for the Jesuits, S Andrea al Quirinale in Rome, was created over a century after the founding of the order, by which time the Baroque style was already established in Catholic art in Rome and beyond.

3. PATRONAGE.

(i) Architecture. The early Jesuits shared with the Oratorians and the Theatines a dependence—complete or partial according to local resources—on wealthy donors for the financing of their building projects. The first permanent Roman church was Il Gesù (*see* ROME, §V, 16 and figs 49 and 50), begun in 1568 and built at the expense of Cardinal Alessandro Farnese, nephew of Pope Paul III, who had first approved the new order. Whereas the Jesuits favoured their own architect, Giovanni Tristano (*d* 1575), the Cardinal promoted the designs of his protégé Jacopo Vignola. Moreover, while the Jesuits preferred a flat wooden ceiling, the Cardinal wanted a vault, which he claimed would give a better acoustic for preaching. On both counts it was the Cardinal who won. In 1571 the Cardinal abandoned Vignola's façade design, however, in favour of a more assertive version by Giacomo della Porta who, in recognition of his patron's support, prominently displayed

Farnese's name across the façade. After the Cardinal's death his family retained rights to the decoration of the tribune area. However, their lack of interest was to hamper the decoration of the church for over a century: the frescoes in the dome, the nave vault and the apse by Gaulli were only completed in 1683.

The chief priority of the Jesuits in the design of churches was that the congregation should be able to see and hear the preacher; sermons, for which the Society was famous, played a major role in the Catholic response to the Reformation. The unimpeded aisleless nave of Il Gesù in Rome came to be regarded as the ideal setting for preaching, while the interconnecting side chapels allowed easy access for priests. The restricted choir area reflected the early Jesuits' lack of interest in church music, though such designers as Carlo Rainaldi and Pozzo were to create settings for Jesuit drama performances, even in this confined space. The two-order pedimented façade with scrolls flanking the upper order became the standard model for Roman Baroque church façades.

The first Jesuit college in Rome was the Collegio Romano, begun by Giovanni Tristano in 1560; his layout was to establish a standard architectural formula based on two cloisters, one for the school, the other for the private use of the Jesuits. Like other secular clergy, the members were housed in individual rooms rather than communal dormitories. The residence adjoining Il Gesù, begun in 1602, became the Casa Professa, where the fully trained Jesuit fathers lived, and in 1566 a separate noviciate was instituted on the Quirinal Hill. These three centres made up the Roman headquarters of the order. In 1626 it was decided to build a church attached to the Collegio Romano, to be dedicated to the newly canonized St Ignatius. The two schemes promoted by their patron, Cardinal Ludovico Ludovisi, both designed by his favourite artist Domenichino, were rejected by the Jesuits, who adopted instead a compromise scheme by one of their own number, the mathematician Orazio Grassi. Grassi was not a competent architect, and many problems punctuated the building work. The church of S Ignazio was saved from mediocrity only by the virtuoso fresco decoration by Pozzo, executed in 1684–1701. Pozzo was also responsible for the sumptuous altar in the chapel of S Ignazio in Il Gesù.

Unlike the two earlier Roman churches, the church that was built for the use of the Roman noviciate was executed rapidly, achieving an exemplary unity between architecture and decoration. This was Bernini's S Andrea al Quirinale (1658–72), built under the generalship of John Paul Oliva, the first Jesuit general to show a serious interest in the visual arts. As well as the Society's benefactor, Prince Camillo Pamphili, Pope Alexander VII himself took a close interest in the scheme, and as the Jesuits bowed to papal authority on all matters they had to accept his interference. It was the Pope, for instance, who insisted on the church being set back from the street. Fortunately, Bernini was not only a favourite of the Pope but also a loyal supporter of the Jesuits and himself practised St Ignatius's *Spiritual Exercises*. His little church forms the setting for a piece of permanent Jesuit theatre on the apotheosis of St Andrew, the spectator's gaze being drawn first to a painting of the Saint above the high altar, then to

Bernini's sculpture of him, rising from the split pediment of the aedicule, which frames the altar.

Although the centralization of the Society's organization ensured that every church design had to be approved by the General in Rome, there is surprisingly little evidence of active interference from Rome. The request of the French Jesuits for a standard church design was rejected in favour of a more flexible approach, and in 1558 and 1565 meetings of the Jesuit General Congregation stressed simplicity, economy and conformity to Jesuit practice only in the most general terms. The offer from Giuseppe Valeriano, a leading Jesuit architect in the later 16th century, to write a treatise on building for the Society came to nothing. In the early days Giovanni Tristano directed all Jesuit architecture, dispatching designs and superintendents throughout Italy. He himself built Jesuit churches in Ferrara, Forlì, Naples, Perugia and Palermo as well as Il Gesù in Rome, where he was put in charge of executing Vignola's project. His standard church design, exemplified by Il Gesù (1564–70) in Palermo, was a Latin-cross, aisleless church with side chapels and a dome. He favoured two-order façades and considered the Doric or Tuscan and Ionic orders simpler and more suitable than the Corinthian or Composite. Another early example of the type was Manuel Pires's Jesuit church of the Espirito Santo (1566–74) at Evora, Portugal. However, even within Italy variations were considerable. For example, Valeriano's Gesù Nuovo (1593–1601) in Naples has a conspicuous façade covered in diamond rustication, retained from the 15th-century palace already on the site. Its groundplan, a Greek cross with one arm slightly extended, is also exceptional in the Jesuit context.

Just as the Jesuits expected their missionaries to wear local costume and speak foreign languages, so, too, did their buildings reflect the traditions of each area. In southern Germany and Flanders the Jesuits borrowed the galleried wall-pillar church type from the Protestants, and most Jesuit churches were built in a belated Gothic style. Two exceptions were Friedrich Sustris's St Michael's (1583–97), Munich, and Peter Huyssens's Jesuit church of St Carolus Borromeus (1615–21) in Antwerp, both accomplished classical designs that had little influence, except in underlining the Jesuit preference for vaulted naves. St Michael's, Munich, is based on Il Gesù but has structural features recalling an older German tradition, while at the Jesuit church in Antwerp, Huyssens revived the Early Christian basilica type, with two-order arcades of marble columns framing the wooden-roofed, tunnel-vaulted nave. In the 18th century the wall-pillar church theme was reworked to create delicate Rococo interiors, a fine example being Christoph Dientzenhofer's Jesuit church of St Nicholas (1703–11), Malá Strana, Prague, in which the tunnel-vaulted nave undulates over a diagonally canted Corinthian order, its ceiling covered with ethereal, luminous frescoes. The French taste for classicism called for a more restrained approach, exemplified in Etienne Martellange's church for the Jesuit noviciate (Rue Pot-de-Fer; begun 1630; destr.) in Paris with its demure, Roman-style, two-order façade. François Derand's ornate, less sophisticated façade for the Paris Maison Professe, begun in 1629, was much criticized. Jesuit designs in Latin America reflect local conditions even more strongly (see §4(ii) below).

(ii) Decoration. Jesuit preferences with regard to decoration are as difficult to define as their policies on architectural design. In the *Spiritual Exercises* St Ignatius wrote 'we ought to praise not only the building and adornment of churches, but also images and the veneration of them according to the subjects they represent'. This suggests that the rather plain appearance of early Jesuit churches reflected economic constraints rather than artistic intentions. In 1579 St Peter Canisius, one of the principal Jesuit anti-Protestant campaigners, reiterated that churches should be richly decorated. Instructions from Rome to the Neapolitan Jesuits in 1592, however, recommended a very plain interior for the Gesù Nuovo, in tufa and white stucco. No marble, plaster ornament, colour or gilding was to be used 'without special permission'. This sentiment was echoed by the French Jesuit Richeôme in his book *La Peinture spirituelle* (Lyon, 1611), in which he asserted that elaborate architectural ornament 'in no way fosters religious sentiment'. Paintings as aids to instruction and devotion in church interiors were another matter, as is shown by the elaborate scheme of 39 canvases by Rubens (destr. 1718) installed on the ceilings of the aisles and galleries of the Jesuit church in Antwerp. A painting of Pope Urban VIII visiting Il Gesù in Rome in 1641, after the celebration of the First Centenary of the Jesuit Order (Rome, Pal. Barberini; see fig.), commissioned from Andrea Sacchi, shows the vault of the nave still bare, although the drum and pendentives are decorated.

Andrea Sacchi, Filippo Gagliardi and Jan Miel: *Urban VIII Visiting Il Gesù during the Centenary Celebrations of the Jesuit Order, 1639,* oil on canvas, 1641–2 (Rome, Palazzo Barberini)

The style of decoration was often determined by the taste of the patron. For example the Rococo ornament of Balthasar Neumann's Jesuit church in Mainz (1742–6, destr. 1805–11), enlivening its already transparent architectural form, reflected the taste of the Schönborn rulers. In Venice the church of the Gesuiti, erected in 1714–29 at the expense of the wealthy Manin family, has one of the most extravagant of all Jesuit interiors, its marble surfaces counterfeiting the appearance of rich oriental damask hung over the walls and draped over the pulpit. The architect was Domenico Egidio Rossi, with the façade by Giovanni Battista Fattoretto (*fl* 1715).

The range and variety of Jesuit artists and architects such as Tristano, Valeriano, Grassi and Pozzo are particularly remarkable. Pozzo's masterpiece was, of course, the fresco decoration of S Ignazio in Rome, but he also designed Jesuit churches as far afield as Prague, Vienna and Dubrovnik. He painted altarpieces as well as frescoes and was a gifted stage designer. Pozzo's influence extended far beyond his own buildings, for his *Perspectiva pictorum et architectorum* (1693–8) was published in many languages, including Chinese. In the Italian context, the importance of Jacques Courtois, who with his brother Giuseppe carried out painted decoration in the Casa Professa and S Andrea al Quirinale in Rome, should also be stressed, while Giuseppe Castiglione was the most remarkable of the Jesuit artists who worked in China (*see* §4(i) below). Most of the churches and colleges erected by Jesuit missionaries were designed and built by their own architects, while their own carpenters did the wood-carving of church furniture and fittings for reasons of economy. Nor were Jesuit artists confined to the sphere of religious art: the renowned Flemish flower painter Daniel Seghers, for example, was a Jesuit. The wide horizons of their activity have rendered the Jesuits supremely important as agents in the transmission of culture, both artistic and intellectual, across the globe.

BIBLIOGRAPHY

J. Braun: *Die belgischen Kirchenbauten* (Freiburg im Breisgau, 1907)
——: *Die Kirchenbauten der deutschen Jesuiten* (Freiburg im Breisgau, 1908–12)
——: *Spaniens alte Jesuitenkirchen* (Freiburg im Breisgau, 1912)
E. Male: *L'Art religieux après le Concile de Trente* (Paris, 1932)
J. Brodick: *The Origin of the Jesuits* (London, 1940)
——: *The Progress of the Jesuits, 1556–79* (London, 1946)
C. Galassi Paluzzi: *Storia segreta dello stile dei Gesuiti* (Rome, 1951)
J. Brodick: *Saint Francis Xavier, 1506–1552* (London, 1952)
P. Pirri: *Giovanni Tristano e i primordi della architettura gesuitica* (Rome, 1955)
P. Moisy: *Les Eglises des Jésuites de l'ancienne assistance de France* (Rome, 1958)
G. Kubler and M. Soria: *Art and Architecture in Spain and Portugal and their American Dominions, 1500–1800*, Pelican Hist. A. (Harmondsworth, 1959)
J. Valléry-Radot: *Le Recueil des plans d'édifices de la Compagnie de Jésus conservé à la Bibliothèque Nationale de Paris* (Rome, 1960)
E. Bassi: *Architettura del sei e settecento a Venezia* (Naples, 1962)
J. R. Martin: *The Ceiling Paintings for the Jesuit Church in Antwerp: Corpus Rubenianum Ludwig Burchard*, i (London, 1968)
J. S. Held: 'Rubens and the *Vita Beati P. Ignatii Loiolae* of 1609', *Rubens before 1620*, ed. J. R. Martin (Princeton, NJ, 1972)
R. Wittkower and I. B. Jaffé: *Baroque Art: The Jesuit Contribution* (New York, 1972)
A. Blunt: *Neapolitan Baroque and Rococo Architecture* (London, 1975)
A. Blunt, ed.: *Baroque and Rococo: Architecture and Decoration* (London, 1978)
C. F. Otto: *Space into Light: The Churches of Balthasar Neumann* (Cambridge, MA, 1979)
F. Haskell: *Patrons and Painters: Art and Society in Baroque Italy* (New Haven, rev. 2/1980)
H.-R. Hitchcock: *German Renaissance Architecture* (Princeton, NJ, 1981)
J. Connors: 'Bernini's S Andrea al Quirinale: Payments and Planning', *J. Soc. Archit. Hist.*, xli (1982), pp. 15–37
R. Boesel: *Jesuitenarchitektur in Italien, 1540–1773*, 2 vols (Vienna, 1985)

DEBORAH HOWARD

4. MISSIONS.

(i) Asia. The Jesuits played an important role in the evangelization of Asia and thereby also introduced local artists to Western aesthetic principles. The order recognized the educational power of the visual image in the propagation of faith and imported illuminated manuscripts, engravings, paintings and tapestries to help convey their religious message. Such examples of Western artistic practice, especially of Western perspective and chiaroscuro, intrigued in varying degrees those schooled in other traditions in India, China and Japan. Illustrations from European publications, which were reproduced by native craftsmen, especially in China, resulted in examples of a new sort of hybrid art that, whether deliberate or not, was consistent with the contemporary Jesuit principles of accommodation. Such images set the Christian narrative against a sinicized background.

Within months of the foundation of the order in 1540, Ignatius Loyola had dispatched to the Orient a group of six missionaries led by Francis Xavier. They arrived in 1542 at GOA, which became an important centre for Jesuits, especially those of Italian and Portuguese origin: churches were built there, for example by Brother Aranha from Portugal, and the tomb and remains of Francis Xavier are in the basilica of Bom Jesus. The Jesuits initially brought figural images to the Mughal court from Goa and eventually became installed in the Mughal centres of Agra and Lahore. Their missions were encouraged in particular by the Mughal emperors Akbar (*reg* 1556–1605) and Jahangir (*reg* 1605–27). Akbar maintained an extremely open-minded court, which was visited by three Jesuit missions: in 1580–83, in 1591 and in 1595–1605. The first of these presented Akbar with a copy of the polyglot Bible produced by the Antwerp printer Christoph Plantin. Akbar had the Baroque engravings copied by his court artists, and works by Dürer and others were also copied by such artists as BASAWAN and his son MANOHAR. Such examples reflected the importance for Goa of Antwerp and other northern European ports, as well as the degree of interest in European art. The European traveller Sebastian Manrique reported that a rendering of *St Ignatius*, together with a *Crucifixion* and a *Virgin and Child*, decorated the gateway of Akbar's tomb at Sikandra, and according to other contemporary European travellers the audience halls of Jahangir's palaces were painted with images of Christ, the Virgin and saints. When South India was evangelized in the early 17th century Roberto de' Nobili (1577–1656), in the spirit of accommodation, built and decorated Roman Catholic churches in Indian style; he is also said to have achieved numerous conversions by dressing as a Brahmin. In addition, Constanzo Giuseppe Beschi (1680–1747) later carved a statue of the Virgin in Tamil dress, but this sort of syncretism was opposed by other missionaries and even by some Jesuits.

In 1549 Francis Xavier and two companions travelled to Kagoshima on Kyushu, Japan. The Italian Jesuit artist Giovanni Niccolò (Nicolao) followed in 1583. By 1603 Niccolò had established the Academy of St Luke in Nagasaki, where he taught Western art techniques. It was also in Nagasaki that *Nanban* ('southern barbarian') painting originated (*see* JAPAN, §VI, 4(vi)(a)), which was later disseminated throughout the country. Although Japan was closed to the outside world in 1639, Western aesthetic techniques continued to influence artists, with Nagasaki again as the principal centre, since this was the only city in which foreigners were allowed to live.

With the arrival of Father Matteo Ricci in China in 1583, the Jesuits established a relationship with the emperors that lasted two centuries and was never later equalled. Following the principle of accommodation, such priests as the lay brother GIUSEPPE CASTIGLIONE who travelled to China in 1714, although not permitted to proselytize, played a major role at the court as they introduced the Chinese rulers to Western aesthetics and knowledge. From the Chinese court elements of this knowledge were also transmitted to the Korean court. At the same time Père François Xavier d'Entrecolles (1664–1741) and others, through voluminous correspondence, stimulated European interest in China, leading to the development in the decorative arts of chinoiserie and the techniques of making porcelain (*see* CHINA, §VII, 6). Indeed, the history of porcelain illustrates the importance of the Jesuits as conduits of cultural exchange, for while introducing Europe to the refinements of Chinese ceramics (*see* CERAMICS, §II, and CHINA, §VII, 4(v)) they are also credited with introducing into China the enamel technique to make *famille rose* (*see* CHINA, §VII, 3(vii)), influenced the decoration of 'Jesuit ware' and also originated the practice of painting Western secular themes on Chinese porcelain.

The Jesuits also introduced Baroque architecture into Asia, but this style did not exert any lasting influence. An isolated monument to this initial foreign impulse is the free-standing façade of São Paulo, the sole remnant of a church erected in Macao in 1602.

BIBLIOGRAPHY
P. du Jarric: *Akbar and the Jesuits* (London, 1926)
F. Guerreiro: *Jahangir and the Jesuits* (London and New York, 1930)
E. D. Maclagan: *The Jesuits and the Great Mogul* (London, 1932)
J. Ferguson: 'Painters among Catholic Missionaries and their Helpers in Peking', *J. N. China Branch Royal Asiat. Soc.*, lxv (1934), pp. 21–35
P. M. Délia: *Le origini dell'arte Cristiana cinese (1583–1640)*, (Rome, 1939)
J. E. McCall: 'Early Jesuit Art in the Far East', *Artibus Asiae*, x (1947), no. 1, pp. 121–37; no. 2, pp. 216–33; no. 3, pp. 283–301; xi (1948), no. 4, pp. 45–69
G. Loehr: 'Missionary Artists at the Manchu Court', *Trans. Orient. Cer. Soc.*, xxxiv (1962–3), pp. 785–800
R. Ettinghausen: 'New Pictorial Evidence of Catholic Missionary Activity in Mughal India (Early XVIIth Century)', *Perennitas: P. Thomas Michels OSB zum 70. Geburtstag*, ed. H. Rahner (Münster, 1963)
A. Lehmann: *Christian Art in Africa and Asia* (London, 1969)
R. Lightbown: 'Oriental Art and the Orient in Late Renaissance and Baroque Italy', *J. Warb. & Court. Inst.*, xxxii (1969), pp. 228–79
M. Sullivan: 'Some Possible Sources of European Influence on Late Ming and Early Ch'ing Painting', *Proceedings of the International Symposium on Chinese Painting: Taipei, 1970*, pp. 595–633
H. Vanderstappen: 'Some Reflections on Chinese Reactions to European Art Introduced by Catholic Missionaries in the 17th and 18th Centuries', *Proceedings of the International Symposium on Chinese Painting: Taipei, 1970*, pp. 785–800
Y. Okamoto: *The Namban Art of Japan* (New York, 1972)
M. Sullivan: *The Meeting of Eastern and Western Art* (London, 1973)
H. Vanderstappen: 'Chinese Art and the Jesuits in China', *East Meets West: The Jesuits in China* (Chicago, 1988)

MARY S. LAWTON, S. J. VERNOIT

(ii) Latin America. The first Jesuits arrived in Brazil in 1549 and in Peru in 1568; further groups followed to other parts of South and Central America and to Mexico during the 1570s. They strove initially to establish power bases in colonial cities, and where possible built their churches and seminaries in a central location. All architectural plans had to be sent to Rome (in duplicate, by separate routes) for approval; nevertheless the type of site and other local conditions ensured great architectural variety throughout Latin America. Plots were often sought that would allow for the construction of, for example, another courtyard for the college (e.g. S Ildefonso; now the Escuela Nacional Preparatoria; Mexico City; completed 1749). Another common feature of Jesuit missions was the system of *reducciones*, settlements for converted Indians built around Jesuit colleges. Aside from providing agricultural self-sufficiency, the involvement of Indians in workshops resulted in their (usually anonymous) contribution, alongside their Jesuit masters, to the construction of churches and their fittings, as well as to the painting and sculpture housed in them.

Although Jesuit churches had no standard overall plan, several are reminiscent of the general scheme of Il Gesù, in Rome, with implied side aisles created by interconnecting lateral chapels. These included the collegiate church at Bahia (completed 1672; now the cathedral), begun by Francisco Días (1538–1623). Some are firmly single-nave, as in SS Pedro y Pablo (c. 1580), Mexico City. Others break the simplicity of the single-nave format with shallow lateral chapels, as at La Compañía, Cuzco (1651–68). The design of Jesuit church façades was very varied: the upwardly arching façade of La Compañía (1668–70) in Cuzco, attributed to Juan Bautista Egidiano, pre-dates equivalent Baroque development in Italy and was reworked elsewhere in Peru, not only on Jesuit churches. La Compañía was also innovative in having the first Latin-cross ground-plan; it was also vaulted in brick rather than timber. Further south and in Brazil the tendency was for sober, predominantly horizontal designs, while in Mexico the exuberant façade of the mission church of S Martín Tepotzotlán (c. 1760) is one of the first examples of the use of the distinctively Mexican *estípite* form of column outside Mexico City. S Martín is also remarkable for its vertical application of Mexican Baroque, integrating the decoration of the façade with the tower; the heavily ornamented interior exemplifies the Jesuits' enthusiasm for richly carved and gilded retables.

In their first rural missions, in Juli in southern Peru, the Jesuits built in the style of their predecessors, the Dominicans: vast single-nave churches with simple, classicizing portals in brick or stone. In more famous missions in Paraguay, Argentina and Bolivia, broad, triple-aisled basilicas with wooden roofs were built; in Paraguay stone walls and piers supported timber roofs, whereas in Bolivia the wooden churches were often described in early documents as being built from the roof down: a framework of tree-trunk pillars would support the roof during its construction

while the adobe walls were added later. Another distinctive feature of many mission churches was the extension of the eaves to create a portico on every side of the building.

Many of the Jesuit artists and architects who worked on the churches and seminaries in Latin America remain anonymous, but the names of some of these figures are known. These include Bartolomé Cardenosa and the Belgian Father Lemer, who worked at the Compañía (c. 1645/54–71) in Córdoba; Johann Kraus, responsible for the church of S Ignacio (1712–34) in Buenos Aires; Diego López de Arbaiza, who built La Compañía (1576–1603) in Mexico City; Marco Guerra, who completed La Compañía (begun 1606 by Ayerdi de Madrigal and Gil de Madrigal) in Quito; GIOVANNI BATTISTA PRIMOLI, who worked in Paraguay and Argentina, frequently with AN-DREA BIANCHI; and the painter BERNARDO BITTI, who was active in Peru and Bolivia between 1575 and 1610 and whose works include the *Adoration of the Shepherds* (c. 1590) in Sucre Cathedral. The Jesuits were eventually expelled from Brazil in 1759 and from all Spanish territories in 1767, but they left a considerable cultural legacy.

BIBLIOGRAPHY

L. Costa: 'A arquitectura dos Jesuitas no Brasil', in *Rev. SPAHN*, 5 (1941), pp. 9–100
M. J. Buschiazzo: 'La arquitectura en madera de las misiones del Paraguay, Chiquitos, Mojos y Maynas', *Latin American Art and the Baroque Period in Europe: Studies in Western Art, Acts of the 20th International Congress of the History of Art: New Jersey, 1963*, iii, pp. 173–90
R. Vargas Ugarte: *Los Jesuitas del Perú y el arte* (Lima, 1963)
T. Gisbert and J. de Mesa: 'Planos de iglesias jesuíticas en el virreinato peruano', *Archv Esp. A.*, clxxiii (1971), pp. 65–101
S. Orienti and A. Terruzi: *Le 'reducciones' gesuitiche nel Paraguay tra il XVII e il XVIII secolo* (Florence, 1982)
M. Díaz: *Arquitectura en el desierto: Misiones jesuitas en Baja California* (Mexico City, 1986)
V. Fraser: 'Architecture and Ambition: The Case of the Jesuits in the Viceroyalty of Peru', *Hist. Workshop J.*, 34 (1992), pp. 17–32

VALERIE FRASER

Jet. Form of lignite, black and consisting largely of carbon. It is driftwood from pines related to the Araucaria genus (monkey-puzzle tree) that has been subjected to chemical action in stagnant water and then to great pressure in the ocean floor. It is found in the bituminous shales of the Upper Lias, which was laid down about 170 million years ago, and occurs in the form of horizontal wedge-shaped strata up to 400 mm wide, 150 mm long and 100 mm deep. Sometimes it is washed up on beaches as pebbles. The best jet is found in England, at Whitby (N. Yorks), and the only other major deposits are in northern Spain in the Asturias. Lesser deposits have been found in France, Germany, the Czech Republic, Slovakia, Italy, Portugal, Canada and the USA.

1. Properties and techniques. 2. History and uses.

1. PROPERTIES AND TECHNIQUES. Jet is compact, smooth, light, warm to the touch and fairly hard. It is frangible and breaks with a conchoidal fracture; sometimes the annual growth rings of the original tree can be seen. It burns with a greenish flame, shrinking back on itself and giving off a great deal of smoke with a bituminous and sometimes fetid smell. If rubbed or warmed, good-quality jet becomes magnetized.

Jet is divided into two grades. The hard variety is found in the lower bed of the Upper Lias and has a hardness of 3 on the Mohs scale. Soft jet is found in the upper bed and has a hardness of 2; it is brittle and flakes easily, so it cannot be engraved or worked in any detail. The best jet is found in a compact block without veins or impurities, which enables it to be cut in any direction, but often the material has inclusions of quartz, lias or alum where the driftwood was cracked, and these affect the way the pieces are worked. Jet is also judged by the size of the pieces, which usually ranges from 30 mm to 150 mm. The figure of St James in the Instituto de Valencia de Don Juan, Madrid (Osma, no. 13), which is 320 mm high, is exceptionally large.

Jet is easily worked with lathes, grindstones, drills, saws, files, knives and engraving tools, but since it breaks easily it is very difficult to carve detailed figures and openwork. When rubbed with a fine abrasive, such as emery-powder, rottenstone or jeweller's rouge, it develops a brilliant reflective polish, which does not lessen with time. In prehistoric times it was polished with scrapings of jet mixed with oil and applied with a piece of sheepskin.

Lignite, Kimmeridge coal, shale and cannel coal have been erroneously called jet. Imitations of jet include black glass (also known as Paris jet), Vauxhall glass, dyed chalcedony, black tourmaline, obsidian, melanite, ebonite and vulcanite. True jet can be identified by the smell it gives off when touched with a heated needle.

2. HISTORY AND USES. Jet was known in antiquity and was described by various Classical writers, including Pliny (*Natural History* X.xxxvi.34, 141), who called it *lapis gagates* (from Gages, a town and river in Lycia, Asia Minor, where the substance was then obtained). He and, earlier, Aristotle noted its efficacy for soothsayers and listed its medicinal properties, including the relief of toothache. Indeed, throughout history talismanic and mystical properties have been attributed to jet on account of its deep black colour, brilliancy and relative scarcity. The 11th-century lapidarium of Marbodus, drawing extensively from the 3rd-century author Solinus, claims that it cures dropsy, fixes loose teeth, relieves afflictions of the womb, reveals epilepsy, lures the viper and chases away the powers of hell, confounds spells, eases the pain of childbirth and tests virginity.

In particular jet was considered to be an effective prophylactic against the evil eye. The effect of this dread force was supposed to 'divide the heart', but jet, by drawing the evil into itself and shattering it, protected the wearer. Belief in the evil eye was deeply rooted among Muslims, and mothers hung hands made of jet around their children's necks; Spanish children wore similar amulets, and in north-west England jet crosses were hung in houses against the evil eye up to the early 20th century. From the medieval period, particularly in Spain, an accumulation of Christian beliefs was added to this pagan tradition.

(i) Spain. (ii) England and Scotland.

(i) Spain. Jet hand amulets have been found in a 3rd-century BC Carthaginian necropolis in Ibiza and in later Roman and Muslim sites on the mainland, but it was only

in the 13th century that a significant jet industry developed in Spain. Although street names connected with jetworkers have been recorded in various cities (e.g. León), the main centre of the industry was undoubtedly Santiago de Compostela. This city, which housed the shrine of St James the Greater, became one of the most important pilgrimage centres in Europe from the 11th century, and the jet industry was inextricably connected with the cult. Initially jet was used by members of the shellmakers guild, but in 1443 the jetworkers formed a guild of their own, the Cofradía de Azabacheros, and drew up regulations to safeguard the industry and its workers. The trade reached its peak in the mid-16th century. It then became dispersed around Compostela and in the Asturias, notably at Villaviciosa, and although it continued to flourish throughout the 18th century the quality of the workmanship declined.

The vast majority of the jet items produced in Compostela were pilgrim badges and religious mementos (*see* PILGRIM BADGE). Since jet was expensive, these carvings were available only to the wealthy, who wore them for the return journey and then hung them in their houses or private chapels. Some of the carvings were pierced with a hole so they could hang from a jewel, and others would be attached to a hat.

One of the principal subjects was St James, who was depicted either alone or accompanied by one or two kneeling pilgrims. It is difficult to establish a chronology for these figures as several models probably co-existed, and their iconographic evolution was slow. It seems that in the earlier pieces the saint was depicted as an apostle holding a pilgrim staff, but at the beginning of the 16th century a standard type was established in which he was shown in full pilgrim dress with bare feet, long hair and a beard, a shell on his hat and holding a staff and book. In the 17th century, when pilgrim dress was proscribed, the saint took on an equestrian pose in his role of *Santiago Matamoros*, killer of the Moors. Several other saints were carved in jet. St Sebastian, who from the early 16th century was the patron of the jetworkers guild, was a frequent subject, as were the apostles Andrew and Bartholomew and the Franciscan saints Francis, Clare and Anthony of Padua.

The Virgin and Child were often depicted, the finest example being that in the Capilla del Condestable in Burgos Cathedral. The Virgin's robe is of highly polished jet, her throne and crown are of gold decorated with pearls and precious stones, and her face, as well as the body of the Christ Child, is of ivory (see Gaborit-Chopin, fig. 11). This remarkable piece may have been carved by a French artist and probably dates from *c.* 1400; a similar Virgin and Child is described in the inventory of 1467 of the collection of Jean II, Duc de Berry. Another popular subject was the Pietà (in an inventory of 1551 of the jetworker Gómez Cotón, 50 such pieces are mentioned), but during the Counter-Reformation the Virgin was more often identified with the Immaculate Conception. There are also depictions of Christ, either bound to the pillar or on the cross flanked by the Virgin and St John.

Another aspect of jet work that brought fame to the guild was the making of liturgical objects, especially the processional crosses used for funeral occasions from the 14th century. One was listed in the inventory of 1504 of

Ferdinand and Isabella. In the 15th and 16th centuries the pax was sometimes made in jet. This was a small tablet kissed before the communion, first by the priest and then by the other clergy and the congregation. The Pietà and the Crucifixion were often represented on the pax; in one example dating from the second half of the 16th century (Madrid, Inst. Valencia Don Juan, see Osma, no. 4) the Crucifixion scene was probably derived from a 15th-century Flemish Book of Hours.

The scallop shell was an important pilgrim emblem, and the jetworkers eventually took over the shell trade. The shell appears on its own, or as an attribute of St James, or as a support for other figures. Rosaries, too, were often made in jet: in the Instituto de Valencia de Don Juan there is a fine example with large and small beads, the large ones decorated in relief with the Calvary scene, apostles and saints and the small ones carved with scallop shells (see Osma, no. 33); the pendant depicts Christ on the Cross and, on the reverse, St James.

Sometimes the rosary pendant took the form of a hand amulet—one of the many instances in which this pre-Christian talisman was combined with a Christian symbol. Hand amulets remained popular in Spain for centuries,

1. Jet hand (*higa*) amulet with silver mount, 39×103×9 mm, from Guadalajara, second half of the 16th century (Madrid, Museo Arqueológico Nacional)

despite occasional disapproval from the Christian author-
ities; they were worn by all social classes from royal
infantes downwards (see the portrait of *Prince Felipe
Próspero* by Diego Velázquez, *c.* 1659–60; Vienna, Ksthist.
Mus.), and even the Christ Child is sometimes depicted
with one around his neck. The earlier, Muslim amulets
took the form of an open hand, known in Europe as the
'hand of Fatima', but in the 16th century the 'fig' or *higa*
gesture largely replaced the open hand. In this, the hand
is clenched, and the thumb is seen protruding between the
index and third fingers in the traditional Latin gesture of
contempt (see fig. 1). From the 16th century to the 18th a
variety of composite images was produced in which the
hand carried an additional image, such as a human-faced
crescent, a heart or a cherub. The wrist was often carved
in an open, skeletal form, or included a further image, of
open hands, a pair of eyes, a saint or a Christian scene.
The use of the *higa* continued up to the early 20th century
in the regions of Asturias and León and still survives,
though largely for decorative rather than protective
purposes.

Jet was used also for secular objects. Two magnificent
mid-16th-century openwork caskets surmounted by lions
and decorated with gilding can be seen in the Instituto de
Valencia de Don Juan (see Osma, nos 23 and 24): these
pieces were often made by apprentices in order to gain
their mastership. Jet was used for seals, perfume bottles
and jewellery, including rings and pendants associated with
mourning (*see* SPAIN, §X, 2). In peasant necklaces dating
from the 17th century to the 19th, jet was sometimes
alternated with coral and other materials.

(ii) England and Scotland. As in Spain, the magical powers
of jet and the limited size of the pieces made it suitable
for use in jewellery as well as amulets from early times. It
was used widely in Britain from the Neolithic period, and
rings, beads, necklaces, toggles, pendants and charms have
been found in Bronze Age burials in Scotland and north-
east England. Since these finds are far from Whitby, the
only source, it appears that jet was used for barter or trade.
The Melfort necklace, for example (London, BM, see Tait,
p. 41), was found in Argyll, Scotland, and dates from
c. 1800–1500 BC; it is formed of triangular and rectangular
plaques, decorated in pointillé designs and connected by
rows of beads.

The Romans traded jet throughout Britain and as far
afield as the Rhineland, Germany. Although much of the
raw material was probably obtained from pebbles, it is
likely that the Romans also mined it, since some of the
objects were fairly large. Although much of the jet-
manufacturing debris was from York, there is evidence
that it was worked at other sites in North Yorkshire,
especially Malton and Goldsborough. The industry seems
to have been fully productive from the end of the 2nd
century AD to the 4th. The most typical products are such
personal ornaments as hairpins, bracelets, finger-rings and
beads. Less commonly found items include relief-carved
betrothal medallions, knife-handles, spindle-whorls and
distaffs; a flat plaque (York, Yorks Mus.), probably
intended for insertion in a box or piece of furniture,
features a dancing figure tentatively identified as a satyr.

In the medieval period jet was used for secular objects,
such as gaming pieces, and for religious items (see, for
example, the jet crook of the last quarter of the 12th
century in Chichester Cathedral; 1984 exh. cat., no. 272).
But it was not until the early 19th century that jet was
extensively mined and a large-scale industry developed in
Whitby. This expansion was initiated by the introduction
soon after 1800 of the treadle-wheel lathe by a retired
naval officer, Captain Tremlett. Two entrepreneurs, Rob-
ert Jefferson and John Carter, were encouraged to establish
a business, and by the 1850s the trade was fully established.
It exhibited successfully at the Great Exhibition of 1851,
London, and in 1856 was producing exports to Europe
and America worth £20,000; at its peak, 1870–72, 1400
workmen were employed.

Much of the success of the Whitby jet industry was due
to the Victorian obsession with mourning, particularly
after the deaths of Arthur Wellesley, 1st Duke of Welling-
ton, in 1852 and Prince Albert, prince-consort of England,
in 1861. Queen Victoria introduced the wearing of jet in
court circles, and among the Whitby suppliers was Thomas

2. Carved jet parure consisting of necklace and pendant, bracelet,
earrings and brooch, female-head medallions in the centre with rose
and leaves surround; necklace, l. 530 mm, pendant, l. 65 mm; brace-
let, diam. central medallion 85 mm; earrings, l. 65 mm; brooch,
l. 52 mm, English, *c.* 1870 (London, Victoria and Albert Museum)

Andrews of New Quay, Jet-ornament Maker to Her Majesty. Mourning jewellery (*see* JEWELLERY, §5) included bracelets, necklaces, pendants, lockets, earrings and brooches (see fig. 2), but other items were also made, such as cardcases, seals and paper-knives. When mourning ceased to be fashionable the industry declined with it. Also, excessive competition had given rise to poor standards of workmanship and the use of soft, inferior jet that gave products a bad reputation. Finally, in the 1880s cheaper substitutes were introduced and the boom was over; by 1884 there were less than 300 jet workers, and by the 1930s the industry was virtually extinct.

BIBLIOGRAPHY

P. Hill: *Whitby Jet* (n.p., n.d.)

J. A. Bower: 'Whitby Jet', *J. Soc. A.*, xxii (1873), pp. 86–7

W. L. Hildburgh: 'Further Notes on Spanish Amulets', *Folk-Lore*, I/xxiv (March 1913), pp. 63–74

——: 'Notes on Spanish Amulets', *Folk-Lore*, II/xxv (June 1914), pp. 206–12

G. de Osma y Scull: *Catálogo de azabaches compostelanos, precedido de apuntes sobre los amuletos contra el aojo, las imágenes del apóstol y la Cofradía de los Azabacheros de Santiago* (Madrid, 1916)

B. I. Gilman: *Hispanic Notes and Monographs: Catalogue of Sculpture (Sixteenth to Eighteenth Centuries) in the Collection of the Hispanic Society of America* (New York, 1930)

Hispanic Notes and Monographs: Jet in the Collection of the Hispanic Society of America (New York, 1930)

H. P. Kendall: *The Story of Whitby Jet: Its Workers from Earliest Times* (Whitby, 1936)

W. Hagen: 'Kaiserzeitliche Gagatarbeiten aus dem rheinischen Germanien', *Bonn. Jb. Rhein. Landesmus. Bonn & Ver. Altertfreund. Rheinlande*, cxlii (1937), pp. 77–144

W. L. Hildburgh: 'Images of the Human Hand as Amulets in Spain', *J. Warb. & Court. Inst.*, xviii (1955), pp. 67–89

A. Webster: 'Amber, Jet and Ivory', *Gemmologist*, xxvii/27 (1958), pp. 65–72

Eburacum: Roman York (1962), i of *An Inventory of the Historical Monuments in the City of York*, Royal Comm. Anc. & Hist. Mnmts & Constr. England (London, 1962)

B. I. Gilman: 'The Use of Jet in Spain', *Homenaje al Prof. Rodríguez-Moñino* (Madrid, 1966)

——: 'A Token of Pilgrimage', *A. VA*, x (1969), pp. 24–31

C. I. A. Ritchie: *Carving Shells and Cameos, and Other Marine Products: Tortoiseshell, Coral, Amber, Jet* (London, 1970)

A. J. Lawson: 'Shale and Jet Objects from Silchester', *Archaeologia* [Soc. Antiqua. London], cv (1976), pp. 241–75

D. Gaborit-Chopin: *Ivoires du moyen âge* (Fribourg, 1978)

H. Muller: *Jet Jewellery and Ornaments* (Princes Risborough, 1980)

J. Musty: 'Jet or Shale?', *Current Archaeol.*, vii (1981), p. 277

L. Allason-Jones and R. Miket: *The Catalogue of Small Finds from South Shields Roman Fort* (Newcastle upon Tyne, 1984)

English Romanesque Art, 1066–1200 (exh. cat., ed. G. Zarnecki and others; London, Hayward Gal., 1984)

V. Monte-Carreño: *El azabache en Asturias* (Principado de Asturias, 1984)

A. Franco Mata: 'Azabaches del M.A.N.', *Bol. Mus. Arqueol. N. Madrid*, iv (1986), pp. 131–67

H. Tait, ed.: *Seven Thousand Years of Jewellery* (London, 1986)

A. Franco Mata: 'El azabache en España', *Compostellanum*, xxxiv (1989), pp. 311–36

——: 'Valores artísticos y simbólicos del azabache en España y Nuevo Mundo', *Compostellanum*, xlvi (1991), pp. 467–531

Additional information was supplied by A. D. Hooley.

ANGELA FRANCO MATA

Jetelová, Magdalena (*b* Semily, Czechoslovakia [now Czech Republic], 4 June 1946). Czech sculptor, draughtswoman and installation artist. She studied sculpture, together with some architecture, history of art and philosophy at the Academy of Fine Arts in Prague (1965–71) and the Accademia di Belle Arti di Brera, Milan (1967–8), where she was a student of Marino Marini. She began exhibiting in 1979 and became known for her large-scale sculptures constructed from rough-hewn tree trunks and timber of various kinds. Her imagery refers to domestic objects and architectural elements including chairs, wardrobes, tables and stairs, partly inspired by the other-worldly architecture of Prague. Early works, such as the pearwood and steel *Chair* (1979–80; Nuremberg, priv. col.), are anthropomorphic with an awkward, childlike quality: an oversized chair (h. 2.15 m), a pair of dwarfed houses, only just large enough to enter, or narrow stairs supported by a pillar and leading nowhere are other examples. Later works have included 'space' drawings, which were photographed laser projections shown at Dean Clough Industrial Park, Halifax (1991–2), entitled *Magdalena Jetelová—New Works* and made at the Henry Moore Sculpture Trust Studio. These drawings were integral to the development of her sculpture, which included the installations at the Cornerhouse, Manchester (1991), also entitled *Magdalena Jetelová—New Works*. Jetelová has works in numerous public collections, including the Centre Georges Pompidou, Paris, the Ludwig Forum für Internationale Kunst, Aachen, and the Wilhelm-Lehmbruck-Museum, Duisburg. From 1985 she lived mainly in Germany.

BIBLIOGRAPHY

Magdalena Jetelová (exh. cat., Baden-Baden, Staatl. Ksthalle, 1986)

CECILE JOHNSON

Jettmar, Rudolf (*b* Zawodzie, nr Tarnów, Poland, 10 Sept 1869; *d* Vienna, 21 April 1939). Austrian painter. He first studied music in Vienna, but in 1885 he joined the general painting course at the Akademie der Bildenden Künste in Vienna under the German painters Franz Rumpler (1848–1922) and August Eisenmenger (1830–1907). In 1892–3 he took a short course at the Badische Kunstakademie at Karlsruhe, earning his living as a scenery painter in Leipzig and Dresden in 1894–5. In 1895 he won the Prix de Rome and a six months' study period in Italy, and from 1897 to 1898 he resumed his studies at the Meisterschule für Graphische Künste in Vienna under William Unger (1837–1932), becoming a member of the Vienna Secession in 1898. In 1910 he was appointed a professor at the Akademie der Bildenden Künste in Vienna, and in 1925 he took over the general painting course.

Jettmar was an important exponent of European Symbolism. His work, related to that of Arnold Böcklin, Ferdinand Hodler and Max Klinger, drew its motifs primarily from his rich imagination. The main theme of his paintings is the human figure, unclothed or in timeless dress, before a heroic landscape or against deserted townscapes with architecture reminiscent of Italy's. Apart from individual works he produced cycles and portfolios, including *Night Hours*, *Eight Etchings on Byron's Cain* and *Ten Labours of Hercules*. He also produced murals and ceiling paintings.

BIBLIOGRAPHY

H. H. Hofstätter: *Rudolf Jettmar* (Vienna, 1984)

HANS H. HOFSTÄTTER

Jeuch, Caspar Josef (*b* Baden, 11 Nov 1811; *d* Baden, 24 Aug 1895). Swiss architect. He studied in Munich

(1829–35) under Friedrich von Gärtner and visited southern Germany and Vienna (1834–5) and Italy (1836). From 1837 he worked in Baden, becoming city building administrator in 1840, then a member of the Aargau building commission and later a town councillor (1856). He worked with simple classical structures, varying the style of ornamentation, either restrained or emphatic, with the type of commission. After some simple Biedermeier houses, such as the Wohnhaus Rohr (1837–8), he produced after 1845 a number of larger buildings, including hotels and spas, such as the Italian Renaissance-style Verenahof (1845–7) in Baden, and a barracks (1847–9) in Aarau, inspired by the Munich Rundbogenstil. In 1851–2 he built the synagogue at Endingen, Germany, in a classical-Moorish style. Jeuch's Roman Catholic church (1851–3) at Leuggern had considerable influence, being one of the first Gothic Revival sacred buildings in Switzerland. It is a hall church with a façade incorporating a single spire. Jeuch produced several variations on this type, such as the Roman Catholic church (1860) at Bünzen and a project (1856; unexecuted) for the St Elizabethenkirche at Basle. Jeuch was one of the first Swiss architects to work in cast iron, with a project (1862; unexecuted) for the Stadtkirche at Glarus and a music pavilion (1880) at Baden. The latter was influenced by the Swiss timber-building style. Jeuch's work also included industrial buildings and alterations to streets and waterways. One of the leading church architects in Switzerland of his day, Jeuch was among the first exponents of the Gothic Revival and his work is distinguished by a restrained, almost classical severity, even when using the Gothic idiom.

SKL

BIBLIOGRAPHY

U. Münzel: 'C. J. Jeuch', *Biographisches Lexikon des Kantons Aargau* (Aarau, 1958), pp. 403–5
——: *Die Reiseskizzen des Badener Architekten C. J. Jeuch* (Baden, 1979)

CORNELIA BAUER

Jeuffroy, Romain-Vincent (*b* Rouen, 16 July 1749; *d* Bas-Primay, nr Marly, 2 Aug 1826). French gem engraver and medallist. He trained in Rouen, where in 1764 he won a prize at the Académie, and in Italy he trained as a gem engraver under Johann Peter Pichler (1766–1807). On his return to France he was appointed Director of the Ecole de Gravure en Pierres Fines and was a founder-member of the engravers section of the Institut in 1803. From 1804 to 1819 he exhibited medals and gems at the Salon. His contributions to the series of Napoleonic medals organized by Baron Vivant Denon in 1804–15 included the medals for the *Invasion of England* (1804), the *Coronation of Napoleon in Paris* (1804), the *Battle of Sommo-Sierra* (1808) and the *Battle of Moscow* (1812). Examples of these are in the Cabinet des Médailles, Bibliothèque Nationale, Paris, as are a number of his gems, including pieces after the Antique and portraits of such contemporaries as *Charles de Wailly* (1729–98) and *Antoine-François Fourcroy* (1755–1809).

Thieme–Becker

BIBLIOGRAPHY

E. Babelon: *Histoire de la gravure sur gemmes en France* (Paris, 1902), pp. 219–21
A. Soubies: *Les Membres de l'Académie des Beaux-Arts depuis la fondation de l'Institut* (Paris, 1904), pp. 206–9

MARK JONES

Jeune Peinture Belge. Belgian group of avant-garde artists active from 1945 to 1948. It was formed on the initiative of an art critic Robert L. Delevoy and a lawyer René Lust, with the intention of promoting the work of young contemporary painters and sculptors through exhibitions. It developed from the groups Route libre (1939) and L'Apport (1941–51). The main exhibitions took place in 1947 in Brussels at the Palais des Beaux-Arts. The 'first generation' of artists involved in the foundation of the group included the sculptor Willy Anthoons (*b* 1911) and the painters René Barbaix (1909–66), Gaston Bertrand (*b* 1910), Anne Bonnet (1908–60), Jan Cox (1919–80), Jack Godderis (*b* 1916), Emile Mahy (1903–79), Marc Mendelson (*b* 1915), Charles Pry (*b* 1915), Mig Quinet (*b* 1906), Rik Slabbinck (*b* 1914) and Louis Van Lint (1909–87).

The members of Jeune Peinture Belge were engaged in a constant searching for new means of representation and were responsible for introducing elements of *Art informel* to Belgian art, for example *Still-life* (1947; Brussels, Mus. A. Mod.) by Van Lint. Although they followed no particular style and were highly individualistic, they all devoted attention to plastic forms and pictorial means. Despite a common interest in Fauvism, Cubism and Surrealism, the artists retained traces of Flemish Expressionism in their work. In later exhibitions additional and younger painters and sculptors joined the original members, including Pierre Alechinsky (*b* 1927), Pol Bury (*b* 1922), Jo Delahaut (*b* 1911), Jules Lismonde (*b* 1908), Jean Milo (*b* 1906), Antoine Mortier (*b* 1908), Luc Peire (*b* 1916), Roger Somville (*b* 1923) and Jan Vaerten (*b* 1909).

After the group's dissolution in 1948 a new organization was established in 1950 under the title Jeune Peinture Belge—Fondation René Lust, which initiated the annual Prix Jeune Peinture Belge, first won by Alechinsky. In 1952 ART ABSTRAIT was formed as a successor to Jeune Peinture Belge.

BIBLIOGRAPHY

R.-L. Delevoy: *La Jeune Peinture Belge* (Brussels, 1946)
M. Seuphor: *Geschiedenis van de abstracte schilderkunst in Vlaanderen* (Brussels, 1963)
P. Mertens: *La Jeune Peinture Belge* (Brussels, 1975)
M. Huys and others: *40 ans Jeune Peinture Belge* (Antwerp, 1990)

JEAN-PIERRE DE BRUYN

Jewellery. Objects of personal adornment, which may fulfil both decorative and functional purposes. Since antiquity protective and magical qualities have been attributed to amulets and talismans. As potent symbols of power and wealth, jewellery was used as a means of distinguishing social status, membership of a guild or political and religious loyalties. Jewellery has been used to commemorate historical and political events, and surviving examples provide valuable information about national and local traditions and customs. Items of jewellery are often given as tokens of love, betrothal and friendship, while *memento mori* jewels are reminders that death is inescapable, mourning jewellery signifies bereavement, and reliquaries (*see* RELIQUARY, §I,2) in the form of pendants or crosses were made to contain religious relics. The art of jewellery-making relies on the technical skill of the craftsmen (for a discussion of some of the techniques involved in jewellery production *see* ENAMEL, §2; GEM-ENGRAVING; and

GOLD, §2). The designs and value of materials used (which often depended on availability and accessibility), as well as quality of craftsmanship and provenance, have determined the value of individual items. Surviving examples of jewellery reflect the affluence of the society in which they were produced and can be closely aligned with styles of DRESS. Constant changes in fashion, as well as economic and political instability, have meant that many items have been melted down and the gems remounted; documentation regarding their existence can be found in inventories, wills and paintings.

This article is concerned primarily with the history and uses of jewellery in the Western world since the early medieval period. Further information on the history of Western jewellery can be found in the separate survey articles on Western countries. For information on non-Western jewellery *see* the separate surveys of non-Western countries, regions and civilizations.

BIBLIOGRAPHY
J. Evans: *A History of Jewellery, 1100–1870* (London, 1953, rev. 1970)
E. Steingräber: *Alter Schmuck: Die Kunst des europäischen Schmuckes* (Munich, 1956)
E. F. Twining: *A History of the Crown Jewels of Europe* (London, 1960)
M. H. Gans: *Juwelen en mensen* (Amsterdam, 1961)
Dix siècles de joaillerie française (exh. cat., Paris, Louvre, 1962)
H. Tillander: *Six Centuries of Diamond Design* (London, 1965)
G. Gregorietti: *Jewellery through the Ages* (Milan, 1969)
J. Lanllier and M.-A. Pini: *Cinq siècles de joaillerie en Occident* (Fribourg, 1971)
H. Tait, ed.: *The Art of the Jeweller: A Catalogue of the Hull Grundy Gift to the British Museum*, 2 vols (London, 1984)
——: *Seven Thousand Years of Jewellery* (London, 1986)
Treasures and Trinkets: Jewellery in London from Pre-Roman Times to the 1930s (exh. cat., ed. T. Murdoch; London, Mus. London, 1991)

1. Before 1500. 2. 1500–1630. 3. 1631–1725. 4. 1726–1830. 5. 1831–1900. 6. After 1900.

1. BEFORE 1500. Little is known of Carolingian jewellery except that both sexes wore magnificent brooches, to fasten the dress and the mantle, and no Carolingian jewels are known to survive. Of 10th- and 11th-century jewellery only a little more is known, with the exception of Imperial Ottonian Germany, from which survive several brooches and cloak-clasps and the complete parure known as the Treasure of the Empress Gisela (*d* 1040), found in Mainz in 1880 (Mainz, Landesmus.; Berlin, Schloss Köpenick). This includes two breast-ornaments, earrings, brooches and cloak-clasps and is heavily influenced by Byzantine styles in jewellery (*see* EARLY CHRISTIAN AND BYZANTINE ART, §VII, 6). Information from documents and surviving objects from the 12th century is also sparse, but it can be assumed that such major pieces as brooches were richly decorated with filigree, since this appears on surviving jewels. It can also be assumed that, like later medieval jewellery, earlier jewellery reflected in miniature current styles in major goldsmiths' work. The technique of mounting stones *à jour* (with an open setting) seems to have been invented in Ottonian Germany. All stones were simply smoothed by polishing until the 13th century, when there is some evidence for a few cut stones. Pre-13th-century jewellery appears to have used a wider range of stones than later jewellery, including topaz and chalcedony: from the 13th

century until the late 15th, when taste once more broadened, the favourite stones were the ruby, sapphire, emerald and diamond. The sapphire was probably the preferred stone of the early Middle Ages, followed by the ruby. In the late 14th century the ruby was the prime stone. Only in the 15th century—after the discovery of diamond-cutting in the 14th century—did the diamond begin to rise nearer to primacy. The pearl was assigned a secondary decorative role. Prophylactic, protective and mystical powers were attributed to all stones when worn as suspensions or ligatures, that is, in rings, bracelets or as pendants; the diffusion, if not the creation, of belief in such properties was much encouraged by the late 11th-century *Liber lapidum* of Marbodus, a poem in Latin hexameters, which by the late 14th century had been rendered into almost all vernaculars. Antique cameos, as in contemporary goldsmiths' work, were much used, chiefly in brooches: certain motifs cut on these were often regarded as sigils.

Medieval jewellery was the work of goldsmiths, who often used gold and stones given to them by the patron. Enamel in its various forms was an important technique (see colour pl. IV, fig. 1), especially in its last major medieval form, *en ronde-bosse* (*see* ENAMEL, §2(iv)). By the late 12th century certain great cities, notably Cologne, Venice and Paris, had established themselves as major centres for the making of jewellery, but from the 13th century the primacy of Paris fashion in jewellery throughout Europe is well documented. Significantly it was in 14th-century Paris that the techniques of stone-cutting, diamond-cutting and *en ronde-bosse* enamel were, if not invented, at any rate developed and improved. It was probably in Paris about the middle of the 13th century that the Gothic style was first applied to the design of jewellery, spreading in the second half of the century to Italy, Germany, Spain, England and Scandinavia, where the style assumed local forms and spirit. The high collet settings typical of the 13th century were displaced in the 14th by collets of geometrical Gothic design. Important centres for the manufacture of cheaper jewellery were Le Puy in the Auvergne, probably from the late 12th century, and Ragusa (now Dubrovnik) in the 14th century.

In the 13th century there was a general establishment and diffusion of what may be called the major types of later medieval jewellery. Earlier jewellery for women comprised brooches worn at the neck, on robe or mantle, sometimes of great size, head-ornaments—bands mounted with metal and precious stones, coifs and chaplets—garlands or frontlets, breast-ornaments suspended from ribands, cloak-clasps, pendants (often a cross or single stones), earrings, bracelets and necklaces. In parures of this kind, barbarian tradition was certainly mingled with Byzantine influence—earrings and bracelets appear to have been Byzantine ornaments. In the 13th century earrings, bracelets and necklaces disappeared, at any rate from princely and aristocratic jewellery, though the earring survived in southern Italy and Sicily and in Hungary. The principal jewels of Gothic Europe were the garland chaplet and circlet, worn by aristocratic men and princely men and women with fleurons as a coronal or crown. Women continued to wear jewelled headbands and coifs. Brooches took the form of ring brooches or solid brooches, both

brooches and pendants. Such forms of love jewels as the heart brooch and the fede brooch (with two hands clasped in a sign of troth) now appeared or at any rate became current. Necklaces of strung stones and pearls and ornaments had persisted in Spain and reappeared in courtly Europe in the late 14th century in the form of the collar of precious metal and stones, perhaps, like some other types of medieval jewels, such as the chaplet, a transmutation into gold and silver of a textile type. As chivalric ornaments or badges, or as ornaments, collars became, together with heavy chains, the principal jewels of the Late Middle Ages, displacing the brooch from its former dominance.

At the same time the rise into fashion of elaborate headdresses for women and of hats for men greatly reduced the importance of the coronal or crown, which survived only for ceremonial life at court or for wear by brides at marriage ceremonies. The bracelet reappeared in the 1380s and 1390s and became a favourite aristocratic ornament of the 15th century. In general bourgeois jewellery was simpler than aristocratic jewellery, though emulation of noble and knightly ornaments was common, and its wearing was much regulated by civic sumptuary legislation from the late 13th century in almost every country of Europe.

BIBLIOGRAPHY

R. Lightbown: *Medieval Jewellery in Western Europe* (London, 1991)

R. W. LIGHTBOWN

1. Cameo brooch (the 'Schaffhausen Onyx'), onyx, with surround of gold set with pearls and precious stones, l. 125 mm, w. 150 mm, Upper Rhenish, *c.* 1230–49 (Schaffhausen, Museum zu Allerheiligen)

types originating in the Dark Ages. Solid brooches, often of cluster form round a single large stone or cameo (see fig. 1), were worn to fasten the mantle or the robe at the neck and, from the 14th century, elsewhere on the breast and eventually as ornaments on the hat. Pendants, worn from a lace, were either of single precious stones, as in the 12th century, or assumed forms largely imitating those of solid brooches. They were often devotional in type (e.g. the cross) and could contain relics. The girdle now became a major item of jewellery and was decorated with a buckle and pendant and with bars, studs or larger mounts of silver, sometimes even of jewelled gold. From the late 13th century the girdle might even be entirely of gold or silver. The taste for luxury became such that from the late 13th century even such articles of devotion as the paternoster (the medieval form of the rosary) might be made either of precious materials (amber, coral, agate, chalcedony) or of gold, precious stones and pearls. The principal jewels of men were much simpler, usually a brooch and girdle, and for noblemen and princes a coronal and perhaps a chain: their paternosters were usually short.

There were several important changes in types and fashion of jewellery during the highly fashion-conscious 14th century. The vogue for personal or family devices, which became general throughout aristocratic and knightly Europe, introduced new motifs into jewellery. It seems too that figurated motifs, relatively infrequent in the 13th century, now may have become more common on

2. 1500–1630. Early Renaissance jewellery is distinguished by an extraordinary unity of vision and style, due in great part to the initial training of many artists in goldsmiths' workshops, regardless of future specialization. Jewellery techniques were described in detail by Benvenuto Cellini in *Due trattati uno intorno alle otto principali arti dell'oreficeria* (Florence, 1568). Jewellery from this period was often based on designs supplied by painters or sculptors who had a profound understanding of technical requirements. However, few of their drawings survived the intense handling they received in busy workshops. In Italian jewellery the influence of such artists as Antonio del Pollaiuolo and Botticelli can occasionally be noticed. In Germany, a few exquisite drawings of saints by Albrecht Dürer have survived (Hamburg, Ksthalle). When Hans Holbein (ii) visited England, his jewellery designs created a new court fashion, as seen in portraits of Tudor society. Few Holbeinesque jewels survive, for their material value was usually less dependent on the cost of precious stones than on the delicacy of figural scenes; because of changes in court fashions, many pieces were remodelled or destroyed. Ancient cameos and intaglios, from French royal collections, were set in precious mounts designed for wear or display. Unless inventories specifically mention Christian subjects or portraits of post-Classical personalities, most pieces may be assumed to have been ancient. This changed when the French king Francis I began to attract Italian gem-cutters, medallists and jewellers to his court. Among the first to arrive was Matteo del Nassaro (*fl* 1515–47) of Verona in 1515. He created a centre for cutting and polishing cameos, intaglios and precious stones in a court workshop (*see* GEM-ENGRAVING, §II, 10) in Paris. Types of 16th-century jewellery include necklaces, link-chains

and belts, rings, pendants, hat badges, hair ornaments and earrings. Finger-rings with family crests or merchants' marks were intended as signets or as identification. Some rings have liturgical significance or include intaglios and cameos, while ornamental rings display precious stones or pearls. Changes in fashions and techniques, particularly engraving and enamelling, provided numerous variations.

During the second third of the 16th century the publication in Nuremberg and Augsburg of engraved pattern books for jewellers and goldsmiths caused fundamental changes. These were initially illustrated with woodcuts, which were soon replaced by copper engravings that allowed for more precise and defined detail. These pattern books introduced a greater choice for jeweller and patron, but such readily available designs tended to reduce the inventive impulses of lesser masters. Dependence on these designs eases dating and identification. Another innovation affecting 16th-century jewellery design was introduced by ERASMUS HORNICK of Antwerp. He had probably settled in Augsburg by 1555 and worked as a goldsmith and ornamental engraver. His two early pattern books appeared in Nuremberg in 1562 and 1565, and most of his other work was subsequently published in Strasbourg by his son Jean Hornick. Hornick invented a new type of pendant where figures were framed by an arched niche. The advantage was that the framework could be made in advance, and the jeweller could add the figures according to his client's taste. As jewellers met prospective clients at diets or seasonal trade fairs, such preparations were advantageous.

The use of figural themes for jewels gained increased importance after the Reformation. As few patrons wished to have their religious convictions evident at first glance, liturgical subjects became increasingly rare in regions of divided faith. The once favoured figures of patron saints were replaced by personifications of such virtues as Charity and Justice (e.g. pendant of the *Three Cardinal Virtues*, *c*. 1560–70; London, BM; see fig. 2) or allegorical figures. Scenes of Greek mythology and Roman history enjoyed continuous favour and were used for example by the engraver ETIENNE DELAUNE, who designed medals, armour and jewels for Henry II. After the King's death in 1559, religious persecution forced Delaune and his family to flee France and to settle, at least temporarily, in Augsburg. Etienne and his son Jean Delaune (*fl c.* 1580) published a series of engraved designs in Strasbourg (1578 and 1580). A characteristic feature is the use of table-cut rubies and diamonds in architectonic designs.

While the publication of Delaune's designs shows his wide-ranging influence, the workshops and the jewellers using them remain anonymous. Individual payments and even some descriptions of commissions are recorded, for example in the *Dépenses secrètes* of the French kings, the *Inventaires des joyaux de la Couronne de France* and the inventories of the Medici, but the listed objects are usually lost or can no longer be identified. Occasionally it is possible to trace an outstanding diamond or other gemstone, although it may have lost its original setting. Famous gems were re-cut for reasons of changing fashion, political situation or economic necessity, and the empty mount was melted down. Cellini's descriptions of the jewellery he made are invaluable, as are the watercolour drawings

2. Pendant of the *Three Cardinal Virtues*, with personifications of Charity (centre), Faith (left) and Hope (right), gold and enamel set with diamonds, rubies, an emerald and pearls, l. 70 mm, w. 59 mm, from Germany or ?Antwerp, *c*. 1560–70 (London, British Museum)

(1729; London, BM) by Francesco Bartoli (1675–1730) showing Cellini's morse for Clement VII, which disappeared during the Napoleonic conquest. However, the anonymity of practising jewellers prevails. By contrast, the *Llibres de Passanties* of the Barcelona guild of goldsmiths, started in 1516, contains jewellery drawings signed and dated by apprentices, who submitted them to gain the freedom of the guild. Yet none of the items shown has led to more than an easier dating of similar pieces.

As the 16th century advanced, fundamental changes in jewellery design occurred, particularly in Spain. The arrival in Barcelona of precious stones from the Americas, including emeralds from Colombia and Peru, heralded a new age. The size of jewels increased, and some of the adventurous spirit of exploration is reflected in the appearance of bold designs of sea monsters reminiscent of those featured on maps. As Spain then ruled the Netherlands, jewellers from the two countries entertained close ties and sometimes worked for the same Spanish overlords. Their readiness in sharing marine imagery was moreover the result of being bordered by the sea, from where both countries derived their wealth through overseas trade. The people of Antwerp had a legend that in the nearby sea there were armoured mermen and nereids, some images of which are seen in Netherlandish pendants. Unlike

Spanish pieces, the pendants from Antwerp were fitted with large baroque pearls. Adventurous ship-captains returned with these irregular pearls, which were unsaleable in East Asia. Tempted by the opportunity, imaginative jewellers incorporated them into specially designed figural pendants, which followed the natural shape of the pearl.

Towards the end of the 16th century a new type of ornament was created in England to celebrate the reign of Elizabeth I: oval pendants containing miniature portraits. Nicholas Hilliard (*see* HILLIARD, (1)), the court painter and jeweller, not only suggested but also probably executed the first ones himself. Initially they portrayed Elizabeth (e.g. Armada jewel, 1595; London, V&A) and subsequently James I and members of the court. Enclosed in enamelled and jewelled frames or lockets, some display the royal cipher laid out in table-cut diamonds. Alternatively the portraits could be in the form of cameos or medals. Elizabeth rewarded services rendered by presenting such jewels to her loyal servants. On the Continent, the closest comparison were *Gnadenpfennige* (enamelled portrait medals) usually with armorials on the reverse. They were set within enamelled scrollwork and worn on gold chains.

European political turbulence in the early 17th century meant jewellers had a difficult existence, some being forced to turn to book illustration. After a return to prosperity, technical advances in diamond-cutting fundamentally changed the character of jewellery. Faceted rose-cutting, practised in Amsterdam and Antwerp, inspired floral designs that owe little or nothing to the figural style and colourful enamelling typical of 16th-century jewellery. Floral diamond garnitures, often worn in large parures, became fashionable and came to represent the age of Absolutism.

BIBLIOGRAPHY

E. Auerbach: *Nicholas Hilliard* (London, 1961)
H. Thoma and H. Brunner: *Schatzkammer der Residenz München* (Munich, 1964)
E. Steingräber: *Royal Treasures* (New York, 1968)
Y. Hackenbroch: *Renaissance Jewellery* (London, 1979)
Princely Magnificence (exh. cat., London, V&A, 1980–81)
H. Tait: *Catalogue of the Waddesdon Bequest*, i: *The Jewels*, London, BM cat. (London, 1986)
Y. Hackenbroch: *I gioielli dell'elettrice palatina al Museo degli argenti* (Florence, 1988)
Prag um 1600: Kunst und Kultur am Hofe Kaiser Rudolfs II, 2 vols (exh. cat., Vienna, Ksthist. Mus., 1988)
Y. Hackenbroch: *Early Renaissance Hat Jewels: Emblems of Faith and Distinction* (in preparation)

YVONNE HACKENBROCH

3. 1631–1725. Parisian leadership in jewellery design reached a climax during the reign of Louis XIV (*reg* 1643–1715), when the jewels worn at Versailles set the standard for the rest of Europe: the Princesse des Ursins, Marie-Anne de La Trémoille (1642–1722), who arrived from Rome in 1678, was obliged to have her jewels remounted as they looked absurdly old-fashioned at the French court. This superior expertise was diffused abroad when the Revocation of the Edict of Nantes (1685) drove Huguenot craftsmen to the Protestant countries of northern Europe. An emphasis on stones rather than settings was made possible by the increased supply of gems resulting from the decision in 1660 by the British East India Company to allow the Marranos Portuguese Jews based in London

to trade independently. At the same time the discovery of the laws of refraction and the principles of analytical geometry stimulated progress in faceting and polishing. Early in the 17th century the rose cut with multiple facets had succeeded the elementary point and table cut, and from the 1660s the brilliant cut, which released even more light from the diamond, became available. The increased demand for pearls tripled their price during the first 60 years of the century, and from 1686 substitutes were made by the firm of Jacqui of Paris, while others were imported from Venice, where imitations of coloured gems were also a speciality. To avoid yellow reflections silver was adopted for setting diamonds, but in Spain gold was still preferred. Enamel was now relegated to a subsidiary role on the back and sides of densely gem-encrusted ornaments but remained the main means of decoration for the cases of watches and miniatures (see fig. 3). The Toutin family were associated with a new technique: opaque-white enamel was applied on a gold surface and then painted in a wide range of colours with still-life, topographical and mythological scenes copied from the canvases of Baroque painters. A further development was enamelling in high

3. Locket containing miniature of *Sir Bevil Grenville*, enamelled gold set with a sapphire, rubies, diamonds, emeralds and opals, l. 86 mm (including pearl), w. 35 mm, English, *c.* 1640 (London, British Museum)

relief to frame cameos and miniatures with garlands of fruit and flowers.

Since fashionable people had their jewels frequently remounted, very little has survived, and the best guide to the sequence of styles is provided by pattern books. The designs of such goldsmiths as François Lefebvre in *Livre de feuilles et de fleurs utiles aux orfèvres* (Paris, 1657) reflect the mid-century passion for flowers, while those of Louis Roupert in *Dessins de feuillage et d'ornements pour l'orfèvrerie et la niellure* (Metz, 1668) show the influence of Versailles classicism. The acanthus motif was adopted internationally, and Marcus Gunter, an itinerant jeweller from Leicestershire who worked in Amsterdam, Rome, Siena and London from 1684 to 1733, made it his speciality.

In the mid-17th century the fashion was for the face to be framed with ringlets, perhaps with a string of pearls entwined in the hair and secured at the side with long bodkins: these might have been topped with jewelled insects—butterflies, dragonflies, caterpillars or snails perched on long-stemmed plants—or by ships, shepherds' crooks and flowers studded with rose-cut diamonds and coloured stones *en cabochon*. As coiffures rose higher, padded out with artificial hair, they were ornamented with aigrettes or large floral sprays bent under the weight of diamonds and pearls. Pleated and stiffened lace Fontanges caps, which originated at Versailles, also sparkled with

clusters of faceted stones scattered on the front and sides of the head. Men's hats were encircled by jewelled bands, chains and strings of pearls around the crown. Loops kept turned-up brims in place: that of Charles II of Spain was shaped as a bow from which hung the celebrated Peregrina pearl (Elizabeth Taylor priv. col.).

Notwithstanding the immense popularity of pear-shaped pearl earrings, there was a continuing demand for gems set in wrought gold or silver. Most characteristic of the period is the girandole, consisting of a top cluster with three pendant drops arranged like a branched candelabrum suspended from a bow-knot. Complex girandoles that incorporated ribbon, crown and flower motifs were designed for Anne of Austria (widow of Louis XIII) by Paul Maréchal. Simpler styles were composed of a single pendant hanging from a button-like cluster set with gold- or silver-foiled stones with enamelled backs. In the Cheapside Hoard (a jeweller's stock hidden *c.* 1650 at Cheapside in London and discovered in 1912) bunches of festive grapes, carved from amethysts, were found, which suggests that other such imaginative designs were made. Seed pearls, if round and even, were threaded into tassels and suspended from earrings. Men also wore earrings: in 1649 Charles I went to his execution wearing a large, pear-shaped pearl earring (Welbeck Abbey, Notts). Large, evenly matched natural pearls were threaded into necklaces

4. Bodice ornament, openwork gold set with table-cut diamonds and emeralds, l. 106 mm, w. 146 mm, Spanish, *c.* 1700 (London, Victoria and Albert Museum)

and tied with ribbon bows, as seen in Lely's portrait of *Anne Hyde, Duchess of York* (*c.* 1660; Edinburgh, N.P.G.; *see* LELY, PETER, fig. 3). But the diamond, with its new brilliance, had asserted its pre-eminence by the early 18th century: at the coronation of Queen Anne in 1702 many peeresses wore necklaces of rose-cut stones in heavy silver mounts enamelled at the back, linked into one or two rows falling like festoons. Enamel plaquettes were incorporated into chains and necklaces and were painted with landscapes and allegorical figures or composed of graduated bow-knots and coloured stars, each centred on a pearl.

Men wore chains as a sign of status: they were the standard reward for diplomatic and official services and were hung with medallic portraits or miniatures. The jewelled insignia of the ORDERS OF CHIVALRY were prominently displayed. An innovation was the sleeve button, which appeared in England in the 1660s, made to fasten the cuff at each wrist, replacing the ribbon. Shoe buckles also appeared for the first time.

Fashion-conscious women almost invariably wore bodice ornaments (see fig. 4) or a large jewel in the centre of the bodice at the neckline, as seen in the portrait by Rubens of his wife *Hélène Fourment* (1630; Munich, Alte Pin.), who wears a large gold and diamond jewel composed of tall stems shooting upwards to each side of a central cluster. Such ornaments as crosses might be pinned to a ribbon tied in a bow, but from the mid-17th century the bow itself was produced in metal and gems: in Marcus Gunter's designs it was combined with acanthus scrolls, which embellish the settings. Interlaced ribbons framed the bouquet of lilies and carnations hanging from a rosette of diamonds, rubies and emeralds worn by Queen Marie Louise, wife of Charles II of Spain. Oblong, jewelled Brandenbourgs, introduced at Versailles at the end of the century, were inspired by the frogging on the jackets of Prussian soldiers: they were made in one or as graduated sets pinned from neckline to waist and were adopted internationally. Matching brooches, buttons, sleeve clasps, earrings, necklaces, aigrettes and buckles were increasingly seen to be more elegant than a miscellany of ornaments, however magnificent. The paste jewels (copied from the originals) on the wax funeral effigy of *Frances Stewart, Duchess of Richmond and Lennox* (1702; London, Westminster Abbey, Undercroft Mus.), illustrate the style of these early parures. Religion, death and politics are recurring themes in 17th-century jewellery: crosses were worn by both Catholics and Protestants, and some were discovered in the Cheapside Hoard. Reliquaries and rosaries were inscribed with such devotional monograms as MRA (Maria), IHS (Jesus) and S (esclavo), which denoted membership of a religious confraternity. Miniature versions of such cult statues as the *Virgin of the Pillar* were typical of Spanish taste. The successive constitutional crises in English politics are evoked by rings, lockets and bracelet slides (worn on velvet bands passing through twin loops at the back) representing Charles I and his children, and later William III and Mary II. Memorial jewels commemorating private individuals were of similar design but were decorated with symbols of death—skulls, crossbones, coffins, skeletons, hour-glasses, the angel-of-death

with trumpet and crown—and usually contained locks of hair identified by gold-wire monograms.

4. 1726–1830. The jewels of the Rococo, Neo-classical and Romantic periods can be divided into two categories: those worn by day with informal clothes and the grander ornaments required with full dress at evening functions. Design emphasis was on stones rather than on settings: from the 1730s the traditional source of diamonds from India was supplemented by imports from Brazil, where the amethysts, peridots, gold and pink topazes, chrysoprases, aquamarines and chrysoberyls so popular in the early 19th century were also mined. France continued as the fount of inspiration, and engravings by such artists as Jean-Henri-Prosper Pouget (*d* 1769) in his publications *Traité des pierres précieuses et de la manière de les employer en parure* (Paris, 1762) and *Nouveau recueil de parures de joyaillerie* (Paris, 1764) diffused French fashions further, giving jewellery an international character.

Seventeenth-century designs—aigrettes, girandole earrings and bow-knots for the bodice—were reinterpreted in the lighter Rococo mood. The acanthus motif was discarded, asymmetry introduced, and ribbonwork used more fluently, interspersed with flowers. From the mid-1760s this naturalistic style became more compact and geometric, while such Neo-classical motifs as the Greek fret, honeysuckle and husks appeared. Tassels and festoons derived from passementerie became fashionable from the late 1770s. Enamel disappeared from the backs of settings, which from the late 1760s were gilded to avoid tarnish, but continued to embellish daytime châtelaines, watchcases and lockets. From the 1760s a distinctive blue enamel outlined settings and coloured the ground for rings and lockets with diamond ciphers and stars. Other popular daytime ornaments included memorial or sentimental jewellery—brooches, rings, bracelet clasps and pendants—enclosing hair, identified by ciphers and framed in small pearls or borders of blue enamel inscribed with loving mottoes, which were almost always in French. From the 1770s fichus were fastened with an oval or navette-shaped brooch with such love motifs as flaming torches, twinned hearts, a padlock or Cupid holding a lover's crown.

Powdered hair sparkled with naturalistic sprigs of flowers, with insects—moths, flies and butterflies—and with birds pecking at berries and bearing olive branches. In the late 18th century they were superseded by stars, crescents, feathers and tiaras. Feathers were secured to hats with brooches decorated with trophies of love and the arts. Earrings were essential for both day and evening wear: for day there were paste clusters matching the colours of the dress or trimmings and *coq-de-perle* (irregularly shaped sections from nautilus or periwinkle shells) combined with marcasite. The most popular formal style was the girandole with triple pendants linked to the top cluster by ribbons and flowers (see fig. 5) and single drops as long as 50 mm. The grandest evening necklaces were set with diamonds: large stones were linked into rivières of graduated stones, while the smaller gems were worked into clusters or intricate garlands of flowers and ribbons with an *esclavage* suspended from the front section. Lines of stones hung in festoons or strung into tassels echoed the fashion for passementerie. Eighteenth-century court dress was embellished with single or multiple stomachers or brooches,

5. Parure comprising (from top to bottom) floral hair sprig, slide, girandole earrings and bodice bow-knot, gold set with blue and white sapphires, l. of bow-knot 100 mm, French, 1760 (London, Victoria and Albert Museum)

which filled the space between neckline and waist and which were designed as floral bouquets or large bows. Smaller versions made *en suite* were pinned to the sleeves and skirt.

The same high standards of style and quality were applied to jewels made from such coloured stones as cornelians, moss agates and garnets foiled to glow like rubies. Such substitutes as pinchbeck (an alloy of zinc and copper) provided a cheap alternative to gold. White, coloured and opaline pastes were perfected and set in jewels, belt buckles, shoes and garters. In Switzerland, where diamonds were forbidden by the sumptuary laws, marcasite was used as a substitute. English cut-steel jewellery was very popular and was exported all over Europe: some pieces were made entirely of steel, while others were mounted with enamels manufactured in Staffordshire or jasperware cameos from the ceramic factory of Josiah Wedgwood (e.g. cut-steel bracelet with cameos, *c.* 1790; Barlaston, Wedgwood Mus.; *see also* METAL, colour pl. II, fig. 3). For admirers of Classical art

JAMES TASSIE reproduced ancient and contemporary cameos and intaglios in a range of coloured pastes, which were set in brooches, necklaces, rings and bracelets (*see* SCOTLAND, fig. 13).

Gentlemen in the 18th century also wore jewels: the privileged few adorned their court dress with the magnificent insignia of the orders of chivalry, but every gentleman owned a sword with jewelled hilt, a watch, a seal, a locket or miniature pendant worn from a chain round his neck and finger-rings (as seen in the portrait of *Philibert Rivière* by Ingres, 1805; Paris, Louvre). The cravat was pinned with a jewel, cuffs were fastened with a pair of buttons, and cut-steel or paste buckles were made for shoes and garters. Buttons might be set with gems or paste and enamelled with subjects indicating the owner's cultural, political or sporting interests. As dress became plainer from the 1770s, buttons became larger.

The simplification of dress in the years preceding the French Revolution (1789) was accompanied by a fashion for less grand jewellery. After 1804 this trend was reversed when Napoleon established his empire and asserted his authority by a great display of wealth. This led to the creation of jewels in a rich version of Roman classicism devised by the court painter David as an expression of the artistic style of the regime. These tiaras, earrings, necklaces, bracelets and brooches incorporating such motifs as the Greek fret, honeysuckle, palmettes and wreaths of vine and laurel were encrusted with diamonds, emeralds, rubies, pearls and engraved gems from the former royal collection and set the pattern for court jewellery everywhere (see fig. 6). This style was adopted by the restored Bourbon monarchy after 1815, but the classical motifs were replaced by scrolls, leaves and flowers. The rest of Europe followed suit. Supplementing the supply of diamonds were coloured stones from Brazil and turquoises—perhaps the favourite stone of the period—set in ostentatious mounts of filigree or stamped gold linked by chains. This combination of brightly coloured stones in gold settings, known as *à l'antique*, evoked the jewels of the Middle Ages and the Renaissance. Other jewels worn with the picturesque clothes of the Romantic period represented knights in armour and pairs of celebrated lovers. Devotional jewels were worn as a response to the religious revival that came as a reaction to the atheism of the French Revolution: belt buckles—exaggerated to emphasize the small waist—might represent pilgrims kneeling at a shrine; rosaries and rosary

6. Laurel wreath with paste cameo, enamelling, gold, pearls and diamonds, l. 295 mm, w. 575 mm, Western European, *c.* 1815 (London, Victoria and Albert Museum)

rings were displayed, and Greek, Latin, Maltese and Jerusalem crosses, decorated with Gothic cusping and tracery, imparted a nun-like air to the 19th-century woman. Locks of hair and miniatures, often of a painted eye, were framed in jewelled hearts, padlocks, rings and lockets (e.g. locket containing a lock of John Keats's hair, c. 1824; London, Keats House). Symbolic motifs included the snake, tail in mouth, signifying eternity, and such emblematic flowers as the pansy and the forget-me-not. Christian names and loving messages—AMITIÉ, DEAREST, SOUVENIR, REGARD—might be spelt out from the initials of the stones used: R(uby), E(merald), G(arnet), A(methyst), R(uby), D(iamond).

Formal social life required jewels for the hair, and women now wore their tiaras with nodding ostrich plumes and a jewelled comb *en suite*. Less grand were the smaller bouquets of flowers, ears of wheat, moths and butterflies mounted *en tremblant*. In 1830 the ferronière appeared, inspired by Leonardo's *La Belle Ferronière* (1499; Paris, Louvre). Simple or splendid, according to the occasion, the ferronière was always centred on an ornament—cameo, drop or large cabochon stone—set over the brow. Equally picturesque were the turbans, evoking the Crusades, pinned with crescent and feather brooches. Long earrings balanced piled-up hair: the girandole and single drops remained popular and were worn *en suite* with crosses or brooches placed *à la sévigné* (named after the Marquise de Sévigné in the centre of the neckline).

Necklace designs achieved a compromise between the desire for rich display and the 18th-century tradition for elegance. Typical of the period was the cluster style composed of single large coloured stones framed with tiny diamonds and hung with a fringe of pendants. The chains and sautoirs, worn diagonally across the body from shoulder to hip and hooked in at the waist, were sometimes composed of enamelled plaques edged with seed pearls but were usually made of gold or pinchbeck, fastened with clasps shaped as a beringed and braceleted woman's hand. Suspended from these were such useful objects as lorgnettes, enamelled watches or vinaigrettes. Bracelets were not only included in full-dress parures but also worn in the daytime. They were made in Gothic style with cusped ogee arches, or they might represent a snake coiled several times round the wrist with a heart-shaped locket hanging from its fangs. The focus of design was usually the clasp, which might be a large and important stone, a miniature or such a motif as two hands clasped, a symbol of fidelity since the Middle Ages. In spite of the great concentration on jewellery for women during this period, such masculine ornaments as gold chains, jewelled studs, pins, lockets, dangling seals and the watch-and-chain were still very evident.

BIBLIOGRAPHY

P. F. Schneeberger: *Les Peintres sur émail genevois au XVIIe et au XVIIIe siècle* (Geneva, 1958)

M. D. S. Lewis: *Antique Paste Jewellery* (London, 1970)

A. Clifford: *Cut Steel and Berlin Iron Jewellery* (Bath, 1971)

S. Grandjean: 'Jewellery under the First Empire', *Connoisseur*, cxciii (1976), pp. 275–81

S. Bury: *Sentimental Jewellery* (London, 1985)

D. Scarisbrick: *Ancestral Jewels* (London, 1989)

——: *Jewels in Britain 1066–1837* (1994)

DIANA SCARISBRICK

5. 1831–1900. During this period of political change and unparalleled industrial expansion, jewels were produced in vast quantities and in a variety of styles. The Parisian makers maintained the lead, receiving much encouragement from Napoleon III, who was declared Emperor in 1852 and who with the Empress Eugénie made his court the most brilliant in Europe. Besides their traditional clientele of royalty, nobility and the burgeoning bourgeoisie, the Paris jewellers attracted a new element: millionaires from both North and South America were ready to pay high prices for pieces of exceptional quality. The discovery of diamonds in South Africa (c. 1867) prompted the emergence of this lucrative market, and from the 1870s the number of women wearing these stones increased. At the same time designs were simplified, often at the expense of artistry, to show off the stone.

The international exhibitions, held at regular intervals after the Great Exhibition of 1851 in London, provided showcases for the best jewellers in each country and helped disseminate new techniques and styles, as well as introducing new materials. The illustrated magazines also kept their readers in touch by reporting the ornaments and dresses worn to social occasions and publishing information about wedding presents, which were most often jewels. Most jewels were made for women, as the sober, black clothing worn by men left little room for jewellery except for watch-chains, rings, scarf-pins and studs. Jewels were closely associated with fashions in dress: there was a clear distinction between formal and informal wear, outfits were worn with appropriate adornments, and mourning was scrupulously observed. The parures of pearls, diamonds and coloured stones worn in the evening were more conservative in design than the gold daytime jewels, which showed more originality. Styles were adapted for mass production in Birmingham, Clerkenwell (London) and Hanau in Germany, making jewellery and trinkets available to almost every woman. The production of British jewellery had become so industrialized by the mid-19th century that ornaments made to traditional Scottish designs, set with local cairngorms and pearls and sold in the shops of Edinburgh and Perth, were in fact supplied by such Birmingham manufacturers as Thomas Fell.

The tradition for regional craftsmanship lasted longer in the rest of Europe, stimulated by the desire of tourists for souvenirs of distant places. From the foundries of Berlin and Silesia came Berlin iron jewellery, which could be worn with mourning attire (*see* BERLIN, §III, 2). Switzerland was famous for enamelled goldwork, bracelets with pictures of peasant girls in regional costume being popular. Such centres as Erbach im Odenwald in Germany and Thun and Brienz in Switzerland produced carved ivory brooches with hunting scenes evoking visits to the Alpine forests. In Italy regional specialities included jewellery with carved coral from Naples and Genoa, hardstone inlay from Florence and micro-mosaic and shell cameos from Rome (see fig. 7). Botanical jewellery was reinterpreted for evening wear with hair garlands and bouquets for both hair and bodice. The masters of this type of ornament were the Parisian firms of Lemonnier and Fossin, who tried to make each bloom as naturalistic as possible, mounting them *en tremblant* and painting the

7. Necklace and pair of pendent earrings with gold-mounted Italian shell cameos, l. of necklace 463 mm, c. 1840 (private collection)

leaves with bright-green enamel, which terminated in trails of diamonds known as *pampilles*. For the Empress Eugénie, who made a cult of her admiration for Marie-Antoinette, the court jewellers Alfred Bapst made many superb botanical jewels (e.g. Théodore Fester's diamond bouquet or corsage spray held by a bow, 1855; see Bury, i, pl. 182), including a diamond parure of currant leaves and berries. The style culminated in the splendid bouquets, or *bijoux modelés*, of Olive Massin (*b* 1829; *d* after 1892), Frédéric Boucheron (1830–1902) and Octave Loeulliard, which drew huge crowds when displayed at the international exhibitions. The snake (symbolic of eternity) remained consistently popular and was Queen Victoria's choice for her engagement ring (Windsor Castle, Berks, Royal Col.). It was also used on necklaces, brooches and bracelets, enamelled royal blue or with turquoise-encrusted scales and jewelled head. Such motifs as ivy leaves, hearts, pansies and forget-me-nots, all redolent of sentiment, are also typical of the period. Some can be found on mourning jewellery made of such black materials as jet (*see* JET, fig. 2), onyx or fossil bog-oak from Ireland.

By the late 1830s jewellery was influenced by the Medieval Revival and interest in historicism. The ferronière encircling the brow and the châtelaine, which hung from the waist, were direct copies of medieval ornaments, but most were combinations of motifs taken from the architecture, sculpture, ceramics, textiles, paintings and miniatures of the past. In France the leading exponent was François-Désiré Froment-Meurice (1802–55), whose sculptural tableaux contrasted with the flat, English styles represented by the popular Holbeinesque oval pendant. A more refined version of enamelling in antique and Renaissance styles was produced by members of the Giuliano

family for a rich clientele. In France miniatures of illustrious ladies demonstrated the success of craftsmen in reviving the skills of the Limoges enamellers (*see* LIMOGES, §1). Mass-produced Renaissance Revival jewels were exported from Vienna, some of the chief firms being Josef Bacher & Sons, Karl Bank and Hermann Ratzersdorfer. Archaeological jewellery was made fashionable by the CASTELLANI family, who produced jewellery that simulated Etruscan, Hellenistic, Roman, Early Christian, Byzantine, medieval and Renaissance ornaments. They used such traditional techniques as granulation, filigree and enamel and sometimes incorporated coins, cameos, mosaics and Latin or Greek mottoes (*see* ITALY, fig. 96). Others who specialized in reinterpreting archaeological and later themes in 19th-century forms were Eugène Fontenay (1823–87) in Paris and John Brogden (*fl* 1842–85) and Robert Phillips (1810–81) in London. Re-creations of Viking jewels (see Scarisbrick, 1989, p. 108) by Copenhagen firms were worn in England after the Danish princess Alexandra brought some with her trousseau on her marriage to the Prince of Wales (later Edward VII) in 1863. Exotic and distant locations inspired such other designs as Moorish knots and tassels, Japanese-style medallions enamelled with flowers and birds by LUCIEN FALIZE and Indian-style necklaces by Carlo Giuliano (1831–95).

The formality of social life required jewels to adorn the hair, and every noble lady wore a tiara. Wreaths of flowers and leaves around the head were succeeded in the 1850s by stately diadems curved to the shape of the head like the rays of the sun. Aigrettes shaped as crescents, birds, wings of Mercury, butterflies, peacock feathers, sprays of corn and Cupid's bow and arrow were worn to the side of the head supporting a spray of osprey feathers. Pins with ornamental finials secured hats worn with day dress. In the 1860s long earrings came back into fashion, and for formal wear large, round pearls were suspended from a diamond top or from diamond chains. Daytime designs included Etruscan-style hoops, miniature Roman oil lamps, insects and such novelties as bells, clogs, miniature 'Willow' pattern plates, stirrups and horseshoes. Necklaces for the evening were usually a simple diamond rivière of graduated silver collets or strings of pearls in the fashion promoted by the Empress Eugénie, as seen in the portrait of Archduchess *Marie of Austria, Duchess of Brabant* by Franz Xaver Winterhalter (1863; Belgian Royal Col.). With day clothes there was more variety, with long gold chains suspending lorgnettes, watches and vinaigrettes, Roman laurel wreaths or Celtic-style collars. From the 1870s there was a fashion for heavy, gold lockets containing photographs, miniatures or locks of hair hung from a velvet ribbon. The gold now had a soft 'bloomed' surface achieved by immersion in an acid solution. Equally ubiquitous were crosses, many reviving Early Christian, medieval and Renaissance designs.

Low necklines were adorned with large brooches, which combined turquoises, pearls, chrysolites, amethysts, pink topazes, garnets and gold. These were sometimes made *en suite* with necklace, pendants, pendent earrings and a pair of bracelets (see fig. 8) or as a demi-parure with just the earrings in a fitted case. They were succeeded by creations in pearls and diamonds as these became more plentiful.

8. Pendant, pair of bracelets and necklace, gold-mounted amethyst and chrysolite, l. of necklace 375 mm, London, *c.* 1840 (private collection)

Towards the end of the century lace and chiffon neckline trimmings were adorned with a profusion of brooches shaped as butterflies, lizards, bumble-bees, stars and bow-knots. Daytime brooches included symbols of sentiment and good luck and reflections of cultural, sporting and political interests. Most representative was the bracelet, often worn in rows on each arm. The broad bands of varicoloured gold or plaited hair clasped by a large stone or a miniature were followed by strap and buckle designs, imitation buttoned cuffs, snakes, and wreaths of symbolic flowers and leaves, many of which were inscribed with mottoes or messages of affection and good luck. With formal attire there was less variety, the wrist being encircled by rows of pearls with diamond clasps, or rigid bangles with stones set all the way round or in a graduated line along the top, which matched the half-hoop rings set in the same manner. The beauty of the stones was of paramount importance to the wearer, and as a result jewellery design became increasingly subdued and unobtrusive.

In England artistic circles of the 1880s and 1890s eschewed the use of diamonds and ostentatious jewellery and condemned the shoddiness of mass-produced pieces. Followers of William Morris and the ARTS AND CRAFTS MOVEMENT preferred individually designed and hand-crafted work emanating from such medieval-inspired guilds as C. R. Ashbee's Guild of Handicraft. At the same time the avant-garde on the Continent brought innovative and daring designs to jewellery in the Art Nouveau style, which combined such naturalistic elements as flora, fauna and insects with the influence of Japanese art and an interest in Symbolism (*see* GERMANY, fig. 68). RENÉ LALIQUE, a leading Parisian designer, produced some of the most remarkable examples of Art Nouveau jewellery (see colour pl. II, fig. 1).

BIBLIOGRAPHY

H. Vever: *La Bijouterie française au XIX siècle*, 3 vols (Paris, 1908–12)
C. Gere: *Victorian Jewellery Design* (London, 1972)
M. Flower: *Victorian Jewellery* (London, 1973)
P. Hinks: *Nineteenth Century Jewellery* (London, 1975)
Les Fouquet: Bijoutiers & joailliers à Paris, 1860–1960 (exh. cat., Paris, Mus. A. Déc., 1983)
G. Munn: *Castellani and Giuliano* (London, 1984)
D. Scarisbrick: *Ancestral Jewels* (London, 1989)
Pariser Schmuck, 1850–1900 (exh. cat., Munich, Bayer. Nmus., 1989–90)
S. Bury: *Jewellery, 1789–1910*, 2 vols (Woodbridge, 1991)
D. Scarisbrick: *Jewels in Britain, 1066–1837* (1994)

MARY FEILDEN

6. AFTER 1900. By 1900 it was accepted that jewellery could be an art in its own right and not simply a fashion accessory or a convenient way of storing and displaying wealth. The work of the art jeweller, studio jeweller or craft jeweller, as he has been variously called, was generally handmade and valued for its design and workmanship rather than for the cost of the gems and metal. It arose from the imagination of its creator and the tastes of its wearer rather than the whims of fashion. The orthodox jeweller, trained and nurtured by 'the trade', however much he affected to despise the art jewellers, often ended up by imitating them. To a great extent the history of jewellery design in the 20th century is concerned with the interaction between the traditional jeweller and the avant-garde; both made an equal contribution.

In 1900 there were clear signs that the passion for Art Nouveau was beginning to fade in Paris, while in Britain the Arts and Crafts Movement was still in the ascendant. In complete contrast to the highly professional Parisian Art Nouveau jewellers, such pioneers of British Arts and Crafts jewellery as Alexander Fisher (1864–1936), Henry Wilson, Georgina Gaskin (1868–1934) and Arthur Gaskin (1862–1938) were self-taught amateurs who worked according to their own arbitrary code of 'honest workmanship'. Most of their work was in silver, hardstones and enamel because these were cheap and appropriate to the popular art the movement was out to establish. They preferred to build up their jewellery piece by piece, rather than pierce it out of sheet metal, and rarely finished it to a smooth polish. The machine was, in theory at least, banished from the workshop, and it is one of the many paradoxes of Arts and Crafts jewellery that some of its most successful creations commercially as well as aesthetically were the 'Cymric' jewels made by Liberty & Co. by a combination of hand and mechanical methods.

Jewellery made according to the guiding principles of the Arts and Crafts Movement was produced in other parts of Europe and in America. Florence Koehler of Chicago won an international reputation for her leafy designs set with informal groupings of gems in 18-carat gold. In Copenhagen, Georg Jensen established a Scandinavian style of plump scrolls and plant forms set with Baltic amber, stained green chalcedony and garnets. C. R. Ashbee and Charles Rennie Mackintosh both visited Vienna, and although the jewellery produced by the Wiener Werkstätte was unmistakably Central European, English and Scottish influence can be traced in the designs of Carl Otto Czeschka and Josef Hoffmann, while those of Dagobert Peche and Kolo Moser are more Viennese. The factory producers of Pforzheim in Germany were quick

to adapt these simple Viennese designs to mass production and thus succeeded in producing the truly popular style that the Arts and Crafts dream had failed to realize.

Arts and Crafts was a reaction not only against the machine but also against the professional jeweller, whose work at this time was remarkably skilled. The introduction of platinum and improvements in diamond-cutting produced jewels whose settings were almost invisible in wear. The result was a neo-classical style of swags, garlands and festoons with overtones of the 18th century. The very hardness of platinum was an advantage because it enabled the craftsman to execute piercing and engraving of almost microscopic fineness. The magnificently swagged and garlanded neo-classical designs produced at this time by such firms as Cartier represent some of the finest diamond jewellery ever made.

Léon Bakst's vibrant designs (1909–21) for Serge Diaghilev's Ballets Russes typified the current fascination for the mystic East. Lotus, papyrus, bamboo and swastika motifs appeared in many jewels. In the years before World War I jewellery became more stylized and two-dimensional, evidence of the transition into Art Deco. It was then that the characteristic Art Deco palette of tango (orange-red), ultramarine, eau de Nil (a pale green), buttercup, lavender and black made its first appearance in jewellery, expressed in enamel, lacquer or a variety of such materials as jade, ivory, lapis lazuli, stained agate, onyx or jet, with the distinctive tango represented by coral or cornelian.

Many of the jewels that are associated with the 1920s—the bandeaux, the plumed aigrettes, the long tasselled neckchains and pendulous earrings—were already established fashions before World War I. Jewels were designed to sway with the body in time to the rhythms of the tango and the Charleston: Oriental fashions took an even firmer hold in the 1920s. Jewels were set with carved precious stones from India and Chinese jades. The Parisian firms of Lacloche, Cartier (see colour pl. II, fig. 3) and Boucheron led the field at this time. The trend towards simplicity and formality became crystallized in the abstract geometrical designs of Jean Fouquet (1899–1984), Raymond Templier (1891–1968), Gérard Sandoz (*b* 1902), Jean Després (1889–1980) and Georges Fouquet (1862–1957; *see* ART DECO, fig. 1).

In 1929, the year of the Wall Street crash, attitudes to jewellery changed, making it a focal point on the costume rather than a complement to the body. Neckchains and aigrettes were out, and long pendent earrings were replaced by compact earclips. Two new styles emerged, both fixed to the dress rather than the person, the plaque brooch, which was exactly what its name suggests, and the clip, secured by clamping it to the neckline or lapel. It was the age of the gadget, and clips were often made in pairs so that the two could be united in a single 'double-clip' brooch or even a bracelet. Jewellery tended to be large and impressive, a symbol of security in an insecure age. Oriental fashions held their own, dominated by Chinese style. The geometrical style manifested itself in the hooked and stepped decoration of Aztec Mexico and in the mechanistic cocktail jewellery of the 1940s.

Between the wars, although a few of the original Arts and Crafts jewellers were still at work, the movement lost

9. Neckpiece by David Watkins, acrylic and gold, made in England, 1975 (London, Victoria and Albert Museum)

much of its impetus. The firm of Georg Jensen continued to produce their tried and tested designs but also commissioned such artists as Nanna Ditzel (*b* 1923) and Henning Koppel (1918–81) to invent clean sculptural forms that more accurately reflected the spirit of the post-war period. In Europe and America after 1945 several painters and sculptors began designing jewellery. One of the most successful was Alexander Calder, who made simple ornaments of forged metal. Georges Braque, Salvador Dalí, Max Ernst and others each produced jewels in his own individual style. It was not until the late 1950s, however, that an alternative art jewellery style emerged that truly reflected the preoccupations of its time. These jewels combined the apparent randomness of action painting and of the *objet trouvé* by mounting uncut natural crystals, meteorites and misshapen pearls in settings of rough or molten gold. Emphasis was on texture, giving these jewels the impression of having been subjected to the heat of a nuclear explosion. By the end of the 1960s many of the

avant-garde who had devised the new style—David Thomas (*b* 1938), John Donald (*b* 1928), Gerda Flockinger (*b* 1927), Andrew Grima (*b* 1921) and Louis Osman (1914–96) in England, Gilbert Albert (*b* 1930) in Switzerland, Arnaldo Pomodoro and Giò Pomodoro in Italy, and Bjorn Weckstrom (*b* 1935) in Finland—had become part of the jewellery establishment.

In Germany at the same time Reinhold Reiling (1922–83) organized his textures by mathematically juxtaposing them with free asymmetrical forms. Reiling in Pforzheim, Friedrich Becker (*b* 1922) in Düsseldorf and Hermann Junger (*b* 1928) in Munich trained a whole generation of jewellers, and in the 1970s the centre of gravity of the new movement shifted from Britain to Germany. After centuries of using much the same traditional materials and techniques, the jeweller awoke to what the space age had to offer: acrylics (see fig. 9) and polyester resins, nylon monofilaments, anodized aluminium and the refractory metals, titanium, zirconium and niobium, with their multicoloured patinas. At the same time the jeweller was using familiar materials that were unconventional in the context of modern Western jewellery—steel, ivory, wood, ceramic, silk and feathers. Other jewellers rejected such materials as ivory or diamonds for ideological reasons. There was experimentation at every level. The body was sometimes reduced to an abstraction by sectioning it visually or even by partially obliterating the face. Some pieces even seem to have been intended to restrict the wearer's movements, thereby increasing his or her own self-awareness. The notion that jewellery should be precious and long-lasting was confounded in ornaments made of postcards, wallpaper or plastic toys. Jewellery was often thought of as sculpture rather than decoration and was designed with a stand to display it. In the 1980s the very nature and purpose of jewellery was re-examined and challenged in objects whose purpose was as much to make a statement or pose a question as to beautify the wearer.

BIBLIOGRAPHY

H. Wilson: *Silverwork and Jewellery* (London, 1903/*R* 1948)
International Exhibition of Modern Jewellery, 1890–1961 (exh. cat., London, Goldsmiths' Co., 1961)
G. Hughes: *Modern Jewellery, 1890–1967* (London, 1968)
C. Gere: *European and American Jewellery, 1830–1914* (London, 1975)
R. Turner: *Contemporary Jewellery* (London, 1976)
Synthetic Jewellery (exh. cat. by B. Beaumont-Nesbitt, Birmingham, W. Midlands A., 1978)
V. Becker: *Antique and Twentieth Century Jewellery: A Guide for Collectors* (London, 1980/*R* New York, 1982)
W. J. Schweiger: *Wiener Werkstätte: Kunst und Handwerk, 1903–1932* (Vienna, 1982; Eng. trans., London, 1984)
P. Hinks: *Twentieth Century British Jewellery, 1900–1980* (London, 1983)
S. Raulet: *Bijoux art déco* (Paris, 1984)
V. Becker: *Art Nouveau Jewellery* (London, 1985)
B. Cartlidge: *Twentieth Century Jewellery* (New York, 1985)
P. Dormer and R. Turner: *The New Jewellery* (London, 1985)
J. Culme and N. Rayner: *The Jewels of the Duchess of Windsor* (London, 1987)
Jewels of Fantasy: Costume Jewelry of the 20th Century (exh. cat., Los Angeles, CA, Co. Mus. A.; Baltimore, MD, Mus. A.; 1993–4)

PETER HINKS

Jewish art. Art created by artists or craftsmen whose religion or culture was Jewish, or made for purposes restricted or peculiar to a Jewish population or setting. The existence of an original and distinctively Jewish style of art, particularly in antiquity or the Middle Ages, is not accepted by all scholars, however, some of whom suggest that Jews simply adapted the art and architecture of their surroundings.

□

I. Introduction. II. Architecture. III. Funerary art. IV. Wall paintings and mosaics. V. Hebrew books and illustration. VI. Ritual objects. VII. Easel painting, sculpture and graphic arts, after 1800. VIII. Museums and collections. IX. Historiography.

I. *Introduction.*

1. History and people. 2. Religion. 3. Attitude to art. 4. Iconography.

1. HISTORY AND PEOPLE. Judaism is the religion and, in a broader sense, the culture of a people that has been variously known as the Hebrews, Israelites and Jews over the course of nearly 4000 years. 'Hebrews' refers primarily to the earliest ancestors of Judaism, the Semitic people of the patriarchal era of Abraham, Isaac and Jacob; Jacob was also called Israel, and 'Children of Israel' or 'Israelites' refers to his progeny and their families, who were grouped in 12 tribes. The kingdom that was thus formed on the eastern seaboard of the Mediterranean and was ruled successively by Saul, David and Solomon, was also called Israel: it retained this name after Solomon's death, and the secession of the tribes of Judah and Benjamin. Judah, the tribe that claimed descent from Jacob's fourth son, gave its name to the breakaway kingdom whose capital was Jerusalem, and later, under Persian, Greek and Roman rule, to the province of Judea. 'Jews' is derived from 'Judeans' and denotes their descendants as well as those who over the centuries have joined them as converts.

In 722 BC the northern kingdom of Israel was invaded by the Assyrians, and its citizens were deported to Mesopotamia, where in the course of time they lost their identity in the local milieu, becoming the 'ten lost tribes'. The tiny southern kingdom of Judah survived another 150 years, until in 586 BC the Babylonians under Nebuchadnezzar besieged Jerusalem, sacked the Temple and deported the religious and civil leadership of the population. Thenceforth, exile and dispersion were to become the typical condition of the Jewish people. From the Babylonian captivity to the present day, the majority of Jews have lived outside the borders of their ancient homeland, in what is collectively called the diaspora. In 538 BC the Persian king Cyrus the Great, having conquered Babylon, gave permission to the Judean exiles to return to Jerusalem and rebuild the Temple. Significantly, it was a minority who chose to take advantage of the royal offer, for the exiles had received a sympathetic welcome in Babylon. From the reign of Nebuchadnezzar until the 11th century AD a large and generally stable Jewish community flourished in Mesopotamia under a succession of Persian, Hellenistic, Parthian, Sasanian and Islamic dynasties. For a time the Jewish population of Egypt was similarly influential, turning the city of Alexandria into a Jewish metropolis. It was for these Jews, no longer conversant with Hebrew, that a translation of the Bible into Greek, known as the Septuagint, was made.

The rise of the Roman Empire, which incorporated the province of Judea, was to have a significant effect on Jewish migration. Refugees found their way to every corner

PLATE I Jewellery

Gold armbands with terminals in the form of a triton and tritoness holding Erotes, h. 150 mm and 159 mm, probably from northern Greece, *c.* 200 BC (New York, Metropolitan Museum of Art)

1. Corsage ornament, gold, enamel, diamonds and opals, l. 190 mm, made by René Lalique, France, 1898–1900 (Lisbon, Museu Calouste Gulbenkian)

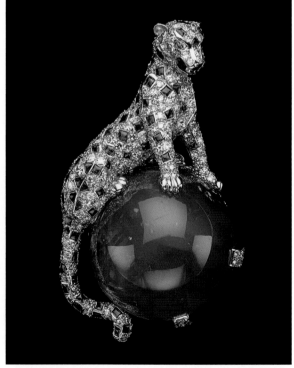

2. Thumb ring, soft gold inset with rubies and emeralds, enamelled interior, diam. 30 mm, from India, Mughal, first half of the 17th century (London, Victoria and Albert Museum)

3. Panther clip, pavé set with diamonds and calibré-cut sapphires on a cabochon sapphire, h. 55 mm, created for the Duchess of Windsor by Cartier, Paris, 1949 (sold Sotheby's, Geneva, 3 April 1987, lot 59)

PLATE III

Jewellery

1. Pendant, gold, cloisonné enamel and turquoise, h. 44 mm, from Egypt, Fatimid period, 12th century (New York, Metropolitan Museum of Art)

2. 'Diane' bracelet, gold, enamel and diamonds, diam. 69 mm, made by Alphonse Fouquet (model by Albert-Ernest Carrier-Belleuse; enamels by Paul Grandhomme), 1883 (Paris, Musée des Arts Décoratifs)

1. Alfred Jewel, gold with a cloisonné enamel portrait, h. 63 mm, Anglo-Saxon, probably 9th century AD (Oxford, Ashmolean Museum)

2. 'Vulture' collar, gold and polychrome glass, w. 480 mm, Egypt, from the tomb of Tutankhamun (*reg c.* 1332–*c.* 1323 BC), New Kingdom, 18th Dynasty (Cairo, Egyptian Museum)

of the empire. Once Christianity became the official state religion under Constantine the Great (*reg* AD 306–37), with a consequent increase in anti-Jewish legislation, Jews travelled still further afield in search of a refuge. The communities that were established in France, Germany and throughout eastern and central Europe are traditionally known as the Ashkenazim, while those that are of Spanish, Portuguese, Middle Eastern or North African descent have been referred to in modern times as the Sephardim. Strictly, Sephardim are descendants only of Spanish and Portuguese Jews.

It is a broadly valid generalization that in the medieval world Jews fared better under Muslim rule than under Christian jurisdiction. Nowhere was this more clearly illustrated than in Muslim Spain. For nearly 500 years the Sephardi Jews there enjoyed a 'golden age', achieving a dazzling synthesis of rabbinic scholarship and secular culture. In contrast, the Ashkenazi Jews of western Europe led a persecuted, insecure existence. The emperor Charlemagne and his successors had encouraged Jewish immigration because of trade connections with the Mediterranean and further east. From their bases in France, Jewish merchants fanned out across eastern Europe and over the Russian steppes to the Middle East, whence they continued to India and China. By the close of the 11th century, Jewish settlement had spread from north-eastern France to the commercial centres along the Rhine and the valleys of the Danube and the Elbe. Jews from Normandy followed William the Conqueror across the Channel and established themselves in London and provincial cities. France, Germany and the neighbouring countries came to house Jewish communities as large and important as those of the Iberian peninsula. The Crusades, however, ushered in for Jews two grim centuries (11th–13th century) of siege, pillage and massacre all the way from the Rhineland to Jerusalem. In 1182 Philip II Augustus of France expelled Jews from the crown domains. Edward II banished them from England in 1290. The communities of Germany and central Europe were subjected to widespread mob violence in 1298 and 1336 and, most terribly of all, after the Black Death of 1348–9.

In 1492, an edict of Ferdinand and Isabella of Spain expelled around 150,000 Jews from the country that had been their home for over a thousand years. Some of the refugees went to North Africa or provinces of the Ottoman empire; others joined their co-religionists in Europe, including Poland, where royal protection was offered as an inducement to settle in sparsely populated territories. Thus over the next 400 years Poland, Lithuania, Romania and southern Russia came to house the largest concentration of world Jewry. By the middle of the 19th century 75% of Jewry (5.7 million people) lived in eastern Europe.

The French Revolution provided a decisive point in Jewish history. Until the Enlightenment of the 18th century and the slow acquisition of civil rights in the wake of the French Revolution, Jewish existence in Europe was, for the vast majority, lived out behind ghetto walls, in strict observance of rabbinic legislation. In Muslim countries the Jews, marked out by inferior *dhimmī* (protected non-Muslim) status, were similarly observant, if less physically circumscribed or oppressed than Western Jews. For both Ashkenazim and Sephardim, the study of the vast accumulation of Jewish law and lore, and the leading of lives regulated by the disciplines of religious teaching, were the palliative against poverty, hostility and suffering. All that changed with the French Revolution, markedly so in Europe, though to a lesser extent in eastern countries, where religion remained more a matter of definition than personal choice. Jewish life has become much less cohesive. Emancipation presented the Jew with options, from conversion or assimilation at one extreme to ardent nationalism at the other, with religious reform, stubborn traditionalism, modified orthodoxy or variants of radical socialism somewhere in between. In its ideological manifestations, Jewish history since 1789 has been a response to modernity and to the opportunities, challenges and dilemmas of confronting society beyond the ghetto walls.

The Russian pogroms of 1881 prompted the start of a mass migration of east European Jewry; nevertheless, when Hitler came to power in Germany in 1932, the bulk of Jewry, about 9.2 million, still resided in eastern Europe. By 1945 only 3.1 million Jews survived in Europe. This has brought about the virtual disappearance of the former major centres of Jewish population in Poland, in the territories of the Habsburg empire and in eastern Europe. Two million Russian Jews are the only significant reminder of centuries of vibrant Ashkenazi Jewish existence. In the late 20th century there were approximately 14 million Jews in the world, including three million in the state of Israel, established in 1948 in the ancient Jewish homeland in Palestine (*see* ISRAEL, §I). The Jewish communities elsewhere account for the remaining 11 million, with by far the largest number—some 5.8 million—living in the USA. The Jews have always retained a presence in, and fervent attachment to, their historic homeland. Nevertheless, they remain essentially a diaspora people, as they have been since the 6th century BC. Their survival, tenacity and resilience owed much to the stubborn fidelity with which they maintained the faith of their ancestors, and also to their knack of adapting their talents and energies to changed circumstances and environments. Being a Jew comprehends not only religious observance but also a keen sense of group identity and tribal loyalty. There is a coherent strand of identity and a sense of shared historical experience that links the secular Israeli, the Hasid (ultrapious worshipper) and the metropolitan intellectual, both to each other and to a past that stretches back to the nomadic wanderings of Abraham almost 4000 years ago.

BIBLIOGRAPHY
I. Abrahams: *Jewish Life in the Middle Ages* (New York, 1896/*R* 1969)
S. Dubnow: *History of the Jews in Russia and Poland*, 3 vols (Philadelphia, 1916–20)
Y. Baer: *A History of the Jews of Christian Spain: Their Social, Political and Cultural Life*, 2 vols (Philadelphia, 1942)
S. Zeitlin: *The Rise and Fall of the Jewish State*, 3 vols (Philadelphia, 1962–78)
A. Sharf: *Byzantine Jewry from Justinian to the Fourth Crusade* (London, 1971)
E. Ashtor: *The Jews of Moslem Spain*, 2 vols (Philadelphia, 1975)
H. M. Sachar: *The Course of Modern Jewish History* (New York, 1977)
N. de Lange: *Atlas of the Jewish World* (London, 1984)
B. Lewis: *The Jews of Islam* (Princeton, 1984)

2. RELIGION. The history of the Jewish religion begins with Moses, who led the Children of Israel out of Egypt

c. 1240 BC. It was he who, during the years of sojourn in the wilderness, promulgated the laws of ritual practice, personal purity and ethical conduct that moulded a disorganized rabble of runaway slaves into a 'chosen' people recognizing a covenant relationship with the God of their ancestors. According to the Bible, that covenant was sealed with the giving of the Law at Mt Sinai in the third month after the Exodus from Egypt. The revelation has ever after been regarded as the greatest single event in the history of the Jewish people. The Law or Torah, which includes the whole of the Pentateuch, as well as a body of oral law, was God's special gift to Israel. Not only those who stood at Sinai, but generations yet unborn were irrevocably bound by the divine exhortation: 'You shall be to Me a kingdom of priests and a holy nation' (Exodus 19:6). All subsequent Jewish religious literature, whether in the collections of rabbinic writings that make up the Mishnah, the Talmud and the Midrash, in the exegesis of medieval commentators or in the legal codifications of Moses Maimonides (1138–1204) and other scholars, is essentially an explanation of or commentary on the statutes, laws and commandments given at Mt Sinai. Broadly speaking, that literature can be classified either as *Halakhah* or *Aggadah*. *Halakhah*, from a Hebrew verb meaning 'to walk', is usually translated as 'law', but includes everything that regulates human conduct and everything that is or can be expressed in the imperative, whether it is enforceable or not; it is prescriptive, it defines and decides. *Aggadah* (Heb.: 'narration') is everything else: theology, history, legend and parable; it is descriptive, it explores and speculates.

Despite being a religion so firmly grounded in the law, Judaism has no creeds in the Christian sense. Judaism spells out what Jews must do rather than what they should believe. It legislates rather than dogmatizes, and it regulates conduct rather than thought. Consequently, there is no one, 'official' Jewish theology. Not even Maimonides's Thirteen Principles of the Faith, which he considered fundamental to Judaism and which were subsequently included in the prayer book (*see* MAIMONIDES MANUSCRIPTS), were ever formally endorsed or declared binding. The beliefs of Judaism are not contained in any catechism but have to be extrapolated from its literature as a whole. What emerges is a theocentric world view, affirming that God is the creator, sustainer and arbiter of all things. Human life is viewed from the perspective of, and in relation to, the Divine Will. Mankind is the crown of God's creation, imbued with the freedom to choose between good and evil. Human nature is inherently pure but is endowed with a good inclination (Heb. *yezer tov*) and an evil inclination (*yezer ha-ra'*). Man's propensity to sin is evident, but its antidote is repentance. Sin breaches the relationship with God; in repenting, man returns to him. The most important festival of the Jewish calendar, the Day of Atonement (Yom Kippur), is spent in fasting, prayer and repentance, in order to confess one's failings to God and draw comfort from the assurance that he will pardon the sincere penitent.

Second only in importance to man's relationship with God are his relationships with fellow human beings. Every aspect of social, marital, civic, legal and economic behaviour is exhaustively analysed in the literature of Judaism.

Man's responsibilities can be summed up thus: to work for a just and compassionate society; to exemplify God's expectations by one's personal conduct; and to bring all peoples to a knowledge of God's law and obedience to his will. The messianic age is envisaged as a time not only when the scattered of Israel will be redeemed, but when all mankind lives together in brotherhood and peace. To speed the coming of that day by individual and collective example is one facet of the Jewish mission to be 'a light unto the nations'. God, Torah and Israel—faith, law and people—have always been the entwined, threefold components of Judaism. The emphasis may alter according to time and circumstances, but there is an underlying continuity that gives to Judaism its essential shape and identity.

BIBLIOGRAPHY

G. F. Moore: *Judaism in the First Centuries of the Christian Era*, 3 vols (Cambridge, MA, 1927–30)
H. Schauss: *The Jewish Festivals* (London, 1938, rev. 1986)
——: *The Lifetime of a Jew* (Cincinnati, 1950)
G. von Rad: *Theologie des Alten Testaments*, 2 vols (Munich, 1957; Eng. trans., London, 1972)
R. J. Z. Werblowsky and G. Wigoder: *The Encyclopaedia of the Jewish Religion* (London, 1967)
L. Jacobs: *A Jewish Theology* (London, 1973)
I. Klein: *A Guide to Jewish Religious Practice* (New York, 1979)
A. P. Bloch: *The Biblical and Historical Background of Jewish Customs and Ceremonies* (New York, 1980)
D. J. Goldberg and J. D. Rayner: *The Jewish People: Their History and their Religion* (London, 1987/R 1989)

DAVID J. GOLDBERG

3. ATTITUDE TO ART. The relationship between art and Judaism has never been easy. The so-called Second Commandment enjoins: 'Thou shalt not make unto thee any graven image, or any likeness of any thing that is in heaven above or that is in the earth beneath or that is in the water under the earth' (Exodus 20:4). According to a widely held view, this ensured Jewish devotion to the 'beauty of holiness', in contrast to the Greek 'worship of beauty'. Scholarly research and archaeological discoveries during the 20th century have refuted this theory—although it is still being quoted—and it is now realized that the Jewish involvement with multiple civilizations, cultures and societies has constantly demanded new interpretations of the biblical injunction.

The pronouncement 'Thou shalt not make unto thee any graven image'—the rest of the text appears to be a much later addition—has been linked by many biblical scholars with the desert experience of the Jews. It may have been formulated to keep the semi-nomads from creating idols or adapting the idols of the many sedentary societies encountered during their wanderings. Moreover, heavy sculptures would have been difficult to carry for a society on the move. However, in the 10th century BC, when the Israelites conquered Canaan and became themselves a sedentary people with a monarch, their attitude towards images changed appreciably. King Solomon built luxurious palaces and a splendid Temple in Jerusalem in imitation of similar palaces and temples in such neighbouring states as Phoenicia. Within the Temple area in Jerusalem there were sculpted images, including the 12 oxen that upheld the sea of bronze and the cherubim throne on which divinity was seated.

Images and *bamot* (sacred high places) generally flourished under both Israelite and Judaean kings until the 7th

century BC and the advent of King Josiah (*reg c.* 640–609 BC), whose iconoclastic movement is described in Deuteronomy 12:3: 'And ye shall overthrow their altars, and break their pillars, and burn their groves with fire; and ye shall hew down the graven images of their gods, and destroy the names of them out of that place'. Josiah's reforms seem to have marked a sudden break in the flow of a society with a reputation for tolerating 'foreign' gods, and his severe strictures do not reflect the entire Jewish historic experience or attitude towards art (although many scholars still claim otherwise).

In the 1st century AD the question of images was raised by Philo (*c.* 20 BC–AD 50), the Alexandrian Jewish philosopher, and by the Jewish historian Flavius Josephus (AD 37–after 93), who wrote in *Against Apion* (II.6): 'Furthermore, our lawgiver forbade the making of images, not as if prophetically indicating that the power of the Romans was not to be honoured, but as though scorning a matter that was useful neither to God nor man'. Josephus' attitude does not necessarily support the strict observance of the Second Commandment, however. It may reveal only his attempt to excuse the Jewish hatred of Rome that had led to demonstrations against Roman images and military standards. Philo revealed a greater indebtedness to Platonic thought than to biblical ideas: '[Moses] banished from his own commonwealth painting and sculpture, with all their high repute and charm of artistry, because their craft belies the nature of truth and works deception and illusions through the eyes to souls that are ready to be seduced' (*On the Giants*, XIII.59).

Figural paintings and mosaics found during 20th-century excavations of synagogue buildings have challenged previous opinions about so-called 'normative rabbinic Judaism' during the Roman period and led to the revision of stereotyped theories on Jewish attitudes towards art in the Early Christian and Byzantine periods. Although terse, there are two statements relating to the flourishing synagogue art in Palestine and elsewhere in the Jerusalem Talmud: 'In the days of Rabbi Jochanan [3rd century AD] they began to paint on walls', and 'in the days of Rabbi Abun [4th century AD] they began to make designs on mosaics, and were not hindered' (*Avodah Zarah* 426).

In medieval times, the 13th-century Rabbi Meir of Rothenburg permitted the decorating of prayerbooks with animal and bird figures, and in Christian Spain, where Jewish aristocrats rose to positions of prominence, exquisitely illustrated Hebrew manuscripts were produced that express in paint what a Spanish Jewish scholar wrote in the late 14th century or early 15th:

> One should always contemplate beautiful books with splendid decorations, fine calligraphy, parchment and bindings. The contemplation of pleasing forms, beautiful images and drawings broadens and stimulates the mind and strengthens its faculties. I want to adorn the Holy Books [for] this matter is worthy and obligatory, and call attention to the beauty, splendour and aesthetic quality to be found in them. As God wanted to adorn His Holy Place with gold, silver, jewels and precious stones, so [should it] be properly done with His Holy Books (*Ma'aseh Efod* 19).

In Islamic lands, however, figural art was not used for religious purposes, and Jews in these countries did not decorate their synagogues or prayerbooks with figural images, as they did in Christian Europe.

In the modern period traditional (Orthodox) Jews have generally refrained from figural art, citing the Second Commandment and later negative rabbinical statements about art. By contrast, liberal (Reform and Conservative) Jews have encouraged art in the home and the synagogue, either ignoring or interpreting leniently the supposed taboo.

Enc. Jud.

BIBLIOGRAPHY

J. Gutmann, ed.: *No Graven Images: Studies in Art and the Hebrew Bible* (New York, 1971)
J. M. Baumgarten: 'Art in the Synagogue: Some Talmudic Views', *The Synagogue: Studies in Origins: Archaeology and Architecture*, ed. J. Gutmann (New York, 1975), pp. 72–9
J. Gutmann, ed.: *The Image and the Word: Confrontations in Judaism, Christianity and Islam* (Missoula, 1977)

JOSEPH GUTMANN

4. ICONOGRAPHY.

(i) Before *c.* 1600. (ii) After *c.* 1600.

(i) Before c. *1600.* As distinct from the earlier Israelite biblical culture, Jewish art and iconography may be said to have come into being with the birth of Judaic culture in the Second Temple period (6th century BC; *see* §1 above), developing in the Hellenistic period in Judea and the Jewish communities in Galilee. After the destruction in AD 70 of the Second Temple, Jewish migration helped to spread this art throughout Europe, North Africa and the Middle East. Because of this dispersion, no unified Jewish style developed, and Jewish artists adopted the style of their host countries. Nevertheless, it was possible for a specifically Jewish iconography to develop, since Jews throughout the diaspora maintained close relations with other communities and shared common beliefs, language, literature, rites, customs, symbols and institutions.

(a) Biblical. (b) Midrashic. (c) Symbolic. (d) Ritual. (e) Classical models and Christian imitations.

(a) Biblical. Any depiction of biblical subject-matter from the period of early Judaism should be considered as illustrative of Jewish iconography, although the gestures and images would have been drawn from Classical art. An early example is a wall painting of the *Judgement of Solomon* (1 Kings 3:16–27) from Pompeii (before AD 79; Naples, Mus. Archaeol. N.; see fig. 1), which may have been fashioned after a scene of a wise Egyptian king (Gutmann, 1972). A coin from Apamea (now Dinar) in Turkey (late 2nd century AD–early 3rd; priv. col., see Narkiss, 1979, 'The Jewish Realm', no. 350) depicts Noah and his wife within and outside the ark with the raven and the dove (Genesis 6:13–8:15); it was probably modelled after wall paintings in the synagogue at Apamea, which claimed to possess parts of Noah's Ark and was therefore named *Kibotos*, i.e. 'Ark'.

Biblical subject-matter with national connotations is clearly Jewish, as for example a scene of the binding of Isaac (Genesis 22), which alludes to the covenant between God and the People of Israel, guaranteeing their existence for ever. Non-biblical visual elements, depicted within a biblical scene, may have derived from Jewish oral tradition or literary sources. The choice of such Jewish elements, their placement in the visual composition and the gestures

1. *Judgement of Solomon*, wall painting from Pompeii, before AD 79 (Naples, Museo Archeologico Nazionale)

of the protagonists, may also identify the scene as Jewish. In the painted scene of the *Binding of Isaac* in the panel above the Torah niche in the synagogue at Dura Europos (AD 244–5; Damascus, N. Mus.; see Kraeling, pl. LI, and Goodenough, xi, pl. III; *see also* DURA EUROPOS, §3), the main elements of the biblical story—Isaac lying bound on the altar while Abraham holds the sacrificial knife and the ram stands below—are joined by others that are not mentioned in the Bible and that carry an additional Jewish interpretation: the hand of God instead of an angel (Genesis 22:11) stopping Abraham from sacrificing his son; the ram standing by a tree, rather than caught in a thicket (Genesis 22:13); and Sarah, Isaac's mother, shown within a mountain or a tent in the top right-hand corner. These changes derive from homiletic rabbinical literature, which interprets the biblical story in a midrashic manner.

(b) Midrashic. The midrashic method involves explaining a complicated verse of the Bible by 'calling' (Heb. *darosh*) on another verse to clarify it. The second verse may relate to the first by word or by topic, and sometimes there are additional stories, legendary (Heb. *agadah*) or legal (*halakhah*), invented by rabbis to help in the interpretation. In the binding of Isaac, God appears rather than an angel, because Abraham was not prepared to accept from an angel any change to the order he had received direct from God himself. The ram had been waiting patiently in paradise since the sixth day of creation, when God created it to be of use during the unfolding of the history of the world. Sarah appears in order to explain her death, which is mentioned in the following chapter of Genesis (23): according to the Midrash, Satan, having failed to prevent Abraham and Isaac from carrying out God's command, carried Sarah to a high mountain and showed her what her husband was doing to their only son, at which moment she died.

A similar representation of this last Midrash appears in an illuminated Hebrew Pentateuch supposedly from Regensburg (*c.* 1300; Jerusalem, Israel Mus., MS. 180/52, fol. 18*v*), in which Satan hoists Sarah on to his back to show her the sacrifice on the left. These two representations of a Jewish interpretation of the story, appear in purely Jewish contexts, a synagogue and a Hebrew manuscript, and are therefore clear examples of Jewish iconography. This Jewish iconographical element also appears in Christian contexts, for example on the painted ceiling of

a funerary chapel at el-Bagawat in the Kharga Oasis in Egypt (5th century AD; see Goodenough, xi, pl. III), where Sarah appears above Abraham and Isaac with her name inscribed in Greek; the ram, which has here become a lamb, according to its Christian interpretation, is not caught in a thicket but tied to a tree with a rope, an element that also appears in the mosaic floor of the BETH ALPHA synagogue in Israel (6th century AD; *in situ*). Some of the early Christian Fathers must have been familiar with parts of the Jewish midrashim, using them either to support their ideas or in their polemics against the Jews, and their teachings may have influenced contemporary or later artists. However, since there is no Early Christian mention of Sarah's appearance in the sacrifice of Isaac, it may be that the Christian artist of el-Bagawat used a Jewish visual model for this painting, possibly without understanding its Jewish roots. The el-Bagawat artist was, however, aware of the Christian interpretation of the scene as a forerunner of the Crucifixion of Christ. The lamb substituted for the ram stresses the Christian reference to Christ, the Lamb of God.

(c) Symbolic. Sometimes it is not only interpretation that determines what is Jewish iconography, but also a juxtaposition of scenic and symbolic elements within one composition. For example, the inclusion of a Temple façade in the panel above the Torah niche next to the *Binding of Isaac* scene at Dura Europos refers to Jewish hopes of national redemption centred on the rebuilding of the destroyed Temple of Jerusalem. The seven-branched menorah placed next to the *lulav* (palm branch) and *etrog* (citron fruit) identifies the Greco-Roman façade as the Jewish Temple, and this combination of scenes and symbols helps to confirm the Jewish context. Another Temple façade, with sanctuary implements, and the scene of the *Binding of Isaac* also appear together on either side of a circle with the signs of the zodiac surrounding Helios in the mosaic floor of the Beth Alpha synagogue (see Sukenik, pl. 27).

These symbolic representations of the Temple of Jerusalem are but two of many such combinations of elements that appeared in early Jewish art. They also occur on funerary monuments such as the Jewish catacombs in Rome, BETH SHEARIM and elsewhere, on tombstones, sarcophagi, ossuaries, gold glass plates, clay and bronze oil

lamps, Torah plaques and coins. Even before the destruction of the Temple, its implements were used as symbols of Jewish statehood in a 1st-century BC graffito found in a priest's house in Jerusalem (Narkiss, 1974, figs 1 and 2) and on many coins of the Hasmonaean dynasty, the earliest of which is a coin of Mattathias Antigonos (40–37 BC) with a seven-branched menorah. These symbols include a typical Greco-Roman temple façade, interpreted either as the Ark of the Covenant in the wilderness or the Torah ark of the synagogue. Other symbols included such sanctuary implements as the menorah with its shovel, the altars and the shewbread table, as well as the two pillars of Solomon's Temple (1 Kings 7:15–22) and the *lulav* and *etrog*, symbolizing the Feast of Tabernacles. The relation of these objects to the Tabernacle in the wilderness and the two Temples immediately renders them symbolic rather than actual representations of one of the sanctuaries. Similar symbolic sanctuary implements appear in Hebrew illuminated Bibles of the 10th century in the Middle East, of the 13th–15th centuries in Spain and of *c.* 1300 in the Regensburg Pentateuch mentioned above (Nordström, 1968; Narkiss, 1969, pp. 42, 98 and 164, pls 1 and 29); indeed, in the Middle East and in Spain the Bible was sometimes referred to as the Temple of God (Heb. *miqdashya*). Other symbolic Temple elements include the 12 gates of Ezekiel's ideal Temple, as shown on Hanukkah lamps from 13th-century Spain.

(d) Ritual. In Jewish religious culture, custom is regarded as more binding than law. It may dictate the function of ritual objects (*see* §VI below) and may differ from one community to another. The most revealing customs depicted before *c.* 1600 occur in illuminated manuscripts (*see* §V, 1 below): there are colourful representations in Ashkenazi, Sephardi and Italian ritual books of such rituals as the machzor (the yearly cycle of prayer) or the Passover Haggadah. Subject-matter varies from illustrations of cooking customs and utensils, the serving of food and clothes, to rituals in the synagogue or at home. One of the most elaborate is the initiation of children into the study of the Torah, as represented in the Leipzig Machzor of *c.* 1320 from southern Germany (Leipzig, U. Bib., MS. V. 1102, I, fol. 131; see Narkiss, 1964, p. 96).

(e) Classical models and Christian imitations. Jewish iconography was initially borrowed from Classical Greek and Roman art. In the scene of the *Binding of Isaac* at Dura Europos, all of the elements—the altar, the knife and certainly the protagonists Abraham and Isaac, as well as the ram and the tree—are based on Roman models. Just as the Jewish artist used pagan models to create his Jewish iconographic composition, so the Christian artist used existing Jewish models to construct his version, stressing the sacrifice rather than the binding of Isaac. Thus, while the visual iconography may be similar in Jewish and Christian art, the context relates it to the Jewish sphere when it appears in a synagogue or a Hebrew illuminated manuscript or to the Christian when it adorns a Christian funerary chapel.

There are other cases where Christian art incorporates specifically Jewish interpretations without any obvious literary sources and at times, apparently, without any conscious knowledge of their Jewish origins. Most of the Old Testament scenes in Early Christian catacombs in Rome are based on Jewish depictions, some of which later completely disappeared from Jewish art. Examples of such descriptions in Christian catacombs are the scene of *Daniel in the Lions' Den*, which also appears in the mosaic floor at Naaran (6th century AD; *in situ*) and *Noah in the Ark*, which was also depicted in Apamaea. A further example is a wall painting (3rd century AD; Rome, Jewish Catacombs, Sacrament Chapel A3) showing Jonah lying naked and hairless under a gourd, a depiction based on a Jewish midrash explaining how his clothes and hair were eaten away by 600,000 little fish in the belly of the fish that swallowed him. The early Christian theologians saw the deliverance of Jonah (Jonah 2:3) after three days in the belly of the fish as a symbol of the resurrection of Christ (Matthew 12:38–40), but only the Jews were interested in the complete pictorial cycle of the story of Jonah as depicted in the catacombs, since for them he was a symbol of repentance (his book is read in the synagogue before the concluding prayer of *Neilah* on the Day of Atonement), and he was regarded as the man who would bring Leviathan to the Feast of the Righteous (see Narkiss, 'The Sign of Jonah', 1979). For the early Christian theologians, the story of Jonah as a symbol of resurrection corresponded well with other biblical figures who survived an ordinary death such as Noah, Isaac, Daniel and Job, and Christians depicted these episodes in their catacombs. The posture of Jonah lying naked under a gourd may have been borrowed by a Jewish artist from the pagan figures of the undying Dionysos or the ever-youthful shepherd Endymion. The creeping gourd symbolized resurrection in Roman art and corresponded to the sea monster depicted swallowing Jonah. The Jewish artist borrowed these images, possibly knowing their pagan interpretation, and used them to construct the cycle of the life of Jonah. The Christian artists may have borrowed the entire visual cycle from Jewish art, introducing into it the Christian interpretation of the risen Christ.

In a later period, during the Byzantine Palaiologan Renaissance, midrashic legends were used to illustrate biblical episodes known from literary midrashic sources but not found in Jewish visual art. One example is of the serpent that tempted Eve, succeeding by disguising itself as a camel, as can be seen in a 12th-century octateuch in Istanbul (Ecumenical Patriarch. Lib., Cod. 8, fol. 43*v*; *see also* EARLY CHRISTIAN AND BYZANTINE ART, §V, 2(iv)(b)). This scene, no longer extant, may have appeared earlier in Jewish art.

Indeed, one of the main problems in the study of Jewish iconography is the fact that many biblical and midrashic episodes that may have existed in late antiquity are extant only from the later Middle Ages. This gap in Jewish art from the 7th to the 13th century can perhaps be filled in part with the appearance of Jewish iconography in Christian art. Jewish art from this period may have been destroyed during the rise of Islam in the 7th century and the period of Byzantine iconoclasm in the 8th and 9th centuries, or as a result of the Crusaders' pillaging and massacre of entire Jewish communities in the 12th century. However, since Jewish iconographical elements appear in both Byzantine and Western art during this period, use

may have been made of Jewish models, a theory that helps to explain the appearance of Jewish midrashic interpretations in Byzantine and western European art, as well as in later Jewish art (Weitzmann, 1971; Nordström, 1967, 1968, 1971; Schubert, 1983; Schubert, 1952; Sed-Rajna, 1987). For example, in the panel from the synagogue at Dura Europos that shows the *Crossing of the Red Sea* (AD 244; Damascus, N. Mus.), the Israelites are crossing by twelve paths rather than one. The miracle is explained by a midrash that states that each of the tribes wanted to be the first to cross the sea, and so Moses cleft it into 12 paths. The appearance of the same midrash in later Hebrew illuminated Bibles and Passover haggadot may not be surprising and perhaps points to a continuous tradition in Jewish art that was also used by Christian artists, for example in the three later copies of the 6th-century Byzantine *Itinerary of Cosmas Indicopleustes* (e.g. *c.* AD 1000; Florence, Bib. Medicea-Laurenziana, MS. Plut. 9, 28, fol. 104) and a 12th-century copy on Mt Sinai (Monastery of St Catherine, Cod. 1186, fol. 73); and in the Spanish Pamplona Picture Bibles (e.g. 12th century; Harburg, Schloss, MS. I, 2, lat. 4° 15, fol. 57*v*). It also appears in the Castilian Duke of Alba Bible (1422–33; Toledo; Madrid, Duke of Alba priv. col., see Nordström, 1967), which was translated from the Hebrew with the help of Rabbi Moses Aragel. The continued use of Jewish iconographic elements in Christian art, probably without conscious understanding, may prove the continuous existence of Jewish art during these obscure centuries and may bridge the gap between early and later Jewish art.

Jewish artists also borrowed iconographical formulae from Christian art, sometimes without knowing the Christian interpretation. One possible example is Eve being pulled from the side of the sleeping Adam by God the Creator, towards whom she stretches out her hands. In Jewish art, mainly in Spanish Hebrew illuminated haggadot of the 14th century, the scene does not show God, although Eve still holds her hands outstretched. Another Christian motif is Moses taking his wife Zipporah and their two sons from Midian to Egypt, which is depicted in the 14th-century Spanish Golden Haggadah (London, BL, Add. MS. 27201, fol. 10*v*; see fig. 2) and resembles representations of the Virgin Mary carrying Jesus on a donkey on the *Flight into Egypt*. The Jewish artist must have seen French or Spanish illuminated Psalters with Old and New Testament illustrations and been inspired by this and other Christian interpretations, which he adapted to a Jewish context.

BIBLIOGRAPHY

E. L. Sukenik: *The Ancient Synagogue of Beth Alpha* (Jerusalem and London, 1932)
K. Schubert: 'Jewish Pictorial Traditions in Early Christian Art', *Jewish Historiography and Iconography in Early and Medieval Christianity* (Minneapolis, 1952), pp. 139–260
E. R. Goodenough: *Jewish Symbols in the Greco-Roman Period*, 13 vols (New York, 1953–68), esp. vols ix–xi
C. H. Kraeling: *The Synagogue* (1956, rev. 1979), viii/1 of *The Excavations at Dura-Europos: Final Report* (New Haven, 1943–)
B. Narkiss: 'The Leipzig Mahzor', *Machsor Lipsiae* (Leipzig, 1964), pp. 85–110 [facs. and intro.]
C. O. Nordström: *The Duke of Alba's Castilian Bible* (Uppsala, 1967)
——: 'Some Miniatures in Hebrew Bibles', *Synthronon*, ii (1968), pp. 89–105
B. Narkiss: *Hebrew Illuminated Manuscripts* (Jerusalem and New York, 1969)

2. *Moses on his Way from Midian to Egypt*, detail (95×80 mm) from a page (247×198 mm) of the Golden Haggadah, Barcelona, *c.* 1320 (London, British Library, Add. MS. 27201, fol. 10*v*)

F. Bucher: *The Pamplona Bibles* (New Haven and London, 1970)
B. Narkiss: *The Golden Haggadah* (London, 1970) [facs. and intro.]
K. Weitzmann: 'The Illustration of the Septuagint', *Studies in Classical and Byzantine Manuscript Illumination*, ed. H. L. Kessler (Chicago and London, 1971), pp. 45–74
J. Gutmann: 'Was There Biblical Art at Pompeii?', *Ant. Kst*, xv/2 (1972), pp. 122–4
B. Narkiss: 'A Scheme of the Sanctuary from the Time of Herod the Great', *J. Jew. A.*, i (1974), pp. 6–14
——: 'The Jewish Realm,' *Age of Spirituality: Late Antique and Early Christian Art, Third to Seventh Century*, ed. K. Weitzmann (New York, 1979), pp. 366–94
——: 'The Sign of Jonah', *Gesta*, xviii/1 (1979), pp. 63–76
G. Sed-Rajna: *The Hebrew Bible in Medieval Illuminated Manuscripts* (Fribourg, 1987)
K. Weitzmann and H. L. Kessler: *The Frescoes of the Dura Synagogue and Christian Art* (Washington, DC, 1990)

BEZALEL NARKISS

(ii) After c. 1600. The conservative attitude of Jews towards visual art and its role in daily and religious life continued to prevail after 1600, both in Christian Europe and the Islamic world. At the same time, this period witnessed an unprecedented flourishing in the production of costly Jewish art objects, decorated with traditional designs and motifs, side by side with new iconography influenced by Baroque decorative arts. While representational art was extremely popular among the Jews of Italy and Germany, other communities, especially in Islamic lands, imitated the iconoclastic tendencies of the host society.

Artistic activity in this period was concentrated around building and decorating new synagogues and furnishing them with silver and textile ritual objects and with creating attractive decorations and objects for the home and life-cycle rituals. The largest selection of visual motifs and

iconographic representations, however, is to be found in the book arts. As the written word continued to be central in Judaism, particular attention was paid to producing attractive books and manuscripts long after the tradition of the illuminated, handwritten book declined in Western society. Wealthy Jewish families commissioned myriad parchment manuscripts, in particular Passover Haggadot (*see* HAGGADAH), Megillot (*see* MEGILLAH) and large, single-page manuscripts such as marriage contracts (*see* KETUBBAH), and various ornamental certificates issued for different occasions.

The single most important object in disseminating Jewish imagery in this period was undoubtedly the illustrated printed book. The easily accessible, inexpensive printed book provided the illuminators of manuscripts and other craftsmen with a wealth of Baroque decorative designs, biblical and ritual episodes and imaginary architectural motifs. The architectural title page, often incorporating the figures of Moses and Aaron, inspired the decoration of manuscripts and such diverse objects as Torah breastplates, Holy Ark curtains, *ketubbot* and even tombstones. The title-page of the Amsterdam Passover Haggadah of 1695 (see fig. 3), illustrated with etchings by the proselyte Abraham bar Jacob, is a good example of popular Jewish imagery, which was profusely imitated throughout the Diaspora from Poland to India.

Not all biblical stories enjoyed equal popularity. The Akedah or Binding of Isaac, for example, was by far the favourite topic in both manuscripts and three-dimensional objects. In keeping with contemporary ideals in neighbouring cultures, biblical heroines, in particular the Apocryphal figure of Judith, were often depicted as well. In Italy, Jews incorporated into their art Christian allegorical representations, mythological scenes and at times even nude female figures. While portraiture had been frowned on in previous generations, from about the mid-17th century more and more rabbis, both Sephardi and Ashkenazi, allowed their portraits to be engraved.

Side by side with the new iconography, old themes and traditional symbols were staunchly preserved. Subjects such as temple implements, especially the Menorah, and conventional images of the Solomonic Temple and Messianic Jerusalem were common in many communities, as was the centuries-old representational technique of MICROGRAPHY. In general, the Hebrew text continued to be a major, if not central, component of Jewish works of art, whether two- or three-dimensional. Traditional motifs constituted the main theme of Jewish art, especially in Eastern Europe. In Poland, for example, representations of the human figure were usually not permitted. Instead, animal motifs, in particular the four 'holy animals' mentioned in Pirkei Avoth (5:23)—leopard, eagle, deer and lion—were extremely popular. In Muslim lands geometric and floral decorations and in some cases animal forms were the accepted norm, in both manuscript illumination and ritual objects. Perhaps the sole exception to this rule was Persia, where, under the influence of Safavid art, literary Jewish works written in Judeo-Persian were illuminated in the 17th century with biblical and other figural representations.

3. Title-page of a printed Passover Haggadah, etching, by Abraham bar Jacob, Amsterdam, 1695 (New York, Jewish Theological Seminary of America Library)

BIBLIOGRAPHY

A. Rubens: *Anglo-Jewish Portraits* (London, 1935)
A. Yaari: *Diglei ha-madpisim ha-ivriyyim me-reshit ha-defus ve'ad sof ha-me'ah ha-tesha-esreh* [Hebrew printers' marks from the beginning of Hebrew printing to the end of the 19th century] (Jerusalem, 1943) [in Heb. with Eng. summary]
A. Rubens: *A Jewish Iconography* (London, 1954, rev. 1981)
E. Naményi: 'La Miniature juive au XVIIe et au XVIIIe siècle', *Rev. Etud. Juives*, cxvi (1957), pp. 27–71
A. M. Habermann: 'The Jewish Art of the Printed Book', *Jewish Art: An Illustrated History*, ed. C. Roth (Tel Aviv, 1961, rev. Greenwich, CT, 1971), pp. 163–74
C. Roth: 'The Illustrated Haggadah', *Stud. Bibliog. & Bklore*, vii (1965), pp. 37–56
A. M. Habermann: *Sha'arei sefarim ivriyyim* [Title-pages of Hebrew books] (Safed, 1969) [in Heb. with Eng. summary]
Y. H. Yerushaimi: *Haggadah and History: A Panorama in Facsimile of Five Centuries of the Printed Haggadah* (Philadelphia, 1975)
M. Metzger: 'Style in Jewish Art of the 17th and 18th Centuries in Relation to the Baroque and the Rococo', *Gaz. B.-A.*, lxxxviii (1976), pp. 181–93
Illustrated Haggadot of the Eighteenth Century (exh. cat. by H. Peled-Carmeli, Jersualem, Israel Mus., 1983) [in Heb. and Eng.]
V. B. Moreen: *Miniature Paintings in Judaeo-Persian Manuscripts* (Cincinnati, 1985)
S. Sabar: 'Manuscript and Book Illustration among the Sephardim before and after the Expulsion', *The Sephardic Journey, 1492–1992* (exh. cat., New York, Yeshiva U. Mus., 1992), pp. 54–93

R. I. Cohen: ' "Ve-hayu einecha ro'ot et moreicha": Ha-rav ke-ikonin' ['And your eyes shall see your teachers': the rabbi as icon], *Zion*, iv (1993), pp. 407–52 [Eng. summary pp. xxxi–xxxii]

S. Sabar: *Mazal Tov: Illuminated Jewish Marriage Contracts from the Israel Museum* (Jerusalem, 1993)

SHALOM SABAR

II. Architecture.

1. Religious. 2. Secular.

1. RELIGIOUS. Solomon's Temple in Jerusalem (*see* §(i)(c) below) held a unique status in Jewish worship, since it housed the Ark of the Covenant, which held the two stone tablets inscribed with the Ten Commandments, and was a place of sacrifice presided over by a caste of priests. Synagogues, on the other hand, served as community meeting-houses for the performance of ritual based on prayer and the reading of the Torah, under the supervision of a rabbi (teacher). There is much dispute as to the chronology of the early development of the synagogue (*see* §(ii) below), and it is difficult to confirm the identification of many of the earliest buildings that have been claimed as synagogues. The institution quickly spread far beyond ancient Israel as Jewish communities dispersed to Europe, Africa and east into Asia, eventually as far as China.

□

(i) Shrines and temples. (ii) Synagogues before *c.* AD 800. (iii) Synagogues after *c.* AD 800.

(i) Shrines and temples.

(a) The Tabernacle. The earliest example of Jewish religious architecture was the Tabernacle, made to house the Ark of the Covenant. The biblical texts concerning the instructions for the construction of the Ark and its setting

(Exodus 25:10–27:19, 30:1–10, 17–21) and an account of the execution (Exodus 35:30–38:31, 39:32–40:33) provide the only description of the structure (see fig. 4). It was a portable, prefabricated temple and was the focus of the Israelite community, who arranged their tents in tribal groups around it in a square (Numbers 2). Wherever it was erected became a sacred place for that period, but not necessarily thereafter, a noteworthy concept of sacred space. A courtyard 100×50 cubits (*c.* 45.7×22.8 m) was made of fine, twisted linen curtains (4a) 5 cubits high (*c.* 2.8 m) hung between wooden posts set on bronze sockets, with silver collars and hooks for the curtain cords. The arrangement of posts and curtains around the eastern entrance is unclear. The curtains screening the entrance were distinguished by blue, purple and scarlet embroidery. Within the enclosure stood a large bronze altar for burnt offerings (4b), then a bronze wash-basin (laver; 4c) and behind these the Tabernacle proper (4d). The walls were a series of wooden frames forming a sort of lattice set on silver bases and held rigid by poles that ran horizontally through rings on each frame. All were plated with gold, the poles also being plated and the rings cast in gold. Curtains of linen worked with brightly coloured figures of cherubim enclosed an area 30 cubits long, apparently 10 cubits wide and 10 cubits high (*c.* 13.7×4.5×4.5 m). The first two-thirds, the Holy place (*hekhal*; 4e), was separated from the Inner Tabernacle (Holy of Holies; 4f) by the veil, a richly embroidered curtain, also worked with cherubim. Friedman has suggested that this curtain formed a tent enclosing the only object in the Inner Tabernacle, the Ark of the Covenant (4g). This was a gold-plated box of acacia-wood containing the tablets inscribed with the Law, guarded by a hammered gold cherub at each end. In

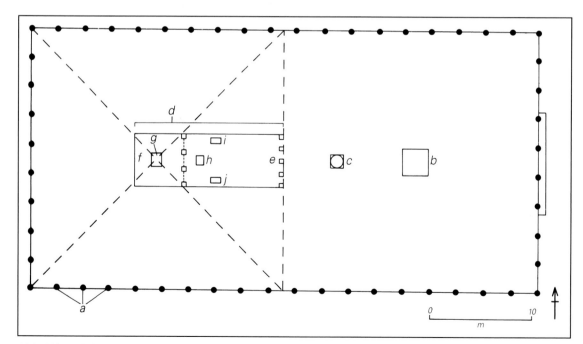

4. The Tabernacle, built to house the Ark of the Covenant, reconstructed ground-plan: (a) curtains hung between posts; (b) bronze altar; (c) laver; (d) Tabernacle proper; (e) Holy place (*hekhal*); (f) Inner Tabernacle (Holy of Holies); (g) Ark of the Covenant; (h) golden incense altar; (i) table for shewbread; (j) menorah

the Holy place stood the golden incense altar (4h), a gold-plated table for the shewbread (4i) and an elaborate, tree-shaped candlestick (the menorah; 4j), also gold-plated. A covering of tanned rams' skins and an outer covering of dugong skins supplied a waterproof roof.

Analysis of the relevant biblical texts led 19th-century scholars, and some in the 20th century (see Childs), to treat them as creations of the 5th century BC, devoid of any factual basis in the Late Bronze Age (c. 13th century BC), where the book of Exodus sets the Tabernacle. The structure was deemed too complicated for the time and the religious concepts too advanced. Archaeological discoveries elsewhere in the Near East, however, have shown that the Tabernacle is a good example of Late Bronze Age technology. Egypt in particular has produced prefabricated, portable pavilions for royalty and gods, with gold-plated wooden frames and richly worked hangings. Tutankhamun's tomb provides examples in the four shrines that contained the body, one covered with a decorated linen pall, and a wooden box with carrying poles (all c. 1330 BC; Cairo, Egyp. Mus.) like those described for the Ark. Winged guardian goddesses on the shrine doors recall the cherubim. Even the arrangement of the Tabernacle's two-room structure within a courtyard, surrounded by the tribes, reflects the position of a pharaoh's two-room tent in an enclosure at the heart of his camped army. It is reasonable to surmise that a people who had recently left Egypt should create a shrine on Egyptian patterns, while the materials (acacia-wood, linen, coloured yarns, goat hair, dugong skins, rams' skins, copper, silver and gold) could all have been obtained in Sinai or by trade or could have been brought from Egypt (Exodus 12:35–6). Regrettably, the biblical texts are not precise blueprints, and no ancient picture of the Tabernacle has survived, so reconstructions involve uncertainties. Only the hangings appear to have been decorated, as the gold- and silverwork was limited to a smooth overlay or functional fittings, and there is no suggestion that, for example, the posts had carved or cast capitals. The rich materials marked the Tabernacle as the awesome house of Israel's God, separate from the people and approachable only by the ritually pure, on a basis of graded sanctity, from the outer court to the Holy of Holies. Materials were similarly graded, from bronze to gold, and colours from crimson to blue, which was reserved for the most sacred.

(b) Israelite shrines. The Israelites encountered many small Canaanite temples, which they were ordered to destroy in order to maintain the purity of their own monotheistic faith (e.g. Exodus 23:23–4). Failure to exterminate the Canaanites, however, meant that these cults continued within the developing nation-state of Israel. Nevertheless, it is striking that no Late Bronze Age shrine was used long into the Israelite Iron Age (after c. 1000 BC). At Tel Dan a stone platform (7×18 m) stood on one side of a courtyard and may have been a 'high place' (Heb. *bāmâ*), conjecturally linked with the shrine established by Jeroboam I (*reg c.* 922–c. 901 BC; 1 Kings 12:28–30), or the podium for a public building. It was enlarged in the 9th century BC and remained in use for some religious purpose into the Hellenistic period. East of Beersheba, Tel Arad yielded a temple (9th–7th century BC) inside a fortress. A

courtyard (10×10 m) had a brick and rubble altar and, at the west end, a room (10.0×2.7 m) with benches against the walls. A niche (1.2×1.2 m) at the centre of the west wall was approached up three shallow steps. Two stone altars with traces of burnt organic matter, perhaps incense, flanked the entrance, and at the back of the niche there was a red-painted stone stele (h. 1 m); two others, disused, were built into the wall. Inscriptions suggest that this was an unorthodox shrine for Judean worship, of the type destroyed by Hezekiah (*reg c.* 715–c. 687 BC) and Josiah (*reg c.* 640–609 BC; 2 Kings 18:1–4, 23:4–16). Although of tripartite plan, the design of the Arad building differs from that of Solomon's Temple (see §(c) below), but comparisons have sometimes been made.

(c) The Temple at Jerusalem. Just as the Tabernacle reflected ancient styles of portable pavilions, so Solomon's Temple (c. 950 BC) mirrored the conventions of its age (*see also* JERUSALEM, §II, 1(ii)). Its tripartite plan (1 Kings 6; 2 Chronicles 3) had antecedents and echoes in Syria (e.g. Ebla, 18th century BC; Tell Tainat, 9th century BC). Decoration was lavish: carvings of cherubim, palm trees and open flowers adorned the cedar-panelled walls and doors, and two olive-wood cherubim (h. 10 cubits; 4.5 m) stood guard in the inner shrine. The carvings, doors, walls, ceiling and floor were all plated with gold, an extravagance within the norms of royal devotion to deities apparent in Egypt, Assyria, Babylonia and Greece. The Ark of the Covenant was transferred to the Temple, and much new cultic equipment was made (1 Kings 7:13–51). Although Israel's God was claimed to be unique, the Temple was still recognizable to any visitor as a major shrine, for however different the God it honoured, it uttered the same architectural message.

The Temple was burnt in 586 BC, although its original splendour had suffered the depredations of Shishak of Egypt soon after Solomon's death. In 538 BC Jewish exiles were allowed to return from Babylonia to rebuild the Temple (completed 516 BC; Ezra 1, 3, 6). No description is given; the only comment compares it adversely with Solomon's Temple (Haggai 2:3), but the Second Temple probably followed the earlier plan. In subsequent centuries the courtyard and adjacent hill to the north were strengthened and became a fortress. Herod the Great rebuilt the Temple Mount from 20 BC on a grandiose scale (*see* JERUSALEM, §II, 1(i)), enlarging the courtyard with precisely cut limestone blocks, each c. 1 m high and up to 12 m long; some remain visible in the south and west sides of the podium (the Wailing Wall). Domed gateways had finely carved floral and geometric motifs that conformed to the biblical law against images, as did the Corinthian-style pillar capitals. The Temple proper followed the Solomonic design, transmuted into Hellenistic style. Work continued on minor parts for many years (John 2:20) and was hardly finished when it was destroyed in AD 70.

BIBLIOGRAPHY

M. Levine: *The Tabernacle* (London, 1969)
B. S. Childs: *Exodus*, Old Testament Library (London, 1974), pp. 512–52
P. D. Miller, P. D. Hanson and S. D. McBride, eds: *Ancient Israelite Religion: Essays in Honor of Frank Moore Cross* (Philadelphia, 1987), pp. 209–47, 249–99 [articles by W. G. Dever and J. S. Holladay]
R. E. Friedman: 'Tabernacle', *The Anchor Bible Dictionary*, ed. D. N. Freedman, vi (New York, 1992), p. 295

K. A. Kitchen: 'The Tabernacle: A Bronze Age Artefact', *Eretz-Israel*, xxiv (1993), pp. 119–29

A. R. MILLARD

(ii) Synagogues before c. AD *800.*

(a) Origins. (b) Ancient Israel. (c) Diaspora.

(a) Origins. Before synagogues existed, Jews worshipped God by oblations offered at the Temple in Jerusalem. The ritual was restricted to priests, while lay worshippers stood in outer courtyards and watched. Later, these sacrifices were replaced by prayer and the reading of the Torah in synagogues, which could be built anywhere. These rituals did not need to be performed by a priest, and worshippers stood inside the building and took an active part in the service.

There is disagreement over where and when the first synagogues came into being. It is clear from the New Testament, from Talmudic sources, from the writings of the Jewish philosopher Philo (*c.* 20 BC–AD 50) and the Jewish historian Flavius Josephus (AD 37–after 93) and from archaeological and epigraphical finds that there were many synagogues in ancient Israel and in the lands of the diaspora by the end of the Second Temple period (AD 70) and that these functioned as the centres of religious, cultural and social life of the Jewish communities; nevertheless, the synagogue developed most substantially after the destruction of the Second Temple. These literary sources suggest that the synagogue was a particularly ancient institution—'For Moses of old time hath in every city them that preach him, being read in the synagogues every sabbath day' (Acts 15:21)—but there is no material proof of this.

Some scholars have placed the beginnings of the synagogue in the Land of Israel before the destruction of the First Temple in 586 BC. They believe the institution developed from religious ceremonies and customs unconnected to temple ritual (such as visiting the prophets on holy days) and from religious reforms in the time of Josiah (*reg c.* 640–609 BC), when all sacrifices outside the Jerusalem Temple were banned. By contrast, other scholars believe that it was developed to provide an alternative form of ritual during the Babylonian exile after 586 BC. Another approach that assumes that the synagogue was formed in exile is based on the fact that the earliest synagogue remains have been found in the lands of the diaspora, and that many synagogues outside the Land of Israel are mentioned in literary sources from the end of the Second Temple period. In addition, Ptolemaic Egyptian inscriptions from the 3rd century BC have been found containing references to prayer houses, and a building on the Greek island of Delos dating from the 1st century BC has been identified by some scholars as a synagogue (*see* §(c) below).

Other approaches date the synagogue to the period of the return to Jerusalem (538 BC)—although scholars differ as to whether it was a strictly secular institution or devoted mainly to the reading of the Torah—or to the rise to power of the Pharisees as a result of the Hasmonean revolt (168–

5. Synagogue at Kefar Bar'am, Galilee, Israel, mid-3rd century AD or later

165 BC). According to this later theory, the synagogue was started as an institution with mixed religious and secular elements as an answer to the contradiction between traditional ways of life and a new social and religious reality created by contact with Hellenistic culture.

(b) Ancient Israel.

The earliest evidence. The earliest excavated synagogue buildings date from the end of the Second Temple period, by which time it appears that they were seen as the centre of communal life, without challenging the sanctity of the Temple and its central importance in national life. They provided a covered, lighted space to hold a large group of believers who took an active part in the ritual, including the reading of the Torah, prayer and study. The buildings were also used for gatherings, communal court hearings and the deposit of public funds. In most examples two or three rows of seats were built in steps along the walls, with additional seating on wooden benches or on mats spread on the floor. Talmudic law (Berakhot 4, 5 and 8c) requires that worshippers face Jerusalem, but the archaeological evidence indicates that this was not reflected in the architecture until the 3rd century AD. It would appear that during the service a movable ark (*see* §V, 1 below) containing the Torah scrolls was placed against the wall facing Jerusalem. Rooms next to the prayer-hall served as hostels for guests and for communal meals. The latter is confirmed by a monumental Greek inscription (late 1st century BC; Jerusalem, Rockefeller Mus.) discovered in Jerusalem, which apparently had been placed in a synagogue and provides the earliest archaeological evidence for such a building in ancient Israel: 'Theodotus, son of Vettenos the priest and *archisynagogos*...built the synagogue for the purposes of reciting the Law and studying the commandments, and the hostel, chambers and water installations to provide for the needs of itinerants from abroad'.

Buildings that have been identified as synagogues, or architectural artefacts that hint at their presence, have been found at more than 100 sites in Israel, from the Golan Heights to the Beersheba plain, and the plans of at least half may be reconstructed. Three of these have been dated to before AD 70. It has been suggested, for example, that a public building at Gamla in the Golan may have served as a synagogue from the beginning, while halls at the Herodian fortress–palaces of MASADA and Herodium may have been used as synagogues by the Zealots after structural changes and additions. These suggest that synagogues of the Second Temple period were undecorated and did not have a unified plan, although all three were rectangular, with columns in the middle and seats along the walls, and none had a set place for the Torah ark. Other characteristics varied, notably the orientation and the placing and numbering of openings or niches.

Variants. The period of the Mishnah and Talmud, from AD 70 to the end of Byzantine rule in AD 638, was one of the most creative in the development of Jewish thought and law. Radical changes were made to the architectural form of synagogues, and daily public prayer was formalized as the centre of the ritual, so that the plan and furnishings

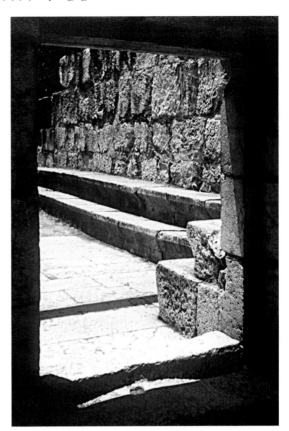

6. Synagogue at Capernaum, Galilee, Israel, completed in the third quarter of the 5th century AD; entrance, partially reconstructed

of the building became more noticeably defined. Decoration now included Hebrew characters and Jewish symbols (see below).

Three main plan forms may be identified. The first is exemplified by more than 40 synagogues, of which the outstanding examples are at Kefar Bar'am (see fig. 5), CAPERNAUM, Korazim, Meiron, Horvat ha-'Amudim, Gush Halav and Nabratein in Galilee, and at Horvat Dikke and Umm el-Kanatir in the Golan. The façade of each was constructed of ashlar blocks and decorated with stone carvings. The rectangular prayer-hall (200–500 sq. m) had a gabled roof supported on three rows of columns that ran parallel to the interior walls, except that of the façade. The corner columns were often heart-shaped. Smaller buildings of this type had only two rows of columns, on either side of the axis. Sometimes the columns supported another row that raised the roof to create a clerestory, and possibly also first-floor galleries; there is no evidence that these were used for women's galleries. The floor was usually paved with flagstones, and there were two or three rows of benches around the walls (see fig. 6). The façade faced south, towards Jerusalem, and had three openings, although in smaller buildings there was only one. The Torah shrine, the focus of the ceremony, was added at a later stage, next to the entrance in the form of one or two niches (aediculae). Sometimes there was a portico along the façade, or the building opened on to a courtyard.

A second group had a ground-plan resembling that of a Christian basilica (*see* CHURCH, §I, 1(i)). These long structures had an entrance in the far wall opposite the direction of prayer, and a round or square apse in the wall facing Jerusalem, in which the Torah shrine was placed on a bema. The latter was usually enclosed by a carved and inscribed chancel screen of stone or marble. The inner rows of columns set along the longer walls divided the space into a nave and aisles. The outer walls, including the façade, were built of hewn stone and plastered. Floor mosaics provided the principal decoration. Characteristic examples are those at BETH ALPHA, Ma'oz Hayyim, Rehov, the upper-level synagogue (destr. AD 630) at Hammath-Tiberias, Na'aran Jericho, Gaza and Nirim.

A further category comprises those of the broadroom type, in which the Torah shrine rested on a bema or stood in a semicircular niche set in the long wall, facing Jerusalem. The entrance was located opposite or in one of the side walls. At Eshtemoa (now Es Samu), Horvat Susiyya and the early structure at Horvat Rimmon, all in the region of Judea, the roof was supported by the outer walls, and the inner space was not divided by columns. In the Galilean synagogues at Hammath-Tiberias (stratum IIA) and Horvat Shema', however, the roof was supported by columns that divided the prayer-hall into several areas. Other synagogues at Arbel, Horvat Summak, Qazrin, En Gedi, Horvat Ma'on and Horvat 'Anim differ slightly in some details from each of the three principal types.

Chronology. Although more than 150 inscriptions from ancient synagogues have been recorded, only a few mention any date. The only dated example from one of the Galilean type was found on the lintel at Nabratein: 'the four hundred and ninety-fourth year to the Destruction [of the Temple]' (i.e. AD 564), a date attributed by many scholars to the second stage of the building. Other dated inscriptions come from basilica-like examples. The mosaic at Gaza, for example, bears a date equivalent to AD 508–9, while that at Beth Alpha mentions Justine, apparently a reference to Justin I (*reg* AD 518–27) or Justin II (*reg* 565–78).

The dating of ancient synagogues has led to much debate, although there is agreement that there is no known example from the 2nd century AD and that the Galilean and Golan type dates from no earlier than the mid-3rd century AD. Some scholars believe that the typological division is also chronological, and that synagogue art and architecture were influenced by and reflect contemporary trends within the region. The synagogues of the Galilean type resemble late Roman shrines in Syria and the Horan area, and may thus be seen as the early type characteristic of the 3rd and 4th centuries AD. Those based on the lateral, broadroom type may be considered a transitional type, particularly common in the 4th century, whereas those influenced by the Christian basilica are a late variety built between the 5th century and the 8th. These scholars do not deny the possibility that early examples continued to exist during the Byzantine period and may even have been restored later, while still maintaining their original plan.

Other scholars, however, place greater emphasis on the evidence provided by excavations, especially beneath synagogues. These suggest that different types appeared at the same time in the same area, especially in Galilee and the Golan. The excavators at Gush Halav, Meiron and Nabratein, for example, concluded that these synagogues, which all belong to the Galilean type, were built in the second half of the 3rd century AD, whereas coins from the foundations at CAPERNAUM, grandest of the Galilean synagogues, indicate that it was completed in the third quarter of the 5th century.

Another view maintains that the architectural types reflect their geographical location, rather than the period in which they were built, with different building traditions in Galilee and the Golan, the Jordan and Beit Sh'an valleys and Judea, the style of which is not found elsewhere. Some scholars have combined this regional division with an approach that attributes chronological significance to the typology.

Architectural decoration. In contrast to the earlier prohibition of figurative art, extensive decoration was used from the 3rd century AD, including the depiction of human and animal figures from pagan mythology. The main ornamental form in synagogues of the Galilean and Golan type was relief-carving, which usually decorated the lintels of doors and windows, and the Torah shrine. In such sumptuously decorated synagogues as those at Capernaum and Korazim, reliefs are also found on convex friezes, cornices and capitals. Jewish symbols appear clearly on these architectural elements, which were modelled formally in the Roman style; symbols included menorahs with between five and nine branches, a menorah with a *shofar* (ram's horn), an incense shovel and an aedicula-shaped Torah shrine. There are also many representations of eagles (e.g. from Capernaum) and lions: in a few synagogues statues of lions may have been placed either side of the Torah shrine. It has been suggested that the pagan motifs, which included two Victories bearing a wreath, garlands and putti, acanthus and vine scrolls containing animals, various fruits, geometrical forms and even human figures harvesting grapes in a frieze from Korazim (?4th century AD; *in situ*), date from a period when pagan religion was not a threat to Judaism. This enabled existing artistic models to be preserved and given new symbolic significance.

Mosaics (*see* §III below) provide further information on interiors and furnishings. A continuously burning 'eternal lamp' was suspended facing the Torah shrine. Seven-branched candlesticks, similar to those shown next to the Torah shrine on mosaics, have been found at Hammath-Tiberias, En Gedi and Ma'on in Judea, although it is unclear how widespread they were and whether they were intended to provide light or were ornamental. In synagogues of the basilican and broadroom types the *bimah*, the raised platform from which the Torah was read, was sometimes enclosed by marble screens decorated in low relief or latticework. White plastered walls sometimes bear traces of drawings and inscriptions in earth colour.

(c) Diaspora. Few synagogues of this period have been discovered in the lands of the Jewish diaspora. Earlier buildings that have been identified as such, although not always conclusively, include those at Delos (1st century BC; *see* DELOS, §2(i)) and the early stage (late 1st century AD) of the synagogue at Ostia, which was remodelled during the 4th century. Others, most of which date from the 3rd century AD to the 7th, are known in Jordan at Gerasa (AD 531), in Syria at Dura Europos (AD 244–5; *see* DURA EUROPOS, §3 and fig. 2) and Apameia (AD 392), in Asia Minor at Priene and Sardis (late 3rd century AD), in Greece at Corinth and Aegina (4th century AD) and in Tunisia at Naro (?6th century AD; now Hammam Lif). Many more, however, are indicated by such signs as inscriptions referring to synagogues and architectural decoration with Jewish motifs, since the exterior and the plan of a building are often insufficient to confirm its purpose. The differing plans of these buildings have none of the homogeneous typology found in Israel, for the design of the diaspora synagogues was influenced by their surrounding cultures, leading to wide variations in plan and decoration. There were, however, certain recurrent characteristics, such as the orientation towards Jerusalem and the use of identifying Jewish symbols in the ornamentation, including the menorah, *shofar*, incense shovel, *etrog* (citron) and *lulav* (palm branch).

BIBLIOGRAPHY

I. Elbogen: *Der jüdische Gottesdienst in seiner geschichtlichen Entwicklung* (Leipzig, 1913), pp. 444–510

H. Kohl and H. Watzinger: *Antike Synagogen in Galilaea* (Leipzig, 1916)

S. Krauss: *Synagogale Altertümer* (Berlin and Vienna, 1922)

L. Finkelstein: 'The Origin of the Synagogue', *Proc. Amer. Acad. Jew. Res.*, i (1928–30), pp. 49–59

S. Zeitlin: 'The Origin of the Synagogue', *Proc. Amer. Acad. Jew. Res.*, ii (1930–31), pp. 69–81

E. L. Sukenik: *Ancient Synagogues in Palestine and Greece* (London, 1934)

C. H. Kraeling: *The Synagogue* (1956, rev. 1979), viii/1 of *The Excavations at Dura-Europos: Final Report* (New Haven, 1943–)

J. Morgenstern: 'The Origin of the Synagogue', *Studi orientalistici in onore di Giorgio Levi Della Vida*, ii (Rome, 1956), pp. 192–201

M. Avi-Yonah: 'Synagogue Architecture in the Classical Period', *Jewish Art*, ed. C. Roth (Tel Aviv, 1961), pp. 155–90

E. Rivkin: 'Ben Sira and the Nonexistence of the Synagogue', *The Time of Harvest: Essays in Honor of Abba Hillel Silver*, ed. D. J. Silver (New York, 1963), pp. 320–54

J. Weingreen: 'The Origin of the Synagogue', *Hermathemma*, xcviii (1964), pp. 68–84

G. Foerster: *Bate-ha-keneset ba-Galil u-mekomam ba-omanut u-ba-arkhitekturah ha-Helenistit veha-Romit* [Galilean synagogues and their relation to Hellenistic and Roman art and architecture] (diss., Jerusalem, Hebrew U., 1972)

J. Gutmann: 'The Origin of the Synagogue', *Archäol. Anz.*, lxxxvii (1972), pp. 36–40

S. Saffrai: 'The Synagogue', *The Jewish People in the First Century*, ed. S. Saffrai and others (Assen, 1976), pp. 908–13

R. P. Goldschmidt Lehmann: 'Ancient Synagogues in Eretz Yisrael', *Cathedra*, iv (1977), pp. 205–22 [in Heb.]

F. Hüttenmeister and G. Reeg: *Die antiken Synagogen in Israel*, 2 vols (Wiesbaden, 1978)

J. Gutmann, ed.: *Ancient Synagogues: The State of Research* (Chico, CA, 1981)

L. I. Levine, ed.: *Ancient Synagogues Revealed* (Jerusalem, 1981)

M. Chiat: *Handbook of Synagogue Architecture*, Brown Judaic Studies, 29 (Chico, CA, 1982)

Z. Safrai: *The Synagogue in the Period of the Talmud and Mishnah* (Jerusalem, 1986) [in Heb.]

Z. Ilan: *Batte khneseth ba-Galil u-bha-Golan* [The synagogues in the Galilee and Golan] (Jerusalem, 1987)

A. Kasher, A. Oppenheimer and U. Rappaport, eds: *Batte khneseth attikim-kovets machkarim* [Synagogues in antiquity] (Jerusalem, 1987) [Eng. summaries]

L. I. Levine, ed.: *The Synagogue in Late Antiquity* (Philadelphia, 1987)

J. Naveh: *Al pesifas va-even: Ha-ketovot ha-aramiyot veha-ivriyot mi-bate-ha-keneset ha-atikim* [On stone and mosaic: the Aramaic and Hebrew inscriptions from ancient synagogues] (Jerusalem, 1987)

L. Roth-Gerson: *Haktovot hayevaniyot mibatei-haknesset b'Eretz Israel* [The Greek inscriptions from the synagogues in Eretz Yisrael] (Jerusalem, 1987)

L. I. Levine: 'From Community Center to "Lesser Sanctuary": The Furnishing and Interior of the Ancient Synagogue', *Cathedra*, lx (1991), pp. 36–84

RINA TALGAM, ZEEV WEISS

(iii) Synagogues after c. AD *800.*

(a) Western. (b) Elsewhere.

(a) Western. Although Jewish communities survived in Europe, there is a gap in the architectural record until the 11th century. The numbers of Jews were much diminished by voluntary or forced conversion to Christianity, and many communities were small and poor. They must, however, have had regular meeting-places for prayer and community activity. When there was some doubt as to their ability to remain in a town and build permanent structures safe from expropriation, one room of a house, perhaps the rabbi's, could have served as the synagogue and housed the ark and the *bimah*, the raised platform from which the Torah was read.

The architectural record is clearer after the 11th century, although few remains exist or were documented until the 13th century. Medieval and Renaissance synagogues were only established in towns where the majority population hoped to increase trade by using the services of Jews, who were literate and numerate when most people were not, or where a ruler found personal or commercial advantage in protecting a number of Jews. Accordingly synagogues and Jewish houses were usually close to the central commercial area or the ruler's residence. If the business district expanded, as at Prague and Rome, the Jews were likely to be moved to a less desirable location near the city walls or on low-lying land beside a river, or to be relegated to a smaller town or suburb. At Nuremberg, for example, the Jews were expelled from the city centre and the synagogue razed before 1349, while the Stora Synagogue (rebuilt 16th century) at Kraków was in the suburb of Kazimierz.

Even purpose-built synagogues were mostly modest in size and external appearance. Since Christian authorities could prevent Jews from owning the land on which the buildings stood, fix the rent to the landowner and regulate the synagogue's size and height, it was either impossible or imprudent to build elaborately, even when there was little threat of expropriation. Until the 19th century synagogues were often hidden from the street, placed either in a Jewish precinct containing other community buildings, such as the ritual bath and the oven for baking unleavened bread, or concealed behind a house.

Plans. The oldest surviving synagogue in Europe is a descendant of that completed at Worms in 1034 and replaced in 1174–5. This had an approximately rectangular main room, intended only for the men; an almost equally large women's annexe was added on the north side, at

7. *Staronová Synagogue at Prague, Interior,* watercolour by Josef Mánes, 1843 (Prague, National Museum)

right-angles to the men's area, in 1212–13. With further alterations (e.g. 1611) it survived until it was vandalized in 1938 and later reduced to rubble by bombing during World War II; it was rebuilt in 1958–61, using much of the original stone. The division of the men's section into two aisles was also adopted in later medieval examples, such as in Prague at the Staronová (*c.* 1280; see fig. 7; *see also* PRAGUE, §IV, 4 and fig. 17). Some opinion holds that this plan was adopted to avoid the customary church plans of a single nave or a nave and aisles. This seems unlikely, however, as a chapel-like, single-naved synagogue plan, sometimes with an apse to hold the ark, was even more commonly used, for example at Speyer (late 11th century). The twin-aisled plan imitates that of many monastic chapter houses, in which meetings, readings and discussions were similarly held.

Since Jews were denied entrance to the masons' lodges and private apprenticeships, synagogues were designed and built by Christians, who adapted plans devised for Christian use. Most synagogues were oblong, although by the 17th century square rooms were often surrounded by annexes for the women or to provide study chambers and offices, especially in eastern Europe. In Spain, plans and the abundant *Mudéjar* ornament suggest the influence of Islamic architectural ideas as well as Christian. A synagogue at Segovia that was converted *c.* 1419 into a church (later Corpus Christi) has three aisles. Some have a single undivided room, which might be small, as at Córdoba (1315; *see* CÓRDOBA (i), §3(ii)), or huge, for example at the synagogue now known as Nuestra Señora del Tránsito (1366), Toledo, which has rich Moorish friezes applied to

the brick walls. Also in Toledo, the Ibn Shoshan Synagogue (rebuilt 1250; now S María la Blanca) has five aisles separated by arcades of octagonal brick piers and was better suited to Muslim practices than Jewish use. The interior arrangement, however, included an ark and a *bimah*, suited to Jewish ritual alone.

Internal layout. The interior arrangements devised for medieval synagogues remained largely unchanged until the advent of the Reform movement in the 19th century (see below). In Europe and European colonies the arrangements varied according to the ritual in use, although the ark was always placed on the wall facing Jerusalem if possible. Early arks, and some more modest examples even into the 20th century, were cabinets placed against a flat wall, for example in the synagogues at Cologne and Frankfurt am Main (*c.* 1150; destr. 1711), at the Talmud Torah Synagogue (1639; destr. 1675) in Amsterdam, and at the synagogues in Livorno (designed by Giovanni di Isidoro Baratta in 1742 and remodelled in 1787 by Ignazio Fazzi; destr. World War II) and Bonyhád (1795). From the late 12th century, when liturgical forms became more fixed in central Europe, the ark was sometimes sheltered by a niche or apse, for example at Sopron (14th century), Fürth (1615), the Scuola Spagnola (*c.* 1655–60) in Venice, and Lengnau (1754). By about 1700, frames were often created around the cabinets; examples included those in all the synagogues of the later 17th century and the 18th in Amsterdam, and at Rovigo (17th century), the Bevis Marks Synagogue (1701, by Joseph Avis) in London, the Heidereutergasse Synagogue (1714) in Berlin, designed by Michael Kemmeter (*d* 1730), Nowe Miasto (1779–80) in Wrocław (18th century) and Mád (1795). Although the resulting compositions closely resembled church reredoses, the designs were probably accepted because they enhanced the status of the ark's contents (for a discussion of the ark itself *see* §V, 1 below).

Ashkenazi. In Ashkenazi synagogues the *bimah* was normally placed at some distance from the ark on the main axis of the building, although not necessarily midway along the interior. It was usually raised on steps, so that the reader might be seen and heard and to give literal prominence to his words. There was often a small depression in the floor underneath, so that prayer could rise 'out of the depths' (Psalms 130:1), following a post-Talmudic tradition. The platform could be approached from the west, or from steps to the north and south, so that one speaker could step down while another ascended. The reading table imitated the wooden pulpit from which Ezra read the Law (Nehemiah 8:4). The *bimah* was surrounded by a parapet or railing that sometimes reached above the reader's head, for example at Worms (1623) and Kirchheim. Some *bimah*s, such as those at the Staronová, Prague, and most of the Polish wooden synagogues of the 17th to the 19th century, were covered by canopies made of metal or wooden ribs. A few *bimah*s survived until World War II covered by elaborate gables, cornices or roofs, for example in Poland at Zabłudów (mid-17th century; remodelled 1765) and Sidra (late 18th century–early 19th), and in Belarus' at Sopotskin (second half of the 18th century). Especially in the Slavic lands west of Russia,

masonry synagogues had a squarish room supported at the centre on four closely grouped piers around the *bimah* platform. These were joined above to create the *bimah* tabernacle, a type of canopy that was integral with the building; among the many examples were those in the Maharshalschul (1567; rebuilt 1656; destr. 1942) in LUBLIN, Vilnius (1633), the Great Synagogue (17th century) in Łańcut and at Mikulov (1689; Czech Republic). These masonry supports were imitated in wood throughout greater Poland, for example at Sidra and Volpa (early 18th century; destr.; Belarus').

Since services might last for many hours and involve both individual and congregational reading, benches (freestanding or attached to the walls) or individual chairs were always provided along the side walls and opposite the ark, surrounding the *bimah* on three sides. Each seat needed an associated reading desk, or at least a chest underneath to store books, prayer shawls and phylacteries. In many synagogues, more elaborate seats for the officers of the congregation were arranged on either side of the ark, facing the congregation. Sometimes seats were also attached to all sides of the *bimah* to provide additional accommodation or to let the congregants benefit from the candles or lamps on the *bimah*. The arrangement of worshippers facing each other increased the sense of community within the congregation and exemplified the mutuality rather than hierarchy in Judaism.

Sephardi. Among Jews of Iberian origin, synagogues were less consistently single- or twin-naved in plan but were sometimes three- and five-naved (see above). The late 15th-century square synagogue at Tomar, Portugal, has four slender columns arranged to divide the interior into nine groin-vaulted bays. This four-support plan appears elsewhere after the expulsion of the Sephardim from the Iberian peninsula (Spain, 1492; Portugal, 1496–7), reflecting Iberian practice or developing independently. It was used in the Ashkenazi Vorstadt Synagogue (1632) at L'viv and, in a form that suggests three aisles rather than a central square, in Elias Bouman's Portuguese (Esnoga) synagogue (1671–5; *see* AMSTERDAM, §V, 3), from which the plan spread in 1796 to St Thomas (now US Virgin Islands). Similarly planned Sephardic synagogues in Turkey, such as the Bikkur Holim Synagogue in Izmir (see fig. 8), were influential in the Balkans while the region was under Turkish rule, for example at Samokov, Bulgaria. In Sephardi synagogues the *bimah* was usually placed on or near the wall opposite the ark, and the axis between them was left empty. Seating was arranged along the other (usually longer) walls, often in rows set behind one another, and worshippers turned to left or right to follow the liturgy at the ark or *bimah*. Synagogues in the American colonies tended to follow models in the mother country: certain aspects of the Bevis Marks Synagogue, for example, may have inspired the plan of the Touro Synagogue (1762–3, by Peter Harrison) at Newport, RI, while the Portuguese synagogue of Amsterdam was clearly the source for the Mikve Israel Synagogue (1732) in Curaçao (*see also* SURINAM, §IV).

In Italian-rite synagogues the *bimah* was often raised by at least four steps on one end wall: at Ancona, for example,

8. Bikkur Holim Synagogue, Izmir, Turkey, interior view towards the *bimah*

it was high enough to accommodate a doorway underneath. In the synagogues that followed the rite used in the Comtat Venaissin district of southern France, for example at Carpentras (1741, by Antoine d'Allemand) and Cavaillon (1772–4, by the Armelins), the *bimah* stands on a balcony on the wall opposite the ark. The Italian and Comtadin rites, and the related local rite used around Asti in north-west Italy, usually followed the Sephardi practice of aligning the worshippers' seats on the long walls.

Stylistic development.

c. 800–c. 1800. Until the mid-19th century, synagogues were not identifiably Jewish in style, although the plan with four central supports, internal arrangements that reflected Jewish practices, and the liturgical furniture and decoration might be specific to the religion. Whereas the altar is usually the primary focus of attention in a church, the synagogue was made distinctive in furnishing and plan by the placement of the *bimah*, providing a second focus in addition to the ark. A historicizing and culture-specific style was generally not demanded or even imagined, although regional styles developed in various parts of Europe, reflecting the indigenous architecture of the host countries.

From the 12th century landowners in Poland had offered inducements for the Jews to settle there and promote commerce. Jewish migration became significant in the late Middle Ages and the 16th century, under the pressures of increased population and discrimination elsewhere, and distinctive variations on local religious architectural forms began to develop. The earliest synagogues in Poland reflect contemporary building practices. The stone and brick Old Synagogue in Kraków is groin-vaulted, with two aisles separated by Renaissance columns. By the late 17th century, however, plans were commonly square

9. Wooden synagogue, Volpa, Belarus', early 18th century

or compactly rectangular, incorporating a four-column *bimah* canopy. Where building stone was not readily available, carpentry techniques were developed for ample, squarish buildings covered by spectacular cascading roofs (see fig. 9). The interiors were occasionally sustained by four central supports, perhaps in imitation of masonry techniques; more often, however, there was nothing under the tiers of roofs to impede views to the *bimah* from all sides.

The inside walls and vaults of many Polish synagogues were painted with animals and plants that had historical and symbolic associations, such as the Lion of Judah or foliage suggesting God's abundant creation, for example at Khodorov in Ukraine (1651; *see also* §III, 3 below). Two-dimensional human imagery and three-dimensional sculpture were generally avoided. Hebrew inscriptions were sometimes elaborately framed or occasionally combined with views of cities associated with the virtues of Jerusalem or with sinful biblical sites, such as the depiction of *Babylon* at Grojec (destr. 1942) to illustrate Psalm 137. More is known of rural eastern European and a few German sites, such as the wooden synagogue (reconstructed in the Israel Museum, Jerusalem; see fig. 15 below) that Eliezer Sussman decorated in 1735 at Horb, Baden-Württemburg, than of town synagogues in western Europe, since congregations at the latter were more likely to become culturally assimilated and less willing to preserve folk traditions.

Italian synagogues, on the other hand, were almost always designed in a contemporary style. They are distinguished from churches by their plans and by the presence of a *bimah*, but the stylistic vocabulary evinced in their furnishings drew on contemporary Christian usage. Along with oblong or square plans with women's annexes, Italian synagogues occasionally feature rooms with integrated galleries, for example at Livorno and Trieste (1797, by Balzoni). In the Ashkenazi and Sephardi synagogues of Venice, women were accommodated in oval galleries within the principal room. This idea may have spread to the Netherlands and England by 1700, and from there to almost all large synagogues in Europe and its colonies by the late 18th century.

c. 1800–c. 1918. The Jews were granted legal equality under the United States Constitution (1787) and after 1792 in France and those parts of Germany, the Low Countries and elsewhere later conquered by Napoleon. They could now build synagogues facing public streets, and in some places they were entitled to apply for state subventions. Whatever the style employed, 19th-century synagogues usually adopted a galleried basilican plan, with a nave and aisles. Some of the resemblance to a contemporary church without transepts may be explained by increasing cultural assimilation and the employment of (usually Christian) architects who had fixed ways of designing religious buildings. Population growth and increased migration to the cities required larger seating

capacities. Several countries, especially France, discouraged traditional small congregations and favoured large synagogues that could be supervised more easily by state religious authorities.

Early Romanticism and growing nationalism promoted the idea that each nation had its own distinctive artistic characteristics. This complemented the historicism of the period, which also promoted the idea that the forms and styles of each age carried such connotations as religiosity, forthrightness or luxurious excess. The problem for European Jews was that political identity was frequently associated with national and regional Christian denominations, so that there was rarely agreement on whether French Jews, for example, were as French as French Christians (and thus equally entitled to use typically French styles). This was especially pressing in the German-speaking lands, which were increasingly preoccupied with regional identity and supra-regional growth towards an integrated nation, and it is not surprising that German architects introduced exotic styles for the Jews. Friedrich Weinbrenner's synagogue (1798; destr. 1871) at Karlsruhe, with Egyptian pylons on the façade (*see* WEINBRENNER, FRIEDRICH), and the Copenhagen synagogue (1829–33, by G. F. Hetsch), with its Egyptian doorways, combined the clarity of Neo-classical, galleried basilican plans with details suggesting the Near East. Examples in Egyptian style were also erected at the Mikveh Israel Synagogue (1825, by William Strickland) in Philadelphia and at Hobart in Tasmania (1843).

Large cupolas and domed basilicas were rare before the mid-19th century, although the Kal Grandi at Sarajevo dates in its present form from 1821. Domed synagogues with a Greek-cross plan, the Byzantine origin of which connected synagogues in the West with the eastern Mediterranean origin of Judaism, were widespread in Europe and North America in the late 19th century and the early 20th. The placement of women's galleries in the cross-arms and nave meant that the congregation was unified in a compact space.

Islamic or Moorish details, often drawn from widely published images of the Alhambra at Granada, were introduced at Ingenheim (1834, by Friedrich von Gärtner) and Speyer (1837, by August von Voit) and became widespread in Germany, for example at Cologne (1861, by Ernst Friedrich Zwirner) and in the Oranienburgerstrasse Synagogue (1859–66; interior destr. 1938–45) in Berlin, designed by Eduard Knoblauch. By the 1870s, however, anti-Semitism made it politically unwise to appear exotic in the newly unified Germany. Elsewhere Moorish forms were adopted in Budapest for the Dohány Street Synagogue (1859, by Ludwig von Förster), the largest European synagogue still in use, and for scores of others, including the Altschul (1868) in Prague, designed by Vojtěch Ignác Ullmann (1822–97), and the synagogue (1874–82) at Florence by Vincenzo Micheli (1830–1905), Marco Treves (1814–97) and Mariano Falcini.

Eastern details, whether Byzantine or Moorish, continued to appear outside Germany, for example at Cincinnati in the thirteen domes and two minarets of the Plum Street Temple of Congregation B'nai Jeshurun (1866), designed by James Knox Wilson (1828–94), and at St Petersburg (1893, by Shaposhnikov). In Byzantine form they even

remained current in Germany until World War I. This usually entailed a broad, low dome and gold-touched detail related to the Arts and Crafts Movement, the Vienna Secession or Art Nouveau; an example is the imposing stone Steelerstrasse Synagogue (1911–13) at Essen, designed by Edmund Körner (*b* 1875). Other examples of this imperfectly defined style include the Friedberger Anlage Synagogue (1907) at Frankfurt, by Peter Jürgensen (*b* 1873) and Jürgen Bachmann ((*b* 1872), the Kazinczy Street Synagogue (1916) in Budapest, by Béla Löffler ((*b* 1880) and Sándor Löffler, Chicago's Temple Isaiah (1924), by Alfred S. Alschuler (1876–1940), who specialized in synagogue design, and the eclectic, flat-roofed Temple Emanu-El (1929) in New York, by Robert David Kohn (1870–1953), Charles Butler (1870–1953) and Clarence Stein (1883–1975).

Moorish art was both admired for its delicate detail and daring, slender supports and scorned for its luxurious decoration, which concealed much of the structure. It was considered to lack measure and 'honesty', faults that might be transferred to those who worshipped in Moorish synagogues. In addition, Eastern styles were associated not with piety and education but with theatres, entertainment venues and pleasure palaces, such as the Royal Pavilion (1815, by John Nash) at Brighton (for illustration *see* BRIGHTON), the dome of which nevertheless served as the model for the Oranienburgerstrasse Synagogue. However, Jews accepted the style if they hoped to celebrate their ethnic and religious differences without fear of discrimination in the modern, enlightened world, or if they succumbed to the suggestions and prejudices of Christian architects.

The few Jewish architects in Europe, especially those in Germany, and the most politically sensitive Jewish clients and Christian architects tended to promote Romanesque as a style that could help to integrate the Jewish minority with its Christian neighbours and be considered appropriate historically, since Romanesque came before Gothic, as Judaism had preceded Christianity. At Dresden, for example, the Romanesque façade of the synagogue (1838–40; building destr. 1938) by Gottfried Semper disguised a lavish interior that combined Byzantine forms and Moorish decoration (see fig. 10). Such architects as Albrecht Rosengarten (1809–93) and EDWIN OPPLER, who were the most widely employed German Jewish architects, and Alfred-Philibert Aldrophe (1834–95), who designed the Rue de la Victoire Synagogue (1874) in Paris, understood that their clients and the public would not approve of Jews using the 'morally superior' Gothic, even though genuine Gothic synagogues could be seen in Prague (see above) and elsewhere. Most of the few experiments in Gothic forms appear inside rather than on the exterior, where the Christian public might disapprove, and date from the 1830s, before public attitudes became rigid. Synagogue architects in North America, however, and apparently also Australia, were less constrained by European nationalist ideology and freer in their choice of styles.

Although some attempts were made before *c.* 1850 to link synagogue designs, usually those showing Egyptian influence, to reconstructions of the Temple at Jerusalem (*see* §(i)(c) above), in Europe and the USA the Temple was seldom used as inspiration for form or exotic style,

10. Dresden synagogue, interior, by Gottfried Semper, 1838–40; destroyed 1938

although enthusiastic rabbis and writers sometimes found analogies. Some synagogues incorporated two columns that recalled those named Jachin and Boaz (1 Kings 7:15), while commentators might connect a forecourt with the courts of the Temple and note similar details. Both rabbis and laymen, however, knew that the Temple was a unique holy site for the offering of sacrifices by a caste of priests, whereas synagogues were for prayer, study and community activities led by a teacher (rabbi): it was therefore correct to keep the two building types apart.

Classical styles were little used for synagogues until a period of Renaissance Revival around 1900. To the generation of 1830, classical styles had seemed outmoded, and many historicist architects considered that their connection with paganism made them inappropriate for Judeo-Christian architecture. Some Jews further eschewed Renaissance styles since that period was associated with such calamities as the expulsion of Jews from Spain (1492) and Portugal (1496), and Pope Paul IV's issue of the bull *Cum nimis absurdum* in 1555, which institutionalized closed ghettos throughout the papal territories. By *c.* 1900, however, it was possible to consider classical styles as neutral, enduring refuges from other historicist styles. Synagogues could safely be associated with the classical mainstream of Western culture, for example at the Shearith Israel Synagogue (1897), New York, by Arnold William Brunner (1857–1925), the Kottbuser Ufer Synagogue (1916, by Alexander Beer) in Berlin, and at least 13

synagogues that were built in Illinois between 1898 and 1925.

In some synagogues of the Reform movement in Ashkenazi Judaism, liturgical additions and customs considered alien to original Judaism were cleared away, resulting in an effect that more closely resembles Protestant churches (*see* CHURCH, §IV, 4). In Reform synagogues, known as temples, the *bimah* was moved closer to the ark, producing a composition resembling that of the pulpit and altar in churches, and seating was arranged in rows facing east. Screens and barriers on the women's galleries were lowered to foster community and family unity.

Despite the greater number of large, urban synagogues, most congregations continued to worship in small buildings or simply in rooms. The most traditionally pious Jews tended to be indifferent to architectural beauty: when strictly Orthodox communities erected a significant building, such as the Art Nouveau Rue Pavée Synagogue (1913, by Hector Guimard), Paris, it was usually the gift of a single wealthy congregant.

After c. 1918. Historicist styles gradually disappeared after World War I. The synagogues at Jacob Obrechtplein (1928) in Amsterdam, designed by Harry Elte (1880–1945), and at Hendon (1935), north London, were influenced by the shifting planes of Cubism. The synagogue at Plauen (1930; destr.), by Fritz Landauer (*b* 1883), was a chaste example of the International Style. A desire for formal simplification and an end to nationalist connotations is apparent in the synagogue (1928–31) by Peter Behrens at Žilina, Slovakia, the Oberstrasse Synagogue (1931) in Hamburg, by Felix Ascher (1883–1950s or later) and Robert Friedmann, and in examples in Paris, Prague and the northern suburbs of London.

The catastrophic destruction of Jews and their synagogues between 1933 and 1945 necessitated the rehabilitation of the remains in cities where Jewish communities survived or were reconstituted after World War II. Some have been used regularly, such as the Nozyk Synagogue, the sole surviving synagogue in Warsaw, while others, including those at Worms, Amsterdam and Kraków, are essentially museums, even if they have been reconsecrated. Those built in Europe since 1945 sometimes reflect Jewish population movement to the suburbs, for example in the principal British cities or, especially in Germany and the Netherlands, where it was necessary to replace those that had been vandalized or bombed. The small Liberal wing, which permits family or mixed seating, has promoted new building in Amsterdam and Paris using simplified modern styles, with smooth walls and an emphasis on geometric forms. Earlier plans are sometimes imitated, as in the galleried basilica (1958) by Claude Meyer-Lévy (*b* 1908) at Strasbourg. Centralized plans are often used, which might be polygonal (e.g. Frankfurt am Main, 1986), circular (e.g. Belfast, 1964, by Yorke, Rosenberg and Mardall), hemispherical (e.g. Essen, 1959, by Dieter Knoblauch (*b* 1928) and Heinz Heise (*b* 1927)) or a domed oval, as at Düsseldorf (1958), by Hermann Guttmann (1917–77). The elongated polygonal synagogue at Livorno (1958–62, by Angelo di Castro), with its prominent ribs and panels of curved concrete, dramatically asserts the survival of Jews

in a city where they had been protected from the Renaissance until late in the Fascist period.

Post-war European synagogues occasionally incorporate symbolic forms. The hexagonal synagogue (1971) at Karlsruhe, for example, has angular forms that suggest the points of the Star of David, like that seen in the central skylight of the principal room. The Darmstadt synagogue (1988, by Alfred Jacoby (*b* 1950)) is faced with large blocks that recall the stonework of Jerusalem, and its three domes also suggest characteristic forms of the Holy City. A wall in front of the Rotterdam synagogue (1956), by Jacob Beers (1886–1956) and Jan van Duin, was similarly intended to evoke the Western Wall. The façade of the Jewish Community Centre (1959, by Knoblauch and Heise), Berlin, incorporates elements from the Fasanenstrasse Synagogue (1912, destr. 1938), by Ehrenfried Hessel (*d* 1915), formerly on the site. In the 1990s, however, there were still few European architects who had tried to create a specifically Jewish style.

Although there have been substantial Jewish communities in Central and South America, there is little scholarly information on their synagogues. In North America, however, the construction of new synagogues continued at a rapid pace. Examples have been built by such prominent architects as Frank Lloyd Wright (Elkins Park, PA, Beth Sholom, 1954), Philip Johnson (Port Chester, NY, Kneset Tifereth Israel, 1956), Louis I. Kahn (Trenton, NJ, Jewish Community Center, 1964), Minoru Yamasaki (Glencoe, IL, Congregation Israel, 1964), Pietro Belluschi (Short Hills, NJ, B'nai Jeshurun, 1972) and ERICH MENDELSOHN, who built four synagogues in the 1940s and 1950s, including the Park Synagogue (1946–52; see fig. 11) at Cleveland, OH. Percival Goodman (1904–89) specialized in synagogue architecture in the 1950s and 1960s, for example at the B'nai Israel Synagogue (1951), Millburn, NJ. James Stewart Polshek (*b* 1930), Robert A. M. Stern and Norman Jaffe (1932–93) drew on research into historic synagogues. Jaffe's Gates of the Grove Synagogue (1987) in East Hampton, NY, for example, emphasizes the central *bimah* traditional in Ashkenazi Judaism. Its wooden walls and skylit gables are intended to recall the cascading roofs of Polish wooden synagogues.

The principal new tendency in post-war synagogue architecture has been to consider the prayer-hall as only one component, although the most prominent, in a larger community centre that may include a home for the aged or a social hall, kitchen and facilities for sports and parking. This makes it desirable to have movable seating and a plan that can be expanded or contracted as required. The community centre movement originated in North America and has gained in importance, especially in Great Britain (e.g. Brighton), France, Germany, Belgium and the Netherlands.

BIBLIOGRAPHY

R. Krautheimer: *Mittelalterliche Synagogen* (Berlin, 1927)

R. Wischnitzer: *Synagogue Architecture in the United States* (Philadelphia, 1955)

M. Piechotka and K. Piechotka: *Bóznice drewniane* [Wooden synagogues] (Warsaw, 1957; Eng. trans., Warsaw, 1959)

R. Meier, ed.: *Recent American Synagogue Architecture* (New York, 1963)

R. Wischnitzer: *The Architecture of the European Synagogue* (Philadelphia, 1964)

J. Gutmann, ed.: *The Synagogue: Studies in Origins, Archaeology and Architecture* (New York, 1975)

Faith and Form: Synagogue Architecture (exh. cat., Chicago, IL, Maurice Spertus Mus. Jud., 1976)

H. Hammer-Schenk: *Synagogen in Deutschland: Geschichte einer Baugattung im 19. und 20. Jahrhundert, 1780–1933*, 2 vols (Hamburg, 1981)

Il centenario del tempio israelitico di Firenze: Atti del convegno: Firenze, 1982

E. Bergman and R. Brykowski: 'Drewniana synagoga: Z problematyki badań nad drewnianą architekturą sakralną w Polsce' [A wooden synagogue: studies of wooden religious architecture in Poland], *Ochrona Zabytków*, xxxvi/1–2 (1983), pp. 112–17

G. Reinisch Sullam: *Il ghetto di Venezia: Le sinagoghe e il museo* (Rome, 1983)

Synagogen in Berlin: Zur Geschichte einer zerstörten Architektur, 2 vols (exh. cat. by V. Bendt and others, Berlin, Berlin Mus., 1983)

H. Kuenzl: *Islamische Stilelemente im Synagogenbau des 19. und frühen 20. Jahrhunderts* (Frankfurt am Main, 1984)

J. F. van Agt and E. van Voolen: *Nederlandse synagogen* (Weesp, 1984)

C. H. Krinsky: *Synagogues of Europe: Architecture, History, Meaning* (Cambridge, MA, 1985, rev. New York, 1996)

S. Levitt, L. Milstone and S. T. Tenenbaum: *Treasures of a People: The Synagogues of Canada* (Toronto, 1985)

A. Sacerdoti: *Guida all'Italia ebraica* (Genoa, 1986)

P. Genée: *Wiener Synagogen, 1925–1938* (Vienna, 1987)

V. Gotovac: *Sinagoge u Bosni e Hercegovini* (Sarajevo, 1987)

J. Hahn: *Synagogen in Baden-Württemberg* (Stuttgart, 1987)

M. Piechotka and K. Piechotka: 'Polish Synagogues in the 19th Century', *Polin*, ii (1987), pp. 163–98

G. Visentini: *Il ghetto vecchio di Padova e le sue sinagoghe* (Padua, 1987)

T. Altaras: *Synagogen in Hessen: Was geschah seit 1945* (Königstein im Taunus, 1988)

H.-P. Schwarz, ed.: *Die Architektur der Synagoge* (Frankfurt am Main, 1988)

Die Synagoge an der Friedberger Anlage, Frankfurt (Frankfurt am Main, 1988)

A. Gazda and others: *Magyarországi zsinagógák* [Hungarian synagogues] (Budapest, 1989)

CAROL HERSELLE KRINSKY

(b) *Elsewhere*. Unlike in the West, where stone architecture lasted for generations, buildings in Asia and North Africa were made of wood, bricks and other materials that did not stand up to the ravages of time. Despite the objections of religious authorities, especially in Islamic countries, Jews could always renovate or rebuild their synagogues, often thanks to the good offices of some liberal ruler, compassionate judge or profiteer. As these buildings lasted no more than 100–150 years, their architectural history and development are hard to trace. However, because features of crumbling old buildings were

11. Park Synagogue, Cleveland, OH, by Erich Mendelsohn, 1946–52

12. Ben Ezra Synagogue, Cairo, interior, 12th century, reconstructed 20th century

often incorporated into new ones, rebuilt edifices reflect their predecessors with some accuracy.

The exceptionally hot climate common in many Eastern countries has given rise to a phenomenon unknown in the West: the open-air synagogue, dating from the time of the Mishnah and the Talmud (AD 70 to the end of Byzantine rule in AD 638). They occur, in different places and from different periods, throughout the Mediterranean basin and Central Asia. One reason for their existence was climate; another was Muslim religious proscriptions. The ways of life in the countries of these regions also affected the nature and design of their synagogues, which were used not only for religious gatherings but also for public, social, educational and cultural encounters. Often such synagogues served small, poor communities who had neither the means nor the desire to impress their neighbours with opulent, ostentatious buildings.

Syria. The Babylonian Talmud (*c.* early 3rd century AD–late 5th; Tractate Bava Batra 3) mentions two sages, Merimar and Mar Zutra, who at the end of winter demolished the 'winter synagogue' and built a 'summer synagogue', and at the end of the summer did the reverse. In Aleppo, a synagogue survives from the 6th century AD. A Christian traveller who visited it in 1625 described the structure, which was known for its beauty and antiquity,

as 'an unroofed yard. . . To the right is a large hall of sorts that is used for prayer in winter, when it is cold or raining, just as the large courtyard is used for prayer on days when the weather is fair.' The complex continues to be known as the summer synagogue and the winter synagogue. A *bimah* stands in the middle of the courtyard; there are three small sanctuaries (*hekhalot*, sing. *hekhal*; 'holy place') at the southern end. The roofed part is strongly reminiscent of the Jewish basilicas that served as synagogues in Talmudic-era Palestine. It is clear, however, that open-air synagogues existed much earlier.

Iraq. In Iraq (formerly Babylonia) a unique type of synagogue design occurs, modelled on the ancient synagogue of Baghdad, Salaat al-Kabiri, which, according to folk legend, dates from the time of the exile of Jews to Babylon (6th century BC) and was built from earth that Yehoiakhin, King of Judah, had brought with him from Jerusalem. Because this synagogue was built of loam and bricks, it fell into ruin periodically and had to be rebuilt. Its last renovation, in 1855, emulated the previous structure, and the synagogue may well be a reasonably faithful replica of its forebear.

Most synagogues in Iraq followed the same pattern as the Salaat al-Kabiri: a large, square, unroofed courtyard, in the middle of which rested a wooden *tevah* (pulpit), shaded by a roof supported on pillars. The courtyard was surrounded by small sanctuaries with vaulted brick roofs. Each such compartment had three walls, around which was a ledge on which members of the congregation sat; the fourth side opened on to the courtyard. In each sanctuary, the exterior wall that faced west had internal niches where precious Torah scrolls were kept. The middle sanctuary in the wall facing west, the *kneset ha-hekhal*, was the main sanctuary, where the president of the community sat. It had three niches for storing scrolls of the Law.

The rear (eastern) sanctuaries and the rear sections of the northern and southern sanctuaries were partitioned into two floors, the lower one for men and a gallery for women. When the number of women present exceeded the capacity of the women's gallery, some of the women would climb to the synagogue roof. The roof was even used by the Rabbi as far back as the Talmudic period. Indeed, the congregation used all parts of the building according to convenience. The courtyard not only provided fresh air and shade but also created space for large gatherings, while the halls offered space and privacy for small groups. On Jewish festivals, the small prayer groups crowded around the central *bimah* and merged into one large congregation.

Central Asia. The same scheme occurs in Central Asia, especially in Kurdistan, where the sanctuaries surrounding the courtyard are exedrae, with wooden beams supporting timber roofs. These sanctuaries are not separate units, such as are found in Iraq, but continuous; the circumferential wall is punctuated with niches where the Torah scrolls are kept. The worshippers sat on rugs on the floor. Because building materials in Kurdistan are flimsy and easily replaced, synagogues were repeatedly demolished and rebuilt. Some of the courtyards were roofed over in the 20th century, although the sky was still visible through a glass roof over the *tevah*.

Most synagogues in the region are of relatively modern construction and display European influences. Some ancient synagogues in Afghanistan have an essentially Byzantine layout, with four large arches juxtaposed at right-angles, demarcating a square space roofed with a pointed dome. In other cases, the open area is bisected by two large, flat, pointed arches, with an elongated dome overhead. The wooden *bimah* stands either in the middle of the hall or in front of the western wall. In a separate room within this wall is housed the ark, in which the Torah scrolls are stored. In early times, before Western influence was felt, these synagogues, like those in Iraq, had a spacious, multi-purpose courtyard with a *bimah* in the middle, where prayer services were evidently held on hot summer days.

East Asia. Jewish merchants of Spanish descent (Sephardim) travelled to mainland South-east Asia from the Netherlands and Italy in the 17th and 18th centuries, and the basilican design of their synagogues recalls Sephardi-Portuguese synagogues in the West. One side contains the ark; a raised women's gallery runs round the other three sides. The ark, the ceilings and the latticework in the women's gallery are embellished with floral ornamentation that strongly resembles that of East Asia and India. In the rear of the women's gallery is a balcony, effectively a raised rear *bimah*, that protrudes into the men's gallery. A similar feature occurs in synagogues in France (Provence) and Turkey, two countries to which Jewish émigrés gravitated after the Spanish expulsion of 1492.

A perspective depiction of the ancient synagogue in Kaifeng, China, drawn by the Jesuit priest Jeane Domenge in 1722, shows a prayer house with a Chinese-style façade and an interior consisting of a main hall and two wings, partitioned by rows of pillars. The *tevah* in the middle of the hall is shaped like a pagoda and resembles a small shrine; the ark at the western end is also modelled after a pagoda. Shelves in front of the *tevah* and the ark at the entrance side are evidently for the placing of gifts, following the Chinese practice.

North Africa. The oldest synagogue site in North Africa is that of Fustat (Old Cairo), which evidently functioned as a Malachite church until the 9th century; the church was abandoned and was bought by the Jews. The original building was demolished; the extant building, an early 20th-century reconstruction, is a basilican synagogue with a women's gallery on three sides. The layout strongly resembles that of Coptic or Early Christian churches, such as the structure in nearby Muallaka. Travellers' accounts suggest that the original synagogue was much like early synagogues and churches in the Galilee, with which it was roughly contemporaneous.

In Tunisia nearly all synagogues were characterized by a spacious peristyle at the front of the synagogue hall. The structure itself was basilican, with overhead illumination from a clerestory. An example is the Khara-Zrira Synagogue in Djerba. In some cases, for example at the Great Synagogue in Tunis and the Khara-Kbira in Djerba, the pillars and arcades were positioned in transverse fashion instead of facing the ark. The large peristyles, where worshippers evidently sat, were roofed over at some later time, forming closed halls, although small, patio-type

central courtyards were sometimes left to admit light. The *bimah* in Tunisia and Algeria was usually situated at the rear of the synagogue hall and was almost always flush with the rear courtyard, suggesting that the courtyard itself was a complementary feature in the synagogue; when the courtyard was used to enlarge the synagogue for services in the spring and summer, the *bimah* became a central element in the entire complex.

In Morocco, too, the *bimah* was placed in the rear of the hall, as at the Ibn-Denan Synagogue in Fez, the Shalom Azawi Synagogue in Rabat, the Rabbi Yaakov Bibas Synagogue and the Rabbi Yaakov Ashraf Synagogue in Salé, the Haheqdesh Synagogue in Marrakesh and most synagogues in Tangier and Tetouan. The practice of placing the *bimah* in the rear of the hall, although not necessarily adjacent to the courtyard, is found in areas where Spanish exiles settled, such as Morocco, Turkey and Italy, and thus probably originated in Spain, even though only one conspicuous example exists in Spain itself (in Córdoba). In Morocco, most commonly in the Atlas Mountains area, a square or rectangular type of synagogue is found, with four or more heavy pillars in the middle bearing a raised ceiling, creating an elevated clerestory. The *bimah* is situated in an enclosed area between the pillars, and light pours in through windows under the raised ceiling. Most of these are primitive mortar-and-brick structures that have fallen into near-total ruin. Examples are the Rabbi Simeon ben Yohai Synagogue in Tiznit, prayer houses in Ifran and Tillin, the Asaka synagogue, the ancient synagogue of Tahala and the two synagogues in Taroudant. This four-pillared synagogue model also occurred frequently throughout Ottoman Turkey, for example in the Yambul Synagogue in Istanbul and the Bikkur Holim (*see* §(a) and fig. 8 above) and Shalom synagogues in Izmir; it seems to have originated in the Iberian peninsula, the oldest example being the medieval synagogue in Tomar, Portugal. Many synagogues in North Africa, with basilican features and European façades, were built under the influence of the European Jewish Enlightenment (Heb. Haskalah; 1770s–early 1880s).

A synagogue of unique design is the Capusi in Cairo, a transverse bipolar structure in which the two poles, the *tevah* and the ark, are positioned very close to each other on opposite walls. A towering dome spans the void between them. Worshippers sit in wings on either side of the axis between the *bimah* and the ark. This plan is similar to that of synagogues in Italy, such as those of Padua or Mantua, which date from the late 17th century or the early 18th, and the design of which attests to the influence of Lurianic cabbala (the esoteric teachings of Judaism as expounded by Isaac Luria (1534–72)), incorporating elements of the cabbalistic Tree of Life.

Yemen. Yemenite synagogues resembled those elsewhere in the East in structure, but they had some features peculiar to the region. The courtyard walls, which were attached to the synagogue façade, had small niches in which worshippers placed their shoes, following the Yemenite custom of entering the devotional chamber barefoot. Beside the *tevah*, which was not elevated, was a ledge

where children could read their Torah portion. Worshippers sat on rugs on the floor.

Palestine. In Palestine, from the time of the conquest of Jerusalem by Salah al-Din in 1187, the Muslim rulers refused to allow adherents of the 'protected' faiths—Christianity and Judaism—to build new devotional structures; it was not until after the peasants' rebellion (1831–2) during the tenure of Ibrahim Pasha (1789–1848) that the Jews were allowed to enclose their synagogues. Open-air synagogues were thus built from the 16th century onwards, as permitted by Islamic law; other places of worship consisted mainly of residential or other structures pressed into service. The Ramban or Nahmanides Synagogue in Jerusalem, for example, was originally a stable and is accordingly narrow and poorly lit, partitioned by a row of pillars along the central axis.

Other synagogue buildings in Palestine had four central pillars and a dome, for example the Ashkenazi Ari Synagogue and the Abohav Synagogue, both in Safed, and the Avraham Avinu Synagogue in Hebron. The Hurva Synagogue in Jerusalem, completed in the mid-19th century, was built on four pilasters, over which soared a large dome carried by four massive pendentives; this design was characteristic of Byzantine areas until the late 19th century. The Hurva was designed, at the request of the Sultan, by the architect Assad Effendi, who had been commissioned to renovate the buildings on the Temple Mount. The Hasidic Tif'ereth Yisrael Synagogue in Jerusalem, built at the same time as the Hurva, is a cubic structure covered by a spherical dome evidently designed by a German architect who followed European principles. Other synagogues consist of transverse rectangles with ceilings borne on arches that are perpendicular to the axis of the prayer-hall (e.g. the Alshekh Synagogue in Safed) or parallel to the axis (the Rabbi Joseph Caro Synagogue, also in Safed). All of these, with the exception of Alshekh, were rebuilt after the earthquake of 1837, and their previous appearance is hard to ascertain.

BIBLIOGRAPHY

A. J. Butler: *Ancient Coptic Churches of Egypt*, 2 vols (Oxford, 1884)
A. Dotan: 'Le-toledot beyt ha-kneset ha-qadmon be-Haleb' [On the history of the ancient synagogue in Aleppo], *Sefunot* (1957), pp. 25–61
I. S. Emmanuel: *Precious Stones of the Jews of Curaçao* (New York, 1957)
D. S. Sasson: *Masa' Bavel* [Journey to Babylonia] (Jerusalem, 1965)
Y. Pinkerfeld: *Batey kneset be-Africa ha-tsefonit* [Synagogues in northern Africa] (Jerusalem, 1974)
The Jews of Konkan (exh. cat. by D. Luxemburg, Tel Aviv, 1981)
The Jews of Kurdistan, Orakh Hayyim, Tradition and Art (exh. cat. by O. S. Beeri, Jerusalem, 1981–2)
M. Pollak: *The Jews of Kaifeng* (Tel Aviv, 1984)
D. Cassuto: *The Rabbi Haim Capusi Synagogue* (Jerusalem, 1987)
——: 'Batey ha-kneset ha-rabbaniuim be-Kahir' [The rabbinic synagogues in Cairo], *Toledoth yehudey mizraim ba-tekufa ha-Otomanit, 1517–1914* [The history of the Egyptian Jews in the Ottoman era, 1517–1914] (Jerusalem, 1988)
Z. Hanegbi and B. Yaniv: *Afghanistan: Beyt ha-kneset ve-ha-bayit ha-yehudi* [Afghanistan: the synagogue and the Jewish home] (Jerusalem, 1991)
Z. Yehuda: *Ma'avaqam shel yehudey Bavel 'al ha-shelita be-qever Yehezqel ha-navi be-'kefel' be-elef ha-sheni la-sefira* [The struggle of Babylonian Jewry for control of the tomb of the prophet Ezekiel in the Kefel in the second millennium C.E.] (Or Yehuda, 1991)
J. Zack: *The Synagogues of Morocco* (New York, 1993)
D. Cassuto: 'La meschita di Palermo', *Architettura judaica in Italia: Ebraismo, sito, memoria dei luoghi*, ed. R. La Franca (Palermo, 1994), pp. 29–39

DAVID CASSUTO

2. SECULAR. The ISRAELITES were settled in Palestine by the end of the 13th century BC, but it is difficult to identify any of their structures before the kingdom of David and Solomon in the 10th century BC. A particular type of domestic house, built of field stones or of stone footings with mud-brick superstructures, according to local resources, was common from *c.* 1200 BC until the 6th century BC. A small courtyard, entered by a single doorway, gave light and access to a room or rooms of varying size on two sides and a long room at the back, sometimes divided into two. Those on one or both sides of the courtyard were often divided from it by a row of pillars instead of a solid wall. The narrow rooms (w. 1.0–2.5 m) could be roofed with readily available timber (tamarisk, acacia, juniper). A few houses had stone exterior staircases, and it is likely that ladders led from the courtyard to an upper storey or the flat roof. Baking and other domestic activities took place in the courtyards by day, and animals were penned in the side rooms at night, while the end rooms or those upstairs were the living-quarters. The distribution of this four-room house plan, often described unsatisfactorily as the 'Israelite house', exceeds the bounds of ancient Israel. Some scholars argue that it was derived from a nomadic tent with an enclosed space in front. In small towns the houses were built side by side, the back walls of the long rooms sometimes doubling as the settlement's defensive wall, and the fronts forming concentric streets. Other streets ran at right angles across the built-up area.

Larger buildings found at some sites (mainly 9th and 8th centuries BC) were official quarters. Although little of the walls of two so-called 'palaces' (10th century BC; Stratum VA-IVB, nos 1723, 6000) at MEGIDDO have survived above ground level, their plans can be interpreted as derived from the Syro-Hittite *bit hilani* plan, with a pillared portico entrance, a reception hall behind and a staircase well (*see* SYRIA-PALESTINE, fig. 6b). At SAMARIA in the 9th and 8th centuries BC the acropolis, which eventually occupied 179×89 m, was enclosed by a casemate wall on three sides. One of the buildings within was probably the palace and may have followed the *bit hilani* plan; others were for storage or administration. At both sites, and at Ramat Rahel, important buildings were adorned with rectangular stone pillars, free-standing or attached, with proto-Aeolic capitals, perhaps based on stylized palm trees. The lower levels of the walls were of ashlar masonry, giving a more compact and stable structure than undressed stone. The outer faces were dressed around the margins only for the foundation courses and laid in patterns of headers and stretchers. The walls were probably plastered. Sometimes the ashlar courses rose considerably above ground-level, while elsewhere there were only a few courses, with mud-brick above. Less prestigious buildings might have ashlar masonry at the corners and as piers at intervals in fieldstone walls. Wooden beams could be laid horizontally between the stone courses, perhaps to introduce elasticity to counter the effects of earthquakes. Ashlar masonry was used in Israel as early as the 10th century BC, and proto-Aeolic capitals may have been introduced then; certainly both were in use in the 9th century BC. They are also found in neighbouring countries, but their origin remains uncertain. Sites where Phoenician craftsmen

worked in southern Syria and Lebanon are little known, but it is significant that Solomon hired Phoenician stone cutters to work in Jerusalem (1 Kings 5:18).

The Palace-Fort at LACHISH was raised well above the town on a great stone podium (37×76 m), built in stages. The original palace (late 10th century BC) was extended by additions along two sides of a large courtyard entered through a six-chambered gate, but the whole is badly ruined. A series of casemate rooms at Ramat Rahel enclosed a partly built-up but badly ruined area where pieces of two stone balusters were found, originally from windows or balconies, carved with volutes and palmette capitals resembling the 'woman at the window' ivory-carvings (9th–8th century BC) from Arslan Tash, Nimrud, Khorsabad and Samaria.

Oblong buildings divided lengthwise by two rows of parallel pillars stood within the Lachish Palace-Fort and at Megiddo, Hazor (see HAZOR, §2) and such smaller sites as Tel Beersheba. The term used to describe them at Megiddo, 'stables', remains in use, although it has been shown that they were more likely storehouses for taxes paid in kind and held for the king as provisions for his officials and forces. The design is simple and practical: donkeys could be led along the central aisle for loading or unloading, tethered to stone pillars and fed from the stone troughs found in some examples.

Most towns had a defensive wall, sometimes incorporating house walls (see above). Casemate walls (e.g. Hazor, Tel Beersheba) and solid walls with towers (e.g. Megiddo, Lachish, Jerusalem) presented formidable bulwarks: the Broad Wall in Jerusalem, for example, is 7 m thick at the base, and part of a tower still stands 8 m high. One style of fortified gateway (10th century BC), known at Ashdod, Gezer, Hazor, Lachish and Megiddo, had a pair of towers flanking the passage with three chambers behind each, lining the road (see MILITARY ARCHITECTURE AND FORTIFICATIONS, fig. 3); those at Gezer, Hazor and Megiddo are often associated with Solomon's works (1 Kings 9:15). Styles with one or two chambers existed earlier and later than the three-chambered variety. A small shrine stood next to the four-chambered gate at Tel Dan (perhaps as early as the 10th century BC), with two round socles carved in a Syrian pattern. Special forts designed to protect southern Judah were simple circular enclosures of casemate rooms, or occasionally rectangular with corner towers. More solid fortresses commanded regions around Arad, east of Beersheba, and Hurbat Rosh Zayit on the edge of the hills inland from 'Akko in the north. The heavily walled rectangular fortress at Tel Arad enclosed various rooms and a shrine (see §1(i)(b) above).

A different design of official residence was introduced after Israel was absorbed into the Assyrian empire (720 BC). The rooms were arranged around a courtyard, with a reception suite, perhaps based on the bit hilani plan, at one side. There were at least two of these 'Assyrian open-court buildings' at Megiddo, and at Hazor there was one in the citadel and one outside the city (Ayyelet Ha-Shahar). They were in use from the late 8th century BC until Persian times (after 539 BC). A comparable example at Lachish was built a little later, to a slightly different plan.

The buildings of ancient Israel were functional, making good use of local materials, but were of little originality in design or motifs. The biblical description of Solomon's palace in Jerusalem (1 Kings 7:1–12; see JERUSALEM, §II, 1(i)) cannot be verified from any material remains, but it accords with evidence from elsewhere in the Ancient Near East and was designed to display the majesty and wealth of the king.

BIBLIOGRAPHY
Y. Shiloh: 'The Proto-Aeolic Capital and Israelite Ashlar Masonry', Qedem, xi (1979) [whole issue]
H. Weippert: Palästina in vorhellenistischer Zeit, Handbuch der Archäologie: Vorderasien, ii/1 (Munich, 1988)
A. Mazar: Archaeology of the Land of the Bible (New York, 1990)
A. Kempinsky and R. Reich: The Architecture of Ancient Israel (Jerusalem, 1992)

A. R. MILLARD

III. Funerary art.

1. Hellenistic and Roman. 2. Medieval and later.

1. HELLENISTIC AND ROMAN. During the Hellenistic and Roman periods (323 BC–AD 330) funerary art flourished among the Jewish people, in Israel as well as in the diaspora. In its style and techniques such art is generally akin to that found in other cultures. Nevertheless, such stylistic tendencies as schematism, symmetry and abstraction, as well as the variety of its ornamental motifs, at times absolutely aniconic, at times figurative and astonishingly syncretistic, distinguish it both from the art of other areas and from other forms of Jewish art.

During the Second Temple period (538 BC–AD 70) Jewish burial in Israel was practised in caves and rock-cut tombs consisting of one or more rooms with loculi excavated in their walls for individual burials. The entrance was small and almost undetectable. Some of the wealthiest families, however, adopting Hellenistic customs, decorated their tombs with monumental façades and massive tower-like monuments (nefesh). Four mausolea of this kind, called Absalom, Jehoshafat, Zechariah and Bene Hezir, survive in the Kidron Valley in Jerusalem; the first three probably date from the 1st century BC to the 1st century AD, the last from the Hasmonean period (c. 2nd century BC–37 BC). Absalom's nefesh is surmounted by an ashlar-built tholos, while that in Zechariah's tomb is decorated with Ionic half-columns supporting a pyramid. Two other tombs in Jerusalem had pyramids: the now reconstructed Jason's Monument and the tomb that, according to the Jewish historian Flavius Josephus (see Jewish Antiquities, XX.iv.3), belonged to the royal family of Adiabene (an ancient kingdom in upper Mesopotamia, c. 1st century AD). In this tomb the present façade retains only the remains of a portico in antis, decorated with a Doric frieze and a band of plant ornament. Other Jerusalem tombs are also decorated with beautiful façades, such as the so-called Tombs of the Sanhedrin and others to the north of the city.

The practice of secondary burial (liqut 'asamot) was adopted by Jews in Israel and in parts of the diaspora during the reign of Herod the Great and disappeared shortly after the destruction of the Temple (AD 70). Evidence survives in the form of thousands of stone ossuaries (Aramaic gluskema) found in the Jerusalem area and Jericho, many of them decorated with artistic carvings on their main faces. This decoration is wholly aniconic, consisting of a basic symmetrical and stylized scheme of

two or more rosettes filling metopes in zigzag or straight lines, and in between, plant or architectural motifs such as palm trees, gates and columns. The meaning of this iconography, partly borrowed from other cultures, is a matter of debate (see Rahmani, 1982, pp. 116–18; Figueras, pp. 78–86; Hachlili, pp. 111–13). Style and technique vary from one group of ossuaries to another, but in general they reflect Hellenistic taste and trends.

Hard-stone ossuaries sometimes had a high-relief decoration similar to that on stone sarcophagi. The latter were a privilege of the wealthiest, and their number is relatively small. During the Second Temple period their decoration, possibly borrowed from ossuaries, was also non-figurative, with schematic flower motifs appearing under garlands or in free rows (see Avi-Yonah, pp. 98–100, pls 15–24). Figurative decorations appeared only on the later sarcophagi from Beth Shearim (House [of the] Gates) and from Rome.

First-rank rabbis and other prominent Jews, not only from Israel but also from the eastern diaspora, were buried in this large complex of underground tombs in western Galilee, from the early 3rd century AD to the late 4th, when it was destroyed (see BETH SHEARIM). The site was rediscovered in 1875. A new trend in Jewish funerary customs and a more tolerant approach to visual art in general permitted the practice of decorating the soft limestone walls of the chambers and hundreds of stone sarcophagi not only with such typical Jewish symbols and motifs as the menorah (see fig. 13), the Torah shrine or

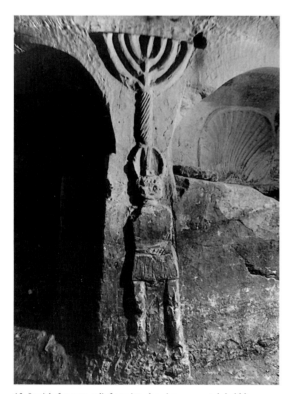

13. Jewish funerary relief-carving showing a menorah held by a man in a Roman legionary's tunic, Beth Shearim, Israel, 3rd–4th centuries AD

Holy Ark and the six-petalled rosette, but also with a range of figurative motifs. Among them were horse-riders, two lions facing a central motif (bullhead or ash-urn), human masks, eagles, single bullheads, fishes and two winged Victories holding a wreath. The pagan and superstitious character of most such motifs, and of others such as the frequent Hercules knot, is obvious, though this fact does not seem to have perturbed the Jewish community of that period: similar subjects also appeared on many synagogue lintels (for illustrations see Hachlili, pp. 199–218, 322–42 and pls 45–9). More surprising was the find, beside the rude local imitations of the Greco-Roman repertory, of fragments of imported marble sarcophagi decorated with Classical reliefs of such mythological stories as Leda and the Swan (for illustration see Avi-Yonah, pl. 38). A few lead sarcophagi of the Sidonian type were also found in Beth Shearim with a series of menorah ornaments.

Similar syncretistic tendencies are reflected in the paintings decorating the walls and ceilings of the underground cemeteries of the Jewish community in Rome, also dated to the 3rd and 4th centuries AD. The best-known of these Jewish catacombs were found in the Via Appia, Monteverde, at the Villa Randanini and the Villa Torlonia. The paintings are rather simple and non-figurative. At the Villa Torlonia geometric designs, stars or a central menorah decorate the ceilings, and the Torah shrine and menorah one of the arcosolia (arched niches over a tomb; for illustrations see Roth, figs 94–6). In the Via Appia, however, in the centre of a ceiling between plants and birds, is a winged Victory crowning a nude male figure (Roth, fig. 93). Painted pagan motifs have their parallels on sculpted sarcophagi found in the same Jewish catacombs, which bear reliefs of such motifs as a menorah in a medallion, flanked by two winged Victories, the Seasons and putti pressing grapes; elsewhere masks depict Jewish attributes, groups of playing putti, the Muse Urania, nude female Seasons and Horae, and other unidentified figures. In some cases the lid of a child's sarcophagus represented a funerary couch with the effigy of a boy (see Konikoff, pls 5–12, 16). Other finds in the catacombs include several glass cups with gilding on the inside, showing the Torah shrine flanked by lions and a double menorah with the usual attributes. Cups such as these were similar in style to those found in Christian catacombs and were probably connected with the funerary ritual.

PAU FIGUERAS

2. MEDIEVAL AND LATER. The oldest medieval Jewish tombstone was found in Narbonne, France, and dates from 668. A number of tombstones from the 13th and 14th centuries have been discovered in France, Germany, Austria and Bohemia. The tombstone of the liturgical poet Meshulam ben Kalonymus (d c. 1020) in Mainz is the earliest surviving Jewish tombstone in Ashkenazi Europe. The tomb of Alexander Wimpfen (d 1307) and of the famous rabbi whose corpse he redeemed from prison—Meir of Rothenburg (c. 1215–93)—are preserved in Worms.

Most medieval cemeteries failed to survive the destruction caused by the Crusaders (1096), the persecutions following the Black Death (1349), the ravages of wars and systematic pillaging during the Holocaust. Fragments of

the stones were converted into building material for churches or city walls. The early stones were decorated only with an inscription in Hebrew, sometimes with a eulogy containing information about the life and profession of the deceased. The form of the Ashkenazi tombstone remained essentially the same until well into the 19th century: a roughly hewn, often irregular oblong slab, usually with a rectangular top but capped rarely with a semicircle and exceptionally with a Gothic trefoil.

The only medieval Jewish cemeteries preserved *in situ* are those of Worms, Frankfurt and Prague. The famous cemetery in the confines of the old Jewish town in Prague contains some 12,000 tombstones, dated between 1439 and 1787. The earliest tombstones are rectangular and undecorated, the Hebrew text being carved within a frame, topped by a frieze. This style, with modifications, was used until the 16th century. Later in that century the impact of the Renaissance became noticeable: the text was surrounded by a cartouche or framed by an arch supported by half-columns with decorated capitals. Pinkish brown marble was often used instead of dark sandstone. The integrated tombstone was stylistically influenced by the late Renaissance and the Baroque. The Hebrew inscription is framed by columns and topped by an architectural or decorative pediment and with a smaller second storey containing an introductory text and a family or professional crest. This portal motif, familiar from church architecture and triumphal arches, also occurs on engraved Hebrew title pages and Torah curtains and may have added symbolic meaning. Tombstones of prominent persons were shaped to resemble actual houses or tents, the vertical stones forming the architectonic façade.

A simplified version of this form of vertical tomb became popular all over Bohemia and Moravia and, with variants, in Poland and the Pale of Settlement (Lithuania, Belarus', Ukraine). The decorations, sometimes painted in colour, are similar to those found on 18th-century ceremonial objects and in painted wooden synagogues in central Europe from southern Germany to Mogilev in Belarus', but they also exhibit features drawn from popular motifs in the host culture. The most common symbols are heraldic lions, blessing hands to indicate that the deceased was of priestly descent, and a basin and ewer to show that the deceased (thus a Levite) assisted the priests by washing their hands before they pronounced the Aaronite blessing in the synagogue. Personal or family names are often symbolized by animals: a goose for Gans, a bird for Feigele, a carp for Karpeles, a lion for Judah, Aryeh or Loeb, a deer for Naftali, Zvi or Hirsch, a bear for Dov or Beer and a wolf for Zeev or Wolf. Animals also illustrate the popular rabbinical exhortation to 'be strong as a leopard, light as an eagle, fast as a deer and heroic as a lion'. Similarly, crowns may appear, in reference to another rabbinical text: 'There are three crowns, the crown of Torah, the crown of Priesthood and the crown of Kingdom; the crown of Good Name excels them all.' The profession of the deceased may be indicated by an appropriate occupational symbol. On a woman's tomb candlesticks may be depicted, relating to her pious duty to light the Sabbath candles; pious men are associated with symbols of the Torah. More ancient iconographical motifs, such as the menorah and other temple utensils, emphasize

Jewish Messianic yearnings: the six-pointed Star of David became particularly popular after *c.* 1900.

The vernacular was first used in the pre-expulsion period (before the late 15th century) on the simple horizontal or vertical tombstones of Sephardi Jews. Famous examples are in the cemeteries of Ouderkerk near Amsterdam (1614), Altona near Hamburg (1611) and Curaçao in the Lesser Antilles (1668), where recumbent tombstones are often elaborately decorated with biblical scenes in relief, coats of arms and funerary symbols such as skulls, hour-glasses and mourning putti. Inspiration came mainly from contemporary Baroque art, particularly Christian Bibles. The Sephardi cemetery of San Nicolò di Lido near Venice (17th century), exceptionally, features no biblical episodes. The art of decorating tombstones developed in the 17th century and reached its peak around 1750, after which the Sephardim made simpler tombs of rectangular, horizontal stone slabs and sometimes prism-shaped tombs with virtually no decoration. Examples occur in the lands of the Ottoman empire in the 17th and 18th centuries. Economic prosperity is reflected in stones decorated with floral motifs and inscriptions in Hebrew and, increasingly, in Ladino, French and Turkish. Comparable tombs can be found in Morocco, where the graves of scholars became the object of veneration and pilgrimage.

By the end of the 19th century, the most prominent members of the rising Jewish bourgeoisie in the major European cities buried their dead under impressive funeral monuments or even mausolea, which reflect contemporary taste and only rarely carry Jewish symbols or even Hebrew inscriptions. Examples can be found in Vienna (Zentralfriedhof, 1863) and Berlin-Weissensee, which has been in use since 1880 and contains over 115,000 graves. Modern Jewish tombstones generally have no decoration and only a short inscription in both Hebrew and the vernacular. The development of Jewish funerary art has received rather less scholarly attention than the linguistic content of epitaphs. For example, architectural historians have largely neglected the many funeral halls at cemeteries, initially used by burial societies to prepare a corpse for the coffin and later as the place for the burial service. The same applies to memorials for Jewish soldiers who perished in World War I and the monuments erected in European cemeteries to commemorate the victims of the Holocaust.

See also §VI, 4(iv) below.

BIBLIOGRAPHY

H. W. Berger and H. Lietzmann: *Die jüdische Katakombe der Villa Torlonia in Rom*, Jüdische Denkmäler, i (Berlin, 1930)
E. R. Goodenough: *Jewish Symbols in the Greco-Roman Period*, 13 vols (New York, 1953–8)
N. Avigad: *Maṣavot qedumot be-naḥal qidron* [Ancient monuments in the Kidron Valley] (Jerusalem, 1954)
I. S. Emmanuel: *Precious Stones of the Jews of Curaçao* (New York, 1957)
E. Urbach: 'The Rabbinic Laws of Idolatry in the Second and Third Centuries in the Light of Archaeological and Historical Facts', *Israel Explor. J.*, iii (1959), pp. 149–65; iv (1960), pp. 229–45
H. J. Leon: *The Jews of Ancient Rome* (Philadelphia, 1960)
J. Gutmann, ed.: *No Graven Images: Studies in Art and the Hebrew Bible* (New York, 1971)
C. Roth: *Jewish Art: An Illustrated History* (London, 1971)
G. Sed-Rajna: *L'Art juif: Orient et occident* (Paris, 1975)

R. Weinstein: *Sepulchral Monuments of the Jews of Amsterdam in the Seventeenth and Eighteenth Centuries* (PhD diss., New York; microfilm, Ann Arbor, 1980)

M. Avi-Yonah: *Art in Ancient Palestine* (Jerusalem, 1981) [collected articles, originally pubd 1930–76]

L. Y. Rahmani: 'Ancient Jerusalem's Funerary Customs and Tombs', *Bibl. Archaeologist*, xlv (1982), pp. 109–19

P. Figueras: *Decorated Jewish Ossuaries*, Documenta et Monumenta Orientis Antiqui, xx (Leiden, 1983)

R. Hachlili: *Ancient Jewish Art and Archaeology in the Land of Israel*, 7/i/2/B of *Handbuch der Orientalistik* (Leiden, New York, Copenhagen and Cologne, 1988)

A. Konikoff: *Sarcophagi from the Jewish Catacombs of Ancient Rome* (Stuttgart, 1990)

A. Parik and J. Fiedler: *Old Bohemian and Moldavian Jewish Cemeteries* (Prague, 1991)

A. Nachama and H. Simon: *Jüdische Grabstätten und Friedhöfe in Berlin* (Berlin, 1992)

S. Sabar and others: *Revival: Rubbings of Jewish Tombstones from the Ukraine* (Jerusalem, 1992)

D. Goberman: *Jewish Tombstones in Bohemia and Moldova* (Moscow, 1993)

P. Steines: *Hunderttausend Steine: Grabstellen grosser Österreicher Konfession auf dem Wiener Zentralfriedhof* (Vienna, 1993)

L. Y. Rahmani: *A Catalogue of Jewish Ossuaries in the Collections of the State of Israel* (Jerusalem, 1994)

EDWARD VAN VOOLEN

IV. Wall paintings and mosaics.

1. Hellenistic and early Roman. 2. Late Roman and Byzantine. 3. 17th–20th centuries.

1. HELLENISTIC AND EARLY ROMAN. Few floor pavements and fragments of wall paintings have survived from the Herodian and early Roman period, before the destruction of the Second Temple (40 BC–AD 70); in those that do exist, local traditions such as *horror vacui* and stylization merged with Hellenistic and Roman characteristics and patterns, the dominance of one component over another depending on the extent of political and cultural resistance to the Hellenistic or Roman rulers. A third component was the Jewish tradition, which in this period seems to have prohibited figural representations. Early floor mosaics and wall paintings were therefore aniconic, though often with geometric patterns and floral motifs. Examples have been found in various Herodian palaces, for instance in Masada, Herodium, Caesarea, Jericho, Cypros, Alexandrium and Machaerus. Further examples have been unearthed in upper-class residences in the upper city of Jerusalem (e.g. a fragment from the 'hall of the mansion' in the Jewish quarter; Jerusalem, Israel Mus.).

2. LATE ROMAN AND BYZANTINE. In the late Roman period figural and narrative art became well established. The Talmud states that in the time of Rabbi Jochanan (3rd century AD) people began to adorn the walls of synagogues with pictures and that he did not object to the practice. The same story is told of Rabbi Abun (4th century) with respect to floor mosaics.

(i) Wall paintings. (ii) Mosaics.

(i) Wall paintings. In some synagogues of the Byzantine period (AD 324–629), mainly in the Galilee and the Golan, painted plaster fragments have been found that have geometric and floral motifs as well as symbolic images, such as the menorah in the Rehov synagogue. These paintings adorned walls and columns and were often combined with Aramaic or Hebrew inscriptions. Such

fragments have been excavated at Rehov (late 4th century AD–early 5th; *in situ* amd Jerusalem, Israel Mus.), Ma'oz Hayyim (5th–6th century), Hammath-Tiberias (4th century), Beth Alpha (6th century), Chorazim (4th century–early 5th) and Asselieh (5th century).

The discovery in 1932 of the elaborate wall paintings in the synagogue of Dura Europos, Syria (reconstruction in Damascus, N. Mus.; *see* DURA EUROPOS, §3 and fig. 2), dramatically changed the evaluation of Late Antique Jewish art, which until then had been considered to be mainly aniconic. The building was erected in its first stage shortly before AD 200 and restored in 244–5, when most of the wall paintings were created. It was built adjacent to the western city wall, and its western wall was reinforced with debris in defence against the Sasanian attack expected to come from the west. When the synagogue fell to the invaders in 256, the wall paintings on the western wall were thus preserved almost entirely and those on the southern and northern walls partly so, while those on the eastern wall were almost completely destroyed.

At the centre of the western wall is the focus of worship, the Torah shrine, adorned with decorative patterns. Various narrative subjects are depicted on the surrounding panels (see fig. 14). At the top of the shrine is a panel depicting temple implements and the sacrifice of Abraham. The decoration above this panel was overpainted twice in a modification of the iconography, which is related to the Messianic period. On one side of the central panels is a depiction of *Moses before the Burning Bush*; on the other, *Moses Receiving the Law*. This application of theophanic and Messianic themes to portrayals of Moses recalls similar arrangements in the apses of the Byzantine churches of San Vitale (*see* RAVENNA, §2(vii)) and St Catherine on Mt Sinai (*see* SINAI, §2(ii)). The synagogue walls are divided into five registers, the highest and lowest of which are decorated with animal, floral and decorative patterns. The other three registers contain narrative scenes from various books of the Old Testament.

Durene art typifies the merging of late Roman stylistic features with local, Eastern traditions. The imitation of *opus sectile* (a technique of cutting and setting stones to create a pattern; *see* ROME, ANCIENT, §VI, 1(i)) and the painted corner pilasters are Roman in character, and parallels can be found in two apartment buildings at Ephesos ('*Hanghäuser*'; see Strocka; see also Tronzo, pp. 36–7) discovered in the late 20th century. The Eastern influence manifests itself in frontality, static postures, expressionless faces, abstraction, hierarchic relations between the figures depicted, isocephaly, scenic division, landscape conventions and colour patterns. The costumes are partly Hellenistic, partly Sasanian. The Durene style has usually been regarded as eclectic and provincial, typical for a remote Roman garrison city at the periphery of the Empire and demonstrating fundamentally Asiatic characteristics. Late 20th-century scholarship, however (see Wharton), has challenged this view, claiming that Dura enjoyed a central trading position in one of the richest agricultural areas in the ancient world and was thus not marginal.

The imagery of almost every painting in the synagogue is strongly influenced by rabbinical literature. The panel depicting the childhood of Moses, for example, shows the

14. Wall painting depicting Aaron, the Temple, the Ark of the Covenant, menorah and sacrificial animals, from the west wall of the synagogue at Dura Europos, AD 244–5 (Damascus, National Museum of Damascus)

Pharaoh commanding the midwives to kill the Hebrew male newborn. The last scene of the sequence shows the infant Moses being handed over to his mother, in keeping with a Midrash (the Hebrew exposition of the Old Testament) relating that Moses' mother and sister appeared before the Pharaoh as midwives in order to save the lives of the infants. In appearance and costume, the two real midwives are identical to Moses' mother and sister. Indeed, the rich Midrashic background of all the paintings makes it clear that the community that commissioned them belonged to the mainstream of normative, rabbinical Judaism.

The panels do not relate biblical history in chronological order but seem to follow an iconographic programme, which has been the subject of scholarly discussion ever since the building was excavated, although some scholars (e.g. Rostovtzeff, Sukenik, Kraeling) question whether an overall programme existed. Du Mesnil de Buisson finds historical content in one register, liturgical in another and moralizing in the third. Sonne considers that the registers may reflect the rabbinical 'three crowns': Torah, priesthood and royalty. Wischnitzer interprets the programme as Messianic and Goodenough as mystical.

The character of the models of the narrative scenes is not determined. The possible existence of Jewish illuminated manuscripts in late Antiquity, some of which may have served as models for the wall paintings, has been suggested by some scholars (see Weitzmann and Kessler) but rejected by others. The scenes are depicted in a narrative style, probably reflecting that of illustrated manuscripts. Because the building itself existed for only 11 years, it cannot have had a direct influence on any other monument, but iconographic concordances between the Dura imagery and later Christian art have been repeatedly observed, and it may be that they share common Jewish models. Midrashic elements have been observed in Late Antique Christian works of art.

Wall paintings have also been uncovered in Jewish catacombs in Rome. The walls of two adjacent Jewish sepulchral chambers on the Via Appia are adorned with motifs borrowed from Classical mythology and from the repertory of Roman funerary art. A painting in the catacomb in the yard of the Villa Torlonia shows more specific Jewish imagery: an open Torah ark with rolls, two menorahs, further temple implements, the sun, the moon (symbolizing the calendar), a curtain above the ark and symbols related to the Jewish liturgical cycle. This programme is an expression of the belief that, since the destruction of the Temple, God's presence (*shekhina*) is resident in the synagogue. Certain eschatological elements represent the hope, distinctive in funerary art, that a new Temple will be erected in the Messianic period, which will also bring eternal life. The style and the technique of these paintings have much in common with those in other Roman catacombs. (*See also* §III above.)

(ii) Mosaics. Mosaic floors dating from the late 4th century AD to the 7th have been unearthed in Israel, some bearing ornamental patterns, others figurative and narrative depictions. Little is known about the mosaicists. In a Greek inscription in the synagogue BETH ALPHA, the names of the artists Marianos and his son Hanina are mentioned,

the latter indicating a Jewish origin. The two are believed to have come from nearby BETH SHAN, and their names also appear in the northern synagogue of that city, in one of the rooms added to the building during the 6th century.

The styles of these mosaic floors reflect prevailing contemporary styles. Early examples from the late 4th century and the early 5th, in Hammath-Tiberias and Ma'oz Hayyim, show a rich variety of ornaments executed in small tesserae, with much gradation of colour to give a three-dimensional effect. In later examples the range of colours is reduced, the tesserae are bigger and the patterns flatter. A group of floors from the 6th century bear medallions with various motifs, mainly animals (e.g. at Maon, Gaza and the southern synagogue of Beth Shan). Whether or not most of these floors were produced by one specific workshop in Gaza is still the subject of scholarly discussion. The floor in Beth Alpha is of interest for the way in which it reflects a preference for local, Eastern stylistic conventions: the figures are shown in frontal position, clearly outlined in intense black and lacking any conformity with the Classical canon of proportions.

The imagery of these floors includes biblical scenes, the zodiac and the well-established theme of the Temple implements. Among the biblical scenes are the animals in *Noah's Ark* (Gerasa, Jordan, 5th century), the *Sacrifice of Isaac* in Beth Alpha, *Daniel in the Lions' Den* in Na'aran (7th century, destr. but still identifiable by inscriptions) and *King David as Orpheus* in Gaza (6th century). As at Dura, the rabbinical tradition figures large in the iconography of these mosaics. The ram in the *Sacrifice of Isaac* panel is bound to a tree, reflecting a Midrashic tradition that had already appeared in the Targum (the Aramaic translation of the Bible and Aramaic portions of the Bible).

The zodiac theme, as at Hammath-Tiberias (late 4th century) and Beth Alpha, shows the wheel with Helios in its centre and personifications of the four seasons in the corners. The traditional assumption that these images represent merely cosmic symbolism and the calendar has been challenged, in the light of modern discoveries and research, and a tentative astrological interpretation could be considered.

The most common motif is the Torah ark flanked by menorahs and sacred objects related to the Jewish liturgical calendar and the Temple. These images express the Jewish concept of the synagogue as replacement for the Temple. The Torah ark is endowed with the formal and substantial features of the Ark of the Covenant, and, as inscriptions make clear, the synagogue is conceived as a 'holy site'.

Fewer ancient synagogues have been found in the lands of the diaspora than in Israel itself; consequently, only a small number of mosaic floors have been discovered. A

15. Wooden synagogue, painted and decorated by Eliezer Sussman from Horb, Baden-Württemberg, 1735; reconstruction (Jerusalem, Israel Museum)

pavement richly decorated with geometric patterns was found in the synagogue at Apameia, Syria (AD 392; *see* APAMEIA, §2; for a similar example *see* ROME, ANCIENT, §VI, 1(iii)(c) and fig. 95). Another, also of an iconic character, and adorned with geometric patterns, floral motifs and animals, was unearthed on Aigina in Greece. The only narrative mosaic, on a floor in Misis Mopsuestia, Turkey (5th century), shows Noah's Ark surrounded by animals; but whether this building was a church or a synagogue has not yet been determined.

3. 17TH–20TH CENTURY. There is a gap in Jewish figural painting between the 7th century and the 13th. The first narrative scenes appeared in 13th-century Hebrew illuminated manuscripts from Germany (*see* §V, 1(d) below). Written sources provide evidence of wall painting and other synagogue decorations from the medieval period, although no examples survive, and most rabbinic authorities seem to have permitted some painted images in synagogues. Between the 17th century and the early 19th a distinctive type of wooden synagogue, often containing wall paintings, developed in eastern Europe, particularly in Poland and parts of western Russia. Most of these buildings were destroyed during World War II. The richly decorated style was influenced on the one hand by Baroque painting and on the other by folk art. Archaic elements, typical more of the 15th century than of the 17th, are often present, for example in the synagogue (*c.* 1650) in Gwoździec (now Gvozdetz, Ukraine). The walls of these buildings were covered with ornaments, symbols, images from daily life and religious themes. The Isaac Synagogue (1640), in Kazimierz, Kraków, contained views of Jerusalem and Hebron, and the synagogue of Khodorov, Ukraine (1651), possessed a depiction of Jerusalem, framed by Leviathan and a tree, known to have been painted in 1714 by Israel ben Mordechai Lisnicki of Jaryczów. Temple implements often formed part of the decorations, as at Yablonov (1674), which also features a painting of an elephant with a tower. Fruits, flowers, vines, palmettes, birds and lions are common, as are zodiac signs, for example in the synagogue of Gwoździec and that in Targowica (*c.* 1800). Narrative themes are rare: an exception is the High Synagogue in Kazimierz, which has depictions of the *Sacrifice of Isaac* and *Noah's Ark*. Sinful biblical sites were sometimes represented, such as the depiction of *Babylon* at Grojec (destr. 1942) to illustrate Psalm 137. The wooden synagogue at Horb, Baden-Württemberg, with paintings and decoration (1735) by Eliezer Sussman, has been reconstructed in Jerusalem (Israel Mus.; see fig. 15).

See also §II, 1(iii)(a) above.

BIBLIOGRAPHY
M. I. Rostovtzeff: *Dura Europos and its Arts* (Oxford, 1938)
R. du Mesnil de Buisson: *Les Peintures de la synagogue de Doura Europos, 245–256 après J.-C.* (Rome, 1939)
I. Sonne: 'The Paintings of the Dura Synagogue', *Heb. Un. Coll. Annu.*, xx (1947), pp. 255–362
E. L. Sukenik: *Beth ha-knesset schel Dura Europos wetsiurav* [The synagogue of Dura Europos and its wall paintings] (Jerusalem, 1947)
R. Wischnitzer: *The Messianic Theme in the Paintings of The Dura Synagogue* (Chicago, 1948)
E. Goodenough: *Jewish Symbols in the Greco-Roman Period*, 13 vols (Princeton, 1952–68) [esp. vols 9–11]

C. H. Kraeling: *The Synagogue* (1956, rev. 1979), viii/1 of *The Excavations at Dura Europos: Final Report* (New Haven, 1943–)
A. Perkins: *The Art of Dura Europos* (Oxford, 1973)
V. M. Strocka: *Die Wandmalerei der Hanghäuser in Ephesos*, (1977) vii/1 of *Forschungen in Ephesos* (Vienna, 1906–)
J. Wilkinson: 'The Beit Alpha Synagogue Mosaic: Towards an Interpretation', *J. Jew. A.*, v (1978), pp. 16–28
M. Chiat: 'Synagogues and Churches in Byzantine Beit Shean', *J. Jew. A.*, vii (1980), pp. 6–15
J. Gutmann, ed.: *Ancient Synagogues: The State of Research* (Ann Arbor, 1981)
I. L. Levine: *Ancient Synagogues Revealed* (Jerusalem, 1981)
M. Dotan: *Hammath Tiberias* (Jerusalem, 1983)
E. Revel-Neher: *Le Signe de la rencontre: L'Arche d'alliance dans l'art juif et chrétien du second au dixième siècle* (Paris, 1984)
C. Krinsky: *Synagogues of Europe: Architecture, History, Meaning* (New York, Cambridge, MA, and London, 1985)
A. St. Clair: 'The Torah Shrine at Dura Europos: A Re-evaluation', *Jb. Ant. & Christ.*, xxix (1986), pp. 109–17
W. Tronzo: *The Via Latina Catacomb: Imitation and Discontinuity in Fourth-century Roman Painting* (University Park and London, 1986)
H. L. Kessler: 'Prophetic Portraits in the Dura Synagogue', *Jb. Ant. & Christ.*, xxx (1987), pp. 145–55
I. L. Levine, ed.: *The Synagogue in Late Antiquity* (Philadelphia, 1987)
R. Ovadiah and A. Ovadiah: *Hellenistic, Roman and Early Byzantine Mosaic Pavements in Israel* (Rome, 1987)
R. Hachlili: *Ancient Jewish Art and Archaeology in the Land of Israel*, 7/i/2/B of *Handbuch der Orientalistik* (Leiden, New York, Copenhagen and Cologne, 1988)
K. Weitzmann and H. L. Kessler: *The Frescoes of the Dura Synagogue and Christian Art* (Washington, DC, 1990)
J. Gutmann, ed.: *The Dura Europos Synagogue: A Re-evaluation (1932–1992)* (Missoula, 1992)
A. J. Wharton: 'Good and Bad Images from the Synagogue of Dura Europos: Contexts, Subtexts, Intertexts', *A. Hist.*, xvii/1 (1994), pp. 1–25

KATRIN KOGMAN-APPEL

V. Hebrew books and illustration.

1. Illuminated manuscripts. 2. Printed books. 3. Bindings.

1. ILLUMINATED MANUSCRIPTS. The art of illumination enjoyed a particular importance in medieval Jewish culture. The manuscript was the only means of disseminating exegetical tradition and philosophical and scientific treatises, and it was also a powerful means of maintaining the cohesion of geographically dispersed communities, thanks to their shared familiarity with the Hebrew language. In the Middle Ages the manuscript was for Jews one of the very few means of access to the visual arts. Jews were forbidden to practise most of the recognized arts and crafts: thus the ornamentation of small books offered to Jewish artists the only field in which they could work freely.

The oldest surviving Hebrew manuscripts are codices of the Bible made in Egypt, Syria and Palestine between the 9th century AD and the 12th. Around 1250 the illumination of manuscripts began to flourish in the major concentrations of European Jewry, enhanced by the coincidental arrival of Eastern traditions in Western Jewish cultural centres, together with the secularization in Christian Europe of the professional painter. The latter phenomenon facilitated professional contact between Jewish and Christian craftsmen, making possible the exchange of techniques and models. In material terms, Hebrew manuscripts were much like the Christian or Islamic ones of the same region. The same methods were used in manufacturing the parchment, preparing the pages and assembling the gatherings (*see* MANUSCRIPT, §III, 3). Like Arabic,

Hebrew was written from right to left. The decorative procedures used in Hebrew codices included MICROGRAPHY, which employed the script as a decorative element. The functional arrangement of the decoration and the pre-eminence of the text over ornament was always respected. It is probably because of the secondary role assigned to the paintings that the signatures of scribes are far more numerous than those of artists, although the work of JOSEPH IBN HAYYIM and JOEL BEN SIMEON offers well-known exceptions to this rule. The styles of Hebrew codices were closely related to their geographical areas and to their time periods; the style of manuscript paintings was also regional. The iconography of the illumination displays considerable unity in its choice of biblical themes, some of which, as in HAGGADAH (pl. Haggadot) illustrations, may relate to ancient traditions. The illustrations created for more recent liturgical books, such as the MACHZOR (for illustration see MICROGRAPHY), contain original elements that are unique to Hebrew books.

The production of certain types of manuscript book or scroll, painted or engraved, long survived the invention and spread of printed books. Two such Jewish products are the KETUBBAH or marriage contract and the Megillah Esther or scroll of Esther (for illustration see MEGILLAH).

(i) Near East. (ii) Iberian peninsula. (iii) France. (iv) Germanic countries. (v) Italy.

(i) Near East. The earliest Hebrew illuminated manuscripts originated in Egypt, Syria and Palestine between the 9th century and the 13th, and there was a late revival in the Yemen in the 15th century. These manuscripts comprised Bibles and prayerbooks; they were embellished with highly stylized floral motifs in gold on parchment, with the addition of a single colour and with dark outlines,

16. Fragment from the St Petersburg Bible, showing a plan of the Tabernacle in the desert, AD 929 (St Petersburg, M.E. Saltykov-Shchedrin State Public Library, MS. II, 17a)

intended to produce a contrast between alternating areas of light and shadow. The arrangement of the decoration was influenced by local tradition: it was strictly functional and included full-page paintings placed outside the text at the beginning or end of the volumes, consisting of continuous carpet-like motifs, detached motifs used to emphasize breaks in the text, and borders surrounding particularly important passages. These elements, common to a given region, were accompanied by a new decorative technique based on the script itself. It employed the juxtaposition of lines of script in varied modules, micrographic decorations shaped out of miniature script, and entire pages covered in continuous motifs whose principal element was the written line: all these exploited the decorative effect of the various forms of Hebrew script.

Because of rabbinical prohibitions, influenced by the Islamic attitude to art, the art of Near Eastern Hebrew manuscripts was non-figurative. However, a symbolic image of the Sanctuary, seen for the first time in these manuscripts, occurs in several of the extant Bibles on a single or double page as a highly stylized image of a gateway (e.g. St Petersburg, Saltykov-Shchedrin Pub. Lib., MS. B 19a). In another fragment in St Petersburg (see fig. 16) the gateway is replaced by a plan of the Tabernacle in the desert, with all its component parts: the parvis; the furniture, including the candelabra, altar and jar of manna; the Mercy Seat with the Ark of the Covenant and the two Tablets of the Law; and cherubim in the form of two wings without any human features. This iconography is believed by some scholars to have been the perpetuation of an already ancient tradition, the development of which may perhaps be traced from the funerary art of the 1st century AD, though positively dated representations date from only the 3rd or 4th century AD to the mosaics of the Galilean synagogues in the 6th century, which depicted the ceremonial objects used in the synagogue ritual. The composition of the St Petersburg Bible later spread to Europe, particularly to Spain, where the art of illuminating books began to flourish just as it was declining in the Near East.

(ii) Iberian peninsula. The oldest illuminated Hebrew manuscripts from this region came from Toledo. During the reign of Alfonso the Wise (reg 1252–84), Toledo was a centre of intense cultural activity. At the court, Jewish, Christian and Arab scribes were at work copying and translating the scientific and philosophical works of Classical and Hellenistic Greece: among the texts translated into Latin were such works of Jewish theology as the *Mekor Hayyim* of Solomon ibn Gabirol (c. 1021–c. 1070), better known by its Latin title of *Fons vitae*. As well as a centre of translation, Toledo was a staging post through which mystic and literary ideas originating in Babylon and Galilee, the Eastern intellectual centres of Judaism, reached European Jewry. An example of such transfer of Eastern traditions to the West is a Bible in four volumes, of which three survive (Marseille, Bib. Mun., MS. 1626/II–III, and St Petersburg, Saltykov–Shchedrin Pub. Lib., MS. II, 53). It is decorated with carpet pages having symmetrical double palmettes: a typical motif, versions of which are to be found throughout the Mediterranean region from the 7th to the 13th century in several media, such as mosaics,

17. Illustrations depicting sanctuary implements on a chequered background, from the Duke of Sussex Catalan Bible, 14th century (London, British Library, Add. MS. 15250, fols 3v–4r)

carved wooden panelling and stucco panels. An inscription in the second volume of this Bible states that it was copied by the scribe Isaac ben Israel, a member of a family of copyists whose name appears in several manuscripts copied in Toledo during the third and fourth quarters of the 13th century. In another Bible (Parma, Bib. Palatina, MS. parm. 2668), copied in 1277 by another member of the same family, Hayyim ben Israel, the two pages preceding the biblical text (fols 7v–8r) display the earliest example in Europe of the symbolic composition depicting the implements of the Sanctuary. Its purpose was to encourage meditation on the Sanctuary Temple of Jerusalem, which remained the dwelling of the Divine Presence and spiritual centre of Judaism even after the destruction of the edifice, and so it perpetuated a tradition that can also be detected in an 11th-century Bible made in the Near East. The style of the Toledo Bible paintings, with their two-dimensionality, their exclusive use of gold and one colour on white parchment, and their geometrical arrangement of objects, proves that the painter of Toledo was working from an Eastern model.

The composition showing the furniture of the Sanctuary became an enduring tradition in Sephardic Bibles of the 13th and 14th centuries. In the Bible made in Perpignan in 1299 (Paris, Bib. N., MS. hébr. 7) this composition closely resembles that of Toledo, although it was executed with a finer technique. Aesthetic considerations are also apparent in another Bible dating to 1301 from the same Perpignan workshop (Copenhagen, Kon. Bib., MS.

hebr. II), in which a Gothic-style chequered background replaces the plain parchment, and increasingly so in the numerous examples made in Catalonia in the 14th century, such as the Duke of Sussex Catalan Bible (see fig. 17). At about the same time, a new element was added: one, two or three olive trees on a hill, evoking the Mount of Olives, whence the Messiah will come at the end of time. This indicated a shift in the symbolism of the paintings, directing meditation towards the Temple of the messianic future, rather than towards the Sanctuary of the past. Despite the importance of symbolism, towards the end of the 15th century this composition showed in one case a tendency to become purely ornamental: the Kennicott Bible (1476; Oxford, Bodleian Lib., MS. Kenn. 1) contains a painting showing the Temple objects in a stylized, barely identifiable form, arranged on the page in a purely decorative manner.

From the 1300s onwards the centres of book production multiplied, and their products diversified. In the Spanish Bibles made in Tudela (Paris, Bib. N., MS. hébr. 20) and Soria (Oxford, Bodleian Lib., MS. Kenn. 2) by the artist–scribe JOSHUA BEN ABRAHAM IBN GAON (fl c. 1312) the calendars, arranged on the page in columns, are decorated with arches. Others are inscribed on free-moving discs and attached to the page by a metal stitch. These Bibles also have micrographic illustrations in the margins; illustrations of the biblical text remain, however, the exception. During the 14th century some large, costly Bibles made in Catalonia had pages of text decorated in a style that showed the Italian influence then dominating the Iberian

peninsula. The traditional composition of the furniture of the Sanctuary had been still further developed to occupy three or four pages, as in the Foa Bible (Paris, Bib. Couvent Pères Sulpiciens Barcelone, MS. 1933) and a Bible made in Saragossa in 1404 (Paris, Bib. N., MS. hébr. 31). In Barcelona in 1348 Isaac Hiyo Caro copied Moses Maimonides's *Guide for the Perplexed* (see fig. 18), the three books of which have illustrated frontispieces and decorated text in a style related to that of the Master of S Marco. The most important manuscripts produced in Catalonia in the second and third quarters of the 14th century were the Haggadot (*see* HAGGADAH). Decorated in the Franco-Italian style favoured in that region, these compilations of Passover ritual often began with a series of biblical illustrations, presented in continuous cycles at the heads of the columns of text. This arrangement of pictures was most probably suggested by that of Latin Psalters and Breviaries, to which some Hebrew manuscripts were related in style (e.g. the Golden Haggadah, London, BL, Add. MS. 27210).

The increasingly precarious circumstances of the Jewish communities in 15th-century Spain had a noticeable impact on the artists; no new work was created, but manuscript production continued throughout the century, with techniques becoming increasingly refined. Some carpet pages (Paris, Bib. N., MSS hébr. 29 and 1314) in extremely

18. Illumination from Moses Maimonides: *Guide for the Perplexed*, 1348 (Copenhagen, Kongelige Bibliotek, Hebrew cod. XXXVII, fol. 114r)

minute micrography are among the most finely executed of the age. Lacking creative inspiration, the artists resorted to highly eclectic models, sometimes ancient ones, for decorating their manuscripts. The Kennicott Bible mentioned above is the most famous example: the painter Joseph ibn Hayyim took the colophon of zoomorphic letters from a Bible of 1300 (Lisbon, Bib. N., MS. II 72), from playing cards and from Oriental carpet pages. The Lisbon workshop was the last in the Iberian peninsula to produce Hebrew manuscripts. Some 20 illuminated manuscripts, dated from 1469 to 1497 (the year of the expulsion of the Jews from Portugal), display art of high technical quality, in which a limited number of types of ornament are unvaryingly repeated. The Lisbon workshop was already making decorations using mechanical techniques, perfectly executed but without variations. Its production was, in fact, already contemporary with the appearance of the first printed books.

(iii) France. Medieval Hebrew manuscripts in France were created in three separate zones. To the south, in the region of Languedoc, the Spanish influence was predominant, and the manuscripts that originated there in the 13th and 14th centuries were Spanish in character as regards methods of manufacture, script, style and iconography. The two Perpignan Bibles (*see* §(b) above) belong to this school, as well as a group of small-format books of ritual, which are likewise Spanish in format but show French influence in the rite itself and sometimes even in their transcription of terms deriving from the Occitan language (e.g. Paris, Bib. N., MS. hébr. 637).

A second group of manuscripts is represented by codices originating in Provence. Their script is of the Spanish type, but with a specifically regional character; their decorations, and sometimes their illustrations, show strong Italian influence, as in a 14th-century copy (Paris. Bib. N., MS. hébr. 1181) of the treatises on medicine by Avicenna (Arab. Ibn Sina; 980–1037). The French influence is occasionally found in conjunction with Italian elements, as in a biblical manuscript copied in Avignon in 1422 (New York, Pierpont Morgan Lib., MS. G 48).

Manuscripts from northern France make up the third group. Their identification is problematic because the script, manufacturing processes and certain ornaments show great affinity with manuscripts from the other side of the Rhine, and it is difficult to pinpoint their origin. Nevertheless, a more sensitive script and marginal drolleries, borrowed from Gothic manuscripts and rendered in micrographic form, often suggest a French origin. The style of the paintings and illuminations of literary subjects follows precise criteria that attest the influence of the Paris school, then at its height. The colours, decorative elements and arrangement of the illumination, and even their iconographic themes, often clearly indicate their origin, although the great mobility of the painters of this period should be borne in mind. Five codices are attributed to northern France, three of them definitely and two conjecturally. Three or four other manuscripts require further analysis. No conclusions can be drawn as to which type of manuscript it was most usual to illustrate, because each of the three definitely attributed manuscripts represents a different genre. One is a collection of various texts

(London, BL, Add. MS. 11639) known as the LONDON MISCELLANY; one is a copy dating from 1296 of Maimonides's *Mishneh Torah* (Budapest, Lib. Hung. Acad. Sci., MS. A 77/I–IV, *see* MAIMONIDES MANUSCRIPTS); and the third is a Bible dating from 1286 (Paris, Bib. N., MS. hébr. 4). The London Miscellany, celebrated for its rich ornamentation and its 40 full-page paintings, includes one of the oldest copies of Isaac de Corbeil's *Sefer Mizwot Katan*.

The characteristics of the northern French school include excellent technique, fine drawing and progress in the representation of the human figure as regards accuracy of proportion and harmony of body and movement. No experiments seem to have been attempted with the representation of space; the background, whether gold or coloured, is always flat and chequered. Each scene shows, in addition to its protagonists, some natural features indicating the setting. Scriptural history is the sole source of the iconographic repertory. The themes sometimes use formulae developed in Christian art, but the choice of themes and their adaptation to a new context indicate a Jewish craftsman or supervisor.

(iv) Germanic countries. The history of manuscripts originating in these countries falls into two distinct periods. The first, from the second quarter of the 13th century to the mid-14th, was distinguished by numerous large-format manuscripts with homogeneous codicological and paleographical characteristics, as well as a new-minted iconography, the variety and originality of which bore witness to a flourishing art. This artistic flowering was blighted by the Black Death of 1348, which brought in its wake disturbances and persecution for many Jewish communities. In the third quarter of the 14th century artistic activity was resumed; it continued until the end of the 15th century, producing works of great technical refinement that contained, however, no narrative painting. At the same time, a more popular trend appeared, mostly in the form of profusely illustrated Haggadot. A systematic study of these manuscripts is hampered by the lack of any indication of their place of origin and by their great uniformity of form, method of manufacture and script.

The oldest Germanic illuminated manuscript (Munich, Bayer. Staatsbib., MS. hebr. 5) is a copy, made in Würzburg in 1233, of the *Commentary on the Pentateuch* by Rabbi Solomon ben Isaac (1040–1105). Each section of the *Commentary* opens with painted panels illustrating biblical episodes in the style of the region: their sole specifically Jewish element is the absence of facial features, by which Jewish painters avoided representing the human face. The earliest known Ashkenazi Bibles have historical paintings in the panels embellishing the first word of each book or, occasionally, full-page paintings at the end of the text. These illustrate important passages such as the *Temptation of Adam and Eve*, the *Sacrifice of Isaac* and *Moses Giving the Law*, or midrashic (exegetic) themes, as in the famous painting of the *Messianic Banquet of the Just*. The two most famous manuscripts are the Wrocław Bible (1236; U. Wrocław Lib., MS. 1106) and the Milan Bible (1238; Milan, Bib. Ambrosiana, MS. B 30–32 inf.), both of which were made in the same workshop in southern Germany and have a similar iconographic programme, although

their styles are different. Manifested here for the first time is the manner of hiding the faces of the figures, either by concealing them behind abundant hair, or by replacing the features with those of birds or animals. The latter method was characteristic of Jewish art in the Rhineland from the mid-13th century to the mid-14th. Micrographic ornaments appeared in a series of large Bibles made between 1285 and 1310. The first letter of each book was embellished with a panel decorated with rinceaux, medallions and grotesque and hybrid creatures. Sometimes a human figure or bust, with the face clearly drawn, can be discerned among the motifs; in some cases there are full-page scenes that include a human figure (e.g. Paris, Bib. N., MS. hébr. 5).

During the 13th century there appeared a new type of liturgical manuscript, known as the MACHZOR. Such works were intended for use in the synagogue and contained prayers, Bible readings and liturgical hymns for the complete yearly cycle of holy days. The texts for each holy day constituted a well-defined literary unit emphasized by painted decorations, the elements of which were ornamented letters, painted panels and pages decorated with arches. These volumes contained numerous paintings of narrative scenes. Their iconographic programme comprised literal illustrations prefacing the hymns and Bible readings that opened the services of the high holy days. These illustrations were used, with a few minor variations, in around ten manuscripts, from 1258 (Oxford, Bodleian Lib., MS. Michael 617, 627) to 1348 (Darmstadt, Hess. Landes- & Hochsbib., Cod. Or. 13). The 13th-century examples had, like the Bibles, human figures with animal heads, a custom that was gradually abandoned during the 14th century. Features of style suggest different origins: southern Germany for the Laud Machzor (Oxford, Bodleian Lib., MS. Laud Or. 321), which is similar in style to the Milan Bible, and also for the machzor in two volumes (Dresden, Sächs. Landesbib, Cod. A 46 a, and U. Wrocław, MS. Or. I, 1). To the upper Rhine area is assigned the Leipzig Machzor (Leipzig, Bib. U., MS. V 1102) and book of ritual in three volumes (Budapest, Lib. Hung. Acad. Sci., MS. A 384; London, BL, Add. MS. 22413; Oxford, Bodleian Lib., Mich. MS. 619). The date of the Darmstadt Machzor, the last of the group, is 1348, the year of the Black Death. The production of such liturgical manuscripts was resumed in the second half of the 14th century, but the later examples were without illustrations. The upper Rhine area was also thought the source of some small-format Bibles with illustrated frontispieces (e.g. London, BL, Add. MS. 15282, see fig. 19; Jerusalem, Schocken Lib., MS. 14840), as well as copies of ritual texts and juridical compilations adorned with extremely delicate filigree.

In the Haggadot produced in the Germanic countries during the 15th century the biblical cycles of illustrations were not separated from the text, as they were in Spanish Haggadot, but were integrated with the didactic and ritual images placed in the margins. They were often rudimentary in style, and their great interest lies in their genre scenes, inspired by everyday life, and in their exegetical scenes, which show that these Jewish homiletic stories constituted a living fund of tradition. Some examples particularly rich in illustrations are the second Nuremberg Haggadah (Jerusalem, Schocken Lib., MS. 24087) and the Yahuda

19. Illuminated frontispiece from a small Bible (London, British Library, Add. MS. 15282, fol. 179*v*)

Haggadah (Jerusalem, Israel Mus., MS. 180/50). The scribes and painters rarely signed their work; an exception was the artist–scribe JOEL BEN SIMEON, whose name appears in six manuscripts. His characteristic style can be seen in seven other manuscripts, probably produced in his workshops scattered around southern Germany and north Italy. The scribes, moving between major centres on both sides of the Alps, carried with them the traditions of their craft.

A revival of illuminated manuscripts took place in the 18th century first in Vienna and later in other Germanic countries: these were commissioned by the families of Jewish financiers in the service of German princes, and the craftsmen employed were normally engaged on the traditional work of copying the scrolls of the Torah (Pentateuch) for use in synagogues. The commissioned Haggadot were illustrated with ritual and biblical scenes, some of which reproduced illustrations from the printed Haggadot made in Amsterdam in 1695 and 1712. Some of these manuscripts were signed, such as a Haggadah by Judah Pinhas (1747; Erlangen, Ubib.), another by Joseph ben David Leipnik (1740; London, BL) and one by Uri Phoebus Segal of Altona (1739; Copenhagen, Kon. Bib.), whose signature also appeared in several Haggadot executed between 1728 and 1751.

(v) Italy. In Italy the cultural life of the oldest Jewish communities flourished without major obstacles from the 1st century AD. Between the 13th century and the 15th their cultural activities were closely connected with those of their Christian neighbours. Their furniture and clothing followed the styles of the local artisan class, and this was also true of their paintings for book illustrations; of these there is evidence from the 13th century onwards, although examples from this period and from the 14th century are scarce. The most important Italian manuscripts of the 13th century originated in the centre of the peninsula. Among them is a Bible (Cambridge, Emmanuel Coll., MS. 1, 1), formerly in the possession of Bishop William Bedell, which is decorated in accordance with the traditional system of carpet pages with continuous *rinceaux* on a gold background, and large-module ornamental letters and arches; this was the work of Abraham ben Yom Tov ha-Kohen of Rome. A workshop in Emilia produced a Psalter (Parma, Bib. Palatina, MS. 1870) in which the panels decorating the first word of each psalm contained literal illustrations. The most striking of the 14th-century manuscripts is a copy of Maimonides's *Mishneh Torah* (Jerusalem, Jew. N. & U. Lib., MS. hebr. 4° 1193), written in Spain or by a Spanish scribe; the painted illustrations were added to the first 40 folios in the style of Matteo di Ser Cambio (active in Perugia at the beginning of the 14th century). Illustrations of ritual also appear in treatises on religious law (e.g. London, BL, Or. MS. 5024). The modelling of the draperies and the finesse of the faces, bodies and movements reveal an advanced technique. The gold backgrounds are replaced by interiors and landscapes ordered in accordance with the rules of perspective.

The 15th century saw a veritable flowering of the art of illumination; workshops in all the major cities of northern Italy produced manuscripts as diverse in their content as in their style of illustration. However, the artists were, more often than not, Christians. Pictorial technique was reaching its apogee: Bibles or parts of the Bible, books of ritual and treatises on religious law or on medicine were embellished with ornaments and small painted pictures in the style of the region. Venice, Padua, Bologna, Ferrara and Florence (as well as some cities in the south, such as Naples) all had their workshops, and each city gave its own style to the paintings produced there, although the subject-matter remained traditional. The frontispieces, with floral borders and painted panels containing the gold or coloured letters of the initial word, remained faithful to the Hebrew manuscripts' traditional system of ornamentation. Their figurative compositions drew on scenes of daily life, but their repertory was increasing; most important, the biblical and ritual scenes were presented in a worldly setting that reflected a new mentality (e.g. Rome, Vatican, Bib. Apostolica, MS. Ross. 555). A compendium of texts (Jerusalem, Israel Mus., MS. 180/51), formerly part of the Rothschild collection, contains a Hebrew illustrated version of Aesop's *Fables*, the MESHAL HA-KADMONI, as well as illustrations of biblical episodes and numerous scenes of ritual. The paintings of animals show a rarely surpassed level of accomplishment in the drawing, anatomy and modelling. This manuscript is the work of Leonardo Bellini, who was active in Venice between 1475 and 1480. From Ferrara comes a copy of Avicenna's *Qanun* (Bologna, Bib. U., MS. 2197), in which each book opens with a painting illustrating the text: scenes of healing

and of lessons in medicine, plants and animals used in compounding remedies, even allegorical figures from the liberal arts and the signs of the zodiac. Several versions of the Siddur (pl. Siddurim), a compendium of ritual prayers, were produced in Pesaro in the 1480s (e.g. Budapest, Lib. Hung. Acad. Sci., MS. 380). The floral borders were spangled with little medallions showing scenes of ritual and family ceremonies, such as circumcision, marriage and mourning. In some cases, in spite of traditional gestures and attitudes, the influence of Christian iconographic models can be seen. There are few illustrated Haggadot, most of them from the workshop of Joel ben Simeon, who must have directed workshops in Italy as well as in Germany: the system of illustration follows the tradition of Ashkenazi ritual books, with biblical and exegetical scenes integrated into the textual illustrations in the margins.

The illumination of Hebrew manuscripts reached the heights of technical perfection in Italy, though to some extent at the expense of new creations. Traditional themes were present, and subjects were still taken from a world dominated by religion, but aesthetic and formal considerations and concern for the elegance of the figures sometimes took precedence over attachment to traditions.

See also BIBLE, §II.

GABRIELLE SED-RAJNA

2. PRINTED BOOKS. The break between the manuscript and the printed book was not sudden: the craftsmen who created the manuscripts also contributed to the development of printing by designing the typefaces and decorating the works. The first typographers came from the ranks of the copyists, as in the case of the Cuzi family of Italian scribes and of Abraham Conat of Mantua (*fl* 1475–77). The incunabula from the presses of Eliézer Toledano (*fl c.* 1488) at Hijar in Spain or in Lisbon had characters identical to those of the manuscripts copied in Lisbon. The continuity in decoration is equally clear. The first printed books appeared without a title-page and with the first page framed by an engraved floral border; the first letter, or often the whole first word, was in a larger module and was ornamented on the pattern of contemporary illustrated manuscripts. The frontispiece used in the first printed books in Portugal and in those from the Soncino presses (Italy, Turkey) are an example of this feature.

From about 1505 decorated frontispieces were replaced by title-pages. Daniel Bomberg (1483–1553), a noted Christian printer of Hebrew books in Venice, introduced many new decorative and typographic features. Following the influence of contemporary Italian and German books, the title-pages of his Hebrew books featured an imaginary gateway, inviting the reader to 'enter' the book. Biblical verses inscribed on the gateway, such as 'This is the gateway to the Lord' (Psalms 118:20), served to enhance the meaning of this image. In addition, the Hebrew term for title-page, *daf ha-sha'ar*, literally means 'the gate page'. The design of the gateway, which originated with simple architectural elements, culminated in the 17th century with complex, even fantastic Baroque forms. Additional symbolic meaning accrued when the columns that supported the arch were designed in the shape of the twisted columns

in St Peter's, Rome, commonly believed at the time to have come from the Temple of Solomon (earliest examples occur in Hebrew books printed by Ruffinelli in Mantua, 1550s).

The fashion spread from Venice and Mantua to other towns in Italy and became popular also in Germany. As early as 1540, the *Arba'ah Turim* of Jacob ben Asher, printed in Augsburg, featured an architectural title-page with biblical episodes, though the entire design was copied from a Christian book. Printed editions of the Vulgate and other Christian Bibles eventually influenced one of the most characteristic features of Hebrew book decoration during the 17th and 18th centuries: the figures of Moses and Aaron. The two large biblical figures, shown carrying their familiar attributes, were incorporated into the architectural design of numerous title-pages, often side by side with small biblical episodes. These designs influenced in their turn the decoration of manuscripts, ceremonial objects and tombstones.

The title-pages of many early Hebrew books also incorporated the device of the printer, which gradually gained artistic and symbolic meaning of its own. The first Hebrew printer to use a decorative device was Eliezer Alantansi (*fl* 1485–90) of Spain. Italian printers developed this feature in the 16th century, displaying emblems that often employed such Jewish symbols as Solomon's Temple (in the shape of the Islamic Dome of the Rock), a pair of hands in the gesture of the priestly blessing (alluding to the name Cohen) or a menorah (alluding to the name Meir: literally, 'giving light'). Hebrew printers in Amsterdam, which in the 17th century superseded Venice as the capital of Hebrew printing, developed this concept further, selecting at times a series of biblical episodes whose heroes bore the same name as that of the printer (or the author). Authors' portraits were occasionally added as well. Amsterdam printers also introduced copper-engraved illustrations at this time, gradually replacing woodblock prints.

The first work to appear with illustrations printed in the text was the MESHAL HA-KADMONI, compiled in the 13th century by Isaac ben Solomon ibn Sahula, which Gershom SONCINO printed in Brescia in 1490–91. The illustrations, designed by the compiler himself, had appeared in every manuscript copy of the work and were faithfully reproduced in the printed edition. Other illustrated books were Yiddish (Judeo-German) versions of popular texts, such as *Sefer Josippon* (Zurich, 1546) and *Sefer Minhagim* (Venice, 1593). The most famous, however, were the illustrated Haggadot, the manufacture of which began in the first years of the 16th century. The first was executed in Prague in 1526, on the printing press of Solomon ha-Kohen. A second edition was published in 1590, a third in 1606 with some additions, a fourth in 1624 and a fifth in 1706. Another series was published in Mantua in 1550, with new editions in 1560 and 1568; this series inspired the 1662 Amsterdam Haggadah. A Haggadah printed in 1609 by Israel ben Daniel Zifroni (*fl* 1567–88) was published in three versions, each with a translation into a different language: Ladino, Yiddish and Judeo-Italian. The Haggadah printed in Amsterdam in 1695, with illustrations taken from Matthäus Merian's *Icones biblicae* (Basle, 1625–6), was the first in a long series of Haggadot with identical

engravings, published in Frankfurt am Main (1710), Sulzbach (1711), Offenbach (1722), Bombay (1846) and elsewhere. It also inspired the revival of manuscript, hand-coloured Haggadot in the 18th century. The art of the printed Haggadah was revived in the 20th century by such Jewish artists as Jacob STEINHARDT, Joseph Budko (1888–1940), Arthur Szyk (1894–1951), Ze'ev Raban (1890–1970) and Nahum Gutman (1898–1981). Of special interest are the innovative designs and themes created for *kibbutz* Haggadot in Israel during the 1930s and 1940s.

SHALOM SABAR

BIBLIOGRAPHY

L. Goldschmidt: *Hebrew Incunables: A Bibliographical Essay* (Oxford, 1948)
A. M. Haberman: 'The Jewish Art of the Printed Book', *Jewish Art: An Illustrated History*, ed. C. Roth (Tel Aviv, 1961), cols 455–92
B. Narkiss: *Hebrew Illuminated Manuscripts* (Jerusalem, 1969)
——: *The Golden Haggadah* (London, 1970)
G. Sed-Rajna: *Manuscrits hébreux de Lisbonne* (Paris, 1970)
Z. Ameisenowa: 'Die hebräische Sammelhandschrift add. 11639 des British Museum', *Wien. Jb. Kstgesch.*, xxiv (1971), pp. 10–48
J. Gutmann, ed.: *No Graven Images: Studies in Art and the Hebrew Bible* (New York, 1971)
M. Metzger: *La Haggadah enluminée* (Leiden, 1973)
L. Avrin: *The Illuminations in the Moshe Ben Asher Codex of 895 CE* (diss., Ann Arbor, U. MI, 1974)
G. Sed-Rajna: 'Toledo or Burgos?' *J. Jew. A.*, ii (1975), pp. 6–21
J. Gutmann: *Hebrew Manuscript Painting* (New York, 1978)
G. Sed-Rajna: 'The Illustrations of the Kaufmann Mishneh Torah', *J. Jew. A.*, vi (1979), pp. 64–77
V. Klagsbald: *Catalogue raisonné de la collection juive du Musée de Cluny* (Paris, 1981)
B. Narkiss, A. Cohen and T. Tcherikover: *Hebrew Illuminated Manuscripts in the British Isles: I. Spain and Portugal* (London and Jerusalem, 1982)
G. Sed-Rajna: 'The Paintings of the London Miscellany', *J. Jew. A.*, ix (1982), pp. 18–30
——: *Le Mahzor enluminé* (Leiden, 1983)
A. Scheiber and G. Sed-Rajna: *The Maimuni Codex* (Budapest, 1984)
M. Metzger and T. Metzger: 'Les Enluminures des MS add. 11639 de la British Library: Un Manuscrit hébreu du nord de la France (fin du XIIIe siècle–premier quart du XIVe siècle): Problèmes iconographiques et stylistiques', *Wien. J. Kstgesch.*, xxxviii (1985), pp. 59–113
B. Narkiss and A. Cohen: *The Kennicott Bible* (London, 1985)
G. Sed-Rajna: *Ancient Jewish Art* (Secaucus, 1985)
——: 'Sur les origines de quelques enluminures juives', *J. Jew. Stud.*, xxxvi (1985), pp. 175–84
M. Beit-Arié, ed.: *The Worms Mahzor* (Jerusalem, 1986) [facs. edn]
G. Sed-Rajna: 'Filigree Ornaments in 14th C. Hebrew Manuscripts of the Upper Rhine', *J. Jew. A.*, xiii (1986–7), pp. 45–54
——: *The Hebrew Bible in Illuminated Manuscripts* (New York, 1987)
S. Sabar: 'Manuscript and Book Illustration among the Sephardim before and after the Expulsion', *The Sephardi Journey, 1492–1992* (exh. cat., New York, Yeshiva U. Mus., 1992), pp. 54–93
U. Schubert: *Jüdische Buchkunst* (Graz, 1992)
G. Sed-Rajna: *L'Art juif* (Paris, 1995)

For additional bibliography see §I, 4 above.

GABRIELLE SED-RAJNA

3. BINDINGS. The Iberian peninsula is the source of the largest number of documents mentioning medieval Jewish bookbinders. Four of them are known in Portugal in the 14th and 15th centuries (see Lima; Ferro Tavares). In Spain, 11 are known in the 14th century (see Castañeda; Vallicrosa). The fact that a papal bull was issued in 1415 expressly forbidding Jews to bind Christian religious books confirms that they were still practising their craft at that time. Moreover, archives show that many bookbinders, forcibly converted at the end of the 14th century, and their descendants continued to practise the craft during the 15th century, and for the same clientele. With a single exception, all the notarized deeds refer to bindings executed for Christians, mainly for ecclesiastical or royal customers but also occasionally for the bourgeoisie. One surviving contract for a Jewish customer, however, indicates that Jewish bookbinders also undertook commissions for their fellow Jews (see Hillgarth and Narkiss). A few deeds referring to bindings commissioned for devotional works at a very high price are clear proof that Jewish bookbinders had achieved a high level of skill.

These bindings were not of cloth but of *guadameci* (see Durliat; *see also* LEATHER, §3(i)(a)), leather worked after the manner of the Arabs in Spain (known as Mudéjars until the taking of Granada in 1492, then as Moriscos), as is known from extant bindings on more than 20 Hebrew books executed for Jewish clients and from the imprints left by leather bindings with openwork geometrical decorations on half-a-dozen others. Most of these bindings date no earlier than the last decades of the 15th century, although some were used for manuscripts written in the 13th and 14th centuries, replacing older bindings. Most were executed in Castile. They were all MUDÉJAR in technique and style, decorated with interlaced bands against a background stamped with small blind tools and punches (see Hueso Rolland; Thomas), and overall they are among the finest Iberian bindings of this kind. Nine of them are box-bindings of a unique type, with sides that protected the edges of the book attached to three sides of the lower cover, which acted as the bottom of the box, and an upper cover that closed over this like a lid, both covers being joined to a spine of the usual European type with raised bands.

Documents show that in the comtat Venaissin (the papal state) the popes and Petrarch retained the services of Jewish binders. Three Hebrew manuscripts (early 15th century) copied for Jewish clients have been preserved with their original bindings. Their decoration of fillets and blind tooling is closer to Italian bindings influenced by the western Islamic style than to any Mudéjar work.

Although Jews certainly bound Hebrew books for Jewish use in medieval and renaissance Italy, some such books displaying stamps and decorative schemes widely used on non-Jewish bindings were doubtless the work of gentiles. The work of Jewish binders can be identified only in the case of a few bindings almost certainly made by refugees from the Iberian peninsula (see Metzger, 1982).

In the Germanic countries, written sources on Jewish binders and bindings are even rarer. They were mentioned at the beginning of the 13th century in the *Sefer ha-hasidim* ('Book of the pious', a major work of Ashkenazi teachings on ethics) and in other documents of the late 14th century and the 15th. Twelve bindings dating from the 14th and 15th centuries have been preserved on Hebrew manuscripts. Of five others, at least four are thought to have been used originally to cover Hebrew manuscripts, on the basis of their structure and decoration (see Husung; Schmidt-Künsemüller). All were richly decorated with incised motifs showing plants and animal, human and hybrid figures. Stamps were rarely and sparingly used. Only one of these bindings (Munich, Bayer. Staatsbib., Cod. hebr. 212) is signed—with the name Meïr Jaffé in Hebrew—but there is no reason why some or all of the others should not prove to be Jewish handiwork too, as

may also be true of some of the bindings made for gentile books. The Munich binding is the only one of all the cuir-ciselé (cut leather) bindings, either Jewish or gentile, to bear the artist's signature and has consequently attracted much scholarly attention and controversy (see Husung; Goldschmidt; Landsberger; Geldner; Schmidt-Künsemüller).

Goldschmidt's theory, followed by Avrin, that both techniques, the Mudéjar and the cut leather, were of the same category and introduced by Jews in the art of bookbinding, and Avrin's hypothesis that Jewish book-binders emigrated from Spain and brought the cut-leather technique to Germanic countries and Central Europe goes against the evidence. The two techniques are completely different, the essence of the Mudéjar technique being blind tooling and that of cuir-ciselé incising the leather; the cut-leather technique is unknown on Jewish bookbindings from the Iberian Peninsula. Needham's suggestion that the Mudéjar style might with equal accuracy be called the Sephardic style is no more acceptable. Jewish craftsmen seem to have practised the cut-leather technique in Germanic countries and the Mudéjar technique on the Iberian Peninsula with predilection and to have excelled in both. There is no evidence that either of the techniques is of Jewish origin. On the Iberian Peninsula Jewish artists were certainly inventive and expert, but, like the Christians, the Jews originally borrowed the technique, the blind tools and the compositions of Mudéjar art from the Arabs in Spain; these were so widely adopted throughout Spain that they may be considered typical of the art of binding in that country.

See also BOOKBINDING, §1, and LEATHER, §2(ii).

BIBLIOGRAPHY

M. J. Husung: 'Über den sogenannten "jüdischen Lederschnitt"', *Soncino-Bl.*, i (1925–6), pp. 29–43

E. P. Goldschmidt: 'Some Cuir-ciselé Bookbindings in English Libraries', *The Library*, 4th ser., xiii (1933), pp. 337–65

M. Lima: *A Encadernação em Portugal (Subsídios para a sua historia)* (n.p., 1933), p. 177

F. Hueso Rolland: *Exposición de encuadernaciones españolas, siglos XII al XIX* (Madrid, 1934), pp. 27–38

H. Thomas: *Early Spanish Bookbindings, XI–XV Centuries* (London, 1939), pp. xxi–xxxii, xlii–xliii

F. Landsberger: 'The Cincinnati Haggadah and its Decorator' *Heb. Un. Coll. Annu.*, xv (1940), pp. 529–58 [esp. 543–52, 556–7]

E. Kyriss: 'Der Lederschneider Meir Jafe', *Allg. Anzeiger Bindereien*, lxiii (1950), p. 373

F. Geldner: 'Bamberger und Nürnberger Lederschnitt-einbände', *Festgabe der Bayerischen Staatsbibliothek für Karl Schottenloher* (Munich, 1953), pp. 31–9

J. M. de Vallicrosa: 'Los judíos barceloneses y las artes del libro', *Sefarad*, xvi (1956), pp. 129–36

V. Castañeda: *Ensayo de un Diccionario Biografico de Encuadernadores españoles* (Madrid, 1958)

R. Ettinghausen: 'Near Eastern Book Covers and their Influence on European Binding: A Report on the Exhibition "History of Bookbinding" at the Baltimore Museum of Art, 1957–58', *A. Orient.*, iii (1959), pp. 113–31

J. N. Hillgarth and B. Narkiss: 'A List of Hebrew Books (1330) and a Contract to Illuminate Manuscripts (1335 from Mallorca)', *Rev. Etud. Juives*, n. s. 2, iii (1961), pp. 297–320

M. Durliat: *L'Art dans le royaume de Majorque: Les Débuts de l'art gothique en Roussillon, en Cerdagne et aux Baléares* (Toulouse, 1962), pp. 335–6

O. Kurz: 'A Copy after the Master E. S. on a Jewish Bookbinding', *Rec. A. Mus., Princeton U.*, xxiv (1965), pp. 3–11

O. Mazal: *Europäische Einbandkunst aus Mittelalter und Neuzeit: 270 Einbände der Österreichischen Nationalbibliothek* (Graz, 1970), pls 20–21

T. Metzger: *Les Manuscrits hébreux copiés et décorés à Lisbonne dans les dernières décennies du XVe siècle* (Paris, 1977), pp. 50–51, 73–4, pls iv, fig. 1; xv and xvi

P. Needham: *Twelve Centuries of Bookbinding, 400-1600* (New York, 1979), pp. 7, 78–81

F. A. Schmidt-Künsemüller: *Corpus der gotischen Lederschnitteinbände aus dem deutschen Sprachgebiet* (Stuttgart, 1980), pp. xiv–xvi, 292, suppls 14–15

T. Metzger: 'Les Manuscrits hébreux et leurs reliures: La Reliure du ms. hébr. 819 de la Bibliothèque Nationale à Paris', *Rev. Fr. Hist. Livre*, xxxvi (1982), pp. 349–70

M. P. Ferro Tavares: *Os Judeus em Portugal no século XV* (Lisbon, 1982–4), ii, pp. 623, 775

L. Avrin: 'The Sephardi Box Binding', *Scripta Hierosolymitana*, xxix (1989), pp. 27–43, pls 1–24

T. Metzger: *La Reliure des livres hébraïques du moyen âge et de la Renaissance* (in preparation)

THÉRÈSE METZGER

VI. Ritual objects.

Traditional Jewish life consists of the fulfilment of various *mitzvot* (Heb.: 'commandments') and observances, many of which require the use of special implements and objects. Over the centuries, immense efforts were invested in producing ritual objects that would enhance the performance of the commandments: it is this field of the visual arts that became the central outlet for artistic creativity among Jewish communities in Christian Europe and the Islamic world. Jewish religious authorities supported the production of aesthetic ritual objects, justifying this by the concept of *hiddur mitzvah*, the embellishment or beautification of the commandment; this was derived from Exodus 15:2, which was interpreted by the rabbis as an exhortation to use attractive ritual implements in the synagogue and at home.

Jewish ritual objects are not sacred in themselves but serve as a means of performing religious duties. No strict rules governed the production of most such objects; they commonly varied in shape and design from one place to another and from period to period. Post-exilic Jews lived in many lands, and their ritual objects and the customs associated with them often reflected practices and styles found in their host countries: some objects were invented in a particular place, being unknown elsewhere.

Little is known about the appearance of ritual objects in antiquity and the Middle Ages: passing remarks in contemporary literature are generally insufficient for their exact reconstruction. The vicissitudes of Jewish life brought about the destruction, loss and robbery of costly ceremonial artefacts. With a few exceptions, surviving objects from European Jewish communities date from not earlier than the 16th century, with most pieces belonging to the 17th and 18th centuries, while those from Islamic countries are mostly of the late 18th century to the early 20th. As European Jews, except for those in Poland, were not allowed to become members of guilds, their silver ceremonial objects were mostly commissioned from Christian craftsmen. In Islamic lands, particularly Yemen, Morocco, Tunisia, Iraq and Iran, Jews excelled as silversmiths, working also for a non-Jewish clientele.

In the 20th century many traditional forms of Jewish ritual object were revived. At the same time, a growing number of artists were engaged in creating new forms and designs for the centuries-old objects. Thus the Jewish Museum, New York, possesses a silver Torah crown (1959) by Moshe Zabani (*b* 1935), a Torah Ark curtain by

Adolph Gottlieb and a set of Passover dishes (1930) by
Ludwig Wolpert (1900–81).

BIBLIOGRAPHY

S. S. Kayser and G. Schoenberger: *Jewish Ceremonial Art* (Philadelphia, 1955, rev. 1959)

S. G. Cusin: *Art in the Jewish Tradition* (Milan, 1963)

J. Gutmann: *Jewish Ceremonial Art* (New York, 1964/*R* 1968)

J. Gutmann, ed.: *Beauty in Holiness: Studies in Jewish Customs and Ceremonial Art* (New York, 1970)

A. Kanof: *Jewish Ceremonial Art and Religious Observance* (New York, 1970)

Hayye ha-Yehudim be-Maroko [Jewish life in Morocco] (exh. cat., ed. A. Müller-Lancet; Jerusalem, Israel Mus., 1973) [Fr. trans. 1986]

R. D. Barnett, ed.: *Catalogue of the Permanent and Loan Collections of the Jewish Museum London* (London, 1974)

I. Shachar: *The Jewish Year*, Iconography of Religions, xxiii/3 (Leiden, 1975)

Y. H. Bialer: *Jewish Life in Art and Tradition from the Collection of Sir Isaac and Lady Edith Wolfson Museum, Hechal Shlomo, Jerusalem* (Jerusalem and New York, 1976, rev. 1980)

V. Klagsbald: *Catalogue raisonné de la collection juive du Musée de Cluny* (Paris, 1981)

I. Shachar, ed.: *Jewish Tradition in Art: The Feuchtwanger Collection of Judaica*, Jerusalem, Israel Mus. cat. (Jerusalem, 1981)

Yehude Kurdistan: Orah hayyim, masoret ve-omanut [The Jews of Kurdistan: daily life, customs, arts and crafts] (exh. cat., ed. O. Schwarz; Jerusalem, Israel Mus., 1981)

A Tale of Two Cities: Jewish Life in Frankfurt and Istanbul, 1750–1870 (exh. cat., ed. V. B. Mann; New York, Jew. Mus., 1982)

D. Altshuler, ed.: *The Precious Legacy: Judaic Treasures from Czechoslovak State Collections* (New York, 1983)

N. L. Kleeblatt and V. B. Mann, eds: *Treasures of the Jewish Museum* (New York, 1986)

J. Ungerleider-Mayerson: *Jewish Folk Art from Biblical Days to Modern Times* (New York, 1986)

C. Benjamin: *The Stieglitz Collection: Masterpieces of Jewish art*, Jerusalem, Israel Mus. cat. (Jerusalem, 1987)

J. Gutmann: *The Jewish Life Cycle*, Iconography of Religions, xxiii/4 (Leiden, 1987)

Sephardi Jews in the Ottoman Empire: Aspects of Material Culture (exh. cat., ed. E. Juhasz; Jerusalem, Israel Mus., 1990)

1. Synagogue. 2. Sabbath. 3. Festivals. 4. Life cycle.

1. SYNAGOGUE. In this central institution of Judaism
ceremonial art centres on the Torah scroll, the most
important synagogal object and the only one to be
intrinsically holy. Detailed regulations govern its prepara-
tion: it must be handwritten in black ink by a specially
trained scribe on one side of parchment made from the
skins of ritually permitted and slaughtered (Heb. *kasher*)
animals. The text comprising the five books of the Penta-
teuch is written in square Hebrew letters without vowels or
punctuation marks. The sheets are then sewn together with
sinews from *kasher* animals to form a long scroll, which
itself may not be touched: its ends are tied to two wooden
rollers called *atzei hayyim* (Heb.: 'trees of life').

These strict regulations made the Torah scrolls uniform
in appearance, but each community strove to the best of
its ability to adorn its own scroll. It became customary to
'dress' the scroll as a princess or bride, with elaborate
garments and costly silver ornaments. In Islamic lands, as
well as among some Greek and Italian communities, the
scroll is contained in a wood or, more rarely, metal case
called a *tik* (pl. *tikim*); for the reading of the Law this is
placed in an upright position on the reader's desk. *Tikim*
may be cylindrical or polygonal and consist of two equal
sections with hinges at the rear; often they terminate in a
bulb-shaped cupola (see fig. 25). The exterior surfaces of
wooden *tikim*, particularly those from Iraq and India, are

25. Torah case (*tik*) from Iraq with Persian *rimmonim* (finials), 1873
(Jerusalem, Israel Museum)

often covered with a layer of colourful velvet decorated
with silver appliqués, as in a wooden *tik* with applied
silver-gilt panels (Basra, 1904; Jerusalem, Wolfson Mus.).
In more elaborate *tikim*, such as one with repoussé and
parcel gilt panels from the Ottoman Empire (*c.* 1860;
Paris, Mus. Cluny), the entire surface is overlaid with silver
sheets hammered in repoussé technique, with floral orna-
mentation and Hebrew inscriptions. Greek and Tunisian
tikim are often colourfully painted with decorative motifs:
the Jewish Museum, Athens, has a late 19th-century Greek
example. Many *tikim* bear a pious dedicatory inscription.

Among the Ashkenazi Jews of northern Europe, Italian Jews and the Sephardi Jews of Spain, Portugal and North Africa, the Torah scroll was covered with a textile mantle, usually called a *me'il*. This was shaped as a sheath, split at the back (Sephardi North African and Italian) or open at the bottom (Ashkenazi), and was placed over the scroll's rollers; unlike the *tik*, it was removed while the Torah scroll was being read. Ashkenazi mantles were usually made of coloured velvet, richly embroidered in gold and silver with symbolic motifs such as Torah crowns, the Tablets of the Law and the Lion of Judah, and also with architectural elements and Hebrew inscriptions; the State Jewish Museum, Prague, has a silk velvet *me'il* embroidered with metallic threads (Prague, 1737–8). Italian mantles are characterized by costly fabrics, embroidered silks and fine ornamental brocades, commonly without other decorations or inscriptions (e.g. silk velvet embroidered with gold and silver, Mantua, 18th century; Jerusalem, Mus. N. A. Ebraica–It.).

Before the *me'il* is put on, the scroll is wrapped in a protective binder, a long strip of cloth usually called a *mappah*. From c. 1500 it was the custom in Germanic lands to make a binder from the swaddling cloth used during a circumcision and to present it to the synagogue on the occasion of the boy's first attendance. The cloth, known as *Wimpel*, was cut into four strips; these were sewn together lengthwise and embroidered (from the 18th century they were sometimes painted) with an inscription containing the boy's name, the day of his birth and the customary wish that he grow up to study the Torah, to marry and to perform good deeds. Accompanying the inscription were naive representations of the appropriate zodiacal sign, a boy reading or holding the Torah scroll and a marriage scene. The large letters were filled with flowers, animals and even figural motifs (e.g. embroidered linen *Wimpel*, Germany, 1732; and painted linen *Wimpel*, Germany, 1793; both Los Angeles, CA, Heb. Un. Coll. Skirball Mus.). In Italy the Torah binder, also called a *fascia*, was made of fine linen or silk brocade and embroidered with the name of the donor (usually a woman).

Placed atop the Torah rollers were ornamental finials known as *rimmonim* (Heb.: 'pomegranates'), or *tapuhim* ('apples'), possibly because they were originally shaped like these fruits. In Islamic lands metal *rimmonim* that generally preserved the spherical shape crowned the staves that protruded from the *tik*. Distinct shapes and ornamentations developed in the various communities. Yemenite *rimmonim* consisted of an elongated shaft with two or three globular elements (e.g. a pair of engraved silver, 19th century; Jerusalem, Wolfson Mus.), while in Iraq a single silver spheroid shape was ornamented with tinkling, drop-shaped bells. In Europe, tower-shaped silver *rimmonim* were favoured: this form is first known from the oldest pair extant, from 15th-century Sicily (Palma de Mallorca, Mus. Catedralicio). The shape of the tower was often inspired by local church and municipal towers, to which decorative bells were added. Some Italian *rimmonim* were shaped as complex, three-storey towers of exceptional size: an example (h. 610 mm, Mantua, late 17th century–early 18th) is in the Jewish Museum, New York. In Western and Eastern Europe *rimmonim* were sometimes replaced by an ornamental crown, called a *keter* Torah,

but the combination of a crown with *rimmonim* was also popular, especially in Italy. These elaborate, bejewelled silver crowns were generally executed by leading Christian craftsmen. They often resembled the country's royal crowns, thus emphasizing the royalty of the Torah. The Israel Museum, Jerusalem, has a parcel gilt *keter* with *rimmonim* from Warsaw (18th century) and another set, of embossed and engraved silver, from Ankara (19th century). In some North African communities, particularly in Libya and Tunisia, the wooden *tik* is topped by an inseperable crown, called *atarah*, also of wood. Probably under Italian influence, a matching metal *atarah* is sometimes attached to the wooden one. Some Indian *tikim* also have ornamental crowns. In most other Islamic communities the *tik* did not carry a separable crown, but the bulbous upper part of Iraqi and Persian *tikim* was perhaps originally modelled on the crowns of the Sasanian dynasty of Persia.

A shield called the *tas* hung by a gold or silver chain on the front of the Torah mantle. Known since the late Middle Ages, the *tas* was originally a metal plaque inscribed with the name of one of the festivals, in order to identify the scroll with the specific readings for that day. In countries such as Germany and Poland, the *tas* later developed into an elaborate silver object ornamented with Baroque architectural elements, floral designs, mythical animals, Temple implements, the figures of Moses and Aaron and occasionally scenes from the Bible (e.g. silver-gilt embossed and engraved *tas*, Nuremberg, after 1717; New York, Col. Temple Emanu-El). Special types of silver Torah shields developed in Italy and Turkey. The Italian *tas* was usually a small pendant in the shape of a flat crown, while in Turkey it was crescent-shaped, with typical Ottoman decorative motifs (e.g. repoussé silver *tas*, Izmir, 19th century; Jerusalem, Israel Mus.).

The sacredness of the Torah scroll (it could not be touched with the bare hand) gave rise to the *yad* or Torah pointer. Extant pointers, from the 17th century onwards, are usually narrow, sceptre-like rods terminating in a miniature hand with outstretched index finger. Many pointers were made of costly materials such as silver, coral or ivory, often set with precious stones (e.g. carved wood *yad*, Bohemia, 1806–7; cast silver chased and engraved *yad*, Vienna, 1867–70; both Prague, State Jew. Mus.). Ashkenazi pointers hung on a chain above the *tas*; in other communities they were usually kept inside the ark. In Islamic lands the pointers were often flat, and the hand resembled the amuletic *hamsa* shape.

When not in use, the 'dressed' Torah scroll (see fig. 26) is enshrined in the ark. Although no ancient arks have survived, already in the Talmudic period (c. 3rd to 6th century AD) the scrolls were housed in elaborate shrines that constituted an integral part of the synagogue structure (see §II, 1(ii)(b) above). The scrolls themselves were put inside a low, portable wooden cabinet, referred to in the Talmud as a *tevah* (Heb.: 'chest'), which was probably brought to the shrine during services or placed in it permanently. Depictions of these cabinet arks, known mainly from funerary art found in the Jewish catacombs in Rome, reveal that in shape and design they resembled Roman cabinets used to house any scrolls or codices. The

26. Torah scroll dressed in the Ashkenazi tradition, with shield and pointer from Nuremberg, *c.* 1660; finials from Augsburg, 1769–71; mantle from Poland, 1867 (Jerusalem, Israel Museum)

decoratively carved doors of the movable arks are commonly shown open, displaying the rolled scrolls lying on shelves in a horizontal position. In medieval Europe the niche and cabinet underwent a major change: they were extended vertically, and the scrolls stood upright in the upper section. Tall, arched niches in the eastern wall survived in some medieval Spanish synagogues (e.g. El Tránsito, Toledo).

Arks produced in Italy and other European countries from the Renaissance were fashioned as highly ornate, large wooden cabinets. Early Italian examples survive from Modena (1472; Paris, Mus. Cluny) and Urbino (*c.* 1500; New York, Jew. Mus.). Both arks are rectangular in shape and double-tiered. However, while the former retains the tall and narrow format known since the Middle Ages, the latter uses forms that became common in later

arks: a central, projecting cupboard flanked by recessed side sections. The ornamentation of the Urbino ark with gilded pilasters, panels with vine scrolls and the Decalogue is also common in many 17th- and 18th-century Italian arks. Typical examples from this period are shaped as fanciful Baroque structures with gilded architectural elements, such as columns—sometimes twisted—covered with rich floral designs, and ornamental cornices surmounted by broken pediments.

Ornate Baroque structures, often reflecting prevalent shapes and motifs of the locale, gained popularity among other European Jewish communities. Monumental arks were erected by both Ashkenazim and Sephardim in countries such as Poland, Germany, the Netherlands and England. Exceptionally large is the ark in the Portuguese synagogue in Amsterdam (1671–5), which comprises five sections of costly Brazilian wood, each framed by Ionic columns and surmounted by a cornice and pediment. The Amsterdam ark displays the Decalogue carved on two tablets placed at the upper part of the central section. This feature, usually with the addition of two rampant lions, has been commonly used down to modern times.

Attractive examples of folk art wood-carving are found in the Polish arks of the 18th century, in which the doors of the ark were carved into a complex of openwork floral and faunal forms painted in bright colours. Jewish symbols are intertwined with rich plant motifs and a variety of animals, in particular the four mentioned in the Talmudic dictum: 'Be bold as a leopard, light as an eagle, swift as a deer and strong as a lion, to do the will of your Father in heaven' (Pirkei Avoth, 5:23). This exhortation is sometimes carved on the arks' doors as well.

With the introduction of the Moorish style into synagogue architecture in the second half of the 19th century (*see* §II, 1(iii)(a) above), many arks were fashioned with pronounced Islamic architectural elements and designs. Ark façades with horseshoe arches were erected in numerous synagogues in Europe and the USA through the first decades of the 20th century. Subsequently, and especially after World War II, artists were commissioned to create synagogue furnishings in innovative styles and techniques. Often working closely with the synagogues' architects, these artists employed new materials, including glass, brass, bronze, concrete and various fabrics, to form modern, monumental arks.

A major adornment of the ark is a textile curtain, now commonly known as a *parokhet*. It is hung in front of the ark's doors (inside the doors, in Italian and some Sephardi synagogues), apparently in allusion to the *parokhet* of the Tabernacle, which separated 'the holy place and the most holy' (Exodus 26:33). Decorative woven curtains appear in depictions of the Torah shrine in the floor mosaics of ancient synagogues, as at Hammath-Tiberias and Beth Shan, and are mentioned in medieval rabbinical sources. The earliest extant examples, however, are from the late 16th century (e.g. 1590; Prague, State Jew. Mus.). The most sumptuous curtains originated in Germany and Bohemia-Moravia in the 17th and 18th centuries. They were commissioned by wealthy patrons or organizations and were made of the finest materials: velvets, brocades, silks and satins, richly embroidered with silver and gold threads. Two notable examples in the State Jewish Museum

in Prague are a silk brocade and velvet *parokhet*, embroidered with metallic thread and sequins (Prague, 1686–7); and another of silk embroidered with metallic and silk threads (Salzburg, 1894–5). Frequently, architectural elements—in particular, two massive columns, sometimes shown twisted—flank a centrepiece, usually depicting familiar Jewish symbols (example from Istanbul, *c.* 1735; New York, Jew. Mus.). Lengthy votive inscriptions commonly appear above and below the centrepiece. Some Jewish embroiderers specialized in this craft, such as Elkanah Naumburg (*fl* Bavaria, 18th century). In Italy, however, the curtains were usually woven by women, who embroidered them with depictions of subjects such as the *Giving the Law on Mount Sinai* and *Walled Jerusalem with the Temple*, and with the symbols of special Sabbaths and festivals (e.g. Venice, Mus. Com. Isr.). Ottoman curtains resembled Muslim prayer rugs, though they sometimes bore biblical quotations. From the 18th century onwards German and Bohemian-Moravian curtains had an additional horizontal valance hung above the curtain, called a *kapporet*, after the cover of the Tabernacle. Such valances were often embroidered with majestic wings representing the cherubim, Temple implements, the Decalogue and symbolic crowns, an example being the silk velvet *kapporet* embroidered with silk and metallic threads and hardstones, in the State Jewish Museum, Prague.

BIBLIOGRAPHY

G. Loukomski: *Jewish Art in the European Synagogues* (London, 1947)
E. R. Goodenough: *Jewish Symbols in the Greco-Roman Period*, iv (New York, 1954), pp. 99–144
Synagoga: Kultgeräte und Kunstwerke (exh. cat., Recklinghausen, Städt. Ksthalle, 1960)
A. Kampf: *Contemporary Synagogue Art: Developments in the United States, 1945–1965* (Philadelphia, 1966)
U. Nahon: *Holy Arks and Ritual Appurtenances from Italy in Israel* (Tel Aviv, 1970) [in Heb., Eng. and It.]
R. Wischnitzer and B. Narkiss: 'Ark', *Encyclopaedia Judaica*, iii (Jerusalem, 1971), cols. 450–58
R. Hachlili: 'The Niche and the Ark in Ancient Synagogues', *Bull. Amer. Sch. Orient. Res.*, ccxxiii (1976), pp. 43–53
Fabric of Jewish Life: Textiles from the Jewish Museum Collection (exh. cat., ed. B. Kirshenblatt-Gimblett and C. Grossman; New York, Jew. Mus., 1977)
C. L. Meyers and E. M. Meyers: 'The Ark in Art: A Ceramic Rendering of the Torah Shrine from Nabratein', *Eretz-Israel*, xvi (1982), pp. 176–85
J. Gutmann: *The Jewish Sanctuary*, Iconography of Religions, xxiii/1 (Leiden, 1983)
E. Revel-Neher: *L'Arche d'alliance dans l'art juif et chrétien du second au dixième siècles* (Paris, 1984)
V. Mann: 'The Recovery of a Known Work', *Jew. A.*, xii–xiii (1986–7), pp. 269–78
B. Yaniv: *Sixteenth–Eighteenth Century Bohemian and Moravian Parochot with an Architectural Motif* (diss., Jerusalem, Hebrew, U., 1987) [Heb., with Eng. summary]
C. Grossman: *A Temple Treasury: The Judaica Collection of Congregation Emanu-El of the City of New York* (New York, 1989)
B. Narkiss: 'The Heikhal, Bimah, and Teivah in Sephardi Synagogues', *Jew. A.*, xviii (1992), pp. 30–47

2. SABBATH. The holiness of the Sabbath, celebrated at home and in the synagogue with special liturgy and ceremonies, inspired the creation of a number of attractive ceremonial objects. At sunset on Friday the housewife ushers in the Sabbath by the ancient rite of kindling lights; over the ages, special lamps were created for this ritual. The earliest type from Europe was a hanging metal lamp derived from medieval German lamps; persisting among the Jews of Germany, it came to be known as the *Judenstern*.

As the name implies, it consisted of a star-shaped oil container, affixed at the centre to a flat or cylindrical shaft, sometimes with an adjustable ratchet that allowed it to be lowered on the eve of the Sabbath. The *Judenstern* was a common Sabbath implement in German-Jewish homes from at least the 14th century and later spread to Eastern and Central Europe. Most lamps of this type were made of brass or bronze (e.g. one of cast brass from Germany, 18th century; Jerusalem, Israel Mus.). Wealthy families commissioned skilled Christian craftsmen to create elaborate ornamental lamps: in an example (see fig. 27) by the Frankfurt goldsmith Johann Valentin Schüler (1650–1720) the shaft is fountain-shaped, with statuettes bearing appropriate Jewish objects. Other types of hanging oil lamps

27. Sabbath hanging lamp by Johann Valentin Schüler, from Frankfurt am Main, *c.* 1680–*c.* 1720 (New York, The Jewish Museum)

28. Ritual silver spice-boxes from Germany, 17th–18th centuries (Jerusalem, Israel Museum)

were common in Italy and among the Sephardi Jews of southern Europe. In Islamic lands the oil containers are of glass or earthenware. In North Africa a special type of lamp, called a *kandil*, was developed. It was made of pierced silver or brass sheet, with floral and bird motifs, as in an example of chased brass from Morocco (late 18th century; Jerusalem, Israel Mus.). Sabbath candlesticks were also commonly used in Jewish homes but have, as a rule, nothing to distinguish them from standard, local examples, except for those from Poland, which were the work of Jewish craftsmen.

The Sabbath table is traditionally covered with a festive tablecloth, which in some communities was embroidered with folk images associated with the Sabbath or the Holy Places. An embroidered piece of cloth was also used for covering the *challah* (braided loaf of bread) of the Sabbath meal. On returning from the synagogue on Friday evening the male head of the family recited the *kiddush* (benediction for the sanctification of the Sabbath) over a cup of wine. *Kiddush* cups are usually made of silver; they sometimes bear the words of the benediction, floral designs, or images related to the Sabbath (e.g. engraved silver *kiddush* cup, Russia, *c.* 1800; Jerusalem, Israel Mus.). Special wine flasks for the *kiddush*, with appropriate inscriptions, were common in both Europe and the Near East: the Jewish Museum, London, has a Sabbath wine bottle of light green glass from Syria (18th–19th century).

The Sabbath terminates on Saturday evening with a ceremony called *havdalah* (Heb.: 'separation', i.e. between the holy day and weekdays). The ceremony is performed at home, with benedictions over wine, spices and light. In Central European communities the candle lit at this ceremony was made of decoratively plaited tapers of different colours; a special holder, commonly of silver, protected it from breaking, and a movable socket allowed the stub to be removed (e.g. embossed and chased silver candle holder, New York, Col. Temple Emanu-El). The most sumptuous and varied Sabbath object is certainly the box or container of spices, called a *hadas*. Spices have been used in the *havdalah* ceremony since antiquity, but a spice-container is first mentioned in rabbinical sources only in the 12th century. Early extant examples, by 16th-century German goldsmiths, were made in the shape of towers, a form that has remained popular in many Ashkenazi communities. Such spice-boxes (see fig. 28) were decorated with turrets, pennants, balustrades and clocks, as well as with human figures shown performing various religious duties. A German 18th-century pewter spice-container (Jerusalem, Israel Mus.) is a box with drawers. In Eastern Europe the boxes were variously shaped as fruits, flowers and fish. A silver one from 18th-century Poland (Jerusalem, Wolfson Mus.) is shaped like a pine-cone; another, from 19th-century Ukraine (Los Angeles, CA, Heb. Un. Coll. Skirball Mus.), is in the form of a silver filigree bird, decorated with hardstones. A silver-gilt spice-box from 19th-century Slovakia (Prague, State Jew. Mus.) has the form of a fruit on a leafy stem. Exquisite and delicate filigree work characterizes many spice-boxes.

BIBLIOGRAPHY
F. Landsberger: 'The Origin of the Ritual Implements for the Sabbath', *Beauty in Holiness: Studies in Jewish Customs and Ceremonial Art*, ed. J. Gutmann (New York, 1970), pp. 167–203
M. Narkiss: 'Origins of the Spice Box', *J. Jew. A.*, viii (1981), pp. 28–41
Towers of Spices: The Tower-shape Tradition in Havdalah Spiceboxes (exh. cat., ed. M. G. Koolik; Jerusalem, Israel Mus., 1982)

3. FESTIVALS. Many ritual objects were created specifically for the ceremonies of the Jewish festivals. On the high holy days of Rosh ha-Shanah (Jewish New Year) and Yom Kippur (Day of Atonement) an ancient wind instrument called a *shofar* (pl. *shofarot*) is sounded. It is made from the horn of a ritually pure animal and is usually unadorned, although some Ashkenazi *shofarot* of the 18th and 19th centuries were incised with appropriate verses and simple decorations (e.g. engraved horn, Germany, 19th century; Jerusalem, Israel Mus.). For Sukkot (Feast of Tabernacles or Booths) the main ceremonial object is a special container for the *etrog* (citron fruit), one of the four species of plants used in this originally agricultural festival. *Etrog* containers, usually made of silver or wood, were common in Europe and the Near East. Many assumed the shape of the fruit itself (e.g. green and yellow faience *etrog* box, Poland, 19th century; Jerusalem, Israel Mus.), while others were square boxes, often bearing quotations and decorations related to Sukkot. The roof and walls of the *sukkah*, the temporary dwelling erected for the festival, were decorated with fruits and vegetables, papercuts and ornamental plaques. The Jewish Museum, New York, has such an ornamental plaque (ink and watercolour on paper, Trieste, *c.* 1775), depicting an astrolabe in micrography: it is the work of Israel David Luzzatto (1746–1806).

One of the most varied and widespread of ritual objects, with distinct types in many lands, is the lamp kindled during the eight-day festival of Hanukkah, commemorating the miraculous rededication of the Temple in Jerusalem by the victorious Hasmoneans in 165 BC. The Hanukkah lamp consists of eight lights, customarily lit by a ninth, the *shammash* or servitor, which is usually placed higher than the rest. In antiquity the lamp probably resembled standard Roman and Byzantine oil lamps with multiple apertures (*see* ROME, ANCIENT, fig. 122). In medieval Europe a cast bronze lamp evolved, with a decorative back panel attached to a row of oil spouts. Typically the back panel was triangular, pierced with a Gothic rose window above a colonnade and a trefoil at the top: the back plate of a 14th-century cast bronze lamp, probably Italian (New York, Coll. Temple Emanu-El), has a central roundel with a phoenix and two side roundels with lions, all in relief. Such lamps could be hung on the wall, as deemed proper by rabbinical authorities; they became the most popular domestic type for many centuries, with attractive variants from place to place. In 16th- to 18th-century Italy the back panel was pierced with such typical Renaissance motifs as cornucopias, putti, dolphins, mermaids, tridents and centaurs. In Poland, brass lamps with the addition of side panels were decorated with architectural, floral and animal motifs (see fig. 29); delicate filigree designs are typical of East European lamps. Popular Jewish symbols and sometimes biblical scenes are found on the back panels of German and some English lamps. Commonly used in European synagogues was a large standing lamp resembling the menorah, the golden, seven-branched candelabrum of the Temple, depicted on the Arch of Titus, Rome; one such lamp, in repoussé silver, made in

Frankfurt am Main in the first half of the 18th century, is in the Musée de Cluny in Paris. In Yemen and North Africa, forms of the ancient bench-type stone lamps (e.g. Yemen, 18th century; Morocco, 19th century; both Jerusalem, Israel Mus.) continued in use into the modern era; typically, however, North African lamps of the 19th century were based on European back-panelled lamps, with the pierced decorations replaced by local designs. In Iraq and India the oil receptacles are of coloured glass, and the brass back panels employ such motifs as the amuletic *hamsa* hands, crescents, stars and the Star of David (e.g. lamp of cast and painted brass, Baghdad, 19th century; Jerusalem, Israel Mus.).

The story of the rescue of the Jews from destruction in ancient Persia, narrated in the Book of Esther, is read in the synagogue on the festival of Purim. The text is written on a parchment scroll or MEGILLAH, which is kept in a special cylindrical case. Such cases were usually of silver, ivory or wood, decorated with floral and animal motifs and scenes from the Esther story (e.g. silver-gilt filigree case set with precious gemstones, Turkey, 18th century; Jerusalem, Wolfson Mus.). Elaborately embossed silver Italian cases are sometimes topped with the owner's coat of arms, as with one from c. 1700 in the Jewish Museum, London. During the reading of the scroll, noisemakers are shaken at every mention of the name of Haman. Most noisemakers were of wood, but some 19th-century decorated silver examples are known (Jerusalem, Israel Mus.). Another Purim custom is giving gifts of food: in Central Europe special pewter plates, engraved with quotations and folk images related to Purim, were used for this purpose (e.g. German pewter plates, 18th century; Los Angeles, CA, Heb. Un. Coll. Skirball Mus.).

The spring festival of Passover also revolves around a miraculous story, the Exodus from Egypt, read from the HAGGADAH during the domestic Seder ceremony. In the centre of the festive table is the Seder plate, on which ritual foods are placed in a prescribed manner. In Europe and West Asia, Seder plates were commonly circular and flat, made of silver, pewter, brass, ceramic, maiolica (in Italy) or faience, and often decorated with Passover scenes. The Jewish Museum, London, has one of pewter, with a star of David in the centre, by John Watts (1749–92); and one (c. 1850) of white Staffordshire porcelain, inscribed in blue with the names of the ritual foods. In the 19th century a three-tiered plate was designed to hold three pieces of *mazzah* (unleavened bread); small decorative vessels, such as miniature silver wheelbarrows, were used for other symbolic foods (see the three-tiered Seder set with wheelbarrows, repoussé silver and parcel gilt, Vienna, c. 1870; Jerusalem, Israel Mus.). The Cup of Elijah, a large wine cup set apart on the table for the Prophet of redemption, was sometimes decorated with a figure representing the Messiah. The Israel Museum, Jerusalem, has a number of examples, such as an engraved silver and parcel gilt cup (Munich, 1679–80) and a 19th-century Bohemian crystal glass. From the second day of Passover forty-nine days are ritually counted to the harvest festival of Shavuot. This counting, known as *sefirat ha-omer* (Heb.: 'counting of the sheaf'), was sometimes facilitated by special calendars in the form of parchment rolls with adjustable rollers, set inside wood or metal boxes (e.g. parchment and wood

29. Brass Hanukkah lamp from Poland, 18th century (Jerusalem, Israel Museum)

calendar depicting Moses and Aaron, Italy, 18th century; Los Angeles, CA, Heb. Un. Coll. Skirball Mus.). In Eastern Europe, delicate ornamental papercuts called *shavouslach* or *raizelach* were made for Shavuot (numerous examples of the late 19th and early 20th century, Tel Aviv, Ha'aretz Mus.).

BIBLIOGRAPHY
M. Narkiss: *Menorat ha-hanukkah* [The Hanukkah lamp] (Jerusalem, 1939) [with Eng. summary]

4. LIFE CYCLE.

(i) Birth and circumcision. Ritual objects were also created for the ceremonies marking significant events in the life of a Jew. In almost every community it was believed that in childbirth the mother and infant needed protection against evil forces. The amulets produced for this purpose were often decoratively designed. In Islamic lands, silver amulets were frequently ornamental pieces of jewellery. Paper and parchment amulets inscribed with cabbalistic formulae and illustrated with appropriate symbols were common in both East and West. Extant examples include an amulet for the birth chamber (watercolour on paper, 19th century; Strasbourg, Mus. Alsac.); an amulet for pregnancy (black and red ink on parchment, early 20th century; Jerusalem, Israel Mus.); and an amulet for childbirth (brown ink on parchment with coloured decorations, Germany, 18th century; Jerusalem, Mus. N. A. Ebraica–It.). In Italy the amulets were placed in attractive silver cases, often with gilt appliqués of Temple implements and other symbols (examples Mus. N. A. Ebraica–It.).

On the eighth day after birth the male baby is circumcised in a ceremony called the *berit milah*, in which a set of special instruments is used. The handles of the circumcision knives were often made of costly materials, sometimes set with precious gemstones. The Israel Museum, Jerusalem, has a silver circumcision knife with carved wood handle depicting the *Sacrifice of Isaac* (Italy, ?18th century), while the Jewish Museum, New York, has a set of utensils (knife, shield, scissors, phials for unguents and bowls) in silver filigree and mother-of-pearl in a silver filigree box (Netherlands, 1827 and 1866). The circumcision chair or bench, known as 'Elijah's chair', was in some cases artistically carved and painted (e.g. carved wood chair, painted and gilded, with embroidered cushion, Mantua, 18th century; Jerusalem, Wolfson Mus.).

(ii) Bar Mitzvah. When a boy reaches the age of 13, the age of religious maturity, the Bar Mitzvah ceremony is celebrated. At this time he usually receives a set of *tefillin*, or phylacteries (Deuteronomy 6:8), and a *tallit*, a prayer shawl with fringes at the four corners (Numbers 15:38–41), such as the late 18th-century silk *tallit* from France (Amsterdam, Joods Hist. Mus.). Decorative silver cases were made for the cubicles of the *tefillin*, especially in Poland and Germany (e.g. silver and parcel gilt case with inscriptions and pairs of lions, eagles, deer and trees, Poland, end of 18th century; Jerusalem, Israel Mus.), while in North Africa the boy was presented with a velvet bag for the *tallit*, richly embroidered in gold threads or covered with pierced and engraved silver sheets inscribed with his name (e.g. Jerusalem, Wolfson Mus.).

SHALOM SABAR

(iii) Marriage.

(a) Rings. According to rabbinic sources the wedding band should be a plain circlet, but some highly elaborate rings were also used. Although undocumented in Jewish literary and pictorial sources, approximately 300 rings survive, including two examples dated no later than 1347 and 1350 (Paris, Mus. Cluny; Halle, Staatl. Gal. Moritzburg; see fig. 30) and one of not later than 1598 (Munich, Residenz). The rings, of gold, silver-gilt or gilt-bronze, may be assigned to several main types, which share two characteristics: the absence of a gemstone, though they may be embellished with enamels, and the Hebrew inscription *mazal tov* (lit. 'lucky star', good luck) or its initials.

The aedicular type, with large, elaborate bezels in the form of arcaded buildings perhaps derived from Temple imagery, represented by the two medieval rings cited, was perhaps in use until the late Renaissance (London, Jew. Mus., 456); the type may have originated in the medieval German empire. These rings would probably have been used only during the wedding ceremony. Schudt mentions *mazal tov* rings in use *c*. 1700 at Jewish weddings in Frankfurt am Main.

Filigree rings related to East European goldsmiths' work, some with imbricated 'roofs' (Oxford, Ashmolean, F442), and the humbler lettered hoops (London, BM, 1348–50) may be considerably later. Boldly enamelled

30. Silver-gilt ring, the bezel in the form of a rectangular Gothic hall, the hipped roof engraved with the Hebrew words *mazal tov*, h. 30 mm, diam. 25 mm, 14th century (Halle, Staatliche Galerie Moritzburg)

lettered bands carrying windowed houses (London, V&A, 4100–1855), and figurative rings (London, BM, 1331–5), may be 19th-century romantic revivals.

BIBLIOGRAPHY
J. J. Schudt: *Jüdische Merckwürdigkeiten* (Frankfurt am Main and Leipzig, 1714)
T. C. Croker: *Catalogue of a Collection of Ancient and Medieval Rings and Personal Ornaments Formed for Lady Londesborough* (London, 1853)
Catalogue of Rings in the Collection of the Hon. Richard Cornwallis Neville (n.d. [c. 1856])
G. Seidmann: 'Marriage Rings, Jewish Style', *Connoisseur*, ccvi (1981), pp. 48–51 [coloured pls]
——: 'Jewish Marriage Rings', *Jewel. Stud.*, i (1983–4), pp. 41–4
GERTRUD SEIDMANN

(b) Other. Many other traditions and ornamental objects are associated with the marriage ceremony and married life. Before the wedding the bride and the groom used to exchange gifts, called *sivlonot*. Among the wealthy families in the Netherlands and Italy the gift was a silver book-binding (for prayerbooks); in Italy this would be embossed with the two families' coats of arms. In Germany special silver *sivlonot* belts (e.g. silver filigree chain belt, Germany, 17th century; Amsterdam, Joods Hist. Mus.; silver belt inlaid with precious stones, Italy, early 18th century; Jerusalem, Israel Mus.) were worn by the bride and groom under the *chuppah* (marriage canopy). The canopy was originally a pavilion or bridal chamber, eventually developing into a piece of decorative cloth stretched over four poles. Such portable canopies were common from the 16th century among the Ashkenazim, who held their weddings in the courtyard of the synagogue. The Israel Museum, Jerusalem, has a silk *chuppah* embroidered with metallic threads, inscribed with the Seven Benedictions (Hungary, 1876). The Sephardim in Europe, whose weddings were celebrated inside the synagogue, generally used canopies fixed to the wall. During the wedding the groom crushes a glass, commonly interpreted as a sign of mourning for the destroyed Temple. In Ashkenazi weddings the glass was thrown against a star-shaped stone called the *Traustein* or *chuppah* stone (e.g. red sandstone *Traustein*, Germany, c. 1700; Jerusalem, Israel Mus.), which was placed on the northern wall of the synagogue; European Sephardim used a silver platter for this purpose. In countries such as Yemen, Morocco, Tunisia and Afghanistan the costumes and jewellery of the brides were particularly elaborate and extensive. In many lands the marriage contract (*see* KETUBBAH) provided a distinct field of artistic embellishment.

A constant reminder of the obligation to perform the commandments is the *mezuzah*, a parchment scroll inscribed with passages from Deuteronomy 6:4–9 and 11:13–21, which is affixed to the right doorpost in every observant Jewish home. Over the centuries it became customary to put the *mezuzah* in a special container, variously made of silver, brass, ceramic, glass or wood and decorated with Hebrew inscriptions, Jewish symbols, floral designs and, sometimes, biblical scenes (examples Jerusalem, Israel Mus.). In North Africa the *mezuzah* cover was usually a small bag of velvet richly embroidered in gold threads (example Jerusalem, Wolfson Mus.).

(iv) Burial. In Jewish communities burial of the dead is handled by an organization called the *chevra kaddisha*

('holy society'). Its members wash the body, using special implements such as silver combs and nail cleaners (examples Prague, State Jew. Mus.). During funerals they used to carry alms boxes of various materials and shapes. In Bohemia-Moravia the members held a festive annual banquet, usually on the day associated with the death of Moses, during which they drank from large glass beakers, colourfully enamelled with illustrations and inscriptions related to the society's activities (numerous examples, Prague, State Jew. Mus.). Such banquets were also held in Germany, where large silver beakers were used. Special motifs and designs were also developed in tombstone decoration. Ashkenazi tombstones were often carved with pictorial symbols related to the name or occupation of the deceased, as well as faunal, floral and common Jewish motifs. Italian tombstones also displayed the family's coat of arms. The tombstones of rich Sephardim in the Netherlands and the Antilles bear representations of biblical scenes and contemporary symbols of death.

SHALOM SABAR

VII. Easel painting, sculpture and graphic arts, after 1800.

One major consequence of political, economic and social emancipation for the Jews from the late 18th century onwards was their increasing secularization and assimilation into gentile society. Only when Jewishness was no longer definable solely in terms of religion did the question of Jewish identity in art become problematic, inasmuch as a distinction could now be made between paintings, sculptures and artefacts with a Jewish content and those created by Jewish artists who nonetheless pursued secular themes. For the first time in their history, Jewish artists began to influence the non-Jewish world, although a desire for acceptance (often combined with a fear of anti-Semitism) led most Jewish artists at this time to deny or underplay their Jewishness. The ethnic and religious origins of Anton Raphael Mengs (*see* MENGS, (2)) and JOHAN ZOFFANY, the two major artists of this period possibly of Jewish birth, thus remain uncertain, and their work contains no overtly Jewish references. Most late 18th- and early 19th-century figures of undisputed Jewish origin, having chosen to convert to Christianity, depicted a wide range of largely non-Jewish subjects, although Nazarene-affiliated painters such as Philipp Veit and Eduard Bendemann did on occasion produce sentimentalized renderings of Old Testament scenes (*see* NAZARENES). Not surprisingly, most Jewish artists in this period hailed from Germany, the cradle of Jewish emancipation.

1. 19th century. 2. Early 20th century. 3. Late 20th century.

1. 19TH CENTURY. The first unconverted Jew to achieve lasting success as an artist was the German Moritz Daniel Oppenheim (1800–82), whose meticulously detailed, idealized and nostalgic renderings of Jewish life and worship appealed to the burgeoning Jewish bourgeoisie of Central and Eastern Europe as a reassuring reminder of a disappearing world. Jewish genre painting of this kind, often popularized through the print medium and closely allied to the folkloristic and regionalist tendencies of Romantic genre painting generally, flourished throughout

20. Solomon Alexander Hart: *Interior of the Synagogue at Livorno (Simchat Torah)*, oil on canvas, 0.87×1.74 m, 1841–2 (New York, The Jewish Museum)

the 19th century. Its best-known exponents included the Hungarian-born Leopold Horovitz and Isidor Kaufmann (1853–1921), the Ukrainian-born Jehuda Epstein (1870–1946), who although resident in Vienna chronicled Jewish life in the small villages of the Austro-Hungarian empire, the Swedish painter Geskel Salomon (1821–1902), the Polish artist Maurycy Gottlieb, the Dutchman Jozef Israëls and the British artist SOLOMON ALEXANDER HART (see fig. 20). At the same time most of these artists, anxious to avoid being identified wholly with Jewish themes, produced works on non-Jewish subjects as well. Although religious conversion was no longer a prerequisite for artistic success, an increasing number of Jewish artists chose almost total assimilation: CAMILLE PISSARRO, for instance, barely considered himself a Jew at all and painted not a single Jewish subject; MAX LIEBERMANN, whose lifestyle represented an almost perfect synthesis of gentile and German-Jewish culture, painted only a few.

2. EARLY 20TH CENTURY. Continuing persecution of Jewish communities in Europe led to their further scattering in the early 20th century. Some artists responded to their new circumstances by experimenting with new trends; others by drawing on Jewish themes and experience.

(i) Russia. (ii) France. (iii) Britain and the USA. (iv) Nazi Germany. (v) Israel.

(i) Russia. The first collective attempt to create a style of art fusing Jewish and national themes took place in Russia in the period before and immediately after the 1917 Revolution. As early as 1878 the critic Vladimir Stasov, a friend of the Jewish realist sculptor Mark Antokol'sky, had been advocating an art based on ethnic loyalties. In 1905 Stasov and David Günzburg, head of the Jewish Academy in the University of St Petersburg, published *L'Ornement hébraïque*; the first Jewish ethnographic expedition, to the villages of Volhynia and Podolia in modern Ukraine, was organized in 1912, and in 1916 the Jewish Historical and Ethnographical Society financed Issachar Ryback (1897–1935) and El Lissitzky in an exploration of the wooden synagogues along the Dnepr River. The 18th-century synagogue of Mogilev in the Ukraine exercised a particular attraction: 'Haim the son of Isaac Segal of Sluzk', who painted its walls, was adopted by Marc Chagall as his fictitious grandfather. The Jewish *lubok*, or woodblock print, was also much admired. Hebrew calligraphy was

considered an important component of a truly Jewish art, as was the use of deep, velvety, 'spiritual' tones of colour.

The 1917 Declaration of the Rights of the People of Russia, which announced 'the abolition of all national and national-religious prejudices and restrictions, and the full development of national minorities and ethnic groups', seemed for a few years to make feasible a truly Russian-Jewish art form. Between around 1916 and 1920, prompted by widespread avant-garde interest in the 'primitive', such artists as Ryback, Lissitzky, Chagall, Iosif Chaykov, David Shterenberg, Boris Aronson (1898–1980) and Natan Al't-man found inspiration in Russian-Jewish folk art. They produced paintings in the naive style depicting synagogues, Jewish customs, character portraits, designs for the Yiddish and Hebrew theatre and illustrations of religious texts, such as the design by EL LISSITZKY for the cover of *Chad Gadya* (the title of a Passover song; see fig. 21). Nearly all these artists were given positions of authority in the new artistic institutions set up by Anatoly Lunacharsky, People's Commissar for Education from 1917 to 1928.

In 1920, however, the running of Jewish communal affairs was handed over to the Yevsektsiya, the Jewish section of the Soviet Communist Party, which, aiming at the revolutionization of the Jewish masses, promptly instigated the systematic eradication of all ethnic aspirations. (Ironically, one of the chief exponents of the school of Socialist Realism, which was ultimately to win the day, was also a Jew, Isaak Brodsky.) Only Chagall, who left the USSR in 1922, continued to celebrate the traditional Jewish culture; most of the others turned to the creation of a geometric abstract art, claiming (probably by way of justification) that 'it is the emphasis on formal aspects of painting rather than the subject-matter which reveals the true racial identity of the artist' (see Ryback and Aronson).

(ii) France. A considerable number of Jewish artists had left Russia well before the 1917 Revolution, seeking freedom both from religious discrimination, if not persecution, and from the constraints of artistic academicism. As the centre for avant-garde art, Paris attracted a large number of non-Jewish foreigners; but a disproportionate number of those who came from around 1905 onwards were Jews, so much so that by the 1920s the notion of an *Ecole juive* as a subdivision of, even a synonym for, the ECOLE DE PARIS had gained currency. The better-known among the Jewish émigrés were MARC CHAGALL, Georges Kars (1882–1945), Michel Kikoïne (1892–1968), Moise Kisling, Pinchus Krémègne, Jacques Lipchitz, Mané-Katz, Amedeo Modigliani, Chana Orloff, Jules Pascin, Chaïm Soutine and Ossip Zadkine. A second generation, which arrived in the 1920s and 1930s, included Sigmund Menkès (1896–1985), Abraham Mintchine (1898–1931) and artists who were later to move to Israel, such as Arie Aroch, Moshe Castel (*b* 1909), Avigdor Stematsky, Yehezkel Streichman and Yosseff Zaritsky.

By far the majority of these artists hailed from Russia and Eastern Europe. Often lodged close together, they tended to share a similar, frequently materially impoverished lifestyle, supported by the same benefactors, notably the dealers Léopold Zborowski, Chéron and Adolphe Basler (1876–1951), and promoted by the same critics, above all the French Jew Waldemar George. The fact that

21. El Lissitzky: title-page of *Chad Gadya*, pen and ink with gouache and traces of pencil on paper, 275×225 mm, 1919 (London, Grosvenor Gallery)

several of these artists, notably Soutine, Pascin and Modigliani, led colourful and often tragic lives gave rise to the myth of the Jewish *peintre maudit*, despite the absence in their work of any explicit indication of their Jewishness. The only collective attempt to create a specifically Jewish art was instigated around 1912 by a group called the Machmadim, or Precious Ones, comprising such relatively minor figures as Krémègne, Henri Epstein (1892–1944), Leo Koenig and the sculptor Léon Indenbaum (1892–1981). Iosif Chaykov, a graphic artist who returned to Russia in 1914, formed an important link between this group's activities and the quest for a Jewish style in Russia. Although Chagall later expressed scorn for the Machmadim, recent evidence (see Steyn) suggests a closer involvement than was hitherto supposed.

Non-Jews as well as Jews acknowledged the conspicuous presence of Jewish artists in Paris. In many cases, the response was overtly anti-Semitic, particularly during the inter-war 'call to order' period, when Jewish artists were accused of treating painting as a speculative business. The 'foreign' Ecole de Paris was frequently accused of undermining the racial and artistic 'purity' of the Ecole française. Attempts were made—and continue to be made—to characterize the oeuvre of Jewish artists working in Paris as essentially expressionist, conveying unease or nostalgia through the use of richly sombre, heavily applied colour, irrespective of subject-matter.

(iii) Britain and the USA. By the end of the 19th century waves of Jewish immigrants had already entered England and the USA, mostly composed of poor Jewish families

22. Ben Shahn: *Identity*, mixed media on paper, 1015×698 mm, 1968 (Madrid, Museo Thyssen-Bornemisza)

from Russia and Eastern Europe fleeing the pogroms of the time. The Jewish artists who emerged in these countries in the early 20th century were thus, unlike their Parisian counterparts, the children of immigrants, who grew to maturity in their parents' adoptive country. In London, support for aspiring young Jewish artists came mainly from the Jewish Educational Aid Society, the Ben Uri Art Society, founded in 1915, and the personal influence of such established Anglo-Jewish artists as Solomon J. Solomon (1860–1927) and William Rothenstein. The Yiddish-language journal *Renaissance*, among others, provided a forum for artistic debate. Once launched into the wider world, however, such painters as David Bomberg, Mark Gertler and Alfred Wolmark (1877–1961) tended to renounce the overtly Jewish subject-matter of their early works, grounded in biblical themes or in the life of London's East End.

In New York, support came mainly from the Educational Alliance, the People's Art Guild, founded in 1915, and, in the 1920s, from the Jewish Art Center. The Yiddish arts journal *Schriften*, founded in 1918, reproduced work by such Jewish artists as Max Weber, Abraham Walkowitz, Chaim Gross and Louis Lozowick (1892–1973). Of the large number of American-Jewish artists of this generation, relatively few, and these mainly of a socialist persuasion and working in a realist mode, chose consistently to depict the world of their childhood. Among those who did so

were Jack Levine, Moses Soyer and Raphael Soyer, William Gropper (1897–1977) and BEN SHAHN (see fig. 22). The sculptor JACOB EPSTEIN first made his mark as an illustrator of Lower East Side life. A number of artists, MAX WEBER, for example, started their careers working in an abstract modernist mode, turning to traditional Jewish motifs only in later years, usually during World War II.

(iv) Nazi Germany. Although the Nazis were to blame what they perceived as the 'degeneracy' of modern art on a Jewish–Bolshevist conspiracy, there were relatively few major 20th-century German-Jewish artists; LUDWIG MEIDNER was a notable exception. Those who left Germany in the 1930s did much to enrich the visual culture of those countries, mainly Britain and the USA, they made their second home, even if their contribution long remained subdued and insufficiently appreciated. Those who remained to become victims of the Nazi Holocaust were to find in their art an aid to survival. Many victims who had never wielded a brush before the war or had merely been amateurs became committed artists by force of circumstance.

The art produced in the camps and ghettos consisted of three main types. There was firstly the art produced to Nazi orders, in the form of portraits, genealogical charts, scenes in 'sentimental realist' style from history or mythology, forgeries of other works of art, landscapes, images of animals, architectural drawings, greetings cards and party invitations. In addition, there was the unofficially

23. Waldemar Nowakowski: *The Jews' Last Road*, watercolour, 152×114 mm, 1943 (untraced)

tolerated art, not done to order but acceptable because deemed unsubversive. It included some of the categories mentioned above, produced as a means of barter. Both these types of art tend to be bland and lacking in individuality.

Contrasted to these were the unofficial 'resistance' works. Despite the diversity of styles employed, the art produced at mortal risk fulfilled the same function for all the victims, acting as a link with their former identities and as an assertion of individuality in the most dehumanizing of experiences. Waldemar Nowakowski's sketch of *The Jews' Last Road* (see fig. 23) is such an example. Although some of these works use an expressionistic style to convey a sense of doom, most stress the dignity of human life in objectively rendered scenes of everyday occurrences, while some of the most poignant depict scenes from happier days. Approximately 30,000 works in a wide variety of often improvised media have survived, representing only a fraction of the victims' total output.

Some of the professional artists, such as Felix Nussbaum (1904–44), perished; others who discovered or consolidated their talent during the war survived to become professionals in the post-war years. The art produced later on the theme of the Holocaust both by survivors such as Leo Haas and Lea Grundig and by Jews who did not experience it at first hand (R. B. Kitaj is a recent example) tends to be more complex and allusive in its imagery.

(v) Israel. Although Israel was to achieve statehood only in 1948, Zionist artists had pinned hopes on Palestine as early as 1906. In that year, BORIS SCHATZ, former artistic adviser and sculptor to the Bulgarian court, founded the Bezalel School of Arts and Crafts in Jerusalem (*see* BEZALEL) with the aim of creating a Jewish art that would pull together strands that had been scattered widely over the past 2000 years. In practice, the dominant mode, represented by teachers in the school such as Ephraim M. Lilien (1874–1925) and Ze'ev Raban (1890–1970), was a kind of orientalized Art Nouveau, a European style grafted on to biblical subject-matter.

The generation that came to maturity in the 1920s, including such artists as Reuven Rubin and Nahum Gutman (1898–1981), rejected this approach; nonetheless, their apparently innocent celebration of the Mediterranean environment and its mainly Arab inhabitants has strong affinities with the idealizing tendencies of much European art of that decade, as exemplified by the work of HENRI ROUSSEAU. The later 1930s and the 1940s saw an increased preoccupation with the Semitic roots to be found in Ancient Near Eastern cultures. This trend is best represented by a group of artists and writers who called themselves the 'Canaanites' and by ITZHAK DANZIGER's sculpture *Nimrod* in particular (see fig. 24). By the 1950s, however, despite the existence of a group of politically committed Social Realist artists (Naftali Bezem (*b* 1924) and Avraham Ofek (1935–89), for example), a lyrical abstraction of nature represented by the NEW HORIZONS group, including such artists as Yosseff Zaritsky and Yehezkel Streichman, dominated the Israeli art scene. Although influenced by the light and colours of the countryside, this style was essentially internationalist in

approach, akin to ART INFORMEL. Since then, although individual artists such as Mordecai Ardon, Moshe Castel and Yosl Bergner have continued to explore the nature of Jewish identity in a post-Holocaust world, the general tendency has been to underplay the question of Jewishness

24. Itzhak Danziger: *Nimrod*, Nubian sandstone, h. 1.0 m, 1939 (Jerusalem, Israel Museum)

in favour of internationalism. If, as in recent Israeli art, the issue of identity arises, it is as an Israeli, with all the historical and geographical factors attendant on this, rather than as a Jew, that the artist confronts it. (Artistic trends and the development of art institutions in Israel are discussed further in ISRAEL, §§III and XI.)

3. LATE 20TH CENTURY. Religion, although no longer the single driving force behind Jewish self-definition, has nonetheless proved a continuing source of inspiration. Craftsmen and craftswomen such as Gerald Benney, Beryl Dean and George Weil in Britain or Ita Aber in America continue to produce Jewish ritual objects for use in home and synagogue, although, as in earlier times, many of the designers–makers are not in fact Jewish. The general tendency is either to perpetuate the Baroque style of traditional artefacts or to marry the geometricizing principles of modern design with a sense of traditional purpose. A number of Jewish artists, particularly in the USA, have worked closely with modern architects to produce paintings and sculptures for use within the context of a synagogue. While the assumed taboo on figuration prevented such artists as Jacob Epstein and, to a certain extent, Marc Chagall from putting their art at the service of the synagogue (among the exceptions are the Chagall windows in the Hadassah Synagogue, Jerusalem), the dominance of the abstract in the post-war period has helped artists to evade that problem. Herbert Ferber, for example, produced a monumental sculpture for the façade of the B'nai Israel Synagogue in Millburn, New Jersey (1951), the first American synagogue to incorporate works of art in its design; while in 1963 the artist Barnett Newman designed an entire synagogue (unexecuted; see H. Rosenberg: *Barnett Newman* (New York, 1978), pp. 226–7). Other post-war artists, for example the Americans Ben Shahn, Hyman Bloom and Leonard Baskin, created paintings, prints and sculptures that allude to traditional Jewish ritual practices.

For a number of Jewish artists the Bible has provided a cogent means of commenting on the present. JACQUES LIPCHITZ, for example, abandoned the Cubist idiom of his pre-war sculptures in favour of a Baroque idiom that openly refers to the world of biblical experience. Marc Chagall is among many Jewish artists (others include Otto Pankok, Emmanuel Levy (*b* 1900) and Michael Rothenstein (1908–93)) to have depicted Jesus as the first Jewish martyr and the Jews during the Holocaust as his modern representatives. The precedent for this approach dates back to the late 19th century, when such artists as Mark Antokol'sky, Maurycy Gottlieb and Max Liebermann, responding to contemporary anti-Semitism, portrayed him in a similar fashion and aroused similar controversy. Another favourite biblical subject has been the Sacrifice of Isaac, which, with its themes of submission and trial, is seen to be relevant to Jewish history in the 20th century.

While Jewish artists and craftsmen of the 19th and 20th centuries showed themselves to be, as ever, profoundly influenced by the culture of the environment around them, certain characteristics were nonetheless singled out repeatedly by Jews and non-Jews alike as being typical of art produced by modern Jewish artists, whether practising Jews or not, and irrespective of subject-matter and cultural

context. Conspicuous among them would appear to be an emphasis on spiritual, rather than material, values; a nervously expressionistic handling of paint and line indicative of a lack of concern for academic propriety; a strong social conscience and moral seriousness and a reluctance, if not inability, to accept the idea of 'art for art's sake' (the modern equivalent, perhaps, of the biblical fear of idolatry); a distinct tendency to melancholy (often expressed through the prominence given to the eyes) and an empathy for all forms of human suffering; an uneasiness with hedonistic sensuousness, especially when it comes to the depiction of the female nude; and finally, a predisposition to abstraction as the purest expression of the divine principle.

BIBLIOGRAPHY

Ryback and Aronson: *The Paths of Jewish Painting* (1919)
H. Rosenberg: 'Is There a Jewish Art?', *Commentary*, xlii (1966), pp. 57–60
C. Roth, ed.: *Jewish Art: An Illustrated History* (London, 1971), pt 3
R. Pincus-Witten: 'Six Propositions on Jewish Art', *A. Mag.*, 1 (1975), no. 4, pp. 66–9
M. Kozloff: 'Jewish Art and the Modern Jeopardy', *Artforum*, xiv/8 (1976), pp. 43–7
Artists of Israel, 1920–1980 (exh. cat. by M. Barasch, Y. Fischer and Y. Zalmona, New York, Jew. Mus., 1981)
Z. Amishai-Maisels: 'The Jewish Jesus', *J. Jew. Art*, ix (1982), pp. 84–104
J. Blatter and S. Milton: *Art of the Holocaust* (London, 1982)
G. Ofrat: 'The Utopian Art of Bezalel', *Ariel*, li (1982), pp. 33–63
I. Golomstok: 'Jews in Soviet Art: The Early Years', *Sov. Jew. Affairs*, xiii/2 (1983), pp. 3–31
The Immigrant Generations: Jewish Artists in Britain, 1900–1945 (exh. cat. by C. Spencer and V. Lipman, New York, Jew. Mus., 1983)
A. Kampf: *Jewish Experience in the Art of the Twentieth Century* (South Hadley, MA, 1984)
J. Steyn: 'The Jewishness of Marc Chagall?', *A. Mthly*, lxxxv (1985), pp. 6–7
The Circle of Montparnasse: Jewish Artists in Paris, 1905–1945 (exh. cat., ed. K. Silver and R. Golan; New York, Jew. Mus., 1985)
Tradition and Revolution: The Jewish Renaissance in Russian Avant-Garde Art, 1912–1928 (exh. cat. by R. Apter-Gabriel, Jerusalem, Israel Mus., 1987)
Gardens and Ghettos (exh. cat., New York, Jew. Mus., 1989), pp. 136–89 [article by E. Braun]
Z. Amishai-Maisels: *Depiction and Interpretation: The Influence of the Holocaust on the Visual Arts* (Oxford and New York, 1993)

MONICA BOHM-DUCHEN

VIII. Museums and collections.

1. TO 1945. The expansion of the scientific study of Judaism in 19th-century Europe brought about an interest in preserving and collecting Jewish cultural material and ceremonial art for purposes of exhibition and study. Before that period, collections of Judaica chiefly consisted of Hebrew manuscripts and books assembled by Jewish bibliophiles and Christian Hebraists. A notable early exception was the small collection of ceremonial objects of Alexander David (1687–1765), a German court Jew; he later bequeathed the objects to his synagogue in Brunswick, where a congregational museum was established *c.* 1875. Larger and more systematic collections were formed after 1850, serving as the basis for the early public exhibitions of Judaica. The first major exhibition was organized for the 1878 Exposition Universelle at the Palais du Trocadéro in Paris. It consisted of the ritual objects collected by the musician Isaac Strauss (1806–88), whose collection was later bought by the Rothschild family and presented in 1890 to the Musée de Cluny, Paris. In 1887

it was shown, together with English collections, at the extensive (2954 items) Anglo-Jewish Historical Exhibition. In the USA, the Judaica collection of Hadji Ephraim Benguiat, an art collector from Izmir, was shown at the 1893 World's Columbian Exposition in Chicago. The Benguiat collection was then housed in the Smithsonian Institution, Washington, DC; in 1924 it was acquired by the Jewish Theological Seminary, New York.

These early exhibitions and the general rise of ethnographic museums in Europe increased the awareness of Jewish art, and a number of societies were founded, dedicated to the preservation of ritual objects and material culture. In 1895 the Gesellschaft für Sammlung und Conservierung von Kunst- und Historischen Denkmälern des Judentums drew up plans for establishing in Vienna the first actual Jewish museum, containing some 400 objects and a library; it was not opened until the beginning of the 20th century, however. A larger museum was established in 1901 in Frankfurt am Main by the Gesellschaft zur Erforschung Jüdischer Kunstdenkmäler, headed by the Director of the Düsseldorfer Kunstgewerbemuseum, Heinrich Frauberger (1845–1920), a Roman Catholic. Jewish museums were subsequently opened in many cities with major Jewish concentrations, including Danzig (now Gdańsk, Poland, 1904), Prague (est. 1906; small displays from 1909; new, larger premises 1926), Warsaw (1910), Budapest (est. 1913, opened 1916), Berlin (1917), Munich, Mainz (1926), Breslau, Silesia (now Wrocław, Poland, 1929), London and Amsterdam (1932), Kraków (1935) and Nikolsburg (now Mikulov, Moravia, 1936). The collections in these museums comprised paintings, including portraits of Jewish subjects, ceremonial objects, Hebrew illuminated manuscripts and documents relating to the history of the local Jewish community. Some of the acquisitions were made through donations or purchases of local private collections. Notable among these were the pioneering collection of Jewish art assembled by the Polish historian Matthias Bersohn (1823–1908) and bequeathed to the Warsaw Jewish community; the collection of Italian and German silver Judaica of Sigmund Nauheim (1879–1935), presented to the Frankfurt am Main Jüdisches Museum; and the collection of ritual objects of the English Zionist leader Arthur Howitt (1885–1967), which was auctioned in 1932 and purchased, in part, for the newly established Jewish Museum in London.

Important Judaica collections were also formed in the Russian Socialist Federal Soviet Republic (later the USSR). In 1912–14 the Jewish Historical and Ethnographical Society (established in 1908), headed by the folklorist S. An-Ski (1863–1920), organized an expedition to record and assemble ethnographic materials throughout the Ukraine, Podolia and Volhynia. The numerous objects collected were housed in the Jewish Ethnographic Museum in St Petersburg (later Leningrad), which was active until the 1930s. Subsequently the government transferred the collections to the State Museum of Ethnography in Leningrad. Before World War II, museums were also established in Kiev and Odessa (1923), Vilna (now Vilnius, Lithuania, 1930), Tblisi (active 1933–50) and Lwów (now L'viv, Ukraine, 1934).

31. Exhibition of Hebrew manuscripts and prints, Klausen Synagogue, Prague

World War II and the Holocaust of European Jewry put an end to most of the Jewish museums in German-occupied territories: the Nazis systematically destroyed, plundered or closed down the flourishing Jewish museums of Europe. A few collections were saved in various ways: in 1939 the entire collection of the Gdańsk museum, packed in ten crates, was sent to New York (now in New York, Jew. Mus.). Paradoxically, the largest collection of Judaica was formed by the Nazis themselves. Wishing to establish a 'museum to an extinct people', they gathered in 1941 objects from 153 Jewish communities in Bohemia and Moravia, housing them in the old synagogues of Prague, such as the Klausen Synagogue. After World War II these formed the basis of the State Jewish Museum in Prague, which has since then been active in preserving and exhibiting its massive and unparalleled collections (see fig. 31) and in publishing journals and catalogues.

2. FROM 1945. The Jewish Museum of New York, the largest in the USA, had its beginnings in 1904 with a modest gift from Judge Mayer Sulzberger; later it received the Benguiat collection and that from Gdańsk, which had been acquired by the Jewish Theological Seminary. In 1947 the Warburg mansion on Fifth Avenue was donated to the Seminary, becoming the Museum's permanent site. The collections grew significantly, thanks to the extensive buying activities of Harry G. Friedman (1882–1965), who set out to rescue treasures from post-war Europe. The Hebrew Union College Museum in Cincinnati, OH, was instituted as early as 1913 but opened to the public only in 1947. Its main holdings consist of the print collection

of the Anglo-Jewish collector Israel Solomons and the ceremonial artefacts collected by the Berlin industrialist Salli Kirschstein (1869–1935) as well as the personal collection of Heinrich Frauberger. In 1972 the museum's collection was moved to Los Angeles, CA, to the renamed Hebrew Union College Skirball Museum. The Skirball Museum Cincinnati Branch is still maintained in Cincinnati.

Other leading Jewish museums in the USA include the Judah L. Magnes Museum in Berkeley, CA (founded 1962); the B'nai B'rith Klutznick Museum, Washington, DC (1964); the Maurice Spertus Museum, Chicago, IL (1968); the Yeshivah University Museum, New York (1973); and the National Museum of American Jewish History, Philadelphia, PA (1976). There are also many smaller museums, often attached to and operated by the local temples. In recent years, both Jewish and non-Jewish organizations have established museums commemorating the Holocaust in major American cities, the largest of which is the Holocaust Memorial Museum in Washington, DC.

With the rise of Zionism and the establishment of Israel, the Jewish state has become a leading centre of museums dealing with Jewish art and biblical archaeology. As early as 1906 the artist BORIS SCHATZ founded in Jerusalem the Bezalel School of Arts and Crafts, which from 1925 housed the Bezalel National Museum (later Bezalel National Art Museum). Its collections of Judaica grew steadily in quality and quantity under the discriminating directorship of Mordechai Narkiss (1897–1957), a leading scholar in the field of Jewish ceremonial art, and in 1964 were transferred to the newly established Israel Museum, which opened to the public a year later. Since then, the much expanded Judaica and Jewish Ethnography departments at the Israel Museum have organized major exhibitions, accompanied by extensive catalogues. Two noted private collections of ceremonial art were acquired for the Museum: the Feuchtwanger Collection in 1969 and the Stieglitz Collection in 1987.

Also housed in Jerusalem are the following collections: illuminated Hebrew manuscripts, in the Jewish National and University Library and the Schocken Library; ceremonial artefacts with many examples from Islamic lands, in the Sir Isaac and Lady Edith Wolfson Museum and the Israel Museum; and Italian Judaica, in the Museum of Italian Jewish Art. In 1988 the Museum of Iraqi Jewry opened in Or Yehud. Additional major collections in Israel are to be found in the ethnography department at Ha'aretz Museum in Tel Aviv; in the Museum of Art (Mishkan Le'omannt) in Ein Harod; and in the Music and Ethnology Museum in Haifa. The Nahum Goldmann Museum of the Jewish Diaspora, or Beth Hatefutsoth, founded in Tel Aviv in 1978, concentrates on the audio-visual materials of Jewish history and maintains an extensive photographic archive.

Since the end of World War II many new Jewish museums have been established in Europe, notably in Venice (1957), Belgrade (1960), Rome and Toledo (both 1964), Basle (1966), Athens (1977), Bucharest (1978) and Florence (1981). In these and a few other smaller museums, emphasis is put on displays of the local Jewish cultural material, and attempts are made to obtain, preserve

and restore local Jewish monuments. The Joods Historisch Museum of Amsterdam survived World War II, recovered some of its looted collections and was established in restored and much expanded premises at the historic Ashkenazi Synagogue. Germany and Austria have also seen a revival of Jewish museums and exhibitions dealing with local Jewish history and art. Such museums, or Judaica departments in general museums, have opened in such German cities as Berlin, Brunswick, Cologne and Frankfurt am Main and also in Austria, in Vienna and Eisenstadt. The expansion of interest is also reflected in the establishment of Jewish museums outside Europe and the USA, in Johannesburg (1957), Cape Town (1958), Buenos Aires (1967) and Melbourne (1982).

The number of private Judaica collectors has likewise increased. The noted Warsaw collector Michael Zagayski (1895–1964), whose first collection was looted by the Nazis, built a new, extensive collection in the USA; this collection has, however, been dispersed in a number of auctions conducted from 1955 to 1968. Important new collections have been formed in towns such as Amsterdam, London, Paris, Vienna, Zurich, Santiago, Tel Aviv and Jerusalem; there are also important collections, for example, in Temple Emanu-El, a Reform synagogue, in New York, and the Beth Tzedec Museum, Toronto, chiefly containing the Judaica collection assembled by the historian Cecil Roth (1899–1970). Small Judaica collections are also kept in some general museums, such as the Smithsonian Museum, Washington, DC, and the Victoria and Albert Museum, London. The majority of the private Judaica collectors today are American, and the leading auction firms of Sotheby's and Christie's hold regular sales of Judaica and Hebraica in the USA.

See also ISRAEL, §IX.

BIBLIOGRAPHY
Enc. Jud.
H. Volavkova: *Příběh Židovského Muzea v Praze* [Story of the Jewish Museum in Prague] (Prague, 1966; Eng. trans., Prague, 1968)
L. Kolb: 'The Vienna Jewish Museum', *The Jews of Austria*, ed. J. Fraenkel (London, 1967), pp. 147–59
A. Kampf: 'The Jewish Museum: An Institution Adrift', *Judaism*, xvii (1968), pp. 282–98
R. D. Barnett, ed.: *Catalogue of the Permanent and Loan Collections of the Jewish Museum London* (London, 1974), pp. xiii–xix
A. M. Feldman, G. Cohen Grossman and J. Gutmann: *The Maurice Spertus Museum of Judaica* (Chicago, 1974)
Y. L. Bialer and E. Fink: *Jewish Life in Art and Tradition* (New York, 1976)
L. Y. Rahamani: *The Museums of Israel* (London, 1976)
N. Rosenan: *L'Année juive* (Zurich, 1976)
W. L. Gross: 'Catalogue of Catalogues: Bibliographical Survey of Temporary Exhibitions of Jewish Art', *J. Jew. A.*, vi (1979), pp. 133–57
W. Hausler and M. Berger: *Judaica: Die Sammlung Berger, Kult und Kultur des europäischen Judentums* (Vienna, 1979)
Danzig 1939: Treasures of a Destroyed Community (exh. cat., New York, Jew. Mus., 1980)
V. Klagsbald: *Catalogue raisonné de la collection juive du Musée de Cluny* (Paris, 1981)
I. Shachar: *Jewish Tradition in Art: The Feuchtwanger Collection of Judaica*, Jerusalem, Israel Mus. cat. (Jerusalem, 1981)
D. Altshuler, ed.: *The Precious Legacy: Judaic Treasures from the Czechoslovak State Collections* (New York, 1983)
G. Ofrat-Friedlander: 'The Bezalel Museum (1906–1929)', *Bezalel: 1906–1929* (exh. cat., ed. N. Shilo-Cohen; Jerusalem, Israel Mus., 1983), pp. 337–59
H. Simon: *Das Berliner Jüdische Museum in der Oranienburger Strasse* (Berlin, 1983)

D. H. Stavroulakis: 'The Jewish Museum of Greece', *Jew. Flklore & Ethnol. Newslett.*, vi/1–4 (1983–4)

Personal Vision: The Furman Collection of Jewish Ceremonial Art (exh. cat., ed. S. L. Braunstein; New York, Jew. Mus., 1985)

Treasures of the Jewish Museum (exh. cat., ed. N. L. Kleeblatt and V. B. Mann; New York, Jew. Mus., 1986)

C. Benjamin: *The Stieglitz Collection: Masterpieces of Jewish Art*, Jerusalem, Israel Mus. cat. (Jerusalem, 1987)

I. Benoschofsky and A. Schreiber: *A Budapesti Zsidó Múzeum* [The Jewish Museum of Budapest] (Budapest, 1987; Eng. trans., Budapest, 1987)

Guide to the Jewish Historical Museum Amsterdam (Amsterdam, 1988)

A. Greenwald: 'Jewish Museums in America', *Enc. Jud. Year Bk* (1989), pp. 167–81

C. Grossman: *A Temple Treasure: The Judaica Collection of Congregation Emanu-El of the City of New York* (New York, 1989)

E. Van Voolen: 'Jewish Museums in Europe', *Enc. Jud. Year Bk* (1989), pp. 182–8

R. I. Cohen: 'Collection and Preserving the Jewish Past: Judaica in the Israel Museum', *Israel Mus. J.*, ix (1990), pp. 51–60

Y. Inbar and E. Schiller, eds.: *Muzei'onim be-Yisrael* [Museums in Israel] (Jerusalem, 1990)

M. E. Keen: *Jewish Ritual Art in the Victoria & Albert Museum* (London, 1991)

R. R. Seldin: 'American Jewish Museums: Trends and Issues', *Amer. Jew. Yb.*, xci (1991), pp. 71–113

SHALOM SABAR

IX. Historiography.

Although barriers to an academic career were not removed until the late 19th century, the traditional Jewish inclination towards scholarship seems to have combined with a burgeoning interest in the visual arts in that century to attract a large number of German Jews to the field of art criticism, a discipline that had its beginnings in Germany. The enforced emigration of many of these scholars during the Nazi period led to their dispersal throughout the world, with the USA and Britain being the main beneficiaries (witness the transfer of Aby Warburg's institute from Hamburg to London in 1933). Many eminent Jewish art historians and critics (Erwin Panofsky and Aby Warburg, for example) have favoured an iconographic approach to their subject.

Apart from a few pioneering publications dating from the late 18th century onwards, foundations for a scientific study of pre-modern Jewish art were laid in the early 20th century by the German Gesellschaft zur Erforschung Jüdischer Kunstdenkmäler, founded in Frankfurt am Main in 1901, and by institutes set up in Russia to investigate Jewish culture and ethnography. The activities of the German society were halted in 1933; German-Jewish émigrés such as Rachel Wischnitzer (*b* 1892) and Franz Landsberger (1883–1964) continued its work elsewhere, especially in the USA. Other important writers on ceremonial Jewish art and architecture include Joseph Gutmann (*b* 1923), Guido Schoenberger (*b* 1891) and Herman S. Gundersheimer (*b* 1903) in the USA, and Mordechai Narkiss (1895–1957), Bezalel Narkiss (*b* 1927) and David Davidovitch (*b* 1905) in Israel. A number of scholars (Alfred Werner (*b* 1911), for example) have made a speciality of writing about modern artists who are also Jewish, but only a few, such as Avram Kampf (*b* 1919), Max Kozloff (*b* 1933), Robert Pincus-Witten (*b* 1935) and Harold Rosenberg (who are better known as critics of modern art generally), have tackled the thorny problem of Jewish identity in modern art. The main institution devoted to the study of Jewish art today is the Center for Jewish Art at the Hebrew University of Jerusalem.

BIBLIOGRAPHY
Enc. Jud.: 'Art Historians and Art Critics'
L. Venturi: *History of Art Criticism* (New York, 1936, rev. 1964)

MONICA BOHM-DUCHEN

Ji'an. *See* JIZHOU.

Jiangling [Chiang-ling]. City and county in Jingzhou District, Hubei Province, China. About 5 km to the north of Jiangling, at Ji'nancheng, are the remains of a walled town identified as Ying, the capital of the state of Chu, destroyed in 278 BC by the state of Qin. The site is marked by an imposing wall of rammed earth (*hangtu*) almost 16 km in circumference. The remains of this are up to 8 m high and 30–40 m wide at the base. Almost rectangular in layout, the enclosure was surrounded by a ditch and had access through seven entrances. Though the site was occupied earlier, the town itself appears to have been established during the 6th or 5th century BC. This is confirmed by a study of the personal effects found in tombs in the area.

About a thousand tombs have been thoroughly excavated. The smallest ones are grouped into cemeteries, while the larger ones are scattered, each covered by a huge tumulus. The construction method of all the tombs is relatively homogeneous, however. The smallest, which contained few personal effects, are distinguished from one another by the presence or absence of a coffin. The medium-sized or large tombs, comparable to those at Changsha and XINYANG, are of characteristic Chu design: each is shaped like an upturned pyramid, with a completely sealed, compartmentalized, wooden structure at the bottom. This structure functioned as an outer coffin, with a funerary chamber that contained little more than the coffin and, according to the wealth and no doubt the status of the owner, one or more compartments for personal effects. A large array of Chu funerary artefacts and other objects was unearthed, including ritual bronzes, generally unadorned, and ceramics that are exact copies of bronzes. There are also many wooden objects, often lacquered in red or black: stylized sculptures of monsters intended to protect the deceased (e.g. *see* CHINA, fig. 345), human figures, zoomorphic sculptures of deer, birds, birds with antlers, or feline creatures, musical instruments such as zithers or drum stands in animal shapes, tableware and sword cases. (For further discussion of Chu wood-carving from Jiangling *see* CHINA, §XIII, 26.) Arms are numerous, some valuable, such as the swords of the kings of Yue (now the Yue state beyond Chu, Zhejiang Prov.). Items such as bronzes inlaid with threads of gold and silver, lacquered pieces, silk garments and embroideries and finely woven bamboo suggest the existence of workshops that specialized in luxury goods.

The conservation techniques used in the tombs and natural conditions there preserved many rare works that convey the cultural wealth of the Chu people. However, there are insufficient comparably well-preserved sites associated with other principalities of the Warring States period (403–221 BC) for a full evaluation of the originality of the Chu.

BIBLIOGRAPHY

N. Barnard, ed.: *Early Chinese Art and its Possible Influence in the Pacific Basin* (New York, 1972)

A. Juliano: 'Three Large Chu Graves Recently Excavated in the Chiangling District of Hubei Province', *Artibus Asiae*, xxxiv (1972), pp. 5–17

Jiangling Yutaishan Chu mu [Chu tombs at Yutaishan Jiangling] (Beijing, 1984)

Jiangling Mashan yi hao Chu mu [Chu Tomb 1 at Mashan, Jiangling] (Beijing, 1985)

Li Xueqin: *Eastern Zhou and Qin Civilizations* (New Haven and London, 1985)

T. Lawton, ed.: *New Perspectives on Chu Culture during the Eastern Zhou Period* (Washington, 1991)

ALAIN THOTE

Jiaohe. *See* YARKHOTO.

Jiayuguan [Chia-yü-kuan]. Town near Jiuquan in western Gansu Province, China, which controlled passage through the Great Wall from the Qin period (221–206 BC) to the late part of the Ming (1368–1644). Located at the western end of the Great Wall in the foothills of the Jiayu Mountains, it was an important strategic point, controlling entry to the Hexi corridor, and a vital communication centre on the Silk Route. As such, it ranks with Yangguan and Yumenguan in Dunhuang as one of the main military posts on the frontier with Central Asia. Under the emperor Wudi (*reg* 141–87 BC) of the Western Han dynasty (206 BC–AD 9), the Great Wall was extended almost 500 km west of Jiayuguan as a measure against the marauding Xiongnu nomads. The town developed into a strong military colony, with a large Chinese population cultivating the surrounding countryside. Numerous graves and tombs dating to the Han (206 BC–AD 220), Wei (AD 220–65) and Eastern Jin (AD 317–420) periods are located near the modern settlements of Guoyuan and Xincheng, to the north-west of JIUQUAN, and indicate the continued importance of this post.

The existing fortress-town dates from the Ming period. From an architectural point of view the walls and towers resemble those found at Xi'an and Beijing, although on a more modest scale; the walls and gates date from the late 14th century, while the wooden towers were added as late as 1506. An inner fort is surrounded by an outer 'city', the whole complex encircled by a fortress wall of brick and stone (h. 11.7 m, circumference 733.3 m) that encompasses an area of more than 33,500 sq. m. The fort has an east and a west gate, on top of which stand wooden three-storey watchtowers (h. 17 m); on both sides of the gates are two broad ramps leading to the top of the wall. The gates are reinforced by a lesser protective wall with a gate opening to the south. Out-cropping watch-towers in brick stand in the four corners of the outer wall. On the rampart in the corners of the inner fortress are movable arrow-throwers: large crossbows mounted on frames, like those used in medieval Europe, which could be lifted by several soldiers and carried to other parts of the parapet. Inside the fortress proper are low, one-storey buildings in brick housing the garrison and military commander, built around an inner courtyard.

In the 1960s Jiayuguan was designated a major tourist attraction on the Silk Route, and the walls and buildings have undergone repair and modifications several times since then. The existing structures are probably reconstructions.

BIBLIOGRAPHY

History and Development of Ancient Chinese Architecture, Chinese Academy of Sciences (Beijing, 1986), pp. 425–8

Gao Fengshan and Zhang Junwu: *Jiayuguan zhi Ming changcheng* [Jiayuguan and the Great Wall during the Ming] (Beijing, 1989)

HENRIK H. SØRENSEN

Jiboku. *See* OGURI SŌTAN.

Jibu. *See* KANŌ, (4).

Jibuti. *See* DJIBUTI.

Jifei Ruyi. *See* SOKUHI NYOITSU.

Jihlava [Ger. Iglau]. Town in Moravia, Czech Republic, at the confluence of the rivers Jihlava and Jihlávka on the borders of Bohemia and Moravia. It has a population of *c.* 54,000. On the old route to eastern Europe, it was originally a Slav settlement around a church dedicated to St John the Baptist, but on the discovery of rich silver deposits it was developed from the mid-13th century and populated by German miners. It acquired a strongly German character, which it retained until the exchange of populations after World War II.

Granted civic and mining rights, which became the pattern for mining communities throughout the Holy Roman Empire, the town grew up on a traditional fortified plan, with a moat, a staple (the right to store merchandise), a hospital and a set of building regulations. During the Hussite Wars of the 1420s Iglau remained Catholic, and in 1436 the Peace of Iglau was promulgated to reconcile the opposing forces. The town's unusually long rectangular market-square (328×114 m; see fig.) contained the sprawling building of the so-called Hradek, probably the original administrative centre (destr. *c.* 1980). The former magistrate's house (later town hall; see below) stands in roughly the centre of the east side of the square. In the square itself the Lady Column (1690) has carvings by Antonín Laghi, and the two fountains (1798) are by Jan Václav Prchal (1744–1811). The parish church of St James (the patron saint of miners) is east of the square, on a headland above the Jihlávka. The Franciscan convent protected the western fortifications, and that of the Dominicans dominated the north-eastern part of the town.

The interior of the oldest church, St John the Baptist, is now Late Gothic and much restored. St James's Church was founded with the town. By the end of the 13th century the presbytery had been built in a Transitional style, together with the outside walls of the three-aisled nave and the foundations of the twin western towers. Under the influence of the Dominicans, however, the presbytery was replaced by the present three-sided apse. The nave piers and vaults were completed in the 1380s together with the portals and the spiral staircases. The octagonal chapel of Our Lady of Sorrows was added to the north side in the 18th century, and a purist restoration of the church was undertaken in the 19th. Liturgical and other furnishings include mid-13th-century wooden sculptures brought from the Franciscan church, a statue of *St Catherine* (before 1400) from the workshop that produced the Krumau Madonna (Vienna, Ksthist. Mus.), and a font with copper reliefs made by J. Hirt in Nuremberg in 1599.

The interior decoration, including the main altars, is Baroque.

The Franciscan convent is first documented in 1257. One range of the cloister, including the chapter house, rib-vaulted with a central column, was built after 1280, and three other ranges, rib-vaulted in brick, were added *c.* 1380. In 1738 the building was raised one storey before becoming redundant. The Franciscan church of St Mary was built apparently before the mid-13th century as a three-aisled basilica and an enclosed choir originally rectangular in plan. The walls, vaults and east portal have survived. The church was enlarged at the end of the 14th century with the addition of two chapels vaulted in brick, and an octagonal belfry was built over the crossing. About 1500 the choir received a five-sided apse and a reticulated vault with sculptured bosses. The Baroque façade was added *c.* 1738. Surviving 14th-century wall paintings include a fragment of the *Crucifixion* on a pier, a female saint and another *Crucifixion* in the gallery, and a *Last Judgement*, with other paintings from the turn of the 15th century. A 16th-century painting in the presbytery depicting an attack on the city in 1502 was repainted in the Baroque period. In 1745 work started on the main altar to a design of Johann Georg Schauberger (*d* 1744) by the sculptor Andreas Zahner (1709–52) with paintings by Johann Georg Etgens (1693–1757), the pulpit being by Schauberger and the altarpieces by Johann Nepomuk Steiner (1725–93). The Dominican church of the Holy Cross, also built in the 13th century, was restyled during the Baroque period and occupied by the army in 1781. The church is one of the first purely Gothic buildings in Bohemia, and its three-aisled, almost square ground-plan became a model for Bohemian churches in the 14th century.

The town hall was built in 1426, but at the end of the 15th century the first floor was converted to a twin-aisled hall of three bays with brick ribbed vaulting. A panelled gallery was built over the courtyard. After fires in the mid-16th century the building was decorated with frescoes, and in 1786 it received another floor, a new façade and a tower. Houses fronting the square retain much of their medieval fabric: the vaulted ground floor of no. 31 dates from 1280; no. 66 (the district archive) has a 15th-century, twin-aisled hall on the ground floor and a fresco of the *Adoration of the Magi*; no. 7 has an oriel window rising through three storeys, relief sculpture and a mid-16th-century hall. Two-storey halls are typical of Jihlava; no. 58 has an arcaded gallery of the 1580s, and no. 57 (formerly the hall of the clothworkers' guild) also has an arcaded courtyard and Renaissance paintings. The two buildings together form the Regional Museum. No. 4 is a palatial type of house, rare in Jihlava, built *c.* 1730 on a Renaissance core, its style influenced by Johann Lukas von Hildebrandt.

As the silver mines were gradually worked out the cloth trade assumed greater importance, and the town reached its heyday in the 16th century, development in the 17th and 18th centuries occurring still within the walls. Renaissance styles affected only house designs. The Jesuits arrived in 1625, sequestered 23 houses on the square and built their college. The adjacent church of St Ignatius was built by Jacopo Brascha (*fl* 1680–89) with an oblong nave flanked by chapels and oratories. The façade, decorated

Jihlava, view of the market-square showing the Jesuit church of St Ignatius (1680–89) and the town hall (1426)

with statues of saints, has square towers. The vault has stucco decoration by G. B. Brentani and paintings (1717) by Carl Franz Töpper (1681–1738), but the side altars were decorated only from the mid-18th century. Two medieval sculptures, the so-called Přemysl cross of *c.* 1300 and a *Pietà* dating from *c.* 1400, were brought from elsewhere, perhaps the Dominican church. The Jesuit school behind the church was built 1720–27, with a fresco of *Parnassus* by Töpper. The college gives access to the extensive system of underground passages, two or three storeys deep, that run under the square and out beyond the town walls, used for storage, refuge and, in modern times, for public utilities.

The fortifications now consist of a rampart with a wall-walk and a moat. In their present state they date from 1500, with further strengthening in the mid-17th century. Of the five square gates with barbicans, only that in the middle of the western section, completed after 1508, has survived. After 1945 various buildings in the town were demolished, and others carefully restored. Since the 1960s the old nucleus has been surrounded by residential developments.

BIBLIOGRAPHY

A. Bartušek: *Umělecké památky Jihlavy* [Jihlava's artistic monuments] (Havlíčkův Brod, 1960)

IVO KOŘÁN

Jiménez, Edith (*b* Asunción, 1921; *d* Asunción, 14 May 1993). Paraguayan painter and engraver. She studied under Jaime Bestard and Lívio Abramo in Asunción and from 1958 in São Paulo, Brazil. Her paintings of the 1950s were Cubist-inspired landscapes and still-lifes in oils. In the late 1950s she began to transpose her schematized pictorial style into wood-engraving; in the early 1960s her engravings were increasingly based on the simple play of black and white and textures, and she then passed through a phase of abstraction related to *Art informel* finally to reach a purified but effectively suggestive abstraction based on organic forms. Her engravings of this period show her skill in synthesis and her capacity for expression: large shapes are realized straightforwardly in black and white but are animated by an intense inner energy. In the 1970s

she embarked on a new technique based on multiple impressions and the use of colour: large masses of strong shades and contrasting tones were superimposed and juxtaposed to provoke special chromatic tensions. This series of engravings, entitled *Puzzle*, won a prize at the São Paulo Biennale in 1955 and is on permanent display in the collection of the Senate in Brasília.

BIBLIOGRAPHY
O. Blinder and others: *Arte actual en el Paraguay* (Asunción, 1983)
T. Escobar: *Una interpretación de las artes visuales en el Paraguay* (Asunción, 1984)

TICIO ESCOBAR

Jiménez, Max (*b* San José, 16 April 1900; *d* Buenos Aires, 3 May 1947). Costa Rican painter, sculptor, engraver and writer. After spending two years in London, in 1922 Jiménez moved to Paris, where he dedicated himself to sculpture, drawing and painting. He came into contact with leading Spanish literary figures, and he discovered the African-influenced work of Picasso and Modigliani, as well as that of the Paris-based Brazilian painter Tarsila do Amaral. These influences led to the monumentality and Afro-Caribbean elements in Jiménez's painting and sculpture, in which traditional concepts of beauty were disregarded and the subjects painted in an exuberant manner (e.g. *Ileana*; see Ulloa Barrenechea, p. 231). In 1925 he returned to Costa Rica, but the lack of galleries or museums and of artistic activity (other than academic) frustrated Jiménez. Having been exposed in Paris to trends far in advance of Costa Rican art and feeling that his avant-garde ideas were not understood, he temporarily ceased to produce art.

In 1928 Jiménez returned to Europe; his collection of poems *Gleba* was published in Paris, and he wrote articles for the Salones Anuales de Artes Plásticas in San José. Also in 1928, he founded the Círculo de Amigos del Arte, an exhibiting society, with Teodorico Quirós. In Spain the following year he met such writers as Ramón del Valle Inclán. From 1928 to 1937 he wrote poems and short stories, which were published in Spain, Chile and Cuba, and he contributed to the Costa Rican periodical *Repertorio americano*. In 1934 he took up wood-engraving and illustrated his own articles. He continued making sculptures (e.g. *Red Head*, 1935; San José, Mus. N. Costa Rica), and in 1938 he returned to painting and had one-man shows in Paris (1939), New York (1940 and 1941) and Havana (1942–3). In 1945 he returned to Costa Rica and exhibited at the Galería L'Atelier. Still dissatisfied with Costa Rica, he went to Chile (1946) and Argentina (1947), where an emotional crisis led to his death. His artistic legacy was to open the way to greater expressionism in the painting and sculpture of Costa Rica.

BIBLIOGRAPHY
J. A. Losada: 'La pintura de Max Jiménez', *Norte*, lxxxxi (Feb 1942)
F. Amighetti: 'La pintura de Max Jiménez', *Rev. A. & Let.*, i/4 (1966)
R. Ulloa Barrenechea: *Pintores de Costa Rica* (San José, 1975), pp. 98–103

JOSÉ MIGUEL ROJAS

Jiménez, Miguel. *See* XIMÉNEZ, MIGUEL.

Jiménez Aranda, José (*b* Seville, 7 Feb 1837; *d* Seville, 6 May 1903). Spanish painter. He trained in Seville under Manuel Cabral and with Eduardo Cano de la Peña, showing an early interest in genre painting. This was perhaps due to the tradition of Romanticism in Seville, and Jiménez Aranda was already exhibiting pictures of this type at the Exposición Nacional in Madrid in 1864. He went to Rome, where he befriended Mariano José Bernardo Fortuny y Marsal, becoming the most representative of his Spanish followers. Jiménez Aranda attempted to exploit Fortuny y Marsal's style, known as *Fortunismo* or 'preciosity', and concentrated on the small genre painting or *tableautin*, with which he gained remarkable success. Fortuny y Marsal's influence can be seen in such works by Jiménez Aranda as *Room behind an Apothecary Shop* and *The Bibliophiles* (1879). These often ironic paintings look back to the 18th century and have something of the atmosphere of Goya's work. However, the skilled draughtsmanship, detailed execution and fine brushwork often bring them closer to the style of Ernest Meissonier than to the minute detailing and brilliant touch of Fortuny y Marsal. Jiménez Aranda also lived in Paris, where his Spanish *tableautin* achieved notable success. Around 1890 he became influenced by realism and was later interested in the problems of painting light as a result of his contact with Joaquín Sorolla y Bastida and Gonzalo Bilbao y Martinez (*b* 1860).

BIBLIOGRAPHY
B. de Pantorba: *Jiménez Aranda: Ensayo biográfico y crítico* (Madrid, 1930)
——: *El pintor Jiménez Aranda: Ensayo biográfico y crítico* (Madrid, 1972)
E. Valdivieso: *Pintura sevillana del siglo XIX* (Seville, 1981)

ENRIQUE ARIAS ANGLES

Jiménez de Cisneros, Francisco. *See* CISNEROS, FRANCISCO JIMÉNEZ DE.

Jiménez Donoso, José (*b* Consuegra, Toledo, *c.* 1632; *d* Madrid, 1690). Spanish painter. His first teacher was his father, and as an adolescent he entered the workshop of Francisco Fernández in Madrid. When Fernández died, *c.* 1649–50, Jiménez Donoso left for Rome, where he remained until 1657, studying painting and architecture. On his return to Madrid he entered the studio of Juan Carreño de Miranda and in the mid-1660s began a long association with CLAUDIO COELLO as his principal collaborator on fresco projects. Their first joint work may have been the decoration (*c.* 1667–8; destr.) of Santa Cruz, Madrid. Later collaboration included frescoes in the Capilla de S Ignacio and the sacristy of the Jesuit Colegio Imperial in Madrid (1673; destr. *c.* 1936–9). Both in fresco and in such easel paintings as the *Vision of St Francis of Paola* (Madrid, Prado), Jiménez Donoso showed a marked preference for the rich colouring and florid manner favoured by artists in Madrid in the later 17th century. The only extant fresco projects by Jiménez Donoso and Coello are two ceiling paintings (1673–4) in the Real Casa de la Panadería, Madrid, and the ceiling (*c.* 1671–3) of the vestry in Toledo Cathedral. In 1685 Jiménez Donoso was named official painter of Toledo Cathedral, and in 1686 he was appointed Maestro Mayor, becoming responsible for architectural and artistic works in the cathedral. Many of his paintings include ambitious architectonic backgrounds, for which he drew on his studies in Rome.

BIBLIOGRAPHY
Ceán Bermúdez
A. A. Palomino de Castro y Velasco: *Museo pictórico* (1715–24/*R* 1947), pp. 1037–40

EDWARD J. SULLIVAN

Jimeno y Carrera, José Antonio (*b* Valencia, 1757; *d* Madrid, after 1807). Spanish illustrator, printmaker and painter. He was nominated Miembro de Mérito of the Real Academia de S Fernando, Madrid, in 1781. He made reproductive engravings of paintings and illustrated such books as Juan Antonio Pellicer's (1738–1806) annotated edition of *Don Quixote* (1797), the *Fábulas morales* (1781–4) by Félix María de Samaniego (1745–1801) and the 1803 edition of the short stories *Novelas ejemplares* by Miguel de Cervantes Saavedra (1547–1616). In his depiction (1790) of the fire in the Plaza Mayor in Madrid and in his interiors of prisons and barracks he pioneered the use of aquatint. He produced the series *Caprichos y bombachadas* and illustrated the title-page of *Ideas y caprichos pintorescos* (Madrid, 1807). He had two sons: Laureano (1802–58), an engraver, and Vicente (1796–1857), a history painter.

BIBLIOGRAPHY
M. Ossorio y Bernard: *Galería biográfica de artistas españoles del siglo XIX* (Madrid, 1868), pp. 350–51
Conde de la Viñaza: *Adiciones al diccionario histórico de los más ilustres profesores de las bellas artes en España de Don Juan Agustín Ceán Bermúdez*, 4 vols (Madrid, 1894)
Baron de Alcahali: *Diccionario biográfico de artistas valencianos* (Valencia, 1897)
T. Miciato: *Breve historia del aquatinta: De Goya a Picasso* (Madrid, 1972)
E. Paez Ríos: 'Unas estampas españolas grabadas al aguatinta en la última década del siglo XVIII', *Homenaje a Guillermo Guastavino* (Madrid, 1974), pp. 111–17
A. Gallego: *Historia del grabado en España* (Madrid, 1979), p. 296
E. Paez Ríos: *Repertorio de grabados españoles en la Biblioteca Nacional* (Madrid, 1981–5)

BLANCA GARCÍA VEGA

Jimon. *See* ONJŌJI.

Jincun [Chin-ts'un; Kin-ts'un]. Site in Henan Province, China, *c*. 115 km north-east of Luoyang. Eight tombs of the late Warring States period (403–221 BC) were discovered there. Lavishly furnished with objects of jade, glass, gold, silver, bronze and similar materials, the tombs were looted by local people from 1928 to 1931. Some 300 items (Toronto, Royal Ont. Mus.) were collected and described by Bishop William Charles White, a Canadian who was stationed at nearby Kaifeng at the time. A selection of about 200 objects from private and public collections all over the world was subsequently published (see Umehara). Several of the artefacts contained in the graves were inscribed and thus can be ascribed to specific centuries and feudal states of the Warring States period, leading to some disagreement as to the origin of the tombs: they are considered either to have been constructed by the House of Zhou and to contain presents and tributary objects from the feudal states, or to have been constructed by the state of Qin and to contain war booty.

A large proportion of the bronze artefacts are mechanical parts for chariots, such as hinges and sockets or such crafted objects as finials and handles, some beautifully cast in the forms of animals' heads. There are also bronze mirrors, vessels, bells, human figures and animals (see fig.); characteristic of bronzes of this period, many objects are inlaid with gold or silver. Some of the mirrors, decorated in relief with the usual dragons and phoenixes on a background of spirals or lozenges, are inlaid with gold, silver or turquoise and show traces of ornamental glass discs (diam. *c*. 5 mm). The bronze vessels comprise

Jincun, bronze horse, h. 215 mm, Warring States period, 403–221 BC (Kansas City, MO, Nelson–Atkins Museum of Art)

three main types: the *hu* wine vessel and related *fang hu* square wine vessel, the *ding* tripod vessel with cover and the *dui* globular food vessel with cover (*see* CHINA, fig. 138). Some ritual vessels and the bronze bells bear inscriptions indicating that they were not intended as burial objects. Bronze sculptures of kneeling humans holding one or two tubes (h. *c*. 250 mm; e.g. Boston, MA, Mus. F.A.; Toronto, Royal Ont. Mus.) are believed to have served as holders for standards. These are shaped without much attention to detail, but traces of ornaments and geometrical patterns of inlaid coloured pigments and silver are discernible. Several bronze miniatures of various animals and ritual vessels (h. *c*. 25–50 mm) are also said to have come from the Jincun tombs.

Other articles reportedly from the tombs include silver cups and figures and various pottery or wooden vessels covered with lacquer. Jade objects are notable for their beauty and the technical skill with which they were executed. Glass in the shape of ritual discs (*bi*), 'eye-beads' (*see* CHINA, §XIII, 10(i)) and applied ornaments played a crucial role in the dating of Chinese glass.

BIBLIOGRAPHY
W. C. White: *Tombs of Old Lo-yang* (Shanghai, 1934)
Umehara Sueji: *Rakuyō Kinson kobo shūei* [Archaeological objects from the ancient tombs of Jincun, Luoyang] (Kyoto, 1936)
C. G. Seligman and H. C. Beck: 'Far Eastern Glass: Some Western Origins', *Östasiat. Mus. [Stockholm]: Bull.*, x (1938), pp. 1–64
B. Karlgren: 'Notes on a Kin-ts'un Album', *Östasiat. Mus. [Stockholm]: Bull.*, x (1938), pp. 65–81
Sun Ji: 'Luoyang Jincun chutu yin zhuoyi renxiang zu shu kaobian' [Some notes on the silver dressed figure from Jincun, Luoyang], *Kaogu* (1987), no. 6, pp. 555–61

BENT NIELSEN

Jindřichův Hradec [Ger. Neuhaus]. Town in the Czech Republic, on the River Nezárka in southern Bohemia. The castle of the Vítkovec family was founded here before 1220 on the site of a 12th-century settlement; the town, with its irregular ground-plan and network of streets

surrounding a trapezoidal square, was established by 1293. Early settlers included the military orders (Templars and German knights) in the early 13th century, succeeded by the Minorites in the 14th century. A Franciscan monastery and church were built in 1476 and a Jesuit seminary, now the local museum, in 1594. The town's fortifications date from the late 13th century and the 15th century. From *c.* 1200–1600 the town enjoyed a period of great prosperity. By the 19th century it had become an important cultural centre for the region. Hradec's stock of historic houses has been badly depleted by a series of fires, the worst of which occurred in 1801. However a number of Gothic and Renaissance examples survive, some modified in the Baroque and Neo-classical periods. It is an urban conservation area.

The parish church of the Assumption (1360s) features a triple nave divided by heavy arcades, and a chancel roofed by low vaulting. The Minorites' monastery (from *c.* 1350) retains Gothic frescoes. Its church of St John the Baptist (*c.* 1275–*c.* 1450) has a double nave: the chapel of St Nicholas (late 1360s) off the south side of the chancel is vaulted from a single central column. The single most important building in the town is the castle. The oldest part of the complex is the medieval palace (13th century) and chapel (14th century), running north to east along the edge of a roughly triangular courtyard. The walls of the palace hall are frescoed with the legend of St George (1338); behind this block, to the west, rises the Red Tower (15th century), with a picturesque display of chimneys and corbelled windows. The north-west side of the courtyard is taken up by the Royal Palace, erected to accommodate Ferdinand I *en route* to his coronation in Prague as King of Bohemia in 1527. The east to south range of the courtyard was developed in two stages by Italian architects: Antonio Ericero (*fl* 1558–74) in the 1560s, followed by Baldassare Maggi in the 1580s. Apartments in the later extension include the Rožmberk Hall, Knights' Hall and Golden Hall (1584), the latter rising through two storeys. Frescoed ceilings depicting mythological subjects survive in the *piano nobile* chambers. Parts of the palace were destroyed by fire in 1773. Beyond the later block stands a tall hexagonal tower. The south-west range of the courtyard is closed off between the Italian architects' building and the Royal Palace by a structure that displays three storeys of arcading—two Tuscan, one Ionic—by Antonio Melana (*fl* 1560s). Its counterpart on the opposite side of the courtyard is a comparably arcaded building (1591) by Antonio Cometta (*c.* 1555–1602), who was also responsible for the rotunda (1597) in the garden, a charming *tour de force* in two storeys with a conical roof surmounted by a belvedere, and a chaplet of dormers capped by finials with little flags, perhaps to the designs of Maggi.

BIBLIOGRAPHY

J. Orth: *Nástin historicko–kulturního obrazu Jindřichův Hradec* [Art-historical and cultural outline of the town], 2 vols (Jindřichův Hradec, 1879–83)

Soupis památek historických a uměleckých, okres Jindřichův Hradec [Register of historical and artistic monuments, the Jindřichův Hradec district], xiv (Prague, 1901)

F. Teplý: *Dějiny města Jindřichova Hradce* [History of the town of Jindřichův Hradec], 7 vols (Jindřichův Hradec, 1926–37)

J. Muk: *Jak kdysi vypadal Jindřichův Hradec* [Jindřichův Hradec: how the town looked in the past] (Jindřichův Hradec, 1937)

A. Matějček and K. Tříska: *Jindřichův Hradec, zámek a město* [Jindřichův Hradec, the castle and town] (Prague, 1944)

J. Hilmera: *Jindřichův Hradec, městská památková rezervace a státní zámek* [Jindřichův Hradec, town monuments and castle] (Prague, 1957)

J. Krčálová: *Jindřichův Hradec: Státní zámek a památky v okolí* [Jindřichův Hradec: the castle and local monuments] (Prague, 1959)

E. Charvátová: *Jindřichuv Hradec* (Prague, 1974)

VLADIMIR HRUBÝ

Jin [Chin] **dynasty.** Chinese dynasty that succeeded the Wei (AD 220–65) at the end of the Three Kingdoms period. The Western Jin had a capital at Luoyang, Henan Province, while the Eastern Jin capital was at Jiankang (modern Nanjing), Jiangsu Province.

1. WESTERN JIN (AD 265–316). Sima Yan, later known as the emperor Wudi (*reg* AD 265–89), deposed the last Wei ruler and in AD 280 defeated the state of Wu, unifying China briefly. During the Western Jin period a high-fired, green-glazed stoneware was produced in the south-east, imitating bronzes in colour and form. These ceramics, as well as bronze mirrors and grave models, were found in tombs. Intrigue and rebellion among powerful families prevented effective political centralization and provoked civil war. Drought and famine compounded the situation. In 311 a leader of the Xiongnu, a northern nomadic people, occupied first Luoyang, then Chang'an (modern Xi'an, Shaanxi Province), bringing to an end the Western Jin and dividing China into northern and southern dynasties until its reunification under the Sui dynasty (AD 581–618).

2. EASTERN JIN (AD 317–420). The Eastern Jin was the second of the Six Dynasties (AD 222–589) that succeeded each other in southern China. With the destruction of Luoyang and Chang'an in 317, the Chinese fled south across the Yangzi River to establish a new southern state. Emperors of the Sima family saw themselves as the legitimate rulers of all China but were never able to reconquer the north, which remained under the sway of various groups known collectively as the Sixteen Kingdoms (AD 310–439). However, the area of modern Sichuan Province was annexed in 347, opening up a route towards Central Asia.

During the Eastern Jin, political weakness was coupled with cultural brilliance. Jiankang, the capital, flourished as a cultural and political centre visited by merchants and Buddhist missionaries from South-east Asia and India, making it one of the world's greatest cities of the time. Literature and the arts were supported by patrons and connoisseurs at court. Important artists included Wang Xizhi (*see* WANG (i), (1)), the single most influential calligrapher in Chinese history, and GU KAIZHI, figure painter and aesthetician. The loss of the northern Chinese heartland raised doubts about the efficacy of the traditional philosophy of Confucianism, and interest in Buddhism increased. The monk Faxian set out on his journey to India to seek Buddhist scriptures in 399, and one of the earliest known Buddhist gilt-bronze images was cast in 338, an imitation of a Gandharan prototype (for illustration *see* CHINA, fig. 62). Literary sources state that Mt Fugui, Nanjing, was the burial ground of the Eastern Jin imperial families, and some tombs of the period have been excavated there. Many kilns of the period have been discovered

both in the north and south; ceramic forms are more innovative than those of the Western Jin.

BIBLIOGRAPHY
H. A. Giles: *The Travels of Fa-Hsien* (Cambridge, 1923)
Yu Chen: 'The Discovery of Two Western Jin Tombs in the Western Suburbs of Peking', *Kaogu* (1964), no. 4, pp. 209–12
A. Juliano: *Art of the Six Dynasties* (New York, 1975)
M. Tregear: *Catalogue of Chinese Greenware in the Ashmolean Museum*, Oxford, Ashmolean cat. (Oxford, 1976)

CAROL MICHAELSON

Jingdezhen [Ching-te-chen]. Town and county seat in north-east Jiangxi Province, China, and the country's main centre of porcelain production. For most of its existence the town was part of Fouliang, in Raozhou Prefecture, and in historical records its ceramics are generally referred to as Raozhou ware. With a continuous history of manufacturing porcelain from the Tang period (AD 618–907), it is the source of most Chinese porcelain.

The imperial kilns were located at Zhushan in the centre of modern Jingdezhen city; many lesser kilns were situated in Hutian, 4 km to the south-east. The area is supplied with fine-quality porcelain stone, the basic raw material for Chinese porcelain; it is surrounded by forests that provided fuel for the kilns; and it is conveniently connected to the major ports of southern China by rivers. Recent excavations have brought to light several different kiln types, including egg-shaped *zhenyao* kilns, bread-roll-shaped *mantou* kilns and dragon kilns (*see* CHINA, §VII, 2(ii)). Compared with contemporary kilns in southern China, most Jingdezhen kilns were fairly small.

Ceramic manufacture in the Jingdezhen area began around the beginning of the Tang period, when simple wares were made, mainly bowls with a greyish-white body and a white or grey-green glaze. For the first centuries of its existence Jingdezhen was a minor ceramic-producing town, one of many such places operating in China. In the Northern Song period (960–1127), when the town received its present name (during the Jingde reign period, 1004–7), its whitewares became more refined; the best pieces of this period already have the translucent, white porcelain body and bluish-tinged glaze known as Qingbai characteristic of Jingdezhen porcelain throughout the Song and Yuan (1279–1368) dynasties. When the Southern Song dynasty (1127–1279) established its capital at Lin'an (modern Hangzhou), and the country's political and cultural centre shifted to the south-east, the kilns were able to meet the sudden rise in demand for high-quality porcelain. Qingbai ware was made in enormous quantities and became one of China's most popular ceramic wares, both at home and abroad. However, it did not receive the ultimate seal of approval, use at court. Neither did *shufu* ware, a whiteware with a more opaque white glaze, also produced at Jingdezhen (*see* CHINA, §VII, 3(v)(a)).

Imperial patronage of Jingdezhen began during the Yuan period, when underglaze-painted porcelains were developed. This decorative technique was at first rejected by the Chinese élite; it was more enthusiastically received by the ruling Mongols, however, and was exported to many countries throughout Asia. Up to this time Jingdezhen had made little besides whitewares, and experiments with celadon and brown glazes had met with limited success. By the Ming period (from 1368) a large variety of

Jingdezhen porcelain dish painted in underglaze blue, diam. 550 mm, early 15th century (Istanbul, Topkapı Palace Museum)

colours were used both as monochrome glazes and for polychrome painted decoration, including the cool blues and turquoises of the alkaline *fahua* range and the warm red, yellow and green tones of the lead-based enamels (*see* CHINA, §VII, 2(iii)).

The court patronized Jingdezhen throughout the Ming and Qing (1644–1911) periods without major interruptions, while usually lower quality Jingdezhen wares were widely exported (see fig.). Some of the best blue-and-white porcelain was made during the Yongle (1403–24) and Xuande (1426–35) periods, when the use of reign marks began (*see* CHINA, §VII, 5). During the so-called 'interregnum' between the Xuande and Chenghua (1465–87) reign periods, quality temporarily declined, only to rise again in the Chenghua period, when some of the finest polychrome porcelains (*doucai*) were made. Output was very high from the Chenghua to Wanli (1573–1620) reign periods, but by around 1600 manufacture for the court seems to have declined sharply. By 1671 Chinese sources once again note the successful completion of imperial orders. In 1683 Jingdezhen received a new impetus with the creation of a new post, Supervisor of the Imperial Kilns, held successively by Zang Yingxuan (between 1683 and 1726), Nian Xiyao (between 1726 and 1736) and Tang Ying (between 1736 and 1756). Under Tang Ying's supervision, porcelain painting rose to its greatest heights, and rigorous quality control resulted in technically perfect items. What followed was endless repetition of a wide spectrum of forms and designs and an indulgence in technical *tours de force*, which failed to recreate the brilliance of the pieces from the 1720s and 1730s. By the late 20th century Jingdezhen was producing some 300 million pieces of household porcelain a year, as well as technically sophisticated reproductions of classic Chinese models.

BIBLIOGRAPHY

G. R. Sayer: *Ching-Te-Chen T'ao Lu or The Potteries of China* (London, 1951)

M. Medley: *The Chinese Potter* (Oxford, 1976, rev. 1980/R 1982)

Liu Xinyuan and Bai Kun: 'Jingdezhen Hutian yao kaocha jiyao' [Reconnaissance of ancient kiln sites at Hutian in Jingdezhen], *Wenwu* (1980), no. 11, pp. 39–49

R. Tichane: *Ching-te-Chen: Views of a Porcelain City* (New York, 1983)

Imperial Porcelain of the Yongle aand Xuande Periods Excavated from the Site of the Ming Imperial Factory at Jingdezhen (exh. cat., Hong Kong, Mus. A., 1989)

G. Baochang: *Ming Qing cigi jianding* [Appraisal of Ming and Qing porcelains] (Hong Kong, 1993)

A Legacy of Chenghua: Imperial Porcelain of the Chenghua Reign Excavated from Zhushan, Jingdezhen (exh. cat., Hong Kong, Tsui Mus. A., 1993)

For further bibliography *see* CHINA, §VII, 3(v)–(vii).

REGINA KRAHL

Jing Hao [Ching Hao; *zi* Haoran; *hao* Hongguzi] (*b* either Qinshui [nr modern Jiyuan] or nr Henei, both Henan Province, *c.* AD 855–80; *d c.* 915–40). Chinese painter. Jing was the foremost of the great monumental monochrome landscape painters of the Five Dynasties period (906–60) in northern China. According to critics he was already recognized as a master among landscape painters at the end of the Tang period (618–907). In Mi Fu's *Hua shi* ('History of painting'; preface 1103) it is recorded that Jing taught Guan Tong and that later his work was studied by Li Cheng and Fan Kuan.

Jing was a Confucian scholar, well versed in the Chinese classics. He may have been a minor official under Zhaozong (*reg* 888–904) at Bianliang (modern Kaifeng), Henan Province, or Chang'an (modern Xi'an), Shaanxi Province. However, from about the age of 35, he led a solitary life at Honggu in the Taihang Mountains, Henan, taking refuge from the fighting prior to the collapse of the Tang dynasty. He apparently supported himself there by farming but continued to paint, adopting the literary name (*hao*) of Hongguzi. While he appears never to have relinquished the influence of his Confucian background, his interpretations of landscape also reflect a Daoist love of nature.

The subject-matter of Jing's paintings was somewhat limited in range. In his mid-20s, while still a city-dweller, he executed a wall painting of the *bodhisattva* Guanyin (Skt Avalokiteshvara) on Mt Potalaka for the Shuanglin si, a temple in Bianliang. Later he was known mainly for landscapes, although apparently he also painted compositions of rocks and trees. His writings describe old gnarled pines, mossy cliffs and mysterious caves as 'familiar companions'. His reflections on natural forms exhibit not only a close observation of nature, but also a reconciliation of Daoist and Confucian principles: 'Every tree grows according to its natural disposition. The pine trees may grow tortuous, but they do not fall in with the deceitful; they are upright from the very beginning. . . . They are like diverging thoughts which must be brought into harmony' (Sirén, 1956–8, p. 236).

An early treatise on landscape painting, the *Bifa ji* ('Notes on brush method', *c.* 925), is attributed to Jing Hao; it reflects the characteristic attitudes of the great landscape painters of the 10th century, setting forth certain general ideas about the study and scope of painting. It deals primarily with the concept of value in painting and the ultimate criterion of good painting as truth, not in terms of outward likeness but of inner reality or spirit, reflecting a background of Confucian morality. It also offers a modified scheme of the Six Laws established by Xie He (*fl c.* 500–35) four centuries earlier (*see* CHINA, §V, 5(i)) and makes comments about, and evaluations of, masters of the Tang and earlier periods. The writing reflects a preference for Tang painters who introduced new techniques, such as Wang Wei. The coarse techniques of the 9th century are considered inferior to the 8th-century fashion of 'axe and chisel' texturing in linear, clear and rational patterns. Concern for diversity of stroke and ink tone is expressed in theories regarding the two aspects of 'brush' and 'ink'. These aspects were later treated by Guo Ruoxu and in the *Xuanhe huapu* ('Xuanhe collection of painting'; *c.* 1120); the latter text explains them: 'To have brush but no ink [means that] the traces of the brush [as such] remain visible throughout, [resulting in] a want of naturalness. To have ink but no brush means that "axe and chisel" strokes are discarded and replaced by too erratic formations' (Loehr, p. 89).

The group of paintings attributed to Jing Hao are so inconsistent in execution that it is questionable whether they are in fact the work of one individual. However, all have certain general qualities, reflecting a preoccupation with the relationship between brush and ink. In defining form and texturing surfaces Jing's brushwork is fluid, with variations both in ink tone and in width of brushstroke, as in cursive script (*caoshu*) calligraphy. He is credited with introducing innovations in the modelling and texturing of rock forms by use of texture strokes (*cun*). Another early technique visible in works associated with Jing is the use of a series of overlapping forms to build up rocks and mountains, though this is somewhat artificial. The compositions identified with Jing suggest a unity of vision not evident in earlier paintings, though they lack the convincing three-dimensional quality of later Chinese paintings.

Travellers in Snow-covered Mountains (hanging scroll, Kansas City, MO, Nelson–Atkins Mus. A.), signed 'Hongguzi' in the lower right-hand corner, was reportedly recovered from a tomb in Shaanxi Province in the late 1930s. It is in poor condition, with some areas totally destroyed. Some minor retouching, done when it was being restored and remounted in Beijing, is not consistent with the original composition. Nevertheless, the painting is significant as a source of study on what is otherwise a virtually unknown period of Chinese painting.

The monumental *Kuanglu Mountains* (see fig.), the best extant work attributed to Jing, is not signed but was identified with him as early as the Southern Song period (1127–1279), as indicated in a short inscription by Emperor Gaozong in the upper right-hand corner. While the painting itself is probably later, the composition may be Jing Hao's, since the style is consistent with what is known of 10th-century landscape. It represents a range of rhythmically patterned, strongly vertical mountain forms gradually disappearing into distant haze. Visual entry into the landscape occurs at the lower left-hand corner; a road wends its way past a group of houses near the base of a waterfall and clustered mountains back to another complex of structures approximately halfway up the left-hand side of the composition. The mountain forms are balanced to the right by a level viewing area defining the rather sharp,

Jing Hao (attrib.): *Kuanglu Mountains*, hanging scroll, ink on silk, 1.85×1.07 m, ?10th century (Taipei, National Palace Museum)

pitched angle of the ground plane. There is a strong sense of isolation, since the few structures provide the only sense of human presence. While the painting represents a major development from earlier, more compartmentalized compositions, it lacks the sense of continuity of later 10th-century conceptions.

BIBLIOGRAPHY

Guo Ruoxu: *Tuhua jianwen zhi* (preface 1075); ed. Huan Miaozi (Shanghai, 1963); Eng. trans. by A. C. Soper as *Kuo Jo-hsü's 'Experiences in Painting' (T'u-hua chien-wen chih): An Eleventh Century History of Chinese Painting* (Washington, DC, 1951/R 1971)
Xuanhe huapu [Xuanhe collection of painting] (preface 1120); R in *Congshu jicheng* (Shanghai, 1935), *juan* 1652–3
O. Sirén: *Chinese Painting: Leading Masters and Principles* (London and New York, 1956–8), i, pp. 185–91
——: *The Chinese on the Art of Painting* (New York, 1963)
K. Munakata: 'Ching Hao's "Pi-fa-chi": A Note on the Art of the Brush', *Artibus Asiae*, suppl. xxxi (1974)
M. Loehr: *The Great Painters of China* (New York, 1980), pp. 89–92
Eight Dynasties of Chinese Painting: The Collections of the Nelson–Atkins Museum of Art, Kansas City, and the Cleveland Museum of Art (exh. cat. by Wai-kam Ho and others, Kansas City, MO, Nelson–Atkins Mus. A.; Cleveland, OH, Mus. A.; Tokyo, N. Mus.; 1980–81), no. 9
T. Miyagawa, ed.: *Chinese Painting* (Tokyo, 1983), p. 173

MARY S. LAWTON

Jin Nong [Chin Nung; *hao* Dongxin] (*b* Renhe, Hangzhou, Zhejiang Province, 1687; *d* 1764). Chinese painter, calligrapher and poet. He was one of the Eight Eccentrics of Yangzhou (*see* YANGZHOU SCHOOL). In his youth he showed promise as a poet, and his talent was appreciated by such leading scholars as Mao Qiling (1623–1716) and Zhu Yizun (1629–1709). His teacher, He Chuo (1661–1722), also praised him as a poet belonging to the tradition of the Tang-period (AD 618–907) poets Meng Haoran (689–740) and Gu Juang (*c.* 725–814), and as the best among his peers. Jin became a notable figure in the Nanping shi she (Nanjing Poetry Club), whose members included such distinguished literati figures and artists as Li E (1692–1752), Huang Shijun (1696–1773), Ding Jing (1696–1765) and Chen Zhuan (1668–after 1748). It was at this time that he acquired the reputation of being aloof and difficult—'eccentric'—which did not, however, prevent him from being known and well received. He was seen frequently among the élites of the cultural and artistic centres of Hangzhou, Zhejiang Province, and Yangzhou, Jiangsu Province, or of other cities visited during his travels. Except for a brief tenure as a family tutor, he had no paid employment. Instead, unlike the literati amateur painters, who sometimes accepted money privately, he made a living by bartering his writings and paintings. Part of his patronage came from wealthy salt merchants and officials in Yangzhou. When he approached the reigning poet, Yuan Mei, with the hope of broadening his clientele, he was good-naturedly chastised. Precarious though his circumstances often were, he indulged in refined, even sensual pleasures and took in servants known for their artistic and literary talents. A connoisseur of antiques, he amassed a notable collection of inkstones (*see* CHINA, §XIII, 13) and thousands of ink rubbings.

Jin's style of calligraphy was inspired by the Han-period (206 BC–AD 220) clerical script (*lishu*), as seen in the inscription on his painting *Bamboo* (see fig.). He developed a uniquely bold, innovative style by combining thickened lateral brushstrokes with attenuated vertical or slanted strokes. In this way he attempted to re-create the engraved impression of stelae of the Northern Wei period (AD 386–534; see CHINA, §IV, 2(vii)).

Jin claimed that it was not until 1736 that he began to paint. In that year he declined candidacy for the prestigious *boxue hongci* ('wide erudition') examination offered by the Qianlong emperor (*reg* 1736–96). Nevertheless, he travelled to Beijing and during the journey had the opportunity to study ancient works in various art collections. An album of paintings attributed to Jin Nong (Zurich, Mus. Rietberg) includes his first attempts at landscape painting. The inscriptions show the artist's predilection for a style of calligraphic inscription on paintings that was so rigid as to be akin to printed forms. The contrast with the fluent strokes and subtle strength seen in his calligraphic works *per se* is marked. Once embarked, at the age of 50, on his painting career, Jin experimented ceaselessly in a wide range of themes. In his 60s he began to explore the theme of bamboo. He also painted plum blossoms, a subject in which he was influenced by Gao Xiang (1688–1754) and Wang Shishen (1686–1759), and horses, a theme of long standing, but rarely tackled by Jin's contemporaries except in official court painting and by Qing Feng (1740–95). In

Jin's paintings of Buddhist subjects and in his portraiture, he attempted a novel iconic approach and a distinct mode of characterization. His painting talent lay less in his technical skill than in his archaic and whimsical presentation of unusual imagery. The impact of the paintings, which are accompanied by inscriptions, is sharpened by the juxtaposition of his rigid, blocklike calligraphy and the wistful lyrics in the inscription.

Jin produced paintings between the 1730s and 1764 only. Two disciples, LUO PING and Xiang Jun, are recorded as having produced works jointly with him, Luo from 1759 and Xiang from 1761. As a result of their collaborations, authentication of Jin Nong's later works often involves careful study of the works of Luo Ping and, to a lesser extent, of Xiang Jun. Of the two it was Luo Ping who succeeded the master and who was also designated one of the Eight Eccentrics of Yangzhou.

BIBLIOGRAPHY

Li Dou: *Yangzhou huafeng lu* [Picture-boats of Yangzhou] (preface 1741/*R* Taipei, 1969)

Jiang Bolin: *Molin jinhua* [Comments on contemporary painters] (Shanghai, 1852/*R* Taipei, 1976)

Li Huan, ed.: *Guochao qixian leizheng chubian* [Classified collection of important Qing-period figures, first draft] (Henan, 1884–91/*R* Taipei, 1966)

Gu Linwen: *Yangzhou bajia shiliao* [The Eight Eccentrics of Yangzhou] (Shanghai, 1963)

Chang Wan-li and Hu Jen-mou: *The Selected Painting and Calligraphy of the Eight Eccentrics of Yangchow* (Hong Kong, 1969)

Chu-tsing Li: 'Bamboo Paintings of Chin Nung', *Archvs Asian A.*, xxvii (1973–4), pp. 53–75

I. Yoshitaka and others, eds: *Jin Nong* (1976), ix of *Bunjinga suihen* [Selections of literati painting] (Tokyo, 1974–9)

Suiboku bijutsu daikan [Survey of ink painting arts], xi (Tokyo, 1978)

Zhu Xuan: *Jin Dongxin pingzhuan* [Biography of Jin Nong] (Taipei, 1981)

M. Aoki: 'The Art of Jin Nong', *Aoki Masaru zenshū* [Complete collection of Aoki Masaru], vi (1983), pp. 3–69

Paintings by Yangzhou Artists of the Qing Dynasty from the Palace Museum (exh. cat., Hong Kong, Chin. U., A.G., 1984–5), pls 57–62 [Chin. and Eng. forward]

Ju-hsi Chou and C. Brown: *The Elegant Brush: Chinese Painting under the Qianlong Emperor, 1735–1795* (Phoenix, 1985)

Lin Xiuwei: *The Yangzhou School of Painting* (Taipei, 1985)

H. van der Meyden: 'Jin Nong: The Life of an Eccentric Scholar and Artist', *Oriental A.*, n. s., xxxi/2 (1985), pp. 174–85

Mu Yiqin: 'Jin Nong de huihua yu Luo Ping de daibi' [Jin Nong's paintings and Luo Ping's substitutes], *Mingbao Yuekan*, xx/1 (1985), pp. 56–8

JU-HSI CHOU

Jiránek, Miloš (*b* Lužec nad Vltavou, 17 Nov 1875; *d* Prague, 2 Nov 1911). Czech painter, critic and writer. He studied at the Charles Ferdinand Czech University in Prague (1894–9) while at the same time studying painting at the Prague Academy of Fine Arts under Maximilián Pirner and Vojtěch Hynais. He played an active part in the Mánes Union of Artists in which he later became a leading light. His earliest art criticism, which first appeared in *Radikalní listy* and more particularly in *Volné směry*, the organ of the Mánes Union, expressed his strong support of the modern point of view, for which he was obliged to leave the Academy before his final exams. In his critical views he was influenced above all by French modern art, and also by the theoretical approach that he had acquired from German Francophiles such as Julius Meier-Graefe. He was not only a modernist but was also interested in national and world traditions in art. He translated works

Jin Nong: *Bamboo*, hanging scroll, ink on paper, 1159×390 mm, 1762 (private collection, on loan to Taipei, National Palace Museum)

by Eugène Fromentin and Maurice Barrès, and in his own book of essays, *Dojmy a potulky*, he stressed the importance of the artist's direct experience of life and nature. As a painter, Jiránek was first influenced by Hynais's Illusionism, and he subsequently became absorbed by French Impressionism. Most of all, he preferred to paint figures in the full natural light, as in *White Study* (1910; Prague, N.G.). In his later years Expressionist elements became more evident in his work, especially in his graphic art.

WRITINGS

Dojmy a potulky [Impressions and wanderings] (Prague, 1908)
Literární dílo [Literary work], 2 vols (Prague, 1959–62)

PETR WITTLICH

Jiricna, Eva (*b* Czechoslovakia, 3 March 1939). Czech architect and interior designer, active in London. She studied engineering and architecture at the University of Prague and received a Master of Arts degree from the Academy of Fine Arts, Prague, in 1967. She went to London for what was intended to be a brief visit in 1968, a few weeks before the Soviet invasion of Czechoslovakia. Her stay became permanent, and she worked in London for the Greater London Council (1968–9), then for the De Soissons partnership (1969–80) and with David Hodge (1980–82). She worked on her own in 1982–5 and with Kathy Kerr in 1985–7, and she established Eva Jiricna Architects in London in 1987. From the mid-1980s Jiricna became an important figure in interior design. Her best-known projects include several works in 1982–5 for Joseph Ettedgui, including L'Express Café, Pour La Maison shop and a private apartment, all in London. These interiors are characterized by an elegant, pared-down minimalism, utilizing polished aluminium, stainless steel, glass and extensive black-painted surfaces, with forms framed within spaces of hard angularity. This approach was somewhat softened in Joe's Café (1985–7), London, in which the corners of bars and counters are rounded; their dark surfaces are accented with horizontal bands of stainless steel that recall the Art Deco 'Moderne' style of the 1930s. Jiricna's design for the Fifth Floor (1993) of Bergdorf Goodman Department Store, New York, displays a modernism of bold, almost brash elegance. A showpiece element is a trademark staircase, a non-functional sculptural piece with a network of steel trusses and filigreed glass plates. The interior space is open and flowing, with mobile island structures (stock rooms and sales desks) marking the circulation routes around the floor. The open ambience was completed by opening up previously blocked windows, which were elegantly framed in black lacquered wood.

BIBLIOGRAPHY

P. Viladas: 'Lean, not Mean', *Prog. Archit.*, lxvii/9 (1986), pp. 132–40
C. Lorenz: *Women in Architecture: A Contemporary Perspective* (New York, 1990)
P. McGuire: 'Manhattan Transfer', *Archit. Rev.* [London], cxciii/1162 (1993), pp. 39–41

WALTER SMITH

Jitokusai. *See* HON'AMI, (1).

Jiun Sonja [Hyakufuchi Dōji; Katsuragi Sanjin; priest's names: Onkō, Sonja] (*b* Osaka, 1718; *d* Kyoto, 1804). Japanese monk–scholar, calligrapher and painter. He is considered one of the most powerful calligraphers in the so-called *Zenga* tradition (*see* JAPAN, §VII, 2(iv)), excelling in Chinese, Japanese and Sanskrit scripts. He was born to a family of samurai–official status; his father was a noted scholar and his mother a calligrapher and devout Buddhist. Jiun initially received a Confucian education, but after his father's death in 1730 he was sent to Hōrakuji in Settsu Province (now part of Hyōgo Prefect.), a temple of the Shingon sect, where he studied Esoteric Buddhism (*mikkyō*) under Ninkō Teiki (1671–1750). He also spent three years at the academy of the Confucian scholar Itō Tōgai (1670–1736), mastering original Confucian texts, before returning to Hōrakuji for the completion of his Buddhist studies. At the age of 21, Jiun officially became an abbot at Hōrakuji. He devoted the rest of his life to teaching, emphasizing the importance of Sanskrit studies because he believed that mastery of the original Buddhist texts was essential to full understanding of the religion. His greatest work of scholarship, the 1000-volume *Bongaku shinryō* ('Examination and treatment of Sanskrit studies'; 1759–72), traces the history of Sanskrit studies in China and Japan and explains Sanskrit grammar.

In 1749, Jiun began the Shōbōritsu ('discipline of the correct doctrine') Buddhist movement in Japan, a subset of Shingon that rose above sectarian lines to combine features of various systems of thought including Esoteric and Zen Buddhism, Shinto and Confucianism. In association with this movement he wrote, for a general audience, the *Jūzen hōgo* ('Sermon of the ten good [Buddhist] deeds', published posthumously in 1814), denouncing the many and varied evils to which people were prone. The text served as a moral code during an age of increased secularism. From his retirement in 1776 until his death, Jiun lived at Kōkiji on Mt Katsuragi, where he produced many works of calligraphy.

Although a Shingon abbot, Jiun studied Zen meditation and lectured on Zen classics, and a number of his works have Zen phrases as their texts. He worked in the basic calligraphy scripts, including *kana* (Japanese phonetic), but is most celebrated for his large-character calligraphic works in Chinese (*Karayō*), many of which reflect the Zen aesthetics of simplicity, immediacy and internal strength. Examples by Jiun include the hanging scroll depicting the character *Hito* ('Man'; Japan, priv. col., see Miura, 1980, pl. 78) and the two-character hanging scroll *Aizan* ('Love of mountains'; Japan, priv. col., see Miura, 1980, pl. 62). Other scrolls by Jiun feature short Confucian or Shinto phrases, as seen in the calligraphy of Zen priests such as HAKUIN EKAKU, again brushed with dramatic strength. Another category of works by Jiun displays his mastery of Sanskrit; in some of these scrolls he wrote out the names of Buddhist deities in their Sanskrit forms, in others a single character, for example the hanging scroll illustrating the Devanagari letter 'A', the first character in Amida (Skt Amitabha; Buddha of the Western Paradise; Japan, priv. col., see Miura, 1980, pl. 88). In all large-scale works, Jiun used a stiff brush in a dry brush technique called 'flying white' (*hihaku*), in which the white of the paper shows through the quickly brushed strokes, as in *A Single Path* (hanging scroll, ink on paper, 1170×520 mm, n.d.; New Orleans, LA, Gitter priv. col.). The striations of the *tatami*

(reed mats) on which he placed his calligraphy paper are often seen in his works.

Jiun also used the 'flying white' technique in a number of smaller-scale calligraphic works, often using his own *waka* (31-syllable classical poems) as texts. These combine *kana* and *kanji* (Chinese characters) and, though more delicately presented, are nonetheless forcefully brushed. In his figurative painting, he chose bold and simple subjects such as a monk's begging bowl or staff. Occasionally he depicted the Zen patriarch Bodhidharma (Jap. Daruma), seen from behind in a meditating position, and rendered with a few powerful strokes of the brush, for example the hanging scroll with the inscription *Fushiki* ('Not knowing'; Japan, priv. col., see Miura, 1980, pl. 55).

WRITINGS

Bongaku shinryō [Examination and treatment of Sanskrit studies], 1000 vols (1759–72)

Jūzen hōgo [Sermon of the ten good (Buddhist) deeds] (1814)

T. Kinami, ed.: *Jiun Sonja hōgoshū* [A collection of Buddhist writings by Jiun Sonja] (Tokyo, 1961)

——: *Jiun Sonja wakashū* [A collection of Jiun Sonja's *waka* poetry] (Kyoto, 1976)

BIBLIOGRAPHY

T. Kinami: *Jiun Sonja, shogai to sono kotoba* [The life and work of Jiun Sonja] (Kyoto, 1961)

Y. Miura: *Jiun* (1979), iv of *Bunjin shofu* [Literati calligraphy album], ed. K. Kanda and T. Minamoto (Tokyo, 1978–9)

——: *Jiun Sonja, hito to geijutsu* [Jiun Sonja: the person and his art] (Tokyo, 1980)

Masters of Japanese Calligraphy, 8th–19th Century (exh. cat. by Y. Shimizu and J. M. Rosenfield, New York, Japan Soc. Gal. and Asia Soc. Gals, 1984–5)

S. Addiss: *The Art of Zen: Paintings and Calligraphy of Japanese Monks, 1600–1925* (New York, 1989)

STEPHEN ADDISS

Jiuquan [Chiu-ch'üan]. Chinese city in Gansu Province. It was founded as a strategic garrison town in 121 BC, together with Wuwei, Zhangye and Dunhuang along the Hexi ('West of the Yellow River') corridor. Jiuquan, the capital of the Western Liang dynasty (AD 400–21), was occupied during the 8th and 9th centuries by the Tibetans and from the 14th century to the early 20th was named Suzhou. The plan of the town is typical: there are four gates in the rectangular town wall, connected by the north–south and east–west streets. At the junction of these stands a drum tower, which is a Ming-period (1368–1644) reconstruction of a 4th-century structure.

A great number of 4th- and 5th-century tombs of rich and powerful local families are located in the Gobi Desert to the north of Jiuquan. Most consist of a pyramidal mound built over a network of underground chambers, typically two or three, accessible through a short, sloping passage. Many of the tombs are enclosed within square walled compounds in groups of two to five. Excavations of 16 tombs were conducted in 1972–7 in Dingjiazha and Xincheng, in Jiayuguan County. Although most burial goods were plundered, in seven of these excavated tombs fine wall paintings are preserved. The paintings, mainly confined to individual bricks, occur on the ceremonial gateways and the walls of the front chambers. A range of subject-matter is depicted, including agricultural scenes, mythical themes and feasting. The paintings, executed mainly in lines with some shading on a whitewashed ground, are predominantly in black and red. Simple but naturalistic and lively figures and animals are portrayed; a few larger paintings depict hunting scenes and military processions. These paintings represent a rare, albeit provincial, collection for the period, illustrating the daily life of a 3rd- to 5th-century border garrison community.

The grottoes of Mt Wenshu are located about 15 km south-west of Jiuquan in Jiayuguan County. The earliest caves date from the early 5th century AD, during the occupation of Jiuquan by the Western Liang people. Most of the caves, however, were created from the 6th century to the 9th, together with a number of other Buddhist grottoes established at various holy sites along the Silk Route. The construction and decorative schemata of the caves at Mt Wenshu closely follow others in the region. Wooden structures serving as entrance gates to the caves were erected in the Ming and Qing (1644–1911) periods, and most of the early wall paintings in the caves were also replaced in later periods.

BIBLIOGRAPHY

M. A. Stein: *Ruins of Desert Cathay*, ii (London, 1912), pp. 285–96

Shi Yan: 'Jiuquan Wenshu shan de shiku siyuan yiji' [Remains of cave-temples at Mt Wenshu, Jiuquan], *Wenwu cankao ziliao* (1956), no. 7, pp. 53–9

'Jiuquan Jiayuguan Jin mu de fajue' [Excavation of Jin-period tombs at Jiuquan and Jiayuguan], *Wenwu* (1979), no. 6, pp. 1–17

Zhang Pengchuan: 'Jiuquan Dingjiazha gumu bihua yishu' [The art of wall painting in the ancient tombs at Dingjiazha, Jiuquan], *Wenwu* (1979), no. 6, pp. 18–21

Jiayuguan bihuamu fajue baokao [Excavation of the tombs with wall paintings at Jiayuguan], Lanzhou, Gansu Prov. Mus. (Beijing, 1985)

PUAY-PENG HO

Jixian. *See under* TIANJIN.

Jizhou [Chichow; Chi-chou; Ji'an; Chi-an]. Site in central Jiangxi Province, China, and former centre of ceramic production. Jizhou is the Sui- to Song-period (581–1279) name for modern Ji'an, a town on the Ganjiang River, which flows northwards into the Yangzi Basin. Ceramic kilns operated from at least the Tang period (AD 618–907) until the end of the Yuan (1279–1368) at the village of Yonghexu, about 8 km outside the town. The site is recorded in Wang Zuo's 1462 edition of the *Gegu yaolun* ('Essential criteria of antiquities'). Archibald Brankston visited it in 1937 and took sherds to England (London, BM), and from 1953 the local authorities have continued the investigation and excavation of the remains of some 20 kilns and other structures.

After some experimentation with whitewares and celadons in the Tang, the kilns' range of activity was developed during the Song (960–1279), especially the Southern Song (1127–1279). They produced tablewares of a rather soft, off-white clay under brown and black glazes, mostly teabowls of conical form with minimal foot-rings. The potters invented a wide variety of decorative techniques mainly for the inside of bowls. These included mottling with phosphatic slip; preserving patterns in brown, probably by using papercuts against a coating of uneven buff slip (see fig.; *see also* CHINA, §VII, 2(iv) and fig. 177); painting with slip; and even dipping a leaf in slip and applying this to the glaze. The bowls decorated inside with painted slip or leaf imprints have plain black exteriors, and those with mottles or papercut decoration have mottled exteriors. Some blackwares have simple painting in the

areas kept free of glaze, and a few white-glazed wares have motifs incised in the glaze. During the Yuan, bottles and other items were made with fine wave or scroll patterns drawn in dark brown on white slip. In 1982 a maker's stamp was found, bearing the name of the Shu family mentioned in the *Gegu yaolun*. A good representative group of pieces produced at Jizhou is in the Schiller Collection at the City of Bristol Museum and Art Gallery.

BIBLIOGRAPHY

Cao Zhao: *Gegu yaolun* (Nanjing, 1387); Eng. trans. by P. David as *Chinese Connoisseurship: The 'Ko ku yao lun', the Essential Criteria of Antiquities* (London, 1971)

A. D. Brankston: 'An Excursion to Ching-te-chen and Chi-an-fu in Kiangsi', *Trans. Orient. Cer. Soc.*, xvi (1938–9), pp. 19–32

J. G. Ayers: 'Some Characteristic Wares of the Yuan Dynasty', *Trans. Orient. Cer. Soc.*, xxix (1954–5), pp. 69–86

Jiang Xuantai: *Jizhou yao* [Jizhou ceramics] (Beijing, 1958)

J. Wirgin: 'Some Ceramic Wares from Chi-chou', *Bull. Mus. Far E. Ant.*, xxxiv (1962), pp. 53–71

'Jiangxi Jizhou yao yizhi fajue jian bao' [Brief report on excavations of Jiangxi's Jizhou-ware kiln sites], *Kaogu* [Archaeology] (1982), no. 5, p. 481

PETER HARDIE

Joachim II, Elector of Brandenburg. *See* HOHENZOL-LERN, (2).

Joanes, Joan de. *See* MAÇIP, (2).

Joanine. Term used to designate the style of *talha* (carved and gilded wood) produced during the reign of John V (*reg* 1706–50; *see* BRAGANZA, (7)) of Portugal. At that time a new type of retable evolved, differing in form and ornament from the National style of the 17th century. The typical Joanine retable is taller and narrower than those of the National style. Concentric arches were abandoned in favour of canopies and baldacchini of architectural form, combined with allegorical statues; these were taken from *Perspectiva pictorum et architectorum* (Rome, 1693–1700) by Andrea Pozzo.

The basis for the new stately style, one that is more dramatic and rhetorical, and for its decorative vocabulary, was Roman Baroque art and architecture, which were the fundamental inspiration of art at the court of John V. It can be said that the King, more than anyone else, was the true author of the courtly style that bears his name. Italian influence was diffused in Portugal through the import by John V of marble sculpture, as well as ecclesiastical goldsmiths' work from Rome; through the arrival in the country of foreign artists; and through the circulation there of engravings and illustrated books. The term Joanine, first used by Robert Smith (ii), has been employed subsequently to describe other art forms of the period, including painting (in particular portraiture), silver, furniture and glazed tiles, as well as interior decoration.

One of the earliest works in the Joanine style is the chancel (1721) of Nossa Senhora da Conceição, Loures, by Bento da Fonseca Azevedo (active *c.* 1721). Other important examples of *talha* in Lisbon include the interior of the church of Nossa Senhora da Pena (*c.* 1713–20), where the transition to the new style can be seen in the apse. One of the most lavish examples is the carved and gilded wood decoration (*c.* 1720) of the church of the royal monastery of Madre de Deus, Lisbon. In the second phase of the style, during the second quarter of the 18th

Jizhou, teabowl, white stoneware with phoenixes and butterflies in brown on a mottled buff and bluish glaze, diam. 114 mm, Southern Song period, 1127–1279 (Bristol, City of Bristol Museum and Art Gallery)

century, wood was used to imitate other materials and in combination with marble. Solomonic columns, modelled on Bernini's baldacchino (1624–33) at St Peter's, Rome, were often used as supports. This is seen on the retable of the church of S Catarina or dos Paulistas (1727–30), Lisbon, by Santos Pacheco de Lima, where the new style appears in its most splendid form. In the apse three tiers of supporting gilt figures and decorative sculpture, by the same carver, are set against coloured marble.

The Joanine style spread to other parts of Portugal, to the Alentejo, where it is seen at S Madalena (1720), Olivença, and in the impressive Calvary Chapel in S Francisco, Évora. The University Library (1717–28) at Coimbra was presented to the University by John V and has one of the most sumptuous interiors in Portugal. It was a work of collaboration by many artists, under the direction of Gaspar Ferreira, and illustrates the essentially decorative nature of the Joanine style. Three lofty, marbled arches with gilt brackets, garlands and targes lead to a portrait of John V, attributed to Giorgio Domenico Duprà, which is surrounded by curtains parted by putti, all simulated in polychromed wood. These scenographic effects are typical of the Joanine style.

There are fine examples of Joanine carving in northern Portugal, where the general lines of the style were continued but where local characteristics were introduced, such as elaborate chancel arches, pilasters alternating with figures and corbels, and retables designed in several tiers, resembling pyramidal thrones. The high altar of Oporto Cathedral was an important point of departure for the north. It was commissioned in Lisbon by the cathedral chapter from Santos Pacheco and ornamented (1727–30) with statues by Claudio de Laprada. This imposing retable served as the model for others, including that of the

Misericórdia (1729), Mangualde; S Gonçalo (1734), Amarante; and the high altar (1731) of Viseu Cathedral, also designed by Santos Pacheco.

The combination of richly gilt surfaces, brilliant and luminous colours and Baroque forms all created a magnificent effect that is characteristic of the best Joanine art.

BIBLIOGRAPHY
R. C. Smith: *A talha em Portugal* (Lisbon, 1962)
——: *The Art of Portugal, 1500–1800* (London, 1968)

JOSÉ FERNANDES PEREIRA

Joanna [Joanna the Mad], Queen of Castile. *See* HABSBURG, §II(1).

Joanna of Austria, Princess of Portugal. *See* HABSBURG, §II(3).

João I, King of Portugal. *See* AVIZ, (1).

João II, King of Portugal. *See* AVIZ, (4).

João III, King of Portugal. *See* AVIZ, (7).

João IV, King of Portugal. *See* BRAGANZA, (3).

João V, King of Portugal. *See* BRAGANZA, (7).

João VI, King of Portugal. *See* BRAGANZA, (11).

João de Ruão [Jean de Rouen] (*b* Rouen, *c.* 1500; *d* Coimbra, 1580). French sculptor and architect, active in Portugal. He was the most important sculptor of the Portuguese Renaissance. The son of a sculptor named Jean de Rouen, at an early age he worked with the artists engaged in the reconstruction of the château of GAILLON, Normandy, directed by Antoine Giusti and Jean Giusti I, who had come from Tuscany under the protection of Cardinal Georges I d'Amboise (on whose tomb João worked) and were transforming the capital of Normandy and nearby Gaillon into one of the most brilliant centres of Renaissance art outside Italy.

In his first period, which lasted until 1545, João de Ruão followed the style of 15th-century Florentine art, especially of masters such as Antonio Rossellino and Desiderio da Settignano, which he had learnt from Antoine Giusti at Gaillon. Later, however, in the cultured university city of Coimbra he encountered new, foreign influences. Gradually he abandoned the gentle, idealistic art derived from Neo-Platonic ideas in favour of the innovations of the Roman school, based on Classical art. This change is also apparent in his architecture, which was stimulated by a study of engravings and treatises. He copied or adapted prints by artists such as Lucas van Leyden and Cornelis Bos.

During his early years in Portugal, João de Ruão devoted himself to architecture, and works attributed to him include the central part of the Jardim da Manga cloister in the Monastery of Santa Cruz, Coimbra, designed on a central plan and with a domed fountain surrounded by four subsidiary chapels linked by buttresses; it is an important work of the early Portuguese Renaissance and was completed in 1535.

It is likely that João de Ruão went to Portugal in the mid 1520s in the company of a Portuguese nobleman, Dom Jorge de Meneses, who returned from exile in Italy and France to his native country on the death of his father (1525), from whom he inherited a property at Tancos. There Meneses rebuilt the church of Our Lady of the Assumption, Atalaia, near Tomar (Ribatejo), to the design of João de Ruão, who also carried out some of the work. The façade (1528) of the church is the first clearly Renaissance façade in Portugal. João de Ruão also built the chancel arch, which was contracted to the architect Diogo de Castilho, with whom he was to work for about 40 years. The portal on the façade is designed to resemble a Roman triumphal arch. The candelabrum columns, which are similar to those illustrated in the first Spanish treatise on the Renaissance style, Diego de Sagredo's *Medidas del Romano* (1526), are used with the deep, broad arch and reappear in the reliefs on the pilasters. The portal ends in a graceful sculptured frieze and has finely carved classical heads in the spandrel discs. João de Ruão's next work was the limestone retable of the Virgin of Mercy (*c.* 1530–35) in the funerary chapel of Dom Jorge de Menenses at Varziela, near Cantanhede. It is a rural chapel, isolated among woods and fields, showing a taste that was followed by other Portuguese humanists among the nobility.

João de Ruão's centre of activity was Coimbra, which had a long tradition of sculpture. He worked mainly for the Monastery of Santa Cruz and, after 1537, for the university and monastic houses during the period when the reinstallation of the university led to a rapid expansion of the city. João won the goodwill of the Conégos Regrantes de Santo Agostinho (Augustinian Canons) of Santa Cruz, and he married a sister of the royal architect, Marcos Pires. At that time Diogo Pires (ii), the principal sculptor of the city, was growing old, and João was well placed to take over his workshop.

João's most important works of sculpture are the Porta Especiosa of the Sé Velha (Old Cathedral) at Coimbra (*c.* 1535); the chapel of the Sacrament in the parish church at Cantanhede (1545); the *Deposition* in a chapel of the Santa Cruz Monastery (1545); the retable in the chapel of the Tesoureiro da Sé (Treasurer of the Cathedral) in S Domingos, Coimbra (1555); the huge high altar of the apse of Guarda Cathedral, the largest retable carved in stone in Portugal (1550–56); and the magnificent chapel of the Holy Sacrament in the Sé Velha, Coimbra (1566), which is a study in Mannerism and iconographically a manifesto of the Counter-Reformation. During more than 40 years of activity João de Ruão employed many carvers and decorators, and his influence can be seen in the sculptural work that was carried out in Coimbra between 1530 and 1580.

BIBLIOGRAPHY
D. de Sagredo: *Medidas del romano* (Toledo, 1526)
P. Q. Garcia: *João de Ruão* (Coimbra, 1913)
V. Correia: 'A escultura em Portugal no primeiro terço do século XVI', *A. & Arqueol.*, i (1930), pp. 29–48
N. C. Borges: *João de Ruão, escultor da renascença coimbrã* (Coimbra, 1980)
Actas do simposio João de Ruão: A introdução da arte da renascença na peninsula iberica: Coimbra, 1981
Pedro Dias: *A arquitectura de Coimbra na transição do gótico para a renascença, 1490–1540* (Coimbra, 1982)
A. Nogueira Gonçalves: *Estudos de história da arte da renascença* (Oporto, 1984), pp. 115–79

PEDRO DIAS

Joass, John James. *See under* BELCHER, JOHN.

Jobbé-Duval, Félix(-Armand-Marie) (*b* Carhaix, Finistère, 16 July 1821; *d* Paris, 2 April 1889). French painter, administrator and museum curator. After completing his secondary education at Quimper he moved to Paris where in 1839 he attended classes in the studio of Paul Delaroche. On 1 April 1840 he entered the Ecole des Beaux-Arts in Paris, becoming a pupil of Charles Gleyre. He made his début in the Salon in 1841 with two works, a portrait of *M. Kgroen* and *Study of a Young Girl*, and continued to exhibit there until 1882. His contributions included a number of religious paintings, such as the *Disappearance of the Virgin* (exh. Salon 1849; Le Mans, Mus. Tessé) as well as depictions of classical subjects, such as the *Mysteries of Bacchus* (exh. Salon 1873; Brest, Mus. Mun.). Jobbé-Duval became a distinguished portraitist and produced likenesses of many contemporary and historical French personages, as in the portrait of *J.-R. Bellot*, the French polar explorer from Rochefort (exh. Salon 1855, Rochefort, Mus. Mun.), and the portraits of the 16th-century architects *Jean Bullant* and *Androuet Du Cerceau* and the sculptor *Antoine Jacquet de Grenoble*, which were reproduced in tapestry by the Manufacture Nationale des Gobelins for the Galerie d'Apollon in the Louvre. He contributed to the decoration of many chapels and churches as well as civic and municipal buildings, both in Paris and in the provinces, creating not only easel paintings but also fresco decorations on walls and ceilings. In 1864–6 he executed five tympana decorations for the nave of the Trinité in Paris; for the chapel of the veterinary school of Lyon he produced colossal paintings of *St Peter* and *St Paul*, which were placed on either side of a *Coronation of the Virgin*. His decorations of civic buildings included a series of allegorical grisailles illustrating the four seasons for the Hôtel de Ville of Lyon, and two medallions, also in grisaille, representing *Agriculture and Commerce* and *Industry and Art* for the Commercial Law Courts of the département of the Seine. In 1864 he also decorated the Théâtre de la Gaîté in Paris.

Jobbé-Duval was deeply involved in the political life of his time, and he has been characterized as a militant republican with socialist tendencies. On his arrival in Paris he joined in the revolutionary agitations of 12 May 1839, and he also took an active part in the street fights of the Revolution of 1848. He later supported Giuseppe Garibaldi, and in 1870, during the Franco-Prussian War (1870–71) and the siege of Paris, he organized the Garde Nationale (the civilian militia) of the 15th arrondissement. On 23 June 1871 he became municipal councillor of the *quartier* Necker (15th arrondissement). He also took an active part in the administration of the arts. He became a member of the administrative commission of the fine arts of Paris and was instrumental in setting up a competition for the reconstruction of the Hôtel de Ville of Paris, which was burnt during the Franco-Prussian War. He ended his career as a curator of the Musée du Luxembourg in Paris.

BIBLIOGRAPHY
Bellier de La Chavignerie-Auvray; Bénézit; DBF
G. Vapereau: *Dictionnaire universel des contemporains* (Paris, 1858, 5/1880), p. 996

G. Lafenestre: 'Salon de 1873', *Gaz. B.-A.*, n. s. 1, vii (1873), pp. 479–82
F. Jaffrenou: *Carhaisiens célèbres* (1940)

ATHENA S. E. LEOUSSI

Jocelyn, Nathaniel (*b* New Haven, CT, 31 Jan 1796; *d* New Haven, 13 Jan 1881). American painter, engraver and abolitionist. He learnt the rudiments of engraving while apprenticed to his father, Simeon, a clockmaker. This talent was encouraged by the inventor and manufacturer Eli Whitney, who saw to it that Jocelyn received further training in Hartford, CT. Jocelyn had wanted to study portrait painting in England, but his plan was thwarted by John Trumbull (a distant relative). He concentrated on engraving instead, forming the N. & S. S. Jocelyn Co. with his brother Simeon Smith Jocelyn (1799–1879) in 1818.

Jocelyn continued to paint, however, producing his first miniatures the following year. In June 1820, Samuel Morse invited Jocelyn to work alongside him in his studio in New Haven. This was the closest to formal instruction that Jocelyn had. In November Jocelyn opened a portrait studio in Savannah, GA, for the winter season, returning again the following year. His success was limited, and he pursued mainly business interests thereafter, though keeping a studio in New Haven until 1849.

In 1829 Jocelyn went to England to study new printing techniques and painting; in November, accompanied by Morse and the architect and inventor Ithiel Town, he toured France and Italy. Later he was a founder of the American Bank Note Co., heading its art department until he retired in 1865. He then had a studio at the new Yale Art School and was Curator of Italian Art there.

Jocelyn was also active in the abolition movement. His most famous portraits are of leading figures in this cause: *Cinqué* (1839; New Haven, CT, Colony Hist. Soc. Mus.), chief of the Amistad blacks who were detained in the New Haven gaol, and *William Lloyd Garrison* (1833; Washington, DC, priv. col., on loan to N.P.G.).

BIBLIOGRAPHY
F. W. Rice: 'Nathaniel Jocelyn 1796–1881', *CT Hist. Soc. Bull.*, xxxi/4 (1966), pp. 97–145
B. Heinz: 'Nathaniel Jocelyn, Puritan, Painter, Inventor', *J. New Haven Colony Hist. Soc.*, xxix/2 (1983), pp. 1–44

BERNARD HEINZ

Jōchō (*b* Heian [now Kyoto], ?late 10th century; *d* 1057). Japanese sculptor. He perfected the joined woodblock technique (*yosegi zukuri*), whereby sections of wood were hollowed, carved and assembled (*see* JAPAN, §V, 1(ii)(b)). This facilitated the rapid, large-scale production of monumental images in the atelier and encouraged the development of the workshop (*bussho*) system. Together with his father, Kōjō (*fl* 990–1020), Jōchō developed a restrained style of Buddhist imagery that reflected the aesthetic ideals of their aristocratic patrons. Jōchō's first commission, as his father's assistant, was for the nine statues of Amida (Skt Amitābha; Buddha of the Western Paradise), completed in 1020 (destr.), for the Nine Amida Hall at the Hōjōji in Kyoto, the private monastery of the regent Fujiwara no Michinaga (966–1027). Michinaga then entrusted Jōchō with the production of statuary for the other halls of the temple. In recognition of Jōchō's work, Michinaga took the unprecedented step of conferring on

him the honorary monastic title of *hokkyō* ('bridge of the law'). From this time onwards, Buddhist sculptors and painters were commonly thus honoured. In 1023 Jōchō and his atelier produced 11 statues for the Main Hall of the Hōjōji and 5 for the Hall of the Five Great Mystic Kings, all of which were larger than life-size, as well as 49 statues to be used by Michinaga in rituals to ensure his felicitous rebirth. By 1026 Jōchō's atelier comprised 105 people, including 20 master sculptors, each with 5 assistants. After Michinaga's death Jōchō enjoyed the patronage of Michinaga's son Yorimichi (992–1074) and daughter Shōshi (988–1074). He worked almost exclusively for Michinaga's family and immediate circle, except for one brief excursion to Nara to replace fire-damaged images at the 8th-century monastery of Kōfukuji (*see* NARA, §III, 7), a clan temple of the Fujiwara. In 1048 he was further elevated by the court to the Buddhist rank of *hōgen* ('eye of the law').

The only extant work securely attributed to Jōchō is the *Seated Amida* (h. 2.84 m; *see* JAPAN, fig. 61) in the Hōōdō (Phoenix Hall) of the Byōdōin at Uji, south of Kyoto, commissioned by Yorimichi and completed in 1053; it is considered an outstanding example of the *wayō* (Japanese style). The figure, characterized by extreme idealization of both the facial expression and the forms of the body, sits on a high multi-layered pedestal and behind it towers a huge mandorla (an almond-shaped nimbus); hanging from the ceiling is an ornate wooden canopy, and attached to the walls are 52 small statues of priests, heavenly musicians and bodhisattvas representing Amida's entourage (*see* JAPAN, §V, 3(iii)). The style of imagery associated with Jōchō was accorded a pre-eminent place by patrons during the rest of the Heian period. Works imitating the formal characteristics of the *Amida* at Byōdōin and other works by Jōchō were occasionally rejected for not following his prototypes closely enough. The EN, IN and KEI schools developed from ateliers set up by Jōchō's disciples.

BIBLIOGRAPHY

Kodansha Enc. Japan

SAMUEL C. MORSE

Jode, de. Flemish family of artists. They were important engravers and print publishers in Antwerp during the 16th and 17th centuries.

(1) Gerard de Jode (*b* Nijmegen, 1509 or 1517; *d* Antwerp, 1591). Engraver, mapmaker and publisher. A native of the northern Netherlands, he was in Antwerp by 1547 at the latest, when he was admitted to the Guild of St Luke as a master. Two years later he became a citizen of Antwerp; he obtained a licence to publish prints in 1551. His first dated print is from 1560. He drew and published various series of maps, some engraved by himself and some by Jan and Lucas van Doetechum. He also republished existing maps, for example a revised reprint of the *Mappa mundi* by Giacomo Castaldi (1560), a *Map of Portugal* (1563), the *Theatrum orbis terrarum* by Abraham Ortelius (1564) and a *Map of Italy* after Castaldi (1568). In 1573 Gerard de Jode republished several of his maps in an atlas entitled *Speculum orbis terrarum*, for which he obtained imperial and royal licences in 1575 and 1577 respectively. This was later reissued several times, including by his son (2) Cornelis de Jode in 1593. One of the earliest

northern print publishers, Gerard de Jode was regarded, after Ortelius, as the second most important publisher of maps and atlases (*see* ATLAS). Besides his activity as a cartographer, he also engraved and published a few historical subjects, mostly after compositions by others, including Marten de Vos, Crispin van den Broeck, Hendrick Goltzius, Maarten van Heemskerck, Michelangelo and Titian.

(2) Cornelis de Jode (*b* Antwerp, 1568; *d* Mons, 17 Oct 1600). Engraver and publisher, son of (1) Gerard de Jode. He studied science at Douai and travelled to Spain and elsewhere in Europe, but from 1595 at the latest he was back in Antwerp, where he joined the Guild of St Luke. Only one engraving by him is known, a portrait of *Philip IV of Spain* (Hollstein, no. 1), after Cornelis Schut. In 1593 de Jode reissued his father's *Speculum orbis terrarum* with a cosmographic introduction.

(3) Pieter de Jode (i) (*b* Antwerp, 1570; *d* Antwerp, 9 Aug 1634). Draughtsman, engraver and publisher, son of (1) Gerard de Jode. Around 1595 he travelled to Rome, and later to Holland, where he was a pupil of Hendrick Goltzius, and Paris. In 1599–1600 he was admitted into the Antwerp Guild of St Luke as a master's son. In 1602 he married Suzanna Verhulst, a sister-in-law of Jan Breughel I, who himself married Pieter's sister Isabella. In 1607–8 and 1608–9 de Jode was respectively dean and chief dean of the Guild. Nicolaes Ryckmans (*fl* 1616–22) became his pupil.

Pieter's early engravings, including the *Nativity* (Hollstein, no. 1), the *Penitent Magdalene* (H 92) and *Mercury and Venus* (H 97), all after Bartholomäus Spranger, reveal

Pieter de Jode (i): *Justus Lipsius*, engraving after Abraham Janssen 320×232 mm, 1605 (London, British Museum)

the influence of Goltzius, though this became less pronounced during his sojourn in Italy. There he engraved works by Francesco Vanni, Titian, Jacopo Bassano, Giulio Romano, Annibale Carracci and others. After his return to Antwerp, Pieter began to make book illustrations, supplying preparatory designs for Christoph Plantin's *Officium B. Mariae Virginis* (engraved by Theodor Galle, 1609) and the *Vita et miracula S. P. Dominici* (after J. F. Nys, engraved by Theodor Galle, 1611). Later de Jode engraved book illustrations for the following works by Jacob Cats: the *Tooneel van de mannelycke achtbaarheut* ('Play about man's dignity'; after designs by Adriaen van de Venne, 1621), the *Self-strud* ('Self-struggle'; 1621) and *Houweluck* ('Marriage'; 1625). Pieter also made engravings after the work of Sebastiaen Vrancx, Otto van Veen, Rubens and van Dyck, among others (see fig.). His own preparatory drawings were also reproduced in prints by Cornelis Galle (i), Egbert van Panderen, Adriaen Collaert, Jean-Baptiste Barbé (1578–1649) and others.

(4) Pieter de Jode (ii) (*b* Antwerp, 22 Nov 1604; *d* ?England, ?1674). Engraver and publisher, son of (3) Pieter de Jode (i). He was a pupil of his father and in 1628–9 was admitted into the Antwerp Guild of St Luke. He was in Paris in 1631 and 1632, together with his father. In 1634–5 Mattheus Borrekens (*c*. 1615–1670) became his pupil. He was active in Brussels in 1667 and probably regularly visited his son Arnold in England.

There is considerable confusion between the engravings of Pieter the elder and Pieter the younger, since the latter probably signed his prints with *junior* only before his father's death in 1634. Pieter the younger's earliest engravings reflect the dry style and technique of his father. In later engravings, after van Dyck and Rubens, a more painterly, free style is evident, as can be seen in the *Christ Child with a Snake on the Globe* (Hollstein, no. 4) and the *Temptation of St Augustine* (H 18), both after van Dyck, and the *Visitation* (H 1), the *Birth of Venus* (H 24), the *Three Graces* (H 25) and *Neptune and Cybele* (H 27), all after Rubens. Among the many other artists whose work was engraved by Pieter (ii) were Jacob Jordaens, Abraham van Diepenbeeck, Otto van Veen, Erasmus Quellinus, Lucas van Leyden, Jan Lievens, Simon Vouet, Artemisia Gentileschi, Titian, Vanni, Federico Barocci and Bernini. He specialized, however, in portrait engravings and became known for his faithful reproductions of works by van Dyck. Various portrait engravings by Pieter (ii) are found in *Les Effigies des souverains Princes et Ducs de Brabant* (published by Johannes Meyssens; H 181–204), a series with *Personalities at the Peace Conference of Munster, 1648* (H 385–515).

(5) Arnold de Jode (*b* Antwerp, *c*. 1638; *d* London, 1667). Engraver, son of (4) Pieter de Jode (ii). He was a pupil of his father and was admitted to the Antwerp Guild of St Luke in 1658–9. In 1666 he was in London. Only a very small oeuvre by him is known. His earliest engraving is a *Landscape* (1658; Hollstein, no. 6) after Lodewijk de Vadder. Three religious subjects, namely the *Christ Child with the Infant John the Baptist* (1666; H 1), a *Crucifixion* (H 2) and a *Penitent Virgin* (H 3), were after compositions by van Dyck, while a mythological subject, the *Upbringing of Cupid by Mercury and Venus* (1667; H 4), is after

Correggio. There are also engraved portraits by Arnold, of which the most important are those of the engraver and author *Alexander Browne* (H 7) after Jacob Huysmans; *Admiral Cornelis Evertsen* (1575; H 8) and *Admiral Johannes Evertsen* (1591; H 9) after Pieter Borsseler; *Catherine Howard, Duchess of Lenox* (H 10) after van Dyck; and *Cardinal Antoniotto Palavicini* (H 12) after Titian.

BIBLIOGRAPHY
Hollstein: *Dut. & Flem.* [H]; Thieme–Becker; Wurzbach
G. K. Nagler: *Neues allgemeines Künstler-Lexikon*, vi (Munich, 1838), pp. 459, 460, 463
C. Le Blanc: *Manuel de l'amateur d'estampes* (Paris, 1856–8), ii, pp. 429, 430
H. Hymans: 'Histoire de la gravure dans l'école de Rubens', *Annu. Acad. Royale Sci., Lett. & B.A. Belgique*, xlii/8 (1879), pp. 20, 83, 90–92, 236, 387–97
J. Denucé: *Oud Nederlandsche kaartmakers*, 2 vols (Antwerp, 1912–13), pp. 163–220, 275–6, 284–6, 296
A. M. Hind: *A History of Engraving and Etching from the 15th Century to the Year 1914* (London, 1923/*R* New York, 1963), pp. 128, 166, 352–3
A. J. J. Delen: *Histoire de la gravure dans les anciens Pays-Bas et dans les provinces belges des origines jusqu'à la fin du XVIIe siècle, II: Le XVIe siècle* (Paris and Brussels, 1934–5)
A. M. Hind: *Engraving in England in the Sixteenth and Seventeenth Centuries*, 3 vols (Cambridge, 1952–64)
F. van Ortroy: *L'Oeuvre cartographique de Gérard et Corneille de Jode* (Amsterdam, 1963)
P. Poirier: 'Un Siècle de gravure anversoise: De Jérôme Cock à Jacques Jordaens, du dessin à l'estampe, 1550–1650', *Mém. Acad. Royale Belgique: Cl. B.-A.*, n. s. 1, xii/1 (1967), pp. 88–9
C. Dittrich: 'Zu zwei Zeichnungen der Familie de Jode', *Dresdn. Kstbl.*, xii (1968), pp. 116–20
H. Mielke: 'Antwerpener Graphik in der 2. Hälfte des 16. Jahrhunderts: Der *Thesauras veteris et novi testamenti* des Gerard de Jode (1585) und seine Künstler', *Z. Kstgesch.*, xxxviii (1975), pp. 29–83
 CHRISTINE VAN MULDERS

Jodhpur. City on the eastern edge of the Thar Desert in Rajasthan, India. Founded in 1459 by Rao Jodha (*reg* 1458–89), a Rajput prince of the Rathor clan who transferred his capital there from Mandor, it was strategically located along the former trade route between Gujarat and Delhi. Rao Jodha built his fort, known as Meherangarh Fort, in an easily defensible location on a steep hill 122 m high in the middle of a vast plain. The fort is approached by seven gates built along its steep southern approach and contains palaces dating from the late 17th century to the early 18th; elements of decoration, including wall paintings, were added as late as the end of the 19th century (*see* INDIAN SUBCONTINENT, §III, 7(ii)(b) and fig. 114). The palace façades, carved from local red sandstone, feature projecting balcony forms (*jharokhās*) and recessed walls punctuated with pierced interlace screens (*jālīs*); in some areas, for example around the Singar Choki Chowk (mid-17th century), the upper storeys were carved to give the appearance of a continuous perforated screen. From 1678 to 1707 Jodhpur came under MUGHAL occupation. After the departure of the Mughals, various additions and renovations were made to the fort, and several new architectural and decorative elements appeared; the most distinctive of these is the pseudo-Ionic type of capital found in the Khabka Mahal Chowk (1704–24), which may have been derived from engravings of European buildings. Representative of the lavishly decorated palace interiors are the Sheesh Mahal (1707–24), which is decorated with

mirrorwork, and the Phul Mahal (1724–49), which has a painted interior executed in 1873–95.

Below the fort, within the old walled city, are several temples of the 16th–19th century, many of which contain wall paintings dating from the 18th century to the early 20th. Their subject-matter relates mostly to the mythology of Krishna and Rama, as in the Tija Maji Temple, but Shaivite subjects including depictions of *yoga* practitioners of the Kanpatha sect are also found, for example at the Mahamandir Temple. Paintings are also found in houses (*haveli*s). The last work of Rajput architecture in Jodhpur, the Umaid Bhavan palace (1929–44) of Maharaja Umaid Singh, was designed by the British architect Henry V. Lanchester (1863–1953) and represents a monumental synthesis of traditional Hindu and Rajput forms with Art Deco. More recent innovative buildings include the University Lecture Theatres (1968–1972), designed by Uttam Jain.

A school of miniature painting that flourished from the 17th century (*see* INDIAN SUBCONTINENT, §VI, 4(iii)) ended during the 1870s under the impact of imported European art; the Government Museum houses some examples, along with sculptures, coins, inscriptions, textiles and pottery. The local arts and crafts of Jodhpur include tie-dyed saris, embroidered shoes and *badla*s, distinctive zinc water containers covered with cloth or wool.

BIBLIOGRAPHY

H. Goetz: 'Marwar (with Some Paintings from Jodhpur in the Collection of Kumar Sangram Singh)', *Marg*, xi/2 (1958), pp. 42–9
S. Toy: *The Fortified Cities of India* (London, 1965)
R. A. Agrawala: *Marwar Murals* (Delhi, 1977)
B. D. Agrawal: *Jodhpur*, Rajasthan District Gazetteers (Jaipur, 1979)
G. H. R. Tillotson: *The Rajput Palaces* (New Haven, 1987)
——: *The Tradition of Indian Architecture* (New Haven, 1989)

WALTER SMITH

Joel [née Lockhart], **Betty** (*b* Hong Kong, 1896; *d* England, 1985). English designer. With her husband David Joel shortly after World War I she founded Betty Joel Ltd, which was based in a workshop at Hayling Island near Portsmouth, Hants. Early Joel furniture was made in oak, teak and mahogany and executed by craftsmen in an idiosyncratic style of Arts and Crafts combined with Neo-Georgian. In the 1930s a shop was opened in Knightsbridge, London, and manufacturing moved to a factory in Kingston-upon-Thames, designed for the company by H. S. Goodhart-Rendel. By this time Joel's designs were influenced by the Modern Movement: mostly expensive pieces made to commission in light-coloured woods and veneers. Serpentine, curved and bow-fronted work was produced, as well as simpler planar and 'stepped' furniture (e.g. oak dressing-table, 1931; London, V&A). Wood, steel and glass were used for the framework of the furniture, with such luxury materials as ivory for the handles. As well as space-saving and built-in furniture for small modern flats, the firm, working to the drawings of the Joels or other designers, produced lavish interiors for such clients as Lord Louis Mountbatten (1900–79) and for the offices and boardrooms of Coutts Bank, the *Daily Express* and Shell. Betty Joel also designed textiles, carpets (e.g. of 1935–7; London, V&A), film and theatre sets, radio cabinets and cast-iron heating stoves. Her design for a bedroom was selected for the exhibition of British Art in Industry (1935) at the Royal Academy, London. She retired in 1937 although the firm continued under the direction of David Joel.

BIBLIOGRAPHY

G. Boumphrey: 'The Designers: Betty Joel', *Archit. Rev.* [London], lxxviii (1935), pp. 205–6
D. Joel: *The Adventure of British Furniture* (London, 1953, rev. 1969 as *Furniture Design Set Free*)

JOHN BAILEY

Joel ben Simeon [Feibush Ashkenazi] (*fl* 15th century). Jewish scribe and illuminator, active in Germany and northern Italy. Although more of his work has been identified than any other medieval Jewish artist–copyist's, all that is known about him is culled from colophons in manuscripts that he either wrote or decorated. He lived in Cologne and Bonn; most of the manuscripts attributed to him are liturgical texts, especially Haggadot (*see* HAGGADAH). He usually named himself as the scribe of a manuscript, as in the following works: First Nuremberg Haggadah (Jerusalem, Schocken Lib., MS. 24086); First New York Haggadah (New York, Jew. Theol. Semin. America Lib., MS. Mic. 4481); a prayerbook dated 1449 (Parma, Bib. Palatina, MS. 3144); a prayerbook dated 1452/3 (Turin, Bib. N. U., MS. A. III. 14); a Haggadah (Cologne, Fond. Martin Bodmer, MS. Cod. Bodmer 81); a prayerbook dated 1469 (London, BL, MS. Add. 26957); the Washington Haggadah, dated 1478 (Washington, DC, Lib. Congr., Hebr. MS. I); and David Kimhi's commentary on the Psalms dated 1485 (Parma, Bib. Palatina, MS. 2841). In two works Joel ben Simeon referred to himself as the artist: the Ashkenazi Haggadah (London, BL, MS. Add. 14762) and six leaves of Tabernacle implements (untraced); while in one manuscript, the Second New York Haggadah (New York, Jew. Theol. Semin. America Lib., MS. Mic. 8279), he described himself as the scribe and decorator. His illustrations were usually emphatically outlined drawings filled in with colour. As the approximately 20 manuscripts attributed to him are somewhat inconsistent in style, it has been assumed that he headed a workshop.

BIBLIOGRAPHY

M. Fooner: 'Joel ben Simeon: Illuminator of Hebrew MSS in the XVth Century', *Jew. Q. Rev.*, n. s., xxvii (1937), pp. 217–32
F. Lansberger: 'The Washington Haggadah and its Illuminator', *Heb. Un. Coll. Annu.*, xxi (1948), pp. 73–103
B. Narkiss: *Hebrew Illuminated Manuscripts* (Jerusalem, 1969), pp. 124, 171–2
J. Gutmann: 'Thirteen Manuscripts in Search of an Author: Joel ben Simeon, 15th-century Scribe-artist', *Stud. Bibliog. Bklore*, ix (1970), pp. 76–95
M. Metzger: *La Haggada enluminée: Etude iconographique et stylistique des manuscrits enluminés et décorés de la Haggada du XIIIe au XVIe siècle*, i (Leiden, 1973), pp. 388–90
M. Beit-Arié: 'Joel ben Simeon's Manuscripts: A Codicologer's View', *J. Jew. A.*, vii (1980), pp. 25–34
D. Goldstein: *The Askenazi Haggadah* (New York, 1985)
M. Weinstein, ed.: *The Washington Haggadah* (Washington, DC, 1991)

EVELYN M. COHEN

Joest [Joesten; Joost; Joosten] **(von Kalkar)** [von Calcar; van Haarlem], **Jan** [Juan de Holanda] (*b* Wesel, nr Rocklinghausen, 1455–60; *d* Haarlem, 1519). German painter, active also in Spain and the Netherlands. He is generally thought to have been taught by Derick Baegert,

who was also born in Wesel and was probably a close relative; outside the lower Rhine, Geertgen tot sint Jans and Gerard David had the greatest influence on his work. Joest was in Kalkar in 1480; in 1490 he was again in Wesel, but the following year he returned to Kalkar. The first references to Jan Joest as an artist, in 1505, document the two works around which scholars have established his oeuvre. Joest painted 20 panels of the *Life of Christ* on the shutters of the high altar of the parish church of St Nikolai, Kalkar (1505–8, *in situ*); the central carvings of the altar are by Master Ludwig Jupan and assistants. In the painted panels, stately biblical figures are mixed with animated accessory figures, their differences often dramatically presented in Joest's eerie light, as in the *Taking of Christ*. He varied his background treatments, from the precise realism of his depiction of the Kalkar Rathaus in the *Raising of Lazarus* to the stylized blue mountains in *Christ and the Woman of Samaria*. The facial types also vary: in *Christ before Pilate* (see fig.), Joest depicted a sorrowful, but sturdy Christ and a grimacing official beside the dignified portraits of the Kalkar citizens observing the scene. In 1505 Joest also received a commission for an altarpiece for Palencia Cathedral, seven panels of which show the *Sorrows of the Virgin*, while a larger eighth panel depicts the donor adoring a grieving Virgin supported by St John. The inscription states that Juan de Fonseca, Bishop of Palencia, commissioned the work in Flanders in 1505, and a cathedral account-book names the artist as Juan de Holanda, whom Friedländer (1916) identified as Jan Joest.

Although the Kalkar and Palencia altarpieces are Joest's most important works, many other paintings, both religious panels and portraits, have been attributed to him,

particularly by Friedländer (1916, 1972) and Stange. A skilled artist, Joest combined archaic, stratified compositions with decorative Renaissance architectural motifs. In 1512 he received a commission for the former Benedictine abbey of St Liudger, Werden, and in 1515 for St Bavo, Haarlem, where he had lived since 1509. Joest's influence spread to Spain through his works, to Antwerp through his pupils Joos van Cleve and the Master of Frankfurt, and to Cologne through his pupil Bartholmaeus Bruyn (i), who was probably his son-in-law and heir.

BIBLIOGRAPHY

Thieme–Becker

M. J. Friedländer: *Van Eyck bis Bruegel* (Berlin, 1916; Eng. trans. of 3rd edn, New York, 1969), pp. 107–12

C. R. Post: *A History of Spanish Painting*, iv (Cambridge, MA, 1933), pp. 32–75

C. P. Baudisch: 'Jan Joest von Kalkar: Ein Beitrag zur Kunstgeschichte des Niederrheins', *Kstgesch. Forsch. Rhein. Heimatbundes*, viii (1940) [incl. docs and oeuvre]

M. J. Friedländer: 'Eine Zeichnung von Jan Joest von Kalkar', *Oud-Holland*, lvii (1940), pp. 161–7

C. R. Post: 'A Second Retable by Jan Joest in Spain', *Gaz. B-A.*, n. s. 6, xxii (1942), pp. 127–34

A. Stange: *Deutsche Malerei der Gotik, VI: Nordwestdeutschland in der Zeit von 1450 bis 1515* (Munich, 1954), pp. 63–72

E. Willemsen: 'Die Wiederherstellung der Altarflügel des Jan Joest vom Hochaltar in St. Nikolai zu Kalkar', *Jb. Rhein. Dkmlpf.*, xxvii (1967), pp. 105–222

G. von der Osten and H. Vey: *Painting and Sculpture in Germany and the Netherlands, 1500–1600*, Pelican Hist. A. (Harmondsworth, 1969), pp. 137–8

M. J. Friedländer: *Early Netherlandish* (1967–76), ix (1972), pp. 11–16

J. Giesen: 'Jan Joest von Kalkar', *Die Kunst*, lxxxiv (1972), pp. 529–32 [incl. good colour pls]

F. Gorissen: 'Meister Matheus und die Flügel des Kalkarer Hochaltars: Ein Schlüsselproblem der niederrheinländischen Malerei', *Wallraf-Richartz-Jb.*, xxxv (1973), pp. 149–206

B. B. Fredricksen: 'A Flemish *Deposition* of *c.* 1500 and its Relation to Rogier's Lost Composition', *Getty Mus. J.*, ix (1981), pp. 133–56

JEAN M. CASWELL

Jo-fen. *See* YUJIAN.

Jogjakarta. *See* YOGYAKARTA.

Johan Maurits, Count of Nassau-Siegen. *See* NASSAU, (1).

Johannes, Frater (*fl* 1490). Hungarian friar and architect. He was head of a Late Gothic workshop in Transylvania, where he was sent by King Matthias Corvinus on 18 Jan 1490 to take charge of building the Minorite house founded by the King at his birthplace, Cluj-Napoca (Ger. Klausenburg; Hung. Kolozsvár). Known as Frater Johannes, he was presumably a Franciscan. Johannes's workshop is perhaps the most clearly identifiable building organization in Hungary. It demonstrates how the mendicant orders persisted with traditional building methods after Renaissance styles had become fashionable in the royal court of Buda.

The particular form of construction at Cluj-Napoca (the articulation of the nave by means of four pairs of strongly projecting buttresses), the details of the vaulting and the western double portal are distinctive features of the workshop, whose activity can be traced in the Dominican friary (now a music school) at Cluj-Napoca, in the Franciscan church at Mediaş (Ger. Mediasch; Hung.

Jan Joest: *Christ before Pilate*, oil on panel, 1.07×0.86 m; one of the 20 scenes from the *Life of Christ* (1505–8) on the shutters of the high altar of St Nikolai, Kalkar

Medgyes) and in the vaulting of the nave of the parish (now Calvinist) church at Dej (Hung. Dés). The details (finely formed corbels in the choir, the scrollwork of the surrounds to the openings) are evidence of a direct relationship with the Late Gothic architectural centres at Buda and Visegrád, which probably reached Transylvania through Stefan Báthori, the voivode of Transylvania, at Nyírbátor (Minorite church and the parish church of St George).

BIBLIOGRAPHY

J. Balogh: *A művészet Mátyás király udvarában* [Art at the court of King Matthias], i (Budapest, 1966), pp. 158–9

G. Entz: 'Baukunst in Ungarn um 1500', *Acta Hist. A. Acad. Sci. Hung.*, xvii (1967), pp. 81–6

GÉZA ENTZ

Johannes Aquila de Rakerspurga [von Radkersburg] (*fl* 1378–92). Austrian painter, active in Styria and Hungary. His name is most likely to have been von Radkersburg, the Latin attribute Aquila probably referring to his patron saint, John the Evangelist. Inscriptions on his wall paintings provide the only extant biographical information. His self-portrait in the chancel of the parish church in Velemér (Hungary) reads *Orate pro me Johannes Aquila pictore*; the date 1377 or 1378 occurs elsewhere on the painting. Stylistically related frescoes can be found in several parish churches near Velemér, including those (signed and dated 1383) in the apse at Turnišče, Slovenia (Hung.: Bántornya); and in the chancel of St Martin's, Martjanci, Slovenia (Hung.: Mártonhely), where a kneeling figure is inscribed *omnes s*[anc]*ti orate p*[ro]*me Johanne Aquila pictore*. The date 1392 above the bottom row of paintings refers to the building of the chancel. A fragmentary sentence, *Per manus Johannis Aquile de Rakespurga oriundi . . .*, follows this and has been erroneously interpreted to mean that he might also have been an architect. The paintings at Martjanci are related both to the nave frescoes at Turnišče and to those in the Pistorhaus in Radkersburg (Austria). Wall paintings uncovered in the former church of the Augustinian hermits at Fürstenfeld (Austria) are inscribed *Orate deum pro me Johanne Aquila pictore*.

Johannes was probably trained in northern Italy, but he was also well acquainted with mid-14th-century Czech painting. From the 1380s he employed assistants following the style of the manuscripts made in Prague for Wenceslas IV, King of Bohemia, which were considered the most up-to-date works of the time. His self-portraits are among the earliest European examples of this genre.

BIBLIOGRAPHY

F. Rómer: *Régi falképek Magyarországon* [Old wall paintings in Hungary] (Budapest, 1874), pp. 26–8

D. Radocsay: *A középkori Magyarország falképei* [Wall paintings of medieval Hungary] (Budapest, 1954)

T. von Bogyay: 'Die Selbstbildnisse des Malers Johannes Aquila aus den Jahren 1378 und 1392', *Stil und Überlieferung in der Kunst des Abendlandes: Bonn, 1964*, iii, pp. 55–9

F. Stele: *Gotsko stensko slikarstvo* [Gothic wall paintings] (Ljubljana, 1972)

ERNŐ MAROSI

Johannesburg. City in Transvaal, South Africa, on the gold-bearing reefs of the Witwatersrand. Established by prospectors in 1886, it became one of the leading centres of 20th-century architecture in South Africa. The cityscape of Johannesburg is determined by the Main Reef (a gold seam running from east to west) and the use of a grid layout in planning until the 1940s. Its suburbs, however, were established as isolated residential pockets with no overall coherence, owing to the private ownership of the land. The first settlement on the Witwatersrand appeared in 1886, on the north of the Main Reef, and consisted of reed huts. In 1890 corrugated iron was the major building material, by which time the first double-storey buildings had also made their appearance. During the 1890s the gold-mining industry boomed, and in 1895 Johannesburg had 100,000 residents. Victorian revival styles adapted to local circumstances (mainly by adding verandahs in wood or cast iron) proliferated. In the business centre sites were small and street blocks short, with buildings given turrets and gables in an effort to compete for attention. In the suburbs, too, the colourful houses with Queen Anne Revival gables in red brick and stucco complemented the natural shapes of the gardens and hills.

Because of its status as a mining town, Johannesburg developed without a proper municipality before 1902. All this changed after the Anglo-Boer War (1899–1902), when the Transvaal became part of the British Empire. In 1903 new regulations allowed building heights up to 44 m and prescribed the grid plan for all subdivisions of land. This led to the first tall iron-skeleton buildings in the centre of town and the layout of new suburbs in the municipal area. The city's boundaries were extended from an area of 1321 ha in 1898 to 21,173 ha in 1903, the largest in the world at that time apart from Tokyo. Large Government buildings appeared, designed in an austere classicist style, and shops and offices followed suit. Edwardian formalism also affected houses, whose plans tended towards a rigid symmetry, while the wide and open verandah was replaced by a narrow stoep with cement pillars and a low brick wall. In this period HERBERT BAKER designed his villas in Parktown (popular with the wealthy since 1892) for Johannesburg's mining magnates on the ridge north of the city centre. The first black residential area, Klipspruit (laid out in 1904 and later called Pimville), was built 19 km to the south-west of the city centre.

After World War I few architectural developments took place, because of the Great Strike of 1922 in the mines of Witwatersrand and the Depression in the late 1920s. In 1921, however, the University of the Witwatersrand was established, and its School of Architecture under the leadership of G. E. PEARSE was to put a lasting stamp on local and South African architectural history. In 1928 Johannesburg attained official city status, the first in South Africa. By then its leading industrial and financial role was fully acknowledged, and in the 1930s it became a centre of wealth during the world depression and the extensive drought in South Africa. To accommodate the influx of people this caused, new suburbs were laid out, housing schemes were established and a flat-land developed in the north-east of the city centre. The unparalleled building boom took three stylistic directions: a continuation of Edwardian design principles (Traditionalism); a mixture of a few basic traditional elements with modernist ornamentation (Modernism); and a smaller trend in the International style. Common to all was the vertical emphasis in

buildings, which had smooth plastered wall planes. Together with the tarred streets and pavements, this created a streamlined impression (see fig.). In the financial area, especially Commissioner Street, building fronts had a closed appearance and little relation to the street, as is the case today.

In the suburbs the shape of the house was divided into articulated blocks with an uneven silhouette. Withdrawn from the shrubs and trees in the garden, the white-walled houses stood like crystals in the suburban landscape. Such architects as DOUGLASS M. COWIN, JOHN FASSLER, Norman Hanson (see HANSON, TOMKIN, FINKELSTEIN), GORDON LEITH, REX MARTIENSSEN and HAROLD LE ROITH designed important residential projects in this manner in the 1930s. In these years a black city, Soweto (the South-Western Townships), also developed in the south-west, next to the white area, with a number of inhabitants equal to that of Johannesburg. A national competition for Orlando (80,000 residents) held in 1931 was won by the Johannesburg architectural firm Kallenbach, Kennedy and Furner (see FURNER, A. STANLEY). Other sections of Soweto followed after World War II. Near Soweto, Nancefield and Riverlea were reserved for 'Coloureds', and Lenasia for Asians, with a few smaller segregated pockets of land for non-whites within the boundaries of historically 'white' Johannesburg. Although provided with road and rail connections to the city centre, the outlying residential areas have not been developed as towns.

The years after World War II were devoted to the reconstruction of the economy. New urban developments signalled a different approach: from the early 1950s huge buildings were designed as isolated monoliths. The first 50-storey building, the Carlton Centre (1970; by SKIDMORE, OWINGS & MERRILL), marked a process of extreme individualism and show of force by the major financial institutions. Recent buildings clad in blue reflective glass (for example 11 Diagonal Street (early 1980s) by HELMUT JAHN) introduced a theatrical effect into the city.

Art life in Johannesburg found an early focus in the Johannesburg Art Gallery, founded in 1910, in a building designed by Lutyens. The Johannesburg Sketch Club (1916–22) included as members J. H. PIERNEEF and PIETER WENNING. In the 1940s the BA Fine Arts course at the University of the Witwatersrand produced important artists, such as CECIL SKOTNES, who in turn supervised the training of emergent black artists at the Polly Street

Johannesburg, aerial view of the city centre, 1936; mine dumps can be seen in the distance

Art Centre (1952–60). By the 1970s, with commercial galleries and the founding of the University of the Witwatersrand Art Galleries (1972), Johannesburg was challenging the traditional dominance of Cape Town in South African art.

BIBLIOGRAPHY
J. R. Shorten: *The Johannesburg Saga* (Johannesburg, 1970)
N. Mandy: *A City Divided: Johannesburg and Soweto* (Johannesburg, 1984)
Johannesburg: One Hundred Years (Johannesburg, 1986)
G.-M. van der Waal: *From Mining Camp to Metropolis: The Buildings of Johannesburg, 1886–1940* (Johannesburg, 1987)
G.-M. VAN DER WAAL

Johannes de Brugis. *See* BOUDOLF, JAN.

Johannes Ivan. *See* IVAN, JOHANNES.

Johannes of Ljubljana [de Laibaco] (*fl c.* 1435–60). Austrian painter. His name and place of origin are known from inscriptions in which he signed himself as Johannes, son of Master FRIEDRICH VON VILLACH and citizen of Laibach (now Ljubljana), on his fresco cycles in Lower Carniola (Slovenia): frescoes of the *Legend of St Nicholas* and *Apostles* and *Saints* (1443; Visoko pod Kureščkom, St Nicholas) and of scenes from the *Childhood of Christ*, *Passion* and *Life of the Virgin* and other subjects (1456; Muljava, Pilgrimage Church). That he was trained in the workshop run by his father, the leading artist in Carinthia, is revealed both in his style and in two wall paintings in Carinthia that he produced before moving to Laibach (*c.* 1435; St Lorenzen/Sillebrücken, St Laurentius; *c.* 1440; Liemberg an der Glan, St Jakob). In his principal works to the south of the Karawanken Alps, the wall paintings at Visoko pod Kureščkom (1443) and Muljava (1456) and those at St Peter's in Kameni vrh nad Ambrusom (1459), he showed himself a true product of the Villach workshop, and his personal style can be detected only in the lyrically conceived, melancholy saints. He apparently worked again with his father in Carinthia (*c.* 1452–5; Deutschgriffen, Jakobikirche). Johannes of Ljubljana is generally considered the best representative of the soft style in central Slovenian painting; he was capable of retaining the original freshness of the old forms that had been superseded elsewhere. Among the works of his successors, the fresco *Holy Sunday* (*c.* 1460; Crngrob, Pilgrimage Church, façade) is interesting in iconographical terms.

BIBLIOGRAPHY
F. Stelè: 'Der Maler Johannes concivis in Laybaco', *900 Jahre Villach* (Villach, 1960), pp. 81–113
J. Höfler: *Stensko slikarstvo na Slovenskem med Janezom Ljubljanskim in Mojstrom sv. Andreja iz Krašc* [Wall painting in Slovenia between Johannes of Ljubljana and the Master of Sv. Andrej at Krašce] (Ljubljana, 1985), pp. 14–15, 45–58
JANEZ HÖFLER

Johannes von Valkenburg [Valke] (*fl* 1299). German scribe, illuminator and Franciscan friar. He probably came from Valkenburg (Fr. Fauquemont) in what is now Limburg, Netherlands. He is known to have written, noted and illuminated two Cologne Franciscan graduals (Bonn, Ubib., MS. 384; Cologne, Erzbischöf. Diöz.- & Dombib., MS. 1B), for the title pages of each bear his name and portrait. Both works are dated 1299 (probably begun one or two years previously), were almost certainly created for use in his own Franciscan house and contain 22 miniatures, including the title pages. Except for one initial, the illuminations are consistently by one hand. Both manuscripts are works of great refinement, although the gradual in Cologne is more ornately decorated than the Bonn manuscript. Characteristic of Johannes's style are the small, supple figures set against tapestry-like ornamented backgrounds, deep, rounded folds of drapery and brilliant, enamel-like colours. These two manuscripts are particularly significant in being the first of a series of large choirbooks in the style typical of Cologne workshops of the first half of the 14th century. Stylistically, however, Johannes von Valkenburg's work stands apart from that of the later Cologne artists. It seems that he developed his style from a series of earlier Cologne manuscripts (*c.* 1280; Baltimore, MD, Walters A.G., MSS 41 and 111) that were also made for Franciscan use and were in turn influenced by contemporary Mosan manuscripts. He also assimilated stylistic elements from Mosan manuscripts of the 1290s and contemporary stained-glass painting in Cologne.

BIBLIOGRAPHY
G. Vitzthum: *Die Pariser Miniaturmalerei von der Zeit des hl. Ludwig bis zu Philipp von Valois und ihr Verhältnis zur Malerei in Nordwest-Europa* (Leipzig, 1907), pp. 198–203
J. Kirschbaum: 'Ein Kölner Chorbuch des frühen 14. Jahrhunderts', *Vor Stefan Lochner: Die Kölner Maler von 1300–1430*, ed. F. G. Zehnder (Cologne, 1977), pp. 76–80
G. Plotzek-Wederhake: 'Zur Stellung der Bibel aus Gross St. Martin innerhalb der Kölner Buchmalerei um 1300', *Vor Stefan Lochner: Die Kölner Maler von 1300–1430*, ed. F. G. Zehnder (Cologne, 1977), pp. 62–75
J. Oliver: 'The Mosan Origins of Johannes von Valke', *Wallraf-Richartz-Jb.*, xl (1978), pp. 23–37

Johannot. French family of illustrators and painters. [Charles-Henri] Alfred Johannot (*b* Offenbach am Main, 21 March 1800; *d* Paris, 7 Dec 1837) and his brother Tony Johannot (*b* Offenbach am Main, 9 Nov 1803; *d* Paris, 5 Aug 1852) were born to a French Protestant family of papermakers and in 1806 went to live in Paris with their father, François Johannot, who, despite financial ruin, was one of the first to try to import the new invention of lithography to France. Alfred and Tony were taught to draw by their father and their elder brother Charles (1795–1824), and they were thoroughly acquainted with the new techniques of illustration: lithography, woodcut and steel engraving. Between 1830 and 1850 French publishing was undergoing a complete change in taste and technique; books were being deluged with images, whether in the form of separately printed plates or more especially small vignettes integrated with the text. The Johannot brothers provided French publishers with thousands of illustrations for major publications of Romantic literature presented in demi-luxe editions for an increasingly large and cultivated public. Their technical virtuosity was allied to a fertile imagination, and they created a graphic style that, with its nervous and dramatic line, contrasting tones, movement, calculated distortion and extravagant expressiveness, could evoke the most powerful emotions. Some of the captions to their illustrations have become famous and reflect the drama of the images: 'Kill us then! I tell you I love him' (illustration by Tony for *La Châtelaine d'Orbec* by Lottin

de Laval, 1832); or, 'She resisted: I killed her!' (illustration by Alfred for *Antony* by Alexandre Dumas, 1831).

The brothers rapidly became successful, and their output covers virtually all illustrated Romantic literature. Walter Scott was their first success (complete works with 88 steel-engraved vignettes, 1826), followed by Fenimore Cooper (complete works, 1827), Lamartine (1830), Chateaubriand (1832), Rousseau (1832) and Byron (1833). They were habitués of Romantic literary circles, especially Charles Nodier's at the Bibliothèque de l'Arsenal, and were the favourite illustrators of the great contemporary authors: Victor Hugo (*Notre-Dame de Paris*, 1831), Balzac (*La Peau de chagrin*, 1831), Charles Nodier (*Histoire du roi de Bohême et de ses sept châteaux*, 1830) and also Alfred de Vigny, George Sand, Alexandre Dumas and Jules Janin. They also worked together on periodical illustrations.

Collaboration between the two brothers was total, and their signatures often appear together or even joined. Tony is usually considered a more lively artist than Alfred, who died of consumption at the age of 37. After his death the rate of Tony's output, far from slowing down, seemed to accelerate, losing in quality what it gained in quantity, at a time when the tide of Romantic illustrated books had passed its peak. In 1836 Tony produced 1000 vignettes for J.-J. Dubochet's great edition of *Don Quixote*. He also illustrated the classics, Molière, Boccaccio and Ariosto, and his last work was a contribution to Victor Hugo's complete works (1856–9).

The Johannot brothers also painted, regularly sending to the Salons canvases scarcely known except in the successful reproductions that were made after them. They also painted watercolours (Rouen, Mus. B.-A.), and took part in decorating the church of Notre-Dame-de-Lorette, Paris (*Life and Deeds of St Hyacinth* by Alfred Johannot, 1836), and the Musée Historique at Versailles (late 1830s). However, the Johannot brothers are chiefly remembered as the representatives *par excellence* of the Romantic vignette.

BIBLIOGRAPHY
H. Beraldi: *Les Graveurs du XIXe siècle: Guide de l'amateur d'estampes modernes* (Paris, 1885–92), viii, pp. 243–77
A. Marie: *Alfred et Tony Johannot, peintres, graveurs et vignettistes* (Paris, 1925)
Inventaire du fonds français après 1800, Bib. N., Cab. Est. cat., xi (Paris, 1960), pp. 406–48
G. Ray: *The Art of the French Illustrated Book, 1700 to 1914*, ii (New York, 1982), pp. 256–67
Histoire de l'édition française, iii (Paris, 1985), pp. 296–312

MICHEL MELOT

Johann von Gmünd. *See* PARLER, (2).

Johann von Troppau. *See* JAN OF OPAVA.

Johansen, John M(aclane) (*b* New York, 29 June 1916). American architect. He received his BSc (1939) and his MArch degree (1942) from Harvard University, Cambridge, MA. His early work for Marcel Breuer (1942) and Skidmore, Owings & Merrill in New York (1945–8), before founding his own office in 1948, helps explain his unique approach, which he has described as 'functional expressionism'. His early Warner House (1957), New Canaan, CT, recalls Philip Johnson's early residences, but his dramatic US Embassy (1963–4), Dublin, Ireland, employed richly moulded precast concrete elements to create an undulating wall. Subsequent buildings were equally dramatic, especially his Clowes Hall (1964; with Evans Woollen), Indianapolis, IN; the Morris Mechanic Theater and the Charles Center (1967), Baltimore, MD; the Goddard Library (1968), Clark University, Worcester, MA; and his Mummer's Theater (1970–71; now the Oklahoma Theater Center), Oklahoma City, OK. In 1968 he moved his office from New Canaan to New York and two years later formed a partnership with Ashok M. Bhavnani, which focused more on multi-storey housing and academic complexes. Johansen closed his practice in 1970.

WRITINGS
'Act and Behavior in Architecture', *Perspecta*, 7 (1961), pp. 43–50
'An Architecture for the Electronic Age', *Amer. Scholar*, xxxv (Summer 1966), pp. 461–71; also in *McLuhan, Hot and Cool* (New York, 1967)

BIBLIOGRAPHY
P. Heyer, ed.: *Architects on Architecture: New Directions in America* (New York, 1966)
P. Blake: 'The Mummer's Theater', *Archit. Forum*, cxxxiv/2 (1971), pp. 30–37

LELAND M. ROTH

Johansen, Viggo (*b* Copenhagen, 3 Jan 1851; *d* Copenhagen, 18 Dec 1935). Danish painter. He trained at the Kongelige Akademi for de Skønne Kunster from 1868 to 1875 under Jørgen Roed. In 1871 he began to visit the fishing hamlet of Hornbæk on the north coast of Zealand, not far from Copenhagen, often with painters such as Peter Severin Krøyer and Kristian Zahrtmann. Here Johansen painted pure landscapes, or alternatively figures from the village's traditional population, seen in their homes. *A Meal* (1877; Copenhagen, Hirschsprungske Saml.) shows an elderly fisherman seated at table eating potatoes, attended by his wife; dull daylight from a window in which a net is drying illumines the frugal interior and worn figures.

Johansen first visited Skagen, the northernmost town in Denmark, with Michael Ancher in 1875. Five years later both men married girls who were cousins from the town. Johansen and his family remained based around Skagen, but passed the winters in Copenhagen. *Kitchen Interior: The Artist's Wife Arranging Flowers* (1884; Skagen, Skagens Mus.) dwells on domestic details and textures, given point by a quiet, preoccupied figure, in a way reminiscent of the Dutch 17th-century interiors that Johansen had admired in the Royal Picture Gallery (now the Statens Museum for Kunst) in Copenhagen.

In 1885 Johansen visited Paris where he exhibited at the Salon. He saw works by the Impressionists and was particularly taken with Monet's paintings. This probably led to a series of experiments with the effects of light during the following years. In a characteristic work of this period, *Evening Interior: The Artist's Wife with Children Around the Table* (1887; Copenhagen, Ordrupgaardsaml.), his five children's faces shine out from a dim interior, lit by a huge kerosene lamp; the shimmering, rapid brush-strokes are clearly inspired by Impressionism. The naturalism of the cosy, homely scene in *Children's Bath* (1888; Copenhagen, Ordrupgaardsaml.) was prepared with the help of photography. Johansen's most ambitious work of

this kind was *Silent Night!* (1891; Copenhagen, Hirschs-prungske Saml.; see fig.), a large canvas, joyful if sentimental, depicting his family dancing around a Christmas tree, the decorations of which provide material for an Impressionist *tour de force*. Much of Johansen's work from Skagen in the late 1880s consists of sketches and studies, which demonstrate his immediate handling of light and colour. *Blind 'Poor Christian' Sitting in the Doorway of his House* (Skagen, Skagens Mus.) conveys a barren landscape, a humble interior, and an isolated figure on the doorstep between, sensing the heat of the sun—all in a few resolute brushstrokes of vibrant colour applied wet on wet. Another work with the same Impressionist qualities of sketchiness, rapid execution, and interest in light is *Christian Bindslev Ill in Bed* (1889; Skagen, Skagens Mus.). Like other Skagen painters, Johansen, influenced by the Norwegian Christian Krohg who worked there in the 1880s, often returned to figures lying in bed, resting, sleeping, or ill. The symbolic overtones of death may have been less important than the desire to depict the effect of sunlight in a room where a still model gave the scene human presence without being unduly distracting. Impressionism also affected his pure landscapes: the *Light Northern Nights* (1894; Copenhagen, Ordrupgaardsaml.) is an ambitious study of atmospheric phenomena at Skagen, in which the shimmering mother-of-pearl tones combine with the deep blue hues of the sky in a manner revealing an affinity between the painter and Monet.

As a mature artist, Johansen received a commission to paint the *Meeting of the Fellows of the Royal Academy of Fine Arts at Charlottenborg* (1904; Copenhagen, Stat. Mus. Kst.). While his firm handling of the difficult task of combining the many figures in the composition is admirable, the work has few other qualities. In his later years he also painted portraits, such as *Karl Madsen* (1927; Skagen, Skagens Mus.). The French critic Maurice Hamel regarded Johansen as the greatest Danish artist of the time, a judgement that holds little weight today. He was at his best when dealing with homely and intimate subjects taken from his own family life.

BIBLIOGRAPHY
K. Madsen: *Skagens malere og Skagens Museum* (Copenhagen, 1929), pp. 68–74
K. Voss: 'Friluftsstudie og virkelighedsskildring' [*Plein-air* studies and representation of real life], *Dan. Ksthist.*, iv (Copenhagen, 1974), pp. 151–8
——: *Skagensmalerne og deres billeder på Skagens Museum* (1975, rev. 1986), pp. 114–30
M. Hamel: 'La Peinture du nord à l'Exposition de Copenhagen', *Gaz. B.-A.* (Nov 1988), pp. 389–404
K. Voss: *Die Maler des Lichts: Nordische Kultur auf Skagen* (Weingarten, 1990)

JENS PETER MUNK

Viggo Johansen: *Silent Night!*, oil on canvas, 1.27×1.58 m, 1891 (Copenhagen, Hirschsprungske Samling)

Johansson, Cyrillus (*b* Gävle, 9 July 1884; *d* Lidingö, 20 May 1959). Swedish architect. He trained at Chalmers Institute of Technology in Göteborg and the Kungliga Akademi för de fria Konsterna in Stockholm (1900–08), before establishing his own practice, which specialized in housing, industrial building and urban planning. In addition he was a consultant architect for a series of small towns and communities and taught urban design at the Kungliga Akademi (1922–32). In his industrial buildings he combined rational planning with a sensitivity to aesthetics and materials: Stockholm Cotton Mill (1916) has internal load-bearing columns with brick façades of austere, classical simplicity. The Wine and Liquor Co. warehouse (1925) in Stockholm is a heavy triangular brick volume arranged around a semicircular courtyard and its concave roofs reflect the Chinese inspiration characteristic of Johansson's work. In the Värmlands Museum (1926–8) in Karlstad, he made use of curved copper roofs, latticework windows and a central arched recess, which are reminiscent of Beijing palace gateways. A number of water towers (e.g. Ljusdal, 1916; Vaxholm, 1923; Höganäs, 1932) present variations on brick or timber architectural styles, while Årsta railway bridge (1924) in Stockholm resembles a Roman aqueduct in concrete. Several urban-planning and housing schemes also develop the vernacular timber tradition. Blocks of flats in Stockholm, however, represent a truly urban architecture with close connections to contemporary neo-classicism of the period. Johansson's production also included ecclesiastical buildings (e.g. the Italianate Essinge Church, 1959) and such institutional buildings as the War Archives (1942) in Stockholm and the Institute of Bacteriology (1937) in Uppsala, both in his distinctive brick style.

<div align="center">WRITINGS</div>

Byggnaden och staden ur en arkitekts verksamhet [The building and the town from a Swedish architect's practice] (Stockholm, 1936) [Swed. and Eng. text]

<div align="center">BIBLIOGRAPHY</div>

Nordisk klassicism/Nordic Classicism, 1910–1930 (exh. cat., ed. S. Paavilainen; Helsinki, Mus. Fin. Archit., 1982) [Swed. and Eng. text]
H. O. Andersson and F. Bedoire: *Swedish Architecture: Drawings, 1640–1970* (Stockholm, 1986)

Jōhekikyo. *See* MASUDA.

John. Welsh family of painters.

(1) Gwen(dolen Mary) John (*b* Haverfordwest, 22 June 1876; *d* Dieppe, 3 Sept 1939). Her artistic training began in 1895 at the Slade School of Fine Art in London, allowing her to escape from her restrictive home life. She remained at the Slade until 1898, one of a group of women students that also included her future sister-in-law Ida Nettleship (1877–1907). In this stimulating environment her work developed rapidly, particularly after a trip to Paris in 1898, when she studied at the Académie Carmen under James Abbott McNeill Whistler.

Self-portraits and portraits of women are Gwen John's most common subjects. Early sitters included her younger sister *Winifred John* (Tenby, Mus. & Pict. Gal.) and student friends, often set against a domestic interior, also a continuing theme. In these portraits, influenced by Whistler, the figure is built up in painstaking detail with smooth, fluid brushstrokes and limpid finish. While living in London between 1899 and 1903 she produced several extremely fine and confident self-portraits, including two oil paintings (London, N.P.G., and London, Tate) and one pencil drawing (Aberystwyth, N. Lib. Wales; see fig.). After her return to France in August 1903, she produced a series of paintings and drawings of her travelling companion Dorothy (Dorelia) McNeill, such as *Dorelia in a Black Dress* (1903; London, Tate), completed in winter, when they were living in Toulouse. After settling in Paris in 1904, Gwen produced further self-portraits in various media, as well as paintings of quiet, empty interiors, among them a *Corner of the Artist's Room in Paris (with Flowers)* (1907–9; Sheffield, City Mus.). She supported herself mainly as an artist's model for British and American women artists and for Auguste Rodin, who became her lover. As well as providing financial support, Rodin gave her great encouragement in her drawing and painting. Later, when she began to exhibit at the Salons, she was recognized as a distinctive artist in her own right.

From 1910 until 1924 Gwen's principal patron was John Quinn, who bought everything she would consent to part with. Despite the attempts of her brother (2) Augustus John to persuade her to return to Britain, she lived in France until her death, returning only on rare visits, although her work was occasionally shown in London. At first she rented rooms in Paris, but in 1911

Gwen John: *Self-portrait*, pencil, 324×246 mm, 1900–03 (Aberystwyth, National Library of Wales)

she took a flat in nearby Meudon and eventually built a chalet studio there at 8, Rue Babie.

Following her conversion to Roman Catholicism in 1913, Gwen undertook a series of portraits of nuns at a convent in Meudon, including paintings of the founder of the nuns' order, Mère Poussepin, such as *Mère Poussepin (Hands in Lap)* (1913–21; U. Birmingham, Barber Inst.). Here the paint is drier and applied more thickly, giving softer lines. The use of colour becomes increasingly subtle, following her interest in the 'passages' from tone to tone. During the 1920s she produced a series of oil paintings in this new style; her chief subjects were local young women, although the still-life and interior remained important. The intimate nature of the subject-matter is reflected in the small dimensions of her oils and watercolours. The latter medium was used particularly for small figure drawings, including studies of members of the congregation at her local church, as in a *Stout Lady, and Others, in Church* (1913–23; Cardiff, N. Mus.). Although she became increasingly unwilling to exhibit her work, even when strongly urged to do so by her brother and by other admirers, she did make regular gifts of small sketches and watercolours to a neighbour, Véra Oumançoff, to whom she had become deeply attached. These included some of the economical but eloquent sketches made of peasant children during her periodic visits to Brittany.

During the last decade of her life Gwen became far less productive, perhaps because of her declining health, and she seems to have concentrated on tiny sketches, often barely larger than a postage stamp, and on developing her personal artistic theory in her notebooks. Both sketches and notes reveal an increasing interest in abstraction, an emphasis on the importance of shapes and forms and their interrelation, rather than on the subject itself. In this respect she acknowledged contemporary ideas in art theory, notably those of André Lhote, but her work in general remained intensely personal and aloof from fashion. At the outbreak of World War II she left Paris for the Channel coast but collapsed and died at Dieppe.

BIBLIOGRAPHY

S. Chitty: *Gwen John* (London, 1981)
M. Taubman: *Gwen John* (London, 1985)
Gwen John: An Interior Life (exh. cat., intro. A. D. Fraser Jenkins, essay C. Langdale; London, Barbican A.G., 1985)
C. Langdale: *Gwen John* (New Haven and London, 1987)
C. Lloyd-Morgan: *Gwen John Papers at the National Library of Wales* (Aberystwyth, 1988, rev. 1995)

(2) Augustus (Edwin) John (*b* Tenby, 4 Jan 1878; *d* Fordingbridge, Hants, 31 Oct 1961). Brother of (1) Gwen John. He was educated locally and at Clifton, but in 1894 he left Wales for London and studied for four years at the Slade School of Fine Art under Henry Tonks and Frederick Brown. Here he soon emerged as a bohemian figure as well as a highly gifted artist. The need to support Ida Nettleship (1877–1907), whom he married in 1901, led him to accept a post teaching art at the University of Liverpool. John Sampson, then University Librarian and an acknowledged expert on gypsies, became a friend and a major influence on him, introducing him to the Romany language and way of life. This led him to spend periods travelling with his growing family in gypsy caravans through Wales and England and inspired much of his

work before World War I, including a series of etchings depicting gypsy life.

Following the birth of their first child in 1902, the Johns moved to Essex so that Augustus could teach, paint and exhibit regularly in London, notably at the New English Art Club. In autumn 1902 he fell in love with Gwen John's friend Dorothy McNeill, to whom he gave the gypsy name Dorelia, and she became his most important model and inspiration, as in *Dorelia in the Garden at Alderney* (1911; Cardiff, N. Mus.; see fig.). After Ida's death in childbirth in 1907, Dorelia became the artist's wife in all but name. The family settled at Alderney Manor, Dorset, in 1911. In 1927 they moved to Fryern Court, Fordingbridge, Hants, which became their permanent home. John, however, continued to spend much time in London, where he maintained a studio.

Augustus John: *Dorelia in the Garden at Alderney*, oil on canvas, 2.01×1.02 m, 1911 (Cardiff, National Museum of Wales)

John's early work is characterized by his exceptional drawings, notably of contemporaries at the Slade including his sister and her friends. His work in oil at this period was still heavily influenced by Old Master painters, notably Peter Paul Rubens, as witness such paintings as *Smiling Woman* (*c.* 1908; London, Tate), a portrait of Dorelia. His visits to North Wales with James Dickson Innes revealed a rich talent for landscape painting and brought out a more modern and impressionistic idiom in his work, for example in *Llyn Treweryn* (1912; London, Tate). The same style, developed further with more vivid colour, can be seen in the paintings made in the south of France, where he spent long periods in the 1920s.

After World War I, when he was briefly employed by the Canadian government as a war artist in France and then painted delegates at the peace conference in Paris, John concentrated on portraiture. Although his portraits were often controversial and sometimes rejected or even defaced by their subjects, he was lionized by society and painted many of the best-known figures of the day, from international politicians (e.g. *Gustav Stresemann*, 1925; Buffalo, NY, Albright–Knox A.G.) to film stars. Bombarded with commissions and unable to refuse, especially since he had a large family to support, he found his time increasingly consumed by this aspect of his work and became frustrated by his inability to develop his personal artistic interests. Hence many of his highly ambitious figure compositions and large-scale imaginative projects, begun between the wars, were left unfinished at his death. A gifted draughtsman, he drew and painted with speed and facility, thus producing a vast quantity of work, albeit of variable quality.

John was made an RA in 1928, resigned in 1938 but was reinstated in 1940. In 1942 he was awarded the OM for services to art, but he remained modest about his achievements, commenting that history would define him as Gwen John's brother.

WRITINGS
Chiaroscuro: Fragments of Autobiography (London, 1952)
Finishing Touches (London, 1964)

BIBLIOGRAPHY
C. Lloyd-Morgan: *Augustus John Papers at the National Library of Wales* (Aberystwyth, ?1966)
J. Rothenstein: *Augustus John* (London, 1967)
M. Easton and M. Holroyd: *The Art of Augustus John* (London, 1974)
M. Holroyd: *Augustus John: A Biography*, 2 vols (London, 1974–5); rev. as *Augustus John: The New Biography* (London, 1976)
Augustus John (exh. cat. by M. Easton and R. John, London, N.P.G., 1975)
Augustus John: Studies for Compositions (exh. cat. by A. D. Fraser Jenkins, Cardiff, N. Mus., 1978)
Some Miraculous Promised Land: J. D. Innes, Augustus John and Derwent Lees in North Wales, 1910–1913 (exh. cat. by E. Rowan, Llandudno, Mostyn A.G., 1982)

CERIDWEN LLOYD-MORGAN

John, Duke of Bedford. *See* LANCASTER, (1).

John, King of Bohemia. *See* LUXEMBOURG, (2).

John I, King of Portugal. *See* AVIZ, (1).

John [Johann] **I**, Prince of Liechtenstein. *See* LIECHTENSTEIN, House of (7).

John II (Komnenos). *See* KOMNENOS, (1).

John II, Duke of Bourbon. *See* BOURBON, §I(1).

John II, King of France. *See* VALOIS, (1).

John II (Kasimir), King of Poland. *See* VASA, (4).

John II, King of Portugal. *See* AVIZ, (4).

John [Johann] **II**, Prince of Liechtenstein. *See* LIECHTENSTEIN, House of (9).

John III, King of Poland. *See* JOHN SOBIESKI.

John III, King of Portugal. *See* AVIZ, (7).

John IV, King of Portugal. *See* BRAGANZA, (3).

John V, King of Portugal. *See* BRAGANZA, (7).

John VI, King of Portugal. *See* BRAGANZA, (11).

John VII, Pope (*b* Rome, *c.* 687; elected 1 March 705; *d* ?Rome, 18 Oct 707). Pope and patron of Greek descent. During his pontificate he sponsored the repainting of large areas of S Maria Antiqua (*see* ROME, §V, 19(ii)). He also donated an ambo with an inscription proclaiming him to be 'the servant of Mary'. In 705–7, he built an oratory (destr.) dedicated to the Virgin in Old St Peter's (*see* ROME, §V, 14(i)(b)). Both the wall paintings in S Maria Antiqua and the mosaics in the oratory are probably by Byzantine artists.

BIBLIOGRAPHY
P. Romanelli and P. J. Nordhagen: *S Maria Antiqua* (Rome, 1964)
P. J. Nordhagen: 'The Mosaics of John VII (A.D. 705–707)', *Acta Archaeol. & A. Hist. Pertinentia*, ii (1965), pp. 121–66
W. Oakeshott: *The Mosaics of Rome from the Third to the Fourteenth Centuries* (London, 1967), pp. 155–9
P. J. Nordhagen: 'The Frescoes of John VII (A.D. 705–707) in S Maria Antiqua in Rome', *Acta Archaeol. & A. Hist. Pertinentia*, iii (1968), pp. 1–125
J. Richards: *The Popes and the Papacy in the Early Middle Ages* (London, 1979)

SUSAN PINTO MADIGAN

John XXII, Pope [Jacques Duèse] (*b* Cahors, 1240–49; elected 1316; *d* Avignon, 4 Dec 1334). French pope and patron. His reign was the longest, most controversial and most significant of any of the Avignon popes. Held in great esteem by many and loathed in equal measure by his opponents, he was responsible for establishing the administrative and financial centralization of the Church, his most lasting contribution. He also participated in the elaboration of canon law and made provocative decisions on critical issues. He commissioned several important works of art.

Before his election to the papacy, John had served as a professor of canon law, Chancellor of the King of Naples, Bishop of Avignon and Cardinal of Porto. Thoroughly versed in financial matters, he was also known as the 'Banker of the Church', and was responsible for restoring its finances. Although already elderly at the time of his accession, he intervened vigorously in political and social issues that touched the Church. Most notably, he entered the disputed election of the Holy Roman Emperor and ignited a feud with Louis of Bavaria that sapped the energies of the Church for years to come. At the same time he forcefully opposed those who challenged Church

doctrine and the Inquisition was at its most active during his term (Mollat). Ironically, John's most controversial theological stance, which stated that no soul could enjoy the Beatific Vision until after the Last Judgement, was itself condemned by many as heresy and was retracted by John's successor.

John's artistic legacy is far less controversial. He was responsible for the extensive restoration and rebuilding of the episcopal palace in Avignon, a structure that later served as the basis for the Palais des Papes, and he also initiated a papal library. During his papacy two papal châteaux were constructed in the nearby villages of Sorgues and Châteauneuf-du-Pape; both structures were decorated with beautifully painted cloths. Letters dated 1325 attest to the Pope's commission of mosaics (destr.) for the façade of S Paolo fuori le Mura in Rome, executed by PIETRO CAVALLINI. The most spectacular work of art associated with Pope John XXII is his magnificent tomb, probably carved by English sculptors, which rests in Avignon Cathedral.

BIBLIOGRAPHY

G. Villani: *Cronica* (early 14th century); ed. L. Muratori, Rerum Italicum Scriptores, xiii (Rome, 1723–51)

E. Baluze, ed.: *Vitae paparum Avenionensium*, 2 vols (Paris, 1693, rev. 1914–27)

G. Mollat: *Les Papes d'Avignon, 1305–78* (Paris, 1912, rev. 9/1950)

L. H. Labande: *Le Palais des Papes d'Avignon*, 2 vols (Marseille, 1925)

Y. Renouard: *La Papauté d'Avignon, 1305–1403* (Paris, 1954)

PAULA HUTTON

John, Jiří (*b* Třešť, 6 Nov 1923; *d* Prague, 22 June 1972). Czech painter and printmaker. He was a locksmith before he studied at the Academy of Decorative Arts in Prague (1946–51). His rural background led at first to a fascination with civilizational motifs. In his painting as well as print-making (mostly drypoint), he interpreted an urban landscape, objects and nature in the literary sense of still-life as 'nature morte'; he was intrigued by subject-matter from nature, which he showed as a continuous process of creation and demise of organic and inorganic substances over time. A monumentally rendered section of landscape is usually dominated by a specific detail that defines the content of what we see: a cleft in the earth's crust, mineral crystals, falling fruit or drops of dew; the movement of an insect in the ridges of a field; footsteps on a seashore; the germination and disintegration of a plant. Despite his intimate approach, his paintings and prints show the world and the universe, humanity and nature as one.

John used an interpretation of time and space inspired by the Cubists but did not hesitate also to use elements of a magic realism. His rhythmic brushwork was based on a pattern of fine linear drawing. In prints he modelled with dense hatching, in painting he alternated local tones and half-tones. His reputation as an artist was enhanced by a number of international prizes and his appointment as a professor at the Academy of Fine Arts in Prague. His later works brought maximum simplification of his means of expression. His paintings and prints are represented in a number of private and public collections in Europe and the USA.

BIBLIOGRAPHY

J. Kotalík: 'Zwei Generationen tschechoslowakischer Kunst', *Kunst unserer Zeit—Malerei und Plastik*, W. Grohman and others (Cologne, 1966), p. 220

J. Šetlík: *Jiří John* (Prague, 1969)

Dílo Jiřího Johna [The work of Jiří John] (exh. cat., intro J. Šetlík; Brno, House A., 1979)

J. Zemina: *Jiří John* (Prague, 1988)

Europa, Europa (exh. cat. by R. Stanislavski and others, vols i and iii, Bonn, 1994)

JIŘÍ ŠETLÍK

John, Master (*fl* 1544–*c*. 1550). Painter, perhaps of German origin. He is known by two portraits: one a three-quarter length of *Mary Tudor*, inscribed and dated 1544, the other, obviously by the same hand, a full-length of *Lady Jane Grey*, *c*. 1550, formerly identified as Catherine Parr (both London, N.P.G.). The first is presumably the portrait for which 'one John' was paid £5 in November 1544 and entered in the princess's privy purse accounts. Both portraits are in the Holbein tradition, but the artist has a distinctive iconic style using a gold-leaf ground. Mary clasps her hands lightly before her in almost exactly the manner of Holbein's *Anne of Cleves* (Paris, Louvre); Lady Jane's beringed fingers are entwined in the Holbein manner, and she stands on a turkey carpet.

Holbein's will of October 1543 was witnessed by a Master John of Antwerp, goldsmith, who received a bequest of £6. This John has been identified with Holbein's *Hans of Antwerp* (Windsor Castle, Berks, Royal Col.), evidently a merchant. It would seem possible that the man in the will was in fact the 'Master John' who painted Princess Mary and Lady Jane; he presumably worked in the master's studio, certainly painted in his style and was commissioned to paint the king's eldest child in the year after the master's death.

BIBLIOGRAPHY

O. Millar: *The Tudor, Stuart and Early Georgian Pictures in the Royal Collection*, i (London, 1963), p. 59, no. 29

R. Strong: *The English Icon: Elizabethan and Jacobean Portraiture* (London, 1969), pp. 8, 64, 75–6

——: *Tudor and Stuart Portraits*, i (London, 1969), pp. 75–6, 78–9, 208–9

MARY EDMOND

John, Sir William Goscombe [Goscombe John, William] (*b* Cardiff, 21 March 1860; *d* London, 15 Dec 1952). Welsh sculptor. He trained under his father Thomas John (1834–93) in 1874–81, executing wood-carving and marquetry details for the rebuilding of Cardiff Castle by William Burges for the 3rd Marquess of Bute. Burges encouraged his studies at the Cardiff School of Art. In 1881–6 he worked with Burges's associate, the London sculptor Thomas Nicholls. Goscombe John learnt clay-modelling techniques from Jules Dalou at the Lambeth City and Guilds School of Art (1881–4) and encountered the New Sculpture movement of Frederic Leighton and Hamo Thorneycroft at the Royal Academy Schools (1884–7). In 1886–7 he worked for Charles Bell Birch (1832–93). He won the Royal Academy Gold Medal Travel Scholarship with *Parting* (1889; plaster, Cardiff, N. Mus.) and spent 1890–91 in Paris, where he modelled *Morpheus* (1890; bronze, Cardiff, N. Mus.), showing the influence of Rodin.

On Goscombe John's return to London, Lord Bute commissioned *St John the Baptist* (1892–5; bronze, Cardiff, N. Mus.), but it was *The Elf* (1898; bronze, Cardiff, N. Mus.; marble, Glasgow, A.G. & Mus.) that led to his becoming an ARA in 1889. His fine modelling and strong

composition made him a leading member of the younger generation of the New Sculpture movement. He executed numerous small-scale works in marble, bronze and precious metals. Among his most notable monumental works are the *7th Duke of Devonshire* (1901; bronze, Eastbourne, Devonshire Place), the *3rd Marquess of Salisbury* (1906; bronze, London, Westminster Abbey), *Viscount Tredegar* (1906; bronze, Cardiff, Gorsedd Gdns) and the Port Sunlight war memorial (1919–21; granite and bronze). Goscombe John became an RA in 1909 and was knighted in 1911. He helped to found the National Museum of Wales in 1912.

BIBLIOGRAPHY

M. H. Spielmann: *British Sculpture and Sculptors of Today* (London, 1901)
K. Parkes: *Sculpture of Today*, 2 vols (London, 1921)
Goscombe John at the National Museum of Wales (exh. cat., ed. F. Pearson; Cardiff, N. Mus., 1979)

FIONA PEARSON

John [Johann] **Adam Andreas**, Prince of Liechtenstein. *See* LIECHTENSTEIN, House of (3).

John de Siferwas [Cyfrewas; Siferwast; Syfrewas] (*b* 1360–65; *d c.* 1430). English illuminator. He is the earliest English illuminator whose career may be traced in detail and whose work is signed. A member of an Anglo-Norman family holding land in southern England, he is first recorded in May 1380 when he was made acolyte by the Bishop of Winchester. Siferwas was then a member of the Dominican convent at Guildford, but an entry in the register of the Archbishop of Canterbury indicates that by September he had been transferred to the London house of Dominicans. In 1382 he was ordained priest in St Paul's Cathedral. This is when he is most likely to have learnt his art, and the documentary evidence suggests that he trained in a London workshop. However, his surviving works were made for patrons in the West Country, where he probably settled around 1400. The last document to mention him, the will of a Somerset cloth merchant, shows that he remained in this region until 1430, although he retained contacts in London, and in 1420 he was a beneficiary of the will of a citizen of London.

Siferwas's earliest work is the Lovell Lectionary (London, BL, Harley MS. 7026) commissioned by Lord John Lovell (*d* 1408) for Salisbury Cathedral. The principal miniature in this manuscript is an unusual scene showing the artist presenting his work to Lovell (fol. 4*v*). Comparison of Siferwas's appearance in this miniature with self-depictions in his other major work, the Sherborne Missal (Alnwick Castle, Northumb., on dep. London, BL, Loan MS. 82; pp. 47, 216, 276), shows that these are true self-portraits and are perhaps the earliest examples of naturalistic self-portraiture by an English painter. These and other self-advertisements, such as his signatures and the use of a personal coat of arms, suggest that Siferwas was not a conventional illuminator of the time. His attitude may be explained partly by his family background and partly through familiarity with contemporary artistic developments abroad.

The decoration in the Lovell Lectionary confirms Siferwas's awareness of continental art. The border style, characterized by its variety and colourful twisting forms,

John de Siferwas: Historiated initial page from the Sherborne Missal, begun *c.* 1404 (Alnwick Castle, on deposit London, British Library, Loan MS. 82, p. 216)

is not English in appearance but may derive from manuscripts made in France *c.* 1400 for Jean, Duc de Berry. The margins of some pages contain tall architectural structures standing on pedestals, a feature of contemporary Lombard illumination. The stiff, inelegant figure style, however, is similar to manuscripts made for Westminster Abbey and clearly betrays Siferwas's English origins.

Siferwas's finest work is the Sherborne Missal (see fig.), commissioned jointly by Robert Bruynyng, Abbot of Sherborne, and Richard Medford, Bishop of Salisbury. Heraldic evidence indicates that work began *c.* 1404 and much of it was finished by 1407 when Medford died. The elaborate decoration includes an extensive sequence of historiated initials illustrating the principal Gospel readings, and borders that are a development of those in the Lovell Lectionary. More than 60 coats of arms and over 30 species of birds feature in the manuscript, mostly labelled with their names written in English. These and other inscriptions on scrolls throughout the border decoration suggest that Siferwas was not only concerned with decorative effect, but held a scholarly attitude towards his art, as befitted a member of his order. His style in the Missal is more refined and neater than in the Lectionary.

It also reveals strong German influence; for example, the soft modelling of the figures is similar to the work of contemporary painters from Cologne such as the Master of St Veronica. The documented presence of German artists in London c. 1400 may account for this.

Siferwas was the greatest and most imaginative exponent of the Late Gothic style in England. His work, however, made little impact on contemporaries, perhaps because his sphere of activity was removed from the main centres of production.

BIBLIOGRAPHY

J. A. Herbert: *The Sherborne Missal*, Roxburghe Club (Oxford, 1920)

M. Rickert: *Painting in Britain: The Middle Ages*, Pelican Hist. A. (Harmondsworth, 1954, rev. 2/1965), pp. 162–6

R. Marks and N. Morgan: *The Golden Age of English Manuscript Painting, 1200–1500* (London, 1981), pp. 23–6, 96–9

B. Yapp: *Birds in Medieval Manuscripts* (London, 1981)

THOMAS TOLLEY

John-George [Johann-Georg] **I**, Elector of Saxony. *See* WETTIN, (6).

Jean le Bon, King of France. *See* VALOIS, (1).

John of Battle [de Bello; de la Bataile] (*fl* 1278; *d* 1300). English architect. From June 1278 to 1280 he was principal assistant to Walter of Hereford at Vale Royal Abbey, Ches, a Cistercian foundation of Edward I. John is next certainly recorded from 1291 to 1293, as master mason of five of the Eleanor crosses (*see* CROSS, §II, 3), those at Stony Stratford, Woburn, Dunstable, St Albans and Northampton. All were constructed by task-work, and for the last two, at least, Simon Pabenham was jointly responsible. Each of Battle's crosses cost over £100; the Northampton, or Hardingstone, cross is the only one to survive. In its use of the ogee arch, polygonal ground-plan, miniature architectural detailing and high degree of surface articulation, as well as its delight in novel tracery forms, the Hardingstone cross adumbrates many themes that were to be developed in buildings of the Decorated style. The influence of John's St Albans cross may be reflected in the shrine base of the saint in the Abbey Church (now the cathedral). He left houses in London and St Albans.

BIBLIOGRAPHY

Harvey

B. Botfield, ed.: *Manners and Household Expenses of England* (London, 1841)

H. M. Colvin, ed.: *The History of the King's Works*, i (London, 1963), pp. 483–4

J. Bony: *The English Decorated Style: Gothic Architecture Transformed, 1250–1350* (Oxford, 1979), pp. 22–3

PHILLIP LINDLEY

John of Lancaster, Duke of Bedford. *See* LANCASTER, (1).

John of Neumarkt. *See* JAN OF STŘEDA.

John of Padua [Johannes de Padua; Johannes de Padwey; John de Padoa; John Padoa]. Italian architect, engineer, artificer and musician active in England. He is known only from a reference in the London will (1551) of a Murano glassmaker, in which he was described as 'architect and servant of the king's majesty', and in Exchequer records (1543–57), as the recipient of fees and an annuity. In the Exchequer payments he was invariably designated an architect but the grant of his fee on 30 June 1544 and renewals in 1549 and 1554 state that it was for his past and future services to the king in architecture and music. He was listed among the 'artificers' at the funeral of Henry VIII, King of England, in 1547; in 1550–51 he appeared as 'John de Padoa Engineer'; in the list of annuities drawn up shortly after 1559 (in which his name was cancelled) he was named 'Johannes de Padwey music' and in the royal establishment list of 1552 he was entered as 'Deviser of buyldings John Padoa'. This last title and that of 'engineer' may indicate that he had played some part in military works for the Scottish war of 1547–50 or the French war of 1549–50, when all available artificers were called into service; otherwise it is only possible to surmise that, in view of his knowledge of music, his architectural role may have been in the creation of pageants. John of Padua's annual fee, albeit only half that of the 'deviser' Stefan von Haschenperg, suggests that his activities, although now obscure, were substantial.

BIBLIOGRAPHY

E. Auerbach: *Tudor Artists* (London, 1954), pp. 57, 180

G. Webb: 'The Office of Devisor', *Fritz Saxl, 1890–1948. A Volume of Essays from his Friends in England*, ed. D. J. Gordon (London, 1957), pp. 297–308

D. R. Ransome: *The Administration and Finances of the King's Works, 1485–1558* (diss., U. Oxford, 1960), pp. 179–91

H. M. Colvin, ed.: *The History of the King's Works*, iii/1 (London, 1975), pp. 43–5

MARTIN BIDDLE

John of St Albans [de Sancto Omero; de Flandria] (*fl* 1249–58). English painter and sculptor. He was Master Carver to Henry III from 1249, when he was in charge of the painting of the King's wardrobe in Westminster Palace (*see* LONDON, §V, 3(i)(b)). He was ordered to make a great lectern for the new chapter house at Westminster Abbey (*see* LONDON, §V, 2(i)) like that in the chapter house at St Albans. In 1251 he was granted a robe of the King's gift. He received a winter robe on 22 December 1257, when he was described as 'sculptor of the king's images', a title that recognizes the emergence of the specialist figure-sculptor. On 2 May 1258 he was said to have worked long on the King's 'candelabrum'. Lethaby plausibly suggested that he would have been the master sculptor for the lost imagery of the north transept portal of Westminster Abbey, and Noppen has attributed the censing angels of the south transept triforium spandrels to him. John may have been one of the leading sculptors involved in the forging of a new style in which the influence of Wells Cathedral is modified in the light of contemporary French imagery.

BIBLIOGRAPHY

Calendar of Close Rolls: 'The Reign of Henry III 1247–51', pp. 203, 495; 'The Reign of Henry III 1256–59', pp. 179, 217

W. R. Lethaby: *Westminster Abbey and the King's Craftsmen* (London, 1906), p. 245

——: *Westminster Abbey Re-examined* (London, 1925), pp. 184–94

J. G. Noppen: 'Sculpture of the School of John of St Albans', *Burl. Mag.*, li (1927), pp. 71–80

L. Stone: *Sculpture in Britain: The Middle Ages*, Pelican Hist. A. (Harmondsworth, 1955, rev. 1972), pp. 3, 122, 155

PHILLIP LINDLEY

Johns, Jasper (*b* Augusta, GA, 15 May 1930). American painter, sculptor and printmaker. With Robert Rauschenberg, he was one of the leading figures in the American Pop art movement, and he became particularly well known for his use of the imagery of targets, flags, maps and other instantly recognizable subjects. Although he attended the University of South Carolina for over a year, and later briefly attended an art school in New York, Johns is considered a self-taught artist. His readings in psychology and philosophy, particularly the work of Wittgenstein; his study of Cézanne, Duchamp, Leonardo, Picasso and other artists; and his love of poetry have all found expression in his work. His attention to history and his logical rigour led him to create a progressive body of work.

1. EARLY WORKS, TO *c.* 1960. In 1954, after a dream, Johns painted a picture of the American flag. At the time he was living in New York, as a struggling young artist. During the three years that followed, Johns painted more flags, as well as targets, alphabets and other emblematic, impersonal images. None of this work was formally exhibited until 1957, when the *Green Target* (1955; New York, MOMA) was included in a group show at the Jewish Museum in New York. The dealer Leo Castelli gave Johns a one-man show at his gallery the following year. Johns's paintings were sold to major private collectors, and three of his paintings were purchased by Alfred Barr for MOMA.

During most of this period Johns lived in the same building as Robert Rauschenberg. The two were close friends, saw each other's work daily and had a considerable influence upon one another. Both Johns and Rauschenberg, in different ways, reintroduced figurative subject-matter to painting, and they are credited with inspiring the transition from Abstract Expressionism to Pop art. *Target with Four Faces* (1955; New York, MOMA; see fig. 1) exemplifies many of the concerns of Johns's earliest paintings. The target focuses attention on the theme of viewing: a target is something to see clearly, something to aim at, a visual display. Here the simple image is executed with deceptive complexity: the target itself in encaustic on collage, a difficult technique, which yields for Johns a rich, sensuous surface. Above the target are mounted four serial plaster casts of a single human face, while a hinged wooden lid offers the possibility of shutting away the disturbing faces. The painting provokes questions of perception, which many of Johns's early paintings seemed to raise by their very existence.

Johns said that he chose to paint flat symbols such as flags (e.g. *Flag*, 1965; *see* COLOUR INTERACTION, colour pl. VIII, fig. 1) and targets because he did not have to design them, because they were 'things the mind already knows. That gave me room to work on other levels.' The ambiguities and contradictions inherent in painting an abstraction with such a beautiful and painterly technique became the focus of critical comment. Although Johns had reintroduced the recognizable image to painting, he had done so in a paradoxical way.

Through Rauschenberg, Johns had met the composer John Cage in 1954. He met the artist Marcel Duchamp in 1959. Johns began his extensive reading of the philosopher Ludwig Wittgenstein in 1961. Through Cage, Johns met Merce Cunningham and for many years worked with the

1. Jasper Johns: *Target with Four Faces*, encaustic on newspaper over canvas surmounted by four tinted plaster faces in wooden box with hinged front, overall dimensions with box open 853×660×76 mm, 1955 (New York, Museum of Modern Art)

Merce Cunningham Dance Company; he designed costumes, and on one occasion designed a set based on Duchamp's *Large Glass*.

Johns had incorporated plaster casts in his earliest paintings, and in 1958 he began to make sculptures of everyday objects, such as lightbulbs and torches. Fashioned in actual size, these sculptures at first glance appeared to be castings, although they were not. The sculptures thus raised questions about what the artist had done, in a manner similar to the paintings of that period. The influential *Painted Bronze* (1960; Basle, Kstmus.), a sculpture of two Ballantine ale cans, was highly controversial at the time it was first shown. The ale cans were in fact fabricated in a complicated way: 'Parts [of the sculpture] were done by casting, parts by building up from scratch, parts by moulding, breaking, and then restoring. I was deliberately making it difficult to tell how it was made.' The artist's humour was evident in such sculptures as *The Critic Smiles* (1959; artist's col.), a toothbrush in which teeth are substituted for bristles. The piece also exemplifies Johns's dictum that 'You can see more than one thing at a time.' In 1964 he painted *According to What* (priv. col., see 1977 exh. cat., pl. 115), a virtual catalogue of representational techniques that included casts of the human figure and imagery drawn from several of his earlier works. Throughout his career he was to execute these major works, which summarize his concerns and imagery at that time. This painting, in turn, led to a series of large-scale works of an increasingly abstract nature.

2. Jasper Johns: *Gray Alphabets*, lithograph, 918×611 mm, 1962 (New York, Museum of Modern Art)

Johns made his first print in 1960, when Tatyana Grosman, founder of Universal Limited Art Editions, brought lithographic stones to his studio. In subsequent years, printmaking became an increasingly important part of the artist's work (see fig. 2). The imagery of Johns's prints reflects that of his paintings, but the relationship between the two is not simple. 'The paintings and the prints are two different situations', he said in 1969. 'Primarily, it's the printmaking techniques that interest me ... a means to experiment in the technique.' He has also said, 'I like to repeat an image in another medium to observe the play between the two: the image and the medium.'

2. THE CROSS-HATCHING PICTURES. In 1972 *Untitled* (Cologne, Mus. Ludwig), a difficult painting in four panels, introduced a new style: the cross-hatching pattern, which Johns employed in so many ways and with such vigour during the next decade. The mathematical precision underlying Johns's cross-hatching pictures is exemplified by *Scent* (1973–4; Aachen, Neue Gal.). Here, three canvases painted in secondary colours are seen to exhibit a complex underlying order. First, one notices that no cross-hatched area in green, orange or purple ever abuts an adjacent area of the same colour. Then too, the canvas panels differ in technique: one panel is painted on sized canvas, the

second on unsized canvas and the third painted in encaustic. Finally, each canvas is divided into three vertical panels, but only the centre panel is unique. Thus if the panels of the first canvas were labelled ABC, the second canvas would be CDE, and the third EFA. Most of Johns's cross-hatching paintings carry a similar underlying idea about the mathematical manipulation of an image, or about the transition across the borders and junctions of the image. These paintings continue the concern with perception that marked Johns's earliest work, while extending those concerns in a precise but apparently impersonal way.

3. WORKS OF THE 1980s. From the start of his career Johns always focused attention away from himself and on to the work. He emphasized the ready-made and impersonal elements of his creations: the pre-existing imagery, the stencilled lettering, the unmixed primary colours, things that were 'not mine, but taken'. In interviews he explicitly denied that his work was to be seen as a reflection of himself or his feelings. In 1981 Johns began a period of more directly personal, self-referential work. *Between the Clock and the Bed* (1981; New York, MOMA) referred to a self-portrait by Edvard Munch of 1949 of the same name (Oslo, Munch-Mus.), yet Johns's painting was entirely abstract. It suggested a self-portrait without making one explicitly. The paintings that followed, such as *Perilous Night* (1982; priv. col., see Francis, pl. 110) and *Racing Thoughts* (1983; New York, Whitney; see fig. 3), were *trompe l'oeil* collages of distinctly personal reference. *Racing Thoughts* presents a view from the artist's bath, complete with taps, wicker linen basket and a framed Barnett Newman print; but additional elements, such as an iron-on transfer Mona Lisa, a photo-puzzle of Leo Castelli, a skull with a Swiss avalanche warning sign, details from Matthias Grünewald's Isenheim altarpiece, pottery by the American ceramicist George Ohr (1857–1918) and a German porcelain vase with the profiles of Queen Elizabeth II and Prince Philip, are unquestionably personal to the artist.

In 1985–6 Johns executed four related paintings, *The Seasons*, which again appeared to summarize concerns, techniques and imagery. The paintings were begun when he moved into a new studio in French St Martin; they derive their initial inspiration from a painting of 1936 by Picasso, *The Minotaur Moves his House*, and very likely from the painting *The Shadow* (1953) as well. Each painting by Johns shows the artist's shadow cast on a wall; the minotaur's cart contributes the ladder and rope, as well as stars and the branch of a tree. These elements, 'taken not mine', are repeated and recombined in the four paintings, along with prior Johnsian imagery: the Mona Lisa, American flags, Ohr cups and the 'device circle' swept out by a human hand and arm.

Johns soon ceased to be closely identified with Pop art, Minimalism or any other movement. Independent and determinedly self-referential, he became closest in spirit to the tradition of the philosopher-painters such as Leonardo, Cézanne and Duchamp, each of whom has been referred to directly in Johns's own work.

Johns's work always fetched high prices: in 1973 his *Double White Map* (1965) was auctioned for £240,000; in 1980 the Whitney Museum of American Art in New York

3. Jasper Johns: *Racing Thoughts*, encaustic and collage on canvas, 1.22×1.91 m, 1983 (New York, Whitney Museum of American Art)

paid £1 million for *Three Flags* (1958). In 1986 *Out the Window* (1959) was sold for £3.63 million to a private collector. In each instance the price set a record for work by a living American artist.

BIBLIOGRAPHY

J. Cage: 'Jasper Johns: Stories and Ideas', *Jasper Johns* (exh. cat., ed. A. Solomon; New York, Jew. Mus., 1964)
M. Kozloff: *Jasper Johns* (New York, 1969)
Jasper Johns: Prints, 1960–1970 (exh. cat., text by R. S. Field; Philadelphia, PA, Mus. A., 1970)
B. Rose: 'The Graphic Work of Jasper Johns', *Artforum*, vii (1970), pp. 39–45
Technics and Creativity: Gemini G.E.L. (exh. cat., ed. R. Castleman; New York, MOMA, 1971)
R. Bernstein: 'Jasper Johns's "Decoy"', *Prt Colr Newslett.* (Sept–Oct 1972), pp. 83–4
L. Steinberg: 'Jasper Johns: The First Seven Years of his Art', *Other Criteria: Confrontations with Twentieth-century Art* (New York, 1972)
B. Rose: 'Decoys and Doubles: Jasper Johns and the Modernist Mind', *A. Mag.*, 1/9 (1976), pp. 68–73
Foirades/Fizzles (exh. cat., ed. J. Goldman; New York, Whitney, 1977)
Jasper Johns (exh. cat., text by M. Crichton; New York, Whitney, 1977)
R. S. Field: *Jasper Johns: Prints, 1970–1977* (London, 1978)
Jasper Johns: Working Proofs (exh. cat., ed. C. Geelhaar; Basle, Kstmus., 1979)
R. Francis: *Jasper Johns* (New York, 1984)
D. Shapiro: *Jasper Johns Drawings, 1954–1984* (New York, 1984)
Jasper Johns: A Print Retrospective (exh. cat., text by R. Castleman; New York, MOMA, 1986)
Jasper Johns: The Seasons (exh. cat., text by J. Goldman; New York, Leo Castelli Gal., 1987)
G. Boudaille: *Jasper Johns* (New York, 1989)
Dancers on a Plane: Cage, Cunningham, Johns (exh. cat. by S. Sontag and others, London, Anthony d'Offay Gal., 1989)
The Drawings of Jasper Johns (exh. cat., Washington, DC, N.G.A.; London, Hayward Gal.; 1990)

MICHAEL CRICHTON

John Sobieski [Jan III; Jana III; John III], King of Poland (*b* Olesko, nr Lwów, 17 Aug 1629; *reg* 1674–96; *d* Wilanów, nr Warsaw, 17 June 1696). Polish ruler and patron. He studied philosophy at the Jagiellonian University in Kraków (1643–6), after which he travelled (1646–8) to Germany, the Netherlands, France and England. In 1665 he married Marie-Casimire de La Grange d'Arquien (1641–1716). His patronage, although modest in comparison with the richest magnates, resulted in the finest examples of Baroque art in Poland. Sobieski admired Italian architecture as well as French and Dutch paintings, sculpture and gardens. His patronage combined the values of western European art with SARMATISM, the culture of Polish gentry. He employed artistic advisers, among others BARTŁOMIEJ NATANIEL WĄSOWSKI.

Sobieski was not fond of the Royal Castle in Warsaw, and he commissioned Augustyn Locci (1650–*c*. 1730), a Polish-born architect of Italian descent, to build a suburban residence, an Italianate villa nuova at his estate of Wilanów. The two-storey palace (built 1677–9, 1681–3 and 1688–96), with a central belvedere, two corner towers and a roof balustrade decorated with statues, is situated between a forecourt flanked by side wings and a Baroque French-style garden. The elaborately sculptured decoration was executed by Andreas Schlüter. Among the court painters were Claude Callot (1620–87), who executed the ceiling painting *Queen Marie-Casimire as Aurora* (*c*. 1690), the fresco painter Michelangelo Palloni (1632–*c*. 1712), and the portrait painters François Desportes, Jan Tricius and the Rome-trained Jerzy Eleuter Szymonowicz-Siemiginowski (*c*. 1660–1711). Sobieski's major sacred

foundation was the Capuchin church and convent in Warsaw, designed in 1683–92 by an architect influenced by Tylman van Gameren. In 1683 Sobieski added to his collection spoils from the Battle of Vienna, including Ottoman tents, exquisite textiles and weaponry (now Kraków, N.A. Cols).

BIBLIOGRAPHY
J. Starzyński: 'Dwór artystyczny Jana III' [The artistic court of John III], *Życie Sztuki*, i (1934), pp. 137–56
T. Mańkowski: 'Malarstwo na dworze Jana III' [Painting in the court of John III], *Biul. Hist. Sztuki*, xii/1–4 (1950), pp. 201–88
A. Miłobędzki: *Architektura polska XVII wieku* [Polish architecture of the 17th century] (Warsaw, 1980), pp. 396–405

ANNA BENTKOWSKA

Johnson. English family of sculptors of Dutch origin. (1) Garat Johnson settled in England in 1566–7 and executed numerous sculptures. Of his children, two sons became sculptors, (2) Nicholas Johnson and Garat Johnson the younger (*fl* 1611–12), who supplied a marble basin (untraced) for a fountain at Hatfield House, Herts, but of whose work nothing else is known for certain. The monuments to *John Combe* (*c.* 1614) and *William Shakespeare* (*c.* 1616) at Holy Trinity, Stratford-upon-Avon, Warwicks, were attributed to him as early as 1653, but the source is not wholly reliable.

(1) Garat [Garret] **Johnson** (*b* Amsterdam; *bur* London, 30 July 1611). He came to England from the Duchy of Gelderland, probably as a Protestant refugee. He anglicized his name, presumably from Janssen, and in 1568 became an English citizen. He settled in Southwark, London, where he raised six children and established a sizeable workshop. In the 1590s he emerged as a prominent craftsman; by 1593 he had four journeymen, two apprentices and an English assistant. He supplied two fountains (1591–2; destr.) for the privy garden at Hampton Court, near London, and a chimney-piece (1595–6; destr.) for Arthur Throckmorton's house at Paulerspury, Northants. Above all, he received important commissions for tombs. Those of *Edward Manners* and *John Manners*, the 3rd and 4th Earls of Rutland (1590–91; Bottesford, Leics, St Mary), are good examples of London work of the day: the effigies stiffly posed with meticulously detailed costume and stereotyped faces, and canopies treated as architecture in a debased classical style. Detailed accounts for them survive that give a vivid picture of their delivery by sea to a convenient port, then overland in carts to the church, where they were erected under the supervision of the sculptor and one of his sons. The latter was probably (2) Nicholas Johnson, with whom Garat collaborated on the monument (*c.* 1594) to *Thomas Wriothesley, 1st Earl of Southampton* (*d* 1550), *Jane Cheyne, Countess of Southampton* (*d* 1574), and *Henry Wriothesley, 2nd Earl of Southampton* (*d* 1581), in St Peter's, Titchfield, Hants. This is a work of unusual design with the effigy of the Countess raised up in the centre and tall obelisks at the corners. Far more conservative are Garat's three memorials (*c.* 1595) to members of the Gage family in St Peter's, West Firle, E. Sussex. *Sir John Gage* (*d* 1557) and his wife are represented by recumbent effigies with no canopy, while *Sir Edward Gage* (*d* 1569) and his wife, and the patron *John Gage* (*d* 1595) and his two wives, are portrayed in brasses set into tomb chests. Simple, linear designs by Johnson for these works have been preserved (Firle Place, E. Sussex, Viscount Gage priv. col.).

A number of other brasses and several carved memorials have been attributed to Garat's workshop. It was clearly responsible for the monument (*c.* 1592) to the 2nd Earl of Southampton's father-in-law, *Anthony Browne, Viscount Montagu* (*d* 1592), and his two wives, now in St Mary's, Easebourne, W. Sussex, formerly in SS Mary Magdalene and Denys, Midhurst, E. Sussex. Before being moved and mutilated in 1851, the tomb was of the same type as the Southampton tomb except that the central effigy of Lord Montagu kneels after the French royal pattern.

(2) Nicholas Johnson [Jonson] (*bur* 16 Nov 1624). Son of (1) Garat Johnson. He remained in Southwark after his father's death. His known work is all tomb sculpture, most of it done in collaboration: the monument to *Thomas Sutton* (1613–15; Charterhouse, London) with Edmund Kinsman (*fl c.* 1613–38) and Nicholas Stone the elder, and that of *James Montague, Bishop of Winchester* (1618–19; Bath Abbey) with William Cure (ii). He was, however, solely responsible for the monument (1618–19) to *Roger Manners, 5th Earl of Rutland* (*d* 1612) and his wife (Bottesford, Leics, St Mary's), which is of the same type as those of the 3rd and 4th earls executed by his father.

BIBLIOGRAPHY
V. Manners: 'The Rutland Monuments in Bottesford Church', *A. J.* [London] (1903), pp. 289–95, 335–9
K. A. Esdaile: 'Some Fellow-citizens of Shakespeare in Southwark', *Ess. & Stud.*, n. s., v (1952), pp. 26–31
M. Whinney: *Sculpture in Britain, 1530–1830*, Pelican Hist. A. (Harmondsworth, 1964, rev. by J. Physick, 1988), pp. 47–51, 70

ADAM WHITE

Johnson, Cornelius. *See* JONSON VAN CEULEN, CORNELIS, I.

Johnson, David (*b* New York, 10 May 1827; *d* Walden, NY, 30 Jan 1908). American painter. He was a member of the Hudson River school and was virtually self-taught except for a few lessons from Jasper Francis Cropsey. He was primarily a landscape artist and a Luminist who rendered subtle effects of light and atmosphere with precise realism. His earliest works were copies of prints, for example *West Point from Fort Putnam* after Robert Havell jr (*c.* 1848; Cooperstown, Mus. NY State Hist. Assoc.). His first painting from nature (executed in the company of John William Casilear and John Frederick Kensett) was *Haines Fall, Kauterskill Clove* (1849; untraced, see Baur, fig. 2), and he began exhibiting the same year.

Johnson travelled widely in the north-east states of the USA, finding subjects in the White Mountains of New Hampshire, the Adirondacks and elsewhere in New York State and in Virginia. He made one trip west to the Rocky Mountains in 1864–5, where he painted *Landscape, Mountains and Lake* (New York, David Findlay Gal.). His most striking works are those depicting rock formations, for example *Forest Rocks* (1851; Cleveland, OH, Mus. A.), *Natural Bridge, Virginia* (1860; Winston-Salem, NC, Reynolda House) and *Brook at Warwick* (1876; Utica,

NY, Munson–Williams–Proctor Inst.). He also did many highly finished and detailed drawings of trees and rocks. Occasionally he experimented with a freer, more painterly technique, generally with less success. His few portraits are all copies of photographs or paintings by other artists. He also painted a few still-lifes, such as *Phlox* (1886; Winston-Salem, NC, Reynolda House).

BIBLIOGRAPHY
J. I. H. Baur: '". . . The Exact Brushwork of Mr. David Johnson": An American Landscape Painter, 1827–1908', *A. J.* [New York], xii (1980), pp. 32–65

JOHN I. H. BAUR

Johnson, (Jonathan) Eastman (*b* Lovell, ME, 29 July 1824; *d* New York, 5 April 1906). American painter and printmaker. Between 1840 and 1842 he was apprenticed to the Boston lithographer John H. Bufford (1810–70). His mastery of this medium is apparent in his few lithographs, of which the best known is *Marguerite* (*c.* 1865–70; Worcester, MA, Amer. Antiqua. Soc.). In 1845 he moved to Washington, DC, where he drew portraits in chalk, crayon and charcoal of prominent Americans including *Daniel Webster*, *John Quincy Adams* and *Dolly Madison* (all 1846; Cambridge, MA, Fogg). In 1846 he settled in Boston and brought his early portrait style to its fullest development. His chiaroscuro charcoal drawings, of exceptional sensitivity, were remarkably sophisticated for an essentially self-trained artist. In 1848 he travelled to Europe to study painting at the Düsseldorf Akademie. During his two-year stay he was closely associated with Emanuel Leutze, and painted his first genre subjects, for example *The Counterfeiters* (*c.* 1851–5; New York, IBM Corp.). He then spent three years in The Hague, studying colour, composition and naturalism in 17th-century Dutch painting. The influence of the Dutch masters on his portrait style was so great that he was called 'the American Rembrandt'. In 1855, after two months in Thomas Couture's Paris studio, he returned to America. He then turned his attention to American subject-matter. He made studies of Indians in Wisconsin, and painted portraits while in Washington (e.g. *George Shedden Riggs*, *c.* 1855; Baltimore, MD Hist. Soc. Mus.) and Cincinnati. He finally settled in New York.

Johnson's painting *Old Kentucky Home—Life in the South* (1859; New York, NY Hist. Soc.) established his reputation and led to his painting a series of sympathetic depictions of American blacks. His *Cornhusking* (1860; Syracuse, NY, Everson Mus. A.), depicting a barn interior, was the culmination of a genre tradition popularized a generation earlier by William Sidney Mount. Between 1861 and 1865 he painted subjects relating to the Civil War, often with a degree of sentimentality or melodrama rarely found in his other works, for example *Ride for Liberty— The Fugitive Slaves* (*c.* 1862; New York, Brooklyn Mus.). His most original works of the 1860s were an extensive series of paintings, oil sketches and drawings made annually in late winter, near Fryeburg, ME, on the subject of life in the maple sugar camps, for example *Sugaring Off* (*c.* 1861–6; Providence, RI Sch. Des., Mus. A.). In contrast to these freely brushed studies of rural life there were several less painterly depictions of the wealthy in rich urban interiors. Among the finest is the *Hatch Family* (1871; New York, Met.), an elaborate conversation piece set in the Eastlake style library of the family's Park Avenue, New York, mansion.

Following his marriage in 1869, Johnson spent each summer on Nantucket Island, MA. While there he developed two of his most complex and successful genre subjects, each preceded by numerous oil sketches and studies that show his heightened interest in the naturalistic depiction of outdoor light: *Cornhusking Bee* (1876; Chicago, IL, A. Inst.) and *Cranberry Harvest* (1880; San Diego, CA, Timken A.G.; see fig.). With their studies and variants, these two works represent Johnson's best achievements as a painter of figures in complex relationship to each other and their environment. In the mid-1880s demand for his genre subjects decreased and

Eastman Johnson: *Cranberry Harvest*, oil on canvas, 695×1388 mm, 1880 (San Diego, CA, Timken Art Gallery, Putnam Foundation)

perhaps a gradual decline in his powers made him return almost exclusively to portraiture. Earlier in the decade he had painted some successful characterizations, including the artist *Sanford Robinson Gifford* (1880) and the double portrait of Johnson's brother-in-law, Robert Rutherford, and the artist Samuel W. Rowse (1822–91) entitled the *Funding Bill* (1881; both New York, Met.). These vigorously brushed likenesses with their dramatic contrasts of light and shade are in the sombre, Rembrandtesque palette Johnson used for portraits. Some have since darkened further from his use of bitumen in areas of shadow. A good example of his later portraits is his *Self-portrait* (see Hills, 1972, p. 116), which depicts him in 17th-century Dutch costume. He painted little after the early 1890s and his visits to Europe in 1885, 1891 and 1897 had no evident effect on his style, which in composition, colour, light and draughtsmanship, especially in scenes of rural life in Maine and Nantucket, is unsurpassed in American 19th-century painting.

BIBLIOGRAPHY

Eastman Johnson, 1824–1906: American Genre Painter (exh. cat., ed. J. Baur; New York, Brooklyn Mus., 1940/*R* 1969)

Eastman Johnson (exh. cat., ed. P. Hills; New York, Whitney, 1972)

P. Hills: *The Genre Painting of Eastman Johnson: The Sources and Development of his Style and Themes* (New York, 1977)

N. Spassky: *American Paintings in the Metropolitan Museum* (New York, 1985), pp. 220–39

M. Simpson and others: *Eastman Johnson: The Cranberry Harvest* (San Diego, CA, 1990)

DAVID TATHAM

Johnson, Garrard [Garrett; Gerard]. *See* JENSEN, GERRIT.

Johnson, George Henry (*b* Nelson, New Zealand, 19 Aug 1926). Australian painter of New Zealand descent. With his close colleagues Roger Kemp and Leonard French, he introduced abstract painting to Melbourne audiences in the 1950s; he has remained, arguably, Australia's most uncompromising and vigorous exponent of non-objectivity. His strongly geometric works have survived three distinct waves of abstract painting and in the 1990s were shown alongside those of younger generations. In New Zealand he studied painting at the Wellington Technical School and joined a group of avant-garde painters that included Gordon Walters and Theo Schoon. After arriving in Australia in 1951, Johnson relinquished all traces of figuration. Like Piet Mondrian and Kazimir Malevich and some artists from ancient and diverse cultures (including those of the Pacific and South America, where he travelled extensively), he turned to pure abstraction, creating images that symbolized a strong commitment to social issues and universalizing ideas. His first exhibition at the Tasmanian Tourist Bureau Gallery, Melbourne, in 1956, established his reputation as one of Australia's most radical abstractionists. Eighteen solo exhibitions followed, including that at the Charles Nodrum Gallery, Melbourne, in 1992 and that at Coventry Gallery, Sydney, in 1995. Johnson has also participated in such influential group shows as the *Pacific Loan Exhibition* (1956; toured the Pacific Ocean on the *Orcades*), *Survey 1* (Melbourne, N.G. Victoria, 1958), *Young Australian Painters* (Tokyo, 1964), *Abstract Art in Australia* (Melbourne, Royal Inst. Technol. A.G., 1983) and *Circle Line Square: Aspects of Geometry* (Campbelltown, NSW, C.A.G., 1994). His works appear in most major collections within Australia and some in New Zealand. These include *Peruvian Twilight* (enamel on jute on composition board, 914×1378 mm, 1956; Melbourne, Heide Museum of Contemporary Art) and *Mount of the Blue Triangle* (acrylic on canvas, 3.05×1.98 m, 1986; Ballarat, F.A. Gal.).

BIBLIOGRAPHY

J. Reed: *New Painting, 1952–62* (Melbourne, 1963), p. 27

A. McCulloch: 'Letter from Australia', *A. Int.* (Jan 1970), pp. 71–6

B. Smith: *Australian Painting, 1788–1970* (Melbourne, 1971), pp. 382, 408, pl. 227

J. Zimmer: 'George Johnson and Ineluctable Abstraction', *A. & Australia*, xxiv/2 (1986), pp. 202–7

Johnson, John G(raver) (*b* Chestnut Hill, PA, 4 April 1841; *d* Philadelphia, 14 April 1917). American lawyer and collector. He was the son of a village blacksmith whose life emphasized the middle-class virtues of industriousness and self-reliance. Johnson was admitted to the bar before completing his formal schooling at the University of Pennsylvania. In Philadelphia he built a reputation in the developing area of corporate law; eventually he represented most of the major trusts of America's 'gilded age', in the process accumulating a fortune sufficient to allow him to create a large and historically important collection of paintings. He also represented several other leading US collectors, including J. Pierpont Morgan and Henry Clay Frick.

Johnson's interest in collecting was sparked by the art exhibition at the Philadelphia Centennial Exposition of 1876 and was encouraged by the establishment of the Pennsylvania Museum in Fairmount Park, Philadelphia. His marriage to the socially prominent widow Ida Powel Morrell and biennial trips to Europe beginning in the 1880s strengthened these earlier propensities, as did his appointment as Commissioner of Fairmount Park. By 1892 he could list in a published catalogue of his collection 281 works of art. With the exception of 27 Old Masters, they were almost all 19th-century French paintings, either by Barbizon artists or by those active in Paris during the last quarter of the century. He believed contemporary art was a safer investment than spurious Old Masters, writing in 1892, 'pedigrees are either manufactured, or if genuine usually begin a century too late'.

In 1844 Johnson bought his first Flemish primitive painting—Jan van Eyck's *St Francis Receiving the Stigmata*, the first work by this master in America. After that the collection expanded rapidly, as Johnson became more committed to early Netherlandish and Italian art. By 1913 Johnson had accumulated almost 1200 paintings and had developed a philosophy of collecting, which insisted upon constant weeding and trading up of works: 'I have put my foot in it at times', he wrote in 1909, 'but I might have fared far worse in the hands of those beside whom base jackals are Innocents—the Dealers in art.' Johnson believed that the collection itself should be a work of art. 'Art is not of one century only, nor of one country', he wrote, '. . .the best art is nearly upon the same plane, and. . .it is possible to hang without jar, side by side, works of the masters of the seventeenth and of the nineteenth centuries.'

On Johnson's crowded walls a few contemporary American and French Impressionist paintings appeared beside Italian Renaissance masterpieces from Florence, Venice and central and northern Italy (including five Botticellis), and a large collection of Flemish primitives (including two monumental panels by Rogier van der Weyden), acquired before such works became popular among collectors following the Dollfus sale in 1912. He also purchased paintings by Hieronymus Bosch, Frans Hals, Pieter de Hooch, Jan Steen, Jacob van Ruisdael, Aelbert Cuyp, Rubens and David Teniers the younger. He bequeathed his collection to the city of Philadelphia; it is housed separately within the Philadelphia Museum of Art.

WRITINGS
Sight-seeing in Berlin and Holland among Pictures (Philadelphia, 1892) [repr. from articles in the *Philadelphia Press*]

BIBLIOGRAPHY
Catalogue of a Collection of Paintings Belonging to John G. Johnson (Philadelphia, 1892)
B. Berenson and W. R. Valentiner: *Catalogue of John G. Johnson Collection*, 3 vols (Philadelphia, 1913–14)
H. M. Allen: 'John G. Johnson: Lawyer and Art Collector', *The Bellman* (12 May 1917), pp. 518–21
M. W. Brockwell: 'The Johnson Collection in Philadelphia', *Connoisseur* (March 1918), pp. 143–53
John G. Johnson Collection: Catalogue of Paintings (Philadelphia, 1941)
B. F. Winkelman: *John G. Johnson, Lawyer and Art Collector* (Philadelphia, 1942)
A. B. Saarinen: *The Proud Possessors* (New York, 1958), pp. 92–117
John G. Johnson Collection: Catalogue of Italian Paintings (Philadelphia, 1966)
John G. Johnson Collection: Catalogue of Flemish and Dutch Paintings (Philadelphia, 1972)
L. B. Miler: 'Celebrating Botticelli: The Taste for the Italian Renaissance in the United States, 1870–1920', *The Italian Presence in American Art*, ed. I. Jaffe (New York, 1992), pp. 1–22

LILLIAN B. MILLER

Johnson [Johnston], Joshua (*fl c.* 1796–1824). American painter, perhaps of West Indian birth. He was probably the first significant Afro-American painter and worked primarily in Baltimore, painting portraits for prosperous, middle-class families. His career and his identity as a 'Free Householder of Colour' are sketchily documented in city records. Circumstantial evidence suggests that he had once been a slave and had arrived from the West Indies before 1790. More than 80 portraits have been attributed to him. *Sarah Ogden Gustin* (*c.* 1798–1802; Washington, DC, N.G.A.) is the only signed work and typifies his early style. Though the figure is woodenly rendered and awkwardly seated within a flattened space, the view through a window reveals a painterly landscape and an attempt at atmospheric perspective. Johnson's early portraits closely resemble compositions by members of Charles Willson Peale's family, particularly Peale's nephew Charles Peale Polk, suggesting that he may have studied under them. His later work is more tightly painted and includes several large family portraits, such as *Mrs Thomas Everette and her Children* (1818; Baltimore, MD Hist. Soc. Mus.). This is the only painting that can be traced to Johnson through a patron's family records. The severely linear, plain style creates a decorative image of middle-class affluence and virtue. Johnson also painted many portraits of children in a charming, doll-like fashion.

BIBLIOGRAPHY
Joshua Johnson: Freeman and Early American Portrait Painter (exh. cat., ed. C. J. Weekley and S. T. Colwill; Williamsburg, VA, Rockefeller Flk A. Col.; Baltimore, MD Hist. Soc. Mus.; 1987)

DAVID BJELAJAC

Johnson, Lester (*b* Minneapolis, MN, 27 Jan 1919). American painter. He studied at the Minneapolis Institute School of Art, the St Paul Art School and the Art Institute of Chicago (1942–7). He moved to New York in 1947 and supported his painting with a variety of part-time jobs. He also studied with Hans Hofmann and shared a studio first with Larry Rivers and then with Philip Pearlstein. Despite his figurative work, Johnson was voted into the 8th Street 'Club'. It met weekly, providing artists with a stimulating forum for exchanging ideas. Johnson's unpopular but complete commitment to the figure helped enlarge the scope of Abstract Expressionism. His early works depicting men, alone or in groups, were first and foremost paintings, full of all the freedom and action to be found in the best works produced at the time. Using sombre colours, these thickly painted compositions are packed with actions and counteractions, pushing and pulling, oscillating on a flattened picture plane (e.g. *Three Crouching Figures*, 1968; New York, priv. col., see Chernow, 1975, p. 9). By the early 1970s females entered Johnson's increasingly congested urban processions, accompanied by a considerably brighter palette. The exuberant colour in varied and strongly patterned fabrics and the strenuous gestures of his voluptuous women brought a heightened energy to the late work. The human figure, whether treated as an archetype or as an individual, remained his favoured subject. His robust figurative paintings provide an important link between Abstract Expressionism and the vehement paintings of the Neo-Expressionists of the 1980s.

BIBLIOGRAPHY
B. Chernow: *Lester Johnson: Paintings—The Kaleidoscopic Crowd* (New York, 1975)
——: 'Lester Johnson', *A. Mag.*, lii/3 (Nov 1977), p. 6
C. Ratcliff: 'Lester Johnson', *A. Int.*, xxiv/9–10 (Aug–Sept 1981), pp. 102–16

BURT CHERNOW

Johnson, Philip (Cortelyou) (*b* Cleveland, OH, 8 July 1906). American architect, critic and collector. The son of a well-to-do lawyer, he early displayed a keen natural intelligence that was diligently cultivated by his mother. He enrolled as an undergraduate at Harvard University, Cambridge, MA, in 1923. A restless nature drew him successively to disciplines as diverse as music, the classics and philosophy, while emotional turmoil led to several breakdowns that delayed his graduation until 1930. By then, however, he had developed a close friendship with the young art historian Alfred H. Barr jr, who in 1929 assumed the directorship of the new Museum of Modern Art in New York. At about the same time Johnson met another art historian, Henry-Russell Hitchcock, whose article on J. J. P. Oud ('The Architectural Work of J. J. P. Oud', *The Arts*, xiii/2 (Feb 1928), pp. 97–103) had suddenly focused Johnson's scattered mental energies on architecture and, more specifically, on modern European architecture of the 1920s.

In 1930 Johnson and Hitchcock toured Europe, studying the work of the architectural avant-garde. On his

return Johnson, appointed by Barr and assisted by both Barr and Hitchcock, organized the epoch-making *Modern Architecture: International Exhibition*, which opened at MOMA in 1932. The show effectively introduced to the American public the work of Walter Gropius, Le Corbusier, Mies van der Rohe and Oud, together with that of other selected architects from around the world. The name International Style, which became associated with the exhibited work, can be traced to several independent sources, but its place in the contemporary vocabulary is traceable chiefly to the title of a book, *The International Style* by Johnson and Hitchcock, that accompanied the MOMA exhibition. Both exhibition and book advanced the concept that early modern architecture, especially in Europe in the 1920s, had qualities in common that suggested a style global in its reach. Johnson and Hitchcock emphasized the formal and aesthetic value of these qualities, while ignoring the social and political dimensions of the architecture in which they were embodied.

Though formally appointed Director of the Department of Architecture at MOMA in 1932, the habitually restless Johnson resigned that post two years later and began a bizarre political career in right-wing politics. The offer of his services in 1935 to the controversial Louisiana populist Senator Huey Long was dismissed, somewhat contemptuously; but Johnson soldiered on, attaching himself more successfully to the famously demagogic radio personality of Detroit, Rev. Charles E. Coughlin, for whose journal *Social Justice* Johnson wrote several articles. Running on the Democrat ticket in 1935, Johnson won nomination to the state legislature from his Ohio district. He later withdrew his candidacy, preferring to work for Coughlin in the latter's own efforts to unseat President Franklin D. Roosevelt in 1936. Coughlin failed at this, whereupon Johnson drew actively closer to an explicit embrace of fascist doctrine. He travelled several times in the mid- to late 1930s to Germany, attracted not only by the aura surrounding Adolf Hitler but by the rapid political advances made at the time by the Nazi government.

The outbreak of World War II in 1939 dampened much of Johnson's political ardour, and by late 1940 he had returned to Harvard as a student of architecture in the university's graduate school. He studied with Gropius and Marcel Breuer, both refugees from Germany and the Bauhaus. Johnson graduated in 1943, served in the U.S. army and was back in New York by the end of the war. He opened his own office, but the sluggishness of the post-war economy prompted him to divide his time between his practice and, following another invitation from Barr, a resumed position as the head of the architecture department at MOMA. During this second tenure at the museum, his most important accomplishment was *The Architecture of Mies van der Rohe* (1947), an exhibition accompanied by a monograph, both offering the first full-scale documentation of Mies van der Rohe's career. Johnson also designed the Abby Aldrich Rockefeller sculpture garden (1952; remodelled by Johnson in 1964) at MOMA before leaving the museum in 1954 to take up architectural practice on a full-time basis.

Johnson's long-standing devotion to Mies van der Rohe was apparent in his early buildings, predominantly suburban residences. Chief among these was the Glass House (1949) at New Canaan, CT, designed for his own use and widely regarded as one of his finest works. Derived from Mies van der Rohe's Farnsworth House (1946–51) at Plano, IL, but more classical in plan, the Glass House attests to Johnson's naturally critical turn of mind and his preoccupation with history. In an article written in 1950 for the *Architectural Review*, he listed the influences behind the Glass House, which included not only Mies van der Rohe but also Le Corbusier, Claude-Nicolas Ledoux, Kazimir Malevich, Karl Friedrich Schinkel and the De Stijl movement.

In the early 1950s Johnson's work veered sharply away from the manner of Mies van der Rohe. A pronounced dependence on historical sources was especially evident in his Kneses Tifereth Israel Synagogue (1956) in Port Chester, NY, which features references to Ledoux and Sir John Soane. Although he accepted Mies van der Rohe's offer to serve as a partner in the design of the Seagram Building (1954–8; with Kahn and Jacobs), New York, his own work of the 1950s and 1960s was marked by a dizzying, eclectic variety of styles underpinned by a steadfast commitment to a formalist aesthetic. Notable completed buildings from the period are the Roofless Church (1960) in New Harmony, IN, with its domed canopy, the geometrically planned Museum for Pre-Columbian Art (1963) at Dumbarton Oaks, Washington, DC, the monumentally classicist New York State Theater (1964; with Richard Foster) within the Lincoln Center, New York, the inventively proportioned Kline Science Center (1965; with Richard Foster) at Yale University, New Haven, CT, and, for his own New Canaan estate, a painting gallery (1965) and a sculpture gallery (1970) to house his personal collection of contemporary art. He was a significant collector, mostly of avant-garde works, and a major donor of painting and sculpture to MOMA. His gifts included work by Jasper Johns, Andy Warhol, Robert Rauschenberg, Frank Stella and Julian Schnabel.

Johnson worked with a number of partners in his practice, including Landes Gores (1919–91) from 1946 to 1951, Richard Foster (*b* 1919) during most of the 1960s and early 1970s and John Burgee (*b* 1933) from 1967 to 1991. It was Burgee's experience with the large commercial firm of C. F. Murphy Associates in Chicago that prompted Johnson to hire him, setting the stage for a remarkably prosperous two-decade-long partnership and a multifaceted catalogue of high-rise buildings. Of these, the IDS (Investors Diversified Services) Building in Minneapolis (1973; with Edward F. Baker Associates) and Pennzoil Place (1986; with Wilson, Harris, Crain & Anderson) in Houston were significant in breaking free of the parallelepiped form common in post-war skyscrapers. IDS featured chamfered, serrated corners, while Pennzoil Place consisted of a pair of trapezoidally-planned, glass-clad towers that nearly touched at the opposing obtuse angles.

During in the 1980s Johnson's penchant for extreme variety of form reasserted itself. The Crystal Cathedral (1980), a glass polyhedron in the late modern manner, in Garden Grove, CA, was followed by a group of structures variously indebted to the historicism of the post-modernist movement. The RepublicBank Center (1984; see fig.), Houston, is abundant in Gothic guildhall allusions, even as the Transco Tower (1985), Houston, bows to the

Philip Johnson: RepublicBank Center (now North Carolina National Bank Center), Houston, TX, 1984

WRITINGS

with H.-R. Hitchcock: *The International Style: Architecture since 1922* (New York, 1932, rev. 1966)
Mies van der Rohe (New York, 1947, rev. London, 1978)
'House at New Canaan, Connecticut', *Archit. Rev.* [London], cviii/645 (1950), pp. 152–9
Writings (New York, 1979)
Deconstructivist Architecture (exh. cat., with M. Wigley; New York, MOMA, 1988)

BIBLIOGRAPHY

J. Jacobus: *Philip Johnson* (New York, 1962)
Philip Johnson: Architecture, 1949–1965, intro. H.-R. Hitchcock (London, 1966)
N. Miller: *Johnson/Burgee Architecture* (New York, 1979)
Philip Johnson/John Burgee: Architecture, 1979–85, intro. C. Knight III (New York, 1985)
F. Schulze: *Philip Johnson: Life and Work* (New York, 1994)

FRANZ SCHULZE

Johnson, Ray(mond Edward) (*b* Detroit, 16 Oct 1927). American painter, draughtsman and performance artist. He studied at the Art Students League, New York (1944–5), and with Josef Albers at Black Mountain College, NC, from 1945 to 1948, where he met John Cage, Merce Cunningham and Richard Lippold. His collages, paintings, drawings and performances have been associated with geometric abstraction, Pop art, Neo-Dada and conceptual art, although they do not fit neatly into any existing categories. Relationship, correspondence, interaction, metaphor and flux are all themes of Johnson's work, which reflects an often witty and satirical, but essentially poetic, perception. Delicate collages such as *Anna May Wong* (1971; New York, Whitney) incorporate found objects, altered photographs, textured surfaces, drawing, painting, words and syllables, printed text and other materials. Similar combinations of text and image were used in his book, *The Paper Snake* (New York, 1965). Operating from 1968 as the New York Correspondence School, and from 1975 as Buddha University, he circulated collages and other materials using the US postal system, establishing CORRESPONDENCE ART as an art form and circumventing the conventional gallery system.

BIBLIOGRAPHY

Correspondence: An Exhibition of the Letters of Ray Johnson (exh. cat., intro. W. Wilson; Raleigh, NC Mus. A., 1976)
Works by Ray Johnson (exh. cat., text by D. Bourdon, Roslyn, NY, Nassau Co. Mus. F.A., 1984)

MARY EMMA HARRIS

Johnson, Richard (*b* 1753; *d* Brighton, 19 Aug 1807). English collector. He went to India in 1770 as a writer in the Bengal Civil Service and spent ten years in Calcutta, occupying various posts including assistant to the Governor-general Warren Hastings. Johnson became very rich, augmenting his salary with private trade, and he also took part in the intellectual life surrounding Hastings, studying oriental languages, commissioning copies of manuscripts for his own use and purchasing paintings. He was in Lucknow as Head Assistant to the Resident (1780–82), where he increased his collection. On returning to Calcutta, he became friends with the Orientalist scholar William Jones (1746–94). Johnson was Resident at Hyderabad (1784–5), where he again extended his collection, especially with Deccani paintings. Recalled to Calcutta, he became involved with the Asiatic Society of Bengal, founded by Jones. In 1786 Johnson joined the Board of Revenue and

classicism of Bertram Goodhue and the PPG (Pittsburgh Plate Glass) Corporate Headquarters (1984), Pittsburgh, is an improvisation in glass based on London's Houses of Parliament. The building that drew the widest attention to Johnson, vaulting him to public superstardom, was the AT&T Building (now the Sony Building; 1979–84; *see* POST-MODERNISM, fig. 1). Various period references, mostly Renaissance and Baroque, were overshadowed by the celebrated Chippendale pediment that provides the building with a unique profile on the Manhattan skyline. While this and other 'signature' commercial structures were spectacular and more often than not satisfying to their clients, they aroused heated controversy among the critics, many of whom rebuked Johnson for his purported fascination with novelty for novelty's sake. Johnson returned to MOMA in 1988 as the guest curator of an exhibition entitled *Deconstructivist Architecture*, billed as a 'development post-dating post-modernism' and notable for the inclusion of such new designers as Daniel Libeskind (*b* 1946) and Zaha Hadid (*b* 1950). In his late eighties, having parted company with Burgee and opened a new office by himself, Johnson turned away from Deconstructivism as he had steadily from previous manners, maintaining only his belief in formalism and, in the mid-1990s, experimenting with ideas drawn from early German Expressionism. His contributions won him numerous awards, principally the gold medal of the American Institute of Architects (1978) and the Pritzker Prize (1979). He was, in sum and incontestably, one of the major American cultural presences of the 20th century.

became Chairman of the General Bank of India, a post he held until his departure from India in 1790. In England he was Member of Parliament for Milborne Port (1791–4) and an active partner in the London and Middlesex Bank. Financial difficulties led him to sell his collection in 1807. Purchased by the East India Company for its library in Leadenhall Street, London (now the India Office Library), the collection consists of 716 manuscripts (in Arabic, Assamese, Bengali, Hindi, Persian, Punjabi, Sanskrit, Turkish and Urdu) and 64 albums of paintings and calligraphy. The paintings cover a wide range of subject-matter, including depictions of Indian life and customs, portraits, *ragamala* paintings and illustrations of Persian literature.

BIBLIOGRAPHY
B. W. Robinson: *Persian Paintings in the India Office Library* (London, 1976)
T. Falk and M. Archer: *Indian Miniatures in the India Office Library* (London, 1981)

S. J. VERNOIT

Johnson, Richard Norman [Peter] (*b* Melbourne, 15 Dec 1923). Australian architect, teacher and writer. He studied at the University of Sydney (BArch 1951) and in 1955 became a partner in McConnel, Smith & Johnson. Early work included his own house (1963) at Chatswood, Sydney, integrated with its steep, wooded site and built with exposed timber and brick (*see also* SYDNEY SCHOOL). McConnel, Smith & Johnson emphasized a team approach to architecture, which Johnson saw as a social art with buildings and spaces designed to serve users' needs, take account of context and fulfil explicit aesthetic aims. This philosophy is expressed in the firm's early interest in environmental design and energy conservation, seen in the Water Board headquarters (1965), Sydney, and its innovative use of concrete cladding panels for solar protection. The Commonwealth State Law Courts (1977), Sydney, a 26-storey steel frame structure inserted into an historic and old-established legal district, was designed after a lengthy research process involving both the client and the public. Other key projects included the Benjamin Offices (1980), Belconnen, Canberra, and a major new wing (1983) for the Royal Prince Alfred Hospital, Sydney, including the restoration of a 19th-century building. Later works reveal more concern for architectural expression, as in the Mechanical and Electrical Engineering building (1984) for the Australian Defence Force Academy, Canberra, which refers to traditional forms of defence building, and the Teluk Intan Hospital (1987; as joint architects), Malaysia, a series of horizontal pavilions with wide verandahs echoing local forms. The Darling Harbour Redevelopment Project (1988), Sydney, a major urban design project for which the firm and its affiliate planning firm were the Project Design Directorate, is further evidence of a concern for the needs of the users and contextual appropriateness. Johnson became Professor of Architecture at the University of Sydney in 1967 and held many public appointments in the profession. In 1988 he became Chancellor of the University of Technology, Sydney.

WRITINGS
with S. Clarke: *Architectural Education: A Survey of Schools* (Sydney, 1979)
with others: *Leslie Wilkinson* (Sydney, 1982)

BIBLIOGRAPHY
H. Sowden, ed.: *Towards an Australian Architecture* (Sydney, 1968), pp. 176–91
C. McGregor: *Australian Art and Artists in the Making* (Melbourne, 1969)
J. Taylor: *Australian Architecture since 1960* (Sydney, 1986, rev. 2/1990)
G. P. Webber, ed.: *The Design of Sydney* (Sydney, 1988)
R. Apperly, R. Irving and P. Reynolds: *A Pictorial Guide to Identifying Australian Architecture* (Sydney, 1989)

LOUISE COX

Johnson, Stefano, Stabilimento S.p.A. Italian company of medallists, founded in 1836 by Stefano Johnson. In that year he struck his first medal in the Milanese workshop of his father, Giacomo Johnson, who had recently moved from Birmingham after a brief period of activity in Lyon. The production of medals and plaquettes received an important stimulus from Stefano's son Federico Johnson, who employed medallists from the Mint in Milan, which had closed in 1887. Having obtained the services of several well-known sculptors, Federico began producing medals to commemorate historical and religious events and every aspect of Italian industrial, commercial and financial activity. The company's products also began to be exported by his son Stefano Johnson II and his grandson Cesare Johnson. Following the destruction of the workshop in air-raids in 1943, Cesare built new premises in Milan. He also increased the cultural status of medals by publishing the magazine *Medaglia* in collaboration with his wife, Velia Johnson, and by cataloguing the company's collection of *c.* 50,000 medals, which is readily accessible to scholars. The company produced medals in collaboration with such major Italian sculptors as Emilio Greco, Luciano Minguzzi, E. Fazzini, F. Bodini, E. Manfrini, Arnaldo Pomodoro and V. Crocetti. In the late 20th century work continued under the guidance of Riccardo Johnson, Mariangela Johnson and her husband, Roberto Pasqualetti.

BIBLIOGRAPHY
M. Johnson: 'Italian Liberty Plaquettes from the Stabilimento Stefano Johnson in Milan', *J. Dec. & Propaganda A.*, ix (1988), pp. 68–85

CESARE JOHNSON

Johnson, Thomas (*bapt* London, 13 Jan 1714; *d c.* 1778). English furniture designer and carver. Nothing is known of his apprenticeship or early work, but he published *Twelve Gerandoles* in 1755, styling himself 'Thomas Johnson, Carver, at the Corner of Queen Street, near the Seven Dials, Soho'. Between 1756 and 1757 he issued some 52 sheets of designs for *Glass, Picture, and Table Frames; Chimney Pieces, Gerandoles, Candle-stands, Clock-cases, Brackets, and other Ornaments in the Chinese, Gothick, and Rural Taste*, publishing the collection as a complete volume in 1758 from a new address in Grafton Street. His designs were marked by a bold use of Rococo, chinoiserie and Rustic motifs, incorporating rocaille and animals. In 1761 he brought out another edition entitled *One Hundred and Fifty New Designs*. It was dedicated to Lord Blakeney, President of the Antigallican Association, a group hostile to new-fangled French fashions and keen to better them. His slight *New Book of Ornaments*, published in 1760, showed experiments in etching that imitated pen-and-wash drawings.

By the early 1760s Johnson seems to have been concerned with teaching. A further set of designs, *A New*

Book of Ornaments (1762), was 'Designed for Tablets and Friezes for Chimney-Pieces Useful for Youth to draw after'. In 1763 Mortimer's *Universal Director* referred to him as a 'Carver, Teacher of Drawing and Modelling and Author of a Book of Designs for Chimneypieces and other ornaments and of several other pieces'. He issued a trade card (London, BM, Heal Col.) inscribed 'Thos. Johnson Drawing Master at ye Golden Boy in Charlotte Street Bloomsbury London'. When declared bankrupt in 1764 he had moved to Tottenham Court Road. His last surviving work is a single sheet dated August 1775 from an otherwise lost series. It illustrates a series of mirrors in the Neo-classical style. He is last recorded in the Grafton Street rent-books for 1778.

No bills relating to Johnson's work as a carver have been traced. It has been suggested that he was employed as a specialist sub-contractor by George Cole (*fl* 1747–74) who in 1761 supplied mirrors to Paul Methuen at Corsham Court, Wilts. A pair of pier-glasses and an overmantel mirror from Newburgh Priory, N. Yorks (on loan to Leeds, Temple Newsam House), are based on Johnson's published designs. Four pier-glasses and three console-tables for the 2nd Duke of Atholl at Dunkeld House, Tayside (1761), and Blair Castle, Tayside (1763), fall into the same category. A set of four Rococo dolphin *torchères* and a pair of girandoles from Hagley Hall, Worcs (Leeds, Temple Newsam House; London, V&A; Philadelphia, PA, Mus. A.) follow Johnson's designs and could have been carved by him.

WRITINGS
Twelve Gerandoles (London, 1755)
Glass, Picture, and Table Frames; Chimney Pieces, Gerandoles, Candle-stands, Clock-cases, Brackets, and Other Ornaments in the Chinese, Gothick, and Rural Taste (London, 1758); rev. as *One Hundred and Fifty New Designs* (London, 1761)
A New Book of Ornaments (London, 1760)
A New Book of Ornaments (London, 1762)

BIBLIOGRAPHY
H. Hayward: *Thomas Johnson and the English Rococo* (London, 1964)
——: 'Thomas Johnson and Rococo Carving', *Connoisseur Yb.* (1965), pp. 94–100
——: 'Newly-discovered Designs by Thomas Johnson', *Furn. Hist.*, xi (1975), pp. 40–42
Rococo: Art and Design in Hogarth's England (exh. cat., ed. M. Snodin; London, V&A, 1984), pp. 176–8
G. Beard and C. Gilbert, eds: *Dictionary of English Furniture Makers, 1660–1840* (Leeds, 1986)

JAMES YORKE

Johnson, Tore (*b* Saint-Leu-la-Forêt, nr Paris, 8 Jan 1928; *d* Stockholm, 14 May 1980). Swedish photographer. He studied from 1943 to 1948 at Viggbyholmsskola, Viggby-holm. In 1948 he was apprenticed to Karl Gullers at the Studio Gullers in Stockholm, but he left in the same year to become a freelance photographer in Paris. He worked there as a stringer for the Magnum picture agency, before moving in 1952 to New York, where he freelanced for European and American magazines. In 1954 he returned to Stockholm, where a selection of his photographs of the everyday lives of the poor in Paris was published in *Okänt Paris*. In 1958 he was one of the founders of the Tio Fotografer (Ten photographers) picture agency. Johnson's photography was inspired by that of André Kertész and was characterized by its concern for the human condition and for outsiders. Towards the end of his life, however, he abandoned street photography and worked in the studio, using a microscope and camera to study the shape of vitamin crystals.

PHOTOGRAPHIC PUBLICATIONS
Okänt Paris [Unknown Paris] (Stockholm, 1954) [text by I. Lo-Johansson]

BIBLIOGRAPHY
Subjektive Fotografie: Images of the 50s (exh. cat. by U. Eskildsen, M. Schmalriede and D. Martinson, San Francisco, CA, MOMA; U. Houston, TX, Sarah Campbell Blaffer Gal.; Essen, Mus. Flkwang; and elsewhere; 1984)

LEIF WIGH

Johnson, William H(oward) (*b* Florence, SC, 18 March 1901; *d* Long Island, NY, 13 April 1970). American painter. His early education was intermittent, but his drawing skills were developed through cartoon work for local newspapers. At 17 he moved to New York, where he found work as a stevedore, cook and hotel porter. From 1923 to 1926 he attended the National Academy of Design in New York and Hawthorne's Cape Cod School of Art at Provincetown. On his graduation funds were raised by supporters to enable further study in Paris, where he stayed for three years, absorbing the impact of such European Expressionists as Chaïm Soutine and simplify-ing his paintings to bold rhythmic compositions. In Paris he met Holcha Krake (1885–1944), a Danish textile designer, whom he married. The couple travelled through Europe, returning to the USA in 1930. Endorsed by the artist George Luks, Johnson received an award from the Harmon Foundation for 'Distinguished Achievement among Negroes'. He subsequently developed a broader technique with richness of texture and colour. With his wife he settled in Denmark, travelling to Tunisia in 1932 to study art and crafts. A visit to Scandinavia inspired dynamic landscapes that found an interested critical re-sponse. This period marked the height of the artist's expressionist phase. After returning to New York (1938), Johnson changed his style to produce flat designs with patterns of brilliant colour, emulating stained glass, de-picting religious subjects and scenes from Black American history, for example *Going to Church* (*c*. 1940–44; *see* AFRICAN-AMERICAN ART, fig. 2). His wife's death was destabilizing and to maintain a precarious existence he took work in the Navy Yard, but he left in 1946 to stay with his wife's family in Denmark. However, he returned to New York to be hospitalized in Islip, Long Island, where he remained until his death. His estate of 1100 works was accommodated by the Harmon Foundation until its closure, when it was dispersed among interested organizations.

BIBLIOGRAPHY
William H. Johnson: 1901–1970 (exh. cat., intro. A. D. Breeskin; Wash-ington, DC, Smithsonian Inst., 1971–2)
William H. Johnson (exh. cat. by R. R. Gosende, Cape Town, N.G., 1972)
William H. Johnson: The Scandinavian Years (exh. cat. by A. D. Breeskin, Washington, DC, N. Mus. Amer. A., 1982)

□

Johnson-Marshall, Stirrat. *See under* ROBERT MATTHEW, JOHNSON-MARSHALL & PARTNERS.

Johnston, David Claypoole (*b* Philadelphia, 25 March 1798; *d* Dorchester, MA, 8 Nov 1865). American print-maker and watercolourist. After training as an engraver

David Claypoole Johnston: *The Militia Muster*, watercolour, 273×381 mm, 1828 (Worcester, MA, American Antiquarian Society)

with Francis Kearney (1785–1837) in Philadelphia (1815–19), he embarked in 1821 on a theatrical career, performing for five seasons with repertory companies in Philadelphia and Boston. From this experience came his most important early work, a series of etched and lithographed character portraits of notable American and British actors. In 1825 he settled permanently in Boston.

Although Johnston occasionally painted in oils, and after 1840 conducted classes in many aspects of art, his reputation was and remains essentially that of a satiric comic artist who worked mainly as a printmaker and watercolourist. He was a prolific designer of wood-engravings, an accomplished etcher and among the earliest American masters of lithography. His etching style was at first derived from the work of George Cruikshank, but grew steadily more individual from the mid-1830s. This transition is particularly evident in the nine numbers of Johnston's *Scraps* published between 1828 and 1849, each consisting of four plates of etched comic vignettes treating a broad range of topical subjects, including fashion, art, politics, religion, women's rights and slavery. His best-known watercolour, *The Militia Muster* (1828; Worcester, MA, Amer. Antiqua. Soc.; see fig.), satirizes the American local militia system. He drew many broadside prints and illustrated dozens of books and magazines.

Johnston was the most able and original of the many satiric artists of his time, partly because he was a better draughtsman than the others and partly because his interests were much wider than those of his contemporaries. His work abounds in literary allusions, especially to Shakespeare but also to many contemporary writers. His knowledge of the history of art was unusual for an American artist who had never travelled abroad. Though he aimed his work at a wider, popular audience, it was also warmly received by cultivated Bostonians, including Washington Allston and Horatio Greenough. He exhibited watercolours in many of the annual exhibitions at the Boston Athenaeum, chiefly genre subjects and landscapes but also comic subjects. The strong anti-slavery feeling of his work in the 1850s developed into caustic assaults on the Confederacy in his work during the Civil War.

BIBLIOGRAPHY

M. Johnson: *David Claypoole Johnston* (Worcester, MA, 1970)
D. Tatham: 'D. C. Johnston's Satiric Views of Art in Boston', *Art and Commerce* (Charlottesville, VA, 1978), pp. 9–24
D. Tatham: 'David Claypoole Johnston's Theatrical Portraits', *American Portrait Prints* (Charlottesville, VA, 1984), pp. 162–93

DAVID TATHAM

Johnston, Edward (*b* Montevideo, Uruguay, 11 Feb 1872; *d* Ditchling, Sussex, 26 Nov 1944). British calligrapher, typographer and teacher. He went to Great Britain to study medicine at Edinburgh. Poor health forced him to abandon medicine, but he took up the study of calligraphy, influenced by his investigations of letter shapes in manuscripts in the British Museum, London. From 1899 until 1912 he taught writing and lettering at the

London County Council School of Arts and Crafts; from 1901 he also taught at the Royal College of Art. From 1910 to 1930 he designed type for the Cranach Press of Graf Harry Kessler (1868–1937) in Weimar and from 1916 to 1929 worked on an alphabet of block letters, based on the proportions of Roman capitals, for London Transport designs and posters. Johnston was a leading member of the artistic community known from 1920 as the Guild of St Joseph and St Dominic, was President of the Arts and Crafts Society (1933–6) and was awarded the CBE in 1939. He produced a wide range of work, from civic and ecclesiastical texts to poetry and inscriptions, usually executed in two colours (black and gold or black and red) on parchment. His influence as a designer of letter forms and as a teacher of calligraphy was widespread; his pupils included Eric Gill. During his last years, when his health was failing, he worked on calligraphic letters to friends.

WRITINGS

Writing and Illuminating and Lettering (London, 1906)
Manuscript and Inscription Letters (London, 1909)

BIBLIOGRAPHY

Memorial Exhibition to Edward Johnston (exh. cat., London, V&A, 1945) [incl. examples of Renaissance callig. known to have influenced his writing]
P. Johnston: *Edward Johnston* (London, 1959/*R* 1976)

LAURA SUFFIELD

Johnston, Frances Benjamin (*b* Grafton, WV, 15 Jan 1864; *d* New Orleans, 16 March 1952). American photographer. She studied art at the Académie Julian in Paris (1883–5) and at the Art Students League, Washington, DC. In 1888, in order to write and illustrate articles for popular magazines, she learnt photography from Thomas William Smillie (1843–1917), director of the Smithsonian Institution's Photography Division, Washington, DC. Upon opening a professional portrait studio in 1894, she became known for images of presidents, government officials and other notables. Her projects included documentation of educational facilities at Hampton Institute, VA and Tuskegee Institute, AL. In 1904 Johnston joined the Photo-Secession. She was a juror for the second Philadelphia Salon of Photography, received four consecutive Carnegie Foundation grants to document historic gardens and architecture of the South, and was made an honorary member of the American Institute of Architects in 1945. She donated most of her negatives, prints and correspondence to the Library of Congress, Washington, DC, in 1948. Johnston is often referred to as America's first female photojournalist.

BIBLIOGRAPHY

The Hampton Album (exh. cat. by L. Kirstein, New York, MOMA, 1966)
P. Daniel and R. Smock: *A Talent for Detail: The Photographs of Miss Frances Benjamin Johnston, 1889–1910* (New York, 1974)

FIONA DEJARDIN

Johnston, Francis (*b* Armagh, 1760; *d* Dublin, 14 March 1829). Irish architect. He was architect to the reconstituted Board of Works, Dublin, from 1805, the premier official appointment in the profession, though ill-health forced him into at least semi-retirement in the 1820s. He was a founder-member of the Royal Hibernian Academy in 1823.

Johnston, who never travelled beyond Britain, was trained by Thomas Cooley in Dublin. On Cooley's death in 1784 he inherited the patronage of Richard Robinson, Archbishop of Armagh, and in the first phase of his career, which lasted to about 1800, he worked mainly in the neighbourhood of Armagh and Drogheda. This period is distinguished by an interesting market building, the Corn Exchange (1796; altered), Drogheda, and by an important country house, Townley Hall (designed 1794; see IRELAND, fig. 3), Co. Louth. The Corn Exchange is important for its extensive colonnades of primitivist Greek Doric columns. Such prolific use of a radically simplified order was unparalleled at the time in Ireland, indeed rare anywhere. In later decades Johnston rejected such avant-garde Hellenism in favour of a more subdued use of Greek Doric detail. He used baseless orders, however, at Townley Hall, where they complement the refined severity of the building. After James Wyatt's Castlecoole, Co. Fermanagh, this is probably the finest major country house in Ireland of the 1790s. Johnston seems to have learnt much at this time from Wyatt, but his castellated houses show little of Wyatt's picturesque flair; the only one entirely designed by him, Charleville Forest (begun 1801), Co. Offaly, wears its innovative asymmetry rather stiffly, and retains something of the look of a gothicized classical block.

Johnston's work showed new maturity in the decade after 1800. He was established by then in Dublin and began work on St George's Church there in 1802. The following year he received the commission to transform the Parliament House in Dublin into a bank and in 1807 started the Dublin Castle chapel. His work on the Parliament House for the Bank of Ireland is distinguished yet discreet, for he respected the work of his predecessors, Edward Lovett Pearce and James Gandon. The Cash Office is one of the finest Neo-classical interiors in Ireland: the vast glazed lantern rising above a cove is structurally startling (Johnston seems to have enjoyed concealing explicit structural supports in his interiors). In its decoration, the room marks a leap beyond the repertory of the late 18th century in favour of a bold, sumptuous style with close affinities with that of Pearce. Nowhere is his decorative ability shown to better advantage, however, than in Dublin Castle chapel. Although the building is structurally unconvincing as Gothic architecture, in detail it is archaeologically correct, even pedantic; its opulent Strawberry Hill interior was of great influence in pre-Pugin Ireland.

Johnston's most conspicuous contribution to Dublin was his General Post Office (designed 1814; gutted 1916). It has a fashionably severe façade; its columns span the public footpath, alluding to James Gandon's portico at the old Parliament House, and the detail is Greek. But despite its up-to-date look, the façade derives from James Gibbs, as had the tower of St George's Church.

Johnston was more conscientious than flamboyant and his most austere buildings, such as Townley Hall, can be noble. Although austerity shades into bleakness in his institutional buildings, the plans of his hospitals and prisons introduced humanitarian reforms that were new to Ireland. His practice was inherited by his nephew William Murray, whose descendants continued the firm into the 20th century.

BIBLIOGRAPHY

J. Betjeman: 'Francis Johnston, Irish Architect', *The Pavilion*, ed. M. Evans (London, 1946), pp. 20–38

M. Craig: *Dublin, 1660–1860* (London, 1952/*R* Dublin, 1980)

E. McParland: 'Francis Johnston, Architect, 1760–1829', *Bull. Irish Georg. Soc.*, xii/3–4 (1969), pp. 61–139

EDWARD McPARLAND

Johnston, Henrietta (*fl* 1705–29). American pastellist. She and her future husband arrived in Charleston, SC, from Ireland in 1705. Records indicate that they married in April of that year. Her husband, an Anglican clergyman, received a position at Charleston, but his salary was poor, and Henrietta eased their financial problems by making and selling modestly priced portraits in pastel, which proved popular. No record exists of any art training, but her pastel technique has much in common with that of Edward Luttrell, an English painter in Dublin. Her portraits, almost always bust-length and normally 229×305 mm, are dated and signed on the back of the wooden frames that she apparently provided. She seldom showed the hands of her sitters and favoured a dark and undefined background that accented her sculptural treatment of the clothing. Strong shadows relieved by bright touches of white suggest the sheen of satin and other fine cloth worn by her subjects. The most characteristic feature of her style, the large liquid dark eyes, have a bright highlight on the left side, suggesting lighting from that direction. She worked only in Charleston, except for some work in New York dated 1725. Most of the pastels are in private collections, with some in the Carolina Art Association (Charleston, SC, Gibbes A. G.) and the Museum of Early Southern Decorative Arts, Winston-Salem, NC.

BIBLIOGRAPHY

M. S. Middleton: *Henrietta Johnston of Charles Town, South Carolina: America's First Pastellist* (Columbia, SC, 1966)

A. W. Rutledge: 'Henrietta Johnston', *Notable American Women, 1607–1959: A Biographical Dictionary*, ed. E. T. James (Cambridge, MA, 1971), ii, pp. 281–2

DARRYL PATRICK

Johnston, William L. (*b c.* 1811; *d c.* 1849). American architect. Details about his early life are obscure. During the mid-1830s he taught drawing at the architectural school run briefly by the Carpenters' Company, Philadelphia. In 1840 and 1842 Johnston exhibited watercolour architectural drawings at the Artists' Fund Society and at about the same time added the 't' to his surname and the middle initial 'L', to avoid confusion with others. Johnston's buildings, all in Philadelphia, were varied in style. His First Methodist Church (1840–41; destr.) incorporated a Greek Ionic order, whereas the Mercantile Library (1844; destr.) and Odd Fellows' Hall (1845–6; destr.) employed Roman elements that approached a Renaissance character. He probably designed a number of residences in Philadelphia and its environs, including an imposing Neo-classical mansion for the chemist George W. Carpenter in Germantown in 1841–4. He was also the designer of Orange Grove (1847–9), the Gothic Revival plantation house of Thomas A. Morgan in Braithwaite, LA; Morgan's wife was from Philadelphia. None of these is extant except for Orange Grove, which is a ruin. Johnston's only surviving major work is the Moorish gate (1849) to Hood Cemetery, Germantown. Johnston is best known as a contributing designer to the seven-storey Granite Building (1848–50; destr. 1957), Philadelphia, also known as the Jayne Building. After Johnston's death from tuberculosis the owner, Dr Jayne, engaged Thomas Ustick Walter to complete it. The pronounced verticality of the Venetian Gothic design, with its recessed lintels, may have influenced Louis Sullivan, then working with Frank Furness, whose office on Chestnut Street overlooked the Jayne Building.

BIBLIOGRAPHY

Macmillan Enc. Architects

C. E. Peterson: 'Ante-bellum Skyscraper', *J. Soc. Archit. Hist.*, ix (1950), pp. 27–8

R. C. Smith: 'The Jayne Building Again', *J. Soc. Archit. Hist.*, x (1951), p. 25

J. C. Massey: 'Carpenters' School, 1833–42', *J. Soc. Archit. Hist.*, xiv (1955), pp. 29–30

W. R. Cullison III: *Orange Grove: The Design and Construction of an Ante-bellum Neo-Gothic Plantation House on the Mississippi River* (diss., New Orleans, Tulane U., 1969)

R. J. Webster: *Philadelphia Preserved: Catalogue of the Historic American Buildings Survey* (Philadelphia, 1976)

LELAND M. ROTH

John the Fearless, 2nd Valois Duke of Burgundy. *See* BURGUNDY, (2).

John the Good, King of France. *See* VALOIS, (1).

John William [Johann Wilhelm], Elector Palatine. *See* WITTELSBACH, §II(3).

Jokansai. *See* MORI SOSEN.

Jokei. *See* SUMIYOSHI, (1).

Jokjakarta. *See* YOGYAKARTA.

Jokwe. *See* CHOKWE AND RELATED PEOPLES, §1.

Joli [Jolli], **Antonio** (*b* Modena, *c.* 1700; *d* Naples, 29 April 1777). Italian painter. He first studied in Modena with il Menia (Raffaello Rinaldi; *fl* 1713). After a period in Rome in the studios of a member of the Galli-Bibiena family and of Giovanni Paolo Panini he worked as a scene painter in Modena and Perugia. By 1735 he was in Venice, where he came into contact with Canaletto and again worked as a scene painter. He travelled widely in Europe, and from Germany went to London, where he lived from 1744 to 1748. He had a managerial position at the King's Theatre, Haymarket, and decorated the Richmond mansion of its director, John James Heidegger, with view paintings (*in situ*). From 1750 to 1754 he worked in Madrid (e.g. *see* MADRID, fig. 3).

In 1754 Joli returned to Venice and in 1755 was elected a founder-member of the Venetian Academy. Before long he had settled in Naples, where he became painter to Charles VII (from 1759 Charles III of Spain), whose court entertainments he organized. His easel paintings consist of architectural capriccios in the tradition of Giovanni Paolo Panini (e.g. *Capriccio*, Caserta, Pal. Reale) and topographical views in the manner of Canaletto. In 1759 he was one of the first artists to paint views of the temples of Paestum (e.g. Caserta, Pal. Reale). He painted many scenes, vivid and highly detailed, of court life in Naples, among them the *Departure of Charles of Bourbon for Spain in 1759* (Naples, Mus. N. S Martino). He was also popular

with Grand Tourists, and painted a series of views of Naples for Lord John Brudenell (some Duke of Buccleuch priv. col.). His paintings have a particular interest as documents of 18th-century urban life.

BIBLIOGRAPHY

E. Croft Murray: 'The Painted Hall in Heidegger's House at Richmond, II', *Burl. Mag.*, lxxviii (1941), pp. 105–12, 155–9, pls i, ii
——: *Decorative Painting in England, 1537–1837*, ii (London, 1970)
J. Urrea Fernández: *La pintura italiana del siglo XVIII en España* (Valladolid, 1977)
The Golden Age of Naples: Art and Civilization under the Bourbons, 1734–1805, 2 vols (exh. cat., Detroit, MI, Inst. A.; Chicago, IL, A. Inst.; 1981), i, pp. 119–21
In the Shadow of Vesuvius: Views of Naples from Baroque to Romanticism, 1631–1830 (exh. cat., ed. S. Cassani; London, Accad. It. A. & A. Applic., 1990), pp. 124–5

JOHN WILSON

Jolin, Einar (*b* Stockholm, 7 Aug 1890; *d* Stockholm, 14 June 1990). Swedish painter. After studying in Stockholm, he worked under Henri Matisse in Paris from 1908 to 1911 and in 1913 exhibited there at the Salon d'Automne. The influence of Matisse is strongly evident in such early paintings as *On the Beach* (1917; Stockholm, Mod. Mus.), with its bright colour and strong outlines. He travelled in Italy (1920–22), North Africa (1922–3) and Spain (1924). These travels inspired a number of works, such as *Outside the Town: Scene from Kairouan* (1923; Stockholm, Mod. Mus.), in which he flattened the space and reduced the figures and other elements to simple geometric forms. His later style was more naturalistic and restrained in colour, as is demonstrated by *Still-life with White Flowers* (1938; Stockholm, Mod. Mus.) and *Woman in Black* (1942; Stockholm, Mod. Mus.).

BIBLIOGRAPHY

Bénézit; Vollmer
Katalogen: Över Moderna Museets samlingar av Svensk och internationell 1900-talskonst [Catalogue of the Moderna Museum's collection of Swedish and international 20th-century art] (Stockholm, 1976), pp. 74–5

☐

Jollain, Nicolas-René (*b* Paris, 1732; *d* Paris, 1804). French painter. A pupil of Jean-Baptiste Marie Pierre, he finished second in 1754 in the Prix de Rome competition with his *Mattathias* (untraced). He was approved (*agréé*) at the Académie Royale in 1765. He was a precocious and original artist, whose works range from historical, allegorical and religious pictures to decorative and genre pieces and portraits. His work frequently divided contemporary critical opinion. His *Belisarius Begging Alms* of 1767 (untraced), for example, was considered well composed by Louis Petit de Bachaumont, who admired the motif of the child begging with an upturned soldier's helmet. Denis Diderot, on the other hand, dismissed the work as 'a bad sketch'. Jollain's particular aptitude was for religious subjects. At the Salon of 1769, for example, he exhibited *The Refuge* (untraced; oil sketch, British priv. col.), which depicts the founder of the Institute of Our Lady of Refuge in an attitude of devotional supplication; it was painted for the Order's convent chapel at Besançon, and the chapel itself appears in the background. Jollain's art was part of the mid-18th-century Baroque revival in French religious painting, and *The Refuge* has some affinity with Gabriel-François Doyen's *Miracle des Ardents* (1767; Paris, St Roch). Jollain's other religious commissions of this

period include the *Entry of Christ into Jerusalem* (1771; untraced) for the Paris Charterhouse. He was received (*reçu*) as a history painter at the Académie in 1773 with the *Good Samaritan* (ex-St Nicolas-du-Chardonnet, Paris, 1972).

Jollain was adept at maintaining the smooth forms of the Rococo style while incorporating fashionable Neoclassical subject-matter or references. A subject from Herodotus, the *Indiscretion of Candaules, King of Lydia* (1775; Paris, Jean de Cailleux priv. col.), with its popular combination of antique and erotic elements, has the *déshabillé* Queen of Lydia in the foreground, with Candaules and his bodyguard, Gyges, appearing in the background as shadowy voyeurs. Shortly after, Jollain again reworked two common themes in the Rococo nude: *The Bath* (see fig.) and *La Toilette* (both Paris, Mus. Cognacq-Jay). In these very small pictures, both of which are painted on copper, Jollain complemented his elegantly proportioned figures with exquisitely detailed accessories. Both were engraved in 1781 by Louis-Marin Bonnet, who augmented them with a blatant erotic charge bordering on the ridiculous. That year Jollain was himself commissioned to provide a companion piece for Hugues Taraval's *Waking of Cupid* for the Chambre de la Reine at the château of Marly. The result was his *Sleeping Child* (London, Wallace), a demonstration of the artist's ability to modify his style to suit specific demands and locations. In the same year he painted his *Christ Among the Doctors* (1781; Fontainebleau, Château) for the chapel at Fontainebleau. In 1788 he was made a curator of the Musée du Roi and in 1792, with François-André Vincent and Jean-Baptiste Regnault, he was a member of the commission for the formation of a Musée National.

Nicolas-René Jollain: *The Bath*, oil on copper, before 1781 (Paris, Musée Cognacq-Jay)

Jollain could not have been prepared for the vitriolic critical assault that followed the open Salon of 1791. Among the works he exhibited were *Aeneas and Dido*, *Blind Oedipus Guided by Antigone* and *Susanna* (all untraced). His pictures were called 'detestable', 'sad' and 'daubs'. The severity of these criticisms resided in the perception of him as an archetypal Academician practising a smooth and gracious style that was associated with a privileged élite. Jollain's cause cannot have been helped by the presence in the same room of Jacques-Louis David's *Death of Socrates* (New York, Met.) and the *Lictors Bringing Brutus the Bodies of his Sons* (Paris, Louvre). He did not exhibit at the Salon again.

During the French Revolution and for a period soon after his death, Jollain was largely forgotten; but although his oeuvre is fragmentary and widely dispersed, he must be considered among the more able figures in the transition from the Rococo to the Neo-classical style in France.

BIBLIOGRAPHY

Lettres analytiques, critiques et philosophiques sur les tableaux du Salon, l'an troisième de la liberté (Paris, 1791), pp. 44–5

M. Roland Michel: 'Concerning Two Rediscoveries in Neo-classical Painting', *Burl. Mag.*, cxix (1977) [adv. supplement, pp. i–vii]

French Eighteenth-century Oil Sketches from an English Collection (exh. cat. by P. Walch, Albuquerque, U. NM, A. Mus., 1980)

SIMON LEE

Jollivet, Pierre-Jules (*b* Paris, 26 June 1794; *d* Paris, 7 Sept 1871). French painter and lithographer. He first studied architecture with Jean-Jacques Huvé (1742–1808) and Charles Famin and then turned to painting, entering the Ecole des Beaux-Arts in Paris on 11 May 1822. He remained there until 1825 and was a pupil of François-Louis Dejuinne (1786–1844) and of Antoine-Jean Gros. He became interested in lithography very early on and in 1826 travelled to Spain to work on the *Colección litographica de cuadros del rey de España el señor Fernando VII* (Madrid, 1826), a catalogue of the art collections of Ferdinand VII, King of Spain, at the Museo Real in Madrid. Jollivet contributed the first 18 plates to this publication and, on his return to Paris, resumed painting. He specialized in painting history and genre subjects, and his journey to Spain supplied him with numerous subjects for the latter, which were much admired at the Salon. He made his début at the Salon in 1831 with the *House of the Alcalde*, *View of the Royal Residence in Aranjuez, Taken Opposite the Waterfall of the Tagus* and *Philip IV and his Children*, after the work by Velázquez. He continued to paint and exhibit Spanish subjects thereafter, and these became one of the hallmarks of his work. In the 1830s he was commissioned by Louis-Philippe to paint a number of large historical compositions for the Musée Historique de Versailles, and this led to such works as the *Battle of Hooglede, 13 June 1794* (Salon 1836) and *Godefroy de Bouillon Holding the First Assizes in the Kingdom of Jerusalem, January 1100* (both Versailles, Château). He also painted such religious subjects as the *Massacre of the Innocents* (exh. Salon 1845; Rouen, Mus. B.-A.), and he decorated the chapels of such churches as St-Ambroise, St-Antoine-des-Quinze-Vingts and St-Vincent-de-Paul, all in Paris.

BIBLIOGRAPHY

Bénézit; DBF; Thieme–Becker

G. Vapereau: *Dictionnaire universel des contemporains* (Paris, 1858, 5/1880)

Inventaire du fonds français après 1800, Paris, Bib. N., Dépt. Est. cat., xi (Paris, 1960), pp. 457–8

B. Foucart: *Le Renouveau de la peinture religieuse en France, 1800–1860* (Paris, 1987), pp. 91–2

ATHENA S. E. LEOUSSI

Jolly, Alexander Stewart (*b* Lismore, 1887; *d* Sydney, 1957). Australian architect. He was the son of a timber merchant and furniture maker and was apprenticed to the furniture trade before practising as an architect. His technical knowledge of timber detailing was combined with a romantic design approach to produce individualistic interpretations of the Californian bungalow style. His most important work was Belvedere (1919), a spreading bungalow in Cranbrook Avenue, Cremorne, Sydney, with a low, pitched roof and deep, shady verandahs on three sides defined by heavily timbered eaves with hefty pylon supports. It has been likened to Frank Lloyd Wright's prairie houses and contained a revolving, labour-saving servery between kitchen and dining room, built-in furniture and simple timber detailing throughout. In the 1930s Jolly retired from architectural practice to speculate in land subdivision on the Palm Beach peninsula north of Sydney. There he designed a series of whimsical, organic, stone and timber houses incorporating natural rocks, tree trunks and forked branches; some resembled animal forms, such as the Elephant House (1935), or large boulders.

BIBLIOGRAPHY

D. Anderson: *Alexander Stewart Jolly: His Life and Works* (BArch thesis, U. Sydney, NSW, 1969)

D. L. Johnson: *Australian Architecture, 1901–1951: Sources of Modernism* (Sydney, 1980), pp. 63–4

M. STAPLETON

Joly [Joli; Yoly], **Gabriel** [Gerardo] (*b* Varipont, diocese of Noyon, Picardy, *c*. 1495; *d* Teruel, 19 March 1538). French sculptor and ?painter active in Spain. He was probably trained in Italy and is first recorded in 1515 as a master of arms ('*Preboste de arte gladiatoria*') in Saragossa, where he lived until 1537, when he moved to Teruel. His contribution to the retable (1519) of S Miguel de los Navarros, Saragossa, is disputed, but he carved a retable in 1520, together with his assistant Gil de Morlanes the younger, for the cathedral of La Seo, Saragossa. It was dedicated to St James, but this was later changed to St Augustine. It has a predella and large central body containing an Italianate medallion of the Virgin. Between 1520 and 1524 he carved some of the statues for the retable of the parish church at Tauste. The retable (1533) for the cathedral at Roda de Isábena was destroyed in 1936, but the quality of its carved images is evident in photographs. It is documented that in 1532 Joly was commissioned to carve the principal retable in the cathedral at Teruel, begun in 1536. This altarpiece, dedicated to the Assumption, is not painted and has three vertical sections and three storeys with cresting. In 1537 Joly was paid for the retable of the Holy Doctors in the church of San Pedro, Teruel. The retable dedicated to St Peter in the same church, containing some handsome groups, is also attributed to Joly. His name is linked professionally with other contemporary sculptors in Saragossa. He was influenced by

Damián Forment, and his art developed the greater expressiveness that is characteristic of the Castilian style. The attitudes of his figures are often skilfully rendered, with elongated proportions, and his reliefs are always harmoniously composed.

BIBLIOGRAPHY

A. Ponz: *Viaje* (1772–94); ed. C. M. de Rivero (1947)
S. Rubinstein: 'Gabriel Yoly, sculpteur sur bois', *Actes du congrès d'histoire de l'art: Paris, 1924*, iii, pp. 505–16
F. Abbad Rios: 'Seis retablos aragoneses de la época del renacimiento', *Archv Esp. A.*, xxiii (1950), pp. 53–71
J. Ibáñez Martín: *Gabriel Yoly* (Madrid, 1956)
A. Novella Mateo and A. Solaz Villa-Nueva: 'La obra de Gabriel Yoly en Teruel', *Semin. A. Aragon.*, 34 (1981), pp. 83–91
A. Hernández Merlo and others: *Aportaciones a la escultura aragonesa del siglo XVI* (diss., U. Saragossa, 1985); summary in *Artigrama*, 2 (1985), pp. 297–304

MARGARITA ESTELLA

Joly, Jules-Jean-Baptiste de (*b* Montpellier, 22 Nov 1788; *d* Paris, 1 Feb 1865). French architect and writer. He was a pupil of Claude Mathieu Delagardette (1762–1805) and Nicolas-Pierre-Jules Delespine (1756–1825) at the Ecole des Beaux-Arts, Paris. He subsequently travelled to Italy and published a collection of classical ornaments in 1819. In the manner typical of 19th-century French architects, Joly's only executed work appears to be a single great public commission, the Chambre des Députés (now Assemblée Nationale), Quai d'Orsay, Paris. In 1821 he succeeded Bernard Poyet as the official architect of the building, his first major work there beginning in 1828, when he erected a large, temporary assembly hall in the garden. In 1829 the construction of his new Salle des Séances began. This large, semicircular chamber has a coffered ceiling and an Ionic colonnade above the highest rank of seats. Its form belongs to the tradition of classical theatres initiated by Andrea Palladio with his Teatro Olimpico (completed 1580), Vicenza. Between the Salle des Séances and Poyet's massive portico, Joly placed a vast lobby articulated by a Giant Corinthian order supporting a coffered barrel vault pierced by thermal windows. Also included in this phase of construction, completed by 1833, was the library. This long room is divided into bays by pairs of piers, from which spring shallow pendentive domes. The richness of these interiors was further augmented by a series of murals (1838–47) by Eugène Delacroix.

WRITINGS
Recueil classique d'ornements et de bas reliefs pris dans les monuments anciens et dans ceux de la Renaissance (Paris, 1819)
Plans, coupes et élévations de la restauration de la Chambre des Députés (Paris, 1840)
Histoire du Palais Bourbon (Paris, 1855)

BIBLIOGRAPHY
L. Hautecoeur: *Architecture classique* (Paris, 1943–57)

RICHARD JOHN

Jōmon period. Period in Japanese archaeological and cultural chronology (*see* JAPAN, §I, 2). The term Jōmon means 'cord-mark design' and was first applied by ED-WARD SYLVESTER MORSE in 1879 to a period in Japanese prehistory during which pottery with this distinctive type of surface patterning was produced. The Jōmon period extends over ten millennia from *c.* 10,000 to *c.* 300 BC and on the basis of ceramic typology (*see* JAPAN, §VIII, 2(i)(a))

has been divided into six phases: Incipient (*c.* 10,000–*c.* 7500 BC), Initial or Earliest (*c.* 7500–*c.* 5500 BC), Early (*c.* 5500–*c.* 3500 BC), Middle (*c.* 3500–*c.* 2500 BC), Late (*c.* 2500–*c.* 1000 BC) and Final or Latest (*c.* 1000–*c.* 300 BC). The characteristic cord-marked vessels noted by Morse date from Early Jōmon.

Japan's long and distinctive ceramic tradition has its origins in the Jōmon period, and pottery from the Incipient phase, for example from Fukui Cave, Nagasaki Prefecture (*c.* 10,750 BC), is among the oldest in the world. The most striking examples of Jōmon pottery are the ornate vessels from the Middle phase. Some large pieces are over 600 mm tall, with monumentally sculptured rim decorations, both representational and non-representational, which at times form half the height. Complex and elegant cord-marked patterns cover the surface of the vessels. Jōmon artefacts also include handmade clay figurines (*dogū*) that combine quasi-zoomorphic and anthropomorphic elements. These figurines, which date from the Middle or Late Jōmon phases and have been found at sites between the island of Kyushu and Aomori Prefecture in the north-east, may have played a role in community rituals. Some examples from the Middle Jōmon phase are as extravagantly patterned as the vessels. This rich variety of form as well as their wide distribution throughout the Japanese islands raise intriguing questions for further archaeological study as to their use and meaning (*see also* JAPAN, §V, 2(ii)).

It was once thought that the Jōmon peoples were nomadic. However, recent comparisons with other prehistoric pottery-making peoples indicate that such large and elaborate vessels imply permanent or seasonal dwelling patterns. A degree of leisure was required to carry out the clear sense of aesthetic purpose expressed in the vessel designs. Jōmon artefacts have intrigued the Japanese for centuries. In earliest historical records they are explained as being the remains of ancient giants, gods and other mythological beings. Much of what is now known about the Jōmon peoples and their culture is derived from an understanding of climatic changes combined with an excavation of dwelling and grave sites. Between *c.* 8000 and *c.* 3000 BC, a warming trend was conducive to the breeding of shellfish. As the trend continued, to *c.* 2500 BC, deciduous trees flourished and many sites were established in upland areas inland, where the hills and valleys yielded berries, nuts and game. When the climate became colder and wetter, *c.* 2500 BC, settlers moved back to the coast: this movement accounts for large shell-mounds such as ŌMORI SHELL-MOUND. Refuse-heaps, storage pits and grave sites, all found near settlements, have yielded the remains of foodstuffs as well as stone and wooden tools, bows and arrowheads, fish-hooks, sinkers, harpoon heads, oars, fragments of nets, bone needles, lacquered combs and ornaments such as bone hairpins and shell earrings. By the Late Jōmon period the same site was being used for several burials. From the Jōmon period too date such archaeological sites as the ŌYU STONE CIRCLES. These sites were perhaps used by more than one village.

Jōmon peoples lived in thatched, semi-sunken dwellings with fireplaces lined with stone slabs and surrounded by post holes (*see* JAPAN, §III, 2). There may have been some internal trade in obsidian and stone between mountain and coastal areas. Some scholars have put forward an

unsubstantiated suggestion that the Latest Jōmon phase in Tōhoku (the northern part of Honshu) was an AINU culture period. If this was so, the Ainu, who now reside in Hokkaido, must have been displaced northwards at a later time.

BIBLIOGRAPHY

J. E. Kidder: *The Birth of Japanese Art* (New York, 1965)
——: *Prehistoric Japanese Arts: Jōmon Pottery* (Tokyo, 1968)
T. Esaka: 'The Origins and Characteristics of Jōmon Ceramic Culture', *Windows on the Japanese Past: Studies in Archeology and Prehistory*, eds. R. J. Pearson, G. L. Barnes and K. L. Hutterer (Ann Arbor, 1986), pp. 223–8

BONNIE ABIKO

Jónás, Dávid (*b* Budapest, 5 Aug 1871; *d* Budapest, 27 April 1951). Hungarian architect. He graduated from the Hungarian Palatine Joseph Technical University, Budapest, in 1894, and worked for a short time with Ferdinand Fellner and Hermann Helmer in Vienna. In 1903 he founded a partnership in Budapest with his brother Zsigmond Jónás (1879–1936), whose role was financial. Between 1903 and World War I he was a leading Hungarian representative of Viennese-influenced pre-modernism, which emphasized geometric form and simplicity. One of his finest achievements was the combined Szénasy & Bárczai shop and residential block (1908), Martinelli Square, Budapest. The lower two floors, devoted to the shop, are glazed from top to bottom. The upper four, residential, floors have riveted portals divided by pilasters that form a ribbon around the building. Bay windows relieve the flatness of the façade. The façade of the Tolnai Világlapja Press Office (1911–13), Dohány Street, Budapest, is composed of contrasting brick and stone in a simplified neo-classical idiom. Jónás built a number of residential blocks and villas in Budapest; the corner building (1909–13) on Jászberényi Street, part of the city's scheme for affordable housing, has a flat brick façade, enlivened with graceful wrought-iron balconies.

BIBLIOGRAPHY

Á. Moravánszky: *Die Architektur der Jahrhundertwende in Ungarn und ihre Beziehungen zu der Wiener Architektur der Zeit* (diss., U. Vienna, 1983)
J. Gerle, A. Kovács and I. Makovecz: *A századfordujó magyar épitészete* [Turn-of-the-century Hungarian architecture] (Budapest, 1990)

ÁKOS MORAVÁNSZKY, KATALIN MORAVÁNSZKY-
GYÖNGY

Jonas, Joan (*b* New York, 13 July 1936). American performance and video artist, film maker, draughtsman and printmaker. She studied sculpture and art history at Mount Holyoke College, South Hadley, MA (1954–8). In 1958 Jonas travelled to Europe before studying sculpture at the Boston Museum School (1959–61) and various subjects at Columbia University (MFA 1964). She was particularly influenced by her experience of the New York art scene in the early to mid-1960s and by the work of John Cage and Claes Oldenberg and their interest in 'non-linear' structure. Believing any potential for innovation in sculpture and painting to be exhausted, Jonas turned to the relatively unexplored area of performance art. Her early performances (1968–71), called *Mirror Pieces*, were held in large spaces and included large and small mirrors, either as a central motif or as props or costume elements. From the early 1970s her works became increasingly symbolic, game-like and ritualistic: in, for example, *Organic*

Honey's Visual Telepathy (1972) Jonas took the role of 'Organic Honey', a part-real, part-mythical and part-fantastical woman, who explores the possibilities of female imagery and eroticism, keeping her narcissism in check by scanning her own image in a video monitor. Jonas's performances, films and videos are characterized by de-synchronized, non-linear, fragmentary features. She also often used drawing as ritual in her performances; the motifs of dogs, the sun and moon, the skull, landscapes and hurricanes, for example, have appeared in her works.

BIBLIOGRAPHY

Joan Jonas: Scripts and Descriptions, 1968–1982 (exh. cat., Berkeley, U. CA, A. Mus., 1982)
Joan Jonas: 'He Saw her Burning' (Berlin, 1982): Videoinstallation, Videobänder, Zeichnungen (exh. cat., W. Berlin, daad gal., 1984)

CECILE JOHNSON

Jones. English family of artists.

(1) John Jones (*b c.* 1740; *d* ?1797). Engraver. His earliest mezzotint, *Dr William Pitcairne* (see Chaloner Smith, no. 62), the first of his 25 mezzotints after Reynolds, is dated 1777. From then until 1780 he engraved mezzotints for publishers; he published three satires jointly with Thomas Rowlandson in 1780, and subsequently published nearly all his own prints. He had great success with his mezzotint of *Charles James Fox* (1784) after Reynolds; the demand was such that he engraved four almost identical plates. Most of Jones's mezzotints were three-quarter lengths, engraved in a much freer and more impressionistic way than usual. From 1785 he engraved in stipple, publishing, in addition to portraits, a number of humorous stipples after Henry William Bunbury, a few of which were by other engravers. In 1789 he took as an apprentice Charles Turner, later one of the best of all English mezzotint engravers. In 1790 he was appointed engraver to the Prince of Wales and also to the Duke of York, shortly after publishing a full-length stipple of the latter (see Hamilton, p. 74) after Reynolds. Nearly all Jones's 90 or so mezzotints were portraits; among his subject plates is *Beatrice, Hero and Ursula* (1791; CS 87) after Henry Fuseli. Another success was *Mrs. Jordan as Hippolyta* (1791; CS 41) after John Hoppner; some impressions of this were printed in colour. Jones issued no prints after 1796, and the publication in 1800 by his wife of a *View of Petersham*, after Reynolds and finished in 1796 (see Hamilton, p. 155), suggests that he had died by then.

BIBLIOGRAPHY

DNB; O'Donoghue; Thieme–Becker
E. Hamilton: *Catalogue Raisonné of the Engraved Works of Sir Joshua Reynolds from 1755 to 1822* (London, 1874, 2/1884, R 1973), pp. 28–9
J. Chaloner Smith: *British Mezzotinto Portraits*, ii (London, 1879), pp. 740–76 [CS]
A. Graves: *The Society of Artists of Great Britain (1760–1791): The Free Society of Artists (1761–1783)* (London, 1907), p. 310
C. E. Russell: *English Mezzotint Portraits and their States: Catalogue of Corrections of and Additions to Chaloner Smith's 'British Mezzotinto Portraits'*, ii (London, 1926), pp. 176–87

DAVID ALEXANDER

(2) George Jones (*b* London, Jan 1786; *d* London, 19 Sept 1869). Painter, son of (1) John Jones. At the age of 15 he entered the Royal Academy Schools, London. Two years later he interrupted his studies when he obtained a

commission in a regiment of militia. On succeeding to a captaincy, he volunteered with his company to serve under Wellington in the Peninsular War. During his years in the army he exhibited mainly views and domestic subjects. It was only after his return to civilian life in 1815 that he began to paint the battle scenes on which his reputation was chiefly built. Several of these portrayed scenes in the Waterloo campaign; his sketch of *Wellington Leading the British Advance* won second prize in the British Institution's Waterloo Competition in 1820 and a commission to paint the work on a large scale (*c.* 3.5×3 m). The painting (1820; London, Royal Hosp.) is a variant of typical late 18th-century battle pieces: it shows a panoramic vista of the battle, with huge plumes of brightly coloured smoke rising from the distant fighting, and incidents and tiny figures judiciously scattered in pools of light and shade in the foreground and middle distance. Jones was thus able to demonstrate his professional knowledge of the overall disposition of troops on the field, avoiding the standard convention of the large-sized portrait group set against a distant battle. A second, somewhat altered version of this work was exhibited to mixed reviews at the Royal Academy in 1822. It was sufficiently well received to secure Jones's election as ARA in 1822 and RA in 1824. His association with the Academy was remarkably long and fruitful: between his début in 1803 and the time of his death he exhibited no fewer than 221 works. Subjects included battles from almost every campaign of the first half of the century, up to and including the Indian Mutiny in 1857, genre scenes, views of continental cities, and biblical and historical episodes. He also painted several large-scale commissioned pictures commemorating important events (e.g. *Funeral of Sir David Wilkie, R.A.*; exh. RA 1842; and the *Opening of the New London Bridge, August 1, 1831*; exh. RA 1832). He served the Academy as Librarian (1834–40), as Keeper of the Schools (1840–50) and, temporarily, as President, when Sir Martin Archer Shee was ill (1845–50).

'Waterloo Jones', as he was known because of his Waterloo pictures, was a genial man with many artist friends, among them the sculptor Sir Francis Chantrey, and Turner. On more than one occasion Turner and Jones exhibited pictures of the same subject in friendly rivalry (e.g. *Shadrach, Meschach and Abednego in the Burning Fiery Furnace*; exh. RA, 1832; London, Tate).

WRITINGS
Sir Francis Chantrey RA: Recollections of his Life, Practice and Opinions (London, 1849)

BIBLIOGRAPHY
DNB
Obituary, *Athenaeum* (25 Sept 1869), p. 404; *A.J.* [London] xxxi (1869), p. 336
M. Lalumia: *Realism and Politics in Victorian Art of the Crimean War* (Ann Arbor, MI, 1984)

PAUL USHERWOOD

Jones, Allen (*b* Southampton, 1 Sept 1937). English painter, sculptor and printmaker. He studied at Hornsey College of Art, London (1955–9, 1960–61), spending 1959–60 at the Royal College of Art, where he was associated with the rise of Pop art. Like Hockney and Kitaj he mixed conflicting styles, for instance in the *Battle of Hastings* (1961–2; London, Tate), but he drew less from contemporary culture than from the colour abstractions of Kandinsky and Robert Delaunay. Klee's writings encouraged him to adopt a pedagogical approach, as shown in his representation of movement through canvas shape in *3rd Bus* (1962; Birmingham, Mus. & A.G.). Motivated by the theories of Jung and Nietzsche, he began in paintings such as *Hermaphrodite* (1963; Liverpool, Walker A.G.) to depict fused male/female couples as metaphors of the creative act. While living in New York (1964–5) he discovered a rich fund of imagery in sexually motivated popular illustration of the 1940s and 1950s. Henceforth, in paintings such as *Perfect Match* (1966–7; Cologne, Mus. Ludwig), he made explicit the previously subdued eroticism, adopting a precise linear style as a means of emphasizing tactility. The full extent of his Pop sensibility emerged in sexually provocative fibreglass sculptures such as *Chair* (1969; London, Tate), life-size images of women as furniture with fetishist and sado-masochist overtones. In the mid-1970s he returned to a more painterly conception in canvases such as *Santa Monica Shores* (1977; London, Tate) and to a playful stylization in figure sculptures, notably *The Tango* (1984; owned jointly by Liverpool, Walker A.G., and Merseyside Development Corp.), a larger than life-size dancing couple made from polychrome steel plate. Lithography, in which his output was prolific, proved an appropriate medium for his graphic flair. Among his publications are *Figures* (Milan, 1969) and *Projects* (London, 1971), the latter including his designs for stage, film and television.

BIBLIOGRAPHY
Allen Jones: Das graphische Werk (exh. cat., Cologne, Gal. Spiegel, 1970)
Allen Jones: Retrospective of Paintings 1957–1978 (exh. cat. by M. Livingstone, Liverpool, Walker A.G., 1979)
M. Livingstone: *Sheer Magic by Allen Jones* (New York, 1979)
C. Jencks, V. Arnos and B. Robertson: *Allen Jones* (London, 1993)

MARCO LIVINGSTONE

Jones, Beatrix. *See* FARRAND, BEATRIX JONES.

Jones, David (*b* Brockley, Kent, 1 Nov 1895; *d* Harrow, nr London, 28 Oct 1974). English painter, draughtsman, printmaker, illustrator and poet. His creative life was largely determined by two experiences. During World War I he served on the Western Front with the 15th Royal Welch Fusiliers, an event that he regarded as epic and imbued with religious, moral and mythic overtones, in which Divine Grace manifested a continual presence, an approach to thinking about the war distilled in the structure of his epic poem *In Parenthesis* (London, 1937). The second experience, related to the first, was his conversion to Roman Catholicism in 1921. This immediately led him to join Eric Gill's community at Ditchling, Sussex, where he was a postulant in the Guild of St Joseph and St Dominic, after having spent three fruitless years at the Westminster School of Art, London, where he had been taught by the English painters Walter Bayes (1869–1956) and Bernard Meninsky (1891–1950) and occasionally by Walter Sickert.

At Ditchling, Jones was first taught carpentry and wood-engraving by Father Desmond Macready Chute (1895–1957). Until 1932 he produced prints that placed him in the top rank of British wood-engravers of that period, such as the set of 13 engravings for *The Book of Jonah* (Waltham St Lawrence, 1926). His engravings were largely

for publishers of de luxe illustrated books such as the Golden Cockerel Press or the guild's St Dominic's Press, but they were fully articulated within the unrarefied guild atmosphere in which he worked, and they reveal how he assimilated Gill's influence without imitating his style. The peak of his output as a printmaker was between 1926 and 1929 and included wood-engravings for *The Chester Play of the Deluge* (Waltham St Lawrence, 1927) and copper-engravings for *Seven Fables of Aesop* (Lanston Monotype Corporation, 1928) and *The Ancient Mariner* (Bristol, 1929). He was forced to give up engraving in 1930 because of eye problems.

The watercolours (e.g. *Chapel in the Park*, 1932; London, Tate) and occasional oil paintings made by Jones can be divided into three main phases punctuated by his two breakdowns in 1932 and 1947. His early work shows the influence of the spare pseudo-medievalist style practised by Gill, with whom he worked for a number of years and to whose daughter Petra he was engaged from 1924 to 1927. *The Terrace* (1929; London, Tate), a still-life in front of a seascape glimpsed through a balcony, typifies the prosaic subject-matter he favoured at that time; the delicate handling of watercolour and sophisticated post-Cubist conflation of interior and exterior bear comparison with work of the same period by Ben Nicholson (who successfully proposed him for membership of the 7 & 5 Society in 1928), Winifred Nicholson and Cedric Morris.

After his first breakdown, and especially after 1936, Jones began to echo the epic quality of his writing, weaving myth and history around modern commonplace motifs. His major works of this period include *Aphrodite in Aulis* (1941; London, Tate), a vivid demonstration of his mature style of crowded imagery, quivering contours and pale washes applied in patches to create a surface shimmering with light. *Vexilla Regis* (1947; U. Cambridge, Kettles Yard), painted soon after his second breakdown, marks the high point of his mythopoeic subject pictures, although he returned to this style in the 1960s in pictures such as *Tristram and Isolde* (unfinished, *c.* 1962; Cardiff, N. Mus.).

From the 1940s until the 1960s Jones also produced inscriptions, essentially private works that form a link between his painting and writing, at once abstract in form and concrete in relaying biblical and other poetic texts in Latin, Greek, Welsh or English. Unlike Gill, who in his carved texts and typography was essentially concerned with the beauty and legibility of the script, Jones generally chose his own texts and sought to convey their meaning by devising an appropriate form. From *c.* 1949 until the mid-1950s Jones made an apparent return to his earlier still-lifes in a series of majestic paintings of flowers held within glass chalices, such as *Flora in Calix-light* (1950; U. Cambridge, Kettles Yard). In summoning up the images of the Eucharist and transubstantiation that had long informed his depictions, these pictures of real things capture the universal in the particular and the breadth of history within the commonplace.

WRITINGS
Epoch and Artist (London, 1959)
The Dying Gaul and Other Writings (London, 1978)

BIBLIOGRAPHY
R. Ironside: *David Jones* (London, 1949)
D. Blamires: *David Jones: Artist and Writer* (Manchester, 1971)
R. Hague, ed.: *Dai Greatcoat: A Self-portrait of David Jones in his Letters* (London, 1980)
D. Cleverdon: *The Engravings of David Jones* (London, 1981)
N. Gray: *The Painted Inscriptions of David Jones* (London, 1981)
David Jones (exh. cat. by P. Hills, London, Tate, 1981)
N. Gray: *The Paintings of David Jones* (London, 1989)

ANDREW WILSON

Jones, George Sydney (*b* Sydney, 2 Aug 1864; *d* Wentworth Falls, NSW, 19 Jan 1927). Australian architect. He studied architecture at the University of London, was articled to Charles Bell (1846–99) in London and joined the RIBA there. He returned to Australia in 1891 after travelling through Europe, Egypt and India, where he became interested in flat-roofed buildings designed for hot climates. His early houses of the 1890s are in an inventive English free-style manner, with added verandahs and sunshading devices. In the early 1900s he designed a number of hospitals, including the Women's Hospital (1905), Paddington, Sydney, and some warehouses in the Romanesque Revival style of H. H. Richardson. He remained best known, however, for his domestic work. Jones was an early proponent of a rationalist architecture adapted to the Australian climate. By 1905 he was advocating new forms using concrete and steel, reflecting modern technology and breaking free from traditional architecture. In 1906 he published plans of an ideal house, with cubic, stripped classical forms, verandahs and 'sleep-outs' in the form of outdoor rooms, and with an axially arranged, open-plan living and dining area. Its most surprising element was a flat roof with a pergola, to be used as a garden. He continued these unconventional themes in three Sydney houses built in 1909–11, notably his own house, Barncleuth, at Pennant Hills. He remained wedded to Arts and Crafts ideals, however, and in practice used concrete and steel only in commercial buildings. Jones's work inspired a number of other Sydney architects to design flat-roofed houses around 1909. The closest parallel to this work outside Australia is that of the English architect Edgar Wood, although architects in Europe and the USA were also experimenting with cubic forms and flat roofs in domestic architecture at this time.

WRITINGS
'Some Thoughts on Australian Architecture', *A. & Archit.*, ii/5 (1905), pp. 215–22

BIBLIOGRAPHY
C. Hamann: 'Forgotten Reformer: The Architecture of George Sydney Jones, 1865–1927', *Archit. Australia*, lxviii/5 (1979), pp. 39–45, 64
L. Martin: *George Sydney Jones: Architect, 1864–1927* (BArch thesis, U. New South Wales, 1979)
J. Phillips: 'In Search of a Modern Idiom for Australian Architecture: The Flat-roofed Houses of George Sydney Jones', *Fabrications*, i (1989), pp. 56–76

RORY SPENCE

Jones, Sir Horace (*b* London, 20 May 1819; *d* London, 21 May 1887). English architect. He was articled to John Wallen (1785–1865) in London and set up his own practice in Holborn, where he specialized mainly in solid commercial work. He is chiefly remembered as Architect to the City of London (1864–87). Although his work was never of high architectural quality, his City markets became well-known features of the London scene: the wholesale meat market (1866) at Smithfield with dignified Italianate halls and domed angle towers; the former wholesale fish market

(1875; now converted to offices) at Billingsgate with vaguely French roofs and fishy weather-vanes; and the retail Leadenhall Market (1881), still glittering with glass and cheerfully vulgar columns.

Jones's chief contribution to London was Tower Bridge (1886–94), which he designed in collaboration with the engineer John Wolfe Barry (1836–1918). Although the Gothic detailing executed after Jones's death is arid, the overall concept and silhouette made it a world-famous landmark. Lesser works included the 'Old' Town Hall (1853) at Cardiff and, in London, the weakly francophile Marshall & Snelgrove shop (1870) in Oxford Street, where Jones preserved some 18th-century houses by James Gibbs at the back (all since rebuilt). Other London works include the Guildhall School of Music (1885–7) and the Temple Bar Memorial (1880) in Fleet Street. Jones served as President of the RIBA (1882–4) and was knighted in 1886.

BIBLIOGRAPHY

Builder, lii (1887), p. 799
RIBA J., xci (1984), p. 48 [biographies of presidents]

PRISCILLA METCALF

Jones, Inigo [Enego] (*b* London, *bapt* 19 July 1573; *d* London, 21 June 1652). English architect, designer and painter. He was celebrated in his own time as a designer of entertainments for the courts of James I and Charles I (*see* STUART, House of), but his posthumous reputation is based on his architectural work. He was one of the first Englishmen to make a detailed study of the buildings of ancient Rome and of the works of the Italian classical architects, particularly Andrea Palladio. Jones introduced into England a rigorous interpretation of the classical language of architecture, including the hierarchical use of the architectural orders and their attendant details arranged through the appropriate use of number, measure and proportion. His influence was curtailed by the English Civil War (1642–51), but it enjoyed a great revival among Palladian architects of the 18th century.

1. Life and work. 2. Architectural and literary legacy.

1. LIFE AND WORK. His father, also called Inigo Jones (*d* 1597), is thought to have been a clothworker in Smithfield, London. After youthful experience as a painter-joiner, Jones entered the service of the Manners family, becoming their 'picture-maker'. In 1598 he began a tour of Europe, probably with Francis Manners, Lord Roos (1578–1632), brother of Roger Manners, 5th Earl of Rutland (1576–1612), and during the summer of 1603 he went with the Earl of Rutland to Denmark, where he entered the service of King Christian IV (*reg* 1588–1648). Jones returned to England in 1604 to work with the poet Ben Jonson on staging masques for the Queen, Anne of Denmark, who was Christian's sister, and this was the beginning of his career as a designer of masques for the court, which continued until 1640 (*see* §(ii) below). He returned to Italy in 1605, where his wider ambitions may have been recognized by an English resident, the historian Edmund Bolton, who gave him a book (Bordino's *De Rebus praeclare . . .*, Rome, 1588; ex-Worcester Coll., Oxford) with an inscription recording his hope that, through Jones, 'sculpture, modelling, architecture, painting, acting and all that is praiseworthy in the elegant arts of the ancients, may one day find their way across the Alps into our England'.

(i) Architecture. (ii) Stage design.

(i) Architecture. Jones returned from Italy in 1606 and soon after produced his first significant architectural designs; these were for Robert Cecil, 1st Earl of Salisbury, for whom he and Jonson had devised entertainments. English architecture at that time was a rich mix of Elizabethan, Flemish, Italian and French Renaissance styles, and this manner was promoted by Simon Basil (*d* 1615), Surveyor of the King's Works. Cecil may have been seeking an alternative approach, for *c.* 1608 he involved Jones with two important projects in London over which he had direct control: the New Exchange, the Strand, and a replacement for the medieval crossing tower of Old St Paul's Cathedral. Jones's designs are transitional between the prevailing Jacobean style and the classicism in the manner of Roman antiquity that he subsequently employed so convincingly. In his New Exchange design (Oxford, Worcester Coll.) he incorporated ornamental elements of contemporary English architecture at roof level, while on the lower two storeys he used classical ornaments arranged hierarchically, with the Ionic order (column and entablature) below and Corinthian above. At first-floor level he proposed a large Venetian window (Serliana), an arched window flanked by lower rectangular ones (a type derived from Book IV of Sebastiano Serlio's treatise on architecture and used by Palladio). A similar blend of disparate motifs appears in the design for the tower of St Paul's (Oxford, Worcester Coll.). No final decision was made on the tower, however, and Basil's design was used for the New Exchange.

These projects provided useful experience for Jones and brought his abilities to the attention of the court of James I; in 1610 Jones was appointed Surveyor of Works to Henry, Prince of Wales, the heir to the throne. Henry, who was already an advocate of Italian and French classicism, planned a great garden at Richmond designed by Salomon de Caus and the Italian sculptor Constantino de' Servi (1554–1622), with Jones acting as overall coordinator. The project ended, however, with the untimely death of the Prince in 1612, at the age of 18. Jones continued to be associated with the court, and in February 1613 he travelled to Heidelberg as part of a royal entourage led by Thomas Howard (*see* HOWARD (i), (1)), 2nd Earl of Arundel, who had been a close supporter of Prince Henry. Arundel and Jones then travelled on to Italy on a Grand Tour, with Jones, the elder by 12 years, acting as Arundel's instructor and guide. In Vicenza in 1613/14 they met the elderly Vincenzo Scamozzi, who had completed some of Palladio's works. Jones had brought with him several books, including his 1601 edition of Palladio's *I quattro libri dell'architettura* (Oxford, Worcester Coll.; see Allsopp), and he annotated these with observations about the monuments he saw. They returned to England in 1614/15 with a large number of paintings, sculptures, miniatures, books on art and architecture and drawings. Arundel had bought several chests of drawings by Palladio and Scamozzi, and he gave Jones some preliminary drawings by Palladio for private and public buildings and some

drawings by Scamozzi (London, RIBA; Chatsworth, Derbys). Jones also received two private commissions for Arundel: he remodelled Arundel's house at Greenwich (1615; destr. 1617) and designed a gallery (c. 1615–17) at Arundel House (destr. 1678) in the Strand, London, for the Earl's new collection of antique sculpture.

In September 1615, on the death of Simon Basil, Jones became Surveyor of the King's Works. Soon after, he designed a house at Greenwich for Queen Anne. Drawings of the scheme (London, RIBA) show a two-storey structure, with a ground-floor of rusticated blocks surmounted by a smooth-walled *piano nobile*; the two main façades each had a triangular pediment concealing the pitched roof. The building had been constructed only up to the rusticated base when the Queen died (1619) and the project was abandoned. Some years later, after the accession of Charles I in 1625, the site became the property of Queen Henrietta Maria, and Jones subsequently revised his earlier design, eliminating the pediments. Sited across a public road running between the gardens of Greenwich Palace and the park (*see* GREENWICH, §1), the building was conceived as a double house, with two rectangular sections connected by a covered bridge. Both sections have tripartite elevations, the south front featuring a central loggia; at the centre of the northern section of the house is a galleried, cubic hall. The Queen's House, completed in 1638 (later altered by John Webb (i)), is a mature work by Jones, original in conception and unlike any specific house by Palladio or other architectural predecessor.

In contrast to many of the 18th-century English Palladian architects, who appropriated Palladio's architecture through translations of *I quattro libri* and pattern books, Jones's interpretations were less literal. In part this was because the Stuart court he served chose to revive the notion of classical antiquity in general, with Palladio being only one of several sources. An appetite for classicism had grown in England in the early 17th century following James I's triumphal entry into London for his coronation in 1604, when a triumphal arch constructed for the occasion had been designed by Stephen Harrison according to harmonic ratios based on musical intervals as described by the Greek philosophers Pythagoras and Plato. It included obelisks and also Tuscan columns, which Jonson, one of the directors of the ceremonies, called 'the principal pillar of those five upon which the Noble Frame of Architecture doth stand' (*Works*, ed. C. Harford and P. Simpson (Oxford, 1925–52), vii, pp. 90–91). This was probably the first application of classical architectural principles in England since Roman times. James I was intent on making London the new capital of the Protestant faith, with architecture to rival that of Catholic Rome. To this end he sought to establish a convincing architectural heritage for Britain and encouraged the evolution of the 'Britannic myth', which asserted that Britain had its own classical tradition, but that it had been obscured by the invasion of the Goths and their 'Gothic' architecture. To investigate this heritage, Jones, as Surveyor, was required to assess Britain's most famous ancient monument, Stonehenge, concluding that its underlying geometrical order and the harmony of its proportions indicated that it was not built by the Druids but was a Roman temple; it thus provided 'evidence' that ancient Britain had its own

brand of classical architecture, of a purity to match the puritanism of the Protestant faith. Jones's notes on Stonehenge were compiled and published only posthumously (1655; *see* §2 below), but this attitude towards antiquity and classicism was undoubtedly reflected in his own architecture.

The purity of Stonehenge, with its bold Tuscan-like orders (as Jones described them), was echoed in Jones's command of the monumental in architecture, which was entirely appropriate to the ambitions of his royal patron. Such monumentality, combined with a clear understanding of the subtleties of Palladio's compositional techniques, is revealed in drawings from the early years of Jones's surveyorship. His designs (1617; Oxford, Worcester Coll.) for the King's Star Chamber (unexecuted) in the Palace of Westminster, London, for example, show a seven-bay façade framed by end pilasters and with the central three bays emphasized by an attached portico in the form of a temple front; this feature incorporates giant, fluted Corinthian half-columns resting on a rusticated base and supporting a pediment. The concept of a projecting centre flanked by simpler, recessed bays, which is characteristic of Palladio's work, appears in several other contemporary designs by Jones. The project (1619; London, RIBA) for the much plainer Prince's Lodging and Clerk of Works' House at Newmarket, for example, shows a seven-bay façade with the three central bays framed by quoins and surmounted by a pediment, and with a central arched opening to the *piano nobile*. The building was constructed with only five bays, although still as a tripartite composition (with pronounced central bays); whether the pediment was retained is unknown as the building was demolished less than 40 years later.

A better-known example of this type of façade composition is Jones's Banqueting House (1619–22; see fig. 1), Whitehall, London, which was intended to be used for royal entertainments and masques. This building, Jones's most important work, is planned as a simple rectangular hall proportioned as a double cube. The elevations are designed in two main storeys with superimposed orders—Ionic and Corinthian—above a rusticated base. Both long sides have their three central bays emphasized by engaged columns, with pilasters articulating the outer bays. The orders are classically detailed, with entasis (swelling) in the columns and a pulvinate (convex) Ionic frieze. Early designs for the Banqueting House (Chatsworth, Derbys) show a pediment over the three central bays; this was subsequently abandoned, and the entablatures at both levels break forward over all the columns and pilasters, providing a marked horizontal effect that was emphasized by the materials originally used: different coloured stone for the basement level, main body and balustrades (later entirely resurfaced in Portland stone). Inside, the Banqueting House has a colonnaded balcony separating the two storeys, and a flat ceiling, for which Jones introduced new construction techniques. The ceiling was painted by Rubens, and the installation of these panels by 1635 ended the building's use as a masquing hall, as smoke from these torchlit events was seen to be damaging the paintings.

Jones's Queen's Chapel (1623–5) at St James's Palace, London, incorporates elements similar to those of the Newmarket design, notably a central arched opening and

1. Inigo Jones: Banqueting House, Whitehall, London, 1619–22

end quoins in its west front; it also has a pediment, although, unlike the Prince's lodging, the façade is devoid of orders. The interior has a distinctive coffered vault based on Palladio's reconstruction (*I quattro libri*, IV) of the 'Temple of the Sun and Moon' (actually the Temple of Venus and Rome). A large Venetian window—the first executed by Jones—dominates the east end. The simple interior was more suited to Protestant use than to the elaborate liturgy of the Catholic Church, although the building was constructed for a Catholic queen (originally intended for the Spanish Infanta but completed for the French Queen Henrietta Maria, for whom Jones also carried out other works; *see* STUART, House of, (6)).

Jones's most important projects were designed for the court, but he also worked for other patrons during the period of his surveyorship. He has been associated with various country houses, notably Wilton House, Wilts, which was designed for Philip Herbert, 4th Earl of Pembroke, in the 1630s by Isaac de Caus with advice from Jones and later reconstructed—again with his advice—after a fire (*see* §2 below). In London he was employed by Francis Russell, 4th Earl of Bedford (*see* RUSSELL, (2)), who in 1631 obtained a licence to build a group of houses and shops on land just north of the Strand. Jones was the executive officer of a commission established in 1618 to

review building practices in London, and his design for Covent Garden reflected not only the principles adopted by the commission (e.g. sound construction in brick and avoidance of high density) but also European experience (especially Italian and French) in achieving an integrated civic environment. Jones's plan, centred on a rectangular piazza bounded by houses and arcades to the north and east, was reminiscent of the Place Royale (now Place des Vosges), Paris, laid out by Henry IV, King of France. At the centre of the west end of the piazza he placed the church of St Paul (1630–31; rebuilt 1795; *see* fig. 2), flanked by gates to the churchyard in which it stood; its Tuscan portico performs a purely civic role in the piazza, for the entrance to the church is at the other end. St Paul's was the first new church in London since the Reformation, the first entirely classical church in England and perhaps Jones's most original contribution to the application of classical principles in a Christian context. The natural rusticity of Jones's composition is in marked contrast to the sophistication of Palladio's Catholic churches in Venice, and it set a tone highly sympathetic to the austerity of the Protestant cause.

In the early 1630s, some 25 years after his project for the tower of Old St Paul's in 1608, Jones was commissioned to undertake more extensive work at the cathedral.

2. Inigo Jones: St Paul's (portico at rear of church), Covent Garden, London, 1630–31

The medieval transepts and nave were encased in a classical skin (a form of Tuscan for the body, and Doric and Ionic for the doorways), and the west front was completely remodelled, with a great Corinthian portico (*see* LONDON, §V, 1(i)(c) and fig. 24). The foundations for the portico were dug in 1635 and paid for personally by Charles I. The restoration work was completed in 1642 and statues of *James I* and *Charles I* were placed above the new portico. It was an achievement on a scale comparable to works of ancient and modern Rome: its height, *c.* 17 m to the top of the entablature, equalled that of the portico of the Pantheon and that of the giant order of pilasters on Michelangelo's buildings on the Capitoline Hill. Jones's design for the cathedral's west front was based on Palladio's reconstruction of the 'Temple of the Sun and Moon', which Jones noted in his edition of *I quattro libri* had been 'built by T. Tatio King of the Romans', an implied comparison that James I would have appreciated. Jones's portico survived the Great Fire of 1666 but much of the old building was destroyed and the cathedral was rebuilt from 1675.

During his reign Charles I revived his father's plans for a vast new palace in London. Although there are several surviving schemes for sites in Whitehall—which would have obliterated the old palace and the Banqueting House—and St James's, the only design definitely in Jones's hand is the 'P' scheme for St James's (*c.* 1638; Oxford,

Worcester Coll.); others that were made during Jones's lifetime were drawn by his pupil and assistant JOHN WEBB (i), presumably under his supervision. The 'P' scheme is for a complex of buildings arranged around a large, square, colonnaded central courtyard and several subsidiary courtyards, some open and some closed. Had it been built, the great ensemble would have been comparable in scale to the Vatican in Rome, the Louvre in Paris and the Escorial in Madrid, all centres of power, authority and dynasty with which the Stuarts wished to compete.

ROBERT TAVERNOR

(ii) Stage design. Jones's work as a stage designer, which extended from 1605 to 1640, is comparable in importance, both intrinsically and historically, with his architecture; this was not always evident to his English contemporaries, nor has it been since. Francis Bacon wrote in his *Essays* of the court masques, 'These things are but toys'; but the royal patrons who commissioned Jones to stage them, in collaboration with Ben Jonson and other poets, took them very seriously. English spectators often had mixed or critical reactions; European visitors, such as the envoys of Italian states, in spite of their imperfect grasp of the dialogue, responded more appreciatively to the visual language of Jones's scenography. As with his architectural designs, Jones was practising an essentially Italian art in an alien English setting. In 16th-century Italian theory stage

design held an esteemed position among the arts; Vitruvius had considered it a part of architecture, and Jones studied both Palladio's various attempts to recreate the Vitruvian stage and Serlio's adaptations of Vitruvius' scenic types. Stage design can thus be seen as a natural part of Jones's work as an architect and an aspect of his endeavours to be a 'universal' artist on the Italian model.

Having been launched as a stage designer by Anne of Denmark, Jones worked in this capacity chiefly for the royal family, first for James I, Queen Anne and Henry, Prince of Wales, and subsequently for Charles I and his Queen, Henrietta Maria. Occasionally he worked for courtiers, such as Robert Cecil, 1st Earl of Salisbury. His collaboration with Ben Jonson lasted until 1631, when they quarrelled. Jones designed plays, tilts (neo-chivalric tournaments given a theatrical context), barriers (tournaments on foot) and 'entertainments' (lesser forms of the masque); but the masque proper remained the predominant form of court theatre. Most of his surviving designs are for masques; an important subsidiary group relates to three pastoral plays produced for Henrietta Maria: *Artenice* (1626), *The Shepherd's Paradise* (1634) and *Florimène* (1635).

From the start Jones was an innovator. He abandoned the old-fashioned settings used for court entertainments, such as moving pageant cars or fixed scenic mansions that could be dispersed about a hall, each becoming 'visible' as the action required. Instead he adapted the kind of stage developed in Italy, particularly at the Florentine court, during the 16th century; this attempted to give the illusion of actuality through realistic representation enhanced by sophisticated mechanics, using complex, changeable scenery organized in a unified perspective scheme. At first his stage machinery was insufficiently advanced for the visual effects he aimed for, but he gradually improved it to Italian standards.

For his early work Jones experimented with various scenic forms and methods of scene changing: curtains painted in perspective that were drawn to reveal more elaborate constructed scenes behind, as in the *Masque of Blackness* (1605); triangular prisms (*periaktoi*), as described by Vitruvius, which could be rotated to show three different aspects, as in *Tethys' Festival* (1610); revolving sets or 'turning machines' (*scena versatilis*) as in the *Masque of Queens* (1609); and flats or 'shutters' (*scena ductilis*) divided in the middle, which could be slid off into the wings along grooves in the stage floor. It was the last of these methods, first employed in *The Barriers* (1610) and *Oberon, the Fairy Prince* (1611), that proved most flexible and became the basis of Jones's mature scenic technology. His perfected system was already in use in 1617 in *The Vision of Delight*; it consisted typically of three or four sets of perspective wings, with up to four in each set, and beyond, a corresponding set of 'back shutters', large movable flats on which the background was painted. Behind these there might be 'scenes of relieve' (cut-outs) to be introduced when required and, furthest upstage, a backcloth. The scene was changed by sliding each front pair of wings out of view, together with the two halves of the back shutter. The sky was represented on the backcloth and perhaps also on cloud borders above the wings, and in this upper region cloud machines and other flying

devices could be manoeuvred; these were used for the appearance of deities, who might also appear on an upper stage at the back. The aerial effects of the 1630s were exceptionally elaborate, as during that period Jones installed a fly gallery, first used in 1631 for *Chloridia*, and subsequently for *Britannia Triumphans* and *Luminalia* (both 1638).

Over 450 drawings (Chatsworth, Derbys) of stage designs in Jones's hand survive: originally there must have been thousands. They show costumes, sets and proscenium arches; a few are production diagrams blocking in groups of masquers, since Jones also directed the masques and had to think in terms of 'plan' as well as 'elevation'. All are working drawings, but they range from rapid sketches to highly finished fair copies. Apart from having to give scene painters and tailors detailed patterns to follow, Jones usually had to submit fair copies of costume designs for approval by the royal and aristocratic masquers. He did not, however, readily surrender design decisions to others: on an annotated presentation drawing of Henrietta Maria's costume for *Chloridia* he deferentially intimated that the Queen should refrain from meddling with it. Beside masquers' costumes, which had to bear some relation to contemporary court dress, there were those for anti-masquers—histrionic, grotesque and often comic characters, whose costumes called for demotic realism or bizarre fantasy. These offered more freedom to the designer, often reflected in his graphic style. The scenery followed the repertory of types developed in the Italian theatre: city scenes of streets or piazzas, with either vernacular or classical architecture; palaces, villas and gardens; rural scenes or natural landscapes; harbours and sea scenes, sometimes submarine; antique ruins; and scenes of heaven or hell. Proscenium arches were designed afresh for each production, because their ornament was allegorical, having specific reference to the occasion: Jones called it 'picture qualified with moral philosophy'. The most elaborate drawing of a proscenium and set together is that for the pastoral play *Florimène* (see fig. 3).

The drawings are mostly in pen and wash, but watercolour was used in two groups of elaborate costume drawings (1605 and 1613). Over this period Jones's draughtsmanship made rapid strides. His early technique was tentative, finicky and laborious, but his design for a *Fiery Spirit* in *The Lords' Masque* (1613) is animated by exceptional skill, and his drawing continued to improve. He may have received instruction from Isaac Oliver, but he was largely self-taught from Italian drawing manuals and by copying other artists' engravings and drawings; thus the figure of *Atlas* for *Coelum Britannicum* (1634) is a careful copy after Francesco Albani. This method of copying, in which Jones persisted throughout his career, was crucial not only for the technique of the masque designs but for their content and ultimate purpose.

Most of Jones's extant designs can be shown to be copied, and probably they all were. Copying was expedient, since Jones was busy, but he also had an ulterior motive that lay in his perpetual eagerness to learn, expressed in his motto 'I know no other pleasure than learning': taken from Daniele Barbaro's 1567 edition of Vitruvius, this refers to Aristotle's theory of imitation. Jones used the stage designs that he copied to educate himself while also

3. Inigo Jones: design for the proscenium arch and standing scene, the *Isle of Delos*, for the pastoral play *Florimène*, pen and ink, 297×353 mm, 1635 (Chatsworth, Derbys)

educating his public, being acutely conscious of England's marginal relationship to the development of Renaissance art. He tried to recapitulate that development in a pleasurably instructive way through his stage designs, the sources of which cover an encyclopedic range: not only Italian, but French, Netherlandish and German, and deriving not only from other stage designs, but also from prints of architecture, sculpture and painting, as well as from original paintings and drawings. He never copied his sources uncritically but adapted them, and not just to fit his stage. In his scenic architecture he would correct disproportions and solecisms; on his proscenium arches ornament became more rational and natural, as Vitruvius demanded; in his landscape scenes Mannerist schemes were recomposed. In a word, he classicized his material, propagating in England a reformed version of Renaissance art.

In 1632 Jones wrote in the text of *Tempe Restored*: 'Indeed these shows are nothing else but pictures with light and motion'. The masques of the 1630s were spectacular triumphs of scenic engineering, but in the printed texts, which he supervised, comments on mechanical ingenuity gave way to descriptions of pictorial effects. Having begun his career as a 'picture-maker', in the theatre he was able to make pictures on a grand scale. He came to conceive his theatre scenes as large-scale paintings, and he used them to supply the monumental art that Protestant England had never known.

JOHN PEACOCK

2. ARCHITECTURAL AND LITERARY LEGACY. Jones's career was virtually ended by the outbreak of the Civil War in 1642. His position as Surveyor of the King's Works (officially terminated in 1643) and his work on court masques marked him as a Royalist; he was taken prisoner at the siege of Basing House, Hants (1645), and his estate was seized, although most of it was restored in 1646. His influence was largely restricted to some followers at the

Office of Works, including JOHN WEBB (i) and Nicholas Stone (i), but they did not have Jones's authority or his direct experience of Roman classical architecture and were unable to sustain the momentous architectural revolution that he had created. Webb, who had married Jones's cousin and heir Anne Jones, inherited the project for Whitehall Palace and was later given the commission for the new palace at Greenwich. He also inherited the major part of the reconstruction work at Wilton House, which had been gutted in a fire in 1647 (*see* WILTON, §1 and fig. 1). Jones had been called in to refurbish it, but because of his age he probably had only a very limited involvement. The pedimented gables to the end towers of the south block, such Palladian motifs as the central Venetian window, and the cube and double-cube rooms of the interior of Wilton House were all highly influential for the British Palladians of the 18th century.

In 1655 Webb compiled and published Jones's observations on Stonehenge, a document that aroused a controversy with architectural repercussions that continued into the next century, especially in the work of John Wood the elder. More importantly for the future of British Palladianism, Jones's library and collection of drawings, both his own and those by Italian Renaissance architects, also passed to Webb. They were mostly dispersed after the latter's death but began to be collected again in the early 18th century, notably by Richard Boyle, 3rd Earl of Burlington (*see* BOYLE, (2)); this signalled a new interest in Britain in the artistic principles that Jones was seen to represent and heralded a second flowering of the Palladian style (*see* PALLADIANISM).

For a portrait of Inigo Jones *see* ARCHITECT, fig. 2.

ROBERT TAVERNOR

UNPUBLISHED SOURCES
The principal collections of drawings by Inigo Jones are held at Chatsworth, Derbys; Oxford, Worcester Coll.; and London, RIBA.

BIBLIOGRAPHY
J. Webb: *The Most Notable Antiquity of Great Britain, vulgarly called Stone-Heng on Salisbury Plain, restored by Inigo Jones Esq.* (London, 1655) [based on notes by Inigo Jones]
——: *A Vindication of Stone-Heng Restored* (London, 1665/R 1725)
W. Kent: *Designs of Inigo Jones, with Some Additional Designs*, 2 vols (London, 1727)
J. Summerson: *Inigo Jones* (Harmondsworth, 1966)
B. Allsopp: *Inigo Jones on Palladio*, 2 vols (Newcastle-upon-Tyne, 1970)
S. Orgel and R. Strong: *Inigo Jones: The Theatre of the Stuart Court*, 2 vols (London, 1973)
The King's Arcadia: Inigo Jones and the Stuart Court (exh. cat. by J. Harris, S. Orgel and R. Strong, London, Banqueting House, 1973)
D. J. Gordon: 'Poet and Architect: The Intellectual Setting of the Quarrel between Ben Jonson and Inigo Jones', *The Renaissance Imagination* (London, Berkeley and Los Angeles, 1975)
R. Strong: *Britannia Triumphans: Inigo Jones, Rubens and the Whitehall Palace* (London, 1980)
J. Harris: *The Palladians* (London, 1981)
J. Peacock: 'Inigo Jones's Stage Architecture', *A. Bull.*, lxiv (1982), pp. 195–216
——: 'The French Element in Inigo Jones's Masque Designs', *The Court Masque*, ed. D. Lindley (Manchester, 1984)
A. Cerutti Fusco: *Inigo Jones Vitruvius Britannicus: Jones e Palladio nella cultura architettonica inglese, 1600–1740* (Rimini, 1985)
J. Orrell: *The Theatre of Inigo Jones and John Webb* (Cambridge, 1985)
J. Peacock: 'Inigo Jones and the Florentine Court Theatre', *John Donne J.*, v (1986), pp. 201–34
J. Harris and G. Higgott: *Inigo Jones: Complete Architectural Drawings* (London, 1989)
R. Tavernor: *Palladio and Palladianism* (London, 1991)

V. Hart: *Art and Magic in the Court of the Stuarts* (London and New York, 1994)

JOHN PEACOCK, ROBERT TAVERNOR

Jones, John (*b* Middlesex, 1799; *d* ?London, Jan 1882). English collector. He made a large fortune manufacturing military uniforms, trading first at 6 Waterloo Place, St James's, and then on Regent Street, London. By 1850 he was able to become a sleeping partner in the company, free to follow his passion for collecting. Although a wealthy, self-made man, he was noted for his frugal habits and modesty. From 1865 he lived at 95 Piccadilly, a moderate-sized town house adjacent to Mayfair's best dealers and sale-rooms. A plaster bust (1882; London, V&A) of Jones by John Lawlor (1820–1901) shows a bony, ascetic face illuminated by a genial expression.

The collection, which Jones bequeathed to the Victoria and Albert Museum, London, is rich in ormolu and marquetry secrétaires, commodes, writing-desks and tables of the Louis XV and Louis XVI periods. He was devoted to the Rococo and could afford signed pieces by such names as Jean-François Oeben, Jean-Henri Riesener, Adam Weisweiler and David Roentgen, as well as chairs by Georges Jacob. He owned a panoply of 18th-century Sèvres, Vincennes and Chelsea porcelain, and some Chinese ceramics mounted with French ormolu. Many works are directly associated with French royalty, and Jones also acquired Indian furniture said to have been made for Tipu Sahib, the Sultan of Mysore (*reg* 1749–?53). The collection was accumulated at a time when the patrimony of an impoverished French nobility was on the market, giving English collectors a chance to buy choice pieces. Together with the Wallace Collection (*see* SEYMOUR-CONWAY, (3)) in London, Jones's legacy to what was then the South Kensington Museum, London, which owned but a handful of examples, consolidated Britain's holdings of French furniture and decorative arts.

BIBLIOGRAPHY

O. Brackett: *Catalogue of the Jones Collection*, i: *Furniture*, 2 vols (London, 1922–30)

W. King and others: *Catalogue of the Jones Collection*, ii: *Ceramics, Ormolu, Goldsmiths' Work, Enamels, Sculpture, Tapestry, Books and Prints* (London, 1924)

D. Sutton: 'A Born Virtuoso', *Apollo*, xcv (1972), pp. 156–61

P. Thornton: 'John Jones: Collector of French Furniture', *Apollo*, xcv (1972), pp. 162–75

Jones, Owen (*b* London, 15 Feb 1809; *d* London, 19 April 1874). English architect and designer. The son of a Welsh antiquary and furrier of the same name, Owen Jones was educated at Charterhouse School, London, before becoming a pupil of the architect Lewis Vuillamy (1791–1871). Following his apprenticeship he set out in 1832 for the Continent on a Grand Tour. In Greece Jones met Jules Goury (1803–34), a young French architect; both travellers had become fascinated by Classical architectural polychromy. In order to pursue this study further they visited Egypt, Turkey and Spain, where they undertook a detailed survey of the Alhambra. After Goury died of cholera in 1834, Jones completed their research, finally printing and publishing it himself as *Plans, Elevations, Sections and Details of the Alhambra* (2 vols; London, 1842–5). His initial publication of the work in 1836–7 was never completed, but the three numbers that appeared (out of ten planned) were the first examples of chromolithography of any consequence to appear in Britain. This quickly led to other similar work for commercial publishers, such as an illuminated edition of J. G. Lockhart's *Ancient Spanish Ballads* (London, 1841). Until the mid-1850s, when his expanding architectural practice would no longer permit it, Jones was as much a printer as an architect.

Jones believed passionately that the 19th century should produce a recognizable style of its own that would result not simply from the study of past styles but from the adoption of new materials. In attempting to carry through this ideology in his own work in the 1840s Jones relied heavily on Islamic sources and was much criticized as a result. Perhaps the most successful building with which he was then concerned was Christ Church (1840–42), Streatham, London, designed by James William Wild (1814–92), who was his brother-in-law. Jones was responsible for the interior decoration and may also have influenced the exterior, with its brick polychromy and Islamic details. He was well known in the 1840s for the design of mosaic and tessellated pavements in geometric patterns. He published two books on this subject and in 1844 submitted a design for the floors of the new Palace of Westminster which, although praised, was not accepted.

In 1851 Jones was involved with the plans for the Great Exhibition. As Superintendent of the Works for the exhibition, his tasks involved the decoration of Joseph Paxton's Crystal Palace, as well as the arrangement of the displays. For the décor he chose the primary colours red, yellow and blue; this plan was initially heavily criticized but, after completion, was much praised and likened to effects in the paintings of Turner. After the Great Exhibition, Jones was involved in re-erecting the Crystal Palace at Sydenham, London, where, with his friend Sir Matthew Digby Wyatt, he undertook the design and furnishing of the Fine Arts Courts. As a result of colouring the Greek Court according to what he believed were the ancient methods, he was obliged to publish an *Apology* (London, 1854), in which he was assisted by his friend the philosopher George Henry Lewes.

Jones's work at the Crystal Palace led him to realize that the principles embodied in earlier art were more important to designers than the forms themselves. In 1852 he began to lecture at the newly formed Department of Science and Art, which was founded by his friend HENRY COLE. In these lectures Jones expounded his philosophy that ornament should be based on geometry. With Cole's help Jones evolved his principles into 37 axioms of design, which appeared in his influential publication the *Grammar of Ornament* (London, 1856), illustrated with examples of historical styles of ornament. Cole perceived this book as a method of spreading knowledge of the collections at the South Kensington Museum (now the Victoria and Albert Museum).

Jones's involvement in the Great Exhibition brought his name prominently before the public both as an architect and as a decorator, and many commissions quickly followed. The most important buildings that he designed were the St James's Concert Hall (1856; destr. 1905), Piccadilly, London; the Crystal Palace Bazaar (1857; destr.

Owen Jones: ceiling decoration in the Moorish style, paint on fibrous plaster, 16 Carlton House Terrace, London, 1867

& Palmer, the biscuit manufacturers, involved the establishment of a clear house style and is an early example of the modern approach to graphic design and marketing.

BIBLIOGRAPHY
M. Darby and D. van Zanten: 'Owen Jones's Iron Buildings of the 1850s', *Architectura* [Munich], iv (1974), pp. 53–75
D. van Zanten: *The Architectural Polychromy of the 1830s* (New York, 1977)
M. Darby: *The Islamic Perspective: An Aspect of British Architecture and Design in the 19th Century* (London, 1983) [incl. extensive list of Jones's pubns]

MICHAEL DARBY

1890), Oxford Street, London; and a gallery (1858; destr. 1926), also in Oxford Street, for F. & C. Osler, the glass manufacturers. Like other designs for 'crystal palaces' on Muswell Hill, London, and at St Cloud, Paris, which were not carried out, these buildings relied to a great extent on iron and glass to produce large spaces ornamented with rich polychromatic patterns. The results were much admired, but the applications for such a building type were comparatively limited; when Jones had to produce more conventional essays in brick, mortar and stone—as, for example, in his unsuccessful design of 1865 for the St Pancras Station and Hotel—the shortcomings of his approach were revealed. Consequently, towards the end of his career Jones was increasingly concerned with decoration and the design of patterns for manufacturers rather than with architecture.

Jones carried out decorative schemes for domestic interiors, working in collaboration with the London firm of Jackson & Graham. His work for Alfred Morrison included interiors in his country house at Fonthill (c. 1863; destr. 20th century), Wilts, and his town house at 16 Carlton House Terrace (1867), London, which contained some fine examples of inlaid and carved work in the Moorish and other styles (see fig.). He designed interiors at the house of James Mason, Eynsham Hall (1872; rebuilt 1906), Oxford. The extensive work for Ismail Pasha, Khedive of Egypt, in 1864 involved the prefabrication of the interiors by Jackson & Graham in London before their shipment and installation in Cairo. Jones's most important decorative schemes for public buildings were those for the Langham Hotel (1864) and for the Fishmongers' Hall (1865), both in London.

Jones worked closely with several firms: he designed wallpapers for Trumble & Sons and for Jeffrey & Co.; carpets for James Templeton & Co. and for Brinton; silks for Benjamin Warner; and numerous paper items for the firm of De la Rue, to name but a few. His association with De la Rue over thirty years covered virtually all the items produced by the firm, from playing cards to stamps. The packaging they produced from Jones's designs for Huntley

Jones, Thomas (*b* Trevonen, Powys, 26 Oct 1742; *d* Pencerrig, Powys, 9 May 1803). Welsh painter. Son of a landowner, he was at first destined for a career in the Church. However, after matriculating from Jesus College, Oxford, in 1759, he entered William Shipley's art school in the Strand, London, in 1761 and later attended the St Martin's Lane Academy. Initially he meant to train as a portrait painter but, dismayed by the cost and length of the apprenticeship, instead studied in 1763–5 under the landscape painter Richard Wilson, also a Welshman. Wilson put Jones through a rigorous programme of copying drawings with black and white chalks on middle-tinted paper in order to train him 'in the principles of light and shade without being dazzled by the flutter of colours'. Jones then joined the Incorporated Society of Artists and in 1767 was awarded a premium by the Society of Arts; he exhibited there between 1765 and 1780 and was much engaged in its affairs. He also developed a close friendship with John Hamilton Mortimer, who occasionally supplied figures for his landscapes. These included history paintings reminiscent of the grand style initiated in England by Wilson's *Destruction of the Children of Niobe* (1759; version New Haven, Yale Cent. Brit. A.), notably *Dido and Aeneas* (1769; St Petersburg, Hermitage), which was engraved in mezzotint by William Woollett in 1787. Among Jones's own paintings, *The Bard* (Cardiff, N. Mus.; see fig.), which was exhibited at the Society of Arts in 1774, depicts the culminating drama in Thomas Gray's poem of that title with apposite contrasts of light and shade. In *Classical Landscape* (1772; Cardiff, N. Mus.) he worked competently in the idiom of Claude Lorrain, but his *Rousham House* (1773; Rousham Park, Oxon), which includes the garden as seen from across the meadows, shows that on occasion he worked in the more insular style used in depictions of topographical scenery and for country-house portraiture. He also drew some town views that were line-engraved for *Six Views in South Wales, Drawn after Nature*, published probably in 1775–6. By the early 1770s he was also using oil on paper for his landscape studies.

In 1776 Jones left for Italy, remaining there (mainly in Rome and Naples) until 1783. He spent the first two years in Rome making views of the city and the Campagna. Between 1778 and 1782 Frederick Augustus Hervey, 4th Earl of Bristol, commissioned five pictures from him, including views of Lake Albano and Lake Nemi. As an artist working in Italy, Jones can be singled out for two reasons: first for his memoirs, which not only offer intimate and valuable insights into his practices and perceptions but also provide information on British artists there at that time (including John Robert Cozens, William

Thomas Jones: *The Bard*, oil on canvas, 1.14×1.68 m, exhibited Society of Arts, London, 1774 (Cardiff, National Museum of Wales)

Pars, Francis Towne, John 'Warwick' Smith and the sculptor Thomas Banks); and second for the substantial number of skilled and interesting oil sketches he produced (e.g. *In the Colosseum*, London, Tate). Wilson had taught him to study landscape directly through oil sketches, and in Jones's own work, which was precise and of a high standard, the subjects he chose were recorded free from studio artifice. In 1778 he visited Naples, moving there two years later with his housekeeper, Maria Moncke, whom he had met in Rome. He made a number of oil-on-paper studies from the windows of his apartment there, showing the walls and roofs of neighbouring buildings, for example *House in Naples* (1782; London, BM). In 1783 Sir William Hamilton (i) bought his *View of the Campi Flegrei from the Camaldolite Convent near Naples*; Jones returned to England later the same year with Mary (whom he married after the birth of their daughter), and the picture was exhibited at the Royal Academy in 1784.

Jones settled in London and continued to exhibit at the Royal Academy, although he had effectively given up professional painting; instead he lived off rents provided by a small estate given him by his father. In 1786 and 1788 he made some topographical views of the house and grounds comprising Thomas Johnes's estate at Hafod, Dyfed. He also produced five small drawings that were engraved for James Baker's *A Picturesque Guide to the Local Beauties of Wales* (1794). In 1789 he inherited the family home at Pencerrig and retired there, painting less in these final years, although he continued to exhibit at the Royal Academy until 1798.

WRITINGS
'Memoirs of Thomas Jones', *Walpole Soc.*, xxxii (1946–8) [whole vol.]

BIBLIOGRAPHY
Thomas Jones (1742–1803) (exh. cat. by R. Edwards and J. Jacob, London, Kenwood House, 1970)
L. Gowing: *The Originality of Thomas Jones* (London, 1985)
Travels in Italy, 1776–1783, Based on the 'Memoirs' of Thomas Jones (exh. cat. by F. W. Hawcroft, U. Manchester, Whitworth A.G., 1988)

MICHAEL ROSENTHAL

Jong, Pieter de Josselin de. *See* JOSSELIN DE JONG, PIETER DE.

Jongh, Claude de (*b c.* 1600; *d* Utrecht, *bur* 16 March 1663). Dutch painter and draughtsman, active also in England. He became a member of the Guild of St Luke in Utrecht in 1627, and a master in 1633. It is possible that he also lived in Haarlem for a while as he is mentioned there in 1630–31. A number of drawings indicate that de Jongh visited England on several occasions: his earliest dated drawing is of *St Augustine's Monastery, Canterbury* (1615; Utrecht, Cent. Mus.). There are sketches of Westminster (e.g. 1625; Windsor Castle, Royal Lib.) and two drawings of *Old London Bridge* (both 1627; London, Guildhall Lib.) as well as sheets dated 1628.

De Jongh's painted oeuvre includes various views of London, which were probably executed from drawings on his return to the Netherlands. The *View of Old London Bridge* (1630; London, Kenwood House) relates to his drawings of 1627 and the *View of Westminster* (1637; New Haven, CT, Yale Cent. Brit. A.) includes details from the sketches of 1625. A painting of *Lyon Cathedral* (Baltimore,

MD, Walters A.G.) attributed to de Jongh suggests that he also visited France.

The rest of de Jongh's drawings and paintings, not many of which have survived, comprise river landscapes, often with ruins or castles, and Italianate landscapes. With the exception of his views of London, which are considered his best work, his pictures are painted in a rather rough manner. They are characterized by simplicity, broadness and strong contrasts of light and shade. Stylistically, his work is close to that of contemporary Dutch landscape painters of the Haarlem school such as Esaias van de Velde and Jan van Goyen. His later work (from *c*. 1635) shows a tendency towards the Italianate, probably under the influence of Adam Elsheimer.

BIBLIOGRAPHY

Thieme–Becker; Wurzbach

J. Hayes: 'Claude de Jongh', *Burl. Mag.*, xcviii (1956), pp. 3–11

Drawing in England from Hilliard to Hogarth (exh. cat. by L. Stainton and C. White, London, BM, 1987), nos 60–61

INGEBORG WORM

Jongh, Ludolf [Leuff] **de** (*b* Overschie, 1616; *d* Hillegersberg, 1679). Dutch painter. He was one of the most versatile Dutch painters of the 17th century, producing portraits, genre paintings of both domestic scenes and soldier life, landscapes with hunting scenes and a few historical subjects. According to Houbraken, he studied with Cornelis Saftleven in Rotterdam, Anthonie Palamedesz. in Delft, and Jan van Bijlert in Utrecht. In 1635 he went to France, where he stayed for seven years. His earliest known paintings are portraits and genre subjects that date from after his return to Rotterdam in about 1642 and strongly reflect the style of Palamedesz.'s work. The genre subjects and numerous hunting scenes (e.g. *Riders before an Inn*; Geneva, Mus. A. & Hist.) painted shortly before the 1650s show the influence of van Bijlert and other Utrecht painters, especially Jacob Duck and Dirck Stoop.

During the 1650s, his most productive period, de Jongh was probably the most prestigious painter in Rotterdam, exerting a noticeable influence on several younger painters, including Pieter de Hooch and Jacob Ochtervelt. During these years his more expressive portraiture and his greater concern for light and more clearly defined space in both portraits and genre scenes (e.g. *Tavern Scene*; Groningen, Groninger Mus.) reflected his participation in the latest stylistic changes in Dutch painting. De Jongh's artistic productivity decreased during the following decades, especially his landscape painting. This was probably due to his business ventures and his duties as an officer in the Rotterdam militia and, later, as *Schout* (sheriff) of Hillegersberg.

Few of de Jongh's paintings are signed, and his skill, versatility and apparent eagerness to stay abreast of stylistic developments in Dutch painting have contributed to his works frequently being wrongly attributed to painters of greater renown and more specialized styles.

BIBLIOGRAPHY

A. Houbraken: *De groote schouburgh* (1718–21/*R* 1976), ii, pp. 33–4

P. Haverkorn van Rijsewijk: 'Ludolf (Leuff) de Jongh', *Oud-Holland*, xiv (1896), pp. 36–46

P. Schatborn: 'Figuurstudies van Ludolf de Jongh', *Oud-Holland*, lxxxix (1975), pp. 79–85

R. E. Fleischer: 'Ludolf de Jongh and the Early Work of Pieter de Hooch', *Oud-Holland*, xcii (1978), pp. 49–67

——: *Ludolf de Jongh: Painter of Rotterdam* (Doornspijk, 1989)

R. E. Fleischer and S. Reiss: 'Attributions to Ludolf de Jongh: Some Old, Some New', *Burl. Mag.*, cxxxv (1993), pp. 668–77

ROLAND E. FLEISCHER

Jonghe, Jean-Baptiste de (*b* Courtrai, 8 Jan 1785; *d* Brussels, 14 Oct 1844). Flemish painter and lithographer. He was a student at the Courtrai Academie and then at the Antwerp Academie where, under the direction of Balthasar-Paul Ommeganck, he discovered his talent for landscape. In 1812 he received a first prize in Ghent for *Approach of a Storm* (1812; Ghent, Mus. S. Kst.). From then on he assiduously submitted works to all the Salons in the north of France and the Netherlands. Little is known about his travels; he must have been to France, England and Scotland, and probably also Italy. Most of his canvases depict his local landscape, views of Flanders or the Ardennes, and are inspired by the 17th-century Dutch school, elements of which he transformed into a 19th-century language. De Jonghe shared with the 17th-century Brabant landscape painters a predilection for forest scenes, in which he often placed wild and domestic animals and, more rarely, human figures (usually added by Eugène Verboeckhoven). His paintings are particularly reminiscent of the works of Jan van Goyen and Jacob van Ruisdael, but they also express a new perception of nature dictated by a concern for objectivity. In such works as *Ardennes Landscape* (Liège, Mus. A. Mod.), each detail is treated with an almost obsessive meticulousness, quite unlike earlier Dutch landscapes, in which leaves, plants and trees are merged together. Around 1823 de Jonghe was involved in illustrating a *Collection historique des vues principales des Pays-Bas* (published in Tournai). Half of the lithographs in this collection are by him and reveal in particular his knowledge of Gothic architecture. At the end of his career he produced more markedly romantic canvases, such as *View of the Ruins at Villiers-la-Ville* (1834; Brussels, Belg. Col. Royales). Other notable paintings by de Jonghe include *View from the Outskirts of Tournai* (1834; Brussels, Mus. A. Anc.) and *In the Ardennes* (n.d.; Antwerp, Kon. Mus. S. Kst.). Recognized as a specialist in landscape, in 1826 he was appointed to the teaching staff at the Academie in Courtrai. At this time he published, doubtless with his students in mind, his *Principes de paysages dessinés d'après nature et exécutés sur pierre*. In 1841 he succeeded Ommeganck as professor at the Academie in Antwerp.

WRITINGS

Principes de paysages dessinés d'après nature et exécutés sur pierre (Brussels, 1826)

BIBLIOGRAPHY

1770–1830: Autour du néo-classicisme en Belgique (exh. cat. by D. Coekelberghs and others, Brussels, Mus. Ixelles, 1985–6), pp. 308–10, 378–9

DOMINIQUE VAUTIER

Jonghelinck [Jongelinck]. Flemish family of artists and collectors. Pierre Jonghelinck was a medallist active in Antwerp; his son (1) Niclaes Jonghelinck, a tax collector, owned a collection of mainly allegorical and mythological paintings. Niclaes's brother, (2) Jacques Jonghelinck, was

a successful medallist and sculptor, patronized by the Habsburgs and important Netherlandish clients.

(1) Niclaes [Nicolaas] **Jonghelinck** (*b* Antwerp, 1517; *d* Antwerp, before 15 June 1570). Merchant, collector and patron. He was appointed collector of Zeeland customs before March 1551 and of Brabant customs in 1559; five years later he was made collector of the wine excise. During the 1560s Jonghelinck speculated in lotteries and insurance underwriting, often using his art collection as collateral. He housed his collection at his large villa, Ter Becken, outside Antwerp. In addition to a painting by Dürer, Jonghelinck owned 16 paintings by Pieter Bruegel the elder, including the artist's famous series of *The Months* (1565; Vienna, Ksthist. Mus.; Prague, N.G., Šternberk Pal.; New York, Met.). This series may have been part of an overall iconographic scheme that incorporated two cycles of paintings (probably totalling 17–18 works) by Frans Floris, the *Labours of Hercules* and the *Seven Liberal Arts*, which were hung in separate rooms. Now lost except for *Hercules and Antaeus* (Brussels, priv. col., see Van de Velde, fig. 1), the paintings are known from engravings made after them by Cornelis Cort and dedicated to Jonghelinck. A fourth series, statues of *Bacchus* (Aranjuez, Pal. Real) and *The Planets* (Madrid, Pal. Real), which Jonghelinck commissioned from his brother (2) Jacques Jonghelinck, may have completed the iconographic programme. Niclaes Jonghelinck died heavily in debt; he owed large sums to the King of Spain, among others. Ter Becken and Jonghelinck's city residence, the Sphera Mundi in the Kipdorp, were awarded to creditors. According to van Mander, the sale of Jonghelinck's possessions took place shortly after his death.

BIBLIOGRAPHY
BNB
K. van Mander: *Schilder-boeck* ([1603]–1604), fol. 268
J. Denucé: *De Antwerpsche 'konstkamers'* (Antwerp, 1932), p. 5
C. Van de Velde: 'The *Labours of Hercules*: A Lost Series of Paintings by Frans Floris', *Burl. Mag.*, cvii (1965), pp. 114–17
——: '*Hercules en Antaeus*: Een teruggevonden schilderij van Frans Floris' [*Hercules and Antaeus*: a rediscovered painting by Frans Floris], *Album Amicorum J. G. van Gelder* (The Hague, 1973), pp. 333–6
I. Buchanan: 'The Collection of Niclaes Jonghelinck, I: '*Bacchus* and *The Planets* by Jacques Jongelinck', *Burl. Mag.*, cxxxii (1990), pp. 102–13
——: 'The Collection of Niclaes Jonghelinck, II: *The Months* by Pieter Bruegel the Elder', *Burl. Mag.*, cxxxii (1990), pp. 541–50

AMY L. WALSH

(2) Jacques Jonghelinck (*b* Antwerp, 21 Oct 1530; *d* Antwerp, 31 May 1606). Sculptor and medallist, brother of (1) Niclaes Jonghelinck. He probably trained and subsequently worked with his father; he may also have had early professional contact with Cornelis Floris. He travelled to Italy in 1552 and may have worked in Milan with Leone Leoni, with whom his work has stylistic affinities. He may also have studied with one of the celebrated Italian medallists, for example Jacopo da Trezzo I or Giampaolo Poggini, who worked in the Netherlands towards the end of the reign of Charles V (*reg* 1517–56). By 1555 Jonghelinck had returned to Flanders, where he worked primarily in Antwerp, although he also owned a house in Brussels. At the request of Margaret of Parma, Regent of the Netherlands and Charles V's daughter, he was made an honorary master of the Brussels Guild in

1567. Jonghelinck married and had two children, one of whom, Anne, later became the wife of the painter Raphael Coxie.

Jonghelinck's first commission was a medal (1555) with portraits of *Charles V* and *Philip II* (*reg* 1556–98), issued in 1556 to mark Charles's abdication. The medal was later reissued in a second version (1557), with a similar obverse and a different portrait of *Philip II* on the reverse. Also in 1556 he cut the seals for the chanceries of Philip II and was appointed official sculptor, metal-caster and seal-engraver to the King, positions he retained under the regency of Archdukes Albert and Isabella. In the same year he made the seal of the Order of the Golden Fleece and the seal and signet for the chancery of Gelderland. Other important official seals by Jonghelinck include those of Brabant (1559), Burgundy (1569) and the three states of Namur. In 1567 he produced the first medal pairing Philip II with the Duque de Alba, whom Philip appointed Regent of the Netherlands in that year, and a second depicting Margaret of Parma in allegorical guise. Jonghelinck also produced medals for important private clients in Antwerp and Brussels, including Viglius de Zichem (1556), president of the privy council; Antoine van Stalen (1556), mayor of Antwerp; and Antoine Perrenot de Granvelle (1560), Bishop of Arras. Jonghelinck was appointed mint-warden of Antwerp in 1572. By 1600 he was regularly assisted by his nephew, Siegebert Waterloos (*d* 1624), who succeeded him as seal-engraver to Albert and Isabella.

Jonghelinck was also active as a sculptor: in 1558–60 he executed the bronze table-tomb of Charles the Bold (*d* 1477), in the church of Onze Lieve Vrouw, Bruges, a monument that is intentionally archaizing in an attempt to produce a suitable pendant to the Gothic tomb of Charles's daughter, Mary of Burgundy (*d* 1482), located in the same chapel. More imposing, however, is his bronze bust of the *Duque de Alba* (1571; New York, Frick), which gives the impression of haughty grandeur in the powerful modelling and characterization of the head, as well as in the fine ornamental chasing on the armour, the sash and the chain of the Golden Fleece. He also produced a life-size bronze statue of the *Duque de Alba* (1571; destr. 1577).

BIBLIOGRAPHY
Thieme–Becker
H. Kenutner: 'Jacques Jonghelinck', *Münchn. Jb. Bild. Kst*, vii (1956), p. 157
L. Forrer: 'Jacques Jonghelinck', *Biographical Dictionary of Medallists* (New York, 1970), iii, pp. 82–5

CYNTHIA LAWRENCE

Jongkind, Johan Barthold (*b* Latrop, 3 June 1819; *d* La-Côte-Saint-André, 9 Feb 1891). Dutch painter and printmaker. After training and working briefly as a notary's clerk, he studied from 1836 at the Academie voor Beeldende Kunsten in The Hague, where he befriended Charles Rochussen and was especially influenced in his watercolour technique by the work of the Director, Andreas Schelfhout. Among his early wash drawings, *Embarkation* (1844; The Hague, Gemeentemus.) provides evidence of a developed sense of this medium. In 1854, in response to a request from Comte Emilien de Nieuwerkerke, Schelfhout proposed Jongkind as a young Dutch artist who might profit from going to Paris to study in the studio of Eugène Isabey; Jongkind therefore accompanied Nieuwerkerke to Paris and was based there for the next ten

years. His work during this period embraced oil painting of a sometimes markedly traditional Dutch character, as in *Winter Scene* (1846; The Hague, Gemeentemus.), and detailed and sharply observant watercolours of streets and squares in Paris, such as the view of the *Barrière Monceau* (*c*. 1851; The Hague, Gemeentemus.). Jongkind also made sketching trips away from Paris, especially during the early 1850s, returning to Dutch settings to paint, and also sketching frequently on the coasts of Brittany and Normandy, where the strong Atlantic light prompted some of his best watercolour work up to that point (e.g. *Etretat*, *c*. 1851; Paris, Louvre).

By 1854 Jongkind had lost his sense of momentum and succumbed to severe depression. Unable to cope, he returned to the Netherlands in 1855 and was based there until 1860, living in relative isolation, although in 1857 he travelled to Paris, where he met Gustave Courbet. This period of rethinking and concentration proved beneficial; his subsequent watercolours in particular are marked by clear advances both in bold and satisfying composition and in the use of more dramatic light and shade, seen for example in *Quay in Rotterdam* (1857) and *Barge on the Canal* (1860; both Paris, Louvre). In 1860 a group of friends, including Corot, arranged a sale of paintings, the proceeds of which provided funds to enable Jongkind to return to Paris. At the same time Jongkind set up an arrangement with the Paris dealer Firmin Martin, and he met Mme Fesser, with whom he was to be closely involved for the rest of his life. He settled again in Paris in 1861, continuing to travel to the Netherlands each summer until 1869, but from this point on he was more closely allied to Parisian art life; he exhibited at the Salon des Refusés and knew Boudin, Monet and other French painters.

In 1862 Jongkind started to produce etchings; a series of six, *Vues de Hollande*, was issued that year. He frequently returned, in this medium, to the Dutch subject-matter for which there was a ready market. In his watercolours, however, he recorded a wide range of responses to his new surroundings, from the amusing and intimate sketch of himself with Mme Fesser and her son Jules, *Promenade at Clamart* (1861; Paris, Louvre), to the uncharacteristically detailed and realistic watercolour of *Bateaux Lavoirs by the Pont Notre-Dame* (1868; Paris, Louvre) and the sweeping, oblique view and sombre, subtle colouring of the *Bank of the Seine in Paris* (1868; Rotterdam, Boymans–van Beuningen). Jongkind also painted in the countryside around Paris, responding especially well to the play of light on land and water, as in the watercolour the *Seine at Argenteuil* (1869; Paris, Louvre).

From 1870 Jongkind spent his summers further from Paris, until 1879 in and near Grenoble and Lyon and thereafter in the south of France; from 1881 he lived at Côte-Saint-André in a house acquired by Mme Fesser's son. In these years there were further developments in his watercolour technique. In *Landscape in the Dauphiné* (1878; The Hague, Gemeentemus.) he achieved a lyrical rendering of mood with bold use of dark and light patches of sky and land and effective silhouetted features. In *At Côte-Saint-André* (1883; The Hague, Gemeentemus.) he used an energetic Impressionist technique to create a sense of the sun-drenched setting. Finally, in the strikingly free moonlit view, *La Côte-Saint-André* (1885; Otterlo,

Kröller-Müller), the play of light and shadow as the moon is obscured by clouds is captured with a remarkably free and vigorous brushstroke.

BIBLIOGRAPHY
E. Moreau-Nélaton: *Jongkind raconté par lui-même* (Paris, 1918)
P. Signac: *Jongkind* (Paris, 1927)
V. Hefting: *Jongkind d'après sa correspondance* (Utrecht, 1968)
——: *Jongkind: Sa vie, son oeuvre, son époque* (Paris, 1975)
The Age of Van Gogh: Dutch Painting, 1880–1895 (exh. cat., ed. R. Bionda and others; Glasgow, Burrell Col., 1990–91)

VICTORINE HEFTING

Joni, I(cilio) F(ederico) [Igino] (*b* Siena, 18 July 1866; *d* Siena, 23 Jan 1946). Italian forger, restorer and writer. He is best known for his autobiography, a broad panoramic portrait of life in provincial Italy at the end of the 19th century, which conveys something of the disquiet concerning the loss of Italy's prestige. He also worked as a skilful forger and restorer at a time when the distinctions between the two activities were blurred. Much of his success as a forger was due to the fact that he imitated either the works of lesser painters (such as Sano di Pietro) or the undistinguished works of more famous artists, which could deceive even a connoisseur. A typical example is his copy of Cecco di Pietro's Agnano polyptych (Pisa, Mus. N. S Matteo), created as a fraudulent substitution for the original (Rome, Pal. Venezia). Few of Joni's fakes have stood the test of time, despite the fact that he was in contact with such critics and collectors as Francis Mason Perkins and Robert Langton Douglas. Research into collecting and the art market in late 19th-century America has identified Joni's role as a restorer in such works as Piermatteo d'Amelia's *Annunciation* (Boston, MA, Isabella Stewart Gardner Mus.) and the half-length figures in Fra Angelico's *Annunciation* (Detroit, MI, Mrs E. Ford priv. col.).

WRITINGS
Le memorie di un pittore di quadri antichi, con alcune descrizioni sulla pittura a tempera e sul modo di fare invecchiare i dipinti e le donature (San Casciano Val di Pesa, 1932); Eng. trans. as *Affairs of a Painter* (London, 1936)

BIBLIOGRAPHY
M. Feretti: 'Falsi e tradizione artistica', *Stor. A.*, x (1981), pp. 115–95
M. Frinta: 'Drawing the Net Closer: The Case of Icilio Federico Joni, Painter of Antique Pictures', *Pantheon*, xl (1982), pp. 217–24
C. Simpson: *Artful Partners* (New York, 1986)
G. Mazzoni: 'Icilio Federico Joni', *Siena tra purismo e liberty* (exh. cat., Siena, Pal. Pub., 1988), pp. 186–206

ALESSANDRO CONTI

Jonson, Nicholas. *See* JOHNSON, (2).

Jonson [Janson; Johnson] **van Ceulen, Cornelis** [Cornelius], **I** (*b* London, 14 Oct 1593; *d* Utrecht, 5 Aug 1661). English painter of Flemish descent, active also in the northern Netherlands. He was the son of Cornelis Jonson of Antwerp and Jane Le Grand, who had fled to London to escape religious persecution. His grandfather Peter Jansen originally came from Cologne, so the family often used the name Jonson van Ceulen. Cornelis Jonson probably trained as a painter in the northern Netherlands, returning to London about 1618, where he worked for the next 25 years as a portrait painter. In 1622 he married Elizabeth Beck [Beek, Beke] of Colchester, a woman of Dutch origin who bore him two sons. The couple are portrayed with their son, Cornelis van Ceulen II (1634–

Cornelis Jonson van Ceulen I: *Family of Arthur, Lord Capel*, oil on canvas, 1.60×2.59 m, *c.* 1639 (London, National Portrait Gallery)

1715), in a portrait by Adriaen Hanneman (*c.* 1637; Enschede, Rijksmus. Twenthe).

1. ENGLAND, *c.* 1618–43. A few signed works by Jonson survive from 1617, but the majority of signed or monogrammed portraits, which number several hundred, date from 1619 and the following decades. Jonson is the first English-born painter known to have produced such a large number of signed portraits. Although he was certainly not a pace-setting portrait painter in early Stuart London, he still received many commissions. In addition to original paintings, he produced copies after the work of other artists, for example a monogrammed copy (1631; Chatsworth, Derbys) of the portrait of *Charles I* by Daniel Mijtens I (1629; New York, Met.). Since Jonson signed the painting it is clear that he was not simply one of Mijtens's studio assistants but rather an independent painter who was commissioned, either through Mijtens or directly, to copy the original. This type of work probably explains the mention of him in 1632 as 'his Majesty's servant in the quality of Picture drawer'.

Most of Jonson's original works during his London period are portraits of people in the higher, but not the highest, social circles. A large majority of these portraits are busts, simple in composition and ably reproducing the sitters' features. Some are set in a *trompe l'oeil* oval, painted to imitate a stone niche. Many of these bust portraits are in English public, and particularly private, collections, for example the portrait of *Sir Thomas Hanmer* (1631; Cardiff, N. Mus.) and the two small pendants *Portrait of a Man* and *Portrait of a Woman* (*c.* 1629; London, Tate). In spite of Jonson's somewhat conservative style, he absorbed some influence from such artists as Daniel

Mijtens I and Anthony van Dyck, particularly in his more ambitious works, such as the three-quarter-length portraits that he painted regularly and the group portrait of the *Family of Arthur, Lord Capel* (*c.* 1639; London, N.P.G.; see fig.), which is strongly inspired by van Dyck. In addition to large-scale paintings, Jonson also produced miniatures in oil on copper, including some signed examples, such as the *Portrait of a Man* (1639; Welbeck Abbey, Notts, see 1972 exh. cat., no. 205) and the portraits of *Peter Vanderput* and his wife *Jane Hoste* (London, Lord Thomson of Fleet priv. col.; see London, Sotheby's, 6 March 1967, lot 75). Some of the miniatures are reduced reproductions of full-size paintings.

2. THE NETHERLANDS, 1643–61. The painter and his household left England in 1643 at the start of the Civil War, settling first in Middelburg. In 1646 Jonson was living in Amsterdam while he painted a large group portrait of the *Magistrates of The Hague* (1647; The Hague, Oude Stadhuis). In subsequent years he painted portraits of the citizens of various Dutch cities, including Middelburg, suggesting that he led an itinerant life for some time. His final place of residence was probably Utrecht.

In the many portraits produced during his Dutch period, Jonson brought his personal style to its greatest perfection. Besides a few group portraits, his paintings were primarily half-length and three-quarter-length portraits notable for their elegance and their accurate rendering of the sitter's features and clothing. The paintings frequently use blue and green backgrounds, not a practice then currently fashionable. Representative examples of Jonson's later portrait paintings include *Helena Leonora de Sieveri* (1650; Utrecht, Cent. Mus.); *Jasper Schade* and *Cornelia Strick*

(both 1654; Enschede, Rijksmus. Twenthe); the *Portrait of a Woman* (1655; London, N.G.); *Prince William III of Orange Nassau as a Child* (1657; Knole, Kent, NT); and the *Portrait of a Woman* (1659; London, Tate). Jonson's most important student was his son Cornelis II, whose style initially resembled his father's but whose later work declined sharply to a mediocre level.

BIBLIOGRAPHY

Foskett; Thieme–Becker; *Waterhouse: 16th & 17th C.*

A. J. Finberg: 'A Chronological List of Portraits by Cornelius Johnson', *Walpole Soc.*, x (1922), pp. 1–37

E. Waterhouse: *Painting in Britain, 1530 to 1790*, Pelican Hist. A. (London, 1953)

M. Whinney and O. Millar: *English Art, 1625–1714*, Oxford Hist. Eng. A. (Oxford, 1957)

The Age of Charles I: Painting in England, 1620–1649 (exh. cat. by O. Millar, London, Tate, 1972), nos 31–8, 140, 205–7

M. Edmond: 'Limners and Picturemakers: New Light on the Lives of Miniaturists and Large-scale Portrait Painters Working in London in the Sixteenth and Seventeenth Centuries', *Walpole Soc.*, xlvii (1978–80), pp. 60–242

D. Foskett: *Collecting Miniatures* (Woodbridge, 1979)

RUDOLF EKKART

Jónsson, Ásgrímur (*b* Rútsstaðahjáleiga, Flói, 4 March 1876; *d* Reykjavík, 5 April 1958). Icelandic painter and draughtsman. He was from the first generation of Icelandic landscape painters, whose attitudes to the country were strongly shaped by a Romantic approach to nature and a growing nationalism. Jónsson became the first professional painter in Iceland. He studied at the Kongelige Danske Kunstakademi in Copenhagen (1900–03), where his teachers included Frederik Vermehren and Holger Grønvold (1850–1923). He held his first one-man exhibition in Reykjavík in 1903, showing works influenced by Romanticism and Symbolism.

On his way to study in Italy in 1908 Jónsson became acquainted with the works of the Impressionists in galleries in Germany. Their influence was apparent a year later in one of his most important works, the volcano *Hekla* (1909; Reykjavík, N.G.), painted in Iceland. Though his technique and attitudes towards his material still placed him close to traditional landscape painting, he concentrated on interpreting colour tones and atmosphere. After 1904 Jónsson worked in both watercolour and oils. Although self-taught, he succeeded within a few years in mastering watercolour, with which he managed to convey the translucent colours of the Icelandic environment, notably in *View from Nesjar in Hornafjörður* (1912; Reykjavík, priv. col., see Schram and Sigurðsson, p. 73). Characteristics of his watercolours are also apparent in his oil paintings from the 1910s and 1920s.

Jónsson's subjects can be divided into three main groups: Icelandic landscapes, which dominate his output; volcanoes, with people and animals fleeing, in which Jónsson emphasized the dramatic tension of the interplay between man and nature; and subject-matter freely derived from Icelandic folk tales, mostly ink and pencil drawings, often portraying trolls and other monsters in pursuit of fleeing and defenceless humans, in which there is a strong psychological overtone. The folk-tale pictures are related to the volcano pictures in that flight is a major theme in both groups. From 1940 Jónsson's art developed from Romantic realism towards Expressionism under the influence of van Gogh. He moved from wider horizons to closer detail, his colours became stronger and his brushstrokes more substantial and vehement. As a teacher of two generations of Icelandic artists, he had a strong influence on the shaping of Icelandic art.

BIBLIOGRAPHY

B. Th. Björnsson: *Íslensk myndlist á 19. og 20. öld* [Icelandic art in the 19th and 20th centuries] (Reykjavík, 1964), i, pp. 69–83; ii, pp. 132-41

H. Schram and H. Sigurðsson: *Ásgrímur Jónsson* (Reykjavík, 1986)

J. Gottskalksdóttir and H. Schram: *Arbok Listasafns Íslands, 1988* [Yearbook of the National Gallery, Iceland] (Reykjavík, 1989), pp. 23–37

H. Schram: *Arbok Listasafns Íslands, 1989* [Yearbook of the National Gallery] (Reykjavík, 1990), pp. 33–42

VIDEO RECORDINGS

H. Schram: *Ásgrímur Jónsson*, Íslenska Ríkissjónvarpið (1986) [TV film]

HRAFNHILDUR SCHRAM

Jónsson, Einar (*b* Árnessýsla, 11 May 1874; *d* Reykjavík, 18 Oct 1954). Icelandic sculptor. He studied wood-carving and sculpture in Copenhagen (1893–9), first in the private art schools of Stephan Sinding and Frederik Vermehren and from 1896 at the Kunstakademi. He lived and worked mostly in Copenhagen until 1914, with sojourns in Rome (1902–3), Berlin (1909–10), London (1911) and the USA (1917–20), after which he returned to Iceland for good. In 1923 a museum and studio home devoted to, and designed by, the artist, and financed by the Icelandic parliament, was opened in the centre of Reykjavík. Jónsson bequeathed all his works to the nation, which now maintains his museum.

Jónsson produced many public sculptures in Reykjavík, including *Outlaws* (1898–1901), *Wave of Waves* (1894–1905) and *Ingólfur Arnarson* (1907). His statue of the Viking explorer *Thorfinn Karlsefni* (1916–18) is in Philadelphia, PA. Although he was Iceland's first sculptor in modern times, his mature work is essentially derived from 19th-century Symbolism, replete with ideas derived from Theosophy and Norse, Greek and Oriental mythologies. During his lifetime Jónsson enjoyed both official and public favour, yet his Symbolist approach, combined with his high-minded attitude to the creative process, tended to isolate him from his more formalist colleagues in Iceland, and thus from mainstream 20th-century Icelandic art.

BIBLIOGRAPHY

J. Auðuns: *Einar Jónsson myndhöggvari* [The sculptor Einar Jónsson] (Reykjavík, 1982) [in Ice. and Eng.; many illus.]

Ó. Kvaran: *Einar Jónssons skulptur: Formutveckling och betydelsevärld* [The sculpture of Einar Jónsson: development and meaning] (diss., U. Lund, 1987) [with Eng. summary]

AÐALSTEINN INGÓLFSSON

Jönsson, Erik. *See* DAHLBERGH, ERIK.

Jónsson, Finnur (*b* Strýta, Hamarsfjörður, 15 Nov 1892). Icelandic painter. On completing his apprenticeship as a goldsmith in 1919, Jónsson studied painting in Copenhagen (1919–21) and in Germany, at the Akademie der Künste, Berlin (1921–5), and Der Weg, Schule für Neue Kunst, Dresden (1922–5). In 1922 he started producing Cubist and geometric paintings, both abstract and with figurative elements. In 1925, the year he returned to

Iceland, he showed works of this kind at Der Sturm-Galerie in Berlin. Despite the stylistic connections with, for instance, Constructivism, the content of Jónsson's geometric works is largely subjective, and the significance of the forms both symbolic and aesthetic. *The Dice of Fate* (1925; Reykjavík, N.G.), for example, is an abstract geometric work, marked by the interplay of two-dimensional forms and planes and depth brought out by the use of colour. The basic geometric forms unite to create a dice, a sphere and a ray, and take on a symbolic meaning in the artist's interpretation of existential questions suggested by the title.

An equivocal attitude to modernism explains in part why Jónsson failed to become a pioneer of abstract art in Iceland, though the main reasons were probably the lack of suitable support in Icelandic culture. Back in Iceland he turned to figurative art using naturalist subjects, such as the life of seamen and Icelandic nature. These works show certain Expressionist influences, such as the use of wide outlines, which add to the dramatic qualities of the subject. After 1940 Jónsson turned also to folk tales and hagiography for subject-matter, and his interpretation became freer. He began *c.* 1960 to paint fantasy landscapes (oceans and suns), and moons and stars in a kind of cosmic space, again, but in a new way, approaching the abstraction that had by then taken over Icelandic art.

Jónsson's brother, Rikharður Jónsson (1888–1977), was a sculptor and wood-carver.

BIBLIOGRAPHY
B. Th. Björnsson: *Íslensk myndlist á 19. og 20. öld* [Icelandic art in the 19th and 20th centuries], i (Reykjavík, 1963)
F. Ponzi and I. Thorsteinsson: *Finnur Jónsson* (Reykjavik, 1985)

JÚLÍANA GOTTSKÀLKSDOTTIR

Jōō. *See* TAKENO JŌŌ.

Joost, Jan. *See* JOEST, JAN.

Joos van Gent. *See* JUSTUS OF GHENT.

Jordaens, Hans, I (*b* Antwerp, *c.* 1555; *d* Delft, *bur* 23 May 1630). Flemish painter, active in the northern Netherlands. In 1572 he was recorded in Antwerp as a pupil of Noe de Noewielle and in 1581 as a qualified master in the Antwerp painters' guild. In 1582 he married Anna Mahu, widow of Frans Pourbus the elder. Abraham Jordaens, presumably his brother, was apprenticed to him in 1585, and in 1601 he is mentioned as a painter in Delft. About 1590 his son Simon was born; he also became a painter. Between 1590 and 1597 Jordaens moved permanently to Delft, perhaps for religious reasons, since he joined the Lutheran community there. On 3 August 1612 he provided sureties for his son Simon, who was granted citizenship of Delft. By 1613 Hans was a member of the Guild of St Luke there and one of the town's best-selling painters. His religious and mythological paintings, such as *Queen Esther before King Ahasuerus* (1610; Montreal, Mus. F.A.), had a more intimate and decorative character than the work of local painters and soon became popular. This is clear from the many works attributed to him in Delft inventories. Of the 146 pictures sold by his widow after his death, only four were attributed to him. Most of them, however, must have been his work. It is thus surprising that so few of his paintings are now known; these include a *Wooded Landscape with Christ and the Woman of Canaan* (sold London, Christie's, 1983; see Briels, p. 318) and two versions of a *Village Feast* (one sold London, Christie's, 1986; the other, untraced; for both, see Briels, p. 131), which he made in collaboration with Willem van den Bundel (1575–after 1653).

BIBLIOGRAPHY
Hollstein: *Dut. & Flem.*; Thieme–Becker
P. Rombouts and T. van Lerius: *De liggeren en andere historische archieven der Antwerpsche Sint Lucasgilde*, i (Antwerp, 1872), pp. 245, 249, 277, 294, 304
F. D. O. Obreen: *Archief der Nederlandsche kunstgeschiedenis* (Rotterdam, 1877–90), i, p. 4; iv, pp. 280ff; v, pp. 57, 125, 203ff, 299, 301; vi, pp. 7, 13, 16, 44
M. Rooses: *Geschiedenis der Antwerpsche schilderschool* (Antwerp and The Hague, 1879), p. 167
F. J. Van den Branden: *Geschiedenis der Antwerpsche schilderschool* (Antwerp, 1883), p. 284
A. Bredius: *Künstler-Inventare: Urkunden zur Geschichte der holländischen Kunst des XVIten, XVIIten und XVIIIten Jahrhunderts* (The Hague, 1915–22), i, pp. 321–2; v, pp. 1816–21
F. C. Legrand: *Les Peintres flamands de genre du XVIIe siècle* (Brussels, [1963]), p. 62
J. M. Montias: *Artists and Artisans in Delft: A Socio-economic Study of the Seventeenth Century* (Princeton, 1982)
J. G. C. A. Briels: *Vlaamse schilders in de Noordelijke Nederlanden in het begin van de Gouden Eeuw, 1585–1630* (Antwerp, 1987)

Jordaens, Hans, III [Lange Jan] (*b* Antwerp, *c.* 1595; *d* Antwerp, 1643). Flemish painter. He trained with his father, Hans Jordaens II (*bapt* Antwerp, 1581; *d* Antwerp, 1635), who was also a painter. On 26 November 1617 Hans III married Maria van Dijck, by whom he had five children. In 1620 he enrolled in the Antwerp Guild of St Luke. He appears to have been a fairly successful painter: although his father is said to have been a poor man, Hans III was living in a large house in 1624. The few paintings known by him are in the style of Frans Francken (ii). There are several versions of the *Israelites Crossing the Red Sea* attributed to him, six of which are signed (e.g. The Hague, Mauritshuis); one is also dated (1624; Berlin, Gemäldegal.). Two depictions of collectors' cabinets have been attributed to him, one signed and formerly in the collection of Leopold William (*c.* 1630; Vienna, Ksthist. Mus.); the other remains doubtful (London, N.G.). He painted the figures in a landscape by Josse de Momper II (Vienna, Ksthist. Mus.) and, with Frans Francken and others, was also responsible for finishing works by Abraham Govaerts after the latter's death in 1626.

BIBLIOGRAPHY
Hollstein: *Dut. & Flem.*; Thieme–Becker
P. Rombouts and T. van Lerius: *De liggeren en andere historische archieven der Antwerpsche Sint Lucasgilde*, i (Antwerp, 1872), p. 561; ii (The Hague), p. 142, 230, 246
F. D. O. Obreen: *Archief der Nederlandsche kunstgeschiedenis* (Rotterdam, 1877–90), v, p. 205
M. Rooses: *Geschiedenis der Antwerpsche schilderschool* (Antwerp and The Hague, 1879), pp. 539–40
F. J. Van den Branden: *Geschiedenis der Antwerpsche schilderschool* (Antwerp, 1883), pp. 669–71
F. Donnet: *Het jonstisch versaem der Violieren: Geschiedenis der rederijkkamer de Olijftak sedert 1480* [The honourable brotherhood of the Stocks: a history of the chamber of rhetoricians of the Olive Branch since 1480] (Antwerp, 1907), p. 124
S. Speth-Holterhoff: *Les Peintres Flamands de cabinets d'amateurs au XVIIe siècle* (Brussels, 1977), pp. 113–16

TRUDY VAN ZADELHOFF

Jordaens, Jacob, the elder (*bapt* Antwerp, 20 May 1593; *d* Antwerp, 18 Oct 1678). Flemish painter, tapestry designer and draughtsman. In the context of 17th-century Flemish art, he emerges as a somewhat complicated figure. His oeuvre, the fruit of a continual artistic development, is characterized by great stylistic versatility, to which the length of his career contributed. His religious, mythological and historical representations evolved from the rhetorical prolixity of the Baroque into a vernacular, sometimes almost caricatural, formal idiom. The lack of idealistic treatment in his work is undoubtedly the factor that most removed Jordaens's art from that of his great Flemish contemporaries Rubens and van Dyck. Jordaens's officially commissioned works included many paintings in which the sublimity of the subject-matter clashed with the vulgarity of some of his figures. Unlike Rubens and van Dyck, both of whom were knighted in the course of their careers, Jordaens was, in fact, completely ignored by the courts of Spain and Brussels, and he did not receive a single significant commission from Italy, France or England. Only once did Charles I of England grant him a commission, and then under less favourable circumstances (*see* §1(ii) below). After Rubens's death in 1640, Jordaens became the most prominent artist in the southern Netherlands. Only then did he receive royal commissions, but these came from the north, where pomp and circumstance were avoided and few demands were made in the way of Baroque perfection. Until then, his patrons had come almost entirely from among the prosperous bourgeoisie. The people of the social circles in which he moved were far less demanding of life, and they manifested a certain indifference towards the values of the culturally refined.

1. Life and career. 2. Works. 3. Critical reception and posthumous reputation.

1. LIFE AND CAREER.

(i) Before 1633. He was the first child of Jacob Jordaens (*d* 5 Aug 1618), a wealthy cloth merchant, and Barbara van Wolschaten (*d* 11 Feb 1633). In 1607, at the age of 14, he apprenticed himself to the Antwerp painter Adam van Noort, who later became his father-in-law. He presumably enjoyed the kind of education then available to boys from good families. In 1615 the 22-year-old Jordaens was inscribed in the Antwerp Guild of St Luke as a *waterschilder* (a painter of watercolours on canvas or paper, which were used as substitute tapestries). From at least 1616, however, he also painted in oil. He showed himself early on to be a talented artist, and, given his success, he probably soon abandoned painting in watercolour on canvas in order to devote his full energies to the more profitable art of oil painting. In 1616–17 he became a member of the Guild's Armenbus (Poor-box), a fund that provided support to sick artists and contributed to their funeral expenses. On 15 May 1616 he married Catharina van Noort (*d* 17 April 1659). The couple had three children: Elizabeth, Jacob Jordaens the younger (*bapt* 2 July 1625), who became a painter, and Anna Catharina. After his marriage, Jacob the elder moved to the Everdijstraat, and as early as 15 January 1618 he was able to buy his own house in the Hoogstraat, the street where he was born. On 28 September 1621 the 28-year-old artist was appointed dean of the Guild of St Luke, a post he occupied for, at most, only a year.

(ii) 1633–48. After the deaths of his father and mother, Jordaens acquired 'Het Paradijs', the house in which he was born. On a professional level, things were going extremely well for him. He broadened his sphere of activities and began to play an increasingly important role in Antwerp artistic circles. He received important commissions from the church authorities, including large altarpieces, and he designed several cycles of real, woven tapestries (see below). Under Rubens's direction, he collaborated in 1634 on the decorations for the Joyous Entry of Cardinal-Infante Ferdinand of Austria, the new governor of the Spanish Netherlands. In 1637–8 he collaborated again with Rubens, this time on the paintings intended for the decoration of the Torre de la Parada, the hunting-lodge of Philip IV outside Madrid. His workshop consequently gradually enlarged, and from this time onwards the records of the guild regularly mention the names of new pupils. (None of these, however, later became famous.) Jordaens's wealth increased, and, in accordance with his improved status (and following Rubens's example), he built an elegant home, suitable for his wide sphere of activities. It was built next to the house that he had bought in the Hoogstraat, and both properties were joined to create one complex. In 1639–40 Jordaens received a commission from Charles I of England for a cycle of 22 paintings illustrating the *History of Psyche*, which were to decorate the cabinet of the Queen's House at Greenwich. The cycle was never completed; only eight paintings ever reached the English court. Shortly after Rubens's death in 1640, Jordaens was asked by his heirs to complete two paintings ordered by Philip IV of Spain in 1639.

Jordaens continued to use the watercolour technique he had learnt as a *waterschilder* for the design of cartoons for woven tapestries, an activity for which he received major commissions virtually throughout his career. Exactly when he began to make such designs is not known. The earliest known cycles of tapestries woven after his designs, the *History of Odysseus* and the *History of Alexander*, can be dated on stylistic grounds to *c.* 1630–35. They were followed by the *Scenes from Country Life* of *c.* 1635 (see fig. 1). The first document referring to tapestry designs by Jordaens is a contract dated 22 September 1644, in which he agreed to furnish the Brussels tapestry-weavers Frans van Cotthem, Jan Cordys and Boudewijn van Beveren with cartoons for a series of *Proverbs*. This series is not only the first to be documented, it is also the first from which cartoons have been preserved (two in Paris, Mus. A. Déc.). Jordaens executed all of his cartoons and his sketches for tapestries on paper. For the latter, he used watercolour and gouache, a choice that undoubtedly reflected his early training.

The fame that accrued to Jordaens outside of Flanders attracted young artists who sought to study with him. Shortly after 1642 the Polish artist Aleksander Jan Tricius became his pupil, and in 1645 Queen Christina of Sweden sent her protégé Joris Waldon to his workshop. Jordaens also received major commissions from the Swedish court. For instance, on 21 April 1648 the Swedish agent Johan-Philips Silvercroon commissioned the artist to paint a

1. Jacob Jordaens: *Piquer Seated among a Pack of Hounds*, brush and brown wash, watercolour and gouache, over traces of black chalk, on sheet composed of five pieces of paper, 355×502 mm, *c.* 1635 (London, Victoria and Albert Museum); design for a tapestry from the series of *Scenes from Country Life*

series of 35 paintings for the ceiling of the council hall of Uppsala Castle. The subjects of these canvases are not known, nor whether the commission was ever completed and, if so, how many paintings reached Sweden. Moreover, Houbraken maintained that Jordaens made 12 paintings representing the *Passion* for King Karl X Gustav (*reg* 1654–60), another undocumented and untraced commission.

In 1646 Jordaens delivered five paintings to Martinus van Langenhoven, who questioned their authenticity and took legal action against the artist. A declaration made on 25 August 1648, before a public notary, indicates that Jordaens admitted that he had, in fact, had his assistants make copies of some of his earlier compositions, which he then touched up with a few autograph brushstrokes.

(iii) 1649 and after. One of the most important commissions Jordaens received was for the decoration of the Oranjezaal at the Huis ten Bosch, a summer home built in The Hague woods by Amalia von Solms, widow of Prince Frederick Henry of Orange (*see* THE HAGUE, §V, 3). Several other Dutch and Flemish masters were also asked to join the project, to which Jordaens contributed the *Triumph of Prince Frederick Henry* and the *Triumph of Time* (both *in situ*). However, this and other commissions that he received did not prevent Jordaens from continuing work on the decorations for his own house in the

Hoogstraat, Antwerp, for which he painted a cycle of eight ceiling pieces illustrating the *History of Psyche* (Antwerp, van der Linden priv. col., see d'Hulst, 1982, p. 233). One of these is dated 1652, probably the year that the series was finished. Several documents from the early 1650s mention Jordaens as the designer of a series of seven tapestries referred to as 'Scenes involving horses' or 'Large horses'. The Antwerp tapestry dealer Frans de Smit had two cartoons for this series in his possession, as is known from a notarial act of 5 July 1652. On 21 November 1651 another Antwerp merchant, Carlos Vincque, placed an order with the Brussels weavers Everaert Leyniers and Hendrik Rydams for this same tapestry cycle to be woven after Jordaens's designs, and on 18 November 1654 Jan de Backer, a third merchant from Antwerp, ordered the same series from these same weavers. One set of this tapestry cycle, also known as the *Riding School*, is preserved (Vienna, Ksthist. Mus.).

In his old age Jordaens became a member of the Dutch Reformed Church. He probably joined it *c.* 1656, but the Catholic authorities had had reason to look askance at him as early as 1649. The trip he took to Brussels in May of that year must have roused their suspicions, for he was required to account for his movements. This he did on 23 July 1649, at which time he explained that his trip was made entirely for business reasons. Several years later,

between 1651 and 1658, he was sentenced to pay the heavy fine of 240 pounds for having published 'blasphemous', that is Protestant, writings. He was 78 years old when, in 1671, he was admitted to Holy Communion by the Reformed congregation in Antwerp known as the Mount of Olives under the Cross. Their religious service, which was held by turns in the private homes of the congregants, took place in Jordaens's home for the first time on 24 December 1674. He subsequently opened the rooms of his magnificent home on many occasions to his persecuted Calvinist friends.

The exact date and the reasons for Jordaens's conversion to the Reformed Church remain unclear. Originally Catholic, he may have been influenced by his father-in-law and master, Adam van Noort, to accept the doctrines of the Reformed Church. His Calvinist sympathies may also have contributed to the commissions he received from foreign courts during the latter half of his career, though he undoubtedly owed most of them to his great renown. The other official commissions that he executed towards the end of his career also came from the Protestant north: the decorations for part of the new town hall in Amsterdam and those for the overmantel of the tribunal in the county hall at Hulst. Until the end of his life, Jordaens also continued to accept commissions to decorate Catholic churches.

Jordaens died of the mysterious Antwerp disease that the same day killed his unmarried daughter Elizabeth, who lived with him. Their bodies were buried together under one tombstone in the Protestant cemetery at Putte, a village just north of the Dutch border, where his wife Catharina had earlier been put to rest. No will by Jordaens has ever come to light, but he probably did make one, for in 1679, the year after his death, his son-in-law Johan Wierts II saw to the transfer of money and a painting representing the *Washing and Anointment of the Body of Christ* to the Maagdenhuis (home for orphaned girls) 'because of the sympathetic disposition that the late Jacq. Jordaens had towards the poor'.

2. WORKS.

(i) Paintings.

(a) History subjects. Jordaens's oeuvre as a history painter can be divided into five periods. From his earliest period (to *c.* 1618), only three dated works are known: the *Adoration of the Shepherds* (1616; New York, Met.), the *Daughters of Cecrops Finding the Child Erichtonius* (1617; Antwerp, Kon. Mus. S. Kst.) and another version of the *Adoration of the Shepherds* (1618; Stockholm, N. Mus.). It is probable that even before he was received as a master in the Antwerp Guild in 1615, that is from *c.* 1612, he had executed independent paintings. During this earliest period he painted mainly mythological and religious scenes, although his first version of the *Satyr and the Peasant* (*c.* 1615–16; Glasgow, A.G. & Mus.), a moralizing fable that he treated repeatedly during his career, also dates to these years. Jordaens came under the influence of Rubens very early and even copied his works. Rubens remained an important source of inspiration to Jordaens throughout his life, but he was also influenced by the late Mannerist cabinet pictures of Hendrik van Balen. Moreover, although

Jordaens never travelled to Italy, his early work manifests Caravaggesque traits: earthy peasant types and strongly modelled shadows. In these early works Jordaens filled the picture plane so completely with figures that he created, as it were, an emphatically three-dimensional and monumental bas-relief. In the beginning he employed rather glaring and variegated local colouring, but gradually his colours became more deeply saturated and were deployed more harmoniously over the picture plane, while at the same time his brushstrokes became looser and more rhythmical.

It was during his second period (1619–27) that he carried out his most celebrated works; yet during this fruitful period there are no dated paintings at all. Besides religious scenes, for example the splendid *St Peter Finding Money in the Mouth of a Fish* (Copenhagen, Stat. Mus. Kst.), he also painted mythological subjects (e.g. *Pan and Syrinx*, *c.* 1620; Brussels, Mus. A. Anc.; see fig. 2) and allegories (e.g. the *'Homage to Pomona'*, or *Allegory of Fertility*, *c.* 1623; Brussels, Mus. A. Anc.; see fig. 3), as well as a number of versions of the *Satyr and the Peasant*.

The same subject categories feature in the work of the third period (1628–41). Jordaens adopted compositions by Rubens for his large altarpieces, such as the *Martyrdom of St Apollonia* for the church of the Augustinian convent in Antwerp (1628; on loan Antwerp, Kon. Mus. S. Kst.) and *St Martin Curing the Possessed Man* (1630; Brussels, Mus. A. Anc.). He eschewed large areas of local colour from this time onwards, and he also broke up the contours of the forms and made frequent use of angular, choppy

2. Jacob Jordaens: *Pan and Syrinx*, oil on canvas, 1.73×1.36 m, *c.* 1620 (Brussels, Musée d'Art Ancien)

3. Jacob Jordaens: '*Homage to Pomona*' (or *Allegory of Fertility*), pen and brown ink and brown wash, over traces of black chalk, 190×260 mm, *c*. 1623 (Brussels, Musée d'Art Ancien)

lines. Muscles were rendered in an exaggerated and anatomically inaccurate fashion. Through the use of a less vivid palette, a certain weakening of the brushstrokes and an abundant application of red, the golden quality characteristic of his early nudes was lost. During this same period he painted '*As the old sang, so the young twitter*' (1638; Antwerp, Kon. Mus. S. Kst.) and *The King Drinks* (Kassel, Schloss Wilhelmshöhe), the first versions of two subjects that were to occupy him from this time onwards (see fig. 4). After 1640 important commissions that had previously been awarded to Rubens came to Jordaens. This is especially true of the years 1642 to 1651. Notable among these are various large altarpieces—for instance the *Adoration of the Magi* (1644; ex-St Nicholaas, Rupelmonde; destr.)—that reveal the influence of Rubens and, through him, that of Veronese and Bassano. Dating from the same period are several representations of gods and demigods, who express their feelings in gestures and attitudes that are artificial and ill-attuned to one another, producing somewhat theatrical effects. There is also a number of allegorical representations, for example the *Allegory of Fertility* (1649; Copenhagen, Stat. Mus. Kst.), and scenes from history and legend, such as *King Candaulus* (1646; Stockholm, Nmus.) and the *Signs of the Zodiac* (Paris, Pal. Luxembourg), a series of 12 ceiling paintings for the decoration of his house, which was completed *c*. 1641, as well as several new versions of '*As the old sang,*

so the young twitter' (e.g. Ottawa, N.G.) and *The King Drinks* (e.g. Vienna, Ksthist. Mus.). All of these works are characterized by a harmonious palette, set in a minor key without strong contrasts, and by sensitively modelled figures. Studio assistants played an increasingly important role in the execution of these works.

In his last years (1652–78) Jordaens's creative powers diminished perceptibly and numerous inferior paintings left his workshop, for which his assistants were either partially or entirely responsible. The last datable works were made in 1669. Besides many religious paintings, the most notable works of the period are the cycle illustrating the *History of Psyche* for his own house and his two contributions to the Oranjezaal of the Huis ten Bosch (*see* §1(iii) above). With a few exceptions, his later works are of low artistic value. Their palettes are often a monotonous grey-blue, in which shrill accents sometimes appear, or a nearly monochrome brown. The paint is applied so thinly that the canvas is visible nearly everywhere.

(b) Portraits. Considering his production in other areas, Jordaens painted relatively few portraits, at least to judge from his extant oeuvre. Those few that survive follow the same stylistic development as his history paintings. His sitters were members of his own family or social circle, in other words the bourgeoisie of Antwerp and its environs. Among the known portraits are a number of self-portraits

4. Jacob Jordaens: *The King Drinks*, oil on canvas, 1.56×2.10 m, *c.* 1640 (Brussels, Musée d'Art Ancien)

(e.g. late 1640s; Munich, Alte Pin.) and some in which the artist portrayed himself in the company of his family (e.g. *c.* 1621–2; Madrid, Prado) or other relatives. He also painted separate portraits of various family members. There are several extant portraits of trustworthy burghers who wished to have themselves eternalized in paint, either as individuals or as married or engaged couples (see fig. 5). Portraits of royalty and members of the nobility do not appear within Jordaens's oeuvre. Nor did he paint portraits of the clergy or those persons who had made names for themselves in literature or art or as founders of charitable institutions.

(ii) Tapestry designs. As a tapestry designer, Jordaens also succumbed to the influence of Rubens. However, Rubens's interest in the art of tapestry-making was limited, while Jordaens devoted a significant measure of his energy to this art form. Virtually every type of subject-matter seemed to appeal to him: religious, mythological, historical and allegorical representations, as well as moralizing genre scenes. A few of his cartoons have been partially or entirely preserved; others are mentioned in documents. Apparently, all of the tapestries fabricated after Jordaens's designs were originally parts of series, for which the *editio princeps* were woven in Brussels workshops. Besides those series already mentioned (*see* §1 above), Jordaens made cartoons for the *History of Charles the Great* (early 1660s) and a

series of *Famous Women*, designed during the latter half of his career.

(iii) Drawings. Jordaens was an extremely prolific draughtsman: no fewer than 425–50 drawings are known by his hand. Together with his contemporaries Rubens and van Dyck, he is an exponent of the trend for Flemish painters of that period to make large numbers of preparatory drawings. Jordaens was a typical painter–draughtsman: his drawings are not primarily linear in character but rather painterly (see fig. 3). To this end, he often employed methods associated with the art of painting, freely applying washes of watercolour or gouache. He was extremely economical in his use of paper: many of his sheets are composed of several strips of paper (see fig. 1), sometimes odd in shape. He often enlarged an existing drawing (either immediately or at a later date) by pasting it on to a larger sheet or by adding strips to it. Neither did he hesitate to cut away parts of drawings or to paste over them. The preparatory drawings that he executed reflect great versatility in both style and technique, doubtless a consequence of the large variety of commissions he received during his long career.

3. CHARACTER AND INFLUENCE. Given the size of his oeuvre, Jordaens must have possessed exceptional drive to maintain such remarkable momentum. Year in, year out, with the regularity of clockwork, he executed a

5. Jacob Jordaens: *?Govaert van Surpele and his Wife*, oil on canvas, 2.13×1.89 m, *c*. 1636–9 (London, National Gallery)

vast number of paintings, sketches, studies and cartoons, which suggests that he disciplined himself to lead an orderly life. He and his family enjoyed the prosperity and the tranquil bourgeois existence of a talented artisan. This is not, however, to say that his daily life was without problems. His life was marked by a number of disagreements with others and especially by his embracement of Calvinist doctrines within a hostile Catholic community.

The disorderly overabundance that characterizes many of Jordaens's works is more the consequence of a limited talent for composition on the part of the artist than of the number of figures or props. His representation of perspective was also often poor, particularly when he was dealing with ethereal beings floating in the air. Jordaens turned to other methods to evoke the intensity of life, emphasizing the raucous laughing and noisy shouting of his over-enthusiastic figures. He did paint masterly works, though these are all too often not masterpieces: many are of high artistic value but lack a certain definitive quality, in particular the lucidity of a harmoniously organized composition. Despite the often eclectic and uneven quality of his oeuvre, through his numerous works in which sensuousness as well as the primacy of light and colour prevail Jordaens infused 17th-century Flemish art with a new, extremely personal quality, one that was thereafter to remain inherent in it, although he had few followers.

BIBLIOGRAPHY

BNB; Thieme–Becker

MONOGRAPHS

P. Génard: 'Notice sur Jacques Jordaens', *Messager Sci. Hist. Belgique* (1852)
P. Buschmann: *Jacob Jordaens: Eene studie naar aanleiding van de tentoonstelling zijner werken ingericht te Antwerpen in MCMV* (Brussels, 1905)
M. Rooses: *Jacob Jordaens: Sa vie et ses oeuvres* (Antwerp, 1906; Eng. trans., London and New York, 1908)
A. Stubbe: *J. Jordaens en de barok* (Antwerp, 1948)

L. Van Puyvelde: *Jordaens* (Paris and Brussels, 1953)
R.-A. d'Hulst: *De tekeningen van Jacob Jordaens* (Brussels, 1956)
——: *Jordaens Drawings*, 4 vols (Brussels, London and New York, 1974) [excellent pls]; review by J. S. Held in *A. Bull.*, lx (1978), pp. 717–32; and by M. Jaffé in *Burl. Mag.*, cxxvi (1984), pp. 783–7
K. A. Nelson: *Jacob Jordaens as a Designer of Tapestries* (diss., Chapel Hill, U. NC, 1979)
R.-A. d'Hulst: *Jacob Jordaens* (Antwerp, 1982; Eng. trans., London, 1982) [excellent pls]; review by M. Jaffé in *Burl. Mag.*, cxxvi (1984), pp. 783–7

EXHIBITION CATALOGUES

Jacob Jordaens (exh. cat., Antwerp, Kon. Mus. S. Kst., 1905)
Exposition d'oeuvres de Jordaens et de son atelier (exh. cat. by L. Van Puyvelde, Brussels, Mus. A. Anc., 1928)
Jacob Jordaens (exh. cat., New York, Mortimer Brandt Gal., 1940)
Tekeningen van Jacob Jordaens (exh. cat. by R.-A. d'Hulst, Antwerp, Rubenshuis; Rotterdam, Mus. Boymans–van Beuningen; 1966–7); review by M. Jaffé in *Burl. Mag.*, cviii (1966), pp. 625–30; and by J. S. Held in *Kunstchronik*, iv (1967), pp. 94–110
Jacob Jordaens, 1593–1678 (exh. cat. by M. Jaffé, Ottawa, N.G., 1968–9); review by J. S. Held in *Burl. Mag.*, cxi (1969), pp. 265–72; by R.-A. d'Hulst in *A. Bull.*, li (1969), pp. 378–88; and by E. Haverkamp-Begemann in *Master Drgs*, vii (1969), pp. 173–8
Jordaens in Belgische bezit (exh. cat. by M. Vandenven, Antwerp, Kon. Mus. S. Kst., 1978)
Jacob Jordaens: Tekeningen en grafiek (exh. cat. by R.-A. d'Hulst, Antwerp, Mus. Plantin–Moretus, 1978)
Jacob Jordaens: Drawings and Prints (accompanying guidebook by J. Wortman, Washington, DC, Smithsonian Inst. Traveling Exh. Serv., 1979–81)
Oeuvres de Jordaens au Musée de Besançon (Besançon, Mus. B.-A. & Archéol., 1981)
Jacob Jordaens: Paintings and Tapestries (exh. cat. by R.-A. d'Hulst, N. De Poorter and M. Vandenven, Antwerp, Kon. Mus. S. Kst., 1993)
Jacob Jordaens: Drawings and Prints (exh. cat. by R. A. d'Hulst, Antwerp, Kon. Mus. S. Kst., 1993)
The Age of Rubens (exh. cat. by P. C. Sutton and others, Boston, MA, Mus. F.A.; Toledo, OH, Mus. A.; 1993–4), pp. 345–58, *passim*

SPECIALIST STUDIES

H. Kauffmann: 'Die Wandlung des Jacob Jordaens', *Festschrift Max-J. Friedländer* (Leipzig, 1927), pp. 191–208
L. Burchard: 'Jugendwerke von Jakob Jordaens', *Jb. Preuss. Kstsamml.*, xlix (1928), pp. 207–18
J. S. Held: 'Nachträglich veränderte Kompositionen bei Jacob Jordaens', *Rev. Belge Archéol. & Hist. A.*, iii (1933), pp. 214–23
D. Schlugleit: 'L'Abbé Scaglia, Jordaens et l'*Histoire de Psyché* de Greenwich-House (1639–1642)', *Rev. Belge Archéol. & Hist. A./Belg. Tijdschr. Oudhdknd. & Kstgesch.*, vii (1937), pp. 139–66
M. Crick-Kuntziger: 'Les Cartons de Jordaens au Musée du Louvre et leurs traductions en tapisseries', *An. Soc. Royale Archéol. Bruxelles*, lxii (1938), pp. 135–46
J. S. Held: 'Malerier og tegninger af Jacob Jordaens i Kunstmuseet', *Kstmus. Årsskr.*, xxvi (1939), pp. 1–43
——: 'Unknown Paintings by Jordaens in America', *Parnassus*, xii/3 (1940), pp. 26–9
——: 'Jordaens' Portraits of his Family', *A. Bull.*, xxii (1940), pp. 70–82
——: '*Achelous' Banquet*', *A.Q.* [Detroit], iv (1941), pp. 122–33
——: 'Jordaens and the Equestrian Astrology', *Miscellanea Leo Van Puyvelde* (Brussels, 1949), pp. 153–6
R.-A. d'Hulst: 'Jacob Jordaens en de *Allegorie van de Vruchtbaarheid*', *Mus. Royaux B.-A. Belgique: Bull.*, i (1952), pp. 19–31
——: 'Jacob Jordaens: Schets van een chronologie zijner werken ontstaan voor 1618', *Gent. Bijdr. Kstgesch. & Oudhdknd.*, xiv (1953), pp. 89–138
——: 'Zeichnungen von Jacob Jordaens aus seiner Frühzeit, bis etwa 1618', *Z. Kstgesch.*, xvi (1953), pp. 208–21
——: 'De tekeningen van Jacob Jordaens in het Museum Boymans', *Bull.: Mus. Boymans*, iv (1953), pp. 44–56; (1954), pp. 73–81
——: 'Jordaens and his Early Activities in the Field of Tapestry', *A.Q.* [Detroit], xix (1956), pp. 236–54
——: 'Nieuwe gegevens omtrent enkele tekeningen van Jacob Jordaens', *Gent. Bijdr. Kstgesch. & Oudhdknd.*, xvii (1957–8), pp. 135–55
——: '*Paul et Barnabé à Lystres* de Jacques Jordaens', *Mus. Royaux B.-A. Belgique: Bull.*, vii (1958), pp. 93–9
——: 'A Portrait by Jordaens', *Bull. John Herron A. Inst.*, xlv (1958), pp. 3–4
J. Duverger: 'De rijschool of grote en kleine paarden in de XVIIe-eeuwse tapijtkunst', *Het herfsttij van de Vlaamse tapijtkunst, Jb.: Kon. Vl. Acad. Wet., Lett. & S. Kst. België* (1959), pp. 121–76

R.-A. d'Hulst: 'Jacob Jordaens: *Apollo heurtelings in strijd met Marsyas en Pan*', *Mus. Royaux B.-A. Belgique: Bull.*, x (1961), pp. 28–36
——: 'Enkele onbekende schilderijen van Jacob Jordaens', *Gent. Bijdr. Kstgesch. & Oudhdknd.*, xix (1961–6), pp. 81–94
——: 'Further Drawings by Jordaens', *Master Drgs*, i/3 (1963), pp. 17–28
J. S. Held: 'Notes on Jacob Jordaens', *Oud-Holland*, lxxx (1965), pp. 112–22
R.-A. d'Hulst: 'Drie vroege schilderijen van Jacob Jordaens', *Gent. Bijdr. Kstgesch. & Oudhdknd.*, xx (1967), pp. 71–86
——: 'Jacob Jordaens en de schilderskamer van de Antwerpse Academie', *Jb. Kon. Mus. S. Kst.* (1967), pp. 131–50
——: 'Enkele tekeningen van Jacob Jordaens', *Miscellanea I.Q. van Regteren Altena* (Amsterdam, 1969), pp. 111–13
M. Jaffé: 'Reflexions on the Jordaens Exhibition', *N.G. Canada Bull.*, xiii (1969), pp. 1–40
R.-A. d'Hulst: 'Jordaens Drawings: Supplement I', *Master Drgs*, xviii/4 (1980), pp. 360–70

R.-A. D'HULST

Jordan, Hashemite Kingdom of [Arab. Al-Mamlaka al-Urdunniyya al-Hāshimiyya]. Independent constitutional monarchy in the Middle East with its capital at Amman. Jordan has an area of 88,946 sq. km, bordered in the north by Syria, in the north-east by Iraq, in the south-east and south by Saudi Arabia and in the west by the West Bank of the Jordan River (under Israeli occupation since 1967). Founded as an independent country in 1924, Jordan was under Ottoman rule from the mid-15th century to World War I, forming part of the Ottoman province of Syria with Damascus as the capital. The population of Jordan is *c.* 4,100,000, of which 93% is Sunni Muslim. The remaining 7% includes minorities of Circassians, Chechens, Druze and Armenians, the Christian population comprising mainly Greek Orthodox and Catholics with a small number of Protestants. The economy is based on agriculture, manufacturing, mining, tourism and remittance from Jordanian professionals working in Saudi Arabia and the Gulf countries. This article covers the art produced in Jordan in the 20th century. For its earlier history *see* ANCIENT NEAR EAST, SYRIA-PALESTINE, EARLY CHRISTIAN AND BYZANTINE ART and ISLAMIC ART.

Jordan was founded in 1924 by 'Abdallah, the son of Sharif Husayn of Mecca, who led the Arab revolt against the Ottomans in 1917. After Ottoman rule was terminated, the British and French divided the Arab lands under their mandate according to the Sykes–Picot agreement. The new State, the Emirate of Transjordan to the east of the Jordan River, was under British mandate until 1946, when it became the Hashemite Kingdom of Jordan and 'Abdallah (*reg* 1924–51) was proclaimed King. After the first Arab–Israeli war in 1948 and the creation of Israel, the West Bank of the Jordan River was annexed to Jordan. In 1951 'Abdallah was shot during Friday prayers at the Aqsa Mosque in Jerusalem. He was succeeded by his son Talal, but in 1952 Talal abdicated in favour of his son Hussein (*reg* 1952–).

The major cities in Jordan, including AMMAN, have undergone considerable development since the 1960s, multiplying in size as a result of migration from rural to urban centres. The first architect to be assigned to the Amman Municipality was Fawaz Muhanna (1900–1967), who studied in Istanbul and came to Transjordan in the early 1930s. The buildings he designed include the Turkish embassy (1950), the Royal Court (1951), the old Municipality Building (1952) in central Amman, Basman Palace (1957), and several private houses. Among the buildings in Amman constructed since the 1970s, those of architectural interest include the Haya Centre (1977), the Martyr's Memorial (1977), the new Parliament Building (1980), the Royal Cultural Centre (1982), the Housing Bank Complex (1983) and the King 'Abdallah Mosque (1989).

Most existing vernacular architecture in Jordan dates from the 19th and early 20th centuries. In Salt, which was the administrative centre for the area during Ottoman rule, examples exist of urban stone houses (*c.* 1890–1920) with Turkish features. Stone was the traditional building material in mountain areas, while mud-brick was used in the desert and the Jordan Valley. Most rural architecture is now made of concrete and old village houses are rare. Traditional forms of artistic expression include rug and textile weaving, embroidery, niello work on silver (introduced by Circassian émigrés), goldsmithing, pottery, painting on glass, wood-carving and calligraphy.

The origins of modern art in Jordan can be traced to the 1920s and 1930s when several artists settled in Amman. The first was Omar Onsi (1901–69), a Lebanese painter who visited Amman between 1922 and 1926. He was followed in 1930 by the Turkish painter Ziauddin Suleiman (1880–1945), who held the first solo exhibition at the Philadelphia Hotel (1938). In 1948 the Russian painter George Alief (1887–1970) arrived from Palestine with the first wave of Palestinian refugees. All three artists enjoyed royal patronage, were instrumental in introducing easel painting to Jordan and contributed to the development of art appreciation among the public.

After 1948 the art movements in Jordan and Palestine were closely connected. Artists numbered among the refugees who crossed the Jordan River, and others were born in Jordan of Palestinian parents. Palestinian artists were employed as instructors by the Jordanian Ministry of Education to teach art at government schools and develop art education within the government's teaching programmes. As in other Arab countries, artists in Jordan were concerned with finding a distinctive style by which they could assert their Arab cultural identity. This was often achieved through the depiction of local subject-matter and the inclusion of folk motifs and Arab calligraphy in their compositions.

In 1951 the artistic committee of the Arab Club, founded by the scholar Shaykh Ibrahim al-Kattan (1916–84), held the first group exhibition in the country, in which eight painters participated. In 1952 the first artistic group, *Nadwa al-fann al-urdunniyya* ('Jordanian art club'), was established; its goal was to spread an awareness of art among the public and encourage amateur artists in their pursuits. Meanwhile, foreign cultural centres such as the British Council, the Goethe Institute and the French Cultural Centre in Amman and Jerusalem held regular exhibitions for local artists and arranged exhibitions from abroad. In the late 1950s the Jordanian government, in need of trained artists to teach at its schools, began to send students on scholarships to Italy. Further scholarships followed for artists to train at other centres, in Arab and Western countries.

The first attempt at formal art training in Jordan took place when the Institute of Music and Painting in Amman was opened in 1952 by John Kayaleh, an ophthalmologist,

Samer Tabbaa: *Monolithic Gathering*, limestone, 1977 (Amman, National Gallery of Fine Art)

musician and art lover. The Italian Armando Bruno (1930–63), who was in charge of the Institute, taught drawing and painting, and the centre became a meeting-place for young artists and intellectuals. The Institute closed in 1962 when Bruno left for the United States. From the early 1960s students who had been sent abroad on art scholarships began to return to Amman and were employed as art teachers. Around the same time the Ministry of Tourism sent works by Jordanian artists for display at international exhibitions, beginning with the New York International Fair in 1965, followed by others in Baghdad, Damascus, Bari, Rome, Copenhagen and Berlin.

In 1966 the Department of Culture and Arts was founded to support and promote cultural activities relating to the fine arts, theatre, music and literature, including exhibitions by local and foreign artists. By the early 1970s there was a considerable increase in artistic activities. In 1972 the Institute of Fine Arts was founded within the Department of Culture and Arts on the initiative of the painter MUHANNA DURRA. At the Institute, where many artists received their initial training, a two-year foundation course in painting, sculpture and graphic art was organized. Art scholarships provided by the Ministry of Education enabled artists to study in Iraq, Syria, Turkey, Pakistan, Europe, USA and the Soviet Union. In 1977 the Artists Association was established in Amman, where artists could meet and exhibitions and lectures were occasionally held.

In 1979 the Royal Society of Fine Arts was founded to promote the visual arts in Jordan and other Islamic countries, and in 1980 the Society established the National Gallery of Fine Arts in Amman. The first gallery of art to open in Jordan, it has a large permanent collection of paintings, sculptures, ceramics, installations and tapestry by contemporary artists from Islamic lands and the developing world, including the Middle East, central and North Africa, and South-east Asia. In 1980 a Fine Arts Department was established at Yarmouk University in Irbid, the first institution in Jordan for higher education in the arts.

Among the painters active in Jordan in the late 20th century have been FAHRELNISSA ZEID, Hafiz Kassis (*b* 1932), Rafik Lahham (*b* 1932), Ahmad Nawash (*b* 1934), Tawfik al-Sayid (*b* 1939), WIJDAN ALI, Ali Jabri (*b* 1943), Aziz Amoura (*b* 1944), Suha Shoman (*b* 1944), Mahmoud Sadiq (*b* 1945), Fuad Mimi (*b* 1949), Khaled Khreis (*b* 1955), Jamal Ashour (*b* 1958) and Ammar Khammash (*b* 1960). Contemporary sculptors include Samer Tabbaa (*b* 1945; see fig.), Kuram Nimri (*b* 1944) and Muna Saudi (*b* 1945), while Mahmoud Taha (*b* 1942) and Hazim al-Zu'bi (*b* 1957) are notable ceramicists.

Archaeological enquiry in Jordan began in the early 19th century: in 1812, for example, the traveller Jean-Louis Burckhardt discovered PETRA, the ruined capital of NABATAEA. In 1868 the inscribed Mesha Stele (Moabite Stone; Paris, Louvre), dating from 840 BC, was discovered in Dhiban. In general, however, Palestine received far more attention from archaeologists in the late 19th century than the area east of the Jordan River because of the Western preoccupation with biblical sites. In 1923 a Department of Antiquities was established in Amman. Since then excavations have been conducted at Amman, Pella (*see* PELLA (i)), the Greco-Roman city of Gadara in Um Qais, Petra, Jerash (*see* GERASA), the crusader castle at Kerak and the Ayyubid castle of al-Rabad in Ajlun. In 1983 Neolithic statuettes were discovered at the prehistoric village of AIN GHAZAL, on the north-eastern outskirts of Amman. Mosaics of the second half of the 4th century AD

were discovered in the church at the Monument of Moses at Mt Nebo, and Byzantine mosaics have been found in various other churches in Nebo and Madaba. There are also scattered throughout the Jordanian desert a number of residences dating to the Umayyad dynasty (*reg* AD 661–750), such as Qasr al-Hallabat, Hammam al-Sarah, QUS-AYR 'AMRA, QASR KHARANA, MSHATTA and Qasr al-Tuba. In 1951 the Jordanian Archaeological Museum was founded in Amman and there are also museums at such locations as Petra, Jerash, Madaba and Kerak.

BIBLIOGRAPHY
G. L. Harding: *The Antiquities of Jordan* (London, 1959)
H. al-Amad: *Cultural Policy in Jordan* (Paris, 1981)
L'Oeil, 306–7 (1981) [issue on the arts in Jordan]
A. & Islam. World, ii/1 (1984) [issue on the arts in Jordan]
A. Khammash: *Notes on Village Architecture in Jordan* (Lafayette, LA, 1986)
W. Ali, ed.: *Contemporary Art from the Islamic World* (London, 1989), pp. 175–95
W. ALI

Jordán, Armando (*b* Coroico, nr La Paz, 1893; *d* Santa Cruz, 1982). Bolivian painter. The son of a cartographer, in 1903 he moved with his family to Santa Cruz, where he was taught to draw by his father; as a painter he was self-taught. Jordán was an art teacher in several public schools in Santa Cruz between 1915 and 1933. Between 1930 and 1965 he concentrated on drawings and paintings, among them small watercolours, illustrations and coats of arms. His most important work consists of a group of oil paintings (1940–65) that portray with ingenious humour the daily events, fiestas, fashions and customs of the life of Santa Cruz. For this reason his work has great documentary value. He made frequent use of photography to develop his subject-matter and also had his own paintings photographed: he then retouched the photographs with oil paint. He believed this technique, which he called oil-photos (*fotóleos*), was a new contribution to the field of art. He exhibited his paintings for the first time in La Paz in 1971. His best-known works include *The Festival of the Cross* (1950) and *No More Dolts* (1965), in which he impishly, but with great critical acumen, developed themes full of characters portraying his friends and other figures of the day. In 1983 a large retrospective of his work was held in the Museo Nacional de Arte in La Paz.

BIBLIOGRAPHY
P. Querejazu: *La pintura Boliviana del siglo XX* (Milan, 1989)
PEDRO QUEREJAZU

Jordán, Esteban (*b* ?León, *c.* 1529; *d* Valladolid, *c.* 1598). Spanish sculptor. He was one of the leading sculptors in the second half of the 16th century based in Valladolid. He probably trained in León, and the classical style apparent in his works may have been derived from Gaspar Becerra, who was in Valladolid in 1557. Jordán's first documented work is a retable (1556–62) at Paredes de Nava, on which he collaborated with Inocencio Berruguete (*fl* 1540–63). He received commissions from other centres such as Medina del Campo, Alaejos, León, Avila and Monserrat. From about 1577 to 1590 he completed the retable started by JUAN DE JUNI, who was an important influence on him, in the church of S Maria del Mediavilla, Medina de Ríoseco. Jordán was also responsible for the

alabaster reliefs and wood figures on the *trascoro* (completed 1585) of León Cathedral. His commissions in Valladolid include the alabaster tomb of *Don Juan de Ortega* in Santi Spiritus, which was commissioned in conjunction with the retable of the *Annunciation* in the same church in about 1582.

An alabaster effigy of a knight of the Order of St John (*c.* 1575–80; London, Mus. Order St John), originally in Valladolid, may be by Jordán. His style combines classical motifs with rich decorative features. The pediments, capitals, fluted columns and pilasters of his retables are embellished with swags of fruit and foliate reliefs. The figures are given classical poses and tend to have large eyes and luxuriantly curled hair. This monumental style was superseded in the early 17th century by the naturalism of such sculptors as Gregorio Fernández.

BIBLIOGRAPHY
Ceán Bermúdez
J. Agapito y Revilla: 'La obra de Esteban Jordán en Valladolid', *A. España*, ii (1914–15), pp. 318–28, 352–63, 397–404; iii (1916–17), pp. 32–41, 240–43
J. J. Martín González: *Esteban Jordán* (Valladolid, 1952)
M. Trusted: 'A Work by Esteben Jordán: An Effigy of a Spanish Knight of the Order of St John', *Bol. Semin. Estud. A. & Arqueol.*, liii (1987), pp. 351–9
MARJORIE TRUSTED

Jörger von Tollet, Johann Septimius (*b* Styria, 3 March 1596; *d* 1672). Austrian collector, draughtsman, engraver and etcher, active in Germany. A scion of the Upper Austrian nobility, he fled temporarily to Venice in 1620 after being involved in the Bohemian uprising in 1618; he left his homeland permanently after being expelled as a Protestant in 1629. After stays in Regensburg, Nuremberg, Würzburg and Frankfurt am Main, in 1636 he settled in Nuremberg. He was elevated to the rank of Reichsgraf in 1659. A long legal wrangle over a property sold illegally led to him fleeing Nuremberg in 1668, leaving his possessions behind. These included a large library and a widely known art collection. Apart from numerous paintings it comprised graphic works, sculptures, jewellery and glass, as well as globes and all kinds of rarities. His art cabinet is depicted in an engraving by Michael Herr (1645; see Wurm, p. 192). Jörger himself attempted works in chalk and red chalk, as well as engravings and etchings (Vienna, Albertina), his main subjects being portraits, mountain landscapes and heraldic allegories. He was praised as a gifted artist by the Württemberg theologian Johann Valentin Andreae (1576–1654), whom he had known since 1648. His portrait was engraved in 1645 by Andreas Kohl (1624–57), working after a *Self-portrait* (untraced); Joachim von Sandrart engraved it in 1653 and again in 1662 (Wurm, p. 176), working after Georg Strauch.

UNPUBLISHED SOURCES
Nuremberg, Staatsarchv, Rep. 60a [Verlässe des Inneren Rates]
Vienna, Haus-, Hof- & Staatsarchv, Reichshofrat, Antiqua, fasc. 673, no. 1
BIBLIOGRAPHY
ADB; Thieme–Becker
D. Wülffer: *Die gekrönte Treu . . . Leichenpredigt für Anna Potentiana Jörger* (Nuremberg, 1656)
C. F. Lochner: *Davids Schreien und Gedeien . . . Leichenpredigt für Regina Jörger* (Nuremberg, 1667)
G. K. Nagler: *Neues allgemeines Künstler-Lexikon*, vi (Munich, 1838), p. 464
F. H. Rheinwald, ed.: *Ioannis Valentini Andreae . . . Vita* (Berlin, 1849), p. 249

C. von Wurzbach: *Biographisches Lexikon des Kaiserthums Österreich*, x (Vienna, 1863), p. 232
H. Wurm: *Die Jörger von Tollet*, iv of *Forschungen zu Geschichte Oberösterreichs* (Graz, Cologne and Linz, 1955)

WERNER WILHELM SCHNABEL

Jörg von Halsbach

Jörg von Halsbach [von Halspach; Ganghofer; von Polling] (*b* ?Halsbach bei Polling; *d* Munich, 6 Oct 1488). German architect. He is first recorded in 1441, carrying out repairs to the cloisters and the choir of Ettal abbey church and building a sacristy there. He bought a house in Polling in 1447, and a meadow near Weilheim in 1453. In 1456 he is named as a juror in Murnau.

From 1468 until his death Jörg von Halsbach was architect to the city of Munich. His masterpiece is the Frauenkirche (the cathedral; *see* MUNICH, §IV, 1), built 1468–88, a hall church with octagonal piers and net vaults over the nave and aisles. In 1470 he worked on the Neuveste and its curtain walls. In that year he also inspected buildings in Augsburg and Ulm. The Altes Rathaus and Tanzsaal of Munich were built under his supervision between 1470 and 1477. In 1478 he visited Hall in Tirol at the request of the town council to inspect the tower of St Nikolaus and other buildings. In 1480–82 he supervised work on the vaulting (destr.) of the nave of Freising Cathedral, which he may also have designed, and in 1483–4 on the vaulting of the Benediktuskapelle in the cloister and the Dreikönigskapelle. He was paid for work on the tower 'bei unserer Frauen Gottesacker' (destr.) in Munich in 1485 and again in 1488, and for work on the Alter Hof and its tower in 1486.

NDB
BIBLIOGRAPHY
A. Mitterwieser: 'Der Dom zu Freising und sein Zubehör am Ausgang des Mittelalters', *Elftes Sammelblatt des historischen Vereins Freising* (Freising, 1918), pp. 1–98
O. Hartig: 'Münchner Künstler und Kunstsachen', *Münchn. Jb. Bild. Kst*, n. s., iii (1926), pp. 273–370
——: 'Jörg von Halsbach, genannt Ganghofer, und Heinrich von Straubing, genannt Heimeran', *Das Bayerland*, xliv (1933), pp. 172–6
M. Schattenhofer: *Das alte Rathaus in München* (Munich, 1972)

FRIEDRICH KOBLER

Jorhan

Jorhan. Family of sculptors of Bohemian descent, active in Bavaria. Johann Wenzeslaus Jorhan (*b* Bilín, Bohemia, *c.* 1695; *d* Griesbach im Rottal, *bur* 16 March 1752) was probably a journeyman in the employ of Joseph Ignaz Reiser (*fl c.* 1705–20) in Passau, before setting up *c.* 1720 as a master in Griesbach. Works of his of particular interest are the sculptures (1732–4) for the altars of the Cistercian monastery church of Seligenthal, Landshut, and the high altar (*c.* 1746) in the Wallfahrtskirche, Anzenberg. His son, Christian Jorhan (i) (*b* Griesbach, *bapt* 6 Oct 1727; *d* Landshut, 8 Oct 1804), trained first with his father and then for many years in such places as Riedlingen an der Donau, Salzburg, Augsburg and under Johann Baptist Straub in Munich; in 1755 he settled in Landshut. His oeuvre is extensive. He supplied individual sculptures and altars and fitted out entire churches, chiefly in Lower Bavaria, but also in the area around Erding. His style was strongly influenced by Straub; many of his sculptures rank with the best Bavarian work of that period. Characteristic works can be seen in the churches of Reichenkirchen (1756–9), Niederding (*c.* 1760–62), Altenerding (1760–80)

and Maria Thalheim (1764–70). Christian Jorhan (ii) (*b* Landshut, 6 Aug 1758; *d* Passau, 14 July 1844), son of Christian Jorhan (i), set up as master in Passau in 1794; as a sculptor, he ranks below his father and grandfather.

BIBLIOGRAPHY
F. Markmiller: 'Christian Jorhan', *Grosse Niederbayern: Zwölf Lebensbilder*, ed. H. Bleibrunner (Landshut, 1973), pp. 83–92
V. Liedke: 'Die Landshuter Maler- und Bildhauerwerkstätten von der Mitte des 16. bis zum Ende des 18. Jh.', *A. Bavar.*, xxvii/xxviii (1982), pp. 47–53, 106–9
F. Markmiller: 'Daten und Fakten zur niederbayerischen Bildhauerfamilie Jorhan', *Jb. Ver. Christ. Kst München*, xv (1985), pp. 155–68
H. Schindler: *Bayerische Bildhauer: Manierismus, Barock, Rokoko im altbayerischen Unterland* (Munich, 1985), pp. 215–41
——: *Christian Jorhan d.Ä. in Landshut: Niederbayerns grosser Rokokobildhauer* (Munich, 1985)
O. Schmidt: *Christian Jorhan d.Ä. 1727–1804: Eine Einführung* (Riemerling, 1986)

PETER VOLK

Jorisz., David

Jorisz. [Joris], **David** [Broek, Jan van; Bruck, Johannes von; Brugge, Johannes von] (*b* Ghent or Bruges, *c.* 1501–2; *d* Basle, 1556). South Netherlandish glass painter and religious sect leader. First mentioned in Delft, where he married and settled in 1524, Jorisz. was trained as a painter of stained glass. A convert first to Lutheranism and later to Anabaptism, he was arrested for blasphemy in 1528 and was fined, whipped and had a hole bored in his tongue. He was then banished from Holland and sentenced (*in absentia*) to be hanged. Calling himself 'the Third David', he founded his own Anabaptist sect, took his family and followers to Basle and passed himself off as a Dutch nobleman, 'Johannes von Bruck'. Living on funds from his Dutch publications—including the *Wunderboeck* (Deventer, 1542), illustrated with his own woodcut designs—and from secret donations, he lived in the Spiesshof on the upper Heuberg in Basle, and in a series of castles in the countryside. Although quite a few citizens of Basle seem to have known his real identity, he was not denounced until three years after his death, when his body was exhumed and burnt under the gallows, together with a portrait and his heretical writings.

Several of Jorisz.'s pen-and-wash designs for painted glass have survived, including the *Freeing of a Prisoner* (Basle, Kstmus.), two designs from a series illustrating the *Seven Acts of Mercy* (Basle, Kstmus.; Weimar, Schlossmus.) and his coat of arms (Karlsruhe, Staatl. Ksthalle). While he lived in Basle the glazier Baltasar Han (1505–78) carried out Jorisz.'s designs, many of which were for windows in his town house and castles. A portrait (Basle, Kstmus.) from Jorisz.'s estate, formerly attributed to Jan van Scorel, is now thought to be a self-portrait.

BIBLIOGRAPHY
R. H. Bainton: *David Joris: Wiedertäufer und Kämpfer für Toleranz im 16. Jahrhundert* (Leipzig, 1937)
P. Burckhardt: 'David Joris und seine Gemeinde in Basel', *Basl. Z. Gesch. & Altertknd.*, xlix (1949), pp. 5–106
H. Reinhardt: 'Sechs Rundscheiben des David Joris', *Hist. Mus. Basel, Jber. & Rechn.* (1950), pp. 26–35
E. Landolt: 'David Joris', *Tobias Stimmer, 1559–1584* (exh. cat., ed. D. Koepplin and P. Tanner; Basle, Kstmus., 1984), nos 303–4, 355–6 and pp. 451–4
J. Luckhardt: 'David Joris (?)', *Heinrich Aldegrever und die Bildnisse der Wiedertäufer* (exh. cat., ed. J. Luckhardt and A. Lorenz; Münster, Westfäl. Landesmus., 1985), no. 63

JANE CAMPBELL HUTCHISON

Jorn, Asger [Jørgensen, Asger Oluf] (*b* Vejrum, Jutland, 3 March 1914; *d* Århus, 1 May 1973). Danish painter, printmaker, decorative artist, ceramicist, sculptor and writer, also active in France. His personality and work exerted a decisive influence on his contemporaries, and he is recognized as one of the most important Scandinavian artists since Edvard Munch. He grew up in the provincial town of Silkeborg, Jutland, but after qualifying as a teacher in 1935 he went to Paris to study under Fernand Léger. He also worked as an assistant to Le Corbusier in 1937 during the Exposition Universelle. In 1938 he held his first exhibition in Copenhagen, with Pierre Wemaëre (*b* 1913). Jorn had to return to Denmark shortly before the outbreak of World War II. In 1941 he set up *Helhesten*, a magazine dealing with art, literature and archaeology. Among its contributors were Ejler Bille, Henry Heerup, Egill Jacobsen and Carl-Henning Pedersen; they developed a concept of spontaneous–abstract art, based partly on the pioneer work of Richard Mortensen and Ejler Bille during the 1930s.

1. EARLY YEARS, 1935–48. Through the occupation of Denmark during World War II Jorn sought to unite ideas from Joan Miró, Max Ernst and other Surrealists with a new, freer, more colour-orientated concept of painting, as in *Horses* (1941–2; Copenhagen, priv. col., see Atkins, 1968, fig. 53). His works combined grotesque and humorous figures with a lyrical spectrum of colour. After the war Jorn went first to northern Sweden and later in 1946 back to Paris. There he met the Dutch painter Constant, whom he visited in Amsterdam on his way back to Denmark; during this stay in Amsterdam he inspired a group of young Dutch artists to publish the magazine *Reflex*, modelled on *Helhesten*. In 1947–8 Jorn was again in France, taking part in several exhibitions, including a one-man exhibition at the Galerie Breteau, Paris (1948). With Wemaëre he made sketches for, and executed, tapestries (e.g. *Bird in the Forest*, 1947; Silkeborg, Kstmus.). During a stay on the Tunisian island of Djerba (1948) he painted a series of pictures with figures inspired by Islamic patterns and reflecting the natural surroundings. The major work of this period was *Automolok* (1948; Silkeborg, Kstmus.). It shows a figure caught up in a web between two female figures. The ambiguous linear composition resembles that developed by Jorn in paintings after 1946 on the basis of automatic drawings, but the linear complex is more successfully interwoven with multitudinous areas of subdued, warm colour.

2. COBRA AND AFTER, 1948–55. In the autumn of 1948 Jorn formed the COBRA group in Paris with Christian Dotremont and Constant. They were joined by Karel Appel, Corneille and others and succeeded in uniting artists of similar ideas from many countries. Over the next three years the group organized several exhibitions and published a series of small monographs, a journal and some illustrated volumes of poetry.

In 1951 a severe attack of tuberculosis forced Jorn to return to Silkeborg, where he spent ten months in a sanatorium. Towards the end of this time he resumed his painting and writing, and in 1952 he published his first book, *Held og hasard*. He also began a series of paintings entitled *The Seasons* (see Atkins, 1968, pp. 75–80) and made three large lithographs for the Second International Biennale of Contemporary Colour Lithography (Cincinnati, OH, A. Mus.). During the summer of 1953 he completed a large series of ceramics, some of which were acquired by the museum in Silkeborg.

In the autumn of 1953 Jorn went to Switzerland, where he made a series of etchings, later published as *Swiss Suite* (Munich, 1961; see Van de Loo and Weihrauch, nos 153–75). He then moved to northern Italy and settled in Albisola, near Savona. There he tried to revive the activities of the Cobra years, holding a large festival of ceramics and an open-air exhibition. Jorn held a one-man exhibition in 1954 at the Galleria l'Asterisco in Rome, and in 1955 he showed his ceramic works at the Danish Museum of Decorative Art and the series of paintings *Dream Pictures* at the Galerie Birch, both in Copenhagen. He continued his critique of Functionalism and industrial design in arguments with Max Bill, forming a movement called MIBI (Mouvement International pour un Bauhaus Imaginiste), which was joined by Enrico Baj and artists from the *Arte nucleare* group.

3. PARIS, 1955–71. In 1956 Jorn settled in Paris, from then on spending only part of the year in Albisola. He started exhibiting at the Galerie Rive Gauche and had a retrospective exhibition at the Institute of Contemporary Arts in London in 1958. At the Exposition Universelle of 1958 in Brussels, Jorn's main work, *Letter to my Son* (1958; London, Tate; see fig.), attracted attention. Figures and images from previous compositions were combined in a suggested landscape, the characters ranging from the ridiculous to the pathetic. Three major works begun in the late 1950s summed up some of his previous efforts: a huge ceramic wall (3.05×27.13 m) was modelled and fired in Albisola and installed in the Århus State High School in 1959; then a large tapestry, *Long Voyage* (completed 1960), was placed in the central hall of the same school, and Jorn also worked on his largest painting, *Stalingrad* (1956–72; Silkeborg, Kstmus.), an image of destruction and chaos.

Jorn's mature painting style developed during the late 1950s, and by continuous experiment he enriched his original concept of the spontaneous–abstract idiom. His use of different materials in combination with oil paint stemmed from his work with ceramics. Among the main influences on Jorn's paintings in the 1950s were the calligraphic works of the Japanese Bokubi group, paintings by Wols and the late work of Jackson Pollock. However, his paintings continued to be based on the principle of ambiguity and the free flow of colour in relation to the figure, as in *In the Wingbeat of the Swans* (1963; Amsterdam, Stedel. Mus.), in which two whirling figures and a lone mask are shown in a suggested landscape, with a red skyline, under which larger figures hover over the couple. The colours are juxtaposed dramatically in a carefully balanced game, as in much of Jorn's mature work.

Jorn helped found the International Situationist Movement, which tried to renew the Surrealist liaison between political and aesthetic thought and practice, presenting its ideas in the magazine *Internationale situationniste* (1958–9). He resigned from the movement in 1961, devoting more

Asger Jorn: *Letter to my Son*, oil on canvas, 1.30×1.96 m, 1958 (London, Tate Gallery)

and more time to a series of lavishly illustrated books on ancient Scandinavian art. He also continued to write many articles and several books, among them *La Langue verte et la cuite* (with Noël Arnaud; Paris, 1968), an illustrated parody of Claude Levi-Strauss. In his last years Jorn continued to build up a collection of his own work and that of his contemporaries and predecessors for the Silkeborg Kunstmuseum.

In his bronze and marble sculptures Jorn pursued the concept of the multi-faceted, ambiguous image. *Brutto scherzo* (1972; Silkeborg, Kstmus.) is a childish mask with zoomorphic traits seen from several angles. In other sculptures he combined crawling beasts, images of birds and masks in shifting, intangible figurations. His graphic oeuvre comprises more than 450 items: lithographs, woodcuts, etchings and experiments with standard techniques. During the war he produced a series of engravings later published as *Occupations* (Paris, 1960). In the 1960s and 1970s he produced several series of large colour lithographs (*Von Kopf bis Fuss*, St Gall, 1967; *9 Intimités graphoglyptiques*, Paris, 1969), woodcuts (*Etudes et surprises*, Paris, 1971) and colour etchings (*Entrée de secours*, Paris, 1971).

WRITINGS

Held og hasard [Luck and chance] (Silkeborg, 1952, 2/1963)
Guldhorn og lykkehjul [The gold horns and the wheel of fortune] (Copenhagen, 1957) [with Fr. trans.]
Pour la forme (Paris, 1958)
Naturens orden [The order of nature] (Copenhagen, 1962)
Vaerdi og okonomi [Value and economy] (Copenhagen, 1962)
Signes gravés sur les églises de l'Eure et du Calvados (Copenhagen, 1964)
Ting og polis [Moot and city state] (Copenhagen, 1964)
with Noël Arnaud: *La Langue verte et la cuite* (Paris, 1968)
Magi og skønne kunster [Magic and the fine arts] (Copenhagen, 1971)
Tegn og underlige gerninger [Signs and wonders] (Copenhagen, 1971)
Indfald og udfald [Cut and thrust] (Copenhagen, 1972)
Folkekunstens Didrek [Theodoric in folk art] (Copenhagen, 1978)
with J. Sonne and N. Lukman: *Gotlands Didrek* [Theodoric in Gotland] (Copenhagen, 1978)
Alfa og omega [Alpha and omega] (Silkeborg, 1980)

BIBLIOGRAPHY

G. Atkins and E. Schmidt, eds: *A Bibliography of Asger Jorn's Writings to 1963* (Copenhagen, 1964)
G. Atkins: *Jorn in Scandinavia 1930–1953* (Copenhagen and London, 1968)
M. di Micheli: *Jorn scultore* (Turin, 1974)
O. van de Loo and J. Weihrauch: *Asger Jorn Werkverzeichnis Druckgraphik* (Munich, 1976)
G. Atkins: *Asger Jorn: The Crucial Years, 1954–1965* (Copenhagen and London, 1977)
R. Renne and C. Serbanne: *Jorn: Tegninger* [Jorn: drawings] (Silkeborg, 1979; Fr. trans., 1979)
G. Atkins: *Asger Jorn: The Final Years, 1966–1973* (Copenhagen and London, 1980)
Asger Jorn (exh. cat., New York, Guggenheim, 1983)
G. Atkins: *Asger Jorn: Supplement to the Oeuvre Catalogue of his Paintings from 1930 to 1973* (London, 1986)
G. Birtwistle: *Living Art: Asger Jorn's Comprehensive Theory of Art between Helhesten and Cobra (1946–49)* (Utrecht, 1986)
Asger Jorn (exh. cat., Munich, Lenbachhaus, 1986)
P. Hofman Hansen: *A Bibliography of Asger Jorn's Writings (1931–1985)* (Silkeborg, 1988)
T. Andersen: *Asger Jorn, en biografi: Aarene 1914–1953* (Copenhagen, 1994)
Asger Jorn (exh. cat., Amsterdam, Stedel. Mus., 1994)

TROELS ANDERSEN

Jōruriji [Kūtaiji; Kūdaiji; Kubonji]. Buddhist temple and garden near Nara in the Sōraku District, Kyoto Prefecture,

Japan. It is a temple of the Pure Land (Jōdo) sect of Esoteric Buddhism. The present compound contains a *honden* (main hall), a pagoda and a pond garden. Alone among Pure Land temples, Jōruriji retains its original 12th-century garden designed to look like the Western Paradise. Temple records indicate that the temple was established in 1047 with the construction of a *honden* dedicated to Yakushi (Skt Bhaishjyaguru; the Buddha of healing). It was reconstructed in 1107 as a hall for the worship of Amida (Skt Amitabha; Buddha of the Western Paradise) and moved to its present position in 1157.

The Amida Hall (Amidadō) stands on the western side of the pond. It is a wooden post-and-beam structure in the *yosemune zukuri* ('hipped-gable roof construction') format, 11 bays long and 4 bays deep, and is the only extant example of a *kūtai Amidadō* ('nine-image Amida hall'), an architectural style popular during the Fujiwara period (AD 897–1185). The nine central bays have doors that open to reveal nine statues of Amida, representing the nine classes of believers who are reborn into Amida's paradise. To accommodate these figures, the building is necessarily long and tall, with a double-shell roof (*see* JAPAN, §III, 3(ii)). Eight of the seated figures are identical, but the central image is larger and holds its hands in a different gesture. These gilt wooden statues follow the 11th-century style of the sculptor JŌCHŌ. Also on the altar is an elaborate polychrome wooden statue of the goddess of wealth and the incarnation of beauty, Kichijōten (Skt Sridevi), dating from the early 13th century. The hall also contains a set of Shitennō (Four Guardian Kings; Skt Caturmāhārajika) from the Heian period (AD 794–1185). Across the pond stands the pagoda, moved to Jōruriji in 1178 from Kyoto. It is a three-storey, wooden post-and-beam structure with a cypress-bark shingle roof. The proportions are delicate, and the interior is brightly painted with floral and geometric patterns. The image of Yakushi inside may pre-date the building. While the Amida Hall and pond garden may re-create paradise on earth, the pagoda as a symbolic reliquary represents human mortality.

The pond garden was laid out in 1160 by Keishin, the temple's abbot, and was restored in the 1970s by the garden historian Mori Osamu. The pond is rectangular except for a peninsula extending west from in front of the pagoda and a spit of land on the south side supporting a bridge to the central island. During the restoration work, several rare examples of 12th-century rock arrangements were uncovered and reset along the edges of the island. The temple stands in a forested valley, and the dense green foliage enhances the overall impression of Jōruriji as a tranquil refuge. Both buildings and sculptures have been designated National Treasures.

BIBLIOGRAPHY

T. Itō and others: 'Kinki' [The Kinki region], *Tanbō Nihon no niwa* [Investigation of Japanese gardens], iv (Tokyo, 1978), pp. 153–4

BRUCE A. COATS

Josefa d'Óbidos. *See* AYALA, JOSEFA DE.

Joseph. *See* BAUMHAUER, JOSEPH.

Joseph, King of Naples and Spain. *See* BONAPARTE, (3).

Joseph, King of Portugal. *See* BRAGANZA, (8).

Joseph, Antonio (*b* Baharona, Dominican Republic, 4 Dec 1921). Haitian painter. Of Haitian parentage, he fled on foot to escape the Dominican Republic during the 1938 massacre of Haitians. He selected tailoring as a means to make a living in Port-au-Prince. He was the first to accept an invitation from the American watercolourist Dewitt Peters (1901–66) to join the Centre d'Art in Port-au-Prince, remaining there as painter and teacher. He studied watercolour with Peters and in 1953 was the first Haitian to win a Guggenheim Fellowship for a year's study in New York; he won a second in 1957. He accompanied Peters to the USA and Europe in 1960 and from 1961 to 1963 lived in the USA, which he continued to visit thereafter. From the first he was considered outstanding among the modernists affiliated to the Centre d'Art.

Joseph amassed an admirable body of work. Peters cited him as a 'brilliant watercolourist' and praised his murals on the walls of the Hotel Ibo Lélé in Port-au-Prince in a speech of 1952. Joseph was fully versed in the academic aspects of painting, in perspective and in colour theory, and he was a superb draughtsman. His work evolved from an expressionistic naturalism to a colourful abstraction. Although he continued to paint and draw from nature, he interpreted his observations with smooth brushwork and closely related, subtle colours suggesting a misty atmosphere, with depth suggested by superposed planes. A subtle symbolism characterized his later pictures, in which figures and objects hint at unexpected relationships of scale and space. Despite his long stays abroad, his feet remained firmly planted in Haiti, from which he drew his subject-matter.

BIBLIOGRAPHY

M.-J. Nadal and G. Bloncourt: *La Peinture haïtienne* (Paris, 1986), p. 52

M. P. Lerrebours: *Haïti et ses peintres*, i (Port-au-Prince, 1989), pp. 393–4

Joseph, Jasmin (*b* Grande Rivière du-Nord, nr Cap-Haïtien, 23 Oct 1923). Haitian sculptor and painter. He began his career as a sculptor, modelling figures in clay while working at a brick factory in Port-au-Prince. In 1948 thirty of these were seen by the American sculptor Jason Seley, who had come from New York to Haiti to work with the American watercolourist Dewitt Peters (1901–66), on a visit to the brick factory to have some of his own pieces fired. The most striking figures were of animals. Seley encouraged Joseph to develop his talent and invited him to the Centre d'Art in Port-au-Prince. Plans were under way for a series of murals at Ste-Trinité Episcopal Cathedral in Port-au-Prince, and Seley suggested that Joseph make a terracotta screen, with sculpted openwork blocks. In addition Joseph produced terracotta *Stations of the Cross* for Ste-Trinité. Upset because his works were being copied while awaiting firing at the brick factory, Joseph turned to painting, favouring muted colours applied in a thin layer to hardboard panels. At about the same time he converted from Vodoun to Protestantism and became a lay priest. Vodoun scenes in his early work were replaced by Christian ones in later compositions, but he continued to represent animals with a wry humour and a not too subtle satire on human foibles. His use of animal tales to point a moral relates to traditions of Haitian folklore. In his later works he featured polar bears and apes interacting in amusing situations.

BIBLIOGRAPHY

S. Rodman: *Where Art Is Joy* (New York, 1988), pp. 123–4

M. P. Lerrebours: *Haïti et ses peintres*, i (Port-au-Prince, 1989), pp. 67–70

DOLORES M. YONKER

Joseph, Peter (*b* London, 18 Jan 1929). English painter. He was essentially self-taught and turned to painting in his mid-thirties after abandoning a career in advertising. His work of the 1960s was boldly geometric, relying on primary colours and on optical effects; during this period he also produced outdoor installations and colour walls of art environment proportions. In the 1970s his paintings became smaller, more private and meditative, coinciding with his increasing interest in poetry, philosophy, metaphysics and music. From 1971 he adopted a basic format for acrylic paintings such as *Dark Blue with Black Border* (*c.* 1979; Southampton, C.A.G.), consisting of a central rectangle of one colour surrounded by a border of a darker hue, with the proportions and colour relationships precisely gauged to convey emotional states and different qualities of light. His work is distinguished from other Minimal art by its fusion of a Romantic sensibility, as represented by the late work of Mark Rothko, and a classical sense of form attested to by his allegiance to the landscapes of Claude Lorrain and Richard Wilson.

BIBLIOGRAPHY

Peter Joseph: Paintings, 1973–1983 (exh. cat. by J. H. Neff and others, Chicago, IL, Mus. Contemp. A., 1983)

MONICA BOHM-DUCHEN

Joseph Clemens, Elector-Archbishop of Cologne. *See* WITTELSBACH, §I(8).

Joseph ha-Zarefati (*fl* ?Tudela, Navarre, and/or ?Soria, Old Castile, *c.* 1300–12). Spanish illuminator of Jewish origin. His signature, a whole-page colophon in zoomorphic characters, is found in only one manuscript, the Lisbon Bible (1299–1300; Lisbon, Bib. N., MS. Il.72; *see also* JEWISH ART, §V, 1). However, another Bible (1312; Zurich, Floersheim Col., previously MS. Sassoon 82) could also be his work. Since the text of the Lisbon Bible was copied in Cervera, Lleida, it has been generally supposed that Joseph trained in an illuminator's workshop in that city. However, the connection with Cervera appears to be accidental (Metzger, 1970), while there are demonstrable links with Tudela and Soria, where JOSHUA BEN ABRAHAM IBN GAON and another scribe copied the *masorah* (apparatus criticus) after May 1300. The decorative painting and penwork were executed in their entirety only after the *masorah* had been copied (Metzger, 'Josué ben Abraham ibn Gaon...', 1990). The confirmed associations between Joseph and Joshua, whose brother Shem tov ben Abraham ibn Gaon of Soria was the copyist of the 1312 Bible, make it highly probable that Joseph was active in both cities. His patronymic, ha-Zarefati [from France], has suggested a possible French influence on his iconography and style; nevertheless his work appears to be characteristically Castilian in all respects. Its rich ornament, variety of motifs, fine draughtsmanship, subtle colouring and masterly technique make Joseph ha-Zarefati one of the most remarkable Spanish illuminators of his time.

BIBLIOGRAPHY

Enc. Jud.

C. Roth: 'An Additional Note on the Kennicott Bible', *Bodleian Lib. Rec.*, vi (1961), pp. 659–62 and pl. XIV, Joseph's colophon]

T. Metzger: 'Les Objets du culte, le sanctuaire du désert et le Temple de Jérusalem, dans les bibles hébraïques médiévales enluminées, en Orient et en Espagne', *Bull. John Rylands Lib.*, lii (1970), pp. 397–436 [pp. 413–14, Joseph's links with Soria]

——: 'La *Masora* ornementale et le décor calligraphique dans les manuscrits hébreux espagnols au moyen âge', *La Paléographie hébraïque médiévale. Colloques internationaux du CNRS, no. 547: Paris, 1972*, pp. 87–116 [103–5], pls XCVII–CXII [CIV–CVIII, MS. Il. 72]

J. Gutmann: *Hebrew Manuscript Painting* (New York, 1978), pp. 19, 59, pl. 10

T. Metzger and M. Metzger: *La Vie juive au moyen âge, illustrée par les manuscrits hébraïques enluminés du XIIIe au XVIe siècle* (Fribourg and Paris, 1982), p. 307, no. 62 and 88 [MS. Sassoon 82 and MS Il. 72]

B. Narkiss, A. Cohen-Mushlin and A. Tcherikover: *Hebrew Illuminated Manuscripts in the British Isles*, i (Jerusalem and London, 1982), pp. 32, 33, 36

T. Metzger: 'Josué ben Abraham ibn Gaon et la masora du Ms. Iluminado 72 de la Biblioteca Nacional de Lisbonne', *Cod. MSS*, xv (1990), pp. 1–27 [1, 3, 7, 9, 10, Joseph's illuminative work]

——: 'L'Illustration biblique dans la bible hébraïque Ms. Iluminado 72 de la Biblioteca Nacional de Lisbonne', *Rev. Bib. N.* [Lisbon], 2nd ser, v (1990), pp. 61–108

Joseph ibn Hayyim (*fl* ?La Coruña, *c.* 1476). Spanish illuminator of Jewish origin. He is one of the few illuminators whose names have been recorded. He signed only one manuscript, known as the Kennicott Bible (Oxford, Bodleian Lib., MS. Kenn. 1); no other manuscripts can be identified as his work. The date (1476) and place (La Coruña) at which this manuscript was copied are the sole evidence for the date, and, possibly, the location of his activity. It has been suggested that he may have been the son or some relation of Abraham ben Judah ibn Hayyim, the putative author of a treatise on colours in Portuguese language and Hebrew letters, composed in the 15th century. T. Metzger (1977) has shown that Abraham was a 13th-century author known only through a small masoretic work completed in Loulé, Portugal, in 1262 and thus wholly unconnected with the 15th-century anonymous and unlocated treatise on colours. (Copies of both treatises have survived in one volume from the second half of the 15th century, bound with seven other texts; Parma, Bib. Palatina, MS. Parm. 1959–De Rossi 945.)

The art of Joseph ibn Hayyim appears unrelated to any other illuminated Jewish manuscript of Spanish origin. The sources of his decorative programme have been traced to the Lisbon Bible (1299–1300; Lisbon, Bib. N., MS. Il.72); some of his motifs seem to have been copied from playing cards. However, Joseph ibn Hayyim's excessively dense and monotonous 'filigree' decorations, disproportionate and deformed figures, heavy contours and flat colours are far removed from the refined art of JOSEPH HA-ZAREFATI, illuminator of the Lisbon Bible, whose colophon in zoomorphic letters, when compared to Joseph ibn Hayyim's very different one, testifies eloquently to the limitations of the latter artist's much overvalued art.

BIBLIOGRAPHY

C. Roth: *The Kennicott Bible* (Oxford, 1957), pp. 3, 4, 6

S. Edmunds: 'A Note on the Art of Joseph Ibn Hayyim', *Stud. Bibliog. Bklore*, xi (1958), pp. 33–40, figs 1–13

C. Roth: 'An Additional Note on the Kennicott Bible', *Bodleian Lib. Rec.*, vi (1961), pp. 659–62 [and pl. XIV, Joseph's colophon]

T. Metzger: 'Les Objets du culte, le sanctuaire du désert et le Temple de Jérusalem, dans les bibles hébraïques médiévales enluminées, en Orient

et en Espagne', *Bull. John Rylands Lib.*, liii (1970–71), pp. 167–209 [pp. 207–8, Joseph's sanctuary iconography]

——: *Les Manuscrits hébreux copiés et décorés à Lisbonne dans les dernières décennies du XVe siècle* (Paris, 1977), pp. 4–6

B. Narkiss, A. Cohen-Mushlin and A. Tcherikover: *Hebrew Illuminated Manuscripts in the British Isles*, i (Jerusalem and London, 1982), pp. 158–9

B. Narkiss and A. Cohen-Mushlin: *The Kennicott Bible* (London, 1985)

THÉRÈSE METZGER

Josephson, Ernst (*b* Stockholm, 16 April 1851; *d* Stockholm, 22 Nov 1906). Swedish painter, draughtsman and poet. He came from a culturally distinguished Jewish family and trained (1867–76) at the Akademi för de Fria Konsterna in Stockholm. Frequent journeys in western and northern Europe allowed him to copy Old Master paintings, and he studied briefly with Jean-Léon Gérôme at the Ecole des Beaux-Arts in Paris in 1874. He copied especially works by Velázquez, Raphael, Titian and above all Rembrandt, whom he took as his principal model both as colourist and as a draughtsman. After further travel abroad in the late 1870s, Josephson settled in France in 1879. Up to this time he produced largely historical and biblical subjects in the spirit of the Renaissance. *David and Saul* (1878; Stockholm, Nmus.) recalls Rembrandt's work in its psychological intensity, achieved through the emphasis on two figures in a dark setting.

Josephson remained in France until 1888: at first in Paris and after 1886 in the country, finally on the Ile de Bréhat off the Brittany coast. His sociable, cheerful and dynamic personality made him the centre of a large group of Scandinavian painters, most of whom had left their own countries in reaction to the conservative artistic climate and old-fashioned academic training. Josephson became one of the leaders of the modernist group Opponenterna (the Opponents) aiming to bring about radical reforms, and he published two inflammatory articles on artistic training. His own painting style, however, was far from resolved: his first contribution to the Paris Salon in 1881, the portrait of *Godfrey Renholm* (1880; Stockholm, Nmus.), bears traces of his admiration for Raphael. His second version of *Spanish Blacksmiths* (1882; Oslo, N.G.; earlier version 1881; Stockholm, Nmus.), with freer brushwork reminiscent of Frans Hals and Velázquez, was regarded as too bold to be admitted to the Salon of 1882. After he had settled in France, Josephson's work began to reveal a stronger influence from contemporary painters such as Edouard Manet. In his portraits, however, Josephson combined a freely executed impressionistic treatment of the background with foreground accessories and facial features executed with sensitive detail to interpret spiritual mood, the psychic dimension that always constituted the core of his interest in the sitter, as in the portrait of *Jeanette Rubenson* (1883; Göteborg, Kstmus.). The principal subject of Josephson's work of the 1880s was the mythical water sprite, a character both dangerous and tragic from Scandinavian mythology, condemned to play its fiddle eternally in the midst of rushing streams, expressing with music a longing for salvation, yet also enticing listeners to their deaths by drowning. Josephson started his studies on this theme in 1878, but his first painting was made in 1882: *Water Sprite* (Göteborg, Kstmus.; see fig.). Here the scene is dominated by a sombre mood, conveyed in

Ernst Josephson: *Water Sprite*, oil on canvas, 1.46×1.14 m, 1882 (Göteborg, Göteborgs Konstmuseum)

dark, saturated colours. His major treatment of the theme, however, is quite different in tone: Josephson used live models from Eggedal in Norway, and showed the water sprite in dazzling sunshine, playing on a golden fiddle (*Water Sprite*, 1884; Stockholm, Prins Eugens Waldemarsudde). Like many mythological scenes painted by the German artist Arnold Böcklin, these works also comment on the artist's own situation; in their attitude to nature they link late 19th-century Symbolism with early 19th-century Romanticism.

Josephson shared the interest in occult phenomena common in the 1880s and 1890s, and it was in connection with spiritualist séances at the Ile de Bréhat in 1887 that his mental instability first became apparent. From this time he suffered continuously from a form of schizophrenia, although he recovered sufficiently from the more severe attacks to be able to continue painting and drawing. He was, in fact, extraordinarily prolific. One of the more curious features of his work was his conviction that certain Old Masters were continuing to work 'through' him; he therefore felt able to sign drawings on their behalf. During the period of instability that continued after his return to Sweden in 1888, Josephson produced many paintings of a visionary character: the portrait of *Ludvig Josephson* (1893; Stockholm, Nmus.) is characterized by a bold, graphic treatment of the image, and the *Goose Girl* (c. 1890; Stockholm, Prins Eugens Waldemarsudde) is striking for its use of colour contrast.

The most remarkable work of Josephson's last years, however, is to be found among the drawings (over 1000 sheets) where his means alternate between a simple

contour style, a detailed ornamental embroidery of strokes and dots, and a dramatic use of ink-stain technique. Josephson's illness, which brought a regression into a childlike fantasy world, allowed great liberty in the approach to external reality without in general impairing the control of means of expression. He could thus accommodate into his work personal thoughts, dreams and visions in which historical, religious and literary figures occupied an important place. Through their expressiveness and visual power, these late works anticipate certain expressionistic forms of modern art. While far from universally appreciated during his lifetime, Josephson was recognized soon after his death, especially in Germany. He also came to have an influence on Expressionist and naive art in Sweden. Although his work during his lifetime was regarded as multifaceted and contradictory, he was eventually regarded as an accomplished colourist and one of the most individual and original of late 19th-century Swedish painters.

BIBLIOGRAPHY

K. Wåhlin: *Ernst Josephson, 1851–1906: En minnesteckning* [Ernst Josephson, 1851–1906: a memoir] (Stockholm, 1911–12)
T. Tzara: 'Ernst Josephson', *Feuil. Libres* (1926)
E. Blomberg: *Ernst Josephson: Hans liv* [Ernst Josephson: his life] (Stockholm, 1951)
——: *Ernst Josephsons konst* [Ernst Josephson's art] (Stockholm, 1956)
I. Mesterton: *Vägen till försoning: En konstpsykologisk studie i Ernst Josephsons religiösa fantasivärld* [The road to reconciliation: an art psychological study of the religious fantasy world of Ernst Josephson] (Goteborg, 1957)
E. Blomberg: *Ernst Josephson från 'Näcken' till 'Gåslisa'* [Ernst Josephson from the *Water Sprite* to the *Goose Girl*] (Stockholm, 1959)
H. H. Brummer: *Ernst Josephson: Målare, romantiker och symbolist* [Ernst Josephson: painter, romantic and symbolist] (Stockholm, 1991)

PONTUS GRATE

Josetsu (*fl c.* 1405–23). Japanese painter and Zen monk. Contemporary biographical information about Josetsu is limited to two references. A brief entry dated 1448 in the diary of the Onryōken, a subtemple of Shōkokuji in Kyoto, mentions that in around 1416 Shogun Ashikaga Yoshimochi consulted with Josetsu about going to the island of Shikoku in search of stone for the carving of a stele in commemoration of Shōkokuji's founder, Musō Soseki. The entry makes no mention of Josetsu as a painter, but it suggests his acquaintance with Yoshimochi and an association with Shōkokuji, which was an important centre in the development of ink painting in the Muromachi period (1333–1568) (*see* JAPAN, §VI, 4(iii)). A colophon by the otherwise unknown Kanjōsō on Josetsu's *Sankyōzu* ('The three doctrines'; Kyoto, Ryōsokuin) states that the painting is by '[Jo]Setsu' (clumsy-like), and that the painter was given this name by Zekkai Chūshin (1336–1405) who took it from the Chinese phrase 'the greatest skill is like clumsiness', an aphorism from the Chinese Daoist classic, *Daode jing*.

Josetsu's fame and artistic standing derive from a single painting in ink and light colours on paper, entitled *Hyōnenzu* ('Catching a catfish with a gourd'; *c.* 1413–15; Kyoto; Myōshinji; *see* JAPAN, fig. 92). The subject, a Zen riddle (*kōan*), poses the seemingly impossible task of how to capture a catfish with a slippery gourd. The painting, originally a screen and now a hanging scroll, bears a preface by Daigaku Shūsu (1345–1423) in the upper right corner

that names both patron and painter: 'the Great Minister (Daishōkō) ordered the monk Josetsu to paint in the new manner (*shin'yō*)'. Daishōkō probably refers to Ashikaga Yoshimochi, himself a devout supporter of the Zen sect and an amateur painter of Zen subjects. The phrase 'new manner' has given rise to numerous interpretations: the new style of Chinese Southern Song period (1127–1279) painters, especially Liang Kai, whose paintings had already entered the shogunal collection; the new iconography of a hermit fisherman straining to capture a taunting catfish; or the new format of a painting as the focus of a literary gathering and the composition of poetry. Regardless of its exact meaning, Daigaku's preface is a rare and an early example of an art-historical comment on a Japanese painting.

BIBLIOGRAPHY

J. Fontein and M. Hickman: *Zen Painting and Calligraphy* (Boston, 1970)
T. Matsushita and T. Tamamura: *Josetsu, Shūbun, San-Ami*, Suiboku bijutsu taikei [Compendium of the art of ink painting], vi (Tokyo, 1974)
T. Matsushita: *Josetsu, Shūbun*, Nihon bijutsu kaiga zenshū [Complete collection of Japanese painting], ii (Tokyo, 1979)
A. Shimao: 'Hyōnenzu no kenkyū: Daigaku Shūsu no jo ni mieru "shin'yō" wo chūshin toshite' [Study of 'Catching a catfish with a gourd': the meaning of 'new manner' in the preface by Daigaku Shūsu], *Bijutsu Kenkyū*, 335 (1986), pp. 24–38
S. Shimada, ed.: *Zenrin gasan: Chūsei suibokuga wo yomu* [Painting inscriptions from Zen circles: reading medieval ink painting] (Tokyo, 1987)
A. Shimao: 'Josetsu hitsu, *Hyōnenzu*: Hyōtan namazu no ikonolojii' [Josetsu's painting *Catching a catfish with a gourd*: the iconology of the gourd and catfish], *Ewa kataru* [Cultural memory in arts] (Tokyo, 1995)

KAREN L. BROCK

Joshua ben Abraham ibn Gaon (*b* ?Soria, Old Castile; *fl c.* 1300–12). Spanish scribe and illuminator of Jewish origin. He worked at Tudela, Navarre, and at Soria, Castile. His colophons allow his hand to be securely identified in five manuscript Bibles. In one case (1306; Oxford, Bodleian Lib., MS. Kenn. 2), he used a conventional colophon; elsewhere, he concealed clues either in the painted illuminations (1302; Paris, Bib. N., MS. hébr. 21) or, more frequently, in the micrography and ornamental forms of the *masorah* (apparatus criticus; *see* MICROGRAPHY) that he copied (Dublin, Trinity Coll. Lib., MS. 16; Lisbon, Bib. N., MS. Il.72, dated 1300; Paris, Bib. N., MS. hébr. 20, dated 1300; and a single page of the Paris Bible of 1302; *see also* JEWISH ART, §V, 1).

From the formulae and placing of Joshua's different colophons, it is possible to deduce the extent and nature of his contribution to the copying and illumination of the manuscripts he signed. As a copyist, writing in square script, he probably worked on the 1300 Paris Bible, on the calendar of the 1302 Paris Bible and on the double initial page of the Oxford Bible. As a scribe trained in micrography, he copied all the *masorah* in the Dublin Bible and the 1300 Paris Bible; more than half in the Lisbon Bible; and a page in the 1302 Paris Bible. He was a decorator rather than a painter, creating clear contrasts with gold, silver and flat colours and producing strongly stylized plant and animal forms and geometrical interlacing. His share of the illuminative work varied; his contribution to painted decoration was probably confined to the two Paris Bibles. In the Oxford Bible, colour is used sparingly, in the borders and in the plan of the sanctuary. In the Dublin

and Lisbon Bibles, the decoration was entrusted to more accomplished artists. The first remains anonymous; the other, JOSEPH HA-ZAREFATI, identified by his colophon, added his own motifs even to the *masorah* that Joshua copied. The latter's contribution consisted of tracing the ornamental forms of the *masorah*, and the addition of some details in gold and colour. Joshua's repertory of ornamental forms is found in manuscripts of which both the *masorah* and the text were copied by other hands (Oxford, Bodleian Lib., MS. Kenn. 2 and MS. Opp. Add. 75–6, and Parma, Bib. Palatina, MS. Parm. 2938–De Rossi 341).

BIBLIOGRAPHY

T. Metzger: 'Les Objets du culte, le sanctuaire du désert et le Temple de Jérusalem, dans les bibles hébraïques médiévales enluminées, en Orient et en Espagne', *Bull. John Rylands Lib.*, lii (1969–70), pp. 397–436 [p. 413, Joshua's patterns]

B. Narkiss and G. Sed-Rajna: 'La Première Bible de Josué ben Abraham ibn Gaon', *Rev. Etud. Juives*, cxxx (1971), pp. 255–69 [258–60], pls I–XV [II–III, Joshua's ornamental colophons]

T. Metzger: 'La *Masora* ornementale et le décor calligraphique dans les manuscrits hébreux espagnols au moyen âge', *La Paléographie hébraïque médiévale. Colloques internationaux du CNRS, no. 547: Paris, 1972*, pp. 87–116 [103–5], pls XCVII–CXII [CIV–CVIII, Joshua's patterns]

C. Sirat and M. Beit-Arié: *Manuscrits médiévaux en caractères hébraïques*, i (Paris and Jerusalem, 1972), p. 25

B. Narkiss, A. Cohen-Mushlin and A. Tcherikover: *Hebrew Illuminated Manuscripts in the British Isles*, i (Jerusalem and London, 1982), pp. 14, 22–7, 29–34

T. Metzger: 'Josué ben Abraham ibn Gaon et la masora du Ms. Iluminado 72 de la Biblioteca Nacional de Lisbonne', *Cod. MSS*, xv (1990), pp. 1–27, figs 1–20 [reproduces all of Joshua's signatures]

——: 'L'Illustration biblique dans la bible hébraïque Ms. Iluminado 72 de la Biblioteca Nacional de Lisbonne', *Rev. Bib. N.* [Lisbon], 2nd ser., v (1990), pp. 61–108 [p. 81, Joshua and Joseph ha-Zarefati]

THÉRÈSE METZGER

Joshua Roll. Byzantine illuminated manuscript (Rome, Vatican, Bib. Apostolica, MS. palat. gr. 431). It consists of 15 separate sheets of parchment, which were originally pasted together to form a roll 315 mm high and 10.42 m long. Although its manufacture is now dated to the mid-10th century (Weitzmann), a wide range of earlier dates were proposed in the older literature. On one side of the parchment is a continuous picture frieze, illustrating events from Joshua 2:15–10:27, with brief biblical excerpts in a contemporary hand below; the *versos* of some of the sheets have various texts added, perhaps in the 13th century. The manuscript is damaged and incomplete at both ends, and Weitzmann proposed that it originally covered the narrative of the conquest of the Promised Land (Joshua 1–12). The picture frieze is the work of a highly accomplished artist working in a technique of thin washes of colour, unusual in a Byzantine manuscript.

The precise significance of this unique manuscript remains a matter for discussion. For early writers it represented a link with antique practices of roll illustration, an approach that was believed to have been imitated on a large scale on the historiated columns of Rome (e.g. Trajan's Column; AD 113; *see* ROME, §V, 7) and Constantinople (e.g. column of Arkadios; AD 400–02). Weitzmann, however, disputed the existence of illustrated rolls of this type in antiquity and proposed that the Joshua Roll had no ancient prototype but was a new creation of the 10th-century 'Macedonian Renaissance', made as an act of highly sophisticated classicism. Lowden has argued that it

is a 10th-century copy, intended almost as a facsimile and made as an act of antiquarianism rather than 'classicism'. Behind it seems to lie an original, possibly of the 7th century AD, itself perhaps a record of, or project for, the monumental decoration of part of the Great Palace in Constantinople.

The manuscript was known to a Byzantine artist of the late 13th century, who adapted some of its compositions for an illustrated Octateuch (Mt Athos, Vatopédhi Monastery, cod. 602; *see* EARLY CHRISTIAN AND BYZANTINE ART, §V, 2). Earlier it may have been consulted in the creation of the common model for all the Byzantine Octateuchs, perhaps in the mid-10th century.

BIBLIOGRAPHY

K. Weitzmann: *The Joshua Roll: A Work of the Macedonian Renaissance* (Princeton, 1948)

O. Mazal: *Josua-Rolle: Vollständige Faksimile-Ausgabe im Originalformat der Codex Vaticanus Palatinus Graecus 431 der Biblioteca Apostolica Vaticana*, Codices Selecti, lxxvii (Graz, 1984)

J. Lowden: *The Octateuchs: A Study in Byzantine Manuscript Illumination* (University Park, 1992), pp. 105–22

JOHN LOWDEN

Josic, Alexis. *See under* CANDILIS-JOSIC-WOODS.

Josselin de Jong, Pieter de (*b* St Oedenrode, 2 Aug 1861; *d* Amsterdam, 2 June 1906). Dutch painter and draughtsman. From 1877 to 1883 he studied at three academies, first in 's Hertogenbosch, where he was taught by P. M. Slager (1841–1912), then in Antwerp, under the sculptor Joseph Geefs (1808–85), and finally in Paris, under Alexandre Cabanel. During his training he concentrated mainly on history painting, in the manner approved by his teachers. Later he became known primarily for his portraits. After his return from Paris in 1883 he settled in The Hague, then an important centre of the arts. Here he painted portraits of prominent citizens, intellectuals and members of the Dutch royal family, including Queen Emma and King William III (both The Hague, Willem V Mus.).

As a portrait painter de Josselin de Jong was obliged to follow his patrons' wishes. It seems hardly surprising, therefore, that occasionally he tried to break away from portrait painting to realize subjects of his own choice. He was inspired by peasants at work in the fields and by factory workers, and painted images of drudgery in mines and steel works. Social commitment played a subsidiary role in these works; de Josselin de Jong was much more concerned with the aesthetic effect, rendering the muscular bodies of the workers in an Impressionist style, with contrasts of light from the blast furnace or smelting chamber.

BIBLIOGRAPHY

P. Haaxman: 'Pieter de Josselin de Jong', *Het schildersboek: Nederlandsche schilders der negentiende eeuw in monographieen door tijdgenoten* [The book of painters: monographs on Dutch 19th-century painters by their contemporaries] (Amsterdam, 1899), p. 246

Pieter de Josselin de Jong, 1861–1906 (exh. cat., ed. P. Hect; St Oedenrode, Raadhuis; Assen, Prov. Mus. Drenthe; 1985)

MARGRIET VAN SEUMEREN-HAERKENS

Jouarre Abbey. Benedictine abbey in Seine-et-Marne, France, famous for its crypt of St Paul, one of the most

important surviving monuments of the Merovingian period. According to the mid-7th-century *Vita Columbani* (see Chaussy, pp. 5–7), the double monastery of Notre-Dame at Jouarre was founded *c.* AD 630 by Ado, ex-treasurer of King Dagobert I (*reg* 623–39). Soon after the foundation three churches were built. Notre-Dame, the most important, was built for the nuns, whose first abbess was Ado's cousin Theodochilde (*d* after 662). Her brother Agilbert became first abbot of the monks, who occupied St Pierre until the 8th century, when they were replaced by canons. SS Martin-et-Paul was a funerary church serving both communities. All three churches were subjected to vast transformations over the centuries. Notre-Dame was rebuilt in the Romanesque period and again in the 17th century; only its medieval tower-porch survived the demolition of 1792, and it was incorporated into a new church built in 1837. St Pierre, which became the parish church after the Middle Ages, now dates from the 15th and 16th centuries. The funerary church was situated in a cemetery, which extended over its foundations after the building was burnt down in the 15th century.

The crypt of St Paul, built to house the tombs of the founders, is the oldest part of the monastery to survive. It was once thought to have been constructed against the chevet of SS Martin-et-Paul as an addition, but excavations begun in 1985 have demonstrated that it formed the crypt of the original church. It was presumably situated beneath an elevated sanctuary with approximately the same floor level as the church, but in the 9th century the church was raised and an underground passage was installed leading from the cemetery at the west of the church to the crypt; the original entrance was on the south face. The exterior is much altered, but in 1978–9 the original Merovingian masonry of the east wall, consisting of regular *petit appareil* laid with yellow mortar, was uncovered, and traces of three original buttresses were found underneath those added in the 17th century. The interior has groin vaults carried by six reused Roman marble columns surmounted by 7th-century capitals (see fig.). While the vaults probably retain their original form, their actual date is controversial. The capitals were probably carved in the Pyrenees, which at that time exported marble capitals throughout Gaul. They are based on Classical Corinthian or Composite types, and the variety in design and height suggests that they did not originally form a homogeneous ensemble.

The interior of the west wall of the crypt, once erroneously thought to represent the exterior east wall of the lost church, is faced with monochrome decorative masonry jointed with pink cement, and it lies behind five pilasters that are unrelated to the bay divisions of the interior. The range of motifs, from top to bottom bands of octagons, *opus reticulatum*, cubes and rectangles, is similar to that found on the polychrome gate-house of Lorsch Abbey. These rare early medieval survivals of skilfully cut decorative masonry were no doubt inspired by Gallo-Roman masonry of the kind now best represented by the city walls of Le Mans. In the 9th or 10th century the church was extended to the south, and the adjoining crypt of St Ebregesild constructed; finally, in the 11th century, this crypt was given a western extension. Both crypts were heavily restored in the 17th and 19th centuries.

Jouarre Abbey, marble capital in the crypt of St Paul, 7th century

The crypt of St Paul contains tombs of the first abbesses and abbots, three of which deserve mention. The sarcophagus of St Theodochilde occupies a central position. Its sides are carved with two bands of classicizing shells alternating with three narrower bands carrying an inscription with characters dated to the early 8th century, while its worn roof is carved with foliage scrolls. Of a completely different character is the sarcophagus of a later abbess, St Aguilberte, carved with typically Merovingian geometric designs. The sarcophagus of St Agilbert, the former Bishop of Winchester and Paris who retired to Jouarre in 685, was set in a corner position and is carved only on two faces and the lid. On one end is *Christ in Majesty* surrounded by the four Evangelist symbols, and on one lateral side an unusual representation of the *Last Judgement*, with Christ enthroned in the centre holding an unfurled scroll and flanked by an angel and orant figures, perhaps representing the Apostles. The iconographic inspiration may have been Coptic.

BIBLIOGRAPHY

D. Fossard: 'Les Chapiteaux de marbre du XIIe siècle en Gaule: Style et évolution', *Cah. Archéol.*, ii (1946), pp. 69–85
Y. Chaussy, ed.: *L'Abbaye royale Notre-Dame de Jouarre*, 2 vols (Paris, 1961)
J.-M. Desbordes: 'Nouvelles Découvertes sur l'abbaye de Jouarre', *Bull. Group. Archéol. Seine-et-Marne*, viii (1967), pp. 19–26
J. Hubert, J. Porcher and W. F. Volbach: *Europe in the Dark Ages* (London, 1969)
J. Coquet: *Pour une nouvelle date de la crypte Saint-Paul de Jouarre* (1970)
Marquise de Maillé: *Les Cryptes de Jouarre* (Paris, 1971)
P. Perrin and L.-C. Feffer, eds: *La Neustrie: Le Pays au nord de la Loire de Dagobert à Charles le Chauve (VIIe–IXe siècles)* (Rouen, 1985)
T. de Montessus: 'Quelques Conclusions archéologiques sur la crypte Saint-Paul de Jouarre après les travaux des monuments historiques', *Bull. Mnmt.*, cxlv/2 (1987), pp. 211–12

KATHRYN MORRISON

Joubert, Gilles (*b* Paris, 1689; *d* Paris, 14 Oct 1775). French cabinetmaker. He was a member of a Parisian family of *menuisiers* and became a *maître-ébéniste* sometime

between 1714 and 1722. After the death of Antoine-Robert Gaudreaus (1751) he became the main supplier to the Crown for 23 years and carried out commissions for 4000 pieces of furniture. Only a few, however, were masterpieces, produced either by Joubert or under his supervision. In 1758 he received the title of Ebéniste Ordinaire du Garde Meuble and in 1763, on the death of Jean-François Oeben, he became Ebéniste du Roi. Gradually, however, his position was taken over by Jean-Henri Riesener. Joubert acted to some extent as a main contractor, and when his workshop could not fulfil commissions he subcontracted to such cabinetmakers as Mathieu Criard, Marchand, Jacques Dubois, François Mondon (1694–1770), Boudin, Foullet, Louis Péridiez (1731–64), Deloose, Simon Oeben (d 1786) and particularly, during his final years of work, to Roger Vandercruse. Joubert did not sign his furniture; the few pieces that have been attributed to him indicate that he progressed smoothly from the symmetrical Louis XV to the Neo-classical style. This is particularly evident in the red, lacquered writing-table (c. 1759; New York, Met.; see LACQUER, colour pl. I, fig. 2) for Louis XV, a formerly lacquered lean-to secrétaire (Louisville, KY, Speed A. Mus.), a pair of clock pedestals (London, Buckingham Pal., Royal Col.) from Louis XV's bedchamber at Versailles and a commode (1769; Malibu, CA, Getty Mus.) made for Princess Louise (1737–87).

BIBLIOGRAPHY

F. de Salverte: *Les Ebénistes du XVIIIème siècle, leurs oeuvres et leurs marques* (Paris, 1923, rev. 5/1962)

P. Verlet: *Le Mobilier royal français*, 4 vols (Paris, 1945–90)

——: *French Royal Furniture: An Historical Survey Followed by a Study of Forty Pieces Preserved in Great Britain and the USA* (London, 1963)

J. Viaux: *Bibliographie du meuble (Mobilier civil français)*, 2 vols (Paris, 1966–88)

JEAN-DOMINIQUE AUGARDE, JEAN NÉRÉE RONFORT

Jouderville [Joudreville], **Isack** [Isaac] **(de)** (b Leiden, 1612–13; d Amsterdam, 1645–8). Dutch painter. His father, who came from Metz, kept a popular inn at Leiden. Isack Jouderville was (with Gerrit Dou) among Rembrandt's earliest pupils and was apprenticed to the artist from late 1629 until the end of 1631. (There are six receipts (Leiden, Gemeentearchf) for the payment of his apprenticeship fees, signed by Rembrandt.) During his last year of apprenticeship, Jouderville went to Amsterdam with Rembrandt. In 1632 he enrolled as a student of philosophy at Leiden University; it may well be, however, that he stayed in Amsterdam to assist Rembrandt in his workshop with his numerous portrait commissions. Jouderville himself painted mainly Rembrandtesque heads or 'tronies' and was such a faithful follower of his master's early work that several of his paintings were at one time attributed to Rembrandt (e.g. *Minerva in the Studio*; Denver, CO, A. Mus.). (Many of these have since been correctly recognized by the Rembrandt Research Project.) In 1636 Jouderville married Maria Le Fevre and settled in Leiden. Between 1641 and 1643 he lived in Deventer, after which he moved to Amsterdam, where he was last recorded in 1645. In 1659 his daughter Marieke married the painter Frederik de Moucheron.

With the possible exception of the (formerly) signed *Bust Portrait of a Young Man* (Dublin, N.G.), possibly an early self-portrait, Jouderville's few signed paintings must have been made in his later years. These are painted in a manner strongly reminiscent of the early work of Dou, and several (e.g. *Young Woman with a Candle, Music Book and Lute*; Lille, Mus. B.-A.), bearing false signatures, were even once thought to be by Dou.

BIBLIOGRAPHY

Thieme–Becker

C. Hofstede de Groot: 'Isaac de Jouderville, leerling van Rembrandt?' [Isaac de Jouderville, a pupil of Rembrandt?], *Oud-Holland*, xvii (1899), pp. 228–36

A. Bredius: *Künstler-inventare: Urkunden zur Geschichte der holländischen Kunst des XVIten, XVIIten und XVIIIten Jahrhunderts* (The Hague, 1915–22), vi, pp. 1940–73; vii, pp. 126–8

W. Martin: *Rembrandt en zijn tijd*, ii of *De Hollandse schilderkunst in de zeventiende eeuw* (Amsterdam, 1935–6), p. 109

W. Bernt: *Die niederländischen Maler des 17. Jahrhunderts* (Munich, 1948–62), iv, no. 147

K. Bauch: *Der frühe Rembrandt und seine Zeit* (Berlin, 1960), p. 224

B. Haak: *Rembrandt: Zijn leven, zijn werk, zijn tijd* (Amsterdam, 1968), p. 48

W. Sumowski: *Drawings of the Rembrandt School*, vi (New York, 1982)

A Corpus of Rembrandt Paintings, Stichting Foundation Rembrandt Research Project (The Hague, 1982–), i, pp. 502–7; ii, pp. 76–87, 654–8, 680–84

The Impact of a Genius: Rembrandt, his Pupils and Followers in the Seventeenth Century (exh. cat., Amsterdam, Waterman Gal., 1983) pp. 59–69, 77, 178–81

W. Sumowski: *Gemälde der Rembrandt-Schüler* (Landau-Pfalz, 1983–), ii, pp. 1434–52

Rembrandt: The Master and his Workshop (exh. cat. by C. Brown, J. Kelch and P. van Thiel; Berlin, Gemäldegal.; Amsterdam, Rijksmus.; London, N.G.; 1991–2), pp. 308–13

TRUDY VAN ZADELHOFF

Jouett, Matthew Harris (b nr Harrodsburg, KY, 22 April 1787–8; d nr Lexington, KY, 10 Aug 1827). American painter. In 1804 he enrolled in Transylvania College in Lexington, KY, and by 1812 he was practising law in the town. After serving in the War of 1812, he began painting portraits. Around June 1816 he travelled to Philadelphia for instruction but soon moved on to Boston, where he spent about four months in the studio of Gilbert Stuart. Returning to Lexington, Jouett set up a practice painting both portraits and miniatures. In the winters he travelled south, seeking commissions in New Orleans, Natchez, MS, and other towns along the Mississippi River. In 1825 he painted a portrait of *General Marie Joseph du Motier, Marquis de Lafayette* (KY Hist. Soc., on loan to Frankfort, KY, State Capitol) at the request of the Kentucky legislature. In addition to portraits, Jouett also attempted landscape painting and organized art exhibitions to benefit various causes. One of the first artists to emerge from America's western frontier, he was lauded by his contemporaries and is today remembered for his pioneering accomplishments.

Jouett's straightforward style owes much to the example of Stuart. His portrait of *John Grimes* (c. 1824; New York, Met.) is typical in its emphasis on head and features, set against a simple background, while such portraits as that of *Justice Thomas Todd* (c. 1825; Frankfort, KY, Hist. Soc.) demonstrate his knowledge of the standard vocabulary of state portraiture.

BIBLIOGRAPHY

W. Dunlap: *A History of the Rise and Progress of the Arts of Design in the United States*, 3 vols (New York, 1834, rev. 3/1965), iii, pp. 100–01, 167

W. Floyd: *Matthew Harris Jouett: Portraitist of the Ante-Bellum South* (Lexington, 1980)

<div align="right">SALLY MILLS</div>

Jouffroy, François (*b* Dijon, 1 Feb 1806; *d* Laval, Mayenne, 25 June 1882). French sculptor. Son of a baker, he attended the Dijon drawing school before enrolling at the Ecole des Beaux-Arts in Paris in 1824. In 1832 he won the Prix de Rome and was charged while in Italy with the task of selecting earlier Italian sculpture for inclusion in the cast collection of the Ecole. Two of his works from the years immediately after his return from Rome stand out from contemporary production: the highly acclaimed *Girl Confiding her Secret to Venus* (marble, exh. Salon 1839; Paris, Louvre), depicting a naked girl standing on tiptoe to whisper into the ear of a herm bust of the goddess, a work recalling Roman genre sculpture as well as the playful gallantry of the 18th century; and the stone pediment for the Institut des Jeunes Aveugles (1840), in the Boulevard des Invalides, Paris, in which Jouffroy rivalled Pierre-Jean David d'Angers in accommodating present-day realities in monumental public sculpture. During the Second Empire (1851–70) Jouffroy participated in the decoration of major public buildings, most conspicuously with the stone groups *Marine Commerce* and *Naval Power* (*c.* 1867–8) for the Guichets du Carrousel of the Louvre and the façade group depicting *Harmony* (Echaillon stone, 1865–9) for the new Paris Opéra. Jouffroy's sculpture classes at the Ecole des Beaux-Arts were attended by some talented students, including Alexandre Falguière, Marius-Jean-Antonin Mercié, Louis-Ernest Barrias, Augustus Saint-Gaudens and António Soares dos Reis, but he is said to have performed his duties there in an increasingly perfunctory manner.

BIBLIOGRAPHY

Lami
A. M. Wagner: *Jean-Baptiste Carpeaux, Sculptor of the Second Empire* (New Haven, 1986), pp. 68, 118, 224, 226–7, 229–30, 250

<div align="right">PHILIP WARD-JACKSON</div>

Jouin, Henry(-Auguste) (*b* Angers, 28 Jan 1841; *d* Hermainville, Calvados, 11 Aug 1913). French art historian, collector and polemicist. He had ambitions to join the priesthood but was turned down on account of his physical frailty, his legs having been crippled when he was very young. Instead he began a career as a journalist, contributing articles on art and social economy to the Angers press, and he continued to write polemically on social and political issues, always from a Catholic viewpoint, throughout his life. In 1874 he joined the Département des Beaux-Arts in Paris, as secretary of the Commission de l'Inventaire des Richesses Artistiques de la France, and until 1906 he supervised the publication of its pioneering volumes cataloguing the holdings in French public collections. He was secretary of the Comité des Sociétés des Beaux-Arts des Départements and from 1891 secretary of the Ecole Nationale des Beaux-Arts. In April 1893 he was named Chevalier of the Légion d'honneur.

Jouin's principal interests were in the field of sculpture, and his two monographs on David d'Angers are of primary importance. He also wrote a number of reviews of sculpture exhibited at the Salon from 1873 to 1883, monographs devoted to contemporary sculptors including Jules Cavelier, James Pradier and Jean-Baptiste-Eugène

Guillaume and two studies of the sculpture of the Paris cemeteries, as well as studies of contemporary painters such as Hippolyte Flandrin, Elie Delaunay, Jean Gigoux and Joseph Nicolas Robert-Fleury. Other works of lasting scholarly value include his edition of the *conférences* (lectures) delivered at the Académie Royale de Peinture et de Sculpture and his biographies of the first secretaries of the Ecole des Beaux-Arts, Joachim Lebreton and Antoine Quatremère de Quincy.

Jouin was an indefatigable supporter of the museums of Angers, particularly the Musée des Beaux-Arts, writing catalogues of the collections (1881, 1885 and 1907) and obtaining the donation of casts of David d'Angers's works from his heirs. He formed his own collection with a view to donating it to Angers, buying old master drawings by artists including Le Brun and Poussin as well as adding judiciously to the municipal collection of works by contemporary artists. Among such works, which were often given by the artists as tokens of friendship, are drawings by Flandrin, Ramey and Pradier as well as sculptures by David d'Angers and J.-B. Debay. This collection is housed in the Musée des Beaux-Arts, Angers.

WRITINGS

Hippolyte Flandrin: Les Frises de St Vincent de Paul (Paris, 1873) [pubd lectures]
La Sculpture aux Salons de 1873 à 1883 (Paris, 1874–84)
Inventaire général des richesses d'art de la France (Paris, 1877–1911) [ed. 1877–1906]
David d'Angers, sa vie, son oeuvre, ses écrits, ses contemporains, 2 vols (Paris, 1878)
Conférences de l'Académie Royale de Peinture et de Sculpture, recueillies, annotées et précédées d'une étude sur les artistes écrivains (Paris, 1883)
Charles Le Brun et les arts sous Louis XIV (Paris, 1889)
David d'Angers et ses relations littéraires, 2 vols (Paris, 1890–94)
Robert-Fleury (Paris, 1890)
Elie Delaunay: Peintre d'histoire (Paris, 1891)
Joachim Lebreton, premier secrétaire perpétuel de l'Académie des Beaux-Arts (Paris, 1892)
Antoine-Chrysostôme Quatremère de Quincy (Paris, 1892)
Cavelier: Statuaire (Paris, 1894)
James Pradier, anecdotes (Paris, 1894)
Jean Gigoux, Artistes et Gens de Lettres de l'Epoque Romantique (Paris, 1895)
Un sculpteur écrivain, M. Eugène Guillaume (Paris, 1898)
La Sculpture dans les cimetières de Paris (Paris, 1898)
Sépultures historiques des cimetières de Paris (Paris, 1900)
numerous contributions to *Gaz. B.-A.*

BIBLIOGRAPHY

'Cabinet d'un amateur angevin', *Inventaire des richesses d'art de la France*, viii (Paris, 1908), pp. 154–5
Dictionnaire historique de Maine et Loire (Angers, rev. 2/1978)

<div align="right">VIVIANE HUCHARD</div>

Joullain, François (*b* 1697; *d* Paris, 5 Oct 1778). French engraver, print-seller and dealer. There is no evidence to prove that he was related to the Jollain family of engravers, as has often been stated. He trained under Claude Gillot, after whom he engraved a series of costume designs (*Nouveaux desseins d'habillements à l'usage des balets, opéras et comédies*, 1725; Paris, Bib. N. cat. no. 9) and a number of other subjects, most of which were theatrical. He showed a particular predilection for interpreting the work of Charles-Antoine Coypel, his 21 engravings after this artist including three for the *Suite de Don Quichotte* (1724; Bib. N. cat. nos 2–4) and six for the *Suite d'estampes des principaux sujets des comédies de Molière* (1726; Bib. N. cat. nos 19–24). He also engraved 17 illustrations after Coypel

for Luigi Riccoboni's *Histoire du théâtre italien* (1728–31; Bib. N. cat. no. 36).

Joullain was also an engraver of ornament, contributing almost all the embellishments designed by Jacques-François Blondel, Gilles-Marie Oppenord and François Boucher (Bib. N. cat. nos 50–52) to the edition of Molière's *Oeuvres* (1734) with illustrations by Laurent Cars after Boucher; he also engraved ornamental designs after Jacques de Lajoue (Bib. N. cat. nos 53–5) and Jean B. H. Toro (Bib. N. cat. nos 56–60). Of his individual engravings, two of the four after Antoine Watteau, *Sick Man Pursued by the Faculty of Medicine* (1727; Bib. N. cat. no. 27) and the *Charms of Summer* (1732; Bib. N. cat. no. 37), are considered to be among his best. He also engraved *fêtes galantes* after Nicolas Lancret (Bib. N. cat. nos 47–9).

Joullain became a member of the Académie de St Luc as both painter and engraver in 1733 and was appointed director there in 1747. His address remained the same throughout his career: Quai de la Mégisserie, at the sign of the Ville de Rome.

The two engravings after paintings by Veronese for the *Recueil Crozat* of 1742 (Bib. N. cat. nos 64–5) are among Joullain's last, as he all but abandoned his career as an engraver to concentrate on dealing and print-selling. In 1760 he published a catalogue of his stock, estimated at the time of his death to be worth 20,000 livres. His contemporaries considered him to be both the most enthusiastic and the best-stocked dealer in rare old portraits in Paris and possibly in Europe. When his son Charles Joullain (*d* 1790) married Catherine Louise Leclerc, the daughter of Sébastien Leclerc (ii), his father made over to him the part of his business that dealt with frames. François-Charles, as he was later known, became one of the most important entrepreneurs of the second half of the 18th century, organizing the sales of, among others, the painter Jean-Siméon Chardin and the former director of the Bâtiments du Roi, the Marquis de Marigny (in collaboration with Pierre-François Basan).

BIBLIOGRAPHY
Inventaire du fonds français: Graveurs du XVIIIe siècle, Paris, Bib. N., Dépt. Est. cat., xii (Paris, 1973), pp. 158–89
M. Préaud and others: *Dictionnaire des éditeurs d'estampes à Paris sous l'Ancien Régime* (Paris, 1987), p. 182

M.-E. HELLYER

Jourdain. French family of artists.

(1) Frantz (Calixte Raphaël) Jourdain (*b* Antwerp, 3 Oct 1847; *d* Paris, 1935). Writer and architect. He studied architecture at the Ecole des Beaux-Arts in Paris in the 1860s. By the 1890s he was a leading art critic, writing disparaging essays about the Ecole. Jourdain's articles were widely published and frequently quoted. He was a supporter of new ideas and became known as a proponent of Modernism and modern art. He was president of the Salon d'Automne from 1903 and a member of the prestigious literary organization, the Société des Gens de Lettres, as well as a founder-member of the Société du Nouveau Paris (a group devoted to the modernization of the city). Jourdain urged young architects to reject their anachronistic academic training and to avoid historical styles, thereby creating new architectural forms. He also criticized the élitist handicraft approach of the English Arts and Crafts movement. He supported unity in the arts and favoured a collaboration between art and industry; he discussed the structural Rationalism of the engineered structures of the Exposition Universelle, Paris (1889), and more significantly the beauty of their iron and glass forms.

Jourdain's major building commission was from Ernest Cognacq for the Art Nouveau department store, La Samaritaine, Paris (1905–10). His design was radical in its use of glass and an exposed steel frame. The brilliantly coloured building was lavishly decorated in naturalistic ornament and despite its appearance was eminently rational, serving perfectly the function for which it was designed. Within a decade, however, La Samaritaine was caught in an abrupt shift in taste that rejected Art Nouveau and was regarded with contempt, especially by younger architects. When the building was enlarged in the late 1920s it was remodelled drastically, its striking projecting glass domes and colourful ornament removed. Nonetheless, Jourdain's ideals, embodied in La Samaritaine and in his writing, provided the foundation for much of the thinking of the modern movement.

WRITINGS
'La Décoration et le rationalisme architecturaux à l'Exposition Universelle', *Rev. A. Déc.*, x (1889), pp. 33–8
'L'Architecture au XIXe siècle', *Architecture* [Paris], iii (1890), pp. 319–20
BIBLIOGRAPHY
R. Rey: *Frantz Jourdain* (Paris, 1923)
G. Besson: 'Frantz Jourdain', *Salon d'Automne* (exh. cat., ed. R. Demeurisse; Paris, Mus. B.-A., 1947)
E. Sarradin: 'En marge de l'hommage à Frantz Jourdain', *Salon d'Automne* (exh. cat., ed. R. Demeurisse; Paris, Mus. B.-A., 1947)
M. L. Clausen: 'Frantz Jourdain and the Samaritaine', *Art Nouveau Theory and Criticism*, ed. E. J. Brill (Leiden, 1987)

MEREDITH L. CLAUSEN

(2) Francis Jourdain (*b* Paris, 2 Nov 1876; *d* Paris, 31 Dec 1958). Designer, writer and painter, son of (1) Frantz Jourdain. He trained as a painter, developing an *intimiste* style related to that of Edouard Vuillard and Pierre Bonnard. In 1911 he gave up painting and, inspired by the writings of Adolf Loos, turned to furniture design. In 1912 he opened a small furniture factory, Les Ateliers Modernes, and designed interiors composed of modular wooden furniture for workers; some were sold through the socialist newspaper *L'Humanité*. By 1919 he owned a shop, Chez Francis Jourdain. From 1913 to 1928 he exhibited regularly at the Salon d'Automne and with the Société des Artistes Décorateurs. He was a prolific writer on modern art and aesthetics and published numerous articles in French journals, arguing against the ostentatious luxury that characterized most French design during this period. In 1929 he was a founder of the avant-garde group the Union des Artistes Modernes, of which he was an active member until 1947; of particular note was his interior for an Intellectual Worker (travailleur intellectuel), exhibited in the pavilion at the Exposition Internationale in Paris in 1937.

Between 1925 and 1930 Jourdain collaborated with Robert Mallet-Stevens, designing interiors for the architect's villas in the Rue Mallet-Stevens (1927), for the Magasin Bally (1928) and for the offices of the magazine *La Semaine à Paris* (1930). Jourdain's designs were characterized by his concern for simplicity and his preference for uncomplicated construction. He was able to create a

sense of spaciousness in the most restricted areas, using his systems of built-in furniture and storage. These were not only functional but also decorative in their lively interplay of geometric forms. Jourdain also took an active interest in politics throughout his career. In 1927, with Henri Barbusse (1873–1935), he founded Les Amis de L'URSS, establishing ties with Soviet artists and architects in Moscow. In 1932 he was a founder of the anti-fascist committee Amsterdam–Pleyel, and of the Association des Ecrivains et Artistes Révolutionnaires.

WRITINGS
'Le Rationalisme en art', *Cah. Rationalistes*, lvii (1937), pp. 1–12
Pierre Bonnard ou les vertus de la liberté (Paris, 1946)
Sans remords ni rancune (Paris, 1953)

BIBLIOGRAPHY
L. Moussinac: *Francis Jourdain* (Geneva, 1955)
A. Fournier: 'Francis Jourdain: Parisien', *Europe*, xlv–xlvi (1968), pp. 320–32
Francis Jourdain (exh. cat. by J. Rollin, Saint-Denis, Mus. A. & Hist., 1976)
A. Despond and S. Tise: *Jourdain* (Paris, 1988)

SUZANNE TISE

Jourdain, Jules (Paul Louis) [Saint-Georges] (*b* Namur, 30 Dec 1873; *d* Woluwé Saint-Lambert, Brussels, 22 Feb 1957). Belgian sculptor, medallist and critic. After secondary education with the Jesuits at Namur and Brussels, he studied law at the Université Catholique in Leuven. He later enrolled at the Institut Saint-Luc in Brussels and then from 1899 to 1903 studied at the Académie Royale des Beaux-Arts in Brussels under Julien Dillens. He also frequented the studio of Constantin Meunier. Both exercised a considerable influence on his work, and in addition he benefited from the advice of Thomas Vinçotte. From 1908 to 1910 he wrote art criticism for the Brussels newspaper *Le Patriote* under the pseudonym Saint-Georges. As a medallist he produced portraits, commemorative and religious medals. Among his best-known sculptures are *Queen Astrid* at the Collège Saint Jean-Berchmans in Brussels and the statue of *Justus Lipsius* (h. 2.90 m), which stands in the square of the same name in Leuven. Between 1922 and 1930 he created several patriotic monuments in Belgium, including those at Walcourt, Rochefort and Casteau.

BNB
BIBLIOGRAPHY
S. Pierron: 'Nos sculpteurs: Jules Jourdain', *Rev. Belge*, 2 (1926), pp. 75–83
J. Toussaint: 'Jules Jourdain', *Nouvelle Biographie Nationale*, i (Brussels, 1988), pp. 205–8

DANIELLE DERREY-CAPON

Jouveau-Dubreuil, Gabriel (Jules Charles) [Dubreuil, Gabriel Jouveau] (*b* 1885; *d* 1945). French art historian. Having received a doctorate in chemistry from the University of Paris, he turned his attention to Indology and submitted a further thesis on southern Indian iconography. He subsequently taught science at the Colonial College, Pondicherry, where he was able to pursue his enquiries into Indian architecture and art. His investigations were published in such journals as *Journal Asiatique*, *Le Semeur*, and the *Bulletin de la Société des Amis de l'Orient*, as well as in larger works. He also wrote about the ancient history of the Deccan and on Joseph Dupleix, the 18th-century French adventurer who was governor of Pondicherry. In 1924, he led an archaeological mission to Afghanistan.

In his approach to the study of Indian architecture, Jouveau-Dubreuil was aware of shortcomings in the work of such scholars as James Fergusson, Alexander Cunningham and James Burgess and emphasized the need for more stylistic analysis, with comparisons and classifications. To this end, he studied the evolution of ornamental motifs in order to understand the evolution of architectural styles. Moreover, he believed in studying ancient monuments with the help of traditional terminology and questioned Indian architects who still worked in a traditional manner. He discovered paintings at Podukotah, on the walls of the Kailashanatha Temple at Kanchipuram and in a number of cave sites, and is credited with correctly identifying Ptolemy's Poduké with Arikamedu, an important centre for Roman trade in India. Many of his stylistic and chronological conclusions remain valid, and his approach was later developed by a group of French scholars, led by Philippe Stern, for the study of Indian sculpture. Scholars of Indian art influenced by his ideas include F. H. Gravely, T. N. Ramachandran and Calambur Sivaramamurti.

WRITINGS
Archéologie du sud de l'Inde, 2 vols, ed. S. K. Aiyangar (Paris, 1914); Eng. trans. of i by K. A. Rau as *Dravidian Architecture* (Madras, 1917/*R* Varanasi, 1972); Eng. trans. of ii by A. C. Martin as *Iconography of Southern India* (Paris, 1937)
'Les Antiquités de l'époque Pallava', *Rev. Hist. Inde Fr.*, i (1916–17); Eng. trans. by V. S. S. Dikshitar as *Pallava Antiquities*, 2 vols (London and Pondicherry, 1916–18)
The Pallavas, Eng. trans. by V. S. S. Dikshitar (Pondicherry, 1917)
Vedic Antiquities (London and Pondicherry, 1922)

BIBLIOGRAPHY
B. Srivastava: 'Dubreuil and his Methodology', *Dravidian Architecture*, ed. S. K. Aiyangar; trans. K. A. Rau (Varanasi, 1972), pp. v–vii

S. J. VERNOIT

Jouvenel [Juvénal] **des Ursins.** French family of patrons. The first Jouvenel of distinction was Jean I (1360–1431), Baron de Trainel, who became provost of the merchants in Paris and president of the parliaments of Poitiers and Toulouse. Jean is remembered today for two fine statues representing the baron and his wife (*d* 1456), designed for their tombs in the family chapel of St Rémi in Notre-Dame, Paris. Though much restored, these lifelike, highly coloured statues are interesting as examples of the kneeling form of effigy made before the type became generally popular. Also probably intended for this chapel is a large painted panel representing Jean, his wife and their 11 adult children (Paris, Louvre, on dep. Paris, Mus. Cluny). Inscriptions identifying the figures and recording their titles indicate that it was executed between 1445 and 1449. The painting has been attributed to the Master of the Munich Golden Legend, a leading illuminator of the second quarter of the 15th century, active in Paris and elsewhere, and a rival of the better-known Bedford Master.

A work associated with the Bedford Master, acquired by Jean's son Jacques Jouvenel (1410–57), is the so-called Pontifical (destr. 1871) begun for the Duke of Bedford in the 1420s and connected with the Sainte-Chapelle in Paris. Copies of its miniatures (e.g. Paris, Mus. Cluny) indicate that Jacques continued the work, perhaps while he was Bishop of Poitiers. A prayerbook (Paris, Bib. N., MS. nouv. acq. lat. 3113) made for Jacques's brother Michel

Jouvenel (1408–70) is in a very different style, by an expressive artist known as the Master of Michel Jouvenel.

Another brother, Jean Jouvenel II (1388–1473), Archbishop of Reims, was an influential diplomat and chronicler. He may have acquired the most important manuscript associated with the Jouvenels, Giovanni da Colonna's *Mare historiarum* (Paris, Bib. N., MS. lat. 4915) of *c.* 1447–55. Its principal illuminator, known as the MASTER OF JOUVENEL DES URSINS (*see* MASTERS, ANONYMOUS, AND MONOGRAMMISTS, §I), was a leading figure in French illumination, linking the fussy style of the Bedford Master with the refined naturalism of Jean Fouquet. One of Fouquet's portraits (*c.* 1460; Paris, Louvre; *see* FOUQUET, JEAN, fig. 2) actually represents Jean's brother, Guillaume Jouvenel (1401–72), twice Chancellor of France and probably patron of the *Mare*. Fouquet's panel is of particular interest because a study for it survives (Berlin, Kupferstichkab.), suggesting that his approach to portraiture had Netherlandish origins. The portrait probably belonged to a larger ensemble intended for the chapel in Notre-Dame, Paris, where Guillaume was buried alongside his brother Louis Jouvenel (*d* ?1445). Their tomb has not survived, but a drawing of it by Roger de Gaignières (Paris, Bib. N., Est. Rés. Pe 9, fol. 94) shows, in contrast to their parents' tomb, a copper slab engraved with their effigies.

Guillaume Jouvenel's correspondence in the 1450s with the humanist Filelfo indicates that his interests included the design of classical letters, early evidence for tastes originating in Italy being introduced into France. Such tastes were taken further when, early in the 16th century, additions were made to the 14th-century Hôtel des Ursins in Paris, already enlarged by Jacques Jouvenel after 1437. Although these additions were destroyed, drawings and engravings show that they were in a fully developed Italianate style. Members of the family also developed antiquarian tastes. In 1454, for example, Guillaume's sister Marie Jouvenel (1399–1479), a nun at Poissy Abbey, acquired the Belleville Breviary (Paris, Bib. N., MSS lat. 10483–4), a celebrated manuscript illuminated in the 1320s.

BIBLIOGRAPHY

P. L. Pechenard: *Jean Juvénal des Ursins: Historien de Charles VI, Evêque de Beauvais et de Laon, Archevêque Duc de Rheims* (Paris, 1876)
L. Batiffol: 'L'Origine italienne des Juvenal des Ursins', *Bib. Ecole Chartes*, liv (1893), pp. 693–717
——: *Jean Jouvenal des Ursins: Prévôt des marchands de la ville de Paris (1360–1431)* (Paris, 1894)
J. Salvini: 'Un Evêque de Poitiers: Jacques Jouvenel des Ursins', *Bull. Soc. Antiqua. Ouest*, 4th ser., vi (1961), pp. 85–107
P. S. Lewis: 'Jean Juvenal des Ursins and the Common Literary Attitude towards Tyranny in Fifteenth-century France', *Med. Aevum*, xxxiv (1965), pp. 103–21
P. du Colombier: *Notre-Dame de Paris: Mémorial de la France* (Paris, 1966), pp. 81–2
C. Schaefer: 'Deux Enlumineurs du Maître de Jouvenal des Ursins à la Biblioteca Nacional à Lisbon', *Arquivs Cent. Cult. Port.*, vii (1974), pp. 117–47
J. Adhémar: 'Catalogue des tombeaux de Gaignières: Seconde partie', *Gaz. B.-A.*, lxxxviii (1976), pp. 3–122, nos 1160, 1209
Jean Fouquet (exh. cat., ed. N. Reynaud; Paris, Louvre, 1981), nos 8, 9
E. König: *Französische Buchmalerei um 1450: Der Jouvenal-Maler, der Maler des Genfer Boccaccio, und die Anfänger Jean Fouquets* (Berlin, 1982)
D. Thomson: *Renaissance Paris* (London, 1984), pp. 60–64
C. Sterling: *La Peinture médiévale à Paris, 1300–1500*, i (Paris, 1987)
C. Reynolds and J. Stratford: 'Le Manuscrit dit "Le Pontifical de Poitiers"', *Rev. A.*, lxxxvi (1989), pp. 61–80

THOMAS TOLLEY

Jouvenet, Jean (*b* Rouen, 1 May 1649; *d* Paris, 5 April 1717). French painter. He was the most prominent member of a large family of painters and sculptors first recorded in Rouen in 1548, and he became one of the most important painters of religious works in France in the late 17th century and the early 18th. His father, Laurent Jouvenet (1609–81), a sculptor and painter, had 15 children, at least five of whom became painters, among them Marie Madeleine, mother of the history painter Jean Restout II.

1. EARLY CAREER, TO 1694. In 1661 Jouvenet left Rouen for Paris. From 1669 he was part of Charles Le Brun's team working on decorative schemes at the royal palaces of Saint-Germain-en-Laye, the Tuileries in Paris and then Versailles (where he contributed to the decoration of the Salon de Mars), thus receiving his true artistic education. In 1673 he painted the May de Notre-Dame (the altarpiece offered each year by the Paris guild of goldsmiths to the cathedral of Notre-Dame), the *Healing of the Paralytic* (destr. 1944). He was received as a member (*reçu*) by the Académie Royale in 1675 with *Esther Swooning before Ahasuerus* (Bourg-en-Bresse, Mus. Ain), in which the influence of Nicolas Poussin, which remained strong throughout his career, is combined with a developing individual style. In *St Peter Healing the Sick with his Shadow* (*c.* 1675; Paris, chapel of the Hôpital Laënnec) the basic elements of his vocabulary are united for the first time: a lucid composition based on diagonals, the groups of protagonists linked by gestures, unidealized faces and a strong impression of life.

An engraving after Jouvenet's portrait of the *Grand Dauphin, Louis de France* (1677; untraced; see Schnapper, no. 9) suggests that he must have enjoyed a considerable reputation as a portrait painter by the 1670s. He was to paint portraits throughout his career in a restrained and unemphatic style, for example *Dr Raymond Finot* (exh. Salon 1704; Paris, Louvre). But above all in this period he seems to have painted mythological subjects, both easel paintings and large decorative schemes. Around 1680 he worked for a number of wealthy Parisian clients, though little of this decorative work survives: he painted ceilings, overmantels and overdoors, notably in the Hôtel Robert (destr.) and in the Hôtel de St Pouange (destr.); from the latter, two paintings of *c.* 1682–3 survive: *Apollo and the Cumaean Sibyl* (Paris, priv. col.) and the *Sacrifice of Iphigenia* (Troyes, Mus. B.-A. & Archéol.). With other artists he decorated Charles Perrault's Cabinet des Beaux-Arts (destr.; one of Jouvenet's pictures is known through an engraving of 1690 by Louis Simonneau). During the 1680s he painted the *Family of Darius* for the Lycée Louis-le-Grand, Paris (*in situ*), a work derived from Le Brun's at the Tuileries, but Jouvenet's figures are placed in a diagonal, closer to the picture plane, thus drawing the spectator into a more dynamic spatial context.

In 1684 Jouvenet was commissioned to decorate the gallery of the Hôtel de Ville in Toulouse, in collaboration with Bon Boullogne and Antoine Coypel; his contribution was the *Foundation of a City by the Tectosages* (Toulouse, Mus. Augustins). As an increasingly important painter of religious works, he provided paintings for his native Rouen, for example the *Annunciation* (1685; Rouen, Mus.

B.-A.), but principally for the churches and religious foundations of Paris, for Notre-Dame at Versailles and for the nearby convent of St Cyr. His *Extreme Unction* (*c.* 1685–90; Paris, Louvre), painted for St Germain-l'Auxerrois in Paris, is a restrained and austere work, a meditation on the Christian concept of the good death. In 1689 he painted for the Charterhouse in Paris the first of the huge canvases on which his reputation was built: *Christ Healing the Sick* (4.18×7.73 m; Paris, Louvre), which demonstrates 'for the first time the quality in which Jouvenet's historical significance consists: his ability to revitalize the classical tradition by realism of inspiration and breadth of execution' (Schnapper, 1974, p. 93). This realism is softened by the idealization of the faces and by the absence of minutiae in the details.

2. AFTER 1694. Jouvenet's *Agony in the Garden* (1694; Rennes, Mus. B.-A. & Archéol.) is admirable in its concentration, its truth of feeling and technical simplicity. By this time his reputation was such that he was commissioned to decorate the Parlement of Brittany (now the Palais de Justice), Rennes, for which he executed six allegorical ceiling paintings depicting the *Triumph of Justice* (1694; *in situ*). Around 1700 he was associated with numerous other artists, notably Charles de La Fosse, on the most important decorative project of the period, the Dôme des Invalides, Paris. While La Fosse painted the upper cupola and the pendentives, Jouvenet frescoed the lower cupola with the *Apotheosis of the Twelve Apostles* (*in situ*). In 1709 Jouvenet collaborated with La Fosse and

Coypel in the decoration of the ceiling of the chapel at the château of Versailles, where he painted the *Pentecost* on the vault above the Tribune du Roi and on the west wall. In the centre, the dove of the Holy Spirit is shown hovering in a blaze of light around which angels descend towards the Virgin and the Apostles.

Jouvenet's last important decorative commission was the ceiling of the Chambre des Enquêtes of the Parlement in Rouen, where he again treated the subject of the *Triumph of Justice* (*c.* 1715; destr. 1812). Paralysed in 1713 in his right hand, he painted this work with his left hand. The surviving oil sketches (Rennes, Mus. B.-A. & Archéol.; Grenoble, Mus. Peint. & Sculp.) suggest that it was somewhat timid in its approach to illusionism, with a large empty sky, around which several figures appear above fictive architectural features that extend the detailing of the walls.

Jouvenet painted his most famous religious works between 1695 and 1707. Among them are the *Deposition* (1697; Paris, Louvre), inspired by both Le Brun and Peter Paul Rubens, yet at the same time extremely personal in style. The four colossal canvases painted in 1703–6 for the Benedictines of St Martin-des-Champs, Paris, are equally impressive: *Christ Driving the Money-changers from the Temple* and the *Feast in the House of Simon* (both Lyon, Mus. B.-A.); the *Resurrection of Lazarus* and the *Miraculous Draught of Fishes* (both Paris, Louvre; see fig. 1). The dynamic composition and lifelike attitudes of these works, as well as the realism of certain details, profoundly impressed Jouvenet's contemporaries.

1. Jean Jouvenet: *Miraculous Draught of Fishes*, oil on canvas, 3.92×6.64 m, 1706 (Paris, Musée du Louvre)

2. Jean Jouvenet: *Latona and the Peasants of Lycia*, oil on canvas, 1.07×1.00 m, *c.* 1700–01 (Fontainebleau, Musée National du Château de Fontainebleau)

When, with the end of the War of the League of Augsburg in 1697, royal commissions began again, Jouvenet executed a painting (badly damaged) for the château of Marly, near Versailles; two for the Château of Meudon: *Latona and the Peasants of Lycia* (*c.* 1700–01; Fontainebleau, Château; see fig. 2) and the *Birth of Bacchus* (1700; untraced); and *Apollo and Thetis* for the apartment of Mme de Maintenon at the Grand Trianon, Versailles (1700; *in situ*). He had earlier (1689) painted for the Trianon's Salon Frais *Zephyr and Flora* (*in situ*), in which the Poussinesque composition was combined with an airy grace reminiscent of La Fosse.

At the very end of his life Jouvenet contributed to the group of eight paintings presented to the cathedral of Notre-Dame, Paris, by Canon de La Porte, supplying a *Visitation* (*in situ*), signed and dated *J. Jouvenet. Dextera paralyticus Sinistra pinxit 1716.* The Virgin is depicted giving thanks to God; both the donor and the artist are included, which suggests that Jouvenet intended to express his own gratitude for the miracle of learning to paint with his left hand.

Jouvenet had a model career, lacking only the title of Premier Peintre du Roi (which remained vacant from the death of Pierre Mignard in 1695 until Antoine Coypel's nomination in 1716). In 1695 he received a royal pension; in 1705 he was elected director of the Académie and in 1707 became its rector. Among his pupils was his nephew Jean Restout II. His contemporary reputation was high, meriting his inclusion in several early 18th-century biographical reference books. He was less highly regarded thereafter until the turn of the century, when a taste for

the Grand Manner and Neo-classical severity was largely restored. During the 19th century his work was respected but out of fashion. It was only in the 1960s, with the burgeoning reappraisal of history painting in France, that his work began to be appreciated afresh. There are good collections of his drawings in Stockholm (Nmus.) and Rouen (Mus. B.-A.).

BIBLIOGRAPHY

Bellier de La Chavignerie–Auvray; Jal; Thieme–Becker
L. F. Dubois de Saint Gelais: *Histoire journalière de Paris pendant l'année 1716 et les six premiers mois de 1717* (Paris, 1717, 2/1885)
A.-J. Dézallier d'Argenville: *Abrégé de la vie des plus fameux peintres* (1745–52, 2/1762), iv, pp. 203–18
L.-A. Bonafons de Fontenai: *Dictionnaire des artistes* (Paris, 1776)
N.-F. Leroy: *Histoire de Jouvenet* (Caen, Paris and Rouen, 1860)
J. Guiffrey, ed.: *Comptes* (1881–1901)
P. Marcel: 'Les Peintures décoratives de l'église des Invalides et de la chapelle de Versailles', *Gaz. B.-A.*, 3rd ser., xxxiv (1905), pp. 265–80
G. Huard: 'Jouvenet et *Le Triomphe de la Justice* aux parlements de Bretagne et de Normandie', *Bull. Soc. Hist. A. Fr.* (1931), pp. 106–14
Jean Jouvenet, 1644–1717 (exh. cat. by A. Schnapper, Rouen, Mus. B.-A., 1966)
A. Schnapper: *Jean Jouvenet et la peinture d'histoire à Paris* (Paris, 1974)

CELIA ALEGRET

Jovellanos, Gaspar Melchor de (*b* Gijón, Asturias, 5 Jan 1744; *d* Puerta de Vega, Asturias, 27 Nov 1811). Spanish lawyer, statesman and collector. He was the tenth child of a family with aristocratic connections. Originally destined for the priesthood, he took minor orders in 1757 but renounced this for a legal and political career. He worked as a lawyer in Seville from 1768 to 1778 and spent the next 12 years in Madrid. Later he fell foul of Charles IV's prime minister, Manuel Godoy, and Queen María Luisa, and was exiled, spending seven years from 1801 to 1808 in Mallorca. He returned to Madrid shortly before the beginning of the Peninsular War (1808–14). In art, as in politics, he favoured change and progress but not revolution. He painted a little himself, including decorative work (destr.) on the walls of the apartment in which he was detained in the castle of Bellver, near Palma de Mallorca, during his exile.

In Seville and Madrid Jovellanos was able to develop his taste for the fine arts and to collect books, drawings, prints and pictures. Mysteriously, the extensive library he had acquired by 1778 gives no indication of an interest in art and architecture. However, the Spanish art chronicler JUAN AGUSTÍN CEÁN BERMÚDEZ stated that Jovellanos, a friend since childhood, had built up his interest in and knowledge of art in Seville. In 1780 Jovellanos was admitted to the Real Academia de S Fernando, Madrid, and the speech he made there in July the following year proves that his aesthetic theories and taste were already well developed and strongly Neo-classical. He referred favourably to Johann Joachim Winckelmann and Anton Raphael Mengs and related the development of art and architecture to rises of 'good taste' on classical lines. He considered Gothic architecture to be magnificent and awe-inspiring but lacking in a proper sense of proportion. He therefore welcomed the Renaissance style and approved of the work of Juan Bautista de Toledo and Juan de Herrera (ii) in Spain. He also admired proportion and symmetry in painting, praising these qualities in the work of Pedro Berruguete and Gaspar Becerra. He condemned

the exaggerated elements of El Greco's style, preferring the more balanced approach of Juan Bautista Maíno and Luis Tristán. He particularly praised Diego Velázquez and Bartolomé Esteban Murillo, both of whom he felt combined a precise study of nature with a proper sense of ideal beauty. Respect for the status of artists and the duty of the nobility to support them were essential to Jovellanos's view of a flourishing state in the arts. He combined friendship with patronage in his relations with Francisco de Goya, who twice painted his portrait (1783, col. Valls y Taberner; 1798; Madrid, Prado), and the sculptor Pedro González de Sepúlveda (1744–1815).

In Madrid, Jovellanos began to form a small gallery of paintings for his residence in the Calle de Juanelo. Ceán Bermúdez obviously helped him considerably. In his will of 1795 Jovellanos referred to several works in his collection: a sketch (Kingston Lacy, Dorset, NT), believed to be original, for Velázquez's *Las meninas* (Madrid, Prado), which was bought at a sale in 1790 and given to him; a portrait by Goya; a *Virgin and Child* by Luis Morales (Madrid, Prado); and another painting of the same subject by Murillo. He subsequently acquired a superb *Immaculate Conception* by Francisco de Zurbarán (Jadraque, Escuela), which he believed to be by Murillo; the sketch for a painting of the same subject by Goya; a portrait of *Cardinal Borja* by Velázquez; and a *Self-portrait* by Juan Carreño de Miranda. He also built up an important collection of drawings by Spanish masters. These included a *Sleeping Woman with Devils in the Background* by Alonso Cano, a *Landscape* by Francisco Collantes and *Three Disciples Sleeping* by El Greco. The drawings were in the Instituto de Gijón until the Spanish Civil War, when they are thought to have been destroyed.

WRITINGS

Oración pronunciada en la junta pública que celebró la Real Academia de San Fernando el día de 14 de julio de 1781 (Madrid, n.d.)

BIBLIOGRAPHY

J. A. Ceán Bermúdez: *Memorias para la vida del Excmo. Señor D. Gaspar Melchor de Jove Llanos y noticias analíticas de sus obras* (Madrid, 1814)
J. Moreno Villa: *Dibujos del Instituto de Gijón* (Madrid, 1926)
R. del Arco: 'Jovellanos y las bellas artes', *Rev. Ideas Estét.*, iv (1946), pp. 31–64
J. H. R. Polt: *Gaspar Melchor de Jovellanos* (New York, 1971)
J. Varela: *Jovellanos* (Madrid, 1988)
J. González Santos: 'Jovellanos por Goya: Precisiones históricas e iconográficas sobre dos conocidos retratos', *Bol. Mus. Prado*, xiii/31 (1992), pp. 45–56

NIGEL GLENDINNING

Joy, George W(illiam) (*b* Dublin, 7 July 1844; *d* Purbrook, Hants, 28 Oct 1925). Irish painter. The brother of the sculptor Albert Bruce Joy (1842–1924), he studied in London at the South Kensington School of Art and later at the Royal Academy Schools under John Everett Millais, Frederic Leighton and G. F. Watts. From 1868 his education continued in Paris under Charles-François Jalabert (1819–1901) and Léon Bonnat. Joy's mature work is largely concerned with the depiction of the human form in narrative and allegorical subjects from historical, Classical, literary and religious sources. His light-hearted but elaborate works on the theme of childhood, such as *Thirty Years before Trafalgar: Young Nelson and his Grandmother* (1883; untraced, photograph in U. London, Courtauld Inst.), gained a wide popularity. Among his outstanding

paintings is the *Death of General Gordon, Khartoum, 26 January 1885* (exh. RA 1894; Leeds, C.A.G.), which represents Joy's patriotic attempt to 'awaken the conscience of the nation' (autobiography, p. 22); it was one of the few Royal Academy exhibits on the subject. *Bayswater Omnibus* (1895; London, Mus. London), a modern-life painting, displays his powers of observation at their keenest. Joy's output consisted principally of oil paintings, and a detailed account of his methods is included in his autobiography. He exhibited at the Royal Academy between 1872 and 1914, and his work was well received at the Salon in Paris.

WRITINGS

The Work of George W. Joy with an Autobiographical Sketch (London, 1904)

BIBLIOGRAPHY

W. L. Woodroffe: 'The Work of George W. Joy', *A. J.* [London] (1900), pp. 17–23

TIMOTHY J. BARRINGER

Joy, Thomas Musgrave (*b* Boughton-Monchelsea, Kent, 9 July 1812; *d* London, 7 April 1866). English painter. He came from a landed family and was allowed to indulge his youthful artistic interests. He studied under Samuel Drummond (1763–1844) in London. He first exhibited at the Royal Academy in 1831 and continued to do so nearly every year until his death. One of Joy's earliest portraits was of *William Ramsay Maule, Lord Panmure* (exh. RA 1838; untraced). Panmure (1771–1852) encouraged Joy to study in France and later placed his protégé John Phillip with him as a pupil. He gave Joy some of his earliest important commissions, portraits of the maritime heroes *William Darling* and *Grace Darling* and the *Wreck of the Forfarshire* (all *c.* 1840; on loan to Dundee, McManus Gals). Between 1841 and 1843 Joy gained the patronage of Queen Victoria and painted two infant double portraits of *Albert Edward, Prince of Wales, and Victoria, Princess Royal* (Windsor Castle, Berks, Royal Col.).

In 1864 Joy painted *The Yard* and *The Ring* (both untraced), two of the works for which he was best known at the time. These show the subscribers to the bloodstock auctioneers Tattersall's meeting before the races and contain portraits of many notable horse-fanciers of the time. In his subject paintings Joy was equally at home with pathos and humour and often used literary sources. His industriousness was legendary, and overwork was supposed to have contributed to his early death.

BIBLIOGRAPHY

A. J. [London] (1866), p. 240
B. Howe: 'A Forgotten Victorian Artist', *Country Life*, cxxxii (4 Oct 1962), pp. 792, 795

PHILIP McEVANSONEYA

Joy, William (*fl* 1329–47). English architect. He was appointed Master Mason of Wells Cathedral on 28 July 1329, and the terms of his appointment indicate that he had worked previously at Wells, presumably under Thomas of Witney, and that he had other projects in hand elsewhere. The last reference to him is in 1346–7, when he was Master of the Works at Exeter Cathedral, acting as consultant in the building of the west porches. His contribution to the architecture of Wells is unclear, much of the new east end having been laid out or completed before his appointment (*see* WELLS, §1(i)). The dominance

of the Bristol-based workshops at both Wells and Exeter also renders individual stylistic distinctions difficult. The transformation of the Wells choir was intended from at least *c.* 1326 with the completion of the adjoining Lady Chapel, and, though completed only *c.* 1350, the general design, with its rich sculptural interior, was probably established before Joy's appointment. Certain stylistic features, however, suggest some revision after *c.* 1335: the tram-lined Perpendicular east window and the meshed net vault indicate knowledge of the choir of Gloucester Abbey (now Cathedral; after 1330), and would thus belong to his mastership. They also indicate a shift away from West Country-based Decorated traditions towards the new grid-like style associated with London.

The dramatic strainer arches in the crossing at Wells Cathedral, with their famous 'X' design, may be a response to the report of 1338 that the fabric was broken and deformed; but, as some scholars date them to *c.* 1350, Joy cannot certainly be credited with one of England's most admired architectural contrivances.

Harvey
BIBLIOGRAPHY
P. Draper: 'The Sequence and Dating of the Decorated Work at Wells', *British Archaeological Association Conference Transactions. Art and Architecture at Wells and Glastonbury: Wells, 1978*, pp. 18–29
FRANCIS WOODMAN

Jōzan. *See* ISHIKAWA JŌZAN.

Juan de Flandes (*b c.* 1465; *d* ?Palencia, before 21 Oct 1519). South Netherlandish painter, active in Spain. Nothing is known of his life or work before he went to Spain, where he is first mentioned in a document of 1496 as 'Juan de Flandes', a painter in the service of Queen Isabella of Castile. Treasury accounts confirm that he held this position until the Queen's death in 1504. On arriving in Spain, he must have lived in Burgos, where he certainly met MICHEL SITTOW, another painter in the Queen's service, who had been at the Castilian court since 1492.

The extraordinary group of 47 small panels of the polyptych known as the *Oratorio de la Reina Católica* certainly belong to this first Burgos period and must have been painted between 1496 and 1504. Only 27 paintings from this important work have survived (15 Madrid, Patrm. N., on loan to the Madrid, Pal. Real; others dispersed among London, N.G.; Vienna, Ksthist. Mus.; Berlin, Gemäldegal.; Paris, Louvre; and New York, Met.; for full details, see 1986 exh. cat.). There is documentary evidence that two of the panels are by Sittow, the *Ascension* (Brocklesby Park, Lincs) and the *Assumption of the Virgin* (Washington, DC, N.G.A.). Although the attribution of the remaining panels to Juan de Flandes is undocumented, it is confirmed by stylistic comparison with later documented works by the artist painted in Salamanca and Palencia. Juan de Flandes's early style is clearly defined in these works, suggesting that by the time he arrived in Spain he was already thoroughly trained in a South Netherlandish idiom. Contact with the court at Castile had a deep impact on his art, though it remained clearly related to the Ghent school, especially the work of the illuminator known as the Master of Mary of Burgundy. Juan may also have spent some time in Bruges, for the calm, meditative

elegance of Hans Memling is detectable in his paintings, as is the influence of early miniatures by Gerard David.

The composition of the scenes in the Oratory is designed to emphasize the main subject, but one of the most attractive features of the panels by Juan de Flandes is the inclusion of figures and details that convey the intimacy of everyday life. The figures are especially graceful and expressive, and the female characters, in particular, have a delicate beauty that is unmistakably his own, with an abundance of gently waving hair framing delicately modelled faces. Equally characteristic are the elegant gestures of the figures' long-fingered hands. The panels also reveal Juan de Flandes's excellent sense of line and colour.

From 1505 to 1508 Juan was in Salamanca, where he received commissions from the university. Dating from 1505–6 is the *St Michael* altarpiece (Salamanca, Mus. Dioc.) from the tomb of Francisco Rodríguez de San Isidro in the cloister of Salamanca Cathedral, which takes its name from the saint in the centre, who is flanked by *St James* and the *Stigmatization of St Francis*. The predella has a *Pietà* between half-length figures of *St Peter* and *St Paul*. Also belonging to this period, and dated by a contract of 1507, are two fragments of a predella, representing *St Apollonia* and *St Mary Magdalene* (both U. Salamanca, Pal. Anaya), from the altarpiece in the university chapel. They show half-length figures under an arch, painted in grisaille on a background of red and green respectively; the figures are enlivened by realistic details such as their shining jewels and the colour of the Magdalene's hair.

Juan de Flandes spent the last period of his life in Palencia, where he was commissioned by Bishop Juan Rodríguez de Fonseca to enlarge the altarpiece for the high altar in the cathedral. The contract is dated 19 December 1509, and the last payments were made to the artist's widow and heir on 21 October and 13 December 1519. The paintings represent scenes from the *Life of Christ* and constitute the most important documented group of works by Juan de Flandes to survive *in situ*. In their present arrangement, there is a gap in the centre of the predella where there was a *Crucifixion* (Madrid, priv. col. see Bermejo, 1962, pl. 34). Two paintings in the upper part of the altarpiece, the *Visitation* and the *Adoration of the Magi*, are by a follower of the artist, possibly Juan Tejerrina. In the panel depicting the *Entombment* (see fig.) a figure in the centre of the background is thought to be a self-portrait of Juan de Flandes. In this splendid group of scenes, the artist's development can be measured by the greater importance given to the figures, which increase in size in relation to their role in the narrative. Juan painted another altarpiece for Palencia during the same period, perhaps between 1514 and 1518, also with scenes from the *Life of Christ*. Surviving panels include the *Raising of Lazarus, Agony in the Garden, Transfiguration* and *Descent of the Holy Ghost* (all Madrid, Prado) and the *Annunciation, Nativity, Adoration of the Magi* and *Baptism* (all Washington, DC, N.G.A.). These paintings also show an increased tendency to present the figures on a larger scale and to bring them into the foreground of the composition.

Other important works that do not belong to any particular group and date from different stages of his

Juan de Flandes: *Entombment* from the altarpiece with scenes from the *Life of Christ*, panel, *c.* 1509 (Palencia Cathedral)

career include the delightful *Pietà* (Madrid, Mus. Thyssen-Bornemisza), *SS Michael and Francis* (New York, Met.) and the *Adoration of the Magi* and *Baptism* (both Cervara de Pisuerga, S María), supposedly part of an altarpiece dedicated to St John the Baptist formerly in the Cartuja de Miraflores (Burgos). Other religious works that have come to light are the *Birth of the Baptist* (Cleveland, OH, Mus. A.), the half-length *St James as a Pilgrim* (priv. col.), the *Virgin and Child* (Saragossa, priv. col., see Bermejo, 1988, pp. 231–41) and another *Virgin and Child* (Madrid, priv. col., see Díaz Padrón, 1990), derived from a well-known model by Memling.

Juan de Flandes was also an excellent portrait painter, as can be seen in his panels of *Philip the Fair* and *Juana the Mad* (both Vienna, Ksthist. Mus.), the *Portrait of a Girl* (Madrid, Mus. Thyssen-Bornemisza) and what is probably a copy of his portrait of *Queen Isabella* (Madrid, Pal. Pardo).

BIBLIOGRAPHY

J. V. L. Brans: *Vlaamse schilders in dienst der Koningen van Spanje* (Leuven, 1959)

C. Eisler: 'Juan de Flandes' *Saint Michael and Saint Francis*', *Bull. Met.*, xviii (1959), pp. 129–37

E. Bermejo: *Juan de Flandes*, Artes y Artistas (Madrid, 1962)

J. Folie: 'Les Oeuvres authentifiées des primitifs flamands', *Bull. Inst. Royal Patrm. A.*, vi (1963), pp. 183–256

J. Thissen and J. Vynckier: 'Note de laboratoire sur les oeuvres de Juan de Flandes et de son école à Palencia et Cervera', *Bull. Inst. Royal Patrm. A.*, vii (1964), pp. 234–47

I. Vandevivere: *La Cathèdrale de Palencia et l'église paroissiale de Cervera de Pisuerga*, Les Primitifs Flamands, I. Corpus de la peinture des anciens Pays-Bas méridionaux au quinzième siècle, x (Brussels, 1967)

E. Bermejo: 'Las tablas del oratorio de Isabel la Católica del Palacio de Oriente', *Reales Sitios: Rev. Patrm. N.*, vi (1969), pp. 14–16

M. Merrill Ross: 'A Technical Study: *Birth and Naming of St John the Baptist*', *Bull. Cleveland Mus. A.*, lxiii/5 (1976), pp. 136–45

A. Tzeutschler Lurie: '*Birth and Naming of St John the Baptist* Attributed to Juan de Flandes: A Newly Discovered Panel from a Hypothetical Altarpiece', *Bull. Cleveland Mus. A.*, lxiii/5 (1976), pp. 118–35

J. De Coo and N. Reynaud: 'Origen del retablo de San Juan Bautista atribuido a Joan de Flandes', *Archv Esp. A.*, 1 (1979), pp. 125–44

Juan de Flandes (exh. cat. by I. Vandevivere, Bruges, Memlingmus., 1985)

Juan de Flandes (exh. cat. by I. Vandevivere and E. Bermejo, Madrid, Prado, 1986)

E. Bermejo: 'Novedades sobre Juan de Flandes, el Maestro de la Leyenda y Jan de Beer', *Archv Esp. A.*, lxi (1988), pp. 231–41

E. Bermejo and J. Portus: *Juan de Flandes*, Los genios de la pintura española (Madrid, 1988, rev. 1990)

Tesoros de las colecciones particulares madrileñas: Tablas españolas y flamencas, 1300–1550 (exh. cat. by E. Bermejo, Madrid, Real Acad. S Fernando, Mus., 1988), pp. 92–7

M. Díaz Padrón: 'Una tabla procedente de la colección Thyssen-Bornemisza, restituida a Juan de Flandes', *Goya*, cxxv (1990), pp. 258–63

ELISA BERMEJO

Juan de Holanda. *See* JOEST, JAN.

Juan [Jean] **de la Huerta** (*b* Daroca, Aragon; *fl* 1431–62).

Spanish sculptor. In 1443 he was working in the Carmelite convent at Chalon-sur-Saône, near Dijon; documents describe him as 'Juan de la Huerta, called Daroca, native of Aragon, a carver of images, resident in Dijon'. On 11 August 1443 he was commissioned by Philip the Good, Duke of Burgundy, to complete the tombs of *John the Fearless and Margaret of Bavaria*, begun by Claus de Werve for the Charterhouse of Champmol, Dijon. The contract specified that the double tomb was to be made of alabaster and was to resemble that of *Philip the Bold* (1384–1410; both tombs Dijon, Mus. B.-A.). Juan worked on the tomb and on other commissions for dignitaries in Dijon until 1456, when he left the city without finishing the ducal effigies (they were later completed by Antoine le Moiturier). He became established for a time in Autun in the service of Cardinal Jean Rolin, working in Chalon-sur-Saône and Mâcon, where he is last mentioned as 'poor and ill' in November 1462. It has been suggested that he subsequently returned to Daroca and was responsible for the altarpiece and wall decoration of the chapel of Los Corporales in the Colegiata of Sta María, but, although this is closely related to Burgundian sculpture (and particularly to work by Claus de Werve), its style suggests an earlier date, in the first quarter of the 15th century. An attribution to Juan would presuppose a change in his style, which is characterized by agitated, demonstrative figures and complex draperies; it is more likely that he was apprenticed in Daroca while the work was being carried out, and that it encouraged him to move to Dijon to seek employment. New documentary evidence reveals that he never broke his ties with Aragon, where he kept *lares et domicilium*, which suggests that certain sculptures that are similar to those documented in Burgundy could be attributed to him. Therefore the image of the *Virgin of Pilar* in Zaragoza, made of multi-coloured wood, can be seen as a work of his that was carried out between 1434 and 1443 and that replaced a previous image destroyed by fire in the chapel of the cloister of the church of Sta María la Major of Zaragoza.

BIBLIOGRAPHY
H. Chabeuf: 'Jean de la Huerta, Antoine le Moiturier et le tombeau de Jean sans Peur', *Mém. Acad. Sci., A. & B.-Lett. Dijon*, 4th ser., ii (1891), pp. 138–271
J. Cabre: 'El tesoro artístico de los corporales de Daroca', *Bol. Soc. Esp. Excurs.*, xxx (1922), pp. 275–92
P. Quarré: 'Jean de la Huerta en Bourgogne', *Jean de la Huerta et la sculpture bourguignonne au milieu du XVème siècle* (Dijon, 1972)
——: 'Le Retable de la capilla de los Corporales de la Collegiate de Daroca et le sculpteur Jean de la Huerta', *Actas del XXIII congreso internacional de historia del arte: Granada, 1973*, i, pp. 455–64
L. C. Lacarra Ducay: 'Virgen Maria del Pilar', *Maria en el arte de la Diocesis de Zaragoza* (Saragossa, 1988), pp. 196–8
P. Camp: *Les Imageurs bourguignons de la fin du moyen âge* (Dijon, 1990), pp. 118–44

Juan de Levi [Levy] (*b* Saragossa; *fl* 1388–1410). Spanish painter. He belonged to a family of converted Jews and was the nephew and pupil of the painter Guillén de Levi. He painted the altarpiece of *SS Laurence, Catherine and Prudence*, commissioned by the brother prelates Fernando and Pedro Pérez Calvillo for their sepulchral chapel, founded in 1376, in Tarazona Cathedral (Saragossa). The altarpiece was finished by 1403, when it was mentioned as a model in a contract that commissioned Juan de Levi to supply a retable for S Jaime, Montalbán (untraced). Other documents record that he executed works in Huesca, Saragossa and Teruel, but none of these survives. The altarpiece in Tarazona Cathedral, Juan's only surviving authenticated work, is one of the most beautiful examples of late 14th-century Aragonese art. It is painted in an expressive and elegant style, and shows great narrative ability. It indicates a development from an Italianizing Gothic style, of Sienese origin, towards a more international manner that incorporated elements derived from the work of north European masters.

BIBLIOGRAPHY
J. M. Sanz Artibucilla: 'Un retablo gótico en Tarazona (Aragón)', *Archv Esp. A.*, xvi (1943), pp. 223–38
——: 'Guillen y Juan de Levi, pintores de retablos', *Sefarad*, iv/1 (1944), pp. 73–98

M. C. LACARRA DUCAY

Juanes, Juan de. *See* MAÇIP, (2).

Juan Yüan. *See* RUAN YUAN.

Juarez [Xuarez]. Mexican family of painters. Luis Juarez (*b c.* 1585; *d* Mexico City, *c.* 1638) painted in the Mannerist style of the Spanish painters settled in Mexico, such as Baltasar de Echave Orio and Alonso Vázquez, although his figures are softer than those of his teachers. He began working in the first decade of the 17th century. His signed *St Teresa* (Guadalajara, Mus. Guadalajara) dates from that time and his *St Anthony of Padua* and the *Ascension* (both Querétaro, Mus. Reg.) from 1610. In 1611 he was commissioned to make the triumphal arch for the reception of the Viceroy of New Spain, Fray García Guerra. During the 1620s he painted the retables in the church of Jesús María, Mexico City, and in S Agustín, Puebla. The finest of his numerous religious works are the *Annunciation*, the *Agony in the Garden*, the *Visitation*, the *Archangel Michael* and *St Raphael* (all Mexico City, Pin. Virreinal); the *Mystic Marriage of St Catherine* and the *Virgin Bestowing the Chasuble on St Ildefonso* (both Mexico City, Mus. N. A.); and the *Education of the Virgin* and the *Ascension* (both Querétaro, Mus. Reg.).

Luis's son José Juarez (*b* Mexico City, 1619; *d* Mexico City, 1662) was influenced by the Spanish painters Francisco de Zurbarán and his pupil SEBASTIAN LÓPEZ DE ARTEAGA, who settled in New Spain in 1640. José's models were often drawn from the paintings of Rubens, popularized by engravings. Among his most important works are the *Holy Family* (Puebla, Mus. Colegio B.A.); *SS Justus and Pastor* and *Porciuncula* (both Mexico City, Pin. Virreinal); and the *Martyrdom of St Lawrence* (Mexico City, U. N. Autónoma, Escuela N. A. Plast.). José's daughter Antonia Juarez married the painter Antonio Rodríguez. The works of their two sons represent a transitional style between the 17th and 18th centuries and helped establish the supremacy of draughtsmanship following a period when the importance of colour had been made fashionable by Cristóbal de Villalpando and Juan Correa. Already a master painter in 1688, Nicolás Rodríguez Juarez (*b* Mexico City, 1667; *d* 1734) produced some of his most interesting works at the end of the 17th century. These include the *Prophet Isaiah* (Mexico City, La Profesa) and the portrait of the *Marqués de Santa Cruz as a Child* (Mexico City, Pin. Virreinal). In 1713 he painted the *Flight*

into Egypt (Colorado Springs, CO, F.A. Cent.) and *St Mary Magdalene* (Mexico City, Pin. Virreinal) as well as works for Mexico City Cathedral. His output was extensive, and his style was influenced by the work of his father, as was that of Juan Rodríguez Juarez (*b* Mexico City, 1675; *d* Mexico City, 1728). Juan's later paintings, however, executed in the early 18th century, are far more rigidly formulaic than the work of his early years. His paintings for Mexico City Cathedral include the *Assumption of the Virgin* and the *Adoration of the Magi* in the retable of the high altar.

BIBLIOGRAPHY

D. Angulo, E. Marco Dorta and J. Buschiazzo: *Historia del arte hispanoamericano* (Barcelona, 1945–56)

M. Toussaint: *Pintura colonial en México* (Mexico City, 1965)

F. de la Maza: 'La pintura colonial mexicana del siglo XVII', *Pintura mexicana, siglos XVI–XVII: Colecciones particulares* (Mexico City, 1966)

G. Kubler and M. S. Soria: *Art and Architecture in Spain and Portugal and their American Dominions, 1500–1800* (Harmondsworth, 1969)

X. Moyssen: 'Una interesante pintura de Luis Xuarez', *Bol. INAH*, xxx (1972)

G. Tovar de Teresa: *Pintura y escultura del renacimiento en México* (Mexico City, 1979)

J. R. Ruiz Gomar: *El pintor Luis Xuarez: Su vida y su obra* (Mexico City, 1987)

MARIA CONCEPCIÓN GARCÍA SÁIZ

Jubbadar, 'Aliquli. *See* 'ALIQULI JABBADAR.

Jubé. French term for a rood screen (*see* SCREEN (i), §3). It derives from the Latin phrase *Jube domine benedicere* ('Let us bless the Lord'), which is often spoken by Catholic priests before the lesson while standing in front of the screen.

Juchipila. *See* PEÑOL DE JUCHIPILA.

Judd, Donald (*b* Excelsior Springs, MO, 3 June 1928; *d* New York, 12 Feb 1994). American sculptor, painter and writer. He studied philosophy and art history at the Art Students League (1947–8; 1950–53) and Columbia University (1949–53; 1957–62), a training that encompassed art theory as well as painting and sculpture. His first works, which he later termed 'half-baked abstractions', were untitled paintings in which he sought to simplify composition and to eliminate the balancing of forms that he felt characterized post-war European art. From 1959 to 1965 he wrote art criticism for American journals such as *Arts Magazine*, championing fellow artists from New York such as Claes Oldenburg, Frank Stella, John Chamberlain and Dan Flavin. During this period he gave up painting in order to devote himself to sculpture, or rather to the object, making painted wooden structures such as *Light Cadmium Red Oil on Wood* (1963; Ottawa, N.G.) that he exhibited in 1963 at the Green Gallery, New York. In their matter-of-factness and simplicity these abstract works were a logical continuation of the Colour field painting practised by American artists such as Barnett Newman. By placing the objects directly on the ground rather than on a plinth or base, Judd further emphasized their self-sufficiency, as in *Untitled* (1963; Ottawa, N.G.).

Between 1964 and 1966 Judd perfected a formal vocabulary that was soon labelled MINIMALISM, which he subsequently developed in different materials. A favourite form was the box, either closed, semi-hollow or transparent, presented neutrally so as to refute any symbolic connotation. In some cases a number of boxes were attached to the wall in the form of a stack of alternating solids and voids of equal size, as in *Untitled* (1965; Stockholm, Mod. Mus.). Many of the works embodied seriality, either as a simple mathematical progression or as a repetition of a standard unit. In works such as *Anodized Aluminium and Brushed Aluminium* (1969; Eindhoven, Stedel. Van Abbemus.) Judd favoured metals such as painted steel, aluminium or galvanized iron as sculptural materials, sometimes in combination with another industrial material, perspex (as in *Untitled*, 1968; Toronto, A.G. Ont.; *see* ABSTRACT ART, fig. 3). Subsequently he used unpolished laminated wood and (for his outdoor sculptures) concrete. He had his works made in a factory in order to obtain a perfect finish without having to rework the material.

Judd belonged to a generation that ignored traditional craft skills in deference to an overriding system or idea. His theories were elaborated in an influential article, 'Specific Objects', in 1965. Judd began in the 1970s to work on a larger scale, gradually creating a type of open-air museum of his work surrounding his studio at Marfa, TX. In 1984 he also began applying the principles of his sculpture to a plain style of furniture.

WRITINGS

'Specific Objects', *A. Yb.*, 8 (1965), pp. 74–82

Complete Writings, 1959–1975 (Halifax, NS, 1975)

Donald Judd: Möbel/Furniture (Zurich, 1985)

Complete Writings, 1975–1986 (Eindhoven, 1987)

BIBLIOGRAPHY

Donald Judd (exh. cat. by W. C. Agee and D. Judd, New York, Whitney, 1968)

Donald Judd: Catalogue Raisonné of Paintings, Objects and Wood Blocks, 1960–1974 (exh. cat., ed. B. Smith, text R. Smith; Ottawa, N.G., 1975)

Donald Judd: Zeichnungen/Drawings, 1956–1976 (exh. cat. by D. Koepplin, Basle, Kstmus.; Halifax, NS, Coll. A. & Des.; 1976)

Donald Judd (exh. cat., intro. R. H. Fuchs and R. Crone; Eindhoven, Stedel. Van Abbemus., 1988)

Donald Judd: Prints and Works in Editions (exh. cat., ed. M. Josephus Jitta and J. Schellmann; The Hague, Gemeentemus., 1993–4) [intro. in Eng. and Ger.]

For further bibliography *see* MINIMALISM.

ALFRED PACQUEMENT

Judenburg, Hans von. *See* HANS VON JUDENBURG.

Judith of Flanders. *See* SALIAN, (3).

Juel, Jens (Jørgensen) (*b* Balslev, Fünen, 12 May 1745; *d* Copenhagen, 27 Dec 1802). Danish painter. Noted for his landscapes and portraits, he painted compositionally balanced works in a harmonious palette, continuing a classical painterly tradition. The son of a vicar at Gamborg on Funen, Juel went to Hamburg (then under Danish sovereignty), where he studied under the German artist Johann Michael Gehrmann (*d* 1770). In 1765 he briefly returned to Fünen and then to Copenhagen, where he studied at the Kunstakademi until 1771. While at the academy he came under the influence of Carl Gustaf Pilo, a professor there from 1748 and best known for his portraits of the Danish royal family. It was also at the academy that Juel perfected his considerable talent in drawing.

Several of Juel's finest portraits stem from his time at the academy, perhaps his greatest being a *Holstein Girl* (1766–7; Copenhagen, Stat. Mus. Kst), a hypnotic work reminiscent in its simplicity of compositions by Jean-Siméon Chardin. Particularly striking are the sphinx-like almond-shaped eyes and the delicately modelled face of the sitter. About two years later Juel was commissioned to paint his first royal portrait, *Caroline Mathilde* (1769; Copenhagen, Stat. Mus. Kst), wife of the Danish king Christian VII. As a result of these successes Juel was awarded the Great Gold Medal of the academy in 1771, making it possible for him to travel to Paris and Rome. Before leaving he painted one of his finest aristocratic portraits, *Christian Ditlev Reventlow and his Wife Charlotte Amalie, née von Holstein* (1772; Brahetrolleborg), a particularly harmonious composition that succeeds in capturing both the character of the sitters and the textures of their clothes. In Juel's portrait of *Ahron Jacobson* (1767; Copenhagen, Stat. Mus. Kst), the 50-year-old Jewish court seal-engraver (*c*. 1717–75) is portrayed with a powerful mixture of idealization and insight as a haughty and very private individual, staring at the viewer with an unashamed directness.

On 16 November 1772 Juel went abroad, spending the winter in Hamburg, where he undertook numerous commissions for portraits. He then went to Dresden, where Anton Graff, then professor at the Kunstakademi, exerted some influence on him. His masterly *Self-portrait* (1773–4; Copenhagen, Stat. Mus. Kst; see fig.) is his most important work of this sojourn and also shows the increasing influence of Dutch 17th-century painting. On 27 March 1774 Juel left Dresden for Rome. He not only enjoyed the

antique ruins of Rome and the stimulating intellectual company of the great Danish Neo-classical artist Nicolai Abildgaard, but was also given the valuable opportunity, not readily available in Denmark, to draw directly from the nude model. In the summer of 1776 he left for Paris, where he came into contact with the important Danish engraver J. F. Clemens, who became a life-long friend; Clemens sat for Juel in 1776 (Copenhagen, Stat. Mus. Kst) and engraved a number of his paintings. In the spring of 1777 Juel and Clemens went to Geneva, where they collaborated in illustrating the collected works of the great naturalist Charles Bonnet. Juel also produced a considerable number of portraits in Geneva, including one of *Goethe* (*c*. 1778–9; chalk copy, Vienna, Österreich. Nbib.).

In 1779 Juel returned to Denmark, arriving in Copenhagen in March 1780. In that year he was appointed court painter and in 1782 a member of the academy. In 1784 he was made professor and in 1790 he married. Juel was now at the height of his career. He was made a director of the academy twice (1795–7 and 1799–1801). Caspar David Friedrich and Philipp Otto Runge were students at the academy during this period, but neither came under Juel's influence, and none of his pupils became well known. Possessing little interest in teaching, he left those duties to his assistant Herman Koefoed (1743–1815). Juel preferred to devote his time to painting, and his greatest landscape was created at this time: the *Rydberg Family Portrait* (1796–7; Copenhagen, Stat. Mus. Kst). The family is depicted in the park of their country house, in the manner of Thomas Gainsborough, whose work he may have known through Clemens. The sitters are presented as an integral part of the natural order, a harmony emphasized by the subdued colours and carefully balanced composition. Juel was among the first Danish artists to paint pure landscapes based on studies from nature. A *Thunderstorm Brewing behind a Farmhouse in Zealand* (1790s; Copenhagen, Stat. Mus. Kst) is a particularly fine example of early Danish Romanticism. Such works exerted a considerable influence on the next generation of Danish artists, notably C. W. Eckersberg, who, though he never met Juel, was to marry his two daughters, Julie, and, after her death, Susanne.

BIBLIOGRAPHY

N. L. Høyen: *Katalogue over Kunstforeningens Juel-udstilling* [Catalogue of the Art Society exhibition on Juel] (Copenhagen, 1828)

H. Glarbo: 'Nogle undersøgelser om Jens Juels slaegt og barndomshjem' [An examination of Jens Juel's family and childhood home], *Kstmus. Aarsskr.*, xiii–xv (1926–8), pp. 207–16

E. Poulsen: 'Studier af Jens Juel til Holmskioldske familieportraet' [Studies by Jens Juel for the Holmskiold family portrait], *Kstmus. Aarsskr.*, xxiv (1937)

C. Elling: 'Jens Juels gennembrud' [Jens Juel's breakthrough], *Festskrift til Hugo Matthiessen Kulturminder* (Copenhagen, 1941)

E. Poulsen: *Jens Juel* (Copenhagen, 1961)

——: 'Jens Juel: Master Portrait Painter', *Connoisseur* (Feb 1962), pp. 70–75

Danish Painting: The Golden Age (exh. cat. by K. Monrad, London, N.G., 1984), pp. 74–85

E. Poulsen: *Jens Juel: Malerier og pasteller* [Jens Juel: paintings and pastels], 2 vols (Copenhagen, 1991) [cat. rais. with excellent illus]

O. Feldbaek, ed.: *Dansk Identitetshistorie*, 4 vols (Copenhagen, 1992)

H. J. Frederiksen and I.-L. Kostrup, ed.: *Ny Dansk Kunsthistorie*, 10 vols (Copenhagen, 1993)

NEIL KENT

Jens Juel: *Self-portrait*, oil on canvas, 565×445 mm, 1773–4 (Copenhagen, Statens Museum for Kunst)

Jugendgruppe. *See* SCHOLLE, DIE.

Jugendstil. *See under* ART NOUVEAU.

Jugoslavija. *See* YUGOSLAVIA.

Jujol (i Gibert), Josep M(aria) (*b* Tarragona, 16 Sept 1879; *d* Barcelona, 5 May 1949). Spanish Catalan architect, teacher and painter. He graduated from the Escuela de Arquitectura, Barcelona, in 1906 and in his earlier years was one of Antoni Gaudí's closest collaborators. Together they formed the studio of the Sagrada Familia, and Jujol's hand may also be seen in works designed by Gaudí in the first decade of the 20th century, such as the Casa Batlló (1904–6), the Casa Milà (1906–10; *see* GAUDÍ, ANTONI, fig. 1) and the Park Güell (1905–14), all in Barcelona, and the new choir for Palma Cathedral, Mallorca (1904–14). Following Gaudí's example Jujol combined structural and constructional invention in his work with a splendid sense of colour and a feeling for the combination of elements and the transmutation of forms. From his youthful decorations for the Manach Store (1911; destr.) in Barcelona to his alterations at the Torre Bofarull (1914–30) in Els Palleresos, Tarragona, he pioneered an architecture based on a 'collage' of diverse and sometimes unusual elements, in which the strength of the violently created associations contrasted with the ethereal fragility of his constructions. Churches were a central part of his work: examples include the church of Vistabella (1918–23), Tarragona, and the unfinished church of Montserrat (1926–9) in Montferri.

During the last years of his life, influenced by a general change in taste, Jujol moved closer to classical styles. Works in this vein, which yet retain his characteristic freedom and strength of composition, include the monumental fountain of the Plaça d'Espanya (1929), Barcelona, and his own house (1932) in Carrer Mossen Cinto Verdaguer, Sant Joan Despí. In addition to his work as an architect, Jujol was professor of drawing at the Escuela de Arquitectura, Barcelona, and produced a number of portraits, collages, watercolours and mixed-media drawings comparable to experimental works then being produced by leading avant-garde artists.

BIBLIOGRAPHY
Josep Maria Jujol (Barcelona, 1977)
C. Flores: *Gaudí y Jujol*, 2 vols (Madrid, 1981)

IGNASI DE SOLÀ-MORALES

Jukō. *See* MURATA SHUKŌ.

Jukun. Nigerian people and kingdom famous for figure sculpture, mask and masquerade, and cast bronze ornaments. Examples of Jukun art are held in various museums and private collections in Europe, North America and Nigeria; some of the masks and figure sculpture collected by Leo Frobenius in the early 1900s are in the Museum für Völkerkunde, Berlin.

1. INTRODUCTION. The Jukun, numbering some 30,000 people, are dispersed across a 56,000 sq. km area of the Middle Belt region of Nigeria, concentrated in village enclaves on both sides of the Benue River. Although the majority of Jukun live in Gongola and Bauchi States, some are settled in parts of Plateau and Benue States. Arnold Rubin has classified Jukun-speaking peoples into two groups whose arts are markedly different: those of

the north-east, living between the towns of Pindiga and Kona; and those of the south-west, living between Wukari, Donga and Takum. The north-eastern Jukun are bounded by the Tangale people to the east and the Wurkun and Mumuye to the south; the south-western Jukun are bounded by the Chamba to the east, the Kutep and Tiv to the south, the Afo and Alago to the west, and the Goemai to the north.

The institution of divine kingship is central to Jukun culture, as are cults, which provide points of access to the ancestors. Jukun chiefs serve as officiants of these cults, enlisting the aid of their predecessors in guaranteeing sufficient rain, agricultural fertility and the well-being of the people. The divine king of the town of Wukari is the titular head of all the Jukun. Some scholars (e.g. Meek and Palmer) considered the Jukun of Wukari to be descendants of the royal line of a major state, called Kororofa (Kwararafa), situated in the Middle Benue region and thought to have flourished between the 14th and 18th century. The association of the Jukun with Kororofa has been disputed by other scholars (e.g. Rubin), who have argued that there is no historical evidence for the rise and hegemony of a Jukun militaristic state.

2. SCULPTURE. The primary art form of the north-eastern Jukun comprises carved wooden figures, used to represent deceased chiefs, their wives and attendants. Jukun ancestral sculptures feature in contexts where the chief makes contact with his royal ancestors. They are appealed to during funerals, annual pre-planting ceremonies and post-harvest thanksgivings. Offerings may also be made to these figures at times of individual crisis and during drought, famine and epidemics. In some Jukun centres other figurative sculptures are used in activities associated with the Mam possession cult, concerned essentially with problems of human fertility.

According to Rubin, the figurative sculpture of the north-eastern Jukun generally conforms to a 'nuclear style', characterized by long, columnar torsos swelling at the shoulders; arms framing the torso and meeting in the front at hip-level; short, heavy legs with rudimentary feet; heads with a pronounced facial overhang and conical crest; eyes indicated by white, metal plugs; and earlobes generally perforated and distended (see fig.).

3. MASK AND MASQUERADE. Like their north-eastern relatives, the south-western Jukun also use cults as points of access to ancestral spirits. However, rather than figurative sculpture, masquerades are used. The pre-eminent masquerade is Aku Maga, 'Lord of the Stick', performed to mourn the death of members of the royal family or any other important person. The masks are always worn by men, who dance in groups consisting of a main male mask, Aku Wa'unu, and one or two female (Aku Wa'uwa) masks.

The male Aku Maga masker wears a wooden mask with an upper plate, slightly concave and elliptical in shape, either with one central lenticular opening or with additional triangular perforations surrounding it. This plate is joined to the lower portion of the mask, dominated by a large, projecting U-shaped mouth. Worn tipped down at an angle of approximately 30°, the mask is dominated by the plate and mouth, the most visible elements. At the back

Jukun figure, wood, h. *c.* 450 mm, Pindiga village, north-east Jukun, Nigeria; from a photograph by Arnold Rubin, 1965

end of the plate is a peg said to represent the lock of plaited hair once worn by all Jukun men.

The female Aku Maga crest mask is worn with a cloth costume and a hood covering the dancer's head and shoulders. The mask is made either of basketry or of carved wood, both versions being distinguished by a high, sagittal crest said to represent a type of woman's coiffure no longer worn. The basketry mask is made in the form of a coiled, inverted bowl with a high, vertical element sewn to its centre. Facial features of twisted raffia thread are sewn in place. The wooden masks consist of a helmet head with pierced eyes, a nose and a mouth, the surface of the face being heavily incised with linear ridges representing facial scarifications.

There is a second important Jukun cult, Akuma, in which masks appear. This cult is found predominantly around the towns of Donga and Takum. As with the Aku Maga masks, male and female pairs dance. The carved, wooden male mask takes four different forms, three of

which are horizontal and have features referring either to a bird, a bush cow or an elephant. The dancer's head fits into a central cap with a mouth projecting at the front and horns or ears projecting at the back. The fourth male mask has a flat, rectangular face with a prominently projecting nose and continuous brows, and two horns at the top. The female Akuma wears a black, netted, fibre shirt over the head and upper body and a cloth wrapper or large skirt of split palm leaves over the lower body. Fibre attachments are used to indicate eyes and breasts, and a large wig of black raffia is attached to the top of the dancer's head.

Some north-eastern Jukun communities, particularly in and around the town of Kona, dance yoke-masks at their agricultural festivals. This type of mask consists of a long neck and head attached to an upside-down U-shaped configuration worn over the face with a 'porthole' for vision. The mask head is in the style of the figure sculptures described above, with an overhanging face, metal eyes and prominent earlobes.

4. OTHER ARTS. Jukun chiefs use as symbols of leadership such cast bronze ornaments as gauntlets, bracelets and leggings with openwork surfaces and small, suspended clapperless bells. The chief of Wukari also keeps a 'sword of justice', whose cast-brass sheath is heavily ornamented with bells. Also at Wukari there is a special healing cult, maintained largely by the Abakwariga, the Jukunized and nominally Muslim Hausa living in the area. Called by the Jukun 'Jonkpa' (i.e. 'spirits', *ajon*, of the Abakwariga) and by the Abakwariga 'Aljanu' (i.e. 'spirits'), the cult is largely comprised of Abakwariga women. During Jonkpa ceremonies, priestesses carry axes that have a cast-brass human head at the end of an iron handle. The axe's long blade, *c.* 400 mm, issues from the mouth of the cast head. Similar axes have been found among the Tiv and Chamba neighbours of the Jukun. It is likely that the Abakwariga served as the main bronze casters in the region prior to the 19th century.

Special textiles are worn by senior men in the Wukari area on ceremonial occasions. The large rectangular cloths are wrapped around the body as a skirt and then tied in a bundle at the waist. Made of narrow strips of cotton cloth woven by men on horizontal looms and sewn edge to edge, they are distinguished by complicated surface patterning. A distinctive resist-dyed textile, traded as far east as the Cameroon grasslands, is also produced in Wukari. Plain-weave cotton strips are sewn edge to edge to form large cloths, which are then stitched with elaborate designs using strips of raffia fibre. The cloths are then dyed with indigo and the stitching removed to reveal the finely executed patterns. The Abakwariga are responsible for producing these and other ceremonial textiles worn by Jukun men. They also have distinctive cloth and fibre masquerades.

BIBLIOGRAPHY

C. K. Meek: *A Sudanese Kingdom: An Ethnographical Study of the Jukun-speaking Peoples of Nigeria*, intro. H. R. Palmer (London, 1931)
A. Rubin: *The Arts of the Jukun-speaking Peoples of Northern Nigeria* (diss., Bloomington, IN U., 1969)
——: 'Bronzes of the Middle Benue', *W. Afr. J. Achaeol.*, iii (1973), pp. 221–31

Interactions: The Art Styles of the Benue River Valley and East Nigeria (exh. cat., ed. R. Sieber and T. Vevers; West Lafayette, IN, Purdue U., 1974)

<div style="text-align: right">MARLA C. BERNS</div>

Juliá, Ascensió [el Pescadoret] (*b* Valencia, ?1767; *d* Madrid, *c.* 1830). Spanish painter and etcher. He was born in a fishing community, and his nickname, 'the little fisherman', was derived from his father's profession. He is documented as being in contact with Goya (*c.* 1798) in Madrid, where he is thought to have assisted the latter with the frescoes for S Antonio de la Florida (1798). Juliá copied Goya's works many times, and Goya painted Juliá's portrait (1798; Lugano, Col. Baron Thyssen-Bornemisza). Juliá executed engravings and painted some small format pictures similar to works by Goya, though more Romantic and lacking his psychological depth, for example *The Duel* (*c.* 1808–14; Madrid, priv. col.). A group of drawings (Madrid, priv. col.) reveal Juliá's ability to capture the atmosphere of everyday life in Madrid, much like Leonardo Alenza y Nieto. Juliá's best painting, *The Smuggler*, which he donated to the Museo de Bellas Artes in Valencia (*in situ*), reflects the combination of different genres that comprise his oeuvre. He executed several portraits and *c.* 1809 produced some engravings of military allegories, including one with the figure of Ferdinand VII.

BIBLIOGRAPHY

F. Boix: 'Un discípulo e imitador de Goya: Ascensió Juliá (El Pescadoret)', *A. Esp.*, x (1930–31), pp. 138–41

J. A. Gaya Nuño: *Arte del siglo XIX*, A. Hisp., xix (Madrid, 1966), p. 101

<div style="text-align: right">JUAN J. LUNA</div>

Juliá, Eusebio (*b* Spain, March 1826). Spanish photographer. He trained in the family traditions of fine arts and music, but he gave these up for photography. He did, however, make photographic reproductions of paintings and portraits of numerous artists. Juliá was renowned in Spain for his commercialization of portrait cartes-de-visite in the second half of the 19th century. He is known almost exclusively for maintaining the most complete and organized gallery of important personages of his time, including politicians, actors and writers. The iconography of Spain's 19th-century figures depends to a great extent on Juliá's work, which complemented the more luxurious photographs made by his contemporaries. At his studio in Madrid he marketed a complete range of photographic paraphernalia; he also wrote several almanacs containing curious data.

BIBLIOGRAPHY

Photography in Spain in the Nineteenth Century (exh. cat. by L. Fontanella, Dallas, TX, Delahunty & Fraenkel Gals, 1984)

<div style="text-align: right">LEE FONTANELLA</div>

Julien. French family of artists. Three members of the Julien family from Toulon became artists. The two most notable, (1) Simon Julien and his brother (2) Laurent Julien, were both painters, and the former was also an engraver. Joseph-Laurent Julien (*d* Toulon, 1805), nephew of both Simon and Laurent and active from the 1790s, was a draughtsman and engraver who made several prints after such works of Simon's as the *Rose Defended* and *Tithonus and Aurora*. He also engraved his own compositions, several of them allegories relating to the upheaval of the French Revolution (e.g. *Love of Glory: To the French Soldiers*, 1791).

(1) Simon Julien (*b* Toulon, 28 Oct 1735; *d* Paris, 23 or 24 Feb 1800). Painter and engraver. He was the most ambitious member of the family. He studied under Michel-François Dandré-Bardon in Marseille and later with Carle Vanloo in Paris. In 1760 he won the prestigious Prix de Rome with a very accomplished painting, the *Sacrifice of Manoah, Father of Samson* (Le Mans, Mus. Tessé), a subject treated earlier by Eustache Le Sueur (*c.* 1648–50; Toulouse, Mus. Augustins) and Charles Le Brun. The clarity of colour in this work recalls that of Le Sueur. After three years of study (1763–6) at the Ecole Royale des Elèves Protégés in Paris, Simon went to Rome, where he remained until 1771. There he was influenced by the style of Charles-Joseph Natoire, Director of the Académie de France, whose preference for attenuated gestures is apparent in Simon's *Rose Defended*. At the age of 48 he exhibited the *Triumph of Aurelian* (Toulon, Mus. Toulon), his *morceau d'agrément* for the Académie Royale de Peinture et de Sculpture, at the Salon of 1783, where it received generally favourable criticism. In their assessment critics noted the harmony, freshness and firmness of line in the painting, although the work was eclipsed at the Salon by that of the younger Jacques-Louis David, who was received (*reçu*) as a full Academician that year with *Andromache Mourning Hector* (1783; Paris, Ecole N. Sup. B.-A., on dep. Paris, Louvre). At the Salons of 1785 and 1787 Simon exhibited several paintings and drawings depicting historical and mythological subjects, none of which received special notice. According to Emile Bellier de La Chavignerie, Simon attempted to become an Academician in 1789 with the presentation of *Tithonus and Aurora* (Caen, Mus. B.-A.), a drawing (ex-Gal. Petit, Paris, 1913) for which he had exhibited at the Salon of 1783. However, he was not elected as a full member of the Académie. Both the subject—Aurora abandoning her immortal, but aged, lover—and the style of the painting must have seemed dated in the light of the more severe Neo-classicism that was then gaining favour in France. *Tithonus and Aurora* was exhibited posthumously at the Salon of 1800, together with several of Simon's drawings. As well as being a painter, he is known to have produced several engravings, depicting *Moses on Mt Sinai*, the *Holy Family* and *Diana and Zephyr*. A drawing related to the last is in the Cabinet des Dessins of the Musée du Louvre, Paris. Simon Julien is often confused with his contemporary Jean-Antoine Julien, known as Julien de Parme.

(2) Laurent Julien (*b* Toulon, 27 June 1740; *d* Toulon, 9 Oct 1820). Painter and teacher, brother of (1) Simon Julien. Except for a visit to Rome in 1764, where he made a small copy of Raphael's *Transfiguration* (1517; Rome, Pin. Vaticana), he seems to have remained in the area of Toulon for most of his life. In 1765 he executed a large painting of *St Carlo Borromeo with Angels* for Toulon Cathedral (*in situ*), but no other works by him are known, except for a *Self-portrait* (Nice, Mus. B.-A.). From 1778 he was a drawing instructor at various schools in the region of Toulon.

BIBLIOGRAPHY

Bellier de La Chavignerie-Auvray; Thieme-Becker

C. Ginoux: 'Peintres et sculpteurs nés à Toulon', *Archvs A. Fr.*, 3rd ser., iv (1888), pp. 145–82

——: 'Origine du Musée Municipal de Toulon', *Réun. Soc. B.-A. Dépt.*, xxiii (1899), pp. 548–58

G. Ménégoz: *Catalogue des tableaux, sculptures. . .du Musée de Caen* (Caen, 1913), p. 52

The Age of Louis XV: French Painting, 1710–1774 (exh. cat. by P. Rosenberg, Toledo, OH, Mus. A.; Chicago, IL, A. Inst.; Ottawa, N.G.; 1975–6), p. 47

MARGARET FIELDS DENTON

Julien, Jean-Antoine [Julien de Parme] (*b* Cavigliano, nr Locarno, 23 April 1736; *d* Paris, 28 July 1799). Swiss painter, active in France and Italy. The son of a mason, Julien received his initial training in Craveggia under a local artist, Giuseppe Borgnis, with whom he spent two years. Julien's earliest works were apparently religious subjects—a *Crucifixion* scene and *St Rose* (both untraced). On leaving Borgnis in 1747, he made his way north into France, sometimes begging and sometimes earning his living as a portrait painter, establishing a way of life he was to follow for the next 13 years. He passed through many provincial French towns, staying six months with a painter named Dubois at Bourges, and stopping again for a time at Châteauroux. He arrived in Paris in July 1756. Despite meetings with the painter Carle Vanloo and the sculptor René-Michel Slodtz, he was unable to find sufficient work to support himself. He left in September for Meaux, where he spent eight months painting portraits, before deciding to go to Italy in order to devote himself more fully to his profession and to expand his skills. On his way south he passed through Autun, Lyon (where he spent the winter of 1758), Marseille and Nice, eventually reaching Genoa in late November 1759. There he received commissions from an ecclesiastic named Corsetti for pictures (untraced) of *Mutius Scaevola* and *Our Lady of Mercy*. At Genoa he also painted his last portraits, having recognized that the Italian preference was for history painting. After some months in Genoa he left for Rome, which he reached in November 1760.

In Rome Julien threw himself into a study of the Antique. He quickly proclaimed his scorn for such contemporaries or immediate predecessors as Bernini and Maratti in Italy and François Lemoyne in France, though he was full of praise for Raphael, Polidoro da Caravaggio, the Carracci and Domenichino. Indeed, Domenichino's work was to exert a very strong influence on him. Despite his lack of formal artistic training, it was not long before his zeal and idealism brought him to the attention of Louis-Auguste Le Tonnelier, Baron de Breteuil (1730–1807), and Guillaume Du Tillot, prime minister of the Duchy of Parma, who was looking for a court painter. Du Tillot offered Julien a pension in return for an annual picture. This allowed Julien time for study, and on this basis he produced works regularly between 1762 and 1771.

The first of these paintings, Julien's earliest known extant picture, a life-size painting of *Cupid* (1762; Parma, Barbieri priv. col.), exemplifies the main features of his style. It is inspired by Classical sculpture, and the effect of the careful composition is heightened by the subordination of colour to line. Several of the other works commissioned by Du Tillot, signed and dated as was Julien's custom, are in the Pitti Palace, Florence: *Thetis Bringing Achilles New Armour* (1766), the *Quarrel between Apollo and Pan* (1767), the *Marriage of Alexander and Roxanna* (1768), *Ulysses and Nausicaa* (1769) and *Aeneas and Astyanax in the Forest of Carthage* (1770). All represent scenes from Classical mythology or ancient history and illustrate Julien's personal preoccupations with form, composition and subject-matter. The implicit sophistication of his aims and ideals is, however, oddly at variance with the untutored and stylized nature of these paintings.

Julien travelled to Venice in 1771 but was unimpressed by what he saw there, preferring instead the work of Giulio Romano at the Palazzo del Te in Mantua, through which he passed on his return to Rome. Although in 1773 he adopted the name of Parma, he never visited that city. In May 1773 he left Italy for Paris. He did not enter the

Jean-Antoine Julien: *Aurora and Cephalus*, oil on canvas, 2.49×1.28 m, 1779 (Madrid, Museo del Prado)

Académie Royale but enjoyed the protection of Du Tillot, who had fallen from power in 1771. After Du Tillot's death in 1775 Julien found another patron, Louis-Jules-Barbon Mancini-Mazarini, Duc de Nivernais (1716–98), for whom he was to work for the next 20 years. Four pictures from this period survive in the Prado, Madrid. Julien's *Diana and Endymion* (1779) is a charming work, directly inspired by Domenichino's frescoes at Bassano di Sutri (Bassano Romano, Pal. Odescalchi). The *Rape of Ganymede* (1778), however, is unimaginative and over-stylized, while the weakness of the perspective and the central pair of figures in *Hector and Andromache* exposes the artist's compositional shortcomings. By contrast, *Aurora and Cephalus* (1779; see fig.) is a considerable achievement, having a well-painted natural landscape, two excellently posed classical figures and a pair of Baroque putti integrated within one upward spiral movement. In 1795 Nivernais died, leaving the artist alone and prey to his depressive and melancholy character.

Julien's 'Mémoire' was supplemented in 1984 by the publication of 50 letters he wrote to the Flemish painter and dealer Andries Cornelis Lens. Covering the years 1768–81, they offer personal insights into the contemporary art world and detail Julien's own artistic preferences and his relations with contemporaries. Of particular interest in this context are his friendship with Robert Ango, his admiration for Esprit-Antoine Gibelin and his lukewarm and suspicious attitude to the champion of 18th-century Neo-classicism, Joseph-Marie Vien.

WRITINGS

'Mémoire', *Précis historique des productions des arts, peinture, architecture et gravure*, ed. C. Landon (Paris, 1801), i, pp. 113–48

BIBLIOGRAPHY

J. J. Lima Fernandez: 'Cuatro lienzos de Julien de Parme en Madrid', *Archv Esp. A.* (1972), pp. 149–59

E. Riccomini: *I fasti, i lumi, le grazie: Pittori del settecento parmense* (Bologna, 1977)

L'arte a Parma dai Farnesi ai Borboni (exh. cat., ed. E. Riccomini; Parma, G.N., 1979), pp. 154–6

P. Rosenberg: 'Une Correspondance de Julien de Parme (1736–1799)', *Archv A. Fr.*, xxvi (1984), pp. 197–245

JOSHUA DRAPKIN

Julien, Pierre (*b* Saint-Paulien, Haute-Loire, 20 June 1731; *d* Paris, 17 Dec 1804). French sculptor. He studied in Le Puy with the minor sculptor Gabriel Samuel (1689–1758) and in Lyon with Antoine-Michel Perrache (1726–79), who in 1758 recommended him to Guillaume Coustou (ii) in Paris. In 1765 Julien won the Prix de Rome with the relief *Albinus Helping the Vestals to Flee the Gauls* (untraced). After three years at the Ecole Royale des Elèves Protégés he went to the Académie de France in Rome (1768–72). Among his works from this time is a reduced copy (marble; Versailles, Château) of the antique statue *Ariadne Abandoned*, then known as *Cleopatra*. In 1773 he returned to Coustou's studio and in 1776 suffered a humiliating check to his career when, on submission of his statue of *Ganymede* (marble; Paris, Louvre), he was refused admission to the Académie Royale (possibly at the instigation of his master). In 1779, however, he became a member of the Académie with the marble statue the *Dying Gladiator* (Paris, Louvre). He subsequently enjoyed a successful career, both working for private clients and receiving public commissions from the Bâtiments du Roi. The most important of his official sculptures were the two life-size, seated marble statues commissioned by the Comte d'Angiviller, director of the Bâtiments du Roi, for the series of 'Illustrious Frenchmen'. Reflecting contemporary critical pleas for historical accuracy, his well-received statue of *La Fontaine* (1783–5; Paris, Louvre) was represented in 17th-century costume, while that of *Poussin* (1789–1804; Paris, Louvre) cleverly depicted the painter in his night-clothes, permitting Julien to carve simplified monumental drapery that might pass for a Classical toga. Like most of his contemporaries Julien eclectically adopted Baroque, Rococo and Neo-classical styles as alternative modes of expression. His terracotta statuette of *Silent Cupid* (exh. Salon 1785; New York, Met.) is fully Rococo in conception, while his most famous work, the group of a *Girl Tending a Goat* or *Amalthea* (marble, 1786–7; Paris, Louvre), executed for Marie-Antoinette's dairy at Rambouillet, modifies a typically Rococo conceit by using a model derived from the antique Capitoline *Venus*. Julien continued to exhibit at the Salons after the French Revolution and *c.* 1800 modelled a terracotta bust of Napoleon (untraced). He was made a member of the Légion d'honneur in the year of his death.

BIBLIOGRAPHY

A. Pascal: *Pierre Julien sculpteur: Sa vie et son oeuvre, 1731–1804* (Paris, 1904)

M. Gagne: 'Une Esquisse de Julien', *Bull. Mus. France*, i (1929), p. 260

M. Benisovich: 'Pierre Julien at Rambouillet', *Burl. Mag.*, lxxix (1941), pp. 43–4

——: 'A Sculpture by Pierre Julien in the United States', *A. Q.* [Detroit], xii (1949), pp. 370–72

F. H. Dowley: 'D'Angiviller's "Grands Hommes" and the Significant Moment', *A. Bull.*, xxxix (1957), pp. 259–77

P. Guth: 'La Laiterie de Rambouillet', *Conn. A.*, 75 (1958), pp. 74–81

W. G. Kalnein and M. Levey: *Art and Architecture of the 18th Century in France*, Pelican Hist. A. (Harmondsworth, 1972)

J. D. Draper: 'New Terracottas by Boizot and Julien', *Bull. Met. Mus. A.*, xii (1977), pp. 141–9

M. P. Worley: 'Catalogue of the Works of Pierre Julien', *Gaz. B.-A.*, n.s. 6, cxii (1988), pp. 185–204

MICHAEL PRESTON WORLEY

Julio Antonio (Rodríguez Hernández) (*b* Mora d'Ebre, 6 Feb 1899; *d* Madrid, 15 Feb 1919). Spanish sculptor. He trained in Tarragona, Barcelona and Madrid (1907), where he was assistant to the Spanish Catalan sculptor Miquel Blay (1866–1936). He became the friend of distinguished writers of the Generación del 98, including Ramon del Valle-Inclán and the Baroja brothers, Pio and Ricardo, and travelled to Italy (1909). Attracted by the spirit of Castile, he sculpted his famous series *Busts of the Race* (examples in Tarragona, Mus. A. Mod.), which synthesized the character of the people from this part of Spain. However, *Mediterranean Venus* (1912; Tarragona, Mus. A. Mod.) indicates that he was also sensitive to Catalan *Noucentisme*. In 1911 he built the monument to the *Heroes of the Siege of Tarragona in 1811* in the Rambla Nova, Tarragona. A large number of his works are housed in the city's Museu d'Art Modern.

BIBLIOGRAPHY

Julio Antonio (exh. cat., text by S. Torroella; Madrid, Dir. Gen. B.A., 1969)

F. Xavier Ricomà: *Julio Antonio* (Tarragona, 1983)

J. M. Infiesta: *Julio Antonio* (Barcelona, 1988)

Julio Antonio y su tiempo (exh. cat., ed. J. de Avalos; Madrid, Real Acad. S
Fernando, 1989)

FRANCESC FONTBONA DE VALLESCAR

Julius II, Pope. *See* ROVERE DELLA (i), (2).

Julius III, Pope. *See* MONTE, DEL (1).

Julius style. Term for a style of German architecture in
which Gothic-style details are imposed on Renaissance
buildings. The name derives from Julius Echter von
Mespelbrunn (1545–1617), Bishop of Würzburg, who, in
his efforts on behalf of the Counter-Reformation, devel-
oped a taste for the earlier architecture of the faith.
Examples of the style include the small rose window
(1586–91) of the tower of the church of Würzburg
University. It persisted into the later 17th century.

Jullienne, Jean de (*b* Paris, 29 Nov 1686; *d* Paris, 20
March 1766). French textile manufacturer, collector and
amateur engraver. He was the nephew of François de
Jullienne, a cloth merchant, and of Jean Glucq, a celebrated
dyer for the Gobelins factory in Paris, and in 1721 he
merged their successful businesses. As a young man he
studied drawing with Jean-François de Troy, and engraving
with François Boucher and Girard Audran, and he was
friendly with François Lemoyne and with Antoine Wat-
teau, whose *Portrait of a Gentleman* (Paris, Louvre) has
been said to be of Jullienne. Shortly before his death
Watteau presented Jullienne with a large number of his
drawings; Jullienne eventually owned more than 500 of
Watteau's drawings. In 1726 he published *Figures de
différents caractères de paysages et d'études, dessinés d'après
nature par Antoine Watteau*, a volume of engravings by
major artists after all the drawings by Watteau then known
(Jullienne himself provided 12 plates). In 1736 Jullienne
was ennobled and created a Chevalier of the Order of St
Michel; in that same year he published four volumes of
the *Oeuvre gravé de Watteau*. On presenting them to the
Académie Royale in 1739 he was made an honorary
member.

In addition to direct acquisitions from contemporary
artists, Jullienne purchased works from the sales of Crozat,
Antoine de La Roque, Jeanne-Baptiste d'Albert de Luynes,
Comtesse de Verrue, and others; he housed his collection
in a gallery in his garden. After his death the collection
was dispersed in a public sale (Paris, Louvre, 30 March–
22 May 1767); comprising close to 1700 items, it included
paintings, the most important of which were Dutch and
Flemish. Among them were 13 paintings by Rembrandt,
Watteau's *Mezzetin* and Titian's *Virgin and Child* (both
New York, Met.) and Philips Wouwerman's *Stag Hunt*
(Paris, Louvre). There were also drawings, prints (among
them 203 prints by Dürer and 250 by Rembrandt),
sculpture, armour, oriental porcelain and lacquer, as well
as furniture, especially pieces by Boulle. The manuscript
catalogue of the sale may be seen at the Pierpont Morgan
Library, New York.

UNPUBLISHED SOURCES

Chevalier de Seré: *Poème sur la galerie de Monsieur de Jullienne, chevalier de
l'ordre du roi, amateur honoraire de l'Académie royale de peinture* [MS,
Paris, Bib. A. & Archéol.]

WRITINGS

Abrégé de la vie de Watteau, included in *Figures de différents caractères de
paysages et d'études, dessinés d'après nature par Antoine Watteau* (Paris,
1726)

BIBLIOGRAPHY

*Catalogue raisonné des tableaux, dessins, estampes et autres effets curieux après
le décès de M. de Jullienne* (sale cat. by P. Remy and C. F. Julliot, Paris,
Louvre, 30 March–22 May 1767)
L. C. de Ris: *Les Amateurs d'autrefois* (Paris, 1877), pp. 286–314
E. Dacier, J. Vauflart and A. Hérold: *Jean de Jullienne et les graveurs de
Watteau au XVIIIe siècle*, 4 vols (Paris, 1921–9)
P. G.: 'Catalogue des tableaux de Mr de Jullienne', *Conn. A.*, l (1956),
pp. 65–9
C. Bille: *De tempel der kunst of het kabinet van den heer Braamcamp*
(Amsterdam, 1961), pp. 1124–30, 1132
M. Hébert and Y. Sjöberg: *Inventaire du fonds français: Gravures au XVIIIe
siècle*, Paris, Bib. N., Cab. Est., xii (Paris, 1973), pp. 235–7
M. Roland Michel: 'Watteau et les *Figures de différents caractères*', *Antoine
Watteau (1684–1721), le peintre, son temps et sa légende*, ed. F. Moreau
and M. Morgan Grasselli (Paris and Geneva, 1987), pp. 117–27

Julliot, Claude-François (*b* 1727; *d* Paris, 1794). French
marchand-mercier, collector and dealer. With his father,
Claude-Antoine Julliot, and his son, Philippe-François
Julliot, he formed one of the most eminent dynasties of
18th-century *marchands-merciers*. He was an exceptionally
knowledgeable expert, a fine connoisseur and editor of
many auction catalogues. He was established under the
sign of the 'Curieux des Indes' from 1752 to 1776, and his
clientele included many eminent European connoisseurs
and collectors. He reintroduced the use of *pietra dura*
panels on furniture and was fond of commissioning lavish
mounts for porcelain plaques. He played a central role in
re-establishing the popularity of furniture by André-
Charles Boulle, and most of it that sold during the third
quarter of the 18th century passed through Julliot's hands.
He organized its restoration and entrusted the furniture
to fine contemporary cabinetmakers who specialized in
this field such as Etienne Levasseur and Philippe-Claude
Montigny (1734–1800). Beyond his role as a restorer,
which ensured the preservation of many masterpieces (and
probably also some fakes), Julliot should be considered
one of the instigators of the Boulle Revival. He was drawn
to the Neo-classical style and designed furniture that, while
inspired by Boulle's work, seems entirely fresh and original.

BIBLIOGRAPHY

P. Lemonnier: 'Les Julliot', *L'Estampille*, ccxxix (1989), pp. 38–47

JEAN-DOMINIQUE AUGARDE, JEAN NÉRÉE RONFORT

Jumièges Abbey. Former Benedictine monastery in Nor-
mandy, France.

1. HISTORY. Founded in 654 by Saint Philibert, Ju-
mièges Abbey was ruined in the Norman invasions from
841. In 942 William I, Duke of Normandy, brought 12
monks from Poitiers to refound it. The church of St Pierre
was rebuilt towards the end of the 10th century. At the
beginning of the 11th century William of Volpiano, Abbot
of St Bénigne, Dijon, was called to Normandy by Duke
Richard II to reform the monasteries of the duchy. His
disciple Thierry, Abbot of Jumièges, envisaged the recon-
struction of the great Carolingian abbey church of Notre-
Dame and probably began the work but died (1027) before
he was able to finish the project. Notre-Dame was built

between 1040 and 1067 under abbots Robert Champart (*d* 1052), Geoffroy and Robert III and was consecrated by Maurille, Archbishop of Rouen, in the presence of William the Conqueror. The Romanesque chapter house, with one straight rib-vaulted bay terminating in an apse, was built *c.* 1110 and vaulted *c.* 1130. During the second half of the 13th century, the choir of Notre-Dame was rebuilt and then that of St Pierre. In 1511 Antoine du Bec Crespin had a dormitory constructed to the south of St Pierre. The Maurist reform intervened in 1617. During the second half of the 17th century François II de Harlay built the abbot's lodgings and the library. A large dormitory parallel to St Pierre was built in the 18th century. After the dispersal of the community (1791), the abbey, sold as property of the State, was used until 1824 as a stone quarry and ruined. It was restored from 1852 by the Lepel Cointet family and has been classified as a historic monument.

2. ST PIERRE. The construction of St Pierre can be assigned to the end of the 10th century. The choir was complete in 993, when Ensulbert, Abbot of Saint-Wandrille, was buried there. It is situated to the south of the choir of Notre-Dame. Of this church there survive the westwork (a porch surmounted by a tribune gallery between two narrow towers) and the first two north bays of the nave. The nave (w. 8.5 m), with unarticulated walls, consists of arcades with plain arches springing from rectangular piers with imposts; above is a row of blind oculi (no doubt originally decorated with painting or inlay), then a narrow circulation gallery returning into the western tribune and open to the nave through paired arches. The appearance of the upper stage, rebuilt in the 14th century, is unknown, but it is logical to assume clerestory windows (reconstructions of Liess and Taralon, as against Lanfry). The arrangement of the westwork follows Carolingian and Ottonian tradition. The circulating gallery can be compared with that of Mettlach (Saar, *c.* 993). Jumièges Abbey is the first known example in Normandy of a wall passage, a form that was to have an important future (e.g. Bernay Abbey, Notre-Dame at Jumièges and St Etienne at Caen).

The later Gothic campaigns included: the rebuilding of the south side of the nave *c.* 1230; the choir, terminating in a three-sided apse, from 1260; and *c.* 1330 the north nave bays in two storeys, with pointed arcade arches, and the top of the north wall. A gable formed a diaphragm arch between choir and nave, and a bell-tower rose to the south of the first choir bay.

3. NOTRE-DAME. The church consisted of a westwork, an aisled nave of four double bays, a choir, a lantern tower and a projecting transept, all partly ruined (see fig. 1). It was built of limestone from Caumont and Vernon, and the Romanesque church is 81 m long. The Romanesque chevet, excavated by Lanfry, had an ambulatory plan like other buildings in Normandy, such as Mont-Saint-Michel, the cathedrals of Rouen and Avranches (destr.) and the Romanesque abbey church of St Wandrille built in the first half of the 11th century; but at Jumièges it appears to have had no radiating chapels. The westwork, with a projecting porch on the façade between two towers with octagonal belfries and surmounted by a tribune opening on to the nave, belonged, like that of St Pierre, to the

1. Jumièges Abbey, Notre-Dame, view from the choir, 1040–67

Carolingian and Ottonian tradition. The wall passages of the lower level recall those of St Lucius at Werden. Irregularities in the junction between the tribune and the tower stairs and a divergence of levels with those of the nave suggest both a change of plan in the course of construction and the at least partial chronological precedence of this block over the central vessel: the plan and part of the westwork were undoubtedly established very early, either in the time of Thierry or during construction of the choir and transepts (1040–52). Then after the two easternmost bays of the nave were constructed, the central vessel was built from west to east in horizontal sections.

The diminishing articulation of the nave elevation (arcades, galleries of moderate height opening on to the nave in triple arcades under a relieving arch, clerestory windows) and the wall structure without clerestory passage are opposite to the design of St Etienne at Caen. The alternation of supports (a column alternating with a compound pier with an attached shaft running up the entire height of the nave), found *c.* 1050 at Norrey-en-Auge and Westminster Abbey and adopted in a different form at St Etienne at Caen, perhaps corresponded to diaphragm arches at every second bay (as at St Vigor at Bayeux). The wall articulation is innovative compared with the earlier examples of Bernay and Coutances. The nave was not vaulted but wooden-roofed, like other great Norman churches of the 11th century. Aisles and galleries were groin-vaulted. The design of the nave was comparable to that of the Romanesque church of Westminster Abbey (finished in 1066). It is probable that close contacts existed between the two workshops.

The Romanesque transept, formerly with a gallery running across the end of each arm (like Bayeux Cathedral in the 11th century), has on the west wall one of the first examples of a passage in the thickness of the wall. This passage, slightly later than the one at Bernay, is an important stage in the development of THICK-WALL STRUCTURE. Of the Romanesque choir there is evidence of the plan (two bays encircled by an ambulatory) and the form of the supports (piers with double columns on a high base, the arrangement that existed at Mont-Saint-Michel). Notre-Dame at Jumièges is a good illustration of Norman architecture of the second third of the 11th century (popularity of the ambulatory plan, tradition of a westwork tribune in the porch and transept, thin wall in the central vessel, first attempts at a thick-wall structure in the transept). The pier alternation and diminishing elevation would be found again in the 12th-century nave of Durham Cathedral.

Capitals (c. 1040–50) survive from the choir, transepts and western tribune (in situ and in the museum; see fig. 2). Their form, connected with a style of manuscript illumination (e.g. Cambridge, Trinity Coll., MS. B.10.4), suggests links with Anglo-Saxon art, perhaps through the agency of Robert Champart.

The rebuilding of the choir and the first Gothic campaign on the transept took place from c. 1254 to c. 1278, with the completion of transepts in the first quarter of the 14th century, but they collapsed in 1819. The ambulatory had seven radiating chapels, the outer wall of which formed a continuous line as at Lonlay (Orne), with a more extended axial chapel. The transept had galleries, adapting the Romanesque arrangement. The choir elevation was very tall and slender, with pointed arcade arches springing from high columns with foliate capitals and on the second storey large clerestory windows and a wall passage (see lithograph after drawing by H. Vernet, 1820, in Taralon, 1955, p. 24; 1979, p. 39).
See also CAEN, §1(i).

2. Jumièges Abbey, Notre-Dame, capital, c. 1040–50 (Jumièges, Musée de l'Abbaye)

BIBLIOGRAPHY

G. Lanfry: L'Abbaye de Jumièges: Plans et documents (Rouen, 1954)
Jumièges, congrès scientifique du 13e centenaire: Rouen, 1954, 2 vols
J. Taralon: Jumièges (Paris, 1955, rev. 1979)
R. Liess: Der frühromanische Kirchenbau des 11. Jahrhunderts in der Normandie (Munich, 1967)
J. Vallery-Radot: 'Le Deuxième Colloque international de la Société française d'Archéologie (1966)', Bull. Mnmt., cxxvii (1969) [with important bibliog.]
M. Baylé: 'La Sculpture du XIe siècle à Jumièges', Aspects du monachisme en Normandie (IVe–XVIIIe siècles), ed. L. Musset (Paris, 1982), pp. 74–90
——: Les Origines de la sculpture romane en Normandie, Art de Basse-Normandie, c (Caen, 1992)

MAYLIS BAYLÉ

Ju Ming. See CHU MING.

Jumsai, Sumet (b Bangkok, 30 March 1939). Thai architect, theoretician and writer. He studied at the University of Cambridge (MA and DipArch, 1963), receiving a number of student awards including the Brancusi Travelling Fund, Breezewood Foundation Scholarship and John D. Rockefeller Fund scholarship. He also received a PhD in architectural studies from Cambridge in 1967. From 1965 to 1969 he worked as an architect for the Thailand Department of Town and Country Planning in Bangkok, and in 1969 he went into private practice there. One of the most intellectual architects in South-east Asia, Jumsai was influenced by Le Corbusier, Colin Rowe and Buckminster Fuller, and he applied contemporary European forms and technical innovations to buildings designed within the Thai context. Between 1969 and 1982, when this modernist expression was prevalent, his office, SJA 3D Co. Ltd, was responsible for over one hundred design and planning projects ranging from residences to office buildings, industrial plants and economic feasibility studies. During this period 62 factories were designed and built, the largest being the Nissan Car Assembly Plant (1977) of c. 24,000 sq. m along the Bangna-Triad Highway, Greater Bangkok. He also undertook large-scale planning projects such as Nava Nakorn Satellite Town near Bangkok for 100,000 people (from 1975). His best-known work from the period is probably the angular Science Museum (1977; with Tri Devakul and Kwanchai Laksanakorn), Bangkok, a technologically conceived design with a dramatic sloping entrance.

In the 1980s Jumsai produced a number of highly visible projects including the Energy Technology Building (1981) at the Asian Institute of Technology (AIT) campus in Bangkok; Thai Oil Refinery Company flats at Siracha (1983); and a seaside complex of flats at Bang Saray (1983). Among his most controversial buildings is the Bank of Asia (1986), Bangkok, in the shape of a traditional toy robot, complete with nuts, bolts and eyes, c. 20 storeys tall. This reflects his theory that a way forward to an architecture of the 21st century, when cultural boundaries will be diminished, is to extend the concepts of High Tech and to develop an amalgamation between humanity and the machine. This is represented by 'robot architecture' where the machine is humanized by people. In the Nation Building (1991) in Bangkok, he refined this approach to create an even more interesting and equally controversial structure.

During this period he also became more concerned with the vernacular context of his work. His later buildings are also his most significant and reflect what he described as 'gradually unlearning what I have learned in architecture' to take into account the traditions of South-east Asian water-borne architecture. In the New Campus for Thammasat University, Rangsit, SJA designed five buildings (completed 1986): the Central Administrative Building, Library, Academic Research & Training Centre, lecture halls and an audio-visual centre. The complex, consisting of low-rise one- and two-storey structures, is given a traditional look by prominent tiled roofs and floors raised on stilts above ground or water. Although unfortunately badly maintained, it is one of his most sensitive works. Other interesting works are the 30 m diameter US Geodesic Dome Pavilion (1988) and the International School (1992), both in Bangkok. Junsai was also involved in a number of larger building and planning projects, including the Sukhumvit Centre (1992) in Bangkok, which includes a 420-room hotel, a department store and parking for some 670 cars.

Jumsai taught at several universities in Thailand and Singapore and at Cambridge; he also served on several committees on historic conservation, environmental and urban development policies. His office received most of the Royal Gold Medal awards for architecture instituted in 1982 by the Association of Siamese Architects, and his works were exhibited at the Triennale of World Architecture (1985) in Belgrade and at an exhibition entitled *Fünfzig berühmte Architekten der Welt* (1986) in Vienna. He is also a columnist for the Thai *Nation* newspaper. Since 1991 he has been a member of the Faculty of Architecture and History of Art at Cambridge University where he spends several months a year.

WRITINGS
Seen: Architectural Forms of Northern Siam and Old Siamese Fortifications (Bangkok, 1970)
Naga: Cultural Origins in Siam and the West Pacific (Oxford, 1988)

BIBLIOGRAPHY
U. Kultermann: *Architecture in the Seventies* (London, 1980), pp. 123–5
——: *Architekten der Dritten Welt* (Cologne, 1980)
T. Porter: *Colour Outside* (London, 1982), pp. 124–5
'Bank of Asia, Bangkok', *Mimar: Archit. Dev.*, 23 (1987), pp. 74–81
B. Lacy: *100 Contemporary Architects: Drawings and Sketches* (London, 1991)
'The Nation Building, Bangkok, Thailand', *A & U*, 262 (July 1992), pp. 64–9

HASAN-UDDIN KHAN

Junagadh and Girnar. City and mountain site in Gujarat, India. The city of Junagadh has numerous monuments of the 18th, 19th and early 20th centuries. Their architecture exhibits a rich mixture of European and Indian forms. However, the oldest and most significant monuments are those of the Uparkot, or Upper Fort, which dates from the Maurya and Gupta periods (4th century BC–7th century AD). The earliest of these monuments is a Jaina cave site known as the Bawa Pyara Math and datable to the 2nd century AD. Cut from the rock on the south side of the citadel hill, its cells form a horseshoe shape around a large apsidal hall in the centre. The Kapra Kodia caves (3rd–4th century AD) to the north of the Uparkot are best known for their cisterns and descending staircases. Near the highest point of the citadel is a Buddhist monastery of

the same period. The square-cut cells of this complex are arranged on two levels linked by a winding staircase; a central court is open to the sky. Approximately 100 m north of the Buddhist caves is a large and splendid 15th-century STEPWELL, the Adi Chadi Vav. Approached by a long, straight flight of stairs, this well was one of the sources of fresh water for the fort. A second stepwell, the Navghan Kuva, has a spiral staircase 52 m deep. The Uparkot was enlarged in 1492 by Mahmud Bigara (*reg c.* 1458–1511) and again in 1683 and 1880. Its later monuments include the exquisite late 19th-century Jami' Masjid, which incorporates many design elements traceable to temple architecture, and the tomb of Nuri Shah.

Mt Girnar, 3 km east of Junagadh, stands about 1000 m above sea-level and is the highest point on the Saurashtra peninsula. At its foot, the Suvarnarekha River emerges near the site of a rock edict of the Mauryan emperor Ashoka (*reg c.* 269–*c.* 232 BC). This inscription promotes the usual doctrines of peace found in the edicts but also notes that Ashoka repaired a dam across the river, forming Lake Sudarsana. This earthwork had been built by Chandragupta, Ashoka's grandfather. This is the earliest mention of a dam (and by inference irrigation) in ancient India. The same site has a second inscription, written in Sanskrit, by a local ruler, Rudradaman (*reg c.* AD 150), noting a second repair of the Mauryan dam and providing an account of Rudradaman's military prowess. The mountain is especially sacred to the Jainas, whose temples, tanks and gateways are found along the path to the summit. About two-thirds of the way up is a temple complex with a large shrine (1128 and later) dedicated to the *tīrthaṅkara* Neminatha; other important temples include the Mallinatha Temple (1231 and later), the temple of Samprati Raja (1453) and the 15th-century Melak Vasahi Temple.

BIBLIOGRAPHY
J. Burgess: *Report on the Antiquities of Kathiawad and Kachh, 1874–5*, Archaeol. Surv. W. India, New Imp. Ser., ii (London, 1876), pp. 205–10
H. D. Sankalia: *The Archaeology of Gujarat (Including Kathiawar)* (Bombay, 1941)
R. N. Mehta: 'Sudarsana Lake', *J. Orient. Inst., Baroda*, xviii/1–2 (1969)
G. Michell and P. Davies: *The Penguin Guide to the Monuments of India*, 2 vols (London, 1989)

GREGORY L. POSSEHL

Junayd (*fl* Baghdad, *c.* 1396). Illustrator. In the preface recounting the history of past and present painters in an album compiled for the Safavid prince Bahram Mirza in 1544 (Istanbul, Topkapı Pal. Lib., H. 2154), the chronicler DUST MUHAMMAD stated that Junayd of Baghdad was a pupil of Shams al-Din, who worked under the Jalayirid sultan Uways I (*reg* 1356–74). The only signed work of Junayd known to survive is *Humay and Humayun on the Day after their Wedding*, one of nine paintings in a manuscript (London, BL, Add. MS. 18113, fol. 45*v*) of the *Dīvān* (collected poetry) of Khwaju Kirmani copied at Baghdad in 1396. All the paintings show the same meticulous finish, lyricism and slender puppet-like figures integrated into complex settings and can be attributed to the hand of Junayd (*see* ISLAMIC ART, §III, 4(v)(c) and fig. 119). Another painting has been detached from the manuscript and included in Dust Muhammad's album,

where it is attributed to 'ABD AL-HAYY. As it is indistinguishable in style from Junayd's work, it too can be attributed to his hand.

BIBLIOGRAPHY

Dūst Muḥammad: Preface to the Bahram Mirza Album (1544); Eng. trans., ed. W. M. Thackston, in *A Century of Princes: Sources on Timurid History and Art* (Cambridge, MA, 1989), p. 345

V. A. Prentice: 'A Detached Miniature from the *Masnavis* of Khwaju Kermani', *Orient. A.*, xxvii (1981), pp. 60–66

Timur and the Princely Vision (exh. cat. by T. W. Lentz and G. D. Lowry, Washington, DC, Sackler Gal.; Los Angeles, CA, Co. Mus. A., 1989), no. 13

Juncal, Fábrica do. *See* FÁBRICA DO JUNCAL.

Juncker. German family of sculptors.

(1) Zacharias Juncker, the elder (*b* ?Walldürn, *c.* 1578; *d* Miltenberg, 1665). He enjoyed a much longer if less spectacular career than his younger brother (2) Hans Juncker. In 1601–2 Zacharias worked with his father, the carver Michael Juncker (*d c.* 1619), on the monumental chimney in the Rittersaal of Schloss Weikersheim. In 1606 he married and moved to Würzburg. He became a citizen of Würzburg in 1608 and two years later made a small sandstone altar for the Engelgarten of the Carthusians. On 3 June 1611 he was registered as a master in the Guild of St Luke and he served as the guild's juryman in 1616. In 1613 Zacharias and the Bamberg sculptor Nicolaus Lenkhart (*fl* 1613–32) completed the wooden high altar for the Cistercian monastery at Ebrach. Unfortunately, while the commission is well documented, the altar must have been destroyed in the Thirty Years War (1618–48), as Zacharias designed a new high altar for this church in 1651. Otherwise, there are no securely documented works prior to 1619, though Bruhns has attributed a few monuments and other carvings to Zacharias's first Würzburg period, for example the monument to *Konrad Kottwitz von Aulenbach* (*c.* 1615–20; Würzburg Cathedral).

In 1619, following the death of his father, Zacharias was commissioned to make the sandstone and alabaster Holy Blood altar in the pilgrimage church in Walldürn. He moved to his native town and completed the altar, his finest work, in 1626. The Würzburg master Hans Ulrich Buhler (*fl* 1613–32) painted the wings. While the general form of the altarpiece resembles his brother's oeuvre, Zacharias was unable to provide his figures with an equal vivacity. The flying angels are attractive yet lack character. The individual reliefs are crowded together and appear over-dependent on their print prototypes.

After 1626 Zacharias and his large family moved to Miltenberg. He made a small red-sandstone and marble Mary altar (1624) and a sandstone pulpit (1635) for the local parish church. With the outbreak of the Thirty Years War (1618), major commissions were scarce, but various monuments and minor carvings in churches around Miltenberg have been ascribed on stylistic grounds to Zacharias. His prosperity is indicated by such purchases as vineyards, gardens and land near Miltenberg. During the 1650s Zacharias and his sons, three of whom—Jakob Juncker, Zacharias Juncker the younger (*c.* 1622/3–1685) and Sebastian Juncker (*b* 1644)—were sculptors, worked in the Klosterkirche, Ebrach, and in Würzburg, where they carved coats of arms on the cathedral chapter house (1652) and on the Marienberg fortress.

(2) Hans [Johannes] **Juncker** (*b* ?Walldürn, *c.* 1582; *d c.* 1624). Younger brother of (1) Zacharias Juncker. He was a prodigy whose talents were recognized and rewarded from an early date. Probably while still associated with his father's workshop, Hans carved the high altar for the Dorfkirche in Darstadt bei Ochsenfurt. The inscription dates the altar to 1598 and gives the artist's age as only 16. The Darstadt Altar's squat, rigid figures and rather awkward gestures testify both to Hans's youth and to his early stylistic reliance on his father's art. The clean lines of the architectural frame, with its free-standing Corinthian columns flanking the large central relief of the *Ascension*, derive from yet significantly improve on the Apostles altar of 1596 in the parish church at Messelhausen, a work attributed to Michael Juncker. Other putative early works include the monument to *Neithard von Thüngen, Bishop of Bamberg* (*d* 1598) in Würzburg Cathedral, where the figures reveal a much greater sense of fluid movement and monumentality than observed in the Darstadt Altar.

Hans probably moved with his parents to Miltenberg in 1598 and *c.* 1602 began working in Aschaffenburg, where he became a citizen in 1607 and spent most of his career. He carved the elaborate pulpit and adjacent monument to *Andreas Weber* (*d* 1599) in the Stiftskirche, Aschaffenburg. The pulpit (*c.* 1602) is made from sandstone and marble, the statuettes and reliefs from alabaster, his preferred material. Free-standing statues of *St Peter, St Andrew* and *St Alexander* are set in shallow niches in the stem of the pulpit. Angel-headed Ionic capitals and fruit garlands ornament the base, while above, statuettes of *The Evangelists* and *Christ as Saviour* alternate with reliefs of *Samson with the Gates of Gaza, Descent into Limbo*, the *Resurrection of Christ* and *Jonah and the Whale*. Throughout his career, Hans borrowed compositional ideas from prints, in this instance taking the *Descent into Limbo* directly from Dürer's woodcut of 1510, while the scenes of Samson and Jonah derive more loosely from Virgil Solis and Dirck Barendsz. Bust figures in high relief of the four Latin church fathers, *St Ambrose, St Augustine, St Gregory* and *St Jerome*, complete the decoration of the pulpit. In spite of the multiple zones of carving, the overall clarity of design and the relegation of details in favour of a legible whole characterize all of Hans's works. In this respect his art is closer in spirit to the balanced sculpture of Hans Ruprecht Hoffmann of Trier than to the more overtly Mannerist artists of northern Germany (Christoph Dehne or the Wolff family) and southern Germany (Hans Degler).

From 1606 until *c.* 1620, Hans is repeatedly documented working in the Stiftskirche SS Peter und Alexander (now Cathedral), Aschaffenburg. In 1606 he renovated a Late Gothic altar (untraced) and added wooden angels, a Crucifix and other figures. Over the next two years he carved monuments to replace those damaged in the Margrave War of 1552: the sandstone monument (1606) to *Ludwig Reinhelt* (*d* 1460) in the cloister and the tomb (1606–8) of *Archbishop–Elector Theoderick Schenk von Erbach* (*d* 1459) in the choir. Hans's red and white alabaster altar of *St Mary Magdalene* (commissioned 1616;

consecrated 1621; see fig. 1) for Canon Johann Grimmel is among his simplest and most beautiful works, with a restrained elegance and subtle monumentality. The central relief of *St Mary Magdalene Kneeling in the Wilderness*, based on an engraving by Jan Sadeler, is flanked by the statues of *St John the Baptist* and *St Margaret in Ecstasy*. The frame, though modern, is modelled after Hans's preparatory drawing for the altar (Aschaffenburg, Schloss Johannisburg, Staatsgal.). The upper part of the altar (untraced) once included statues of the *Virgin*, the *Crucifixion* and *St John the Evangelist*, as well as the donor's coat of arms.

In 1607 Hans began his long association with Elector Johann Schweickard von Kronberg, Archbishop of Mainz (*reg* 1604–26), the builder of the new Schloss in Aschaffenburg. The elaborate courtyard portal of the palace chapel was constructed by the architect Georg Riedinger and adorned with Hans's sandstone statues of *St John the Baptist* and *St John the Evangelist*, the patron saints of the palace. Above the lintel is a large relief of the *Baptism*, after an engraving by Cornelis Cort, and, at the apex, the statue of the *Virgin and Child*. Inside the chapel, Hans made the sandstone angels in the spandrels of the prince's gallery, the red and white marble high altar (1609–13) and the red and white marble pulpit (completed 1618). The pulpit is a rather more sumptuous version of the earlier example by Hans in the Stiftskirche. The most interesting addition is the playful angel holding an acanthus vine in the niche of the stair-well. The sinuous curving of the vine

is echoed by the contrapposto and animated gesture of the angel.

The high altar with the *Passion* (see fig. 2) in the palace chapel is certainly Hans's finest work. Despite the inclusion of about 150 alabaster figures, the overall arrangement of this huge altar is immediately clear. Hans adroitly differentiated the various horizontal and vertical stages: for example the eight small reliefs of the *Passion* in the central section function as an internal, devotional frame for the larger *Crucifixion*, with its free-standing and relief figures. Flanking Corinthian columns, reminiscent of the early Darstadt Altar, separate the Passion narrative from the two still-larger niche statues of *St Martin*, the patron of the archbishopric, and the donor, *Elector Johann Schweickard von Kronberg*, who holds a model of the palace in his right hand. Although Hans repeatedly borrowed compositional ideas from Dürer, Goltzius, Cort, the Sadelers and other engravers, he transcended his sources as he imbued each figure with an individual character, each moving in the fluid, graceful dance of this holy drama. Every figure, from the smallest angel to the large St Martin, contributes to the spiritual impact of the ensemble. Hans's superb sense of design elevates his finest works beyond those of his contemporaries.

Hans Juncker's monuments and religious statues can also be found in the Katharinenspital Kapelle and Jesuitenkirche, Aschaffenburg, and in Mainz Cathedral. His premature death left a void in the Main region of Franconia

1. Hans Juncker: altar of *St Mary Magdalene*, alabaster, 1616–21 (Aschaffenburg Cathedral)

2. Hans Juncker: high altar with the *Passion*, alabaster, 1609–13 (Aschaffenburg, Schloss Johannisburg, chapel)

that later masters, notably Michael Kern (1580–1649) and Leonhard Kern, were only partially able to fill.

BIBLIOGRAPHY

NDB

F. Mader: *Die Kunstenkmäler von Unterfranken und Aschaffenburg, XIX: Stadt Aschaffenburg* (Munich, 1918), pp. 54–6, 60, 72–95, 248–57

L. Bruhns: *Würzburger Bildhauer der Renaissance und des werdenden Barock, 1540–1650* (Munich, 1923), pp. 235–304 [Hans Juncker]; pp. 305–53, 557–9 [Zacharias Juncker]

M. H. von Freeden: 'Der grosse Kamin in Weikersheim, ein Werk Michael Junckers', *Mainfränk. Jb. Gesch. & Kst.*, ii (1950), pp. 139–45

R. Vierengel: 'Neue archivalische Funde zur Biographie der fränkischen Bildhauerfamilie Juncker', *Aschaffenburger Jb.*, iii (1956), pp. 249–58

H. F. Friedrichs: *Aschaffenburg im Spiegel der Stiftsmatrikel, 1605–1650* (Aschaffenburg, 1962)

I. Luhmann: 'Ein kiedricher Flügelaltar aus dem Umkreis des Johannes Juncker', *Mainz und der Mittelrhein in der europäischen Kunstgeschichte: Studien für Wolfgang Volbach* (Mainz, 1966), pp. 437–79

I. Luhmann-Schmid: 'Ein unbekanntes Schnitzwerk von Hans Juncker', *Mainzer Z.*, lxvii/lxviii (1972–3), pp. 195–200

B. von Roda: *Schloss Aschaffenburg und Pompejanum: Amtlicher Führer* (Munich, 1982)

JEFFREY CHIPPS SMITH

Jung, Carl Gustav (*b* Kesswil, 26 July 1875; *d* Küsnacht, 6 June 1961). Swiss psychiatrist and analytical psychologist.

He studied medicine at the University of Basle (1895–1900), afterwards taking a post at the University of Zurich's Burghölzli Asylum. Here he started to develop ideas about the role of 'libido' in human personality which put him in sympathy with the concurrent work of SIGMUND FREUD. The intellectual alliance between the two psychologists ended, however, by 1912, when Jung published his first major work, *Wandlungen und Symbole der Libido*. While Freud understood libido as an essentially sexual force, Jung interpreted it as a more general energy to desire, present in all human motivation. He was concerned in his therapeutic work with the need for all aspects of the personality to develop and find expression, distinguishing 'introverts', individuals who focused their energies on unresolved inner conflicts, from 'extroverts', turned towards the problems of the outer world.

In accounting for the diversity of ways libido might be expressed, Jung was led increasingly to consider human personality as an entirety. From the 1920s his thinking, taking on perspectives ranging from anthropology to alchemy, posited a new model of the 'unconscious'. Besides the particular residue of individual experience on the unconscious mind, there also existed a 'collective unconscious', a level of the psyche shaped by the cumulative experience of the human race. The shaping took the form of 'archetypes'—innate predispositions to respond to major common experiences (e.g. sexual love, childbearing, bereavement) within set patterns of expression. The archetypes were thus present in the creation of symbols, myths and dreams: Jung's approach asserted the value of all these imaginative forms. These ideas were promulgated by such writings as *Modern Man in Search of a Soul* (1933) and were widely circulated through the Western world by 'Jungian' psychoanalysts.

Jung did not presume to give a total account of art, feeling that it had aesthetic aspects that were distinct from its psychological causes. He was, however, personally involved in painting and modelling as a way of exploring his own unconscious and promoted their use within therapy. He encouraged the patient to follow the 'active imagination', creating according to the drift of feeling rather than by conscious decision: this irrationalism would counterbalance the domineeringly rationalistic demands of the age, giving the unconscious its own physical reality. Jackson Pollock, who underwent Jungian analysis in 1948–50, may have been influenced by these ideas. Following his distinction of the individual and the collective, Jung distinguished in art the 'semiotic', where the artist works on an image of given significance, from the 'symbolic', where the artist's creative energy gives shape to archetypal material that would otherwise be inexpressible. The conception of archetypes naturally offered itself as an approachable model within which many artists of the mid- and late-20th century could interpret their practice and validate their iconography.

WRITINGS

Wandlungen und Symbole der Libido (Leipzig, 1912; Eng. trans. as *Psychology of the Unconscious*, London, 1916)

'Picasso', *Wirklichkeit der Seele* (Zurich, 1934), trans. in *The Spirit of Man in Art and Literature*, Collected Works of C. G. Jung, xv (London, New York and Princeton, 1967), pp. 135–41

Modern Man in Search of a Soul (London and New York, 1933)

with R. Schärf: *Symbolik des Geistes* (Zurich, 1948)
R. Schärf, ed.: *Man and His Symbols* (London 1964)

BIBLIOGRAPHY
E. Neumann: *Art and the Creative Unconscious* (New York, 1959) [Jung and art theory]
A. Storr: *Jung* (London, 1973)

Jung, Moriz [Moritz; Burger, Nikolaus; Mölzlagl, Simon](*b* Nikolsburg [now Mikulov na Moravě, Czech Republic], Moravia, 22 Oct 1885; *d* Lubna, nr Rakovnik, 11 March 1915). Austrian printmaker. From 1901 to 1908 he attended the Kunstgewerbeschule in Vienna, where he was taught by Alfred Roller, Carl Otto Czeschka and Bertold Löffler. He revealed his exceptional talent as an illustrator in woodcuts, linocuts, lithographs and book images. During his studies he published a book of coloured woodcuts, *Freunden geschnitten und gedruckt von Moriz Jung* (Leipzig and Vienna, 1906), an alphabetical primer in the form of animal pictures, and in 1907 he designed a *Poster for the Cabaret Fledermaus* (Vienna, Hist. Mus.) for the Wiener Werkstätte in Vienna that consisted of caricatures of the actors Grete Kunkel, Else Saldern, Egon Dorn, Hilde Radnay and Oskar Steiner. For the Cabaret Fledermaus he illustrated the *Second Programme Notes* (1907) with various scenes of the production. Also for the Wiener Werkstätte, Jung drew illustrated broadsheets in 1907–8, among others *Wonder Reptile* and the *Giant and the Cherry Tree* (both Vienna, Hist. Mus.); and in 1908, a series of 24 comic picture postcards.

In 1908 Jung took part in the third Vienna *Kunstschau* with art and craft designs for the Wiener Werkstätte. For several years after this he designed vignettes, letterheads and calendars for the commercial firm Rosenbaum, and worked in a similar capacity for the Lobmeyr glass company in Vienna. He designed illustrations and book jackets, for example the cover of *Das sind Zeiten* (1913), a book of sketches by Ludwig Hirschfeld. In addition he produced woodcuts for magazines such as *Ver Sacrum*, and he worked as an illustrator for the *Sportrevue des Wiener Fremdenblatts* and for the satirical paper *Glühlichter*, for which he sketched occasionally under the pseudonyms Nikolaus Burger and Simon Mölzlagl.

In 1914 Jung won first prize for a woodcut portrait of *Emperor Franz Josef I*, printed in the catalogue of the Austrian section of the *Internationale Ausstellung für Buchgewerbe und Graphik*, held in the Österreichisches Haus in Leipzig. In the spring exhibition of the Vienna Secession in 1914 he was represented by a linocut, *Showbooth*. He was also active as a writer. Extracts from his war diary written when he was serving with the Austrian army in Galicia were published in the *Arbeiter-Zeitung* and in *Westermanns Monatsheften*.

BIBLIOGRAPHY
H. Fuchs: *Die österreichischen Maler der Geburtsjahrgänge, 1881–1900*, 2 vols (Vienna, 1976–7)
W. J. Schweiger: *Wiener Werkstätte: Kunst und Handwerk, 1903–32* (Vienna, 1982; Eng. trans., London, 1984)

GUDRUN SCHMIDT

Jungala, Uta Uta. *See* UTA UTA.

Junge, Johannes (*fl* 1406; *d* after 1428). German sculptor. He is the first named artist in Lübeck and was probably trained in northern France. He worked in wood, stone and, above all, alabaster. In 1406 he acquired a house in Lübeck, which he had to vacate in 1422. Soon after 1428 he died in poverty.

In 1423 King Erik VII of Denmark (*reg* 1412–39) commissioned from Junge the alabaster tomb of *Queen Margaret I* (*d* 1412), now in the choir of Roskilde Cathedral. Owing to the war between Denmark and Lübeck Junge was never paid, and his sons sued the city fathers in 1446. The tomb, with sarcophagus and effigy, is still in the 14th-century tradition. The original head of the Queen (now Lübeck, St Annen-Mus.) had to be replaced by the sculptor because of a defect in the material. The end walls of the sarcophagus have six reliefs of the *Life of the Virgin* and two of the *Crucifixion*, and the long sides have weepers (bishops, knights, Apostles and female saints) in architectural settings (all rest. between 1862 and 1962).

Other works in alabaster can be attributed to Junge: the *Pietà* from Sønder-Alslev, Falster (now Copenhagen, Nmus.), and the *Agnus Dei* (Stockholm, St Nikolai), attributed to Junge by Schädler, who propsed King Erik of Pomerania as patron. The stone figures of the *Virgin*, *St Catherine* and three *Apostles* from Niendorf (Lübeck, St Annen-Mus.) are stylistically very similar to the fragments of the alabaster reliefs on the Roskilde tomb and could also have been made *c.* 1420; they probably once stood in the church of St Peter, Lübeck. Junge's style combines serene naturalism with abstract austerity, showing the idealizing influences of France and the southern Netherlands, which he could have absorbed either directly or through intermediary works of art. As the only stone-carver in Lübeck, Junge had significant influence on the city's artistic development.

BIBLIOGRAPHY
Thieme–Becker
G. Schwarzenski: 'Deutsche Alabasterplastik des 15. Jahrhunderts', *Städel-Jb.*, i (1921), pp. 166–213
M. Hasse: 'Das Grabmal der Königin Margarethe von Dänemark und der Lübecker Bildhauer Johannes Junge', *Z. Ver. Lübeck. Gesch. & Altertknd.*, xxxviii (1958), pp. 138–41
T. Müller: *Sculpture in the Netherlands, Germany, France and Spain, 1400–1500*, Pelican Hist. A. (Harmondsworth, 1966), pp. 28–9, 205
A. Schädler: 'Ein spätgotisches "Lamm Gottes" in der St Nikolai-Kirche zu Stockholm', *Pantheon*, xxvii (1969), pp. 364–9
M. Hasse: 'Lübecks Kunst im Mittelalter', *Kirchliche Kunst des Mittelalters und der Reformationszeit: Die Sammlung im St-Annen-Museum, Lübeck*, ed. J. Wittstock (Lübeck, 1981), pp. 25–6, 92–8
N. Jopek: *Studien zur deutschen Alabasterplastik des 15. Jahrhunderts* (Worms, 1988), pp. 49–59, 163, 181–4 [with detailed bibliog.]

F.-J. SLADECZEK

Jungnickel, Ludwig Heinrich (*b* Wunsiedel, Upper Franconia [now Germany], 22 July 1881; *d* Vienna, 14 Feb 1965). German painter and printmaker. He was the son of a master joiner. In 1885 he moved with his family to Munich, where he attended the Ludwig Gymnasium and the Kunstgewerbeschule. In 1897 he went on a walking tour, finally arriving in Rome and Naples, where he copied oil paintings and earned a living as a portrait draughtsman. The archaeologist Orazio Maruchi enabled him to gain access to the Vatican collections. In 1898, like many artists, he was attracted to the Secession in Vienna; he enrolled at the Akademie der Bildenden Künste there in 1899 and began studying with Christian Griepenkerl (1839–1916). After only a year, however, he left. To earn a living he

worked as a drawing tutor, also designing carpets, fabrics and murals. Among his contemporaries in Vienna, Gustav Klimt particularly impressed him. Stylistically Kolo Moser also influenced him, although he never worked in such an intellectual, aesthetic way as the Secession artists.

In 1905 Jungnickel went to Munich, where his tutor was the painter Carl Marr (1858–1936), and the following year he completed his studies with a further term at the Akademie der Bildenden Künste in Vienna. Meanwhile he participated in numerous exhibitions, for example the *Kunstschau* in Vienna (1908) and the exhibitions of the Sonderbund. Also in 1908 Klimt persuaded him to collaborate on the decoration of the Palais Stoclet in Brussels. The building was erected between 1905 and 1911 and was decorated and furnished by artists of the WIENER WERKSTÄTTE. Jungnickel's contribution was a frieze for the nursery, in which he depicted several animals in picturesquely fluid silhouettes. In 1909 he received a similar commission from the Oberst-Kämmereramt, producing a series of pictures of animals from the menagerie at Schönbrunn.

In 1911 Jungnickel moved to Frankfurt am Main, where, until 1912, he was a professor at the Kunstgewerbeschule. He cut short his stay, however, since he was unable to realize his progressive ideas about art there, although he produced a series of woodcut views of the city (1911–12; see 1988 exh. cat., pp. 20–23). Despite his close connections with the Vienna Secession, of which he was never a member, although he participated in an exhibition in 1918, his interest in the highly cultivated and refined forms of *Jugendstil* artists waned. Journeys to Hungary, Bosnia and Herzegovina brought him into contact with uneducated people who he felt lived in direct harmony with nature without the decadent trappings of West European civilization. For his own creative work, the insights he had gained in the Balkans marked a turning-point towards a new expressive power. Similarly a visit to Rome in 1921 inspired him to produce 40 lithographs of his *Italienisches Skizzenbuch* (1922; see 1978 exh. cat., pl. 208). In 1924 he became a member of the Vereinigung des Künstlerhauses in Vienna. In 1937 he received the Österreichische Staatspreis für Bildende Kunst.

Jungnickel's favourite subject-matter was landscape, and above all animal depictions. He often found inspiration in non-Western art, such as East Asian pictures in India ink, whose qualities he allowed to appear in his watercolours. His main medium was the print—woodcuts, lithographs and etchings—and a special spray technique by which, using stencils, he could produce a series of identical replicas. As an artist who had grown out of *Jugendstil* he sought to give his works a two-dimensional impact. His starting-point was the line, which he applied with little effort but to maximum effect, often simply as an outline. He demonstrated this particularly well in the designs for carpets and textiles produced for various firms, including the Wiener Werkstätte. He rarely painted in oil. Although Jungnickel never produced abstract work, nor was he avant-garde, the Nazis condemned his art as degenerate (*see* ENTARTETE KUNST) and removed it from museums, possibly because of certain connections with non-Western art. In 1939 Jungnickel emigrated to Yugoslavia and settled in Split and then Opatija. He did not return to his homeland until 1952, living in Villach and Vienna.

BIBLIOGRAPHY

P. Baum: 'Ludwig Heinrich Jungnickel zum Gedenken: Rückblick auf Leben und Schaffen des im Vorjahr verstorbenen Künstlers', *Alte & Mod. Kst*, xi/84 (1966), pp. 44–5
E. Kanizsai-Nagy: *Ludwig Heinrich Jungnickel: Leben und Werk* (diss., U. Vienna, 1978)
Oskar Laske, Ludwig Heinrich Jungnickel, Franz von Zülow (exh. cat. by M. Bisanz-Prakken, Vienna, Albertina, 1978)
Ludwig Heinrich Jungnickel (exh. cat., Hannover, Gal. J. H. Bauer, 1988)
K. A. Schröder and H. Szeeman, eds: *Egon Schiele and his Contemporaries: Austrian Painting and Drawing from 1900 to 1930 from the Leopold Collection, Vienna* (Munich, 1989), pp. 277, 288–9

ELKE OSTLÄNDER

Juni, Juan de (*b* ?Joigny, Burgundian border, *c.* 1507; *d* Valladolid, 9–17 April 1577). French sculptor, active in Spain. The equestrian statue of *St Thibault*, dated 1530, on the façade of the church of St Thibault in Joigny can be securely attributed to Juni and confirms that he came from the region of Champagne. His style, based on Burgundian art, was enriched by a visit to Italy before 1530, where he was influenced by the Classical group of the *Laokoon* (2nd half of the 1st century AD, rediscovered 1506; Rome, Vatican, Mus. Pio-Clementino) and by the work of Michelangelo. The influence of Jacopo della Quercia, Niccolò dell'Arca and Guido Mazzoni is apparent in his work, which also has certain similarities to that of Antonio Begarelli.

Around 1533 Juni was working on the medallions and reliefs of historical subjects on the façade of the monastery of San Marcos, León, of the Order of Santiago. He also carved the stalls in the upper choir and some in the lower choir. He made the polychrome terracotta groups of *St Jerome* and the *Martyrdom of St Sebastian* (*c.* 1537) for the Admiral of Castile, Don Fadrique Enríquez (Medina de Rioseco, Church of S Francisco). The alabaster *Virgin and Child* (*c.* 1535) in the parish church of Capillas, León, belongs to the same period. In 1540 he moved to Salamanca, where he carved the tomb of *Gutierre de Castro* in stone with polychrome (*c.* 1540; Vieja Cathedral, *in situ*).

Juni was commissioned by Bishop Fray Antonio de Guevara to carve an *Entombment* (1545; Valladolid, Mus. N. Escul.) for his funerary chapel in the former monastery of S Francisco in Valladolid. His knowledge of French and Italian monumental sculpture is evident in this group, which has a classical composition combined with Mannerist rhythms. Further commissions in the Valladolid region followed, and in 1545 Juni won the contract for the high altar of S María la Antigua (Valladolid Cathedral) in competition with Francisco Giralte, a pupil of Alonso Berruguete. A noted designer of altars, Juni made an innovative plan, with a reticulated form that contrasts with earlier Plateresque types. He was also responsible for carrying out the architectural frame, sculpture and polychrome painting in this altarpiece on the *Life of the Virgin*, the most elaborate of the period in Spain. In 1550 he planned the high altar in the cathedral of Burgo de Osma, Soria, following the model of his earlier altarpiece in the church of S María la Antigua, Valladolid. In 1557 he was commissioned to design the chapel for the banker Alvaro de Benavente (Medina de Rioseco, S María del Mediavilla),

spectator. In 1573 he designed the altarpiece of Avila Monroy (Arevalo, El Salvador), which was carried out by his pupil and natural son, Isaac de Juni (1539–97).

Juni's late work, when he came under the influence of Gaspar Becerra, is distinguished by its calmness, by a greater refinement and by his ability to convey a sense of anguish. This is apparent in his *St Francis* (wood and polychromy, 1570–77; Valladolid, Convent of S Isabel) in the expressive gesture of the hand (see fig.), as well as in the *Virgin of los Cuchillos* (wood and polychromy, 1570s; Valladolid, Church of Nuestra Señora de las Angustias), in which the seven knives (added *c.* 1650) symbolize the Seven Sorrows. In the alabaster tomb-statue of *S Segundo* (1572–3; Avila, S Segundo) he attained perfection. Juni's followers included Juan de Angés (*fl* 1587–90) in León and the Master of Sobrado in Galicia. His influence was felt in the Basque country, La Rioja and Navarre, where Juan de Anchieta was recommended to complete the high altar of S María del Mediavilla in Medina de Rioseco.

BIBLIOGRAPHY

J. Martí y Monsó: *Estudios histórico-artísticos relativos principalmente a Valladolid* (Valladolid, 1901), pp. 326–73

J. Agapito y Revilla: *La obra de los maestros de la escultura vallisoletana*, i (Valladolid, 1920), pp. 115–91; ii (Valladolid, 1929), pp. 177–212

E. García Chico: *Documentos para el estudio del arte en Castilla: Escultores* (Valladolid, 1941), pp. 26–63

J. J. Martín González: 'Juni y el Laoconte', *Archv Esp. A.*, 25 (1954), pp. 59–66

S. Sebastián: 'El programa de la capilla funeraria de los Benavente de Medina de Rioseco', *Traza y Baza*, 3 (1973), pp. 17–25

Juan de Juni y su época: Exposición conmemorativa del IV centenario de la muerte de Juan de Juni (exh. cat. by J. J. Martín González, Madrid, Ministerio de Educación y Ciencia, 1977)

M. J. Redondo Cantera: 'Aportaciones al estudio iconográfico de la capilla Benavente', *Bol. Semin. Estud. A. & Arqueol.*, xlvii (1981), pp. 245–64

J. J. Martín González and J. Cruz Solís: *El Entierro de Cristo de Juan de Juni: Historia y restauración* (Valladolid, 1983)

J. J. Martín González: 'Con Juan de Juni en Joigny', *Bol. Real Acad. B. A. San Fernando*, 59 (1984), pp. 249–59

J. J. Martín González and J. González Paz: *El Maestro de Sobrado* (Orense, 1986)

J. J. MARTÍN GONZÁLEZ

Junius, Franciscus [Francis; Du Jon, François], the younger (*b* Heidelberg, 1589; *d* Windsor, 19 Nov 1677). English writer and antiquary of German birth. A leading philologist and lexicographer, he travelled to England in 1621, where he was employed by the bibliophile Samuel Harsnet, Bishop of Norwich; Junius subsequently became librarian to Thomas Howard, 2nd Earl of Arundel. His published works include an edition (1655) of the Anglo-Saxon religious verses then thought to be by the 7th-century author Caedmon, an example of Junius's pioneering scholarly work on medieval manuscripts. In 1637 he published *De pictura veterum*, which was translated into English as *The Painting of the Ancients* (1638; *see* DISEGNO E COLORE) and dedicated to the Countess of Arundel. The impetus for this book, which is a tribute to the Earl of Arundel's informed patronage, came from John Selden's *Marmora Arundelliana* (1627), a compendium of inscriptions discovered in Asia Minor by William Petty; this in turn had led the Dutch philologist John Gerard Vossius to suggest to Junius the idea of the *De pictura veterum*. The result is a dense compilation (with commentary) of all the references to the visual arts that Junius could recover from

Juan de Juni: *St Francis* (detail), wood and polychromy, h. 1.27 m, 1570–77 (Valladolid, Convent of S Isabel)

the most sumptuous and elaborate funerary chapel in 16th-century Spain; the altarpiece has a complex iconography and is dedicated to the Immaculate Conception. He also carved the altarpiece and *Crucifixion* (contract 1567) in the Alderete Chapel (Tordesillas, S Antolin). Juni's design for the altarpiece of the *Entombment* (*c.* 1570; Capilla del Entierro, Segovia Cathedral) shows a new structure based on the shape of the square and influenced by Andrea Palladio. Here the exaggerated poses of the two soldiers, which appear to be influenced by religious theatrical drama, were intended to attract and move the

Classical sources. Its purpose was to serve the interests of both scholars and orators, but it was also a tract for the times. The poet and playwright Ben Jonson, and Inigo Jones, the leading architect of the period, who together had designed numerous court masques for Charles I, had quarrelled over whether or not the visual arts were superior to literature, a recurring theme in Renaissance PARAGONE. Junius used *The Painting of the Ancients* as a means of intervening on Jones's side, thus supporting the supremacy of the visual arts in this acrimonious debate. The book is also a vigorous defence of the power of the visual arts to inspire a virtuous life among those who actively pursue them, and a reply to William Prynne's *Histrio-mastix* (1633), a scabrous attack on the Court and its love of the arts.

Junius had an uneasy relationship with the Earl of Arundel, whose service he periodically left, although he was still attached to the family's household while they were in exile during the English civil wars of the 1640s. Junius spent his later years in the Netherlands but returned to England in 1674, shortly before his death. In 1676 he presented a number of Anglo-Saxon manuscripts, including those attributed to Caedmon, and part of his philological collection, to the Bodleian Library, Oxford.

UNPUBLISHED SOURCES
Oxford, Bodleian Lib., Rawlinson MSS [letters]

WRITINGS
De pictura veterum (Amsterdam, 1637); Eng. trans. as *The Painting of the Ancients* (London, 1638); Dutch trans. as *De schilder-konst der oude* (Middelburg, 1641) [see also Aldrich, Fehl and Fehl below]

BIBLIOGRAPHY
DNB
D. Howarth: *Lord Arundel and his Circle* (London, 1985)
K. Aldrich, P. Fehl and R. Fehl, eds: *The Painting of the Ancients*, i, *A Lexicon of Artists and their Works*, ii, CA Stud. Hist. A. (Berkeley and Oxford, 1991)

DAVID HOWARTH

Junk art. Term first used by the critic Lawrence Alloway in 1961 to describe an urban art in which found or ready-made objects and mechanical debris were transformed into paintings, sculptures and environments by welding, collaging, décollaging or otherwise assembling them into new and unusual forms. The name evolved from the phrase 'junk culture', which had been used in the late 1950s and early 1960s, particularly in Great Britain and the USA, by writers such as Hilton Kramer (*b* 1928) to describe the vulgar and kitsch qualities of objects with built-in obsolescence produced in industrial nations after World War II.

Precedents for Junk art prior to World War II include collages by Pablo Picasso and Georges Braque, Marcel Duchamp's ready-mades, Dada assemblages, Kurt Schwitters's *Merzbau* constructions and Surrealist objects such as Meret Oppenheim's fur-lined teacup known as *Object* (1936). Urban junk featured in the sculptural form known as ASSEMBLAGE, which often included discarded pieces of chipped, painted wood; rusted metal; partially destroyed or non-functional objects; torn, stained or burnt cloth or newspapers; ripped linoleum; and other found objects characterized by a worn appearance and urban associations. Notable among the artists working in this idiom in the late 1950s and early 1960s in both Europe and the USA were Americans such as Robert Rauschenberg (*see*

RAUSCHENBERG, ROBERT, fig. 1), Lee Bontecou, Allan Kaprow, John Chamberlain, Carolee Schneemann (*b* 1939) and Richard Stankiewicz (see fig.); the Argentinian Kenneth Kemble; British artists such as John Latham and Eduardo Paolozzi; Europeans associated with NOUVEAU RÉALISME, such as César (for illustration *see* CÉSAR) and Jean Tinguely; and other Europeans, such as Ettore Colla, Alberto Burri and Lucio Fontana. In California, and especially in the San Francisco Bay area, Junk art developed into a form identified by the critic Peter Selz (*b* 1919) as Funk art, which was characterized by an association with the sensual, earthy beat of Jazz and Blues music and with the work of the Beat poets; the idiosyncratic use of materials such as used stockings, black leather, vinyl, fur and torn and stained pictures of pin-up girls contributed to the sometimes erotic, humorous and scatological suggestions of the assemblages, paintings, sculptures and ceramics of artists such as Bruce Conner (*b* 1933), Robert Arneson (*b* 1930), Jay Defeo (*b* 1929), Joan Brown (*b* 1938), Harold Paris (*b* 1925), Wallace Berman (*b* 1926) and David Gilhooly (*b* 1943).

The presence of commercial and urban refuse in art not only emphasized the relative value of contemporary objects but commented ironically on the relativity of the history of value in a society that rapidly discards objects only to have them reappropriated and elevated to the status of art. Using this waste material to create a new

Junk art by Richard Stankiewicz: *Our Lady of All Protections*, iron and steel, h. 1.3 m, 1958 (Buffalo, NY, Albright–Knox Art Gallery)

hierarchy in the order of things, Junk art used common objects democratically in an artistic context while contradicting and confounding preciousness. In bringing mass-produced things from the urban environment into the context of fine art, it laid the foundations for further appropriation of popular imagery that was to follow in the early 1960s with the advent of Pop art.

BIBLIOGRAPHY

L. Alloway: 'Junk Art', *Archit. Des.*, 31 (March 1961)
The Art of Assemblage (exh. cat. by W. C. Seitz, New York, MOMA, 1961)
A. Kaprow: *Environments, Assemblages and Happenings* (New York, 1966)
D. Zack: 'Funk Art', *A. & Artists*, ii (April 1967)
——: 'Funk Art: The Grotesque Show at Berkeley, California', *A. & Artists*, ii (Oct 1967)
J. Nuttall: *Bomb Culture* (London, 1970)
J. Pierre: 'Funk Art', *L'Oeil*, 190 (Oct 1970), pp. 18–27

KRISTINE STILES

Junker von Prag ['Young men of Prague']. Unidentified group of masons mentioned in various late 15th- and 16th-century sources. The earliest surviving reference to the Junker of Prague is in two manuals for masons written towards the end of the 15th century: both Mathes Roriczer's booklet on pinnacle correctitude and Hanns Schmuttermayer's booklet on pinnacles refer to the Junker as earlier authorities on architecture. Although they have been linked to the Parler family of architects in Prague, they cannot be identified with either the Parlers or any other specific group of masons. The concept of the 'Junker von Prag' probably reflected the fame of the Prague masons' lodge and the late medieval masters who came from there. By the 16th century their origins were already so confused that the Strasbourg city architect Daniel Specklin (1538–89) associated them with Johann Hültz in the building of the cathedral's west tower, as did Wolfgang Lazius in his *De gentium aliquot migrationibus* (Basle, 1557). A medal struck in 1565 is inscribed with their name, and the words *Juncker von Brag* are written in a later hand on two connected drawings in Erlangen and Dessau. Specklin also attributed a sculpture to them.

BIBLIOGRAPHY

J. Neuwirth: 'Die Junker von Prag', *Mitt. Gesch. Dt. Böhmen*, xxxiii (1895), pp. 17–93
B. Schock-Werner: 'Die Parler', *Die Parler und der Schöne Stil*, iii (exh. cat., ed. A. Legner; Cologne, Schnütgen-Mus., 1978), p. 7

BARBARA SCHOCK-WERNER

Jun Miyagawa. *See* MIYAGAWA, JUN.

Junnar [Junnār; Junna-nagara; Jirna-nagara; anc. Omenagara of Ptolemy]. Buddhist cave site in Pune District, Maharashtra, India, which flourished from the 1st century BC. Within a radius of 8 km around the old habitation site of Junnar is a concentration of nearly 184 rock-cut caves, excavated in nine locations in five different hill ranges. All the caves are affiliated with Hinayana Buddhism. Junnar lies on the ancient caravan route connecting the port towns Sopara (anc. Surparaka) and Kalyan (anc. Kaliyana) on the Konkan coast with towns in the Deccan. At the head of a mountain pass called Narneghat, about 27 km north-west of Junnar, is a cave with a famous inscription (*c.* 1st century BC) of the Satavahana queen Naganika, the wife of Sri Satakarni. Early Satavahana coins have been found at Junnar, but the most significant find was an image

of the Greek god Eros in alabaster. This, together with a number of Prakrit and Brahmi inscriptions referring to Yavana (Greek) donors, has prompted some scholars to identify Junnar with the elusive site of Dhenukakata, the Yavana settlement mentioned in the donative inscriptions at Karle, Kanheri and Shelarvadi.

The Tulaja Lena group of caves (1st century BC) is the oldest at Junnar. It includes a circular *caitya* hall (diam. 8.2 m) with 12 octagonal pillars surrounding a stupa, the pillars supporting a hemispherical dome on a high drum. The pillars bear traces of paintings. On Manmodi Hill (anc. Manamukada) are three cave groups: Bhuta Lena (also known as Budhalena), Amba/Ambika and Bhimashankar, each containing a *caitya* and a monastic residence (*vihāra*). The *caitya* hall (1st century AD) in the Bhuta Lena group is significant as it contains sculptural decoration, a standing image of Gaja Lakshmi above the entrance carved in a large half-lotus medallion. The other petals of the medallion contain two semi-divine beings, one with a serpent (*nāga*) hood. Above, flanking the pinnacle of the entrance arch, are two winged figures recalling the style of the donor figures at Karle.

The *caitya* (Cave 6) in the Ganesha Lena group (also called Lenyadri, 'mountain containing caves') is noteworthy for its apsidal plan with pillared verandah in front, the pillars resembling those of the *vihāra* in Cave 3 at Nasik. The adjoining *vihāra* (Cave 7) is exceptionally large (17.39 m deep, 15.55 m broad) and contains some 20 cells for monks. The cave was used for the worship of the elephant-headed god Ganesha during medieval times, when the name Ganesha Lena came into use. Of the other cave groups, the oblong *caitya* hall (Cave 48) in the Sivaneri group is noteworthy for the mural paintings on the ceiling depicting series of lotuses in yellow and red on mud plaster. An inscription in Cave 36 mentions the existence of a monastery within the town for nuns of the Dharmottariya sect. The Sivaneri fort at Junnar is famous as the birthplace of the Maratha hero and empire-builder Shivaji (*reg* 1620–80).

BIBLIOGRAPHY

J. Fergusson and J. Burgess: *The Cave Temples of India* (London, 1880)
J. Burgess and I. Bhagavanlal: *Inscriptions from the Cave Temples of Western India* (Bombay, 1881)
J. Burgess: *The Buddhist Cave Temples and their Inscriptions*, Archaeol. Surv. W. India, iv (London, 1883)
V. Dehejia: *Early Buddhist Rock Temples: A Chronological Study* (London, 1972)
S. V. Jadhav: 'Rock Cut Cave Temples at Junnar' (diss., U. Pune, 1980)
——: *Junnar Sivaneri Perisar*, Department of Archaeology and Museums, Maharashtra (1982)

M. N. DESHPANDE

Junzō Sakakura. *See* SAKAKURA, JUNZŌ.

Junzō Yoshimura. *See* YOSHIMURA, JUNZŌ.

Jupan [Jupe; Jupen; Juppe; Juppen], **Ludwig** [Lodewig; Meister Loedewich] (*fl* 1486; *d* Marburg, 1538). German sculptor. First mentioned in Marburg from 1486 to 1498, he was probably active in Frankenberg in 1493–5, in Kalkar in 1498–1508 (always as Meister Loedewich) and then again in Marburg until his death.

Jupan's first surviving work in Marburg, the heraldic relief at the castle (1493), shows his indebtedness to the tradition of Nicolaus Gerhaert with the depiction of a

couple leaning over a parapet. In 1498 he was commissioned by the Kalkar Liebfrauenbruderschaft (Brotherhood of the Virgin) to complete Master Arnt's unfinished high altar for the church of St Nikolai (for illustration *see* KALKAR, ST NIKOLAI). In contrast to Arnt's plan to set almost free-standing figures in a landscape in the style of Hans Memling, Jupan designed a series of separate basreliefs, notably at the sides of the shrine (central panel). This style becomes clearer in the Kalkar altar of the Virgin, which was probably a joint commission by Johan Koppers and the Liebfrauenbruderschaft *c.* 1507–8. The edge of the shrine is a frame filled with figures of the prophets: painted wings were added only in 1638. There are ten reliefs of the *Life of the Virgin*, from the *Rejection of Joachim's Offering* to the *Assumption*, contained in three rows of scenes with the *Assumption* in a raised shrine. The type is isolated and must have been inspired by southern Netherlandish altarpieces with scenes in several rows. Except in the three upper scenes, there is no architectural frame for the reliefs, which are separated only by pillars placed as part of the background to the scenes. The reliefs, which are almost square, contain slender, fashionably dressed figures set in interiors carved in great detail. The scenes are composed around a central point and framed by figures in profile. Jupan also produced predella reliefs for several altars in Kalkar, consisting of scenes conceived in a painterly way and set in landscape or architectural backgrounds.

After returning to Marburg, Jupan and his workshop produced four altars for St Elisabeth's church, the burial place of the Landgraves of Hesse. Two altarpieces in the form of semicircular niches with wall paintings had been placed on the east wall of each transept. Between 1510 and 1514 Jupan returned to the old form of altarpiece, filling the niches with sculptured panels (to which Johann von der Leyten (*d* 1530) added painted wings): in the north transept the altars of St Elisabeth (*c.* 1510) and the Holy Kindred (1511), in the south the altars of St John (1512) and SS George and Martin (1514). The first and last of these are each filled with three scenes set in landscapes or interiors. The altar of St John combines three scenes from the life of the saint in a unified landscape in the style of the Kalkar high altar, while the altar of the Holy Kindred brings the extended Holy Family together with SS Barbara and Catherine in a church interior. As in Kalkar the figures are slender, some of them fashionably clothed, with powerfully flowing drapery.

In 1516 Jupan received the commission for the tomb of Landgrave William II of Hesse (*d* 1509). The tomb, designed by Johann von der Leyten, is of grey alabaster on two levels, with the armoured figure of the Landgrave placed above a representation of his cadaver, a Western type of *memento mori* that first became known in Germany with the tomb made by Gerhaert for Archbishop Jakob von Sierck in Trier (1462). In 1524 Jupan executed the city coat of arms for Marburg Town Hall, to which he added the half-length figure of St Elisabeth carrying the arms of Hesse and a model of St Elisabeth's church. The figure is elegantly set in a niche shaped like the choir of a church.

As a central German sculptor, Jupan had learnt enough Netherlandish stylistic elements to enable him to complete Master Arnt's characteristically Netherlandish high altar in Kalkar, but the style he developed in Kalkar was not considered alien when he returned to Marburg. His adaptable and modest talent was displayed equally well in both places.

BIBLIOGRAPHY

Thieme-Becker
C. Justi: 'Johann von der Leyten und Ludwig Juppe: Zwei Marburger Künstler vom Ausgang des Mittelalters', *Z. Bild. Kst*, xx (1885), pp. 259–64
F. Küch: 'Die Altarschreine in der Elisabethkirche zu Marburg', *Hessenkst* (1908), pp. 8–14
H. Neuber: *Ludwig Juppe von Marburg: Ein Beitrag zur Geschichte der deutschen Plastik am Ausgang des Mittelalters* (Marburg, 1915)
H. Appel: 'Eine Johannesfigur vom Meister des Kalkarer Hochaltars', *Pantheon*, xxii (1938), pp. 345–7
F. Gorissen: *Ludwig Jupan von Marburg*, Die Kunstdenkmäler des Rheinlandes, 13 (1969); review by R. Haussherr in: *Rhein. Vjbl.*, xxxiv (1970), pp. 394–401
W. Eckhardt: 'Eine unbekannte Heilige aus Ludwig Juppes Kalkarer Zeit', *Wallraf-Richartz-Jb.*, xxxii (1970), pp. 257–62
G. de Werd: *Die St Nicolaikirche zu Kalkar* (Munich, 1983)

HERIBERT MEURER

Ju Peon. *See* XU BEIHONG.

Juraj Matejev Dalmatinac. *See* GIORGIO DA SEBENICO.

Juran [Chü-jan] (*b* Zhongling [modern Jin xian], Jiangxi Province, or Jiangning [modern Nanjing], Jiangsu Province; *fl* AD 975–93). Chinese painter. Juran and his predecessor DONG YUAN practised what was known in the Northern Song period (960–1127) as scholar painting (*shidaifu hua*) and are widely regarded as founders of the so-called SOUTHERN SCHOOL of scholar–amateur idealist painting.

Juran was initially a Buddhist monk in Jiangning, the Southern Tang (AD 937–75) capital. After Tang capitulation to the Northern Song in 975, he moved to the Song capital of Bianliang (Kaifeng) where, living in the Kaiyuan Temple, he produced landscape scrolls and murals and achieved fame as a painter. Between 985 and 993, Su Yijian, scholar at the Hanlin Academy, built two studio-pavilions east and west of the Jade Hall, part of the Hanlin Academy, and commanded Juran to paint their exterior walls. Juran produced *Yanlan xiaojing* ('Smokey mountain vapours at dawn'), which became celebrated. Hong Zunyi wrote in his *Hanyuan qunshu* that Juran's 'brush traces [were] wild and untrammelled like Li Cheng, yet he achieved the marvels of his own distinct style'.

Before 1059 Liu Daoshun (*fl* mid-11th century) ranked Juran in the third class of painters of landscapes and woods, as one 'excellent at capturing the essential flavour of scenes'. In 1075 Guo Ruoxu (*fl* 11th century) wrote, 'woods and trees are not his forte', although otherwise his 'brush and ink are elegant and moist; he excels in misty, vaporous effects [in painting], tall and expansive desolate vistas of mountains and streams'. Shen Gua (1030–94) wrote, 'Monk Juran followed the methods of Dong Yuan, attaining the utmost in marvellous principles. Both their works are best viewed from afar. Their brushwork is rather cursory, not resembling anything at close range. But from a distance objects and scenes emerge brilliantly, inspiring profound feelings and distant thoughts, as if one were contemplating unknown lands'.

Mi Fu, writing *c.* 1100, gives the most detail about Juran's paintings and his techniques. He observed that 'Juran followed Dong Yuan. There are many paintings extant with pure and moist vapours achieving a natural and naive quality in their construction. In his youth Juran used too many alum-heads [on the mountain slopes, but] in old age he attained a lofty flavour in unassertiveness'. On a Juran painting entitled *The Ocean Wilderness* (untraced), Mi wrote, partly in verse, 'At the river's edge by the ocean wilderness the vistas are broad, woods are far, mists dispersed, pale to the ends of the skies; evening tides rise up by the wooded hamlet, stars in array, the night skies over the fishing village are alive', giving an impression of thematic content and imagery. Mi also noted the similarity between Juran's works and those of Liu Daoren ('Daoist Liu'), also a follower of Dong Yuan.

The *Xuanhe huapu* ('Xuanhe collection of painting'; compiled before 1119), a catalogue of Emperor Huizong's collection, lists 136 works ascribed to Juan, indicating the high regard in which he was held. These include six sets of six panels, four sets of four panels, eight triptychs and twelve double panels. Panels were hung side by side or mounted as screens to create a broad, and in the case of six-panel series, horizontal panorama. The *Xuanhe huapu* also describes many of the motifs used in Juran's works:

> Besides pinnacled ranges, mountain caverns, between wooded glens in his landscapes, he painted pebbles, pines and cedars, bamboo, rushes and grasses in mutual correspondence. With lonely streams and narrow paths, bamboo fences and thatched huts, broken bridges and precarious plank roads, his paintings exude the flavour of real mountain scenery. Some people say that his substantive style is soft and weak. This is not so. The ancients used to say, '[A painting that has] secluded places in which one can live, level areas where one can roam, nature-made places that amaze one, sheer drops and precipitous cliffs that frighten one, is truly a good painting.' While Juran's work is fine and fragmented, its spirit is rather like this ... his painting of water, with crashing waves and billowing foam, causes people's hair to stand on end, with the smoke and clouds transforming right before our eyes.

The importance of Juran in Chinese painting since the early 12th century cannot be overestimated. Mi Fu (*see* MI, (2)) extolled Juran and Dong Yuan's unassertive style of misty southern hills and condemned the work of almost every other artist. In particular, he criticized the vigorous representation of hoary northern mountains with angular, granite crags as vulgar and extravagantly attention-seeking. Mi also initiated, with mixed emotions, a reverence for LI CHENG, who used ink sparingly, 'as if it were gold'. Early writers' references to Li Cheng's sparing use of ink and Juran's adoption of Li Cheng's style, and to reconstructions of Mi Fu's own works, suggest that Mi promoted a rather amorphous style of painting, relying on dextrous use of graded ink wash, sometimes extremely pale, deployed over large areas of the painting surface. Subsequent scholar–gentry criticism tended to follow suit and extol the southern Dong–Ju and Li–Guo (Li Cheng and Guo Xi) styles. In the Yuan period (1279–1368) scholar–amateur painters, notably the Four Masters of the Yuan—Huang Gongwang, Ni Zan, Wu Zhen and Wang Meng—followed the Dong–Ju style as perceived through attributed works. An important feature was the 'hemp-fibre stroke' (*pima*

cun) used for texture modelling, moistened with graded ink wash to accentuate light and dark. By the 14th century, a limited vocabulary of tree groupings and mountain forms had become established as the Dong–Ju mode.

Many unsigned attributions to Juran in the National Palace Museum, Taipei, feature the 'hemp-fibre stroke', as finalized in the Yuan, notably *Xiao Yi zhuan 'Lanting xu'* ('Xiao Yi steals [Wang Xizhi's] "Orchid Pavilion Preface"'), a Yuan copy of a late Northern Song composition; *Nangqin huaihe* ('Cherished companions: crane and lute'),

Juran (attrib.): *Qishan lanruo* ('Buddhist retreat by stream and mountain'), hanging scroll, ink on silk, 1.85×0.58 m, possibly one of an original set of six panels, probably 11th century with post-14th-century additions (Cleveland, OH, Cleveland Museum of Art)

a 14th-century accretion; *Qiushan tu* ('Autumn mountains'), a 15th-century close copy of a Yuan composition; and *Qiushan wendao* ('Asking the way in autumn mountains'), a 15th-century accretion. Two earlier attributions from the late 11th to early 12th centuries are *Cengyan congshu* ('Layered peaks and clumps of woods'; untraced) and *Qishan lanruo* ('Buddhist retreat by stream and mountain'; see fig.), the latter a title given in the *Xuanhe huapu* as a six-panel panorama. These works feature a less clearly defined 'hemp-fibre stroke' and less schematized mountain contours and echo woods and trees, reminiscent of those mentioned by early writers in connection with Juran, and alum-heads as described by Mi Fu. Using moist, pale ink wash in lieu of linear 'hemp-fibre stroke' modelling, they represent an earlier stage in the evolution of the Juran tradition. The dramatic contrast in light and shade and disappearance into mist are typical of early Northern Song rendering.

BIBLIOGRAPHY

Liu Daoshun: *Shengchao minghua ping* [Critique of famous paintings of the present [Song] dynasty] (1059), *juan* 2

Guo Ruoxu: *Tuhua jianwen zhi* (preface 1075), *juan* 4; Eng. trans. by A. C. Soper as *Kuo Jo-hsü's Experiences in Painting* (Washington, DC, 1951)

Mi Fu: *Hua shi* [History of painting] (*c.* 1100), *juan* 1

Xuanhe huapu [Xuanhe collection of paintings] (preface 1120), *juan* 12

Wai-kam Ho: *Eight Dynasties of Chinese Painting* (Cleveland, 1980), pp. 15–19

Zhongguo meishujia renming cidian [Dictionary of Chinese artists] (Shanghai, 1981), p. 161

Chen Gaohua: *Song Liao Jin huajia shiliao* [Historical material on painters of the Song, Liao and Jin] (Tianjin, 1984), pp. 195–203

JOAN STANLEY-BAKER

Jürgen-Fischer, Klaus. *See under* SYN.

Jurjaniyya. *See* KUNYA-URGENCH.

Jurkovič, Dušan (*b* Stará Tura, Slovakia, 23 Aug 1868; *d* Bratislava, 21 Dec 1947). Slovak architect and designer. He studied architecture at the Staatsgewerbeschule, Vienna, and began his career in Martin, Slovakia. He was inspired by the traditional vernacular architecture of the region and applied its principles to the design of several timber houses including the Maměnka and Jídelna tourist hostels (1897–9) at Pustevny pod Radhoštěm, Moravia, and the Rezek holiday house (1900–01) near Nové Město nad Metují, Bohemia, as well as in the poetically conceived plan of the Luhačovice Spa, Moravia, and some houses there (all 1901–3). Jurkovič was also influenced by the Arts and Crafts Movement in Britain, particularly the work of M. H. Baillie Scott (1865–1945) and Charles Rennie Mackintosh, as well as that of Eliel Saarinen and Armas Lindgren in Finland. He transformed these ideas, blending them with the local vernacular tradition to develop an individual style of Art Nouveau, as seen in his own house (1906) in Brno and the Náhlovský house (1907) in Bubeneč, Prague.

Shortly before World War I, Jurkovič reconstructed the château of Nové Město nad Metují (1908–13), designing some very fine interiors and furniture (*see* CZECH REPUBLIC, §V, 4). During the war, in 1916–18, he designed several military cemeteries in Galicia, again using the principles of traditional timber architecture. After the Czechoslovak Republic was created in 1918 he moved to Bratislava to organize the reconstruction of historic monuments, especially the castle at Zvolen (1924–5). His work culminated in the stone monument (1926–8) of General Milan Rastislav Štefánik at Bradlo, Slovakia, the design of which was based on classical models from ancient Mesopotamia. Jurkovič, who was a member of the Mánes Union of Artists and the Association of Architects, was one of the most important figures in Czechoslovak culture at the turn of the 20th century; his work helped it to shed its provincialism and introduce modern European ideas.

BIBLIOGRAPHY

A. Karplus: *Neue Landhäuser und Villen in Österreich* (Vienna, 1910), pp. 44–6

F. Žákavec: *Dílo Dušana Jurkoviče: Kus dějin československé architektury* [The work of Dušan Jurkovič: a slice of Czechoslovak architectural history] (Prague, 1929)

Z. Lukeš and V. Šlapeta: 'Dušan Jurkovič', *Tschechische Kunst, 1878–1914: Auf dem Weg in die Moderne* (exh. cat., Darmstadt, 1984), pp. 106–9

VLADIMIR ŠLAPETA

Jussow, Heinrich Christoph (*b* Kassel, 9 Dec 1754; *d* Kassel, 26 July 1825). German architect. He studied architecture from 1778 at the Collegium Carolinum in Kassel under Simon Louis Du Ry. His earliest surviving designs show a close allegiance to the architecture of the Prussian court in Berlin and Potsdam. At about this time he taught architecture under Du Ry. In 1783 Jussow received a bursary from Landgrave Frederick II of Hesse-Kassel (*reg* 1760–85), which enabled him to stay in Paris until 1785. There he was a pupil of Charles de Wailly, who had produced various designs for a new residential palace and a pleasure palace, both at Weissenstein (later Wilhelmshöhe), for the Kassel court. In de Wailly's studio Jussow drew up his first scheme for Schloss Wilhelmshöhe, which exhibits the direct influence of Claude-Nicolas Ledoux, who was also working on projects for Landgrave Frederick at the time. Jussow also spent a year in Italy (1785–6) and was one of the first German architects to study and draw the ancient temples at Paestum. Landgrave William IX of Hesse-Kassel (*reg* 1785–1821) awarded Jussow a further bursary to travel to England, where he stayed until the end of 1787, studying English landscape gardening and styles of building.

In 1788 Jussow began to work as architect and landscape gardener to the new palace and park at Wilhelmshöhe, the grandest example of the landscape garden in Germany. Du Ry had started a wing of the Wilhelmshöhe pleasure palace in 1786, and in 1791 Jussow won the commission to design the *corps de logis*. He built the central range of the building in a style reminiscent of English Palladianism, with a giant hexastyle frontispiece on each long front and a circular dome. This monumentality again reflected the influence of French Revolutionary architecture in the manner of Etienne-Louis Boullée and Ledoux. Schloss Wilhelmshöhe (completed 1801) is an effective townscape feature closing the vista of the long avenue that links the town of Kassel with the park of Wilhelmshöhe. The park itself shows the influence of the mature English landscape garden in the style of William Chambers and Capability Brown. Jussow erected two artificial ruins in the middle of it: the Roman Aqueduct (1788–92) and the Löwenburg (1793–1801). The Löwenburg, which was intended to serve as a mausoleum for the Landgrave, and in which

suggestions from Sanderson Miller's sham castles and Horace Walpole's Strawberry Hill are united, is one of the most important examples of the Gothic Revival in Germany (*see* KASSEL, §3). This incidental architecture was integrated in several stages into a complete, habitable garden palace. Jussow's fascination with ruins was so great that he wanted to replace the *corps de logis* of Schloss Wilhelmshöhe with a classical ruin. Other projects in Kassel included several new buildings, for example a mausoleum (1826) for Wilhelmine Caroline (*d* 1820). However, a new palace, the Chattenburg, remained unfinished and was demolished in the 19th century.

BIBLIOGRAPHY

A. Holtmeyer: *Die Bau- und Kunstdenkmäler im Regierungsbezirk Cassel*, iv (Marburg, 1910); vi (Kassel, 1923)
Heinrich Christoph Jussow: Baumeister in Kassel und Wilhelmshöhe (exh. cat., ed. H. Vogel; Kassel, Hess. Landesmus., 1958–9)
A. Bangert: *Architektur von H. C. Jussow in Kassel um 1800* (PhD diss., Munich, Tech. U., 1969)
H.-C. Dittscheid: 'Stadtbaukunst in Kassel unter Landgraf Wilhelm IX/Kurfürst Wilhelm I, 1785–1821', *Stadtplanung und Stadtentwicklung in Kassel im 18. Jahrhundert*, ed. G. Schweikhart (Kassel, 1983), pp. 53–67
——: *Kassel-Wilhelmshöhe und die Krise des Schlossbaues am Ende des Ancien Régime: Charles de Wailly, Simon Louis Du Ry und Heinrich Christoph Jussow als Architekten von Schloss und Löwenburg in Wilhelmshöhe, 1785–1800* (Worms, 1987)

HANS-CHRISTOPH DITTSCHEID

Justi, Carl (*b* Marburg, Hesse, 1832; *d* Bonn, 1912). German art historian. After studying theology and philosophy in his native city, he took his doctorate at the University of Berlin in 1859 (pub. 1860) with a thesis on the aesthetic element in Platonic philosophy. He taught theology and philosophy at the universities of Marburg and Kiel but from 1872 concentrated on teaching art history at the University of Bonn. Justi belongs to the school of art historians that includes Eugène Muntz and Max Dvořák who focused on the study of art in a cultural context in the spirit of JACOB BURCKHARDT. An academic and the author of important studies and monographs on Johann Joachim Winckelmann, Hieronymus Bosch and Michelangelo, Justi made his first significant visit to Spain in 1872. This marked the beginning of an intense, fruitful period of studies on Spanish art, the characteristics of which had been overlaid by myths created by the Romantics, and virtually unsupported by any truly sound scientific publications. After 20 years of research and visits in Spain, Justi published monographs on Diego Velázquez and Bartolomé Esteban Murillo, as well as numerous scholarly and critical articles on Spanish art and culture.

WRITINGS

Die ästhetischen Elemente in der Platonischen Philosophie (Marburg, 1860)
Winckelmann und seine Zeitgenossen, 2 vols (Leipzig, 1866–72, rev. 3/1923)
Diego Velázquez und sein Jahrhundert (Bonn, 1888)
'Die Werke des Hieronymus Bosch in Spanien', *Jb. Preuss. Kstsamml.*, x (1889), pp. 141–4
Murillo (Bonn, 1892)

BIBLIOGRAPHY

E. Tormo: 'Necrológicas de 1912: El Doctor Justi', *Bol. Soc. Esp. Excurs.*, xx (1912), pp. 303–6
J. A. Gaya Nuño: 'Después de Justi. Medio siglo de estudios velazquistas', *Velázquez y su siglo* (Madrid, 1953) [appendix]
H. Kehrer: *Deutschland in Spanien. Beziehung, Einfluss und Abhängigkeit* (Munich, 1953)

FRANCISCO CALVO SERRALLER

Justice scenes. Themes of justice taken from biblical and literary texts and used to decorate the courtrooms of town halls; their message was often moralizing, encouraging the aldermen, who administered justice, to shun corruption. Early justice scenes are found in wall paintings, but from the 15th century they are usually on panel or canvas as well as in such other media as sculpture. From the 15th century until the end of the 17th, justice scenes were most popular in the Netherlands and the Holy Roman Empire.

1. THE LAST JUDGEMENT. The most common subject, based on texts in Matthew and Revelations, was the Last Judgement. In the Netherlands, the earliest documented justice scene is a *Last Judgement* panel (1388; untraced) painted by Jan Coene the elder (*fl* 1387–1408) for the Bruges magistrates. The earliest known justice scene (untraced) in Germany was perhaps painted in Cologne as early as 1387; although justice scenes (untraced) in Nuremberg have been claimed to date from 1378, documentary evidence does not support a date earlier than 1423. This subject was painted by many artists, among whom Lieven van de Clite (*fl* 1386–1422) painted a version (Diest, Stedel. Mus.) for the Council of Flanders in Ghent in 1413. Dieric Bouts the elder was commissioned in 1468 to paint this scene (central panel, untraced; wings, perhaps those on dep. at Lille, Mus. B.-A. from Paris, Louvre) as part of a series for the town council of Leuven (*see* BOUTS, (1)). Lanceloot Blondeel executed a *Last Judgement* (untraced) in 1540–47 for the aldermen's room in Blankenberge. In 1551 Pieter Pourbus completed this scene (Bruges, Grœningemus.) for the aldermen's room of the Bruges Stadhuis. At the end of the 16th century Gaspard Heuvick (*c.* 1550–after 1590) painted a version (1589) for the Oudenaarde Stadhuis.

In order to indicate the susceptibility of all mankind to the final judgement, medieval artists began including in judgement scenes not only emperors and princes but also popes and cardinals in both the heavenly and the infernal company. The anti-clerical tendency in Last Judgement scenes became significant in the 16th century. An extremely prominent placement of the pope in Hell is shown, for instance, in a *Last Judgement* window (1505) designed by Hans Holbein the elder for the bishops' burial room in Eichstätt Cathedral. Netherlandish examples include the wall painting (1518–19; *in situ*) by Jacob Cornelisz. van Oostsanen in the apse of St Laurenskerk in Alkmaar, in which a tonsured monk is prominent among the damned being pulled into Hell. Surviving depictions of the Last Judgement in various media (panel, wall painting, wood and stone sculpture, stained glass) include those executed for the town halls of Rostock (*c.* 1358), Überlingen (1492–4), Nuremberg (*c.* 1500; rest.), Zug (1506), Augsburg (1614–35 and *c.* 1625) and Schwäbisch-Hall (*c.* 1735).

2. OTHER SUBJECTS. Sculptural ensembles such as the Nine Worthies also represent a significant tradition combining both the symbolic idea of justice and the specific moralizing narrative of the sculpted justice scene. The Nine Worthies were usually divided into three groups of three figures: Hector, Alexander the Great and Julius Caesar; Joshua, David and Judas Maccabeus; and King

Arthur, Charlemagne and Godefroi de Bouillon. Sculptures of the *Nine Worthies* (*c.* 1384–5; *in situ*) as symbols of justice were executed by Jan van Mansdale I (*c.* 1350–1425) for the consoles of the Schepenhuis in Mechelen, and sculptures of the same subject also featured on the walls of town halls in Cologne, Lüneburg, Osnabrück, Hamburg, Bremen and Danzig (now Gdańsk). In order to give greater reality and immediacy to their justice scenes, painters often revived medieval or even contemporary stories, as did Rogier van der Weyden when he painted the medieval *Legend of Emperor Trajan and Herkinbald* (1439–before 1450; destr. 1695; *see* WEYDEN, (1)) on the walls of the Brussels Stadhuis, known through tapestry copies (before 1461; Berne, Hist. Mus.). Dieric Bouts the elder turned to another medieval legend in his *Justice of Emperor Otto III* diptych (inc. 1475; Brussels, Mus. A. Anc.), commissioned by the aldermen of Leuven in 1468. Albrecht Dürer made a series of designs after Rogier van der Weyden's justice scenes, which he intended to have painted in Nuremberg with the assistance of Hans Suess von Kulmbach, Hans Springinklee and Hans Schäufelein the elder.

Gerard David's diptych, the *Justice of Cambyses* (1498; Bruges, Groeningemus.; see fig.), which was commissioned by pro-Habsburg Bruges magistrates, is one of the rare Netherlandish 15th-century justice panels based on sources derived from Classical antiquity, in this case a Persian legend recorded in the *Histories* (V. 25) of Herodotus. Only one other contemporary depiction of the theme is recorded, executed on canvas (1497–8; untraced) by Martin de Hauchin for the aldermen of Mons. Gerard David's *Justice of Cambyses* was not only an *exemplum iustitiae* but also a unique political manifesto aimed at changing the moral and political behaviour of the citizens of Bruges after their ill-fated revolts (1488–91) against

Maximilian I, Duke of Guelders (later Holy Roman Emperor). It was not until the 16th century that the legend of Cambyses became more popular in the visual arts, including stained glass, tapestry and medals. In 1542 an anonymous master painted this subject (untraced) for the aldermen's room of Douai Hôtel de Ville, and the tradition continued well into the 17th century, as exemplified by the *Justice of Cambyses* (1671) by Victor Boncquet (1619–77) in the Onze Lieve Vrouw, Nieuwpoort.

As the 16th century progressed, various biblical scenes became popular, such as the Judgement of Solomon, Susanna and the Elders and Esther and Ahasuerus. Guyot de Beaugrant executed four reliefs for an alabaster frieze depicting the story of *Susanna and the Elders* (1529–31; Bruges, Vrije Mus.) for the Schepenzaal (aldermen's room) of the Bruges Vrije, and an anonymous 16th-century tapestry with *Susanna and the Elders* was hung in the Halle in Oudenaarde, where an anonymous sculptor also carved a *Judgement of Solomon* (*c.* 1530). Frans Floris painted the latter scene (1547–56) for Antwerp Stadhuis, and this thematic tradition was continued in two lost works, one (1559–60) by Jan Massys and the other (1583) by Michiel Coxcie. In the 16th and 17th centuries other *exempla iustitiae* were based on such Classical stories as those of Apelles, Curius Dentatus, Zaleukos, the sons of Brutus, Herod the Great, Damokles, Scipio, Marcus Curtius, Coriolanus, Lucretia, Diana and Actaeon, Horatius Cocles, Mucius Scaevola and Solon, among others. Lesser-known stories include that depicted in Marten de Vos's *Brabant Minter's Oath* (1594; Antwerp, Rockoxhuis), painted for the aldermen's room of the Brabant Mint in Antwerp; in the *Son who Has to Behead his Father* (1608; Ghent, Oudhdknd. Mus. Bijloke) by Pieter Pieters (1578–1631) for the aldermen's room in Ghent Stadhuis; and in the *Tomyris with the Head of Cyrus* (1610; Bruges, Vrije Mus.)

Gerard David: *Justice of Cambyses*, left and right panel, oil on panel, each panel 1.82×1.59 m, completed 1498 (Bruges, Groeningemuseum)

by the same artist for the Bruges Vrije. Analysis of the many justice scenes testifies to the variety and richness of the artistic and judicial tradition in the Netherlands and Germany.

BIBLIOGRAPHY

U. Lederle: *Gerechtigkeitsdarstellungen in deutschen und niederländischen Rathäusern* (Philippsburg, 1937)

G. Troescher: 'Weltgerichtsbilder in Rathäusern und Gerichtsstätten', *Wallraf-Richartz-Jb.*, xi (1939), pp. 139–214

C. Harbison: *The Last Judgment in Sixteenth-century Northern Europe: A Study of the Relation between Art and Reformation* (New York, 1976)

J. H. A. De Ridder: 'Gerechtigheidstaferelen in de 15de en 16de eeuw, geschilderd voor schepenhuizen in Vlaanderen' [Justice scenes in the 15th and 16th centuries, painted for town halls in Flanders], *Gent. Bijdr. Kstgesch.*, xxv (1979–80), pp. 42–62

——: *Gerechtigheidstaferelen voor schepenhuizen in Vlaanderen in de 14de, 15de en 16de eeuw* [Justice scenes for town halls in Flanders in the 14th, 15th and 16th centuries] (diss., Ghent U., 1986)

H. J. Van Miegroet: 'Gerard David's Justice of Cambyses: *Exemplum iustitiae* or Political Allegory?', *Simiolus*, xviii (1988), pp. 116–33

HANS J. VAN MIEGROET

Justin II, Emperor of Byzantium (*reg* 565–78; *d* Constantinople [now Istanbul], 4–5 Oct 578). Byzantine ruler and patron. He was a nephew of Justinian I and his successor; his wife Sophia (before 530–after 600) was the niece of Justinian's wife Theodora (*d* 548). Sophia had considerable influence over Justin and with the onset of his attacks of insanity persuaded him to appoint his successor, Tiberios I (*reg* 578–82). Although few datable works survive from his reign, literary sources indicate that Justin commissioned numerous buildings, sculptures and smaller objects. Sophia was influential in most of these projects and was the first empress to appear on Byzantine coins with the emperor. Among the small objects attributed to the couple are the cross of Justin II (Rome, Vatican, Mus. Stor. A. Tesoro S Pietro; *see* CROSS, §III, 1(i) and fig. 3) and a reliquary of the True Cross, which was sent to Radegund, Queen of France (*d* 587); it has been identified by some with an enamelled plaque framing a Byzantine cross (Poitiers, Ste Radegonde). Statuary and buildings (largely destr.) erected by Justin in Constantinople included a group of statues placed at the harbour of Sophia depicting *Justin*, *Sophia*, their daughter *Arabia* and a fourth person, variously identified as Narses, Justin's minister, or Vigilantia, Justin's mother. A second group of statues on the 4th-century Milion (the tetrapylon on Constantinople's main street) represented *Sophia*, *Arabia* and *Helena*, Sophia's niece. Justin reconstructed the harbour of Julian; he named it and two new palaces after his wife. He erected the Deuteron Palace in the city's north-west suburb and a fourth palace on the island of Prinkipo (now Büyükada). Other projects attributed to him include the reconstruction of the patriarchal palace (565–77), the restoration of the public baths in the Forum Tauri and the construction of the domed, octagonal Chrysotriklinos ('golden throne room'; after 565) in the Great Palace, which was decorated with scenes from the *Life of Christ* (*see* ISTANBUL, §III, 12). Justin is credited with founding several new churches in and around Constantinople as well as undertaking work in four existing churches, including the adornment (destr.) of the church of the Holy Apostles and Hagia Sophia, and some structural work in the church of the Virgin at Chalkoprateia and in the Blachernai Palace church.

BIBLIOGRAPHY

M. Conway: 'St Radegund's Reliquary at Poitiers', *Antiqua. J.*, iii (1923), pp. 1–12

C. Mango: *The Art of the Byzantine Empire, 312–1453: Sources and Documents* (Englewood Cliffs, 1972/R Toronto, Buffalo and London, 1986)

Averil Cameron: 'The Empress Sophia', *Byzantion*, xlv (1975), pp. 5–21

——: 'The Artistic Patronage of Justin II', *Byzantion*, l (1980), pp. 62–84

E. Kitzinger: 'Der kranke Justin II und die ärztliche Haftung bei Operationen in Byzanz', *Jb. Österreich. Byz.*, xxxvi (1986), pp. 39–44

KARA HATTERSLEY-SMITH

Justinian I, Emperor of Byzantium [Flavius Petrus Sabbatius Justinianus] (*b* Tauresium, nr Naissus [now Nish, Serbia], *c.* AD 482; *reg* 527–65; *d* Constantinople, 15 Nov 565). Byzantine ruler and patron. He was a nephew of Emperor Justin I (*reg* 518–27), upon whose accession he was brought to Constantinople. He was prepared for political power by receiving the rank of *comes illustris* and according to contemporary sources he was the real power behind the throne during Justin's reign. In 521 he became consul and in 523 he married Theodora (*d* 548), who was to exercise considerable influence over him. He became Emperor on 4 April 527. Among his most lasting achievements was the codification of laws in the *Corpus juris civilis*, which he issued in 534. The most closely analysed aspect of his reign, however, is his artistic and architectural contribution during what has become known as the first golden age of Byzantine art.

Justinian aimed at the restoration and revival of the empire by re-establishing its political and religious unity. His imperial triumphs included the reconquests of Africa and eastern Spain from the Vandals (534) and Italy from the Ostrogoths (535). These events were recorded in two works of art (both lost): the ceiling mosaic in the Chalke Gate of the Great Palace (*see* ISTANBUL, §III, 12); and the vestment made for Justinian's funeral, which was described by Flavius Cresconius Corippus. Among the spoils from Africa were the Menorah and vessels from the temple of Solomon, which were returned to Jerusalem and kept in various churches there. As the guardian of Orthodoxy, he pursued a repressive religious policy against non-believers and heretics. Despite his efforts to resolve the Monophysite controversy, he failed to obtain a secure basis for peace between the opposing religious parties in the East and West, and at the end of his life was regarded as a heretic.

Many important monuments survive from Justinian's reign, and many more are known from literary sources, particularly Procopius' *De aedificiis* (*c.* 553–5), which he probably commissioned. Although it exaggerates the extent and importance of his building programme, it contains invaluable source material, for example details of the reconstruction of Constantinople following the Nika riot (532). His many utilitarian projects there included six hospices and two of the city's largest underground cisterns, both still extant: the Basilica Cistern (Turk. Yerebatan Sarayı; *c.* 141×66.5 m) and the Cistern of Philoxenus (Turk. Binbirdirek; *c.* 65×57 m). Other works included the reconstruction of the Chalke Gate, the baths of Zeuxippus, and the senate house, in front of which he had a column and bronze equestrian statue of himself erected. He is also said to have instigated the building or restoration of several suburban palaces and as many as 33 churches, of which

Bridge commissioned by Justinian I over the River Sangarius (now Sakarya), near Sapanca, Turkey, south side, l. *c.* 439 m, completed AD 560

F. Cresconius Corippus: *In laudem Iustini Augusti* (565), I.272–93; Fr. trans., ed. S. Antès as *Eloge de l'empereur Justin II* (Paris, 1981), pp. 27–8

G. A. Downey: *Constantinople in the Age of Justinian* (Norman, OK, 1960)

R. Browning: *Justinian and Theodora* (London, 1971)

C. Mango: *Architettura bizantina* (Milan, 1974; Eng. trans., New York, 1976)

E. Kitzinger: *Byzantine Art in the Making* (London, 1977)

A. Cameron: *Continuity and Change in Sixth Century Byzantium* (London, 1981)

D. Pringle: *The Defences of Byzantine Africa from Justinian to the Arab Conquest*, 2 vols (Oxford, 1981)

M. Maas: *Innovation and Restoration in Justinianic Constantinople* (diss., Berkeley, U. CA, 1982)

K. W. Weitzmann: *Studies in the Arts at Sinai* (Princeton, 1982)

G. G. Archi, ed.: *Il mondo del diritto nell'epocà Giustineanea* (Ravenna, 1985)

M. Whitby: 'Justinian's Bridge over the Sangarius and the Date of Procopius' *De aedificiis*', *J. Hell. Stud.*, xv (1985), pp. 129–48

CHARLES MURRAY

Justiniana Prima. *See* CARIČIN GRAD.

Justus of Ghent [Giusto da Guanto; Joos van Gent; Juste de Gand; Justus van Gent] (*fl c.* 1460–80). South Netherlandish painter, active also in Italy. He is commonly identified with JOOS VAN WASSENHOVE, master at Ghent, who is said to have gone to Rome some time between 1469 and 1475. Many of Justus's works have been attributed to the Spaniard Pedro Berruguete (*see* BERRUGUETE, (1)), and problems remain in this area. Justus is documented between 1473 and 1475 in Urbino, where he ran a workshop, and he was the only major Netherlandish painter working in 15th-century Italy.

1. Identity. 2. Life and work. 3. Attributional controversies. 4. Working methods and technique.

1. IDENTITY. Contractual documents refer to Giusto da Guanto as the author of the altarpiece of the *Communion of the Apostles* (Urbino, Pal. Ducale; see fig. 1), painted for the Confraternity of Corpus Domini at Urbino in 1473–4; Vasari also mentioned him in this context. Justus is reasonably assumed to be the master said to have been summoned from Flanders by Federigo II da Montefeltro, Count and later Duke of Urbino, and to have painted numerous works for him, notably a series of 28 portraits of *Famous Men* (Urbino, Pal. Ducale; Paris, Louvre) in the *studiolo* of the Palazzo Ducale. The authority for this is the biography of Federigo written by his former librarian, Vespasiano da Bisticci, in the 1480s. Justus's stay at Urbino is documented only in the records of the Confraternity of Corpus Domini between 12 February 1473, when he received the first instalment for the altarpiece, and 7 March 1475, when he is said to have undertaken to paint a banner for the Confraternity.

2. LIFE AND WORK.

(i) The Netherlands. There are no documented works by Justus in the Netherlands, but on the basis of stylistic analogy with the *Communion*, two works are commonly attributed to his Netherlandish period: an *Adoration of the Magi* on cloth (New York, Met.) and a large triptych of the *Calvary* (Ghent, St Bavo). The latter, painted for the Burgundian courtier Laurent de Maech and his wife, consists of a central *Crucifixion* with related scenes from

Hagia Sophia (dedicated 27 Dec 537), Hagia Eirene (begun 532), the church of the Holy Apostles (536–50) and SS Sergios and Bacchos (526–37) are the most famous (*see* ISTANBUL, §III, 1(ii), 4, 8 and 9(i)). They reflect the growing popularity of centrally planned churches surmounted by a dome, although most churches were still in the form of a basilica. The interiors of these buildings were usually decorated with multicoloured marbles and mosaics, and objects in precious metals were deployed to their fullest effect.

Outside Constantinople, Justinian continued the work begun by Anastasios I (*reg* 419–518) of consolidating the empire's fortifications, the most elaborate of which were set up on the eastern border, as at Dara (nr Nusaybin, Turkey) and Zenobia (now Malabiye, Syria). Although research on the frontier forts is incomplete, excavations have revealed that at least in Africa much of the building programme was completed. He also commissioned numerous aqueducts, cisterns and bridges, such as the bridge over the River Sangarius (now Sakarya) near Sapanca, Turkey (completed 560; see fig.). Another noteworthy project was the foundation of the city of Justiniana Prima, plausibly identified with CARIČIN GRAD, Serbia, in honour of his birthplace. Justinian replaced Constantine's octagonal church of the Nativity (*see* BETHLEHEM, §1) with a large trefoil transept and chancel church (*c.* 57×28 m). The church (548–65) within the fortress monastery of St Catherine on Mt Sinai (*see* SINAI, §2) is one of the best preserved of his buildings. The superb mosaic of the *Transfiguration* in the apse is contemporary with the building and has been attributed to a workshop from Constantinople. He is also associated with the church of S Vitale in Ravenna (consecrated 547; *see* RAVENNA, §2(vii)), where mosaics in the chancel portray him and Theodora offering gifts. The construction of the church was apparently funded by a wealthy local banker, Julianus Argentarius, and not by the Emperor. Justinian is now variously regarded as a liberal patron of the arts or as a repressive dictator, hostile to all expressions of culture that could be interpreted as dissent.

BIBLIOGRAPHY

Procopius: *De aedificiis* (*c.* 553–5); ed. H. B. Dewing and G. Downey, *Procopius*, viii (London and New York, 1940)

1. Justus of Ghent: *Communion of the Apostles*, oil on panel, 2.83×3.04 m, 1473–4 (Urbino, Palazzo Ducale)

the *Life of Moses* on the wings; the grisaille reverses, severely damaged, show the donors' patron saints. Justus was a gifted exponent of the south Netherlandish tradition, and both the triptych and the *Adoration* reveal the influence of his friend Hugo van der Goes (whom he in turn probably influenced). The works also show a familiarity with those by the van Eycks, Rogier van der Weyden and especially Dieric Bouts I, in whose Leuven workshop Justus possibly spent some formative years.

(ii) Urbino. On arrival in Italy, Justus may have gone to Rome, where a *St Mark* (cloth; Rome, S Marco) is attributed to him. At Urbino, the remarkable cultural ambience of Federigo's court and contact with such artists as Piero della Francesca inevitably affected him. The *Communion of the Apostles* for the Confraternity of Corpus Domini, Justus's only documented work, for which he received payments from 12 February 1473 to 25 October 1474, was destined for the high altar of the church of Corpus Domini, Urbino; its predella (Urbino, Pal. Ducale)

had already been painted (1467–8) by Paolo Uccello. The complex iconography and unusual subject, Christ giving his disciples their first communion, were shown by Aronberg Lavin to have been apt for both the Confraternity and Urbino. Included in the scene are several portraits, of which only that of Federigo da Montefeltro is securely identifiable. There is reason to suppose that the bearded figure beside him represents a Persian ambassador; the figure itself is a quotation from the *Martyrdom of St Erasmus* (Leuven, Collegiate church of St Peter) by Dieric Bouts I. The characteristically Netherlandish high viewpoint and decoratively organized surface of the *Calvary* are modified in the *Communion*, while the size of the figures relative to the picture space is increased. The figure-style in the *Communion* is still Netherlandish, but ungainly, lacking the decorous charm of the *Calvary*. Justus may have experienced difficulties with the exceptional scale of the work, its near life-size figures and unfamiliar monumental idiom.

2. Justus of Ghent: *Federigo da Montefeltro, his Son, Guidobaldo, and Others Listening to a Discourse*, oil on panel, 1.30×2.12 m, *c.* 1480 (London, Hampton Court, Royal Collection)

The remaining works attributable to Justus were all painted for Federigo. The 28 portraits of *Famous Men* mentioned by Vespasiano in Federigo's *studiolo* in Urbino were perhaps begun *c.* 1473 and probably finished before 1476, the presumed date of the *studiolo's* completion. Famous men were a popular theme in Renaissance decorative cycles; at Urbino the choice of philosophers, poets and theologians, ancient and modern, was appropriate to the room's function. Justus's increasing mastery of monumental form and perspective construction is evident in the *Famous Men*, despite their cramped design, as is the transmutation of the bony Netherlandish physiognomies into softer, Italianate types. The scholar Laurent Schrader, who saw the panels *in situ* in 1592, recorded an inscription originally running beneath them, on which reconstructions of their arrangement have been based. Rotondi's reconstruction, using evidence uncovered during restoration of the *studiolo*, can be considered definitive and has been followed in the re-hanging of the portraits in superimposed pairs above the intarsias.

Vespasiano also mentioned a portrait of Federigo by Justus, which is usually identified with the full-length double portrait of *Federigo da Montefeltro and his Son Guidobaldo* (Urbino, Pal. Ducale), datable to *c.* 1476 from the apparent age of Guidobaldo, who was born in 1472. It is both a dynastic portrait and an expression of the Renaissance ideal of the active and contemplative life, which Federigo embodied: he is shown reading, dressed in armour and state regalia, his young heir at his knee (*see* URBINO, fig. 1). It is often assumed to have been part of the *studiolo* decoration, although Vespasiano's text is ambiguous on this point. Another portrait attributed to

Justus is that of *Federigo da Montefeltro, his Son, Guidobaldo, and Others Listening to a Discourse* (London, Hampton Court, Royal Col.; see fig. 2), datable to *c.* 1480, again from Guidobaldo's age. The *Discourse* is customarily assumed to represent a specific event but is interpreted by Campbell as a generalized image of the learned activities of Federigo's court. It has been suggested that its original location was the library of the palace at Urbino or Federigo's *studiolo* in the palace at Gubbio.

More widely accepted as having come from the Gubbio *studiolo* are two paintings: *Music* and *?Rhetoric* (both London, N.G.). These, with two paintings of *Astronomy* and *?Dialectic* (both Berlin, Kaiser-Friedrich Mus., destr.), are believed to have been part of a series of the *Liberal Arts*. They are not mentioned in early sources. It is not known how many pictures the series comprised, but a partial reconstruction is possible from fragments of a running inscription on the known panels. There were probably pictures above the intarsias in the Gubbio *studiolo* as at Urbino, and an inscription from the intarsias (New York, Met.) may well relate to the *Liberal Arts*. The kneeling men below the allegorical figures are apparently portraits, but only that of Federigo in *?Dialectic* is identifiable. The *studiolo* is thought to have been begun by Federigo and completed after his death in 1482 by Guidobaldo, which provides an approximate date for the *Liberal Arts*, assuming they came from it. Technically and stylistically they are similar to the *Discourse* of *c.* 1480.

The *Communion* and the *Famous Men* are transitional works in which Justus was assimilating the novel approaches of Italian art, a process that was completed in the double portrait of Federigo and his son and refined in

the *Discourse* and the paintings of the *Liberal Arts*. His perspective and handling of space became so ambitious that it is sometimes contended that he was advised in this by an Italian, although the creative ambience of Urbino may be sufficient explanation. In Urbino, Justus's late style matured into formal elegance, a unique and unexpected hybrid of Italian economy and grandeur with Netherlandish tone and lustre. Finally, it is believed that Justus was responsible for painting or repainting Federigo's hands, and perhaps his helmet, in Piero della Francesca's Brera Altarpiece (*Virgin and Child*; Milan, Brera) of the mid-1470s. The hands have long been noted as different in technique from the rest of the picture and are very like Federigo's hands in the Urbino double portrait.

3. ATTRIBUTIONAL CONTROVERSIES. The group of works for Federigo da Montefeltro shows stylistic and technical affinities with the *Communion* and is essentially homogeneous, although the *Famous Men* show variations in quality and method of execution. The paintings are evidently the work of a painter grounded in Netherlandish technique but strongly and increasingly affected by Italian approaches. Justus of Ghent would therefore reasonably appear to be the author, but, on the arbitrary premise that a 15th-century Netherlandish painter was incapable of developing in this way, the attribution to him of some or all of these works has been contested. Various alternative artists have been proposed, including Giovanni Santi, Melozzo da Forlì and Donato Bramante, but only the Castilian Pedro Berruguete is now treated as a serious contender. Berruguete's partisans are not unanimous regarding his role, some maintaining that he was Justus's collaborator on the *Famous Men*, others that he completed the series begun by Justus, reworked or even masterminded it; nor are they agreed which of the *Famous Men* to assign to Berruguete. They generally concur in giving him the other works in the group.

The case for Berruguete is as follows. First, a document cited in 1822 by Luigi Pungileoni, but no longer traceable, records the presence at Urbino in 1477 of a 'Pietro Spagnuolo pittore'; it is, however, noted by Clough (1974) that Spagnuolo was the name of a family resident at Urbino in the 15th century. Second, a reference to the *Famous Men* by Pablo de Cespedes in 1604 is sometimes interpreted as an attribution to Berruguete (Clough, 1974); in fact Cespedes stated that they were by a Spanish painter 'other' than Berruguete. Possibly Cespedes thought Justus was Spanish, as did Michelangelo Dolci, who in 1775 named the author of the *Famous Men* as 'Giusto da Guanto pittore spagnolo' (see Lavalleye, 1964, p. 40). Third, the page of a book in the portrait of *Albertus Magnus* (Urbino, Pal. Ducale) is apparently written in Castilian, which may indicate the participation of a Castilian painter. Fourth, certain works attributed to Berruguete in Spain, datable after *c.* 1480, apparently recall the Urbino pictures (basically the *Famous Men*) and the architecture of the Palazzo Ducale; for example, the altarpiece of *St Thomas Aquinas* (Avila, S Tomas) and the *Beheading of St John the Baptist* (Santa Maria del Campo, Burgos, Parish Church). These pictures are, however, technically and stylistically inferior to those at Urbino and cannot reasonably be accepted as the work of the same artist.

In favour of Justus, Vespasiano's evidence must be stressed, since he was personally acquainted with Federigo's court and wrote shortly after the works were painted. Technological investigation of the *Famous Men* has revealed similarities with the *Communion*, notably in the underdrawing, confirming the stylistic continuity between these works. It has also revealed a number of changes in composition and execution (Reynaud and Ressort, 1991) as evidence that the series was reworked by Berruguete. These changes could, though, be due to the standard 15th-century practice of workshop collaboration, to the demands of the patron or even to developments in Justus's own working process, brought about by the Italian milieu. Berruguete may well have worked in Urbino, but presumably only as a subordinate member of the Justus's workshop.

4. WORKING METHODS AND TECHNIQUE. None of Justus's works is in good condition; nevertheless, his technique reveals some distinctive features. His underdrawing is precise yet bold, and in the *Communion* and the *Famous Men*, typically Netherlandish. The Montefeltro portraits and the *Liberal Arts* make use of the Italian technique of incising the outlines of architectural forms in the ground. Colour in the early works is unusually delicate: mauves, pinks and hyacinth blues mingling with the more familiar Netherlandish reds and greens; the latter, rich and sonorous, are increasingly dominant later on. Jewels, brocade and glinting metalwork feature prominently in his Italian works, perhaps in response to local admiration of Netherlandish lustrous effects. While the paint structure of the *Calvary* is fairly standard, the Italian works show some variation from Netherlandish norms, and the brushwork becomes relatively broad. Some areas show extensive craquelure, implying misuse of drying oil. Justus's technique would have been modified by Italian materials: different wood and ground preparation and possibly inferior drying oil. Local practice, and the collaboration of assistants unfamiliar with Netherlandish methods, must also have affected the technical quality of his work.

It can be assumed that Justus ran a workshop at Urbino, which provided a significant means of disseminating Netherlandish forms and technique at a time when Italian interest in them was high. The six pictures of *Apostles* (all Urbino, Pal. Ducale) are probably an example of its output. As the only major Netherlandish painter demonstrably working in 15th-century Italy, Justus's importance should be emphasized, not only for the increasingly Netherlandish orientation of Piero della Francesca but also for Raphael, to whom a sketchbook containing copies of the *Famous Men* (Venice, Accad.) is sometimes attributed.

BIBLIOGRAPHY

Thieme–Becker

G. Vasari: *Vite* (1550, rev. 2/1568); ed. G. Milanesi (1878–85), i, p. 185
V. da Bisticci: *Vite di uomini illustri del secolo XV* (Rome, 1839); ed. E. Aeschliman and P. d'Ancona (Milan, 1951)
A. de Ceuleneer: 'Juste de Gand', *A. Anc. Flandre*, v (1911), pp. 58–109
J. Lavalleye: *Juste de Gand* (Leuven, 1936)
M. Davies: *The Early Netherlandish School*, London, N.G. cat. (London, 1948, rev. 3/1968), pp. 69–78
E. Panofsky: *Early Netherlandish Painting*, i (Cambridge, MA, 1953), pp. 340–42
M. Davies: *The National Gallery, London*, Les Primitifs Flamands, I/iii (Antwerp and Brussels, 1953–70), ii, pp. 142–57

Juste de Gand, Berruguete et la cour d'Urbino (exh. cat. by J. Lavalleye, Ghent, Mus. S. Kst., 1957)

F. Winkler: 'Dieric Bouts und Joos van Gent', *Kunstchronik*, xi (1958), pp. 1–11

N. Verhaegen and others: 'Het Calvarie-drieluik toegeschreven aan Justus van Gent en de bijhorende predella', *Bull. Inst. R. Patrm. A.*, iv (1961), pp. 7–43 [with Fr. summary]

J. Lavalleye: *Le Palais Ducal d'Urbin*, Les Primitifs Flamands, I/vii (Brussels, 1964)

M. Aronberg Lavin: 'The Altar of Corpus Domini in Urbino', *A. Bull.*, xlix (1967), pp. 1–24

C. H. Clough: 'Federigo da Montefeltro's Private Study in his Ducal Palace of Gubbio', *Apollo*, lxxxvi (1967), pp. 278–87

M. J. Friedländer: *Die alterniederländische Malerei* Berlin, 1924–37); Eng. trans. as *Early Netherlandish Painting* (Leiden, 1967–76), iii, pp. 43–58, 84–5

P. Rotondi: 'Ancora sullo studiolo di Federigo da Montefeltro nel Palazzo Ducale d'Urbino', *Restauri nelle Marche: Testimonianze, acquisti e recuperi* (Urbino, 1973), pp. 561–602

C. H. Clough: 'Pedro Berruguete and the Court of Urbino', *Notizie da Palazzo Albani*, iii (1974), pp. 17–24

Disegni umbri del rinascimento da Perugino a Raffaello (exh. cat., ed. S. Ferino Pagden; Florence, Uffizi, 1982), pp. 134–216

L. Campbell: *The Early Flemish Pictures in the Collection of Her Majesty the Queen* (Cambridge, 1985), pp. 59–65

L. Cheles: *The Studiolo of Urbino: An Iconographic Investigation* (Wiesbaden, 1986)

N. Reynaud and C. Ressort: 'Les Portraits d'hommes Ilustres du studiolo d'Urbino au Louvre par Juste de Gand et Pedro Berruguete', *Rev. Louvre*, 41 (1991), pp. 82–116

M. Evans: '"Uno maestro solenne": Joos van Wassenhove in Itay', *Ned. Ksthist. Jb.*, xliv (1993), pp. 75-110

PAULA NUTTALL

Juvarra, Filippo (*b* Messina, 16 June 1678; *d* Madrid, 31 Jan 1736). Italian architect, draughtsman and designer. His work reinforced a Late Baroque classical tradition while also drawing on the leavening criticism of that tradition by Francesco Borromini. His work is characterized by clarity and directness, his architectural conceptions defined by a drastically reduced structure and complex conglomerate spaces; his surfaces were adorned with elaborate decorative systems the originality of which pointed the way to a light-hearted Rococo. In 1714 he became first architect of Victor-Amadeus II of Savoy, King of Sicily. Juvarra's mandate was to accomplish the transformation of Turin begun in the 17th century. During a 20-year residence in Turin he built sixteen palaces and eight churches, and designed numerous church ornaments. He also designed furniture, theatre scenery and urban complexes.

1. Early life and work in Rome, to 1713. 2. Turin and Piedmont, 1714–34. 3. Spain, 1735 and after.

1. EARLY LIFE AND WORK IN ROME, TO 1713. Between 1693 and 1701 Juvarra worked with his father and brothers as a silversmith in Messina. He also studied there for the priesthood and was ordained in 1703. In 1704 he moved to Rome and was presented to Carlo Fontana (iv), professor of architecture at the Accademia di S Luca and, as inheritor of Bernini's projects and social position in Rome, then the most important architect in the city. Under Fontana's guidance Juvarra studied the buildings of Michelangelo, Bernini and Francesco Borromini, and in 1705 he won the Concorso Clementino—the Accademia's prize for the final year of study—with an unusual design for a villa to be occupied by three aristocrats

of equal rank. Subsequently, while teaching at the Accademia (1706–8 and 1711–12), he participated in competitions for buildings in Naples, Lucca and Genoa, and he provided drawings for the printers Antonio Rossi and Giovanni Maria Salvioni.

Juvarra's principal employment in Rome, however, seems to have been as a stage designer, in which he established his reputation with designs for Cardinal Pietro Ottoboni's theatre in the Palazzo della Cancelleria (1708–14) and for the Teatro Capranica (1712–13). This interest in stage design is demonstrated in his preparatory drawings for a representation (untraced) of the Capitol in antiquity, as well as in his only architectural work in Rome, the Antamoro Chapel (1708–10) in S Girolamo della Carità: clad in green, brown and dark yellow marbles and enriched with gilded coffers, stucco reliefs and carved white marble bases and capitals, and having a large, oval, yellow-and-orange stained-glass window representing the Holy Spirit as a globe of fire, the chapel became an influential colouristic composition.

Juvarra was a talented draughtsman, and of the important collection of beautiful drawings he left (mostly Turin, Bib. N. U.; New York, Met.; London, V&A), over 1000 survive from his first ten years in Rome. They depict both imaginary schemes and studies of buildings ranging from the Pantheon to the works of Borromini, and they reflect his pedagogical approach to architecture developed at the Accademia; they served as a quarry of inspiration for his own architectural compositions.

2. TURIN AND PIEDMONT, 1714–34. In 1714 Juvarra entered the service of Victor-Amadeus II, becoming his principal architect and moving to Turin. In the same year he was invited to compete for the commission to build the sacristy of St Peter's, Rome, but although his model was considered to be the best, his scheme was unsuccessful.

(i) Churches. (ii) Secular buildings. (iii) Urban planning.

(i) Churches. Among Juvarra's first commissions in Turin was the church and monastery at Superga (1717–31; see fig. 1), a votive offering by the King that, although situated on a hill outside the city, was intended to be clearly visible from within it. Juvarra's solution, a central plan church with a dome raised on a tall drum, flanking towers and a square, tetrastyle temple portico emerging from a large monastery structure, made an imposing silhouette visible from as far as Rivoli, the royal villa west of Turin. The interior of the church is flooded with light that enters through the large windows of the drum; the central space of the nave is defined by great Corinthian columns that support a continuous entablature above the arches leading into the perimeter chapels and on which the drum rests. Elaborate stucco reliefs, rich carving in the capitals and window frames and the use of light-coloured marbles endow the space with an unusual solemn vivacity.

For the exterior of the church at Superga, Juvarra drew upon several Roman and Sicilian models: the temple portico, for example, emulates and improves on that of the Pantheon and recalls, in the spacing of its front columns, the porticos of the twin churches by Bernini and by Carlo Rainaldi in the Piazza del Popolo, Rome, as well

1. Filippo Juvarra: church at Superga, near Turin, 1717–31

as the entry façades of the colonnade around St Peter's Square at the Vatican. The twin flanking towers that link the church with the monastic block behind echo the towers of Borromini's S Agnese in Agone, Rome, as well as the composition (and hill site) of such Sicilian churches as the cathedral of Palma di Montechiaro by Angelo Italia. At the same time, the tower-like dome (its height equal to that of the body of the church) frees the church from the attached complex.

Juvarra's first church project in Turin itself, S Filippo Neri, has a complex early history. Its original dome, designed by Michelangelo Garove, collapsed in 1714 and was rebuilt by Juvarra, who prepared plans (c. 1715) for a reconstruction of the church; these were altered when the principal building campaign began in 1730–32, then work was interrupted again and the church was completed only in the first half of the 19th century by Giuseppe Talucchi (1782–1863), but to Juvarra's design. This consists of a wide nave of three equal bays with apsidal side chapels, the nave being narrowed at both ends by curving piers that meet the entrance and the apse. Paired pilasters and two levels of boxes above each opening decorate the piers between the side chapels. The arched openings of the side chapels spring from engaged columns and reach to the entablature of the main order. The tall vaults above the chapels open into large windows of nearly circular form and are banded with arches. The light, warm and gilded tones of the interior suggest secular tastes in decoration that prevailed at the beginning of the 18th century.

Concurrent with his work on the church at Superga and S Filippo Neri, Juvarra prepared façade designs for the twin churches of S Carlo (built 1619) and S Cristina (1639) in the Piazza S Carlo, Turin, which had been designed by Carlo di Castellamonte. Juvarra executed only the façade for S Cristina (begun 1715), although that for S Carlo, finally constructed in the 19th century, drew heavily upon his composition and proportions. S Cristina has a two-storey elevation indebted to Carlo Fontana's façade for S Marcello al Corso, Rome; it is concave, with the lower level extended laterally, and with columns at the upper level flanking an oval window, above which the entablature of the pediment is recessed. The silhouette is enlivened with tall candelabra placed above the pediment and with sculptures raised on pedestals above the lower entablature; these pedestals are as high as those of the adjacent columns. The exuberant use of columns around the corner of the façade and flanking its sides recalls the façade of the cathedral in Catania, which was probably known to Juvarra, and accentuates the difference between the church and the sombre, uniform, porticoed façades of the residential blocks that line the longer sides of the square.

The third of Juvarra's four churches in Turin is the centrally planned Santa Croce (1718–30), Piazza Carlo Emanuele II (Piazza Carlina). A longitudinal oval in plan, it has a ribbed and coffered dome springing directly from a Composite-order entablature. The entry from the piazza is unadorned since the façade was not finished; the design as realized is less innovative than the daring early scheme.

A bolder composition than Santa Croce or his centralized chapel of S Uberto (begun 1716; *see* §(ii) below) at the Venaria Reale, near Turin, was produced by Juvarra for his later church of S Andrea (*c.* 1728; destr. 19th century), Chieri. It had a circular plan with arms extended to form a Greek cross, with the fourth arm replaced by a rectangular bay crowned with a dome. The central space was covered with a hemispherical dome interrupted by huge tripartite windows inserted between its ribs and dipping down into the impost entablature. It was a much more sophisticated composition than that of the church at Superga, and it coincided with the equally innovative designs for the reconstruction of Turin Cathedral that Juvarra produced (1730; unexecuted) for Victor-Amadeus II, whose plans to enlarge the royal chapel that formed a link between the royal palace and cathedral would have involved the latter's destruction. In Juvarra's best scheme for the cathedral, one of the centrally planned projects, he combined the vertical structure used at S Andrea, Chieri, with the carved-out spaces used at S Uberto, Venaria Reale, in a form that skeletized the entire building.

Juvarra's contribution to religious architecture is crowned by his design for the church of the Carmine (1732–6; see fig. 2) in the western part of Turin, which is generally considered to be his most original and influential project. While the plan is conventional, with side chapels and narrower ends, and recalls the layout of S Filippo

2. Filippo Juvarra: interior of the church of the Carmine, Turin, 1732–6

Neri, the interior nave elevation and the section of the chapels are entirely novel and thoroughly accomplished in their vertical explosion. The result is a skeletal structure—with nave piers and main barrel vault reduced to minimal dimensions—that also drew on his studies for the new cathedral. The sides of the nave are dematerialized through the stretching of the side piers that are then perforated and isolated revealing the vertical structure that supports the nave vault. The arch of the side chapels cuts deeply into the vault of the nave, stretching into individual drums and oval domes that bring light down into the sides of the church by reaching above the barrel vault of the nave. The tall arches emphasize the verticality of the slender piers; in effect, Juvarra took his scheme for the nave wall of S Filippo Neri and tore away the entablature above the chapel unifiying it with the clerestory window above. A final, dramatic innovation is the insertion of a vertiginous archway which is decorated with elaborate inner arches placed above each side chapel at the height of the entablature of the coupled pilasters that define the piers. These arches, their richly moulded forms expressing their non-structural nature and their theatricality compounded by immense coats of arms leaning into the nave, are drawn from Juvarra's repertory of stage designs and they serve to modulate further the immaterial nave wall. The open, stretched, carved-out interior of this church, together with the design of S Andrea at Chieri, was decisive in altering the Rome-influenced direction of architectural development in the 18th century.

(ii) Secular buildings. In 1715 or 1716 Juvarra took over the works at the Venaria Reale, the hunting lodge northwest of Turin built in the 1660s by Amedeo di Castellamonte, which Garove was rebuilding after it had been sacked by the French army in 1693. Juvarra's work consisted of the grand gallery, the royal chapel and, between 1720 and 1729, the stables and orangery. The gallery, entered through apsidal portals placed at each end, was splendidly decorated with stucco reliefs, lit from great windows cut into the vaults. The composition of the chapel of S Uberto contained a number of elements that were developed in Juvarra's later designs: the pierced central piers and the chapels reaching the entire height of the building in the manner of a hall church, for example, were subsequently reiterated at Stupinigi (see below) and the church of the Carmine (*see* §(i) above). The Greek-cross plan of the chapel included an upper level for Victor-Amadeus II and his family; the intense interior light was due not only to the oval windows in the dome and openings in the satellite chapels, but also to the white and gilded interior surfaces that contrasted with the altar furnishings.

In 1718 Juvarra worked on a thorough replanning of the medieval castello of Rivoli, an important suburban residence of the House of Savoy to the west of Turin that had been restored, then burnt, in the 17th century and begun again by Victor-Amadeus II. Juvarra's design (unexecuted) was illustrated in four exterior views painted by Giovanni Paolo Panini and Andrea Locatelli, which were originally hung in the castello (now Turin, Gal. Civ. A. Mod., and Racconigi, Castello). They provide the best description of Juvarra's scheme, which incorporated a

great *salone* and a terraced slope south of the castle, with ramps and stairs. In the late 20th century the shell of the building was transformed into a sophisticated museum of modern art.

Juvarra's most important secular work in Turin was the transformation of the Palazzo Madama (1718–21; *see* ITALY, fig. 21), which took its name from the title ('Madama Reale') adopted by the 17th-century royal duchesses of Savoy. Originally the Porta Decumana, one of the Roman gates of the city, the building was transformed into a fortress in the Middle Ages and subsequently into a residence of the House of Savoy. It is situated at a focal point in the city centre in the Piazza Castello, which the building divides into two parts; in the 17th century it was connected to the north and south sides of the piazza with shallow wings. On an axis with the main street of Roman Turin to the west (Via Doragrossa) it is also the focus of the main street, connecting the centre east to the bridge over the Po. Juvarra's reconstruction would have transformed the side wings as well as the palace itself. He ultimately completed the nine-bay façade of the building, which contains one of the most impressive staircases in Western architecture, but little else of his plan was executed. The grand façade, a regal structure, is divided into a lower, rusticated level and an upper part where the giant order unifies the *piano nobile* and the attic supports a majestic entablature complete with balustrade and statues. The tall arched windows of the *piano nobile* were perhaps intended to remain or to appear unglazed, recalling the garden façade of the château of Versailles, while the two-part composition topped by a balustrade also suggests a Roman antecedent.

Parallel to the façade on the interior is the great staircase hall of Palazzo Madama whose two flights of stairs begin either side of the central bay on the inner wall; they rise along the inner walls with intermediate landings at the second and eighth bays, and converge again at the centre of the façade, from where a bridge-like entry leads into the guard-room and main *salone*. The 360° circular movement from the entrance of the palace to the door of the *salone* recalls the entrance and staircase at the Palazzo Carignano, Turin, designed by Guarino Guarini in 1679. The elaborately coffered, ribbed and stuccoed vault above the stairs and the light pastel of the decoration ensure a majestic and effortless rise to the upper level.

From 1718 to 1721 Juvarra undertook a series of journeys that took him to Lisbon, Paris, London and Rome; his work in Turin continued during his absence, however, and three new projects designed by him were begun while he was away: the Palazzo del Senato (eventually completed after 1741 by Benedetto Innocente Alfieri), the campanile of the cathedral, built to the attic and then left unfinished, and the Scala dei Forbici ('scissors' staircase; begun 1720) in the Palazzo Reale, the only one of the three to be completed. Placed next to the guard hall and constructed in three parts, the Scala dei Forbici leads from the *piano nobile* to the second residential floor of the palace; inventive decoration masks the arched structural support of the open staircase, and its manipulation of mass, space and light endows it with exuberance and vigour, emphasized by the monochrome decoration of the enclosing walls.

In 1729 construction began on Juvarra's design for the palazzina of Stupinigi, *c.* 10 km south of Turin, which ultimately became one of the most extensive complexes of its type in Italy. It was built on a wooded estate owned by the aristocratic order of S Maurizio, which carried out the work on behalf of Victor-Amadeus II, the master of the order, and here Juvarra was able to design without the constraint of earlier work. At the focus of his scheme is a central oval pavilion with four radiating wings that diminish in height as they extend outwards, the two in front linked to the buildings of the octagonal forecourt. Construction proceeded rapidly and by early 1731 the oval

3. Filippo Juvarra: main façade of the Palazzina di Caccia, Stupinigi, near Turin, 1729–35

salone could receive its painted decorations. Juvarra's drawings show the evolution of the project, originally a single-storey pavilion with mezzanine and four lower single-storey wings with mezzanines. The changes made, probably before construction began, resulted in an increase in height of the overall scheme and a modulation of the different levels that gave great animation to the central pavilion and forecourt (see fig. 3). The *salone* in the central pavilion was raised to two storeys; a mezzanine was inserted between the storeys, separating the tall, arched windows at ground level from those above; the mezzanine was continued in the attic of the radiating wings; a balustrade with urns was added to crown the central oval, thus raising it above the rest of the complex; and the *salone* was transformed by the insertion of four piers supporting a saucer dome, thus altering the sequence and vaulting of the spaces at the upper level. A team of painters worked on the decoration of the building, beginning in 1731; the most lavishly ornate room was the central *salone*, which, despite its garish colours, stage-like quality and sham grandeur, is a convincing rhetorical confirmation of ephemeral architecture transformed into the background for the permanent performance of the relationship between the ruler and his court. Work on Stupinigi continued after Juvarra left Turin in 1735, with further extensions supervised by Alfieri.

(iii) Urban planning. Juvarra's urban planning work in Turin (*see also* TURIN, §I, 1) included the squares around the western and northern gates, Porta di Susa and Porta Palazzo. As part of a layout for a large area of expansion centred on the new Piazza Savoia in the western part of Turin, he designed the Piazza d'Armi in front of the western gate, framed by two L-shaped brick barracks buildings, the Quartieri Militari (begun 1716), that enclosed the rectangular piazza on three sides. The two buildings are separated by the Via del Carmine, which then runs eastward, bisecting the Piazza Savoia and connecting the Quartieri Militari to the Palazzo di Città in the middle of the old town. Both buildings have tall arcades at ground level, with large windows in the main floor and smaller ones above; the pediments of the latter intrude into the entablature of the giant order of pilasters—raised on pedestals—that articulates the buildings. The pilasters are coupled on the side flanking the entry street. Although these buildings have their own detailing and proportions, their overall composition reflects the design of the Piazza Castello and Piazza S Carlo, the main 17th-century squares of Turin, as well as that of Via Po. They also allude to the 17th-century brick-clad fortifications of the city and its citadel.

A similar spatial solution was adopted for the design of the Piazza di Porta Palazzo (begun 1729; now Piazza di Milano) in front of the northern gate. Vittorio Amedeo may have wanted to raise this neglected entry to the same level of architectural elaboration enjoyed by the other three gates, even though, unlike the south, east and west roads, the road emerging from it did not lead to any significant royal buildings or important cities. It is also rectangular, flanked on three sides by two L-shaped buildings arcaded at ground and mezzanine levels; these two tall storeys and a lower attic level are united by a giant pilaster order. In contrast to the Quartieri Militari, the buildings surrounding the Piazza di Porta Palazzo were covered with white stucco like Juvarra's Palazzo Madama; the capitals of the giant order were decorated with bulls' heads, the symbol of Turin. The Via Milano, leading from this arcaded entry square to the square in front of the Palazzo di Città, was widened and straightened and, halfway along, another small piazza was opened, lozenge-shaped to conform to the angled façade of the church of SS Maurizio e Lazzaro, and flanked by three uniform buildings that serve to set off the church. Their angled façades have symmetrically placed portals and blind arches at ground level, and their diagonal relationship across the piazza echoes the plan of Stupinigi, under construction at the same time.

3. SPAIN, 1735 AND AFTER. In 1735 Juvarra travelled to Madrid at the request of Philip V, King of Spain, who wanted him to design a palace intended to replace the royal residence destroyed by fire in 1734. By January 1736 a large model (Madrid, Mus. Artilleria) of Juvarra's design for the palace had been built. Conceived on a grandiose scale that anticipated Luigi Vanvitelli's immense royal palace at Caserta and would have made Versailles appear to be a summer retreat, the design had a garden front of 79 bays; the palace and the chapel complex framed a huge courtyard and included many other courtyards and wings. After Juvarra's sudden death in 1736 this design was greatly reduced and built by his assistant, GIOVANNI BATTISTA SACCHETTI, who also completed the façade of La Granja palace at San Ildefonso, near Segovia, closely following Juvarra's design.

With the church at Superga and the Palazzo Madama, Juvarra elaborated the architectural language inherited from Bernini through Carlo Fontana. He transformed that language by giving it a specifically Piedmontese character, notably at Stupinigi and the church of the Carmine, which provided inspiration for architects in Piedmont and north of the Alps for the next half century.

BIBLIOGRAPHY
Macmillan Enc. Architects
A. E. Brinckmann: *Theatrum novum pedemontii: Entwürfe und Bauten von Guarini, Juvarra, Vittone* (Düsseldorf, 1931)
L. Rovere, V. Viale and A. E. Brinckmann: *Filippo Juvarra* (Turin, 1937)
R. Wittkower: *Art and Architecture in Italy, 1600 to 1750*, Pelican Hist. A. (Harmondsworth, 1958, rev. 2/1973)
Filippo Juvarra, architetto e scenografo (exh. cat., ed. V. Viale; U. Messina, 1966) [with Sacchetti's cat. of drgs, modern cat. and bibliog.]
A. Griseri: *Le metamorfosi del barocco* (Turin, 1967)
R. Pommer: *Eighteenth-century Architecture in Piedmont: The Open Structures of Juvarra, Alfieri, and Vittone* (New York, 1967)
L. Mallé: *Palazzo Madama in Torino* (Turin, 1970)
M. Viale Ferrero: *Filippo Juvarra: Scenografo e architetto teatrale* (Turin, 1970) [with cat. of theatrical drgs]
L. Mallé: *Stupinigi, un capolavoro del settecento europeo tra barochetto e classicismo: Architettura, pittura, scultura, arredamento* (Turin, 1972)
S. Boscarino: *Juvarra architetto* (Rome, 1973)
M. L. Myers: *Architectural Ornament and Drawings: Juvarra, Vanvitelli, the Bibiena Family and Other Italian Draughtsmen* (New York, 1975)
N. Carboneri: *La reale chiesa di Superga di Filippo Juvarra* (Turin, 1979)
J. Pinto: 'Filippo Juvarra's Drawings Depicting the Capitoline Hill', *A. Bull.*, lxii (1980), pp. 598–616
H. A. Millon: *Filippo Juvarra: Drawings from the Roman Period, 1704–1724* (Rome, 1984)

F. Caresio: *Il castello di Rivoli* (Turin, 1987)

——: *Stupinigi: La real palazzina di caccia* (Biella, 1987)

<div align="right">MARTHA POLLAK</div>

Juvénal des Ursins. *See* JOUVENEL DES URSINS.

Juvenel. German family of painters of Flemish origin.

(1) Nicolas Juvenel I [Nicolas Nicolai] (*b* Dunkirk, Flanders, before 1540; *d* Nuremberg, 1 Aug 1597). Between 1550 and 1554 he worked on the decoration of the castles of Mariemont, near Mons, and Binche (both destr. 1554). As a Calvinist refugee from religious persecution he went to Kassel, where the future Landgrave Wilhelm (*reg* 1567–92) recommended that he go to Nuremberg. He arrived there with other Protestants from the Netherlands in 1561 and was granted citizenship that year. He first distinguished himself as an architectural painter, praised especially for his views of churches and temples in which he placed biblical characters as staffage figures, as in his panel painting of the *Interior of a Church* (ex-Paulus Praun priv. col., Nuremberg, 1797; see von Murr, no. 95). Foremost among his patrons in Nuremberg were the Tucher family, for whom in 1572 he restored the epitaph of Lorenz Tucher (*d* 1503) and the *Sacra Conversazione* (Nuremberg, St Sebaldus) by Hans Suess von Kulmbach. Also in 1572 he painted the portrait of *Ludwig of Bavaria* (Munich, Bayer. Nmus.), subsequently Elector Ludwig VI of the Palatinate.

Like his fellow-countryman and mentor Nicolas Neufchatel, who had come to Nuremberg with him, Juvenel also became known as a portrait painter elsewhere. Recommended to the Augsburg collector and patron Hans Fugger, in 1580 Juvenel travelled to Augsburg with one of his sons, but Fugger first sent him on to Duke William V of Bavaria in Munich. Juvenel painted three portraits for the Duke, one of which so pleased Fugger that at Easter 1581 he again summoned Juvenel to Augsburg and commissioned him to paint a series of portraits of members of his family (1581–9; Kirchheim im Schwaben, Fuggerschloss), intended to hang in his newly extended castle at Kirchheim, near Mindelheim, Swabia. Juvenel spent several months in Augsburg, presumably preparing sketches, though some of the portraits, all in the same format, were based on other artists' preliminary material. In 1590 and 1591 he painted three-quarter-length portraits of *Andreas (Endres) Tucher* (1551–1630), a Nuremberg judge, and his first wife, *Barbara Schnitter* (*d* 1608), whose parents, *Hieronymus Schnitter* and *Justina Nützel*, he had painted in 1570. Both pairs of portraits are still in the room known as the Schnitter-Zimmer of the Tucherhaus, Nuremberg. In 1595 he copied a portrait of *Emperor Sigismund*, possibly that painted by Albrecht Dürer for the Nuremberg council (1512–13; Nuremberg, Ger. Nmus.).

Two paintings that hung at the entrance to the emperor's rooms at the Kaiserburg in Nuremberg, *Christ with the Adultress in the Temple* and *Picture of the Imperial Jewels* (Nuremberg, Ger. Nmus.), have been ascribed to Juvenel (Schwemmer, 1949), as has *Christ as Judge of the World*, a painting on the door leading from the main residential block into the imperial chapel. Although Juvenel has been mentioned occasionally as a glass painter, there is no evidence of such work. One of his pupils was the Nuremberg painter Johann Kreuzfelder (*d* 1632–6), and the portrait painter Lorenz Strauch was also influenced by him. There is an etching (1670) by Michael Kestner (1608–74), which is probably based on a self-portrait by Juvenel.

BIBLIOGRAPHY

Thieme–Becker

C. G. von Murr: *Description du cabinet de Monsieur P. de Praun à Nuremberg* (Nuremberg, 1797)

G. Lill: *Hans Fugger (1531–1598) und die Kunst*, ii of *Studien zur Fugger-Geschichte* (Leipzig, 1908)

W. Schwemmer: 'Aus der Geschichte der Kunstsammlungen der Stadt Nürnberg', *Mitt. Ver. Gesch. Stadt Nürnberg*, xl (1949), pp. 97–206 (105)

——: 'Das Mäzenatentum der Nürnberger Patrizierfamilie Tucher vom 14. bis 18. Jahrhundert', *Mitt. Ver. Gesch. Stadt Nürnberg*, li (1962), pp. 18–59 (36, 47–8)

<div align="right">PIA GRUBER</div>

(2) Paul Juvenel I (*b* Nuremberg, *bapt* 22 Dec 1579; *d* Pozsony, Hungary [now Bratislava, Slovakia], 1643). Son of (1) Nicolas Juvenel I. He trained with his father, sharing his interest in perspective and in architectural views. Among his earliest works is a drawing of the walls of Mantua (Berlin, Kupferstichkab.) that he executed on a trip to Italy some time before 1613. Like many painters in Nuremberg, Juvenel received commissions to copy and to restore works by Albrecht Dürer. In 1607 Archduke Maximilian I of Bavaria ordered Frederik van Valckenborch and Juvenel to replicate Dürer's *Assumption of the Virgin and her Coronation by the Holy Trinity* (destr. 1729), the central panel of the altar of *St Thomas*, donated by Jakob Heller (*c.* 1460–1522), then in the Dominikanerkirche (destr. 1944) in Frankfurt am Main; their copy is untraced. Juvenel executed four paintings (Bamberg, Obere Pfarrkirche) after scenes from Dürer's series of woodcuts of the *Life of the Virgin*. His *Presentation in the Temple* (1611; Gdańsk, N. Mus.) reveals the influence of Adam Elsheimer and Paul Bril, whose pictures he probably saw in Rome. In 1613 and 1614 Juvenel, Georg Gärtner, Jobst Harrich (*fl* 1580–1617) and Gabriel Weyer were commissioned by the Nuremberg City Council to restore the paintings in the great hall of the Rathaus. This extensive ensemble, which included mural paintings of the *Triumphal Procession of Emperor Maximilian I*, the *Calumny of Apelles* and the *Power of Women*, had been designed by Dürer and painted *c.* 1521–2 by Georg Pencz, Hans Springinklee, and perhaps Hans Süss von Kulmbach. Before embarking on the restoration programme, Juvenel painted a view of the hall for the city architect, Wolf Jakob Stromer. Not only is this small picture (Nuremberg, Ger. Nmus.) the oldest depiction of the great hall, but it also shows how it appeared before the destruction in 1619 of the west end of the room.

Paul Juvenel is best known for his ceiling and façade paintings. In 1607 he created the *Fall of Phaëthon* (Nuremberg, Stadtmus. Fembohaus) for the Schöne Zimmer of the Pellerhaus, Martin Peller's lavish house on the Egidienplatz. Between 1615 and 1620 he designed and helped to paint the façades of two important houses in Nuremberg. Large drawings for these projects are in the Germanisches Nationalmuseum in Nuremberg. The story of *David Learning of the Death of Saul* was the basis of a painting that formerly adorned the façade of the Meierhaus (Hauptmarkt 26). Much more elaborate was Juvenel's design for the house, formerly at Königstrasse 2, of Bartholomäus

Viatis (1538–1624), Nuremberg's wealthiest citizen. It included illustrations of such stories as *Judith and Holofernes* and the *Fall of Phaëthon*, as well as smaller paintings of the *Labours of Hercules* and the *Exploits of Samson*. The city council also paid Juvenel 400 gulden in 1622 for painting on the ceiling of the Schöne Zimmer in the Rathaus scenes from Roman history glorifying personal sacrifice for the good of the state (*in situ*). In the following year Juvenel made another cycle of ceiling paintings for the house that formerly stood at Albrecht Dürer Platz 10; at least two additional drawings for another ceiling project are now in Berlin (Kupferstichkab.).

In addition to these large decorative ensembles, Juvenel continued to paint religious scenes, often done on small copperplates. These include *Christ Carrying the Cross* (1625; Nuremberg, Heiligen-Geist-Spital) and *Christ Blessing Little Children* (1630; Pommersfelden, Schloss Weissenstein). He worked in Nuremberg until 1638, when he moved first to Vienna and then to Pozsony (now Bratislava), where he died. His last known composition,

the drawing of the *Presentation in the Temple* (Erlangen, Ubib.), is inscribed with the date of 28 October 1642. Paul's three sons, Friedrich Juvenel (1609–47), Johann Philipp Juvenel (active in Vienna 1645–8) and Johann Juvenel, and his daughter Esther Juvenel, were all painters.

BIBLIOGRAPHY

NDB; Thieme–Becker

E. Mummerhof: *Das Rathaus in Nürnberg* (Nuremberg, 1891)

W. Drost: 'Ein frühes Architekturbild des Paul Juvenel', *Pantheon*, ix (1932), pp. 122–3

R. Schaffer: *Das Pellerhaus in Nürnberg* (Nuremberg, [1934])

Barock in Nürnberg, 1600–1750 (exh. cat., Nuremberg, Ger. Nmus., 1962)

Das alte Nürnberger Rathaus: Baugeschichte und Ausstattung des grossen Saales und der Ratstube (exh. cat., ed. M. Mende; Nuremberg, Altes Rathaus, 1978), i, pp. 178–81

Zeichnung in Deutschland: Deutsche Zeichner, 1540–1640 (exh. cat., ed. H. Geissler; Stuttgart, Staatsgal., 1979), i, pp. 212–14

Nuremberg: A Renaissance City, 1500–1618 (exh. cat. by J. C. Smith, Austin, U. TX, Huntington A.G., 1983)

JEFFREY CHIPPS SMITH

Juyan. *See* KARAKHOTO.

K

Ka-aper. *See* SHEIKH EL-BELED.

Kaaz, Carl Ludwig (*b* Karlsruhe, 22 Jan 1773; *d* Dresden, 14 July 1810). German painter and draughtsman. His training began with an apprenticeship in bookbinding in Pforzheim. From 1792 Kaaz trained as an engraver and miniature painter with Moise Perret-Gentil (1744–1815) in La Chaux de Fonds, Switzerland, and he then studied at the Kunstakademie in Stuttgart. In 1796 he went to Dresden, where from 1797 he attended the Kunstakademie, being influenced particularly by his teacher Johann Christian Klengel and by the landscape painter Jacob Wilhelm Mechau (1745–1808). These two painters recommended that Kaaz study the paintings of Jacob Ruisdael and Claude Lorrain in the Dresden Gemäldegalerie, and these works had a lasting influence on Kaaz's landscape style. This may be seen in the earliest of his few surviving paintings, for example the *Landscape with Waterfall* (1800; Dresden, Gemäldegal. Neue Meister). Kaaz's work from this time is marked by wide orderly spaces and an arcadian harmony. In Dresden he benefited from the patronage of Baroness Elisa von der Recke (1754–1833), and he became a friend of Friedrich Schiller. Kaaz also attracted the interest of the portrait painter Anton Graff, whose daughter he later married.

In 1801, with Traugott Pochmann (1762–1830) and Graff's son Carl Anton Graff (1774–1832), Kaaz embarked on three years of travel. He went via Switzerland to Paris, and then, in the spring of 1802, to Italy. He stayed in Rome and Naples until 1804. Here he continuously studied from nature, amassing a large number of sketches in pencil, pen, chalk and watercolour (album in Frankfurt am Main, Goethemus.). On returning to Dresden, Kaaz exhibited five landscape paintings from Italian motifs, which were warmly applauded. These included *Lake Nemi* (1805; Dresden, Gemäldegal. Neue Meister). A fresco of the same subject was completed in 1805 for Schloss Frohburg, Borna.

From this time Kaaz's landscapes became more Romantic in content and style, as in *Evening: Two Knights Riding to an Old Castle* (1805; untraced) or a work inspired by Goethe: the *Peace of Noon: Romantic Landscape—How it Can Inspire the Poet to Greater Achievements* (1807; untraced). Kaaz was prompted to produce such compositions by enthusiasts for his work in the Romantic literary circles around Ernst and Caroline Schlegel in Dresden. A work poised between Romanticism and Biedermeier is the *View of the Plauenscher Grund in Dresden through the Window of the Painter Grassi's Villa* (1807; Dortmund, priv. col., see Geller, p. 4), a window picture of the kind favoured by the German Romantics. Kaaz was especially pleased by Goethe's friendly encouragement of his work and his request that Kaaz teach him the technique of working in a combination of India ink, watercolour and gouache. Between 1807 and 1809 he spent much time in Karlsbad (now Karlovy Vary, Czech Republic) and Weimar with Goethe, who provided support in many ways, in particular introducing Kaaz more thoroughly to the art of Caspar David Friedrich, which probably inspired the *View of the Plauenscher Grund*.

BIBLIOGRAPHY

H. Geller: *Carl Ludwig Kaaz: Landschaftsmaler und Freund Goethes, 1773–1810* (Berlin, 1961)
H. J. Neidhardt: *Die Malerei der Romantik in Dresden* (Leipzig, 1976), pp. 24–6

HANS JOACHIM NEIDHARDT

Kab, el- [Arab. al-Kāb; anc. Egyp. Nekheb; Gr. Eileithyiaspolis]. Ancient Egyptian site that flourished particularly during the New Kingdom (*c.* 1540–*c.* 1075 BC). El-Kab is located approximately 80 km south of Luxor on the east bank of the Nile, opposite ancient Nekhen (*see* HIERAKONPOLIS). As at Nekhen, there are remains from the beginning of the historical period (such as the Predynastic drawings on the Rock of the Vultures) and also traces of a Palaeolithic culture. The site was first excavated by James Edward Quibell in 1897–8, and it has been in the Belgian archaeological concession since the 1930s.

Nekheb was the cult centre of the vulture-goddess Nekhbet, the protective deity of Upper Egypt, and it must have served in early historic times as the religious centre opposite to the administrative centre of Nekhen. These towns were part of the 3rd Upper Egyptian nome, the location of the capital of which varied. In the New Kingdom this honour was held by Nekheb.

The site of el-Kab consists of three main parts: the temple town, the rock tombs and the desert temples. The town site was clearly in use for much of the historical period. A granite block bearing the name of Khasekhemwy (*c.* 2925–*c.* 2575 BC) suggests the existence of an Early Dynastic temple, parallel to that known from Hierakonpolis. Building work is attested from the Middle Kingdom (*c.* 2008–*c.* 1630 BC) and the Second Intermediate Period (*c.* 1630–*c.* 1540 BC). In the 1820s Jean-François Champollion saw a colossal sandstone statue of Sesostris I (*reg c.* 1918–*c.* 1875 BC), but this has now disappeared. Some fragments of a sphinx from el-Kab in the Hyksos style are

now in the Egyptian Museum, Cairo (CG 391). The main temple of Nekhbet was constructed by rulers of the New Kingdom, and additions made by, among others, rulers of the 25th to 30th dynasties. The site is still surrounded by a mud-brick wall of impressive dimensions. Outside this wall is a cemetery of the Old and Middle Kingdoms that includes the tombs of two 4th Dynasty local notables.

The earliest rock tombs date to the 12th and 13th dynasties. Those for which el-Kab is best known date to the New Kingdom and reflect the importance of the town at that time. The composition and style of the scenes in these tombs have much in common with contemporary private tombs in the Theban necropolis, suggesting that artistically at least Nekheb was very much under the influence of Thebes. Most of the tomb chapels consist of one decorated room, perhaps with small chambers to the side; a distinctive feature is the frequent use of vaulted ceilings. Most of the decoration is executed in relief of very high quality, but generally flatter than contemporary work at Thebes.

The tomb of Pahery (c. 1380 BC), of the reign of Amenophis III, is the best known. Its decoration includes a notable series of scenes showing agricultural work and the production and processing of grain (see fig.). Many of the motifs in this tomb are taken up again in the Ramessid tomb of Setau, which is laid out in a very similar manner with the addition of a few of the religious scenes so common in Ramessid tombs. The oldest tomb of the New Kingdom group is that of Ahmose, son of Ebana: there a long historical text describes campaigns fought under the kings Ahmose, Amenophis I and Tuthmosis I (c. 1540–c. 1482 BC), which is essential for the understanding of the early years of the 18th Dynasty. The tomb of Reneni dates to the reign of Amenophis I (c. 1514–c. 1493 BC), and its well-executed decoration makes it an important element in one of the less understood periods of 18th Dynasty art. It includes one of the very rare scenes of pigs on an Egyptian tomb wall.

The desert temples are situated at the entrance to and just inside the Wadi Hillal. Ptolemy VIII (reg 170–163; 145–116 BC) and Ptolemy IX (reg 116–107 BC) constructed a small rock temple for the goddess Shesmetet near to an older shrine built by Setau, the viceroy of Kush (lower Nubia), on behalf of Ramesses II (reg c. 1279–c. 1213 BC). Slightly further inside the wadi is the best-preserved temple of the three, erected by Amenophis III to Nekhbet and Hathor and decorated in a style close to that in use during his reign in Luxor.

LÄ

BIBLIOGRAPHY

J. J. Tylor and F. L. Griffith: *The Tomb of Paheri at el-Kab* (London, 1895)

El-Kab, relief decoration in the tomb of Pahery, showing Pahery inspecting corn, c. 1380 BC

J. E. Quibell: *El Kab* (London, 1898)
J. J. Tylor: *The Tomb of Renni* (London, 1900)
J. Baines and J. Málek: *Atlas of Ancient Egypt* (Oxford, 1982), pp. 80–81

NIGEL STRUDWICK

Kabáh. Pre-Columbian MAYA site *c.* 18 km south-east of UXMAL and 7 km north of SAYIL in the Puuc region of the Northern Maya Lowlands in Yucatán, Mexico. It flourished during the Late Classic (*c.* AD 600–*c.* 900) and Early Post-Classic (*c.* AD 900–*c.* 1200) periods. Kabáh was one of the major Puuc sites that rose to prominence at a critical juncture in the development of Maya civilization, when the great Classic-period sites of the Southern Lowlands had collapsed and the cultural and demographic centre of lowland civilization shifted to the Northern Lowlands. Although it is clearly one of the largest Puuc sites, Kabáh is not as well known as other centres, due to its relative lack of large-scale archaeological research. The centre of Kabáh appears to cover *c.* 1 sq. km, with the east–west axis of the site marked by two large building complexes. The architecture conforms to the typical Puuc style, with an emphasis on decorated walls surmounting medial mouldings or cornices; repetitive stone-mosaic designs comprising stylized geometric or naturalistic patterns; stone-mosaic masks above doorways; decorated

roof-combs and carefully cut stone-veneer masonry. However, few of the buildings at Kabáh have been reconstructed. As at Sayil and LABNÁ, a causeway runs along the north–south axis, but at Kabáh this is linked to the long causeway that connected the site to Uxmal (for illustration *see* CAUSEWAY). A free-standing monumental arch on the route may have marked the formal entrance to the site. The major pyramid at Kabáh is situated at the north end of the internal causeway, but it is ruined and has not been restored. Originally there was a structure on the summit, and a pair of single rooms flanking the foot of the main stairway on the southern face.

The best-known building at Kabáh is a multi-roomed 'palace' structure known as the Codz Poop or 'Palace of the Masks', which forms part of the 'East' or 'Palace' group. This building is unusual in having exterior decoration in the form of a repeating design of stylized stone-mosaic masks executed both above and below the medial moulding (see fig.). The long-nosed mask portrayed is believed by some scholars to represent the rain god Chac. In addition, Room 21 has well-preserved sculpted door-jambs depicting battle scenes. The building has a solid central core that may have been put in place as the potential foundation for a second storey that was never

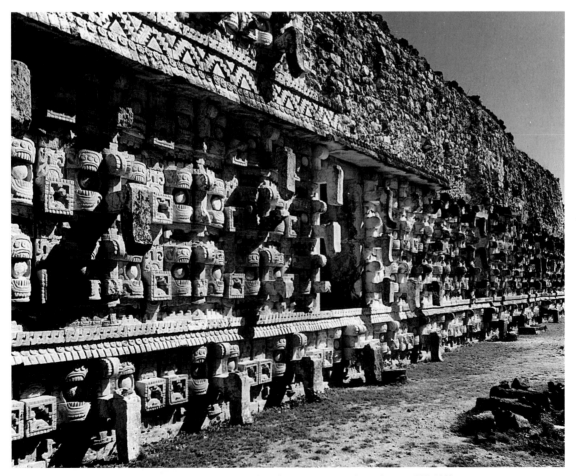

Kabáh, Yucatán, façade of the Codz Poop ('Palace of the Masks') showing stone-mosaic masks, *c.* AD 800–1000

constructed; instead, the single-storey building has a simple roof-comb. A number of altars, many of them carved, were found at Kabáh, along with a single crude stele.

BIBLIOGRAPHY

T. Proskouriakoff: *An Album of Maya Architecture* (Cambridge, MA, 1946, rev. Norman, OK, 2/1963)

I. Marquina: 'Arquitectura prehispánica', *Memorias del Instituto Nacional de Antropología e Historia*, i (Mexico City, 1950, rev. 2/1964/*R* 1981)

G. F. Andrews: *Maya Cities: Placemaking and Urbanization* (Norman, OK, 1975)

H. E. D. Pollock: 'The Puuc: An Architectural Survey of the Hill Country of Yucatan and Northern Campeche, Mexico', *Mem. Peabody Mus. Amer. Archaeol. & Ethnol.*, xix (1980) [whole issue]

JEREMY A. SABLOFF

Kabakov, Il'ya (Iosifovich) (*b* Dnepropetrovsk [now Dnipropetrivs'k], 30 Sept 1933). Russian graphic, conceptual and installation artist of Ukrainian birth. In 1957 he graduated from Surikov Art Institute in Moscow, where he specialized as an illustrator. Many years of producing artwork for children's literature, for the Moscow Detskaya Literatura and Malysh publishing houses and the magazines *Murzilka* and *Vesyolyye kartinki*, partly shaped his slyly ironic graphic style; working as an illustrator was his only means of earning a living when avant-garde experimentation was officially banned. After experimenting with Abstract Expressionism and an absurd neo-Surrealist grotesque style, in 1970–78 he produced distinctive albums which, through a subtle interplay of visual and verbal elements, reveal disturbing existential contradictions. Best known is the album *Okno* ('The window'), published in 1985 in Berne. Since 1978 Kabakov's art has become more conceptual and he has created what he calls *zhek* picture displays (from the acronym ZhEK, referring to housing management), which parody wall newspapers and Soviet posters. These works are typical of SOTS ART, of which he was a founder: a style that employs and devalues the clichés of Soviet mass culture. In the 1980s he turned to large installations (e.g. *The Man who Flew into Space from his Apartment*, 1981–8; New York, Ronald Feldman Fine Art), bringing together in three dimensions domestic refuse, personal items and 1950s propaganda stereotypes. Here he produced a strange symbiosis of images of ordinary life and the political myths of totalitarianism, which connect his work with the political and economic transformation (*perestroyka*) of the period in Russia.

BIBLIOGRAPHY

Jankilevsky. Kabakov. Steinberg. (exh. cat., U. Bielefeld, Zentrum für Interdiszip. Forsch.; Bochum, Mus. Bochum, Kstsamml.; 1985)

Ilya Kabakov: Am Rande (exh. cat., Düsseldorf, Kstver., 1986)

Ilya Kabakov: Que sont ces petits hommes? (exh. cat., Paris, Gal. de France; Amsterdam, De Appel; Philadelphia, U. PA, Inst. Contemp. A.; 1989)

Ilya Kabakov: Ten Characters (exh. cat. with texts by the artist, ed. J. Lingwood; London, ICA; Zurich, Ksthalle; 1989)

Ilya Kabakov, Boris Groys. Die Kunst des Fliehens. Dialoge... (Munich and Vienna, 1991)

M. N. SOKOLOV

Kabardino-Balkaria. *See under* RUSSIA, §XII, 1.

Kabel, Adriaan van der. *See* CABEL, ADRIAAN VAN DER.

Kabnak. *See* HAFT TEPE.

Kabotie, Fred (*b* Shungopori, AZ, *c*. 1900; *d* 28 Feb 1986). Native American Hopi painter. He was born into a farming family and educated in traditional Hopi customs. As a child he scratched images of *kachina*s (supernatural beings) on rocks in his father's field. He continued to draw such images when he attended the Santa Fe Indian School (*see* NATIVE NORTH AMERICAN ART, §IV, 2), later claiming that he did so to relieve his loneliness and to remind him of home. In 1918 he joined the informal painting sessions given at the school by Elizabeth DeHuff (1887–1983). Kabotie became one of the first Hopi artists to gain national recognition when in 1920 his work was shown at the annual exhibition of the Society of Independent Artists in New York City. He was at his most productive in the 1920s and 1930s, executing such works as the *Snake Dance* (watercolour, *c*. 1922–30; New York, Mus. Amer. Ind.). His descriptive manner of shading and modelling, close attention to detail, meticulous brushwork and sophisticated use of and emphasis on colour became distinctive features of later Hopi painting. Kabotie also used traditional Native American techniques, such as painting on hides. In 1941 his reconstruction of a prehistoric AWATOVI mural (Cambridge, MA, Harvard U., Peabody Mus.) was shown in the exhibition *Indian Art of the United States* at the Museum of Modern Art, New York City. In 1945 Kabotie received a Guggenheim fellowship, and in 1954 he was awarded the French government's Palmes d'Académique for his contribution to Native American art. As a founder-member, in 1941, of the Hopi Silvercraft Cooperative Guild and of the Hopi Cultural Center, both located in Second Mesa, AZ, Kabotie contributed to the preservation of traditional Hopi arts and encouraged younger artists, including his son Michael Kabotie (*b* 1942). Michael was a founder-member of the Artist Hopid, an organization formed in 1973 to promote Hopi arts and culture.

WRITINGS

Designs from the Ancient Mimbreños with a Hopi Interpretation (Arizona, 1949/*R* 1982)

with B. Belknap: *Fred Kabotie: Hopi Indian Artist* (Flagstaff, 1977)

BIBLIOGRAPHY

C. L. Tanner: *Southwest Indian Painting: A Changing Art* (Tucson, 1957/*R* 1973)

P. J. Broder: *Hopi Painting: The World of the Hopis* (New York, 1978)

ARTHUR SILBERMAN

Kabul [Kābul]. Capital of Afghanistan. With its excellent location on the Kabul River in a fertile plain surrounded by mountains and hills, Kabul is a natural strategic site and has a history of settlement dating back 3000 years. In pre-Islamic times Buddhism flourished in the region. Despite earlier Muslim raids, Islam began to be established only in the 9th century AD under the Saffarids of Sistan (*reg* 867–*c*. 1495). Under the Ghaznavids (*reg* 977–1186) Kabul served as a military depot for the army and had a strong citadel and prosperous commercial quarter. The city gradually developed as Ghazna declined, and from 1504 with the arrival of the Timurid prince Babur it flourished. Babur created numerous gardens, such as the quartered Bagh-i Vafa ('Garden of Fidelity') to the south of the city overlooking the river. He also used Kabul as a staging point for his campaigns into India, where he became the first Mughal emperor. On his death in 1530,

Babur was interred at Agra, but in 1597 his remains were conveyed to the Bagh-i Naw ('New Garden') south-west of Kabul, and the site became known as the Bagh-i Babur ('Garden of Babur'). The site houses a marble mosque (rest. 1964–6) built in 1646 by the Mughal emperor Shah Jahan (*reg* 1628–58) to celebrate his capture of Balkh. Kabul remained an important centre under the Mughals (*reg* 1526–1858); gold and silver coinage, for example, was minted there until the reign of 'Aziz al-Din 'Alamgir (1754–60). In 1738 Kabul was captured by the Afsharid ruler Nadir Shah (*reg* 1736–47) on his way to India, but after his death it passed to Ahmad Shah Durrani of Qandahar (*reg* 1747–73). His son Timur Shah (*reg* 1773–93) made Kabul the capital of the Durrani empire, and his unfinished tomb is a massive octagonal structure modelled on Mughal tombs in India.

The city suffered in various wars, including the second Anglo-Afghan War (1878–80). The old citadel, Bala Hissar ('High Fort'), was destroyed and was replaced by a new palace, the Arg, built by 'Abd al-Rahman (*reg* 1880–1901). His tomb in Zarnigar ('Adorned with Gold') Park in the centre of the city is a small private palace, the dome and minarets of which were added by his son Habib Allah (*reg* 1901–19) after the building was transformed into his tomb. Habib Allah also finished the 'Id Gah ('Praying Place'), the large mosque outside the city used for public holidays (*see* Musalla). Some six miles to the south-west of the city centre, Aman Allah (*reg* 1919–29) had a new capital, Dar al-Aman, laid out; the parliament building was designed by André Godard. Near by is the Kabul Museum, which houses an impressive collection of artefacts from such sites as Begram and Ai-Khanum, Kafir statues from Nuristan and a superb numismatic collection. Extensive bombing and looting during the civil war in the early 1990s, however, left the collection in an uncertain state.

BIBLIOGRAPHY

Enc. Islam/2

Bābur: *Bābur-nāma*, trans. A. S. Beveridge (London, 1921)

N. H. Dupree: *An Historical Guide to Afganistan* (Kabul, 1971), pp. 67–90

M. T. S. Parpagliolo: *Kābul: The Bāgh-i Bābur* (Rome, 1972)

N. H. Dupree: *The National Museum of Afghanistan: An Illustrated Guide* (Kabul, 1974)

——: 'Early Twentieth Century Afghan Adaptations of European Architecture', *A. & Archaeol. Res. Pap.*, xi (1977), pp. 15–21

Kaceli, Sadik (*b* Tiranë, 24 March 1914). Albanian painter and engraver. He adopted a realist style while studying at the School of Drawing in Tiranë, as in his *Portrait of a Peasant* (1933; Tiranë, A.G.), and at the Ecole Nationale Supérieure des Beaux-Arts in Paris (1936–41). He painted in various genres using different techniques, favouring landscapes, for example *Himara* (1961; Tiranë, A.G.) and *Terraces on the Coast* (1966; Tiranë, A.G.). He is also distinguished for his linocuts, for example *Petrela* (1947; Tiranë, A.G.), and for his skilful compositions, as in *Wedding* (1945; priv. col., see B. Luca, in *Pionieri* (Tiranë, 1975), pl. 9). His work is valued for its poetic quality and freshness of palette.

UNPUBLISHED SOURCES

Tiranë, A.G. [manuscripts]

BIBLIOGRAPHY

Lett. Alb., 2 (1986), pp. 128–39 [untitled article on Kaceli, with 12 repr.]

GJERGJ FRASHËRI

Kadıasker Mustafa İzzet. *See* Mustafa İzzet.

Kadirampuram. *See under* Hampi, §4.

Kadishman, Menashe (*b* Tel Aviv, 1932). Israeli sculptor and painter. From 1947 to 1950 he studied with the Israeli sculptor Moshe Sternschuss (*b* 1905) at the Avni Institute in Tel Aviv and in 1954 with the Israeli sculptor Rudi Lehmann (1903–77) in Jerusalem. In 1959 he moved to London, studying there until 1962. He remained in London until 1972 and had his first one-man show there in 1965 at the Grosvenor Gallery. His sculptures of the 1960s were Minimalist in style and so designed as to appear to defy gravity. This was achieved either through careful balance and construction, as in *Suspense* (1966; Jerusalem, Israel Mus.), or by using glass and metal so that the metal appeared unsupported, as in *Segments* (1968; New York, MOMA), and the glass allowed the environment to be part of the work.

Through the 1970s Kadishman extended this tendency to incorporate nature into his art. In 1975 he created the *Canvas Forest* in the grounds of the Israel Museum in Jerusalem: large canvas tarpaulins were suspended from a cable into which were cut holes in the shape of trees. The canvas rustled in the wind, and through the apertures the visible landscape again fused into the work. Kadishman took this idea to an extreme by exhibiting 18 penned sheep, partly stained blue, at the Venice Biennale in 1978; this alluded to his experience on a kibbutz and fulfilled his wish to exercise all the senses of the viewer. Colourful Expressionist paintings on the obsessive theme of sheep included *Untitled* (1988; see 1988 exh. cat., pl. 10). In his later sculpture he cut figurative shapes out of sheet steel, as in *Prometheus* (1988; see 1988 exh. cat., pl. 6).

BIBLIOGRAPHY

Menashe Kadishman: Israel (exh. cat. by A. Brazel, Venice, Biennale, 1978)

Menashe Kadishman (exh. cat. by E. F. Fry, New York, Nohra Haim Gal., 1988)

Kadjar. *See* Qajar.

Kadlik, František. *See* Tkadlík, František.

Kadmos Painter. *See* Vase painters, §II.

Kaendler, Johann Joachim. *See* Kändler, Johann Joachim.

Kaessmann, Rutger. *See* Kassmann, Rutger.

Kafarnaum. *See* Capernaum.

Kaffa [Kafa, Kefe; anc. Theodosia; now Feodosiya, Ukraine]. City of the Genoese Republic on the east coast of the Crimea that flourished in the 14th and 15th centuries. It was founded in the 6th century BC, and became a major trading centre for Bosporan grain in the 4th and 3rd centuries BC. The name Kafa first appears in the 10th-century *De administrando imperio* of Constantine Porphyrogenitos. It remained an obscure settlement until

1266–7 when, with the permission of the Tatar-Mongol overlords, it became a fortified trading station of the Genoese republic, linking the Black Sea with the major cities on the River Volga. Ship-building, iron-working, textiles and glass-making developed in the city, and in the 14th century Kaffa became a notable centre for production of books, jewellery and ceramics. After the 1420s the city minted its own money, issuing bilingual coins on which the Genoese castle (from 1453, St George) appeared on one side, while the stamp of the Tatar-Mongol Golden Horde (from 1433, the stamp of the ruling Giray Khans) appeared on the other. In 1475 the city fell to the Turks; from 1783 it was part of Russia and from 1917 to 1991 part of the USSR.

Three stages can be distinguished in the urban development of Kaffa during the Genoese period. Until the fire of 1308, the settlement consisted of wooden buildings divided between the citadel and town. In the second stage, up to the early 1360s, the citadel became associated with the Roman Catholic community, and the south-eastern district of the town with the Armenian and Greek communities. Between 1340 and 1352 the wooden citadel was replaced by a stone building with walls extending 718 m. The third stage (second half of the 14th century) was a time of radical changes, during which Kaffa became a major maritime centre. By 1385 the citadel's perimeter walls had been extended to a total of 4200 m. Several fortification towers were also built, including those of S Teodoro, S Tommaso, the Holy Apostles, Constantine (1382–1448) and Giovanni di Scapo (1342). The public buildings of Kaffa included the Palazzo Pubblico, two slaughterhouses and an arsenal. The main church in the Catholic district was that of S Agnese; there were about 40 other Catholic churches. The Armenians had three churches, although according to an 18th-century source, this number rose to twenty-four, and the Greeks ten, while the Muslims and Jews possessed their own places of worship. When the city was taken by the Turks it had a population of around 70,000. Among the noteworthy buildings of the Turkish period is the Mufti mosque (1623). From the second half of the 19th century a variety of architectural styles was adopted, and numerous dachas and private houses were built. In the Soviet period the city became the principal health resort of the Crimea. The Ayvazovsky Picture Gallery houses 400 works by Ivan Ayvazovsky, and the Ethnographical Museum contains ancient and medieval art.

BIBLIOGRAPHY

O. Kh. Khalpakhch'yan: 'Etapy planirovki i zastroyki Feodosii (s drevneyshikh vremyon do kontsa XVIIIv.)' [Stages in the layout and building of Feodosiya (from the earliest times until the end of the 18th century)], Arkhit. Nasledstvo, xxv (1976)
V. D. Blavatsky: 'Feodosiya VI–IV vv. do n.e. i ego nazvaniye' [Feodosiya from the 6th to 4th centuries BC and its name], Sov. Arkheol., iv (1981)
P. Stringa: Genova e la Liguria nel Mediterraneo: Insediamenti e culture urbane (Genoa, 1982)
Ye. A. Aybabina: 'Oboronitel'nyye sooruzheniya Kaffy' [The defensive works of Kaffa], Arkhitekturno–arkheologicheskiye issledovaniya v Krymu [Architectural–archaeological researches in the Crimea] (Kiev, 1988)

M. KRAMAROVSKY

Kafir Kala. Early medieval settlement, probably founded in the 2nd or 3rd century AD, on the western outskirts of the modern town of Kolhozabad in Tajikistan. The site, which has been excavated since 1956, has been identified as the main town in the Vakhsh domain (Chin. U-sha), one of the 27 domains in Tokharistan. Three periods in the history of the town have been identified: before the mid-6th century AD, mid-6th century to mid-7th, and late 7th century to mid-8th. The town was apparently destroyed and abandoned c. 740, when the Arab invasions devastated many other sites in northern Tokharistan, such as Adzhina Tepe. A main irrigation canal extending more than 100 km supplied water to the town and surrounding area. The square town (300×300 m) was surrounded by powerful mud-brick walls with embrasures and towers and by a large moat (50–60×5 m), beyond which lay other buildings and a necropolis to the east. A main street linked the city gates on the east and west. One building within the town had a large ceremonial room (17×7 m) with a niche in the end wall flanked by three-quarter columns made of finely ground clay on a wooden frame. The room was decorated with ornamental wall paintings, much deteriorated from the salinity of the soil. The citadel (70×70×12 m), containing suites of ceremonial and residential rooms, occupied the north-east corner of the town, from which it was separated by a moat (12–15×6 m). Flat roofs were reserved for large rooms (e.g. the ceremonial room in the citadel; 10×10 m), and different kinds of vaulting were used extensively. A round room dating from the middle period, several rooms in the towers and the Buddhist chapel were domed. A stone head of the Buddha and a stone altar pre-date the founding of the town. Finds from the late period include a ceramic tile (450×340 mm; 7th–8th century) showing a rider shooting an arrow at a mountain goat, another ceramic tile (140×130 mm) showing a rider hunting a lion, a cornelian seal with falcon hunting, and a fragment of a ceramic chalice (125×85 mm) with a central medallion containing a walking deer with branchy antlers. In the later period the domain issued silver coins imitating Sasanian drachmas of Peroz (reg ?457–84) and cast-copper coins of Chinese type with a hole in the centre.

BIBLIOGRAPHY

B. A. Litvinsky and V. A. Solov'yov: Srednevekovaya kul'tura Tokharistana v svete raskopok v Vakhshskoy doline [Medieval culture in Tokharistan in the light of excavations in the Vakhsh Valley] (Moscow, 1985), pp. 8–48
Drevnosti Tadzhikistana [Antiquities of Tajikistan] (exh. cat., ed. Ye. V. Zeymal'; Leningrad, Hermitage, 1985), pp. 156–7, 162–3

T. I. ZEYMAL'

Kafka, Bohumil (b Nová Paka, Bohemia [now Czech Republic], 14 Feb 1878; d Prague, 24 Nov 1942). Czech sculptor and teacher. He studied at the School of Sculpture at Hořice in Bohemia (1891–5), the School of Applied Art, Prague (1896–8), under Stanislav Sucharda, and at the Academy of Fine Arts, Prague (1889–1901), under Josef Vaclav Myslbek. He was an assistant to Sucharda (1901–4), Professor of Decorative Sculpture at the School of Applied Art, Prague (from 1916), and Professor of Sculpture at the Academy of Fine Arts, Prague (from 1925). Although on the whole a typical representative of early 20th-century Czech academicism, he played a distinguished part in the development of Czech sculpture at the beginning of the century, being strongly influenced by Rodin. This work reached its climax during his stay in Paris (1904–8) when it was characterized by expressive

symbolism (e.g. *Somnambula*, 1906; Prague, N.G., Zbras-lav Castle). He also, however, had an excellent grounding in decorative sculpture, and a number of his bas-reliefs executed before he lived in Paris are distinctly Art Nouveau in style and spirit. He was an outstanding modeller, and his sculptures show an extreme sensitivity to light, exploiting its effects both sensually and symbolically (e.g. *Victims of Love and Death*, 1907–8; Prague, N.G., Zbraslav Castle). This is also true of his intimate portraits, especially of women. In about 1910 his views on sculpture underwent a change towards a new synthetism of form, and in his endeavours to reach a new monumentality his statues progressively acquired an ever more traditional academic character (e.g. *Orpheus*, 1915; Prague, N.G., Zbraslav Castle). Later he made his reputation mainly with his statues in Prague, which continue the traditions established by Myslbek (e.g. the statue of the artist *Josef Mánes*, 1932, Palach Square, and the colossal equestrian statue of the military and religious leader *Jan Žižka*, 1940, in front of the National Monument on Žižkov Hill).

BIBLIOGRAPHY
K. B. Mádl: *Bohumil Kafka: Jeho dílo od r. 1900 do r. 1913* [Bohumil Kafka: his work from 1900 to 1913] (Prague, 1919)
P. Wittlich: 'Mladý Bohumil Kafka' [The young Bohumil Kafka], *Výtvarné umění*, xii (1962), p. 353

PETR WITTLICH

Kaftantzoglou, Lysandros (*b* Thessaloniki, 1811; *d* Athens, 5 Oct 1886). Greek architect and teacher. He studied at the Accademia di Belle Arti, Rome (1826–36), and in 1833 he was awarded the first prize in the architectural competition for the design of the Università di Milano. In 1838, after two years in France, he returned to Greece to live in Athens. He exhibited his designs and projects there, among them the monument to the *Heroes of the War of Independence of 1821* (unexecuted), for which he had won an award at the Ecole des Beaux-Arts in Paris. After a period in Turkey (1839–43), he was appointed Director of the Royal School of Fine Arts in Athens in 1844 (later the National Technical University). He was promoted by the wealthiest and most influential of the Greek bourgeoisie, the expatriate merchants who financed most public projects. He contributed enormously to the development of the University and the establishment of Neo-classicism in Greece, both as an ideology and as a viable form of architecture. The austerity and rigour of the Greek version of Neo-classicism corresponded well with his attachment to the classical canon, which he used effectively to create an urban morphology of rhythmical volumes and regulatory grids, an orderly environment that would represent the freedom and progress of modern Greece.

Kaftantzoglou was commissioned to execute buildings designed by other architects, for example the Eye Clinic of Athens by Theophilus Hansen. During construction (1844–54), Kaftantzoglou, on the explicit wishes of King Otto (*reg* 1832–62), changed Hansen's Neo-classical composition into a neo-Byzantine one. The building is considered his best attempt to integrate the Byzantine tradition into his strict Neo-classical system. His first large-scale project was the Arsakeion school building (1845–52), Panepistimiou Street, Athens, the rigour and austerity of which were repeated in the Tositseion school building

(1865; destr. 1900), Athens, and in his major work, the National Technical University of Athens (1861–76); this project he undertook while he was Director of the Royal School of Arts, and he was accused of commissioning himself. His authoritarian personality and his connections with King Otto made him an unpopular figure, and in 1862 he was obliged to resign from the school.

Kaftantzoglou designed and executed a number of churches in Athens, mainly Neo-classical in style but with a number of Byzantine references. These include Hagia Irini (1846–92) on Aeolou and Perikleous streets and Hagios Konstantinos (1869–93) on Hagiou Konstantinou street.

BIBLIOGRAPHY
F. Loyer: *Architecture de la Grèce contemporaine* (diss., U. Paris III, 1966)
E. Demosthenopoulou: *Öffentliche Bauten unter König Otto in Athen* (diss., Munich, Ludwig-Maximilians U., 1970)
B. Efstathiadis: 'Lysandros Kaftantzoglou', *Protoi Ellines technikoi epistimones periodou Apeleftherosis* [Early Greek technical scientists after Independence] (Athens, 1976), pp. 171–94

ALEXANDER KOUTAMANIS

Kagaku Murakami. *See* MURAKAMI, KAGAKU.

Kager, Johann Matthias (*b* Munich, 1575; *d* Augsburg, 1634). German painter and draughtsman. He trained in Munich (1588–98) as a painter of miniatures. He probably worked subsequently among a group of artists decorating the Munich Residenz according to Italian models. Kager's early works, such as the drawing of the *Last Judgement* (Munich, Staatl. Graph. Samml.), show the influence of Friedrich Sustris, Christoph Schwarz and Hans Rottenhammer I. There is no evidence that Kager himself visited Italy. His drawings from the first years of the 17th century show that he had studied the art of Rudolfine Prague, including the works of Bartholomäus Spranger and Hans von Aachen: *Venus, Apollo and Amor* (Copenhagen, Stat. Mus. Kst), *Diana and Callisto* (Bremen, Ksthalle) and *Perseus and Andromeda* (1603; Berne, Kstmus.). Some copper engravings by Kager date from 1600 to 1603.

In 1603 Kager was granted the civic rights of Augsburg and the right to work as a painter of portraits and miniatures. From 1605 he received increasingly large commissions from the city and the Catholic clergy. He painted the façades of important buildings with historical scenes and allegories: Zunfthaus der Weber, 1605–7; three town gates, 1610–11. He produced altarpieces, notably the *Proof of the True Cross* (1608; ex-Frauenkirche, Munich; Freising, Diözmus.; see fig.), the *Assumption of the Virgin* (1609; Hall, Jesuitenkirche) and works for churches in Augsburg such as the *Presentation of the Virgin* (1616; Heiligen Kreuz). In addition Kager also designed copper engravings (for Matthäus Rader's *Bavaria sancta et pia*, 1615–28), organ cases, building façades and other *objets d'art* such as the *Pomeranian Cabinet* (1617; Berlin, Tiergarten, Kstgewmus.). The *Cabinet* was a project organized by the Augsburg art dealer Philipp Hainhofer, for whom Kager also painted miniatures. Other commissions came from the Wittelsbach court in Munich, the Fugger family of Augsburg, Prince-Bishop Wolf Dietrich von Raitenau of Salzburg (1559–1617) and from religious orders in south Germany refurbishing churches in the wake of the

Johann Matthias Kager: *Proof of the True Cross*, oil on canvas, 3.15×2.15 m, 1608 (Freising, Diözesanmuseum)

Counter-Reformation; for these he produced many paintings, such as the *Martyrdom of St Andrew* (1627; Landshut, St Martin).

In 1615 Kager was appointed town painter of Augsburg. As such he received his most important commission, the decoration of the Rathaus, newly built (1615–19) by Elias Holl. Kager had overall artistic control, but he personally executed the ceiling and wall paintings for the Goldener Saal as well as paintings for the various administrative offices (1619–29). Alongside his artistic activities Kager held a series of public offices in Augsburg from 1611, rising to become burgomaster in 1631–2.

Kager was of an eclectic nature. He knew how to exercise a high degree of virtuosity in whatever he produced, and to react promptly to new impressions. He was influenced above all by the art of northern Italy, by the Mannerism of Rudolfine Prague and by the printed graphics of the Counter-Reformation. The works of his middle period thus reveal, in composition and iconography, his regard for the artistic theory of the Counter-Reformation. They also show that he must have studied the work of the artists Johann Rottenhammer and Johann König, who had returned to Augsburg from Italy. When the works of Rubens first reached south Germany in the early 1620s, Kager applied himself to studying his figure style. Kager himself, like most of his German contemporaries, did not actually establish his own school of painting. Throughout his oeuvre religious themes are dominant:

mythological subjects appear only in the early work. He moved from small-scale formats to work on a large scale, being chiefly active as an art administrator, a disseminator of ideas, a designer and a mediator.

BIBLIOGRAPHY

S. Netzer: *Johann Matthias Kager, Stadtmaler von Augsburg* (Munich, 1980)
Welt im Umbruch, 2 vols (exh. cat., ed. B. Bushart; Augsburg, Städt. Kstsammlungen, 1980)
Wittelsbach und Bayern, ii/1 (exh. cat., ed. H. Glaser; Munich, Residenz, 1980), pp. 172, 197, 205, 315, 337
Zeichnungen in Deutschland. Deutsche Zeichner, 1540–1640, i (exh. cat. by H. Geissler, Stuttgart, Staatsgal., 1980), pp. 256–9, nos F24–7
Drawings from the Holy Roman Empire, 1540–1680 (exh. cat. by T. D. Kaufmann, Princeton U., NJ, A. Mus.; Washington, DC, N.G.A.; Pittsburgh, PA, Carnegie Mus. A.; 1982–3), pp. 106–9
Elias Holl und das Augsburger Rathaus (exh. cat., ed. W. Baer and others; Augsburg, Stadtarchv, 1985)

SUSANNE NETZER

Kähler, Herman August (*b* Næstved, 6 March 1846; *d* Næstved, 16 Nov 1917). Danish ceramic manufacturer. He received his training as an apprentice at the Kähler ceramic factory. The concern had been founded in Næstved in 1839 by his father, Joachim Christian Herman Kähler (1808–84), who was a potter and tiled-stove manufacturer. Kähler attended the technical colleges in Næstved and Copenhagen (1864–5) and assisted as a modeller in the studio of the sculptor Hermann Wilhelm Bissen. He then travelled abroad until 1867.

In 1872 the concern was divided between Kähler and his brother Carl Frederik Kähler (1850–1930), but the latter withdrew in 1896. Kähler took over the manufacture of tiled stoves and faience and increasingly experimented with glaze and lustre effects. In 1888 Karl Hansen Reistrup (1863–1929) joined the concern as artistic director. Kähler achieved recognition for the factory at the Great Nordic Exhibition of 1888, held at the Industrial Association in Copenhagen. At the Exposition Universelle of 1889 in Paris he received international acclaim when he launched a red-lustre glaze. This was used particularly on Reistrup's sculpturally formed, cast vases, which are characterized by the incorporation of animal heads. In addition Reistrup carried out a number of monumental wall friezes, including *Aegir and his Daughters* (1892; Copenhagen, Rådhus) after a drawing by Lorenz Frølich (untraced). Kähler also manufactured vases decorated in high temperature colours in collaboration with such artists as Thorvald Bindesbøll (*see* BINDESBØLL, (2)).

At the beginning of the 20th century, Kähler's son Herman Hans Christian Kähler (1876–1940) influenced the factory's production by retaining old pottery methods and creating pieces that were hand-moulded and decorated with horn-painting (slip-trailing, using a cow's horn through which liquid clay is applied). These wares were shown at the Exposition Universelle of 1900 in Paris and became widely popular. Later in the 20th century such potters as Svend Hammershøi (*see* HAMMERSHØI, (2)) and Jens Thirslund (1892–1942) contributed to the concern's image. In 1913 the concern was turned into a limited family company; in 1974 it was sold, and its collections went to Næstved Museum.

BIBLIOGRAPHY

J. Thirslund: *Kähler-keramik gennem 100 aar* [Kähler ceramics over 100 years] (Copenhagen, 1939)

E. Bülow and N. Hobolth: *Kähler keramik: Fra pottemageri til kunstindustri, 1839–1974* [Kähler ceramics: from pottery to applied art, 1839–1974], Nordjyllands Kstmus. Inf. leaflet, no. 119 (Ålborg, 1982)

LENE OLESEN

Kahlo (y Calderón), (Magdalena Carmen) Frida (*b* Mexico City, 6 July 1907; *d* Mexico City, 13 July 1954). Mexican painter. She began to paint while recovering in bed from a bus accident in 1925 that left her seriously crippled. She made a partial recovery but was never able to bear a child, and she underwent *c.* 32 operations before her death in 1954. Her life's work of *c.* 200 paintings, mostly self-portraits, deals directly with her battle to survive. They are a kind of exorcism by which she projected her anguish on to another Frida, in order to separate herself from pain and at the same time confirm her hold on reality. Her international reputation dates from the 1970s; her work has a particular following among Latin Americans living in the USA.

Small scale, fantasy and a primitivistic style help to distance the viewer from the horrific subject-matter of such paintings as *Henry Ford Hospital* (oil on sheet metal, 1932; Mexico City, Mrs D. Olmedo priv. col., see Herrera, 1983, pl. IV), in which she depicts herself haemorrhaging after a miscarriage, but her vulnerability and sorrow are laid bare. Her first *Self-portrait* (1926; Mexico City, A. Gomez Arias priv. col., see Herrera, 1983, pl. I), painted one year after her accident, shows a melancholy girl with long aristocratic hands and neck depicted in a style that reveals her early love for Italian Renaissance art and especially for Botticelli.

Kahlo's art was greatly affected by the enthusiasm and support of Diego Rivera, to whom she showed her work in 1929 and to whom she was married in the same year. She shared his Communism and began to espouse his belief in *Mexicanidad*, a passionate identification with indigenous roots that inspired many Mexican painters of the post-revolutionary years. In Kahlo's second *Self-portrait* (oil on masonite, 1929; Mexico City, Mrs D. Olmedo priv. col., see Herrera, 1983, pl. II), she no longer wears a luxurious European-style dress, but a cheap Mexican blouse, Pre-Columbian beads and Colonial-period earrings. In subsequent years she drew on Mexican popular art as her chief source, attracted by its fantasy, naivety, and fascination with violence and death. Kahlo was described as a self-invented Surrealist by André Breton in his 1938 introduction for the brochure of the first of two Kahlo exhibitions held during her lifetime, but her fantasy was too intimately tied to the concrete realities of her own existence to qualify as Surrealist. She denied the appropriateness of the term, contending that she painted not dreams but her own reality.

The vicissitudes of Kahlo's marriage are recorded in many of her paintings. In *Frida and Diego Rivera* (1931; San Francisco, CA, MOMA) he is presented as the great maestro while she, dressed as usual in a long-skirted Mexican costume, is her husband's adoring wife and perfect foil. Even at this early date there are hints that Rivera was unpossessable; later portraits show Kahlo's increasing desire to bind herself to her philandering spouse. *The Two Fridas* (1939; Mexico City, Mus. A. Mod.), in which her heart is extracted and her identity split, conveys her desperation and loneliness at the time of their divorce in 1939; they remarried in 1940.

Kahlo's health deteriorated rapidly in her last years, as attested by *Self-portrait with the Portrait of Dr Farill* (1951; Mexico City, Mrs E. Farill priv. col., see Herrera, 1983, pl. XXXIV). This depiction of herself sitting bolt upright in a wheelchair, painted after spending a year in hospital undergoing a series of spinal operations, was conceived as a kind of secular ex-voto and given to the doctor whom she has represented as the agent of her salvation.

In 1953 Kahlo's right leg was amputated at the knee because of gangrene. She turned to drugs and alcohol to relieve her suffering and to Communism for spiritual solace. Several late paintings, such as *Marxism Heals the Sick* (Mexico City, Mus. Kahlo), show Marx and Stalin as gods; they are painted in a loosely brushed style, her earlier miniaturist precision having been sacrificed to drug addiction. Her last work, a still-life of a watermelon entitled *Long Live Life* (1954; Mexico City, Mus. Kahlo), is both a salute to life and an acknowledgement of death's imminence. Eight days before she died, almost certainly by suicide, she wrote her name, the date and the place of execution on the melon's red pulp, along with the title ('VIVA LA VIDA') in large capital letters.

For illustration of her work *see* MEXICO, fig. 11.

BIBLIOGRAPHY
T. del Conde: *Vida de Frida Kahlo* (Mexico City, 1976)
R. Tibol: *Frida Kahlo: Crónica, testimonios y aproximaciones* (Mexico City, 1977)
H. Herrera: *Frida Kahlo: Her Life, Her Art* (diss., New York, City U., 1981)
Frida Kahlo and Tina Modotti (exh. cat. by L. Mulvey and others, London, Whitechapel A.G., 1982)
H. Herrera: *Frida: A Biography of Frida Kahlo* (New York, 1983)
M. Drucker: *Frida Kahlo: Torment and Triumph in her Life and Art* (New York, 1991)
H. Herrera: *Frida Kahlo: The Paintings* (London, 1991)
For further bibliography *see* RIVERA, DIEGO.

HAYDEN HERRERA

Kahn, Albert (*b* Rhaunen, nr Mainz, 21 March 1869; *d* Detroit, 8 Dec 1942). American architect. He grew up in Echternach but emigrated to Detroit with his family in 1880, at which time his formal schooling ended. His architectural training was with the Detroit architectural firm of Mason & Rice (1884–95) where he rapidly became chief designer, working in the mode of H. H. Richardson and the Shingle style. His designs of this period may include the Grand Hotel on Mackinaw Island, MI (1888). He spent 1891 in Europe on a travelling scholarship. During his time with Mason & Rice his admiration began for the work of McKim, Mead & White, which led in the 1920s to his designs for the William L. Clements Library at the University of Michigan, Ann Arbor, and the General Motors building in Detroit.

In 1903 Kahn became architect for Packard Motor Car Company in Detroit and in 1906 for the George N. Pierce Company of Buffalo, NY, makers of the Pierce-Arrow car. For Pierce he made the first roof-lit factory for heavy industry. This innovation freed interior planning from its prior dependence on wall windows, allowing the plan to spread horizontally to follow whatever configuration the manufacturing process required. In 1908 he was engaged

Albert Kahn: glass building at the Ford Rouge Plant, Rouge River, near Detroit, MI, 1922

by Henry Ford to design a new factory (now mostly demolished) in Highland Park in Detroit for the Model T. In this factory Ford used assembly-line methods for the first time in heavy industry in 1913, leading Ford and Kahn to consider a vast new industrial complex to build the Model T by assembly-line process. The resultant factory, the Ford Rouge Plant on the Rouge River southwest of Detroit, begun in 1917, became the largest industrial complex in the world in the 1920s and 1930s and arguably the most efficient. It consisted entirely of one-storey roof-lit steel-framed structures. Its glass building (1922; see fig.) is an example of the sophistication of Kahn's architecture at this time, a building whose trim envelope sheaths a structure precisely tailored to the enclosed manufacturing process.

Kahn also worked for General Motors, Chrysler Corporation and Glenn Martin Aircraft, among others; during his career he designed over 2000 factories. From 1929 to 1932 he also maintained an office in Moscow, executing 531 factories there and training hundreds of Soviet architects for industrial work. The Dodge Half-Ton Truck Plant at Warren, near Detroit (1937; see UNITED STATES OF AMERICA, fig. 9), later extensively remodelled, is an excellent example of his late work. It achieved unusually wide column spacings through use of steel cantilevers, which determined the location of sloped glazed roof surfaces for daylighting. Glass and stucco walls expressed the structural configuration and also possessed a crystalline beauty. The inspired functionalism of Kahn's work influenced Modernist architects such as Walter Gropius and Mies van der Rohe.

BIBLIOGRAPHY

G. Nelson: *The Industrial Architecture of Albert Kahn* (New York, 1939)
W. H. Ferry: *The Buildings of Detroit: A History* (Detroit, 1968)
The Legacy of Albert Kahn (exh. cat. by W. H. Ferry, Detroit, MI, Inst. A., 1970)
G. Hildebrand: *Designing for Industry: The Architecture of Albert Kahn* (Cambridge, MA, and London, 1974)

GRANT HILDEBRAND

Kahn, E(ly)-J(acques) (*b* New York, 1 June 1884; *d* New York, 5 Sept 1972). American architect. His Austrian–Jewish family background afforded him early intimacy with European decorative arts, particularly those of Vienna. He was educated at Columbia University, New York, graduating from the architecture school in 1907. He spent the next four years at the Ecole des Beaux-Arts in Paris, where he met Raymond Hood and Ralph Walker, whose careers and attitudes ran parallel with his. After assisting various architects, in 1915 he joined Buchman & Fox in New York and became a partner in 1919. The firm was successively known as Buchman and Kahn, E.-J. Kahn and later Kahn & Jacobs.

Kahn was outstandingly creative during the short-lived boom in high-rise buildings in New York from 1925 to 1930. His firm specialized in 'loft' buildings for light manufacturing (notably garment-making) as well as in offices, and this in part distinguished his architecture from that of Hood and other exponents of the set-back, commercial skyscraper. He evolved a clever, colourful decorative vocabulary, inspired to some extent by the Exposition Internationale des Arts Décoratifs et Industriels Modernes, Paris (1925), but developed with wit, discrimination and an outstanding grasp of the applied arts of Europe, Asia and Pre-Columbian America. The best of his buildings in New York of this period are 261 Fifth Avenue, with its 'woven' textured façade and lobby, and the grand 2 Park Avenue, an unusually proportioned building with a powerful scheme of coloured terracotta worked out in association with L. V. Solon (1872–1957).

No later building by Kahn was of such quality, although the concrete-arched New York Municipal Asphalt Plant (1944) was admired for its frank functionalism, then still a rare architectural commodity in that city. In the years following World War II the Kahn & Jacobs office, always large and efficient, confined its ambition to well-organized practicality. Besides designing many large buildings of their own, they were executant architects and in part the planners of Ludwig Mies van der Rohe's Seagram Building

(1954–8), New York. Kahn himself was decreasingly responsible for the looks of the designs produced by his office but became an authority on the workings of the large American architectural practice.

Kahn was a sociable, civilized and literate individual who devoted much time to teaching, debating the issues of architectural training, and organizing exhibitions of applied arts, particularly in the 1930s. His first loyalty was to the Beaux-Arts Institute of Design, a New York-based organization founded by American graduates of the Ecole des Beaux-Arts in Paris. His one substantial book, *Design in Art and Industry* (1935), demonstrates his range of attainments and curiosity.

UNPUBLISHED SOURCES
New York, Columbia U., Avery Archit. Mem. Lib. [autobiography]

WRITINGS
Ely-Jacques Kahn, foreword A. T. North (New York, 1931)
Design in Art and Industry (New York, 1935)
'American Office Practice', *RIBA J.*, lxiv (1957), pp. 443–51 [RIBA lecture]
'Tall Buildings in New York', *RIBA J.*, lxvii (1960), pp. 451–6 [RIBA lecture]
A Building Goes Up (New York, 1969)

BIBLIOGRAPHY
C. Robinson and R. H. Bletter: *Skyscraper Style* (New York, 1975)

Kahn, Gustave (*b* Metz, 21 Dec 1859; *d* Paris, 5 Sept 1936). French writer, theorist and critic. The family moved to Paris in 1870, during the Franco-Prussian War, and Kahn was then educated at the Ecole des Chartes and the Ecole des Langues Orientales. In 1879 he met Jules Laforgue and Stéphane Mallarmé and published his first 'poèmes en prose'. After Charles Baudelaire, Mallarmé was the greatest influence on his poetry and artistic theories. From 1880 to 1884 he did his military service in North Africa and on his return to Paris he soon became involved in the world of literary symbolism. He ran several periodicals, including *La Vogue* and *Le Symboliste* in 1886, and the *Revue indépendante* in 1888. Kahn was a pioneer, though not the sole creator, of 'free verse', poetry free of conventional syntactic, metrical and other restrictions. In 1887 he published *Les Palais nomades*, the first collection of 'free verse' poetry.

In his article 'Réponse des symbolistes' (1886) Kahn outlined the essentials of Symbolist theory. He assumed an evolutionary view of man: as ideas and sensations change, so language and poetry must evolve to facilitate new modes of expression. Kahn demanded freedom from contemporary subject-matter and called for a 'return of the imagination to the epic and the marvellous'. Characteristically a philosophical idealist, he claimed the world to be a mere representation, the task of the artist being to probe beneath its surface using symbols.

Kahn's ideas were further elaborated in later articles, most especially in the *Revue indépendante*, and were also central to pictorial Symbolism, which likewise strove to create new artistic forms. He most admired the work of Pierre Puvis de Chavannes and Gustave Moreau. In their work, as in that of other Symbolists, the fantastic and mythological appear in timeless settings, as demanded by Kahn. After 1901 he turned increasingly towards art criticism, publishing his book *Symbolistes et décadents* soon

afterwards. In 1919 he became the art correspondent for the *Mercure de France* and for the *Quotidien* in 1923, positions he held until his death.

WRITINGS
'Réponse des symbolistes', *L'Evénement* (28 Sept 1886)
Symbolistes et décadents (Paris, 1902)
Les Origines du symbolisme (Paris, 1936)

BIBLIOGRAPHY
J. Rewald: *Post-Impressionism* (London, 1956), pp. 148–51, 160, 162, 186, 189, 426
J. C. Ireson: *L'Oeuvre poétique de Gustave Kahn* (Paris, 1962)
A. G. Lehmann: *The Symbolist Aesthetic in France 1885–1895* (Oxford, 1950, 2/1968), pp. 46, 144, 241–3

Kahn, Louis I(sadore) (*b* Ösel Island, Russia [now Saaremaa Island, Estonia], 20 Feb 1901; *d* New York, 17 March 1974). American architect and teacher of Russian birth. He moved with his family to Philadelphia in 1905. Although they lived in poverty he received a good education at Central High School and the Public Industrial Art School. An obligatory course on architecture deflected Kahn from a career in art; from 1920 to 1924 he studied architecture at the University of Pennsylvania, Philadelphia, under Paul Cret, following Beaux-Arts principles. He then worked until 1926 for the City Architect's office, acting as chief of design for the Sesquicentennial Exposition, Philadelphia (1926). In 1928–9 he travelled in Europe; although he was attentive to recognized historical works, there is little evidence of any concern with major innovations in modern architecture in those years. Returning to Philadelphia he worked in Cret's office (1929–30).

In the midst of the Depression, Kahn founded and directed the Architectural Research Group for unemployed architects and engineers (1932–3). Thus his concern for urban and housing issues began, pursued in work for the City Planning Commission and the Housing Authority of Philadelphia. He entered practice with Alfred Kastner in 1935; in 1941 he formed a partnership with George Howe, which Oskar Stonorov joined in 1942. In 1943 this became Kahn & Stonorov, which existed until 1948; they designed a number of public housing commissions, of which Mill Creek project for the Philadelphia Housing Authority (1946–62; with Kenneth Day (?1901–1958) and others) is the best-known. In 1947 Kahn was a visiting critic at Yale University, New Haven, CT. His excellence as a teacher led to his reappointment there as senior critic (1950–57).

While a fellow at the American Academy in Rome (1950–51), Kahn received the commission for the Yale University Art Gallery (1951–3). Before his involvement a very specific brief had been prepared for the gallery, which was an addition to existing facilities. Despite these constraints and a preceding unexecuted design for a similar project on the same site by Philip Goodwin (1885–1958), Kahn's gallery won general recognition. The building was to provide studio space for architecture before eventually serving only as a gallery. It faced south to an active street while the north side adjoined the university. He designed a windowless façade to the street, modern yet deferential to its neo-Gothic neighbour: it was sympathetic in height, tonality of masonry and in scale, with horizontal mouldings marking each storey. In sharp contrast the north façade,

favoured with quiet conditions, a view and naturally controlled light, is an expanse of glass in well-proportioned frames. The principal feature of the building is the exposed reinforced-concrete floor structure that appears to be a space frame but is actually a system of beams braced with triangulating ribs. The deep openwork of this tetrahedral structure accommodates utilities, lighting and acoustical materials.

At a moment when the diverse potentials of modern architecture were being limited to glass boxes, Kahn organized a discourse of new and old materials and forms, and of real constraints of site and project. This was seen again in the changing-rooms built for the Jewish Community Center, Trenton, NJ (1955–6). In this project he also introduced the concept of 'servant and served spaces', which he extended in the Richards Medical Research Laboratories, University of Pennsylvania (1957–61). This referred to the primary spaces within the building ('served') and the spaces reserved for equipment or ancillary uses ('servant'). The larger, internally undivided 'served' spaces of the Richards towers employ an innovative and finely scaled precast concrete frame that reveals its jointing and the attenuation of forces from support to periphery. The complement of this articulate structure is the finely detailed brick infill and fenestration. The intended complementarity of site, structure, space, function, construction, materials and form at the Richards Laboratories provided an invigorating stimulus to the rethinking of architecture c. 1960. Both the formal issues and the mechanical complexity encountered in the project were re-examined in Kahn's designs for the Salk Institute for Biological Studies, La Jolla, CA (1959–65). A major part of its programme was the monumental representation of a new institution in a new location, and Kahn responded with a site plan that echoed his Beaux-Arts training: two study/laboratory wings flank a formal axial courtyard with a view to the sea; they were to have been connected by oblique linking paths to a village-like residential area and a meeting building. Mechanical services for the laboratories are accommodated in walk-through inter-floor spaces, a method that became standard practice in hospitals and laboratories.

Central to Kahn's architectural philosophy was the concept of institution, by which he understood not the momentary state of a client but rather the underlying social responsibilities and potentials of social organizations. At the root of the archaism often recognized in Kahn's buildings was his desire to probe the beginnings of social commitments and to redefine what an institution should continue to be. He used the words 'order' or 'form' for the fundamental organizations that animate an institution and thus are to be maintained through the exigencies of design, of realizing a particular building. A clear demonstration of this process is his 'form diagram' and successive designs for the First Unitarian Church, Rochester, NY (1959–67).

In 1957 Kahn became a professor at the University of Pennsylvania. From 1962 until his death he undertook two major projects in the Indian subcontinent: the Institute of Management, Ahmadabad, India, and the Sher-e-Bangla-Nagar, the new capital in Dhaka, Bangladesh, which was commissioned by the former government of East Pakistan (see BANGLADESH, fig. 2). These works exemplify Kahn's use of a double wall: a bold, tectonic exterior wall yielding a first range of environmental control around a less strictly ordered physical enclosure. The library for Phillips Exeter Academy, Exeter, NH (1966–72), brilliantly summarizes the characteristics of Kahn's approach already discussed.

Louis I. Kahn: interior of south-west gallery of Kimbell Art Museum, Fort Worth, completed 1972

The Kimbell Art Museum, Fort Worth, TX (1966–72), was one of two art galleries that were Kahn's last major commissions. Evocatively sited, with a lateral approach under trees or vaults, along pools and over a gravel courtyard, it is nevertheless an internalized building, extraordinary for its space and light, as congenial to the visitor as to the works of art it enhances. The galleries and all major public spaces occupy a single level under structurally ambiguous, spatially effective, vault-like concrete constructions carried on widely spaced concrete columns (see fig.). A long slit skylight running the length of each construction, with diffusers below, yields luminous bays that alternate, laterally, with narrow, low, comparatively dark zones, a continuation of Kahn's ever more generalized and flexible 'served' and 'servant' spaces. The Yale Center for British Art (1969–77) stands opposite his first major work, the Art Gallery at Yale University. Its form differs considerably from that of the Kimbell, employing pewter-coloured stainless steel, glass and wood as planes within a remarkably simple concrete frame. Despite this seemingly conventional structure and the provision for retail facilities at street level, the excellence and impressiveness of the museum spaces are undiminished.

WRITINGS

R. S. Wurman, ed.: *The Notebooks and Drawings of Louis I. Kahn* (Philadelphia, 1962)
A. Mohler and P. Papademetriou, eds: *Louis I. Kahn: Talks with Students*, Architecture at Rice, 26 (Houston, 1969)
R. S. Wurman, ed.: *What Will Be Has Always Been: The Words of Louis I. Kahn* (New York, 1986)
A. Latour, ed.: *Louis I. Kahn: Writings, Lectures, Interviews* (New York, 1991)

BIBLIOGRAPHY

V. J. Scully: *Louis I. Kahn* (New York, 1962)
R. Giurgola and J. Mehta: *Louis I. Kahn* (Boulder, 1975)
A. Komendant: *18 Years with Architect Louis I. Kahn* (Englewood, 1975)
H. Ronner, A. Vasella and S. Jhaveri: *Louis I. Kahn: Complete Works, 1935–74* (Basle, 1977, rev. 2/1987)
The Travel Sketches of Louis I. Kahn, Pennsylvania Academy of Fine Arts (Philadelphia, 1978)
A. Tyng: *Beginnings: Louis I. Kahn's Philosophy of Architecture* (New York, 1984)
J. P. Brown: *Louis I. Kahn: A Bibliography* (New York, 1987)
The Louis I. Kahn Archives: Personal Drawings, University of Pennsylvania, Architectural Archives, and Pennsylvania Historical and Museum Commission, 7 vols (New York, 1987)
P. C. Loud: *The Art Museums of Louis I. Kahn* (Durham, NC, 1989)
Louis I. Kahn: In the Realm of Architecture (exh. cat. by D. B. Brownlee and D. G. De Long, Philadelphia, PA, Mus. F.A.; Paris, Pompidou; New York, MOMA; and elsewhere; 1991–4) [intro. by V. Scully; bibliog.]

STANFORD ANDERSON

Kahn & Jacobs. *See under* KAHN, E.-J.

Kahnweiler, Daniel-Henry (*b* Mannheim, 25 June 1884; *d* Paris, 11 Jan 1979). German art dealer, publisher and writer, active in France. In 1902 he left the Jewish community of Mannheim for Paris, where he assiduously visited museums, galleries and salons, while training for a career as a banker or stockbroker. In spring 1907 he obtained sufficient funds from his family to launch the tiny Galerie Kahnweiler at 28, Rue Vignon. That year he purchased works at the Salon des Indépendants and at the Salon d'Automne (by Kees van Dongen, Matisse, Derain and Braque), and in the same year he met Picasso and visited his studio in the Bateau-Lavoir. There he saw the recently completed *Demoiselles d'Avignon* (1907; New York, MOMA). The visit was decisive. Kahnweiler immediately supported Picasso and also Braque, whose exhibition of November 1908, one of Kahnweiler's rare one-man shows before World War I, prompted the coining of the term Cubism. Kahnweiler proved instrumental in promoting the style, numbering among his few faithful clients Hermann Rupf from Berne, Gertrude Stein, the Russians Sergey Shchukin and Ivan Morosov, the Czech Vincenc Krámař and the Frenchman Roger Dutilleul. He also achieved success as a publisher, introducing poets to painters and launching their successful collaborations, such as Guillaume Apollinaire's *L'Enchanteur pourrissant* (1909), illustrated by Derain, and Max Jacob's *Saint-Matorel* (1911), illustrated by Picasso.

In 1912 Kahnweiler signed exclusive contracts with Braque, Picasso and Derain, and the following year with Maurice de Vlaminck and Léger. These arrangements, purely verbal after 1920, formed the basis of professional relationships, resting on mutual trust and commitment, that benefited artist and dealer alike. Kahnweiler systematically photographed each work as it entered his stock, a method that proved an effective means of publicity, both in art magazines and abroad. His connections before 1914, with both collectors and dealers, helped to establish international reputations for his artists in important avant-garde exhibitions held in Germany, Hungary, the Netherlands, England, Czechoslovakia, Russia and in the American Armory Show of 1913.

During World War I Kahnweiler chose to live in neutral Switzerland, at the suggestion of his friend Rupf. His living conditions in Berne were relatively insecure since all his possessions, including his stock, had been impounded by the French state as German property. Forced to curtail his dealing activities, Kahnweiler took advantage of his enforced leisure and systematically continued his philosophical and aesthetic education. The most important of his texts, published in part in 1916 in the Zurich periodical *Die Weissen Blätter*, was *Der Weg zum Kubismus* (1920), in which he unequivocally expressed his support for an art that addressed both the mind and the eye. For Kahnweiler a Cubist painting, like a piece of writing, could only reveal its meaning after it had been read, so the viewer had first to learn its language. (He would later condemn all abstraction as 'hedonistic', as of no more consequence than an amusing optical game.)

At the end of the war Kahnweiler immediately renewed contact with all his artists, returning in February 1920 to Paris, where he established his new Galerie Simon, named after his partner André Simon, on the Rue d'Astorg. He renewed his contracts with Braque, Léger, Derain, Vlaminck and Gris, and he initiated new ones with the sculptors Henri Laurens and Manolo. Picasso remained with his new dealer, Paul Rosenberg, a serious blow to Kahnweiler, second only to the dispersal by the French government of his entire pre-war stock in four sales held between 1921 and 1923. The Press were delighted to see Cubism being sold off cheaply at the time of the 'rappel à l'ordre'. Kahnweiler bought back a few dozen works through the intermediation of a group of friends, but the sales were for him a financial and moral catastrophe. Nevertheless, he determinedly set up another gallery,

signing up several new painters such as André Masson, André Beaudin, Eugène de Kermadec and Gaston-Louis Roux (*b* 1904), and he continued with his publishing ventures, meeting a new generation of painters, poets and writers. He was the first to publish Antonin Artaud, André Malraux and three of Masson's friends: Michel Leiris, Georges Limbour and Georges Bataille. Kahnweiler's circle also included musicians such as Erik Satie. Masson, whose early paintings were influenced by Gris's Cubism, was the only Surrealist under contract to him, although during the 1930s Kahnweiler also exhibited the work of Klee.

Forced into hiding during World War II, Kahnweiler left the running of his gallery to his daughter-in-law Louise Leiris, who had been working with him since 1920, and he named it after her following the war. In 1957 the gallery moved to spacious new premises on Rue de Monceau, where Kahnweiler remained an influential dealer, recovering his hold over the market for paintings by Picasso and continuing to champion the artists whose talents he had recognized and nurtured from an early age.

WRITINGS

'Der Kubismus', *Weissen Bl.*, iii (1916), pp. 209–22; rev. and enlarged as *Der Weg zum Kubismus* (Munich, 1920; Eng. trans., New York, 1949)
Juan Gris: Sa vie, son oeuvre, ses écrits (Paris, 1946; Eng. trans. and rev., New York, 1947)
'L'Art nègre et le cubisme', *Présence Afr.*, 3 (1948), pp. 367–77
Mes galeries et mes peintres, entretiens avec Francis Crémieux (Paris, 1961)

BIBLIOGRAPHY

M. Gee: *Dealers, Critics and Collectors of Modern Painting: Aspects of the Parisian Art Market between 1910 and 1930* (diss., U. London, Courtauld Inst., 1977)
D.-H. Kahnweiler (exh. cat., Paris, Pompidou, 1984)

ISABELLE MONOD-FONTAINE

Kahukiwa, Robyn (*b* Sydney, 14 Sept 1941). New Zealand painter. She was essentially self-taught as a painter, and her return to New Zealand in 1960 focused her artistic development on her Maori cultural heritage. A series of images of women in Maori myth provided the theme for a travelling exhibition (1983) and publication (1984) entitled *Wahine toa* (Women of prestige); the precisely modulated naturalistic image of *Hinetitama* ('Dawn maiden') (1980; Palmerston North, Manawatu A.G.), cloaked in symbolic references to her position within the pantheon of Maori gods, is characteristic of the series. A carved, semi-naturalistic image of a child-suckling mother from a traditional east coast Maori meeting-house provided the inspiration for a dramatic change of style in 1985. A limited palette of broad planes of juxtaposed colour, applied to large unframed canvases, empowered Kahukiwa's ancestral images. The 'aspective convention' (traditional representational conventions) inherent in traditional Maori art replaced the illusionistic preoccupation of previous work. Kahukiwa's brushwork comprised lashes rather than strokes in *Te whenua, te whenua, engari kaore he turangawaewae* ('The land, the placenta, but nowhere to stand'; 1988; Auckland, C.A.G.), in which figures dance across the canvas and jostle in cramped, zonal niches. Maori people have always populated Kahukiwa's paintings, from the disenfranchised youth of suburbia to ancestral images, from anonymous women resurrected from photographic archives to women as

vessels of humankind. Humanity prevails as Maori links to ancestors and the earth mother evoke messages of rights to land, equality and self-determination.

WRITINGS
with P. Grace: *Wahine toa: Women in Maori Myth* (Auckland, 1984)

BIBLIOGRAPHY
D. Nicholas and K. Kaa: *Seven Maori Artists* (Wellington, 1986) [interview pp. 34–7]
Whakamamae [To inflict/feel pain] (exh. cat. by I. Ramsden, C. Lyndon and K. Kaa, Wellington, NZ, C.A.G., 1988)

ROBERT H. G. JAHNKE

Kahun. *See under* LAHUN, EL-.

Kaigetsudō. Name used by members of a school of Japanese painters and print designers, which flourished in Edo (now Tokyo) during the first half of the 18th century. They specialized in paintings and prints of courtesans of the Yoshiwara pleasure quarter, depicted in monumental, standing poses and dressed in luxurious kimonos. The founder of the school was (1) Kaigetsudō Ando, who was strongly influenced by Hishikawa Moronobu and Sugimura Jihei (*fl c.* 1681–1703). They worked in the *ukiyoe* ('pictures of the floating world') genre (*see* JAPAN, §§VI, 4(iv)(b) and IX, 2(iii)). Kaigetsudō Ando's direct pupils included (2) Kaigetsudō Anchi, Doshin (*fl* 1710s), (3) Kaigetsudō Dohan, and Doshu and Doshū (both *fl* 1710s). Their own pupils and followers continued the Kaigetsudō tradition into the mid-18th century, influencing such well-known *ukiyoe* artists as Miyagawa Chōshun, Shunsui (*fl* 1740s–1760s) and Shunshō and Katsushika Hokusai. Overall, the output of the school shows a remarkable uniformity of technique and subject-matter.

RICHARD LANE

(1) Kaigetsudō Ando [Okazawa Yasunori] (*fl* Edo [now Tokyo], *c.* 1700–14). Painter. He founded the Kaigetsudō school of *ukiyoe* painters and print designers. A specialist in *nikuhitsuga* ('original paintings'; polychrome paintings), he never designed woodblock prints. He took his artist's name from the studio (*eya*) he managed in the Suwachō district of Edo. His work shows the influence of the earlier *ukiyoe* artists, HISHIKAWA MORONOBU and Sugimura Jihei (*fl c.* 1681–1703). He specialized in *nikuhitsu bijinga* ('original pictures of beautiful women'; *see* JAPAN, fig. 167), which set the standard of feminine beauty in *ukiyoe* at the beginning of the 18th century. Ando's tall, elegant and somewhat haughty *bijin* typify the dignity of the high-class courtesans of the Yoshiwara quarter (located 2 km north of Ando's studio). They are dressed in luxurious kimonos, which he executed with a characteristically dark palette and a rough brushline. His representative works include *Courtesan and Attendant* ('Yūjo ni kamaro', colours on paper, 930×503 mm; Tokyo, N. Mus.; see fig.) and *Scroll of Customs and Manners* ('Fūzoku zukan'; Boston, MA, Mus. F.A.). Ando was exiled to Izu (now Kanagawa Prefect.) for his part in the Ejima scandal in 1714, but he is thought to have resumed his artistic career when he returned to Edo in 1733.

TADASHI KOBAYASHI

(2) Kaigetsudō Anchi [Chōyōdō] (*fl* Edo [now Tokyo], *c.* 1710s). Painter and print designer. He was a direct pupil of the school's founder, (1) Kaigetsudō Ando. Like

Kaigetsudō Ando: *Courtesan and Attendant*, colours on paper, 930×503 mm (Tokyo, National Museum)

all the artists of the school, Anchi specialized in monumental, full-length portraits of courtesans from the Yoshiwara pleasure quarter. His artistic style is characterized by a manner more coyly erotic than that of his teacher: his women are aristocratic, self-absorbed and disdainful—a mode well suited to the depiction of Yoshiwara ladies of the night. In addition to his impressive *kakemono* (hanging-scrolls), Anchi is known for several large monochrome prints, sometimes hand-coloured by the publisher. His prints, which make full use of the graphic potential of the woodblock printing technique, are probably more effective than his paintings.

(3) Kaigetsudō Dohan (*fl* Edo [now Tokyo], *c*. 1710s). Painter and print designer. He was a direct pupil of (1) Kaigetsudō Ando and, like him, produced full-length portraits of courtesans from the Yoshiwara pleasure quarter. In his *kakemono* (hanging scroll) paintings Dohan's style is stiffer and more formal than that of Ando or of his colleagues (2) Kaigetsudō Anchi, Doshin, Doshu

and Doshū. When his work was translated into the medium of the woodblock print, Dohan's faults were often overcome by the skills of the block carver. He is one of the undisputed early masters of the Japanese print.

BIBLIOGRAPHY
R. Lane: *Kaigetsudō* (Tokyo, 1959)
——: *Masters of the Japanese Print* (New York and London, 1962)
——: *Images from the Floating World* (London and New York, 1978)
RICHARD LANE

Kaihō school. *See under* KAIHŌ YŪSHŌ.

Kaihō Yūshō (*b* Ōmi Province [now Shiga Prefect.], 1533; *d* 1615). Japanese painter. He was the fifth son of a samurai retainer of the Asai clan, the rulers of Ōmi Province on the shores of Lake Biwa. In his youth he entered Tōfukuji, an important Zen temple in Kyoto, serving first as a page and later as a lay priest, reportedly with some reluctance. His service at Tōfukuji did, however, spare him the fate that befell the rest of his family in 1573, when the Asai clan was destroyed by Oda Nobunaga.

As a painter, Yūshō is said to have received early encouragement at Tōfukuji and training under a master of the KANŌ school, the leading school of painting at the time. He may have studied with Kanō Motonobu or perhaps with Kanō Eitoku, but he did not stay in the Kanō studio. During his formative years he was also exposed to the works of the Chinese painter LIANG KAI, who had achieved great popularity in Japan during the Muromachi period (1333–1568). Some of Yūshō's monochrome works combine long, vigorously executed brushstrokes with more abbreviated brushwork (*genpitsu*) that is said to derive from Liang Kai's technique and also to reflect his own samurai training in swordsmanship.

Whatever the precise mix in Yūshō's artistic training, he began as a painter of monochrome ink subjects (*suibokuga*; *see* JAPAN, §VI, 4(iii)), and his style, while based on the Kanō tradition, was noted for its inventive freedom, intense brushwork and subtle tonal variations. In 1573 Yūshō left Tōfukuji to become a professional painter. His many contacts among Zen priests of Kyoto then stood him in good stead, for he found ready patronage at a number of Zen temples. When Kenninji, which had been heavily damaged by fire and storm, was being rebuilt about 1599, the abbot commissioned Yūshō to paint the sliding door panels (*fusuma*) of his living quarters (*hōjō*). These and other *byōbu* (folding screen) and *fusuma* paintings in the Zenkyōan and Reitōin subtemples of Kenninji are Yūshō's most important works in ink.

As the fashion for paintings executed in bright colours on a gold-foil ground (*kinpeki*) grew, Yūshō worked more frequently in that medium. A painting widely regarded as his masterpiece of that type is the pair of screens *Peonies and Camellias in a Landscape* (late 16th century–early 17th; Kyoto, Myōshinji; *see* fig.). The right-hand composition consists of peonies growing out of a rocky outcrop silhouetted against a background of golden earth and cloud. The peony, long associated with abundance and power in China, had become a popular emblem in Japan, and Yūshō's depiction combines profusion with selection, as the blooms and leaves spread rhythmically across the surface of the screen, but seldom overlap the golden

Kaihō Yūshō: *Peonies and Camellias in a Landscape*, pair of six-panel folding screens, ink and colour on gold-foiled paper, each screen 1.77×3.56 m, late 16th century–early 17th (Kyoto, Myōshinji)

ground. The use of green ink for the rocky outcrops was one way in which Yūshō distanced his work from the pictorial conventions of the Kanō school. The left-hand screen presents a more complex composition. Yūshō again used green ink for the rocks that emerge from golden mists to form the bank of a golden stream; camellias bloom in front of a brushwood fence, while a plum tree arches overhead. Traces of Yūshō's *genpitsu* technique can be seen in the energy of the strokes used for the plum branches. The brushwood fence was executed in monochrome ink in such a way that the gold foil shines through. It is a masterful display of brush technique consistent with the concern for variety of texture, shape and brushstroke

that is evident in the work as a whole. In each screen there is a limited sense of spatial depth, and forms are arranged asymmetrically, so that, taken together, the peonies on the right and the plum tree on the left act as framing agents for the nearly blank panels at the centre.

In addition to painting and Zen, Yūshō was also interested in swordsmanship, poetry and tea. It was at a tea ceremony that he met the warlord Toyotomi Hideyoshi, who asked him to assist with the decoration of his residence in Kyoto, the Jurakudai. Yūshō also received commissions from the Emperor Goyōzei (*reg* 1586–1611). With such patrons, it is no wonder that by the end of his life Yūshō was respected in all quarters of Kyoto society.

Along with the painters Hasegawa Tōhaku and UNKOKU TŌGAN, Yūshō was one of only a handful of artists who managed to achieve prominence and success in the Momoyama period outside of the dominant Kanō school. The Kaihō school that Yūshō established continued until the end of the Edo period (1600–1868), first under his son Kaihō Yūsetsu (1598–1677). However, it did not retain the prominence it had attained during the lifetime of its founder; from the time of Yūsetsu onwards Kaihō works, of which few survive, closely resemble those of the Kanō school.

BIBLIOGRAPHY

T. Takeda: *Tōhaku, Yūshō*, Suiboku bijutsu taikei [Compendium of the art of ink painting], ix (Tokyo, 1973)

Momoyama: Japanese Art in the Age of Grandeur (exh. cat., ed. J. Meech; New York, Met., 1975)

M. Kawai: *Yūshō/Tōgan*, Nihon bijutsu kaiga zenshū [Complete collection of Japanese painting], xi (Tokyo, 1978)

M. Cunningham: 'A New Discovery: Screens Attributed to Kaihō Yūshō', *Bull. Cleveland Mus. A.*, lxxvi (1989), pp. 88–95

The Triumph of Japanese Style: 16th Century Art in Japan (exh. cat., ed. M. Cunningham; Cleveland, OH, Mus. A., 1991)

JOAN H. O'MARA

Kaii Higashiyama. *See* HIGASHIYAMA, KAII.

Kaikei [An Amida Butsu] (*fl* Nara area, 1183–1223). Japanese sculptor. He is associated with the KEI school of Buddhist sculpture and is thought to have been a disciple of KŌKEI. The first reference to Kaikei occurs in the Lotus Sutra (Jap. *Hokkekyō* or *Myōhō renge kyō*; 1183; Ueno priv. col.), transcribed by UNKEI and others, in which he is recorded receiving a *kechien* (establishing a tie with Buddha, in order to be entitled to his benefits). It is believed that he sculpted the *Miroku* (Skt Maitreya) for the temple of Kōfukuji in Nara (*see* NARA, §III, 7) in 1189 (Boston, MA, Mus. F.A.). In 1192 he made a wooden image of the *Miroku* for Daigoji in Kyoto (*in situ*; *see* KYOTO, §IV, 3(i)). From then on, until he was received into the official priesthood (*sōgō*), he usually went by his artist's name (*gō*), An Amida Butsu.

In 1194 he carved the wooden *Amida* (Skt Amitabha; Buddha of the Western Paradise) for the temple of Kengōin in Kyoto (*in situ*) and began production, together with his Kei-school colleague Jōkaku (*b c.* mid-12th century), on *Niten* ('Two devas'; destr.) for the Chūmon (middle gate) at Tōdaiji in Nara (*see* NARA, §III, 4(i)). The following year he made the wooden *Amida sanzon* (*Amida Triad*) for the Jōdoji in Hyōgo (*in situ*), a temple constructed by the Buddhist monk Chōgen [Shunjōbō Chōgen] (1121–1206). In 1196 he again collaborated with Jōkaku on the *Kannon* (Skt Avalokiteshvara; the *bodhisattva* of mercy; destr.) for the Daibutsuden (Great Buddha Hall) at Tōdaiji, for which he also made one of the four *Shitennō* (Skt Caturmaharajika; Four Guardian Kings; destr.). Other works by Kaikei for Tōdaiji include the *Sōgyō Hachiman* ('Hachiman as a monk'; 1201; *in situ*), a standing wooden statue of *Amida* at the Shunjōdō (1202; *in situ*) and another standing wooden figure of *Miroku* at the Kōkeidō (after 1203). The *Kongō rikishi* or *Niō* (temple gate guardians called 'adamantine strengths') at the Nandaimon (southern main gate; *in situ*) were made by Kaikei, Unkei and others in about two months in 1203; at over 8.3 m high they are among the largest wooden sculptures

in Japan and convey their ferocity through exaggerated naturalism. In 1201 and 1202 respectively, Kaikei produced the *Amida ragyō* ('Nude Amida'; *in situ*) and the *Bosatsumen* (*bodhisattva* masks) for Jōdoji, and the *Amida Triad* (of which only the head of the central figure is extant) at the Shindaibutsuji in Ōyamada, Mie Prefecture (*in situ*). In 1203 he sculpted the wooden *Monju gozon* (*Monju Quintet*; Skt Manjushri; *bodhisattva* of supreme wisdom) for the Monjuin in Nara (*in situ*). Other extant works from this period, all made of wood, include a statue, discovered in the 20th century, of *Dainichi* (Skt Mahavairocana; the Buddha who expounded Esoteric Buddhism) at Ishiyamadera in Shiga; the *Shitennō* at KONGŌBUJI in Wakayama, and images of the *Amida* at the Henshōkōin in Wakayama, the Hachiyōrengeji in Osaka and the Saihōji in Nara (all *in situ*).

In 1203 he received the ecclesiastical rank of *hokkyō* (Bridge of the Law), and between 1208 and 1210 he was further elevated to the rank of *hōgen* (Eye of the Law), in recognition of the restoration work he did on temples in Nara and Kyoto, particularly under the inspiration of Chōgen. Subsequently he made the wooden standing figure of *Amida* for the Tōjuin in Okayama (1211; *in situ*), and he participated in the production (1215) of Buddhist images related to the retired Emperor GoToba (*reg* 1183–98). The *Jizō* (the *bodshisattva* Kshitigarbha), made between 1203 and 1211 for the Kōkeidō at Tōdaiji (*in situ*), was decorated with crystal eyes. Together with his disciples, he created the wooden *Jūdai deshi* ('Ten great disciples') *c.* 1219 at the Daihōonji in Kyoto (*in situ*), and in the same year he took part in the restoration of the standing wooden figures of the *Jūichimen Kannon* (Skt Ekadasamukha Avalokiteshvara; Eleven-headed Kannon; destr.) at the Hasedera in Nara. These were followed by the *Amida Triad* for the Kōdaiin in Wakayama (*c.* 1221; *in situ*) and the standing *Amida* for the Kōrinji in Nara (1221, both in wood; *in situ*). In 1223, with one of Unkei's sons, Tankei (1173–?1256), he produced the statuary for the Enmadō at Daigoji; this is his last known work (destr.). There are several other extant works from his *hōgen* period.

Kaikei's style in the first half of his artistic life was massive and rich in movement, like that of other Nara Buddhist sculptors in the early Kamakura period (1185–1333). However, even in his earlier works, he began to show more naturalism and softness than did others of the Kei school. The *Miroku* of Daigoji displays a gentleness of face and body and symmetrically arranged drapery. For the figures at Jōdoji and the many figures he did during the restoration of Tōdaiji, he worked under the direction of Chōgen and took as models the Buddhist paintings of the Chinese Song period (AD 960–1279), about which Chōgen was knowledgeable. Commissioned to produce Buddhist images for powerful nobility and for contemporary monks such as Myōe (Kōben; 1173–1232), Jōkei (Gedatsubō; 1155–1213) and others, and following his elevation to *hōgen*, he developed an increasingly individualistic style. In the works at Kōdaiin and the *Jizō* statues at the Tōdaiji Kōkeidō, for example, his figures are characterized by a thinning of the torso, a minutely rendered drapery and a painterly attention to surface detail. Kaikei concentrated more than did his contemporary Unkei on popular images that were easy to understand,

such as the three-*shaku* (*c.* 0.9 m) high standing *Amida raigō* ('Amitabha welcoming souls into his Paradise'). This image must have been in great demand, since Kaikei made several. Moreover, his *Amida raigō* inspired many works on the same theme by his followers, such as the wooden example at the Amidaji in Shiga Prefecture made by his disciple, the Buddhist sculptor Gyōkai (*fl* first half of 13th century). His style was called the An' amiyō ('An' ami style'), from his artist's name of An Amida Butsu, which itself reflected his fervent devotion to Amida Buddha. It became a model for Buddhist sculpture in later centuries. Among the elements of technical style was the wide use of *kindei* (gold paint) as a surface finishing technique. Compared to *kinpaku* (gold leaf), gold paint produced a harmonious but matt effect. From Kaikei's time onwards it was very popular. Kaikei seems to have been the first sculptor to use the narrower chisel that was developed in the late 12th century and was well suited to the detailed carving he undertook. Like other Kei-school sculptors, he adorned his images with beautiful and elaborate metal openwork accessories, such as canopies or halos. Nearly all of Kaikei's extant works are signed, and his signature has become an important factor in tracing the development of the artist's style.

For further discussion *see* JAPAN, §V, 3(iv).

BIBLIOGRAPHY
EWA; Kodansha Enc. Japan, 'Buddhist Sculpture', 'Kaikei', 'Kei School'
H. Mōri: *Busshi Kaikei ron* [Essay on the *busshi* Kaikei] (Tokyo, 1961, rev. 1987)
T. Kobayashi: 'Kōshō An Amida Butsu Kaikei' [The skilled An Amida Butsu Kaikei], *Nara Kokuritsu Bunkazai Kenkyūjo Gakuhō*, xii (1962) [whole issue]
K. Mizuno: *Unkei to Kamakura chōkoku* [Unkei and Kamakura sculpture] (Tokyo, 1972)
S. Tanabe, ed.: 'Unkei to Kaikei' [Unkei and Kaikei], *Nihon No Bijutsu*, lxxviii (1972) [whole issue]
HIROMICHI SOEJIMA

Kaioku. *See* NUKINA KAIOKU.

Kairakuen [Jap.: 'garden with a multitude of pleasures']. Japanese garden in the city of Mito, Ibaraki Prefecture. Together with the Kōrakuen in Okayama (*see* OKAYAMA, §2) and the Kenrokuen in Kanazawa (*see* KANAZAWA, §2(ii)), it is considered one of Japan's three notable daimyo gardens. In 1665 Tokugawa Mitsukuni (1628–1700), the second-generation head of the Mito branch of the Tokugawa family, rulers of Japan during the Edo period (1600–1868), created a pond garden on the site, which imitated the famous Western Lake in China. He also constructed the Kōchintei (Pavilion of Deep Contemplation). The present Kairakuen was created as a private garden by Tokugawa Nariaki (1800–60), the ninth-generation Mito head. It was completed in 1842 and named Kairakuen.

The Kairakuen site, originally 33,487 *tsuba* (110,478 sq. m), consists of several low hills and broad valleys densely planted with trees, especially *ume* (Japanese plum). Nariaki reportedly brought 10,000 *ume* from all over Japan, and more than 3000 trees still provide a spectacular display of blossoms. Nariaki constructed several pavilions at Kairakuen for enjoying views of the trees, a lake and nearby mountains. The Kōbuntei (Pavilion for the Love of Literature) was completed in 1842 (rebuilt 1969) as a gathering place for Nariaki and local literati.

The three-storey, wooden-framed building with a roof of cypress-bark shingles (*hiwadabuki*) has rooms for poetry parties and the tea ceremony. The plantings and rockwork around the Kōbuntei were kept deliberately simple to emphasize the natural beauty of the surrounding mountains. Paths for strolling once led to the lake created by Mitsukuni, but unfortunately a road and railway lines now separate Kairakuen from the lake area.

BIBLIOGRAPHY
T. Soga, ed.: *Kantō, Tōhoku* (1979), x of *Tanbō Nihon no niwa* [Investigation of Japanese gardens] (Tokyo, 1978–9), pp. 73–91
BRUCE A. COATS

Kairouan [al-Qayrawān; Qairouan]. City in Tunisia. It was founded in AD 670 by 'Uqba ibn Nafi', the Arab conqueror of North Africa, on the site of a ruined Roman or Byzantine town; the site, slightly elevated above the great interior plain, afforded protection from surprise attacks and floods. In the 9th century Kairouan was the capital of the semi-independent Aghlabid dynasty (*reg* 800–909) and the most important city between the Nile and the Atlantic.

In 1054–5 the city was sacked by the Hilali tribe of bedouin and the town reduced to ruins. Its decline was further exacerbated by the growing importance of Tunis in Mediterranean maritime trade. Under the relative peace established by the Hafsids, the city recovered somewhat, and many hospices (Arab. *zāwiya*) were built to accommodate the growing number of local Sufi saints (marabouts). The *zāwiya* of Sidi Sahib, for example, was constructed in the 14th century over the tomb of Abu Zama'a al-Balawi, a companion of the Prophet Muhammad. The present buildings were reconstructed by Hammuda Pasha in the 17th century and were restored in the 19th. The arcaded portico adorned with glazed tiles and carved stucco is particularly fine. The *zāwiya* of Sidi 'Amur 'Abbada, known as the mosque of the Sabres because of the weapons stored within, was erected *c.* 1860. Its five cupolas show the continuation of local forms. The building houses the Museum of Popular Arts and Traditions.

The most important building in Kairouan is the Great Mosque, known also as the mosque of Sidi 'Uqba after its founder (for illustration *see* MAGSURA). The original mosque, a simple building of sun-dried brick, was rebuilt several times. In AD 836 it was demolished and rebuilt in its present form by the Aghlabid ruler Ziyadat Allah (*see* ISLAMIC ART, fig. 25). Additional work was completed in AD 862 in the reign of Abu Ibrahim Ahmad. The mosque is a roughly rectangular structure with maximum interior dimensions of 122×70 m; it has a court surrounded by arcades and a hypostyle prayer-hall occupying about one-third of the surface area. The prayer-hall, which has 17 aisles perpendicular to the qibla wall, has domes at either end of the wider central aisle. One stands over the bay in front of the mihrab, and the other abuts the courtyard. The colonnades of the central aisle were doubled in the later 9th century to strengthen the building. The mihrab itself is decorated with carved marble panels and surrounded by lustre tiles, and the carved wooden minbar is the oldest such pulpit preserved in Islam. To the right of the minbar the magnificent wooden *Maqsūra*, or enclosure for the sovereign, was added by the Zirid ruler al-Mu'izz

ibn Badis (*reg* 1016–62). The three-storey minaret opposite the prayer-hall was modelled on the lighthouse at Salakta (anc. Sullecthum) near by. The mosque was restored by the Hafsids (*reg* 1228–1534), who rebuilt the court arcades and added the eastern entrance known as the Bab Lalla Rihana (1294; *see* ISLAMIC ART, fig. 62), and again in the 17th and 18th centuries by the beys of Tunis, who remodelled the ceilings. The mosque was a centre of orthodoxy in western Islamic lands, and the city seems to have been important for the production of Koran manuscripts. The prestige of the mosque made it a model for others at Tunis and Mahdia, for example.

Another Aghlabid building is the mosque of the Three Doors (Tleta Biban; AD 866), a small structure (9.05×8.60 m) of nine domes arranged in a square with no courtyard. The finely carved stone façade is decorated with floral and geometric motifs and an elegant kufic inscription stating that it was ordered by Muhammad ibn Khayrun al-Ma'afari, the Andalusian. In 1440–41 a small minaret was added to the left side of the façade. The interior has been entirely rebuilt.

Several satellite towns were built around Kairouan under the Aghlabids. Ibrahim ibn al-Aghlab (*reg* 800–12) founded a new residential quarter, al-'Abbasiyya, which he modelled on Baghdad, but little remains of the site. Ibrahim II (*reg* 875–902) built another royal suburb at Raqqada to the south of Kairouan, where there are remains of a large brick palace, cisterns and a trapezoidal lake (182×171 m) used for water-tournaments. To the north of the city two other cisterns, fed by an extensive system of aqueducts, were built by Abu Ibrahim Ahmad (*reg* 856–63). The larger is a 48-sided polygon (diam. 128 m) that originally had a pavilion in the centre; the smaller (diam. 37.4 m), 17-sided settling tank lies to one side. A third satellite city, known as Sabra/al-Mansuriyya, was built in 947–8 by the Fatimid caliph al-Mansur. It too had palaces, gardens and extensive waterworks. A palace at Raqqada, constructed for President Habib Bourguiba in 1970, has been converted into the National Museum of Islamic Art.

Kairouan is an important centre of carpet manufacture, and Kairouan carpets have been imitated throughout Tunisia. Although Tunisia has long been known for the production of fine woollens, the industry was probably inspired by carpets imported from Anatolia in the 18th century. Their designs usually consist of an elongated hexagonal medallion within a central field surrounded by borders. In the early 20th century the traditional palette, characterized by a striking red, began to be replaced with shades of undyed wool.

BIBLIOGRAPHY

Enc. Islam/2: 'Ḳayrawān'

G. Marçais: *Coupole et plafonds de la Grande Mosquée de Kairouan* (Paris, 1925)

——: *Les Faïences à reflets métalliques de la Grande Mosquée de Kairouan* (Paris, 1928)

K. A. C. Creswell: *Early Muslim Architecture*, 2 vols (Oxford, 1932–40/vol. i *R* and enlarged 1969)

G. Marçais and L. Poinssot: *Objets kairouanais: IXe au XIIIe siècle: Reliures, verreries, cuivres et bronzes, bijoux*, 2 vols (Tunis, 1948–52)

B. Roy and L. Poinssot: *Inscriptions arabes de Kairouan*, 2 vols (Paris, 1950–58)

M. Solignac: 'Recherches sur les installations hydrauliques de Kairouan et des steppes tunisiennes du VIIe au XIe siècle (J.C.)', *An. Inst. Etud. Orient. U. Alger*, x (1952), pp. 5–273; xi (1953), pp. 60–170

G. Marçais: *L'Architecture musulmane d'occident* (Paris, 1954)

P. Sebag: *La Grande Mosquée de Kairouan* (Zurich, 1963; Eng. trans. by R. Howard, New York, 1965)

A. Lézine: *Architecture de l'Ifriqiya: Recherches sur les monuments aghlabides* (Paris, 1966)

L. Golvin: 'Le Mihrab de Kairouan', *Kst Orients*, v (1968), pp. 1–38

G. Kircher: 'Die Moschee des Muhammad ibn Hairun in Qairawan', *Mitt. Dt. Archäol. Inst.: Abt. Kairo*, xxvi (1970), pp. 141–68

I. Reswick: *Traditional Textiles of Tunisia and Related North African Weavings* (Los Angeles, 1985)

□

Kaiser, Eduard (*b* Graz, 22 Feb 1820; *d* Vienna, 30 Aug 1895). Austrian lithographer and painter. He trained at the Akademie der Bildenden Künste in Vienna under Josef Danhauser and swiftly established a reputation as a portrait lithographer, his principal rival being Josef Kriehuber (1800–76), the leading Viennese exponent of the genre. Kaiser took a leading role in the 1848 Revolution and recorded the portraits of many of his fellow insurgents. In 1849, following the accession of Emperor Francis Joseph I, he was commissioned to produce the first of a series of portrait lithographs of the Emperor and his wife, the Empress Elisabeth. Kaiser's other sitters included Clara and Robert Schumann, the poet Friedrich Hebbel, and the singer Adelaide Ristori.

From 1852 until 1853 Kaiser was in Rome. On his return to Vienna he continued his career as a portrait lithographer, but from 1860 onwards he turned increasingly to watercolour painting. He made watercolour copies of the paintings in the Belvedere in Vienna. In 1867 he travelled again to Italy, where he remained for the next 20 years, and he was twice elected a member of the Deutscher Künstlerverbund in Rome. He embarked on a long series of watercolour studies to record the remains of Classical art in Italy. This ambition was furthered (and the scope of his endeavours enlarged) as the result of an exhibition of his watercolours in Florence, at which he attracted the notice of the English Arundel Society. Over the next two decades the Society commissioned from him over 150 watercolour copies of Italian works of art, including the frescoes in the Lower Church of S Francesco at Assisi and Raphael's frescoes in the Vatican Loggie. These watercolours were subsequently published as chromolithographs. In the course of his dealings with the Society, Kaiser made several visits to England. In 1886 he finally returned to Austria, where he resumed his career as a portrait painter. In 1892 his work was accorded a large retrospective exhibition in Vienna.

BIBLIOGRAPHY

Bénézit; Thieme–Becker

COLIN J. BAILEY

Kaiser, Victor. *See* KAYSER, VICTOR.

Kaiseraugst. *See under* AUGST.

Kaisermann, Franz (*b* Yverdon, Vaud, 13 March 1765; *d* Rome, 4 Jan 1833). Swiss painter. He began sketching at an early age and as a youth studied in Lausanne. In 1789 he went to Rome to be an assistant in the workshop of Louis Ducros. Tensions developed between them, however, and Kaisermann found himself destitute and without patronage. Princess Borghese (née Pauline Bonaparte) and her husband Camillo Borghese (1775–1832) became his

patrons and commissioned from him large, accurately drawn watercolours of well-known Roman sites (e.g. *Pyramid of Cestius, c.* 1792; Lausanne, Pal. Rumine). These topographical *vedute* (*see* VEDUTA) were very much in favour at the time, and by 1800 his reputation was firmly established, his works selling regularly to wealthy Roman clients and tourists. He rarely varied from his preferred formula, although various figure studies (e.g. *Italian Peasants*; La Sarraz, Château) reveal his facility in rendering the human form. Like Ducros, whose influence he absorbed, his style was replete with minutiae and finely coloured details that especially appealed to British and German tourists, as seen in *View of Paestum* (*c.* 1820; Lausanne, Pal. Rumine). The staffage in his paintings was often done by Bartolomeo Pinelli. A large watercolour, *View of Athens* (*c.* 1819; La Sarraz, Château), suggests that he also travelled outside Italy. In his last years he had achieved considerable fame and wealth, and his paintings were greatly sought after by Roman collectors. In Switzerland, however, he enjoyed only a minor reputation, and his works were rarely collected outside Lausanne and La Sarraz.

BIBLIOGRAPHY
D. Agassiz: 'François Kaisermann: Un Paysagiste suisse à Rome, 1765–1833: Notice biographique', *Rev. Hist. Vaudoise*, xxxviii (1930), pp. 65–81
H. Perrochon: *Artistes vaudois à Rome* (Lausanne, 1962)

WILLIAM HAUPTMAN

Ka'it Bay. *See* MAMLUK, §II, 2(10).

Kaji (*fl* early 18th century). Japanese poet and calligrapher. Along with her adopted daughter YURI, also a poet and calligrapher, she ran the Matsuya tea house in Kyoto, where intellectuals and literary figures gathered to hear her recite poetry. Her *waka* (31-syllable classical verse) poems were written casually and for the moment; hence few examples are extant. The calligraphy in these, however, is remarkable for its boldness, energy and flair, effects created by dramatic variations in the thickness of the lines. In 1707, 120 of Kaji's *waka* were collated by the Edo-period (1600–1868) poet Ameishi in the three-volume *Kaji no ha*, illustrated by Miyazaki Yūzen. Kaji was one of the most widely recognized Japanese poets of the 18th century and continues to be celebrated, along with other famous people of various eras, in the Jidai Matsuri (Festival of the Ages), held each October at the Heian Shrine in Kyoto.

For general discussion of Japanese calligraphy *see* JAPAN, §VII, 1(iii).

BIBLIOGRAPHY
Japanese Women Artists, 1600–1900 (exh. cat. by P. Fister, Lawrence, U. KS, Spencer Mus. A., 1988), pp. 69, 72–3

Kakabadze, David (Nestorovich) (*b* Kukhi, nr Kutaisi, 20 Aug 1889; *d* Tbilisi, 10 May 1952). Georgian painter, collagist, stage designer and film maker. He was born into a peasant family and studied from 1909 to 1916 in the Faculty of Physics and Mathematics at the University of St Petersburg. From 1910 to 1915 he also studied painting and drawing in the studio of L. Ye. Dmitriyev-Kavakazsky (1849–1916). With PAVEL FILONOV he became a member of the St Petersburg artistic group Intimnaya Masterskaya (The Intimate Studio). The group's manifesto (1914) proclaimed the beginning of a new era in art, awarded a central importance to Filonov's principle of *sdelannost'* ('madeness') and drew attention to the fundamental structural principles of artistic language. The manifesto was one of the most original developments of the pre-revolutionary avant-garde in Russia.

Kakabadze was an outstanding representative of the artistic avant-garde in Georgia. In his work innovation was always combined with a deep interest in Georgian national traditions, on which he was an expert. He studied medieval Georgian ornament while still a student, and in 1914 he wrote an essay on the art of Beka Opizari, an outstanding figure in 12th-century Georgian metalwork. Subjects from nature (e.g. *Imereti Landscape with a Tower*, 1919; Tbilisi, Georg. Pict. Gal.; *see* GEORGIA, fig. 10) and daily life in the Caucasus in the pictures of his Imeretiya (an old name for the region) period (1911–19) are marked by Art Nouveau features and are full of monumental grandeur (e.g. *Imeretiya—My Mother*, 1918; Tbilisi, Mus. A. Georgia).

From 1920 to 1927 Kakabadze lived and worked in Paris. He pursued Byzantine studies under the direction of Gabriel Millet and produced views of Paris in black chalk and oil and of Brittany in watercolour, achieving the greatest rhythmic precision with each brushstroke and each patch of colour. In the work of his Parisian period a special place is occupied by numerous compositions intended to express the dynamic experience of space, one of the manifestations of the post-Futurist transition to abstract art. In conflict with the Cubists, Kakabadze considered that the right angle was not able to express the contemporary 'machine spirit', and he preferred curved lines, usually tending towards oval or spiral forms. Dissatisfied with the static quality of the traditional representation of space, from 1924 Kakabadze introduced mirrors, lenses and shining metal surfaces into his collages (e.g. Tbilisi, Mus. A. Georgia). Developing his interest in kinetic form, in 1923 he constructed a film camera that produced the illusion of relief and thus became one of the pioneers of three-dimensional cinema.

Having returned to Georgia in 1927, Kakabadze continued the national and romantic themes of his Imeretiya period in new monumental decorative landscapes, including industrial landscapes (e.g. *Rion Hydro-electric Power Station*, 1934; Tbilisi, Mus. A. Georgia). From 1928 he was also active in the theatre, producing, for example, designs for Ernst Toller's play *Gop-lya—my zhivyom* (*Hoppla—wir leben*) at the theatre in Kutaisi, and in the cinema, with designs for the film *Poyezd* ('The train'), directed by Mikhail Chiaureli, employing the same artistic principles. In 1934 he directed the film *Drevniye pamyatniki Gruzii* ('Ancient monuments of Georgia').

WRITINGS
Du tableau constructif (Paris, 1921)
Paris, 1920–23 (Paris, 1924)
Iskusstvo i prostranstvo [Art and space] (Paris, 1925)

BIBLIOGRAPHY
G. Alibegashvili: *David Kakabadze* (Tbilisi, 1958)
L. Rcheushvili: *David Kakabadze* (Tbilisi, 1977)

M. N. SOKOLOV

Kakatiya [Kākatīya]. Dynasty that ruled portions of the eastern Deccan, India, from the 11th century to the 14th. Originally feudatories of the Chalukyas of Kalyana (*see* CHALUKYA, §2), the Kakatiyas emerged as a power of note under Parola I, a tributary of Someshvara I (*reg c.* 1043–68). Parola II (*reg c.* 1115–58) asserted independence after the death of Vikramaditya VI (*reg c.* 1076–1126) and ruled the territories between the Godavari River and the Krishna River, with capitals at HANAMKONDA AND WARANGAL. Unusually for India, the capital at Warangal had circular ramparts and four roads converging at a temple of Shiva in the centre of the city. The extant monumental gates of the ruined temple are reminiscent of those at Sanchi. The Kakatiya king Prataparudra (*reg c.* 1290–1326) faced an attack on Warangal by armies of the Khalji sultanate of Delhi led by Malik Kafur in 1309–10. Prataparudra preserved his position through tribute and began an aggressive campaign of expansion that was ended by a Tughluq invasion and his capture in 1322.

BIBLIOGRAPHY
R. C. Majumdar, ed.: *The Struggle for Empire*, v of *The History and Culture of the Indian People* (Bombay, 1957, 2/1966), pp. 198–203
P. V. Parabrahma Sastry: *Kakatiya caritra* [Kakatiya deeds] (Hyderabad, 1977) [with Eng. preface]

J. MARR

Kakei. *See* MATSUMURA KEIBUN.

Kakiemon ware [*kakiemonde*: 'Kakiemon style']. Japanese porcelain made in the ARITA district of Hizen Province (now Saga Prefect.). Sakaida Kinzaemon (later Kakiemon; 1596–1666) is traditionally credited with making the first porcelain in Japan in 1643 at the family kiln in Nangawara, but recent archaeological excavations have shown that 'Kakiemon' wares were widely produced in the region during the early Edo period (1600–1868). Kakiemon ware is chiefly represented by polychrome overglaze enamels (*iroe*), but it also includes underglaze blue-and-white porcelain (*sometsuke*) and white porcelain (*hakuji*; *see* JAPAN, §VIII, 3(iii)). Polychrome pieces show the harmonious combination of gold with soft reds, blues, yellows, violets and greens over a translucent milky-white body (*negoshide*). Typical forms include plates, bowls, jars, water pitchers, teapots and animal and human figurines. The ware was widely exported, and popular designs, such as quail and millet, tiger and bamboo, deer and maple and bird-and-flower motifs, were imitated by several European manufacturers, most notably by the Meissen potteries during the 18th century (*see* MEISSEN, §3(i)). In the 1990s the head of the school was Sakaida Kakiemon XIV (*b* 1934).

BIBLIOGRAPHY
R. Cleveland: *Two Hundred Years of Japanese Porcelain* (Cleveland, OH, 1970)

HIROKO NISHIDA

Kakō. *See* KATSUSHIKA HOKUSAI.

Kakovatos [Nestora]. Site in Triphylia, south-western Greece, which flourished in Late Helladic (LH) I and II (*c.* 1600–*c.* 1390 BC). Excavated by Wilhelm Dörpfeld in 1906, it is chiefly significant for the discovery there of pottery, and ornaments made from exotic materials, related

to Minoan works of the same period. These objects are now in the Museum of Pylos and the National Archaeological Museum at Athens. On a small acropolis Dörpfeld uncovered stretches of a possible circuit wall built of large stones, and the remains of a building complex containing storage rooms and a courtyard, which he identified as a small palace. A considerable 'lower town' of the same period was also found in 1961, extending down the slopes. On a nearby ridge are three plundered tholos tombs, from which Dörpfeld salvaged fragmentary weapons, ornaments of bone, ivory and gold, and jewellery of Baltic amber, gold, glass and iron. A series of locally made jars of the 'Palatial' class, finely decorated with floral and marine subjects of Minoan derivation (*see* HELLADIC, §III, 4), dates the burials to the 15th century BC. Following Strabo (*Geography* VIII.iii.17), Dörpfeld equated Kakovatos with Homeric Pylos, an identification that prevailed until the discovery in 1939 of the Palace of Nestor in Messenia.

BIBLIOGRAPHY
W. Dörpfeld: 'Tiryns, Olympia, Pylos', *Athen. Mitt.*, xxxii (1907), pp. vi–xvi
——: 'Alt-Pylos', *Athen. Mitt.*, xxxiii (1908), pp. 295–317
K. Müller: 'Alt-Pylos', *Athen. Mitt.*, xxxiv (1909), pp. 269–328
R. Hope Simpson: *Mycenaean Greece* (Park Ridge, 1981), p. 96

S. L. PETRAKIS

Kalaat Seman. *See* QAL'AT SIM'AN.

Kalachuris of Chedi. *See* HAIHAYA.

Kalachuris of Maharashtra [Kalacuris of Kalyāṇa]. Dynasty that ruled in Maharashtra, India, in the 12th century. The Kalachuris were an offshoot of the HAIHAYA or Chedi family that ruled at Tripuri (mod. Tewar) near Jabalpur, Madya Pradesh, and was also related by marriage to the Chalukyas of Kalyana (*see* CHALUKYA, §2) and the RASHTRAKUTA royal house. Dates for the earliest Kalachuri rulers are not known. The first prince of this family was Krishna, who is spoken of as Vishnu. The sequence of father-to-son successions was Krishna, Jogama, Paramardin and Vijjana (or Bijjala, *reg* 1156–68). Vijjana was a feudatory of the Chalukya king Tailapa III (*reg* 1150–65), who repulsed the attacks of the Chalukya Kumarapala of Gujarat (*reg c.* 1145–72) and the Chola king Kulottunga II (*reg c.* 1133–50) but was taken prisoner when he marched against the Kakatiya ruler Parola II (*reg c.* 1115–58). Subsequent to this event, Vijjana practically had sovereignty over the Deccan though acknowledged the nominal sway of the Chalukya house until the death of Tailapa III. Vijjana humbled all his enemies and also subdued a religious revolution led by his minister Basava. He abdicated in 1168 in favour of his son Someshvara, who with his three younger brothers, Sankama, Ahavamalla and Singhana, reigned in succession until 1184, when Singhana surrendered to the Chalukya king Someshvara IV (*reg c.* 1181–9), acknowledging his sovereignty. After this date there is no trace of this branch of the Kalachuri house.

BIBLIOGRAPHY
R. G. Bhandarkar: *Early History of the Deccan* (Bombay, 1895, rev. Calcutta, 3/1928)
R. C. Majumdar, ed.: *The Struggle for Empire*, v of *The History and Culture of the Indian People* (Bombay, 1957, 2/1966)

H. V. TRIVEDI

Kalacuris of Tripuri. *See* HAIHAYA.

Kalaibaland. *See under* URA TYUBE.

Kala-i Kafirnigan [Tokkuz-tepa]. Site in Tajikistan, 80 km south-west of Dushanbe, at Esambai on the Kafirnigan River. The site (3.5 ha; 275×*c.* 100–150 m) was excavated in 1974–80 by an expedition under B. A. Litvinsky. The Uzbek name Tokkuz-tepa means 'Nine Hills'. The pentagonal citadel with defensive walls and projecting towers of rammed earth and mud-brick, surrounded by a moat, occupies the south-east part of the site. Remains dating from the 2nd or 3rd century AD have been found, and there may be still earlier strata, but it is mainly the upper cultural layers of the settlement, dating from the second half of the 7th century AD to the 8th, that have been excavated.

A quadrangular hall in one of the buildings was surrounded by corridors and had a two-tiered ledge along the walls with a raised part of it opposite the entrance. The wooden ceiling, with carved beams decorated predominantly with vine motifs, rested on four carved columns, and wooden reliefs on the walls included a 2-m panel of confronted peacocks. A stone sacrificial altar stood on a pisé platform in the centre of the room. A small Buddhist temple in the northern half of a nearby building originated as a single room (4.69×4.95 m) with four entrances similar in plan to a Zoroastrian fire temple. Later a new domed cella, a portico supported by four wooden columns on stone bases and a courtyard were added, while two of the entrances were bricked up and became niches. In the sanctuary surrounded by a corridor running along three sides were a large base with projections for standing statues in the centre and four small ones in the corners. As at Adzhina Tepe the clay sculpture was made using a series of standard moulds; the heads were covered with a fine plaster wash and then painted. A wall niche contained a seated image of the Buddha. The surrounding corridor also had a niche containing a large statue of the Buddha seated on a pedestal. Fragments included a Buddha head, part of a statue representing a Lokapala (guardian of the regions), the body of a kneeling male relief figure and the torso of another.

Paintings covered the corridor walls and vaults. A large well-preserved wall painting (78.5×102.0 m), in two tiers divided by an ornamental pearl band, depicts local Tokharistan nobles participating in the ceremony of *pranidha*, a ritual offering of flowers to the Buddha (see fig.). In the upper tier are two standing figures and the Buddha in yellow robes seated in *padmāsana* (the lotus position) on

Kala-i Kafirnigan, wall painting depicting donors at the ceremony of *pranidha* (detail), 78.5×102.0 m, second half of the 7th century AD to the 8th

a cushioned throne decorated with entwined stems and leaves. The lower tier illustrates a procession of two female donors carrying a candle, vessel and flowers, and two male figures, one with a large lotus flower, the other (less well preserved) in yellow robes. In the background are three smaller male donor figures. Finds are in the Donish Institute of History, Archaeology and Ethnography, Dushanbe.

BIBLIOGRAPHY
B. A. Litvinsky: 'Buddiyskiy khram Kala-i Kafirnigan (yuzhnyy Tadzhikistan) i problemy istorii kul'tury Tsentral'noy Azii' [The Buddhist Temple at Kala-i Kafirnigan (south Tajikistan) and questions of the history of Central Asian culture], *Istoriya i kul'tura Tsentral'noy Azii* [The history and culture of Central Asia] (Moscow, 1983), pp. 283–305
Drevnosti Tadzhikistana [Antiquities of Tajikistan] (exh. cat., ed. Ye. V. Zeymal'; Leningrad, Hermitage, 1985), pp. 160–61, 171, 187–88
T. I. ZEYMAL'

Kala-i Kakhkakh. *See under* BUNDZHIKAT.

Kala-i Mug. Site in Tajikistan, 70 km east of Pendzhikent, where the Kum River falls into the Zarafshan. After a chance find on a high cliff (Mt Mug) of a basket containing fragments of manuscripts written in an unknown language, excavations were begun in November 1933 by the USSR Academy of Sciences and by the Tajik section. The remains of a castle (19.5×18.5 m; 7th century–early 8th) were uncovered, with a corridor on the north side providing access to five narrow (2 m) vaulted rooms used to store provisions. An upper residential storey was destroyed. The microclimate of the high location helped to preserve organic materials that would have had no chance of preservation under normal conditions. Some 500 objects were retrieved, the majority of which are in the Oriental Department of the Hermitage, St Petersburg. The 150 fragments of cotton, silk (local and Chinese), linen and woollen textiles included a few entire items (children's stockings, socks, swaddling cloths and a purse for an amulet) and three patterned hairnets. Everyday wooden utensils included footed dishes, a ladle, cups, a large trowel, a two-sided comb, a box, willow baskets and boxes, loom fittings and brightly painted arrowshafts. A leather-covered and painted wooden shield had a mounted Sogdian warrior wearing a coat of mail and carrying a mace depicted on the outer side; the inner side was painted to resemble leopard skin (*see* CENTRAL ASIA, §I, 4(iv)(a)).

A manuscript archive (St Petersburg, Acad. Sci., Inst. Orient. Stud.) contained 76 texts in Sogdian, Arabic and Chinese on leather, paper and wood. The archive contained Sogdian diplomatic correspondence, a marriage contract, a contract for the lease of a windmill and various household notes and lists (*see* CENTRAL ASIA, fig. 5). Interpreted together with historical sources, these documents suggest that the castle, known as Abargar, belonged to Devastich, lord of the town of Panch (*see* PENDZHIKENT) in eastern Sogdiana. In AD 722–3 Devastich and his family, together with a hundred families from Pendzhikent, set out for this remote mountain area in order to escape Arab invaders, but he was surrounded and crucified. The importance of the finds from Kala-i Mug lies not only in the amount and quality of the material but also in their precise date.

BIBLIOGRAPHY
Sogdiyskiy sbornik: Sbornik statey o pamyatnikakh sogdiyskogo yazyka i kul'tury, naydyonnykh na gore Mug v Tadzhikskoy SSR [Sogdian anthology: a collection of articles on monuments of the Sogdian language and culture found on Mount Mug in the Tajik SSR] (Leningrad, 1934)
V. P. Vinokurova: 'Tkani iz zamka na gore Mug' [Fabrics from the castle on Mount Mug], *Izvestiya Otdeleniya Obshchestvennykh Nauk*, xiv (1957), pp. 17–32
I. B. Bentovich: 'Nakhodki na gore Mug (sobraniye Gosudarstvennogo Ermitazha)' [Finds on Mount Mug (collection of the State Hermitage)], *Mat. & Issledovaniya Arkheol. SSSR*, lxvi (1958), pp. 358–83
Sogdiyskiy dokumenty s gory Mug [Sogdian documents from Mount Mug], i–iii (Moscow, 1962–3)
Yu. Yakubov: *Pargar v VII–VIII vekakh nashey ery* [Pargar in the 7th–8th century AD] (Dushanbe, 1979)
T. I. ZEYMAL'

Kalamis (*fl c.* 470–*c.* 440 BC). Greek sculptor. Active in the Early Classical period, he worked primarily in bronze, although marble and chryselephantine statues are also recorded. He is frequently referred to as a Boiotian, but the evidence that he came from Athens is stronger. His most securely dated work is the group of two racehorses and riders that flanked Onatas' chariot in the dedication of Hieron at Olympia; the group was set up after Hieron's death in 467/466 BC. A group of praying boys attributed by Pausanias to Kalamis (*Guide to Greece* V.xxv.5) was also dedicated at Olympia, possibly in 450 BC. A base with his signature from the Athenian Agora dates to the 440s BC, and he was said to have made a *Zeus Ammon* for Pindar, who died in 438 BC. Pausanias' comment (I.iii.4) that Kalamis' *Apollo* in Athens received the epithet 'Alexikakos' after the plague of 429 BC need not be an indication of its date, while the Kalamis whose pupil Praxias died soon after beginning work on the pedimental statues for the Temple of Apollo at Delphi (Pausanias: X.xix.4) may have been a later sculptor.

Cicero (*Brutus* xviii.70) placed Kalamis after Kanachos and before Myron with respect to the degree of naturalism achieved by the artists. Likewise Quintilian (*Practice of Rhetoric* XII.x.7) put him between Kallon and Hegias on the one hand, and Myron on the other. Fronto (*Letters* p. 113.7) implied that works by Kalamis lacked subtlety, but Dionysios of Halikarnassos (*Isokrates* iii.6) praised his style for its delicacy and elegance. Kalamis was most famous for his representations of horses (Propertius: *Elegies* III.ix.10; and Ovid: *Letters from Pontus* IV.i.33), although Pliny (*Natural History* XXXIV.xix.71) gave him equal praise for his human subjects, citing as an example his *Alkmene*. Lucian of Samosata (*Dialogues of the Courtesans* iii.2) based his portrait of Panthea on the sculptor's *Sosandra*. Kalamis also created a colossal bronze *Apollo* for Apollonia del Ponto (Strabo: *Geography* VII.vi.1), which was taken to Rome by L. Licinius Lucullus in 72 BC. He seems to have been a versatile artist, working on different scales and with a range of subjects, which may have contributed to the apparent contradictions in the literary sources about his style. Unlike some of his contemporaries, however, he does not seem to have depicted athletes.

Late Hellenistic coins from Apollonia represent the *Apollo* there with a bow in his left hand and a laurel tree in his right. A similar Apollo depicted on Athenian coins is probably the *Apollo Alexikakos*. The latter is sometimes associated with the so-called Omphalos *Apollo* (Roman

copy in Athens, N. Archaeol. Mus.), but the Apollo on the Athenian coins closely resembles the Kassel *Apollo* (Roman copy in Kassel, Schloss Wilhelmshöhe). The *Sosandra* on the Acropolis was probably identical to the *Aphrodite* dedicated by Kallias and seen by Pausanias (I.xxiii.2), and is perhaps reproduced by the Kore Albani (Roman copy in Rome, Villa Albani), certainly not by the *Aspasia* (Roman copy in Berlin, Pergamonmus.), as once believed. Other statue types associated with Kalamis include the seated *Olympias* (Roman copy in Rome, Mus. Torlonia) and the Barberini *Suppliant* (Roman copy in Paris, Louvre). He may well have been active in Athens at the beginning of the Periclean building programme and perhaps worked on the metopes of the Parthenon with their figures of centaurs, given his skill at rendering horses.

BIBLIOGRAPHY

Enc. A. Ant.; Pauly–Wissowa

F. Studniczka: *Kalamis: Ein Beitrag zur griechischen Kunstgeschichte* (Leipzig, 1907)

J. Dörig: 'Kalamis-Studien', *Jb. Dt. Archäol. Inst.*, lxxx (1965), pp. 138–265

W. M. Calder III: 'Kalamis Atheniensis?', *Gr., Roman & Byz. Stud.*, xv (1974), pp. 271–7

CHARLES M. EDWARDS

Kalandario, Filippo. *See* CALENDARIO, FILIPPO.

Kal'at Bani Hammad. *See* QAL'AT BANI HAMMAD.

Kalavasos. Village near the south coast of Cyprus, halfway between Limassol and Larnaca, with important Aceramic Neolithic and Late Bronze Age settlements near by. Evidence for initial occupation of the region comes from the Aceramic Neolithic site of Kalavasos–Tenta (*c.* 6000 BC), where a village of curvilinear mud-brick and stone dwellings was surrounded by a wall and ditch. Pottery was unknown, but finely made stone vessels (Larnaca, Archaeol. Mus.) were in frequent use. A wall painting, probably depicting two human figures with upraised arms, was found on the central pier of an otherwise undistinguished building (Nicosia, Cyprus Mus.). Occupation of the region continued, perhaps after a long break, in the Late Neolithic, Chalcolithic and Bronze Ages. By the later part of the Late Bronze Age (13th century BC) a major population centre had grown up at Kalavasos–Ayios Dhimitrios. The town was well planned, with at least one long straight street; a large public building (Building X; *c.* 1300–*c.* 1200 BC), incorporating much finely cut ashlar masonry, lay on the north-east side of the town, while structures of a more domestic character occurred elsewhere. No evidence was found for a defensive wall around the settlement. The location of the town astride important routes and close to the Kalavasos copper mines suggests that the copper trade was significant in the local economy. Evidence for metallurgy (including slag, crucible and ingot fragments) has been found, together with pottery of local and foreign types (Larnaca, Archaeol. Mus.). An undisturbed rock-cut chamber tomb (*c.* 1375 BC) adjacent to Building X contained quantities of gold jewellery and other ceramic, ivory, stone and glass artefacts (Nicosia, Cyprus Mus.), many imported: the wealth of the Kalavasos area in the Late Bronze Age clearly rivalled that of the eastern Cypriot towns such as Enkomi and Kition.

BIBLIOGRAPHY

I. A. Todd: *Vasilikos Valley Project 6: Excavation at Kalavasos-Tenta*, i (Göteborg, 1987)

A. K. South, P. J. Russell and P. S. Keswani: *Ceramics, Objects, Tombs, Specialist Studies* (1989), ii of *Vasilikos Valley Project 3: Kalavasos-Ayios Dhimitrios* (Göteborg, 1989–)

A. K. South: 'Kalavasos-Ayios Dhimitrios 1991', *Rep. Dept Ant., Cyprus* (1992), pp. 133–46

IAN A. TODD

Kalawan. *See* MAMLUK, §II, 2(2).

Kalckreuth, Leopold (Karl Walter), Graf von (*b* Düsseldorf, 15 May 1855; *d* Eddelsen, nr Hannover, 1 Dec 1928). German painter and etcher. The son of the late Romantic landscape painter Eduard Stanislaus, Graf von Kalckreuth (1820–94), he studied from 1875 to 1878 under Ferdinand Schauss (1832–1916), Willem Linnig (1819–85) and Alexander Struys (1852–1941) at the Kunstschule in Weimar founded by his father. In 1879, after military service, he enrolled at the Akademie in Munich, where he attended Gyula Benczúr's drawing classes and continued his study of painting under Karl Theodor von Piloty and Wilhelm von Diez (1839–1907). In 1883 he travelled to the Netherlands and then to Italy and France. In 1885 he accepted a teaching appointment at the Kunstschule in Weimar, but in 1890 he resigned and returned to Munich. During the next five years he worked at Höckricht in Silesia (now Jędrzychowice, Poland), perfecting his oil technique. In 1892 he was a founder-member of the Munich Secession. Kalckreuth's work from this period reflects the influence of several contemporaries; the portrait of the *Artist's Wife* of 1888 (Leipzig, Mus. Gesch.) recalls the portraits of Franz von Lenbach and Max Liebermann, while the visionary element brought to the genre scene *Rainbow* (1894–6; Munich, Neue Pin.) is close to the work of Fritz von Uhde.

From 1895 to 1899 Kalckreuth taught at the Akademie in Karlsruhe. In 1895 he started making prints, often treating themes similar to those in his paintings and initially with a similar approach (e.g. the etching of the *Artist's Wife by Lamplight*, 1895), but soon a marked degree of stylization appeared. In his painting, meanwhile, a traditional approach, as in the portrait of *Justus Brinckmann* (1901), coexists with a heightened lyricism in his treatment of the theme of man and nature, as in the scene *Harvest (The Hayrick)* (1900; both Hamburg, Ksthalle). In 1900 he visited Paris, and from 1900 to 1905 he was director of the Akademie in Stuttgart; in 1903 he became the first president of the Deutscher Künstlerbund in Weimar. From 1907 until his death he lived with his family at Eddelsen.

BIBLIOGRAPHY

F. Beck: 'Der Maler Leopold Graf von Kalckreuth', *Städel-Jb.*, ii (1948), pp. 131–44

J. Kalckreuth: *Wesen und Werk meines Vaters: Lebensbild des Malers Graf Leopold von Kalckreuth*, ed. H. Mollier (Hamburg, 1967)

COLIN J. BAILEY

Kalf [Kalff], Willem (*b* Rotterdam, 1619; *d* Amsterdam, 31 July 1693). Dutch painter, art dealer and appraiser. He was thought for a long time to have been born in 1622, but H. E. van Gelder's important archival research established the artist's correct place and date of birth. Kalf came from a prosperous patrician family in Rotterdam,

where his father, a cloth merchant, also held municipal posts. In the late 1630s he travelled to Paris and spent a long time in the circle of Flemish artists in St Germain-des-Prés, Paris. In Paris he painted mostly small-scale rustic interiors and still-lifes. Kalf's rustic interiors are dominated by accumulations of buckets, pots and pans and vegetables, which he arranged as a still-life in the foreground (e.g. *Kitchen Still-life*, Dresden, Gemäldegal. Alte Meister). Figures usually appeared only in the obscurity of the background. Though painted in Paris, these pictures belong to a pictorial tradition practised primarily in Flanders in the first half of the 17th century by such artists as David Teniers (ii). The only indications of their French origin are a few objects that Flemish exponents of the same genre would not have incorporated into their works. Kalf's rustic interiors had a major influence on French art in the circle of the Le Nain brothers. The semi-monochrome still-lifes Kalf produced in Paris form a link with the *banketjes* or 'little banquet pieces' painted by the Dutch artists Pieter Claesz., Willem Claesz. Heda and others in the 1630s. During the course of the 1640s Kalf developed the *banketje* into a new form of sumptuous and ornate still-life (*pronkstilleven*), depicting rich accumulations of gold and silver vessels. Like most still-lifes of this period, these were usually *vanitas* allegories.

Kalf returned to Rotterdam from Paris in 1646 but did not stay there. He moved to Hoorn, West Friesland, where in 1651 he married Cornelia Pluvier (*b c.* 1626; *d* 6 Feb 1711), a cultivated young woman in the circle of Constantijn Huygens. There are no dated works between 1646 and 1653. By 1653 he was in Amsterdam, where he remained until his death.

It was not until after 1653 that he produced his most elaborate and colourful still-lifes (e.g. *Still-life with a Chinese Bowl*; Berlin, Gemäldegal.; see fig.), which established his central position in the history of Dutch still-life painting. These still-lifes also had their roots in the *banketje* tradition, but Kalf refined the type he had developed in Paris still further. He focused on a limited number of valuable objects: silver vessels, Chinese porcelain dishes or plates, expensive cut glass, gold goblets, Persian carpets, lobsters, oranges, peaches and the ubiquitous partially peeled lemons, which he arranged in differing positions according to a strictly axial compositional pattern. He was a master at capturing the effects of light, whether reflected through a glass or on the edge of a silver platter. His paintings create the illusion of reality with such virtuosity that his work is often compared to that of Vermeer. An essential feature of Kalf's still-life paintings was the fact that he often produced his compositions in series. He frequently rearranged or replaced a number of objects within the same basic pattern, allowing the viewer to interpret the composition in various ways. Several objects in his still-lifes can still be identified as specific individual items, for example the drinking-horn (Amsterdam, Rijksmus.) of the Amsterdam St Sebastian or Arquebusiers' Guild (*Cloveniersgilde*), which appears in the still-life of *c.* 1653 in the National Gallery, London, or a 16th-century rock-crystal bowl (Munich, Residenzmus.) designed by Hans Holbein the younger for Henry VIII, which appears in the still-life of 1678 in the Statens Museum for Kunst, Copenhagen. It is not certain whether these pictures were commissions.

Willem Kalf: *Still-life with a Chinese Bowl*, oil on canvas, 640×530 mm, 1662 (Berlin, Gemäldegalerie)

Among his late works is a small group of still-lifes with mussels (e.g. Zurich, Ksthaus). He lived to the age of 73, but after 1663 he appears to have painted less and less. According to Houbraken, he became an art dealer and appraiser towards the end of his life. Kalf ranks as the most accomplished painter of the third generation of 17th-century Dutch still-life artists, who were active in the 1650s when the genre reached its height. Owing to his remarkable pictorial skills, he extended the illusionistic possibilities of the genre, but in so doing he deprived it of some of its traditional iconographic intent.

BIBLIOGRAPHY
A. Houbraken: *De groote schouburgh* (1718–21)
H. E. van Gelder: *W. C. Heda, A. van Beyeren, W. Kalf* (Amsterdam, [1941])
——: 'Aantekeningen over Willem Kalf en Cornelia Pluvier' [Notes concerning Willem Kalf and Cornelia Pluvier], *Oud-Holland*, lix (1942), pp. 37–46
R. von Luttervelt: 'Aantekeningen over de ontwikkeling van W.K.' [Notes concerning the development of W.K.], *Oud-Holland*, lx (1943), pp. 60–68
I. Bergström: *Dutch Still-life Painting in the Seventeenth Century* (London, 1956)
L. Grisebach: *Willem Kalf, 1619–1693* (Berlin, 1974/*R* 1978); review by S. A. C. Dudok van Heel in *Mdbl. Amstelodamum*, lxi (1974), pp. 94–6; review by B. Haak in *Antiek*, ix/6 (1975), pp. 645–6
Still-life in the Age of Rembrandt (exh. cat. by E. de Jongh and others, Auckland, C.A.G., 1982)

LUCIUS GRISEBACH

Kalibangan [Kala Vangu]. Site on the south bank of the dry bed of the Ghaggar or Hakra River (anc. Sarasvati) near its confluence with the Drishadvati or Chautang River

in Ganganagar District, northern Rajasthan, India. The site contains two occupation levels: a Pre-urban or Sothi settlement (*c.* 3000–2550 BC) and a later occupation associated with the Mature or Urban Phase of the Harappan or Indus civilization (*c.* 2500–2000 BC). L. P. Tessitori discovered and excavated Kalibangan in 1917, but the finds meant little at the time, since nothing was yet known of the Indian Bronze Age or the Indus civilization. Aurel Stein also visited the site during his exploration of the Sarasvati river in the early 1940s. Following the realization of the archaeological potential of the site by Amalananda Ghosh in 1950, the Archaeological Survey of India undertook nine seasons of excavation (1960–69) under Braj Bashi Lal and Bal Krishen Thapar.

The Pre-urban settlement is an irregular parallelogram in plan (*c.* 250×170 m). The first phase of the mud-brick fortification wall was laid to a thickness of *c.* 1.9 m. Subsequently the thickness of the fortification was increased to 3–4 m. There is an entrance at the north-west corner designed to protect this vulnerable point; later construction probably obscured other openings. One street of this period was found (w. 1.5 m); the others are covered by later remains. The mud-brick houses were well made and were orientated to the cardinal points. The bricks were laid with alternating rows of headers and stretchers. One house of the period had a drain of fired brick, but fired bricks were not used in any abundance. The rooms of the houses were arranged around a courtyard and had domestic facilities including ovens. A ploughed field outside the settlement is attributed to this phase of occupation and has notable parallels with 20th-century agricultural techniques used in the area. Copper finds include bangles, beads and a knife in a form termed *parasu* that has parallels at Mitathal (Suraj Bhan, p. 7, fig. 14a) and Rojdi (Possehl and Raval, fig. 77). Terracotta and shell bangles and agate, cornelian and shell beads were also found. Evidence of disturbance in the upper strata suggests that an earthquake might have led to the abandonment of the Pre-urban settlement (Lal, 1979, p. 75).

When Kalibangan was reoccupied (*c.* 2500 BC) the ceramics initially included many of the shapes and fabrics of the earlier occupation, before being superseded by a more Harappan ceramic corpus (Thapar, 1989, p. 196). The same trend is also apparent at other Indus civilization sites in the north-east. The Urban Phase settlement conforms to the classic Harappan 'Citadel' and 'Lower Town' plan (*see* INDIAN SUBCONTINENT, §III, 2(ii)). The Citadel or High Mound covers most of the abandoned earlier settlement. To the east is the Lower Town, built primarily on virgin soil. Building materials from the earlier site were reutilized. The eastern wall of the Pre-urban settlement formed part of the western wall of the new Lower Town, thereby reducing the original width of the Citadel and creating a rectangular Citadel enclosure of the same proportions as at Mohenjo-daro. The north-western entrance of the earlier settlement remained in use, with additional entrances on the east and south sides. The fortifications of the High Mound were initially constructed of large bricks (400×200×100 mm). Later, smaller bricks (300×150×75 mm) were used throughout, both for the fortifications and for buildings. The southern half of the High Mound has a series of high, mud-brick platforms with access via stairways in the adjacent passages. Oval, sunken ritual structures on the platforms were lined with mud plaster or bricks and had a cylindrical or faceted clay 'stele' in the centre. The structures or 'fire-altars' contained ash and charcoal and were orientated so that the worshippers faced east. The northern half of the Citadel contained houses, possibly of an élite group associated with the religious ritual of the platforms. A badly eroded second religious area or 'Ritual Complex' is located *c.* 75 m east of the Lower Town. It consists of an impressive mud-brick wall, which apparently surrounded a room containing four or five 'fire-altars' of the standard Kalibangan type.

The fortification wall of the Lower Town was tapered and plastered with mud. The town had blocks of houses laid in a grid with three or four streets orientated east–west and four streets running north–south the length of the settlement (but not parallel to the fortifications), with two converging on the principal entrance in the north-west corner of the settlement. Buildings at some street intersections had wooden fenders to limit the damage of passing traffic. Habitation extended beyond the fortifications in the protected area south of the High Mound and west of the Lower Town. The mud-brick houses consisted of rooms set around courtyards, many with their own wells. The flat roofs had wooden rafters supporting a covering of reeds and mud. Only one building had stairs suggesting a second storey. Floors were of rammed earth, or occasionally paved. Cooking was generally done in a corner of the courtyard. The rooms were mostly used for living purposes. One room contained many large jars embedded in the ground that seem to have been for the storage of grain.

Finds include numerous copper-based objects, three of which could be classed as low tin bronzes, a wide range of Harappan cubical stone weights, a terracotta graduated measuring scale and an ivory comb with tube drill decoration. Copper objects include beads, bangles, axes, at least one miniature hatchet, points and a very finely crafted bull figurine. The large variety of seals and sealings (Joshi and Parpola, pp. 298–326) includes unicorn and zebu motifs. A flat, stamp seal is inscribed in Indus script and has a human or animal device. A cylinder seal has a similar motif and a second scene of a central human figure covered by two arching branches held by two flanking figures. This scene may be related to the 'human in pipal tree' motif on a seal from Mohenjo-daro. A large broken Harappan triangular terracotta cake has scenes incised on both sides, one depicting the typical Harappan motif of a 'human' figure with horns and a plant growing out of the top of its head, the other, a human figure apparently pulling a roped animal.

An Urban Phase cemetery, about 300 m west-southwest of the settlement, contained three types of burial: extended inhumations in rectangular or oval pits, urn burials in circular pits, and cenotaphs comprising pottery and other grave goods in pits; the latter two types both lacked skeletal remains. The first two types were most common, and each was confined to a specific area of the cemetery, while the cenotaphs were scattered throughout the area used for extended inhumations. The occurrence

of inhumations in groups indicates the possibility of family burial areas (Sharma, p. 298).

See also INDIAN SUBCONTINENT, §I, 2(i).

UNPUBLISHED SOURCES

New Delhi, Cent Archaeol. Lib. [MS. of L. P. Tessitori: *Exploration in Rajasthan* (1918–19)]

BIBLIOGRAPHY

M. A. Stein: 'A Survey of Ancient Sites along the "Lost" Sarasvati River', *Geog. J.*, xcix (1942), pp. 173–82

A. Ghosh: 'Exploration in Bikaner', *E. & W.*, iv/1 (1953), pp. 31–4

B. B. Lal: 'A New Indus Valley Provincial Capital Discovered: Excavation at Kalibangan in Northern Rajasthan', *Illus. London News* (24 March 1962), pp. 454–7

B. B. Lal and B. K. Thapar: 'Excavations at Kalibangan: New Light on Indian Civilization', *Cult. Forum*, ix/4 (1967), pp. 78–88

R. L. Raikes: 'Kalibangan: Death from Natural Causes', *Antiquity*, xlii (1968), pp. 286–91

B. B. Lal: 'Perhaps the Earliest Ploughed Field So Far Excavated Anywhere in the World', *Puratattva*, iv (1970–71), pp. 1–3

Suraj Bhan: *Excavations at Mitathal (1968) and Other Explorations in the Sutlej–Yamuna Divide* (Kurukshetra, 1975)

B. K. Thapar: 'Kalibangan: A Harappan Metropolis beyond the Indus Valley', *Expedition*, xvii/2 (1975), pp. 19–32

B. M. Pande: 'Inscribed Harappan Material from Kalibangan: Some Remarks on Methodology and Approach', *Puratattva*, viii (1978), pp. 156–7

B. B. Lal: 'Kalibangan and Indus Civilization', *Essays in Indian Protohistory*, ed. D. P. Agrawal and D. Chakrabarti (Delhi, 1979), pp. 65–9

A. K. Sharma: 'The Harappan Cemetery at Kalibangan: A Study', *Harappan Civilization*, ed. G. L. Possehl (Delhi, 1982), pp. 287–91

B. B. Lal: 'Some Reflections on the Structural Remains at Kalibangan', *Frontiers of the Indus Civilization*, ed. B. B. Lal and S. P. Gupta (Delhi, 1984), pp. 55–62

J. P. Joshi and A. Parpola, eds: *Collections in India*, Corpus of Indian Seals and Inscriptions, i (Helsinki, 1987)

S. P. Gupta, ed.: *An Archaeological Tour along the Ghaggar–Hakra River* (Meerut, 1989)

G. L. Possehl and M. H. Raval: *Harappan Civilization and Rojdi* (Delhi, 1989)

B. K. Thapar: 'Kalibangan–1, –2', *An Encyclopaedia of Indian Archaeology*, ed. A. Ghosh, ii (Delhi, 1989), pp. 194–6

GREGORY L. POSSEHL

Kalide, (Erdmann) Theodor (*b* Königshütte, Upper Silesia [now Chorzów, Poland], 8 Feb 1801; *d* Gleiwitz [now Gliwice, Poland], 23 Aug 1863). German sculptor. At the age of 15 he was apprenticed at the Königliche Eisengiesserei in Gleiwitz, where he soon began sculpting cast-iron plaques. In 1819 Johann Gottfried Schadow summoned him to Berlin, where he was instructed in chasing by Coué and worked in the Berlin Eisengiesserei. In 1821 he transferred to the studio of Christian Daniel Rauch. Following Rauch's example and under his influence, Kalide produced such large animal sculptures as the *Resting Lion* and the *Sleeping Lion* (several casts, e.g. zinc, 1824; Berlin, Schloss Kleinglienicke). From 1826 to 1830 Kalide worked on equestrian statuettes, including those of *Frederick William II* (zinc), after the model by Emanuel Bardou (1744–1818), and *Frederick William III* (e.g. cast iron; both Berlin, Schloss Charlottenburg, Schinkel-Pav.). In 1830 he became a member of the Berlin Akademie. His most popular works included the life-size bronze group *Boy with a Swan* (1836), which was installed on the Pfaueninsel in Berlin as a fountain (several casts, all untraced). Kalide achieved wide recognition and aroused violent controversy with his almost life-size marble figure *Bacchante on the Panther* (1848; Berlin, Schinkelmus., badly damaged). This work transgressed the accepted boundaries

of classical art, above all in the figure's provocative pose, and was perceived as shocking. In its uninhibited sensuality and its blending of the human and the animal, it offended the conservative Berlin public, and consequently Kalide received few new commissions. He had no success with competition designs and became increasingly embittered. He spent his last years at Gleiwitz, where he died.

BIBLIOGRAPHY

K. Bimler: 'Der Bildhauer Theodor Kalide', *Oberschlesien*, xv (1916–17), pp. 353ff

I. Wirth: 'Theodor Kalide, ein Berliner Bildhauer aus Oberschlesien', *Schlesien*, viii/3 (1963), pp. 141–50

P. Bloch and W. Grzimek: *Das klassische Berlin: Die Berliner Bilderhauerschule im 19. Jahrhundert* (Vienna, 1978), pp. 135–8

Ethos und Pathos: Die Berliner Bildhauerschule, 1786–1914 (exh. cat., ed. P. Bloch, S. Einholz and J. von Simson; Berlin, Hamburg. Bahnhof, 1990), pp. 138ff

JUTTA VON SIMSON

Kalimantan. *See under* INDONESIA.

Kalina, Jerzy (*b* Garwolin, nr Warsaw, 15 April 1944). Polish painter, sculptor, performance artist and film maker. He trained as a painter at the Academy of Fine Arts in Warsaw (1965–71) under Stefan Gierowski. His 'ritual actions' organized in streets in Warsaw attracted the attention of critics and passers-by. Carefully planned to avoid the appearance of a 'happening', they reflected Kalina's concern with a number of artistic and social issues. In 1977 Kalina created *The Passage* (sculptures now at Wrocław, N. Mus.), a monument to an anonymous pedestrian: for a week on the pavement at a crossroads in Warsaw he placed life-size, grey figures of people going up and down an imaginary subway and intermingling with real crowds. He also joined other artists in boycotting state-organized artistic events and took part in independent exhibitions held in churches, such as *Apokalipsa—Światło w ciemnościach* ('Apocalypse—light in the darkness'), held in the church of the Holy Cross in Warsaw in 1984. In 1986 he made the tomb of Father Jerzy Popiełuszko (Warsaw, St Stanisław Kostka), the priest murdered in 1984 by the Polish secret police. Subsequent works included a performance of his play *Pielgrzymi i tułacze* ('The pilgrims and the exiles') in 1989 at the Studio Art Centre in Warsaw, the installation *Cathedral* and the performance *Welcome to Poland* (1991; London, Serpentine Gal.).

BIBLIOGRAPHY

Jerzy Kalina: Catalogue of Performances and Installations (exh. cat., ed. Z. Taranienko; Warsaw, Studio A. Cent., 1989) [Pol. and Eng. text]

Kaliṅganagara. *See* MUKHALINGAM.

Kalinin. *See* TVER'.

Kaliningrad [formerly Ger. Königsberg; Pol. Królewiec]. Russian city and capital of the province of the same name on the River Pregel, with a population of *c.* 360,000. Its site near the Baltic Sea has made it an important trading centre and military base. There was a settlement of pagan Prussians near the present Old Town; in 1255 the Knights of the Teutonic Order built a wooden castle (destr. 1262–3) there. Königsberg was named after King Přemsyl Ottakar II of Bohemia, who took part in the crusade.

The medieval town was made up of three separate settlements that gradually merged: the first of these, Königsberg, developed to the south of the castle and was granted town rights in 1286; Löbenicht was situated to the east and given its charter in 1300; and in 1327 Kneiphof, situated on the island to the south, also received its charter. The first castle was replaced *c.* 1300 with one in stone that became a commandery of the Teutonic Knights and later (1457–1525) the residence of the Order's Grand Master. Königsberg Cathedral was built in Kneiphof *c.* 1330–80, with an elongated choir and a five-bay aisled nave that was initially designed as a basilica but was changed during construction to a pseudo-basilica. In line with a document of 1333 that stipulated that the west façade should be based on the façade (completed 1333) of St Mary, Kulm (now Chełmno), it was built as a powerful two-tower structure articulated by several tiers of string courses, lancet windows and blind arcades.

Although from 1340 Königsberg belonged to the Hanseatic League, the city's development was fairly slow until 1525, when it became the capital of Ducal Prussia (a hereditary fief under Polish overlordship), with the former Grand Master Albert becoming the first Hohenzollern Duke of Prussia (*reg* 1525–68). As such, Königsberg became a leading centre of the Reformation as well as of learning and the arts. In this period it also reached the height of its success as a centre for amber-carving (*see* AMBER (ii), §3), with such specialized artists as GEORG SCHREIBER. Duke Albert was a significant patron of the arts, and he encouraged the manufacture of secular objects and lowered the cost of raw amber.

Numerous artists were employed by the court: Cornelis Floris and his workshop in Antwerp were commissioned to carve numerous monuments for the cathedral, including the magnificent marble funerary monument to *Duke Albert* (from 1569; destr.). This was partly executed by Floris's pupil, Willem van den Blocke, who settled in Königsberg in 1569 and carved the monument in the cathedral to *Margravine Elizabeth* (1578–82; destr.), wife of George Frederick (1539–1603), Margrave of Brandenburg-Ansbach. In the 1580s Blasius Bernwart I built the west wing of the castle with its chapel, which became a model for Protestant church architecture.

In 1618 the duchy passed to the Hohenzollern Electors of Brandenburg (Kings of Prussia from 1701). The three towns that made up Königsberg were officially united in 1724, and the city developed rapidly over the next two centuries. IMMANUEL KANT taught at the city's university in the 18th century. Annual art exhibitions were held from 1833, and the Academy of Fine Arts was established in 1844. New fortifications were built (1843–61), the suburbs were developed, and numerous churches were constructed around the turn of the 20th century. The cathedral was thoroughly restored (1901–7), and a mausoleum to Immanuel Kant (1923–4; *in situ*), built by Friedrich Lahrs (*b* 1880) in a pared down, classicizing style, was installed on the exterior.

Königsberg was the capital of East Prussia until its conquest by the USSR in 1945; it was renamed Kaliningrad the following year. The 19th-century suburbs survive to some degree, but the inner city, castle and cathedral were seriously damaged in 1944, and almost no post-war restoration was undertaken. New buildings replaced old ones: for example, a monumental party headquarters was built on the site of the castle, which was demolished in the early 1970s. The cathedral is the only major historic building in the city centre, but it survives in a gutted state; reconstruction, funded by Germany, commenced in 1992, and the west towers were almost complete by late 1994.

BIBLIOGRAPHY
A. Boetticher: *Die Bau- und Kunstdenkmäler in Königsberg* (Königsberg, 1897)
H. M. Mühlpfordt: *Königsberger Skulpturen und ihre Meister, 1255–1945* (Würzburg, 1970)
L. Pudłowski: 'Czternastowieczne przedstawienie krzyżowców z katerdry w Królewcu' [14th-century image of crusaders in Królewiec Cathedral], *Akta 35 sesji historyków sztuki: Portret: Funkcja, forma, symbol: Toruń, 1986* [Acts of the 35th session of the society of art historians: portrait: function, form, symbol: Toruń, 1986], pp. 351–63
R. Albinus: *Lexikon der Stadt Königsberg Pr. und Umgebung* (Leer, 1988)
G. von Glinski and P. Wörster: *Königsberg: Die ostpreussische Hauptstadt in Geschichte und Gegenwart* (Berlin, 1990)
A. Rzempołuch: *Przewodnik po zabytkach sztuki dawnych Prus Wschodnich* [Guide to the art monuments in former East Prussia] (Olsztyn, 1992)

LIDIA POLUBIEC, with ANDRZEJ POLOCZEK

Kalkar, Jan Joest von. *See* JOEST, JAN.

Kalkar, Jan Steven van. *See* CALCAR, JAN STEVEN VAN.

Kalkar [Calcar], **St Nikolai.** Principal church of Kalkar, Nordrhein-Westfalen, Germany. The town was granted its first charter in 1230 by Dietrich V of Cleves (*reg* 1202–60), and in the Middle Ages it was a Hanseatic town. St Nikolai contains an important collection of late medieval carved wooden altarpieces. The survival of nearly half the original 15 gave rise to a theory of a 'Kalkar school' of wood-carving, but this is disproved.

The present church replaced a building burnt down in 1409. The chancel was vaulted in 1423 and after the church achieved parochial status in 1441, the nave was rebuilt as a hall church, consecrated in 1450. The earliest altarpiece is the painted triptych on the St Anthony altar, made in 1460 by a local workshop, perhaps in Wesel. The main group of altarpieces was made between *c.* 1480 and *c.* 1550, many for the Liebfrauenbruderschaft (Brotherhood of Our Lady). They have a carved shrine (central panel) and painted wings. Both the paintings and the polychromy on the sculpture were often omitted for lack of money, but the impression given today of unpainted altarpieces is unintentional. The sculptors, none originally from Kalkar, included Master Arnt, Ludwig Jupan and Arnt van Tricht.

The shrine of the St George altar (before 1484), with its original paint, is attributed to MASTER ARNT, who was also commissioned in 1490 to make the high altar retable. This was finished after his death by Jan van Halderen (*fl* 1491–1511) and LUDWIG JUPAN, who reworked the uncompleted areas and introduced a new formal arrangement more clearly separating the individual scenes (see fig.). The wings were painted from 1505 to 1509 by Master Mathaus and JAN JOEST VON KALKAR, whose contributions are indistinguishable, both characterized by strong colour, spacious landscapes and atmosphere, and many portraits, possibly of members of the Brotherhood, which match in quality contemporary Netherlandish painting. The Brotherhood commissioned the altar of the Virgin

from Jupan in 1507 and that of the *Seven Sorrows of the Virgin* from Henrik Douvermann (*fl* 1510–44) in 1518. In the former the scenes unfold like carved pictures; several compositions are after engravings by Israhel van Meckenem (ii). The latter has a Tree of Jesse entwining the whole composition and a series of many-figured high reliefs with a Calvary in the raised centre.

Two reconstructed altarpieces represent a type also current in south Germany, with saints standing side by side in the shrine: the St James altar of *c.* 1503 by a pupil of Master Arnt, and the St Crispin altar, with the patron saint of cobblers, made *c.* 1510, possibly by Kerstken van Ringenberg. The figures retain their original colour. The two altarpieces by ARNT VAN TRICHT, the Trinity altar of *c.* 1530–40 and the St John altar of 1541–3, both show the influence of the Netherlandish Renaissance and an awareness of current fashions and ornament derived from patterns by Heinrich Aldegrever and Dirk Vellert.

The choir-stalls, completed in 1508, were made by the Wesel sculptor Henrik Bernts (*d* 1509) and modelled on Master Arnt's choir-stalls of 1474 in the Minoritenkirche at Cleves. The relief decoration on the sides of the stalls and the misericords is a dry reflection of Arnt's courtly and elegant formal vocabulary. The nave is dominated by the great Marienleuchter, the candelabrum commissioned from Bernts in 1508 and completed by Kerstken van Ringenberg. It consists of a pedestal with figures to which iron candleholders are attached; on this stands a double image of the Virgin standing on the moon, in a burst of sun rays and completely surrounded by a Tree of Jesse. It is a well-preserved example of a once-numerous type and a precursor of the *Annunciation* by Veit Stoss in St Lorenz, Nuremberg. It was later altered by Douvermann and Arnt van Tricht.

Only a few works were added in the Baroque period: there are some monuments for refugees from the Reformation in the Netherlands, and a few of the medieval altarpieces received their painted wings. Other furnishings include material brought in 1818 from the Dominican friary in Kalkar: the St Anne altar and a *Virgin and St John* from a rood, all made *c.* 1500 by the same artist in a heavy Burgundian style. There are individual statues by Arnt and Douvermann, and a *Tomb of Christ* by Arnt. The restoration work on the church that became necessary during the 19th century was partly paid for by the sale of some furnishings, but they are still rich and well preserved.

BIBLIOGRAPHY

J. A. Wolff: *Die St Nicolai-Pfarrkirche zu Calcar: Ihre Kunstdenkmäler und Künstler archivalisch und archäologisch bearbeitet* (Kalkar, 1880)
P. Clemen: *Die Kunstdenkmäler des Kreises Kleve* (Düsseldorf, 1892), pp. 472–506
R. Klapheck: *Kalkar am Niederrhein* (Düsseldorf, 1930)
F. Witte: *Tausend Jahre deutscher Kunst am Rhein* (Berlin and Leipzig, 1932)
H. M. Schwarz: *Die kirchliche Baukunst der Spätgotik im klevischen Raum* (Bonn, 1938)
H. P. Hilger: *Kalkar* (1964), ii of *Kreis Kleve*, 5 vols, Die Kunstdenkmäler des Rheinlandes (Düsseldorf, 1964–70)
F. Gorissen: *Ludwig Jupan von Marburg*, Die Kunstdenkmäler des Rheinlandes, xiii (Düsseldorf, 1969)
G. de Werd: 'Die Kreuzigungsgruppe der ehemaligen Dominikanerkirche zu Kalkar und das Oeuvre des Meisters des Kalkarer Annenaltares', *Pantheon*, xxix (1971), pp. 459–73

Kalkar, St Nikolai, detail of high altar retable by Master Arnt, completed by Ludwig Jupan, wood, 1490–1500

F. Gorissen: 'Meister Matheus und die Flügel des Kalkarer Hochaltars: Ein Schlüsselproblem der niederrheinländischen Malerei', *Wallraf-Richartz-Jb.*, xxxv (1973), pp. 149–206
G. de Werd: *Die St Nicolaikirche zu Kalkar* (Munich and Berlin, 1983)

HERIBERT MEURER

Kallenbach, Otto (*b* Trippstadt, 3 Dec 1911). German sculptor and medallist. From 1925 until 1929 he trained in Kaiserslautern as a stone-carver under the sculptor Karl Dick. His earliest commissions were for architectural sculpture, sometimes following designs by others. From 1934 to 1939 he studied at the Hochschule für Bildende Künste in Munich, where, under the influence of the sculptor Josef Henselmann (*b* 1898), he became familiar with the theories of Adolf von Hildebrand and began carving direct in stone and wood without the use of preliminary models. He also worked in stucco and cast iron. Among his commissioned works are many sculptures for public and private buildings, such as the statue of the *Archangel Michael* (1948; *in situ*) for the parish church of Manning, Niederbayern. In the early 1950s he began producing cast medals and plaquettes, the models for which he carved in negative, and these were to make him one of Germany's foremost 20th-century medallists. His first official medal (bronze, 1952), for the Bayerische

Akademie der Schönen Künste, Munich, has the geometric forms and sharp-edged lettering that are a feature of his medallic work. The Hambach medals of 1982, celebrating the sesquicentennial of the Hambach Festival, Rheinland-Pfalz, show the influence of earlier 20th-century German medallists such as Ludwig Gies. From 1950 until 1975 he taught stone-carving at the Akademie der Bildenden Künste, Munich.

BIBLIOGRAPHY

Vollmer

Die Medaillen des Otto Kallenbach, intro. by M. Tauch (Landau, 1981)

PHILIP ATTWOOD

Kallikrates [Callicrates] (*fl* 5th century BC). Greek architect. He is known through inscriptions and later authors such as Plutarch (*Perikles* XIII.4–5) as the designer of the Temple of Athena Nike on the Athenian Acropolis (*see* ATHENS, §II, 1(i)); the Middle Wall, part of the fortifications linking Athens and Peiraeus; and, especially, as one of the two architects of the Parthenon (*see* ATHENS, §II, 1(i)). The nature of the collaboration between Kallikrates and IKTINOS in designing the Parthenon has been the subject of controversy: Carpenter, for example, proposed that the two men did not work together, but that Kallikrates was the original designer, and that his plans were later revised and completed by Iktinos. Nevertheless, Kallikrates is traditionally assumed to have been responsible for the Ionic elements in the Parthenon, a view based on his association with the Ionic Temple of Athena Nike. The tetrastyle amphiprostyle plan of this elegant building, as well as details of its Ionic order, closely resembled those of a temple (now destroyed) by the Ilissos River in Athens, which was roughly contemporary with or slightly earlier than the Nike Temple and is widely accepted as the work of Kallikrates. Two other buildings, the so-called Temple of the Athenians at DELOS (*see* §1(i)) and the Erechtheion on the Athenian Acropolis (*see* ATHENS, §II, 1(i)), have also been proposed as works by Kallikrates. If these attributions are correct, he thus emerges as the chief exponent of the Ionic style in Athens during the second half of the 5th century.

BIBLIOGRAPHY

I. M. Shear: 'Kallikrates', *Hesperia*, 32 (1963), pp. 375–424

R. Carpenter: *The Architects of the Parthenon* (Harmondsworth, 1970)

ANASTASIA N. DINSMOOR

Kallimachos [Callimachus] (*fl* second half of the 5th century BC). Greek sculptor. Almost nothing is known of his life. He probably came from Corinth since, according to Vitruvius (*On Architecture* IV.i.9–10), Kallimachos invented the Corinthian capital (presumably before its earliest known use—in uncanonical form—at BASSAI). His technical abilities were also displayed in the golden lamp (late 5th century BC) he made for the Erechtheion in Athens, which burnt for a year without refilling and had a chimney in the shape of a palm (Pausanias: *Guide to Greece* I.xxvi.6), i.e. a hollow column with an Aeolic 'reed' capital, rare before the Hellenistic period (323–31 BC). Kallimachos' technical punctiliousness may be the reason for his ancient nickname, *katatexitechnos* ('he who pines away because of art'; Vitruvius IV.i.10), given to him, according to Vitruvius, because of the 'subtlety' of his work in marble. His care in drilling the stone led Pausanias to use

a play on words, calling him *kakizotechnos* ('he who spoils art'; I.xxvi.7). Both nicknames occur in some manuscripts of Pliny the elder (*Natural History* XXXIV.xix.92), who implied that Kallimachos destroyed any grace in his work by the very pains that he took over it, referring specifically to his *Lakonian Dancers*. There may be echoes of this group (probably six girls wearing short chitons) in neo-Attic reliefs (e.g. Berlin, Pergamon-mus., see Blümel, no. K 184-5). Another group attributed to Kallimachos, six ecstatic *Maenads*, is preserved in numerous copies (e.g. Rome, Mus. Conserv.). They wear floor-length drapery skin-tight in places, of thin material that allows the bodies to appear as if nude; this style of drapery was the basis for the attribution to Kallimachos of the original of the Fréjus *Aphrodite* (Paris, Louvre; *see* GREECE, ANCIENT, §IV, 2(iii)(b) and fig. 59). The structure of this figure and the emphasis of the articulation of its limbs are wholly influenced by POLYKLEITOS and his followers. It has been called 'a laterally reversed female Doryphoros in the spirit of the first generation of followers, wearing close-fitting drapery', which is gathered in dense bunches of folds between the legs and at the side, as in the Landsown–Sciarra *Amazon* of Polykleitos. The original of the Fréjus *Aphrodite* stood in Troizen, and Kallimachos seems to have been one of the followers of Polykleitos.

BIBLIOGRAPHY

C. Blümel: *Römische Kopien griechischer Skulpturen des IV. Jahrhunderts v. Chr.* (Berlin, 1931 and 1938), iv and v of *Katalog der Sammlung antiker Skulpturen*

W. Fuchs: *Die Vorbilder des neuattischen Reliefs* (Berlin, 1959)

B. Ridgway: *Fifth Century Styles in Greek Sculpture* (Princeton, 1981), pp. 97, 126, 184, 200

A. Stewart: *Greek Sculpture: An Exploration* (New Haven and London, 1990), pp. 271–2

A. LINFERT

Kallon (*b* Aigina; *fl c.* 500–450 BC). Greek sculptor. Inscriptions of *c.* 500 BC show that he worked on the Acropolis of Athens as a young man. A bronzeworker, he is mentioned as a pupil of Tektaios and Angelion (Pausanias: *Guide to Greece* II.xxxii.5) and the contemporary of Kanachos (i) (Pausanias, VII.xviii.10). Coins from Troizen help to identify his *xoanon* (wooden statue) of Athena as the archetype for a marble copy in Madrid (Prado); its angular outlines and severe standing posture suggest a date for the original of *c.* 470/460 BC. A contemporary marble *Demeter* (*c.* 460 BC; Corinth, Archaeol. Mus.) is based on a bronze model that, along with an *Aphrodite* and an *Artemis* by Gitiadas (*fl* first quarter of the 5th century BC) of Sparta, decorated three tripods in Amyklaion, south of Sparta. Kallon is also credited with the so-called *Aspasia* or *Europa*, probably made for Pylos, which was later depicted on Roman coins. The fragmentary marble *Athena* in Athens (Acropolis Mus. store) is presumably a copy of one of his bronzes.

BIBLIOGRAPHY

Pauly–Wissowa: 'Kalon I'

A. E. Raubitschek: *Dedications from the Athenian Acropolis* (Cambridge, MA, 1949), pp. 91–5, 508–9

J. Dörig: 'The Early Classical Period: The Severe Style, 500–450 B.C.', *The Art and Architecture of Ancient Greece*, ed. J. Boardman and others (London, 1957), pp. 283–7

B. Ridgway: *The Severe Style in Greek Sculpture* (Princeton, 1970), pp. 71–2, 88

JOSÉ DÖRIG

Kalmyk region [Kalmykia]. *See under* RUSSIA, §XII, 1.

Kalna. Town and temple site in West Bengal, India, about 80 km north of Calcutta. Located on the banks of the Bhagirathi River, it was once an important port and commercial centre, but by the late 19th century its importance had declined owing to the silting up of the river and the opening of the East Indian Railway. It is now best known for several temples built during the 18th and 19th centuries by wealthy landowners, merchants and officers of local governors. Many are dated by inscription. Built of brick, they are decorated with dense arrangements of terracotta reliefs depicting scenes from the *Rāmāyaṇa*, the Krishna legend and scenes of everyday life, including figures in European dress. A variety of temple types are seen; the most common have squat, curvilinear superstructures, sometimes double-storey, or upper levels consisting of several towers (*see* INDIAN SUBCONTINENT, §III, 7(ii)(d)). The Lalji Temple (1739) has a central structure capped by an arrangement of 25 spirelike towers. In contrast, the Pratapeshvara Temple (1849) is set on a high plinth supporting a single, tall, curved superstructure. Its base mouldings and vertical wall divisions are packed with terracotta sculptures, primarily single human figures compartmentalized within rectangular frames. Other buildings in the town include the palace compound of the local ruler built in Neo-classical style.

BIBLIOGRAPHY

N. K. Sinha: *The History of Bengal (1757–1905)* (Calcutta, 1967)

G. Michell, ed.: *Brick Temples of Bengal: From the Archives of David McCutchion* (Princeton, 1983)

WALTER SMITH

Kalopanagiotis [St John Lampadistis]. Byzantine monastery in Cyprus, *c.* 50 km west of Nicosia. The only information concerning its foundation is that which can be gleaned from the three adjoining churches of the katholikon and their decoration. All are of different date with a narthex common to the central and southern churches. A massive, pitched, timber roof, of a type common among the Cypriot mountain churches, covers the complex.

The south church, dedicated to St Herakleidius, has a conventional cross-in-square plan, and probably dates from the 11th century. A painting, possibly of the 12th century, on the dado of the central apse, depicts two monks, possibly donors, in *proskenesis*; there are traces of an earlier painting beneath. A particularly interesting group of paintings (*c.* 1250–1300) comprises the Pantokrator, the *Sacrifice of Isaac*, the *Entry into Jerusalem*, the *Raising of Lazarus*, the *Crucifixion*, the *Ascension*, individual figures of Christ and the Virgin, prophets and saints. The *Crucifixion*, *Sacrifice of Isaac* and *Ascension* reflect Crusader models, combining Byzantine and Western medieval iconographical elements. The Cypriot character of the paintings is retained, however, through liberal use of red paint, as in the background to the *Crucifixion*, the depiction of local saints, the unconventional settings of the scenes and an archaic figural style. A second series of paintings (*c.* 1400) consists of a richly illustrated New Testament cycle, emphasizing the *Passion of Christ*, as well as a fragmentary Tree of Jesse, an orant Virgin, Fathers of the Church, and

individual saints and prophets. The narrative scenes are colourful and rustic in character with much genre detail.

The central chapel is dedicated to a local saint, St John Lampadistis. Although the original structure and a few fragments of painting are dated to the 12th century, the barrel-vaulted roof is part of a later reconstruction. The date of the timber-roofed narthex is uncertain, although A. Stylianou and J. Stylianou attributed the paintings on its north, south and east walls to the mid-15th century. These paintings concentrate on the miracles of Christ and his appearances after the Resurrection, and they are accompanied by lengthy quotations from the Gospels; they also include a *Last Judgement*. A fragmentary inscription over the south door identifies the artist as coming from Constantinople (now Istanbul), perhaps a refugee after the fall of the city in 1453. A second undated inscription, referring to Western donors, reveals that the katholikon was also used for the Latin rite. To the north is the 'Latin Chapel', a tall, vaulted structure whose principal decoration (*c.* 1500) consists of finely executed illustrations to the 24 stanzas of the *Akathistos* hymn to the Virgin. This programme is the most complete series of the Italo-Byzantine school in Cyprus, and it was produced by an artist who may have had first-hand knowledge of contemporary Italian painting.

BIBLIOGRAPHY

A. Stylianou: 'An Italo-Byzantine Series of Wall Paintings in the Church of St John Lampadistis, Kalopanagiotis, Cyprus', *Akten des XI internationalen Byzantinistenkongresses: München, 1958*, iii, pp. 595–8

A. H. S. Megaw and A. Stylianou: *Cyprus: Byzantine Mosaics and Frescoes* (Paris, 1963), pls xix–xxii

A. Papageorghiou: 'Idiazousai bizantinai toichographiai tou 13 aionos en Kypro' [Characteristic Byzantine frescoes of the 13th century in Cyprus], *Praktika tou protou diethnous Kyprologikou synedriou* [Proceedings of the 1st international Cypriot conference]: *Nicosia, 1969*, ii, pp. 202–5

——: 'The Narthex of the Byzantine Churches in Cyprus', *Rayonnement grec: Hommages à Charles Delvoye* (Paris, 1982), p. 441

S. H. Young: *Byzantine Painting in Cyprus during the Early Lusignan Period* (diss., University Park, PA State U., 1983), pp. 144–245

A. Stylianou and J. Stylianou: *The Painted Churches of Cyprus: Treasures of Byzantine Art* (London, 1985), pp. 292–320

SUSAN YOUNG

Kalpokas, Petras (*b* nr Rokiškis, 12 April 1880; *d* Kaunas, 6 Dec 1945). Lithuanian painter. He studied first in Mitava (now Jelgava) under Jānis Valters and Vilhelms Purvītis, and then in Riga. In Munich he studied at the Anton Ažbe school (1905–8) and attended classes in the decorative and applied arts, drawing and history of art, while at the same time exhibiting with the Munich Secession. Catalogues show that his first works after his return to Lithuania were influenced by the Symbolist movement in Munich, for example the *Fiery Horseman* (1912). In 1914 Kalpokas went to Switzerland, where he prepared for an exhibition that was to take place in Germany, but at the onset of World War I 120 of his works were lost. He then lived in poverty in Italy, working as a retoucher near Genoa. A painting from this period, *Italian Fisherman* (1919; Vilnius, priv. col.), reveals the influence of the Italian Renaissance and a desire to emulate the classical style of the 1830s. In 1921 Kalpokas returned to Lithuania but was untouched by the phase of National Romanticism in contemporary Baltic art. Instead he painted landscapes with echoes of Art Nouveau, as in *Autumn* (1921; Kaunas, Ciurlionis A.

Mus.). He produced portraits and executed wall paintings in the spirit of Hans von Marées's German 'idealism' (e.g. 1937–8; Vilnius, Lith. Cent. Trade & Indust.; destr. 1943). During the 1920s he became engaged in teaching activities in Kaunas, and from 1940 he taught at the State Institute of Applied and Decorative Art there.

BIBLIOGRAPHY
P. Gudinas: *Kalpokas* (Moscow, 1957)
N. Timéniene: *Petras Kalpokas* (Vilnius, 1983)

SERGEY KUZNETSOV

Kalraet, Abraham (Pietersz.) van. *See* CALRAET, ABRAHAM VAN.

Kalte Kunst. *See* COLD ART.

Kaluga. Russian town 170 km south-west of Moscow, on the River Oka. It was first mentioned in 1371, when it was a fortress enclosed by earthen ramparts and wooden walls on the frontier with Lithuania. By the 16th century a town had grown up, with new fortifications, and by the second half of the 17th century Kaluga had a rectangular wooden kremlin with 12 towers; in the town there were 24 wooden and 3 stone-built churches and a school of icon painting. Examples of religious sculpture, rare in Russia, and silver jewellery have survived. In the second half of the 18th century Kaluga was replanned in Neo-classical style by P. R. Nikitin, I. D. Yasygin and N. Sokolov successively. The old part of the town retained most of its original layout. A system of squares for trade and administration was laid out in the town centre, while on the periphery a wide main road was built round the entire settlement, with two circuses and a rectangular square along its route. The numerous churches erected in the second half of the 18th century (e.g. St John the Baptist, SS Cosmas and Damian, the Trinity) combined traditional Russian forms with Neo-classical decoration. Magnificent town mansions of the late 18th century and early 19th, for example the Kologrivova House (1805–8; now a folk museum) and the Meshkov House (now the state bank), have survived, together with their sculptural ornament, fragments of interior decoration and service buildings. There are also wooden buildings in the Empire style and a trading arcade (1784–1821), the first commercial building in Russia in a romantic, neo-Gothic style. Neo-classicism prevailed in Kaluga until the 1920s. Notable buildings of the Soviet period include the neo-classical theatre (1958) and the Museum of the History of Space Exploration (1967; by B. G. Barkhin). There is a Regional Local History Museum, and the Regional Art Museum displays Russian medieval art and that from the 18th to the 20th century.

BIBLIOGRAPHY
D. Malinin: *Kaluga* (Kaluga, 1912)
S. V. Bezsonov: *Kaluzhskiy derevyannyy ampir* [The Kaluga wooden Empire style] (Kaluga, 1928)
M. Fekhner: *Kaluga* (Moscow, 1971)

D. O. SHVIDKOVSKY

Kalvach, Rudolf (*b* Vienna, 22 Dec 1883; *d* Kosmanos [now Kosmonosy], Bohemia, 13 March 1932). Austrian painter and printmaker. His family moved to Trieste in 1901. He studied at the Hochschule für Angewandte Kunst, Vienna, under Alfred Roller. His woodcut series *Il*

porto di Trieste is characteristic of his artistic activity during this period. With Oskar Kokoschka and Egon Schiele he took part in the first exhibition of the Kunstschau at Schwarzenbergplatz, Vienna (1908; held by a group of artists who had left the Secession as the Klimtgruppe (1905)).

Bertold Löffler, Kokoschka and Kalvach all designed posters for the Kunstschau (1908) and consequently their styles are strongly analogous during this period. Kalvach's compositions are even more expressive than Kokoschka's. Kalvach also produced postcards for the Wiener Werkstätte (publ. 1908, 1909 and 1910), in which dramatic expression, under the veil of satire, makes itself even more apparent. They evoke a tragic feeling touched with the grotesque. Kalvach was also active as a member of the NEUKUNSTGRUPPE.

Kalvach painted in tempera and in oil, on canvas and on panel. His early themes reflect the influence of Löffler. These works were often composed of large, monochromatic, brilliant patches of colour. Little remains of his monumental oil paintings, such as *The Hunt* (*c.* 1.5×2.0 m; exh. Vienna, Gal. Miethke, *c.* 1918; untraced). He worked as an advertising artist for the Austrian Lloyd; *The Studio* (1910) published reproductions of the Lloyd posters he designed. After he studied enamel under Adele von Stark at the Kunstgewerbeschule (1909–12), he made studies for enamels in tempera and watercolour, which were exhibited at the Galerie Miethke (1913). Satire and social criticism were important factors in Kalvach's productivity between 1908 and 1912. Preferring the woodcut technique, he never tired in portraying every aspect of the worker's life in Trieste harbour. He attempted to express diverse moods by enhancing his woodcut prints with watercolours. He also taught at the Volkshochschule for adult education, founded by the Social Democrats in 1901 in Ottakring, a traditional workers' district in Vienna. On 29 May 1912 he was admitted as a patient to a mental hospital where he was diagnosed as schizophrenic. Despite his discharge in September 1915 he was readmitted between 1921 and 1926 and died in another institution.

BIBLIOGRAPHY
A. Uboni and G. Uboni: 'Rudolf Kalvach—Leben und Werk', *Expressive und dekorative Graphik in Wien zwischen 1905 und 1925* (exh. cat., Vienna, Mus. Angewandte Kst, 1979)
Le arti a Vienna (exh. cat., Venice, Pal. Grassi, 1984)

CYNTHIA PROSSINGER

Kalydon [Calydon]. Site of ancient Greek city in Aitolia on the northern side of the Corinthian Gulf, situated on two hills overlooking the plain of the River Euenos. It flourished from the Late Bronze Age until 30 BC, when its inhabitants were transferred to Nikopolis. It featured in Greek mythology as the home of Oineus and his sons Tydeus and Meleager and as the location of the Kalydonian boar-hunt, while the more northerly of its two hills was a Mycenaean acropolis and bears traces of possible Late Bronze Age fortifications. The area has also produced Late Bronze Age pottery, and Dark Age (12th century BC) pottery, including Protogeometric work (*c.* 1050–*c.* 900 BC), occurs in its tombs. Although Kalydon's site was strategically important and Strabo (*Geography* X.ii.3) called it an ornament to Greece, it had little impact on

Greek history. The Classical city remains unexcavated, although traces of its fortifications survive, extending for some 4 km. Only a section in the south-west has been published on a contoured plan, along with details of the west gate. The wall forms a series of jogs rather than a continuous straight line, and has square towers, suggesting an early Hellenistic date.

The principal archaeological remains lie outside the city walls, to either side of the road leading up from the plain to the west gate. Most notable is the Sanctuary of Artemis Laphria, on a terrace supported by massive retaining walls. This was approached along a 'sacred way', which led first to a forecourt, where it was flanked by a two-aisled stoa (3rd or 2nd century BC), and then to a propylon, of which little survives. The remains inside the actual sanctuary date back at least to the 7th century BC and include two temples, A and B (see fig.). Temple A (probably early 6th century BC), at the end of the precinct, is the smaller (c. 10.40×15.60 m) and was in the Doric order, probably distyle *in antis*. Offerings found near by suggest that it was dedicated to Dionysos or perhaps Apollo. It is chiefly of interest for its terracotta embellishment, consisting of metopes, a coffered cornice and a decorated sima and tiles, as well as fragments of pedimental sculpture. Temple B, which stands on a large paved platform and was dedicated to Artemis, was first erected in the late 7th century BC, rebuilt in the 6th (B2) and again in the 4th (B3). The plans of the earlier temples are unclear, but both were Doric and again had interesting painted terracotta metopes. The remains of the final temple are rather more substantial, and include some fragments of the superstructure. It was Doric, and measured 13.28×30.63 m on the stylobate with 6 by 13 columns: its plan was apparently altered to make the porch deeper than originally intended. The proportions of the columns are not precisely known but apparently support a date of c. 360 BC. Its waterspouts took the form of hunting dogs' heads, not conventional lions, suiting its dedication to Artemis. It may be by the same architectural school as the temple at nearby Molykrion, although that too is fragmentary.

The road to the west gate is flanked by graves, including the spectacular heroön to its east, an interesting example of a Hellenistic monumental tomb designed to act as a focus for the funerary cult of a prosperous individual. It was constructed for a certain Leon, who was accorded semi-divine status after his death as the New Herakles. The building (37.5×34.4 m; late 2nd century BC) consists of a courtyard with a Doric peristyle flanked by rooms on its east, south and north sides. The single room to the south is long and narrow, while the central rooms on the east and north sides are open with complex Ionic columns *in antis*. In the north-west corner is a room with a cement floor and supports for benches against its walls, probably used for formal meals. The central room on the north side also had benches; its walls bore roundels with high-relief busts of gods and heroes. Behind it is a projecting exedra with massive side walls, presumably designed to support a vault; it probably contained statues of Leon and his wife. Directly beneath it is the vaulted funerary chamber, approached by an angled staircase. This had stone doors like those of similar Macedonian vaulted tombs and contained two sarcophagi carved to resemble couches.

Kalydon, Temple A and Temple B3, probably early 6th century BC and 4th century BC

Clearly the commemorative cult comprised an annual celebratory meal, part of which was offered to the dead couple in the exedra above their tomb. A similar monument is located near by.

BIBLIOGRAPHY

E. Dyggve, F. Poulsen, and K. Rhomaios: *Das Heroon von Kalydon* (Copenhagen, 1934)

E. Dyggve: *Das Laphrion: Der Tempelbezirk von Kalydon* (Copenhagen, 1948)

——: 'A Second Heroon at Kalydon', *Studies Presented to David M. Robinson* (St Louis, 1951), pp. 360–64

K. A. Rhomaios: *Keramoi tēs Kalydonos* [Terracottas from Kalydon] (Athens, 1951)

H. Knell: 'Der Artemis Tempel in Kalydon und der Poseidon Tempel in Molykreion', *Archäol. Anz.* (1973), pp. 448–61

R. Hope-Simpson: *A Gazetteer of Aegean Civilisation in the Bronze Age*, i (Göteborg, 1979), p. 103

R. A. TOMLINSON

Kalyx krater. *See* CALYX KRATER.

Kamakura. Japanese city in southern Kanagawa Prefecture. It is located at the head of the Miura Peninsula, along the lower course of the River Nameri, and is bordered on the south by Sagami Bay.

1. Urban development and art life. 2. Buildings.

1. URBAN DEVELOPMENT AND ART LIFE. The city centre comprises an area of flat land near the river. To the north, east and west are thickly forested hills transected by numerous ravines (*yato*), many of which are occupied by Zen temples. The name Kamakura is believed to derive from this topography, which is likened to a kiln (*kamado*). The city is divided into 31 neighbourhoods, many of which originated in the KAMAKURA PERIOD (1185–1333), when Kamakura was the national capital. From the 13th to the 15th century Kamakura ranked with NARA and Heian (now KYOTO) as an urban centre and as a political and cultural seat. Unlike Nara and Heian, however, Kamakura was developed and administered as a capital by military leaders, namely, the heads of the Minamoto, Hōjō and ASHIKAGA families. During the 13th century Kamakura was the seat of the shogunate (*bakufu*) formed by Minamoto no Yoritomo (1147–99) in 1180. In the 14th and

15th centuries, the city flourished as the regional seat of Ashikaga government. Much of its significance lies in its role as a centre for the development of a medieval military high culture, preserved in the numerous Buddhist temples, such as Kenchōji (*see* §2 (i) below) and Engakuji (*see* §2(ii) below), and Shinto shrines, such as the Tsurugaoka Hachimangū (Hachiman Shrine), with which the city is so richly endowed.

(i) Before 1222. (ii) 1222–1333. (iii) After 1333.

(i) Before 1222. Archaeological investigations show that the Kamakura site was settled as early as the Jōmon period (*c.* 10,000–*c.* 300 BC). Historical sources indicate that by the 8th century AD Kamakura existed as a village in Kamakura District, Sagami Province. In 801 Tatsumi Jinja (Tatsumi Shrine, Ōgigayatsu) is believed to have been founded by the legendary warrior Sakanoue no Tamuramaro (758–811), and in 1104 Egara Jinja (Egara Shrine, Nikaidō) was established. The Egara Shrine later enjoyed the patronage of Yoritomo and his Hōjō and Ashikaga successors. The Tendai-sect temple Sugimotodera (Nikaidō) is believed to have been founded in 734, possibly by Gyōki (668–749), an itinerant monk from Nara, and is the oldest temple in Kamakura.

By the late Heian period (794–1185) Kamakura was the regional seat of the Kawachi Genji, the Kawachi lineage of the Minamoto family, whose mansions were built in and around what is now Ōgigayatsu. In 1063 Yoriyoshi (995–1082), victorious in a war against a rival in Mutsu Province (now Aomori Prefect.), gratefully brought Hachiman, tutelary god of the Kawachi Genji, from the Iwashimizu Hachiman Shrine in Yamashiro Province (now Kyoto Prefect.) to Tsurugaoka Wakamiya, the 'junior' shrine he had constructed for the deity in the Yuigahama neighbourhood of Kamakura.

Historical sources indicate that Yoritomo was based at Kamakura from 1177. In 1180, with his shogunate complex at Ōzō (now Nikaidō), Yoritomo moved Tsurugaoka Wakamiya from Yuigahama to a site near his headquarters. The relocated shrine (now in Yukinoshita) became the heart of Kamakura, and the city was subsequently built around it in a fan-like layout, with Tsurugaoka the pivot. In 1182 Yoritomo ordered construction of a main thoroughfare, called Wakamiya Ōji, which ran north, through three *torii* (post-and-lintel gates), from Yuigahama to the shrine; intersecting avenues were also laid out. The shrine complex burnt down in 1191 but was promptly rebuilt and thereafter was known by the title Tsurugaoka Hachimangū (Hachiman Shrine).

Yoritomo and his relatives also commissioned a number of temples in Kamakura, mostly in what are now the Jōmyōji and Nikaidō neighbourhoods. In 1184 Yoritomo commissioned the Shōchōjuin (in Jōmyōji) as a memorial to his father Yoshitomo (1123–60); it was consecrated in 1185. Although nothing survives of the building, records state that it was a Tendai-sect temple with an *Amidadō* (hall for the worship of the Buddha Amida; Skt Amitabha) as its principal structure. In 1188 the Shingon-sect Jōmyōji was built by Ashikaga Yoshikane (*d* 1199) and Taikō Gyōyū (*d* 1241), a Shingon monk. In the 13th century Jōmyōji became a Rinzai-sect temple, which it has remained. In 1191 Yoritomo, impressed by the immense,

two-storey *Amidadō* called Daichōjuin that he had seen at Chūsonji in Hiraizumi (*see* HIRAIZUMI, §2(i)), built the temple Yōfukuji (in Nikaidō) in imitation of that hall. Only the bare outlines of the temple's pond survive. In 1200 Yoritomo's wife Hōjō Masako (1157–1225) and the Rinzai monk Myōan Eisai (Yōsai; 1141–1215) founded the temple Jufukuji in Ōgigayatsu, on the site of Yoshitomo's 12th-century villa.

It is deduced from historical sources that Yoritomo, Masako and other sponsors invited artists to Kamakura to work on temple projects. For example, the Nara-school sculptor Seichō (*d* ?1194) arrived in Kamakura in 1185, at Yoritomo's request, to work at Shōchōjuin, for which he sculpted the *honzon* (principal object of worship). The Kyoto painter Fujiwara no Tamehisa (*fl* 12th century), a member of the TAKUMA school (*see also* JAPAN, §VI, 3(i)), was commissioned by Yoritomo to render the interior wall paintings at the Shōchōjuin *Amidadō*. Although Tamehisa quickly returned to Kyoto, Seichō apparently settled in Kamakura; his descendants are believed to have long served the city's warrior houses and its temples.

(ii) 1222–1333. After 1222, with the Hōjō shogunal regency firmly entrenched and the shogunate complex relocated to Utsunomiya (now in Yukinoshita), Kamakura entered a period of florescence. Under the Hōjō it was developed more fully as a commercial centre and as a port geared towards trade with the Asian continent. A community of merchants grew up in the central and coastal sections of Kamakura, while the warrior families increasingly moved their residences into the hilly sections bordering this business district. The Hōjō regents built their own mansions almost exclusively in the Yamanouchi neighbourhood.

Although Yoritomo and Masako had patronized Zen (Chin. Chan) Buddhist monks, notably Eisai and his disciple Gyōyū, the Hōjō regents Tokiyori (1227–63), Tokimune (1251–84) and Sadatoki (1271–1311) were still more enthusiastic in soliciting the support of Zen masters, cultivating them as personal mentors, building monasteries for them and generally promoting Zen culture among the warrior aristocracy. They also sponsored a number of Chinese monks of the Linji (Jap. Rinzai) sect of Zen and brought them to Japan; it is not surprising, therefore, that Kamakura emerged as a national Zen centre with strong ties to Chinese Buddhist culture of the Song (960–1279) and early Yuan (1279–1368) periods.

Near their residences in Yamanouchi the Hōjō regents built, during the 13th century, a cluster of temples for their Rinzai teachers. Most of these temples have survived, albeit in reconstructed form. Nearly all were based originally on the architecture and ground plans of the great Zen monastic complexes of Jingshan si and Tiantongshan si in Hangzhou, China. There is evidence that architects may have been among those accompanying the Zen masters settling in Japan; the Hōjō regents also dispatched Japanese artists to China for study and training. As the Yamanouchi monasteries were built and flourished, lineages of architects and other craftsmen apparently developed.

Six major Zen establishments were built in Ōfuna and Yamanouchi during the 13th century. In 1237 Yasutoki

(1183–1242) began work on Jōrakuji; the project was completed by his son Nagatoki (1229–64) in 1243 and the monk Lanxi Daolong (RANKEI DŌRYŪ) took up residence there in 1246. Between 1268 and 1269 Zenkōji was founded by Tokimune and Lanxi. In 1282 Tokimune consecrated Engakuji, and in 1283 Tokimune's son Munemasa (*fl* 13th century) dedicated Jōchiji. In 1285 the Rinzai convent Tōkeiji was founded; Tokimune's wife, Kakusan Shidō (*fl* 13th century), became the founding abbess (*kaisan*) and Sadatoki the lay founder (*kaiki*).

Despite the strength of Rinzai influence under the Hōjō regency, Kamakura was not exclusively a Zen enclave. Monks of the Esoteric Buddhist Shingon (*mikkyō*) and Jōdo (Pure Land) sects were welcomed and often sponsored by Hōjō leaders. Even Nichiren (1222–82), notorious for his anti-Zen jeremiads, was allowed to proselytize vigorously in Kamakura. A number of important Shingon, Jōdo and Nichiren temples were constructed in the city, most of the latter in the business district.

Of the Shingon-sect temples, Kakuonji, Myōōin and Gokurakuji (all extant) were influential. Kakuonji was first built in Nikaidō by Hōjō Yoshitoki (1163–1224) in 1218; in 1296 it was expanded to its present size by Sadatoki. Myōōin, in nearby Jūniso, was built in 1235 by Fujiwara no Yoritsune (1218–56), a Hōjō retainer, and flourished as the seat of Shingon ritual for the shogunate. Gokurakuji, in the western section of Kamakura (now called Gokurakuji), was first founded by Hōjō Shigetoki (1198–1261) and later more fully developed by his son Nagatoki (1230–64) and the monk Ninshō (1217–1303).

Of the Jōdo-sect temples, Kōmyōji and Jōkōmyōji are noteworthy. Kōmyōji, in Zaimokuza, was founded in 1240 by Hōjō Tsunetoki (1214–46) and the monk Ryōchū (1198–1287). It was later much patronized by the Hōjō, Ashikaga and Tokugawa houses and is well-known for its collection of paintings, in particular the 13th-century illustrated handscroll entitled *Taima mandara engi* ('History of the Taima *maṇḍala*'). Jōkōmyōji, in Ōgigayatsu, was founded *c.* 1251 by Nagatoki. It eventually evolved into a 'four-sect' (*shishū kengaku*) complex for the study of Shingon, Ritsu, Zen and Jōdo doctrine. During the 14th century Jōkōmyōji was the memorial temple of the Ashikaga shogunal deputies in Kamakura.

Another example of the influence of Jōdo teachings in Kamakura under the Hōjō regents was the *Daibutsu* (Great Buddha) of Hase in Kamakura. Administered by the Jōdo-sect temple Kōtokuin, this monumental bronze sculpture of Amida is 11.36 m high. The original *Daibutsu* was apparently a wooden sculpture *c.* 24 m high, commissioned in 1238 at the behest of the shogunate by a monk called Jōkō (*fl* 13th century) at Fukasawa, the Hōjō enclave in Hase. It seems to have been conceived in imitation of the *Daibutsu* at Tōdaiji (*see* NARA, §III, 4). In 1241 a *Daibutsuden* (Great Buddha hall) was built over it, and in 1243 the image was formally consecrated. In 1252, under the Hōjō regent Tokiyori, a bronze cast of the *Daibutsu* was made from the earlier wooden figure. The sculpture has stood in the open since at least 1495, when the *Daibutsuden* was destroyed by a *tsunami* (a very high sea wave).

Myōhonji in Komachi and Ankokuronji in Ōmachi were among the major early temples of the local Nichiren sect, which garnered a significant lay following among the commoners of Kamakura's low-lying coastal areas. Myōhonji was founded in 1260 by the monk Nichirō (1242–1320) on the site where Nichiren first preached in Kamakura. It is noted for its collection of Buddhist paintings and sculptures. Ankokuronji was constructed in 1274 on the site of the hall where Nichiren first developed the *daimoku* (the practice of chanting a phrase affirming devotion to the Lotus Sutra) and wrote his polemic against the Jōdo movement, *Risshō ankokuron* ('A treatise on pacifying the state by establishing orthodoxy'; 1260), a copy of which is preserved at the temple.

Virtually nothing is known about the studios of sculptors, painters and other artists that must have existed either at the principal monasteries of Kamakura or in the city. It is probable that the larger Zen establishments maintained their own studios for the talented monks, who made the portrait paintings and sculptures (*chinsō*), ink paintings and calligraphy displayed in monastery halls. Certainly many Zen masters, such as Yishan Yining (Issan Ichinei; 1247–1317) at Kenchōji and Engakuji, were themselves noted calligraphers and connoisseurs of painting. At least one Kamakura workshop is known to have developed a unique technique in sculpture called *domon* ('motifs in clay'), in which floral and other designs were formed in clay or clay-like substances and glued to wooden sculptures, which were then covered in gold leaf. An example of this technique is preserved in the late 13th-century *Amida Triad* (*Amida sanzon*) at Jōkōmyōji.

(iii) After 1333. After 1333 the shogunate was relocated to Kyoto, but Kamakura continued to flourish as a regional capital under the hegemony of the Ashikaga, whose shogunal deputies were posted there. It was in this period that the *gozan* ('five mountains') monastic network of Zen schools, initiated at Kenchōji by Hōjō Tokiyori, was fully articulated on a national basis. The system was borrowed from Song-period China, where large monasteries were built on five sacred mountains (*wu shan*). Five endowed temples in Kyoto and in Kamakura dominated the hierarchy. Kamakura's 'five mountains' were Kenchōji, Engakuji, Jufukuji, Jōchiji and Jōmyōji, each of which enjoyed Ashikaga patronage.

As well as the Ashikaga deputies and their relatives, the Uesugi house and to some extent that of the Nikaidō contributed actively to the continued development of Kamakura as a Buddhist cultural centre, sponsoring a number of Rinzai temples. In 1327 Zuisenji was founded in Nikaidō by Nikaidō Michimori (*fl* early 14th century), with MUSŌ SŌSEKI as its founding abbot (*kaisan*). It was expanded under Ashikaga Motouji (1340–67). It is noted for its garden, designed by Musō, and for a 14th-century portrait sculpture of the patriarch. Hōkokuji, in Jōmyōji, was founded *c.* 1334 by Uesugi Shigekane (*fl* 14th century). Uesugi Norikata (1335–94) founded Meigetsuin in Yamanouchi in the mid-14th century. This temple flourished throughout the Edo period (1600–1868) through its connection with the Uesugi family and then the Hōjō family of Odawara. It houses a celebrated 13th-century portrait sculpture of an Uesugi patriarch, Shigefusa (*fl* 13th century).

Other sects continued to be represented in Kamakura in the 14th century, despite the strength of its Zen

institutions. The Tendai-sect Hōkaiji in Komachi was founded in 1352 by Ashikaga Takauji (1305–58) on the site of an old Hōjō mansion. It is believed that Takauji thus honoured a command issued by his erstwhile ally Emperor GoDaigo (*reg* 1318–39) to erect a memorial to the vanquished Hōjō family. Nitta Yoshisada (1301–38) founded a Jōdo-sect temple, Kuhonji, in Zaimokuza early in the 14th century. Many Nichiren-sect temples were founded in the early 15th century, such as Honkakuji in Komachi, which was built in 1436.

With the disintegration of the Ashikaga hegemony, Kamakura's history as a capital came to an end. In 1455 Imagawa Noritada (*b* 1408) and his army attacked the city and most of Kamakura's temples were either wholly destroyed or left in ruins. Bereft of its administrative and cultural apparatus, Kamakura quickly declined into a provincial town. During the Edo period the Mito branch of the Tokugawa family was active in redeveloping the city, rebuilding many of its temples, which have flourished into the modern era.

BIBLIOGRAPHY

Azuma Kagami [Mirror of the East] (late 13th century); mod. trans., 8 vols (Tokyo, 1926) [Jap. and *kandun* text]
Kamakura shishi [A history of Kamakura], Kamakura Shishi Hensan Iinkai (Tokyo, 1956–9)
Y. Watanabe: *Kamakura* (Tokyo, 1963)
S. Kawazoe: *Kamakura bunka* [The culture of Kamakura] (Tokyo, 1978)
M. Collcutt: *Five Mountains: The Rinzai Zen Monastic Institution in Medieval Japan* (Cambridge, MA, and London, 1981)

MIMI HALL YIENGPRUKSAWAN

2. BUILDINGS.

(i) Kenchōji. (ii) Engakuji.

(i) Kenchōji. This was the first temple in Japan implicitly recognized as belonging to Zen as an independent branch of Japanese Buddhism. It became head temple of the Kenchōji branch of the Rinzai sect, an important Japanese Zen sect. It was also the first to be built in the 'Chinese style' (*Karayō*) that was to characterize much of subsequent Japanese Zen temple architecture. During the Kamakura

Kamakura, Kenchōji, Zen Buddhist temple, Triple or Mountain Gate (Sanmon), 1251–3

(1185–1333) and Muromachi (1333–1568) periods, the temple was central to the Kamakura area system of Zen monasteries known as *gozan* ('five mountains'; see §1(iii) above). Kenchōji continued to play a significant role in the Edo period (1600–1868). It remains one of the most important modern Zen centres, attracting many visitors.

Kenchōji was first built in 1251–3 under the patronage of Hōjō Tokiyori (1227–63), the fifth shogun of the Kamakura period and the first Hōjō regent to show an interest in Zen Buddhism and culture. Tokiyori's patronage arose out of his efforts to build the regional military garrison and recently established political centre of Kamakura into a rival to Kyoto, the imperial capital and a venerable centre of Japanese culture. After selecting a former execution ground as the site, Tokiyori requested assistance in designing the temple from the Chinese Zen monk Lanxi Daolong (RANKEI DŌRYŪ), the first Chinese Zen master of the Rinzai (Chin. Linji) sect to come to Japan in the Kamakura period. Lanxi was to be the founding abbot (*kaisan*) of Kenchōji.

The plan of Kenchōji was based on that of the large Chinese metropolitan monasteries, such as that of Tiantongshan. This design is known from what is believed to be a copy (1331; Kamakura, Kenchōji) of an earlier drawing of the temple complex. The original plan included a series of gates and buildings ascending the gently sloping mountain and aligned roughly south–north, from the Triple or Mountain Gate (Sanmon; see fig.), to the Buddha Hall (Butsuden), Dharma or Lecture Hall (*hattō*) and abbot's quarters (*hōjō*). The Buddha Hall and Dharma Hall were both two-storey, the upper halls apparently being used for devotional purposes. Other, functional buildings were also placed symmetrically alongside this central axis, including a dining hall with administrative offices, a bathhouse, a latrine and—perhaps the most distinctive Zen building—the monks' hall (*sōdō*), where the practising monks meditated, ate and slept. Unlike earlier Japanese Zen temples, Kenchōji provided no buildings for devotional or ritual practices from the rival Shingon and Tendai Buddhist sects. Kenchōji became the model for the construction and rebuilding of other Japanese Zen temple complexes, including the important temples Tōfukuji and Tenryūji in Kyoto. It expanded greatly during its height of influence between the 14th and 16th centuries, when it included more than 50 subtemples (*tatchū*), but by the Edo period their number had dwindled to ten or so.

Much or all of the temple was destroyed by fire in 1293, 1315 and 1414, as well as in a hurricane in 1540, as a result of which the plan changed over the centuries. The temple bell (2.09×1.24 m at base; National Treasure), believed to have been cast in 1255, is one important object surviving the original buildings; it was cast in a Heian-period (794–1185) style and is decorated with lotus and flying cloud patterns and a verse by Lanxi. The modern temple layout includes a Buddha Hall (Butsuden) and Mountain Gate (Sanmon), both designated Important Cultural Property, which were moved to their present location in 1647 by the third Tokugawa shogun Iemitsu (1604–51), while the kitchen quarters and administrative centre have been rebuilt along the central axis. Little remains of the other original flanking buildings. One of the most important

additions to the original plan was a complex of buildings to the south-east of the Buddha Hall honouring Lanxi and his younger contemporary, the Song-period (960–1279) Chinese monk Wuxue Zuyuan (Mugaku Sōgen; 1226–86), who also served as abbot of Kenchōji. This complex includes the oldest extant building presently on the temple grounds, the Worship or Main Hall (Shōdō; 1458; Important Cultural Property), which was substantially restored after being damaged in the Great Kantō Earthquake of 1923.

Among the important art works belonging to the temple are two that are designated National Treasures: a *chinsō* portrait of Lanxi (1048×464 mm) in monochrome ink and light colour on silk (Kamakura, N. Treasure House) and two scrolls (851×415 mm and 848×409 mm) of monochrome ink calligraphy by Lanxi (Kamakura, N. Treasure House). Also notable are Lanxi's tomb (Kamakura, Kenchōji); an unusual standing *chinsō* portrait entitled *Walking Figure of Lanxi Daolong* (909×387 mm; Kamakura, Kenchōji); and a number of devotional paintings, calligraphies and documents (all Important Cultural Properties; *see* JAPAN, §§VI, 3(i), VII, 2(i) and (iv)).

BIBLIOGRAPHY

H. Ōta: *Chūsei no kenchiku* [Architecture of the Middle Ages] (Tokyo, 1957)
Y. Fujimoto, J. Ōsaragi and T. Fukuyama: *Kenchōji, Engakuji* (1961), xii of *Nihon no tera* [Temples of Japan] (Tokyo, 1958–61)
J. Ogisu: *Nihon chūsei Zenshūshi* [A history of medieval Japanese Zen] (Tokyo, 1965)
T. Nuki and others: *Kenchōji* (Kamakura, 1973)
M. Collcutt: *Five Mountains: The Rinzai Zen Monastic Institution in Medieval Japan* (Cambridge, MA, and London, 1981)

JOSEPH D. PARKER

(ii) Engakuji [Enkakuji, Enkakuji Kōshō Zenji, Zuirokusan]. This Buddhist temple occupies *c.* 6 ha of the hilly Yamanouchi section of Kamakura. It is the head temple of the Engakuji school of the Rinzai sect of Zen Buddhism and ranks second after Kenchōji (*see* §(i) above) in the Kamakura *gozan* hierarchy of Zen monasteries (*see* §1 above). Engakuji was built and flourished in a period when Zen Buddhist monks from Song-period (960–1279) China were settling in Japan, to be welcomed enthusiastically by the warrior aristocracy (*see* §1 above).

As early as 1278 the Hōjō regent Tokimune (1251–84) had worked out a preliminary layout for the temple and chosen its site near his own residence. The celebrated Chinese monk Lanxi Daolong (RANKEI DŌRYŪ), who died before the project was realized, was to have been founding abbot (*kaisan*), which title fell to another Chinese monk, Wuxue Zuyuan (Mugaku Sōgen; 1226–86), whose assistance Tokimune sought in 1281. The name Engakuji was apparently coined when a copy of the widely chanted Zen *sūtra Engakukyō* (Chin. *Yuanjue jing*) was retrieved from a stone receptacle unearthed at the site.

Wuxue's dedicatory sermon at Engakuji's consecration in 1282 boded well for the monastery. Legend has it that white deer gathered among the surrounding trees to listen, so erudite were his words. The temple's *sangō* (mountain name) is a reference to this event. In 1283 Tokimune named Engakuji an invocatory temple for the shogunate, which amounted to a national endowment. On Tokimune's death, the subtemple (*tatchū*) Butsunichian was constructed within Engakuji's precincts as his mausoleum,

and the temple also took on a role as the *bodaiji* (memorial temple; literally, 'Nirvana temple', from Skt *bodhi*) of the Hōjō house. Nevertheless, it remained one of the most important Rinzai establishments of its day. The celebrated Zen master and connoisseur Yishan Yining (Issan Ichinei; 1274–1317) was abbot from 1299 and attracted scores of students, among them MUSŌ SŌSEKI.

Engakuji continued to flourish after 1333, with the fall of the Hōjō family and the consolidation of the Ashikaga hegemony. In particular it enjoyed the patronage of the Ashikaga leaders who served as shogunal deputies in Kamakura. By 1386 it was secure in its position within the *gozan* system and was one of the largest Zen complexes in Japan. However, a series of damaging fires during the 15th and 16th centuries and a decline in patronage under the Odawara Hōjō led to difficulties for Engakuji in the early part of the Edo period (1600–1868). Under the sponsorship of the Tokugawa family of the Mito domain (now part of Ibaraki Prefect.), much of Engakuji was reconstructed in the first half of the Edo period, only to be destroyed in a violent earthquake in 1703. A further rebuilding lasted until 1923, when the temple was once again levelled by the Great Kantō Earthquake. The present temple is almost wholly a modern reconstruction.

Of the original 13th-century temple nothing survives, but historical sources indicate that its plan was typical of a Song-period Zen temple and that it was modelled on one of the high-ranking Chinese temples in HANGZHOU, probably Jingshan si. The formal approach to Engakuji was via its main gate, the Sanmon (Triple or Mountain Gate), which opened on to a tree-lined path leading north to the Buddha Hall (Butsuden). To the east of the Buddha Hall was a building containing the kitchen and office (*kuin*), to the west, the monks' quarters (*sōdō*). Directly north of the Buddha Hall were the Dharma or Lecture Hall (*hattō*) and the abbot's quarters (*hōjō*). The Buddha Hall and the monks' quarters had been completed by the time the temple was consecrated in 1282. The remainder of the complex was probably finished around 1284. A Buddhist reliquary hall (*shariden*), brought from Daijiji (now in the Jūniso neighbourhood of Karakura), was added in 1285.

The principal structure for which Engakuji is now noted is a Buddhist reliquary hall called Shōzokuin, which belonged initially to the convent–temple Taiheiji, some distance to the north. It is a one-storey building of 3×3 bays in the *irimoya zukuri* ('hip-and-gable roof construction') format, with a surrounding *mokoshi* (lean-to pentroof construction). The main roof is thatched (*kaya buki*), that of the *mokoshi* shingled (*kokera buki*). The date of the reliquary hall is uncertain, as is its date of removal to Engakuji. Most scholars hold that the present structure is the second, perhaps even the third, reconstruction of a 13th-century hall. The building is generally recognized as one of the purest examples of 'Chinese-style' (*Karayō*) Zen architecture of the Muromachi period (1333–1568). Representative features include pillars with smartly tapering ends (*chimaki*); a heavy masonry floor (*sōban*); ogee-arched windows (*katōmado*); a complex and showy bracketing system; the fan-shaped rafters (*ōgidaruki*) of the eaves and especially the brisk upward curvature and incised or moulded ornamentation (*kurigata*) of the end-pieces

(*kibana*) of head tie-beams (*kashiranuki*) and floor-plates (*daiwa*). The 'shrimp-shaped' rainbow beams (*ebi kōryō*) of the *mokoshi* are also typical of this style. The interior of the Buddhist reliquary hall is noted for its reverse view of an elaborate 'cosmetic roof' (*keshōyane*) construction.

BIBLIOGRAPHY

Kamakura shishi [A history of Kamakura], Kamakura Shishi Hensan Iinkai (Tokyo, 1956–9)

Y. Fujimoto, J. Ōsaragi and T. Fukuyama: *Kenchōji, Engakuji* (1961), vi of *Nihon no tera* [Temples of Japan] (Tokyo, 1958–61)

M. Collcutt: *Five Mountains: The Rinzai Zen Monastic Institution in Medieval Japan* (Cambridge, MA, and London, 1981)

MIMI HALL YIENGPRUKSAWAN

Kamakura period. Period in Japanese history, 1185–1333 (*see also* JAPAN, §I, 2). It began with the rout by the forces of the Minamoto (Genji) clan of the Taira (Heike) in the sea battle at Dannoura. Thus ended the five-year Taira–Minamoto or Genpei War and 30 years of bitter rivalry. The Minamoto established the first of the military governments that were to rule Japan until 1868 (*see also* EDO PERIOD), moving the political capital from the imperial seat of Heian (modern Kyoto; *see also* HEIAN PERIOD) to their headquarters in the eastern province of Kamakura, near Edo (now Tokyo). During the Kamakura period, the Minamoto, and later their relatives the Hōjō as shogunal regents (*shikken*), ruled virtually unopposed, until they were abruptly overthrown and imperial rule briefly restored. The values and practices of the increasingly powerful warrior class began to permeate culture and society in general, supplanting the aesthetic, courtly tastes of the sheltered Heian nobility.

The ravages of war, frequent natural disasters and finally the two Mongol invasions of 1274 and 1281 were seen by scholars and priests as overwhelming evidence that the world had entered the period of *mappō* (the end of Buddhist law). As the nexus between Buddhism and the aristocracy was severed, new populist sects of Buddhism emerged, which centred on the Amida Buddha (Skt Amitabha) and the Lotus Sutra (*see* BUDDHISM, §III, 10). Charismatic monks travelled the countryside disseminating the promise of salvation for all who devoutly repeated the name of the Amida Buddha, a practice known as *nenbutsu*. The monk Shinran (1173–1263), founder of the Shin Jōdo Shū ('True Pure Land' sect), introduced a revolutionary element into Buddhism by advocating marriage and family life for the clergy. Nichiren (1222–82), founder of the Hokkeshū (Lotus sect), wrote his name using the Chinese characters for Japan and Lotus, thus combining Japanese national sentiment with the teachings of the Lotus Sutra. The popularity of these monks is demonstrated by their representation in the arts of the period. The diminutive wooden sculpture by Kōshō (*fl* early 13th century) of the monk Kūya (AD 903–72) in the Rokuharamitsuji in Kyoto, with its finely modelled features, inset crystalline eyes and six small figures of Amida emerging from the mouth, is a fine example of the genre (*see* JAPAN, §V, 5). At the same time, Zen (Chin. Chan) Buddhism was reintroduced from China and flourished among the warrior class and in artistic and scholarly circles. Zen monks acted as a channel for the transmission of Chinese literati culture and were responsible for the development in Japan of ink painting (Jap. *suibokuga*, Chin. *shuimohua*; *see* JAPAN, §VI, 3). Zen

temples were constructed in the *Karayō* (Chinese) style (*see* JAPAN, §III, 4(i)), based on architecture of the Southern Song period (1127–1279).

The direct appeal of religious teachings was reflected in styles of literature, painting and sculpture. Military tales (*gunki monogatari*), such as the narrative of the Genpei War, the *Heike monogatari* ('The tale of the Heike'), embodied the knightly values and Buddhist sensibility characteristic of this age. The two great adversaries of the clan wars, Taira no Kiyomori (1118–81) and Minamoto no Yoritomo (1147–99), are commemorated in Japan's earliest secular portrait art, called *nisee*, or likeness painting (*see* JAPAN, §VI, 3(iii)(f)). A distinctly Japanese art form was *emakimono*, visual story-telling in the form of narrative picture scrolls (*see* JAPAN, §VI, 3(i) and (iii)(d)). Of some 400 known to have been produced between the 12th and 14th centuries, about 100 are extant, covering religious and secular, historical and imaginary subjects. They include the *Jigoku-zōshi* ('Scrolls of hell'), which warn the errant Buddhist of the various hells awaiting him in his afterlife (Tokyo, N. Mus.; Nara, N. Mus.), and the 12 scrolls of the *Ippen shōnin eden* ('Pictorial biography of the monk Ippen'), a record of the travels of Ippen (1239–89), founder of the Ji ('Time') sect of Pure Land Buddhism, which constitute a unique source of information on the customs and habits of the 12th-century Japanese (Kyoto, Kankoji; Kyoto, N. Mus.). The art of visual story-telling was perfected in the scroll of the *Heiji monogatari* ('The tale of the Heiji disturbance'), in which several stages of a *coup d'état* unfold in a single continuous narrative scene. With the rebuilding of temples in Nara in the aftermath of the Genpei War, monumental religious sculpture reached a climax of expressive energy under the direction of the KEI school of sculptors, who further developed the innovative sculptural techniques in wood inaugurated by JŌCHŌ in the mid-11th century. Distinctive Japanese styles of ceramics were created and the ascendancy of the warrior class ensured that the production of arms and armour became an important branch of applied art.

BIBLIOGRAPHY

H. Mori: *Unkei to Kamakura chōkoku* [Unkei and the sculpture of the Kamakura period], Nihon no bijutsu [Arts of Japan], xi (Tokyo, 1964); Eng. trans. by K. Eickmann as *Sculpture of the Kamakura Period*, Heibonsha Surv. Jap. A., xi (New York and Tokyo, 1974)

H. Okudaira: *Emakimono*, Nihon no bijutsu [Arts of Japan], ii (Tokyo, 1966); Eng. trans. by E. ten Grotenhuis as *Narrative Picture Scrolls*, Arts of Japan, v (Tokyo, 1973)

Emaki: Narrative Scrolls from Japan (exh. cat., ed. M. Murase; New York, Asia Soc. Gals, 1983)

H. Varley: *Japanese Culture* (Honolulu, 1984)

BONNIE ABIKO

Kamal al-Din Bihzad. *See* BIHZAD.

Kamāl al-Mulk. *See* GHAFFARI, (3).

Kamalapuram. *See under* HAMPI, §4.

Kamares. Minoan sacred cave in central Crete, which flourished *c.* 2050–*c.* 1650 BC. Situated at the west end of the Mesara Plain, beneath the eastern summit of a twin-peaked mountain on the south flank of the Ida massif, around 1700 m above sea-level, the Kamares cave is impressive and remote, and the vast arch of its entrance is

visible even from the plain, especially against the snows of winter. It was explored by Antonio Taramelli in 1904 and more extensively by Richard MacGillivray Dawkins in 1913.

The cave descends quite steeply for some 100 m, forming two main chambers; some built walls may have supported terraces. No clear focus of worship has been detected: the finds seem scattered without pattern. The earliest material found is Final Neolithic (*c.* 4000–*c.* 3500/3000 BC), although whether this represents habitation or is the result of some religious impulse is undetermined; the same may be true for the scanty Pre-Palatial ceramics from Early Minoan (EM) to Middle Minoan (MM) I (*c.* 3500/3000–*c.* 1900 BC). A dramatic increase in activity is witnessed in Proto-Palatial times (later MM I to MM II (*c.* 2000–*c.* 1675 BC)). Only a restricted range of shapes is known from the cave, as opposed to what is available in the settlements, suggesting that its sacred character was established by this time. These forms include two-handled spouted jars, bridge-spouted jars, cups and many coarser vessels: lidded jars, plates, jugs, basins and even small pithoi. Most of these were clearly receptacles for liquids, although some evidence exists for offerings of cereals too. The quality of the finest ware has given the name Kamares to the whole class of pottery, characterized by a black lustrous ground on which elaborate and often repeating patterns in white, red, orange and yellow are picked out, sometimes with barbotine ornament (*see also* MINOAN, §III, 4(ii)). Metal and other non-ceramic votives are absent: even allowing for some loss by looting, this bias is probably significant.

The reduced quantity of material from the Neo-Palatial period (MM III to Late Minoan (LM) I (*c.* 1675–*c.* 1425 BC)) suggests a decline in the cave's status, and, although a few pieces datable to LM II and IIIA: 1 (*c.* 1425–*c.* 1360 BC) are attested, no later Minoan artefacts have been found, despite the existence of a LM IIIA–C (*c.* 1390–*c.* 1050 BC) settlement and tombs near the modern village of Kamares.

BIBLIOGRAPHY

R. M. Dawkins and M. L. W. Laistner: 'The Excavation of the Kamares Cave in Crete', *Annu. Brit. Sch. Athens*, xix (1912–13), pp. 1–34
S. G. Spanakis, ed.: *Kentriki-anatoliki* [Central and eastern] (1964), i of *I Kriti* [Crete] (Herakleion, 1964–73), pp. 292–7
G. Walberg: *Kamares: A Study of the Character of Palatial Middle Minoan Pottery* (Uppsala, 1976)

D. EVELY

Kambara, Tai. *See* KANBARA, TAI.

Kameda Bōsai [Kameda Chōkō; Kameda Hōsai] (*b* Edo [now Tokyo], 1752; *d* Edo, 1826). Japanese painter, poet, calligrapher and book illustrator. The son of an Edo merchant, he studied calligraphy from a very early age under the noted Chinese-style calligrapher Mitsui Shinna (1700–82). He also received a Confucian education, unusual at that time for a merchant's son. From about 1765 to 1774 Bōsai trained under Inoue Kinga (1732–84), an influential Confucian scholar of eclectic doctrines as well as a painter and calligrapher, at the Seijūkan, a private academy near Yokohama. Bōsai opened a Confucian academy in Edo in 1774. In 1790, however, the Tokugawa shogunate issued an edict aimed at curtailing the popularity

of such schools as Bōsai's, where students were encouraged to develop their own moral philosophy rather than accept the government-sponsored Confucianism of the Chinese Song-period (AD 960–1279) philosopher Zhu Xi. Bōsai gradually lost his pupils and in 1797 closed his school.

Bōsai's artistic activity increased from 1799 to 1812, in part because he returned the hospitality of those who welcomed him into their homes by giving them paintings, poetry and calligraphy. He developed a relaxed style of literati (Jap. *Bunjinga* or *Nanga*; *see* JAPAN, §VI, 4(vi)(d)) landscape painting with strong simple compositions, calligraphic brushwork and an adroit use of light colours, which exhibited the influence of Chinese Ming-period (1368–1644) literati painters and of his teacher, Kinga. Extant examples of his first landscape paintings from this period include hanging scrolls such as *Truly a Dream* (1803; Switzerland, C. and S. Ouwehand priv. col., see 1984 exh. cat., fig. 10). By this time Bōsai's calligraphy, for which he is best known, was well developed. Later in this period his calligraphic style was influenced by the works of his friend the monk–poet Ryōkan. Works such as the pair of six-fold screens, *Eight Immortals of the Wine Cup* (London, priv. col., see 1984 exh. cat., fig. 13), created a flowing style of alternating tension and release in a cursive script that came to be much admired by Japanese literati.

Bōsai returned to Edo in 1812 and belonged in his last 14 years to a circle that included artists such as the literati painter Tani Bunchō and the Rinpa painter Sakai Hōitsu as well as poets, printmakers, actors and scholars. Bōsai was asked to write prefaces for artistic and scholarly books such as the *Kōrin hyakuzu* ('One hundred pictures by Kōrin', pt 1, 1815; London, BM) and to add poetic inscriptions to paintings. In addition, he was besieged by requests for his own painting and calligraphy, which by this time had reached full stylistic maturity. His calligraphy from this time combines the sinuous aesthetic of the Japanese *kana* (phonetic) syllabary with the balanced freedom of Chinese cursive scripts, as in the inscription on the hanging scroll *Gourd* (1820; New Orleans, LA, Man'yōan priv. col., see 1984 exh. cat., fig. 39). His paintings represent the poetic ideal of expressing a personal vision of nature in soft, relaxed brushwork, either in his individual works, such as the landscape designs in the famous literati woodblock-printed book *Kyōchūzan* ('Mountains in my heart', 1816; e.g. London, BM), or in *gassaku* (joint art work) with other artists.

For illustration of his work *see* JAPAN, fig. 131.

BIBLIOGRAPHY

E. Sugimura: *Kameda Bōsai* (Tokyo, 1979)
Bōsai Soc. Newslett. [Lawrence, KS], 1–6 (1979–83)
E. Sugimura: *Kameda Bōsai shibunshogashū* [Collection of paintings and literature of Kameda Bōsai] (Tokyo, 1982)
The World of Kameda Bōsai (exh. cat. by S. Addiss, New Orleans, LA, Mus. A., 1984)

STEPHEN ADDISS

Kamegaoka. Japanese site near Kizukuri, Aomori Prefecture, and the name applied both to a large class of pottery made in northern Japan in the Latest Jōmon period (*c.* 1000–*c.* 300 BC) and to the culture that produced such wares. Referred to in feudal land records as early as 1623,

Kamegaoka was first excavated in 1896, was designated a National Historical Site in 1944 and was systematically excavated in 1950 by Keio University in Tokyo.

The lowest culture layers yielded abundant artefacts, including highly finished small pottery vessels, clay figurines (*dōgu*; *see* JAPAN, §V, 2 and fig. 50), engraved pottery plaques, stone swords and phalli, *magatama* (comma-shaped beads), antler and bone tools and wooden and lacquered objects. The burial of figurines with other artefacts indicates a site of communal ritual activity. The figurines are characterized by 'snow goggle' (*shakōki*) eyes and elaborate headdresses, distinctive features that also appear in figurines found outside the Kamegaoka culture.

The pottery associated with the name Kamegaoka is often burnished, painted with red iron oxide and/or lacquered. It consists mostly of plates, bowls, spouted pots, vases, beakers, incense burners, stemmed cups and bowls. Undecorated ceramics were also excavated at the site. The predominance of utilitarian wares over finely made ceremonial vessels suggests an established social order based on ceremony and status. Pottery from the Latest Jōmon-period cultures is generally classified according to the types found in the shell-mounds of Ōbora in Iwate Prefecture, Tōhoku district; examples of the Ōbora A, B, C1 and C2 types were unearthed at Kamegaoka. The last two stages illustrate the stylistic climax of the Ōbora typology and are represented at Kamegaoka by meticulously finished vessels with low-relief 'cloud scroll', S-shaped and similar exterior decoration, often cord-marked in repeated horizontal bands (*see also* JAPAN, §VIII, 2). Some scholars argue (see Yamanouchi) that such configurations, producing multiple rhythmic patterns, must have had their origins in earlier Jōmon pottery, although few examples to substantiate this view are at present known. The influence of this Kamegaoka style is detected as far south as the Kansai region, in such sites as Kashiwara, Nara Prefecture.

BIBLIOGRAPHY

J. Shimizu: *Kamegaoka iseki* [The remains of Kamegaoka] (Tokyo, 1959)
S. Yamanouchi: 'Monyōtai keitōron' [The typology of decoration bands], *Jōmon shikidoki* [Jōmon earthenware], ed. S. Yamanouchi, I. Kōno and T. Esaka (1964), i of *Nihon genshi bijutsu* [The primitive arts of Japan] (Tokyo, 1964–6)
M. Isozaki: 'Banki no doki' [Pottery of the latest period], *Jōmon shikidoki* [Jōmon earthenware] ed. S. Yamanouchi, I. Kōno and T. Esaka (1964), i of *Nihon genshi bijutsu* [The primitive arts of Japan] (Tokyo, 1964–6)
T. Kobayashi and M. Kamei: *Dōgu, Haniwa* (1977), iii of *Nihon tōji zenshū* [Complete collection of Japanese ceramics], ed. T. Tanikawa (Tokyo, 1975–8)

J. EDWARD KIDDER JR

Kameiros. *See under* RHODES.

Kamejurō. *See* TORII, (6).

Kamekura, Yusaku (*b* Niigata, 6 April 1915). Japanese graphic designer. He studied principles of Constructivism at the Institute of New Architecture and Industrial Arts, Tokyo, a private institute established and run by Renshichiro Kawakita with the aim of introducing Bauhaus design theories in Japan; he graduated in 1935 and in 1938 joined the Nippon Kōbō design studio (now Publishing on Design Inc.). For over a decade from 1937 he worked as art director on a number of Japanese magazines,

including *Nippon* and *Commerce Japan*. In 1951 he participated in the establishment of the Japan Advertising Arts Club, which secured social recognition for the profession of graphic designer. In 1955 he took part in the 'Graphic '55' exhibition, together with Hiromu Hara, Paul Rand and others. Kamekura received an award from the Japan Advertising Arts Club in 1956 for a poster calling for peaceful use of atomic power. He co-founded the Nippon Design Centre (Tokyo) in 1960 with Ikko Tanaka and as its director succeeded in bringing together graphic designers and industry at a period when Japanese business was deeply influenced by Western ideas. He designed posters, books, magazines, corporate symbols, logos, street signs and packaging. His work is distinguished by its dynamic composition, technical expertise and visual inventiveness, making full use of photography, colour and geometric elements. Outside Japan, his best-known designs are his posters for the 1964 Tokyo Olympic Games and for Expo '70 in Osaka. Exhibitions of his work were held at the Museum of Modern Art, New York (1953), and Normandy House, Chicago (1956). He is credited with inventing the term 'corporate identity graphics' to describe the 'visual excellence' he sought to promote. In 1978 he became chairman of the newly founded Japan Graphic Designers Association, which publishes lavishly illustrated books on the work of Japanese graphic designers. For his exhibition 'The Universe of Curved and Straight Lines: Designs by Yusaku Kamekura' he received the 25th Mainichi Arts Award in 1983. A successful teacher, lecturer and writer, he has won many awards for his designs, both in Japan and abroad, and his work is in many public collections (e.g. New York, MOMA; Amsterdam, Stedel. Mus.).

WRITINGS

Trademarks of the Western World (New York and Tokyo, 1956)
ed.: *Paul Rand: His Work from 1946 to 1958* (New York and Tokyo, 1959)
Kamekura Yusaku no dezain/ The Work of Kamekura Yusaku (Tokyo, 1983) [bilingual text]
with H. Kashiwagi: *Graphic Design in Japan*, vii (New York and Tokyo, 1987)
ed.: *C[orporate] I[dentity] Graphics in Japan* (Tokyo, 1988)

BIBLIOGRAPHY

W. Amstutz, ed.: *Who's who in Graphic Art* (Zurich, 1962; rev. Dübendorf, 1982)
P. B. Meggs, ed.: *A History of Graphic Design* (New York, 1983)
A. L. Morgan: *Contemporary Designers* (London, 1985) [with bibliog. and writings list]
Posters/Japan, 1800's–1980's (Nagoya, 1989)

HIROSHI KASHIWAGI

Kamensky, Valentin (Aleksandrovich) (*b* Tula, 29 Sept 1907; *d* 1975). Russian urban planner and architect. He graduated from the Institute of Communal Construction Engineers, Leningrad (now St Petersburg), in 1931. He came to prominence in the 1960s as the director and principal architect of the master plan of 1966 for Leningrad. He was faced with the contradiction between an urgently needed quantitative expansion of housing, and the preservation of the historic centre of the city. His solution, similar to the conclusions of numerous other design teams around the Soviet Union, was the development of fully integrated satellite communities (Rus. *mikrorayon*), beyond the main city. With the architect

Aleksandr Naumov, he proposed a scheme, based on ideas from before World War II, that Leningrad should grow in an organic and coordinated manner away from the existing structural plan towards the shores of the Gulf of Finland and Vasilyevsky Island, where it would terminate in a sea port. This was to result in the construction of new boulevards flanked by extensive areas of high residential blocks, built of prefabricated, mass-produced elements and set in parkland. He also designed the 4000-seat Oktyabr'sky (October) Concert Hall (1967), Ligovsky Prospekt, Leningrad, and the *Monument to the Defenders of Leningrad* (1975; with Mikhail Anikushin and Sergey Speransky) in Victory Square, Leningrad, which both show a heroic and spectacular approach characteristic of Soviet architecture of the 1930s.

BIBLIOGRAPHY

V. A. Kamensky, intro. by I. I. Fomin (Leningrad, 1967)

A. V. Ryabushin and I. V. Shishkina: *Sovetskaya arkhitektura* [Soviet architecture] (Moscow, 1984), pp. 95, 112, 163, 194

A. M. Shuravlev, A. V. Ikonnikov and A. G. Rochegov: *Arkhitektura Sovetskoy Rossii* [The architecture of Soviet Russia] (Moscow, 1987)

A. V. Ikonnikov: *Russian Architecture of the Soviet Period* (Moscow, 1988)

JONATHAN CHARNLEY

Kames, Lord. *See* HOME, HENRY.

Kamid el-Loz [Arab. Kămid al-Lawz; anc. Kumidi]. Site in Lebanon that flourished in the 2nd and 1st millennia BC. Kamid el-Loz is a ruin mound 50 km south-east of Beirut, at the south-eastern end of the Biqaʿ, the broad valley between the Lebanon and Anti-Lebanon ranges. The mound rises 26 m above the surrounding plain and measures 240×300 m. A. Kuschke discovered the site in 1954 and excavated there with R. Hachmann in 1963. Hachmann continued the excavations from 1966 to 1981. Finds are in the Musée National in Beirut.

The site was occupied in Neolithic times (7th–6th millennia BC), and there is evidence of Early and Middle Bronze Age settlements (3rd–2nd millennia BC). The excavators concentrated on six Late Bronze Age levels of the second half of the 2nd millennium BC, when the settlement was fortified and mentioned in the Amarna correspondence (*see* AMARNA, EL-) as Kumidi, the capital of an Egyptian province in Asia at the time of Amenophis III (*reg* c. 1390–c. 1353 BC) and Akhenaten (*reg* c. 1353–c. 1336 BC).

A Middle Bronze Age temple and palace, on either side of a public square, were succeeded respectively by three levels of Late Bronze Age temples and five levels of palaces. Two of these palaces (P4 and P5) had workshops attached, in which bronze and iron tools were produced. Seven letters written in the cuneiform script were found in an archive room in P4; two of them date to the reign of Amenophis III. Two storerooms in the royal quarters of P5 contained much gold and silver-gilt jewellery and other objects, numerous ivory carvings, stone vessels and a large amount of locally produced pottery and ceramics imported from Cyprus and Egypt. In Persian times (5th–4th centuries BC) 94 graves were dug into the Early Bronze Age levels.

BIBLIOGRAPHY

R. Hachmann: *Kamid el-Loz, 1977–81*, Saarbrücker Beiträge zur Altertumskunde, 36 (Bonn, 1986) [incl. complete bibliog.]

R. HACHMANN

Kaminaljuyú. Site of Pre-Columbian MAYA city within the limits of modern Guatemala City. It was a centre of religious, civic and political power in the Middle to Late Pre-Classic (c. 1000 BC–c. AD 250) and Classic (c. AD 250–c. 900) periods and is the largest known Highland Maya city. Occupation dates from the Middle Pre-Classic period (from c. 800 BC) to c. AD 1520. Alfred Maudslay surveyed the site around 1900, and excavations have been conducted by the Carnegie Institution of Washington, DC (1930s), directed by A. V. Kidder, J. D. Jennings and E. M. Shook, and by Pennsylvania State University (1968), directed by W. T. Sanders and J. W. Michels. C. D. Cheek studied the architecture in the 1970s. Pottery and stone sculptures from the site are in the Museo Nacional de Arqueología y Etnología, Guatemala City.

In the Early Pre-Classic period (c. 2000–c. 1000 BC) there was only scattered habitation in the vicinity, but high-quality monochrome and bichrome pottery was produced. In the Middle and Late Pre-Classic periods Kaminaljuyú became a regional centre arranged along avenues of north–south axis, with brightly painted adobe mound groups (more than 300), plain columnar basalt stelae and stelae carved with early hieroglyphs (possibly precursors of Maya script). Rich tombs, comprising stepped, rectangular, log-roofed chambers were built within some platforms. The dead were placed in an extended position on the tomb floors, accompanied by the bodies of male, female and child retainers and grave goods (see fig.). An *incensario* cult using effigy-shaped incense burners flourished, crude hand-modelled figurines were produced and Usulután pottery was used (decorated with parallel light lines, produced with multiple brushstrokes, on orange-brown backgrounds; *see* MESOAMERICA, PRE-COLUMBIAN, §VII, 2). Stone sculpture included large boulder heads and potbellied figures stylistically similar to those at IZAPA and MONTE ALTO on the Pacific coast, tenoned silhouette carvings, censers, mushroom stones and jade and other stone figurines. Beneath a pyramid stairway an unworked jade boulder weighing over 90 kg was found, with marks where smaller portions had been sawn from it for carving. Boulder sculptures represent fat, sexless figures with rounded shoulders and clasped knees. Faces have flat noses, thick lips, fat cheeks and long, spool-pierced ears. They were deliberately damaged, presumably for ritual purposes, when the site was abandoned, which is reminiscent of similar action at the Gulf Coast Olmec sites of SAN LORENZO TENOCHTITLÁN and LA VENTA. Other carvings include jaguars, *pisotes* (or *coatis*, racoon-like arboreal animals), monkeys and humans, and a frog altar in the round. Carved stelae include a standing human figure wearing a cape decorated with four 'dragon' masks and holding a ceremonial stone axe and 'eccentric' flint; and a black basalt sculpture of a figure with a jaguar face and human body, and a long hieroglyphic text between outstretched arms.

Kaminaljuyú was abandoned briefly at the end of the Pre-Classic period but was reoccupied in the Early Classic

Kaminaljuyú, plan of Tomb II, mound E-III-3, Late Pre-Classic period: (a) jade beads; (b) obsidian flake blades; (c) mica sheets; (d) jade mosaic element; (e) stuccoed gourds; (f) pebbles; (g) basalt implements; (h) human teeth; (i) jade mosaic mask or headdress; (j) obsidian stones; (k) pyrite-encrusted sherd; (l) soapstone implement; (m) bone objects, fish teeth and quartz crystals; (n) sting-ray spines; (o) spatulate bone object; (p) retainers; all other circular objects are pottery vessels.

period (c. AD 250–c. 600), from c. AD 400, when plazas and temple platforms became more elaborate and showed strong stylistic influences from TEOTIHUACÁN in the Basin of Mexico, especially in the employment of TALUD-TABLERO construction, using cut pumice blocks set in adobe mortar, plastered and painted. Ballcourts were introduced, and 13 were eventually built. Tombs were placed in front of platforms rather than inside them, and the dead were seated cross-legged, still lavishly provided with jade and obsidian objects, polished pyrite mirrors and

pottery, the position and objects also reflecting Teotihuacán influence. Teotihuacán pottery was also imported, especially vessels with tripods and slab legs, Thin Orange pottery and mould techniques (*see* MESOAMERICA, PRE-COLUMBIAN, §VII). The earlier calendrics and hieroglyphic notations were absent, and the stelae and figurine cults disappeared in favour of the central Mesoamerican pantheon, including Tláloc, god of rain, and Xipe Totec, god of fertility.

Politically, Kaminaljuyú was a powerful city state, with several subordinate or rival cities in the Highland Maya area. The Guatemala Valley was an inland port and centre for traders from central Mesoamerica and the rest of the Maya region. It is debated whether the Teotihuacán influence represents actual colonization and the presence of a Teotihuacán governing élite, or simply the adoption of Teotihuacán fashions by the Kaminaljuyú élite. Other stylistic influences came from MONTE ALBÁN in the Southern Highlands and TAJÍN in the Gulf Coast. Kaminaljuyú declined again in the Late Classic period (*c.* AD 600–*c.* 900), when valley sites were abandoned in favour of hilltop fortresses. Maya and Toltec–Maya influences and Plumbate ceramics prevailed, as well as Tiquisate cream-coloured pottery from the Pacific coast, Fine Orange pottery from the Gulf Coast region and moulded human effigy censers; but there were fewer jade ornaments. The use of Fine Orange and Plumbate wares continued into the Early Post-Classic period (*c.* AD 900–*c.* 1200) but ended, seemingly abruptly, by the 13th century. Thereafter the site continued as a valley town but declined in importance as hilltop fortress city states were established throughout the Highland Maya area.

BIBLIOGRAPHY
A. V. Kidder, J. D. Jennings and E. M. Shook: *Excavations at Kaminaljuyú, Guatemala*, Carnegie Institution Publication dlxi (Washington, DC, 1946)
E. M. Shook and A. V. Kidder: *Mound E-III-3, Kaminaljuyú, Guatemala*, Carnegie Institution Publication dxcvi (Washington, DC, 1952)
W. T. Sanders and J. W. Michels, eds: *The Pennsylvania State University Kaminaljuyú Project—1968 Season, Part 1: The Excavations*, Pennsylvania State University Occasional Papers in Anthropology ii (University Park, 1969)
M. P. Weaver: *The Aztecs, Maya and their Predecessors: Archaeology of Mesoamerica* (New York, 1972, rev. 2/1981)
C. B. Hunter: *A Guide to Ancient Maya Ruins* (Norman, 1974, rev. 2/1986), pp. 188–91
W. T. Sanders and W. J. Michels, eds: *Teotihuacán and Kaminaljuyú: A Study in Prehistoric Culture Contact* (University Park, 1977)
J. Kelly: *The Complete Visitor's Guide to Mesoamerican Ruins* (Norman, 1982), pp. 410–11

DAVID M. JONES

Kaminets'-Podil's'ky [Rus. Kam'yanets-Podil's'ky]. Ukrainian town *c.* 320 km south-west of Kiev. It was founded in the late 11th century and became part of the Galitsko-Volynskoye principality in the 13th–14th century. Annexed by Lithuania in the second half of the 14th century, it was taken over in 1430 by the Poles who built a fortress there. It was briefly captured by Turkey in the late 17th century, then returned to Poland. From 1793 until Ukrainian independence in 1991 it was part of Russia (subsequently the USSR). Ukrainians, Armenians and Poles lived in separate settlements, and the architecture of the town was varied, with stone towers named after the guilds that built them rising above the skyline. Although the fortress was refurbished between the 15th and 18th centuries, it retains a stylistic unity. Its ten towers, which appear to be a continuation of the rocks on which they stand, include a 15th-century pentagonal tower and several round towers. South of the fortress is the wooden church of the Exaltation of the Holy Cross (Krestovozdvizhenskaya; 1799). Other monuments include the 16th-century stone church of SS Peter and Paul (Petropavlovskaya), the Gothic Roman Catholic church (15th–19th centuries) and the house of the former Polish magistracy (16th–18th centuries). In 1890 the Depository of Antiquities was founded; it is now a museum-reserve.

BIBLIOGRAPHY
Ye. Setsinsky: *Gorod Kamenets-Podol'sky: Istoricheskoye opisaniye* [The town of Kamianets'-Podil's'ky: a historical account] (Kiev, 1895)
Ye. T. Plamenits'ka and others: *Kaminets'-Podil's'ky* (Kiev, 1968)

L. I. POPOVA

Kamini. *See under* NAXOS, §1.

Kamman Chapra. *See* VAISHALI.

Kampen, de Stomme van. *See* AVERCAMP, (1).

Kampmann, Hack (*b* Abeltoft, 6 Sept 1856; *d* Frederiksberg, 27 June 1920). Danish architect, painter and teacher. After technical school and apprenticeship to a bricklayer, he attended the School of Architecture of the Kongelige Danske Kunstakademi in Copenhagen in 1873. He was taught by Hans Jørgen Holm, an advocate of a national style based on the free use of historically associative elements, and Ferdinand Meldahl, who espoused a more 'correct' and thus more international architecture. After leaving the Kunstakademi in 1878, Kampmann worked for Holm and Meldahl before going to Paris, where, at the Ecole des Beaux-Arts, he learnt the 'wet' watercolour technique that he later passed on to his pupils Edvard Thomsen, Aage Rafn, Kay Fisker and his sons Hans Jørgen Kampmann and Christian Kampmann. He was awarded the large gold medal in 1884 and then embarked on a Grand Tour on which he executed travel sketches of Germany, Italy and Greece, capturing in watercolour textures and atmospheres.

In his buildings, logic and legibility informed Kampmann's approach throughout. For his home town of Hjørring he built a hospital (1888–90), technical school (1891) and savings bank (1893), all of which were in a style designed to strengthen the town's identity. As Royal Surveyor for Jutland he built the Provincial Archives (1889–91) in Viborg, and the Custom House building (1895–7), Århus Theatre (1897–1901), National Library (1898–1902) and Marselisborg Castle (1902), all in Århus. Kampmann was interested also in architecture as a medium for pleasure and entertainment. He had no fixed style but would draw on any idiom to create a building that reflected his client's interests and needs: his own villa Kampen ('The Fight', 1902), also in Århus, follows English principles of planning and garden layout. In other works the Parisian *fin-de-siècle*, the English Arts and Crafts movement and Italian Medieval and Renaissance styles were transformed into a personal language characterized by a wealth of detail. On this eclectic basis he argued in favour of the addition of a picturesque steeple to C. F. Hansen's Church

of Our Lady in Copenhagen, in opposition to his pupils, who supported Carl Petersen's campaign against this potential disfiguring of the major work of Danish classicism. In other works, where he felt it was appropriate, Kampmann was happy to work in a classical style. In 1892 he built the villa at Valby Langgade, Copenhagen, where the brewer Carl Jacobsen had his first Glyptotek. He was also responsible for the extension to the Ny Carlsberg Glyptotek (1901–06). Here columns were appropriate, and the museum's great hall is in the form of a temple turned inside out.

As a restorer, Kampmann was meticulous, taking into account the function of every detail and evaluating its overall effect, but he also kept in mind the idea that an old building would function better if it could serve modern requirements. In the new headquarters for the Copenhagen Police, classicism was again the natural style. The plans were complete by the time Kampmann died, and the work was finished in 1924 under Holger Jacobsen and Aage Rafn. As Professor of Architecture at the Kongelige Danske Kunstakademi in Copenhagen (1908–18), Kampmann emphasized the supremacy of Classical Greek temple architecture. He reinvigorated the 'Temple Class' and established a 'Danish Class', teaching his students to analyse the aesthetic effects of proportion and material. His student Kay Fisker recorded that in the 'Temple Class' Kampmann expounded the conscious architectural ordering of elements, using his watercolours and measured drawings as the basis of his teaching.

BIBLIOGRAPHY
'Aarhus' nye Theater', *Arkitekten* [Copenhagen], iii (1900), pp. 13–21
A. Rafn: 'The Police Headquarters in Copenhagen', *A. Mnmts & Mém.*, iv (1936), pp. 157–216
K. Fisker: *Arkitekten, professor Hack Kampmanns rejsebreve og skitser* [The architect Professor Hack Kampmann's letters and travel sketches] (Copenhagen, 1946)
E. Sejr: *Statsbiblioteket, for historie og tilblivelse* [The National Library: early history and origin] (Århus, 1963)
D. Zanker-von Meyer: 'Die Bauten von J. C. und Carl Jacobsen', *Kstwiss. Stud.*, lii (1982)
LISBET BALSLEV JØRGENSEN

Kampuchea. *See* CAMBODIA.

Kamsetzer, Jan Chrystian [Baptist] (*b* Dresden, 1753; *d* Warsaw, 25 Nov 1795). German draughtsman, engraver and architect, active in Poland. He studied under Friederich August Krubsacius at the Akademie der Bildenden Künste, Dresden (1771). In 1773 he arrived in Warsaw, where he entered the service of Stanislav II, King of Poland (*reg* 1764–95), as an architect. He worked under the supervision of Jakub Fontana (1710–73) and later of Domenico Merlini. From the beginning of his career he won fame as a talented illustrator of historical scenes, including the *Election of Stanislav II* (1775). Towards the end of the 1770s he designed furnishings for the White House at Łazienki as well as for the Royal Castle (both Warsaw), where he introduced some Neo-classical elements to Merlini's plan for the Great Hall (from 1777; *see* WARSAW, fig. 8). Around 1780 Kamsetzer designed the Bagatela Villa, Warsaw, for the Italian painter Marcello Bacciarelli. Its asymmetrical plan, with a tower in one corner, was widely imitated in Poland in the late 18th century and the early 19th.

In 1780–83 Kamsetzer travelled at Stanislav II's expense to Italy, Sicily, France, England, Holland and Germany, producing many drawings of ancient and modern buildings. Kamsetzer's contact with British architecture, notably the work of Robert Adam, was particularly significant in his later career. Following his return to Warsaw he continued to work on the interior of the Royal Castle, finishing the Knights' Hall and designing much of the décor and furnishings, including the mantelpieces in the Library and the throne in the Throne Room. In 1784–93 he again worked at Łazienki, where he designed several pavilions and garden buildings, the north elevation of the main palace (1788; *see* WARSAW, fig. 9) and the interiors of the Ballroom (1793) and the Picture Gallery. The two-storey north elevation, in thirteen bays articulated by a giant order of pilasters and set off by a four-column pedimented portico in the centre, displays the influence of English Palladianism. In 1790 he built an amphitheatre in the grounds of the palace, the stage of which is on an island in the lake. Kamsetzer was also employed by the Polish nobility: he rebuilt the palace (1787; destr. 1944; rebuilt 1948–50) in Warsaw for Kazimierz Raczyński (1739–1824), while his palace (1786–92; destr. 1944; rebuilt after 1945), also in Warsaw, for Ludwik Tyszkiewicz (1751–1808) has lavish Neo-classical interiors, making extensive use of ungilded stucco.

Kamsetzer's most important buildings are in Greater Poland. His villa at Sierniki (1787), near Poznań, was the model for Polish country house architecture at the turn of the 19th century. Rectangular in plan, it combines an English Palladian exterior with the plan of a French *maison de plaisance*, featuring a circular salon that projects into the garden on the axis of the Ionic portico that articulates the front elevation. His most famous work was the decoration of the interiors of the first floor of Maksymilian Mielżyński's palace (1788–96) at Pawłowice, near Leszno. Kamsetzer's only church was that of St Dorothy (1791–5) at Petrykozy, near Opoczno, a building that is striking in its simplicity. In the last years of his life he drew up plans for the King's Study and the King's Bedchamber at the Royal Castle, Warsaw (realized during the reconstruction, 1971–84), as well as plans for a bridge over the Vistula (1794). Kamsetzer was the most outstanding architect of Polish Neo-classicism and popularized the urban palace and the country house (*see* POLAND, §II, 3). He developed an individual style, which was expressed above all in his stucco decorations of palace interiors, and which, though initially influenced by Adam and his contemporaries, was distinguished by the greater vividness and clear naturalism of its detail.

UNPUBLISHED SOURCES
Kraków, N. Mus. [drgs]
Warsaw, N. Mus. [drgs]
U. Warsaw, Lib. [drgs]

BIBLIOGRAPHY
Z. Ostrowska-Kębłowska: *Architektura pałacowa drugiej połowy XVIII wieku w Wielkopolsce* [Palace architecture of the second half of the 18th century in Greater Poland] (Poznań, 1969)
N. Batowsky, Z. Batowscy and M. Kwiatkowski: *Jan Chrystian Kamsetzer, Architekt Stanisława Augusta* [Jan Chrystian Kamsetzer, architect to Stanislav II] (Warsaw, 1978)
ANDRZEJ ROTTERMUND

Kamyn [Kamień; Kamin], **Erazm** [Erasmus] (*fl* first half of the 16th century; *d* Poznań, 1585). Polish engraver and goldsmith. He was the son of the goldsmith Benedykt Kamyn (*d* 1564). From 1541 to 1546 he was apprenticed to his future brother-in-law, Andrzej Gwóźdź, and from 1553 was noted in the goldsmiths' guild book as a master. Although he is known to have headed a large workshop, his gold and silver works have not been identified. His engravings, however, are extant, for example a collection of pattern engravings for goldsmiths (1552) and a coat of arms in *Librum insigniorum regionum atque clenodiorum Regni Poloniae . . .* (1575). These skilfully cut engravings show small designs for jewellery, weapon ornament and gold and silver work, influenced by Flemish grotesques, for example those of Cornelis Bos. Kamyn's engravings rarely introduce figurative or zoomorphic themes, but are characterized by the use of cartouches, arabesques and naturalistic ornament. Their influence on the work of craftsmen in Poznań in the first half of the 17th century can be detected in the wares of the region.

BIBLIOGRAPHY

M. Sokołowski: 'Erazm Kamyn: Złotnik poznański i wzory przemysłu artystycznego u nas w XV i XVI wieku' [Erazm Kamyn: the goldsmith from Poznań and engraving in Poland during the 15th and 16th centuries], *Sprawozdania Kom. Hist. Sztuki*, v (1896), pp. 129–32

J. Samek: *Polskie rzemiosło artystyczne: Czasy nowożytne* [Polish artistic crafts: the modern period] (Warsaw, 1984), p. 20

——: *Polskie złotnictwo* [Polish goldsmithery] (Wrocław, 1988), pp. 100–101

TADEUSZ CHRZANOWSKI

Kanachos (i) (*fl* 6th century BC). Greek sculptor. He was from Sikyon and made statues of bronze, wood, gold and ivory, and marble, becoming one of the most famous sculptors of the early Archaic period (*c.* 750–475 BC); none of his work has survived. Kanachos is best known for his bronze cult statue of *Apollo Philesios*, made for the Temple of Apollo at Didyma, in Turkey. The nude figure held a stag in one hand and a bow in the other, and its feet were mechanized to rock back and forth, creating a more realistic effect (Pliny: *Natural History* XXXIV.lxxv). Pausanias recorded that the Persians took the statue to Ecbatana, thus providing a *terminus ad quem* of 480 BC for his work (*Guide to Greece* I.xvi.3). A wooden image of *Apollo Ismenios* that was similar in appearance to the *Apollo Philesios* was set up in Thebes (*Guide to Greece* IX.x.2) Other works included a chryselephantine cult statue of *Aphrodite* for the city of Sikyon, a group of boys on racehorses and a statue of a *Muse* that he sculpted with his brother, Aristokles.

BIBLIOGRAPHY

Pauly–Wissowa

J. Overbeck: *Die antiken Schriftquellen zur Geschichte der bildenden Künste bei den Griechen* (Leipzig, 1868), nos 395, 403–10, 418, 477, 529, 796

G. F. Carretoni: 'L'Apollo della Fonte di Giuturna e l'Apollo di Kanachos', *Boll. A.*, xxxiv (1949), pp. 193–7

——: 'Kanachos', *Enciclopedia dell'arte antica, classica e orientale*, ed. B. Bertoni, iv (Rome, 1961) pp. 308–10

J. J. Pollitt: *The Art of Greece, 1400–31 B.C.* (Englewood Cliffs, 1965), pp. 25–7, 34, 221

Kanachos (ii) (*fl c.* 400 BC). Greek sculptor. Pliny (*Natural History* XXXIV.i) placed him in the 95th Olympiad (400–397 BC) as a contemporary of the sculptors Naukydes, Deinomenes and Patrokles. Pausanias (*Guide to Greece* VI.xiii.7) recorded that he was a student of Polykleitos. At Olympia Kanachos made a statue of Bukelos, the first Sikyonian to win the boys' boxing competition in the Olympic games; this was probably an idealized athlete in the Classical style, rather than a true portrait. Kanachos collaborated with Patrokles in creating a victory monument at Delphi to commemorate the battle at Aigispotomoi (404 BC), consisting of 10 statues of the victorious naval officers. None of his works has survived.

BIBLIOGRAPHY

Pauly–Wissowa: 'Kanachos 2'

J. Overbeck: *Die antiken Schriftquellen zur Geschichte der bildenden Künste bei den Griechen* (Leipzig, 1868), nos 979, 983, 984

DIANE HARRIS

Kanaoka. *See* KOSE NO KANAOKA.

Kanazawa. Japanese city in Ishikawa Prefecture, central Honshu. As a castle town (*jōkamachi*) for the Maeda lords who ruled Kaga Province from the late 16th century onwards, Kanazawa was a leading economic and artistic centre of Japan in the Edo period (1600–1868) and the most important city on the Japan Sea coast. It remains the political, economic and cultural centre of the Hokuriku region.

1. INTRODUCTION. Although the first Maeda lord Toshiie (*c.* 1538–99) supported the warlord Toyotomi Hideyoshi, who became one of the unifiers of Japan, his heirs wisely supported the victorious Tokugawa family at the Battle of Sekigahara (1600). As a reward they received Kaga Province, Japan's wealthiest owing to its production of more than one million *koku* of rice annually (*c.* 180,000 cu. m., theoretically enough to feed a million people for a year). Spared bombing in World War II, modern Kanazawa preserves much of its heritage as a wealthy provincial capital. The defensive function of the curving street plan around the central castle grounds (*see* §2(i) below), the spacious Kenrokuen garden (*see* §2(ii) below), the Nagamachi samurai quarter in the west, the Teramachi temple quarter in the south and the Higashi-yama pleasure quarter in the north-east all reflect features of traditional castle-town planning. The city was also a centre of craft production, and, from the details of its traditional architecture to the art works preserved in the several good museums, Kanazawa preserves its artistic heritage.

Most of the Maeda family art collection is housed in the Ishikawa Prefectural Museum, near the Seisonkaku villa in the grounds of Kenrokuen. The Edo-period paintings are surpassed in number and quality by the collection of local KUTANI ceramics. The adjacent Honda and Nakamura museums, displaying the collections of, respectively, a senior Maeda vassal and a modern sake brewer, also preserve good examples of samurai armour, tea ceremony ceramics and Edo-period painting. The vitality of the Kanazawa artistic tradition is preserved in the Museum for Traditional Products and Crafts (Ishikawa-Kenritsu dentō Sangyō Kōgeikan), where modern artisans carry on the work of their ancestors in making gold leaf, *makie* (decorated lacquerware), Kanazawa-style Kaga *yūzen* (printed silk) dyeing (*see* JAPAN, §XI), and ceramics, both of the old Kutani style and in the Ōhi style,

which is derived from RAKU ware. In the Nagamachi quarter some of the old houses feature beams covered with gold leaf and walls coloured with ochre and cobalt blue—another indicator of Kanazawa's material wealth and lack of restraint in displaying it.

BIBLIOGRAPHY
R. Stevens: *Kanazawa: The Other Side of Japan* (Kanazawa, 1979)
J. L. McClain: *Kanazawa: A Seventeenth-century Castle Town* (New Haven, 1982)

KEN BROWN

2. BUILDINGS AND GARDENS.

(i) Castle. Kanazawa Castle is a *hirayamajiro* ('flat mountain castle'; castle on a low-lying plateau on a plain) and occupies high ground between the Sai and Asano rivers. It was built by Maeda Toshiie (*c.* 1538–99), who was the founder of the powerful Maeda daimyo family, on the former site of the Ishiyama Honganji, the local temple headquarters of the Jōdo Shinshū (True Pure Land) Buddhist sect. The castle grounds are now the campus of Kanazawa University. Construction of the external castle walls began in 1592, encompassing an area 670 m north–south by 675 m east–west. The major moat systems were dug between 1592 and 1615, and the castle was divided internally by walls and moats into nine enceintes. The Main Enceinte (Honmaru) in the south-east was the original home of the daimyo's family. It had walls 60 m high in places and was the site of the original donjon (*tenshu*), which was struck by lightning in 1602 and subsequently replaced by a three-storey tower. The tower burnt down in 1759 during the worst of the 30 or so conflagrations that beset the castle between 1602 and 1881.

Since demolition works by the Meiji government in the 1870s and repeated fire damage, only two buildings survive. One is the armoury known as the Sanjūken Nagaya (Thirty-bay-long House), a two-storey gallery 55 m long added in 1858. The other is the Ishikawa Gate, a double-barbican (*masugata*) courtyard at the rear of the castle opposite the Kenrokuen garden, which was rebuilt between 1785 and 1788. It consists of a triple-roofed gate (*kōrai mon*), a two-storey gatehouse (*yagura mon*) and a corner tower (*sumiyagura*) featuring a cusped gable with a protruding copper-clad window. Particularly famous are the white plaster walls with horizontal rows of terracotta tiles, and the lead-tiled roofs.

BIBLIOGRAPHY
K. Hattori, ed.: *Kokuhō: Nihon kenchiku: Shiro* [Treasures of Japanese architecture: castles] (Tokyo, 1962), pp. 227–8
M. Ōrui: *Nihon jōkaku jiten* [Dictionary of Japanese castles] (Tokyo, 1969), pp. 81–2
M. Hinago: *Shiro* [Castles], Nihon no bijutsu [Arts of Japan], liv (Tokyo, 1970); Eng. trans. by W. H. Coaldrake as *Japanese Castles*, Japanese Arts Library (Tokyo and New York, 1986), pp. 49–50
J. L. McClain: *Kanazawa: A Seventeenth-century Japanese Castle Town* (New Haven, 1982)

S. C. THOMPSON

(ii) Kenrokuen. The garden was originally laid out in the 17th century adjacent to the Maeda family castle in Kanazawa, but it was redesigned in the 19th century, and it opened as a public park in 1874. The name Kenrokuen means 'six combinations' or 'six qualities' and refers to the features of vastness, solemnity, careful arrangement, venerability, scenic variety and coolness found at the site. The

Maeda intended Kenrokuen to be one of the great gardens of the Edo period (1600–1868). It was also part of an engineering project that brought water into the castle grounds. Kanazawa University now occupies the site to the north-west of Kenrokuen where the castle (*see* §(i) above) once stood.

The irregularly shaped garden covers 10 ha, and it is filled with ponds and streams, winding paths and artificial hills. Many of its trees are centuries old, and over 400 cherry trees make the park a popular place for flower-viewing. Near the centre of the garden is the Kasumigaike (Misty Pond), famous for its turtle-shaped island and its re-creation of the Eight Views of Ōmi, a scenic area near Kyoto. Bridges, lanterns and pavilions are carefully set into the naturalistic landscape of the pond and its borders. Other parts of the garden are more contrived, with rocks arranged to resemble the Seven Gods of Good Fortune and a mound surmounted by a corkscrew path. The varied character of the garden with its many walkways and vistas makes it an outstanding example of the Japanese stroll garden (*kaiyū*; *see* GARDEN, §VI, 3 and fig. 31). The grounds of the Kenrokuen contain several pavilions built by the Maeda family. The tea house Yūgaotei (1774) has a rustic farmhouse exterior but an interior elegantly appointed in the style of Kobori Enshū. The elaborate two-storey Seikonkaku, an extraordinary example of *Shoin*-style architecture (*see* JAPAN, §III, 4(ii)(a)), was erected in 1863 by Maeda Nariyasu, the 13th governor of Kaga, as a retreat for his mother. This building is famous for its boldly coloured interior, with walls of red, gold and purple, its ornately carved woodwork and its window with Dutch glass. The entire Kenrokuen complex has long been considered one of the three great country estates of Japan, along with the Kōrakuen in Okayama (*see* OKAYAMA, §2) and the KAIRAKUEN in Mito.

BIBLIOGRAPHY
T. Soga, ed.: *Tōkai, Hokuriku* (1979), ix of *Tanbō Nihon no niwa* [Investigation of Japanese gardens] (Tokyo, 1978–9), pp. 117–24

BRUCE A. COATS

Kanbara [Kambara], **Tai** (*b* Sendai, 23 Feb 1898). Japanese painter. His family returned to Tokyo from Sendai, where his father had been posted, shortly after his birth. Accomplished in English, French and Italian, Kanbara was exposed at an early stage not only to the traditional ideas of European art but also to new trends. Learning of Futurism through Ikuma Arishima (1882–1974), he read Umberto Boccioni's *Pittura, scultura futuriste, dinamismo plastico* (Milan, 1914) and corresponded with Filippo Tommaso Marinetti. When he was 19 he published a collection of late Cubist poems, which also showed the influence of Futurism. In 1917 he showed an abstract painting at the fourth exhibition of the Nikakai (Second Division Association), and in 1920 he held a one-man show entitled *Seimei no ryūdō, ongakuteki sōzō* ('The fluidity of life, musical creation'), at the same time publishing the *Dai ikkai Kanbara Tai sengensho* ('First manifesto of Tai Kanbara'), in which he asserted a need to express 'the fluidity of life and fluidity itself'.

From this time Kanbara began to act as the theoretical leader of the new artistic movements of the Taishō period (1912–26), forming the avant-garde group Action in 1922, and, in their first exhibition, showing the series of ten

works, *Notes of a Pessimist* (1923; five in Tokyo, N. Mus. Mod. A.; five in Sendai, Myagi Prefect. Mus. A.). In 1924 he was one of the founders of the Sanka, which brought together many avant-garde artists of the Taishō period and which showed Kanbara's *A Subject from 'The Poem of Ecstasy' by Skryabin* (1922; Tokyo, N. Mus. Mod. A.) at its first exhibition. After Sanka's dissolution many of the former members tended towards Socialist Realism, and when the group reorganized into the Zōkei Bijutsuka Kyōkai (Plastic Artists' Association) in 1927 Kanbara left and retired from practical involvement in the art world. He was one of the earliest Japanese artists to paint abstract works, and he is responsible for introducing and explicating the work of the Cubists and Futurists in Japan. The results of his study of Picasso are collected in *Homage to Picasso* (1975).

BIBLIOGRAPHY
T. Asano: *Genshoku gendai Nihon no bijutsu: Dai 8 kan zen'ei kaiga* (The illustrated arts of modern Japan, viii: avant-garde painting] (Tokyo, 1978)
——: 'Sanjō ni tatte aizu suru hito—Taishōki shinkōbijutsuundō no naka no Kanbara Tai' [The man who signalled from the mountain top—Tai Kanbara in the new Taishō art movements], *Kanbara Tai sengosakuhin jisenten* [An exhibition of Tai Kanbara's post-war works selected by the artist] (exh. cat., Tokyo, Nantenshi Gal., 1986)
TŌRU ASANO

Kanchipuram [Kāñcīpuram, 'the (golden-)belt city'; Kanchi; Conjeevaram]. Sacred city 75 km inland and slightly south of Madras in Tamil Nadu, south India. The city is an important centre of pilgrimage, and it is noted for its silk-weaving industry.

1. HISTORY. Kanchipuram served for at least two millennia as a cosmopolitan bridgehead between Aryan north India and the Dravidian south. It also played a vital role in the dissemination of art and ideas by sea to Southeast Asia and China via MAMALLAPURAM, the ancient port with which it is linked by the Vegavathi River.

Political power was concentrated at Kanchipuram by the PALLAVA dynasty and by individual sovereigns of subsequent dynasties, but the city always enjoyed greater distinction as a centre of learning and religious authority. With an ecumenism rarely equalled, it provided sanctuary to followers of both the major heterodoxies of India, namely Buddhism and Jainism, as well as to adherents of Shaiva, Vaishnava and Shakta Hinduism. Royalty and scholars from neighbouring kingdoms and abroad came for instruction and to debate in its famed *ghaṭika*, a Brahmanical 'college', and other religious establishments.

One of Kanchipuram's most celebrated inhabitants was Bodhidharma (called Daruma in Japan), said to be a Pallava prince, who is credited with introducing Chan (Jap.: Zen) Buddhism into China in *c.* AD 520. Other Buddhist luminaries associated with the city include Dinnaga, the 5th-century AD logician, and two centuries later Dharmapala (*c.* 770–810), a major commentator on the Pali canon, and Siddha Nagarjuna, a Tantric adept. No archaeological traces have been discovered of the stupa erected at Kanchipuram by the Maurya emperor Ashoka (*reg c.* 269–233 BC), but according to the Chinese pilgrim, Xuanzang (AD 602–64), it stood 30 m high, surrounded by monasteries, on the city's south side. As elsewhere in India, the Buddhist presence eventually vanished from Kanchipuram, leaving only a few sculptures (e.g. Madras, Govt Mus. & N.A.G.) and literary references, the latter from as late as the 14th century.

Jainism also flourished in the region from an early period, as is evident from inscriptions in Brahmi script found in rock shelters throughout Tamil Nadu. Kanchipuram itself is associated by tradition with Samantabhadra (2nd century AD), a foremost teacher of the Digambara ('sky-clad') sect. Like Buddhists, Jainas suffered episodes of repression, mostly at the instigation of Shaiva revivalists during the 7th and 8th centuries; but whereas Buddhism eventually disappeared from the region, a Jaina community survived in the south-west quadrant of the city, Tiruparuttikunram. One km south of the Vegavathi River, a shrine dedicated to the Jaina teacher (*tīrthaṅkara*) Chandraprabha incorporates rearing-lion pilasters that appear to date from the late Pallava period. The larger adjacent temple dedicated to Vardhamana—the 24th teacher, known also as Mahavira—dates in its present form from the 12th century with later renovations including 17th-century ceiling murals depicting the lives of the Jaina teachers Rishabhanatha and Neminatha and of Krishna.

For Hindus, Kanchipuram is pre-eminent among India's seven most sacred cities as the only one venerated by Shaivas and Vaishnavas alike. (Three others, Varanasi, Haridwar and Ujjain, are predominantly Shaiva centres, while Ayodhya, Mathura and Dwarka are associated with Vishnu's incarnations Rama and Krishna.)

2. TEMPLES. Many temples of undoubted antiquity, but in most cases repeatedly renovated, are located throughout the city, including twenty-one dedicated to Shiva, nine each to Vishnu and the Goddess, two to Ganesha, and one apiece to his brother Subrahmanya (Murugan, Skanda, Karttikeya) and Rama's lieutenant Hanuman. Two of these temples outweigh the rest in art-historical importance: the early 8th-century Shiva temple popularly called Kailasanatha (originally Rajasimheshvara or Rajasimha-Pallaveshvara) and the late 8th-century Vishnu temple called Vaikunthaperumal. Placed on opposite sides of the central urban core, the Kailasanatha facing east from the western outskirts and the Vaikunthaperumal facing west from the east, they testify to the antiquity of the city's putative division into sectarian quadrants. Both preserve on a monumental scale, and relatively free of later accretion, the visible fabric of Dravidian-order architecture during the first great period of its flowering under the direct patronage of the Pallava kings (*see also* INDIAN SUBCONTINENT, §III, 5(i)(i), which includes an illustration of the Kailasanatha Temple, and §IV, 7(vi)(a)).

The Goddess, under the name 'Auspicious Mother with Impassioned Eyes' (Tamil: Śrī Kāmākṣī Amman), is worshipped in a large temple complex near the heart of the city. There, in the 8th century AD, the monistic philosopher Shankara is said to have pacified the formerly wrathful Goddess by interposing between her sanctuary and court of audience the famous meditation diagram, or *yantra*, called the Sri-Chakra. This temple still serves as pontifical seat for an important lineage of Shankara's successors, who remain influential arbiters of orthodoxy.

In its present configuration the Kamakshi Amman Temple is a typical Vijayanagara-period complex of the 16th century. The entire precinct of 2 ha is hidden behind high enclosure walls known as the outer *prākāra* with modest *gopura*s (towered gateways) roughly centred on each side. The principal gate, or Raja-*gopura* ('royal portal'), with an elaborately sculpted superstructure of five diminishing storeys and a flaring vault, is oriented to the south-east, as are most of the buildings within the third and innermost enclosure. Just inside the Raja-*gopura* are Durga, slayer of the buffalo demon, and Bhairava, the frightful aspect of Shiva, enshrined to serve as guardians. Proceeding clockwise around the outer enclosure the visitor encounters offering podia aligned with the inner sanctum, a shrine to Shiva facing east, a yellow-flowering Champaka tree, a ceremonial bathing tank and, finally, a hundred-pillared hall (*maṇḍapa*) on the north-east side with granite base walls, column shafts and brackets all richly carved with narrative, iconic and ornamental reliefs. A further succession of shrines is distributed around the two inner enclosures, all covered by a common roof through which only the gilt tower of the sanctum sanctorum emerges. Most of the subsidiary shrines contain permanent stone images of various aspects of the Goddess, with corresponding festival bronzes standing by. The main image of Sri Kamakshi Amman is said to be 'self-manifest' having arisen from a fissure in the earth beneath the sanctum at the invocation of all the other gods. Holy pictures show her seated above diminutive images of the male pantheon, holding in her four hands a lotus blossom, sugar-cane stalk, noose and elephant goad.

The largest temple complex in Kanchipuram is the Ekambareshvara, dedicated to Shiva and located 1 km north-west of the Kamakshi Temple. Its name derives from an ancient mango tree, still extant, beneath which the Goddess earned Shiva's favour by making a sand *liṅga* and then protecting it in her embrace from a sudden flood. The sanctuary, containing a large *liṅga* (equated with the original), faces east from the centre of a vast 19-ha precinct of surrounding structures. The Raja-*gopura*, however, is positioned asymmetrically near the east end of the south side of the outer *prākāra* so as to align with a major city street. Dedicated by the Vijayanagara emperor Krishnadeva Raya (*reg* 1509–27) in 1509, this is the largest of the temple's three towered gateways (h. 58.5 m; see fig. 1). Typically for the period, its superstructure of brick and plaster consists of nine diminishing storeys, each with a symbolic portal centred over the actual passageway (h. 12 m) at ground-level that cuts through the richly articulated base-courses of granite. Images of deities are set into regularly spaced niches in the stonework, but the aediculae on the superstructure are devoid of figural sculpture. Of the many pillared corridors, free-standing pavilions and subshrines that occupy the temple's four concentric enclosures, the most notable structure is the 'Thousand-pillared Hall'. Erected between the gardens of the outer *prākāra*, not far west of the main *gopura*, its crisply faceted pillars (in fact, only 540 in number) with figural panels projecting from each face, present a compendium of Hindu myth and iconography.

The principal Vaishnava temple is located near the south-eastern edge of Kanchipuram. Dedicated to Vishnu

1. Kanchipuram, Raja-*gopura*, Ekambareshvara Temple, granite entablature with brick and plaster superstructure, 1509; view from the north-east

as Varadarajasvami ('Vow-fulfilling Lord'), known alternatively as Devarajasvami ('King of Gods'), the temple faces west towards the city centre. High walls encompass a rectangular precinct of 8 ha, with high *gopura*s at the west and east ends. The west *gopura*, the main entrance, has the slightly squatter proportions of the 13th century and rises eight storeys (h. 49 m). The ten-storey (including the ground entry level) east tower (h. 55 m) is comparable in style and date to the Raja-*gopura* of the Ekambareshvara. Neither of the *gopura*s of the Varadarajasvami has figural sculpture, but the complex boasts a richly embellished 'Hundred-pillared Hall', the Kalyana Mandapa (wedding chamber). Prominently positioned just inside the west *gopura* and adjacent to a large step-lined bathing tank, the hypostyle platform has a dramatically animated periphery, with columns fashioned to resemble warriors mounted upon rearing horses, leonine composites or giant birds (see fig. 2). The presence of a rifleman among them aids in dating the baroque ensemble to the 16th century. Interior columns are embellished with delicately carved images of Vishnu's incarnations and a fabulous array of dancing girls, stolid ascetics, amorous couples and other curiosities. Purely decorative motifs are interspersed with epic narrative panels along the base mouldings, and virtuosic stone chains hang from the eaves, as they do from the heights of two adjacent four-pillared pavilions that mark the temple's processional axis. A smaller *gopura*

and two intermediate courtyards with subsidiary shrines lead to the inner sanctum. Raised 12 m above surrounding structures, the sanctuary is said to crown 'Elephant Mountain' where Vishnu appeared with his consorts Sri (Fortune) and Prithivi (Earth) in fulfilment of a sacrificial rite by the creator Brahma.

See also INDIAN SUBCONTINENT, §III, 6(i)(f).

BIBLIOGRAPHY

Si-u-ki, Buddhist Records of the Western World, Translated from the Chinese of Hiuen Tsang, trans. S. Beal, 2 vols (London, 1884 and 1906; *R* Delhi, 1969)

A. Rea: *Pallava Architecture*, Archaeol. Surv. India, New Imp. Ser., xxxiv (Madras, 1909; *R* Varanasi, 1970)

T. A. Gopinatha Rao: 'Buddha Vestiges in Kanchipuram', *Ind. Antiqua.*, xliv (1915), pp. 127–9

A. H. Longhurst: *Pallava Architecture: Pt III: The Later or Rajasimha Period*, Mem. Archaeol. Surv. India, xl (Calcutta, 1930; *R* Delhi)

T. N. Ramachandran: 'Tirupparuttikuṇram and its Temples', *Bull. Madras Govt Mus.*, n.s., General Section, I, pt 3 (Madras, 1934)

P. Brown: *Indian Architecture: Buddhist and Hindu Periods* (?Bombay [1941], rev. Bombay, 1956)

C. Minakshi: *The Historical Sculptures of the Vaikuṇṭhaperumāl Temple, Kāñchī*, Mem. Archaeol. Surv. India, lxiii (Delhi, 1941)

V. M. Narasimhan: 'Two More Pallava Temples in Rajasimha Style', *Lalit Kala*, iii–iv (1956–7), pp. 63–6

T. G. Aravamuthan: 'The Early Pallavas and Kanchi', *Trans. Archaeol. Soc. S. India* (1962) [Silver Jubilee vol.], pp. 51–84

R. Dessigane, P. A. Pattabiramin and J. Filliozat: *Les Légendes caivites de Kanchipuram: Analyse des textes et iconographie* (Pondicherry, 1964)

K. R. Venkataraman: *Devi Kamakshi in Kanchi: A Short Historical Study* (Madras, 1968)

T. V. Mahalingam: *Kancipuram in Early South Indian History* (Bombay, 1969)

S. Kuppusamy and C. K. Moorthy: *The Shrines of Kanchi* (Kanchipuram, 1972)

A. Ghosh, ed.: *Jaina Art and Architecture*, 2 vols (New Delhi, 1974–5)

K. G. Krishnan: 'Jaina Monuments of Tamilnadu', *Aspects of Jaina Art and Architecture* (Ahmadabad, 1975), pp. 87–108

K. V. Raman: *Sri Varadarajaswami Temple, Kanchi* (New Delhi, 1975)

S. R. Sastrigal: *The Famous Kanchi Kamakshi Amman Temple Guide* (Kanchipuram, 1975)

R. Tatacharya: *Varadaraja, Kanchi: A Critical Survey of Dr K. V. Raman's Sri Varadarajaswami Temple, Kanchi* (Madras, 1978)

C. R. Srinivasan: *Kanchipuram through the Ages* (Delhi, 1979)

M. Meister, ed.: *South India, Lower Drāviḍadeśa, 200 B.C.–A.D. 1324*, i, pt 1 of *Encyclopaedia of Indian Temple Architecture*, 2 vols (New Delhi and Philadelphia, 1983)

K. Zvelebil: 'The Sound of the One Hand', *J. Amer. Orient. Soc.*, 107 (1987), pp. 125–6

N. Krishna, ed.: *Art Heritage of Kanchi* (Madras, 1992)

D. Hudson: 'Kanchipuram', *Temple Towns of Tamil Nadu*, ed. G. Michell (Bombay, 1993), pp. 18–39

D. Hudson: *The Body of God: Text, Image, and Liturgy in the Vaikuntha Perumal Temple at Kanchipuram* (in preparation)

MICHAEL D. RABE

Kandinsky, Vasily [Vassily; Wassily] **(Vasil'yevich)** (*b* Moscow, 4 Dec 1866; *d* Neuilly-sur-Seine, 13 Dec 1944). Russian painter, printmaker, stage designer, decorative artist and theorist. A central figure in the development of 20th-century art and specifically in the transition from representational to abstract art, Kandinsky worked in a wide variety of media and was an important teacher and theoretician. He worked mainly outside Russia, but his Russian heritage continued to be an important factor in his development.

1. Early years and Munich, before 1914. 2. Russia, 1914–21. 3. The Bauhaus period, 1922–33. 4. Paris, 1934–44.

1. EARLY YEARS AND MUNICH, BEFORE 1914. Kandinsky grew up in Odessa and from 1886 to 1893 studied

2. Kanchipuram, Kalyana Mandapa or 'Hundred-pillared Hall', Varadarajasvami Temple, granite, interior h. 6 m, early 16th century

economics, ethnography and law in Moscow, where he wrote a dissertation on the legality of labourers' wages. He married his cousin Anya Shemyakina in 1892 (divorced 1911). In 1896 Kandinsky decided to become an artist and went to Munich. There he studied from 1896 to 1898 at the art school of Anton Ažbe, where he met Alexei Jawlensky and Marianne von Werefkin, and then in 1900 at the Akademie with Franz von Stuck. The following year he was a co-founder of the Phalanx exhibiting society, where he showed his work and taught at the art school. In 1902 one of the students in his painting class was GABRIELE MÜNTER, who later became his companion. Kandinsky's early work consisted of figure studies, scenes of knights and riders, romantic fairytale subjects and other rather fanciful reminiscences of Russia, such as *Twilight* (1901; Munich, Lenbachhaus). After 1902 his prints (mostly colour woodcuts) acquired both a technical proficiency and a stylistic identity and cohesiveness. (Kandinsky had learnt about lithographic techniques while working for a printing firm in Moscow *c.* 1895.) At the turn of the century Munich was a centre for *Jugendstil*, and Kandinsky's early prints grew out of *Jugendstil* as well as Russian art. Similar subjects and motifs appeared frequently in both the woodcuts and the paintings done in tempera and gouache on black backgrounds (*Farbige Zeichnungen*), which date from 1901 to 1908. Kandinsky later used a

1. Vasily Kandinsky: *Landscape with Tower*, oil on cardboard, 327×402 mm, 1908 (Munich, Städtische Galerie im Lenbachhaus)

variety of printmaking techniques, including etching and drypoint.

At this time Kandinsky began to paint small oil sketches *en plein air*, executing works with the palette-knife on canvas board. Between 1903 and 1909 he and Münter travelled extensively in the Netherlands (May–June 1904), Tunisia (Dec 1904–April 1905), Italy (Dec 1905–April 1906), France (May 1906–June 1907) and throughout Germany (including Sept 1907–April 1908 in Berlin). Oil studies such as *Rotterdam* (1904; Paris, Pompidou) record what he saw and capture the high-keyed colours and intense light that he encountered while travelling and working from nature: their small format was also suited to travel. While in France, Kandinsky and Münter stayed in Sèvres, outside Paris, where at the time paintings by Gauguin, the Nabis, Matisse and other Fauves were being exhibited. Kandinsky responded to these influences, and his colours became more brilliant and vibrant, freed from the restriction of descriptive function. From around this time until 1923 he did not varnish his canvases, although he did later, sometimes selectively varnishing certain areas. Between 1904 and 1908 he maintained his contacts with Russia and participated in art exhibitions in Moscow and St Petersburg as well as in the Berlin Secession and the Salon d'Automne in Paris. His woodcuts *Stikhi bez slov*

('Poems without words') were published in Moscow in 1903, and he began the woodcuts for a further publication, *Klänge*, in 1907. Another series of photogravures, *Xylographies*, was published in Paris in 1909. Kandinsky was a co-founder of the Neue Künstlervereinigung München (NKVM) in 1909, exhibiting with them at the Moderne Galerie Thannhauser in Munich in December of that year.

In 1908 Kandinsky and Münter had begun to divide their time between Munich and Murnau, a small village near by. The Bavarian landscape dominated his paintings, and specific motifs such as the Murnau church tower recur in his work, for example *Landscape with Tower* (1908; see fig. 1) and *Church in Murnau* (1910; both Munich, Lenbachhaus). At this time Kandinsky had already developed a distinctive style of painting in which motifs were still recognizable, but the work gradually became more abstract, emphasizing the synthesis of colour, line and form over straightforward representation. *Blue Mountain* (1908–9; New York, Guggenheim) exemplifies his assimilation of Russian, French and German art. Horses and riders, trees and the blue mountain rise upward with metaphysical energy. Strident hues of red and green, intense violet and bright yellow create dissonant and complex colour harmonies. Pictorial elements are reduced to dark lines and

flat, coloured shapes. Space has been compressed into several distinctly planar zones that reinforce the upward thrust of the composition. Kandinsky increasingly attenuated the forms in his paintings so that they ultimately lost their identity as representational images.

Kandinsky's shift away from landscape painting towards abstraction was paralleled by a change in the character of his titles. In 1909 he painted his first *Improvisation*, the following year the first *Composition* and in 1911 the *Impressions*. These titles, to which numbers were assigned, were impersonal, non-specific, abstract categories derived from musical terminology. In his book *Über das Geistige in der Kunst* (Munich, 1912), on which he worked for a decade, Kandinsky defined *Improvisations* as the 'largely unconscious, spontaneous expression of inner character, non-material nature' and *Impressions* as the 'direct impression of nature, expressed in purely pictorial form'. He considered his *Compositions* to be the most important of these works and described them as consciously created expressions of a 'slowly formed inner feeling, tested and worked over repeatedly and almost pedantically'. *Über das Geistige in der Kunst* further discusses the spiritual foundations of art and the nature of artistic creation and includes an analysis of colour, form and the role of the object in art, as well as the question of abstraction. Kandinsky was unwilling to abandon representational images altogether because of his belief in the expressive function of art as communication. Like the Symbolists, he emphasized the effects of colour and discussed the associative properties of specific colours and the analogies between certain hues and the sounds of musical instruments. He loved music and had learnt to play the piano and cello as a child. Also in this treatise he referred to theosophy and to the writings of Rudolf Steiner and Mme Blavatsky (1831–91). Occultism in general and THEOSOPHY in particular appear to have influenced his thinking about abstraction.

By 1911 Kandinsky's paintings no longer represented objects in nature, and the non-mimetic intention of his art was evident. In *Lyrical* (Jan 1911; Rotterdam, Mus. Boymans–van Beuningen) his favourite image of the horse and rider (familiar in his art since 1901) is reduced to essential lines. In formulating *Improvisations* and other canvases between 1911 and 1913, he frequently made preparatory watercolour sketches in which he gradually moved away from the object and obscured specific motifs so that only traces of their representational origins remained. Both *Composition IV* (Feb 1911; Düsseldorf, Kstsamml. Nordrhein–Westfalen) and *Composition V* (Nov 1911; Switzerland, priv. col., see Roethel and Benjamin, 1982–4, i, p. 388) present radically abstracted images. In the latter, images can be deciphered only with difficulty and only in relation to other works by Kandinsky. The jury of the NKVM rejected *Composition V*, and this, together with other contributing factors, led Kandinsky, Franz Marc and Alfred Kubin to break with the group at the end of 1911.

2. Vasily Kandinsky: *Painting with White Border*, oil on canvas, 1.4×2.0 m, 1913 (New York, Guggenheim Museum)

In 1911 Kandinsky and Marc began to prepare *Der Blaue Reiter Almanach*, which was published in Munich in the spring of 1912. This anthology contained Kandinsky's essays 'Über die Formfrage' and 'Über Bühnenkomposition'. The latter showed Kandinsky's interest in the theatre, which he considered an ideal vehicle for the synthesis of the arts. His libretto for *Der gelbe Klang*, an abstract stage composition, which he, Marc, August Macke and other Munich artists hoped to produce in the Münchner Künstlertheater in spring 1914, was also included in *Der Blaue Reiter Almanach*. *Klänge*, Kandinsky's volume of prose, poems and woodcuts, was published in Munich in 1912. Both *Der Blaue Reiter Almanach* and *Über das Geistige in der Kunst* reveal the great diversity of Kandinsky's intellectual and artistic awareness. In December 1911 the first exhibition of the editorial board of *Der Blaue Reiter* opened at the Moderne Galerie Thannhauser in Munich, followed by a second exhibition in February 1912. Around this time Kandinsky formed friendships with Hans Arp and Paul Klee and corresponded with Robert Delaunay, Natal'ya Goncharova and Mikhail Larionov. His work was included in important exhibitions in the years before World War I: the Jack of Diamonds exhibition in Moscow (1912), the Sonderbund in Cologne (1912), the Moderne Bund in Zurich (1912), the Armory Show in New York (1913) and the Moderne Kunstkring in Amsterdam (1913). Between 1912 and 1918 Herwarth Walden's Sturm-Galerie in Berlin showed Kandinsky's work.

In 1913 Kandinsky executed major paintings, including *Composition VI* (St Petersburg, Hermitage) in March, *Painting with White Border* (New York, Guggenheim; see fig. 2) in May and *Composition VII* (Moscow, Tret'yakov Gal.) in November. Many watercolours and oil sketches preceded *Painting with White Border* and *Composition VII* and reveal the gradual evolution of the apocalyptic imagery in each painting. *Composition VII* marks the culmination of themes of the Last Judgement, the Resurrection, the Deluge and the Garden of Love. The artist's essays on *Composition VI* and *Painting with White Border* as well as his 'Reminiscences' were published in the Sturm monograph *Kandinsky, 1901–1913* (Berlin, 1913). In December 1913 Kandinsky painted *Light Picture* and *Black Lines* (both New York, Guggenheim). Years later the artist singled out these two canvases as non-objective pictures, that is totally abstract works rather than abstractions from objects. Neither painting relies on the perception or observation of nature, and each breaks free from the restrictions of objective origins.

2. RUSSIA, 1914–21. Since Kandinsky was a Russian citizen, he was forced to leave Munich immediately after the outbreak of World War I on 1 August 1914. Kandinsky and Münter stayed for several months near Goldach on Lake Konstanz in Switzerland, where he made the notes he used later in his treatise *Punkt und Linie zu Fläche* (published as a Bauhaus booklet in Munich in 1926). At the end of 1914 he went back to Russia. During the war years Kandinsky's art changed decisively; he did not execute any oils in 1915 or 1918. In December 1915 he travelled to Stockholm, where Münter had gone to wait for him, and he stayed with her until the middle of March 1916. There he executed *Painting on Light Ground* (1916;

Paris, Pompidou) as well as the fanciful, figurative watercolours or 'bagatelles', as Kandinsky called them, which were exhibited at Carl Gummeson's Konsthandel in February. His essay *Om konstnären* ('On the artist'; Stockholm, 1916) was published on the occasion of Münter's exhibition there. Not long after he returned to Moscow, Kandinsky met a young Russian woman, Nina von Andreyevskaya, whom he married in February 1917. Thus his long relationship with Gabriele Münter came to an end.

Between 1915 and 1919 Kandinsky produced numerous drawings and watercolours, as well as prints and paintings on glass (similar to the *Hinterglasbilder* he had done in Germany in 1909–13). At times he reverted to a more representational style: he painted numerous realistic landscapes, views of Moscow and figure paintings, as well as many fairytale scenes. However, his work encompassed totally abstract ink drawings, and gradually geometric shapes became more prevalent in his work. He encountered the abstract, geometric Suprematist painting of Kazimir Malevich and the Constructivist work of Vladimir Tatlin. In Moscow he lived in the same building as Aleksandr Rodchenko, and he met Malevich, Tatlin, Ivan Klyun, Naum Gabo, Antoine Pevsner, Lyubov' Popova and Varvara Stepanova, among others. Soon after the October Revolution of 1917, Narkompros was established and Anatoly Lunacharsky was named Commissar. Within Narkompros (the People's Commissariat for Enlightenment), the Department of Visual Arts (IZO) was set up under Tatlin, who invited Kandinsky to participate in January 1918. In April the innovative Svomas (Free Art Studios) was formed.

Kandinsky's activities as a teacher, writer, administrator and organizer took much of his time and energy. He played an active role in Narkompros, where he was director of the theatre and film sections as well as editor of a journal for IZO, and he was also head of a studio at Moscow Svomas. In 1918 the Russian edition of 'Reminiscences' was published in *Tekst khudozhnika* ('Text by the artist') by IZO in Moscow. When the Museums of Painterly Culture were founded in Moscow, Petrograd (now St Petersburg) and other cities in February 1919, Kandinsky became the first director of the organization and worked to establish a system of 22 provincial museums. He worked on the *Entsiklopediya izobrazitel'nogo iskusstva* ('Encyclopedia of fine arts'), which was never published, and was appointed honorary professor at the University of Moscow. In May 1920 Kandinsky was active in the organization of Inkhuk (the Institute of Artistic Culture) in Moscow and was its head until his programme was rejected, and he left the Institute at the end of the year. He was also active in Vkhutemas (the Higher Artistic and Technical Workshops), which replaced Svomas. In 1921 Kandinsky was active in establishing RAKhN (the Russian Academy of Artistic Sciences), was appointed vice-president and submitted a plan for the physico-psychological department.

Kandinsky also found time to produce large, innovative canvases and many watercolours and drawings. After an initial return to earlier styles, he developed distinctive modes of pictorial organization that emphasized oval forms and relied on borders or diagonal bands of colour to define the perimeters of his compositions. By 1921 he

began to use the circle in several canvases and depicted it in an emphatically geometric manner in *Multicoloured Circle* (1921; New Haven, CT, Yale U. A.G.), which reflects the artist's understanding of Russian avant-garde art. Kandinsky continued his interest in the applied arts and in 1920–21 made several designs for cups and saucers.

3. THE BAUHAUS PERIOD, 1922–33. In subsequent years Kandinsky pursued his long-standing interest in a variety of art forms, his predilection for geometric forms becoming clearly articulated during the Bauhaus period. Although he had participated in various programmes of Narkompros and had exhibited and published often, Kandinsky no longer exercised any significant influence and was alienated from the Russian avant-garde. In autumn 1921 he was invited by Walter Gropius to visit the Bauhaus in Berlin. The Kandinskys reached Berlin in December

1921. After his arrival, he was offered a professorship at the Bauhaus in Weimar. He moved there and began to teach in June. He became master of the wall painting workshop and taught one of the courses on the theory of form. The faculty, which included Lyonel Feininger, Johannes Itten, Paul Klee and Oskar Schlemmer, developed innovative theoretical courses, led practical workshops and instruction in crafts and sought to reunite all artistic disciplines.

On his return to Germany, Kandinsky had one-man shows of his work at Galerie Goldschmidt-Wallerstein in Berlin (1922) and at the Moderne Galerie Thannhauser in Munich (1922). In Berlin during 1922 he designed wall paintings for the entrance room of the *Juryfreie Kunstausstellung*, exhibited in the *Erste russische Kunstausstellung* at the Galerie van Diemen, and had a portfolio of his graphic

3. Vasily Kandinsky: *Several Circles*, oil on canvas, 1.4×1.4 m, 1926 (New York, Guggenheim Museum)

works, *Kleine Welten*, published. In 1923 he held a one-man show in New York at the Société Anonyme, of which he became the first honorary vice-president. In 1924 the Blue Four exhibition group, which comprised Feininger, Jawlensky, Klee and Kandinsky, was formed by Galka Scheyer, who became their representative in the USA. At the Bauhaus, Kandinsky executed some three hundred oils and several hundred watercolours. From the beginning, he had systematically recorded his paintings in a handlist, and, after 1922, he catalogued the watercolours as well. The watercolours assumed an important and independent role in his work during the Bauhaus period. He also produced many drawings, which frequently related to his pedagogical theories.

By 1923 Kandinsky had formulated new images and a new way to organize pictorial elements. In *Composition VIII* (New York, Guggenheim) precise lines and simple geometric shapes are strewn over the large canvas: circles, semicircles, triangles, squares, curved lines and acute angles are placed without central focus or spatial unity. A large black circle surrounded by a pink aura dominates the upper left corner. *On White* (1923; Paris, Pompidou) emphasizes the strictly geometric forms, new colour harmonies and the clear differentiation between figure and ground that emerged in his work. *Circles in a Circle* (1923; Philadelphia, PA, Mus. A.) contains 26 circles within a tondo; *Several Circles* (1926; New York, Guggenheim; see fig. 3) derives its meaning from the repetition of overlapping, coloured circles. For Kandinsky, the circle, the most elementary form, had symbolic, cosmic meaning: 'the circle is the synthesis of the greatest oppositions. It combines the concentric and the excentric in a single form, and in equilibrium' (Grohmann, 1958, p. 188). During the Bauhaus period, Kandinsky used circles, squares, triangles, zigzags, chequer-boards and arrows as components of his abstract vocabulary. They became meaningful pictorial elements just as the abstract images of towers, horses, boats and rowers had carried connotations in his art in earlier years. As the artist explained in 1929 (Grohmann, 1958, p. 188):

> If I make such frequent, vehement use of the circle in recent years, the reason (cause) for this is not the geometric form of the circle, or its countless variations; I love the circle today as I formerly loved the horse, for instance—perhaps even more, since I find more inner potentialities in the circle, which is why it has taken the horse's place.

In the mid-1920s the theoretical aspect of Kandinsky's work became increasingly apparent. He painted *Yellow–Red–Blue* (1925; Paris, Pompidou) while working on the manuscript of *Punkt und Linie zu Fläche*, which he had begun in 1914. The title of the painting refers to the three primary colours, which dominate the canvas and are arranged in the same sequence as in the colour scale. In *Punkt und Linie zu Fläche* he elaborated on the significance of colour, geometric forms, placement of compositional elements and directionality. When the Bauhaus moved from Weimar to Dessau in June 1925, Kandinsky devoted his time to writing and planning exhibitions of his work in addition to his teaching and administrative duties. On the occasion of his 60th birthday in 1926, an exhibition of his

work travelled to several German cities, including Brunswick, Dresden, Berlin and Dessau, and the first issue of the periodical *Bauhaus* was dedicated to him. In Dessau, Kandinsky shared a double house with Klee, and the close relationship between the two artists is reflected in their influence on each other's work. Between 1926 and 1932 Kandinsky's production of watercolours and oils was prolific, and the development of his style was consistent with the Weimar years. He retained an interest in the theatre and published a Bauhaus booklet, *Über die abstrakte Bühnensynthese*, in 1923. In 1928 he directed the staging of Musorgsky's *Pictures at an Exhibition* for the Friedrich-Theater in Dessau, producing ambitious scenery and costumes influenced by Oskar Schlemmer and dividing the score into 16 scenes. Abstract and geometrical props, some of them in motion, were suspended in front of a black backdrop to create the impression of an extended painting, which had temporal and spatial dimensions. An annotated visual score by Paul Klee's son Felix records the cues for props and lighting (Paris, Pompidou). In 1931 Kandinsky designed ceramic tiles for a music room at the Deutsche Bauausstellung in Berlin. After the Nazis forced the closure of the Bauhaus in Dessau in August 1932, Kandinsky joined the short-lived effort to re-establish it in Berlin until it closed for good in July 1933. At that time the Kandinskys went to France, where they settled at the end of the year in Neuilly-sur-Seine near Paris.

4. PARIS, 1934–44. Kandinsky's first Paris pictures, which date from February 1934, are a continuation in many ways of his last work in Berlin. The hieratic pictorial organization, the essential structure based on geometric forms, the use of mixed-media techniques and the addition of sand to oil paintings were all introduced during the last years at Dessau. Kandinsky's reputation preceded his arrival, since his work had been included in exhibitions in Paris in 1929–30 and reproduced in French publications. His involvement with both the Abstraction–Création group and the Surrealists began before his residence in Paris. His work in Paris is characterized by the introduction of biomorphic forms, the incorporation of sand with pigment in well-defined areas of the painting and a new delicacy and brightness in his colour harmonies. He preferred pastel hues to the primary colours he had used in the 1920s. In his Parisian work he favoured new images derived from biology, zoology and embryology. Amoebae as well as embryonic and cellular forms can be identified in *Each for Itself* (1934; Paris, priv. col., see Roethel and Benjamin, 1982–4, ii, p. 930) and *Division–Unity* (1934; Tokyo, Seibu Mus. A.).

Between 1934 and 1944 Kandinsky executed 144 oil paintings, approximately 250 watercolours and several hundred drawings. The Parisian work reveals his personal response to prevailing artistic tendencies: the free, organic shapes of Surrealism, on the one hand, and the geometric abstraction of *Art concret* and Abstraction–Création on the other. Thus, he employed a combination of biomorphic and geometric forms as the basis for an abstract style. In the painting *Thirty* (1937; Paris, Pompidou) the rigid, grid-like format with alternating light and dark squares and the

4. Vasily Kandinsky: *Composition IX*, oil on canvas, 1.14×1.95 m, 1936 (Paris, Pompidou, Musée National d'Art Moderne)

emphasis on positive and negative forms present a geometric, even mathematical solution, whereas *Accompanied Contrast* (1937; Paris, priv. col., see Roethel and Benjamin, 1982–4, ii, p. 973) relies on vivid pastel hues, wavy lines, spiky forms and imaginative floating shapes. Kandinsky made two detailed drawings and squared one with a grid in preparation for the final canvas. Increasingly, he made preliminary drawings for watercolours as well as for oils. In these he worked out the entire composition, specified details and indicated colours by abbreviated notations in Russian.

During the summer of 1937 Kandinsky's work was included in the ENTARTETE KUNST exhibition organized by the Nazis in Munich. The same year he participated in the exhibition *Origines et Développement de l'Art International Indépendant* at the Jeu de Paume in Paris. In 1938 he had a one-man show at the Guggenheim Jeune Gallery in London, and his poems and woodcuts were published in New York in *Transition* (xxvii, pp. 104–9). The French government purchased *Composition IX* (1936; Paris, Pompidou; see fig. 4) in 1939. That summer Kandinsky was denied renewal of his German passport but obtained French citizenship just before war was declared in September. During the occupation of France, the Kandinskys spent most of their time in Neuilly. Kandinsky's last large paintings date from 1939 to 1942. In many works, including the monumental canvas *Composition X* (1939; Düsseldorf, Kstsamml. Nordrhein–Westfalen), the last in the series, he used black backgrounds. In his late gouaches these backgrounds can be interpreted as a reprise of his early *Jugendstil*-inspired work of 1901 to 1908. Kandinsky's penultimate canvas, *Reciprocal Accord* (1942; Paris, Pompidou), is large in scale and balanced in composition: it epitomizes the elegance and grandeur of his art.

Kandinsky continued to write during his years in Paris but limited himself to shorter texts that expressed familiar points of view. The essay *Abstract concreet* (Amsterdam, 1938) expressed his belief in totally abstract art, which he preferred now to call 'concrete art'. In the essay *L'Art concret* (Paris, 1938) Kandinsky emphasized the correspondence between painting and music as he had done almost 30 years earlier in *Über das Geistige in der Kunst*. He wrote the preface for the portfolio *10 Origin* (Zurich, 1942), edited by Max Bill, and contributed the preface for an album of César Domela's work (Paris, 1943). His continuing interest in the applied arts and in the theatre and music was reflected in his designs for fabric and in his discussions with Léonide Massine (1895–1979) for a proposed multimedia ballet. In the early 1940s his production of drawings was prolific. Because of the war, Kandinsky could not obtain canvas and other materials; consequently, his last works are painted on board. He painted 48 small pictures on wood or canvas board between the summer of 1942 and March 1944. His last watercolours and drawings date from the summer of 1944. Kandinsky's work is remarkable for its technical proficiency. Throughout his life he used a variety of painting materials, including water-soluble pigments, varnish, bronze and aluminium paint and grains of sand in his oil paintings. His sketchbooks are in the Städtische Galerie im Lenbachhaus in Munich and in the Musée National d'Art Moderne in Paris.

See also ABSTRACT ART, §§2 and 3.

WRITINGS

H. K. Roethel and J. Hahl-Koch, eds: *Autobiographische Schriften*, i of *Kandinsky: Die gesammelten Schriften* (Berne, 1980)

K. C. Lindsay and P. Vergo, eds: *Kandinsky: Complete Writings on Art*, 2 vols (Boston, 1982) [best source of information on Kandinsky's published writings, with excellent Eng. trans.]

BIBLIOGRAPHY

K. C. Lindsay: *An Examination of the Fundamental Theories of Wassily Kandinsky* (diss., Madison, U. WI, 1951)

K. Brisch: *Wassily Kandinsky: Untersuchungen zur Entstehung der gegenstandslosen Malerei an seinem Werk von 1900–1921* (diss., U. Bonn, 1955)

J. Eichner: *Kandinsky und Gabriele Münter: Von Ursprungen moderner Kunst* (Munich, 1957)

W. Grohmann: *Wassily Kandinksy: Leben und Werk* (Cologne, 1958; Eng. trans., London, 1959) [basic source]

P. Overy: *Kandinsky: The Language of the Eye* (New York, 1969)

S. Ringbom: *The Sounding Cosmos: A Study in the Spiritualism of Kandinsky and the Genesis of Abstract Painting* (Turku, 1970)

H. K. Roethel: *Kandinsky: Das graphische Werk* (Cologne, 1970) [cat. rais.]

E. Hanfstaengl: *Wassily Kandinsky: Zeichnungen und Aquarelle: Katalog der Sammlung in der städtischen Galerie im Lenbachhaus München* (Munich, 1974)

N. Kandinsky: *Kandinsky und ich* (Munich, 1976) [memoirs of the artist's widow]

H. K. Roethel and J. K. Benjamin: *Kandinsky* (New York, 1979)

P. Weiss: *Kandinsky in Munich: The Formative Jugendstil Years* (Princeton, 1979)

Kandinsky: Trente Peintures des musées soviétiques (exh. cat., ed. C. Derouet; Paris, Pompidou, 1979)

J. E. Bowlt and R.-C. Washton Long, eds: *The Life of Vasilii Kandinsky in Russian Art: A Study of 'On the Spiritual in Art'* (Newtonville, 1980)

R.-C. Washton Long: *Kandinsky: The Development of an Abstract Style* (Oxford, 1980)

Kandinsky in Munich, 1896–1914 (exh. cat., ed. P. Weiss; New York, Guggenheim, 1982)

H. K. Roethel and J. K. Benjamin: *Kandinsky: Catalogue Raisonné of the Oil Paintings*, 2 vols (London, 1982–4)

V. E. Barnett: *Kandinsky at the Guggenheim* (New York, 1983) [complete cat.]

Kandinsky: Russian and Bauhaus Years, 1915–1933 (exh. cat. by C. V. Poling, New York, Guggenheim, 1983)

C. Derouet and J. Boissel: *Kandinsky* (Paris, 1984) [cat. of Nina Kandinsky's bequest to Mus. N. A. Mod., Paris]

Kandinsky in Paris, 1934–1944 (exh. cat. by C. Derouet and V. E. Barnett, New York, Guggenheim, 1985)

C. V. Poling: *Kandinsky's Teaching at the Bauhaus* (New York, 1986)

Wassily Kandinsky: Die erste sowjetische Retrospektive (exh. cat. by N. Avtonomova, Frankfurt am Main, Schirn Ksthalle, 1989)

Theme and Improvisation: Kandinsky and the American Avant-garde, 1912–1950 (exh. cat. by G. Levin and M. Lorenz, Dayton, OH, A. Inst., 1992)

V. E. Barnett: *Kandinsky Watercolours: Catalogue Raisonné*, 2 vols (New York and London, 1992–4)

P. Weiss: *Kandinsky and Old Russia: The Artist as Ethnographer and Shaman* (New Haven, 1995)

VIVIAN ENDICOTT BARNETT

Kandler, Charles (Frederick) (*fl* 1727–*c*. 1750). English silversmith of German birth. He is known only by a small quantity of elaborate silver, characterized by the use of decoration in high relief and three-dimensional form that has led to the belief that he was related to the renowned German porcelain modeller, Johann Joachim Kändler. He was first mentioned in the register of the Goldsmiths' Company in London as a 'largeworker' in 1727 in St Martin's Lane, with a partner, James Murray (*d c*. 1730). In 1735 he was recorded as a goldsmith in Jermyn Street near St James's church and used the initials CK or KA as his mark. Another goldsmith named Charles Frederick Kandler, possibly a cousin or nephew, was entered in the register in 1735, located at the same address. He was known as Frederick Kandler and used the initials FK and KA as his mark.

Charles Kandler's pieces rival those of his better-known contemporaries, Paul de Lamerie and Nicholas Sprimont. All three were active in England when the French Rococo style, particularly the designs of Juste-Aurèle Meissonnier, was a major influence on English silver. Kandler's silver tureens, salvers, coffeepots, candlesticks and other wares are enriched with elaborate ornament: naturalistic fruit, flowers, foliage and mythological figures. A silver tea kettle and stand made by Kandler (1727–37; London, V&A) has a handle consisting of two mermaids with twisted tails, while a conch-blowing triton forms the tap-operated spout. The sides are decorated in relief with figures of Neptune and his court, seaweed and shells; on the stand three mermen spring from a base placed on a triangular salver.

Kandler's masterpiece is the massive wine-cooler (St Petersburg, Hermitage), made after a design by the antiquary and engraver George Vertue and a subsequent wax model by Michael Rysbrack. A London entrepreneur and goldsmith, Henry Jerningham (or Jernegan; *fl* 1735; *d* 1761), commissioned the piece, which took from 1732 to 1735 to complete at immense cost. The vast, oval-shaped bowl rests on four chained, crouching leopards or panthers. The two handles are in the form of male and female terms, while on the sides are chased oblong panels that depict putti enjoying Bacchanalian revels. The rocky base is worked with bunches of grapes, frogs, newts and shells. It was sold in a national lottery in 1737 and was rediscovered in Russia in 1880 by an English silver expert among state property confiscated from a member of the Russian royal family. G. R. Elkington & Co. of Birmingham made reproductions of the wine-cooler in electrotype silver plate (examples in London, V&A; New York, Met.) from moulds taken at the Hermitage in 1880–81.

BIBLIOGRAPHY

C. Oman: *English Domestic Silver* (London, 1934, 5/1962)

N. M. Penzer: 'The Jerningham-Kandler Wine-Cooler', *Apollo*, lxiv (1956), no. 379, pp. 80–82; no. 380, pp. 111–15

J. Culme and J. G. Strang: *Antique Silver and Silver Collecting* (London, 1973)

C. Hernmarck: *The Art of the European Silversmith, 1430–1830* (London, 1977)

Kändler [Kaendler], **Johann Joachim** (*b* Fischbach, 15 June 1706; *d* Meissen, 17 May 1775). German sculptor and porcelain modeller. He worked in Dresden with the court sculptor Benjamin Thomae (1662–1751) from 1723 and during this period was involved in the decoration of the Grünes Gewölbe in the castle. In 1730 he was appointed court sculptor by Frederick-Augustus I, Elector of Saxony, and in June 1731 was employed at the Meissen Porcelain Factory as a modeller. Initially he worked with Johann Gottlob Kirchner, and, after his departure in 1733, Kändler became Modellmeister and continued the production of the large, white birds and animals for the Elector's Japanisches Palais in Dresden (e.g. Paduan cockerel, *c*. 1732; Dresden, Porzellansamml.). For the next 40 years Kändler was the dominant figure in the plastic production at Meissen. His role was one of constant conflict with his colleague Johann Gregorius Höroldt, who was in charge of both the painters' studio and the kilns. The battle was fought over the surface of the factory's wares where moulded detail, initially limited to spouts and

handles, gradually invaded the surface of the wares thus reducing the flat areas available for the painters to display their skills. The apogee of this style was the 'Schwanenservice' created by Kändler with the assistance of Johann Friedrich Eberlein between 1737 and 1741 for Heinrich, Graf von Brühl; the entire surface of each piece was moulded with shells, swans and herons, and the coloured decoration was reduced to a very secondary role (*see* MEISSEN, fig. 2).

As a result of his work on the large animals for the Japanisches Palais, which, though extraordinary in artistic conception, were difficult to produce and sell, Kändler began production of birds on a smaller and more accessible scale (e.g. cockatoo, 1734; Amsterdam, Rijksmus.). These are characterized by their outstanding observation of nature and their charm and humour. From 1736 he concentrated on the production of small-scale pieces, notably a series of figures and groups of characters from the *commedia dell'arte*. A few figures dealing with this theme had already been made at Meissen before Kändler's arrival, but none was endowed with the originality and humour with which Kändler's creations are charged. They represent one of the major creative achievements of the Late Baroque in Germany and established the appropriate scale for the porcelain figure. In 1744 Kändler and Peter Reinicke produced the first complete series of figures from the *commedia dell'arte* for the Duke of Weissenfels and set the pattern for the numerous series subsequently made by almost all the German factories. Although Kändler continued as Modellmeister until the end of his life, his art was less well suited to the emerging Rococo style, and his output became much less significant. In the charming *Cris de Paris* series of 1755, the style of Reinicke is dominant and Kändler would seem to have only played a minor role.

Kändler was the first of the great porcelain modellers. He was responsible for the establishment of the porcelain figure as a specific art form in its own right, and it is against his achievements that all subsequent figure modelling must be judged (*see* CERAMICS, colour pl. I, fig. 2).

BIBLIOGRAPHY

J. L. Sponsel: *Kabinettstücke der Meissner Porzellanmanufaktur von Johann Joachim Kaendler* (Leipzig, 1900)
W. B. Honey: *Dresden China* (London, 1954)
R. Ruckert: *Meissener Porzellan* (Munich, 1966)
O. Walcha: *Meissener Porzellan* (Dresden, 1973; Eng. trans., London, 1981)

HUGO MORLEY-FLETCHER

Kandy [formerly Senkadagala]. City in the central hill region of Sri Lanka on the Mahaveli River, which served as capital from the 15th century AD to 1815. Both the hills and the river provided natural protection against enemy intrusions.

Early settlement in the region is indicated by Brahmi inscriptions of the 2nd century BC to 2nd century AD in caves, once occupied by forest monks, along the river banks and by a 7th-century Buddhist monastery at Hindagala about 5 km west of Kandy. The founding of Kandy, known originally as Senkadagala, is traceable to the 14th century, when the ruling power was installed at Gampola (anc. Gangasiripura). Senasammata Vikramabahu (*reg* 1473–1511) was the first ruler to ascend the throne in the new city. Turbulent times resulted from the foundation of another seat of government in the low country at Sitavaka (close to the modern capital Colombo) and the arrival of the Portuguese later in the 16th century. With increasing colonial intrusions along the coasts, Kandy became the inland stronghold of the Sinhalese. From the reign of Vimaladharmasuriya I (*reg* 1592–1604) Kandy remained the capital of Sri Lanka until the island came under British rule in 1815. Narendrasimha (*reg* 1707–39) was the last Sinhalese ruler as such; his marriage to a south Indian princess paved the way for the introduction of Nayakkar rule in Sri Lanka. The last four kings of Kandy—Sri Vijaya Rajasimha (*reg* 1739–47), Kirti Sri Rajasimha (*reg* 1747–82), Rajadhirajasimha (*reg* 1782–98) and Sri Vikrama Rajasimha (*reg* 1798–1815)—belonged to the Nayakkar clan. Yet these last few kings of Kandy, of south Indian stock and Hindu by religion, maintained the traditional culture of the Sinhala Buddhists. Kirti Sri Rajasimha outshone the others in his efforts to sustain Buddhist culture, bringing about a renaissance of the Buddhist art of Sri Lanka, evidenced by numerous image-shrines filled with late medieval paintings in all parts of the island (*see also* SRI LANKA, §V, 2(iii)).

The palace complex featuring the Dalada Maligava (Palace of the tooth relic; *see* SRI LANKA, fig. 5) also includes the 'King's Palace', 'Queen's Palace', 'Queen's Bath' and Audience Hall. The inner shrines of the Dalada Maligava and Audience Hall, both with outstanding wood-carving (*see* SRI LANKA, §VI, 11), are Kandy's finest surviving structures. What remains of the King's Palace houses the Archaeological Museum, while the King's Harem, built around a small central courtyard, houses the National Museum. Excavations at the site in the 1990s revealed much of the layout of the palace complex in the 18th century.

The modern commercial city is located to the west of the citadel. The esplanade beside Kandy Lake, built by Sri Vikrama Rajasimha, adds scenic beauty to the city. To the north of the esplanade are walled terraces containing two ancient shrines, the Natha Devale (a Mahayana Buddhist shrine dedicated to the worship of Avalokiteshvara, subsequently transformed into a Hinayana shrine to the *bodhisattva* Maitreya, the Future Buddha) and Pattini Devale (a Hindu shrine dedicated to the goddess). To the north of the Natha Devale is the Vishnu Devale, perched on a high terrace. A shrine dedicated to the god Kataragama (Skanda) is located within the commercial section of the city. These four shrines play a significant role in the annual Dalada Perahera, the pageant of the tooth relic. The two major Buddhist monasteries are the Malvatta Vihara on the southern border of Kandy Lake and the Asgiri Vihara on the western side of the city. The prelates of these monasteries, together with the lay chieftain, function as the custodians of the sacred tooth relic.

The President's Lodge is a British-period construction within a large and spacious garden. St Paul's Cathedral, within the sacred area close to the Pattini Devale, displays significant features of 19th-century cathedral architecture with Gothic arches and an attractive stained-glass window at the back of the chancel. Modern Kandy remains a craft centre, noted for ivory combs decorated with a variety of iconic and decorative motifs, tapestry, lathework, lacquer

products, mat-weaving, brassware and other minor crafts. Within a few kilometres of Kandy there are numerous examples of the architecture, sculpture and painting of the Kandy period at the Gangarama, Degaldoruva, Medavala, Suriyagoda, Hindagala, Gadaladeniya and Lankatilaka monasteries and the Embekke Devale (*see also* SRI LANKA, §§III, 3 and IV, 4).

BIBLIOGRAPHY
A. C. Lawrie: *Gazetteer of the Central Province*, i–ii (1896–8)
A. Coomaraswamy: *Mediaeval Sinhalese Art* (Broad Campden, 1908/*R* New York, 1956)
A. M. Hocart: *The Temple of the Tooth in Kandy*, Memoirs of the Archaeological Survey of Ceylon, iv (London, 1931)
C. E. Godakumbura: *Embekke Devale Carvings*, Art Series 1 (Colombo, 1963/*R* 1981)
L. S. Devaraja: *Kandyan Kingdom, 1707–1760* (Colombo, 1972)
L. K. Karunaratne: 'The Wooden Architecture of Sri Lanka', *Ceylon Hist. J.*, xxv/1–4 (1978), pp. 174–85
S. Gunasinghe: *Paintings of the Kandyan Period* (Colombo, 1981)
P. L. Prematilleke: *Kandy Project, Archaeological Excavation Reports*, 1–4, UNESCO–Sri Lanka Cultural Triangle Project (Colombo, 1983–9)
A. Seneviratne: *Kandy: An Illustrated Survey of Ancient Monuments, with Historical, Archaeological and Literary Descriptions of the City and its Suburbs* (Colombo, 1983)
H. Welandawe: *A Study of the Role of the Secular Buildings in the Last Palace Complex of the Kandyan Kingdom* (diss., U. Moratuwa, 1983)
N. Karunaratne: *From Governor's Pavilion to President's Pavilion* (Colombo, 1985)
——: *Udawattakale: The Forbidden Forest of the King of Kandy* (Colombo, 1986)
N. de Silva: *First Architectural Conservation Report*, UNESCO–Sri Lanka Cultural Triangle Project (Colombo, 1990)

P. L. PREMATILLEKE

Kane, John (*b* West Calder, Midlothian [now Lothian], 19 Aug 1860; *d* Pittsburgh, PA, 10 Aug 1934). American painter of Scottish birth. In 1879 Kane emigrated to western Pennsylvania. He worked as a bricklayer, coal miner, steel worker and carpenter in the Ohio River valley and, in 1890, began to sketch local scenery. After losing his leg in a train accident in 1891, he was employed painting railway carriages. When his son died in 1904, Kane left his family and spent years wandering and working in odd jobs; his earliest surviving paintings date from around 1910. Settling in Pittsburgh, he worked as a house painter and in his spare time painted portraits, religious subjects, the city's urban landscape and memories of his Scottish childhood. In 1927 the jury of the Carnegie International Exhibition, Pittsburgh, encouraged by the painter–juror Andrew Dasburg (*b* 1887), accepted Kane's *Scene in the Scottish Highlands* (1927; Pittsburgh, PA, Carnegie Mus. A.). Kane's success, at first considered a hoax by the press, was based on the modernist interest in primitive and folk art. His work was regarded as non-academic and boldly original, and he became the first contemporary American folk artist to be recognized by a museum. *Larimer Avenue Bridge* (1932; Pittsburgh, PA, Carnegie Mus. A.) is characteristic of his style with its meticulous detail, flat colour and dominant green and red. Though he sketched and painted on the site, Kane freely transposed pictorial elements to create a more pleasing composition. This innate compositional sense is evident in his *Self-portrait* (1929; New York, MOMA). The angularity of his rigidly frontal body is contrasted by the arches above his head. He received numerous honours and his work was exhibited at major museums in the years before his death.

WRITINGS
Skyhooks: The Autobiography of John Kane (Philadelphia, 1938) [as told to M. McSwigan]

BIBLIOGRAPHY
L. Arkus: *John Kane, Painter* (Pittsburgh, 1971) [reprint of *Skyhooks* and cat. rai.]
John Kane: Modern America's First Folk Painter (exh. cat. by J. Kallir, New York, Gal. St. Etienne, 1984)

ELISABETH ROARK

Kane, Paul (*b* Mallow, Co. Cork, 3 Sept 1810; *d* Toronto, 20 Feb 1871). Canadian painter of Irish birth. He grew up in Toronto (then York), where his parents had emigrated in 1819. His early days there and in nearby Cobourg (*c.* 1826–34) were spent as a painter of ornamental work on chairs for a furniture factory. It is probable that he also received private art lessons at Upper Canada College in York (*c.* 1830–34). In 1841–2 he travelled in Europe, studying and copying Old Masters in galleries in Rome and northern Italy. In London in 1843 he met George Catlin, the American painter of Native American tribes in the western USA. Kane determined to follow Catlin's example and create a series of paintings of the Native Americans of Canada's West before their cultures had become too contaminated by European settlers.

Kane returned to Toronto in 1845 and in June began his trip to the Lake Michigan, Lake Huron and Georgian Bay areas. On this trip Kane made contact with officials of the Hudson's Bay Company, and through them obtained the support of the Governor of the Hudson's Bay Territory, Sir George Simpson (*c.* 1787–1860), who gave him financial assistance for his second, lengthier trip. By December 1845 Kane was back in Toronto, where he began working up into paintings the portfolio of sketches he had made of such tribes as the Ojibway and Menominee. On his second trip (May 1846–Oct 1848) he travelled through areas of present-day Manitoba, Saskatchewan, Alberta, British Columbia, Washington and Oregon. He was the first white artist to cover this sparsely populated region so extensively and was also the first Canadian artist to make a thorough visual documentation of the tribes west of the Great Lakes region. Kane intended to use the sketches produced on this trip as material for his proposed cycle of 100 oil paintings depicting Native American life from the Great Lakes to the Pacific Coast.

Staying at Hudson's Bay Company forts *en route*, Kane portrayed such tribes as the Assiniboine, Blackfoot, Cree, Clallam and Kwakiutl. He kept copious journals of his trip and sketched in pencil, watercolour and oils the various chieftains and elders of the tribes, singly or in groups (e.g. *Tomaquin, Cascade Chief, Columbia River*, 1847; Toronto, Royal Ont. Mus.). Kane depicted the Native Americans and Métis at work and leisure, recording such indigenous events as the salmon harvests and the buffalo hunts (e.g. *Métis Chasing a Buffalo Herd*, 1846). He also noted the ceremonial costumes, masks and implements used by the different tribes he visited (e.g. *Medicine Masks of the Northwest Coast Tribes*, 1847) and took great care to record any unusual customs or rituals practised (e.g. *Child Having its Head Flattened*, 1847). He produced a large number of landscape sketches, again intended as source material for

his cycle (e.g. *White Mud Portage, Winnipeg River*, 1846; all Orange, TX, Stark Found.).

In late 1848 Kane was back in Toronto with approximately 500 sketches, and began to seek financial support for his project. George William Allan (1822–1901), a lawyer from Toronto, agreed to buy the 100 paintings from Kane, which were finished *c.* 1855 (now in Toronto, Royal Ont. Mus.). The Canadian Government also commissioned 12 canvases from Kane, replicas of paintings from his large cycle (one destr.; eleven Ottawa N.G.). After these tasks were completed, he did little painting, hampered by increasing blindness in later years. His last major undertaking was the publication in 1859 of his travel journals, with illustrations after his sketches and finished paintings.

Kane's oil paintings were very much in the accepted mode of 19th-century European art. Such works as *Indian Horse Race* (*c.* 1851–6; Ottawa, N.G.) show evidence of heavy glazing, subdued colour, an overlay of 'European' haze and a somewhat artificial composition relying heavily on a repoussoir of trees or figures. For his tribal portraits he employed a conventional Romantic formula of bust-length three-quarter pose and smoky atmospheric backdrop (e.g. *Mah-Min or 'The Feather', Assiniboine Chief, Rocky Mountain House*, *c.* 1851–6; Montreal, Mus. F.A.). Only in his field sketches is there an indication of a certain spontaneity and freshness of vision.

For illustration *see* CANADA, fig. 4.

WRITINGS
Wanderings of an Artist among the Indians of North America from Canada to Vancouver's Island and Oregon through the Hudson's Bay Company's Territory and Back Again (London, 1859/*R* 1968; rev. ed. J. R. Harper, Toronto, 1971)

BIBLIOGRAPHY
D. Bushnell jr: *Sketches by Paul Kane in the Indian Country, 1845–1848*, Smithsonian Miscellaneous Collections (Washington, DC, 1940)
K. Kidd: 'The Wanderings of Kane', *Beaver* (Dec 1946), pp. 3–9
——: 'Paul Kane, Painter of Indians', *Royal Ont. Mus. Archaeol., Bull.*, xxiii (1955), pp. 9–13
J. R. Harper: *Early Painters and Engravers in Canada* (Toronto, 1970)
Paul Kane, 1810–1871 (exh. cat. by J. R. Harper, Fort Worth, TX, Amon Carter Mus.; Ottawa, N.G.; 1971)
M. Benham: *Paul Kane* (Don Mills, 1977)
B. Haig: *Paul Kane, Artist* (Calgary, 1984)

KIRK MARLOW

Kanerva, Aimo (Ilmari) (*b* Lahti, 19 Jan 1909). Finnish painter. He studied at the Central School of Applied Arts, Helsinki (1931–4), and at the School of Drawing of the Finnish Arts Association, Helsinki (1934–5 and 1937). Because of World War II his career did not really get under way until the mid-1940s. Kanerva was one of the central figures in the movement towards expressionism among the younger generation of Finnish artists of the period. His sombre self-portraits of the time, with their sharp, black outlines (e.g. *Self-portrait*, 1946; priv. col., see 1983 exh. cat., p. 28), and his landscapes, with their broad, passionate strokes and few, often very brilliant, colours (e.g. *Yellow Meadow*, 1945; Helsinki, City A. Mus.), constituted a fierce assault on the establishment and on academic classicism. At this stage it was probably Vincent van Gogh and Georges Rouault, as well as the Swedish expressionist Carl Kylberg (1878–1952), who inspired him. His affinity with the sparse and intensive style of the Finnish painter Helene Schjerfbeck can also be detected in his work, particularly in his early watercolours. Kanerva's expressionist style tended towards abstraction.

During the 1940s Kanerva joined the October group, for whom he had already felt a certain affinity during the 1930s. This group advocated the promotion of Finnish nationalism in art, especially through landscape painting. Kanerva became one of the most influential figures in the group and dedicated himself to depicting the special character of the Finnish landscape. The pathos and emotional expression of the early period gave way to a dispassionate observation of nature. From this time on he concentrated on depicting the forest, particularly the tall pine groves and the vast mountainscapes so characteristic of Finland. These are landscapes that convey a stark and grave atmosphere, and Kanerva returned to them constantly, at different times of the year. The painting *Vuokatinvaara* (1949; Helsinki, Athenaeum A. Mus.) is a typical, darkly toned scene in blues and greens, which portrays the massive contours of the landscape and conveys its rigorous unapproachability with its almost blunt, black lines. The walls of pine forest, the wilderness opening or closing on to a great silence, with the occasional mountain or lake, are recurrent scenes in Kanerva's work that later became established images in Finnish cultural life. Working outside in the Finnish landscape became a way of life for Kanerva, and he lived in the countryside for the majority of the 1950s; for about 20 years from 1956 he made long journeys into Lappland and elsewhere in the north of Finland in order to paint. He worked in watercolour as well as oil, and the robust style of his oils became more lyrical. His watercolours tend to use clean, simple lines and a few spontaneous hints of colour, as in, for example, *Spring on the Ounasjoki River* (1968; Rovaniemi, A. Mus.). He was not drawn to the mystical or the picturesque, preferring a direct observational approach that betrays a certain tenderness.

From the 1960s onwards Kanerva depicted an increasing number of flowers, including heather (Fin. 'kanerva'), as well as wild rosemary, cornflowers and tall buttercups. The range is extensive, and his approach to this theme is similarly direct and precise. *Vetchling* (1962; Helsinki, Anderson Mus. A.) demonstrates this simple, unaffected style. The adoption of this subject-matter represented a move towards the increased concentration on detail. He was probably attracted to this theme by the risk of sentimentality. Kanerva was always willing to question established concepts and attitudes. He began in the 1980s to further extend the scope of his work by painting landscapes abroad, for example in Iceland, Greece and Madeira. He also painted the human figure, particularly in stern, reticent self-portraits and portraits of others, including many writers, for example *Mika Waltari* (1956; Helsinki, Athenaeum A. Mus.).

BIBLIOGRAPHY
J. Boulton Smith: *Modern Finnish Painting and Graphic Art* (London, 1970), pp. 30–31
M. Waltari: *Aimo Kanerva: Suomalaista maisemaa etsimässä/In Search of the Finnish Landscape* (Espoo, 1977) [contains autobiog. notes]
Aimo Kanerva (exh. cat. by A. Kanerva and P. Suhonen, Helsinki, A. Exh. Hall, 1983)

Ekspressionisteja 1940-luvulta [Expressionists of the 1940s] (exh. cat. by S. Sinisalo, Helsinki, Acad. F.A. and Sinebrychoff A. Col., 1983), pp. 3–7, 28–9

U. Pallasmaa: 'Aimo Kanerva ja maiseman eksistenssi' [Aimo Kanerva and the nature of landscape], *Taide*, 6 (1987), pp. 52–7 [with Eng. summary]

Aimo Kanerva (exh. cat. by T. Valjakka, Helsinki, Gal. Krista Mikkola, 1987)

SOILI SINISALO

Kanesh. *See* KÜLTEPE.

Kang (i). Hollow brick platform constructed against the interior façade wall of houses in northern China, beneath the lattice windows (*see* CHINA, §II, 5(ii)). Heated from the inside by small, free-standing braziers or flues connected to cooking stoves, kang are usually used as sleeping areas at night and seats during the day. They are usually the width of one bay (*see* CHINA, §II, 1(i)) and about 1 m high and 1.5 m deep. Kang are not found in the warmer areas of southern China, south of the Yangzi River. Evidence from pottery models of houses found in tombs suggests that kang existed during the Han period (206 BC–AD 220); they are still found in the countryside, though they are rare in cities. The decline of kang in urban areas probably began with the introduction of movable Western-style furniture in the 1920s.

Kang are usually covered with mats, although in Shanxi Province they are draped with brightly painted black oilcloths decorated with flowers, phoenixes, dragons and good-luck symbols. Major items of furniture associated with kang include low, narrow wooden tables, footrests and quilted silk cushions. The Manchus from north-eastern China also used kang and often built several into one room, instead of the single platform of the Chinese. Wooden platforms similar to kang, furnished with tables and cushions, were installed in the imperial Summer Palace (*Yihe yuan*) in Beijing under the Qing emperors (1644–1911) and in the residential palaces of the Forbidden City.

See also HYPOCAUST, §2.

BIBLIOGRAPHY

E. Ysbrants Ides: *Driejaarige reize naar China, te lande gedaan door den Moskovischen afgezant* [Three years' travel from Moscow overland to China] (Amsterdam, 1704; Eng. trans. of 1st edn, 1706), pp. 54–5

J. Dickinson: *Observations on the Social Life of a North Chinese Village* (Beijing, 1925), p. 12

J. Needham, Wang Ling and Lu Gwei-Djen: *Civil Engineering and Nautics* (1971), iv/3 of ed. J. Needham (Cambridge, 1954–88), pp. 134–5.

FRANCES WOOD

Kang (ii). Korean family of calligraphers and scholar-painters. They were related by marriage to the royal house of the Chosŏn dynasty (1392–1910). (1) Kang Hŭi-an is probably the best known of the group. He and his younger brother, (2) Kang Hŭi-maeng, were cousins of the kings Munjong (*reg* 1450–52) and Sejo (*reg* 1455–68) and of Prince Anp'yŏng, also known as Yi Yŏng, famous for his collection of Chinese painting. Kang Hŭi-maeng, like his father Kang Sŏktŏk (1395–1459), established himself as a master of the 'three perfections'—poetry, calligraphy and painting.

(1) Kang Hŭi-an [*cha* Kyŏngu; *ho* Injae] (*b* 1419; *d* 1464). In 1462 he travelled to China, where his talents were admired. The best-known Korean scholars of his day

Kang Hŭi-an: *Scholar Gazing at the Water*, ink on paper, 234×157 mm, mid-15th century (Seoul, National Museum of Korea)

wrote colophons for his works, and these indicate that he painted in several styles. However, when his sons asked him to give them instruction in painting, he rejected the request by telling them that it would damage a scholar's reputation if he left behind works of the 'inferior arts' of calligraphy and painting. *Scholar Gazing at the Water* (see fig.) bears the seal 'Injae'; although scholars doubt the seal's authenticity, they regard this album page as the most representative example of Kang Hŭi-an's painting style. Kang's style has been likened to that of the Zhe school, however it is more convincingly linked to the style of Chinese Chan Buddhist painting of the Song (960–1279) and Yuan (1279–1368) periods (see CHINA, §V, 3(ii)) that may well have influenced Korean painting from as early as the Koryŏ period (918–1392). *Scholar Gazing at the Water* is characterized by its vivacious style, strong contrasts and tendency to geometric simplification. Other works attributed to Kang Hŭi-an to some extent reflect the stylistic tendencies of the 16th century that linked early Korean literati painting with the late Chinese Zhe school.

(2) Kang Hŭi-maeng [*cha* Kyŏngsun; *ho* Unsong kŏsa] (*b* 1424; *d* 1483). Younger brother of (1) Kang Hŭi-an. In 1447 he passed the highest civilian examination (*munkwa*). At the high point of his career he held the office of councillor of state, and in 1463 he took part in a mission to China.

His observations on painting clearly show the influence of the Chinese Song-period (960–1279) theory of literati painting as outlined by SU SHI. Kang Hŭi-maeng attempted to establish literati painting as a medium of perception, meditation and expression within the philosophical framework of Neo-Confucianism, differentiating it sharply from court painting. Nevertheless, he also defended the Bureau of Painting (Tohwasŏ) against the criticisms of purist Confucian officials. Furthermore, discussions from 1478 set down in the *Sillok* ('Chronicles of the Chosŏn dynasty') show how vehemently several powerful officials rejected his paintings. The only surviving work of art known to be by Kang Hŭi-maeng is *Solitary Fisherman* (hanging scroll, ink on paper, 1315×857 mm, mid-15th century; Tokyo, N. Mus.), which carries a poem written in the painter's hand with the signature *Unsong kŏsa*. The subject and composition indicate the influence of Chinese literati painting of the Yuan period (1279–1368), especially that of Li Kan and his son Li Shixing. Kang Hŭi-maeng's painting is characterized by his spacious treatment of landscape, his masterly brushwork and the strong contrasts that are also seen in Kang Hŭi-an's work. These could well be the characteristic features of a particular style of Korean literati painting that dates back to the Koryŏ period (918–1392).

BIBLIOGRAPHY

O Se-ch'ang: *Kŭnyŏk sŏhwa ching* [Dictionary of Korean calligraphers and painters] (Taegu, 1928/*R* Seoul, 1975), pp. 56–7

Ko Yu-sŏp: 'Injae Kang Hŭi-an sogo' [A short study of Kang Hŭi-an], *Hanguk misul munhwasa nonch'ong* (Seoul, 1966, 3/1983), pp. 283–93

Yu Pok-yŏl: *Hanguk hoehwa taegwan* [Pageant of Korean painting] (Seoul, 1969), pp. 73–7

Chōsen no kaiga [Exhibition of Korean painting of the Koryŏ and Chosŏn dynasties] (exh. cat., Nara, Yamato Bunkakan, 1973)

Ahn Hwi-joon [An Hwi-jun], ed.: 'Hanguk chŏlpa hwap'ung-ŭi yŏn'gu' [A study of Korean painting of the Zhe school style], *Misul Charyo*, xx (1977), pp. 24–62

Yoshida Hiroshi: 'Riko-chō, Seisō-chō no kaiga jijō' [The circumstances of painting under the reign of King Songjong of the Chosŏn dynasty], *Chōsen Shi Kenkyū Kairon Bunshū*, xxi (1984), pp. 17–24

Treasures from Korea (exh. cat., intro. R. Goepper, ed. R. Whitfield; London, BM, 1984)

Hong Sŏn-p'yo: 'Injae Kang Hŭi-an-ŭi 'Kosa kwansu to' yŏn'gu' [A Study of Kang Hŭi-an's 'Scholar Gazing at the Water'], *Chŏngsin munhwa yŏngu*, xxvii (1985), pp. 93–106

B. Jungmann: *Die koreanische Landschaftsmalerei und die chinesische Che-Schule vom späten 15. bis zum frühen 17. Jahrhundert* (Stuttgart, 1992), pp. 62–89

BURGLIND JUNGMANN

Kangakuin. *See under* ONJŌJI.

Kangavar. Site in western Iran, halfway between Kirmanshah and Hamadan. Extensive archaeological remains have been identified as the ruins of a Seleucid or early Parthian (3rd–1st century BC) Temple of Artemis (probably to be equated with the Iranian goddess Anahita) mentioned by Isidore of Charax (c. AD 25). Excavations from 1969, directed by Kambakhsh-e Fard and Massoud Azarnoush, have led some scholars to suggest that the site was that of a late Sasanian palace (6th–7th century AD). The remains are composed of several platforms, built of stone rubble and gypsum mortar in at least three levels, on a rocky hill about 32 m high. The lowermost platform is a massive, partially preserved roughly quadrilateral construction (c. 224×209 m) around the hill; it is c. 18 m wide, and its height was probably rarely less than 8 m. It was reached by two facing flights of stairs on the south and by a third, poorly preserved flight near the north-east corner. The platform was faced with cut stones of various dimensions. This façade, now mostly collapsed, was topped by a cyma recta cornice and a row of columns, except for the section between the two flights of stairs. The total height of the base, shaft (diam. c. 1.44 m) and capital is c. 3.54 m. The span between the columns may have been covered by a horseshoe arch. The middle platform (c. 93×9.3 m) stands on the southern half of the hill. A third platform at the top of the hill has been only partially uncovered. The complex at Kangavar has been dated to the 3rd–1st century BC on the basis of stylistic comparisons between its capitals and those of the Doric order, although there are differences, particularly relating to the proportions between the height of the shaft and its diameter. Archaeological discoveries, however, support a late Sasanian date.

BIBLIOGRAPHY

Enc. Iran.

Isidore of Charax: *Parthian Stations* [c. AD 25]; ed. and Eng. trans. W. H. Schoff (Philadelphia, 1914), p. 7

V. Lukonin: 'Khram Anakhity v Kangavare' [The temple of Anahita in Kangavar], *Vestnik Drevney Istorii*, n. s., cxl (1977), pp. 105–11

M. Azarnoush: 'Excavations at Kangavar', *Archäol. Mitt. Iran*, xiv (1981), pp. 69–94

MASSOUD AZARNOUSH

Kanggonaemal (*fl* c. AD 755). Korean sculptor. He is the only known sculptor of the Unified Silla period (AD 668–918). The name Kanggonaemal is composed of two elements: Kanggo, the name of the artisan, and naemal, also written nama, which is the title of the 11th of the 17 government ranks of the time and indicates the high position of the artisan. It is probably because of his aristocratic status that his name was recorded.

The 13th-century *Samguk yusa* ('Memorabilia of the three kingdoms') describes a gilt-bronze statue of the healing Buddha, the Yaksa Yorae (Skt: Bhaisajyaguru), made in the 14th year of the reign of Kyŏngdŏk (742–65), that is, 755. The statue was made for Punhwang Temple at Kyŏngju, the Silla capital, one of the seven great temples of Korea. The *Samguk yusa* states that the weight of the statue was 306,700 *kŭn* (1 *kŭn* equals 601.04 g) and its maker was Kanggonaemal. The statue itself has not survived. In estimating the size of the statue, a comparison can be made with the Divine Bell of King Sŏngdŏk (Kyŏngju, N. Mus.), begun during Kyŏngdŏk's reign but not completed until after Hyegong came to the throne in 765. The *Samguk yusa* gives its weight as 120,000 *kun*. It is 3.3 m high, over 1.5 m in diameter and 200 mm thick. Kanggonaemal's gilt-bronze statue might be the one recorded as the Changyukpul (*chang* is a measure of length equal to 3.3 m; *yuk* signifies the number six; *pul* means Buddha). The height of the Changyukpul is recorded as having been about 5 m.

BIBLIOGRAPHY

Iryŏn: *Samguk Yusa: Legends and History of the Three Kingdoms of Ancient Korea* (13th century AD); Eng. trans. Tae-Hung Ha and G. K. Mintz (Seoul, 1972)

E. B. Adams: *Kyŏngju Guide* (Seoul, 1979), p. 51

Hwang Su Yong [Hwang Su-yŏng]: *Buddhist Art*, iii of *The Arts of Korea* (Seoul, 1979), pp. 138–47

KANG WOO-BANG

Kang Hŭi-ŏn [*cha* Kyŏngun; *ho* Tamjol] (*b* 1710; *d* after 1781). Korean painter. After passing the military examination in 1754, he took up a military post. Although he is not counted among the literati painters, it is clear that he had contact with them. Nearly all his surviving paintings bear inscriptions by KANG SE-HWANG, and an eight-panelled screen (ink and colour on silk, each panel 909×429 mm) painted by Kim Hong-do (see KIM (iv), (1)) in 1778 bears an inscription by Kang Hŭi-ŏn (Seoul, N. Mus.; see An Hwi-jun, 1985, pls 118–20). Kim Hong-do further painted a scroll (1781; Seoul, priv. col.) to commemorate a gathering, depicting Kang Hŭi-ŏn in the company of himself and a third person.

Kang Hŭi-ŏn painted landscape and genre scenes. *Mt Inwang* (handscroll, ink and light colour on paper, 426×246 mm; Seoul, priv. col.; see Kim, Choi and Im, no. 75), which displays the stylistic influence of Chŏng Sŏn, is representative of his work. However, Kang Hŭi-ŏn's painting of Mt Inwang differs in two important respects from that of Chŏng Sŏn (see, e.g., Kim, Choi and Im, no. 66): the mountain is further off, and, despite his detailed outlining of many small ridges, Kang depicts the mountain as a complex whole. In his inscription Kang Se-hwang points out that one of the dangers of reproducing real landscape is that you could end up creating a map. However, this picture, he continues, is true to nature while also exploring the inherent possibilities of painting. The 20th-century art historian Yi Tong-ju classifies Kang Hŭi-ŏn's figure painting as literati-style genre painting. Three album leaves (each 260×210 mm; Seoul, priv. col.; see An Hwi-jun, 1985, pls 89–91) show scholars painting, writing poetry and shooting arrows. These were painted to commemorate a summer gathering with a group of friends including Kang Se-hwang, the author of the colophon. In the background of the arrow-shooting picture there are women washing clothes in a brook, a scene that anticipates similar paintings by Sin Yun-bok. In another picture (Seoul, priv. col.; see Maeng In-jae, pl. 57), which depicts the well-known Han-period (206 BC–AD 220) story of Wang Zhaojun's journey to see the nomadic Xiongnu people, Kang Hŭi-ŏn portrays women in a style strikingly similar to that of Sin Yun-bok. Kang Hŭi-ŏn also devotes a small picture to the work of quarrymen (1754; Seoul, N. Mus.). The composition of this album leaf is reminiscent of similar genre paintings by Yun Tu-sŏ, while it also represents a link to the style of Kim Hong-do.

See also KOREA, §IV, 2(iv)(b).

BIBLIOGRAPHY
Yi Tong-ju: *Urinara-ŭi yet kŭrim* [Ancient Korean paintings] (Seoul, 1975), pp. 186, 217
Kim Won-yong [Kim Wŏn-yong], Choi Sun U (Ch'oe Sun-u) and Im Chang-soon [Im Ch'ang-sun], eds: *Painting*, ii of *The Arts of Korea* (Seoul, 1979)
An Hwi-jun, ed.: *Sansuhwa* [Landscape painting], ii (1982), xii of *Hanguk-ŭi mi* [Beauties of Korea] (Seoul, 1977–85), pp. 232, 240, pls 18, 71
——: *P'ungsokhwa* [Genre painting] (1985), xix of *Hanguk-ŭi mi* [Beauties of Korea] (Seoul, 1977–85), pp. 223–4, pls 88–91
Maeng In-jae, ed.: *Inmulhwa* [Figure painting] (1985), xx of *Hanguk-ŭi mi* [Beauties of Korea] (Seoul, 1977–85), pp. 211–13, pls 57–9
BURGLIND JUNGMANN

Kang Se-hwang [*cha* Kwangji; *ho* P'yoam, P'yo'ong] (*b* 1713; *d* 1791). Korean painter, calligrapher and critic.

He was born into a prominent literati family in Seoul and became the most influential connoisseur and critic of his time. At the age of 31 he moved to Ahnsan, near Seoul, where he lived for about 30 years. During this time he developed and completed his artistic identity, concentrating on producing various works of art–poetry, calligraphy and paintings. At the age of 61 he took up a civil service post for the first time. This presumably caused him to move back to Seoul, where he lived until his death. While he was in the service he did not lose his enthusiasm for creating art. His late works show a greater refinement and nobleness. In 1784 he travelled to China as an envoy to Beijing, where his paintings and calligraphy were greatly admired.

Kang Se-hwang played a pivotal role in the Korean artistic world of the late Chosŏn period through his comments and criticism and his innovations. He adapted the style of the Chinese Southern school, producing a Korean literati style (*see* KOREA, §IV, 2(vi)) and was instrumental in the development of the 'true-view' school of landscape painting (*see* KOREA, §IV, 2(ii)) and the popularization of genre pictures and portraits (*see* KOREA, §IV, 2(iv)(b) and (v)). His assessment of a contemporary's work might appear as an inscription on the artist's painting: for example, *Summer Landscape* by Chŏng Sŏn (Seoul, N. Mus.; see 1984 exh. cat., pl. 229), which carries an inscription dated 1773 by Kang. Kang's style shows the influence of the Chinese WU SCHOOL, while nonetheless incorporating distinctively Korean elements of execution and depicting scenes from the Korean countryside. He mainly painted landscapes and flowers and plants; in his later years he enjoyed painting ink bamboo. He left a number of self-portraits. A relatively large number of his works is extant, and in many cases the dates of production are known. *Scenic Spots of Songdo* is a set of 16 album leaves depicting scenes of Songdo (Kaesŏng), which was the capital of the Koryŏ dynasty (918–1392). One of the set, *White Rock Pool* (album leaf, ink and light colours on paper, 328×534 mm; Seoul, N. Mus.; see 1984 exh. cat., p. 201, pl. 236a), shows overlapping layers of square rocks executed in graded ink tones. The accompanying inscription by Kang says of *White Rock Pool* that 'its rocks are white as snow, and square as a chessboard. A clear flow spreads over them: the mountains all around are so green that they seem about to drip'. Kang's pioneering approach to painting was highly influential. Among those who followed his style were Kim Hong-do and Sin Wi.

BIBLIOGRAPHY
S. Cox: 'An Unusual Album by a Korean Painter, Kang Se-hwang', *Orient. A.*, xix/2 (1973), pp. 157–68
5000 Years of Korean Art (exh. cat., ed. R.-Y. Lefebvre d'Argencé; San Francisco, CA, Asian A. Mus.; Seattle, WA, A. Mus.; Chicago, IL, A. Inst.; and elsewhere; 1979–81), pp. 184–5, pls 232a–c
An Hwi-jun: *Sansuhwa* [Landscape painting], ii (1982), xii of *Hanguk-ŭi mi* [Beauties of Korea] (Seoul, 1977–85), pls 111–14
Treasures from Korea (exh. cat., intro. R. Goepper, ed. R. Whitfield; London, BM, 1984), p. 201, pls 236a–c
Pyŏn Yŏng-sŏp [Byun Young-Sup]: *P'yoam Kang Se-hwang hoehwa yŏn'gu* [A study of the paintings of Kang Se-hwang] (Seoul, 1988), pp. 227–9
PYŎN YŎNG-SŎP

Kang So Lee [Lee Kang-so; Yi Kang-so] (*b* Taegu, 1943). Korean artist. He studied at Seoul National University and Kyemyong University, Taegu, and has exhibited in Korea,

Japan, the USA, Europe and elsewhere. A leading modernist and active member of the Korean Avant Garde Association, Lee played a decisive role in the first Korean contemporary art festival in 1974. He has experimented with many techniques, from painting, drawings, prints and photography to installation, performance and video art. In the mid-1980s he began to concentrate on paintings in oil, employing subdued blues and greys. On such surfaces he placed images of ducks, deer and boats, executed in brushstrokes that in their calligraphic quality acknowledge Korean traditions. His subjects are seen as symbolic of shamanist images (see KOREA, §I, 5) and reveal a perceptive awareness of nature. His use of after-images, especially of ducks, hints at the shifting movement of the birds.

BIBLIOGRAPHY
Flow from the Far East (exh. cat., ed. C. Adams; London, Barbican Cent., 1992), pp. 96–119
Working with Nature (exh. cat., ed. L. Biggs; Liverpool, Tate, 1992), pp. 98–111
E. Heartney: 'The New Players', *A. America*, lxxxi/7 (1993), pp. 35–41
SUSAN PARES

Kang Youwei [K'ang Yu-wei; *zi* Nanhai] (*b* Nanhai, Guangdong Province, 19 March 1858; *d* Qingdao, Shandong Province, 31 March 1927). Chinese reformer, scholar and calligrapher. He is best known as the instigator of the Hundred Days Reform, which lasted from 16 June to 21 September 1898, when the Guangxu emperor (*reg* 1875–1908) accepted Kang's proposals for far-reaching change. Kang convinced the emperor of the importance of incorporating Western methods into Chinese culture so as to strengthen China against foreign aggression. The profoundly conservative dowager empress Cixi (1835–1908) staged a coup which brought the movement to an end. Kang fled the country and did not return until 1913, after the fall of the Qing dynasty (1644–1911).

Kang's formal education in calligraphy and epigraphy began under the tutelage of the eminent scholar, Zhu Ciqi (1807–81). Kang later chose a few models and copied them avidly: the *Shimen ming*, calligraphy carved into a cliff face in Shanxi Province in AD 509 by Wang Yuan, and the works of Chen Tuan (*d* AD 989). Kang's favourite more recent calligraphy was that of Zhang Yucao (1823–94). After 1888, he worked on an enlargement of BAO SHICHEN's *Yizhou shuangji* ['Oars of the boat of art'] called *Guang Yizhou shuangji* ['The expanded oars of the boat of art']. Kang's version brought the classification of calligraphers influenced by stelae up to date, and greatly expanded the list of important stelae first presented by Bao. The book was the last major treatise on calligraphy to be written in the Qing period. Kang's own calligraphy is limited almost exclusively to large running script (*xingsun*) or combinations of cursive script (*caoshu*) and running script. In *Your Writing Will Last a Thousand Autumns* (pair of hanging scrolls; see 1977 exh. cat., no. 90, p. 165) the characters are quickly brushed, open, free and strong. The preponderance of loose, broad, upturned strokes derives from Kang's study of stelae such as the *Shimen ming*.

See also CHINA, §IV, 2(vii)(c) and (viii)(a).

BIBLIOGRAPHY
K. Shimonaka, ed.: *Shodō zenshū* [Complete collection of calligraphy], vi (Tokyo, 2/1959); xxiv (Tokyo, 2/1962), pp. 166–7, pls 94–7
H. L. Boorman, ed.: *Biographical Dictionary of Republican China* (New York, 1968), pp. 228–33
Traces of the Brush: Studies in Chinese Calligraphy (exh. cat. by Shen Fu and others, New Haven, CT, Yale U. A.G.; Berkeley, U. CA, A. Mus.; 1977), pp. 137–8, 290, no. 90
Yu Jianhua: *Zhongguo meishujia renming cidian* [Dictionary of Chinese artists] (Shanghai, 1981), p. 803
ELIZABETH F. BENNETT

K'ang Yu-wei. *See* KANG YOUWEI.

Kanha (*fl c.* 1580–early 1590s). Indian miniature painter. He is best known for his animal studies, which influenced Miskin and Mansur. His single illustration in the *Dārābnāma* ('Story of Darab'; *c.* 1580–85; London, BL, Or. 4615, fol. 67*r*) presaged five designs in the *Razmnāma* ('Book of wars'; 1582–6; Jaipur, Maharaja Sawai Man Singh II Mus., MS. AG. 1683–1850; fols 38–9, 114 and 115–16) and five as colourist for the master Basawan (fols 69, 95, 132 and 138–9). His colouring of Daswanth's design for the *Great Deluge* (fol. 21) shows brilliant control of texture and palette in depicting the animals in the Ark, a subject and technique adapted by Miskin in the *Anvār-i Suhaylī* ('Lights of Canopus'; 1596–7; Varanasi, Banaras Hindu U., Bharat Kala Bhavan), the *Dīvān* (collected poems; *c.* 1595; Washington, DC, Freer, 48.8) of Hafiz and two other versions (priv. cols). With eight natural history studies in the first *Babarnāma* ('History of Babar'; *c.* 1590; London, V&A, I.M. 276 and A-1913 and dispersed), Kanha was the principal contributor to that section, guiding Mansur, who painted *Wild Buffalo* and *Hog Deer* (Washington, DC, Freer, 54.29*r* and *v*); he also illustrated six natural history studies in the *'Ajā'ib al-makhlūqāt* ('Wonders of creation'; *c.* 1590; Dublin, Chester Beatty Lib., Ind. MS. 6). However, his compositions in the first *Akbarnāma* ('History of Akbar'; *c.* 1590; London, V&A, I.S.2.1896.117; fols 12, 13, 64, 57 and 97) depict dramatic scenes of battling armies in which he developed the daring Persian device of a blank middle ground to establish psychological space and used a strong diagonal composition to expand the action beyond the margins. The absence of this great talent from later historical manuscripts and from all the literary manuscripts except a *Dīvān* of Hafiz (1588; Rampur, Raza Lib.) suggests that his career ended in the early 1590s.

BIBLIOGRAPHY
The Imperial Image: Painting for the Mughal Court (exh. cat. by M. C. Beach, Washington, DC, Freer, 1981)
P. Vaughan: 'Miskin', *Master Artists of the Imperial Mughal Court*, ed. P. Pal (Bombay, 1991), pp. 17–38
PHILIPPA VAUGHAN

Kanheri [Kaṇheri; anc. Kṛṣṇagiri; Kṛṣṇasaila; Kaṇhasela]. Buddhist cave site about 42 km north of Bombay in Maharashtra, India. The monastic establishment here, the largest in western India, flourished for at least 1100 years from *c.* 1st century BC to 11th century AD. The site comprises about 120 rock-cut caves, of which 6 have been identified as prayer-halls (*caitya*s), 53 as monastic residential complexes (*vihāra*s) and 8 as halls (*maṇḍapa*s); there are also water cisterns for drinking and bathing and benches for sitting.

The most important and impressive monument is Cave 3, a prayer-hall measuring 26.36×13.66×12.90 m and dating from the 2nd century AD. It is approached through a courtyard delineated by a railing and containing two pillars originally surmounted respectively by lions and celestial beings; the crowning wheels (*dharmacakra*) are no longer extant. The hall is basically a development of that at KARLE, although it lacks the latter's grandeur. As at Karle, it is preceded by an outer screen (which shows mortices for provision of a wooden façade) and consists of two tall, square pillars and two pilasters supporting a colonnade. The main entrance and two side doorways, set in the verandah are flanked by figures of 'donor couples' that do not have the individuality and vitality of those at Karle. The hall is divided into a nave and two aisles by colonnades that meet behind the stupa in the apse. In all, there are 34 octagonal columns; several of these have pot-like bases and bell-like capitals. The columns are surmounted by carvings of religious motifs such as elephants worshipping the *bodhi* tree or the stupa.

Other distinctive monuments at Kanheri include a congregation room (*uposathaśālā*), an almonry, a dam to irrigate the nearby monastery fields and a row of stupas erected in memory of illustrious monks and teachers. Of the 75 Prakrit and Sanskrit inscriptions known at the site, most are epitaphs associated with this 'stupa gallery' and show that from *c.* AD 550 to 700 there was a succession of Buddhist teachers well versed in Buddhist lore. A number of the caves are notable for sculptures of the VAKATAKA period (3rd–5th century), chiefly Buddha figures, *bodhisattva*s and *nāga*s. Among the most remarkable of these is a figure of the *bodhisattva* Avalokiteshvara represented with four arms and eleven heads (Cave 41).

See also INDIAN SUBCONTINENT, §§III, 3(ii)(d) and IV, 5(iii)(b).

BIBLIOGRAPHY

J. Fergusson and J. Burgess: *The Cave Temples of India* (London, 1880), pp. 348–60

V. Dehejia: *Early Buddhist Temples: A Chronological Study* (London, 1972), pp. 132–3, 183–4

S. Nagaraju: *Buddhist Architecture of Western India* (New Delhi, 1982), pp. 190–221, 303–5, 333–6

S. Gokhale: *Inscriptions of Kanheri* (Pune, 1991)

A. P. JAMKHEDKAR

Kanikaria, Panagia. *See* LYTHRANKOMI, PANAGIA KANIKARIA.

Kan Izue. *See* IZUE, YUTAKA.

Kanjirō Kawai. *See* KAWAI, KANJIRŌ.

Kanka [Kharadzhet; Kharashket]. Site in Uzbekistan near Tashkent on the Akhangaran River, a tributary of the Syr, which flourished from the 5th century BC to the 12th century AD. Kanka has been identified with Antiochia in Scythia (*c.* 3rd century BC). From the early 1st century AD the city was the capital of the Kangian, a minor tribe of the Yuehchih, and later the capital of CHACH (3rd–7th century), with monumental architecture of the Hephthalite and Turkish periods. At the beginning of the 10th century, Kanka, the second most important city in Chach, was a trading centre for weaving, metal, ceramic and glass wares. The city was abandoned in the 12th century when the Akhangaran River changed course. The site was first noticed by the Russian painter Vasily Vereshchagin in 1887 and investigated by M. Ye. Masson in 1934. Excavations were carried out in 1969–72 by the Central Department for the Conservation of Monuments of Material Culture (GUOPMK), and from 1974 onwards by Yu. F. Buryakov, Institute of Archaeology, Academy of Sciences, Uzbekistan.

The site, bounded by the river on the north-eastern side, comprises a square citadel (1 ha; h. 40 m) enclosed by moats, an adjoining square city centre (I) of 6.5 ha surrounded by walls and moats, a subsequent expanded rectangular city area (II) of 42 ha and a final enlarged rectangular walled city (III) of 150 ha, surrounded by suburbs of 60 ha. The citadel, a fortified stronghold with square bastions, bypass tunnels and an entrance ramp, contained a fire temple and dwellings of the 5th–8th century AD, and later buildings of the 10th–12th century AD, when it was the seat of the Qarakhanid rulers of the city. The cultural layer of the adjoining area (I) was up to 17.5 m thick. The subsoil contained mud houses and modelled ceramic objects of the 5th–3rd century BC. In the 3rd–2nd century BC, solid fortified walls with circular rammed-earth bastions were built on raised earthworks surrounded by a berm and ditch. Above these, a mud-brick double wall was constructed in the first centuries AD. On the next level are fortifications of the 4th–8th century and, in the centre of the city, a monumental 4th–6th-century temple, decorated with wall paintings, reliefs and figural terracotta slabs.

In the 6th century houses in the city area (II) were enclosed by a fortified wall. The adjoining area (III) comprised a stronghold of the 7th–8th century, additional fortified structures including gate-houses, a caravanserai and an artisans' quarter of the 9th–12th century. Outside the city were ceramic workshops (6th–8th and 10th–11th century). Finds included silver and copper coins (3rd–11th century), anthropomorphic and zoomorphic terracotta statuettes, metal-, bone- and stone-working tools, ceramics, glassware and gold ornaments set with hardstones.

BIBLIOGRAPHY

M. E. Masson: *Akhangaran: Arkheologo-topograficheskiy ocherk* [Akhangaran: an archaeological-topographical outline] (Tashkent, 1953)

Yu. F. Buryakov: *Istoricheskaya topografiya drevnikh gorodov Tashkentskogo oazisa* [The historical topography of the ancient cities of the Tashkent oasis] (Tashkent, 1975)

——: *Genezis i etapy razvitiya gorodskoy kul'tury Tashkentskogo oazisa* [The origins and evolution of the city culture of the Tashkent oasis] (Tashkent, 1982)

YU. F. BURYAKOV

Kaňka, František Maximilián (*b* Prague, *bapt* 19 Aug 1674; *d* Prague, *bur* 14 July 1766). Bohemian architect. He was apprenticed to his father, Vít Václav Kaňka (1650–1727), and to Pavel Ignác Bayer (?1656–1733), and he combined in his long life a builder's practice with design activities. He was among the busiest and most productive architects in Bohemia in the 18th century and made an important contribution to the character of Baroque architecture. His work particularly followed Giovanni Battista Alliprandi's decorative style and Giovanni Santini's monumentalism; indeed, he often cooperated on the buildings of both designers, some of which he also completed after

their deaths. Kaňka's churches are characterized by simple and clearly organized ground-plans, as at the town church (1724), Donaueschingen, and the church of St John of Nepomuk (1734–52), Kutná Hora; such plans were adopted with various modifications in village churches throughout Bohemia. Inspired by Santini's 'Baroque-Gothic', he also successfully solved the problem of rebuilding medieval churches, including St Prokop at Třebíč (1727–33) and Holy Mary at Roudnice (1725). His secular buildings also create a harmonious effect, with the emphasis on rich three-dimensional décor; examples include mansions at Kolodĕje (1706–12), Vinoř (1718–22) and Krásný Dvůr (1720–24), or the stair hall (*Treppenhaus*) at the Černín Palace (1717) in Prague. His aptitude for well-thought-out composition and gradation of masses is evident in the Vrtba Gardens (1718–21), which are ingeniously situated in the country of the Prague basin. Kaňka's versatility is impressive. He embraced all areas of architecture, including small works of a decorative nature, such as altars, memorials and statues, which he sometimes undertook in conjunction with Matyáš Bernard Braun's workshop. In 1709 Kaňka was one of the artists who petitioned the authorities to establish an Academy of Arts in Prague. The tendency towards a refined and restrained decorativeness in Kaňka's late works from *c.* 1730 already signals the artistic influence of Kilián Ignác Dientzenhofer.

Thieme–Becker

BIBLIOGRAPHY

Z. Wirth: *František Maximilián Kaňka: Cestami umění* [František Maximilián Kaňka: the ways of art] (Prague, 1949), pp. 161–75
E. Poche and P. Preiss: *Pražské paláce* [Prague palaces] (Prague, 1973), pp. 69–82
E. Poche: 'František Maximilián Kaňka', *Encyklopedie českého výtvarného umění* [Encyclopedia of Czech art] (Prague, 1975), p. 201
P. Macek, P. Vlček and P. Zahradník: 'František Maximilián Kaňka "In regno Bohemiae aedilis famossissimus"', *Umění* (1992), pp. 180–227

JIŘÍ T. KOTALÍK

Kann, Rodolphe [Rudolf] (*b* 1845; *d* Paris, 1905). French collector. He began collecting in 1880, with the purchase of the first of 11 paintings by Rembrandt; during the next 20 years he built an important collection of Old Master paintings, which he purchased, following his own judgement, in Paris and London. His preference was for picturesque, high-quality, well conserved works in the Grand style, especially those of Rembrandt, Frans Hals and Meindert Hobbema; consequently, the strength of his collection was the Dutch paintings, including Vermeer's *Girl Asleep at a Table* and Rembrandt's *Aristotle Contemplating a Bust of Homer* (both New York, Met.). His interest in paintings and *objets d'art* from later periods, including bronzes and Gobelins tapestries, was primarily decorative.

Kann's collection was displayed in his house on the Avenue d'Iéna in Paris, decorated in the style of Louis XVI. Two large rooms with skylights displayed the 17th-century paintings, while the 15th- and 16th-century works, including Ghirlandaio's *Giovanna Tornabuoni* (Madrid, Mus. Thyssen-Bornemisza), were shown in a central salon. Doors on the second floor connected the house to the adjoining one belonging to Kann's brother, Maurice Kann, also an important collector; by opening them, a single large gallery was created. However, the brothers' original plan to make the two houses into one museum was never carried out, because they quarrelled over the acquisition of works of art. After Rodolphe Kann's death his collection, which had been inherited by his two sons, was sold *en bloc* in August 1907 for almost £900,000 to Duveen Brothers, who opened the Kann house in Paris to important clients. These included the American collectors Benjamin Altman, J. Pierpont Morgan and John G. Johnson; it was through them that many of Kann's paintings entered the Metropolitan Museum of Art in New York and other public collections in the United States.

BIBLIOGRAPHY

W. von Bode: *Die Gemälde-Galerie des Herrn R. Kann in Paris* (Vienna, 1900)
E. Michel: 'La Galerie de M. Rodolphe Kann', *Gaz. B.-A.*, n. s. 2, xxv (1901), pp. 386–400, 493–506
A. Marguillier: 'La Collection de M. Rodolphe Kann', *Les Arts* [Paris] (1903), no. 13, pp. 2–10; no. 14, pp. 19–31; no. 15, pp. 2–7
W. von Bode: *Catalogue of the Rodolphe Kann Collection*, 2 vols (Paris, 1907)
C. J. Holmes: 'Recent Acquisitions by Mrs C. P. Huntington from the Kann Collection', *Burl. Mag.*, xxii (1908), pp. 195–233
M. Nicolle: 'La Collection Rodolphe Kann', *Rev. A. Anc. & Mod.*, xxiii (1908), pp. 187–204
E. Fowles: *Memories of Duveen Brothers* (London, 1976), pp. 36–42

AMY WALSH

Kannas, Tell. *See under* HABUBA KABIRA.

Kannauj [Kanauj, Kanoj; anc. Kānyakubja, Mahodayapura, Gādhinagara, Kuśika]. Capital of the premier ruling dynasties of north India from the 6th century AD to the early 11th, in Farrukhabad District, Uttar Pradesh, India. Excavation revealed four periods of cultures dating from *c.* 1000 BC to 'medieval', the early phases being marked by small finds and terracotta figures. Barring these and some early stone images, the bulk of available remains, consisting of loose sculpture and architectural fragments, relates mainly to the 9th and 10th centuries, when the GURJARA-PRATIHARA dynasty was at the height of its power. Among the leading 9th-century works are a *liṅga*—phallic emblem of Shiva—carved with four faces (Kannauj, priv. col.), a Durga image (Lucknow, State Mus.), and a panel depicting Shiva's marriage with Parvati (Kannauj, priv. col.). Also of note are depictions of Vishnu in his Vishvarupa or universal form; two such images are in worship as Rama and Lakshmana in a modern shrine in Kutlupur, a locality in the suburb of Makarandanagar. Other distinctive sculptures represent Bhairava (*see* INDIAN SUBCONTINENT, fig. 182) and Mahishasuramardini (both Kannauj, Puratattva Sangrahalaya), and the anointment of Skanda (New Delhi, N. Mus.). A particularly remarkable work is a panel depicting the divine mothers (Skt *mātrikā*s) Vaishnavi, Varahi, Aindri and Chamunda (Kannauj, Puratattva Sangrahalaya; *see* INDIAN SUBCONTINENT, fig. 5).

Kannauj declined after it was sacked by Mahmud of Ghazna in 1018; the site of the city and its forerunners is marked by huge mounds. Among the later structures in various states of preservation are the Jami' Masjid (1476) and the coeval tomb of Maqdum Jahaniya. The mosque, with finely proportioned colonnades, has an ogee-arched mihrab and a portal with intricately carved brackets and decorative panels. The tombs of Bala Pir and Shaykh Mahdi (both 17th century) are square domical structures

set side by side on a high stone plinth. A caravanserai of 1682 is reported from Saraimiran, a suburb of Kannauj.

See also INDIAN SUBCONTINENT, §IV, 7.

BIBLIOGRAPHY

A. Cunningham: *Four Reports Made during the Years 1862–63–64–65*, Archaeol. Surv. India, i (Simla, 1871/*R* Varanasi, 1972), pp. 279–93
Indian Archaeology, 1955–56: A Review, Archaeol. Surv. India (New Delhi, 1956), pp. 19–20
B. N. Puri: *The History of the Gurjara–Pratihāras* (Bombay, 1957)
M. M. Mukhopadhyay: *Sculptures of Ganga–Yamuna Valley* (New Delhi, 1984)
T. S. Maxwell: *Viśvarūpa* (Delhi, 1988)
A. Ghosh, ed.: *An Encyclopaedia of Indian Archaeology*, ii (New Delhi, 1989), pp. 199–200
M. M. Mukhopadhyay: 'Kanauj Sculptures: An Overview', *Prachi Prabha: Perspectives in Indology* [essays in honour of Prof. B. N. Mukherji], ed. D. C. Bhattacharya and Devendra Handa (New Delhi, 1989), pp. 277–88
A. L. Shrivastava: 'Kannauja sangrahalaya ki Harsha-kalin Uma-Maheshwara pratima' [Umā–Maheśvara image of the times of Harsa in the Kannauj Museum], *Bull., Mus. & Archaeol. U.P.*, 43–4 (1989), pp. 103–8
I. A. Khan: 'The Kārwānsarāys of Mughal India: A Study of Surviving Structures', *Ind. Hist. Rev.*, xiv/1–2 (1990), pp. 111–37

R. N. MISRA

Kano. City in Nigeria. The third largest city in the country, in the 1980s it had an estimated population of over 1,000,000. Its geographical location, in the north of the country and 480 km from the perimeter of the Sahara, makes it an influential commercial centre in the West African Sudan zone, a factor responsible for its size and prosperity.

Records of the early development of the city are limited, but the evidence indicates that it was probably founded *c.* AD 900. The earliest settlement was at Dala Hill, a granite outcrop now within the city limits. There the water table was high, and the presence of ores encouraged the development of an iron-working community.

The Daura legend tells of the founding by a family of invaders of seven city states, collectively known as the Hausa *Bakwai* (Arnett, 1910). Kano was one of these states and was an early industrial centre, specializing in textile-weaving and leatherworking, but later developed as a great market at the terminus of a caravan route connecting it to the Mediterranean world. In the 14th century Islam was introduced from Mali, and the city reached its zenith under the *sarki*, Rumfa (1463–99). Rumfa extended the city walls, established the present Kurmi market and built a new palace, of which only the gate is extant. Islam was strengthened within the city by the Fulani jihad in the 19th century, but, nevertheless, Kano was occupied by the British in 1903. The rail connection to Lagos was completed in 1911, giving impetus to the city's commercial growth (Hogben and Kirk-Greene, 1966).

Kano consists of several well-defined areas. At the centre is the walled city, the ancient seat of political and religious power occupied by the local Hausa and Fulani. Surrounding the old city are a number of distinct strangers' quarters. Fagge is a district occupied by Arabs, Tuareg and Lebanese, as well as Hausa and Fulani. The Government Reserved Area, once the British colonial town, is now inhabited by government officials. Muslim northerners occupy Tudun Wada, while other Nigerians live in Sabon Gari (a new town). In the late 20th century Kano was

expanding to the south and east with a large development area that was first designated in a plan dating from the early 1960s (Trevallion, 1963; *see also* NIGERIA, §IV). The old city is surrounded by the remains of the city walls (*see* MILITARY ARCHITECTURE AND FORTIFICATION, §IX). The main routes from the gates pass through a broad band of agricultural land before converging on the market and the long, wide public space known as the *dendal*, which is the main civic, religious and ceremonial focus of the city and which is where the whole community gathers for the greater and lesser Sallah, when the emir's subjects express loyalty to him in front of the palace entrance (*see* AFRICA, §III, 1 and fig. 17). Around the edge of the *dendal* are the emir's palace, Gidan Sarki (*see also* PALACE, §VIII), the administrative buildings and the city's main Friday mosque, Masalla cin Jumma'an, built for Emir Abdullahi Bayero in 1951 after his second pilgrimage to Mecca. Each Friday the emir progresses from the palace to the mosque to lead the community in prayer. The residential area divides into wards (*ungugoyi*), which are sometimes associated with a particular gateway and are occupied by groups practising the same trade. Wards comprise family compounds, with communal open spaces on to which the compound doors open, along with the administrative, religious and mercantile focuses provided by the home of the ward head, a small local mosque and, possibly, a street market, respectively (Moughtin, 1985).

Although the old city contains fine examples of traditional architecture (Dmochowski, i, 1990), in the early 1990s many mud and thatch roofs were being replaced by tin roofing and mud walls by concrete blockwork. Despite these innovations and other developments in infrastructure, the traditional form of the house continued, the Islamic requirement of strict privacy resulting in a single entrance, high compound wall and one or more courtyards (Schwerdtfeger, 1982).

BIBLIOGRAPHY

E. J. Arnett, trans.: 'A Hausa Chronicle', *J. Afr. Soc.*, ix (1910), pp. 161–7
B. A. W. Trevallion: *Metropolitan Kano* (Oxford, 1963)
S. J. Hogben and A. H. M. Kirk-Greene: *The Emirates of Northern Nigeria* (Oxford, 1966)
F. W. Schwerdtfeger: *Traditional Housing in African Cities: A Comparative Study of Houses in Zaria, Ibadan, and Marrakech* (Chichester, 1982)
J. C. Moughtin: *Hausa Architecture* (London, 1985)
Z. R. Dmochowski: *Northern Nigeria* (1990), i of *An Introduction to Nigerian Traditional Architecture* (London and Lagos, 1990)

J. C. MOUGHTIN

Kanō. Japanese family of painters. They are presumed to be descended from a line of warriors from the Kanō district in what is now Shizuoka Prefecture. Their immediate forebear, Kanō Kagenobu, seems to have been a retainer of the Imagawa family and is reported to have painted a picture of Mt Fuji for the visit of the shogun Ashikaga Yoshinori (1394–1441) in 1432. Kagenobu's son, (1) Kanō Masanobu, was a professional artist whose surviving work is in a style derived from the *Kanga* (Chinese-style) tradition of ink painting, and Masanobu's descendants formed the core of the Kanō school of secular ink painters (see fig.; *see also* KANŌ SCHOOL). One of the most enduring and influential artistic lineages in Japanese history, the Kanō family dominated official painting from

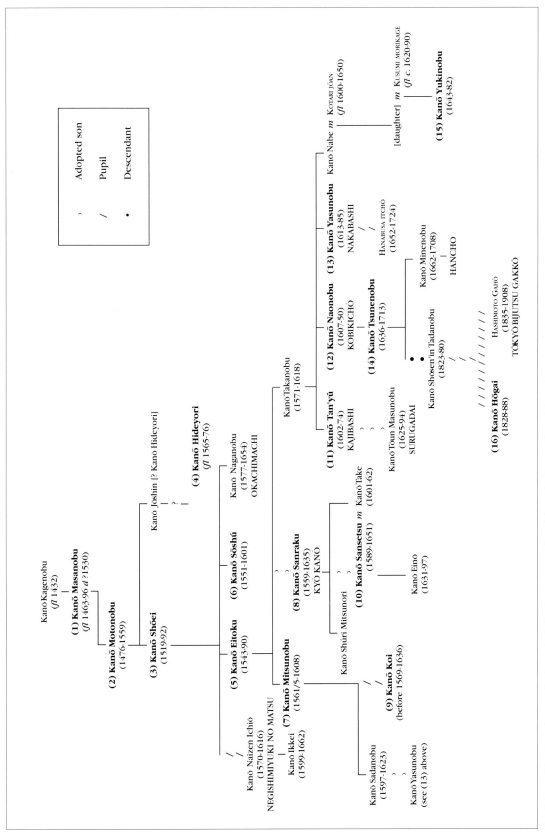

Family tree of the Kanō dynasty of painters, including important pupils and the main Kanō studios of the 17th century and after

the end of the Muromachi period (1333–1568) to the end of the Edo period (1600–1868).

For bibliography *see* KANŌ SCHOOL.

(1) Kanō Masanobu [Hakushin; Shōgen; Yūsei; Masanobu] (*fl* 1463–96; *d* ?1530). At an early age he went to Kyoto, where he is thought to have studied *Kanga* (Chinese-style ink painting) with OGURI SŌTAN, the painter-in-residence (*goyō eshi*) to the Ashikaga shogun. Sōtan lived at the Shōkokuji, a Zen temple in Kyoto patronized by the Ashikaga family, and the earliest record of Masanobu's activity as an artist—the execution of a lost series of screen-and-wall paintings (*shōhekiga*) for a subtemple of the Shōkokuji in 1463—is found in the *Inryōken nichiroku*, the official journal kept by the monks there. During the Ōnin Wars (1466–77), Masanobu fled the devastation in Kyoto for Nara. After Sōtan's death in 1481, Masanobu's name began to appear frequently in the *Inryōken nichiroku*, particularly in connection with commissions by the shogun Ashikaga Yoshimasa (1436–90) and the Shōkokuji, but it is not clear whether Masanobu inherited Sōtan's post of painter-in-residence.

In 1483 Yoshimasa had Masanobu decorate Higashiyama Villa, his newly constructed residence in eastern Kyoto, with screen-and-wall paintings depicting *Eight Views of the Xiao and Xiang Rivers* (destr.), but most of the works by the artist recorded in the *Inryōken nichiroku* were formal portraits and religious paintings in colour. In 1485, for example, he painted a set of sliding doors depicting *Ten Monks* (untraced) for Higashiyama Villa,

Kanō Masanobu: *Bamboo and White Crane* (detail), six-panel folding screen, h. *c.* 1.57 m, Muromachi period (1333–1568) (Kyoto, Daitokuji, Shinjūan)

and he later produced memorial portraits of *Ashikaga Yoshimasa* (after 1490) and his wife *Hino Tomiko* (after 1496; both destr.). Masanobu's increasing eminence was reflected in the series of honorary court and religious titles he received during the 1480s; by 1490 he was *hokkyō* (Bridge of the Law), and, according to later family records, he eventually achieved the rank of *hōgen* (Eye of the Law).

Masanobu's surviving works—all undated—are in the *Kanga* tradition of monochrome ink painting. They include large-scale bird-and-flower paintings (*kachōga*), such as the folding screen *Bamboo and White Crane* (Kyoto, Daitokuji, Shinjūan; see fig.), which are close in style to the powerful manner of Masanobu's contemporary Tōyō Sesshū. These bird-and-flower paintings later became a speciality of the Kanō school, and Masanobu's bold contours, regular brushstrokes and overall balance of compositional motifs foreshadow the Kanō school style. Among the artist's best-known works are several hanging scrolls on Chinese themes executed primarily in ink with slight additions of colour. In *Chinese Mountain Landscape* (Itami, Konishi priv. col.), for example, he emulated the towering vertical designs of the 15th-century Zen monk and painter Tenshō Shūbun. In these works Masanobu contributed to the secularization of *Kanga*, removing it from its Zen context and developing it into a more decorative style that appealed to his patrons among Japan's military rulers: his portrait of the jovial, pot-bellied saint *Hōtei* (Chin. Budai; Tokyo, Kuriyama priv. col.) is in a crisp, angular style ostensibly derived from that of the Chinese master Liang Kai, but Masanobu's swarthy and hirsute *Hōtei* is distinguished by a peculiar worldliness. Each of these representative works is characterized by the clarity and order that define Masanobu's style.

BIBLIOGRAPHY
H. Watanabe: 'Kanō Masanobu', *Bijutsu Kenkyū*, cxli (1947), pp. 5–105 [incl. early sources]
T. Doi: *Motonobu/Eitoku*, Suiboku bijutsu taikei [Compendium of the art of ink painting], viii (Tokyo, 1974)
T. Yamaoka: *Masanobu/Motonobu*, Nihon bijutsu kaiga zenshū [Complete collection of Japanese painting], vii (Tokyo, 1978)

(2) Kanō Motonobu [Eisen; Genshin; Motonobu; Ko-Hōgen] (*b* Kyoto, 1476; *d* Kyoto, 1559). Son of (1) Kanō Masanobu. He was probably trained in *Kanga* (Chinese-style ink painting) by his father, from whom he may also have acquired his skill as a portrait painter (e.g. the *Priest Tōrin*, 1521; Kyoto, Ryūanji). Later sources claimed that he married the daughter of Tosa Mitsunobu, the leading proponent of *Yamatoe* (Japanese-style painting) in Masanobu's youth. Works by Motonobu in the *Yamatoe* style, such as the set of handscrolls *Seiryōji engi* ('Origins of Seiryōji', 1515; Kyoto, Seiryōji), show his mastery of its conventions. By the age of nine Motonobu had begun to serve the retired shogun Ashikaga Yoshimasa (1436–90), one of his father's main patrons, and he subsequently painted for Yoshimasa's successors, Ashikaga Yoshitane (1465–1522), Yoshizumi (1478–1511) and Yoshiharu (1511–50). He worked for other members of the military élite, such as Hosokawa Takakuni (1484–1531), who commissioned him in 1513 to paint a set of narrative handscrolls, *Kuramadera engi* ('Origins of Kurama temple'; untraced), and his clientele also extended to the imperial court and the merchant class of Kyoto and

Sakai. One of his earliest documented contracts was for a set of votive plaques (*ema*) depicting the *Thirty-six Immortal Poets* ordered by a group of Sakai merchants in 1515 for the Shinto shrine of Itsukushima in what is now Hiroshima Prefecture. In 1526 he was invited by the Sanjōnishi, an eminent family associated with the imperial court, to give a virtuoso painting performance on a two-panel folding screen before a party of guests, and on at least two occasions he presented folding screens to Emperor GoNara (*reg* 1526–57).

Though the second generation head of the Kanō school, Motonobu is regarded as its patriarch, since he placed it on a firm footing through a combination of artistic talent, versatility and commercial acumen. He was proficient in all the major pictorial styles of his time, which he codified so that they could be emulated by his disciples, thereby establishing the classical Kanō repertory. He applied the threefold classification of calligraphy styles—the formal *shintai* ('new form'), the informal *gyōtai* ('running form') and the cursive *sōtai* ('grass form')—to ink painting, for example. His greatest achievement was the creation of a new mode of painting that formed the basis of the early Kanō school style. Known as *Wakan* ('Japanese–Chinese') painting, it combined the spatial solidity and careful brushwork techniques of *Kanga* with the fine line, decorative patterning and use of colours and gold leaf associated with *Yamatoe*. This synthesis is illustrated by two series of sliding wall panels depicting *Birds and Flowers of the Four Seasons* now mounted as hanging scrolls, one dating from *c.* 1513 (Kyoto, Daitokuji, Daisen'in), the other from 1543–9 (Kyoto, Myōshinji, Reiun'in). The later cycle used all three ink painting techniques and is simpler in style than the earlier cycle. The *Story of Xiang yan* (Tokyo, N. Mus.; see fig.) is a further example of the emerging Kanō style; despite its underlying Chinese philosophy, the active figure in the foreground, the rendering of landscape nearly in one vertical plane and the type of brushstroke and composition make the painting distinctively Japanese in temperament. Motonobu established a workshop in northern Kyoto, where he trained members of his family and other apprentices to execute his designs on items ranging from folding fans to the increasingly popular screen-and-wall paintings (*shōhekiga*). His involvement in the marketing of the work of his studio is illustrated by the broad spectrum of patronage he received and, more concretely, by the petition he presented to the shogun in conjunction with the merchant Hasuike Hideaki (*fl* 1539–50), in which they applied for a monopoly over the production and sale of fans.

Motonobu's workshop became the most famous in Kyoto, and the esteem in which he was held by his contemporaries is evident from the nature of some of his commissions: between 1539 and 1553 he was involved in the decoration of Ishiyama Honganji in Osaka, the chief temple of the Jōdo Shinshū (Pure Land) sect of Buddhism, even though he was a member of the Nichiren or Hokke sect, the arch-enemies of the Jōdo Shinshū; and in 1541 one hundred fans and three folding screens from his workshop were sent to China as gifts for the Ming emperor. Like his father, Motonobu received a series of honorary court and religious titles, culminating in that of *hōgen* (Eye of the Law), which he was using by 1546.

Kanō Motonobu: *Story of Xiang yan*, ink wash on paper, h. 2.12 m, Muromachi period, 1513 (Tokyo, National Museum)

BIBLIOGRAPHY
N. Tsuji: 'Kanō Motonobu', *Bijutsu Kenkyū*, ccxlvi (1966), pp. 10–29; cclxx (1970), pp. 41–79; cclxxii (1970), pp. 150–67
T. Doi: *Motonobu/Eitoku*, Suiboku bijutsu taikei [Compendium of the art of ink painting], viii (Tokyo, 1974)
T. Yamaoka: *Masanobu/Motonobu*, Nihon bijutsu kaiga zenshū [Complete collection of Japanese painting], vii (Tokyo, 1978)
C. Wheelwright: 'Kanō Painters of the Sixteenth Century AD: The Development of Motonobu's Daisen'in Style', *Archvs Asian A.*, xxxiv (1981), pp. 6–31

(3) Kanō Shōei [Naonobu; Tadanobu; Shōei] (*b* Kyoto, 1519; *d* Kyoto, 1592). Son of (2) Kanō Motonobu. In 1553 he and his father were received at the Ishiyama Honganji, the temple in Osaka where Motonobu had been working since 1539, and 'Genshichi' (Shōei's youthful name) was paid for a pair of folding screens (untraced) painted in ink. Later Shōei accompanied Motonobu in decorating the walls of the Zuihōin, a subtemple of the Daitokuji in Kyoto built by the daimyo Ōtomo Sōrin (1530–87). On his father's death in 1559 Shōei succeeded as head of the Kanō school, presumably after the early deaths of his two elder brothers, Kanō Yūsetsu Munenobu (1514–?1545) and Kanō ?Jōshin. Soon afterwards the Daitokuji employed Shōei to create an immense hanging scroll of *Parinirvāṇa* ('Death of Buddha'; 6.33×3.81 m; 1563; Kyoto, Daitokuji), the only work by him on a Buddhist theme known to survive and his earliest datable work. In 1566 he returned to the Daitokuji, this time with his son (5) Kanō Eitoku, to decorate the Jukōin, the mortuary chapel for the daimyo Miyoshi Nagayoshi (Chōkei; 1523–64). The screen-and-wall paintings (*shōhekiga*) at the Jukōin have traditionally been ascribed solely to Eitoku, but a number of compositions—the *Eight Views of the Xiao and Xiang Rivers* in the south-west

room; *Monkeys* and *Tigers and Leopard* in the north-west room; and the small panels in the Buddhist altar room called *Fish and Birds in a Lotus Pond*—are closer in style to Shōei's softly diffused rendering of the informal *gyōtai* ('running form') mode of ink painting.

In 1568–9 Shōei was summoned to Bungo Province (now Ōita Prefect.) in Kyushu by Ōtomo Sōrin. En route he stopped at the celebrated Shinto shrine at Itsukushima on the island of Miyajima, where he executed the Rajōmon *ema*, a votive plaque (untraced; known from a 19th-century print) showing Minamoto no Yorimitsu subjugating the three-eyed demon of the Rajōmon Gate. A pair of six-panel folding screens in monochrome ink depicting the Chinese theme *Twenty-four Paragons of Filial Piety* (Gifu Prefect., Andō Shōji)—an excellent example of Shōei's figure style—is also thought to have been painted by him at the shrine. References to Shōei cease after 1572, and he may have entered the priesthood at this time, exchanging his artist's name Naonobu for the priestly name Shōei and transferring the direction of the Kanō school to Eitoku.

Shōei's particular forte was large-scale bird-and-flower paintings such as the two sets of six-panel folding screens *Birds and Flowers of the Four Seasons* (Tokyo, Nagasaki Tarō), which is in the *gyōtai* ink style and imprinted with Shōei's Naonobu seal, and *Cock and Pine-tree* (Boston, MA, Mus. F.A.), which is in the formal *shintai* ('new form') ink style and bears an authentication by (11) Kanō Tan'yū. Both paintings are conceived in terms of Motonobu's spacious lake landscapes, with elegant birds and lush plants in the foreground, an expanse of water in the background and large trees bracketing the two outermost panels, but Shōei's own temperament is expressed in his comparatively relaxed brushwork, his uniform tonal values and his more loosely organized compositional structures.

Under Shōei the Kanō workshop also produced fan paintings and other small-scale works that are frequently preserved mounted on hanging scrolls or folding screens. Some of Shōei's fans and at least one hanging scroll, the *Kitano Shrine* (monochrome ink; Kamakura, Tokiwayama Bunko), feature scenes of famous places in Kyoto (*kyō meishoe*), which may be linked to the development of genre painting (*fūzokuga*).

BIBLIOGRAPHY

M. Narazaki: 'Shōei Naonobu ni tsuite' [Regarding Shōei Naonobu], *Kokka*, dcclxxxv (1957), pp. 251–9

——: 'Sasama-ke zō senmen gachō' [An album of fan paintings in the Sasama Collection], *Kokka*, dccxlv (1962), pp. 339–59

N. Tsuji: 'Kanō Shōei hitsu Nijushikō zu byōbu' [A folding screen of the *Twenty-four Paragons of Filial Piety* by Shōei], *Bijutsu Kenkyū*, cclxxiii (1965)

N. Tsuji and others: *Daitokuji Shinjūan/Jukōin* (1971), viii of *Shōhekiga zenshū* [Complete collection of screen-and-wall painting], ed. T. Tanaka and others (Tokyo, 1966–72)

T. Doi: *Eitoku/Mitsunobu*, Nihon bijutsu kaiga zenshū [Complete collection of Japanese painting], xxv (Tokyo, 1978)

C. Wheelwright: *Kanō Shōei*, 2 vols (diss., Princeton U., 1981)

——: 'Late Medieval Japanese Nirvana Painting', *Archv Asian A.*, xxxviii (1985), pp. 67–94

(4) Kanō Hideyori [?Shinshō; ?Jibu, Jibukyō, Jibushō] (*fl* 1565–76). Professional painter of the late Muromachi (1333–1568) and early Momoyama (1568–1600) periods. Edo-period (1600–1868) biographies and art histories contradict each other about his identity. Most texts identify him as the grandson of (2) Kanō Motonobu, but the *Honchō gashi* ('History of Japanese painting'; 1693) by Kanō Eino (1631–97) and the *Koga biko* ('Handbook of classical painting'; Edo (now Tokyo), *c.* 1845–53) claim that he was Motonobu's son. Modern scholars differ on the same point; Hiroshi Matsuki argued that Hideyori was Motonobu's second son, Jōshin. Hideyori is most famous for the six-panel folding screen painting *Maple Viewing at Takao* (*Takao Kunpū-zu*; Tokyo, N. Mus.). Its focus on human figures of various classes enjoying themselves makes it one of the earliest examples of Japanese *fuzōkuga* (genre painting; *see* JAPAN, §VI, 4(iv)(a) and fig. 94). The depiction of famous places and seasonal motifs also reflects the origins of *fuzōkuga*: the traditional modes of *meishoe* (paintings of famous places) and *shikie* (paintings of four seasons). To these traditional themes, Hideyori added a new emphasis on scenes of contemporary society, creating a work that anticipates early modern Japanese painting. Dated paintings bear the Hideyori seal, providing a fuller picture of the artist and a chronology of his activities. Inscriptions on the hanging scroll *Tenjin Crossing the Sea* (*Totō Tenjin zu*; 1564–7; Yabumoto Sōgorō priv. col.) mark Hideyori's earliest date of activity. This painting, as well as *Three Laughers of Tiger Valley* (*Kokei sanshōzu*; untraced) and *Drunken Li Bai* (*Sui Rihaku zu*; Klaus Naumann priv. col.), were inscribed by Zen monks associated with the temple Myōshinji, Kyoto, and the priest Sakugen Shūryō (1500–78), and suggest Hideyori's connection with this religious and cultural circle. The variety of works he produced—fan paintings of birds and flowers, hanging scrolls of ink landscapes, figures, paintings of oxherding scenes and votive plaques—indicate that Hideyori was a professional painter.

BIBLIOGRAPHY

Kanō Eino: *Yakuchu Honchō gashi* [Annotated history of Japanese painting]; annotated by M. Kasai, S. Sasaki and A. Takei (Kyoto, 1985)

N. Tsuji: 'Kanō Motonobu, Part II', *Bijutsu Kenkyū*, 249 (1966), pp. 1–31

——: 'Kanō Hideyori kō', *Kokka*, 986 (1976), pp. 9–15

C. K. Wheelwright: *Kano Shōei* (diss., Princeton U., NJ, 1981)

H. Matsuki: 'Kanō Hideyori no denki o megutte' [Concerning Kanō Hideyori's biography], *Kobijutsu*, 97 (1991), pp. 86–96

MELISSA McCORMICK

(5) Kanō Eitoku [Kuninobu; Eitoku] (*b* Kyoto, 1543; *d* Kyoto, 1590). Son of (3) Kanō Shōei. Having received his early training from his grandfather, (2) Kanō Motonobu, he is said to have shown extraordinary artistic talent as a child, and by his early 20s he had established himself as the leading painter of Kyoto. His father may have entered a monastery *c.* 1572, from which date Eitoku would have been head of the Kanō school. His success was due to his creation of a monumental style of painting, later known as *taiga* ('big painting'): this was based on the Kanō school style established by his grandfather but incorporated larger compositions, massive forms and rugged brushwork. According to Kanō Einō (1631–97), the author of the *Honchō gashi* ('History of Japanese painting'; 1693), Eitoku developed this *taiga* style because the increasing demand for his work meant that he had no time for meticulous brushwork, and he began to use a coarse brush of straw for his ink painting. Eitoku is best known for his screen-and-wall paintings in vivid colours and gold leaf (*kinpeki shōhekiga*), but he also worked in a

saiga ('small' or 'elaborate painting') style. The former were popular with the rival warlords of the Azuchi–Momoyama period (1568–1600), who employed the artist to decorate their residences in a manner grand enough to satisfy their aggressive ambitions. With the *taiga* style, Eitoku transformed the aesthetic vision of a whole generation of artists and patrons. The sheer bravado of his brushwork appealed especially to members of the military establishment. Typically Eitoku's bold designs swept kinetically across continuous wall panels of residential halls, amplifying the grandeur of the architecture. Most of these buildings were destroyed in the wars of the period, so little of Eitoku's work survives despite his prodigious output.

1. BEFORE 1576. The two earliest series of paintings reliably attributed to Eitoku adorn the abbot's quarters (*hōjō*) in the Jukōin subtemple of the Daitokuji in Kyoto, built in 1566 as a memorial chapel for the samurai Miyoshi Nagayoshi (Chōkei; 1522–64). Eitoku shared the commission with his father, and the son's work can be seen in the master's room (*danna no ma*), where Chinese men appear in a serene lake landscape on the eight sliding wall panels of his *Four Accomplishments* (*Kinki shoga zu*), and in the central room (*shitchū*), where a continuous composition of a *Landscape with Flowers and Birds* covers 16 panels (*see* KANŌ SCHOOL, fig. 1). For the *Four Accomplishments* Eitoku employed *shintai* ('new form'), the formal ink painting technique of his father and grandfather, but for the panels in the central room he used his distinctive *taiga* style. In the latter, massive plum and pine trees drawn in the fluid *sōtai* (cursive or 'grass form') technique form the dominant motifs, and a new concept of pictorial space was created by severely cropping the design at the top and bottom so that it appeared to extend beyond the panels into real space. It is a measure of Eitoku's rising status that he was chosen to decorate the two main rooms of the subtemple, while his father, who was officially the head of the Kanō school at the time, was relegated to side rooms. A year later Eitoku led his own group of assistants when he went to paint wall panels (1567; destr.) for the residence of the courtier Konoe Sakihisa (1536–1612) in Kyoto.

An early masterpiece in the *saiga* style is a pair of six-panel folding screens painted in colours and gold leaf in *Scenes in and out of the Capital* (*Rakuchū rakugai zu*; Yamagata Prefecture, Uesugi priv. col.; see Doi, pls 6–7). The screens, which are considered the first examples of Japanese genre paintings (*fūzokuga*; *see* JAPAN, §VI, 4(iv)(a)), were given to the daimyo Uesugi Kenshin (1530–78), ancestor of the present owners, by Oda Nobunaga together with a pair of screens depicting the *Tale of Genji* (untraced). They are generally accepted as Eitoku's work in the *Yamatoe* style (*see* JAPAN, §VI, 3(iii)): unlike his *taiga* paintings, the brushwork is concise, and the forms richly coloured. Over 2000 figures are shown scattered over the two screens in scenes depicting the lively commercial and recreational activities of contemporary Kyoto, including the annual Gion parade with its huge floats.

2. 1576–82. Oda Nobunaga continued to be an important patron of Eitoku, and in 1576 he gave the artist his most important commission, the decoration of AZUCHI CASTLE. Nobunaga had begun to build this colossal

fortified residence in 1574, and it was largely completed by 1579. Eitoku and his assistants finished their work in 1581, and Eitoku was given the religious title of *hōin* (Seal of the Law), the highest honorary rank awarded to artists. The castle was burnt to the ground the next year in the violent aftermath of Nobunaga's assassination, but, despite its brief existence, it set a precedent for fortified residences throughout Japan (*see* JAPAN, §III, 4(ii)(c)) and established

1. Kanō Eitoku: *Zhao Fu and his Ox*, hanging scroll, ink on paper, h. 1.25 m, Momoyama period (1568–1600) (Tokyo, National Museum)

Eitoku's semi-legendary fame as an artist. A detailed account of the interior decoration in the seven-storey donjon was left by Ōta Gyūichi (1527–?1610) in his *Shinchō-kō ki* ('Biography of Lord Nobunaga'). The general tone of the decoration was one of magnificence, with widespread use of brilliant colours and gold on both the interior and exterior. Each room contained a single continuous composition that gave it its name (e.g. the 'Pine Room', the 'Civet Room' etc), the choice of subject being determined by the function of the room. Bird-and-flower paintings were most common, followed by representations of Chinese worthies, animals and a landscape.

The nature of Eitoku's work at Azuchi Castle can be gauged from other work of the period, especially the oversize folding screen *Chinese Lions* (Tokyo, Imp. Household Col.). The screen was originally part of a pair, and, according to legend, Oda Nobunaga's successor, Toyotomi Hideyoshi, presented the two to his adversary Mōri Terumoto (1553–1625) as a peace gesture in 1582; the screen's robust style and aggressive subject-matter would have made it suitable for this. The pictorial elements are reduced to a minimum so that the lions (traditional emblems of valour and energy), the rocks and the background of gold leaf are in stark contrast, and the power of the composition is intensified by Eitoku's saturated colours and the swirling patterns of the manes and tails. Scholarly consensus that the screen is by Eitoku is supported by the authentication of (11) Kanō Tan'yū, which lies along the bottom right-hand edge of the painting. The figure painting at Azuchi Castle may have resembled that of a pair of undated hanging scrolls depicting the legendary hermits and symbols of purity of conduct, *Xu Yu and Zhao Fu and his Ox* (both Tokyo, N. Mus.; see fig. 1); these were executed with coarse but incisive brushstrokes in the informal *gyōtai* technique and in tones ranging from silvery grey to jet black.

3. AFTER 1582. After Nobunaga's death Eitoku was employed by his flamboyant successor, Toyotomi Hideyoshi, on a series of major projects including the decoration of Osaka Castle (1583–6) and the palace of Jurakudai (1587–8) in Kyoto (both destr.). These schemes were reputedly even more splendid than those at Azuchi Castle. He also decorated the palace in Kyoto of the retired emperor Ōgimachi (*reg* 1560–86). A series of wall panel paintings now in the chief abbot's quarters (Daihōjō) at the Nanzenji in Kyoto may have been taken from Ōgimachi's palace, or they may have been executed by Eitoku's studio after his death for the ceremonial residence (Seiryōden) of Emperor GoYōzei (*reg* 1586–1611) in Kyoto. In 1599 Hideyoshi commissioned Eitoku to restore the massive dragon on the ceiling of the main hall (*hatto*) of the Tōfukuji (damaged 1995) in Kyoto; the original painting, by Chōdensu Minchō, had been damaged in a fire. Eitoku fell ill while working on the dragon and left his apprentice, (8) Kanō Sanraku, to complete it. In 1589–90 he had recovered sufficiently to undertake the decoration of the Tenzuiji, the memorial chapel for Hideyoshi's mother at the Daitokuji, and to obtain the commission for the restoration of the imperial palace in Kyoto despite a challenge from the rival workshop of Hasegawa Tōhaku. Eitoku's sudden death a month later left the Kanō school in a weaker position with regard to its rivals.

The authenticity of works attributed to Eitoku has often been questioned, and this is particularly so in the case of works supposedly produced by him in the last years of his life. These include the pair of screens *Pines and Hawks* (Tokyo, U. F.A. & Music), which was ascribed to Eitoku by Kanō Einō, and the eight-panel folding screen *Cypress Trees* (Tokyo, N. Mus.; see fig. 2), which may have been one of the pieces produced by Eitoku's studio in 1590 for the palace of Prince Toshihito (1579–1629).

BIBLIOGRAPHY
Y. Yamane and others: *Nanzenji honbō* [The chief abbot's quarters at Nanzenji] (1968), x of *Shōhekiga zenshū* [Complete collection of screen-and-wall painting], ed. T. Tanaka and others (Tokyo, 1966–72)
N. Tsuji and others: *Daitokuji: Shinjūan/Jukōin* (1971), viii of *Shōhekiga zenshū* [Complete collection of screen-and-wall painting], ed. T. Tanaka and others (Tokyo, 1966–72)
T. Doi: *Motonobu/Eitoku*, Suiboku bijutsu taikei [Compendium of the art of ink painting], viii (Tokyo, 1974)
T. Takeda: *Kanō Eitoku*, xciv of *Nihon no bijutsu* [Arts of Japan] (Tokyo, 1974); Eng. trans. by H. Horton and C. Kaputa as *Kanō Eitoku*, iii of *Japanese Arts Library*, ed J. Rosenfeld (Tokyo, New York and San Francisco, 1977)
A. Naito: 'Azuchi-jō no kenkyū' [Research on Azuchi Castle], *Kokka*, cmlxxxvii–cmlxxxviii (1976)

2. Kanō Eitoku (attrib.): *Cypress Trees*, eight-panel folding screen, colours and gold leaf on paper, h. 1.70 m, ?1590 (Tokyo, National Museum)

T. Doi: *Eitoku/Mitsunobu*, Nihon bijutsu kaiga zenshū [Complete collection of Japanese painting], xxv (Tokyo, 1978)

T. Sakazaki, ed.: *Nihon kaigaron taikei* [Outline of Japanese painting treatises], ii (Tokyo, 1979), pp. 365–466 [for the references from Kanō Einō]

C. Wheelwright: 'A Visualization of Eitoku's Lost Paintings at Azuchi Castle', *Warlords, Artists and Commoners: Japan in the Sixteenth Century*, ed. G. Elison and B. Smith (Honolulu, 1981), pp. 87–112

M. Okami and A. Satake: *Hyōchū Rakuchū rakugai zu byōbu: Uesugi-bon* [The screens *Scenes in and out of the Capital* annotated: the Uesugi version] (Tokyo, 1983)

H. Suzuki: *Eitoku/Tōhaku*, Meihō Nihon no bijutsu [Famous treasures of Japanese art], xvii (Tokyo, 1983)

N. Tsuji: 'Uesugi-bon Rakuchū rakugai zu saikō: Imatani-shi no setsu ni taishite' [A re-examination of the screens *Scenes in and out of the Capital* in the Uesugi version: in reference to Mr Imatani's theories], *Kokka*, mcv (1987), pp. 47–59

(6) Kanō Sōshū [Motohide; Genshū; Shinsetsu; Sūshin; Sōshū] (*b* 1551; *d* 1601). Son of (3) Kanō Shōei and brother of (5) Kanō Eitoku. He acted as head of the Kanō studio in 1576–9 while Eitoku was employed by Oda Nobunaga at Azuchi Castle. From 1582 he worked for Toyotomi Hideyoshi (1536–98) in Harima province (now part of Hyōgo Prefect.), for whom he painted a series of wooden panels depicting the *Thirty-six Immortal Poets* (*Sanju rokkasen zu*; Kyoto, Hōkoku Shrine). He returned to Kyoto by 1590, and sometime before 1596 he was awarded the honorary religious title *hōgen* (Eye of the Law) given to artists of high standing. Sōshū's last major commission was the decoration (1599–1600; destr.) of the *shinden* (main house) of the Katsura Detached Palace (*see* KYOTO, §IV, 10) for Prince Toshihito (1579–1629).

Sōshū was a follower of Eitoku's style in his large screen-and-wall paintings in colours and gold leaf, but Sōshū's compositions, as in the pair of six-panel folding screens *Flowers and Birds of the Four Seasons* (ex-K. Taman priv. col., Osaka; see Doi, pl. 23), tend to be denser and more profusely textured, producing a rich decorative surface. These more sumptuous designs appealed to an audience living in the comparatively settled conditions of the 1590s. Sōshū is also known for refined examples of paintings in the *Yamatoe* style (*see* JAPAN, §VI, 3(iii)), as in the set of handscrolls *Ippen shonin eden* ('Biography of the holy man Ippen', 1594; Yamagata Prefect., Kōmyōji), and for portraits, in which he used clear silhouetted forms and figures with penetrating expressions (e.g. *Abbot Nishin*, 1596; Kyoto, N. Mus.).

Before his death Sōshū entrusted the training of his son Jinkichi (later Kanō Jinnojō; *fl c*. 1595–1644) to (7) Kanō Mitsunobu. Jinnojō inherited Sōshū's jar-shaped Motohide seal, and his prolific use of it on his own works has made it difficult to distinguish them from those of his father. The seal appears frequently on small folding fans such as a set depicting *Scenes in Kyoto* (dispersed; see Takeda, 1977, p. 116), which has been identified as representative of Sōshū's *saiga* ('small painting') style.

BIBLIOGRAPHY

O. Asaoka: *Koga bikō* [Handbook of classical painting] (n.p., *c*. 1845–53); rev. K. Ota as *Zōtei Koga bikō* [Presentation of the *Koga bikō*] (Tokyo, 1904), pp. 1583–4, 1607–10

T. Akiyama: 'Taman-shi zō Shiki kachō zu byōbu to hissha Motohide ni tsuite' [Regarding the screen *Flowers and Birds of the Four Seasons* in the Taman collection and its painter Motohide], *Gasetsu*, lvii (1941)

K. Mochimaru: 'Kanō Sōshū ni tsuite' [Regarding Kanō Sōshū], *Bijutsu Kenkyū*, cxlvii (1948), pp. 74–83

S. Tani: 'Kanō Sōshū ni kansuru ichi shōjireki' [A short factual history of Kanō Sōshū], *Bijutsu Kenkyū*, cxlvii (1948), pp. 69–73

T. Takeda: *Nanzenji senmen byōbu* [Nanzenji fan screens], Bijutsu senshi [Selected works of art], vi (Kyoto, 1973)

——: *Kanō Eitoku*, xciv of *Nihon no bijutsu* [Arts of Japan] (Tokyo, 1974); Eng. trans. by H. Horton and C. Kaputa as *Kanō Eitoku*, iii of *Japanese Arts Library*, ed. J. Rosenfield (Tokyo, New York and San Francisco, 1977)

T. Doi: *Kanō Eitoku/Mitsunobu*, Nihon bijutsu kaiga zenshū [Complete collection of Japanese painting], xxv (Tokyo, 1978)

(7) Kanō Mitsunobu [Ukyō; Ukyōnoshin; Ko-Ukyō; Mitsunobu] (*b* Kyoto, 1561 or 1565; *d* Kuwana, Seshū Province [now in Mie Prefect.], 1608). Son of (5) Kanō Eitoku. As a young man he accompanied his father on a number of painting commissions, including the decoration of Azuchi Castle in 1576–81 (destr. 1582) for Oda Nobunaga and of Osaka Castle (1583–6) and the palace of Jurakudai (1587–8; both destr.) in Kyoto for Toyotomi Hideyoshi. With the untimely death of his father in 1590, Mitsunobu became head of the Kanō school and assumed responsibility for Eitoku's unfinished commissions. So complete was his mastery of his father's style that many of his works are attributed to Eitoku. Possibly Mitsunobu's earliest datable work is a preparatory drawing (now mounted as a six-fold screen, Saga, Prefectural Mus.) for a screen painting of *Nagoya Castle* (untraced), which, according to records, was executed *c*. 1592 by Mitsunobu, Kanō Naizen (1570–1616) and others for Toyotomi Hideyoshi. In 1600 he executed bird-and-flower paintings (*kachōga*) on 12 sliding wall panels in the Kangakuin, a subtemple of Onjōji (Miidera) in Ōtsu (now in Shiga Prefect.). Flowering trees and groves of cypress, drawn with precision and naturalism, quietly alternate across a solid surface of gold leaf. The success of the Kangakuin project contributed to the revival of the Kanō school's popularity in the face of competition from other studios. In 1605 Mitsunobu worked with (9) Kanō Kōi and Watanabe Ryōkei (*d* 1645) on the bird-and-flower paintings that decorate the guest room of the memorial chapel built for Toyotomi Hideyoshi by his wife Kita no Mandokoro at the Kōdaiji (damaged in an earthquake in 1995) in Kyoto. In both these commissions Mitsunobu substituted a more delicate style for the bold and heroic manner associated with his father, Eitoku; influenced by *Yamatoe*, it is characterized by greater detail and a layering of pictorial motifs, as when gold clouds are used to create an illusion of depth in *Flowers and Trees of the Four Seasons* in the guest room at the Kangakuin. Several genealogies compiled in the Edo period (1600–1868) state that Mitsunobu married into the TOSA family of *Yamatoe* painters.

In 1606–8 Mitsunobu travelled frequently to Edo (now Tokyo) to secure commissions from the Tokugawa government and apparently to prepare for the transfer of the Kanō school to the new capital. It was on one of these trips that he fell ill and died at an inn.

BIBLIOGRAPHY

T. Minamoto: 'Kanō Mitsunobu no isaku' [Extant works by Kanō Mitsunobu], *Bukkyō Bijutsu*, xiv (1929), pp. 94–104

M. Narazaki: 'Hizen Nagoya-jō zu to Kanō Mitsunobu' [Kano Mitsunobu and a painting of Nagoya Castle in Hizen], *Kokka*, cmxv (1968), pp. 51–60

T. Takeda: *Kanō Eitoku*, xciv of *Nihon no bijutsu* [Arts of Japan] (Tokyo, 1974); Eng. trans. by H. Horton and C. Kaputa as *Kanō Eitoku*, iii of *Japanese Arts Library*, ed. J. Rosenfield (Tokyo, New York and San Francisco, 1977)

T. Doi: *Eitoku/Mitsunobu*, Nihon bijutsu kaiga zenshū [Complete collection of Japanese painting], xxv (Tokyo, 1978)

(8) Kanō Sanraku [Kimura Heizō; Shūri; Mitsuyori; Sanraku] (*b* Shiga Prefect., 1559; *d* Kyoto, 1635). Apprentice and adopted son of (5) Kanō Eitoku. His father was Kimura Nagamitsu (*fl c.* 1570), a samurai and amateur painter who supposedly studied with (2) Kanō Motonobu. In the 1570s Sanraku served as a page to Toyotomi Hideyoshi, who recognized his artistic talent and arranged for him to become apprenticed to Eitoku, the leading artist of the day. Sanraku distinguished himself among Eitoku's pupils and was eventually adopted into the Kanō family. Eitoku and Sanraku evidently developed a close working relationship: when Eitoku fell ill in 1588 while restoring the dragon painting on the ceiling of the main hall of the Tōfukuji in Kyoto, he left the completion of the project to Sanraku, whose immense dragon (l. 54.5 m; destr. 1884) was coiled within a ring of clouds painted by his master. Many works once attributed to Eitoku have been reassigned to his pupil, who developed a more lyrical and mannered version of the *taiga* style of screen-and-wall painting in colours and gold leaf (*kinpeki shōhekiga*) originated by Eitoku. Free-standing folding screens have been reliably attributed to Sanraku by means of a rectangular intaglio seal reading *Shūri*, a square tripod seal reading *Mitsu* (with a complex second character which has not been deciphered definitively) and a tripod seal without square reading *Mitsuyori*. After Eitoku's death in 1590, Sanraku continued to receive commissions from Toyotomi Hideyoshi. In 1594 he and (7) Kanō Mitsunobu undertook the decoration of Momoyama Castle in Fushimi (now part of Kyoto; destr.), the residence to which Hideyoshi had retired. Sanraku's loyalty to the house of Toyotomi outlived its fall in 1615, when the artist took refuge at the Takinomotobō Hachiman Shrine in the mountains of Otokoyama. The literatus and monk Shōkadō Shōjō interceded on his behalf, and he was granted an audience by the new shogun, Tokugawa Ieyasu (1542–1616), at Sunpu Castle. By that time he had become a monk and had probably assumed the Buddhist name Sanraku, by which he is best known. He subsequently received the honorary religious title *hokkyō* (Bridge of the Law). Although the main Kanō workshop had moved to the new capital at Edo (now Tokyo), Sanraku remained in Kyoto, where he established the Kyō Kanō studio, but he continued to be patronized by the military hierarchy in Edo, especially the second Tokugawa shogun, Tokugawa Hidetada (1579–1632).

1. GENRE AND BIRD-AND-FLOWER PAINTINGS. Many more works by or attributed to Sanraku have survived than is the case with Eitoku and earlier members of the Kanō family. These cover an enormous range of themes, including genre subjects (*fūzokuga*) such as dog-baiting on horseback (e.g. a pair of six-panel folding screens; Kamakura, Tokiwayama Cult. Mus.) and *Nanban* screens depicting European traders and missionaries (e.g. a pair of six-panel folding screens; Tokyo, Suntory Mus. A.; *see* JAPAN, §VI, 4(vi)(a)). Among the earliest dated paintings positively ascribed to Sanraku are two pairs of votive plaques depicting horses (*ema*; 1614; Kyoto, Myō-hōin; and 1625; Shiga Prefect., Kaizu Tenjin Shrine), which have the massive forms, taut contours and dramatic silhouettes of Sanraku's mature style. A wooden panel painting of about the same date, *Manjushri on a Lion* (1618; Tokushima Prefect., Kirihataji), is the only work on a Buddhist theme attributed to Sanraku. It is in a conservative polychrome style and was originally part of Hidetada's reconstruction of the Sumiyoshi shrine in Settsu (now part of Osaka).

Sanraku's most characteristic works are screen-and-wall paintings of birds and flowers. In these the boldly drawn and organically textured motifs were carefully arranged against a denaturalized background of gold leaf. For two sets of screen-and-wall paintings (*c.* 1619–20), *Red Plum Blossoms* and *Peonies*, in the main hall (*shinden*) at the Daikakuji in Kyoto, Sanraku followed the practice established by Eitoku of featuring a dominant tree or flower motif, which sweeps across the multiple panels enclosing the room. Yet the sensual beauty of Sanraku's compositions, contrasting as it does with the rugged dynamism of

1. Kanō Sanraku: *Birds of Prey*, folding screen, ink wash, h. 1.53 m, Momoyama period (1568–1600) (Shiga Prefecture, Nishimura collection)

2. Kanō Sanraku (attrib.): *Battle of the Carriages*, four-panel folding screen, colours and gold leaf on paper, 1.75×3.70 m, Momoyama period (1568–1600) (Tokyo, National Museum)

his teacher's work, reflects the new aesthetic preferences of Edo-period (1600–1868) society. Another building at the Daikakuji, the Seishinden, is decorated with screen-and-wall paintings in monochrome ink attributed to Sanraku: these represent *Hawks*, a masculine subject favoured by the military establishment. A similar theme appears on the pair of folding screens *Birds of Prey* (Shiga Prefect., Nishimura priv. col.; see fig. 1), for which Sanraku employed ink wash to create an austere mood enhancing the violence of the subject. While he showed himself to be Eitoku's heir in the restless energy of his ink paintings, Sanraku's work is distinguished by the greater attention to detail in his brushwork and his tendency towards naturalistic description.

Between 1631 and 1635 Sanraku is thought to have collaborated with his adopted son (10) Kanō Sansetsu on the celebrated screen-and-wall paintings at the Tenkyūin subtemple of the Myōshinji in Kyoto. Extreme stylization characterizes the gnarled tree trunk in the famous composition of *Plum Tree and Pheasant* in the western room, which is noted for its brilliant colours, the solid curtain of gold leaf, faceted rocks and its crystalline sense of realism.

2. FIGURE PAINTING. A set of 17 sliding wall panels depicting the *Biography of Prince Shōtoku* (1618–23; Osaka, Shitennōji) was commissioned by Hidetada to replace an earlier set by Sanraku (1600) destroyed in a fire. They are in the *Yamatoe* (traditional Japanese-style painting) manner, with characteristically colourful settings and small figures in the court dress of the Heian period (AD 794–1184). Another work in the *Yamatoe* style, the four-panel folding screen *Battle of the Carriages* (Tokyo, N. Mus.; see fig. 2), is also attributed to Sanraku. Its subject was a famous incident in the ninth chapter of the 11th-century prose masterpiece *Tale of Genji*, the scuffle between the footmen of Genji's wife, Lady Aoi, and those of his mistress, Lady Rokujō, during the Kamo festival. The spirited rendering of the white-robed attendants and the vignettes of commoners looking on from behind the coaches are closely related to the figures in Japanese genre paintings of the early 17th century (*see* JAPAN, §VI, 4(iv)(a)).

Paintings of legendary Chinese figures and of Confucian themes comprised an important part of Sanraku's commissions from the Tokugawa government, who had adopted a Neo-Confucian ideology. Sanraku is credited with being the first Japanese artist to paint the Chinese theme *Mirror of Good and Evil Emperors*, which was based on a collection of stories compiled by the Chinese statesman Zhang Juzheng (1524–82) and printed in 1573. A pair of screens with 12 panels painted with this theme (priv. col.; see Doi, 1976, pls 30–32) depicts six exemplary and six despotic rulers; the precision of the ink painting suggests that Sanraku relied heavily on Chinese prints as models. Chinese figural subjects on a larger scale include two pairs of screens that have also been attributed to KAIHŌ YŪSHŌ (Kyoto, Myōshinji). One pair represents the *Emperor Wen Wu Meeting the Fisherman Lu Shang* and the *Four Sages of Mt Shang*; the other depicts the *Three Laughers of Tiger Ravine* and the *Scholar Yan Ziling with Emperor Guang Wu di*.

BIBLIOGRAPHY
Y. Yamane, N. Tsuji and T. Toda: 'Tenkyūin shōhekiga no kenkyū' [Studies on the Tenkyūin screen-and-wall paintings], *Kokka*, dcccxxxix (1962), pp. 51–100
T. Doi and others: *Daikakuji* (1967), iii of *Shōhekiga zenshū* [Complete collection of screen-and-wall painting], ed. T. Tanaka and others (Tokyo, 1966–72)
N. Tsuji: *Myōshinji, Tenkyūin* (1967), ii of *Shōhekiga zenshū* [Complete collection of screen-and-wall painting], ed. T. Tanaka and others (Tokyo, 1966–72)
T. Doi: *Eitoku to Sanraku*, Hito to rekishi [Man and history] (Tokyo, 1972)
——: *Kanō Sanraku/Sansetsu* (1976/R 1981), Nihon bijutsu kaiga zenshū [Complete collection of Japanese painting], xii (Tokyo, 1976–80/R 1980–82)

(9) Kanō Kōi [Ogawa Sadanobu; Kanō Sadanobu; Shinpo; Kōi] (*b* Shimotsuke [now in Tochigi Prefect.], Izu [now in Shizuoka Prefect.] or Musashi [now in Saitama

Prefect.], before 1569; *d* Edo [now Tokyo], 1636). Pupil of (7) Kanō Mitsunobu. He taught the sons of Mitsunobu's younger brother Kanō Takanobu (1571–1618), (11) Kanō Tan'yū, (12) Kanō Naonobu and (13) Kanō Yasunobu. Perhaps in recognition of this service, Kōi was allowed to use the name Kanō and to set up his own studio in Kyoto. He was eventually awarded the honorary religious title of *hokkyō* (Bridge of the Law).

Architectural decoration comprised most of Kōi's documented activity. In 1605 he and Watanabe Ryōkei (*d* 1645) assisted Mitsunobu in creating *kinpeki* (colour and gold-leaf wall paintings) at the Kōdaiji in Kyoto (*see* KANŌ, (7)); he participated in the decoration of the residence of Empress Tōfukumon'in (1607–78) in Kyoto during the Genna era (1615–24); and in 1626 he was a member of the large team of Kanō masters whom the shogun Tokugawa Iemitsu (1604–51) commissioned to redecorate Nijō Castle in Kyoto (*see* KYOTO, §IV, 9) for the visit of Tōfukumon'in's husband, Emperor GoMizunoo (*reg* 1611–29). Large-scale bird-and-flower compositions by Kōi, such as the *fusuma* (sliding door panel) paintings *Bamboo and Sparrow in the Snow*, still decorate part of the Minomaru Palace within the castle.

While his early work was done in a crisp style influenced by Mitsunobu, in his maturity he developed an individual style of *Kanga* ink painting that was inspired by the work of the 13th-century Chinese master Muqi and the 15th-century Japanese ink painter Tōyō Sesshu. In a pair of six-panel folding screens with landscape scenes (Tokyo, N. Mus.), for example, Kōi's clean and elegant brushwork is accented by areas of powdered gold dust, a combination later used by Kōi's greatest pupil, Kanō Tan'yū. Kōi's debt to Muqi is more directly seen in the hanging scroll triptych of the *Bodhisattva Kannon* (Skt Avalokiteshvara; Chin. Guanyin) flanked by *Tiger* and *Dragon* (Nagano Prefect., Kenfukuji), which was based on a triptych by the Chinese master (Kyoto, Daitokuji). The cool detachment of each of these works signalled a new era of Kanō painting in the second half of the 17th century.

At some point Kōi became *okakae eshi* ('painter in exclusive service') to the branch of the Tokugawa family that held the domain of Kii (now Wakayama Prefect.). His eldest son, Kanō Kōho (*d* 1660), succeeded him at Kii, and Kōho's younger sons, Kanō Kōya (*d* 1672) and Kanō Kōshi (*d* 1643), were installed as *okakae eshi* at other Tokugawa domains in Mito (now in Ibaraki Prefect.) and Owari (now in Aichi Prefect.); in this way Kōi's descendants came to hold a virtual monopoly over commissions from the Gosanke, the 'three successor houses' of the Tokugawa ruling clan.

BIBLIOGRAPHY
O. Asaoka: *Koga bikō* [Handbook of classical painting] (n. p., *c.* 1845–53); rev. by K. Ōta as *Zōtei Koga bikō* [Presentation of the *Koga bikō*] (Tokyo, 1904), pp. 1803–10
A. Morrison: *The Painters of Japan*, 2 vols (London, 1911) [esp. p. 132]
A. Shishizaki: 'Nijō rikyū Shiroshoin ni okeru Kōi no heki shōga' [Screen paintings by Kōi in the Shiroshoin of Nijō Palace], *Kokka*, cccxl (1918), pp. 90–91
'Kanō Kōi hitsu Yuima zu kai' [The portrait of Vimalakirti by Kano Kōi], *Kokka*, cdxxxiii (1926), pp. 324–5
S. Taki: 'Taimadera engi gakan Kōi hitsu no ichi dan' [A passage by Kōi of the illustrated handscroll *Origins of the Taimadera*], *Kokka*, dxcviii (1940), pp. 249–51
T. Minamoto: 'Genna Kan'ei ki ni okeru kikagakuteki kōzu keishiki' [Principles of geometric composition in paintings of the Genna and Kan'ei eras], *Bijutsushi*, I (1963), pp. 33–40 [with Eng. summary]
T. Doi: *Eitoku/Mitsunobu*, Nihon bijutsu kaiga zenshū [Complete collection of Japanese painting], ix (Tokyo, 1978)

(10) Kanō Sansetsu [Senga Hata (Chiga Shin); Kanō Heishirō; Jasokuken; Shōhakusanjin; Tōgenshi] (*b* Hizen Province, Kyushu [now part of Nagasaki Prefect.], 1589; *d* Kyoto, 1651). Pupil and adopted son of (8) Kanō Sanraku. He was apprenticed to Sanraku after the death of his father, Senga [Chiga] Dōgen (*d* 1605). By 1619 he had married his master's daughter, Kanō Take (1601–62), and assumed the professional name Kanō Heishirō. After the early death of Sanraku's eldest son, Kanō Shūri Mitsunori, Sanraku adopted Sansetsu and designated him his successor as head of the Kyō Kanō studio (*see* KANŌ SCHOOL, §3).

Sansetsu's painting style was clearly modelled on Sanraku's bold example: it shares his technical accomplishment, sense of compositional balance and decorative sensibility, but it was later marked by increasing stylization. Sansetsu is thought to have collaborated with his master on the composition *Plum Tree and Pheasant*, which forms part of the programme of screen-and-wall paintings (1631–5) in the Tenkyūin subtemple of the Myōshinji in Kyoto; Sansetsu's nascent personal style is detectable in the slight rigidity and mannered quality of the forms. In a wooden votive plaque (*ema*: 'horse picture') dedicated in 1637 to the Kiyomizudera in Kyoto, Sansetsu's acute interest in the vivid patterns of the horse's harness and blanket distinguishes it from the muscular steeds frequently painted by Sanraku. Sansetsu's mastery of grand compositions and splendid decorative effects can be seen in the pair of folding screens entitled *Winter Seascape with Birds* (Shiga Prefect., Kawamoto priv. col.; *see* fig.), in which he employed relief techniques for the silver waves and contrasting tones of gold leaf for the clouds and mist to create a rich backdrop for his orchestration of flying plovers and gulls. The sumptuous materials and restless linear quality of the design are strongly reminiscent of works of the Rinpa school (*see* JAPAN, §VI, 4(v)).

In contrast to his master, Sansetsu had a distinctly scholarly temperament. The colourful nicknames he adopted—Tōgenshi ('peach blossom spring') and Shōhakusanjin ('pine oak hermit')—reflected his knowledge of Chinese literature and folklore, and his interest in Chinese painting catalogues led him to compile several works of the same type. However, his most important endeavour was his research for the comprehensive *Honchō gashi* ('History of Japanese painting'), edited and published by his son Kanō Einō (1631–87). Sansetsu's intellectual predilections brought him to the attention of the learned Sinologues who served the Tokugawa shogunate. In 1632 SHŌKADO SHŌJŌ introduced Sansetsu to the Neo-Confucian scholars Hayashi Razan (1583–1657) and Hori Kyōan (1585–1642), who commissioned *Twenty-one Portraits of the Great Confucian Sages* (*Rekisei daiju zō*; divided between Tokyo, N. Mus. and Coll. Educ.) for Razan's newly built Confucian temple at Shinobugaoka. Inscriptions by Razan and Kyōan are also found on a small hanging scroll by Sansetsu, depicting Razan's mentor, *Fujiwara Seika in his Mountain Cottage* (Tokyo, Nezu A.

Kanō Sansetsu: *Winter Seascape with Birds* (detail), pair of six-panel folding screens, ink, colours, silver and gold leaf on paper, each screen 1.54×3.60 m, 1630s (Shiga Prefecture, Kawamoto private collection)

Mus.). Among major works attributed to Sansetsu is a set of four brilliantly coloured eight-panel folding screens (Kyoto, Zuishin'in) entitled *Composing Poetry by a Stream at the Orchid Pavilion*, depicting a famous literary gathering held by the 4th-century AD Chinese master of calligraphy, Wang Xizhi, and representing the scholarly ideal.

In 1647 the Kujō family of courtiers commissioned Sansetsu to replace two lost scrolls from a set of thirty-three by CHŌDENSU MINCHŌ depicting the *Bodhisattva Kannon* (Skt Avalokiteshvara; Kyoto, Tōfukuji). Following the completion of these scrolls, Sansetsu was awarded the honorary religious title of *hokkyō* (Bridge of the Law) by the imperial court. In the same year he completed a massive rectangular design of a dragon on the ceiling of the Relic Hall (Shariden) of the Senyōji in Kyoto, as well as *Old Plum* (New York, Met.), a set of sliding wall panels originally in the Tenshōin at Myōshinji; the latter, marked by extreme exaggeration and abstraction, typifies Sansetsu's late manner. In 1649 Sansetsu was imprisoned for an unknown crime of which he claimed he was innocent; the trauma of the experience is thought to have precipitated his death.

WRITINGS
Zukai hōkan meiroku [Catalogue of famous treasures in painting]
Genji monogatari zugaki [Notes on the illustrations in the *Tale of Genji*]
Buryō zakki [Miscellaneous notes on Wu ling (of the peach-blossom spring)]
Gadan [Discussion of paintings]

BIBLIOGRAPHY
Kanō Einō: *Honchō gaden* [Record of Japanese painting] (n.p., 1691); rev. as *Honchō gashi* [History of Japanese painting], 5 vols, with preface by Hayashi Gahō dated 1678 (n.p., 1693)
Y. Yamane, N. Tsuji and T. Toda: 'Tenkyūin shōhekiga no kenkyū' [Studies on the Tenkyūin screen-and-wall paintings], *Kokka*, dccccxxxix (1962), pp. 51–100
N. Tsuji: *Myōshinji, Tenkyūin* (1967), ii of *Shōhekiga zenshū* [Complete collection of screen-and-wall painting], ed. T. Tanaka and others (Tokyo, 1966–72)
T. Doi: *Kanō Sanraku/Sansetsu* (1976/R 1981), Nihon bijutsu kaiga zenshū [Complete collection of Japanese painting], xii (Tokyo, 1976–80/R 1980–82)
——: *Sanraku to Sansetsu* [Sanraku and Sansetsu], clxxii of *Nihon no bijutsu* [Arts of Japan] (Tokyo, 1980)
S. Okudaira: 'Kanō Sansetsu hitsu *Rakugai zu* ni tsuite' [Regarding *Views around the Capital* by Kanō Sansetsu], *Kokka*, mci (1987), pp. 13–31
M. Murase: *Masterpieces of Japanese Screen Painting: The American Collections* (New York, 1990)

(11) Kanō Tan'yū [Hakurenshi; Morinobu; Shirōjirō; Tan'yūsai] (*b* Kyoto, 1602; *d* Edo [now Tokyo], 1674). Grandson of (5) Kanō Eitoku. He was the foremost Kanō school painter of the early Edo period (1600–1868), known for a spare, elegant painting style that appealed to the tastes of the Tokugawa military government, throughout whose rule Tan'yū and his followers prevailed as the academic mainstream of official painting.

1. LIFE AND CAREER. His father was the painter Kanō Takanobu (1571–1618) and his mother a daughter of the daimyo Sasa Narimasa (1535–88), a retainer of Oda Nobunaga (1534–82). He is said to have begun painting by the age of four, and at the age of twelve he executed a scene of blossoms and kittens (untraced) for the second Tokugawa shogun, Hidetada (1579–1632). In 1617 Tan'yū was appointed *goyō eshi* (painter-in-residence) to the Tokugawa shoguns. He turned over the management of his father's Kyoto studio to his younger brother, (12) Kanō Naonobu, and concentrated thereafter on shogunal commissions, both in Kyoto and in Edo. In 1621 Hidetada granted him a large residence in the Kajibashi district of Edo, where he established the Kajibashi Kanō studio. As official painter, Tan'yū received the most important artistic commissions of the day, including the vast renovation programmes at Osaka Castle (1623–4) and Nijō Castle in Kyoto (1626) ordered by the third Tokugawa shogun, Iemitsu (1604–51). In the screen-and-wall paintings (*shōhekiga*) he produced for these buildings, such as the sequence *Pines and Peacocks* in the Great Hall (Ōhiroma) of the Ninomaru Palace at Nijō (see fig.), Tan'yū's use of sumptuous colours and gold leaf and his commanding designs served to emphasize the shogun's authority, and

Kanō Tan'yū: *Pines and Peacocks* (detail), four stationary wall paintings and four sliding door panel paintings, each wall panel 2.37×2.35 m, each sliding door panel 2.30×1.87 m, ink, colours and gold leaf on paper, 1626 (Kyoto, Nijō Castle, Ninomaru Palace)

his extension of the pictorial motifs above the level of the lintel created an effect of immense grandeur.

In 1634–6 Tan'yū led his studio in decorating the TŌSHŌGŪ SHRINE, the mausoleum of the deified Tokugawa Ieyasu (1543–1616) at Nikkō; he also produced a number of brilliantly coloured formal portraits of the shogun and the *Tōshōgū engi* ('Origins of Tōshōgū'; 1639–40; Nikkō, Tōshōgū), a set of five narrative handscrolls dramatizing his life. On the completion of this work, Tan'yū was awarded the honorary religious title *hōgen* (Eye of the Law). About 1640 he became a monk, adopting the name Tan'yūsai, and in 1662 he followed his grandfather Eitoku in being elevated to *hōin* (Seal of the Law), the highest rank given to artists.

2. PAINTING STYLES. Tan'yū's *genpitsu* ('reductive brush') method of ink painting revolutionized the practice of that art. Derived from the *Kanga* (Chinese-style ink painting) tradition established by Tōyō Sesshū as taught to Tan'yū by his childhood master (9) Kanō Kōi, it was characterized by simple forms, restrained brushwork, the omission of deep space and an unprecedented use of blank areas of paper. Pale tonal values and the application of gold-leaf dust (*sunago*) often give an impression of glowing light. Tan'yū used the *genpitsu* method for the three modes of ink painting formulated by (2) Kanō Motonobu. In the six-panel folding screen *Hermits and Tigers* (Kyoto, Kaenji), for example, he employed the cursive mode known as *sōtai* ('grass form') to create a mood of spontaneity and humour.

Besides large-scale paintings in a grander manner Tan'yū also created delicate works in the *Yamatoe* (traditional Japanese) style, such as the set of 36 album leaves entitled *Portraits of Famous Japanese Poets* (Tokyo, N. Mus.).

3. CALLIGRAPHY AND OTHER ACTIVITIES. Tan'yū was a noted calligrapher whose style was modelled on the elegant work of the great 9th-century master Kūkai (Kōbō Daishi), an example of which Tan'yū is said to have owned. In his practice of the tea ceremony, Tan'yū followed the methods of the premier tea master of the day, Kobori Enshū, whose chapel at the Daitokuji in Kyoto, the Kohōan, Tan'yū decorated. The artist also established himself as a leading connoisseur of Japanese and Chinese paintings, and many pieces were brought to him for appraisal. In his later years he made a huge number of miniature sketches of such paintings, known as the *Tan'yū shukuzu* ('Tan'yū's connoisseur sketches'), and these testify to his awareness of the foundations of his own painting tradition. At the same time he began to make sketches from nature with remarkable freedom, becoming one of the earliest Japanese artists to record observed phenomena systematically. This freedom of inquiry, not to mention his extraordinary talent, distinguished Tan'yū's works from the diligently produced but often conventional paintings of his later followers. In all his various intellectual pursuits, Tan'yū probably received guidance from his good friend Ezuki Sōgen (1574–1643), the abbot of Daitokuji in Kyoto, who was also an accomplished calligrapher and connoisseur.

For further illustration *see* JAPAN, fig. 7.

BIBLIOGRAPHY
T. Takeda: *Nagoya-jō* [Nagoya Castle] (1967), iv of *Shōhekiga zenshū* [Complete collection of screen-and-wall painting], ed. T. Tanaka and others (Tokyo, 1966–72)
Y. Yamane, ed.: *Nanzenji honbō* [The chief abbot's quarters at the Nanzenji] (1968), x of *Shōhekiga zenshū* [Complete collection of screen-and-wall painting], ed. T. Tanaka and others (Tokyo, 1966–72)
M. Kōno: 'Tan'yū o chūshin to suru Daitokuji Gyokurin'in shōhekiga' [Interior paintings of the Gyokurin'in at Daitokuji by Tan'yū and his assistants], *Bijutsu Kenkyū*, ccxcviii and ccxcix (1975)
T. Nakamura: *Kanō Tan'yū sōmokuka shasei* [Kanō Tan'yū's sketches of grasses, trees and flowers] (Kyoto, 1977)
T. Takeda: *Kanō Tan'yū* (1978/*R* 1980), Nihon bijutsu kaiga zenshū [Complete collection of Japanese painting], xv (Tokyo, 1976–80/*R* 1980–82)
——: *Motonobu/Eitoku/Tan'yū* (1979), Nihon no bijutsu: Bukku obu bukkusu [Arts of Japan: Book of books], liii (Tokyo)
Tan'yū shukuzu [Tan'yū's connoisseur sketches], Kyoto, N. Mus. cat., 2 vols (Kyoto, 1981)
Y. Shimizu: 'Some Elementary Problems of the Japanese Narrative, *Hiko-hoho-demi no Mikoto*', *Problems in the Relation between Text and Illustration*, Studia Artum Orientalis et Occidentalis, i (1982)
T. Kobayashi: *Edo kaiga shiron* [Essays on the history of Edo painting] (Tokyo, 1983)

SHAUNA GOODWIN

(12) Kanō Naonobu [Shume; Jitekisai] (*b* Heian [now Kyoto], 1607; *d* 1650). Brother of (11) Kanō Tan'yū and (13) Kanō Yasunobu. After the death of their father Kanō Takanobu (1571–1618), (9) Kanō Kōi instructed Naonobu and Yasunobu in painting. Since Tan'yū had already become an official painter-in-residence (*goyō eshi*) to the shogunate in Edo (now Tokyo), his brother Naonobu inherited his father's estate. In 1625, Naonobu, along with Tan'yū, Yasunobu, Kōi and other Kanō artists, worked on the sliding-door (*fusuma*) paintings of Nijō Castle (*see*

KYOTO, §IV, 9), which was in the process of being prepared by the shogun Tokugawa Iemistu (1604–51) for an imperial visit. In 1630 Naonobu moved to Edo, became an official painter and received an estate in Takekawachō, where he founded the Kobikichō branch of the Edo Kanō school, one of four lines of *oku eshi* ('painters of the inner quarters') descending from Takanobu and exclusively serving the shogunate. Their pupils and more distantly related Kanō artists established lines of *omote eshi* ('painters of the outer quarters') who served daimyo. Naonobu's status as an *oku eshi* granted him direct access to the shogun, the right to carry a sword and a substantial annual stipend.

Naonobu's representative works include *fusuma* paintings at the Chion'in temple (1641); *fusuma* at the temple Shōjūraigoji (1642), depicting the *Seven Sages of the Bamboo Grove* (*Chikurin shichikenzu*) and the *Four Sages of Mt Shang* (*Shōzan shikōzu*); a pair of six-panel folding screens of the *Eight Views of the Xiao and Xiang Rivers* (*Shōshō hakkeizu*) (Tokyo, N. Mus.); and a pair of screens entitled a *Cuckoo in the Imperial Garden* (*Kin'en kakkōzu*; priv. col.). Naonobu used minimal contour lines, diffused painted areas into unpainted ones, leaving large patches of empty, atmospheric space, and contrasted extremely pale ink with dark ink accents. While these characteristics suggest the influence of his more famous brother Tanyū's style, Naonobu combined this type of brushwork with an innovative compositional approach.

BIBLIOGRAPHY

R. T. Paine and A. Soper: *The Art and Architecture of Japan* (Harmondsworth, 1955, rev. 3/1981)

T. Doi, ed.: *Chion'in*, ix of *Shōhekiga zenshū*, [Complete collection of screen-and-wall painting] (Tokyo, 1969)

T. Doi: 'Chion'in no ikkō satsu' [A consideration of the Chion'in], *Kinsei Nihon kaiga no kenkyū* [Research on Japanese paintings of early modern times] (Tokyo, 1970)

MELISSA MCCORMICK

(13) Kanō Yasunobu [Bokushinsai; Eishin; Kanō Genshirō; Ukyōnoshin] (*b* Kyoto, 1613; *d* Edo [now Tokyo], 1685). Brother of (11) Kanō Tan'yū and (12) Kanō Naonobu. He received his formal instruction as a painter from (9) Kanō Kōi, who had also taught his brothers. At the age of ten he was selected to succeed Kanō Sadanobu (1597–1623), the son of (7) Kanō Mitsunobu, as head of the Kanō school and was given the artist's name Ukyōnoshin, which had formerly been used by Mitsunobu. Evidence of his talent at this young age is seen in a pair of six-panel folding screens depicting the Chinese themes of the *Seven Sages of the Bamboo Grove* and the *Four Sages of Mt Shang* (*c.* 1624; Kyoto, Shōjuraigōji). In 1630 Yasunobu moved to Edo, where he served, like his brothers, as *goyō eshi* (painter-in-residence) at the shogunal court. He was granted a residence in the Nakabashi district of Edo, where he founded the Nakabashi Kanō atelier, one of the four highest-ranking Kanō studios (*see* KANŌ SCHOOL, §3). In 1634–5 Yasunobu collaborated with his brothers in the decoration of Tōshōgū, the Tokugawa shogunal mausoleum at Nikkō (now in Tochigi Prefect.); the three brothers also executed the screen-and-wall paintings (*shōhekiga*) in the Middle Shoin (1641) of the *shinden* ('sleeping hall') of Katsura Detached Palace (*see* KYOTO, §IV, 10) for Prince Toshitada (1619–62). In 1662 Yasunobu received the honorary religious title *hōgen*

(Eye of the Law), bestowed on artists of merit, and in 1663 he carried out an important painting commission, *Portraits of the Great Chinese Sages* (untraced) for the Ceremonial Hall (*shishinden*) in the Imperial Palace in Kyoto. Yasunobu also executed a large number of folding screens and small-scale works that illustrate his judicious brushwork and close adherence to contemporary canons of the Kanō School.

Despite his participation in a number of prestigious painting commissions, Yasunobu has rarely been considered the equal of Tan'yū or Naonobu as an artist and is better known as a connoisseur and theoretician. His authentications are found on many Kanō works, and his *Gadō yōketsu* ('Essence of the art of painting'; 1680), which stressed technical training (*gakuga*) over innate cleverness or creativity (*hitsuga*), remained the standard reference source for practising Kanō artists until the end of the Edo period (1868).

WRITINGS

Gadō yōketsu [Essence of the art of painting] (n. p., 1680); repr. in *Bijutsu Kenkyū*, xxxvii (1935), pp. 34–43

BIBLIOGRAPHY

O. Asaoka: *Koga bikō* [Handbook of classical painting] (n. p., *c.* 1845–53); rev. by K. Ōta as *Zōtei Koga bikō* [Presentation of the *Koga bikō*] (Tokyo, 1904), pp. 1586, 1612–15

'Kanō Yasunobu', *Kokka*, lxii (1894)

'A Landscape by Yasunobu Kanō', *Kokka*, ccc (1915), pp. 270–72

'Kanō Yasunobu hitsu Sōkei zu kaj' ['Cock and hen' by Kanō Yasunobu], *Kokka*, cdxxiv (1926)

M. Hosono: *Edo Kanō to Hōgai* (1978), Nihon no bijutsu: Bukku obu bukkusu [Arts of Japan: book of books], lii (Tokyo) [see discussion of the *Gadō yōketsu*, pp. 148–52]

T. Takeda: *Motonobu/Eitoku/Tan'yū* (1979), Nihon no bijutsu: Bukku obu bukkusu [Arts of Japan: book of books], liii (Tokyo)

——: *Jinbutsuga, kange kei jinbutsu* [Figure painting, Chinese themes] (1980), iv of *Nihon byōbu-e shūsei* [Collection of Japanese folding-screen paintings], ed. T. Takeda and others (Tokyo, 1977–81) [see Yasunobu's screens on pls 128–9, 132–3]

SHAUNA GOODWIN

(14) Kanō Tsunenobu [Seihakusai; Ukon; Yōboku] (*b* Kyoto, 1636; *d* Edo [now Tokyo], 1713). Eldest son of (12) Kanō Naonobu. After his father's death in 1650, he became head of the Kobikichō line of the Kanō school. In 1704 he received the honorary title of *hōgen* (Eye of the Law) and in 1709 the most coveted title of *hōin* (Sign of the Law). He was buried at Honmonji, a temple in the Ikegami area of Edo (now Tokyo).

Tsunenobu's career was dominated by commissions for screen-and-wall paintings during rounds of construction at the imperial palace in the Jōō (1652–5), Kanbun (1661–73), Enpō (1673–81) and Hōei (1704–11) eras (see fig.). During the last such round, he was commissioned to paint *Chinese Worthies and Sages* on sliding door panels. Paintings of this Confucian subject had been a standard part of the decoration of the palace since antiquity, and examples by Tsunenobu's grandfather Kanō Takanobu (1571–1618) survive at Ninnaji, Kyoto. The fact that Tsunenobu received this prestigious commission indicates his supreme status in the Kanō school at that time. Among Tsunenobu's surviving works, the best known is *Phoenix and Paulownia* (Tokyo, U. F.A. & Music), which reveals his adherence to the stylistic precedents laid down by his more famous uncle, (11) Kanō Tan'yū. Like Tan'yū, Tsunenobu

Kanō Tsunenobu: *Landscapes of the Four Seasons* (detail), six-panel folding screen, h. 1.31 m, Edo period (Boston, MA, Museum of Fine Arts)

created numerous sketches of famous paintings, collectively known as *Tsunenobu shukuzu* ('Tsunenobu's connoisseur sketches').

BIBLIOGRAPHY

M. Hosono: 'Edo no Kanōha' [The Kanō school in Edo], *Nihon No Bijutsu*, 262 (Tokyo, 1988) [whole issue]
Kanōha no kyoshō tachi [Great masters of the Kanō school] (exh. cat., Shizuoka, Prefect. Mus., 1989)

GENE PHILLIPS

(15) Kanō Yukinobu [Kanō Sesshin; Kiyohara Yukinobu] (*b* 1643; *d* 1682). Great-niece of (11) Kanō Tan'yū. Her maternal grandparents were Nabe, Tan'yū's younger sister, and the Kanō painter Kōtari Jōan (*fl* first half of the 17th century). Her grandfather and her father, KUSUMI MORIKAGE, were regarded as two of Tan'yū's four greatest pupils, and Yukinobu herself was apprenticed to Tan'yū by the age of 16. Her debt to him can be seen in her deft manipulation of ink wash in hanging scrolls such as the *White-robed Kannon* (the *bodhisattva* Avalokiteshvara; New York, M. and J. Burke priv. col.; see *Kokka* (1894), p. 281) and her portrait of *Wang Zhaojun*, the legendary Chinese beauty of the Han period (206 BC–AD 220; Tokyo, ex-M. Hisada priv. col.; see *Kokka* (1940), p. 239), but the pale tones used in these works and the emotional warmth of the figures recall the style of her father. While still apprenticed to Tan'yū, she eloped with a fellow pupil, Hirano Ihei Morikiyo (*fl* mid-17th century), and they were both forced to leave the Kanō school. Her daughter, Harunobu, also became a talented artist.

Yukinobu specialized in depictions of the beautiful women celebrated in Japanese and Chinese literature, as in *Yang Guifei at her Toilet* (hanging scroll; Tokyo, N. Mus.). These delicate figures were tinged with nostalgia for the classical past, although the women's costumes were rendered with a care that appealed to a contemporary audience. Her refined treatment of classical subjects reflected her interest in traditional Japanese-style painting (*Yamatoe*), and she may have collaborated with the painter Tosa Mitsuoki (1617–91). In contrast to the propriety and reserve of her paintings, Yukinobu had an independent spirit rare in a Japanese woman of the 17th century; she was one of the few female painters of the Kanō school to achieve fame.

BIBLIOGRAPHY

O. Asaoka: *Koga bikō* [Handbook of classical painting] (n. p., *c.* 1845–53); rev. by K. Ōta as *Zōtei Koga bikō* [Presentation of the *Koga bikō*] (Tokyo, 1904), pp. 1879–81
'Yukinobu', *Kokka*, lxiii (1894), p. 281
A. Morrison: *The Painters of Japan*, 2 vols (London, 1911), pp. 139–40, pl. lii
'Kiyohara Yukinobu hitsu Ōshōkun zu' [The painting of *Wang Zhaojun* by Kiyohara Yukinobu], *Kokka*, dxcvii (1940), p. 239
'Kiyohara Yukinobu hitsu chū, *Sei Shonagon*, sayū, *Uzura* zu' [Kiyohara Yukinobu's triptych *Sei Shonagon* (centre) and *Quails* (left and right)], *Kokka*, dcv (1941), p. 116
M. Narazaki: 'Kiyohara Yukinobu hitsu *Nyōbō sanjūrokkasen* zu' [*Thirty-six Immortal Poetesses* by Kiyohara Yukinobu], *Kokka*, dccxii (1951), pp. 255f
——: 'Yukinobu hitsu *Yōkihi* zu' [The painting of *Yang Guifei* by Yukinobu], *Kokka*, dcccxxix (1961), pl. 1
T. Kobayashi and S. Sakakibara: *Morikage/Itchō* (1978/*R* 1982), Nihon bijutsu kaiga zenshū [Complete collection of Japanese painting], xvi (Tokyo, 1976–80/*R* 1980–82), pl. xxxvi

(16) Kanō Hōgai [Kōrin; Shōkai Tadamichi; Shōrin] (*b* Chōfu, Nagato Province [now Shimonoseki, Yamaguchi Prefect.], 1828; *d* Tokyo, 1888). Son of Kanō Seikō (*fl* first half of the 19th century). He was one of the last practising artists of the Kanō school, and his unique blend of Japanese and Western techniques, known as *Wayō setchū* ('Japanese–Western mixture'), contributed to the development of modern Japanese-style painting (*Nihonga*; see JAPAN, §VI, 5(iii)). He received his early training in the Kanō-school style from his father while also studying traditional Japanese-style painting (*Yamatoe*; see JAPAN, §VI, 3(iii)) with Morokuzo Shūkin (*fl* mid-19th century), a painter of the TOSA SCHOOL, and literati painting (*Nanga, Bunjinga*; see JAPAN, §VI, 4(vi)(d)) with Watarai Tomei (*fl* mid-19th century). For ten years from 1846 he received a stipend from the lords of the Chōfu domain to undertake formal painting instruction with Kanō Shōsen'in Tadanobu (1823–80), master of the Kobikichō Kanō studio in Edo (now Tokyo). He showed exceptional promise but grew impatient with the tired conventions of 19th-century Kanō painting and turned for inspiration to the ink painting of the Muromachi period (1333–1568), notably that of Tōyō Sesshū and Sesson Shūkei. Frequently in disagreement with his Kanō teachers over matters such as proper

colour application and brush method, Hōgai was nearly expelled from the school in Edo and was saved only by the mediation of a colleague. He completed his apprenticeship in 1851, and from 1852 to 1856 he studied with Sakuma Shōzan (1811–64), a scholar of Western studies who had opened a school adjacent to the Kobikichō Kanō school. Hōgai was drawn to Western pictorial concepts such as linear perspective and modelling in light and shade.

Hōgai received his first major commission in 1859, when he undertook ceiling paintings at Edo Castle for the Tokugawa shogunate. The fall of the Tokugawa regime in 1868 left him without patrons, and he was unable to earn his living as a painter (among other things he raised silkworms and drew designs for export porcelains). At last he was engaged by the Shimazu family in Tokyo, with whom he remained from 1879 until 1882. In 1884 he entered several works in the second Domestic Competitive Exhibition (Naikoku Kaiga Kyōshinkai) and found an unexpected supporter in the American scholar ERNEST FRANCISCO FENOLLOSA, an advocate of traditional Japanese art. By this time he was producing works in a fully developed form of the *Wayō setchū* style, such as *Eagles in a Ravine* (Boston, MA, Mus. F.A.; *see* KANŌ SCHOOL, fig. 2), and in 1886, at the second biennial exhibition of the Painting Appreciation Society (Kangakai) founded two years earlier by Fenollosa and Tenshin Okakura, Hōgai won first prize with an unconventional polychrome rendition of a traditional Buddhist theme, *Niō Capturing a Demon* (1886; Japan, priv. col., see Hosono, pl. 62). His use of the new, more intense pigments imported from Europe, of Western devices of pictorial illusion and of exotic elements such as a chandelier and parquet flooring give the painting a strong sense of European Romanticism that is also visible in two other Buddhist paintings by Hōgai (both Tokyo, U. F. A. & Music): the *Fudō Myōō* (Skt Acalanatha; 1887) and his last and most celebrated work, the *Hibō Kannon* (Avalokiteshvara, the *bodhisattva* of compassion; 1888). Hōgai's principal inspiration for the latter was a European lithograph, and in his preparatory sketches for it he depicted the *bodhisattva* as a pregnant mother, a female nude, a winged angel and a European Madonna. It has been suggested that Hōgai's death was hastened by his inhalation of gold dust while he was working on the *Hibō Kannon*.

BIBLIOGRAPHY

K. Kumamoto: 'Kanō Hōgai banki no sakuhin' [The late works of Kanō Hōgai], *Bijutsu Kenkyū*, clxxxiv (1956), pp. 201–8
C. Seki: 'Kanō Hōgai hitsu Fudō Myōō' [Fudō Myōō by Kanō Hōgai], *Kokka*, dccxxxv (1961), pp. 441–3
H. Katsura: *Bakumatsu no eshi: Wakaki hi no Kanō Hōgai* [Artists of the last years of the Tokugawa shogunate: Kanō Hōgai in his youth] (Tokyo, 1972)
M. Hosono: *Kanō Hōgai* (1976), i of *Nihon no meiga* [Celebrated paintings of Japan] (Tokyo, 1975–7)
——: *Edo Kanō to Hōgai*, Nihon no bijutsu: Bukku obu bukkusu [Arts of Japan: book of books], lii (Tokyo, 1978)
Kanō Hōgai seitan 150 nen kinen tokubetsu ten [Special memorial exhibition of the 150th anniversary of the birth of Kanō Hōgai] (exh. cat., Yamaguchi Prefect. Mus., 1979)

SHAUNA GOODWIN

Kanoria, Gopi Krishna (*b* Patna, 9 May 1917; *d* 16 Oct 1987). Indian collector. He was born into a poor family, with which he spent the formative years of his life. These years in comparative poverty, however, gave him an awareness of life and a depth of understanding and sensitivity that he most certainly would not have had if he had been born into the wealthy banking family that eventually adopted him. He became the heir to a property and banking business that allowed him to indulge his passions: Hindi and Sanskrit literature and, as an adjunct, Indian painting and sculpture.

He began to collect Indian miniatures seriously in the early 1940s. Patna, which was the base of his adopted inheritance, had at this time three important collectors who knew each other and Kanoria: the barrister P. C. Manuk, Miss G. M. Coles and Mr Jalan. As chance would have it, William George Archer (*see* ARCHER, (1)) was posted as District Magistrate to Patna in 1941. Over and above these influences on Kanoria was that of RAI KRISHNADASA of Banares, a city in which the Kanoria family had property interests. Once Rajasthani paintings started to appear on the market, the effect they had on Kanoria was immediate: 'The pictures burst upon him with all the force of a new revelation and, discarding for the moment the purchase of pictures from the Punjab Hills, he concentrated on collecting paintings from Rajasthan and Malwa. The result is a collection which enables us to see for the first time the course of painting in these two important regions' (see Archer, 1957, p. 7).

The miniatures in the Kanoria Collection are in the main connected with Sanskrit or Hindi poetry. Kanoria's appreciation of poetry illuminated his collecting. He saw the paintings as visual poems, and his deep knowledge of both Sanskrit and Hindi allowed him to understand and appreciate these paintings at a time when most people thought them to be naive and simple. They are, in fact, complex with pictorial images that have great symbolism. Kanoria would recite the verse, which often appears written in the top margin of the painting, and would point out the various ways in which the artist had visually played with the words. Without such insight into literature, much of the content and therefore the understanding of Indian miniature painting is missing.

WRITINGS
'An Early Dated Rajasthani Ragamala', *J. Ind. Soc. A.*, xix (1952–3), pp. 1–5

BIBLIOGRAPHY
W. G. Archer: *Indian Paintings from Rajasthan: Catalogue of an Exhibition of Works from the Collection of Sri Gopi Krishna Kanoria of Calcutta* (London, 1957)
W. Archer and M. Archer: *India Served and Observed* (London, 1994)

INDAR PASRICHA

Kanō school. Japanese school of secular professional ink painters active from the end of the 15th century. It was organized along hereditary lines within the KANŌ family, who guarded their painting traditions closely and passed the leadership of the school from father to son or to the nearest male relative (for illustration of family tree *see* KANŌ). Young men of artistic talent from outside the Kanō family were also taken on as apprentices, and in exceptional cases, such as those of Kanō Sanraku and Kanō Kōi (*see* KANŌ, (8) and (9)), they were adopted into the family and granted the right to establish studios of their own. In rare instances women were recognized as members of the family, as in the case of Kanō Yukinobu

(*see* KANŌ, (15)). The hereditary apprentice system permitted Kanō masters to undertake enormous painting projects that were possible only with the collaboration of a team of assistants; it also encouraged the preservation and transmission of the practices of the Kanō school over many generations.

1. Introduction. 2. Before 1600. 3. 1600–1868. 4. After 1868.

1. INTRODUCTION. The Kanō school originated as one of several late 15th-century studios in Kyoto working in *Kanga*, a style derived from the Chinese ink-painting traditions of the Southern Song (1127–1279) and Yuan (1279–1368) periods and first practised in Japan by Zen monks (*see* JAPAN, §VI, 4(iii)). Early Kanō masters forged a distinctive school style that combined the expressive brushwork and structural solidity of *Kanga* with the simple designs and vivid colours of *Yamatoe*, the native Japanese painting style (*see* JAPAN, §VI, 3(iii)). The resulting *Wakan* ('Japanese–Chinese') synthesis was particularly suitable for decorating spacious interiors of feudal buildings. Masters of the Kanō school served as official painters to the Ashikaga shogunate of the Muromachi period (1333–1568), the rival warlords of the Momoyama period (1568–1600) and the Tokugawa shogunate of the Edo period (1600–1868), but at the same time their workshops received commissions from the imperial court, Buddhist temples and Shinto shrines, provincial lords and rich merchants. In order to meet the demand from such a broad spectrum of patrons, Kanō artists produced work in a variety of formats, ranging from small folding fan paintings and narrative handscrolls to formal portraits, Buddhist scrolls and votive plaques. Their most important works, however, were large-scale paintings on folding screens (*byōbue*) and screen-and-wall paintings (*shōhekiga*, also *shōbyōga*), typically decorated with landscape, figural or bird-and-flower themes. One type of screen-and-wall painting, the sliding wall panel (*fusuma*), consisting of paper pasted over a wooden framework, comprises the majority of large-scale works by Kanō-school masters. Early Kanō-school masters such as Masanobu's son Kanō Motonobu (*see* KANŌ, (2)) continued the *Kanga* tradition of screen-and-wall painting, albeit in a style that was more decorative, as seen in the sliding wall panels (1543–9) now mounted as hanging scrolls that he painted for the Reiun'in subtemple of Myōshinji in Kyoto (for illustration *see* KANŌ, (2)). As one of the foremost professional studios, the Kanō school was instrumental in setting the direction for screen-and-wall painting, not only in the *Kanga* ink-painting tradition but also in colours and gold leaf (*kinpeki*). The use of colours and gold leaf was characteristic of the Momoyama period, the golden age of screen-and-wall painting.

Screen-and-wall paintings by Kanō artists appeared in structures such as Buddhist temples, palaces and castles. The scale and layout of these decorative programmes were dictated by the size and purpose of the buildings; subject and style were chosen according to the function of a room and often varied from room to room within the same building. In particular, the grand scale of castle architecture in the Momoyama period had a profound effect on screen-and-wall painting. Vast decorative programmes such as

that for the seven-storey donjon of Azuchi Castle (1576–81; destr. 1582), executed entirely in colours and gold leaf by Kanō Eitoku (*see* KANŌ, (5)), ushered in a period of florescence of screen-and-wall painting at the end of the 16th century.

Kanō-school artists employed a broad repertory of Chinese and Japanese subject-matter, although they were best known for their landscapes and bird-and-flower paintings. Figure painting was also important and included portraits of sages, immortals and hermits. Classical Chinese figures, the main theme of *Kanga* figure painting, created an erudite atmosphere in the elegant suites and reception rooms of feudal residences and were executed both in ink and in colours and gold leaf. An example is the pair of folding screens entitled the *Seven Sages of the Bamboo Grove* and the *Four Sages of Mt Shang* (1552; Tokyo, N. Mus.), which Motonobu painted in the formal (*shintai*) ink mode; both screens extolled the Confucian virtues of Chinese sages who took refuge in nature to escape the political turmoil and corruption of the Qin period (221–206 BC). Paintings in colours and gold leaf of ornate Chinese palaces, embellished with exotic species of flowers, were popular at the end of the 16th century and in the first half of the 17th, as in a pair of screens (Washington, DC, Freer) attributed to Kanō Mitsunobu (*see* KANŌ, (7)) illustrating the *Poem of Everlasting Sorrow* by Bai Juyi (AD 772–846), the tragic love story of the Tang emperor Xuanzong (*reg* AD 712–56) and his consort Yang Guifei. While these subjects were Chinese in origin, Kanō artists painted them in their own Japanese style. They were also familiar with the native themes of *Yamatoe*, which they reproduced in traditional formats such as the narrative handscroll or adapted for other uses, as in the four-panel folding screen the *Battle of the Carriages* (Tokyo, N. Mus.; *see* KANŌ, (8), fig. 2) attributed to Sanraku.

Buddhist temples were among the Kanō school's principal patrons, and, besides the large number of screen-and-wall painting programmes executed for them by Kanō artists, they were also supplied with icons and devotional paintings, while wooden votive plaques known as *ema* ('horse paintings'; *see* JAPAN, §XV) were made for Shinto shrines. In devotional paintings such as *Nirvana* (Jap. *Nehan zu*; 1563; Kyoto, Daitokuji) by Kanō Shōei (*see* KANŌ, (3)), which depicts the death of the Buddha Shakyamuni, Kanō painters used their fundamentally secular style for religious themes. At the end of the 16th century the Kanō school played a leading role in the genesis of new categories of painting. These included genre scenes (*fūzokuga*) portrayed on folding screens and *Nanban* ('southern barbarian') painting, a type of related genre scene portraying European missionaries and merchants. Kanō Eitoku's pair of six-panel folding screens *Scenes in and out of the Capital* (*Rakuchū rakugai zu*; *c.* 1574; Yamagata Prefect., Uesugi priv. col., see Doi, 1981, pls 6–7) shows a panorama of Kyoto bustling with commercial and street activity, while *Maple Viewing at Takao* (Tokyo, N. Mus.) by Kanō Hideyori (*see* KANŌ, (4)) is considered the earliest Japanese genre painting since its main subject is contemporary people and their activities rather than the customary references to the seasons or famous places. The Kanō school's contribution to *Nanban* painting can be seen in a pair of six-panel folding screens

(Kobe, City Mus. Nanban A.) with the seal and signature of Kanō Naizen (1570–1616), the right-hand screen depicting the arrival of Portuguese traders in Nagasaki and the left-hand screen giving an imaginary view of their home port in Portugal.

2. BEFORE 1600. The first important painter of the Kanō family, traditionally credited with founding the school, was Kanō Masanobu (*see* KANŌ, (1)), who came from a small village called Kanō in Izu Province (now Shizuoka Prefect.), whence the surname. He is thought to have studied painting with the Zen monk Oguri Sōtan who was associated with Shōkokuji, the Zen temple in Kyoto that had been an important centre for the development of *Kanga* painting in Japan. Sōtan, following in the tradition established by Tenshō Shūbun, led one of several groups of *Kanga* painters in the capital and seems to have provided Masanobu with the basis of his ink-painting style. Masanobu adopted the aesthetic values of the Zen-inspired *Kanga* tradition, such as the restrained and suggestive use of line (e.g. the unsigned hanging scroll *Chinese Mountain Landscape*; Itami, Konishi priv. col.); however, unlike earlier *Kanga* painters, he was not a Zen monk but a lay member of the Nichiren (Hokke) sect of Buddhism. The isolation of *Kanga* from its Zen cultural and philosophical roots was part of a more general trend in Japanese culture during the second half of the 15th century: the Zen monks who had advised the early Ashikaga shoguns on religious, intellectual and cultural matters were gradually supplanted by a circle of lay companions (*dōbōshū*), while the Ōnin Wars (1466–77)

prompted many artists to flee Kyoto, where they had been attached to particular temples, and to establish workshops under the aegis of provincial warlords. Each of these developments tended to encourage the appearance of independent secular artists such as Kanō Masanobu. By the 1480s Masanobu must have held a prominent place among the painters attached to the shogunal court, for he received a number of important commissions, such as the decoration (1483; destr.) of the Higashiyama Villa in eastern Kyoto for the retired shogun Ashikaga Yoshimasa (1436–90).

Masanobu's eldest son, Kanō Motonobu (*see* KANŌ, (2)), heralded what is considered the golden age of Kanō achievement. He set up an independent workshop in northern Kyoto, where members of his family and other apprentices were trained to execute works ranging from small folding fans to screen-and-wall paintings; and he established the Kanō repertory by producing copybooks that codified each of the major pictorial modes current at the beginning of the 16th century. In the case of *Kanga* ink painting, for example, he applied a threefold classification based on calligraphy styles: the formal *shintai* ('new form'), the informal *gyōtai* ('running form') and the cursive *sōtai* ('grass form'). His most important contribution, however, was the creation of the *Wakan* ('Japanese–Chinese') style of painting, a synthesis of *Kanga* ink painting and the decorative tradition of *Yamatoe*, which formed the basis of later Kanō-school painting. Specifically, he invented *kinpeki shōhekiga*, a mode of screen-and-wall painting completely covered with gold leaf and

1. Kanō Eitoku: *Plum Tree and Birds*, detail from *Landscape with Birds and Flowers*, sliding wall panel paintings (*fusuma*), each panel 1.75×1.42 m, 1566 (Kyoto, Daitokuji, Jukōin)

brilliant colours. Motonobu was one of the most successful artists in Kyoto, and under his determined leadership the Kanō studio flourished despite the unsettled conditions in the capital in the period between *c.* 1490 and 1573—the Age of the Country at War (*sengoku jidai*).

The *Wakan* style of painting was continued by Motonobu's son Shōei (*see* KANŌ, (3)) and was transformed into an art of heroic proportions by Shōei's son Kanō Eitoku (*see* KANŌ, (5)) and his followers in the second half of the 16th century. Eitoku was the pre-eminent artistic figure of the Momoyama period and initiated a monumental painting style known as *taiga* ('big painting'), which was executed in colours and gold leaf using boldly stylized forms, vigorous brushwork and magnified, close-up compositions. The influence of Eitoku's new style spread beyond the boundaries of his Kanō workshop into those of his rivals, such as HASEGAWA TŌHAKU, KAIHŌ YŪSHŌ and UNKOKU TOGAN. Eitoku decorated some of the huge and ostentatious residences erected by the rival warlords of the period, including Oda Nobunaga's Azuchi Castle, Toyotomi Hideyoshi's Osaka Castle (1583–4) and the Jurakudai (1587–8), the same patron's palace in Kyoto, but these buildings and Eitoku's decorations were destroyed within a few years of their creation. Among the few extant works by Eitoku widely accepted as genuine, the series of screen-and-wall paintings in monochrome ink entitled *Landscape with Birds and Flowers* (1566; Kyoto, Daitokuji, Jukōin; see fig. 1) and a six-panel folding screen in colours and gold leaf depicting *Chinese Lions* (Tokyo, Imp. Household Col.) are representative of his *taiga*. The gnarled trunk of a plum tree that sweeps across four of the panels in the Jukōin typifies the spatial tension, kinetic execution and monumental sweep of the large-scale motifs of Eitoku's powerful style.

After Eitoku's death in 1590 his closest followers, including his younger brother Kanō Sōshū (*see* KANŌ, (6)), his adopted pupil Kanō Sanraku and his eldest son, Kanō Mitsunobu (*see* KANŌ, (8) and (7) respectively), continued to produce works in the same grand manner. The eight-panel folding screen *Cypress Tree* (*c.* 1591; Tokyo, N. Mus.) is generally thought to be the work of a member of this group. Gradually, however, they abandoned Eitoku's style in favour of the increasingly refined, highly decorative manner that prevailed during the opening decades of the 17th century.

3. 1600–1868. The main body of the Kanō school moved to Edo (now Tokyo) soon after it became the capital in 1600, but Sanraku, who is usually regarded as the ablest of Eitoku's pupils, remained in Kyoto, where his studio became known as the Kyō Kanō. Sanraku maintained the verve and scale of Eitoku's *taiga* in works such as *Pine Tree and Hawk* (Kyoto, Daikakuji, Shōshinden), a screen-and-wall painting in monochrome ink, but he achieved an unprecedented and exquisite frozen beauty in the most characteristic Kanō format of the late 16th century, the large-scale bird-and-flower painting in colours and gold leaf. This can be seen in the screen-and-wall paintings *Red Plum Blossoms* and *Peonies* (*c.* 1620) in the main hall (*shinden*) of the Daikakuji and in *Plum Tree and Pheasant* (*c.* 1631–5; Kyoto, Myōshinji, Tenkyūin), which is generally regarded as the product of collaboration by

Sanraku and his adopted son-in-law Kanō Sansetsu (*see* KANŌ, (10)). It was Sanraku's more romantic style of crystallized forms that fuelled the fantastic mannerisms of Sansetsu, who succeeded his father-in-law as head of the Kyō Kanō school.

A gentler vision influenced by the aesthetics of *Yamatoe* can be seen in the works of Eitoku's son Mitsunobu, as in the 12 sliding wall panels with bird-and-flower paintings that he produced in 1600 for the Kangakuin, a subtemple of Onjōji (Miidera) in Ōtsu. This tradition was transmitted to the main Kanō workshop in Edo by Mitsunobu's pupil Kanō Kōi (*see* KANŌ, (9)) and was taken up by Mitsunobu's nephew Kanō Tan'yū (*see* KANŌ, (11)), the foremost Kanō painter of the Edo period. In 1617, when Tan'yū was 15 years old, he was invited to become painter-in-residence (*goyō eshi*) to the Tokugawa shogunate and was given a large house in the Kajibashi district of Edo. There the painter established an atelier, with the help of which he undertook commissions from the shoguns for the decoration of Edo Castle (1622), Osaka Castle (1623–4), Nijō Castle in Kyoto (1626), Nagoya Castle (*c.* 1634; destr.) and the Tōshōgū Shrine (1634–6), the mausoleum of the Tokugawa family at Nikkō. In 1626 the shogun Tokugawa Iemitsu (1604–51) commissioned Tan'yū to renovate the Ninomaru Palace in Nijō Castle in preparation for a formal visit by Emperor GoMizunoō (*reg* 1611–29). In the main audience chamber (*ōhiroma*) the artist painted the screen-and-wall composition *Pines and Peacocks* (colours on a gold-leaf ground), in which the sweep of the great pine is reminiscent of Eitoku's work. However, in asserting the academic perfection of the forms over the plastic force of their interaction, Tan'yū set the tone for the mainstream Kanō-school style of the Edo period. Tan'yū's ink-painting style was marked by cool restraint, for he employed lighter-toned ink and emphasized the clean expanse of the paper. This innovative approach, which contributed to renewed interest in work in monochrome ink in the 17th century, was felt to be particularly appropriate for Chinese didactic subjects, as in the set of screen-and-wall paintings illustrating the *Mirror of Good and Evil Emperors* that Tan'yū and his assistants executed at the Jōraku Palace in Nagoya Castle (destr. 1945).

Under the aegis of the Tokugawa shogunate the Kanō school developed into an elaborate network of studios that operated throughout Japan. Besides the Kyō Kanō line in Kyoto, the four highest-ranking lineages were based in Edo. They were led by descendants of Tan'yū and his brothers (for illustration of family tree *see* KANŌ): the main Nakabashi line was descended from Tan'yū's youngest brother, Kanō Yasunobu (*see* KANŌ, (13)); the Kajibashi line from Tan'yū himself; the Kobikichō line from his younger brother, Kanō Naonobu (*see* KANŌ, (12)); and the Hanchō (or Hamachō) line from Kanō Minenobu (1662–1708), the second son of Naonobu's heir, Kanō Tsunenobu (*see* KANŌ, (14)). These four masters, who held the title of 'painter of the inner quarters' (*oku eshi*), were in the direct service of the shogun and his family and were allowed to wear swords like samurai and seek audience with the shogun. These privileges were denied the 12 to 16 'painters of the outer quarters' (*omote eshi*), who also received lower stipends from the shogunal

government. Notable *omote eshi* lineages include the Surugadai line founded by Tan'yū's adopted son Kanō Tōun Masunobu (1625–94); the Okachimachi line descended from Eitoku's youngest brother, Kanō Naganobu (1577–1654); and the Negishimiyuki no matsu line, who were the successors of Kanō Naizen (1570–1616). A third category of Kanō painters, known as the 'painters in exclusive service' (*okakae eshi*), worked for powerful lords in the provinces, as in the case of the descendants of two of Mitsunobu's pupils, the line founded by Kanō Kōi in the Kii region (now Wakayama Prefect.) and that established by Watanabe Ryōkei (*d* 1645) in the Matsuura region (now Shimane Prefect.). At the bottom of the Kanō hierarchy were vast numbers of 'town Kanō' (*machi Kanō*), painters who had been trained in the Kanō school but were not members of the Kanō family; they operated independent workshops in the towns, where they catered for the general public. Most were content to reproduce Tan'yū's compositions, which were largely reduced to standardized formulae, so that Kanō painting gradually lost its vitality, coming to be regarded as the fountainhead of academic conservatism and orthodoxy. A few individualists, such as KUSUMI MORIKAGE, Tan'yū's nephew by marriage, and Yasunobu's pupil HANABUSA ITCHŌ, broke away to develop their own styles (according to some accounts, they were expelled). Others who trained with a Kanō master before going on to found rival studios of their own were the Rinpa masters Ogata Kōrin (*see* OGATA, (1)) and WATANABE SHIKŌ (1683–1755), the naturalistic painter MARUYAMA ŌKYO, the literati painter TANI BUNCHŌ and prominent woodblock-print designers such as KITAGAWA UTAMARO and Chōbunsai Eishi (1756–1829).

A number of Kanō artists of the Edo period also played significant roles as writers on art and connoisseurs. Kanō Ikkei (1599–1662), the son of Kanō Shōei's pupil Kanō Naizen, wrote the *Tansei jakuboku shū*, one of the earliest biographies of Japanese painters. This was followed by the more comprehensive *Honchō gashi* ('History of Japanese painting') begun by Kanō Sansetsu and completed in five volumes by his son Kanō Einō (1631–97). It remains an important source, especially for the biography of Kanō painters, but was outstripped by the *Koga bikō* ('Handbook of classical painting') by Asaoka Okisada (1800–56), a member of the school; it remains the most extensive premodern work on Japanese art. The most influential theoretical work of the Edo period was the *Gadō yōketsu* ('Essence of the art of painting') by Kanō Yasunobu, one of the central tenets of which was the superiority of training over creativity. Yasanobu and his brothers Tan'yū and Naonobu were highly regarded for their connoisseurship, and their attributions can be found on many anonymous works of the 16th and 17th centuries. Tan'yū also had an interest in the art of the past, and in the *Tan'yū shukuzu* ('Tan'yū's connoisseur sketches'), a series of miniature ink studies of Japanese and Chinese works, he recorded many important pre-17th-century paintings that no longer survive.

4. AFTER 1868. The social and economic uncertainty that accompanied the collapse of the Tokugawa shogunate, the main source of support to the Kanō school, and the re-establishment of imperial rule in 1868 forced many Kanō artists to turn to other means of earning their livings. Among the few who persisted were Kanō Hōgai (*see* KANŌ, (16)) and HASHIMOTO GAHŌ, both of whom had been pupils of Kanō Shōsen'in Tadanobu (1823–80) of the Kobikichō Kanō studio. Without rejecting their academic training, Hōgai and Gahō sought to revitalize Kanō painting by returning to its 15th-century roots. They

2. Kanō Hōgai: *Eagles in a Ravine*, hanging scroll, ink and colours on paper, 928×1655 mm, 1885 (Boston, MA, Museum of Fine Arts)

integrated the traditional subject-matter, the powerful *Kanga* line and the lucid compositions of the classical Kanō tradition with Western concepts such as atmospheric perspective and chiaroscuro modelling of figures, producing a hybrid style known as *Wayō setchū* ('Japanese–Western mixture'; e.g. Hōgai's *Eagles in a Ravine*; Boston, MA, Mus. F.A.; see fig. 2). With the theorist Tenshin Okakura and the American connoisseur ERNEST FRANCISCO FENOLLOSA, Hōgai and Gahō helped to establish the Kangakai (Painting Appreciation Society), for the evaluation and preservation of traditional Japanese painting, and the Tokyo Art School (now the Tokyo University of Fine Arts and Music), which was founded in 1887. There Gahō taught a style of painting that derived from that of the Kanō school and was the basis for *Nihonga*, the 'classical' painting style of modern Japan (*see* JAPAN, §VI, 5(iii)).

BIBLIOGRAPHY

EARLY SOURCES
Kanō Ikkei: *Tansei jakuboku shū* (n.p. [before 1662])
Kanō Yasunobu: *Gadō yōketsu* [Essence of the art of painting] (n.p., 1680); repr. in *Bijutsu Kenkyū*, xxxvii (1935), pp. 34–43
Kanō Einō: *Honchō gaden* [Record of Japanese painting] (n.p., 1691); rev. as *Honchō gashi* [History of Japanese painting] (n.p., 1693); ed. T. Sakazaki in *Nihon kaigaron taikei* [Outline of Japanese art treatises], ii (Tokyo, 1979), pp. 365–466
Asaoka Okisada: *Koga bikō* [Handbook of classical painting] (Edo, c. 1845–53); rev. K. Ota as *Zōtei koga bikō* [Presentation of the Handbook of classical painting] (Tokyo, 1904)

GENERAL
A. Morrison: *The Painters of Japan*, 2 vols (London, 1911)
T. Doi: *Momoyama no shōhekiga* [Momoyama screen-and-wall painting] (1964), xiv of *Nihon no bijutsu* [Arts of Japan] (Tokyo, 1959–69); Eng. trans. by E. B. Crawford as *Momoyama Decorative Painting* (1977), Heibonsha Surv. Jap. A., xiv (New York and Tokyo, 1972–7)
T. Matsushita: *Suibokuga* [Ink painting], xii of *Nihon no bijutsu* [Arts of Japan] (Tokyo, 1967); Eng. trans. by M. Collcutt as *Ink Painting*, vii of *Arts of Japan* (New York and Tokyo, 1974)
Y. Yamane: *Momoyama no fūzokuga* [Momoyama genre painting] (1967), xvii of *Nihon no bijutsu* [Arts of Japan] (Tokyo, 1959–69); Eng. trans. by J. M. Shields as *Momoyama Genre Painting* (1973), Heibonsha Surv. Jap. A. (Tokyo, 1972–7)
——: *Nanzenji honbō* [The chief abbot's quarters at Nanzenji] (1968), *Shōhekiga zenshū* [Complete collection of screen-and-wall painting], ed. T. Tanaka and others (Tokyo, 1966–72)
T. Doi: *Kinsei kaiga shi kenkyū* [Research in early modern painting] (Tokyo, 1970)
——: *Motonobu/Eitoku* (1974), Suiboku bijutsu taikei [Compendium of the art of ink painting], viii (Tokyo, 1973–5)
Momoyama: Japanese Art in the Age of Grandeur (exh. cat., New York, Met., 1975)
T. Doi: *Sanraku/Sansetsu* (1976/R 1981), Nihon bijutsu kaiga zenshū [Complete collection of Japanese painting], xii (Tokyo, 1976–80/R 1980–82)
G. C. Weigl: *Foundations of a Momoyama Theme: Birds and Flowers of the Four Seasons in a Landscape*, 2 vols (diss., U. Michigan, 1976)
C. Wheelwright and Y. Shimizu, eds: *Japanese Ink Paintings* (Princeton, 1976)
T. Akiyama: *Japanese Painting* (Geneva, 1977)
T. Doi: *Eitoku/Mitsunobu* (1978/R 1981), Nihon bijutsu kaiga zenshū [Complete collection of Japanese painting], ix (Tokyo, 1976–80/R 1980–82)
H. Munsterberg: *The Art of Modern Japan, from the Meiji Restoration to the Meiji Centennial, 1868–1968* (New York, 1978)
Museum, cccxlii (1979) [issue ded. to Kanō-school ptg]
T. Takeda: *Motonobu/Eitoku/Tan'yū*, Nihon no bijutsu: Bukku obu bukkusu [Arts of Japan: Book of books], liii (Tokyo, 1979)
——: *Jinbutsuga: Kanga kei jinbutsu* [Figure painting: Chinese-style figures], iv of *Nihon byōbue shūsei* [A compilation of Japanese folding-screen paintings] (Tokyo, 1980)
Imperial Japan: The Art of the Meiji Era, 1868–1912 (exh. cat. by F. Baekeland, Ithaca, NY, Cornell U., Johnson Mus. A., 1980)
Kanō-ha no kaiga [Kanō-school painting] (exh. cat., Tokyo, N. Mus., 1980)
Y. Shimizu: 'Workshop Management of the Early Kanō Painters ca. A.D. 1530–1600', *Archvs Asian A.*, xxxiv (1981), pp. 32–47
C. Wheelwright: 'Kanō Painters of the Sixteenth Century A.D.: The Development of Motonobu's Daisen-in Style', *Archvs Asian A.*, xxxiv (1981), pp. 6–31
T. Kobayashi: *Edo kaiga shiron* [Essays on the history of Edo painting] (Tokyo, 1983)
B. Klein: 'Japanese Kinbyōbu: The Gold-leafed Folding Screen of the Muromachi Period (1333–1573)'; trans. and expanded by C. Wheelwright, *Artibus Asiae*, xlv/1–3 (1984), pp. 5–33, 101–73
Ōta Dōkan kinen bijutsuten: Muromachi bijutsu to Sengoku gadan [Ōta Dōkan memorial art exhibition: artists' circles of the Muromachi and Sengoku periods] (exh. cat., Tokyo, Met. Teien A. Mus., 1986)

SHAUNA GOODWIN

Kanō Sesshin. *See* KANŌ, (15).

Kanō Yeitan Masanobu. *See* FENOLLOSA, ERNEST FRANCISCO.

Kanpur [Kānpur; Cawnpore]. Industrial city 79 km southwest of Lucknow in Uttar Pradesh, India. Located on the River Ganga, Kanpur was a river port and grain market that came under British control from 1801. Trade in grain grew, especially after the opening of the Ganga canal (1854). Monuments of the first half of the 19th century include the Gothic-style Christ Church (1836–40) and Kacheri Cemetery; the noteworthy tomb of *General Sir John Horsford* (d 1817) consists of a pedestalled funerary urn in a circular pavilion with Roman Doric pillars. Also notable is the mausoleum of *Agha Mir*, a prime minister of the Avadh nawabs, who fled to Kanpur from the court in Lucknow.

On one occasion during the mutiny against British rule in 1857, many British inhabitants of Kanpur were killed and thrown into a well. A memorial garden at the site featured an octagonal stone screen round the well by Sir Henry Yule and a marble angel by Carlo Marochetti. The gardens have since been renamed Nana Rao Park, and the angel has been removed to All Saints' memorial church (1862–75), a Lombardo-Gothic building designed by Walter L. B. Granville (1819–74). Kanpur grew rapidly during the second half of the 19th century. The Government Harness and Saddlery Factory was opened in 1863. Its first superintendent, Colonel John Stewart, provided the Bhagvandas Temple and bathing ghat for factory workers; the temple retains two fascinating reliefs of Stewart and his family. European merchants opened numerous industrial concerns, such as the Elgin (1869) and Muir (1875) cotton mills. The Elgin Mills, with their restrained façade of pedimented windows, the Cawnpore Club and various residential bungalows along the river are among the leading monuments of this period, when there also developed a congested city with workers' colonies and slums squeezed between the river, railway sidings and canal.

In the 1920s town planning by the Improvement Trust (1919) led to railway realignments around the new Central Station (1930), a bold exercise in Indo-Saracenic architecture. New colleges included Sanathan Dharma College, a functional structure employing traditional architectural elements. The Sri Radhakrishna Temple in Kamla Nagar, with its soaring spires, is a monument to the J. K. industrial empire founded by Lala Kamlapath Singhania in the 1920s.

BIBLIOGRAPHY
H. G. Keene: *A Hand-book for Visitors to Lucknow: With Preliminary Notes on Allahabad and Cawnpore* (Calcutta and London, 1875, rev. Calcutta, 2/1896)
J. W. Shepard: *A Personal Narrative of the Outbreak and Massacre at Cawnpore* (Lucknow, 1894)
H. H. Singh: *Kanpur: A Study in Urban Geography* (Varanasi, 1972)
C. S. Chandrasekhara: 'Growth of an Industrial Metropolis: Social Contours of an Industrial City', *Million Cities of India*, ed. R. P. Misra (Delhi, 1978)
Z. Yalland: *Traders and Nabobs: British in Cawnpore, 1765–1857* (London, 1988)

J. B. HARRISON

Kansas City. Name of two American cities in Kansas and Missouri divided by the Missouri River at its confluence with the Kansas River. Although as two cities they are separate politically, together they comprise a single economic unit. Kansas City, MO, is, however, three times the size of Kansas City, KS, the former with a population of *c*. 435,000, the latter with *c*. 150,000. Kansas City evolved from a frontier trading post, which functioned as the river landing for nearby Westport, founded in 1835, a town serving the overland trails to the west. Kansas City was formally established in 1850, but its development suffered greatly from partisan conflict over the issue of the extension of slavery into Kansas and then from the effects of the Civil War (1861–5). Recovery and then growth were accelerated when the first bridge over the Missouri River was built in the city (opened 1869). Transformation of the raw frontier town into a city of substance was complicated by the irregular terrain of hills, ravines and steep riverbanks, and throughout the 19th century considerable effort was expended to create manageable street gradients and then to adjust building sites accordingly, especially in the area nearest the river.

Major development occurred in the late 1880s, including the New York Life Building (completed 1890) by McKim, Mead & White. A nationally significant park and boulevard plan by George Kessler (1862–1923) was launched in 1893 and was essentially complete by 1915. The first steel-framed skyscrapers in the city were built in 1906–7, and the Boley Building (1909) by Louis Curtiss (1865–1924) is an early example of curtain-wall construction. Systematically planned residential development on a large scale by the J. C. Nichols Company began in 1908, and civic centre planning, influenced by the City Beautiful aesthetic, was given impetus by the building of the enormous Neoclassical Union Station (completed 1914; see fig.) by Jarvis Hunt (1859–91). The Liberty Memorial (first phase completed 1926) by H. Van Buren Magonigle (1868–1935), and the Nichols Company's Country Club Plaza, a planned shopping centre with free, off-street car parking (begun 1922), drew national attention. A major building surge in the 1920s included some important Art Deco work, such as the Power and Light Building (completed 1931) by Hoit, Price & Barnes. The Great Depression of the 1930s limited major work to that principally funded by government, such as the high-rise city hall (1937) by Wight & Wight.

Reform of the corrupt city government (1940–42) enabled the new city manager, L. P. Cookingham, to introduce professional city planning. Post-war development included a programme of annexation that increased the city's area from 155 sq. km in 1947 to 777 sq. km by 1963. Concurrent development of a motorway network, including a ring-road, contributed to a decline in the population of the city centre, which had only briefly ever exceeded 500,000. In Kansas City, KS, the Northeast Johnson Co., KS, has attracted considerable residential and commercial development since 1970. In the older city, Crown Center, a large, private, multi-use, urban renewal project by various architects (begun 1967), sponsored by Hallmark Cards, Inc., is a major success. Historic building conservation began around 1970 and contributed to a revitalization of parts of the city centre as well as of a number of older, residential neighbourhoods.

Kansas City, view from the Liberty Memorial with Union Station in the foreground

Art life in Kansas City for a considerable time was modest and conservative until the W. Rockhill Nelson Gallery opened in 1933 (renamed Nelson–Atkins Museum of Art *c.* 1980). A major museum with an internationally recognized Oriental collection, it has been a significant influence on the art community, as has the Kansas City Art Institute (which evolved from a sketching club begun in 1885). The Art Institute and the University of Missouri-Kansas City (founded 1933) offer major teaching programmes in art. They also present regular calendars of exhibitions, principally of contemporary art. In addition, other non-profit-making and commercial galleries bring a variety of art before the public; most are located in Kansas City, MO. Among historically recognized artists, George Caleb Bingham and Thomas Hart Benton were residents for extended periods.

BIBLIOGRAPHY

F. Howe: 'The Development of Architecture in Kansas City, Missouri', *Archit. Rec.*, xv/2 (1904), pp. 134–57

G. Mitchell: *There is No Limit: Architecture and Sculpture in Kansas City* (Kansas City, 1934)

W. Wilson: *The City Beautiful Movement in Kansas City* (Columbia, MO, 1964)

A. Brown and L. Dorsett: *K.C.: A History of Kansas City, Missouri* (Boulder, 1978)

G. Ehrlich: *Kansas City, Missouri: An Architectural History, 1826–1976* (Kansas City, 1979); rev. as *Kansas City, Missouri: An Architectural History, 1826–1990* (Columbia, MO, 1992)

S. Piland and E. Uguccioni: *Fountains of Kansas City: A History and Love Affair* (Kansas City, 1985)

W. Worley: *J. C. Nichols and the Shaping of Kansas City: Innovation in Planned Residential Communities* (Columbia, MO, 1990)

J. Mobley and N. Harris: *A City within a Park: One Hundred Years of Parks and Boulevards in Kansas City, Missouri* (Kansas City, 1991)

GEORGE EHRLICH

Kansawh al-Ghawri. *See* MAMLUK, §II, 2(11).

Kanshū. *See* NAGASAWA ROSETSU.

Kant, Immanuel (*b* Königsberg [now Kaliningrad], 22 April 1724; *d* Königsberg, 12 Feb 1804). German philosopher. He spent most of his adult life as a member of the University of Königsberg; he enrolled as a student there in 1740 and was accepted as a *Privatdozent* in 1755, becoming professor of logic and metaphysics in 1770. His contribution to aesthetics and the philosophy of art, which forms one part of the far-reaching enquiry he pursued into the fundamental conditions of human thought and experience, is contained in the last of the three famous *Critiques* he published between 1780 and 1790. The first of these, the *Kritik der reinen Vernunft* (Riga, 1781), was primarily concerned with establishing the status and scope of theoretical knowledge, while the second, the *Kritik der praktischen Vernunft* (Riga, 1788), was addressed to investigating the nature and foundations of morality. In the third, his *Kritik der Urteilskraft*, Kant undertook the task of providing an account of what was involved in, and presupposed by, judgements of taste. He was profoundly dissatisfied with earlier approaches to the subject; in particular, he considered that they had failed to recognize the autonomy of the aesthetic consciousness, tending either to reduce it to some mode of objective cognition or else—at the other extreme—to portray it as being a matter of personal feeling that could claim no kind of universal validity. In propounding his own theory Kant wished instead to do justice to its distinctive character and to identify and resolve comprehensively the various issues this raised.

1. THE NATURE OF AESTHETIC JUDGEMENT. Kant's discussion is conducted at a very general level. In contrast to some of his philosophical predecessors, he was impressed by the fact that we ascribe beauty to products of nature as well as to works of art, and references to the former tend to predominate in his overall treatment of judgements of taste. Even so, it was essential to realize that judging things to be beautiful was not a question of applying determinate concepts to what we perceived in the manner characteristic of our claims to knowledge about the world. Aesthetic claims are of a wholly different order from cognitive ones: they are crucially concerned with the fashion in which we react or respond to a given object, the response being that of an experience of pleasure or satisfaction; there is thus a clear sense in which their determining ground cannot, in Kant's words, 'be other than subjective'. Nonetheless, he also insisted that they must be sharply distinguished from judgements relating to what he termed 'the agreeable'. To say that something is agreeable is to say no more than that it gratifies a particular desire or preference on the part of the speaker, but this is not true of our ascriptions of beauty. In the first place, such ascriptions are essentially disinterested, not being based on any specifically personal or practical concern we might have with their objects. And, secondly, they involve a claim to acceptance by other percipients. Although in calling a thing beautiful we are necessarily giving expression to our own reactions to it, we are at the same time doing more than this. For we are also implying—demanding even—that others should respond in a similar manner. According to Kant, this accounts for the capability of ascriptions of beauty to arouse contention in ways in which statements about the merely agreeable do not.

It is one thing, though, to maintain that in making aesthetic judgements we lay claim to general agreement; it is another to maintain that we are justified in so doing. Kant went on to argue that the implicit claim to universal validity can be shown to be warrantable, and his attempt to demonstrate this is connected with the account he gave of the distinctive nature and source of aesthetic pleasure. Here the notion of purposiveness plays a key role. He did not deny that there is in fact an 'impure' or 'dependent' sense in which something can be appraised as beautiful in an objectively ascertainable fashion; that is so when, for example, it is apprehended as serving some definite purpose or when, again, it is regarded as conforming to certain requirements that such objects are intended or supposed to meet. But any satisfaction we might derive therefrom involves the application of concepts or specifiable criteria and consequently is not properly classifiable as aesthetic. There is, however, another type of purposiveness to be considered: it is possible for an object to be perceived as manifesting an appearance of purposive order or design without that design subserving or conforming to any determinate end. And it is the pleasure that the apprehension of such purely formal coherence produces that, in Kant's view, constitutes the authentically aesthetic response.

Kant suggested that this aesthetic response occurs when two of our mental faculties—imagination and understanding—are activated in a quite special way. Whereas in cognition the imagination is 'at the service of' the conceptualizing understanding when it imposes order on the data provided by sensation, in the contrasting case of aesthetic experience the two faculties mutually engage or mesh together in a state of what Kant called 'free play' or unconstrained harmony. This free accord is something the individual subject is directly aware of, occasioning satisfaction in a fashion that is not determined by concepts and that entails no reference to rules or formulable reasons. At the same time, an aesthetic judgement founded on it can rightfully claim intersubjective validity provided that the psychological source of the pleasure experienced has been correctly identified. For the faculties in question are necessarily common to all human beings inasmuch as they are capable of acquiring and communicating knowledge. It follows that other people can justifiably be expected or called on to react similarly when exposed to the conditions that evoked the original aesthetic response.

Kant's various allusions to the 'free play of imagination and understanding' as a means of validating aesthetic claims are somewhat problematic and obscure, presupposing controversial elements of his general epistemology. Nonetheless, there are features of his account that can be appreciated independently and that have attracted wide interest. This is particularly true of his treatment of beauty in terms that abstract from all cognitive or practical considerations and centre instead on the self-subsistent purposiveness of form or design, which Kant held to characterize the proper objects of aesthetic appreciation. Among other things, such a position led some commentators to accredit him with an essentially formalist conception of the significance and value of works of art.

2. THEORY OF ART. Kant's comprehensive emphasis in the earlier sections of his *Kritik der Urteilskraft* on the notion of free beauty as a matter of purely formal relationships might suggest that he supposed there to be no important differences between the appreciation of nature and the appreciation of art. This indeed is a view that he seems on occasions to endorse. Thus pleasingness of form is spoken of as being intrinsic to both natural objects and human artefacts insofar as they are candidates for aesthetic judgement, Kant treating flowers and abstract arabesques alike as 'self-subsisting beauties' that appeal to us 'freely and on their own account'. Moreover, the implication that formal considerations, rather than ones relating to cognitive or expressive content, are crucially relevant in the case of art receives apparent corroboration in his suggestion that attention to matters of meaning or representation may detract from the aesthetic enjoyment of artistic products, restricting the play of the imagination in the 'contemplation of the outward form': so far as the visual arts are concerned the design is expressly said to be 'what is essential', this being 'the fundamental prerequisite for taste'. For such observations Kant has often been seen as anticipating the conception of 'significant form' that was popularized by such British writers as Roger Fry and Clive Bell more than a century after his own work appeared. And in a later connection Kant was cited by the American critic and advocate of formalism Clement Greenberg as a precursor of modernist theory.

Such interpretations are understandable in the light of much that Kant initially implied. Even so, they appear less adequate to what he had in mind when, at a later stage of his discussion, he addressed himself specifically to the question of what constituted fine art. For in the latter context two themes are developed that qualify in important respects the position to which he originally seemed committed. The first concerns the relation between art and nature. Whereas previously he gave the impression of assimilating these to one another from the standpoint of aesthetic appreciation, he now went out of his way to stress the intentional aspect of art and the significance of this for the estimates we form of it—'a product of fine art must be recognized to be art and not nature'. It is true that, in making this point, Kant was anxious to insist that a work should not appear to be in any way contrived or 'laboured'; it must be clothed 'with the aspect of nature', allowing free play to the cognitive faculties and not striking the spectator as if its production were constrained by arbitrary or mechanical rules that have their source in the understanding alone. To that extent, then, the presence of formal harmony or design, of the kind ascribable to free as opposed to dependent beauty, remains a necessary condition of artistic worth. It is not, however, sufficient: he now implied that it must also in some sense answer to the content of a work, recognition of the intentional dimension of art being connected with a further factor to which he attached the greatest significance and which involves the expression of what he referred to as 'aesthetic ideas'. These were said to be the product of genius, not of taste: taste might impart a pleasing and universally communicable form to works of art, but it is genius that, as the creative source of the ideas they embody, infuses works of art with 'soul' or 'spirit'.

Kant's conception of aesthetic ideas is—as he himself indicated—hard to specify with any exactitude. He made it clear, though, that such ideas should not be equated with rational ideas or concepts. On the contrary, while they are capable of inducing in the mind of the spectator an inexhaustible wealth of imaginative presentations, no definite thoughts can ever be 'adequate' to them; they always and necessarily overflow the boundaries of linguistic formulation, defying attempts to render them fully intelligible in conceptual terms. This does not mean, on the other hand, that they can be explained by reference to the mere reproduction or imitation of natural appearances. In giving concrete realization to an aesthetic idea the artist certainly draws on materials supplied by his perceptual awareness of the world; yet it is with the aim of transmuting these into something that 'surpasses nature' that he does so, general features of life and experience being 'bodied forth to sense with a completeness of which nature affords no parallel'. In such passages, with their stress on the revelatory though conceptually inexponible power of artistic representation, Kant's final view of art seems far removed from the austerely formalist position that has commonly been attributed to him. If anything, it points forward rather to approaches later followed by Friedrich Schiller and Georg Wilhelm Hegel, and particularly to the latter's portrayal of the visual arts as modes of expression

in which thought and sensuousness are indissolubly united. Unlike Hegel, however, Kant's lifelong confinement to Königsberg meant that he had practically no first-hand acquaintance with these arts. In consequence his own allusions to the subject, although indisputably suggestive and influential, were inevitably schematic and bereft of detailed illustration or substantiation.

WRITINGS

Kritik der Urteilskraft (Berlin, 1790); Eng. trans. by J. C. Meredith as *The Critique of Judgement* (Oxford, 1952)

BIBLIOGRAPHY

H. W. Cassirer: *A Commentary on Kant's Critique of Judgement* (London, 1938)
M. Podro: *The Manifold of Perception: Theories of Art from Kant to Hildebrand* (Oxford, 1972), chap. 2
D. Crawford: *Kant's Aesthetic Theory* (Madison, 1974)
P. Guyer: *Kant and the Claims of Taste* (Cambridge, MA, 1979)
E. Schaper: *Studies in Kant's Aesthetics* (Edinburgh, 1979)
T. Cohen and P. Guyer, eds: *Essays in Kant's Aesthetics* (Chicago, 1982)
M. Mothersill: *Beauty Restored* (Oxford, 1984)
M. A. McCloskey: *Kant's Aesthetics* (London, 1987)
A. Savile: *Aesthetic Reconstructions: The Seminal Writings of Lessing, Kant and Schiller*, Aristotelian Soc. Ser., viii (Oxford, 1987), chaps 4–6
P. Gardiner: 'Kant's *Critique of Judgement*', *The Age of German Idealism*, ed. R. C. Solomon and K. M. Higgins (London and New York, 1993), pp. 103–37

PATRICK GARDINER

Kantharos (i). *See under* PEIRAEUS.

Kantharos (ii). Ancient form of goblet, used as a drinking cup (*see* GREECE, ANCIENT, figs 71(iv)i–j and 73 and HELLADIC, fig. 7b and d).

Kanthos, Telemachos (*b* Alona, 24 Feb 1910; *d* Nicosia, 18 Nov 1993). Cypriot painter, engraver and teacher. He finished his studies at the Higher School of Fine Arts in Athens in 1938, where he showed independence from his teachers by studying, and being influenced by, the works of Cézanne. Kanthos then returned to Cyprus and worked as a painter and teacher based in Nicosia. From early on his main interest lay in the landscapes of Cyprus. As well as painting pure landscapes, many of his subjects are taken from rural and village life, as in *The Belfry* (1952; Nicosia, State A.G.), although harmonization of surfaces and colours and the schematization of forms and backgrounds always went beyond exterior detail to provide a sense of place and inner meaning. His recurring hallmark is a vibrancy and purity of colour. After 1960 Kanthos's work acquired a new immediacy and expressive power. The schematized forms and broad surfaces of *Village* (artist's col., see Christou, fig. 9) are characteristic of his understanding of local atmosphere and his ability to express the feeling that underlies external appearance. His engravings provide a marked contrast to his paintings. Vigorous and dramatic, and often with considerable expressive force, they tend to be frugally composed and contain powerful symbolic content. *On the Rock of Patience* (1976; Nicosia, State A.G.), executed in 1976 as part of the series *Hard Times*, depicts a characteristically monumentalized seated male figure, the contrasts of light and shade highlighting his strength and long endurance. Kanthos's later engravings are particularly striking for their expression of intensities of inner mood and emotion.

BIBLIOGRAPHY

Telemachos Kanthos (exh. cat., Athens, N.G. and Alexander Soutsos Museum, 1982)
C. Christou: *Sindomi istoria tis neoteris kai synchronis kypriakis technis* [A brief history of modern and contemporary Cypriot art] (Nicosia, 1983)
Telemachos Kanthos (exh. cat., Nicosia, State A.G., 1994)

MICHAEL GIVEN

Kantor, Tadeusz (*b* Wielopole, nr Kraków, 6 April 1915; *d* Kraków, 8 Dec 1990). Polish painter, draughtsman, theatre director and stage designer. He studied painting and stage design under Karol Frycz (1877–1963) at the Academy of Fine Arts in Kraków, graduating in 1939. After the outbreak of World War II he organized in Kraków an experimental underground theatre (1942–4), exhibitions and art discussions. He painted and produced numerous drawings and stage designs for future performances. He was influenced by various artistic movements such as Constructivism, Expressionism and Futurism, as well as by the writings of Bruno Schultz (1892–1942) and Stanisław Ignacy Witkiewicz (ii), whose plays he later staged. In 1947 he went to Paris, where at the Palais de la Découverte he 'discovered' the infinity of nature that he examined through the microscopic images of cells and cross-sections of minerals. As the scientific approach to this was beyond his means, he began to explore the natural world by developing the concept of inner, intellectual and spiritual space through the act of artistic creation. He called it 'the umbrellic space'. A series of abstract and metaphorical paintings and drawings followed, with the motif of an umbrella that could 'fold' and 'unfold' the space (e.g. *Umbrella Space*, a series of drawings, 1975; Borowski, pp. 27–30, figs 8–9 and 12–16).

Kantor stimulated the revival of artistic life in post-war Kraków. He initiated the exhibition of Polish contemporary art in 1948 at Pałac Sztuki. In 1956, together with Maria Jarema, he founded the strolling theatre Cricot², which rejected academic convention and bureaucratic organization. He co-founded the Group of Young Artists (1945) and the Kraków Group II (1957). Fundamental to all the disciplines of his art was the idea of unembellished reality with rough, wrecked objects and characters, called by him 'the reality of the lowest rank' (e.g. an unrealized idea of setting Stanisław Wyspiański's play *The Return of Ulysses* in a laundry or at a railway station). Kantor's interest in the spontaneity of artistic creation led him to action painting, as in *Ramamaganga* (1957; Poznań, N. Mus.), and 'informel theatre'. Simultaneously with 'zero theatre', theatre without action, he started to create the emballages, the wrapping of objects and people (*The Manifesto of Emballages*, 1963) and assemblages: objects stuck to the canvas often accompanied by painted, fragmented human figures, as in *Umbrella and the Invisible* (1973; Warsaw, N. Mus.). In 1965 at the Galeria Foksal in Warsaw, he organized the first Happening in Poland, *Cricotage*, and introduced Happenings into his theatre productions. He continued to interweave his theatrical and artistic experiences. The concept of 'impossible theatre' was developed simultaneously with the idea of *Multipart* (1970; Warsaw, Gal. Foksal) 'the art of multiplication and participation'. It eliminated the artist's act of creation, as he passed the initiative on to the spectators. With the theatrical performance of *The Dead Class* (1975) and the

publication of *Manifesto of the Theatre of Death* (1975) Kantor moved from the description of 'reality of the lowest rank' to the representation of degradation of life itself.

WRITINGS
Emballages (Chexbres, 1963)
Multipart (Warsaw, 1970)
Teatr Śmierci (manifest) [Theatre of Death (manifesto)] (Warsaw, 1975), Fr. ed. as *Le Théâtre de la mort* (Lausanne, 1977)

BIBLIOGRAPHY
Tadeusz Kantor: Emballages (exh. cat. by W. Borowski and R. Stanisławski, Łódź, Mus. A., 1975)
Tadeusz Kantor. Emballages, 1960–76 (exh. cat. by R. Stanisławski, London, Whitechapel A.G., 1976)
W. Borowski: *Tadeusz Kantor* (Warsaw, 1982)

ANNA BENTKOWSKA

Kantounis [Candounis]**, Nikolaos** [Nicolas] (*b* Zakynthos, 28 Jan 1768; *d* Zakynthos, 25 April 1834). Greek painter. He became a priest at the age of 19, as had Nikolaos Koutouzis, whom he took as a model both as regards his way of life and his painting. Italian and in particular Venetian painting remained a common source for them both. Kantounis was a good draughtsman and also possessed notable compositional abilities, as can be seen from his more densely populated pictures. He concentrated on religious subjects and portraits. Some of his more important works are: *Scenes from the Life of Christ* (Zakynthos, Mus.), which were originally in the churches of SS Cosmas and Damian and of St George in Kypriana, Zakynthos, *SS Basil, John and Gregory* (Zakynthos, Mus.), a portrait of the pharmacist *Dikopoulos* and a portrait of *Elizabeth Martinengou* (both Athens, N.G.).

BIBLIOGRAPHY
S. Lydakes: *Lexiko ton hellenon zographon kai charakton* [Dictionary of Greek painters and engravers] (1976), p. 161, iv of *E ellenes zographoi* [The Greek painters], ed. S. Lydakes and A. Karakatsane (Athens, 1974–6)
A. Charalampidis: *Symvole ste melete tes ephtanesiotikes zographikes tou 18ou kai 19ou aiona* [Contribution to the study of Ionian painting of the 18th and 19th centuries] (Ioannina, 1978), pp. 55–61, 90–93
N. Misirli: *Helleneke zographeke–18ou–19ou aionas* [Greek painting of the 18th and 19th centuries] (Athens, 1993), pp. 28–30, 203

ALKIS CHARALAMPIDIS

Kanvinde, Achyut (*b* Achara, Maharashtra, 9 Feb 1916). Indian architect, teacher and writer. He was educated under Walter Gropius at Harvard University, where he graduated with a master's degree in architecture in 1947. After returning to India in 1948 he worked on the planning and design of several laboratories for the Council of Scientific and Industrial Research. His early projects for the ATRIA (Ahmadabad Textiles Industries Research Association) and the headquarters for the Council of Scientific and Industrial Research, New Delhi (both 1954), demonstrate the austere simplicity of the Bauhaus style. Kanvinde set up a private practice with the architect Shaukat Rai (*b* 1922) in 1955 and designed numerous institutional buildings, housing and industrial complexes for both the government and private clients. Most of these are facilities for education and research and include the Indian Institute of Technology (1960–65), Kanpur, the National Dairy Development Board (1974), Anand, the Nehru Science Centre (1982), Bombay, and the National Science Centre (1984), New Delhi. All Kanvinde's buildings were conceived in a strict modernist vocabulary. The Nehru Science Centre, for example, has a concrete frame structure infilled with brick panels and plastered in a fine stone grit finish. The building accommodates a complex of workshops, library, lecture halls and observatory, and takes advantage of sloping terrain to isolate each function. Kanvinde served as a member of the Delhi Urban Arts Commission (1974–9) and was also President of the Indian Institute of Architects (1974–6). He guided the allocation of research funds as Chairman (1970–75) of the Scientific and Finance Section of the Central Building Research Institute, Roorkee, the government's primary experimental building organization. He served on juries for national and international competitions and projects and lectured at the schools of architecture in New Delhi, Ahmadabad and Bombay. Kanvinde also co-authored *Campus Design in India*, which was sponsored by the United States Agency for International Development (USAID). In 1975 he received the Padma Shree, a national award for excellence, and in 1985 the Gold Medal of the Indian Institute of Architects.

WRITINGS
with H. James Miller: *Campus Design in India: Experience of a Developing Nation* (Manhattan, KS, 1969)

BIBLIOGRAPHY
M. Chatterjee: 'The Evolution of Contemporary Indian Architecture', *Architecture in India* (Paris, 1985)

GAUTAM BHATIA

Kanyakumari [Kanniyakumari; Cape Cormorin]. Southernmost tip of the Indian subcontinent. Venerated as a Hindu holy place, the rocky promontory is associated with the cult of Parvati, who sought to win the god Shiva by doing penance. At first unsuccessful, she swore to remain a virgin (Skt *kanyā*), and she is worshipped here as such. The Kanyakumari Temple, entered through a gateway (*gopura*), is quite small. Overlooking the sea where the Bay of Bengal, the Indian Ocean and the Arabian Sea meet, it is hidden behind a high wall, and a rocky pool for ritual bathing adjoins it. Some 500 m out to sea is the Vivekananda Rock, a large granite outcrop upon which Swami Vivekananda sat meditating in 1892 prior to beginning his preaching mission in India and abroad. In 1970 the rock's appearance was transformed when a memorial pavilion in 'neo-Dravida' style was built upon it. Ashore is the Gandhi Mandapa, commemorating Mahatma Gandhi.

J. MARR

Kanzan. *See* OKADA, (2).

Kanzan Shimomura. *See* SHIMOMURA, KANZAN.

Kao Chien-fu. *See* GAO JIANFU.

Kao Ch'i-p'ei. *See* GAO QIPEI.

Kao Feng-han. *See* GAO FENGHAN.

Kao K'o-kung. *See* GAO KEGONG.

Kao Shih-ch'i. *See* GAO SHIQI.

Kaō Sōnen [Kaō Ryōzen] (*b* Chikugo Prov. [now Fukuoka Prefect.]; *d* Kyoto, 1345). Japanese painter and Zen monk. Although he was not a professional artist and painted as part of his religious austerities, Kaō is one of the most important *suibokuga* ('ink painting') painters of his age (*see* JAPAN, §VI, 4(iii)). He began his religious training at Kenchōji in Kamakura. In 1319 he travelled to China to study Zen (Chin. Chan) Buddhism. During his stay in China, Kaō received instruction from the Zen recluses Zhongfeng, Hingbon, Shicheng (1270–1342) and Gulin Quingmou, with whom he studied poetry composition and devotional ink painting. In 1326 Kaō returned to Japan with Qingzhao Zencheng. He then served as abbot both of several *Gozan* ('five mountains'; hierarchy of Zen temples) temples, including Manjūji, Kenninji and Nanzenji in Kyoto, and of Sūfukuji Temple in Hakata (now Fukuoka Prefect.). Kaō's representative works include *Kanzan* (Hattori priv. col.), *Portrait of Kensu Ōsho* (Tokyo, N. Mus.) and *Sparrows and bamboo* (Nara, Yamato Bunkakan).

BIBLIOGRAPHY

H. Kanazawa: *Shoki suibokuga* [Early Japanese ink painting], Nihon no bijutsu [Arts of Japan], lxix (Tokyo, 1972); Eng. trans. by B. Ford as *Japanese Ink Painting: Early Zen Masterpieces*, Japanese Arts Library, viii (Tokyo and New York, 1979)

MASAMOTO KAWAI

Kao-tsung, Emperor of the Ch'ing dynasty. *See* QIANLONG.

Kao-tsung, Emperor of the Song dynasty. *See* GAOZONG.

Kapilavastu. *See under* LUMBINI.

Kāpiśī. *See* BEGRAM.

Kapists [Capists; Pol. Kapiści, from 'Komitet Paryski': Parisian Committee]. Polish group of painters. In 1924 a number of students of Józef Pankiewicz at the Academy of Fine Arts in Kraków formed a committee, whose aim was to organize a study trip to Paris. Jan Cybis (1897–1972), Hanna Rudzka-Cybisowa (1897–1988), Zygmunt Waliszewski, Artur Nacht-Samborski, Piotr Potworowski and Józef Czapski were among the painters who therefore founded the Paris branch of the Kraków Academy from 1924 to 1930. They gained fame after two successful exhibitions at the Galerie Zak in Paris (1930) and the Galerie Moos in Geneva (1931). Most of the artists returned to Poland in 1931, where they were still known as the Kapists. They were a loose association, and, although they had no clearly defined programme, they were principally influenced by the work of Pierre Bonnard. The members were Post-Impressionist painters representing the trend known as Polish Colourism, and they stressed the importance of good craftsmanship in painting. Generally their work is associated with a particular sensitivity to colour, its harmony and contrasts. Forms were built with colour, and the use of perspective and chiaroscuro was limited, as in Rudzka-Cybisowa's *Still-life with Armchair* (*c.* 1956; Poznań, N. Mus.). They painted from nature but did not imitate it, and their compositions were sometimes close to abstraction (e.g. *Shells* by Jan Cybis, 1953–4; Poznań, N. Mus.). Zygmunt Waliszewski was the only member of the group who did not reject literary subject-matter (e.g. the *Toilet of Venus*, 1933; Warsaw, N. Mus.). Kapists were well-represented on the staff of the Academy of Fine Arts, Warsaw, opened in 1945. Along with Constructivism, the Polish Colourism introduced by the Kapists became one of the most popular trends in Polish painting in the first half of the 20th century.

BIBLIOGRAPHY

M. Wallis: *Sztuka polska dwudziestolecia* [Polish art, 1918–39] (Warsaw, 1959)

J. Pollakówna: *Malarstwo polskie między wojnami, 1918–1939* [Polish painting between the wars, 1918–1939] (Warsaw, 1982)

T. Dobrowolski: *Malarstwo polskie ostatnich dwustu lat* [Polish painting of the last two hundred years] (Wrocław, 1989)

ANNA BENTKOWSKA

Kapo [Reynolds, Mallica] (*b* Bynloss, St Catherine, 1911; *d* Kingston, 1989). Jamaican painter and sculptor. He painted his first important painting, a Black Christ seated by the Sea of Galilee, in 1947. It is moving in its directness and its economy of means, but he soon abandoned painting for wood sculpture and between 1948 and 1969 produced a remarkable output that was unmatched by most Caribbean carvers. The inspiration for many of these carvings came out of Revivalism, and the works are imbued with its rhythms and intense emotionalism; as the flamboyant Revivalist Shepherd and Patriarch Bishop of St Michael's Revival Tabernacle, Kapo had absorbed the spectacle and ritual of this hybrid Afro-Christian religion. His other carvings are simple portraits that are attempts to iconicize and particularize, and to draw on Jamaican history and the rich folklore of the people, such as his sculpture of the national hero *Paul Bogle*, holding aloft a stone as he leads his revolution.

Kapo began to paint again in the early 1960s, and as his powers as a carver declined so his abilities as a painter increased, and for the 20 or so remaining years of his life he produced a body of paintings that is matched only by that of John Dunkley, Jamaica's other leading 'primitive' artist. Kapo is best known for his paintings of the Jamaican landscape, particularly the lush hills of St Catherine, dotted with red-roofed huts and groves of exotic fruit trees, but it is in his figurative works that his unrivalled sense of invention is given full rein. Many of the best paintings, such as his *Be Still*, *There she Go Satan* and *Revivalist Going to Heaven*, all in the Larry Wirth Collection of Kapo at the National Gallery of Jamaica in Kingston, show some of the colourful, or at times mystical, aspects of Revivalist practices. In *There she Go Satan*, it is Kapo himself who is depicted doing battle with the agents of the devil.

Kapo also attempted traditional Christian themes, such as the Crucifixion in *Crucifix* (1967; Kingston, priv. col.), the Madonna and Child in *Dark Madonna* (1978; Amsterdam, Stedel. Mus.) and the Nativity in *Silent Night* (1979; Kingston, Inst. Jamaica, N.G.). These were painted with such directness and innocence that the Italian primitives are immediately recalled. He painted portraits too, again of an uncompromising simplicity and purity. His portrait of the beautiful young *Elena Ball*, also known as *Laura* (1970; Kingston, priv. col.), is deservedly recognized as one of his finest works.

BIBLIOGRAPHY

Kapo: The Larry Wirth Collection (exh. cat. by S. Rodman and others, Kingston, Inst. Jamaica, N.G., 1982)

Jamaican Art 1922–1982 (exh. cat. by D. Boxer, Washington, DC, Smithsonian Inst.; Kingston, Inst. Jamaica, N.G.; 1983)

DAVID BOXER

Kapoor, Anish (*b* Bombay, 12 March 1954). British sculptor of Indian birth. He was one of a generation of British-based sculptors who became established in the international arena during the 1980s and is prominent among his contemporaries for the quality of hermetic lyricism that permeates his work. He has acknowledged a bearing on his art of both Western and Eastern culture. The powerful spiritual and mythological resonances of his sculptures arise in part from frequent return visits to India. Natural materials such as sandstone, marble and slate are impregnated with raw powdered pigment of vivid hues, thus enhancing a feeling of inner radiance. In the early 1990s he introduced a more enigmatic slant by boring holes in the flanks of standing stones, while in *The Earth* (1992; installed San Diego, CA, Mus. A.; Des Moines, IA, A. Cent.; Ottawa, N.G.; and elsewhere) a perfect circle was removed from the gallery floor to intimate the generative effect of negative space. In other works impressions of weightlessness stem from the skilled transformation of materials by an almost alchemical process; earth slabs coated with brilliant blue pigment become signs for sky and water. By imaginative combination of disparate materials in meditative structures, attention is focused on qualities of interior balance and well-being.

BIBLIOGRAPHY
An International Survey of Recent Paintings and Sculpture (exh. cat. by K. McShine, New York, MOMA, 1984)
Anish Kapoor (exh. cat. by J. C. Ammann, Basle, Ksthalle, 1985)
Anish Kapoor (exh cat. by L. Forsha, La Jolla, CA, Mus. Contemp. A., 1992)

Kapova. Cave site in Russia, on the western slopes of the southern Ural Mountains, in the Belaya Valley *c.* 200 km south of Ufa, Bashkirskaya. It is important for its cave art of the Late Upper Palaeolithic period (*c.* 20,000–*c.* 10,000 BP; *see also* PREHISTORIC EUROPE, §II). Two kilometres of passages have been investigated since paintings were first discovered in 1959 by A. V. Ryumin, who with O. N. Bader conducted the first research and analysis. Work resumed in 1982, when V. Shchelinsky began to make new plans and drawings of the paintings and to examine the archaeological evidence. This produced not only the standard regional stone-tool assemblage but also some oddities, such as a partly burnt clay cup (perhaps used as a lamp or to contain paint) and pierced green serpentine beads. A lump of limestone painted with a mammoth had been dislodged into the cultural layer, which has yielded radiocarbon dates of 14,680±150 BP and 13,930±300 BP; the paintings are thus of a date comparable to the Late Upper Palaeolithic cave paintings of southern France.

The paintings occur in four galleries, at distances of 170 m and 300 m from their entrances. Most are set at a fairly low level and could have been executed without climbing, although some are on the roofs of small niches. There are over 30 paintings of animals and abstract signs, executed in ochre directly on to the limestone walls. Most of the animals are mammoths and horses, but a rhinoceros and a bison are also represented. The signs comprise trapezoids filled with lines and triangles, squares with loops and triangles filled with smaller triangles; truncated cones with loops are the most common. A differential distribution of the figures has been recognized: large groups with four or more figures; small groups with two or three figures; and some isolated paintings. The largest animal measures 1.06 m long and the smallest 580 mm; the smallest sign is just 60 mm across. The animals are drawn in profile or in silhouette, with or without contours and occasionally with rough outlines. In addition to the predominant red ochre, a violet-brown ochre and some black pigment were employed.

BIBLIOGRAPHY
O. N. Bader: *The Kapova Cave: Palaeolithic Art* (Moscow, 1965)
V. E. Shchelinsky: 'Some Results of New Investigations at the Kapova Cave in the Southern Urals', *Proc. Prehist. Soc.*, lv (1989), pp. 181–91

SARA CHAMPION

Kapros. *See under* AMORGOS.

Kaprow, Allan (*b* Atlantic City, NJ, 23 Aug 1927). American performance artist. From 1945 to 1949 he was at New York University as an art major and from 1947 to 1948 also studied painting with Hans Hofmann at the Hans Hofmann School of Fine Arts in New York. On graduation from New York University Kaprow began working for an MA in philosophy but left the following year to study for an MA in art history at Columbia University, New York, under Meyer Schapiro. On completing his thesis, *Piet Mondrian: A Study in Seeing*, in 1952 he began to devote himself to his own work and co-founded the Hansa Gallery in New York with other former students of Hofmann, holding his first one-man exhibition there in 1953. From 1953 to 1961 he taught art history at Rutgers University, New Brunswick, NJ.

The influence of Jackson Pollock, whose work had impressed Kaprow as early as 1949, is evident in Kaprow's 'action-collages' of 1956–7, such as *Stained Glass Window* (1956; Cologne, Mus. Ludwig), in which he used a variety of materials such as newspaper, straw and wire overpainted in a gestural manner reminiscent of Abstract Expressionism. From 1957 to 1959 Kaprow studied musical composition at the New School for Social Research in New York under John Cage, whose elevation of chance as a working tool was influential on his art. From this time he ceased to exhibit as a painter or sculptor in the traditional sense, becoming more interested in the conceptual and philosophical framework of art and turning instead to sculptural installations that he termed Environments (*see* ENVIRONMENTAL ART) and to Happenings, an influential form of PERFORMANCE ART. His first Environments included *Penny Arcade* (1956; destr., see 1986 exh. cat., p. 14), an assemblage using sound and light. In 1958 he composed music for the Eileen Passloff Dance Company in New York and produced his first public Happening at Douglass College in Rutgers University. The term Happening, which gained currency among other artists working in the New York area, was first used by him in an article published at Rutgers in 1959. That year he also created a public awareness of Happenings through shows at the Reuben Gallery in New York. The first of these was the sound

Happening *Intermission Piece*, which took place in June, followed in October by *18 Happenings in 6 Parts* (see B. Haskell: *Blam!*, New York, 1984, p. 33).

Throughout the 1960s Kaprow developed Happenings and Environments. The Environments ranged from the simple *Yard* (1961; see 1986 exh. cat., p. 27), in which he filled the space full of car tyres for people to walk over, to the more sophisticated *Words* (1961; New York, Smolin Gal.), a 'rearrangeable' work that included sounds, lights and sheets bearing largely randomly selected words. In 1964 he constructed the Environment *Eat* (see 1986 exh. cat., p. 63) inside the former Ebling Brewery in the Bronx borough of New York. After 1965, however, he ceased producing Environments in order to concentrate on Happenings. Some of these, such as *A Service for the Dead I* (Maidman Playhouse, New York, 1962), were ritualistic in style. Others, for example *Gas* (1966; see 1986 exh. cat., pp. 76–7), which took place over a large area at Montauk Point, NY, were less controlled and more spontaneous. After 1968, when Kaprow adopted the term Activity in place of Happening, his work became more intimate. Activities were less strictly governed by rules and consequently less theatrical. They included a series of *Work Pieces* (1967–71) in which physical labour became a field of play, as in *Sweet Wall* (1970; see 1986 exh. cat., p. 97), which involved the construction by a few people in West Berlin of a wall in which the blocks were 'cemented' together with bread and jam and then destroyed. The Activities were simply scripted so that they could be acted out by anyone. Kaprow's later works in this vein included *The Perfect Bed* (see 1986 exh. cat., p. 75), staged in various locations throughout Germany in 1986, which required each participant to find his or her favourite bed and then take it to an outdoor location.

WRITINGS
'The Demiurge', *Anthologist* (spring 1959) [first pubd use of the term 'Happening']
Assemblage, Environments and Happenings (New York, 1966)
Untitled Essay and Other Works (New York, 1967)
Warm-ups (Cambridge, MA, 1975)
Allan Kaprow (exh. cat., ed. A. Kaprow; Dortmund, Mus. Ostwall, 1986) [incl. texts by artist and list of his pubns]

BIBLIOGRAPHY
Allan Kaprow (exh. cat. by B. Berman, Pasadena, CA, A. Mus., 1967)

Karaburun. *See under* ELMALİ.

Karachi. Seaport and former national capital of Pakistan. Karachi has been identified with Krokala, visited by Alexander the Great's fleet under the command of Nearchus in 326 BC, and in the *Mohi't*, a collection of sailing directions compiled in 1558 by the Turkish captain Sidi 'Ali, 'Kaurashi' appears to be well known as a port and harbour of refuge (Baillie, p. 20). However, it remained small until the British conquest of Sind in 1843.

Lt John Porter, visiting 'Crochey Town' in 1774–5, found it fortified by a slight mud wall and flanked with round towers. He says that 'it formerly belonged to the Bloachees, but the Prince of Scindy, finding it better situated than any part of his sea coast for the caravans from the Inland Countries, made an exchange with some other place for it' (Baillie, p. 21).

The first modest port, named Kharak Bundar, was established by the Kalhoras near Karachi in the mid-18th century, and by the British conquest of 1843, a walled city of *c.* 40 ha, with a population of 14,000, was in existence. The first private villas were built near Clifton in 1851, and the Karachi Municipal Corporation was established in 1852; in 1861 the railway line was laid, and during the next few years (1861–5) Karachi experienced a boom due to its cotton exports. By 1870 the city spread over 15.5 sq km, and by 1872 there were 10,747 houses. The first master plan for Karachi was prepared in 1922–3. World War II highlighted the strategic importance of the port, and, following the establishment of a separate province of Sind in 1938, several major buildings were constructed.

In 1947 Karachi became the capital of the new state of Pakistan. The city's population grew to 1.1 million by 1951, and its area to 724 sq km by 1959. Despite the decision in that year to shift the capital to Islamabad, Karachi continued to grow. By 1961 the population had reached 2 million, and in 1990 Karachi Division had a total area of 3365 sq km, with a built-up area of 1812 sq km and a population of 8 million. Of the colonial buildings to have survived this phenomenal growth, nearly 40 have been declared historic in a new master-plan document.

In the decade after independence, the Modern Movement began to influence the city's architecture. Its leading exponent was Mehdi 'Ali Mirza. Both in Babar 'Ali's residence and in his own house, the influence of Frank Lloyd Wright is easily recognized in the floating horizontal planes, the boldly cantilevered concrete slabs, the integration of the building with the site by means of careful landscaping and use of stone, the exploitation of the expressive potential of structural form, and the thoughtful detailing, particularly of the woodwork and joinery. The best work of the next generation of architects includes the house by YASMEEN LARI for Commodore Haq (1967), in which the simplicity and refinement of plan and structure and the discipline of load-bearing blocks and spanning concrete are rigorously adhered to and clearly expressed. In her own house and studio the open plan, chunky concrete and storey-high glazed panels are all in the best traditions of post-war British architecture. Similarly inspired by Le Corbusier's functional mannerism are Habib Fida 'Ali's offices for Pakistan Burmah Shell and Unit 4's PIA squash complex. Karachi University complex, designed in the late 1950s by the French architect Echochard and also in the Corbusian tradition, exploits simple materials—yellow stone, cement, sand and aggregate—native to this region.

In the Institute of Business Administration designed by American architect William Perry, who lived and worked in Pakistan in the 1960s, the distinction between structural concrete and non-load-bearing brick panels is emphasized by the insertion of glazing and timber shutters. His Karachi American School has the simpler structural arrangement of load-bearing walls and concrete beams. Finally, the 700-bed Aga Khan Hospital and Medical College (now University) completed in 1985 and designed by Payette Associates, reflects the Late Modernist concern with surface, texture, colour and cultural metaphor.

See also PAKISTAN, §II.

BIBLIOGRAPHY

A. F. Baillie: *Kurrachee: Past, Present and Future* (Calcutta, 1890/R Karachi, 1975)

Sind Madressah-tul-Islam Karachi (Karachi, 1985) [documentation of hist. bldgs]

K. K. Mumtaz: *Architecture in Pakistan* (Singapore, 1985)

KAMIL KHAN MUMTAZ

Karagöz. *See* ISLAMIC ART, §VIII, 15.

Karaka, Emily (*b* Auckland, NZ, 1952). Maori painter. Her tribal affiliation is Ngai Tai, Waishu, Ngati Hine, Ngati Wai. Largely self-taught, she acknowledged the encouragement of such artists as Arnold Manaaki Wilson, Colin McCahon and Ralph Hotere. She exhibited regularly after her first one-woman show at the Outreach Gallery in Auckland in 1980. Her work, which shows a highly personal and expressive style, is often political and drawn from both Maori and European art traditions. Many of the figures in her painting recall carvings from the *whare whakairo* (Maori meeting houses). She used bright colours, often applied with fast expressionistic strokes, and texts (predominantly Maori) to address viewers to the political and cultural issues affecting society. She wished to 'bring into the chamber-vaults of reflection, the mirrored stories of the cost, changes, growth, life and death of our society'. She was one of the women artists who brought a new force to the Maori art movement in the 1980s.

BIBLIOGRAPHY

M. Penfold and E. Eastmond: *Women and the Arts in New Zealand, Forty Works: 1936–86* (Auckland, 1986), pl. 22 [incl. biography]

Kohia ko taikaka anake: Artists Construct New Directions. New Zealand's Largest Exhibition of Contemporary Maori Art (exh. cat., Wellington, NZ, N.A.G., 1990–91)

'Emily Karaka', *A. NZ*, 60 (1991), p. 78

MEGAN TAMATI-QUENNELL

Karakhoja. *See* KHOCHO.

Karakhoto [Moshui; anc. Mongol. Etzina: 'black city'; Chin. Juyan]. Site of a major fortress–town and frontier post of the Xixia state (1032–1227) of the Tanguts, near Ejin Qi (Dalain Hob), in the Inner Mongolian Autonomous Region of China. The circumstances of the founding of Karakhoto remain unclear. From archaeological findings, however, it is evident that it was a flourishing centre of culture and trade with a multinational population of Tanguts, Chinese and Tibetans. Karakhoto was visited by the Venetian Marco Polo in the 13th century. Significant portions of the city walls and remains of lesser structures can still be seen.

However, what is most important is the large number of artefacts excavated, including religious paintings, sculptures and a vast amount of manuscripts and printed scriptures, mostly written in the Xixia language. Most of this rich material relates to Buddhism and shows how Xixia Buddhist art was multifaceted, containing elements from Chinese, Tibetan and indigenous traditions. Many of the Tantric wall paintings, including such motifs as *maṇḍala*s, *yab yum* (Tib.: 'father–mother', a deity represented in sexual union with a consort) and Adi Buddhas, are stylistically related to central and western Tibetan painting as found in monasteries in the Ladakh region. In contrast, most of the recovered Buddhist sculptures bear a strong resemblance to styles of the late Tang (AD 618–907) and Northern Song (AD 960–1127) periods. The sculptures are generally made of clay over a wood-and-straw frame (*see also* CENTRAL ASIA, §II, 3(i)).

The first excavation at Karakhoto was undertaken by the Russian explorer Pyotr Koslov, who discovered the town in 1908. Later Aurel Stein and Langdon Warner (1881–1955) also worked there. Most of the artefacts taken from Karakhoto are presently housed in the Hermitage museum, St Petersburg, the British Museum, London and in the museum of Ningxia Province. A number of clay sculptures are in the Fogg Art Museum, Cambridge, MA.

See also TEMPLE, fig. 6; MILITARY ARCHITECTURE AND FORTIFICATION, §VI, 2.

BIBLIOGRAPHY

S. F. Oldenburg: *Buddiiskaya ikonografiya Khara-Khoto* [Buddhist iconography from Karakhoto] (St Petersburg, 1914) [Fr. summary]

The Silk Route and the Diamond Path: Esoteric Buddhist Art on the Trans-Himalayan Trade Routes (exh. cat. by D. E. Klimburg-Salter, Los Angeles, UCLA; New York, Asia Soc. Gals; Washington, DC, Smithsonian Inst.; 1982–3), pp. 118–49

Xixia wenwu [Xixia artefacts] (Beijing, 1988)

Lost Empire of the Silk Road : Buddhist Art from Khara Khoto (X–XIIIth century) (exh. cat., ed. M. Piotrovsky; Milan, 1993)

HENRIK H. SORENSEN

Karakoyunlu. *See* QARAQOYUNLU.

Kara Memi [Mehmed-i Siyah; Kara Mehmed Çelebi] (*fl* 1545–66). Ottoman illuminator. The greatest student of ŞAHKULU, Kara Memi developed a new naturalistic style that quickly spread to other court arts including textiles, rugs, ceramics and tiles and survived for many centuries. He is one of the few artists employed in the imperial Ottoman painting studio under Süleyman I (*reg* 1520–66) whose name is recorded in archival documents and extant works. First mentioned on a payroll register dated 1545, Kara Memi rose quickly so that by the early 1550s his wages for Koran illumination were the highest given to any artist working on manuscripts commissioned by the Süleymaniye Mosque; by 1557–8 he was head painter (Ott. *nakkaşbaşı*). A librarian's note on the flyleaf of a Koran manuscript transcribed by 'ABDALLAH SAYRAFI in 1344–5 and refurbished for the Ottoman grand vizier Rüstem Pasha in the mid-1550s (Istanbul, Topkapı Pal. Lib., E.H. 49) credits Kara Memi with the illumination, and he signed the illumination in a spectacular manuscript of the *Dīvān-i Muḥibbī*, Süleyman's collected poems written under the pseudonym Muhibbī (Istanbul, U. Lib., T. 5467), copied in February–March 1566. In these splendid illuminations, Kara Memi combined traditional themes such as split leaves, lotus blossoms and *çintimani* (three balls over two wavy lines) with scrolls and naturalistic sprays of flowers and trees. Each of the 370 folios in the manuscript bears a different design; the margins are decorated with gold drawings tinted with pastel colours, while the panels separating the verses within the text block display the full artistic vocabulary of the age. This volume must have been the artist's last work, for his name is missing from the payroll register of July–October of that year.

BIBLIOGRAPHY

A. S. Ünver: *Müzehhib Kara Memi: His Life and Works* (Istanbul, 1951)

Z. Tanındı: '13–14. yüzyılda yazılmış Kur'anların Kanuni döneminde yenilenmesi' [13th–14th-century Korans restored in the time of Süleyman], *Topkapı Sarayi Müz.: Yıllık*, i (1986), pp. 140–52

The Age of Sultan Süleyman the Magnificent (exh. cat. by E. Atıl, Washington, DC, N.G.A.; Chicago, IL, A. Inst.; New York, Met.; 1987–8), nos 14 and 26, pp. 31, 54–6 and 68–9

ESIN ATIL

Karan. *See* KITAO SHIGEMASA.

Karana, Tell. *See under* ESKI MOSUL REGION.

Karanovo. Site of a prehistoric settlement mound in the Tundza Valley, central Bulgaria. One of a series of settlement mounds or tells, it was probably a high-status settlement and is important as a key site showing the development of material culture in the period *c.* 6500–3000 BC, from the first farming communities of the region (probably immigrants from south-west Asia) to a time roughly coeval with the beginning of Aegean civilization. Karanovo was partially excavated from 1936 to 1957 by Vasil Mikov and Georgi Georgiev, and the material recovered is held by the Archaeological Museum at Nova Zagora and the National Archaeological Museum, Sofia. Measuring 12 m high and 150×250 m at its base, the mound built up naturally as the result of repeated occupation and the decay of the mud used for house construction. Rows of simple timber-framed houses have been found; later examples have two rooms. There were internal clay hearths and ovens. Seven main strata of cultural material have been found, each subsuming several phases of occupation: phases I–VI belong to the Neolithic period and phase VII to the Early Bronze Age.

The cultural sequence is characterized by a wide range of handmade pottery, the finer wares decorated by painting, incision and impression (see fig.). Recurrent forms include closed and open ring-footed bowls, necked jars and, from later phases, wide, open bowls with narrow, flat bases. Particularly striking are the red-on-white painted ring-footed tulip bowls of Karanovo I (7th millennium BC), decorated with geometric designs, and the diagonally fluted, plain closed bowls of Karanovo V. The graphite-painted open bowls of Karanovo VI (5th/4th millennium BC) were painted with curvilinear or geometric patterns before firing, first in oxidizing, then in high-temperature reducing conditions. Other notable artefacts from the site include small, highly stylized anthropomorphic figurines, usually female, of clay, stone and bone, many decorated with incised and impressed motifs. The faces are strangely inscrutable, while the arms and ears are often perforated, probably for the attachment of other material, such as the copper strips found at other sites. These figurines are generally regarded as cult objects. There was knowledge of copper-working in the region by the time of Karanovo V–VI, and of bronzeworking by Karanovo VII. Cast-copper hammer-axes with cast-in shaftholes from Karanovo VI testify to the metallurgical skills attained by that date.

For further discussion of the arts and architecture of Neolithic and Early Bronze Age Europe *see* PREHISTORIC EUROPE, §§IV and V.

BIBLIOGRAPHY

V. Mikov: 'The Prehistoric Mound of Karanovo', *Archaeology*, xii (1959), pp. 88–97

G. Georgiev: 'Kulturgruppen der Jungsteinzeit und der Kupferzeit in der Ebene der Thrazien (Südbulgarien)', *L'Europe à la fin de l'âge de la pierre*, ed. J. Böhm and S. J. De Laet (Prague, 1961), pp. 45–100

ALASDAIR WHITTLE

Karantinos, Patroklos (*b* Constantinople [now Istanbul], 1903; *d* Athens, 4 Dec 1976). Greek architect and teacher. He studied at the School of Architecture at the National Technical University of Athens (1919–24) and worked for Auguste Perret in Paris (1927–8). In Greece he worked for the Ministry of Education (1930–39) in the Programme of New School Buildings, where he and Nikolaos Mitsakis were the most productive architects. Karantinos's schools, such as the building (1932) on Kalisperi Street, Athens, are characterized by a consistent application of Modernism to elements that refer to the Mediterranean tradition of antiquity: white prismatic volumes, regular fenestration, *brises-soleil* and access balconies penetrated or supported by free-standing pillars. He also designed the Archaeological Museum (1933) in Herakleion, Crete, where there is a mixture of direct and indirect natural lighting and an articulation of exhibition areas through projecting or recessed prismatic volumes. In 1932 he was co-founder of the Greek group of CIAM, in 1934 he organized the *Exhibition of Greek Modern Architecture* in Athens and in 1938 he edited *Ta nea scholika ktiria*, a publication on Modernist school buildings in Greece. From 1959 to 1968 he was Professor of Architectural Composition at the Aristoteleion University of Thessaloniki. He continued to design a number of major buildings, among them the Archaeological Museum (1960) in Thessaloniki, where varieties of natural lighting result from the use of atria and recesses from the street fronts.

WRITINGS

ed.: *Ta nea scholika ktiria* [The new school buildings] (Athens, 1938) [Gr. with Fr. captions]

'Les Ecoles en Grèce', *Archit. Aujourd'hui*, xx/25 (1949), pp. 38–57

BIBLIOGRAPHY

F. Loyer: *Architecture de la Grèce contemporaine* (diss., U. Paris III, 1966)

A. Giacumakatos and E. Godoli: *L'architettura delle scuole e il Razionalismo in Grecia* (Florence, 1985)

ALEXANDER KOUTAMANIS

Karas, Vjekoslav (*b* Karlovac, 19 May 1821; *d* 5 July 1858). Croatian painter. He was apprenticed to the furniture trade, which he soon abandoned to join the workshop of the painter F. Hamerlitz. Apart from learning his craft, he was employed painting houses and churches. His first patron, Colonel Franjo Kos von Kossen, along with other Karlovac notables, raised enough money to send him on

Karanovo, decorated pottery: (a) red-on-white tulip bowl, Karanovo I; (b) fluted jar, Karanovo V; (c) graphite-painted dish, Karanovo VI

a scholarship to Italy. In 1838 he arrived in Florence, where he was first taught by A. Corsi and subsequently by G. Meli. He became associated with the painter Francesco Salghetti-Drioli and copied Old Masters such as Fra Angelico and Ghirlandaio. In 1841 he left Florence and travelled to Rome via Siena. In Rome he fell under the influence of the NAZARENES and in particular of their ideological leader, Friedrich Overbeck, as can be seen in his *Moses at the Riverbank* (Karlovac, City Mus.) and other religious paintings of that period. After a short visit home Karas returned to Rome in 1844 and began to paint genre subjects (e.g. *Girl with a Lute*, *c*. 1844; Zagreb, Gal. Mod. A.). In 1847, his funds exhausted, he left Rome for Trieste, where he painted portraits of the bourgeoisie, returning to Karlovac in 1848. The following year he taught in the School of Drawing in Zagreb. In 1851 he travelled to Bosnia, where he was commissioned to paint the portrait of *Omer Pasha Latas* (*c*. 1851; ex-Omer Pasha Latas, priv. col., Travnik), after which he returned to Karlovac, again earning an income from portraiture. His best-known and most successful work dates from this period (e.g. portraits of *Anna and Miško Krešić* and *Alois Duquenois*, and *The Boy*; all Zagreb, Gal. Mod. A.). He was one of the best representatives of the rising, independent development of 19th-century Croatian painting, but under the absolutist and anti-Slavonic rule of the Viennese Court, Karas lacked support and understanding. He drowned himself in the River Korana near Karlovac.

BIBLIOGRAPHY
I. Kukuljević-Sakcinski: *Slovnik umjetnikah jugoslavenskih* [Dictionary of Yugoslav artists] (Zagreb, 1858), pp. 409–10
L. Babić: *Umjetnost kod Hrvata* [Art in Croatia] (Zagreb, 1943), pp. 52–63
A. Simić-Bulat: *Vjekoslav Karas* (Zagreb, 1958)

BORIS VIŽINTIN

Karasujō. *See* MATSUMOTO CASTLE.

Karasumaru Mitsuhiro (*b* 1579; *d* 1638). Japanese courtier, poet and calligrapher of the early Edo period (1600–1868). He was the son of the courtier Karasumaru Mitsunobu (1549–1611) and in 1606 himself became Councillor of State (Sangi) and Minister of the Right (Udaijin). In 1609, shortly after being moved to the post of Minister of the Left (Sadaijin), he was dismissed after a scandalous affair between court nobles and women chamberlains known as the Inokuma Incident. In 1611, having been pardoned by the shogun Tokugawa Ieyasu (1543–1616), he was reinstated and in 1620 he rose to the position of Senior Second Rank (Shōnii) and the post of Major Counsellor (Dainaigon). He served as an emissary between court and shogunate and was energetically involved in the construction of the TŌSHŌGŪ SHRINE at Nikkō.

An erudite man of many talents, Mitsuhiro was skilled in the tea ceremony, calligraphy, *renga* (linked verse) and *waka* (classical Japanese 31-syllable poetry). He studied *waka* with Hosokawa Yūsai, whose daughter he married, and in 1603 began to receive instruction in the poetry of the *Kokinwakashū* ('Collection of Japanese poems from ancient and modern times'), commonly known as the *Kokinshū*. Through his contact with Yūsai he was introduced to Zen and converted from the Nichiren to the Zen sect of Buddhism. In his calligraphy, he initially studied

the Jinyōin *ryū* (Jinyōin school or lineage), a native offshoot of the Sesonji *ryū* (Sesonji school or lineage; *see* JAPAN, §VII, 2(ii)), popular in the late Muromachi period (1333–1568). He received instruction in calligraphy techniques from the Junior Counsellor (Chūnaigon), Jinyōin Mototaka, a youth barely 17 years old. In his 30s he devoted much study to the style of Hon'ami Kōetsu (*see* HON'AMI, (1), §1) and at the same time, through private study, learnt the calligraphic styles of the Heian period (AD 794–1185). At the same time, in step with the rise of the tea ceremony, the styles of calligraphy masters of the Heian and Kamakura (1185–1333) periods (*kohitsu*: 'old brushes') and calligraphy by Zen monks (*bokuseki*: 'ink traces') were becoming popular with all classes. Mitsuhiro too collected treasured examples of famous calligraphy, such as a copybook (*sōshi*), a late work by Fujiwara no Sadayori. His highly prized collection of *kohitsu-gire* ('old writing fragments') became known as the *Karasumaru-gire* ('Karasumaru fragments').

Later in life he experimented with many calligraphy styles, such as that associated with Fujiwara no Teika (*see* FUJIWARA (ii), (7)), in whose style Mitsuhiro inscribed the poems on the *Tsuta no hosomichi zu byōbu* ('Folding screens of scenes of the ivy walk'; Osaka, Manno Mus.) by TAWARAYA SŌTATSU. Anecdotes reflect his wild personality and reveal his frequently changing, free and individual calligraphic style. Indeed, it is the special mark of Mitsuhiro that each of his works has its own individual character. He dismantled the framework of Wayō (Japanese-style) calligraphy, which by this time had lost its brilliance and fallen into a set pattern. For his talent and his strong, independent views he was praised by the Kanei no Sanpitsu (Three Brushes of the Kan'ei era; 1624–44; *see* HON'AMI, (1), KONOE NOBUTADA and SHŌKADŌ SHŌJŌ).

A collection of poetry, the *Kōyō wakashū* ('Collection of yellow leaves'; pubd 1669) is reliably attributed to Mitsuhiro. His travelogues, *Azuma no michi no ki* ('Record of the road of the east') and *Haru no akeba no no ki* ('Record of the spring dawn'), which give accounts of his experiences on leaving the capital of Edo (now Tokyo), are of considerable art-historical interest. The documentary account of Mitsuhiro's life and works, the *Karasumaru Mitsuhirokyō gyōjō* ('Manners of his Lordship, Karasumaru Mitsuhiro'), was edited by his grandson Sukeyoshi. A portrait of Mitsuhiro is housed in the Hōun'in in Kyoto, constructed by the Zen monk Isshi Bunshu (1608–46).

See also JAPAN, §VII, 2(v) and fig. 128.

BIBLIOGRAPHY
S. Komatsu: *Nihon shōryu zenshi* [History of Japanese Zen calligraphic lineages] (Tokyo, 1970)
S. Komatsu, ed.: *Nihon shoseki taikan* [Collection of calligraphy of leading persons in Japan], xiv–xxv (Tokyo, 1978–80)
Masters of Japanese Calligraphy 8th–19th Century (exh. cat. by Y. Shimizu and J. M. Rosenfield, New York, Japan House Gal. and Asia Soc. Gals, 1984–5)

TADASHI KOBAYASHI

Karataş–Semayük. *See under* ELMALI.

Kara Tepe. *See* TERMEZ, §2(i).

Karatepe. Hilltop site in Turkey, on the west bank of the middle River Ceyhan north-east of the Cilician plain. The

site, with reliefs of *c.* 900–700 BC, was discovered in 1946 by H. T. Bossert, who excavated it principally between 1947 and 1950. Further excavation and restoration continued under the leadership of Bossert and, after 1960, Halet Çambel. The reliefs are *in situ*.

Karatepe, a small fortress surrounded by a traceable circuit of walls, is notable mainly for its two monumental gateways, the North (Lower) Gate and the South (Upper). The wall-footings of these typical Hittite structures were faced by basalt orthostats, mostly sculptured and some inscribed, and at the main points in each gate passage the orthostats were carved into flanking pairs of guardian lions and sphinxes. The North Gate was the better preserved, with most of the orthostats found *in situ* or simply fallen from their plinths; only in the left-hand gate-chamber were they in a fragmentary and incomplete state. In the South Gate very little was found *in situ*; the orthostats were scattered, and many were fragmentary or missing. The surviving ones have been placed in hypothetical positions only.

The inscriptions on both gates formed two duplicate pairs, one in alphabetic Phoenician, the other in hieroglyphic Luwian. As such they offer a long Phoenician–Luwian bilingual text, which has been crucial in the decipherment of hieroglyphic Luwian. Inside the South Gate, to the left of the way, a colossal storm-god statue was found, with another version of the Phoenician inscription on its skirt. It is similar to the colossal statue from Gerçin (*see* ZINCIRLI).

The bilingual inscription was written by Azatiwatas (Azatiwaras), who was promoted, apparently as a local vassal king, by Awarikus, King of Adana. The inscription details the benefits conferred by Azatiwatas on Adana, including the establishment of his lord's (i.e. Awarikus's) family, the 'house of Mopsos', on the throne and the maintenance of peace and prosperity. It also reports the building of the city itself, named Azatiwataya, and lays a protective curse against spoliation on the city and inscription. The date and historical context of the monument are much disputed. Awarikus of Adana has been identified with Urikki of Que (i.e. Cilicia), known from Assyrian sources as active *c.* 738–709 BC, thus placing the work *c.* 700 BC. While this may well be correct, Awarikus could also have been an earlier namesake and predecessor of Urikki, which would leave open the possibility of an earlier dating.

Other criteria of date have been sought in analysis of the style and motifs of the sculptures, but with contradictory results. The sculptures are crudely executed, in comparison with the best of Syro-Hittite art, and often appear unfinished. Also, two distinct styles have been identified, one showing links with Aramaean art, the other with Hittite.

Style A shows similarities to the early Aramaean art of Zincirli, especially that from the monumental gateways of the Outer Citadel and the South City Gate. It is characterized particularly by a distinctive representation of the human face in profile: prominent nose, pursed lips and receding forehead and chin. In general the style is lively but crude. At Karatepe it is recognized in the reliefs along both sides of the North Gate entrance. That on the right shows a figure of the Egyptian god Bes, an archer with a

bear, a hero grappling antithetic lions surmounted by vultures with a dead animal, a spearman with a bear and an eagle taking a hare, a mother suckling a child beside a date palm, a four-winged griffin-demon supporting a sun-disc, and an armed man carrying a lamb across his shoulders (see fig.). The relief on the left has two registers of men on horseback, two registers of musicians and dancers, an armed warrior, and an archer shooting a stag above two butting bulls set above a lotus-frieze.

Style B has closer links with late Syro-Hittite art seen in Zincirli, Sakça Gözü and Carchemish. The figures tend to have disproportionately large heads but with much more natural features than those of Style A. The style is also crude, or perhaps rather unfinished. The sculptures of the inner right gate-chamber of the North Gate all belong to this style, except for the orthostat of a Bes-figure and a trireme, both in Style A, on either side next to the passage. The Style B sculptures show processions of human figures, humans attacking a lion and a lion attacking a goat, an antithetic pair of armed warriors, a pair of antithetic goats with a sacred tree, a further procession, a horseman surmounted by a row of figures, and a bull sacrifice. By

Karatepe, basalt relief of an armed man carrying a lamb, h. 1.48 m, from the west series of orthostats of the North Gate, *c.* 700 BC

the late 1990s the left-hand gate chamber was in the process of restoration and had not yet been published.

Of the surviving orthostats of the South Gate, only two are of Style A, one significantly, with a two-register scene showing the feasting ruler. Equally significantly the adjoining two-register scene showing, above, attendants with vessels and food, and below, musicians, is in Style B. Opposite this pair of orthostats are two showing a throned ruler with attendant, and a pair of bull-men with spears, all in Style B.

In the North Gate, the Phoenician inscription is on four adjoining orthostats on the left side of the entrance passage, from which it runs over on to the portal lion and terminates. This *in situ* version establishes the order of reading of the text. The hieroglyphic version, occupying much more space, is inscribed in disjointed segments spread over orthostats, sculptures and plinths mostly on the right of the entrance passage and gate-chamber, although parts are also found in the left gate-chamber. The duplicate inscriptions of the South Gate are incomplete and restored, to the left side Phoenician, and to the right hieroglyphic.

The lack of order in the North Gate hieroglyphic inscription strongly suggests the repositioning of the elements after it was cut. The controversy over the dating of the sculptures may be resolved by the suggestion that the slabs with Style A are indeed earlier, executed in the early 9th century BC, and brought for reuse from the neighbouring site of Domuztepe across the river opposite Karatepe. Azatiwatas would thus have incorporated them, along with his own reliefs in Style B, in his work dating *c.* 700 BC. The generally crude workmanship may be explained by the provincial character of the site.

RLA

BIBLIOGRAPHY

H. T. Bossert and H. Çambel: *Karatepe: A Preliminary Report on a New Hittite Site* (Istanbul, 1946)
H. T. Bossert and U. B. Alkim: *Karatepe, Kadırlı and its Environs* (Istanbul, 1947)
H. T. Bossert and others: *Die Ausgrabungen auf dem Karatepe* (Ankara, 1950)
W. Orthmann: *Untersuchungen zur späthethitischen Kunst* (Bonn, 1971)
J. D. Hawkins and A. Morpurgo Davies: 'On the Problems of Karatepe: The Hieroglyphic Text', *Anatol. Stud.*, xxviii (1978), pp. 103–19
F. Bron: *Recherches sur les inscriptions phéniciennes de Karatepe* (Paris, 1979)
J. D. Hawkins: 'Who Was Azatiwatas?', *Anatol. Stud.*, xxix (1979), pp. 153–7
I. J. Winter: 'On the Problems of Karatepe: The Reliefs and their Contexts', *Anatol. Stud.*, xxix (1979), pp. 115–51
J. Deshayes, M. Sznycer and P. Garelli: 'Remarques sur les monuments de Karatepe', *Rev. Assyriol.*, lxxv (1981), pp. 31–60
J. C. L. Gibson: *Textbook of Syrian Semitic Inscriptions*, iii (Oxford, 1982), no. 15

J. D. HAWKINS

Karatsu. Centre of ceramics production in Japan. High-fired ceramic ware was manufactured from the late 16th century in kilns (119 identified by 1986) located in and around present-day Karatsu (Kyushu, Hizen Prov., now Saga Prefect.). Geographical and historical circumstances destined Karatsu to be the meeting-place of the advanced ceramic technology of Chosŏn-period (1392–1910) Korea and the sophisticated aesthetics of the Japanese tea ceremony (*see* JAPAN, §§VIII, 3(i) and XIV, 3). The region became a centre for the dissemination of both techniques and finished products. Historical documents and several

datable heirlooms suggest that Karatsu antedates other Kyushu and western Honshu teaware kilns founded after Toyotomi Hideyoshi's abortive Korean campaigns of 1592 and 1597. The earliest Karatsu kilns, known as the Kishidake group, were built around the fortress of the Hata clan, local daimyo until 1594. Excavations at Handōgame, one of the Kishidake kilns, revealed what is considered to be Japan's first single-vaulted multi-chambered climbing kiln (*waridake noborigama*; *see* JAPAN, §VIII, 1(v)). Except for a few tea-ceremony wares, its products appear to have been for everyday use, made either on the fast-turning kick wheel or by the distinctive coil-and-paddle (*tataki*) technique. Karatsu clay is sandy in texture with a moderate iron content. The feldspathic glazes—including those formulated with common ash (transparent), straw ash (opaque) and iron (dark-brownblack)—were typical of the ware throughout its history. Most of these techniques can be traced to southern Korea, except for the opaque straw-ash glaze, used at Hobashira, another Kishidake kiln, which is associated with the north.

The second major phase of Karatsu was instigated by the Korean invasions. With Toyotomi Hideyoshi and his official tea master FURUTA ORIBE in frequent attendance at Nagoya Castle, the campaign headquarters just northwest of Karatsu, enthusiasm for teawares spread among the field commanders. Korean potters were brought to Japan to create fine teawares and also to establish profitable commercial potteries. In 1594 Hata Chikashi (*fl* late 16th century) was replaced by Terasawa Hirotaka (1563–1633), a tea devotee familiar with the new ceramic styles originating in the MINO region under the influence of Furuta Oribe. Under Terasawa's influence, the Matsura kiln group superseded Kishidake, and three new centres were established at Taku, Takeo and Hirado. Although the master potters were Korean, they abandoned the Korean-inspired simple, monochromatic Kishidake styles and emphasized contrasting glazes, underglaze painting and inlay design and the production of sets—mostly in the manner of conscious deformation associated with Furuta Oribe. Only teabowls generally continued to be made in the more modest Korean-derived styles. These early wares are referred to as Old Karatsu (*Kogaratsu*).

The Old Karatsu period ended with the fall of the Terasawa in 1647. By that time porcelain production had begun to surge in the Karatsu region (*see* JAPAN, §VIII, 3(iii)). Workshops unable to locate porcelain clays fell back on making household stonewares, especially in the style of inlay patterning (*mishima*) derived from 15th- and 16th-century Korean *punch'ŏng* wares (*see* KOREA, §VI). A few stoneware kilns also enjoyed clan sponsorship, beginning with the Terasawa. In 1707 the Doi clan sponsored a new official kiln at Bōzumachi, near modern Karatsu. The traditional style was continued there until 1734, when the kiln was moved to Tōjinmachi, now inside the city itself. Until it closed in 1871, the kiln produced more refined and decorated products to be used as clan gifts and as tableware for formal occasions.

BIBLIOGRAPHY

T. Nakazato: *Karatsu*, Famous Ceramics of Japan, ix (Tokyo, 1983)
J. Becker: *Karatsu Ware: A Tradition of Diversity* (Tokyo, 1986)
Kogaratsu [Old Karatsu], Tokyo, Idemitsu Mus. A. cat. (1986)

RICHARD L. WILSON

Karavan, Dani (*b* Tel Aviv, 7 Dec 1930). Israeli sculptor. He studied art in Tel Aviv and then attended the Bezalel Academy of Arts and Crafts in Jerusalem, with further study from 1955 to 1957 in Florence and in Paris. Throughout his career he produced large-scale public works from Minimalist forms, designed to relate to their climate and landscape as well as to the wider social environment. In the 1960s and early 1970s he also designed wall reliefs and theatre and ballet sets.

Karavan's first important work was the *Negev Monument* (1963–8), on a hill overlooking Beersheba. It consists of a cluster of concrete forms covering an area of one hectare, with wind-driven sound pipes in the central tower and inscribed doodles and writing on the surfaces. In the late 1970s he produced a number of temporary *Environments for Peace*, including one for the Venice Biennale in 1976. This work, made from concrete Minimalist forms, was bisected by 'drawings' of running water. The viewers were requested to walk over the structure barefoot to feel its texture, and near an olive tree incorporated into the design were the words: 'Olive trees should be our borders.' He continued to produce environments in the 1980s, such as the permanent, urban environment *Axe majeur* (1986; Cergy-Pontoise, France), and occasionally used laser beams (*see* LASER).

BIBLIOGRAPHY
A. Barzel: *Dani Karavan* (Tel Aviv, TAL Int., 1977)
Dani Karavan, Dialog (exh. cat. by U. Kempel and others, Düsseldorf, Kstsamml. Nordrhein-Westfalen, 1989)

□

Karcher [Carchera; Charchera], **Nicolas** [Nicola; Niccola] (*b* ?Brussels; *d* Mantua, 1562). Flemish tapestry weaver. From *c.* 1517 he and his brother Giovanni Karcher (*fl* 1517–62) were working for the Este court in Ferrara (*see* FERRARA, §3), organizing a large workshop for Ercole II d'Este, Duke of Ferrara and Modena. That same year Nicolas went to Brussels and returned with eight weavers, including JAN ROST. Nicolas worked with his brother on the *Battle of the Gods and Giants* (four pieces; destr.), the cartoons of which were by the Dossi brothers and Giulio Romano. In 1539, however, Karcher was invited to set up his own workshop in Mantua by Federico II Gonzaga, 5th Marchese and 1st Duke of Mantua, and took ten workers with him to Mantua (*see* MANTUA, §3). In October 1545 Karcher moved to Florence. His workshop first wove a trial *Lamentation* (1546; Florence, Uffizi) and a trial pack-cover (destr.), before a three-year contract was signed by Cosimo I, Duke (later Grand Duke) of Tuscany, on 20 October 1546. Karcher's rival Rost had also established a workshop in Florence at this time, but on 17 November 1550 Karcher's contract was renewed until 21 October 1553. Karcher participated in the weaving of tapestries for the Duke including the *Story of Joseph* series (1546–?53; ten, Florence, Sopr. B.A. & Storici Col., and ten, Rome, Pal. Quirinale; *see* FLORENCE, §III, 3 and fig. 11), and the *Resurrection* altarpiece (*c.* 1546; Florence, Uffizi) after Salviati, for Benedetto Accolti, Cardinal of Ravenna. In January 1554 Karcher finished his work in Florence and apparently returned to Mantua. On 15 July 1555 Marchese Guglielmo Gonzaga gave Karcher an eight-year patent to weave in Mantua, with 11 other workers. His workshop's masterpiece from this period is the set of the six *Stories of Moses* with *spalliere* of *Putti with Garlands* (four, Milan, Mus. Duomo; three destr.). Karcher must be ranked high among Europe's most gifted 16th-century tapestry weavers. He favoured juxtaposing bright colours and the use of flamelike hatching.

BIBLIOGRAPHY
M. Battistini: *La Confrérie de Sainte-Barbe des Flamands à Florence: Documents relatifs aux tisserands et aux tapissiers* (Brussels, 1931), pp. 36–43, 186–90, 197–201
M. Viale Ferrero: *Arazzi italiani del cinquecento* (Milan, 1963), pp. 18–20, 22–4
N. Forti Grazzini: 'Arazzi', *Giulio Romano* (exh. cat., Mantua, Pal. Ducale and Mus. Civ. Pal. Te, 1989), pp. 474–9

CANDACE J. ADELSON

Kardovsky, Dmitry (Nikolayevich) (*b* Pereslavl'-Zalessky, Yaroslavl' province, 6 Sept 1866; *d* Pereslavl'-Zalessky, 9 Feb 1943). Russian illustrator and stage designer. After studying law at Moscow University, he enrolled in 1892 at the Academy of Arts in St Petersburg, where his principal mentors were Pavel Chistyakov (1832–1919) and Il'ya Repin. In 1896 he moved to Munich and with Grabar' attended the private studio of Anton Ažbé. In 1900 he returned to St Petersburg, receiving his Academy diploma (1902) and in 1907 becoming a professor there. Kardovsky was one of the foremost students of the great draughtsman Chistyakov, whose graphic principles he maintained in his precision, sobriety and sense of measure. Although Kardovsky explored various styles, including Impressionism and *Jugendstil*, and enthusiastically supported Mikhail Vrubel', whose posthumous exhibition he organized in 1912, he was concerned more with faithful representation than with formal experiment, demonstrating his consistency and common sense from 1902 in his prolific output as a book illustrator. Occasionally Kardovsky explored the discipline of political caricature, as in his illustrations for the radical journals *Zhupel* (Bugbear) and *Adskaya pochta* (Hellish Post) of 1905–6, but he was devoted primarily to the Russian literary classics: Chekhov, Gogol', Lermontov and Tolstoy. He is remembered especially for his interpretations of Griboyedov's *Gore ot uma* (Woe from Wit; St Petersburg, 1913) and Tolstoy's *Voyna i mir* (War and Peace; St Petersburg, 1912), in which he combined historical accuracy with sharp irony.

Moving to Moscow in 1920, Kardovsky taught at Vkhutemas and began to design for the stage, for example for the Maly Theatre productions of Gogol''s *Revizor* (The Government Inspector; 1922) and Aleksandr Ostrovsky's *Bednost' ne porok* (Poverty Is No Crime; 1924). Kardovsky continued to teach in the 1930s and, with his technical expertise and clarity of narrative, was an important link between the canons of the 19th-century academy and the demands of Socialist Realism. As a result he exerted a considerable influence on the new generation of Russian graphic artists and painters, such as Dementy Shmarinov.

PUBLISHED WRITINGS
E. Kardovskaya, ed.: *Ob iskusstve: Vospominaniya, stat'i, pis'ma* [On art: reminiscences, articles, letters] (Moscow, 1960)

BIBLIOGRAPHY
O. Podobedova: *Dmitry Nikolayevich Kardovsky* (Moscow, 1957)
D. N. Kardovsky (exh. cat., Leningrad, Acad. A., 1966)

JOHN E. BOWLT

Karelia. *See under* RUSSIA, §XII, 2.

Karelin, Andrey (Osipovich) (*b* Selezna, Tambov province, 16 July 1837; *d* Nizhny Novgorod, 31 July 1906). Russian photographer, collector, painter and draughtsman. He was born into a peasant family, and he studied briefly as an icon painter before entering the Academy of Arts in St Petersburg in 1857. After graduating in 1864, he stayed in St Petersburg to learn photography, and he opened a portrait studio in Nizhny Novgorod in 1869. Like many of his colleagues at the Academy, he had worked as a retoucher of photographs for the sake of employment, and initially he regarded photography merely as material support. He gradually became more interested in the medium, however, especially in the decade 1875–85, when it supplanted his painting.

Karelin made many photographic portraits and genre studies, and he is important in both the technical and the aesthetic sense. His studio was larger than usual, with numerous windows, top lighting and glazed walls. He disdained the use of painted props, preferring instead to use real domestic furnishings. He was especially concerned to achieve a sharp focus in all fields in the photograph, and to this end he studied optics, independently realizing the connection between the focal length of the lens and the size of the aperture for depth of clarity. To achieve his ends he therefore introduced into portrait photography the use of additional diverging and converging lenses. He also managed, through the use of lenses, to overcome the more common distortions. This technical achievement gained him many gold medals at international photographic exhibitions in the 1870s and 1880s.

Karelin saw the arts of photography and painting as being close. He was friendly with a number of Russian painters, in particular Il'ya Repin and Ivan Kramskoy. Many of his acquaintances from the Academy joined the Peredvizhniki (the Wanderers) and advocated a more 'democratic' national subject-matter. Karelin shared their concerns, producing such works as *Wandering Singers* (*c*. 1880; see Morozov, 1977, fig. 14), which also reveals his concern for carefully composed natural groupings and light effects. The use of natural pose and the skilful use of lighting is seen again in *Almsgiving* (*c*. 1880; see Morozov, 1977, fig. 13). Karelin was opposed to retouching, and despite his concern for even focus was an advocate of Pictorialism, which required softening in the image, for which he used the method devised by Andrey Den'yer of printing through two negatives. He was interested in natural group shots utilizing unusual portrait angles and oblique lighting, as in the *Domestic Group* (*c*. 1880; see Morozov, 1977, fig. 12), and depictions of patterned materials. About 1900 he began to photograph groups *en plein air*.

Karelin also ran a drawing school for 30 years, and he was well known as a collector of Russian folk artefacts: carpets, furniture, costumes, textiles, religious items and icons. His collection was given to the State Hermitage Museum and other state collections after his death.

BIBLIOGRAPHY

G. Boltyansky: *Ocherki po istorii fotografii v SSSR* [Studies in the history of photography in the USSR] (Moscow, 1939), pp. 59, 60, 62

S. Morozov: *Pervyye russkiye fotografy-khudozhniki* [The first Russian photographer-artists] (Moscow, 1952)

——: 'Early Photography in Eastern Europe: Russia', *Hist. Phot.*, i/4 (1977), pp. 327–47

——: *Tvorcheskaya fotografiya* [Creative photography] (Moscow, 1986)

A. A. Semyonov, M. M. Khorev and V. A. Filippov, eds: *Andrey Osipovich Karelin: Tvorcheskoye naslediye/Andrey Osipovich Karelin: Creative Heritage* (Nizhny-Novgorod, 1990)

KEVIN HALLIWELL

Karfík, Vladimír (*b* Idrija, 26 Oct 1901). Czech architect of Slovenian birth. He graduated in architecture from the Czech Technical University, Prague, and then worked in Paris with Le Corbusier (1925) before going to the USA (1926–30) where he worked with Frank Lloyd Wright (1928–9). From 1930 to 1945 Karfík was Chief Architect of the Baťa Company in Zlín; he co-founded the Zlín style of architecture that typified his work there. His architectural work is based on the application of industrial methods and technologies, and on a Rationalist approach that tended towards a universal concept of form. The basis of all his industrial, commercial and public buildings for the Baťa company is a precast reinforced-concrete skeleton with circular columns planned on a module of 6.15 m and with infill walls of bare brickwork, which fulfils a variety of functions and creates a universal architectural form. This principle was applied by Karfík to his two most important works at Zlín: the Community House Hotel (1932–3) and the Baťa Company administrative building (1937). He also designed several department stores, whose façades were interpreted either as cantilever walls unified by strip windows, for example the store at Liberec (1931), or as curtain walls, for example the stores at Brno (1930), Bratislava (1931) and Amsterdam (1937). During his time at Zlín Karfík also designed a range of standard and individual family houses that were characterized by the use of bare brickwork. After World War II he concentrated on the design of research institutes and schools in Slovakia. From 1946 to 1971 he was a professor at the Technical University in Bratislava and from 1979 to 1982 a professor at the University of Malta.

BIBLIOGRAPHY

Š. Šlachta: 'Prof. Ing. Arch. Vladimír Karfík: 75-ročný', *Projekt* [Bratislava], xviii/10 (1976), pp. 56–8

——: 'Zlín Architecture: Interview with Vladimír Karfík', *Archithese*, x/6 (1980), pp. 41–3

Š. Šlachta and V. Šlapeta: 'Erinnerungen von Vladimír Karfík', *Bauforum*, xvii/103 (1984), pp. 21–31

——: 'Vladimír Karfík racconta', *Parametro*, 133 (1985), pp. 50–64

VLADIMÍR ŠLAPETA

Karger, Mikhail (Konstantinovich) (*b* Kazan', 17 May 1903; *d* Leningrad [now St Petersburg], 26 Aug 1976). Russian archaeologist and art historian. He graduated from the social sciences department at Petrograd University in 1923 and became a lecturer at the renamed Leningrad State University in 1929. In the 1920s and 1930s he was on the staff of both the State Russian Museum and the State Academy for the History of Material Culture. He was one of the founders of the department of the theory and history of art at the institute of painting, sculpture and architecture at the Russian Academy of Arts, becoming head of the department of Russian art in 1939. In 1949 he was made a professor and head of the department of the history of Russian art at Leningrad State University, and

he directed the Leningrad division of the Institute of Archaeology of the USSR Academy of Sciences from 1964 to 1972. In 1928–36 he made a study of Novgorod architecture, including the 12th-century cathedral of St George in the Yur'yev Monastery. From 1938 to 1952 he led the Kiev archaeological expedition, publishing the results of his research in *Drevniy Kiyev* (1958–61). He also conducted excavations in the Old Russian cities of Vyshgorod and Pereyaslavl', among others. In 1955–9 he directed excavations in Volyn' (Volhynia), uncovering the remains of 12th- and 13th-century churches in Halich (Galich) and Vladimir-Volynsky and a pottery workshop in Halich that had manufactured maiolica tiles. He also investigated the links between the architecture of Galicia and the art of western Slavonic countries. In 1957–64 he excavated fully the Old Russian city of Izyaslavl', which had been destroyed during the Mongol–Tatar invasion of the 13th century, and in the second half of the 1950s he also worked in towns in Belarus', including Potack (Polotsk) and Turaǔ (Turov). In the latter years of his life he resumed his study of the architecture of Novgorod and conducted excavations of an archaeological site not far from the city: the church of the Annunciation (1103). In all, he directed archaeological and restoration work in 20 Old Russian cities.

WRITINGS
Drevniy Kiyev [Old Kiev], 2 vols (Moscow, 1958–61)
Novgorod Veliky [Novgorod the Great] (Leningrad, 1960/*R* 1966)
Zodchestvo drevnego Smolenska [The architecture of Old Smolensk] (Leningrad, 1964)

BIBLIOGRAPHY
M. Artamonov, ed.: *Mikhail Konstantinovich Karger: Kul'tura i iskusstvo drevney Rusi* [Mikhail Konstantinovich Karger: the culture and art of Old Rus'] (Leningrad, 1967) [bibliog.]
A. N. Kirpichnikov: 'Mikhail Konstantinovich Karger', *Sov. Arkheol.*, iii (1977), pp. 333–4

V. YA. PETRUKHIN

Kargopol'. Russian town on the left bank of the River Onega, 150 km east of Lake Onega. One of the best-preserved historic settlements of the area, it was a centre for the colonization of the inaccessible northern territories during the Middle Ages and an important commercial settlement in the 16th and 17th centuries. The town was planned to be seen from the river: most of the churches stand near it, and the Valuyki fortress, which has existed since the 16th century and was repeatedly strengthened during the 17th century and the early 18th, was built on its banks. Stone churches began to appear in the 16th century. The influence of the architecture of Novgorod can be seen in the forbidding, almost fortress-like mass of the cathedral of the Nativity (Khristorozhdestvensky Sobor; 1561–2), but in the 17th century a distinctive local style developed. In the large number of five-domed churches built at this time, such as those of the Resurrection (Voskreseniye; 1648), the Nativity of the Mother of God (Rozhdestvo Bogoroditsy; 1680) and the Annunciation (Blagoveshcheniye; 1692), windows, cornices and domes were decorated with a characteristic type of fine brick patterning that resembles folk embroidery. This style survived into the 18th century, when churches continued to be built in an archaic, late-medieval manner, as is the case with the churches of the Entry into Jerusalem (Vkhod v Iyerusalim; 1732) and St Nicholas (1741), for example.

In 1766 a regular plan with an orthogonal grid of streets was adopted for the town, and during the late 18th century and the 19th this was built up with stone and timber houses in the Neo-classical style; many of the houses survive. The town's ancient churches continue to act as vertical reference points within this composition. Local craftsmen still produce traditional earthenware toys, and some of the surrounding villages contain remarkable timber buildings of the 18th and 19th centuries.

BIBLIOGRAPHY
T. Alferova: *Kargopol' i Kargopol'ye* [Kargopol' and its district] (Moscow, 1973)
G. P. Gunn: *Kargopol'ye-onega* (Moscow, 1989)

D. O. SHVIDKOVSKY

Karinger, Anton (*b* Ljubljana, 23 Nov 1829; *d* Ljubljana, 14 March 1870). Slovenian painter. He trained in landscape painting at the Akademie der Bildenden Künste in Vienna from 1845 to 1847, in portrait painting at the Akademie der Bildenden Künste, Munich (1848), and in architectural painting at the private school of Albert Emil Kirchner. In 1849 Karinger joined the Austrian army and started to draw and paint views and military and folk subjects from northern Italy, Dalmatia, Montenegro and Albania. He retired from military service in 1861 and lived in Ljubljana, where he became a member (1862), and later president, of the Österreichischer Künstlerverein, and its organizer of exhibitions for Ljubljana. He travelled through Slovenia, Carinthia, Bavaria and the Tyrol, painting Romantic landscapes such as the *Triglav from Bohinj* (1861; Ljubljana, N.G.). He was a distinguished watercolourist and took part in many exhibitions in central Europe.

BIBLIOGRAPHY
Anton Karinger, 1829–1870 (exh. cat. by P. Vrhunc and F. Zupan, Ljubljana, N.G., 1984)

KSENIJA ROZMAN

Karl III, Duke of Brunswick-Wolfenbüttel. *See* WELF, (7).

Karl XIV [Jean-Baptiste Jules Bernadotte], King of Sweden and Norway (*b* 26 Jan 1763; *reg* 1818–44; *d* 8 March 1844). Swedish ruler and patron. The son of a French lawyer, he joined the French army in 1780 but was elected Crown Prince of Sweden in 1810 and in 1813 joined the allies fighting against Napoleonic France. As king his buildings included Rosendal Castle (1823–7), a French Empire-style palace by Frederik Blom (1781–1853). He also commissioned works from the painter Fredric Westin, who attempted to emulate Jacques-Louis David, and the sculptor Hans Michelsen.

□

Karl II August, Duke of Zweibrücken. *See* WITTELSBACH, §III(2).

Karlbeck, Orvar (*b* 1879; *d* 20 Sept 1967). Swedish collector and art historian. After graduating as a civil engineer in 1904 from the Royal College of Engineering in Stockholm, he travelled to China in 1906, where he worked first as a superintendent of reinforced concrete construction and then, from 1908, as a section engineer for the Tientsin–Pukow (Tianjin–Pukou) Railway Company. As objects of art were frequently discovered during

the construction of railways, Karlbeck soon became interested in Chinese archaeology and art and formed an important collection of early Chinese bronzes. When the Swedish Crown Prince, later King Gustav VI Adolf, who was himself a collector and connoisseur of Chinese art, visited Pukow in 1926, he was greatly impressed by the collection, which was purchased and brought to Sweden. This began Karlbeck's new career as a buyer of Chinese art for museums and private collectors. In 1927 he gave up his railway work because of political disturbances in China and returned to Sweden. The following year, however, he returned to China to acquire Chinese art objects. The visit was so successful that he made a further three journeys to China on behalf of museums and private collectors. The objects he acquired included a large number of bronzes of the Shang (*c.* 1600–*c.* 1050 BC) and Zhou (*c.* 1050–256 BC) periods and of the ancient Chu kingdom of the Warring States period (403–221 BC), as well as ceramic wares, especially tomb figures, most of which are today in the Östasiatiska Museum (Museum of Far Eastern Antiquities) in Stockholm. The Chinese collection in the museum was in fact built up with many items acquired from Karlbeck. He developed a sensitive eye and a sound judgement for Chinese art, particularly for early wares. He also pursued his own researches: foremost among his interests were the problems of casting.

WRITINGS

'Ancient Chinese Bronze Weapons', *China J. Sci. & A.*, iii (1925), no. 3, pp. 127–32; no. 4, pp. 199–206
'Notes on the Archaeology of China', *Bull. Mus. Far E. Ant.*, ii (1930), pp. 193–207
'Some Chinese Bronze Hu from Anyang', *Ethnos*, ii/1 (1937), pp. 2–6
Catalogue of the Collection of Chinese and Korean Bronzes at Hallwyl House (Stockholm, 1938)
'Notes on the Wares from the Chia-tso Potteries', *Ethnos*, viii/3 (1943), pp. 81–95
'Early Yüeh Ware', *Orient. A.*, ii/1 (1949), pp. 3–7
'Proto-porcelain and Yüeh Wares', *Trans. Orient, Cer. Soc.*, xxv (1949–50), pp. 33–48
Catalogue of the Collection of Ceramic Art of China and Other Countries of the Far East at the Hallwyl Museum (Stockholm, 1950)
'Selected Objects from Ancient Shou-chou', *Bull. Mus. Far E. Ant.*, xxvii (1955), pp. 41–130
Skattsökare i Kina (Stockholm, 1955); Eng. trans. by N. Walford as *Treasure Seeker in China* (London, 1957)
'Notes on the Fabrication of Some Early Chinese Mirror Moulds', *Archvs Chin. A. Soc. America*, xviii (1964), pp. 48–54
'Notes on Some Chinese Wheel-axle Caps', *Bull. Mus. Far E. Ant.*, xxxix (1967), pp. 53–74

BIBLIOGRAPHY

J. Wirgin: 'Orvar Karlbeck', *Trans. Orient. Cer. Soc.*, xxxvii (1967–9), p. xv
——: 'Orvar Karlbeck', *Orient. A.*, n. s., xiv/3 (1968), p. 211

S. J. VERNOIT

Karle [Kārlī, Kārlā; anc. Valuraka]. Site of rock-cut Buddhist shrines and monasteries near BHAJA and BEDSA in Maharashtra, India. Sited on an ancient trade route, the 16 caves at Karle belong to the early phases of rock-cut architectural activity in western India. However, the intrusive figures in the verandah of Cave 8, traces of paintings in the hall of the same cave and sculpture in some of the other caves, as well as architectural features (Cave 4), show that the site continued to be occupied even after the introduction of the Buddha image.

The prayer-hall (*caityagrha*) is perhaps the most remarkable example of its type. It shows an advance over earlier

Karle, interior of the prayer-hall (*caityagrha*), *c.* 1st century BC–1st century AD

prayer-halls, including its immediate predecessor at Bedsa. Preceding the prayer-hall is a large column with a lion capital, the only parallel being at KANHERI. The hall proper is fronted by a verandah (about 16×4.5 m) and an outer screen of two pillars supporting a colonnade of four dwarf pillars. Entry to the hall is through a doorway and two side doors, which open into the nave and aisles respectively. Flanking the entrances are six couples (*mithuna*s) and two more on the inner side of the verandah facing them (*see* INDIAN SUBCONTINENT, fig. 147). The date of these sculptures, arguably the finest produced in early India, is controversial and may range from the 1st century BC to 1st century AD. Decorating each side wall of the verandah is a row of three colossal elephants. The façade in its upper reaches is plain compared to Bhaja but has four tiers of arches, giving the impression of a multistory mansion. Near the foot of the great arched opening (*see* OGEE) above the three entrance doors are flying *gandharva* couples. Internally the hall (37.8×13.8×14.6 m) is divided into nave and aisles by two rows of octagonal pillars (see fig.). At the far end is the stupa, consisting of two drums marked on the upper end with the railing pattern, followed by a dome (*anda*) and a box (*harmikā*) capped with the inverted pyramid that supports the staff of the wooden parasol. A rectangular cavity on top of the inverted pyramid contained the sacred relics of the saint in whose memory this monument was carved. The pillars are surmounted with elephant riders resting against a triforium over which wooden ribs rise along the curve of the vault. The octagonal pillars on the side and in the back of the stupa look plain in comparison to those in the nave. The shafts of the pillars rise from pots resting on stepped pyramids and have bell-shaped capitals surmounted by inverted stepped pyramids.

The prayer-hall was funded by lay devotees from different walks of life whose contributions have been recorded in 31 inscriptions in such parts of the caves as pillars, railings and decorative elephants. This popular effort was recognized at royal level by Usavadata and later by Gautamiputra Satakarni and Vasithiputra Pulumavi of the SATAVAHANA dynasty, who donated land in the nearby villages for the maintenance of the monks.

BIBLIOGRAPHY

J. Fergusson and J. Burgess: *The Cave Temples of India* (London, 1880), pp. 232–42

D. Barrett: *A Guide to the Karla Caves*, Ancient Monuments of India (Bombay, 1957)

V. Dehejia: *Early Buddhist Rock Temples: A Chronological Study* (London, 1972)

S. Nagaraju: *Buddhist Architecture of Western India* (New Delhi, 1982)

A. P. JAMKHEDKAR

Karl Eugen, Duke of Württemberg. *See* WÜRTTEMBERG, (2).

Karlgren, (Klas) Bernhard (Johannes) (*b* Jönköping, 5 Oct 1889; *d* Stockholm, 20 Oct 1978). Swedish sinologist and specialist on Chinese bronzes. He was an outstanding scholar of Chinese linguistics, to which achievement he added research on ancient Chinese bronzes as his second main specialization. He applied the same lucid and un-swerving logic in his argumentation for dates and patterns of bronzes as he did to linguistics. As a result of his studies on early bronzes, in 1939 he was made Director of the Östasiatiska Museum (Museum of Far Eastern Antiquities) in Stockholm, which possesses an important collection of such bronzes. Most of the articles presenting his research are published in the museum bulletin.

WRITINGS

'Yin and Chou in Chinese Bronzes', *Bull. Mus. Far E. Ant.*, viii (1936), pp. 9–156

'New Studies in Chinese Bronzes', *Bull Mus. Far E. Ant.*, ix (1937), pp. 9–118

'The Dating of Chinese Bronzes', *J. Royal Asiat. Soc. GB & Ireland* (1937), pp. 33–9

'Huai and Han', *Bull. Mus. Far E. Ant.*, xiii (1941), pp. 1–124

'Some Early Chinese Bronze Masters', *Bull. Mus. Far E. Ant.*, xvi (1944), pp. 1–24

'Bronzes in the Hellström Collection', *Bull. Mus. Far E. Ant.*, xx (1948), pp. 1–38

'Some Bronzes in the Museum of Far Eastern Antiquities', *Bull. Mus. Far E. Ant.*, xxi (1949), pp. 1–25

'Notes on the Grammar of Early Bronze Décor', *Bull. Mus. Far E. Ant.*, xxiii (1951), pp. 1–34

A Catalogue of the Chinese Bronzes in the Alfred F. Pillsbury Collection, Minneapolis, MN, Inst. A. (Minneapolis, 1952)

'Bronzes in the Wessén Collection', *Bull. Mus. Far E. Ant.*, xxx (1958), pp. 177–96

with J. Wirgin: *Chinese Bronzes: The Natanael Wessén Collection, Mus. Far. E. Ant. Monograph*, i (Stockholm, 1969)

BIBLIOGRAPHY

S. Egerod and E. Glahn: *Studia Serica Bernhard Karlgren Dedicata* (Copenhagen, 1959)

S. Egerod: 'Bernhard Karlgren', *Annual Newsletter of the Scandinavian Institute of Asian Studies*, xiii (Copenhagen, 1979), pp. 3–24

ELSE GLAHN

Karlovy Vary [formerly Carlsbad; Karlsbad]. Town in the Czech Republic, once a centre of glass engraving and stonecutting. The tradition for engraving was established there in the 18th century by such artists as Andreas Teller (1754–1809) and Andreas Mattoni (1779–1864). In the 19th century well-known engravers included A. H. Pfeiffer (1801–66), Emanuel Hoffmann (1819–78) and his son Johann Hoffmann (1840–1900). The most renowned glass enterprise was the workshop and merchandise business founded in 1857 by Ludwig Moser (1833–1916), who employed a number of leading engravers from Karlovy Vary and northern Bohemia. During the Art Nouveau movement the works excelled in deep, floral engraving, and extended its repertory to include coloured, facet-cut glass. While glass coloured by rare pigments became a speciality, the firm also continued to produce high-quality tableware. From 1918 to 1939 it collaborated with a number of Czech, German and Austrian artists, including Heinrich Hussmann (*b* 1897), Alexander Pfohl (1894–1957) and Hilde Zadikow-Lohsing (*b* 1890). In 1922 the Moser enterprise merged with the Meyr glassworks in Vimperk. In 1936 it was sold, but it continued to use the Moser family name. After World War II it was nationalized. In the late 20th century new designs have been provided by such artists as Oldřich Lípa (*b* 1929), Luboš Metelák (*b* 1934), Pavel Hlava (*b* 1924) and Jiří Šuhájek (*b* 1943). In 1990 the factory became a joint-stock company.

BIBLIOGRAPHY

G. Pazaurek: *Gläser der Empire- und Biedermeierzeit* (Leipzig, 1923)

J. Hájek: 'Karlovy Vary: Cradle of the Glass of Kings', *Glass Rev.*, xxix (1964), no. 2, pp. 42–6; no. 3, pp. 72–81

L. Baldwin and L. Carno: *Moser Artistry in Glass* (Marratta, 1988)

A. Adlerová: 'The Moser Glassworks at Karlovy Vary', *Glass Rev.*, xlvi (1991), no. 7, pp. 4–27

ALENA ADLEROVÁ

Karlsruhe. German industrial town and port of *c.* 280,000 inhabitants in Baden-Württemberg, situated on the right bank of the River Rhine. It was founded in 1715 by Margrave Charles III (*reg* 1709–32) as the seat of the Baden-Durlach branch of the Zähringen dynasty and the capital of Baden. The ruling princes took most of the architectural and artistic initiatives in the town until the abolition of the monarchy in 1918. Karlsruhe was badly damaged in World War II, and many of the major buildings have been restored, some with altered interiors.

1. HISTORY AND URBAN DEVELOPMENT. The original town plan, an absolutist design with the ruler's seat in the centre of a circle, was by Johann Friedrich von Batzendorf. Its apex was the octagonal tower at the back of the half-timbered Schloss, from which 32 streets radiated across the town and the forest to the ring road (see fig.). The intersection of the ring road and Schloss-Strasse (now Karl-Friedrich-Strasse) was marked by the Konkordienkirche (destr. 1807). Von Batzendorf also built half-timbered town houses. Under Charles's grandson, Margrave Charles-Frederick (*reg* 1738–1811), the town was extended and rebuilt in stone, as were the Schloss and tower (1752–5), but the plan was essentially that of 1715. Balthasar Neumann was one of several architects competing for the commission, and the building, by Albrecht Friedrich von Kesslau (*fl* 1743–85), was based on several of the proffered schemes. A central pedimented section was flanked by three-storey wings with a rusticated ground-floor (destr. 1944; rest. 1959 as the Badisches Landesmuseum). Kesslau also replanned the Schlossplatz.

At this time Karlsruhe had about 4000 inhabitants, and it was only in the late 18th century and the early 19th that the rest of the town was laid out according to the strict Neo-classical principles of Friedrich Weinbrenner, who was town architect from 1797 to 1826. The raising of the Margraves to the rank of Grand Duke in 1806 was the occasion of further public works. The Konkordienkirche was swept away, and along the Schloss-Strasse Weinbrenner created the Rondellplatz and Marktplatz as new focal

Karlsruhe, bird's-eye view from the south; engraving by J. M. Steudlin, 1739, based on a drawing by Christian Thran (Karlsruhe, Generallandesarchiv)

points with, at the far end, the Doric Ettlinger Tor (destr.); he built the Margrave's Palace in the Rondellplatz in 1803 (the central wing survives, rest.), and on Marktplatz he built the Protestant Stadtkirche (1807–16; see WEINBREN-NER, FRIEDRICH, fig. 1), with a Roman temple front, and the Rathaus (1815–25). In 1823 Weinbrenner designed a sandstone pyramid to mark the founder's tomb in the Marktplatz, which was further enhanced by a fountain in 1832, when the Column of the Constitution was erected in the Rondellplatz. Weinbrenner's Catholic church of St Stephan (1808–14; rest. 1951–4) is a domed structure over a Greek cross, partly based on the Pantheon in Rome.

In the 19th century Karlsruhe became an industrial town, with the foundation of the Technische Hochschule (later the university) in 1825. Weinbrenner's successor as town architect, Heinrich Hübsch, was a historicist, designing delicately proportioned buildings in Roman, Byzantine and Italian Renaissance styles (e.g. the Staatliche Kunsthalle, 1843–6; partly destr. and altered). The late 19th-century architects Joseph Berckmüller (1800–79) and Josef Durm were inspired by French and Italian Baroque styles, Durm's Vierordtbad of 1873 having Renaissance domes and chimneys disguised as minarets.

More contemporary styles emerged in Friedrich Ostendorf's garden city of Rüppurr (1907), one of the most remarkable examples of the type in Germany, and in the design by WALTER GROPIUS for the suburb of Dammerstock, drawn up in 1928–9 according to the ideals of the Bauhaus movement. The Badisches Staatstheater, built by Weinbrenner in 1808 and bombed in 1944, was rebuilt in 1970–75 by Helmut Bätzner as a polygonal structure with aluminium cladding. The earliest building for the university was by Hübsch in 1832–6; among buildings added since are those by Durm (1892) and Heinrich Müller (1950s).

2. ART LIFE AND ORGANIZATION. Margrave Charles-Frederick not only rebuilt the Schloss but also educated artistically gifted young people within his territories and ensured commissions for their work. In 1785 he founded the Zeichenakademie, a drawing school for young painters, sculptors and architects, directed by Philipp Jakob Becker (1759–1829). Charles-Frederick put the art collection of his late wife, Caroline Louise, at the disposal of the academy for study purposes, together with much of the Zähringen Collection and works acquired in 1803 as a result of church secularization.

Grand Duke Leopold (reg 1830–52) commissioned Hübsch to build the museum that is now the Staatliche Kunsthalle (1837–46; wings added 1896, 1908 and 1990), and for the first time a state grant was provided for further acquisitions. Besides paintings the museum housed collections of plaster casts from antique originals, and antique and medieval works, but after 1875 the latter were moved to the Sammlungsgebäude built by Berckmüller. After 1918 they were transferred to the disused Schloss, where they form the core collection of the Badisches Landesmuseum.

In 1854 Frederick I (*reg* 1858–1907), patron of the painter Anselm Feuerbach, founded the Grossherzogliche Kunstschule (now the Staatliche Akademie der Bildenden Kunst), personally defraying its costs until 1876. The programme was modelled on that of the Düsseldorf Akademie: Düsseldorf was to be influential on the art of Karlsruhe, as the first director of the Kunstschule, Johann Wilhelm Schirmer, came from there, and Friedrich Lessing, who had followed Schirmer from Düsseldorf, became director of the Kunsthalle in 1858. Both men represented academic composition and the primacy of line over colour, in contrast to Hans Canon, who was active in Karlsruhe in the 1860s, without an official teaching post, and exerted a strong influence on younger painters. In the last decades of the 19th century Karlsruhe painters under the leadership of Gustav Schönleber (1851–1917) were interested in painting landscapes direct from nature. As the Kunstschule did not take women students, a private academy was set up for them in 1885, which survived until 1923.

In 1901 the Karlsruhe maiolica factory was established, its output embracing both serial production and individual pieces to designs by leading artists such as Hans Thoma. Thoma became director of both the Kunstschule and the Gemäldegalerie of the Kunsthalle in 1899, and until his death in 1924 he played a leading role in Karlsruhe. Another influential figure was Wilhelm Trübner, director of the Kunstschule from 1903 to 1917, and through the 1920s most fashionable movements in art were represented there, although after 1933 some teachers, such as Karl Hubbuch, were dismissed by the National Socialists, while others left voluntarily. Thoma's influence survived through his younger contemporaries until World War II, when the Kunstschule building was destroyed. Artists who taught at the reopened Akademie from 1949 included such international figures as Erich Heckel, Horst Antes, Georg Baselitz, Hubbuch, Horst Kalinowski, Markus Lupertz and Georg Meistermann.

One institution founded by the citizens rather than the court was the Badischer Kunstverein, established in 1818 as the earliest society for connoisseurs in Germany. In 1900 the Verein acquired the Art Nouveau house designed by Friedrich Ratzel (1869–1907), and it holds both retrospective exhibitions and those of contemporary art. The Städtische Galerie in the former Prinz-Max-Palais (1881–4; by Josef Durm), which opened in 1981, holds the collections of the city of Karlsruhe, while the Zentrum für Kunst und Medientechnologie is concerned with the issues of modern art in collaboration with the other city institutions.

BIBLIOGRAPHY
A. Valdenaire: *Karlsruhe: Die klassisch gebaute Stadt* (Augsburg, 1928)
H. Curjel: *Zur künstlerischen Physiognomie Karlsruhe* (Karlsruhe, 1966)
G. Bussmann, ed.: *Festschrift zum 150jährigen Jubiläum des Badischen Kunstvereins Karlsruhe, 1818–1968* (Karlsruhe, 1968)
J. Hotz: *Karlsruhe* (Amorbach, 1968)
C. H. Bohtz: *Karlsruhe* (1970)
Karlsruher Majolika: Die grossherzogliche Majolika-Manufaktur, 1901–1927, die staatliche Majolika-Manufaktur, 1927–1978 (exh. cat., ed. M. Bachmayer and others; Karlsruhe, Bad. Landesmus., 1979)
Kunst in Karlsruhe, 1900–1950 (exh. cat., ed. H. Vey; Karlsruhe, Staatl. Ksthalle, 1981)
H. Schmitt, ed.: *Denkmäler, Brunnen und Freiplastiken in Karlsruhe*, Veröffentlichungen des Karlsruher Stadtarchivs, vii (Karlsruhe, 1987)
D. Watkin and T. Mellinghof: *German Architecture and the Classical Ideal, 1740–1840* (London, 1987)

'*Klar und lichtvoll wie eine Regel*'. *Planstädte der Neuzeit vom 16. bis zum 18. Jahrhundert* (exh. cat., Karlsruhe, Bad. Landesmus., 1990) [traces hist. geometrically planned cities and then focuses on Karlsruhe]

JAN LAUTS

Karlštejn Castle. Fortress in central Bohemia, Czech Republic, on a cliff above the River Berounka, *c.* 30 km south-west of Prague (*see* CZECH REPUBLIC, fig. 2). It was built by Charles IV, Holy Roman Emperor, to protect the crown jewels and state treasure of the Empire, and its unique design was greatly influenced by the presence of the holy relics. It retains much of its important programme of painted decoration (*see* §2 below). The foundation stone was laid on 10 June 1348 by Arnošt of Pardubice, Archbishop of Prague, and by 1355 the Emperor was already living there. In 1357 he founded the castle chapel, and in the same year two chapels—to the Stigmata and the Virgin—were consecrated.

1. ARCHITECTURE. The core of the castle lies behind a massive inner wall with the outer castle in front of it; there are two gates and an independently fortified residential quarter with a moat and well tower. The buildings of the inner castle (the palace, Church Tower and Great Tower) are built on three stepped terraces, the design reflecting Karlštejn's special function.

On the lowest terrace stands the rectangular imperial palace, the internal design of which is related to a type created in Bohemia in the second half of the 13th century, with three floors, each with a series of rooms. West of the central hall there is always a wood-panelled chamber and to the east a parlour (*see* ZVÍCHOV CASTLE). The second floor was the Emperor's apartment, comprising a large central hall with a flat, wooden ceiling, linked to the adjacent study on the east, and the tower chapel of St Nicholas (mentioned in 1353). The top floor contained the Empress's apartments. From the second floor a bridge leads to the first floor of the Church Tower on the second terrace. This is a two-storey rectangular building, the second floor of which originally contained a hall with a wooden ceiling. An oriel chapel with two rib-vaulted bays is let into the south wall. This was at first the Emperor's private oratory, where important relics were kept; but when the chapter was founded in 1357, the southern half of the hall was converted to the church of the Virgin (sometimes called the Lady Chapel), while the oratory was temporarily dedicated to the Stigmata, as recorded in the consecration of both chapels in the same year. Subsequently, however, the oratory was rededicated to St Catherine.

The crowning feature of the castle is the huge, rectangular, three-storey Great Tower on the highest terrace. Accessible from the second floor of the Church Tower, it has exceptionally massive masonry and is protected by its own fortification wall. A staircase on the south side leads to the second floor and the most sacred room in Karlštejn, the chapel of the Holy Cross, consecrated in 1365. It is a spacious rectangular chapel with two bays of rib vaulting. This chapel was ultimately dedicated to the Stigmata, and became the repository of the imperial crown jewels.

The Emperor himself may well have had a hand in the design of Karlštejn, drawing inspiration partly from the

royal residences in Paris. The master mason was evidently local, trained in Bohemia in the second quarter of the 14th century: the influence of Peter Parler is not seen until the final phases of building. Painting continued after construction was finished. In the 16th century the castle was renovated in a Renaissance style, to be restored to Gothic under the direction of Josef Mocker from 1887 to 1896.

BIBLIOGRAPHY
V. Dvořáková and D. Menclová: *Karlštejn* (Prague, 1965)
——: *Karlštejn: Státní hrad* [Karlštejn: State castle] (Prague, 1972)
D. Menclová: *České hrady* [Czech castles] (Prague, 1972), ii, pp. 48–63

H. SOUKUPOVÁ

2. PAINTING. All three of the main buildings at Karlštejn were richly decorated with wall paintings, panel paintings and, to a lesser extent, stained glass. Painting began with the building programme and reflected the changing function of the rooms (*see* §1 above). The most important areas were decorated in gold relief stucco with encrusted hardstones.

The decoration of the imperial palace has not survived, but there were at least two interesting cycles of wall paintings. The first, mentioned in the *Chronicle of Bohemia* (1358) by Giovanni Marignolli, Bishop of Bisignano (*d* 1359), depicted the *Miracle of the Finger of St Nicholas*, which occurred in 1353 in the Franciscan convent in Prague. It was painted in the Emperor's chamber (probably near the palace chapel) and was evidently the earliest painted decoration. Of utmost importance was the so-called Luxemburg Genealogy painted in the main hall of the palace after 1355, depicting about 65 fictitious and actual members of the family, starting with Noah and ending with Charles IV. The Genealogy is documented in the *Chronica nobilissimorum ducum Lotharingiae et Brabantiae ac regum Francorum* (1413; Brussels, Bib. Royale Albert 1er) by Edmond de Dynter (*d* 1448), old descriptions of the castle and two copies of *c.* 1575 (the Codex Heidelbergensis, Prague, N.G., Convent of St George; Vienna, Österreich. Nbib., MS. 8330). Two altarpieces, signed by TOMASO DA MODENA and probably painted from 1355 or soon after, were originally housed either in the palace or in the Church Tower: the triptych depicting the *Virgin with SS Wenceslas and Palmatius* (moved to the chapel of the Holy Cross in 1365) and the diptych with the *Virgin and Child, Man of Sorrows* and the *Archangels Michael and Gabriel* (found during the 19th century in the church of St Palmác in the lower castle, now in the church of the Virgin).

The oldest wall paintings of the Church Tower have survived, some painted before the consecration of 1357: in the altar niche of St Catherine's Chapel is a votive picture of the *Virgin and Child*, with *SS Peter and Paul* on the sides of the niche. The altar frontal bears a *Crucifixion* (see fig. 1) with *St Catherine* at the side. Above the entrance to the chapel, the Emperor and Empress are depicted holding the reliquary cross, and on the side wall below the vault are the remains of the figures of SS Vojtěch, Wenceslas, Vitus and four unidentified saints holding the relics of the Holy Cross. The painted decoration was partly destroyed when the walls were covered in an encrustation of hardstones and nails to secure the relics. The window contains the only surviving glass painting at Karlštejn, a

1. Karlštejn Castle, St Catherine's Chapel, *Crucifixion*, panel painting, *c.* 1357

Crucifixion (*c.* 1360), and in the so-called connecting corridor is a wall painting of an angel with a censer.

In the adjoining chapel of the Virgin (formerly the hall) there were originally four cycles of wall paintings, all dating from after 1357, of which only one has survived: the *Relic Scenes* showing Charles IV accepting, from two different rulers, the relics of Christ's Passion and placing them into a reliquary cross. The second, partly destroyed cycle, which occupies much of the remaining walls, depicts scenes from the *Apocalypse*. The third cycle, originally above some of the *Apocalypse* scenes, is lost, but it depicted the Holy Trinity, Prophets and Apostles, set between figures of Charles IV and his first three wives, Blanche of Valois (1317–48), Anne of the Palatinate (1329–53) and Anne of Svidnica (1339–62). The fourth cycle consisted of small Christological and Marian scenes in the window embrasures, remains of which survive. Also belonging to this group is a badly decayed, illusionistic picture of four people looking out of a window and a jewelled box with relics of the Passion and the Virgin.

Charles IV paid most attention to the decoration of the chapel of the Holy Cross in the Great Tower. The niche containing the crown jewels above the altar is concealed behind Tomaso da Modena's triptych (see above). The vaults are covered with gold leaf and gilded glass, and the lower walls encrusted with hardstones, as in St Catherine's Chapel. The upper walls contain nearly 130 half-length figures of saints painted on framed panels, originally with relics fixed to their frames: a crocodile's head, probably thought to be a relic of St George, was found in the wall. Five panels showing only the preliminary sketches are preserved. Under the vault on the altar wall is depicted the

Crucifixion (for illustration *see* THEODORIC, MASTER). The windows were originally glazed with hardstones; the embrasures contain the remains of the cycles of the *Life of the Virgin* and *Life of Christ* (see fig. 2), and scenes of the Revelation, including the *Adoration of the Lamb* and the apocalyptic God with angels and Evangelist symbols. The Emperor's painter, Master Theodoric, was paid for the decoration of the chapel in 1367.

The staircase of the Great Tower had three cycles of paintings, finished after 1370 and now crudely painted over and copied on to new plaster: the first depicted the *Life of St Ludmilla*, the second the *Life of St Wenceslas*, and the third showed Czech rulers and other important historical figures. Over the entrance to the chapel of the Holy Cross, Charles IV was shown standing before the reliquary cross and reading a book, in the presence of the Empress and the heir to the throne, the future Wenceslas IV, his wife and high ecclesiastical office-holders. The vault was decorated with angels holding musical instruments. Even here relics were found bricked up in the wall.

The decorative programme at Karlštejn expressed Charles's personal and dynastic ambitions while publicizing his interpretation of imperial power and the cult of religious relics. Except for the altars by Tomaso da Modena, the decoration is by artists who came to the Prague imperial court from the west, and whose main work was apparently the lost decoration of Prague Castle (*see* PRAGUE, §II, 1). These painters laid the basis of the flourishing school of Bohemian painting in the second half of the 14th century. The wall and panel paintings of Karlštejn are of superb quality, with sophisticated colouring, the use of light and shade in drapery forms and naturalistic physiognomies.

The lost Luxemburg Genealogy and paintings in the Church Tower were by several different painters. The so-called Masters of the Genealogy apparently worked in a style influenced by French court paintings and specialized in 'portraiture'. The *Relic Scenes* in the church of the Virgin are usually attributed to the same painters. The painter of the *Apocalypse* is presumed to be independent of this group. The part played by other artists cannot safely be determined. The Masters of the Genealogy worked on other paintings in Karlštejn, notably the sketches for panel paintings and some of the wall paintings in the chapel of the Holy Cross. The panels and the remaining wall paintings in this chapel were by younger painters. The decoration of the chapel of the Holy Cross was the culmination of the so-called Soft style, the later panels and wall paintings showing a move towards new concepts of space and more slender figures. This new style took over in the staircase paintings, which were the immediate predecessors of the paintings from the second half of the 1370s in Prague Cathedral.

The Emperor's painter, Nicholas Wurmser of Strasbourg, was clearly involved in the first campaign of decoration. He is often identified as the main Master of

2. Karlštejn Castle, chapel of the Holy Cross, *Adoration of the Magi*, fresco, before 1367

the Genealogy or as the Master of the Apocalypse. Wurmser had an estate in the village of Mořina, near Karlštejn, as did the Emperor's second painter, MASTER THEODORIC. The latter is accredited mainly with panel paintings in the chapel of the Holy Cross (*see* GOTHIC, fig. 83), but if the panel painters were merely assistants to the masters of the preliminary sketches, Theodoric could also have helped on the Genealogy. The staircase cycles are usually attributed to MASTER OSVALD, on the assumption that he worked on Karlštejn before going to Prague Cathedral. Despite the literature on the paintings of Karlštejn, a number of questions remain unresolved.

BIBLIOGRAPHY
J. Neuwirth: 'Mittelalterliche Wandgemälde und Tafelbilder der Burg Karlstein in Böhmen', *Forsch. Kstgesch. Böhmens*, i (1896)
A. Friedl: *Mistr Karlštejnské apokalypsy* [Masters of the Karlštejn Apocalypse] (Prague, 1950)
——: *Magister Theodoricus* (Prague, 1956)
——: *Mikuláš Wurmser, mistr královských portrétů na Karlštejně* [Nicholas Wurmser, master of the king's portraits at Karlstejn] (Prague, 1956)
K. Möseneder: 'Lapides vivi: Über die Kreuzkapelle der Burg Karlštein', *Wien. Jb. Kstgesch.*, xxxiv (1981), pp. 39–71

JAKUB VÍTOVSKÝ

Karl Theodor, Elector Palatine of the Rhine and Elector of Bavaria. *See* WITTELSBACH, §II(4).

Karlukovo. Village in Bulgaria *c.* 40 km east of Vratsa. Painted caves on the banks of the adjacent River Iskar were in Byzantine times used as chapels or inhabited by hermits. Two of these chapels are particularly noteworthy: that of St Nicholas, also known as 'Gligora', which was built rather than carved from the rock, and the rock-cut chapel (5.50×3.90 m) consecrated to St Marina, which has one façade built in masonry. Both date from the 14th century and are now in poor condition; both have had their murals partly repainted.

The principal images painted in the chapel of St Marina include one in the conch of the apse showing the *Virgin Greater than the Heavens* (Platytera) holding Christ to her breast, and another lower down of the *Eucharist*, represented by *Two Officiating Bishop-saints* and the Holy Lamb placed on the paten; the scene of the *Annunciation* is divided between the two sides of the apse, while the figure of *Christ* with both hands raised in blessing appears above it. A picture of the *Christ of Mercy* was painted in the prothesis apse, and a number of scenes occupy the west wall. These include *Pentecost*, the *Transfiguration*, the *Dormition of the Virgin*, the *Raising of Lazarus* and the *Entry into Jerusalem* (fragmentary). A number of images can still be made out on the exterior of the west wall, including *God the Father* at the very top, followed by the *Hospitality of Abraham*, the *Sacrifice of Isaac*, *St Marina with the Demon*, the *Archangels Michael and Gabriel* and *SS Joachim and Anne*. The figures on the exterior south wall include the donor, his spouse and their son offering a small model of the church to a bust of St Marina. Saints depicted as full-length figures and in the form of busts survive throughout the building.

In the chapel of St Nicholas the only images to have survived in relatively good condition are those in and around the apse. In the apse, the *Virgin* is depicted at prayer with *Four Officiating Bishop-saints* shown below. *Pentecost* is seen above the figure of Mary, while the two

figures of the *Annunciation* appear flanking the apse. Lower down, beneath the archangel's feet, is depicted the *Mandylion*. Other paintings include a number of prophets depicted full-length, some scenes from the *Life of St Nicholas* and a large fragment of the *Harrowing of Hell*, all of which are in relatively good condition.

BIBLIOGRAPHY
L. Mavrodinova: *Skalnite skitove pri Karlukovo* [The rock sketes at Karlukovo] (Sofia, 1985)
D. Piguet-Panayotova: *Recherches sur la peinture en Bulgarie du bas moyen âge* (Paris, 1987)

LILIANA MAVRODINOVA

Kármán & Ullmann. Hungarian architectural partnership formed *c.* 1896 by Géza Kármán (*b* Budapest, 24 Feb 1871; *d* Budapest, 24 Oct 1939) and Gyula Ullmann (*b* Budapest, 1872; *d* Budapest, 11 June 1926). Kármán studied in Munich, while Ullmann graduated from the Hungarian Palatine Joseph Technical University, Budapest. They mainly designed residential blocks and a few public buildings, primarily in Budapest. Of the fin-de-siècle Hungarian architects they were the most influenced by the Viennese Secession. One of their finest works is the King's Bazaar Building (1899–1902), Károlyi M. Street 3–5, Budapest, the decorative façade of which is animated with gypsum medallions, including Egyptian elements and female heads, and is dynamically accentuated with iron bands. On other works the entire wall area is devoted to Secessionist motifs, for example in the building (1899–1901) at Szabadság Square 10–12, Budapest. After the eclecticism of their early work, in response to changes in the Viennese style, Kármán & Ullmann built simpler houses with floral decoration, for example at St István Boulevard 10–12 (1904). The Fischer Building (*c.* 1910) on the corner of Bécsi Street and Harmincad Street is more robust, with masses widening as they reach upwards, showing a German influence. Another example of their work from the same period is the headquarters of the River and Sea Shipping Office (1909–12), Budapest. On the string course above the first storey ships' bows project from wave motifs, and a frieze representing sea life decorates the top storey. The partnership produced little of significance, however, after 1914.

BIBLIOGRAPHY
Der Architekt, v (1899), p. 39
Magyar Építőművészet, iv/9 (1910)
Magyar Építőművészet, v/1 (1911)
Magyar Építőművészet, vii/1 (1912)

F. BOR

Karmi. Israeli family of architects. Dov Karmi (*b* Odessa, 1905; *d* Tel Aviv, 14 May 1962) settled in Palestine in 1921. He studied (1923–6) at the Bezalel School of Painting and Sculpture, Jerusalem, then trained in architecture and engineering (1926–30) at the Rijksuniversiteit, Ghent. He returned to Palestine *c.* 1930 and set up a private practice in Tel Aviv in 1936. His early designs, mainly for residential buildings, were severe, cubic structures that adapted Le Corbusier's solutions for sunny climates, such as *brises-soleil*, recessed balconies and the raising of buildings on pilotis for improved air circulation. His school building (1930s) for the Armenian monastery in Jaffa demonstrates a sophisticated mix of Arabic and European idioms in its flat roof and rough ashlar façade, articulated with arched

openings. His designs did much to inaugurate Modernism in Israel, and he was awarded important commissions, for example the Histadrut Headquarters (1950–56), Tel Aviv, and the Knesset Building (completed 1966; with Joseph Klarwein), Jerusalem. From 1952 to 1956 he served as President of the Association of Israeli Architects.

Ram Karmi (b Jerusalem, 1931), a son of Dov Karmi, studied (1949–50) at the Technion, Haifa, and then at the Architectural Association School, London, where he graduated in 1955. He joined his father's firm, with Z. Melzer, in 1956. In the late 1950s and early 1960s the work of Karmi-Melzer-Karmi became increasingly structurally expressive, and they were among the first architects in Israel to advocate the use of such materials as exposed reinforced concrete and naturally finished wood. The El Al Office Building (1962–3), Tel Aviv, characterizes their work of the period, with its streamlined curved end wall, roughly textured surface, fenestration shaded by pre-cast concrete panels and an exposed spiral fire-escape. This move towards a more sculptural style was continued under Ram Karmi's direction following his father's death. In 1964 the architect and teacher Ada Karmi-Melamede (b 1936), a daughter of Dov Karmi, joined the firm, which was renamed Karmi Associates. During a period of strong growth of building activity in Israel, the firm contributed designs for such buildings as the Hadar Dafna Office Complex (1964–8), Tel Aviv, and the Lady Davies Amal Technical School (1974), Tel Aviv, which utilized rough-cast concrete for massed, strongly modelled forms that display the influences of the Brutalist movement that Ram Karmi had absorbed as a student in London. From 1969 Ada Karmi-Melamede taught at Columbia University, New York, where she was responsible for several urban planning studies, and in 1972 Karmi Associates established a New York office. Ram Karmi held a number of influential positions in Israel, including chief architect (1975–9) to the Ministry of Housing, and holder of a Special Chair in Architecture (1968–85) at the Technion, Haifa.

BIBLIOGRAPHY

G. Canaan: *Rebuilding the Land of Israel* (New York, 1954)

A. Harlap: *New Israeli Architecture* (East Brunswick, NJ, and London, 1982)

White City: International Style Architecture in Israel: A Portrait of an Era (exh. cat. by M. Levin, Tel Aviv Mus. A.; New York, Jew. Mus., 1984–5)

☐

Karmir Blur [anc. Teishebaini]. Site on the outskirts of modern Erevan, Armenia. It was a major fortress and settlement of the kingdom of Urartu in the 7th century BC and one of the richest sources of archaeological evidence for URARTIAN civilization. The citadel is a single complex edifice constructed on a rocky elevation beside the River Razdan. On lower ground is a settlement area covering c. 40 ha, but the most important finds come from the fortress. Excavations at Karmir Blur began in 1939 and were conducted with greatest intensity in the two decades following World War II by a joint expedition of the Armenian Academy of Sciences and the Hermitage Museum, St Petersburg (formerly Leningrad), headed by B. B. Piotrovsky. Although there had been earlier archaeological work at Urartian sites in Turkey, particularly at TOPRAKKALE (anc. Rusahinili), the Karmir Blur expedition was the first to publish systematically and to provide extensive contextual information for finds.

Cuneiform inscriptions indicate that Teishebaini was founded by Rusa II, a ruler who built prodigiously and is securely dated by an Assyrian synchronism of 673 BC. Thus the construction actually post-dates the zenith of Urartian power in the 8th century BC, when the kingdom clashed with the Assyrian empire for supremacy in the Near East. Archaeologically, however, the 7th century BC is also well represented in Urartu, since two other great sites, Toprakkale and BASTAM (anc. Rusai URU.TUR), were exactly contemporary with Karmir Blur. All were violently destroyed at a date that remains controversial, perhaps as early as 640 BC and no later than 585 BC.

1. ARCHITECTURE. The architecture of Karmir Blur conforms to standard Urartian building practices. The fortress walls were composed of large sun-dried mud-bricks and stood on stone socles averaging c. 1 m high. The building had several storeys, with floors and windows at different levels to exploit the slope on which it was built. Karmir Blur is unusual in its state of preservation: in some cases the walls stand to a height of 6 m, and the debris that collapsed at the time of destruction sealed the lower rooms so completely that normal processes of decay were unable to operate on many of the organic materials.

For the lowest level of the building, which served to support the upper storeys, the plan is virtually complete (see fig.). Two gates, one much more elaborate than the other, gave entrance to the fortress via a large courtyard. From this a ramp led into the building itself at a level that has not survived. The excavations have primarily exposed basement storerooms and workshops containing both use assemblages and material that fell from upper floors when the building collapsed.

Only a small portion of the settlement below the citadel at Karmir Blur was excavated, but it was enough to

0 50
m

Karmir Blur, plan of the basement level of the fortress, destr. ?c. 640–585 BC

demonstrate considerable variation in the dwellings there. Some of the less well appointed ones were regularly laid out and testify to planned construction. Larger independent residences are thought to represent the houses of a higher social class.

2. ART AND ARTEFACTS. Among the basement rooms of the fortress building were more than six magazines for liquid storage in which pithoi holding *c.* 100 litres were buried up to their shoulders in multiple rows. Most were apparently empty of their normal contents at the time of the destruction, and some had been used to conceal precious objects. Other storerooms contained many trefoil jars and bronze bowls. In one room there was specialized beer-brewing equipment, and another was packed with burnt animal bones, which the excavators believed were the remains of sacrifices.

Many pieces of bronze military and equestrian equipment were found at Karmir Blur, including helmets, quivers, shields, belts, projectile points, swords, horse trappings and chariot parts. The Urartian helmet was particularly distinctive, being conical with concave sides and often decorated with an applied frontal ornament. Many bronze objects from Karmir Blur are inscribed with the names of 8th-century BC kings, apparently having come from the earlier neighbouring site of Erebuni. The materials from Karmir Blur are important for evaluating the numerous unprovenanced Urartian artworks.

Unlike contemporary Neo-Assyrian palaces, the citadel at Karmir Blur was apparently not adorned with reliefs. In fact, no monumental sculpture was found there, although Urartian reliefs are known from such other sites as Adılcevaz. Smaller pieces of sculpture in the round were recovered, the most celebrated examples being a horse's head and a figure thought to represent Teisheba, the Urartian storm god after whom the site was named. Several small wooden statuettes, so far unique in Urartian art, were also found. Three of these depicted gods in warrior attire, and the fourth a goddess.

The excavations were also noteworthy for recovering small artefacts. Jewellery included both locally manufactured pieces and imports from as far away as Egypt. Among the numerous seals and seal impressions, most comprised cylinder seals and the more distinctively Urartian combined stamp-cylinder type. In the latter case, designs on the friezes produced by rollings often portrayed winged genii and sacred trees, whereas the stamping design on the end of the cylinder was usually a miniature animal. The seal was suspended from a loop at the non-stamping end of the cylinder. The Karmir Blur seals included a number with quite rudimentary scratched designs, which contrast with the well-modelled figures of more refined examples known elsewhere. In jewellery, seals and the decorative arts generally, the Urartian predilection for animals, particularly of mixed form, is manifest.

The epigraphic materials from the site are also important, if not particularly abundant. In addition to fragments of display inscriptions and the short dedications on bronze objects, eleven letters and edicts inscribed on cuneiform tablets were discovered. Documents of this type are rare in Urartu, in contrast to royal building inscriptions, and provide historical and linguistic insights into the internal make-up of the kingdom that would otherwise be unavailable. In addition to cuneiform, the Urartians also used a poorly understood hieroglyphic writing system. No long texts of this type have survived, but the numerous individual glyphs on bronze bowls that are accompanied by cuneiform dedications provide a clue to some of the symbols.

BIBLIOGRAPHY
B. B. Piotrovsky: *Karmir-blur I* (Erevan, 1950)
R. D. Barnett and W. Watson: 'Russian Excavations in Armenia', *Iraq*, xiv (1952), pp. 132–47
B. B. Piotrovsky: *Karmir-blur II* (Erevan, 1952)
K. L. Oganesjan: *Karmir-blur IV: Architektura Teishebaini* [Karmir-blur IV: the architecture of Teishebaini] (Erevan, 1955)
B. B. Piotrovsky: *Karmir-blur III* (Erevan, 1955)
R. D. Barnett and W. Watson: 'Further Russian Excavations in Armenia', *Iraq*, xxi (1959), pp. 1–19
A. A. Martirosjan: *Gorod Teishebaini* [The city of Teishebaini] (Erevan, 1961)
B. B. Piotrovsky: *The Ancient Civilization of Urartu* (Geneva, 1969)

PAUL E. ZIMANSKY

Karmravor. *See under* ASHTARAK.

Karnak. *See* THEBES (i), §II.

Karolik, Maxim (*b* Akkerman, Bessarabia [now Belgorod Dnestrovskiy, Ukraine], 1893; *d* Newport, RI, 20 Dec 1963). American singer and collector. Trained as a tenor and actor in Odessa, he emigrated to America in 1922. In 1928 he married Martha Codman (*d* 1948) of Boston, heiress of Elias Hasket Derby (1739–99), the Salem merchant and patron of the architect and wood-carver Samuel McIntire. Following a tradition begun by Mrs Karolik in 1923 of giving family treasures to the Museum of Fine Arts, Boston, Mr and Mrs Karolik formed a collection, of great artistic quality, of American portraits, furniture and decorative art of the late 18th century, which they presented to the Museum in 1939. Included were eight portraits and nineteen drawings by John Singleton Copley and documented furniture by Edmund Towsend of Newport, RI, Benjamin Randolph of Philadelphia, and the Derby furniture by McIntire and John and Thomas Seymour of Boston.

The Karoliks' enthusiasm for American art led them to form a second collection of American painting dating from 1815 to 1865 for the Museum. Karolik's excellent eye and daring judgement led him to collect works by many relatively unknown artists, such as Martin Johnson Heade and Fitz Hugh Lane (e.g. *Owl's Head, Penobscot Bay, Maine*, 1862; Boston, MA, Mus. F.A.; for illustration *see* LANE, FITZ HUGH), thus bringing them to prominence. The quality of painters such as James Goodwyn Clonney, Charles Deas, David Gilmour Blythe and George Cochran Lambdin was recognized by Karolik, and their works were placed in his collection beside those of such accepted artists as Thomas Cole, Albert Bierstadt, Jasper Francis Cropsey and Asher B. Durand. The collection of 232 works by 85 painters was presented in 1949. A third collection of American drawings of the 19th century, illustrating the range of draughtsmanship from academically trained to folk artists, was presented to the Museum in 1962. The Karolik collections have led to a greater understanding of American 19th-century artists, especially the so-called 'Luminists'.

UNPUBLISHED SOURCES
Karolik file, Boston, MA, Mus. F.A.

BIBLIOGRAPHY

E. J. Hipkiss: *Eighteenth Century American Arts: The M. and M. Karolik Collections* (Cambridge, MA, 1941)

M. and M. Karolik Collection of American Paintings, 1815–1865, intro. J. Baur (Boston, 1949)

H. P. Rossiter: *M. and M. Karolik Collection of American Water Colors and Drawings, 1800–1875* (Boston, 1962)

J. R. Lane: 'Maxim Karolik: Benefactor to the Museum of Fine Arts, Boston', *Amer. A. Rev.*, ii/1 (1975), pp. 103–13

RICHARD H. RANDALL

Karos. *See* KEROS.

Karpff, Jean-Jacques [Casimir] (*b* Colmar, 12 Feb 1770; *d* Versailles, 24 March 1829). French painter, miniaturist and draughtsman. He had an early love for drawing and was given a rudimentary training under Joseph Hohr in Colmar. He travelled to Paris in 1790; there he became one of the first pupils of Jacques-Louis David. In his atelier, he acquired the name Casimir because 'Karpff' was found difficult to pronounce. In 1793 he toyed with the idea of travelling to Rome to complete his studies but decided to carry on for a further two years under David. His training instilled a love for classical and mythological subjects, but most of his paintings on these subjects were without distinction. He always felt uneasy with colour, and soon learnt that it was wisest to restrict himself to monochrome painting and drawing. In 1795 he was called from Paris to Colmar to teach drawing at the newly founded art school; he also organized the local Republican festivals through his association with David. While in Colmar he drew portraits (untraced) of the poet *Théophile-Conrad Pfeffel* (1736–1809) and of *Général Jean Rapp* (1772–1821). In 1806 he was summoned to the château of Saint-Cloud to draw the portrait of the *Empress Josephine Bonaparte* (untraced), after she had been impressed by his portrait of *Général Rapp*; he never returned to Colmar. The portrait of the Empress won a gold medal at the 1809 Salon and drew from David the comment that 'the art of drawing could be extended no further'. The work made Karpff famous and sought after. Soon after its exhibition he was invited by the poet Victoire Babois (1760–1839) to live in Versailles, where he remained for the rest of his life. Among the numerous portraits he executed are *Portrait of the Artist's Father* (1789; Colmar, Mus. Unterlinden), the miniature of the *Mother of the Painter Auguste Bigand* (Avignon, Mus. Calvet) and the *Portrait of the Poet Victoire Babois* (Versailles, Château).

BIBLIOGRAPHY

H. Lebert: 'J.-J. Karpff, dit Casimir', *Rev. Alsace* (July 1856), pp. 289–304

R. Ménard: *L'Art en Alsace-Lorraine* (Paris, 1876), p. 97

Karphi. Minoan site in Crete. Karphi was a large town on the slopes of a prominent peak about 1250 m high (itself named Karphi, or 'nail', after its rocky, knob-like summit), on the north side of the Lasithi Mountains in eastern Crete. It was inhabited in the Late Minoan (LM) IIIC (*c.* 1190–*c.* 1050 BC) and Sub-Minoan (*c.* 1050–*c.* 1000 BC) periods and possibly too for some years in the Protogeometric period (*c.* 1000–*c.* 900 BC). The 'nail' was probably also the site of a Middle Minoan (*c.* 2050–*c.* 1600 BC) peak sanctuary.

The excavations by J. D. S. Pendlebury and others in 1937–9 of much of the settlement (main area 130×130 m; east area 150×70 m) and some of its tombs gave a rare chance to see a large Cretan settlement of the very end of the Bronze Age with many details of its daily life preserved. Although on a high and bleak spot, Karphi seems to have enjoyed a surprisingly sophisticated way of life for a period generally thought to have been one of impoverishment. Finds of pottery, dress pins and other metalware attest to connections with settlements elsewhere in Crete, in the Aegean and even in Cyprus. The finds from the site (Herakleion, Archaeol. Mus.) are predominantly of LM IIIC date, although unpublished finds of Protogeometric pottery suggest that the settlement and cemeteries may have continued in use into the 10th century BC.

The site was chosen probably to be a mountain stronghold, commanding the north entrance to the Lasithi plain and routes to southern Crete, as well as overlooking all north-central Crete from Mount Ida and the region of Herakleion and Knossos on the west to the Bay of Mirabello on the east. The houses, streets and paved yards of the town are spread from the 'nail' across a saddle to an adjoining peak. The houses, of split but undressed limestone, are mainly of one storey, although some are preserved only to basement level. The free-standing shrine or temple (room 1) on the mountain summit was a bench sanctuary of 5×8 m, which contained five terracotta figurines of goddesses with upraised arms and which seems to have been the focus of the settlement. Other buildings in the town also seem to have had shrines. Among these are the Great House, apparently a dwelling of megaron type derived from mainland Greece (*see* MINOAN, §II), the Priest's House and another probable megaron. The cemeteries near by are composed of wholly or partly free-standing tholos tombs.

BIBLIOGRAPHY

H. W. Pendlebury, J. D. S. Pendlebury and M. B. Money-Coutts: 'Excavations in the Plain of Lasithi. III: Karphi: A City of Refuge of the Early Iron Age in Crete', *Annu. Brit. Sch. Athens*, xxxviii (1937–8), pp. 57–145

M. Seiradaki: 'Pottery from Karphi', *Annu. Brit. Sch. Athens*, lv (1960), pp. 1–37

V. R. d'A. Desborough: *The Last Mycenaeans and their Successors: An Archaeological Survey, c. 1200–c. 1000 B.C.* (Oxford, 1964), pp. 172–6

L. V. Watrous: *Lasithi: A History of Settlement on a Highland Plain in Crete* (Princeton, 1982), pp. 8, 13, 19–20, 40

G. C. Gesell: *Town, Palace and House Cult in Minoan Crete*, Stud. Medit. Archaeol., lxvii (Göteborg, 1985), pp. 45–6, 79–83, 147

B. Rutkowski: *The Cult Places of the Aegean* (New Haven and London, 1986), pp. 167–8

G. Cadogan: 'Karphi', *The Aerial Atlas of Ancient Crete*, ed. J. W. Myers, E. E. Myers and G. Cadogan (Berkeley, 1992), pp. 114–17

GERALD CADOGAN

Karpiński, Zbigniew (*b* St Petersburg, 17 April 1906; *d* Warsaw, 29 March 1983). Polish architect and teacher. He studied architecture at Warsaw Technical University (1925–37) and was one of the young Modernist architects active in Poland in the 1930s. He participated in many competitions, one of his most notable designs being that for the Polish Savings Bank (1934; with Tadeusz Sieczkowski and Roman Soltynski; unexecuted), Poznań. His major work of the 1930s was the Law Courts (1934–8), Gdynia, also designed with Sieczkowski and Soltynski. After World War II, avoiding the ostentatious eclecticism

prevailing at the time, he designed some simple, high-quality office buildings in Warsaw, including the Ministry of Construction (1949–51) and the Metalexport Building (1950–52; with Tadeusz Zieliński). He also built some blocks of flats (1954) in Warsaw and the Polish Embassy (1958–60) in Beijing. In 1955 he began to teach architectural and landscape design at Warsaw Technical University, where he became Professor and Head of Design of Public Buildings in 1966. From 1958 to 1968 Karpiński was Chief Architect of the East Wall shopping centre in Warsaw's principal street, Marszałkowska Street, producing the master-plan for the scheme and coordinating the other architects working on individual buildings. His competition-winning plan attempted to maintain the 19th-century street pattern in the area and to create a human-scale pedestrian precinct in spite of the high-rise flats, hotels and huge department stores that were planned. The development was comparable to large-scale shopping centres in such other European cities as Stockholm.

BIBLIOGRAPHY
E. Olszewski, ed.: *Politechnika Warszawska, 1915–1965* [Warsaw Technical University, 1915–1965] (Warsaw, 1965)
T. Zieliński: 'Architekt Zbigniew Karpiński, 1906–1983', *Tygodnik Powszechny*, 20 (1983), p. 3

WANDA KEMP-WELCH

Karrik, Vil'yam [Vasily (Andreyevich)]. *See* CARRICK, WILLIAM.

Kars. Town in eastern Turkey. Dominated by a great citadel, it was the capital of the Armenian Bagratid kingdom from AD 928 to 961, when it became the capital of the Armenian kingdom of Vanand. It was captured by the Saljuq sultan Alp Arslan in 1064 and incorporated into the Georgian kingdom in 1206–7. Conquered by the Ottomans by 1534, it remained in their hands until 1828, when it was taken by the Russians. It was returned to Turkey in 1919. The most important monument is the cathedral of the Holy Apostles (begun 930), which comprises a cubic stone base with four arms supporting a cylindrical drum covered with a dome under a conical roof. The drum is decorated with blind arcades and 12 crude figures of the Apostles carved in low relief. The citadel and the city walls, ruined in Persian attacks, were extensively reconstructed in 1579. Other buildings from the Ottoman period include several modest mosques, two baths and a bridge. A small museum contains finds from a nearby Urartian cemetery, architectural sculpture, kilims, costumes and jewellery.

Enc. Islam/2
BIBLIOGRAPHY
T. A. Sinclair: *Eastern Turkey: An Architectural and Archaeological Survey*, i (London, 1987), pp. 349–56

GODFREY GOODWIN

Karsen [Karssen], **Kasparus** [Kaspar] (*b* Amsterdam, 2 April 1810; *d* Bieberich, 24 July 1896). Dutch painter. He was a student at the academy in Amsterdam from 1825 to 1827, and thereafter a pupil of his uncle Pieter George Westenberg (1791–1873) and of the latter's pupil H. G. ten Cate (1803–56). From 1830 to 1834 he was a decorative artist under D. Vettewinkel (1787–1841). In 1836 he painted the *Courtyard of the Old Exchange in Amsterdam* (Amsterdam, Rijksmus.). He made his first study trip along

the Rhine and Danube in 1837, recording views of the German towns. These reappeared continually in such later paintings as *Imaginary View on the Rhine* (Amsterdam, Rijksmus.). He also made trips to Prague. He lived and worked in Haarlem between 1824 and 1844 and later in Amsterdam. In his lifetime Karsen was less well known than Jan Hendrik Weissenbruch and Cornelis Springer, but his work subsequently became very popular.

Karsen's three marriages caused him increasing financial problems. He opened a photographic studio in Amsterdam, but it did not ease his difficulties. However, in the late 1840s the Amsterdam shipowner Paul van Vlissingen became his patron and gave him such commissions as the large *View of the Nieuwe Vaart* (1849; Amsterdam, Werkspoor-Mus.). In the last year of his life he made another trip along the Rhine, but he died on the return journey.

Karsen's townscapes are, more often than those of his contemporaries, imaginary compositions, in which recognizable buildings and architectural fragments were combined in the manner of the 17th-century painter Jan van der Heyden. He was primarily interested in the buildings themselves and the treatment of space rather than topographical accuracy or the people in the streets, although he did also make topographical scenes that were fairly truthfully rendered. Among the many works he submitted to exhibitions between 1830 and 1886 were views of Nuremberg, Metz and other German cities, Prague, and many of Amsterdam, such as *View of the Sugar Refinery 'Java' in Amsterdam* (*c*. 1850; Amsterdam, Hist. Mus.). Among his pupils were Cornelis Springer and his own son Eduard (1866–1941).

BIBLIOGRAPHY
Scheen
A. M. Hammacher: *Eduard Karsen en zijn vader Kaspar* (The Hague, 1947)
H. C. de Brüyn: 'Kaspar Karsen (1810–1896): Verteller van gedroomde steden', *Tableau*, 8/1 (1985), pp. 56–61
The Age of Van Gogh: Dutch Painting, 1880–1895 (exh. cat., ed. R. Bionda and others; Glasgow, Burrell Col.; Amsterdam, Van Gogh Mus.; 1990–91)

WIEPKE F. LOOS

Karsh, Yousuf (*b* Mardin, Turkish Armenia, 23 Dec 1908). Canadian photographer of Turkish Armenian birth. He moved to Canada in 1924 and worked as an assistant in his uncle's photographic studio in Montreal (1926–8). He studied photography in Boston from 1928 until 1931. He opened his own portrait studio in Ottawa in 1932. His front cover for *Life* magazine (30 Dec 1941), a portrait of *Winston Churchill*, was the basis for his fame and career as a portrait photographer, which involved many of the most important contemporary figures from the worlds of politics, science and the arts.

Karsh's photography used strongly focused lighting and dark backgrounds, creating a chiaroscuro effect seen, for example, in *Ingrid Bergman* (1946; see Karsh, 1983, p. 169). He tried to reflect a characteristic image of the person photographed through the pose, for example in the contemplative profile portrait of *Ronald Reagan* (1982; see Karsh, 1983, p. 51). From 1969 he also taught at many universities and academies in North America.

WRITINGS
In Search of Greatness: Reflections of Yousuf Karsh (Toronto, 1962)

PHOTOGRAPHIC PUBLICATIONS

Faces of Destiny (New York, 1946)
Karsh Portfolio (Toronto, 1967)
Yousuf Karsh: A Fifty-year Retrospective (New York, 1983)

BIBLIOGRAPHY

Photographs of Yousuf Karsh: Men Who Make our World (exh. cat., Montreal, Expo '67, Can. Pav., 1967)
P. Booth, ed.: *Master Photographers: The World's Great Photographers on their Art and Techniques* (London, 1983), pp. 125–31

REINHOLD MISSELBECK

Kar-Shalmaneser. *See* TIL BARSIP.

Karsten, Ludvig (Peter) (*b* Christiania [now Oslo], 8 May 1876; *d* Paris, 19 Oct 1926). Norwegian painter. He studied at the Royal School of Design in Kristiania (1891–5) and in 1896 studied with Karl Raupp (1837–1918) in Munich. Back in Norway, he obtained tuition from Christian Krohg and other eminent artists before applying to the Kunstakademie in Munich in 1900. The same autumn he studied with Eugène Carrière in Paris, where he met several of the future Fauvists, including Henri Matisse and André Derain. The greatest influence on his development as a painter was, however, Edvard Munch, whom he met in 1901. Karsten's favourite subjects during this period were figures, portraits and landscapes. *Consumption* (1907; Oslo, N.G.), a full-length frontal presentation of an old, sick woman, was directly inspired by Munch's portrait of his sister *Inger* (1892; Oslo, N.G.), although it also reveals an independent talent.

From 1900 Karsten was mostly in Paris, and Munch's influence receded as impressions from the work of Paul Gauguin, Paul Cézanne and Vincent van Gogh came to affect his painting. *Reclining Nude* (1909; Norway, priv. col., see 1976 exh. cat., p. 25), with its more active and vibrant use of colour, clearly reveals the sudden change in Karsten's compositions. For a short time a pupil of Matisse in 1910, Karsten afterwards lived mostly in Copenhagen. One summer in Norway he painted two of his best-known pictures, the interior views *Red Kitchen* and *Blue Kitchen* (both 1913; Oslo, N.G.). In the latter, as in a number of later paintings, the play of light constituted his real subject. Among his major works were the fantasies that took as points of departure paintings by Jacopo Bassano, Jusepe de Ribera and Rembrandt, for example *Bathsheba, after Rembrandt* (1910; Trondheim, Trøndelag Kstgal.). Karsten was recognized by his contemporaries as a highly gifted painter.

NKL

BIBLIOGRAPHY

P. Gauguin: *Ludvig Karsten* (Oslo, 1949)
R. Revold: *Norges billedkunst i det 19. og 20. åhundre* [Norway's pictorial art in the 19th and 20th centuries], ii (Oslo, 1953), pp. 48–54
L. Østby, ed.: *Nasjonalgalleriet: Katalog over norsk malerkunst* (Oslo, 1968)
Ludvig Karsten (exh. cat. by M. Malmanger and N. Messel, Oslo, N.G.; Bergen, Billedgal.; 1976)
M. Lange and N. Messel: *Nasjonal vekst* [National growth] (1981), v of *Norges kunsthistorie*, ed. K. Berg and others (Oslo, 1981–3), pp. 271–8
M. Malmanger: *Form og forestilling* [Form and conception] (Oslo, 1982), pp. 45–55
M. Werenskiold: *The Concept of Expressionism: Origin and Metamorphoses* (Oslo, 1984)
——: 'Matisse og Skandinavia', *Louisiana Revue*, xxv/2 (1985), pp. 42–5
Modernismens genombrott: Nordiskt måleri, 1910–1920 [Breakthrough of modernism: Scandinavian painting, 1910–1920] (exh. cat., ed. C. T. Edam, N.-G. Hökby and B. Schreiber; Göteborg, Kstmus.; Oslo N. G.; Stockholm, Mod. Mus.; and elsewhere; 1989–90), pp. 146–53
M. Lange and T. Skedsmo: *Norske malerier*, Oslo, N. G. cat. (Oslo, 1992)
N. Messel: *Ludvig Karsten* (Oslo, 1995)

INGEBORG WIKBORG

Karthaia. *See under* KEA.

Kar Tukulti Ninurta. Site in northern Iraq on the east bank of the River Tigris, 3 km north of Assur. It was for a time the Middle Assyrian capital city, founded by Tukulti-Ninurta I (*reg* 1243–1207 BC) after his conquest of Babylon in his 11th year. It ceased to be the capital after its founder's murder, but texts indicate that habitation continued throughout the Neo-Assyrian period (until 612 BC). The site was excavated by the German Assur expedition under Walter Bachmann's direction between October 1913 and March 1914. The main collection of finds is housed in the Pergamonmuseum, Berlin, with lesser collections in the Iraq Museum, Baghdad, the Archaeological Museum in Istanbul and the British Museum, London. The inner city was roughly square (*c.* 800×800 m) with an area of 62 ha. The west side was protected by the Tigris, and the others had a massive inner city wall, although the north segment is lost. There were at least four gates, one of which was excavated. A temple and a palace stood in the north-west quarter of the city. According to a stone tablet from the ziggurat (Berlin, Pergamonmus.), the temple was dedicated to the god Assur and was called 'the temple of totality'. Another text (London, BM) suggests that it was dedicated to Assur, Adad, Shamash, Ninurta, Nusku, Nergal, the Seven Gods and Ishtar. It consisted of a lower temple (52×53 m) built against a ziggurat (30×30 m). The closest parallels to the lower temple are in Babylonia. It was planned around a square courtyard, with the main entrance hall at the east opposite the principal cult chamber at the west against the ziggurat. To the north and south were subsidiary shrines. The ziggurat's height and the character of any architecture on its summit are unknown. Two sections of the palace were excavated. The North Palace (80×65 m) had a gate-chamber, two large reception rooms and several smaller rooms. Some 140 m to the south-east was the South Palace, of which only the mud-brick terrace was preserved (75×37 m). Fragmentary wall paintings, fallen from the rooms above, were found at the foot of the north and south sides of the terrace. New excavations and an archaeological survey were begun in 1986 under Reinhard Dittman. The discovery of the outer town's earthen rampart *c.* 1.5 km south of Gate D has extended the known area of the city to 240 ha, although originally it must have been larger still, as the west and north outer boundaries have not been established. The survey showed that parts of the city area were inhabited from early in the Old Assyrian period (*c.* 2000 BC) until at least the 8th century BC.

RLA

BIBLIOGRAPHY

W. Andrae: *Coloured Ceramics from Ashur* (London, 1925)
T. Eickhoff: *Kār Tukulti Ninurta: Eine mittelassyrische Kult- und Residenzstadt*, Abhandlungen der Deutschen Orient-Gesellschaft (Berlin, 1985)
R. Dittman: 'Ausgrabungen der Freien Universität Berlin in Assur und Kār-Tukulti-Ninurta in den Jahren 1986–89', *Mitt. Dt. Orient-Ges. Berlin*, cxxii (1990), pp. 157–71
——: 'Aššur and Kār-Tukultī-Ninurta', *Amer. J. Archaeol.*, xcvi (1992), pp. 307–12

JOHN M. RUSSELL

K'asagh. Site located in the village of Aparan, Armenia, which includes ruins of a palace and Early Christian basilica (4th–5th centuries). The site is first mentioned by Ptolemy as 'Casala' and later became part of the Nig region of the historic province of Ayrarat. A Greek inscription by King Trdat III (*reg* 287–98) of the Arsacid dynasty indicates that he gave this area to the Gnt'uni feudal princes, who constructed a palace and administrative centre there. Excavations were undertaken by A. Sahinyan between 1944 and 1947. The architectural details of the basilica indicate that it was built in the late 4th century AD and transformed into the Christian church of the Holy Cross (Sourb Khatch; 20.87×10.0 m) by the addition of an eastern apse probably at the end of the 5th century. Later additions are the rectangular chamber at the north-east corner of the church, a vaulted hall constructed along the north wall and a small basilica adjacent to the hall. The complex is constructed of black tufa facing a rubble core, and it rests on a three-stepped platform made of large blocks of basalt. The exterior walls of the basilica, the apse, the transverse arches of the south aisle, and portions of the north chamber and hall have been preserved, but the barrel vaults and tiled pitched roof have collapsed. The interior is divided into three aisles by three pairs of T-shaped piers. The projecting eastern apse is pentagonal on the exterior but horseshoe-shaped on the interior.

K'asagh is also important for the relief sculpture on the lintels of its three portals. They are among the earliest examples in Armenia and similar to the sculpture at the royal mausoleum (AD 364) at Aghts' and the basilica of Yereruyk' (5th–6th centuries). The lintel of the west façade portal has a cross between stags, a vine scroll, bunches of grapes and palm trees, with circular motifs at the bottom and sides. The easternmost portal of the south façade is pedimented and has an inscribed cross flanked by pairs of animals, possibly lions, in combat, at the centre of its lintel. Its decoration includes a vine scroll and circular motifs. The other portal on the south façade is accompanied by inscriptions to one side and has a lintel carved with an archaic equal-armed Greek cross at the centre. K'asagh is now being restored.

BIBLIOGRAPHY

A. Sahinyan: *K'asaghi bazilikayi tjartarapetut'yunê* [The architecture of the basilica of K'asagh] (Erevan, 1955)

A. Khatchatrian: *L'Architecture arménienne du IVe au VIe siècle* (Paris, 1971), pp. 58–62

L. D. Manuelian: *Armenian Architecture*, intro. by K. Maksoudian, Armenian Architectural Archives, ed. V. L. Parsegian, ii (Zug, 1983)

J.-M. Thierry and P. Donabedian: *Les Arts arméniens* (Paris, 1987; Eng. trans., New York, 1989)

P. Cuno: *Architettura dal quarto al diciannovesimo secolo*, i (Rome, 1988), pp. 168–9

LUCY DER MANUELIAN, ARMEN ZARIAN

Kasatkin, Nikolay (Alekseyevich) (*b* Moscow, 25 Dec 1859; *d* Moscow, 17 Dec 1930). Russian painter. He trained at the Moscow School of Painting, Sculpture and Architecture (1873–83) under Vasily Perov, who exerted a decisive influence on him, and he was a member, from 1891, of the WANDERERS, and, from 1922, of the ASSO-CIATION OF ARTISTS OF REVOLUTIONARY RUSSIA (AKhRR). The theme of the proletariat and images of an industrial hell, as in *Coal Miners: Changing Shift* (1895; Moscow, Tret'yakov Gal.), held centre stage in Kasatkin's socially critical realism, which has a dramatic severity. His genre portraits (e.g. *Woman Miner*, 1894; Moscow, Tret'yakov Gal.) convey the spontaneity of everyday life; after the Revolution of 1917 he tried to capture the characteristics of the people of the new society, as in *Country Newspaper Correspondent* (1927; Moscow, Cent. Mus. Revolution). Kasatkin's oeuvre provides a direct link between 19th-century critical realism and the work of AKhRR, of which he was the oldest member; in his work the social commitment of the Wanderers appears as the direct prologue to Socialist Realism, with its mission of embodying life 'in its revolutionary development'.

BIBLIOGRAPHY

K. A. Sitnik: *N. A. Kasatkin* (Moscow, 1955)

G. G. Serova: *N. A. Kasatkin* (Leningrad, 1970)

M. N. SOKOLOV

Kaschauer, Jakob [Jacob] (*fl* 1429; *d* 1463). Austrian painter and ?wood-carver of south German origin. Long considered one of the most significant practitioners of the realistic style pioneered by Hans Multscher, he was the wealthiest and most respected artist in Vienna in his day. His first recorded house was next to the Hofburg, and in 1444 and 1445 he received payments from Albert VI of Styria (*reg* 1424–63), perhaps as court artist. The lost altarpiece in the Michaelerkirche, finished in 1449, may have been a ducal commission. He was also responsible for the high altar retable of Freising Cathedral, consecrated in 1443 by Bishop Nicodemus della Scala (shrine figures in Munich, Bayer. Nmus., and Stuttgart, Württemberg. Landesmus.).

Kaschauer probably moved from Munich, where in 1410 a 'Hans Kassauer' is mentioned. He was married to a Nuremberg woman. A south German origin is further suggested by the provenance of his earliest extant work, a *Virgin Enthroned* from Weil-der-Stadt (Stuttgart, Württemberg. Landesmus.). It shows a certain dependence on the art of the Bavarian Master of Seeon, who anticipates Kaschauer's realism in the 'crescent-moon' head of the *Virgin* in Weildorf parish church (*c.* 1429). Somewhat later is a fragmentary *Coronation of the Virgin* (Berlin, Bodemus.), which already heralds Kaschauer's characteristic swirling drapery style. This seems Netherlandish in origin, as is the figure type used by Kaschauer for three figures of the *Virgin* from Purgstall, Hainburg (both New York, Cloisters), and the Freising Cathedral high altar (Munich, Bayer Nmus.), which seem to presuppose acquaintance with the *Virgin and Child* (Frankfurt am Main, Städel. Kstinst.) by the Master of Flémalle, who in a panel of the *Virgin and Child* (St Petersburg, Hermitage) also used the motif of the Child lying across and pulling away from his mother, which is characteristic of Kaschauer. There are also close stylistic affinities between Kaschauer's figures and those of Konrad Witz. The figure type of the enthroned *St Peter* (Vienna, Belvedere) recalls the figures of the *Queen of Sheba before King Solomon* on the wings of the Heilspiegel ('Mirror of Human Salvation') altarpiece (Berlin, Gemäldegal.).

Kaschauer's sculptures are most closely related to the panels of the Vienna Master of the Albrecht Altar, whom Perger identified with Kaschauer on historical grounds. A figure of *St Nicholas* in Oberhautzenthal parish church

(Lower Austria) forms a stylistic link with the 'little Albrecht Altar' (Budapest, Mus. F.A.; Vienna, Belvedere; ex-Kaiser-Friedrich Mus., Berlin, destr.), while a *Man of Sorrows* from the Vienna Hofburgkapelle (Vienna, Akad. Bild. Kst.) is similar to the Christ on the painted Geuss memorial (Vienna, Dom- & Diözmus.). Busts of female saints in Budapest (Mus. F.A.) and Esztergom (Mus. Christ.) and the half-figure of a female saint in Munich (Bayer. Nmus.) also come from Kaschauer's workshop. Of the two groups of the *Virgin and Child with St Anne* in the pilgrimage church of Annaberg near Mariazell and in the church of St Gertrud at Gars-Thunau (Lower Austria), only the first bears Kaschauer's personal style. The other is closer to the female figures on the altarpiece from St Nicholas, Znojmo (Moravia, Czech Republic; now Vienna, Belvedere), which may have been commissioned by King Albert II of Germany (*reg* 1404–39). Its almost crudely direct treatment of the three *Passion* scenes is very closely related to contemporary painting in Munich, above all that of the Master of the Worcester Bearing of the Cross. The style of one of the two wood-carvers is very close to that of Kaschauer and may originate from his workshop.

A few late works have survived. As well as the *Mariazeller Brunnenmadonna* (St Lambrecht, abbey church), which is not entirely by Kaschauer's hand, there are two figures of the *Virgin* in the Württembergisches Landesmuseum, Stuttgart, and the Emil Delmár Collection, Budapest. A probable late work, whose maturity shows knowledge of the late style of Hans Multscher, is the statue of the Holy Roman Emperor *Frederick III* (after 1453) on the heraldic wall of the Georgskapelle at Wiener Neustadt.

BIBLIOGRAPHY

NDB; Thieme–Becker

B. Fürst: *Beiträge zu einer Geschichte der österreichischen Plastik in der 1. Hälfte des 15. Jahrhunderts* (Leipzig, 1931), pp. 50–52, 61

K. Garzarolli von Thurnlackh: 'Jakob Kaschauers und seiner Werkstatt Wappenwand der Georgskapelle in Wiener Neustadt', *Belvedere*, xiii (1938–43), pp. 148–54

L. Baldass: 'Malerei und Plastik um 1440 in Wien', *Wien. Jb. Kstgesch.*, xv (1953), pp. 7–22

L. Muckenhuber: 'Zwei Holzplastiken in niederösterreichischem Privatbesitz', *Unsere Heimat*, xxv (1954), pp. 199–203

D. Radocsay: 'Der Hochaltar von Kaschau und Gregor Erhard', *Acta Hist. A. Acad. Sci. Hung.*, vii (1960), pp. 19–50

F. Dworschak and H. Kühnel, eds: *Die Gotik in Niederösterreich: Kunst, Kultur und Geschichte eines Landes im Spätmittelalter* (Vienna, 1963), pp. 133–5, pls 90–95 [colour pls]

W. Hofstätter: 'Eigenhändige Madonnendarstellungen des Jakob Kaschauer', *Alte & Mod. Kst*, cxxiv–cxxv (1972), pp. 13–21

R. Perger: 'Die Umwelt des Albrechtsaltars', *Der Albrechtsaltar und sein Meister*, ed. F. Röhrig (Vienna, 1981), pp. 16–20

G. Schmidt: 'Die Madonna von der Wiener Neustädter Wappenwand', *Orient und Okzident im Spiegel der Kunst: Festschrift H. G. Franz zum 70. Geburtstag* (Graz, 1986), pp. 315–27

Európai szobrászat szerzemények Delmár Emil gyűjteményéből [European sculpture from the collection of Emil Delmár] (exh. cat., Budapest, Mus. F.A., 1986), no. 28

L. Schultes: 'Zur Herkunft und kunstgeschichtlichen Stellung des Znaimer Altars', *Österreich. Z. Kst & Dkmlpt.*, xlii (1987), pp. 31–3

——: 'Unser und des Reichs Bildhauer', *Kstjb. Stadt Linz* (1992–3), pp. 163–4

G. Schmidt: 'Bildnisse eines Schwierigen: Beiträge zur Ikonographie Kaiser Friedrichs III. Festschrift für Hermann Fillitz', *Aachen. Kstbl.*, lx (1994), pp. 354–5

LOTHAR SCHULTES

Käsebier, Gertrude (Stanton) (*b* Fort Des Moines [now Des Moines], IO, 18 May 1852; *d* New York, 13 Oct 1934). American photographer. She studied painting at the Pratt Institute, Brooklyn, NY (1889–93), and in France and Germany (1894–5). She began her professional photographic career *c.* 1894, as a magazine illustrator, and then *c.* 1898 she opened a portrait studio on Fifth Avenue in New York. Her simplified portrait style dispensed with scenic backdrops and fancy furniture and was soon widely emulated. Robert Henri, Auguste Rodin, Stanford White and the chorus girl Evelyn Nesbit were among her subjects. Beginning in 1898, her studies of mothers and children as well as her portraits were acclaimed at major photographic exhibitions such as the Philadelphia Photographic Salons. Käsebier was a founder-member of the Photo-Secession in 1902, and *'Blessed art thou among women'* was among the photographs featured in the first issue of *Camera Work* in 1903. By 1907 she had begun to drift from the Photo-Secession, exhibiting with them for the last time in 1910. She resigned in 1912. During the second and third decades of the 20th century she was allied with the Pictorial Photographers of America. She closed her portrait studio *c.* 1920, and a retrospective of her photographs was held at the Brooklyn Institute of Arts and Sciences in 1929.

Käsebier generally printed in platinum or gum bichromate emulsions and frequently altered her photographs by retouching a negative or by rephotographing an altered print. She was the leading woman pictorialist photographer of her day and, as a married woman with children who attained success and fame, she became a model for others, including Imogen Cunningham.

WRITINGS

'Studies in Photography', *Phot. Times* [New York], xxx (June 1898), pp. 269–72; repr. in *A Photographic Vision: Pictorial Photography, 1889–1923*, ed. P. C. Bunnell (Salt Lake City, 1980)

BIBLIOGRAPHY

B. L. Michaels: 'Rediscovering Gertrude Käsebier', *Image*, xix (June 1976), pp. 20–32

A Pictorial Heritage: The Photographs of Gertrude Käsebier (exh. cat., ed. W. I. Homer; Wilmington, DE A. Mus., 1979)

B. L. Michaels: *Gertrude Käsebier: The Photographer and her Photographs* (New York, 1992)

BARBARA L. MICHAELS

Kasen'e. Japanese paintings or woodblock prints depicting famous poets and poetesses often accompanied by the inscription of their names, with or without additional biographical information, and representative verses. By integrating calligraphy, poetry and painting in a single format, *kasen'e* ('pictures of poetic immortals') illustrate well the close interrelationship between these three art forms.

1. BEFORE 1185. Originally the poets and poetesses designated in *kasen'e* as sages or 'immortals' (*kasen*) were accomplished masters of *waka*, the 31-syllable Japanese poetic form (also called *tanka*). According to tradition, a debate over the merits of various *waka* poets led the poet and critic Fujiwara no Kintō (966–1041) to name 31 men and 5 women from the Nara (AD 710–94) and Heian (794–1185) periods as 'poetic immortals'. Although the *kasen* were selected, canonized and anthologized during the Heian period, the earliest surviving depictions date from the Kamakura period (1185–1333). They were divided

Lady Saigū Nyōgo Yoshiko (detail), attributed to Fujiwara no Nobuzane, 279×511 mm, handscroll mounted as a hanging scroll, ink and colour on paper, from the Agedatami version of *sanjūrokkasen'e* ('pictures of the 36 poetic immortals', seated on mats), 13th century (Washington, DC, Freer Gallery of Art)

into teams of Right and Left, as if they were contemporaries engaging in a poetry competition of the sort that was common among Heian-period aristocrats.

2. KAMAKURA PERIOD (1185–1333). *Kasen'e* from this period exemplify a taste for decoration and colour, with rich papers and bright pigments; less often they were done in the monochrome *hakubyō* ('white writing') technique, with light tints sometimes added. Many Kamakura-period examples are attributed, some correctly, to Fujiwara no Nobuzane (*see* FUJIWARA (ii), (8)). His father, Fujiwara no Takanobu (*see* FUJIWARA (ii), (6)), is said to have depicted political leaders (e.g. *Minamoto no Yorimoto*, 1179; copy, Kyoto, Jingoji) with a mixture of incisive realism and decorative pattern. While the *kasen'e* attributed to Nobuzane are called 'portraits', they are imaginary ones. Instead of being depicted by a single slanting stroke, Nobuzane's *kasen* have eyes with pupils, and there are some variations in the facial types. His portraits (*nisee*; 'likeness pictures') thus differ from the abstracted doll-like forms found in much court narrative painting.

These works are important early examples of the collaborative impulse in Japanese art: the inscribed portions of the *kasen'e* were often done by leading calligraphers. The names of the 'immortals' and biographical information were inscribed in *kanji* (Chinese characters), while the representative verses were executed in the *kana* (Japanese phonetic) syllabary and a more slender, flowing script. Most Kamakura-period versions of the *sanjūrok-kasen'e* ('pictures of the 36 poetic immortals') were handscrolls, later divided and mounted as hanging scrolls, with one 'immortal' per scroll. Two of the best-known surviving

versions, both traditionally attributed to Nobuzane, are the mid-13th century Satake version named after a former owner and the slightly later Agedatami version (so called because the subjects are depicted raised (*age-*) on *tatami* mats rather than isolated against a blank background). A section of the Satake version can be seen in the depiction of the poetess *Ko Ōgimi* (Nara, Yamato Bunkakan). The Agedatami version is represented by the portrait of the *Lady Saigū Nyōgo Yoshiko* (Washington, DC, Freer; see fig.). The calligraphy in the Agedatami version is attributed to Fujiwara no Tameie (1198–1275), a cousin of Nobuzane.

As the practice of *waka* became less exclusively a courtly pastime, so *kasen'e* broadened to admit a number of variations. Ordinary tradesmen were depicted rather than the usual list of the *kasen*, as for example in *Tōhokuin shokunin uta awasee* ('Picture of the poetry competition among members of various occupations held at the Tōhokuin'; late Kamakura period; Tokyo, N. Mus.).

3. MUROMACHI PERIOD (1333–1568) AND LATER. In the Muromachi period and thereafter *ema* (votive plaques) bearing images and verses of the *kasen* began to be dedicated to various shrines and temples, for example a set by Hinaya Ryūho (1595–1669) in the Myōōin in Fukuyama. Ryūho was also responsible for another variant in which he posed the *kasen* informally and gave them new props and anecdotal touches. He also accompanied their images with inscriptions, not of their *waka*, but with 17-syllable verses (*haiku*) of his own making. Ryūho produced these *kyūsoku kasen'e* ('pictures of relaxing

poetic immortals') in both painted and woodblock-printed versions.

Artists of the Rinpa tradition (*see* JAPAN, §VI, 4(v)) depicted the traditional *kasen* but showed them grouped together as if socializing at a poetry gathering. This variant on the *kasen'e* theme dispensed with inscriptions of name, biography or representative verse and depicted the 'immortals' with varying degrees of gentle caricature. Such treatment of a classical subject demonstrates how thoroughly ingrained the subject was by the middle of the Edo period (1600–1868), even among the merchants for whom the Rinpa artists were painting.

Some later variants used *haikai*, the 17-syllable verse form also known as *haiku*, instead of *waka*. YOSA BUSON was the first to apply the *sanjūrokkasen* theme to 36 followers of the great *haikai* master Matsuo Bashō (1644–94). Buson's painted series, with the figures depicted in an abbreviated fashion that was appropriate for the shorter poetic form of *haiku* and the cursive script (or 'grass script'; *sōsho*) used for the inscription, was published posthumously in several woodblock-printed editions, for example the *Haikai sanjūrokkasen'e* ('Pictures of the 36 immortals of *Haikai*'; 1799 edition; Berkeley, CA, Keigensai Col.). MATSUMURA GOSHUN, YOKOI KINKOKU and others followed with their own versions of the 'immortals' of *haikai*. Although orthodox versions of the *kasen'e* continued to be produced, it was the range of these later variants that gave the tradition its enduring vitality.

See also JAPAN, §§VI, 3(iv) and VII, 2(ii).

BIBLIOGRAPHY

T. Mori: 'Kyūsoku kasen'e ni tsuite' [Concerning the pictures of relaxing poetic immortals], *Kokka*, 852 (1963), pp. 5–17
——: *Uta awasee no kenkyū: Kasen'e* [Research on poetry competition pictures] (Tokyo, 1970, rev. 1978)
Y. Shirabata: 'Kasen'e' [Pictures of poetic immortals], *Nihon No Bijutsu*, 96 (Tokyo, 1974) [whole issue]
T. Mori: *Sanjūrokkasen'e* [Pictures of the 36 poetic immortals], Shinshū Nihon emakimono zenshū [Complete collection of Japanese picture scrolls, new edition], xix (Tokyo, 1979)
M. Graybill: *Kasen'e: An Investigation into the Origins of the Tradition of Poet Pictures in Japan* (diss., Ann Arbor, U. MI, 1983)
T. Kobayashi: 'Yosa Buson no haisenzu' [Yosa Buson's pictures of the immortals of *haikai*], *Edo kaiga shiron* [Discussion of Edo-period painting] (Tokyo, 1983), pp. 169–83
M. Graybill: 'The Immortal Poets', *Masters of Japanese Calligraphy, 8th–19th Century* (exh. cat., ed. Y. Shimizu and J. M. Rosenfield, New York, Japan House Gal. and Asia Soc. Gals, 1984–5), pp. 96–111
T. Mori: 'Shokunin uta awasee ni tsuite' [Concerning pictures of poetry competitions among members of various occupations], *Kobijutsu*, lxxiv (1985), pp. 6–36
Sanjūrokkasen'e [Pictures of the 36 poetic immortals] (exh. cat., Tokyo, Suntory Mus. A., 1986)

JOAN H. O'MARA

Kasetsudō. See KUWAYAMA GYOKUSHŪ.

Kashan [Kāshān]. Town in central Iran *c.* 185 km south of Tehran. Although the region has a long history of settlement (e.g. the ancient site of TEPE SIALK to the south-west) and Kashan itself may have existed in Sasanian times, the founding of the Islamic town is often attributed to Zubayda, wife of the Abbasid caliph Harun al-Rashid (*reg* 786–809). The town became a centre of Imami Shi'ism and was known for its scholars and craftsmen. The Friday Mosque (also known as the mosque of the Old Maydan) was constructed in the 11th century during the period of Saljuq rule; the minaret is dated 1073–4 and the stucco mihrab may be contemporary. The solitary Zayn al-Din Minaret (h. 47 m) may date from the same period. In the 13th and 14th centuries, Kashan was known for the production of ceramics, particularly those overglaze-decorated with lustre or enamel (*see* ISLAMIC ART, §V, 3(iii) and fig. 160). In 1224 the town was attacked by the Mongols, but it regained prosperity in the following decades, and lustre-painted tiles continued to be made there into the 14th century (*see* ISLAMIC ART, §V, 4(i)). The principal building is the Maydan Mosque (1263–4), built by 'Imad al-Din Mahmud Shirvani as part of an ensemble that included a *khānaqāh* on the west and madrasa and hospital opposite. Situated on the south side of a large stone-paved square, the mosque has four iwans and a domed prayer-hall. The magnificent glazed and lustred mihrab (1226; Berlin, Pergamonmus.) was reused from an earlier structure. The qibla iwan and prayer-hall were revetted with glazed tiles when the fine tiled minbar (*c.* 1468) was constructed.

Kashan reached its apogee under the Safavid dynasty (*reg* 1501–1732), when a palace, gardens (*see* GARDEN, §V, 4 and fig. 17), avenues and bazaar were added. Under 'Abbas I (*reg* 1588–1629) the Kurud Dam was constructed to increase the water-supply to the town. The ruler's cenotaph was placed in the Imamzada Habib ibn Musa, the tomb of the son of the seventh Shi'ite imam and the major shrine in the city. In addition to a thriving silk industry, velvets, brocades and carpets were manufactured in Kashan under Safavid rule (*see* ISLAMIC ART, §VI, 4(iii)(c)). The town declined after the fall of the Safavids, and although Karim Khan Zand (*reg* 1750–79) began to rebuild the town following an earthquake in 1779, it never regained its former prosperity. Under Qajar rule several important buildings were constructed, including the Madrasa-yi Sultani (also known as the Masjid-i Shah; 1806–14), the Madrasa-yi Agha (1846–51) and many bazaars. The Bagh-i Fin, a garden watered by a perennial spring some 6 km south-west of the city, contains a palace of Fath 'Ali Shah (*reg* 1797–1834). Decorated with portraits of the Shah and his sons, the palace fell into neglect in the mid-19th century but was restored in 1935. In the 20th century wide streets were cut through the town in an attempt to modernize it and encouragement given to the velvet and carpet industries.

Enc. Islam/2
BIBLIOGRAPHY
R. Ettinghausen: 'Evidence for the Identification of Kāshān Pottery', *A. Islam.*, iii (1936), pp. 44–75
O. Watson: 'Persian Lustre-painted Pottery: The Rayy and Kashan Styles', *Trans. Orient. Cer. Soc.*, xl (1973–5), pp. 1–18
——: *Persian Lustre Ware* (London and Boston, 1985)
B. O'Kane: 'The Tiled Minbars of Iran', *An. Islam.*, xxii (1986), pp. 133–54
L. Golombek and D. Wilber: *The Timurid Architecture of Iran and Turan* (Princeton, 1988), i, pp. 390–92
S. S. Blair: *The Monumental Inscriptions from Early Islamic Iran and Transoxiana* (Leiden, 1992), pp. 147–8

□

Kashani. See *under* ABU TAHIR.

Kashgar [Kashi; Chin. Shufu, Shule]. Important trading town in the western part of the Xinjiang Uygur Autonomous Region, China. Kashgar is located where the northern and southern branches of the SILK ROUTE met before

the crossing of the Pamirs into Afghanistan and India. Buddhism is likely to have been introduced here as early as the 1st century AD. Information on ancient Kashgar can be found in the *Fa xian zhuan* ('Faxian account') by the pilgrim–monk Faxian (*fl* 4th–5th century) and in the *Da Tang xiyou ji* ('Great Tang record of travelling to the west') by Xuanzang (600–64). The latter reports that the town was a centre of the Sarvastivadin sect of Buddhism, and that the local community consisted of some 10,000 monks living in several hundred temples. This source also mentions that the people of Kashgar made fine carpets of wool. The town was under Chinese control from 685 until the late 8th century. The Korean monk Hyech'o's account from the late 8th century mentions the presence of the Dayun Temple run by Chinese monks in the town. At that time the ruler was a Nestorian prince. From the mid-10th century onwards the town came under the influence of Islam as Kashgar became the main centre of the Turkic Qarakhanid khanates (*c.* 930–1130).

There are few traces of Buddhism in present-day Kashgar and its vicinity. Most notable is the stupa in Moritim. South of the town there are three small votive caves, now called Sanxian dong (Three Immortals Caves), which contain fragments of wall paintings and clay statues dating to the 3rd century AD or early 4th. The main structures are all connected with Islam, the most prominent being the Atikar (Aidkah) Mosque, built during the Ming period (1368–1644). It has a central gate with one minaret on either side. The prayer-hall is 32 bays wide; it is open at the front and has a large inner sanctum, which protrudes into the main hall from the back wall. There is a series of ancillary buildings along the walls of the mosque. An old Muslim school, the Maidelis, from the Qarakhanid period, is in the town centre. Outside Kashgar are a number of Muslim tombs and old residential buildings including the tomb and mosque of the 17th-century ruler Abakh Khoja, the ruins of the palace at Hanoyi *c.* 30 km to the east, and the Sudanmazha and Arslanmazha mausolea of prominent rulers of the Qarakhanid khanates.

BIBLIOGRAPHY

H. G. Franz, ed.: *Kunst und Kultur entlang der Seidenstrasse* (Graz, 1986/*R* 1987)
Zongjiao jianzhu [Religious architecture] (1988), iv of *Zhongguo meishu quanji* [Collection of Chinese art] (Beijing), pls pp. 180–83, text pp. 58–9
Xinjiang shiku bihua [Wall paintings in the caves of Xinjiang] (1989), xvi of *Zhongguo meishu quanji* [Collection of Chinese art] (Beijing), pls pp. 5–7, text pp. 1–2

HENRIK H. SØRENSEN

Kashi. *See* VARANASI.

Kasia. *See* KUSHINAGARA.

Kasım Ağa (*b* Garmish, Berat, Albania; *d* Istanbul, *c.* 1660). Ottoman architect. He followed the typical career path for an architect at the Ottoman court: recruited as a janissary, he was trained in the imperial palace in Istanbul before his appointment (by 1626–7) as chief court architect. Twice exiled because of court intrigues and the fall of fellow Albanian officials, he always managed to return to the capital. Although Kasım Ağa had general responsibility for all imperial foundations during his tenure as chief court architect (*c.* 1623–44 and 1645–51) and for many of

the projects commissioned by senior members of the Ottoman ruling élite, his exact role in the design and execution of these projects is unclear. Works frequently credited to him personally include the Çinili complex (1640) at Üsküdar in Istanbul and the Revan and Baghdad kiosks (1635 and 1638) in the Topkapı Palace there. He is said to have completed the Sepetciler Kasrı (1643) at Sarayburnu and to have worked on the Yeni Valide Mosque at Eminönü. He was almost certainly in charge of the conversion in 1638–9 of the baptistry to the south of Hagia Sophia into a tomb for Sultan Mustafa I (*reg* 1617–23 with interruption). It is uncertain whether Kasım was directly involved in the design of the Sultan's fountains at Berat in Albania, mentioned by the Ottoman traveller Evliya Çelebi (1611–84), or other pious foundations mentioned in the Sultan's endowment deed. The only buildings for which documentary evidence exists about Kasım's role are the stables (1630–34) and Baltacılar Dairesi (1639–40), which he erected in the Üsküdar Palace at Istanbul, but both these buildings have been destroyed.

BIBLIOGRAPHY

Enc. Islam/2; *İslam Ansiklopedisi*
Evliya Çelebi: *Seyâhatnâme* (*c.* 1684) [Book of travels], viii (Istanbul, 1928), p. 695
A. Refik: *Türk mimarları* [Turkish architects] (Istanbul, 1936), pp. 34–48
L. A. Mayer: *Islamic Architects and their Works* (Geneva, 1956), p. 114
S. Eyice: 'Mimar Kasım hakkında' [Concerning the architect Kasım], *Türk Tarih Kurumu: Belleten*, xliii (1979), pp. 767–808

HOWARD CRANE

Kasimir III, King of Poland. *See* PIAST, (1).

Kaskipuro, Pentti (*b* Helsinki, 10 Oct 1930). Finnish printmaker. He was self-taught, and he first exhibited publicly in 1953, becoming almost immediately the leading figure among the younger generation of Finnish graphic artists. During the 1950s he explored etching and drypoint, producing realistic depictions of such subjects as the fleeting landscape seen from a train window or human figures from his immediate environment. At the beginning of the 1960s he adopted the intimate, simplified still-life that remained his subject area. His work, in response to contemporary developments in art or in society, remained unchanged.

Kaskipuro's still-lifes use aquatint and drypoint. They have their origins in everyday, realistic themes, such as a block of wood, bread, vegetables or a milk carton on a table (e.g. *Egg, Sausage and Fork*, 1975; *Three Onions*, 1979; both artist's col.). These closely observed arrangements are encompassed by a still, dusky light, showing that Kaskipuro's intentions lie beyond simple, realist still-life. They contain timeless, unreal and solemn qualities reminiscent of Surrealism, and they thus transcend the everyday. As a teacher, Kaskipuro was a major influence on the younger generation of graphic artists in Finland.

BIBLIOGRAPHY

W. Timm: 'Pentti Kaskipuro', *Projekt* (1977), no. 2
J. Weichardt: 'Pentti Kaskipuro Finnland', *12 Künstler aus 12 Ländern* (exh. cat., Wilhelmshaven, Ksthalle, 1977), pp. 19–22
L. Hamberg: 'Pictorial Artist of the Year Pentti Kaskipuro', *Suomi—Finland U.S.A.*, 4 (1979) [bilingual text], Eng. pp. 29–31
One and a Half Potatoes: Pentti Kaskipuro (exh. cat. by J. O. Mallander, Helsinki, Cathedral crypt, 1979)
S. Niinivaara: *Pentti Kaskipuro: Grafiikkaa/Grafik/Graphics, 1952–1982* (Helsinki, 1982), Eng. pp. 21–7

K. Mestari: *Juhlakirja Pentti Kaskipuron täyttäessä 60 vuotta 10.10.1990* (Vantaa, 1990)

LEENA PELTOLA

Kaspé, Vladimir (*b* Harbin, Manchuria [now China], 3 May 1910). Mexican architect, teacher and writer, of Russian descent. In 1926 he settled in Paris, where between 1929 and 1935 he studied at the Ecole des Beaux-Arts under Georges Gromort. He moved to Mexico in 1942, where he combined editorial work on the periodical *Arquitectura México*, run by Mario Pani, with his first commissions in Mexico City, among them the 'Albert Einstein' Secondary School (1949), with walls of exposed brick. Other examples of his educational architecture, notable for their formal austerity, include the Liceo Franco-Mexicano (1950) and the Facultad de Economía (1953; with J. Hanhausen), Ciudad Universitaria, both in Mexico City. From the 1950s to the 1970s Kaspé continued building in Mexico City; outstanding examples of his work are the Centro Deportivo Israelita (1950–62), Periférico Norte; the Laboratorios Roussel (1961), Avenida Universidad y M. A. Quevedo; and the offices of Supermercados S. A. (1962), Calzada Vallejo. Between 1945 and 1975 he also built more than 30 houses in Mexico City. He was an outstanding teacher of the theory and analysis of architecture at the Universidad Nacional de México (1943–73) and at other universities in Mexico City.

WRITINGS
Arquitectura como un todo (Mexico City, 1986)

ALBERTO GONZÁLEZ POZO

Kasper, Ludwig (*b* Gurten, 2 May 1893; *d* Braunau, 28 Aug 1945). Austrian sculptor. From 1909 to 1912 he attended a wood-carving school at Hallstadt in Upper Austria. A patron was instrumental in arranging his entry into the household of the landscape painter Toni von Stadler (1850–1917), where he became a friend of his host's son, Toni Stadler. He began a course at the Kunstakademie in Munich in 1912, but this was interrupted by World War I. Until 1925 he studied under Hermann Hahn (ii). After a further year of study in Paris in 1928–9 and his first stay in Berlin, he worked in Berna in Silesia (1930–33). While there he began his series of statues of young girls, men and children; with their severe poses and careful, prescribed arm movements the figures give the impression of being spellbound (e.g. *Standing Girl*, 1931; Linz, Oberösterreich. Landesmus.). When Kasper moved to Berlin in 1933 his tectonic style was already fully developed. He and his wife Ottilie Kasper (*b* 1906), a painter and sculptor, were among the first artists to join the studio cooperative known as Klosterstrasse in 1933, and both soon became the centre of a heterogeneous circle of artists. Ludwig Kasper had a strong influence on his colleagues, including Hermann Blumenthal, and also on Gerhard Marcks.

In 1936 Kasper was awarded a scholarship for a six-month period of study in Greece. His encounter with ancient sculpture confirmed his style, for example *Caryatid* (1936) and *Kore I* and *II* (1937; both Linz, Oberösterreich. Landesmus.). The Rome Prize of the Preussische Akademie der Künste, which he won in 1939, enabled him to spend a year in Italy. In 1943 he started teaching in Brunswick, but after heavy bombing in 1944 he moved back to Upper Austria. The works from his estate are in the Oberösterreichisches Landesmuseum at Linz.

BIBLIOGRAPHY
C. G. Heise: 'Ludwig Kasper', *Kst Alle: Mal., Plast., Graph., Archit.*, lii/1 (1936), pp. 42–7
W. Haftmann: *Ludwig Kasper* (Berlin, 1939)
——: *Der Bildhauer Ludwig Kasper* (Frankfurt am Main, Berlin and Vienna, 1978)
G. Schmidt: *Ateliergemeinschaft Klosterstrasse, 1933–1945* (Berlin, 1988)

URSEL BERGER

Kasprzycki, Wincenty (*b* Warsaw, 1802; *d* Warsaw, 27 May 1849). Polish painter and lithographer. He first studied painting under Konstanty Villani (1751–1824), who managed the gallery owned by Kasprzycki's patron, Count Józef Kajetan Ossoliński (1764–1834). He continued his studies first at the Department of Fine Arts at Warsaw University, then (1821–8) at the University of Vilna (now Vilnius, Lithuania) under Jan Rustem (1762–1835). He settled in Warsaw and in 1828 exhibited five oil paintings, one of which, *View of an Exhibition of Fine Arts in Warsaw in 1828* (1828; Warsaw, N. Mus.), is the first Polish visual record of an exhibition of paintings and visitors, including in this case Kasprzycki himself and the artists Antoni Brodowski, Jan Antoni Blank (1775–1844) and Marcin Zaleski (1796–1877).

From 1832 until at least 1843, Kasprzycki worked for Count Aleksander Potocki (1776–1845). In 1832–4 he painted seven views of the Count's residences near Warsaw, including the Wilanów and Natolin palaces, viewed from the yard and the park, and a view of Morysinek (all Warsaw, N. Mus.). In these works the competent rendering of architecture linked with a record of the surrounding parks marked a new trend in Polish landscape painting. A few years later he made a series of drawings and watercolours showing picturesque details of Potocki's residences and palace interiors, nine of which were exhibited and won prizes in 1838 (destr. 1944). Kasprzycki's further views of Warsaw and interiors of the city's palaces and churches were clearly influenced by the treatment of light in the work of Bernardo Bellotto, as in *Bank Square* (1833) and *Demolition of St Clare's Church and Bernardine Nunnery* (1843; both Warsaw, Mus. Hist. City). A late painting, *Vistula Embankment* (1847; Warsaw, N. Mus.), is an almost pure landscape with elements of both realism and romantic sentiment. He painted some genre scenes and portraits, and he also produced lithographs, including portraits of the actor *Wojciech Piasecki* (*c.* 1840) and the dancer *Teodora Gwozdecki* (*c.* 1837–43) and such landscape views as *Belvedere Palace (Warsaw)* (1844). After 1840 he made four cosmoramas (destr.), incorporating naturalistic effects. With Zaleski, Kasprzycki was ranked by contemporaries as among the foremost painters working in the tradition of Bellotto.

SAP

BIBLIOGRAPHY
A. Ryszkiewicz: 'Wincenty Kasprzycki, *Widok wystawy sztuk pięknych w Warszawie w 1828 r.*' [Wincenty Kasprzycki, *View of the Fine Arts Exhibition in Warsaw in 1828*], *Biul. Hist. Sztuki*, xiv/3 (1952), pp. 84–91
S. Kozakiewicz: *Malarstwo Polskie: Oświecenie, Klasycyzm, Romantyzm* [Polish painting: Enlightenment, Classicism, Romanticism] (Warsaw, 1976)

ZOFIA NOWAK

Kasr el-Heir. *See* QASR AL-HAYR EAST and WEST.

Kassai, István. *See* STEFAN.

Kassák, Lajos (*b* Ersekujvar, Hungary, 21 March 1887; *d* Budapest, 22 July 1967). Hungarian writer, painter, theorist, collagist, designer, printmaker and draughtsman. His family moved to Budapest in 1904, and, after finishing an apprenticeship as a blacksmith, in 1908 he began publishing stories and poems. In 1909–10 he travelled across Western Europe and spent some time in Paris, becoming acquainted with modern art and anarchist ideas. He published short stories, plays and poems in Budapest and from November 1915 he edited the periodical *A Tett* ('The deed'), which was anti-militarist and discussed socialist theories and avant-garde ideas. In summer 1916 he spent time in the Kecskemét artists' colony with his brother-in-law Béla Uitz and under his influence executed his first ink drawings (e.g. *Landscape*, 1916; Budapest, N.G.). Progressive young artists and aesthetes grouped themselves around Kassák; after *A Tett* was banned in September 1916, he started in November a new periodical, *MA* ('Today'; *see* MA GROUP), which he edited with Uitz (to 1919) in Budapest. From 1916 he promoted the Hungarian Activists (*see* ACTIVISTS) and contemporary Hungarian and international trends in *MA*; he went against tradition, trusting in the collective force of artistic activity and referring to the art of other cultures. He also organized both one-person and group exhibitions of the latest Hungarian art at the *MA* premises. Kassák refused to accept the tyranny of the Hungarian Soviet Republic, which was hostile to *MA*'s activities, and after *MA* was banned (July 1919) he moved to Vienna in 1920, where he continued to publish it (1920–26). In 1921 he published the pamphlet *Bildarchitektur* (repr. with linocuts as 'Kép-architektura', *MA*, vii/4, 1922), in which he described his new concept of 'building on the flat surface'; he strove to link up with international modern art trends, amalgamating Eastern and Western constructivist ideas; he produced a series of graphics and paintings with geometric compositions, at first with Sándor Bortnyik, such as *Pictorial Architecture* (1922; Nuremberg, Ksthalle), containing imaginary futurist constructions. His style at that time bore a relation to El Lissitzky's *Proun* works. Kassák published the *Buch neuer Künstler* (1922) with László Moholy-Nagy, which described his new pictorial approach and technique and his pursuit of pictorial parallels in modern art.

Kassák maintained relations with a number of European avant-garde groups; he visited Berlin in 1922 and exhibited in 1924 in the Sturm-Galerie there, and in Vienna. He continued writing poetry and prose and in 1924 began his autobiography, *Egy ember élete* ('The life of one man'). He also organized artistic events and took part in *MA* events outside Hungary in 1921 and 1922. He experimented with plastic forms in the spirit of the De Stijl movement, his use of geometric blocks being similar to that of Georges Vantongerloo. There was a close relationship between *MA* and De Stijl: Kassák published the writings of Theo van Doesburg and his circle, and Kassák's works were reproduced in the *De Stijl* periodical. His *Dynamic Construction* (1924; see Vadas) was published by *Der Sturm*, and *Plan of an Advertising Kiosk* (1922; Nuremberg,

Ksthalle) reflects the influence of the German Bauhaus in its use of simple forms and planes. He also continued his activities as a graphic artist, and he designed (and intended to write) the planned 18th volume of the Bauhausbücher on Hungarian Activism. In 1922 he started making collages; his earliest pieces, such as *Collage Dad* (1923; untraced, see 1987 Budapest exh. cat., no. 136), reveal a strong Dadaist influence; *Collage 1925* was made for a Viennese theatre; the *Self-portrait* of 1964 (both Budapest, Lajos Kassák Mem. Mus.) was a remodelling of a 1923 original. From 1926 he edited *2X2* and *Dokumentum*, both short-lived Activist periodicals. He produced the periodical *Munka* (1928–39) and organized the Munka-Kört ('Working circle'), a group of Socialist young workers, intellectuals, painters and documentary photographers who worked together; he also organized a unique speech choir. His poetry, novels and articles were published in series during this period. After World War II he belonged to Európai Iskola (*see* EUROPEAN SCHOOL) and edited the literary periodicals *Alkotás* and *Kortárs*, but between 1949 and 1956 he had to leave Budapest for political reasons, and he turned once more to fine art, producing line drawings, figurative compositions and continuing with his 'Bildarchitektur' in a series of oils (*Pictorial Architecture*, 1958; Budapest, Lajos Kassák Mem. Mus.; *Monumental*, 1966; Budapest, N.G.). In 1957 he had a retrospective exhibition at the Csók Galería in Budapest and another in 1961 at the Galerie Denise René in Paris of 12 screenprints made with Viktor Vasarely, which he published as a Constructivist portfolio. In 1965 ten of his early linocuts were published in Basle as *Bildarchitektur Kassák*.

PRINTS

with V. Vasarely: *Kassák et Vasarely: 12 sérigraphies* (Paris, 1961)

WRITINGS

'A plakat és az uj festészet' [The poster and the new painting], *MA*, i/1 (1916), pp. 2–4
'Az Aktivizmus' [Activism], *MA*, iv/1 (1919), p. 4
with L. Moholy-Nagy: *Buch neuer Künstler* (Vienna, 1922)
Az új Művészet él [The new art lives] (Cluj, 1926)
Egy ember élete [The life of one man], 8 vols (Budapest, 1927–34)
Vallomás 15 Művészről [Statement about 15 artists] (Budapest, 1942)
Művészetünk Nagybányától napjainkig [Our art from Nagybanya until today] (Budapest, 1947)
MA (Basle, 1968)
with I. Pán: *Az Ismusok története* [The history of Isms] (Budapest, 1972)

BIBLIOGRAPHY

E. Gáspár: *Lajos Kassák: The Man and his Work* (Vienna, 1924)
I. Bori and E. Körner: *Kassák Irodalma és festészete* [Kassák's literature and painting] (Budapest, 1967)
G. Rónay: *Lajos Kassák* (Budapest, 1971)
T. Straus: *Kassák* (Cologne, 1975)
J. Vadas: *Kassák a konstruktőr* [Kassák the constructor] (Budapest, 1979)
Lajos Kassák, 1887–1967 (exh. cat., ed. E. Körner and others; Budapest, N.G., 1987)
Lajos Kassák, 1887–1967 (exh. cat., E. Berlin, Akad. Kst. DDR, 1987) [Essays by F. Csaplár, T. Frank]
Wille zur Form (exh. cat., ed. J. Schilling; Vienna, Hochsch. Angewandte Kst, 1993) [Pol. and Hung. avant-garde in Vienna]

For further bibliography *see* ACTIVISTS.

ÉVA BAJKAY

Kassel [Cassel; anc. Cassala]. German town in Hesse. Until 1866 it was the capital of Hesse and until 1945 of Hesse-Nassau. It is situated on the banks of the River Fulda, in a valley known as the Kassel Basin, and before

its destruction in World War II it was regarded as one of the most picturesque towns in Germany.

1. History and urban development. 2. Centre of ceramics production. 3. Wilhelmshöhe.

1. HISTORY AND URBAN DEVELOPMENT. Kassel was first mentioned in AD 913 and was elevated to the status of a town at the beginning of the 13th century by the Landgraves of Thuringia. Henry I, Landgrave of Hesse (*reg* 1265–1308), built a new town (Unterneustadt) on the right bank of the river opposite the old town (Altstadt); in 1328 Landgrave Henry II (*reg* 1311–28) founded the area known as Freiheit, south-west of the Altstadt on the left bank, where he built the St Martinskirche, which was made collegiate in 1364. From the 15th century Kassel was the seat of the Landgraves of Hesse (*see* HESSE-KASSEL). In 1527 the ideas of the Reformation were accepted in the principality.

The son of Philip the Generous, Landgrave William IV (*reg* 1567–92), who founded the Hesse-Kassel dynasty, completed the castle, thus creating the first of Kassel's focal points. His son and successor, Maurice, tried to increase the prosperity of the small residential town from 1615 by encouraging the settlement of the Dutch. It was under Charles, Landgrave of Hesse-Kassel, however, that the town's fortunes rose; and it was Charles who was responsible for the creation of two notable landmarks in urban building and garden history: Karlsaue Park on the left bank of the Fulda, and Karlsberg (later Wilhelmshöhe; *see* §3 below) on the slopes of the Habichtswald.

The development and prosperity of Kassel increased significantly with the arrival of the Huguenots, for whom Charles issued a 'freedom concession' on 18 April 1683. In the following years some 4000 Huguenots settled not only in several newly established villages in the region but also in the capital. A completely new district of Kassel, the Oberneustadt (destr. 1944), was built for them from 1688 on the area known as Weinberg, directly south-west of the Altstadt and separated from it by the city walls. The gradual expansion of Oberneustadt and its union with the Altstadt took nearly a century to complete.

The Du Ry family was closely associated with the layout and expansion of Oberneustadt. The first house in the area, for which the foundation stone was laid in 1688, was the home of Paul Du Ry (*see* DU RY, (2)), an architect and army captain who entered the service of Landgrave Charles, on the recommendation of William III, Prince of Orange, after the revocation of the Edict of Nantes in 1685. The basic layout of Oberneustadt had probably largely been established when he took office, as suggested by numerous earlier sketches, but he is credited with the further elaboration of the plans, particularly the design of the houses. Four parallel streets still influence the appearance of the town: Obere Königsstrasse, Karlsstrasse, Frankfurterstrasse and Schöne Aussicht. The private buildings constructed by Du Ry in the Frankfurterstrasse and Karlsstrasse were almost all two-storey houses, each of only three bays and uniform in appearance. Each block was conceived as a complete entity, and only the corner houses were articulated with pilasters. In addition to many houses, Paul Du Ry built the Calvinist Karlskirche (1698–1710) in Oberneustadt, which formed the architectural

focus of the entire scheme, as well as Prince Wilhelm's Palais (1703–11) and his small Schloss Bellevue (1714; altered 1790 by Simon Louis Du Ry; now the Brüder Grimm-Museum), originally intended as an observatory.

Paul Du Ry's son, Charles Louis Du Ry, took over his father's office as chief architect of the new town in 1715 and was responsible for extending Karlsstrasse as far as Wilhelmsplatz (now Messplatz) and Königsstrasse as far as Wilhelmsstrasse (*see* DU RY, (3)). Besides his own house in Karlsstrasse, other buildings by him include the mint (Münze) on Karlsplatz and the home of the manufacturer Landré on Königsstrasse; he was also involved in building the Gemäldegalerie.

Simon Louis Du Ry (*see* DU RY, (4)) was commissioned to link Oberneustadt to the Altstadt after the fortifications had been dismantled in 1765. The esplanade leading to Friedrichsplatz was altered, and Königsplatz was laid out according to his plans. The layout of Opernplatz and Wilhelmsplatz is also his work. He built the Palais Jungken in 1767, the Elisabethkirche in 1770–74 and the Museum Fridericianum—one of Europe's first museums—from 1769 to 1779 (for illustration *see* DU RY, (4)), all on Friedrichsplatz; the Posthaus, Schliefen's house, and the house of the sculptor Johann August Nahl on Königsplatz; and the house of General von Spohr (later the palace of the Princess of Hanau) and Zanthier's house (later Lyzeum Fridericianum) on Königsstrasse. Opernplatz was created in 1765 when Du Ry converted Prince Maximilian's Palais into an opera house, building as a companion piece the house of the manufacturer Roux. He also designed the Palais Waitz zur Eschen, which closed off the square. The Messhaus (1769–73), the Rathaus (1770–75), the French hospital (1769–73) and his own private residence were all built to his designs on Wilhelmsplatz. He built the barracks of the Gens d'Armes in 1768. The building of the Auetor (1782) completed the construction of the town walls. Oberneustadt was regarded as a copybook example of a Huguenot town, with rows of rectangular buildings of identical size such as had been traditional in towns founded *c.* 1600 and with the Karlskirche as its focus. In the later parts of the development the squares and façades were also regular in shape.

Other important Baroque buildings in Kassel included the Orangerieschloss (1703–30; destr. 1944) in Karlsaue park, built by Landgrave Charles with the probable involvement of Paul Du Ry, possibly according to a design first laid down by Giovanni Francesco Guerniero (1665–1745), architect of the Riesenschloss on Wilhelmshöhe. The Orangerie itself was almost totally destroyed in 1944 and was rebuilt in 1977 as an exhibition hall. The Marmorbad (1722–30), also in Karlsaue park, contains a decorative scheme that is dominated by busts and marble reliefs by PIERRE-ETIENNE MONNOT, who created a mythological cycle for the building dated 1720 and executed in Rome.

The Karlsaue itself, which is *c.* 3 km long, was converted from a Renaissance garden to form a formal Baroque park, the complete restoration of which had yet to be carried out by the late 1990s. In the post-war redevelopment of Kassel, the Karlsaue has effectively been separated from the town, not only by large office buildings of the 1960s but also by the layout of the roads.

Between 1757 and 1760, during the Seven Years War, Kassel was besieged several times by the French. The dismantling of the town's fortifications by Landgrave Frederick II opened up new possibilities for urban development. Hessian soldiers were hired out to England for its war against the rebellious American colonies, bringing substantial sums of money into the region and enabling Frederick II's successor, Landgrave William IX (later Elector William I; *reg* 1785–1821), to embark on an extensive building programme. The nearby Schloss at Wilhelmsthal, begun under William VIII to designs by François de Cuvilliés I, decorated and furnished under Frederick II, was completed, and Schloss Wilhelmshöhe was built.

From 1806 to 1813 Jérôme Napoléon, King of Westphalia and the younger brother of Napoleon I, ruled from Kassel. He helped to propagate the Empire style in the town, and he was particularly active in encouraging arts and crafts until the collapse of Napoleonic rule. Elector William II (*reg* 1821–47) oversaw the completion of several building projects, particularly in the park at Wilhelmshöhe. In 1866, following the Prussian War, Kassel became the capital of the Prussian province of Hesse-Nassau and the favourite summer residence of Emperor William II.

The transport developments of the 19th century, particularly the construction of the railway, led to the further expansion of Kassel, including the Vorderer Westen district, where several large houses of the period have survived. Other pre-war developments at Kassel included the construction of the Bildergalerie (1878–80; now the Neue Galerie) and the Hessisches Landesmuseum (1913). In 1944 Kassel was almost completely destroyed by bombing, but it has since been rebuilt as a modern town. The international contemporary art exhibition Documenta was initiated in the ruins of the town in 1955 by Professor Arnold Bode.

BIBLIOGRAPHY
Die Karlsaue in Kassel: Amtlicher Führer der Verwaltung der staatlichen Schlösser und Gärten (Bad Homburg, n.d.)
A. Holtmeyer: *Alt-Cassel* (Marburg, 1913)
——: *Kassel-Stadt* (1923), vi of *Die Bau- und Kunstdenkmäler im Regierungsbezirk Kassel* (Kassel, 1901–34)
D. Watkin and T. Mellinghoff: *German Architecture and the Classical Ideal, 1740–1840* (London, 1987), pp. 237–45
H. Stubenvoll and W. Stubenvoll: *Hugenottenstädte in Deutschland* (Frankfurt am Main, 1989)

W. STUBENVOLL

2. CENTRE OF CERAMICS PRODUCTION. In 1680 Charles, Landgrave of Hesse-Kassel, built a faience factory in Kassel for the production of blue-and-white wares, which were influenced by Delftware. It was first directed by Georg Kumpfe; then, in 1694, it was leased to Esaias de Lattré, the first of many leaseholders who were all faced with financial difficulties. Nevertheless, production of faience continued until *c.* 1780. From 1766 to 1788 porcelain was also produced under the manager Baron Waitz. At first the factory produced such wares as tea- and coffee-services, boxes and small baskets; later production included complete table-services, chandeliers and figures. The painting and relief decoration were mainly inspired by the factories of Meissen and Fürstenberg.

BIBLIOGRAPHY
S. Ducret: *Die Landgräfliche Porzellanmanufaktur Kassel, 1766–1788* (Brunswick, 1960)
A. Klein: *Deutsche Fayencen* (Brunswick, 1975)

WALTER SPIEGL

3. WILHELMSHÖHE. The castle and park, known as Wilhelmshöhe since 1798, lie *c.* 7 km west of Kassel, at the foot of the Habichtswald. The present layout was begun by Landgrave Charles of Hesse-Kassel, who, inspired by buildings and gardens seen on his journey to Italy in 1699–1700, decided to replace the Moritz-Schloss built by Landgrave Maurice (*reg* 1592–1626). The focal point of the layout, and the symbol of Kassel, is Giovanni Francesco Guerniero's monumental Riesenschloss (see fig.), an octagonal pavilion on the summit of the hill, surmounted by a copy (9.7 m high) made of beaten copper in 1713–17 of the Farnese *Hercules*. Guerniero planned a series of cascades descending in 600 stepped levels for 1 km from a pool below the Riesenschloss to the Green Fountain; but only the top third of the scheme was completed (1701–18). The creation of the 'Chinese' village of Mulang within the grounds during the reign of Landgrave Frederick II marked the transition of the Italian Baroque layout of the park to English-style landscape gardens (1782–5).

Schloss Wilhelmshöhe itself lies on the axis between the *Hercules* figure above the cascades and the Königsallee leading to the centre of Kassel. Landgrave William IX (*reg* 1785–1803; Elector William I 1803–21) was responsible for creating the present huge complex, for which he

Kassel, Wilhelmshöhe, the Riesenschloss and cascades by Giovanni Francesco Guerniero, 1701–18

employed Simon Louis Du Ry and Heinrich Christoph Jussow. The Weissenstein wing to the south was built first; its interior decorations are among the finest examples of the Biedermeier and Empire styles. The church wing to the north followed. The central block was built 1791–1801. Thus the new Schloss building consisted of three separate wings linked by open terraces that were later enclosed (1829). After damage sustained in World War II, the central block was reconstructed (1960s) and an art gallery established there. To the north of the castle a series of single buildings was erected, for example a theatre (1808–9) by Leo von Klenze, which later became a ballroom (1828). Elsewhere in the park were many little houses (of which only a few survive), as well as a pagoda, a tomb of *Virgil* (*c*. 1775), grottoes, a Hermitage of Socrates (1780), a temple to Mercury (1782–3), a pyramid, and many waterfalls and other attractions. HEINRICH CHRISTOPH JUSSOW designed two ruins, the Roman aqueduct and the Löwenburg, built between 1793 and 1801 in the south-west area of the park. Created to resemble a ruined 'English' medieval castle, it was intended to serve as the Landgrave's mausoleum and as a historical museum: its fine interior decorations and furnishings have been completely preserved.

BIBLIOGRAPHY

G. F. Guerniero: *Deliniatio montis* (Rome, 1705; Ger. trans., Kassel, 1706)

A. Holtmeyer: *Kreis Kassel-Land* (1910), iv of *Die Bau- und Kunstdenkmäler im Regierungsbezirk Kassel* (Kassel, 1901–34)

Schloss Wilhelmshöhe: Amtlicher Führer der Verwaltung der staatlichen Schlösser und Gärten (Bad Homburg, 1939, rev. 3/1974)

W. STUBENVOLL

Kasselik. Hungarian family of architects, of Austrian descent. Fidél Kasselik (*b* Waidhofen an der Ybbs, Lower Austria, *c*. 1760; *d* Pest [now Budapest], 26 May 1830) studied in Vienna. In his early works, such as the single-towered parish church (1803–9) in the Erzsébetváros district of Pest, he used elements of the late Baroque. The twin-towered façade of the parish church (1810–14) in the Józsefváros district is more classical in appearance. He built several apartment houses in Pest in a simple Neo-classical style, yet the unpretentious country house (*c*. 1812–15) of the Ürményi family at Vereb, in the county of Fejér, still displays Baroque features. In 1816 he prepared a design (unexecuted; Budapest, Pest Co. Archv) for a theatre in Pest. His son Ferenc Kasselik (*b* Pest, 1795; *d* Budapest, 9 Dec 1884) studied in Vienna, then visited Germany, Paris and London. He was a building contractor as well as an architect and was responsible for more than 400 buildings in Pest. Among these are a great number of residential blocks, some villas in a restrained Neo-classical style and the large Neo-classical Emmerling Hotel (1840). The county hall (1833–5) at Balassagyarmat was also erected to his design; it is a long, Neo-classical building comprising two storeys. He remodelled the town hall of Pest (from 1836; destr. 1900), adding to it a third storey and a tower with a spire derived from the Baroque style. His designs (1842; unexecuted; Budapest, Kiscelli Mus.) for a parish church at Lipótváros, Pest, show that he envisaged a large, awkward structure with a high drum and flat dome.

BIBLIOGRAPHY

A. Zádor and J. Rados: *A klasszicizmus építészete Magyarországon* [The architecture of Neo-classicism in Hungary] (Budapest, 1943), pp. 137–50

JÓZSEF SISA

Kassite. A people who ruled MESOPOTAMIA for almost 500 years in the 2nd millennium BC. Though their reign was longer than any other dynasty, little is known about them. They were probably of Caucasian stock, governed by an Indo-Aryan aristocracy; this is reflected in their names and those of their gods, which first appear in the 18th century BC. They were thought to have come from the Zagros, but there is little evidence for this, and they are more closely connected with Hana (*see* TERQA) on the middle Euphrates, where a king bearing the Kassite name Kashtiliash ruled *c*. 1700 BC. When the First Dynasty of Babylon fell to the Hittites in 1595 BC, the Kassites stepped into the power vacuum. From the king lists it is known that a succession of Kassite kings reigned in Babylon, but for almost two hundred years archaeological and written records are lacking.

One of the reasons for this 'dark age' is the fact that the Kassites completely assimilated Mesopotamian language and culture. There is no cultural and artistic break, and existing buildings were maintained and restored. The first Kassite building known is the Inanna temple built by Karaindash *c*. 1420 BC at Uruk. It is rectangular, with the cella at the end of the long axis, and has remarkable bastions reinforcing the four corners. In typical Mesopotamian fashion the outer wall was decorated with niches, but these contained alternating life-size figures of gods and goddesses linked by carved bands of water flowing from the vessels they held. The figures were made of moulded bricks (Berlin, Pergamonmus.; Baghdad, Iraq Mus.).

The chronology of the 14th century BC is complicated by the fact that there were at least two kings bearing the name Kurigalzu, and it is not known which was responsible for the extensive remodelling of the sacred enclosure at Ur. The letters of 14th-century Kassite kings and the Egyptian pharaohs were found at EL-AMARNA and contain descriptions of elaborate and costly gifts exchanged between the two courts. The pharaohs frequently asked for lapis lazuli; a treasure of lapis lazuli cylinder seals, some of them belonging to the reign of King Burnaburiash II (*reg* 1359–1333 BC), was found at Thebes in Greece (Thebes Mus.). Two Kassite rock-crystal seals, one with gold caps, were discovered on the Ulu Burun shipwreck off the south coast of Turkey (Bodrum Mus.) and also testify to active trade in the eastern Mediterranean during the Amarna period (*c*. 1353–*c*. 1332 BC). Although many seals name Kurigalzu, it is not known to which reign they belong, and the use of three styles simultaneously confuses the chronology. Seals depicting elongated figures, with the addition of symbols such as crosses, rosettes, flies and lozenges, and with a long inscription (*see* ANCIENT NEAR EAST, fig. 18), are contemporary with more elaborate scenes that frequently depict water and mountain deities and stylized trees; the seals were made of variegated stones, cornelian, lapis lazuli and glass. A third group was originally thought to be immediately post-Kassite but is now known to have been in part contemporary with the

Kassite head of lioness or wolf, terracotta, h. 50 mm, from Dur Kurigalzu, 14th–12th centuries BC (Baghdad, Iraq Museum)

other two; typical examples show animals on either side of a tree, with borders of hatched triangles imitating the gold granulation that decorated the richer Kassite seals; the materials used are less colourful and less rare.

The Kassite city of Dur Kurigalzu (AQAR QUF), northwest of Baghdad, is dominated by a typically Mesopotamian ziggurat (for illustration *see* AQAR QUF) and was the capital from *c.* 1400 BC until the fall of the dynasty to the Elamites in 1157 BC. The partly excavated temples and palaces contain some original features. In Annexe H the courtyard was surrounded by a colonnade of piers, and its entrances were decorated with wall paintings depicting processions of figures. Storerooms with vaulted niches had been looted during the sack of the city. Among objects found in the destruction level were fragments of elaborately decorated glass and gold jewellery with much use of granulation, which bear tantalizing witness to the wealth of the Kassites and to their technical mastery in the minor arts. A small terracotta wolf or lioness (see fig.) and a painted terracotta male head (both Baghdad, Iraq Mus.) are modelled with exceptional sensitivity.

In the realm of sculpture the Kassites are best known for the *kudurru* (boundary stones), which continue into the Neo-Babylonian period (6th century BC). These were set up in temples to record land grants and are roughly shaped blocks of stone, often black diorite, on which divine symbols were carved. Later examples depict rulers in Babylonian dress.

BIBLIOGRAPHY

T. Beran: 'Die babylonische Glyptik der Kassitenzeit', *Archv Orientforsch.*, xviii (1957–8), pp. 255–78
G. Roux: *Ancient Iraq* (London, 1964; Harmondsworth, 1966, rev. 1980)
U. Seidl: 'Die babylonischen Kudurru-Reliefs', *Baghdad. Mitt.*, iv (1968), pp. 7–220
A. Moortgat: *The Art of Ancient Mesopotamia* (London, 1969)
E. Porada: 'The Cylinder Seals Found at Thebes in Boeotia', *Archv Orientforsch.*, xxviii (1981), pp. 1–78

DOMINIQUE COLLON

Kassmann [Kaessmann; Kaseman; Kossmann], **Rutger** [Ruetger; Roetger] (*b* ?Prague, ?*c.* 1585–95; *d* ?after 1645).

German cabinetmaker and engraver. He is recorded as a journeyman joiner in Cologne in 1615 and as resident in Düsseldorf *c.* 1630. He may be credited with essentially three works, each issued in several versions and editions. The first, *Architectur, nach antiquitetischer Lehr und geometrischer Ausstheilung: Seulen Termen Bochg* (Cologne, 1610), includes copper engravings based on woodcuts from Hans Blum's *Quinque columnarum exacta descriptio . . .* (1550). A later, large-format engraving (1627; Hollstein, nos 1–25) published by Kassmann presents the five orders of Classical architecture according to Blum, as seen in the 1610 edition. The second, Kassmann's first largely independent work, *Architectura Lehr Seiulen-Bochg. Nach reichtier Mas und Semeitrei Austeilung deir Funf Sulen Tuscana, Dorica, Jonica, Corinica, Composita Gar Fleischg Auss dien Antiquitettien Giezogien . . .* (Cologne, 1615), has column orders again based on Blum, but its portals, fountains, fireplaces, tombs and ornaments (chiefly scrollwork) follow those of Wendel Dietterlin and Gabriel Krammer. A new version (Cologne, 1616) was supplemented with caryatids: in 1622 it appeared in Paris as *Livre d'architecture*.

The third of Kassmann's works, *Architectur nach antiquitetischer Lehr und geometrischer Ausstheylung . . .* (Cologne, 1630), enjoyed the largest circulation. It consists of two pages of introductory text followed by copperplate prints. Though apparently synthesizing its predecessors, it remains broadly independent of them, with a content close to Krammer's *Architectura* (Zurich, 1600). Sheet 30 shows plans and elevations for two large buildings (? town halls) in Lower-Rhenish Renaissance style, which may have been designed by Kassmann himself. He reportedly styled himself an architect, but no works of architecture or joinery by him are known.

Kassmann's pattern books number among the most important documents of their kind to be produced north of the Alps in the earlier 17th century. In continuing the 16th-century tradition of column books based on the Vitruvian orders, they were important, too, for the development of Baroque ornamentation, with their 'classical' content simply providing, from at least the time of Wendel Dietterlin, a starting-point for fantasy and paraphrase.

BIBLIOGRAPHY

Hollstein: *Ger.*; Thieme–Becker

J. J. Merlo: *Kölnische Künstler* (Bonn and Cologne, 1852); ed. E. Firmenich-Richartz (Düsseldorf, 1895), col. 476f.
W. K. Zülch: *Entstehung des Ohrmuschelstiles*, Heidelberg. Kstgesch. Abh., xii (1932), pp. 112–15
E. Forssman: *Säule und Ornament: Studien zum Problem des Manierismus in den nordischen Säulenbüchern und Vorlageblättern des 16. und 17. Jahrhunderts*, i of *Acta Universitatis Stockholmiensis* (Stockholm, 1956), pp. 220–22
R. Zöllner: *Deutsche Säulen-, Zieraten- und Schildbücher, 1610 bis 1680: Ein Beitrag zur Entwicklungsgeschichte des Knorpelwerkstils* (diss., Kiel, 1959), pp. 23–37, 62–73 [details of edns and bibliog.]
H. Günther: 'Die Nachfolger Blums in Deutschland', *Deutsche Architekturtheorie zwischen Gotik und Renaissance*, ed. H. Günther (Darmstadt, 1988), pp. 146–8

JÜRGEN ZIMMER

Kastner, Alfred (*b* Thuringia, 1901; *d* Washington, DC, July 1975). American architect of German birth. He served briefly in the German Army in World War I before enrolling at the University of Hamburg, where he graduated in 1922. He worked in architects' offices in Austria,

Germany and the Netherlands before moving to the USA in 1924, working then as a draughtsman in offices including those of Joseph Urban and the firm of Raymond Hood, Godley and Fouilhoux in New York. In 1929 he won first prize in a competition for the Ukrainian National Theatre at Khar'kov (now Kharkiv). In 1930 he became a partner of Oskar Stonorov in Philadelphia, winning second prize in a competition for the Palace of the Soviets, Moscow, with an Expressionist design. In 1932, in partnership with Stonorov and W. Pope Barney (1890–1968), Kastner participated in the design of the Carl Mackley Houses (1932), a housing project in Philadelphia that was an early example of International Style Modernism in the USA and one of the most advanced of the Public Works Administration projects of the early 1930s.

From 1935 until 1943 Kastner was employed by the US Resettlement Administration, a Depression-era project developed under the Roosevelt administration. In this role he was responsible for housing projects in Philadelphia and a project at Hightstown (1936), NJ, which was backed by Albert Einstein. A fine example of Kastner's work is an associated Community Center building at Hightstown (completed 1938). During World War II he was employed by the US War Housing Administration. After the War he led his own firm, in Washington, DC, whose work included residences, motels, a car showroom and the Westgate Industrial Park at McLean, VA.

BIBLIOGRAPHY
C. Abrams: *The Future of Housing* (New York, 1946)
R. Pommer: 'The Architecture of Urban Housing in the USA during the Early 1930s', *J. Soc. Archit. Hist.*, xxxvii/4 (1978), pp. 237–44
D. P. Handlin: *American Architecture*, World A. (London, 1985)

JOHN F. PILE

Kastoria. Greek town in western Macedonia, capital of the nome of Kastoria. It is built on an elongated, mountainous peninsula that projects into Lake Kastoria from the west shore; the lake is fed by the Aliakmon River. There are still a large number of Byzantine and post-Byzantine churches, most of which retain some or all of their wall paintings, and several *archontika* (old mansions) of the 17th and 18th centuries. The town also has a Byzantine museum with a fine collection of icons.

1. History and urban development. 2. Art life and organization. 3. Buildings.

1. HISTORY AND URBAN DEVELOPMENT. According to local legend Kastoria was founded in 840 BC by Castor, one of the Dioskouri twins. The site is also identified with the Roman town of Keletron, first mentioned by Livy (*History of Rome*, XXI.xl). In the 6th century AD Justinian I transferred the neighbouring city of Dioklitianopolis, which had been ruined by barbarian assaults, to the narrow peninsula in Lake Kastoria (Procopius: *Buildings*, IV.iii.1–5). The earliest references to the town of Kastoria date to the 10th century, when it was twice captured by the Bulgars (*c.* 950 and 990). It was recaptured by Emperor Basil II (*reg* 976–1025) in 1018, and it remained under Byzantine control until 1204, except for a brief spell between 1082 and 1083 when it was held by the Normans.

After the dissolution of the Byzantine empire by the Latins in 1204, Kastoria became the centre of a political struggle in the Balkans between the Despotate of Epiros and the 'empire' of Nicaea. Following the Byzantine reconquest of Constantinople (now Istanbul) in 1261, Kastoria once again became part of the Byzantine empire. In the early 14th century it was ruled by John II Doukas of Neopatras (*reg* 1303–18) and after his death by the independent lord of Thessaly, Stephen Gavriilopoulos (*reg c.* 1320–32/3). For a time during the Palaiologan civil war the town was held by Andronikos II Palaiologos (*reg* 1282–1328) until early in 1328, when it was taken by Andronikos III Palaiologos (*reg* 1328–41). In 1334 it was captured by Serbian troops under the command of the Byzantine nobleman Syrgiannis (*c.* 1290–1334). The Serbian occupation lasted only a few months and ended in a peace treaty between the Serbs and the Byzantines. It was finally taken by the Serbian King Stephen Uroš IV Dušan (*reg* 1331–55) in 1342/3 and after his death in 1355 was governed by Symeon Uroš Palaiologos (*d* after 1369). In 1372 Kastoria was ceded to the Albanians and between 1385 and 1390 to the Turks. It was liberated by Greek forces in 1912 to form part of Greece.

The fortress, built high on a rock at the north-west end of the peninsula, was the centre of the Byzantine town, although settlement also extended beyond its walls. The earliest surviving churches (10th–11th century) are found both within the original fortified area and in the central part of the peninsula, known as Eleousis, which was the most densely populated district outside the walls. During the Turkish occupation the Turks expelled the Christians from the fortress and also settled on the north and east sides of the town overlooking the lake. The new Christian quarters were concentrated on the south and west sides; there was also a Jewish quarter, located outside the walls on the west side of the town near the lake. Most of the Greek *archontika* on the south side were built in the final years of the Turkish occupation.

2. ART LIFE AND ORGANIZATION. Many of Kastoria's churches as well as their wall-painting programmes and individual painted panels were paid for by high-ranking clergy, monks and wealthy laymen, some of whom belonged to the local aristocracy and some of whom were foreign potentates such as the Bulgarian Michael Asen and Albanian Mouzakis brothers (*see* §3(ii) and (vii) below). During the 10th and 11th centuries local workshops produced provincial copies of contemporary constantinopolitan styles, as in the first layer of painting in the Taxiarchis Mitropoleos, Hagios Stephanos and Hagioi Anargyroi. In the 12th century, however, a vigorous school of wall painting and icon production developed in the town. The high quality of the paintings in Hagioi Anargyroi (2nd layer, *c.* 1170–*c.* 1200; see fig. 1), Hagios Nikolaos Kasnitzis and Hagios Stylianos, and the high ranks of their donors, attest the arrival of workshops from important artistic centres.

After 1204, when Constantinople ceased to be a centre of artistic production, an anti-classical style emerged in Kastoria (e.g. 1st layer of painting, Panagia Mavriotissa, some panels in Hagios Stephanos), which links it with the art of the Frankish dominated parts of the eastern Mediterranean. Moreover, the spread of sculpted, wooden icons as cult objects can be related to the commercial, economic

1. Kastoria, Hagioi Anargyroi, wall painting depicting *St Demetrios*, *c.* 1170–*c.* 1200

of the Balkans (e.g. METEORA). The wall paintings in at least five of the town's churches are attributed to this workshop (Hagios Nikolaos tis Monachis Evpraxias, Hagios Nikolaos Theologinas, Hagios Spyridonas, some paintings in Hagios Dimitrios in the Eleousis district, Hagios Nikolaos Magaleiou). The works of the Kastoria workshop are characterized by an anti-classical tendency and attempts to rejuvenate the Byzantine painting tradition with innovations culled from Western art.

3. BUILDINGS. Most of Kastoria's churches are small and can be divided into two main types: the three-aisled basilica with elevated clerestory and the single-aisle church. In the churches of the 10th century and early 11th (Taxiarchis Mitropoleos, Hagios Stephanos, Koumbelidiki, Hagioi Anargyroi) the masonry consists of bands of stone divided by double rows of brick. Dogtooth friezes, brickwork ornament—either as single motifs in the bands of stonework or as patterns worked on the blind arcades of the façades—and friezes made of tile all combine to great decorative effect on the exterior walls (see fig. 2). In the later churches the masonry is mainly rubble with some brickwork, and it is reinforced with horizontal timber supports. The *archontika* have the characteristically fortified appearance of the northern Greek *archontika* of the Ottoman period. They are three storeys high with two lower floors built of stone and occasional timber supports, and a top floor of wood, plastered with slaked lime. Their windows were originally of coloured glass, and wall paintings decorated their interiors.

(i) Hagios Stephanos. This three-aisle, barrel-vaulted basilica (*c.* 900) lies on a low hill on the north-east side of the town. It has a galleried narthex and a low synthronon in

and cultural ties Kastoria had with the cities of the Adriatic, in particular Venice. Successive military campaigns resulted in a decline in artistic production in the first half of the 14th century. This was followed in the second half of the century by increased activity when numerous wall-painting programmes in an anti-classical style were created probably by a local workshop or one that employed many artists from Kastoria (e.g. 2nd layer, Taxiarchis Mitropoleos, Hagios Nikolaos Kyritsis, Hagios Nikolaos Tzotzas, Panagia Faneromeni, Hagios Nikolaos Petritis and certain wall paintings in the nave of Hagios Nikolaos tou Vounou). The same stylistic tendency can be seen in other monuments in western Macedonia and in OHRID. Several icons (Kastoria, Byz. Mus.) from this period are also attributed to a local workshop (*see* EARLY CHRISTIAN AND BYZANTINE ART, §VI, 4(ii)).

In the 15th century Kastoria enjoyed a period of intense intellectual and artistic activity, with the sanction of the Turkish authorities. It was probably here that a travelling workshop was formed and launched, which operated in the last quarter of the 15th century throughout a wide area

2. Kastoria, Hagios Stephanos, view from the east, *c.* AD 900

the sanctuary apse with a bishop's throne; in the south part of the narthex gallery is a small chapel, the so-called *askitario* (hermit's cell). Surviving fragments of the original decorative programme (first quarter of the 10th century) include portraits of saints (mostly military saints) in the nave and a monumental composition representing the *Last Judgement* in the vault of the narthex. The second layer of paintings (12th century or early 13th) in the nave vault shows New Testament scenes, hagiographic portraits and a rare sequence of three medallion busts of Christ as *Christ Emmanuel*, the *Ancient of Days* and *Christ Pantokrator*. On the lower walls and piers donors have added dedicatory wall paintings at various times. In the narthex the priest Theodore Limniotis is depicted above his tomb in the guise of a donor (late 13th century–early 14th).

(ii) Taxiarchis Mitropoleos. It is a three-aisle, barrel-vaulted basilica (*c.* 900); the north aisle was destroyed and rebuilt in a broader form. The numerous depictions of various dates of 'those who have fallen asleep' in all their finery in the blind arcades on the exterior of the south wall, the dedication of the church to the Archangel Michael and its situation on the south-east edge of the town all suggest that it was a cemetery church for members of the local aristocracy. The portraits of the Bulgarian leader Michael Asen and his mother, Eirene, on the west façade can be dated to between 1246 and 1256/7. The interior of the church has two layers of painting dated to the first quarter of the 10th century and 1359/60.

(iii) Panagia Koumbelidiki. A triconch church (*c.* 900), it lies within the south wall of the fortress. It is surmounted by a particularly tall dome and has a narthex to which a square outer narthex was later added. The inner narthex vault includes one of the earliest, non-allegorical representations of the *Trinity* (*c.* 1260–80). The wall paintings, characterized by subtle colours, monumental figures and well-balanced compositions, are a less sophisticated version of the paintings in the Holy Trinity Monastery (*c.* 1260) at Sopoćani (*see* SOPOĆANI, HOLY TRINITY). They can be dated to 1260–80 and attributed to a local workshop. The church also preserves fragments of wall paintings from the 15th and 17th centuries.

(iv) Panagia Mavriotissa. This single-aisle, barrel-vaulted church (*c.* 1000) lies 3 km south-east of the town on the shore of Lake Kastoria and originally served as the Katholikon of the Panagia Mavriotissa Monastery. It has a narthex that was enlarged in the post-Byzantine period to form a *lite*. The paintings in the conch of the apse and on the side walls of the sanctuary belong to the earliest surviving layer (?early 13th century), as do those on the west wall of the nave and the east and south walls of the *lite*. They are marked by their expressionistic rendering of the human figure, which borders on caricature. In a later phase (1259–64) the sanctuary and the paintings in the apse were restored, and the paintings on the south façade were added. The *Baptism*, which was painted over the first layer on the east wall of the narthex, cannot be related on stylistic grounds to these paintings. The portrait of the suppliant monk Mogilas in the conch of the apse suggests that he was responsible for the restoration work and the repainting of the church. Several paintings on the church's

south façade have survived, including a variation of the *Virgin Hodegetria*, identified as 'Mavriotissa'; *St Peter*; a *Tree of Jesse*; *SS George and Demetrios*; and two emperors. One of the imperial portraits is identified by inscription as Michael VIII Palaiologos (*reg* 1261–82) and the other, on the basis of iconographical evidence, as Alexios I Komnenos (*reg* 1081–1118). This iconographic programme with its pronounced symbolic and political content demonstrates one of the ways in which the usurper Michael VIII attempted to legitimize his claim to the Byzantine throne.

(v) Hagioi Anargyroi. It is a three-aisle, barrel-vaulted basilica (first third of the 11th century) on the north side of the town. It has a narthex extending its full width, the central part of which is covered by a transverse barrel vault, while the north and south ends have trough vaults. The church was decorated with fine marble sculpture. Fragments of the first layer of wall paintings (first third of the 11th century) survive in the north part of the narthex and on the north wall of the north aisle. Three painted inscriptions refer to the repainting and restoration of the church. Portraits of the donors Theodore Limniotis, his wife, Anna Radini, and their son, Ioannis—members of the local aristocracy—are situated on the south wall of the north aisle. Another member of the Limniotis family, the monk Theophilos, is depicted as a donor on the west wall of the south aisle. In the south aisle the church's patrons, the doctor saints Cosmas and Damian, are depicted together with scenes of their miraculous works. The north aisle is dedicated to St George, and it contains depictions of scenes from his life. On account of its close stylistic affinity with works of the so-called Dynamic style, in particular with the paintings (1191) in St George at Kurbinovo (*see* KURBINOVO, ST GEORGE; EARLY CHRISTIAN AND BYZANTINE ART, §III, 4), the second layer of paintings in the Hagioi Anargyroi is dated to the last 30 years of the 12th century. A graffito of 1198 dates the paintings on the west façade also to the 12th century. A third layer of paintings (19th century) covers most of the narthex interior.

(vi) Hagios Nikolaos Kasnitzis. This single-aisle, barrel-vaulted church with narthex (12th century) is on the south side of the town. According to an inscription, the church's founder was the Magistros Nikiphoros Kasnitzis, a member of the local aristocracy. His portrait and that of his wife, Anna, decorate the east wall of the narthex. Also in the narthex are scenes from the life of St Nicholas. The paintings are dated on stylistic grounds to the last third of the 12th century.

(vii) Hagios Athanasios Mouzakis. A small, wooden-roofed, basilican-plan church, it lies on the east side of the town. According to a painted inscription, it was built in 1384/5 by two Albanian brothers, Stoia and Theodore Mouzakis, who are identified as 'lords' of Kastoria, and the monk Dionysios; the narthex was added later. In the *Deësis* on the north wall of the church *Christ Enthroned* and the *Virgin* are depicted wearing imperial dress, an iconographic detail that has been associated with Hesychasm. Among the saints' portraits in the church are those of Germanos (*c.* 634–*c.* 733), Patriarch of Constantinople,

and two local Macedonian saints, Nicholas the Younger and Alexander of Pydna or of Thessaloniki. The paintings are characterized by well-balanced compositions, realism and a wealth of costume detail. They are thought to be by the artist who painted the Nativity Church (1369) at Mali-Grad and the 'Fountain of Life' Church (1390) at Borje, Albania.

BIBLIOGRAPHY

A. K. Orlandos: 'Ta byzantina mnimeia tis Kastorias' [The Byzantine monuments of Kastoria] (1938), iv of *Archeion ton byzantinon mnimeion tis Ellados* [Ancient Byzantine monuments of Greece] (Athens, 1935–73)
S. Pelekanides: *Byzantinai toichographiai* [Byzantine wall paintings], i of *Kastoria* (Thessaloniki, 1953–)
L. Grigoriadou: 'L'Image de la Deisis Royale dans une fresque du XIVe siècle à Castoria', *Actes du XIVe congrès international des études byzantines: Bucarest, 1971*, pp. 47–52
Ch. Mavropoulou-Tsioume: *Oi toichographies tou 13ou aiona stin Koumbelidiki tis Kastorias* [The 13th-century wall paintings in Koumbelidiki at Kastoria] (Thessaloniki, 1973)
T. Malmquist: *Byzantine 12th Century Frescoes in Kastoria: Agioi Anargyroi and Agios Nikolaos tou Kasnitzi* (Uppsala, 1979)
A. Wharton Epstein: 'Middle Byzantine Churches of Kastoria: Dates and Implications', *A. Bull.*, lxii (1980), pp. 190–207
S. Pelekanides and M. Chatzidakis: *Kastoria* (Athens, 1985)
E. N. Tsigaridas: 'La Peinture à Kastoria et en Macédoine grecque occidentale vers l'année 1200: Fresques et icônes', *Actes du colloque: Studenica et l'art byzantin autour de l'année 1200: Belgrade, 1986*, pp. 309–20
M. Panayotidi: 'The Character of Monumental Painting in the Tenth Century: The Question of Patronage', *Proceedings of the Second International Byzantine Conference: Constantine VII Porphyrogenitus and his Age: Delphi, 1987*, pp. 299–310
M. Garidis: *La Peinture murale dans le monde orthodoxe après la chute de Byzance (1450–1600) et dans les pays sous domination étrangère* (Athens, 1989), pp. 68–75
T. Papamastorakis: 'Ena eikastiko enkomio tou Michael VIII Palaiologou: Oi exoterikes toichographies sto katholiko tis Monis tis Mavriotissas stin Kastoria' [A visual encomium of Michael VIII Palaeologos: the exterior wall paintings of the Mavriotissa at Kastoria], *Deltion Christ. Archaiol. Etaireias*, 4th ser., xv (1989–90), pp. 221–40
——: 'I aphierotiki epigraphi tis Panagias Koumbelidikis stin Kastoria' [The dedicatory inscription of the Panagia Koumbelidiki at Kastoria], *Abstracts of Papers of the 10th Symposium of Byzantine and Postbyzantine Archaeology and Art: Athens, 1990*, pp. 71–2
E. Drakopoulou: *I christianiki Kastoria me vasi tis epigraphes ton naon tis, 12os-arches 16ou aiona* [Christian Kastoria on the base of the epigraphical evidence of its churches, 12th–16th century] (diss., U. Athens, 1991)
S. Kalopissi-Verti: *Dedicatory Inscriptions and Donor Portraits in Thirteenth-century Churches of Greece* (Vienna, 1992), pp. 94–8, 103
N. Moutsopoulos: *Ekklesies tis Kastorias: 9os–10os aionas* [The churches of Kastoria: 9th–10th century] (Athens, 1992)

JENNY ALBANI

Kastraki. See ASINE.

Kastri. See under KYTHERA.

Katayama, Tōkuma (*b* Hagi Prov., now Yamaguchi Prefect., 20 Dec 1854; *d* Tokyo, 24 Oct 1917). Japanese architect. He was one of the first four students to graduate from the Department of Architecture, Imperial College of Engineering (now Tokyo University) in 1879. After a short spell in the Ministry of Public Works, he became an architect in the Ministry of the Imperial Household in 1886, a position he held for the rest of his life. As the first court architect Katayama designed palaces, villas and residences for the imperial family, but his output also included the imperial (now national) museums (all extant) in Nara (1894), Kyoto (1908) and Tokyo (Hyōkeikan, 1909). His style, which was neo-classical with a French

Beaux-Arts flavour, was regarded as the most suitable to express the enlightened atmosphere of the Japanese court. He visited European countries and the USA in 1882–4, 1886–7, 1897–8, 1899 and 1902–3. His last three visits were undertaken in connection with the design of his best and largest work, Akasaka Detached Palace or Akasaka Rikyū, Tokyo (1909, now the State Guesthouse; *see* JAPAN, §III, 5 and fig. 38). The design of the front and the garden façades of this palace owe much to the Neue Hofburg in Vienna and the Louvre in Paris respectively, and the building is regarded as a masterpiece of Revivalist architecture in Japan.

BIBLIOGRAPHY

D. Finn: *Meiji Revisited: The Sites of Victorian Japan* (New York and Tokyo, 1995)

HIROYUKI SUZUKI

Kate, Herman Frederik Carel ten (*b* The Hague, 16 Feb 1822; *d* The Hague, 26 March 1891). Dutch painter and printmaker. Like his contemporaries David Bles, A. H. Bakker Korff and Charles Rochussen, he favoured historical genre scenes, specializing in military subjects. Between 1837 and 1841 he was a pupil of Cornelis Kruseman; from 1840 to 1841 he travelled in Belgium, Germany, Italy and France. In Paris he took advice from Ernest Meissonier, who influenced his work. After his return to The Hague he trained at the municipal academy until 1842.

Most of the smoothly painted historical scenes for which ten Kate became famous feature soldiers in historical dress from the time of the Eighty Years War, for example *Soldiers in a Guardroom* (exh. Amsterdam 1867; Amsterdam, Rijksmus.). They are often set in a tavern in the manner of David Teniers the younger. The Historisch Museum in Amsterdam has five paintings by ten Kate, including two that were painted for the collection of works illustrating the history of the Netherlands, created by Jacob de Vos (1803–82); it also owns five of his watercolours. In 1847 ten Kate became a member of the Koninklijke Akademie. For several years he was chairman of the Amsterdam society Arti et Amicitiae. Apart from paintings and watercolours (for example *see* NETHERLANDS, THE, fig. 36) he also made lithographs. Among his pupils were P. Haaxman (1854–1937) and his younger brother, J. M. H. ten Kate (1831–1910).

BIBLIOGRAPHY

Scheen, p. 260 [with extensive bibliog.]

WIEPKE F. LOOS

Kathmandu [anc. Yāpriṅ]. Capital of Nepal, situated on the Bagmati River. According to legends recorded in Hindu and Buddhist texts, in ancient times the entire Kathmandu Valley was a lake—a story given credibility by the type of alluvial soil found in the valley. The city of Kathmandu appears to have developed out of two small towns that grew partly because of the fertility of the soil and partly because a principal trans-Himalayan trade route passed through them. The limits of the two towns are still vaguely remembered in the designated routes and areas for such traditional cultural activities as chariot festivals and processions of an image of a local divinity.

In the Lichchhavi period (*c.* AD 300–800) the two sections of this city were known as Koligrama and Dakshina

('southern') Koligrama. A massive inscribed stone threshold has helped to identify the location of a no longer extant Lichchhavi palace known as Dakshina-rajakula ('Southern palace'), situated in the southern section on part of the site where the Hanuman Dhoka palace now stands. An older palace was located at Hadigaon, about 6 km north-east of the Southern Palace. Little survives of Kathmandu's Lichchhavi-period monuments, though art historians have identified a range of works from this period in the city and its environs.

During the unsettled times of the Transitional Period (*c.* 800–1200), the two sections of Kathmandu were known as Yambu and Yangvala and were controlled by two different local rulers. Many of the city's magnificent early buildings date to the period of the Malla kings (*reg c.* 1200–1769); much of the prosperity of the Malla rulers of Kathmandu depended on the collection of taxes levied on the trade route, well travelled by Indian, Chinese and Tibetan merchants. Like other capital cities of this time, Kathmandu was fortified with massive walls and moats, traces of which survive.

On the crossroad of the trade route in the heart of the city is a huge building called Kashthamandapa ('Wooden pavilion'; see fig.), for which both the city and the valley are named. The earliest reference to this building is found in a 12th-century manuscript. Architecturally it is a Newar-style *dega* or 'pagoda' with three layers of roofs. It was built as a public meeting hall and shelter for local people and travellers, not as a temple. The latter is usually raised with a thick wall of brick enclosing a narrow sanctuary as

its nucleus. This edifice, however, is erected on massive wooden pillars leaving a wide space in the middle. The water supply for this building is provided by the ever-running water fountain behind it. According to an ancient architectural text, such a fountain is mandatory for a public building of this nature.

Also on the trade route was the Malla palace, the Hanuman Dhoka, named after the 17th-century statue of the monkey god Hanuman protectively standing at the golden gate of the palace. In modern times, the palace compound and vicinity are often referred to as Darbar Square. Like other Malla palaces of the valley the compound is a cluster of temples and quadrangles for gods and divine monarchs. A prominent defensive feature is the lack of any hallway or corridor, an inner quadrangle or a room being accessible only after crossing an outer one.

Perhaps the most impressive temple of the palace complex is the Taleju temple. A regulation once existed that no one could build a house higher than this superstructure, since it is a temple of the most venerated tutelary goddess of the Malla kings. The immediately discernible stylistic development in the Taleju temple is the multi-terraced, high, pyramid-like plinth, an unprecedented feature that became increasingly popular in later times. The roofs of this temple are steeper than those of earlier buildings, and characteristically, it shows a less dramatic decrease in the size of the upper roof compared with the Kashthamandapa and the few other surviving older buildings. Apparently, the steepness and the size of the roof of the Taleju temple were modified in order to proportion them to the terraced pyramid.

Kathmandu, Nepal, Kashthamandapa ('Wooden pavilion'), built before the 12th century and repeatedly renovated

Other sites of importance to art historians include Buddhist monasteries such as Kathesimbhu, Matsyendra-bahal, Te-bahal, and Tham-bahil, which is also known as Vikramashila since it was a substitute for the celebrated monastery of the same name in northern India. Equally significant are Buddhist stupas, the sunken water fountains originally built close to important residences, and the ubiquitous free-standing temples of Brahmanical divinities.

See also NEPAL, especially §§I–IV.

BIBLIOGRAPHY

H. A. Oldfield: *Sketches from Nipal*, 2 vols (London, 1880)
S. Levi: *Le Népal: Etude historique d'un royaume hindou*, 3 vols (Paris, 1905–8/*R* Delhi, 1990)
D. L. Snellgrove: 'Shrines and Temples of Nepal', *A. Asiat.*, viii (1957), pp. 3–10, 93–120
L. Petech: *Medieval History of Nepal* (Rome, 1958, rev. 1984)
Itihāsa-samśodhanako pramāṇa-prameya [Sources for correct history], pt 1, Samshodhana-Mandala (Patan, 1962)
D. Vajracharya: 'Mallakālamā deśarakṣāko vyavaṣṭhā ra tyasaprati prajāko kartavya' [The conduct of the country's defence in Malla times and the citizen's duty towards this], *Purnima*, i/2 (1964), pp. 20–33
D. Regmi: *Medieval Nepal*, 3 vols (Calcutta, 1966) [A fourth vol. pubd privately in Patna by the author in 1966]
Madanjeet Singh: *Himalayan Art* (London, 1968)
M. Slusser and G. Vajracharya: 'Two Medieval Nepalese Buildings: An Architectural and Cultural Study', *Artibus Asiae*, xxxvi (1972), pp. 169–218
D. Vajracharya: *Licchavikālakā abhilekha* [Lichchhavi-period inscriptions], Institute of Nepal and Asian Studies, Historical Collection Series, vi (Kathmandu, 1973)
G. Vajracharya: 'Yaṅgala, Yambu', *Contrib. Nepal. Stud.*, i/2 (1974), pp. 90–98
H. A. Oldfield and M. A. Oldfield: *Views of Nepal, 1851–1864*, Bibliotheca Himalayica, Ser. 3, v (Kathmandu, 1975)
G. Vajracharya: *Hanumāndhoka Rajadarabāra* (Kirtipur, 1976)
M. Slusser: *Nepal Mandala: A Cultural Study of the Kathmandu Valley*, 2 vols (Princeton, 1982)

GAUTAM VAJRACHARYA

Kato Paphos. *See* PAPHOS, NEW.

Kato Zakros. Minoan palace and town in Crete that flourished in the Neo-Palatial period (*c.* 1650–*c.* 1425 BC). The smallest of the Minoan palaces, Kato Zakros lies at the edge of a very small fertile plain that opens on to the Bay of Zakros on Crete's eastern coast. The palace and town seem to have owed their position to the sheltered anchorage afforded by the bay and to have been important as a trading centre, perhaps receiving goods brought by ship to Crete from the East. The unworked elephants' tusks and copper ingots found within the palace are probably examples of such imports. Excavations carried out in 1901 by D. G. Hogarth, of the British School of Archaeology at Athens, revealed extensive remains of Minoan houses, but it was not until Nicholas Platon began work on the site in 1962 for the Greek Archaeological Society that the palace, and further substantial areas of the town, began to be revealed. Investigation of the site is still continuing. While traces of early buildings show that the town was occupied from the Proto-Palatial period (*c.* 1900–*c.* 1650 BC), the palace and most of the houses now visible date from Neo-Palatial times. It is not clear whether the palace had a Proto-Palatial predecessor, although remains of this period have been found at various points beneath it. It was destroyed by fire *c.* 1425 BC.

Though relatively small—its central court is about a third the size of that of KNOSSOS—the palace of Zakros was finely built. Local limestone and poros stone, along with mud-brick and timber, were the basic materials, with breccia, ironstone and serpentine used for column bases, and schist or plaster with small pebbles for floors. Walls were covered with plaster, often painted, and sometimes also with relief decoration. Elaborate floors with rectangular areas marked out by red-painted plaster are found in the main rooms of the west wing. The wealth of the palace is clear from its architectural refinements and is underlined by the finds made there (the site was largely undisturbed and unplundered).

In common with the larger palaces, Zakros is constructed around a rectangular central courtyard. The orientation is north-east to south-west, like that of the central court at MALLIA: those at Knossos and PHAISTOS are more accurately aligned on a north–south axis. The layout of the surrounding rooms and areas also has much in common with Mallia, particularly on the west side of the central court, where three entrances lead to a large pillared 'Hall of Ceremonies' lit by a paved light well, a small room that may have been a shrine, and a corridor that gave access to a kitchen area, above which may well have been a banqueting hall. In the light well were found a chlorite rhyton in the form of a bull's head, like the well-known steatite example from Knossos (*see* KNOSSOS, fig. 4), and another on which an elaborate depiction of a peak sanctuary is carved (both *c.* 1650–*c.* 1480 BC; Herakleion, Archaeol. Mus.).

West of the pillared hall lies a series of storerooms, which probably had more spacious apartments above, and in which fine examples of Floral- and Marine-style pottery were found. Beyond these is the paved west court of the palace, while in the south-west corner lies an important group of rooms. These have been identified as a shrine, with a bench for revered objects and offerings, and a so-called lustral basin (a paved bathing or cleansing area at a lower level than surrounding rooms, reached by a short staircase). Adjacent to these lie an archive room, where Linear A tablets were found, and a treasury, with associated workshop and storeroom.

In the treasury, built-in chests of mud-brick with plaster floors contained remarkable finds, including fine pottery, faience vases in the shape of sea-shells and, perhaps most notably, an array of stone vases, of various shapes and exquisitely made. Most are ovoid or conical rhyta, although jugs and chalices were also found. The stones used include marble, porphyry, alabaster and basalt. Perhaps finest of all is the justly famous miniature rhyton in rock-crystal, ovoid in shape and pointed at the end, with a handle made of rock-crystal beads on a bronze wire, and a collar decorated with pieces of gilded ivory (before *c.* 1425 BC; Herakleion, Archaeol. Mus.).

A paved verandah with two pillars overlooks the central court at its northern end, and this gives access to the stairs that must have led to the banqueting hall above the kitchen. The main entrance to the palace from the north comes into the central court at the east end of the verandah, and directly to the east of this lies another lustral basin, in a position analogous to that near the north entrance at Knossos. A second entrance comes into the central court

at its south-west corner, and the rooms at this south end of the court are mainly workshops, with evidence for the working of faience, crystal and ivory, and perhaps also for scent-making. As at the other main palaces, the royal apartments lay to the east of the central court. Unfortunately, at Zakros the east wing is not well preserved, and only foundations survive of what appear to have been two spacious and elegant halls.

BIBLIOGRAPHY

Praktika Athen. Archaiol. Etaireias, cxxvii– (1961–) [excav. rep. by N. Platon]

N. Platon: *Zakros: The Discovery of a Lost Palace of Ancient Crete* (London, 1971)

G. Cadogan: *Palaces of Minoan Crete* (London, 1976), pp. 49, 124, 126–8

J. LESLEY FITTON

Katsuhiro Yamaguchi. *See* YAMAGUCHI, KATSUHIRO.

Katsukawa. Name used by members of a school of Japanese woodblock print designers active during the mid-Edo period (1600–1868). They worked in the *ukiyoe* ('pictures of the floating world') genre (*see* JAPAN, §IX, 2(iii)) and specialized in *yakushae* ('pictures of actors'; prints of scenes and characters from *kabuki* and *nō*). The main force behind the school was painter and print designer (1) Katsukawa Shunshō, who introduced *yakusha nigaoe* ('pictures of likenesses of actors') prints in the 1770s. The Katsukawa school dominated *yakushae* until the 1790s, but by the beginning of the 19th century it was showing signs of decline, overwhelmed by competition from the newly emerging UTAGAWA school. Shunshō's most gifted students were (2) Katsukawa Shunkō, (3) Katsukawa Shun'ei, (4) Katsukawa Shunchō, and Shunrō, who later became famous as KATSUSHIKA HOKUSAI, after his expulsion from the school. Shun'ei had many students, among whom (5) Katsukawa Shunsen (Shunkō II), Shunkō (Shunshō II, *fl* 1800–40) and Shuntei (1770–1820) became major *ukiyoe* artists.

(1) Katsukawa Shunshō [Yanagi Masaki; Shōgasei, Ririn, Yūji, Kyokurōsei, Rokurokuan; Gifu] (*b* ?Kamigata [Kyoto–Osaka region], 1726; *d* Edo [now Tokyo], 1792). Print designer and painter. He was the leading artist of the Katsukawa school. Shunshō came to Edo to study *haiku* (17-syllable poems) with Shima Kensai and *ukiyoe* ('pictures of the floating world') painting (*see* JAPAN, §VI, 4(iv)(b)) with Miyagawa Shunsui (*fl* 1741–70), a pupil of MIYAGAWA CHŌSHUN. Shunsui changed his artist's name (*gō*) to Katsukawa when Chōshun was disgraced. Unlike other students of the Miyagawa school, who were predominantly painters, Shunshō was best known for his woodblock prints of actors. Shunshō produced his first prints around 1760, when he was living in the house of the publisher Hayashiya Shichiemon. His early works included portraits of the actors *Ichikawa Danzō IV, Nakamura Chūzō I* and *Nakamura Sukegorō*. A seal in the shape of a jar (*tsubo*), containing the surname Hayashi, appears on the prints Shunshō designed during this period, leading some to conjecture that Shunshō and Hayashiya Shichiemon were the same person.

In 1765 Shunshō collaborated with SUZUKI HARUNOBU in the production of the first *nishikie* ('brocade pictures'; full-colour prints). Shunshō's *yakushae* ('pictures of actors') and *bijinga* ('pictures of beautiful women') of the late 1760s show the restraining influence of Harunobu's graceful style. It was only after Harunobu's death in 1770 that Shunshō developed a radically new, naturalistic type of *yakushae*, *yakusha nigaoe* ('pictures of likenesses of actors'; *see* JAPAN, fig. 169), which broke with the moribund stylistic conventions of the TORII school and better captured the vibrant *kabuki* of the day. Shunshō produced his best work between 1770 and 1780, including his masterpiece the *Azuma ōgi* ('Eastern fans') series (Tokyo, N. Mus.), for which he chose the extra-large fan-shaped format rather than the *hosoban* (narrow; *c.* 300×140 mm) format he usually employed. He designed *sumoe* ('pictures of *sumo*') and *mushae* ('pictures of warriors') but few *bijinga* prints. Although best known for his prints, Shunshō achieved his full potential as a colourist and designer in his *nikuhitsuga* ('original paintings'; polychrome paintings) of *bijin*, which include the *mitatee* ('parody picture') *Chikurin shichikenzu* ('Seven Sages of the Bamboo Grove'; Tokyo, Tama A. U.) and *Fujo fūzoku jūnikagestu* ('Customs and manners of women of the 12 months'; Atami, MOA Mus. A.; *see* JAPAN, fig. 95).

Shunshō collaborated with several *ukiyoe* artists in the production of illustrated books (*ehon*). With IPPITSUSAI BUNCHŌ he created the *Ehon butai ōgi* ('Picture book of theatrical fans'; 3 vols; 1770), which features 106 half-length portraits of actors. With KITAO SHIGEMASA, Shunshō produced *Seirō bijin awase sugata kagami* ('A mirror of the forms of beauties of the greenhouses compared'; 1776; London, BM), which depicts scenes of the Yoshiwara pleasure quarter in Edo. Among the books he produced on his own are *Yakusha natsu no Fuji* ('Summer Mt Fuji actors'; 1780; Tokyo, N. Diet Lib.), a book concerning the everyday life of actors (the title refers to a comparison between actors without make-up and the snowless slopes of Mt Fuji in summer), *Ehon chiyo no tomo* (1787) and *Ehon Ibukiyama* ('Picture book of Mt Ibuki'; 1793; U. Tokyo, Lib.).

Several of Shunshō's pupils became leading *ukiyoe* artists, notably (2) Katsukawa Shunkō, (3) Katsukawa Shun'ei, (4) Katsukawa Shunchō, and Shunrō, who was expelled from the school and later became famous as KATSUSHIKA HOKUSAI. Shunshō was succeeded as head of the school by Shunkō, who became Shunshō II.

(2) Katsukawa Shunkō [Kiyokawa Denjirō; Kotsubo] (*b* Edo [now Tokyo], 1743; *d* Edo 1812). Print designer. Along with (3) Katsukawa Shun'ei he was one of the most gifted students of the *ukiyoe* ('pictures of the floating world') painter and print designer (1) Katsukawa Shunshō. Shunkō began studying under Shunshō at an early age. His student name, Kotsubo [Small Jar], was chosen out of deference for his master, who used a jar-shaped (*tsubo*) seal. Shunkō started producing *yakushae* ('pictures of actors') around 1770. He entered his mature period in the 1780s, but palsy, contracted around 1788, incapacitated his right hand and forced him to retire. Even after his retirement, however, Shunkō occasionally worked with his left hand. His faithfulness to his master's style can be seen in his bold *yakushae*. Shunkō developed the *ōkubie* ('large-head pictures'), which Shunshō had produced in great

number, and introduced *ōgaoe* ('large-face pictures'), in which an actor's face fills the entire picture. *Yakushae* reached its highest point at this time, and Shunkō paved the way for the *yakushae* of TŌSHŪSAI SHARAKU. Among Shunkō's representative works are *Ichikawa Ebizō no Shibaraku* ('The actor Ichikawa Ebizō as Shibaraku') and *Yonsei Iwai Hanshirō* ('The actor Iwai Hanshirō IV'; Boston, MA, Mus. F.A.). Shunkō also produced *degatarizu* ('pictures of *degatari*'), depicting actors and accompanists on stage, a genre in which Torii Kiyonaga was prolific (*see* TORII, (8)). Shunkō rarely produced *bijinga* ('pictures of beautiful women'), but his powerful drawing style was particularly well suited to *sumoe* ('pictures of *sumo*'), in which the massive physiognomies of the wrestlers dominate the picture. Unlike Shunshō, Shunkō rarely painted *nikuhitsuga* ('original paintings'). Book illustrations by Shunkō are also rare. Perhaps because of his early retirement at around the age of 45 Shunkō had no known students. He was succeeded by (5) Katsukawa Shunsen (Shunkō II), a student of Shun'ei.

BIBLIOGRAPHY
Y. Hayashi: *Shunkō* (Tokyo, 1963)

(3) Katsukawa Shun'ei [Isoda Hisajirō; Kutokusai] (*b* Edo [now Tokyo], 1762; *d* Edo, 1819). Print designer and book illustrator. Shun'ei became (1) Katsukawa Shunshō's student at an early age, and by 1782 he was already producing illustrations for *kibyōshi* ('yellow cover' books; comic novels). Originally, Shun'ei's strength was *mushae* ('pictures of warriors'), and many of his early *nishikie* ('brocade pictures'; full-colour prints) deal with this theme. Shun'ei started making *yakushae* ('pictures of actors') around 1790. Like his fellow student (2) Katsukawa Shunkō, Shun'ei produced prints in the style of Shunshō. At the same time Shun'ei developed *yakushae* in his many *ōkubie* ('large-head pictures'). *Sansei Segawa Kikunosuke no Aburaya Osome* ('The actor Segawa Kikunosuke III as Aburaya Osome') and *Ichikawa Ebizō no Mita no Tsukau* ('The actor Ichikawa Ebizō as Mita no Tsukau'; woodblock, 1795; Honolulu, HI, Acad. A.; see fig.) are two of Shun'ei's representative works.

Shun'ei's exaggerated drawing style affected later *ukiyoe* ('pictures of the floating world') artists, including Tōshūsai Sharaku. Like the other members of the Katsukawa school, Shun'ei was skilled at *sumoe* ('pictures of *sumo*'). Although Shun'ei produced few *bijinga* ('pictures of beautiful women'), his *Oshiegata* ('Teaching') series of *onnagata* (male actors who play female roles) posing in dancing stances is well known. The most remarkable among Shun'ei's many book illustrations are *Kaidan hyakki zue* ('Pictures of 100 ghosts'; 1783) and *Shibai kinmō zui* ('Illustrated theatre guide'; 1803, Tokyo, N. Mus.). The latter is an introduction to *kabuki*, a favourite pastime of Shun'ei, who was an avid theatregoer versed in the performing arts. The text is by Shikitei Samba (1776–1822), and there are some illustrations by Utagawa Toyokuni I (*see* UTAGAWA, (2)). Shun'ei left a few *nikuhitsuga* ('original paintings'; polychrome paintings), but these are not highly regarded. Unlike Shunkō, who had no students, Shun'ei had many followers, including Shunshō II, Shunsen, (5) Katsukawa Shunkō, Shungyoku (*fl* 1776–85), Shuntei (1770–1820) and Shunwa (*fl* 1790–1820).

Katsukawa Shun'ei: *Actor Ichikawa Ebizō as Mita no Tsukau*, woodblock print, 1795 (Honolulu, Honolulu Academy of Arts)

(4) Katsukawa Shunchō [Yūshidō; Shien; Tōshinen; Chūrinsha; Kissadō; Sankō] (*fl* Edo [now Tokyo], 1783–1821). Print designer, book illustrator and painter. Among (1) Katsukawa Shunshō's students, only Shunkō and (5) Katsukawa Shun'ei excelled Shunchō. Shunchō's earliest extant works are the illustrations for the *kibyōshi* ('yellow cover' book; comic novel) *Tsūjin kokoroe chigai* ('Misunderstanding by a man about town', 1783; Tokyo, Dai Tōkyū Mem. Found.). While Shunchō produced few book illustrations, he designed many *bijinga* ('pictures of beautiful women') *nishikie* ('brocade pictures'; full-colour prints). Although a member of the Katsukawa school, Shunchō emulated the style of Torii Kiyonaga (*see* TORII, (8)); many of Shunchō's best *bijinga* bear a striking resemblance to those by Kiyonaga. Shunchō depicted *Takashima Ohisa* and *Naniwaya Okita* (both *c.* 1793; Chicago, IL, A. Inst.), well-known beauties of the time who appear in many of Kitagawa Utamaro's works. Shunchō briefly competed with Kiyonaga, but never developed his own style. Shunchō gave up *nishikie* around 1790, when Kiyonaga became the fourth-generation head of the TORII school. Shunchō also produced *yakushae* ('pictures of actors') that show the style of Kiyonaga. Shunchō's *nikuhitsuga* ('original paintings'; polychrome paintings) are clearly influenced by his teacher, Shunshō (*see* JAPAN, §VI, 4(iv)(b)). Among his few book illustrations, his best known are *Ehon Chiyo no Aki* ('Picture

book of eternal autumn', *c.* 1790; Cologne, Gerhard Pulverer priv. col.), *Ehon momiji no hashi* ('Picture book of maple bridge') and *Ehon sakaegusa* ('Picture book of prosperous house', 1790; Tokyo, N. Diet Lib.). The *hanashibon* ('story-book') *Buji shūi* ('Collection of quiet life', 1798; Tokyo, N. Diet Lib.) is the last book Shunchō illustrated. Around that time Shunchō gave up *ukiyoe* altogether; he became a student of the poet and *ukiyoe* artist, KUBO SHUNMAN and wrote verse under the pseudonym Kissadō Shunchō.

BIBLIOGRAPHY
Y. Hayashi: *Kiyonaga to Shunchō* [Kiyonaga and Shunchō] (Tokyo, 1976)
SUSUMU MATSUDAIRA

(5) Katsukawa Shunsen [Shunrin; Shunkō II; Kashōsai; Tōryūsai] (*fl* Edo [now Tokyo], 1806–21). Print designer and book illustrator. He studied with Tsutsumi Tōrin III (*c.* 1743–1820) and later with (3) Katsukawa Shun'ei. He changed his name to Katsukawa Shunsen in 1806. His first work is *Katakiuchi gen gorofuna*, illustrating the first *gōkan* ('bound together volume'; historical novel) by Tōzaian Nanboku. The introduction states that this was 'the first work of Kōjimachi Shunsen'. Subsequently, he produced many illustrations for *gōkan* and also experimented with *nishikie* ('brocade prints'; full-colour prints), which include *Enoshima* and *Tsukiji monzeki* ('Tsukiji priest prince'). In 1820 he succeeded Katsukawa Shunkō I, becoming Shunkō II. The following year he signed the illustrations for a *gōkan*, *Aware nari onna karukaya*, '*Shunsen aratame Katsukawa Shunkō*' ('Change of Shunsen to Katsukawa Shunkō'). At around the same time he designed a series of landscape prints of famous places in Edo, which used Western principles of vanishing perspective and colour shading. He illustrated *Awase kagami onna shunkan* (1819–22), a *gōkan* written by his wife under the pseudonym Gekkōtei Shōju, and the *gōkan Onna jirai nari* and *Onna nadaemon* (both 1821). In the late 1820s he decorated ceramics, distancing himself from the production of *ukiyoe* prints.

TADASHI KOBAYASHI

Katsushika Hokusai [Shunrō; Sōri; Kakō; Tatsumasa; Gakyōjin; Taito; Iichi; Manji] (*b* Edo [now Tokyo], 1760; *d* Edo, 1849). Japanese painter, draughtsman and printmaker. His work not only epitomized *ukiyoe* ('pictures of the floating world') painting and printmaking (*see* JAPAN, §§VI, 4(iv)(b) and IX, 2(iii)) but represented the essence of artistic endeavour and achievement over a period of 70 years of single-minded creativity. He was a voracious student of a huge range of artistic techniques, ranging from painting of Ming period (1368–1644) China to the styles of the KANŌ SCHOOL, SUMIYOSHI SCHOOL, Rinpa painting (*see* JAPAN, §VI, 4(v)) and his contemporaries of Edo period (1600–1868) Japan, to Western-style painting (*Yōga*; *see* JAPAN, §VI, 5(iv)). His work also covered a spectrum of art forms: *nikuhitsuga* (polychrome or ink paintings); *surimono* ('printed things'; de luxe, small-edition woodblock prints) and *nishikie* (polychrome prints); woodblocks for *eirihon* (illustrated books) and *kyōka ehon* (illustrated books of poems called *kyōka*); and printed book illustrations for *kibyōshi* ('yellow cover' books, often moralizing tales and adventures) and *yomihon*

('reading books', sometimes historical novels). He was one of the main *shunga* (erotic picture) artists of the Edo period (*see* EROTIC ART, fig. 10). Hokusai is thought to have made in all at least 30,000 drawings and the illustrations for 500 books. He led a life of singular variety, sustained by his inexhaustible energy. Since the late 19th century, his work has had a significant impact on Western artists such as Gauguin and van Gogh, as well as receiving universal acclaim from art lovers and critics.

1. EARLY AND MIDDLE YEARS, 1778–*c.* 1810. Hokusai was born in the Honjo Warigesui district of Edo. He was adopted by Nakajima Ise, a mirror maker in the service of the shogunate. From the age of 15 to 18 he was apprenticed to a woodblock engraver. In 1778, aged 19, he became a pupil of the leading *ukiyoe* master, Katsukawa Shunshō (*see* KATSUKAWA, (1)), and made his debut in artistic circles in the following year, producing prints in the *hosoban* (narrow print) format, including *yakushae* ('actor pictures') in the style of the Katsukawa school under the *gō* (artist's name) of Shunrō; he also designed illustrations for *kibyōshi*. In 1795, having quarrelled with the masters of the Katsukawa school, Hokusai jettisoned the name Shunrō—thus marking the end of his period of training—and, inheriting the *gō* of the Rinpa-school master Tawaraya Sōri, began to produce *hanshitae* (final preparatory drawings for woodblock prints) for *kyōka ehon*, *egoyomi* ('picture calendars') and *surimono*, to which his skills were eminently suited. For the next four years, under the name of Sōri, he also produced some highly individual *bijinga* ('pictures of beautiful women'), in which the smooth lines and elegant, voluptuous charm of the forms distinguished them from the works of his contemporary KITAGAWA UTAMARO. Of all his styles, this was perhaps the most graceful.

From 1798, having changed his name to Hokusai, he immersed himself in *ukiyoe*. With his vigorous, sensitive and humorous style that combined the various painting techniques of Japan, China and the West, Hokusai revitalized the *ukiyoe* tradition, adding landscape to its subject repertory. He became its leading exponent, along with his rival ANDŌ HIROSHIGE. At the same time, he maintained enthusiastic contacts with schools unconnected with *ukiyoe*, such as that of Tsutsumi Tōrin III, and was a diligent student of works in Western styles, such as those of SHIBA KŌKAN, and of such devices as vanishing perspective. During this period he contributed copiously to *yomihon* written by *gesakusha* ('authors of *gesaku*'; popular fiction), such as Takizawa Bakin (1767–1848), with whom he worked from about 1807 until mutual jealousy ended their collaboration. Popular from their introduction, *yomihon* differed from other types of entertaining fiction in containing some moral instruction or advice. Hokusai illustrated the climax of the narrative with theatrical images that were sometimes mysterious, at other times brutal or even fantastic. He took scrupulous care to match the images perfectly to the story. Indeed, Hokusai was probably the premier Edo-period designer of black-and-white illustrations.

2. MATURITY AND OLD AGE, *c.* 1810–49. Hokusai continued (from 1810 under the name Taito) to work on

kyōka ehon and *surimono* and to produce illustrated books and *gafu* (picture books or albums), designed for amateur artists and vehicles for his own art even late in life. The most famous of these, the series *Hokusai manga* ('Hokusai sketches', 15 vols, 1814–78; the last vol. published posthumously), are vivid examples of his minute workmanship, energetic brushwork, phenomenal understanding of the human figure and the acute observation he brought to this dedicated attempt to 'illustrate the universe'. This random collection of drawings of real and imaginary subjects, executed in a multitude of styles, is a veritable encyclopedia of Japanese life and landscape and probably his most memorable work. The *Hokusai manga*, moreover, reveal him to have undergone training (*Hasshū kengaku*) in the teachings of Hasshū (Eight Sects) Buddhism, which had been widely diffused in the Heian period (AD 710–94). From about 1820 to 1834 (using the name Iichi), he produced primarily *shikishiban* (square-paper-format) *surimono* and *nishikie* of various sizes. He continued to produce the popular *nishikie* throughout his life. These popular prints featured mostly landscapes and birds and flowers. Hokusai also had a lifelong preoccupation with the processes of drawings and produced some charming manuals (in 1812 and 1823) setting out his favourite techniques.

In his representative sequential collections of landscapes, the *Fugaku sanjūrokkei* ('Thirty-six views of Mt Fuji'; actually 46 prints; 1831; Tokyo, N. Mus.; see fig.), the *Shokoku taki meguri* ('A journey to the waterfalls of all the provinces'; *c.* 1832; Tokyo, N. Mus.) and the *Shokoku meikyō kiran* ('A journey along the bridges in all the provinces'; *c.* 1831–2), Hokusai's individualistic style came to the fore. The scenes were not depicted as they existed in nature but instead represented images from the artist's inner world. Many of the pictures of Mt Fuji, a sacred site in traditional belief, are composite views as if seen from several directions and in varied circumstances and reveal the artist's extensive knowledge of his subject-matter. These works, in which imagination poses a challenge to naturalism, are quite different in character from similar landscapes by Hiroshige; Hokusai indeed created landscape pictures (*fūkeiga*) that others were unable to imitate. He is believed to have been the first Japanese artist to use Prussian blue, which, unlike the fugitive dyes previously used in printing, was permanent.

Hokusai also developed a novel style of extraordinarily graphic brushwork in his bird-and-flower designs (*kachōga*), which were published in tandem with his landscapes. In these too Hokusai took liberties with accurate representation, creating abbreviated or exaggerated images that seemed to express the drama of his life—which continued to offer unending challenges to his talents as a painter. His tenacious determination to attain complete mastery of his media and the application of his superb techniques to each of his works, combined with his personal qualities of rigorous rationality and deep humanity, endowed his depictions of landscapes and birds and flowers with an

Katsushika Hokusai: *Great Wave of Kanagawa*, woodblock print, 250×371 mm, from *Fugaku sanjūrokkei* ('Thirty-six views of Mt Fuji'), 1831 (London, Victoria and Albert Museum)

intensity that was absent from the temperate manner of Hiroshige.

The mature Hokusai stimulated numerous flourishing artistic movements, although he himself began to show signs of a decline in the strength of his brush compared with that of his illustrations for *yomihon* made before about 1830. This is confirmed by the inclusion of a number of mediocre prints in the *Fugaku sanjūrokkei*. Nevertheless, and in spite of intermittent paralysis, he continued his researches into painting techniques and remained indefatigably productive, as befitted his own self-description, Gakyō Rōjin ('the old man mad with painting'). In 1834, aged 75, he ceased producing *nishikie hanshitae* and instead took his subject-matter from *nikuhitsuga* and printed books such as *ehon*. Unlike the earlier multicoloured works intended for connoisseurship, picture books (*eirihon*) were tending to become didactic works, in which the pictures were objects of study. Hokusai had produced such illustrations throughout his career, but in his late period he preferred to adopt unworldly subjects, such as Shōki (the 'demon queller'), *oni* (devils) and *rakan* (*arhat*s or enlightened beings), as well as Shishi (Chinese lion), dragons and tigers. The compositions so created are novel, startling, even ghostly. His *nikuhitsuga* display a dynamic and sublimely beautiful brush character, unparalleled for an artist of such an advanced age, and represent the culmination of the master's achievement.

Although by now partially eclipsed in popularity by Hiroshige, he continued to produce inspired works such as the *Hyakunin isshu uba ga etoki* ('A hundred poems explained by the nurse'; *c.* 1838) and the *Shika shashinkyō* ('A true mirror of Chinese and Japanese poems'; *c.* 1828–33), which evinced the interest in classical subjects he developed in later years.

3. REPUTATION AND INFLUENCE. Hokusai's attachment to life grew stronger as the years passed and he prayed constantly for a few more years of its enjoyment, in expectation of which he affixed the seal *hyaku* ('one hundred') to his works. At the age of 74 he had written that he had produced nothing of much value before he was 70 but that, at 110, 'each dot, each line shall surely possess a life of its own'. However, he attained neither the age nor the artistic perfection of which he believed himself capable and died at 89, his brush apparently still near to hand. His endless quest for improvement and desire for change were reflected in his constant need to change his artist's name and were also manifest in his restless, unconventional life. He moved house 93 times and, though adept at self-advertisement, spent most of his life in poverty. Anecdotes of his eccentric and flamboyant conduct abound. In his early years he travelled around the country giving displays of his artistic prowess that were forerunners of action painting; he sometimes created paintings 200 sq. m in area in front of festival crowds, rushing over the huge sheets of paper with a broom and a bucket of ink. In a famous competition with TANI BUNCHŌ, he dipped the feet of a chicken in red paint and let it run about freely on a sheet of paper he had just covered in blue paint; he called the resulting design *Maple Leaves on a River*. Hokusai had some 200 pupils, most of whose work was derivative, if not imitative. Of the more notable, Hokuju (*fl c.* 1802–34) created many attractive landscape prints, and Hokkei produced some admirable figure prints and elaborately printed *surimono*. Little is known, however, about many aspects of Hokusai's life and work, nor is there a full catalogue of his extant works.

BIBLIOGRAPHY
WORKS
Hokusai manga (1993)

GENERAL
J. R. Hillier: *Hokusai: Paintings, Drawings and Woodcuts* (London, 1955)
T. Bowie: *The Drawings of Hokusai* (Bloomington, 1964)
S. Ozaki: *Hokusai* (Tokyo, 1967)
J. Suzuki and others: *Hokusai tokuhon sashie shūsei* [Collection of Hokusai's book illustrations], 5 vols (Tokyo, 1971–3)
N. Tsuji: *Hokusai*, Nihon no bijutsu: Bukku obu bukkusu [Arts of Japan: book of books], xxxi (Tokyo, 1973)
M. Forrer and E. de Goncourt: *Hokusai* (London and Paris, 1988)
R. Lane: *Hokusai, Life and Work* (London, 1989)
S. Nagata: *Hokusai Bijutsukan* [The Hokusai Art Museum], Tokyo, Hokusai A. Mus. cat., 5 vols (Tokyo, 1990)

MASATO NAITŌ

Katsu Shikin [Shōen Gyofūro, Toan]. (*b* Osaka, 1739; *d* Osaka, 1784) Japanese poet, seal-carver and doctor. He was born into a medical family; his father, Hashimoto Teijun, a famous doctor, had died young, and Shikin was brought up by one of Teijun's pupils, Usui Itsuō. In his youth he studied in Kyoto, but he later succeeded to the family medical tradition in Osaka. He studied Confucianism under Suga Kankoku (1690–1764) and his pupil Enoraku Kō. Like the seal-carver SŌ SHII, he was a member of Katayama Hokkai's (1723–90) poetry group, the Konton shisha, and his fresh and technically adept verse was said to be the group's finest. He studied seal-carving under KŌ FUYŌ, retaining the principal elements of Fuyō's style while incorporating a graceful opulence, which fully exploited the special characteristics of the Archaic school, as seen in his extant five-volume seal album, *Gyofūro inpu* ('Gyofūro seal album'; 1784). He ran the Gyofūro inn in northern Osaka, which attracted cultured clients throughout the year. The name Gyofūro (Honourable Mansion of the Wind) was, like Shikin, derived from the Chinese classic *Zhuangzi*. His closest friend was the Confucianist Rai Shunsui (1746–1816), father of the literatus RAI SAN'YŌ, who in his reminiscences of Osaka life made many references to Shikin. Shikin's collected verse has been handed down in various copied versions such as *Katsu Shikin shisa* and *Katsu Shikin shi*. Shikin was also an accomplished performer on the *shō* (a reed instrument) and the *hichiriki* (similar to a flageolet) and had the light-hearted custom of giving his acquaintances nicknames that imitated the sounds of the Dutch language, the study of which was popular among Japanese intellectuals at the time. He died no more than ten days after his teacher Fuyō and was buried at the temple Rittōji, Osaka. His eldest son succeeded him under the name Hashimoto Jōgen II.

See also JAPAN, §XVI, 20.

BIBLIOGRAPHY
K. Nakai: *Nihon in hitozute* [Accounts of Japanese seal-carvers] (1915)
N. Mizuta: 'Kō Fuyō to sono ippa' [Kō Fuyō and his school], *Nihon no tenkoku* [Japanese seal-carving], ed. Y. Nakata (Tokyo, 1966), pp. 147–82 ['Katsu Shikin', pp. 161–3]
——: *Nihon tenkoku-shi ronkō* [Study on the historical treatises of Japanese seal-carving] (Tokyo, 1985)

NORIHISA MIZUTA

Katz, Alex (*b* New York, 24 July 1927). American painter, sculptor and printmaker. He studied (1946–50) in New York and in Skowhegan, ME. In the early 1950s he was influenced by the work of Jackson Pollock and other Abstract Expressionists and produced swiftly executed pictures of trees as well as various works based on photographs. In the mid-1950s, working from life, he painted spare, brightly coloured works of landscape, interiors and figures and soon afterwards also produced simplified images in collage. These early works emphasized the flatness of the picture plane while remaining representational, and this insistence on figuration placed him outside the contemporary avant-garde mainstream, in which abstraction and chance were key qualities. He developed his style in the portrait works of ordinary people from the late 1950s, such as *Ada with White Dress* (1958; artist's col., see Sandler, pl. 55). This resolution of the demands of formalism and representation looked forward to the Pop art of the following decade. In the 1960s Katz's works became more realistic and were executed in a smoother, more impersonal style, as in *Frank and Sheila Lima* (1965; Wichita, KS, A. Mus.). Though concentrating on figures in interiors and in urban environments, he also painted a number of landscape and flower pieces, such as *White Petunia* (1968; Cincinnati, OH, A. Mus.). After experimenting with the technique in the late 1950s, from the mid-1960s he made a number of free-standing cut-out figure works painted on wood or aluminium, such as *Rudy and Edwin* (1968; artist's col., see Sandler, pl. 115). Similarly, after early forays in the 1950s, Katz concentrated more on printmaking in the 1960s, making very simplified lithographs and screenprints, such as the screenprint *Row Boat* (1966; see Maravell, pl. 14). After the 1960s he continued producing similar figure paintings, such as *Night* (1976; Philadelphia, PA Acad. F.A.), as well as prints. He achieved great public prominence in the 1980s, and among the works of that decade were a number of multi-panel paintings, such as *Pas de deux* (1983; Paul Jacques Schupf priv. col., see 1986 exh. cat., pp. 130–31).

BIBLIOGRAPHY
I. Sandler: *Alex Katz* (New York, 1979)
N. P. Maravell: *Alex Katz: The Complete Prints* (New York and London, 1983)
Alex Katz (exh. cat. by R. Marshall and R. Rosenblum, New York, Whitney, 1986)

Katz, Mané. *See* MANÉ-KATZ.

Katzenellenbogen, Adolf (*b* Frankfurt am Main, 19 Aug 1901; *d* Baltimore, MD, 30 Sept 1964). German art historian, active in America. He graduated from the Justus-Liebig-Universität, Giessen, in 1924 and was awarded a DPhil. from the Universität Hamburg in 1933. His teaching career in Hamburg ended when he was interned in a concentration camp after he voiced his humanitarian objections to the activities of the Nazis. On his release in 1939 he emigrated with his wife, first to London, then to the USA, where he took up a post as visiting lecturer at Vassar College, Poughkeepsie, NY. In 1947 he became Professor there and in 1953 a member of the Institute of Advanced Studies at Princeton University. From 1958 he was Professor and Chairman of the Fine Art Department at Johns Hopkins University in Baltimore, and in the year before his death was able to return briefly to Germany as a guest professor at the Albert-Ludwigs-Universität of Freiburg im Breisgau. His teachings in the history of art revealed his rich background knowledge of theology, history and literature, and his approach to his subject was as a part of the general history of ideas. He was a member of the American Renaissance Society and of the College Art Association of America, which awarded him the Charles Rufus Morey Prize in 1959 for his study of the sculpture of Chartres Cathedral.

WRITINGS
The Allegory of the Virtues and Vices in Medieval Art (London, 1939)
The Sculptural Programmes of Chartres Cathedral (New York, 1959)
Regular contributions to *A. Bull.* and *Gaz. B.-A.*

BIBLIOGRAPHY
Who Was Who in America (Chicago, 1960–)
H. Bober: Obituary, *A. J.* [New York], xxiv/4 (1965), p. 347

JACQUELINE COLLISS HARVEY

Katzheimer, Wolfgang (*b c.* 1430–35; *d* Bamberg, late 1508). German painter, draughtsman and designer. He ran a painting and woodcarving workshop in Bamberg from 1465, his main patrons being the town of Bamberg and the bishop's court. Although he was generally commissioned to supply objects for everyday use, these have not survived; nor have the stained-glass windows for which he made preliminary drawings. Extant works based on his designs include a carved stone coat of arms (1494) on the Alte Hofhaltung in Bamberg, made by a Nuremberg master, and the tomb plaque of Bishop Georg Marschalk von Ebneth (*d* 1505) in Bamberg Cathedral, cast by Peter Vischer I in Nuremberg. However, both works are more expressive of the masters who executed them than of the designer. Thus the only basis for judging Katzheimer's style lies in the 22 woodcuts for the *Halsgerichtsordnung* (Bamberg, 1507), printed by Johann Pfeyll, for which he supplied the preliminary drawings. The compositions are simple, with the figures lined up horizontally, diagonally or in tiers (the traditional way of suggesting depth), and the interior spaces are usually represented in outline only. Two reliefs relating to the *Legend of St Pancras* (1501–5; Schesslitz, Gügel-Kapelle), which show the same distinguishing features, are fragments of a small altar commissioned by two bishops of Bamberg and made in Katzheimer's workshop. Although no authenticated paintings by Katzheimer have survived, on the basis of stylistic comparison with the *Halsgerichtsordnung* woodcuts two panels of the *Life of St Bartholomew* (*c.* ?1500–05; Bamberg, Neue Residenz, Staatsgal.) may be ascribed to him. The work of the MASTER OF THE HERSBRUCK HIGH ALTAR (*see* MASTERS, ANONYMOUS, & MONOGRAMMISTS, §I) has also been connected with Katzheimer. It is not yet clear whether his sons Wolfgang Katzheimer the younger (*fl* 1478–93) and Bernhard Katzheimer (*fl* 1508) collaborated with him.

BIBLIOGRAPHY
DNB; Thieme–Becker
K. Arneth: 'Die Malersippe Katzheimer in Bamberg', *Wiss. Beil. Jber. Gym. Bamberg* (1941)
K. Sitzmann: *Künstler und Kunsthandwerker in Ostfranken* (Kulmbach, 1957), pp. 283–7
A. Stange: *Deutsche Malerei der Gotik*, ix (Munich and Berlin, 1958), pp. 99–105

F. Anzelewsky: 'Eine spätmittelalterliche Malerwerkstatt: Studien über die Malerfamilie Katzheimer in Bamberg', *Z. Dt. Ver. Kstwiss.*, xix (1965), pp. 134–50

R. Baumgärtel-Fleischmann: 'Bamberger Plastik von 1470–1520', *Ber. Hist. Ver. Bamberg*, civ (1968), pp. 33–9, 146–50, 306–15

A. Stange: *Kritisches Verzeichnis der deutschen Tafelbilder vor Dürer*, iii (Munich, 1978), pp. 117–21

RENATE BAUMGÄRTEL-FLEISCHMANN

Kauffer, E(dward Leland) McKnight (*b* Great Falls, MT, 14 Dec 1890; *d* New York, 22 Oct 1954). American designer and painter, active in England. He studied painting first, at evening classes at the Mark Hopkins Institute, San Francisco (1910–12), at the Art Institute of Chicago, with lettering (1912), and in Paris at the Académie Moderne (1913–14). In 1912 he adopted the name of an early patron, Professor Joseph McKnight (1865–1942), as a gesture of gratitude. In 1914 he settled in Britain.

From 1915 McKnight Kauffer designed posters for companies such as London Underground Railways (1915–40), Shell UK Ltd, the *Daily Herald* (*see* POSTER, fig. 7) and British Petroleum (1934–6). One of his master works, *Soaring to Success! Daily Herald—The Early Bird* (1919; see Haworth-Booth, fig. 4), was derived from Japanese prints and from Vorticism. In 1920 he was a founder-member of GROUP X with Wyndham Lewis and others. McKnight Kauffer's designs included illustrations for T. S. Eliot's *Ariel Poems* (London, 1927–31) and for publications by the Nonesuch Press and Cresset Press, using the pochoir process of coloured hand-stencilling (*see* STENCILLING); he also designed photomurals ephemera such as luggage labels; and theatre and ballet costumes and sets, including *Checkmate* (1937; see Haworth-Booth, fig. 63). He made skilful use of the airbrush and the montage technique, often applying his knowledge of modern art movements such as Constructivism and Surrealism. In 1940 he went to New York, where he designed posters for war relief agencies, the United Nations and American Airlines (1946–53), as well as many book jackets and illustrations.

BIBLIOGRAPHY
E. McKnight Kauffer: Poster Art, 1915–1940 (exh. cat. by M. Haworth-Booth, London, V&A, 1973)

M. Haworth-Booth: *E. McKnight Kauffer: A Designer and his Public* (London, 1979)

MARK HAWORTH-BOOTH

Kauffman [Kauffmann; Kaufmann], **(Maria Anna) Angelica** [Angelika] **(Catharina)** (*b* Chur, Graubünden, 30 Oct 1741; *d* Rome, 5 Nov 1807). Swiss painter and etcher. She was a serious and prolific painter of portraits and one of relatively few women artists painting in the Neo-classical style to specialize in subject pictures as well. She attracted glittering and international patronage (the family of George III in Britain, Grand-Duke Paul and Prince Nikolay Yusupov in Russia, Stanislav II Poniatowski and Stanislav Kostka Potocki in Poland, Queen Caroline of Naples and Emperor Joseph II of Austria) and was much admired by her fellow artists. In Rome she was accepted into the Accademia di S Luca at the precocious age of 23, and in London she was a founder-member of the Royal Academy and an invited participant in virtually every important public project involving painting, from the abortive scheme to decorate St Paul's Cathedral to the decorations for the Royal Academy's own rooms at Somerset House and John Boydell's Shakespeare Gallery. The final tribute paid to Kauffman in Rome at her funeral, which was arranged by Antonio Canova and attended by representatives from both the Roman and foreign academies, was the carrying along in triumph of two of her own works, in obvious emulation of Raphael's funeral.

1. Early years to 1766. 2. London, 1766–81. 3. Italy, 1781–1807.

1. EARLY YEARS TO 1766. Kauffman's father, Joseph Johann Kauffman (1707–82), a minor ecclesiastical muralist and portrait painter, oversaw her artistic education as they moved about Switzerland, Austria and northern Italy in search of commissions. She was recognized as a child prodigy, assisting her father in church decorations and accepting several independent portrait projects before she was 15. In June 1762 they arrived in Florence, where, for the first time, she met artists involved with the nascent style of Neo-classicism, including the American painter Benjamin West, who had been studying in Rome, and J. F. von Reiffenstein, a German artist and a close friend of the chief theoretician of Neo-classicism, Johann Joachim Winckelmann. Her own style at this time, sprightly, if provincial, is demonstrated in her *Self-portrait in Bregenz Native Dress* (1762; Florence, Uffizi). In January 1763 the Kauffmans went to Rome, where they quickly made connections with the extensive British community there (*see* ROME, §III, 6). She studied English with Matthew Nulty and painted the portrait of *Abbé Peter Grant* (Edinburgh, N.P.G.), a long-term member of the Roman art colony. In Naples from July 1763 to April 1764 she painted after works in the royal collection, made some etchings and painted several portraits, notably *David Garrick* (Burghley House, Cambs), the first of her works to be sent to a public exhibition in London, the Free Society of Artists (1765).

Back in Rome Kauffman continued to paint portraits, including that of *Johann Joachim Winckelmann* (signed and dated 1764; Zurich, Ksthaus), and to study Classical sculpture; several examples are recorded in her sketchbook (London, V&A). However, by this time she was evidently determined no longer to confine herself to portraiture, but instead to become proficient in history painting, a prestigious branch of art that for so long had been virtually closed to women, largely because of prejudices against their studying anatomy. Kauffman obviated this difficulty by substituting statuary for the living male model. She also took lessons in perspective, probably from Giovanni Battista Piranesi and Charles-Louis Clérisseau (both of whom are depicted in the V&A sketchbook). While in Rome she painted two subject pictures: *Penelope at her Loom* (Hove, Mus. & A.G.) and *Bacchus and Ariadne* (Bregenz, Vorarlberg. Landesmus.). These intelligently amalgamate the styles of such 'first-generation' Neo-classical painters as Pompeo Girolamo Batoni, Gavin Hamilton and Nathaniel Dance, all of whom she knew personally.

In July 1765 the Kauffmans left Rome, travelling through Bologna and Parma to Venice, where Kauffman drew after works by Titian and his contemporaries and executed many etchings: a nearly complete collection of

her graphic work may be found at the British Museum, London. She came to the notice of the wife of Joseph Smith, the English diplomatic representative in Venice, who invited her to travel to England. Kauffman accepted and, separated from her father for the first time, arrived in London in June 1766.

2. LONDON, 1766–81. Kauffman had chosen a propitious moment to come to England. During the early years of the reign of George III London was second only to Rome as the artistic centre of Neo-classicism (*see* LONDON, §III, 4). Benjamin West and Nathaniel Dance were already there, having preceded Kauffman from Rome, and Joshua Reynolds provided a theoretical voice and social respectability for contemporary art in the Grand Manner. It was largely Reynolds's example that gave rise to the establishment in 1768 of the Royal Academy of Art. Kauffman's rapid emergence as a leading painter in London may be deduced from her selection as one of its founder-members (*see* LONDON, §VI), one of only two women to be so honoured (the other was Mary Moser).

Kauffman's first years in London were largely occupied with painting portraits, always the most lucrative branch of her career. Among her sitters were such prominent members of society as *Anne Seymour Damer* (signed and dated 1766; Chillington Hall, Staffs), *Augusta, Duchess of Richmond* (signed and dated 1767; London, Buckingham Pal., Royal Col.) and *Joshua Reynolds* (signed and dated 1767; Saltram House, Devon, NT). The founding of the Academy and the establishing of its annual exhibitions prompted her return to history painting, and at the first Royal Academy exhibition, in 1769, her *Hector and Andromache* and *Venus Showing Aeneas and Achates the Way to Carthage* (both Saltram House, Devon, NT) were singled out for special praise. In subsequent years she showed subject pictures of consistently innovative iconography, ranging from contemporary German literature (*Samma the Demoniac*, from Friedrich Klopstock's *Messiah*; exh. RA 1770), to Classical Antiquity (*Cleopatra Adorning the Tomb of Marc Antony*; exh. RA 1770), to Ossian, the ancient Celtic bard 'discovered' (actually, forged) by James Macpherson (*Trenmore and Imbaca*, exh. RA 1773). Kauffman was also the first artist to exhibit at the Royal Academy a scene from English medieval history. Her *Vortigern and Rowena* (exh. RA 1770; Saltram House, Devon, NT) inaugurated a taste for national history that would remain alive in British art throughout the 19th century.

Kauffman, of all the artists working in London during the later 18th century, came as close as any to fulfilling Reynolds's doctrines concerning history painting. However, neither she nor those of her contemporaries (Benjamin West, James Barry and Henry Fuseli, to name but three) who wished to bring history painting to prominence in Great Britain succeeded; English patrons steadfastly maintained their preference for portraits. Without a steady market for history paintings, Kauffman had to earn the greater part of her substantial income from portraits. Most of her sitters were female; many were allegorized in the manner of Reynolds to raise them closer to the status of history paintings. The *Marchioness Townshend and her Son* (Burghley House, Cambs), for example, are shown as

1. Angelica Kauffman: *Genius*, oil on canvas, oval, 1.33×1.50 m, 1779–80 (London, Royal Academy of Arts)

Venus and Cupid, while *Frances Hoare* (Stourhead, Wilts, NT) has a sacrificial offering to a statue of Minerva.

Kauffman also produced numerous designs for decorative paintings set into the walls and ceilings of Neo-classical interiors. Her name is particularly associated with houses designed by Robert Adam (i), and, although she herself did not paint many of the numerous panels ascribed to her, she was certainly prominent in evolving a gentle, pliant version of Neo-classicism as an appropriate complement to these domestic interiors. Her most famous decorative project was, however, for a semi-public building, the Royal Academy at Somerset House. In 1778–80 Kauffman painted four handsome allegorical ovals for the ceiling of the lecture hall of the academy's new rooms, designed by William Chambers. These ovals, representing *Colour, Design, Composition* and *Genius* (see fig. 1), are now in the vestibule of Burlington House, London, the Royal Academy's home from 1869.

3. ITALY, 1781–1807. In 1767 Kauffman had been duped into marrying an adventurer named Brandt, who had been masquerading in London society as the Swedish Count de Horn. He died in 1780, leaving Kauffman, a devout Catholic, free to remarry, which she did in 1781. Her second husband was Antonio Zucchi, another artist who specialized in interior decoration, evidently a choice dictated by prudence rather than by passion. As Kauffman's elderly and ailing father had hoped, Zucchi devoted most of his energies to managing his wife's finances. The Kauffmans and Zucchi returned to the Continent in 1781 and settled for a time in Venice, where Joseph Kauffman died (1782). More happily, it was also there that Kauffman met and enjoyed the patronage of Grand-Duke Paul of Russia. In mid-1782 Kauffman and Zucchi moved on, first, briefly, to Rome, and then to Naples, where she was offered but declined the position of court painter to King

Ferdinand and Queen Caroline. She did, however, undertake a large portrait of the *Royal Family* (Naples, Capodimonte), which she finished in Rome after her return in November 1782.

Over the next 15 years Kauffman painted some of her finest works. Her *Virgil Reading the 'Aeneid' to Augustus and Octavia* (signed and dated 1788; St Petersburg, Hermitage; see fig. 2) and *Hero and Leander* (signed and dated 1791; Arolsen, priv. col.) are typical of these mature paintings: bold in scale, richly coloured and articulate in composition, they are suitable embellishments for the palaces they were commissioned to adorn. European princes understood the Grand Manner better than her British clients.

Nonetheless, Kauffman continued to send paintings back to England, including *Valentine, Proteus, Sylvia and Giulia in the Forest* (signed and dated 1788; Wellesley Coll., MA, Mus.) and *Cressida and Diomed* (Petworth House, W. Sussex, NT), which were executed for John Boydell's 'Shakespeare Gallery', a vast undertaking designed to assemble works by the best British artists illustrating Britain's finest playwright. Kauffman's participation in this project indicates the high regard she continued to enjoy in London. She also received many honours in Italy. In 1788 she submitted a *Self-portrait* (Florence,

Uffizi) for inclusion in the famous collection of self-portraits in the gallery of the Grand Duke of Tuscany. After the death of Batoni in 1787, she was the most famous and most successful living painter in Rome, a central figure in Roman society. A visit to Kauffman's studio was considered essential for every fashionable tourist. Johann Wolfgang von Goethe and Johann Gottfried Herder spent much time with her during their respective Italian sojourns, as did Grand Duchess Anna Amalia of Saxe-Weimar.

After 1795 Kauffman became less active as an artist. Zucchi died that year, leaving her to manage her finances on her own, while the Napoleonic Wars disrupted the flow of visitors to Rome, reducing the number of commissions available to her in the last dozen years of her life. However, she continued to work, though at a much slower pace, and was fêted as the unofficial head of the Roman school of painting by local artists, who gave banquets and wrote poetry in her honour. Kauffman left no close followers. She rarely had pupils in her studio: only Robert Home (1752–1834) in England and Giovanni Battista dell'Era (1765–98) in Rome are said to have studied with her. The attempt to introduce heroic-scale subject painting in England was largely a failure, although the prestige of the English school was enhanced by her accomplishments,

2. Angelica Kauffman: *Virgil Reading the 'Aeneid' to Augustus and Octavia*, oil on canvas, 1788 (St Petersburg, Hermitage Museum)

while in Italy the aesthetic and political shifts of the Napoleonic years permanently deflected art from Neoclassicism. Kauffman's paintings, with their broad range of style and iconography, and with their vitality and ambition, are characteristic of the best of the late 18th century.

BIBLIOGRAPHY

G. G. de Rossi: *Vita di Angelica Kauffmann, pittrice* (Florence, 1811) [good, early biographical source]

F. A. Gerard: *Angelica Kauffmann: A Biography* (London, 1892, rev. 1893)

V. Manners and G. C. Williamson: *Angelica Kauffmann, R.A.* (London, 1924)

Exhibition of Paintings by Angelica Kauffmann (exh. cat., foreword E. Bayliss; London, Kenwood House, 1955)

E. Croft-Murray: *Decorative Painting in England, 1537–1837*, i (London, 1962), pp. 53, 55–6, 67–8, 227b–9b, 247b

E. Thurnher: *Angelika Kauffmann und die deutsche Dichtung* (Bregenz, 1967)

C. Helbok: *Miss Angel: Angelika Kauffmann—eine Biographie* (Vienna, 1968)

A. M. Clark: 'Roma mi è sempre in pensiero', *Studies in Roman Eighteenth-century Painting*, ed. E. P. Bowron (Washington, DC, 1981), pp. 125–38

PETER WALCH

Kauffmann, Aage B(asse) G(ustav) von (*b* Copenhagen, 14 June 1852; *d* 1922). Danish architect, active in Germany. He studied (1870–74) at the Polytechnikum, Zurich, where his ideas were shaped by the teaching devised by Gottfried Semper, who had left for Vienna in 1869. He then worked in Frankfurt am Main (until 1879) with two of Semper's pupils, Karl Jonas Mylius (1839–83) and Alfred F. Bluntschli, his main responsibility being to supervise the building of Schloss Stumm (1874–8; design begun by Carl Schäfer and completed by Mylius and Bluntschli) at Rauischholzhausen, near Marburg. In 1879 he set up his own practice in Frankfurt, and for Ferdinand von Stumm he designed the Protestant church (1879–81) at Rauischholzhausen. It is one of the first sacred buildings to have made use of the asymmetrical twin-nave plan frequently found in the architecture of the medieval mendicant orders in Hessen and Upper Saxony, and which returned to favour for Protestant churches of this period. Another noteworthy church by Kauffmann is the Christuskirche (1883) in Frankfurt. Most of his work, however, derived from private commissions, which included the remodelling of Schloss Eyrichshof (1883), near Ebern, Schloss Pflugensberg, near Eisenach, and a palace for Gräfin Reichenbach-Lessonitz (*c.* 1895) in Frankfurt. In particular, Kauffmann produced imposing houses for the wealthy middle classes in the Renaissance Revival style, with richly formed façades often reminiscent of palace architecture. He was in partnership (1884–96) with Ludwig Neher (1850–1916), and in 1903 he returned to Copenhagen, where his subsequent work, if any, is not known.

BIBLIOGRAPHY

Thieme–Becker

H. Weizsäcker and A. Dessoff: *Kunst und Künstler in Frankfurt am Main im neunzehnten Jahrhundert*, i (Frankfurt am Main, 1907), pp. 94–5; ii (Frankfurt am Main, 1909), pp. 70–71

K. Merten and C. Mohr: *Das Frankfurter Westend*, Materialien zur Kunst des 19. Jahrhunderts, x (Munich, 1974), pp. 26, 35–6, 167, 171, 181, 192

J. Schuchard: *Carl Schäfer, 1844–1908: Leben und Werk des Architekten der Neugotik*, Materialien zur Kunst des 19. Jahrhunderts, xxi (Munich, 1979), pp. 21, 66, 86, 204–5, 250

JUTTA SCHUCHARD

Kauffmann, Hermann, the elder (*b* Hamburg, 7 Nov, 1808; *d* Hamburg, 24 May, 1889). German painter. He trained in 1824 in the studio of the history and portrait painter Gerdt Hardorff the elder (1769–1864) in Hamburg and also made his own studies after nature. He first exhibited his work in 1826. The following year he moved to Munich and joined a circle of landscape painters working *en plein air* with Christian Morgenstern. The paintings *Upper Bavarian Landscape* and *Mountain Valley in Upper Bavaria* (both 1829; Hamburg, Ksthalle) are typical of Kauffmann's early style: they are pure landscapes with lively colours, directly descriptive and infused with a poetic mood. In the 1830s and 1840s, under the influence of popular Munich genre painters such as Heinrich Bürkel (1802–69), Kauffmann's pictures became anecdotal, sometimes even dramatically so, but not sentimental. Most contain large groups of figures, for example *Bear Dance in the Village* (1836; Hamburg, Ksthalle). Kauffmann was also a gifted portrait painter.

In the 1830s Kauffmann moved back to Hamburg. He then took his subjects from peasant life, domestic and farm animals, and the landscape of Bavaria, the Lüneburg Heath, the Elbe estuary and Schleswig-Holstein. By the 1850s his style had become more atmospheric, loosely structured, tending to monochrome and using few figures: for example *Timber Cart in the Snow* (1858; Hamburg, Ksthalle). By the 1860s Kauffmann's factitious, descriptive, narrative form of landscape and genre painting had come to seem old-fashioned; and in his later years Kauffmann concentrated on studies from nature in the form of vivid, small-scale watercolours.

BIBLIOGRAPHY

A. Lichtwark: *H. Kauffmann* (Munich, 1893)

Katalog der Meister des 19. Jahrhunderts in der Hamburger Kunsthalle, cat. (Hamburg, 1969), pp. 145–51

RUDOLF M. BISANZ

Kauffmann, Richard [Heb. Yitzchak] (*b* Frankfurt am Main, 20 June 1887; *d* Jerusalem, 3 Feb 1958). Israeli architect and urban planner of German birth. He first studied painting at the Städel Kunstakademie in Frankfurt am Main and then architecture at the Grossherzogliche Hochschule in Darmstadt. In 1909 he began painting landscapes in the studio of Hans von Hayek (*b* 1869) in Dachau and studied at the Königlich Bayerische Technische Hochschule in Munich under Theodor Fischer, Paul Pfann (1860–1919), Heinrich Freiherr von Schmidt (1850–1928), Friedrich von Thiersch and others. After his studies he worked in the office of Georg Metzendorf (*b* 1874) on the Margarethenhöhe near Essen, where he was involved in urban development work of a garden city nature for Emst, Hamm and Remscheid, as well as a group of houses for the Krupp estate in Margarethenhöhe and various works for the Werkbundausstellung in Cologne (1914). He received third prize for his building plan and six house types for the small Bickendorf housing estate near Cologne. He had his own office in Frankfurt for a few months until he was called up in 1915. He received first prize for his building plan for the garden city of Raigorod near Charkow.

In 1919 Kauffmann began working in the office of the Norwegian architect Paul Oscar Hoff (1875–1942) in

Christiania (now Oslo) and won a number of competitions at this time. Thereafter he worked in the architecture department of the state housing office under Harald Hals. In October 1920 he went to Palestine at the invitation of Dr Arthur Ruppin, Director of the settlement department of the Palestine Zionist Executive. He received a contract from the Palestine Land Development Company in Jerusalem to take over as architect and urban planner after Patrick Geddes, and also one from the Jewish Agency (Immigration and Land Settlement Corporation); he retained both posts until 1932.

In Palestine Kauffmann made a name for himself as a pioneering planner, particularly of agricultural settlements; it was not only his designs that were important but also his still continuing influence on the town builders who were constructing the country. He designed c. 80 town settlements and developments for the Palestine Land Development Company, including the towns of Ramat-Gan, Herzliya, Bat-Yam and an unexecuted plan for 'Afula as an urban centre in 'Emek-Yizreel (Valley of Yizreel) as well as nearly all of Mount Carmel and its surrounding area in Haifa and the Jerusalem neighbourhoods of Bet-Hakerem, Talpiot, Rehavia and Kiryat-Moshe. He designed c. 160 rural settlements for the Zionist organization, among them *Kibbutzim* Afikim, Bet-Alfa, Bet-Sera, Dan, 'En Harod (Meuhad), Gewat, Hasore'a, Kfar-Ruppin, Kfar-Szold, Kinneret, Kiryat-'Anavim, Ma'ale-Hachamisha, Ramat-Rachel, Rosh-Hanika, Tel-Yossef and Yagur *moshavim* (cooperative settlements) as well as the Beer-Towya, Bet-Shearim, Bet-Yossef, Hawazalet-Hashoroa, Kfar-Baruch, Kfar-Bilu, Kfar-Hittim, Kfar-Witkin, Kfar-Yecheskel, Kfar-Yehoshu'a, Moledet, Shoresh, Tel-Adashim and Yokne'am. In these plans Kauffmann tried to unite and express the social and agricultural ideals of the Zionist movement (as found in the writings of Yizhak Wilkansky, Jakob Oettinger, Franz Oppenheimer and Eliezer Joffe) with the aims of the European garden city movement. His ideas were influenced by Neo-classicism, producing clear structures with a certain tendency towards monumentality. Nevertheless the settlements are logically and functionally built, topographically and climatically suited to their environment.

Kauffmann's most famous settlement is probably the *moshav-'ovdim* of Nahalal. It was his first agricultural settlement in Israel and so the first to be designed there according to the principles of modern town building. The plan is characterized by a simple and clear structural concept. It consists of an oval core and a periphery. Eight eccentric paths lead from the central (communal) area to the outside and divide the settlement into eight equal parts. Two concentric bands surround the centre. The inner one circles the communal grounds and consists of the land of non-farming families. The outer one consists of the farmers' land and surrounds the inner circle. In addition to the topographic, strategic and hygienic reasons for choosing this oval form, symbolic of cooperation, the layout of Nahalal possesses many technical advantages in spite of the restrictions of its shape.

Kauffmann's two regional plans for the bay of Haifa and 'Emek-Hefer (Valley of Hefer) were of particular significance. Although unexecuted, the plan for the Bay of Haifa (1926–8) was to move Haifa's harbour north and thereby stimulate the development of the town and its surroundings. By 1936 the regional plan to divide Palestine's central coastal area, 'Emek-Hefer, into plots had led to the construction of 15 settlements. As an architect of individual buildings Kauffmann designed c. 330 plans, including 160 houses and private buildings. Although as a student he was exposed to South German regionalism, he later developed in a Neo-classical direction. His personal style had developed by the end of the 1920s; it was a balanced mixture of contemporary tendencies (Functionalism and International Style), and Kauffmann attempted to build in Israel in a way that was formally and stylistically appropriate. His construction of a double roof for the buildings in the particularly hot areas of the Jordan Valley and near the Dead Sea was well planned. The peak of his career lay in the years between 1929 and 1933 when he built the houses Kruskal, Ussishkin, Pomerantz, the Carmel Sanatorium and the pavilion Tozeret Haaretz. The buildings all have a clear and functional ground-plan, a simple form, rationally calculated structural details (such as roof projections, concrete panels to provide protection from the sun, high ceilings, wide windows and ventilation holes) and use reinforced concrete as a visible loadbearing element.

Kauffmann was a member of the Town Planning Institute and the International Federation for Housing and Town Planning in London; chairman of the building committee of the Palestine Zionist Executive and member of the Central Town Planning Commission in Jerusalem when it was a British mandatory territory, as well as a member of the board of the Bezalel Art School in Jerusalem and adviser to the town engineer there.

WRITINGS

'Die Städtebauliche Anlage jüdischer Siedlungen in Palästina', *Städtebau*, xxi/9–10 (1926) [plus special issue]
'Planning of Jewish Settlements in Palestine', *Town Planning Rev.*, xii/2 (1926), pp. 206–11

BIBLIOGRAPHY

A. Neumeister, ed.: 'Kleinwohnungssiedlung in Bickendorf bei Köln', *Dt. Konkurrenzen*, xxx/358 (1914)
G. Canaan: *Rebuilding the Land of Israel* (New York, 1954)
M. Kuhn: 'Richard Kauffmann', *Baumeister*, 1 (1962)
U. M. Adiv: *Richard Kauffmann (1887–1958)—das architektonische Gesamtwerk* (diss., W. Berlin, Tech. U., 1985)

URIEL M. ADIV

Kaufmann, Oszkár [Oscar; Oskar] (*b* Újszentanna [now Santa Ana, Romania], 2 Feb 1873; *d* Budapest, 6 Sept 1956). Hungarian architect and interior designer, active in Germany and Palestine. After studying music in Budapest, he studied architecture at the Technische Hochschule, Karlsruhe, where he obtained his Diploma of Architecture in 1899. In 1900 he settled in Berlin, where he worked first as an interior designer for private clients. Later he specialized in designing theatres and cinemas. In contrast with reform movements, he advocated the strict separation of the stage from the auditorium (the realm of illusion from that of reality), and the traditional arrangement of the auditorium with balconies and intimate boxes. His first major work was the Hebbeltheater (1907–8; with San Micheli Wolkenstein and Albert Weber), Berlin. The almost monolithic severity of the façade and the building's imposingly dynamic composition are emphasized by the

intimate, refined elegance of the interior, a contrast characteristic of his subsequent work. The wall-coverings of silk and wood and the decentralized light-sources combine to create a warm, salon-type interior. Similar designs include the Municipal Theatre (1910–11; with Ebbencrone and Karl Machlup), Bremerhaven, and the Volksbühne (1913–14) in Bülowplatz, Berlin, with Eugen Stolzer and others. In the 1920s he carried out reconstructions, for example the Krolloper (1922–3; destr.) in Königsplatz and the Renaissance Theatre (1926–7), Hardenberg Street, both with Stolzer, in Berlin. In his pioneering cinema architecture his design for the Cines–Company in Berlin (1912–13; destr.) in Nollendorferplatz, Berlin, was strikingly novel, its simple volume being windowless and stone-faced, decorated by statues and pilasters. In Kaufmann's other theatre and cinema designs in Berlin and in Vienna, Königsberg and Győr, the similar use of freely adapted historicist forms and the striving for atmospheric effect are apparent. In 1933 he moved to Palestine, where he designed the Habimah Theatre (1936), Tel Aviv. Between 1939 and 1941 he lived in Bucharest and then Budapest, where he was involved in rebuilding the Madách Theatre (1954–60; Pál Mináry and Ottó Fábry).

WRITINGS
'Der moderne Theaterbau', *Dt. Bühne*, i (1909), pp. 302–6

BIBLIOGRAPHY
O. Bie: *Der Architekt Oscar Kaufmann* (Berlin, 1928)
H. Zielske: *Deutsche Theaterbauten bis zum zweiten Weltkrieg* (Berlin, 1971)
R. Riedel, ed.: *Berlin und seine Bauten*, v (Berlin and Munich, 1983), pp. 78–86

ÁKOS MORAVÁNSZKY,
KATALIN MORAVÁNSZKY-GYÖNGY

Kaukab el Hawā. *See* BELVOIR CASTLE.

Kaulak [Cánovas del Castillo, Antonio; Kavlak] (*b* Madrid, 1874; *d* Madrid, Sept 1933). Spanish photographer. He followed his uncle, a prominent conservative, into politics, but in the early 1890s, with his brother's encouragement, he took up photography. By the next decade, recognized as one of the most important photographers in Madrid, Kaulak was one of the two vice-presidents of the newly formed Real Sociedad Fotográfica (Madrid) and a founder of its periodical, *La Fotografía* (first issue published 1 Oct 1901). Here he published images and articles on a great variety of technical and aesthetic subjects. In 1904 he took charge of the Portela gallery in the centre of Madrid (on Alcalá 4) and made it one of the most fashionable portrait studios of that era; for many years it housed his complete archives. Kaulak is also known for exquisite hand-painted portrait photographs, for example an *Imitation of Velázquez (a Pseudo Margarita)*, in keeping with the painterly pictorial mode that characterized the Real Sociedad Fotográfica.

BIBLIOGRAPHY
L. Fontanella: *La historia de la fotografía en España desde sus orígenes hasta 1900* (Madrid, 1981)

LEE FONTANELLA

Kaulbach. German family of artists. Philipp Karl Friedrich Kaulbach (*b* Arolsen, Waldeck [now Hessen], 25 Nov 1775; *d* Mühlheim an der Ruhr, 10 Dec 1846) was a goldsmith, engraver and amateur painter. His two sons were (1) Wilhelm von Kaulbach and Karl Kaulbach (*b*

Arolsen, 5 March 1808), the latter a sculptor and painter. Wilhelm von Kaulbach's son Hermann Kaulbach (*b* Munich, 26 July 1846; *d* Munich, 9 Dec 1909) was a history and genre painter. Christian Kaulbach (1777–1847), brother of Philipp Karl Friedrich Kaulbach, was a cabinetmaker; he was the father of (2) Friedrich Kaulbach. Friedrich Kaulbach's son Friedrich August von Kaulbach (*b* Munich, 2 June 1850; *d* Ohlstadt bei Murnau, Bavaria, 26 July 1920) was a portrait and genre painter.

BIBLIOGRAPHY
E. Lehmann and E. Riemer: *Die Kaulbachs: Eine Künstlerfamilie aus Arolsen* (Arolsen, 1978)

(1) (Bernhard) Wilhelm (Eliodorus) von Kaulbach (*b* Arolsen, Waldeck [now Hessen], 15 Oct 1804; *d* Munich, 7 April 1874). Painter and illustrator. After initial instruction from his father, Kaulbach received his principal education, from 1822 to 1826, at the Kunstakademie, Düsseldorf, under Peter Cornelius. Six months after Ludwig I, King of Bavaria, had summoned Cornelius to Munich, Kaulbach followed his tutor to the Bavarian capital, where he worked on various collaborative ventures with other pupils of Cornelius, and completed his practical training on such projects as the decoration of the Odeon (destr.) in 1826, and of the Hofgartenarkaden, from 1826 to 1829 (now painted over). More independent work followed with 16 frescoes on the theme of Cupid and Psyche for the Festsaal of the Herzog-Max-Palais (1829–35; now Munich, Neue Pin.), and in the throne-room, salon and queen's bedroom of the newly erected Königsbau of the Residenz (1832–5; partly destr.).

With the painting *Battle of the Huns* (1834–7; Poznań, N. Mus.), Kaulbach broke away from a classically linear style and the Cornelius tradition of mural painting. Although the work never progressed beyond a sepia version, this large-scale undertaking established a reputation for Kaulbach, partly because his idealistic view of history clearly appealed to contemporary taste. From 1837 Kaulbach was court painter to Ludwig I. Kaulbach used a six-month stay in Italy (1838–9) mainly to make landscape studies in oil, and in the 1840s he produced a number of large-scale oil portraits (some in Munich, Neue Pin.). The most important work of this period, however, was in his established idealizing vein: a monumental oil painting, the *Destruction of Jerusalem* (1836–46; Munich, Neue Pin.). In 1841 Ludwig I took over the original commission (from a Russian princess) increasing the scale of the work to *c*. 6×7 m and using this as a pretext to construct a third Munich museum, the Neue Pinakothek, to house the painting (which was already the most expensive picture so far commissioned in the 19th century). For the new museum Ludwig commissioned Kaulbach to provide 19 designs (oil sketches, Munich, Neue Pin.) on which to model large-scale exterior frescoes (destr. 1945; see Von Ostini, pp. 60–61; Schulze, pls xx–xxii). As a vital element in the building's decoration, these frescoes, on themes such as *Artists Receiving Commissions from Ludwig I*, served an important function in glorifying the patron and his artistic policy. Kaulbach, however, used the commission to make ironically critical observations on the art world of Ludwig's Munich, and this led to violent protests. Kaulbach painted a second version of the *Destruction of*

Jerusalem (1847–65; destr.; cartoons Berlin, Altes Mus.), commissioned by the Prussian Regent, Friedrich Wilhelm IV, as part of a complex picture cycle in the stairwell of the Neues Museum in Berlin. In this cycle, Kaulbach's major achievement, he depicted, in 39 different large oil murals, the stages in the development of human cultural history. Responding to contemporary self-confidence and optimism, he showed world history reaching its apotheosis in the Germany of the day.

Kaulbach revealed his ironic edge most strikingly in his illustrations for *Reineke Fuchs* (original drawings 1846–7; Munich, Lenbachhaus, numerous editions). These continued the critically realist trend of Kaulbach's drawings from the 1830s and 1840s, such as the *Madhouse* scenes and the illustrations for Schiller's play *Verbrecher aus verlorener Ehre* (all Berlin, Altes Mus.). The cycles of drawings produced in the 1850s and 1860s, however, especially the illustrations to Goethe, Schiller and Shakespeare, were largely concessions to bourgeois taste, aiming at neither artistic innovation nor political impact. From 1849 to 1874 Kaulbach was director of the Kunstakademie in Munich, where his 'historical-symbolist' style was presented as a model to several generations of students.

Thieme–Becker

BIBLIOGRAPHY

F. von Ostini: *Wilhelm von Kaulbach* (Bielefeld, 1906) [with extensive illus.]
E. Lehmann and E. Riemer: *Die Kaulbachs: Eine Künstlerfamilie aus Arolsen* (Arolsen, 1978)
A. Menke: 'Wilhelm von Kaulbach', *Spätromantik und Realismus*, v of *Bayerische Staatsgemäldesammlungen*, cat. (Munich, 1984), pp. 192–250 [with illus. and bibliog.]
S. Schulze: *Bildprogramme in deutschen Kunstmuseen des 19. Jahrhunderts* (Frankfurt am Main, 1984), pp. 83–109, 240–57
A. Menke: *Wilhelm von Kaulbachs kulturhistorischer Zyklus im Treppenhaus des Neuen Museums in Berlin* (diss., Bonn, Rhein. Friedrich-Wilhelms-U., in preparation)

ANNEMARIE MENKE

(2) Friedrich Kaulbach (*b* Arolsen, Waldeck [now Hessen], 8 July 1822; *d* Hannover, 17 Sept 1903). Painter, cousin of (1) Wilhelm von Kaulbach. From the age of 14 he began to execute portraits and flower paintings. In 1839 he studied at the Akademie der Bildenden Künste in Munich under Wilhelm von Kaulbach. After a visit to Venice in 1844, he broke away from his teacher and eventually painted his first independent history painting, *Adam and Eve by Cain's Body* (1848; Leipzig, Mus. Bild. Kst.), as a result of which he was offered a professorship at the Akademie in Munich, although he did not take up the position. In 1850 he made his first trip to Paris, where he executed further history paintings, as well as commissions for portraits. In 1850 Maximilian II of Bavaria (*reg* 1848–64) commissioned him to paint the *Coronation of Charlemagne* for the Maximilaneum in Munich (*in situ*). In 1856 Kaulbach was summoned to Hannover by George V (*reg* 1851–66), whose portrait he painted several times (e.g. *Blind King George V, c.* 1866; Hannover, Niedersächs. Landesmus.). He was later appointed court painter and Professor at the Technische Hochschule, where, in 1862, he began his major work, *Juliet Capulet's Wedding Morning* (Hannover, Niedersächs. Landesmus.), which was not completed until 1903. His history paintings are exceptional because of the detailed manner in which they are painted, and they contain figures carefully drawn from individual

studies. However, in accord with prevailing taste, a theatrical effect is often present. His portraits, such as that of the sculptor *Elisabeth Ney* (1860; Hannover, Niedersächs. Landesmus.), are striking because of the empathy he establishes with his sitter and the soft, yet at times precisely detailed, manner in which they are painted.

BIBLIOGRAPHY

L. Schreiner: *Die Gemälde des neunzehnten und zwanzigsten Jahrhunderts in der Niedersächsischen Landesgalerie Hannover*, 2 vols (Munich, 1973, rev. Hannover, 1990), i, pp. 168–76; ii, pp. 159–67, figs 297–316
E. Lehmann and E. Riemer: *Die Kaulbachs: Eine Künstlerfamilie aus Arolsen* (Arolsen, 1978)

JOSEF STRASSER

Kaunas [Pol. Kowno]. City in Lithuania, situated on the River Nemunas (Rus. Neman). The town existed in the 11th century, and in the 13th, when the castle was built, it was an important base in the struggle between the Grand Duchy of Lithuania and the Teutonic Knights. From 1569 it was part of the Kingdom of Poland and from 1795 to 1920 part of the Russian empire. It was known as Kowno until 1917, and was part of the USSR until 1991. In the Old Town, which is fundamentally medieval and situated at the north end of the city at the confluence of the rivers Nemunas and Neringa, is the castle (13th–17th centuries) and also the notable Gothic brick church of Vytautas (founded 1400) and the cathedral of SS Peter and Paul (15th–17th centuries). Of the old residential buildings the house of Perkūnas (15th–16th centuries) has a brick gable with flamboyant mouldings. Renaissance principles are apparent in the town hall (rebuilt 1638) and in the palace of the Massalkis family (beginning of the 17th century). The Jesuit church (1666–1726) and the complex of the Camaldolese monastery in Pažaislis (1667–1712) designed by the architects Gian Battista Frediani (*fl* 1672–95), Carlo Putini and Pietro Putini, are fully Baroque in style. In the 19th century the New Town grew up at the east end of the Old Town on a regular plan. From the 1920s to the 1940s, during the Lithuanian republic, attempts to discover a national style of architecture (e.g. the bank, 1925, by Mikolas Songayla) were combined with both Neo-classicism and Constructivism. Kaunas was later subject to an overall plan drawn up in 1966 by Petras Yanulis (*b* 1906) that provided for the creation of new self-contained residential communities (Rus. *mikrorayon*) and the restoration of the historic areas and groups of buildings. The M. K. Čiurlionis Art Museum has a collection of Lithuanian art of the 17th to 20th centuries, including the Čiurlionis gallery, which contains Čiurlionis's principal works, a gallery of stained glass, sculpture and a gallery showing western European and Soviet pictures.

BIBLIOGRAPHY

V. Bičiūnas: *Kaunas, 1030–1930* (Kaunas, 1930)
V. Zeliukas: *Kaunas* (Vilnius, 1958)
A. Gubinskiene, V. Černeckis and P. Kažinaitis: *Kaunas, jo praeitis, dabartis ir ateitis* [Kaunas, its past, present and future] (Vilnius, 1960)
K.-A. Yanulaytis: *Po Nemanu v Litve* [Along the River Nemunas in Lithuania] (Moscow, 1979)

SVETLANA M. CHERVONNAYA

Kaunitz-Rietberg, Prince **Wenzel Anton** (*b* Vienna, 2 Feb 1711; *d* Vienna, 27 June 1794). Austrian statesman and patron. The son of a count, he rose through a diplomatic career in Italy, the Netherlands and Paris to

become Austrian State Chancellor in 1753. As such, he achieved a long-sought policy goal with the Austro-French Treaty of 1756. He became and remained the closest confidant of Empress Maria-Theresa (being made a prince in 1764) and the man with chief responsibility for Austria's intellectual, political and domestic development until 1792. Enlightened, broad-minded and acutely intelligent, he made a decisive mark on his era.

In 1766 Kaunitz-Rietberg opened the Kupferstichakademie in Vienna, established by Jakob Matthias Schmutzer (1733–1811). In 1772 this was combined with the Akademie der Maler, Bildhauer und Baukünstler and the Graveurakademie to form the Akademie der Bildenden Künste, under Kaunitz-Rietberg's protection. He emphasized at this point the artist's value for the economic development of the state and the importance of the visual arts for raising the level of national education and prestige, thus acknowledging that promoting art was an important function of the state; this view was later embodied in his 'Protektoratsdekret' of 30 August 1788 (Novotny). Accordingly, he improved public training for artists and encouraged the free development of the Akademie students' creative abilities. He fostered many artists personally, including Franz Anton Zauner and Heinrich Friedrich Füger, often awarding pensions for foreign study. Kaunitz-Rietberg's tastes, formed by his travels, inclined to the Neo-classical rather than the Rococo. His palace in Vienna, the Kaunitz-Esterházy-Palais (for illustration see ESTERHÁZY), housed an important art gallery. His own collection was sold between 1820 and 1830.

NDB
BIBLIOGRAPHY
Catalogue des tableaux provenant d'une ancienne galerie célèbre (Vienna, 1820)
A. Novotny: *Staatskanzler Kaunitz als geistige Persönlichkeit* (Vienna, 1947), suppl. 18 [incl. Protektoratsdekret]
G. Mraz and G. Mraz: *Österreichische Profile* (Vienna, 1981), pp. 103–19
T. Simányi: *Kaunitz* (Vienna, 1984)

INGRID SATTEL BERNARDINI

Kaus, Max (*b* Berlin, 11 March 1891; *d* Berlin, 5 Aug 1977). German painter and printmaker. After a practical training as a decorative artist, he attended the Kunstgewerbeschule in Charlottenburg, Berlin. In 1914 a stay in Paris aroused his interest in fine arts. Before he was able to develop in this field, World War I broke out; Kaus worked as an ambulance driver in Flanders. In 1917 Erich Heckel became his military superior in Ostend. The German painters Otto Herbig (1889–1971) and Anton Kerschbaumer (1885–1931) also belonged to his division. The influence of these artists, particularly Heckel, is clear in Kaus's early work, for example *Self-portrait I* (1919; priv. col., see 1991 exh. cat., p. 121). His paintings are marked by brooding doubt and existential loneliness. In 1920 he became a member of the Freie Sezession and met Karl Schmidt-Rottluff and Otto Mueller. In the early 1920s he travelled by boat through the Brandenburg Marshes, to Mecklenburg and the Baltic, producing paintings of landscapes and bathers, as in *Bathers in the Bay at Hiddensee* (1922; priv. col., see 1991 exh. cat., p. 43). He became a teacher in 1926 at the Meisterschule für Kunsthandwerk in Berlin, and in 1933 he moved to the Vereinigte Staatsschulen. The Nazis disapproved of his work, and in 1938 he had to give up his teaching post. In

1943 his studio was destroyed in a bombing raid, as was his graphic work in 1945. In the latter year he became a teacher at the Staatliche Hochschule für Bildende Künste in Berlin, where he taught until 1968. His subjects were closely connected to his life and to nature, although in the years after 1945 his images were increasingly dominated by rhythmic patterns coming close to abstraction, as in *Temple Ruins II, Rome* (1957; priv. col., see 1991 exh. cat., p. 159).

BIBLIOGRAPHY
Gemälde von Max Kaus, 1917–1970 (exh. cat., ed. L. Reidemeister; W. Berlin, Brücke-Mus., 1971)
Max Kaus Graphik; Lithographien, Holzschnitte, Radierungen; Sammlung Buchheim (exh. cat. by L.-G. Buchheim, Hamburg, Altonaer Mus., 1973)
Max Kaus: Werke und Dokumente (exh. cat. by K. Z. von Manteuffel and U. Schmitt-Wischmann, Nuremberg, Ger. Nmus.; Berlin, Staatl. Ksthalle; Darmstadt, Ksthalle; 1991)

B. E. BUHLMANN

Kausambi [Kauśāmbī; Kosam]. Site of an ancient city in Allahabad District, Uttar Pradesh, India. The ruins of Kausambi are spread over a 20 sq. km area beside the River Yamuna. Although it is generally agreed that Kausambi was one of the major cities of India in the 5th century BC, the date of its origin is debated. Excavators have suggested as early as the 12th century BC. A fortification wall, 6.5 km in circuit and roughly rectangular in plan, was enlarged and faced with brick. The battered wall of this rampart survives to a height of 154 courses, making it one of the most impressive early structures in India. A palace uncovered by excavation has ashlar walls and openings spanned by true arches.

The Buddha (5th century BC) spent time on the city's outskirts in Ghositarama, where a monastery was established. The ruins have been excavated, showing it to have had rooms around a courtyard with a stupa in the centre. The column bearing edicts of Asoka (reg c. 269–232 BC) in the Allahabad fort is believed to have been brought from Kausambi; portions of a second pillar carved from buff sandstone and burnished in the characteristic style of the 3rd century BC are still at the site. Of the same period are several stone discs with low reliefs (Allahabad Mus.; *see also* INDIAN SUBCONTINENT, §IV, 3(ii)). About 100 BC a stupa railing with figural sculpture (Allahabad Mus.) was made at Kausambi; it recalls a similar railing at Bodhgaya (*see* BODHGAYA AND GAYA). In the second year of Kanishka's reign (*c.* early 2nd century AD), a standing Buddha (Allahabad Mus.) carved from Mathura sandstone was provided at Kausambi, according to its inscription, by the nun Buddhamitra. This is the earliest documented image of the Buddha. Later, probably about the end of the 2nd century when the Magha dynasty ruled Kausambi, two seated Buddha images (Allahabad U., Archaeol. Mus.) were dedicated during the reign of a king named Bhadramagha. These are local products, somewhat different in style from approximately contemporary works of Mathura. A standing image of Shiva and Parvati (Calcutta, Ind. Mus.), dated in the year 139 during the reign of Bhimavarman, probably belongs to the 4th century. Other Buddhist sculptures also date to the 4th and 5th centuries, confirming the observations of the Chinese traveller Faxian, who found the site active but not particularly important in the 5th century. Kausambi declined rapidly

after the invasion of the Hunas (*c.* 500); in the time of the Chinese pilgrim Xuanzang (7th century) the monasteries were in ruin.

BIBLIOGRAPHY

R. D. Banerji: 'Some Sculptures from Kosam', *Archaeol. Surv. India Annu. Rep.* (1913–14), pp. 262–4

G. R. Sharma: 'Excavations at Kauśāmbī, 1949–1955', *Annu. Bibliog. Ind. Archaeol.*, xvi (1948–53), pp. xxxvi–xlv

S. C. Kala: *Terracotta Figurines from Kausambi* (Allahabad, 1950)

G. R. Sharma: *The Excavations at Kauśāmbī, 1957–59* (Allahabad, 1960)

A. Ghosh, ed.: *Archaeological Remains, Monuments and Museums*, 2 vols (Delhi, 1964)

G. R. Sharma: *Excavations at Kausambi, 1949–50*, Mem. Archaeol. Surv. India, lxxv (Delhi, 1969)

P. Chandra: *Stone Sculpture in the Allahabad Museum* (Pune, 1970)

J. Harle: *Gupta Sculpture* (Oxford, 1974)

J. Irwin: 'The Ancient Pillar-cult at Prayāga (Allahabad): Its Pre-Aśokan Origins', *J. Royal Asiat. Soc. GB & Ireland* (1983), pp. 253–80

K. S. Ramachandran: 'Kauśāmbī', *An Encyclopaedia of Indian Archaeology*, ii: *A Gazetteer of Explored and Excavated Sites in India*, ed. A. Ghosh (Leiden, 1990), pp. 212–15

FREDERICK M. ASHER

Kauser, József (*b* Pest [now Budapest], 7 May 1848; *d* Budapest, 25 July 1919). Hungarian architect. He studied in Budapest and Vienna, then in Paris at the Ecole des Beaux-Arts and with Charles Laisné. He was briefly employed in Theophilus Hansen's office in Vienna. A true example of the academic architect, Kauser was equally well-versed in all revival styles, but his buildings tend to be impersonal. The large residential block (1883) of the Pension Institute of the Hungarian State Railway Company, Budapest, is in a French Renaissance Revival style. The architectural details of the new Calvinist Grammar School (1888–90), Budapest, have a restraint derived from the Italian Renaissance Revival style, but its brick façade (one of Kauser's favoured features) is structurally polychrome. The School of Industrial Design (1892), Budapest, revives the Transitional style of the medieval period with a blend of Romanesque and Gothic elements, as does the church of the Heart of Jesus (1888–90), Budapest. Kauser considered his version of this style traditionally Hungarian, referring it to Hungarian medieval churches such as those at Ják, Zsámbék, Horpács and Lébény. From 1891 to 1906 he was in charge of the completion of Budapest's largest church, St Stephen's Basilica (1851–1906), a huge domed structure in a Renaissance style left unfinished after the death of Miklós Ybl. Kauser designed the magnificent interior decoration and furnishings. During this time he repeatedly visited Italy in order to study its church architecture. He also built several hospitals and clinics and a number of pedestals for statues.

BIBLIOGRAPHY

J. Lechner: 'Kauser József emlékezete' [In memory of József Kauser], *A Magyar Mérnök—és Épitész-Egylet Közlönye*, lv (1921), pp. 123–5

JÓZSEF SISA

Kauzlarić, Mladen (*b* Gospić, 10 Jan 1896; *d* Zagreb, 6 June 1971). Croatian architect and teacher. He studied at the School of Building (1911–15) and the Academy of Fine Arts (1926–30) in Zagreb under Drago Ibler. Kauzlarić regularly exhibited his works with the group Zemlja (The Land). He worked in the studio of Hugo Ehrlich (1921–31) and between 1931 and 1941 was in partnership with Stjepan Gomboš in Zagreb, where they built several villas, including the Villas Ladany and Schön, and the Farmers' Union Building. Their activities on the Dalmatian coast included the remodelling of the seaside promenade in Dubrovnik and the design of several villas on the islands of Korčula and Hvar. In 1933 they completed the restoration of the Arsenal in the Old Port at Dubrovnik and transformed it into the celebrated City Grand Café. After World War II Kauzlarić worked in the Institute of Architecture and Town Planning, Zagreb, and was responsible for the interior design (1946) of the premises of the newspaper *Borba*, the Yugoslav Bookshop (1946) and the Students' Centre (1963), all in Zagreb. He also designed the Archaeological Museum (1954), Split, and three hotels (1958) in Dubrovnik and received the Federal Prize for his designs for the Rade Končar factory in Zagreb. In his work he followed the principles of Ehrlich and Viktor Kovačić, showing a mastery of scale and balance between details and the whole. His buildings are always furnished with high-quality interiors. He taught architecture from 1940 (from 1958 as a professor of interior design) at the Architectural Faculty of the University of Zagreb.

BIBLIOGRAPHY

S. Sekulić-Gvozdanović: 'Deset godina od smrti Mladena Kauzlarića' [Ten years after the death of Mladen Kauzlarić], *Covjek & Prostor*, xxix/342 (1981), p. 8

PAUL TVRTKOVIĆ

Kavčič, Franc. *See* CAUCIG, FRANCESCO.

Kaveripattinam [anc. Poompukar; Puhar; Pukar]. Ancient port city, now a village, at the mouth of the Kaveri River in eastern Tamil Nadu, India. Excavations around an 8 km radius of Kaveripattinam (including several surrounding villages) revealed remains dating from the early centuries BC to *c.* 10th century AD. Fragments of Red-and-black ware are datable to the 3rd–1st century BC. At Kilaiyur village, a large platform of fired brick (18.28×7.62 m) contained remains of wooden corner posts that are datable by radiocarbon analysis to *c.* 316–103 BC. Located near the sea, this platform may have been an ancient wharf. Foundations of water tanks and large buildings, possibly warehouses, again of fired brick, were also found in the area. The remains of a Buddhist monastery (Skt *vihāra*) at Pallavanisvaram village show general affinity with the architecture of Nagarjunakonda (*fl* 3rd–4th century AD), although evidence of continual repairs suggests occupation at least until the 7th century. Buddhist sculptures include a *Buddhapāda* ('footprints of the Buddha') of *c.* 2nd–3rd century AD and a small bronze seated Buddha. A bronze image of Parvati with Skanda (*c.* 10th century) was also found at Pallavanisvaram, while a gilt-copper figure of the *bodhisattva* Maitreya (*c.* 8th century) was found at Melaiyur. Small terracotta figures and hardstone beads were recovered at Kaveripattinam. Square and irregular copper coins of Indian production and Roman coins were also found in the area.

These discoveries complement descriptions of Kaveripattinam/Pukar found in various texts. Kaveripattinam is generally equated with 'Khaberi's Emporium', the thriving Indian port and centre of trade with Rome described in Ptolemy's *Geography* (2nd century AD). The city is also described in such Indian sources as the Pali *Milindapañha* ('Questions of Milinda'), perhaps most

vividly in the Tamil epic *Cilappatikaram* ('The story of the anklet', *c.* 5th century), the first part of which is set in Pukar. These texts attest to the material splendour of the city and describe Buddhist and Jaina *vihāra*s and temples dedicated to Brahmanical deities. From the 9th to the 12th centuries Kaveripattinam was a principal port of the CHOLA dynasty for commerce with South-east Asia. Kaveripattinam now has a museum, modelled after the south Indian temple type, which houses modern tableaux depicting the *Cilappatikaram*.

BIBLIOGRAPHY
K. A. Nilakanta Sastri: *The Colas* (Madras, 1955)
R. Nagaswami: *Art and Culture of Tamil Nadu* (Delhi, 1980)
K. S. Ramachandran: *Archaeology of South India: Tamil Nadu* (Delhi, 1980)
R. Parthasarathy: *The Cilappatikaram of Ilanko Atikal: An Epic of South India* (New York, 1993)

J. MARR

Kaviyur. Temple site in Alleppey District, southern Kerala, India. It is known for two Hindu temples: the Mahadeva Temple of the late 10th century AD and an earlier rock-cut shrine dedicated to Shiva. The latter is of unknown date, although it is believed to pre-date the Kulashekhara dynasty (*c.* 800–1124). It demonstrates strong stylistic affinities with excavations of the Pandya period in lower Tamil Nadu (*see* INDIAN SUBCONTINENT, §III, 5(i)(j)). The façade pillars rise from a square base to an octagonal mid-section; the bevelled corbels support pendent volutes. The beautifully executed relief carvings in the hall preceding the shrine include a human figure that may represent a chieftain (*see* INDIAN SUBCONTINENT, fig. 215). Steps lead up to the sanctum, which contains a rock-cut *linga* (Skt: phallic emblem of Shiva). The nearby Mahadeva Temple is a circular shrine of the Kerala type, with a sloping tiled roof, a granite base and exterior walls of carved wood (*see* INDIAN SUBCONTINENT, fig. 352). The complex is approached through a tall, Kerala-style gateway (*gopura*) on the east; the shrine itself is preceded by a detached square, pillared hall with a pyramidal roof. The circular exterior wall is completely carved with depictions of Hindu deities and probably dates from the 18th century. It encloses a square inner sanctum (*garbhagrha*) with a double circumambulatory path containing a row of columns and four openings facing the cardinal points.

See also INDIAN SUBCONTINENT, §IV, 7(vi)(b).

BIBLIOGRAPHY
H. Sarkar: *Architectural Survey of Temples of Kerala* (New Delhi, 1978)
M. Meister and M. A. Dhaky, eds: *South India Lower Drāvidadēśa, 200 BC–AD 1324* (1983), i/1 of *Enc. Ind. Temple Archit.*

M. E. HESTON

Kavlak. *See* KAULAK.

Kavos [Cavos], **Al'bert (Katarinovich)** (*b* 1801; *d* 1862). Russian architect of Italian descent. He studied in Padua and began his architectural career as assistant to Karl Rossi on the building of the Aleksandrinsky (now Pushkin) Theatre (1828–32) in St Petersburg. He designed several private houses and public buildings in St Petersburg and spent five years working with his son, Tsezar Kavos (1824–83), on the reconstruction of the buildings of the postal service. (Kavos's daughter married the architect Nikolay

Benois (*see* BENOIS, (1)), who also did some work with him.) His greatest achievement was the reconstruction of the 18th-century stations for diligences that opened out on to Great Naval (Bol'shaya Morskaya) and Post Office (Pochtamtskaya) streets. The buildings combined well-thought-out provisions for the comfort of passengers with Renaissance Revival façades in the style of Leo von Klenze. Kavos's main work, however, was the construction of theatres. In 1843 he restored the unusual wooden theatre on Stone Island (Kamenny ostrov), and in 1847–8 he built a theatre-cum-circus on Theatre (Teatral'naya) Square and restored it in 1859–60 after a fire. The Renaissance Revival façade and the interiors of the theatre, now known as the Mariinsky or Kirov, were altered (1883–6) by Viktor Shreter. In 1855–6 Kavos won a competition to restore the façades and interiors of the Bol'shoy Theatre in Moscow after a fire there. He retained the Empire-style façade but reworked the interiors in neo-Baroque style. Kavos also restored the interiors of the Mikhaylovsky Theatre in St Petersburg (now the Mussorgsky Small (Maly) Theatre of Opera and Ballet), adding to the Antique motifs of Aleksandr Bryullov—who built the theatre in 1831–3—elements of Renaissance Revival and neo-Baroque styles, and using different types of wood, silver and velvet in the amphitheatre and the surrounding rooms.

WRITINGS
Traité de la construction des théâtres (Paris, 1847)
Grand Théâtre de Moscou (Paris, 1859)

SERGEY KUZNETSOV

Kawa [Egyp. Gem-Aten]. Site of a large town in Sudan, on the east bank of the Nile in the fertile Dongola Reach, 5 km south of New Dongola. The earliest known monuments were set up by Tutankhamun (*reg c.* 1332–*c.* 1323 BC), although the town may have been founded in the reign of Amenophis III (*reg c.* 1390–*c.* 1353 BC) or Akhenaten (*reg c.* 1353–*c.* 1336 BC). Only the main temples have so far been excavated. A small temple (designated 'A') was built by Tutankhamun; it associates the King with the god Amun as 'lion over the south country', in the form of a ram-headed sphinx.

The main temple ('T') was dedicated to the Gem-Aten aspect of Amun; it dates to the reign of the Kushite pharaoh Taharqa (*reg* 690–664 BC), but it may have been built on the site of an earlier, 18th Dynasty temple. The construction of the temple and its furnishings are described in a series of large stelae of Taharqa. They record that the King had artisans and architects brought from Memphis to carry out the work. This is particularly important as the architecture and decoration of the building are fine examples of the archaizing tendencies of 25th Dynasty (*c.* 750–656 BC) art. The temple conforms to the classic Egyptian New Kingdom plan, with processional way, pylon, court and hypostyle hall. However, as with other temples of Taharqa at Sanam and Tabo, there is also, to the south of the sanctuary, a room with pillars and dais that is not found in the typical Egyptian temple and that may be associated with a peculiarly Kushite royal ritual. The courtyard is surrounded by a colonnade, in which the date-palm capitals are stylistically derived from those in the 5th Dynasty temple of Sahure (*reg c.* 2458–*c.* 2446 BC) at ABUSIR. Further copying from Old Kingdom Memphite

models is found in the decoration of the pylon, which has scenes of the King, in the form of a sphinx, trampling Libyan captives. These derive from reliefs in the Old Kingdom funerary complexes of Sahure and Neuserre (*c.* 2416–*c.* 2392 BC) at Abusir and that of Pepy II (*c.* 2246–*c.* 2152 BC) at Saqqara.

The sandstone shrine of Taharqa and screen wall of Aspelta (*reg* 593–568 BC), both from the hypostyle hall (and both now in the Ashmolean Museum, Oxford), are good examples of Napatan relief, conforming to Egyptian traditions but showing the kings with typical Kushite regalia, combining Egyptian and indigenous elements. An interesting pair of reliefs discovered in temple 'B' are described as 'neo-Ramessid'; these are thought to belong to the late Napatan or early Meroitic periods (*c.* 350–200 BC). The King is shown wearing highly stylized, elaborately pleated robes. Small finds of later objects of Meroitic date (*c.* 300 BC–*c.* AD 360) include several imported Hellenistic and Roman bronze figures, and a fine ivory figure (Oxford, Ashmolean). This representation of a dancing maenad, which probably decorated a casket, seems influenced by the work of the Greek sculptor SKOPAS (*fl c.* 350 BC).

BIBLIOGRAPHY

M. F. L. Macadam: *The Temples of Kawa*, 2 vols (London, 1949–55)

R. G. MORKOT

Kawabata, Minoru (*b* Tokyo, 22 May 1911). Japanese painter and teacher. His grandfather was the celebrated *Nihonga* (Japanese-style) painter Gyokushō Kawabata. In 1934 Kawabata graduated from the Tokyo School of Fine Arts (now the Tokyo University of Fine Arts and Music). From 1939 to 1941 he lived in Italy and France. In 1950 he became a professor at the Tama Art University, Tokyo, and the following year he exhibited at the first São Paulo Biennale. In 1953 he was a founder-member of the Nihon Abusutorakuto Āto Kurabu (Japanese Abstract Art Club) with Jirō Yoshihara, Takeo Yamaguchi and others. In 1958 Kawabata went to the USA and participated in an international exhibition at the Solomon R. Guggenheim Museum, New York, where he was awarded a prize. He exhibited *Rhythm* (1958; Tokyo, N. Mus. Mod. A.) at the Sengo No Shūsaku (Post-war Outstanding Works of Art Exhibition) at the National Museum of Modern Art in Tokyo (1959). In the same year he started lecturing in painting at the New School for Social Research in New York. He exhibited *Work (B)* (1961; Kamakura, Kanagawa Prefect. Mus. Mod. A.) at the sixth Nihon Kokusai Bijutsuten (International Art Exhibition, Japan), Metropolitan Art Museum, Tokyo. One-man exhibitions of his work were held at the Kanagawa Prefectural Museum of Modern Art, Kamakura (1975), and at the Jack Tilton Gallery, New York (1988). He painted in an Abstract Expressionist style in the 1950s and in a colour field style after the 1960s.

BIBLIOGRAPHY

Kawabata Minoru ten [Exhibition of Minoru Kawabata] (exh. cat., essay J. Harithas; Kamakura, Kanagawa Prefect., Mus. Mod. A., 1975)
Minoru Kawabata (exh. cat., essay A. Munroe; New York, Jack Tilton Gal., 1988)

YASUYOSHI SAITO

Kawada, Kikuji (*b* Ibaragi, 1 Jan 1933). Japanese photographer. He studied economics at Rikkyō University (1951–

5) and was self-taught in photography. His first photographic success was in the monthly contest of *Camera* magazine (1952), which was judged by Ken Domon and Ihei Kimura. After graduation he became a staff photographer for the Shichōsha publishing company, and in 1959 a freelance photographer. He was one of the founders of the Vivo group, with EIKOH HOSOE and others; at this point he began to take the photographs that were published in such collections as *Chizu* ('The map'; Tokyo, 1965), a deeply subjective series (see Shigemori, p. 84). Images such as the Japanese flag, the remains of fortifications, the walls of the 'atomic dome' in Hiroshima and photographs of dead soldiers were combined to form a highly contrasted collection. An overwhelming feeling of death suffuses these vivid images of a world where symbolic objects of different orders of reality are thrown together. Kawada's style, marked by his attraction to the physical properties of objects and to the world of imagination, was developed in the publications *Seinaru sekai* (also published as *Sacré Atavism*; Tokyo, 1971), *Ludwig II no shiro* ('Castle of Ludwig II'; Tokyo, 1979) and *The Nude* (Tokyo, 1984).

BIBLIOGRAPHY

New Japanese Photography (exh. cat. by J. Szarkowski and S. Yamagishi, New York, MOMA, 1974), pp. 52–5
A. Goldsmith: 'Kikuji Kawada', *Pop. Phot.* (June 1975)
Japan: A Self-portrait (exh. cat. by C. Capa, T. Tamioka and S. Yamagishi, New York, Int. Cent. Phot., 1979), pp. 47–51
K. Shigemori: *The Pictured City*, Complete Hist. Jap. Phot., vii (Tokyo, 1986), pp. 84–5
M. Holborn: *Beyond Japan: A Photo Theatre* (London, 1991), pp. 15–39

KOHTARO IIZAWA

Kawaguchi, Kigai (*b* Wakayama Prefect., 10 Nov 1892; *d* Tokyo, 5 June 1966). Japanese painter. He started painting while at school and in 1912 went to Tokyo to study at the Taiheiyō Gakkai Kenkyūjō. In 1917 he first showed work at the exhibition of the Nikakai. During this period he modelled himself on Sōtarō Yasui. From 1920 to 1923 and 1924 to 1929 he lived in France: during the first stay he made many copies of works by Domenico Tintoretto and Titian; on the second occasion he studied under André Lhôte and Fernand Léger, his work tending towards that of Auguste Renoir and Marc Chagall. His fantastic and Surrealist pre-war works, for example *Girl and Shells* (1934; Wakayama, Prefect. Mus. Mod. A.), were attempts to create an individual style from the influences under which he had come during his studies in France. After World War II his work moved towards abstraction (e.g. *Strange Shadow*, 1953; Tokyo, N. Mus. Mod. A.), as is clear from his role in the formation of the Japanese Abstract Art Club in 1953, and he created a form of abstract painting in the manner of Léger and Paul Klee.

BIBLIOGRAPHY

Kawaguchi Kigai to sono shūhen [Kawaguchi Kigai and his surroundings] (exh. cat., Wakayama, Prefect. Mus. Mod. A., 1980)

SHIGEO CHIBA

Kawai, Gyokudō (*b* Aichi Prefect., 24 Nov 1873; *d* Tokyo, 30 June 1957). Japanese painter. He was trained in the techniques of Japanese-style painting (*Nihonga*) at the school of Kōno Bairei in Kyoto; however, in 1896 he became the student of Hashimoto Gahō in Tokyo. As Gahō's protégé, he exhibited in the early Inten exhibitions

of the Japan Art Institute. In 1914, during the institute's revival by Yokoyama Taikan (1868–1958) and others, he did not participate with them and was principally active in the official exhibitions such as the Bunten (of the Ministry of Education), the Teiten (of the Imperial Art Academy) and the New Bunten. Kawai introduced some of the techniques of Western Realism into his style, which was based on the traditional Kanō and Maruyama–Shijō schools, thus establishing an extremely clear Naturalist style. Using graceful brushstrokes he primarily illustrated scenes of rural life and mountain villages. His most important works include *Fleeting Spring* (1916) and *Tinted Rain* (1940; both Tokyo, N. Mus. Mod. A.). In 1919 he became a member of the Imperial Art Academy, and in 1940 he was awarded the Order of Cultural Merit. There is a museum devoted to his paintings in Omi, where the artist lived.

BIBLIOGRAPHY
Kawai Gyokudō sakuhin zuroku [Pictorial catalogue of the works of Gyokudō Kawai] (Tokyo, 1958)
Kawai Gyokudō, 2 vols (Tokyo, 1987)

YOSHIKAZU IWASAKI

Kawai, Kanjirō (*b* Shimane Prefect., 24 Aug 1890; *d* Kyoto, 18 Nov 1966). Japanese potter. In 1914 he graduated from the department of ceramics of the Tokyo Technical College and researched such subjects as glazes at the Kyoto Municipal Institute of Ceramics. In 1920 he obtained a climbing kiln (*noborigama*), the Shōkeiyō, with eight chambers, at Gojōzaka in Kyoto. In the following year he made his début with technically skilled works imitating the classical wares of China and Korea, for which he gained immediate prominence. In 1926 with Muneyoshi Yanagi and others he promoted the MINGEI ('folk crafts') movement; his own work moved towards the use of simple organic forms influenced by folk crafts. An example of his later work is a diamond-shaped vase with floral design of 1939 (Kyoto, N. Mus. Mod. A.).

After World War II Kawai discovered his own personal style: dignified forms gave way to rich irregular shapes and, using creative methods such as 'splashed' with multi-colour glazes and 'brushed slip' with cobalt blue and other colours, he constructed a highly original range of forms. He also carved unusual wooden sculptures and wrote extensively. Kawai's former home, together with his own works, his collection of folk crafts, his kiln and other property, were restored and opened in 1973 as 'Kawai Kanjirō's House' in Kyoto.

WRITINGS
Inochi no mado [Window of existence] (Kyoto, 1948)
Hi no chikai [The pledge of fire] (Tokyo, 1953)

BIBLIOGRAPHY
Y. Kawai and T. Kawai: *Kawai Kanjirō sakuhin shū* [Ceramics and wood carvings by Kanjirō Kawai] (Tokyo, 1980)
Kawai Kanjirō: Kawakatsu korekushon [Kanjirō Kawai: catalogue of the Kawai collection] (exh. cat., Kyoto, N. Mus. Mod. A., 1983) [with Eng. intro.]
Kanjirō Kawai: Master of Modern Japanese Ceramics (exh. cat. by M. Hasebe, Tokyo, N. Mus. Mod. A., 1984) [in Jap. and Eng.]

MITSUHIKO HASEBE

Kawai, Senro [Senro; Bokusen; Usen; Tansō; Kyūsetsu Jōjin; Chigen Dojin] (*b* Kyoto, 1871; *d* Tokyo, 10 March 1945). Japanese seal-carver, scholar and connoisseur. He was the son of Kawai Sen'emon, a Kyoto seal-engraver. He studied Chinese classics with Hayashi Sōkyo and became the pupil of Shinoda Kaishin (1827–1902), who followed the style of seals used by painters of the Chinese Zhe school in the 15th and 16th centuries; in this genre Senro showed exceptional ability. In 1900 Senro went to China, where he studied under WU CHANGSHI, with whom he had previously corresponded. Under Wu he learnt modern carving techniques. After returning to Japan and passing his family name to a pupil, he went to live in Tokyo at the invitation of the patron Mitsui Teihiyō [Takakata] (1867–1945). Subsequently he visited China almost every year and concentrated on importing and studying Qing period (1644–1911) calligraphy, painting and culture. With the calligrapher and scholar Chikuzan Takada (1861–1946) he founded the Society for the Study of Calligraphy for Seals (Kikkin Bunkai), and, with the noted seal-carver Randai Nakamura (1856–1915), the Seal-carvers Society (Teibi Insha). He made great efforts to promote epigraphy and modern seal-carving (*see also* JAPAN, §XVI, 20). He was knowledgeable about writing systems, introduced carving on turtleshell and animal bones and was also an able connoisseur of painting and calligraphy. He supervised the editing and assisted in the publication, in Tokyo, of such multi-volume works as *Shodō zenshū* ('Complete collection of calligraphy'; 27 vols, 1932), *Shinananga taisei* ('Compendium of literati painting'; 16 vols, 1935–7) and *Shinabokuseki taisei* ('Compendium of ink traces'; 12 vols, 1937–8). In his latter years he created no works of art but devoted himself to connoisseurship and collection. He amassed a large collection of paintings by ZHAO ZHIQIAN and others, works of calligraphy and rare books. All these were lost and Kawai Senro himself was killed when his house was destroyed by bombing in World War II. His gravestone is in the temple Shōtokein in Kyoto. Aside from his scholarly achievements, Senro ranks as the foremost figure in modern Japanese seal-carving. His albums include the *Hōshogan inkō* ('Straw seals of Hōshogan'; 1907), *Senro inzon* ('Extant seals of Senro'; 1932), *Keijutsudō inzon* ('Extant seals of Keijutsudō'; 1947), and *Senro inpu* ('Seal album of Senro'; 1956).

BIBLIOGRAPHY
Y. Nakata, ed.: *Nihon no tenkoku* [Japanese seal-carving] (Tokyo, 1966)
Y. Nishikawa: *Kawai Senro no tenkoku* [The seal-carving of Kawai Senro] (Tokyo, 1978)

NORIHISA MIZUTA

Kawanabe Kyōsai [Kawanabe Gyōsai; Seisei Kyōsai; Shōjō Kyōsai] (*b* Koga, Shimōsa Prov. [now in Ibaraki Prefect.], 1831; *d* Tokyo, 1889). Japanese painter and woodblock-print designer. He is best known for his lively painting style, weird and fantastic subject-matter and for his exploits as a drinker and teller of tall tales. His work covers a range of sizes and formats and virtually every subject and stylistic tradition found in Japanese painting and printmaking. He was an individualistic artist who came of age during the transition from the Edo (1600–1868) to the Meiji (1868–1912) periods in Japan; this may account for the complexity, apparent contradictions and evolving mixture of the traditional and the progressive in his life and art. At the age of six Kyōsai entered the studio of Utagawa Kuniyoshi (*see* UTAGAWA, (6)) and from the age

of nine was a student of the academic KANŌ SCHOOL. He became independent professionally from *c*. 1857. He was much influenced by his study of a great variety of Japanese and Chinese painting. Although not a Western-style painter, he was nevertheless involved with contemporary trends and was associated with Westerners such as Emile Guimet, Ernest Fenollosa, Mortimer Menpes and the architect JOSIAH CONDER, who was his pupil. Rather than relying solely on his technical skills, Kyōsai believed in balancing knowledge gained from working from nature with traditional Japanese ideals in design, colour, patterning and the representation of the figure, which he learnt from a broad study of old and new masters. He also selectively incorporated into his art prevalent Japanese aesthetic sensibilities such as the idea of producing fresh angles and creative twists on conventional themes. Applying these ideas to current topics, Kyōsai created playful and humorous images, which can often be read simultaneously in a number of ways, such as parodies of old themes, satires of contemporary events or references to more than one legend or tradition in the same work. At the same time he produced more serious artistic works.

Examples of his wide range include the rapidly sketched *Portrait of Régamey* (ink and light colours on paper, 1876; Paris, Mus. Guimet) and the large *kabuki* curtain for the Shintomiza Theatre (ink and colours on cotton, 1880; Tokyo, Waseda U.) in which well-known actors of the day appear in the guise of One Hundred Demons rampaging across the face of the curtain. The sombre beauty of the polychrome *Kannon Riding on a Dragon* (*Ryūzu Kannon*; hanging scroll, colours on silk, n.d.; Tokyo, Sensōji) contrasts with the playful *Beauty Looking at Frogs* (*Bijin kan'a gizu*; ink and colours on silk, n.d.; Japan, priv. col.; see *Kyōsai*, 25 (1985) frontispiece). Kyōsai's satirical response to contemporary events is revealed in the colour woodblock print, the *Enlightenment of Fudō Myōō* (*Fudō Myōō kaika*, in the *Kyōsai rakuga* series; single-sheet polychrome prints; 1874). Themes that emphasize juxtaposition and opposition, such as predator and prey or beauty and beast, abound in his work, as seen in woodblock-printed books such as the *Kyōsai gadan* (1887) or *Kyōsai rakuga* (1881) or full-scale polychrome paintings of the priest Ikkyū and Jigokudayū (the Hell Courtesan). In the early years of the Meiji period (1868–1912) he attained considerable popularity with his political caricatures, for which he was arrested and imprisoned in 1870. He participated in the First Paris Japanese Art Exhibition of Meiji 16 (1883) and the Second Paris Japanese Art Exhibition in 1884.

For illustration of work *see* JAPAN, fig. 119.

BIBLIOGRAPHY
J. Conder: *Paintings and Studies by Kawanabe Kyōsai* (Tokyo, 1911)
Kyōsai [journal of the Kawanabe Kyōsai Mem. A. Mus.]
K. Iijima: *Kawanabe Kyōsai ō den* (Tokyo, 1984)
B. G. Jordan: *Strange Fancies and Fresh Conceptions: Kyōsai in an Age of Conflict* (diss., Lawrence, U. KS, 1993)
Demon Painting: The Art of Kawanabe Kyōsai (exh. cat. by T. Clark, London, BM, 1993–4)

BRENDA G. JORDAN

Kawara, On (*b* Kariya, Aichi Prefect., 2 Jan 1933). Japanese painter, draughtsman and conceptual artist, active in the USA. After graduating from Kariya High School in 1951, he moved to Tokyo, exhibiting at the Yomiuri Independent Exhibitions. His sensibility for a cold materialism became apparent in his series of drawings *Bathroom*, of dismembered grotesque nude bodies (1953–4; Tokyo, N. Mus. Mod. A.). Kawara went to Mexico in 1959 and travelled through Europe. He settled in New York in 1965. His renowned series of *Date Paintings* (from 1965), made in various cities on his travels, juxtapose a detail from a local newspaper with a simple record of the date in typographical letters and numbers on monochrome canvases using acrylic. The paintings' principal meaning was that the artist and viewer shared the numbers that signified a date they both had lived. In the series of telegrams in the 1970s, which sent the message 'I am still alive' to his friends, he used the verification of his own existence as a statement in a medium whose abstraction, regardless of the artist's hand, paradoxically gave his work a tense reality. His other work in book form, *One Million Years* (*Past*, 1970–71; and *Future*, 1980; both artist's col., see 1980 exh. cat., pp. 116–23, 124–9), consists of one million years typewritten year by year. Such works exploring concepts of time and space led Kawara to be regarded as a leading conceptual artist.

BIBLIOGRAPHY
On Kawara: 97 Date-paintings consécutives et journaux de 1966 à 1975 (exh. cat. by P. Hulten, Paris, Pompidou, 1977)
On Kawara: Continuity/discontinuity, 1963–1979 (exh. cat., ed. B. Springfeldt; Stockholm, Mod. Mus., 1980)

AKIRA TATEHATA

Kawachi. *See* CAHUACHI.

Kawkab al-Hawā. *See* BELVOIR CASTLE.

Kawm al-Ahmar. *See* HIERAKONPOLIS.

Kawm al-Gi'eif. *See* NAUKRATIS.

Kayalıdere. Site of an Urartian fortress of the 8th century BC, commanding a bend in the River Murat (a southern branch of the River Euphrates) in the province of Muş in eastern Turkey. It consisted of a citadel and an upper and lower town, and it probably served as a provincial administrative centre (*see* URARTIAN) before it was destroyed and burnt. The citadel was partly excavated in 1965 by Charles Burney and Seton Lloyd. Finds are in the Museum of Anatolian Civilizations in Ankara and the Archaeological Museum in Erzurum.

A temple of the standard Urartian square plan on the summit was constructed of massive dressed blocks. In front of the entrance stood a shattered stele base and a small area of paving slabs with emplacements for a tripod. There was a paved approach road and forecourt with storerooms beyond. A typical storeroom excavated on an upper terrace on the northern side of the site had three rows of huge jars, many over 2 m high but set deep into the floor. Column bases were found on the citadel but not *in situ*. At the south end of the site a rock-cut dromos led to a tomb with six chambers: the third and fifth had wall niches and a bottle-shaped shaft *c*. 6.5 m deep sunk into the floor. The third chamber also contained a rock-cut grave, and the sixth had 36 round, shallow depressions in the floor.

Pottery included storage jars with characteristic Urartian decoration of sunken squares and triangles; each had pictographic inscriptions stamped on the rim before firing and incised on the neck afterwards—evidently representing capacity and the nature of the contents respectively. A goblet of fine, polished red ware was also excavated.

The plentiful metalwork, mostly bronze, included a characteristic Urartian bronze lion from the temple forecourt, similar to one found at Patnos (both Ankara, Mus. Anatol. Civiliz.; *see* URARTIAN, fig. 2), and parts of a bronze belt (probably 8th century BC) with stitch-holes for a leather backing, incised with scenes from a lion-hunt with chariots containing a charioteer, archer and spearman. Three hoards of metalwork, probably looted from the buildings, were found buried above the burnt level. Iron was extensively used for arrowheads, shield hoops, a pan and the pegs of two massive wall-nails (2.7 kg) with bronze heads torn from the temple walls. There were bronze quivers and an undecorated bronze shield. One hoard also contained fragments of furniture elements including bronze volutes, palmettes and feet in the shape of a bull's hooves and lion's paws; these illustrate the cosmopolitan character of Near Eastern craftsmanship in the early 1st millennium BC, since similar pieces are illustrated on 9th-century BC reliefs from Nimrud in Assyria and 8th-century BC reliefs from Zincirli (Berlin, Pergamonmus.) in Turkey (*see* ZINCIRLI).

BIBLIOGRAPHY

C. A. Burney: 'A First Series of Excavations at the Urartian Citadel of Kayalıdere', *Anatol. Stud.*, xvi (1966), pp. 55–111
C. A. Burney and D. M. Lang: *The Peoples of the Hills* (London, 1971), pp. 145–6, 150–53

C. A. BURNEY

Kayama, Matazō (*b* Kyoto, 2 Sept 1927). Japanese painter. He graduated from the *Nihonga* department of the Tokyo School of Fine Arts in 1949 and was seen in Japanese art circles after World War II as the representative of a new Japanese style (*Nihonga*; *see* JAPAN, §VI, 5(iii)). Kayama's early work reflected the depressed conditions following the defeat of Japan in the war. Taking animals as his subject-matter, he produced works that expressed the instability of human life in modern society. He also depicted such subjects as *Winter* (1957; Tokyo, N. Mus. Mod. A.). In the early 1960s he created refined landscapes suggestive of the decorative character of classical Japanese painting. After 1980 his style changed again, towards an individualistic approach visible in his large ink paintings of Chinese and Japanese natural life, such as *Thousand-winged Crane* (1970; priv. col.). This style was essentially a revival of the unique decorative character of Japanese art, but with a modern sense of form and mood. Kayama also experimented with jewellery and kimono design and with painting on ceramics.

BIBLIOGRAPHY

Kayama Matazō zenshū [Complete collection of Matazō Kayama], 5 vols (Tokyo, 1990)

YOSHIKAZU IWASAKI

Kayiga, Kofi [Wilkins, Ricardo] (*b* Kingston, Dec 1943). Jamaican painter and teacher. He studied at the Jamaica School of Art, Kingston, and the Royal College of Art, London. He started exhibiting in the 1960s. In the early 1970s he lectured at Makerere University, Kampala, Uganda. He headed the painting department at the Jamaica School of Art from 1973 to 1981, subsequently moving to Boston, MA, where he lectured at the Massachusetts College of Art. His work showed an emotional and spiritual response to his experience as a black man in a post-colonial New World environment and his allegiance to Africa as his ancestral homeland. Most of his paintings and works on paper are abstract or semi-abstract with a strong emphasis on colour, pattern and rhythm, for example *Untitled (Apartheid)* (1978; Kingston, Inst. Jamaica, N.G.). They represent a synthesis of North American Abstract Expressionism and the artist's African–American cultural and philosophical heritage. His paintings have a spontaneous, discordant and moody quality reminiscent of jazz music, another New World art form.

BIBLIOGRAPHY

Jamaican Art, 1922–1982 (exh. cat. by D. Boxer, Washington, DC, Smithsonian Inst.; Kingston, Inst. Jamaica, N.G.; 1983), pp. 21, 78

VEERLE POUPEYE

Kayser [Kaiser], **Victor** (*b* ?Augsburg, before 1516; *d* Augsburg, 1552 or 1553). German sculptor. In 1516 he began an apprenticeship with the Augsburg sculptor Jakob Murmann I (1467–1547); from 1525 he is referred to as a master in his own right. Two large relief carvings in Solnhofen stone, *Abraham and Melchisedek* (destr. World War II) and *Susanna Bathing* (Berlin, Skulpgal.), have been generally considered as firmly attributed works: both were signed VK, and both are close in style to small-scale sculpture of the period from Augsburg. They combine a Late Gothic style with expressive and also inventively caricatured human representation. The draperies have elaborate linear folds, and hair and hemlines assume calligraphic forms. There are striking resemblances to Chinese lacquerwork (which the artist may well have known) in the bizarre clouds and trees, presumably modelled on contemporary graphic art.

A *Holy Family* after Albrecht Dürer (Paris, Louvre) and, more recently, the *Pharaoh Sinking in the Red Sea* (Augsburg, untraced since World War II) have been convincingly classified with the signed works. Altogether, about 15 reliefs have been attributed to Kayser. Stone reliefs of this kind appear to have been produced in large numbers at that time in Augsburg, some as altarpieces (generally representing the *Passion*), others as funerary monuments. It is likely that many similar works cautiously attributed by Feuchtmayr (Thieme–Becker) to anonymous contemporaries of Kayser are in fact by him.

BIBLIOGRAPHY

Thieme–Becker

P. von Stetten: *Kunst-, Gewerbe- und Handwerksgeschichte der Reichsstadt Augsburg* (Augsburg, 1779), p. 452
W. Pfeiffer: 'Der Entwurf zu einem Augsburger Renaissancerelief', *Anz. Ger. Nmus.* (1965), pp. 120–28
M. Baxandall: *Victoria and Albert Museum: South German Sculpture, 1480–1530* (London, 1974), p. 66, no. 17
J. Rasmussen: *Deutsche Kleinplastik der Renaissance und des Barock*, Bilderhefte des Museums für Kunst und Gewerbe Hamburg, xii (Hamburg, 1975), p. 86, no. 7
T. Müller: 'Zu Victor Kayser: Nachruf für ein verschollenes Werk', *Anz. Ger. Nmus.* (1976), pp. 77–82
Welt im Umbruch: Augsburg zwischen Renaissance und Barock (exh. cat., Augsburg, Zeughaus and Rathaus, 1980), ii, pp. 182–6, nos 542–8

DOROTHEA DIEMER

Kayseri [Kayṣerīye; Kaisareia]. Town in central Anatolia (Turkey). Located in a fertile plain at the intersection of well-defined trade routes, the site has been settled for millennia. The Byzantine city of Kaisareia was taken by Danishmendid Turkomans following the Battle of Manzikert in 1071. Under the Saljuq sultans of Rum, who took the city in 1168, Kayseri became a leading centre of commerce and culture second only to KONYA. Plundered by the Mongols in the 13th century, it became the capital of the Eretna dynasty in the 14th and was controlled by the Karamanid dynasty for most of the 15th century. It came under Ottoman control some time after 1474. It is notable for several fine buildings from the pre-Ottoman period.

The congregational mosque (Turk. *ulu cami*) was founded in 1135 by the Danishmendid Malik Muhammad as a basilican structure with a dome in the bay in front of the mihrab and a small open dome in the centre, but the irregularity of the plan and the diversity of the materials used attest to repeated repairs and restorations over the centuries. An inscription on the north wall states that the building was restored by Muzaffar al-Din Mahmud ibn Yaghıbasan in 1205–6 during the reign of the Saljuq sultan Kaykhusraw I. On the west, an octagonal plinth supports a thick cylindrical minaret of brick dating from the Saljuq period. The mosque of Kölük, which was repaired in 1210–11 by Atsız Elti, daughter of Mahmud ibn Yaghıbasan, and again in the middle of the 14th century by Kölük Şemseddin (to whom it owes its present name), resembles the congregational mosque. Rectangular piers of varied sizes support pointed barrel vaults and domes in the centre and over the bay in front of the mihrab. A magnificent mihrab in tile mosaic replaced the original stone mihrab in the second half of the 13th century.

The Huand Hatun (Khwand Khatun; 1237–8) complex comprises a mosque, madrasa, mausoleum and public bath. It was completed by Mahperi Khwand Khatun, wife of the Saljuq sultan ʿAla al-Din Kayqubadh I (*reg* 1219–37), during the reign of her son. The mosque, the largest in Kayseri, has walls with rectangular buttresses on the exterior. Portals on the east and west façades give access to the interior, which comprises a grid of square stone piers supporting broken barrel vaults. The four bays in front of the mihrab are covered by a single hemispherical cupola, and a square open court in the centre was covered with a cupola in the 19th century. The mausoleum of the founder occupies six bays in the north-west corner. Standing on a white marble plinth, the mausoleum has a richly decorated octagonal body and pyramidal roof. Adjacent and connected to the mausoleum is the madrasa (*c.* 1240), which has a rectangular court with an encircling portico, cells on either side and a large iwan on the entrance axis.

Several other madrasas and related structures, characterized by an internal court surrounded by porticos with iwans on the axis and chambers in between, were erected in the 13th century. The so-called Çifte ('twin') Medrese (1205) was built by Ghiyath al-Din Kay Khusraw (*reg* 1192–1210 with interruption) and his sister Jawhar Nasiba as a madrasa and hospital sharing a common wall. The madrasa also contains a domed tomb, perhaps that of Jawhar Nasiba. The more spacious hospital has a large

vaulted iwan opposite the entrance. The Sahibiye Madrasa (1267–8), erected by the Saljuq vizier Sahib Ata Fakhr al-Din ʿAli, has a richly decorated portal, with lions' heads on the capitals of the small engaged columns, and gargoyles in the form of animals' heads. Long dormitories surround the courtyard. The lateral iwans of the Saraceddin Madrasa, built by the amir Saraj al-Din Badr in 1238–9, have been shifted to form a group with the iwan opposite the entrance.

Kayseri is known for several medieval mausolea, most of which have octagonal or cylindrical bodies and pyramidal or conical caps. An early example is the Çifte Kümbed ('twin tomb'; 1247–8), with a cubic plinth supporting an octagonal body. The most elaborate is the Döner Kümbed ('turning tomb'; *c.* 1275), which stands on a prismatic base. Its dodecagonal body is richly decorated with arcaded mouldings and geometrical, floral and figural motifs, and a cylindrical roof. The so-called Köşk Medrese (1339), built by Eretna and his wife Suli Pasha, has crenellated walls of hewn stone enclosing a courtyard surrounded by porticos. In the centre stands the mausoleum, a high square base supporting an octagonal body and a conical cap. Two rectangular halls to the left and right of the entrance served as a hostel for itinerant dervishes. Other examples from the mid-14th century include the simpler Sırçalı Kümbed ('tiled tomb'), a plain cylinder of hewn stone that originally had a conical roof of turquoise blue-glazed tiles, and the mausoleum of Ali Cafer (ʿAli Jaʿfar; *c.* 1350), which has a rectangular entrance hall on the north, an octagonal body and a pyramidal roof.

Civil architecture in the region is represented by the kiosk of Haydar Bey (mid-13th century), a sturdy building comprising a dozen cells on either side of a rectangular courtyard covered with a broken barrel vault, and the similar Erkilet Kiosk (1241) on the summit of a tumulus, which is remarkable for its richly decorated marble portal.

BIBLIOGRAPHY

H. Edhem: *Kayṣerīye şehri* [The city of Kayseri] (Istanbul, 1334/1915; rev. Ankara, 1982)

A. Gabriel: *Monuments turcs d'Anatolie* (Paris, 1931), i, pp. 3–100

K. Özdoğan: *Kayseri tarihi: Kültür ve sanat eserleri* [History of Kayseri: culture and art] (Kayseri, 1948), ii

O. Yalçın: *Kayseri* (Istanbul, 1957)

RAHMI HÜSEYIN ÜNAL

Kayser & von Grossheim. German architectural partnership formed in 1872 by Heinrich Kayser (*b* Duisburg, 28 Feb 1842; *d* Berlin, 11 May 1917) and Karl von Grossheim (*b* Lübeck, 15 Oct 1841; *d* Berlin, 5 Feb 1911). Von Grossheim trained initially as a joiner, then worked as a draughtsman and clerk of works in Hamburg before studying at the Bauakademie, Berlin, from 1866. He became a respected figure in Berlin's architectural circles, a member of the Königliche Akademie der Künste from 1880 and its president from 1910 to 1911. Kayser trained in the family firm as a tinsmith from the age of 14. He later turned to building and worked for the municipal building authorities of Bonn and Berlin from 1861 to 1866, when he began a study of architecture at the Bauakademie, Berlin. Throughout his career he was active in seeking to raise the standing of the architectural profession as chairman of the Vereinigung Berliner Architekten and the Verein Berliner Künstler. In 1897, as

part of a committee of experts, he was responsible for Berlin's new building regulations, mainly designed to end overcrowded housing conditions.

Formed in 1872, the year after the foundation of the German Empire, the practice of Kayser & von Grossheim was the epitome of a successful architectural firm in the reign of Emperor William II. Based in Berlin, their output was extensive and included domestic, commercial and public commissions. In their first year they won the second prize in the prestigious first competition (1872) for the Reichstag building, Berlin. They entered numerous other competitions, two major but unsuccessful entries being for the Neue Börse in Frankfurt am Main and the Rathaus in Hamburg. The partners soon moved away from the austere design principles of the Schinkel school and adopted the eclectic historicism of the late 19th century. Their private houses were often characterized by the use of polychrome building materials, which heightened the impression of wealth and grandeur already conveyed by the rich Renaissance ornaments and details, an example being Palais Reichenheim (1879–81), Berlin. The building boom in Berlin during the 1870s and 1880s was strongest in the field of commercial architecture, exemplified by Kayser & von Grossheim's designs for banks and insurance companies. The building for the Norddeutsche Grund- und Kreditbank (1872–3), Berlin, was characteristic of the Renaissance Revival movement in Germany in the 1870s: the Renaissance palazzo type was used for the façade, although the planning and room layout were entirely modern. Their insurance office building for the Lebensversicherungs- und Aktiengesellschaft 'Germania' (1887–90; destr.) in Stettin (now Szczecin, Poland) was overpoweringly rich in its ornamentation of columns, pilasters and sculpture, disregarding the existing townscape and completely dominating its surroundings.

BIBLIOGRAPHY

Thieme–Becker; Wasmuth
K. Milde: *Neorenaissance in der deutschen Architektur des 19. Jahrhunderts* (Dresden, 1981)

Kazakhstan. Central Asian republic bounded by Russia to the west and north, China to the east and Kyrgyzstan, Uzbekistan and Turkmenistan to the south (see fig. 1). The Caspian Sea forms much of the south-west frontier, and the Aral Sea constitutes part of the border with Uzbekistan. Apart from the Ural Mountains in the north and the Tian shan Range and Altai Mountains in the south-east it is essentially steppe. The capital is ALMATY, close to the border with Kyrgyzstan.

1. Introduction. 2. Architecture. 3. Painting, graphic arts and sculpture. 4. Decorative arts.

1. INTRODUCTION. Central and northern Kazakhstan was from the first appearance of man in Central Asia the preserve of nomadic tribes whose herds grazed the steppe; historically it has parallels with southern Siberia (see RUSSIA, §II). The Shaka (see SCYTHIAN AND SARMATIAN ART and ANIMAL STYLE) were predominant in southern and south-eastern Kazakhstan between the 7th and 2nd centuries BC. In southern Kazakhstan the SILK ROUTE emerged during the Greco-Bactrian period (mid-3rd century–2nd BC).

The Kazakhs are descended from Turkic and Mongol tribes who arrived by the end of the 1st century BC. By the 6th century AD the region was dominated by the Turkish Khaqanate, a loose federation of tribes lasting

1. Map of Kazakhstan; those sites with separate entries in this dictionary are distinguished by CROSS-REFERENCE TYPE

until the 8th century. From the 10th century to the 12th, southern Kazakhstan passed to the Qarakhanids; they were defeated by the Qara Khitays, who gave way to the Mongols in 1219–21. The White Horde, Mongols descended from Genghis Khan, held the lower Syr River; their subjects were Turkic. They were followed by the Nogais and Uzbeks, the latter taking Khwarazm in 1430–31. TURKESTAN, a major religious centre in the 11th century famous for the Sufi Ahmad Yasavi (d 1146), gained prominence under the Timurids; a mausoleum was constructed there by Timur for the holy man in 1394. Timurid power waned in the 15th century, and the Kazakh tribes increased their hold. They were united under Qasim Khan (reg 1511–18) but soon reverted to infighting. From the 16th century the Islamic trading cities were controlled by lesser khanates. In the 17th century three Kazakh hordes evolved: the Great Horde in Semirechye; the Little Horde on land between the Aral and Caspian seas; and the Middle Horde on the steppes. These were increasingly menaced by the Oirots from Mongolia and as a result turned to Russia for protection in the 1730s and 1740s; by that time Russia had aleady begun to infiltrate the area (e.g. Semipalatka (now Semipalatinsk) was founded as a fort in 1718). Growing Russian power led to the abolition of all three hordes by 1848, by which time there were well-established Russian administrative trading and commercial institutions across the region, and a major garrison was established at Vernoje (Verny, now Almaty) in 1854.

Political upheaval followed the 1917 Russian Revolution, with civil war in 1918–20. The area was named the Kirgiz ASSR in 1920, with the Syr River and Semirechye provinces, populated mainly by Kazakhs, added to it in 1924. Karakalpak was removed to Uzbekistan in 1932 and the Kazakh ASSR made the Kazakh SSR in 1936. During the Soviet era widespread arable farming was attempted on the steppe, and many towns were completely rebuilt especially after World War II (e.g. Almaty, Chimkent). Waves of Russian and Ukrainian immigration to newly established industrial sites (e.g. Karaganda) reduced the Kazakhs to a minority. Building projects relied on orthodox Soviet policy and styles rather than indigenous forms. Attempts to collectivize farming effectively destroyed much of the nomadic way of life as the Kazakhs slaughtered millions of their animals rather than adopt the new procedures. In the 1950s and 1960s Kazakhstan was the centre of Soviet astronautical activity. With the collapse of the USSR, Kazakhstan declared its independence on 16 December 1991. The sections that follow cover the art of Kazakhstan from the period of Russian control; for discussion of pre-19th-century art in the region see CENTRAL ASIA, §I, and ISLAMIC ART.

2. ARCHITECTURE. During the first half of the 19th century Russian forts were built (Verny, now Almaty, was founded in 1854 on the site of medieval Almata) as well as outposts of the Central Asian khanates (Ak-mechet', now Kzyl-Orda); these gradually grew from trading settlements into towns. In the second half of the 19th century, in northern and eastern Kazakhstan these towns normally consisted of a fort, a Cossack village (Rus. *stanitsa*), a 'Tartar settlement' and the town itself. After their final absorption into Russia in the 1860s, the old towns of southern Kazakhstan (Taraz or Auliye-Ata, now ZHAMBYL) had a two-part structure: the traditional 'Old' town contrasted with the Europeanized 'New' town, with wide, tree- and shrub-lined streets and squares, together with civic buildings, a station and a bank in the style of Russian provincial architecture. The layout of streets was either rectangular (Verny), or radial and circular (Auliye-Ata). Single-storey wooden or mud-brick houses predominated.

Local architecture usually comprised mausolea constructed of stone and fired or unfired brick to form a cube, with a high portal over a lancet-shaped entrance (e.g. the mausoleum of Zhuzden' in Karagandinskaya region, by Serami Elamanov, mid-19th century), or resembling a tent, as for example the hexagonal mausoleum of Ergali (early 19th century: the foundationless stone boundary walls are slightly inclined towards the dome, curving outwards in their upper reaches to resemble cloth hanging on poles) or the Bisembay Mausoleum (1814).

Religious and memorial buildings continued to be built in Kazakhstan up to the beginning of the 20th century. One type was the *sagana-tam*—a grave monument that was rectangular in plan, roofless and with high walls decorated with carving or painting. Examples include the *sagana-tam* of Tul'taya on the River Embe by the Karazhusupov brothers, 1890, or the *sagana-tam* in the Chat area, early 20th century. A second type was the *kulup-tas*—a carved stone memorial pillar. Monumental buildings are usually faced with cut stone, with terracotta or glazed slabs decorated with traditional carving or painting, the interiors being stuccoed in *ganch* (a Central Asian stucco material). A characteristic Kazakh decorative style consists of symmetrically arranged, large stylized plants and symbols (the horn of a sheep, camel tracks, a snake's head), probably inspired by early fetishes and tribal totems; there are also solar signs. By the end of the 19th century the pattern often included primitive genre scenes or individual pictures; there are shoes, women's slippers and a mosque in a panel in the mausoleum of Omar and Tur in the Sam district (1897; designed by the Karazhusupov brothers), and daggers on a *kulup-tas* in Uali. The decoration of *sagana-tam* and mausolea often recalls the design of the yurt (see TENT, §II, 2), the most common type of dwelling for the people of Kazakhstan in the 19th century and first third of the 20th (and still in use in certain districts). The detailed design of the yurt varies from tribe to tribe, but in general it consists of a frame made of latticed wood and poles set in a circle, over which pieces of felt or matting are laid.

In Soviet times, from the beginning of industrialization in the 1920s and 1930s, during World War II and in the post-war years, intensive construction of industrial centres (the town of Balkhash, Karaganda etc) and workers' villages took place. At the same time, the old towns of Almaty, Guryev and others were rebuilt and improved. When the so-called Virgin Lands, which had not been ploughed for some centuries, were being reclaimed (a Komsomol initiative during the premiership of Nikita Krushchev) between 1954 and 1960, many new villages and collective farms came into existence. Architecture and town construction and the republic followed the same process of development that was taking place in all Soviet

architecture. Many imposing structures were built in Almaty and other towns by the Soviet architects Moisey Ya. Ginsburg, Alexander I. Gegello (1891–1965) and ALEKSEY SHCHUSEV (the Kazakh Academy, Almaty; 1944) in the spirit of CONSTRUCTIVISM and Neo-classicism, occasionally with elements of traditional architecture, mostly decorative. From the 1960s to the 1980s local associations of architects played an increasing part in urban planning and construction of towns and villages in Kazakhstan (the Medeo Sports Centre, 1972, by Vladimir Katsev (b 1929), A. Kaynarbayev and others; the Kazakh Theatre of Drama, 1980, by O. Baymursayev, M. Zhaksylykov and others; and the Palace of Pioneers, 1983, by Vladimir Kim (b 1937) and others; all in Almaty). In subsequent projects there has been a trend towards multi-storey construction, concision, planned spatial grouping and use of national decorative styles.

3. PAINTING, GRAPHIC ARTS AND SCULPTURE. The figural art of Kazakhstan goes back to the work of the first Kazakh artist and scientist Chakan Valikhanov (1835–65), which consisted of pencil and watercolour sketches of landscapes, daily life, portraits and ethnographic subjects. Other notable 19th-century artists were the Ukrainian writer and artist TARAS SHEVCHENKO, in exile in Kazakhstan from 1847 to 1857, and the Russian artist Nikolay Chludov (1850–1935), who lived in Almaty from 1877 and taught many Kazakh artists; his style was strictly academic in manner. The sketches and paintings of Vasily Vereshchagin and other Russian WANDERERS made the Russian public familiar with the landscape, life and culture of Kazakhstan.

After the establishment of Soviet rule in the 1920s, the activities of artists who came to Kazakhstan from the European part of the USSR (Valentin Antoshchenko-Olenev (b 1900), Leonid Leont'ev (1913–83), Abram Cherkassky (1886–1967) and others) prepared the way for the first indigenous painters and graphic artists (Abylkhan Kasteyev (1904–73), Khodja Khodzhikov (1910–53) and Aubakir Ismailov (b 1913)), who began their work in the 1930s. The formation of the Kazakh school of Soviet figural art, however, was brought about by professional artists who had studied in Moscow and Leningrad (now St Petersburg), returning to the republic in the late 1950s and early 1960s. The strongest romantic and lyrical note in Kazakh art of this period was sounded in the paintings of Kanafiy Tel'zhanov (b 1927), while those of Sabur Mambeyev (b 1928) are intimate and lyrical. National expression was embodied in the pictures of Aisha Galimbayeva (b 1917) and Gulfairus Ismailova (b 1929), who were inspired by folk art and the customs and habits of nomadic life in Kazakhstan. The attempt to integrate the concepts of European figural art and Kazakh traditional ornamental and decorative thought can be followed in the work of Salikhitdin Aytbayev (b 1938), who moved from easel painting to the production of monumental decorative panels, and in Eugene Sidorkin's (1930–82) colourful lithographs.

In the 1960s and early 1970s, figural art in Kazakhstan turned away from topical narrative subjects in the style of SOCIALIST REALISM to stylized folklore and an epic approach to specific subjects depicted in formalized imagery.

This style was called 'folklore-epic', and it is distinguished by its decorativeness and clear, flat composition derived from the principles of ornamentation (S. Aytbayev, Shaimardan Sariyev (b 1927) and Abrashid Sydykhanov (b 1937)). In the 1970s, as their art and personal positions strengthened, these artists brought Kazakh art back to concrete images and forms. The main art forms from this period were easel paintings (Maris Khitakhunov, b 1939, Bakhtiyar Tabiyev, b 1940) and graphic works (Isataj Isabayev, b 1936), which were imbued with imagery from past and present, and psychologically perceptive sculptural portraits (Erkin Mergenov, b 1940). At the end of the 1970s and in the 1980s Kazakh art became much more intellectual (Erbolat Tulepbayev, b 1956, and Kaliolla Akhmetzhanov, b 1949), with many, often contradictory, aims, including constructive borrowing from world art past and present.

4. DECORATIVE ARTS. In the 19th century and early 20th the decorative and applied arts of Kazakhstan were strongly linked with the furniture of the yurt (see TENT, §II, 2) and the life of the nomad encampments. The patterned fabrics of the strips (bau) and the ribbon-friezes (baskur) used to tighten the yurt from the outside revealed the tectonics of this portable cupola-like structure. Inside the yurt many woven, embroidered, braided, cut and painted articles made up a unique colourful harmonious ensemble, permeated by the rhythms of large curved ornamentation, inspired by the shapes of cattle and sheep, in which spiral-paired 'ram's horns' motifs predominated. The floors and walls of the yurt were insulated and decorated with rugs of FELT and carpets of various make and purpose. The floor rugs of felt (tekemet) were executed by rolling and pressing coloured wool in a loose humid felt base, which is why the large geometrical pattern acquired a picturesque irregularity and vagueness. The syrmak (another type of felt floor rug) bedding of inlaid patchwork was distinguished by clear-cut contrasting patterns. Cut out from two different coloured felts, the pieces were joined edge-to-edge and outlined with bright coloured cord to form a pair of counter-charged covers. The main aesthetic note in the interior of the yurt was sounded by the wall carpet (tuskiyiz) marking out the place of honour, facing the entrance. In the first half of the 19th century felt wall carpets with appliqué in small pieces of rich fabrics, with additional embroidery, predominated. Later, with the spread of imported cloth, velvet and silk, wall carpets on a rich fabric background appeared. Two unusual examples in the national collection (Almaty, State Mus. A. Kazakhstan) date from the end of the 19th century: one sewn from two skins of white snow leopards, framed with black velvet with gold embroidery and trimming of mink and otter fur, the other decorated with ornamented silver plaques and embroidered coloured silk and red coral. Appliqué and embroidery were widely used in the mounting of felt and knotted-carpet cases and bags, chests, and other articles, in the decoration of clothing (for example, robes of the nobility embroidered with solar signs and large plant patterns) and footwear.

The decoration of saddle-bags and braided fringes recalls satin stitch embroidery. Kazakh pile carpets have rich, dark coloured tones, with pictures in the shape of

2. Silver temple pendant, stamped and engraved, with chainwork, from Kazakhstan, 20th century (Moscow, Museum of Oriental Art)

distinguished by a happy combination of silver with cornelian, coral and turquoise, by plastic patterns of large stylized shapes with small worked details, and by the mastery of practically all types of artistic working of silver (see fig. 2): coins, blackening, engraving, grains, filigree etc (*see* CENTRAL ASIA, §I, 8(vi)(b)). Engraved or carved contour patterns on wood or bone show features common to all Kazakh ornament: executed in flat relief, they are often toned or brightly coloured and display the typical proportion of pattern and background, uniformity of plan and a predominance of large horn-shaped and stylized plant motifs. The frame of the yurt, furniture and musical instruments were inlaid with ornamented hide plates pierced with fretwork. Under the plates were laid pieces of coloured fabric, which showed through the fretwork; the whole was held in place by tacks with high silvered heads, adding to the rich decorative effect. Objects made of wood, decorated with bone and metal carved facings are also found. Features of Kazakh decorative art from the 19th century and early 20th were revived and cultivated by such 20th-century artists as Darkembaj Chakparov (*b* 1946; wood-carving), Ivan Brjakin (*b* 1927) and Gennady Ivanov (*b* 1940; both jewellery), Garif Djalmulchanov (*b* 1936; wood- and metalwork) and Batima Zaurbekova (*b* 1946; tapestry); the main collection of Kazakh artists' works is held in the Kazakhstan State Museum of Arts, Almaty.

BIBLIOGRAPHY

N.-B. Nurmukhamedov: *Iskusstvo Kazakhstana* [Art of Kazakhstan] (Moscow, 1970)

Narodnoye dekorativno-prikladnoye iskusstvo Kazakhov [National decorative and applied arts of the Kazakhs] (Leningrad, 1970)

Zhivopis' Kazakhskoy SSR [Painting of the Kazakh SSR], intro. N.-B. Nurmukhamedov (Moscow, 1970)

Ocherki istorii izobrazitel'nogo iskusstva Kazakhstana [Studies in the history of fine arts in Kazakhstan] (Alma-Ata, 1977)

A. A. Kakimzhanova: 'Kazakhskaya grafika 1960–70kh godov' [Kazakh graphic arts in the 1960s and 1970s], *Sov. Graf.*, 8 (1984)

A. Kh. Margulan: *Kazakhskoye narodnoye prikladnoye iskusstvo* [Kazakh national decorative arts], 2 vols (Alma-Ata, 1986–7)

B. A. Glandinov, M. G. Seydalin and A. S. Karpikov: *Arkhitektura sovetskogo Kazakhstana* [Architecture of soviet Kazakhstan] (Moscow, 1987)

B. K. Barmankulova, intro.: *Izobratitel'noye iskusstvo sovetskogo Kazakhstana* [Fine arts of soviet Kazakhstan] (Alma-Ata, 1990)

T. KH. STARODUB

stepped squares and hornlike figures; they were made in southern Kazakhstan and in what are now the Kzyl-Ordin, Guryev and Aktyubinsk districts. Woollen flatweave wall carpets (*takyr-kilem*), patterned on two sides, were made everywhere. The art of braiding was widely developed in Kazakhstan; from the Steppe grass (*shi*), often plaited with coloured wool, were woven simple and ornamented *shim shi* mats. Integral to nomadic life were articles made of stamped (with the help of stencilled boards) and engraved hide (utensils, vessels for fermented mares' milk, cases for *pial* etc). Professional craftsmen worked in metal, wood and hide: jewellers (*zergery*) and carvers, either in wood (*agashi*) or in bone (*cyuyushi*). Articles of jewellery (adornment for female and male attire, horse harnesses and saddles, the saddles themselves, the wooden frame of the yurt, chests, beds, hide and wooden vessels) were

Kazakov, Dimitar (*b* Tzarski Izvor, nr Veliko Tŭrnovo, 22 June 1933; *d* Sofia, 1992). Bulgarian painter, draughtsman and sculptor. In 1965 he studied graphic art with Evtim Tomov at the Academy of Art, Sofia. Although he executed drawings and monumental wooden sculptures, he was primarily a painter. From 1966 he participated regularly in group exhibitions and held many one-man shows in Sofia, Paris, Moscow, Vienna and Athens, as well as in cities in Germany and Japan. His paintings, original in composition and employing warm, light tones, are based on themes from Bulgarian folk tales and motifs from old Trakian myths and legends. Examples of such works are *Master Manol*, *Fairy-Tale World*, *Legend of Kaliakra* (all 1976), *Woman and Nature*, *Young Women* and *Narrative Poem about Time* (all 1978). Much of his work is located in the National Art Gallery, Sofia, and the Sofia City Art Gallery.

MARIANA KATZAROVA

Kazakov, Matvey (Fyodorovich) (*b* Moscow, 1738; *d* Ryazan', 26 Oct/7 Nov 1812). Russian architect and teacher. He was a leading exponent of Neo-classicism in Russia and one of the most important late 18th-century Russian architects. While carefully preserving the past, Kazakov, his colleagues and pupils transformed Moscow, which, by the early 19th century, was one of the most beautiful of contemporary cities (*see* MOSCOW, §I, 2).

1. Early life and public commissions. 2. Private commissions and royal palaces.

1. EARLY LIFE AND PUBLIC COMMISSIONS. Kazakov studied in Moscow (1751–60) at the school of architecture run by Dmitry Ukhtomsky. While gaining a grasp of architecture and building through practical experience, he also studied the Classical treatises and the works of contemporary foreign architects, and thus, although he never left Russia, he became a genuine classicist. His early works represent something of a transition from the Baroque to Neo-classicism. He took part under P. R. Nikitin in the rebuilding of TVER' (1763–7), which had burnt down in 1762, designing the Town Hall, Gentry Club, a school and a salt store, which together formed a central, octagonal square. A common characteristic of these externally similar buildings and Catherine II's Putevoy Dvorets (coaching palace; formerly the Archbishop's Palace; remodelled 1760s to Kazakov's design) is the rejection of the rich plasticity of Baroque decoration, a greater restraint of form and the classical regularity of the façades. Similar features distinguish the church of the Saviour (1774–83) on the Nakoshchins' estate at Ray Semyonovskoye.

From 1768 to 1774 Kazakov was a member of Vasily Bazhenov's team that was formed to execute the latter's project for the Great Kremlin Palace and a general remodelling of the Kremlin in Moscow. Kazakov's drawings provide valuable evidence of this work and of the foundation-laying ceremony for the palace in June 1773. Bazhenov's project was not ultimately carried out, but, for all those involved, the years spent in his team enabled them to perfect their architectural skills and gain a knowledge of Neo-classicism, then new to Russia.

In the spring of 1775 Kazakov received the title of architect and began to realize his own projects. His designs of the 1770s rejected the Baroque but retained a richly plastic handling of walls and a refinement of line. His Senate in the Kremlin (1776–87; later the Supreme Soviet and Council of Ministers of the USSR) is among the best works of Russian Neo-classicism. Kazakov's task there was to incorporate a new building into an established ensemble (*see* MOSCOW, §IV, 1(i)). Opposite the Arsenal and alongside the monastery of the Miracle, on an awkward triangular site, Kazakov erected a majestic edifice. A precisely organized Neo-classicism was set off against the picturesque grouping and stylistic diversity of the Kremlin buildings. The regular rhythm of rectangular windows, pedimented on the *piano nobile*, and of Tuscan pilasters, together with a high rusticated plinth, articulate the long external façades, while elegant arched niches with columns embellish the splayed corners of the main façades. The magnificent entablature crowning the façades can also be seen from Red Square, where it presents an effective

parallel to the Kremlin wall. One façade alone features a central Ionic portico giving access to a pentagonal courtyard. The grand hall of the Senate is surrounded by a Giant order of Corinthian columns, between which is a series of low reliefs. It is roofed by a coffered dome, the lightness and majesty of which, covering as it does a span of 24.6 m, were unusual for the time. Precise structural calculation is reflected in its section, which approximates a parabola and which is thus in ideal relationship to the curve of thrust. The rotunda also overlooks Red Square: by placing it behind a low tower (thenceforth known as the Senate Tower), between the Saviour and Nikol'sky towers, Kazakov created a strong architectural accent with the spatial composition of the square in mind.

The full flowering of Kazakov's talent took place in the 1780s and 1790s. He possessed a virtuoso command of the rich architectural and artistic vocabulary of Neo-classicism, and he unfailingly took account of the surroundings of a building and its urban context. Moreover, his work in the Kremlin Office of Works gave him *de facto* supremacy in the architectural life of Moscow until his retirement in 1801. He was on several occasions involved in urban planning: he took part (from 1790) in drawing up a plan for Moscow (unfinished), and he projected a square in front of the commander-in-chief's house on Tver' Street (1791). He was also in charge of drafting an axonometric plan of Moscow on 40 sheets (1801–4; destr.).

Kazakov designed major public buildings with a view to the organization of entire districts of the city: the university (1782–93; largely destr. 1812 and subsequently remodelled by Domenico Gillardi) on Mokhovaya Street and the Golitsyn Hospital (1794–1801; now First Municipal Hospital; see fig.) on Kaluzhskaya Street. On an inverted U-shaped plan, they stood out prominently among the surrounding buildings. The façade of the university, which faced the Kremlin, was adorned by Ionic porticos, and the centre was topped by a high attic, the sculpture on which made an effective show against the dome surmounting the columned assembly hall. By rounding off the outer angles of the wings, which advanced to the street line, Kazakov marked the beginning of Bol'shaya Nikitskaya Street (now Herzen Street). The Golitsyn Hospital is laid out as a Palladian town palace, with a *cour d'honneur* between two-storey wings and a three-storey main block, where a hexastyle Tuscan portico gives access to the columned rotunda of the former hospital chapel. Together with two smaller domes, the dome of the chapel, topped by an elegant pedestal with a cross, announces the building from afar and set the character and scale of future building in an area then far from the city centre. On the basis of a single layout, with separate rooms opening on to a corridor and symmetrically disposed around a centre in which the formal interiors were concentrated, Kazakov developed rational designs for public and administrative buildings, for example the Pavlovsky Hospital (1802–7) in Moscow.

2. PRIVATE COMMISSIONS AND ROYAL PALACES. Considerably different from the planning of Kazakov's public buildings was that of his private houses: their layout and traditional division into service, formal and living

floors accorded with the lifestyle of their owners. He designed palaces and town houses with a multiplicity of outbuildings and picturesque gardens, compact detached residences, relatively small houses, and buildings that combined domestic and commercial functions. The houses were sited mainly along the street, forming an ensemble with their subsidiary buildings that often occupied an entire block. In other cases the subsidiary and service buildings were placed in a rear courtyard.

Kazakov's buildings embellished Tver' Street, with Y. I. Kozitskaya's house (1790s) of particular note. This was remodelled as a grand department store by its later owners, the Yeliseyev family. Now only the proportions of the walls and the shape of the windows in the upper floors recall the Neo-classical façade, which was adorned with Corinthian columns, balconies and elegant low reliefs, while only drawings recall the refined appointments of the original interiors. Through the variation of individual devices, Kazakov designed an astonishing range of houses. Thus, although the façade of A. N. Golitsyn's house (late 1770s) on Lubyanka Street lacks columns, its decoration is supplied by a balcony on elegant brackets and the delicate patterning of the window surrounds. Without disrupting the profile of A. P. Gubin's house (1790s) relative to the narrow Petrovka Street, the slight projection of the façade provided the base for a powerful Corinthian portico, which was effectively juxtaposed with the fortress-like wall of the Vysoko-Petrovsky Monastery. A deep Corinthian portico also lent prominence to the façade of I. I. Baryshnikov's low, elongated, two-storey house (1797–1802) on Myasnitskaya Street. In the house of N. S. Kalinin and A. I. Pavlov (1785–90), as well as in that of P. Khryashchev (1780s; built on Il'inka Street; destr.), the regular rhythm of the arcades on the ground floor, which accommodated commercial premises and shops, recalled the ancient traditions of Russian bazaars.

Kazakov's other impressive Moscow houses were included in the Kazakov albums (1797–1802; Moscow, Shchusev Res. & Sci. Mus. Rus. Archit.), a set of 13 books of drawings in which are collected the designs of Kazakov and his assistants, as well as drawings recording earlier buildings. The albums also record the interior decoration of houses. Among Kazakov's surviving formal interiors of Moscow before the fire of 1812 (domestic interiors now lost) are the splendid suites of rooms in the houses (late 1780s) of I. I. Baryshnikov and I. I. Demidov on Gorokhovyy Lane. In the former, low columns and pilasters accentuate the shapes of the circular, rectangular and other rooms, articulating them and dividing one room from another; low reliefs on the walls echo their rhythm, and even the stove recesses constitute an architectural motif. The mellow gilding, the skilfully selected tints of the walls, and the ceiling painting (comprising garlands of many-coloured flowers) together produced the refined palette of the 'Golden Rooms' in the Demidov house, which are rendered especially beautiful by gilded, carved ornamentation. Light and delicate, it embellishes the space above the windows and doors, the doors themselves and their jambs. Exotic plants, flowers and fruit are entwined into ovals, the lines twisting into entrancing bows, to form panels, which are themselves framed by thin fillets.

Pictorial panels and painted ceiling decoration once embellished the Hall of Columns of the Nobles' Club (1784; remodelled from Dolgorukov's house). The immense hall, rectangular in plan and covered by a smooth, flat ceiling with coves penetrated by openings for high-level windows, has a majestic Corinthian colonnade running around its perimeter. Timber was used for the ceiling and the columns themselves. The columns, finished in a warm-coloured imitation marble, looked particularly effective in evening candlelight. Modifying the accepted rules for the Corinthian order and preferring greater simplicity of form, Kazakov visually intensified the sculpturesque quality of the capitals and, with a view to overall effect, accentuated certain nuances in the relationship of the details of the entablature.

The rotunda was one of Kazakov's favourite motifs. He incorporated it into compositions for both public buildings and private houses, and also designed centrally planned churches. An early example is the church of the Metropolitan Philip (1777–88) on Vtoraya Meshchanskaya Street (now Prospect Mira), externally an elegantly planar building with severe porticos, and which inside exults in the beauty of columns and the rich plasticity of a decoration that still retains hints of the Baroque.

In designing centrally planned buildings and town and country houses, Kazakov more than once adopted elements derived from the work of Palladio. Among his early Palladian buildings in the Moscow area was his design for a mansion (1776) for the Demidovs at Petrovsky-Knyazhishchiv, where he erected a two-storey house on a square plan with cut-off angles, and a circular central hall surmounted by a dome that is similar to that at Palladio's Villa Rotonda (begun c. 1565/6; see PALLADIO, ANDREA,

Matvey Kazakov: Golitsyn Hospital (now First Municipal Hospital), Moscow, 1794–1801

fig. 5). Except for the steps, all four façades, embellished with loggias of Giant Tuscan columns, were identical.

The neo-Gothic occupies a special place in Kazakov's oeuvre. He became familiar with the style while working with Bazhenov, while providing settings for ceremonies on the Khodynskoye Field (1774–5), and while restoring ancient buildings, particularly at Kolsmenskoye (late 1770s). An original treatment of the forms of old Russian art and western European Gothic is Catherine II's suburban Petrovsky Palace (1775–82; now Zhukovsky Air Force Academy; *see* MOSCOW, fig. 3 and ROMANOV, (3)) in red brick with stone trim, where the handling of volume and plan is Neo-classical, but the details are a fantastic mixture of old Russian porches with barrel-like columns and pendants, pointed window surrounds, Gothic finials, Baroque volutes and classical pediments. Less successful was Kazakov's design for a palace at Tsaritsyno (begun 1786), also for Catherine II. Traditionally tripartite, it is a compromise in its stylistic mingling of classical and Gothic forms. Kazakov achieved a certain decorative effect by cleverly juxtaposing the massive corner towers—set off by three-quarter-length columns—with the open arcades of pointed arches, handling classical forms originally and emphasizing the beauty of the white stone details against the brick walls. When designing country palaces near Moscow at Kon'kovo and Bulatnikovo (1793–1803; unfinished), he offered both Neo-classical and neo-Gothic versions. In his project for remodelling the Kremlin (1797), he sought to endow the ensemble with a strict classicism and regularity.

Kazakov devoted much time to training future architects. In the 1780s, after taking over the architecture school in Moscow from Bazhenov, he maintained it under the auspices of the Kremlin Building Office, and in 1805 the school received official status as the College of Architecture. As Napoleon's troops closed in on Moscow in the early 19th century, the ailing Kazakov was moved by his family to Ryazan'. The news of the great fire of 1812 in Moscow and the destruction of his works hastened his end.

WRITINGS

Y. E. Beletskaya, ed.: *Arkhitekturnyye al'bomy M. F. Kazakov: Podgotovka k izdaniyu, stat'ya i kommentarii Ye. A Beletskoy. Al'bom'y partikuyarnkh stroyeniy. Zhilyye zdaniya Moskvy XVIII veka* [The architectural albums of M. F. Kazakov: albums of private buildings and residential buildings of 18th-century Moscow] (Moscow, 1956)

BIBLIOGRAPHY

M. K. Kazakov: 'O Matveye Fyodoroviche Kazakove' [On Matvey Fyodorovich Kazakov], *Russkiy Vestnik*, xi (1816), pp. 6–14

I. Y. Bondarenko: *Matvey Fyodorovich Kazakov* (Moscow, 1912)

——: *Arkhitektor Matvey Fyodorovich Kazakov* [The architect Matvey Fyodorovich Kazakov] (Moscow, 1938)

Vystavka Moskvy, 1938: K 200-letnemu yubileyu so dnya rozhdeniya arkhitektora Fyodorovicha Kazakova, 1738–1938. Katalog vystavki [Moscow exhibition, 1938: the bicentenary of the birth of the architect Matvey Fyodorovich Kazakov, 1738–1938] (exh. cat., Moscow, 1938)

N. F. Gulyanitsky: 'Issledovaniya nekotorykh ordernykh kompozitsiy V. Ye. Bazhenova i M. F. Kazakova' [Studies of some compositions based on the Classical orders by V. Y. Bazhenov and M. F. Kazakov], *Voprosy teorii arkhitekturnoy kompozitsii* [Questions of the theory of architectural composition], i (Moscow, 1955), pp. 77–109

M. A. Il'in: *Kazakov* (Moscow, 1955)

A. I. Vlasyuk, A. I. Kaplun and A. A. Kiparisova: *Kazakov* (Moscow, 1957)

M. A. Il'in: 'Fasadicheskiy plan Moskvy M. F. Kazakova' [M. F. Kazakov's façade plan of Moscow], *Arkhit. Nasledstvo*, ix (1959), pp. 5–14

——: 'M. F. Kazakov i yego shkola' [M. F. Kazakov and his school], *Istoriya russkogo iskusstva* [History of Russian art], vi (Moscow, 1961), pp. 130–65

N. A. YEVSINA

Kazaks, Jēkabs (*b* Riga, 18 Feb 1895; *d* Riga, 30 Nov 1920). Latvian painter. Like many Latvian modernists, his formal artistic training and the choice of his most compelling subjects derived from his experience as a refugee during World War I. In 1915 he was evacuated from the Art School in Riga to the one in Penza, south-east of Moscow, where he remained until 1917. In Moscow he saw Sergey Shchukin's and Ivan Morozov's collections of modern French art. He was also profoundly inspired by the series of *Refugee* and *Riflemen* paintings of his fellow countryman Jāzeps Grosvalds, bringing to these themes his own intimist painter's sensitivity. *Refugees* (1917; Riga, Latv. Mus. F.A.) combines the modesty and witty minutiae of naive art and a classical pictorial structure. Similarly, Kazaks often recorded his experiences as a soldier with humour and warmth, eschewing the overtly heroic or patriotic. After World War I, he became the leader in Latvia of the avant-garde association Ekpresionisti, which evolved into the RIGA ARTISTS' GROUP. Accordingly, Kazaks's work assumed stronger colour, increased angularity and flatness of form, and, at times, bleaker moods. *Circus* (1918; Riga, Latv. Mus. F.A.) is a portrait of two anxious clowns backstage, and its psychological—even sexual—ambiguity is unprecedented in Latvian art. His early death has itself been attributed to extreme anxiety arising from a malicious public debate over the validity of modernism, instigated by four Latvian academic artists led by Ižnis Roberts Tillbergs, who were incensed by the local modernists' popularity and success. This defamation of his work, complete with a spectacular parody of abstract art known as 'Ballism' (as opposed to Cubism), was particularly unwarranted in Kazaks's case, for his acceptance of avant-garde ideas had always been conditional, his work resolutely representational, and his professional successes modest.

BIBLIOGRAPHY

S. Cielava: *Latviešu glezniecība buržuāziski demokrātisko revolūciju posmā, 1900–1917* [Latvian painting in the era of bourgeois democratic revolution, 1900–17] (Riga, 1974), pp. 161–9

J. Siliņš: *Latvijas māksla, 1915–1940* [The art of Latvia, 1915–1940], i (Stockholm, 1988–93), pp. 34–52

MARK ALLEN SVEDE

Kazan. *See* WATANABE KAZAN.

Kazan'. Russian city, capital of Tatarstan. Kazan' was founded in 1177 on the left bank of the River Volga, from the 13th to the 15th century in the centre of territories controlled by the Islamic Tatar-Mongol forces known as the Golden Horde. It subsequently became the capital of Kazan', a separate Tatar khanate, from 1429 until 1552, when Tsar Ivan IV (*reg* 1533–84) conquered Kazan' and incorporated it into the Russian State.

Under the Khans, Kazan' expanded: the population grew to *c.* 30,000 and palaces and mosques were built there with ashlar walls and moulded details, but none of these has survived intact. In 1555 the tsar ordered the construction of the Kremlin, a strong stone citadel incorporating 13 towers. Built by craftsmen from Pskov under the

Kazan', the Kremlin (begun 1555) with the Syuyumbeki Tower (centre), view from the north

direction of Postnik Yakovlev (*fl c.* 1550–62), the architect of St Basil's Cathedral in Moscow, it has formidable walls lightened by the elegance of the towers. The most famous of these is the Syuyumbeki Tower (see fig.), a rare survival of Tatar architecture built in red brick and comprising seven receding storeys, the first three square, the remainder octagonal. During the 16th century ten churches were built in the city as well as the monasteries of the Transfiguration and the Trinity. The largest church building of the period was the cathedral of the Annunciation (1556–62; rest. 18th and 19th centuries) by Postnik. During the 17th century and the first half of the 18th a large number of monumental churches were built; in these, and other buildings, the interpretation of the Baroque into Russian provincial architecture may be seen in its various stages, from the inclusion of Baroque elements in buildings that are essentially medieval in character to the combination of Baroque and Neo-classical elements in the 1770s. Examples include the church of the Veil of the Mother of God (mid-17th century), the cathedral of SS Peter and Paul (1723–6), the Seminary (1730s) and the Admiralty Office (1760s), from which the Caspian fleet was administered.

Kazan' has a significant Neo-classical urban-planning and architectural heritage. In 1778 a new urban-planning scheme was put forward, which has been more or less implemented. Many dwellings in Neo-classical style were erected according to model designs sent out from St Petersburg. The Mel'nikov and Zharkov residences, the University complex (1825) and the Gymnasium building are of interest. In the second half of the 19th century in Kazan' a distinctive type of eclecticism developed, which in mosque design combined the traditions of East and West, developing at the beginning of the 20th century into an unusual variety of Modernism. The Constructivist buildings of the Soviet period are also of interest, particularly the House of the Press (1933) by Semyen Pen (1897–1970). Local art of the past and present is well represented in the Museum of Fine Arts. In the late 20th century the population was *c.* 875,000.

BIBLIOGRAPHY
P. Dul'sky: *Pamyatniki kazanskoy stariny* [Monuments from Kazan''s past] (Kazan', 1914)
——: *Kazan' v XIX stoletii* [Kazan' in the 19th century] (Kazan', 1943)
N. Agafonov: *Kazan' i kazan'tsy* [Kazan' and its inhabitants] (Kazan', 1966)
A. Grigor'yev: *Kazanskiy Kreml'* [The Kazan' kremlin] (Kazan', 1969)
M. Fekhner: *Velikaya Bulgariya, Kazan', Sviyazhsk* [Great Bulgaria, Kazan' and Sviyazhsk] (Moscow, 1978)
N. Kh. Kalitov: *Pamyatniki arkitektury Kazani XVIII–nachala XIXvv.* [Monuments of Kazan''s architecture of the 18th to the beginning of the 19th century] (Moscow, 1989)

D. O. SHVIDKOVSKY

Kazanluk. Iron Age tomb in Bulgaria. It is the best preserved of a small number of Thracian brick-built vaulted (*tholos*) tombs that were decorated with Greek-influenced wall paintings. The tomb was looted in antiquity, but it can be dated on the basis of its form and the types of object that appear in the painting to the early 3rd century BC. The burial mound is entered through a

rectangular stone-built antechamber, finely plastered: this leads into a rectangular brick-built passage (*dromos*) painted with scenes of warfare, and then a circular central chamber with a corbelled beehive-shaped vault, beautifully painted in a manner comparable to the Macedonian tombs of VERGINA and Lefkadia. Above a band of alternating bulls' heads (*bucrania*) and red-and-blue rosettes there is a broad frieze depicting the funerary banquet, and a lively upper frieze of racing charioteers. Hoddinott (p. 126) described the painting as 'a unique synthesis of Hellenistic art and Thracian ritual' (*see* THRACIAN AND DACIAN ART, fig. 1).

In the paintings the deceased chief is shown seated on a silver-legged chair with a distinctively Thracian black-and-white striped woollen cushion. His feet rest on a low footstool beneath a three-legged rectangular table. His right hand holds a silver drinking cup (*phiale*), while his left forearm is entwined with that of a woman who sits on an elaborate throne-like wooden chair with silver fittings. Servants to the right bring pomegranates and a second cup of wine. The funeral meal laid out on the table is hard to identify but includes two flat loaves and two of each other item. The implication of this, as of the chief's gesture and the arrival of the second drink, is that the woman is being invited to join her husband in death: Herodotus recorded that the wives of a Thracian chief would vie with one another at his funeral to be elected the most favoured and thus be buried with him.

See also GREECE, ANCIENT, §VI and THRACIAN AND DACIAN ART.

BIBLIOGRAPHY
V. Mikov: *Antichnata grobnitsa pri Kazanluk* [Ancient burial site at Kazanluk] (Sofia, 1953)
I. Venedikov and T. Gerassimov: *Thracian Art Treasures* (London, 1975)
R. F. Hoddinott: *The Thracians* (London, 1981)

TIMOTHY TAYLOR

Kazar, Vasile (*b* Sighetul-Marmaţiei, 30 July 1913). Romanian draughtsman, printmaker and illustrator. After a short period studying art in Baia Mare and in Budapest, he provided illustrations in the early 1930s for such left-wing magazines as *Stînga* and *Cuvîntul liber*. In 1932 he had a one-man exhibition in Cluj, and in 1937 he published in Oradea the album *Pita de mălai* ('Corn bread'), which includes 12 drawings of the peasant life of Maramures; these were dramatically detailed, showing the influences of Pieter Bruegel I and of Japanese prints. In Paris in 1938 Kazar studied at the Académie de la Grande Chaumière and exhibited at the Contemporaines gallery. In 1944–5 he was imprisoned in Nazi concentration camps, a nightmarish experience that appears only rarely in his drawings. From the late 1940s until *c.* 1958 he tried to conform to the aesthetic and ideological precepts of Socialist Realism, but in the early 1960s he reverted to the expressionism that had characterized his work of 1945–7, producing drawings that displayed a dreamlike touch in their scratchy line and biomorphic imagery. He developed this style in the 1970s and 1980s in such series of drawings as *Apparitions at the Old Court* and *From my Bestiary*. He subsequently evolved a very subtle use of colour, which became much harsher. He was an outstanding illustrator, for example of editions of the poems of Catullus (Bucharest, 1969) and of Rainer Maria Rilke's *Duino Elegies* (Bucharest, 1978). He occasionally made prints. From

1950 to 1976 he was a professor at the Institute of Fine Arts 'N. Grigorescu' in Bucharest, where he influenced a younger generation of illustrators and designers. In 1992 Kazar donated 103 drawings, 7 prints and 6 sketchbooks to the Museum of Art in Bucharest.

BIBLIOGRAPHY
Vasile Kazar: Deseme (exh. cat., preface I. Frunzetti; Bucharest, Gal. A. Dalles, 1973)
Vasile Kazar (exh. cat., preface R. Bogdan; Bucharest, Gal. A. Dalles, 1984)
D. Grigorescu: *Vasile Kazar* (Bucharest, 1988)

GHEORGHE VIDA

Kazi Kasba. *See under* VIKRAMPUR.

Kazimierz Dolny [Kazimierz-on-the-Vistula; Lower Kazimierz]. Polish town on the Vistula, *c.* 40 km west of Lublin in Małopolska (Lesser Poland), lying between loess hills with gorges cutting through them. In the first half of the 14th century a royal town replaced the former settlement; on a hill to the north-east of the town a cylindrical tower, part of a royal castle, survives from that period. Nearer the town, on a small ridge, are the ruins of a second castle (first half of the 16th century); Gothic and Renaissance in style, it was rebuilt in the first half of the 17th century. The town's most magnificent development occurred in connection with the growth of Vistulan trade, particularly in corn, from the late 16th century to the mid-17th. The buildings were financed by the upper middle classes, and they represent a regional version of Polish late Renaissance style, with Mannerist elements. The parish church near the rectangular market place is a remarkable artistic achievement by members of the Lublin builders' guild. The nave and tower were built in 1586–9; the presbytery was erected in 1610–13 by the Lublin mason Jakub Balin (*fl* 1590–1623), its vaulting covered with stucco decoration typical of the time and region; along the nave are two memorial chapels of the Kazimierz bourgeoisie: the Górski Chapel (1625–9) and the Radzik Chapel (1646–53), both with cupolas. Also in the church are Mannerist wood-carvings, including one of the oldest organ surrounds in Poland (1607–20). Other ecclesiastical buildings include the Mannerist church of the Holy Spirit (1649–70) with a hospital (before 1635) next to it; and the Baroque Reformati Monastery (1639–68) with church (*c.* 1680–90) and exterior steps (1680 and 1815). Two notable houses in the market place belonged to the rich tradesmen from the Przybyła family (both 1615, one 'under the sign of St Christopher', the other 'under the sign of St Nicholas'), with arcades and lofty attics and façades covered with low reliefs that include human figures, animals and motifs drawn from Dutch patterns (*see* POLAND, fig. 3). On Senatorska Street the building erected *c.* 1635 for Bartłomiej Celej has sculpted window decoration and a lofty attic in Kazimierz style, like the window of the Górski Chapel, the gable of the hospital of the Holy Spirit and the portal of the church at nearby Gołąb. In the suburbs along the Vistula there are a few surviving granaries dating to the first half of the 17th century. In the late 18th century Kazimierz became of interest for painters and engravers, and in the late 19th century it became a summer resort. Between 1918 and 1939 public buildings and private villas designed by, among

others, Jan Witkiewicz-Koszczyc, Karol Siciński (1884–1965) and Romuald Gutt were built. Between 1947 and 1958 the town's monuments were restored by Siciński.

BIBLIOGRAPHY

W. Husarski: *Kazimierz Dolny* (Warsaw, 1953)
H. Rutkowski: *Kazimierz Dolny: Krajobraz i architektura* [Kazimierz Dolny: landscape and architecture] (Warsaw, 1965) [with Eng. summary]
J. Z. Łoziński: *Grobowe kaplice kopułowe w Polsce, 1520–1620* [Memorial chapels with cupolas in Poland, 1520–1620] (Warsaw, 1973), pp. 219, 225–6, 280
A. Miłobędzki: *Architektura polska w XVII wieku* [Polish architecture in the 17th century] (Warsaw, 1980), IV/i of *Dzieje sztuki polskiej* [Polish works of art], pp. 145–7, 151–3, 299–303
J. Teodorowicz-Czerepińska: *Kazimierz Dolny: Monografia historyczno-urbanistyczna* [Kazimierz Dolny: a monograph on its history and town planning] (Kazimierz, 1981)

JERZY Z. ŁOZIŃSKI

Kazuki, Yasuo (*b* Misumi-chō, Ōtsu-gun, Yamaguchi Prefect., 25 Oct 1911; *d* Yamaguchi Prefect., 8 March 1974). Japanese painter. He studied at the Western painting (*yōga*) department of the Tokyo Art School (now Tokyo University of Fine Arts and Music) from 1931 to 1936 in the studio of Takeji Fujishima. As a student he exhibited in the Kokugakai (National Painting Society), where his work attracted the attention of Umehara Ryūzaburō. In 1940 he became a member of the society and continued to exhibit with them until 1961. During World War II, he was drafted into the army (1943) and while moving through Korea and Manchuria he was captured in the Chinese city of Shenyang, Liaoning province. After disarmament he was sent to a labour camp in the Krasnoyarsk district in Siberia, where he was interned for two years. He was repatriated in 1947. After that time he produced works in his native town, Misumi-chō, and after the opening of his first one-man show in 1959 he exhibited his works principally through one-man exhibitions. In 1967, with Tatsuo Takayama, he participated in a retrospective exhibition at the Kanagawa Prefectural Museum of Modern Art, Kamakura. In 1976 the Yamaguchi Prefectural Museum organized an exhibition that travelled to Kita-Kyūshū, Kyoto and Tokyo.

In maturity, Kazuki's most representative works are the *Siberia* series, a body of work which draws upon recollections of his experiences of internment and of the cruelty of war. Beginning in 1947 he continued to paint works on the theme of *Ox* throughout his life. Each is a requiem to his fellow countrymen, who died from malnutrition and hard labour in the camps, and of the inhumanity of war; the subjects, rendered in impastoed black and faint yellows, are reminders of the vast, frozen land of Siberia and are expressed in acutely angled, symbolic forms reminiscent of Gothic art. Forty-five of the fifty-seven works in the series were donated to Yamaguchi Prefecture after Kazuki's death and housed in the Yamaguchi Prefectural Museum of Art.

BIBLIOGRAPHY

'Gashū Kazuki Yasuo' [Collected works of Yasuo Kazuki], *Asahi shimbunsha* (1979)
Kazuki Yasuo—Sono zōkei to jojō no kiseki [Yasuo Kazuki—His formation and the tracks of his expression] (exh. cat., Yamaguchi, Prefect. Mus., 1981)

ATSUSHI TANAKA

Kazumasa Yamashita. *See* YAMASHITA, KAZUMASA.

Kazunari Sakamoto. *See* SAKAMOTO, KAZUNARI.

Kazuo Yagi. *See* YAGI, KAZUO.

Kazvin. *See* QAZVIN.

Kea [Keos; Ceos; Zea]. Greek island at the north-western extremity of the Aegean Cyclades. It has several Bronze Age sites, by far the most important of which, in terms of both architecture and finds, is the settlement of Ayia Irini, on a small promontory in the sheltered western bay of Ayios Nikolaos. First identified (1956) as an important prehistoric site by K. Scholas, it was excavated (1960–*c.* 1971) by the late J. L. Caskey for the University of Cincinnati. Ayia Irini was occupied for most of the Bronze Age. Some houses date from the Early Cycladic (EC) period (*c.* 3500/3000–*c.* 2000 BC), while the chief Middle Cycladic (MC; *c.* 2000–*c.* 1600 BC) remains are of fortifications—one system with horseshoe-shaped bastions and a later one with square towers (*see* CYCLADIC, §II, 2). There are some cists and more elaborately built tombs of the MC and Late Cycladic (LC) periods. The Late Cycladic (*c.* 1600–*c.* 1050 BC) town consists of a series of large house-blocks, separated by narrow alleys. The one independent structure is a long, narrow temple, which produced various cult objects (*see* CYCLADIC, §II, 3). Most of these are modest (pottery, a few figurines), but there is a unique series of over 50 large terracotta figures (Kea, Archaeol. Col.), some as big as life-size, perhaps assembled as a symbolic band of worshippers. They are Minoan in style, with exposed breasts and long flaring skirts, and many, if not all, had painted decoration (*see* CYCLADIC, §I, 4(iii)). Terracotta feet (Kea, Archaeol. Col.) from a nearby building may have belonged to cult statues, chiefly made of perishable material. The sequence of pottery from the site is clear and important, but few pieces are outstanding. There is good Burnished ware from early EC III (*c.* 2300–*c.* 2000 BC), a fine vase decorated with griffins in the Melian Black-and-red style (Kea, Archaeol. Col.) and evidence of local trends in the basically Minoanizing material of the LC I–II periods (*c.* 1600–1390 BC). The site was destroyed by an earthquake *c.* 1450 BC. Also on the island are the remains of the four Classical (*c.* 475–*c.* 323 BC) towns of Koressca (now Korissia), Ioulis (now Khora), Poieessa (now Pisses, on the west coast) and Karthaia, remote in the south east. Only Karthaia has been excavated and the Temples of Athena and Apollo identified. Near Khora is a fine Archaic (*c.* 750–*c.* 475 BC) reclining lion carved on a rock. At the monastery of Ayia Marina (near Pisses) is a well preserved 4th-century tower.

For the wall paintings from Ayia Irini, *see* CYCLADIC, §VI, 3.

BIBLIOGRAPHY

G. Welter: 'Von griechischen Inseln', *Archäol. Anz.* (1954), pp. 48–93
J. L. Caskey: 'Excavations in Keos', *Hesperia*, xxxi (1962), pp. 263–83; *Archaeology*, xvi (1963), pp. 284–5
——: 'Investigations in Keos, Part 1: Excavations and Explorations, 1966–70', *Hesperia*, xl (1971), pp. 359–96
——: 'Investigations in Keos, Part 2: A Conspectus of the Pottery', *Hesperia*, xli (1972), pp. 357–401
W. W. Cummer and E. V. Schofield: *Ayia Irini: House A* (1984), iii of *Keos* (Mainz, 1977–)
J. L. Davis: *Ayia Irini: Period V* (1984), v of *Keos* (Mainz, 1977–)
M. E. Caskey: *The Temple at Ayia Irini: The Statues* (1986), ii/1 of *Keos* (Mainz, 1977–)

J. C. Overbeck: *The Stratigraphy and the Find Deposits*, i of *Ayia Irini: Period IV* (Mainz, 1989)
J. F. Cherry and others: *Northern Keos in the Cycladic Islands* (Los Angeles, 1991)

R. L. N. BARBER

Keating, John [Céitinn, Seān] (*b* Limerick, 29 Sept 1889; *d* Dublin, 21 Dec 1977). Irish painter. He studied drawing at the Technical School in Limerick; in 1911 he moved to the Metropolitan School of Art in Dublin on a scholarship and became a pupil of William Orpen, moving to London as his assistant in 1915. The following year he returned to Dublin; in 1919 he was appointed a teacher of painting at the Metropolitan School of Art, becoming Professor of painting from 1936 until his retirement in 1954. He was a regular exhibitor at the Royal Hibernian Academy, becoming a full member in 1919 and President from 1948 to 1962. He held his first one-man show in 1921 and was commissioned during the 1920s to paint a series of pictures depicting the building of the Shannon hydroelectric scheme (Dublin, Electricity Supply Board). During the 1930s he exhibited in the Victor Waddington Gallery in Dublin and at international exhibitions abroad. He favoured an idealized, heroic interpretation of Ireland, evident in *Men of the West* (1917; Dublin, Hugh Lane Mun. Gal.) and in other pictures of people of the west of Ireland. He also painted decorative murals, religious pictures and portraits. He was a strong traditional draughtsman, who opposed modernism in painting. He had major status in Irish art from the 1920s to the 1950s as the leading exponent of nationalist themes.

BIBLIOGRAPHY
John Keating: Paintings—Drawings (exh. cat. by J. White, Dublin, Mun. Gal. Mod. A., 1963)
Irish Art, 1900–1950 (exh. cat. by H. Pyle, Cork, Crawford Mun. A.G., 1975), pp. 41–2

JOHN TURPIN

Keban region. Area of central eastern Turkey on the Upper Euphrates (Tur. Firat). This region is now flooded by the Turkish Euphrates dam, the building of which prompted an international archaeological salvage programme between 1968 and 1975. The area had been settled since the 6th millennium BC, and handmade grit-tempered black burnished pottery was produced. About 3500 BC contact with urban Mesopotamians in search of metal led to the introduction of wheel-made pottery. Copper and silver weapons and ornaments are plentiful in the mud-brick tombs at Korucutepe from this proto-urban phase, which was succeeded by the Early Transcaucasian culture around 3000 BC. Branches of this culture have been found from the Caucasus to Palestine. They are characterized by a handmade black burnished ware with relief decoration consisting of animal shapes simplified to lozenges, and by anthropomorphic clay hearth supports. Superb examples of both were excavated at Pulur near Keban.

Towards 2300 BC the Keban region provides evidence for the development of a stratified society. Smaller population centres were abandoned except for their temples (e.g. at Korucutepe), while the seat of the regional ruler grew into an extensive storehouse–palace (Norşuntepe). Fluted pottery imitating metal and stone weapons reflects an interest in status symbols. In the Old Hittite period (1800–1600 BC) some earlier centres were fortified. Jar

sealings and the remains of massive architecture indicate that the kingdom of Isuwa, contemporary with the Hittite empire (1400–1200 BC), had one of its establishments at Korucutepe. In the Iron Age the Upper Euphrates area contained Urartian outposts, then Roman frontier forts and then, in the 13th and 14th centuries AD, Mongol strongholds.

BIBLIOGRAPHY
M. J. Mellink: 'Archaeology in Asia Minor', *Amer. J. Archaeol.*, lxxiii (1969), pp. 209–11; lxxiv (1970), pp. 164–5; lxxv (1971), pp. 167–8; lxxvi (1972), pp. 173–5; lxxvii (1973), pp. 175–7; lxxviii (1974), pp. 112–13; lxxix (1975), pp. 206–7; lxxx (1976), pp. 268–70
Keban Project Publications, Middle East Technical University, I, i–vii (Ankara, 1970–82); III, i–ii (Ankara, 1976–9)
M. N. van Loon, ed.: *Korucutepe*, 3 vols (Amsterdam, 1975–80)
R. Whallon: *An Archaeological Survey of the Keban Reservoir Area*, University of Michigan Museum of Anthropology Memoirs 11 (Ann Arbor, 1979)

M. N. VAN LOON

Keck & Keck. American architectural partnership formed in Chicago in 1946 by George Fred Keck (*b* Watertown, WI, 17 May 1895; *d* Chicago, 21 Nov 1980) and his brother William Keck (*b* Watertown, Dec 1908). George Keck graduated from the University of Illinois, Urbana (1920), where he also taught, and he worked for various architectural firms in Chicago before establishing his own practice there in 1926. One of his first works was the Newton B. Lauren House (1927) in Flossmoor, IL, a mixture of modern and traditional styles. In 1929 he designed Miralago, a night club in Wilmette, IL, with a smooth white exterior, which was one of the first buildings of the early Modern Movement in Chicago. In 1931 William Keck joined the practice after graduating from the University of Illinois. The pioneering Modernist buildings of the Keck brothers, mostly residences, are characterized by technical innovation and aesthetic refinement inspired by such architects as Le Corbusier, Frank Lloyd Wright and R. Buckminster Fuller. The practice gained national attention in 1933 with their House of Tomorrow (now the Miller House, Beverley Shores, IN) for the *Century of Progress Exposition* in Chicago, a dodecahedral glass box on two levels, the upper set back from the lower, which shows the influence of Fuller's Dymaxion House (1927) in its mode of assembly and use of advanced materials and services. Another building for the same exhibition was the Crystal House, an equally uncompromising design with glass walls hung from a steel structure.

During the 1930s the practice became well established in residential design and continued its technological innovation, for example in the Wilde House (1935), Watertown, their first attempt at passive solar design. By experimenting with orientation, roof overhangs, external blinds, Thermopane glass, radiant heating, central air conditioning and ventilation louvres, they were able to evolve an innovative application of solar heating to their houses that received much media attention, particularly in the 1940s and 1950s. Other notable works of the 1930s included the Herbert Bruning House (1935–6), Wilmette, which featured a free-standing helicoidal staircase within a semicircular wall of glass brick; the Bertram J. Cahn House (1936–7), Lake Forest, IL; and the Kellett House (1939), Menasha, WI, in which Modernist principles were combined with more organic materials.

In 1938 George Keck became head of architecture at Chicago's Institute of Design, which he helped found with László Moholy-Nagy and Gyorgy Kepes (*b* 1906) as an American version of the Bauhaus in Berlin. Like many of the European modernist architects by whose work he was influenced, particularly Peter Behrens and Walter Gropius, George Keck believed strongly that contemporary architecture should be a democratic art expressing the needs and requirements of society. From 1942 to 1946, when the brothers established their partnership together, the practice developed a prefabricated housing system to help alleviate the housing shortage after World War II. Refining earlier research into modern materials and building techniques, they evolved a practical assembly-line concept in conjunction with Green's Ready Built Homes; houses at Rockford, IL, and Lake Geneva, WI, were constructed with flexible interior layouts and folding walls hung from the ceilings.

The partnership maintained its innovative approach over the decades, for example increasing mechanization of the house with such features as electric eye doors and working on modular construction, but its work was for a time eclipsed by Chicago's explosion in large-scale commercial building in the 1950s and 1960s and by changing stylistic developments in the 1970s. They continued to design residences; later work also included occasional public projects such as a child care centre (1961) at 5467 University Avenue, Chicago, which was notable for its use of Corbusian design elements such as pilotis and ramps, and cooperative housing, for example Harper Square (1970–71), 4800 Lake Park Avenue, Chicago. George Keck was also a watercolourist of some note, holding several exhibitions of his work throughout the USA.

WRITINGS

George Fred Keck: *House of Tomorrow: America's First Glass House* (Chicago, 1933)

——: *Homes for Tomorrow's Happy Living* (New York, 1943)

BIBLIOGRAPHY

Keck on Architecture: An Exhibition Organised by the Taylor Museum of the Colorado Springs Art Center (exh. cat. by R. Tague, Colorado Springs, CO, F.A. Cent., 1947)

B. Kelly: *The Prefabrication of Houses* (Cambridge, MA, 1951), pp. 26, 231, 369

C. W. Condit: *Chicago, 1930–70: Building, Planning and Urban Technology* (Chicago, 1974)

Keck & Keck: Architects (exh. cat. by N. G. Menocal, Madison, U. WI, Elvehjem A. Cent., 1980)

J. Christopher: *Keck & Keck: A Bibliography* (Monticello, IL, 1984)

R. Boyce: *Keck & Keck* (New York, 1992)

Kecskemét colony. Hungarian artists' colony established in 1911 at Kecskemét, *c.* 80 km south-east of Budapest. The town provided studios for artists and offered commissions. The studios were designed in Hungarian Secessionist style by the colony members Béla Jánszky (1884–1945) and Tibor Szivessy (1884–1963). In the Secessionist spirit of *Gesamtkunst* the colony's activities ranged from ceramics to tapestry. A weaving school was set up, and free courses in art and industrial design were held in the town. Members came in part from the NAGYBÁNYA COLONY: the initiator of the colony and its first leader was the painter Béla Iványi Grünwald, and Elek Falus (1884–1950) played a significant role in the foundation of the colony and went on to direct its textile workshop. From 1920 the colony was led by Imre Révész (1859–1945), a noted genre-painter. Artists also came from the SZOLNOK COLONY, and the sculptors Zsigmond Kisfaludi Strobl and Imre Csikász (1884–1914) also worked there.

Unlike the Nagybánya and the Gödöllő colonies, Kecskemét artists had no common programme or unified style. They held only two joint exhibitions, in 1913 and 1919. While some of the artists maintained the traditions of *plein-air* painting acquired at Nagybánya, others continued under the influence of Szolnok, and of Secessionism. Iványi Grünwald's own Kecskemét paintings (e.g. *Summer*, 1912; Budapest, N.G.) are Secessionist in character, and he created large-scale decorative compositions (e.g. his design for the interior of the Kecskemét Casino). He also painted biblical subjects and, along with Vilmos Perlrott Csaba, used a number of well-known gypsy themes. Perlrott Csaba's paintings, influenced by Cubism, display many characteristic Kecskemét motifs, as in *Calvary* (1912; Kecskemét, Katona Mus.). Falus, a versatile Secessionist artist, was mainly preoccupied with tapestry, but he also worked in book design and illustration, the skills for which he had acquired in England. Another Secessionist artist, Géza Faragó (1877–1928), produced a number of accomplished poster designs. The number of artists working at the colony grew during World War I. Some came to prominence, in various styles and genres, such as the Cubist János Kmetty, the activist Béla Uitz and the important Hungarian avant-garde artist Lajos Kassák.

BIBLIOGRAPHY

Z. Farkas: 'A kecskeméti művésztelep' [The artists' colony of Kecskemét], *Vasárnapi Újság* (1912), pp. 705–7

K. Sztrakoniczky: 'Kecskeméti művésztelep' [The artists' colony of Kecskemét], *Művészet* (1912), pp. 395–400

Kecskemét múltja a képzőművészetben [Kecskemét's past in the fine arts] (exh. cat., foreword K. Telepy; Kecskemét, Katona Mus., 1968)

G. Sümegi: 'A kecskeméti művésztelep ellentmondásai' [The contradictions of the Kecskemét artists' colony], *Forrás* (1980), no. 2

K. Telepy: 'A kecskeméti művésztelep' [The Kecskemét artists' colony], *Magyar művészet, 1890–1919* [Hungarian art, 1890–1919] (Budapest, 1981), pp. 318–22

KATALIN GELLÉR

Kecskeméti, W. Péter (*b* Nagyvárad, Hungary [now Oradea, Romania], *c.* 1610; *d* Kassa, Upper Hungary [now Košice, Czech Republic], *c.* 1680). Hungarian goldsmith and writer. He studied in his birthplace and later worked in various towns in Transylvania. In 1655 he returned to Nagyvárad and became a member of the goldsmiths' guild. He fled from the Turkish invasion to Kassa in Upper Hungary, where, in 1663, he obtained citizenship and was accepted in the guild. His few extant marked works include a late Renaissance-style cup (1664; Kosiče, Protestant church) and a Baroque-style communion plate (Miskolc, Protestant church). Several extant unmarked works are attributed to him. His autobiography contains valuable information concerning the techniques used by Transylvanian goldsmiths in the mid-17th century.

BIBLIOGRAPHY

A. Ballagi: 'Kecskeméti W. Peter ötvőskőnyve' [The goldsmiths' book of W. Peter Kecskeméti], *Archeologiai értesítő*, iv (1884), pp. 201–392

FERENC BATÁRI

Keely, Patrick Charles (*b* Kilkenny, 9 Aug 1816; *d* Brooklyn, NY, 11 Aug 1896). American architect of Irish birth. He was the son of a builder and received no formal training. He emigrated to the USA and settled in Brooklyn where, in 1847, he designed his first church, the imposing church of SS Peter and Paul in the Gothic Revival style. Over 600 churches are popularly attributed to Keely, and although the total appears exaggerated (only 150 commissions have been documented), it reflects his reputation as the pre-eminent Roman Catholic architect. He earned the sobriquet the 'American Pugin' and won the Roman Catholic Laetare Medal for distinguished service. He was hampered throughout his career by demands for commodious but inexpensive churches, leading him to design large, simple structures, frequently with galleries and plain lath and plaster ceilings. When given greater freedom, he showed skill and refinement in his interpretation of English Gothic, supplemented after 1870 by Romanesque and French Empire designs. Of his few Classical Revival works, the best is the robust domed church of St Francis Xavier in Manhattan (1882).

Keely designed nearly 20 cathedrals during the course of his 50-year career. His most ambitious work, the Immaculate Conception in Brooklyn (destr. 1931), was to have been the largest Gothic Revival cathedral in America. Construction began in 1865, but work progressed slowly and often halted; when Keely died funeral services were held in the unfinished cathedral. J. F. Bentley subsequently prepared plans (unexecuted) for its completion.

MEA

BIBLIOGRAPHY
W. A. Daley: *Patrick Charles Keely: Architect and Church Builder* (MA thesis, Washington, DC, Catholic U., 1934)
H. L. Wilson: *The Cathedrals of Patrick Charles Keely* (MA thesis, Washington, DC, Catholic U., 1952)
F. W. Kervick: *Patrick Charles Keely, Architect: A Record of his Life and Work* (South Bend, IN, 1953)

JANET ADAMS

Keene, Charles (Samuel) (*b* London, 10 Aug 1823; *d* London, 4 Jan 1891). English illustrator and caricaturist. Keene's family left London for Ipswich where he spent two years at school; thereafter, he preferred to be known as an 'Eastern Counties man', not as a cockney 'like Hogarth and Cruikshank'. Encouraged by his mother, Keene followed apprenticeships with an architect and with Whympers, the wood-engravers, pursuing his studies at the Clipstone Street Art society. Early work for the *Illustrated London News* was followed by employment with *Punch*. Keene's illustrations for *Punch* introduced, wherever possible, the social side of the magazine's political concerns. This emphasis prevailed from his first design, *A Sketch of the New Paris Street-sweeping Machines* (Dec 1851), which gave an observer's view of the cannon used by Louis Napoleon to suppress opposition to his recent *coup d'état*, to his last, *'Arry on the Boulevards* (Aug 1890), in which an aging middle-class Englishman ponders his newspaper, unaware of the eye of the French waiter upon him. His fascination with dialect and other marks of provincial difference suited *Punch*'s persistent investigation of the aspects of national identity. The French classed Keene with Degas, Adolph Menzel and Pissarro, while the English veered between suppressed embarrassment and censure. Ruskin, for example, thought him 'coarse'.

Keene's graphic skills are everywhere evident, such as in his satire on the 1870 Education Act, which shows a worker, or 'rough', captioned as saying 'We're a goin' to be edgicated now, 'ompulsory, or else go to the treadmill'. Keene also illustrated books such as *Robinson Crusoe* and F. C. Burnand's *Tracks for Tourists* (1864). *Our People* (1881) brought together much of the best of his *Punch* work. Lord Leighton called him 'an unsurpassed student of character'.

BIBLIOGRAPHY
G. S. Layard: *The Life and Letters of Charles Samuel Keene* (London, 1892)
J. Pennell: *The Work of Charles Keene* (London, 1897) [catalogue of etchings and bibliog. of illus. books]
J. Lindsay: *Charles Keene: The Artist's Artist* (London, 1934)
F. L. Emanuel: *Charles Keene: Etcher, Draughtsman and Illustrator* (London, 1935) [further cat. of etchings]
D. Hudson: *Charles Keene* (London, 1947) [useful bibliog.]
Drawings by C. K., 1823–1891 (exh. cat., ACGB, 1952)

LEWIS JOHNSON

Keene, Henry (*b* 15 Nov 1726; *d* London, 8 Jan 1776). English architect. He was the son of a master carpenter. Nothing is known of his training, but he is said to have been 'bred to the profession of architecture'. In 1746 he was appointed surveyor of the estates of the Dean and Chapter of Westminster and in 1752 Surveyor of Westminster Abbey, with responsibility for its fabric. He had connections with Ireland that began in the 1750s when he and John Sanderson made the working drawings for the west front of Trinity College, Dublin, designed by the amateur architect Theodore Jacobsen. From 1763 to 1766 Keene is mentioned in Irish records as 'Architect to the Barrack Board' in Dublin. Through the patronage of Sir Roger Newdigate (1719–1806), MP for the University of Oxford, Keene obtained a number of commissions there, notably the remodelling of the hall (1766) at University College, the Fisher Building (1768–9) at Balliol College, the Provost's Lodgings (1773–6) at Worcester College and the Radcliffe Observatory (design begun 1772), although in 1773 he was superseded as architect of the last building (1776–94) by James Wyatt. His practice was continued by his son Theodosius Keene (*b c.* 1754), for whom the last recorded date is 1787.

Although Keene designed several buildings in an elegant late Georgian style, his failure to respond to Neo-classical taste inevitably relegates him to a secondary place in the history of English classical architecture. The Guildhall (1757), High Wycombe, Bucks, and the Provost's Lodgings at Worcester College are good examples of his work in this category. As a designer in the 'Gothick' taste he was, however, a pioneer, and his Rococo-Gothic interiors are among the most delightful of their kind. Unlike his contemporary James Essex, Keene was not a serious student of Gothic structure, but his position as Surveyor of Westminster Abbey made him familiar with a famous medieval church, and decorative details from the abbey can often be recognized in his work. At Arbury Hall, Warwicks, for instance, the drawing-room fireplace is copied directly from the tomb of Aymer de Valence, Earl of Pembroke (*d* 1324), while the fan vaulting in the dining-room is obviously derived from Henry VII's Chapel. At

Arbury Keene was working for a patron, Sir Roger Newdigate, who was himself an amateur of Gothic architecture, and in a house where some work in that style had already been done under the direction of another amateur, Sanderson Miller. Keene was, however, the first professional architect to specialize in the Gothic style, which he used in several of his designs, notably the striking octagonal church (1753–5), now a ruin, at Hartwell, Bucks, the interior (*c.* 1750) of the episcopal chapel at Hartlebury Castle, Worcs, the hall at University College, Oxford, and the folly known as the Vandalian Tower (1774) at Uppark, W. Sussex. Like Horace Walpole at Strawberry Hill, Twickenham, Keene took forms of vaulting and panelling designed for masonry and transformed them into decorative features made of plaster and wood. Later Gothic Revivalists would despise these Georgian-'Gothick' interiors as lacking in structural integrity, but, seen as an indigenous form of Rococo, they are as characteristic a feature of Georgian taste as Chippendale furniture or the illustrations by Richard Bentley (1708–82) to Thomas Gray's *Poems* (1753).

BIBLIOGRAPHY

Colvin

T. Mowl: 'Henry Keene', *The Architectural Outsiders*, ed. R. Brown (London, 1985), pp. 82–97

HOWARD COLVIN

Keep. *See* DONJON.

Keerinckx, Alexander. *See* KEIRINCKX, ALEXANDER.

Keetman, Peter (*b* Wuppertal, 27 April 1916). German photographer. He became interested in photography through his father, a passionate amateur photographer. From 1925 he attended the Bayerische Staatslehranstalt für Lichtbildwesen in Munich, later working in the studio of the photographer Gertrud Hesse in Duisburg and as an industrial photographer for the firm of C. H. Schmeck in Aachen. He then completed his studies with Adolf Lazi (1884–1955) in Stuttgart in 1948. He was one of the founder-members of the Fotoform group in 1949 with OTTO STEINERT and others. He showed with them at the first Photokina exhibition in 1950, proving one of the strictest and most consistent representatives of the new 'Subjektive Fotografie'. His preference for black and white enhanced his strong designs, often based around the effects of light on the subject. Keetman's reputation was based on his experimental photographs of drops of water, such as *Drops of Water Reflected* (1959; see 1987 exh. cat., p. 10), tubes and abstractions of the Volkswagen car factory, *Eine Woche in Volkswagenwerk*. His work was also published in *München, Lebenskreise einer Stadt* and *Bayerisches Seenland, Natur und Kunst vor Münchens Toren*. From 1980 he worked as a freelance commercial and industrial photographer in Thiersee, Austria.

PHOTOGRAPHIC PUBLICATIONS

Eine Woche im Volkswagenwerk (Berlin, 1953)

München: Lebenskreise einer Stadt (Lindau, 1955)

Bayerisches Seenland: Natur und Kunst vor Münchens Toren (Lindau, 1957)

BIBLIOGRAPHY

Deutsche Lichtbildner: Wegbereiter der zeitgenössischen Photographie (exh. cat. by R. Misselbeck, Cologne, Mus. Ludwig, 1987), pp. 9–11, 134

REINHOLD MISSELBECK

Kefallinia. *See* KEPHALLINIA.

Kefar Nahum. *See* CAPERNAUM.

Kefe. *See* KAFFA.

Kefkalesi. Urartian fortress near the north-west shore of Lake Van in eastern Turkey, high above the town of Adılcevaz, dating to the 7th century BC. There has been some Turkish excavation of the citadel at Kefkalesi. Contemporary Urartian reliefs have been found in the vicinity (*see also* URARTIAN).

Kefkalesi was one of four major fortresses attributable to the reign of Rusa II (*reg c.* 680–*c.* 640 BC; *see also* TOPRAKKALE, KARMIR BLUR and BASTAM). It was impregnable on all sides except one, where the citadel defended the easy approach from the high ground to the north. An extensive outer enclosure stretched south of the citadel, with a perimeter wall following the edge of the rocky escarpment. In the citadel was a palace with storerooms containing large jars for commodities such as grain or wine; the roofs of the halls were supported by two rows of massive piers, the lower parts of which were elaborately recessed basalt ashlar with mud brick above. The citadel was destroyed at the beginning of the 6th century BC at the time of the Urartian kingdom's fall, and the mud-brick walls were heavily burnt. The use of cuneiform script rather than hieroglyphs for the brief inscriptions on the storage jars probably indicates that Kefkalesi was a royal residence and administrative centre, although it also served a cultic function.

A series of identical reliefs in basalt (Ankara, Mus. Anatol. Civiliz.) provides one of the finest representations of the façade of an Urartian royal citadel with two storeys, towers with three storeys and narrow windows. The roof was probably flat or very low-pitched, the towers are buttressed, and both walls and towers are crowned by ornate parapets, presumably of mud-brick with timber reinforcements. Stunted trees in tubs stand against each tower. Two identical winged divinities stand on the backs of lions, each holding a bowl and cone, and, in a theme derived from Assyrian reliefs, poised for lustration of a central tree. Inscriptions identify these deities as Haldi, leader of the Urartian pantheon. Birds of prey, each holding a rabbit by the tail, perch on the wall between the towers; there are stylized palmettes between each pair of birds.

Incorporated into the masonry of the ruined medieval castle of Adılcevaz beside Lake Van below Kefkalesi are blocks chiselled out of a very large basalt relief, originally well over 3 m high, which was probably carved from two pieces rather than in one monolith. Almost certainly this formed at least half of a symmetrical composition, possibly with a recessed niche or false door flanked by divinities. This relief should probably also be attributed to Rusa II owing to the general similarity in design, although not in scale, with the Kefkalesi reliefs. No earlier large-scale reliefs are known. The relief was probably associated with a shrine, and this would explain its superiority of execution compared with the repetitive reliefs from Kefkalesi. The god of the large relief stands on a bull and is most probably Tesheba, the Hurrian storm-god, but the sun-disc topping

his headdress could indicate Shivini, the sun-god of Urartu. He is beardless and is clad in an ornately decorated robe, probably depicting the gold-brocade cope placed over divine statues. He sprinkles holy water on a sacred tree that resembles a candelabrum, with leaves like spearheads; the spear appears frequently as an Urartian religious symbol, often but not exclusively the attribute of Haldi. A similar treatment of twisted stems occurs in gold plaques (London, BM) from the rich treasure of ZIWIYEH in north-west Iran. Similar designs are found on some Urartian cylinder seals (e.g. from Bastam; Tehran, Archaeol. Mus.) and on bronze belts (e.g. from Zakim; St Petersburg, Hermitage).

Kefirkalesi, a summer refuge of rough cyclopean construction, stands beneath Mt Süphan. It could be Urartian or it may date to the troubled 6th century BC.

BIBLIOGRAPHY
C. A. Burney and G. R. J. Lawson: 'Urartian Reliefs at Adılcevaz, on Lake Van, and a Rock Relief from Karasu, near Birecik', *Anatol. Stud.*, viii (1958), pp. 211–18
E. Bilgiç and B. Öğün: 'Adılcevaz Kef Kalesi Kazıları' [Excavations at Kef Kalesi of Adılcevaz], *Anatolia*, viii (1964), pp. 93–124
M. J. Mellink: 'Archaeology in Asia Minor', *Amer. J. Archaeol.*, lxix (1965), p. 141; lxx (1966), pp. 150–51; lxxi (1967), p. 164; lxxiii (1969), p. 212; lxxiv (1970), p. 166; lxxviii (1974), p. 115
'Recent Archaeological Research in Turkey: Adılcevaz', *Anatol. Stud.*, xvi (1966), pp. 28–9
'Recent Archaeological Research in Turkey: Kef Kalesi (Adılcevaz)', *Anatol. Stud.*, xviii (1968), pp. 25–7
'Recent Archaeological Research in Turkey: Adılcevaz, 1972', *Anatol. Stud.*, xxiii (1973), pp. 25–7
B. Öğün: 'Die Ausgrabungen von Kef Kalesi bei Adılcevaz und einige Bemerkungen über die urartäische Kunst', *Archäol. Anz.*, lxxxii (1976), pp. 481–503
C. A. BURNEY

Kei. School of Japanese sculptors. It was active from the late 12th century to the 19th but flourished particularly during the Kamakura period (1185–1333). The name has been applied by modern art historians to sculptors in this mode from KŌKEI onwards, and derives from the suffix *-kei*, which many of its members used. The school traced its ancestry to Raijo (1044–99), a grandson of the early 11th-century master JŌCHŌ, and established a new style of Buddhist sculpture that perhaps represented a dissatisfaction with the traditions of the IN and EN schools of sculpture and a renewal of the classical style of the 8th-century Nara period. The style was naturalistic and robust and showed the influence of Chinese sculpture of the Song period (AD 960–1279). The Kei sculptors were based first at Kōfukuji in Nara (*see* NARA, §III, 7) and then at the Shichijō Street workshop (*bussho*), whence they were called *Nara busshi* (Nara sculptors). Of the many sculptors associated with the Kei school, the most important include Kōkei, UNKEI and KAIKEI, as well as Unkei's younger brother Jōkaku (*b* mid-12th century), Unkei's sons Tankei (1173–?1256), Kōun, Kōben and Kōshō (all *fl* early 13th century), and his pupil Higojōkei (Jōkei; *b* 1184; *fl* 1224–56).

See also JAPAN, §X, 4(vi).

BIBLIOGRAPHY
Kodansha Enc. Japan
T. Kobayashi: *Nihon chōkoku sakka kenkyū* [Research on the artists of Japanese sculpture] (Yokohama, 1978)
HIROMICHI SOEJIMA

Keibun. *See* MATSUMURA KEIBUN.

Keij. *See* KEY.

Keil, Alfredo (*b* Lisbon, 1854; *d* Hamburg, 24 Oct 1907). Portuguese painter. His family was of German origin, and in 1868 he went to Bavaria, where he attended the studios of August von Kreling (1819–76) in Nuremberg and Wilhelm Kaulbach in Munich. He returned to Portugal in 1870, where he continued his studies with Miguel Ângelo Lupi. From 1868 to 1880 he exhibited at the Sociedade Promotora de Belas-Artes. Keil painted intimate scenes and interiors with soft and harmonious light effects, and he was a Romantic who resisted the new move towards Naturalism. In his early works, such as *Study Table* (1868; Lisbon, Mus. N. A. Contemp.) or *The Letter* (1874; Lisbon, Mus. N. A. Contemp.), he shows an affinity with the paintings of Alfred Stevens, with their quiet and yet luxurious bourgeois interiors.

Keil was fond of depicting coastal sunsets and seascapes, as in *Seascape* (Lisbon, Mus. N. A. Contemp.). He avoided the brilliant colours used by the Naturalists, and his tones are softer and more evocative. In his small views of Colares, Sintra, the light filters through dense foliage painted in shades of green without any brilliant or shimmering effects. He took part in the Exposition Universelle, Paris, both in 1878, receiving honourable mention, and in 1900. In 1879 he exhibited at the International Exhibition in Rio de Janeiro, where he received a gold medal, and in 1886 in Madrid, where he received the Order of Charles III. In Lisbon in 1890 he showed about 250 works at an exhibition in his own studio. Keil was also a musician, and his operas were very successful in Portugal and Italy. In 1891 he composed the music that in 1910 became the Portuguese national anthem. In 1910 and 1912 retrospective exhibitions of his work were held at the Academia de Belas-Artes in Lisbon.

BIBLIOGRAPHY
R. Arthur: *Arte e artistas contemporâneos*, ii (Lisbon, 1898), pp. 3–10
D. de Macedo: *Alfredo Keil: Um independente* (Lisbon, 1950)
J. A. França: *A arte em Portugal no século XIX*, ii (Lisbon, 1966), pp. 447–8
LUCÍLIA VERDELHO DA COSTA

Keil [Keilhau], Bernhard [Eberhard; Monsù Bernardo] (*b* Helsingör, 1624; *d* Rome, 1687). Danish painter, active in Italy. The son of a German painter working at the court of Christian IV of Denmark, he was apprenticed to the Copenhagen court painter Maarten van Steenwinckel (1595–1646) and as a master continued his training (1642–4) with Rembrandt in Amsterdam. He then opened his own studio and taught young artists until 1651, when he travelled to Italy. In Venice he obtained commissions for portraits, decorated palaces and was employed by churches and religious orders, executing works such as the *Virgin with St Elia* for the Carmelites in Venice and the *Virgin and St Dominic* for the refectory of the monastery of S Bartolomeo in Bergamo. In 1656 he arrived in Rome, where he remained until his death. During his sojourn in Italy he was converted to Catholicism.

As 'Monsù Bernardo' apparently never signed his works, their attribution has posed problems. Study of his work has been limited mainly to the genre pieces, though he

Bernhard Keil: *Family Group in an Interior*, oil on canvas, 0.99×1.37 m (Rotterdam, Museum Boymans–van Beuningen)

also painted portraits and religious subjects. Some of his genre pieces have an allegorical or moralizing meaning: for example, the musical companies that he often painted can be interpreted as an allegory on the sense of hearing. His range of motifs is limited. They include women and girls with sewing on their laps, as in *Family Group in an Interior* (Rotterdam, Mus. Boymans–van Beuningen; see fig.), lacemakers, musical companies and children either lying on cushions or with fruit or flowers, such as the *Little Girl with Bunches of Grapes* (ex-Gal. Kurt Meisnner, Zurich; Sumowski, no. 958).

The *Flute-playing Hunter* (1654; ex-Faerber Col., Göteborg, see Sumowski, no. 954) is exceptional among Keil's works in showing the influence of Rembrandt. Generally he seems much more a representative of Flemish Baroque painting, influenced also by Bernardo Strozzi, Domenico Fetti and Giovanni Battista Langetti. In the monumental compositions of Keil's maturity, the strong characterization of the figures and the lack of three-dimensional effect are notable. The broad brush technique, pronounced chiaroscuro and restless surface of the textiles attract attention. In general he used expressive colours such as pink and red against a darker background.

BIBLIOGRAPHY

Thieme–Becker

F. Baldinucci: *Cominciamento e progresso dell'arte dell'intagliare in rame, colle vite di molti de' più eccellenti maestri della stessa professione* (Florence, 1686), pp. 78ff

R. Longhi: 'Monsù Bernardo', *Crit. A.*, iii (1938), pp. 121–30

R. Wittkower: *Art and Architecture in Italy, 1600 to 1750* (Harmondsworth, 1958), p. 324

W. R. Juynboll: 'Bernhard Keil en de genreschilderkunst van zijn tijd', *Bull. Mus. Boymans-van Beuningen*, xiii (1962), pp. 1–12

M. Liebmann: 'I "pittori della realtà" in Italia nei secoli 17–18', *Acta Hist. A. Acad. Sci. Hung.* (1969), pp. 257ff

W. Sumowski: *Gemälde der Rembrandt-Schüler* (Landau [Pfalz], 1983), iii, pp. 1459–79

M. Heimbürger: *Bernardo Keilhan detto Monsù Bernardo* (Rome, 1988)

NETTY VAN DE KAMP

Keirinckx [Carings; Cierings; Cierinx; Keerinckx; Keirincx; Keirings; Keyrincx]**, Alexander** [Alexandre] (*b* Antwerp, 23 Jan 1600; *d* Amsterdam, 1652). Flemish painter. He was the son of Matthijs Keirinckx and Anna Masson. In 1619 he became a master in Antwerp's Guild of St Luke, he married Clara Matthausen on 18 June 1622, and in 1624 he took on Artus Verhoeven as an apprentice. From 1636 onwards he is regularly recorded in Amsterdam, where he was registered as a citizen in the year of his death. He visited Great Britain, possibly in 1625 (Walpole mentions two signed and dated drawings of London views from this year) and definitely in 1640–41, when he undertook commissions from King Charles I to paint views of royal castles and palaces. His collaboration with Cornelis van Poelenburch suggests that he also spent some time in Utrecht.

His numerous surviving signed and dated paintings make it possible to chart his stylistic evolution. His earliest works, often featuring a wooded landscape with a lake, river or sandy road (e.g. *Forest Landscape with River*, 1620; Dresden, Gemäldegal. Alte Meister), are clearly related to

similar paintings by Gillis van Coninxloo, Jan Breughel I and David Vinckboons. The foreground is occupied by several large trees, the centre shows a river or road and the background is closed off by a screen of foliage. These compositions demonstrate a skilful use of colour, with brown and green the dominant tones, and an eye for picturesque detail. A number of landscapes made *c.* 1630, such as the *Forest Landscape with Hunters* (1630; Rotterdam, Mus. Boymans–van Beuningen), have a nervous rhythm that could be characterized as Baroque. Their restrained colour scheme (grey, green and brown) is enlivened by sharp contrasts of light and shade. Gradually these dramatic Baroque qualities were abandoned in favour of a calmer style of landscape (e.g. the *Temptation of Christ*; Munich, Alte Pin.) with simpler compositions and evenly graduated perspective receding to a low horizon. He often relied on assistants for painting the figures, van Poelenburch in the case of the *Arcadian Landscape* (1633; Bremen, Ksthalle), which they both signed. Other collaborators were Paulus van Hillegaert (1595/6–1640), Bartholomeus Breenbergh and Jan van Kessel (i).

BIBLIOGRAPHY

H. Walpole: *Anecdotes of Painting in England (1762–71)*, ed. R. N. Wornum (1849)

F. J. van den Branden: *Geschiedenis der Antwerpse schilderschool* (Antwerp, 1883), pp. 1059–60

E. Greindl: 'La Conception du paysage chez Alexandre Keirincx', *Jb.: Kon. Mus. S. Kst.* (1942–7), pp. 115–20

Y. Thiéry: *Le Paysage flamand au XVIIe siècle* (Paris and Brussels, 1953), pp. 82–3

HANS DEVISSCHER

Keisai. *See* IKEDA EISEN.

Keith, Thomas (*b* St Cyrus, Kincardineshire [now Grampian], May 1827; *d* London, 9 Oct 1895). Scottish photographer and doctor. He was active as an amateur photographer from *c.* 1852 to 1857, using the waxed paper process of Gustave Le Gray to make salted paper prints. Most of his known photographs were taken in Edinburgh and Iona. He treated traditional subjects, such as historic Edinburgh, with originality in response to the medium itself, stressing the abstract nature of the compositions as tonal contrasts and sequences of solids and voids, and emphasizing the geometry of buildings, for example *Holyrood Abbey* (Edinburgh, N.P.G.; see Hannavy, p. 24) and *Edinburgh Castle from Greyfriars Churchyard* (Edinburgh, Cent. Lib.; see Hannavy, pl. 1). His work was admired by Alvin Langdon Coburn, who included some of his prints in the Royal Photographic Society Exhibition of 1914.

BIBLIOGRAPHY

J. Hannavy: *Thomas Keith in Scotland* (Edinburgh, 1981)

JULIE LAWSON

Keith, William (*b* Oldmeldrum, Aberdeenshire [now Grampian], 21 Nov 1838–9; *d* Berkeley, CA, 13 April 1911). American painter of Scottish birth. He arrived in New York as a boy in 1850 and was hired as a wood-engraver by the publishing firm of Harper & Brothers in 1857. In 1859 he established himself as a wood-engraver in San Francisco. Keith soon began to make watercolours of the state's spectacular mountain scenery, and in 1868 he turned to oil painting. After spending two years (1870–72) travelling first to Düsseldorf, where he admired the landscapes of Andreas Achenbach, then to Paris, where he saw the work of the Barbizon painters, and to New York and Boston, he returned to the American West. There he travelled widely during the next decade with the photographer Carleton E. Watkins and the naturalist and conservationist John Muir (1838–1914). From 1883 to 1885 Keith studied informally in Munich; he returned to Europe in 1893 and 1899. In the mid-1880s he was influenced by the philosophical teachings of Emanuel Swedenborg (1688–1772); in response his art moved progressively from the light-filled panoramas of Californian mountains, as in *Headwaters of the San Joaquin* (1878; Oakland, CA, Mus.), to atmospheric renderings of haze-filled meadows and oak groves, as in *Glory of the Heavens* (1891; San Francisco, CA, F.A. Museums). Keith's later paintings, constructed with complicated scumbles and glazes, became more suggestive of a mood than descriptive of a particular place. A prolific artist until only months before his death, Keith lost over 2000 paintings when his studio in San Francisco burnt down following the earthquake of 1906.

BIBLIOGRAPHY

E. Neuhaus: *William Keith: The Man and the Artist* (Berkeley, 1938)

Brother Cornelius, FSC: *Keith: Old Master of California*, i (New York, 1942), ii (Fresno, CA, 1956)

A. C. Harrison jr: *William Keith: The Saint Mary's College Collection* (exh. cat., Moraga, CA, Hearst A. G., St. Mary's Coll., 1988)

MARC SIMPSON

Ke Jiusi [K'o Chiu-ssu; *zi* Jingzhong, *hao* Zhouqiu Sheng] (*b* Tiantai, Zhejiang Province, 1290; *d* Suzhou, Jiangsu Province, 1343). Chinese calligrapher, painter, connoisseur and collector. He was appointed connoisseur to the imperial art collection housed at the newly constructed Kuizhang Pavilion in Beijing in 1330, by the Yuan emperor Wenzong (*reg* 1330–32). He was given the title of Master Connoisseur of Calligraphy, and was responsible for the verification of all the painting and calligraphy that entered the collection. After the death of Wenzong in 1332, Ke retired to Suzhou, where he spent the rest of his life.

Ke owned a large collection of painting and calligraphy and was often asked to authenticate works and write inscriptions. His calligraphy appears on paintings such as *Lowland with Trees* (handscroll, ink on paper, n.d.; New York, John M. Crawford jr priv. col.) by Guo Xi, *Early Autumn* (handscroll, ink and colour on paper, 267×1020 mm, n.d.; Detroit, MI, Inst. A.) by Qian Xuan and one of the three genuine Tang copies of Wang Xizhi's *Orchid Pavilion Preface* (*Lanting xu*; AD 353; *see* CHINA, §IV, 2(ii)). He knew Yu Ji (1272–1348) and Zhao Mengfu personally; their inscriptions often appear next to his. Ke inscribed many of Zhao's paintings, among them his *Bamboo, Rocks and Lonely Orchids* (handscroll, ink on paper, 505×1442 mm, n.d.; Cleveland, OH, Mus. A.). The painting *Duck by a Riverbank* (hanging scroll, ink and colours on paper, 4.75×3.57 m, 1301; Taipei, N. Pal. Mus.) by Chen Lin (*fl c.* 1300) is accompanied by comments written by Ke, Zhao and Qiu Yuan. Although Ke painted landscapes and ink flowers, he is best known for bamboo, which he modelled after the Song bamboo painter, WEN TONG (*see* CHINA, §V, 3(vi)). In this subject, too, he sometimes joined with a friend to paint: he collaborated

with Ni Zan, for instance, on a painting of ink bamboo at the Beijing Palace Museum.

Ke was best known as a calligrapher. He studied the Tang calligrapher OUYANG XUN and his son Ouyang Tong (*d* AD 691), specializing, as they did, in regular (*kaishu*) and running (*xingshu*) scripts. Ke's *Palace Poems* (n.d.; Princeton U., NJ, A. Mus.) shows the influence of his models, who emphasized the careful articulation of each movement of the brush. Ke appropriated and exaggerated certain mannerisms, such as the leftward curl of the brush on entrance to vertical strokes, and simplified others, as in the corner strokes, in which he tended to remove the shoulder produced by the brush as it turns and rests before coming down at a right angle. He delighted in contrasting thick strokes to others as fine as tendrils, so that the page seems to breathe in a waxing and waning movement. In the inscription to Guo Xi's *Lowland with Trees* the calligraphy is less fanciful and more business-like. The same balance of characters and accuracy of technique are retained, but less attention is given to contrast of line, making the flow of characters smooth and purposeful.

BIBLIOGRAPHY

K. Shimonaka, ed.: *Shodō zenshū* [Complete collection of calligraphy], xvii (Tokyo, 2/1956), p. 188, pls 50–51

J. Cahill: *Hills Beyond a River: Chinese Painting of the Yüan Dynasty, 1279–1368* (New York and Tokyo, 1976)

Traces of the Brush: Studies in Chinese Calligraphy (exh. cat. by Shen Fu and others, New Haven, CT, Yale U. A.G.; Berkeley, U. CA, A. Mus.; 1977), pp. 141–2, 183, 291, 302, 304

J. Cahill: *An Index of Early Chinese Painters and Paintings* (Berkeley and Los Angeles, 1981), pp. 290–2

Yu Jianhua: *Zhongguo huajia da zidian* [Dictionary of Chinese painters] (Shanghai, 1981), p. 600

Zhungguo shufa da zidian [Dictionary of Chinese calligraphy] (Hong Kong, 1984), pp. 655–6

ELIZABETH F. BENNETT

Kekushev, Lev (Nikolayevich) (*b* Simbirsk [formerly Ul'yanovsk], 7 Feb 1862; *d*?1918). Russian architect, designer and teacher. He studied at the Institute of Civil Engineers in St Petersburg from 1883 to 1888, and then in 1890 he went to Moscow, where in a brief, 15-year career he went on to execute more than 60 buildings, as well as designing decorative objects for mass production. His first buildings there are examples of late historicism. The Korobkov House on Pyatnitskaya Street and the Geyer Almshouse in Krasnosel'skaya Street, for example, display an eclectic blend of method, have a rich plasticity of volume, a slightly exaggerated sculptural quality in the architectural forms, and appeal to the legacy of Renaissance, Baroque and Romanesque architecture. From the late 1890s, however, Kekushev began to work in the Russian version of the Art Nouveau style (Rus. *modern*). He was one of the style's pioneers in Russia and one of its leading exponents in Moscow, although some features of his earlier historicist works, such as accentuated plasticity, extensive and weighty forms and fidelity to Baroque and Romanesque motifs, continued to appear in his work. This is the case with a series of private residences (1898–1903), such as the List House (1898–9), Glazovsky Lane, the Kekushev House, on Ostozhenka, and the Nosov House (1903), Vvedenskaya Square, with their complex but static compositions, made up of independent volumes and large-scale, emphatically heavy forms.

At about the same time a second form of modernist reinterpretation of Romanesque and classical architecture began to be evident in Kekushev's work, partly linked to the trend towards the Viennese Secessionist style. This prevailed initially in buildings with façades that extended along a street, such as the Revenue House, on Ostozhenka, Moscow. Among other examples of this style are Kekushev's most famous buildings: the Mindovsky House (1903–4), Povarskaya Street; the Isakov block of flats on Prechistenka; the Skalkina Restaurant (1908) in Petrovsky Park; and the Praga Restaurant (1903, 1914) on the Arbat, all built between 1903 and 1908. These combine his characteristic heavy decoration, in arched windows and entrances, undulating, highly protruding cornices and curvilinear attics and oriels, with an overall composition that is symmetrical and traditional. The emphatically modern elements of these buildings are offset by the traditional angularity and height of their façades. A sensitivity to innovations in style is combined in Kekushev's work with extensive use of technical and constructional developments: new types of bathrooms and lavatories and the most recent systems for heating, ventilation, sewerage and lifts. From 1898 to 1901 he taught at the Stroganov School of Technical Drawing, Moscow. After 1908 there is no evidence of further designs.

BIBLIOGRAPHY

G. V. Baranovsky: *Yubileynyy spravochnik svedeniy o deyatel'nosti byvshikh vospitannikov Instituta grazhdanskikh inzhenerov: Stroitel'nogo uchilishcha, 1842–1892* [Anniversary reference book on the work of former pupils from the Institute of Civil Engineers: School of Architecture, 1842–1892] (Paris, 1893)

E. V. Bagina: 'Lev Kekushev', *Stroitel'stvo & Arkhit. Moskvy*, ix (1984), pp. 25–7

Ye. S. Bashirova: 'Lev Nikolayevich Kekushev', *Problemy russkoy arkhitektury kontsa XIX–nachala XX rekov* [Issues in Russian architecture at the end of the 19th and start of the 20th century], ed. F. O. Shekhtel (Moscow, 1988), pp. 103–7

YE. I. KIRICHENKO

Keldermans [van Mansdale]. Netherlandish family of artists. 'What makes the family of stone masons van Mansdale, alias Keldermans, so remarkable in the first place is not so much the high quality of their artistic output, but the fact that we are able to follow their doings through nearly two centuries' (Meischke). Nevertheless, the attribution of specific buildings to them is difficult. The characteristics of their style are typical of the period, and several members of the family often worked on one building. Many of them worked as consultants, with no direct artistic influence on the buildings they inspected. The Keldermans family also traded in stone, ranging from cannonballs to second-hand altarpieces.

Jan van Mansdale I (*d* 1424/5), the founder of the dynasty, originated in Brussels. He was a sculptor who worked in, among other places, Mechelen, where between 1377 and 1385 he made the corbels in the Hall of Judges (now Archives). (1) Jan Keldermans II was the first known master mason and consultant of the family. Of his four sons Jan III (*fl* 1450–57) worked at the Oude Kerk of Delft and at the town halls of Gouda and Middelburg, while Matthijs (*d* 1479) did the same at Leuven and at Middelburg. Rombout I (*fl* 1455–75) was a glazier in Leuven. His work is also known in St Gommaire, Lier. (2) Andries Keldermans I was mainly a sculptor. One of

Andries I's sons, Matthijs II (*fl* 1478–1524), owned a quarry near Brussels and is known chiefly for his deliveries of (white) stone. Another son, (3) Anthonis Keldermans I, was a famous architect and sculptor. Two sons of Matthijs II, Andries III (*fl* 1512–40) and Matthijs III (*fl* 1503–27), collaborated in the production of carved choir-screens, for which the Keldermans family was renowned. Matthijs III was the successor of Alard Duhamel at Leuven. Another son, Laureys I (*fl* Brussels, 1485–1512), is often confused with Laureys II (*d* 1534), son of his cousin Anthonis II. Anthonis II (*d* 1515) and his brother (4) Rombout Keldermans II, the sons of Anthonis I, were architects and were both Master of the Works to Emperor Charles V. Anthonis II had another son, Anthonis IV (*d* 1564), who worked mainly in Hoogstraten and in the province of Gelderland. The exact place of Marcelis (*d* 1557) in the Keldermans family tree has not yet been established. He lived at Utrecht from *c.* 1530, where he modernized Vredenburg Castle. He also had contacts with the architects of the new school of fortification (Donato di Boni, *fl* 1540–54; Willem van Noort, *d* 1558; Sebastian van Noije, 1523–57). The style of the Keldermans family developed from Brabantine High Gothic to an over-ornamented Late Gothic. The later members of the family were not influenced by Renaissance architecture.

(1) Jan Keldermans II (*d* Mechelen, 1445). Architect, probably the son of Jan van Mansdale I. In 1399 he became a member of the masons' guild of Brussels. Twenty-five years later he was Master of the Works of St Gommaire, Lier, a post he retained until his death, directing the building of the nave. At Leuven he was master mason of the town and of St Pieterskerk. In 1427–32 and 1441–5 he did maintenance and civil engineering work for the town of Mechelen. He might be the designer of St Rombout's tower there, although the involvement of the Keldermans family in that building started only in 1452. He may have designed the church of Breda.

(2) Andries Keldermans I (*d* Mechelen, *c.* 1500). Sculptor and architect, son of (1) Jan Keldermans II. He worked with his father on municipal works in Leuven and in his home town of Mechelen from 1439 to 1443. In 1481 he acted as consultant, with Herman de Waghemakere, testing the strength of the spire of St Pieterskerk, Leuven; on this occasion he was described as Master of the Works of the ducal court of Brabant. It is very doubtful that he designed the tower of the church of Zierikzee, as is sometimes said; his son (3) Anthonis Keldermans I seems to be a more likely candidate.

Andries I supplied sculptural work for the town halls of Leuven (1450), Middelburg (1455–9; destr.), Mechelen (1469) and Veere (1475–6). With his son Anthonis I, he produced carved stone choir-screens (destr.) for the church of Bergen op Zoom in 1471 and St Katelijnkerk, Mechelen, in 1473. The contract for the Mechelen screen reveals that it was 5.64 m high, with a gallery supported on an arcade of four columns with capitals. In later Keldermans screens the two single outer arches are set at an oblique angle to the three central ones, a design for which the Bergen op Zoom and Mechelen screens were perhaps the prototypes. Andries I and Anthonis I are

thought to have been responsible for the choir-screen (destr.) formerly in St Rombout, Mechelen.

In 1478 Andries I and Anthonis I carved a Virgin in a niche (destr.) to surmount the *Sacraments* altarpiece of Dieric Bouts in St Pieterskerk, Leuven. They worked together on a tabernacle (destr.) for the church of Axel in 1479. In 1482 they inspected the work on the Town Hall of Middelburg.

(3) Anthonis Keldermans I (*d* Mechelen, 15 Oct 1512). Architect and sculptor, son of (2) Andries Keldermans I. The life and works of Anthonis I show nearly all aspects of the Keldermans' activities through the years. In 1476–7, while working with his father, Andries I, Anthonis I became the town workman of Bergen op Zoom. He designed a large, new church to replace its recently completed predecessor, but by 1545 only the transept was finished. He also advised on the town defences and waterways. As Master of the Works to the Marquis of Bergen op Zoom, he modernized the fortifications of the castle of Wouw (1492–1504). He also worked at the Marquis's court (Markiezenhof) at Bergen op Zoom. By 1509 Anthonis I had become Master of the Works at the Burgundian court at Brussels, where he designed the railings of the Baliënhof. He is mentioned as Master Workman of Mechelen, where he worked at the residence of Margaret of York, wife of Charles the Bold, Duke of Burgundy, which in the end developed into the palace of Margaret of Austria, Regent of the Netherlands. His sons Anthonis II and (4) Rombout II also shared in the execution of that complex of buildings.

From 1497 to 1501 Anthonis I was designer and Master of the Works at the new church at Alkmaar, probably because he was also able to procure good white stone from Brabant. There he worked with his son Anthonis II and with his brother Matthijs, who delivered stone. He also worked at the church of Veere (1479), where he succeeded Evert Spoorwater (*d* 1474), the crossing tower of St Bavo, Haarlem (1502–7), and the Oude Kerk of Delft (1511), where he also made additions to the Nieuwe Kerk (before 1512). Anthonis I is the most likely candidate for architect of the majestic tower of the church of Zierikzee. The Town Hall of Middelburg is one of those buildings to which generations of Keldermans contributed: Anthonis I designed its tower (1506–11) in collaboration with his son Rombout II.

A stone choir-screen was made for St Sulpice, Diest (1483), a tabernacle for Alkmaar (1500) and a large window-frame for the church of the Grey Friars at Mechelen (1499–1500). In 1512 Anthonis I inspected the tower of Sint Pieterskerk, Leuven, with Domien de Waghemakere.

(4) Rombout Keldermans II (*b* Mechelen, *c.* 1460; *d* Antwerp, 15 Dec 1531). Architect, son of (3) Anthonis Keldermans I. Of all the members of the Keldermans family who worked in the building trade, it was Rombout II who achieved the greatest social status: he was knighted, probably after succeeding his brother Anthonis II as the King's (later Emperor Charles V's) Workman General in the Netherlands in 1516. Nevertheless Rombout's work was as varied as that of his father. With Anthonis II he continued his father's activities. Younger members of the

family such as his nephew Laureys II and Marcelis worked under him. More exceptional is Rombout's close and long-standing cooperation with Domien de Waghemakere of Antwerp, with whom he designed, among many other buildings, the extension of Ghent Town Hall from 1517 onwards. In 1519 Rombout II moved to Antwerp, where he lived until his death.

As Workman General to Charles V he travelled widely, especially in the northern Netherlands. Owing to the unstable political situation in and around the bishopric of Utrecht and the duchy of Gelder, he was involved in the design of fortifications. As he died shortly before the introduction of the Italian pentagonal bastion into the Netherlands, his designs are either downright old-fashioned (Schoonhoven, 1524), clearly transitional (Vredenburg Castle at Utrecht, 1529; see fig.) or highly experimental (as with his designs for Castle Ter Eem and Duurstede, c. 1529).

Through this military work, Rombout was in close contact with Antoine de Lalaing, Count of Hoogstraten and Stadholder of Holland, Zeeland and Utrecht. He not only extended and fortified de Lalaing's castle at Hoogstraten (1526) but also designed the Town Hall and the church there (1525). Rombout's younger relatives remained closely connected to the counts of Hoogstraten.

While in Spain, Hendrik III, Count of Nassau, sent plans for his castle at Breda to Rombout, asking him to correct them, but Rombout did not design any of the Renaissance features of that building.

In 1515 Rombout II succeeded his brother as Master of the Works of the 'town and tower' of Mechelen, where he finished the imposing St Rombout's tower. In the following years he worked at the palace of Margaret of Austria, for which he designed the majestic staircase (1517–18). Again, the Renaissance work at this palace is certainly not to be attributed to Rombout II. The Palace of the Great Council, designed in 1529, was never finished, but the fine drawings for its gables still survive (Mechelen, Stadsmus. Hof van Busleyden).

Rombout II became Master of the Works of Bergen op Zoom in 1517. He had already been mentioned there in 1504–5 in a position of command at the building of the church. He continued the Keldermans' involvement with the Marquis's court. His most famous work there is the finely carved chimney-piece depicting St Christopher, but his authorship of that sculpture is still a matter of debate. He also continued work on church buildings begun by his predecessors: in 1512 he worked at Veere, from 1514 to 1521 at the Oude Kerk of Delft. The churches of

Rombout Keldermans II: Vredenburg Castle, Utrecht, begun 1529; engraving by C. Decker, 1656, after an anonymous painting c. 1540 (Utrecht, Gemeente Archief)

Steenbergen and possibly the church of Wouw were, however, designed by him. He made a magnificent drawing (1529) for the upper part of the tower of Zierikzee, but the plan was never executed. He designed a chapel in Brussels for Charles V in 1522. Together with his nephew Laureys II, Rombout worked at Tongerloo Abbey (1515, 1522–8) and in 1516–17 did maintenance work at Turnhout Castle.

Domien de Waghemakere and Rombout II worked together at a number of important buildings, notably the enlargement of Antwerp Cathedral from 1520 onwards, in which year they also started at the prison there, called Het Steen. In 1525 St Jacobskerk, Antwerp, was begun. The Maison du Pain (Broodhuis) in Brussels and the extension of Ghent Town Hall are highlights of the late medieval civil architecture that the two of them created. Rombout II also carried out inspections of buildings and constructions of other architects such as the Great Sluice at Lier in 1516.

BIBLIOGRAPHY

E. Neeffs: *Histoire de la peinture et de la sculpture à Malines* (Ghent, 1876)

P. Lefèvre: 'Textes concernant l'histoire artistique de l'abbaye d'Averbode', *Rev. Belge Archéol. & A.*, v (1935), pp. 51, 53

R. de Roo: 'De Keldermansen naar de documentatie uit het Mechelse stadsarchief', *Hand. Kon. Kring Oudhdknd., Lett. & Kst Mechelen/Bull. Cerc. Archéol., Litt. & A. Malines*, lvi (1952), pp. 68–89

J. Squilbeck: 'Notices sur les artistes de la famille Van Mansdale, dite Keldermans', *Hand. Kon. Kring Oudhdknd., Lett. & Kst Mechelen/Bull. Cerc. Archéol., Litt. & A. Malines*, lvi (1952), pp. 90–137; lvii (1953), pp. 99–140

J. Steppe: 'Het Koordoksaal in de Nederlanden', *Acad. Anlct.: Kl. S. Kst.*, vii (1952)

T. J. Hoekstra: 'Marcelis Keldermans, mr. van den wercken van de starckte Vredenborch en boumeester der vesteijcheden van de stercksten in Gelderland (ca 1500?–1557)', *Liber Castellorum: 40 variaties op het thema kasteel*, ed. T. J. Hoekstra, H. L. Janssen and I. W. L. Moerman (Zutphen, 1981), pp. 170–86

R. Meischke: 'Reizende bouwmeesters en Brabantse handelsgotiek', *Keldermans: Een architectonisch netwerk in de Nederlanden*, ed. J. H. van Mosselveld (The Hague, 1987), pp. 183–90

TARQ HOEKSTRA, KIM W. WOODS

Keleti [Kelety; Klette], **Gusztáv** (*b* Pozsony [now Bratislava, Slovakia], 13 Dec 1834; *d* Budapest, 2 Sept 1902). Hungarian painter, draughtsman, illustrator and critic. He studied drawing with his father, the landscape painter Karl Klette von Klettenhof (1793–1874), while he was a law student at the University of Pest. In Vienna he continued as a law student and also attended Carl Rahl's art school in 1855. In 1861 he studied at the Akademie der Bildenden Künste in Munich under Eduard Schleich and Friedrich Voltz (1817–86) and in the private school of Johann Heinrich Fischbach (1797–1871). In 1867–8, under the patronage of the liberal Romantic writer Baron József Eötvös, Keleti undertook a long European tour to study teaching methods in art academies, with the intention of establishing such an institution in Hungary. The Design and Drawing Teachers' Institute was founded in Budapest in 1871, and Keleti was its Director until his death. In the 1870s he became a well-known painter of historical landscapes and views. His detailed and picturesque drawings were in the Neo-classical and Romantic style of his father and of his professors. His most famous painting is *Park of an Emigrant* (1870; Budapest, N.G.), which depicts a desolate garden with fallen sculptures and a swineherd, but he also contributed illustrations to a series

of books on the various regions of the Austro-Hungarian Empire (*Az Osztrak Magyar Monarchia irásban és képben*, Budapest, 1896). He also often drew and painted the surroundings of his native town, for example *View of Pozsony* (oil; Bratislava, Mun. Mus.), as well as the medieval ruins of the old royal castle of Visegrád and the park of the royal castle in Gödöllő (drawings in Budapest, N.G.). Keleti's works are conservative and academic, and his art criticism was also conservative, but he gave accurate analyses of contemporary art exhibitions and artists in various art magazines; only Symbolism and Impressionism were beyond his scope.

WRITINGS

Művészeti dolgozatok [Artistic essays] (Budapest, 1910)

BIBLIOGRAPHY

Thieme–Becker

K. Lyka: 'Gusztáv Kelety chez les Eötvös', *Magyar Nemzeti Gal. Évkönyve*, i (1970), pp. 51–72

Művészet Magyarországon, 1830–70 [Hungarian art, 1830–70] (exh. cat., ed. J. Szabó and G. Széphelyi; Budapest, N.G., 1981), pp. 259–60, 437–8

JULIA SZABÓ

Keller, Albert von (*b* Gais, Switzerland, 27 April 1844; *d* Munich, 16 July 1920). German painter of Swiss birth. He studied law in Munich and briefly attended the Akademie (1866). He also started painting privately under Ludwig von Hagn (1819–98) and Arthur von Ramberg (1819–75), both of whom encouraged his innate feeling for colour and urged him to look on the work of Giovanni Battista Tiepolo and the Dutch masters (especially Gerard ter Borch (ii)) as stylistic models. Keller's celebrated early and best work, *Chopin* (1873; Munich, Neue Pin.), is a small cabinet picture showing two fashionable young women in an elegant interior playing the piano. Exquisitely harmonized colours and sumptuous textures evoke a mood of aesthetic rapture. Keller had great success with a series of similar works and also with portraits of society ladies.

Among Keller's more complex and ambitious pictures was the biblical scene the *Raising of the Daughter of Jairus* (1886; Munich, Neue Pin.), which reflects Keller's interest in spiritualism. From the mid-1880s similar supernatural subjects enlarged on his growing fascination with parapsychology. His aesthetic commitment to the principles of *plein-air* painting and to the abstract and decorative properties of colour inspired him to co-found the Munich Secession (1892). Like John Singer Sargent and Alfred Stevens, Keller was an eclectic painter, combining an eye for detail, decorative flair and selective borrowing from the techniques of Impressionism. As with these society painters, Keller served the decadent tastes of the later 19th-century upper middle class in evoking a sense of refined and fashionable material luxury and a languorous mood.

BIBLIOGRAPHY

H. Rosenhagen: *Albert von Keller* (Leipzig, 1912)

H. Uhde-Bernays: *Die Münchner Malerei im 19. Jahrhundert*, ii (Munich, 1927, rev. 1983)

RUDOLF M. BISANZ

Keller [Cöeler; Cöler; Keler; Köler], **Georg** (*bapt* Frankfurt am Main, 9 Sept 1568; *d* Frankfurt am Main, 8 Nov 1634). German engraver, woodcutter, painter and draughtsman. He spent four years (from ?1582) training as a painter and engraver in the workshop of JOST AMMAN

in Nuremberg. From 1595 he worked mainly in Frankfurt am Main, chiefly as a watercolourist and engraver. Much of his graphic work comprises printed illustrations in the Frankfurt *Messrelationen* (an early form of illustrated newssheet) between 1596 and 1628. A number of single sheets are also known, including illustrations of coronation ceremonies in Prague and portrait engravings of famous contemporaries. His early connection with the court of Frederick V, Elector Palatinate (*reg* 1610–23), is attested by his series of 25 illustrations depicting the *Arrival of the 'Winter King's' Bride, Princess Elizabeth of England* (1596–1662) at Heidelberg in 1613.

In Frankfurt am Main Keller worked with PHILIPP UFFENBACH and ADAM ELSHEIMER for the publishers MERIAN and DE BRY. Although resident in Frankfurt, he evidently travelled extensively and seems to have stayed several times in Nuremberg, where in 1614 the *Tabulae Rudolphinae* by Johannes Kepler (1571–1630) was published; Keller signed its title-page, representing the *Temple of Astronomy*. Foremost among Keller's engravings for books are 23 engravings of the stucco reliefs in the Kaisersaal at Schloss Johannisburg, Aschaffenburg, published in *Beschreibung und Abbildung dess kayserlichen Saals Historien* (1614), and illustrations in *Architectur des Maintzischen churfürstlichen neuen Schlossbawes St Johannsburg zu Aschaffenburg* (1616) by Georg Riedinger.

Only two drawings by Keller are known: an *Apollo with the Muse of Painters* (Bamberg, Staatsbib., I.P. 113), executed in Augsburg during his journeyman period, and a sheet from an *album amicorum* (1627; Frankfurt am Main, Städel. Kstinst., 6285). Two painted altarpieces in Regensburg are attributed to him, including a *St Mary Magdalene* in the Obermünster.

BIBLIOGRAPHY

Hollstein: *Ger.*; Thieme–Becker
W. K. Zülch: *Frankfurter Künstler, 1223–1700* (Frankfurt am Main, 1935), pp. 444–6
J. Zimmer: 'Der Turm der Frauenkirche zu Neuburg a.d. Donau und andere Türme', *Neuburg. Kollkthl.*, cxxxi (1978), pp. 12–14
Zeichnungen in Deutschland: Deutsche Zeichner, 1540–1640 (exh. cat. by H. Geissler, Stuttgart, Staatsgal., 1979–80), ii, p. 60

JÜRGEN ZIMMER

Keller, Gottfried (*b* Zurich, 19 July 1819; *d* Zurich, 15 July 1890). Swiss writer, painter and critic. In his youth in Zurich he considered the professions of writer and painter and initially chose the latter. His artistic interests were probably inherited from his father, an amateur artist, and he developed his talents through continuous sketching. In 1834–5 he was apprenticed to an engraver, Peter Steiger (1804–74), who encouraged his talent but gave little advice on painting or artistic theory. He began to paint landscapes in earnest after 1835, when he was inspired by an exhibition of the works of François Diday. In 1837 he worked with the landscape painter Rudolf Meyer (1803–57), who trained Keller's eye and hand to observe and record nature. At this time Keller also began to paint watercolours *en plein air* (e.g. *View on the Sihl*, 1837; Zurich, Zentbib.). His meticulous studies have strong similarities to the topographical paintings of Johann Jakob Biedermann and Johann Ludwig Aberli, whose work Keller admired. His subject-matter became influenced by the prevailing Romanticism of the period, as in *Medieval Town* (*c.* 1839;

Zurich, Zentbib.), which is a product of his imagination rather than observation. He painted his first oils in 1839 but continued to work mainly in watercolour, a medium that particularly suited his temperament. He also broadened his style considerably, working more deliberately to capture atmospheric effects (e.g. *View near Zurich*, 1839; Zurich, Zentbib.) and to employ a rich array of blue and green tones. In 1840 he went to Munich, where he lived in poverty. In 1841 he exhibited his works for the first time; they were favourably received by critics, who observed that he had been influenced by such German landscape painters as Carl Rottmann (e.g. *Scene of the Limmat Valley from the Hottinberg*, 1842; St Gall, Kstmus.). Keller's paintings are also similar to the classically inspired landscapes of Joseph Anton Koch, as seen in *Heroic Landscape* (1841; Zurich, Zentbib.). Critics noted that this work was a carefully contrived essay in landscape composition, giving evidence of a close study of the paintings of Poussin and Claude. He returned to Zurich in 1842 and by this time was beginning to develop a career in literature. He felt that his talents did not lie in the visual arts, although he continued to paint for his own pleasure, producing mainly watercolours of great imagination and vivid colour (e.g. *Mondsee*, 1873; Winterthur, Kstmus.) until his death.

Keller was one of the most significant writers working in Switzerland in the 19th century, producing volumes of poetry and fiction from the 1840s. His most important novel was *Der grüne Heinrich* (Berlin, 1855). Evidence of his immense popularity at the end of the 19th century was the creation of the Gottfried Keller-Stiftung (Winterthur; *see* SWITZERLAND, §XII) in 1890, the purpose of which was to buy works of art to be deposited in Swiss museums. Among its first advisers were Arnold Böcklin and Albert Anker. Through the efforts of the Stiftung, hundreds of Swiss museums acquired native works of art.

WRITINGS

Gedichte (Zurich, 1846)
Der grüne Heinrich (Berlin, 1855)

BIBLIOGRAPHY

C. Brun: 'Gottfried Keller als Maler', *Neujbl. Stadtbib. Zürich J. 1894* (1894) [whole issue]
H. E. von Berlepsch: *Gottfried Keller als Maler* (Leipzig, 1895)
P. Schaffner: *Gottfried Keller als Maler* (Zurich, 1942)
B. Weber: 'Der Maler Gottfried Keller', *Palette*, xxxvii (1971), pp. 3–18
W. Baumann: *Gottfried Keller: Leben, Werk, Zeit* (Zurich, 1986)
B. Weber: *Gottfried Keller: Landschaftsmaler* (Zurich, 1990)
H. Landolt: *Gottfried Keller-Stiftung: Sammeln für Schweizer Museen* (Berne, 1990)

WILLIAM HAUPTMAN

Keller, Heinrich, II (*b* Zurich, 17 Feb 1771; *d* Naples, 21 Dec 1832). Swiss sculptor, historian, archaeologist and poet. A meeting with the sculptor Joseph Anton Maria Christen convinced Keller that he too must become a sculptor. Having sided with Switzerland's revolutionaries, in 1794 he went into voluntary exile in Florence and later in Rome, where he gravitated towards the German–Danish circle of Asmus Jakob Castens and Bertel Thorvaldsen, completed his artistic training and received his first modest commissions. The marble monolith *Diomedes at the Palladium* (1796; Zurich, Ksthaus) was evidence of his immense talent and bridged the gap between Alexander Trippel and Thorvaldsen, whose *Jason with the Golden*

Fleece (1801–4; Copenhagen, Thorvaldsens Mus.) bears some slight resemblance to Keller's work. When commissions grew scarce in Rome after the arrival of the French army, Keller decided to try his luck under the new government of the Swiss Republic but the group he sent them, *Liberty Flanked by Pallas Athena and by Hercules* (1801; probably destr.), failed to win favour. Political instability in Switzerland reduced his chances of obtaining official commissions, but he later executed several cenotaphs for aristocratic families (e.g. *Friedrich von Graffenried*, 1812; marble, Berne, Hist. Mus.), including works that are numbered among the most important of Swiss Neoclassical sculpture. Although Keller made a considerable (albeit still poorly documented) contribution to Roman Neo-classical sculpture in the period after Trippel's death and before the emergence of Antonio Canova, his greatest success was a work that was rather modest in relation to his ambitions and manifest talent: the *Birth of Venus*, of which he executed seven versions in marble (e.g., Zurich, Ksthaus), two in alabaster and thirteen smaller versions in bronze (e.g., *c.* 1800; Zurich, Ksthaus). When failing health forced him to curtail his activities as a sculptor, Keller devoted himself increasingly to patriotic history, poetry and archaeology.

BIBLIOGRAPHY

H. von Matt: *Joseph Maria Christen: Sein Leben, sein Werk und seine Zeit*, iii of *Quellen und Forschungen zur Kulturgeschichte von Luzern und der Innerschweiz*, ed. J. Schmid (Lucerne, 1957), pp. 31–6, 41–54

C. Klemm: 'Heinrich Keller, 1771–1832: Diomedes mit dem Palladium', *Bericht der Gottfried Keller-Stiftung 1981–1984* (Berne, 1985), pp. 98–106

P.-A. Jaccard: *La Sculpture* (1992), vii of *Ars Helvetica: Arts et culture visuels en Suisse*, ed. F. Deuchler (Disentis, 1987–93), pp. 166–9 [text in Ger., Fr., It. and Romansch]

PAUL-ANDRÉ JACCARD

Kellerthaler [Kellerdahler; Kellerdaller; Kolertal]. German family of goldsmiths, medallists, engravers, draughtsmen and painters. Three generations are documented in Dresden between 1554 and 1662. Johann Kellerthaler I (*b c.* 1530), a master in Dresden in 1554, was formerly assigned various engravings of *Martin Luther, Charles V* etc, now known to be the work of Jobst Kammerer (*fl* 1552–8). His brother Christoph Kellerthaler I (*c.* 1535–1592/1612), a master by 1573 and an elder of the goldsmiths' guild in 1579, did various works for the Electors Augustus, Christian I and Christian II of Saxony: in the Dresden Frauenkirche, some chains (1572), silver cutlery sets (1584), cups (1588) and a chalice (1598) can tentatively be assigned to him. Christoph took on his three sons as apprentices between 1576 and 1589; these were (1) Johann Kellerthaler II, Christoph Kellerthaler II (*fl* 1587–1639)—a goldsmith to whom no works can definitely be attributed—and (2) Daniel Kellerthaler. The son of Christoph Kellerthaler II, Friedrich Kellerthaler (1620–1662/76), was apprenticed to his father (1634–9) and became a master in 1647. Works attributed to him include an austerely designed mortar (Dresden, Grünes Gewölbe), a trophy cup (1662; Nuremberg, Ger. Nmus.) and, according to Rosenberg, two chalices decorated with coats of arms (1657, 1658; Dresden, Protestant Hofkirche). A family connection with the Frankfurt am Main goldsmith Hermann Kolertal or Cöllertail (*d* 1518) remains conjectural.

(1) Johann [Hans] **Kellerthaler II** (*b* Dresden, *c.* 1560–62; *d* 1611). Goldsmith, sculptor, engraver and painter. He became a master in 1585 (?or after 1593) but seems not to have gained the right to trade until 13 July 1603. In 1611 he bequeathed his Dresden house to his brothers and sisters and therefore probably died childless. Kellerthaler is seen as an outstanding goldsmith of Late Renaissance and Mannerist Germany. His 1585 jewellery cabinet (Dresden, Grünes Gewölbe) for the Electoral Princess Sophie of Saxony, made of ebony with silver and silver-gilt plaques showing an extensive range of allegorical images (*Victory of Truth over Vice*), is one of the earliest examples of cupboards as works of art. Four engravings of 1589 depict the *Elements*; another of 1592 is in the Wallraf-Richartz-Museum, Cologne. In 1602 he engraved nine plates for *Annali sopra la statua di Nabuchodonosor* by the Dresden court architect and sculptor Giovanni Maria Nosseni (1544–1620), some after models by Nosseni. In 1607 he executed a relief portrait of the Electoral *Princess Hedwig* on a silver-gilt medal. In 1608 he made a family altar for Christian II (Dresden, Grünes Gewölbe) in ebony with silver reliefs and cast-silver figures that were possibly models for later Augsburg pieces. Its theme, the *Carrying of the Cross*, may derive from an Augsburg plaque (see Weber, i, p. 341; ii, no. 794, pl. 220) and is repeated on the Augsburg family altar of Hans IV Pfleger (see Seling, i, fig. 42); the central relief showing the *Resurrection* appears also on the silver plaque of the Schneeberg coffin-makers.

(2) Daniel Kellerthaler (*b* Dresden, *c.* 1574–5; *d* Dresden, *c.* 1648). Goldsmith, medallist, draughtsman and engraver, brother of (1) Johann Kellerthaler. After finishing his apprenticeship in 1593 he travelled with his brother Christoph, probably visiting Nuremberg, Augsburg and Munich, possibly also Italy. He returned *c.* 1600 to Dresden, where he created various items in worked gold for the court. Though he failed to gain a permanent position at court, further contracts were not lacking. He was granted rights to trade on 30 April 1608, becoming a master probably in the same year. He became a guild elder in 1618 and occasionally (1621, 1623) assessed artistic items for the Elector. His last known recorded work dates from 1641. His daughter Marie (1622–74) married the Dresden court jeweller and subsequent councillor Michael Göppert. Having become wealthy through his work, Kellerthaler ran financial affairs as a sideline and is referred to as the owner of several properties. Already described by Philipp Hainhofer as 'one of the most distinguished artists in Dresden' and favoured by the Elector John George I, who gave him much work, Kellerthaler is viewed today as the principal master of Baroque goldsmithing in Dresden, of the same standing as Christoph Jamnitzer. He was influenced by the work of the Dutchman Paulus van Vianen (court goldsmith to Emperor Rudolf II from 1603) and, like him, by the court art of Rudolfine Prague.

Daniel's signed works include drawings done in 1598 (Dresden, Kupferstichkab.) and 1603 (*Judgement of Paris*; Dessau, Anhalt. Gemäldegal.), a 1606 portrait of the Electoral *Princess Hedwig* (Copenhagen, Rosenborg Slot), and medals of 1601 (*Elector Christian II*), 1608 (*John George I* and his wife *Magdalene Sibylle*), 1609 (*Philipp*

Daniel Kellerthaler: rosewater basin, silver gilt, 650×820 mm, 1629 (Dresden, Grünes Gewölbe)

Julius of Pomerania) and 1611 (the Electoral Princess *Hedwig*, in gold and lead). Two later medals record the *Capture of Bautzen* (1620/21) and the *Duchess Sophie of Pomerania* (after 1620), in gold and enamel. Kellerthaler's engravings include a *Rape of the Sabine Women* (1613), *Elector John George*, on horseback (1620), *Baptism* (1624), a *Stag* and *Banquet of the Gods* (both 1631) and *Diana and Callisto* (1641). As a goldsmith, Kellerthaler made a trefoil-shaped font for the Wettins (1613/15; Dresden, Schloss Moritzburg) from extraordinarily finely beaten and partly gilded silver, showing the *Circumcision, Presentation in the Temple* and *Baptism of Christ*; in 1617 he made a jug for this font. A double-sided bowl with an *Angel of the Annunciation* beaten on the inside and a wave pattern on the outside (1618; Dresden, Kstgewmus. Staatl. Kstsamml.), together with a tankard probably made the same year, reveal Kellerthaler to be a thoroughly mature Baroque goldsmith in some aspects of decoration—the cast heads of the cherubs, the design of the tap-hole etc. The Historisches Museum in Dresden has his 1625 silver-and-gold-plated stirrup for Elector John George I. The Grünes Gewölbe contains a beaten, gold-plated relief plaque in an ivory frame (1626) with an *Adoration* derived from a plaque by Giovanni Bernardo da Castelbolognese (*d* 1553); it also has a rosewater basin of 1629 (see fig.), an oval plaque with *Apollo and Marsyas*, distinctly reminiscent of Rudolfine court art, a matching tankard with a *Midas* figure of extraordinary plasticity and a 1629 relief of *St John the Evangelist*. Kellerthaler's large imperial seal of 1637 for John George I (Dresden, Staatsarchv) follows a seal of 1586 but is given a character of its own by his sensitivity for plastic form; the same year he made a seal for the Privy Council. A series of gold-plated copper and silver plaques with engravings, made between 1613 and 1654, are in the Kupferstichkabinett, Dresden. Two examples of his so-called *Bornkinnl*—cherub figures with features of the Child Jesus—have survived in the Grünes Gewölbe.

BIBLIOGRAPHY

Forrer; Thieme–Becker
P. Hainhofer: 'Reise-Tagebuch', *Balt. Stud.*, ii/2 (1834), p. 141
G. K. Nagler: *Monogrammisten*, iii (1863), pp. 443ff; iv (1875), pp. 221ff
W. Stengel: 'Die angeblichen Punzenarbeiten Johann Kellerthalers d. Ä.', *Mitt. Ges. Vervielfält. Kst* (1913), pp. 61ff

M. Rosenberg: *Der Goldschmiede Merkzeichen*, i (Frankfurt am Main, 1923), no. 1729
W. Holzhausen: 'Die Medaillen des Daniel Kellerthaler', *Z. Numi.*, xxxvi (1926), pp. 238–48
W. F. Zülch: *Frankfurter Künstler, 1223–1700* (Frankfurt am Main, 1935)
W. Holzhausen: 'Die Kellerthaler', *Neues Archv Sächs. Gesch. & Alterknd.*, lx (1939), pp. 214–23
——: 'Objets d'art et de haute curiosité', *Die Weltkunst*, xxiii/8 (1953), pp. 5ff
G. Grzimek: 'Strovogl und Kellerthaler', *Die Weltkunst*, xxxi/5 (1961), pp. 9ff
W. Holzhausen: *Prachtgefässe, Geschmeide, Kabinettstücke, Goldschmiede-kunst in Dresden* (Tübingen, 1966), p. lxxv
W. Schade: *Dresdener Zeichnungen, 1550–1650* (Dresden, 1969), pp. 58ff
I. Weber: *Deutsche, niederländische und französische Renaissanceplaketten, 1500–1650* (Munich, 1975)
Zeichnung in Deutschland: Deutsche Zeichner, 1540–1640 (exh. cat., ed. H. Geissler; Stuttgart, Staatsgal., 1979–80), ii, pp. 100–02
H. Seling: *Die Kunst der Augsburger Goldschmiede, 1529–1868* (Munich, 1980)
D. Alfter: *Die Geschichte des Augsburger Kabinettschranks* (Augsburg, 1986), p. 39
Barock in Dresden (exh. cat., ed. U. Arnold and W. Schmidt; Essen, 1986), pp. 370, 377
Deutsche Goldschmiedekunst vom 15. bis zum 20. Jahrhundert (exh. cat., ed. K. Pechstein; Hanau, 1987; Ingolstadt, 1988), p. 133

SILVIA GLASER, WERNER WILHELM SCHNABEL

Kells. Former monastery in Co. Meath, Ireland. The Annals of Ulster record the construction of a new 'civitas' at Kells in 807. Following the transfer of the shrine and relics of Columba from Iona in 878, it became the most important monastery in the Columban federation. In addition to the BOOK OF KELLS (Dublin, Trinity Coll. Lib., MS. 58, A. I. 6), a crosier in the British Museum, London, and a book shrine in the National Museum of Ireland, Dublin, the principal remains consist of a round tower, a building known as St Columba's house, four high crosses and the base of a fifth. St Columba's house, situated north-west of the Protestant parish church, belongs to a small but structurally interesting group of Irish buildings that have barrel vaults surmounted by corbelled roofs of stone. Although it was once assigned to the years 807–14, most scholars now attribute St Columba's house to the early Romanesque period, the 11th century or the early 12th.

The high crosses vary in both style and iconography, and give a good impression of the range of Irish sculpture in the 9th and 10th centuries. The Tower Cross (see fig.) is usually thought to be the earliest. Relatively small (3.3 m high), it bears an inscription describing it as 'the cross of Patrick and Columba'. Although characteristically Irish in its structure, it is unusual in that its surfaces are not divided into separate panels, abstract ornament and Christian iconography flowing together without dividing frames. A large *Crucifixion* was placed on the west face of the shaft below the cross arms, an unusual arrangement that provides a link with the south cross at Clonmacnois. The focal point in the cross arms is occupied by a *Christ in Majesty*. On the east face the corresponding position is filled by abstract ornament, evidently modelled on a metal plaque. Other carvings on this face represent Old Testament subjects (the *Fall*, the *Three Hebrews in the Burning Fiery Furnace, David in the Lions' Den* and the *Sacrifice of Isaac*) as well as the *Miracle of the Loaves and Fishes* and the *Meeting of SS Paul and Anthony*. Although it has usually been attributed to the early 9th century, some scholars

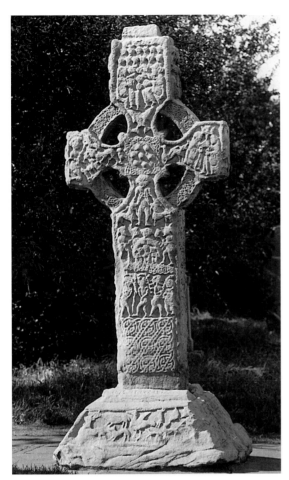

Kells, Cross of Patrick and Columba (Tower Cross), h. 3.3 m, late 9th century; east face

have dated this cross to the time of abbot Mád Brigte mac Tornáin (888–927).

The Market Cross is a larger monument, usually assigned to the 10th century, which displays a variety of connections with both the scripture crosses at the monasteries of MONASTERBOICE, Durrow and Clonmacnois (see CLONMACNOIS MONASTERY, §2) and a group in Ulster. It was carved in stronger relief than the Tower Cross, but it has suffered considerable damage, losing both its capstone and the top of the shaft. Twenty-four figural subjects are depicted, with additional carvings of animals, processions, and a battle scene on the base. In contrast to the Tower Cross it is almost devoid of abstract ornament. The cross is now incorrectly orientated, but its original west face has a *Crucifixion* in the centre, with *Daniel in the Lions' Den* corresponding to it on the east side. Other prominent subjects include the *Resurrection*, *Christus Militans*, a series of Old Testament scenes and two of Christ's miracles. In its original state, this was an imposing monument, the equal of Muiredach's cross at Monasterboice, with which it has much in common.

The Broken Cross is severed below the ring, and the sections above are lost. What is left measures 3.9 m in height, indicating an exceptionally tall monument. Like the west cross at Monasterboice, shaft and ring were constructed of separate stones. Five Old Testament subjects, including the *Fall*, *Noah's Ark* and *Moses Crossing the Red Sea*, are depicted on the west side, whereas the same space on the east contains six New Testament subjects. These include the *Baptism of Christ*, the *Miracle of Cana* and the *Entry into Jerusalem*. Although the compositions tend to be cramped and the figures have disproportionately large heads, the sculpture is well organized and precise, particularly the abstract ornament that fills the side panels.

The Unfinished Cross provides a rare insight into the techniques used by medieval Irish sculptors. The angles of the cross have been cut back, leaving projecting flat panels still to be carved. Some of the interlace on the ring is finished, but the *Crucifixion* in the centre of the east face is only half complete.

The Tower, Market and Broken Crosses are all accomplished pieces of sculpture, and the range of iconography underlines the importance of Kells as a centre of art and learning. Connections with the Book of Kells, however, are few, although sculptors and illuminators did share some decorative themes.

See also INSULAR ART, §4.

BIBLIOGRAPHY
H. G. Leask: *Irish Churches and Monastic Buildings*, i (Dundalk, 1955)
H. M. Roe: *The High Crosses of Kells* (Kildalkey, 1959, rev. 1966)
F. Henry: *Irish High Crosses* (Dublin, 1964)
——: *Irish Art during the Viking Invasions (800–1020 AD)* (London, 1967)
M. Herbert: *Iona, Kells and Derry: The History and Hagiography of the Monastic Familia of Columba* (Oxford, 1988)
D. Kelly: 'Crucifixion Plaques', *Irish A. Rev. Yb., 1990–1991*, pp. 204–8
P. Harbison: *The High Crosses of Ireland* (Bonn, 1992)
R. A. Stalley: 'Scribe and Mason: The Book of Kells and the Irish High Crosses', *The Book of Kells: Proceedings of a Conference Held at Trinity College, Dublin: 6–9 September 1992*, pp. 257–65

Kells, Book of. Manuscript of the four Gospels, in Latin, written and illuminated on vellum probably in the second half of the 8th century AD. It is the most extravagant and complex of the Insular Gospel books, representing the climax of a development that began in the 7th century AD with such manuscripts as the Book of Durrow (Dublin, Trinity Coll. Lib., MS. 57). The 340 folios (originally about 370; present size 330×255 mm) are now bound into four volumes (Dublin, Trinity Coll. Lib., MS. 58). As well as the four Gospels the manuscript contains a sequence of ornate canon tables, decorated with architectural frames and symbols of the Evangelists, and other introductory material. St Matthew's Gospel opens with a whole page devoted to the symbolic beasts (fol. 27*v*), one of several such pages designed to underline the harmony of the four Gospels. This is followed by a portrait of *St Matthew* (fol. 28*v*) and an elaborate initial (fol. 29*r*). A similar sequence of decorated pages was probably intended for the other Gospels, but the portraits of *St Mark* and *St Luke* are now missing. The account of the birth of Christ (Matthew 1:18) is accorded similar emphasis, with a portrait of *Christ* (fol. 32*v*; see fig.), a carpet page comprising a double armed cross with eight circles (fol. 33*r*) and a stunningly intricate version of the chi-rho initials

Book of Kells, *Christ*, miniature preceding St Matthew's Gospel, 330×255 mm, 8th century AD (Dublin, Trinity College Library, MS. 58, fol. 32*v*)

(fol. 34*r*; *see* INITIAL, MANUSCRIPT, fig. 1). There is also a portrait of the *Virgin and Child* (fol. 7*v*), as well as two 'illustrative' pages, the latter full of symbolic allusions. One depicts an enigmatic scene, traditionally identified as the *Arrest of Christ* (fol. 114*r*), the other a more explicit scene of the *Temptation of Christ* (fol. 202*v*; *see* IRELAND, fig. 7). It is likely that there were once several further pictures, including a *Crucifixion* opposite the words 'tunc crucifixerant XRI' (fol. 124*r*). The text is written in a superb majuscule, enlivened with hundreds of brightly coloured initials, ingeniously composed of animals, interlace and human forms.

The art of the Book of Kells is a complicated synthesis of Christian iconography, derived from the Mediterranean world, and the northern European predilection for brilliant colour and abstract pattern. In the religious scenes, abstract values dominate at the expense of naturalism, imbuing the images with a detached, visionary quality. The bulk of the painting, however, appears to be as much decorative as religious in content, and the artists exploited a vast repertory of motifs: circles, spirals and trumpet patterns from the Celtic tradition, interlace and fret designs, plus a wide variety of animal ornament, with snakes and cats to the fore. Human beings, contorted, knotted or entangled, are another fundamental ingredient in the bewildering ornamental jungle, where humour and imagination abound. Many of the decorative themes may have symbolical connotations, but how far such interpretations can or should be taken is open to debate. The minute scale of the ornament, which has its parallel in contemporary

metalwork (*see* INSULAR ART, §2), can be seen as a deliberate attempt to excite wonder and convey a semimiraculous impression. The lavish nature of the book is further underlined by the wide range of pigments employed, many obtained from distant sources, and the fact that approximately 185 calf skins were required to provide the vellum.

Errors and confusions in the text suggest that the book was never intended to be read or studied at length. When it was stolen from the monastery of KELLS in 1007, it was described as the great Gospel book of Columcille (St Columba; *c.* AD 521–97); there is little doubt that it was executed as an act of homage to the Irish saint, much as the LINDISFARNE GOSPELS were prepared in honour of St Cuthbert (*c.* AD 634–87). On the controversial question of provenance, most modern scholars favour IONA, the island monastery founded by St Columba in AD 563, which had the resources and motives necessary to undertake the work. The unusual iconography of the *Virgin and Child* (fol. 7*v*) is reflected on St Martin's cross and St Oran's cross at Iona, and many decorative parallels with Pictish carving in Scotland are explicable in this environment. In view of the plunder of Iona by the Vikings in 802 and 806, it is likely that the book was prepared before 806 but after 721 (the *terminus ante quem* for the Lindisfarne Gospels). There is no agreement about the number of scribes and artists employed, but it is generally accepted that the project must have involved several individuals over many years. Even so, several pages (notably fols 29*v*–31*r*) are unfinished, and on some the ornament is barely started. During the Celtic Revival in the late 19th century, the Book of Kells came to be revered as a symbol of Irish nationalism, a status that it emphatically retains.

BIBLIOGRAPHY

The Book of Kells (8th century AD; Dublin, Trinity Coll. Lib., MS. 58); facs. ed. E. H. Alton and P. Meyer, *Evangeliorum quattuor codex cenannensis*, 3 vols (Berne, 1951); facs. as *The Book of Kells* (Lucerne, 1989)
A. M. Friend: 'The Canon Tables of the Book of Kells', *Studies in Memory of Arthur Kingsley Porter*, ii (Cambridge, MA, 1939), pp. 611–41
O. K. Werckmeister: *Irisch-northumbrische Buchmalerei des 8. Jahrhunderts und monastische Spiritualität* (Berlin, 1967)
M. Werner: 'The Madonna and Child Miniature in the Book of Kells', *A. Bull.*, liv (1972), no. 1, pp. 1–23; no. 2, pp. 129–39
F. Henry: *The Book of Kells* (London, 1974)
C. Nordenfalk: *Celtic and Anglo-Saxon Painting: Book Illumination of the British Isles, 600–800* (London, 1977)
J. J. G. Alexander: *Insular Manuscripts, 6th to the 9th Century* (London, 1978), pp. 71–6
I. Henderson: 'Pictish Art and the Book of Kells', *Ireland in Medieval Europe: Studies in Memory of Kathleen Hughes*, ed. D. Whitelock, R. McKitterick and D. Dumville (Cambridge, 1982), pp. 79–105
G. Henderson: *From Durrow to Kells: The Early Insular Gospel-books, 650–800* (London, 1987)
P. Meyvaert: 'The Book of Kells and Iona', *A. Bull.*, lxxi/1 (1989), pp. 6–19
P. Fox, ed.: *The Book of Kells: MS. 58 Trinity College Library, Dublin: Commentary* (Lucerne, 1990)
The Book of Kells: Proceedings of a Conference at Trinity College, Dublin: 6–9 September 1992

ROGER STALLEY

Kellum, John (*b* Hempstead, NY, 27 Aug 1809; *d* Hempstead, 24 July 1871). American architect. He initially trained as a carpenter, and his architectural career began in the early 1840s when he entered the office of the Brooklyn architect Gamaliel King. Kellum opened his own office in 1859. He worked within the established

stylistic currents of the period, designing primarily in the Italianate and Second Empire styles. He received several notable commercial commissions, including the first permanent building for the New York Stock Exchange (1863–5; altered 1880–81; destr. 1901), Wall Street, New York, and one major civic monument, the New York County Courthouse (1861–81; completed by Leopold Eidlitz; main entrance stair removed), City Hall Park, New York, commonly known as the 'Tweed Courthouse'. Kellum was among the first architects to design buildings with cast-iron fronts. His Cary Building (1856–7; with Gamaliel King), Chambers and Reade streets, New York, with its iron façades cast in imitation of rusticated stone, is among the early masterpieces of the genre. Much of Kellum's work was undertaken for the department store magnate Alexander Turney Stewart. In New York he designed Stewart's cast-iron store on Broadway (1859–68; destr. 1956), his marble mansion on Fifth Avenue (1864–9; destr. 1901) and his Working Women's Hotel (later the Park Avenue Hotel) on Park Avenue (1869–79; destr. 1926), each of which was the largest building of its type yet erected in the USA. Kellum also prepared the master-plan for Stewart's financially unsuccessful suburban community of Garden City, Long Island, NY. Shortly before his death he laid out the community on a modified grid plan and designed houses (1871; some destr. or altered), a hotel (1871; destr.) and a railway station (1871; destr.), all in the Second Empire style.

BIBLIOGRAPHY

W. Weisman: 'Commercial Palaces of New York, 1845–1875', *A. Bull.*, xxxvi (1954), pp. 285–302

SoHo Cast-iron Historic District Designation Report, New York City Landmarks Preservation Commission (New York, 1973)

M. Gayle and E. Gillon: *Cast-iron Architecture in New York: A Photographic Survey* (New York, 1974)

J. Cantor: 'A Monument of Trade: A. T. Stewart and the Rise of the Millionaire's Mansion in New York', *Winterthur Port.*, x (1975), pp. 167–97

D. Gardner: *The Architecture of Commercial Capitalism: John Kellum and the Development of New York, 1840–1875* (diss., New York, Columbia U., 1979)

A. Bedell and M. Dierickx: *The Tweed Courthouse Historic Structure Report* (New York, 1980)

A. Robins: *Cary Building Designation Report*, New York City Landmarks Preservation Commission (New York, 1982)

ANDREW SCOTT DOLKART

Kelly, Ellsworth (*b* Newburgh, NY, 31 May 1923). American painter, sculptor and printmaker. He was one of the major practitioners of abstract art in the USA after World War II; as early as the 1950s he developed an individual approach that influenced the course of Minimal art, colour field painting, hard-edge painting and Post-painterly Abstraction without becoming fully a part of any of these movements. He was encouraged at high school by a sympathetic art teacher, although his parents were reluctant for him to be an artist and agreed to support only his training in the technical arts, which he pursued at the Pratt Institute in Brooklyn, New York (1941–2). In 1943 he was inducted in the US Army where, at his request, he was assigned to the camouflage unit. In 1944 he travelled to Europe, where a short stay in Paris inspired him to return to France at the end of the decade. Following his military discharge (1945), he studied at the Boston Museum of the Fine Arts School (1946–7). With the support of a US education grant on the G.I. Bill, he returned in 1948 to Paris, using it as a European base for six years. During this period he made a trip to Colmar to see Matthias Grünewald's Isenheim Altarpiece; the construction of his later painting may have been prompted in part by its multi-panel format.

In Paris, Kelly continued to paint the figure, but by May 1949 he had made his first abstract paintings. As a painter and sculptor he worked from then on in an exclusively abstract mode, although throughout his career he continued to make outline drawings and prints of nature and people. Picasso had been Kelly's initial influence, but in Paris he became involved with the Surrealist technique of automatic drawing and with the exploitation of chance by dancer and choreographer Merce Cunningham and the composer and writer John Cage, both of whom he had met as fellow guests at his Paris hotel. Also important were his encounters in Paris with the artists Michel Seuphor (*b* 1901), George Vantongerloo, Constantin Brancusi, Joan Miró, Alexander Calder and with the work of Sophie Taeuber-Arp. Kelly became enthralled by Parisian 20th-century architecture and by the play of light and shadow over its stark surfaces; he used them as reference points for his paintings, such as *Window, Museum of Modern Art, Paris* (1949; priv. col., see 1982 exh. cat., p. 15); only later, however, when he was confident of his originality, did he publish photographs documenting these sources. His insistence in such works on deriving abstract form, contour, tonal or colour contrast from observed reality distinguished his work from that of such contemporary American painters as Josef Albers and Ad Reinhardt, whose theories and concepts of abstraction were not significant forces on his art. Kelly's interest in the painting as an object anticipated Jasper Johns and Pop art.

In 1954 Kelly moved back to the USA in the belief that Abstract Expressionism was not so dominant as to preclude an acceptance of his art. He moved into a loft in Manhattan within a community of artists that included Agnes Martin, James Rosenquist and Kelly's colleague from Paris, Jack Youngerman (*b* 1926). He progressed from wood relief panels to large painted canvases such as *Atlantic* (1956; New York, Whitney; see fig.), which juxtaposed blocks of single, flat colours with silhouetted shapes, abstracted from organic forms.

By the late 1950s Kelly had an international reputation. He was also producing sculptures such as *Wave Relief I* (1959; priv. col., see 1982 exh. cat., p. 30) in which he cut out flat forms and silhouetted them against interior walls, or sometimes placed them in the natural environment. While his painting stressed shape and planar masses (often assuming non-rectilinear formats), his sculpture was insistently two-dimensional. For a period in the mid-1960s, Kelly came close to Op art in his use of geometric configurations and colour contrasts that stressed perceptual ambiguities. His work of this period also provided a useful bridge from the vanguard American geometric abstraction of the 1930s and early 1940s to the Minimalism and reductive art of the mid-1960s and 1970s.

In 1970 Kelly left the city to live in upstate New York. Having gone through a period of rectilinear geometry in his painting, he began again to employ curves in two-colour paintings made of separate panels and in sculptures

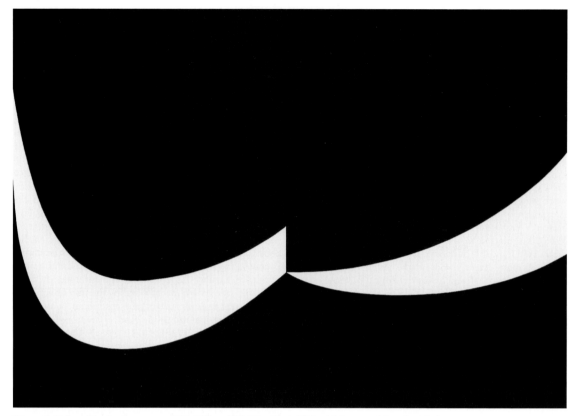

Ellsworth Kelly: *Atlantic*, oil on canvas, 2.03×2.90 m, 1956 (New York, Whitney Museum of American Art)

in a subtle homage to his new pastoral surroundings, for example *Blue Curve III* (oil on canvas, 1972; Los Angeles, CA, County Mus. A.). In another response to his new environment, in 1973 Kelly began regularly making large-scale outdoor sculpture, often in totem-like configurations such as *Curve XXIII* (stainless steel, 1981; New Haven, CT, Yale U. A.G.). He used steel, aluminium, stainless steel and in the 1980s, bronze. In these he was not concerned with colour, except for that of the material itself in order to stress shape and give the pieces consistency and easier maintenance. From 1964 he produced prints and editioned sculptures at Gemini G.E.L. in Los Angeles and Tyler Graphics Ltd near New York City. His prints related to his work in other media; his first published series was *Suite of Twenty-seven Colour Lithographs* (1964–5), for example *Blue and Orange and Green* (see Axsom, p. 39). He also worked in a large scale for major public pieces, including commissions for Lincoln Park, Chicago (1981), Dallas (1985) and Barcelona (1986). Drawings and works on paper, particularly figure and numerous plant drawings, consistently partnered painting and sculpture in his productive career.

For further illustration *see* HARD-EDGE PAINTING.

BIBLIOGRAPHY

D. Waldman: *Ellsworth Kelly: Drawings, Collages, Prints* (Greenwich, CT, 1971)
J. Coplans: *Ellsworth Kelly* (New York, 1973)
Ellsworth Kelly (exh. cat. by E. C. Goossen, New York, MOMA, 1973)
Ellsworth Kelly: Paintings and Sculptures, 1963–1979 (exh. cat. by B. Rose, Amsterdam, Stedel. Mus., 1979)
Ellsworth Kelly: Recent Paintings and Sculptures (exh. cat. by E. C. Baker, New York, Met., 1979)
Ellsworth Kelly: Sculpture (exh. cat. by P. Sims and E. R. Pulitzer, New York, Whitney; St Louis, MO, A. Mus.; 1982)
R. H. Axsom: *The Prints of Ellsworth Kelly: A Catalogue Raisonné, 1949–1985* (New York, 1987)
Ellsworthy Kelly: Works on Paper (exh. cat. by D. Upright, Fort Worth, TX, Fort Worth A. Mus., 1987)

PATTERSON SIMS

Kelly, Florencio (*b* Galway, Ireland; *d* Madrid, 6 July 1732). Spanish surgeon and dealer of Irish birth. By 1717 he was in Spain as surgeon to Philip V and his family. He married Felicia López de Haro, by whom he had three children. He was actively engaged in trade, importing jewellery and other luxury goods as well as paintings from various European countries. The names of those who owed him money, listed in his will, reveal that his customers included many members of the royal family and the aristocracy. There is no detailed evidence of his commercial activities, but it is known that in 1717 he authorized the sale in Amsterdam of four paintings by Anthony van Dyck that belonged to him.

The inventory made on Kelly's death in 1732 included 72 paintings of the Flemish, Italian and Spanish schools. Part of this collection was inherited by his son, Juan, and on his death his widow offered it to the Bourbon king Charles III, who in 1764 sent the artist Anton Raphael

Mengs to select the most important works. Twenty paintings were chosen, for which 143,600 reales were paid, including (all Madrid, Prado) two by Andrea Vaccaro, the *Penitent Magdalene* and *Meeting of Isaac and Rebecca*; an important work by Antoine Coypel, *Susanna Accused of Adultery* (*c.*1704); and others by Bartolomé Esteban Murillo, *Adoration of the Shepherds* (*c.* 1655–60) and *Annunciation* (*c.* 1648–55), which indicate the continuing revaluation of this painter's work during the 18th century.

BIBLIOGRAPHY
Marqués del Saltillo: 'Casas madrileñas del siglo XVIII y dos centenarias del siglo XIX', *A. Esp.* (1948–9), pp. 17–20
E. de Ochoa: 'Epistolario español: Colección de cartas de españoles ilustres antiguos y modernos', *Bib. Aut. Esp.*, lxii/2 (Madrid, 1965)

MERCEDES AGUEDA

Kelly, Mary (*b* Albert Lea, MN, 7 June 1941). American conceptual artist, teacher and writer. She studied fine art and music at the College of St Teresa, Winona, MN, and fine art and aesthetics at the Pius XII Institute, Florence, Italy (MA 1965). She later received a postgraduate certificate in painting at St Martin's School of Art, London. From 1968 Kelly worked in London as artist, teacher, curator, editor and writer. Her first solo exhibition was in 1976 at the Institute of Contemporary Arts, London, where she showed three of the six 'Documents' from her extended project *Post-Partum Document* (1973–7). This large-scale installation work both visualizes and analyses the mother–child relationship of Kelly and her son over a period of four years, and includes drawings, graphs and charts, objects and sound recordings. *Post-Partum Document* was later published in book form (London 1983) and was exhibited in its entirety at the Yale Center for British Art, New Haven, CT, in 1984. Kelly's work is renowned for its inquiry into cultural identity, particularly the construction of femininity and power in Western capitalist society, and it draws on and criticizes the work of Sigmund Freud, Jacques Lacan and other cultural theorists. Kelly moved to New York in 1989. Works are held in the Tate Gallery, London, the Australian National Gallery, Canberra, and the New Museum of Contemporary Art, New York.

WRITINGS
with L. Mulvey: 'Mary Kelly and Laura Mulvey in Conversation', *Afterimage*, xiii/8 (1986), pp. 6–8

BIBLIOGRAPHY
Interim (exh. cat., essays by M. Tucker, N. Bryson and G. Pollock, interview by H. Foster, New York, New Mus. Contemp. A., 1990)

CECILE JOHNSON

Kelly, Oisín (Austin Ernest) (*b* Dublin, 17 May 1915; *d* Dublin, 7 April 1986). Irish sculptor. He studied languages at Trinity College, Dublin, from 1933 to 1937. A scholarship to study philology in Frankfurt am Main brought him into contact with German Expressionism and the work of Ernst Barlach. Among his other influences were Gothic sculpture in Ireland and the work of David Jones. On his return from Germany he attended evening classes at the National College of Art in Dublin and studied woodcarving, settling again in Dublin in 1946 but studying briefly under Henry Moore in England from 1947 to 1948. As early as *Dancing Man* (1946; M. Scott priv. col., see 1978 exh. cat., p. 30), a small carving in wood, Kelly

consistently favoured traditional Irish subjects worked in a simplified Expressionist idiom; later examples of such themes include *Children of Lir* (1966; Dublin, Garden of Remembrance) and *Chariot of Fire* (1978; Dublin, Irish Life Cent.).

From 1949 Kelly produced many religious works, often on commission, including carved reliefs such as the *Last Supper* (1963; Knocknanure Church, Co. Kerry). Throughout his career he also produced portrait heads and busts, in copper and bronze, and works on social themes such as *Marchers* (1969; Dublin, D. Downes priv. col.), which he carved from a single piece of yew to reinforce the unified spirit of the protesters under their banner. In other works shoals of fish and flocks of birds were similarly rendered as single entities. His commemorative statues include *Working Men* (1966; ex-Liberty Hall, Dublin), now outside the County Hall in Cork, and portraits of *Roger Casement* (1971) and *James Larkin* (1978; both Dublin, O'Connell Street). Kelly's work influenced that of younger Irish sculptors such as John Behan (*b* 1932).

BIBLIOGRAPHY
The Work of Oisín Kelly, Sculptor (exh. cat., essay D. Walker; Dublin, A.C. Ireland, 1978)
Irish Art, 1943–1973 (exh. cat. by C. Barrett, Cork, Crawford Mun. A.G., 1980)

HILARY PYLE

Kemah. *See* ANI.

Kemalettin [Kemalettin Bey] (*b* Istanbul, 1870; *d* Ankara, July 1927). Turkish architect. He studied at the College of Civil Engineering in Istanbul, graduating in 1891, and at the Charlottenburg Technische Hochschule in Berlin (1896–8). After his return to Turkey in 1900, he taught at the College of Civil Engineering in Istanbul and became chief architect of the Ministry of Pious Foundations (1909), entrusted with the restoration of historical monuments and the design of new buildings. This work enabled him to analyse the principles of Ottoman architecture and formulate a revivalist idiom. He built mosques, mausoleums, office blocks, schools, prisons and hospitals; the small mosque (1913) at Bebek, Istanbul, is a fine example of his revivalist style. The Fourth Vakıf Han (1912–26), a large seven-storey office block in Istanbul's Bahçekapı district, epitomizes Ottoman revivalist architecture, also known as the First National Architectural Style (*see* ISLAMIC ART, §II, 7(i)). Its well-ordered stone façade with rich carvings and coloured tiles hides a sophisticated steel framework. His last building complex in Istanbul, the Harikzedegan apartments (1919–22) located next to the 18th-century Laleli Mosque, was designed for families who had lost their homes during a fire in 1918. It comprises four six-storey blocks of flats with inner courts surrounded by open corridors. Mixing Ottoman and contemporary features, it is a notable early example of reinforced-concrete construction in Turkey.

In the early 1920s Kemalettin worked in Jerusalem on the restoration of the Aqsa Mosque and the Dome of the Rock. In 1925 he was commissioned to design a portal for the National Assembly Building in Ankara, designed by VEDAT, and also worked on the Ankara Palace Hotel (1924–7), a rectangular two-storey building that reflects a nostalgia for the Ottoman heritage in its façades. Notable

among Kemalettin's late works is the Gazi Teachers' Training College (1926–30) in Ankara, a symmetrical five-storey building of reinforced concrete with exterior walls covered with cut stone. His disciples include the architect Arif Hikmet Koyunoğlu (1888–1982).

BIBLIOGRAPHY

Y. Yavuz: *Mimar Kemalettin ve birinci ulusal mimarlık dönemi* (Kemalettin and the First National Architectural Period) (Ankara, 1981) [Turk. text]

R. Holod and A. Evin, eds: *Modern Turkish Architecture* (Philadelphia, 1984), pp. 12–15, 46–50, 54–8, 65–7

S. J. VERNOIT

Kemble, Kenneth (*b* Buenos Aires, 10 July 1923). Argentine painter, critic and teacher. He studied in Paris under André Lhôte, the French painter Georges Dayez (*b* 1907) and Ossip Zadkine. In the mid- to late 1950s, after his return to Argentina, he investigated collage, contributed to the development of *Art informel* and experimented with assemblage and gestural and calligraphic abstraction. He played a leading part in helping to extend the boundaries of art beyond the conventions of traditional media in the early 1960s, for example by his participation in an exhibition, *Arte destructivo* (1961), at the Galería Lirolay, Buenos Aires, at which he showed burnt, broken and half-destroyed objects. A supreme formalist, Kemble arrived at an exultant and evocative abstraction simulating the characteristics of collage in *trompe l'oeil*. He also taught and wrote art criticism, and he lived for periods in Los Angeles and Boston.

WRITINGS

'Autocolonización cultural: La crisis de nuestra crítica de arte', *Pluma & Pincel*, 9 (1976), pp. 1–4

BIBLIOGRAPHY

J. López Anaya: *Kemble* (Buenos Aires, 1981)

HORACIO SAFONS

Kemeny, Zoltan (*b* Banica, Transylvania [now Romania], 21 March 1907; *d* Zurich, 14 June 1965). Swiss sculptor, painter and designer of Hungarian birth. He was apprenticed first to a local sign-painter (1917) and then to a cabinetmaker (1921–3), attending technical drawing classes for furniture design at the same time. Kemeny continued his studies in Budapest, at the School of Decorative Arts (1924–7) and at the School of Fine Arts (1927–30). In 1930 he moved to Paris, where he worked as a designer of wrought-iron lamps and other objects and as a fashion designer. He married the painter Madeleine Szemere in 1933. In 1940 he left Paris, settling in 1942 in Zurich, where he again worked as a fashion designer and editor but also resumed painting. His work from this period, such as *Head* (1946; Paris, Pompidou), reveals a somewhat selfconscious primitivism coupled with an evident debt to Surrealism. His first one-man show took place in 1945 at the Galerie des Eaux-Vives, Zurich.

An encounter with the 'Hautes Pâtes' work of Jean Dubuffet in 1946 and the friendship that developed between the two artists proved crucial, and Kemeny began to work in low relief, incorporating unorthodox materials such as string, rags, pebbles and buttons into a ground of glue and sand or plaster, the whole often being coloured with a coat of oil paint (e.g. *The Gardener* series, first exhibited in 1949). In 1950 he produced his first luminescent reliefs by placing an electric light behind the sheet of wired glass acting as a support for the other materials. In 1954 he made his first metal reliefs; this was the medium in which he worked for the rest of his life and which brought him international recognition. In 1957 he was granted Swiss nationality, and in 1960 he gave up his work in fashion to devote himself entirely to sculpture. Kemeny's reliefs were the outcome of slow and careful planning. Full-scale designs for the actual relief, similar to technical blueprints, were preceded by many small preparatory drawings. Although he used a wide range of metals, including iron, zinc, lead, brass, tin and later mainly copper or aluminium, each relief would comprise only one kind of metal and one shape of component part (although the size of those parts might vary). The component parts were either prefabricated industrial objects such as nails, springs and wire or specially constructed by processes he kept secret. They were arranged on the wooden board that served as a support and welded or bolted on to that surface. Changes in colour due to heating the metal were accepted as part of the piece; if deemed necessary, chemical means were used to achieve further colour changes.

Kemeny sought to ally modern scientific and technical discoveries with the notion of harmonious organic growth and poetic metaphor. Inspired by forms seen under a microscope or through a telescope, electronic diagrams and aerial views of archaeological sites, his work possesses both a pronounced architectonic and a dynamic evolutionary quality. An emphasis on sound craftsmanship is implicit throughout. Titles such as *Fusion of Thought and Matter* (1961; Paris, priv. col., see 1967 exh. cat., no. 23), *Quest for the Essential* (1962; Duisburg, Lehmbruck-Mus.) and *Metallo-magic* (1963; Paris, Pompidou) attest to his strongly metaphysical orientation and interest in alchemy. In the early 1960s Kemeny received large-scale commissions for the St Gall Graduate School of Economics (1963), the Frankfurt Municipal Theatre (1963) and the Swiss National Exhibition in Lausanne (1964); shortly before his death, he began to make sculpture in the round, such as *Wing* (1964; Zurich, priv. col., see 1982 exh. cat., p. 76), experimenting with double or many-sided relief effects.

BIBLIOGRAPHY

M. Ragon: *Zoltan Kemeny* (Neuchâtel, 1960)

Zoltan Kemeny, 1907–1965 (exh. cat. by A. Bowness, London, Tate, 1967)

C. Giedion-Welcker: *Zoltan Kemeny* (St Gall, 1968)

G. Picon and E. Rathke: *Kemeny, reliefs en métal* (Paris, 1973)

Kemeny (exh. cat. by M. Ragon, Saint-Paul-de-Vence, Fond. Maeght, 1974)

Zoltan Kemeny (exh. cat. by H. C. von Tavel and H.-J. Heusser, Berne, Kstmus., 1982)

MONICA BOHM-DUCHEN

Kemkaran. *See* KHEM KARAN.

Kemp, George M(eikle) (*b* ?Hillrig, Biggar, Strathclyde, 1795; *d* Edinburgh, 1844). Scottish architect. He was apprenticed to a carpenter in the Borders in 1809–13, later working as a millwright in Galashiels, Borders. He was a superb draughtsman and his early interest in ecclesiastical architecture is recorded in his drawings of the Borders abbeys of Dryburgh, Jedburgh and Melrose. He moved to Edinburgh for work and to advance his architectural studies, and then moved to London in 1824 and to France, continuing his recording of Gothic monuments. Returning to Scotland, he was employed as a draughtsman by William

Burn in 1831–2. In 1834 he made detailed drawings of St Mungo's Cathedral, Glasgow, including a perspective showing a proposed restoration. These drawings were later plagiarized by James Gillespie Graham and published in 1836; only in 1840 did Kemp prove that Graham had knowingly used his proposals.

After the death of Sir Walter Scott in 1832, plans were made for a commemorative monument in Edinburgh and several architects were asked to submit designs. Kemp submitted his design under the pseudonym of John Morow, the medieval master mason of Melrose Abbey, and was placed third but subsequently won the competition with a revised design. His Gothic monument was built in 1840–46. The principal details of the design derive directly from Melrose Abbey, with other components from French Gothic sources. The Gothic details are archaeologically correct and brilliantly put together, giving a visually satisfying experience in the romantic surroundings of central Edinburgh. His other works did not match this outstanding achievement and include an addition to Woodhouselee (1843; destr.), Lothian, for James Tyler and the West Church (1836–40), Maybole, Strathclyde.

UNPUBLISHED SOURCES
Edinburgh, Royal Incorp. Architects [drawings for the Scott monument]

BIBLIOGRAPHY
Colvin
The Dictionary of Architecture, 8 vols (London, 1852–92)
J. Colston: *History of the Scott Monument* (Edinburgh, 1881)
T. Bonnar: *Bibliographical Sketch of George Meikle Kemp* (Edinburgh, 1892)

CATHERINE H. CRUFT

Kemp, Henry (Hardie). *See under* USSHER & KEMP.

Kemp, Roger (*b* Bendigo, 1908; *d* 14 Sept 1987). Australian painter and tapestry designer. Largely self-taught and self-educated, he was influenced early in his career by theosophy, seeing in painting the means of unveiling the hidden order of things. Although admired by a small circle of artists and critics throughout the 1950s, it was not until the end of the 1960s that Kemp began to gain wider public esteem and support. He won some of the larger art prizes in Australia during the 1960s, including the Georges Invitation Art Award, the McCaughey and the Blake Prize for religious art in 1969. Around this time his work changed greatly, increasing in scale and painterly freedom.

On an extended visit to England in 1970–72 Kemp worked on a monumental and epic scale, and the experience shaped his later work, which united architectonic design with a full flowing painterliness. In the 1980s he received a steady stream of tapestry commissions, the most notable being for a series of large-scale tapestries to decorate the Great Hall in the National Gallery of Victoria in Melbourne.

BIBLIOGRAPHY
Roger Kemp: Cycles and Directions, 1935–1975 (exh. cat., Clayton, Victoria, Monash U. Exh. Gal., 1976)

PATRICK MCCAUGHEY

Kempe, (Johan) Carl (*b* Stockholm, 8 Dec 1884; *d* Örnsköldsvik, 7 July 1967). Swedish collector. His first interest was in the polychrome porcelains of the Qing period (1644–1911), which were imported into Sweden in large quantities during the 18th century by the Swedish East India Company, founded in 1731. During a visit to China in 1935 his attention was drawn to monochrome wares of the Song period (960–1279) and white wares of the early part of the Ming period (1368–1644). He also acquired fine examples of porcelains and porcellanous stonewares of the Tang period (AD 618–907). Other white wares in his collection included Ding, Ming-period porcelains and white wares from Dehua, Fujian Province (*see* CHINA, §VII, 3(iv)(b) and (vi)(c)). He also acquired celadons from the kilns at Longquan in Zhejiang Province and Yue wares (*see* CHINA, §VII, 3(iv)(b)). It was the shape and the glazes of ceramics, rather than their decoration, that fascinated him most.

Kempe also possessed an important collection of Chinese gold and silver. A catalogue of 175 pieces of gold and silver belonging to him, dating from the late Zhou period (*c.* 1050–256 BC) to the 18th century, was published in 1953 by Bo Gyllensvärd. Kempe's third collection was of Chinese glass, which ranged over the same broad period and consisted of about 350 pieces (Stockholm, Östasiat. Mus.). Other items in his possession included Chinese and Japanese lacquer and snuff bottles. His entire collection is housed in his former home, now the Ekolsund Museum, north of Stockholm. The first tour of his precious metal objects to the United States was in 1954–5, followed by a travelling exhibition of precious metals and white porcelain in 1971.

BIBLIOGRAPHY
SBL
B. Gyllensvärd: *Chinese Gold and Silver in the Carl Kempe Collection* (Stockholm, 1953)
——: *Chinese Ceramics in the Carl Kempe Collection* (Stockholm, 1965)
——: Obituary, *Trans. Orient. Cer. Soc.*, xxxvii (1967–9), pp. xiii–xiv
Chinese Gold, Silver and Porcelain: The Kempe Collection (exh. cat. by B. Gyllensvärd, New York, Asia House Gals; Seattle, WA, A. Mus.; San Francisco, CA, de Young Mem. Mus.; and elsewhere; 1971)

S. J. VERNOIT

Kempeneer, Peter [Peeter] de [Campaña; Pedro (de)] (*b* Brussels, *c.* 1503; *d* Brussels, *c.* 1580). South Netherlandish painter, tapestry designer and sculptor, active also in Italy and Spain. His biography is known almost exclusively from Spanish sources. The date of his birth is given as 1503 by Pacheco in the *Arte* (1649; although this contradicts his earlier *Libro de retratos* 1599); the same birthdate was provided by Palomino and by Céan Bermúdez, who, unlike the earlier writers, added a death date in Brussels of 1580. Kempeneer belonged to a well-known Brussels family of painters and tapestry designers. Before leaving for Italy, he must have trained as a tapestry designer, under the influence of Raphael's tapestry cartoons of the *Acts of the Apostles* (*see* RAPHAEL, fig. 5), which at this date were in Brussels, and those of the *Scuola Nuova* from Raphael's workshop. Kempeneer also trained under Bernard van Orley, in whose workshop he painted the grisailles on the back of a *Last Judgement—St Stephen and St Mark Giving Alms* (left) and *St Lawrence and St Elizabeth Giving Alms* (right) (1525; Antwerp, Kon. Mus. S. Kst.)—and the prophets on the wings of the triptych of the *Virgin of the Seven Sorrows* (Besançon, Mus. B.-A. & Archéol.), as well as three panels illustrating episodes in the *Life of the Virgin*, strongly influenced by Albrecht Dürer's engravings.

According to Pacheco, in 1530 Kempeneer was in Bologna, where he assisted with the decorations (untraced)

erected for the coronation of Charles V. From his Italian period of about ten years (assuming he arrived in *c.* 1527) date the *Christ Washing the Feet of the Disciples* (Milan, Ambrosiana), the *Adoration of the Shepherds* (Cento, Pin. Civ.) and the supposed portrait of *Renée of France* (Frankfurt am Main, Städel. Kstinst. & Städt. Gal.). In these he combined the training he received in Brussels with a knowledge of the work of Raphael, Parmigianino, Baldassare Peruzzi, Girolamo da Carpi and Girolamo da Treviso.

Under the hispanicized name of Pedro (de) Campaña, he became the foremost painter of Seville. His presence there is recorded from 1537, when he was paid for painting organ shutters (untraced) in the cathedral, until 7 August 1561, when he received payment for an altarpiece (untraced) for the monastery church of Regina Coeli, Seville. The earliest of his extant works painted in Seville reveal a knowledge of the paintings of Perino del Vaga and especially of Polidoro da Caravaggio, whose expressionist vein he accentuated in the *Hermit SS Anthony and Paul* (Seville, S Isidoro), as well as in the *Flagellation* (Warsaw, N.Mus.) and the *Crucifixion* (Paris, Louvre), both from the same altarpiece; and in *Christ at the Column* (Seville, S Caterina) and two circular panels, *Christ Carrying the Cross* and the *Resurrection* (Spain, priv. col., see Dacos, 1980, figs 4–5). The colours are clearer in the *Deposition* from S María de Gracia (Montpellier, Mus. Fabre) and in the monumental panel of the same subject that he painted for Santa Cruz, Seville, in 1547 (Seville, Cathedral, sacristia mayor; see fig.); both combine his understanding of Italian culture with reminiscences of Netherlandish realism and interpret these influences in the impassioned and mystical tradition of Andalusia. Luis de Vargas, who had returned to Seville from Italy by 1555, brought a knowledge of the art of the late Perino del Vaga Francesco Salviati, and through him Kempeneer was revitalized and created some of his finest works, the altarpiece of the *Life of the Virgin* (1555; Seville, Cathedral, Capilla del Mariscal), which also reveals his skill as a portraitist, *St Nicholas* (Córdoba, Cathedral, Capilla de S Nicolas de Bari) and *St Anne* (1557; Seville, S Ana de Triana, high altar).

Kempeneer was again in Brussels on 28 May 1563, when he was appointed by the city, in place of Michiel Coxcie, to design tapestry cartoons. The style that he developed in Spain is also found in the tapestry in ten panels of *SS Peter and Paul*, for the abbey of St Peter, Ghent, between 1563 and 1567 (five France, priv. col., and three in Ghent, Oudhdknd. Mus. Bijloke, see Dacos, 1980, figs 11–19). Under the influence of Raphael's cartoons, Kempeneer's style became calmer and more classical, and this is apparent in the eight tapestry panels of the *Wars of Judaea* (Marsala, Mus. Arazzi Fiamminghi), probably commissioned in connection with the truce proclaimed in Antwerp in 1570, as well as in the initial design for the first tapestry of the series (formerly New York art market). Dating from Kempeneer's late years in Brussels (after 1563) are the small-scale panels that, according to Pacheco, the artist sent to Seville, including three versions of the *Crucifixion* (Prague, N.G., Kinský Pal.; New York, Stanley Moss priv. col., on loan New York, Met.; and one in the form of a triptych, Barcelona, priv. col., see Dacos, 1980, fig. 42). These compositions are increasingly refined, and the figures are reduced almost

Peeter de Kempeneer: *Deposition*, oil on panel, 3.2×1.9 m, 1547 (Seville Cathedral)

to symbols. Kempeneer also made prepatory drawings for a series of engravings of Old Testament subjects, but the project was never realized

Nothing is known of Kempeneer's activity, recorded by Pacheco, as an architect, theoretician of perspective, astrologer and engineer for the 3rd Duque de Alba (1507–82) in Brussels. His activity as a sculptor, however, also recorded by Pacheco, can be connected with a series of statues made after his designs (*Vision of Isaiah*, 1552; *Kings*, 1553–6, Seville, Cathedral, Capilla Real) and *Virgin and Child*, in alabaster, which he must have sent to Spain (Seville Cathedral, sacristy).

Ceán Bermúdez

BIBLIOGRAPHY

F. Pacheco: *Libro de verdaderos retratos de ilustres y memorables varones* (Seville, 1599); ed. F. J. Sanchez Cantón, *Fuentes literarias para la historia del arte español*, ii (Madrid, 1932), pp. 55–7
——: *Arte* (1649); ed. F. Sánchez Cantón, ibid., ii, pp. 129–30, 132, 147, 154, *passim*
A. A. Palomino de Castro y Velasco: *El Parnaso español pintoresco laureado* (Madrid, 1724); ed. F. J. Sánchez Cantón, ibid., iv, p. 27
D. Angulo Iñiguez: 'Algunas obras de Pedro de Campaña', *Archv Esp. A.*, xxiv (1951), pp. 225–46
F. Bologna: 'Osservazioni su Pedro de Campaña', *Paragone*, iv/43 (1953), pp. 27–49

A. Griseri: 'Perino, Machuca, Campaña', *Paragone*, viii, 87 (1957), pp. 13–21

A. Morales: 'Pedro de Campaña y su intervención en la Capilla Real de Sevilla', *Arch. Hisp.*, 185 (1977), pp. 189–94

N. Dacos: 'Pedro Campaña dopo Siviglia: Arazzi e altri inediti', *Boll. A.*, n. s. 6, lxv (1980), pp. 1–44

G. Delmarcel: 'Peter de Kempeneer (Campaña) as a Designer of Tapestry Cartoons', *A. Textiles*, x (1981), pp. 155–62

F. Sricchia Santoro: 'Pedro de Campaña in Italia', *Prospettiva*, 27 (1982), pp. 75–85

N. Dacos: 'Fortune critique de Pedro Campaña—Peeter de Kempeneer: De Pacheco à Murillo et à Constantin Meunier', *Rev. Belge Archéol. & Hist. A.*, liii (1984), pp. 91–117

——: 'Autour de Bernard Van Orley: Peeter de Kempeneer et son compagnon', *Rev. A.*, 75 (1987), pp. 17–28

——: 'La *Crucifixion* du Louvre et les premières œuvres espagnoles de Peeter de Kempeneer', *Rev. Louvre*, iii (1988), pp. 230–36

——: 'Peeter de Kempeneer/Pedro Campaña as a Draughtsman', *Master Drgs*, xxv/4 (1988), pp. 359–89

NICOLE DACOS

Kempers, August Johan Bernet. *See* BERNET KEMPERS, AUGUST JOHAN.

Kempf-Hartenkampf, Gottlieb Theodor von (*b* Vienna, 23 June 1871; *d* Achrain, nr Kitzbühel, Tyrol, 17 March 1964). Austrian painter, etcher and illustrator. He studied at the Akademie der Bildenden Künste in Vienna under the Austrian painters Julius Berger (1850–1902), Leopold Karl Müller (1834–92), Josef Mathias von Trenkwald (1824–97) and August Eisenmenger (1830–1907). He also learnt etching from the Austrian etcher William Unger (1837–1902). From 1899 he worked as an illustrator on the *Austro-Hungarian Monarchy in Words and Pictures* and *Allegories and Emblems* and for the *Meggendorfer Blätter*. From 1899 to 1901 Kempf exhibited his work at the art exhibitions of the Vienna Secession. During this period he produced the oil paintings *Listening*, *Frog King*, *Flower Fairy*, *Early Spring* and *Madonna's Head*, as well as making over 100 engraving plates. He belonged to the Gesellschaft bildenden Künstler Wiens from 1902, having taken part in all their exhibitions since 1895. In 1903 he founded a group of artists in Fahrafeld near Böheimkirchen (Lower Austria), which included the Austrian painters Adolf Zudrazil (*b* 1868), Josef Jungwirth (1869–1950), Anton H. Karlinsky (*b* 1872) and Fritz Schönpflug (1873–1951).

In 1903 Kempf had a one-man show in the Künstlerhaus in Vienna, and received the Kenyon travel grant for his ceiling painting *Ver, Vita, Juventus* at the World Exhibition in St Louis, MO. After the dissolution of the Fahrafeld group in 1908 he moved back to Vienna. His work was interrupted by army service in World War I, but in the 1920s he regularly exhibited at the Künstlerhaus in Vienna, with paintings such as the *Wise and Foolish Virgins*, *Susanne* and *Easter Saturday Atmosphere*. In 1931 he received the state prize for the picture the *Immanence of God on Earth*, and in 1939 he was commissioned by the Viennese office of culture to paint three watercolours of the most important theatres in Vienna. In 1941 his work was included in two large group exhibitions in the buildings of the Vienna Secession, and in 1942 he became an honorary member of the Akademie der Bildenden Künste.

BIBLIOGRAPHY
'G. Th. Kempf-Hartenkampf (1871–1964)', *Alte & Neue Kst*
REGINE SCHMIDT

Kempis, Thomas à [Hemerken, Thomas; Malleolus] (*b* Kempen, ?1379–80; *d* Agnietenberg, nr Zwolle, 25 July 1471). Netherlandish writer. From 1393 to 1398 he was a student at Deventer under Florent Radewijns (1350–1400; *see* BRETHREN OF THE COMMON LIFE). In 1399 Thomas entered the convent of Agnietenberg, where his brother John was prior, and was ordained in 1413. He held the office of sub-prior in 1425 and 1448, but his life was chiefly dedicated to writing devotional tracts, sermons, a chronicle of his convent and biographies of his mentors, Gerard Groote (1340–84) and Radewijns. He was an outstanding representative of the *Devotio moderna* movement. He also copied a Bible (1427–39; Darmstadt, Hess. Landes- & Hochschbib., MS. 324).

Thomas's best-known work is *De imitatione Christi*, which is first documented in 1418; the colophon of the autograph copy (Brussels, Bib. Royale Albert 1er, MSS 5855–61) is dated 1420–41. It is the most widely distributed religious work, apart from the Bible: more than 700 manuscripts and 3000 printed editions are known, and it has been translated into at least 30 languages. Although his authorship has sometimes been doubted, the testimony of his contemporaries and modern scholarship prove it convincingly. Its direct appeal to religious sentiment, through the simplicity and sincerity of pious devotion, reflects the spirituality expressed in late medieval painting and sculpture in northern Europe.

WRITINGS
M. J. Pohl, ed.: *Opera omnia*, 7 vols (Freiburg im Breisgau, 1902–22)

BIBLIOGRAPHY
L. M. J. Delaissé: *Le Manuscrit autographe de Thomas à Kempis et 'L'Imitation de Jésus-Christ': Examen archéologique et édition diplomatique du Bruxellensis 5855–61*, 2 vols (Paris and Brussels, 1956)

J. Huijben and P. Debongnie: *L'Auteur ou les auteurs de l'Imitation* (Leuven, 1957)

S. G. Axters: *De imitatione Christi: Een handschrifteninventaris bij het vijfhonderdste verjaren van Thomas-Hemerken van Kempen* (Kempen, 1971)

Thomas à Kempis et la dévotion moderne (exh. cat., Brussels, Bib. Royale Albert 1er, 1971)

ROSEMARIE BERGMANN

Ken-Amun, tomb of. *See* QENAMUN, TOMB OF.

Kendall, F(ranklin) K(aye) (*b* Melbourne, 2 Jan 1870; *d* Cape Town, 20 Nov 1948). South African architect. His parents were English, and he was educated in London and worked for a builder, S. J. Jerrard, from 1885 to 1887; he then studied architecture at the University of London (1887–90). In 1889 he was articled to Roger Smith & Gale, London, and he subsequently worked for them, for William Emerson and for Ernest George & Yates before leaving for South Africa early in 1896. He settled in the Cape, working for J. Parker, Sydney Stent and then for HERBERT BAKER in Cape Town, all in 1896. He became a junior partner in the firm of Baker & Masey (*c.* 1899), and from 1902 to 1905 he ran the office in Bloemfontein while he supervised work on the new government offices for the Orange River Colony. In 1906 he became a senior partner and, on Francis Masey's departure in 1910, a principal in the new partnership of Baker & Kendall, responsible for the Cape Town office. Major works in Cape Town with which Kendall was involved included the Renaissance-inspired Rhodes Building (1900–08) and

Marks Building (1903–5) as well as several churches. His church designs were more exotic than Baker's or Masey's: for example, his St Peter's Chapel (1915) for the Diocesan Training College, Grahamstown, was Byzantine in form and decoration. On the dissolution of his practice with Baker in 1918 Kendall began a series of partnerships, and he was appointed consulting architect for Cape Town Garden Suburb in 1919; he continued to work in the Italianate and vernacular styles that Baker and Masey had popularized and was considered to be the successor to Baker in the Cape. Important jobs included the restoration of Groot Constantia, the well-known historic Cape Dutch farmhouse on the Cape Peninsula, parts of which dated back to the 17th century, after a fire (1926) destroyed almost everything except the walls. He also acted as resident architect for the construction of the north transept (1930–36) of St George's cathedral, Cape Town, a building started by Baker & Masey that continued for 50 years. Kendall amended Baker's Norman design with some Late Gothic details; he was awarded a bronze medal by the Cape Institute of Architects for this work in 1936. Kendall was instrumental in the establishment of a School of Architecture at the University of Cape Town, and he also secured the Elliott Collection for the nation.

BIBLIOGRAPHY
Obituary, *RIBA J.*, lvi/3 (1949), p. 143
D. E. Greig: *Herbert Baker in South Africa* (Cape Town, 1970)
J. J. Oberholster: *The Historical Monuments of South Africa* (Cape Town, 1972), pp. 51, 82

C. J. M. WALKER

Kenji Imai. *See* IMAI, KENJI.

Kenkō Shōkei [Sekkei; Hinrakusai; Gen'ei] (*b* Utsunomiya, Shimotsuke Prov. [now Tochigi Prefect.]; *fl c.* 1478–1506; *d c.* 1518). Japanese Zen priest and painter. A scribe at Kenchōji in Kamakura, he is often called Kei shoki ('Clerk Kei'). He first studied painting with Chūan Shinkō (*fl c.* 1444–57) at Kenchōji, then journeyed to Kyoto in 1478 to study with Shingei Geiami (*see* AMI, (2)). In 1480 he returned to Kamakura with Geiami's *Kanbakuzu* ('Viewing a Waterfall'; 1480; Tokyo, Nezu A. Mus.), given to him by the artist as a parting gift. Shōkei's training with Shinkō and Geiami, as well as his exposure in Kyoto to Chinese Song (AD 960–1279) and Yuan-period (1279–1368) painting in the shogunal collection, led him to paint in a remarkable range of styles. Shōkei's *Umazu* ('Horses and Grooms'; Tokyo, Nezu. A. Mus.), for instance, reflects his intimate knowledge of the Yuan painter REN RENFA's works on the same subject. He is also often associated with the stylistic tradition of TENSHŌ SHŪBUN. Shōkei's most characteristic style, emphasizing swinging horizontal strokes and sharp tonal contrasts, shows an evolution of XIA GUI style as filtered through Geiami. His landscapes (Tokyo, Nezu. A. Mus., Seikadō Bunko; Kanazawa Ishikawa Prefect. Mus.) demonstrate the style that was to set the tone for later Kantō-area ink painters. Similarly, the dynamic brushwork in figure paintings such as *Shōki bakki gansei-zu* ('Shōki Gouging a Demon's Eyes'; Nishinomiya, Egawa A. Mus.) and *Rakusan Rikō mondozu* ('Liao and Yuenshan in Discourse'; Kansas City, MO, Nelson–Atkins Mus. A.) is also reflected in the work of Shōkei's followers, Keison (*fl* late 15th century–early 16th), Keisō (*fl* early

16th century), Kōetsu (*fl* late 15th century–early 16th), Chōryusai (*fl* early 16th century) and Senka (*fl* 1520–38).

For further discussion *see* JAPAN, §VI, 4(iii).

BIBLIOGRAPHY
S. Shimizu and C. Wheelwright, eds: *Japanese Ink Painting* (Princeton, 1976)

KEN BROWN

Kennedy, Edward G(uthrie) (*b* Garvagh, Co. Londonderry, 1849; *d* New York, 8 Oct 1932). American art dealer, collector and writer of Irish birth. In 1867 he arrived in Boston, where he was employed in an art business. In 1877 he moved to New York to work for the print dealer Hermann Wunderlich (1839–91), a job that involved frequent travel to negotiate sales. During his annual visits to Europe he met and became friends with James McNeill Whistler. Following his purchase in 1901 of a large collection of Whistler prints from B. B. Macgeorge of Glasgow, he compiled a catalogue raisonné, published in 1902 by Wunderlich & Co., which was a notable improvement on earlier authors' attempts. With Whistler's approval, he then gathered together photographs of all his known prints. The resources of the Grolier Club in New York, of which he was president at that time, financed the publication of *The Etched Work of Whistler* (1910) and *The Lithographs by Whistler* (1914). He eventually became the head of Wunderlich & Co., which by the year of his retirement (1916) had become the Kennedy Galleries. After retirement he continued to travel, and many of the books and prints that he collected on his journeys were donated to the Grolier Club.

WRITINGS
The Etched Work of Whistler (New York, 1910)
The Lithographs by Whistler: Arranged According to the Catalogue by Thomas R. Way (New York, 1914)

BIBLIOGRAPHY
Obituary, *New York Times* (9 Oct 1932)

DARRYL PATRICK

Kennedy, Louise St John (*b* Perth, 27 Dec 1950). Australian architect. She graduated with a BSc in psychology from the University of Western Australia (1970) and gained a degree in architecture from the University of Melbourne (1978). Before starting her own firm in Perth in 1980 she worked for Gunn Hayball in Melbourne and Cameron, Chisolm & Nichol in Perth. She was active in the Western Australian Chapter of the Royal Australian Institute of Architects, as a registration examiner from 1984 and as a member of architecture school accreditation panels and of many awards committees. Her awards include the prestigious Robin Boyd Award for the most outstanding domestic architecture in 1983 (Downes-Stoney House, Waterloo Crescent, East Perth). She completed 24 houses in an eight–year period but her portfolio of realized work also includes recreational and commercial buildings in Perth: Mosman Bay Boatshed and Tearooms (1986), Mosman Park; San Lorenzo restaurant (1987), Claremont; Nicholson Road offices (1988), Subiaco; and Club Bay View Night Club (1988), Claremont. Kennedy describes her work as the exploration of themes: her award-winning house (1980) in Rupert Street, Subiaco,

explored psychological aspects of space and space perception, contrasting 'masculine' (dynamic, angular, active, light) and 'feminine' (dark, static, enclosed) aspects of space through the introduction of oppositions in plan and architectural treatment. Later work investigates the representation of various aspects of the inner self as well as the way design can support lifestyle demands, for example those of career and children. Her architecture is expressive, drawing on a varied palette of materials, textures and colours, supported by close attention to landscape design.

BIBLIOGRAPHY
R. Pegrum: *Details in Australian Architecture* (Red Hill, ACT, 1984), pp. 88–9
Australian Built: A Photographic Exhibition of Recent Australian Architecture (exh. cat., ed. M. Griggs and C. McGregor; Sydney, Des. A. Board Austral. Council, 1985), p. 45
Interior Des., 6 (1987); 12 (1988); 19 (1989)
C. Lorenz: *Women in Architecture* (New York, 1990), pp. 66–9
ANNA RUBBO

Kennington, Eric (Henri) (*b* London, 12 March 1888; *d* Reading, Berks, 14 April 1960). English painter and sculptor. Following his training at Lambeth School of Art (1905–7), he was successful with the *Costermongers* (1914; Paris, Luxembourg Pal.), a painting noted for its frank depiction of London street life. A year of service in the army directly informed *Kensingtons at Laventie* (1915; London, Imp. War Mus.), a chilling document of endurance and sacrifice praised for its unusual oil-on-glass technique. Throughout his employment as an Official War Artist in 1917–18, and again in 1940–42, a large number of idealized pastel portraits concentrated solely on the ordinary serviceman. Although he is perhaps best known for his lively illustrations for T. E. Lawrence's *Seven Pillars of Wisdom* (1926), sculpture began to assume considerable importance. The war memorials to the 24th Division (1924) in Battersea Park, London, and the Allied Forces in Soissons (1928), France, established his position as a direct carver working on a monumental scale. For the remainder of his career, however, he worked in isolation, producing reliefs for schools, colleges and churches. Works that actively contributed to their environment, they often employed unsophisticated, symbolic imagery as in the panel for the Faculty of Engineering, Glasgow University (1960). He adopted an academic portrait style for the recumbent effigy of *T. E. Lawrence* (1939) at St Martin's, Wareham, Dorset.

BIBLIOGRAPHY
R. Storrs: *Drawing the R.A.F.* (London, 1942)
MARK THOMPSON

Kensett, John Frederick (*b* Cheshire, CT, 22 March 1816; *d* New York, 14 Dec 1872). American painter and engraver. Born into a family of skilled engravers, he learnt the craft first from his father, Thomas Kensett (1786–1829), and then from his uncle Alfred Daggett (1799–1872). From this training he acquired the consummate skill that made him an exceptional draughtsman. The engraver's attention to tonal modulation of the grey scale also contributed to Kensett's extraordinary exploration of colour values and saturation in his paintings.

In 1840, in the company of Asher B. Durand, John Casilear and Thomas Rossiter (1818–71), Kensett went to Europe, where he remained for seven years, studying Old Master works and developing his skills as a painter in London, Paris and Rome. On his return to America he was immediately recognized as one of the most gifted painters of his time. He was soon elected an associate (1848) and then a full member (1849) of the National Academy of Design, New York. Kensett exhibited there in 1838, 1845 and then annually from 1847 until his death.

Kensett's work as a landscape and coastal view painter is endowed with superb draughtsmanship, a suffusive aerial perspective and refined palette. *The White Mountains, from North Conway* (1851; Wellesley Coll., MA, Mus.) demonstrates his total and skilful assimilation of the style and techniques of the HUDSON RIVER SCHOOL. His experimentation with the saturation and values of hues resulted in a warm shimmering effect of light that permeates his finest compositions (*see* LUMINISM (i)). The broad vistas across valleys and over wide expanses of water, which typify his work, always create a distinct articulation of hour and mood. *Marine off Big Rock* (1864; Jacksonville, FL, Cummer Gal. A.) is a mature example of Kensett's departure from Hudson River school imagery and the development of his own unique handling of the style and techniques of landscape painting of the period; the work contains a sense of balanced, geometric precision and a spareness that contrasts with his earlier, more crowded pictures. *Sunset on the Sea* (1872; New York, Met.) typifies the final phase of Kensett's career: a distillation of forms, a simplicity of design and a rich evocation of hue. His last paintings explore colour and create a mood of intimate tranquillity, expressing a spirituality that is noteworthy in 19th-century American art.

Kensett's ideas influenced Ogden Rood, whose book, *Modern Chromatics* (New York, 1879), was significant to the development of Georges Seurat's colour theory. Kensett's stature in the art community is reflected in his prominent role in the functions and affairs of the National Academy of Design and the Artists Fund Society. He was a founder-member of the Century Association and in 1870 a founder of the Metropolitan Museum of Art, New York.

BIBLIOGRAPHY
E. Johnson: 'Kensett Revisited', *A. Q.*, xx (1957), pp. 71–92
John F. Kensett: Drawings (exh. cat. by J. Driscoll, University Park, PA State U., Mus. A., 1978)
John F. Kensett: An American Master (exh. cat. by J. Driscoll and J. K. Howat, Worcester, MA, A. Mus., 1985)
JOHN DRISCOLL

Kent, Dukes and Earls of. *See under* GREY.

Kent, Rockwell (*b* Tarrytown, NY, 21 June 1882; *d* Au Sable Forks, NY, 13 March 1971). American painter, printmaker, illustrator, writer and sailor. He first studied architecture but turned to painting, studying in New York at the schools of William Merritt Chase and of Robert Henri. In his realistic landscapes, the most famous of which related to his long sojourns in such remote and rugged places as Alaska, Tierra del Fuego and Greenland (e.g. *Eskimo in a Kayak*, 1933; Moscow, Pushkin Mus. F.A.), he favoured a precise rendering of forms with strong contrasts of light and dark. He was also renowned for the many books that he illustrated and wrote about his adventures. His considerable reputation as an illustrator

was based on his striking drawings for such classics as Voltaire's *Candide* (New York, 1928) and Herman Melville's *Moby Dick* (Chicago, 1930). His simple but distinctive graphic designs, such as *God Speed* (wood engraving, 1931; see Kent, 1933, p. 87), were widely imitated.

WRITINGS
Rockwellkentiana (New York, 1933)
It's Me O Lord: The Autobiography of Rockwell Kent (New York, 1955)

BIBLIOGRAPHY
D. Burne Jones: *The Prints of Rockwell Kent: A Catalogue Raisonné* (Chicago, 1975)
F. Johnson: *Rockwell Kent: An Anthology of his Work* (New York, 1982)
FRIDOLF JOHNSON

Kent, William (*b* Bridlington, *bapt* 1 Jan 1685; *d* London, 12 April 1748). English architect, painter, landscape gardener and designer. He was the most exuberant and innovative architect and designer active in England in the first half of the 18th century. He was trained as a painter but was not particularly successful or remarkable in this work, showing greater skill as a draughtsman. As an architect he was highly versatile, practising in both the Palladian and Gothick styles, and this versatility extended to his work as a designer, which included interior decoration, furniture and silverware, book illustration, stage sets and gardens.

1. Early life and years in Italy, 1709–19. 2. 1720 and after.

1. EARLY LIFE AND YEARS IN ITALY, 1709–19. Kent was born into a poor family in the East Riding of Yorkshire. Nothing is known of his early education, nor of the circumstances that led to his apprenticeship to a coach-painter in Hull at about the age of 15. Kent is first recorded in London in 1709, when he applied for a passport to go to Italy. He was then 24 and, according to GEORGE VERTUE, a group of Yorkshiremen were financing his studies in Rome. Kent travelled to Italy with John Talman (*see* TALMAN, (2)) and Daniel Lock, landing at Livorno in October 1709. After a month in Pisa, with visits to nearby Lucca, they moved to Florence where they remained for five months. There Kent became familiar with the work of the sculptor Giovanni Battista Foggini, who influenced some of his later designs for furniture, and of the amateur Francesco Maria Niccolò Gabburri, who commissioned some drawings from him and in whose manuscript *Vite di pittori* Kent appears. In 1710 Kent and his companions left Florence for Rome. Vertue claimed that in Rome Kent trained under Benedetto Luti; he must also have attended classes at the Accademia di S Luca because in 1713 he took part in their annual competition, the Concorso Clementino. Kent won second prize in the class reserved for students of painting with a drawing of the *Miracle of St Andrew Avellino*. The following year he received further recognition, when the Florentine Accademia del Disegno elected him to associate membership.

By 1714 Kent had entered the studio of Giuseppe Bartolomeo Chiari, a leading painter in the classicist revival inspired by the works of Raphael. As well as copying works by Renaissance and Baroque masters, Kent studied literature and history. Some of his own original works were shown at the annual exhibitions organized in churches on various religious feast-days. In August 1716, for the feast of St Roch, Kent exhibited *Cyrus, King of Persia, Allowing the Jews to Return to Jerusalem* (untraced), a painting that had been commissioned two months before by Cardinal Pietro Ottoboni, the most important patron in Rome at the time, and it earned Kent a second commission from the Cardinal. Under Chiari, Kent also trained in fresco painting, which he then practised independently on the ceiling of S Giuliano dei Fiamminghi, Rome. The contract (signed 12 July 1717), for which Kent had to obtain a special dispensation, states that the ceiling was to be decorated with a composition of one or more figures according to the artist's own fancy. On the whole this fresco, depicting the apotheosis of the church's patron saint, betrays Kent's many weaknesses as a painter and shows a tendency towards a Rococo lightness both in colour and composition.

While studying in Rome, Kent supported himself from two main sources: the gifts of patrons and his work as a dealer. He soon benefited from a new class of patron: those wealthy English Grand Tourists whom he met in Rome. These included Sir William Wentworth of Bretton Hall, W. Yorks—perhaps introduced to Kent in 1710 by the Irish painter Henry Trench (*d* 1726)—and Burrell Massingberd, a Lincolnshire gentleman who travelled to Italy in 1711–12. The latter undertook to help Kent, and after his return to England (1713) Massingberd succeeded in gathering the support of Sir John Chester of Chicheley Hall, Bucks. They sent Kent money; in return he bought for them paintings and sculpture. A similar arrangement was established with Thomas Coke (later 1st Earl of Leicester), whom Kent met in 1714 in Chiari's studio. Kent acted as a buyer for Coke who, in return, paid for Kent's two journeys to the north of Italy in 1714 (for which Kent's diary survives) and 1716, as well as one to Naples in 1716. Kent, however, was not inspired by the art of other Italian regions and, writing to Massingberd, he said 'I find Rome ye best place to make a painter'. In Rome he found the best examples of classicism in painting, drawing his inspiration from Raphael, Annibale Carracci, Pietro da Cortona and Carlo Maratti.

Kent's encounter with Thomas Coke turned into a lasting friendship and eventually led to his involvement in the design of Coke's country seat at Holkham Hall, Norfolk. Even more influential was the friendship struck in Rome with Richard Boyle, 3rd Earl of Burlington (*see* BOYLE, (2)), whom Kent met in 1719. Pressure to return home had been mounting from his English patrons, and for a long time Kent had successfully delayed making the decision, but he could not resist Burlington's invitation to return to London and work for him at his new house in Piccadilly. From the moment they arrived in England in December 1719 until Kent's death over 28 years later, the two were virtually inseparable; together with Lady Burlington—a woman of independent taste and influence—they constituted a powerful artistic partnership.

2. 1720 AND AFTER. On his return to England Kent was initially employed as an interior decorator. He won many prestigious commissions through Burlington, including positions in the royal Office of Works, and he subsequently worked on many large country houses in England, first on interior decoration, then architecture and

garden design. As well as Holkham Hall (*see* COKE, (1), and BRETTINGHAM, (1)), these included Burlington's new CHISWICK HOUSE, Middx; Houghton Hall, Norfolk; ROUSHAM, Oxon; STOWE, Bucks; Euston Hall, Suffolk; Esher Place, Surrey, and CLAREMONT, Surrey.

(i) Interior decoration and furniture design. (ii) Architecture. (iii) Book illustration and miscellaneous works. (iv) Garden design.

(i) Interior decoration and furniture design. Kent's first commission in London was for Burlington House, Piccadilly. He painted the ceilings of the Saloon and two other front rooms and also took a pervasive interest in the overall decoration of the house. The success of his work was such that James Brydges, 1st Duke of Chandos, and Sir Richard Childe, Viscount Castlemain, commissioned ceilings for their country seats at Canons (1720; destr.), Edgware, London, and Wanstead (1721; destr.), Essex. He then began work for George I (*reg* 1714–27) at Kensington Palace (1721–7), one of the best examples of his style in interior decoration. Kensington was an exceptional commission for so young and untried an artist, and it gives a measure of his charisma and of the impact of his earlier work, as well as the influence of his patrons. The Kensington Palace interiors show how deeply Kent had absorbed the Mannerist style he had studied in Rome and the degree of his commitment to it. The rooms were commissioned piecemeal; first he was employed for the ceiling of the Cupola or Cube Room (completed 1722), then for the ceiling of the King's Great Drawing Room (1723), Privy Chamber (1723), Presence Chamber (1724), the King's Gallery (1725) and the King's Grand Staircase (1727). He succeeded, nevertheless, in creating a scheme that, while varied, retained its cohesion and unity throughout. Indeed, the Grand Staircase was his best achievement in the grand manner of Italian 16th-century illusionist painting. It was also a masterpiece in composition, since it managed to introduce the whole range of decorative motifs previously employed in the other rooms.

The solutions developed at Kensington Palace for ceilings and walls provided the basic elements of Kent's vocabulary for interiors. Walls are divided into two basic categories: those acting as a backdrop for paintings, where attention is concentrated on ceilings, cornices, doorcases and fireplaces (as in the Saloon, 1725, at Houghton Hall; the Blue Velvet Room, *c.* 1729, at Chiswick House; the Saloon, 1744, at 44 Berkeley Square, London; and the Great Room, 1750, at 22 Arlington Street, London); and those that are receptacles for sculpture. In the latter case the ultimate aim was to recreate an antique tablinum, the main room in the Roman Classical house. Consequently, the treatment of walls is three-dimensional: semicircular niches or aediculae are scooped out, large scroll brackets tacked on to support smaller pieces of sculpture and marble or plaster reliefs encrust them. This approach is exemplified by the Cube Room (1723) at Kensington Palace, the Marble Hall (1725) at Houghton (see fig. 1), the Gallery and Rotunda (*c.* 1730) at Chiswick and the Dining-room (*c.* 1740) at Holkham Hall. Where financial resources or physical conditions prohibited real sculpture, it was replaced by imitations in paint, as, for example, on the walls of the Grand Staircase (1727) at Kensington Palace, the staircase walls at Houghton (1726) and those

1. William Kent: the Marble Hall, Houghton Hall, Norfolk, 1725

at Raynham Hall (*c.* 1727), Norfolk. The way in which such sculpture, whether real or painted in chiaroscuro, was assembled by Kent was based upon Roman Mannerist examples he knew well, such as the façades of the Villa Medici, Palazzo Branconio dell'Aquila (destr.) and the Casino of Pius IV in the Vatican gardens. This organization of the wall surfaces reinforces the idea conveyed by the exterior of Kent's buildings: a solid and continuous wall mass.

Kent's treatment of the painted area of ceilings can be divided into four large categories. The first covers ceilings in the tradition, established by the Carraccis in the Farnese Gallery, Rome, of the so-called *quadro riportato* (as in the King's Gallery at Kensington Palace). The second consists of grotesque ceilings modelled on Renaissance precedents by Raphael and Giovanni da Udine (which were inspired by Roman Classical examples) and possibly revived first by Kent in the 18th century (as in the Presence Chamber, Kensington Palace; Lady Burlington's Summer Parlour, *c.* 1735, at Chiswick; and the Drawing-room, 1739, at Rousham House). The third category is made up of ceilings in feigned mosaic—ultimately inspired by Raphael's ceiling in the Stanza della Segnatura, Rome—with cameos in chiaroscuro mimicking inserted low reliefs (as in the King's Staircase, Kensington Palace; the Saloon at Houghton; and the Hall at Stowe, 1730). The fourth type consists of ceilings inspired by the stucco decoration of Udine and Giulio Romano in the loggia of the Villa Madama, Rome, and in Palazzo del Te, Mantua, the best examples being represented by the ceilings of the Saloon at 44 Berkeley Square and the Great Room at 22 Arlington Street. In all four types Kent used gilding lavishly and showed a preference for bright colours, both in the painted areas

2. William Kent (attrib.): settee, gilt wood with red velvet, h. 1.1 m, *c.* 1735–40 (Wilton House, Wilts, The Earl of Pembroke and Montgomery)

and, whenever used, in wall hangings. These highly original painted ceilings, so different from anything done before in England, were set within a strong architectural framework of intersecting beams that formed a grid of compartments and coffers. Here Kent's sources were more varied: besides the obvious Italian examples, he was deeply influenced by the drawings and executed works of Inigo Jones. Most of Kent's borrowings from Jones date from 1724 and after, during the years of his editorial involvement in the *Designs of Inigo Jones* (1727), sponsored by Burlington. Jones inspired not only the architectural structure of Kent's ceilings but also the fireplaces that became increasingly important in his work.

Kent's rich treatment of rooms was reinforced by the furniture he designed; this was made for him by leading English cabinetmakers, principally James Moore (1670–1726) and Benjamin Goodison (*d* 1767). His interest must have begun quite early, for his Houghton designs of 1725 elaborate upon ideas first explored in his book illustrations of 1720. Kent was the first British architect to conceive of a building as an integral unity in which furniture demanded equal attention. His furniture was to some extent influenced by Florentine precedent, such as the works of Foggini, but it was the Roman school that more powerfully moulded his taste. He had a wide knowledge of works by leading Roman wood-carvers of the late 17th and early 18th centuries, artists who were equally at home designing carriages and furniture of unparalleled flamboyance and complexity.

Many characteristic features of Kent's furniture, as well as his silverware, can be traced back to Ciro Ferri, Johann Paul Schor, Giovanni Battista Leinardi (1656–1704) and Giovanni Giardini. From their work Kent learnt to mould wood into scrolls, conchs, sea-horses, dolphins, eagles, ostrich legs, palm branches and merfolk. His flamboyancy in furniture design surprised an English public used to

great simplicity in designs and materials, but it became immediately fashionable and led to Kent's court appointment (1726) as Master Carpenter in the Office of Works and to widespread imitation of his style. This was helped by publication in 1744 of John Vardy's *Some Designs of Mr Inigo Jones and Mr William Kent.* The furniture Kent designed included pier and console tables (*see* ENGLAND, fig. 53), settees and chairs, with rare forays into exceptional pieces such as mirror frames (for Frederick, Prince of Wales, and for Henry Somerset, 3rd Duke of Beaufort, at Worcester Lodge, Glos), a state bed for Sir Robert Walpole at Houghton (based on Schor's state bed for Maria Mancini Colonna), an organ case (Vardy, pl. 47) and the extraordinary royal barge, loosely based on the Venetian Doge's state barge (the *Bucentaur*) and the state galley of the Grand Duke of Tuscany (*see* BARGE, CEREMONIAL, fig. 1).

Kent's furniture was usually made of wood—white-painted pine, or mahogany—either partly gilded or of gilded gesso. Settees and chairs had frames of the same materials, and they were upholstered in cut-Genoa velvet or damask in bright colours to complement wall hangings (see fig. 2). The aprons of console tables and settees often included anthropomorphic or naturalistic elements from the coats of arms of his patrons. These emblematic elements also appeared in the designs of picture frames. An excellent example of Kent's attention to the overall design of a room is provided by Lady Burlington's Summer Parlour, Chiswick, for which he designed the so-called 'Owl Suite' (now at Chatsworth, Derbys); owls from the Savile coat of arms decorate the pier-glasses and console tables as well as appearing in paint in the ceiling.

(ii) Architecture. Kent's architecture belongs to the mainstream of PALLADIANISM but departs from it in boldness and monumentality. Like his patron, Lord Burlington, who encouraged his shift from painting to architecture, Kent admired and used the works of Palladio and Inigo Jones, although he was never a pedantic and obsessive imitator of them. He was deeply affected by Roman High Renaissance architecture, and this was reflected both in the compactness of his buildings and in their strongly pictorial and textural qualities. Although considerably tamed, there was also a pervasive Baroque streak in his work, evident in his use of advanced and recessed planes and of concave surfaces, all pointing to a close scrutiny of Bernini's architecture.

Kent's position in the royal Office of Works as Master Mason and Deputy Surveyor (from 1735) afforded him more opportunities than the other Palladians to design and build on a grand scale. His Royal Mews (1731–3; destr.), Charing Cross, and Treasury Buildings (1733–7; see fig. 3) and Horse Guards (designed 1748, built 1750–59; *see* VARDY, JOHN), both Whitehall, London, were all executed. Like his projects for a royal palace in Hyde Park (the wooden model survives: London, V&A) and his designs for rebuilding the Houses of Parliament (see below), they show Kent's skill and sensitivity in handling the complex problems posed by such extended buildings. One of their most distinctive marks is the bold use of rustication, which Kent chose not to confine to garden elevations. Rustication was applied to main façades and taken well beyond the ground floor, up to the cornice, as

3. William Kent: preliminary design, of 17 bays, for the north elevation of the Treasury Buildings, Whitehall, London, 1733–7 (London, Sir John Soane's Museum)

seen at the Treasury and Horse Guards. In all these designs, as well as in the unexecuted projects for the east front of Holkham Hall (*c.* 1731–5) and the south front of Euston Hall (*c.* 1737), Suffolk, he used a rough type of rustication for the ground floor and chamfered rustication for upper storeys. Pier-like supports for the arches of the first floor rise above each segment of solid wall in the ground floor, creating the effect of an almost self-supporting arcade system that has been filled in and within which windows have been punched. This structural use of rustication had an important consequence for Kent's architecture, since it made possible the reduction, if not complete elimination, of classical decoration. This is clearly visible in the first storey of the Treasury and, at its best, at the Horse Guards. The monumental and aesthetic values of architecture were thus conveyed by its visual qualities and the tectonic logic of the rustic order alone. In these buildings the façade is articulated as a wall mass, in which the rustic order (the *bugnato*) alone outlines the structural skeleton of the building. If the source of this type of 'wall' architecture was provided by the Roman school (specifically by Bramante, Raphael and Giulio Romano), the source for the articulation of Kent's buildings is to be found elsewhere: a combination of elements borrowed from Pietro da Cortona and Bernini but controlled by the proportioning system of Palladio.

Unlike Burlington, who by 1731 had produced in the York Assembly Rooms what amounts to the first Neo-classical statement in British architecture (*see* BOYLE, (2), fig. 4), Kent took longer to shed the legacy of the Renaissance. In the Marble Hall (1731–5; with Thomas Coke) at Holkham Hall he created a space of astonishing classical feeling, yet it was not so much a Neo-classical room as an archaeological reconstruction filtered through the imagination of the Renaissance. Around the time it was conceived Kent was busy collaborating with Burlington on the preparation of *Fabbriche antiche* (London, 1730), a two-volume edition of Palladio's reconstructions of the Imperial Roman baths, the drawings of which were by then in the Earl's collection. Kent's close study of Palladio's drawings and material by other 16th- and 17th-century architects spurred him to a new phase, best illustrated by his many designs for the proposed new Houses of Parliament (London: V&A; RIBA Lib.; Soane Mus.; PRO). Kent produced different schemes in 1733, 1735 and 1739, when the outbreak of war with Spain, followed by the War of the Austrian Succession, prevented the project from being undertaken. In these ground-plans, elevations and sections Kent abandoned his 'wall' architecture in favour of one in which intersecting volumes are highlighted by smooth, astylar surfaces, or else are suggested through the transparency of porticos. The Classical

orders, with columns used as strictly load-bearing elements, appear far more often than in any of his previous works. The handling of internal spaces, using a sequence of rooms of differing shapes clustered around a major central space, prefigures the competition drawings of many French architects later in the century. Yet this new style was not employed by Kent in any of his executed buildings until the mid-1740s, and even then they were isolated episodes.

In 1742–4 he designed and built a small *palazzo* for Lady Isabella Finch at 44 Berkeley Square, but its exterior conforms to the tradition established by Colen Campbell at Grosvenor Square and followed by Burlington on his building estate north of Piccadilly; and the interior maintains Kent's usual arrangement and decoration of rooms except for a remarkable and thoroughly Neo-classical oval staircase, which culminates in a free-standing screen of columns on the first-floor landing (see fig. 4). The only building where Kent succeeded in designing a coherent Neo-classical façade was Wakefield Lodge (1746), Northants, for Charles Fitzroy, 2nd Duke of Grafton. Here he dispensed entirely with rustication, leaving the walls smooth and astylar except for the projecting Ionic portico. The structure is a series of undisguised, interpenetrating

4. William Kent: staircase and landing of 44 Berkeley Square, London, 1742–4

volumes, pierced by Diocletian windows and simple, unframed ones.

Kent's numerous commissions outside London, coupled with his frequent visits to Burlington's seat at Londesborough in the East Riding of Yorkshire, forced him to travel widely through counties where much of the past, from Roman to medieval ruins survived. It must have been on such occasions that the picturesque and romantic qualities of medieval architecture captured his imagination, and GOTHICK struck him as a style in which he might also practise. He perceived no contradiction in using two distinct architectural vocabularies (Classical and Gothic) that were normally held to be mutually exclusive. Although his theoretical commitment and aesthetic preference favoured classical architecture, it should be recognized that for Kent each style merely represented different facets of a wider and more complex preoccupation with an understanding of the past. His use of Gothick was a response to a growing concern in antiquarian circles for a reappraisal of the past and its styles of building, but his interest in Gothick was very different from that of such architects as Vanbrugh and Hawksmoor; for him it was limited to restoration work and to buildings for which a picturesque mood was required. For Kent, the monumental and the heroic could only be expressed through the classical style. He began to work in Gothick only three years after his return to England, and for some time afterwards these commissions were mainly for restorations; they included the conversion of the gate-house (1722–5) at Bolton Hall, Yorks; the Clock Court gateway (1732) at Hampton Court, London, with reconstruction of the adjoining apartment; the addition of wings (*c.* 1733; destr.) and alterations to 'Wolsey's Tower' at Esher Place, Surrey; and the addition of wings (1737–41) to the north front of Rousham. For the screen in Westminster Hall (1739), London, the folly at Aske Hall (1740s), N. Yorks, the York Minster pulpit and choir (1741), and the Gloucester Cathedral choir screen (1741), a consciously stylistic choice was made. In all these works Kent showed no deep understanding of the structural principles of Gothic architecture, only an easy and sympathetic handling of a limited vocabulary. This mainly consisted of ogee arches, quatrefoils, battlements and extremely simplified capitals and mouldings. Yet, despite the lack of scholarly accuracy and its inherent superficiality, this style had immense appeal to a number of his patrons, for it rescued the native Gothic tradition from its state of decline, turning it into a language as alive and expressive as that of Palladianism.

For further illustrations *see* GATE-LODGE and STABLES, fig. 2.

(iii) Book illustration and miscellaneous works. Like the artists of the Italian Renaissance, Kent turned his hand to almost anything that might be 'designed'. This led to his work on book illustration, as well as designs for theatre sets and pageantries, including costumes. His illustrations for John Gay's *Poems* (London, 1720) and for Pope's translation of Homer's *Odyssey* (London, 1725) are particularly interesting because in these Kent explored ideas on furniture design, interior decoration and architecture that he subsequently implemented in his commissioned work. In the illustrations for James Thomson's *Seasons* (London, 1730) and Edmund Spenser's *Faerie Queene* (London,

1751), Kent's major preoccupation was with landscape and the buildings set within it. His designs prefigure many of the solutions he later adopted in his gardens. His work as a theatre designer, because of its ephemeral nature, is not well documented, but it is known that in December 1731 he designed costumes for a masquerade organized by the Prince of Wales, and that in 1736 he designed the scenery for *La festa d'Imeneo* staged to celebrate the Prince's marriage. For George II's coronation in 1727 Kent was responsible for designing a triumphal arch in Westminster Hall and for the overall planning of the pageantry.

(iv) Garden design. Kent occupies a very important place in the history of the English landscape garden. He was one of the spearheads of the movement from formal to informal layouts, and it was he who found visual means of expression for the ideas of such theorists as Alexander Pope and Joseph Addison. His training as a painter made him ideally suited to 'work without line or level', as Sir Thomas Robinson described it, and to create highly contrived gardens that appeared to be the work of nature. Landscape painting provided him with more inspiration than any actual garden he may have visited in Italy or France, and it was from the idealized images of Claude Lorrain, Gaspard Dughet and Nicolas Poussin that he derived his preference for pastoral and elegiac landscape.

Kent's first official venture as a garden designer was in 1730 with the gardens (destr.) of Carlton House, London, for the Prince of Wales; an engraving by William Woollett shows a semicircular lawn terminated by a domed pavilion—one not too dissimilar from the later Banqueting Temple (1746) at Euston Hall, Suffolk. This suggests Kent's style in gardening was already crystallized, at least in its broad lines, by 1730. Using transparent screens of trees, he fragmented his gardens into a number of minor spaces that could be perceived individually or in conjunction; moving between them, a visitor could re-create the overall spatial unity and allegorical meaning of the place. Each individual area was composed as a painting might be, with plants of darker foliage in the foreground and lighter ones more distant, thus creating a sensation of depth. Small buildings were used as focal points, their shape and style setting the mood of the landscape over which each presided. The majority of these garden buildings were modelled on Roman Classical tombs and temples; examples include the temples of Venus (before 1732) and Ancient Vertue (*c.* 1734) at Stowe; the rustic island temple (*c.* 1736) at Claremont; the arcaded Praeneste terrace (1739) at Rousham; and the peripteral Ionic temple (*c.* 1743; unexecuted) intended for the hillside at Chatsworth, Derbys. Among the 'natural' design elements most frequently employed by Kent were artificial serpentine rivers (Chiswick and Stowe, both *c.* 1733), pre-existing ones skilfully woven into the garden's design (Esher, *c.* 1733; Claremont, 1734–8; and Rousham, 1738–41); islanded lakes with irregular shores (Stowe and Claremont); rustic cascades of unhewn blocks (Stowe, Claremont, Rousham, Chiswick and Horseheath Hall, Cambs, the last-mentioned built 1746); and, finally, woodland on a rising hill (as in the three Surrey gardens, Claremont, Esher and Richmond, and proposed for Chatsworth and

Rousham; for illustration *see* ROUSHAM). He also designed grottoes, most notably at Stowe and, for Queen Caroline (1683–1737), at Richmond (destr.; for illustration *see* HERMITAGE; *see also* FOLLY).

Only in the early 1740s did Kent's garden designs become looser and even more naturalistic. Such a change was induced principally by the nature of his later commissions, conceived more as parks than gardens: at Holkham Hall (from the mid-1730s), Euston Hall (late 1730s) and Badminton, Glos (*c.* 1740), he favoured wide sweeps of lawn and clustered plantations. His concern had shifted by this time from the perambulator's experience of garden space to that of the beholder looking out through a window from within the house. Kent's aim was to relate the house visually to its surrounding landscape; this was achieved by elevating the point of view and cutting wide vistas through woods; these led to prominent architectural landmarks (often by Kent), such as obelisks, gateways and temples, or to such pre-existing landmarks as parish church towers.

Many of Kent's ideas on garden design had far-reaching effects, and not only in Britain. By the mid-18th century the *jardin anglais*, with its temples and pavilions, had become fashionable throughout Europe.

UNPUBLISHED SOURCES
Chatsworth, Derbys, Trustees of the Chatsworth Settmt [corr. with Lord and Lady Burlington]
Florence, Bib. N., MS. Pal. E.b.9.5 [MS. of F. M. N. Gabburri: *Vite di pittori*]
Lincoln, Lincs Archv, MSS 2MM.B21 [*Italian Letters, 1712–19*, corr. with Burrell Massingberd]
Oxford, Bodleian Lib., MS. Rawl. D1162 [Kent's *Remarks by Way of Painting & Archit.*]

WRITINGS
Designs of Inigo Jones, with Some Additional Designs, 2 vols (London, 1727)

BIBLIOGRAPHY
Colvin
I. Ware: *Designs of Inigo Jones and Others* (London, ?1733)
J. Vardy: *Some Designs of Mr Inigo Jones and Mr William Kent* (London, 1744)
M. Jourdain: *The Work of William Kent* (London, 1948)
E. Croft-Murray: 'William Kent in Rome', *Eng. Misc.*, i (1950), pp. 221–9
U. Middeldorf: 'William Kent's Roman Prize in 1713', *Burl. Mag.*, xcix (1957), p. 125
J. Harris: 'A William Kent Discovery: Designs for Esher Place, Surrey', *Country Life*, cxxv (1959), pp. 1076–8
J. P. Eicholz: 'William Kent's Career as a Literary Illustrator', *Bull. NY Pub. Lib.*, lxx (1960), pp. 620–29
W. O. Hassall: 'The Temple at Holkham Hall, Norfolk', *Country Life*, cxliii (1968), pp. 1310–14
G. Beard: 'William Kent and the Royal Barge', *Burl. Mag.*, cxii (1970), p. 488
G. Clarke: 'Grecian Taste and Gothic Virtue: Lord Cobham's Gardening Programme and its Iconography', *Apollo*, xcvii (1973), pp. 566–71
——: 'William Kent: Heresy in Stowe's Elysium', *Furor Hortensis: Essays in the History of the English Landscape Garden*, ed. P. Willis (Edinburgh, 1974), pp. 48–56
R. Wittkower: 'Lord Burlington and William Kent', *Palladio and English Palladianism* (London, 1974), pp. 115–32
K. Woodbridge: 'William Kent as Landscape-gardener: A Reappraisal', *Apollo*, c (1974), pp. 126–37
——: 'William Kent's Gardening: The Rousham Letters', *Apollo*, c (1974), pp. 283–91
G. Beard: 'William Kent and the Cabinet Makers', *Burl. Mag.*, cxvii (1975), p. 867
D. Stroud: 'The Gardens at Claremont', *NT Yb.* (1975–6), pp. 32–7
M. Batey: 'The Way to View Rousham, by Kent's Gardener', *Gdn Hist.*, xi (1983), pp. 125–32
P. Campbell, ed.: *A House in Town: 22 Arlington Street, its Owners and Builders* (London, 1984)

M. I. Wilson: *William Kent: Architect, Designer, Painter, Gardener* (London, 1984)

A Tercentenary Tribute to William Kent (exh. cat., ed. J. Wilton-Ely; Hull, Ferens A.G., 1985)

C. M. Sicca: 'A Kent Drawing for the Ceiling of the King's Drawing Room at Kensington Palace', *Apollo*, cxxii (1985), p. 310

——: 'Like a Shallow Cave by Nature Made: William Kent's "Natural" Architecture at Richmond', *Architectura* (1986), pp. 68–82

——: 'On William Kent's Roman Sources', *Archit. Hist.*, xxix (1986), pp. 134–57

CINZIA MARIA SICCA

Kenya, Republic of. Country in eastern Africa, bordered by Sudan and Ethiopia to the north, by Somalia to the east, by Uganda to the west, by Tanzania to the south-west and by the Indian Ocean to the south-east. The capital is Nairobi. Kenya gained independence in 1963. It has a population of 24,872,000 (UN estimate, 1989), and the national languages are Swahili and English. Kenya owes its diversity of climate and geography to the Rift Valley, which has influenced the population's distribution and livelihood. Most of the population are engaged in agriculture or pastoralism, and only 20% work in urban areas.

People of four distinct language groups have settled the area, resulting in a strongly localized system of social organization. Among the *c.* 50 different ethnic groups, the typical political units are clans and age-sets, with only Swahili towns having centralized hierarchies. Despite a long history of foreign influence via Indian Ocean trade, extensive up-country contact with Europeans began only in the late 19th century. A widespread sense of being East African is manifest in the ubiquitous *kanga* (a cloth wrapper of set format, similar to Swahili decorative design), which is at once responsive and adaptive to Kenya's cultural diversity.

This entry covers the art produced in Kenya since colonial times. For art of the region in earlier periods *see* AFRICA, §VII, 7. *See also* MAASAI and SWAHILI.

1. Continuing traditions. 2. Architecture. 3. Painting and graphic arts. 4. Sculpture. 5. Patronage and art institutions.

1. CONTINUING TRADITIONS. Most artistic activity in the 1990s is based on local and ethnic traditions. As in other areas of eastern Africa, the basic art media are dwellings and personal adornment, with differentiations in pattern and form indicating collective and individual identity. The 18 kinds of Maasai earrings, the variety of Mijikenda chokers of twined beads and the different styles of Borana scrap-metal medallions and bangles exemplify this sort of distinguishing variety. Even more striking examples are such elaborate warrior hairstyles as the Turkana clay chignon and the Maasai and Samburu plaits, which contrast boldly with the pervasive shaved baldness of non-warriors. Familial values are affirmed by such embellishment of artefacts as the symbols of fertility on Gabra woven milk containers and the inlaid chain motifs, signifying home, on Kamba safari stools. A sense of community is reinforced by the commemorative sculptured posts (*vigango*) made for important Mijikenda men and the Kikuyu story-teller's pictograph rattle (*gichandi*). Modern techniques often supplement ancient methods:

the decoration of Luo fishing boats combines such traditional conventions as a geometric layout and the attachment of cattle horns with the use of acrylic paints and such contemporary imagery as the owner's portrait and Kenya's flag.

The strength of craftwork in modern Kenya may be ascribed to the important part it plays in the nation's economy. For example, in the 1980s the traditional Kamba and Kikuyu twined basket (*kiondo*) was the largest foreign-exchange earner of all art-related items. Small-scale projects have been set up by both public and private enterprises throughout Kenya to provide training in both craft skills and marketing. At African Heritage's workshop, for example, local artists produce jewellery derived from pastoralist ornaments. There has been considerable development in textiles. The oldest workshop, Maridadi Fabrics (est. 1966), Nairobi, continues to hand-print local designs. There has, as well, been rapid growth in commercial hand-spinning and loom-weaving, which was introduced in 1973 by Jisaidie Industries; 20 years later 40 such projects exist. A further dimension of continuing traditions in craftwork is exemplified by the ceramics of Magdalene Odundo (*b* 1950), who moved to London in 1971. Her hand-formed, unglazed vessels combine aspects of traditional African pottery with more modernist innovation and refinement.

2. ARCHITECTURE. Vernacular architecture exemplifies the extraordinary diversity of traditions in rural Kenya. Nearly every group has its distinctive domestic units, that is to say its own form and kind of dwelling or shelter, and a pattern for their arrangement. Formally, dwellings can be likened to large containers in that their fabrication involves similar natural materials and methods of construction. Homesteads are of key importance in these localized societies: for example, the same word denotes house and family in Kikuyu, while the centre of the homestead is the centre of the universe in Maa cosmology.

Kenya's urban architecture attests to its British legacy and its diverse non-African population. The Imperial style is seen in the government houses in Mombasa and Nairobi (1925–8), the Law Courts, Nairobi, and numerous other public buildings (1927–early 1930s) that were designed by the architect to the government, Sir Herbert Baker. These elegant Neo-classical buildings are the core of the Kenya Centre in the capital's master-plan. More cosmopolitan influences are apparent in buildings for worship. There is a remarkable variety of style in mosques and Hindu and Sikh temples, while Christian churches range from solid neo-Gothic buildings of the 1900s to airy constructions of the 1970s. Nairobi also has International Style buildings. The Kenyatta Conference Centre (1979) by K. H. Nøstvik is a well-sited and well-proportioned high-rise complex: its main elements, a cylindrical tower and a conical roof, are evocative of traditional circular huts.

3. PAINTING AND GRAPHIC ARTS. Although many 20th-century Kenyan artists were inspired by East African phenomena and concerns and worked in accessible idioms, during the 1980s the imagery of painting and graphics changed significantly because of the growth in participation by local and non-urban artists. This was related to a

new and widespread cultural value for picturing, the result of increased familiarity with two-dimensional media through both schooling and sign painting. Local publishers helped in this dissemination, as well as creating a demand for illustrators (especially of school textbooks) and cartoonists. The types of graphic art may be grouped by content. The ethnographic painted drawings of Joy Adamson (1910–80), Fred Oduya (b 1951) and Etale Sukuro (b 1954) document ethnic traditions. Land and animals are popular subjects. Treatments vary from the closely observed nature paintings of British artist David Shepherd to such innovative approaches by women artists as Robin Anderson's (b 1933) introduction of silk printing; Theresa Musoke's (b 1944) Fauvist mixed-media works; the elaborate watercolour forests of Geraldine Robarts (b 1937); and the emblematic thorn trees in diverse media by Jony Waite (b 1936). The animals that figure in the art of Jak Katirakawe (b 1940), Ancent Soi (b 1939) and Sane Wadu (b 1947) are treated more imaginatively, usually with a narrative purpose, as seen in the allegorical musings of Katirakawe's livestock in *A Man's Dream* (see fig. 1).

Social narrative painting presents real and imagined versions of everyday life, as presented in the work of Rosemary Karuga (b 1928), Soi and Katirakawe. Karuga uses the roughness of torn-paper collage to convey women's work and life. Soi creates pictures of busy people, accentuating their dynamism through spatial elements and bright patterns. Using a softer palette and a more impressionistic technique, Katirakawe paints witty moral pictures that dramatize the dreams, follies and trials of ordinary people. Traditional life is also depicted in imaginative ethnographic drawings by Joel Oswaggo (b 1944), who renders Luo stories in painstaking detail, and Kivuthi Mbuno (b 1947), whose recreations of Kamba customs in bold figuration echo curio carving. The work of younger artists displays great freedom and fantasy. Sukuro's satires of urban dilemmas painted in the 1980s and 1990s are surreal in style. Lincoln Omondi (b 1950s) uses dense surface designs laced with Christian symbols to convey concern about the Church. An important breakthrough was made by the expressive painting of Sane Wadu, who employs a fluid technique in unusual compositions and hard-hitting commentary, edged with humour. He draws inspiration from Ngecha, his peri-urban home village, where he encourages others to paint.

4. SCULPTURE. Activity in contemporary sculpture is tremendous, from public monuments to curio carvings. Kamba wood-carving and Gusil stone sculpture are major adaptations of domestic carving skills. During his World War I military service in Tanganyika, Mutisya Munge (b c. 1892), a Kamba carver, saw a range of Zaramo artefacts including figurines, which he later adopted into the Kamba carving repertory. Four stylistic phases can be identified: before and after World War II, tourist and contemporary. Generally, works were more distinguished before the onset of mass tourism, which has favoured wildlife motifs. However, during the 1980s there was greater variety in imagery, in part due to MAKONDE influences. By the late 1980s most of the c. 10,000 Kamba wood-carvers and

1. Jak Katirakawe: *A Man's Dream*, linocut, 340×510 mm, 1983 (Frankfurt am Main, Museum für Völkerkunde)

2. Elkana Ongesa: *Enyamuchera*, soapstone, h. 182 mm, 1978 (Paris, UNESCO)

c. 4000 Gusil stone sculptors worked in cooperatives. Two outstanding sculptors, Samwel Wanjau (*b* 1936) and El-kana Ongesa (*b* 1944), have close links with these developments. A Kikuyu who carved guns during the liberation war of the 1950s, Wanjau developed his skills by serving an apprenticeship in a Kamba workshop. He then developed a unique style of satirical sculpture, examples of which can be seen in the Paa-ya-Paa Art Centre, Nairobi. Ongesa came from a family of soapstone craftsmen and used his training (at the Trowell School of Fine Art, Makere University, Kampala Uganda) to extend the medium for modernist expression. His seven-tonne *Enyamuchera* (Kisii: shrike; 1978) represents the Gusii bird of good fortune and displays an extraordinary formal treatment of volume (see fig. 2). Francis Nnaggenda (*b* 1936) has produced two contrasting sculptures—a massive concrete *Maternity* and a jagged welded-metal *Freedom Fighter* (Nairobi, N. Mus.).

Terracotta figurines are a smaller-scale and popular sculptured form. Many examples are noted for their social commentary. Edward Njenga (*b* 1932), Flora Omare (*b* 1926) and Benson Apollo (*b* 1959) have produced work of this type. More dynamic modelling is seen in John Dianga's early work (*b* 1945), which became abstract when he started working in soapstone.

5. PATRONAGE AND ART INSTITUTIONS. The over-arching precondition that supports contemporary art is sustained political stability. In Kenya in the 1990s direct government involvement extended across four ministries: Home Affairs and National Heritage; Education; Economic Planning and Social Services; and Culture. All of Kenya's museums have displays of material culture. The National Museum, Nairobi, has separate galleries for Joy Adamson's paintings and for temporary exhibitions of contemporary art as well as a permanent display of the material cultures of the peoples of Kenya. The National Archives, Nairobi, houses Joseph Murumbi's collection of East African art. Throughout Kenya crafts and curios have an extensive local clientele, whereas patronage for fine art is located in the capital and dependent on the tourist industry and expatriates. There are three long-standing private galleries. The Paa-ya-Paa Art Centre, Nairobi, started in 1965 as a cooperative, and it has been directed from its foundation by Elimo Njau (*b* 1932). It has a fine permanent collection of East African art. In 1969 Gallery Watatu was established for showing and marketing contemporary fine art. In 1984 Ruth Shaffner became its Director and greatly extended the participation of black artists. In 1972 former Vice-President Joseph Murumbi and American businessman and crafts entrepreneur Alan Donovan founded the movement known as African Heritage to revitalize Kenyan crafts and to promote pan-African art. It has been enormously successful in the development of ethnic fashion, including Miss Africa 1984, Khadija Adam. Other important sources of support for exhibitions etc are foreign cultural agencies such as the Goethe-Institut.

Until the late 20th century, most of Kenya's artists were either self-taught, such as Katirakawe, Oswaggo and Wadu, or trained through apprenticeship, for example Wanjau. Only a few, such as Diang'a, had formal art training, and of these the best-known, Njau and Ongesa, were educated at the Trowell School of Fine Art, Makere University, Kampala (*see* UGANDA). A very few, including Musoke and Elizabeth Orchardson-Mazrui (*b* 1952), had overseas post-graduate experience. Major reforms were carried out by the Ministry of Education in 1985, leading to certification at all levels. 'Art and craft' became a required subject in primary schools, and revised school-level curricula based on material culture were introduced. Post-secondary school opportunities were extended to include architecture and design, anthropology and material culture, fine arts and teacher education. Some higher level research takes place in Nairobi at the Institute of African Studies and the British Institute in Eastern Africa. Despite these developments, the general situation for academic art in the early 1990s remained poor. Nonetheless, the population's youthfulness, universal primary education and tourism are generating momentum for cultural change and signal dynamic times ahead for Kenya's visual arts.

BIBLIOGRAPHY

M. Trowell: 'Modern African Art in East Africa', *Man*, xlvii/1 (1947), pp. 1–7 and pl. A
L. Thornton White, L. Silberman and P. Anderson: *Nairobi Master Plan for a Colonial Capital: A Report Prepared for the Municipal Council of Nairobi* (London, 1948)
W. Elkan: 'The East African Trade in Woodcarvings', *Africa*, xxviii/4 (1958), pp. 314–23
J. Adamson: *The Peoples of Kenya* (London, 1967, rev. 1973)
D. Shepherd: *An Artist in Africa* (London, 1969)
T. Hirst: 'Samwel Wanjau: Kenyan Carver', *Afr. A.*, iii/3 (1970), pp. 48–51, 99

J. Brown: 'Traditional Sculpture in Kenya', *Afr. A.*, vi/1 (1972), pp. 16–21, 58, 88

J. von D. Miller: *Art in East Africa: A Guide to Contemporary Art* (London and Nairobi, 1975)

E. Court and M. Mwangi: 'Maridadi Fabrics', *Afr. A.*, x/1 (1976), pp. 38–41

K. B. Andersen: *African Traditional Architecture: A Study of the Housing and Settlement Patterns of Rural Kenya* (Nairobi, Oxford and New York, 1977/*R* 1978)

E. Burt: *An Annotated Bibliography of the Visual Arts of East Africa* (Bloomington, 1980)

M. Amin and P. Moll: *Portraits of Africa* (London, 1983)

E. Orchardson: *A Socio-historical Perspective of the Art and Material Culture of the Mijikenda of Kenya* (diss., U. London, 1986)

Vigango: The Commemorative Sculpture of the Mijikenda of Kenya (exh. cat., ed. E. Wolfe; Williamstown, MA, Williams Coll. Mus. A., 1986)

L. Prussin: 'Gabra Containers', *Afr. A.*, xx/2 (1987), pp. 36–45, 81–2

Kenya Past & Present, 20 (1988) [issue on ornament]

Proceedings of a Conference on African Material Culture: New York, 1988 [incl. several ess. on Kenya]

J. Barbour and S. Wandibba, eds: *Kenyan Pots and Potters* (Nairobi, 1989)

Drawing on Culture: Catalogue for a Travelling Exhibition of Children's Drawings from Rural Kenya (exh. cat. by E. Court, U. London, Inst. Educ., Dixon Gal.; Harare, N.G.; Bulawayo, A.G.; and elsewhere; 1989)

J. Agthe: *Wegzeichen: Kunst aus Ostafrika, 1974–1989/Signs: Art of East Africa, 1974–1989*, Frankfurt am Main, Mus. Vlkerknd. cat. (Frankfurt am Main, 1990) [incl. interviews with artists]

N. Parvitt: *The Samburu* (London, 1991)

ELSBETH COURT

Kenyon, Kathleen Mary (*b* London, 5 Jan 1906; *d* Wrexham, 24 Aug 1978). English archaeologist. She was educated at St Paul's Girls' School, London, and Somerville College, Oxford. She became Secretary of the Institute of Archaeology, University of London, on its foundation in 1935 and was its Acting Director throughout World War II. From 1948 to 1962 she was lecturer in Palestinian archaeology at the Institute, and from 1962 until her retirement in 1973 she was principal of St Hugh's College, Oxford. In 1973 she was made a DBE. Among many other appointments, she was Honorary Director and later Chairman of the British School of Archaeology in Jerusalem.

During the late 1920s and 1930s she excavated extensively in Britain on Iron Age and Romano-British sites, basing her methods, of closely controlled and recorded stratigraphical excavation, on those developed by Sir Mortimer Wheeler at Verulamium (St Albans). She first applied these methods in the Levant at the Crowfoot excavations at Samaria in Palestine (1931–4) and as Co-Director of the excavations by the British School at Rome at Sabratha in Libya (1948–51). Her two most important excavations followed: she directed the excavations by the British School of Archaeology in Jerusalem at JERICO from 1952 to 1957 and at Mount Ophel in Jerusalem from 1961 to 1967.

Her methods of excavation have been criticized for being preoccupied with the minutiae of stratigraphy. Her recording was meticulous, however, and she is generally acknowledged to have been one of the greatest field archaeologists of the century. Her discoveries at Jerico rank with the most important ever made in the Levant.

WRITINGS

with T. A. Holland: *Excavations at Jericho*, 5 vols, London, 1960–83

BIBLIOGRAPHY

N. J. H. Lord and A. C. Western: 'A Bibliography of Dame Kathleen Kenyon up to 1975', *Archaeology in the Levant: Essays for Kathleen Kenyon*, eds P. R. S. Moorey and P. J. Parr (Warminster, 1978), pp. xi–xiv

P. R. S. Moorey: 'Kathleen Kenyon and Palestinian Archaeology', *Palestine Explor. Q.* (1979), pp. 3–10

PETER DORRELL

Kenzan (i). *See* OGATA, (2).

Kenzan (ii). *See* ASHIKAGA YOSHIMOCHI.

Kenzō Okada. *See* OKADA, KENZŌ.

Kenzō Tange. *See* TANGE, KENZŌ.

Keos. *See* KEA.

Kephallinia [Cephalonia; Kefallinia]. Greek island in the Ionian Sea, opposite the entrance to the Gulf of Patras. In the Homeric poems it is recorded under the name Sami as part of the kingdom of Odysseus. Palaeolithic flints were found at Skala in the south of the island; in later Mycenaean times it was clearly well populated, since local versions of the Mycenaean chamber tomb, with rows of burial pits in their floors, occur at Lakkithra, Metaxata and Mazarakata. These contained poorly made idiosyncratic local pottery with Mycenaean characteristics, as well as bronze weapons and ornaments. Some of the latter are of 'European' types, showing that trade with Italy and central Europe persisted even after the destruction of the Mycenaean palaces (*c.* 1200 BC). Mycenaean pottery was also found during excavations at the Classical acropolis of Krane, which may indicate the existence of a prehistoric stronghold at that site. At Skala there are foundations of an Archaic temple (6th century BC). By Hellenistic times the island was divided into four regions, Krane, Pale, Pronnoi and Sami, each with its own strongly fortified acropolis. Long sections of 3rd-century BC fortifications and some gateways are well preserved. At Skala an extensive Roman villa (2nd century AD) has been excavated beneath the ruined church of Hagios Athanasios; mosaics signed by Krateros depict *Envy Being Devoured by Wild Beasts*. The first excavation of Mycenaean graves took place in the early 19th century under the Swiss colonel De Bosset. Further systematic exploration was conducted in the 1930s under Professor Spiridon Marinatos and at the expense of the Dutch philanthropist Cornelis Goekoop. The Archaeological Museum in the island's capital, Argostoli, houses the finds made on Kephallinia.

The site of the Agios Georgios, near modern Argostoli, was already fortified in the Byzantine period, but the present remains date from the second period of Venetian rule in the 16th century, as do those (1595) of the ancient citadel of Assos in the north of the island. The collection of the Corgialenios Historical and Cultural Museum and Library in Argostoli records much of the island's former architectural splendour under Venetian and British rule.

BIBLIOGRAPHY

S. Marinatos: 'Ai anaskaphai Goekoop en Kephallinia' [Goekoop's excavations on Kephallinia], *Archaiol. Ephimeris* (1932), pp. 1–47

——: 'Ai en Kephallinia anaskaphai Goekoop' [The excavations of Goekoop in Kephallinia], *Archaiol. Ephimeris* (1933), pp. 68–100

A. W. Lawrence: *Greek Aims in Fortification* (Oxford, 1979), p. 182

K. A. WARDLE

Kephisodotos (*fl* end of 5th century BC–*c.* 360 BC). Greek sculptor. His primary importance is as the teacher and father (or, according to some scholars, possibly the father-in-law or brother) of PRAXITELES. His career can be dated by his collaboration with STRONGYLION on a group of nine *Muses* on Mt Helikon (late 5th century BC), his statues in Megalopolis (founded 368/367 BC) and his *Eirene and Ploutos* (*c.* 375–360 BC; copy in Munich, Glyp.; *see* GREECE, ANCIENT, fig. 39). The draped figure of Eirene (Peace) recalls a type of *peplos*-wearing female statue of the later 5th century BC associated with Alkamenes and his workshop. Eirene holds the infant Ploutos (Wealth) in her left arm, with her head and upper body turned towards its upturned face. The original statue must have been created before 360/359 BC, since it is represented on Panathenaic amphorae of that date (see also Pausanias: *Guide to Greece* IX.xvi.2).

According to Pliny (*Natural History* XXXIV.xix.87), Kephisodotos also produced a statue of *Hermes with the Infant Dionysos*, and Klein has identified copies of this (e.g. Madrid, Prado, 39E) with the help of an engraving by G. B. de Cavalieri (see Klein, fig. 100). The group is similar in conception to the *Eirene and Ploutos*, but Hermes is made to lean on a herm, which has archaistic features resembling those of Alkamenes' *Hermes Propylaios*. At the same time, Hermes' youthful body and his relaxed pose recall works by Polykleitos and his first-generation followers. The same retrospective tendency is visible in the work of Praxiteles, whose *Hermes* (Olympia, Archaeol. Mus.) is almost a repetition of Kephisodotos' work.

BIBLIOGRAPHY

J. Overbeck: *Die antiken Schriftquellen zur griechischen Kunst des IV. Jhs. BC* (Leipzig, 1868/*R* Hildesheim, 1959), nos 1137–43
W. Klein: 'Über die Hermesgruppe eines Praxitelesschülers', *Jhft. Österreich. Archäolog. Inst. Wien*, xiv (1911), pp. 98–111
G. Lippold: *Die griechische Plastik* (1950), III/i of *Handbuch der Archäologie* (Munich, 1939–)
E. La Rocca: 'Eirene e Plutos', *Jb. Dt. Archäol. Inst.*, lxxxix (1974), pp. 112–36
H. Jung: 'Zur Eirene des Kephisodot', *Jb. Dt. Archäol. Inst.*, xci (1976), pp. 97–134

A. LINFERT

Kephisodotos the younger. *See under* PRAXITELES, §2.

Keppler, Arie (*b* Amsterdam, 15 Oct 1877; *d* Amsterdam, 3 April 1941). Dutch administrator and urban planner. He studied civil engineering at the Polytechnic School (now the Technical University) in Delft and in 1905 began working on a voluntary basis for the Building and Housing Control Service (Bouw en Woningtoezicht) in Amsterdam, later becoming head of department. In 1915 he became the first director of the Amsterdam Housing Department, where he devoted his energies to the construction of council houses and became closely involved with local housing associations. A member of the Social Democratic Workers' Party, he was strongly supportive, along with his brother-in-law F. M. Wibaut (1856–1936) of the party's council housing. Under his leadership, numerous housing estates, all of outstanding quality, were built. Such notable architects as H. P. Berlage and K. P. C. de Bazel were brought in to work for the Department, as well as other architects who were already known for their work in this area, such as J. E. van der Pek. By 1917 Keppler and Wibaut had drawn up a plan for 3500 dwellings, including a complex of council houses designed by Berlage, Jan Gratama and Gerrit Versteeg (1872–1938) in the Transvaal quarter in Amsterdam-Oost. The principal part of the plan, however, was for a garden suburb in Amsterdam-Noord. Keppler was an admirer of Ebenezer Howard, and his urban plans, strongly influenced by Howard's garden city ideas, ultimately determined the appearance of Amsterdam-Noord, which at that time was still virtually unbuilt. They comprised small, rustic one-family homes, each with a small garden, built around small squares, for example in the Van der Pek quarter.

Keppler was also an important promoter of experiments in industrial housing construction, and especially in the use of concrete, for example at Betondorp (1923) in the Watergraafsmeer, in Amsterdam-Oost. Here the district was transformed into a garden suburb with a radial street plan around a central square. The development was innovative not only in its use of concrete but also in the flat-roofed designs for the houses. The Amsterdam garden suburbs attracted international attention at the Town Planning Congress of 1924, organized by Keppler and others. However, in the period that followed, his increasingly ambitious schemes, such as an expansion programme later known as the General Expansion Plan for Amsterdam, drawn up in the 1920s (*see* AMSTERDAM, §II, 5), began to be resented by such bodies as the Department of Public Works (Publieke Werken), who saw Keppler's projects as encroachments on their own area of responsibility. In 1928 he lost his position as urban planner; disappointed, he left the Housing Service in 1937.

WRITINGS

Gemeentelijke woningbouw, Amsterdam [Council housing construction, Amsterdam] (Amsterdam, 1913)
with H. P. Berlage, W. Kromhout and J. Wils: *Arbeiderswoningen in Nederland* (Rotterdam, 1921)
with F. M. Wibaut: *De gemeente en de volkshuisvesting* [The council and public housing] (Amsterdam, 1924)

BIBLIOGRAPHY

E. Ottens: *Ik moet naar een kleinere woning omzien want mijn gezin wordt te groot* [I have to look for a smaller house because my family is becoming too large] (Amsterdam, 1975)
R. Roegholt: *Amsterdam in de 20e eeuw: Deel I, 1919–45* (Utrecht and Antwerp, 1976)
M. G. Emeis: *Amsterdam buiten de grachten* [Amsterdam beyond the canals] (Amsterdam, 1983)
H. Hellinga: 'Het Algemeen Uitbreidingsplan van Amsterdam' [The General Expansion Plan for Amsterdam], *Het nieuwe bouwen Amsterdam, 1920–60* [New building Amsterdam, 1920–60] (Delft, 1983)
H. Hellinga and P. de Ruijter: *Algemeen Uitbreidingsplan Amsterdam 50 jaar* [General Expansion Plan Amsterdam 50 years] (Amsterdam, 1985)

HELMA HELLINGA

Kera. *See* KRITSA.

Kerch [Rus. Kerch'; anc. Gr. Pantikapaion, Lat. Panticapeum]. Ukrainian city in the eastern Crimea. It was built on the site of ancient Pantikapaion, founded *c.* 600 BC on a spot previously the capital of the Cimmerian kingdom of the Bosporus. Later the city became one of the furthest outposts of the Byzantine empire; a silver dish (mid-4th century; St Petersburg, Hermitage) with a representation of Constantius II acclaimed by a Victory was found at Kerch. In 1318 the city came under Genoese rule and

enjoyed a period of prosperity until its capture by the Turks in 1520. It was part of the Russian (later Soviet) empire from 1774 until Ukrainian independence in 1991. Four km north-east of Kerch is an important burial monument, the so-called King's Mound, in which a ruler from the Spartocid dynasty is buried. The mound (h. 17 m, circumference 260 m) was built in the second half of the 4th century BC. A dromos (l. 36 m) leads to a chamber (4.39×4.25 m) in the centre of the mound covered by a conical stepped false cupola consisting of 12 circular tiers of progressively diminishing diameter. The church of St John the Baptist was for a long time considered to be the earliest example of Byzantine architecture in Russia, but recent research has suggested that it was built and decorated during the period of Genoese rule, that is in the mid-14th century rather than the 8th. However, the existence of a church on the site as early as the 10th century is attested by the presence of burials from that period. The interior follows a traditional plan with four central piers supporting a tall drum and a dome.

BIBLIOGRAPHY

I. Marchenko: *Gorod Pantikapey* [The town of Panticapeum] (Simferopol', 1974)

Pamyatniki gradostroitel'stva i arkhitektury Ukrainskoy SSR [Monuments of town-building and architecture of the Ukrainian SSR], ii (Kiev, 1985)

OXANA CLEMINSON

Kerch style. Term formerly applied to a group of 4th-century BC Attic vases found near the Crimean town of KERCH (Ancient Panticapeum) in the later 19th century. It is, however, ill-defined and often confusing: first coined by Furtwängler, it was subsequently divided by Schefold (see 1930, 1934) into early, middle and late phases and the vases attributed to several different artists. Even so, it is still sometimes applied to Attic vases that are clearly later than those by the MEIDIAS PAINTER (*see under* VASE PAINTERS, §II), but whose exact dates and attribution are uncertain. In general, modern study tends to focus instead on the personal styles of the most outstanding individual late Attic Red-figure artists.

The earliest of these is the Helen Painter (*fl c.* 375–*c.* 350 BC), who seems to have stimulated a revival in the quality of Attic Red-figure by introducing new techniques, notably the increased use of clay relief for certain parts of figures, a broader palette and some compositional and stylistic innovations, while retaining ties with his predecessors, especially the Jena Painter. Apart from the MARSYAS PAINTER (*see under* VASE PAINTERS, §II), his most significant immediate successor was the Eleusinian Painter (*fl c.* 355–*c.* 330 BC), who experimented with volumes by drawing convincing three-quarter-view faces. He covered the remaining parts of his figures with minute details, some picked out in gold. The Painter of Athens 1472 was a follower of the Marsyas Painter, but with a lesser talent. Two later artists, the Judgement of Paris Painter and Abegg Painter (both *fl c.* 330–*c.* 310 BC; see Lebel), together with the Apollonia Group (*fl c.* 340–*c.* 320 BC), made still more extensive use of gilded clay relief and added a few colours to the existing range.

Though the styles of all these painters have some common features, notably the adoption of new techniques, the increasing use of gold and other colours, a liking for tall, dignified figures in paratactic compositions and a tendency to depict heads in three-quarter or full front view, their works are too individualistic to constitute a single uniform group.

BIBLIOGRAPHY

A. Furtwängler and K. Reichhold: *Griechische Vasenmalerei*, 3 vols (Munich, 1904–32), i, pp. 204–8, ii, pp. 36–61, 102–5, 136–8

P. Ducati: *Saggio di studio sulla ceramica attica figurata del secolo iv av. Cr.* (Rome, 1916)

K. Schefold: *Kertscher Vasen* (Berlin, 1930)

——: *Untersuchungen zu den Kertscher Vasen* (Berlin, 1934)

J. M. Bohác: *Kerěské Vázy* (Prague, 1958)

A. Lebel: *The Marsyas Painter and Some of his Contemporaries* (diss., Oxford U., 1989)

A. LEBEL

Kerckhoven, Jacob van de. *See* CASTELLO, GIACOMO DA.

Kerkouane. *See under* CARTHAGE, §1.

Kerkyra. *See* CORFU.

Kerma. Site of Kushite town in Sudan, on the east bank of the Nile south of the third cataract, that flourished *c.* 2150–1500 BC. Kerma was first excavated by G. A. Reisner from 1913 to 1916. Reisner interpreted the remains as evidence of an Egyptian trading settlement, which eventually degenerated due to the admixture of the Egyptian and local populations. Reisner's views are now discounted and the site of Kerma is recognized as the chief centre of a major Kushite culture. In the 1980s the excavations of C. Bonnet uncovered a town site and added to our understanding of the monuments already studied by Reisner.

The site is dominated by a huge mud-brick structure (52×26 m), the Western Deffufa, which is internally almost solid and still preserved to a height of some 19 m. Inside, a narrow stairway led to the now lost upper region. It dates to the Kerma Classic III phase (*c.* 1600–1550 BC) and the brickwork and timber bonding indicate Egyptian work or influence. The town site lay around and to the west of the Deffufa. Many of the houses were of the traditional circular plan with thatched roof, although some were rectangular.

The cemeteries, situated to the north-east of the settlement, cover an area 1.5 km long and 0.8 km wide. They were in use for around 500 years, the earliest being at the northern end and the latest being the great tumuli of the southern group. The tumuli had brick substructures and contained large numbers of subsidiary burials of servants killed at the time of the main interment. There were over 300 subsidiary burials in Tumulus 'K X', which dates to Kerma Classic II (*c.* 1650–1600 BC). The burial goods included imported Egyptian objects and statuary such as the grey granite figures of Hepdjefa and Sennuwy (*c.* 1950 BC; Boston, MA, Mus. F.A., 14.720). There were also many locally made pieces, including thin sheets of mica carved in the shape of ostriches and vultures, which may have been cap ornaments, and ivory inlays from funerary beds (Boston, MA, Mus. F.A., and Leipzig, Ägyp. Mus.).

Associated with the southern cemetery was the Eastern Deffufa, like the Western Deffufa an almost solid large rectangular brick structure dating to Kerma Classic III (53×33 m). Possibly a funerary chapel, the interior has two narrow stone-floored rooms, each with a single line of

Kerma, painted pot, h. 159 mm, Second Intermediate Period, *c.* 1630–*c.* 1540 BC; reconstruction from a watercolour by Dows Dunham, 149×192 mm (Boston, MA, Museum of Fine Arts)

columns. The walls were plastered and painted, some parts being decorated with blue faience. The massive brick structure 'K XI' (*c.* 42×27 m), perhaps another funerary chapel, was similar in plan, although the outer walls were stone-faced. The painted decoration depicted giraffes and at least eight rows of hippopotami.

Kerma pottery, a very fine black-topped red ware, was discovered in large quantities at the site. This pottery reached its finest level in the latest phase of the Kerma culture (*c.* 1650–1500 BC), when many different vessel forms were manufactured. Elaborate painted wares (see fig.) and those with plastic or incised decoration are also common in this phase. Faience was locally manufactured, although the technique derived from Egypt (for further discussion of faience at Kerma *see* EGYPT, ANCIENT, §XVI, 5).

BIBLIOGRAPHY
G. A. Reisner: *Excavations at Kerma I–V*, 2 vols (Cambridge, MA, 1923)
B. Gratien: *Les Cultures Kerma: Essai de classification* (Lille, 1978) [chronology of cemeteries]
Africa in Antiquity (exh. cat. by S. Wenig, New York, Brooklyn Mus., 1978), ii, pp. 30–41, 145–61 [illustrations of objects from Kerma]
D. Dunham: *Excavations at Kerma VI* (Boston, 1982)
C. Bonnet: 'Kerma, royaume africain de Haute Nubie', *Nubian Culture: Past and Present*, ed. T. Hägg (Stockholm, 1987), pp. 87–111
 R. G. MORKOT

Kermadec, Eugène de (*b* Paris, 21 May 1899). French painter. He spent his early childhood in Guadeloupe and moved to Paris in 1910. From 1915 to 1917 he studied in Paris at the Ecole des Arts Décoratifs, the Ecole des Beaux-Arts and the Académie Colarossi successively. Though he had originally wished to be a sculptor, his interests turned increasingly towards painting. He first exhibited at the Salon des Indépendants in 1919 but was never a regular exhibitor. His work in the 1920s was basically naturalistic, but in the early 1930s his painting showed the influence of synthetic Cubism, using overlapping planes and flat areas of colour as in *Seated Woman and Child* (1932; Paris, Gal. Louise Leiris). By the second half of the 1930s, however, his style had become calligraphic, composed around an armature of flowing lines, as in *The Studio* (1938; Paris, D.-H. Kahnweiler priv. col., see 1957 exh. cat., pl. 11).

Kermadec's work thereafter retained this style, while becoming more expressive and abstract; it mostly depicted either the female figure or landscapes. These later paintings resemble some of the sand paintings of André Masson in their apparent spontaneity of execution, as in *The Bather* (1956; Paris, Gal. Louise Leiris). In 1949 Kermadec illustrated *Le Verre d'eau* by Francis Ponge (1899–1984), and in 1961 he won the Prix de la Fondation Européenne de la Culture in Amsterdam. While having a small group of devoted collectors, which included Daniel-Henry Kahnweiler, he remained largely unknown to a wider public.

BIBLIOGRAPHY
E. de Kermadec: Peintures 1927–1957 (exh. cat. by R. de Solier, Paris, Gal. Louise Leiris, 1957)
E. de Kermadec (exh. cat. by F. Meyer, Berne, Ksthalle, 1958)
E. de Kermadec, 1899–1976 (exh. cat. by C. Seibel, Paris, Gal. Louise Leiris, 1977)

Kerman. *See* KIRMAN.

Kern, Anton (*b* Tetschen, Bohemia, 1709; *d* Dresden, 8 June 1747). German painter and draughtsman, active also in Italy and Bohemia. He trained first with the Saxon court painter Lorenzo Rossi (*c.* 1690–1731), whom he accompanied to Venice in 1723. There in 1725 he joined the workshop of GIAMBATTISTA PITTONI, with whom he worked until moving to Prague in 1735, where he matriculated at the Karlsuniversität. In 1738 he was summoned to Dresden by Frederick-Augustus II. In the same year he made a study trip to Rome, returning to Dresden in 1741. After his return, he was appointed court painter and completed a series of public and private commissions in Dresden, where he worked until his death.

Kern's early work is marked by its strong dependence on Pittoni, of whose works he made numerous copies. The resemblance is often so close that several of Kern's drawings and paintings have been wrongly attributed to Pittoni. After his return from Venice, Pittoni's influence on his work gradually waned. But the influence of Venetian painting on his art was decisive, even though he was subsequently affected by the works of Bohemian painters such as Petr Brandl and Václav Vavřinec Reiner. The most important paintings of his Prague period include the *Virgin and Child Enthroned with Saints* (Prague, N.G., Šternberk Pal.). In 1738 he produced designs for the altar and ceiling paintings in the Catholic Hofkirche in Dresden, but they were not executed. During his stay in Rome he painted the *Massacre of the Innocents* (Dresden, Gemäldegal. Alte Meister). In his late period in Dresden, Kern adopted a Rococo, pastel style of painting, which characterizes his paintings of *Diana and Bacchus* and *Venus and Ceres* (both 1747; Nuremberg, Ger. Nmus.).

BIBLIOGRAPHY
Thieme–Becker
K. Garas: 'Anton Kern', *Studies in the History of Art and Civilization in Honour of Prof. Dr. Stanislaw Lorentz* (Warsaw, 1969), pp. 65–90

F. Zava Boccazzi: 'Nota sulla grafica di Anton Kern', *A. Ven.*, xxix (1975), pp. 246–50

A. Binion: 'Anton Kern in Venice', *Münch. Jb. Bild. Kst*, 3rd ser., xxxii (1981), pp. 183–206

——: *I disegni di Giambattista Pittoni* (Florence, 1983), pp. 9–29

S. TRÄGER

Kern, Leonhard (*b* Forchtenberg, Hohenlohe, 22 Nov 1588; *d* Schwäbisch Hall, 4 April 1662). German sculptor. Coming from a family of masons, he served an apprenticeship from 1603 to 1609 with his brother, the sculptor Michael Kern (1580–1649), working closely with him in Würzburg and elsewhere. He spent the next four years chiefly in Italy. He stayed in Rome, where he learnt life drawing, possibly at the Accademia di S Luca, and pursued architectural studies; he also stayed in Naples, from where he travelled to North Africa, and in Venice. He visited Laibach (now Ljubljana) in 1613. From 1614 to 1620 he worked in Forchtenberg, Heidelberg and Nuremberg, and from then on until his death he supervised a large studio in Schwäbisch Hall.

Because the Thirty Years War (1618–48) made commissions difficult to come by, Kern had to exhibit versatility as a sculptor. It was only in the first third of the century that he had a few isolated opportunities to create large-scale monumental stone sculptures, such as the gable figures on the Nuremberg Rathaus (1617) and the sculptures on the Regensburg Rathaus (1632). From then on he specialized exclusively in small, easily transportable collector's pieces, using almost every imaginable sculptural material, including ivory, boxwood, soapstone, alabaster and bronze. Although his subject-matter was equally divided between the sacred and the profane, he almost always depicted his figures in the nude, as this displayed most effectively his virtuoso carving technique. He vividly demonstrated his broad artistic horizon, adapting Italian and northern models in an original manner. His style reveals his knowledge of the most modern developments in Rome around 1600, as in his *St Sebastian* (ivory, *c.* 1615–20; Munich, Residenz). He also displayed his familiarity with Flemish Baroque in the style of Rubens in his so-called larger *Eve* (wood, *c.* 1645; Brunswick, Herzog Anton Ulrich-Mus.). In addition, Kern's work makes obvious reference to then popular small-scale Renaissance sculptures, especially Albrecht Dürer's Crucifix (*c.* 1625–30; Vienna, Ksthist. Mus.).

Kern's oeuvre consists almost entirely of attributions, for he signed only very few works (his monogram was LK), and only in exceptional cases can the sculptures be reconciled with archival records. It is impossible to date with certainty any single small-scale sculpture. However, despite its heterogeneous references, Kern's naturalistic and monumental style remains unmistakable even in his small-scale works. Kern's success is attested by his appointment in 1648 as court sculptor to Frederick William von Hohenzollern, Elector of Brandenburg, and, more significantly, by the large number of his works that have survived. He died rich and famous; sculptures by him were probably to be found in most of the aristocratic art collections of the 17th century. He clearly satisfied contemporary collectors' taste. He was both a typical representative of 17th-century German small-scale sculptors and, at the same time, one of the most individualistic. He was undoubtedly one of the most important sculptors of the Early Baroque in Germany.

BIBLIOGRAPHY

E. Grünenwald: *Leonhard Kern: Ein Bildhauer des Barock* (Schwäbisch Hall, 1969)

Leonhard Kern (exh. cat., ed. H. Siebenmorgen; Schwäbisch Hall, Häll.–Fränk. Mus., 1988)

FRITZ FISCHER

Kernstok, Károly (*b* Budapest, 23 Dec 1873; *d* Budapest, 10 June 1940). Hungarian painter and decorative artist. In 1892 he was a pupil of Simon Hollósy in Munich, then he spent three years studying at the Académie Julian in Paris. Returning to Hungary in 1897 he painted the *Factory Canteen: Agitator* (Budapest, N.G.), a Realist picture imbued with a socialist message. This was followed by more joyful scenes of peasant life often in bold and glowing colours (e.g. the harvesting scene *Plums*; 1901, Budapest, N.G.). In 1905 he settled in Nyergesújfalu, becoming the leading figure of a group of artists with radical bourgeois views. In 1906, however, he left for Paris once more, where he was impressed by the style of the French Fauves, especially the work of Matisse. This is evident in Kernstok's richly coloured portrait of *Béla Czóbel* (1906; Budapest, N.G.).

Kernstok's most original contribution to the development of modern Hungarian painting came after 1910 when he started to concentrate on the subjects of boy nudes and nude horsemen, shown in a decorative but vigorous style with heavy contours and emphasis on the overall structure of the picture, as in *Horsemen on the River Bank* (1910) and *Boy Nude Leaning against a Tree* (1911; both Budapest, N.G.). The former became a key work for THE EIGHT (iii) (formed in 1909 and disbanded in 1912), who were similar to the Fauves in their use of colour. Kernstok was the leading figure of this group. From 1907 he received several commissions for monumental wall paintings, mosaics and stained-glass windows. The most significant of these is the stained-glass window for the Schiffer Villa in Budapest (1912; see Dévényi, pl. 36). Kernstok took an active part in the art programme of the Hungarian Republic of 1919, designing posters, for example, like many other artists. With the fall of the Republic he was driven into exile. From 1919 to 1926 he lived mostly in Berlin, where he worked on his painting of the *Last Supper* (Budapest, Kiscelli Mus.), Expressionist in style and alluding to the failed revolution. After his return to Hungary his style became more naturalistic, as in the scene with riders *Daybreak: Dewy Morning* (1932; Budapest, N.G.).

BIBLIOGRAPHY

A. Körmendi: *Kernstok Károly* (Budapest, 1936)

B. Horváth: 'Károly Kernstok, 1873–1940', *Acta Hist. A. Acad. Sci. Hung.*, xiii (1967), pp. 353–87

I. Dévényi: *Kernstok Károly* (Budapest, 1970)

For further bibliography *see* THE EIGHT (iii).

MÁRIA SZOBOR-BERNÁTH

Keros [Karos]. Small Greek island of the Aegean Cyclades, to the south of Naxos. Though no longer inhabited, it was evidently important in prehistoric times. There was a settlement on the small islet of Daskalio, now off the western tip of Keros but perhaps originally part of the main island. On the mainland opposite are extensive traces

of what may have been a cemetery. Relatively little professional excavation has been carried out on Keros, though work has been under way since 1987. There has, however, been a great deal of illicit digging, and many fine objects are certainly or possibly from Keros, including marble vases and figurines. Among the latter are the famous musicians playing the lyre or pipes (Athens, N. Archaeol. Mus.). They are Early Cycladic II (*c.* 2800/2600–*c.* 2300 BC) in date and similar in style to the folded-arm type, though more complex—the lyre-player, for instance, is seated (*see* CYCLADIC, §IV, 1 and fig. 10). Although the plethora of marble finds from Keros has usually been taken to indicate the existence of cemeteries (and thus quite substantial settlement), it has been suggested that the island may have been a religious centre and that these finds are the debris of ritual, not of funerary activity. This would explain the discovery of such rich finds on an island that seems unlikely to have supported a large population.

BIBLIOGRAPHY

C. Renfrew: *The Emergence of Civilization* (London, 1972), pp. 178, 521 [summary comments, with further refs to excavation reports]
P. Getz-Preziosi: 'The "Keros Hoard": Introduction to an Early Cycladic Enigma', *Antidoron: Festschrift für Jurgen Thimme*, ed. D. Metzler and B. Otto (Karlsruhe, 1983), pp. 37–44
——: *Sculptors of the Cyclades: Individual and Tradition in the 3rd Millennium BC* (Ann Arbor, 1987), pp. 134–9

R. L. N. BARBER

Kerr, Robert (*b* Aberdeen, 17 Jan 1823; *d* London, 21 Oct 1904). Scottish architect and writer. After training in Aberdeen he first practised in New York, but in 1844 he returned to Britain. In 1847 he became a founder and first President of the Architectural Association; he was elected Fellow of the RIBA in 1857, served on its Council and played an important role in the Institute's development. Between 1860 and 1902 he was District Surveyor of St James's, Westminster, and between 1861 and 1890 he was Professor of the Arts of Construction at King's College, London. His most important buildings were the National Provident Institution (1863; destr.), Gracechurch Street, London, and four large country houses: Dunsdale, Kent (1863; destr.), Bear Wood, Berks (1865–8; *see* COUNTRY HOUSE, fig. 5), Ascot Heath House (1868; destr.), Berks, and Ford House (1869; now Greathed Manor), Surrey. He entered competitions for the Foreign Office (1856), the Palais de Justice (1861), Brussels, the Natural History Museum (1864), London—for which he was awarded the second premium—and the Reichstag Gebäude (1873), Berlin. He was a prominent figure in the debates on which style of architecture was most suitable for 19th-century Britain, and he himself built in an eclectic mixture of Jacobean, Renaissance and Second Empire styles, all of which he employed in an idiosyncratic and forceful manner.

Kerr was best known in his own day for his writings. He was a frequent contributor to *The Builder* and various professional journals, having begun his writing career in 1846 with *The Newleafe Discourses*, a parody of the architectural profession. His most important work was *The Gentleman's House*, hitherto the most complete published analysis of the planning and design of a country mansion. It was the foundation of his country-house practice, but this failed to flourish, due in part to his eccentric style, his miscalculation of costs and a combative personality that alienated clients.

WRITINGS

The Newleafe Discourses on the Fine Art, Architecture (London, 1846)
The Gentleman's House; Or, How to Plan English Residences, from the Parsonage to the Palace (London, 1864, 3/1871)

BIBLIOGRAPHY

J. Summerson: *Victorian Architecture* (London, 1970)
M. Girouard: *The Victorian Country House* (London, 1971, rev. 1979), pp. 263–72, 440
N. Pevsner: *Some Architectural Writers of the Nineteenth Century* (Oxford, 1972, 2/1977), pp. 217–21, 224–6, 233–6, 291–314
J. Franklin: *The Gentleman's Country House and its Plan, 1835–1914* (London, 1981)

JILL ALLIBONE

Kerricx. Flemish family of artists.

(1) Guillielmus [Willem] **Kerricx** (*b* Dendermonde, 2 July 1652; *d* Antwerp, 22 June 1719). Sculptor. He was apprenticed to the Guild of St Luke in Antwerp, becoming a master in 1674. He produced numerous works for the churches of Antwerp, including two elegant marble reliefs of *Our Lady of the Rosary* (1688) for St Paulus and, in collaboration with Henricus-Franciscus Verbrugghen, a superb communion bench (marble, 1695) for St Jacob. It seems likely that between about 1702 and 1709 he worked abroad, possibly in England. Dating from the later part of his career are two carved confessionals (wood, 1711) for the Premonstratensian Abbey of Grimbergen, near Brussels, and the funerary monuments of *Abbot C.-F. de Fourneau* and *Abbot A.-C. de Pallant* (both marble, 1714–15; Leuven, St Gertrudis). Both the latter include portrait reliefs of the deceased, of striking realism. Kerricx also executed the high altar for St Gertrudis (marble; destr. World War II).

Kerricx's masterpiece is his bust of *Maximilian II Emanuel of Bavaria*, governor of the Spanish Netherlands (marble, 1694; Antwerp, Kon. Mus. S. Kst.). This virtuoso work, with its hints of Rococo grace, can be compared with the finest Italian and French court portraits of the late Baroque period. A number of Kerricx's drawings are kept in the Stedelijk Prentenkabinet in Antwerp, while the Musée d'Art Ancien, Brussels, holds a collection of his terracotta models. Among the more than 20 apprentices who trained in his studio at Antwerp was his son (2) Willem Ignatius Kerricx.

BIBLIOGRAPHY

NBW, xiv (1992), col. 349–52
A. Jansen and C. Van Herck: 'Guillielmus Kerricx: Antwerpsch beeldhouwer, 1652–1719', *Jb. Antwerpens Oudhdknd. Kring*, xvii (1941), pp. 41–117
Tentoonstelling van tekeningen, maketten en beeldhouwwerk (exh. cat., Antwerp, 1947), pp. 3–22
G. Gepts-Buysaert: 'Guillielmus Kerricx: Antwerps beeldhouwer, 1652–1719', *Gent. Bijdr. Kstgesch. & Oudhdknd.*, xiii (1951), pp. 61–125
M. Smeyers: 'Het voormalige hoogaltaar van de Sinte-Geertruikerk te Leuven: Een werk van Guillielmus Kerricx' [The former high altar of St Gertrudis Church in Louvain: A work by Guillielmus Kerricx], *Meded. Gesch.- & Oudhdknd. Kring Leuven & Omgev.*, vii/3 (1967), pp. 180–208
La Sculpture au siècle de Rubens dans les Pays-Bas méridionaux et la principauté de Liège (exh. cat., Brussels, Mus. A. Anc., 1977), pp. 130–38
G. Van Hemeldonck and I. Kockelbergh: 'De werken van meester beeldhouwer Henricus Franciscus Verbrugghen in de abdijkerk van Grimbergen', *Eigen Schoon en de Brabander*, lxviii/4–6 (1985), pp. 129–50

HELENA BUSSERS

(2) Willem [Guillielmus; Guillaume] **Ignatius Kerricx** (*b* Antwerp, *bapt* 22 April 1682; *d* Antwerp, *bur* 4 Jan 1745). Sculptor, architect and painter, son of (1) Guillielmus Kerricx. He was apprenticed to his father and to the painter Godfried Maas (*c.* 1649–1700). In 1703–4 he became a master in the Antwerp Guild of St Luke, later serving as its dean (1718–19 and 1723–4). His work is typical of late Baroque sculpture in Flanders, where elements of French classicism are blended with a decorative Rococo spirit. One of the best surviving groups of his work is in the Onze-Lieve-Vrouwkerk, Kruibeke, where he executed the Communion rail (1712), the choir-stalls (1714), the altar of St Blasius (1722) and four statues for the confessionals (1733), all in wood. He produced several important wood pulpits, including those at St Amandus, Geel (1715); St Ludgerus, Zele (1716); Onze-Lieve-Vrouw over de Dijle, Mechelen (1718); and St Lambertus, Heist-op-den-Berg (1737). Among his architectural works are the classical conventual buildings at Tongerloo Abbey (1725–6), where he also carved eight life-size statues for the confessionals, and the restoration of St Walburga, Antwerp, where he designed new foundations for the structure, which was sinking, as well as a new wooden frame (destr.) for Rubens's *Raising of the Cross*. Among Kerricx's later works are two altars (1744) in the church of the Capuchins, Dendermonde, and ephemeral decorations for the triumphal entry of Charles of Lorraine into Antwerp in 1744. Theodor Verhaegen was among his pupils.

BIBLIOGRAPHY
Thieme–Becker
U. Kulturmann and others: 'Guillielmus Ignatius Kerricx', *Europäische Barockplastik am Niederrhein: Grupello und seine Zeit* (exh. cat., Düsseldorf, Kstmus., 1971), pp. 289–92

CYNTHIA LAWRENCE

Kerry, Charles (Henry) (*b* Monaro Uplands, NSW, 3 April 1858; *d* Sydney, 26 May 1928). Australian photographer. He worked as an operator in a *carte-de-visite* business in Sydney. When popularity for this photographic form of portraiture collapsed in the 1870s, he turned to a new and eventually lucrative business: scenic views of rural and urban Australia. Coinciding with the invention of the collodion dry plate process, which gave him more freedom of movement, he used the recently expanded railway system to reach places of photographic interest. By the 1890s his work dominated the photographic view business in Sydney; he had become more of a businessman than a photographer, employing several touring operators to meet his commitments.

The severe depression of the 1890s forced many photographers to close their businesses, and the demand for views dwindled alarmingly. Kerry, sensing that the growing postcard trade could become the basis for commercial advancement, began to produce photographic postcards. By 1910 Kerry & Co emerged as Australia's largest publishers of postcards. Using presses in Germany to print his huge orders, and operating out of a large, four-storey building in Sydney, he had the income to indulge other interests such as horse racing, skiing and fishing. Kerry's photographs, and those of his assistants, were avowedly commercial in subject-matter; they showed, through a misty-eyed nationalism, the heroic toil of settlers breaking in the land and the optimistic growth of Australia's principal cities. Kerry and his company confirmed a young nation's perception about itself, with images that have become visual icons of Victorian colonial Australia.

BIBLIOGRAPHY
D. P. Millar: *Charles Kerry's Federation Australia* (Sydney, 1981)

DAVID P. MILLAR

Kerseboom [Casaubon]. German family of painters. Both (1) Friedrich Kerseboom and his nephew (2) Johann Kerseboom settled in Covent Garden, London, in the 1680s.

(1) Friedrich [Frederick] **Kerseboom** (*b* Solingen, 1632; *d* London, *bur* 30 March 1693). According to Buckridge, he studied in Amsterdam and from 1650 in Paris under Charles Le Brun before proceeding to Rome. He remained there for 14 years, two of which were spent in Nicolas Poussin's studio. After having moved to London, he produced history paintings, known now from engravings, in Poussin's manner. He apparently discovered portrait painting to be more lucrative in England, but relatively few examples of his work are known. His portrait of *Theophilus Leigh*, signed and dated 1683, is rigidly posed and drily painted, while its companion, *The Hon. Mary Leigh* (both ex-Stoneleigh Abbey, Warwicks), is a timid work strongly influenced by Willem Wissing. Buckridge stated that Kerseboom also painted on glass.

(2) Johann [John] **Kerseboom** (*fl c.* 1683; *d* London, *bur* 26 Oct 1708). Nephew of (1) Friedrich Kerseboom. He first worked in Germany, where his sitters included the *Electress Sophia Dorothea*; the painting (untraced) is known from an engraving (London, BM) by William Faithorne, who also executed six mezzotints after him. In 1689 Kerseboom painted the prototype of the *Hon. Robert Boyle* (*c.* 1689; London, Royal Soc.), of which numerous versions exist; this portrait is one demonstration of his idiosyncrasies: the long, angular face, the extended figures and an emphasis on accessories.

Kerseboom worked closely with other artists, most notably with JAN VAN DER VAARDT, who often provided drapery and backgrounds as he had earlier done for Willem Wissing. Portraits were sometimes jointly signed, and their individual styles are difficult to disentangle. The team perpetuated the Wissing tradition, although Kerseboom favoured warmer and more varied colours. An early work such as *Lady Grace Carteret* (Petworth House, W. Sussex, NT; engr. John Smith (i)) is barely distinguishable from a late Wissing, and Kerseboom's portraits of women and young children, such as the *Hon. James Thynne* (*c.* 1692; Longleat House, Wilts), were often merely decorative. On the other hand, his later male portraits are often sympathetic and robust: the full-length *Thomas Osborne, 1st Duke of Leeds* (1704; London, N.P.G.), signed by both artists, aptly conveys Kerseboom's sympathetic observation, while it is also a fine example of the grand 'parade' portrait.

BIBLIOGRAPHY
Thieme–Becker
B. Buckridge: 'An Essay towards an English School of Painters', *The Art of Painting* (London, 1706, 3/1754/*R* 1969), pp. 361–2 [Eng. trans. by J. Savage of R. de Piles: *Abrégé de la vie des peintres* (Paris, 1699)]

C. H. Collins Baker: *Lely and the Stuart Portrait Painters*, ii (London, 1912), pp. 49–53
'The Note-books of George Vertue', *Walpole Soc.*, xxiv (1936), xxvi (1938) [indexed in xxix (1947)]
E. K. Waterhouse: *Painting in England, 1530 to 1790*, Pelican Hist. A. (London, 1953, rev. 4/1978), p. 345, n. 10
M. Whinney and O. Millar: *English Art, 1625–1714* (Oxford, 1957), p. 192, n. 3

RICHARD JEFFREE

Kersting, Georg Friedrich (*b* Güstrow, Mecklenburg, 22 Oct 1785; *d* Meissen, 1 July 1847). German painter. He trained at the academy of art in Copenhagen from 1805 to 1808, adopting the clarity and brilliance characteristic of the Danish school. In 1808 he went to Dresden, where he met and associated with Caspar David Friedrich and his circle. With Friedrich, Kersting went on a walking tour through the Zittau Mountains and the Riesengebirge in July 1810. Kersting was also a close friend of the painter Gerhard von Kügelgen, at whose house he was a frequent guest. His first two portraits in individual interiors (a genre he was to make his own), *Caspar David Friedrich in his Studio* (Hamburg, Ksthalle) and *Gerhard von Kügelgen in his Studio* (Karlsruhe, Staatl. Ksthalle), attracted much attention on their exhibition at the Dresden Kunstakademie in 1811. Kersting continued to produce works of this very appealing type, linking the sitter with his surroundings: they are an epitome of early Romantic interest in the spirit of the individual and point beyond the ephemeral, genre-like aspects of the subject to a symbol of the interaction between man and the space in which he works or lives. In 1812 Kersting painted *The Embroiderer* (*see* GERMANY, fig. 39), *The Elegant Reader* and *Man at a Desk* (all Weimar, Schlossmus.). For the last of these, Kersting used the young painter Louise Seidler as a model. Seidler was instrumental in enabling Kersting to send several of his works to Johann Wolfgang von Goethe in Weimar in 1813. Goethe strongly recommended that Grand Duke Charles Augustus buy *The Embroiderer*, and he also encouraged further sales by promoting a lottery.

In the fervent patriotic mood of the period of the Napoleonic Wars, Kersting enlisted in the Lützow volunteer corps in the spring of 1813. On his return from the campaign he painted subjects connected with the wars: *On Outpost Duty* and *Woman Winding Wreaths* (Berlin, Neue N.G.), as a memorial to friends who had died. From 1816 to 1818 he worked as a drawing-master in the house of Princess Anna Sapieha in Warsaw. To provide for his material needs and enable himself to marry and start a family, in 1818 Kersting accepted the post of supervisor of painting at the Meissen Porcelain Factory. By training qualified porcelain painters and providing designs for new shapes and ornamentation, he played a decisive role in raising the previously low artistic standing of the products. His own flower still-life paintings are a reflection of his work at this time, although he now found the subject-matter for his pictures mainly in the domestic setting of his own family. A loving comprehension of the psychology of the young distinguishes the portraits of his children shown at a window, by a birdcage or with cats: these are almost genre paintings. The intellectual and formal tension of the earlier interior portraits is absent from these pictures. And the portraits, which are mainly head-and-shoulders compositions, lie between late 18th-century convention

and a coolly pragmatic Biedermeier realism. The finest example is the portrait of his wife *Agnes Kersting* of 1832 (Karlsruhe, priv. col.). Kersting's oeuvre was not extensive, and his work went through a long period of oblivion after his death, until the rediscovery of German Romantic painting as a result of the centennial exhibition of German art in Berlin in 1906.

BIBLIOGRAPHY

O. Gehrig: *Georg Friedrich Kersting* (Schwerin, 1932)
G. Vriesen: *Die Innenraumbilder Georg Friedrich Kerstings* (Berlin, 1935)
Georg Friedrich Kersting, 1785–1847 (exh. cat., Güstrow, Mus. Stadt, 1985)
W. Schnell: *Georg Friedrich Kersting* (diss., W. Berlin, Freie U., 1986)
H. Gärtner: *Georg Friedrich Kersting: Leben und Werk* (Leipzig, 1988)

HANS JOACHIM NEIDHARDT

Kertész, André [Andor] (*b* Budapest, 2 July 1894; *d* New York, 27 Sept 1985). American photographer of Hungarian birth. As a young man he used to wander around Budapest and visit the Ethnographic Museum. At this time Béla Bartók and Zóltan Kodály were rediscovering Hungarian folk music, and Hungarian poets and painters were looking at their ancient vernacular traditions for inspiration. Kertész, who started taking photographs at the age of 12, also tried to reflect these interests, both in his choice of countryside subjects and in the simplicity of his style. Self-taught, he often took his camera with him when he went to visit relatives in the small peasant towns of the Hungarian heartland, the *puszta* (see *Kertész on Kertész*, p. 15). He tried to go beyond mere recording of holiday memories, or of the idyllic relationship of the country people to nature; he rather sought out timeless and essential qualities in the ordinary day-to-day events that he saw around him.

From 1912 to 1914 Kertész worked at the stock exchange; during World War I he served in the infantry, taking his camera with him to produce photographs such as *Behind the Lines, Gologory, Poland* (1915; see *Kertész on Kertész*, p. 21) and images of soldiers at their posts, for example *Gologory, Poland* (1915; see *Kertész on Kertész*, p. 23). He also photographed war-ravaged villages where life went on regardless of the devastation. He won a prize in a competition in the magazine *Borsszem Janko* in 1916, and some of these early photographs were published in an important early illustrated magazine, *Erdékes Ujság*, in 1917.

After the war Kertész returned to Budapest and to the position of clerk at the stock exchange, a job in which he had no interest. He did, however, take his camera with him on lunch breaks, and he photographed at weekends. Although many of these pictures were taken when Hungary was in a period of revolution, they reflect a sense of release rather than political interest or involvement. Gradually he became more isolated in Hungary as many of his friends left for the cultural activity of Berlin or Paris. In autumn 1925 he, too, left for the French capital.

Kertész's early works in Paris reveal his position as an outsider; he took many photographs of tourist sights such as the Place de la Concorde, or the *Eiffel Tower* (1925; see 1985 exh. cat., p. 127). One of the first pictures that he took on his arrival was a view from his hotel window, *Paris* (1925; see *Kertész on Kertész*, p. 40). He took many photographs of the *clochards*, for example *Canal St Martin,*

Paris (1926; see *Kertész on Kertész*, p. 42); in the *Stairs of Montmartre* (1926; see exh. cat., p. 135) the figure is dwarfed by the abstract pattern of stairs and shadows.

Through photographs of Hungarian artists and their friends, Kertész became acquainted with many important artistic figures living in the city. By 1926 Piet Mondrian, Adolf Loos and Tristan Tzara appeared in photographs by Kertész. In 1927 Kertész had an exhibition at the Galerie Au Sacre du Printemps with an abstract painter, Ida Thal. Both Thal and Kertész were acquainted with the poets Michel Seuphor and Paul Dermée. Both men had ties to the abstract geometrical art of the period as well as to international developments, from Futurism and Dada to Constructivism and Surrealism. In works such as *Chez Mondrian* (1926; see fig.) and *Fork* (1928; see exh. cat., p. 160) Kertész's awareness of geometrical ideas is sensitively absorbed: in *Chez Mondrian* Kertész appreciates Mondrian's planar geometries but also emphasizes the artist's individual spirit by focusing on an artificial flower that Mondrian kept in his doorway, painted white; *Fork* was made after a dinner with friends and shows the utilitarian machine-tooled object bathed in gentle light and resting against a common but beautiful plate.

By 1928 Kertész purchased his first Leica, a hand-held camera that allowed him to go out into the streets and photograph instantaneously. An example of a photograph taken with this new freedom is *Meudon* (see exh. cat., p. 165), in which a man is seen walking towards the camera, carrying a dishevelled package; juxtaposed with

him is the train running on the viaduct overhead. There is a sense of unease in this picture, a quality he developed in a series of photographs commissioned for the erotic magazine *Sourire*. Kertész produced a series of nudes but transformed them into grotesque, hallucinatory images, for example *Distortion No. 167* (1933; see exh. cat., p. 191).

Although Kertész received critical acclaim in Paris, the flood of photographers who entered France from Germany with the rise of Nazism greatly reduced his opportunities for success in the French capital. He was offered a 'sabbatical' by the Keystone agency, to work in the USA. In 1936 he sailed for New York. From 1937 to 1949 he was a freelance photographer for such magazines as *Harper's Bazaar*, *Vogue*, *Town and Country* and *Look*. In 1949 he joined Condé Nast Publications and worked, mainly on *House and Garden* magazine, as a contract photographer until 1962. While photographing the interiors of wealthy homes for a living, Kertész also tried to maintain his own personal photography, but the quantity and quality of this aspect of his output decreased. When illness forced him to leave Condé Nast, he embarked once again on photographing subjects that interested him. A large number of his late works were made from the windows of his apartment in New York on Fifth Avenue, overlooking Washington Square, for example *Washington Square, Winter* (1954; see exh. cat., p. 255). The bird was a motif that he closely identified as part of nature in a dehumanized setting, free to escape. Kertész's last important series was of Polaroid photographs of still-life objects, set against his New York windows. He produced them as tributes to the memory of his wife Elizabeth (for example *New York City*, 1979; see *Kertész on Kertész*, p. 115).

PHOTOGRAPHIC PUBLICATIONS

Paris vu par André Kertész (Paris, 1934)
Day of Paris (New York, 1945)
André Kertész: Sixty Years of Photography, 1912–1972 (New York, 1972) [with poems by Paul Dermée]
J'aime Paris: Photographs since the Twenties (New York, 1974)
Distortions, intro. H. Kramer (New York, 1976)
Of New York (New York, 1976)
Hungarian Memories (New York, 1982)
Kertész on Kertész: A Self-portrait (London, 1985)

BIBLIOGRAPHY

A. Farova: *André Kertész* (New York, 1966)
André Kertész: Of Paris and New York (exh. cat. by S. S. Phillips, D. Travis and W. J. Naef, Chicago, IL, A. Inst.; New York, Met.; 1985)
André Kertész à la France, Collections donations, Ministère de la Culture, Association française pour la diffusion du patrimoine photographique (Paris, 1990)

SANDRA S. PHILLIPS

Kessel, van. Flemish family of artists. (1) Hieronymus van Kessel II, the son of the draper Jan van Kessel I and Martha Boerens, is known only as a portrait painter. His son (2) Jan van Kessel II was the most versatile member of the family: registered in the Antwerp Guild of St Luke as a flower painter, he also depicted, in both oil and watercolour, animals, birds, fish and insects, as well as a variety of still-life subjects. Jan II taught two of his seven sons to paint, Ferdinand van Kessel (1648–96), who painted in the style of his father, and (3) Jan van Kessel III, who followed in the portrait tradition of his grandfather. The Dutch landscape artist Jan van Kessel was apparently unrelated.

André Kertész: *Chez Mondrian*, 1926 (Paris, Pompidou, Musée National d'Art Moderne)

(1) Hieronymus [Jeroom] **van Kessel II** (*bapt* Antwerp, 6 Oct 1578; *d* ?Antwerp, 1636 or after). Painter, active also in Germany and Italy. In 1594 he was apprenticed to Cornelis Floris, and in later years he may also have studied in Paris under Hieronymus Francken I. Before 1606 he was working in Frankfurt, but early in 1606 he moved to Augsburg, where he first lived in the house of Abraham Wilden and later with Max Fugger. He worked as a portrait painter, which brought him into conflict with local artists, who nevertheless failed to oust him. Around 1609 he must have been in Innsbruck, but in the summer of 1610 he was again in Augsburg, before leaving for Italy in the autumn of the same year. He was in Rome by 1613, the year in which he painted a signed portrait of a *Family with Two Children* (Nuremberg, Ger. Nmus.). He subsequently returned to Innsbruck, where he came under the protection of Archduke Maximilian of Austria and the archduchesses Maria Christierna (1575–1621) and Eleonore (1582–1620). In 1615 he was registered as a painter in Cologne, where his work included the signed *Portrait of a Man Aged 41* (1615; Cologne, Wallraf-Richartz-Mus.). He remained in Cologne until 1616, although he returned there regularly to paint portraits, including his *Portrait of a Man Aged 32* (1620; Hannover, Niedersächs. Landesmus.). On the occasion of a possible return visit to Antwerp in 1616, Archduke Albrecht granted Hieronymus certain professional privileges on the recommendation of Archduke Maximilian.

According to Van den Branden, Hieronymus collaborated with Jan Breughel I, assisting him with the painting of landscapes. He began to work more independently in 1622 and, as a result, was registered as a master of the Antwerp Guild of St Luke. In 1624 he married Breughel's eldest daughter Paschasia, with whom he lived in the Orgelstraat in Antwerp and had three daughters and two sons, the elder of whom, (2) Jan van Kessel II, became a talented painter. In 1627 Hieronymus took on one pupil and in 1632 two. In 1636 he paid 12 guilders to the Guild for permission to sell his paintings publicly on the Meir in order to finance an urgent voyage, the destination of which remains unknown. He died shortly afterwards.

Hieronymus van Kessel was a skilled craftsman who was able to paint his subjects objectively and characterfully, as is evident for example in a signed *Portrait of a Man and a Woman* (1618; Schleissheim, Altes Schloss). There are two surviving engravings by Raphael Sadeleer I after portraits by Hieronymus van Kessel (both untraced): *Archduke Leopold, Bishop of Passau and Strasbourg* (1609) and *Hippolytus Guarinonius* (1610).

BIBLIOGRAPHY
Hollstein: *Dut. & Flem.*; Thieme–Becker
F. J. Van den Branden: *Geschiedenis der Antwerpsche schilderschool* (Antwerp, 1883), pp. 1097–8

1. Jan van Kessel II: *Insects*, oil on copper, 197×292 mm, 1661 (Cambridge, Fitzwilliam Museum)

2. Jan van Kessel II: *Europe*, oil on copper, central panel 485×675 mm, outer panels 145×210 mm, 1664–6 (Munich, Alte Pinakothek); from the *Four Continents* series

R. A. Peltzer: 'Der Antwerpener Bildnismaler Hieronymus van Kessel in Deutschland, 1605–1621', *Münchn. Jb. Bild. Kst*, n. s. ii (1925), pp. 258–66

(2) Jan van Kessel II (*b* Antwerp, *bapt* 5 April 1626; *d* Antwerp, 18 Oct 1679). Painter and draughtsman, son of (1) Hieronymus van Kessel. He began his training as a painter in 1635 with Simon de Vos and was also taught by his uncle Jan Breughel II. In 1645 he was registered with the Antwerp Guild of St Luke. At his marriage to Maria van Apshoven (*d* 1678) in 1647, one of the witnesses was his uncle David Teniers (ii), who had married Breughel's daughter Anna ten years previously. In 1655 Jan van Kessel II bought a house opposite the cemetery of the St Joriskerk in Antwerp, but by the end of his life all his possessions were heavily mortgaged in order to pay off his debts.

Jan van Kessel produced mostly small-scale oil paintings on copper or wood, although larger oil paintings as well as pen-and-ink drawings and watercolours, usually on parchment, also appear among his oeuvre. He used two different signatures, which led to the erroneous assumption that two different painters were involved. The cursive, more decorative signature, more suitable to larger formats, would have been difficult to read in a smaller painting. Many of his subjects can be traced back to a single prototype by some eminent predecessor. The work of Joris Hoefnagel, for instance, seems to have inspired van Kessel's watercolours and paintings of insects, for example *Insects and a Spider* (1660; Strasbourg, Mus. B.-A.) and its two pendants (1661; Cambridge, Fitzwilliam; see fig. 1). Jan showed a preference for beetles, caterpillars and butterflies, for example *Butterflies and Other Insects* (Arnhem, Gemeentesmus.), and occasionally arranged caterpillars so that they spelt out his name, as in *Snakes and Caterpillars Forming the Artist's Name* (1657; Zurich, David M. Koetser). Also notable are his paintings on copper of fish, such as *Fish and Shellfish with an Estuary View* (1660; Stuttgart, Staatsgal.), while there also exists an exceptionally fine painting of seashells (*Garland, Masks and Rosettes of Shellfish*, 1656; Paris, Fond. Custodia, Inst. Néer). He took his inspiration for the painting of animals from Jan Breughel I, Roelandt Savery and Frans Snyders. He also painted flowers, as bouquets in vases (e.g. *Flowers in a Vase*; Schleissheim, Altes Schloss), as garlands around a picture or as wreaths surrounding figures (e.g. *Garland with the Infant Christ and St John the Baptist*; Madrid, Prado), which are deeply indebted to Daniel Seghers. Van Kessel also painted a great variety of still-lifes depicting fruit and vegetables, dead and live animals, food and

household utensils, weapons and all sorts of ornamental objects.

Jan II's paintings with figures frequently exhibit an allegorical content in the manner of Jan Breughel I, a remarkable example being the series of the *Four Continents* (1664–6; Munich, Alte Pin.; see fig. 2), painted on copper with the assistance of Erasmus Quellinus (ii). Each of the large paintings contains 16 small scenes grouped around a bigger central piece; the whole is enclosed by a single frame. The same series is repeated in a similarly arranged composite work consisting of 40 small paintings of animals, each 170×230 mm and also on copper (1660; Madrid, Prado).

Jan van Kessel's work frequently exhibits a fascination with the bizarre and the exotic, even with the grotesque, for example *Cannibalistic Indians* (ex-art market, Amsterdam, 1989), one of his most individual and unconventional paintings. His vision is reliant on the precise depiction of copiously filled scenes in which each object is depicted with almost scientific accuracy. The illusion of reality is ultimately prevented, however, by the painter's obsession with picturesque detail. His technique is accurate and accomplished and his work is executed in a light and colourful style. He regularly made use of illustrated scientific texts but according to Jakob Weyerman, who was one of his son Ferdinand's pupils, he also frequently worked from nature. Some of van Kessel's paintings are ostensibly of biblical or mythological scenes, although such subjects interested him only in so far as they presented an opportunity to paint animals and still-lifes, for example *Noah's Ark* (Antwerp, Kon. Mus. S. Kst.) and *Venus in Vulcan's Forge* (St Petersburg, Hermitage).

Thieme–Becker
BIBLIOGRAPHY
C. Sterling: *La Nature morte de l'antiquité à nos jours* (Paris, 1952)
M. L. Hairs: *Les Peintres flamands de fleurs au XVIIe siècle* (Brussels, 1955), pp. 112–13, 225–8
E. Greindl: *Les Peintres flamands de nature morte au XVIIe siècle* (Brussels, 1956), pp. 127–8, 176–7
Le Siècle de Rubens (exh. cat., Brussels, Mus. A. Anc., 1965), pp. 125–7
Jan van Kessel d. Ä.: Die vier Erdteile (exh. cat. by U. Krempel, Munich, Alte Pin., 1973)
Rubens e la pittura fiamminga del seicento nelle collezioni pubbliche fiorentine (exh. cat. by D. Bodart, Florence, Pitti, 1977), pp. 164–73
Pedro Pablo Rubens: Esposición homenaje (exh. cat. by M. Díaz Padrón, Madrid, Pal. Velázquez, 1977–8), pp. 72–3
Le Siècle de Rubens dans les collections publiques françaises (exh. cat., Paris, Grand Pal., 1977–8), pp. 119–21
W. Laureyssens: 'Jan van Kessel de Oude', *Bruegel: Une Dynastie van schilders* (exh. cat., Brussels, Pal. B.-A., 1980), pp. 313–32
The Age of Rubens (exh. cat. by P. C. Sutton and others, Boston, MA, Mus. F.A.; Toledo, OH, Mus. A.; 1993–4), pp. 512–15

(3) Jan van Kessel III (*b* Antwerp, 1654; *d* Madrid, 1708). Painter, son of (2) Jan van Kessel II. He was taught painting by his father. By 1680 he was in Spain where he established a reputation as a portrait painter in Madrid, particularly with his *Queen Marie Louise of Orléans* (untraced). In 1686 he became a portrait painter at the court of King Charles II, thereby making him a wealthy man, but from 1700, during the reign of Philip V, the grandson of Louis XIV, King of France, he was overlooked in favour of French artists. As can be seen in his signed *Family Portrait* (1679; Warsaw, N. Mus.) and the copy he made of it (1680; Madrid, Prado), his style is somewhat stiff and his compositions overcrowded. His work is anecdotal in character, portraying an excessive concern with precision and detail.

Wurzbach
BIBLIOGRAPHY
F. J. Van den Branden: *Geschiedenis der Antwerpsche schilderschool* (Antwerp, 1883), pp. 1104–5
J. V. L. Brans: *Vlaamse schilders in dienst der koningen van Spanje* (Leuven, 1959), pp. 158–60
Le Siècle de Rubens (exh. cat., Brussels, Mus. A. Anc., 1965), p. 127
E. Valdivieso: 'Un nuevo retrato de familia de Jan van Kessel, el Joven', *Bol. Semin. Estud. A. & Arqueol.*, xlix (1983), pp. 492–3
W. LAUREYSSENS

Kessel, Jan [Johan] **van** (*b* Amsterdam, *bapt* 22 Sept 1641; *d* Amsterdam, *bur* 24 Dec 1680). Dutch painter and draughtsman. He was a follower, and probably a pupil, of Jacob van Ruisdael and covered the same range of subjects painted by Ruisdael, with the exception of marine paintings. However, van Kessel is best known for his townscapes and panoramic views, as exemplified by the *Sluice and the New City Ramparts of Amsterdam in Winter* (Amsterdam, Hist. Mus.) and the *Bleaching Grounds near Haarlem* (Brussels, Mus. A. Anc.). He imitated the watermills and village scenes of his friend Meindert Hobbema, as well as the waterfalls of Allaert van Everdingen, the wooded landscapes of Jan Wijnants and the winter scenes of Jan van de Cappelle. Many of van Kessel's 120 surviving pictures, including *The Avenue* (Stuttgart, Staatsgal.) and the *Ford in the Woods* (Dresden, Gemäldegal. Alte Meister), were once attributed to van Ruisdael and these other masters (often with an authentic signature covered by the better-known name). Van Kessel is also frequently confused with other minor artists in van Ruisdael's circle, especially Jan Vermeer van Haarlem the younger, Isaac Koene (1637/40–1713), Jacob Salomonsz. van Ruysdael (1629/30–1681) and Anthonie van Borssom. As a draughtsman, van Kessel emulated van Ruisdael's mature style, working almost exclusively in black chalk and grey wash. The best of his 70 drawings are townscapes, although his studies of trees and depictions of farmsteads are noteworthy. A number of correlations exist between his sketches and paintings. There is no known relationship with the Flemish artists of the same name.

Thieme–Becker
BIBLIOGRAPHY
A. I. Davies: *Jan van Kessel, 1641–1680*, Aetas aurea (Doornspijk, 1992)
ALICE I. DAVIES

Kessels, Mathieu (*b* Maastricht, 20 May 1784; *d* Rome, 3 March 1836). Flemish sculptor. He gave up his apprenticeship as a goldsmith in Venlo to attend the Ecole des Beaux-Arts in Paris. He then went to Hamburg and subsequently stayed in St Petersburg between 1806 and 1814, where he probably trained with the Antwerp sculptor Joseph Camberlain (1756–1821). In 1814 he returned to the Low Countries and spent several months at Anne-Louis Girodet's studio in Paris, where he exhibited at the Salon of 1819. In the same year he went to Rome, where his terracotta *St Sebastian Martyr* (sketch in Brussels, Mus. A. Mod.) won the first prize in a competition organized by Antonio Canova. During this period he began working in the studio of Bertel Thorvaldsen, whose pupil and assistant he became. From the beginning of the 1820s in his numerous variations on the theme of the Diskobolos (plaster; examples in Brussels, Mus. A. Mod.), Kessels demonstrated his devotion to Classical and Hellenistic